Grove Encyclopedias of
European Art

*Encyclopedia of
Italian Renaissance
& Mannerist Art*

Grove Encyclopedias of
European Art

Encyclopedia of
ITALIAN RENAISSANCE
& MANNERIST ART

Volume I
Abacco to Lysippus

Edited by
JANE TURNER

Grove Encyclopedias of European Art
Encyclopedia of Italian Renaissance & Mannerist Art
Edited by Jane Turner

Published in the United Kingdom by

MACMILLAN REFERENCE LIMITED, 2000
25 Eccleston Place, London, SW1W 9NF, UK
Basingstoke and Oxford
ISBN: 0–333–76094–8
Associated companies throughout the world
http://www.macmillan-reference.co.uk

British Library Cataloguing in Publication Data
Encyclopedia of Italian Renaissance and Mannerist Art
 1. Art, Renaissance—Italy—Encyclopedias
 2. Mannerism (Art)—Italy—Encyclopedias
 3. Art, Italian—Encyclopedias
 I. Turner, Jane, 1956–
709.4'5'09024
ISBN 0-333-76094-8

Published in the United States and Canada by
GROVE'S DICTIONARIES, INC
345 Park Avenue South, New York, NY 10010-1707, USA
ISBN: 1–884446–02–7

Library of Congress Cataloging-in-Publication Data

Encyclopedia of Italian Renaissance and Mannerist art / editor, Jane Turner
 p. cm – (Grove library of world art)
Includes bibliographical references and index.
ISBN 1–884446–02–7 (alk. paper)
 1. Art, Renaissance—Italy Encyclopedias.
 2. Mannerism (Art)—Italy Encyclopedias.
 I. Turner, Jane Shoaf. II. Series
N6370 .E53 1999
709'.45'03–dc21

 99–41597
 CIP

Typeset in the UK by William Clowes Ltd, Beccles, Suffolk
Printed and bound in the UK by William Clowes Ltd, Beccles, Suffolk

Jacket illustration: Andrea Mantegna: *Parnassus*, tempera on canvas, 1.50x1.92 m, 1495/6–7 (Paris, Musée du Louvre/photo: Scala, Florence)

Contents

Preface

This is the third reference work in the Grove Library of World Art, an exciting new publishing programme devoted to specialist topics, offering the award-winning scholarship of the 34-volume *Dictionary of Art* (London and New York, 1996) in more accessible and affordable one- to three-volume encyclopedias.

The Grove Library of World Art will initially be organized in six separate series:

> *Grove Encyclopedias of African Art*
> *Grove Encyclopedias of Ancient Art*
> *Grove Encyclopedias of Asian Art*
> *Grove Encyclopedias of Australasian Art*
> *Grove Encyclopedias of European Art*
> *Grove Encyclopedias of the Arts of the Americas*

The *Encyclopedia of Italian Renaissance and Mannerist Art* is the first title in the penultimate series, the *Grove Encyclopedias of European Art*. The second volume in this series, the *Encyclopedia of Northern Renaissance Art*, is scheduled to appear next year. There are plans to follow these two volumes in due course with the *Encyclopedia of Medieval European Art*, the *Encyclopedia of European Baroque Art* and the *Encyclopedia of European Decorative Art*.

For this and all other spin-off volumes, we have gone back to the original specialist authors and invited them to revise and update their entries. Several biographies, from those on lesser-known artists such as Lorenzo Luzzo to those of major figures such as Dosso Dossi, have been completely rewritten to take account of the latest research. Other articles, including those on cities and towns, have been edited to focus on the Renaissance and Mannerist periods. Besides revisions incorporated from authors, our own in-house editorial staff has checked each heading in the encyclopedia for new bibliographical items, using the following bibliographical databases: the *Bibliography of the History of Art*, published by the J. Paul Getty Trust, and *Art Abstracts*, published online by the H.W. Wilson Co.; this has resulted in the addition of hundreds of recent bibliographical items. The number of illustrations has also been greatly increased, with the addition of some 200 sumptuous new colour illustrations.

These two alphabetically arranged volumes cover all the major artistic developments in Italy from *c.* 1400 to *c.* 1600. Beginning with transitional Late Gothic artists such as Giotto, the biographies trace the evolution of new modes of artistic expression, from scientific naturalism and the development of linear perspective to the exploration of new secular themes derived from Classical literature and mythology. All three phases of Italian Renaissance art are

covered—early, middle and late (the latter period also known as Mannerist). This was an extraordinary period in the history of art, one that witnessed the rebirth of the humanistic spirit of antiquity and also produced some of the most famous artists of all time, including Leonardo da Vinci, Raphael and Michelangelo. So rich, in fact, is the artistic tradition of the Italian Renaissance that it was necessary to restrict the topics contained within these two volumes to the art produced in Italy itself and to exclude the work of Italian Renaissance artists when active outside the peninsula, for example in the extended Venetian Empire, Austria, Hungary, England, Spain and Portugal.

Although some material has had to be left out for reasons of space, the coverage in the present encyclopedia, like that of *The Dictionary of Art*, is not limited to artists' biographies. In order to accommodate the wide range of topics of interest to modern students and historians of Italian Renaissance art, the *Encyclopedia of Italian Renaissance and Mannerist Art* also offers entries on patrons, collectors and writers (e.g. Petrarch and Marsilio Ficino), as well as articles on art forms (e.g. cartoon, *cassone*), building types (e.g. palazzo), Italian cities with substantial Renaissance traditions, and a comprehensive survey of all the fine and decorative art forms in Italy from the early 15th century to the late 16th. Maps at the beginning of the Italy survey show which sites and cities have individual entries in the encyclopedia.

Introduction

I. Alphabetization and identical headings. II. Article headings and structures. III. Standard usages. IV. Cross-references. V. Locations of works of art. VI. Illustrations. VII. Bibliographies and other sources. VIII. Authors. IX. Appendices. X. Index.

I. *Alphabetization and identical headings.*

All main headings in this dictionary are distinguished by bold typeface. Headings of more than one word are alphabetized letter by letter as if continuous, up to the first true mark of punctuation, and again thereafter: the comma in **Costanzo, Marco** therefore breaks the alphabetization, and his biography precedes the article on **Costanzo da Ferrara**.

Parenthesized letters or words and square-bracketed matter are ignored in alphabetization: for example, the article **Cola (di Matteuccio) da Caprarola** precedes that on **Cola dell'Amatrice**. Roman numeral epithets of generation, as in **Cosimo I, Grand Duke of Tuscany**, are also ignored for the purposes of alphabetization. The abbreviations of 'Saint', 'San', 'Santo' etc are alphabetized as if spelt out in full (e.g. the **Master of St Veronica** precedes the **Master of S Marco**).

The entry **Masters, anonymous, and monogrammists** contains articles on all Italian Renaissance and Mannerist anonymous masters. The article is subdivided into: *I. Anonymous masters*; *II. Dated masters*; and *III. Monogrammists*. Anonymous masters are alphabetized ignoring the title 'Master' and such intervening words as 'of' or 'the'; dated masters are organized chronologically; and the monogrammists alphabetically by initials.

II. *Article headings and structures.*

1. BIOGRAPHICAL. All biographies in this encyclopedia start with the subject's name and, where known, the places and dates of birth and death and a statement of nationality and occupation. In the citation of a name in a heading, the use of parentheses indicates parts of the name that are not commonly used, while square brackets enclose variant names or spellings:

> **Soderini, Piero (di Tommaso)**: full name Piero di Tommaso Soderini, referred to as Piero Soderini
>
> **Pizzolo** [Pizolo]**, Niccolò** [Nicolò]: usually referred to as Niccolò Pizzolo but sometimes in the form of Niccolò Pizolo, Nicolò Pizzolo or Nicolò Pizolo
>
> **Lafréry, Antoine** [Lafreri, Antonio]: Antoine Lafréry's name has the alternative version of Antonio Lafreri only
>
> **Moderno** [Mondella, Galeazzo]: Galeazzo Mondella is known chiefly by his pseudonym of Moderno

Statements of places and dates of birth and death are given with as much precision as the evidence allows and may be replaced or supplemented by dates of baptism (*bapt*), burial (*bur*)

or regnal years (*reg*). Where information is conjectural, a question mark is placed directly before the statement that it qualifies. Where dates of birth and death are unrecorded but there is documentary evidence for the subject's activity between certain fixed dates, *floruit* (*fl*) dates are given; when such evidence is circumstantial, as for instance in the case of an anonymous master, this is cited as '*fl c*.'.

If the subject changed nationality or country of activity, this is stated where significant, as may also be the subject's ancestry; otherwise this information is evident from the parenthesized matter after the heading or is conveyed in the text. The subject's nationality is followed by a definition of occupation, that is to say the activity (or activities) of art-historical significance that justified inclusion in the dictionary; for non-artists, the subject's profession is also stated (e.g. 'Italian banker and patron').

Biographies are generally structured to present information in chronological order. Longer biographies usually begin with a brief statement of the subject's significance and are then divided into sections, under such headings as 1. Life and work. 2. Working methods and techniques. 3. Character and personality. 4. Critical reception and posthumous reputation; within sections there may be further divisions to aid the reader in finding specific information.

The biographies of two or more related artists or patrons and collectors are gathered in 'family' entries, alphabetized under the main form of the surname; monarchs, popes, rulers and aristocrats who were members of a family of patrons and collectors appear under their dynastic or family name, rather than under their given name or title. Within a family article, individual members of significance have their own entries, beginning with an indented, numbered bold heading; for the second and subsequent members of the family, a statement of relationship to a previous member of the family is included wherever possible. Members of the same family with identical names are usually distinguished by the use of parenthesized small roman numerals after their names:

> **Sangallo, da.** Italian family of artists.
> **(1) Guiliano da Sangallo** (*b* . . .; *d* . . .).
> **(2) Antonio da Sangallo (i)** (*b* . . .; *d* . . .).
> **(3) Bastiano da Sangallo** (*b* . . .; *d* . . .).
> **(4) Antonio da Sangallo (ii)** (*b* . . .; *d* . . .). Nephew of (2) Antonio da Sangallo (i).

The numbers allocated to family members are used in cross-references from other articles:

> 'He commissioned the artist Antonio da Sangallo (ii) (see SANGALLO, DA, (4)) . . .;'

2. NON-BIOGRAPHICAL. As with biographies, the headings of all non-biographical articles provide variant spellings, transliterations etc in square brackets, where relevant, followed by a definition. Longer articles are divided as appropriate for the topic and are provided with contents lists after the heading, introductory paragraph or each new major subheading. In all articles the hierarchy of subdivisions, from largest to smallest, is indicated by large roman numerals (I), arabic numerals (1), small roman numerals (i) and letters (a). A cross-reference within a long survey to another of its sections takes the form '*see* §I, 2(iii)(b) above'. The extensive survey of the arts of **Italy** includes a detailed table of contents of all sections and subsections.

III. Standard usages.

For the sake of consistent presentation in this encyclopedia, certain standard usages, particularly in spelling and terminology, have been imposed throughout. In general, the rules of British orthography and punctuation have been applied, except that wherever possible original sources are followed for quoted matter and for specific names and titles. Many of the conventions adopted in this encyclopedia will become evident through use, for example the

general abbreviations (which are listed at the front of the first volume); some of the other editorial practices are explained below.

1. WORKS OF ART. Titles of works of art are generally cited in italics and by their English names, unless universally known by a foreign title. Some subjects, religious and mythological in particular, have been given standard titles throughout. The use of 'left' and 'right' in describing a work of art corresponds to the spectator's left and right. For locations of works of art *see* §V below.

2. FOREIGN TERMS AND TRANSLITERATION SYSTEMS. For citations of foreign-language material, a basic reading knowledge of art-historical terms in Italian, French, German and Spanish has been assumed (although wherever there is an exact English equivalent of a foreign term this has been used). Foreign words that have gained currency in English are cited in roman type, whereas those that have not are italicized and are qualified with a brief definition, unless this is clear from the context. The conventions of capitalization in foreign languages are generally adhered to within italicized matter (e.g. book titles) but not in running, roman text for job titles, for names of institutions, professional bodies and associations and for recurring exhibitions. Abbreviations for foreign periodical titles cited in bibliographies (see §VII below) are capitalized, despite the relevant foreign-language conventions.

3. DATES. We have attempted, wherever possible, to provide biographical dates in parentheses in running text at the first mention of all art-historically significant individuals who do not have their own entries in the encyclopedia. (For the citation of conjectural dates of birth and death *see* §II, 1 above.) Where no dates are provided, the reader may assume that there is a biography of that individual in the encyclopedia (or that the person is so obscure that dates are not readily available). The use of a question mark, for example in the date of a work of art, queries an indistinct digit(s), as in 148(?7), or an illegible one, as in 148(?).

4. MEASUREMENTS AND DIMENSIONS. All measurements are cited in metric, unless within quoted matter or if the archaic form is of particular historical interest. Where two dimensions are cited, height precedes width; for three dimensions, the order is height by width by depth. If only one dimension is given, it is qualified by the appropriate abbreviation for height, width, length, diameter etc.

IV. Cross-references.

This encyclopedia has been compiled in the spirit of creating an integrated and interactive whole, so that readers may gain the widest perspective on the issues in which they are interested. The cross-referencing system has been designed and implemented to guide the reader easily to the information required, as well as to complementary discussions of related material, and in some cases even to alternative views. External cross-references (i.e. those to a different heading) take several forms, all of which are distinguished by the use of small capital letters, with a large capital to indicate the initial letter of the entry to which the reader is directed. External cross-references appear exactly as the bold headings (excluding parenthesized matter) of the entries to which they refer, though in running text they are not inverted (e.g. 'He collaborated on the project with FRA CARNEVALE. . .;').

Cross-references are used sparingly between articles to guide readers to further discussions or to articles they may not have considered consulting; thus within a phrase such as 'He was influenced by Michelangelo' there is not a cross-reference to MICHELANGELO (though the reader can assume that there is a biography of Michelangelo, since there are no dates after his name). In the following passage the reader is alerted to useful descriptions in the related biographical and style entries: 'Painting in Florence during the 14th century was dominated by GIOTTO, whose frescoes of *c.* 1305 in the Arena Chapel, Padua (*see* PADUA, fig. 2), are

distinguished by their unprecedented naturalism. . ..' Cross-references have also been used to direct the reader to additional illustrations and bibliography.

Another type of cross-reference appears as a main bold heading, to direct the reader to the place in the encyclopedia where the subject is treated:

> **Caravaggio, Polidoro da.** *See* POLIDORO DA CARAVAGGIO.
> **Julius II**, Pope. *See* ROVERE, DELLA, (2).
> **Murano.** *See under* VENICE, §III, 3.

V. Locations of works of art.

For each work of art mentioned specifically, every attempt has been made to cite its correct present location. In general this information appears in an abbreviated form, in parentheses, directly after the first mention of the work. The standard abbreviations used for locations are readily understandable in their short forms and appear in full in Appendix A. Pieces that are on loan or on deposit are duly noted as such, as are works that are *in situ*. Works in private collections are usually followed by the citation of a published illustration or a catalogue raisonné number to assist in identification. Similarly, objects produced in multiples, such as prints and medals, are identified with a standard catalogue number. Works for which the locations are unknown are cited as untraced or are supplied with the last known location or, in the case of pieces that appeared on the art market, are given the city, auction house or gallery name and, when known, the date of sale and lot number or a reference to a published illustration; works that are known to have been destroyed are so noted.

VI. Illustrations.

As often as possible, pictures have been integrated into the text of the article that they illustrate, and the wording of captions has been designed to emphasize the subject to which the picture is related. For an article with a single illustration, the textual reference appears as '(see fig)'; multiple illustrations are numbered. References to colour illustrations are in the form '(see colour pl. 1, XII2)', with the volume number appearing first in arabic, the plate number second in large roman numerals, and the figure reference third in arabic. There are frequent cross-references to relevant illustrations appearing in other articles, and all captions have been indexed.

VII. Bibliographies and other sources.

All but the shortest of entries in the encyclopedia are followed by bibliographies and may also have sections on unpublished sources, writings and print publications. These function both as guides to selected further reading and as acknowledgments of the sources consulted by authors. In some family entries and in longer surveys, bibliographies may be located directly after the introduction and/or at the end of each section. All bibliographies are chronologically arranged by the date of first edition (thus providing an abstract of the topic's historiography); longer bibliographies are divided into categories, in which the items are also in chronological order. Items published in the same year are listed alphabetically by authors' names and, where by the same author, alphabetically by title; items with named authors or editors take precedence over exhibition catalogues, which are cited by title first. Abbreviated references to certain alphabetically arranged dictionaries and encyclopedias (listed in full in Appendix C, List A) appear at the head of the bibliography (or section) in alphabetical order. The title of the article in such reference books is cited only if the spelling or form of the name differs from that used in this dictionary or if the reader is being referred to a different subject. Some other frequently

cited works (*see* Appendix C, List B) are given in an abbreviated form, but in their correct chronological position within the bibliography and usually with their volume and page numbers. Appendix C, List C, lists the abbreviations used for works from publishers' series.

For books that have appeared in several editions, generally the earliest and the most recent have been cited (unless there was a particular reason to include an intermediate edition), and where page numbers are provided these refer to the most recent edition. Revisions are indicated by the abbreviation 'rev.', reprints with '*R*' and translations with 'trans.' prefaced by an abbreviation to indicate the language of the translation. Where the place or date of publication does not appear in a book this is rendered as 'n.p.' or 'n.d.' as appropriate; where this information can be surmised it appears in square brackets. Volume numbers usually appear in small roman numerals, both for citations from multi-volume publications and for periodicals; issue numbers of periodicals are in arabic numerals. The titles of periodicals are cited in abbreviated forms, a full list of which appears in Appendix B. Exhibition catalogues are provided with the name of the host location (not the place of publication) according to the list of location abbreviations (*see* Appendix A). Collected papers from conferences and congresses are arranged chronologically by date of their oral presentation rather than by the date of their publication in hard copy. Dissertations are included in the bibliography sections (rather than as unpublished sources), with an abbreviated form of the degree (diss., MA, MPhil) and awarding institution; if available on microfilm, this is noted.

Lists of unpublished sources, apart from dissertations, include such material as manuscripts, inventories and diaries. They are organized alphabetically by the location of the holdings, with an indication of the contents given in square brackets. Lists of selected writings are included in biographies of subjects who wrote on art; these are ordered according to the same principles as the bibliographies.

Throughout the production time of this encyclopedia authors were asked to submit important new bibliography for addition to their articles. Some contributors did so, while others left updating to be done by the editors. For the additions that were made by the editorial staff, this may have resulted in the text of an article apparently failing to take into consideration the discoveries or opinions of the new publications; it was nevertheless felt useful to draw readers' attention to significant recent literature that has appeared since *The Dictionary of Art* was published in 1996.

VIII. Authors.

Signatures of authors, in the form of their choice, appear at the end of the article or sequence of articles that they contributed. In multipartite articles, a section (or sections) that is unsigned is by the author of the next signed section. Where two authors have jointly written an article, their names appear in alphabetical order:

CHARLES JONES, BETTY SMITH

If, however, Smith was the main author and was assisted or had her text amended by Jones, their signatures appear as:

BETTY SMITH, with CHARLES JONES

In the event that Jones assisted with only the bibliography to Smith's text, this would be acknowledged as:

BETTY SMITH (bibliography with CHARLES JONES)

Where an article or introduction was compiled by the editors or in the few cases where an author has wished to remain anonymous, this is indicated by a square box (□) instead of a signature.

IX. Appendices.

Readers' attention is directed to the Appendices at the back of the second volume of this encyclopedia. These comprise full lists of: abbreviated locations of works of art (A); abbreviated periodical titles (B); standard reference books and series (C); authors' names (D).

X. Index.

All articles and illustration captions in this encyclopedia have been indexed not only to provide page numbers of the main headings but also to pinpoint variant names and spellings and specific information within articles and captions.

Acknowledgements

The preparation of the 34 volumes of *The Dictionary of Art* (London and New York, 1996) represented an enormous collective effort, one that took over 14 years and involved literally a cast of thousands. By contrast, the *Encyclopedia of Italian Renaissance and Mannerist Art* has taken just over 14 months to prepare. To a large extent, however, we continue to be indebted to the same cast of thousands. We are particularly grateful to the countless former *Dictionary of Art* contributors who updated their entries and approved their proofs within the very tight deadline allowed for these two volumes.

Further formal acknowledgements are divided into three sections: outside advisers, in-house staff and other outside sources. Although space limitations prevent us from being able to mention everyone who participated in the creation of the *Encyclopedia of Italian Renaissance and Mannerist Art* (whether before 1996 or during the past 14 months), we should like to express our thanks to all for their role in making this prize-winning scholarship available to an even wider public.

1. OUTSIDE ADVISERS AND CONSULTANTS.

(i) Editorial Advisory Board. Our first debt of gratitude must again go to the members of the distinguished Editorial Advisory Board to *The Dictionary of Art* for the guidance they provided on matters of general concept and approach. The editorial policy that they helped to shape will continue to inform all of the subsequent reference works that are derived from *The Dictionary*:

Prof. Emeritus Terukazu Akiyama (formerly of the University of Tokyo)
Prof. Carlo Bertelli (Université de Lausanne)
Prof. Whitney Chadwick (San Francisco State University)
Prof. André Chastel (formerly of the Collège de France) †
Prof. Oleg Grabar (Institute for Advanced Study, Princeton)
Prof. Francis Haskell (University of Oxford)
Prof. Alfonso E. Pérez Sánchez (formerly of the Museo del Prado, Madrid)
Prof. Robert Rosenblum (Institute of Fine Arts, New York University)
Dr Jessica Rawson (University of Oxford and formerly of the British Museum, London)
Prof. Willibald Sauerländer (formerly of the Zentralinstitut für Kunstgeschichte, Munich)
Mr Peter Thornton (formerly of the Sir John Soane's Museum, London)
Prof. Irene Winter (Harvard University, Cambridge, Massachusetts)

† deceased

(ii) Area advisers. For *The Dictionary of Art*, a number of outside experts were formally invited to develop plans for the coverage of the arts in their areas of specialization. Governed only by a general word allocation and suggestions for certain basic patterns of coverage, each was asked to prepare an outline (or report) with proposed headings, relative word lengths and

names of potential authors. The following advisers offered guidance on our coverage of Italian Renaissance art:

Italian architecture in the 15th and 16th centuries
Howard Burns
Senior Lecturer in the History of Architecture, Harvard University, Harvard, MA

Italian decorative arts
Renato Ruotolo

Italian painting in the 15th century
Jane Martineau

Italian painting in the 16th century
Martin Kemp
University Professor of the History of Art, Trinity College, Oxford

Italian sculpture
Charles Avery
Bruce Boucher
Anthony Radcliffe

2. EDITORIAL AND ADMINISTRATIVE STAFF. Among my editorial colleagues, I should like first to express my gratitude to my Deputy Editor, Diane Fortenberry, who shared with me the responsibility of devising the Grove Library of World Art publishing programme. In the preparation of this particular encyclopedia, I am indebted to former *Dictionary of Art* area editor for Italian Renaissance art, Lucinda Hawkins, who selected the colour plates, and to Michael Dagon, who searched for bibliographical updates for each article. The task of implementing the editorial changes and updates was carried out by Octavia Nicholson. Gillian Northcott, who supervised the creation of the original index of some three quarters of a million references for *The Dictionary of Art*, also expanded and updated the index for the present two volumes.

Although two volumes are certainly easier to prepare than thirty-four, the administration of a project of even this size—with 1722 entries, 1108 illustrations and 1793 authors—is a formidable task. The entire *Dictionary of Art* text database is now stored electronically under the watchful eye of Richard Padley, who directed its conversion into an online product (*The Grove Dictionary of Art*), and we are grateful for his help in extracting the relevant articles for these two volumes. The illustrations database for the first three spin-off encyclopedias has been maintained by Veronica Gustavsson, who handled all photo orders and reproduction permissions. As always, we greatly benefited from the return of former *Dictionary of Art* staff member Sophie Durlacher, who as Editorial Manager once again applied her excellent project management skills. On the production side, we were fortunate to be able to count on the patience and perseverance of Senior Production Controller Claire Pearson, working under the expert guidance of Publishing Services Manager Jeremy Macdonald. For the page makeup, it was a pleasure to work again with John Catchpole and his colleagues at William Clowes.

3. OTHER OUTSIDE SOURCES. Many people and organizations outside of the Macmillan editorial offices have provided generous help to us and to our contributors. We are particularly grateful to the staff of the Getty Research Institute, who provided excellent resources and cordial hospitality to Michael Dagon throughout his work on the project and to me during the initial planning stages in the summer of 1998. Special thanks are owed to several photographic sources and copyright-holders, who processed especially large orders from us, especially Scala Picture Library and Fratelli Alinari. The colour plates were designed by

Michelle Draycott and the book jacket cover by Lawrence Kneath. The specific sources for all images in the encyclopedia, both black-and-white and colour, are acknowledged in the list of picture credits.

Jane Turner
London, 1999

General Abbreviations

The abbreviations employed throughout this encyclopedia, most of which are listed below, do not vary, except for capitalization, regardless of the context in which they are used, including bibliographical citations and for locations of works of art. The principle used to arrive at these abbreviations is that their full form should be easily deducible, and for this reason acronyms have generally been avoided (e.g. Los Angeles Co. Mus. A. instead of LACMA). The same abbreviation is adopted for cognate forms in foreign languages and in most cases for plural and adjectival forms (e.g. A.=Art, Arts. Arte, Arti etc.); not all related forms are listed below. For the reader's convenience, separate full lists of abbreviations for locations and periodical titles are included as Appendices A and B at the back of this volume.

A.	Art, Arts	ARA	Associate of the Royal Academy	BC	Before Christ
A.C.	Arts Council			BC	British Columbia (Canada)
Acad.	Academy	Arab.	Arabic	BE	Buddhist era
AD	Anno Domini	Archaeol.	Archaeology	Beds	Bedfordshire (GB)
Add.	Additional, Addendum	Archit.	Architecture, Architectural	Behav.	Behavioural
addn	addition	Archv, Archvs	Archive(s)	Belarus.	Belarusian
Admin.	Administration			Belg.	Belgian
Adv.	Advances, Advanced	Arg.	Argentine	Berks	Berkshire (GB)
Aesth.	Aesthetic(s)	ARHA	Associate of the Royal Hibernian Academy	Berwicks	Berwickshire (GB; old)
Afr.	African	ARIBA	Associate of the Royal Institute of British Architects	BFA	Bachelor of Fine Arts
Afrik.	Afrikaans, Afrikaner			Bibl.	Bible, Biblical
A.G.	Art Gallery	Armen.	Armenian	Bibliog.	Bibliography, Bibliographical
Agrar.	Agrarian	ARSA	Associate of the Royal Scottish Academy	Biblioph.	Bibliophile
Agric.	Agriculture			Biog.	Biography, Biographical
Agron.	Agronomy	Asiat.	Asiatic	Biol.	Biology, Biological
Agy	Agency	Assist.	Assistance	bk, bks	book(s)
AH	Anno Hegirae	Assoc.	Association	Bkbinder	Bookbinder
A. Inst.	Art Institute	Astron.	Astronomy	Bklore	Booklore
AK	Alaska (USA)	AT&T	American Telephone & Telegraph Company	Bkshop	Bookshop
AL	Alabama (USA)			BL	British Library
Alb.	Albanian	attrib.	attribution, attributed to	Bld	Build
Alg.	Algerian	Aug	August	Bldg	Building
Alta	Alberta (Canada)	Aust.	Austrian	Bldr	Builder
Altern.	Alternative	Austral.	Australian	BLitt	Bachelor of Letters/Literature
a.m.	ante meridiem [before noon]	Auth.	Author(s)	BM	British Museum
Amat.	Amateur	Auton.	Autonomous	Boh.	Bohemian
Amer.	American	Aux.	Auxiliary	Boliv.	Bolivian
An.	Annals	Ave.	Avenue	Botan.	Botany, Botanical
Anatol.	Anatolian	AZ	Arizona (USA)	BP	Before present (1950)
Anc.	Ancient	Azerbaij.	Azerbaijani	Braz.	Brazilian
Annu.	Annual	B.	Bartsch [catalogue of Old Master prints]	BRD	Bundesrepublik Deutschland [Federal Republic of Germany (West Germany)]
Anon.	Anonymous(ly)	*b*	born		
Ant.	Antique	BA	Bachelor of Arts	Brecons	Breconshire (GB; old)
Anthol.	Anthology	Balt.	Baltic	Brez.	Brezonek [lang. of Brittany]
Anthropol.	Anthropology	*bapt*	baptized	Brit.	British
Antiqua.	Antiquarian, Antiquaries	BArch	Bachelor of Architecture	Bros	Brothers
app.	appendix	Bart	Baronet	BSc	Bachelor of Science
approx.	approximately	Bask.	Basketry	Bucks	Buckinghamshire (GB)
AR	Arkansas (USA)	BBC	British Broadcasting Corporation	Bulg.	Bulgarian

| | | | | | | |
|---|---|---|---|---|---|
| Bull. | Bulletin | Colloq. | Colloquies | DE | Delaware (USA) |
| *bur* | buried | Colomb. | Colombian | Dec | December |
| Burm. | Burmese | Colon. | Colonies, Colonial | Dec. | Decorative |
| Byz. | Byzantine | Colr | Collector | ded. | dedication, dedicated to |
| C | Celsius | Comm. | Commission; Community | Democ. | Democracy, Democratic |
| C. | Century | Commerc. | Commercial | Demog. | Demography, Demographic |
| *c.* | *circa* [about] | Communic. | Communications | Denbs | Denbighshire (GB; old) |
| CA | California | Comp. | Comparative; compiled by, compiler | dep. | deposited at |
| Cab. | Cabinet | | | Dept | Department |
| Caerns | Caernarvonshire (GB; old) | Concent. | Concentration | Dept. | Departmental, Departments |
| C.A.G. | City Art Gallery | Concr. | Concrete | Derbys | Derbyshire (GB) |
| Cal. | Calendar | Confed. | Confederation | Des. | Design |
| Callig. | Calligraphy | Confer. | Conference | destr. | destroyed |
| Cam. | Camera | Congol. | Congolese | Dev. | Development |
| Cambs | Cambridgeshire (GB) | Congr. | Congress | Devon | Devonshire (GB) |
| *can* | canonized | Conserv. | Conservation; Conservatory | Dial. | Dialogue |
| Can. | Canadian | Constr. | Construction(al) | diam. | diameter |
| Cant. | Canton(s), Cantonal | cont. | continued | Diff. | Diffusion |
| Capt. | Captain | Contemp. | Contemporary | Dig. | Digest |
| Cards | Cardiganshire (GB; old) | Contrib. | Contributions, Contributor(s) | Dip. Eng. | Diploma in Engineering |
| Carib. | Caribbean | Convalesc. | Convalescence | Dir. | Direction, Directed |
| Carms | Carmarthenshire (GB; old) | Convent. | Convention | Directrt | Directorate |
| Cartog. | Cartography | Coop. | Cooperation | Disc. | Discussion |
| Cat. | Catalan | Coord. | Coordination | diss. | dissertation |
| cat. | catalogue | Copt. | Coptic | Distr. | District |
| Cath. | Catholic | Corp. | Corporation, Corpus | Div. | Division |
| CBE | Commander of the Order of the British Empire | Corr. | Correspondence | DLitt | Doctor of Letters/Literature |
| | | Cors. | Corsican | DM | Deutsche Mark |
| Celeb. | Celebration | Cost. | Costume | Doc. | Document(s) |
| Celt. | Celtic | Cret. | Cretan | Doss. | Dossier |
| Cent. | Centre, Central | Crim. | Criminal | DPhil | Doctor of Philosophy |
| Centen. | Centennial | Crit. | Critical, Criticism | Dr | Doctor |
| Cer. | Ceramic | Croat. | Croatian | Drg, Drgs | Drawing(s) |
| cf. | confer [compare] | CT | Connecticut (USA) | DSc | Doctor of Science/Historical Sciences |
| Chap., Chaps | Chapter(s) | Cttee | Committee | | |
| | | Cub. | Cuban | Dut. | Dutch |
| Chem. | Chemistry | Cult. | Cultural, Culture | Dwell. | Dwelling |
| Ches | Cheshire (GB) | Cumb. | Cumberland (GB; old) | E. | East(ern) |
| Chil. | Chilean | Cur. | Curator, Curatorial, Curatorship | EC | European (Economic) Community |
| Chin. | Chinese | | | | |
| Christ. | Christian, Christianity | Curr. | Current(s) | Eccles. | Ecclesiastical |
| Chron. | Chronicle | CVO | Commander of the [Royal] Victorian Order | Econ. | Economic, Economies |
| Cie | Compagnie [French] | | | Ecuad. | Ecuadorean |
| Cinema. | Cinematography | Cyclad. | Cycladic | ed. | editor, edited (by) |
| Circ. | Circle | Cyp. | Cypriot | edn | edition |
| Civ. | Civil, Civic | Czech. | Czechoslovak | eds | editors |
| Civiliz. | Civilization(s) | $ | dollars | Educ. | Education |
| Class. | Classic, Classical | *d* | died | e.g. | *exempli gratia* [for example] |
| Clin. | Clinical | d. | denarius, denarii [penny, pence] | Egyp. | Egyptian |
| CO | Colorado (USA) | | | Elem. | Element(s), Elementary |
| Co. | Company; County | Dalmat. | Dalmatian | Emp. | Empirical |
| Cod. | Codex, Codices | Dan. | Danish | Emul. | Emulation |
| Col., Cols | Collection(s); Column(s) | DBE | Dame Commander of the Order of the British Empire | Enc. | Encyclopedia |
| Coll. | College | | | Encour. | Encouragement |
| collab. | in collaboration with, collaborated, collaborative | DC | District of Columbia (USA) | Eng. | English |
| | | DDR | Deutsche Demokratische Republik [German Democratic Republic (East Germany)] | Engin. | Engineer, Engineering |
| Collct. | Collecting | | | | |

Engr., Engrs	Engraving(s)	ft	foot, feet	Human.	Humanities, Humanism
Envmt	Environment	Furn.	Furniture	Hung.	Hungarian
Epig.	Epigraphy	Futur.	Futurist, Futurism	Hunts	Huntingdonshire (GB; old)
Episc.	Episcopal	g	gram(s)	IA	Iowa
Esp.	Especially	GA	Georgia (USA)	ibid.	*ibidem* [in the same place]
Ess.	Essays	Gael.	Gaelic	ICA	Institute of Contemporary Arts
est.	established	Gal., Gals	Gallery, Galleries		
etc	*etcetera* [and so on]	Gaz.	Gazette	Ice.	Icelandic
Ethnog.	Ethnography	GB	Great Britain	Iconog.	Iconography
Ethnol.	Ethnology	Gdn, Gdns	Garden(s)	Iconol.	Iconology
Etrus.	Etruscan	Gdnr(s)	Gardener(s)	ID	Idaho (USA)
Eur.	European	Gen.	General	i.e.	*id est* [that is]
Evangel.	Evangelical	Geneal.	Genealogy, Genealogist	IL	Illinois (USA)
Exam.	Examination	Gent.	Gentleman, Gentlemen	Illum.	Illumination
Excav.	Excavation, Excavated	Geog.	Geography	illus.	illustrated, illustration
Exch.	Exchange	Geol.	Geology	Imp.	Imperial
Excurs.	Excursion	Geom.	Geometry	IN	Indiana (USA)
exh.	exhibition	Georg.	Georgian	in., ins	inch(es)
Exp.	Exposition	Geosci.	Geoscience	Inc.	Incorporated
Expermntl	Experimental	Ger.	German, Germanic	inc.	incomplete
Explor.	Exploration	G.I.	Government/General Issue (USA)	incl.	includes, including, inclusive
Expn	Expansion			Incorp.	Incorporation
Ext.	External	Glams	Glamorganshire (GB; old)	Ind.	Indian
Extn	Extension	Glos	Gloucestershire (GB)	Indep.	Independent
f, ff	following page, following pages	Govt	Government	Indig.	Indigenous
		Gr.	Greek	Indol.	Indology
F.A.	Fine Art(s)	Grad.	Graduate	Indon.	Indonesian
Fac.	Faculty	Graph.	Graphic	Indust.	Industrial
facs.	facsimile	Green.	Greenlandic	Inf.	Information
Fam.	Family	Gr.-Roman	Greco-Roman	Inq.	Inquiry
fasc.	fascicle	Gt	Great	Inscr.	Inscribed, Inscription
fd	feastday (of a saint)	Gtr	Greater	Inst.	Institute(s)
Feb	February	Guat.	Guatemalan	Inst. A.	Institute of Art
Fed.	Federation, Federal	Gym.	Gymnasium	Instr.	Instrument, Instrumental
Fem.	Feminist	h.	height	Int.	International
Fest.	Festival	ha	hectare	Intell.	Intelligence
fig.	figure (illustration)	Hait.	Haitian	Inter.	Interior(s), Internal
Fig.	Figurative	Hants	Hampshire (GB)	Interdiscip.	Interdisciplinary
figs	figures	Hb.	Handbook	intro.	introduced by, introduction
Filip.	Filipina(s), Filipino(s)	Heb.	Hebrew	inv.	inventory
Fin.	Finnish	Hell.	Hellenic	Inven.	Invention
FL	Florida (USA)	Her.	Heritage	Invest.	Investigation(s)
fl	*floruit* [he/she flourished]	Herald.	Heraldry, Heraldic	Iran.	Iranian
Flem.	Flemish	Hereford & Worcs	Hereford & Worcester (GB)	irreg.	irregular(ly)
Flints	Flintshire (GB; old)			Islam.	Islamic
Flk	Folk	Herts	Hertfordshire (GB)	Isr.	Israeli
Flklore	Folklore	HI	Hawaii (USA)	It.	Italian
fol., fols	folio(s)	Hib.	Hibernia	J.	Journal
Found.	Foundation	Hisp.	Hispanic	Jam.	Jamaican
Fr.	French	Hist.	History, Historical	Jan	January
frag.	fragment	HMS	His/Her Majesty's Ship	Jap.	Japanese
Fri.	Friday	Hon.	Honorary, Honourable	Jav.	Javanese
FRIBA	Fellow of the Royal Institute of British Architects	Horiz.	Horizon	Jew.	Jewish
		Hort.	Horticulture	Jewel.	Jewellery
FRS	Fellow of the Royal Society, London	Hosp.	Hospital(s)	Jord.	Jordanian
		HRH	His/Her Royal Highness	jr	junior

Juris.	Jurisdiction	MD	Doctor of Medicine; Maryland (USA)	Mt	Mount
KBE	Knight Commander of the Order of the British Empire	ME	Maine (USA)	Mthly	Monthly
		Mech.	Mechanical	Mun.	Municipal
KCVO	Knight Commander of the Royal Victorian Order	Med.	Medieval; Medium, Media	Mus.	Museum(s)
		Medic.	Medical, Medicine	Mus. A.	Museum of Art
kg	kilogram(s)	Medit.	Mediterranean	Mus. F.A.	Museum of Fine Art(s)
kHz	kilohertz	Mem.	Memorial(s); Memoir(s)	Music.	Musicology
km	kilometre(s)	Merions	Merionethshire (GB; old)	N.	North(ern); National
Knowl.	Knowledge	Meso-	Meso-American	*n*	refractive index of a medium
Kor.	Korean	Amer.		n.	note
KS	Kansas (USA)	Mesop.	Mesopotamian	N.A.G.	National Art Gallery
KY	Kentucky (USA)	Met.	Metropolitan	Nat.	Natural, Nature
Kyrgyz.	Kyrgyzstani	Metal.	Metallurgy	Naut.	Nautical
£	libra, librae [pound, pounds sterling]	Mex.	Mexican	NB	New Brunswick (Canada)
		MFA	Master of Fine Arts	NC	North Carolina (USA)
l.	length	mg	milligram(s)	ND	North Dakota (USA)
LA	Louisiana (USA)	Mgmt	Management	n.d.	no date
Lab.	Laboratory	Mgr	Monsignor	NE	Nebraska; Northeast(ern)
Lancs	Lancashire (GB)	MI	Michigan	Neth.	Netherlandish
Lang.	Language(s)	Micrones.	Micronesian	Newslett.	Newsletter
Lat.	Latin	Mid. Amer.	Middle American	Nfld	Newfoundland (Canada)
Latv.	Latvian	Middx	Middlesex (GB; old)	N.G.	National Gallery
lb, lbs	pound(s) weight	Mid. E.	Middle Eastern	N.G.A.	National Gallery of Art
Leb.	Lebanese	Mid. Eng.	Middle English	NH	New Hampshire (USA)
Lect.	Lecture	Mid Glam.	Mid Glamorgan (GB)	Niger.	Nigerian
Legis.	Legislative	Mil.	Military	NJ	New Jersey (USA)
Leics	Leicestershire (GB)	Mill.	Millennium	NM	New Mexico (USA)
Lex.	Lexicon	Min.	Ministry; Minutes	nm	nanometre (10^{-9} metre)
Lg.	Large	Misc.	Miscellaneous	nn.	notes
Lib., Libs	Library, Libraries	Miss.	Mission(s)	no., nos	number(s)
Liber.	Liberian	Mlle	Mademoiselle	Nord.	Nordic
Libsp	Librarianship	mm	millimetre(s)	Norm.	Normal
Lincs	Lincolnshire (GB)	Mme	Madame	Northants	Northamptonshire (GB)
Lit.	Literature	MN	Minnesota	Northumb.	Northumberland (GB)
Lith.	Lithuanian	Mnmt,	Monument(s)	Norw.	Norwegian
Liturg.	Liturgical	Mnmts		Notts	Nottinghamshire (GB)
LLB	Bachelor of Laws	Mnmtl	Monumental	Nov	November
LLD	Doctor of Laws	MO	Missouri (USA)	n.p.	no place (of publication)
Lt	Lieutenant	Mod.	Modern, Modernist	N.P.G.	National Portrait Gallery
Lt-Col.	Lieutenant-Colonel	Moldav.	Moldavian	nr	near
Ltd	Limited	Moldov.	Moldovan	Nr E.	Near Eastern
m	metre(s)	MOMA	Museum of Modern Art	NS	New Style; Nova Scotia (Canada)
m.	married	Mon.	Monday		
M.	Monsieur	Mongol.	Mongolian	n. s.	new series
MA	Master of Arts; Massachusetts (USA)	Mons	Monmouthshire (GB; old)	NSW	New South Wales (Australia)
		Montgoms	Montgomeryshire (GB; old)	NT	National Trust
Mag.	Magazine	Mor.	Moral	Ntbk	Notebook
Maint.	Maintenance	Morav.	Moravian	Numi.	Numismatic(s)
Malay.	Malaysian	Moroc.	Moroccan	NV	Nevada (USA)
Man.	Manitoba (Canada); Manual	Movt	Movement	NW	Northwest(ern)
Manuf.	Manufactures	MP	Member of Parliament	NWT	Northwest Territories (Canada)
Mar.	Marine, Maritime	MPhil	Master of Philosophy		
Mason.	Masonic	MS	Mississippi (USA)	NY	New York (USA)
Mat.	Material(s)	MS., MSS	manuscript(s)	NZ	New Zealand
Math.	Mathematic	MSc	Master of Science	OBE	Officer of the Order of the British Empire
MBE	Member of the Order of the British Empire	MT	Montana (USA)		
				Obj.	Object(s), Objective

Occas.	Occasional	Physiol.	Physiology	red.	reduction, reduced for		
Occident.	Occidental	Pict.	Picture(s), Pictorial	Ref.	Reference		
Ocean.	Oceania	pl.	plate; plural	Refurb.	Refurbishment		
Oct	October	Plan.	Planning	*reg*	*regit* [ruled]		
8vo	octavo	Planet.	Planetarium	Reg.	Regional		
OFM	Order of Friars Minor	Plast.	Plastic	Relig.	Religion, Religious		
OH	Ohio (USA)	pls	plates	remod.	remodelled		
OK	Oklahoma (USA)	p.m.	post meridiem [after noon]	Ren.	Renaissance		
Olymp.	Olympic	Polit.	Political	Rep.	Report(s)		
OM	Order of Merit	Poly.	Polytechnic	repr.	reprint(ed); reproduced, reproduction		
Ont.	Ontario (Canada)	Polynes.	Polynesian				
op.	opus	Pop.	Popular	Represent.	Representation, Representative		
opp.	opposite; opera [pl. of opus]	Port.	Portuguese	Res.	Research		
OR	Oregon (USA)	Port.	Portfolio	rest.	restored, restoration		
Org.	Organization	Posth.	Posthumous(ly)	Retro.	Retrospective		
Orient.	Oriental	Pott.	Pottery	rev.	revision, revised (by/for)		
Orthdx	Orthodox	POW	prisoner of war	Rev.	Reverend; Review		
OSB	Order of St Benedict	PRA	President of the Royal Academy	RHA	Royal Hibernian Academician		
Ott.	Ottoman			RI	Rhode Island (USA)		
Oxon	Oxfordshire (GB)	Pract.	Practical	RIBA	Royal Institute of British Architects		
oz.	ounce(s)	Prefect.	Prefecture, Prefectural				
p	pence	Preserv.	Preservation	RJ	Rio de Janeiro State		
p., pp.	page(s)	prev.	previous(ly)	Rlwy	Railway		
PA	Pennsylvania (USA)	priv.	private	RSA	Royal Scottish Academy		
p.a.	per annum	PRO	Public Record Office	RSFSR	Russian Soviet Federated Socialist Republic		
Pak.	Pakistani	Prob.	Problem(s)				
Palaeontol.	Palaeontology, Palaeontological	Proc.	Proceedings	Rt Hon.	Right Honourable		
		Prod.	Production	Rur.	Rural		
Palest.	Palestinian	Prog.	Progress	Rus.	Russian		
Pap.	Paper(s)	Proj.	Project(s)	S	San, Santa, Santo, Sant', São [Saint]		
para.	paragraph	Promot.	Promotion				
Parag.	Paraguayan	Prop.	Property, Properties	S.	South(ern)		
Parl.	Parliament	Prov.	Province(s), Provincial	s.	solidus, solidi [shilling(s)]		
Paroch.	Parochial	Proven.	Provenance	Sask.	Saskatchewan (Canada)		
Patriarch.	Patriarchate	Prt, Prts	Print(s)	Sat.	Saturday		
Patriot.	Patriotic	Prtg	Printing	SC	South Carolina (USA)		
Patrm.	Patrimony	pseud.	pseudonym	Scand.	Scandinavian		
Pav.	Pavilion	Psych.	Psychiatry, Psychiatric	Sch.	School		
PEI	Prince Edward Island (Canada)	Psychol.	Psychology, Psychological	Sci.	Science(s), Scientific		
		pt	part	Scot.	Scottish		
Pembs	Pembrokeshire (GB; old)	Ptg(s)	Painting(s)	Sculp.	Sculpture		
Per.	Period	Pub.	Public	SD	South Dakota (USA)		
Percep.	Perceptions	pubd	published	SE	Southeast(ern)		
Perf.	Performance, Performing, Performed	Publ.	Publicity	Sect.	Section		
		pubn(s)	publication(s)	Sel.	Selected		
Period.	Periodical(s)	PVA	polyvinyl acetate	Semin.	Seminar(s), Seminary		
Pers.	Persian	PVC	polyvinyl chloride	Semiot.	Semiotic		
Persp.	Perspectives	Q.	quarterly	Semit.	Semitic		
Peru.	Peruvian	4to	quarto	Sept	September		
PhD	Doctor of Philosophy	Qué.	Québec (Canada)	Ser.	Series		
Philol.	Philology	*R*	reprint	Serb.	Serbian		
Philos.	Philosophy	*r*	*recto*	Serv.	Service(s)		
Phoen.	Phoenician	RA	Royal Academician	Sess.	Session, Sessional		
Phot.	Photograph, Photography, Photographic	Radnors	Radnorshire (GB; old)	Settmt(s)	Settlement(s)		
		RAF	Royal Air Force	S. Glam.	South Glamorgan (GB)		
Phys.	Physician(s), Physics, Physique, Physical	Rec.	Record(s)	Siber.	Siberian		
Physiog.	Physiognomy			Sig.	Signature		

Sil.	Silesian	Tech.	Technical, Technique	USA	United States of America	
Sin.	Singhala	Technol.	Technology	USSR	Union of Soviet Socialist Republics	
sing.	singular	Territ.	Territory			
SJ	Societas Jesu [Society of Jesus]	Theat.	Theatre	UT	Utah	
Skt	Sanskrit	Theol.	Theology, Theological	*v*	*verso*	
Slav.	Slavic, Slavonic	Theor.	Theory, Theoretical	VA	Virginia (USA)	
Slov.	Slovene, Slovenian	Thurs.	Thursday	V&A	Victoria and Albert Museum	
Soc.	Society	Tib.	Tibetan	Var.	Various	
Social.	Socialism, Socialist	TN	Tennessee (USA)	Venez.	Venezuelan	
Sociol.	Sociology	Top.	Topography	Vern.	Vernacular	
Sov.	Soviet	Trad.	Tradition(s), Traditional	Vict.	Victorian	
SP	São Paulo State	trans.	translation, translated by; transactions	Vid.	Video	
Sp.	Spanish			Viet.	Vietnamese	
sq.	square	Transafr.	Transafrican	viz.	*videlicet* [namely]	
sr	senior	Transatlant.	Transatlantic	vol., vols	volume(s)	
Sri L.	Sri Lankan	Transcarpath.	Transcarpathian	vs.	versus	
SS	Saints, Santi, Santissima, Santissimo, Santissimi; Steam ship	transcr.	transcribed by/for	VT	Vermont (USA)	
		Triq.	Triquarterly	Vulg.	Vulgarisation	
		Tropic.	Tropical	W.	West(ern)	
SSR	Soviet Socialist Republic	Tues.	Tuesday	w.	width	
St	Saint, Sankt, Sint, Szent	Turk.	Turkish	WA	Washington (USA)	
Staffs	Staffordshire (GB)	Turkmen.	Turkmenistani	Warwicks	Warwickshire (GB)	
Ste	Sainte	TV	Television	Wed.	Wednesday	
Stud.	Study, Studies	TX	Texas (USA)	W. Glam.	West Glamorgan (GB)	
Subalp.	Subalpine	U.	University	WI	Wisconsin (USA)	
Sum.	Sumerian	UK	United Kingdom of Great Britain and Northern Ireland	Wilts	Wiltshire (GB)	
Sun.	Sunday			Wkly	Weekly	
Sup.	Superior	Ukrain.	Ukrainian	W. Midlands	West Midlands (GB)	
suppl., suppls	supplement(s), supplementary	Un.	Union	Worcs	Worcestershire (GB; old)	
		Underwtr	Underwater	Wtrcol.	Watercolour	
Surv.	Survey	UNESCO	United Nations Educational, Scientific and Cultural Organization	WV	West Virginia (USA)	
SW	Southwest(ern)			WY	Wyoming (USA)	
Swed.	Swedish			Yb., Y.-b.	Yearbook, Year-book	
Swi.	Swiss	Univl	Universal	Yem.	Yemeni	
Symp.	Symposium	unpubd	unpublished	Yorks	Yorkshire (GB; old)	
Syr.	Syrian	Urb.	Urban	Yug.	Yugoslavian	
Tap.	Tapestry	Urug.	Uruguayan	Zamb.	Zambian	
Tas.	Tasmanian	US	United States	Zimb.	Zimbabwean	

A Note on the Use of the Encyclopedia

This note is intended as a short guide to the basic editorial conventions adopted in this encyclopedia. For a fuller explanation, please refer to the Introduction.

Abbreviations in general use in the encyclopedia are listed on pp. xix-xxiv; those used in bibliographies and for locations of works of art or exhibition venues are listed in the Appendices.

Alphabetization of headings, which are distinguished in bold typeface, is letter by letter up to the first comma (ignoring spaces, hyphens, accents, and any parenthetized or bracketed matter): the same principle applies thereafter. The abbreviation of 'Saint' is alphabetized as if spelt out.

Authors' signatures appear at the end of the article that the authors have contributed. Where the article was compiled by the editors or in the few cases where an author has wished to remain anonymous, this is indicated by a square box (□) instead of a signature.

Bibliographies are arranged chronologically (within section, where divided) by order of the year first publication and, within years, alphabetically by authors' names. Abbreviations have been used for some standard reference books; these are cited in full in Appendix C as are abbreviations of periodical titles (Appendix B). Abbreviated references to alphabetically arranged dictionaries and encyclopedias appear at the beginning of the bibliography (or section).

Biographical dates when cited in parentheses in running text at the first mention of a personal name indicate that the individual does not have an entry in the encyclopedia. Where no dates are provided for an artist or patron, the reader may assume that there is a biography of that individual in the encyclopedia (or, more rarely, that the person is so obscure that dates are not readily available).

Cross-references are distinguished by the use of small capital letters, with a large capital to indicate the initial letter of the entry to which the reader is directed; for example . 'He commissioned NICOLÒ DELL' ABATE. . .' means that the entry is alphabetized under 'A'.

A

Abacco, Antonio. *See* LABACCO, ANTONIO.

Abate [Abbate], **Nicolò** [Niccolò] **dell'** (*b* Modena, 1509–12; *d* ?Fontainebleau, 1571). Italian painter and draughtsman. He was one of the most important artists of the first Fontainebleau School, which was developed at the French court by Rosso Fiorentino and Francesco Primaticcio, and he introduced the Italian Mannerist landscape into France.

1. ITALY, BEFORE 1552. He was almost certainly trained by his father, Giovanni dell'Abate (*d* 1559), a stuccoist, and by the sculptor Antonio Begarelli. Apparently after a period as a soldier, by 1537 he was working in Modena as a painter under Alberto Fontana (*fl* 1518–58). There the two artists decorated the façade of the Beccherie (Slaughterhouse) from which certain paintings survive (e.g. *St Geminian* and an allegory of the *Wine Harvest*; both Modena, Gal. & Mus. Estense). His early paintings clearly show the influence of Correggio and of such Ferrarese artists as Dosso Dossi. They also display a love of the picturesque and the pastoral, with frequent variations on the theme of the concert, as in the fragment of a concert scene (Reggio Emilia, Mus. Civ. & Gal. A.) from the façade decorations of the Palazzo Pratonieri in Reggio Emilia. Around 1540 he painted a series of frescoes based on Virgil's *Aeneid* in a study of a castle owned by the Boiardo family at Scandiano, near Modena. Some of these paintings survive (Modena, Gal. & Mus. Estense) but greatly altered by damage and restoration. Engravings after the paintings (published by G. B. Venturi, Modena, 1821) give some indication of their original state. The scheme of the room probably included 12 paintings, each representing a book of the *Aeneid*, many depicting several events. Below these were battle scenes; above them were lunettes containing landscapes. In the spandrels were eight female figures reaching up to the octagon of the ceiling, where dell'Abate painted portraits of members of the Boiardo family playing instruments and singing, a scene recalling the oculus of Andrea Mantegna's *Camera picta* (Mantua, Pal. Ducale). Although Dosso's *Aeneas* cycle (dispersed, U. Birmingham, Barber Inst.; Ottawa, N.G.; Washington, DC, N.G.A.), painted *c.* 1520 for Alfonso I d'Este, probably influenced dell'Abate, the Scandiano frescoes were the most extensive treatment of the Virgilian narrative in the period. They show dell'Abate's love of landscape, both for its own sake and to enhance narrative compositions. The figure style in these works suggests the influence of Parmigianino and Correggio.

The Scandiano project was undoubtedly instrumental in gaining other large commissions for dell'Abate. In 1546 he and Fontana were employed to decorate the Sala dei Conservatori of the Palazzo Pubblico in Modena. This decoration includes scenes from Roman history, once again set in idyllic landscapes. The treatment of landscape reflects Venetian and Emilian traditions, which in turn were shaped by those of northern European art. The decorations are restricted to a frieze under the cornice, a form often found in Emilian Renaissance palazzi. While this format is in the local tradition, the border of flowers and fruit underlining it shows an awareness of decorative schemes derived from those of Giulio Romano at the Palazzo del Te in Mantua or of Raphael at the Villa Farnesina in Rome.

Although dell'Abate was most influential for his contribution to large-scale decorative schemes, he executed a variety of other works, including altarpieces, for example that with a martyrdom of saints for SS Pietro e Paolo, Modena, in 1547 (ex-Gemäldegal., Dresden, destr.). In the same year he went to Bologna, where he encountered works by Lorenzo Costa, Francesco Salviati, Giorgio Vasari and, most importantly, Parmigianino. In Bologna he developed the decorative skills he later used in France. One of the most important schemes he worked on in Bologna was the Palazzo Torfanini (now Zucchini-Solomei), where his decorations included stories from Ludovico Ariosto's *Orlando furioso*. A series of arches frame the narrative scenes, which again have fantastical and elaborate settings, both natural and architectural. Garlands suspended between the arches are held by draped and nude figures sitting in the spandrels. Their poses recall figures by Michelangelo on the ceiling of the Sistine Chapel, Vatican, Rome, but they are treated with a more mannered elegance. It is difficult to assess the effect of the scheme, as only two of the eight scenes are well preserved.

Around 1550 dell'Abate was commissioned to decorate four rooms in the Palazzo Poggi, Bologna. These decorations, again limited to friezes (see fig. 1 and colour pl. 1, I1), include episodes from the *Life of Camilla*, from the *Aeneid*, as well as simple decorative landscapes and such ornamental devices as groups of putti playing with huge garlands. The landscapes are set in a fictive architectural structure, with garlands draped along the bottom cornice. The scheme is reminiscent of Baldassare Peruzzi's illusionistic decorations in the Sala delle Prospettive in the Villa Farnesina, Rome. Although the decorations are all painted, they appear to be composed of sculpted, painted and real

1. Nicolò dell'Abate: *Card-players* (*c.* 1550; detail), frescoed frieze, Palazzo Poggi, Bologna

elements. The scenes are separated by putti or larger figures, in rather disdainful poses, which are Mannerist in their elongation and refinement. The decorative works dell'Abate executed in Bologna were influential for future generations of artists there, including the Carracci family. They probably also helped him procure the appointment as assistant to the Bolognese artist Francesco Primaticcio in France, at the court of Henry II (*reg* 1547–1559)

2. FRANCE, FROM 1552. Dell'Abate was in France from 1552 until his death in 1571, mainly working at the royal château of Fontainebleau. He was involved in major decorative projects there, following the precedent set by Rosso Fiorentino in the Galerie François I. Initially dell'Abate seems to have been subordinate to Primaticcio, whose influence on him is often noted. Writers, including Béguin (see 1969 exh. cat.), however, also stress dell'Abate's impact on Primaticcio, who increasingly concentrated on design, producing drawings for projects that dell'Abate executed. Dell'Abate's contributions to the schemes designed by Primaticcio have been identified mainly on stylistic grounds, as few are documented. Many of the large-scale projects do not survive or are in poor condition. Dell'Abate was largely responsible for the execution of the decoration of the Galerie d'Ulysse, for example, which was destroyed in 1738. The decorations, a complex programme of stories from the *Life of Ulysses*, are recorded in a series of preparatory drawings, mostly by Primaticcio (e.g. Florence, Uffizi; Paris, Louvre), and prints, notably *Les Travaux d'Ulysse* (Paris, 1633) by Théodore van Thulden (1606–69). It may have been dell'Abate's handling of paint and fine touch that provoked Vasari's comment that the Galerie seemed to have been painted in just one day. Another large-scale project on which dell'Abate worked was the decoration of the Galerie Henri II or Salle de Bal (1552–6). The theme of music appears throughout the scheme, which has been heavily damaged and repainted. In the Chambre de la Duchesse d'Etampes (Escalier du Roi), the fresco of *Alexander Preserving the Works of Homer* is attributed to dell'Abate alone; no drawing for it by Primaticcio survives.

Dell'Abate's commissions apart from those at Fontaine-bleau included frescoes (before 1558) for the château of Fleury-en-Bière, for which drawings survive (e.g. Paris, Louvre). The constable, Anne, Duc de Montmorency (1493–1567), was a valuable patron, and dell'Abate's drawings (e.g. Paris, Louvre) for his Paris residence (destr.) show the artist's adoption of the rich decorative style developed at Fontainebleau by Rosso and Primaticcio. He also painted portraits in France, for example the enamelled double portrait of *Henry II and Catherine de' Medici* (1553; Paris, Louvre) for the Sainte-Chapelle in Paris. As a court artist, he designed tapestries and ephemeral decorations for court celebrations and for triumphal entries, such as that of Charles IX (*reg* 1560–74) into Paris in 1571.

In addition, dell'Abate produced small-scale paintings, often of mythological subjects. In some examples the narrative is almost completely subordinated to the landscape, as in the *Story of Aristaeus* (or *Death of Eurydice*; *c.* 1565; London, N.G.; see fig. 2), in which the sky and the fantastical background, littered with figures derived from the Antique, appear agitated. In the *Continence of Scipio* (*c.* 1555; Paris, Louvre) the figures dominate the composition, their poses and attitudes interlocking across the picture plane. The elegant forms and the softness of the treatment are reminiscent of Salviati, who was in France in this period. The idyllic classical style that dell'Abate brought to France, derived from Italian Mannerism, greatly influenced the treatment of landscape in French art. After his death, painting at Fontainebleau was supervised by his son, Giulio Camillo dell'Abate (1552–82), who is one of those identified with the Master of Flora.

BIBLIOGRAPHY

G. Vasari: *Vite* (1550, rev. 2/1568); ed. G. Milanesi (1878–85), vi, pp. 481–2; vii, pp. 410–11

L. Dimier: 'Niccolò dell'Abate et les tapisseries de Fontainebleau', *An. Soc. Hist. & Archéol. Gâtinais*, xiii (1895)

A. Venturi: 'Il Mauriziano. Casa Fioribelli: Affreschi di Nicolò dell'Abate', *L'Arte*, iv/9–10 (1901), p. 356

C. Gamba: 'Un ritratto e un paesaggio di Nicolò dell'Abate', *Cron. A.*, i (1924), pp. 77–89

G. Zucchini: 'La scoperta di affreschi di Nicolò dell'Abate in Bologna', *Com. Bologna* (June 1929)

G. Fabrizi: 'L'*Eneide* nei dodici quadri di Nicolò dell'Abate', *Capitolium*, vi/9 (1930), pp. 504–16

W. Bombe: 'Gli affreschi dell'*Eneide* di Nicolò dell'Abate nel Palazzo di Scandiano', *Boll. A.*, x (1931), pp. 529–53

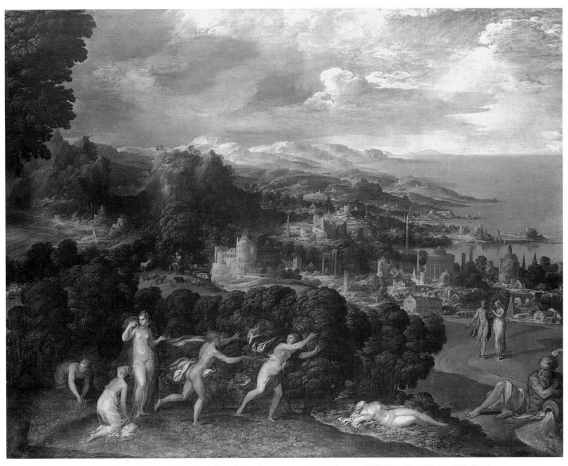

2. Nicolò dell'Abate: *Story of Aristaeus* (or *Death of Eurydice*), oil on canvas, 1.9×2.3 m, *c.* 1565 (London, National Gallery)

E. Bodmer: 'L'attività artistica di Nicolò dell'Abate a Bologna', *Com. Bologna*, i–ii (1934), pp. 3–39

H. Tietze and E. Tietze Conrat: 'Some Drawings by Niccolò dell'Abate', *Gaz. B.-A.*, n. s. 5, xxviii (1945), pp. 378–9

S. Béguin: *L'Ecole de Fontainebleau: Le Maniérisme à la cour de France* (Paris, 1960)

——: 'Niccolò dell'Abbate en France', *A. France*, ii (1962), pp. 112–45

E. H. Langmuir: 'Nicolò dell'Abate at Bologna', *Burl. Mag.*, cxi (1969), pp. 635–9

A. Paolucci: 'Nicolò dell'Abate', *A. Illus.*, ii/23–4 (1969), pp. 90–93

Mostra di Nicolò dell'Abate (exh. cat., ed. S. Béguin; Bologna, Pal. Archiginnasio, 1969)

A. Mezzetti: *Per Nicolò dell'Abate, affreschi restaurati* (Modena, 1970)

A. Ottani Cavina: 'Il paesaggio di Nicolò dell'Abate', *Paragone*, 245 (1970), pp. 8–19

L'Ecole de Fontainebleau (exh. cat., ed. S. Béguin; Paris, Grand Pal., 1972)

Fontainebleau: L'Art en France, 1528–1610 (exh. cat., ed. S. Béguin; Ottawa, N.G., 1973)

G. Godi: *Nicolò dell'Abate e la presunta attività del Parmigianino a Soragna* (Parma, 1976)

I. Wardropper: 'Le Voyage italien de Primatice en 1550', *Bull. Soc. Hist. A. Fr.* (1981), pp. 27–31

S. Béguin, J. Guillaume and A. Roy: *La Galerie d'Ulysse à Fontainebleau* (Paris, 1985)

J. Winkelmann: 'Nicolò dell'Abate in Palazzo Torfanini: La storia "pinta sul camino"', *Atti & Mem. Accad. Clementina Bologna*, 33–4 (1994), pp. 25–9

DORIGEN CALDWELL

Abbondi, Antonio. *See* SCARPAGNINO, ANTONIO.

Abrugia, Niccolò di Bartolomeo dell'. *See* NICCOLÒ PISANO.

Acquaviva d'Aragona, Andrea Matteo III, Duca d'Atri (*b* Conversano, Puglia, Jan 1458; *d* Conversano, 9 Jan 1529). Italian patron. He was the son of Giulio, Duca d'Atri (*d* 1481), and Caterina Orsini, Contessa di Conversano (Apulia), a cousin of Queen Isabella of Castile; in 1477 he married Isabella Piccolomini of Aragon (*d* 1504). His extensive territories included much of the Abruzzo and Apulia, and through his second marriage to Caterina della Ratta, Contessa di Caserta, he gained lands in Campania, Lucania and Calabria. Andrea Matteo led a tumultuous political and military career, alternately supporting the Aragonese and the Angevins and losing and regaining his lands several times. From 1505, however, he settled in Naples, devoting himself increasingly to cultural activities. He was one of the most important humanist princes in southern Italy, and a member of Giovanni Pontano's Neapolitan academy; Pontano (1422–1503) dedicated his *De magnanimitate* to the Duca, whom he saw as the incarnation of Renaissance man, while Paolo Giovio praised him as '*heros antiquae virtutis*'.

Andrea Matteo had a thorough knowledge of Greek literature, writing a commentary on Plutarch's *De virtute morali* (1526), which he published in his own press, installed in 1518–19. He also took an interest in astrology and music. His rich library (MSS in Vienna, Österreich. Nbib.; Naples, Bib. Girolamini; and various European and

North American collections) must have possessed the most important Classical works. He collected manuscripts from his early youth and commissioned such illuminators as Cola Rapicano, CRISTOFORO MAJORANA, Gioacchino di Gigantibus de Rottenburg and REGINALDO PIRAMO DA MONOPOLI to decorate his books. He also employed illuminators from Ferrara and Siena, as well as some showing the influence of Antonello da Messina and Bramante. His manuscripts have complex iconographic schemes, revealing Andrea Matteo to have been a man of broad culture, and they also illustrate the evolution of taste during the period. The earliest examples, illuminated during the 1470s and 1480s, contain the popular white-scroll decoration. These are followed by books with classicizing architectural frontispieces in the Paduan style, while the later manuscripts bear elegant frames with grotesque decoration. In 1506–7 Andrea Matteo had a votive chapel built in Atri Cathedral, for which he commissioned panels of the *Nativity* and *Flagellation*. The artist, Pedro de Aponte, a Spaniard in the entourage of Ferdinand II (*reg* 1479–1516), also illuminated a copy of Pliny for the Duca (Naples, Bib. Girolamini, MS. C FIII 6).

DBI
BIBLIOGRAPHY

A. Putaturo Murano: *Miniature napoletane del rinascimento* (Benevento, 1973)

M. Santoro: 'La cultura umanistica', *Storia di Napoli*, iv/2 (Naples, 1974), pp. 317–400

F. Bologna: *Napoli e le rotte mediterranee della cultura da Alfonso il Magnanimo a Ferdinando il Cattolico* (Naples, 1977), pp. 215–36

F. Tateo: *Chierici e feudatari del Mezzogiorno* (Bari, 1984)

E. Cassec: 'La miniatura italiana in Olanda: Risultati di ricerche nella collezione della Biblioteca dell'Università di Leida', *La miniatura italiana tra gotico e rinascimento. Atti del II congresso di storia della miniatura: Firenze, 1985*, pp. 155–74

P. Giusti and P. Leone de Castris: 'Forastieri e regnicoli': La pittura moderna a Napoli nel primo cinquecento* (Naples, 1985), pp. 103–4

A. Putaturo Murano, A. Perriccioli Saggese and A. Locci: 'Reginaldo Piramo da Monopoli e i miniatori attivi per Andrea III Acquaviva', *Monopoli nell'età del rinascimento. Atti del convegno internazionale di studio: Monopoli, 1985*, pp. 1102–68

GIOVANNA CASSESE

Adriano Fiorentino [Adriano di Giovanni de' Maestri] (*b* ?Florence, *c.* 1450–60; *d* Florence, before 12 June 1499). Italian sculptor. Like his collaborator Bertoldo di Giovanni, he may have started his working life as a servant in the house of Lorenzo de' Medici. An 'Adriano nostro' is recorded delivering letters for Lorenzo in 1483 and again in March 1484, when Lorenzo referred to him as 'Adriano formerly our groom' (*staffiere*).

Adriano's best-known enterprise is the bronze statuette of *Bellerophon and Pegasus* (Vienna, Ksthist. Mus.; *see* BERTOLDO DI GIOVANNI, fig. 2), which he cast after a model of Bertoldo's. Its underside is signed *Expressit me Bertholdus. Conflavit Hadrianus.* Marcantonio Michiel, who saw the piece in a Paduan collection, took this to mean that Adriano was Bertoldo's assistant in casting. Bertoldo's influence is certainly apparent in Adriano's signed bronze statuette of *Venus* (Philadelphia, PA, Mus. A.; see fig.). The nude *Hercules* (J. W. Frederiks priv. col., on loan to Rotterdam, Mus. Boymans–van Beuningen), formerly attributed to Bertoldo, matches the *Venus* in both its facture and its stance. A signed *Venus and Cupid*, reproduced by Fabriczy (1886), has since disappeared. Important evi-

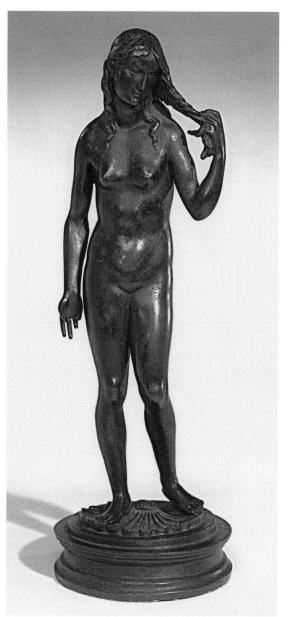

Adriano Fiorentino: *Venus*, bronze, h. 422 mm, *c.* 1490 (Philadelphia, PA, Museum of Art)

dence of Adriano's activity in the production of small bronzes was provided by the discovery of his signature beneath a leering *Pan* with tautly flexed legs (Vienna, Ksthist. Mus.); this is the finest example in the group of statuettes attributed to him and the one most likely to have been made in Florence. He also signed a marble statuette of a *Sleeping Satyr* (Berlin, Skulpgal.).

According to a deposition of May 1499, Adriano served for a time with Buonaccorso Ghiberti, a fortifications expert and founder of artillery who worked for over two years under Virginio Orsini, the condottiere commander of the Aragonese army. Buonaccorso's service ended in June 1488. The hardy simplicity of Adriano's *Venus* and

Hercules statuettes perhaps reflects his experiences with the casting of cannonry during this period.

In 1493 Adriano is recorded living in the household of King Ferdinand (*reg* 1458–94) in Naples and the following year in the house of the Duke of Calabria, where his brother Amadeo wrote to him with the news of Michelangelo's flight from Florence. The three medals of *Ferdinand II* (Hill, *Corpus*, nos 335–7) and the portrait medals of the Neapolitan writers *Pietro Compatre*, *Giovanni Pontano* and *Jacopo Sannazaro* (Hill, *Corpus*, nos 339–43) probably date from this time. The heads of the writers are shown in striking, classical profile, while the faintly sketched figures on the reverses are reminiscent of antique encaustic painting. The *Pontano* medal prompted the attribution to Adriano of a bronze bust of that humanist (Genoa, Gal. Pal. Bianco), a balding, staring head set at an ungainly angle in a Roman tunic. The medal and bust, in turn, determined his authorship of a slightly more classical marble relief portrait of *Pontano* (New York, Met., since 1991).

Adriano's search for work took him northward; in a letter of May 1495 Elisabetta Gonzaga, Duchess of Urbino, urged her brother Francesco II, Marquis of Mantua, to employ Adriano. She had been sufficiently impressed by his talents during his three-month stay in Urbino to praise him as 'a good sculptor' who 'has made here some very beautiful medals', adding that he was 'a good composer of sonnets, a good player of the lyre, and he also improvises rather outstandingly'. Adriano's medal of the *Duchess of Urbino* (Hill, *Corpus*, no. 344) dates from this time. He then worked in Germany, where he made a bust of *Frederick the Wise of Saxony* in bell-metal, signed and dated 1498 (Dresden, Grünes Gewölbe). This owlish portrait with carefully studied details of costume has more in common with the spirit of contemporary German painting than with Italian sculpture.

BIBLIOGRAPHY

Thieme–Becker

C. von Fabriczy: 'Ein bisher unbeachtetes Werk des Adriano Fiorentino', *Kst & Gew.*, xx (1886), p. 7

——: 'Adriano Fiorentino', *Jb. Kön.-Preuss. Kstsamml.*, xxiv (1903), pp. 71–98

G. F. Hill: *Corpus* (1930), pp. 82–7

G. L. Hersey: *Alfonso II and the Artistic Renewal of Naples, 1485–1495* (New Haven, 1969), pp. 29–30

J. D. Draper: *Bertoldo di Giovanni: Sculptor of the Medici Household* (Columbia, MO, 1992), pp. 44–52, 69, 181

The Currency of Fame: Portrait Medals of the Renaissance (exh. cat., ed. S. K. Scher, entries by J. D. Draper; New York, Frick, 1994)

JAMES DAVID DRAPER

Aesthetics. Branch of Western philosophy concerned primarily with the arts, especially the fine arts, although it often treats the concepts of natural beauty and appreciation of nature as well. Three main themes were developed and repeated in aesthetic thought during the Renaissance and mannerist periods between 1400 and 1600: synthetic beauty, a theme with literary origins; spiritual beauty, a notion ultimately derived from NEO-PLATONISM; and physical beauty, a type based on measurements and proportions that stem from Aristotelian philosophy. To these should be added the feminine ideal of the Renaissance, as exemplified in Petrarchan poetry. These ideas,

formulated in the 16th century, remained the main basis for discussion until the end of the 17th.

1. SYNTHETIC BEAUTY. Pliny relates that the painter Zeuxis, in order to represent Helen of Troy, selected the five most beautiful maidens of the town of Crotona and synthesized their most striking features into a perfect image. This idea that in order to produce a perfect image the artist must select and combine the best parts of everything belongs to a topos that permeated other disciplines such as rhetoric and ethics. In Renaissance art theory the notion appears in Leon Battista Alberti's treatise *De pittura* (1435), and it was repeated in every art treatise of the 16th century. Indeed, it affected art education, as the young artist was expected to distil his own style from the study of nature and the great masters, as well as the Antique. The notion of synthetic imitation developed further, giving rise to what was later called eclecticism. This doctrine is prefigured by Giulio Camillo in his treatise on imitation (1544), which suggests that, since the best art has already synthesized the best of nature, artists need only look at other works of art to gather a synthesis of the perfect visible. A few years later Paolo Pino in his *Dialogo di pittura* (1548) wrote that the best painting would be drawn by Michelangelo and coloured by Titian; but the culmination of this view is to be found later in a sonnet attributed to Agostino Carracci (1557–1602), describing the best art as a synthesis of the talents of the best painters.

2. SPIRITUAL BEAUTY. It is through Marsilio Ficino's commentary (1469) on Plato's *Symposium*, rather than the original text, that Plato's doctrine of love became increasingly popular in the 16th century. Platonic love is a spiritual journey. It begins with the visual or auditory perception of beauty and ends with the ecstatic vision of God (Ficino, *Commentary*, VII, 14). Given the incorporeal nature of true beauty, it can be perceived only by incorporeal senses—sight and hearing (V. 2). In Baldassare Castiglione's *Il libro del Cortegiano*, Pietro Bembo speaks of this type of love whose strength 'guides the soul from the particular beauty of one body to the universal beauty common to all bodies' (IV, 68). This spiritual ascent begins with visual perception. These texts were influential, in so far as they led to an emphasis on spiritual love at the expense of physical love and beauty. They explain the emergence of an aesthetics based on the appreciation of incorporeal qualities perceived through the eye or the ear. From this emerged a vocabulary suited to describe purely visual qualities, which, in turn, were easily transferable to works of art.

Agnolo Firenzuola in his *Dialogo delle bellezze delle donne* (Florence, 1548) offers a good example of this phenomenon of transposition. This author fully agreed with Ficino on the effect of beauty, as a reflection of divine beauty, although he limited its field to beautiful women. While he defined physical *bellezza* (beauty) in terms of measurements and proportions (fols 73ff), he opposed it to spiritual *bellezza*, of which he identified six qualities: *leggiadria*, *venustà*, *grazia*, *vaghezza*, *aria* and *maestà*. English approximations to these are, consecutively, 'prettiness', 'beauty', 'grace', 'charm', 'demeanour' and 'dignity', but they remain beyond the reach of any verbal definition. Blended in ideal

proportions, these features will produce a likeness of the idea of the perfect woman, capable of plunging man into a mystic state of divine ecstasy.

In the field of the visual arts, where categories such as *venustà*, *grazia* and *aria* were currently applied, these notions never implied that images could lead the soul to the contemplation of God through the graphic expression of divine beauty. Notions such as *bellezza* and *grazia*, however, became the mundane criteria through which writers spoke about the style and qualities of painting in an empirical, if not intuitive, fashion. Their use is connected to another theme, introduced by Castiglione, the concept of *sprezzatura*, i.e. the specific quality emerging from something difficult done with ease and elegance. It is precisely this criterion, used in conjunction with the notion of grace, that Lodovico Dolce, in his *Dialogo della pittura* (1557), invoked in order to praise Raphael and Titian and to attack Michelangelo's *Last Judgement* (1536–41; Rome, Vatican, Sistine Chapel; see colour pl. 2, VII3), not only for its lack of decency but also, from a stylistic point of view, for the affectation and absence of grace of the figures that 'display all the difficulty of the art'.

3. PHYSICAL BEAUTY AND THE PETRARCHAN IDEAL. The Renaissance ideal of feminine beauty is inspired by the love poetry of Petrarch. The physical features of Laura, Petrarch's mistress and muse—long blond hair, fine eyebrows, dark sparkling eyes, slightly rosy cheeks, long and slender neck, firm and white breasts, well-proportioned arms on which no veins can be seen and small, delicate white hands, together with perfect proportions—were paired with spiritual qualities in the appreciation of paintings of beautiful women. Pino confirmed this when referring to the 'true beauty' (*vaghezza*) of his art in his *Dialogo di pittura*: 'The painter is not worthy of praise for depicting all his [feminine] figures with pink cheeks and blond hair ... but true beauty is nothing else than *venustà* and *gratia*; it is generated through a deep understanding of things as well as a proportion in things.' The opposition set by Pino between physical characteristics and painterly qualities is exemplified in Benedetto Varchi's *Della beltà e grazia* (*c.* 1550), which opposes a 'spiritual and platonic beauty' (*grazia*) to an Aristotelian beauty 'which consists in the proportion of the limbs'. This notion is further developed by the sculptor Vincenzio Danti, in his *Trattato delle perfette proporzioni* (1567), with the Aristotelian addition that beauty lies not only in perfect proportions but also in the harmony between the shape of an object or a limb and the function it is intended to fulfil.

BIBLIOGRAPHY
D. Mahon: *Studies in Seicento Art and Theory* (London, 1947)
E. Panofsky: *Idea* (Eng. trans. by J. S. Peake, New York, 1968)
E. Cropper: 'On Beautiful Women, Parmigianino, *Petrarchismo* and the Vernacular Style', *A. Bull.*, 58 (1976), pp. 374–94
D. Summers: *Michelangelo and the Language of Art* (Princeton, 1981)
T. Puttfarken: *Roger de Piles' Theory of Art* (London, 1985)
M. Rogers: 'Reading the Female Body in Venetian Renaissance Art', *New Interpretations of Venetain Renaissance Painting*, ed. F. Ames-Lewis (London, 1994), pp. 77–90
FRANÇOIS QUIVIGER

Agabiti [Agapiti], **Pietro Paolo** (*b* Sassoferrato, *c.* 1470; *d* Cupramontana, *c.* 1540). Italian painter and possible wood-cutter. He spent his early years in Sassoferrato, where his family owned a ceramics workshop. Around 1497 he probably visited the Veneto region, since his *Virgin and Child with Saints* (Padua, Mus. Civ.) painted that year shows the strong influence of painters active there such as Cima da Conegliano. The painting also reflects the Bolognese style of Francesco Francia and that of the Romagnian Marco Palmezzano. In Venice, Agabiti may have made woodcuts after the illustrations for Francesco Colonna's *Hypnerotomachia Poliphili* (Venice, 1499). By 1502 he had returned to the Marches, where he executed a painting (untraced) for S Rocco, Jesi, the town where in 1507 he is documented as residing. After 1510 he was again in Sassoferrato, where in 1511 he signed and dated both the *Virgin and Child Enthroned with Saints* (Sassoferrato, Gal. A. Mod. & Contemp.) and the *Nativity* in S Maria del Piano. In 1518, for the same church, he signed and dated an altarpiece depicting the *Virgin and Child with SS Catherine and John the Baptist* (*in situ*). In S Fortunato, Sassoferrato, he executed the *Virgin and Child with Saints* (1521; *in situ*), in which the influence of Marco Palmezzano is even more evident.

Between 1522 and 1524, in collaboration with Andrea da Jesi the younger, Agabiti executed a series of frescoes in the Palazzo di Città, Jesi. In 1524, for Santa Croce, Sassoferrato, he painted a panel with *SS Benedict, Maurus and Placid* on the front and *SS Peter Damian and Scholastica* on the rear (Fonte Avellama, Abbazia; Urbino, Pal. Ducale). In 1528 he painted the *Virgin and Child Enthroned with SS John the Baptist and Anthony* (Jesi, Pin. Civ.). The lunette depicts *St Francis Receiving the Stigmata* and the predella shows the *Nativity*, the *Adoration of the Magi* and various *Saints*. Here the links with Cima da Conegliano and Marco Palmezzano are again in evidence, and there are also references to Carlo Crivelli's use of colour. In 1530 Agabiti painted the *Virgin and Child with Saints* for the Badia, San Lorenzo in Campo. The following year he retired to the Convento dell'Eremita, Cupramontana, where he remained until his death. Agabiti's work is retardataire; he did not adapt his style to suit 16th-century taste and remained instead nostalgically attached to the formal language of the 15th century.

BIBLIOGRAPHY
DBI; Thieme–Becker
R. Pallucchini: 'La pala dell'Agabiti per S Francesco di Corinaldo', *Festschrift Ulrich Middeldorf*, ed. O. Kosegarten and P. Tigler (Berlin, 1968), pp. 213–17
S. Salvadori: 'Pietro Paolo Agabiti', *Lorenzo Lotto nelle Marche* (exh. cat., ed. P. dal Poggetto and P. Zampetti; Ancona, Chiesa del Gesù, S Francesco alle Scale and Loggia Mercanti; 1981), pp. 132–4
A. Parronchi: 'Lo xilografo della *Hypnerotomachia Poliphili*: Pietro Paolo Agabiti', *Prospettiva*, 33–6 (1983–4), pp. 101–11 [Luigi Grassi *Festschrift*]
GENNARO TOSCANO

Agniolo di Cosimo di Mariano Tori Bronzino. *See* BRONZINO, AGNOLO.

Agnolo, Andrea d'. *See* SARTO, ANDREA DEL.

Agnolo, Baccio d'. *See* BACCIO D'AGNOLO.

Agnolo di Polo (*b* Florence, 1470; *d* after 1498). Italian sculptor. He belonged to a family of well-known artisans;

his grandfather Agnolo di Lippo di Polo had worked as an assistant on the stained glass for the cupola of Florence Cathedral and took the name de' Vetri, sometimes also used by his descendants. Agnolo's father, Polo di Agnolo, made masks and had his workshop on the Ponte Vecchio, Florence, and his brother Domenico engraved precious stones and medals. Vasari said that Agnolo was a pupil of Verrocchio, adding that 'he worked very well in clay and has filled the city with works from his hands'. Given the artist's birth date and that Verrocchio left Florence forever in 1483, Agnolo's apprenticeship would have been very brief; it is probable that he stayed on in the workshop when it was directed by Lorenzo di Credi.

Two of Agnolo's works are documented. On 16 August 1495 the Ufficiali della Sapienza commissioned a statue of *St Mary Magdalene* for the oratory of the Spedale della Morte at Pistoia, restored three years later by the artist himself because it was broken. This has been identified as the *Female Saint* (New York, Met.), which has many stylistic similarities with his only other known documented work, the terracotta bust of the *Redeemer* (Pistoia, Mus. Civ.), commissioned from him in 1498 by the same Ufficiali for their audience-chamber in Pistoia. Several versions of the bust of the *Redeemer* seem to derive either from the Pistoia bust or from a lost prototype by Verrocchio. Not all can be attributed to Agnolo, but a polychrome terracotta bust (Florence, Loggia del Bigallo) is of comparable size to another example (San Miniato, Mus. Dioc. A. Sacra) and perhaps even comes from the same mould; two other terracotta busts of the *Redeemer* (London, V&A; Florence, Mus. Horne) are very close. They are all derived ultimately from the head of Christ in the *Doubting Thomas* group (Florence, Orsanmichele).

Agnolo's documented works are stylistically very close to the work of Lorenzo di Credi, Pietro Torrigiani and of later members of the della Robbia family. He may have had contacts with the Dominicans of S Marco, Florence, where Savonarola was Prior. This might account for the profusion of small terracotta sculptures; the use of this malleable material enabled large numbers of comparatively inexpensive sacred images to be produced for private devotional use. The realistic representation of traditional subjects was designed to inspire intense spiritual fervour. Further works by Agnolo di Polo may yet be recognized among sculpture attributed to the della Robbia workshop.

BIBLIOGRAPHY

Thieme–Becker

G. Vasari: *Vite* (1550, rev. 2/1568); ed. G. Milanesi (1878–85), iii, pp. 371–2

P. Bacci: 'Agnolo di Polo, allievo del Verrocchio', *Riv. A.*, iii (1905), pp. 159–71

J. Mesnil: 'Polo del Maestro Agnolo dei Vetri', *Riv. A.*, iii (1905), pp. 256–8

J. Pope-Hennessy: *Catalogue of Italian Sculpture in the Victoria and Albert Museum*, i (London, 1964), p. 209

F. Rossi: *Il Museo Horne a Firenze* (Milan, 1967), p. 152

J. Goldsmith Phillips: 'A Sculpture by Agnolo di Polo', *Met. Mus. A. Bull.*, xxx/1 (1971), pp. 81–9

H. Kiel: *Il Museo del Bigallo a Firenze* (Milan, 1977), p. 127

La civiltà del cotto: Arte della terracotta nell'area fiorentina dal XV al XX secolo (exh. cat., Impruneta, Mus. Santuario, 1980), p. 102

FRANCESCA PETRUCCI

Agostino dei Musi. *See* MUSI, AGOSTINO DEI.

Agostino (di Antonio) di Duccio (*b* Florence, 1418; *d* ?Perugia, after 1481). Italian sculptor and architect. His father, Antonio di Duccio, a weaver, reported in his *catasto* (land registry declaration) of 1427 that Agostino was eight years old. On his father's death, the young Agostino enrolled in the company of the mercenary Giovanni da Tolentino, with whom he was serving in 1433. He may be the apprentice named Agostino who was working on the external pulpit for Prato Cathedral on 14 May 1437; this would suggest that he trained in the circle of Michelozzo and Donatello. What may be his earliest known work, datable *c.* 1440 (Rosenauer, 1977), is a marble statue of the *Virgin and Child* (Florence, S Maria del Carmine), influenced by Michelozzo.

Agostino's first certain work, commissioned by Ludovico Forni for Modena Cathedral, was an antependium that included four relief scenes from the *Life of St Geminian* (1442; dismembered, statue of *St Geminian* in Modena Cathedral sacristy, reliefs built into the cathedral's outer wall). The scenes are carved in high relief, the figures arranged in a stiff frieze formation. In 1446 he was in Venice, having apparently fled there after he and his brothers Costantino and Cosimo were accused in 1441 of stealing silver from the Compagnia dell'Osservanza in SS Annunziata, Florence. Agostino may have worked in the Venice studio of Bartolomeo Bon (*d* 1529), whose influence is apparent in the statue of *St Louis of Toulouse* (Venice, S Alvise) attributed to him (Brunetti, 1950).

From 1449 to 1456 Agostino was in Rimini, employed by Sigismondo Pandolfo Malatesta on the decoration of the interior of the church of S Francesco (transformed and remodelled by Leon Battista Alberti and Matteo de' Pasti; *see* RIMINI, §1(ii)). There Agostino supervised a large group of sculptors working on the most richly sculptured Renaissance building in Italy. He was probably personally responsible for all the major figural carving in the six chapels that were built in the church (*see* RIMINI, fig. 4). In these he developed an individual, gothicizing linear style of great intensity, revealing a knowledge of Donatello's work and perhaps reflecting the use of line in paintings by Andrea del Castagno and Filippo Lippi. In 1454 Agostino also worked in Cesena, carving the elephant relief over the entrance to the Biblioteca Malatestiana, and at Forlì, making a tabernacle with a relief of the *Trinity* and a statue of the *Virgin and Child* on the façade for the sanctuary of the Madonna at Fornò. In 1456 his brother, Ottaviano di Antonio di Duccio (*b* 1422; *d* after 1478), a sculptor and goldsmith, joined him as an assistant at S Francesco, Rimini. (Ottaviano's only certain work is the tomb of *Antonio Malatesta* (1467) in Cesena Cathedral.)

Between 1457 and 1461 Agostino was working on the façade of the oratory of S Bernardino, Perugia. Although the architectural framework of the façade recalls Alberti's design for S Francesco, the sculpture, originally highly polychromed, is rich and intricate, emphasizing line and movement. Above a double door framed by reliefs of angels, a high tympanum contains a relief of *St Bernardino in Glory. God the Father* appears in the upper pediment, and four aedicules contain statues. Agostino also carved a large stone and terracotta dossal (dismantled and reconstituted in 1484) for the altar of S Lorenzo, in the church of S Domenico, Perugia, for the heirs of Lorenzo di Ser

Giovanni. Between December 1462 and February 1463 Agostino was in Bologna, where he presented a wooden model (untraced) for the façade of S Petronio.

In 1463 Agostino returned to Florence and enrolled in the Arte dei Maestri di Pietra e Legname (the sculptors' guild). In 1463–4, for the Opere del Duomo, he made a colossal figure (untraced) to be placed in the cathedral tribune; they commissioned a second colossal statue from him in 1464, but this was abandoned, the marble block later being used by Michelangelo for his *David* (Florence, Accad.; *see* ITALY, fig. 22). For SS Annunziata he made a terracotta *Resurrection* (1470; untraced). Also belonging to this Florentine period are the marble relief of the *Virgin and Child with Angels* (Florence, Bargello), originally in the Carmine, Florence, and a tabernacle with *Two Angels Holding Back a Curtain* (Florence, Bargello) from the church of the Ognissanti, Florence; both works are carved in an intricate, linear style. The highly wrought marble relief of the *Virgin and Child*, known as the d'Aubervilliers *Madonna* (Paris, Louvre), and the terracotta statue of the *Angel of the Annunciation* (Budapest, Mus. F.A.) would seem to be of the same date.

In 1473 Agostino returned to Perugia as architect in charge of the design and execution of the Porta S Pietro, left unfinished at the time of his death. He also executed the altar of the *Pietà* (1473; destr. 1625; fragments Perugia, G. N. Umbria) for Perugia Cathedral, commissioned by the hospital of the Misericordia, and the marble low reliefs of *Christ Taking Leave of his Mother* (New York, Met.) and the *Virgin and Child* (c. 1473; Washington, DC, N.G.A.; see fig.). Among his other contemporary com-

missions, from small towns in Umbria and Lazio, are two *Archangels* for Acquapendente Cathedral (Viterbo) and two wall tombs, both originally in S Francesco, Amelia (Terni), those of *Giovanni Geraldini, Bishop of Catanzaro* (1476; Amelia Cathedral) and of *Matteo and Elisabetta Geraldini* (1477; *in situ*). Brunetti (1965) attributed the tomb slab of *Bishop Ruggero Mandosi* (Amelia Cathedral) to Agostino, which would imply that he was still alive in 1484, the year of the Bishop's death; however Agostino was last documented in 1481 working on the Porta S Pietro. He died before 1498, when his wife remarried.

BIBLIOGRAPHY

DBI; Thieme–Becker
A. Rossi: 'Prospetto cronologico della vita e delle opere di Agostino d'Antonio, scultore fiorentino, con la storia e documenti di quelle da lui fatte in Perugia', *G. Erud. A.*, iv (1875), pp. 3–25, 33–50, 76–83, 117–22, 141–52, 179–84, 202–11, 241–9, 263–75
A. Venturi: *Storia* (1901–40), vi, pp. 388–406, 1024
A. Pointner: *Agostino d'Antonio di Duccio* (Strasbourg, 1909)
A. Colasanti: 'La tomba di *Giovanni Geraldini*, opera di Agostino di Duccio', *Rass. A.*, iii (1916), pp. 38–42
C. Ricci: *Il tempio Malatestiano* (Milan, [1924]), pp. 103–37
C. L. Ragghianti: 'La mostra della scultura italiana antica a Detroit', *Crit. A.*, iii (1938), pp. 178–9
H. W. Janson: 'The Beginnings of Agostino di Duccio', *A. Bull.*, xxix (1942), pp. 330–34
R. Mather: 'Documents, Mostly New, Relating to Florentine Painters and Sculptors of the Fifteenth Century', *A. Bull.*, xxx (1948), pp. 20–22
G. Brunetti: 'Il soggiorno veneziano di Agostino di Duccio', *Commentari*, i (1950), pp. 82–4
C. Ravaioli: 'Agostino di Duccio a Rimini', *Stud. Romagn.*, ii (1951), pp. 113–20
C. L. Ragghianti: 'Problemi di Agostino di Duccio', *Crit. A.*, vii (1955), pp. 2–21
C. Brandi: *Il tempio Malatestiano* (Turin, 1956), pp. 29–47
F. Santi: 'L'altare di Agostino di Duccio in S Domenico a Perugia', *Boll. A.*, i–ii (1961), pp. 162–73
A. Zanoli: 'Il tabernacolo di Fornò di Agostino di Duccio', *A. Ant. & Mod.*, no. 13 (1961), pp. 148–50
G. Marchini: *Il tesoro del duomo di Prato* (Milan, 1963), pp. 73–5
J. Pope-Hennessy: *Italian Renaissance Sculpture* (London, 1963, rev. 3/1985), pp. 83–9, 324–8
A. Zanoli: *Perugia: Oratorio di San Bernardino*, Tesori d'Arte Cristiana (Bologna, 1963)
G. Brunetti: 'Sul periodo "Amerino" di Agostino di Duccio', *Commentari*, xvi (1965), pp. 47–55
M. Bacci: *Agostino di Duccio*, I Maestri della Scultura (Milan, 1966)
Sigismondo Pandolfo Malatesta e il suo tempo (exh. cat., ed. F. Arduini and others; Rimini, Pal. Arengo, 1970), pp. 75–95, 125–64
M. Kühlenthal: 'Studien zum Stil und zur Stilentwicklung Agostino di Duccios', *Wien. Jb. Kstgesch.*, xxiv (1971), p. 60
A. Rosenauer: 'Bemerkungen zu einem frühen Werk Agostino di Duccios', *Munchn. Jb. Bild. Kst*, xxviii (1977), pp. 133–52
P. Meldini and P. G. Pasini: *La cappella dei pianeti nel tempio Malatestiano* (Milan, 1983)
P. G. Pasini: *I Malatesti e l'arte* (Milan, 1983)
——: 'Una *Madonna* di Agostino di Duccio a Fornò', *Culture figurative e materiali tra Emilia e Marche: Studi in onore di Mario Zuffa*, ii (Rimini, 1984), pp. 533–5
P. Santi: *Galleria Nazionale dell'Umbria: Dipinti, sculture e oggetti dei secoli XV e XVI*, Perugia, G.N. Umbria cat. (Rome, 1985), pp. 227–34
G. Cuccini: *Agostino di Duccio: Itinerari di un esilio* (Perugia, 1990)
La basilica cattedrale del S Sepolcro di Acquapendente (exh. cat. by P. M. Fossati, Bolsena, 1990)
S. Kokole: '*Cognitio formarum* and Agostino di Duccio's Reliefs for the Chapel of the Planets in the Tempio Malatestiano', *Quattrocento adriatico: Fifteenth-century Art of the Adriatic Rim: Florence, 1994*, pp. 177–206
M. A. Jacobsen: 'Agostino di Duccio's *Virtues* at San Bernardino, Perugia', *Ant. Viva*, xxxiv/5–6 (1995), pp. 12–18
D. Carrier: 'Agostino di Duccio: Symbolic Relief with the *Young Christ and the Virgin*', *Source*, xv/4 (Summer 1996), pp. 8–10
 PIER GIORGIO PASINI

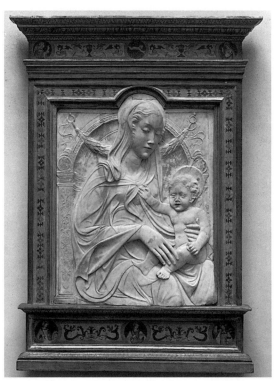

Agostino di Duccio: *Virgin and Child*, marble relief, 720×573 mm, *c.* 1473 (Washington, DC, National Gallery of Art)

Agostino Veneziano. *See* MUSI, AGOSTINO DEI.

Agrate, Marco d' [Marco Ferreri; Ferrari d'Antonio d'Agrate] (*b* Agrate, *c.* 1504; *d* Milan, *c.* 1574). Italian sculptor. He came from a Lombard family of sculptors, collaborating with his brother Gianfrancesco on a funerary monument to *Sforzino Sforza* (1524–31) in S Maria della Steccata, Parma. Records show that Marco was in the service of Milan Cathedral from 1522. From 1541 to 1571 he worked for the Opera del Duomo and may have contributed reliefs for the façade of the Certosa di Pavia. This suggests that his style was formed by the classicizing environment of Agostino Busti, Andrea Fusina and Cristoforo Lombardo. In 1547 d'Agrate was contracted to complete the four remaining sarcophagi, with reclining figures above, for the Trivulzio Chapel in S Nazaro Maggiore, Milan. The chapel had been left incomplete by Bramantino and was continued by Lombardo. The austere funerary monument of *Giovanni del Conte* (Milan, S Lorenzo) dates from 1556 to 1558. The architectural structure is the work of Vincenzo Seregni, but the recumbent effigy of the deceased is by d'Agrate.

Only two works for Milan Cathedral survive: the marble relief of the *Marriage at Cana* (1562; *in situ*), mentioned by Vasari, and the celebrated marble *St Bartholomew* (*c.* 1562; *in situ*), on the base of which is the self-glorifying inscription *Non me Praxiteles sed Marc' finxit Agrat*. This is a life-size *écorché* statue: the skin is draped around the flayed body of the saint, who carries a knife and an open book. The inscription may date from 1664, when the statue was removed from its original location to its present position in the right transept. Much praised in the past and admired by Grand Tourists and literary travellers, the statue is an essay in academic skill, indebted in many ways to Leonardo's anatomical drawings.

BIBLIOGRAPHY

G. Vasari: *Vite* (1550, rev. 2/1568); ed. G. Milanesi (1878–85), vi, p. 517

C. Baroni: 'Intorno a tre disegni milanesi per sculture cinquecentesche', *Riv. A.*, xx (1938), pp. 392–410

L. Price Amerson: 'Marco d'Agrate's *San Bartolomeo*: An Introduction to Some Problems', *Il Duomo di Milano: Atti del congresso internazionale* (Milan, 1969), i, pp. 189–206 [with bibliog. and crit. hist.]

M. T. Franco Fiorio and A. P. Valerio: 'La scultura a Milano tra il 1535 e il 1565: Alcuni problemi', *Omaggio a Tiziano: La cultura artistica milanese nell'età di Carlo V* (exh. cat., Milan, Pal. Reale, 1977), p. 126

MARIA TERESA FIORIO

Aimo [Amio; de Amis; de Jami; Lamia; da Varignana], **Domenico** [il Bologna; il Varignana; il Vecchio Bolognese] (*b* Varignana, *c.* 1460–70; *d* Bologna, 12 May 1539). Italian sculptor and architect. He was the son of Giovanni da Varignana and is mentioned in a contemporary poem as a pupil of Andrea Sansovino. According to Vasari, after the discovery in 1506 of the *Laokoon* (1st century AD; Rome, Vatican, Mus. Pio-Clementino), Aimo participated in a contest arranged by Bramante to make the best copy in wax of the ancient marble statue for later casting in bronze. His fellow competitors were Zaccaria Zacchi, Alonso Berruguete (1488–1561) and Jacopo Sansovino. Raphael, who had been appointed as judge, decided in favour of Sansovino.

A payment to Aimo of 21 January 1511 documents two sculptures for the lunette of the Porta Magna of S Petronio, Bologna: an archivolt relief depicting a half-length figure of *Moses*, and a statue of *St Ambrose*. The latter was commissioned to provide a symmetrical counterpart to Jacopo della Quercia's *St Petronius*, which is also in the lunette. St Ambrose's robe, held together by a clasp, is gathered up to hip level by the right hand; below this is rich drapery with numerous dish-shaped folds. The figure as a whole is stockier than della Quercia's and stands upright in contrast to the Gothic swing of *St Petronius*. The theory that the statue was constructed by della Quercia and merely reworked by Aimo is unacceptable. The figure of a *Sibyl*, in S Petronio, may also be by Aimo (Brugnoli).

In 1514 Aimo received a commission from the Roman senate to execute a statue of *Pope Leo X* in the Palazzo dei Conservatori, Rome. The statue (now Rome, S Maria in Aracoeli), resting on a plinth that bears three inscriptions, was installed in the Palazzo dei Conservatori in 1521. The Pope is shown seated, and his face is rendered realistically. The figure as a whole does not have an imposing effect, and even if this were intentional, Aimo's lack of artistic force can still be felt.

Probably in 1518 Aimo produced a design for the façade of S Petronio (Bologna, Mus. S Petronio, n. 1a; *see* BOLOGNA, §IV, 2), incorporating the existing plinth and the vertical divisions determined by the original architect. At portal level Aimo planned a row of niches, freeing the lower area for sculptures. Horizontal bands divide the façade above the portal. Large quantities of obtrusive plaques surmount the cusps over the whole area. Aimo's sculptural talents are revealed in the decoration of the gable ends and the wall sections, which end in tabernacles. The ornamentation of these sections is lavish: especially striking are the half-leaping, half-flying angels sounding trumpets on the abundant, foliated finials. In terms of architectonic detail, the central window complex and the corner sections are particularly striking. Altogether the design presents a mixture of styles and creates the impression of an oversized stage set. Owing only to conflicts within the building committee, the façade decoration was undertaken following Aimo's drawing and was completed to the present level by the end of the 1550s. Around 1520, Aimo undertook to execute a relief of the *Death of the Virgin* for the Santa Casa, Loreto Cathedral. He worked on the sculpture in Ancona from the end of 1523 until 5 August 1525. Aimo, Niccolò Tribolo and Francesco da Sangallo received payment on 31 December 1536 on completion of the work. In the meantime Aimo had again taken up residence in Bologna.

BIBLIOGRAPHY

DBI; Meissner

G. Vasari: *Vite* (1550, rev. 2/1568); ed. G. Milanesi (1878–85)

R. Bernheimer: 'Gothic Survival and Revival in Bologna', *A. Bull.*, xxxvi (1954), pp. 263–84

J. Pope-Hennessy: *Italian High Renaissance and Baroque Sculpture* (London, 1963, 2/1970)

J. H. Beck: 'A Document Regarding Domenico da Varignana', *Mitt. Ksthist. Inst. Florenz*, xi (1963–5), pp. 193–4

M. G. Ciardi Dupré: 'La scultura di Amico Aspertini', *Paragone*, xvi/189 (1965), pp. 3–25

A. M. Matteucci: *La porta magna di S Petronio* (Bologna, 1966)

H. H. Brummer and T. Janson: 'Art, Literature and Politics: An Episode in the Roman Renaissance', *Ksthist. Tidskr.*, xlv (1976), pp. 79–93

M. V. Brugnoli: 'Problemi di scultura cinquecentesca', *La basilica di San Petronio in Bologna*, 2 vols (Bologna, 1983), ii, pp. 103-16

ANDREW JOHN MARTIN

Alamanno, Pietro. *See* ALEMANNO, PIETRO.

Alari-Bonacolsi, Pier Jacopo di Antonio. *See* ANTICO.

Alba, Macrino d' [Alladio, Gian Giacomo d'] (*b* Alba; *fl* 1495–1515; *d* before 1528). Italian painter. Inscriptions on his altarpieces indicate he was born in Alba. He probably trained elsewhere; his early works, with the exception of the portrait of *Andrea Novelli, Bishop of Alba* (Isola Bella, Mus. Borromeo), cannot be traced to a precise location. His patrons were mainly from the Paleologo court at Casale Monferrato, where he was the official painter. His earliest signed and dated work is the triptych of the *Virgin Enthroned between SS John the Evangelist, James the Greater, John the Baptist and Thomas Aquinas and Two Donors* (1495; Turin, Mus. Civ. A. Ant.), and it and the *Virgin and Child between SS Nicholas and Martin* (Rome, Pin. Capitolina) show the influence of Lombard painters, particularly Ambrogio Bergognone; some writers have suggested that this may indicate a journey through central Italy, perhaps to Rome.

By 1496 Alba's *Virgin Enthroned between SS Hugh and Anselm* had been placed in the Certosa di Pavia (*in situ*). This painting, now incorporated in a polyptych of which the upper section (1488; destr.) was by Bergognone, contains the first appearance in his work of antique ruins, which later became so typical. In the same year Alba was at Asti working in the Certosa on frescoes (destr.). There in 1498 he completed the *Virgin in Glory between SS John, James the Greater, Hugo and Jerome* (Turin, Gal. Sabauda). His style in this period is dry and metallic, with strong, cold colours and a sense of abstraction. The face of the Virgin was used again in his triptych of the *Virgin and Child between SS Augustine and John the Baptist with a Donor* (1499; Tortona, Pal. Vescovile) for the abbey of Lucedio, commissioned by Annibale Paleologo, the natural son of Marchese Guglielmo Paleologo, and then repeated in the *Virgin and Child with SS Francis and Thomas and Two Female Donors* (1501; Alba, Pal. Com.).

Alba's style reached a high-point in the altarpiece of the *Virgin Enthroned between SS John the Baptist and James, a Bishop Saint and St Jerome* (1503; Casale Monferrato, Santuario Crea) commissioned by Giovanni Giacomo Biandrate of San Giorgio Monferrato. It is a sober and dignified composition, flooded with light and colour. Also in this period he executed the wings of the altarpiece of the *Virgin and Child* (Frankfurt am Main, Städel. Kstinst. & Städt. Gal.), depicting *St Joachim* and the *Meeting of SS Joachim and Anne.* These suggest a new influence from northern European art. He also executed numerous paintings of the *Nativity* (e.g. 1505; New York, NY Hist. Soc.; Kansas City, MO, Nelson–Atkins Mus. A.; signed and dated 150(?8), Alba, S Giovanni Battista). The polyptych with *SS Paul and Luigi* (Turin, Gal. Sabauda) dates from 1506. Late works, such as the *Mystic Marriage of St Catherine* (Neviglie, S Giorgio), are characterized by increased simplicity and elegance. His last known dated work is the *Virgin Enthroned* (21 Oct 1513; priv. col., see Romano, 1970, fig. 3). In 1515 Alba was replaced by Gian Francesco Caroto as court painter at Casale Monferrato. He died before 1528, the year he was commemorated by the Alban poet Paolo Cerrato (*c.* 1485–*c.* 1540) in *De Virginitate* (Paris, 1528).

BIBLIOGRAPHY

Thieme–Becker

A. M. Brizio: *La pittura in Piemonte dall'età romanica al cinquecento* (Turin, 1942), pp. 65–73, 237–42

G. O. Della Piana: *Macrino d'Alba* (Como, 1962)

B. Berenson: *Central and North Italian Schools*, i (1968), pp. 236–7

G. Romano: *Casalesi del cinquecento: L'avvento del manierismo in una città padana* (Turin, 1970), pp. 4–6

——: 'Schede Vesme', *L'arte in Piemonte*, iv (Turin, 1982), pp. 1450–67

RICCARDO PASSONI

Alberti (da Ferrara), Antonio (di Guido) (*b* ?Ferrara, ?1390s; *d* before 1449). Italian painter. His early career is hard to determine; Vasari improbably described him as a pupil of Agnolo Gaddi. He must have been well known in Ferrara before working for the condottiere Braccio Fortebraccio at Montone in Umbria, where he is documented in either 1420 or 1423. Frescoes at S Francesco in Montone depicting the *Life of St Francis* are almost certainly by him. In the same year he was in Urbino, where Vasari reported that he was working on frescoes (destr.) at S Francesco. The frescoes in the chapel of S Martino in S Maria, Carpi (the Sagra di Carpi; see fig.), are of a similar date. They show a style in which formal elements deriving from Serafino Serafini are put into a Late Gothic context, under the influence of work by Gentile da Fabriano seen in central Italy. Other work by Alberti from between 1419 and 1431 includes the triptych of the *Virgin and Child between SS Bartholomew and Benedict* (Città di Castello, Pin. Com.), on the basis of which the votive panel of *Pietro de' Lardi* (Paris, Trotti priv. col.) should probably be assigned to him; the fresco of scenes from the *Life of St Anthony* (Città di Castello, S Domenico) and the scenes from the *Life of St John the Evangelist* (Ferrara, Pin. N.) have also been assigned to his earlier phase (Longhi).

There are records of payments to Alberti in Urbino in 1435, 1437 and 1438. Some are probably connected to the frescoes in the Cella at Talamello signed *Antonio de Ferraria habitator Urbini Pixit* and dated 1437. On 10 July 1438 he was paid for a standard (Urbino, Pal. Ducale), which also contains a polyptych signed and dated 1439. A *St Agatha*, stylistically related to the polyptych, has been assigned to Alberti's later work, as have the *Virgin and Child with Four Saints, Crucifixion* and an *Annunciation* dated 1436 (all Urbino, Pal. Ducale). It has been suggested that he returned to Ferrara *c.* 1438 to paint frescoes of the *Council of Ferrara* (destr.) in the Palazzo del Paradiso for Niccolò III d'Este, but this would have been only a brief visit, as Alberti is documented in Urbino shortly thereafter and until 1442. Renewed contact with Emilian painting would help to account for a new robustness entering his Late Gothic manner in the later works, probably stemming from the rough and forceful rhythms of Giovanni da Modena and the Bolognese painters of the earlier 15th century.

BIBLIOGRAPHY

Bolaffi

R. Longhi: *Officina ferrarese* (Rome, 1934, rev. Florence, 1940, rev. 2/1955, rev. 3/1975)

F. Zeri: 'Arcangelo di Cola da Camerino: Due tempere', *Paragone*, i (1950), no. 7, pp. 33–8

M. T. Zanchi: 'Antonio Alberti da Ferrara e il suo itinerario umbromarchigiano', *Commentari*, n. s., xv/3–4 (1964), pp. 173–85

P. Zampetti: *La pittura marchigiana da Gentile a Raffaello* (Venice, 1969)

S. Padovani: 'Materiale per la storia della pittura ferrarese nel primo quattrocento', *Ant. Viva*, xiii/5 (1974), pp. 3–21

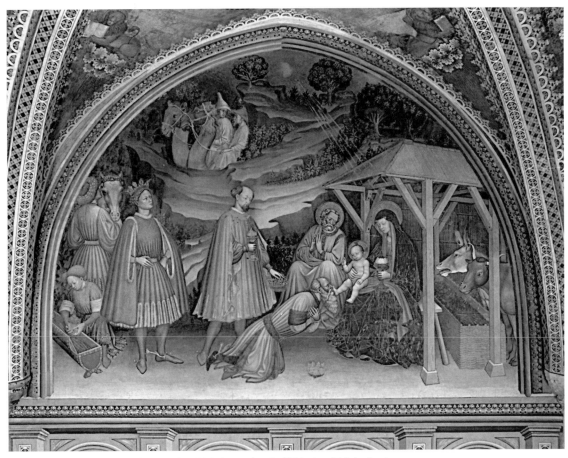

Antonio Alberti: *Adoration of the Magi* (early 1420s), fresco, chapel of S Martino, S Maria, Carpi

——: 'Nuove personalità della pittura emiliana nel primo quattrocento', *Paragone*, xxvii (1976), nos 317–19, pp. 40–59
——: 'La decorazione pittorica della cappella del Castello di Vignola', *Il tempo di Nicolò III: Gli affreschi del Castello di Vignola e la pittura tardogotica nei domini estensi* (exh. cat., Vignola, Rocca, 1988), pp. 61–77

MARIA CRISTINA CHIUSA

Alberti, Leon Battista (*b* Genoa, 14 Feb 1404; *d* Rome, April 1472). Italian architect, sculptor, painter, theorist and writer. The arts of painting, sculpture and architecture were, for Alberti, only three of an exceptionally broad range of interests, for he made his mark in fields as diverse as family ethics, philology and cryptography. It is for his contribution to the visual arts, however, that he is chiefly remembered. Alberti single-handedly established a theoretical foundation for the whole of Renaissance art with three revolutionary treatises, on painting, sculpture and architecture, which were the first works of their kind since Classical antiquity. Moreover, as a practitioner of the arts, he was no less innovative. In sculpture he seems to have been instrumental in popularizing, if not inventing, the portrait medal, but it was in architecture that he found his métier. Building on the achievements of his immediate predecessors, Filippo Brunelleschi and Michelozzo di Bartolomeo, he reinterpreted anew the architecture of antiquity and introduced compositional formulae that have remained central to classical design ever since.

I. Life and career. II. Theory. III. Works. IV. Influence and posthumous reputation.

I. Life and career.

1. CHILDHOOD AND EDUCATION, TO 1432. Alberti was the illegitimate second son of Lorenzo di Benedetto Alberti, a member of a prominent Florentine banking family. Although born in Genoa during a period of his family's exile from their native city, Alberti quickly removed with them to Venice and from there in 1416 to Padua, where he perhaps attended the school of Gasparino Barzizza. There he may have met other pupils who later became leading humanists and thinkers, including Vittorino da Feltre. From 1421 to 1428 Alberti studied canon law at Bologna University and was thus the only artist of the period to receive a university education and a thorough grounding in the classics. It was during this period that his illegitimacy dealt him a severe blow: soon after he had embarked on his university education, his father died and grasping relatives claimed his inheritance. Nevertheless, despite financial worries and illness, Alberti, in addition to pursuing his course of study, became particularly interested in geometry and mathematics, and he gave free rein to his emerging literary bent by writing a Latin comedy, *Philodoxeus* (1424). This work marked the start of his career as a prolific author that continued until the end of his life.

Nothing is known of his activities between 1428 and 1432, although unsupported claims have been made that he served as a secretary to Cardinal Albergati.

2. PAPAL SERVICE, 1432–64. In 1432, through Bishop Biagio Molin, he went to Rome and entered papal service as a secretary (*abbreviatore apostolico*) to Eugenius IV (*reg* 1431–47).

(i) *Career as a writer.* The security of his new job for the Pope enabled Alberti to pursue his researches, which resulted in a series of literary works beginning with his *Della famiglia* (*c.* 1433–4), a treatise on family ethics. Shortly afterwards his interests turned towards the visual arts. In 1434 Eugenius IV took refuge in Florence from republican rioting in Rome, and Alberti, as a member of the papal *curia*, followed him there. The ban exiling the Alberti family from Florence had been lifted in 1428, but this may well have been his first visit to his family's native city and his first full contact with the revolutionary renascence in the arts led by Brunelleschi, Donatello, Lorenzo Ghiberti and Masaccio. His enthusiasm for this movement and his acquaintance with three of these artists had an immediate impact and led him to produce in 1435 the first Renaissance treatise on the arts, *De pictura*, which was a truly theoretical analysis of its subject rather than a practitioner's handbook (*see* §II, 1 below); for the benefit of practising artists, he translated the work the following year from Latin into Italian. After moving with the papal court to Bologna later in 1436, Alberti went to Ferrara in January 1438 to attend the ultimately fruitless congress (transferred to Florence in 1439) convened to consider the reunification of the Roman and Orthodox churches; while there he forged a close friendship with Lionello d'Este, 13th Marchese of Ferrara, to whom he dedicated a treatise on horses (*De equo animante*). In 1441–2 he was invited by Lionello to judge a competition for an equestrian monument to *Niccolò III d'Este* (destr.). Alberti's involvement in this scheme has led to speculation that he designed the monument's surviving pedestal, which stands outside the Palazzo del Comune, and the campanile of the nearby cathedral (begun 1451), but there is no documentary foundation for such claims. He was, however, urged by Lionello to set about the study of Vitruvius with a view to publishing a work on architecture to set beside his earlier volume on painting.

In 1443, after nine years' residence in Florence and northern Italy, Eugenius IV returned with his court to Rome, where Alberti was based for the rest of his life. During the remaining years of the 1440s he seems to have written his monumental study of architecture, *De re aedificatoria* (brought to final completion in 1452; *see* §II, 3 below), his treatise on sculpture, *De statua* (*see* §II, 2 below), and also his *Descriptio urbis Romae*, in which he proposed a means of accurately surveying the city of Rome by using an instrument of his own design. It was in the same period that Alberti's practical skills as an archaeologist were sought by Cardinal Prospero Colonna in an unsuccessful attempt (1446) to raise a Roman ship from the bed of the Lago di Nemi, a project that led Alberti to compose a treatise on the ships of antiquity (*Navis*). At the end of the decade he may even have played an active

part, perhaps as an architectural adviser, in the vigorous programme of urban renewal for Rome that was conceived by Pope Nicholas V as the manifestation of a revitalized papacy.

(ii) *Career as an architect.* In the early 1450s Alberti became a practising architect (*see* §III below). The constraints of his employment at the Vatican, however, meant that, unlike other architects, he could never supervise construction; he consequently conducted operations from afar and sent designs and instructions by post to local executants, including Matteo de' Pasti and Luca Fancelli. Alberti's first major commission was the renovation (*c.* 1450) of S Francesco in Rimini for Sigismondo Pandolfo Malatesta, Lord of Rimini. He subsequently began to act as architect for the Florentine banker Giovanni Rucellai, who was most likely a personal friend, providing him with designs for a façade (begun *c.* 1453) to his new palace in Florence, for the façade (*c.* 1458) of S Maria Novella, the city's principal Dominican church, and for a funerary chapel (*c.* 1458) in S Pancrazio. Alberti may also have designed the new apse of the Florentine priory church of S Martino a Gangalandi at Lastra a Signa. In this case he himself seems to have been the patron, since the apse bears the family arms and he had been granted the benefice in 1432. No date for the structure is known, but even though it is mentioned as being unfinished in Alberti's will, it would appear for stylistic reasons to be an early work.

The late 1450s and early 1460s was a particularly busy time for Alberti in his capacity as an architect. In 1459 he accompanied the papal court to Mantua, where the recently elected pope, Pius II, was staging a congress to promote a crusade against Ottoman expansionism. While there, Alberti produced several designs for their host, Ludovico II Gonzaga, 2nd Marchese of Mantua, whose father, Gianfrancesco Gonzaga, had been the dedicatee of the revised Latin version of Alberti's treatise on painting; one design was for the votive church of S Sebastiano and another was for the redevelopment of the Piazza dell'Erbe and the nearby Romanesque rotunda of S Lorenzo (unexecuted). There is no documentary evidence that Alberti ever worked for Pius II as an architect, although he seems to have been valued highly by the Pope, who, in his *Commentarii* (1462), recorded walking around the aqueducts of Rome in his company. Yet it is conceivable that he acted for him as an architectural adviser, especially as many of the buidings erected by Pius display Albertian features, most of all his palace in Pienza, the Palazzo Piccolomini by Bernardo Rossellino, which is closely modelled on the Palazzo Rucelli in Florence.

3. POST-PAPAL CAREER, FROM 1464. Following Pius' death (1464), Alberti's career as papal secretary came to an abrupt end when the new pope, Paul II, disbanded the college of *abbreviatori apostolici*. With less reason to be tied to Rome, Alberti was increasingly drawn towards other artistic centres. He became closely associated with the intellectual circle in Florence centred around the young Lorenzo de' Medici, to whom he dedicated his treatise on oratory, *Trivia* (1460s), and he may have played a direct part in the reformulation of architectural ideas in Florence at around this time. Lorenzo certainly maintained his

acquaintance with Alberti and was guided around Rome's antiquities by him on a visit to the city in 1471. Moreover, a design for a villa sent in 1474 by Bernardo Rucellai (Giovanni Rucellai's son and a friend of Alberti's) to Lorenzo, his brother-in-law, who was then planning his own villa at Poggio a Caiano, may very possibly have been one prepared earlier by Alberti himself.

Alberti was also in the custom of spending some time each year with his friend Federigo II da Montefeltro, Count (later Duke) of Urbino and himself an enlightened patron of the arts and expert in matters architectural. These visits occurred at precisely the time that Federigo was rebuilding the Palazzo Ducale at Urbino to designs prepared by Luciano Laurana, about which Alberti was presumably consulted at some considerable length. A drawing by Alberti for a bath complex (Florence, Bib. Medicea–Laurenziana, Cod. Ash. 1828 App., fols 56*v*–57*r*; *see* ARCHITECTURAL DRAWING, fig. 1) may have been one of his own proposals for the palace. Alberti's last works were commissioned by Ludovico Gonzaga, for whom in 1470 he set about the completion of SS Annunziata in Florence, a building begun by Michelozzo in 1444 (*see* FLORENCE, §IV, 3); also in 1470 Alberti sent Ludovico designs for his masterpiece, S Andrea in Mantua. Little of S Andrea had been realized at the time of his death; indeed none of his major projects had been completed.

Alberti's insatiable passion for knowledge, which embraced not only the visual arts but also ethics, mathematics, philology and even cryptography, is epitomized by his *impresa* (see fig. 1): an eye carried on speeding wings alludes to his perceptiveness; its shape with flaming corners, perhaps based on Jupiter's thunderbolt, refers to his incisiveness; the surrounding laurel suggests his confidence in success; and the accompanying motto, '*quid tum*' (what next?), points to a willingness to embrace new fields of endeavour and indicates that the modern understanding of Alberti as a 'universal man' is essentially one he cultivated himself.

II. Theory.

1. *De pictura*. 2. *De Statua*. 3. *De re aedificatoria*.

1. 'DE PICTURA'. Alberti was inspired to write his treatise on painting, *De pictura*, soon after he arrived in Florence (*c.* 1434), where he encountered for the first time and with evident enthusiasm the recent innovations in the visual arts. The original Latin text was written in 1435, and it was soon followed by an Italian version (*Della pittura*), produced before July of the following year and dedicated to Brunelleschi, who had presumably become a personal acquaintance. Alberti's aim in writing the treatise was to give the art of painting, the 'mistress' of the three visual arts, a theoretical model based on antique precept and precedent. Indeed, *De pictura* was the first truly theoretical work on the visual arts, and Alberti was quite clear about its importance when he declared that he was 'the first to write about this most subtle art' (Bk III). The truth of this remarkable claim is borne out when the work is compared with previous treatments of the subject. First, the treatise is quite different in conception from antique accounts of painting, as Alberti himself emphasized when remarking that he was 'not writing a history of painting like Pliny [the elder] but treating art in an entirely new way' (Bk II). Alberti's was a work of theory, not history, even though many of the principles he elicited and all the examples on which he drew, except for a lone reference to Giotto, were derived from Pliny the elder's *Natural History* and other ancient sources. Second, the treatise marks an abrupt departure from more recent treatments of the subject, such as Cennino Cennini's early 15th-century handbook on painting, *Il libro dell'arte*, a departure that in its intention could not have been much greater. Cennini's book deals with the practicalities of the artist's profession, providing such sundry information as how to prepare panels for tempera painting, or how to mix the *intonaco* for fresco, and it is based on the implicit notion that the painter is a craftsman. Alberti's treatise, on the other hand, presents a

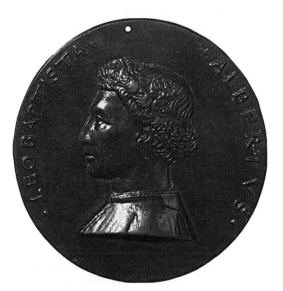
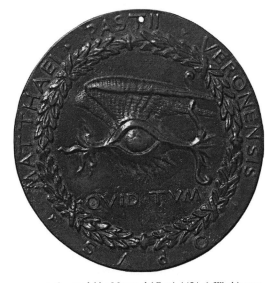

1. *Leon Battista Alberti* and his *impresa*; obverse and reverse of a bronze commemorative medal by Matteo de' Pasti, 1454–6 (Washington, DC, National Gallery of Art)

coherent analysis of the forms and aims of painting, and its underlying argument is founded on the new or renewed conviction that the art of painting is primarily the product of the intellect.

In the first of the three books of *De pictura*, Alberti set out a scientifically accurate method for the illusionistic representation of three-dimensional objects on a two-dimensional surface, the method now usually known as one-point linear perspective. Although Brunelleschi has been accredited with the original formulation of the method, or one very much like it, and although Masaccio followed a similar procedure in his *Trinity* fresco (*c.* 1425–7; Florence, S Maria Novella; see colour pl. 2, III1), Alberti's analysis is the first as well as one of the fullest and clearest written expositions of the subject. The stated aim of his account is to construct an image that would resemble a 'view through a window', the 'view' corresponding with the pictorial image and the 'window' to the picture surface. Alberti conceived his method in terms of lines of sight (later known collectively as the 'visual pyramid') that radiate from the eye of the artist, linking it with the various objects in the 'view', and which, when intersected by the plane of the 'window', produce the pictorial composition. The illusion of the 'view through a window' described by Alberti is achieved by making all orthogonal lines in the image (i.e. all those at right angles to the picture plane) converge at a single point on the horizon (later known as the 'vanishing point'), and hence the name 'one-point' perspective. Alberti's method also enables the artist to establish with precision the relative sizes of objects in the picture, however close or far they may be from the position of the viewer. Alberti gave as an example the problem of how to create an illusion of a chequerboard floor so that the gradual diminution of the tiles is believable. The key difficulty resides in how to establish the precise position of the horizontals as the floor recedes into the distance. To do so, the artist must mark their position on the 'window' while keeping his eye at a constant distance from it. As Alberti himself recognized, the effectiveness of the perspective illusion depends to a great extent on the picture being seen from a single, ideal viewing point at exactly the same distance and height as the artist was in relation to the supposed 'window'. Indeed, it was the concept of the chequerboard floor as a means of creating space as much as the method itself that influenced subsequent artists.

In the second book, Alberti dealt primarily with what later became known in Florentine art theory as 'design' (*disegno*), a concept that embraces both drawing outlines and pictorial composition. He began by dividing painting itself conceptually into three constituent elements: *circumscriptio*, *compositio* and *receptio luminum*. The first of these, *circumscriptio*, refers to the definition of all objects, or parts of objects, by means of very fine outlines, in supposed imitation of the Greek painter Apelles. The second element, *compositio*, is broader in meaning than the modern term 'composition', which usually refers to the disposition of the principal elements within an image. Alberti's term refers instead to a more elaborate notion of *compositio* borrowed directly from rhetoric; it embraces a four-tier hierarchy in which 'parts of the *historia* [i.e. the subject-matter] are bodies, a part of the body is a member, and a

part of a member is a surface', a system in which the whole of the image is thus related to what are conceived as its smallest delineated constituents. The third element, *receptio luminum*, concerns the supplementary applications of tone and hue to the delineated image, of which the former is regarded as demanding from the artist much the greater skill and is consequently the more important.

Alberti particularly censured the customary use of gold leaf as opposed to the skilful imitation of the appearance of gold achieved through tone and hue. He then examined at length the notion of the *historia*, which for him was the highest form that the art of the painter could take. Although the term can be broadly understood as meaning 'narrative painting', it is not used to mean only the depiction of stories, since it also encompasses purely allegorical imagery. Crucial to an understanding of Alberti's concept of the *historia* are his attitudes towards decorum and variety, which ultimately proved to be enormously influential. Alberti conceived of such paintings primarily as idealized figure compositions that are limited, for the sake of clarity, to around ten appropriately conceived individuals who, through their actions, gestures and expressions, contribute as fully as possible to the meaning of the work while at the same time, for the sake of interest, being differentiated from one another as much as possible (for further discussion *see* ISTORIA).

In the third and final book, Alberti dealt primarily with the education of the artist. He placed an unprecedented emphasis on the artist's innate character and broader learning, stating that he should be 'a good man, well versed in the liberal arts' and arguing that only by being equipped in this way would he be able to fulfil his potential and achieve fame. Such a view underlies Alberti's primary objective of raising the status of the artist to that of an intellectual, an objective that was further supported by his reference to ancient custom, when painting was not considered merely a craft and 'was given the highest honour by our ancestors'.

Alberti enjoined artists to imitate nature. For example he stressed the value of practice through drawing, an exercise that, so as not to foster bad habits, should be conducted whenever possible directly from nature or, failing this, from sculpture, but never from the paintings of other artists. For Alberti, however, copying from nature would not by itself result in beauty, a quality he regarded as essential to art. Nature had to be improved if beauty was to be attained. In support of this principle he cited the example of Demetrios, who failed to obtain the highest praise because he was devoted more to likeness than to beauty. The method Alberti advocated was that of Zeuxis, who created an idealized image of Helen of Troy by selecting the most perfect features of several models and combining them, a composite procedure modelled on Aristotle's notion of the ideal. A basic ingredient of beauty for Alberti was decorum: for example when devising compositions, beauty could be attained only if measure and harmony were observed and when the 'members' of figures accorded with one another in size, function, kind and colour.

Alberti's treatise, although responding to recent developments in the visual arts such as those in the work of Masaccio, in effect amounted to a manifesto by offering

painters a new and compelling vision of their art. This vision, founded on references to painting in ancient texts, suggested alternatives not only for the treatment of form in a picture but also for its possible subject-matter. Indeed, the Italian version of Alberti's treatise, with its detailed accounts of such long-lost masterpieces as Apelles' *Calumny*, became a prime source of information for painters who could not read the Latin or Greek of the original ancient texts. In this respect, therefore, Alberti succeeded in laying the foundations for the mythological and allegorical genres that were soon afterwards revived.

2. 'DE STATUA'. The later and much shorter treatise on sculpture, *De statua*, is of much narrower scope than that on painting, although it is again highly innovative. Alberti's aim here was not to present a full and methodical examination of the art, which would have duplicated much of what he had already written about painting, but instead to outline a technical method for designing a statue that might potentially be realized at any scale from the less than life-size to the colossal.

The discussion hinges on two main concepts, that of *dimensio*, which concerns the main dimensions and proportions of the ideal human figure, and that of *finitio*, which concerns the disposition of the ideal figure in a particular pose. Under *dimensio* Alberti described an apparatus of his own invention with which to measure the component parts of the body, consisting of a vertical rod and a device for gauging widths. Reaffirming that beauty is dependent on proportion, he then supplied a detailed list of the measurements based on his own researches for an ideal man, which, presumably inspired by the lost 'canon' of Polykleitos, was the earliest such list of the Renaissance. Under *finitio* Alberti also described another apparatus of his own invention, a *finitorium*, with a rotating arm and plumb line, which enabled the relative position of key points on the surface of any figure or statue to be recorded. As he observed, the *finitorium* made it possible to cut into a solid substance by a precise amount and consequently to replicate a particular pose in stone, a process thereby anticipating that of 'pointing' employed in subsequent times by such sculptors as Canova (1757–1852).

3. 'DE RE AEDIFICATORIA'. By far the most extensive of Alberti's three works on the visual arts, this treatise was the first comprehensive treatment of architecture of the Renaissance and the first fully to address Classical architecture since Vitruvius' *On Architecture*, the sole surviving architectural treatise from antiquity. Although *De re aedificatoria* was the last of Alberti's three works to be completed, he may have been considering it as early as the 1430s. In its final form, it must certainly postdate 1445, as it mentions Filarete's doors of St Peter's, Rome, which were unveiled in that year; it was presumably completed by 1452 when, according to the diary (Florence; Bib. N. Cent. and Bib. Medicea–Laurenziana) of Mattia Palmieri (1406–75), it was presented to Pope Nicholas V. On its eventual publication in 1485, it was in fact the very first book on architecture to leave the printing presses, anticipating the publication of Vitruvius' text by a year.

In its conception Alberti's treatise is in many respects modelled on that of Vitruvius. Both are written in Latin, both are divided into ten books and both cover much the same material, including even the discussion of such ancient building types as amphitheatres, which by Alberti's day were of academic interest only. Indeed, Alberti may originally have set out to produce a critical edition of Vitruvius' work, but through increasing dissatisfaction with the obscurities of the text he may have felt forced to abandon this idea and to compose an alternative treatise instead. Criticisms of Vitruvius appear throughout the work, most explicitly at the beginning of Book VI, where Alberti commented that Vitruvius' language was such 'that the Latins might think that he wanted to appear a Greek, while the Greeks would think that he babbled Latin', adding that 'his very text is evidence that he wrote neither Latin nor Greek, so that as far as we are concerned he might just as well not have written at all since we cannot understand him'. By contrast, Alberti declared his own intention of writing 'in proper Latin and in comprehensible form'. For this reason, he deliberately avoided almost all Greek terminology, so that, for example, when referring to a temple with a frontal portico, he abandoned Vitruvius' Greek-derived term 'prostyle' in favour of the more literal and Latin '*porticus pro fronte*'. The same approach was even embodied in his actual title for the work *De re aedificatoria*, which is little other than a pointed latinization of Vitruvius' (*De architectura*).

Alberti also set out to give his work a much more systematic and coherent structure than Vitruvius had done. Although basing his discussion on the Vitruvian concepts of strength, utility and beauty, unlike Vitruvius he used the same concepts as the basis for organizing the work, devoting the first half (Bks I–V) to the practical considerations of strength and utility and Bks VI–IX of the second half to the aesthetic considerations of beauty. In its scope the treatise is comprehensive, combining a discussion of sometimes recondite literary and archaeological material with sound practical advice of value to a contemporary builder. In the first half of the treatise, following a discussion of basic definitions and concepts, including that of architectural drawing (Bk II), Alberti ran through the various building materials (II) and discussed matters of construction (III) before considering the form and disposition of the city and its public buildings (IV) and analysing the arrangements of private dwellings (V), including villas (*see* VILLA, §3). In the second half of the treatise Alberti introduced the concept of beauty in architecture (VI) before examining its applicability to religious buildings (VII), to public buildings (VIII) and to domestic buildings (IX). He concluded with some discussion of faults and abuses in architecture, appending miscellaneous information about such matters as restoration and water supply (X).

In his quest to make better sense of Classical architecture, Alberti adopted many of the typical methods of humanist scholarship. Sometimes he resorted to etymology as a means of elucidating Vitruvian terminology; for example, he interpreted the term 'amphitheatre' to mean two theatres joined together as one, on the basis that *amphi-* can mean 'both' or 'around'. More frequently he adopted the philological method of comparing the infor-

mation given by Vitruvius with examples drawn from his own observations of ancient buildings. In some instances he was even prepared to discount Vitruvius where archaeological confirmation was lacking, as in the notable case of his discussion of the Ionic base. Being unable to find a base with precisely the same sequence of mouldings specified by Vitruvius (*On Architecture* III.v.3; from bottom upwards: plinth, scotia, astragal, astragal, scotia, torus), he described instead the one used for the Corinthian columns of the portico of the Pantheon (from bottom upwards: plinth, torus, scotia, astragal, astragal, scotia, torus).

Alberti's readiness to amend Vitruvius' treatment of a subject is also evident in his discussion of the orders. Unlike Vitruvius, he conceived of them as a hierarchy in which the various kinds of column are differentiated from one another much more systematically. Moreover, he made a further significant departure from Vitruvius with his observation that ancient Roman architects had commonly used a type of capital not mentioned by Vitruvius at all, a type Alberti termed 'Italic', thus conceiving it as a specifically Roman rather than Greek variety; this later became known as Composite. By adding a fifth specific column type to those mentioned by Vitruvius (i.e. Tuscan, Doric, Ionic and Corinthian), Alberti played an important role in the eventual formulation of the canon of five orders that was to remain at the very heart of subsequent theory.

In *De re aedificatoria* Alberti set out a conception of beauty much more fully than in his earlier treatises, and with customary clarity of thought he developed a consistent and cogent theory. His central premise is that beauty in architecture can be achieved only if the design is founded in nature, or in other words on natural laws and universal principles. This view accords with the Platonic notion that beauty is intrinsic to an object and does not depend on individual taste, the latter being an attitude that Alberti explicitly condemned when he declared (VI.ii): 'Some . . . maintain that beauty . . . is judged by variable criteria, and that the forms of buildings should vary according to individual taste and must not be bound by any rules of art. This is a common fault among the ignorant, to deny the existence of anything they do not understand.'

On the other hand, Alberti also took account of the Aristotelian notion that beauty is in part dependent on fitness of purpose. For this reason he linked beauty itself inextricably with the two other elements of the Vitruvian triad, strength and utility, on the grounds that 'they have such a mutual agreement with one another that, where any one of them is wanting, the others also lose their commendation' (VII.i). As an example, he cited how beauty might contribute to strength (VII.ii): 'The Ancients, especially the Etruscans, preferred to use vast, squared stone for their walls. . . . I approve of this form of construction very much: it has a certain air of antique severity, which is an ornament to the city. This is how I would build the city walls, that the enemy might be terrified by their appearance and retreat, his confidence destroyed.' For Alberti, fitness of purpose or decorum had moral overtones not evident in Vitruvius' interpretation of the concept. His text frequently includes such comments as: 'we decorate our property as much to distinguish family and country as for any personal display (and who would deny this to be the

responsibility of a good citizen?)' (IX.i). This moralizing notion of decorum probably derives from Cicero's *De officiis*.

In his analysis of how beauty can be attained in architecture, Alberti subdivided beauty into a number of constituent elements, chief among which is *concinnitas* (harmony). The term *concinnitas* is the precise equivalent of the Vitruvian term *symmetria* and concerns the harmonious proportional relationship between a building's constituent parts: beauty thus arises when there is a '*concinnitas* of all the parts such that nothing can be added or taken away except for the worse' (VI.ii). It was defined by Alberti as the product of the correct application, according to natural principle, of *numerus* (number), *finitio* (dimensional proportion) and *collocatio* (placement). In designs for buildings, *numerus* and *collocatio* should follow natural principle, for example by adopting an even number of supporting members like humans and animals and by arranging them in accordance with such principles as symmetry. *Finitio* is described as a 'certain correspondence between the lines that define the dimensions, one dimension being length, another width and the third height'; in concerning the disposition of proportionate dimensions, it is thus a development of the similar concept he had previously employed in *De statua*.

Through this idea of *concinnitas* as the harmonious composition of proportionally related parts, Alberti conceived beauty as residing not so much in the physical fabric of a structure but in the metaphysical disposition of its design. In this sense, his conception of beauty in architecture mirrors precisely his earlier conception of beauty in painting, where it was considered to reside in the *disegno* rather than in the materials. Even though he commended material richness and variety, he thus firmly rejected the medieval notion that allied beauty in architecture with its material worth.

Alberti also made a critical distinction between a building's intrinsic beauty and its 'ornament', which he defined as an 'auxiliary brightness and complement to beauty'. As used by Alberti, the term 'ornament' has a much broader meaning than the modern one of applied decoration; although it embraces the latter, it refers rather to a component of any larger entity. Thus while a console may indeed be an 'ornament' to a window, or a capital an 'ornament' to a column, by the same token a watchtower may be an 'ornament' to a road and a building or even a park an 'ornament' to a city. The mistaken interpretation of this term to mean only 'applied decoration' has given rise to the false impression that the treatise is in certain passages inconsistent, particularly in its conception of the column. Having first established that a row of columns 'is nothing else but a wall open and discontinued in several places' (I.x), and hence that a column is a structural element, he later referred to the column as 'the principal ornament of architecture' (VI.xiii). In Alberti's terms the two passages are not contradictory, since 'ornament' can refer to both supporting members and elements of applied decoration. A further key distinction between 'beauty' and 'ornament' in Alberti's theory is that beauty lies in the building's design, whereas ornament lies in the building's fabric.

III. Works.

1. Painting and sculpture. 2. Architecture.

1. PAINTING AND SCULPTURE. Not only did Alberti write about painting and sculpture, but he also apparently practised both arts, at least to a limited extent. He is recorded in the 15th century as having produced a number of portraits, some painted and others modelled in wax (*Vita di Leon Battista Alberti*, ed. A. Bonucci), and he is credited by Vasari with several other works of painting, including a small triptych with perspectives and a 'picture of Venice in perspective'. A number of surviving works of sculpture are also commonly attributed to Alberti. These include two bronze portrait medals (Paris, Louvre; Washington, DC, N.G.A.) with depictions of Alberti himself (the Washington example bearing the inscription L.BAP). Since they appear to represent a man in his early thirties, they have been assigned to the mid- to late 1430s and so may well precede the earliest portrait medal by Pisanello, that of *John VIII Palaeologus, Emperor of Byzantium* (1439–40; *see* PISANELLO, fig. 4). Even if they do not, they are still very early examples of their type and consequently hold an important position in the emergence of a new genre. Unlike Pisanello's medals, which are circular and two-sided, Alberti's are oval and one-sided and are thus conceived more as plaquettes than as medals. Other sculptures in bronze that are attributed to Alberti include a bust of *Ludovico Gonzaga* (*c.* 1460; versions Berlin, Skulpgal.; Paris, Mus. Jacquemart-André). The naturalistic style of all these works, with their controlled roughness and rawness of surface, suggests a considerable debt to Donatello.

2. ARCHITECTURE. Although it is not clear precisely when Alberti made the transition from architectural theorist to practitioner, it presumably began while he was writing *De re aedificatoria* in the late 1440s. He certainly refers to himself in the treatise as, for example, having 'not inconsiderable experience' in the construction of roofs (II.i), which may suggest that he had acquired practical expertise by this time, although he still could have gained his 'experience' as an interested observer rather than as a working architect, for example on Nicholas V's projects for Rome. All that can be said for sure is that he was sufficiently equipped in the skills of his profession by the mid-point of the century and the time of his first certain design, S Francesco in Rimini (see below).

(i) Rome and Rimini. (ii) Florence. (iii) Mantua. (iv) Sources and development.

(i) Rome and Rimini. The building programme inaugurated in Rome by Pope Nicholas V in the late 1440s included the partial reconstruction of St Peter's, which was at least supervised by Bernardo Rossellino; the redevelopment of the Vatican Palace; the fortification and replanning of the surrounding district, the Borgo, together with the refurbishment of the nearby Ponte Sant' Angelo; and other works throughout the city. While Alberti is often considered to have played a central role in this programme, it is difficult to establish the nature of his contribution or indeed to substantiate these claims at all. There is no mention of his involvement in any early account of

Nicholas V's improvements, and Alberti makes no mention of his involvement himself in *De re aedificatoria*, where, for example in his several references to St Peter's, he would have had ample opportunity to do so. The only written evidence specifically linking Alberti with any of these schemes is a comment by Vasari, who claims to have had in his possession a drawing by Alberti of a colonnade for the Ponte Sant' Angelo. This evidence is very unreliable, however: it was written a century after the event, and it is based on an attribution by a man whose connoisseurship of 15th-century drawings has proved to be notoriously untrustworthy. Persuasive evidence suggesting that Alberti had little to do directly with these schemes is provided by a contemporaneous note in Mattia Palmieri's diary, which records that Alberti actually advised the Pope to halt the work on St Peter's. Nevertheless Alberti may still have been involved in some indirect way, perhaps as a general adviser, as Vasari claims.

The radical *all'antica* classicism espoused in *De re aedificatoria* has much more in common with some of these schemes than it does with mid-15th-century architecture in Florence. It underlies, for example, the new transept of St Peter's, which was closely modelled on the Basilica of Maxentius, and the stonework design of the Vatican Tower of Nicholas V, which is derived from that of the Round Temple by the Tiber. The same ethos underlies a number of other projects from this time or a little later, such as the courtyard of the Palazzo Venezia, the façade of S Marco and the Benediction Loggia (destr.) commissioned by Pius II for St Peter's; the latter, with arches supported not on columns but on piers in the manner of the Colosseum, accorded with one of the key principles in Alberti's treatise (VII.xv).

Alberti's first certain work as an architect was the external casing of S Francesco in Rimini, more commonly known as the Tempio Malatestiano (*see* RIMINI, §1(i); *see also* MALATESTA, (1)). It was designed for Sigismondo Malatesta in 1450, the date recorded on the façade and on the commemorative foundation medal, or perhaps a little earlier. Sigismondo had already begun (1447) to refashion the interior of the 14th-century building, founding new chapels there for himself and his mistress (later his wife), Isotta degli Atti. Alberti, who can have played no part in devising the internal decoration, with its Classical detailing uncertainly superimposed on Gothic forms, was responsible for encasing the building in a virtually free-standing white limestone shell of resolutely Classical design, and he also proposed the addition of a vast domed rotunda to the east end (unexecuted). The effect of his scheme was to transform the building from a Franciscan church that happened to house Malatesta tombs into a Malatesta monument that commemorated not just members of the immediate family but the whole court. The tombs of Sigismondo and Isotta were apparently in the first instance to be located on the façade (ultimately erected inside the church), while those of the *letterati* who made up the court were to be accommodated in a less prestigious location along the sides, as indeed many eventually were. Construction, supervised by Matteo de' Pasti, who also designed the foundation medal (1450), seems to have begun around 1453, the stone in part being pilfered from Early Christian churches in Ravenna, most notably S Apollinare in Classe.

The work ground to a halt in 1461 when Sigismondo fell from power, leaving the upper façade and much of the north side incomplete.

By the conventions of the period, the façade of the Tempio Malatestiano is innovative and highly uncompromising. Its design, known from the foundation medal (*see* RIMINI, figs 1 and 3), holds an important position in Renaissance architecture, as it is the first attempt, partially realized, to apply Classical architecture to the standard medieval format produced by a tall nave and lower aisles or (as in this case) side chapels. It is composed in a two-tier arrangement, with a one-bay upper storey linked to a three-bay lower storey by flanking quadrants (replaced in 1454 by triangular elements) and intended to be crowned by a richly embellished semicircular cornice. In its curvilinear silhouette the façade has no parallel in either Florence or Rome and in this respect is sometimes regarded as an innovation. However, medieval façades of similar shape are in fact relatively common in North Italy, where Alberti had spent his youth, with examples in Mantua (cathedral; refaced), Milan (cathedral; refaced) and especially in Venice (S Aponal and the Frari). In the precise arrangement of the lower storey, with arches on piers, applied half-columns and roundels in the spandrels, the design is directly dependent on the nearby ancient Arch of Augustus, thus establishing a parallel between antiquity in Rimini and its revival there under Sigismondo. Its triumphal associations are presumably deliberate and would refer both to the Christian idea of life triumphant over death and to the Classical idea of fame triumphant over oblivion. The arcaded system of the façade is continued along the sides of the building, although without the half-column articulation. This difference establishes an appropriate architectural distinction between façade and side elevation, which, given the probable arrangement of the sarcophagi, matches neatly the social distinction between Sigismondo and his courtiers.

Alberti's ideas for the completion of the building are known only in outline. The frontal part of the church, according to a letter of his of 1454, would have been vaulted in wood, an idea probably again inspired by ecclesiastical architecture in northern Italy, and particularly that of the Veneto region. The domed rotunda intended for the east end was presumably inspired, like Michelozzo's for SS Annunziata in Florence, by such ancient prototypes as the Mausoleum of St Helena, which is joined to the rear of the church of SS Pietro e Marcellino outside Rome. Its diameter, as indicated by the image on the foundation medal—which presumably follows the orthogonal method of representation Alberti recommended in *De re aedificatoria* and may even be based on a drawing by Alberti himself—would have been the same as the façade's. Its height, as again indicated by the medal, would have been only a little more than the diameter, presumably on the model of the Pantheon, a building Alberti specifically cited in his 1454 letter when objecting to the taller proportions for domes preferred by his Florentine contemporary Antonio di Ciaccheri Manetti.

(ii) Florence. Alberti's works in Florence for Giovanni Rucellai are all likely to postdate his design for the Tempio Malatestiano. Rucellai, a wealthy banker closely allied to

the anti-Medicean faction led by the Strozzi family, initiated four major projects in the city: a new palace, a free-standing loggia opposite, a funerary chapel in the nearby church of S Pancrazio and a façade for S Maria Novella, the principal church in his quarter of the city. Alberti's involvement, which is not documented, must have resulted from his presumed personal friendship with Rucellai (who certainly owned one of Alberti's self-portrait medals), a friendship that was subsequently continued with his son Bernardo Rucellai. Alberti was probably responsible not for all the works, as Vasari claims, but for the façade of the Palazzo Rucellai, the funerary chapel in S Pancrazio and the scheme for S Maria Novella, the designs that accord best with Alberti's approach and with the ideas propounded in *De re aedificatoria*.

(a) Palazzo Rucellai. The earliest of the designs, the innovative façade of the Palazzo Rucellai, was probably begun around 1453 under the supervision of Bernardo Rossellino. As was customary in Florentine practice, the façade was grafted on to a number of pre-existing houses. It is three storeys high and was constructed out of the local *pietra forte* sandstone. The design was originally conceived with five bays, soon afterwards extended to eight bays when the palace was enlarged, the final bay remaining uncompleted. The key innovation of the Palazzo Rucellai façade lies in the application to the three storeys of superimposed orders of pilasters (see fig. 2). Although Brunelleschi had used pilasters for the façade of the Palazzo di Parte Guelfa (begun 1420s) and the Ospedale

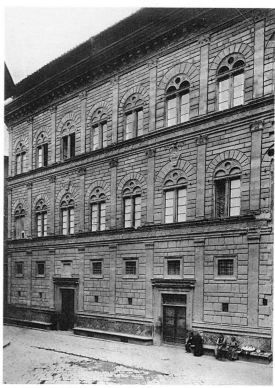

2. Leon Battista Alberti: façade of the Palazzo Rucellai, Florence, begun *c.* 1453

degli Innocenti (begun 1419), Florence, where superimposed orders may originally have been intended, he did so simply to frame the design rather than to articulate it as a grid. Alberti may have had in mind the elevations of the Colosseum or the Theatre of Marcellus, Rome, which are articulated with superimposed orders of half-columns, but he may have also been aware of such ancient domestic buildings as the Praetorium at Hadrian's Villa in Tivoli or, most notably, the Roman villa at Anguillara, which have façades articulated with pilasters.

Alberti's grid of pilasters imposes on the design a more rigorous organization than had been customary in Florentine palaces of the period. Unlike earlier buildings, such as Michelozzo's Palazzo Medici (begun 1444; for illustration *see* PALAZZO), where there are large arches on the ground storey that do not correspond with the window openings above, the ground-floor openings of the Palazzo Rucellai are precisely aligned with the windows above. The only departure from the regularity of the grid is in the slightly greater width given to the two portal bays, a variation sanctioned by Vitruvius in his discussion of temples and by ancient temples themselves. In the choice of order used for each of the three storeys, Alberti was guided by customary differences in their relative status, although he did not follow the sequence used in the Roman buildings: for the lower storey of the Palazzo Rucellai, used primarily for storage, the pilasters are of a plain Doric type; for the *piano nobile*, the principal floor, they are of a lavish Corinthian type; and for the top storey, the subsidiary living floor, they are of a rather less lavish Corinthian type. The greater height of the lower storey, which little befits its lowly status, is ingeniously concealed by raising the Doric pilasters on pedestals.

The detailing of the façade is typically resourceful. The most innovative of the three types of pilaster is the Doric, the capital of which has a fluted neck with an echinus of egg-and-dart. Although in design not unlike the colonnettes of Donatello's Cantoria (1433–9; Florence, Mus. Opera Duomo), it is the first such appearance of the order in the Renaissance. The Corinthian type used for the *piano nobile*, the capitals of which are embellished with both acanthus and egg-and-dart, is similar to that once decorating the base of the Mausoleum of Hadrian. Further allusions to Classical antiquity are provided by the square-topped portals in place of the arched entrance traditional for Florentine palaces, their design closely following Vitruvius' description of an Ionic doorway, and by the imitation *opus reticulatum* that decorates the pedestal level of the lower storey. Despite its novelty, the façade is in many respects dependent on local Florentine example. Several features have precedents in the Palazzo Medici, such as the continuous bench and the large crowning cornice, and the way in which the three storeys are successively of diminishing height. Even the ashlar work of the Palazzo Rucellai, with its horizontal bands of varying height and haphazardly arranged vertical joints, has a close parallel in the *piano nobile* of the Palazzo Medici.

(b) S Maria Novella. The second design commissioned by Giovanni Rucellai, the spectacular green-and-white patterned stone façade of S Maria Novella (see colour pl. 1, I2), was begun in or soon after 1458, the year in which

Rucellai obtained rights of patronage, and was probably completed in 1470. For this project, Alberti was not only faced with the problem of devising a classical scheme for a church with a tall nave and lower side aisles, but he was also required to incorporate the beginnings of an earlier façade. This had been begun in the previous century under the patronage of the Baldesi family, and when the rights of patronage were transferred to Rucellai it was agreed that those parts already built should be retained. Precisely how much of the lower part of the existing façade was built before Alberti's time is still not clear, but the earlier work must have included the tomb-filled niches (*avelli*) with their pointed arches as well as the side portals with their pointed arches and crocketed gables. Alterations were, however, made even to this lower level with the insertion of a new main portal, its pilasters supporting a coffered arch inspired by the portal of the Pantheon in Rome, a pair of framing Corinthian half-columns and a further pair coupled with wider pilasters to mark the façade's corners, a motif derived from the Baptistery in Florence.

As with the Tempio Malatestiano, Alberti again conceived the façade in two storeys, a wider one at the bottom and a narrower one at the top. In this instance the lower one, articulated by the inserted half-columns and corner pilasters, carries an attic, and the upper one, articulated by four pilasters, carries a pediment. To provide a visual transition from the wider lower storey to the narrower upper one, Alberti installed a pair of giant S-shaped scrolls, inspired by those of Brunelleschi's lantern (designed 1436) at Florence Cathedral (*see* BRUNELLESCHI, FILIPPO, fig. 7), and these became the façade's most imitated feature. There are again medieval precedents for the format of the façade, especially in the local church of S Miniato al Monte, but not for the classical rigour of its decoration. In this respect, Alberti was not prepared to compromise, let alone continue the façade in the Gothic style in which it was begun. For him, the only beautiful style was that based on Classical principle and example. It seems that Alberti made every effort to conceive the façade in conformity with his notion of beauty and to base the design on strict proportional relationships. The façade is thus arranged so that its total width is equal to its total height, its two storeys are of the same height and its lower storey is twice the width of its upper storey. The design can also be imagined as fitting neatly into a square, with the lower storey occupying the bottom half and the upper storey occupying one half of the top half, a conceptualization that may have been intentional.

The need to tailor the façade to the pre-existing medieval structure imposed severe difficulties, which Alberti obviated with consummate skill. One particular problem resulted from the edges of the upper part of the façade being situated directly above the side-portals, an arrangement contrary to the Classical principle of solid above solid and void above void. To distract attention from this unfortunate alignment, Alberti decorated the attic of the lower storey with a bold pattern of squares that corresponds neither with the architectural articulation above nor with that below. Another problem resulted from the presumably pre-existing rose window's being situated in an ungainly manner right at the bottom of the upper level.

To make the window less conspicuous, Alberti incorporated other roundels (modelled on a Romanesque floor design in S Miniato) into the design of the giant scrolls at either side, which he centred at a slightly lower level.

(c) Rucellai Chapel, S Pancrazio. This was the third design for Giovanni Rucellai and was finalized a little after the two earlier projects. Rucellai had initially thought about building himself a funerary chapel, to be dedicated to the Holy Sepulchre, as early as 1448, around the time he first conceived his extensive building programme. He was then undecided whether he should attach it to S Maria Novella, where in the right transept his family already had patronage rights, or to the church of S Pancrazio, which stood immediately to the rear of his palace. He finally decided on S Pancrazio when he resolved to build the façade of S Maria Novella in 1458. Construction of the chapel was certainly under way by 1464–5 and was probably completed in 1467, the date appearing in an inscription.

Although much altered, the chapel's original appearance can be reconstructed confidently. It takes the form of a rectangular structure, with one of its longer sides abutting the left wall of the church. Access was originally gained via a wide trabeated columnar screen in the nave wall, which was subsequently removed when the opening into the chapel was blocked and then inserted into the church's façade. The chapel is covered with a magnificent barrel vault, a form of ceiling revived in fact by Michelozzo in his projects for the library at S Marco and the Palazzo Medici, and one much favoured by Alberti. At the chapel's centre stands a small, richly decorated marble-faced structure, articulated with pilasters and crowned with a lantern (see fig. 3), and designed in imitation of the structure in Jerusalem that marks the supposed site of Christ's burial. Derivatives, or 'copies', of the Holy Sepulchre were fairly common in funerary contexts throughout the Middle Ages, and the tradition persisted into the Renaissance, one well-known 'copy' being Brunelleschi's Old Sacristy at S Lorenzo (begun 1421). This is crowned with a lantern supporting a spirally fluted, ogee-shaped dome, a motif derived from the prototype in Jerusalem and one that Alberti himself used for the S Pancrazio structure. Compared with the Old Sacristy, however, the S Pancrazio Holy Sepulchre is a far more literal derivative in its shape and arrangement, perhaps indicating that Alberti adopted a more scholarly approach towards 'copying'.

(iii) Mantua. The designs commissioned by Ludovico Gonzaga *c.* 1460 came at a very busy time for Alberti, who had three projects in hand in Florence, but the opportunity they presented was considerable. In 1459, following the arrival in Mantua of Pope Pius II and the delegates he had invited to attend his congress (*see* §I above), the city suddenly became the focus of national and international attention. Ludovico hastily set about refurbishing it and asked Alberti, who had accompanied the Pope to Mantua, to put some ideas on paper. As well as supplying outline designs (1460) for the central Piazza dell'Erbe, which involved providing it with a tower and a 'loggia' (realized soon afterwards), Alberti may also have provided outline proposals at this time for rebuilding the nearby church of S Andrea, a project he eventually developed a decade later.

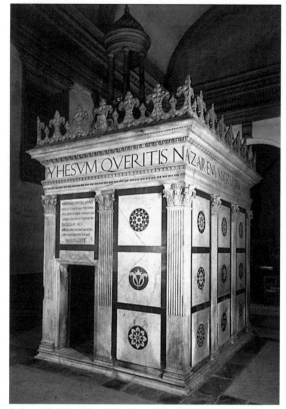

3. Leon Battista Alberti: interior of Rucellai Chapel, S Pancrazio, Florence, *c.* 1464–7

In addition, he provided detailed plans for a new church dedicated to S Sebastiano, work on which was begun straight away.

(a) S Sebastiano. With the commission for S Sebastiano (1459), Alberti for the first time had the opportunity to design a building for a virgin site unencumbered by pre-existing structures. The result was a revolutionary design planned as a Greek cross, the first such layout of the Renaissance (see fig. 4). So novel was the plan that Ludovico's son, Cardinal Francesco Gonzaga, said in bewilderment that he did not know whether the building was 'a church, a mosque or a synagogue'. The church as it stands reflects Alberti's original scheme, if only in outline. The main body of the church is raised on to an extremely tall undercroft and has a central, square groin-vaulted crossing (10×10 m) with four short barrel-vaulted arms (3.6×6 m), three terminating in a small apse and the fourth connected with a frontal block that accommodates an entrance portico. The brick-built façade (see fig. 5) rises from an arched basement and is articulated with four pilasters, two flanking the main portal and two at the corners; the latter support a tall entablature, broken in the middle by a window with an arch above, and a crowning pediment. There are five portals in all, a large rectangular one at the centre, two smaller rectangular ones at either side, and two arched ones at either end, to which rise two modern (1925) flights of steps. A further flight of steps,

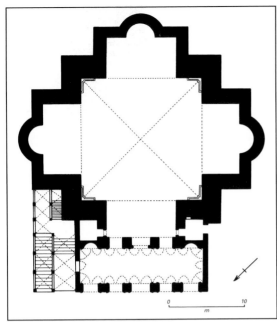

4. Leon Battista Alberti: plan of S Sebastiano, Mantua, designed 1459–60

installed late in the 15th century, joins the portico at its northern end.

Alberti's drawings were sent to Ludovico Gonzaga on 27 February 1460 and work must have begun soon after. Construction at first proceeded quickly, and the undercroft appears to have been vaulted by 1462; but it slowed down considerably afterwards, and the vault in the crossing was begun only *c.* 1499. During the course of construction, supervised in Alberti's absence by Luca Fancelli, a number of changes appear to have been made to the design. At least one of them was made by Alberti himself who, in a letter of 1470, sought permission to 'reduce the piers (*pilastri*) of the portico'. Although obscure in its precise meaning, which has been the subject of much debate, the instruction probably refers to a reduction in the size of the piers of the arched basement rather than to the reduction in the number of pilasters on the façade from a presumed six to the existing four.

More radical changes were made after Alberti's death in 1472, as can be established from a list of measurements on a drawing of the church (Florence, Uffizi, inv. no. 1779A) made by Antonio Labacco in the 16th century, which records Alberti's original scheme with some precision. It appears that originally the building would have been much taller than at present and that the crossing would have been covered by a dome (*cupola*) rather than a groin vault. What presumably happened is that work on the building was eventually discontinued, perhaps at Alberti's death in 1472. At this stage the walls would have been rather lower than their present height but higher than the top of the apses, since the dimension given by Labacco for the height of the apses is the same as in the actual building. Indeed, this is the only height dimension that corresponds with those recorded by Labacco. The walls would then have been vaulted over as the building was

being left in its present truncated state. A small elevational sketch by Labacco for the exterior is often used as the basis for a reconstruction of the original project, but it is much less reliable as evidence. Indeed, considering its size and sketchiness and its placement on the sheet, it may be little other than Labacco's own attempt at a reconstruction based on his list of measurements. The portico façade may well have been altered in its upper reaches, at least in detail, as the uncanonical frieze with dentils and open oculi is typical of Fancelli's style and untypical of Alberti's. For access, Alberti may have originally proposed flights of steps at either end of the portico, an arrangement implied in Labacco's ground-plan drawing and one that is similar to those in marginal illustrations from Filarete's treatise (Florence, Bib. N. Cent., Cod. Magliabechianus II, IV, 140, fols 108*r* and 119*v*).

The measurements given in Labacco's list suggest that Alberti used a method of designing the interior elevation that was new to Renaissance architecture. The method is essentially different from the one employed earlier by Brunelleschi, as at Santo Spirito (begun 1436), Florence, in which one element is related to another visually rather than proportionally, so that a smaller arch might support an entablature, which becomes the impost of a larger arch and so on. In Alberti's scheme at S Sebastiano, however, it is proportion that organizes and unites the design, and a standard width-to-height ratio of 3:5 governs the main portal, the apses, the arms and the crossing.

In the design of S Sebastiano, Alberti also drew more heavily than before on ancient prototypes, a dependency

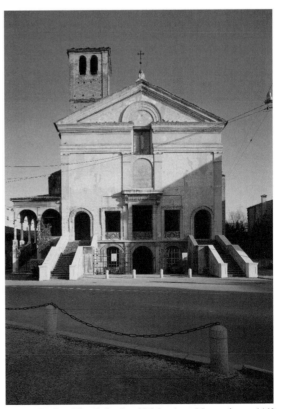

5. Leon Battista Alberti: façade of S Sebastiano, Mantua, begun 1460

that is evident not just in the detailing but in the building's whole conception. The Greek-cross plan appears to have been inspired by ancient mausolea, such as the one subsequently illustrated in Book IV (Venice, 1537) of Serlio's treatise *Regole generali*. The arrangement of the raised portico and perhaps its steps may have been derived from the Tempietto of Clitumnus, near Spoleto, which may well be 'the ancient Umbrian shrine' Alberti mentions (*De re aedificatoria* I.viii) as being partly buried by the build-up of soil at the foot of the mountains. The arrangement of the façade, with the break in the entablature capped by an arch, recalls the side elevation of the Arch of Tiberius at Orange, southern France, Alberti again adapting Roman triumphal architecture to the needs of the Christian Church. On the other hand, Alberti again drew on medieval precedents as well, the general layout of the undercroft and the arrangement of the niches in the apses there being apparently derived from the plan of St Mark's in Venice.

(b) *S Andrea.* Alberti's design for rebuilding S Andrea (1470) was a particularly prestigious commission as the church housed a much-venerated relic of Christ's blood and was Mantua's foremost pilgrimage shrine. An initial proposal to rebuild the church seems to have been made around 1460, and it may have formed part of an ambitious scheme to redevelop not only the Piazza dell'Erbe but the surrounding area as well. At this stage Alberti may have been consulted, and one of the leading Florentine architects of the day, Antonio di Ciaccheri Manetti, is known to have sent in a detailed design; but the project was blocked for a decade by the intransigence of the incumbent abbot. In 1470, when it finally became possible to proceed with the project, Alberti sent his own unsolicited design to Ludovico Gonzaga, together with a letter (Mantua, Archv Stato) comparing his scheme with Manetti's and arguing that his was both more suitable and cheaper. Manetti's scheme may have had a basilican layout like Brunelleschi's S Lorenzo, Florence, with a nave and two aisles separated by arches on columns. Alberti considered it inconveniently cluttered and needlessly costly, since the stone for the columns could have been imported into Mantua only at enormous expense. His own scheme, with a wider nave and no aisles, he considered more practical, as it would enable a greater number of people to see the precious relic, and also more economical, since it could be built entirely from brick. With Alberti's design duly approved, construction began at the west end in 1472, and the nave and principal façade were both largely complete by 1488. Subsequent work progressed at a greatly reduced rate; the north portico was built in the years around 1550, the south transept was still unbuilt in 1629, and the dome was eventually added by Filippo Juvarra (1678–1736) in 1733.

The church has a Latin-cross plan with a broad nave and a domed crossing (see fig. 6). To either side of the nave, which is covered by a vast, longitudinal barrel vault, are three smaller domed chapels alternating with three larger chapels with transverse barrel vaults. The nave walls are articulated with tall pilasters to form a sequence of alternating bays, with low portals in the small bays giving access to the smaller chapels and broad open arches in the

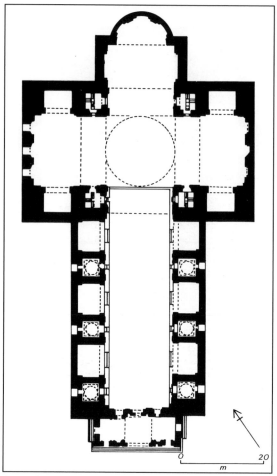

6. Leon Battista Alberti: plan of S Andrea, Mantua, designed 1470

wide bays giving access to the larger ones. The dome at the crossing rests on pendentives, and the three other arms of the church, which are around the same size, continue the pilaster articulation of the nave.

Few Renaissance church interiors can match S Andrea in sheer drama and monumentality (see fig. 7). In conceiving of his vast barrel-vaulted nave, Alberti rejected the aesthetic preference for trabeated ceilings that Brunelleschi had established, but he may have been influenced by the newly built choir of St Peter's in Rome or the Badia (after 1456) in Fiesole, both projects having barrel vaults of a comparable scale. Alberti drew his inspiration principally from antique example, however, as he makes clear in his letter to Ludovico Gonzaga, where he referred to the design as a *templum etruscum* (a temple of Etruscan type). As a specific model he may have had in mind the Basilica of Maxentius, an enormous vaulted structure with three exedrae on either side: in *De re aedificatoria* he describes the *templum etruscum* as a building of a very similar shape and arrangement to the Basilica of Maxentius, prescribing the overall proportions of 5:6 (breadth:length) that were eventually used for the nave of S Andrea. Regarding the building as a whole, it is not clear from Alberti's letter whether the original design was just for a nave and chapels,

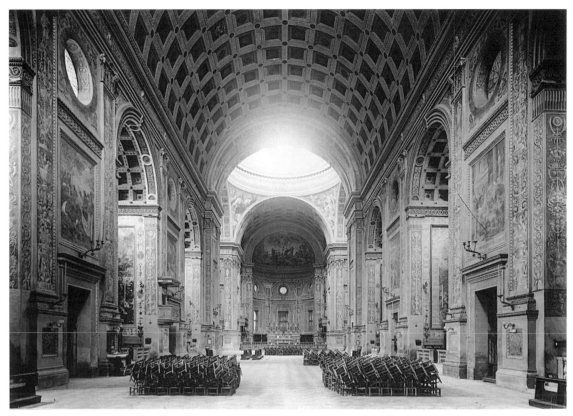

7. Leon Battista Alberti: interior of S Andrea, Mantua, begun 1472

an inference that has been drawn, or whether it was for the complete Latin-cross layout eventually constructed. That he did in fact intend a Latin cross is suggested by the design of the crossing piers (later refaced), which originally had roundels facing both the nave and the transept. If so, this would imply, not unreasonably, that Alberti had adapted his notion of the *templum etruscum* to Christian uses and traditions.

For the first time in Alberti's architecture the internal arrangement of the building is mirrored in the façade. This is attached not directly to the main body of the church but, as in S Sebastiano, to a frontal block accommodating a portico. The portico has a tall central passageway with a longitudinal barrel vault and two lower lateral passageways with transverse barrel vaults. The façade (see fig. 8) is articulated with four giant pilasters, arranged so as to give a wider bay at the centre for the main passageway and narrower bays at each side punctuated vertically by niches set above the side portals, the latter giving access into the lateral passageways. The arrangement of the façade and portico is thus strikingly similar to the internal elevation of the nave walls and to the internal disposition of spaces, though it may also have been partly inspired by the internal transept ends of Brunelleschi's S Lorenzo. The fact that the façade is unusually much less wide than the nave and chapels combined was determined by the need to retain the medieval campanile to the left. In addition, as with S Sebastiano, the façade carries associations with ancient triumphal arches and, being crowned by a pediment, with

ancient temples. Above the pediment is the façade's most puzzling feature, that of an arched canopy known as the *ombrellone*. Although its precise purpose remains unclear, it certainly serves to reduce the amount of direct light entering the nave, which, being otherwise lit only from individual roundels at the back of each chapel, is particularly dark. This darkness accords with Alberti's expressed preference in *De re aedificatoria* (VII.xii) that churches should be dimly lit in order to concentrate the mind on the holy.

(iv) Sources and development. In the preface to the Italian version (1436) of his treatise on painting, Alberti had expressed a profound admiration for Brunelleschi's architecture, but in his own designs he gradually began to distance himself from Brunelleschi's principles. Whereas Brunelleschi, in applying his rigorously systematic classicism, had relied on plan types that were essentially medieval—Santo Spirito, for example, depends on such medieval prototypes as SS Apostoli in Florence and Pisa Cathedral—Alberti introduced plan types, as in S Sebastiano and S Andrea, that were largely based on antique models. In architectural detailing there is a broadly similar difference. Whereas Brunelleschi relied for his details largely on such Florentine Romanesque buildings as the Baptistery, which he may have believed to have had an ancient pedigree, and only later turned on occasion to genuine antiquities, Alberti always used a much broader range of models, which included the Baptistery (for the

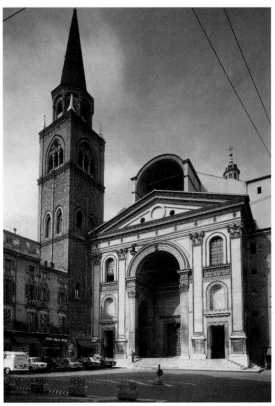

8. Leon Battista Alberti: façade of S Andrea, Mantua, begun 1472

corner pilasters at S Maria Novella) and other Florentine Romanesque buildings but much more frequently included actual Roman buildings, such as the Pantheon (for the portal of S Maria Novella) and the Mausoleum of Hadrian (for the *piano nobile* pilasters of the Palazzo Rucellai).

Moreover, Alberti was always much more concerned than Brunelleschi with principles derived from antique buildings. Brunelleschi, for example, often marked an axis with a supporting element, as in the plan of Santo Spirito, where there is a column, or in the main domes of the Old Sacristy at S Lorenzo, where there is a rib (*see* BRUNELLESCHI, FILIPPO, fig. 3); Alberti, by contrast, almost always followed antique models in placing openings or niches rather than supports on the axes of his plans and coffers rather than ribs on the axes of his vaults.

More vexing is the question of whether Alberti's style developed during his career. Certainly his buildings in Rimini, Florence and Mantua are very different, and their differences might suggest a development in style. Equally, however, they might reflect differences in patronage, local styles, site and physical context, availability of building materials and a host of other factors. Indeed, it is probable that the appearance of the earlier Florentine buildings is due to their being commissioned by a Florentine banker, realized in a city with strong local traditions, constructed in very restrictive urban contexts and built of stone; and that the appearance of the later Mantuan buildings is due to their being commissioned by an imperial marchese, realized in a city with comparatively ephemeral local traditions, constructed on free sites and built of brick.

IV. Influence and posthumous reputation.

Alberti's influence is difficult to overestimate and it affected patrons and artists alike. Although not noble, the Alberti family had great status in Florentine society, a status that placed Leon Battista Alberti on almost equal terms socially with many of his patrons and that may have allowed him to persuade them of the virtue of his ideas more easily than would otherwise have been possible. His ideas and theories, before the advent of printing, were initially disseminated as much by his peripatetic lifestyle as papal secretary, which took him from his base in Rome to Ferrara, Florence, Mantua and Urbino, as they were by the manuscript writings themselves. In fact only six manuscript copies of *De re aedificatoria* survive, all of which can be dated to the period 1480–85.

By the end of the 15th century, most Italian painters and sculptors would have been inspired directly or indirectly by his treatises. His revolutionary formulation of the principles of linear perspective in particular marks a turning-point in the development of naturalistic representation, and his method was subsequently exploited in the works of many mid-century painters, above all Paolo Uccello, Domenico Veneziano and Piero della Francesca. His more general concept of the *historia* underlies many of the great 15th-century cycles of narrative painting, especially those of Fra Angelico in the Nicholas V Chapel in the Vatican (*c.* 1448–9; *see* ANGELICO, FRA, fig. 6) and Filippo Lippi in Prato Cathedral (begun 1452), as it does subsequently the history paintings of Raphael and Titian. His concept of ideal beauty in nature remained central to aesthetic appreciation until it was rivalled by that of Michelangelo; and his belief in the pre-eminence of drawing as the basis of art remained a fundamental feature of subsequent painting despite the challenge of Giorgione and Titian, who advocated the practice of applying paint directly to the canvas without making a series of drawings. Other suggestive ideas may have also borne fruit in the fertile minds of younger artists—his recommendation that artists might copy sculpture, for example, perhaps influencing Mantegna in his partiality for ancient statuary, while his view of painting as the 'mistress' of the three arts may well have fuelled the later debate between painters and sculptors concerning the primacy of their respective arts (*see* PARAGONE; *see also* UT PICTURA POESIS).

Patrons, too, may have been influenced by the treatises on painting and sculpture, thereby themselves contributing to a change in taste. As the 15th century progressed, they increasingly came to value the kind of art commended by Alberti, demanding works that exhibited skill in *disegno* rather than costliness of material. They also increasingly demanded the kinds of picture described in *De pictura*, especially works of mythological or allegorical subject-matter, and the kind of sculpture envisaged in *De statua*, most particularly the large-scale, male nude statue. Alberti's treatises thus contributed in no small part to a shift in taste and custom that eventually resulted in the commissioning of Botticelli's *Calumny of Apelles* (1490s; Florence, Uffizi) and Michelangelo's *David* (1501–4; Florence, Accad.; *see* ITALY, fig. 22).

Directly or indirectly, *De re aedificatoria* had a considerable impact on subsequent architecture. Initially its direct

influence may have been limited because, being written in Latin, it was accessible to few architects until published in Italian (Florence, 1550) by Cosimo Bartoli. Through verbal dissemination, however, Alberti's ideas may have had much greater impact. For example, in the trabeated colonnades at S Maria Maddalena de' Pazzi (early 1490s; *see* SANGALLO, DA, (1), fig. 2), Cestello, or the transverse barrel-vaulted *salone* and pedimented portico at the Villa Medici (1480s), Poggio a Caiano (*see* VILLA, fig. 1), Giuliano da Sangallo may well have followed Alberti's recommendations, but he most likely knew of them though Lorenzo de' Medici, who was familiar with *De re aedificatoria* in the original Latin.

De re aedificatoria had little immediate influence on subsequent 15th-century theorists, who apparently did not read or fully understand it. Neither Filarete, writing in the early 1460s, nor Francesco di Giorgio Martini, at least during the 1470s, can have been aware of the extent to which Alberti had understood the terminology, forms and uses of the orders of architecture; and their own attempts to make sense of Vitruvius and to relate his text to ancient buildings are dismal by comparison. It was only at the beginning of the 16th century that architects seem to have read Alberti's treatise themselves. Raphael may have known it, for in his famous letter to Pope Leo X (1519; Vatican; see V. Golzio: *Raffaelo nei documenti*, Vatican City, 1936) he reiterated Alberti's contention that good architecture depends on the use of rich and varied materials and his list is remarkably similar to that in *De re aedificatoria* (VI.v). Giulio Romano, Raphael's pupil, certainly owned a copy. Later in the century, Serlio and Palladio both freely acknowledged their debt to Alberti, a debt that lay not only in the elucidation of Vitruvius and the language of Classical architecture but also in the establishment of an aesthetic based on natural law and reason.

It is, however, through his buildings, which have exerted so powerful and enduring a hold over the imagination of subsequent periods, that Alberti's influence has been greatest. The Palazzo Rucellai, with its applied architectural orders, established a norm for palazzo façade design for centuries thereafter; the S Maria Novella façade, with its two-storey format linked with S-shaped scrolls, established the standard elevational formula for subsequent churches; S Sebastiano, with its centrally planned Greek-cross layout, established a new plan-type in Renaissance ecclesiastical architecture; and S Andrea, with its wide, barrel-vaulted nave and side chapels, supplied one of the key models for future Latin-cross churches. These were truly visionary buildings.

WRITINGS

De pictura (MS., 1435; Basle, 1540); It. trans. as *Della pittura* (MS., 1436); ed. in H. Janitschek: *L. B. Albertis kleinere kunsttheoretische Schriften* (Vienna, 1877); ed. L. Mallè (Florence, 1950)
De statua (MS., *c.* 1440s); ed. in H. Janitschek: *L. B. Albertis kleinere kunsttheoretische Schriften* (Vienna, 1877)
De re aedificatoria (Florence, 1485); It. trans. and ed. G. Orlandi and P. Portoghesi (Milan, 1966); Eng. trans. by J. Rykwert, N. Leach and R. Tavernor as *On the Art of Building in Ten Books* (Cambridge, MA, and London, 1988)
G. Mancini, ed.: *Opera inedita et pauca separatim impressa* (Florence, 1890)
C. Grayson, ed. and trans: *An Autographed Letter from Leon Battista Alberti to Matteo de' Pasti, November 18, 1454* (New York, 1957)
C. Grayson, ed.: *Opere volgari*, 3 vols (Bari, 1960–73)
G. Orlandi, ed.: 'Descriptio urbis Romae', *Ist. Elem. Archit. & Rilievo Mnmt. Quad. [Genova]: Quad.*, 1 (1968), pp. 60–88

C. Grayson, ed. and trans.: *On Painting and Sculpture: The Latin Texts of 'De pictura' and 'De sculptura'* (London, 1972)
H.-K. Lücke, ed.: *Index verborum to L. B. Alberti's 'De re aedificatoria'*, 4 vols (Munich, 1975–9) [with facs. of original edn]

DBI

BIBLIOGRAPHY

EARLY SOURCES

G. Vasari: *Vite* (1550, rev. 2/1558); ed. G. Milanesi (1878–85)
M. Palmieri: 'De temporibus suis, Rerum italicum scriptores', ed. J. Tartinius, i (Florence, 1748), col. 241
'Vita di Leon Battista Alberti', *Opere volgari di Leon Battista Alberti*, ed. A. Bonucci (Florence, 1843)

GENERAL

R. Wittkower: *Architectural Principles in the Age of Humanism* (London, 1949, rev. 4/1973)
M. Baxandall: *Giotto and the Orators: Humanist Observers of Painting in Italy and the Discovery of Pictorial Composition, 1350–1450* (Oxford, 1971)
L. H. Heydenreich and W. Lotz: *Architecture in Italy, 1400–1600*, Pelican Hist. A. (Harmondsworth, 1974), pp. 27–38
M. Kemp: *The Science of Art: Optical Themes in Western Art from Brunelleschi to Seurat* (New Haven and London, 1992)
C. Smith: *Architecture in the Culture of Early Humanism: Ethics, Aesthetics and Eloquence, 1400–1470* (New York and Oxford, 1992); review by J. S. Ackerman in *Speculum*, lxix/3 (1994), pp. 886–9

MONOGRAPHS

G. Mancini: *Vita di Leon Battista Alberti* (Florence, 1882, rev. 2/1911)
J. Gadol: *Leon Battista Alberti: Universal Man of the Early Renaissance* (Chicago, 1969)
F. Borsi: *Leon Battista Alberti: L'opera completa* (Milan, 1975; Eng. trans., London, 1977, 2/New York, 1986)
Leon Battista Alberti (exh. cat., ed. J. Rykwert and A. Engel; Mantua, Pal. Te; 1994); review by A. C. Ambesi in *Third Eye*, xx/4 (Dec 1994), pp. 16–17

THEORY

P. H. Michel: *La Pensée de L. B. Alberti* (Paris, 1930)
M. Gosebruch: ' "Varietà" bei Leon Battista Alberti und der wissenschaftliche Renaissancebegriff', *Z. Kstgesch.*, xx (1957), pp. 229–38
C. Grayson: 'The Humanism of Alberti', *It. Stud.*, xii (1957), pp. 37–56
——: 'The Composition of Alberti's *Decem libri De re aedificatoria*', *Münchn. Jb. Bild. Kst.*, xi (1960), pp. 152–61
R. Krautheimer: 'Alberti and Vitruvius', *Studies of Western Art: The Renaissance and Mannerism. Acts of the XXth International Congress of the History of Art: Princeton, 1963*, pp. 42–52; repr. in *Studies in Early Christian, Medieval and Renaissance Art* (New York, 1969), pp. 323–32
J. Białostocki: 'The Power of Beauty: An Utopian Idea of Leon Battista Alberti', *Studien zur toskanischen Kunst: Festschrift für Ludwig Heinrich Heydenreich* (Munich, 1964), pp. 13–19
S. Lang: '*De lineamentis*: L. B Alberti's Use of a Technical Term', *J. Warb. & Court. Inst.*, xxviii (1965), pp. 331–5
R. Krautheimer: 'Alberti's *Templum Etruscum*', *Studies in Early Christian, Medieval and Renaissance Art* (New York, 1969), pp. 65–72
H. Lorenz: *Studien zum architektonischen und architekturtheoretischen Werk L. B. Albertis* (diss., U. Vienna, 1971)
J. Onians: 'Alberti and Filarete: A Study in their Sources', *J. Warb. & Court. Inst.*, xxxiv (1971), pp. 96–114
L. Vagnetti: '*Concinnitas*: Riflessioni sul significato di un termine albertiano', *Stud. & Doc. Archit.*, ii (1973), pp. 139–61
E. Battisti: 'Il metodo progettuale secondo il *De re aedificatoria* di L. B. Alberti', *Il Sant' Andrea di Mantova* (Mantua, 1974), pp. 131–3
P. Naredi-Rainer: 'Bemerkungen zur Säule bei L. B. Alberti', *Jb. Ksthist. Inst. Graz*, xi (1976), pp. 51–61
——: 'Musikalische Proportionen, Zahlenästhetik und Zahlensymbolik in architektonischen Werk L. B. Albertis', *Jb. Ksthist. Inst. Graz*, xii (1977), pp. 81–213
R. Feuer-Toth: 'The "*apertionum ornamenta*" of Alberti and the Architecture of Brunelleschi', *Acta Hist. A. Acad. Sci. Hung.*, xxiv (1978), pp. 147–52
L. Vagnetti: 'Lo studio di Roma negli scritti albertiani', *Accademia Nazionale dei Lincei. Convegno internazionale indetto nel V centenario di Leon Battista Alberti: Rome, 1979*, pp. 73–144
J. Andrews Aiken: 'L. B. Alberti's System of Human Proportions', *J. Warb. & Court. Inst.*, xlii (1980), pp. 68–96
H. Mühlmann: *Aesthetische Theorie der Renaissance: Leon Battista Alberti* (Bonn, 1981)

R. Tavernor: *Concinnitas in the Architectural Theory and Practice of L. B. Alberti* (diss., U. Cambridge, 1985)

H. Biermann: 'Die Aufbauprinzipien von L. B. Albertis *De re aedificatoria*', *Z. Kstgesch.*, liii/4 (1990), pp. 443–85

K. Weil-Garris Brandt: 'The Relation of Sculpture and Architecture in the Renaissance', *Renaissance from Brunelleschi to Michelangelo: The Representation of Architecture* (London, 1994), pp. 74–98

G. Morolli: *Leon Battista Alberti, i nomi e le figure: Ordini, templi e fabbriche civili: Immagini e architetture dai libri VII e VIII del De re aedificatoria* (Florence, 1994)

C. Wilde: 'Painting, Alberti and the Wisdom of Minerva', *Brit. J. Aesth.*, xxiv/1 (1994), pp. 48–59

A. Grafton: 'Panofsky, Alberti and the Ancient World', *Meaning in the Visual Arts: Views from the Outside. A Centennial Commemoration of Erwin Panofsky (1892–1968)* (Princeton, 1995), pp. 123–30

J. M. Greenstein: 'On Alberti's "Sign": Vision and Composition in Quattrocento Painting', *A. Bull.*, lxxix (1997), pp. 669–98

ARCHITECTURE

C. Ricci: *Il Tempio Malatestiano* (Milan, 1925)

C. Mitchell: 'The Imagery of the Tempio Malatestiano', *Stud. Romagn.*, ii (1951), pp. 77–90

L. H. Heydenreich: 'Die Cappella Rucellai', *De artibus opuscola: Essays in Honour of Erwin Panofsky* (New York, 1961), p. 219

E. Hubala: 'L. B. Albertis Langhaus von Sant' Andrea in Mantua', *Festschrift Kurt Behrend* (Berlin, 1961), p. 83

G. Kiesow: 'Die gotische Südfassade von S Maria Novella in Florenz', *Z. Kstgesch.*, xxv (1962), pp. 10ff

C. Perina: *La basilica di Sant' Andrea in Mantova* (Mantua, 1965) [very full bibliog.]

P. Portoghesi: *Il Tempio Malatestiano* (Florence, 1965)

M. Dezzi Bardeschi: 'Il complesso monumentale di S Pancrazio a Firenze e il suo restauro', *Quad. Ist. Stor. Archit.*, xiii (1966), pp. 1–66

——: *La facciata di S Maria Novella* (Florence, 1970)

G. Guidetti: 'L. B. Alberti direttore della fabbrica di S Sebastiano', *Il Sant' Andrea in Mantova* (Mantua, 1974), pp. 237–41

C. W. Westfall: 'Alberti and the Vatican Palace Type', *J. Soc. Archit. Historians*, xxxiii (1974), pp. 101–21

E. Johnson: *Alberti's Church of S Andrea in Mantua* (London and University Park, 1975)

M. Spallanzani: 'L'abside dell'Alberti a San Martino a Gangalandi', *Mitt. Ksthist. Inst. Florenz*, xix (1975), pp. 241–50

K. Forster: 'The Palazzo Rucellai and Questions of Typology in the Development of Renaissance Buildings', *A. Bull.*, lviii (1976), pp. 109–13

H. Lorenz: 'Zur Architektur L. B. Albertis: Die Kirchenfassaden', *Röm. Jb. Kstgesch.*, xxix (1976), pp. 65–100

D. S. Chambers: 'Sant' Andrea at Mantua and Gonzaga Patronage, 1460–1472', *J. Warb. & Court. Inst.*, xl (1977), pp. 99–127

B. Preyer: 'The Rucellai Loggia', *Mitt. Ksthist. Inst. Florenz*, xxi (1977), pp. 183–98

B. L. Brown: *The Tribuna of SS Annunziata in Florence* (diss., Evanston, IL, Northwestern U., 1978)

A. Calzona: *Mantova città dell'Alberti* (Parma, 1979)

R. Lamoureux: *Alberti's Church of S Sebastiano in Mantua* (London and New York, 1979)

H. Burns: 'The Church of San Sebastiano', *Splendours of the Gonzaga*, ed. D. Chambers and J. Martineau (London, 1981), pp. 125–6

B. Preyer: 'The Rucellai Palace', *Giovanni Rucellai ed il suo Zibaldone*, ii (London, 1981), pp. 155–224

J. Rykwert and R. Tavernor: 'Sant' Andrea in Mantua', *Architects' J.*, clxxxiii/21 (1986), pp. 36–57

M. Naldini and D. Taddei: *La piazza, la loggia, il Palazzo Rucellai* (Florence, 1989)

H. S. Ettlinger: 'The Sepulchre on the Façade: A Re-evaluation of Sigismondo Malatesta's Rebuilding of S Francesco in Rimini', *J. Warb. & Court. Inst.*, liii (1990), pp. 133–43

C. Hope: 'The Early History of the Tempio Malatestiano', *J. Warb. & Court. Inst.*, lv (1992), pp. 51–155

A. Calzona and L. Volpi Ghirardini: *Il San Sebastiano di Leon Battista Alberti* (Florence, 1994); review by P. Davies in *Burl. Mag.*, cxxxvii/1112 (Nov 1995), pp. 754–5

SPECIALIST STUDIES

K. Badt: 'Drei plastische Arbeiten von Leon Battista Alberti', *Mitt. Ksthist. Inst. Florenz*, vii (1958), p. 81

R. N. Watkins: 'L. B. Alberti's Emblem, the Winged Eye, and his Name Leo', *Mitt. Ksthist. Inst. Florenz*, ix (1960), pp. 256–8

A. Parronchi: 'Leon Battista Alberti as a Painter', *Burl. Mag.*, liv/712 (1962), pp. 280–88

G. Morolli: 'Saggio di bibliografia albertiana', *Stud. & Doc. Archit.*, i (1972), pp. 11–56

F. W. Kent: 'The Letters Genuine and Spurious of Giovanni Rucellai', *J. Warb. & Court. Inst.*, xxxvii (1974), pp. 342–9

H. Burns: 'A Drawing by L. B. Alberti', *Archit. Des.*, xlix/5–6 (1979), pp. 45–56

K. Andersen: 'The Problem of Scaling and of Choosing Parameters in Perspective Construction, Particularly in the One by Alberti', *Anlct. Romana Inst. Dan.*, xvi (1987), pp. 107–28

P. W. Lehmann: 'Alberti and Antiquity: Additional Observations', *A. Bull.*, lxx/3 (1988), pp. 388–400

M. Tafuri: '*Cives esse non licere*: Niccolò V e Leon Battista Alberti', *Ricerca del rinascimento*, ed. M. Tafuri (Turin, 1992), pp. 33–88

PAUL DAVIES, DAVID HEMSOLL

Albertinelli, Mariotto (di Biagio di Bindo) (*b* Florence, 13 Oct 1474; *d* Florence, 5 Nov 1515). Italian painter. Albertinelli's contribution to the Florentine High Renaissance was inspired by the work of FRA BARTOLOMMEO, and the two artists worked together in a partnership, their paintings appearing to be the product of a single hand. Albertinelli, however, always retained artistic independence, as is revealed in certain paintings that are eccentrically archaic and in others that show a preference for conventions more typical of the early Renaissance.

1. LIFE AND WORK.

(i) Before 1503. According to Vasari, Albertinelli and Fra Bartolommeo were both apprenticed to Cosimo Rosselli. The two young painters became friends and after their emancipation operated a joint workshop in the 1490s. Vasari also stated that in an interlude before 1494 Albertinelli worked exclusively for Alfonsina Orsini, the wife of Piero II de' Medici (*reg* 1492–4), but the works made for her cannot be identified. Albertinelli initially specialized in small, elegantly framed paintings destined for the homes of sophisticated patrons. These works were produced independently of Fra Bartolommeo and are stylistically distinguishable. From Piero di Cosimo, the most creative personality in Cosimo Rosselli's workshop, Albertinelli absorbed Flemish techniques, a spirited versatility in imitation and a tendency towards eccentricity. For example, the *Virgin and Child* depicted in the central panel of a portable triptych (1500; Milan, Mus. Poldi–Pezzoli) refers to Filippino Lippi, the right shutter of *St Barbara* to Flemish painting, and the architecture on the left shutter showing *St Catherine of Alexandria* derives from Perugino. Another portable triptych (Chartres, Mus. B.-A.) recalls, in a bizarre fashion, works of the 14th century.

Albertinelli and Fra Bartolommeo collaborated on larger paintings; the *Annunciation* (1497; Volterra Cathedral), a medium-sized altarpiece, has been attributed to both painters, but their collaboration is proved by Albertinelli's drawing for the grotesque on the left pilaster (Florence, Uffizi), while a study for the angel (Florence, Uffizi) is by Fra Bartolommeo. In March 1501 Albertinelli completed the fresco of the *Last Judgement* (Florence, Mus. S Marco) that Fra Bartolommeo had left unfinished in July 1500, when he entered the Dominican Order and renounced painting for four years. The artists' collaboration had allowed Albertinelli to master Fra Bartolommeo's technique sufficiently to paint in a style that blended with that

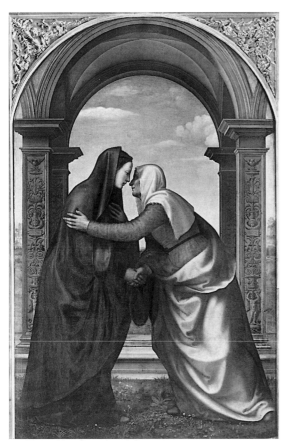

1. Mariotto Albertinelli: *Visitation*, main panel from the S Martino Altarpiece, oil on canvas, 2.32×1.46 m, 1503 (Florence, Galleria degli Uffizi)

the early Renaissance. Dating from these years are the large fresco of the *Crucifixion* (1505; Florence, Certosa dell Galluzzo (also known as di Val d'Ema), chapter house) and the *Virgin and Child with SS Jerome and Zenobius* (1506; Paris, Louvre), painted for the chapel of Zanobi del Maestro in Santa Trinita, Florence. The undated altarpiece of the *Annunciation with SS Sebastian and Lucy* (Munich, Alte Pin.) appears, stylistically, to belong to the same period.

In 1506 Albertinelli was commissioned to paint the *Annunciation with God the Father* (Florence, Accad.; see fig. 2) for the altar of the chapel of the Canons in Florence Cathedral. He received payments in 1507 and 1508 and completed it in 1510. A dispute arose over its value, and Perugino, Francesco Granacci and Ridolfo Ghirlandaio were called in to mediate. It is the first altarpiece of the period to show a glory of life-sized figures suspended in an architectural interior that acts as a dramatic component of the representation, rather than being projected as a symbol of harmony. Its novelty in the interplay of colours with light and dark was Albertinelli's own interpretation of the synthesis achieved by Fra Bartolommeo, after his visit to Venice in 1508, between Venetian luminosity and Leonardo da Vinci's monochromatic underpainting.

of his partner (Vasari). Fra Bartolommeo had painted the upper tier with the *Apostles*; Albertinelli started on the three angels below *Christ*, for which he made new drawings despite the pre-existing ones by his partner. He also made new studies for the *St Michael* and included portraits of monks at S Maria Nuova, one of Giuliano Bugiardini and his own self-portrait (Vasari). He managed to make these changes to the composition without distorting the original concept.

(ii) 1503–9. In 1503 Albertinelli completed the high altarpiece for S Martino, Florence; the main panel shows the *Visitation* (see fig. 1), and the predella illustrates the *Circumcision*, the *Adoration of the Child* (see colour pl. 1, II1) and the *Annunciation* (all Florence, Uffizi). Although the figural composition of the *Visitation* was based on drawings by Fra Bartolommeo, a black chalk study for the *Virgin* (Berlin, Kupferstichkab.) by Albertinelli shows that he replaced Fra Bartolommeo's strong contrasts in light and dark with smoother gradations of tone. In the painting, too, he made minimal use of monochrome and worked in soft highlights and colours in imitation of Perugino, who was also the source for the background arcade. For the next two years Albertinelli was guided more by Perugino and Piero di Cosimo than by Fra Bartolommeo, and his works were conceived in stylistic frameworks typical of

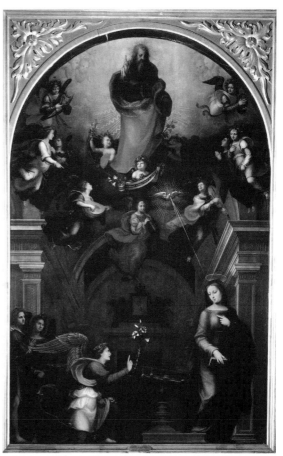

2. Mariotto Albertinelli: *Annunciation with God the Father*, oil on panel, 3.35×2.30 m, 1506–10 (Florence, Galleria dell'Accademia)

(iii) 1509–13. In 1509 Albertinelli and Fra Bartolommeo, who had resumed painting, entered into a partnership under the auspices of the convent of S Marco, Florence. The partners were on an equal footing, each entitled to half the profit of a shared commission. The partnership was dissolved in January 1513, as is evidenced by the survival of the relevant document. Fragmentary records of payment also survive for some works, though Vasari did not mention the partnership in Albertinelli's *Vita*. In July 1509 Albertinelli's name appears in the records of S Marco in connection with *God the Father with SS Magdalene and Catherine of Siena* (Lucca, Villa Guinigi), originally commissioned from Fra Bartolommeo by the Dominican convent of S Pietro Martire in Murano. The same year he collaborated with his partner on the *Virgin and Child with SS Catherine, Mary Magdalene, John the Baptist, Nicholas, Peter Martyr and Benedict* (Florence, S Marco), and through this experience he adopted the process by which Fra Bartolommeo gave instability to colours, but altered it by dividing them sharply on the forms. He also received almost half the profit for the *Virgin and Child with SS Stephen and John the Baptist* (Lucca Cathedral) and was named in the document concerning the Great Council Altarpiece (Florence, Mus. S Marco), although the commission was Fra Bartolommeo's alone. In January 1513 Albertinelli relinquished his rights to the Great Council Altarpiece, but in compensation he was given, among others, two paintings begun by Fra Bartolommeo, the *Pietà* (Florence, Pitti) and *Adam and Eve* (Philadelphia, PA, Mus. A.).

The collaboration between the partners on individual panels must have been selective: there is no evidence that Albertinelli participated in Fra Bartolommeo's two paintings of the *Mystic Marriage of St Catherine of Siena* (Paris, Louvre; Florence, Accad.), but he obviously worked on the Pitti *Pietà* and on the altarpiece for Ferry Carondelet comprising the *Coronation of the Virgin* (fragments Stuttgart, Staatsgal.) and the *Virgin and Child in Glory with SS Sebastian, John the Baptist, Stephen, Anthony Abbot and Bernard and the Donor Ferry Carondelet* (Besançon Cathedral). The Carondelet Altarpiece is the supreme accomplishment of both artists. A sketch for the composition in black chalk (Rotterdam, Mus. Boymans–van Beuningen) proves that Albertinelli contributed to the invention of the central panel; in addition, the *Coronation*, originally in the arched top of the panel, was entirely painted by him. In the *Annunciation* (1511; Geneva, Mus. A. & Hist.), though signed by both artists, Albertinelli's style is dominant.

Meanwhile Albertinelli continued to work independently. The *Virgin and Child with the Infant St John the Baptist* (1509; Harewood House, W. Yorks) is signed only by him. Also his are two paintings for the convent of S Giuliano, Florence: the *Virgin and Child with SS Julian, Dominic, Nicholas and Jerome* and the *Trinity* (both Florence, Accad.). Why the partnership was abruptly terminated in January 1513 is not known. For Albertinelli it had unquestionably been a financial success, reflected in his acquisitions of property in Florence and vineyards in the countryside.

(iv) 1513–15. Vasari claimed that Albertinelli's career ended in 1512. More accurately he reported that Albertinelli stopped painting for some months and ran two public houses in Florence: documents show that at the time of his death Albertinelli received an income from a tavern near the Ponte Vecchio. The interruption was brief and occurred immediately after the dissolution of the partnership. Proof that he returned to painting is the existence of an altarpiece that is signed and dated 1514 (Volognano, Pontassieve, S Michele) and Vasari's report that Albertinelli painted a *Faith, Hope and Charity* (untraced) for Leo X on his elevation to the papacy on 11 March 1513. Also true is Vasari's account of Albertinelli's visit to Viterbo and Rome in the summer of 1513, because his hand is recognizable in the upper part of the *Coronation of the Virgin* (Viterbo, S Maria della Quercia), which he left unfinished and which was later completed by Fra Paolino. Several small panels of 1513–15 done in Albertinelli's late style also prove that he remained active to the end of his life; their style is either wilfully archaistic or eccentric. Typical examples include the *Creation* (U. London, Courtauld Inst. Gals), the *Expulsion from the Garden* (Zagreb, Slika Gal.) and *Cain and Abel* (Bergamo, Gal. Accad. Carrara), which recall 15th-century Flemish paintings. In his *Virgin and Child* (Venice, Semin. Patriarcale), the figures, drastically out of scale with the framing architecture, represent a rejection of the ideals of the High Renaissance.

Vasari pictured Albertinelli as a libertine, excessively fond of good living and politically opposed to the faction of Savonarola. Records for two loans he contracted and failed to make good confirm his disorderly life style: he was excommunicated posthumously in 1516 for not having repaid a loan granted to him by the prioress of the convent of S Giuliano, and in 1517 Raphael sued his estate for a loan made many years earlier, which again had remained unpaid. Antonia, Albertinelli's wife since 1506, agreed to repay both loans.

2. WORKING METHODS AND TECHNIQUE. On account of Vasari's statement that Albertinelli knew he was a less gifted draughtsman than Fra Bartolommeo (as a remedy he took to drawing after the ancient statues in the Medici collection), later historians found it difficult to attribute drawings to Albertinelli. From the few of them known in 1903, Berenson concluded that Albertinelli could not draw and that he relied entirely on his partner's draughtsmanship. However, later attributions of drawings to Albertinelli show him to be quite proficient, capable of either following or modifying Fra Bartolommeo's drawings, and of making his own original contributions. He abandoned metalpoint as early as Fra Bartolommeo, adopting the pen and black chalk as his favourite media for studies, either for compositions or for single figures; he also achieved good effects with red chalk.

As a painter engaged in large productions, Albertinelli needed assistants. Giuliano Bugiardini, who rented quarters next to his in 1503, certainly became one. In 1506 Fra Bartolommeo's younger brother, Piero, entered the workshop under terms of a guardianship that called for Albertinelli to instruct him in painting. According to Vasari, Franciabigio, Pontormo and Innocenzo da Imola also worked under Albertinelli, but the dates of their apprenticeships are problematic. Vasari also spoke of a certain

Visino who supposedly went to Hungary after making his name in Florence, but he has not been identified.

BIBLIOGRAPHY

DBI; Meissner; Thieme–Becker

G. Vasari: *Vite* (1550, rev. 2/1568); ed. G. Milanesi (1878–85), iv, pp. 217–31

V. Marchese: *Memorie dei più insigni pittori, scultori ed architetti domenicani*, 2 vols (Florence, 1854, rev. Bologna, 2/1879)

J. A. Crowe and G. B. Cavalcaselle: *A History of Painting in Italy* (London, 1865–6, rev. 2/1903–14), iii, p. 484

G. Gruyer: *Fra Bartolommeo della Porta et Mariotto Albertinelli* (Paris, 1886)

A. Castan: *La Physionomie primitive du retable de Fra Bartolommeo à la cathédrale de Besançon* (Besançon, 1889)

A. Venturi: *Storia* (1901–40), IX/i, p. 348

B. Berenson: *The Drawings of the Florentine Painters* (London, 1903, rev. Chicago, 2/1938)

F. Knapp: *Fra Bartolommeo della Porta und die Schule von San Marco* (Halle, 1903)

P. Bagnesi-Bellincini: 'Due documenti sul *Giudizio universale* di Fra Bartolommeo', *Riv. A.*, vi (1909), pp. 245–50

H. von der Gabelentz: *Fra Bartolommeo und die Florentiner Renaissance* (Leipzig, 1922)

H. Bodmer: 'Opere giovanili e tarde di Mariotto Albertinelli', *Dedalo*, ix (1928), pp. 598–620

Mostra del cinquecento italiano (exh. cat., Florence, Pal. Strozzi, 1940), p. 24

S. J. Freedberg: *Painting of the High Renaissance in Rome and Florence* (Cambridge, MA, 1961, rev. New York, 2/1972)

B. Berenson: *Florentine School*, i (London, 1963), pp. 1–2

L. Borgo: 'Albertinelli, Fra Bartolommeo and the *Pietà* for the Certosa di Pavia', *Burl. Mag.*, cviii (1966), pp. 463–8

M. Winner: 'Zwei unbekannte Zeichnungen von Fra Bartolommeo und Albertinelli', *Festschrift H. Mühle* (Berlin, 1967)

L. Borgo: 'The Problem of the Ferry Carondelet Altarpiece', *Burl. Mag.*, cxiii (1971), pp. 362–71

S. J. Freedberg: *Painting in Italy, 1500–1600*, Pelican Hist. A. (Harmondsworth, 1971), p. 52

C. von Holst: 'Florentiner Gemälde und Zeichnungen aus der Zeit von 1480 bis 1530', *Mitt. Ksthist. Inst. Florenz*, xv (1971), pp. 1–64

L. Borgo: 'Mariotto Albertinelli's Smaller Paintings after 1512', *Burl. Mag.*, cxvi (1974), pp. 245–50

C. von Holst: 'Fra Bartolommeo und Albertinelli', *Mitt. Ksthist. Inst. Florenz*, xviii (1974), pp. 273–318

S. R. McKillop: *Franciabigio* (Berkeley, 1974), p. 253

L. Borgo: *The Works of Mariotto Albertinelli* (New York, 1976)

M. Natale: *Peintures italiennes du XIVe au XVIIIe siècle*, Geneva, Mus. A. & Hist. cat. (Geneva, 1979), p. 2

Il primato del disegno (exh. cat., Florence, Pal. Strozzi, 1980), p. 49

Le XVIe Siècle florentin au Louvre (exh. cat. by S. Béguin, Paris, Louvre, 1982)

Disegni di Fra Bartolommeo e della sua scuola (exh. cat. by C. Fischer, Florence, Uffizi, 1986)

A. M. Petrioli Tofani: *Gabinetto disegni e stampe degli Uffizi, Inventario, 1: Disegni esposti*, Florence, Uffizi cat. (Florence, 1986)

R. Bartoli: 'In Mugello, tra Quattro e Cinquecento', *Paragone*, xlv/529–33 (March–July, 1994), pp. 35–40

LUDOVICO BORGO, MARGOT BORGO

Alemanno [Alamanno], **Pietro** (*b* Göttweich, Austria, *c*. 1430; *d* Ascoli Piceno, the Marches, between 18 Sept 1497 and 22 Nov 1498). Italian painter of Austrian birth. He is first documented in 1477 in his adopted home of Ascoli Piceno. A badly preserved fresco of the *Virgin and Child with Saints* in the church of the Madonna delle Rose in Torre San Patrizio, near Ascoli, has been attributed to him; it is dated 1466, providing possible evidence of his presence in the area two years before his master, Carlo Crivelli, was first documented there. Alemanno's style was based on Crivelli's work of the 1470s and hardly evolved at all throughout his career. His expressionistic, anatomical distortion may be derived from Giorgio Schiavone. The

Virgin and Child Enthroned and the *St Lucy* (both Montefortino, Pin. Com.), which formed part of a dismembered polyptych dating from *c*. 1470, are typical of his work, with their dark outlines and strong hatching in both shadows and highlights.

Alemanno produced mostly polyptychs with the Virgin and Child enthroned, framed by standing saints on separate panels, or small-scale, half-length Virgin and Child pictures, ultimately deriving in form from similar compositions by Donatello. An exception is the *Annunciation* (Ascoli Piceno, Pin. Civ.), painted in 1484 for the city government of Ascoli: it is Alemanno's only surviving unified altarpiece with an architectural setting. Alemanno worked in or near Ascoli, where most of his works can still be found, until his death.

BIBLIOGRAPHY

L. Serra: *L'arte nelle Marche*, ii (Pesaro, 1934), pp. 395–405

P. Zampetti: *La pittura marchigiana del quattrocento* (Milan, 1969; Eng. trans., 1971), pp. 188–93

JEANNETTE TOWEY

Alesio, Mateo Pérez de. *See* PÉREZ DE ALESIO, MATEO.

Alessandro da Padova. *See* PADOVANO, ALESSANDRO.

Alessi, Galeazzo (*b* Perugia, 1512; *d* Perugia, 30 Dec 1572). Italian architect and writer. He was the leading High Renaissance architect in both Genoa and Milan, his villas and town palazzi establishing a definitive pattern for the genre. His greatest sacred building was S Maria Assunta in Carignano, the central planning of which shows the influence of Donato Bramante and Michelangelo.

1. Training and early career, *c*. 1530–48. 2. Genoa, 1548–57. 3. Later works, 1557–72.

1. TRAINING AND EARLY CAREER, *c*. 1530–48. The Perugia of Alessi's youth was an important centre of the Papal States, with a lively humanist and philosophical cultural life. Alessi received his early training in the school of the architect and painter Giovan Battista Caporali, whose edition of Vitruvius is notable for its tendency to rationalize the Antique and for its reference to music as a means of further perfecting the study of harmonic proportion in the visual arts. Alessi was also friendly with the architect Giulio Danti (1500–75), who was equally well versed in rhetoric and philosophy.

Alessi's diverse cultural experience recommended him to the papal court in Rome, where he moved in 1536. There he worked for Cardinal Lorenzo Campeggia and Cardinal Girolamo Glinucci and, most notably, for Cardinal Agostino Parisani, Bishop of Rimini. He became familiar with the architectural projects carried out in Rome for the papal court under Paul III, and particularly with the work of Antonio da Sangallo (ii) at St Peter's (1520–46), at the Vatican Palace (Sala Regia and Pauline Chapel, 1540) and at the Palazzo Farnese (1514–46). When Parisani was appointed papal legate for Perugia, Alessi returned with him and worked on a scheme drawn up by Sangallo for the fortress known as the Rocca Paolina (1543–8). According to Vasari, Alessi was responsible for the principal apartments (destr.; the loggia is recorded in a 19th-century drawing, see *Genova, 1975*, fig. 108).

Alessi assumed an even more important role in 1545, when Cardinal Parisani was replaced as papal legate by Cardinal Tiberio Crispo, who became the driving force behind the architectural renewal of the city (*see* PERUGIA). Alessi probably designed for Crispo the loggia on the upper floor of the Corso façade of the Palazzo dei Priori, which, like that of the Rocca, is built in the Doric order and which focuses the eye on the legate's apartment, formed from the existing rooms of the Priori. Alessi was probably responsible also for the construction for Crispo of the public loggia (1545–8), with pillars emphasized by Doric pilaster strips and simply profiled framing arches; the loggia was subsequently transformed into the oratory of Sant' Angelo della Pace. Stylistically, Alessi's work on the loggia recalls such Roman models as the Loggia of Paul III at the Castel Sant'Angelo, built by Raffaello da Montelupo.

Further works by Alessi in Perugia include the church of S Maria del Popolo (1547), which recalls Sangallo's design for the Pauline Chapel in the Vatican Palace, Rome, both in the entrance and in the plan of the interior, with its aisleless nave roofed by a coved vault intersected by four segments of barrel vaulting. In 1548 he received payment for the design and model for the convent of S Giuliana (now S Caterina), where, despite later modifications, it is still possible to identify traces of his work.

Although the opening up of the Via Nuova between the Corso and the Sopramuro at Perugia has sometimes been attributed to Alessi, it is now clear that this was carried out by Sangallo.

Alessi's work in Perugia reveals his early competence in various specialized fields of architecture, employing a vocabulary, based on the classicizing Roman style of Sangallo and on the works of other early 16th-century Italian architects, which he continued to recall even in his later years. He articulated internal space by robust yet simple pilasters, emphasized by an order (generally Doric) and covered by vaults that are frequently coffered. Already it is possible to see his cultivated and intelligent understanding of his classicizing sources.

2. GENOA, 1548–57.

(i) Patrons and urban development schemes. From early on Alessi was capable of maintaining relationships of mutual trust and respect with his patrons. His employment with the papal legates in Perugia enabled him to meet members of the rich Genoese families that provided the administrators of the Papal States. Among them were members of the Sauli family, who were responsible for many of Alessi's commissions: Stefano Sauli, apostolic protonotary, who as early as 1543 is recorded as having made a loan to Alessi, and Gerolamo Sauli and Bartolomeo Sauli, treasurers of

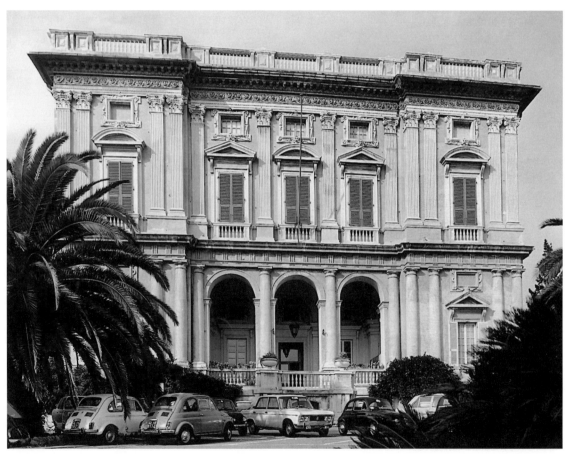

1. Galeazzo Alessi: Villa Giustiniani (now Villa Cambiaso), Albaro, Genoa, 1548

the papal administration in Perugia in the 1540s. These contacts opened the way for Alessi's transfer to Genoa in 1548 and then brought him his first commissions there——for the basilica of S Maria Assunta in Carignano, the family church of the Sauli, and for the villa (see fig. 1) in Albaro of Luca Giustiniani, who was married to a Sauli (*see* §(iii) below). Further commissions came from other noble families of Genoa, such as the Grimaldi and the Pallavicini, while Gerolamo Sauli, who was appointed Archbishop of Genoa in 1550, was associated with Alessi's work in Genoa Cathedral and in the Palazzo Comunale, Bologna, during his time as papal vice-legate (1550–55); Alessi's contribution to the palazzo included the main entrance, another doorway off the courtyard and part of the chapel.

In contrast to other architects in the city, Alessi was treated as an equal by his patrons, participating at all levels in the transformation of Genoa throughout one of the most important periods of architectural innovation in the later 16th century. His buildings provided the central points of reference for the transformation of the city. He also drew up plans for the reorganization of the hill of Carignano involving the development of Sauli properties in the area, but they remained unexecuted, while the development of the Strada Nuova in Genoa, formerly attributed to Alessi, has been shown to be the work of other hands (*see* GENOA, §1).

(ii) S Maria Assunta in Carignano. The contract between Alessi and the Sauli for the construction of S Maria Assunta in Carignano (see fig. 2) dates from September 1549, but the foundation stone was laid only in 1552, the wooden model was constructed between 1552 and 1554, and by 1567 it had reached the stage of vaulting; only then was thought given

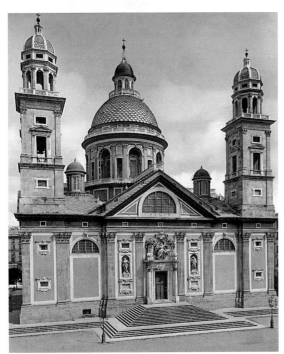

2. Galeazzo Alessi: S Maria Assunta in Carignano, Genoa, 1552–1603

to the dome, with probable variations made to the original model. The church was completed in 1603.

The model for the Sauli church was clearly derived from Bramante's work in Rome—not just from St Peter's, but also, and more precisely, from the church of SS Celso e Giuliano (destr. 1733), which was built under Sangallo's direction. The plan of the building is centralized, consisting of a Greek cross set within a square, with a central dome and smaller domes over the arms of the cross and four bell-towers emphasizing the corners of the square. Deriving from the same Roman background are the powerful, solid pillars and the coffered vaults, where the contrast of light and shade is brought out by the white plaster walls. The façade, with its alternating areas of white and pink, achieves a remarkable clarity of composition, both defining and emphasizing the structural elements without detracting from the ample, interlinking areas of wall surface that surround the dome. The high podium planned for the church was partly built only in the 19th century, and the completion of the altar and the entrance date from the Baroque period. Despite the church's centralized plan, a sense of orientation, towards the sea and the heart of the old city, was stressed during construction by eliminating two of the four planned bell-towers; it is possible this axiality may have been envisaged in the original plans. The link with the landscape and the surrounding natural environment must have been strongly felt by Alessi, and during the construction of the church he changed the design of the dome, providing it with a drum in the form of a covered arcade opening on to four high terraces on each of the sides, access to which is gained by four convenient spiral stairways.

Between 1550 and 1557 Alessi provided his services free for the rebuilding of Genoa Cathedral and probably drew up an overall plan. This was never carried out in its entirety, but his hallmark can be seen in the dome resting on a polygonal drum, elegantly coffered within and articulated on the exterior by Ionic columns and pilaster strips on high bases decorated with panels.

(iii) Villas. Alessi's first project in Genoa was the Villa Giustiniani at Albaro (1548; renamed Villa Cambiaso and now the headquarters of the Faculty of Engineering, Università di Genova). It was planned as a solid block without a central courtyard, but its hilltop location made it a focal-point for the surrounding countryside. The elevation is composed of two floors, and the seaward side is decorated with a superimposed order of Doric half columns on the ground floor and fluted composite pilasters in the upper floor, paired at the ends of the wall in order to balance the opening on the ground floor created by the central triple-arched portico (see fig. 1). The layout is based on the two loggias between the two slightly projecting wings: the loggia of the entrance front is on the ground floor, while that at the rear is on the upper floor, giving access to a salon situated over the lower portico. The loggias are rectangular in plan, with an apse at each end, and while the stylistic solutions once again derive from Roman models and from Sangallo, the treatment of the façade walls is more decorative, with details suggesting the influence of Michelangelo. Inside, the solid architectural orders and coffered ceilings are complemented by decorative elements, such as herms, caryatids and tablets,

recalling Perino del Vaga and the pupils of Raphael. These characteristics—a compact plan with variety provided by the decoration—were subsequently developed by Alessi in other villas.

The Villa Pallavicino (*c.* 1555; also known as the Villa delle Peschiere; *see* VILLA, fig. 3) is a looser reworking of the plan for the Villa Giustiniani. The central block, opening out on to the garden, has two entrances of equal importance, one at the centre of the U-shaped layout, the other dominating the garden-front terrace above the nymphaeum. The latter, reached through a portico divided in three by Doric pilasters, is elliptical in plan; it is a fine example of grotesque decoration executed in multicoloured pebbles, imitated later in other Genoese buildings.

Between 1552 and 1554 Alessi also designed a villa for Giovanni Battista Grimaldi (renamed Villa Sauli). Here great play was made of the relationship of the building with the space surrounding it, the courtyard in front being articulated by a series of *serliane*, which were repeated, in two superimposed orders, on the façade of the villa itself. The villa has been transformed into apartments, and only the original cornice remains, with its emphatic carved decoration of vegetation and masks. Alessi's solutions are found echoed in many villa buildings that were once attributed to him but are in fact the work of others: the Villa Grimaldi (called La Fortezza), the Villa Lercari and the villa built for Vincenzo Imperiali have now been attributed respectively to Bernardo a Spazio, Bernardino da Cantone, and Domenico and Giovanni Ponzello.

(iv) The Porta del Molo. Alessi's early experience on the Rocca Paolina site at Perugia had given him a certain knowledge of military architecture, in terms not only of defensive techniques of fortification, and in particular of the Rocca Paolina *tenaille*, but also of the influence of the military style on the city itself. He used this experience at Genoa in 1553 when he built the Porta del Molo (or Porta Siberia) and also, once again, referred back to Sangallo, in particular to the Porta di Santo Spirito in Rome (from 1540). He resolved the problem of the seaward fortifications by borrowing from the *caudate*, or tail-shaped, designs described in Classical treatises, creating between the two lateral ramparts a curved, semi-elliptical space with a central gateway in a Doric order. The columns and walls of the gateway are covered by bands of rustication, recalling the work of Giulio Romano and designs represented in Sebastiano Serlio's treatise *Regole generali* (Venice, 1537). By contrast, the city side, with its portico articulated by pairs of pilasters supported by piers and framing arches, has an elegant linear rhythm. Alessi did not undertake this type of fortification again, but it forms the probable basis of the attribution to him by Baldini of a manual of military architecture now in the Biblioteca Estense, Modena. The manual provides a systematic illustration of systems of fortification, but the analogy with Alessi's designs is not very persuasive, and the attribution remains somewhat uncertain.

3. LATER WORKS, 1557–72.

(i) Lombardy.

(a) Palazzo Marino. Tommaso Marino, a banker from a family of Genoese origin, summoned Alessi to Milan in 1557 and commissioned a design for a mansion, which developed in an urban context several ideas already used in the Genoese villas. The closed and compact external block of the building is in fact made up of three separate elements: courtyard, salon and garden. The exterior of the mansion is unified by a solid wall of breccia articulated by three orders: Doric half columns on the ground floor embrace window aedicules that sport a rusticated minor order; Ionic pilaster strips on the *piano nobile* frame tapered window surrounds that support pediments, broken to enclose grotesque heads, and prop the mezzanine window surrounds. The top-floor pilasters have flutings that converge downwards, while their capitals take the form of female heads linked by a richly decorated frieze. The façade on to the present Piazza della Scala is a 19th-century addition; originally the house was only roughly finished on this side, which overlooked a passageway separating it from other buildings.

The courtyard (see fig. 3), with direct access to the street, has a two-storey elevation with a portico and loggia articulated by *serliane*; on the ground floor these are relatively plain, but the upper floor is enriched with an exuberant decoration of caryatids bearing baskets and garlands of flowers and fruit, as well as ornamental tablets. The decorative programme of the courtyard is for the most part inspired by themes from Ovid's *Metamorphoses*; the same source was employed for the stucco and fresco decoration of the salon, where the legends of Perseus and Psyche are depicted following a programme (reconstructed in Scotti) derived from engravings and medals associated with the school of Raphael. The Grand Salon has, in addition to its access from the courtyard, a second entrance directly from the road; this served to connect, and at the same time separate, Marino's own apartments and those of his two sons, which extended around the garden lying behind the house.

The many alterations made to the house over the centuries have left intact only the courtyard and part of the salon, where the vaults were destroyed by bombing in 1943. The design of the courtyard at the Palazzo Marino, however, influenced other Milanese buildings, such as Vincenzo Seregni's Palazzo dei Giureconsulti (begun 1561), for which Alessi provided the design of a door.

3. Galeazzo Alessi: Palazzo Marino, Milan, view of courtyard, begun 1558

(b) Church designs. Probably at the request of the Sauli family, Alessi also collaborated on the rebuilding of SS Barnaba e Paolo, Milan, a church belonging to the Barnabites, who were supported by Alessandro Sauli. Alessi's contribution to the reconstruction, which began as early as 1547, is documented in 1561 in connection with the rebuilding of the choir. His involvement, however, extended to the redesigning of the entire church, which has an aisleless nave flanked by chapels and covered with a barrel vault decorated with delicate stucco ornament. The rebuilt church of S Barnaba comprised a succession of three communicating but distinct spaces: the nave, presbytery and choir, each with a different vaulting system and with the presbytery raised three steps above the nave (now transformed by the 19th-century opening of the crypt below). It was one of the earliest churches in Milan to fulfil the requirements of the Counter-Reformation, in which the Barnabite Order was deeply involved. The solutions adopted by Alessi, enhanced by the vaults and their delicate and subtle stuccowork, accentuate his perception of space as a matter of proportion, harmony and intellectual order.

Around 1560 Alessi must also have prepared a design for the rebuilding of the Olivetan church of S Vittore, Milan, following his earlier intervention to provide the design for a tripartite Doric window for the monastery there. The church was planned with a nave and two aisles, chapels, a high dome and an elongated presbytery with a monks' choir ending in an apse.

Through his contacts with Marino, Alessi came to the attention of other Lombard patrons, including the d'Adda family. Giacomo d'Adda turned to him for the designs required to complete the façade and the interior decoration (the inside wall of the façade and the choir) of the church of S Maria presso S Celso, of which he was the administrator. In the mid-1560s Alessi drew up an extensive corpus of designs (now Milan, Bib. Ambrosiana), arranging above the Doric ground floor a further four storeys articulated not by Classical rules but by a free association of tablets and frames, pilaster-strips and half columns, creating through continuous, vibrant chiaroscuro an architecture that is both directed and affirmed by the values of the wall surface. This harmony of surface and decoration is a lively feature of the designs for the inside wall of the façade and the choir but is less evident in the actual construction of the building, which was carried out after 1570 under the direction of Martino Bassi.

(c) Design of the Sacro Monte, Varallo. Also under the patronage of Giacomo d'Adda, Alessi produced designs for the restructuring of the Sacro Monte in Varallo, the home town of d'Adda's wife. These form a complete corpus of designs in a volume entitled *Il libro dei misteri* (Varallo Sésia, Bib. Civ.), which Perrone has dated to 1565–9 and reattributed, in its entirety, to Alessi. The Sacro Monte was the work of the Franciscan Bernardino Caimi (*d* 1499), who returned from Jerusalem *c.* 1486 with the aim of reproducing the form and layout of the holy sites there in a series of chapels (*see* VARALLO, SACRO MONTE). In his *Libro dei misteri*, Alessi worked out a complex new overall design, which considerably extended the scope of the Sacro Monte, subdividing it into three distinct zones, dedicated respectively to the Life of Christ (but with an antecedent in the form of a chapel dedicated to Adam and Eve), to the Passion, and to representations of Limbo, Purgatory and Hell. The first zone was to be located on the side of the hill, the densely covered and uneven slopes of which were to form a backcloth for the clear-cut outlines of the chapels, distributed over a winding course. The second zone was to be situated on the level summit of the hill. Around an octagonal piazza (the true centre of the plan) were to have been laid out the buildings most representative of the city of Jerusalem (the Courthouse and the Temple). Finally the third zone, situated in a large valley, was to have housed chapels intended to be seen from above in a complex scenic plan. Alessi thus devised a sacred hill based on works of architecture and designed to take best advantage of the surrounding space. Even the sacred scenes and the mysteries depicted inside each chapel became subordinated to the architecture: in many chapels the scenes were contained in shrines, as precious objects to be contemplated on a separate, intellectual, level.

Between 1565 and 1568 the main gate and the chapel of Adam and Eve were erected according to Alessi's designs, and the entire route on the hillside was cleared. The chapels and structures built after 1569, however, were based on a new plan dictated by Cardinal Carlo Borromeo's insistence that there should be a greater concentration on the emotional involvement of the faithful, rather than on the intellectual contemplation of a sacred theme.

(ii) Umbria. Alessi returned to his native Umbria four times in the 1560s, both for family reasons and to act as a consultant. In 1567, for example, he supplied designs for a tabernacle (destr.) for the basilica of S Pietro at Perugia and for the south door of the cathedral there. In 1569, however, he returned for good and took on such demanding projects as the restructuring of the convent of S Pietro, where he added the Chiostro delle Stelle (1571), and the reorganization of the Palazzo dei Priori.

Work started on construction of the basilica of S Maria degli Angeli, below Assisi, to Alessi's designs in 1569. This was intended as a tangible reminder to the pilgrims, who arrived in great numbers, particularly during the local feast of Pardon (1–2 August), of the birth of the Franciscan movement: the church enclosed, as in a shrine, the venerated chapels associated with the movement, the Porziuncola (the original little oratory of St Francis) and the chapel of the Transito. The basilica was planned with a nave, two aisles with side chapels, a transept contained within the main block and a deep presbytery, all decorated in the Doric order. Following Alessi's designs, the nave and aisles with their chapels were built fairly rapidly; in this part of the church a severe architectural style prevailed, based on solid, robust piers and with alternating barrel and groin vaults. The transept, dome and presbytery, however, were built only during the 17th century, to a partial modification of the original plans. The interior of the nave and aisles and the external walls of the chapels reflect Alessi's designs with some accuracy, despite the reconstruction of the vaults following the earthquake of 1832. The façade, on the other hand, rebuilt in a totally

different style in 1924–30, destroys the original scheme's characteristic linking of elements.

During the same period Alessi was also working on designs for the internal rebuilding of the cathedral of S Rufino at Assisi; work began in 1571, although once again he never returned to the site once he had submitted his designs. The old Romanesque building was transformed into a modern church with a nave and two aisles in the Doric order and plastered surfaces, while both the barrel vaults of the nave and the groin vaults of the aisles are lower than in the original building. Finally, Alessi eliminated the original rise to the presbytery and organized the space at the end of the church as a tribune on an octagonal plan, with four of its sides pierced to form a cross with the apsidal chapel longer than the others. Access to the tribune was to have been from the nave (the present additional entrances from the aisles were opened up at a later date), while the dome was to have been lit only indirectly, from the wings and the central oculus. Again Alessi appears to have intended an extremely purist architecture, based on the exclusive use of a single order, in all its severity, emphasized further by the simplicity of the wall surfaces. The only departure from this eminently rational and intellectual perception of space is the presence of single elements of refined ornamentation. Alessi also designed the precious tabernacle made by Vincenzio Danti for the church of S Francesco (Assisi, Tesoro Mus. Basilica S Francesco), applying these same principles of rationality.

Alessi's approach to design was reflected in his working practices, and throughout his career he concentrated above all on the intellectual aspects and hence the purely planning side of his work, progressively distancing himself from any direct contact with the actual construction of his buildings. Once he had provided the model, the design of the complete building and the decorative elements, he ceased to intervene, leaving the work to well-trained site managers with whom he often communicated in writing.

WRITINGS

Il libro dei misteri (MS.; 1565–9; Varallo Sésia, Bib. Civ.); ed. A. M. Brizio and S. Perrone as *Galeazzo Alessi: Il libro dei misteri: Progetto di pianificazione urbanistica, architettonica e figurativa del Sacro Monte di Varallo in Valsesia* (Bologna, 1974)

BIBLIOGRAPHY

DBI

G. Vasari: *Vite* (1550, rev. 2/1568); ed. G. Milanesi (1878–85), vii, pp. 552–5

F. Alberti: *Elogio di Galeazzo Alessi da Perugia* (MS.; *c.* 1573; Perugia, Bib. Augusta); ed. L. Beltrami (Milan, 1913)

L. Pascoli: *Vite de' pittori, scultori ed architetti moderni*, 2 vols (Rome, 1730–36/*R* 1933), i, pp. 279–87

S. Varni: *Spigolature artistiche nell'archivio della Basilica di Carignano* (Genoa, 1877)

E. de Negri: *Galeazzo Alessi, architetto a Genova* (Genoa, 1957)

M. Tafuri: *L'architettura del manierismo nel cinquecento europeo* (Rome, 1966)

A. Peroni: 'Architetti manieristi nell'Italia settentrionale: Pellegrino Tibaldi e Galeazzo Alessi', *Boll. Cent. Int. Stud. Archit. Andrea Palladio*, ix (1967), pp. 272–92

L. Vagnetti, ed.: *Genova: Strada Nuova* (Genoa, 1967)

E. Poleggi: *Strada Nuova: Una lottizzazione del cinquecento a Genova* (Genoa, 1968, 2/1972)

——: 'Genova e l'architettura di villa nel secolo XVI', *Boll. Cent. Int. Stud. Archit. Andrea Palladio*, xi (1969), pp. 231–42

E. Robbiani: 'Un'opera milanese di Galeazzo Alessi: Palazzo Marino', *Ist. Elem. Archit. & Rilievo Mnmt. [Genova]: Quad.*, 2 (1969), pp. 151–82

M. Labò: 'G. Alessi, architetto perugino', *I palazzi di Genova di P. P. Rubens ed altri scritti d'architettura* (Genoa, 1970), pp. 56–73

Galeazzo Alessi e l'architettura del cinquecento: Atti del Convegno internazionale di studi: Genova, 1975 [extensive bibliographies]

G. Fusconi: 'Perino del Vaga e Galeazzo Alessi: Influssi della seconda attività romana di Perino sul formarsi della decorazione alessiana', *Commentari*, xxvii (1976), pp. 69–81

N. Carboneri: 'Le chiese dell'Alessi', *Boll. Cent. Int. Stud. Archit. Andrea Palladio*, xix (1977), pp. 191–8

P. Carpeggiani: 'Per una bibliografia sistematica su Galeazzo Alessi', *Riv. Semest. Stor. A.*, vi/2 (1977), pp. 38–49

A. Scotti: 'Per un profilo dell'architettura milanese (1535–1560)', *Omaggio a Tiziano: La cultura artistica milanese nell'età di Carlo V* (exh. cat., ed. M. Garberi; Milan, Pal. Reale, 1977), pp. 103–5, 114–17

G. Baldini: 'Un ignoto manoscritto d'architettura militare autografo di Galeazzo Alessi', *Mitt. Ksthist. Inst. Florenz*, xxv (1981), pp. 253–78

N. Houghton Brown: *The Milanese Architecture of Galeazzo Alessi*, 2 vols (New York and London, 1982)

E. Poleggi and F. Caraceni: 'Genova e Strada Nuova', *Stor. A. It.*, ed. P. Fossati, xii (Turin, 1983), pp. 301–61

F. Vignoli: 'L'Alessi in Assisi', *Atti Accad. Properz. Subasio-Assisi*, vi/13 (1986), pp. 197–243

F. F. Mancini and A. Scotti, eds: *Storia e architettura* (1989), i of *La Basilica di S Maria degli Angeli* (Perugia, 1989–)

K. Zeitler: *Galeazzo Alessis Villen Giustiniani-Cambiaso und Grimaldi Sauli: Ein Genueser Beitrag zur Villenarchitektur im Cinquecento* (Munich, 1993)

AURORA SCOTTI TOSINI

Alexander VI, Pope. *See* BORGIA, (2).

Alfani, Domenico (di Paride) (*b* Perugia, 1479–80; *d* 1549–57). Italian painter. The son of a goldsmith, he was a pupil of Perugino and a friend of Raphael, whose style influenced him strongly. An undated letter (Lille, Mus. B.-A.) from Raphael to Alfani, which includes a drawing of the *Holy Family*, asks Alfani to intervene with Atlanta Baglioni, for whom Raphael had painted the *Entombment* (1507; Rome, Gal. Borghese), to ask her to settle a fee. In 1510 Alfani became a member of the Perugian painters' guild. Alfani's earliest surviving work, painted in 1518 for S Gregorio della Sapienza, Perugia, depicts the *Virgin and Child Enthroned with SS Gregory and Nicholas* (Perugia, G.N. Umbria) and is based on Raphael's *Virgin and Child* (the Orléans *Madonna*, *c.* 1506–7; Chantilly, Mus. Condé). Alfani based the design of an altarpiece executed with Pompeo d'Anselmo in 1520 for S Simone del Carmine, Perugia (Perugia, G.N. Umbria), on the drawing sent to him by Raphael. In the mid-1520s Alfani came under the influence of the Florentine Mannerists, particularly Rosso Fiorentino, to whom he gave shelter in 1527 when the artist was fleeing the Sack of Rome. According to Vasari, Rosso gave Alfani a drawing of the *Three Magi* (destr.), on which he based his altarpiece for S Maria dei Miracoli, Castel Rigone (ex-Rinuccini priv. col., Florence). In 1553 Alfani was commissioned to paint a *Crucifixion* for S Francesco, Perugia. He was assisted by his son Orazio Alfani (*c.* 1510–83), who continued his father's business. In 1556 Orazio received payment for work he had executed for the choir of S Pietro, a commission his father had undertaken in 1547.

BIBLIOGRAPHY

G. Vasari: *Vite* (1550, rev. 2/1568); ed. G. Milanesi (1878–85)

W. Bombe: *Geschichte der Peruginer Malerei*, Italienische Forschungen, v (Berlin, 1912), pp. 13, 127, 335, 346

E. Jacobsen: *Umbrische Malerei* (Strasbourg, 1914), pp. 139–41 [illus.]

E. A. Caroll: 'Lappoli, Alfani, Vasari and Rosso Fiorentino', *A. Bull.*, xlix (1967), pp. 297–304

J.-R. Gaborit: 'L'*Adoration du Christ mort*: Terre cuite ferraraise du Musée du Louvre', *Mnmts Piot*, lix (1975), pp. 209–30

SUSANNE KIEFHABER

Alfei, Francesco di Bartolomeo (*b* ?Montalcino, 1421; *d* Siena, after 1491). Italian painter. In 1453 he was living in Siena in the district called the Chompagnia di Realto et Chartagine, where he had a painter's studio ('*buttiba de l'arte de dipentori*'; Siena, Pal. Piccolomini, Archv Stato, *Lira*, MS. 139.c.50). He was chiefly employed by the Sienese Republic but also worked for Pope Pius II in 1460 (see Müntz), for the diplomat Leonardo Benvoglienti, for the Ottieri della Ciaia family and for Sinolfo di Castellottieri. In 1455 Alfei was paid by the magistrates of Siena for his painting of Monte Argentario near Orbetello (Siena, Pal. Piccolomini, Archv Stato, *Balia*, MS. 1.c.215), work that Alessi suggests may be recognized in the *Town by the Sea* and the *Castle by the Sea* (both Siena, Pin. N.), previously attributed to Ambrogio Lorenzetti and to Sassetta. In 1473 the Sienese Republic recommended Alfei to the papal legate, Cardinal Roverella, on the occasion of the artist's visit to the Marches; the Cardinal's reply confirms that Alfei executed works there. Alessi and Scapecchi have proposed that the anonymous MASTER OF THE OSSERVANZA (*see* MASTERS, ANONYMOUS, AND MONOGRAMMISTS, §I) can be identified with Francesco di Bartolomeo Alfei. They demonstrated that the works attributed to the Master were produced between 1440 and 1470, not in the 1430s and 1440s as previously believed. The dated inscription of 1436 on the *Virgin and Child with SS Jerome and Ambrose*, which was thought to refer to the date of execution, is in fact the date of the foundation of the chapel in S Maurizio, Siena. Given the revised dating, the Master cannot be identified with Sano di Pietro, as has also been proposed, but Alfei had many connections with Sano, which would account for the two painters' stylistic similarities.

It is likely that the scenes from the *Life of St Anthony Abbot* from a dispersed altarpiece (panels in Washington, DC, N.G.A.; New York, Met.; Wiesbaden, Mus. Wiesbaden; and elsewhere), attributed first to Sassetta and later to the Master of the Osservanza, originally came from the region of the Marches and the Abruzzi, an area in which Alfei was active. The *Charity of St Anthony Abbot* (Washington, DC, N.G.A.) bears the coat of arms of the Martinozzi family, and the connection between Alfei and that family is documented by Sano di Pietro's assessment in 1475 of paintings made by Alfei for Ludovico Martinozzi. Pope-Hennessy, however, does not accept the identification of Alfei with the Master of the Osservanza.

BIBLIOGRAPHY

E. Romagnoli: *Biografia cronologica de bellartisti senesi* (*c*. 1835, Bib. Com. di Siena, MS.L.II.3); facs. iv (Florence, 1976), pp. 139–48

G. Milanesi: *Documenti per la storia dell'arte senese*, ii (Siena, 1854), pp. 299–300, 327, 329–30, 355–6, 396–7, 421

E. Müntz: *Les Arts à la cour des papes*, i (Paris, 1878), pp. 264, 309

S. Borghesi and L. Banchi: *Nuovi documenti per la storia dell'arte senese* (Siena, 1898), pp. 238–9, 260–61, 277–8, 350

C. Alessi and P. Scapecchi: 'Il maestro dell'Osservanza: Sano di Pietro o Francesco di Bartolomeo', *Prospettiva*, 42 (1985), pp. 13–37

J. Pope-Hennessy: *Italian Paintings in the Robert Lehman Collection*, New York, Met. cat. (Princeton, 1987), pp. 105–11

CECILIA ALESSI

Alghisi, Galasso (*b* Carpi, nr Modena, *c*. 1523; *d* Ferrara, 1573). Italian architect and writer. He worked intermittently in Rome from 1549 to 1558, probably on the Palazzo Farnese under Michelangelo and on the city fortifications decreed by Pope Paul III. He was in Loreto in 1549, working on the basilica of S Maria, and in 1550, outside Macerata, began the church of S Maria delle Vergini, on which work continued for the rest of his life. The plan is a Greek cross, with a tall, octagonal drum over the crossing, in which are set large rectangular windows that transmit a bright but diffused light to the centre of the church. The interior is impressive in its refined simplicity, with almost all architectural elements reduced to their most essential forms. The great square nave piers, for example, are devoid of decoration other than their simple plinths and cornice-like capitals. The church is built throughout in brick, which is left exposed, with decorative inlaid panels, in the cross-vaulting to the right-hand eastern chapel. The façade (1581) is attributed to Lattanzio Ventura da Urbino (*fl* 1575–87).

In 1558 Alghisi submitted a design for a municipal tower at Macerata, but most of his subsequent career was spent at Ferrara in the service of Duke Alfonso II d'Este, for whose palace he built a theatre and the Loggiata dei Camerini. An unexecuted scheme by Alghisi for a new palace in Ferrara was engraved (1566) at Bologna by Domenico Tibaldi; from the same year a contract survives for the construction of a campanile to Alghisi's design for the Carthusian monastery of S Cristoforo in Ferrara. Alghisi published a three-volume work on military architecture (1570) that invoked the traditional apparatus of Renaissance scholarship to produce such geometrical *tours de force* as 18 versions of a star polygon with bastions at the points. The treatise had some influence on Dutch fortification theory in the 17th century.

WRITINGS

Delle fortificationi di M. Galasso Alghisi da Carpi, architetto dell'ecc. Signor Duca di Ferrara libri tre, all'invittissimo Imperatore Massimiliano Secondo, Cesare Augusto, 3 vols (Venice, 1570/*R* 1575)

BIBLIOGRAPHY

DBI; Thieme–Becker

G. Vasari: *Vite* (1550, rev. 2/1568); ed. G. Milanesi (1878–85)

A. Venturi: *Storia* (1901–40)

G. Natale: 'Un tempio bramantesco poco noto (S Maria delle Vergini a Macerata)', *Raccolta di scritti in onore del Prof. Giacinto Romano* (Pavia, 1907)

A. Colasanti: *Loreto* (Bergamo, 1910)

L. Serra: *L'arte nelle Marche*, 2 vols (Pesaro, 1929)

□

Aliense. *See* VASSILACCHI, ANTONIO.

Alladio, Gian Giacomo d'. *See* ALBA, MACRINO D'.

all'antica [It.: 'after the Antique']. Style of decoration in a work of art that mimics, quotes or derives from a Classical model (*see* ANTIQUE, THE, fig. 1).

□

Allegri, Antonio. *See* CORREGGIO.

Altarpiece [Fr. *postautel, retable*; Ger. *Altar, Altaraufsatz, Altarbild, Altarretabel, Altarrückwand, Retabel*; It. *ancona, dossale, pala (d'altare)*; Sp. *retablo*]. An image-bearing structure set on the rear part of the altar, abutting the back of the altarblock, or set behind the altar in such a way as to be visually joined with the altar when viewed from a distance. It is also sometimes called a retable,

following the medieval term *retrotabulum* [*retabulum, retrotabularium*].

1. Definition. 2. Historical overview.

1. DEFINITION. The altarpiece was never officially prescribed by the Church, but it did perform a prescribed function alternatively carried out by a simple inscription on the altarblock: to declare to which saint or mystery the altar was dedicated. In fact, the altarpiece did more than merely identify the altar; its form and content evoked the mystery or personage whose cult was celebrated at the altar. This original and lasting function influenced the many forms taken by the altarpiece throughout its history. Since the altarpiece was not prescribed by the Church, its form varied enormously. For this reason, it is often impossible, and historically inaccurate, to draw neat distinctions between the altarpiece and other elements occasionally associated with the altar apparatus. For example, movable statues, often of the Virgin and Child, were occasionally placed on altars according to ritual needs, and at those times fulfilled the function of the altarpiece. Altarpieces also often contained relics, and in those instances served both as altarpiece and reliquary. Sacrament tabernacles, although often placed on a wall to the side of the altar, were occasionally placed on or above the altar and effectively assumed the role of the altarpiece. The reredos, originally a decorated hanging or screen behind the altar, was so often associated with the function of the altarpiece that the term has become an antiquated alternative to that of altarpiece. Finally, the original association of the Christian altar with the tomb of a saint, and theologically with the tomb of Christ, sometimes resulted in the amalgamation of a decorated tomb structure (traditionally that of a saint but eventually also of important lay figures) with the altarpiece.

Altarpieces adorned both high altars and side altars. High altars, which sustained the dedication of the entire church and served the purposes of High Mass, often carried large altarpieces with elaborate programmes. Side altars served a more private piety and their altarpieces were often endowed by private individuals. Such altars could be used by the faithful for extra-liturgical, private prayer more easily than the altarpiece on high altars, which were often concealed behind screens separating the choir from the nave of the church. Private devotional images often took the form of altarpieces and are frequently described as such, but they do not strictly belong to that category except in the relatively rare cases when they served on consecrated altars.

2. HISTORICAL OVERVIEW.

(i) Origins and early history. (ii) Forms and development.

(i) Origins and early history. The altar, a square block free on all sides, traditionally stood alone as the primary focus of the church. In the Early Christian Church nothing was allowed on the sacred table, or *mensa*, except for the sacred books and the instruments (pyx, chalice and paten) necessary for celebrating the Eucharist. A free-standing ciborium was one means devised to adorn the simple altar without violating this rule. By AD 1000, the altar had evolved into a rectangular form with a more defined front and back (Bishop, 1918). This development prepared the way for the appearance, on the rear edge of the altar table, of a panel decorated with sacred figures: the altarpiece.

A crucial development in the history of the altarpiece was the practice of setting relics, traditionally embedded within or underneath the altar, in decorated reliquaries on top of the altar. Smaller reliquary shrines were placed towards the rear of the altar. Large ones containing the entire body of a saint were set either lengthwise on a block behind the altar or transversely, with one end resting on the back edge of the altar and the other on a support set up behind (Bishop). Another type of reliquary took the form of a statue and was placed on the altar or on a support behind it. The appearance of this new source of imagery on the altar was a precedent for the later development of the altarpiece as a permanent feature of the altar apparatus. Another source of imagery on the altar was provided by the decoration, either textile or sculpted, covering the front of the altarblock and known as the antependium or altar frontal. The early format and composition of the altarpiece, a rectangular field containing a row of frontal figures usually arranged under an arcade, strongly resembles the earlier antependium type.

The advent of the altarpiece marks a significant development not only in the history of the altar, but also in the nature and function of the Christian image. The autonomous image now assumed a legitimate position at the centre of Christian worship. Rather than adorning the outer surface of another sacred object, whether reliquary, altar frontal or church wall, it now stood in a structure made for no purpose other than to hold the image up to view. As a part of the altar apparatus, the image was now an important element of church architecture in its own right. The appearance of this new element on or behind the altar accompanied changes in the positions assumed by priest, deacon and subdeacon while celebrating mass. Until the 10th century, it was common for the celebrant to stand on the far side of the altar, facing the congregation, but later he came to stand before the altar, with his back to the congregation. As long as the celebrant stood on the far side of the altar, it can be assumed that an altarpiece would have constituted an impermissible obstruction. The records, however, are scattered so sparsely over the period between the 9th and the 11th centuries that it cannot be determined whether the changes they document are causes or consequences of the appearance of the altarpiece.

Although claims have been made to document or to date altarpieces to the 8th century or 9th, significant numbers of records of their existence appear only in the 11th century, and the earliest surviving group of any size dates from the 12th century. The basic form of the earliest known altarpieces is an antependium-like rectangular panel, usually showing a series of saints flanking a central figure of Christ or the Virgin. This basic form was also sometimes given extensions on the upper border of the frame. Gabled panels in a vertical format representing a full-length saint flanked by scenes of his or her life (sometimes called *vita* retables) were also popular in 13th-century Italy, especially in mendicant settings. Although the early history of the painted altarpiece in Italy is marked by experiments with these various formats, the most important source for its later development was the hori-

zontal painted panel, often known as a dossal. It followed from the antependium tradition, with a central figure of Christ or the Virgin flanked by figures of saints. These soon developed single-gabled forms and painted or carved arcades above the figures. By the 1280s, this type had evolved a many-gabled tier above the arcade.

The development of an elaborate gabled outer structure enframing several vertically conceived individual compartments, in contrast to the earlier, horizontally unified single panel, paved the way for the development of the polyptych in the 14th century. The new several-tiered format was probably related to the simultaneous appearance of the predella, the decorated step-like block that developed to support this enlarged structure and to ensure the entire altarpiece's visibility. Polyptychs were increasingly elaborate, their frames often featuring piers, colonettes, cusped arches, tracery, pinnacles, crockets and finials, eventually transforming the altarpiece into an architectonic structure resembling in detail and spatial principles the façades of contemporary full-scale Gothic architecture (see colour pl. 2, XXXIX3).

(ii): c. 1400–c. 1600. In the 15th century there was a proliferation of altarpieces, largely the result of the growing initiative of non-ecclesiastical and non-aristocratic patrons. The endowment of altars and chapels was often the concern of individual families or confraternities, and by the end of the 15th century churches north and south of the Alps were filled with privately endowed altars, each with its own altarpiece. The prevalence of private sources of patronage is reflected in the frequent appearance of donor portraits in altarpieces of this period.

In 15th-century Italy the polyptych was largely outmoded by the unified, framed panel. This development involved changes both in altarpiece construction and pictorial convention. If the traditional polyptych was a painted and gilded piece of ecclesiastical furniture, the new type of altarpiece, known as the *pala*, was closer to a framed picture. The single, large panel was now made and painted independently of its frame, which, supported by the predella, was now designed in the style of classical architecture, with flanking pilasters mounted by an entablature. Within the frame, the painting was treated as a window giving on to a natural or architectural space and was thus differentiated pictorially as well as structurally from the frame. This pictorial realm was typically inhabited by saintly figures arranged around the Virgin and Child in a *sacra conversazione* (e.g. Domenico Veneziano's *St Lucy* altarpiece, *c.* 1445–7; main panel Florence, Uffizi; *see* DOMENICO VENEZIANO, fig. 2 and colour pl. 1, XXVIII1; Fra Angelico's S Marco Altarpiece, *c.* 1438–40; Florence, Mus. S Marco; Piero della Francesca's Brera Altarpiece, *c.* 1475; Milan, Brera; see colour pl. 2, XVI2). In several Venetian altarpieces of this period the frame stands as the architectural entrance into a fictive chapel, conceived as an extension of the church space (e.g. Giovanni Bellini's S Zaccaria Altarpiece, 1505; Venice, S Zaccaria; for illustration *see* SACRA CONVERSAZIONE). The strong interest in natural setting and figural expression gave new dramatic force to narrative subjects (e.g. Leonardo da Vinci's *Adoration of the Magi, c.* 1481; Florence, Uffizi; *see* LEONARDO DA VINCI, fig. 1, Raphael's *Entombment*, 1507;

Rome, Gal. Borghese; see colour pl. 2, XX2; Titian's *Assumption of the Virgin*, 1518; Venice, S Maria Gloriosa dei Frari; see fig.), and prompted an increased use of narrative scenes as the main subjects of the altarpiece, which had hitherto more often consisted of a simple grouping of saintly figures.

The rise of the single painted panel as the predominant format for altarpieces was of great consequence for the history of European art. It encouraged the rise of the art of panel painting and paved the way for the predominance of the easel picture in the following centuries. A single picture commanding ceremonious attention at the focus of Christian worship, the Italian *pala* set a powerful structural and functional precedent for the easel pictures which, despite any religious context, were later appreciated as works of art in museums (Belting, 1987). The histories of several Renaissance altarpieces themselves document this transition; for example Raphael's *Entombment* (1507; Rome, Gal. Borghese; see colour pl. 2, XX2) was taken

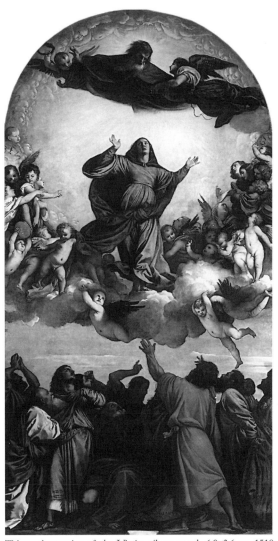

Titian: *Assumption of the Virgin*, oil on panel, 6.9×3.6 m, 1518 (Venice, S Maria Gloriosa dei Frari)

from its church within a century and hung in a private gallery, where it has remained to this day.

Italian sculpture and sculpted altarpieces also underwent important changes in this period. Donatello's high altar with the *Virgin and Child with Saints* (1443–50; Padua, Santo) and Niccolò Baroncelli's *Crucifixion and Saints* (1450; Ferrara Cathedral) were early examples of the transposition of the *sacra conversazione* into bronze sculpture and played an important role in disseminating the type in North Italy, both for painted and sculpted altarpieces. Relief sculpture, in both terracotta and marble, was also commonly used on Italian altarpieces, for example Antonio Rossellino's *Nativity* (1470–75; *see* NAPLES, fig. 4) and Benedetto da Maiano's *Annunciation* (1489; both Naples, S Anna dei Lombardi) and Luca della Robbia's *Virgin and Child with SS Blaise and James* (*c.* 1465–70; Pescia, Palazzo Vescovile). Large statuary, free of an altarpiece structure, made a dramatic appearance on the altar at the turn of the 16th century with Michelangelo's *Pietà* (*c.* 1497–1500; Rome, St Peter's; *see* MICHELANGELO, fig. 1) and his Bruges *Madonna* (1503; Bruges, Onze Lieve Vrouwe) and Andrea Sansovino's *Virgin and Child with St Anne* (1511–12; Rome, S Agostino).

The Protestant religious reforms of the 16th century brought new attention and some important changes to the form and function of the altarpiece while in northern Europe, the Counter-Reformation in Italy also stimulated the reform of altars. In the interest of clarity and unity, numerous medieval screens separating the choir and high altar from the nave were removed. The reforming authorities also worked to regain control over the endowment and the dedication of side altars, and thereby also to regulate the form and iconography of their altarpieces. The late medieval profusion of private altars and chapels gave way to systematically conceived schemes in which all chapels of the same church were given the same design, with their altarpieces planned as a cycle through the entire church. Such were the schemes conceived in 1565 by Duke Cosimo I de' Medici for the Florentine churches of Santa Croce and S Maria Novella, which were adorned with altarpieces by Giorgio Vasari and his school. A similar, even more regular scheme was conceived by Andrea Palladio and the Capuchin friars at the Venetian church, Il Redentore, in the late 1570s.

BIBLIOGRAPHY

RDK: 'Altarretabel'
G. Rohault de Fleury: *La Messe: Etudes archéologiques sur ses monuments,* i (Paris, 1883)
J. Burckhardt: 'Das Altarbild', *Beiträge zur Kunstgeschichte von Italien* (Basle, 1898), pp. 3–161; Eng. trans. and ed. by P. Humfrey as *The Altarpiece in Renaissance Italy* (New York, 1988)
F. Bishop: 'On the History of the Christian Altar', *Liturgica historica: Papers on the Liturgy and Religious Life of the Western Church* (Oxford, 1918/*R* 1962), pp. 20–38
J. Braun: *Der christliche Altar in seiner geschichtlichen Entwicklung,* 2 vols (Munich, 1924)
H. Hager: *Die Anfänge des italienischen Altarbildes: Untersuchungen der Entstehungsgeschichte des toskanischen Hochaltarretabels* (Munich, 1962)
C. Gardner von Teuffel: 'Lorenzo Monaco, Filippo Lippi, Filippo Brunelleschi: Die Erfindung der Renaissance Pala', *Z. Kstgesch.,* xxxxv (1982), pp. 1–30
J. I. Miller: *Major Florentine Altarpieces from 1430–1450* (PhD thesis, New York, Columbia U., 1983; microfilm, Ann Arbor, MI, 1984)
H. van Os: *Sienese Altarpieces, 1215–1460,* i (Groningen, 1984)
H. Belting: 'Vom Altarbild zur autonomen Tafelmalerei', *Kunst: Die Geschichte ihrer Funktionen,* ed. W. Busch and P. Schmook (Weinheim and Berlin, 1987), pp. 128–49
P. Humfrey and M. Kemp, eds: *The Altarpiece in the Renaissance* (Cambridge, 1991)
E. Borsook and F. S. Gioffredi, eds: *Italian Altarpieces, 1250–1550: Function and Design* (Oxford, 1994)
A. Chastel: *La Pala, ou le retable italien des origines á 1500* (Paris, 1993)
P. Humfrey: *The Altarpiece in Renaissance Venice* (New Haven and London, 1995)

ALEXANDER NAGEL

Altissimo, Cristofano (di Papi) dell' (*fl* 1552; *d* Florence, 21 Sept 1605). Italian painter. He was a pupil of Pontormo and Bronzino. In July 1552 he was sent to Como by Cosimo I de' Medici to copy the portraits of famous men in Paolo Giovio's museum. By the end of May 1553, Cristofano had sent 24 finished portraits to Florence, followed by 26 more by September 1554 and another 25 by October 1556. The following month Cristofano received 100 scudi from Cosimo. By 1591 the works had been transferred to the corridors of the Uffizi, where they form part of the museum's large collection of portraits. During his stay in Como, Cristofano travelled to Milan to execute two portraits of the *Duchess Ippolita Gonzaga* in competition with Bernardino Campi, who was declared the winner. (One of the portraits went eventually to her father, Giuliano Groselino.) In November 1562 Cristofano was noted as treasurer of the Accademia del Disegno in Florence, which received its official recognition in January 1563. On 18 January 1564 Vasari wrote to Angelo Riffoli, the ducal treasurer, requesting payment for ten portraits executed by Cristofano for Cosimo. On 5 April 1565 Vincenzo Borghini recommended Cristofano to Cosimo for employment in connection with the preparations for the marriage of Cosimo's son Francesco (later Francesco I de' Medici, Grand Duke of Tuscany) to Joanna of Austria. On 22 February 1567 Cristofano enrolled in the Arte dei Medici e Speziali. Between 1587 and 1589 he sent another group of works to Florence from the Giovio museum. The following year he was back in Florence, and in 1596 his lawsuit against Donato Bandinelli, concerning a portrait and drawing depicting *Francesco Ferrucci*, was submitted to a tribunal of the Accademia.

BIBLIOGRAPHY

Colnaghi; Thieme–Becker
G. Vasari: *Vite* (1550, rev. 2/1568); ed. G. Milanesi (1878–85)
F. Baldinucci: *Notizie* (1681–1728); ed. F. Ranalli (1845–7)
A. Venturi: *Storia* (1901–40)
Gli Uffizi: Catalogo generale (Florence, 1979) [entries by S. Meloni Trkulja and W. Prinz], pp. 601–2

CARMEN FRACCHIA

Altoviti, Bindo (*b* Rome, 26 Nov 1491; *d* Rome, 22 Jan 1557). Italian banker and patron. He was born of a noble Florentine family. At the age of 16 he inherited the family bank in Rome and, after the closure in 1528 of the rival bank founded by Agostino Chigi, became the most important papal financier in the city. Despite his position as Florentine consul in Rome, he was vigorously opposed to the Medici regime and his residence near the Ponte Sant'Angelo became the gathering place of many Florentine exiles. This palazzo was restored by Altoviti in 1514 (destr. 1888) and housed a rich collection of antiquities from Hadrian's Villa and many commissioned works. Raphael painted for Altoviti the *Madonna dell'Impannata* (1511–16; Florence, Pitti) and his portrait, which is gen-

erally agreed to be the one (*c.* 1518) that is now in the National Gallery of Art, Washington, DC. In 1534 Francesco Salviati also executed a portrait of Altoviti (untraced) and frescoed the arms of Pope Paul III on the façade of the palazzo. Benvenuto Cellini made a magnificent bronze portrait bust of the banker (*c.* 1550; Boston, MA, Isabella Stewart Gardner Mus.; *see* CELLINI, BENVENUTO, fig. 5), which was greatly admired by Michelangelo. Unfortunately, a disagreement over his fee caused Cellini to fall out with his patron.

Altoviti was a close friend and supporter of Giorgio Vasari. He commissioned from Vasari a painting for his chapel in SS Apostoli, Florence, an *Immaculate Conception* (1541; *in situ*; *see* VASARI, (1), fig. 3), together with a miniature replica (Florence, Uffizi) for his private collection. Other commissions included a *Pietà* (1542), now known from a drawing (Paris, Louvre), with a small replica (Siena, Col. Chigi–Saracini), also a *Venus and Cupid*, based on a cartoon by Michelangelo and a *Virgin and Child* (untraced). In 1553 Vasari decorated two loggias for Altoviti, both based on programmes by Annibal Caro: one was at his palazzo, with frescoes of the *Worship of Ceres* and personifications of the months (Rome, Pal. Venezia), the other was at Altoviti's villa (destr.) in the Prati near Castel Sant'Angelo, Rome, where the decoration followed a similar scheme of planetary gods, the seasons and the zodiac, but is known only from engravings by Tommaso Piroli (1752–1824). It was Altoviti who, together with Paolo Giovio, introduced Vasari to a future patron, Cardinal Alessandro Farnese.

Altoviti had a taste, precocious for his time, for collecting preparatory drawings and modelli as well as finished works of art. He was given by Michelangelo the cartoon for the *Drunkenness of Noah* on the Sistine Chapel ceiling, and he acquired a modello for the marble figure of *St James the Greater* (Florence Cathedral) from Jacopo Sansovino. The latter also designed a fireplace for Altoviti's Florentine palace, a residence that was subsequently confiscated by the Medici. Altoviti is buried in his chapel in Santa Trinità dei Monti, Rome.

BIBLIOGRAPHY

DBI

L. Passerini: *Genealogia e storia della famiglia Altoviti* (Florence, 1871)

D. Gnoli: 'Il Palazzo Altoviti', *Archv Stor. A.*, i (1888), pp. 202–11

C. Belloni: *Un banchiere del Rinascimento* (Rome, 1935)

C. Avery: 'Benvenuto Cellini's Bronze Bust of Bindo Altoviti', *Connoisseur*, cxcviii (1978), pp. 62–72

C. Davis: 'Per l'attività romana del Vasari nel 1553', *Mitt. Ksthist. Inst. Florenz*, xxiii (1979), pp. 197–223

Giorgio Vasari (exh. cat., ed. L. Corti and M. D. Davis; Arezzo, Mus. Casa Vasari, 1981), pp. 86–8

CLARE ROBERTSON

Alunno, l'. *See* NICCOLÒ DA FOLIGNO.

Alunno di Domenico. *See* BARTOLOMEO DI GIOVANNI.

Alvaro di Pietro. *See* PIREZ, ALVARO.

Amadei, Giuliano. *See* AMEDEI, GIULIANO.

Amadeo, Giovanni Antonio (*b* Pavia, *c.* 1447; *d* Milan, 28 Aug 1522). Italian sculptor and architect. He was principally active in Bergamo, Cremona, Milan and Pavia.

His professional success, in terms of the architectural and sculptural commissions and official appointments that he received, was far greater than that of any of his contemporaries in Lombardy in the late 15th century, including Bramante. Amadeo's influence in both fields, for example in his use of *all'antica* ornament of local origin, was considerable.

1. Before 1490. 2. From 1490.

1. BEFORE 1490. He was trained as a sculptor and evidently apprenticed to Francesco Solari (*fl* 1464–71) in Milan and at the Certosa di Pavia (*see* PAVIA, §2(ii)). In 1466 Amadeo assisted in the decoration of the large cloister of the Certosa and was apparently responsible for the terracotta lavabo in the small cloister. His first signed work, directly influenced by the Late Gothic style of Solari, is the carved portal in the small cloister with a lunette of the *Virgin and Child with SS John the Baptist and Bruno with Carthusians*. In 1469 Amadeo and Martino Benzoni agreed to carve a *Lamentation* (untraced) for Monza Cathedral consisting of eight wooden figures. During the first half of the 1470s Amadeo executed the tomb of *Medea Colleoni* (*d* 1470; not completed until after Bartolomeo Colleoni's death in 1475) for the Dominican sanctuary of S Maria at Basella (near Urgnano, Bergamo). Simultaneously he supervised the construction of the Colleoni Chapel in S Maria Maggiore at Bergamo (where the tomb of *Medea Colleoni* was moved in 1842; *see* BERGAMO, fig. 2) and carved the tomb of the condottiere *Bartolomeo Colleoni* (see fig. 1). Amadeo's style by this time had changed radically from that manifested in his earliest works at the Certosa di Pavia. Although in terms of its organization the Colleoni tomb can be related to earlier Lombard monumental sculpture, Amadeo made considerable use of *all'antica* ornament. The narrative reliefs for which he is presumed to have been responsible (the two reliefs on the ends of the sarcophagus are generally assigned to the so-called Flagellation Master) retain some similarity to the style of the Certosa lunette, but are infinitely more sophisticated in composition and execution. The design of the Colleoni Chapel is dependent both on the Portinari Chapel in S Eustorgio, Milan, and, more particularly, on Antonio Filarete's design for Bergamo Cathedral, from which Amadeo took the form of the cupola and the delight in using multicoloured stone surfaces. The chequerboard pattern of the façade is antique in origin, and Amadeo included for the first time on a large scale in Lombardy numerous quotations from antique coins to provide the decoration for the tondi and lozenges, a technique he used again on a grand scale at the Certosa di Pavia. This mode of decoration, involving the use, wherever possible, of locally available *all'antica* sources, dominated the work of Lombard architects and tomb sculptors for the next 30 years and was the most important single element in Amadeo's legacy.

Amadeo left Bergamo in 1475, without completing the work on the Colleoni Chapel and tomb. He moved temporarily to Milan, where he was immediately employed at the cathedral to execute figures, including a free-standing statue of *St Elizabeth*, and decorative sculpture for the altar of S Giuseppe, a project begun for Galeazzo Maria

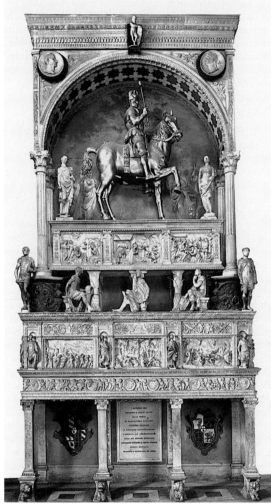

1. Giovanni Antonio Amadeo: tomb of *Bartolomeo Colleoni*, marble, *c.* 1470–75 (Bergamo, S Maria Maggiore, Colleoni Chapel)

Mantegazza brothers agreed that each would take responsibility for half of the façade.

In 1481 the reigning Duke of Milan proposed that Amadeo should succeed his father-in-law Boniforte (or Guiniforte) Solari as chief architect of Milan Cathedral. The cathedral's deputies did not approve his nomination at this stage, however, and the position eventually went to the Austrian architect Hans Niesenberger (*c.* 1415/20–before 1493). During the 1480s Amadeo continued working at the Certosa as well as on a number of other sculptural projects, usually collaborative. In 1480 he was engaged to complete the tomb of the *Persian Martyrs* for Cremona Cathedral (dispersed in the 19th century: Cremona Cathedral; Milan, Castello Sforzesco; Paris, Louvre), originally commissioned from Piatti a year before his death by Antonio Meli, Abbot of S Lorenzo, Cremona. In view of the fragmentary condition of the work, Amadeo's contribution is difficult to assess. From 1482 to 1484 Amadeo worked on another project for Cremona, the

2. Giovanni Antonio Amadeo: detail of a window in the façade of the Certosa di Pavia, *c.* 1473

Sforza, Duke of Milan, in 1472. The extent of Amadeo's contribution is not precisely known. A large number of other sculptors were involved and the altar itself was dismantled in the late 16th century (untraced). In 1478 he produced a design for the *Edicula Tarchetta* commissioned by Alesso Tarchetta and installed in the left aisle of the cathedral. In its present restored state, it reveals nothing of Amadeo's original intentions. Some decorative relief fragments (Milan, Mus. Civ. Milano) from the cathedral have been associated with it. In 1473 Amadeo, his brother-in-law Lazzaro Palazzi (*fl* 1473–1508), Giovanni Giacomo Dolcebuono, Giovanni Antonio Piatti (*d* 1479) and Angelo da Lecco agreed to share the profits and losses should any of them be commissioned to execute the façade of the Certosa di Pavia. Shortly afterwards, Amadeo was engaged in this capacity by the Certosa authorities (see fig. 2). In the same year, the Carthusians stipulated another contract for work on the façade, this time with Antonio Mantegazza and his brother Cristoforo Mantegazza. Difficulties arose over the division of labour, and in 1474 Amadeo and the

tomb of *St Arealdo* (non-autograph fragments, Cremona Cathedral). During the same period he was paid by the Opera del Duomo authorities for a relief, the marble *St Imerio Giving Alms* (now mounted in a pier to the right of the presbytery) for the front of the tomb of *St Imerio*. Amadeo's works of the early 1480s are characterized by complex compositions filled with rather thin, angular figures clad in chartaceous—that is paper-like—draperies. These qualities, particularly the drapery type, represent a departure from the style of the Colleoni tomb reliefs and have been seen as evidence of the influence on Amadeo of the Mantegazza brothers. While their importance is undeniable, they were by no means the only practitioners of this style, and it is more likely that Amadeo's adaptation of it may be attributed to his extensive collaboration with Piatti.

2. FROM 1490. In the late 1480s and early 1490s Amadeo was employed by officials of the Duchy of Milan on a number of civil engineering projects in the Valtellina region. On 27 June 1490 Amadeo and Dolcebuono were entrusted with building the *tiburio* (completed 1500) of Milan Cathedral. Amadeo was responsible for the first of the exterior pinnacles and also performed the normal supervisory tasks of chief architect, a post he held from 1490 until his death. His solution to the problem of constructing the *tiburio* rejected the proposals of some of the most celebrated architects of the day, including Bramante, Leonardo, Francesco di Giorgio Martini, Giovanni Battagio and Luca Fancelli, returning to a modified form of the system of triangulation suggested, and in part carried out, by the mathematician Gabriele Stornaloco at the end of the 14th century. The resulting structure conforms stylistically and geometrically with the rest of the cathedral and with local construction techniques. In 1492 Amadeo's work on the altar of S Giuseppe in the cathedral, suspended since 1480, was resumed, and between 1493 and 1499 he executed a large number of sculptures for it, including a history relief; an *Adoration of the Child* that included twelve figures of children; a number of decorative relief panels, some with ducal arms; a relief panel depicting *Hercules and Antaeus*; two nymphs; a kneeling *St Joseph*; a kneeling shepherd; a kneeling child and four angels (all untraced).

During the 1490s and the first decade of the 16th century Amadeo undertook several other sculptural and architectural projects. These included work for: S Maria di Canepanuova, Pavia (from 1492); the Casa Bottigella, Pavia (from 1492); the Ospedale Maggiore, Milan (1493–4), where he was appointed general architect in 1495, although he never actually served in this capacity; the cupola of S Maria presso S Celso, Milan (from 1494); S Maurizio, Ponte in Valtellina (1495–8, completed by Tomaso Rodari and his brother Giacomo Rodari (*fl* 1487–1526)); Pavia Cathedral (from 1497); S Maria delle Grazie, Milan, and the church of the Incoronata at Lodi (from 1498); the cupola of the sanctuary at Saronno (1505); the castle in San Colombano al Lambro (1506) and S Maria alla Fontana, Milan (from 1508). Amadeo was involved in the first discussions relating to the vast cathedral of Pavia (1488) and was later appointed its engineer (1497). The design appears to be essentially that of Bramante, who initially planned a centralized structure that was altered,

probably by Amadeo after 1497, by the addition of a nave and a great increase in the height of the structure.

Between 1492 and 1499 Amadeo and Antonio Mantegazza directed the decoration of the façade of the Certosa di Pavia. Among those engaged to work on this project were Benedetto Briosco, Antonio della Porta and Cristoforo Solari. Before August 1501 Amadeo completed the reliefs of the *Life of St Bruno* for the socle of the main portal, undertaken with Briosco. The ornamentation of the portal was later completed under Briosco's supervision. Probably in 1498 Amadeo received the commission to execute the tomb of *St Lanfranco* for S Lanfranco, outside Pavia. In 1508, pressed by his patron, Pietro Pallavacino da Scipione, he promised to finish it as soon as possible. In 1507 he made a model for two tombs for the funerary chapel of the family of Filippo Bottigella, and in the same year he carved a relief sculpture intended for S Fedele, Milan, commissioned by Francesco Corio.

Both the (collaborative) tomb of *St Lanfranco* and the reliefs from the portal of the Certosa are calmer and more classical than the Cremonese reliefs. The *St Lanfranco* monument may be to some extent old-fashioned, but Amadeo had, nonetheless, by this date clearly been influenced by the younger generation of sculptors he had helped to train. Some of the narrative reliefs are carved in extremely high relief, a technique later carried to its practical limits by Agostino Busti. In 1503 Amadeo, as chief architect of Milan Cathedral, presided over discussions about the design of the Porta versus Compedum, an issue never definitively settled. In 1505 he executed his last marble sculptures for the cathedral: the *Virgin and Child* and the *Four Evangelists* for the baldacchino over the high altar (untraced). After 1512 he cut back on his routine work at the cathedral, although he oversaw the construction of a wooden model of it. In 1514 he arranged for a sum of money to be left to the cathedral on his death to be used to create dowries for the daughters of indigent stonecutters and minor sculptors and to found a school of design in the Camposanto.

Amadeo's architectural career has never been studied seriously despite its vast local influence. His stature in Lombardy is indicated by the fact that he seems to have been the executive architect of the new tribune of S Maria delle Grazie, the mausoleum of Ludovico Sforza, Duke of Milan. Although the design of the interior clearly owes much to Bramante's ideas, both the interior and especially the exterior exhibit many indications of Amadeo's architectural presence and reliance on local sources, particularly S Lorenzo. Thereafter Amadeo's work as an architect is difficult to understand: the designs of the Palazzo Bottigella in Pavia and the cupola at Saronno are comprehensible in relation to the Colleoni Chapel, the façade of the Certosa and S Maria delle Grazie, but the architecture of S Maria alla Fontana (1508) contains elements, particularly the Doric arcade below, that are difficult to reconcile with what is known of his work.

BIBLIOGRAPHY

Macmillan Enc. Architects
C. Magenta: *La certosa di Pavia* (Milan, 1897)
R. Maiocchi: 'Giovanni Antonio Amadeo: Secondo i documenti negli archivi pavesi', *Boll. Soc. Pavese Stor. Patria*, iii (1903), pp. 39–80
F. Malaguzzi-Valeri: *Gio. Antonio Amadeo: Scultore e architetto lombardo (1447–1522)* (Bergamo, 1904)

U. Middeldorf: 'Ein Jungendwerk des Amadeo', *Kunstgeschichtliche Studien für Hans Kauffmann* (Berlin, 1956)

J. A. G. Bernstein: 'A Reconsideration of Amadeo's Style in the 1470s and 1480s and Two New Attributions', *A. Lombarda*, 13 (1968), pp. 33–42

——: *The Architectural Sculpture of the Cloisters of the Certosa of Pavia* (diss., New York U., 1972)

R. V. Schofield: 'Amadeo, Bramante and Leonardo and the *tiburio* of Milan Cathedral', *Achad. Leonardi Vinci: J. Leonardo Stud. & Bibliog. Vinciana*, ii (1989), pp. 68–100

R. V. Schofield, J. Shell and G. Sironi, eds: *Giovanni Antonio Amadeo: Documents/I documenti* (Como, 1989) [docs and bibliog.]

J. G. Bernstein: 'Milanese and Antique Aspects of the Colleoni Chapel: Site and Symbolism', *A. Lombarda*, 100 (1992), pp. 45–52

R. V. Schofield: 'Avoiding Rome: An Introduction to Lombard Sculptors and the Antique', *A. Lombarda*, 100 (1992), pp. 29–44

J. Shell: 'The Mantegazza Brothers, Martino Benzoni and the Colleoni Tomb', *A. Lombarda*, 100 (1992), pp. 53–60

L. Chiappa Mauri and others: *Giovanni Antonio Amadeo: Scultura e architettura del suo tempo* (Milan, 1993)

M. P. Zanoboni: 'Il contratto di apprendistato di Giovanni Antonio Amadeo', *Nuova Riv. Stor.*, lxxix/1 (1995), pp. 143–50

RICHARD SCHOFIELD, JANICE SHELL

Amadeus I, Duke of Savoy. *See under* SAVOY.

Amalteo, Pomponio (*b* Motta di Livenza, 1505; *d* San Vito al Tagliamento, 9 March 1588). Italian painter and draughtsman. His father's name was Leonardo, his mother was Natalia Amalteo, sister of the humanist poet Paolo Amalteo and the Latin scholar Francesco Amalteo. Probably in 1515 Pomponio entered Pordenone's workshop and is thought to have collaborated in the numerous works executed by Pordenone in Friuli between 1524 and 1529. Amalteo's first independent works were frescoes of *Virtues* inspired by Roman historical subjects for the Palazzo del Consiglio dei Nobili, Belluno (1529, destr. 1838; fragments Belluno, Mus. Civ.; Treviso, Mus. Civ. Bailo; Venice, Correr). Although the influence of Pordenone is strong, the fragments reveal an original artistic personality capable of producing compositions of classical dignity, less bold perhaps than his master but employing a more spirited and luminous range of colours.

In 1534, with his career as a panel painter well established, Amalteo married Pordenone's daughter. His earliest surviving altarpieces and panels date from around this time. After Pordenone's departure from Friuli in 1535 and his death four years later in Ferrara, Amalteo became the leading artist in Friuli, taking over his father-in-law's commissions. These included fresco decorations at the Loggia in Ceneda (1535–6), Santa Croce in Casarsa (1536–8), near Pordenone, S Maria Assunta in Lestans (1548), near Spilimbergo, the organ shutters for Valvasone Cathedral (1549) and the design for the façade of the Palazzo Comunale in Pordenone (after 1542).

Because of their close relationship, the work of Amalteo and Pordenone has often been confused. A prolific artist, Amalteo produced high-quality works until his last years. He was highly regarded by his contemporaries and received prestigious commissions, for example the frescoes for the hall of the castello at Udine (1568) and the corona over the main altar in Aquileia Cathedral (1569, destr.). Drawing was an essential stage in the production of his works, and there is a close interdependence between the paintings and the surviving drawings (e.g. Paris, Louvre; Vienna, Albertina). Notwithstanding Pordenone's influence, Amalteo absorbed new developments in both Venetian painting and Central Italian Mannerism and was able to exercise a decisive influence on Friulian painting throughout the 16th century.

BIBLIOGRAPHY

Meissner; Thieme–Becker

G. Vasari: *Vite* (1550, rev. 2/1568); ed. G. Milanesi (1878–85)

F. di Maniago: *Storia delle belle arti friulane* (Udine, 1819, rev. 2/1823), pp. 65–73, 152–64

R. Zotti: *Pomponio Amalteo: Pittore del sec. XVI* (Udine, 1905)

P. Goi and F. Metz: 'Alla riscoperta del Pordenone: Ricerche sull'attività di Giovanni Antonio Pordenone in Friuli', *Noncello*, 33 (1971), pp. 119–24; 34 (1972), pp. 7–20

C. E. Cohen: 'Drawings by Pomponio Amalteo', *Master Drgs*, xi (1973), pp. 239–67

——: *I disegni di Pomponio Amalteo* (Pordenone, 1975)

P. Goi and F. Metz: 'Amalteiana', *Noncello*, 45 (1977), pp. 195–218; 48 (1979), pp. 25–60; 50 (1980), pp. 5–46; 51 (1981), pp. 173–90

Amalteo (exh. cat., ed. L. Menegazzi; Pordenone, Mus. Civ. Pal. Ricchieri and Cent. Odorico, 1980)

C. Furlan: 'Novità sull'Amalteo decoratore: Gli affreschi nel castello di Zoppola', *A. Ven.*, xxxvi (1982), pp. 204–10

PAOLO CASADIO

Amatrice, Cola dell' [dall']. *See* COLA DELL'AMATRICE.

Ambrogini, Angelo. *See* POLIZIANO, ANGELO.

Ambrogio, Pietro di Giovanni d'. *See* PIETRO DI GIOVANNI D'AMBROGIO.

Ambrogio (d'Antonio) Barocci [da Milano; da Urbino]. *See* BAROCCI, AMBROGIO.

Amedei [Amadei], **Giuliano** (*b* Florence, before 12 March 1446; *d* Lucca, 1496). Italian painter and illuminator. He was a Camaldolite monk; his appointment, from 1470, as Abbot of Agnano, Arezzo, and Val di Castro, Fabriano, was disputed, since he never resided at either abbey. His work is known from a signed triptych of the *Virgin and Child Enthroned with Saints* (1460–67) in SS Martino e Bartolomeo at Tifi, Arezzo (*in situ*). It shows the influence of the most fashionable Florentine artists of the time, such as Neri di Bicci, and such artists from the Marches as Giovanni Boccati and Gerolamo di Giovanni da Camerino. The most noteworthy aspect of the altarpiece, however, is its chromatic quality. This undoubtedly derives from the work of PIERO DELLA FRANCESCA and has made it possible to identify Amedei as the collaborator to whom Piero entrusted the small predella scenes and pilaster figures of the polyptych of the *Misericordia* (Sansepolcro, Pin.), a work that can be dated by the final payments made in 1462. It is also possible to attribute the illuminations in a copy of Plutarch's *Lives* (*c.* 1450; Cesena, Bib. Malatestiana, MSS S.XV.1–2, S.XVII.3) to Amedei on stylistic grounds.

Amedei is documented as a painter in Rome between 1467 and 1472, and a coherent group of miniatures painted in Rome between these dates has been attributed to him, including those in three manuscripts in the Biblioteca Vaticana, Rome (MSS Vat. Burgh. 366, Vat. lat. 7628 and Urb. lat. 261), as well as the illustrations for Books xv–xxxvii of a copy of Pliny the elder's *Natural History* (London, V&A, MS. L. 1504–1896). These attributions, however, have been questioned, owing to the lack of firm documentary evidence and to the stylistic variations be-

tween these works and the altarpiece at Tifi. The illuminations are much closer to the work of Jacopo da Verona (*fl* Pesaro, 1459–60). None of the attempts to identify Amedei's presence at the papal court has proved convincing, while the 19th-century idea that he may have worked on the choirbooks of Lucca Cathedral appears to have come into being simply because he died in that city.

BIBLIOGRAPHY

E. Müntz: *Les Arts à la cour des papes pendant le XVe et le XVIe siècle*, ii (Paris, 1879), pp. 31, 41, 43, 78–81, 108–9

M. Salmi: 'Piero della Francesca e Giuliano Amedei', *Riv. A.*, xxiv (1942), pp. 25–44

——: 'Arte e cultura artistica nella pittura del primo rinascimento a Ferrara', *Rinascimento*, ix (1958), pp. 123–39

J. Ruysschaert: 'Miniaturistes "romains" sous Pie II', *Enea Silvio Piccolomini: Papa Pio II* (Siena, 1968), pp. 245–82

Arte nell'Aretino (exh. cat. by A. M. Maetzke, Arezzo, S Francesco, 1974), no. 34, pp. 94–6

J. I. Whalley: *Pliny the Elder: Historia naturalis*, London, V&A cat. (London, 1982)

ALESSANDRO CONTI

Amedeo di Francesco. *See* MEO DA CAPRINO.

Amio, Domenico. *See* AIMO, DOMENICO.

Amis, Domenico de. *See* AIMO, DOMENICO.

Ammanati [Ammannati], **Bartolomeo** [Bartolommeo] (*b* Settignano, nr Florence, 18 June 1511; *d* Florence, 13 April 1592). Italian sculptor and architect. He was a major figure in Italian art in the second and third quarters of the 16th century. His extensive travels in North and Central Italy gave him an unequalled understanding of developments in architecture and sculpture in the era of Mannerism. His style was based inevitably on the example of Michelangelo but was modified by the suaver work of Jacopo Sansovino. In both sculpture and architecture Ammanati was a highly competent craftsman, and his masterpieces, the tombs of *Marco Mantova Benavides* and two members of the del Monte family, the Fountain of Juno and the Fountain of Neptune and the courtyard of the Palazzo Pitti, are among the finest works of the period.

1. Sculpture. 2. Architecture.

1. SCULPTURE. Orphaned at the age of 12, Ammanati earnt his living in the 'Academy' of Baccio Bandinelli *c*. 1523–7, after which time he left Florence, which was in political turmoil, for Venice. Jacopo Sansovino had just arrived there after the Sack of Rome (1527), and Ammanati was probably involved on some of Sansovino's early commissions. Also at this time Ammanati may have executed the life-size stone figure of *Neptune* for the Palazzo Strozzi in Padua, which shows a mixture of influences from Bandinelli and Sansovino as well as from Michelangelo, whom Ammanati strove to emulate. Ammanati left Venice after about five years, perhaps because Sansovino was becoming absorbed with architecture, and returned to Tuscany. He collaborated briefly with Stagio Stagi at Pisa Cathedral, where a lunette of *God the Father* (1536) carved in deep relief is generally accepted as Ammanati's on the evidence of his early biographers (e.g. Borghini). The energetic torsion and bearded head of the large seated figure recall Michelangelo's *Moses* for the tomb of *Julius II* (Rome, S Pietro in Vincoli; see colour pl. 2, VII2) as well as Bandinelli's approach to designing reliefs.

Following this work in Pisa, Ammanati returned to Florence, where he carved a statue of *Leda*, possibly for Guidobaldo II, Duke of Urbino: this has been identified (Kinney) as a statue formerly attributed to Vincenzo Danti (London, V&A). It is a variation on a Hellenistic type (e.g. Florence, Uffizi) as well as on an antique *Callipygian Venus* (Naples, Capodimonte). There is a preparatory pen sketch for it (Boston, Mus. F. A.). Ammanati's composition also appears to amalgamate those of two related bronze statuettes made by Bandinelli in 1529–30, a *Leda* and a *Cleopatra* (both Florence, Bargello).

From 1536 to 1538 Ammanati worked with Giovanni Angelo Montorsoli on the tomb of the poet *Jacopo Sannazaro* (1457–1530) for S Maria del Parto, Naples, carving statues of *Apollo/David*, *Minerva/Judith*, *St Nazarius* and two putti below. Ammanati's heavy participation in the carving of the figures was due to Montorsoli's absorption with work on the *St Cosmas* for the Medici tombs in the New Sacristy of S Lorenzo, Florence. Both sculptors became deeply imbued with the influence of Michelangelo through the statues that he had left behind, some of them not quite finished, for the Medici tombs. Ammanati's seated, yet actively posed figures are obviously indebted to Michelangelo's tomb figures of the Medici, but they exude a greater feeling of calm, classical beauty, and this betrays Ammanati's debt to Jacopo Sansovino. In Ammanati's *St Nazarius*, the head, with its cap of curly hair, aquiline nose and sulky mouth, closely resembles Michelangelo's *Giuliano de' Medici* (see colour pl. 2, V1); its pose is not unlike that of a statue that Ammanati much later admitted admiring, in a letter to the Accademia del Disegno: Jacopo Sansovino's *St James the Greater* (1511–18; *see* SANSOVINO, (1), fig.1) in the crossing of Florence Cathedral. Finally, the pair of putti below have the Herculean forms and vigorous poses beloved of Michelangelo. Late in 1538 Ammanati received the commission for the tomb of *Francesco Maria I della Rovere, Duke of Urbino* (*d* Oct 1538) in S Chiara, Urbino, although it may not have been executed until 1542–3 (destr.).

A major commission in Florence intervened, a tomb in SS Annunziata for the soldier *Mario Nari* (*d* Oct 1539). Kinney has shown that Nari was a supporter of Duke Cosimo I de' Medici and a figure of importance, as can be inferred from the remains of his splendid tomb; it was installed by 1550, although not unveiled, as there were religious objections because Nari had died in a duel. The controversy was stirred up by Bandinelli, feigning piety, who was jealous of his pupil's success. This ultimately led to the tomb being dismantled before 1581: the beautiful, although artificially posed allegorical group of *Victory*, modelled on one of Michelangelo's unexecuted groups for the tomb of *Julius II*, and the recumbent effigy of the deceased, clad in antique Roman armour, are now in the Bargello, Florence. Jacopo Sansovino visited Florence in October 1540, and Ammanati followed him back to Venice shortly after finishing the sculptures for the tomb: his presence there was recorded in Lorenzo Lotto's account book in January/April 1541/2. Ammanati carved a stone statue of *Neptune* for the roofline balustrade on Sanso-

vino's Libreria Marciana (it fell and shattered *c.* 1740); he also collaborated on several river gods on the spandrels and some lion-masks on the keystones of the arches on the short, northern façade.

Ammanati was documented as active in Padua and Vicenza intermittently between 1544 and 1548. He carved a colossal *Hercules* (h. 6.4 m) for the courtyard of the Paduan palazzo of the humanist jurist and antiquarian Marco Mantova Benavides (*in situ*). This was followed by a triumphal arch in the garden of the palazzo, with statues of *Jupiter* and *Apollo* (finished 1547; *in situ*), and by the tomb of *Marco Mantova Benavides* (unveiled 1546) in the church of the Eremitani, Padua. This is reminiscent of Michelangelo's Medici wall tombs (Florence, S Lorenzo, New Sacristy) with a tiered architectural setting. It is topped with a statue of *Immortality* flanked by nude youths. In the middle zone are three pedimented embrasures (like blank windows) framing statues of the deceased flanked by *Honour* and *Fame*. Below stands a sarcophagus with an unusual segmental lid, ending in volutes (again like the Medici tombs), and on either side of this are allegorical figures of *Work* and *Wisdom*. The figures are solidly built, with bold poses and simple gestures: the torsions of their contrapposti and diagonals of their limbs balance symmetrically to create a visual unity within the sculptural components. They animate the austere, but noble, classical architecture; Ammanati here achieved an exact balance between the two diverse art forms, which makes his tomb a masterpiece. His scheme gives an impression of the balanced grandeur that Michelangelo would have achieved in the New Sacristy, had he completed its sculpture. At Pusterla, near Vicenza, Ammanati designed fountains (1545–6; destr.) for Girolamo Gualdo's garden, and the attempts made to reconstruct them from literary descriptions suggest that they were in an architectural setting (Gualdo).

In Urbino on 17 April 1550 Ammanati married the poetess Laura Battiferri (1523–89), later the subject of an extraordinary portrait by Agnolo Bronzino (*c.* 1555; Florence, Pal. Vecchio). They travelled to Rome to solicit work from the newly elected pope, Julius III. This resulted in a commission for a pair of tombs, for the Pope's uncle, *Cardinal Antonio Maria Ciocchi del Monte*, and for *Fabiano del Monte* (finished *c.* 1553) in S Pietro in Montorio. The arrangement, with allegorical statues (*Religion, Justice*) standing in the niches over each effigy, recumbent below, is closer to Ammanati's own earlier monument to Nari than to the design that had been supplied by Vasari. When Julius III died in 1555, Ammanati was summoned by Vasari back to Florence to enter the service of Duke Cosimo I de' Medici. He shortly received a major commission for the spectacular Fountain of Juno for the Sala Grande of the Palazzo Vecchio. The fountain was never erected in the hall but was set up out of doors at Pratolino; a drawing after Ammanati by Giovanni Guerra (Vienna, Albertina) shows six figures mounted around a rainbow, a fantastic design recalling the table decorations made by Mannerist goldsmiths. This was technically ingenious and amusingly erudite in its theme; it was called by Michelangelo 'una bella fantasia' (Heikamp, 1979–80, p. 156, doc. xi). The handsome seated *Juno* (see fig. 1), one of the six over life-size marble fountain figures (all Florence, Bargello), has the active contrapposto pose and *mouvementé* drapery characteristic of Ammanati.

1. Bartolomeo Ammanati: *Juno with her Peacocks*, marble, over life-size, from the Fountain of Juno, late 1550s (Florence, Museo Nazionale del Bargello)

In 1559–60 Ammanati successfully cast in bronze the great terminal group of *Hercules and Antaeus* (h. 2 m) for Niccolò Tribolo's Fountain of Hercules (for illustration *see* TRIBOLO, NICCOLÒ) on the lowest terrace of the gardens behind Cosimo's villa of Il Castello; this technical feat had previously defeated Vincenzo Danti on account of the complexity of the composition. The giant Antaeus is represented as being lifted bodily off the ground by Hercules, his head is thrown back in the throes of death, and from his mouth a great spout of water gushes vertically upwards, symbolizing his last gasp of life. The flow of the fountain is thus rationalized by its iconography, and the water splashing down over the figures into the basins below gives an effect of life and movement to the drily mythological composition. Between 1563 and 1565 Ammanati also modelled and cast a half-length giant in bronze to represent the mountain range of the Apennines. It is the centrepiece of the fishpond on the highest terrace of the gardens of Il Castello: the naked giant, seeming to shiver with cold, appears to rise out of an islet in the centre of the sheet of water. The top of his head is pierced to emit water, which drips down over his shoulders and in winter forms icicles.

Ammanati's best-known sculpture is the Fountain of Neptune (*c.* 1560–75) in the Piazza della Signoria, Florence. The central figure (see fig. 2) was carved out of a colossal block of marble that had been begun by Bandinelli before

2. Bartolomeo Ammanati: *Neptune*, marble, over life-size, on the Fountain of Neptune, marble and bronze, h. *c.* 9 m, *c.* 1560–75, Piazza della Signoria, Florence

his death (1560), and this inhibited Ammanati's treatment. Consequently (by general consent) the *Neptune* is neither characteristic nor aesthetically satisfactory. More successful are the surrounding bronze figures of four recumbent deities and a troop of gesticulating fauns and satyrs (all 1571–5), modelled and cast under his supervision by a team of assistants. The general design and character of these figures, as well as an allegorical female nude statuette personifying *Ops* (1572–3), which Ammanati contributed to the *studiolo* of Francesco de' Medici, epitomize his mature style, which, while distantly derived from Michelangelo, Bandinelli and Sansovino, concentrated on grace of form and movement at the expense of emotion in a way that was typical of Mannerism.

In 1572 Ammanati was commissioned by Pope Gregory XIII to create a tomb for his nephew, Giovanni Boncompagni, which was erected in the Camposanto of Pisa. It consists of an aedicula framing a central statue of the *Risen Christ*, draped and showing his wounds. This is derived from a similar statue (1558), wearing only a loincloth, carved by Montorsoli for the high altar of S Maria dei Servi, Bologna. Flanking Christ at a lower level are allegorical statues of *Peace* and *Justice* in the guise of lightly draped females. There is no effigy, only a white marble sarcophagus; the architecture is multicoloured and patterned with variegated marbles, giving a sumptuous appearance and setting off the three white marble statues and the sarcophagus to good effect. By 1582 Ammanati had become so strongly influenced by the Counter-Reformation and the Jesuits, with whom he had been in contact since 1572, that in a famous letter to the Accademia del Disegno in Florence, printed on 22 August 1582, he denounced on moral grounds the public display of nude sculpture (of which he had been most guilty himself in his Fountain of Neptune in the government square of the city and in his Fountain of Juno). In a later letter (*c.* 1590), addressed to Ferdinand I de' Medici (who had been a cardinal), he begged the Grand Duke 'not to allow the sculpting or painting of nude things' (see Holt, 1958).

2. ARCHITECTURE. As well as being a sculptor, Ammanati was also a gifted architect, generally following the lead of Michelangelo's designs for the Biblioteca Laurenziana (*see* MICHELANGELO, fig. 8) and for the New Sacristy in S Lorenzo, both in Florence. Ammanati's tombs and major fountains had involved him in this field from early in his career, and in the 1540s he had worked on Sansovino's Libreria Marciana in Venice and on the Benavides triumphal arch in Padua. In the following decade, in Rome, he began more specifically architectural work for Pope Julius III, in the sunken courtyard and fountain grottoes of the Villa Giulia, alongside Jacopo Vignola and Vasari (1552). He also furnished a wooden model for a classicizing fountain on a street corner in Via dell'Arco Oscuro, which was later modified and installed in the Casino of Pius IV in the Vatican Gardens. Also for Julius III he remodelled the Palazzo Cardelli (now Palazzo di Firenze), which Julius acquired in 1553 for his brother, Baldovino del Monte (*d* 1556).

This experience was valuable to Ammanati when he reached Florence after 1555, for in addition to the various elaborate fountains that Cosimo ordered, he was also

commissioned to improve (1560–77) the Palazzo Pitti, which had been acquired (1549) as a residence for the Duchess, Eleonora of Toledo. His masterpiece there is the half-sunken courtyard (see colour pl. 1, II2), with the surrounding building rising a full three storeys on three sides of a rectangle, and, above a fountain grotto on the fourth side, framing a view over the Boboli Gardens, which were being laid out axially up the steep hill that rises towards the Belvedere fortress. It is architecture of a peculiarly sculptural variety, well adapted to make a visual transition between palace and garden on account of its heavily rusticated masonry, which was used in a capricious and deliberately anti-classical way. This recalls the fortress-like building for the Mint (Zecca) in Venice by Sansovino and designs published by Serlio in 1537. The foundations were laid in 1560, and Ammanati was designated sole architect in the following year, succeeding Vasari, who thenceforth had to concentrate on the Uffizi.

Ammanati designed several other palazzi in Florence, including one (1557–74) for Ugolino Grifoni in the Via dei Servi; another for the Giugni in the Via degli Alfani; and another (1568) for the Ramirez di Montalvo family in the Borgo degli Albizzi. Several more are attributed to him, such as the palazzi Mondragone, Pucci, del Nero and Peruzzi–Bagnoli. They are characterized by a continual and inventive variety of forms. Ammanati was inspired by the recently deceased Tribolo and by Bernardo Buontalenti in his use of grotesque elements to enliven the otherwise severe forms of his architecture: he concentrated on the play of solid and void and loved to connect his interiors with exterior surroundings by the employment of wings and porticos. In 1558 the Ponte di Santa Trinita in Florence was destroyed when the River Arno flooded. After an unsuccessful initial approach to Michelangelo in Rome, Ammanati received the commission for its reconstruction to a new design (1567–70). Its arches were derived from chainlike curves and so look long and low, as they spring from substantial and high piers with pointed breakwaters; they are the resolution of complex static and dynamic forces into a whole that displays both energetic robustness and airy lightness.

In Lucca, Ammanati was commissioned to reconstruct the Palazzo degli Anziani (1577–81; now Palazzo della Provincia); he finished the minor façade but left incomplete the Cortile degli Svizzeri and the great courtyard. In Volterra, he designed the cloister of the abbey of SS Giusto e Clemente and the Palazzo Viti; in Arezzo, S Maria in Gradi; and in Seravezza, a project for the palazzo of Cosimo I (1564). Ammanati was in Rome in 1560 and in 1572, designing a palazzo for Lodovico Mattei (Palazzo Caetani; 1564) in the Via delle Botteghe Oscure, and for the Rucellai a palazzo (Palazzo Ruspoli; begun 1586) on the Via del Corso. Cardinal Ferdinand I de' Medici consulted Ammanati when restoring and enlarging the villa of Cardinal Giovanni Ricci (now Villa Medici) on the Pincian Hill. There are two drawings (Florence, Uffizi) related to this scheme, and a model for the villa is documented (Andres, i, p. 440).

Ammanati was in contact with the Jesuit Order from 1572, when they were proposing to enlarge their college in Florence and to reconstruct the neighbouring church of S Giovannino (1579–85). The basic design of the Collegio Romano was also his, according to some authorities, having been chosen by Pope Gregory XIII, but was revised and actually built by a Jesuit, G. Valeriani. (In their wills Ammanati and his wife left all their property to the Jesuits in Florence, as they had no children.) By 1584 he had started to prepare an elaborate treatise on architecture and town planning (untraced). A collection of plans of building types, known as *La città*, is in the Uffizi, some drawings are also in the Uffizi and in the Biblioteca Riccardiana, and papers left to the Jesuits are in the Biblioteca Nazionale Centrale, all in Florence.

BIBLIOGRAPHY

DBI; Thieme–Becker

G. Vasari: *Vite* (1550, rev. 2/1568); ed. G. Milanesi (1878–85)

R. Borghini: *Il riposo* (Florence, 1584); ed. M. Rosci, 2 vols (Milan, 1968), pp. 67, 165, 590–95

G. Gualdo: *Giardino di cà Gualdo* (MS., 1650); ed. L. Poppi (Florence, n.d.)

F. Baldinucci: *Notizie* (1681–1728); ed. F. Ranalli (1845–7), vi (Florence, 1769), pp. 3–132

A. Venturi: *Storia* (1901–40), x/2 (1936), pp. 346–432; xi/2 (1939), pp. 212–350

E. Holt: *Michelangelo and the Mannerists*, ii of *A Documentary History of Art* (Garden City, 1958)

M. G. Ciardi-Dupré: 'La prima attività di Ammanati scultore', *Paragone*, cxxxv (1961), pp. 3–29

H. Keutner: 'Die bronze *Venus* des Bartolommeo Ammanati', *Münchn. Jb. Kstgesch.*, xiv (1963), pp. 79–92

J. Pope-Hennessy: *Italian High Renaissance and Baroque Sculpture*, ii (London, 1963), p. 72

C. Avery: *Florentine Renaissance Sculpture* (London, 1970)

M. Fossi, ed.: *Bartolomeo Ammannati: La città* (Rome, 1970)

H. Utz: 'A Note on Ammannati's Apennine and on the Chronology of the Figures for his Fountain of Neptune', *Burl. Mag.*, cxv (1973), pp. 295–300

G. M. Andres: *The Villa Medici in Rome*, 2 vols (New York, 1976), pp. 438–40

P. Kinney: *The Early Sculpture of Bartolomeo Ammanati* (New York and London, 1976)

C. Davis: 'The Tomb of Mario Nari for the SS Annunziata in Florence', *Mitt. Ksthist. Inst. Florenz*, xxi/1 (1977), pp. 69–94

F. Bottai: 'Bartolomeo Ammannati: Una reggia per il Granducato di Toscana', *Ant. Viva*, xviii/5–6 (1979), pp. 32–47

D. Coffin: *The Villa in the Life of Renaissance Rome* (Princeton, 1979)

D. Heikamp: 'Ammannati's Fountain for the *Sala Grande* of the Palazzo Vecchio in Florence', *Fons sapientiae: Renaissance Garden Fountains. Fifth Dumbarton Oaks Colloquium on the History, Landscape Architecture: Washington, DC, 1979–80*, pp. 117–73

D. Heikamp: 'A Bronze Bust of Cosimo I de' Medici for the Courtyard of the Pitti Palace', *Art, the Ape of Nature: Studies in Honor of H. W. Janson*, ed. M. Barasch, L. Freeman Sandler and P. Egan (New York and Englewood Cliffs, 1981), pp. 265–73

A. Nova: *The Artistic Patronage of Pope Julius III* (diss., U. London, 1982)

B. Toulier: 'La Villa Médicis', *Mnmts Hist.*, cxxiii (1982), pp. 25–45

A. Nova: 'Bartolomeo Ammannati e Prospero Fontana a Palazzo Firenze', *Ric. Stor. A.*, xxi (1983), pp. 53–76

——: 'The Chronology of the del Monte Chapel in S Pietro in Montorio in Rome', *A. Bull.*, lxvi (1984), pp. 150–54

S. Cocchia, A. Palminteri and L. Petroni: 'Villa Giulia', *Boll. A.*, lxxii/42 (1987), pp. 47–90

H. Keutner: 'Julius III huldigt Michelangelo: Uber zwei Bronzereliefs des Bartolomeo Ammannati', *Mitt. Ksthist. Inst. Florenz*, xxxv/2–3 (1991), pp. 211–26

R. J. Tuttle: 'Vignola e Villa Giulia, Rome', *Casabella*, lxi (June 1997), pp. 50–69

D. Heikamp: 'Marte Gradivo', *Magnificenza alla Corte dei Medici* (exh. cat., Florence, Pitti, 1997), no. 15

CHARLES AVERY

Ancona. Italian city on the Adriatic coast. The principal city of the Marches, it stands on a promontory that comprises the easternmost spur of Mt Conero, in a natural

amphitheatre that forms the only major harbour between Venice and Bari. According to legend, Ancona was founded as a Greek colony by Dionysus of Syracuse *c.* 390 BC, on the site of an earlier and well-protected settlement on the northern slopes of the promontory. To the south were the Picene people and to the north the Gauls. The colonists built an acropolis and a temple dedicated to Venus Euplea, the remains of which have been found beneath the 11th- to 12th-century cathedral of S Ciriaco. In 268 BC Ancona was conquered by the Romans and became a municipal town. It doubled in size, and because of its proximity to the Via Salaria and the Via Flaminia its trade with the hinterland increased. In 49 BC it was fortified by Julius Caesar, and it continued to flourish as a port under the Roman emperors. It was favoured by Trajan, who commissioned Apollodoros of Damascus to renovate the port so as to improve links between Italy and the eastern Mediterranean. Despite the city's declining prosperity after the 3rd century AD, several Early Christian monuments were built. By the 6th century AD, however, Ancona had become no more than a fortress, subject to the nearby town of Osimo. In the late 6th century Ancona passed from the Goths to the Byzantine empire and became a member of the Exarchate. A period of recovery ensued, and the city developed along traditional mercantile lines. In the late 12th century and early 13th it became an independent maritime republic.

In the 15th century during the Renaissance period the Piazza Nuova (now the Piazza Plebiscito) with the Hospital (destr.) dedicated to St Thomas Becket was laid out. At a slightly higher level the Palazzo degli Anziani (Palace of the Elders) was begun by Pietro Amoroso in 1493, perhaps after designs by Francesco di Giorgio Martini. Lower down, in the Piazza di S Nicola, was the Palazzo del Podestà, which housed the law courts and the prison. The palaces of the most prominent families overlooked the sea. The churches of S Francesco alle Scale (1323) and S Agostino (1338; destr.) were embellished in 1454–9 and 1460–?70 respectively with portals in late Venetian Gothic style by Giorgio da Sebenico (*fl* 1441–73), who also designed the façade of the Loggia dei Mercanti (1451–4).

In 1532 Ancona was absorbed into the Papal states. The fortifications were modernized, and the Capodimonte fortress was built (1532–43) after designs by Antonio da Sangallo (ii). The city lost its independence, but its commercial importance increased and the population rose to 23,000. Many foreign merchants established themselves there and were thus able to circumvent the Venetian monopoly of the trade route between northern Europe and the East. Between 1558 and 1561 Pellegrino Tibaldi (*see* TIBALDI, (1)) resided in Ancona and painted the frescoes in the Loggia dei Mercanti (destr.), perhaps the frescoes (now Mus. Archeol. N. Marche) that once decorated the hall on the first floor of the Palazzo Ferretti and a panel of the *Baptism* in S Francesco delle Scale. This church also contains an altarpiece of the *Assumption of the Virgin* (1550) by Lorenzo Lotto. Paintings by Lotto, as well as Carlo Crivelli, Titian and Andrea Lilli are also on display in the Pinacoteca Comunale. Objects of interest in the cathedral include an antependium (15th century) in red velvet and gold with six scenes from the *Life of St*

Lawrence and the monument to the *Blessed Girolamo Giannelli* (1509) by the sculptor Giovanni da Trau.

BIBLIOGRAPHY
A. Ricci: *Memorie storiche delle arti e degli artisti della Marca di Ancona*, 2 vols (Macerata, 1834)
L. Serra: 'Ancona: Monumenti', *Enc. It.*, iii (1929), pp. 152–5
——: *L'arte nelle Marche: Il periodo del rinascimento* (Rome, 1934)
M. Moretti: *Ancona* (Rome, 1945)
G. Marchini: *La Pinacoteca Comunale di Ancona* (Ancona, 1960)
M. Natalucci: *Ancona attraverso i secoli*, 3 vols (Città di Castello, 1960–61)
F. Farinelli: 'Ancona', *Atlante* (1976), vi of *Storia d'Italia* (Turin, 1972–6), pp. 398–404
R. Paci, M. Pasquali and E. Sori, eds: *Ancona e le Marche nel cinquecento* (Ancona, 1982)
R. Pavia and E. Sori: *Ancona* (Rome, 1990)
ADRIANO GHISETTI GIAVARINA

Ancona, Andrea d'. *See* LILLI, ANDREA.

Ancona, Cyriac of. *See* CYRIAC OF ANCONA.

Andrea, Salvi d'. *See* SALVI D'ANDREA.

Andrea Cordeliaghi. *See* PREVITALI, ANDREA.

Andrea (di Guido) da Fiesole [de Fesulis] (*fl c.* 1393; *d* 1427). Italian sculptor and architect. The only work that can definitely be attributed to him is the tomb of *Bartolomeo da Saliceto* (1412; ex-S Domenico, Bologna; Bologna, Mus. Civ. Med.), which is dated and signed *opus Andreae de Fesulis*. Saliceto was a reader in law at Bologna University, and the tomb sculpture represents him among his pupils. Motifs and facial types are borrowed directly from the tombs in the Bolognese tradition of *Giovanni di Legnano* (1383) by Pierpaolo dalle Masegne and of *Carlo, Roberto and Riccardo Saliceto* (1403; both Bologna, Mus. Civ. Med.), a work indebted to Masegne, but despite this Andrea's Tuscan origins remain apparent. Gnudi was of the opinion that Andrea da Fiesole was in Florence until *c.* 1410. However, Andrea subsequently moved away from the Tuscan Renaissance tradition towards a northern Gothic style, following his contact with Venetian–Emilian sculpture. This can be seen in the tomb of *Bernardino Zambeccari* (1424; ex-S Martino, Bologna; Bologna, Mus. Civ. Med.) attributed to him (Gnudi). As for Andrea's work as an architect, it is known that he built the chapel of S Domenico in the church of that name in Bologna, of which only two tall, pointed-arched windows survive. In 1416 he was working on the construction of the Palazzo di Notai. He has in the past been confused with Andrea di Piero Ferrucci (da Fiesole) and also—in work done before 1398—with Guido da Firenze (*fl* 1393–1424).

BIBLIOGRAPHY
DBI; Thieme–Becker
S. Bettini: 'Un'opera sconosciuta di A. da Fiesole', *L'Arte*, xxxiv (1931), pp. 506–12
G. Gnudi: 'Intorno ad A. da Fiesole', *Crit. A.*, iii (1938), pp. 23–39
MARIA CRISTINA CHIUSA

Andrea da Firenze (*b* Florence, 1388; *d* Florence *c.* 1455). Italian sculptor. He is probably identical with Andrea di Onofrio, also called Andrea Nofri. In Neapolitan documents he is also called Andrea Ciccione. In 1419 he was documented as executing a coat of arms over the door of

the lodgings of Pope Martin V in the cloister of S Maria Novella, Florence. In 1420 he sculpted statues and ornamentation for the chapel of St Lawrence in S Lucia de' Bardi, Florence. Five years later he assessed one of Donatello's statues for the Campanile (probably the *Jeremiah*). Later he worked in the cloister of S Francesco at Prato and in November 1428 in Florence as a 'lastrajuolo' (stonecutter) for Michelozzo and Donatello.

By 1428 Andrea was in Naples working on the funeral monument of *King Ladislas of Durazzo* (reg 1386–1414) in S Giovanni a Carbonara, commissioned by Queen Joanna II, which had probably been started after 1427. This is documented by an inscription formerly on the tomb of *Simone Vigilante, Bishop of Senigallia* (d 1428), originally in S Francesco alle Scale, Ancona, and dismembered in the 18th century, which read: 'the work of Andrea of Florence who also executed the tomb of King Ladislas'. There is no critical accord on whether Andrea worked on the tomb or for which part he might have been responsible.

The tomb of *Ruggero Sanseverino* (d 1433) in the chapel of St Monica of the oratory of SS Filippo e Giacomo attached to S Giovanni a Carbonara is signed by Andrea. The tomb is a compromise of Late Gothic and early Renaissance forms, some iconographic motifs deriving from the Bertini brothers' tomb of *Robert of Anjou* (Naples, S Chiara), others from Donatello's and Michelozzo's *Brancacci* monument (Naples, S Angelo a Nilo). Slightly earlier, Andrea had also carved the portal of the chapel of St Monica. The tomb of *Simone Vigilante* must date from after Andrea's sojourn in Naples. The tomb of *Ser Gianni Caracciolo* (Naples, S Giovanni a Carbonara) attributed to Andrea Ciccione by de Dominici and others, however, does not seem to be his work, both on stylistic grounds and because it was not started before 1441, by which time Andrea had probably returned to Florence.

In 1441–2 Andrea is documented working on the gallery of the cupola of Florence Cathedral. In 1453 Andrea Nofri was recorded in Florence as a 'lastrajuolo'; by 1459 he had been dead for some years. His style is known only from the works in Naples; it can be interpreted as a tentative up-dating of a Late Gothic style derived from Michelozzo's early work. However, the identification of Andrea da Firenze, documented in Naples in the 1420s and 1430s, with Andrea di Onofrio is not universally accepted: it has been variously suggested that the sculptor working in Naples was Andrea Ferrucci (Filangieri), Andrea Guardi (Abbate), a follower of Nanni di Banco (Venturi) or a follower of Jacopo della Quercia and brother of a Marco da Firenze, both brothers having been active in Padua in 1424 (Causa).

BIBLIOGRAPHY
DBI: 'Andrea di Onofrio'; Thieme–Becker
B. de Dominici: *Vite* (1742–5), i, pp. 187–200
M. Buglioni: *Istoria del Convento di San Francesco d'Ancona* (Ancona, 1795)
G. A. Galante: *Guida sacra della città di Napoli* (Naples, 1872); ed. N. Spinosa (Naples, 1985), pp. 29–32, 40–43
N. F. Faraglia: 'Il sepolcro di re Ladislao', *Archv Stor. Prov. Napolet.*, vii (1882), 169–71
C. von Fabriczy: 'Zur Biographie des Bildhauers Andrea de Florentia', *Repert. Kstwiss.*, ii (1888), p. 96
A. Venturi: *Storia* (1901–40), vi, p. 839
A. Munoz: 'Studi sulla scultura napoletana del rinascimento', *Boll. A.*, iii (1909), pp. 55–73, 83–101
R. Filangieri: 'La scultura a Napoli nei primi albori del rinascimento', *Napoli Nob.*, i (1920), p. 89
A. Filangieri di Candida: *La chiesa e il monastero di San Giovanni a Carbonara* (Naples, 1924)
C. Gnudi: 'Intorno ad Andrea da Fiesole', *Crit. A.*, iii (1938), pp. 23–39
R. Causa: 'Contributi alla conoscenza della scultura del '400 a Napoli', *Sculture lignee della Campania* (exh. cat., Naples, Pal. Reale, 1950), pp. 105–9
F. Abbate: 'Problemi della scultura napoletana del '400', *Storia di Napoli* (Naples, 1967–78), iv, pp. 449–94 (451–6)
G. L. Hersey: *The Aragonese Arch at Naples, 1443–1475* (New Haven and London, 1973), pp. 18, 30
R. Pane: *Il rinascimento nell'Italia meridionale* (Milan, 1975–7), i, pp. 107–11
'Saint Jean-Baptiste et Saint Jacques le Majeur (Tempera on wood, ca 1360–65)', *Burl. Mag.*, cxl (Jan 1998)

GIOVANNA CASSESE

Andrea dal Monte Sansovino. *See* SANSOVINO, ANDREA.

Andrea da Murano (*fl* 1463; *d* 25 Feb 1512). Italian painter. He is first recorded working as a gilder at S Zaccaria, Venice, in 1463–5. He was one of a number of artists from the island of Murano. Among these he is closest to Bartolomeo Vivarini, whose pupil he may have been. The two collaborated in 1468 on a narrative canvas (destr.) for the Scuola di S Marco, Venice, which probably depicted scenes from the *Life of Abraham*. The rather harsh sculptural quality of his forms owes much to the influence of Mantegna and Donatello in Padua, and his work has often been associated (and sometimes confused) with that of Andrea del Castagno. He did not, however, ignore the more recent developments of Giovanni Bellini. His triptych depicting *SS Vincent Ferrer, Roch, Sebastian and Peter Martyr*, with a lunette of the *Madonna of Mercy and Four Saints* (Venice, Accad.), probably painted in the late 1470s, shows a real concern with light and colour. By the mid-1480s Andrea had settled in Castelfranco on the mainland, chiefly painting altarpieces in the (by then well established) Venetian *sacra conversazione* form. The altarpiece (1484–1502) in the parish church at Trebaseleghe, nr Padua, is a variation on the form, with Christ embracing the plague saints Sebastian and Roch above and other saints and musicians below, all showing the high degree of expression characteristic of his works. It is one of his finest paintings and also perhaps the most expensive Venetian altarpiece of its day. The altarpiece depicting the *Virgin Enthroned with SS Peter, Nicholas of Bari, John the Baptist and Paul* (1502; Mussolente, Santuario della Madonna dell' Acqua) is typical of Andrea's work and shows both the strengths and limitations of his art: firm draughtsmanship and expressive qualities combined with a rather conservative composition and somewhat ungainly figures.

BIBLIOGRAPHY
F. Zeri: 'A Note on Andrea da Murano', *A. Q.* [Detroit], xxxi (1968), pp. 76–82
A. De Nicolò Salmazo: 'Per una ricostruzione della prima attività di Andrea da Murano', *Saggi & Mem. Stor. A.*, x (1976), pp. 7–29
——: 'Andrea Murano', *La pittura in Italia: Il quattrocento*, ed. F. Zeri (Milan, 1987), pp. 555–6
I. Matejcic: 'Contributi per il catalogo delle sculture del rinascimento in Istria e nel Quarnero', *A. Ven.*, xlvii (1995), pp. 6–19

JOHN G. BERNASCONI

Andrea d'Ancona. *See* LILLI, ANDREA.

Andrea del Castagno. *See* CASTAGNO, ANDREA DEL.

Andrea di Cosimo. *See* FELTRINI, ANDREA.

Andrea di Giusto (Manzini) (*b* Florence, *c.* 1400; *d* Florence, 2 Sept 1450). Italian painter. He was an eclectic minor Florentine master who was influenced by, and at different times imitated, the styles of Masaccio, Masolino, Lorenzo Monaco, Fra Angelico and Domenico Veneziano. In 1426 he was an assistant of Masaccio in the execution of the altarpiece for the Carmine church in Pisa (London N.G.; Naples, Capodimonte; Berlin, Gemäldegal.; Malibu, CA, Getty Mus.; Pisa, Mus. N. & Civ. S Matteo) and painted its predella panels of the *Legend of St Julian* and the *Charity of St Nicholas* (Berlin, Gemäldegal.). His name appears in the tax registers of the Florentine Archivio delle Decime from 1427 to 1447 and in the protocols of the Arte della Calimala in 1436, the same year in which he received 60 florins for an altarpiece (destr.) for S Lucia dei Magnoli. In 1437 he signed and dated the *Assumption of the Virgin with SS Catherine and Francis* (Florence, Accad.). His other dated works are a *Virgin and Child with Four Saints* (1435; Prato, Mus. Com.), which is a copy of Lorenzo Monaco's Monte Oliveto Altarpiece of 1410 (Florence, Pal. Davanzati); a *Virgin and Child* (1435; Florence, Villa I Tatti), a rustic interpretation of a *Virgin and Child* by Fra Angelico (Turin, Gal. Sabauda); and an altarpiece with the *Adoration of the Magi with Four Saints* (1436; Figline, S Andrea a Ripalta) commissioned by Bernardo Serristori. Towards the end of his life, Andrea painted three frescoes, the *Martyrdom of St Stephen*, the *Burial of St Stephen* and the *Marriage of the Virgin* (probably completed 1447) in the Cappella dell'Assunta in Prato Cathedral. He was the father of GIUSTO D'ANDREA.

BIBLIOGRAPHY
Thieme–Becker
G. Vasari: *Vite* (1550, rev. 2/1568); ed. G. Milanesi (1878–85), iii, pp. 54–5
A. Sanesi: 'Gli affreschi della Cappella Boccherini nel Duomo di Prato', *Prato*, i/1 (1960), pp. 45–50
G. Marchini: *Due secoli di pittura murale a Prato* (Prato, 1969), pp. 51–133
R. Fremantle: *Florentine Gothic Painters* (London, 1975), pp. 513–22 [with full bibliog.]
J. Beck: *Masaccio: The Documents* (Locust Valley, 1978), p. 22
H. Wohl: *The Paintings of Domenico Veneziano* (New York, 1980), passim
Andrea di Giusto: Trittico di San Valdarno a Mormiano (exh. cat., Incisa Valdarno, Sala Consiliare and S Allessandro, 1984)
HELLMUT WOHL

Andrea di Niccolò (di Giacomo) (*b c.* 1445; *d c.* 1525). Italian painter. Most scholars since Berenson have considered this minor Sienese painter to have been a pupil of Vecchietta. The influence of such Sienese painters as Neroccio de' Landi, Vecchietta and Matteo di Giovanni can be seen in his earliest signed and dated painting, the *Virgin and Child with Saints* (1498; Casole d'Elsa, Collegiata). In the early years of the 16th century Andrea's work began to show the influence of the foreign artists then working in Siena, including Pinturicchio, Perugino, Sodoma and Signorelli. This is especially evident in the landscape of the *Crucifixion with Saints* (1502; Siena, Pin. N.). Other works include a signed *Virgin and Child with Saints* (1500; Siena, Pin. N.); a signed *Virgin and Child with Angels and Saints* (1504; Cincinnati, OH, A. Mus.); and another *Virgin and Child with Saints* (1510; Siena, S Mustiola delle Rose).

BIBLIOGRAPHY
DBI; Thieme–Becker
E. Romagnoli: *Biografia cronologica de' bell'artisti senesi del secolo XII a tutto il XVIII*, v (MS., *c.* 1835; Siena, Bib. Com. Intronati); facs. edn (Florence, 1976)
G. L. McCann: 'A Sienese Altarpiece in the Museum Collection', *Cincinnati A. Mus. Bull.*, ix (1934), pp. 22–9
L. Vertova: 'On Pacchiarotto's Dismembered *Assumption* and a Cut-up Altarpiece by Andrea di Niccolò', *Gaz. B.-A.*, 6th ser., lxix (1967), pp. 154–68
B. Berenson: *Central and North Italian Schools* (1968), i, p. 10
E. Carli: *Sienese Painting* (New York, 1983)
L. Vertova: 'Cicli senesi di virtù: Inediti di Andrea di Niccolò e del Maestro di Griselda', *Scritti. . .di storia dell'arte in onore di Federico Zeri*, i (Milan, 1984), pp. 200–12
B. Cole: *Sienese Painting in the Age of the Renaissance* (Bloomington, 1985)
D. Vatne: *Andrea di Niccolò, c. 1445–c. 1525: Sienese Painter of the Renaissance* (diss., Bloomington, IN U., 1989)
LINDA CARON

Andreani, Andrea (*b* Mantua, 1558–9; *d* 1629). Italian woodcutter and printer. He was the only printmaker to produce a significant number of chiaroscuro woodcuts in Italy in the second half of the 16th century; he also reprinted chiaroscuro woodblocks originally cut 60 or 70 years earlier. He made at least 35 prints in both black and white and colour (many multiple-sheet), using a sophisticated style of cutting characterized by thin, closed contours. Based in Florence in 1584–5 and from 1586 in Siena, by 1590 he was also finding work in his native Mantua, where he is documented as establishing a workshop. He reproduced the designs of artists in diverse media with great fidelity: for example he made several prints (1586–90) after Domenico Beccafumi's intarsia pavement designs in Siena Cathedral, three prints (1584) from different angles of Giambologna's marble sculpture of the *Rape of the Sabines* (Florence, Loggia dei Lanzi; *see* GIAMBOLOGNA, fig. 2), as well as of the bas-relief on the base of the same group and of Giambologna's relief of *Christ before Pilate* (Florence, SS Annunziata), both in 1585; in the same year he also made prints after paintings and wash drawings by Jacopo Ligozzi (1547–1627) and in 1591–2 others after Alessandro Casolani (1552–1608). His admiration for the woodcuts of Titian's workshop is evident in his copies of the *Triumph of Faith* (his only work published in Rome, ?*c.* 1600) and *Pharaoh Crossing the Red Sea* (Siena, 1589) and in his practice of making very large prints composed of many joined sheets. Usually he used four overlapping chiaroscuro blocks per sheet; his most ambitious projects could call for 40 to 52 blocks each, as in the *Sacrifice of Isaac* (1586) after Beccafumi's pavement, the *Deposition* (1595) after Casolani's painting in S Quirico, Siena, and the *Triumph of Caesar* (1598–9) based on drawings by Bernardo Malpizzi after Andrea Mantegna's cartoons (London, Hampton Court, Royal Col.). The fact that Andreani dedicated prints to so many different people, as the inscriptions on his prints show, suggests he had difficulty in finding patrons, though he briefly enjoyed assistance from the Gonzagas. This scarcity of patronage doubtless led to his reprinting, and, where wear or damage required, recutting earlier blocks, probably acquired from Niccolò Vicentino. In the period 1608 to 1610 the quality of Andreani's printing seriously declined.

BIBLIOGRAPHY
DBI; Thieme–Becker
A. von Bartsch: *Le Peintre-graveur* (1803–21), xii

C. d'Arco: *Di cinque valenti incisori mantovani* (Mantua, 1840)

H. T. Goldfarb: 'Chiaroscuro Woodcut Techniques and Andrea Andreani', *Bull. Cleveland Mus. A.*, (1981)

C. Karpinski: *Italian Chiaroscuro Woodcuts*, 48 [XII] of *The Illustrated Bartsch*, ed. W. Strauss (New York, 1983)

M. E. Boscarelli: 'New Documents on Andrea Andreani', *Print Q.*, i/3 (1984), pp. 187ff

JAN JOHNSON

Andreoli, Giorgio [Giorgio da Gubbio; Mastro Giorgio] (*b* Intra or Pavia, *c.* 1465–70; *d* Gubbio, 1555). Italian potter. He probably learnt the rudiments of pottery at Pavia and seems to have moved to Gubbio *c.* 1490, together with his brothers Giovanni Andreoli (*d c.* 1535) and Salimbene Andreoli (*d c.* 1522). He became a citizen of Gubbio in 1498. He is particularly well known for his lustrewares, and other potters, especially from the Metauro Valley, sent their work to be lustred in his workshop. His wares made in 1518–19 were frequently signed and dated. His *istoriato* (narrative) wares (e.g. plate decorated with *Hercules and the Hydra*, *c.* 1520; Oxford, Ashmolean) can be dated until at least 1537. In 1536 the workshop seems to have been taken over by his sons Vincenzo Andreoli (Mastro Cencio) and Ubaldo Andreoli.

BIBLIOGRAPHY

G. Mazzatinti: 'Mastro Giorgio', *Il Vasari*, iv (1931), pp. 1–16, 105–22

F. Filippini: 'Nuovi documenti interno a Mastro Giorgio e alla sua bottega (1515–1517)', *Faenza*, xxx (1942), pp. 76ff

G. Polidori: 'Errori e pregiudizi su Mastro Giorgio', *Stud. A. Urbin.*, ii (1953), pp. 13–29

P. Mattei and T. Cacchetti, eds: *Mastro Giorgio: L'uomo, l'artista, l'imprenditore* (Perugia, 1995)

C. Fiocco and G. Gherardi: *Mastro Giorgio da Gubbio: Una carriera folgorante* (Florence, 1998)

CARMEN RAVANELLI GUIDOTTI

Angelico, Fra [Fra Giovanni da Fiesole; Guido di Piero da Mugello] (*b* nr Vicchio, *c.* 1395–1400; *d* Rome, 18 Feb 1455). Italian painter, illuminator and Dominican friar. He rose from obscure beginnings as a journeyman illuminator to the renown of an artist whose last major commissions were monumental fresco cycles in St Peter's and the Vatican Palace, Rome. He reached maturity in the early 1430s, a watershed in the history of Florentine art. None of the masters who had broken new ground with naturalistic painting in the 1420s was still in Florence by the end of that decade. The way was open for a new generation of painters, and Fra Angelico was the dominant figure among several who became prominent at that time, including Paolo Uccello, Fra Filippo Lippi and Andrea del Castagno. By the early 1430s Fra Angelico was operating the largest and most prestigious workshop in Florence. His paintings offered alternatives to the traditional polyptych altarpiece type and projected the new naturalism of panel painting on to a monumental scale. In fresco projects of the 1440s and 1450s, both for S Marco in Florence and for S Peter's and the Vatican Palace in Rome, Fra Angelico softened the typically astringent and declamatory style of Tuscan mural decoration with the colouristic and luminescent nuances that characterize his panel paintings. His legacy passed directly to the second half of the 15th century through the work of his close follower Benozzo Gozzoli and indirectly through the production of Domenico Veneziano and Piero della Francesca. Fra Angelico was undoubtedly the leading master in Rome at mid-century,

and had the survival rate of 15th-century Roman painting been greater, his significance for such later artists as Melozzo da Forlì and Antoniazzo Romano might be clearer than it is.

I. Life and work. II. Working methods and technique.

I. Life and work.

1. Early career, to 1433. 2. *c.* 1433–9. 3. S Marco, *c.* 1440–45. 4. *c.* 1446–55.

1. EARLY CAREER, TO 1433. Fra Angelico's baptismal name was Guido di Piero. At an unknown date he and his brother Benedetto (*d* 1448) moved to Florence, where they were trained in the manuscript industry then flourishing in the parish of S Michele Visdomini. The identity of their master has never been established, but it is clear that Benedetto was trained as a scribe and Guido as an illuminator. By 1417 Guido had begun to receive commissions for small panel paintings, and by 1425 he was sufficiently well known to be indicated as the author of an altarpiece, apparently never executed, for the Medici family's parish church of S Lorenzo, Florence. The document refers to the artist as a friar of St Dominic, which means that at some date between 1417 and 1425 he had entered the Order of Preachers at the recently founded reformed, or Observant, convent of S Domenico, Fiesole, where he took the name Fra Giovanni. The name Angelico is first documented 14 years after the artist's death.

The 16th-century chronicle of S Domenico, Fiesole, states that three altarpieces were in place when the church was consecrated in 1435, but scholars disagree as to both the reliability of this account and the relative chronology of the altarpieces and other works from these years. Similarly, considerable disagreement makes it impossible to establish a firm canon for Fra Angelico's early period, although his authorship of the three altarpieces for S Domenico is now generally accepted. The triptych depicting the *Virgin and Child Enthroned, with Eight Angels, SS Barnabas, Dominic, Peter Martyr and Thomas Aquinas* (Fiesole, S Domenico) was probably painted around 1426 (but greatly modified in 1500). The *Annunciation* (Madrid, Prado) is probably datable to shortly before 1430 and the *Coronation of the Virgin* (Paris, Louvre) to soon thereafter.

The S Domenico Triptych executed for the high altar follows the conventional Tuscan format showing the Virgin and Child surrounded by angels and flanked in the wings by pairs of saints appropriate to the Order and to the convent's benefactor, Barnaba degli Agli (*d* 1418). The predella (London, N.G.) depicts the *Risen Christ Adored by Angels, Saints and Blessed Persons of the Dominican Order*. The figures in the main panels testify to Fra Angelico's close study of both Masolino and, more importantly, Gentile da Fabriano, whose *Virgin and Child with Angels and Four Saints* (the Quaratesi Altarpiece; 1425) was then in S Niccolò sopr'Arno, Florence (now dispersed). The two later altarpieces for Fiesole reflect Fra Angelico's knowledge of Masaccio's painting, particularly the *Virgin and Child Enthroned* (1426; London, N.G.; *see* MASACCIO, fig. 1) from the polyptych (now largely destr.) for S Maria del Carmine, Pisa, and the collaborative work with Masolino, the *Virgin and Child with St Anne* (1423–

5; Florence, Uffizi), while acknowledging a continuing debt to Gentile, whose sophisticated handling of light and colour seems to have held even more attraction for Fra Angelico than the chiaroscuro of Masolino and Masaccio. The two later altarpieces for Fiesole required a descriptive ambience for the action, and Fra Angelico may have derived the setting for the *Annunciation* from Masaccio's untraced painting of the same subject for S Niccolò sopr'Arno, Florence. The perspectival space of the *Coronation* is an elaboration of the system of geometric perspective based on the vanishing-point construction invented by Brunelleschi *c*. 1413 but employed with consistent success before Fra Angelico's attempts only by Masaccio. In the latter's work the space is controlled by a single point rather than by the complex of superimposed projections that Fra Angelico designed for the *Coronation*.

The scriptorium at S Domenico was headed by Fra Angelico's brother, the scribe Fra Benedetto, who had also joined the Order and who, like the painter, continued to practise his trade. Illuminations by Fra Angelico and assistants in a Missal (Florence, Mus. S Marco, MS. 558) produced in the early 1430s at the scriptorium display the narrative liveliness and vivid coloration characteristic of Florentine illumination of the period, features that the artist extended with great effect to predella panels. Taken as a group, these early works show that Fra Angelico entered the mainstream of Florentine painting far more skilled as an illuminator than as a panel painter.

Apart from the Missal and the three altarpieces for S Domenico, Fiesole, the most important surviving works from Fra Angelico's early period are the altarpiece depicting the *Virgin and Child with SS Dominic, John the Baptist, Peter Martyr and Thomas Aquinas* executed for the Dominican nuns at the Florentine convent church of S Pietro Martire and the *Annunciation* for S Domenico, Cortona (*c*. 1432; Cortona, Mus. Dioc.). The S Pietro Martire Altarpiece was installed by March 1429. Of main interest is its curved pediment with scenes in the spandrels depicting the *Preaching and Death of St Peter Martyr*. The close relationship between Fra Angelico's evident pleasure in designing historiated predellas or, as here, filling the spandrels and his early training as an illuminator is most evident in a comparison of these spandrel scenes with the historiated initial depicting the *Death of St Peter Martyr* in the Missal (fol. 41*v*). They share the robust action, chromatic brilliance and sure but suggestive brushwork associated with late medieval manuscript illumination. The altarpiece's curved pediment does not derive from Florentine tradition but is a prominent feature in contemporary works by the Sienese painters Sassetta and the Master of the Osservanza. The nuns at S Pietro Martire were closely associated with the Observant reform promulgated by Sienese friars, and the unusual altarpiece type possibly reflects the regional loyalties of particular Dominican communities. At any rate, Fra Angelico's interest in Sienese painting steadily increased over the next four or five years.

Fra Angelico's skill in working on a small scale is fully evident in a group of four reliquaries (Florence, Mus. S Marco) painted in the early 1430s for Fra Giovanni Masi (*d* 1434), sacristan of S Maria Novella, the major Dominican house in Florence. The reliquaries and a *Coronation of the Virgin* painted for the nuns of S Maria Nuova (*c*.

1. Fra Angelico: *St James the Great Freeing Hermogenes*, tempera on panel, 260×240 mm, *c*. 1431 (Fort Worth, TX, Kimbell Art Museum)

1431–5; Florence, Uffizi) confirm the painter's determination to expand the preciosity of manuscript illumination on to larger formats. Two predella panels from an untraced altarpiece datable to *c*. 1431 depicting the *Naming of St John the Baptist* (Florence, Mus. S Marco) and *St James the Great Freeing Hermogenes* (Fort Worth, TX, Kimbell A. Mus.; see fig. 1) — an episode from Voragine's *Golden Legend* — epitomize Fra Angelico's achievements in the period. The planimetric composition of the *St James* panel and the sheets of light falling behind the figures in the second rank reveal Fra Angelico's scrutiny of Masaccio's *Adoration of the Magi* (1426; Berlin, Gemäldegal.; see MASACCIO, fig. 2) from the predella of the Pisa Polyptych.

2. *c*. 1433–9. The sumptuous winged triptych depicting the *Virgin and Child Enthroned with SS John the Evangelist, John the Baptist, Mark and Peter* (1433–6; Florence, Mus. S Marco), commissioned by the Florentine Arte de' Linaiuoli and thus known as the Linaiuoli Tabernacle (see fig. 2), is Fra Angelico's earliest surviving painting of unambiguous date. It epitomizes the artist's early maturity and the processes by which he reached it. In the autumn of 1432 the officers of the Linenworkers Guild commissioned Lorenzo Ghiberti to design for the interior of their guildhall a marble frame to house an image of the Virgin that would be even larger and more sumptuous than the panel by Bernardo Daddi of 1347, standing over the altar of the miraculous Virgin at nearby Orsanmichele. The frame was ready by the summer of 1433, and on 11 July Fra Angelico agreed to paint the triptych for 190 florins, a staggering sum by comparison with what is known of his income before that date. The choice of Fra Angelico for the commission has been explained by the fact that in 1430 the treasurer of the Arte de' Linaiuoli was Filippo

2. Fra Angelico: Linaiuoli Tabernacle, tempera on panel, 2.66×1.32 m (central panel), 1433–6 (Florence, Museo San Marco)

de' Lapaccini, whose son Giuliano entered the Dominican Observance at S Domenico, Fiesole, in 1433 (Orlandi).

The painting is the largest single-panel image of the Virgin and Child executed in the 15th century. The central panel depicts the Virgin seated in a richly draped, barrel-vaulted chamber with Christ, shown as a child, not an infant, standing on her left thigh. The Dove of the Holy Spirit hovers just above them and God the Father is sculpted in the pediment of the marble frame. Thus all three persons of the Trinity are represented on the tabernacle. On the curved inner frame, surrounding the main panel and standing on clouds, are 12 musicmaking angels. When open, the shutters show *St John the Baptist* on the left and the patron saint of the guild, *St Mark*, usually wrongly identified as St John the Evangelist, on the right. When closed, *St Mark* appears again on the left and *St Peter* on the right. The predella consists of three independent, framed scenes. On the left is *St Peter Preaching* (see fig. 3), a scene that shows St Mark writing down the sermon on a tablet, an illustration of the ancient tradition that St Mark's gospel is essentially St Peter's eye-witness account. On the right is the *Martyrdom of St Mark*, which shows the dead body of the saint being dragged through the streets of Alexandria in a hailstorm. The central scene depicts the *Adoration of the Magi*.

The pose and psychological bearing of the Virgin and Child are much more stable and solemn than in their counterparts by Daddi. Fra Angelico's Virgin accommo-

dates the mass and weight of the frontally posed Child with only the slightest shift backwards and to the left of her centre of gravity, her head and gaze only barely turning off the main axis of her body. The Child, unlike Daddi's gurgling infant, stands calm and expressionless, regally dressed in a belted tunic, both arms extended to hold an orb in the left hand and to raise the right in blessing. This young Christ's royal status has already deprived him of the innocence and vulnerability of childhood. In the Linaiuoli Tabernacle, Fra Angelico has eschewed reflective gold surfaces and at the same time chosen to enhance the plasticity of the Virgin and Child. Although figures and ground participate in the same representational discourse, Fra Angelico's painting has little to do with the feelings of real human mothers and babies for each other. Even more than highly idealized representations of a young woman and a little boy, these are theophanic figures and, as such, vehicles of dogma. Icons of majesty, they exist fixed and motionless within a draped chamber, the curtains of which have been pulled back to reveal divinity. Once the subject-matter and the requirements of the commission are thus understood, Fra Angelico's formal solution becomes perfectly intelligible, if not predictable. The general form of the Linaiuoli Tabernacle recalls Giotto's Ognissanti *Madonna* (*c.* 1310; Florence, Uffizi; *see* GIOTTO, fig. 6) and late 13th-century panels such as Duccio's Rucellai *Madonna* (begun 1285; Florence, Uffizi).

Like Masaccio, Fra Angelico looked to sculpture rather than to painted images to achieve an effect of monumentality in large-scale standing figures, and Ghiberti's work provided the model for the four saints in the wings (Middeldorf). Fra Angelico had the intellectual capacity to understand the recent innovations in Florentine art, and these greatly interested him, but only to the degree that they served expressive ends. His stylistic decisions were motivated by notions of decorum and were always in the service of the function and subject-matter of the work. The Linaiuoli Tabernacle reveals an artist of faultless technical accomplishment who fully understood and exploited the typological symbolism inherent in, for example, the large Virgin and Child panels of the 13th century. He not only respected but even celebrated the chromatic brilliance and dazzling patterning of 14th-century Sienese panel painting. He was wary of full-scale capitulation to chiaroscuro modelling as it was shortly to be developed by Fra Filippo Lippi, because of his unwillingness to forgo the brilliant palette that he had inherited from the 14th century.

The commission for the Linaiuoli Tabernacle caught the attention of a wider circle of rich and powerful citizens. Among these were Cosimo de' Medici and Palla Strozzi, rivals both in politics and business. Within a year or so of beginning work for the Arte de' Linaiuoli, Fra Angelico was working for both men, perhaps at the same time. Palla Strozzi is known to have commissioned Fra Angelico to paint the *Deposition* (Florence, Mus. S Marco), to hang in the sacristy of Santa Trinita, Florence, with Gentile da Fabriano's *Adoration of the Magi* (1423; Florence, Uffizi; *see* GENTILE DA FABRIANO, fig. 3). The *Deposition*, which was not an altarpiece, had been left unfinished at Lorenzo Monaco's death, *c.* 1425. The frame dates to that period and the three scenes in the gables are by Lorenzo. Fra

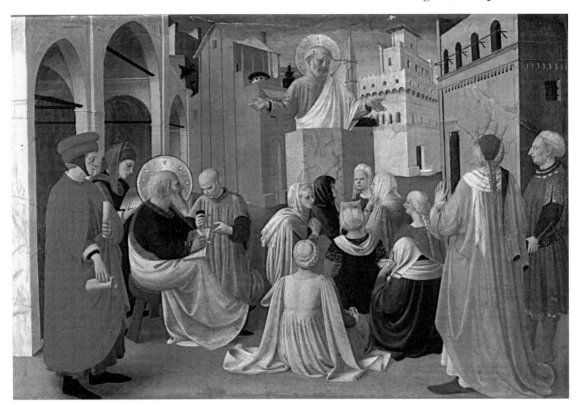

3. Fra Angelico: *St Peter Preaching*, tempera on panel, predella panel from the Linaiuoli Tabernacle, 1433–6 (Florence, Museo San Marco)

Angelico's shop executed the 12 standing figures on the pilasters and the *Deposition*, with its sublime landscape, in the main panel, but there is no consensus among scholars as to when the work was undertaken. In Fra Angelico's surviving large-scale work nothing resembles the vast landscape, whose vistas extend into distant invisibility and beyond the lateral edges of the painted field, though the *tour de force* views of hills and valleys in the Cortona *Annunciation* predella seem to have prepared the way. The exactitude of his sympathetic penetration of human psychology in the central group around the dead Christ is incomparable, except perhaps in the tremulous exchange between the Virgin and the Angel Gabriel in, again, the Cortona painting. The groups of women to the left of centre and men to the right were undoubtedly designed by Fra Angelico, although probably executed by others. The painter of the left-hand group has been identified as present in Fra Angelico's shop from an early period. He stayed for a number of years and is recognizable as part of the team that later worked at S Marco. Highly trusted, this painter was largely responsible for the execution of the *Lamentation* (1436; Florence, Mus. S Marco), painted for the Florentine Confraternity of S Maria della Croce al Tempio. The master responsible for the right-hand group appeared briefly in Fra Angelico's shop from *c*. 1432 to *c*. 1437. Among his first assignments was extensive work on the *Coronation of the Virgin* (*c*. 1430–35; Paris, Louvre) executed for S Domenico, Fiesole. Around 1434–5 Fra Angelico entrusted to him most of the execution of the *Virgin and Child Enthroned with SS Peter Martyr, Cosmas,*

Damian, John the Evangelist, Lawrence and Francis (ex-S Vincenzo d'Annalena, Florence; Florence, Mus. S Marco), a work most probably commissioned by the Medici family. Prestigious commissions such as the Annalena Altarpiece, the Strozzi *Deposition* and the Linaiuoli Tabernacle make it plain that Fra Angelico had emerged as the dominant painter in Florence by the mid-1430s.

Ordered less than eight months earlier, the Croce al Tempio *Lamentation* was finished by 2 December 1436. This is the last documented notice of Fra Angelico until March 1438, when he was in Cortona and it is possible that he was already in Umbria by the autumn of 1437. The *Virgin and Child Enthroned with Angels between SS Dominic, Nicholas of Bari, John the Baptist and Catherine of Alexandria* (Perugia, G. N. Umbria), executed for the chapel of S Niccolò dei Guidalotti, S Domenico, Perugia, belongs to this period and was Fra Angelico's last essay in the polyptych format, which was soon to be superseded by the rectangular, single-field *pala* commonly associated with Florentine Renaissance altarpieces. The Guidalotti Altarpiece may have been painted in Cortona and can be compared with the altarpiece depicting the *Virgin and Child Enthroned between SS (?)Mark, John the Baptist, John the Evangelist and Mary Magdalene* made for S Domenico, Cortona, earlier in the decade (Cortona, Mus. Dioc.), where Fra Angelico had responded deeply to the Sienese style of Sassetta, whose own triptych of the same date formed a pendant to Fra Angelico's. Just as the congress of natural and pictorial light and the brilliance of saturated hues are found in the Linaiuoli tabernacle of 1433–6, so

the presence of these qualities locate the Perugia panel in the mid- to late 1430s. Moreover, the searching but tender exploration of human feeling registered in facial expressions, carried to such heights in the Strozzi *Deposition*, here enlivens the standing figures of saints and angels, whose psychological presence on altarpieces such as this is usually unmotivated.

3. S MARCO, *c.* 1440–45. In 1436 Pope Eugenius IV ceded the Sylvestrine monastery of S Marco, Florence, to the Dominicans of Fiesole, who thus expanded the Observant presence into the city. Cosimo de' Medici and his brother Lorenzo (1395–1440) guaranteed the financial resources necessary to renovate the dilapidated fabric of S Marco, which stood at the north-east boundary of the neighbourhood dominated by the Medici family. Until his death in 1464, Cosimo was S Marco's only real patron, spending, in the five years between 1441 and 1455, approximately 36,000 ducats on the convent, where he also established and largely furnished the first public library since antiquity. His favourite architect, Michelozzo di Bartolomeo, was entrusted with the design and construction of the new church, library (*see* MICHELOZZO DI BARTOLOMEO, fig. 2) and other adjacent buildings, and the complex was consecrated on 6 January 1443 in ceremonies attended by the Pope himself. Fra Angelico was entrusted with a programme of decoration that included an altarpiece for the church and over 50 frescoes for the convent itself, the largest group of related works to survive almost intact from the workshop of a single Renaissance painter. The payment records for the refurbishment and decoration of S Marco seem to have perished, and neither the chronological sequence of the works nor the number and names of Fra Angelico's assistants has ever met with universal consensus, although it is likely that Fra Angelico himself was heavily involved with the project until he left for Rome, probably in 1445. The altarpiece was almost certainly the first work executed, probably in 1440–41. Work in the conventual buildings seems to have proceeded intermittently, some parts remaining unpainted until the early 1450s.

(i) The altarpiece. The central panel (Florence, Mus. S Marco) shows the *Virgin and Child Enthroned* against an extensive landscape that is glimpsed through a luxuriant screen of trees. They are surrounded by angels and six standing saints (Lawrence, John the Evangelist, Mark, Dominic, Francis and Peter Martyr), with SS Cosmas and Damian kneeling in the foreground. In the predella, scenes from the *Lives of SS Cosmas and Damian* flank the central panel of the *Entombment* (Dublin, N.G.; Florence, Mus. S Marco; Munich, Alte Pin.; Paris, Louvre; Washington, DC, N.G.A.). A small, rectangular, framed *Crucifixion* rises directly above the centre of the predella and cuts into the space of the ornately patterned foreground. Disastrously cleaned in the 19th century, the S Marco Altarpiece has lost almost all of its surface refinement, but here and there its original brilliance and sharpness of focus are discernible.

Fra Angelico began work on the painting just as Fra Filippo Lippi was completing his earliest documented altarpiece, the *Virgin and Child with SS Fredianus and Augustine* (Paris, Louvre; *see* LIPPI, (1), fig. 1), begun in 1437 for the Barbadori Chapel, Santo Spirito, Florence. The placing of two kneeling figures well into the foreground in both works suggests that Fra Angelico may have studied the younger painter's design before he began to plan his altarpiece, although Sassetta had preceded both Florentine painters with this invention in his *Madonna of the Snow* (Florence, Pitti; *see* SASSETTA, fig. 1), commissioned in 1430. The iconography of the S Marco Altarpiece is a subtle fusion of Dominican and Medicean interests. All but the central scene of the predella depict scenes from the *Lives of SS Cosmas and Damian*, major patron saints of the Medici family in general and of Cosimo in particular. In the main panel the two kneeling figures of these saints in the foreground serve to introduce the Medici as patrons into the scene. The patron saints of Cosimo's closest male relations are also represented in the main field: SS Francis, Peter Martyr, Lawrence and John the Evangelist. Fra Angelico wrapped these Medicean interests in a cloak of Dominican iconographical conventions. The Infant Christ holding the orb that symbolizes the world is a motif traceable in Dominican art at least to the mid-14th century. The verses on the borders that embellish the Virgin's cloak and the specific varieties of trees in the landscape background derive from Dominican liturgical usage. The central panel of the predella refers to the adoration of the Eucharist, and other features fall into a long tradition of Dominican altarpieces as far back as Simone Martini's S Caterina Altarpiece (1319–20; Pisa, Mus. N. S Matteo).

(ii) Frescoes. In accordance with custom, frescoes embellished the public spaces of S Marco. Half-length saints appear in pointed lunettes over each doorway in the cloister, and on the north wall Fra Angelico painted a large representation of *Christ on the Cross Adored by St Dominic* (after 1442) on an axis with the main entrance from the Piazza S Marco. The entire north wall of the chapter room was reserved for a huge, semicircular *Crucifixion with Saints* (1441–2). The south wall of the refectory, opposite the entrance, was covered by a painting of unknown subject (destr. 1554) but probably either a Crucifixion or a miraculous episode from the life of St Dominic, or possibly both. Upstairs in the dormitory, each of the 43 original cells received a frescoed composition and three others were painted in the corridors. There is no precedent in known schemes of conventual decoration for such an extensive suite of frescoes in a dormitory, Dominican or otherwise.

(a) Ground-floor. Although the extent and location of the ground-floor decoration is conventional, Fra Angelico's choice of subject for the most public painting of all, *Christ on the Cross Adored by St Dominic*, is without precedent. In the 15th century, cloisters and their adjacent rooms—the sacristy, chapter room, refectory and guest quarters—were generally accessible to all men, both lay and clerical, though not to women. The social function of these spaces was to mediate between the private monastic enclosure of the monks or friars and the public sphere that surrounded it. In the second quarter of the 15th century a number of Florentine religious communities adopted a local and short-lived Sienese practice of the early 14th century by commissioning extensive cycles of

fresco decoration for their cloisters. Most commonly, cloister decoration, in Florence as elsewhere, lacked any chronological, stylistic or iconographical cohesiveness. The formal and ideological integrity of carefully planned programmes, such as those in Florence at S Maria Novella, the Badia, S Miniato and others, was new in this period. These pictorial cycles were forms of institutional propaganda orientated towards the public and thus different in both kind and effect from the private self-representations of religious institutions that were preserved in the texts and other instruction directed towards their members only. Unexceptionally, these programmes stressed the relevant order's history and mission in the Church. By contrast, Fra Angelico stressed St Dominic's inner or mystical life and thus by association the mystical lives of the friars at S Marco.

The *Crucifixion* in the chapter room pairs and even opposes sacred history and its interiorization by means of disciplined contemplation. To the left of the figure of Christ, Fra Angelico included the biblical figures traditionally represented at the scene of the Crucifixion with SS Mark, Lawrence, Cosmas and Damian. On the right, however, he arranged a group of 11 standing and kneeling figures representing Dominican saints and renowned monastic reformers. All of them are shown in attitudes of prayer and meditation and can therefore be understood as models for the contemplation of Christ's saving death, serving as examples for the friars who gathered daily in the chapter room to examine and expose their faults. Such joining of two levels of representation, the narrative and contemplative, within the same field also characterizes some of the cell frescoes in the dormitory.

(b) Dormitory. As early as the 13th century the Constitution of the Order of Preachers stipulated that dormitories were to be decorated with an image of the Virgin in the corridor and that the cells were to contain images of Christ or the Virgin. It is thought that the Dominicans were the first order to specify the use of images in this context, though apart from those at S Marco no other such suites are known. A number of small panels with secure Dominican provenances showing St Dominic or some other Dominican figure kneeling before Christ on the Cross may be relics of this practice, and Fra Angelico's *Crucifixion with the Virgin, St John the Evangelist and Cardinal Juan de Torquemada* (*c.* 1450–55; Cambridge, MA, Fogg) is probably one of these. S Marco must therefore be understood as a special case of a broad phenomenon, its extraordinary survival accountable in part to the medium of fresco. Fra Angelico certainly executed at least one fresco (Paris, Louvre) for the dormitory corridor at S Domenico, Fiesole, and he may also have painted the dormitory at S Domenico, Cortona, in 1438–9, although that structure was destroyed and no description survives.

The dormitory corridor at S Marco contains three frescoes, one of which is entirely by Fra Angelico. The

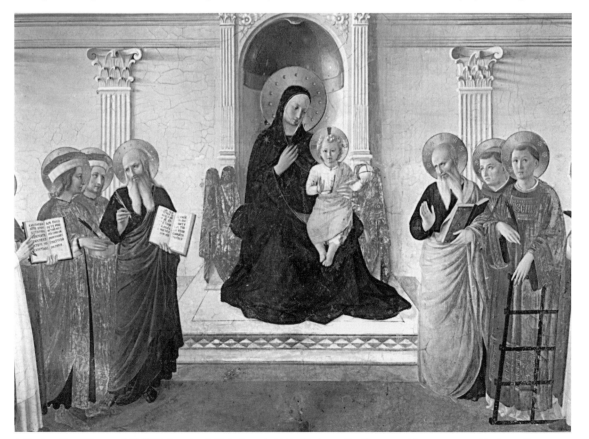

4. Fra Angelico: *Virgin and Child Enthroned with Eight Saints* (*c.* 1440–45), fresco (detail), east corridor, monastery of S Marco, Florence

composition and iconography of the *Virgin and Child Enthroned with Eight Saints* (the *Madonna of the Shadows*; see fig. 4) in the east corridor, designed but probably not entirely executed by Fra Angelico, recalls the S Marco Altarpiece and suggests that this was the spot where the community gathered to sing the Night Office of the Virgin, which the Constitutions specify was to be sung in the dormitory. *Christ on the Cross Adored by St Dominic*, on an axis with the east corridor, is a variation of the cloister fresco and may be a late 15th-century addition in the style of Fra Angelico.

The autograph *Annunciation* (see colour pl. 1, III1) opposite the head of the staircase leading from the ground-floor is the first image to greet the visitor on entering the most private area of the complex. In the 15th century only Dominican and Franciscan friars were permitted to enter the Order's dormitories. A Dominican would have been singularly well equipped to read the messages of the *Annunciation* fresco because the traditional theme is embedded in the Order's ethos. For example, the inscription across the bottom reads, 'When you come before the figure of the intact Virgin, do not fail to say a Hail Mary'. It was the custom for Dominicans to greet the Virgin with the angelic salutation on entering the dormitory, and as this was done while genuflecting—just as the Angel Gabriel does in the *Annunciation*—Fra Angelico's painting forged an indissoluble link between the image and its beholder. Exactly the same purpose informs the frescoes in the cells.

The attribution and chronology of the 43 frescoes in the cells is an enormous and probably insoluble problem. The overall conception and the design of most of the individual scenes are undoubtedly Fra Angelico's. The frescoes wholly or almost wholly painted by the master are those in cells 3, 6, 7, 9 and 10, depicting, respectively, the *Annunciation*, the *Transfiguration* (see fig. 5), the *Mocking of Christ* (see colour pl. 1, III2), the *Coronation of the Virgin* and the *Presentation in the Temple*. Others show signs of his intervention alongside an assistant, and still others were executed on his designs but wholly independently. Iconographically, with the exception of two scenes, the cell frescoes fall into three groups, each corresponding to the section of the community assigned to live there. Novices were housed in the seven cells along the south corridor, clerics in the twenty on the east corridor, and lay brothers and guest friars probably in the north corridor, where cells 38 and 39 were reserved for the private use of Cosimo de' Medici. These two were decorated, appropriately, with a *Crucifixion with Patron Saints of the Medici Family* in Cell 38 and the *Adoration of the Magi*, a subject with strong Medicean associations, in Cell 39.

The frescoes in the novitiate are the most uniform group. They are white-ground vertical rectangles in which St Dominic kneels before the Cross, the only variation from fresco to fresco being in the gestures employed by the saint. These are derived from the gestures both described and illustrated in *De modo orandi*, a Dominican textbook for prayer based on eye-witness observations of the founder's attitudes during personal prayer. Compiled in the 13th century, the text fell largely out of use but was revived by the Dominican Observance in its houses all over Europe in the 15th century.

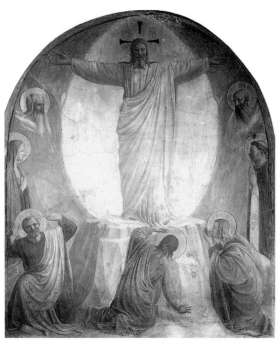

5. Fra Angelico: *Transfiguration* (*c.* 1440–45), fresco, Cell 6, monastery of S Marco, Florence

The cells in the east corridor continue the theme of *De modo orandi* in compositions signifying feasts of Christ or the Virgin. The symbol of the Cross used in the novitiate is replaced with more historiated references that include ancillary figures and descriptive settings rather than the reduced *dramatis personae* and the flat, white ground of the first group of frescoes. Fra Angelico here expanded the repertory of exemplars to include other saints as well as Dominic. In the *Annunciation* (Cell 3), for example, St Peter Martyr observes the colloquy between the Virgin and the Angel with a gesture that was believed to induce humility, while the gesture of the same saint when he reappears in the *Presentation in the Temple* (Cell 10) indicates that he is interceding on behalf of the brethren. In the clerics' cells, therefore, as in the north corridor *Annunciation* or the *Crucifixion* in the chapter room, the friars were encouraged to identify with the mystical life of notable forerunners, mostly Dominican, as they meditated on the liturgical texts associated with the major feasts of the calendar.

At this period lay brothers were assumed to be untutored in Latin and would not have undergone even the minimal theological preparation required for ordination. Accordingly, the frescoes in their cells, on the south side of the north corridor, are devoid of the liturgical and even mystical references woven into the paintings made for novices and clerics. The compositions are fully narrative illustrations of various scenes from the *Life of Christ*, drawn mostly from the Passion cycle beginning with the *Last Supper* (Cell 35) and ending with the *Noli me tangere* (Cell 1). Here as elsewhere in the dormitory nothing determines the sequence of scenes from cell to cell. Fra Angelico, or perhaps his assistant Benozzo Gozzoli, seems intentionally to have based these frescoes on the didactic

cycle in the chapter room, with its chapel of Corpus Domini, at S Maria Novella, Florence. As early as the S Domenico Altarpiece, Fra Angelico had made reference to the art of the mother house, as it was from there that the convent at Fiesole had been founded. A free variation of the S Marco chapter room *Crucifixion* embellishes the large Cell 37, indicating that the room served a parallel function for the lay brothers, who were not voting members of the Conventual Chapter itself. Finally, the cells along the north side of the north corridor display rather conventional Crucifixions with saints, indicating that, as guest cells, their programme was not designed to reinforce the mentality appropriate for each of the three segments of an Observant Dominican community.

4. *c.* 1446–55. Probably towards the end of 1445 Fra Angelico left Florence for a sojourn of about four years in Rome. In March 1446 Antonino Pierozzi, the former prior of S Marco, became Archbishop of Florence. According to Vasari, in an anecdote that has persisted as an example of the artist's legendary good nature, Pope Eugenius IV (*reg* 1431–47) offered the post first to Fra Angelico, who turned it down out of modesty and suggested instead the name of his former superior and novice master. A close relationship between Pope and painter undoubtedly existed, dating from the nine years when Eugenius IV's court had been housed in Florence at S Maria Novella. The only recorded commissions of the Roman years were for large-scale mural decorations, a task that the Pope could confidently entrust to the artist in view of his familiarity with Fra Angelico's Florentine works.

Fra Angelico was assigned a number of tasks in St Peter's and the Vatican Palace, although only one of them survives, the cycle of the *Lives of SS Stephen and Lawrence* (1448–9) in the private chapel of the humanist pope NICHOLAS V. Varying accounts of these commissions and the widespread reconstruction of the Vatican complex in the 16th century all but obscure the number and location of the projects apart from this chapel. It has been argued that there were four papal commissions in all: the chapel of St Peter (1447), located near or on the site of the Sistine Chapel at that level, accessible from both the palace and the basilica; the chapel of Nicholas V in the palace (1448–9); a studio for Nicholas V (1449); and a chapel of the Sacrament in the palace, painted either in 1446 or 1452, during Fra Angelico's second Roman sojourn.

With the return of Eugenius IV to Rome in 1443, the popes established their major residence at the Vatican rather than at the Lateran, the official seat of the Roman pontiffs since the 4th century AD. The papal palace was therefore the site of constant building and renovation. Nicholas V expanded the palace and incorporated a 13th-century tower into the new edifice, and it was here that a small but lofty chapel (6.6×4 m) was built for his private use, dedicated to the deacon martyrs, SS Stephen and Lawrence. Entirely preserved except for the altarpiece, which probably depicted the *Deposition*, a sumptuous programme of decoration covers the vaulted ceiling and three walls in three horizontal zones. The *Four Evangelists* appear in the vault against a blue field studded with gold stars and the pilasters supporting the vault depict the *Eight Doctors of the Church* standing in tabernacles reminiscent

of the classicizing Gothic style of the throne in Fra Angelico's *Coronation of the Virgin* (Paris, Louvre). Half-length figures alternate with rosettes in the pair of window mullions in one long wall and *trompe l'oeil* brocaded damask covers all three walls in the lower zone. In 1447 Fra Angelico's Roman shop included Benozzo Gozzoli and three other painters, all of whom may have worked in the chapel, though numerous restorations make it difficult to assign parts of the cycle to specific assistants.

Six scenes from the *Life of St Stephen* appear in the three lunettes of the upper zone, while five depicting the *Life of St Lawrence* follow in the rectangular fields below. The dedication to the two deacon martyrs reflects the Pope's desire to underscore the legitimacy of the Roman pontiffs in a period ridden with schisms. St Stephen's traditional tomb in S Stefano Rotondo was one of the major pilgrimage sites in Rome, as was the funerary basilica dedicated to the 3rd-century Roman martyr St Lawrence. Religious humanists of the 15th century, among whom Nicholas V was a leading figure, were especially interested in Christian antiquity, and Nicholas may have dedicated his chapel with propagandist purposes deriving from his own Christian antiquarianism. The correspondences between the two ordination scenes must be attributed to Nicholas: in the *Ordination of St Stephen* the bishop is depicted, appropriately, as St Peter; in the *Ordination of St Lawrence*, Nicholas V is portrayed as the bishop and thus shown to be the successor to St Peter, Bishop of both Jerusalem and Rome. Other interests of the Roman humanists in this period may be discerned in Fra Angelico's frescoes. Although many of the architectural backgrounds in the scenes may be traced directly to earlier panel paintings, others do not appear in Fra Angelico's work before his transfer to Rome. The strongly differentiated Classical orders and contemporary Roman architectural motifs in the *Ordination of St Stephen*, the *Ordination of St Lawrence* and *St Lawrence Distributing Alms* (see fig. 6) suggest that these scenes may have been inspired or even designed by the architect and humanist Leon Battista Alberti, then present at the papal court.

It is difficult to analyse the development of Fra Angelico's monumental narrative style because of the disappearance of the other three fresco cycles from the Vatican Palace. The more recondite, non-narrative paintings at S Marco are far removed from the active and even didactic manner of such episodes as *St Stephen Preaching* and *St Stephen Addressing the Council*, although these may be felt to recall the predella scenes from the S Marco Altarpiece. The expanse of space, the clarity of gesture and expression and the carefully adjusted light in the chapel of Nicholas V profoundly reveal Fra Angelico's long scrutiny of Masaccio's frescoes in the Brancacci Chapel, S Maria del Carmine, Florence (see colour pl. 2, III2). The poignantly humane sensitivity to the poor that informs Masaccio's *St Peter Healing with his Shadow* is also apparent in Fra Angelico's scene of *St Lawrence Distributing Alms*.

In the summer of 1447 Fra Angelico and his shop journeyed to Orvieto, where he had accepted a commission to paint the chapel of S Brizio in the cathedral, now better known for Luca Signorelli's wall paintings of the *Last Judgement* and the *End of the World* (1499–1503; *see* SIGNORELLI, LUCA, fig. 4). Fra Angelico's contribution

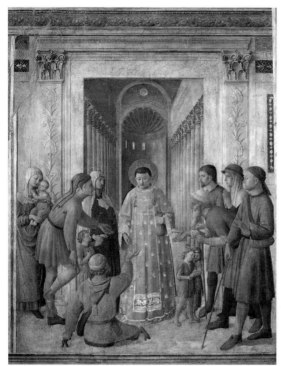

6. Fra Angelico: *St Lawrence Distributing Alms* (1448–9), fresco, chapel of Nicholas V, Vatican Palace, Rome

was confined to the vaults, where *Christ in Glory* appears in the compartment over the altar, with 16 *Prophets* appearing in the compartment to the right. Fra Angelico never returned to Orvieto and the contract was nullified in 1449.

By early 1450 Fra Angelico had returned to Tuscany from Rome to assume the priorate of S Domenico, Fiesole, for the standard period of two years. The altarpiece depicting the *Virgin and Child Enthroned with Two Angels and SS Anthony of Padua, Louis of Toulouse, Francis, Cosmas, Damian and Peter Martyr* (Florence, Mus. S Marco), commissioned by Cosimo de' Medici for the Observant Franciscans of S Bonaventura, Bosco ai Frati, near Florence, probably dates from this period. The church and convent, near Cosimo's favourite villa at Cafaggiolo, were designed by MICHELOZZO DI BARTOLOMMEO and are a simpler and more rustic version of S Marco. The general design of the altarpiece resembles both the Annalena Altarpiece and the S Marco Altarpiece, although its sumptuous surfaces, grander rhythms and more substantial figures reflect Fra Angelico's recent Roman experiences.

In the same period Fra Angelico accepted another Medici commission: to decorate, for SS Annunziata, Florence, a complex group of shutters (Florence, Mus. S Marco) covering the cabinet where the silver votive offerings to a miraculous image were stored. In 1448 Piero de' Medici, Cosimo's son, had assumed the patronage of the shrine, commissioning Michelozzo to erect, among other works, a magnificent marble tabernacle before the image. The 35 extant panels depicting scenes from the *Life of Christ* thus belonged to an ensemble. The compositions are related to those of similar subjects in the cells

at S Marco, although the numerous biblical inscriptions demonstrate that a complex iconographic programme united an otherwise traditional array of episodes.

Fra Angelico's tenure as prior of S Domenico would have expired in the spring of 1452, and in March of that year he journeyed to Prato to discuss the fresco decoration for the main chapel of the cathedral. He declined the offer, and the commission subsequently went to Fra Filippo Lippi. Fra Angelico's decision not to accept what would have been not only a prestigious but lucrative commission must be weighed against the fact that he and his brother Fra Benedetto, until his death in 1448, were the main supporters of S Domenico. Unlike its sister convent at S Marco, S Domenico had no patron comparable with Cosimo de' Medici and although the bequest of Barnaba degli Agli had provided funds for the convent's construction, the friars of Fiesole lacked steady income and remained very poor throughout the period of S Marco's ascendancy. Fra Angelico's decision not to take the Prato commission was most probably made in light of some other opportunity and this is likely to have been in Rome. A possible theory is that he had another commission at the Vatican, or that he had been engaged to paint the cloister of S Maria sopra Minerva, Rome, the Dominican Order's main Roman foundation. At about this time, the distinguished Dominican jurist and Master of the Papal Palace, Cardinal Juan de Torquemada (*d* 1468), designed an extensive programme of decoration for the cloister, and it is plausible to assume that he wanted Fra Angelico to be responsible for it. The two men had been acquainted since the time of Torquemada's residence in Florence in the 1430s, and Torquemada owned the *Crucifixion* panel by Fra Angelico in which he is portrayed (Cambridge, MA, Fogg). The cloister has entirely disappeared, but its iconographical programme is preserved in a manuscript, probably in Torquemada's own handwriting (Rome, Vatican, Bib. Apostolica), and a woodcut edition was printed at Subiaco in the 1460s. Despite his long spiritual and artistic associations with S Domenico in Fiesole and S Marco in Florence, Fra Angelico died in Rome and was buried at S Maria sopra Minerva, where his tomb is now venerated as a shrine to his beatitude, which was implied in biographies of the artist since the 16th century and finally declared by Pope John Paul II (*reg* 1978–) in 1984.

II. Working methods and technique.

Considerable disagreement among scholars and often sparse documentation has made it difficult to establish a firm canon for Fra Angelico. For the great programmes in S Marco and in Rome, the difficulty is to disentangle the contribution of Fra Angelico from that of the various assistants who worked together as a team in his shop. Evidence for the existence of such teams dates from the early 1430s. A large number of works in all media and sizes can suddenly be assigned to Fra Angelico's shop between 1430 and 1437. So great an increase in production and of such high quality presupposes that his workshop underwent rapid expansion and that he was forced to employ not just *garzoni* (shop boys) and assistants, but skilled journeymen, painters in whom he could have great confidence even though they had come to him fully trained

by others. Some assistants, mostly anonymous, appear to have remained attached to his workshop for considerable lengths of time. His closest follower was Benozzo Gozzoli. The names of those who assisted Fra Angelico at Orvieto and in Rome are not known.

Finding patrons was not Fra Angelico's responsibility. As a Dominican friar he was guaranteed his living, something that his secular colleagues had to wrest for themselves in the pressures of a competitive market. Unlike them, however, he was committed to developing an expressive repertory that would reinforce the theological and liturgical traditions of the Dominican Order. These traditions were both very strong and very old, and throughout his career they conditioned the artist's attitude to all Dominican commissions, including various parts of the S Marco complex.

Fra Angelico's facility in small-scale production, seen in the Missal (Florence, Mus. S Marco, MS. 558), led naturally to particularly lively and detailed predella scenes, but if thinking on a small scale came naturally to Fra Angelico, the major impulse of his self-education in the early years of his career was aimed at developing the skills necessary for painting on a monumental scale. This required the development of a system for representing volume that did not depend on the refined, calligraphic application of points of colour appropriate to manuscript illumination. For this reason the altarpieces of the 1420s reveal his close study of recent exercises in modelling in light and shade. However, for Fra Angelico the chief problem was that chiaroscuro implicitly made redundant the brilliance of local hues that characterized 14th-century painting, a quality he sought to retain in spite of the concomitant difficulty of rendering mass and space convincingly. Around 1432 he abandoned the chiaroscuro technique then current in Florence and turned instead to an invention of his own. This was a method of rendering the plasticity of solids in space by exploiting the opposition between complementary colours, particularly red and green. To achieve this, he studied early 14th-century Sienese painting, especially that of Duccio (*fl* 1278–1319) and Simone Martini (*c.* 1284–1344), and was guided by his Sienese contemporary Sassetta. He seems to have met Sassetta in the early 1430s and to have remained in contact throughout the decade. This profound orientation towards a Sienese rather than a Florentine way of seeing accounts for the discontinuous nature of Fra Angelico's development from around 1429 to 1433.

Other visual effects whose extravagance is more closely allied with Sienese than Florentine taste may be seen in, for example, the Linaiuoli Tabernacle. Here, apart from the planes of prestigious and costly ultramarine blue and carmine red, which were themselves luxury ornaments in early 15th-century Florentine painting, the entire surface of the inner panel is covered with magnificent passages of complicated *sgraffito* work in no fewer than four separate patterns of cloth-of-gold damask, brocade and embroidered satin. The musicmaking angels around the frame are similarly executed in a rapidly changing sequence of costly pigments, the shimmer of their wings achieved by spreading transparent layers of colour thinly across the gold ground. These refined techniques were traditional painters' devices for conveying God's ineffable majesty,

and as such none were new to Fra Angelico or his generation, although their most recent and most lavish appearance had been in Gentile da Fabriano's Quaratesi Altarpiece.

BIBLIOGRAPHY

G. Vasari: *Vite* (1550, rev. 2/1568); ed. G. Milanesi (1878–85)
J. Pope-Hennessy: *Fra Angelico* (Oxford, 1952, rev. London, 1972)
S. Orlandi OP: *Beato Angelico: Monografia storica della vita e delle opere con un' appendice di nuovi documenti inediti* (Florence, 1954)
U. Middeldorf: 'L'Angelico e la scultura', *Rinascimento*, vi (1955), pp. 179–94
Mostra delle opere del Beato Angelico nel quinto centenario della morte (1455–1955) (exh. cat., ed. M. Salmi and others; Florence, 1955)
U. Baldini: *L'opera completa dell'Angelico* (Milan, 1970)
A. Greco: *La Cappella di Niccolò V del Beato Angelico* (Rome, 1980)
G. Fallani: *Vite e opera di Fra Giovanni Angelico* (Florence, 1984)
Beato Angelico: Miscellenea di studi, Postulazione Generale dei Dominicani (Rome, 1984)
U. Baldini: *Beato Angelico* (Florence, 1986)
D. Dini and G. Bonsanti: 'Fra Angelico e gli affreschi nel convento di San Marco (*ca.* 1441–50)', *Tecnica e stile: Esempi di pittura murale del rinascimento italiani*, ed. E. Borsook and F. Superbi Gioffredi (Florence, 1986), pp. 17–24
L. Castelfranchi Vegas: *L'Angelico e l'umanesimo* (Milan, 1989)
G. Didi-Huberman: *Fra Angelico: Dissemblance et figuration* (Paris, 1990)
La chiesa e il convento di San Marco a Firenze, Cassa di Risparmio di Firenze, ii (Florence, 1990)
W. Hood: *Fra Angelico at San Marco* (New Haven, 1993)
M. Boskovits: 'Attorno al Tondo Cook: Precisazioni sul Beato Angelico su Filippo Lippi e altri', *Mitt. Ksthist. Inst. Florenz*, xxxix/1 (1995), pp. 32–68
W. Hood: *Fra Angelico: San Marco, Florence* (New York, 1995)
C. C. Wilson: 'Fra Angelico: New Light on a Lost Work', *Burl. Mag.*, cxxxvii/1112 (1995), pp. 737–40
F. Russell: 'An Early Crucifixion by Fra Angelico', *Burl. Mag.*, cxxxviii (1996), pp. 315–17
J. T. Spike: *Fra Angelico* (Paris, 1996); Eng. trans. by C. Bonnafont
C. Gardner von Teuffel: 'Fra Angelico's Bishop Saints from the High Altar of S Domenico, Fiesole', *Burl. Mag.*, cxxxix (1997), pp. 463–5

WILLIAM HOOD

Angelo (di Pietro) del Macagnino (da Siena) [Parrasio, Angelo] (*fl* Ferrara, 1447; *d* 1456). Italian painter. He was court painter to Borso d'Este, Duke of Ferrara, and, with Cosimo Tura, decorated the Duke's *studiolo* at the Villa Belfiore (destr.) from 1447. The iconographic programme was provided by Guarino da Verona. In 1449 Cyriac of Ancona saw two finished paintings of *Clio* and *Melpomene* (both untraced) in Angelo's workshop, probably destined for the *studiolo*. No work by him has been identified.

BIBLIOGRAPHY

A. Lazzari: 'Il "Barco" di Lodovico Carbone', *Atti & Mem. Deput. Ferrar. Stor. Patria*, xxiv (1919), pp. 5ff
R. Longhi: *Officina ferrarese* (Rome, 1934); rev. in *Opere complete di Roberto Longhi*, v (Florence, 1963)
M. Davies: *The Earlier Italian Schools*, London, N.G. cat. (London, 1961, rev. 2/1961/R 1986), pp. 519–20

JANE MARTINEAU

Anguissola [Angosciola; Anguisciola; Angussola]. Italian family of painters. Six sisters from a noble family of Cremona, daughters of Amilcare Anguissola and Bianca Ponzoni, were painters of some renown: (1) Sofonisba Anguissola, (2) Lucia Anguissola, Europa (*c.* 1542–*c.* 1578), Elena (*fl* 1546–84), Minerva (*fl* 1558–69) and Anna-Maria (*c.* 1555–*c.* 1611) Anguissola. Sofonisba and Elena studied painting with Bernardino Campi from *c.* 1545 and with Bernardino Gatti from 1549. Elena entered the convent of S Vincenzo in Mantua, where she was recorded in 1585, and may be the subject of the *Portrait of a Nun* (1551;

Southampton, C.A.G.) attributed to Sofonisba. Vasari, who visited the family in 1566, praised the sisters' work. He noted that Sofonisba's *Family Portrait* (1560s; Nivå, Nivaagaards Malsaml.) shows Minerva, her father and her brother Asdrubale. Europa executed a portrait of their mother (untraced), according to Vasari, and she signed the *Calling of SS Andrew and Peter* (Vidiceto, Parrocchiale). The *Holy Family* (Cremona, Mus. Civ. Ala Ponzone) is signed by Anna-Maria.

BIBLIOGRAPHY

Thieme–Becker

I. Kühnel-Kunze: 'Zur Bildniskunst der Sofonisba und Lucia Anguissola', *Pantheon*, xx/2 (1962), pp. 83–96

L. Nochlin and A. Sutherland: *Women Artists, 1550–1950* (Los Angeles, Co. Mus. A.; Austin, U. TX., A. Mus.; 1976) [published in conjunction with travelling exhibition]

G. Greer: *The Obstacle Race: The Fortunes of Women Painters and their Work* (New York and London, 1979), pp. 3, 12, 69–70, 136, 180–85, 251

R. Parker and G. Pollock: *Old Mistresses: Women, Art and Ideology* (London, 1981), pp. 18, 47, 84–6

I Campi e la cultura artistica cremonese del cinquecento (exh. cat., ed. M. Gregori; Cremona, Mus. Civ. Ala Ponzone, 1985), pp. 171–8, 301–2

F. Caroli: *Sofonisba Anguissola e le sue sorelle* (Milan, 1987)

C. L. Schwok-Bionda: 'Autour de Sofonisba Anguissola et de ses soeurs', *L'Oeil*, 467 (1994), pp. 32–7

MARCO TANZI

(1) Sofonisba Anguissola (*b* Cremona, *c.* 1532; *d* Palermo, Nov 1625). The best known of the sisters, she was trained, with Elena, by Campi and Gatti. Most of Vasari's account of his visit to the Anguissola family is devoted to Sofonisba, about whom he wrote: 'Anguissola has shown greater application and better grace than any other woman of our age in her endeavours at drawing; she has thus succeeded not only in drawing, colouring and painting from nature, and copying excellently from others, but by herself has created rare and very beautiful paintings'. Sofonisba's privileged background was unusual among woman artists of the 16th century, most of whom, like Lavinia Fontana (*see* FONTANA (ii), (2)), FEDE GALIZIA and Barbara Longhi (*see* LONGHI (i), (3)), were daughters of painters. Her social class did not, however, enable her to transcend the constraints of her sex. Without the possibility of studying anatomy, or drawing from life, she could not undertake the complex multi-figure compositions required for large-scale religious or history paintings. She turned instead to the models accessible to her, exploring a new type of portraiture with sitters in informal domestic settings. The influence of Campi, whose reputation was based on portraiture, is evident in her early works, such as the *Self-portrait* (Florence, Uffizi). Her work was allied to the worldly tradition of Cremona, much influenced by the art of Parma and Mantua, in which even religious works were imbued with extreme delicacy and charm. From Gatti she seems to have absorbed elements reminiscent of Correggio, beginning a trend that became marked in Cremonese painting of the late 16th century. This new direction is reflected in *Lucia, Minerva and Europa Anguissola Playing Chess* (1555; Poznań, N. Mus.) in which portraiture merges into a quasi-genre scene, a characteristic derived from Brescian models.

Many of Sofonisba's works were self-portraits, and at least 12 survive, including examples in Boston, MA (1552; Mus. F.A.), Vienna (1554; Ksthist. Mus.), Naples (1559;

Capodimonte) and Milan (*c.* 1555; Mus. Poldi Pezzoli). She depicted herself with various attributes, some relating to her artistic profession, some to the literary and musical accomplishments typical of contemporary noblewomen. In the latest dated *Self-portrait* (1561; Althorp House, Northants; see fig.), she is shown seated at a spinet, watched by a chaperone, also an allusion to her status. Although the rendering of perspective in the keyboard is not convincing, the background figure of the chaperone gives some illusion of space. Her approach to portrait painting was personal, not coldly realistic, and she showed an interest in the psychology of her sitters, although it was never fully realized. This interest is evident in a series of drawings and paintings that explore the physical expression of emotions, such as *Child Bitten by a Crayfish* (*c.* 1554; Naples, Capodimonte), which influenced Caravaggio (1571–1610), or *Old Woman Learning the Alphabet, Mocked by a Young Girl* (*c.* 1550; Florence, Uffizi). Anguissola's Cremonese works also include a small number of religious paintings, mainly for private devotion, as is evident from the small size of the *Holy Family* (350×300 mm, 1559; Bergamo, Gal. Accad. Carrara), which is based on a prototype by Camillo Boccaccino (Glasgow, A.G. & Mus.); however, the *Pietà* (*c.* 1570; Milan, Brera), which is traditionally attributed to her, is not characteristic of her style and is certainly by Bernardino Campi.

In 1559 Sofonisba was invited to the court of Madrid through the offices of Ferdinand Alvarez de Toledo (1508–82), Duke of Alba, and of the Duca di Sessa, the Governor of Milan, one of Campi's principal patrons. There, she was chosen by Philip II (*reg* 1556–98) to be an attendant to the Infanta Isabella (1566–1633), and she also became lady-in-waiting to the queen, Elizabeth of Valois (1545–1568).

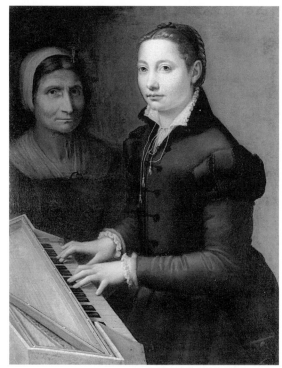

Sofonisba Anguissola: *Self-portrait*, oil on canvas, 812×635 mm, 1561 (Althorp House, Northants)

In Spain, Sofonisba pursued her work as a portrait painter, although the Althorp *Self-portrait* is the only securely attributed work surviving from this period. In Madrid *c.* 1571 she married the nobleman Fabrizio de Moncada, brother of the Viceroy of Sicily, Francesco II, and she then settled in Sicily. In 1584, after his death, she married the Genoese nobleman Orazio Lomellino and moved to his native city. In both Palermo and Genoa she continued to paint and to preserve her links with the aristocracy, as is evinced by the visit of the Spanish Infanta, who was in Genoa in 1599, the date of her portrait of the *Infanta Isabella Clara Eugenia* (Vienna, Ksthist. Mus.). Anthony van Dyck visited Anguissola in Palermo in July 1624 and drew a portrait of her in his so-called Italian Sketchbook (London, BM), on which he noted that she was 96 (if true, this would alter her presumed birthdate) but still lucid and enthusiastic about painting. In the few surviving paintings from her Genoese period there appears to be considerable borrowing from the work of Luca Cambiaso. Indeed, the *Virgin Suckling the Infant Christ* (Budapest, Mus. F.A.) was attributed to Cambiaso until cleaning revealed a signature that confirmed it as the work of Anguissola, dated 1588. The *Holy Family with St Anne and the Young St John* (1592; Coral Gables, FL, U. Miami, Lowe A. Mus.), which is signed, like the Budapest painting, with her husband's surname, Lomellino, is also based on the work of Cambiaso.

DBI

BIBLIOGRAPHY

G. Vasari: *Vite* (1550, rev. 2/1568); ed. G. Milanesi (1878–85), v, p. 81; vi, pp. 498–502; vii, p. 133

A. Lamo: *Discorso intorno alla scoltura e pittura* (Cremona, 1584) [appended to Zaist, see below]

R. Soprani: *Le vite de' pittori, scultori et architetti genovesi* (Genoa, 1674/R Genoa, 1768–9), pp. 411–16

F. Baldinucci: *Notizie* (1681–1728); ed. F. Ranalli (1845–7), ii, pp. 619–36

G. B. Zaist: *Notizie istoriche de' pittori, scultori ed architetti cremonesi* (Cremona, 1774/R Cremona, 1975), pp. 227–36

I. Kühnel-Kunze: 'Zur Bildniskunst der Sofonisba und Lucia Anguissola', *Pantheon*, xx/2 (1962), pp. 83–96

E. Tufts: 'Sofonisba Anguissola, Renaissance Woman', *ARTnews*, lxxi (1972), pp. 50–53

M. Kusche: 'Sofonisba Anguissola en España', *Archv Esp. A.*, lxii (1989), pp. 391–420

I. S. Perlinghieri: *Sofonisba Anguissola: The First Great Woman Artist of the Renaissance* (New York, 1992)

M. D. Garrard: 'Here's Looking at Me: Sofonisba Anguissola and the Problem of the Woman Artist', *Ren. Q.*, xlvii/3 (1994), pp. 556–622

F. Jacobs: 'Woman's Capacity to Create: The Unusual Case of Sofonisba Anguissola', *Ren. Q.*, xlvii/1 (1994), pp. 74–101

Sofonisba Anguissola e le sue sorelle (exh. cat., Cremona and Milan, 1994)

C. King: 'Looking a Sight: Sixteenth-century Portraits of Woman Artists', *Z. Kstgesch.*, lviii/3 (1995), pp. 381–406

C. Pedretti: 'Sofonisba: Filo indiretto con Leonardo', *Achad. Leonardo Vinci: J. Leonardo Stud. & Bibliog. Vinciana*, viii (1995), p. 246

MARCO TANZI

(2) Lucia Anguissola (*b* Cremona, 1536 or 1538; *d* ?Cremona, ?1565, before 1568). Sister of (1) Sofonisba Anguissola. She probably trained with her sister, and her work, mainly portraits, is similar in style and technique. Her only signed painting, a portrait of a Cremonese doctor, *Pietro Maria* (early 1560s; Madrid, Prado), was praised by Vasari, who saw it when he visited the family after her death. It is a sensitive portrayal, in a restricted palette of greys and browns, and may be a pendant to Sofonisba's *Portrait of a Lady* (1557; Berlin, Gemäldegal.). Lucia also painted a *Virgin and Child* (untraced; for copy, see Caroli, 1973) and a half-length *Self-portrait* (*c.* 1557; Milan, Castello Sforzesco). A *Portrait of a Woman* (early 1560s; Rome, Gal. Borghese) is thought to be either a self-portrait by her or Sofonisba, or a portrait of Lucia by Sofonisba. Two portraits (Brescia, Pin. Civ. Tosio–Martinengo; Milan, Mus. Poldi Pezzoli), probably of Minerva Anguissola, may also be by Lucia.

BIBLIOGRAPHY

G. Vasari: *Vite* (1550, rev. 2/1568); ed. G. Milanesi (Milan, 1878–85)

F. Caroli: 'Antologia d'artisti: Per Lucia Anguissola', *Paragone*, 277 (1973), pp. 69–73

——: 'Marco d'Oggiono: Un modello per Lucia Anguissola', *Achad. Leonardo Vinci: J. Leonardo Stud. & Bibliog. Vinciana*, viii (1995), p. 247

□

Anna, d'. Italian family of patrons. Probably from Brussels originally, the d'Anna family were wealthy merchants who settled in Venice at the beginning of the 16th century. Martin [Martino] d'Anna (*b* ?1475; *d* Venice, 11 Nov 1556) acquired Venetian citizenship in 1545. He bought a palace on the Grand Canal from Lodovico Talenti on 7 December 1538 (Venice, Archv Stato, Notarile atti, Ba. 3258, fols 126–8). Talenti, not Martin, must have commissioned from Pordenone the famous frescoes (*c.* 1534; destr., known from prints) that decorated the building's façade. Martin continued embellishing this residence, and in his will (1553, Venice, Archv Stato, Notarile testamenti, Ba. 1218/x42) he requested that his heirs neither destroy nor disperse the decorations and furniture.

The sons of Martin d'Anna, Daniele (*d* Venice, 26 Dec 1579) and Giovanni (*d* 1580), were also important patrons. They asked Leone Leoni to engrave several medals for them (e.g. portrait medals 1544–5; Milan, Castello Sforzesco). This sculptor was close to Titian at the time, and it was probably the latter who introduced him, as Giovanni d'Anna was also a friend of Titian. The latter painted several works for him in the style of Vasari, including the *Ecce homo* of 1543 (Vienna, Ksthist. Mus.), which features several members of the family. Daniele was the dedicatee of the *Praecipua aliquot romanae antiquitatis ruinarum monumenta* (Venice, 1561), a collection of prints by Battista Pittoni depicting views of the main ruins of Rome. In his dedication Pittoni asserted that Daniele was a great lover of painting and architecture. Giovanni's son Paolo (*d* 1582) is the last member of the family on whom there is any information. Francesco Sansovino dedicated to him his *Osservationi della lingua volgare* (Venice, 1562), praising his magnificence. In 1577 Paolo was appointed Guardian grande of the Scuola di S Rocco. The painter Baldassare d'Anna (*fl c.* 1560) was probably related to this family.

BIBLIOGRAPHY

G. Vasari: *Vite* (1550, rev. 2/1568); ed. G. Milanesi (1878–85), v, p. 115; vii, pp. 429–30, 457

C. Ridolfi: *Maraviglie* (1648); ed. D. von Hadeln (1914–24), i, p. 120

E. A. Cicogna: *Delle inscrizioni veneziane* (Venice, 1824–53), iv, pp. 197–9

M. Hochmann: *Peintres et commanditaires à Venise, 1541–1628* (Rome, 1991), pp. 201–4

MICHEL HOCHMANN

Ansano di Matteo. *See* SANO DI MATTEO.

Ansano di Pietro di Mencio. *See* SANO DI PIETRO.

Anselmi, Michelangelo (*b* Siena or Lucca, ?1492; *d* Parma, 1556). Italian painter and draughtsman. He was arguably the most imaginative painter in Parma in the early 16th century after Correggio and Parmigianino. However, he was trained in Siena, though his only surviving work there, a *Visitation* in the church of Fontegiusta, shows the importance of Sodoma in the formation of his art. Anselmi's family was apparently from Parma, but he is not securely documented there until 1520. In that year he began to paint in S Giovanni Evangelista, where he decorated the ribs of the nave vaults, the apses of both transepts and at least two chapels: the chapel in the north transept, with frescoes of *SS Agnes and Catherine*, and the sixth chapel on the left of the nave, with frescoes of the *Four Doctors of the Church*. It has also been suggested that he executed the frescoes of *SS Nicholas and Hilary* in the fourth chapel on the left, which have been attributed to Parmigianino. In 1525 Anselmi was one of the group of prominent artists consulted about the construction of S Maria della Steccata, Parma, where his most extensive works in fresco were subsequently painted. These comprise the *Coronation of the Virgin* (1541–2, altered 1547) in the main apse, a commission that was given to him after the death of Parmigianino in 1540 and for which he was required to work from a 'coloured drawing' by Giulio Romano, and, on the facing apse and vault over the west door, an *Adoration of the Magi* and *Four Prophets*, which were completed by Bernardino Gatti.

In 1522 Anselmi was one of the select group who received commissions from the cathedral authorities; his task was to decorate the vault of the south transept, but the work was not completed until the signing of a second contract of 1548. The frescoes do not survive but were replaced by what appear to be accurate copies. As a fresco painter, he also decorated the dome and pendentives of the oratory of the Immaculate Conception in Parma, where the role of his collaborator Francesco Maria Rondani must have been a distinctly subsidiary one; he also executed a series of grisaille *Apostles* and four biblical narratives for the Palazzo Lalatta (now Collegio Maria Luigia) in Parma and a cycle of the *Church Fathers* for the chapel of the Immaculate Conception in the collegiate church at Busseto. Furthermore, both documents and preparatory drawings reveal that he executed a steady stream of coats of arms for external display.

In conjunction with his activity as a fresco painter, Anselmi produced a considerable number of altarpieces and smaller-scale religious works. The majority of the altarpieces seem to have been executed for churches in Parma. Three of the best remain *in situ*: *Christ Carrying the Cross* in S Giovanni Evangelista, and a *Virgin and Child with Four Saints* and a *St Agnes* both in the cathedral. The one notable exception outside Parma is the *Baptism* in S Prospero, Reggio Emilia (see fig.), which is probably his most successful altarpiece. A single *Cupid* (ex-Agnew's, London, see Ghidiglia Quintavalle, fig. 43) is his sole surviving generally accepted mythological painting, but the drawings of *Leda* and *Hercules and Cacus* (both Paris, Louvre) suggest a wider interest in this type of subject, as does a *Lucretia* (Naples, Capodimonte), traditionally given to Bedoli, which has all the hallmarks of Anselmi's style. A productive and extremely stylish draughtsman, he almost

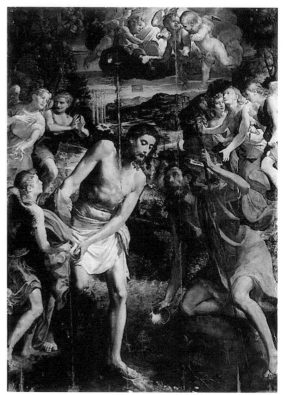

Michelangelo Anselmi: *Baptism*, oil on panel, 2.58×1.87 m, 1530s (Reggio Emilia, S Prospero)

invariably employed red chalk, generally with great fluency and at times with extraordinary tonal richness (e.g. London, BM; Paris, Louvre).

The works from Anselmi's early years in Parma mark him as a genuine original, and it may be that between 1520 and 1525 he had more to teach Correggio and Parmigianino than to learn from them, especially concerning boldly luminous colour and daring *sfumato*. In terms of style he remained his own man, but later there are occasional compositional borrowings from Correggio and Parmigianino, as well as a gradual but undeniable fading of inspiration. His reputation has not been helped by the fact that his one major work outside Italy, an altarpiece of his maturity, the *Virgin and Child with SS John the Baptist and Stephen* (Paris, Louvre), is not usually exhibited.

BIBLIOGRAPHY
A. E. Popham: *Correggio's Drawings* (London, 1957), pp. 107–13, 169–72
A. Ghidiglia Quintavalle: *Michelangelo Anselmi* (Parma, 1960)
F. Viatte: 'Dessins de l'école de Parme', *Rev. Louvre*, 5–6 (1982), pp. 351–5
Correggio and his Legacy: Sixteenth-century Emilian Drawings (exh. cat. by D. De Grazia, Washington, DC, N.G.A.; Parma, G.N.; 1984), pp. 194–207
The Age of Correggio and the Carracci (exh. cat., Bologna, Pin. N.; Washington, DC, N.G.A.; New York, Met.; 1986–7), pp. 53–5
D. Ekserdjian: 'Parmigianino in San Giovanni Evangelista', *Florence and Italy: Renaissance Studies in Honour of Nicolai Rubenstein*, ed. P. Denley and C. Elam (London, 1988), pp. 448–50

DAVID EKSERDJIAN

Ansuino da Forlì [Ansuyn da Furlì] (*fl* Padua, 1451). Italian painter. A document dated 30 Oct 1451 records a

payment for a fresco, signed OPVS ANSVINI, that depicted *St Christopher Preaching* (destr. 1944; fragments survive) in the middle compartment of the right-hand wall of the Ovetari Chapel in the church of the Eremitani, Padua. Ansuino and others had been appointed in place of Giovanni d'Alemagna and Antonio Vivarini to produce six scenes from the *Life of St Christopher* after Giovanni's death in 1450. Scholars have identified the 'Ansuyn depentore' of the Ovetari document with the Ansuyn da Furlì mentioned by Marcantonio Michiel as Filippo Lippi's and Niccolo Pizzolo's collaborator in the decoration (1434–7; destr.) of the chapel of the Podestà, Padua. The style of the Ovetari fresco is fairly close to that developed in the workshops of Pizzolo and Mantegna around 1450. Schmarsow assigned to Ansuino the two scenes in the lunette at the top of the right-hand wall of the Ovetari Chapel depicting *St Christopher and the Devil* and *St Christopher Taking Leave of the King*. Longhi and Zeri, however, have assigned the latter to Girolamo di Giovanni da Camerino.

BIBLIOGRAPHY

DBI

M. Michiel: *Notizia d'opere di disegno* (MS.; *c.* 1520–40); ed. G. Frizzoni (Bologna, 1884), pp. 64, 76

A. Schmarsow: *Melozzo da Forlì* (Berlin and Stuttgart, 1886), pp. 302–8

——: 'Maîtres italiens à la Galerie d'Altenburg', *Gaz. B.-A.*, n.s. 2, xviii (1897), pp. 177–95

R. Longhi: *Lettera pittorica a Giuseppe Fiocco* (1926); also in *Saggi e ricerche, 1925–1928*, II/i of *Edizione delle opere complete di Roberto Longhi* (Florence, 1967), pp. 87–92

F. Zeri: *Due dipinti, la filologia e un nome* (Turin, 1961), pp. 75–6

☐

Antichi [Scavezzi], **Prospero** [il Bresciano; Prospero da Brescia] (*b* Brescia, 1555–65; *d* Rome, 1592). Italian sculptor. According to Baglione, he went to Rome from his native Brescia as a youth. He studied anatomy and the art of ancient Rome, and he gained fame for his anatomical models and small *bozzetti*. His skill as a modeller resulted in several commissions from Gregory XIII, including stucco angels (1580–81) for the Pauline Chapel and the Scala Regia in the Vatican. The success of these elegant, classicizing figures led to the commission (after 1585) for the sculptural components of the tomb of *Gregory XIII* in St Peter's, consisting of a seated statue of the Pope, allegorical figures of *Charity, Faith, Religion* and *Justice*, and two angels bearing the papal arms. The tomb has undergone numerous transformations and much of its sculpture has been lost; its original appearance is recorded, however, in several engravings and in a drawing (Florence, Uffizi) by Ciro Ferri (1634–1689). The surviving stucco figures of *Religion* and *Justice*, which now adorn the tomb of *Gregory XIV*, exemplify Antichi's style. Standing in contrapposto poses and enveloped in broad masses of finely modelled drapery, these highly classicizing figures, reminiscent of the work of Andrea Sansovino, reveal the artist's profound debt to the art of antiquity.

Antichi also produced many works for Sixtus V, often in collaboration with other artists, as was typical of the Sistine period. Working with Francesco (Cecchino) da Pietrasanta (*fl* late 16th century), he provided the clay models for the bronze lions (1587) below the Vatican obelisk, and with the same sculptor he produced the marble *Nativity* group (1587) in the *confessio* of the Sistine

Chapel at S Maria Maggiore. He also collaborated with Leonardo Sormani on the marble statues of *St Peter* and *St Paul* (1587–8) for the same chapel and on the much disparaged colossal marble statue of *Moses* for the Fountain of the Acqua Felice (1587–8). Although ridiculed by Baglione and many other critics, this ill-proportioned work was highly praised by Giambattista Marino and was the basis for the poet's inclusion of Antichi in his famous *La galeria* (Venice, 1630).

BIBLIOGRAPHY

DBI; Thieme–Becker

G. Baglione: *Vite* (1642); ed. V. Mariani (1935), pp. 42–4

A. Venturi: *Storia* (1901–40), X/iii (1937), pp. 574–7

A. Riccoboni: *Roma nell'arte: La scultura nell'evo moderno dal quattrocento ad oggi*, i (Rome, 1942), pp. 115–17

R. Montini: *Le tombe dei papi* (Rome, 1957), pp. 337–40

S. Pressouyre: *Nicolas Cordier: Recherches sur la sculpture à Rome autour de 1600*, 2 vols (Rome, 1984)

STEVEN F. OSTROW

Antico [Alari-Bonacolsi, Pier Jacopo di Antonio] (*b* ?Mantua, *c.* 1460; *d* Gazzuolo, 1528). Italian sculptor. An expert in goldsmith work, bronze sculpture and medals, he earned his nickname 'Antico' because of his 'astonishing penetration of antiquity' (Nesselrath). He achieved lasting fame through his small-scale re-creations (often also reinterpretations) of famous, but often fragmentary, statues of antiquity (e.g. the *Apollo Belvedere*, Rome, Vatican, Mus. Pio-Clementino, and the *Spinario*, Rome, Mus. Conserv.). Most of these bronze statuettes were made for the Gonzaga family, notably for Ludovico, Bishop of Mantua, and for Isabella d'Este, wife of Francesco II Gonzaga, 4th Marchese of Mantua. Antico also restored ancient marble statues and acted as an adviser to collectors.

1. Life and work. 2. Working methods and technique.

1. LIFE AND WORK. A birth date of 1460 has been calculated on the basis of Antico's earliest recorded commission (1479), and he is presumed to have been born in Mantua because his father, a butcher, owned a house there and he himself was granted the privilege of owning a stall in the meat market by Federico I Gonzaga, 3rd Marchese of Mantua. A training as a goldsmith is inferred from the fact that he began as a medallist in relief and in intaglio. In addition, he is documented (see below) as the maker of a pair of silver gilt vases and later demonstrated great skill at casting and chasing bronze statuettes, and at gilding and inlaying them with silver. His restoration of antique marble statues also implies an expertise in working that material, but nothing is known of how he acquired this skill.

Antico's first recorded commission (1479) was for a pair of medals to celebrate the wedding of Gianfrancesco Gonzaga, Conte di Rodigo and Lord of Bozzolo, with Antonia del Balzo. These are signed with the abbreviated form of Antico, ANTI, implying that by this time his pseudonym was widely recognized. He was employed by Federico I Gonzaga, whose court included Andrea Mantegna, probably until Federico's death (1484). Antico seems to have then moved to the court of Federico's younger brother, Gianfrancesco, at Bozzolo for a period of *c.* 12 years. In November 1493 a letter was sent to

Francesco II Gonzaga, commending Antico, and by June 1494 the artist was making a portrait of Francesco.

By 1495 Antico was in Rome, employed by Pope Alexander VI to work on the Castel Sant'Angelo. It was presumably during this period that he restored one of the antique sculptural groups known as the *Horse-tamers* (Rome, Piazza del Quirinale). In 1496 Gianfrancesco Gonzaga died at Bozzolo, and in the inventory of his possessions was listed a pair of silver gilt vases (untraced) by Antico. These were probably similar to the bronze Gonzaga Vase (Modena, Gal. & Mus. Estense), which bears Gianfrancesco's and Antonia's personal devices. The design of the bronze vase was probably influenced by Mantegna, who was recorded in 1483 as having designed vases to be produced by the goldsmith Gian Marco Cavalli. Also listed, without giving the sculptor, were several *all'antica* bronzes, their titles in some cases matching those of surviving statuettes in Antico's inimitable style: *Meleager* (London, V&A) and *Hercules* (Madrid, Mus. Arqueol. N.). Others mentioned include a group of a *Horse-tamer* (untraced), doubtless a reduction after Antico's restoration of the original, and an equestrian *Marcus Aurelius* (untraced).

Antico may have returned to Mantua at this juncture, for in 1497 he was sent back to Rome by Francesco II Gonzaga, on a mission to acquire antiquities for Isabella d'Este. In 1498 Antico was again in Bozzolo, employed by Ludovico Gonzaga, Bishop of Mantua. A letter written by Ludovico in November of that year mentions two statuettes: an *Apollo Belvedere* (three examples survive, ?earliest: Frankfurt am Main, Liebieghaus; see fig. 1), for which Antico had to reconstruct the statue's missing arm (not restored on the original marble until later), and a *Venus Kneeling on a Tortoise* (Madrid, Mus. Thyssen–Bornemisza), after the statue that is now in the Museo del Prado, Madrid. By this time Antico was also working in marble, which his patron was busy acquiring from Venice. From this period date a *Hercules* (still unfinished May 1499; New York, Frick) and a *Head of Scipio* (1499; untraced), which was made for Bishop Ludovico. By 1499 Antico had also made a bronze statuette of the *Spinario* (New York, Wrightsman priv. col., see Allison, 1994, pp. 210–12, pls 165–8) and a *Satyr* (New York, Met.), which was intended as a companion piece to the *Venus Kneeling on a Tortoise*. Also from around this time date a group of *Hercules and Antaeus* and the *Fate Atropos* (both London, V&A).

In March 1500 Isabella d'Este (*see* ESTE (6)) commissioned from Antico some bronzes to decorate her suite of rooms in the Castello di S Giorgio, Mantua, and by March 1501 Antico had provided a replica of his statuette of the *Spinario*, and two years later another seated figure, this time female: *Andromeda* (ex-Baron Gustave Rothschild priv. col., Paris, see Allison, 1994, pp. 183–4, pls 130–31). However, Antico was still working mainly for Ludovico and held a position at Gazzuolo as *camerero* (Gentleman of the Bedchamber) with a good salary (1501). From 1504 there survives an exchange of letters between the rival patrons and the artist about the production of a gold statuette of the *Young St John the Baptist* (untraced). Further surviving correspondence between Antico and Isabella mentions not only bronze statuettes but also the

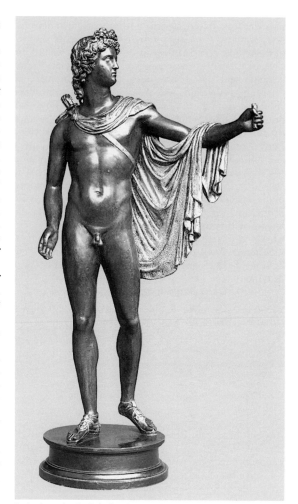

1. Antico: *Apollo Belvedere*, bronze, h. 413 mm, ?c. 1498 (Frankfurt am Main, Liebieghaus)

acquisition and restoration of ancient sculptures. Antico went on to make for Isabella a horse's head and an eagle for casting in silver, and in 1506 he restored Classical heads of a *Minerva* and a *Cupid* (all untraced). After Mantegna's death in 1506, Antico took over his role of general adviser to Isabella on artistic matters. Following the death of her husband Francesco (1519), Isabella decided to create a new *studiolo* and grotto in the Corte Vecchia of the Palazzo Ducale, Mantua, for which she requested from Antico casts of all the bronzes that he had produced 20 years earlier for Bishop Ludovico. In a letter to her (1519) he proposed to provide her with eight statuettes, of which five survive in the Kunsthistorisches Museum, Vienna; her posthumous inventory of 1542 mentions *Hercules and Antaeus* (see fig. 2), identified as being the version in the Kunsthistorisches Museum, Vienna, by the inscription on the base, and the equestrian *Marcus Aurelius* (untraced). The 1542 inventory also indicates how the statuettes were displayed: along a cornice running round the walls of the grotto, with bronze busts on another cornice, higher up. Unlike the original statuettes for Ludovico, none of those for Isabella was gilded or

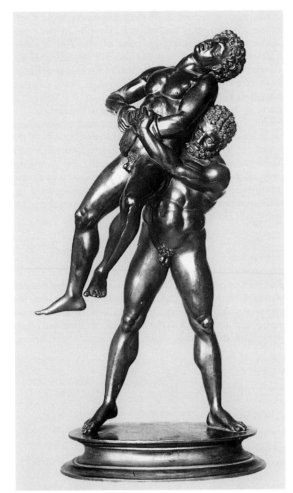

2. Antico: *Hercules and Antaeus*, bronze, h. 432 mm, *c.* 1519 (Vienna, Kunsthistorisches Museum)

cately chiselled details of hair, drapery and accoutrements, which are often gilded, with the eyes sometimes being inlaid with silver. His overtly opulent creations appealed to his courtly patrons, in contrast to the more intellectual and romantic evocations of ancient mythology by the other great sculptor of the bronze statuette, Andrea Riccio, whose clientele were sensitive humanists, the professors and learned clerics of Padua University.

Antico's talent may be likened to that of Canova (1757–1822), who centuries later gave a new lease of life to ancient forms through an instinctive understanding of the artistic ideals that they embodied.

2. WORKING METHODS AND TECHNIQUE. Antico was the first sculptor to realize the commercial advantages of being able to cast identical replicas of his compositions. Previously, particularly in Florence, bronze statuary had been made directly from the master model in a unique cast, probably rather a rough one, which was then chased, hammered and filed into its final shape. This remained true until the time of Benvenuto Cellini. Antico departed from this method in making an original master model in wax around an iron armature and finishing it highly: from this he would take piece-moulds in plaster, which could be carefully removed (leaving the master model intact) and then reassembled. Wax could be poured or packed into the resultant cavity to make the actual casting model—often in separate components (e.g. head, torso and limbs)—which could then be assembled by slight melting at the joints and smoothing out any traces with a warm spatula. This secondary model would then of necessity be lost in the casting process. Antico used a steel burnisher to scrape the cast metal smooth, as can be seen or felt occasionally from parallel striations on the surface.

Despite the commercial potential of this approach to casting, Antico did not put it to use seriously, never casting more than three examples of a given composition, perhaps owing to the jealousy of his patrons. They would have set great store by the exclusiveness of their statuettes and permitted replicas only for close relations.

inlaid with silver eyes. After this commission, the actual casting of which was subcontracted, Antico seems to have turned more towards architecture, designing new sculptural decorations for Gazzuolo, which were much admired, but have long since been destroyed.

As with many neo-classical sculptors, Antico's work needs to be closely compared with its prototypes to discover where his sculptural talent lay, as distinct from a mere facility in copying what was before his eyes. So damaged were his models that great scope existed for the imaginative reintegration of missing arms, legs and attributes: these, as in the case of his *Apollo Belvedere*, may differ from the subsequent restorations that are familiar today. Antico had to use much imagination and archaeologically orientated surmise in order to re-create the imagined perfection of the lost or damaged originals. Through sometimes gross marble copies, his enthusiast's eye could discern the pristine magnificence of lost ancient Greek bronze originals.

His style is a sculptural counterpart to Mantegna's in painting, emphasizing the anatomical articulation and the smooth, rotund forms of the human body. He loved to contrast polished and darkly patinated surfaces with intri-

BIBLIOGRAPHY

DBI

W. von Bode: *Die italienische Bronzestatuetten der Renaissance* (Berlin, 1906; Eng. trans., London, 1907–12); rev. and ed. J. Draper (New York, 1980)

H. J. Hermann: 'Pier Jacopo Alari-Bonacolsi, genannt Antico', *Jb. Ksthist. Samml. Allhöch. Ksrhaus.*, xxviii (1909–10), pp. 219–20

A. Allison: 'Four New Busts by Antico', *Mitt. Ksthist. Inst. Florenz*, xx (1976), pp. 213–24

A. F. Radcliffe: 'Antico and the Mantuan Bronze', *Splendours of the Gonzaga* (exh. cat., ed. D. Chambers and J. Martineau; London, V&A, 1981–2), pp. 46–9, 132–40

A. Nesselrath: 'Antico and Monte Cavallo', *Burl. Mag.*, cxxiv (1982), pp. 353–7

R. Stone: 'Antico and the Development of Bronze Casting in Italy at the End of the Quattrocento', *Met. Mus. J.*, xvi (1982), pp. 87–116

C. M. Brown: *La grotta di Isabella d'Este: Un simbolo di continuità dinastica per i duchi di Mantova* (Mantua, 1985)

The Liechtenstein Collection (exh. cat., New York, Met., 1985), no. 133

Natur und Antike in der Renaissance (exh. cat., Frankfurt am Main, Liebieghaus, 1985), nos 3, 22–4, 94–5, 97–8, 104, 116, 120, 128

Die Bronzen der Fürstlichen Sammlung Liechtenstein (exh. cat., Frankfurt am Main, Liebieghaus, 1986), pp. 257–61, no. 58

Renaissance Master Bronzes from the Kunsthistorisches Museum, Vienna (exh. cat., Washington, DC, N.G.A., 1986), nos 8–10

L. N. Amico: 'Antico's *Bust of the Young Marcus Aurelius*', *Getty Mus. J.*, 16 (1988), pp. 95ff

K. Fittschen: 'The Bronze Bust of the *Young Marcus Aurelius* by Antico and its Antique Model', *Getty Mus. J.*, 18 (1990), pp. 113–26

I. Martin, ed.: *The Thyssen-Bornemisza Collection: Renaissance and Later Sculpture, with Works of Art in Bronze* (London, 1992), pp. 154–61 [entries by A. Radcliffe]

A. H. Allison: 'The Bronzes of Pier Jacopo Bonacolsi, called Antico', *Jb. Ksthist. Samml. Wien*, 89–90 (1994), pp. 35–310

The Currency of Fame: Portrait Medals of the Renaissance (exh. cat., ed. S. K. Scher; New York, Frick, 1994), pp. 77–80, nos 16–17

M. Leithe-Jasper: 'Isabella d'Este und Antico', *Isabella d'Este, Fürstin und Mäzenatin der Renaissance* (exh. cat., ed. S. Ferino-Pagden; Vienna, Ksthist. Mus., 1994), pp. 317–61

Von allen Seiten schön: Bronzen der Renaissance und des Barock (exh. cat., Berlin, Staatl. Museen Preuss. Kultbes., 1995), nos 15–20

CHARLES AVERY

Antique, the. Term used between the 15th and the 18th century to refer in a general way to the civilizations of ancient Greece and Rome. It was used to appeal to qualities and standards common, or thought to be common, to the art of that period. It was widely believed that such qualities should be revived, should inspire and (no less important) should control the productions of the modern artist. Progress in taste involved a return to the Antique. Such a vague index of excellence could not have survived for centuries had it not commanded general consent, and for this very reason it is fundamental to any understanding of European culture in this period. The Antique was indeed in many respects equivalent to the Classics—a category, quite as vague, that constituted the body of generally admired ancient Greek and Roman literature. These were also recommended as models, but for modern literature in the modern languages. Implicit in the pedagogic invocation of the Antique as a standard was the assumption that antique art was generally superior: it was not believed that all ancient Greek and Roman art and architecture were of the highest quality, but it was assumed that most of it was of high quality and worthy of special study. Moreover, within the four or more centuries of Greek and Roman civilization held up for special admiration, little development or variation was allowed for. This was certainly a false picture, but it is based on one important truth: patrons of high art of the Roman Empire and of the Hellenistic kingdoms seem to have acknowledged that certain models of excellence in art and architecture had been achieved that should be faithfully imitated and that could never be surpassed. It was indeed precisely because the concept of the superior ancient model was so powerful in antiquity that the Antique could reassume an equivalent role in the modern world.

1. *All'antica* decoration. 2. Writing, lettering and printing. 3. Architecture. 4. Sculpture. 5. Response to the Antique: 18th century and later.

1. 'ALL'ANTICA' DECORATION. In 15th-century Italy the new art inspired by the Antique was simply described as *all'antica* (in the ancient mode). A whole new vocabulary of ornament was involved: trophies of Roman armour like those found on some ancient sculpture (e.g. the reliefs on the base of Trajan's Column, Rome) and also on some coins; skulls, masks and swags found in the friezes of ruined temples and on pagan altars; playful male nude children (putti) found on some marble carvings and on numerous engraved cameos. Such ornaments were rapidly adopted for all sorts of circumstances, including Christian altarpieces, but tended to be most richly on display where it was most appropriate, as, for example, in the finely illuminated first manuscript page of the *Life of Julius Caesar* by Suetonius (Paris, Bib. N., MS. lat. 5814; see fig. 1), which probably dates from the 1480s and may be the work of a Paduan artist, Lauro Padovano. Many Classical texts were rediscovered in the 15th century, but Suetonius' *Lives of the Caesars* had been known throughout the Middle Ages. What was new was the interest in illustrating, or at least complementing, the text with a revival of the visual art of the same period (see also colour pl. 2, X2). This may remind us that the careful study, the systematic collection and the imitation of ancient Roman coinage and inscriptions, which had been steadily increasing since the early 14th century, were closely associated with the restoration of Classical scholarship.

2. WRITING, LETTERING AND PRINTING. European writing, lettering and printing were profoundly affected by the passion of 15th-century Italian antiquarians for ancient Roman lettering. Something more or less Roman became standard throughout Europe, although Gothic lettering survived, mainly in Germany. The illuminated Suetonius manuscript reflects the tastes of the circle of learned artists who worked in Padua, chief among whom was Andrea

1. Antique ornament from Suetonius: *Life of Julius Caesar*, fol. 1, illuminated by ?Lauro Padovano, with capitals by Bartolomeo Sanvito, probably 1480s (Paris, Bibliothèque Nationale, MS. lat. 5814)

Mantegna. The coloured epigraphic capitals of its first page, together with the Italic script of the text that follows, have been attributed to a Paduan scribe, Bartolomeo Sanvito. They reveal a careful study of the forms of letters used by the ancient Romans, for the student of Roman inscriptions had come to take an interest in style in a visual as well as literary sense. (Sanvito had copied the inscriptions collected by the noted antiquarian Fra Giovanni Giocondo of Verona.)

The capital A, the initial letter with which the text commences, is of special interest because it is represented as if of three dimensions and free-standing, and it has a golden brown colour in imitation of the separately cast bronze capital letters that the ancient Romans used for some of the inscriptions on the friezes of their great public buildings. Such letters with their facets and sharp extremities represented reversals of the letters cut into bronze and marble by the Romans with gravers and chisels, which left a cut with a V section and tapered to a point. Implicit in this capital letter is admiration not only for the style of ancient Roman inscriptions but also for the superb quality of their casting in bronze.

In this same period and in the same area of North Italy the earliest known treatise on the design of ancient Roman letters, the *Alphabetum romanum* (c. 1460), was made by Felice Feliciano, a poet, printer, alchemist and, above all, antiquarian: indeed, he was known to his friends as *l'antiquario, the* antiquarian. In the famous epistolary description of an excursion (probably imaginary) on Lake Garda, made by Felice and Mantegna, an inscription cut on a marble column in 'the most handsome letters' excites quite as much enthusiasm as any sculpture. The first book to be printed in Roman type was Cicero's *De oratore* in 1465; probably the earliest competent imitation of the inscriptions of the late Republic or early Empire in an actual stone inscription is that on the tomb of *Pope Nicholas V* (d 1455; Rome, St Peter's); and the earliest notable revival of the monumental capitalized inscriptions on modern public buildings can be associated with Leon Battista Alberti a little earlier.

Feliciano's treatise, which was never published and is of uncertain date, was followed by the *Trattati delle lettere antiche* by Damiano Moille (fl 1480s), published in Parma about 1480. Moille was primarily concerned to produce a pattern-book for craftsmen, and it was perhaps partly for this reason that he showed how the antique letters could be regulated by a geometric framework, inscribed within a square or circle and with segmental cusps. But this geometric aspect of the fascination of ancient Roman letters also reflects the convictions of the learned that there were laws that determined the pleasing shapes of such letters just as there were laws underlying the harmonious proportions of antique architecture, and this emerges clearly in Luca Pacioli's treatise *De divina proportione*, published in Venice in 1509.

3. ARCHITECTURE. The establishment of Roman lettering coincided with that of the architectural orders, or different classes, of ancient Greek and Roman architecture, each with its own rules. By the end of the 15th century there was no major architect in Italy who was not employing the principal elements of antique architecture:

cylindrical columns, fluted pilasters, Corinthian and Ionic capitals, domical vaults, semicircular arches, pediments and entablatures. That these were familiar all over Europe by the close of the 16th century was chiefly owing to the publications by two highly influential practising architects. The first of these was Sebastiano Serlio's *Regole generale*, published in Venice in 1537, which illustrated the range of ancient Roman architecture as studied from actual ruins and as imaginatively reconstructed not only by Serlio himself but by other earlier architects, most notably Baldassare Peruzzi, whose drawings (many Florence, Uffizi) he inherited. Serlio also expounded the idea of the orders.

Still more influential than Serlio's treatise of 1537 and far more cogent in expository style and lucid in presentation was Andrea Palladio's *I quattro libri dell'architettura*, which was published in 1570, also in Venice. Palladio's book was probably intended chiefly for other architects, although it certainly reached a much larger public. It had three interconnected aims: to expound the basic principles of building and design, to illustrate the exemplary masterpieces of antiquity and to publish Palladio's own buildings and projects. Behind this book and Serlio's, as also behind earlier writing on the architecture of antiquity, there lay the ten books *On Architecture* by Vitruvius (*see* VITRUVIUS), the earliest surviving treatise on architecture known and the only literary work on architecture to survive from antiquity. Palladio had indeed collaborated with his patron, the Venetian nobleman Daniele Barbaro, in the publication (1556) of an illustrated edition of Vitruvius with a translation (apparently the earliest) and annotations. It was with reference to Vitruvius that Palladio and others felt able to establish the rules behind the practice of antique architecture, to reconstruct whole buildings from surviving fragments and to create novel structures that had no direct relationship with any antique building but which they nevertheless felt to be antique in spirit.

4. SCULPTURE. Whereas ancient Roman buildings were all known in the 15th century, with sculpture, the situation was different: the canon was constantly expanding as more statues were excavated.

(i) The rediscovery of ancient sculpture: collections and museums. (ii) Prints and plaster casts after the Antique.

(i) The rediscovery of ancient sculpture: collections and museums. The *all'antica* decoration of Suetonius' *Life of Julius Caesar* owed little to figural relief sculpture and free-standing statues, although the artist probably did have some knowledge, not necessarily first hand, of the battle narratives on sarcophagi and columns. One might suppose, too, that he had seen an antique statue of Victory inscribing a shield (but this motif is more likely to have been derived from a coin). Moreover, the Pegasus restrained by the two warriors at the top of the page may echo the colossal marble groups in the Piazza del Quirinale, Rome, the so-called *Horse Tamers*.

Yet few of the sculptures by which the Antique would come to be identified were known by the 1480s. In addition to the groups in the Piazza del Quirinale, the reliefs of Trajan's Column and those on the triumphal arches of Constantine and Titus were visible in Rome, as

well as numerous sarcophagi in Rome and elsewhere, some of which had been reused as modern tombs. There was also an important group of bronzes that had been displayed near the Lateran Palace in Rome, but Pope Sixtus IV had recently donated these to the Palazzo dei Conservatori on the Capitol (where they remain to this day): the *She-wolf*, the *Camillus* and *Spinario* (Rome, Mus. Conserv.). The largest and most important of all the ancient bronzes to have survived more or less complete from ancient times was the equestrian statue of *Marcus Aurelius* (Rome, Mus. Capitolino), which had long been mistaken for a statue of the first Christian emperor, Constantine. This remained at the Lateran until 1538, when it too was transferred to the Piazza del Campidoglio, as Sixtus IV had planned, and the placed on the pedestal designed for it by Michelangelo.

In the late 15th century and the early 16th a number of spectacular discoveries doubled the number of major antique statues known in Italy: the *Apollo Belvedere* was excavated in the 1490s, the *Laokoon* group in 1506 (both Rome, Vatican, Mus. Pio-Clementino) and the *Commodus as Hercules* (Rome, Mus. Conserv.) in 1507; the *Cleopatra* (Rome, Vatican, Mus. Pio-Clementino) was first recorded in 1512, the year in which the colossal *Tiber* (Paris, Louvre) was excavated and a year before the colossal *Nile* (Rome, Vatican, Braccio Nuo.). All these sculptures were taken to a courtyard with fountains and niches and orange trees, part of the Villa Belvedere built in the antique style by Bramante in 1503 for Pope Julius II, the nephew of Sixtus IV. The famous Belvedere *Torso* (Rome, Vatican, Mus. Pio-Clementino) was also displayed here, and so too would be the statue believed to represent *Antinous* (Rome, Vatican, Mus. Pio-Clementino) after its discovery in 1543. The Palazzo dei Conservatori had been turned by Sixtus IV into a sort of public collection of sculpture. The Cortile di Belvedere was a museum of antique sculpture, the first such museum since antiquity itself.

Gradually other collections and other museums were formed in the palaces and villas of Rome, which enjoyed a similar esteem. The first of these consisted of the group of marbles assembled by the Farnese in their Roman palace during the last few years of the pontificate of the Farnese pope Paul III (*d* 1549): the colossal group of the Farnese *Bull*, the colossal Farnese *Hercules* and Farnese *Flora*, and the *Callipygian Venus* (all Naples, Mus. Archeol. N.) were the most notable items. Then there were the statues assembled by the Medici in their villa on the Pincio towards the close of the century: these included the *Niobe Group*, *The Wrestlers* and the *Venus de' Medici* (all Florence, Uffizi; see fig. 2).

(ii) Prints and plaster casts after the Antique. Anthologies of prints of these antique statues were published in Rome in the 1560s and 1570s by ANTOINE LAFRÉRY and GIOVANNI BATTISTA DE' CAVALIERI. These may be regarded as equivalent to the publications of Serlio and Palladio. Of far more significance were plaster casts. Plaster casts after the Antique played an important part in the studio equipment of Italian artists (painters as well as sculptors) from the mid-15th century.

BIBLIOGRAPHY

S. Serlio: *Regole generali di architettura sopra le cinque maniere de gli edifici cioè Thoscano, Dorico, Ionico, Corinthio, et Composito* (Venice, 1537)

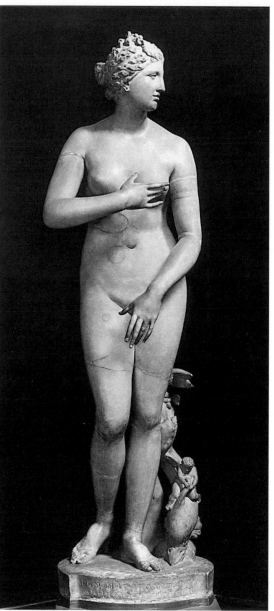

2. *Venus de' Medici*, marble, h. 1.53 m, ?1st century BC (Florence, Galleria degli Uffizi)

M. P. Vitruvius: *I dieci libri dell'architettura* (Venice, 1556)
A. Palladio: *I quattro libri dell'architettura* (Venice, 1570)
C. Perrault: *Parallèle des anciens et des modernes en ce qui regarde les arts et les sciences . . .*, 4 vols (Paris, 1688–97)
N. Pevsner: *Academies of Art Past and Present* (Cambridge, 1940)
B. Ashmole: 'Cyriac of Ancona', *Proc. Brit. Acad.*, xcv (1957), pp. 25–41
J. Summerson: *The Classical Language of Architecture* (London, 1963/R 1980)
R. Weiss: *The Renaissance Discovery of Classical Antiquity* (Oxford, 1969)
H. Burns: *Andrea Palladio, 1508–1580* (London, 1975)
Antiquity in the Renaissance (exh. cat. by W. Steadman Sheard, Northampton, MA, Smith Coll. Mus. A., 1978–9)
F. Haskell and N. Penny: *Taste and the Antique* (London and New Haven, 1981)
P. P. Baber and R. O. Rubinstein: *Renaissance Artists and Antique Sculpture* (London, 1986)

J. Onians: *Bearers of Meaning: The Classical Orders in Antiquity, the Middle Ages and the Renaissance* (Princeton, 1988)

NICHOLAS PENNY

Antonello da Messina [Antonello di Giovanni degli Antonii] (*b* Messina, *c.* 1430; *d* Messina, between 14 and 25 Feb 1479). Italian painter. He was the greatest Sicilian artist of the 15th century and the only one to achieve international renown. His work combines Italianate concerns for form, structure and measured space with a south Netherlandish interest in the detailed depiction of surface and texture. Antonello is traditionally credited with the introduction into Italian art of the systematic use of oil glazing, developed in northern Europe by Jan van Eyck (1395–1441). His visit to Venice in 1475–6 enabled the technique to be disseminated there, and this had a crucial effect on the art of Giovanni Bellini and on late 15th-century Venetian painting in general. Antonello painted fashionable portraits as well as religious works, and his reputation among contemporaries must have been largely based on his skills in this field: he was instrumental in establishing a new, vital type of portraiture in Italy, again based on south Netherlandish models. He also played an important role in the development of the Venetian Renaissance altarpiece. Antonello established a workshop in Messina, in which his son JACOBELLO D'ANTONIO and his nephews Antonio and Pietro DE SALIBA and SALVO D'ANTONIO participated. In the work of these *Antonelleschi*, the provincial inheritance of his art can be seen.

1. Life and work. 2. Working methods and technique.

1. LIFE AND WORK.

(i) Training and early years, before *c.* 1465. (ii) Middle years, *c.* 1465–75. (iii) Trip to Venice, 1475–6. (iv) Last years: Sicily, 1476–9.

(i) Training and early years, before c. *1465.* Antonello was one of the four children of a stone mason of Messina. According to Vasari, who is not always reliable, he died at the age of 49. His death certainly occurred in 1479, between 14 February (when he made his will) and 25 February (when his son Jacobello renewed workshop contracts in his own name), and the fact that he was survived by both his parents, for whom he made provision in his will, might support the idea that he was then relatively young; a birthdate of *c.* 1430 is therefore usually accepted.

Antonello is first documented in 1457, when he was running his own workshop in Messina, but he appears to have received training in Naples: a letter dated 1524 from Pietro Summonte in Naples to Marcantonio Michiel in Venice describing the history of Venetian painting mentions that Antonello was the pupil of NICCOLÒ COLANTONIO, who (according to Summonte) had received instruction in the methods of Netherlandish painting at the court of King René I of Naples (*reg* 1438–1442). This would seem to explain the south Netherlandish qualities of Antonello's style. It is possible, however, that Antonello received further instruction elsewhere: Wright (1980) argued that both stylistically and technically Colantonio's painting is almost entirely French, rather than Netherlandish, in character, most closely resembling the work of the Master of the Aix Annunciation. Moreover,

only Antonello's very early *Crucifixion* (Bucharest, N. Mus. A.) resembles in technique the work of his supposed teacher; his other early works are much closer to finely glazed Netherlandish models (Wright, 1994). Although Antonello could have become familiar with Netherlandish paintings in Naples (there were a number of examples in collections there, including that of Alfonso I, who owned works by Rogier van der Weyden (1399–1464) and Jan van Eyck), the Eyckian glazing technique was far too complex to be learnt by observation alone, and he may have travelled to the Netherlands for further study, an event perhaps underlying Vasari's improbable assertion that he was the direct pupil of Jan van Eyck, who had died in 1441. The hypothesis that Antonello received training in Milan under Petrus Christus (1410–1475) is based only on the ambiguous appearance of the names 'Piero de Bruges' and 'Antonello de Sicillia' in the ducal payment records of 1456 under *provissionati* (those in receipt of a stipend), in the company of crossbowmen. The training under Colantonio would probably have taken place *c.* 1443–50, with the Bucharest *Crucifixion* presumably dating from the end of this period, *c.* 1450–53, before Antonello's postulated second phase of instruction.

A number of documents provide an outline of Antonello's activities from 1457 to 1465, but no dated works survive from these years. On 5 March 1457 he signed a contract to produce a *gonfalone* (untraced) for the confraternity of S Michele dei Gerbini in Reggio Calabria, and in April he was dealing with an assistant who had broken the terms of his contract. He subsequently left Sicily for the mainland, taking his family and his servants with him, for in January 1460 his father hired a brigantine to transport them back to Messina from Amantea on the Calabrian coast. The removal of his household suggests a prolonged absence, and conjectured destinations have included Calabria (the source of the *gonfalone* commission) and Rome (where Antonello could have seen works by Piero della Francesca, crucial to the formation of his mature style); apparent knowledge of the work of Enguerrand Quarton (1420–1466) has also suggested contact with Provençal painting during this period. In January 1461 Antonello was re-established in Messina and had taken his brother Giordano di Giovanni (*fl*1461–88) as an apprentice. From then until 1465 records survive of a number of contracts and payments, but the works to which they refer are untraced.

Paintings attributed to Antonello from this period include the finely glazed but badly damaged *Penitent St Jerome*, the fragment of the *Hospitality of Abraham* (both Reggio Calabria, Mus. N.) and *St Jerome in his Study* (London, N.G.; see fig. 1). The last is often thought to be a mature work of *c.* 1475, but its proximity in style, technique and iconography to Eyckian painting, which influenced Antonello in its purest form in his early career, places it more happily in the period before 1465. Its empirical method of perspective also suggests an early date; in his later works Antonello adopted the mathematically controlled system of Italian origin. The painting was first recorded by Michiel in the house of Antonio Pasqualino in Venice in 1529; significantly, it was then commonly believed to be by Jan van Eyck or Hans Memling (1430/40-1494), demonstrating its thoroughly

1. Antonello da Messina: *St Jerome in his Study*, oil on panel, 460×365 mm, *c.* 1460–65 (London, National Gallery)

Netherlandish character. Michiel, however, personally favoured an attribution to Antonello because the face was finished *alla italiana* (presumably a reference to the profile view). According to Puppi, Antonello may have taken the painting to Venice in 1475 as an example of his work. The composition is probably at least partly based on the wing of Jan van Eyck's Lomellini Triptych, which depicted *St Jerome in his Library* (untraced) and which, according to Bartolomeo Facio (*De viris illustribus*, 1456), was given to Alfonso I by Battista Lomellini in 1444; it apparently inspired a number of representations of the saint, of which the version attributed to Colantonio is the earliest (Naples, Capodimonte). Jolly demonstrated that Antonello's picture incorporated an extensive use of disguised symbolism, indicating the artist's understanding of complex Netherlandish programmes.

Further attributions to Antonello for the years up to *c.* 1465 include the *Virgin Annunciate* (Como, Mus. Civ. Stor. Garibaldi), the *Virgin Reading* (Venice, Forti priv. col.) and the Salting *Virgin and Child* (London, N.G.), which are often grouped with the *St Rosalie* (Baltimore, MD, Walters A.G.). Only the badly rubbed *St Rosalie* approaches the sensitivity and refinement of Antonello's work, however, in some respects resembling the Bucharest *Crucifixion*. The rest of this group can be better designated as by various *anonimi*, perhaps working in Antonello's circle and influenced particularly by Hispanic models popular in both Naples and Sicily at this time. The *St Zosimo* (Syracuse Cathedral, Treasury) is also often thought to be an early work, but it is more likely to be by a follower at a later date, and it can be associated by both scale and provenance with the *Virgin of the Uccelluzzo*, which has

been attributed to various members of Antonello's workshop.

(ii) Middle years, c. 1465–75. Antonello's mature style and character as an artist were formed in this period, from which some signed and dated works survive, including a number of portraits. The absence of documentary references to him in Sicily between 1465 and 1471 has led to speculation that he travelled abroad, possibly to Venice, which might explain some otherwise puzzling aspects of his career: his possible knowledge of Giovanni Bellini's *St Vincenzo Ferrer* altarpiece (Venice, SS Giovanni e Paolo; see colour pl. 1, XI1) in the *St Gregory* polyptych of 1473, and the award of the important Venetian commission for the S Cassiano Altarpiece in 1475 to an apparently unknown foreigner (*see* §(iii) below).

Antonello's first signed and dated work may be the *Salvator mundi* (London, N.G.). It bears the date 1465, but this is qualified by the accompanying inscription *viije Indi* (8th indiction), which could refer to either 1460 or 1475 but not 1465 (the 13th indiction). Previtali favoured the later date (1475), but the contradiction is more reasonably explained by an error in calculation or a calligraphic slip, writing *viije* instead of *xiije* (13th). The use of a *cartellino* (label) for the inscription introduces a device derived from Netherlandish *trompe l'oeil* effects, which Antonello was to use throughout his later career to sign his works. It appears to be fixed to the front of the parapet behind which the figure is set, and its bottom edge curls forwards, rather wittily suggesting a projection from the picture plane into real space.

The frontal depiction of the bust of Christ suggests a northern source, possibly Petrus Christus's 'figure of Christ *in maiestate*', described in Summonte's letter and at that time in the Sannazzaro collection in Naples. The pose could also indicate knowledge of versions of the Christ Blessing type, which were ultimately derived from the central panel of Rogier van der Weyden's Braque Triptych (Paris, Louvre) of the early 1450s. An Italianate character is imposed on this essentially Netherlandish format, however, by the simplified, geometric forms (the fingers are rendered as cylinders lit from above and to the left) and by the placing of the blessing hand directly in front of the bust in strong foreshortening. This establishes clear spatial relationships in the picture and also suggests that Antonello was aware of the work of Piero della Francesca. He was evidently experimenting here: pentimenti, seen in detail under infra-red light, show that Christ's neckline was originally higher and his blessing hand more vertical and less emphatically volumetric. A number of versions of the *Ecce homo* (New York, Met.; Genoa, Pal. Spinola) can be seen as developments of the Christ Blessing model, culminating in the signed picture of 1473 (Piacenza, Coll. Alberoni), Antonello's first dated work after the Sicilian documents begin again in 1471 when he appears to have been in Noto.

The signed and dated altarpiece of the *Virgin and Child with SS Gregory and Benedict* (1473; Messina, Mus. Reg.) has a badly damaged surface with some clumsy repainting. The missing central panel from the upper register almost certainly depicted a *Pietà*. A unified space is created in the three main panels—the *Virgin and Child, St Gregory* and

St Benedict—by the extension of the cast shadows and the Virgin's raised dais behind the (lost) frame. The polyptych format was rare in southern Italy at this date, but it was fairly common in the north; whether or not Antonello knew Bellini's *St Vincenzo Ferrer* altarpiece, the *St Gregory* polyptych shows his own attempts, on a monumental scale, to fuse the surface effects of Netherlandish painting with the expression of forms as geometric volumes. This tendency is usually attributed to an increased awareness of the work of Piero della Francesca, and parallels have been drawn between the figures of *SS Gregory and Benedict* and the standing saints from Piero's *St Augustine* altarpiece (Lisbon, Mus. Gulbenkian; London, N.G.; Milan, Mus. Poldi Pezzoli; New York, Frick). An interest in illusionistic effects is demonstrated by the way in which the feet of the standing saints and the rosary on the semicircular projection of the dais overlap the edge of the platform to which the *cartellino* is attached. The work is lit from the left, but the viewpoint is slightly to the right of centre, creating a pleasing and subtle counterpoise.

The fine but badly damaged *Annunciation* (1474; Syracuse, Pal. Bellomo) shows a similar combination of Netherlandish and Italianate concerns. The setting, a domestic interior that opens on to an adjoining room on the right, with shuttered windows through which a landscape can be seen, is reminiscent of the work of the Master of Flémalle (*fl c.* 1420–*c.* 1440) and Petrus Christus, but the trabeated colonnade in the foreground is Italian; the monumental column separating Gabriel from the Virgin seems to recall Piero della Francesca's frescoed *Annunciation* in S Francesco, Arezzo.

In this period Antonello also made significant innovations in portraiture. The 12 surviving examples, all of male sitters, constitute a radical departure for the genre in Italy. Antonello understood not only the bone structure of the head but its relationship to the overlying muscles and sinews, and he could represent nuances of expression by accurately depicting the play of muscles across cheeks and jaws and around the eyes and mouth. His mastery of oil glazing also enabled him to model the heads continuously, imperceptibly blending light and shade. The portrait type that he evolved was again based on south Netherlandish models. The sitters are shown in three-quarter view and bust length, with the arms excluded. They face into the light, which falls diagonally from the left illuminating the right cheek and modelling the nearside of the face with chiaroscuro. They are depicted simply, wearing unostentatious contemporary dress, with no emblems or symbols to detract from the direct communication with the spectator in their steady gaze.

The dating of Antonello's portraits is hindered by their condition. The so-called *Pirate of Lipari* (Cefalù, Mus. Mandralisca; see colour plate 1, IV1) is generally thought to be the earliest, probably dating from the later 1460s. It establishes the general character of his portrait style, although the handling is more linear than in his later works. Nonetheless, the individuality of the sitter is strongly conveyed, in his twinkling eyes and half-smiling lips. Slightly later portraits probably include two of unknown male sitters (Pavia, Pin. Malaspina; Madrid, Mus. Thyssen-Bornemisza) and the Altman *Portrait of a Young Man* (New York, Met.). The last shows a softness of touch and subtlety of expression comparable with the *Virgin Annunciate* from the *St Gregory* altarpiece of 1473, suggesting a date of *c.* 1472–3. The signed and dated *Portrait of a Youth* (1474; Berlin, Gemäldegal.) shows a greater monumentality and assurance than the earlier examples. The carefully modulated tonal variations in the flesh create a powerfully defined sense of form, while the fully modelled pleats on the tunic lend robustness to the sitter, who has a direct gaze and slightly parted lips, subtly animating the face. This first dated portrait may be a little later than the expressive *Portrait of a Man* (Rome, Gal. Borghese), which is slightly more linear and tentative in handling. Although damaged and retouched, the Johnson *Portrait of a Man* (Philadelphia, PA, Mus. A.) shows signs of having been a work of great tonal richness. Like the Berlin portrait, to which it must be closely related in date, the fully modelled head and bust give a powerful sense of volume. A slightly chaotic personality is sympathetically evoked by the bemused expression, the wispy hair disarrayed by the pressure of the hatband, the doublet, which falls open to reveal a splendid fur lining, and the loosened, escaping shirt-tie. The *Portrait of a Man in a Red Cap* (London, N.G.) is similar in character but slightly more awkward in handling and must also date from *c.* 1473–4. On the back of the panel an early 18th-century inscription records a lost parapet and *cartellino*; it was thought to be a self-portrait, but the owner may have mistaken the artist's signature for a title.

(iii) Trip to Venice, 1475–6. Antonello arrived in Venice between November 1474, the contracted delivery date of the Syracuse *Annunciation*, and August 1475, when he received the commission for the S Cassiano Altarpiece. His conjectured earlier visit to Venice may have led to this commission, but it is also possible that the patron Pietro Bon, who was elected Venetian consul to Tunisia in 1469, may have visited Messina on his way to North Africa and initiated the invitation to the artist there (Puppi).

Only fragments survive from the S Cassiano Altarpiece (Vienna, Ksthist. Mus.; see fig. 2), the *Virgin and Child* and four of the attendant saints, who are truncated at the waist—*SS Nicholas of Bari and Mary Magdalene, Ursula and Dominic*. Wilde proposed a reconstruction of the main figure group with the help of copies by David Teniers II (1610–1690) of fragments now lost (e.g. Princeton U., NJ, A. Mus.; Vienna, Ksthist. Mus.), as well as engravings made from these copies for his *Theatrum pictoricum* of 1658. The *Virgin and Child* were enthroned and raised above the surrounding saints in the interior of a building, and all were seen from a low viewpoint. The details of the architecture were unresolved, but Robertson indicated that the light source must have been within the choir and proposed a curved rather than a windowless, square-ended setting. Interest in the architectural background is particularly keen because it is debated whether this type of altarpiece, which was to become standard in Venetian painting in the last quarter of the 15th century, was introduced by Antonello, or whether he adopted the form from Giovanni Bellini, integrating with it his own understanding of the work of Piero della Francesca.

Antonello's portraits had an important influence on Venetian painters, particularly Bellini and Alvise Vivarini.

2. Antonello da Messina: *Virgin and Child with SS Nicholas of Bari and Mary Magdalene, Ursula and Dominic* (detail), fragment of the S Cassiano Altarpiece, oil on panel, w. 1.33 m, 1475 (Vienna, Kunsthistorisches Museum)

Michiel praised two examples (untraced), said to be of the collectors Michele Vianello and Alvise Pasqualino, which were in the collection of Antonio Pasqualino in Venice in 1532, commenting on their 'great power and vivacity, especially in the eyes'. Two surviving portraits were painted during these years in Venice: the *Portrait of a Man*, known as *The Condottiere* (Paris, Louvre; see fig. 3), of 1475 and the Trivulzio *Portrait of a Man* (Turin, Mus. Civ. A. Ant.) of 1476. They demonstrate Antonello at the height of his powers as a portraitist and show compelling psychological power of expression.

Antonello's concern with volume and structure is combined with a technical virtuosity and an apparently renewed enthusiasm for the details of surface and texture, seen also in the exquisite little *Crucifixion* (1475; Antwerp, Kon. Mus. S. Kst.). The muscular tension across the cheek and jaw of the Condottiere, the slight pull of the flesh around the scar on his upper lip and the sensuous suggestion of moisture on his full lower lip are acutely observed. The Trivulzio portrait, sometimes thought to depict Pietro Bon, shows a similar immediacy in such details as the softly modelled, sagging jawline, the slightly hooded eyelids and unruly eyebrows.

The *St Sebastian* (Dresden, Gemäldegal. Alte Meister) is Antonello's most essentially Italianate work and represents the culmination of his attempts to integrate the figure in an architectural background. The Venetian square is carefully defined by the surrounding buildings, and courtiers and courtesans, merchants, churchmen, a mother and a soldier go about their daily lives apparently unaffected by the monumental vision of the martyred saint in the foreground. Antonello may have known Bellini's

Coronation of the Virgin (Pesaro, Mus. Civ.) when he conceived the architectural setting, but it is equally likely that both artists were independently inspired by Piero della Francesca, who may have created this type of composition (Longhi, 1914). Antonello must also have known Mantegna's versions of the theme (Paris, Louvre; Vienna, Ksthist. Mus.), and his handling of the setting may point to knowledge of Mantegna's frescoed *Martyrdom of St Christopher* in the Eremitani, Padua (*see* MANTEGNA, ANDREA, fig. 1).

In 1581 Francesco Sansovino recorded a *St Christopher* by Antonello and a *St Sebastian* by Pino da Messina flanking a wooden sculpture of *St Roch* in S Giuliano, Venice. However, he may have accidentally transposed the names of the painters: the *St Sebastian* was probably this work by Antonello, while the *St Christopher* (untraced) may have been by Pino, probably Antonello's son Jacobello.

(iv) Last years: Sicily, 1476–9. Antonello was still in Venice in March 1476, completing the S Cassiano commission, when Gian Galeazzo Sforza, Duke of Milan (*reg* 1476–94), contacted Pietro Bon through his agent in Venice about the possibility of acquiring Antonello's services. The agent praised a painting, presumably a portrait, for its figure described as *cavata dal naturale*. It is not known whether Antonello went to Milan. By September 1476 he is documented back in Messina in connection with his daughter's dowry. Very few works are recorded in these final years: a commission for a *gonfalone* (June 1477), a record of a gift of barley and wheat in compensation for work done in Catania (October 1477) and a commission for a 'banner of red silk' for Ruggero de Luca di Randazzo (November 1478), all of which are untraced. Paolini (1979) proposed that the discrepancy between the numerous paintings attributed to Antonello's Venetian period and

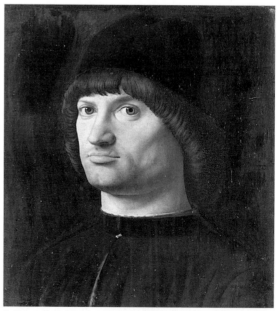

3. Antonello da Messina: *Portrait of a Man*, known as *The Condottiere*, oil on panel, 350×280 mm, 1475 (Paris, Musée du Louvre)

the few to his final years was due to a return trip to Venice between October 1477 and November 1478, but there is no firm evidence for this.

A few works can, however, be attributed to Antonello's last years. The small *Crucifixion* (London, N.G.; see fig. 4) has a dated *cartellino* with an illegible final cipher. It is sometimes placed with the Antwerp *Crucifixion* of 1475, but the simple geometry of the composition and the eloquence of its controlled pathos suggest that it is the result of more mature reflection: it may belong to 1477. The *Virgin Annunciate* (Palermo, Gal. Reg. Sicilia) is often placed in the period before Antonello went to Venice, *c.* 1474, and compared with the Syracuse *Annunciation* and the Piacenza *Christ Blessing*, but the more confident and almost geometrically conceived depiction of the Virgin is closer to the monumental form of the *St Sebastian*, making a post-Venetian date more likely.

The *Portrait of a Man Set against a Landscape* (Berlin, Gemäldegal.) probably dates from 1478, because it can be associated with a work bearing that date seen by Zanetti in the Vitturi collection in the late 18th century. The landscape background, unique in Antonello's portraiture, is more schematic than his other landscapes (e.g. the Syracuse *Annunciation*), and Longhi (1953) suggested that

it was a later addition, like the inscription beneath. The bust was evidently narrowed during the course of execution to allow for the inclusion of the landscape, however, and the stratification of the painting along the left-hand edge of the panel reveals that the green of the landscape and the blue of the sky are laid directly on to the whitish priming, so they must belong to the original conception (Wright, in *Atti* 1981). Whether or not the landscape was executed by Antonello, its inclusion perhaps reflects knowledge of the work of Hans Memling, whose painting was known in Italy by *c.* 1470.

In this period Antonello's son Jacobello seems to have worked as his principal assistant. Previtali convincingly suggested that a number of works from Antonello's last years, such as the *Pietà* (Madrid, Prado; see colour pl. 1, IV2) and the Benson-Mackay *Virgin and Child* (Washington, DC, N.G.A.), were collaborations between father and son; other works, for example the *Virgin and Child* (Bergamo, Gal. Accad. Carrara), were probably planned by Antonello but executed by Jacobello after his father's death. In the last, Jacobello paid final and fitting tribute to his father, signing himself 'the son of Antonello, a painter of no human kind'.

2. WORKING METHODS AND TECHNIQUE. Antonello's assimilation of south Netherlandish techniques is best seen in such early works as the *Salvator mundi* (?1465; London, N.G.), which is almost entirely composed of very thin translucent layers of paint and glazes, with delicate and refined underdrawing. This technique, which closely resembles that of Jan van Eyck's portrait of a *Man in a Red Chaperon* (1433; London, N.G.), enabled the artist to create subtle surface effects and to achieve continuity of modelling, and it contrasts with Colantonio's thicker, more opaque use of paint. It can also be seen in the central part of the London *St Jerome in his Study* and in the Berlin *Portrait of a Young Man* (1474), where the underpaint seems to have been applied in a thin scumble with feathery brushstrokes, again close to van Eyck's method. Nervous hatching strokes are particularly noticeable in Antonello's work. In subsequent paintings, however, he seems to have simplified the layer structure to produce work that was adequate to his needs but less time consuming. Only briefly in Venice, in 1475, perhaps freshly inspired by south Netherlandish paintings, did he return to the more complex technique of the *Salvator mundi*, resulting in such works as the Louvre *Condottiere*.

A drawing (London, BM) with studies for an altarpiece of the Virgin and Child (with sketches of individuals, animals and limbs, including a torso and legs, on the *verso*) may possibly be attributed to Antonello's workshop; it apparently conflates two works by Petrus Christus, the Northern artist whom it would appear he is most likely to have known: the *Annunciation* (1452; Berlin, Gemäldegal.) and the *Virgin and Child* (*c.* 1450–60; Kansas City, MO, Nelson–Atkins Mus. A.).

BIBLIOGRAPHY

DBI; Thieme–Becker
B. Facio: *De viribus illustribus* (1456); ed. L. Mehus (Florence, 1745)
M. Michiel: *Notizia d'opere di disegno nella prima metà del secolo XVI* (MS.; 1524–43); ed. J. Morelli (Bassano, 1880; rev. Bologna, 1884)
G. Vasari: *Vite* (1550, rev. 2/1568); ed. G. Milanesi (1878–85), ii, pp. 563–89

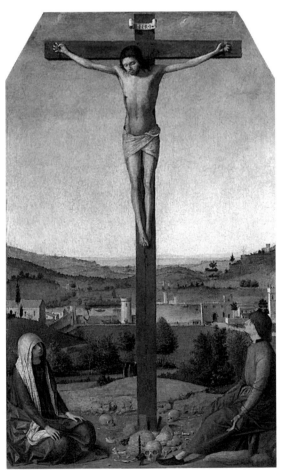

4. Antonello da Messina: *Crucifixion*, oil on panel, 412×247 mm, 1475 or 1477 (London, National Gallery)

F. Sansovino: *Venetia città nobilissima et singolare* (Venice, 1581)

G. Di Marzo: *Di Antonello da Messina e dei suoi congiunti* (Palermo, 1903/ R 1983)

R. Longhi: 'Piero della Francesca e lo sviluppo della pittura veneziana', *L'Arte*, xvii (1914), pp. 189–221; repr. in *Opere complete di Roberto Longhi*, i (Florence, 1961), pp. 61–106

F. Nicolini: *L'arte napoletana del rinascimento e la lettera di Pietro Summonte a Marcantonio Michiel* (Naples, 1925), pp. 157–75

J. Wilde: 'Die *Pala di San Cassiano* von Antonello da Messina: Ein Rekonstruktionsversuch', *Jb. Ksthist. Samml. Wien*, n.s., iii (1929), pp. 57–72

J. Lauts: *Antonello da Messina* (Vienna, 1940)

S. Bottari: *Antonello da Messina* (Messina and Milan, 1953) [bibliog.]

G. Carandente: 'I restauri compiuti dall'Istituto Centrale del Restauro per la mostra di Antonello da Messina e del quattrocento siciliano', *Boll. Ist. Cent. Rest.*, 14–15 (1953), pp. 67–88

R. Longhi: 'Frammento siciliano', *Paragone*, xlvii (1953), pp. 3–44; repr. in *Opere complete di Roberto Longhi*, viii/1 (Florence, 1975), pp. 143–77

Antonello da Messina e la pittura del '400 in Sicilia (exh. cat., ed. G. Vigni and G. Carandente; Messina, Pal. Com., 1953); rev. by S. Bottari in *A. Ven.*, vii (1953), pp. 189–92; M. Davies in *Burl. Mag.*, xcv (1953), pp. 207–8; R. Longhi in *Paragone*, iv/47 (1953), pp. 3–44 and repr. in *Opere complete di Roberto Longhi*, viii/1 (Florence, 1975), pp. 143–77

M. Bernardi: *Antonello in Sicilia* (Turin, 1957)

S. Bottari: *Arte in Sicilia* (Messina and Florence, 1962)

R. Causa: *Antonello da Messina*, Maestri Colore (Milan, 1964)

G. Consoli: 'Ancora sull'Antonello di Sicilia: Precisazioni su alcuni documenti sforzeschi', *A. Lombarda*, xxi (1967), pp. 109–12

G. Robertson: 'The Architectural Setting of Antonello da Messina's San Cassiano Altarpiece', *Studies in Late Medieval and Renaissance Painting in Honour of Millard Meiss* (Oxford, 1977), pp. 368–72

M. Lucco: 'Due problemi antonelliani', *Antol. B.A.*, 9–12 (1979), pp. 27–33

M. G. Paolini: 'Antonello e la sua scuola', *Stor. Sicilia*, v (1979), pp. 3–61

——: 'Problemi antonelliani: I rapporti con la pittura fiamminga', *Stor. A.* (1980), pp. 151–84

G. Previtali: 'Da Antonello da Messina a Jacopo di Antonello', *Prospettiva*, xx (1980), pp. 27–34; xxi (1980), pp. 45–57

J. Wright: 'Antonello da Messina: The Origins of his Style and Technique', *A. Hist.*, iii (1980), pp. 41–60

S. Tramontana: *Antonello e la sua città* (Palermo, 1981)

Antonello da Messina (exh. cat., ed. A. Marabottini and F. Sricchia Santoro; Messina, Mus. Reg., 1981) [contains documents]

Atti del convegno di studi. Antonello da Messina: Messina, 1981 [incl. articles by M. Muraro, L. Puppi and J. Wright]

L. Castelfranchi-Vegas: *Italia e Fiandra nella pittura del '400* (Milan, 1983)

P. Howell Jolly: 'Antonello da Messina's *St Jerome in his Study*: An Iconographic Analysis', *A. Bull.*, xlv (1983), pp. 238–53

E. Battisti: *Antonello: Il teatro sacro, gli spazi, la donna* (Rome, 1985)

F. Sricchia Santoro: *Antonello e l'Europa* (Milan, 1986) [excellent pls and full bibliog.]

P. Humfrey: 'Competitive Devotions: The Venetian *Scuole piccole* as Donors of Altarpieces in the Years around 1500', *A. Bull.*, lxx (1988), pp. 401–23

J. Wright: 'Antonello in formazione: Un riesame della *Crocifissione* di Bucarest', *A. Ven.*, xlv (1994), pp. 21–31

B. Ridderbos: 'Vlaamse meesters en Italiaanse opdrachtgevers in de vijftiende eeuw/Flemish Masters and Italian Patrons in the Fifteenth-century', *Millennium*, viii/2 (1994), pp. 148–61

'St Jerome in his Study by Antonello', *A. Rev.*, xlvii (1995), pp. 44–5

JOANNE WRIGHT

Antoniazzo Romano [Antonio di Benedetto Aquilio] (*b* before 1452; *d* between 15 April 1508 and 1512). Italian painter. He was the leading painter of the Roman school during the 15th century. His first recorded commission dates from 1461 when he made a replica (untraced) of the miraculous *Virgin and Child of St Luke* in S Maria Maggiore, Rome, for Alessandro Sforza, Lord of Pesaro; by 1464 he was working for the papal court. Antoniazzo was influenced at first by the decorative manner of Benozzo Gozzoli and by the local painters of Lazio. The central figures in his early signed and dated triptych of the *Virgin and Child with Saints* (1464; Rieti, Mus. Civ.) appear

animated but stiff and artificially arranged. By the 1470s he had fully mastered the representation of three-dimensional form, stimulated by his contact with Melozzo da Forlì and Florentine artists. The Umbrian painters Perugino and Bernardino Pinturicchio, who were working in Rome, also influenced Antoniazzo; his figures acquired gentle expressions and their garments were ornamented with decorative patterns. Nevertheless, medieval features survived right into his later works. The fresco of the *Virgin and Child Enthroned* (c. 1470; Rome, S Maria della Consolazione) shows attention to the naturalism of form but also retains the gold background befitting a miraculous image. The signed triptych of the *Virgin and Child with SS Peter and Paul and a Donor* (c. 1474–9; Fondi, S Pietro) demonstrates Antoniazzo's skill as a portrait painter. The donor (probably Onorato II Gaetani, Lord of Fondi) is shown on a diminutive scale compared to the Virgin and saints, yet his features are striking. Antoniazzo was one of the three founders of the Compagnia di S Luca, the guild of painters in Rome, and signed the statutes in 1478. He participated in the fresco decoration of the Biblioteca Latina (now Biblioteca Apostolica) in the Vatican Palace with Domenico Ghirlandaio in 1475 and with Melozzo da Forlì in 1480–81.

Antoniazzo's reputation and production increased during the 1480s. The autograph painting of the *Virgin and Child with St John and Angels* (c. 1480; Cambridge, MA, Fogg) shows his ability to simulate the restrained emotion and design of an icon. In the signed *Virgin and Child with SS Paul and Francis* (?late 1480s; Rome, Pal. Barberini) he continued the medieval tradition of using a gold background. In 1491 he accepted a commission to produce a fresco cycle at the Castello Orsini (now Odescalchi) in Bracciano. Finished by 1493, this is his only known secular work. Part of the scheme consists of two scenes from the life of the patron, Gentil Virginio Orsini (now detached, but in the same castle). Of his numerous frescoes for chapels in the major Roman churches, the few surviving include the *Legend of the True Cross* in Santa Croce in Gerusalemme (after 1491; *in situ*) and those for S Pietro in Montorio (c. 1495; *in situ*). In his later years Antoniazzo varied his treatment of traditional themes. The signed and dated *Virgin Enthroned* (1494; Paris, Louvre) exhibits a naturalism and solidity of form suggestive of the High Renaissance. His authenticated works from the late 1490s are sparse. His last known paintings were commissioned in 1501, although he painted a banner (untraced) for a confraternity in Rieti in 1505. On 25 March and 15 April 1508 he dictated a will and codicil, but evidence of his death does not appear until 1512.

Apart from a brief absence in 1471–4, Antoniazzo lived in Rome throughout his career, though extant altarpieces show that he sometimes worked in outlying areas such as Velletri and Capua. Documents for fresco commissions provide evidence that he supervised the most prolific workshop in Rome at the time. It originated c. 1470, the principal members being the painter's relatives: his brother Nardo (*fl* 1452–78), his nephew Evangelista (*fl* 1480–1524) and others. During Antoniazzo's later years his assistants took over the execution of major projects. His school, including his eldest son, Marcantonio (*fl* 1505–21), and his second son, Bernardo (*fl* 1508–49), remained

active after his death, primarily in Rome, though Marcantonio worked in Rieti. Various works have been associated with anonymous masters from his school, such as the Master of the Liverpool Madonna, the Master of the Avignon Altarpiece and, more recently, the Master of Tivoli. Relatively few frescoes can be attributed to Antoniazzo's hand, while the prevalence of workshop pieces has meant that his oeuvre is often associated with paintings of inferior quality. This problem is further compounded by the fact that Antoniazzo frequently collaborated with other artists. Nevertheless, he did successfully manage to forge a personal style, which combines the innovative with the archaic.

BIBLIOGRAPHY

R. van Marle: *Italian Schools* (1923–38), xv, pp. 244–304
F. Negri Arnoldi: 'Madonne giovanili di Antoniazzo Romano', *Commentari*, xv (1964), pp. 202–12
——: 'Maturità di Antoniazzo', *Commentari*, xvi (1965), pp. 225–44
V. Golzio and G. Zander: *L'arte in Roma nel secolo XV* (Bologna, 1968), pp. 275–85
G. Noehles: *Antoniazzo Romano: Studien zur Quattrocento Malerei in Rom* (diss., Münster, Westfäl. Wilhelms-U., 1973)
G. Hedberg: *Antoniazzo and his School* (diss., New York U., Inst. F.A., 1980)
A. Cavallaro: 'Antoniazzo Romano e le confraternite del quattrocento', *Ric. Stor. Relig. Roma*, v (1984), pp. 335–65
E. Howe: 'Antoniazzo and a Madonna of Santa Maria Maggiore', *Burl. Mag.*, cxxvi (1984), pp. 417–19
F. Floccia: 'Ancora un contributo, e un'ipotesi, per Antoniazzo Romano', *Stor. A.*, iii (1985), pp. 15–21
A. Cavallaro: *Antoniazzo Romano e gli Antoniazzeschi* (Udine, 1992)
A. Paolucci: *Antoniazzo Romano (1430/1435–1508/1512)* (Florence, 1992)
M. J. Gill: 'Antoniazzo Romano and the Recovery of Jerusalem in Late Fifteenth-century Rome', *Stor. A.*, lxxxiii (1995), pp. 28–47
A. Paolucci: 'Prodigy Mother: Frescoes in the Convent of Tor de' Specchi', *F.M.R. Mag.*, lxxv (August 1995), pp. 78–95

EUNICE D. HOWE

Antonio, Biagio d'. *See* BIAGIO D'ANTONIO.

Antonio, Francesco d'. *See* FRANCESCO D'ANTONIO.

Antonio, Jacobello d'. *See* JACOBELLO D'ANTONIO.

Antonio, Jacopo di. *See* JACOPO DI ANTONIO.

Antonio, Nicola di Maestro. *See* NICOLA DI MAESTRO ANTONIO.

Antonio, Salvo d'. *See* SALVO D'ANTONIO.

Antonio (Leonelli) da Crevalcore (*b* Crevalcore; *d* before 1525). Italian painter and musician. Although Antonio da Crevalcore was highly regarded by his contemporaries as both a painter of still-lifes and a musician, his artistic oeuvre remains the subject of debate. It has been suggested that he trained in Ferrara, because of the stylistic similarities his work shares with other Ferrarese painters working in Bologna, such as Francesco del Cossa and Ercole de' Roberti. The influence of Cossa's Bolognese painting on Crevalcore is clear, especially of the *Pala dei Mercanti* (Bologna, Pin. N.), but the connection between Cossa's Ferrarese works or Ercole de' Roberti's later Ferrarese paintings and Crevalcore is less evident.

Crevalcore is first documented in Bologna in 1478 and recorded as 'Master Antonio, the painter of the Cappella S Proclo' in 1491. The date of his death has been deduced from his inclusion in Girolamo Casio de' Medici's book of epitaphs (1525). His only signed and dated painting was the *Holy Family* (1493; ex-Kaiser-Friedrich Mus., Berlin, destr.). Other works attributed to him include the portrait of the *Sacrati Family* (Munich, Alte Pin.), the *Holy Family with St John the Baptist* (Stuttgart, Staatsgal.), the *Portrait of a Young Man* with the sigil *A.F.P.* [?*Antonius Ferrariensis pinxit*] (Venice, Correr) and three large tempera paintings on canvas of the *Virgin and Child with an Angel*, *St Paul* and *St Peter* (London, priv. col., see Sgarbi, 1985).

BIBLIOGRAPHY

Thieme–Becker

G. P. Achillini: *Il viridario nel quale nomina litterati bolognesi e di altre città* (Bologna, 1513), p. 188
G. Casio de' Medici: *Libro intitulato: Cronica ove si tratta di epitaphii: di amore: e di virtute . . .* (Bologna, 1525)
L. Alberti: *Descrittione di tutta l'Italia* (Bologna, 1550), p. 304
A. Venturi: 'Nuovi documenti: Quadri di Lorenzo di Credi, di Antonio da Crevalcore e di un discepolo del Francia', *Archv Stor. A.*, i (1888), p. 278
L. Coletti: 'Über Antonio da Crevalcore', *Belvedere*, xiii (1928), pp. 9–11
G. Bargellesi: *Notizie di opere d'arte ferraresi* (Rovigo, 1954), pp. 37–9
F. Zeri: 'An Addition to Antonio da Crevalcore', *Burl. Mag.*, cviii (1966), pp. 422–5
F. Filippini and G. Zucchini: *Miniatori e pittori a Bologna: Documenti del secolo XV* (Rome, 1968), pp. 19–20
V. Sgarbi: *Antonio da Crevalcore e la pittura ferrarese del quattrocento a Bologna* (Milan, 1985)

KRISTEN LIPPINCOTT

Antonio da Fabriano [Antonio di Agostino di ser Giovanni] (*fl* 1451–89). Italian painter and sculptor. He worked mainly in the Marches, but it has been suggested that he was in Naples in 1440–45 and possibly trained there (Donnini). This is reinforced by the apparent influence of Antonello da Messina in his two dated autograph paintings, *St Jerome in his Study* (1451; Baltimore, MD, Walters A.G.) and a *Crucifixion* (1452; Matelica, Mus. Piersanti). The composition of another early work, the *Death of the Virgin* (Fabriano, Pin. Civ. Mus. Arazzi), also reflects prototypes produced in southern Italy. Works attributed to him include a fresco fragment of *St Bernardino of Siena* (1451) and a triptych of the *Virgin and St Anne with SS Joseph and Joachim* (both Gualdo Tadino, Pin. Com.), a panel of *St Jerome* and a double-sided standard of the *Virgin and Child* and *St Clement* (both Genga, S Clemente). From 1468 to 1471 he was in Sassoferrato, where for the Palazzo Comunale he painted a *Virgin and Child with Saints* (1468; destr.). Also from this period is a double-sided standard of the *Madonna della misericordia* and *SS Bernardino and John the Baptist* (Milan, U. Cattolica). A signed triptych of the *Virgin and Child with Angels and Saints* (Genga, S Clemente) is dated by documents to 1474. The frescoes of the *Crucifixion with Dominicans* and *Christ with Dominican Saints* (both Fabriano, Convent of S Domenico) have a suggested date of *c.* 1480 (Borgogelli). Antonio da Fabriano's approach to light and volume reflects the influence of Piero della Francesca, perhaps acquired through the work of Gerolamo di Giovanni da Camerino and Giovanni Boccati. Antonio's only signed work of sculpture is a marble tabernacle (Fabriano Cathedral).

DBI

BIBLIOGRAPHY

B. Molajoli: 'Un tabernacolo di Antonio da Fabriano', *Rass. March.*, vi (1927–8), pp. 301–3
G. Donnini: 'Sui rapporti di Antonio da Fabriano e di Matteo di Gualdo con Girolamo di Giovanni', *Ant. Viva*, x/1 (1972), pp. 4–7
A. Borgogelli: 'Antonio da Fabriano e gli affreschi di S Domenico', *Not. Pal. Albani*, ii/1 (1973), pp. 29–36
A. Tambini: 'Uno stendardo di Antonio da Fabriano', *Paragone*, xxxvi/429 (1985), pp. 77–9
P. Zampetti: *Pittura nelle Marche: Dalle origini al primo rinascimento* (Florence, 1988), pp. 336–7, 343–4, 382–5

HELEN GEDDES

Antonio da Mercatello Bencivenni. *See* BENCIVENNI, ANTONIO.

Antonio da Negroponte. *See* FALIER, ANTONIO.

Antonio da Trento (*b* Trent; *fl* Bologna, *c.* 1527). Italian printmaker. Of six documented chiaroscuro woodcuts by the artist (two signed, four mentioned by Vasari), five are skilfully cut in a very controlled two-block style, for example *Nude Man in a Landscape* (B. p. 148, no. 13). The sixth, the *Martyrdom of Two Saints* (B. p. 79, no. 28; see fig.), is among the best of Italian multiple-block chiaroscuros. All are after designs by Parmigianino. According to Vasari, Parmigianino, arriving in Bologna after the Sack of Rome in 1527, stayed with a friend for several months and retained Antonio to instruct him in the cutting of two- and three-block prints. Elsewhere, though, Vasari stated that Parmigianino prepared many other designs to be incised in copper and printed, and he implied that Antonio was also employed for this purpose. The project foundered because of Parmigianino's painting obligations, where-upon Antonio stole all the prints (or possibly matrixes—Vasari is not clear) in copper and wood and as many drawings as possible and disappeared. Since the 18th century attempts have been made to rediscover him in the person of the etcher and painter Antonio Fantuzzi, active at Fontainebleau between 1537 and 1550. Four etchings (out of over 100) by Fantuzzi copy Parmigianino drawings and correspond to chiaroscuro designs. This overlap, the hiatus in Antonio da Trento's career, the mention of copperplates by Vasari and the likelihood that such highly prized designs would find a further use enhance the theory, which, however, lacks firm substantiation. All of Antonio's chiaroscuros were recut for later editions, though not those issued by Andreani.

BIBLIOGRAPHY

Thieme–Becker
Vasari: *Vite* (1550, rev. 2/1568); ed. G. Milanesi (1878–85)
A. von Bartsch: *Le Peintre-graveur* (1803–21), xii [B.]
G. Suster: 'Di Antonio da Trento e dei suoi chiaroscuri', *Archv Trent.*, xvii (1902), pp. 5ff
F. Zava Boccazzi: 'Antonio da Trento incisore (prima metà XVI sec.)', *Collana di artisti trentini* (Trent, 1962)
C. Karpinski: *Italian Chiaroscuro Woodcuts*, 48 [xii] of *The Illustrated Bartsch*, ed. W. Strauss (New York, 1971)
L. Lambertini and N. Rasmo: *L'incisione trentina dalle origini ai giorni nostri* (Trent, 1971), pp. 24–5
D. Landau and P. Parshall: *The Renaissance Print, 1470–1550* (New Haven and London, 1994), pp. 146, 154–5, 157, 159, 267, 289, 299; fig. 162

JAN JOHNSON

Antonio Dei, Pietro di. *See* BARTOLOMEO DELLA GATTA.

Antonio de Saliba. *See* SALIBA, DE, (1).

Antonio di Niccolò di Lorenzo (di Domenico) (*b* Florence, 1445; *d* Florence, 28 March 1527). Italian

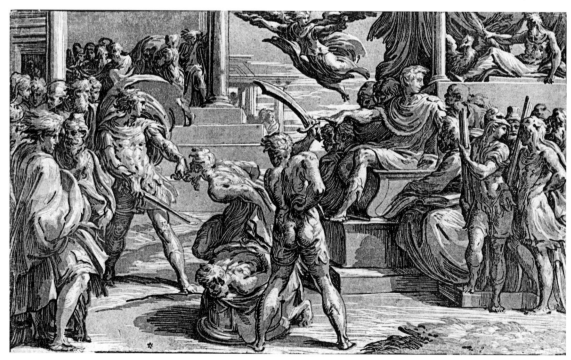

Antonio da Trento (after Parmigianino): *Martyrdom of Two Saints*, chiaroscuro woodcut, 293 x 481 mm, *c.* 1527 (Detroit, MI, Institute of Arts)

illuminator and stationer. He was trained in the climate created by such painters and illuminators as Zanobi Strozzi and Apollonio di Giovanni, who were important during the 1450s. Their influence accounts for the dynamism and the sculptural treatment of his figures, which gives them a courtly flavour reminiscent of the work of Andrea del Verrocchio or Antonio del Pollaiuolo. Antonio di Niccolò di Lorenzo's interest in larger-scale works—frescoes or panel paintings—is apparent from his repeated depiction, especially in border decoration, of metal objects, individually characterized interiors, portraits and contemporary fashions. He took his inspiration from scenes painted on *cassoni*, and from Apollonio's late work. Stylistic affinities between Antonio and Francesco di Antonio del Chierico have sometimes led to confusion between their work; however, enough of Antonio's works have been traced to distinguish him substantially from the del Foro *bottega*, Giovanni Boccardi and many other illuminators.

The discovery of a catalogue recording the sale in 1468–9 of a Psalter (ex-De Marinis priv. col., Florence, MS. 261) for the convent of S Francesco in Fiesole shows the success of the artist, even in his youth. In a later Gradual (Lucca, Bib. Stat., MS. 2676) from the convent of S Francesco in Lucca, the monumentality and sculptural forms of the human figures, elaborated in the manner of panel painting, suggest that Antonio was familiar with the work of Sandro Botticelli, Filippino Lippi and Domenico Ghirlandaio. Antonio is known primarily for the documented graduals (1473–5; Florence, Bib. Capitolo, graduale A and F) executed for the Compagnia dei Servi of SS Annunziata in Florence; these were formerly the only known works of the artist. The *Fior di virtù* (Florence, Bib. Riccardiana, MS. 1711), in which allegorical and moralistic themes predominate, was illuminated by Antonio for Agnolo Bardi. Apart from the evident stylistic affinities with Botticelli's work, the presence in this codex of a drawing of *Urania* that was clearly influenced by Botticelli supports the hypothesis that the two were in direct contact. Antonio illuminated a copy of the *Storia fiorentina* (Florence, Bib. N. Cent., MS. II.III. 53–4), a translation (1473) by Donato Acciaiuoli (1429–78) of a Latin original, for the Strozzi family, in which his early interest in Verrocchio seems to have been revived. He made some bindings for Ripoli Monastery in 1480–82. The only known work produced by Antonio after 1484 is in the incipit page of a choir-book (Pisa, Mus. Sinopic Composanto Mnmtl, corale A).

BIBLIOGRAPHY

M. Levi D'Ancona: *Miniatura e miniatori a Firenze dal XIV al XVI secolo* (Florence, 1962), pp. 19–22
A. Garzelli: *Miniatura fiorentina del rinascimento, 1440–1525: Un primo censimento*, i (Florence, 1985), pp. 249–53

PATRIZIA FERRETTI

Antonio Maria da Villafora (*fl* Padua, 1469; *d* Padua, 1511). Italian illuminator. His place of origin is cited as 'Villa Fuora Territorii Policinis'; the surname Sforza, sometimes attributed to him, belonged only to his adopted son Bartolomeo. Antonio Maria is mentioned in a document of 1482 among the illuminators of the law faculty at Padua University, and numerous payments were made to him there during the years 1481–1511 for the decoration of philosophical and legal texts, mostly commissioned by Pietro Barozzi, Bishop of Padua (1487–1507). Although they were produced in the Veneto, these manuscripts have strong Ferrarese characteristics, which have convinced some scholars that the artist was of Emilian origin, but there is no evidence for his identification with the Antonio Maria Casanova documented in Ferrara in 1470 and 1475, nor for the inclusion of three Olivetan graduals (Modena, Bib. Estense, MSS lat. 1013, 1014, 1022) among his early works (Mariani Canova, 1987). There is no doubt, however, about the Ferrarese background to his work, which shows the influence of Guglielmo Giraldi and especially Franco dei Russi, in whose workshop he may have been trained. Antonio Maria was also evidently acquainted with the Roverella *Decretals* of Gratian (Ferrara, Mus. Civ. A. Ant. Pal. Schifanoia), which was printed in Venice by Jenson in 1474 and probably illuminated in the Veneto by Ferrarese artists.

Antonio Maria was probably responsible for a canon law book (Rome, Vatican, Bib. Apostolica, MS. Vat. lat. 4097), presented to Pope Sixtus IV (*reg* 1471–84), and for a Bible (Modena, Bib. Estense, MS. alpha B. 1. 15) published in Venice by Jenson in 1476, which is closely related in style and decoration to contemporary Emilian illumination. Shortly afterwards Antonio Maria must have decorated a Missal (Milan, Bib. N. Braidense, MS. AE. X. 30), perhaps for a Benedictine nunnery in Padua. Among the numerous manuscripts decorated for Pietro Barozzi are a Missal (Padua, Bib. Capitolare, MS. 260), which is identifiable with that published by Hamman in Venice in 1491, for which Antonio Maria received payment in 1494, and the *Commentary on the Twelve Prophets* of St Jerome (Padua, Bib. Capitolare, MS. 202), decorated in 1500. Although Levi D'Ancona considered that the payments for the Missal referred only to the filigree letters, attributing the rest of the decoration to Benedetto Padovano, the identification of this artist with BENEDETTO BORDON has enabled the attribution of the Barozzi Missal to Antonio Maria to be reaffirmed.

Towards the end of his life Antonio Maria decorated a Psalter (Padua, Mus. Civ., MSS CM 811–12), which came from S Giustina, Padua, and is mentioned in its necrology. A Missal (London, BL, Add. MS. 15813) is also cited; it was partly illuminated by Antonio Maria but finished by another artist, perhaps after his death (Mariani Canova, 1976).

BIBLIOGRAPHY

Thieme–Becker

M. Cionini Visani: 'Di alcuni codici quattrocenteschi della Biblioteca Capitolare di Padova: Il Maestro dei Delfini e Antonio Maria da Padova', *A. Ven.*, xxi (1967), pp. 45–56
M. Levi D'Ancona: 'Benedetto Padovano e Benedetto Bordone: Primo tentativo per un corpus di Benedetto Padovano', *Commentari*, xviii (1967), pp. 3–42
———: 'Precisazioni sulla miniatura veneta', *Commentari*, xix (1968), pp. 268–72
G. Mariani Canova: *La miniatura veneta del rinascimento, 1450–1500* (Venice, 1969), pp. 80–96, 130–36
L. Montobbio: *Miniatori, scriptores, rilegatori di libri della cattedrale di Padova* (Padua, 1972)
M. Billanovich Dal Zio: 'Bidelli, cartolai e miniatori allo studio di Padova nel secolo XV', *Quad. Stor. U. Padova*, vi (1974), pp. 59–72
G. Mariani Canova: 'Manoscritti miniati veneti nelle Biblioteche di Cambridge e Boston (Mass.)', *A. Ven.*, xxix (1975), pp. 97–104
Dopo Mantegna (exh. cat., Padua, Pal. Ragione, 1976), pp. 157–8 [entry by G. Mariani Canova]

G. Castiglioni: 'Di alcune miniature di Antonio Maria da Villafora nel Museo Civico di Verona', *Boll. A.*, lxvii/15 (1982), pp. 109–14

G. Mariani Canova: 'Libri miniati in Friuli e problemi di miniatura in Veneto: Franco dei Russi, Antonio Maria da Villafora, il Decretum Gratiani Roverella', *Miniatura in Friuli, crocevia di civiltà: Udine, 1985* (Pordenone, 1987), pp. 119–37

MILVIA BOLLATI

Apollonio di Giovanni (di Tomaso) [Dido Master; Master of the Jarves Cassoni; Virgil Master; Compagno di Pesellino] (*b* Florence, *c.* 1416; *d* Florence, 1465). Italian painter and illuminator. He was trained by illuminators in the circle of Bartolomeo di Fruosino and Battista di Biagio Sanguini (1393–1451) and became a member of the Arte dei Medici e degli Speziali in 1442 and of the Compania di S Luca in 1443. Apollonio was influenced by Filippo Lippi, Lorenzo Ghiberti and Paolo Uccello. For much of his working life, from *c.* 1446 to 1458 and perhaps later, he was in partnership with Marco del Buono di Marco (?1403–after 1480). Apollonio specialized in work for the secular sphere, painting *cassoni* (chests; see CASSONE), *deschi da parto* (birth trays), *spalliere* (panels attached to furniture or set into wall panelling; see SPALLIERA), images for private devotion and other furnishings, as well as illuminating manuscripts. His clients were Florentine merchants, bankers, notaries and others.

In 1902 Heinrich Brockhaus found a 17th-century copy of Apollonio di Giovanni's and Marco del Buono's workshop book, a fragmentary record of commissions, which Schubring published in 1915. Stechow (1944) identified one of its entries as *Xerxes' Invasion of Greece* (Oberlin Coll., OH, Allen Mem. A. Mus.) on the basis of coats of arms painted on the panel, thus enabling him to link the bulk of those works previously grouped under various names (Virgil Master, Master of the Jarves Cassoni, Dido Master and Compagno di Pesellino) to the workshop of Marco del Buono and Apollonio di Giovanni. Gombrich (1955) was able to ascribe the two *cassone* panels with scenes from Virgil's *Aeneid* (New Haven, CT, Yale U. A.G.)—those formerly in the Jarves collection to which two of the above names allude—to Apollonio on the basis of a poem by the contemporary humanist Ugolino Verino (1438–1516). This describes in detail a lost painting of the *Aeneid* by Apollonio. As a consequence, all the panels associated with the workshop are in fact in Apollonio's style, leaving Marco del Buono's hand unknown, although his life is well documented.

The framework for Apollonio's stylistic development is provided by two dated works; the autograph manuscript of 1442 in which he painted three initials for Dante's *Divine Comedy* and six illustrations to Petrarch's *Trionfi* (Florence, Bib. Medicea–Laurenziana, MS. Med. Pal. 72) and a shop piece, the *cassone* with the *Conquest of Trebizond* (New York, Met.; see CASSONE, fig. 1) painted under his direction between late 1461 and the summer of 1465. Apollonio's earliest work, a *desco* with the *Allegory of Music* (ex-priv. col., see Callmann, 1974, no. 1) from the late 1430s, abounds in characteristics of the Late Gothic style. Yet here and in the *Trionfi* of 1442 he already employed the facial types he was to keep throughout his life—sweet, youthful visages with only an occasional beard to indicate age. Under the influence of the early Renaissance masters, however, he soon adopted Classical proportions and

anatomical detail. Moreover, he created a figural style and compositions notable for their histrionic expressiveness and narrative force, as in the Virgil Codex (Florence, Bib. Riccardiana, MS. 492). In his works of the 1440s he espoused the light palette of Fra Filippo Lippi's and Domenico Veneziano's work of those years, as, for example, in *cassoni* illustrating scenes from the Homeric epic, the *Odyssey* (two pairs, one, an autograph work, formerly in the Lankoroński Collection and now in Wawal Castle, Krakow, and a workshop pair, Chicago, IL, A. Inst.; see fig.; panel, Pittsburgh, PA, Frick A. Mus.; with a small fragment, Cambridge, MA, Fogg). By the 1450s, like other Florentine painters, he had turned to deeper, more sombre tones, as in the *Aeneid cassoni* at New Haven. In his last years he discarded the flat, frieze-like composition characteristic of contemporary *cassoni* in favour of a more flowing movement and a deeper and more integrated space, as can be seen in the Oberlin panel and its pendant, the *Triumph of the Victorious Greeks* (ex-Wittmann priv. col., Bath, destr.), the *Triumph of Scipio Africanus* (Cambridge, Fitzwilliam) and the *Conquest of Trebizond*.

The organization and working methods of this large workshop may be reconstructed through an analysis of its oeuvre and is informative about 15th-century artistic practices. Though Apollonio painted little himself, he had firm control over the shop's output. He seems to have devised the basic composition for each subject himself and probably executed the first example of it; thus, the early, autograph *Tournament in the Piazza Santa Croce* (New Haven, CT, Yale U. A.G.) has his lively inventiveness, while the later *cassone* of the same subject (London, N.G., 4906) is a stiff shop piece. Once a basic composition was established, variants could be left to assistants because they were guided by a set of model drawings consisting of a large assortment of figures, horses, hats etc, none of which survive. At other times Apollonio did the underdrawing but others laid in the colours; thus, the painted portraits in MS. Strozz.174 (Florence, Bib. Medicea–Laurenziana) are mediocre, but where paint has flaked off the underdrawings are outstanding. The ability of assistants and apprentices varied greatly and their assignments accordingly; hence the less prominent backs, insides of lids and end panels of *cassoni* are usually of comparatively low quality.

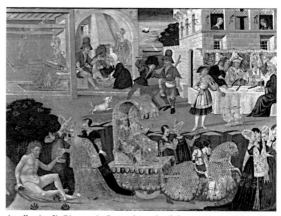

Apollonio di Giovanni: *Scenes from the Odyssey* (detail), tempera on panel, 420×1317 mm, *c.* 1440 (Chicago, IL, Art Institute of Chicago)

Apollonio introduced a host of new subjects to Renaissance painting. He may have been the first to illustrate Petrarch's *Trionfi* and to depict recent events of personal significance to the patron. He was the first Renaissance painter to illustrate scenes from ancient Greek and Roman mythology and history, and he created an extensive new repertory of previously unknown compositions.

Most of the works Apollonio executed himself illustrate the *Aeneid* or the *Odyssey*, presumably reflecting his personal taste. Scenes of Roman battles and triumphs, as well as biblical stories, tales from Boccaccio, devotional images etc were left to assistants. More than 60 *cassoni* panels, some half dozen *deschi* and an equal number of devotional images and manuscripts survive from this prolific shop, and there is documentary evidence of other types of work for the interior—painted ceilings, mouldings, *spalliere* set above chests etc—and even frescoes. Apollonio played a formative role in the creation of the sumptuous domestic interiors that evolved during the second half of the 15th century.

BIBLIOGRAPHY

P. Schubring: *Cassoni, Truhen und Truhenbilder der italienischen Frührenaissance* (Leipzig, 1915, Suppl., 1923)

W. Stechow: 'Marco del Buono and Apollonio di Giovanni, Cassoni Painters', *Bull. Allen Mem. A. Mus.*, i (1944), pp. 5–21

E. H. Gombrich: 'Apollonio di Giovanni: A Florentine Cassone Workshop Seen through the Eyes of a Humanist Poet', *J. Warb. & Court. Inst.*, xviii (1955), pp. 16–34; also in E. H. Gombrich: *Norm and Form* (London, 1966), pp. 11–28

E. Callmann: *Apollonio di Giovanni* (Oxford, 1974)

——: 'An Apollonio di Giovanni for an Historic Marriage', *Burl. Mag.*, cxix (1977), pp. 174–81

F. W. Kent and D. Kent: 'Messer Manno Temperani and his Country Cousins', *Rinascimento*, xxiii (1983), pp. 246–7

A. Garzelli: 'Micropittura su temi virgiliani prima e dopo Apollonio di Giovanni, Apollonio, Giovanni Varnucci, Mariano del Buono e altri', *Scritti di storia dell'arte in onore di Federico Zeri* (Milan, 1984), pp. 147–62

——: *Miniatura fiorentina del rinascimento, 1440–1525*, Inventari e cataloghi toscani, i (Florence, 1985), pp. 41–8

E. Callmann: 'Apollonio di Giovanni and Painting for the Early Renaissance Room', *Ant. Viva*, xxvii/3–4 (1988), pp. 5–18

ELLEN CALLMANN

Apulia, Nicolaus de. *See* NICCOLÒ DELL'ARCA.

Aquila, Silvestro dell'. *See* SILVESTRO DELL'AQUILA.

Aquileia, Patriarchs of. *See* GRIMANI.

Aquilio, Antonio di Benedetto. *See* ANTONIAZZO ROMANO.

Arazzeria Medicea. *See under* FLORENCE, §III, 3(ii).

Arca, Niccolò dell'. *See* NICCOLÒ DELL'ARCA.

Arcangelo di Cola (di Vanni) da Camerino (*fl* 1416–29). Italian painter. From Macerata, he is first documented in 1416, when he received a payment for frescoes (destr.) in the Sala del Maggior Consiglio in the Palazzo Pubblico, Città di Castello. By 1420 he was in Florence, where he enrolled in the Arte dei Medici e degli Speziali and the Compania S Luca. In June 1421 he was commissioned by Ilarione de' Bardi to execute an altarpiece (untraced) for S Lucia dei Magnoli, Florence. A predella panel of the *Martyrdom of St Lawrence* (Venice, Fond. Cini) and two pinnacle panels of the *Archangel Gabriel* and the *Virgin Annunciate* (New York, priv. col.) may be from this altarpiece. Around the same time he received payments for a painting intended for the parish church at Empoli, but this was never completed. In 1422 he was in Rome, where he executed work (untraced) for Pope Martin V and may have contributed to the decoration of the nave of S Giovanni in Laterano for the Jubilee of 1423. Arcangelo returned to the Marches early in 1423, and his last documented painting was a signed triptych of the *Crucifixion with Saints* (1425; destr. 1889) for the monastery of Isola di Cessapalombo, Macerata: it is recorded in a photograph (Venturi). A fresco fragment of *St George and the Dragon* in the church portico of the monastery has also been attributed to him. He is last documented in Camerino, in 1429.

Although none of Arcangelo's documented works survives, several paintings have been assigned to him on the basis of the photograph of the destroyed triptych and a diptych of the *Virgin and Child Enthroned with Angels* and the *Crucifixion* (New York, Frick), attributed to him in an inscription on the reverse. These include a triptych of the *Virgin and Child Enthroned with Saints* (Urbino, Pal. Ducale); a fragment of the *Virgin and Child Enthroned with Four Angels* (New Haven, CT, Yale U. A.G.); a *Virgin and Child with Six Angels* (Bibbiena, SS Ippolito e Donato); a *Virgin and Child Enthroned with Two Angels* (Camerino, Mus. Pin. Civ.); five predella panels (Modena, Gal. Mus. Estense) and two panels of *Saints* (Prague, N.G., Kinský Pal.). His style reflects Late Gothic painting in the Marches, in particular that of Carlo da Camerino (*fl* 1396), which combined naturalism with decorative preciosity. This may be seen, for example, in the *Madonna of Humility* (Ancona, Pin. Com.) attributed to Arcangelo (Zeri, 1950). Familiarity with the innovations of Masaccio and Lorenzo Ghiberti can be seen in the treatment of volume in the *Virgin and Child* at Bibbiena and the central panel of the Urbino Triptych. Another strong influence was the work of Gentile da Fabriano, seen, for example, in Arcangelo's refined facial types and elegant drapery, and it has been suggested that the two may have met and even worked together (Venturi).

BIBLIOGRAPHY

DBI

A. Venturi: 'Di Arcangelo di Cola da Camerino', *L'Arte*, xiii (1910), pp. 377–81

F. Zeri: 'Arcangelo di Cola: Due tempere', *Paragone*, 7 (1950), pp. 33–8

G. Vitalini Sacconi: *Pittura marchigiana: La scuola camerinese* (Trieste, 1968), pp. 97–8

F. Zeri: 'Opere maggiori di Arcangelo di Cola', *Ant. Viva*, vii/6 (1969), pp. 5–15

P. Zampetti: *Pittura nelle Marche*, i (Florence, 1988), pp. 222–6

La pittura in Italia, ii (Milan, 1988), pp. 565–6

A. De Marchi: 'Arcangelo di Cola a Firenze', *Prospettiva*, 53–6 (1988–9), pp. 190–99 [issue dedicated to Giovanni Previtali]

HELEN GEDDES

Arcangelo di Jacopo, Jacopo. *See* SELLAIO, JACOPO DEL.

Archinto. Italian family of patrons and collectors. They were one of the wealthiest and most celebrated patrician families of Milan. The earliest records of them date from 1228, when they made lavish donations to the monastery

of Chiaravalle, near Milan. Giuseppe Archinto (i) (*d* 1476), Chancellor under Duke Galeazzo Maria Sforza (*reg* 1466–76), added to the family's wealth. His grandson Francesco Archinto (*d* 1551), a jurist, was the favoured commissary of Louis XII in the area of Chiavenna; a portrait of him, preserved by the family, is attributed to Leonardo da Vinci. Francesco's cousin Filippo Archinto (1500–58) was appointed Senator by Duke Francesco Maria Sforza and in 1530 represented Milan at the coronation of the Emperor Charles V in Bologna. Filippo held various Imperial posts, including that of Ambassador to Rome, where Pope Paul III ordained him Bishop. In 1566 the Pope appointed him Archbishop of Milan, in which capacity his portrait (*c.* 1557; New York, Met.) was painted by Titian. In this evocative and emblematic work the bearded face and the figure are largely veiled by a light transparent curtain, which probably alludes to the fact that Filippo, opposed by the Spanish and by members of the local clergy, had to retire to Bergamo within the borders of the Venetian Republic.

BIBLIOGRAPHY

Enc. It.; *EWA*: 'Titian'

P. Litta: *Archinto di Milano*, Famiglie celebri italiane, xlvi (Milan, 1843)

F. Arese: 'Genealogie patrizie milanesi', *La demografia del patriziato milanese nei secoli XVII–XIX*, ed. D. E. Zanotti (Pavia, 1972) [appendix]

D. Giorgetti: 'Silloge Archinto', *Accad. & Bib. Italia*, xlviii (1980), pp. 262–71

GIORGIO TABARRONI

Architectural drawing. Representation in graphic form of a building or part of a building, either as a stage in the planned construction of an actual edifice or as an imaginative act in its own right. One of the most profound changes in architectural drawing occurred in Italy in the second half of the 15th century, when the production of paper was hugely increased as a result of the invention of printing. As paper replaced expensive parchment, it encouraged a greater freedom in design and drawing methods, with communication between architect and builder coming gradually to depend less on oral and written instructions. It was in Renaissance Italy that the most significant developments in architectural drawing took place, for while all medieval architects were trained as building craftsmen, some notable Italian architects of the later 15th century were also painters and sculptors and received their initial training in those arts. Leonardo da Vinci, Donato Bramante, Baldassare Peruzzi and Raphael were among the artist-architects who invented or perfected new ways of representing architectural designs during this period.

Very few architectural drawings made in Italy before the 16th century survive, however: only two minor drawings by LEON BATTISTA ALBERTI are known, for example (see fig. 1), and none by Filippo Brunelleschi. These two

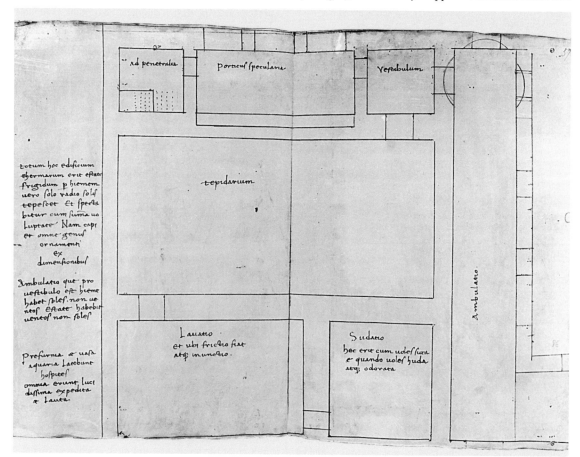

1. Architectural drawing (275×195 mm) by Leon Battista Alberti: project for a bath complex, *c.* 1470 (Florence, Biblioteca Medicea–Laurenziana, MS. Laur. App. 1828, cc. 56*v*–57*r*)

architects played a vital role in the development of drawing by formulating the laws of linear perspective in the early 15th century. It seems that most designs at this time were represented by a ground-plan and, often, by an architectural model. Elevations were usually unnecessary since the builder, by means of simple geometrical and modular formulae, could determine the disposition and measurements of the major vertical elements of a design from the proportions inherent in the ground-plan. Models gave the general form and scale of a proposed building and were the basis for discussion between architect, patron, mason and advisers. It is likely that full-size details of capitals, architraves and other classical elements were made by the mason from measured drawings taken by the architect from antique examples. The ruins of Roman buildings were an important source for Renaissance architecture, and their construction, plans, proportions and details were studied and recorded in sketchbooks and portfolios by architects from Brunelleschi's generation onwards.

Alberti, in *Della pittura* (1436), his book for painters, was the first to codify the system of one-point perspective devised by Brunelleschi a decade earlier. However, in his architectural treatise *De re aedificatoria* (1485), written *c.* 1450, he advised architects against 'illusionistic' perspective drawing, because it could be inaccurate and misleading; instead he recommended the use of a model together with plans and elevations drawn orthogonally and on separate sheets. All the same, while the need to convey to the builder accurate information based on proportion and measurement is best achieved by the rational and methodical system of orthography, perspectives, because of their greater realism, are often more easily understood by the patron and are also cheaper and quicker to produce than models. Because they depict three-dimensional form they also help the architect at the early stages of a project to work through various design solutions and to picture the inter-relationship of a ground-plan, exterior and space.

The bird's-eye view (a type of perspective drawn from a high vantage-point) was introduced into architectural drawing *c.* 1490 by Leonardo da Vinci, who also used it for anatomical and engineering studies as well as for relief maps. It shows an object as an entity and when used with a bird's-eye view section answered the problem of explaining the multi-domed, centralized buildings proposed by Leonardo. Thus, as late 15th-century architecture became more complex and more plastic, new methods of representation developed. In Bramante's circle the form and volume of an interior space (extant or proposed) might be shown by a bird's-eye view section in which shade and light were used to model the projections and recesses of walls. Another perspectival sectional method, used by Giuliano da Sangallo for a drawing of an antique circular temple (see fig. 2), employed the novel convention of 'ruinizing' the building so as to reveal its interior.

Although both methods of representation were suited to the plain centralized interior of a circular temple (e.g. the Pantheon in Rome), they were inadequate for larger, more complex centralized buildings or for those with a longitudinal interior—that is to say, having intricate spaces that cannot be taken in at a glance but need 'the cumulative effect of many impressions'. Experiments were made with multiple perspective, in which more than one vanishing

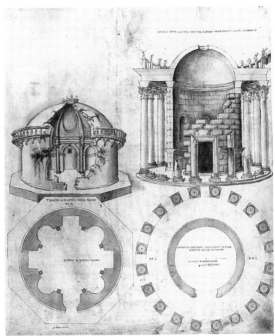

2. Architectural drawing (diam. 380 mm) by Giuliano da Sangallo: antique circular temple, *c.* 1500 (Rome, Vatican, Biblioteca Apostolica, Cod. Barb. Lat. 4424, fol. 32)

point is used, and with drawings that mixed orthography and central perspective. An example of the latter is Peruzzi's 'ideal view' of St Peter's, Rome, a drawing of *c.* 1515 that daringly combined plan, section, perspective and horizontal sections and which came close to isometric projection. Peruzzi, who was associated with St Peter's until his death in 1536, continued his experiments with both perspective and 'mixed' projections all his life. St Peter's, with its changing programme for a Greek or Latin cross plan, became a kind of forcing house for the resolution of architectural drawing practice. Building work began in 1506 under Bramante, and subsequent architects included Giuliano da Sangallo, Raphael, Antonio da Sangallo (ii) and, from 1546, Michelangelo. The need for consistency in drawing up designs was appreciated by Raphael, and in a letter of 1519 to Pope Leo X he argued (much as Alberti had) for a three-fold system of plan, elevation and section all drawn to the same scale, a system probably first fully explored by Antonio da Sangallo (ii). Orthogonal drawing gradually became the architect's way of seeing and representing, and since it is less illusionistic and more abstracted than perspectival drawing it can be said to mark the separation of architects from artists. The standardization of drawing practice helped free the architect from the need for day-to-day site supervision and laid the foundations for the architectural office, with its assistants and draughtsmen.

From the evidence of the 330 or so drawings that survive (examples at Chatsworth, Derbys; London, RIBA; and elsewhere) of the thousands he must have made, ANDREA PALLADIO used only orthogonal projection (see fig. 3). Two-thirds are studies of Roman buildings rather than design drawings for new buildings (the majority of

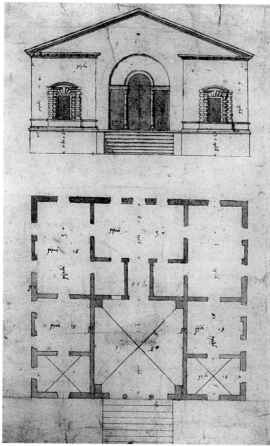

3. Architectural drawing by Andrea Palladio: plan and elevation for the Villa Valmarana, Vigardolo, 1541 (London, Royal Institute of British Architects)

illustrations, with a plan and elevation often together on the same page, not only demonstrated his design principles but also his preference for orthography over perspective. A very different book, *Les Plus Excellents Bastiments de France* (1576–9) by Jacques Androuet Du Cerceau (i), introduced in a published form the bird's-eye topographical view. Its large engraved plates showing some of the great royal and private châteaux of France set in their gardens is the first systematic (though not very accurate) survey in this form. It was presumably a development from mapmaking since most town plans until the mid-18th century were drawn as bird's-eye views, despite Leonardo's invention *c.* 1502 of ichnography. With this method all topographical features are drawn as if reflected on a single horizontal plane: the mapmaker's equivalent of orthography. Other developments during the 16th century in astronomy, military engineering and land surveying, calling for exact measurement and accurate draughtsmanship, effectively marked the beginning of technical drawing. By 1600 drawing scales, protractors, adjustable set-squares, parallel rulers, proportional compasses and dividers, wing-compasses and dividers and other measuring and drawing instruments were all available to draughtsmen.

extant 16th-century Italian drawings are *of* rather than *for* buildings), and this can perhaps be explained by the importance of Roman buildings as sources of design both for the architects who measured and drew them and for their successors. Almost all Palladio's initial sketch designs are lost, as are the working drawings that must have been worn out through use on the building site. It is certain that Palladio used models for his important projects and that he prepared full-size profiles of mouldings from which masons made their templates. His preliminary designs were first drawn freehand, while in drawings made to scale the main elements were first drawn without ink, using a stylus and compasses. A quill pen was then used to draw over the incised construction lines and to complete the drawing, either freehand or with a straight-edge. Sometimes the first or under-drawing was made in red or brown chalk or in lead and then traced over with pen and ink. Palladio's drawing instruments must have included styluses (of wood or ivory, or of metal with a rounded point), quill pens, holders for chalk and lead, compasses, dividers, straight-edges and set-squares. He would also have had a magnetic compass, a level, a plumb-line and a case of travelling instruments for measuring and drawing the remains of Roman buildings.

Palladio's enormously influential *Quattro libri dell'architettura* was published in 1570. The clear woodcut

BIBLIOGRAPHY
GENERAL
W. Burges: 'Architectural Drawings', *Trans. RIBA*, 1st series, xi (1861), pp. 15–28

RIBA Drawings Series, 8 vols (London, 1968)

J. Lever, ed.: *Catalogue of the Drawings Collection of the Royal Institute of British Architects*, 20 vols (Farnborough, 1969–89) [mainly British material]

S. Kostof, ed.: *The Architect: Chapters in the History of the Profession* (Oxford, 1977)

C. Cable: *The Architectural Drawing: Its Development and History, 1300–1950* (Monticello, IL, 1978) [bibliog.]

H. Powell and D. Leatherbarrow, eds: *Masterpieces of Architectural Drawing* (New York, 1982)

J. Lever and M. Richardson: *Great Drawings from the Collection of the Royal Institute of British Architects* (London, [1983])

S. Lambert: *Drawing: Technique and Purpose* (London, 1984)

J. Lever and M. Richardson: *The Art of the Architect* (London, 1984)

J. A. Ackerman: *The Re-invention of Architectural Drawing, 1250–1550*, Annual Soane Lecture 3 (London, 1999)

TECHNIQUES
J. Dubreuil: *Perspective Practical* (London, 1672)

R. Brown: *The Principles of Practical Perspective* (London, 1815)

C. A. Farey and A. Trystan Edwards: *Architectural Drawing, Perspective and Rendering* (London, 2/1949)

Y.-A. Bois: 'Metamorphosis of Axonometry', *Daidalos*, i (1981), pp. 41–59

M. Scolari: 'Elements for a History of Axonometry', *Archit. Des.*, iv (1985), pp. 73–8

MEDIA AND INSTRUMENTS
R. A. Skelton: 'Colour in Mapmaking', *Geog. Mag.*, xxxii (1960) pp. 534–53

M. Hambly: *Drawing Instruments: Their History, Purpose and Use for Architectural Drawings* (London, 1982)

HISTORY
J. White: 'Developments in Renaissance Perspective', *J. Warb. & Court. Inst.*, xii (1949), pp. 58–79

J. S. Ackerman: 'Architectural Practice in the Italian Renaissance', *J. Soc. Archit. Historians*, xiii (1954), pp. 3–11

H. Saalman: 'Early Renaissance Architectural Theory and Practice in Antonio Filarete's *Trattato di architectura*', *A. Bull.*, xii (1959), pp. 89–106

S. Y. Edgerton jr: 'Florentine Interest in Ptolemaic Cartography as a Background for Renaissance Painting, Architecture and the Discovery of America', *J. Soc. Archit. Historians*, xxxiii (1974), pp. 275–92

P. Marconi, A. Cipriani and E. Valeriani: *I disegni di architettura dell'archivo storico dell'Accademia di San Luca*, 2 vols (Rome, 1974)

J. A. Pinto: 'Origins and Development of the Ichnographic City Plan', *J. Soc. Archit. Historians*, xxxv (1976), pp. 35–50

W. Lotz: *Studies in Italian Renaissance Architecture* (London, 1977)

C. Cable: *Architectural Drawing and Architectural Practice during the Late Fifteenth and Early Sixteenth Centuries in Italy* (Monticello, IL, 1979) [bibliog.]

J. A. Gere and P. Pouncey: *Italian Drawings in the Department of Prints and Drawings in the British Museum: Artists Working in Rome, c. 1550–c. 1640* (London, 1983)

Drawing in the Italian Renaissance Workshop (exh. cat. by F. Ames-Lewis and J. Wright, London, V&A; Nottingham, A.G.; 1983)

C. Loi: 'Alcune osservazini sul disegno dall'antico: Colloquio con Arnaldo Bruschi', *Dis. Archit.*, 9 (1994), pp. 3–5

H. Millon and V. Magnago Lampugnani, eds: *Rinascimento da Brunelleschi a Michelangelo: La rappresentazione dell'architettura* (Milan, 1994)

JILL LEVER

Ardenti, Alessandro (*fl* 1539; *d* Turin, 20 Aug 1595). Italian painter. Probably a native of Faenza, although sometimes thought to have been from Pisa or Lucca, he worked in a Mannerist style and enjoyed a long and prolific career. Ardenti's earliest known work is a *Nativity* in the parish church at Antraccoli, near Lucca, signed *Alexander Ardentius faventinus* and dated 1539. Other extant dated paintings bearing the same signature are the *Virgin and Child with Saints* (1565; Lucca, S Paolino), the *Madonna of Mercy* (1565; Lucca, S Salvatore) and an *Assumption* (1567; Sesto, parish church). The signature *Alexander Ardentius lucensis* appears on a canvas depicting *St John the Baptist with SS Jerome and Joseph* in the parish church at Lunata, near Lucca. About 1572 Ardenti moved to Turin, where he was employed as a painter and sculptor to the Savoys, first by Duke Emanuel-Philibert (*reg* 1558–80) and then by his successor Duke Charles-Emanuel I (*reg* 1580–1630). Documents confirm Ardenti's marriage in 1583 and a journey to Milan the following year. His widow and children received a pension after his death. While a noticeable hardness is evident in his work at Lucca, the Turin paintings reveal an affinity with the Roman school (Lanzi). Stylistic differences between some of the paintings possibly indicate the hands of two different artists, both named Alessandro Ardenti, perhaps a father and son (Sardini).

UNPUBLISHED SOURCES

Lucca, Archv Stato [Arch. Sardini, MS. 124 n. 14—MS. of G. Sardini: *Notizie dei due Ardenti*]

BIBLIOGRAPHY

DBI; Thieme–Becker

L. Lanzi: *Storia pittorica della Italia* (Bassano, 1795–6; Eng. trans., London, 1847)

G. M. Valgimigli: *Dei pittori e degli artisti faentini dei secoli XV e XVI* (Faenza, 1871), p. 162

A. Baudi di Vesme: 'L'arte alla corte di Emanuele Filiberto e di Carlo Emanuele I nei primi anni del suo regno', *Atti Soc. Piemont. Archeol. & B.A.*, xi (1929), pp. 146–66

SUSANNE JULIANE WARMA

Aretino [del Tura], Pietro (*b* Arezzo, 19 or 20 April 1492; *d* Venice, 1556). Italian art critic, writer, poet and collector. He was one of the most engaging literary figures of the Italian Renaissance, known not only for his famous *Lettere* but also for political lampoons, erotic books and religious writings. He was the son of a shoemaker, Luca del Tura. From before 1510 until 1517 he lived in Perugia. A book of poems that he published during these years, *Opera nova* (1512), suggests by its subtitle, in which the author is called 'Pietro pictore Aretino', and by a note to the first sonnet in which he claims to be 'studioso . . . in pictura', that he had some training as an artist. About 1517 he moved to Rome, after a short period in Siena, and joined the household of Agostino Chigi. He became friendly with Raphael, Michelangelo, Sebastiano del Piombo and Jacopo Sansovino. At this time too he became known for his political lampoons. For a period Aretino was a valet to Pope Leo X; on Leo's death in 1522 he left Rome and entered the service of Giovanni dalle Bande Nere, but returned to Rome in 1523.

In 1524 one of Aretino's friends, Marcantonio Raimondi, was imprisoned by Bishop Giovanni Matteo Giberti for making and circulating 16 engravings after '*modi*' or sexual positions drawn by Giulio Romano (9 fragments, London, BM), whereupon Aretino wrote the '*sonetti lussuriosi*' (describing the '*modi*'), which were published with another edition of Raimondi's prints *c.* 1525. This edition seems to be extinct but at least one copy of an edition of 1527, printed in Venice and containing woodcut illustrations instead of Raimondi's prints, survives in a private collection. For this defiant act Aretino was obliged to leave Rome to escape imprisonment. On his return, however, he was attacked and stabbed, at the instigation of Bishop Giberti. He departed from the city once more (1525), this time for good, briefly staying at the court of Duke Federico Gonzaga at Mantua before moving in 1527 to Venice, where he lived for the rest of his life.

In Venice, Aretino became friendly with Titian and other artists working there and began to write the letters (*Lettere*, Venice, 1538–57), some of them to the publisher LODOVICO DOLCE, that established his reputation as a writer. Over 600 of the letters are about art or artists, and some of them have been widely discussed, such as those of 16 September 1537 and November 1545 to Michelangelo, concerning his *Last Judgement* (1535–41; Rome, Sistine Chapel; see colour pl. 2, VII3), and one dated May 1544 to Titian, which evocatively describes the view of the Grand Canal at sunset. Other letters reveal his unusual sympathy with Venetian art, particularly that of Titian, whose use of colour Aretino often praised.

It can be seen in his *Lettere* that Aretino practised essentially two kinds of criticism, as did other Renaissance writers on the subject of art. One kind is analytical and prescriptive, as in the letter of 1545 concerning Michelangelo's *Last Judgement*, a work that Aretino knew only from an engraving. The critic praised the painting's beauty of invention, but censured the artist for representing the genitalia of his figures in so holy a place as the Sistine Chapel; he even suggested that the offending anatomical parts should be painted over. The other kind of criticism practised by Aretino and his contemporaries is known as Ekphrasis, and is laudatory and evocative in nature. In a letter of 9 November 1537 describing Titian's *Annunciation of the Birth of Christ* (untraced), for example, Aretino conveys something of the dramatic action of the figures, the quality of the composition, the beauty of the colouring and the power and sense of the illusion. On occasion Aretino broadened the range of his ekphrastic descriptions to include his practical or analytical criticism, thereby creating a third mode of criticism. It can be seen in the

letter of 15 December 1540 praising Vasari's cartoon of the *Fall of Manna*, or in that of August 1545 about a print after Francesco Salviati's *Conversion of Saul* (Rome, Gal. Doria–Pamphili). In these examples Aretino evoked the scenes before him but also praised the invention of the compositions, the grace of the figures and the expressiveness of their gestures.

Aretino's associations with artists resulted in numerous portraits of him, some of them no longer extant. He commissioned an engraved portrait from Raimondi (Paris, Bib. N.) and painted portraits from Sebastiano del Piombo (Arezzo, Pal. Comm., Sala Consiglio) and Titian (Florence, Pitti; New York, Frick), which served as models for a number of woodcuts. He was also painted by Francesco Salviati. He is portrayed on medals (Brescia, Mus. Civ. Armi Marzoli) by Alessandro Vittoria and Leone Leoni, and his likeness appears in works by Titian (*Ecce homo*, 1543; Vienna, Ksthist. Mus.), Sansovino (bronze doors of the sacristy, Venice, S Marco) and others.

Aretino possessed a relatively small collection of works of art. Ceiling paintings by Tintoretto showing *Apollo and Marsyas* (1545; Hartford, CT, Wadsworth Atheneum) and *Mercury and Argus* (untraced) adorned his residence in the Ca' Bollani, Venice, but were left behind in 1551, when he moved to his much grander quarters of the Ca' Dandolo. In 1549 Giorgio Vasari sent him the cartoon of his *Fall of Manna* (untraced) which the critic had praised, and at Aretino's request drew for him two of Michelangelo's sculptures in the Medici Chapel, S Lorenzo, Florence.

The art of contemporary painters seems to have been influenced by Aretino's religious books, the imagery of which had been at times influenced by his knowledge of works of art. A description of the Last Judgement in his version of the first book of the Bible, *Il Genesi* (Venice, 1538), may have inspired the composition of Titian's *Trinity* (c. 1554; Madrid, Prado), painted for Emperor Charles V (*reg* 1519–56). And Veronese's *Marriage at Cana* (1562–3; Paris, Louvre), which contains a portrait of Aretino, seems to rely on his description of the same event in *La humanità di Christo* (Venice, 1535).

WRITINGS
Lettere, 6 vols (Venice, 1538–57)
F. Pertile and E. Camesasca, eds: *Lettere sull'arte di Pietro Aretino*, 3 vols (Milan, 1957–60)
G. Bull, ed. and trans.: *Selected Letters* (Harmondsworth, 1976)
L. Lawner, ed. and trans.: *I Modi—The Sixteen Pleasures: An Erotic Album of the Italian Renaissance* (Evanston, IL, 1988)

BIBLIOGRAPHY
P. Fehl: 'Veronese's Decorum: Notes on the *Marriage at Cana*', *Art the Ape of Nature: Studies in Honor of H. W. Janson*, ed. M. Barasch and L. F. Sandler (New York, 1981), pp. 344–58
A. Luzio: *Pietro Aretino nei primi suoi anni a Venezia e la corte dei Gonzaga* (Bologna, 1981)
L. A. Palladino: *Pietro Aretino: Orator and Art Theorist* (diss., New Haven, Yale U., 1981) [extensive bibliog.]
D. Rosand: *Painting in Cinquecento Venice: Titian, Veronese and Tintoretto* (New Haven and London, 1982), pp. 195–7
D. Rosand, ed.: *Titian: His World and his Legacy* (New York, 1982), pp. 16–22, 73–133
J. Anderson: 'Pietro Aretino and Sacred Imagery', *Interpretazioni veneziane: Studi di storia dell'arte in onore di Michelangelo Muraro*, ed. D. Rosand (Venice, 1984), pp. 275–90
N. E. Land: 'Ekphrasis and Imagination: Some Observations on Pietro Aretino's Art Criticism', *A. Bull.*, lxviii (1986), pp. 207–9
N. Land: 'Pietro Aretino's Art Criticism', *The Viewer as Poet: The Renaissance Response to Art* (University Park, PA, 1994), pp. 128–50
W. Busch: 'Aretinos Evokation von Tizians Kunst', *Z. Kstgesch.*, lxiii (1999), pp. 91–105

NORMAN E. LAND

Arezzo [anc. Arretium]. Italian city and diocese in Tuscany, *c.* 75 km south-east of Florence. Set on a small hill on the plain between the upper Arno and Valdichiana valleys, it stands on one of the principal ancient routes between Rome, Florence and Emilia-Romagna. A flourishing town in antiquity, it also contains many fine works of art from the Gothic and Renaissance periods. In Etruscan and early Roman times, Arezzo owed part of its prosperity and fame to bronze, earthenware and gold products (the latter industry still thrives today). By the 5th century BC Arezzo was walled and had become one of the 12 most important Etruscan towns. Examples of characteristic black-glazed pottery from this period survive, as do some exceptional bronze statues, including the *Chimaera* (early 4th century BC) and a later *Minerva* (both Florence, Mus. Archeol.), which were discovered in 1553 and 1541 respectively and appropriated by Cosimo I, Grand Duke of Tuscany, for whom they helped legitimize the importance of the art of Etruria/Tuscany. Linked to Rome by the Via Cassia, Arezzo became a Roman municipium during the Republican period. Celebrated Aretines of this period included Caius Cilnius Maecenas (*d* 8 BC), friend of the Emperor Augustus and of the poet Horace, whose name provides the Italian word for patronage of the arts, *mecenatismo*.

After centuries of decline, the diocese of Arezzo expanded from the 8th century AD to within a few miles of Siena and Florence, and the power of its bishop-lords during the Middle Ages was expressed in the building of an imposing cathedral outside the city walls (consecrated 1032; destr. 1561) and the fine Romanesque Pieve di S Maria (early 12th century), with an unusual colonnaded façade and campanile (early 14th century).

A local school of painting flourished in Arezzo *c.* 1350–1450 with Andrea di Nerio, Spinello Aretino (*see* SPINELLI, (1)) and his son Parri Spinelli. In 1384 the city came under the dominion of Florence and commissions to 15th-century masters reveal the influence of Florentine culture, which was enriched by the presence in Florence of such Aretine humanists and chancellors as Leonardo Bruni and Carlo Marsuppini. BARTOLOMEO DELLA GATTA was among the painters active in Arezzo at this time, and PIERO DELLA FRANCESCA painted his greatest work in Arezzo: the fresco cycle of the *Legend of the True Cross* (after 1447) in the choir of S Francesco (see colour pl. 2, XVI1). In architecture, a link between the Gothic and early Renaissance vocabularies can be seen in Bernardo Rossellino's upper storey (1433–5) of the Palazzo della Fraternità (*see* ROSSELLINO, (1)), the seat of the Fraternità di S Maria della Misericordia (founded in 1262 and still active) in the main square of Arezzo, the Piazza Grande. Also in the mid-15th century was built the Palazzo Bruni–Ciocchi, later extended and now housing the Galleria e Museo Medioevale e Moderna). During the last quarter of the 15th century S Maria delle Grazie, built *c.* 1440 outside the city gates, was provided with a graceful loggia and porticoed piazza—for which Benedetto da Maiano provided a design (*c.* 1478)—to accommodate large crowds of church-goers, and from the 1490s the 14th-century SS Annunziata was enlarged, partly by Antonio da Sangallo (i).

The Roman High Renaissance was brought to Arezzo by the stained-glass maker and painter Guillaume de Marcillat, who lived in Arezzo from 1519. He painted several works for the cathedral, SS Annunziata and S Francesco. His pupils included Giorgio Vasari (*see* VASARI, (1)), possibly the most famous Aretine native since Petrarch. The legacy of Vasari, whose chauvinist praise for Arezzo echoes throughout his *Vite* (1550), includes the decoration (1542–8) that he produced for his own house (now Mus. Casa Vasari; see fig.), and also the loggias (1572) that he designed for the Piazza Grande. A huge defensive system was commissioned by Cosimo I at the beginning of the 16th century from Giuliano da Sangallo and Antonio da Sangallo (i), with a large fortress (destr. *c.* 1800) on the site of an old Roman castle at the top of the hill and a bastioned wall a short distance out from the 14th-century enceinte. Within these walls was built the monastery of S Bernardo (*c.* 1550; now the Museo Archeologico Ciao Cilnia Mecenate) from the ruins of the ancient amphitheatre near by. The fortunes of Arezzo nevertheless began to decline thereafter and it came to be overshadowed by Florence.

BIBLIOGRAPHY

P. Farulli: *Annali ovvero notizie istoriche dell'antica nobile valorosa Juan città di Arezzo in Toscana* (Foligno, 1717/*R* Bologna, 1968)

U. Pasqui and U. Viviani: *Guida illustrata storica e artistica di Arezzo e dintorni* (Arezzo, 1925/*R* Rome, 1981)

M. Salmi: *Civiltà artistica della terra aretina* (Novara, 1971)

A. Tafi: *Immagine di Arezzo: Guida storico-artistica* (Arezzo, 1978)

——: *Immagine di Arezzo: La città oltre le mura medicee e il territorio comunale* (Cortona, 1985)

V. Franchetti Pardo: *Arezzo*, Le città nella storia d'Italia (Bari, 1986)

FRANK DABELL

Argenta, Jacopo Filippo d'. *See* JACOPO FILIPPO D'ARGENTA.

Ariosto, Ludovico (*b* Reggio Emilia, 8 Sept 1474; *d* Ferrara, 6 July 1533). Italian poet. His father was a captain in the service of the ruling Este family at Ferrara, and Ariosto studied Latin literature and philosophy at the *studium* (university) there. From 1503, he served first Cardinal Ippolito I d'Este and then his brother, Alfonso I d'Este, Duke of Ferrara, in various administrative and diplomatic capacities, finally retiring around 1526. His supervision (1526–33) of the ducal theatre at Ferrara enabled him to collaborate with, among others, Dosso Dossi and Battista Dossi, who designed sets for several of his comedies. Despite the brilliance of these and of his seven *Satires* (1517–25), Ariosto's fame rests on his romance-epic in Italian, *Orlando furioso* (Ferrara, 1516, 1521, 1532). The poem, begun in 1502 and completed only shortly before his death, uses Charlemagne's war against the Saracens as a backdrop to explore typical Renaissance themes such as love, madness and fidelity. It highlights Ariosto's interest in art in several ways, containing many *ekphrases* (for example iii, xxxiii, xlii, xlvi) and a detailed description of a woman (vii, 11–15), often cited in subsequent theoretical discussions of descriptive poetry, for example Lodovico Dolce's *Dialogo della pittura* (Venice, 1557) and Gotthold Ephraim Lessing's *Laokoon* (Berlin, 1766). The poem praises nine contemporary artists at xxxiii, 2, and its structure, according to some scholars, mirrors the classical harmony found in the art of the

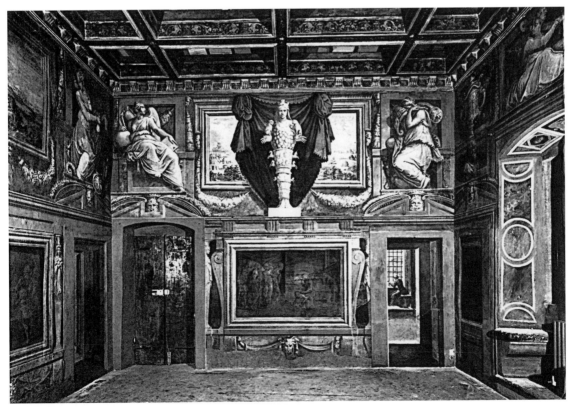

Arezzo, Giorgio Vasari's house, 1540–48; the Sala Grande with the statue of *Diana of Ephesos*

period (Gnudi). The definitive third edition includes a woodcut portrait in profile of Ariosto said by contemporary sources to be after a drawing by Titian. Published in over 60 different, often illustrated, editions before 1600, *Orlando furioso* has been a source of inspiration for leading European painters and anonymous craftsmen alike since the 16th century. In Italy its characters and themes have often been used for the decoration of artworks and artefacts.

BIBLIOGRAPHY

M. Catalano: *Vita di Ludovico Ariosto*, 2 vols (Geneva, 1930–31)

P. Barocchi: 'Fortuna dell'Ariosto nella trattatistica figurativa', *Critica e storia letteraria: Studi offerti a Mario Fubini*, i (Padua, 1970), pp. 388–405

C. Gnudi: 'L'Ariosto e le arti figurative', *Congresso Internazionale Ludovico Ariosto: Rome, 1975*, pp. 331–401

R. W. Lee: *Names on Trees: Ariosto into Art* (Princeton, 1977)

R. Cesarani: 'Ludovico Ariosto e la cultura figurativa del suo tempo', *Studies in the Italian Renaissance*, ed. G. P. Biasin and others (Naples, 1985), pp. 145–66 [extensive bibliog.]

Signore cortese e umanissimo: Viaggio intorno a Ludovico Ariosto (exh. cat., ed. J. Bentini; Reggio Emilia, 1994)

DENNIS LOONEY

Aristotile da Bologna [Aristotele di Fieravanti]. *See* FIORAVANTI, ARISTOTELE.

Arretium. *See* AREZZO.

Arrigo, Giuliano d'. *See* PESELLO.

Ascoli Piceno [Lat. Asculum Picenum]. Italian city, a provincial capital in the Marches built at the confluence of the Castellano and Tronto rivers and on the ancient Via Salaria, which links Rome with the Adriatic Sea. After being conquered and destroyed by the Romans in 89 BC, Ascoli Piceno was rebuilt on a rectangular grid, which it has retained to this day. Because of its geographical position, the city always enjoyed a certain economic well-being, and the River Castellano provided the energy for mills and paper factories from the Middle Ages. Throughout the city's history, this wealth favoured the production of many noteworthy works of art. Its architectural monuments, built of the local Travertine marble, are set in a medieval and Renaissance urban fabric of considerable interest.

The cathedral (almost totally transformed in the 15th century) was originally medieval, as were the baptistery and a number of churches: SS Vincenzo ed Anastasio (of Early Christian origin; enlarged in the 10th and 11th centuries and drastically remodelled in the 14th century, when it acquired its panelled façade, decorated with interlaced mouldings), S Maria Intervineas (also Early Christian; enlarged 12th and 13th centuries), and S Tommaso Apostolo (*c.* 1064; rebuilt 13th century). In the 15th and 16th centuries numerous architectural projects and paintings were commissioned in Ascoli Piceno and the surrounding area. Even the simplest houses were often embellished with portals and windows of notable artistic quality. Renaissance architecture was brought to the city mainly by Lombard sculptors, who took their inspiration from the decorative motifs of the Ducal Palace in Urbino and the nearby sanctuary of Loreto. The small palazzo of Francesco Calvo (later Palazzo Bonaparte) dates from 1507. With its richly carved main door, flanked by pilasters and surmounted by a lunette, and its mullioned and transomed windows on the first floor, this is one of the most important examples of Ascoli's domestic architecture. Shortly afterwards, *c.* 1509, the Piazza del Popolo (see fig.) was laid out with porticoed buildings around three sides (broken by the Palazzo del Capitano del Popolo, first erected in the 12th and 13th centuries, but transformed in the 16th, and the side of the church of S Francesco); these were probably planned by an architect from the Po Valley. To the same period belong the monument to *Julius II* on the side door of the church of S Francesco (1510); the Loggia dei Mercanti (1509–19), a light, elegant structure, still showing the influence of Filippo Brunelleschi; and the Papal *cartiera* or paper mill (1512). This last was the work of Alberto da Piacenza (*fl* 1501–16), a collaborator of Donato Bramante.

Bramante's style of Roman classicism reached Ascoli Piceno through the work of COLA DELL'AMATRICE, whose work on such structures as the Palazzo del Capitano del Popolo and the cathedral (where he designed the façade, 1525) brought about a significant change in building styles during the 16th century. Among the most notable works of that century are the Palazzo Roverella (begun 1532); part of the Bishop's Palace, with frescoes by the Venetian painter Marcello Fogolino; and the imposing Palazzo Malaspina (1535–83), which has an unusual loggia motif of columns in the form of trunks with cut-off branches in the manner of Bramante's loggia at S Ambrogio, Milan. The portal of Palazzo del Capitano del Popolo, surmounted by a monument to *Paul III*, dates from 1549, and the Fortezza Pia was completed in 1564. The Fortezza Malatesta, built in 1349, was modernized by Antonio da Sangallo the younger in 1540.

In the field of painting the most important works in Ascoli Piceno are those of the Renaissance: Carlo Crivelli (*see* CRIVELLI, (1), fig. 2), Pietro Alemanno, Marcello Fogolino and Cola dell'Amatrice are the most illustrious representatives of a throng of artists who left numerous panels and frescoes throughout the territory of Ascoli.

Ascoli Piceno, Piazza del Popolo (*c.* 1509), with, left, the Palazzo del Capitano del Popolo (12th–13th centuries; door with the monument to Paul III, 1549) and, in the background, the side of the church of S Francesco (1290, remodelled 14th century), with the monument to *Julius II* above the door

These works reflect various influences, from Venetian to Umbrian painting, and also show evidence of contact with the art of the Abruzzi.

BIBLIOGRAPHY

T. Lazzari: *Ascoli in prospettiva* (Ascoli Piceno, 1724)
B. Orsini: *Descrizione delle pitture, sculture ed architetture dell'insigne città di Ascoli nella Marca* (Perugia, 1790)
G. B. Carducci: *Su le memorie e i monumenti di Ascoli nel Piceno: Discorso* (Fermo, 1853)
C. Mariotti: *Ascoli Piceno* (Bergamo, 1913)
G. Fabiani: *Ascoli nel quattrocento*, 2 vols (Ascoli Piceno, 1950–51)
——: *Cola dell'Amatrice secondo i documenti ascolani* (Ascoli Piceno, 1952)
E. Sisi: 'Caratteri urbanistici: Ascoli Piceno', *Urbanistica*, xxvi/20 (1956), pp. 142–5
L. Benevolo: *Ascoli Piceno* (Milan, 1957)
G. Fabiani: *Ascoli nel cinquecento*, 2 vols (Ascoli Piceno, 1957–9)
W. Lotz: 'Italienische Plätze des 16. Jahrunderts', *Jb. Max-Planck-Ges. Förderung Wiss.* (1968), pp. 41–60; Eng. trans. as 'Sixteenth-century Italian Squares', *Studies in Italian Renaissance Architecture* (Cambridge, MA, and London, 1977), pp. 74–92
A. Ghisetti Giavarina: *Cola dell'Amatrice architetto e la sperimentazione classicistica del cinquecento* (Naples, 1982)
Ascoli e il suo territorio: Struttura urbana e insediamenti dalle origini ad oggi (Cinisello Balsamo, 1984)
D. Ferriani: *Pinacoteca Civica: Ascoli Piceno* (Florence, 1995)

ADRIANO GHISETTI GIAVARINA

Aspertini, Amico (*b* Bologna, 1474–5; *d* Bologna, 19 Nov 1552). Italian painter, sculptor, illuminator, printmaker and draughtsman. He was born into a family of painters, and his youthful facility reportedly astonished his contemporaries. His work developed in the Emilian–Ferrarese tradition of Ercole de' Roberti, Lorenzo Costa the elder and, above all, Francesco Francia. Until the re-evaluation by Longhi, critical assessment of Amico's oeuvre was over-reliant on literary sources, especially Vasari's unsympathetic account of an eccentric, half-insane master working so rapidly with both hands (the 'chiaro' in one, the 'scuro' in the other) that he was able to finish decorating an entire house façade in one day.

Longhi presented Amico as a creative master whose expressive intensity and sensitive use of colour rescued Bolognese painting of the early 16th century from sterile echoes of Raphael. Today Aspertini is viewed as an influential precursor of Mannerism, and his highly individual study of antiquity has been brought to the fore by the publication of his sketchbooks. Amico was not a mere imitator of ancient artists, but their imaginative rival, whether in his grotesques derived from the decorations of Nero's Domus Aurea in Rome (e.g. the Parma sketchbook and the borders of his *Adoration of the Shepherds* in the Albani Hours, 1492–1503; London, BL, Yates Thompson MS. 29, fol. 15*v*), the pilasters for his fresco cycle (1506–8/9) in the chapel of S Agostino, Lucca, his monochrome reliefs *all'antica* (e.g. in *St Sebastian*, 1504–5; Washington, DC, N.G.A.) or in narrative works such as his major surviving fresco cycles (e.g. that of 1505–6 in the oratory of S Cecilia in S Giacomo Maggiore, Bologna, and the cycle of 1506–8/9 in S Frediano, Lucca).

There is general agreement on the main features of Amico's career, although questions remain about attributions and chronology. Most scholars accept his presence in Rome in 1500–03 and the attribution to those years of his sketchbook after the Antique (Wolfegg Codex, Schloss Wolfegg, Fürstl. Samml.). Some scholars extend his service

in and around Rome during the papacy of Alexander VI to activity in Bernardino Pinturicchio's workshop.

Amico's return to Bologna is documented in 1504. Two signed, though undated, altarpieces, the *Adoration of the Shepherds* (Berlin, Gemäldegal.) and a *Nativity* (Bologna, Pin. N.), are generally placed at this stage of his career. Under the patronage of the Bentivoglio family, in 1505–6 he joined Costa, Francia and assistants in carrying out the fresco cycle for the newly restored oratory of S Cecilia. Universally attributed to Amico are the *Martyrdom of SS Valerian and Tiburtius* and their *Burial* (see fig.). In these frescoes Amico's calculated opposition of certain postures antedated counterpoised figures in Michelangelo's Sistine Chapel ceiling (Rome, Vatican), and elements of his colour harmony and composition anticipated Raphael's Vatican frescoes. Acknowledged influences from Perugino, however, explain the latter, while the former derives from ancient art. There are other Rome-inspired details in the *Burial*: a view of the Castel Sant'Angelo in the background and a direct quotation from painted decorations in the Domus Aurea.

Amico's next major commission, the frescoes of the chapel of S Agostino in S Frediano, Lucca, includes 'historical' events, notably *St Frediano Changing the Course of the River Serchio*, based on a comparable representation on Trajan's Column in Rome. All display the value of Amico's antiquarian studies. He devoted most of the following two decades to sculpture, although he also produced paintings, including a *Pietà* (1519; Bologna, S Petronio) and the sides of the organ (1531) in S Petronio (discovered hidden beneath its Baroque enclosure and restored in the late 1970s). His work for the façade of S Petronio, documented from 1510 to 1530, includes a bust of a prophet for the main portal (identified as the relief half-figure of *Moses* in the archivolt) and the *Dead Christ in the Arms of Nicodemus* in the lunette of the right portal.

Some indication of Aspertini's contemporary reputation may be gained from his selection in 1529 with another artist to decorate a triumphal arch for the entry into Bologna of Pope Clement VII and Emperor Charles V. The few surviving examples are not sufficient for appreciation of Amico's fame as a monochrome painter of architectural embellishments in which he had free rein to indulge his antiquarian lore. In the pictorial freedom and melting colour of his last works, such as the altarpiece of the *Holy Family* (Paris, St Nicolas-des-Champs), however, it is possible to comprehend Malvasia's likening of Amico to Giorgione.

BIBLIOGRAPHY

DBI; Thieme–Becker

G. Vasari: *Vite* (1550, rev. 2/1568); ed. G. Milanesi (1878–85), v, pp. 77, 179–82
C. C. Malvasia: *Felsina pittrice* (1678); ed. M. Brascaglia (1971), pp. 105–11
R. Longhi: *L'opera completa* (Florence, 1956/*R* 1975), pp. 81–5, 181–8, 238–9
P. P. Bober: *Drawings after the Antique by Amico Aspertini: Sketchbooks in the British Museum*, Stud. Warb. Inst., xxi (London, 1957)
M. Calvesi: *Gli affreschi di Santa Cecilia in Bologna* (Bologna, 1960)
P. Venturoli: 'Amico Aspertini a Gradara', *Stor. A.*, 1–4 (1969), pp. 417–32 [bibliog. on youthful works]
Ric. Stor. A., xvii (1982) [articles by G. Romano, M. Tazartes, P. Venturoli]
G. Schweikhart: *Der Codex Wolfegg: Zeichnungen nach der Antike von Amico Aspertini*, Stud. Warb. Inst., xxxviii (London, 1986)

Amico Aspertini: *Burial of SS Valerian and Tiburtius* (1505–6), fresco, oratory of S Cecilia, S Giacomo Maggiore, Bologna

M. Faetti: 'New Drawing by Amico Aspertini', *Master Drgs*, xxix (1991), pp. 145–72

M. Iodice: 'Integrazioni al regesto di Amico Aspertini: Vicende pubbliche e familiari de un grande pittore', *Schede Umanistiche*, i (1994), pp. 95–110

M. Faietti and A. Nesselrath: 'Bizar piu che reverso de medaglia: Un codex avec grotesques, monstres et ornements du jeune Amico Aspertini', *Rev. A.*, cviii (1995), pp. 44–88

M. Faietti and D. Scagliatti Kelescian: *Amico Aspertini* (Modena, 1995)

K. Brugnara: 'Recent Drawing Acquisitions at the J. Paul Getty Museum', *Drawing*, xix/3 (Winter/Spring 1998), pp. 99–100

PHYLLIS PRAY BOBER

Assisi, Tiberio (Ranieri di Diotallevi) d' (*b* Assisi, ?1460–70; *d* Assisi, before Oct 1524). Italian painter. He possibly received his early training from L'Ingegno [Andrea Alovigi d'Assisi] (*c.* 1470–1516). It is very probable that Tiberio subsequently joined the shop of Pinturicchio and accompanied him to Rome to work in S Maria del Popolo (1485–9) and on the Borgia apartments in the Vatican Palace (1492–*c.* 1495). In 1492–3 Tiberio was paid by the Comune of Assisi for various works, and in 1495 he was employed in Perugia Cathedral.

At the beginning of the 16th century, Tiberio was active in Assisi and Perugia. In 1510 he painted the Augusti family chapel in S Francesco, Montefalco, and during the next few years he worked at the convent of S Martino, Trevi. Subsequent documents record his intensive activity in Umbria up to 1524, when he painted several coats of arms for the Comune of Assisi, a commission for which payment was made to his heirs in October of that year. Despite the apparently high regard in which he was held (a document of 1504 described him as a 'sublime and almost divine painter'), Tiberio d'Assisi is now considered to be an extremely weak artist. Lacking originality, he was satisfied, throughout his career, with reproducing models borrowed from the repertory of Perugino.

BIBLIOGRAPHY

Thieme–Becker

U. Gnoli: 'Documenti inediti sui pittori perugini', *Boll. A.*, ix (1915), p. 312

——: *Pittori e miniatori nell'Umbria* (Spoleto, 1923/*R* Foligno, 1980), pp. 328–31

P. Scarpellini and F. F. Mancini, eds: *Pittura in Umbria tra il 1480 e il 1540* (Milan, 1984), p. 206

G. Briganti, ed.: *La pittura in Italia: Il cinquecento*, ii (Milan, 1988), pp. 851–2

GENNARO TOSCANO

Atri, Andrea Matteo III, Duca d'. *See* ACQUAVIVA D'ARAGONA, ANDREA MATTEO III.

Attavanti, Attavante [Vante di Gabriello di Vante Attavanti] (*b* Castelfiorentino, 1452; *d* Florence, 1520–25). Italian illuminator. He has been praised by art historians since his own times, although many of his autograph works were incorrectly assigned to his workshop. New attributions, supported by archival material, have made it possible to reconstruct his oeuvre and life more accurately. He worked for celebrated patrons and collaborated with the most important illuminators and painters of Florence: Francesco di Antonio del Chierico, the Master of the Hamilton Xenophon, the brothers Gherardo and Monte di Giovanni di Miniato del Foro and Domenico Ghirlandaio, and documents indicate contacts also with Leonardo da Vinci. Attavanti probably trained with del Chierico in 1471–2, while working on the Antiphonary for Florence Cathedral (Florence, Bib. Medicea–Laurenziana, MS. Edili 148). Among the work of late 15th-century illuminators, that of Attavanti is distinguished by his citations from the Antique, his ideas derived from Netherlandish and Florentine panel painting and his illustration of philosophical themes. Recurrent motifs include frontispieces with entablatures on columns, copies of sarcophagi as altar frontals, cameos, allegorical figures within medals and richly dressed figures isolated in framed medallions or symmetrically grouped.

Attavanti's individual style emerged as early as 1473 in his work on a manuscript in collaboration with Ghirlandaio, who signed the work (Rome, Vatican, Bib. Apostolica, MS. Ross. 1193). The latter's influence on Attavanti can be seen clearly in the scenic illustrations and in some of the initials in the Bible made for the Duke of Urbino, Federigo II da Montefeltro (1477–8; Rome, Vatican, Bib. Apostolica, MSS Urb. lat. 1–2), for example the miniatures of *Pentecost* (fol. 283*r*) and the *Martyrdom of the Seven Maccabee Brothers* (fol. 174*v*) in the second volume, which contain landscape backgrounds and views of contemporary Florentine palazzi. In the borders the inclusion of jewels among naturalistic floral motifs and the figures depicted beside a window opening on to a landscape are reminiscent of Ghirlandaio's work. In 1483 Attavanti signed and dated a Missal made for Thomas James, Bishop of Dol (Lyon, Bib. Mun.; detached *Crucifixion*, Le Havre, Mus. B.-A.). This work especially shows Attavanti's attention to antique objects, often represented with a precision that shows his consummate skill in copying from life: for example the della Valle–Medici Sarcophagus (Florence, Uffizi) and topographical depictions of the Castel Sant'Angelo, the Pantheon and St Peter's, Rome.

For Matthias Corvinus, King of Hungary (*reg* 1458–90), Attavanti produced a considerable number of signed works, including numerous non-liturgical books (all Modena, Bib. Estense) and a Missal (Brussels, Bib. Royale Albert 1er, MS. 9008), dated 1485 on the frontispiece (fol. 8*v*; see fig.) and 1487 on the miniature of the *Last Judgement* (fol. 206*r*). In these works there are clear references to the works of Ghirlandaio, Botticelli, Verrocchio and Leonardo, as in the representations of the *Baptism* and *Last Supper* in the Brussels Missal (fol. 205*v*) and the single leaf of the Missal of the Bishop of Dol. After the King's death, most of the codices were acquired by the Medici. A Breviary of 1487, still in progress in 1492 (Rome, Vatican, Bib. Apostolica, MS. Urb. lat. 112), includes archaeological

Attavante Attavanti: frontispiece miniature to a Missal, 1485 (Brussels, Bibliothèque Royale Albert ler, MS. 9008, fol. 8*v*)

references (e.g. *Neptune*, fol. 7*r*). This was followed by a copy of the work of Nicholas of Lyra, illuminated between 1494 and 1497 for Manuel I (*reg* 1495–1521), King of Portugal (Lisbon, Arquiv. N.), to which Gherardo and Monte del Foro also contributed. In this work Attavanti integrated archaeological motifs into images of monastic life: in the incipit to the First Epistle of St Paul to the Corinthians there are compositions of arms, shield and helmet in Classical style and sequences of pairs of *Amazons*. In a series of incipits with scenes of *St Jerome in his Study*, Attavanti provided variations on the theme, which are sometimes directly inspired by Netherlandish models (e.g. Jan van Eyck) and Florentine art (e.g. Ghirlandaio). They present a vast repertory of private Florentine *studioli* of the period, with acute observation of daily life. In his works for the Medici, Attavanti sometimes aimed at economy in his settings, taking great care with the representation of interiors. Particularly noteworthy are the pages of the Hours of Laudomia de' Medici (1502; London, BL, Yates Thompson MS. 30), on which Giovanni Boccardi, Mariano del Buono di Jacopo and Stefano Lunetti (a pupil of del Monte) also collaborated. In the *Ginesio* translated from the Latin of Marsilio Ficino (Florence, Bib. Medicea–Laurenziana, MS. 82.15) there are portraits from life with lighting effects reminiscent of Leonardo. From 1505 to 1514 Attavanti collaborated on the antiphonaries for Florence Cathedral (all Florence, Bib. Medicea–Lauren-

ziana and Mus. Opera Duomo). Later documentation is scarce. The recognition of his hand in a *Cerimoniale dei Vescovi* (ex-Spitzer col.), which is dated 1520, has caused the presumed date of his death to be changed from 1517 to between 1520 and 1525, when he is mentioned as deceased.

BIBLIOGRAPHY

G. Milanesi: *Nuove indagini con documenti inediti per servire alla storia della miniatura italiana* (Florence, 1850), pp. 161–352

M. Levi D'Ancona: *Miniatura e miniatori a Firenze dal XIV al XVI secolo* (Florence, 1962), pp. 88, 254–9, 296, 350–52

A. Garzelli: *La bibbia di Federico da Montefeltro* (Rome, 1977)

——: *Miniatura fiorentina del rinascimento, 1440–1525: Un primo censimento*, 2 vols (Florence, 1985), pp. 217–45

The Painted Page: Italian Renaissance Book Illumination, 1450–1550 (exh. cat., ed. J. J. G. Alexander; London, RA, 1994)

PATRIZIA FERRETTI

Auria, d'. Italian family of sculptors.

(1) Giovan Domenico d'Auria (*fl* Naples, 1541; *d* before March 1573). He trained with Annibale Caccavello in the workshop of Giovanni Marigliano and, with Caccavello, became Marigliano's assistant. After leaving the workshop, the two embarked on a lifelong partnership that was a model of cooperation for later sculptors. In 1541 d'Auria was paid for work on the Fontana dell'Olmo (destr.), Naples, commissioned from Marigliano by the Viceroy of Naples, Pedro de Toledo, and between 1544 and 1545 he is mentioned in connection with payments made to Marigliano for the tombs of members of the Sanseverino di Saponara family in SS Severino e Sossio, Naples. In 1547, with Caccavello, he worked on the tomb of *Nicola Antonio Caracciolo*, Marchese di Vico, in S Giovanni a Carbonara, Naples, probably executing the statue of the deceased.

The first independent work of d'Auria and Caccavello is the bas-relief with the *Virgin and Child in Glory with Souls in Purgatory* (Capua, Mus. Prov. Campano), commissioned in June 1550 by Bishop Luca Rinaldo for S Caterina, Capua. Mainly executed by d'Auria, the serenity and solemn classicism of the work derive from Marigliano. In addition to independent works, such as the bas-relief depicting the *Conversion of St Paul* (sometimes attributed to Caccavello) for the Poderico Chapel, S Maria delle Grazie a Caponapoli, Naples, d'Auria collaborated with his partner between 1553 and 1557 on a bas-relief (untraced) depicting the *Deposition*, for the Carlino Chapel in S Maria la Nova, Naples, and, from 1557, on the prestigious sculptural group for the di Somma Chapel, S Giovanni a Carbonara, Naples. In 1557, working mainly on his own, he executed the tomb of *Hans Walter von Hiernheim* in S Giacomo degli Spagnoli, Naples. Between 1560 and 1562, again with Caccavello, he worked on the Fontana Quattro al Molo (named after the four figures of rivers that adorned the fountain) formerly on the wharf at Naples (removed to Spain, 1670). From 1563, payments made to the two sculptors by the poet Bernardino Rota are documented. In 1569 d'Auria began work on his most important commission, the poet's tomb in the Rota family chapel at S Domenico Maggiore, Naples. In the same year he received payment for the tomb of *Traiano Spinelli*, Prince of Scalea, in S Caterina a Formiello, a work that was probably later completed by Salvatore Caccavello and

Giovan Domenico's son, (3) Geronimo d'Auria. On 16 March 1573 a payment is recorded from Fabrizio Brancaccio to the heirs of the sculptor.

(2) Giovan Tomasso d'Auria (*fl* Naples, *c.* 1550–1600). His exact relationship to (1) Giovan Domenico d'Auria is unknown. He probably trained in the workshop of Giovanni Marigliano since he appears as a witness in the contracts for the Sanseverino di Saponara tombs in SS Severino e Sossio, Naples, and he is also recorded in payments registered in the *Diario* of Annibale Caccavello. In 1566 he collaborated with Giovan Domenico on the restoration of the Fontana della Selleria, Naples, while in 1573 he created a number of decorative elements for the Santini Altar in S Domenico Maggiore, Naples, and a white marble door for the palazzo of Marino Caracciolo. In the same year he carved the base of the statue of *Marcello Caracciolo*, Conte di Biccari, in the Carraciolo di Vico Chapel, S Giovanni a Carbonara.

(3) Geronimo d'Auria (*fl* Naples, 1573–1619). Son of (1) Giovan Domenico d'Auria. After the death of his father, in 1573 he worked on the completion of the tomb of *Fabrizio Brancaccio* in S Maria delle Grazie a Caponapoli, Naples. In June of that year he received payment for a statue of *Marcello Caracciolo*, Conte di Biccari, for the Caracciolo di Vico Chapel, S Giovanni a Carbonara, Naples, and in September he received further payment, from Bernardino Rota, for works carried out by his father in the Rota Chapel, S Domenico Maggiore, Naples. From 1576 Geronimo received a series of important commissions for the church of the Annunziata, Naples. Apart from the lavabo in the sacristy, based on the designs of the Neapolitan painter Giovan Bernardo Lama and executed in collaboration with Salvatore Caccavello, other surviving works by Geronimo include the wooden panels with scenes from the Old and New Testaments on the sacristy benches, again executed in collaboration with Caccavello and, in the decorative sections, with the Neapolitan carver Nunzio Ferraro. The work, one of the greatest achievements of Neapolitan sculptural art from the second half of the 16th century, reveals considerable variations in both style and quality. The scenes created by Geronimo often contain echoes of the classicizing academicism of his father and rarely achieve the extraordinarily dramatic quality of his more gifted colleague Salvatore Caccavello, to whom several figures of *Prophets* have been attributed. After this early phase Geronimo later developed a style that was markedly influenced by the Counter-Reformation and by the presence in Naples of the Florentine sculptors Michelangelo Naccherino (1550–1622) and Pietro Bernini (1562–1629), who dominated Neapolitan sculpture during the 16th and 17th centuries.

DBI BIBLIOGRAPHY

B. de Dominici: *Vite* (1742–5), ii, pp. 166–76

G. B. D'Addosio: *Origine, vicende storiche e progresso della R. S. Casa dell'Annunziata di Napoli* (Naples, 1883)

G. Filangieri di Satriano: *Documenti per la storia, le arti e le industrie delle provincie napoletane* (Naples, 1883–91), iv, pp. 355–62

G. Ceci: 'Per la biografia degli artisti del XVI e XVII secolo: Nuovi documenti II scultori', *Napoli Nob.*, xv (1906), pp. 133–9

G. B. D'Addosio: 'Documenti inediti di artisti napoletani dei secoli XVI e XVII dalle polizze dei banchi', *Archv Stor. Prov. Napoletane*, xxxviii (1913), pp. 585–90

O. Morisani: *Saggi sulla scultura napoletana del cinquecento* (Naples, 1941)

Sculture lignee nella Campania (exh. cat., ed. F. Bologna and R. Causa; Naples, Pal. Reale, 1950)

M. Rotili: *L'arte del cinquecento nel regno di Napoli* (Naples, 1972)

F. Abbate: 'Il sodalizio tra Annibale Caccavello e Gian Domenico d'Auria e un'ipotesi per Salvatore Caccavello', *An. Scu. Norm. Sup. Pisa*, n. s., 2, vi (1976), pp. 129–45

G. Toscano: 'La bottega di Benvenuto Tortelli e l'arte del legno a Napoli nella seconda metà del cinquecento', *An. Fac. Lett. & Filos. U. Napoli*, n. s., xiv (1983–4), pp. 229–69

For further bibliography *see* CACCAVELLO, ANNIBALE.

GENNARO TOSCANO

Avelli, Francesco Xanto (*b* Rovigo, ?1486–7; *d* ?1542). Italian maiolica painter. More is known about Avelli than any other maiolica painter because of his many signed works and the autobiographical details included in his sonnets in honour of Francesco Maria I della Rovere, Duke of Urbino. Avelli considered himself to be not only an artist but also a poet and courtier. His intellectual abilities set him apart from his colleagues, even if as a painter he was not the most talented. He seems never to have directed his own workshop, but he is known to have worked in Urbino from 1530, the year of his first unequivocally signed and dated plate; some pieces from the 1520s signed F.R. and F.L.R. may also be ascribed to him. His familiarity with Classical and contemporary literature is evident in his choice of secular and religious subjects, taken from such authors as Virgil and Ovid, Ariosto and Petrarch (e.g. plate, 1531; London, BM). He also depicted contemporary events, sometimes in allegorical form, for example the Sack of Rome (1527). His style is characterized by a strong sense of line, an interest in anatomy and architecture and the use of a broad and usually harmonious palette that sometimes included iridescent lustres. His imaginative compositions frequently relied on a montage technique in which he juxtaposed figures drawn from prints, occasionally borrowing an entire scene from one graphic source. Several of his commissions were for important services, among them one for a member of the Pucci family of Florence.

BIBLIOGRAPHY

Atti del convegno internazionale di studi, Francesco Xanto Avelli da Rovigo: Rovigo, 1980

F. Cioci: *Xanto e il Duca di Urbino* (Milan, 1987)

T. Wilson: *Ceramic Art of the Italian Renaissance* (London, 1987)

B. Talvacchia: 'Professional Advancement and the Use of the Erotic in the Art of Francesco Xanto', *16th C. J.*, xxv/1 (Spring 1994), pp. 121–53

WENDY M. WATSON

Averlino, Antonio di Pietro. *See* FILARETE.

Aviano, Girolamo di Bartolomeo Strazzarolo da. *See under* GIROLAMO DA TREVISO (i).

B

Bacchiacca [Bachiacca; Ubertini, Francesco] (*b* Florence, 1 March 1494; *d* Florence, 1557). Italian painter and draughtsman. He belonged to the generation of Pontormo and Rosso Fiorentino, but, with a conservative disposition and limited talents, he never regarded style as a vehicle for creative expression as much as they did. His contribution to the evolution of Mannerism is, nevertheless, the central issue for critics of his work. Although he studied with Perugino and was heavily influenced by him, he did not demonstrate an exclusive allegiance to any one style even in his earliest works. In *Adam and Eve with their Children* (*c.* 1517; Philadelphia, PA, Mus. A.), for example, the figures of the parents are borrowed from Perugino's *Apollo and Marsyas* (Paris, Louvre), but the landscape comes from the print of *Adam and Eve* (1504) by Albrecht Dürer (1471–1528) and the children are taken from *God Appearing to Noah*, engraved by Marcantonio Raimondi. The curious transformation of Perugino's Apollo into Eve is telling evidence of Bacchiacca's unfamiliarity with the nude, a shortcoming he never overcame. Throughout his career, he effected a compromise between conservative and progressive elements. His reference to a northern print in *Adam and Eve* suggests an acquaintance with advanced practices then current in Florence. Perhaps the most lasting legacy of his training with Perugino was the habit of relating form and content only superficially. While other artists of his generation employed a variety of sources to achieve a creative synthesis, Bacchiacca's eclecticism remained merely a pragmatic solution to the problem of providing a wide variety of characters for his scenes.

Borrowings from northern prints also appear in Bacchiacca's scenes from the *Life of Joseph* (*c.* 1517; London, N.G.; Rome, Gal. Borghese; see colour pl. 1, V1) painted for the house of Pierfrancesco Borgherini in Florence. The primary influence behind his effort to achieve a dramatic style in these panels was, however, Franciabigio's recently completed *Marriage of the Virgin* (1513; Florence, SS Annunziata). Quotations from northern prints became pervasive only in his paintings for Giovan Maria Benintendi, such as the *Baptism of Christ* (*c.* 1523; Berlin, Gemäldegal.). In this work he employed references to Lucas van Leyden (1494–1533), but with a symmetry and clarity that diminishes the eccentricities of Lucas's compositions. The particular charm of Bacchiacca's mature works is in their unusual combinations of colour. In the *Baptism* the lowering sky is composed of hues that range from lavender to orange. While passages of this sort may indicate Mannerist influence, the closest precedent is again

in the work of Franciabigio and then in that of Andrea del Sarto. Vasari noted that del Sarto assisted Bacchiacca in matters of art, and here his instruction may have proved particularly beneficial.

The difficult, cerebral style of Pontormo and other early Mannerists seems to have eluded Bacchiacca's understanding, and it had little influence on his work before the early 1530s. The *Christ before Caiaphas* (Florence, Uffizi) from this time reflects the nocturnal effects and discomfiting architectural perspectives of Pontormo. This tendency reached its culmination towards the middle of the decade in the crowded surface and ambiguous, subjective space of *Moses Striking the Rock* (Edinburgh, N.G.; see fig.). By the early 1540s, when he painted the *Gathering of Manna* (Washington, DC, N.G.A.), Bacchiacca had returned to a more conventional classicism. In this landscape the space is more precisely measured, the costumes are less fanciful and the figures more reliant on Italian models, particularly those found in Michelangelo's work. In Bacchiacca's later

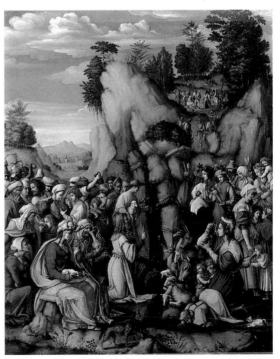

Bacchiacca: *Moses Striking the Rock*, oil and gold on panel, 1.00×0.80 m, *c.* 1535 (Edinburgh, National Gallery of Scotland)

works, such as the series of tapestries of the *Labours of the Months* (*c.* 1552–3; Florence, Uffizi), for which he was responsible for the cartoons, the implications of this development are fully manifest. The influence of Agnolo Bronzino is suggested in the substantial proportions and extreme regularity of the features of the peasants depicted in these compositions.

One of Bacchiacca's most characteristic works is his decoration (possibly as early as 1541) of a small study in the Palazzo Vecchio, Florence (*in situ*). Painted in oil directly on the ceiling vault, it incorporates genre scenes, Classical motifs and accurate renderings of fish and birds in an illusionistic arbour. The interior suggests rustic environs, yet the view from the window is of the heart of urban Florence. This surprising contrast, the shape of the room and the detailed depiction of flora and fauna foreshadow many of the features of the more celebrated *studiolo* of Francesco I de' Medici in the same building.

Since his anti-classical inclinations remained superficial, Bacchiacca was able to achieve a reconciliation of sorts with the second generation of Mannerists represented by Bronzino, Vasari and Francesco Salviati. Salviati in particular proved a rich source for the motifs Bacchiacca used in his grotesque tapestries (*c.* 1546–53; Florence, Uffizi) and the decoration of the terrace (*c.* 1554) of the Palazzo Vecchio, Florence. Bacchiacca's compositions, however, never bear the heavy load of learned allusions and conceits favoured by Vasari and his contemporaries. Nor did he consider drawing an integral part of the creative process. His drawings are often tightly finished and they exhibit little inclination to experiment. The designs for the Borgherini commission (e.g. Florence, Uffizi, no. 350F) are typical in this respect. (On these grounds the series of landscapes attributed to him by Marcucci can be excluded from his oeuvre.) Even in his most pastoral passages, as in the *Labours of the Months*, Bacchiacca relied on stock types, which hardly suggests he consulted nature for either his settings or his figures.

Patronage played a more important part in Bacchiacca's career than in those of his more famed contemporaries. They surpassed him in technical facility, but his eclecticism was of a similar extent, and this has confused scholars. Perhaps identifying him as a domestic Mannerist, an appellation that acknowledges the impact made by his commissioners, would help to clarify his position in the Florentine context. Viewed without the expectations accorded to a Pontormo or a Bronzino, there is much in Bacchiacca's work to enchant and delight.

BIBLIOGRAPHY

Thieme–Becker: 'Ubertini, Francesco'

G. Vasari: *Vite* (1550, rev. 2/1568); ed. G. Milanesi (1878–85), vi, pp. 454–6

M. Tinti: *Il Bachiacca* (Florence, 1925)

H. Friedmann: 'Bacchiacca's *Gathering of Manna* in the National Gallery', *Gaz. B.-A.*, 6th ser., xxxii (1947), pp. 151–8

L. Marcucci: 'Contribuito al Bacchiacca', *Boll. A.*, xlii/4 (1958), pp. 26–39

H. Merritt: *Bacchiacca Studies* (diss., Princeton U., NJ, 1958)

——: 'Francesco Ubertini Called il Bacchiacca', *Baltimore Mus. A. News Q.*, xxiv/2 (1961), pp. 19–34

G. Rosenthal: 'Bacchiacca and his Friends', *Baltimore Mus. A. News Q.*, xxiv/3 (1961), pp. 20–21

F. Abbate: 'L'attività giovanile del Bacchiacca', *Paragone*, xvi/189 (1965), pp. 26–49

L. Nikolenko: *Francesco Ubertini Called il Bacchiacca* (New York, 1966)

S. J. Freedberg: *Painting of the High Renaissance in Rome and Florence*, i (New York, 1972), pp. 500–03

F. R. Shapley: *Paintings from the Samuel H. Kress Collection: Italian Schools, XVI–XVIII Century* (New York, 1973)

C. D. Colbert: *Bacchiacca in the Context of Florentine Art* (diss., Cambridge, MA, Harvard U., 1978)

A. Braham: 'The Bed of Pierfrancesco Borgherini', *Burl. Mag.*, cxxi (1979), pp. 754–65

C. Adelson: 'Bacchiacca, Salviati and the Decoration of the Sala dell'Udienza in Palazzo Vecchio', *Le arti del principato mediceo* (exh. cat., Florence, Pal. Vecchio, 1980), pp. 141–200

CHARLES COLBERT

Baccio d'Agnolo [Bartolommeo d'Agnolo di Donato Baglione] (*b* Florence, 19 May 1462; *d* Florence, 6 May 1543). Italian wood-carver and architect. He was the son of a hosier turned woodworker, and he trained as a wood-carver, becoming the foremost Florentine craftsman of his day for picture frames, intarsia inlay, ceilings and all manner of wooden ornament. In his architectural work he helped import the forms of Bramante and Raphael from Rome to Florence.

1. WOOD-CARVING. Baccio's first important work in wood was the panelling (*c.* 1485–90) for the high altar chapel of S Maria Novella, and between 1490 and 1530 he produced frames for many painted altarpieces in Florence, collaborating with such artists as Filippino Lippi, Perugino, Domenico Puligo, Andrea del Sarto and Pontormo. He seems subsequently to have acted as an entrepreneur, negotiating commissions for painters and designing elaborate settings for their work, including the celebrated bedroom (from 1515) of Pierfrancesco Borgherini in the Palazzo Borgherini (now Roselli del Turco), Florence, with its paintings by del Sarto, Pontormo, Francesco Granacci and Bacchiacca, and the antechamber (from 1523) of Giovan Maria Benintendi, with panels by del Sarto, Franciabigio, Bacchiacca and Pontormo.

In 1496 Baccio began a long association with the fabric and decoration of the Palazzo della Signoria (now Palazzo Vecchio), Florence, when he collaborated on the ceiling of the great hall of council (later Salone del Cinquecento). He gradually assumed a dominant role, becoming head of the office of works in 1499, a position he occupied with only a few interruptions until the end of his life. There, as well as furnishing woodwork of all kinds, the frame for Filippino Lippi's altarpiece (1501–2) and the apartment (from 1502) of Piero Soderini, he designed (according to Vasari) the door in the Sala de' Dugento (*c.* 1506–12) with trophies and republican inscription, as well as the chapel of the Priors and the rearranged great hall (1512–13) for the newly returned Medici regime. His last works in the Palazzo della Signoria were carved and painted coats of arms (1531 and 1534) for the first Medici duke, Alessandro.

In 1506 Baccio was elected head of the cathedral works in Florence, with Cronaca, Giuliano da Sangallo and Antonio da Sangallo (i). In 1508 he began construction of the arcaded gallery (*ballatoio*) between the drum and the dome of the cathedral. Denounced by Michelangelo as a 'crickets' cage' for its small scale, it has a main order derived from Cronaca's S Salvatore al Monte (completed 1504), with old-fashioned columnar balustrades above. Work was suspended after only one of the eight faces had

been completed. Other projects for the cathedral works included the restoration of the choir (1519) and (according to Vasari) the pavement, as well as the organ of S Maria Novella (now in Rueil-Malmaison, SS Pierre et Paul) with its gallery (London, V&A; both plausibly dated 1507–11 by Cecchi). His last important work in wood was the choir (1532–3) of S Agostino in Perugia.

2. ARCHITECTURE. Architecture was a natural development for Baccio, and it became increasingly dominant in his career. His models and designs encompassed whole churches in Florence (e.g. S Marco, 1512, unexecuted; S Giuseppe, 1518, reduced and modified in execution), bell-towers (e.g. Santo Spirito, from *c.* 1511, completed 1567–71; S Miniato, 1518) and chapels (including Bernardo Bini's oratory of S Sebastiano from *c.* 1521, a convincing modern attribution by Cecchi). More significant, however, was the series of palazzi he designed for some of the most prominent patrician families in Florence. His sober early palazzi (e.g. Palazzo Borgherini–Rosselli del Turco, *c.* 1506–15; Palazzo Taddei–Ginori, from *c.* 1513) are derived from Cronaca's Palazzo Guadagni: they have plastered façades with drafted masonry quoins and arched rusticated window and door surrounds. In the case of the Sertini (1515–20) and Lanfredini (1515) palazzi, the plaster was decorated in *sgraffito* designed by Andrea Feltrini. The richly carved capitals and fireplaces in the palazzi interiors were furnished by such stone-carvers as Benedetto da Rovezzano. In addition to his palazzi, Baccio also designed villas for the Borgherini and Bartolini Salimbeni families at Bellosguardo (*c.* 1518) and Brancoli respectively. However, with the exception of these and a trip to Foligno in 1514 to advise on the cathedral there, his architectural work was limited to Florence. Other projects included work for Giovanni Bartolini at his Casino (1511–25) in the Via Gualfonda, Florence, an urban villa in the Roman style, with loggias, gardens, fountains and statuary (by Sansovino), and a collaboration with Antonio da Sangallo (i) on the Loggia dei Servi with terraced houses behind (from 1516) on the west side of Piazza SS Annunziata.

Vasari stated that Baccio went to Rome to study, a trip now dated to 1510–11, and this seems to have been an important stylistic influence. Certainly his architecture after *c.* 1515 shows a greater, though still limited, awareness of antique and High Renaissance detail. From this date (see Cecchi) he adopted almost exclusively a particular form of Doric order, the capitals embellished with rosettes and egg-and-dart; early examples are in the Palazzo Taddei–Ginori and the Villa Borgherini; these are both close to Giuliano da Sangallo's order in the Cappella Gondi (from 1504) in S Maria Novella. Baccio later adopted a more elaborate type with a high neck and fluted collar, for example at the Palazzo Bartolini–Salimbeni (1520–23; see fig.), designed for Giovanni Bartolini (1472–1544). This was Baccio's most ambitious building, and here Baccio and his son Giuliano Baglione (1491–1555) also furnished much of the woodwork, including the fine ceiling in the Sala Grande. The plan of the building is narrow and deep, the three-sided loggia of the courtyard occupying much of the ground-floor space. The layout, as in contemporary Roman palazzi, emphasizes such semi-public spaces, including in this case the ample *ricetto* (vestibule) on the first

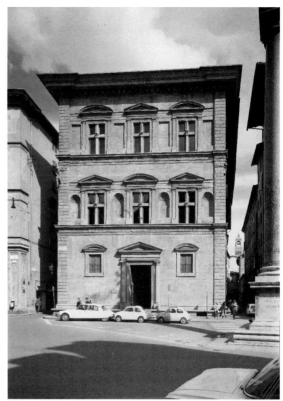

Baccio d'Agnolo: Palazzo Bartolini–Salimbeni, Florence, 1520–23

floor between the stairs and the Sala Grande, the latter occupying the whole width of the façade. An airy inward-facing terrace runs around the top of the building at the level of the exterior frieze and cornice.

The façade uses Roman motifs in a Florentine three-storey arrangement with rusticated quoin pilasters. The massive *all'antica* cornice, a literal copy of that of the Temple of Serapis in Rome, gives the impression, as Vasari observed, of an over-large hat. The fenestration derives partly from Raphael's design, in Florence, for the Palazzo Pandolfini (*c.* 1516; with pedimented tabernacle windows on the top floor linked by sunken panels and continuous horizontal mouldings), while the *piano nobile* is enlivened by shell niches between the windows in a manner recalling Raphael's Palazzo Branconio dell'Aquila (destr.) in Rome. Peculiar to Baccio are the curious superimposed colonnettes attached to the window mullions on the front and the rusticated rectangular window-frames on the side façade.

In the late 1520s Baccio's personal output dwindled, and he increasingly made way for his sons. One of his last documented architectural projects was the continuation of the Palazzo Strozzi (1531–6) and the designs for its piazza, his only securely attributable drawings (Florence, Uffizi). Despite his earlier collaboration on the first wooden model (destr.) for the façade of S Lorenzo (1516–17), Baccio's architecture never moved in the direction of Michelangelo's Mannerism, which became so dominant in Florence.

UNPUBLISHED SOURCES
Florence, Uffizi [designs for Palazzo Strozzi and its piazza, 1531–6]

BIBLIOGRAPHY
DBI; Thieme–Becker
G. Vasari: *Vite* (1550, rev. 2/1568); ed. G. Milanesi (1878–85)
C. Botto: 'L'edificazione della chiesa di S Spirito in Firenze', *Riv. A.*, n.s.
 1, xiv (1932), pp. 37–40
G. Pampaloni: *Palazzo Strozzi* (Florence, 1963/*R* 1982)
L. Ginori Lisci: *I palazzi di Firenze nella storia e nell'arte*, 2 vols (Florence,
 1972)
L. Bartolini Salimbeni: 'Una fabbrica fiorentina di Baccio d'Agnolo: Le
 vicende costruttive del Palazzo Bartolini Salimbeni attraverso i docu-
 menti d'archivio', *Palladio*, xxvii (1978), pp. 7–28
V. Varrani: 'Il modello della chiesa di S Giuseppe', *Ant. Viva*, xxi/1
 (1982), pp. 30–36
C. Elam: 'Piazza Strozzi: Two Drawings by Baccio d'Agnolo and the
 Problems of a Private Renaissance Square', *I Tatti Studies. Essays in the
 Renaissance*, i (1985), pp. 105–35
E. Andreatta and F. Quinterio: 'La loggia dei Servi in Piazza SS Annunziata
 a Firenze', *Riv. A.*, xl/4 (1990), pp. 169–331
A. Cecchi: 'Percorso di Baccio d'Agnolo legnaiuolo e architetto fiorentino
 dagli esordi al Palazzo Borgherini. 1', *Ant. Viva*, xxix/i (1990), pp. 31–
 46
——: 'Percorso di Baccio d'Agnolo legnaiuolo e architetto fiorentino dal
 Ballatoio di Santa Maria del Fiore alle ultime opere', *Ant. Viva*, xxix/
 2–3 (1990), pp. 40–55
G. Dalli Regoli: '"Iam securis ad radicem arborum posita est": La scure di
 San Giovanni, un attributo e un indizio', *Artista* (1994), pp. 66–73
R. Corazzi: *Il rilievo per il recupero: La gabbia dei grilli di S Maria del Fiore
 a Firenze: Loggia di Baccio d'Agnolo sulla cupola di Santa Maria del Fiore*
 (Florence, 1995)
J. Nelson: 'The High Altarpiece of SS Annunziata in Florence: History,
 Form and Function', *Burl. Mag.*, cxxxiv (Feb 1997), pp. 84–91
 CAROLINE ELAM

Baccio della Porta. *See* BARTOLOMMEO, FRA.

Badile. Italian family of artists. At least six generations of artists, mostly painters, were active in Verona. The earliest recorded member of the family is the painter Niccolò Badile (*d* before 1393); the exact relationship between him and Antonio Badile I (*d* before 1409), the father of (1) Giovanni Badile, is unclear. Giovanni had at least three sons who were painters: Antonio Badile II (*fl* 1424–1507), Bartolomeo Badile I (*fl* 1445–51) and Pietro Paolo Badile II (*fl* 1446–76). One of Bartolomeo I's sons became an artist, Antonio Badile III (*fl* 1492), as did three of Antonio II's sons: Bartolomeo Badile II (*fl* 1464–1544), Girolamo Badile (*fl* 1465–1531) and Francesco Badile I (*fl* 1476–1544). Francesco Badile II (*fl* 1505–57) was the son of Bartolomeo II, and (2) Antonio Badile IV was the son of Girolamo. Among the last recorded artists in the family was the 16th-century painter Angelo Badile, presumably either the son or nephew of Antonio IV.

BIBLIOGRAPHY
V. Cavazzoca Mazzanti: 'I pittori Badile', *Madonna Verona*, vi/1 (1912),
 pp. 11–84

(1) Giovanni Badile [Johannes Baili] (*b* Verona, *c.* 1379; *d* before 26 June 1451). Painter and ?draughtsman. He is mentioned frequently in Veronese records from 1409 until 1448, when he made his will. Although he apparently enjoyed local esteem and was well connected with important Veronese families, Vasari did not mention him. Giovanni's only certain works are the frescoes of 1443–4 illustrating scenes from the *Lives of SS Filippo Benizzi and Jerome* in the Guantieri Chapel, S Maria della Scala, Verona, and the signed altarpiece depicting the *Virgin and Child with Saints* (Verona, Castelvecchio), which is clearly inspired by Michelino da Besozzo. The Guantieri Chapel frescoes (documented by an act of 1443) show not only the influence of Michelino da Besozzo and Stefano da Verona on Badile, but also his admiration for Pisanello, four of whose medals are reproduced on an enlarged scale between the windows. The polyptych of the *Virgin and Child with a Donor and Saints*, known as the dell'Aquila Altarpiece because of the presence of an eagle on the coat of arms (Verona, Castelvecchio), is signed *Johes Baili*. Although the signature was questioned by many scholars in the early 20th century, the altarpiece, which comes from the church of S Pietro Martire, Verona, is stylistically extremely close to the frescoes in S Maria della Scala.

A signed fresco of the *Virgin and Child with SS John the Baptist and Anthony and a Donor* was recorded in S Pietro Martire, Verona (mentioned by Cignaroli, 1749), but has disappeared. Around these few sure works, an even larger number of paintings and frescoes has been attributed to Badile; many of these were formerly given to Stefano da Verona (better appreciated in the literature) or were catalogued as anonymous works of the Veronese school. Among the pictures, a *Virgin and Child with a Donor* from S Bartolomeo della Levata, a *Virgin Enthroned with SS George, Martin, Michael and Gabriel* dated 1428, a *Virgin and Child* (all Verona, Castelvecchio), as well as a *St Christopher* (Vicenza, Pin. Palazzo Chiericati), have been attributed to Giovanni Badile. Doubts persist about the Fracanzani Altarpiece (1428; Verona, Castelvecchio), which some scholars (see Guzzo in *AKL*) consider belongs to an archaizing phase in the painter's career. As the frescoes in the Guantieri chapel clearly demonstrate, Giovanni Badile was a skilled fresco painter, to whom several fresco decorations in Veronese churches have recently been reattributed: the *Virgin and Child between SS Bartholomew and Anthony* (S Giovanni in Valle), the *Virgin and Child with St James Presenting a Donor* (S Anastasia, Salerni chapel) and *St Peter Martyr with Angels* (S Anastasia) show close links with Badile's accepted works. More problematic are the *Virgin and Child with Angels* (Illasi parish church, province of Verona), formerly attributed to Stefano da Verona, and especially the fresco cycle of the *Story of St Valentine* (Bussolengo parish church), which combines the fantasy of the Late Gothic style with the tentative attempts at realism made by artists such as Altichiero. Some drawings, such as the *Betrayal of Christ* and the *Presentation of the Virgin in the Temple* (both Munich, Staatl. Graph. Samml.), are attributed to Badile; the latter is inscribed in a 16th-century hand *di M*[aestr]*o Joane primo Badille*. This inscription, as well as similar ones that appear on a group of pen-and-ink portrait drawings (e.g. Chicago, IL, A. Inst.; ex-I. Woodner priv. col., New York; others sold Sotheby's, London, 21 Oct 1963), has been identified as in the hand on Antonio Badile II, who *c.* 1500 gathered a group of his family's drawings into a notebook and inscribed each with the particular artist's name (see Degenhart and Schmitt).

BIBLIOGRAPHY
AKL; *DBI*; Meissner; Thieme–Becker
L. Venturi: *Le origini della pittura veneziana* (Venice, 1907), pp. 72, 75
G. Gerola: 'Questioni storiche artistiche veronesi, Johannes Baili', *Ma-
 donna Verona*, ii/24 (1908), pp. 166–73
E. Sandberg-Vavalà: *La pittura veronese del trecento e del quattrocento*
 (Verona, 1926), pp. 309–21

Da Altichiero a Pisanello (exh. cat. by L. Magagnato, Verona, Castelvecchio, 1958), pp. 54–7

Italienische Zeichnungen der Frührenaissance (exh. cat. by B. Degenhart, Munich, Staat. Graph. Samml., 1966), pp. 58–9

B. Degenhart and A. Schmitt: *Corpus der italienischen Zeichnungen, 1300–1450* (Berlin, 1968–), i, p. 50, nos 3–4

M. T. Cuppini: 'L'arte gotica a Verona nei secoli XIV e XV', *Verona e il suo territorio*, III/ii (Verona, 1969), pp. 364–6

M. Azzi Visentini: 'Giovanni Badile', *Maestri della pittura veronese* (Verona, 1974), pp. 75–82

Museo ritrovato: Restauri, acquisizioni, donazioni, 1984–1986, (exh. cat. by M. Lucco, Vicenza, Basilica Palladiano, 1986), pp. 113–14

Arte in Lombardia tra gotico e rinascimento, (exh. cat. by M. Boskovits, Milan, Pal. Reale, 1988), pp. 32–3, 268–9, figs 24 and 28

M. Cova: *La cappella Guantieri in S Maria della Scala a Verona* (Verona, 1989)

E. Moench: 'Verona', *La pittura veneta: Il quattrocento*, i (Milan, 1990), pp. 175–6

M. Cova: *Giovanni Badile in S Maria della Scala a Verona* (Verona, 1991)

F. M. Aliberti Gaudioso, ed.: *Pisanello: I luoghi del gotico internazionale nel Veneto* (Milan, 1996)

E. Moench: 'Verona: Gli anni venti del quattrocento', *Pisanello* (exh. cat., ed. P. Marini; Verona, Musei Civ., 1996), pp. 68–70

ESTHER MOENCH

(2) (Giovanni) Antonio Badile IV (*b* Verona, 1518; *d* Verona, 1560). Painter, great-grandson of (1) Giovanni Badile. His father was the engraver Girolamo Badile and his uncle the painter Francesco Badile. Antonio IV is best known as a teacher of Paolo Veronese. He was probably trained by his uncle and may also have received training from Gian Francesco Caroto. Compared to other artists active in Verona during the 1540s, Badile was among the more conservative painters.

The *Virgin and Child with Angels* (ex-Uva Secca; Verona, Seminary) is signed with Badile's monogram, and 1539 is inscribed in Roman numerals on the step of the throne. The Virgin's pencilled brows, slender nose and tiny mouth resemble those of female faces in Caroto's *Resurrection of Lazarus* (1531; Verona, Pal. Vescovile). The figural types anticipate those of Badile's richer and better-known signed altarpieces in S Nazaro (1543) and from Santo Spirito (1544; Verona, Castelvecchio, 244). The S Nazaro altarpiece is better preserved and shows Badile's strength as a colourist and his skill in rendering rich fabrics and embroidery. His study of Titian's *Assumption* (Verona Cathedral) and Moretto da Brescia's altarpieces in Verona of 1540 and 1541 is evident, particularly in the motif of the nimbus with cherubim. In the Cappella degli Avanzi (Verona, S Bernardino) is another signed and dated work by Antonio IV, the *Resurrection of Lazarus* (1546), in which the artist attempted an ambitious biblical scene and utilized repoussoir figures, perhaps learnt from Mannerist contemporaries. Two unsigned works that are associated with each other as Badile's are the *Presentation in the Temple* (Turin, Gal. Sabauda, 567) and the *Architectural View* (Philadelphia, PA, Johnson priv. col., 729). The latter has recently been assigned to Agostino Tassi (see Chiarini) but not convincingly. Both works feature ambitious architectural settings and relatively small figures, including such exotica as dogs and dwarfs. Another painting that has been incorrectly assigned to Badile is the large *Christ among the Doctors* (Princeton U., NJ; on loan to Verona, S Procolo). Numerous portraits were produced by Badile, including at least two that bear his signature: *Frate Salvo Avanzi* (1540; Vicenza, Mus. Civ. A. & Stor.) and the

Portrait of a Man (1552; Verona, Delaini priv. col.). Another portrait generally accepted as his is the fine *Unknown Lady* (Madrid, Prado).

BIBLIOGRAPHY

R. Borghini: *Il riposo* (Venice, 1584; Milan, 3 vols, 1807), iii, p. 129

C. Ridolfi: *Maraviglie* (1648); ed. D. von Hadeln (1914–24), i, pp. 297–8

B. dal Pozzo: *Le vite de' pittori, scultori e architetti veronesi* (Verona, 1718), i, pp. 59–60, 78

R. Brenzoni: 'Un dipinto sconosciuto di Antonio Badile', *Atti Accad. Agric., Sci. & Lett. Verona*, iii (1926), pp. 1–5

B. Berenson: *Italian Pictures of the Renaissance* (Oxford, 1932), p. 129

L. dall'Angola: 'Quando naque Antonio Badile', *Nova Hist.*, xvii–xviii (1952), p. 742

John G. Johnson Collection Catalogue of Italian Paintings (Philadelphia, 1966), pp. 6, 220

B. Berenson: *Central and North Italian Schools* (1968), i, p. 23

M. Azzi Visentini: 'Un'opera inedita di Antonio Badile', *A. Ven.*, xxviii (1974), p. 245

D. Gisolfi Pechukas: 'Veronese's Masters: Antonio Badile and Giovanni Caroto', *The Youth of Veronese* (diss., U. Chicago, 1976), pp. 112–64

M. Chiarini: 'Agostino Tassi: Some New Attributions', *Burl. Mag.*, cxxi (1979), pp. 613–18

D. Gisolfi Pechukas: 'Two Oil Sketches and the Youth of Veronese', *A. Bull.*, lxiv (1982), pp. 395–413

Veronese e Verona (exh. cat. by S. Marinelli and others, Verona, 1988), nos 31–9, pp. 131–44

D. Gisolfi: '"L'anno veronesiano" and Some Questions about Early Veronese and his Circle', *A. Ven.*, xliii (1989–90), pp. 30–42 (31–2)

D. Gisolfi 'The School of Verona in American Collections', *Artibus & Hist.*, xxxiv (1996), pp. 177–91

DIANA GISOLFI

Baglione, Bartolommeo d'Agnolo di Donato. *See* BACCIO D'AGNOLO.

Bagnacavallo [Ramenghi, Bartolomeo] (*b* Bagnacavallo, 1484; *d* Bologna, 1542). Italian painter. In Bologna by 1503, he probably entered the prosperous workshop of Francesco Francia, whose style is apparent in the early half-length *Holy Family* (Urbino, Pal. Ducale). By the second decade of the 16th century, Bagnacavallo was well established in Bologna, although most of the paintings recorded in this period remain untraced. The earliest securely dated work is the *Crucifixion* painted in 1522 for the chapel of the Boncompagni family in S Pietro, Bologna (*in situ*). According to Vasari, Bagnacavallo travelled to Rome during Raphael's sojourn there (1508–20) accompanied by Biagio Pupini, with whom he collaborated on the frescoes (destr.) for S Pietro in Vincoli, Rome. The nature of Bagnacavallo's relationship to Raphael is uncertain, but the common assertion that he worked as an assistant on the decoration of the Vatican Logge is unsubstantiated. That Raphael was the dominant influence on Bagnacavallo's mature career is, however, evident from such paintings as the *Virgin and Child Enthroned with SS Roch and Sebastian* (Bologna, S Maria della Purificazione and S Domenico della Mascarella) and the *Virgin and Child in Glory with Saints* (Bologna, S Donnini). Bagnacavallo's son, Giovanni Battista Ramenghi (1521–1601), was also a painter, whose work was influenced by the schools of Fontainebleau and Bologna.

BIBLIOGRAPHY

G. Vasari: *Vite* (1550, rev. 2/1568); ed. G. Milanesi (1878–85)

A. Venturi: *Storia* (1901–40), IX/iv, pp. 354–65

C. Bernardini: 'Bartolomeo Ramenghi detto il Bagnacavallo', *Pittura bolognese del '500*, i, ed. V. Fortunati Pietrantonio (Bologna, 1986), pp. 117ff

Bagnaia, Villa Lante. Italian estate near Viterbo, *c.* 65 km north-east of Rome. It was built for Cardinal Gianfrancesco Gambara, Bishop of Viterbo, from *c.* 1568, and the design of the whole estate, comprising small twin palaces (*palazzine,* called casinos in the 17th century), a formal garden and a park, is attributed to Jacopo Vignola. The garden and the first *palazzina* were mostly completed by 1578 under the direction of the local architect and hydraulic engineer Tommaso Ghinucci. Carlo Maderno (1555/6–1629) built the second *palazzina* for Cardinal Alessandro Peretti Montalto between 1611 and 1613. The two buildings were planned from the start and have identical exteriors. Their cubical form, with hipped roof and central belvedere, resembles those of the Villa Vecchia at Frascati and the hunting-lodge at Caprarola, both designed by Vignola. Rural and urban architectural traditions were united in the design of the buildings. The simple block with central projection recalls the towers and dovecotes typical of the countryside, while the exterior stone revetment and classical articulation is reminiscent of urban palaces. The floor plan is a variation on a common tripartite plan with a long central space. In the second *palazzina* the common rural plan is rejected in favour of fewer and larger rooms.

The fresco decoration of the Palazzina Gambara includes topographical views, astrological scenes after Hyginus, northern-inspired landscapes, friezes with elaborate decorative frameworks typical of late Roman Mannerism, and, in the compartments, scenes from the *Lives of SS Peter and Lawrence.* Raffaellino da Reggio has been identified as the principal painter of the main decorative scheme, carried out *c.* 1574–6. A date of 1578–9 has been suggested for Antonio Tempesta's landscapes. (The later decoration of the Palazzina Montalto (1613–15) was also executed by two workshops, those of Cavaliere d'Arpino (1568–1640) and of Agostino Tassi (*c.* 1580–1644), which represent the stylistic alternatives of conservative academicism and avant-garde realism.)

The garden of the Villa Lante is terraced, with a design based on circles and squares and architectural *all'antica* fountains along the central axis; the park has unaltered terrain, with long avenues but no geometric design, and for the most part low fountains enclosed by greenery. The two *palazzine* are set within the garden overlooking the first terrace and are fully integrated into its design (*see* GARDEN, fig. 1): their square form is repeated throughout the garden in plantings, ponds and architecture; and they are the most prominent of several pairs of structures along the terraced slope.

Influenced by Bramante's Cortile del Belvedere at the Vatican and Michelangelo's double staircase on the Capitoline Hill, Rome, the design of the garden and fountains also evokes their ancient Roman antecedents with Classical references throughout. Contemporaries marvelled at the beauty of this garden and commented in particular on the inventive water displays—the work of Tommaso Ghinucci—and on the pure spring water brought in by aqueduct. Garden and park complement each other in design, planting and ornamentation, and in the themes that these convey. The wooded park with its fountains of Pegasus, Bacchus, acorns and both mythical and real animals evokes an earthly paradise of the remote Golden Age. In contrast, the garden, with its ordered planting and architectural fountains, suggests the contemporary or present age, in which the Classical past and the ancient identity of Bagnaia, referring to its salubrious waters, are renewed.

The Villa Lante, which belonged to the Lante della Rovere family for three centuries, is in excellent condition. The most significant change from the original plan is in the garden parterre, the principal fountain of which was added by Cardinal Montalto. In place of the original 12 squares planted with herbs and fruit trees, French arabesque designs of box were planted in the 18th century.

BIBLIOGRAPHY

L. Salerno: 'A Study of Some Frescoes in the Villa Lante Bagnaia: Cavaliere d'Arpino, Tassi, Gentileschi and their Assistants', *Connoisseur,* cxlvi (1960), pp. 157–62

A. Cantoni, F. Fariello, M. V. Brugnoli and G. Briganti: *La Villa Lante di Bagnaia* (Milan, 1961)

D. R. Coffin: 'Some Aspects of the Villa Lante at Bagnaia', *Arte in Europa: Scritti di storia dell'arte in onore di Edoardo Arslan* (Milan, 1966), pp. 569–75

H. Hibbard: *Carlo Maderno and Roman Architecture, 1580–1630* (University Park, PA, 1971)

C. Lazzaro-Bruno: *The Villa Lante at Bagnaia* (diss., Princeton U., 1974)

D. R. Coffin: *The Villa in the Life of Renaissance Rome* (Princeton, 1979)

F. Sricchia Santoro: 'Antonio Tempesta fra Stradano e Matteo Bril', *Relations artistiques entre les Pays-Bas et l'Italie à la Renaissance: Etudes dédiées à Suzanne Sulzberger* (Brussels, 1980), pp. 227–37

C. Lazzaro: 'Rustic Country House to Refined Farmhouse: The Evolution and Migration of an Architectural Form', *J. Soc. Archit. Historians,* xliv (1985), pp. 346–67

——: *The Italian Renaissance Garden: From the Conventions of Planting, Design, and Ornament to the Grand Gardens of Sixteenth-century Central Italy* (New Haven, 1990)

P. Cavazzini: 'New Documents for Cardinal Alessandro Peretti-Montalto's Frescoes at Bagnaia', *Burl. Mag.,* cxxxv/1082 (1993), pp. 316–27

CLAUDIA LAZZARO

Baili, Johannes. *See* BADILE (1).

Balbas [Balbo], **Alessandro** (*b* Ferrara, *c.* 1530; *d* Ferrara, 10 Sept 1604). Italian architect. He was active in Ferrara from *c.* 1559. In 1574 he entered the service of Alfonso II d'Este, Duke of Ferrara, working at first on the reconstruction of the castle, the Castello Estense. He became Head of Ducal Munitions in 1582 and was employed on a varied range of projects. Working in a style inspired by Andrea Palladio and Jacopo Vignola, Balbas often collaborated with other architects, including Pirro Ligorio, with whom he designed the tower of Rigobello (1587), and Giovanni Battista Aleotti, with whom he worked on several schemes. Balbas's plans were frequently modifications to existing buildings. For example, he redesigned the façade of the Este family's old Palazzo del Paradiso when it was remodelled in 1586 to serve as the seat of the University of Ferrara; he also helped to build the tower there (completed by Aleotti, 1610). His other works include the imposing portal added to the façade of the Palazzo Contughi (attrib. Girolamo da Carpi), the fourth order of the campanile of Ferrara Cathedral (collab. Aleotti, 1579–94), and the porch of the tempietto of the Preziosissimo Sangue in S Maria in Vado (1590). Balbas's most complex and articulated construction is the Santuario della Ghiara (1596) in Reggio Emilia, the plan for which was selected in a competition. This well-proportioned project, a domed building on a Greek-cross plan influenced by St Peter's, Rome, was realized after Balbas's death; it was completed

by Francesco Pacchioni (*fl* 1588–1626) in 1609 except for the campanile, which remained unfinished.

BIBLIOGRAPHY

DBI

M. A. Guarini: *Compendio historico dell'origine, accrescimento e prerogative delle chiese e luoghi pii della città e diocesi di Ferrara* (Ferrara, 1621)

G. Padovani: 'Alessandro Balbi', *Boll. Stat. Com. Ferrara* (Winter 1931)

——: *Architetti ferraresi* (Rovigo, 1955), pp. 109–14

L. Spezzaferro and J. Bentini: *L'impresa di Alfonso II* (Bologna, 1987)

ALESSANDRA FRABETTI

Baldassare da Urbino. *See* LANCI, BALDASSARE.

Baldassare d'Este [Baldassare da Reggio] (*b* Reggio Emilia, *bapt* 20 June 1432; *d* after 29 Jan 1506). Italian painter and medallist. He was brought up as the adopted son of a certain Giovanni Bonayti, but a document of 1489 records him as the (illegitimate) son of Niccolò III d'Este, Marquis of Ferrara. In most documents, however, he is called 'Baldassare da Reggio'.

Baldassare is first recorded as a painter in a document of 16 January 1461 from the Visconti Sforza ducal registers in Milan, in which he is given permission to travel for two years. This suggests that he had been working for the Dukes of Milan for some time. In 1466, he was paid two lire for an altarpiece for the Ospedale Maggiore in Milan. In February 1469 he painted portraits of *Galeazzo Maria Sforza, Duke of Milan* and his wife, *Bona of Savoy*, in the ducal castle at Pavia.

In late September 1469, with high recommendations from Galeazzo Maria (in a letter of 5 June 1469), Baldassare arrived in Ferrara. There he painted portraits of *Borso d'Este, Duke of Ferrara* and members of the ducal court. His only signed and dated works are three medals of 1472 depicting *Ercole I d'Este*, the newly invested Duke of Ferrara. In 1472, he evaluated Cosimo Tura's work in the Este chapel at Belriguardo. In 1473, Baldassare painted two portraits of *Ercole I*, to be sent to the Duke's betrothed, Eleanora of Aragon, and was commissioned to 'touch up' the frescoes, including 36 portraits of Borso, of the Salone dei Mesi in the Palazzo Schifanoia in Ferrara. A portrait of *Borso d'Este* (Milan, Castello Sforzesco) has been attributed to Baldassare, because of its similarity to the portraits in the Schifanoia frescoes. Other works that have also been attributed to him include the portrait of *Tito Vespaziano Strozzi* (Venice, Fond. Cini) and an unidentified female figure in the much damaged fresco of the *Stigmatization of St Francis* (Ferrara, Pin. N.).

Baldassare is also documented as painting a series of frescoes depicting the *Life of St Ambrose* in the Ruffini Chapel of S Domenico, Ferrara, and an altarpiece with the *Twelve Apostles* for the nuns of Mortara in S Maria delle Grazie. Baruffaldi recorded two further altarpieces by him: one, of *St Thomas Aquinas and St Catherine*, in S Maria degli Angeli, Ferrara, and the other in S Maria della Consolazione, Ferrara, the predella of which illustrated scenes from the *Life of Abbot Carlo Lalli*. All these works, with the possible exception of the *Twelve Apostles*, which Venturi (1887) suggested might be the large panel of the *Death of the Virgin* (Milan, Bib. Ambrosiana), are untraced.

Longhi (1934) created the persona of 'Vicino da Ferrara', under which name he grouped a number of paintings stylistically close to Ercole de' Roberti's early work. In 1940, Longhi suggested that this group of works might be by Baldassare d'Este; later (1940–55) he identified 'Vicino da Ferrara' with Baldassare (all these articles are reprinted in Longhi, 1975). It is hard to accept, however, most of these rather awkward paintings as the work of an artist famed for his skill as a portrait painter, and so the question of the extent of Baldassare's oeuvre must remain open.

In 1476 Baldassare was appointed Capitano of the Porta Castello in Reggio Emilia; though apparently not well suited to the post, he continued in it for at least 30 years.

BIBLIOGRAPHY

Thieme–Becker

G. Baruffaldi: *Vite de' pittori e scultori ferraresi* (Ferrara, 1844–6)

G. Veronese: *Vita di Baldassare d'Este* (Venice, 1852)

A. Venturi: 'Beiträge zur Geschichte der ferraresischen Kunst', *Jb. Kön.-Preuss. Kstsamml.*, viii (1887), pp. 71–88

——: 'Di chi fosse figlio il pittore Baldassare d'Este', *Archv Stor. A.*, i (1888), pp. 42–3

E. Motta: 'Il pittore Baldassare da Reggio (1461–71)', *Archv Stor. Lombardo*, xvi (1889), pp. 403–9; xvii (1890), pp. 999–1000

H. Cook: 'Baldassare d'Este', *Burl. Mag.*, xix (1911), pp. 228–33

W. Gräff: 'Ein Familienbildnis des Estense in der alten Pinacothek', *Münchn. Jb. Bild. Kst*, vii (1912), pp. 207–24

F. Malaguzzi-Valeri: 'Baldassare da Reggio e il suo ritratto del Duca Borso d'Este', *Rass. A.*, xii (1912), pp. 101–13

P. Pecchiai: 'Pittori del quattrocento che lavorarono per conto dell'Ospedale Maggiore di Milano', *Archv Stor. Lombardo*, vi (1919), pp. 490–93

M. Dobronsky: 'Baldassare d'Este', *Old Master Drgs*, vii (1932–3), p. 41

M. Meiss: 'Five Ferrarese Panels, 2: An Altarpiece by "Vicino"', *Burl. Mag.*, xciii (1951), p. 70

M. Calvesi: 'Nuovi affreschi ferraresi dell'Oratorio della Concezione', *Boll. A.*, n. s. 4, xliii (1958), pp. 141–56

F. R. Shapley: 'Baldassare d'Este and a Portrait of Francesco II Gonzaga', *Studies in the History of Art Dedicated to William E. Suida on his Eightieth Birthday* (London, 1959), pp. 124–8

E. Ruhmer: 'Baldassare d'Este: Ein Problem und seine wahrscheinlichste Lösung', *Pantheon*, xxv (1967), pp. 250–58

R. Longhi: *Officina ferrarese* (Florence, 1975)

V. Nironi: 'Una medaglia del reggiano Baldassare d'Estense nell'Archivio di Stato di Reggio Emilia', *Atti & Mem. RR. Deput. Stor. Patria Prov. Moden. & Parm.*, n. s. 1, xii (1977–8), pp. 89–94

D. Benati: 'Per il problema di "Vicino da Ferrara" (alias Baldassare d'Este)', *Paragone*, xxxiii (1982), pp. 3–26

KRISTEN LIPPINCOTT

Baldini, Baccio (*b* ?1436; ? *bur* Florence, 12 Dec 1487). Italian goldsmith and engraver. According to Vasari, he was a follower of Maso Finiguerra and engraved a series of 19 prints after designs by Botticelli. These illustrate an edition of Dante's *Divine Comedy* published in 1481. A group of prints in the same Fine Manner style is attributed to Baldini. His designs incorporate figures and motifs derived from Botticelli, Piero Pollaiuolo and also German printmakers, such as the Master E.S. (*fl c.* 1450–67) and Martin Schongauer (*c.* 1435/50–91), but particularly from Finiguerra. Baldini's Fine Manner style developed from Finiguerra's niello print technique; the rendering of spatial recession in the large *Judgement Hall of Pilate* (435×598 mm) suggests it was designed by Finiguerra. With the other prints, however, it shares the decorative quality and emphasis on pattern characteristic of Baldini.

Prints attributed to Baldini include the series of *Planets* (*c.* 1465), based on northern woodcuts, and a series of *Prophets and Sibyls* (early 1470s), as adapted from the characters in a mystery play; the exotic costumes reflect those worn in festival processions. Antonio Bettini's *Monte sancto di Dio* (1477) includes three illustrations by Baldini.

Finally, a number of circular prints showing scenes of love or hunting, intended to decorate the lids of gift boxes, are in Baldini's late style, which is more delicate in its modelling. These are called 'Otto Prints' after a Hamburg collector.

Baldini was probably also a niellist and draughtsman; the niello pax *Descent from the Cross* (*c.* 1470–75; Rome, Vatican, Mus. Sacro Bib. Apostolica) is one example that has been attributed to him. The unfinished *Florentine Picture Chronicle* (*c.* 1470–75; London, BM), a book of pen-and-ink drawings, was originally attributed to Finiguerra but is now thought to be by Baldini and his shop. It was loosely based on the traditional scheme of a universal history, presented through figures selected from the Bible, ancient history and mythology. The technique and style of the drawings is closely related to the prints attributed to Baldini.

BIBLIOGRAPHY

G. Vasari: *Vite* (1550, rev. 2/1568); ed. G. Milanesi (1878–85), iii, pp. 317–18; v, p. 396

A. M. Hind: *Early Italian Engraving*, i (London, 1938), pp. 1, 9, 30, 76, 99, 135, 311

J. G. Philips: *Early Florentine Designers and Engravers*, xxi (Cambridge, MA, 1955), pp. 42, 56, 80–81, 86–7

Early Italian Engravings from the National Gallery of Art (exh. cat. by J. A. Levenson, K. Oberhuber and J. L. Sheehan, Washington, DC, N.G.A., 1973), pp. 13–39

P. Dreyer: 'Botticelli's Series of Engravings "of 1481"', *Prt Q.*, i (1984), pp. 111–15

D. Landau and P. Parshall: *The Renaissance Print, 1470–1550* (Yale, 1994), pp. 67, 72–3, 76, 83, 89, 108, 162, 387, n. 26

L. Whitaker: 'Maso Finiguerra, Baccio Baldini and *The Florentine Picture Chronicle*', *Florentine Drawing at the Time of Lorenzo the Magnificent. Papers from a Colloquium Held at the Villa Spelman: Florence, 1992*, pp. 181–96

M. J. Zucker: *Early Italian Masters, Part I (1997)*, 24 [XIII/i] of *The Illustrated Bartsch*, ed. W. Strauss (New York, 1978–)

L. Whitaker: 'Maso Finiguerra and Early Florentine Printmaking', *Drawing 1400–1600: Invention and Innovation* (Aldershot, 1998), pp. 45–71

LUCY WHITAKER

Baldovinetti, Alesso [Alessio] (*b* Florence, ?14 Oct 1425; *d* Florence, 29 Aug 1499). Italian painter. Belonging to the generation of Florentine painters that followed Domenico Veneziano and Fra Filippo Lippi, he worked all his life in Florence and kept a notebook of commissions. He experimented with painting techniques, sometimes with unfortunate results. His sense of pattern and decoration was particularly suited to the design of mosaic, intarsia and stained glass.

1. LIFE AND WORK.

(i) Before 1460. Baldovinetti was the eldest son of a wealthy merchant and rejected the prospect of a career in commerce to become an artist. In 1448 he enrolled in the Compagnia di S Luca and the following year began to keep a notebook of commissions and transactions. His earliest attributable works, *c.* 1449, form part of the decoration of the doors of the silver cupboard (Florence, Mus. S Marco) formerly in the chapel of the Annunciation in SS Annunziata, Florence, for which Baldovinetti painted the *Marriage at Cana*, the *Baptism* and the *Transfiguration*; their traditional iconography was possibly determined by Fra Angelico, whose workshop was responsible for the commission. It is likely that Baldovinetti was recommended as an assistant for the project by his probable

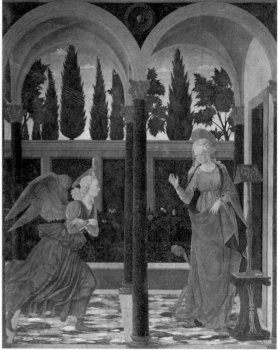

1. Alesso Baldovinetti: *Annunciation*, tempera on panel, 1.67×1.37 m, *c.* 1457 (Florence, Galleria degli Uffizi)

master, Domenico Veneziano, whose influence is evident in the scenes. Certain characteristics employed by Baldovinetti throughout his career are already present: only characters essential to a clear presentation of the event are included, and their scale relates to their status rather than to the laws of perspective. While the illusions of space and volume are conveyed through the composition and lighting, they are subordinate to the artist's interest in linear pattern, which finds expression, for example, in draperies and in formalized rocks and foliage.

Baldovinetti's first recorded independent work was an altarpiece of *St Ansano* (1450; untraced) for the Pieve di Borgo S Lorenzo in the Mugello. In 1453 he designed and executed a mosaic in the soffit of the north door of the Florentine Baptistery and provided the mosaics framing Ghiberti's east doors in 1455. He may have learnt the art of mosaic from Andrea del Castagno. Baldovinetti helped Castagno in the execution of a *Last Judgement* (untraced) painted on canvas in 1454 for Ludovico Gonzaga.

The altarpiece of the *Virgin and Child with Saints* (*c.* 1454; Florence, Uffizi; see colour pl. 1, V2) was painted for the Medici Villa at Caffagiolo and illustrates the continued impact of Castagno's work. The composition is based on Fra Angelico's *Virgin and Child Enthroned with Saints* (Florence, Mus. S Marco; *see* ANGELICO, FRA, fig. 4), painted for the high altar of S Marco. The rich colours, the decorative gold curtain behind the figures and the patterns in the drapery folds and foliage reflect both the artist's delight in detail observed directly from life and the taste of his patron, Piero de' Medici. Baldovinetti did not allow the detail to detract from the visual coherence of the painting. The scale of the figures, however, is still

hierarchical, for although SS Francis and Dominic kneel in the foreground, they are smaller than the standing saints flanking the even larger Virgin and Child.

The tall slender columns of the loggia in the *Annunciation* (*c.* 1457; Florence, Uffizi; see fig. 1), painted for S Giorgio sulla Costa, echo the proportions of the elongated Virgin. Little concession was made to the underlying structure of the body; outlines and shapes are emphasized rather than volume. Baldovinetti's decorative sense found full expression in the marbling of the panels of the garden wall, the colourful paving and the plants. These latter are similar to those in the charming plant designs he made *c.* 1458 for Luca della Robbia's terracotta frame around the tomb of *Bishop Federighi* for S Pancrazio, Florence (now Florence, Santa Trìnita).

(ii) 1460 and after. In May 1460 Baldovinetti was commissioned to fresco a *Nativity* (completed 1462) in the atrium of SS Annunziata, Florence. While he adhered to the conventional grouping of the main characters on a rocky plateau, he introduced a landscape at the left so as to include the Annunciation to the Shepherds and to provide a panorama based on his first-hand observation of the Arno Valley. It is possible that an awareness of Netherlandish painting encouraged his interest in landscape; his interpretation of naturalistic detail, however, was controlled by a strong decorative instinct.

In 1461 Baldovinetti worked on the frescoes in the choir of S Egidio, Florence, having agreed to complete the programme of scenes from the *Life of the Virgin* (destr.) begun by Domenico Veneziano and continued by Castagno. Baldovinetti probably painted the *Marriage of the Virgin*. The hospital of S Egidio provided his materials and keep, but the artist gave his services 'for the love of God'. He used a modified version of the composition of the SS Annunziata *Nativity* for a design for an intarsia for the north sacristy (Sagrestia delle Messe) in Florence Cathedral, commissioned in 1463 by Giuliano da Maiano, who executed the intarsias. Baldovinetti provided several other designs of his own and coloured the heads in intarsia scenes designed by Maso Finiguerra. In the same year he collaborated with Giuliano da Maiano on other works, including designs for bed heads.

A small panel of a *Virgin and Child* (Paris, Louvre), attributed to Baldovinetti, probably also dates from the 1460s. The winding river in the valley behind the figures echoes the folds of the Virgin's robe and the swaddling band held by the Child. The subtle tones of the landscape and the slight blurring of detail reveal the artist's increased sensitivity to the effects of light. In his *Portrait of a Lady in Yellow* (*c.* 1465; London, N.G.; see fig. 2) Baldovinetti painted clusters of tiny dots to suggest highlights, which enliven the surface and enhance the profile offset against a background of brilliant azure.

In January 1465 Baldovinetti undertook to provide a design for the figure of Dante for a painting for Florence Cathedral to be painted by Domenico di Michelino. This was done, and in June 1465 the artist joined Benozzo Gozzoli and Neri di Bicci to evaluate Domenico di Michelino's painting of *Dante Explaining to Florence the 'Divine Comedy'* in Florence Cathedral (*in situ*). He was also arbitrator in the evaluation of a painting by Neri di

Bicci in 1466. For the Cardinal of Portugal's chapel in S Miniato al Monte, Florence, Baldovinetti frescoed the lunettes and spandrels with the Four Evangelists, the Church Fathers and prophets (begun 1466) and painted the panel of the *Annunciation* on the wall of the Cardinal's throne. The visual unity of the chapel is reinforced by the complementary use of colours in Baldovinetti's figures in the vault and Luca della Robbia's terracotta tiles and tondi, and the real stone panelling and that painted by Baldovinetti in the *Annunciation*.

In 1466 Baldovinetti provided a cartoon for the stained-glass window of the Gianfigliazzi Chapel in Santa Trìnita, Florence, which he had also coloured. For the same chapel he painted the high altarpiece of the *Trinity* (Florence, Accad.), and in 1471 he was commissioned to decorate the chapel with frescoes over a period of seven years. Only the four patriarchs in the vault, *Noah*, *Abraham*, *Moses* and *David*, survive. There were scenes from the Old Testament on the walls, including the *Sacrifice of Isaac*, *Moses on Mt Sinai* and the *Death of Abel*, and Vasari recorded the inclusion of contemporary portraits in scenes of the *Queen of Sheba*. The frescoes were evaluated in 1497 by Benozzo Gozzoli, Fra Filippo Lippi, Perugino and Cosimo Rosselli.

In 1467 Baldovinetti was paid for a mosaic of *St John the Baptist* for the south door of Pisa Cathedral (*in situ*).

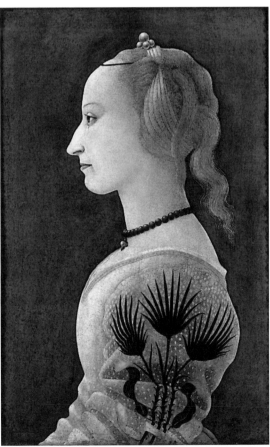

2. Alesso Baldovinetti: *Portrait of a Lady in Yellow*, tempera and oil on panel, 629×406 mm, *c.* 1465 (London, National Gallery)

During the last 18 years of his life, he was increasingly engaged on the restoration of mosaics. He repaired the mosaic on the façade of S Miniato al Monte, Florence, in 1481 and in 1483 was made curator for life of the Florentine Baptistery mosaics. He was also a member of the committee elected in 1491 to discuss plans for the façade of Florence Cathedral. He had no pupils, but he may have passed on the art of mosaic to Domenico Ghirlandaio. His influence persisted in Florentine book illumination, for which his sensitive linear style was well suited.

2. WORKING METHODS AND TECHNIQUE. Baldovinetti's experiments with media have resulted in the deterioration of many of his paintings. The best-preserved works are paintings in tempera on panel such as the scenes for the silver cupboard of SS Annunziata and his altarpiece of the *Trinity*, which he prepared with conventional gesso grounds. He drew on to the gesso in charcoal but also incised many outlines with a sharp tool. He made few changes, therefore, in the course of painting. The fluent and often intricate character of the incised lines indicate the confident handling Baldovinetti developed through his association with the arts of engraving, intarsia, stained glass and mosaic. He described shadow in the same way as printmakers by hatching dark lines over appropriate areas. He also used hatching with light-hued pigments along the edges of drapery folds and defined highlights with minute white dots, as in the *Marriage at Cana* (Florence, Mus. S Marco) and the *Portrait of a Lady in Yellow* (see fig. 2).

The pallor and shallow relief of the heads and hands of Baldovinetti's figures owe their appearance to his break from the traditional practice of representing flesh tones with *terra verde*. He applied facial features and other details in dry pigment with fine brushes once the main areas had been painted. He used both egg and linseed oil to temper pigments as in the landscape behind the *Virgin and Child* (Paris, Louvre).

Vasari recorded the poor condition of the frescoes in Santa Trìnita. Areas of thick incrustation had developed where Baldovinetti, having used *buon fresco* to establish the main elements, had then applied detail in pigment mixed with egg yolk and hot varnish. According to Vasari, Baldovinetti hoped this combination would protect his frescoes from dampness. He had earlier treated his *Nativity* in the manner of a tempera painting rather than a fresco. The sky was applied in *buon fresco*, but, where egg tempera was used in the angels' garments and the Virgin's robes, the colours have flaked off to reveal the underdrawing. Traces of pouncing in some frescoes, for example around the spandrel figures in S Miniato al Monte, indicate that Baldovinetti used cartoons, but no drawings can be attributed firmly to the artist. Baldovinetti's notebooks record his diligence in obtaining pigments of the highest quality and his care over preparation for projects, but his experiments with media failed to meet his aspiration to develop new and improved techniques.

WRITINGS

G. Pierotti, ed.: *Ricordi di Alesso Baldovinetti, pittore fiorentino del secolo XV* (Lucca, 1868)

BIBLIOGRAPHY

DBI; Thieme–Becker

G. Vasari: *Vite* (1550, rev. 2/1568); ed. G. Milanesi (1878–85), vol. iii, pp. 591–9, 601

H. P. Horne: 'A Newly Discovered *Libro di ricordi* of Alesso Baldovinetti', *Burl. Mag.*, ii (1903), pp. 22–32, 167–74, 377–90

R. Fry: 'Portrait of a Young Woman in the National Gallery', *Burl. Mag.*, xviii (1911), pp. 311–12

R. W. Kennedy: *Alesso Baldovinetti: A Critical and Historical Study* (New Haven, 1938)

E. Borsook: *The Mural Painters of Tuscany: From Cimabue to Andrea del Sarto* (London, 1960, rev. Oxford, 2/1980), pp. 105–10

F. Hartt, G. Corti and C. Kennedy: *The Chapel of the Cardinal of Portugal, 1434–1459, at San Miniato in Florence* (Philadelphia, 1964)

B. Degenhart and A. Schmitt: *Corpus der italienischen Zeichnungen, 1300–1450*, I/ii (Berlin, 1968), pp. 516–18

M. Haines: *The Sagrestia delle Messe of the Florentine Cathedral* (Florence, 1983)

AILSA TURNER

Balletta, il. *See* FRANCESCO D'ANTONIO DA VITERBO.

Bambaia [Busti, Agostino] (*b* ?Busto Arsizio, *c.* 1483; *d* Milan, 11 June 1548). Italian sculptor. The earliest documentary information on the artist, an application by Agostino Busti and his brother Polidoro for employment as sculptors in the workshop of Milan Cathedral, dates from 1512, when he was about 30. The reply, though it refers to him as a master, shows that Agostino was not yet well known in Milan, for he was asked to produce a statue to show his skill. The application describes the brothers as 'of Busto', which suggests that they came from Busto Arsizio in Varese. According to Vasari, Agostino was known by the nickname Bambaia (under which name he generally appears in the literature). It is likely that Agostino began his training with Benedetto Briosco, as Vasari referred to his work for the Certoso di Pavia, where Briosco worked for years. Vasari also mentioned that he was 'greatly helped' by Bernardo Zenale.

The first work generally attributed to Bambaia is the funeral monument to the Milanese poet *Lancino Curzio* (marble; Milan, Castello Sforzesco), commissioned in 1513 for S Marco, Milan. Modelled on an antique funeral stele, it has mythological and allegorical figures but no religious references, despite the fact that it was intended for a church. A document of 1515 in the cathedral archives indicates that the sculptor Cristoforo Lombardo, who collaborated with Bambaia on other projects, was called in to complete the monument, though probably only the final details. Bambaia's failure to finish the work may have been due to his absence from Milan in 1514. A sketchbook with this date (Berlin, Kupferstichkab.), attributed to him, contains drawings of Roman friezes and sarcophagi, which suggests that he was in Rome.

In 1515 Bambaia is documented in Milan in a contract with Girolamo della Porta (*d* 1527) and Lombardo for the marble decoration surrounding an image of the Virgin in the church of S Angelo; nothing is known of this work. A document in the Milan state archives gives 1516 as the date of the contract for the funeral monument of *Francesco Orsini*, originally in S María della Scala and subsequently dispersed (Milan, Castello Sforzesco and S Fedele). The most demanding commission undertaken by Bambaia in the early years of his maturity was the monument to the French condottiere *Gaston de Foix* intended for S Marta, Milan. In 1517 he was working on the project with a

number of assistants, but construction was interrupted owing to the difficulties of the French rulers of Milan, who had commissioned the project, and it was left unfinished when they abandoned the city in 1522. There are pieces of the monument in various collections (Milan, Ambrosiana; Turin, Mus. Civ. A. Ant.; London, V&A), but the nucleus, including the effigy, is in the Castello Sforzesco in Milan (see fig.). A drawing in London (V&A) is generally agreed to show the plan of the *Foix* monument, a great free-standing tomb consisting of an architectural structure containing the sarcophagus with the recumbent figure surrounded by Apostles and Virtues. The narrative reliefs may have been designed for the upper part, as in the tomb of *Gian Galeazzo Visconti* by Giovanni Cristoforo Romano (1493–7; Pavia, Mus. Certosa), but the artist also must have known the contemporary tomb of the French king *Louis XII* in Saint-Denis Abbey.

Few works by Bambaia are documented from the 1520s. The tomb of *Gian Marco and Zenone Birago* bore an inscription with the sculptor's name and the date 1522. Vasari saw the marble tomb installed in the Chapel of the Passion in S Francesco Grande, Milan, but it was dismantled when the chapel was destroyed in 1606. Parts are in Isola Bella (Mus. Borromeo), Pavia (Mus. Certosa) and Milan (Ambrosiana and, perhaps, Castello Sforzesco). The sculpture later incorporated in the tomb of the Venetian condottiere *Mercurio Bua* (1562; Treviso, S María Maggiore) must also date from the early 1520s. The three reliefs, five statues of *Virtues* and two small angels (all marble), originally made by Bambaia for an unknown patron, were taken from Pavia by Bua as spoils of war between 1527 and 1528. Perhaps because the monument is incomplete, it does not seem entirely congruent with Bambaia's style of this period. The contract for the tomb of *Giovanni Antonio Bellotti* in S Marta, Milan, which was also dispersed, dates from 1528.

From 1535 Bambaia was regularly mentioned in the records of Milan Cathedral as a sculptor in the workshop, commissioned to carve statues for one of the side doors and to instruct young apprentices. His responsibility for particular statues has not been defined. Works by him in the cathedral include the grandiose marble monument to *Marino Caracciolo* (*d* 1538), perhaps the best work of his later years, the small marble monument to *Canon Giovanni Vimercati* (*d* 1548) and the marble altar of the *Presentation of the Virgin* (commissioned in 1543). He probably only provided the model for the last; he was then an old man and the marble altarpiece at the centre is noticeably different from his style.

It was probably at the beginning of the 1530s that Bambaia produced the monument to an unknown prelate (marble; Milan, S Fedele, ex-S Maria della Scala). From that work there remains the statue of the deceased (which shows signs of collaboration by Lombardo) and probably a tondo with the arms of the Toscani, perhaps the family to which the prelate belonged. One project on which Bambaia certainly worked with Lombardo is the marble tomb of *St Evasio* in Casale Monferrato Cathedral. Some elements were completed by 1536, but when work was interrupted on 22 December 1547 as a new contract was being drawn up, Bambaia had only a few months to live; the tomb was completed in 1564 by the sculptor Ambrogio Volpi (*fl* 1563–80).

BIBLIOGRAPHY

DBI; Thieme–Becker

G. Vasari: *Vite* (1550, rev. 2/1568); ed. G. Milanesi (1878–85), iv, pp. 542–3; vi, pp. 514–15

P. Dreyer and M. Winner: 'Der Meister von 1515 und das Bambaia-Skizzenbuch in Berlin', *Jb. Berlin. Mus.*, vi (1964), pp. 53–94

R. Bossaglia: 'Scultura', *Il Duomo di Milano*, ii (Milan, 1973)

G. Agosti: *Bambaia e il classicismo lombardo* (Turin, 1990)

Il Bambaia: Il monumento di Gaston de Foix, Castello Sforzesco: Un capolavoro acquisito (exh. cat. by M. Garberi, M. T. Fiorio and J. Shell, Milan, Castello Sforzesco, 1990)

M. T. Fiorio: *Bambaia: Catalogo completo delle opere* (Florence, 1990) [full bibliog.]

MARIA TERESA FIORIO

Banco, Nanni di. *See* NANNI DI BANCO.

Bandinelli, Baccio [Brandini, Bartolomeo] (*b* Gaiole in Chianti, 17 Oct 1488; *d* Florence, 7 Feb 1560). Italian sculptor, painter and draughtsman. He was the son of Michelagnolo di Viviano (1459–1528), a prominent Florentine goldsmith who was in the good graces of the Medici and who taught Cellini and Raffaello da Montelupo. Baccio remained loyal to the Medici, despite their being in exile from 1494 to 1513, and this led to a flow of commissions

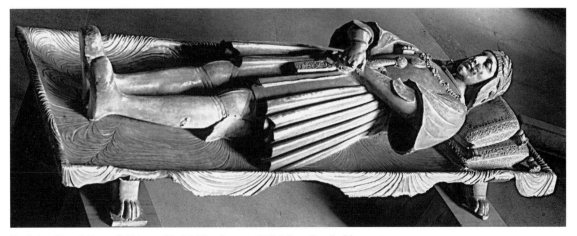

Bambaia: effigy of *Gaston de Foix*, marble, l. 2.15 m, begun *c*. 1517 (Milan, Castello Sforzesco)

after the elections to the papacy of Leo X (Giovanni de' Medici) in 1513 and of Clement VII (Giulio de' Medici) a decade later; after Cosimo de' Medici became Grand Duke of Tuscany in 1537, these increased still further. This political stance made him unpopular with most Florentines, including Michelangelo, who were Republican at heart, and this lay at the root of much of the adverse criticism—not always justified—that greeted Bandinelli's statues.

1. Life and work. 2. Critical reception and posthumous reputation.

1. LIFE AND WORK.

(i) Before c. 1522. (ii) c. 1522–1527. (iii) 1527–c. 1542. (iv) c. 1542–1560.

(i) *Before* c. *1522.* Baccio seems to have had an ambitious and impatient temperament, which led to frequent changes of master and of direction when he was learning his art. Until *c.* 1512 he was set on becoming a painter and so was initially apprenticed to a minor figure, Girolamo del Buda (*b* 1463), subsequently approaching in vain Andrea del Sarto and Rosso Fiorentino to take him on. According to Vasari, Bandinelli made drawings after sculptures by Donatello and Verrocchio, as well as after paintings by Fra Filippo Lippi: many of his drawings, engravings and reliefs reflect this intense study. Baccio also drew assiduously from Michelangelo's cartoon (destr.) for the fresco of the *Battle of Cascina* and became a competent draughtsman. In 1512 he suffered a setback, however, when he failed to complete on time a major commission for a fresco of the *Marriage of the Virgin* in the atrium of SS Annunziata, Florence.

Probably before 1508, he had also worked with the sculptor Giovanni Francesco Rustici and would therefore have been aware of the drawings and sculpture of Leonardo da Vinci, with whom Rustici was then creating the bronze group of *St John the Baptist Preaching* (Florence Cathedral, Baptistery; for illustration *see* RUSTICI, GIOVANNI FRANCESCO). Bandinelli also learnt from them how to model sculpture in wax and clay for casting into bronze: Vasari praised a wax model (*c.* 1 m) of *St Jerome in Penitence* (untraced), which Baccio presented to Giovanni and Giuliano de' Medici when they returned to power in 1513. It was thanks to the latter that Bandinelli was awarded the commission for his first important sculpture: a *St Peter* in marble (1515–17), for the crossing of Florence Cathedral, which was inspired by Donatello's statue of *St Mark* on Orsanmichele of a century earlier.

For the ceremonial entry of the new pope into his native city, Baccio produced, among other decorations, a colossal clay figure of *Hercules* (destr.) for the Loggia dei Lanzi, where it was adjacent to Michelangelo's *David* (*see* ITALY, fig. 22): this was the beginning of rivalry between the sculptors over which of them was to carve a pendant to the *David*, to stand on the other side of the portal of the Palazzo della Signoria. The appearance of the *Hercules* is recorded in Vasari's painting of *Pope Leo X Returning to Florence after his Election* (Florence, Pal. Vecchio). It was the earliest of a long series of projects for monumental statues of muscular, nude Classical gods or heroes—often showing Hercules, but sometimes Neptune—which obsessed the sculptor. Only a few of these were actually executed, but they are recorded in a plethora of drawings

(see fig. 1). (A few years later, for instance, Baccio modelled in stucco a large pair of Herculean *Giants* (1519–20; *in situ*, but three arms missing) for the garden of the Villa Madama, which Cardinal Giulio de' Medici was building outside Rome.) Bandinelli next proposed to Leo X a model of *David Severing Goliath's Head* to replace Donatello's *David* (Florence, Bargello; see colour pl. 1, XXIX1), which had been removed from the courtyard of the Palazzo Medici, Florence, by the Republicans, but instead he was commissioned to carve a statue of *Orpheus* (*c.* 1519; *in situ*) for this position. Its composition was unashamedly derived from that of the *Apollo Belvedere* (Rome, Vatican, Mus. Pio-Clementino), and it is accounted one of his best early works. This exercise in the style of antiquity was followed by a direct copy (*c.* 1520–22; Florence, Uffizi) of the famous *Laokoon* (Rome, Vatican, Cortile Belvedere), the Hellenistic sculptural group that had been excavated as recently as 1506 and was also in the Belvedere of the Vatican.

Before this, Baccio was sent off to Loreto to help Andrea Sansovino with one of the large reliefs for the marble revetment of the Santa Casa (*see* LORETO, fig. 3) inside the basilica; he made several preparatory sketches and began carving the *Birth of the Virgin* between 1517 and 1519 (*in situ*), but abandoned work about half way through (the panel was eventually finished, 1530–33, by Raffaello da Montelupo). It is a rather arid and static rendering of the scene, perhaps reflecting a lack of

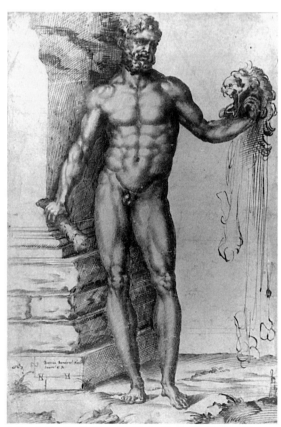

1. Baccio Bandinelli: *Hercules with the Head of the Nemean Lion*, pen and brown ink, 384×220 mm, *c.* 1548 (Paris, Musée du Louvre)

enthusiasm for the remote Loretan commission that was shared by other Florentine sculptors. Returning to Rome in mid-1519, Bandinelli was drawn by papal patronage into the circle of Raphael and designed a large and complex *Massacre of the Innocents* to be engraved (*c.* 1520–21; B. 21) by Marco Dente: its debt to Marcantonio Raimondi's engraving of the same subject after Raphael has always been acknowledged, but it did much to enhance Baccio's reputation internationally. He also received a major commission from King Henry VIII of England (*reg* 1509–47) for a massive tomb and created a fantastic model in wood and wax (untraced) embodying no fewer than 142 life-size figures, as well as numerous bronze reliefs: Bandinelli's megalomania was his undoing, however, for the enormous expense precluded the King from employing him.

(ii) c. 1522–1527. During the brief papacy (1522–3) of Adrian VI, Baccio returned to Florence and concentrated on drawing, but when his protector, Giulio de' Medici, was elected pope as Clement VII he again began to receive major commissions: one of the first was the decorations for the papal coronation in November 1523; he also continued to carve his copy of the *Laokoon*. Another project, a pair of huge frescoes on the walls of the choir in S Lorenzo, Florence, the Medicean parish church, was once again abortive, though he received a Knighthood of St Peter for his pains. Only one design, depicting the *Martyrdom of St Lawrence*, is preserved in an engraving (1524–7) by Marcantonio Raimondi.

In July 1525 a colossal block of marble that had been quarried many years before at Carrara and had been intended for Michelangelo to carve a pendant to his own *David* was brought to Florence on the orders of the Pope and handed over to Bandinelli, to avoid distracting Michelangelo from his current work on the New Sacristy tombs and to spur him on. Baccio had created a very melodramatic wax model, which was described in detail by Vasari (traditionally identified with one in Berlin, Bodemus.). However, this turned out not to fit the shape of the block, and Bandinelli had to revert to a more traditional, vertical and static composition instead. Having made the full-size model in clay, he began to carve the marble, but was interrupted by the Sack of Rome in 1527 and the consequent ejection of the Medici from Florence, which left the city in Republican hands. The following August the Florentine government returned the rights over the block of marble to Michelangelo, who decided to change its subject into Samson slaying two Philistines, an idea recorded in a number of bronze casts presumably made from a wax model of his. However, with the Siege of Florence, Michelangelo became involved in fortifying the city, and when it fell in 1530 he first fled and then returned obediently to continue the statuary in the New Sacristy, leaving the block once again to Bandinelli. Bandinelli carved out of it his colossal group of *Hercules and Cacus* (Piazza della Signoria, *in situ*; see fig. 2), which he gradually brought to completion over the next five years.

The signed and dated work was finally unveiled in 1534 and attracted much instant and gratuitous ridicule because of a general political bias against its author (who was gravely compromised in the eyes of the Florentines for having assisted the besieging forces). Nevertheless it is

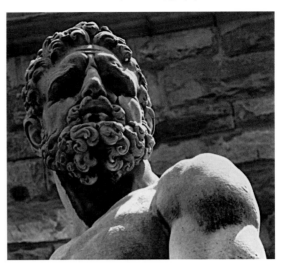

2. Baccio Bandinelli: *Hercules and Cacus* (detail), colossal marble, 1527–34, Piazza della Signoria, Florence

well composed for the particular location for which it had always been intended, the south-eastern corner of the piazza. Bandinelli canted the shoulders and chest of Hercules diagonally across the depths of the block, so that it faced spectators coming from the north-west, the principal approach across the square leading from the direction of the market and cathedral. But he kept the head looking straight out from the front of the block: this gives it a strong profile when viewed from the north, along the dais in front of the palazzo, or from the south, from the direction of the River Arno and the buildings now housing the Uffizi. Baccio made Cacus into a crumpled victim, defeated though perhaps not yet dead, entwined between the open legs of Hercules. He carved the muscles boldly and the features emphatically, in order that they might show to good advantage in the bright light of day, in the manner of ancient Roman colossal figures, such as the *Castor and Pollux* (*in situ*) on the Capitol in Rome or the *Horse Tamers* now on the Quirinal Hill.

From the time of the inception of the *Hercules and Cacus* in 1525, Bandinelli was simultaneously engaged on a variety of projects, including some abortive ones for paintings: when exhibited publicly, a cartoon for a *Dead Christ* attracted severe criticism from none other than Michelangelo. As was often the case, its design was admired, but the use of colour deprecated. So ashamed was Baccio of this failure that he decided to abandon painting, though he continued to draw compositions for others to colour.

(iii) 1527–c. 1542. When Florence turned Republican in 1527, Bandinelli fled first to Lucca. Two years later he received a commission in Genoa to produce a monument to Admiral Andrea I Doria, initially conceived by the government as a bronze statue. After some preparatory drawings had been made by Baccio, its material was changed to marble to save money and to suit his predilections. This commission had a chequered history and was abandoned in 1538, resulting only in several marvellous drawings for the statue and its pedestal (Paris, Louvre)

and a roughed-out group with the Admiral in the guise of Neptune standing tamely and improbably on the heads of a pair of dolphins (Carrara, Piazza del Duomo).

While in Genoa in 1529, Bandinelli had an opportunity to present to Charles V (reg 1516–56) a bronze relief of the *Deposition*, which is very well designed (untraced, but known from drawings and another, later, cast (Paris, Louvre) by Antonio Susini). He was rewarded with a knighthood in the Order of Santiago, which he had long coveted, and this occasioned an impressive painted *Self-portrait* (Boston, MA, Isabella Stewart Gardner Mus.); there are two engraved portraits as well, probably showing him with a selection of his models. Having proceeded in early 1530 to Bologna for Charles's coronation as Holy Roman Emperor by Clement VII, Bandinelli returned to the comparative safety of Rome with the Pope, who wanted him to produce, in fulfilment of a vow that he had made during the sack of the city, a series of great statues in bronze for the gate-tower of the Castel Sant'Angelo: these were to depict *St Michael the Archangel*, triumphing over the Seven Deadly Sins, recumbent below. As so frequently happened, nothing resulted, apart from a full-scale clay model of one of the sins (destr.) and a series of rather good statuettes of Classical deities (Florence, Bargello), which Bandinelli modelled and had cast into bronze by way of experiment towards fulfilling the big commission. The sculptor was distracted by the final stint of carving the *Hercules and Cacus* and its pedestal in Florence (1533–4): whatever the reservations of the public, it made Bandinelli's name and established him beyond challenge as the official sculptor to the new regime of the Medici dukes, first Alessandro and later Cosimo I.

Before the death of Clement in late 1534, Bandinelli made models in wood and wax (untraced) for his tomb and one for Leo X, but by 1536 the architectural design was allocated instead to Antonio da Sangallo the younger, with only the statues and reliefs being reserved for Baccio. After many prevarications, he actually delivered c. 1541–2 four statues of apostles and six narrative reliefs, while the seated portraits of the Medici popes (Rome, S Maria sopra Minerva; *in situ*) were carved by others. Bandinelli had in the meantime become distracted by his aim of cheating Niccolò Tribolo of a commission for a tomb in S Lorenzo for the father of Duke Cosimo, Giovanni delle Bande Nere. He succeeded in 1540, but even so, he never brought it to completion, though the elaborate pedestal with a handsome and extremely Mannerist relief was erected in the Piazza S Lorenzo: his indifferent statue of *Giovanni delle Bande Nere Seated*, a travesty of Michelangelo's *Captains* in the New Sacristy, was put on top only in 1851.

(iv) c. 1542–1560. Such débâcles became all too prominent a feature of Bandinelli's career, as he sought to monopolize all the commissions for sculpture contemplated by Cosimo: once he had suggested an ambitious project and obtained the commission, by fair means or foul, he tended to rush off designs, and occasionally whole statues, that were not at all satisfactory; those then had to be replaced and adapted to other ends, which called into doubt both his sincerity and his capacity. The first of these great undertakings was for the Udienza, or stage, in the Salone del Cinquecento in the Palazzo della Signoria,

which Cosimo had taken over as his residence. The interior of the northerly window wall and the adjacent flanking walls was given a revetment of marble niches in which were ensconced statues of prominent members of the new Medici dynasty, to bolster the legitimacy of its claims to power: Cosimo himself, his predecessor and father and the two popes. That of Alessandro was flatteringly derived from Donatello's marble *St George* (Florence, Bargello) but is risibly inferior to it in conviction and characterization, while the sculptor did not achieve much greater success with such of the other statues as he actually began, or delivered, between 1542 and 1547: once again, the project had to be brought to completion later on by other sculptors (e.g. Giovanni Battista Caccini and Vincenzo de' Rossi).

The next distraction was a scheme to replace Brunelleschi's octagonal wooden choir enclosure and altar under the crossing of Florence Cathedral with a grand new marble one, decorated with bronze reliefs and marble statuary (begun 1547). Its balustrade survives and once contained a series of 88 upright rectangular panels of individual *Old Testament* figures, depicted in a great variety of poses and from different angles, in characteristically academic fashion (64 panels *in situ*, the rest in Florence, Mus. Opera Duomo). They are carved in a creditable imitation of Donatello's shallow relief: some (see fig. 3) on the western side are initialled BBF and dated 1555. With the statuary, however, Bandinelli set himself ambitious goals that he was hard put to achieve: a group of the *Temptation of Adam and Eve* (Florence, Bargello), a colossal figure of *God the Father in Benediction* and, on the altar itself, a group with the *Dead Christ Supported by Two Angels* (both Florence, Santa Croce). Most turned out badly, and several were hastily converted by simple changes in their attributes into equivalent figures from Classical mythology, for display elsewhere: for example the former nude pair were transmogrified into *Bacchus* and *Ceres* (Florence, Grotto of Buontalenti, façade), while *God the Father* became, appropriately, *Jupiter* (Florence, Boboli Gdns)! By 1549 Baccio had carved replacements for all of them, which were rather more satisfactory, though not such as to dissipate the ridicule he had incurred. The second *Adam and Eve* group (1551; Florence, Bargello) is made up of perfectly respectable academic figures, well carved and finely detailed, with the facial features of Cosimo and his duchess, but they lack any sense of character or mood such as would be appropriate to the dire event in which they are meant to be participating. Less reprehensible from a spiritual point of view is the *Dead Christ* (Florence, Santa Croce, Baroncelli Chapel); indeed it was praised by even the inimical Vasari.

Bandinelli's megalomaniac tendencies and ethical shortcomings did not go unnoticed by the Grand Duke, though the Grand Duchess, Eleonora of Toledo, remained a staunch supporter, especially against Cellini, whom she could not bear: Cellini had returned in 1545 from his employment at Fontainebleau by the King of France and immediately made démarches to Cosimo, in the hope of displacing Baccio from his near-monopoly of official, Medicean commissions. Cosimo exploited their professional rivalry and personal animosity to spur them on: in 1545 he commissioned a portrait in bronze from each,

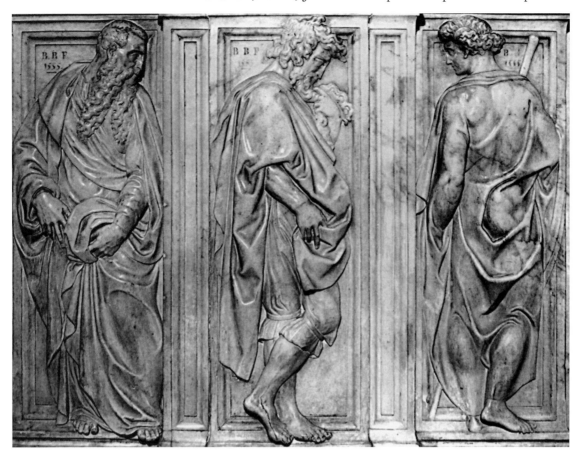

3. Baccio Bandinelli: *Prophets and Saints* (1555), marble reliefs, each 980×360 mm, choir enclosure, Florence Cathedral

which resulted in the almost frighteningly characterful bust by Cellini (Florence, Bargello) and the grave but benign image provided by Bandinelli (Florence, Pitti), which he followed with a similar one in marble (Florence, Bargello). Predictably, Cosimo preferred Bandinelli's less perturbing interpretation of his ruthless character.

The ultimate success of Cellini's *Perseus with the Head of Medusa* (1545–53; Florence, Loggia dei Lanzi; *see* CELLINI, BENVENUTO, fig. 6) was a severe blow to the morale of his rival, who had always experienced problems with statuary in bronze. Cellini also managed to produce some very credible carvings in marble, thus threatening Baccio in his chosen field, while pressure mounted after 1555, when Vasari and Ammanati both returned to Florence to work for the Grand Duke and Ammanati was awarded the desirable sculptural commission for the Fountain of Juno (*see* AMMANATI, BARTOLOMEO, fig. 1). Bandinelli contented himself with finishing off, in collaboration with his son Clemente (1534–54), an over life-size group of the *Dead Christ Supported by Nicodemus*, the latter given his own features, for his tomb in SS Annunziata. This was doubtless inspired by the knowledge that Michelangelo was working on a *Pietà* for his tomb (Florence, Mus. Opera Duomo). Bandinelli's design was derived from his ideas for the choir of the cathedral, and though a peculiar composition, given the awkward physical relationship between the figures, it is reasonably satisfactory and well carved in detail.

In 1558, with the help of Eleonora of Toledo, Baccio gained assent to carve a statue of *Neptune* out of another colossal block that had been quarried at Carrara: it was to celebrate one of the major public works of the Medici Grand Duke, a fountain at the corner of the Palazzo della Signoria that provided, via an aqueduct, a new and copious source of water in the city centre. Cellini and Ammanati were jealous, and Cosimo, probably in a cynical attempt to encourage Baccio, allowed them to make rival models. Baccio's wax or clay model (untraced) was promising, as is borne out by a bronze statuette cast from it posthumously (Rome, Gal. Colonna). Indeed, it was the summation of his life's work in terms of Herculean, colossal, male nude statues: it is very vivacious, granted the restrictions imposed by the traditional shape of the block, which, like that of *Hercules and Cacus*, did not permit any radical extensions into surrounding space. No sooner had Baccio secured the commission in the teeth of his rivals than death intervened, cheating him of what might have turned out to be his greatest masterpiece.

2. CRITICAL RECEPTION AND POSTHUMOUS REPUTATION. Bandinelli excelled at *disegno*, that combination of design and drawing that underlay contemporary artistic practice and theory. His graphic compositions and carved reliefs, both of large, complex groups and of single figures in sophisticated poses, have been universally ad-

mired. His renderings of statues *all'antica*, the theoretical ideal of the Renaissance, were also expert. However, faults tended to manifest themselves when the sculptor was confronted with figures that had to be carved fully in the round and/or on a large scale: it was his misfortune to be born with a highly ambitious character and an irascible and impatient temperament, for these led him into megalomaniac projects, which he did not then have the natural ability or pertinacity to bring satisfactorily to fulfilment.

He was nevertheless a prolific and gifted draughtsman and, unlike Michelangelo, had an ability to work with others and to convey his ideas to younger artists, presumably as long as they recognized their subordinate position: he commemorated this positive achievement by authorizing the publication of two engravings (early 1540s; B. 49.1 and 49.2) by Enea Vico showing the darkened interior of his studio—grandly entitled 'Academy' (*see* ITALY, fig. 42). His own son Clemente learnt from him, as did two major sculptors of the latter part of the century, Giovanni Bandini and Vincenzo de' Rossi, the latter closely imitating his vibrant pen-and-ink compositional sketches, heavily hatched as though with a chisel, as well as his melodramatic renderings in sculpture of particularly ferocious mythological heroes and monsters in violent conflict.

Despite his genuine artistic achievements, Bandinelli suffered from 'a bad press' from his contemporaries: from Vasari, because of Bandinelli's supposed jealousy of Michelangelo, who was the hero of the *Vite* (this was expressed in Baccio's alleged destruction of the tattered remnant of the cartoon for the *Battle of Cascina* and in their rivalry in the 1520s over the commission and colossal block of marble for the group of *Hercules and Cacus*); and from Cellini, because of professional jealousy over Medicean patronage, which was vituperatively expressed in Cellini's *Vita*. This view has also tended to colour more recent critical opinion. Baccio's own *Memoriale*, although interesting for the personal details it conveys and some theoretical treatises that are lost, did little to correct this negative impression, for it is burdened with an unpleasing element of social climbing, notably his attempts to justify a change of surname from Brandini to Bandinelli on the pretence of a connection with that aristocratic Sienese family in order to be eligible to receive the Order of the Knights of Santiago, which was restricted to the nobility.

BIBLIOGRAPHY

DBI

G. Vasari: *Vite* (1550; rev. 2/1568); ed. G. Milanesi (1878–85); *Vita di Baccio Bandinelli . . .* (1568), ed. D. Heikamp (Milan, 1964)

A. Colasanti, ed.: 'Il *Memoriale* di Baccio Bandinelli', *Repert. Kstwiss.*, xxviii (1905), pp. 406–43

U. Middeldorf: 'A Bandinelli Relief', *Burl. Mag.*, lvii (1930), pp. 65–71

——: 'Alessandro Allori e il Bandinelli', *Riv. A..*, xiv (1932), pp. 483–8

——: 'A Group of Drawings by Baccio Bandinelli', *Prt Colr Q.*, 4 (1937), pp. 290–304

D. Heikamp: 'Die Bildwerke des Clemente Bandinelli', *Mitt. Ksthist. Inst. Florenz*, ix/2 (1960), pp. 130–36

J. Shearman: 'Rosso, Pontormo, Bandinelli and Others at SS Annunziata', *Burl. Mag.*, cii (1960), pp. 152–6

D. Stillman: *Drawings by Baccio Bandinelli: Their Style and Sources* (M.A. thesis, New York, Columbia U., 1961)

J. Pope-Hennessy: *Italian High Renaissance and Baroque Sculpture* (London, 1963, rev. 1970)

D. Heikamp: 'Baccio Bandinelli nel Duomo di Firenze', *Paragone*, xv/169 (1964), pp. 32–42

M. G. Ciardi Duprè: 'Per la cronologia dei disegni di Baccio Bandinelli fino al 1540', *Commentari*, xvii (1966), pp. 146–70

——: 'Alcuni aspetti della tarda attività grafica del Bandinelli', *Ant. Viva*, v/1 (1966), pp. 22–31

D. Heikamp: 'In margine alla *Vita di Baccio Bandinelli* del Vasari', *Paragone*, xvii/191 (1966), pp. 51–62

——: 'Die Entwurfszeichnungen für die Grabmäler der Medicer-Päpste Leo X und Clemens VII', *Albertina-Stud.*, iv/3 (1966), pp. 134–52

M. G. Ciardi Duprè: 'Il modello originale della *Deposizione* del Bandinelli per Carlo V', *Festschrift Ulrich Middeldorf* (Berlin, 1968), i, pp. 269–75

C. Lloyd: 'Four Drawings by Bandinelli at Christ Church', *Burl. Mag.*, cxi (1969), pp. 371–4

C. Avery: *Florentine Renaissance Sculpture* (London, 1970), pp. 194–203

J. Beck: 'Precisions Concerning Bandinelli *Pittore*', *Ant. Viva*, xii/5 (1973), pp. 7–11

V. L. Bush: 'Bandinelli's *Hercules and Cacus* and Florentine Tradition', *Studies in Italian Art History* (Rome, 1980), i, pp. 163–89

R. Ward: 'Some Late Drawings by Baccio Bandinelli', *Master Drgs*, xix (1981), pp. 3–14

K. Weil-Garris: 'Bandinelli and Michelangelo: A Problem of Artistic Identity', *Art the Ape of Nature: Studies in Honor of H. W. Janson* (New York and Englewood Cliffs, 1981), pp. 223–51

R. Ward: *Baccio Bandinelli as a Draughtsman* (PhD thesis, U. London, Courtauld Inst., 1982)

H. Keutner: 'Un modello di Bandinelli per il Nettuno della fontana di Piazza della Signoria a Firenze', *Scritti di storia dell'arte in onore di Roberto Salvini* (Florence, 1984), pp. 417–26

J. Cox-Rearick: 'From Bandinelli to Bronzino: The Genesis of the *Lamentation* from the Chapel of Eleonora di Toledo', *Mitt. Ksthist. Inst. Florenz* (1988)

Baccio Bandinelli: Drawings from British Collections (exh. cat. by R. Ward, Cambridge, Fitzwilliam, 1988)

F. Vossilla: 'L'Altar Maggiore di Santa Maria del Fiore di Baccio Bandinelli', *Architetture di altari e spazio ecclesiale: Episodi a Firenze, Prato e Ferrara nell'età della Controriforma*, ed. C. Cresti (Florence, [1995]), pp. 36–79

CHARLES AVERY

Bandini, Giovanni (di Benedetto) [Giovanni dell'Opera] (*b* Castello, 1540; *bur* Florence, 18 April 1599). Italian sculptor. His apprenticeship in Baccio Bandinelli's Florentine workshop probably began *c.* 1555. With his master's death in 1560, he was asked to complete the choir-screen of Florence Cathedral, begun by Bandinelli in 1547; he executed the bas-reliefs on the western side of the screen, completed in 1572 (*in situ*). Also in 1572, he sculpted a portrait bust of *Cosimo I de' Medici*, placed over the entrance to the Cathedral Works (Opera del Duomo), and began two column statues of Apostles for the cathedral: *St James the Lesser* (1576) and *St Philip* (1577), all *in situ*. From his many years of service to the Cathedral Works, Bandini came to be known as Giovanni dell'Opera. He achieved recognition early in his career. In 1563 he became a member of the newly established Accademia del Disegno in Florence and the following year was asked to create the personifications of *Architecture* and the *Tiber* for the catafalque of Michelangelo. Cosimo I was so impressed with these figures that he commissioned Bandini to execute the marble personification of *Architecture* for Michelangelo's tomb (Florence, Santa Croce). The figure was completed by 1568 but was installed only in 1574. The *bozzetto* (London, Soane Mus.) gives an impression of movement, though the statue itself appears stable and calm. It has been suggested (Pope-Hennessy, 1964) that *Architecture* is derived from a figure of *Virtue* on Bartolomeo Ammanati's tomb of *Marco Mantova Benavides* (1546; Padua, Eremitani), yet her solemn grandeur seems to owe more to Michelangelo's *Giuliano de' Medici* (1526; Florence, S Lorenzo, New Sacristy; see colour pl. 2, V1).

From the late 1560s until his departure to Pesaro in 1582, Bandini was the foremost portrait sculptor in

Florence, executing some 20 busts of antique subjects (all untraced) as well as ten busts of the Grand Dukes of Tuscany. Of his five marble busts of *Cosimo I*, only two are extant: the one mentioned above, in Florence, and one in California (Los Angeles, CA, Co. Mus. A.), also executed *c.* 1572. In both busts the Grand Duke is dressed *all'antica*, an emulation of Roman imperial portraiture in keeping with Cosimo's view of himself as an Augustus reborn, and he is shown as aloof, expressionless and virtually static, with only a hint of movement in the turn of the head. Only one of Bandini's five marble busts of *Francesco I* survives (1582–3; Florence, Bargello).

During the 1570s Bandini worked for Francesco I and his circle. The most important work of this period is his first commission in bronze, the statuette of *Juno*, created for the *scrittorio* of Francesco I in the Palazzo Vecchio (1572–3; *in situ*; see fig.). The figure, wearing the crescent moon of chastity and accompanied by her traditional peacock (a separate piece apparently not sculpted by Bandini), is orientated frontally, as it was designed for a niche. Her stance and gestures suggest that Bandini was emulating Michelangelo's *David* (1501–4; Florence, Accad.; *see* ITALY, fig. 22), much as Agnolo Bronzino had transformed *David* into Galatea in his *Pygmalion and Galatea* (*c.* 1530; Rome, Pal. Barberini). There is a change in political significance as well, for Bandini transformed Michelangelo's Republican hero into a Medicean heroine, a tribute to Francesco I's mother, Eleonora de' Medici, who was commonly compared to the chaste Juno.

Giovanni Bandini: *Juno*, bronze, h. 960 mm, 1572–3 (Florence, Palazzo Vecchio)

While Bandini was completing the *Juno*, he was commissioned to make a marble *Hercules and the Hydra* by Giovanni Niccolini (1544–1611), a diplomat for Francesco I, who had busts by Bandini of *Cosimo I* and *Francesco I* at his Florentine palazzo. The statue (1578) was installed in the garden loggia of the Palazzo Niccolini around 1595 (*in situ*). Like the portrait busts, the *Hercules* was a homage to the Medici, who had taken the mythological founder of Florence as their symbol in the 15th century. For his statue Bandini referred to earlier Medicean treatments of Hercules, adopting the figure's stance from Antonio del Pollaiuolo's painting of *Hercules and the Hydra* (1471; Florence, Uffizi) and the frontal viewpoint and muscularity from Bandinelli's *Hercules and Cacus* (1534; Florence, Piazza della Signoria; *see* BANDINELLI, BACCIO, fig. 2). During the 1570s, for the Gaddi family, he carved marble reliefs of the *Presentation of the Virgin* and the *Marriage of the Virgin* for their chapel (Florence, S Maria Novella; *in situ*). For the Grifoni family he executed a *Jason* (untraced) and a *Bacchus*, possibly the one attributed to him in the Bargello, Florence, as well as two statues of Venus (untraced), one of which may be reflected in his bronze *Venus and Cupid* (London, V&A).

In 1582 Bandini was called to Pesaro by Francesco Maria II della Rovere, Duke of Urbino, to execute a marble *Venus* and an *Adonis* (both untraced), which may have bronze counterparts (London, V&A). His art so appealed to the Duke that Bandini was appointed the first court sculptor of the duchy. The following year he created a bronze group, *Meleager*, identified by Middeldorf (see Pope-Hennessy, *Burl. Mag.*, 1963) as one in Madrid (Prado). For this uncharacteristically dynamic grouping he probably drew on antique sculpture, a Hippolytus sarcophagus, and on a *Wild Boar* in the ducal collection (Florence, Pitti). The change in Bandini's style is evident also in the marble *Pietà* (1583–5; Urbino, Cathedral, oratory of the Grotta), generally considered his masterpiece, which was probably influenced by Sebastiano del Piombo's *Pietà* (*c.*1513; Viterbo, Mus. Civ.; *see* SEBASTIANO DEL PIOMBO, fig. 2) after Michelangelo's design, and also by the antique Niobe Group (Florence, Uffizi), especially the son of Niobe, excavated the year Bandini began the work. Portraits commissioned by Francesco Maria II include marble busts of *Francesco Maria I* (*c.* 1582–3; Florence, Bargello) and *Francesco Maria II* (Florence, Poggio Imp.) and the full-length statue of *Francesco Maria II* of 1585, installed in the vestibule of the Villa Imperiale of Pesaro in 1587, but transferred to the Doge's Palace, Venice, in 1624 (*in situ*). While the busts continue Bandini's emulation of antique imperial portraiture, the full-length figure, again derived from Michelangelo's *David*, attests to his more lively and energetic figural style in the 1580s. Bandini continued to work for the Duke of Urbino until 1595, when he was called to Pisa to collaborate on the bronze door of the cathedral. At this time he was also commissioned to execute a monumental statue of Grand Duke *Ferdinand I* for the Piazza Micheli, Livorno (*in situ*), and two years later he created a marble bust of *Ferdinand I* (untraced). His last commission, a marble *Meleager* (Genoa, Pal. Belimbau-Negretto Cambiaso), is signed JOHES BANDINVS FLORENTINVS F. *1598*, revealing his allegiance to Tuscany.

Its frontal pose, reduction to essentials and sense of calm are characteristic of his Florentine manner.

BIBLIOGRAPHY

DBI

G. Vasari: *Vite* (1550, rev. 2/1568); ed. G. Milanesi (1878–85), vii, pp. 298, 304, 317, 638

R. Borghini: *Il riposo* (Florence, 1584); ed. M. Rosci (Milan, 1968), pp. 108, 160, 637

F. Baldinucci: *Notizie* (1681–1728); ed. F. Ranalli (1845–7), ii, p. 500; iii, pp. 529–30; iv, pp. 85, 346; vii, pp. 13, 82

A. Venturi: *Storia* (1901–40), X/ii, pp. 241–70

U. Middeldorf: 'Giovanni Bandini, detto Giovanni dell'Opera', *Riv. A.*, ix (1929); also in *Raccolta di scritti*, i (Florence, 1980), pp. 77–92

——: 'Drawings by Giovanni dell'Opera', *A. Q.* [Detroit], ii (1939); also in *Raccolta di scritti*, ii (Florence, 1980), pp. 7–10

J. Pope-Hennessy: 'Italian Bronze Statuettes II', *Burl. Mag.*, cv (1963), pp. 58–71

——: *Italian High Renaissance and Baroque Sculpture: An Introduction to Italian Sculpture* (London, 1963, rev. Oxford, 3/1986)

——: 'Two Models for the Tomb of Michelangelo', *Studien zur toskanischen Kunst: Festschrift für Ludwig Heinrich Heydenreich zum 23. März 1963* (Munich, 1964), pp. 237–43

D. Heikamp: '*Hercules Slaying the Hydra of Lerna*: A Forgotten Statue by Giovanni Bandini detto Giovanni dell'Opera', *Essays Presented to Myron P. Gilmore*, ed. S. Bertelli and G. Ramakus, ii (Florence, 1978), pp. 239–44

A. S. Wethey and H. E. Wethey: 'Titian: Two Portraits of Noblemen in Armor and their Heraldry', *A. Bull.*, lxii (1980), pp. 76–96

S. Schaefer: 'Three Centuries of European Sculpture: Bandini to Berthold', *Apollo*, cxxiv (1986), pp. 414–19

C. Avery: 'Giovanni Bandini (1540–1599) Reconsidered', *Antol. B.A.*, new ser., 48–51 (1994), pp. 16–27

F. Vosilla: 'Alcune note ed un proposta per Giovanni Bandini', *Mitt. Ksthist. Inst. Florenz*, xl/3 (1996), pp. 375–83

CORINNE MANDEL

Baptista Veneziano. *See* FRANCO, BATTISTA.

Barbagelata, Giovanni di Nicolò (da) (*fl* Liguria, 1481–before Nov 1508). Italian painter. He is first documented in guild records in 1481, and in the mid-1480s he obtained the most prestigious commissions in Genoa: a polyptych (untraced) for the members of the Brigittine Order, to be modelled on the one made by Vincenzo Foppa for the Spinola Chapel in S Domenico, and frescoes (1489–90) for Archbishop Leonardo de Fornari's chapel in S Maria delle Vigne. Barbagelata's earliest surviving works were produced in the last years of the century and include a polyptych depicting the *Annunciation with Saints* in Calvi (Corsica), in which both the painting and the wood-carving must be based on Giovanni Mazone's polyptych of the *Annunciation* (Genoa, S Maria di Castello), and the *St Nicholas* (1498; Pietra Ligure, Parish Church). Other works of this period include the triptych of *St John the Baptist* (1499; Casarza Ligure, nr Sestri Levante, Genoa, S Giovanni Battista) and the polyptych of *St Ambrose* (1500; Varazze, S Ambrogio). In the structure of the wooden framework, the abundant use of gilding, the use of chiaroscuro to suggest volume and the attention given to architectural perspectives, these polyptychs show close links with the works of those painters whom the patrons had recommended as models, such as Foppa and Mazone. To the same period must belong the triptych of *St Louis* (Moneglia, nr Genoa, S Giorgio), in which the sections are linked by their architectural perspective as in some works by Mazone. A *Virgin and Child with a Votive Nun* (Switzerland, priv. col., see Boskovits, fig. 39), in which the throne is modelled on the one in Mazone's *St Mark*

with Four Saints (Liverpool, Walker A.G.), is perhaps identifiable with a commission of 1498. A section of a polyptych depicting *Two Saints* (sold New York, Sotheby's, 13 Oct 1989, lot 56) attests to the influence of Carlo Braccesco during the 1490s.

In 1502–3 Barbagelata collaborated with Louis Bréa and Lorenzo Fasolo (*fl* 1494–?1518) in works (untraced) executed for the cathedral and S Maria del Carmine, Genoa. He was also associated with Luca Baudo, who married his sister Bianchinetta in 1491. Barbagelata's later style is comparatively soft, but his efforts to keep abreast of new developments were accompanied by a certain falling-off in quality. His triptych of the *Virgin and Child with a Pope and St John the Baptist* (Albenga, Santuario Ponte Lungo) dates from 1502. The polyptych of the *Madonna della Vittoria* (Genoa, S Lorenzo), particularly influenced by Bréa, dates from after 1503, the date of the foundation, in the church, of the oratory of the Madonna della Vittoria. Also to this last period belong *SS Peter and Paul* (Genoa, oratory of SS Pietro e Paolo) and the triptych of *St Dominic* (ex-S Caterina, Finalborgo; Genoa, Pal. Bianco). Giovanni Antonio Fasolo took over his Genoa workshop in November 1508.

BIBLIOGRAPHY

DBI

G. V. Castelnovi: 'Giovanni Barbagelata', *Boll. A.*, xxxvi (1951), pp. 211–24

——: 'Il quattro e il primo cinquecento', *La pittura a Genova e in Liguria dagli inizi al cinquecento*, ed. C. Bozzo Dufour, i (Genoa, 1970, rev. 1987), pp. 112, 149

M. Boskovits: 'Nicolò Corso e gli altri: Spigolature di pittura lombardo-ligure di secondo quattrocento', *A. Crist.*, lxxv (1987), pp. 351–86 (364–8)

G. Algeri and A. De Floriani: *La pittura in Liguria: Il quattrocento* (Genoa, 1991), pp. 428–32, 491

VITTORIO NATALE

Barbari, Jacopo de' (*b* ?Venice, *c.* 1460–70; *d* Mechelen or Brussels, before 17 July 1516). Italian painter and printmaker. He was the first Italian Renaissance artist of note who travelled to the courts of Germany and the Netherlands. His earliest known works appear to date from the late 1490s, suggesting that he was born *c.* 1460–70. The birthdate of *c.* 1440 traditionally assigned to him reflects the misinterpretation of a document of 1512 in which his patron, Margaret of Austria, Regent of the Netherlands, awarded him a stipend because of his 'weakness and old age'. In fact, at this date a man could be described as 'old' while in his fifties or even younger (Gilbert).

Barbari probably trained with Alvise Vivarini in Venice in the 1490s. His earliest dated work, the celebrated bird's-eye *View of Venice* (see VENICE, fig. 1), a monumental woodcut produced between 1497 and 1500, can be securely attributed to him on the basis of style (12 extant copies, e.g. London, BM; original blocks in Venice, Correr). It also bears the caduceus, with which Barbari signed nearly all his works. Two other large woodcut compositions, the *Battle of Nude Men and Satyrs* and the *Triumph of Nude Men over Satyrs*, also appear to date from Barbari's years in Venice.

The dating of Barbari's engravings is controversial; the present writer follows Kristeller in using the development of his engraving technique as the key to dating. Thus, the

earliest of Barbari's 29 known engravings, possibly produced while he was still in Venice, include the *Victory of Fame* and the *Large Sacrifice to Priapus*. These show a residual use of the parallel hatching employed by Andrea Mantegna in his engravings, combined with a developing understanding of Albrecht Dürer's use of curvilinear modelling to render the nude.

The *View of Venice* was published by Anton Kolb, a Nuremberg merchant who lived in Venice, and Kolb probably introduced Barbari to his first German patron, Emperor Maximilian I (*reg* 1493–1519). Barbari became court artist to Maximilian in April of 1500 and took up residence in Nuremberg. By 1503 he had entered the service of Frederick III (the Wise; *reg* 1486–1525), Elector of Saxony, and had moved to Wittenberg. Most of Barbari's dozen or so extant paintings appear to date from his years in Nuremberg and Wittenberg. The *Virgin and Child with SS John the Baptist and Anthony Abbot* (*c.* 1501–3; Paris, Louvre) combines a Venetian *sacra conversazione* reminiscent of Alvise Vivarini with a landscape that reflects contemporary works by Dürer. Three of his paintings, *Christ Blessing* (*c.* 1503), *St Catherine* and *St Barbara* (all Dresden, Gemäldegal. Alte Meister) were in the collection of Lucas Cranach the younger (1515–1586). His best-known painting is the *Still-life with a Dead Partridge* (1504; Munich, Alte Pin.), a *trompe l'oeil* probably executed for one of the palaces of the Saxon dukes. The panel is the earliest known independent still-life painting of the Renaissance. The small panel of a *Sparrowhawk* (London, N.G.) is probably contemporary with the *Still-life*.

The engravings that date from Barbari's years in Nuremberg and Wittenberg include traditional religious scenes such as the *Virgin and Child Reclining against a Tree* and mythological compositions such as *Apollo and Diana* (see fig.) and the *Satyr's Family*, which were probably intended for the circle of humanists and university professors with whom he associated. In these engravings Barbari mastered Dürer's sinuous modelling of line and his use of engraved burr to convey textures.

While the influence of Barbari's idiosyncratic facial and figural types can be found in the early works of such contemporary masters as Lucas Cranach the elder (1472–1553), Albrecht Altdorfer (1480–1538), Hans von Kulmbach (*c.* 1485–1522) and Jan Gossart (1478–1532), scholars have focused on his relationship with his most significant German contemporary, Albrecht Dürer (1471–1528). In a letter to a friend written from Venice in 1506, Dürer referred somewhat disparagingly to Barbari's abilities as an artist, but in two draft introductions to his treatise on human proportions, written in 1523, he credited Barbari with awakening his interest in the study of proportions. He also admired paintings by Barbari when he visited Margaret of Austria's collection at Mechelen in 1521, and figural types and motifs from Barbari's prints reappear in Dürer's nudes and mythological scenes, especially in the years preceding his second trip to Italy in 1505–7.

Barbari appears to have left Wittenberg in 1506; he worked at the courts of Mecklenburg and Brandenburg in 1507 and 1508 and reached the Netherlands shortly thereafter. His last two patrons were Philip of Burgundy, Bishop of Utrecht (a natural son of Philip the Good), and Margaret of Austria, daughter of Maximilian. Barbari is

Jacopo de' Barbari: *Apollo and Diana*, engraving, 160×100 mm, *c.* 1500–06 (Oxford, Ashmolean Museum)

described as dead in an inventory of Margaret's pictures dated 17 July 1516. Few paintings from these later years survive, although Barbari appears to have continued his career as a printmaker. In the last group of engravings, probably produced in the Netherlands, Barbari developed a softer, more tonal style of modelling that anticipates the engravings of Lucas van Leyden (1494–1533). These works, which include *Cleopatra*, *Mars and Venus* and *St Sebastian*, reflect the strong formal influence of Giovanni Bellini. It is likely that Barbari returned to Italy, perhaps accompanying Philip of Burgundy (as did the Netherlandish artist Jan Gossart) on an embassy to Rome in 1508–9.

BIBLIOGRAPHY
Thieme–Becker
P. Kristeller: *Engravings and Woodcuts by Jacopo de' Barbari*, International Chalcographical Society (Berlin, 1896)
R. Bruck: *Friedrich der Weise als Förderer der Kunst*, Studien zur deutschen Kunstgeschichte, 45 (Strasbourg, 1903)
E. Panofsky: 'Dürers Darstellungen des Apollo und ihr Verhältnis zu Barbari', *Jb. Preuss. Kstsamml.*, xli (1920), pp. 359–77
A. de Hevesy: *Iacopo de' Barbari, le maître au caducée* (Paris and Brussels, 1925)
A. M. Hind: *Early Italian Engraving: A Critical Catalogue* (London, 1938–48), i, p. 2; v, p. 141; vii, pl. 699–716
L. Servolini: *Jacopo de' Barbari* (Padua, 1944)
T. Pignatti: 'La pianta di Venezia di Jacopo de' Barbari', *Boll. Mus. Civ. Ven.*, ix (1964), pp. 9–49
C. Gilbert: 'When Did a Man in the Renaissance Grow Old?', *Stud. Ren.*, xiv (1967), pp. 7–32

J. A. Levenson, K. Oberhuber and J. L. Sheehan: *Early Italian Engravings from the National Gallery of Art*, Washington, DC, N.G.A. cat. (Washington, DC, 1973), pp. 341–81

J. A. Levenson: *Jacopo de' Barbari and Northern Art of the Early Sixteenth Century* (diss., New York U., Inst. F.A., 1978)

J. Schulz: 'Jacopo de' Barbari's *View of Venice*: Mapmaking, City Views and Moralized Geography before the Year 1500', *A. Bull.*, lx (1978), pp. 425–75

A. J. Martin: 'Anton Kolb und Jacopo de' Barbari: Venedig im Jahre 1500: Das Stadtportrait als Dokument venezianisch-oberdeutscher Beziehungen', *Pinxit, sculpsit, fecit: Kunsthistorische Studien: Festschrift für Bruno Bushart*, ed. B. Hamacher and C. Karnehm (Munich, 1994), pp. 84–94

JAY A. LEVENSON

Barbarigo. Italian family of statesmen and patrons. The early history of the Barbarigo is obscure, although it is possible that they emigrated from the Trieste region and settled in Venice in the 8th or 9th century AD. The growth of their prominence is indicated by their entry into the hereditary nobility from the 13th century. One of the several branches of the clan was established in the Venetian colony of Crete in the 14th century. Members of the clan followed various careers and enjoyed differing degrees of wealth and political standing; one of the better documented is Andrea Barbarigo (*b* Venice, 1399; *d* Venice, 1449). He began a mercantile career in 1418 with modest assets, owing to his father's financial ruin, but amassed a respectable fortune through family connections, minor offices and an assiduous attention to business. At its peak his commercial activity stretched from Alexandria to London.

The brothers Marco Barbarigo (*b* Venice, *c.* 1413; *d* Venice, 14 Aug 1486) and Agostino Barbarigo (*b* Venice, *c.* 1420; *d* Venice, 20 Sept 1501) were the sons of Francesco Barbarigo ('il Ricco', *c.* 1380–*c.* 1449) of the S Trovaso branch of the family and were much more active in politics. A career possibly as a merchant encouraged Marco to travel; he was Venetian consul in London in 1449, when his portrait (London, N.G.) was painted by a follower of Jan van Eyck (*c.* 1395–1441). In his later political career Marco became Procurator of S Marco (1478) and he was elected Doge on 19 November 1485. Although he died within a year, work on the east wing of the Doge's Palace continued under Antonio Rizzo, and a number of medals was struck during Marco's term of office. A panegyric was addressed to him on 4 May 1486 by his nephew Vettore Capello; the frontispiece (London, BL, Add. MS. 21463), attributed to Giovanni Pietro Birago, shows the Doge receiving the work. Other portraits exist by Gentile Bellini (Venice, Correr) and by an unidentified artist (Ajaccio, Mus. Fesch).

After a close contest Marco was succeeded as doge by his brother Agostino Barbarigo, who had previously attained the office of procurator in an active political career. Of an imperious disposition, he chose to accentuate the princely qualities of his office. Celebratory inscriptions and his coat of arms and portrait adorn those areas of the Doge's Palace, notably the Scala dei Giganti, that were advanced during his dogeship under the direction of Rizzo and, after 1498, Pietro Lombardo (*see* VENICE, §IV, 4(i) and (ii)). Agostino urged the completion by Mauro Codussi of the Torre d'Orologio in the Piazza San Marco, which featured a portrait (destr. 1797) of the Doge kneeling before the Lion of St Mark. Medals struck during his term of office include one by Sperandio to celebrate Venice's

role in the Battle of Fornovo (1495; Washington, DC, N.G.A.). His portrait was painted numerous times; notable examples include those by Gentile Bellini (ex-Nuneham Park, Oxon) and Giorgione (untraced). He features with his brother in an altarpiece by Giovanni Bellini in S Pietro Martire on Murano. Perhaps the most explicit attempt to celebrate his achievements and the greatness of his family was in the double tomb (after 1486–*c.* 1501) for himself and his brother in the former church of S Maria della Carità (now the Galleria dell'Accademia); the identity of the architect and sculptor is disputed, most often between Rizzo, Codussi and Lombardo. Three bronze reliefs (Venice, Cà d'Oro) that decorated the altar are attributed to the so-called MASTER OF THE BARBARIGO RELIEFS (for discussion and illustration *see* MASTERS, ANONYMOUS, AND MONOGRAMMISTS, §I). Although the tombs were demolished in 1808, a kneeling statue of *Doge Agostino Barbarigo* is preserved in S Maria della Salute, Venice, as well as a limestone relief of the *Resurrection* (Venice, Scu. S Giovanni Evengelista). After his death an inquiry was held into Agostino's conduct, but posthumous disgrace did not end the celebration of his dogeship in works of art.

BIBLIOGRAPHY

DBI

A. Da Mosto: *I dogi di Venezia* (Milan, 1939), pp. 139–146

F. C. Lane: *Andrea Barbarigo* (Baltimore, 1944)

J. McAndrew: *Venetian Architecture of the Early Renaissance* (Cambridge, MA, 1980), pp. 76–9, 382, 389

E. Muir: *Civic Ritual in Renaissance Venice* (Princeton, 1980), pp. 265–71

G. Benzoni, ed.: *I dogi* (Milan, 1982)

A. M. Schulz: *Antonio Rizzo: Sculptor and Architect* (Princeton, 1983)

JOHN LAW

Barbaro. Italian family of patrons. They were endowed with intelligence and artistic gifts, as well as wealth and influence, and they included some of the most eminent humanist scholars of the 15th century: Francesco di Candiano Barbaro (*c.* 1395–1454), a Latin and Greek scholar, and Ermolao Barbaro (1453–97), the author of important commentaries on Aristotle, later edited by (1) Daniele Barbaro. The family's principal palace on the Grand Canal, Venice, has remained one of the least altered of the city's Gothic palaces, apart from the enlargements (1694–8) of Antonio Gaspari (1670–1730). From 1534 onwards, Fra Zuanne Barbaro was one of the two friars who took special responsibility for the rebuilding of S Francesco della Vigna in Venice to the design of Jacopo Sansovino. His brother Francesco Barbaro was the first Venetian noble to purchase one of the family chapels in the new church. The Barbaro family owned huge estates in the Veneto above Treviso. It was here in the 1550s that Andrea Palladio built one of his best-known villas, the Villa Barbaro at Maser (*see* (1) below), for Francesco's sons Daniele and (2) Marc'Antonio Barbaro.

(1) Daniele Barbaro (*b* Venice, 8 Feb 1514; *d* Venice, 13 April 1570). Patron and theorist. In *Venetia città nobilissima . . .* (Venice, 1581) Francesco Sansovino named as the three best architects in Venice his own father, Jacopo Sansovino, Palladio and Daniele Barbaro (see fig.). Although the exact nature of Daniele's role as a practising architect remains uncertain, his artistic importance is generally acknowledged, particularly as a patron of Palladio

Daniele Barbaro by Paolo Veronese, oil on canvas, 1.21×1.05 m (Amsterdam, Rijksmuseum)

and translator of an annotated edition of Vitruvius's treatise on architecture.

Following the family tradition Daniele received an excellent humanist education, first in Verona and then at the University of Padua. In 1545 he was appointed Superintendent of the University's newly established botanic gardens; it is possible that he may have designed the garden, a walled, circular enclosure divided into four intricate knot gardens. His career as a public servant was short; after a brief period as Venetian ambassador in England in 1549–50, he was appointed Patriarch Elect of Aquileia, but this was merely nominal since the Patriarch of the time, Giovanni Grimani, outlived him. Thus relieved of public duties, he was free to devote his life to scholarship and the arts. In the 1550s he began to collaborate with Palladio: in 1552 they were together in Trent, and in 1554 Daniele took Palladio to Rome. Palladio provided the illustrations for Barbaro's commentary on Vitruvius, *I dieci libri dell'architettura di M. Vitruvio* (Venice, 1556; *see* VITRUVIUS, fig. 2), which anticipated many of the ideas that Palladio developed in his own treatise *I quattro libri dell'architettura* (1570). Although several editions of Vitruvius had been published earlier in the century, most notably Fra Giovanni Giocondo's pioneering and scholarly illustrated Latin edition (Venice, 1511) and Cesare di Lorenzo Cesariano's more imaginatively illustrated Italian translation (Como, 1521), the work remained confusing and difficult. Barbaro's edition, with its learned commentary, was the most accurate translation and, with its informative illustrations, the most intelligible version yet produced. Barbaro acknowledged the importance of Palladio's collaboration, not only as a draughtsman but also for his archaeological and theoretical expertise. Barbaro's commentary is aptly called a treatise within a treatise, coherently explaining many of the more technical passages, and

expanding from an Aristotelian standpoint on many philosophical issues concerning the relationship between architecture and nature. His Aristotelian insistence on scientific observation never left him. In 1568 he published *La pratica della perspettiva*, a book on perspective for artists and architects, while his last will of 1570 refers to his collection of astronomical instruments 'both bought and home-made'.

The Barbaro family's villa at Maser, rebuilt during the 1550s, has a façade inscription revealing that the joint patrons were Daniele and his brother Marc'Antonio. Although the building is illustrated by Palladio among his own works in his *Quattro libri*, Daniele's influence on the design was probably significant: the style of the villa, with its broken pediment and exuberant stucco ornament, sets it apart from Palladio's other works of the time (for further discussion and illustration *see* MASER, VILLA BARBARO; *see also* PALLADIO, ANDREA, §I, 1(ii)). The interior was decorated in fresco *c.* 1561 by PAOLO VERONESE, while Alessandro Vittoria worked on the stuccos. This illustrious team probably also collaborated on an unusual suburban palace, the Palazzo Trevisan in Murano, completed in 1557. The palace has been variously attributed to Palladio and Daniele Barbaro, either separately or together. The garden fountains, an unusual asset in Venice but one shared by the Villa Barbaro at Maser, were much admired. Daniele's interest in garden hydraulics is further attested by the dedication of his Vitruvius edition of 1556 to Cardinal Ippolito II d'Este, patron of the Villa d'Este at Tivoli. A devout churchman, Daniele renounced his inheritance in favour of Marc'Antonio and asked not to be buried in the family chapel in S Francesco della Vigna, Venice, for which he had commissioned the altarpiece of the *Baptism of Christ* (*c.* 1555) by Battista Franco (for illustration *see* FRANCO, BATTISTA). Instead he was buried in an unmarked grave in the monks' cemetery behind the church.

WRITINGS

Exquisitae in Porphirium commentationes Danielis Barbari (Venice, 1542)
ed.: E. Barbaro: *Compendium ethicorum librorum Hermolai Barbari* (Venice, 1544)
ed.: *Compendium scientiae naturalis ex Aristotele* (Venice, 1545)
ed. and trans.: *I dieci libri dell'architettura di M. Vitruvio* (Venice, 1556)
Della eloquenza, dialogo del reverendiss. Monsignor Daniel Barbaro (Venice, 1557)
La pratica della perspettiva (Venice, 1568)

(2) **Marc'Antonio Barbaro** (*b* Venice, 22 Sept 1518; *d* Venice, 4 July 1595). Brother of (1) Daniele Barbaro. His interest in architecture and sculpture emerged in the 1550s when he and his brother commissioned Palladio to build their family villa at Maser. Marc'Antonio's particular responsibility seems to have been the garden nymphaeum, where he is said by Ridolfi to have worked for recreation (*per ricreazione*) on the rich sculptural decoration. Aretino had also remarked on his skill in stuccowork, as well as in painting and engraving (see Aretino, ii, 1957, pp. 158–9). In 1558 Marc'Antonio and Daniele attempted to secure Palladio's employment in Venice, supporting his design for a new façade for the cathedral of S Pietro di Castello. During the last two decades of his life Marc'Antonio used his political status and his position as a senator to influence public architecture in Venice, although with limited suc-

cess. In 1574, after the great fire in the Doge's Palace, he tried unsuccessfully to persuade the Senate to approve Palladio's project for its radical rebuilding. He argued vigorously in favour of Palladio's centrally planned design for the church of the Redentore in 1576, but again he was out-voted. As if to make up for this disappointment, he commissioned Palladio to design a circular chapel, the Tempietto, for the family estate at Maser, and himself supervised its execution (1580–83). After Palladio's death, Marc'Antonio transferred his support to Vincenzo Scamozzi, whom he regarded as Palladio's true artistic heir: in 1587–8 he supported Scamozzi's project for a triple-arched Rialto Bridge, although this was rejected in favour of the single-arched bridge by Antonio da Ponte. Finally, in 1593–4 Marc'Antonio was one of the Venetian nobles in charge of the building of the star-shaped fortress town of Palmanova in Friuli. He was buried in the family chapel in S Francesco della Vigna, Venice.

BIBLIOGRAPHY
DBI
P. Aretino: *Lettere sull'arte di Pietro Aretino*, 6 vols (Venice, 1538–57); ed. F. Pertile and E. Camesasca, 3 vols (Milan, 1957–60)
C. Ridolfi: *Meraviglie* (1648); ed. D. von Hadeln (1914–24), i, pp. 302–3
C. Yriarte: *La Vie d'un patricien à Venise au XVIe siècle* (Paris, 1874)
E. Bassi: *Palazzi di Venezia* (Venice, 1976), pp. 528–43
B. Boucher: 'The Last Will of Daniele Barbaro', *J. Warb. & Court. Inst.*, xlii (1979), pp. 277–82
M. Azzi Visentini: *L'orto botanico di Padova e il giardino del rinascimento* (Milan, 1984)
D. Battilotti: 'Villa Barbaro a Maser: Un difficile cantiere', *Stor. A.*, liii (1985), pp. 33–50
M. Tafuri: *Venezia e il rinascimento* (Turin, 1985)
M. Muraro: 'A Villa of Abundance: Villa Barbaro', *F.M.R. Mag.*, xiv (1994), pp. 28–44

□

Barbatelli, Bernardo. *See* POCCETTI, BERNARDINO.

Barbiere, Alessandro del. *See* FEI, ALESSANDRO.

Barbo, Pietro. *See* PAUL II.

Bardi (i). Italian family of patrons and painters. They were prominent in northern Central Italy between the 14th and 16th centuries. The merchant and statesman Andrea Bardi (*fl* Florence, 1332; *d* 1368) became involved in the Florentine conspiracy of 1340 and was twice exiled. He returned to Florence in 1346 and was the city's ambassador to Avignon in 1351. He was buried in the Bardi family chapel of S Silvestro (Florence, Santa Croce), which contains Giotto's frescoes depicting scenes from the *Life of St Francis* (*c.* 1320). Bartolomeo Bardi (*d* Spoleto, 1349) was appointed Bishop of Spoleto in 1320 and initiated the restoration of S Pietro, Spoleto, from 1329, at about which date, in his capacity as papal governor, he is supposed to have promoted the construction of the aqueduct known as the Acqua Bardesca, near Terni.

The works of the painter (1) Donato de' Bardi show his assimilation of European styles. His younger brother Boniforte Bardi (*b* Pavia; *fl* Genoa, 1434–53) was documented in Genoa as a painter, probably executing heraldic devices and other decorations; no work by him has been identified. Giovanni Maria Bardi (*b* Florence, 5 Feb 1534; *d* Florence, Sept 1612) was a politician, humanist and composer. In 1589 Ferdinando I, Grand Duke of Tuscany,

entrusted him with the preparation of court entertainments with scenery designed by the architect Bernardo Buontalenti.

The sculptor Donatello [Donato di Niccolo di Betto Bardi] belonged to a minor branch of the family.

BIBLIOGRAPHY
DBI
Grove 6: 'Bardi, Giovanni de'
U. Baldini, B. Nardini, L. Bartoli and others: *Il Complesso monumentale di Santa Croce: La basilica, le cappelle, i chiostri, il museo* (Florence, 1983)
ROBERTO CORONEO

(1) Donato de' Bardi (*b* Pavia; *fl* Genoa, before 1426; *d* Genoa, before 30 June 1451). Painter. Three Genoese documents attest to his aristocratic Lombard origin and provide skeletal information about his career. The first mentions the execution of an altarpiece in 1433 for Genoa Cathedral, representing *St Mary Magdalene with Four Saints*; four panels of *St Catherine*, *St John the Evangelist*, *St John the Baptist* and *Abbot Benedict* (all Genoa, Mus. Accad. Ligustica B.A.) have been identified as part of this work. The *Virgin and Child* (Genoa, Arcivescovado), datable before 1430, probably belonged to the same polyptych. Stylistically they all show the influence of the Lombard paintings of Michelino da Besozzo and, in part, the earlier work of Giusto de' Menabuoi, and they also make explicit references to the Ligurian works of Taddeo di Bartolo.

Probably in the 1430s Donato painted and signed the *Virgin of Humility with SS Philip and Agnes* (New York, Met.). With its strong emphasis on Gothic linearism and French preciosity of colouring, this work is a key example of the exchanges between North Italy and transalpine Europe. It not only illustrates his links with the North Italian styles of Antonio Pisanello and Jacopo Bellini but also shows the influence of French Late Gothic culture, spread mainly through illuminations; the arrangement of rectangular panels calls to mind Provençal works such as the triptych by Jacques Iverni (Turin, Gall. Sabauda).

In his later works Donato swiftly assimilated new trends: the *Presentation in the Temple* (ex-Lorenzelli priv. col., Bergamo, see Zeri, 1988, pl. 57), while preserving some aspects of Lombard Gothic, seems to reflect recent Florentine ideas on perspective and on the construction of the figures. Above all, he used light in a typically Netherlandish manner, as in the work of Jan van Eyck (*c.* 1395–1441) and Petrus Christus (*c.* 1410–1475/6). These imported elements similarly come together, though not always in total harmony, in the *Tomb of St John the Baptist* (Genoa, Cathedral Treasury), executed by Ligurian goldsmiths between 1438 and *c.* 1450. A possible connection between this work and Donato's activity may be suggested by a further document, dated 1438, which attests relations between the painter and the goldsmiths' guild of Genoa.

Donato's sensitivity to the South Netherlandish figurative tradition pervades such late works as the signed *Crucifixion* (Savona, Pin. Civ.; see fig.) or the sections of a dismembered polyptych depicting *St John the Baptist* (London, Helikon Gal.), *St Jerome* (New York, Brooklyn Mus. A.), *St Stephen* and *St Ambrose* (Milan, Cicogna Mozzoni priv. col., see Zeri, 1988, pls 64–7), which have been dated 1445–50. In the *Crucifixion* he used a solution

Donato de' Bardi: *Crucifixion*, ?tempera on canvas, 2.38×1.65 m, 1440–50 (Savona, Pinacoteca Civica)

adopted by van Eyck in 1437 in the triptych (Dresden, Gemäldegal. Alte Meister) executed for the Giustiniani family of Genoa, which has a *trompe-l'oeil* frame bearing a sacred inscription. The *Crucifixion* is a work of very high quality and a fundamental point of reference for the understanding of later developments in Lombard painting, from Vincenzo Foppa to Ambrogio Bergognone. Particularly important for Foppa, who first visited Genoa in 1461, was the *Virgin Suckling the Infant Christ* (Milan, Mus. Poldi Pezzoli), which has been ascribed to Donato. It shows the strong influence of Rogier van der Weyden (*c.* 1399–1464), who was especially popular in north-west Italy, and it appears stylistically close to the above-mentioned dismembered polyptych. The time of Donato's death may be inferred from a document dated 30 June 1451, in which the painter Giovanni Giorgio da Pavia (*fl* 1451–55) was commissioned to complete an unfinished *Maestà*.

BIBLIOGRAPHY

DBI

R. Maiocchi: *Codice diplomatico di Pavia dall'anno 1330 all'anno 1550*, i (Pavia, 1937), pp. 40, 48, 65, 70

G. V. Castelnovi: 'Il quattro e il primo cinquecento', *La pittura a Genova e in Liguria dagli inizi al cinquecento*, i (Genoa, 1970, rev. 1987), pp. 73–5, 140

E. Rossetti Brezzi: 'Per un'inchiesta sul quattrocento ligure', *Boll. A.*, xvii (1983), pp. 1–28

L. Bellosi: 'Donato de' Bardi e un disegno dell'Albertina', *Boll. A.*, xxx (1985), pp. 37–40

M. Natale: 'Pittura in Liguria nel quattrocento', *La pittura in Italia: Il quattrocento*, ed. F. Zeri (Milan, 1987), pp. 15–30 (16–18)

G. Algeri: 'Nuove proposte per Giovanni da Pisa', *Boll. A.*, xlvii (1988), pp. 35–48 (46 and fig. 18)

F. Frangi: 'I pittori pavesi in Liguria nel quattrocento', *Pittura a Pavia dal romanico al settecento*, ed. M. Gregori (Milan, 1988), pp. 69–74, 205–8

F. Zeri, ed.: *Giorno per giorno nella pittura* (Turin, 1988) [incl. 'Rintracciando Donato de' Bardi', pp. 35–43; 'Un problema nell'area di Donato de' Bardi', pp. 47–8]

G. Algeri and A. De Floriani: *La pittura in Liguria: Il quattrocento* (Genoa, 1991), pp. 168–71, 501–2

VITTORIO NATALE

Bardi (ii). *See* MINELLO.

Barga, Pietro (Simone) da (*b* ?Florence; *fl* 1574–88). Italian sculptor. Documents suggest that, although primarily a sculptor in bronze, he may also have executed works in stone, ivory and silver. A Tuscan, he worked in Rome for Cardinal Ferdinando de' Medici (later Ferdinando I, Grand Duke of Tuscany): his identity is sometimes confused with the humanist scholar Pietro Angeli da Barga, who was also a member of the Cardinal's court at approximately the same time. The Cardinal, an avid collector of antique works, employed Pietro da Barga to create small-scale bronze copies of sculptures unobtainable in the original. The Medici *Inventario di guardaroba* lists Barga's sculptures for the years 1574–88. Many of these statuettes ornamented the Cardinal's *studiolo* and door-lintels at the Villa Medici on the Pincio Hill. Barga maintained a workshop near the villa: a Maestro Bastiano Tragittore cast the bronzes from Barga's models.

Among the works securely attributed to Barga are the reduced-size copies (Florence, Bargello) of the *Laokoon* (Rome, Vatican, Mus. Pio-Clementino), the Farnese *Hercules* (Naples, Mus. N. S. Martino) and Michelangelo's *Bacchus* (Florence, Bargello). Each is a detailed representation (h. *c.* 30 cm), partially gilded, with a green patina. Although he concentrated on copying from the Antique, Barga also created replicas in various sizes of more contemporary sculptures, such as Michelangelo's *Dawn* and *Dusk* (Florence, S Lorenzo, New Sacristy). The larger versions of these, and other statuette copies, went to decorate the *studiolo* of the painter Jacopo Zucchi. Barga followed in the tradition of Jacopo Alari Bonaccolsi (*c.* 1460–1528), who had created bronze replicas of antique sculptures for the Gonzagas at Mantua. Pietro's works remained faithful to the full-size originals. Despite simplifying some of the pieces, he always included enough detail to simulate the prototype convincingly. His work represents a type of art much esteemed by Renaissance collectors, executed by a sculptor who combined a sensitive understanding of the Antique with considerable technical ability.

BIBLIOGRAPHY

G. De Nicola: 'Notes on the Museo Nazionale of Florence: II', *Burl. Mag.*, xxix (1916), pp. 362–73

A. M. Massinelli: 'Identità di Pietro Simone da Barga', *Crit. A.*, lii (1987), pp. 57–61

ROBIN A. BRANSTATOR

Bargiella, Andrea di. *See* CASTAGNO, ANDREA DEL.

Bari, Nichollò de. *See* NICCOLÒ DELL'ARCA.

Barocci, Ambrogio (d'Antonio) [Ambrogio da Milano; Ambrogio da Urbino] (*b* Milan; *fl c.* 1471; *d* after 1520). Italian architect and sculptor. He was one of the most able and prolific of the late 15th-century peripatetic Lombard masons and was recorded by Giovanni Santi in *La vita. . .di Federico da Montefeltro duca d'Urbino* (1484–7) as being among the great artists of the period. His career has, however, sometimes been confused with that of other artists named Ambrogio da Milano, in particular the sculptor who signed the tomb (executed in collaboration with Antonio Rossellino) of *Bishop Lorenzo Roverella* (1475; Ferrara, S Giorgio), and his oeuvre may still not have been fully defined.

Barocci was probably involved in the sculptural decoration of Pietro Lombardo's enlargement (begun *c.* 1471) of S Giobbe, Venice. By *c.* 1475 he was in Urbino, where, under the direction of Luciano Laurana and Francesco di Giorgio Martini, he executed numerous designs for stonework for the Palazzo Ducale. Some of this work (e.g. the portals of the Sala del Trono and the fireplace in the Salotto della Duchessa) is notable for the extremely fine low relief carvings of foliage enlivened with birds and other naturalistic details, a characteristic of Barocci's work that Santi singled out for special praise. It is closely related in style and quality to the carvings in S Giobbe and S Maria dei Miracoli, Venice (where Barocci may have worked with Pietro Lombardo from 1485). Other work, for example the remarkable series of 72 stone plaques ornamented with weapons and machines of warfare that decorated the plinth of the main façade (now inside), is very different in character. According to Baldi, the plaques were executed by Barocci to Francesco di Giorgio Martini's designs.

Barocci maintained a base at Urbino but spent lengthy periods working in other towns. He seems to have been responsible for the portals of S Maria Nuova (*c.* 1476) and S Michele (1480s) in Fano, and, as 'Ambrogio da Milano', he is recorded in connection with two architectural works, both of which can be related to Roman prototypes. The campanile of S Maria della Quercia (near Viterbo) was built (1481–4) as four storeys articulated with stout pilasters, the two at the bottom arranged as two bays per face accommodating small, shell-headed niches, and the two at the top (replaced by one following damage caused by lightning in 1624) originally arranged as single bays accommodating large multi-light windows ornamented with colonnettes. In the application of the orders, the division into pairs of bays and the use of windows with colonnettes, the design recalls the campanile (1471) of Santo Spirito in Sassia, Rome, and it may also have been inspired by the four-storey campanile proposed (*c.* 1450) for St Peter's, Rome. The second architectural work is the design of the portico (1491) of Spoleto Cathedral, which takes the form of a projecting arcade of five main bays and two narrower end-bays for external pulpits and is articulated with elegant half-columns supporting a delicately carved entablature and a crowning balustrade. The most immediate models are such overtly classical buildings in North Italyas the façade (begun 1488) of S Maria dei Miracoli, Brescia, and the Palazzo della Loggia (begun 1492), Brescia, but the ultimate models were the arcaded façade of S Marco (late 1460s), Rome, and the Benediction Loggia (early 1460s); destr.) of St Peter's, Rome.

BIBLIOGRAPHY

Thieme–Becker

B. Baldi: *Descrizione del Palazzo Ducale di Urbino* (Venice, 1590)

P. Rotondi: *Il Palazzo Ducale di Urbino*, 2 vols (Urbino, 1950)

E. Bentivoglio: 'L'attività di Ambrogio Barocci da Milano', *A. Lombarda*, 65 (1983), pp. 73–8

P. Dittmar: 'Die dekorative Skulptur der venezianischen Frührenaissance', *Z. Kstgesch.*, xlvii (1984), pp. 158–85

——: 'Barocci, A.', *Allgemeines Künstlerlexicon*, iii (Munich, 1992), pp. 142–5

DAVID HEMSOLL

Barocci, Federico [Federigo] (*b* Urbino, *c.* 1535; *d* Urbino, 30 Sept 1612). Italian painter. The leading altar painter in Italy in the second half of the 16th century, he enjoyed a greater popularity and exerted a more profound influence on the art of his time than any of his contemporaries. His patrons included the Pope, Emperor, King of Spain and Grand Duke of Tuscany, and among his admirers were Lodovico Cigoli (1559–1613), Annibale Carracci (1560–1609), Rubens (1577–1640) and Guido Reni (1575–1642). However, his work did not begin to receive the acclaim accorded that of Tintoretto or El Greco (1541–1614) until the mid-20th century. Several factors have obscured his importance, notably the relative inaccessibility and scarcity of his painted works, most of which were done on commission for specific locations in remote parts of Italy (where they have remained), and the type of painting he produced, which was almost exclusively devoted to religious subjects. He executed very few easel paintings. No autograph example of his painted work has ever left Europe, the portrait of *Quintilia Fischieri* (*c.* 1600; Washington, DC, N.G.A.) and pair of portraits of *Federigo Ubaldo, Prince of Urbino* (1606–7; Detroit, MI, Inst. A.) being the work of studio assistants.

1. Life and work. 2. Working methods and technique. 3. Patronage.

1. LIFE AND WORK.

(i) First works, *c.* 1555–63. (ii) The discovery of Correggio, 1563–1570. (iii) A popular approach to divine mystery, *c.* 1570–79. (iv) 1579–1612.

(i) First works, c. 1555–63. In his earliest documented work, *St Cecilia with Four Saints* (*c.* 1555–6; Urbino Cathedral), Barocci adhered to the principles of Central Italian Mannerism inherited from his teacher, Battista Franco. A reformulation of Raphael's composition of the same subject (Bologna, Pin. N.), known to Barocci through a print by Marcantonio Raimondi (B. xiv, 116), the painting demonstrates many features characteristic of the master: the flattened space in which the figures stand; the elongated torsos and limbs; the emphasis on plastic definition; and the overall relief-like effect of the composition. The *modello* for Barocci's earliest surviving commission (Stuttgart, Staatsgal.) is similarly indebted to Franco in its brittle, elongated contours, flickering washes and decorative highlights. Franco schooled Barocci in the importance of studying antique sculpture and the works of Michelangelo and also encouraged him to draw, in particular to copy the masterworks of antiquity and of the High Renaissance in Rome.

In the mid-1550s Barocci travelled for the first time to Rome, where he copied Raphael's frescoes in the Villa

Farnesina and, with Taddeo Zuccaro, examined the works of various High Renaissance masters. On his return to Urbino, and following a visit to Pesaro where he saw paintings by Titian and other Venetian masters in the della Rovere collections, he executed for Urbino Cathedral the *Martyrdom of St Sebastian* (1558–60), the first work in which he combined Venetian and Central Italian elements. The dramatic gathering of the figures in the lower part of the picture is derived from Sebastiano del Piombo's *Martyrdom of St Agatha* (1520; Florence, Pitti), which Barocci sketched in Pesaro (London, BM). Barocci's return to Rome in 1560 drew him away from the Venetian colourists in the direction of the Roman Mannerism practised by the Zuccaro family. In the fresco of the *Holy Family* that he painted on the vault of the large room on the lower floor of the Casino of Pius IV in the Vatican, he recast the central group in Giulio Romano's *Virgin with Kitten* (Naples, Capodimonte) in a broader space, introducing a novel system of modelling in light and imposing a forceful unity on the scene by means of a system of crossing diagonals. This work, according to Vasari, established Barocci as a youth of great promise.

(ii) The discovery of Correggio, 1563–c. 1570. The art produced by Barocci after his return to Urbino in 1563 reveals an orientation away from the complicated and elongated figure poses of the Zuccari and Central Italian Mannerism, as well as the colouristic and naturalistic richness of Venetian art, towards a more refined lyricism and delicacy. It remains a matter of conjecture whether Barocci travelled to Emilia to see Correggio's altarpieces and frescoes or whether, as Bellori stated, he became familiar with Correggio's work via cartoons and coloured drawings.

In Barocci's first work finished after his return from Rome, the *Virgin and Child in a Landscape with Kneeling St John the Evangelist* (c. 1565; Urbino, Pal. Ducale), the principal figures are united along a single diagonal running from one corner of the composition to another, a common device in Correggio's paintings. Barocci's emulation of Correggio is more explicit in the *Virgin and Child with SS Jude and Simon* (1565–7; Urbino, Pal. Ducale), a painting executed shortly thereafter for the church of S Francesco in Urbino. This picture employs no motifs from Correggio's work, except for the red curtain (cf. Correggio's *Virgin and Child with St Jerome*, 1526–8; Parma, G.N.), but it exploits the *sfumato* effects of Correggio's art to dissolve the forms into delicately coloured mists. In the famous altarpiece of the *Deposition* (see fig. 1), undertaken in 1567 for the chapel of S Bernardino in Perugia Cathedral and completed in 1569, Barocci adopted the psychological and painterly effects of Correggio's work but achieved a more integrated effect. The design recalls that of various Roman prototypes, in particular Daniele da Volterra's *Deposition* in the Orsini Chapel of Trinità dei Monti, Rome (see colour pl. 1, XXVI1), and Raimondi's engraving after Raphael (B. xiv, 37, 32), but transcends these by its emotional treatment of draperies, faces and colours and by its dramatic unity of action and expression. The sudden release of Christ's body from the Cross impels the wind-blown draperies of the figure standing on the ladder to the left, while the position of the ladder on the right along

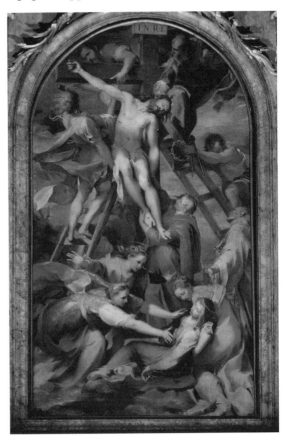

1. Federico Barocci: *Deposition*, oil on canvas, 4.12×2.32 m, 1567–9 (Perugia Cathedral, chapel of S Bernardino)

a line formed between the face of S Bernardino and that of Christ underscores the former's meditation on the event. The head of Christ occupies the centre of a series of concentric rings formed by figures who express different levels of grief and comprehension, intersected by the Cross and ladders as connecting spokes of a large wheel.

(iii) A popular approach to divine mystery, c. 1570–79. The *Deposition* represents an extreme point in Barocci's development and a limit beyond which he was unable to go without forsaking his classical roots. The works he produced in the 1570s reveal a relaxation of feeling and a retreat from the highly pitched emotionalism of the *Deposition*.

The small easel painting, the *Virgin with Kitten* (London, N.G.; see fig. 2), finished before 1577, echoes Raphael's *Madonna of the Goldfinch* (Florence, Uffizi), but in the softness of the forms and intimacy of the scene Barocci re-created the mood that Correggio had employed in his *Virgin with Basket* (London, N.G.). Such pictures of domestic devotion accorded with the spirit of the Counter-Reformation, especially with the interpretation of the Gospels by St Filippo Neri, founder of the Oratorians, as a vehicle for reaching the hearts and minds of simple people. Barocci's interest in Raphael also manifests itself in the contemporary altarpiece in the church of S Francesco in Urbino, known as '*Il Perdono*' (*Vision of St*

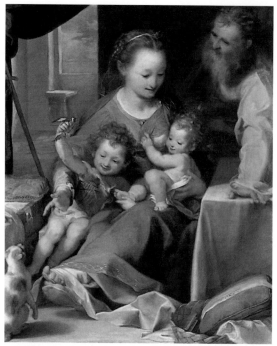

2. Federico Barocci: *Virgin with Kitten*, oil on canvas, 1127×0.927 mm, finished before 1577 (London, National Gallery)

Francis) (see colour pl. 1, VI1), in which the Virgin intervenes with Christ on behalf of St Francis's request for a plenary indulgence for all those who pray at the shrine near Assisi. The dynamic figure of the triumphant Christ appearing in a radiant shower of natural light in the upper half of the composition is derived from Raphael's flying Mercury in the Loggia of Psyche in the Villa Farnesina, Rome. Barocci copied this figure several times and used a tracing of the figure, in reverse, as a basis for one of the early drapery studies for the figure of Christ (Florence, Uffizi, 11374F). In a manner recalling Raphael's *Transfiguration* (Rome, Pin. Vaticana; *see* RAPHAEL, fig. 6) Barocci divided the composition into upper and lower zones united by various artificial means to create an ideal whole. In Barocci's case light is used symbolically to join the two parts. As Bellori observed, the artist emphasized the miraculous appearance by showering Christ in natural light while allowing the supernatural radiance emanating from him to illuminate the head of the kneeling St Francis which emerges from the darkness of the chapel entrance below. By this device Barocci reinforced, in formal terms, the meaning of the work and also suggested an analogy with standard representations of the monk's more popular miracle of the stigmatization. In fact, Barocci subsequently adapted the pose of the kneeling St Francis for both a painting (Fossombrone, Mus. Civ. Vernarecci) and print of that subject.

(iv) 1579–1612. Barocci's development away from the formal symbolism of *Il Perdono* to the more mystical naturalism of his next major work, the *Madonna del popolo* (1579; Florence, Uffizi; *see* fig. 3), is the most significant change in his career as a painter. In this work, painted for

the confraternity of S Maria della Misericordia in Arezzo, Barocci moved beyond dependence on Correggio. From a theme that combines the Virgin's role as Madonna of Mercy (with outstretched mantle protecting supplicants) and as Madonna Mediatrix (intervening with Christ, as in *Il Perdono*), Barocci evolved a design that links these two functions—one earth-directed and the other heavenly—and that draws the viewer into the union as well. The impulse of the design emerges from the background and moves forward, round and upward through the supplicants until it reaches the gesture of the heavenly Christ. The viewer completes the scene by occupying a position in the front part of the circle of figures in the foreground and receives Christ's blessing which is meant as much for the spectator as for the population in the picture. Barocci's altarpiece expresses a more convincing relationship between divine and human beings than had been previously attempted in Italian painting. The composition exerted a profound effect upon Annibale and Ludovico Carracci (1560–1609 and 1555–1619), Cigoli and many younger painters, predating by almost a decade Annibale Carracci's *Assumption of the Virgin* (1587; Dresden, Gemäldegal. Alte Meister), a painting that represents the Virgin's appearance in a similar down-to-earth and dramatic fashion, although without the soft *sfumato* or shimmering tones of Barocci's work.

In the 1580s Barocci produced a series of more traditional altarpieces that emphasize emotional restraint, simplicity and order. These works, notably the *Entombment*

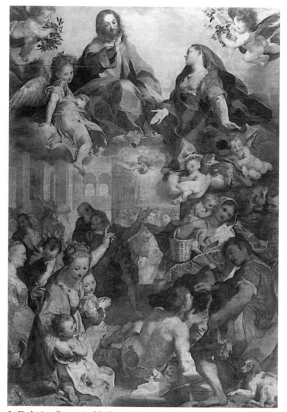

3. Federico Barocci: *Madonna del popolo*, oil on panel, 3.59×2.52 m, 1579 (Florence, Galleria degli Uffizi)

(1580–82; Senigallia, Santa Croce), *Annunciation* (1582–4; Rome, Pin. Vaticana), *Visitation* (1583–6; Rome, S Maria in Valicella) and *Calling of St Andrew* (1580–83; Brussels, Mus. A. Anc.), underlie the subsequent development of 17th-century classicism. In the *Calling of St Andrew*, a copy of which arrived in Spain by the mid-1580s, Barocci included a landscape background whose amplitude and tonal restraint foreshadow the subsequent achievements of Annibale Carracci and Domenichino (1581–1641). The *Entombment* reformulates Raphael's painting of the same subject (Rome, Gal. Borghese) according to more advanced theories of colour, landscape and spatial organization. The *Visitation*, before which St Filippo Neri is said to have taken his daily prayers, exhibits a naturalism that unites with apparent simplicity the complex variety of expressions, poses and phenomena of nature, so the observer not only feels the objectivity of the scene (with the Palazzo Ducale of Urbino in the background) but also senses the chain of relationships, meanings and habits fundamental to human existence.

The climax of Barocci's development in this decade was the altarpiece of the *Circumcision* (1590; Paris, Louvre; see fig. 4). Commissioned by the Compagnia del Nome di Gesù at Pesaro, this painting weds the informality of spatial organization seen in the *Madonna del popolo* (though now based on a downward serpentine movement rather than a spiral ascent) with the emotional restraint of the *Calling of St Andrew* and *Entombment*. The picture also introduces a developed *sfumato* that foreshadows the tonal unity of the art of Caravaggio (1571–1610), but with a

subtlety and softness in the chiaroscuro effects that is akin to late Baroque or early Rococo painting, as exemplified by that of the Bolognese artist Giuseppe Maria Crespi (1665–1747), who is known to have copied Barocci's compositions in Pesaro. The utensils and earthenware depicted in the right foreground of the *Circumcision* have a monumentality and organizational clarity that bring still-lifes by Chardin (1699–1779) to mind.

Towards the end of his career Barocci produced various works with ecstatic themes that foreshadow the Baroque style pioneered by Ludovico Carracci and subsequently developed by Giovanni Lanfranco (1582–1647) and other younger artists in Rome. The *Madonna of the Rosary* (finished *c.* 1593; Senigallia, Pal. Vescovile) and the *Blessed Michelina* (*c.* 1606; Rome, Pin. Vaticana) give tangible expression to the human desire to melt into the divine, without the support of abstract symbols. In the *Michelina* the heavens open with a burst of cherubic light, but only the tertiary saints see what is beyond. Barocci achieved here a pure and literal statement of the ultimately private nature of mystical experience. It was more than a decade before Lanfranco attempted the same sort of effect in his *St Margaret in Ecstasy* (Florence, Pitti) and three decades before the sculpted *St Teresa in Ecstasy* (Rome, S Maria della Vittoria, Cornaro Chapel) by Bernini (1598–1680), in which the external movement of the drapery expresses the internal convulsion of the spirit.

2. WORKING METHODS AND TECHNIQUE. Barocci's working methods are admirably described by Bellori, whose first and most general observation is that he always worked from the life ('not allowing himself to paint even a small part without first having observed it', 1672, p. 239); Bellori also described how Barocci laboured over his independent exploration of light, colour, perspective and other formal problems. Barocci's large production of preparatory drawings—more than 2000 survive—attests to a continuous process of adjustment and refinement. He made numerous sketches and studies from life to establish the poses of individual figures and to refine the draperies and particular parts of the figures; there were 800 such drawings in his studio at his death. However, many of these studies did not depend on an observed model but were derived from copying, transfer and elaboration independent of observation; squaring and incising were his favoured means of transfer. Barocci was content to re-use a figure or motif without making any preparatory drawings, occasionally even copying the work of other artists. For example, he began his studies for the heroic figure of St Sebastian in the *Crucifixion* for Genoa Cathedral by making a *ricordo* (Florence, Uffizi, 11370F) of a figure from the *Laokoon* (Rome, Vatican, Cortile Belvedere) and, as noted above (§1(iii)), executed a drapery study for the figure of Christ in *Il Perdono* over the traced contours of a copy taken from Raphael's figure of Mercury in the Villa Farnesina.

According to Bellori, Barocci developed his multi-figured compositions by making life studies of groups of *garzone* working in his studio, a common practice of Raphael that Bellori would seem to have imposed upon Barocci. He often sketched more than one figure on a single sheet but rarely made drawings from nude models

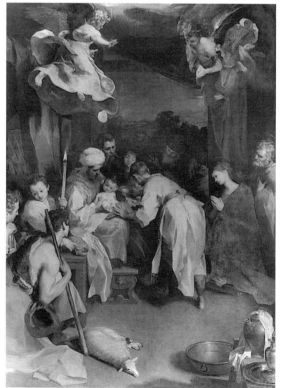

4. Federico Barocci: *Circumcision*, oil on canvas, 3.56×2.51 m, 1590 (Paris, Musée du Louvre)

posed according to a preconceived plan of the composition, which was Raphael's habit. Barocci's nude studies are invariably of individual figures, and his compositional studies are of two kinds: purely imaginary pen or chalk sketches produced in early planning; and more developed compositional studies, the *disegno compito*, from which he developed the full-scale cartoon.

Barocci concerned himself with local colour, lighting and even texture as early as his first life studies. One of the most reliable yardsticks in establishing the relationship of any particular sketch or life study with an individual painting is the correspondence of the lighting, an element of the painting that was fixed in the early stages and remained relatively constant throughout the development of the composition. Moreover, Barocci's choice of medium and support in his drawings reflects the colouristic and lighting effects he sought to create in the final painting. The natural blue paper or beige-tinted paper used in his life studies serves as a middle tone between the highlights and shadows (the light and dark chalks), shortening the tonal range and unifying the lighting. This ground colour in his studies may also be compared with the grey and brownish priming of the final painting, on which he sketched the design in chiaroscuro tones of black and yellow. Barocci was equally disciplined in his use of local colours in his drawings, limiting himself to the precise effects he sought in the final work. For example, light pink pastels might serve for the flesh tones, a yellowish ochre for the hair and red chalk for the eyelids, ridge of the nose, ears and other critical features of the face; these would be applied over a soft black outline and lit with white chalk and smoothed and blended with the stump to create the desired texture and continuity of surface. Barocci even studied certain individual figures and heads in oil, as did Rubens and Reni in the next century, and on more than one occasion corrected an aspect of a painting by doing a separate study in oil on a piece of paper which was then applied to the surface of the final painting (*Virgin and Child with SS Jude and Simon* and *Il Perdono*). In this way the entire preparation and execution became one single, continuous process.

While Bellori asserted that Barocci concerned himself with the matter of lighting and colour only at an advanced stage in the development of the composition, it is inconceivable that Barocci would have studied the sculptural masses of the composition without considering the pictorial problems of light and colour. The only *cartoncino per i colori* (small cartoon or model of the colour arrangement) described by Bellori which can be identified with any degree of certainty is the *bozzetto* in oils (Urbino, Pal. Ducale) for the *Entombment* in Santa Croce, Senigallia. This suggests that Barocci may have found it necessary to make an independent *modello* to study the colours only for certain works. There are more surviving chiaroscuro studies (which Bellori called *cartoncini per i lumi*), the best known of which are those for the *Madonna of the Rosary* (Oxford, Ashmolean) and for the *Last Supper* (Florence, Uffizi, 819F). However, these drawings appear to have been done at an early stage in the creative process, probably before the bulk of the large pastel heads and other detailed life studies.

Similarly, Barocci's surviving cartoons preceded most of his large-scale life studies. This is documented in the case of *Aeneas's Flight from Troy* (1586–9; Rome, Gal. Borghese), where he revised the entire background after executing the full-scale cartoon (Paris, Louvre) and considered making further changes in the composition. Invariably changes occurred in the design between the incised outlines of the cartoon and the finished design of the painting— changes that were not merely made *alla prima* as the artist was painting but were carefully thought out in separate chalk studies. An example of this is the *Calling of St Andrew*, in which the hands of the kneeling Andrew are rearranged between the incised cartoon and the finished version of the painting.

3. PATRONAGE. As much as Barocci's working methods earned him the praise of classicist critics such as Bellori, they exasperated the patience of patrons who awaited completion of orders. Due to the incurable illness (possibly a chronic gastric or peptic ulcer) that forced him to flee Rome in 1563, Barocci was able to paint for only one hour in the morning and one at night, spending the rest of the day drawing or in other pursuits. Duke Francesco-Maria II della Rovere, his principal patron, not only provided him with accommodation but befriended him and acted as an intermediary with various clients, including Emperor Rudolf II (*reg* 1576–1612), Pope Clement VII and King Philip II of Spain (*reg* 1556–98). The Grand Duke of Tuscany, Francesco I de' Medici, tried to persuade him to abandon the court of Urbino for that of Florence, but Barocci was content to remain in Urbino with its strong artisan tradition (Barocci's family were accomplished makers of mathematical instruments) and refined court life. Besides religious paintings, Barocci produced a small number of outstanding portraits of members of the ruling ducal family, including *Francesco-Maria II della Rovere* (*c.* 1573; Florence, Uffizi (see colour pl. 1, VI2); 1583, Weimar, Goethe-Nmus. Frauenplan) and *Giuliano della Rovere* (1595; Vienna, Ksthist. Mus.), and exhibited his drawings and cartoons in a hall reserved for that purpose in the Ducal Palace. His one secular painting, *Aeneas's Flight from Troy*, was executed expressly for the collection of Rudolf II. For a brief period around 1580 he experimented in printmaking, issuing etchings that reproduce two of his most famous compositions, *Il Perdono* and the *Annunciation*, as well as the *Stigmata* (Urbino, Pal. Ducale) and *Madonna in the Clouds* (untraced). His subsequent compositions were commercially published in prints, presumably based on drawings by the artist, almost as soon as the paintings reached completion. Barocci profited from his art and left a sizeable estate, including a studio full of cartoons, drawings and unfinished pictures that upon his death attracted the immediate interest of collectors and artists.

BIBLIOGRAPHY

DBI; Thieme–Becker
G. Vasari: *Vite* (1550, rev. 2/1568); ed. G. Milanesi (1878–85), vii, p. 91
G. P. Bellori: *Vite* (1672); ed. E. Borea (1976) [Eng. trans. of essay on Barocci in 1978 exh. cat.]
A. von Bartsch: *Le Peintre-graveur* (1803–21) [B.]
A. Venturi: *Storia* (1901–40/*R* 1967), ix, pp. 879–953
A. Schmarsow: 'Federigo Barocci: Ein Begründer des Barockstils in der Malerei', *Abh. Philol.-Hist. Kl. Kön. Sächs. Ges. Wiss.*, xxvi/4 (1909), pp. 1–168

——: 'Federigo Baroccis Zeichnungen: Eine kritische Studie', *Abh. Philol.-Hist. Kl. Kön. Sächs. Ges. Wiss.*, xxvi/5 (1909), pp. 1–40; xxviii/3 (1911), pp. 1–46; xxix/2 (1911), pp. 1–32; xxx/1 (1914), pp. 1–44

W. Friedländer: *Das Kasino Pius des Vierten* (Leipzig, 1912)

R. Krommes: *Studien zu Federigo Barocci* (Leipzig, 1912)

F. di Pietro: *Disegni sconosciuti e disegni finora non identificati di Federico Barocci negli Uffizi* (Florence, 1913)

Studi e notizie su Federico Barocci, La Brigata Urbinate degli Amici dei Monumenti (Florence, 1913)

H. Voss: *Die Malerei der Spätrenaissance in Rom und Florenz*, ii (Berlin, 1920), pp. 472–98

G. Gronau: *Documenti artistici urbinati* (Florence, 1936)

H. Olsen: *Federico Barocci: A Critical Study in Italian Cinquecento Painting* (Uppsala, 1955)

M. Aronberg Lavin: 'Colour Study in Barocci's Drawing', *Burl. Mag.*, lxlviii (1956), pp. 435–9

H. Olsen: *Federico Barocci* (Copenhagen, 1962)

G. Bertelà: *Disegni di Federico Barocci* (Florence, 1975)

Mostra di Federico Barocci (exh. cat., Bologna, Mus. Civ., 1975)

G. Smith: *The Casino of Pius IV* (Princeton, 1977)

The Graphic Art of Federico Barocci: Selected Drawings and Prints (exh. cat. by E. Pillsbury and L. Richards, Cleveland, OH, Mus. A.; New Haven, CT, Yale U. A.G.; 1978) [incl. Eng. trans. of Bellori's *Vite*, 1672, pp. 11–24]

E. Pillsbury: 'The Oil Studies of Federico Barocci', *Apollo*, cviii (1978), pp. 170–73

G. Walters: *Federico Barocci: Anima naturaliter* (New York, 1978)

A. Emiliani: *Federico Barocci (Urbino 1535–1612)*, 2 vols (Bologna, 1985) [illustrations]

EDMUND P. PILLSBURY

Baroncelli, Niccolò [Nicolò] (*b* Florence; *fl* 1434; *d* between 24 and 29 Oct 1453). Italian sculptor and bronze-caster. According to Vasari, he was a disciple of Filippo Brunelleschi. He is first mentioned on 27 April 1434 as having completed a large wooden Crucifix (destr.) for S Margarita, Vigonza (Padua). Baroncelli is identified with the 'Nicholo da Fiorenza', who was paid from 15 December 1436 to 16 March 1437 for two tondi in the Santo, Padua; they are identified with two marble tondi with half-figures of saints, which flank the rear entry to the choir. In 1436 he was commissioned to make the monument to the *Santasofia Family* (destr.) in the Eremitani, Padua. This comprised statues of 10 professors, the recumbent effigy of *Galeazzo Santasofia*, 12 statues of pupils and four unspecified statues. It was still unfinished in 1446. On 27 January 1440 Baroncelli was commissioned to execute 25 figures in relief for the monument to *Battista Sanguinacci* in the Eremitani, but Sanguinacci was instead buried in the tomb of his grandfather Ilario, which was decorated with an equestrian statue and a God the Father (both destr.). On 12 July 1440 the Confraternità dei Fabbri e Maniscalchi commissioned an altarpiece (completed 1442) for their altar in S Clemente, Padua, from which survives a terracotta relief of the *Miracle of St Aegidius* (Padua, Mus. Civ.; see fig.).

Baroncelli was commissioned on 28 August 1442 to make the south-west portal of the Eremitani. This includes the *Labours of the Months*, the *Annunciation*, angels, putti and *rinceaux* carved in low relief and shows the influence of Fra Filippo Lippi, who worked in Padua in 1434. Lorenzoni tentatively attributed to Baroncelli three terracotta reliefs with stories from the *Life of St Nicholas* in the predella of the altarpiece with *SS Philip, Bernard and James*

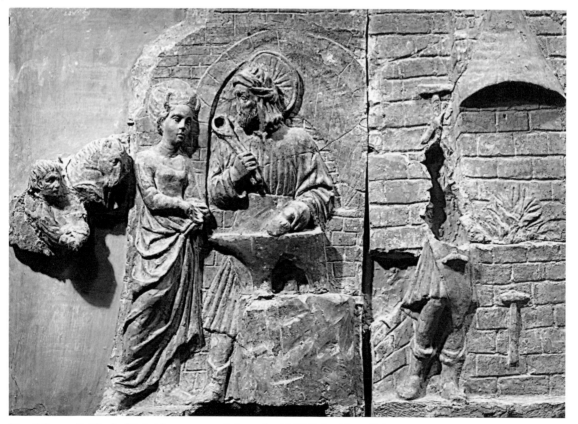

Niccolò Baroncelli: *Miracle of St Aegidius*, terracotta relief, completed 1442 (Padua, Museo Civico)

in the Eremitani and a relief of the *Death of the Virgin* in S Maria in Tomba, Adria. Puppi rightly cast doubt on Fiocco's attribution (1969–70) to Baroncelli of the house and the bank of Palla Strozzi in Padua.

In 1443 Lionello d'Este decided to erect a bronze equestrian monument in Ferrara to his predecessor, *Niccolò III d'Este, Marquess of Ferrara* (destr. 1796). Two models, by Baroncelli and Antonio di Cristoforo da Firenze, were submitted on 27 November 1443. The monument, dedicated on 2 June 1451, was originally set up in the piazza facing the cathedral and was moved in 1472 to the main entrance of the Castello Estense. Documentary evidence indicates that Antonio executed the effigy of Niccolò and that Baroncelli made the horse. Thereafter he was called 'Niccolò del Cavallo'. His workshop included his son Giovanni and son-in-law Domenico di Paris. Baroncelli may have executed the extant stone pedestal according to Alberti's design. This bronze equestrian monument was the first Renaissance example of a form known only from Classical prototypes, such as the equestrian monument to *Marcus Aurelius* (Rome, Campidoglio). Baroncelli was also commissioned to make a marble monument to *Borso d'Este, Duke of Ferrara* (destr. 1796). He received a first payment on 1 September 1451 and before his death had bought the marble and done some preparatory work; it was completed by Giovanni and Domenico di Paris and other assistants and erected on 19 December 1454 in front of the Palazzo della Ragione. In 1472 it was made a pendant to the Niccolò monument.

In 1450 Baroncelli was commissioned to make life-size bronze statues of the *Crucified Christ*, the *Virgin, St John the Evangelist, St George* and *St Maurelius* to be placed on an architrave before the high altar in Ferrara Cathedral (now in the right arm of the transept). With his son Giovanni he completed the first three statues. In style and pose, *St Maurelius* shows close affinities with Donatello's statues for the high altar in the Santo.

Baroncelli's other documented works in Ferrara have been destroyed. They included a life-size polychromed wax ex-voto figure of a *Falconer*, commissioned by Duke Borso d'Este in 1443; six bronze angels for the Estense palace chapel (1445–6); and further angels (1447), a *Virgin Mary* and a *St John the Baptist* (1448), all for the cathedral sacristy wardrobe. He also reworked the cathedral vestment borders (1452).

Rigoni (1926–7) rightly observed that Baroncelli cannot be identified with the Nicolò Coccari da Firenze (*fl* 1443/ 4–77) who was paid in 1448 and 1449 for work on the tabernacle that housed Donatello's *Virgin and Child with Saints* for the high altar of the Santo.

BIBLIOGRAPHY
DBI; Thieme–Becker
Libellus de magnificis ornamentis regie civitatis Paduae Michaelis Savonarolae (c. 1446); ed. A. Segarizze in *Rerum italicarum scriptores*, XXIV/ii (Città di Castello, 1902), p. 40
G. Vasari: *Vite* (1550, rev. 2/1568); ed. G. Milanesi (1878–85), ii, p. 386
A. Frizzi: *Memorie riguardanti per la storia di Ferrara* (Ferrara, 1791–1809), iv, pp. 8, 24, 45
G. Antonelli: 'Appendice', *Memorie originali italiane riguardanti le belle arti*, ed. M. Gualandi, iv (Bologna, 1843), pp. 33–48; v (Bologna, 1844), pp. 178–83
L. N. Cittadella: *Notizie relative a Ferrara per la maggior parte inedite ricovrate da documenti ed illustrate*, i (Ferrara, 1864), pp. 46–9, 74, 415–22

——: *Documenti ed illustrazioni riguardanti la storia artistica ferrarese* (Ferrara, 1868), pp. 21, 221
C. Ephrussi: 'Les Médailleurs de la Renaissance', *Gaz. B.-A.*, n. s. 2, xxvii (1883), pp. 77–86
A. Venturi: 'I primordi del rinascimento artistico a Ferrara', *Riv. Stor. It.*, i (1884), pp. 591–631
——: 'L'arte a Ferrara nel periodo di Borso d'Este', *Riv. Stor. It.*, ii (1885), pp. 689–749
G. Gruyer: 'La Sculpture à Ferrare', *Gaz. B.-A.*, n. s. 3, vi (1891), pp. 177–203
G. Agnelli: 'Relazione dello stato di Ferrara di Orazio della Rena (1589)', *Atti & Mem. Deput. Ferrar. Stor. Patria*, viii (1896), p. 279
G. Gruyer: *L'Art ferrarais à l'époque des princes d'Este*, i (Paris, 1897), pp. 42, 62, 287, 301, 309, 475, 510–17, 559, 593
G. Agnelli: 'I monumenti di Niccolò III e Borso d'Este in Ferrara', *Atti & Mem. Deput. Ferrar. Stor. Patria*, xxiii (1918), pp. 1–32
E. Rigoni: 'Il soggiorno in Padova di Nicolò Baroncelli', *Atti & Mem. Reale Accad. Sci., Lett. & A. Padova*, n.s., xliii (1926–7), pp. 215–38; also in *L'arte del rinascimento in Padova: Studi e documenti* (Padua, 1970), pp. 75–96
G. Fiocco: 'Sulle relazioni tra Toscana e Veneto nei secoli XV e XVI', *Riv. A.*, xi (1929), pp. 439–40, 447–8
——: 'La casa di Palla Strozzi', *Atti & Mem. Accad. N. Lincei, Atti Cl. Sci. Morali*, v (1954), pp. 362–82
G. Medrin: *La scultura a Ferrara* (Rovigo, 1957), pp. 45–50
G. Lorenzoni: 'L'attività padovana di Nicolò Baroncelli', *Riv. A.*, xxxvi (1961–2), pp. 27–52
J. Pope-Hennessy: *Italian Renaissance Sculpture* (London, 1963, rev. 3/ 1985), pp. 53, 74
P. Sambin: 'Nuovi documenti per la storia della pittura in Padova dal XIV al XVI secolo: Sulla fraglia dei pittori', *Boll. Mus. Civ. Padova*, liii (1964), pp. 21–47
G. Fiocco: 'Il banco degli Strozzi a Padova', *Atti & Mem. Accad. Patavina Sci., Lett. & A.*, lxxxii/3 (1969–70), pp. 191–200
E. Rigoni: 'Una terracotta di Nicolò Baroncelli a Padova', *L'arte del rinascimento in Padova: Studi e documenti* (Padua, 1970), pp. 75–96, 97–102, 103–23
C. M. Rosenberg: *Art in Ferrara during the Reign of Borso d'Este (1450–1471): A Study in Court Patronage* (diss., Ann Arbor, U. MI, 1974), pp. 47–64
A. Sartori: *Documenti per la storia dell'arte in Padova* (Vicenza, 1976), pp. 451, 456
W. Wolters: *La scultura veneziana gotica, 1300–1450*, i (Venice, 1976), pp. 94–5, 271
A. Puppi: *Filippo Brunelleschi: La sua opera e il suo tempo*, ii (Florence, 1980), pp. 741–2, 750–51

JILL E. CARRINGTON

Barovier. Italian family of glassmakers. The family are recorded as working in Murano, Venice, as early as 1324, when Iacobello Barovier and his sons Antonio Barovier and Bartolomeo Barovier (*b* Murano, ?1315; *d* Murano, ?1380) were working there as glassmakers. The line of descent through Viviano Barovier (*b* Murano, ?1345; *d* Murano, 1399) to Iacobo Barovier (*b* Murano, ?1380; *d* Murano, 1457) led to the more noteworthy Barovier family members of the Renaissance. Iacobo was responsible for public commissions in Murano from 1425 to 1450. From as early as 1420 he was a kiln overseer, with a determining influence on the fortunes of the Barovier family.

During the 15th century Iacobo's sons, notably Angelo Barovier (*b* Murano, ?1400; *d* Murano, 1460), and his sons Giovanni Barovier, Maria Barovier and Marino Barovier (*b* Murano, before 1431; *d* Murano, 1485) were important glassmakers (see colour pl. 1, VI3). From as early as 1441 Angelo owned a glass furnace. As a pupil of the philosopher Paolo da Pergola, he gained a scientific education, which, together with the empirical nature of his trade, enabled him to invent *cristallo* (c. 1450) and probably *lattimo* (milk) and chalcedony glass. In 1455 he was a guest at the court of the Sforza family in Milan, and in 1459 he

was invited, without success, to work for the Medici family in Florence. His son Marino worked with him in 1455 at the Sforza court, where he met Antonio Filarete, who referred to both father and son in his *Trattato di architettura* (1461–4). After his father's death, Marino inherited the furnaces in Murano. As a steward of the glassworkers' craft (1468, 1482), he was active in the promotion and defence of Muranese glassworking. During the 16th century one of Marino's sons, Angelo Barovier or Anzoleto Barovier, owned a famous glass furnace, the emblem of which was an angel. Between the 16th and 17th centuries various members of the Barovier family moved to other European countries where they continued making glass.

BIBLIOGRAPHY
L. Zecchin: 'Angelo Barovier, 1450–1460', *Riv. Staz. Spermntl Vetro*, vi (1976), pp. 209–12
——: 'Ancora sugli antichi Barovier muranesi', *Riv. Staz. Spermntl Vetro*, xiii (1983), pp. 71–6

ROSA BAROVIER MENTASTI

Barozzi da Vignola, Jacopo. *See* VIGNOLA, JACOPO.

Bartolo, Domenico di. *See* DOMENICO DI BARTOLO.

Bartolo, Nanni di. *See* NANNI DI BARTOLO.

Bartolomeo, Michelozzo di. *See* MICHELOZZO DI BARTOLOMEO.

Bartolomeo, Niccolò di. *See* NICCOLÒ PISANO.

Bartolomeo Alfei, Francesco di. *See* ALFEI, FRANCESCO DI BARTOLOMEO.

Bartolomeo della Gatta [Pietro di Antonio Dei] (*b* Florence, 1448; *d* Florence, Dec 1502). Italian painter, illuminator and architect. The son of a goldsmith, he was enrolled in the Florentine goldsmiths' guild at the age of five. Later he must have frequented the workshops of Antonio and Piero Pollaiuolo and, particularly, that of Andrea Verrocchio, where the major artists of his generation, such as Botticelli, Ghirlandaio, Leonardo da Vinci, Lorenzo di Credi, Perugino and Signorelli, used to meet. He probably also had contacts with artists in Arezzo, especially Piero della Francesca, and in Urbino, where Piero, Melozzo da Forlí, Donato Bramante, Justus of Ghent (*fl c.* 1460–80) and Pedro Berruguete (*c.* 1450–*c.* 1500) worked. Early links with Urbino are also suggested by his friendship, noted by Vasari, with Gentile de' Becchi of Urbino (later Bishop of Arezzo) and by a miniature of the *Martyrdom of St Agatha*, definitely by his hand, in gradual D of Urbino Cathedral (Cathedral archv). In 1468 he took holy orders, probably in the Camaldolese monastery of S Maria degli Angeli, Florence, which his brother Nicolò had already entered. In 1470 he was in Arezzo at the convent of S Maria in Gradi and had the adopted name of Bartolomeo ('della Gatta' apparently refers to his fondness for a female cat). He spent most of the rest of his life in Arezzo, where he became abbot of S Clemente.

Florentine characteristics and echoes of Piero della Francesca are combined in a few fragmentary frescoes by Bartolomeo in S Domenico in Cortona; these include a *St*

Roch and scenes from the *Life of St Anthony*, which are among the earliest of his surviving works. Also for Cortona, probably in the mid-1470s, he painted his greatest work, the *Assumption of the Virgin* (Cortona, Mus. Dioc.; see fig.), formerly in the Benedictine convent of the Contesse. The influence of Piero is apparent in the bright, diffused light and in the solemn monumentality of the earthly figures. The nervous elegance in the drawing of the celestial figures is reminiscent of Botticelli, and Flemish influence is suggested by the intricate fragmentation of some of the draperies and a realistic rendering of certain heads, obviously drawn from life. This is a complex, sophisticated art, in some ways more advanced than that of Bartolomeo's contemporaries Signorelli and Perugino. Piero's influence appears in other works that Bartolomeo painted shortly afterwards in Arezzo: the fresco of *St Lawrence* (1476) in the church of the Badia; and two paintings of *St Roch*, one executed in 1478–9 for the Fraternità dei Laici, the other perhaps a little later for S Maria della Pieve (both Arezzo, Gal. & Mus. Med. & Mod.); a third *St Roch* is in Florence (Mus. Horne).

According to Vasari, Bartolomeo painted a narrative scene in the Sistine Chapel, Rome, with Signorelli and Perugino; this is generally accepted as the *Last Days of Moses*, in which he collaborated with Signorelli; others see

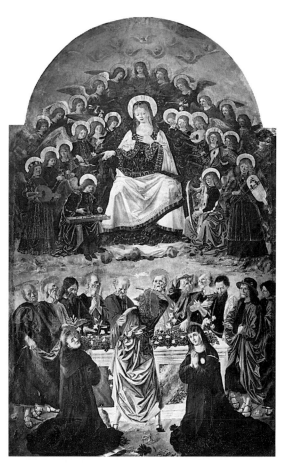

Bartolomeo della Gatta: *Assumption of the Virgin*, tempera on canvas, 3.89×2.37 m, mid-1470s (Cortona, Museo Diocesano)

Bartolomeo's hand in Perugino's painting of *Christ Handing the Keys to St Peter*. In 1482 Bartolomeo returned to Arezzo, where, probably soon afterwards, he executed the fresco of the *Penitent St Jerome* (Arezzo, Mus. Dioc.), with many motifs from Signorelli and Pollaiuolo, and a fresco of the *Crucifixion* in Sansepolcro Cathedral. In the *Virgin and Child with SS Peter, Paul, Michael and Julian* (1486; Castiglion Fiorentino, collegiata di S Giuliano), Bartolomeo brought new grandeur and dynamism to the Florentine altarpiece, with its symmetrical lines of figures, by using varied poses and a freer handling of spatial relationships. The *Stigmata of St Francis* (Castiglion Fiorentino, Pin. Com.), painted soon afterwards, demonstrates his brilliant eclecticism. Its subtle effects of light in the crepuscular landscape recall Flemish art and also that of Provence. The *Virgin and Child with SS James and Christopher* (Manciano della Chiana, SS Andrea & Stefano) also dates from this period. There is little evidence of Bartolomeo's work as a painter after 1487, although his hand can be identified in the altarpiece of the *Virgin and Child with SS Fabian and Sebastian* (Arezzo, Mus. Dioc.) by Domenico Pecori (*c*. 1485–1527), for which he provided the general scheme; he appears to have drawn a few of the heads, including that of St Fabian.

Bartolomeo designed the church of SS Annunziata, Arezzo, after 1490, on a Latin-cross plan; it was not completed in his lifetime but was later completed and enlarged by Antonio da Sangallo the elder. Vasari mentioned architectural projects planned by Bartolomeo for his friend Gentile de' Becchi, but never built, and he also noted that Bartolomeo was a skilled musician and that he built organs (all untraced). Bartolomeo was, after Piero, the greatest artist in Arezzo in the second half of the 15th century, and one of the major painters of his generation. Because he produced few works and was active in a restricted provincial area, and because he had no workshop to propagate his style, which was in any case too personal and eclectic to be easily imitated, he is not regarded as highly as such contemporaries as Perugino and Signorelli, but his work is in no way inferior. In the period between 1470 and 1480, in particular, his art is especially strong. His followers, such as Pecori, Matteo Lappoli (*d* 1504) and Angelo di Lorentino, all seem to have been mediocre provincial artists.

BIBLIOGRAPHY

G. Vasari: *Vite* (1550, rev. 2/1568); ed. G. Milanesi (1878–85), iii, pp. 213–25

A. Martini: 'The Early Work of Bartolomeo della Gatta', *A. Bull.*, xlii (1960), pp. 133–41

Arte in Valdichiana (exh. cat., ed. L. Bellosi, G. Cantelli and M. Lenzini Moriondo; Cortona, Fortezza Girifalco, 1970), pp. 30–35

E. Ruhmer: 'Eine Madonna des Bartolomeo della Gatta', *Studi di storia dell'arte in onore di Antonio Morassi* (Venice, 1972), pp. 75–84

Arte nell'Aretino: Recuperi e restauri dal 1968 al 1974 (exh. cat., ed. E. Edam and A. Maetzke; Arezzo, S Francesco, 1974–5), pp. 103–10

Arte nell'Aretino: Dipinti e sculture restaurati dal XIII al XVIII secolo (exh. cat., ed. A. Maetzke; Arezzo, S Francesco, 1979–80), pp. 49–59

A. Garzelli: *La miniatura fiorentina, 1440–1525* (Florence, 1985), pp. 260–62

A. M. Maetzke: *Nel raggio di Piero* (exh. cat., ed. Marsilio; Sansepolcro, Casa Piero, 1992), pp. 125–65

The Painted Page: Italian Renaissance Book Illumination, 1450–1550 (exh. cat., ed. J. J. G. Alexander; London, RA, 1994)

M. Levi D'Ancona: 'Addenda a Bartolomeo della Gatta miniatore', *Bibliofilia*, xcvi/3 (Sept–Dec 1994), pp. 313–33

P. SCARPELLINI

Bartolomeo di Antonio Varnucci. *See* VARNUCCI, BARTOLOMEO DI ANTONIO.

Bartolomeo di Fruosino (*b* Florence, 1366; *d* Florence, 17 Dec 1441). Italian painter and illuminator. In 1394 he was among the pupils of Agnolo Gaddi working on the decoration of the chapel of the Sacro Cingolo in Prato Cathedral. In the same year he joined the Compagnia dei Pittori in Florence, and between 1386 and 1408 he appears to have been a member of the Arte dei Medici e Speziali there. In 1411 he was commissioned to paint a *Crucifix* for S Maria Nuova, Florence, which Levi D'Ancona (1961) identified with a painted cross in the Accademia, Florence (3147).

In the following years, until 1438, Bartolomeo's name appears in the account books of S Maria Nuova for unspecified works. In 1421 he signed a Missal illuminated for S Egidio, Florence (Florence, Mus. S Marco, MS. 557), which has formed the basis for further attributions. Bartolomeo may also have collaborated with Lorenzo Monaco on the *Annunciation* triptych and fresco cycle of the Bartolini Salimbeni Chapel in Santa Trìnita, on some detached miniatures (Paris, Mus. Marmottan, no. 14; Detroit, MI, Inst. A., no. 37133) and on other manuscripts (Florence, Bib. Medicea–Laurenziana, MS. 3; Florence, Bargello, MSS H. 74 and G. 73). He probably painted the triptych with *SS Lawrence, Ansanus and Margaret* (1407; Avignon, Mus. Petit Pal.), together with the predella panels now in the Vatican (nos 215–17). The works attributed to Bartolomeo di Fruosino confirm his Late Gothic Florentine training and reveal him as one of the most attentive, if not the most sensitive, collaborators of Lorenzo Monaco.

BIBLIOGRAPHY

M. Levi D'Ancona: 'Bartolomeo di Fruosino', *A. Bull.*, xliii (1961), pp. 85–97

——: *Miniatori e pittori a Firenze dal XIV al XVI secolo* (Florence, 1962), pp. 44–8

M. Meiss, C. Singleton and S. Brieger: *Illuminated Manuscripts of the Divine Comedy* (Princeton, 1969), pp. 40, 106, 374–6

M. Boskovits: 'Su Don Silvestro, Don Simone e la scuola degli Angeli', *Paragone*, xxiii/265 (1972), pp. 35–61

P. F. Watson: 'A *desco da parto* by Bartolomeo di Fruosino', *A. Bull.*, lvi (1974), pp. 4–9

L. Bellosi: 'Due note in margine a Lorenzo Monaco miniatore: Il Maestro del Codice Squarcialupi e il poco probabile Matteo Torelli', *Studi di storia dell'arte in memoria di M. Rotili* (Naples, 1984), pp. 307–14

M. Eisenberg: *Lorenzo Monaco* (Princeton, 1989)

MILVIA BOLLATI

Bartolomeo di Giovanni [Alunno di Domenico] (*fl* Florence, *c*. 1475–*c*. 1500/05). Italian painter, draughtsman and designer. His only documented works are the seven predella panels (see fig.) for Domenico Ghirlandaio's altarpiece of the *Adoration of the Magi* (Florence, Gal. Osp. Innocenti), painted in 1488 for S Maria degli Innocenti, the church of the Foundling Hospital, Florence (Bruscoli). Berenson (1903), before he knew the artist had been identified, grouped a body of work around the painter of the Innocenti panels under the name Alunno di Domenico ('pupil of Domenico'). Later archival work (Pons) revealed that Bartolomeo di Giovanni was not the same person as Bartolommeo di Giovanni di Miniato, a bookseller and brother of the illuminators Gherardo and Monte del Foro, as Venturi proposed. Nor is it likely that

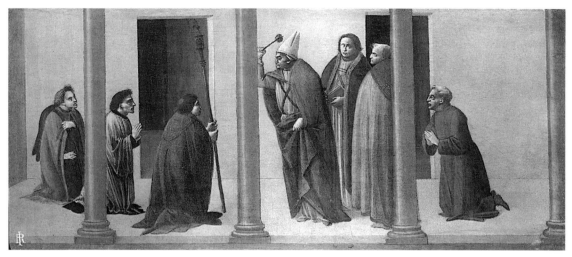

Bartolomeo di Giovanni: *Consecration of S Maria degli Innocenti, the Church of the Foundling Hospital, Florence*, panel from the Innocenti Predella, 230×590 mm, 1488 (Florence, Musei dell'Ospedale degli Innocenti)

he was the same person as the Bartolomeo di Giovanni Masini, who was a painter of banners (*sargie*) cited in the Red Book of the Compagnia di S Luca, Florence (Fahy, 1973, 1976); Fahy also believed that Masini was one of the del Foro brothers.

Bartolomeo di Giovanni probably began his career working for Domenico Ghirlandaio. The earliest work attributed to him is the predella to Ghirlandaio's *Sacra conversazione* (*c.* 1475–80; Lucca Cathedral) with scenes of the *Liberation of St Peter*, *St Clement Thrown into the Sea*, the *Martyrdom of St Paul*, the *Pietà* and figures of *St Matthew* and *St Lawrence*. Bartolomeo provided the predella with scenes from the lives of St Clement, St Dionysius, St Dominic and St Thomas Aquinas for Ghirlandaio's altarpiece of the *Virgin and Child Enthroned with Saints* (Florence, Uffizi) and the predella for Ghirlandaio's *Coronation of the Virgin* (1486; Narni, Pin. Com.) with scenes of the *Stigmatization of St Francis* and *St Jerome in the Desert*. He also painted background scenes both in altarpieces, such as the Massacre of the Innocents in the background of the *Adoration of the Magi* (Florence, Gal. Osp. Innocenti), and in frescoes, such as the figures in the middle ground in the *Calling of SS Peter and Andrew* in the Sistine Chapel, Rome, of *c.* 1482. He also apparently collaborated with Botticelli on the *spalliera* of *Nastagio degli Onesti's Banquet in the Wood* (*c.* 1483; Madrid, Prado; see colour pl. 1, XIV2).

Bartolomeo's copious production of painted predellas and decorative furniture, such as *spalliere* and *cassoni*, includes the *Myth of Thetis* (Paris, Louvre), the *Rape of the Sabine Women* and the *Peace Between the Sabines and the Romans* (both Rome, Gal. Colonna) and suggests that he specialized in small-scale paintings (*see* SPALLIERA). Relatively few larger-scale paintings are attributed to him; among these is the *Deposition* (Toronto, A.G. Ont.), in which, however, the animated figures are stylistically treated in the same way as those in his small predella panels. His style, while revealing the strong influence of Ghirlandaio, is distinguished by a greater sense of movement and a taste for almost caricatured facial expressions.

Bartolomeo's method of working as a specialist artisan for some of the greatest masters in 15th-century Florence was typical of studio organization at that date. He also worked with Pinturicchio in the Sala dei Misteri in the Borgia apartments (Rome, Vatican, Appartamento Borgia), particularly on the scenes of the *Adoration of the Magi* and the *Nativity* (De Francovich). It would seem likely that he acquired certain Umbrian stylistic traits at this stage, and that they are not, as De Francovich believed, dependent on his presence in Perugia in 1501. He also produced a large number of drawings, designs both for embroideries (e.g. Florence, Uffizi, 339E, 352E) and for woodcuts to be used as book illustrations (e.g. *Epistolae et evangelii*, ed. P. Pacini, Florence, 1495).

BIBLIOGRAPHY

A. Venturi: *Storia* (Milan, 1901–40), VII, i, p. 773
G. Bruscoli: *Tavola di Domenico Ghirlandaio nella chiesa degli Innocenti: Opuscolo per le nozze Canevaro Ridolfi* (Florence, 1902)
B. Berenson: 'Alunno di Domenico', *Burl. Mag.*, i (1903), pp. 1–20
G. De Francovich: 'Nuovi aspetti della personalità di Bartolomeo di Giovanni', *Boll. A.*, vi (1926), pp. 65–92
B. Berenson: *Florentine School* (1963) i, pp. 24–7
E. Fahy: 'Bartolomeo di Giovanni Reconsidered', *Apollo*, xcvii (1973), pp. 462–9
A. Garzelli: *Il ricamo nella attività artistica di Pollaiuolo, Botticelli, Bartolomeo di Giovanni* (Florence, 1973)
E. Fahy: *Some Followers of Domenico Ghirlandaio* (New York, 1976), pp. 33–45, 126–66
N. Pons: *Bartolomeo di Giovanni pittore e disegnatore* (diss., U. Florence, Istituto di Storia dell'Arte, 1987)

NICOLETTA PONS

Bartolomeo di Giovanni Corradini. See CARNEVALE, FRA.

Bartolomeo di Giovanni del Fora. *See under* FORA, DEL.

Bartolomeo di Tommaso (da Foligno) (*b* Foligno, 1408–11; *d* Rome, before 6 Feb 1454). Italian painter. He is first documented in 1425 in Ancona, where he may have trained with Olivuccio di Ceccarello (*fl* 1388–1439). Possible early works include a *Virgin and Child* (Milan, Brera) and two scenes from the *Life of St Francis* (Venice,

Fond. Cini; Baltimore, MD, Walters A.G.). His first secure work is the panel of the *Virgin and Child with St John the Baptist and the Blessed Pietro Crisci* from a triptych commissioned for S Salvatore, Foligno, in 1432, and this shows his familiarity with the work of Sassetta and possibly Masaccio. From 1434 Bartolomeo worked at Fano, where he executed frescoes (1434–9; destr.) on the façade of S Guiliano. He received an important commission in 1439, to execute the high altarpiece (destr.) for S Francesco, Cesena. From 1441 to 1451 he lived in Foligno and executed works including frescoes of *St Barbara*, the *Madonna of Loreto* and *St Anthony Preaching* (all 1449; Foligno, Pin. Civ.), the Rospigliosi Triptych (*c.* 1450; Rome, Pin. Vaticana) and the fresco of the *Last Judgement* (*c.* 1450; Terni, S Francesco). He was in Rome *c.* 1451–2 in the service of Pope Nicholas V, but no work survives. In 1452 he donated a triptych (possibly Venice, Fond. Cini) to S Maria Maddalena, Foligno. Bartolomeo's imaginative and expressionistic treatment of subject-matter and innovative compositions influenced artists in the Marches, particularly Nicola di Maestro Antonio and Andrea Delitio.

BIBLIOGRAPHY

M. Sensi: 'Documenti per Bartolomeo di Tommaso da Foligno', *Paragone*, xxviii/325 (1977), pp. 103–56

B. Toscano: 'A proposito di Bartolomeo di Tommaso', *Paragone*, xxviii/325 (1977), pp. 80–85

R. Cordella: 'Un sodalizio tra Bartolomeo di Tommaso, Nicola da Siena, Andrea Delitio', *Paragone*, xxxviii/451 (1987), pp. 89–122

La pittura in Italia: Il quattrocento, ii (Milan, 1987), pp. 573–4

□

Bartolomeo Veneto (*fl* 1502; *d* Turin, Dec 1531). Italian painter. He worked in Venice, the Veneto and Lombardy in the early decades of the 16th century. Knowledge of him is based largely on the signatures, dates and inscriptions on his works. His early paintings are small devotional pictures; later he became a fashionable portraitist. His earliest dated painting, a *Virgin and Child* (1502; Venice, priv. col., see Berenson, i, pl. 537), is signed 'Bartolomeo half-Venetian and half-Cremonese'. The inscription probably refers to his parentage, but it also suggests the eclectic nature of his development. This painting is clearly dependent on similar works by Giovanni Bellini and his workshop, but in a slightly later *Virgin and Child* (1505; Bergamo, Gal. Accad. Cararra) the sharp modelling of the Virgin's headdress and the insistent linear accents in the landscape indicate Bartolomeo's early divergence from Giovanni's depiction of light and space. An inscription on his *Virgin and Child* of 1510 (Milan, Ercolani Col.) states that he was a pupil of Gentile Bellini, an assertion supported by the tightness and flatness of his early style. The influence of Giovanni is still apparent in the composition of the *Circumcision* (1506; Paris, Louvre), although the persistent stress on surface patterns and the linear treatment of drapery and outline is closer to Gentile. Bartolomeo's experience as a painter at the Este court in Ferrara (1505–8) probably encouraged the decorative emphasis of his style. In the half-length *Portrait of a Man* (*c.* 1510; Cambridge, Fitzwilliam) the flattened form of the fashionably dressed sitter is picked out against a deep red curtain so that the impression of material richness extends across the entire picture surface. The precise layout and meticulous attention to costume detail are also characteristic of Bartolomeo's style in sacred subjects.

Bartolomeo was probably in Padua in 1512, and from 1520 he was in Milan, where he obtained a number of important portrait commissions. The mediocre Milanese portrait tradition had been revitalized by Leonardo da Vinci in the late 15th century and further developed by his follower Andrea Solario. Bartolomeo's immediate response to this tradition, evident in the *Girl Playing the Lute* (1520; Milan, Brera; another autograph version Boston, MA, Isabella Stewart Gardner Mus.), is characterized by sharp chiaroscuro that gives a new structural coherence and freedom. These features are also present in the series of half-length portraits of fashionably dressed young men (1520; Washington, DC, N.G.A.; Houston, TX, Mus. F.A.; Rome, Pal. Barberini). Although Bartolomeo continued to demonstrate an interest in decorative detail in these portraits, the subtle play of light across the sitters' faces gives a new psychological suggestiveness reminiscent of Leonardo. Two later portraits show a further stylistic progression. The *Portrait of a Woman* (1530; ex-Mentmore Towers, Bucks; sold London, Sotheby's, 25 May 1977) and the portrait of *Ludovico Martinengo* (1530; London, N.G.; see fig.) are both three-quarter length, with softer, more fluid handling and a greater sense of volume, depth and movement. These elements indicate Bartolomeo's awareness of the portraiture of Titian, although the interest in elaborate costume and the promi-

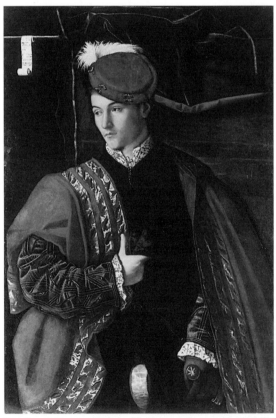

Bartolomeo Veneto: *Ludovico Martinengo*, oil on panel, 1050×711 mm, 1530 (London, National Gallery)

nent use of a dusky red colour are continuations from his own earlier style.

The documents confirming Bartolomeo's death at Turin in 1531 suggest he had been living there for some time, although it is likely that he was still active in the Milan area in June 1530 when he painted Martinengo, an aristocrat from nearby Brescia. Portrait drawings by Bartolomeo survive at Modena (Gal. & Mus. Estense), Milan (Bib. Ambrosiana) and Vienna (Albertina).

BIBLIOGRAPHY

DBI

A. Venturi: 'Bartolomeo Veneto', *L'Arte*, ii (1899), pp. 432–62
E. Michalski: 'Zur Problematik des Bartolomeo Veneto', *Z. Bild. Kst*, lxi (1927–8), pp. 280–88, 301–9
A. Mayer: 'Zur Bildniskunst des Bartolomeo Veneto', *Pantheon*, ii (1928), pp. 571–81
E. Michalski: 'Zur Stilkritik des Bartolomeo Veneto', *Z. Bild. Kst*, lxv (1931–2), pp. 177–84
B. Berenson: *Venetian School* (1957), i, pp. 11–13
C. Gilbert: 'Bartolomeo Veneto and his *Portrait of a Lady*', *Bull. N.G. Can.*, 22 (1973), pp. 2–16
C. Boselli: 'Il pittore Bartolomeo Veneto alla luce di nuovi documenti', *A. Ven.*, xxviii (1974), pp. 295–6
M. S. Newton: 'The Dating of a Portrait by Bartolomeo Veneto', *A. Ven.*, xxx (1976), pp. 157–8

TOM NICHOLS

Bartolommeo [Bartolomeo], **Fra** [Porta, Baccio della] (*b* Florence, 28 March 1472; *d* Florence, 31 Oct 1517). Italian painter and draughtsman. Vasari and later historians agree that Fra Bartolommeo was an essential force in the formation and growth of the High Renaissance. He was the first painter in Florence to understand Leonardo da Vinci's painterly and compositional procedures. Later he created a synthesis between Leonardo's tonal painting and Venetian luminosity of colour. Equally important were his inventions for depicting divinity as a supernatural force, and his type of *sacra conversazione* in which the saints are made to witness and react to a biblical event occurring before their eyes, rather than standing in devout contemplation, as was conventional before. His drawings, too, are exceptional both for their abundance and for their level of inventiveness. Many artists came under his influence: Albertinelli, Raphael, Andrea del Sarto, Titian, Correggio, Beccafumi, Pontormo and Rosso Fiorentino.

1. Life and work. 2. Workshop.

1. LIFE AND WORK. Fra Bartolommeo was the son of Paolo, a muleteer and carter. After 1478 he lived in a modest family house outside the Porta S Pier Gattolini in Florence and consequently was dubbed Baccio (a Tuscan diminutive for Bartolommeo) della Porta. In 1485 he is documented as an apprentice of Cosimo Rosselli to whom he had been introduced, according to Vasari, by Benedetto da Maiano. His real teacher, however, was, as Bernard Berenson first proposed, Piero di Cosimo, the senior assistant in Rosselli's workshop. Piero transmitted to Fra Bartolommeo his interest in the painterly techniques of the Netherlandish school, such as how to make tempera more flexible by the additions of oils, and opened Fra Bartolommeo's eyes to examples of German art available through engravings. Piero also encouraged Fra Bartolommeo to investigate the developments taking place in the workshops of Botticelli, Filippino Lippi, Verrocchio and Lorenzo di Credi, Perugino, Ghirlandaio and Signorelli.

Vasari also reported that MARIOTTO ALBERTINELLI and Fra Bartolommeo became fast friends while working under Rosselli. Together they left their master at an unknown date to set up a joint workshop.

(i) Paintings. (ii) Drawings.

(i) Paintings.

(a) *c.* 1495–1503. (b) 1504–8. (c) 1509–13. (d) 1513–17.

(a) c. 1495–1503. The first certain dated painting by Albertinelli and Fra Bartolommeo is the *Annunciation* (1497; Volterra Cathedral). However, a few paintings entirely by Fra Bartolommeo have been convincingly dated earlier. They are mostly small works such as diptychs or tabernacles. The *Adoration of the Child* (Louisville, KY, Speed A. Mus.), a tiny panel, was certainly part of a diptych, still influenced by Piero di Cosimo. The figure of the Virgin, however, demonstrates that the young artist had also studied early Quattrocento masters, in this case Fra Filippo Lippi. According to Vasari, he studied Masaccio's frescoes in the Brancacci Chapel (*see* MASACCIO, fig. 6 and colour pl. 2, II2) assiduously and, consequently, was able to give weighty form to his figures even when working on a miniature scale.

By the late 1490s Fra Bartolommeo had begun to attract significant commissions. For Piero del Pugliese he painted panels of the *Adoration of the Child* and the *Presentation in the Temple* with the *Annunciation* on their reverse for a tabernacle (Florence, Uffizi) made to frame a marble relief by Donatello. By this time he was an artistically erudite painter: the *Annunciation* is painted in grisaille, imitating the Netherlandish technique, the figures in the *Presentation in the Temple* have a formal solidity reminiscent of Masaccio and the landscape in the *Adoration of the Child* is as detailed as the background in a painting by Hans Memling (1430/40–94), while also showing knowledge of Perugino.

Two paintings from the last years of the 1490s reveal Fra Bartolommeo's discovery of Leonardo da Vinci: the *Madonna and Child with the Young St John the Baptist* (New York, Met.; see fig. 1), based on the composition of Leonardo's Benois *Madonna* (St Petersburg, Hermitage), and the *Adoration of the Child* (Rome, Gal. Borghese), with its deep understanding of Leonardo's procedures for creating tonal unity through monochromatic preparation of the forms. From Lorenzo di Credi he gained some of the technical secrets developed by Leonardo, who had been Lorenzo's associate before his departure in 1482 for Milan. But Fra Bartolommeo was chiefly fascinated, as his early drawings show (*see* §(ii) below), by Leonardo's interaction of light and shadows on forms. For this he studied the unfinished works Leonardo had left in Florence: the *Adoration of the Magi* (Florence, Uffizi; *see* LEONARDO DA VINCI, fig. 1) and the *St Jerome* (Rome, Pin. Vaticana), absorbing directly Leonardo's preparation of the composition in a strictly monochromatic range of values.

In 1499 Gerozzo Dini commissioned Fra Bartolommeo to paint a monumental fresco of the *Last Judgement* (Florence, Mus. S Marco) for a cemetery chapel in S Maria Nuova, in which the artist quoted the pose of Leonardo's *St Jerome*. It is uncertain, however, how much of the total

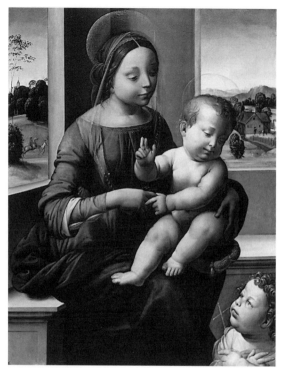

1. Fra Bartolommeo: *Madonna and Child with the Young St John the Baptist*, tempera on panel, 584×438 mm, late 1490s (New York, Metropolitan Museum of Art)

composition was derived from Leonardo because of the changes made to the lower half by Albertinelli and later restorers. No drawing for the whole composition exists. Still, Fra Bartolommeo's reliance on an ideal process of invention is clear: he organized the composition in large geometrical blocks, seeking stylish poses full of movement and inflated drapery patterns for the most prominent figures. The *Last Judgement* and its preparatory studies influenced the young Raphael. This can be detected in Raphael's *Coronation of the Virgin* (1503; Rome, Vatican Mus.), in the *Trinity with Saints* (Perugia, S Severo) and the *Disputa* in the Stanza della Segnatura (Rome, Vatican Pal.).

On 26 July 1500 Fra Bartolommeo entered the convent of S Domenico di Prato, where, one year later, he took the vows of the Dominican Order and adopted the name of Fra Bartolommeo. He renounced the art of painting, although he continued to draw and provided Albertinelli with studies for the figures in the *Visitation of the Virgin* (1503; Florence, Uffizi). He also made drawings after Botticelli's floating angels in the *Mystic Nativity* (London, N.G.) and arranged for Albertinelli to finish the *Last Judgement*. These drastic decisions were precipitated by the Dominican preacher Fra Girolamo Savonarola's trial and execution in 1498. As Vasari reported, Fra Bartolommeo was an ardent follower of Savonarola and was in the convent of S Marco on the night of Savonarola's arrest on 8 April 1498. By the end of 1501 Fra Bartolommeo was a member of S Marco's congregation. His lasting devotion to Savonarola is proved by his posthumous portrait of him (Florence, Mus. S Marco); its original inscription identifies the preacher as a prophet sent by God.

(b) 1504–8. Fra Bartolommeo resumed painting in 1504 probably at the instigation of Sante Pagnini, then prior of S Marco. All his paintings until 1516 are recorded in an inventory prepared in December of that year by Fra Bartolommeo Cavalcanti (Florence, Bib. Medicea–Laurenziana 903, *Ricordanze* B., pp. 127–9). First listed are small paintings either donated to friends of S Marco or bought by agents who resold them. The best known of the latter are Girolamo Casio, an intermediary for Isabella d'Este, Marchioness of Mantua, and Domenico Perini who sent the *Noli me tangere* (Paris, Louvre) to France to become part of the royal collection.

In November 1504 Fra Bartolommeo signed the contract for the *Vision of St Bernard* (Florence, Uffizi; see fig. 2), an altarpiece ordered by Bernardo del Bianco for his newly built chapel in the Badia of Florence. Del Bianco contested the finished painting's worth, engendering a bitter dispute that was eventually settled in July 1507. Botticelli's late works were a major influence on Fra Bartolommeo at this time. The hovering angels accompanying the apparition of the Virgin are inventions rooted in Botticelli's formulations for the depiction of ecstatic religious feelings. However, the cohesive flow they form and the impact they create are derived from Leonardo's formal principles of design. According to the contract, Fra Bartolommeo was to paint only a standing Virgin flanked by saints, but instead he created a vision of the floating Virgin and angels appearing to St Bernard. This was symptomatic of a new religious conviction in transcendentalism as a governing principle for the artistic representation of apparitional and celestial themes, reversing the prevalent 15th-century convention that allowed the representation of supernatural phenomena as ordinary physical events.

During this period Fra Bartolommeo accepted only two other commissions for monumental altarpieces: the *Assumption of the Virgin* (1507; ex-Kaiser-Friedrich-Mus., Berlin, destr.) and the *God the Father with SS Mary*

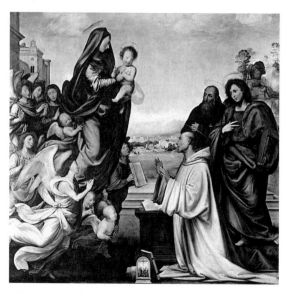

2. Fra Bartolommeo: *Vision of St Bernard*, oil on panel, 2.15×2.31 m, 1504–7 (Florence, Galleria degli Uffizi)

Magdalene and Catherine of Siena (Lucca, Villa Guinigi). He was given this latter commission during his visit to Venice in the spring of 1508 by the Dominican convent of S Piero Martire in Murano; however, the altarpiece, which was finished in 1509, never went to Murano and in 1513 was secured by Sante Pagnini for S Romano, Lucca. This altarpiece is another example of Fra Bartolommeo's innovative depiction of a transcendental vision: the two saints are lifted lightly off the ground by their rapture in the divine apparition. An angel holds a scroll inscribed DIVINUS AMOR EXTASIM FACIT, a phrase taken from Dionysius the Areopagite (*Divine Names*, iv) and often used by Savonarola. Thus, to a degree, the programme of the altarpiece is dependent on Savonarola's belief that the love of God produces ecstatic transport. The resonance of the sky is achieved by quantities of Venetian blue that Fra Bartolommeo had acquired in Venice in 1508. Other effects of his absorption of Venetian painterly techniques are seen in the intensity of colour and the intermittent transmission of light through it. It is evident that Albertinelli collaborated on the painting.

(c) 1509–13. By the beginning of 1509 Albertinelli was working in equal partnership with Fra Bartolommeo, entitled to half the profits produced by each shared commission. This partnership was sponsored and administered by S Marco, where the painters had their workshop. It lasted for approximately three years, during which time Fra Bartolommeo consistently painted large altarpieces and was also acknowledged as the leader of the Florentine school of painting.

The two artists collaborated only on selected projects. Other major projects were handled by Fra Bartolommeo with the help of minor assistants. In 1509 Fra Bartolommeo painted, by himself, the *Virgin and Child with SS John the Baptist and Stephen* for Lucca Cathedral (*in situ*). When the patrons of that work asked for another altarpiece, he refused. The partners were concentrating on altarpieces for Florence or on commissions for internationally important institutions or individuals.

In 1510 the partners painted the *Virgin and Child with SS Catherine, Mary Magdalene, John the Baptist, Nicholas, Peter Martyr and Benedict* for the altar of Piero Cambi in the church of S Marco, Florence, the only large altarpiece by Fra Bartolommeo still in its original location. Late that year the Signoria of Florence and the gonfalonier, Piero Soderini, granted Fra Bartolommeo the most important commission of his life: the Great Council Altarpiece, a large-scale *sacra conversazione* destined for the Hall of Great Council in the Palazzo della Signoria. The commission had been given to Filippino Lippi in 1491 but had not been finished; Fra Bartolommeo did not complete it either, preparing only the underpainting of the composition in monochrome (Florence, Mus. S Marco). In 1511 he finished another altarpiece for S Marco, the *Mystic Marriage of St Catherine of Siena* (Paris, Louvre; see fig. 3). The Signoria of Florence acquired it and sent it to France as a present for Bishop Jacques Hurault, the French ambassador to Florence. In 1512 Fra Bartolommeo replaced it with a second *Mystic Marriage of St Catherine of Siena* (Florence, Accad.; see colour pl. 1, VII2).

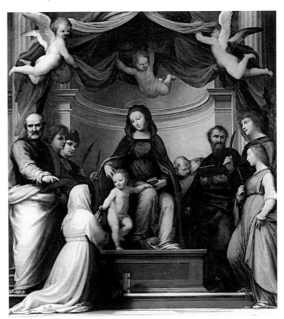

3. Fra Bartolommeo: *Mystic Marriage of St Catherine of Siena*, oil on panel, 2.57×2.28 m, 1511 (Paris, Musée du Louvre)

In the Great Council Altarpiece and in the two depictions of the Mystic Marriage of St Catherine architectural backgrounds of grandiose, spheroid niches are harmonized with the figure arrangements. Giovanni Bellini's large *sacra conversazione*, which Fra Bartolommeo could have seen in Venice, provided the stimuli for these architectural inventions. Other features, however, such as the animation of the figures and the circular canopies in the two mystic marriages appear to be influenced by Raphael's *Madonna and Child Enthroned with Saints*, the '*Baldacchino*' (Florence, Pitti). In his large *sacra conversazione* Fra Bartolommeo strove to create ideal forms endowed with axial and circular rhythm. In this same picture and in the unfinished *Adam and Eve* (Philadelphia, PA, Mus. A.), he fused Venetian flexibility of colour with an ambient chiaroscuro. This he achieved by preparing the composition in monochrome on the panels, a technique first used by Leonardo. He also made excessive use of ivory black (prepared by charring bones) for darkening the colours. In the second *Mystic Marriage of St Catherine* the black particles continued to disperse in the colours, making the painting much darker and less transparent than intended.

Meanwhile Fra Bartolommeo was working with Albertinelli on two other prestigious commissions: the *Pietà* (Florence, Pitti) for the high altar of the Certosa di Pavia and the altarpiece for Ferry Carondelet, a complex composition originally showing the *Coronation of the Virgin* (Stuttgart, Staatsgal.) in its arched top and the *Virgin and Child in Glory with SS Sebastian, John the Baptist, Stephen, Anthony Abbot, Bernard the Donor and Ferry Carondelet* (Besançon Cathedral) below. Contrary to previous belief, Albertinelli made decisive contributions as Fra Bartolommeo's partner. For the Ferry Carondelet Altarpiece he created the determinative drawing (Rotterdam, Mus. Boymans–van Beuningen, Album M 181) and painted the *Coronation*. The *Annunciation* (1511; Geneva, Mus. A. &

Hist.), originally framed with panels by Perugino, also shows the imprint of Albertinelli's personal style and bears both artists' signatures plus the mark of the workshop of S Marco, a cross with a double ring. The mark appears on several other workshop paintings from the partnership years. Without the two men's signatures, it indicates only workshop production by assistants under the supervision of the partners. The participation of each partner in any execution should be assessed case by case.

During this period Fra Bartolommeo produced only a few smaller panels. Some were reserved as gifts for important political personages such as Piero Soderini and Giovanni de' Medici, the future Pope Leo X. Documents show that the partners painted a picture for Averardo Salviati, probably the *Adoration of the Child* (London, N.G.). Entirely by Fra Bartolommeo is the *Holy Family with the Infant St John* (Firle Place, E. Sussex), his supreme achievement in paintings of this size.

(d) 1513–17. Fra Bartolommeo is documented as being in Rome in July 1513. He probably went for Leo X's elevation to the papacy in March. It appears he also visited the convent of S Maria della Quercia in Viterbo. In Rome he worked on two panels for Mariano Fetti, prior of S Silvestro, *St Peter* and *St Paul* (both Rome, Pin. Vaticana), but he fell ill and returned to Florence, leaving *St Peter* unfinished. According to Vasari, it was completed by Raphael. While recovering from the illness that plagued him for the rest of his life, Fra Bartolommeo spent the summer of 1514 in the hospice of S Maria Maddalena on the outskirts of Florence where he painted, aided by two unidentified assistants, three frescoes of the *Virgin and Child*, two of which have survived (Florence, Mus. S Marco).

On 5 November 1513 the partnership with Albertinelli was dissolved. The document recording this transaction explains how the paintings held in common were divided. Fra Bartolommeo retained the *God the Father with SS Mary Magdalene and Catherine of Siena*, the Great Council Altarpiece and other unidentified smaller paintings. Of the paintings received by Albertinelli, two have been identified: the *Pietà* for the Certosa di Pavia and the small *Adam and Eve*, both of which had been left unfinished by Fra Bartolommeo.

In 1515 Fra Bartolommeo resumed painting on a large scale. After his Roman experience in 1513, he became the first Florentine painter to be caught stylistically between the revolutionary and contrasting innovations of Michelangelo and Raphael. His response was equitable. In the *Madonna of Mercy* (Lucca, Villa Guinigi), painted for the new chapel erected by Fra Sebastiano Montecatini-Lombardi in S Romano, Lucca, the central figures isolated like statues on pedestals were derived from the Victories that Michelangelo had planned to have on Pope Julius II's tomb in projects of 1505 and 1513. Fra Bartolommeo's colossal fresco of the standing figure of *St Mark* (Florence, Pitti) is also a tribute to Michelangelo. It was painted on the choir wall of S Marco, Florence, with *St Sebastian* (destr., copy Fiesole, S Francesco) as a pendant. The latter became famous because women complained that the saint's nudity interfered with their devotions (Vasari).

The *St Sebastian* was eventually sold to King Francis I (*reg* 1515–47) of France. The small *Annunciation with Six Saints* (Paris, Louvre) appears to have been sent to the King in 1516, and an unconfirmed report that the King had invited Fra Bartolommeo to France is credible. Another important painting, the *Virgin and Child with Angels* (1515; St Petersburg, Hermitage), was made for Lorenzo II de' Medici, the future Duke of Urbino. Visiting Ferrara in March 1516, Fra Bartolommeo promised Alfonso I d'Este, Duke of Ferrara, to paint a *Feast of Venus* for his Camerino d'Alabastro. The painting was never executed, and the commission went to Titian. That year Fra Bartolommeo completed the *Salvator Mundi*, a large triptych for the chapel of Salvatore Billi in SS Annunziata, Florence, comprising *Christ and the Four Evangelists* (Florence, Pitti; see colour pl. 1, VII1) flanked by *Isaiah* and *Job* (both Florence, Accad.), both showing the influence of Michelangelo. The large *Holy Family with the Infant St John* (Rome, Pal. Barberini) was painted for Agnolo Doni, one of the greatest patrons in Florence at that date. The *Presentation in the Temple* (1516; Vienna, Gemäldegal. Akad. Bild. Kst.) was painted for the novitiate chapel of S Marco, Florence.

Towards the end of his life Fra Bartolommeo was working on the *Abduction of Dinah* (Vienna, Gemäldegal. Akad. Bild. Kst.), left unfinished. It was completed by Bugiardini, who drastically altered part of the figure composition. Fra Bartolommeo also completed several frescoes for the hospice of S Maria Maddalena at Le Caldine, near Florence, where he was a patient. His last painting seems to have been the *Noli me tangere* (1517), painted in the garden chapel, a large fresco of great importance because it provides an idea of the artist's landscape style in this medium: an arrangement of soft muted colours free of shadows, it shows what a great landscape painter Fra Bartolommeo was. All the knowledge he had accumulated in his life with his drawings of idyllic views in the countryside came to complete fruition in this fresco.

(ii) Drawings. Two inventories were made of Fra Bartolommeo's drawings and other material found in his shop after his death: the author of the first is anonymous, Lorenzo di Credi made the second. Some of the items in the first inventory are missing from the second, such as two Flemish paintings and more than 50 drawings of landscape in pen. They were probably retained by the authorities of S Marco as collectable or saleable objects. The rest passed to Fra Paolino and after his death in 1547 to Plautilla Nelli (1523–88), a painter and a nun of the convent of S Caterina di Siena in Florence. Besides providing an insight into some of Fra Bartolommeo's working procedures, the inventories prove that drawing was the main outlet for his creativity. Almost 900 loose sheets of drawings, as well as 180 others bound in 12 small sketchbooks, are listed by category. Thus, allowing for inevitable losses, the artist's total output in drawings must be estimated at more than a thousand.

The drawings' first systematic collector was Leopoldo de' Medici. By 1675 he owned 245 (Florence, Uffizi). In 1725 Francesco Maria Niccolò Gabburri acquired from the convent of S Caterina di Siena approximately 600

sheets, formerly the property of Plautilla Nelli, which he bound in at least three albums (two, containing over 500 drawings, Rotterdam, Mus. Boymans–van Beuningen; third dispersed, 1957, see Gronau). Other substantial collections of the artist's drawings are in the British Museum, London; the Royal Library, Windsor Castle; the Ashmolean, Oxford; the Kupferstichkabinett, Berlin; the Graphische Sammlung, Munich; and the Albertina, Vienna.

Fra Bartolommeo's knowledge of German prints is shown in one drawing by him (Paris, Louvre, RF 471) after Martin Schongauer's *Christ Carrying the Cross* (B. 16) and another (Paris, Louvre, RF 5565 *r*) after Dürer's *Great Satyr* (B. 73). Two more (Paris, Louvre, RF 470) are either copies after unknown German works or free variations after Schongauer's series of engravings of the *Wise and Foolish Virgins* (B. 77–83). In this way Fra Bartolommeo developed the hypersensitive linear precision found in his youthful pen drawings. Also, his early attraction to the elegance of Late Gothic art explains where he first discovered the expressive potential of inflated draperies and convolutions of folds that he exploited throughout his life.

By the mid-1490s Fra Bartolommeo used two systems of hatching in his pen drawings: one was of parallel lines, the other of lines crossing each other in varied patterns. The first he (and Albertinelli) learnt from the practices of Cosimo Rosselli and Piero di Cosimo, the second from the engravings of Schongauer and the drawings of Ghirlandaio. Later in Rome, he was influenced by the works of both Michelangelo and Raphael. Drawings made in 1515–17, where his handling became charged with an impetuosity that brought his creations to the verge of disorder, stem from Raphael. Several of these drawings, including two studies for an *Assumption* (Munich, Staatl. Graph. Samml., 2158 and 2159), the *modello* (Rotterdam, Mus. Boymans–van Beuningen, Album M 197) for the *Madonna of Mercy* and the study (Florence, Uffizi, 1269E) for the *Feast of Venus*, were seen by Titian in Ferrara and became decisive stimuli for the transformation of his style. In other late drawings Fra Bartolommeo developed a figure composition that completely filled the space of the sheet without smooth transitions. This device was adopted by Rosso Fiorentino and became a principal feature of his style.

Few examples of Fra Bartolommeo's drawing in metalpoint exist; however, the autograph study (Florence, Uffizi) for the angel in the *Annunciation* (1497; Volterra Cathedral) proves that he alone at that date could capture through that technique the mobility of light essential in Leonardo's art. Many drawings of cast drapery (draperies created by dipping cloth in plaster and arranging it on a clay model) have been attributed to Fra Bartolommeo. This practice of drawing on linen with the brush in distemper was started by Leonardo in Verrocchio's workshop. Only one, however, a study for Christ (Florence, Uffizi) in the *Last Judgement*, can be positively identified as his. He is known to have used lay figures for studies of draperies and figures.

Fra Bartolommeo pioneered the development of drawings in black chalk, using this medium to obtain forms modelled in strong contrasts of light and shade. By the mid-1490s he was already relying on it and used it extensively in 1498 for the studies of the single figures of the *Last Judgement*. Pen and black chalk remained his favourite media for the rest of his life, though after 1509 he also employed red chalk.

2. WORKSHOP. Fra Bartolommeo is known to have had a workshop with several assistants; this was certainly in operation by 1509, when he went into partnership with Albertinelli. The *Virgin and Child with SS Mary Magdalene, Peter Martyr, Catherine of Alexandria, Barbara and Dominic* (1510; Vienna, Ksthist. Mus.), an altarpiece executed entirely by assistants, is signed with the mark of the cross and double ring.

Only three assistants are named in documents: FRA PAOLINO; Fra Agostino, who worked with Fra Paolino on the *Crucifixion* (1516; Siena, S Spirito); and Francesco de Filippo da Firenze, who signed an apprenticeship in 1516. Vasari also mentioned Cecchino del Frate, Benedetto Cianfanini and Gabriele Rustici, but they have not been identified. The precise contribution of not one of the assistants—not even Fra Paolino—can be identified in any school work, not even in works such as the *Assumption of the Virgin* (Naples, Capodimonte), which is believed to have been executed largely by assistants.

BIBLIOGRAPHY
DBI; Thieme–Becker

EARLY SOURCES
G. Vasari: *Vite* (1550, rev. 2/1568); ed. G. Milanesi (1878–85), iv, pp. 175–216

V. Marchese: *Memorie dei più insigni pittori, scultori e architetti domenicani*, 2 vols (Florence, 1854, rev. 2/Bologna, 1879)

E. Ridolfi: 'Notizie sopra varie opere di Fra Bartolommeo', *G. Ligust. Archeo. & Stor.*, v (1878), pp. 81–126

P. Bagnesi-Bellincini: 'Due documenti sul *Giudizio universale* di Fra Bartolommeo', *Riv. A.*, vi (1909), pp. 245–50

GENERAL
J. A. Crowe and G. B. Cavalcaselle: *A History of Painting in Italy* (London, 1865–6, rev. 2/1903–14), iii, p. 427

H. Wölfflin: *Die klassische Kunst* (Munich, 1899; Eng. trans., 1952)

A. Venturi: *Storia* (1901–40, R/1967), IX/i, p. 223

R. Fry: *Transformations* (London, 1927), p. 82

B. Berenson: *Italian Pictures of the Renaissance* (Oxford, 1932)

Mostra del cinquecento toscano (exh. cat., Florence, Pal. Strozzi, 1940), p. 21

Italian Art and Britain (exh. cat., London, RA, 1960), pp. 50–51, 120

S. J. Freedberg: *Painting of the Renaissance in Rome and Florence* (Cambridge, MA, 1961, rev. 2/New York, 1972)

B. Berenson: *Florentine School* (Oxford, 1963), i, pp. 22–4

S. J. Freedberg: *Painting in Italy, 1500–1600* (Harmondsworth, 1971), p. 49

C. von Holst: 'Florentiner Gemälde und Zeichnungen aus der Zeit von 1480 bis 1580', *Mitt. Ksthist. Inst. Florenz*, xv (1971), pp. 1–64

La Collection de François Ier (exh. cat., ed. J. Cox-Rearick; Paris, Louvre, 1972), pp. 26–30

L. Borgo: *The Works of Mariotto Albertinelli* (New York, 1976)

R. Steinberg: *Fra Girolamo Savonarola: Florentine Art and Renaissance Historiography* (Athens, OH, 1977)

C. Gilbert: 'Some Findings on Early Works of Titian', *A. Bull.*, lxii (1980), pp. 36–75

C. Hope: *Titian* (London, 1980), pp. 42–3, 56

M. Hirst: *Sebastiano del Piombo* (Oxford, 1981), p. 25

Le XVI Siècle florentin au Louvre (exh. cat. by S. Béguin, Paris, Louvre, 1982), pp. 9–16

MONOGRAPHS
E. Frantz: *Fra Bartolommeo* (Regensburg, 1879)

G. Gruyer: *Fra Bartolommeo della Porta et Mariotto Albertinelli* (Paris, 1886)

A. Castan: *La Physionomie primitive du rétable de Fra Bartolommeo à la cathédrale de Besançon* (Besançon, 1889)

F. Knapp: *Fra Bartolommeo und die Schule von San Marco* (Halle, 1903)

H. von der Gabelentz: *Fra Bartolommeo und die florentiner Renaissance*, 2 vols (Leipzig, 1922)

SPECIALIST STUDIES

H. Swarzenski: 'Donatello's *Madonna in the Clouds* and Fra Bartolommeo', *Bull. Mus. F.A. Boston*, xl (1942), pp. 64–77

L. Borgo: 'Fra Bartolommeo, Albertinelli and the *Pietà* for the Certosa of Pavia', *Burl. Mag.*, ciii (1966), pp. 463–8

E. Fahy: 'The Beginnings of Fra Bartolommeo', *Burl. Mag.*, cviii (1966), pp. 456–63

——: 'The Earliest Works of Fra Bartolommeo', *A. Bull.*, lxi (1969), pp. 142–54

L. Borgo: 'The Problem of the Ferry Carondelet Altarpiece', *Burl. Mag.*, cxiii (1971), pp. 362–71

J. Cox-Rearick: 'Fra Bartolommeo's *St Mark the Evangelist* and *St Sebastian with an Angel*', *Mitt. Ksthist. Inst. Florenz*, xvii (1974), pp. 329–54

E. Fahy: 'A *Holy Family* by Fra Bartolommeo', *Bull. LA Co. Mus. A.*, xx (1974), pp. 9–17

C. von Holst: 'Fra Bartolommeo und Albertinelli', *Mitt. Ksthist. Inst. Florenz*, xvii (1974), pp. 273–318

L. Borgo: 'Fra Bartolommeo's Beginnings: Once More with Berenson', *Burl. Mag.*, cxviii (1977), pp. 89–93

C. Fischer: 'Remarques sur le *Mariage mystique de Sainte Catherine de Sienne*', *Rev. Louvre*, xxxi (1982), pp. 167–80

L. Borgo: 'Fra Bartolommeo e Raffaello: L'incontro romano del 1513', *Atti del congresso internazionale di studi su Raffaello: Urbino, Firenze, 1984*, pp. 65–76

Fra Bartolommeo e la Scuola di San Marco (exh. cat. by S. Padovani, Florence, Pal. Pitti and Mus. S Marco, 1996)

DRAWINGS

H. von Zahn: 'Die Handzeichnungen des Fra Bartolommeo im Besitz der Frau Grossherzogin Sophie von Sachsen-Weimar', *Jb. Kstwiss.*, iii (1870), p. 174

B. Berenson: *The Drawings of the Florentine Painters* (London, 1903, rev. 2/Chicago, 1938, rev. 3/Milan, 1961)

C. Gamba: *Disegni di Baccio della Porta*, Florence, Uffizi cat., II/ii (Florence, 1914)

O. Fischel: 'Three Unrecorded Drawings for Fra Bartolommeo's *Last Judgement*', *Old Master Drgs*, iv (1929), pp. 33–6

E. Sandberg-Vavalà: 'Four Drawings by Fra Bartolommeo', *Burl. Mag.*, lv (1929), pp. 3–15

B. Degenhart: 'Eine Gruppe von Gewandstudien des jungen Fra Bartolommeo', *Marburg. Jb. Kstwiss.*, xi (1934–6), pp. 222–31

O. H. Giglioli: 'Alcuni disegni di Fra Bartolommeo attribuiti a Ghirlandaio', *Boll. A.*, xxix (1936), pp. 489–91

W. Ames: 'Sketches for an *Assumption of the Virgin* by Fra Bartolommeo', *Gaz. B.-A.*, vi/1 (1944), pp. 215–20

A. Mongan and P. Sachs: *Drawings in the Fogg Art Museum* (Cambridge, MA, 1946)

A. E. Popham and J. Wilde: *Italian Drawings of the XV and XVI Centuries in the Collection of His Majesty the King* (London, 1949)

K. T. Parker: *Catalogue of the Drawings in the Ashmolean Museum: Italian Schools* (Oxford, 1956)

C. Gronau: *Drawings of Landscapes and Trees by Fra Bartolommeo* (London, 1957) [sale cat., London, Sotheby's, 20 Nov 1957]

R. W. Kennedy: 'A Landscape Drawing by Fra Bartolommeo', *Smith Coll. Mus. A. Bull.*, xxxix (1959), p. 1

A. Seilern: *Italian Paintings and Drawings at 56 Princes Gate* (London, 1959)

I. Härtt: 'Zu Landschaftzeichnungen Fra Bartolommeos und seines Kreises', *Mitt. Ksthist. Inst. Florenz*, ix (1959–60), pp. 125–30

L. S. Richards: 'Three Early Italian Drawings', *Bull. Cleveland Mus. A.*, il (1962), p. 172

M. Winner: 'Zwei unbekannte Zeichnungen von Fra Bartolommeo und Albertinelli', *Festschrift H. Möhle* (Berlin, 1967), p. 21

Disegni di Raffaello e di altri italiani del museo di Lille (exh. cat. by A. Châtelet, Florence, Uffizi, 1970), pp. 26–30

E. Maggini: *Disegni di Fra Bartolommeo* (Florence, 1977)

Il primato del disegno (exh. cat., Florence, Pal. Strozzi, 1980), pp. 72–6

Zeichnungen aus der Sammlung des Kurfürsten Carl Theodor (exh. cat. by R. Harprath, Munich, Staatl. Graph. Samml., 1983), pp. 17–20

A. M. Petriolo Tofani: *Gabinetto disegni e stampe degli Uffizi, Inventario 1: Disegni esposti* (Florence, 1986)

Disegni di Fra Bartolommeo e della sua scuola (exh. cat. by C. Fischer, Florence, Uffizi, 1986)

Florentine Drawings of the Sixteenth Century (exh. cat. by N. Turner, London, BM, 1986), pp. 54–77

Fra Bartolommeo: Master Draughtsman of the High Renaissance: A Selection from the Rotterdam Albums and Landscape Drawings from Various Collections (exh. cat. by C. Fischer, Rotterdam, Mus. Boymans – van Beuningen; Boston, MA, Mus. F.A.; Fort Worth, TX, Kimbell A. Mus and elsewhere; 1991–2)

Fra Bartolomeo, en mester fra højrenaessancen/Fra Bartolomeo, a Master of the High Renaissance (exh. cat. by C. Fischer, Copenhagen, Stat. Mus. Kst, 1993–4)

LUDOVICO BORGO, MARGOT BORGO

Bartolommeo, Maso di. *See* MASO DI BARTOLOMMEO.

Basaiti [Basiti, Basitus, Baxaiti, Baxiti], **Marco** (*fl* Venice, 1496–1530). Italian painter. He is documented only once, in 1530, when he was recorded in the Mariegola dei Pittori Veneziani (the Venetian painters' guild) as a painter of figures, but many of his paintings are dated, the earliest in 1496 and the last in 1527. The spelling of his signature varies, and Vasari erroneously believed that two Venetian painters existed, named Marco Bassarini and Marco Bassiti. Ridolfi stated that Basaiti was born in Friuli, while Lanzi asserted that Basaiti was born of Greek parents in Friuli. Babinger convincingly proposed that Basaiti was of Albanian origin; a family of Balkan mercenaries in Venetian pay named Bòzhajt or Bòzhejt was documented in Venice at the beginning of the 16th century. This would explain the variations on Basaiti's name and also account for his lack of documentation, since Albanian, Greek and Dalmatian communities living in Venice kept to their own laws and usually do not appear in Venetian documents.

Not enough is known about the structure of Venetian workshops at this date to say where Basaiti trained. A signed *St Jerome in the Wilderness* (Budapest, Mus. F.A.) is a copy of a painting by Cima da Conegliano (Harewood House, W. Yorks); usually such copies could be made only in the master's studio. The fact that Basaiti received the commission to complete the altarpiece of *St Ambrose Enthroned with Saints* (1503; Venice, Frari; see colour pl. 2, XXXIX2), left unfinished at Alvise Vivarini's death, might indicate that he was considered the best assistant in Alvise's workshop and his artistic heir. On the other hand, a *Lamentation over the Dead Christ* (ex-Kaiser Friedrich Mus., Berlin, destr.), a typical work by Basaiti, had the remains of a signature '*Iohannes Bellinus p.*'. There is evidence to suggest that assistants were exchanged from one workshop to another at this date. The most likely hypothesis is that Basaiti was one of Alvise Vivarini's assistants and that he kept the workshop running after his master's death but was also in touch with Cima and Giovanni Bellini. Basaiti's figures usually have the strong volumetric forms typical of Alvise, but the atmospheric landscape settings are close to Cima, while the compositions and the soft, warm tones in many of Basaiti's paintings are derived from Giovanni Bellini.

Basaiti's first extant work, a *Portrait of a Boy* (Kruishoutem, Veranneman priv. col.; formerly Bennebroek, von Pannwitz priv. col.), shows the sitter behind a parapet in the manner of Antonello da Messina and Alvise Vivarini; its originality lies in the background, no longer a plain wall but an open landscape, comparable to Giovanni Bellini's backgrounds in paintings of the Virgin and Child. At this date Bellini had not used a landscape background in a portrait, and the idea probably derived from Netherlandish

paintings, especially the work of Hans Memling, which were well known in Venice at that date. A group of panels painted by Basaiti between *c.* 1496 and *c.* 1500 is stylistically close to Alvise Vivarini: idealized forms with smooth surfaces are painted in bright colours; they include the *Portrait of a Boy* (London, N.G.), the *Virgin and Child with a Donor* (Venice, Correr; see colour pl. 1, VII3), the signed *Sacra conversazione* (Padua, Mus. Civ.) and several paintings of the *Virgin and Child* (Berlin, Gemäldegal.; London, N.G.; Vaduz, Samml. Liechtenstein). Although Basaiti was a conservative painter with a Quattrocento repertory of subjects (he never attempted historical or mythological scenes), he adopted contemporary stylistic developments. Between 1500 and 1505 his paintings have a compositional harmony and proportion that show his awareness of Lorenzo Costa's proto-classicism, as in *St Catherine* (Budapest, Mus. F.A.), in two paintings of *St Sebastian* (Rome, Doria–Pamphili; ex-Kaiser-Friedrich Mus., Berlin, destr.) and in *Two Saints* and a *Dead Christ and Angels* (both Venice, Accad.).

After the second visit of Albrecht Dürer to Venice in 1505–6, Basaiti's style changed abruptly to a Germanic, anti-classical emotionalism, as is evident in the *Lamentation over the Dead Christ* (Munich, Alte Pin.) and the *St Jerome in the Wilderness* (sold, Rezzonico sale, Milan, 1898), in which rocks and trees are painted in a particularly Germanic style and the scale of the figures is small in comparison to their settings. Basaiti was also aware of Lombard painting and of the work of Lorenzo Lotto, and a combination of a Germanic, emotional rendering of nature with calm, classicizing figures in the Venetian tradition became typical of him: it is particularly evident in the *Resurrected Christ* (*c.* 1510; Milan, Bib. Ambrosiana) and the *Calling of the Sons of Zebedee* (signed and dated 1510; Venice, Accad.; see fig.), painted for S Andrea della Certosa. This large altarpiece is one of the most innovative of its date in Venice in the unusually large amount of space given to the landscape—the true subject of the painting. The foreground is given over to a stony shore and a boat, while the sacred event is placed in the middle ground. It is also the first narrative altarpiece to include many figures that are not part of the biblical story. The signed *Agony in the Garden* (Venice, Accad.) was painted for an altar of the Foscari family in S Giobbe and is dated either 1510 or 1516; the latter date is usually accepted, but on stylistic grounds the earlier date is preferable (Lucco), given its similarity to the *Calling* in its unusual light effects. These two works were extremely successful, and in 1515 Basaiti painted a replica of the *Calling* set in a *trompe l'oeil* frame (Vienna, Ksthist. Mus.). A *Lamentation over the Dead Christ* (Milan, S Giorgio al Palazzo) was painted about this date for the abbey church of Sesto al Reghena in Friuli; the compact group of figures, compositionally close to a German sculpted *Vesperbild*, is placed in a calm summer landscape reminiscent of Giorgione or Lotto.

From 1510 to 1520 Basaiti produced portraits in the Giorgionesque idiom, abandoning Antonello's outdated style. A portrait, probably of Copernicus (ex-Lubomirski Col., Warsaw; untraced), was dated 1513. The *Head of the Redeemer* (Bergamo, Gal. Accad. Carrara), signed and dated 1517, has the quality of a portrait, the face being individualized and delicately lit. The *Portrait of a Man* (Bergamo,

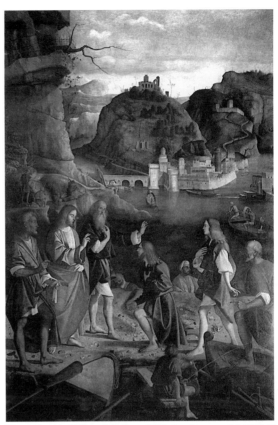

Marco Basaiti: *Calling of the Sons of Zebedee*, oil on panel, 3.86×2.68 m, 1510 (Venice, Galleria dell'Accademia)

Gal. Accad. Carrara), signed and dated 1521, shows the calm, imposing figure in front of a broken wall; the figure's monumentality, equal almost to Titian or Palma Vecchio, is created by the use of large volumetric planes. Other successful paintings of this date include two *sacre conversazioni* (Urbino, Pal. Ducale; Amsterdam, Rijksmus.), the beautiful *Virgin Adoring the Christ Child* (Washington, DC, N.G.A.) and the *Holy Family with Saints* (ex-Böhler Col., Munich; untraced), the latter signed and dated 1519.

By contrast, Basaiti's contemporary public commissions lack originality: *St Peter Enthroned* (Venice, S Pietro in Castello) is old-fashioned, while the *St George Killing the Dragon* (Venice, Accad.), painted for the same church, is even more feeble, although Pietro Carpaccio copied it (Baltimore, MD, Walters A.G.). After 1521 it is difficult to trace the evolution of Basaiti's style; his last signed and dated work, the *Lamentation over the Dead Christ* (St Petersburg, Hermitage), is merely a bad replica of an earlier composition (Milan, Brera).

BIBLIOGRAPHY
DBI; Thieme–Becker
G. Vasari: *Vite* (1550, rev. 2/1568); ed. G. Milanesi (1878–85), iii, pp. 646–7
C. Ridolfi: *Le maraviglie dell'arte* (Venice, 1648)
M. Boschini: *La carta del navegar pitoresco* (Venice, 1660)
A. M. Zanetti: *Della pittura veneziana e delle opere pubbliche de' veneziani maestri* (Venice, 1771)
L. Lanzi: *Storia pittorica della Italia* (Bassano, 1809)
F. Zanotto: *Storia della pittura veneziana* (Venice, 1837)
O. Occioni: *Marco Basaiti, pittore veneziano* (Venice, 1868)

J. A. Crowe and G. B. Cavalcaselle: *A History of Painting in North Italy* (London, 1871); rev. edn by T. Borenius (2/1912), i, pp. 66, 146, 194, 265–76

J. Lermolieff [G. Morelli]: *Le opere dei maestri italiani nelle gallerie di Monaco, Dresda e Berlino* (Bologna, 1886)

B. Berenson: *Lorenzo Lotto, An Essay in Art Criticism* (New York and London, 1895)

G. Gronau: 'Über ein Madonnenbild des Marco Basaiti', *Repert. Kstwissen.*, xx (1897), pp. 301–3

P. Paoletti and G. Ludwig: 'Neue archivalische Beiträge zur Geschichte der venezianischen Malerei', *Repert. Kstwiss.*, xxii (1899), p. 455

B. Berenson: *The Study and Criticism of Italian Art* (London, 1901)

A. Venturi: *Storia* (1901–40/*R* 1967), VII/iv, pp. 614–22

B. Berenson: *Venetian Paintings in America* (New York, 1916), p. 234

R. van Marle: *Italian Schools* (1923–38), xvii

B. Berenson: *Italian Pictures of the Renaissance* (Oxford, 1932)

R. Buscaroli: *La pittura di paesaggio in Italia* (Bologna, 1935)

B. Degenhart: 'Dürer oder Basaiti?', *Mitt. Ksthist. Inst. Florenz*, v (1940), pp. 423–8

R. Longhi: *Viatico per cinque secoli di pittura veneziana* (Florence, 1946)

S. Moschini-Marconi: *Gallerie dell'Accademia di Venezia: Opere d'arte dei secoli XIV e XV* (Rome, 1955)

B. Berenson: *Venetian School*, i (1957), pp. 13–15

L. Coletti: *Cima da Conegliano* (Venice, 1959)

R. Pallucchini: *I Vivarini* (Venice, 1961)

M. Stcherbacheva: 'La Pietà di Marco Basaiti nell'Ermitage', *A. Veneta*, xv (1961), pp. 228–9

F. Babinger: 'L'origine albanese del pittore Marco Basaiti', *Atti Ist. Ven. Sci., Lett. & A.*, cxx (1961–2), pp. 497–500

F. Heinemann: *Giovanni Bellini e i Belliniani* (Venice, 1962)

S. J. Freedberg: *Painting in Italy, 1500–1600*, Pelican Hist. A. (Harmondsworth, 1971, rev. 2/1983), p. 171

B. B. Fredericksen and F. Zeri: *Census of Pre-nineteenth-century Italian Paintings in North American Collections* (New York, 1973)

M. Lucco: 'Basaiti: Un dipinto ritrovato e un consuntivo', *Paragone*, xxv/297 (1974), pp. 41–55

B. Bonario: *Marco Basaiti: A Study of the Venetian Painter and a Catalogue of his Works* (Ann Arbor, 1983)

M. Lucco: 'A l'occasion de la redécouverte d'un tableau du Musée des Beaux-Arts: Nouveau regard sur l'oeuvre de Marco Basaiti', *Bull. Mus. & Mnmts Lyon.*, 1 (1993), pp. 2–37

MAURO LUCCO

Bassano [Ponte, da; Ponte, dal]. Italian family of painters. Its members were active in Venice and the Veneto from the early 16th century to the early 17th and acquired the surname 'dal Ponte' because their workshop in Bassano del Grappa was close to the bridge. The name 'Bassano' was used in Venice first for (2) Jacopo Bassano and then for the family.

(1) Francesco Bassano *il vecchio*, a minor provincial master, was the father of Giambattista Bassano (i) (*b* Bassano del Grappa, *c.* 1517; *d* Bassano del Grappa, before 5 June 1548), who worked as his assistant, and (2) Jacopo Bassano, who with Titian, Jacopo Tintoretto and Paolo Veronese was one of the leading Venetian artists of the 16th century. (2) Jacopo Bassano had four artist sons, two of whom, (3) Francesco Bassano *il giovane* and (4) Leandro Bassano, had considerable success in Venice. The other two, Giambattista Bassano (ii) (*b* Bassano del Grappa, 4 March 1553; *d* Bassano del Grappa, 9 March 1613) and (5) Gerolamo Bassano, were artists of more modest ability. Giambattista was known mainly for his copies of Jacopo's work.

UNPUBLISHED SOURCES

Vienna, Österreich, Nbib. [autograph draft of MS. of G. B. Volpato: *La verità pittoresca*, work on (2) Jacopo Bassano; other copies in Bassano del Grappa, Bib. Civ., and Venice, Bib. N. Marciana]

Bassano del Grappa, Bib. Civ. [*Libro secondo di dare e avere della famiglia Dal Ponte con diversi per pitture fatte*; MS., 1512–56]

Bassano del Grappa, Bib. Civ. [*Pittura e società: Il Libro dei conti e la bottega dei Bassano*; synthesis of lectures given by Prof. M. Muraro at Padua U. during the academic year 1982–3; incl. info. from Bassano family accounts book]

BIBLIOGRAPHY

DBI: 'Dal Ponte'; Thieme–Becker

G. Vasari: *Vite* (1550, rev. 2/1568); ed. G. Milanesi (1878–85)

R. Benedetti: *Ragguaglio delle allegrezze, solennità, e feste, fatte in Venezia per la felice vittoria* (Venice, 1571)

L. Marucini: *Il Bassano* (Venice, 1577)

R. Borghini: *Il riposo* (Florence, 1584)

G. P. Lomazzo: *Trattato dell'arte de la pittura* (Milan, 1584)

K. van Mander: *Schilder-boeck* ([1603]–1604)

C. Ridolfi: *Meraviglie* (1648); ed. von Hadeln, 2 vols (Berlin, 1914–24); i, pp. 374, 384–410; ii, pp. 165–71

M. Boschini: *La carta del navegar pitoresco* (Venice, 1660)

——: *Le ricche miniere* (Venice, 1674)

A. M. Zanetti: *Descrizione di tutte le pubbliche pitture della città di Venezia . . .* (Venice, 1733)

——: *Della pittura veneziana* (Venice, 1771)

G. B. Verci: *Notizie intorno alla vita, e alle opere de' pittori, scultori, e intagliatori della città di Bassano* (Venice, 1775), pp. 35–218

G. B. Roberti: *Lettera del Signor Conte Abate Giambattista Roberti al Signor Cavalier Giambattista Giovio e risposta del medesimo sopra Giacomo Da Ponte pittore* (Lugano, 1777)

F. Algarotti: *Saggio sopra la pittura* (Venice, 1784)

F. Milizia: *Dizionario delle belle arti del disegno*, 2 vols (Bassano, 1797)

B. Berenson: *The Venetian Painters of the Renaissance* (New York, 1894)

L. Zottmann: *Zur Kunst der Bassani* (Strasbourg, 1908)

A. Venturi: *Storia dell'arte italiana*, IX/iv (1929), pp. 1113–331

W. Arslan: *I Bassano* (Bologna, 1931)

E. [W.] Arslan: *I Bassano*, 2 vols (Milan, 1960) [pubd sources & bibliog.]

R. Pallucchini: *Bassano* (Bologna, 1982)

M. Muraro: *Il libro secondo di Francesco e Jacopo dal Ponte* (Bassano del Grappa, 1992)

F. Sbordone: 'Le proprietà urbane nel catastico Stecchini del 1728 e la casa di Jacopo del Ponte', *Boll. Mus. Civ. Bassano*, n.s. 13–15 (1992–4), pp. 178–203)

F. Signori: 'La Casa dei Bassano', *Archv Ven.*, cxl (1993), pp. 5–26

M. Muraro: 'The Altarpiece in the Bassano Workshop: Patronage, Contracts and Iconography', *Italian Altarpieces, 1250–1550: Function and Design*, ed. E. Borsook and F. S. Gioffredi (Oxford, 1994), pp. 231–58

Bassano et ses fils dans les musées français (exh. cat. by J. Habert and C. Loisel Legrand, Paris, Louvre, 1998)

I. Family members. II. Family workshop. III. Critical reception and posthumous reputation.

I. Family members

(1) **Francesco Bassano** *il vecchio* (*b* Bassano del Grappa, *c.* 1475; *d* Bassano del Grappa, 1539). He was the son of a tanner, and he may have been a pupil of Bartolomeo Montagna. In 1504 Francesco married Lucia Pizzardini and in 1523 a certain Francesca; he had seven children. An early work by Francesco is the altarpiece of the *Virgin and Child Enthroned with SS John the Baptist and Bartholomew* (Bassano del Grappa, Mus. Civ.), in which the dry compositional scheme and agitated forms reveal the influence of Montagna. In his altarpiece of the *Virgin and Child Enthroned with SS Peter and Paul* (1519; Bassano del Grappa, Mus. Civ.) the perspective and decoration are still in the style of the 15th century; it was clearly painted by an eclectic, backward-looking artist influenced by various painters of the Venetian mainland, including Montagna and Liberale da Verona. Also from *c.* 1519 is Francesco's altarpiece for the parish church of Foza (Vicenza), the *Virgin and Child Enthroned with SS John and Benedict*, which is hieratic and rather cold, enlivened only by the naturalism of such passages as the two little angels, one with a bird and the other with a black

squirrel. For the parish church of Solagna (Vicenza), his altarpiece with *St Justina with SS Michael and George*, signed and dated 1520 (*in situ*), is a harmonious and balanced work with clear echoes of the style of Montagna.

Despite the war between Venice and the League of Cambrai (1508–18), Francesco earned a comfortable living and social standing from his workshop, and in 1522 he was appointed to the town council of Bassano del Grappa. The main altarpiece of the *Pentecost* (1523) for the parish church of Oliero, Vicenza (*in situ*), is the most vigorous of Francesco's career. Behind the marble tabernacle carved in arabesques and the splendid golden throne are unusually dynamic figures of the Apostles, and the Virgin is stylistically similar to that frescoed at 52 Via Matteotti, Bassano del Grappa, dated 5 November 1523. The composition of the signed *Virgin and Child Enthroned with SS Matthew and John the Evangelist* (1523–5; Asiago, S Matteo) has a rhythmic quality that belongs to the 16th century. In the fine painting of *St Michael* (*c.* 1523; Bassano del Grappa, Mus. Civ.) the imposing and vigorous figure is complemented by the pictorial fluidity of the armour.

The works of Francesco's late maturity show the participation of his son, (2) Jacopo Bassano, who certainly painted the gentle face of the Virgin, the realistic heads of the ox and ass and the landscape in the *Nativity* (1528; Valstagna, Vicenza, parish church). Francesco's paintings were often based on copying north European engravings; Jacopo was inspired by a greater realism. His collaboration with his father is even more noticeable in the altarpiece of the *Lamentation* (1534; Bassano del Grappa, Mus. Civ.) in the free and luminous brushwork, especially in the faces of the Magdalene and St John and the lovingly described landscape. The *St Sebastian* (1529; Rosà, Vicenza, parish church), the altarpiece of the *Virgin Enthroned with SS Donato and Michael* (1529; Bassano del Grappa, S Donato), the *Apostle Peter* and *St John the Baptist* (1531; both Bassano del Grappa, Mus. Civ.) and the *Virgin and Christ with SS Sebastian and Roch* (1533; Oliero, Vicenza, parish church) show a decline in Francesco's ability. His last known work (untraced) was the map of a mountain, which was disputed between the towns of Angarano and Valstagna. In his last years he painted little despite remaining head of the workshop, although Jacopo's role became increasingly important. Fairly well educated, in his last years Francesco experimented with alchemy.

BIBLIOGRAPHY

G. Gerola: 'Il primo pittore bassanese: Francesco da Ponte il Vecchio', *Boll. Mus. Civ. Bassano*, iv (1907), pp. 77–95

——: *Bassano* (Bergamo, 1910), p. 91

G. Lorenzetti: 'De la giovinezza artistica di Jacopo Bassano', *L'Arte*, xiv (1911), pp. 201–4

A. Moschetti: 'Un dipinto di Francesco da Ponte il Vecchio', *Boll. Mus. Civ. Padova*, iii/20 (1927), pp. 71ff

Il Museo Civico di Bassano del Grappa: Dipinti dal XIV al XX secolo (exh. cat. by L. Magagnato and B. Passamani, Venice, 1978), pp. 11–14

(2) Jacopo Bassano (*b* Bassano del Grappa, *c.* 1510; *d* Bassano del Grappa, 13 Feb 1592). Son of (1) Francesco Bassano *il vecchio*.

1. Training and early paintings, to 1542. 2. Mannerism and the influence of prints, 1543–*c.* 1562. 3. Experimentation and family collaboration, *c.* 1562–81. 4. The last years, 1582–92.

1. TRAINING AND EARLY PAINTINGS, TO 1542. He was apprenticed to his father, with whom he collaborated

on the *Nativity* (1528; Valstagna, Vicenza, parish church). In the first half of the 1530s Jacopo trained in Venice with Bonifazio de' Pitati, whose influence, with echoes of Titian, is evident in the *Flight into Egypt* (1534; Bassano del Grappa, Mus. Civ.). He continued to work in the family shop until his father's death in 1539. His paintings from those years were mainly altarpieces for local churches; many show signs of collaboration. He also worked on public commissions, such as the three canvases on biblical subjects (1535–6; Bassano del Grappa, Mus. Civ.) for the Palazzo Communale, Bassano del Grappa, in which the narrative schemes learnt from Bonifazio are combined with a new naturalism. From 1535 he concentrated on fresco painting, executing, for example, the interior and exterior decoration (1536–7) of S Lucia di Tezze, Vicenza, which demonstrates the maturity of his technique.

Between 1535 and the early 1540s Jacopo often visited Venice, where he saw the late works of Pordenone, whose influence is apparent in works such as the *Last Supper* (1537), painted for Ambrogio Frizier and rediscovered in the late 20th century in Wormley parish church, Herts, in the altarpiece of the parish church of Borso (Treviso), in the *Supper at Emmaus* (Cittadella, parish church) and in the same subject (commissioned 1538; Fort Worth, TX, Kimbell A. Mus.), painted for the Podestà of Cittadella, Cosimo da Mosto. Jacopo's study of Pordenone's work led him *c.* 1539 towards Mannerism, as shown in the frescoes on the façade of the dal Corno house, Bassano del Grappa (1539; now Bassano del Grappa, Mus. Civ.), and in the canvas of *Samson and the Philistines* (*c.* 1539; Dresden, Gemäldegal. Alte Meister). The limbs and construction of the muscles are defined by drawing, and the cold, enamel-like colours are clearly contained rather than diffuse in the manner of Bonifazio.

In Jacopo's small altarpiece of *St Anne* (1541; Bassano del Grappa, Mus. Civ.) the effect of tension, derived from Pordenone, is created by the bodies crowded into a curve in the foreground. The cold, sharp colours and the realistic vigour of the figures clearly show familiarity with Lombard naturalism (in this case that of Giovanni Girolamo Savoldo). In other works painted shortly after *St Anne* the influences of Moretto and Lorenzo Lotto can also be seen, for example in the *Adoration of the Magi* (*c.* 1542; Edinburgh, N.G.), the *Virgin and SS Martin and Anthony Abbot* (1542–3; Munich, Alte Pin.) and the *Flight into Egypt* (Pasadena, CA, Norton Simon Mus.). These paintings have an exceptional quality of light and naturalistic vitality; the juxtaposition of dissonant hues gives the colour a constructive force far removed from the Venetian tonality of Bonifazio's workshop. After 1540 Jacopo lived permanently in the family house at Bassano del Grappa and directed the workshop. In Bassano del Grappa he frescoed the *Lion Walking* and *Marcus Curtius* (1541–2) on the façade of the Porta Dieda; these were commissioned by Podestà Bernardo Morosini, whose portrait he also painted (Kassel, Schloss Wilhelmshöhe).

2. MANNERISM AND THE INFLUENCE OF PRINTS, 1543– 1562. Jacopo kept up with artistic trends by studying a wide range of graphic material, including prints by or after Titian, by Dürer (1471–1528), Giulio and Domenico Campagnola, Agostino Veneziano, Andrea

Schiavone, Marcantonio Raimondi and Ugo da Carpi. Typically he alternated between direct observation of nature and reference to graphic prototypes. Like Titian and Jacopo Tintoretto, he followed the Mannerist trend, influenced by the Tuscan painters who came to Venice, notably Francesco Salviati, Giuseppe Porta Salviati and Giorgio Vasari. The *Road to Calvary* (*c.* 1543–4; Cambridge, Fitzwilliam) and the *Martyrdom of St Catherine* (1544; Bassano del Grappa, Mus. Civ. see fig. 1), both inspired by Raphael, mark his move from naturalism to an abstract approach, which reflects Mannerist stimuli.

In the *Road to Calvary* (*c.* 1545; London, N.G.) the accentuated elegance of the brushwork and the colour give the first indication of Jacopo's contact with Parmigianino through the engravings of Andrea Schiavone. An expanded spatiality dominates the *Miraculous Draught of Fishes* (1545; Washington, DC, N.G.A.), which was inspired by the xylography of the same subject that Ugo da Carpi had taken from Raphael's cartoon for a tapestry in the Sistine Chapel, Rome. Jacopo referred to these prints in each phase of his development while continuing to give close attention to Venetian artists, from Tintoretto to Paolo Veronese and above all to Titian. Jacopo married Elisabetta Merzari (*d* 1601) of Bassano del Grappa, in 1546, and they had four sons who became painters. By 1546–7 he had reached an equilibrium between the preciousness of the Mannerist style and a renewed desire for truthful representation. In those years he produced his warmest and most delicate works of that decade: the *Adoration of the Shepherds* (*c.* 1546; London, Hampton Court, Royal Col.) and the *Rest on the Flight into Egypt* (*c.* 1547; Milan, Ambrosiana; see colour pl. 1, VIII2). In the latter the landscape and facial types are studied from life, but some details show an extraordinary formal refinement and chromatic exuberance. The iconography of the *Holy*

Trinity (1547; Bassano del Grappa, Santa Trinità) is derived in part from northern European prints but reinterpreted in an original way. In other works produced during this experimental phase Jacopo substantially modified Mannerist suggestions derived from prints. The *Last Supper* (1546–8; Rome, Gal. Borghese) was inspired by Raphael and by Dürer; the exaggerated figures, agitated drawing and strong shadows reflect Tintoretto. A more prosaic truth is expressed in the painting of *Two Hunting Dogs* (1548; Paris, Louvre).

After these naturalistic experiments Jacopo returned to the study of Parmigianino through Schiavone in the *Virgin in Glory with SS Anthony Abbot and Ludovico of Toulouse* (1548–9; Asolo Cathedral). The change is illustrated by the *Beheading of St John the Baptist* (1550; Copenhagen, Stat. Mus. Kst), with its elegant forms and refined brushwork in short strokes, in the *Pentecost* (1551; Lusiana, Vicenza, parish church) and in the dramatic *Road to Calvary* (*c.* 1552; Budapest, Mus. F.A.), in which elongated figures with sharply drawn faces are crowded in a chiaroscuro setting. In *Dives and Lazarus* (*c.* 1554; Cleveland, OH, Mus. A.) the forms derived from Parmigianino and the violent atmosphere assume a naturalistic aspect, which is underlined by such details as the dog in the foreground. Jacopo's return to the study of Parmigianino in the mid-1550s is apparent in the *Adoration of the Magi* (*c.* 1555; Vienna, Ksthist. Mus.), which shows a powerful and imaginative use of colour and light. Its elegant composition and sophisticated figures are also present in other works of the period, such as *Susanna and the Elders* (*c.* 1555–6; Ottawa, N.G.). These paintings display a balanced synthesis of light and colour that is lacking in the works from 1557–9; in the *Good Samaritan* (*c.* 1557; London, N.G.) light is intensified at the expense of colour, creating vigorous figures that are indebted more to Salviati's Mannerism than to that of Parma. In the *Annunciation to the Shepherds* (*c.* 1558; two versions, Washington, DC, N.G.A.; Rome, Accad. N. S Luca), one of his first explorations of landscape and pastoral, and in *St John the Baptist* (1558; Bassano del Grappa, Mus. Civ.) the constructive power of light is emphasized by the darkening of the sky.

Towards the end of the 1550s Jacopo received commissions from local clients; in 1558, in addition to *St John the Baptist*, he painted the frescos in the town hall (untraced except for a small fragment *in situ*); and *c.* 1559 he produced a *Pentecost* (Bassano del Grappa, Mus. Civ.). In the latter his experiments with light during that decade reached a highpoint, and he acknowledged the magical impressionism of Titian in such works as the *Martyrdom of St Lawrence* (1557; Venice, Gesuiti). Titian's influence is still evident in *St Christopher* (*c.* 1558–9; Havana, Mus. N. B.A.). Shortly after, however, Jacopo's renewed study of Parmigianino through Schiavone's engravings brought about a change of direction, as seen in *St Paul's Sermon* (1559; Padua, Mus. Civ.), one of the few surviving sketches by the artist, the altarpiece of *St Justina and Saints* (Enego, S Giustina) and *Jacob's Journey* (*c.* 1560; London, Hampton Court, Royal Col.; see fig. 2). Compared with the *Adoration of the Magi* (*c.* 1555) in Vienna, these show the revitalizing effect of Jacopo's recent studies of light: the figures have

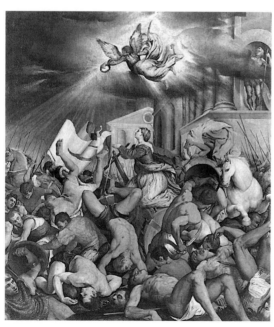

1. Jacopo Bassano: *Martyrdom of St Catherine*, oil on canvas, 1.60×1.30 m, 1544 (Bassano del Grappa, Museo Civico)

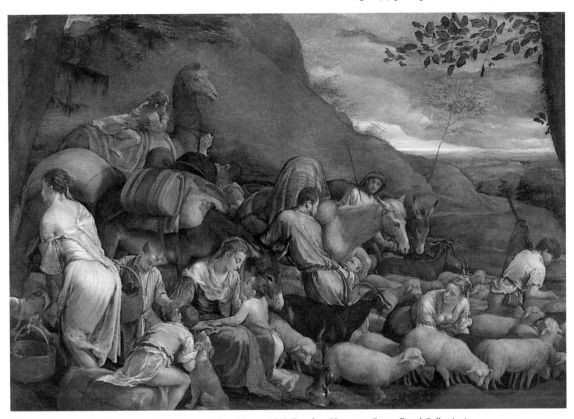

2. Jacopo Bassano: *Jacob's Journey*, oil on canvas, 1.28×1.84 m, *c.* 1560 (London, Hampton Court, Royal Collection)

a more relaxed elegance, and the colours are more transparent.

About 1561 Jacopo received an important commission from Venice, a painting for the church of the Umiltà, *SS Peter and Paul* (Modena, Gal. & Mus. Estense). Its more classical forms and constructive use of light show the influence of Paolo Veronese, who painted the canvases for the ceiling of the same church. During this brief return to the Venetian tradition, Jacopo painted the *Parable of the Sower* (*c.* 1561; Madrid, Mus. Thyssen-Bornemisza), a work demonstrating his renewed interest in pastoral–biblical subjects. The combination of rustic simplicity and elegant stylization also occurs in the *Adoration of the Shepherds* (*c.* 1562; Rome, Pal. Corsini).

3. EXPERIMENTATION AND FAMILY COLLABORATION, *c.* 1562–81. The *Crucifixion with Saints* (1562–3; Treviso, Mus. Civ. Bailo) is a key work, because it indicates the end of Jacopo's Mannerist studies and a return to a more relaxed classicism. The scene was inspired by Titian but dominated by limpid colour in the style of Veronese. In other works of the period, such as *St Jerome* (Venice, Accad.) and *Tamar Led to the Stake* (*c.* 1563; Vienna, Ksthist. Mus.), there is no trace of Mannerism: colour, no longer the primary means of expression, is subordinated to the unifying power of light. In the altarpiece of the *Vision of St Eleuterius* (*c.* 1565; Venice, Accad.) for S Maria Bombardieri in Vicenza, Jacopo produced an inventive synthesis of the pastoral genre and

the demands of an altarpiece. New formal interests can be seen in the portrait-like treatment of the faces. Freed from Mannerist preoccupations, Jacopo turned his attention to current developments in Italian painting and continued to paint with a new interest in observation from life and with a Mannerist attention to design.

Jacopo's new objectivity and well-established formal rigour are also evident in such portrait paintings of *c.* 1566 as *Man with Gloves* (London, Hampton Court, Royal Col.) and *Torquato Tasso* (Kreuzlingen, Heinz Kisters). On returning to biblical themes, Jacopo interpreted them in a pastoral key, with increased use of light. In such works of the period 1565–8 as *Jacob's Journey* (*c.* 1566; ex. Wallraf-Richartz-Mus., Cologne) and its pendant the *Meeting of Jacob and Rachel at the Well* (*c.* 1566; Turin, Galleria Antichi Maestri Pittori), the composition is dominated by light, partly due to the minute brushwork, which fragments the form. The effect is completely different from that in the pastoral scenes of the early 1560s, for example in the *Parable of the Sower* (Madrid, Mus. Thyssen-Bornemisza), where the colour has a certain autonomy and there is a high level of abstraction. Also new in the depictions of biblical history is the use of naturalistic foreground figures and animals without the strained poses of Mannerism.

Jacopo's search for a new iconography is documented in such drawings as the *Reclining Shepherd* (Frankfurt am Main, Städel. Kstinst., inv. no. 15216). The small pastoral pictures became popular with Venetian collectors, and to meet the demand Jacopo collaborated with his son (3)

Francesco Bassano *il giovane*. The biblical–pastoral pictures of 1565–70 (e.g. *Pastorale, c.* 1568; Budapest, Mus. F.A.) may be termed classical, as they are without any inflections from Parmigianino and Salviati. The altarpiece for S Giuseppe, Bassano del Grappa, the *Adoration of the Shepherds* (1568; Bassano del Grappa, Mus. Civ.), is the culmination of the new pastoral altarpiece, which began with the *Vision of St Eleuterius*. The forms have an air of classical solemnity, and each minute detail is visible in the crepuscular light.

During the 1570s Jacopo painted large altarpieces for churches in the Veneto and Trentino that show an increased sense of monumentality based on perspective. Often set in twilight, the graduated figures recede diagonally towards the background landscape. Among these works are the *Martyrdom of St Lawrence* (1571; Belluno Cathedral); the extraordinary *St Roch Visiting the Plague Victims* (*c.* 1570–73; Milan, Brera), which synthesized Jacopo's pictorial experiments, and the *Entombment* (1574; Padua, S Maria in Vanzo; see colour pl. 1, VIII1), reflecting Titian's late works. Evening light also dominates the large biblical compositions of the period, such as the *Return of Tobias the Younger*, the *Israelites Drinking the Miraculous Water* (both *c.* 1573; Dresden, Gemäldegal, Alte Meister) and the *Return of Jacob* (*c.* 1573–4; Venice, Doge's Pal.). An important civic commission is the large lunette with the *Rectors of Vicenza before the Virgin* (1573; Vicenza, Mus. Civ. A. & Stor.), showing an interest in naturalistic description and the luminous effects that also characterize other paintings, of a small format, of the early 1570s, for example *A Greyhound* (*c.* 1571; Turin, priv. col., see Ballarin, 1995, fig. 244), *Portrait of an Old Man* (Oslo, N.G.) and *Portrait of a Man with Three Books* (Rome, Gal. Spada), formerly attributed to Leandro and now in Jacopo's catalogue (Ballarin, 1995).

St Paul Preaching (1574; Maróstica, S Antonio Abate) is the first large-scale work signed by Jacopo and Francesco, who also assisted in the execution of the series of the *Four Seasons* (Vienna, Ksthist. Mus.), painted that year. In these small collectors' pieces the biblical motif, often relegated to the background, was mainly a pretext for portraying seasonal labours in a landscape observed from life. Four scenes from the *Story of Noah* were also painted in 1574, including the *Sacrifice of Noah* (Potsdam, Bildergal.); another edition was produced (*c.* 1577; Kroměříž, Archbishop's Pal.) in collaboration with Francesco. To meet the demand from collectors from *c.* 1575, Jacopo had many copies of his works made by apprentices and by his sons, Francesco, the relatively untalented Giambattista Bassano (ii) and (4) Leandro Bassano, who showed great ability, especially in portrait painting. One of Jacopo's few remaining frescoes is the cycle (1575) in the chapel of the Rosary in the parish church of Cartigliano (Vicenza), in which Francesco painted the whole right-hand wall and minor passages elsewhere. For these frescoes Jacopo made preparatory drawings of which a few survive (e.g. *Sacrifice of Isaac*, charcoal and coloured chalk; Paris, Louvre, inv. no. 2913). Also dating from 1575 is a series of night scenes. Among numerous workshop copies and variants Ballarin (1988) identified a few autograph works by Jacopo, including the *Agony in the Garden* (two versions, Modena, Gal. & Mus. Estense; Burghley House, Cambs), the

Annunciation to the Shepherds (Prague, N. G. Sternberk Pal.) and the *Crucifixion* on black stone (Barcelona, Mus. B.A. Cataluña). Another masterpiece, the *Baptism of St Lucilla* (*c.* 1575; Bassano del Grappa, Mus. Civ.), is characterized by soft lighting and refined colour effects. The same qualities are found in the paintings (*c.* 1575) in the parish church of Civezzano (Trento), two also signed by Francesco.

Probably in 1576–7 Jacopo invented another type of collectors' picture: a medium-sized biblical subject in a genre setting (e.g. kitchen or courtyard). Some originals survive, many signed by both Jacopo and Francesco. Such scenes as *Supper at Emmaus* (Crom Castle, Co. Fermanagh), the *Return of the Prodigal Son* (Rome, Gal. Doria–Pamphili), *Christ in the House of Mary and Martha* (Houston, TX, Sarah Campbell Blaffer Found.) and the *Mocking of Christ* (Florence, Pitti) are known in many versions painted by Jacopo's sons and followers, who copied them until well into the 17th century. Other works dating from the productive years 1576–7 are the allegories of the *Elements* (e.g. two, Sarasota, FL, Ringling Mus. A.) and new versions of the *Four Seasons* (Rome, Gal. Borghese) and of biblical subjects painted during the 1560s, for example the *Good Samaritan* (Vienna, Ksthist. Mus.). In these compositions, indebted to Giorgione, the figures are immersed in the landscape with no perspectival devices; the forms are not drawn but modelled with colour in a warmer register with dense brushwork.

Among the last works Jacopo executed with Francesco, who moved to Venice in 1578, is the altarpiece, the *Circumcision* (1577; Bassano del Grappa, Mus. Civ.), signed by both, for Bassano del Grappa Cathedral. This shows a renewed interest in spatial construction: the figures are no longer arranged diagonally but placed in groups balanced by converging and diverging movements. In this and other paintings of the period there is also a new style of figure drawing, as in the small votive altarpiece the *Podestà Sante Moro* (1576; Bassano del Grappa, Mus. Civ.). Clearly Jacopo was seeking a more expressive way of using light through re-examining his own past and that of Venetian painting from Titian to Tintoretto, as seen, for example, in the *Forge of Vulcan* (*c.* 1577; U. Barcelona, on dep. Madrid, Prado), in the portrait of *Doge Sebastiano Venier* (sketch, oil on copper, 1577; ex-Stuttgart, priv. col., now Bassano del Grappa, Mus. Civ.; see Rearick in *Jacopo Bassano, c. 1510–1592*, 1992 exh. cat., fig. 58) and in the portrait of *Francesco I de Medici* (*c.* 1578; Kassel, Schloss Wilhelmshöhe) traditionally attributed to Francesco *il giovane* and now in Jacopo's catalogue (Ballarin, 1995). Jacopo's new language developed further in the altarpiece of *St Martin* (*c.* 1578–9; Bassano del Grappa, Mus. Civ.), where the scene is not represented naturalistically but evoked through colours saturated with light, and in the altarpiece of the *Virgin in Glory with SS Agatha and Apollonia* (1580; Bassano del Grappa, Mus. Civ.).

4. THE LAST YEARS, 1582–92. After Francesco left for Venice, Jacopo collaborated with (4) Leandro. Ballarin (1966; 1966–7) has shown that Jacopo continued to be active in his last ten years. Based on the date of 1585, discovered in *Susanna and the Elders* (Nîmes, Mus. B.A.), Ballarin compiled a list of these late works, which has

been augmented by Rearick (1967) and Pallucchini (1981). In these years Jacopo no longer painted altarpieces but concentrated on smaller religious pictures, especially episodes of the Passion, painted with highly dramatic lighting. Apart from the *Susanna*, he produced *Christ Driving the Money-changers from the Temple* (*c.* 1585; London, N.G.), the *Mocking of Christ* (*c.* 1590; Oxford, Christ Church College Pict. Gal.) and the *Baptism* (New York, priv. col., see Rearick, 1967, fig. 118). According to Rearick, this last, incomplete work should be identified with the one in the inventory of paintings in the workshop at Jacopo's death. During the 1580s he used a thick impasto, blurred the forms and handled space expansively; and, loyal to the Venetian tradition, he seemed to be rethinking Mannerism in terms of dramatic and anguished tension.

Jacopo left most of his goods and the ownership of the famous studio to his least talented sons, Giambattista (ii) and (5) Gerolamo Bassano; a smaller share went to (4) Leandro and the bare legal minimum to Francesco *il giovane*, because, he said, the last two had been trained by him and their works had brought them fame and fortune. All Jacopo's biographers praised him for his humility. He led a secluded life in the small provincial city where he was born, and he declined invitations to serve foreign princes.

Jacopo maintained close friendships with some of the most important artists of his time, such as Tintoretto, Annibale Carracci (1560–1609) and Paolo Veronese. He was an expert musician, and Veronese in the *Marriage at Cana* (1562–3; Paris, Louvre), paid him a splendid tribute by depicting him playing in an ensemble with Titian, Tintoretto and himself. Jacopo was a keen reader, especially of holy scripture, and had a rigorous moral code, such that he would never paint scenes or figures that might arouse scandal. His interest in botany shows in the realistic flowers and plants in his paintings.

BIBLIOGRAPHY

S. Bettini: *L'arte di J. Bassano* (Bologna, 1933)
R. Longhi: 'Calepino veneziano: Suggerimenti per J. Bassano', *A. Ven.*, ii (1948), pp. 43–55
W. R. Rearick: 'The Burghley House "Adoration" of J. Bassano', *A. Ven.*, xii (1958), pp. 197–200
R. Pallucchini: 'J. Bassano e il manierismo', *Studies in the History of Art Dedicated to W. E. Suida* (London, 1959), pp. 258–66
W. R. Rearick: 'J. Bassano 1568–9', *Burl. Mag.*, civ (1962), pp. 524–33
A. Ballarin: 'L'orto del Bassano', *A. Ven.*, xviii (1964), pp. 55–72
——: 'Osservazioni sui dipinti veneziani del cinquecento nella Galleria del Castello di Praga', *A. Ven.*, xix (1965), pp. 65–70
——: 'Chirurgia bassanesca (I)', *A. Ven.*, xx (1966), pp. 112–36
——: 'La vecchiaia di J. Bassano: Le fonti e la critica', *Atti Ist. Ven. Sci. Lett. & A.*, cxxv (1966–7), pp. 151–93
——: 'J. Bassano e lo studio di Raffaello e dei Salviati', *A. Ven.*, xxi (1967), pp. 77–101
W. R. Rearick: 'J. Bassano's Last Painting, the *Baptism of Christ*', *A. Ven.*, xxi (1967), pp. 102–7
——: 'J. Bassano's Later Genre Paintings', *Burl. Mag.*, cx (1968), pp. 241–9
A. Ballarin: 'Introduzione ad un catalogo dei disegni di J. Bassano, I', *A. Ven.*, xxiii (1969), pp. 85–114
——: 'Introduzione ad un catalogo dei disegni di J. Bassano, II', *Studi di storia dell'arte in onore di A. Morassi* (Venice, 1971), pp. 138–51
I. Smirnova: 'Due serie delle *Stagioni* bassanesche', *Studi di storia dell'arte in onore di A. Morassi* (Venice, 1971), pp. 129–37
A. Ballarin: 'Introduzione ad un catalogo dei disegni di J. Bassano, III', *A. Ven.*, xxvii (1973), pp. 91–124
L. Borgo: 'J. Bassano's *Temptation of St Anthony*', *Burl. Mag.*, cxvii (1975), pp. 603–7, pl. 46

I. Smirnova: *J. Bassano i pozdnee vozrozhdenie v Vencii* [J. Bassano and the late Renaissance in the Veneto] (Moscow, 1976)
W. R. Rearick: 'Early Drawings of J. Bassano', *A. Ven.*, xxxii (1978), pp. 161–8
——: 'J. Bassano and Changing Religious Imagery in the Mid-cinquecento', *Essays Presented to Myron P. Gilmore*, 2 vols (Florence, 1978), pp. 331–43
L. Alberton Vinco da Sesso and F. Signori: 'Il testamento di J. Bassano', *A. Ven.*, xxxiii (1979), pp. 161–4
W. R. Rearick: *Biblioteca dei disegni: Maestri veneti del cinquecento* (Florence, 1980), pp. 8–32
——: 'The Portraits of J. Bassano', *Artibus & Hist.*, i (1980), pp. 99–114
R. Pallucchini: 'Aggiunte all'ultimo Bassano', *Ars Auro Prior Studia Ioanni Bialostocki Sexagenario Dicata* (Warsaw, 1981), pp. 271–7
W. R. Rearick: *Jacobus a Ponte Bassanensis: Disegni giovanili e della prima maturità, 1538–1548*, i (Bassano del Grappa, 1986)
——: *Jacobus a Ponte Bassanensis: Disegni della maturità, 1549–1567*, ii (Bassano del Grappa, 1987)
——: 'Jacopo Bassano e Paolo Veronese', *Boll. Mus. Civ. Bassano*, n. s., iii–vi (1987–8), pp. 31–40
A. Ballarin: 'Jacopo Bassano: S Pietro risana lo storpio', *Catalogue Galleria Antichi Maestri Pittori* (Turin, 1988)
S. J. Freedberg: *La pittura in Italia dal 1500 al 1600* (Bologna, 1988), pp. 651–61
B. Ajkema: 'L'immagine della carità veneziana', *Nel regno dei poveri: Arte e storia dei grandi ospedali veneziani in età moderna, 1474–1797*, ed. B. Ajkema and D. Meijers (Venice, 1989), pp. 74–9
W. R. Rearick: *Jacobus a Ponte Bassanensis: Disegni della tarda maturità, 1568–1574*, iii (Bassano del Grappa, 1989)
A. Ballarin: 'Jacopo Bassano *Incontro di Giacobbe e Rachele al pozzo*', *Da Biduino ad Algardi, Catalogue Galleria Antichi Maestri Pittori* (Turin, 1990), pp. 117–45
P. Joannides and M. Sachs: 'A *Last Supper* by the Young Jacopo Bassano and the Sequence of his Early Work', *Burl. Mag.*, cxxxiii (1991), pp. 695–9
W. R. Rearick: *Jacobus a Ponte Bassanensis: Da Cartigliano a Civezzano, 1575–1576*, iv (Bassano del Grappa, 1991)
L. Alberton Vinco da Sesso: *Jacopo Bassano: I dal Ponte: Una dinastia di pittori: Opere nel Veneto* (Bassano del Grappa, 1992)
Jacopo Bassano, c. 1510–1592 (exh. cat., eds B. L. Brown and P. Marini; Bologna, 1992)
La famiglia di Jacopo nei documenti d'archivio (exh. cat., eds F. Signori, G. Marcadella and M. L. De Gregorio; Bassano del Grappa, 1992)
E. Bordignon Favero: 'I Frizier "dal la nave" e un affresco inedito di Jacopo Bassano', *A. Ven.*, xliv (1993), pp. 24–33
W. R. Rearick: *Jacobus a Ponte Bassanensis: Disegni della vecchiaia, 1577–1592*, v (Bassano del Grappa, 1993)
——: 'La *Pesca miracolosa* di Jacopo Bassano', *A. Ven.*, lxiv (1993), pp. 8–23
Le Siècle de Titien: L'Age d'or de la peinture à Venise (exh. cat., Paris, 1993), pp. 647–50, 685–92, 995–9
L. Alberton Vinco da Sesso: 'La raccolta di "quadri di eccellente pittura" della famiglia Stecchini e il fondo di dipinti bassaneschi degli ultimi discendenti dei Dal Ponte: Episodi di collezionismo bassanese tra la fine del '600 e l'inizio del '700', *Boll. Mus. Civ. Bassano*, n.s. 13–15 (1992–4), pp. 204–17
R. Cocke: 'Civic Identity and the Venetian Art Market: Jacopo Bassano and Paolo Veronese', *New Interpretations of Venetian Renaissance Painting*, ed. F. Ames-Lewis (London, 1994), pp. 91–7
F. Rossi: 'Una cucina di Jacopo Bassano e il suo modello nordico', *Verona Illus.*, vii (1994), pp. 57–64
Z. Wazbinski: 'Dwie wystawy Jacopo da Ponte: Punkt zwrotny w badaniach nad malarstwem Bassanów?/Deux expositions consacrées à Jacopo da Ponte: Un tournant dans les recherches sur la peinture des Bassano?', *Biul. Hist. Sztuki*, lvii/1–2 (1995), pp. 137–40
B. Aikema: *Jacopo Bassano and his Public: Moralizing Pictures in an Age of Reform, ca. 1535–1600* (Princeton, 1996); Eng. trans. by A. P. McCormick
A. Ballarin: *Jacopo Bassano (1531–1568): Tavole*, ii (Cittadella, 1996)
P. Berdini: *The Religious Art of Jacopo Bassano: Painting as Visual Exegesis* (Cambridge and New York, 1997); review by J. M. Greenstein in *Burl. Mag.*, cxl/1144 (July 1998), pp. 483–4
T. Ketelsen: 'A Newly Discovered Drawing by Jacopo Bassano', *Master Drgs*, xxxv (Summer 1997), pp. 182–4
A. Ballarin: *Jacopo Bassano: Nuove ricerche, regesti e apparati di catalogo* (Cittadella) [in preparation]

(3) Francesco Bassano *il giovane* (*b* Bassano del Grappa, 7 Jan 1549; *d* Venice, 3 July 1592). Son of (2) Jacopo Bassano. He was trained in his father's workshop between 1560 and 1570, when Jacopo was moving from Mannerist experiments to an increased naturalism in the Venetian tradition. Francesco attempted to imitate his father's style in his contributions to their painting of the *Vision of St Eleuterius* (*c.* 1565; Venice, Accad.). They also collaborated on new versions of the biblical themes Jacopo had treated *c.* 1560; Francesco executed some preparatory drawings and parts of the paintings themselves. These works were in considerable demand from Venetian collectors and Francesco produced such skilful replicas that they are difficult to distinguish from the originals.

Francesco's precocious talent is evident in the *Miracle of the Quails* (Verona, priv. col., see Arslan, 1960, i, p. 184; ii, fig. 207), the earliest work signed with his name alone, which from Jacopo's interventions can be dated to 1566–7. From the large altarpieces produced by his father in the 1560s and 1570s Francesco learnt how to relate figures to their architectural surroundings and how to structure a composition using receding diagonals, as in *St Paul Preaching* (1574; Maróstica, S Antonio Abate), in which Jacopo first officially acknowledged his son's mastery by signing with Francesco. In this altarpiece their techniques are similar but distinguishable; Francesco's brushwork is heavier and his style of description more modest. Other works signed by father and son, especially collectors' pieces, include a *Mocking of Christ* (*c.* 1575; Florence, Pitti), *Christ in the House of Mary and Martha* (Houston, TX, Sarah Campbell Blaffer Found.), the *Vision of Joachim* (*c.* 1576–7; Corsham Court, Wilts), a new version of the *Departure of Abraham for Canaan* (Berlin, Gemäldegal.) and the *Return of the Prodigal Son* (*c.* 1576–7; Rome, Gal. Doria–Pamphili).

In this period Francesco and Jacopo also collaborated on new biblical themes, for example the *Stories of Noah* (*c.* 1577; Kroměříž, Archbishop's Pal.), where Francesco's hand is evident despite the single signature of Jacopo. It is more difficult to identify Francesco's hand in paintings produced *c.* 1575, when the workshop was reorganized for large-scale production. The pictures are not signed or individually documented, and Francesco closely imitated his father's style. Of the works from 1575–7, however, a greater number can be attributed to Francesco, for example, *Christ Driving the Money-changers from the Temple* (Isola Bella, Mus. Borromeo), and the cycles of the *Four Seasons* (e.g. *Summer*; Modena, Gal. & Mus. Estense) and the *Elements*, which were devised by Jacopo in the period of collaboration between father and son from 1574–6. In the *Annunciation to the Shepherds* (Kraków, Wawel Castle) the handling of light is less vibrant than in the version by Jacopo (1575; Prague, N.G., Šternberk Pal.), and Francesco's characteristic smooth drawing and heavy brushwork are evident.

Dating from this period (*c.* 1575) are the four altarpieces with predellas for the parish church of Civezzano, Trento (all *in situ* except the predella with the *Temptation of St Anthony*; priv. col., see Borgo, 1975, fig. 46) executed by Jacopo and Francesco in collaboration. Two altarpieces of the series, the *Sermon of St John the Baptist* and the *Meeting of Joachim and Anna*, are signed by both artists. They also collaborated on frescoes (1575) for the parish church of Cartigliano, Vicenza: the wall scenes on the right, *Eve Offering the Apple to Adam* and the *Expulsion from the Garden of Eden*, belong to Francesco and show his characteristic pyramidal figure groups, full brushwork and contorted drapery. In the *Circumcision* (Bassano del Grappa, Mus. Civ.), signed jointly, they used a new frieze-like composition, which reappears in the *Flood* (1577; Kroměříž, Archbishop's Pal.) from the *Stories of Noah* and in the great *Forge of Vulcan* (U. Barcelona, on dep. Madrid, Prado). These experiences were fundamental to Francesco's development and for the demanding enterprise of the four *Battles of the Serenissima* for the ceiling of the Sala del Maggiore Consiglio in the Doge's Palace, Venice, which he painted in the spring and summer of 1578.

Francesco had worked in Venice before, probably earlier in 1578 when he executed the altarpiece with the *Virgin in Glory with St Nicholas of Bari* (on which his signature was discovered in the 1990s) and the painting of the *Sermon of St John the Baptist*, both for the Dolzoni Chapel in S Giacomo dell'Orio (both *in situ*) and reminiscent of the Civezzano cycle. This suggests that he was known in Venice before he moved there permanently in 1578, the year of his marriage to Giustina Como of Bassano del Grappa. He opened his own workshop there but maintained a close relationship with his father, who assisted in the design and execution of the paintings on the ceiling of the council chamber.

Jacopo may have helped Francesco with other works in the Doge's Palace, particularly with such demanding compositions as the oval *Capture of Padua at Night* (*c.* 1580) on the ceiling of the Sala dello Scrutinio. Thus the nature of the collaboration changed, with Jacopo supplying sketches for Francesco's prestigious commissions, such as the *Rape of the Sabine Women* (Turin, Gal. Sabauda), and working with him, as in the *Forge of Vulcan* (*c.* 1584; Poznań, N. Mus.), which is signed by both. In other works Francesco repeated his father's compositions, with a few variations, as in the *Adoration of the Magi* (Padua Cathedral), which contains his distinctive dense, brilliant colours, short stocky Magi and a massive Virgin. In such nocturnal scenes painted *c.* 1580 as the *Capture of Padua at Night* in the Doge's Palace, the *Baptism of St Afra* for S Afra, Brescia, the *Agony in the Garden* and the *Adoration of the Shepherds* (both Bassano del Grappa, Mus. Civ.), Francesco also used ideas from Titian and Tintoretto, as well as prototypes from his father's workshop.

According to Ridolfi, his move to Venice was due to the requirements of the art market. There, in addition to major commissions, he painted night scenes, with moonlight and vivid artificial light effects, for which he showed a particular aptitude. Many of his genre pictures were variations of designs by Jacopo, for example the *Four Seasons* (Vienna, Ksthist. Mus.), and the allegories of the elements, *Fire* and *Earth* (Vaduz, Samml. Liechtenstein), which show how far Francesco had moved from the formal approach of Jacopo: the colours glow more vividly, the paint is thicker, the figure masses expanded and weighty. Some of these pictures, such as *Hercules* (Vienna, Ksthist. Mus.), indicate the Mannerist influence brought to Venice by Paolo Fiammingo.

Francesco's creations, linked to the 16th century Venetian tradition and to his father's inheritance, were marked by a pastoral tone. The 'nocturne' remained an important theme, in which light is not purely descriptive. His father's teaching is still clear in his monumental episodes from the *Life of the Virgin* (Bergamo, S Maria Maggiore), of the late 1580s, in the broadly conceived composition, the soft, brilliant colouring and the wide brushstrokes. A movement towards the style of (4) Leandro Bassano, who moved to Venice in 1588, can be seen in the *Assumption* (Rome, S Luigi dei Francesi), and particularly in one of Francesco's last works, the *Presentation at the Temple* (Prague, Hradčany Castle), in which the emphasis is on description, with pale colours, broad, simple forms and more fragmented compositions.

In his last years he suffered from deep depression, worn out by the intense labour of painting, ill with tuberculosis and obsessed with a persecution mania. In November 1591 he threw himself from a window of his house in S Canciano, the house in which Titian had lived. He survived only another few months, and his commissions were completed by Leandro.

BIBLIOGRAPHY

G. Gerola: 'I testamenti di Francesco il Giovane e di Gerolamo da Ponte', *Boll. Mus. Civ. Bassano*, ii (1905), pp. 103–14
M. Muraro: 'Gli affreschi di Jacopo e Francesco da Ponte a Cartigliano', *A. Ven.*, vi (1952), pp. 42–62
E. Arslan: 'Due storie dell'Arca di Francesco e Jacopo Bassano', *Ant. Viva*, vi/3 (1967), pp. 3–7
S. Mason Rinaldi: 'Francesco Bassano e il soffitto del Maggior Consiglio in Palazzo Ducale', *A. Ven.*, xxxiv (1980), pp. 214–19
T. Fomiciova: 'I dipinti di Jacopo Bassano e dei suoi figli Francesco e Leandro nella collezione dell'Ermitage', *A. Ven.*, xxxv (1981), pp. 89–94
R. Pallucchini: *La pittura veneziana del seicento* (Milan, 1987), pp. 27–8
F. Lugato: 'I dipinti di Francesco dal Ponte il Giovane nella chiesa di San Giacomo dell'Orio', *Boll. Mus. Civ. Bassano*, n. s., vii–xii (1989–91), pp. 57–61
Da Bellini a Tintoretto: Dipinti dei Musei Civici di Padova dalla metà del quattrocento ai primi del seicento (exh. cat. by A. Ballarin and D. Banzato, Rome, 1991), pp. 213–14
Sulle tracce di Jacopo Bassano (exh. cat. by L. Alberton Vinco da Sesso and V. Romani, Bassano del Grappa, 1994), pp. 46–7, 52–5, 56–61
F. Nodari: 'Disegni de Francesco Bassano tra il 1571 e il 1590', *Paragone*, xlv/535–7 (Sept–Nov 1994), pp. 48–80

(4) Leandro Bassano (*b* Bassano del Grappa, 10 June 1557; *d* Venice, 15 April 1622). Son of (2) Jacopo Bassano. He entered the workshop of his father when very young and soon developed a style of painting strongly based on drawing. Leandro used fine brushwork, with cool, light colours, smoothly applied in well-defined areas, unlike his father, who painted with dense and robust brushstrokes. From 1575 Leandro's participation in the workshop increased, and he became his father's principal assistant after (3) Francesco Bassano *il giovane* moved to Venice in 1578. Jacopo's will indicated that Leandro should take over the running of the shop, for Francesco was infirm after his suicide attempt, Giambattista was mediocre and incompetent and Gerolamo was combining the painter's trade with medical studies at the Univeristy of Padua.

In Leandro's youthful works, such as *Moses Striking the Rock* (Dresden, Gemäldegal. Alte Meister), the precise colour areas give the effect of intarsio. In 1577–8 he was taken to Venice by Jacopo. His ability was soon recognized, and *c.* 1580 he painted several altarpieces, some signed jointly with his father, for parish churches around Bassano del Grappa. Venetian influence is evident in his early portraits, including *Andrea Frizier* (1581; Padua, Mus. Civ.), painted in the manner of Tintoretto, and *Girolamo Campagna* (*c.* 1581; London, Hampton Court, Royal Col.). The portrait of *Frizier* was the first of about 70 known portraits by Leandro, who showed particular talent for the genre. He moved from Venetian models to being influenced by Emilian painting, especially that of Bartolomeo Passarotti. Finally, he established his own style, as seen in the portrait of *Orazio Lago with his Wife and a Customer* (*c.* 1590; Vienna, Ksthist. Mus.), which is characterized by a new naturalism that recalls the scenes of money-changing painted by Flemish artists.

In 1588 Leandro joined Francesco in Venice, where he enrolled in the painters' guild and opened a workshop of his own. His fame as a portrait painter increased and in 1595 he was named a knight of St Mark for his impressive portrait of *Doge Marino Grimani* (Dresden, Gemäldegal. Alte Meister), after which he added the title of 'Eques' (knight) to his signature. Leandro maintained contacts with the family workshop at Bassano del Grappa at least until 1592. In the late 1580s he contributed to the development of naturalistic and allegorical subjects, especially in the cycle of the *Months* (nine in Vienna, Ksthist. Mus.; two in Prague, Hradčany Castle). These detailed scenes, rich in figures and landscape vignettes, are described with a fresh sensibility, reflecting the Mannerist influence of Paolo Fiammingo, who was then working in Venice. The large votive altarpiece of *Podestà Cappello at the Feet of the Virgin* (1590; Bassano del Grappa, Mus. Civ.) shows his new style: the composition is clearer, the colour distinct, the forms smooth and well turned, but there is a certain academic coldness.

Of the Bassano family, Leandro had the greatest aptitude for large historical and religious scenes. He executed numerous altarpieces for Venice and the mainland and helped to decorate the halls of the Doge's Palace. His interest in Mannerism is evident in the *Feast of Cleopatra* (1595–6; Stockholm, Nmus.), in which the compositional scheme is typical of the Bassano school, but the colour is smooth, like porcelain, and applied precisely. He completed the *Meeting of Pope Alexander III with Doge Sebastiano Ziani* for the Sala del Consiglio dei Dieci left unfinished by Francesco at his death in 1592. The composition was set by Francesco, but Leandro's taste is revealed in the strongly characterized portraits, the brilliant pinks and blues and the solemn atmosphere.

In 1604–5 Leandro painted *Alexander III Offering the Blessed Candle to Doge Ziani* for the Sala del Maggior Consiglio, in which the delicate faces, slender hands and attenuated figures recall El Greco. Characteristics of this painting are also found in the religious paintings of his late period, for example, the cycle of three paintings (the *Meeting of Mary and Elizabeth*, the *Birth of St John the Baptist* and the *Annunciation of the Angel to Zachary*) for the chapel of the Visitation (Venice, S Cassiano) and the altarpiece with *St Augustine and other Saints* (Venice, S Geremia), where the colours are restricted to a range of greys, browns and black and the insistent psychological portrayal of the various characters confers an austere and serene quality to the works.

Leandro was ambitious and pleasure-loving. He flaunted his wealth and paid poets to celebrate his work. His devotion to Venice, however, caused him to refuse an invitation from the Holy Roman Emperor Rudolf II to come to Prague as court painter.

BIBLIOGRAPHY

R. Burgess: 'A *Nativity* by Leandro Bassano at the Wellcome Institute', *Gaz. B.-A.*, n. s. 5, cxiii (1971), pp. 177–82

E. Merkel: 'Il rifacimento ex-novo dei mosaici marciani quale metodo di "restauro" in un esempio del seicento tra Aliense e Leandro Bassano', *A. Ven.*, xxii (1978), pp. 305ff

B. Boucher: 'A Statuette by Girolamo Campagna and a Portrait by Leandro Bassano', *A. Ven.*, xxxiv (1980), pp. 159–64

T. Fomiciova: 'I dipinti di Jacopo Bassano e dei suoi figli Francesco e Leandro nella collezione dell'Ermitage', *A. Ven.*, xxxv (1981), pp. 89–94

R. Pallucchini: *La pittura veneziana del seicento* (Milan, 1987), pp. 28–9

A. Bassotto: 'Alcuni dipinti della tarda attività di Leandro dal Ponte detto Bassano: La *Nascita di San Giovanni Battista* di San Giacometto di Rialto e il ciclo di San Cassiano a Venezia', *Boll. Mus. Civ. Bassano*, n. s., vii–xii (1989–91), pp. 49–55

Da Bellini a Tintoretto: Dipinti dei Musei Civici di Padova dalla metà del quattrocento ai primi del seicento (exh. cat. by A. Ballarin and D. Banzato, Rome, 1991), pp. 216–19

C. Kryza-Gersch: 'Leandro Bassano's *Portrait of Tiziano Aspetti*', *Burl. Mag.*, cxl/1141 (April 1998), pp. 265–7

(5) Gerolamo Bassano (*b* Bassano del Grappa, 3 June 1566; *d* Venice, 8 Nov 1621). Son of (2) Jacopo Bassano. Trained in the family workshop, in 1580 and 1581 he signed receipts for payment for the altarpiece of the *Virgin with SS Apollonia and Agatha* (Bassano del Grappa, Mus. Civ.), but the skilful drawing and painting technique indicate that it was executed by his father. Gerolamo also studied medicine at Padua University until at least 1592, although he never finished the course.

It is difficult to distinguish Gerolamo's contributions to workshop productions. In his first independent works, however, he closely followed his father's style, with its dense and vibrant impasto textures. According to late 20th-century studies, an *Adoration of the Shepherds at Night* (Padua, Mus. Civ.) and the *Raising of Jesus on the Cross* (Bassano del Grappa, Mus. Civ.), which belonged to the cycle executed for S Antonio Abate, Brescia, also date from this period. None of his surviving signed works are dated, but some are documented. Among his early works is the signed altarpiece of the *Virgin with SS Mark and Justina* (Cismon, Nostra Signora del Pedancino), in which the faces recall those in Jacopo's Mannerist works; the rippling folds of the drapery are characteristic of Gerolamo's paintings. Other works include altarpieces depicting the *Virgin and Child with SS Martin and Lucy* (1598; Campese, parish church), the *Three Martyr Saints* (London, Hampton Court, Royal Col.), the *Nativity* (Bassano del Grappa, S Maria in Colle) and the copy (Vienna, Ksthist. Mus.), with variations and omissions, of Jacopo's *Adoration of the Shepherds* of 1568.

Gerolamo continued to work with his brother Giambattista in the family shop until 1595, when he moved to Venice. There he opened his own shop and married Zanetta Biava, although he maintained his connection with Bassano del Grappa. After his father's death, Gerolamo moved towards the style of his brother, (4) Leandro Bassano. In this late period he executed several altarpieces in Venice and the Bassano del Grappa region, as well as

biblical–pastoral and allegorical pictures in the family tradition. In the signed *Virgin and Child with SS Fortunatus and Hermagora* (Bassano del Grappa, Mus. Civ.) the perspective is uncertain and the colour arid; it shows Gerolamo's typical drapery style and fragmented lights. Other works include the altarpiece depicting the *Virgin and Child with SS Justina, Barbara and Mark and the Donor* (Bassano del Grappa, Mus. Civ.), with his preferred violet and silver-grey tones, and the *Apparition of Christ and the Virgin to Two Franciscan Saints* (Tolmezzo, S Martino), striking for the resonating colour and warm shadows.

BIBLIOGRAPHY

G. Gerola: 'I testamenti di Francesco il Giovane e di Gerolamo da Ponte', *Boll. Mus. Civ. Bassano*, ii (1905), pp. 103–14

A. Niero: 'Aggiunte di Giannantonio Moschini al Federici', *A. Ven.*, xxiii (1969), pp. 248, 252

Il Museo Civico di Bassano del Grappa: Dipinti dal XIV al XX sec. (exh. cat. by L. Magagnato and B. Passamani, Venice, 1978), pp. 14–16

R. Pallucchini: *La pittura veneziana del seicento* (Milan, 1987), p. 29

V. Sgarbi: 'Tintoretto, Bassani e Persone a Rovigo', *F.M.R. Mag.*, lv (1987), p. 82, illus. pp. 80–81

Da Bellini a Tintoretto: Dipinti dei Musei Civici di Padova dalla metà del quattrocento ai primi del seicento (exh. cat. by A. Ballarin and D. Banzato, Rome, 1991), pp. 214–15

II. Family workshop.

The workshop was in the family house in the Contrà del Ponte quarter of Bassano del Grappa. Information about its organization and operation in the period 1512–56 can be deduced from the surviving volume of workshop account books (*Libro secondo di dare e avere della famiglia Dal Ponte con diversi per pitture fatte*; Bassano del Grappa, Bib. Civ.; see Muraro, 1992).

The first master of the workshop, (1) Francesco Bassano *il vecchio*, collaborated with his sons (2) Jacopo Bassano and Giambattista Bassano (i) as well as pupils and assistants. The master received the commission, even if the work was then, on occasions, done by others; he drafted and signed contracts with clients, fixing the subject of the painting, its dimensions, the price and the date of delivery. The Bassano shop was active in all the sectors of the trade mentioned in the Venetian statutes for the painters' guild. In addition to fine art, it produced objects of applied art, for example furniture, clothing, shoes, lamps, Easter candles, banners and games, which the painters would decorate. This craft production was the daily work of the shop; it was more in demand and more economically important than the paintings. Before 1538 the workshop produced mainly religious paintings, altarpieces, devotional pictures and frescoes for the parishes, convents and confraternities of Bassano del Grappa and neighbouring villages. In 1538 for the first time a lay authority, the Podestà of Cittadella (Padua), Cosimo da Mosto, contracted with Francesco for two paintings to be executed by Jacopo. After that the production of paintings broadened and diversified, as the shop was increasingly patronized by political figures, nobles, rich bourgeois individuals and art dealers.

Jacopo took a growing role in the workshop as his father grew older, and after Francesco's death he brought about a dramatic improvement in the quality of its production. Jacopo collaborated with his brother Giam-

battista until his death in 1548, and later with his sons, (3) Francesco Bassano *il giovane*, Giambattista Bassano (ii), (4) Leandro Bassano and (5) Gerolamo Bassano. It is not easy to distinguish their individual hands, especially from the 1570s, when the shop was organized to produce replicas. The prototypes were provided by Jacopo, who sometimes added his signature to his sons' paintings as a guarantee of authenticity and a sign of prestige.

Defining the relationship between Jacopo and his son Francesco is particularly problematic. Their long collaboration is attested by the works signed by both. It has been shown, however, that Francesco both worked on paintings that were signed by his father alone and painted entire works that bear only Jacopo's signature. It is also uncertain whether Francesco was the sole painter of the few works that bear his signature only. An inventory made after Jacopo's death listed 188 paintings in the workshop, in various stages of execution. It suggests that production declined after Francesco and Leandro had left Bassano del Grappa for Venice. When Gerolamo followed his brothers in 1595, only Giambattista remained, turning out feeble reproductions of Jacopo's works. Thus ended the century-long tradition of the Bassano workshop.

III. Critical reception and posthumous reputation.

In the 16th century the Bassano family was only briefly mentioned by Vasari (1568), Benedetti (1571), Marucini (1577), Lomazzo (1584) and Borghini (1584). They praised (2) Jacopo Bassano for his ability to paint men and animals, for his naturalism and for the success in Venice of his genre pictures.

Critical comprehension of the family's art came only in the 17th century. In his *Schilder-boeck* ([1603]–1604), Karel van Mander (1548–1606) produced the first biography of Jacopo, who was admired for his painting of night scenes and animals and for his illusionist skill. The history of the whole family was first traced by Ridolfi (1648). He devoted most of his account to Jacopo, whom he placed among the great Venetian artists of the 16th century. Boschini (1660; 1674) considered Jacopo a model for later generations for his strong colours, sculptural figures and free brushwork.

Zanetti (1771) also saw Jacopo as the master of a new style, equal to those of Titian, Tintoretto and Veronese. Volpato, who was from Bassano del Grappa, traced Jacopo's stylistic evolution in the manuscript *La verità pittoresca*. His ideas were developed by Verci (1775), whose research assisted the cataloguing of the Bassano family's work. Although enlightened observations about Jacopo's art were made in the 18th century by, for example, Giambattista Tiepolo (according to G. B. Roberti, 1777) and Francesco Algarotti (1784), a classicist attitude inimical to the true understanding of the art of the Bassano family also developed. Critics from this school, for example Milizia (1797), condemned Jacopo for his unidealized view of nature, his inaccurate drawing and his bizarre composition. These negative views were in part due to the mistaken attribution to Jacopo of mediocre workshop products.

An authoritative re-evaluation of Jacopo's work was undertaken by Berenson (1894), who claimed that Jacopo elevated humble subject-matter through his lighting and atmospheric effects, and that he was the first modern landscape artist. The reputation of Jacopo and interest in the Bassano family increased during the 20th century, particularly through the efforts of Venturi (1929), Arslan (1931; 1960), Bettini (1933), Ballarin, Rearick and Pallucchini. In recent years notable studies by Aikema (1996) and Berdini (1997) have focused on the religious aspects of Jacopo's art.

For bibliography *see* family introduction above.

LIVIA ALBERTON VINCO DA SESSO

Bassarini [Bassiti]**, Marco.** *See* BASAITI, MARCO.

Bassi, Martino (*b* Seregno, 1544; *d* Milan, 15 Nov 1591). Italian architect. He was apprenticed to Vincenzo Seregni, probably in the building works at Milan Cathedral, where he is documented from 1567. In 1568 or 1569 he was admitted to the Collegio degli Architetti Ingegneri ed Agrimensori. His apprenticeship should traditionally have prepared him as his master's successor, but in 1567 Pellegrino Tibaldi was appointed architect of the cathedral instead. Two years later Bassi questioned Tibaldi's work at the cathedral, contesting both Tibaldi's perspectival solutions in the sanctuary and his choice of architectural forms, and maintaining that he had distorted the unity of the building's Gothic style. Having consulted such architects as Andrea Palladio and Jacopo Vignola, Bassi later published the debate (1572).

Tibaldi retained his position of dominance at the cathedral, but Bassi became known through the debate and was soon active in various Milanese building projects. In 1570 he succeeded Galeazzo Alessi at S Maria presso S Celso, the façade of which was completed according to Alessi's designs, although Bassi simplified the decorative elements and hardened the compositional lines; he was also engaged in the marble decoration of the interior and in the layout of the choir and the altar of the Virgin. This work was characteristic of his practice in general, revealing a solid basis in the working methods of the Lombard building tradition reinforced by examples of constructional form from the work of Bramante. These included the use of solid piers, strong coffered vaults and a decorative chiaroscuro obtained by the opening up of surfaces by placing statues and reliefs in squares and niches. Alessi was also an enduring influence on Bassi, for example at S Vittore, Milan, which was reconstructed on a model probably ascribable to Alessi and where Bassi worked from 1570 to 1588.

In addition to the influences of Alessi and Bramante, Bassi also drew on Classical and contemporary treatises, above all the volumes then available of Sebastiano Serlio's *Trattato di architettura*. These he referred to especially in his plans for the dome of S Lorenzo, Milan, after it collapsed in 1573. At S Lorenzo (see fig.) Bassi transformed the Early Christian quatrefoil plan of the church by reinforcing the internal angles of the inner square with pilasters; he thereby transformed it into an octagon with unequal sides suitable for carrying a coffered, polygonal dome, intended to be illuminated only by a single central oculus, after the model of the Pantheon. The project

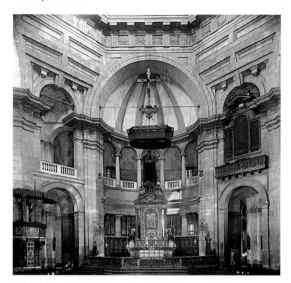

Martino Bassi: interior (begun 1577) of S Lorenzo, Milan

approved by Carlo Borromeo in 1577, however, with a dome having a slightly sloping ogival curvature, in part also visible externally, refers also to the solutions of Bramante, as deduced from Serlio's treatise. The forms proposed were of a severe and monumental classicism, and they provoked a series of disputes at the end of the 1580s: Bassi's critics, who included the Roman architect Tolomeo Rinaldi, protested against his monumental design, preferring a more delicate dome, with a drum pierced by windows and with ribs rather than coffers. Bassi was forced to review his plans, producing instead a tall octagonal drum punctuated by windows, with the corners defined by pairs of Ionic pilasters. This forms the external base to the segments of the octagonal dome, while on the inside broad vertical bands connect the drum to the lantern. The execution of the dome was entrusted to Bassi in 1590 but was eventually carried out by Rinaldi.

There are few other surviving architectural works executed by Bassi, although numerous drawings (Milan, Bib. Ambrosiana S. 150 Sup., Ferrari Col.) demonstrate his style. From 1573 he enlarged S Maria della Passione, Milan, transforming the earlier Greek-cross church (begun 1486 by Giovanni de Domenico Battaggio) into a Latin-cross plan with a broad nave and two side aisles with semicircular chapels. He also prepared designs (unexecuted) for the façade, in which many features of Alessi's style reappear, notably the treatment of the entrance door and niches. For the same patrons, the Lateranensi canons, Bassi erected (1582–7) the church of the Bernate Ticino convent, giving it a single nave carrying a coffered barrel vault with an octagonal dome, disguised externally by a *tiburio*. He employed thermal windows for the church but varied this theme by employing Venetian windows (Serliana) for the choir. In 1578 he executed the marble revetment of the sanctuary of the Certosa di Pavia near Milan and in the same year began the structural work on S Maria della Rosa (destr.) in Milan.

In 1583 Bassi was summoned to Novara for consultations on the design of S Gaudenzio, being built to Tibaldi's plan; he succeeded Tibaldi after 1586 in many building operations in Milan, including S Fedele and the cathedral, where he was nominated Architetto del Veneranda Fabbrica. At the cathedral he executed (1586–91) two series of project drawings for the façade: the first series was characterized by the presence of a severe and monumental colonnade along the whole front. For the Jesuits he worked on plans for adapting the former convent of the Umiliati di S Maria di Brera (now Pinacoteca di Brera) to a convent with an adjoining college, proposing that the lecture rooms be disposed around a wide, colonnaded courtyard; this was carried out in the following century to designs by Francesco Maria Ricchini. At Lodi he worked on the restoration and strengthening of the cathedral as well as at the Ospedale (1588–9) in the monastery of S Vincenzo for the Benedictines, and in the Palazzo Episcopale. At Mortara he was engaged on the internal alterations (destr.) to the cathedral of S Lorenzo and probably also at Santa Croce.

In 1590 Bassi prepared designs (Milan, Bib. Ambrosiana) for the reconstruction of S Maria del Paradiso, drawing up various proposals on the theme of the central plan, which he was also considering in various designs for the church of the Vergini Spagnole. S Maria del Paradiso was eventually built by an unknown architect who followed Bassi's plans, with some modifications. Bassi also drew up various plans for the Milanese nobility. Among his surviving drawings are plans for buildings for the Durini and the Visconti families, although it is not possible to relate these to any extant buildings.

WRITINGS
Dispari in materia di architettura e prospettiva (Brescia, 1572)
Dispari in materia di architettura e prospettiva con l'aggiunta degli scritti del medesimo interno all'insigne tempio di San Lorenzo Maggiore (Milan, 1771)

BIBLIOGRAPHY
C. Baroni: *Documenti per la storia dell'architettura lombarda nel rinascimento e nel barocco*, i (Florence, 1940), ii (Rome, 1968)
M. L. Gatti Perrer: 'Martino Bassi, il Sacro Monte di Varallo e Santa Maria presso San Celso', *A. Lombarda* (1964), no. 2, pp. 21–61
M. R. Bascape: 'I disegni di Martino Bassi nella raccolta Ferrari', *A. Lombarda* (1967), no. 2, pp. 33–64
A. Scotti: 'Disegni di architettura', *Il seicento lombardo*, iii (Milan, 1973)
G. B. Sannazaro, G. Bora and A. Scotti: *Santa Maria della Passione e il conservatorio Giuseppe Verdi* (Milan, 1981)
G. A. Dell'Acqua, ed.: *La basilica di San Lorenzo in Milano* (Milan, 1985)

AURORA SCOTTI TOSINI

Bastiani, Lazzaro (*b* Venice; *fl* 1449; *d* 1512). Italian painter. He is first recorded in 1449, as a painter in Venice and in 1460 he was paid for an altarpiece in S Samuele there. Although no extant work is securely documented, several are signed and two are dated. The influence of Andrea del Castagno is clear in his early works, of the 1460s: the signed mosaic of *St Sergius* (Venice, S Marco), the *Archangel Gabriel* (Padua, Mus. Civ.) and the signed *Pietà* (Venice, S Antonino). Also assigned to this period are the *Adoration of the Magi* (New York, Frick), the polyptych of *St Francis* (Matera, S Francesco), the *St Jerome* (Monopóli Cathedral) and the 'tarot cards of Mantegna', which show links with the work of Bartolomeo Vivarini. A painting of the *Story of David* (destr. 1485) was commissioned by the Scuola di S Marco in Venice in 1470.

In the 1480s Bastiani moved towards the language of Gentile Bellini, as seen in the portrait of *Doge Francesco Foscari* (Venice, Correr), and he worked with the latter for

the Scuola Grande di S Marco. From this experience came such works as the *Nativity* (Venice, Accad.), the signed *Annunciation* (Venice, Correr) and *St Augustine Giving the Rule* (Montevideo, priv. col.; see Planiscig), which show his interest in perspective and space. Also datable to the 1480s are the signed *St Anthony in the Walnut Tree* (Venice, Accad.), the *St Jerome* (Asolo Cathedral), the lunette of the *Virgin and Child with Saints and a Donor* (1484; Murano, SS Maria e Donato), the *Madonna delle Grazie* (Zadar, Croatia, S Francesco), the signed *Virgin and Child* (London, N.G.) and the signed *St Veneranda* (Venice, Accad.). These paintings are characterized by conventional compositional forms and rigorous perspective. The increasing aridity of Bastiani's art is clear in the *Coronation of the Virgin* (1490; Bergamo, Gal. Accad. Carrara), which again shows links with Vivarini, especially in the drapery. Later in the 1490s he painted the large canvas with the *Donation of the Relic of the True Cross* (c. 1495; Venice, Accad.) for the Scuola di S Giovanni Evangelista, Venice. A triptych was in the collection of Sir Henry Howorth in England. It has been suggested that Vittore Carpaccio was his pupil (Ludwig and Molmenti).

BIBLIOGRAPHY

DBI; Thieme–Becker

G. Ludwig and P. Molmenti: *Vittore Carpaccio* (Milan, 1906), p. 7

L. Planiscig: 'La tavola di S Agostino di Lazzaro Bastiani', *Riv. Venezia*, viii (1929), pp. 257–280

G. Mariacher: *Il Museo Correr di Venezia* (Venice, 1957), pp. 29–42

A. Rizzi: 'Un polittico inedito di Lazzaro Bastiani', *A. Ven.*, xxiii (1969), pp. 21–30

P. Humfrey: 'The *Life of St Jerome* Cycle from the Scuole di S Gerolamo in Cannaregio', *A. Ven.*, xxxix (1985), pp. 41–6

——: 'Lazzaro Bastiani', *La pittura in Italia: Il quattrocento* (Milan, 1986), ii, p. 575

MARIO DI GIAMPAOLO

Bastianino, il. See FILIPPI, (2).

Battaggio [Battagio; da Lodi], **Giovanni di Domenico** (*fl* second half of the 15th century). Italian master builder and architect. During 1465 and 1466 his name appears in the wages book of the Ospedale Maggiore of Lodi, for which he produced doors, oculi and windows in terracotta. In 1479 he was appointed engineer of the city of Milan, and in 1489 he is mentioned as ducal engineer. He worked on the fortifications at Biasca in 1481, and in the same year Gian Galeazzo Sforza, Duke of Milan (*reg* 1476–94), recommended Battaggio and Giovanni Antonio Amadeo to succeed Guinoforte Solari as architect to the Fabbrica del Duomo. Amadeo was appointed, but Battaggio did not manage to enter the conservative Milanese workshop either then or two years later, when Ludovico Sforza proposed him in preference to Hans Niesenberger (*c.* 1415/20–before 1493). In 1484 Conte Manfredo Landi III (*d* 1491) commissioned Battaggio and Agostino Fonduli to finish and decorate the façade of his palazzo in Piacenza (now the Palazzo dei Tribunali). This work included the window-frames, the string course bearing heads of Roman emperors and scenes of the marine thiasos and the *Battle of the Lapiths and the Centaurs*, the top cornice with frieze and shield-like busts, and the return cornice at the angles.

The design of S Maria della Passione, Milan, begun by 1486, is generally attributed to Battaggio. It was centrally

planned, a domed octagon in shape, with quadrangular apsed chapels on the main axes and semicircular ones on the oblique sides, in a florid version of Bramante's Milanese style. The nave was added by Martino Bassi between 1573 and 1591. A centralized, octagonal plan and prolific ornament also characterize Battaggio's design for the church of the Incoronata (begun 1488), Lodi. On each side wedge-shaped pilasters at the vertices of the octagon mark the opening of a trapezoidal chapel. An annular gallery runs around the walls above the chapels, and the building is crowned with an internal dome enclosed within the rectilinear walls of the *tiburio*. In 1489, after Giovanni Giacomo Dolcebuono and Lazzaro Palazzi (*fl* 1473–1508) tested the foundations of the church, Battaggio was dismissed from the project and replaced by Dolcebuono; the general plan nevertheless follows Battaggio's design. It would appear that the design of the Incoronata was inspired by the imperial mausolea of Milan, such as the mausoleum of Maximian (*reg* AD 286–305) later incorporated into S Vittore al Corpo (destr. mid-16th century), and the baptisteries to which Bramante had given a modern interpretation in the sacristy of S Maria presso S Satiro, Milan; the illusionistic choir of the latter probably inspired the highly foreshortened perspective scheme of the chapels of the Incoronata.

In 1490 Battaggio was engaged on S Marcellino, Milan (destr.), competed unsuccessfully for the lantern of Milan Cathedral and designed his most complex structure, the church of S Maria della Croce, Crema (see fig.). This church too is central in plan, circular outside and octagonal inside. The oblique walls of the octagon open on to apsidal chapels that do not project from the external profile; the straight sides open on four chapels with an exterior octagonal profile and a Greek-cross plan inside. The

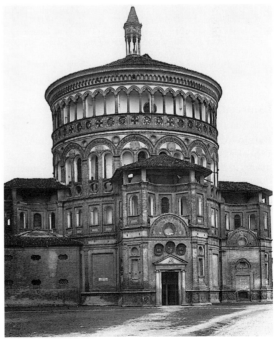

Giovanni di Domenico Battaggio: S Maria della Croce, Crema, 1490–1500

exterior is executed in polychromed terracotta. An arcaded gallery runs around the circular *corps de logis* that rises above the ensemble of projecting chapels. The plan of the church reflects the influence of Classical and Early Christian models: the central plan with satellite wings comes from S Lorenzo in Milan, the scheme of the octagon inscribed in a circle from Roman mausolea, and the plan of the peripheral chapels recalls that of the chapel of S Ippolito in S Lorenzo. Similarly, on the upper level the system of superimposed galleries shows the influence of the *tiburio* of S Lorenzo (after 1124; destr. 1573) and such medieval monuments as the baptistery of Cremona. According to the records, Battaggio was dismissed from the project *c.* 1499 because of a disagreement with his clients. The master builder Antonio Montanaro of Cremona brought the church to completion in 1500, introducing Gothic decorative elements to the Renaissance plan.

Battaggio is generally included among the Lombard followers of Bramante, who, together with Leonardo da Vinci, aroused his interest in Renaissance forms and themes. He stands out, however, as one of the first to make systematic use of the centralized plan; his constant references to ancient architecture are also distinctive. Battaggio had several brothers who were also active as master builders. They included Giacomino Battaggio; Gabriele Battaggio, who worked in 1475 at the Ospedale of Lodi and in 1487 at S Maria presso S Satiro; and Antonio Battaggio, a master builder and contractor who worked on the Ospedale of Lodi in 1466 and 1475, built the sacristy of Lodi Cathedral in 1487 and constructed the bridge over the Lambro at Melegnano in 1489.

BIBLIOGRAPHY

DBI; Thieme–Becker
V. Mariani: 'Novità sul Battaggio', *Studi bramanteschi: Atti del congresso internazionale: Milan, Urbino and Rome, 1970*, pp. 239–44
S. Maria della Passione e il conservatorio G. Verdi a Milano (Milan, 1981)
C. Alpini and others: *S Maria della Croce a Crema* (Crema, 1982)
L. Giordano: 'Giovanni Battaggio e l'Incoronata: Per la storia architettonica dell'Incoronata: Documenti e analisi', *Le stagioni dell'Incoronata* (1988), pp. 61–101
C. Alpini and others: *La basilica di S Maria della Croce a Crema* (Crema and Milan, 1990)

LUISA GIORDANO

Battista da Covo. *See* COVO, BATTISTA DA.

Baudo (da Novara), Luca (*b* Novara, Piedmont; *fl* 1481–1509/10). Italian painter. His early training, though mainly in the Lombard tradition, in the circle of Vincenzo Foppa, was modified by a calligraphic attention to detail typical of such Ligurian painters as Nicolò Corso and Louis Bréa, who were particularly attracted by south Netherlandish art. This quality is evident in the first of Baudo's known works, the signed and dated *Nativity* (1493; Genoa, Pal. Bianco). His later works are characterized by elements derived from Foppa, though in the signed and dated *Presentation in the Temple* (1497; Le Mans, Mus. Tessé) he abandoned the polyptych structure that still predominated in Liguria and placed the figures in an architectural setting opening on to a landscape, thereby introducing elements of Paduan and Venetian painting. These can also be seen in the *St Augustine between SS Monica and Ambrose*, commissioned by the Lomellini

family in 1497 for their chapel in S Teodoro, Genoa (*in situ*).

In the same year Baudo undertook commissions to paint the portrait of *Eustacchio Parenti* (untraced) and, possibly with Francesco da Pavia, a polyptych for the town of Bonifacio, Corsica (untraced), where, in 1500 and 1503, he was again commissioned to paint further sacred works. During his years as Consul of the Painters' Guild of Genoa, from 1498 to 1500, he showed an interest in new ideas coming from Lombardy. He did not, however, go beyond pure quotation of Leonardo da Vinci's rocky landscapes in the signed and dated *Adoration of the Child* (1499; Savona, Pin. Civ.), nor of Bramante's architectural ideas as recorded in the engraving by Bernardo Prevedari (1481), in his signed *Adoration of the Child* (Turin, Cassa di Risparmio). In 1501 Baudo signed and dated the *Nativity* (Milan, Mus. Poldi Pezzoli). Originally the latter work was probably in Albenga, where the side panels depicting *St Eligius* and *St Ampelio* still remain.

Baudo's later works include a triptych depicting *St Bartholomew* (1503; Pontedassio, parish church) and two panels representing the *Annunciation* (St Petersburg, Hermitage). He is documented until 1509 as working in Genoa where two decades earlier he had married Bianchinetta, the sister of GIOVANNI DI NICOLÒ BARBAGELATA. By 1510 he was apparently dead, and the following year his workshop near Scurreria was taken over by Bernardino Fasolo (1489–after 1526).

DBI
M. Salmi: 'Luca Baudo da Novara', *Boll. A.*, v (1925–6), pp. 502–12
G. V. Castelnovi: 'Il quattro e il primo cinquecento', *La pittura a Genova e in Liguria dagli inizi al cinquecento*, i (Genoa, 1970, rev. 1987), pp. 109–12, 148–9
M. Natale: *Museo Poldi Pezzoli: Dipinti* (Milan, 1982), pp. 78–9
S. Vsevolojskaïa: *La Peinture italienne XIIIe–XVIIIe siècles: Musée de l'Ermitage Leningrad* (Leningrad, 1982), p. 267
F. Boggero: 'La pittura in Liguria nel cinquecento', *La pittura in Italia: Il cinquecento*, ed. G. Briganti (Milan, 1987), i, pp. 19–21
M. Tanzi: 'Proposte per Luca Baudo', *Prospettiva* [Florence] (1988–9), pp. 281–3
G. Algerci and A. De Floriani: *La pittura in Liguria: Il quattrocento* (Genoa, 1991), pp. 432–8, 493

VITTORIO NATALE

Baviera [Bononia, Baveram de; Carocci, Baverio de'] (*fl c.* 1515–after 1527). Italian printer. From northern Italy, possibly of German descent, he was an assistant in Raphael's workshop in Rome. From 1515–16 he was the workshop printer of the engraved plates that Raphael commissioned from Marcantonio Raimondi. He is mentioned in documents dated 1515, 1516 and 1523. After Raphael's death in 1520, he evidently continued in his position under the new head of the workshop, Giulio Romano. He became an independent printer in 1524 and was still working in Rome after the Sack in 1527. According to Vasari, Baviera printed plates engraved by Giovanni Jacopo Caraglio, including the *Labours of Hercules* (B. 44–9), the *Gods and Goddesses in Niches* (B. 24–43), the *Loves of the Gods* (B. 9–23) and the *Rape of the Sabine Women* (B. 63).

BIBLIOGRAPHY
Thieme–Becker: 'Carocci, Baverio de'
G. Vasari: *Vite* (1550, rev. 2/1568); ed. G. Milanesi (1878–85), iv, p. 354; v, pp. 424, 611

S. Boorsch, J. Spike and M. C. Archer: *Italian Masters of the Sixteenth Century* (1985), 28 [xv/i] of *The Illustrated Bartsch*, ed. W. Strauss (New York, 1978–) [B.]
The Engravings of Marcantonio Raimondi (exh. cat. by I. Shoemaker, Lawrence, U. KS, Spencer Mus. A.; Wellesley Coll, MA, Jewett A. Cent.; Chapel Hill, U. NC, Ackland A. Mus.; 1982)

CHRISTOPHER L. C. E. WITCOMBE

Baxaiti [Baxiti], Marco. *See* BASAITI, MARCO.

Bazzacco. *See* PONCHINO, GIAMBATTISTA.

Bazzi, Giovanni Antonio. *See* SODOMA.

Beccafumi [Mecarino, Mecherino], Domenico (di Giacomo di Pace) (*b* Cortine in Valdibiana Montaperti, 1484; *d* Siena, between Jan and May 1551). Italian painter, sculptor, draughtsman, printmaker and illuminator. He was one of the protagonists, perhaps even the most precocious, of Tuscan Mannerism, which he practised with a strong sense of his Sienese artistic background but at the same time with an awareness of contemporary developments in Florence and Rome. He responded to the new demand for feeling and fantasy while retaining the formal language of the early 16th century. None of Beccafumi's works is signed or dated, but his highly personal *maniera* has facilitated almost unanimous agreement regarding the definition of his corpus and the principal areas of influence on it. However, some questions concerning the circumstances of his early career and the choices available to him remain unanswered. The more extreme forms of Beccafumi's reckless experimentation underwent a critical reappraisal only in the later 20th century.

1. To 1517. 2. 1518–27. 3. After 1527.

1. TO 1517. The primary sources of information concerning Beccafumi are Vasari's biography (1568) and archival findings, mostly 19th century, relating to the artist. Vasari, although a direct acquaintance of Beccafumi in his last years and in a position to gather information from mutual friends, was, predictably, unreliable in regard to his early career. According to Vasari, Mecherino, the son of a poor farmer named Giacomo di Pace, became the protégé of Lorenzo Beccafumi, a rich Sienese citizen from whom he took his name and who apprenticed the boy to a minor Sienese painter. After seeing some work by Perugino in Siena, Beccafumi left for Rome, where he studied the works of Michelangelo and Raphael. Encouraged by the success of his fellow citizen Sodoma, Beccafumi returned to Siena. A document of 1507 (Moscadelli), in which Beccafumi is described as a Sienese painter, records the sale of a piece of land belonging to him, suggesting that his career was already established at this early date and that his origins were less humble than Vasari indicated. A further reference for this early activity is a *Virgin and Child with St John* (Berlin, Gemäldegal.).

The earliest documented works by Beccafumi are the altarpiece triptych of the chapel dedicated to the Madonna del Manto in the Ospedale di S Maria della Scala, Siena, depicting the *Trinity with SS Cosmos, John the Baptist, John the Evangelist and Damian* (1513; Siena, Pin. N.), and the *Meeting at the Golden Gate*, the only surviving part of the frescoes in the same chapel, datable after the triptych on stylistic grounds. They display a highly personal style influenced principally by the art of Florence, where the works of Fra Bartolommeo, Leonardo, Michelangelo and Raphael had already laid the foundation for the *maniera moderna* before the end of the first decade of the 16th century. The effects of Beccafumi's sojourn in Rome are hardly perceptible, except for the parallel in the *Trinity* between Raphael's earliest Roman work and the agitated tangle of angels that supports the Trinity. Also, the tightly compressed perspectival framing of the lateral saints in a narrow, dark interior recalls the work of Bramantino, who was in Rome in 1508–9. The influence of Sodoma, though much filtered, is perceptible in these works by Beccafumi, and it may be argued that he, rather than Perugino, was the focus of Beccafumi's early interests.

Sodoma departed for Rome in 1508 (before Raphael's arrival there), after being recommended to Julius II by Sigismondo Chigi when the Pope was planning the decoration of the new rooms in the Vatican Palace. The suggestion that Beccafumi may have followed him immediately is supported by the fact that both artists acquired skill in painting façades with *all'antica* monochrome decoration (an activity cultivated by Baldassare Peruzzi) and by the existence of a drawing (*c.* 1513; London, BM) for the façade of the Palazzo Borghesi alla Postierla, Siena (a commission mentioned by Vasari), which is very close to the work of Sodoma and Peruzzi.

The effect of Beccafumi's Roman experience on his early work was limited compared to the influence gained through his contact with Florence, the city in which Lorenzo Beccafumi attended to the interests of the Sienese Republic. This is apparent in a number of works that could, at least in part, precede that for the chapel of the Madonna del Manto and justify, on the basis of their quality, that important commission being given to Beccafumi by Pandolfo Petrucci, who planned the decoration not long before his death in 1512. The two versions of the *Virgin and Child* (both *c.* 1514; Siena Pin. N.) and the *Holy Family* (*c.* 1513–14; Pesaro, Mus. Civ.) attempt to assimilate, still through Sodoma, the innovations of Leonardo's last Florentine works. In these paintings, as in the triptych of the *Trinity*, the subtle and enveloping vibration of the light is already central to Beccafumi's art: it soaks the colour, invests the forms with a restless animation and confers a visionary instability on the image. In the badly preserved frescoed lunette of the *Meeting at the Golden Gate* in the chapel, remarkable in its almost modern freedom of handling, this intense play of light breaks up the classically conceived compositional scheme and manipulates it to convey the powerful emotive tension visible on the faces of the principal figures. In this work Beccafumi embarked, well before Rosso Fiorentino and Pontormo, on the road to Mannerist freedom, understood in the positive sense as the intellectual re-elaboration and reinvention of the formal and pictorial innovations that had accumulated in Florence in the first decade of the 16th century (*see* MANNERISM).

The altarpiece depicting the *Stigmatization of St Catherine with SS Benedict and Jerome* (1514–15; Siena, Pin. N.; see colour pl. 1, IX2) recalls the altarpieces executed by

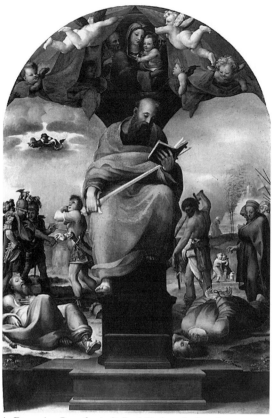

1. Domenico Beccafumi: *St Paul Enthroned*, oil and tempera on panel, 2.3×1.5 m, 1516–17 (Siena, Museo dell'Opera del Duomo)

Fra Bartolommeo in Lucca (*God the Father with SS Mary Magdalene and Catherine of Siena*, 1509, Lucca, Villa Guinigi; *Virgin and Child with SS Stephen and John the Baptist*, 1509, Lucca Cathedral), notwithstanding Beccafumi's use of fleeting shadows among the arches of the architectural framework and on the geometric design of the floor. The profile of the ecstatic saint stands out against a supernatural blaze that enfolds the distant landscape. Beccafumi's knowledge of the Lucca paintings implies that he would also have encountered the eccentric inventions of Amico Aspertini in S Frediano, Lucca. Though tied to a more archaic cultural environment, these works help to explain the compositional freedom and narrative humour that characterize Beccafumi's *St Paul Enthroned* (1516–17; Siena, Mus. Opera Duomo; see fig. 1). Close in date to these new pictorial experiments is the splendid tondo of the *Holy Family* (Munich, Alte Pin.), which reformulates ideas drawn from the most fluid and complicated Sienese Gothic tradition by integrating the circular format of the panel with the curvature of the figures. Beccafumi's painting also challenges Michelangelo in the uncompromising pose of St Joseph, shown with his back towards the viewer.

2. 1518–27. Two frescoes executed by Beccafumi for the oratory of S Bernardino, Siena (both *in situ*), and paid for at the end of 1518, represent a change in style. In the *Death of the Virgin* the broader and more majestic masses

of the figures are almost overwhelmed by the dominant motif of the open-armed Christ gliding towards the recumbent body of his mother amid rays of light that reflect off the onlookers and intensify the sense of confused and restless animation communicated by their looks and gestures. The *Marriage of the Virgin*, probably the earlier of the two, shows signs of a recent encounter with Roman culture. The idealized grace and sophistication of the women who answer the call of the trumpeters, the curly hair of the youths and the buildings adorned *all'antica* with friezes and grotesque decorations recall the elegance of the decorations planned for Agostino Chigi's Villa Farnesina, built by Peruzzi. Some scholars have claimed to identify, with varying degrees of certainty, the hand of Beccafumi in the grotesque decorations of the pilaster strips that divide the wall in the Farnesina on which Raphael's *Galatea* (see colour pl. 1, XXII1) is painted. The same spirit pervades the series of panel paintings executed by Beccafumi *c.* 1519, which perhaps formed part of the decoration of the bedroom of Francesco Petrucci (1488–after 1526): the *Venus* (U. Birmingham, Barber Inst.), *Tanaquil* and *Marcia* (both London, N.G.) and *Cornelia* (Rome, Gal. Doria–Pamphili) and the two panels representing the *Feast of Lupercalia* and the *Cult of Vesta* (both Florence, Martelli priv. col.).

Beccafumi's ability to keep abreast of artistic developments in Rome, albeit in a highly personal manner, is not supported by documented visits to the city. However, it is reasonable to assume that, in addition to the influence of such other artists as Sodoma or Bartolomeo di David (1482–1545/6), these visits did take place. In the scenes from the *Story of Elijah and Ahab* for the marble hexagons of the pavement of Siena Cathedral, on which Beccafumi began to work in 1519, the disposition and attitudes of the eccentrically elongated figures allude to the rhythmic cadences of Raphael's tapestry cartoons depicting the *Acts of the Apostles* (*c.* 1516; London, V&A; *see* RAPHAEL, fig. 5). In the long frieze on the cathedral pavement showing *Moses Striking the Rock*, designed in 1525, the large number of figures in a restricted space, animated and sustained by means of a contrasting monochrome scheme, recalls his passion for the Antique and the style of Polidoro da Caravaggio. The entrusting to Beccafumi of the completion of this prestigious public commission confirmed his pre-eminent position in Siena, notwithstanding Sodoma's continued presence. Beccafumi was engaged on this undertaking, which received unstinting praise from Vasari, for almost three decades.

Like the *Moses* frieze, the celebrated ceiling fresco that Beccafumi executed (1519) in one of the rooms of the Palazzo Venturi, Siena (later Palazzo Bindi–Sergardi), also reflected developments in Roman art. Specifically it shows the influence of the works of the more independent pupils of Raphael, particularly Perino del Vaga, through the brilliant decorative subdivision of the surface and the freedom of handling, which results in the most unusual effects of light and colour. Greek and Roman stories celebrating civic virtues, drawn from the repertory of Valerius Maximus' *Factorum et dictorum memorabilium libri*, are represented in a fantastic and spirited key with the occasional ironic accent in the tondi on the ceiling spandrels. The intensely vibrating light relates this work to the

Nativity (*c.* 1522; Siena, S Martino) where, again, a connection with Perino del Vaga (who is known to have sought a temporary refuge in Siena from the plague) is evident in the nervous and refined grace of the protagonists and in the romantic presence of the ruined arch.

Suggestions of the more agitated side of Florentine Mannerism, precipitated by the presence of Michelangelo, can be found a little later in the first, unfinished version of the *Fall of the Rebel Angels* (*c.* 1524; Siena, Pin. N.), executed for S Niccolò del Carmine, Siena. The movement in the scene appears convulsed in the vibrant light of the celestial radiance and the infernal flames that wrest silhouettes of entangled figures from the darkness and project the foreshortened nudes into the foreground. This impressive panel is related, through its disconcerting use of light, to the compositionally more conservative altarpiece depicting the *Mystic Marriage of St Catherine* (1528; Siena, Monte Paschi). A kind of synthesis of the two tendencies takes place in the more balanced construction of the second version of the *Fall of the Rebel Angels* executed for the Carmine (*c.* 1528; *in situ*), which, with its emphatically plastic figures strikingly outlined against the light, recalls Peruzzi, who, fleeing the Sack of Rome (1527), had returned to Siena.

3. AFTER 1527. Between 1529 and 1532 and, after a break, again in 1535, Beccafumi decorated the walls and ceiling of the Sala del Concistoro in the Palazzo Pubblico, Siena (*see* SIENA, fig. 5). The influence of Peruzzi is discernible in the illusionistic ceiling architecture created through the marked projection of the three painted cornices and the framework dividing up the ceiling space. Allegories and exemplary episodes from ancient history, drawn once again from Valerius Maximus, are represented within a rigorous scheme of tondi, octagons and rectangles. The gestures and poses of the figures strongly echo those of Michelangelo. The scenes are alternately set against the open sky within daringly foreshortened settings or depicted as tapestries between decorative borders. The brilliant luminosity of Beccafumi's chromatic harmonies (see colour pl. 1, IX1) intensifies the expressiveness of certain faces, executed from drawings of great quality (exh. cat. 1990, pp. 452–7, nos 117–23). This imposing formal arrangement is even more successfully repeated in the scenes depicting *Moses on Mt Sinai* (1531) on the pavement of Siena Cathedral, and it perhaps also characterized Beccafumi's work (destr.) in the Genoese palace of Andrea I Doria, where Perino del Vaga also worked after the Sack of Rome.

Beccafumi was freed from the constricting rhythms of this compositional style in the *Descent into Limbo* (*c.* 1536; Siena, Pin. N.) and the brilliantly lit panels for the apse of Pisa Cathedral, depicting the *Punishment of Korah, Moses Breaking the Tablets of the Law* and the *Four Evangelists*. These panels were executed in Siena between 1537 and 1538 and were then sent to Pisa. Among the memorable works that Beccafumi produced in the last decade of his activity are the diaphanous and restless frescoes in the apse of Siena Cathedral depicting scenes from the *New Testament* (1535–44), inspired by the perspective ideas of Peruzzi, the *Annunciation* (1546; Sarteano, SS Martino e Vittoria) and the *Sacrifice of Isaac* (1547), with its great

landscape of airy luminosity and pictorial richness—the last of the scenes he designed for the pavement of Siena Cathedral.

Almost at the end of his life, between 1547 and 1551, Beccafumi was entrusted with one more major task: a series of eight bronze angels for the piers of the nave of Siena Cathedral, facing the altar (see fig. 2). Beccafumi wanted personally to oversee their casting. The supple gracefulness of the poses, the sharp contrasts between the smooth brilliance of the naked parts and the intense pictorial vibration created by the minute folds in the fine draperies that cling to the rounded bodies combine, while still looking back to Francesco di Giorgio Martini and Vecchietta, to produce once more a work of the great *maniera moderna*. As well as his activities in painting and sculpture, Beccafumi made occasional but interesting forays into the field of engraving and woodcuts (e.g. the series of ten woodcuts illustrating the *Practice of Alchemy*) in which he sometimes combined the impressions from various blocks. Four folios of a manuscript (Siena, Osp. S Maria della Scala) contain illuminations by Beccafumi, depicting the *Resurrection, Pentecost*, the *Nativity* and the *Miracle of the Snow*, datable to *c.* 1520.

BIBLIOGRAPHY
G. Vasari: *Vite* (1550, rev. 2/1568); ed. G. Milanesi, v (1880)
G. Milanesi: *Documenti per la storia dell'arte senese*, iii (Siena, 1856), pp. 165–8
S. Borghesi and L. Banchi: *Nuovi documenti per la storia dell'arte senese* (Siena, 1898)
J. Judey: *Domenico Beccafumi* (Berlin, 1932)
G. Briganti: *La maniera italiana* (Rome, 1961), pp. 26–7

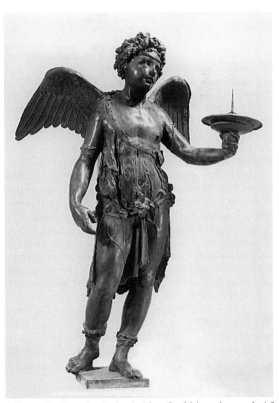

2. Domenico Beccafumi: *Angel with a Candelabrum*, bronze, h. 1.5 m, 1547–51 (Siena Cathedral)

A. M. Francini Ciaranfi: *Beccafumi* (Florence, 1966)

D. Sanminiatelli: *Domenico Beccafumi* (Milan, 1967)

M. Jenkins: 'The Iconography of the Hall of the Consistory in the Palazzo Pubblico Siena', *A. Bull.*, liv/4 (1972), pp. 430–51

D. Cavallotti Cavallero: 'Mecherino miniatore: Precisazioni sull'esordio senese', *Stor. A.*, 38–40 (1980), pp. 225–32

R. Guerrini: *Studi su Valerio Massimo (con un capitolo sulla fortuna nell'iconografia umanistica: Perugino, Beccafumi, Pordenone)*, Biblioteca di studi antichi (Pisa, 1981), pp. 61–136

F. Sricchia Santoro: 'Ricerche senesi, 5: Agli inizi del Beccafumi', *Prospettiva* [Florence], 30 (1982), pp. 58–65

S. Moscadelli: 'Domenico Beccafumi "Pictor de Senis" nel 1507', *Mitt. Ksthist. Inst. Florenz*, xxxiii (1989), pp. 394–5

Domenico Beccafumi e il suo tempo (exh. cat., ed. A. Bagnoli, R. Bartalini and M. Maccherini; Siena, Pin. N., Pal. Pub; and elsewhere; 1990) [includes bibliog.]

A. Pinelli: 'Messaggi in chiaro e messaggi in codice: Arte, umanesimo e politica nei cicli profani del Baccafumi', *Umanesimo a Siena: Letteratura, arti figurative, musica*, ed. E. Cioni and D. Fausti (Siena, 1994), pp. 383–435

G. Medicus: 'Contents and Style in Domenico Beccafumi's *Holy Trinity with Saints*', *Gaz. B.-A.*, cxxv (April 1995), pp. 221–36

FIORELLA SRICCHIA SANTORO

Bedoli, Girolamo Mazzola (*b* Viadana, *c.* 1505; *d* Parma, *c.* 1569–70). Italian painter and draughtsman. His career was intimately linked with that of Parmigianino, whose principal disciple he was. According to Vasari, who met him in 1566, Bedoli and Parmigianino fled Parma together during the war of 1521–2, which points to a very early connection. Bedoli probably received training in the rudiments of his art in the workshop of Parmigianino's uncle, Pier'Ilario Mazzola, whose daughter he married in 1529. Bedoli later added Mazzola to his name. Many of Bedoli's finest works, such as the *Virgin and Child with St Bruno* (Munich, Alte Pin.), were once attributed to Parmigianino, and there is still controversy concerning their respective oeuvres.

Bedoli's first securely documented painting, the *Allegory of the Immaculate Conception* (Parma, G.N.; see fig.) was executed for the oratory attached to S Francesco del Prato, Parma, between 1533 and 1537, but other pictures can be dated earlier on stylistic grounds. A stylistically unique altarpiece, the *Virgin and Child with the Infant John the Baptist, SS John the Evangelist and James* (ex-Galli priv. col., Carate Brianza; see Milstein, fig. 150), for which there is a preparatory drawing (Paris, Louvre), is clearly dependent on Parmigianino's *Mystic Marriage of St Catherine* (Bardi, S Maria) and must represent the artist's first manner of the 1520s. Bedoli's works of the 1530s, by contrast, reflect Parmigianino's style after his return to North Italy in 1527. They include a *Nativity with SS Francis, Nicholas of Tolentino and John the Baptist* (Naples, Capodimonte), a small altarpiece of the *Virgin and Child with the Infant John the Baptist, SS Francis and Sebastian* (Dresden, Gemäldegal. Alte Meister) and a *Holy Family with St Francis* (Budapest, Mus. F.A.). To these may be added a much overpainted altarpiece of the *Virgin and Child with Two Saints* (*c.* 1535; sold London, Sotheby's, 5 July 1989; preparatory drawing, Windsor Castle, Royal Lib.), which is directly inspired by Parmigianino's first ideas for the *Madonna of the Long Neck* (begun 1534; Florence, Uffizi; *see* PARMIGIANINO, fig. 3).

After Parmigianino's death in 1540, Bedoli became the most sought-after painter in Parma. His main activity was the production of altarpieces, first for Parma and Viadana,

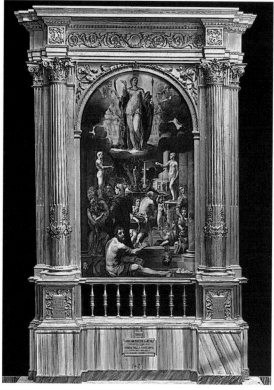

Girolamo Mazzola Bedoli: *Allegory of the Immaculate Conception*, oil on canvas, 3.65×2.10 m, 1533–7 (Parma, Galleria Nazionale)

later for Mantua, San Benedetto Po and Pavia. In the 1540s, under the influence of Giulio Romano, his style became more frozen and mannered, with strong effects of chiaroscuro and a marked interest in nocturnal illumination. The change is tellingly chronicled by two paintings of the *Annunciation*, both executed for churches in Viadana (*c.* 1539, Milan, Ambrosiana; and *c.* 1550, Naples, Capodimonte). In addition to altarpieces, Bedoli decorated organ shutters for S Giovanni Evangelista, Parma (Piacenza, Mus. Civ.), and Parma Cathedral (Parma, G.N.).

Bedoli was no less in demand as a painter of frescoes in Parma. He is generally, but not invariably, credited with the frescoes of *SS Cecilia and Margaret* in S Giovanni Evangelista; there is an autograph drawing for St Cecilia (Rennes, Mus. B.-A. & Archéol.). Between 1538 and 1544 he worked on the decoration of the apse and the choir vault of Parma Cathedral, which had been left unfinished after the deaths of Correggio in 1534 and Giorgio Gandini del Grano in 1538, and was later responsible for the design and at least some of the execution of the nave vault as well. In S Maria della Steccata he followed Parmigianino and Michelangelo Anselmi and was responsible for the *Pentecost* in the north apse (1547–53) and the *Nativity and Adoration of the Shepherds* in the south apse (1553–67), as well as the decoration of the corresponding barrel vaults. Here, the general scheme followed Parmigianino's *sottarco* with the *Wise and Foolish Virgins* and involved a combination of three-dimensional gold rosettes, animal and vegetable embellishments, and figures both coloured and in grisaille. As a fresco painter on the grand scale, Bedoli

was more notable for efficiency than for inspiration, but this must have served him well in a city where his great precursor, Parmigianino, was notorious for his inability to complete commissions.

It is striking that only two mythological paintings by Bedoli are known. The first, a half-length *Lucretia* (Naples, Capodimonte), must date from *c.* 1540 and has tended to be confused with Parmigianino's untraced painting of the same subject of much the same date. The second, a *Sleeping Cupid with Putti* (*c.* 1555; Chantilly, Mus. Condé), was painted for Ottavio Farnese, 2nd Duke of Parma and Piacenza, and shows Bedoli at his most polished. By contrast, he was a productive as well as a gifted portrait painter, both of members of the Farnese family and of local notables. *Parma Embracing Alessandro Farnese* (*c.* 1555; Parma, G.N.) and the portrait of *Anna Eleonora Sanvitale* (1562; Parma, G.N.) are both unaffectedly charming images of children. To these should be added the *Boy of the Bracciforte Family of Piacenza* (U. Rochester, NY, Mem. A.G.), hitherto attributed to Nicolò dell'Abate, which is in fact by Bedoli and datable to *c.* 1540. Among the adult portraits, the '*Philosopher*' (London, Wollheim priv. col.; see Milstein, fig. 138), a *Dominican as St Thomas Aquinas* (Milan, Brera) and the *Family Group* (Castle Howard, N. Yorks) are among his finest and reveal his considerable psychological insight. The family business was continued into the 17th century by Bedoli's son, Alessandro Mazzola (1547–1612), who was notably less able than his father.

Bedoli's drawings have tended to be confused with those of Parmigianino, but they are by no means identical. Although he used pen to explore compositional ideas, as in the study for a *Virgin and Child with St Bruno* (Bergamo, Gal. Accad. Carrara), Bedoli's favoured medium was chalk, whether red or black. This he applied with a feathery touch to achieve results that are at once subtle and atmospheric (e.g. *Virgin and Child with a Saint*; Lulworth Castle, Dorset).

BIBLIOGRAPHY

G. Vasari: *Vite* (1550, rev. 2/1568); ed. G. Milanesi (1878–85), v, pp. 235–8

L. Testi: 'Una grande pala di Girolamo Mazzola alias Bedoli, detto anche Mazzolino', *Boll. A.*, ii (1908), pp. 369–95

A. E. Popham: 'The Drawings of Girolamo Bedoli', *Master Drgs*, ii (1964), pp. 243–67

A. E. Popham and M. Di Giampaolo: *Disegni di Girolamo Bedoli* (Viadana, 1971)

M. Mattioli: 'Girolamo Bedoli', *Contrib. Ist. Stor. A. Med. & Mod.*, ii (1972), pp. 188–230

A. Milstein: *The Paintings of Girolamo Mazzola Bedoli* (New York and London, 1978)

Correggio and his Legacy (exh. cat. by D. DeGrazia, Washington, DC, N.G.A.; Parma, G.N.; 1984), pp. 208–17

The Age of Correggio and the Carracci (exh. cat., Bologna, Pin. N.; Washington, DC, N.G.A.; New York, Met.; 1986–7), pp. 65–73

M. Di Giampaolo: *Girolamo Bedoli (1500–1569): Città di Viadana* (Florence, 1997)

Disegni di Girolamo Bedoli (1500–1569) (exh. cat. by M. Di Giampaolo, Viadana, Mus. Civ., 1998)

DAVID EKSERDJIAN

Begarelli. Italian family of sculptors.

(1) Antonio Begarelli (*b* Modena, ?1490s; *d* 28 Dec 1565). He was the son of a kiln owner, and his formative influences probably included works by the Emilian terra-cotta sculptors Benedetto degli Erri, Galeotto Pavesi, Guido Mazzoni and Giovanni dell'Abate. He may have trained with Giovanni, and it has been suggested that he was apprenticed to Alfonso Lombardo in Bologna; certainly he was aware of artistic developments in Bologna, Ferrara and Parma. Possibly the earliest mention of him is a document of 1522 about a terracotta *Virgin and Child*, but the authenticity of this is uncertain. A more reliable source, of 1524, refers to the *Pietà* group made for the Compagnia di San Bernardino, finished in 1526. During this period he produced the funeral monument of *Gian Galeazzo Boschetti* (*d* 1524), in the parish church of San Cesario near Modena. The depiction of the deceased leaning on his elbow and reading was inspired by a tomb by Bartolomeo Spani in Reggio Emilia Cathedral. Begarelli's approach to the wall tomb was pictorial, emphasizing the contrast between the grey stone of the sepulchre and the warm colour of the terracotta. In 1527 his *Crib* was installed in Modena Cathedral (*in situ*). The following year a large statue of the *Virgin* was installed on the façade of the town hall, and he received a small pension. In 1529 he was commissioned by Giacomo Belleardi to create a family tomb in S Francesco, Modena; known through a 19th-century description, this must have been similar to the Boschetti tomb but with two figures.

The success of Begarelli's early works brought him numerous commissions from the 1530s on. In August 1531 two works were exhibited to the public: a statue of *St Mary Magdalene* (untraced), and a *Deposition* for S Cecilia (now Modena, S Francesco). The following year he undertook to execute four statues for the dormitory of the monastery of S Pietro in Modena, the first of a series of works for the Benedictine order, of which he became a lay member. A terracotta group for S Salvatore, including the *Virgin and Child with the Infant St John the Baptist* (see fig.), the *Baptism* and *Christ with Angels* (all Modena, Gal. & Mus. Estense), can be dated to shortly after 1534. In 1536 he is documented in Ferrara, working for Alfonso I d'Este. For the Benedictine monks of Parma he modelled four statues (*Virgin and Child, St Felicity, St Benedict* and *St John the Evangelist*) before 1543, when they were restored and gilded. According to Vasari, he coated the terracotta with a thin layer of plaster painted in ivory tempera, with details in gold leaf; the statues have been repainted, however. The classical quality of his works of the 1530s indicates that his interests extended beyond Modena. Paintings by Raphael were already known in Emilia (the *Virgin of St Sixtus* was in Piacenza and *St Cecilia* in Bologna), as were those of Girolamo da Carpi, Garofalo and Francesco Francia. According to early writers, Begarelli prepared terracotta models for Correggio during the decoration of the dome of Parma Cathedral, but this is probably apocryphal.

Between 1544 and 1546 Begarelli produced the *Pietà* group for a chapel in the presbytery of S Pietro in Modena (*in situ*). He often collaborated with his nephew (2) Ludovico Begarelli in this period. In 1548 both were away from Modena, probably in Aversa, where Antonio had been invited to make 13 statues for the convent of S Lorenzo. In 1553 the two were commissioned to create statues for the altar of S Pietro, Modena. Antonio's terracottas were by now sought after throughout Europe.

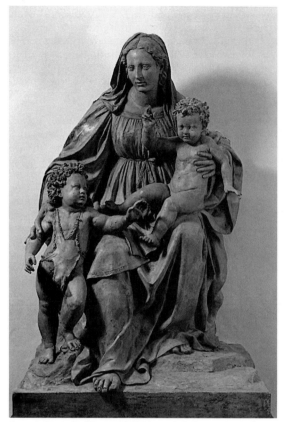

Antonio Begarelli: *Virgin and Child with the Infant St John the Baptist*, terracotta, 1.90×1.15 m, *c.* 1535 (Modena, Galleria e Museo Estense)

Recorded among the decorations for the marriage in 1554 of Philip (later Philip II of Spain; *reg* 1556–98) and Mary I, Queen of England (*reg* 1553–8), was a triumphal arch with an equestrian statue of *Philip* by Antonio. In March 1559 he signed a contract to produce more than 30 statues for S Benedetto in Polirone (Mantua), but he died before these were completed.

(2) **Ludovico Begarelli** (*b* Modena, 1515–24; *d* Modena, 1577). Nephew of (1) Antonio Begarelli. He was trained as a sculptor by his uncle, with whom he then worked. It is difficult to establish the extent of his contribution to his uncle's works, but the tasks entrusted to him alone were of minor importance, e.g. decorations for festive occasions. After his uncle's death, he completed the statues for the altar of S Pietro, Modena, commissioned in 1553, and those ordered for S Benedetto, Polirone, in 1559 (*in situ*). From 1560 he carried out numerous projects for the confraternity of St John the Baptist. Some critics have attempted to distinguish his artistic personality from that of Antonio others regard his works as simply inferior.

BIBLIOGRAPHY

DBI; Thieme–Becker

A. Venturi: *Storia*, X/i (Milan, 1940), pp. 611–43

U. Schlegel: 'Eine neuerworbene Christusbueste des Ludovico Begarelli', *Berlin. Mus.: Ber. Staatl. Mus. Preuss. Kulthes.*, xi (1961), pp. 44–51

R. W. Lightbown: 'Correggio and Begarelli', *A. Bull.*, xlvi (1964), pp. 7–21

S. Zamboni: *Antonio Begarelli*, Maestri Colore 59 (Milan, 1966)

P. Piva: *Paragone*, xxxi (1980), pp. 83–9

Scultura a corte (exh. cat., Vignola, Castello, 1996); review in *Gaz. B.-A.*, cxxviii (Sept 1996)

CHIARA STEFANI

Belbello da Pavia [Luchino di Giovanni Belbello] (*fl c.* 1430; *d* after 1473). Italian illuminator. He was one of the principal and most distinctive manuscript illuminators active in Lombardy in the mid-15th century. Filippo Maria Visconti, 3rd Duke of Milan, commissioned him to complete a Book of Hours (Florence, Bib. N. Cent., MS. Landau Finaly 22; see fig.) left unfinished by Giovannino de Grassi and Salomone de Grassi. Three miniatures in an *Acta sanctorum* (Milan, Bib. N. Braidense, MSS AE. XIV. 19–20), the first volume of which is dated 1431, are close in style, and probably in date, to Belbello's work in the Visconti Hours. He also contributed to the illumination of the Breviary of Marie of Savoy (Chambéry, Bib. Mun., MS. 4). This is likely to have been painted after Marie's marriage to Filippo Maria in 1428, but before 1434, the year Belbello completed a Bible (Rome, Vatican, Bib. Apostolica, MS. Barb. lat. 613) for Niccolò III d'Este, Marchese of Ferrara.

In 1449 Belbello went to Mantua to work on a Missal, begun in 1439 for Gianlucido Gonzaga, but had to leave in 1450 when he was convicted of sodomy. In 1458 he petitioned Barbara of Hohenzollern, Marchioness of Mantua (1422–81), to resume work on a Missal that was probably, but not certainly, the one he had worked on earlier. He was still illuminating this manuscript in Pavia in 1461, when the Marchioness had the Missal returned to Mantua in order that a young artist, under the direction of Mantegna, should complete it. This Missal is probably that known as the Missal of Barbara of Brandenburg (Mantua, Mus. Dioc.), in which the work of GIROLAMO DA CREMONA is found with that of Belbello. If this is the case, the artist working under Mantegna can be identified as Girolamo. Belbello had offered, apparently to no avail, to complete the work without payment.

Still in Pavia in October 1462, Belbello offered to work for Bianca Maria Sforza, Duchess of Milan, making whatever she might wish. A copy of Apollinare de Offredi's *Quaestiones*, dated 1462, has a *bas-de-page* attributed to Belbello (Venice, Bib. N. Marciana, MS. lat. VI. 32 [3017]). Even though his style may have been out of favour at the courts of northern Italy, it is possible that he spent some time in Venice working for ecclesiastical patrons. Several of the cuttings and manuscripts attributed to his late career, for example in the choir-book made for S Giorgio Maggiore in Venice (Venice, S Giorgio Maggiore, MS. Corale M) and cuttings from a choir-book probably in the same series (Venice, Fond. Cini, Bib., inv. 2093–4), also contain the work of Venetian or Paduan illuminators or have other indications of Venetian patronage. By 1473 Belbello was in Pavia, where Galeazzo Maria Sforza, Duke of Milan, arranged for the Carthusians to take him in, suggesting that his ability to paint might be of use to the brothers.

Belbello's style, already fully developed in the Visconti Hours, is characterized by a dramatic psychological intensity imparted to his frequently massive figures by compressed features and swarthy, scowling faces. The distorted perspective of his architectural settings, the energy of

Belbello da Pavia: *Annunciation to the Shepherds*; miniature from the Visconti Hours, *c.* 1430 (Florence, Biblioteca Nazionale Centrale, MS. Landau Finaly 22, fol. 18*v*)

posture and gesture of his figures and the brilliance of his palette—glowing yellows, reds, blues and pinks—reveal a strong and eccentric artistic personality. These same characteristics are also found in his fanciful designs for initials, where he frequently elaborated on the architectural fantasies of Giovannino de Grassi. He also developed Giovannino's initials of billowing clouds into more brightly coloured variants and created monochromatic visions of angels, landscapes and animals shot with iridescent highlights of gold. His borders in the Visconti Hours are sometimes bold and overpowering, again combining Giovannino's architectural pinnacles with heavy, rich and succulent foliage, irregular gold fields and strewn flowers, or free variations on French ivy *rinceaux* borders. In his miniatures for the Este Bible and the Gonzaga Missal in Mantua, however, his figures manifest a more consistent massiveness through dramatic interplay of light and shade, enlivened with active gestures and sumptuously coloured modelling. In his late works, whether in miniatures or historiated initials, he simplified and expanded this sense of monumentality, placing a few well-modulated figures against plain gold backgrounds. Although Belbello evinces a distinctive and highly personal style, he was also influential on the illuminators active in Lombardy, Venice and Ferrara during the 1450s to 1470s.

BIBLIOGRAPHY

P. Toesca: *La pittura e la miniatura nella Lombardia dai più antichi monumenti alla metà del quattrocento* (Milan, 1912), pp. 536–49

G. Pacchioni: 'Belbello da Pavia e Gerolamo da Cremona miniatori', *L'Arte*, xviii (1915), pp. 241–52, 368–72

M. Salmi: 'Contributo a Belbello da Pavia', *Miscellanea Giovanni Galbiati, Fontes Ambrosiani*, ii (Milan, 1951), pp. 321–8, pls 22–5

S. Samek Ludovici: *Miniature di Belbello da Pavia dalla Bibbia Vaticana e dal Messale Gonzaga di Mantova* (Milan, 1954)

Arte lombarda dai Visconti agli Sforza (exh. cat., ed. G. Belloni and others; Milan, Pal. Reale, 1958), pp. 79–80

M. Levi d'Ancona: *The Wildenstein Collection of Illuminations: The Lombard School* (Florence, 1970), pp. 35–59

M. Meiss and E. W. Kirsch: *The Visconti Hours* (New York, 1972)

G. Mariani Canova: *Miniature dell'Italia settentrionale nella Fondazione Giorgio Cini* (Venice, 1978), pp. 44–8

A. Cadei: *Studi di miniatura lombarda: Giovanni de Grassi, Belbello da Pavia*, Studi di Arte Medievale (Rome, 1984)

E. W. Kirsch: 'Milanese Manuscript Illumination in the Princeton Art Museum', *Rec. A. Mus., Princeton U.*, liii/2 (1994), pp. 22–34

ROBERT G. CALKINS

Bellano, Bartolomeo (*b* Padua, 1437–8; *d* Padua, 1496–7). Italian sculptor. He was the son of a goldsmith and, according to both Vasari and Scardeone, a pupil of Donatello. Although this is undocumented, it may well be true, since shortly after Donatello's return to Florence from Padua in October 1456, Bellano is mentioned in connection with payments for Donatello's bronze statue of *Judith Slaying Holofernes* (Florence, Pal. Vecchio; *see* ITALY, fig. 18). Bellano is documented in Padua again in May 1458 when he, together with Francesco Squarcione, assessed a work of art. Bellano's earliest documented works are four terracotta reliefs with figures of boys, which

were commissioned *c.* 1460 by Antonio Mainardi, one of which can probably be identified (Lyon, Mus. B.-A.). Although Bellano's indebtedness to Donatello can be seen in this work, his own figure style is already evident in the powerfully modelled boys' figures.

From 1463 until Donatello's death in December 1466, Bellano probably collaborated with his master on the bronze pulpits in S Lorenzo, Florence. His contribution would have been limited to the casting and finishing of some of the panels, but the influence of Donatello's late style left its mark on all Bellano's subsequent work. Around 1466–7, Bellano was summoned to Perugia, where he executed a life-size bronze statue of *Pope Paul II* (destr. 1798), which was placed outside the cathedral. The statue was dated 10 October 1467. This important commission was possibly first given to Donatello, who passed it on to his favourite pupil (according to Scardeone). Vasari mentioned 'numerous small works in marble and bronze' made by Bellano for Pope Paul II in Rome; they are undocumented. However, it cannot be ruled out that the Pope, a Venetian, would have employed a Paduan sculptor.

In 1468–9 Bellano executed the monument to *Raimondo Solimani* (destr.) in the Eremitani church in Padua, which was, according to Scardeone, a 'magnificent tomb'. Two fragments still in the church, one of a youthful saint holding a pennant, the other of a cherub, probably belonged to the monument. Between 1469 and 1472 Bellano executed his largest work in stone, the marble decoration of a reliquary chest in the sacristy of the Santo, Padua, which was financed by money bequeathed by the condottiere Erasmo da Narni, known as Gattamelata (1370–1443). It is possible that the architectonic construction of the chest was based on Donatello's Santo altar, which has not survived in its original form. Marble figures of saints and angels, almost completely free-standing, are integrated into the richly decorated architectural surround. The large oblong marble relief of the *Miracle of the Mule*, in contrast to Donatello's bronze relief of the same subject, shows a group of figures witnessing the miracle in a mood of calm humility and lacks Donatello's drama.

In 1479 the Venetian government sent Bellano and the painter Gentile Bellini to Constantinople (now Istanbul) to execute works for Mehmed II (*reg* 1544–81). The sultan, however, appears to have been dissatisfied with Bellano's work, for, in a letter dated March 1480, he expresses a wish for a better sculptor than the one sent to him. In July 1479 the Venetian government decided to erect an equestrian monument to the condottiere *Bartolomeo Colleoni* (*d* 1475). According to Vasari, the monument was first commissioned from Verrocchio, but, after he had made a model, the figure of Colleoni was assigned to Bellano, whereupon Verrocchio is said to have destroyed his model

Bartolomeo Bellano: *Samson Destroying the Temple of the Philistines* (1484), bronze relief, 660×835 mm, from the choir-screen, Il Santo, Padua

of the horse and to have left Venice in anger. The execution of the whole monument (Venice, Campo SS Giovanni e Paolo) was eventually re-assigned to Verrocchio.

Between 1484 and 1490 Bellano made ten bronze reliefs illustrating scenes from the Old Testament for the choir-screen in the Santo in Padua. Initially, the commission had been given to Bertoldo di Giovanni and Giovanni Fonduli, but their trial reliefs were found to be unsatisfactory, and in November 1484 Bellano was commissioned to make the whole cycle. Bellano's first relief, *Samson Destroying the Temple of the Philistines* (*in situ*; see fig.), is his masterpiece. Vasari praised the dramatic depiction of the scene. The panels are remarkable for their unconventional compositions in which numerous small-scale figures and animals stand out in high relief against mountainous landscape settings. Bellano proved himself to be a remarkable narrative artist. His only important pupil, Andrea Riccio, added two further reliefs (1507) to the cycle, which are indebted to Bellano in their composition, although for the younger sculptor, antique models were of greater significance than they were to his master.

Bellano is recognized as being one of the earliest sculptors of the Italian Renaissance to make bronze statuettes. None of the statuettes attributed to him is documented, but stylistically they are extremely close to his Santo reliefs. Vasari wrote that Bellano created many small-scale works for Pope Paul II; possibly the statuette of *St Jerome with the Lion* (Paris, Louvre) was one of them. It can be safely assumed that Baldassare Olzignano, a Paduan cloth dealer and Bellano's friend and patron, owned several of his works, including bronze statuettes. Bellano's masterpiece in this genre is the small-scale statuette of *David with the Head of Goliath* (New York, Met.), which was copied many times. It is heavily indebted to Donatello's bronze *David* (Florence, Bargello; see colour pl. 1, XXIX1) and displays Bellano's characteristic traits: emphatic treatment of the eyes, a bold chiselling of the drapery so that it looks like 'crumpled paper' (von Bode, 1891), and tight, wrinkled sleeves. Bellano's monument to *Pietro Roccabonella* (*d* 1491) in S Francesco, Padua, was completed by Andrea Riccio in 1498 after Bellano's death. The tomb has not survived in its original form, but two large bronze reliefs, one of the *Virgin and Child with SS Anthony of Padua and Peter Martyr* and the other showing Roccabonella in his study with students, formed part of it and are still in the church. The second relief was a model for other scholars' tombs in the early 16th century. A number of undocumented works in Padua can be attributed to Bellano on stylistic grounds. However, many attributions given in earlier literature can no longer be upheld. The humanist Pomponius Gauricus, who championed the classicizing artistic principles that were employed by his contemporaries Riccio and Tullio Lombardo, described Bellano in his treatise *De sculptura* (1504) as a 'clumsy craftsman'. Bellano's unconventional compositional style, which ignored almost totally the example of Classical antiquity and the Renaissance discovery of perspective, has also been judged negatively by later scholars.

BIBLIOGRAPHY

DBI; Thieme–Becker

P. Gauricus: *De sculptura* (Florence, 1504); ed. A. Chastel and R. Klein (Paris, 1969)

G. Vasari: *Vite* (1550, rev. 2/1568); ed. G. Milanesi, ii (1878-85), pp. 604–8

B. Scardeone: *De antiquitate urbis Patavii* (Basle, 1560)

W. von Bode: 'Lo scultore Bartolomeo Bellano', *Archv. Stor. A.*, iv (1891), pp. 397–416

A. Scrinzi: 'Bartolomeo Bellano', *Arte*, xxxix (1926), pp. 248–60

L. Planiscig: *Andrea Riccio* (Vienna, 1927), pp. 27–74

S. Bettini: 'Bartolomeo Bellano "ineptus artifex"?', *Riv. A.*, xiii (1931), pp. 45–108

E. Rigoni: 'Notizie riguardanti Bartolomeo Bellano e altri scultori padovani', *Atti & Mem. Reale Accad. Sci., Lett. & A. Padova*, n. s., xlix (1932–3), pp. 199–219; also in E. Rigoni: *Arte rinascimentale in Padova: Studi e documenti* (Padua, 1970), pp. 123–39

A. Sartori: *Documenti per lo studio della storia dell'arte a Padova*, Fonti e studi per la storia del Santo a Padova, ed. C. Fillarini (Vicenza, 1976)

——: *Basilica e convento del Santo*, Archivio Sartori, i (Padua, 1983)

F. Negri Arnoldi: 'Bellano e Bertoldo nella bottega di Donatello', *Prospettiva*, xxxiii–xxxvi (1983–4), pp. 93–101

G. Lorenzoni: 'Dopo Donatello: Da Bartolomeo Bellano ad Andrea Riccio', *Le sculture del Santo di Padova*, ed. G. Lorenzoni (Vicenza, 1984), pp. 95–109

Italian Renaissance Sculpture in the Time of Donatello (exh. cat., Detroit, MI, Inst. A., 1985)

V. Krahn: *Bartolomeo Bellano: Studien zur Paduaner Plastik des Quattrocento* (Munich, 1988)

J. D. Draper: *Bertoldo di Giovanni: Sculptor of the Medici Household* (Columbia, MO, and London, 1992), pp. 35–7

Von allen Seiten schön: Rückblicke auf Ausstellung und Kolloquium (exh. cat., Berlin, Altes Mus., 1995), p. 136

VOLKER KRAHN

Belli Italian family of artists. The family, active mainly in Bergamo, was headed by Giovanni Belli di Ponteranica (*c.* 1482–*c.* 1530). In 1516 he made a lectern for S Maria Maggiore in Bergamo and in 1521 constructed a wooden model for its high altar (destr.): this was to have been executed by such artists as Andrea Riccio and Lorenzo Lotto but was unfinished by 1581. Giovanni is best remembered for his part in the elaborate wooden choir and presbytery of S Maria Maggiore, for which he was engaged as carpenter, clerk and intarsia maker. The enterprise was begun in 1522, under the project's master of works Gianfrancesco Capoferri di Lovere (*c.* 1497–1533/4), also an intarsia maker. A payment was made in 1530 to 'Master Giovanni or his sons' for work on this early stage of the choir and presbytery.

After Giovanni's death, his eldest son Alessandro Belli (*c.* 1508–82) and another son Giacomino Belli (*d* after 1592) continued their involvement in the project, working especially on the intarsias. These were based primarily on designs by Lotto, with some by another brother, Giuseppe Belli (*c.* 1520–86). They were rightly praised (see Berenson) for their successful rendering of complex, painterly designs in wood. Among the intarsias attributable to Alessandro are two panels showing the *Ascension* (based on a design by Giuseppe) and panels of *Hope, Justice* and *Fortitude*, all in the choir apse; he signed a panel of grotesques in the same area HVIVS ORNAMENTV[M] OPERIS ALEXA[N]DER BELLVS FECIT. Work on the choir and presbytery project was halted in 1533–4 (at Capoferri di Lovere's death), resuming in 1547 under Alessandro's direction (together with Paolo di Pesaro, another intarsia maker), assisted by Giacomino and their youngest brother Andrea Belli. The project was completed in 1555, but Giacomino was recalled in 1572 to repair damage caused by a flood in 1564. Alessandro also contracted in 1539 to make wooden figures of *St John the Baptist, St Peter, St John the Evangelist*, the *Virgin Enthroned with the Christ Child* and half-length sculptures of *St Roch* and *St Sebastian* for an altarpiece in the church of S Giovanni Battista di Fuipiano in Valle

Imagna; these are now in the sacristy of the church, together with busts of the *Apostles* and a tympanum depicting *God the Father*.

Giuseppe Belli, who had probably also begun as a worker in wood, later became a painter. His two known paintings are a portrait of *Gasparo Alberti*, the choir master at S Maria Maggiore (signed and dated 5 Sept 1547; Carrara, Accad. B.A. & Liceo A.) and a depiction of *St Peter*, in papal garb between SS Paul and Alexander, for the high altar of S Pietro in Boccaleone, near Bergamo, for which he received payment in 1553. He studied under Lotto and was influenced by Giovanni Battista Moroni. He received a payment in 1555 for intarsia designs for S Maria Maggiore. Alessandro's son Antonio Belli and Giacomino's son Filippo Belli, also sculptors in wood and intarsia makers, received a payment in 1593 for four angels that they carved for the organ-case in S Maria Maggiore.

BIBLIOGRAPHY

Thieme–Becker
B. Berenson: *Lorenzo Lotto* (New York and London, 1895, rev. 1956), pp. 64–6
S. Angelini: *S Maria Maggiore in Bergamo* (Bergamo, 1968), pp. 95–114
F. Cortesi Bosco: *Il coro intarsiato di Lotto e Capoferri per Santa Maria Maggiore in Bergamo* (Bergamo, 1987) [esp. i, pp. 17–63; and ii, p. 126]

DONALD MYERS

Belli [Vicentino], Valerio (*b* Vicenza, *c.* 1468; *d* Vicenza, 1546). Italian gem-engraver, goldsmith and medallist. The most important part of his career was spent in Rome, where he worked for Clement VII and his successor Paul III. He also spent a short period in Venice, returning from there to Vicenza in 1530 and remaining in the latter city for most of the time until his death. In Rome he was a well-established member of artistic and literary circles, associating, for example, with Michelangelo and the humanist scholar Pietro Bembo. No specimens of his work as a goldsmith survive, but he is called 'aurifex' in contemporary documents and may have made the settings for his carved gems.

Belli specialized in cutting gems and crystal and in carving dies for coins and medals. Although his work demonstrates technical ability of the highest order, his talent was not an original one. His style followed that of his contemporaries working in the major arts or was governed by his study of ancient coins and gems. His best-known works are those made for his papal patrons, many consisting of or incorporating carvings in rock crystal or semiprecious stones. The most splendid of these is a silver-gilt casket adorned with 24 carvings in crystal showing scenes from the *Passion* (1532; Florence, Pitti; *see* ITALY, fig. 33), for which, according to Vasari, he received the large sum of 2000 gold scudi. It was completed in 1532 and sent by Clement VII to France as a wedding present on the occasion of the marriage of the Dauphin, later Henry II (*reg* 1547–59), to Catherine de' Medici (1519–89). Some of Belli's engraved crystals, such as those in the Museo Civico d'Arte e Storia, Vicenza, have been separated from the works that they once adorned. Bronze plaquettes after Belli's works are sometimes found (e.g. Washington, DC, N.G.A.), produced by taking plaster or sulphur casts. Plaquettes or casts of this kind can be helpful in suggesting the form of lost works, as may be the case with the missing engraved crystals from a rock crystal Crucifix (London,

V&A), which was one of his last commissions from Clement VII.

Belli is also known to have been connected with the papal mint, although no specific issues of coins can be attributed to him, and the remains of his work as an official medallist are scanty. The best known of his works in this field is a private rather than an official work, a medal bearing a portrait of *Pietro Bembo* (e.g. Washington, DC, N.G.A.), with a reverse representing him reclining in a pastoral setting. Specimens also survive of a portrait medal that is almost certainly a self-portrait from dies engraved by Belli. This is known in several versions (e.g. Washington, DC, N.G.A.), each bearing a classicizing mythological scene on its reverse. Vasari attributed to Belli a series of portraits of the *Twelve Caesars*. No complete set is known to survive, although there are many copies (e.g. Berlin, Bodemus.). More interesting and unusual is a group of some 50 medals representing mythological and historical figures of the ancient world. These combine portraits, imaginary or based on ancient coins, with a variety of reverses inspired more or less directly by ancient models. Some of these were designed to show their subjects as symbols of supposed ancient virtues, and although there is no overriding theme or message, they are an interesting document in the history of 16th-century humanism. Struck specimens are rare (e.g. *Helen of Troy*, Washington, DC, N.G.A.), but many reproductions of them in the form of metal casts survive (e.g. Washington, DC, N.G.A.; London, BM).

BIBLIOGRAPHY

DBI [with extensive bibliog.]; Forrer; Thieme–Becker
F. Magrini: 'Sopra cinquanta medaglie di Valerio Belli', *Atti Reale Ist. Ven. Sci., Lett. & A.*, 3rd ser., xvi (1871), pp. 469–502
J. Pope-Hennessy: *Renaissance Bronzes from the Samuel H. Kress Collection*, Washington, DC, N.G.A. cat. (London, 1965), pp. 8–13; figs 349–74
G. F. Hill and G. Pollard: *Renaissance Medals from the Samuel H. Kress Collection at the National Gallery of Art*, Washington, DC, N.G.A. cat. (London, 1967), pp. 72–3, 131; pls 386–7, 385a
G. Pollard: *Medaglie italiane del rinascimento*, Florence, Bargello cat. (Florence, 1986), iii, pp. 1328–30
S. E. Lawrence: 'Imitation and Emulation in the Numismatic Fantasies of Valerio Belli', *Medal*, xxix (Autumn 1996), pp. 18–29

JOHN R. MELVILLE-JONES

Bellini. Italian family of artists. Primarily painters, the Bellini were arguably the most important of the many families that played so vital a role in shaping the character of Venetian art. They were largely responsible for introducing the Renaissance style into Venetian painting, and, more effectively than the rival Vivarini family, they continued to dominate painting in Venice throughout the second half of the 15th century. The art of (1) Jacopo Bellini, a slightly older contemporary of Antonio Vivarini, is stylistically transitional. In his earlier career it was still strongly reflective of the Late Gothic manner of his master Gentile da Fabriano, but from *c.* 1440 it was increasingly Renaissance in character. It is not easy to trace Jacopo's development, and accurately to assess his achievement, since only a small fragment of his painted oeuvre now survives; but two large albums of drawings (London, BM; Paris, Louvre) testify to his capacity for inventiveness and to his involvement with artistic concerns characteristic of the Renaissance.

Jacopo's sons (2) Gentile Bellini and (3) Giovanni Bellini were presumably both trained in his workshop. In the

1460s they collaborated with him as trained assistants on a number of important projects; but already by the beginning of the decade they were also working as independent masters. They are not recorded collaborating with one another independently of Jacopo; but it is possible that they did so on occasion, since they remained on friendly personal terms, and in his will Gentile requested that any works left incomplete on his death should be completed by Giovanni. Gentile, almost certainly the elder of the two brothers, specialized in the production of large-scale narrative cycles on canvas, but was also celebrated as a portrait painter. A high proportion of his work is now lost, but what does survive probably accurately reflects his qualities and limitations as an artist. Giovanni is one of the greatest of all Venetian painters and one of the greatest artists of the 15th century. He mastered all of the types of painting then current in Venice and also added new ones. Jacopo's nephew, (4) Leonardo Bellini, helped to revitalize the genre of illumination in Venice.

BIBLIOGRAPHY
G. Gronau: *Die Künstlerfamilie Bellini* (Bielefeld and Leipzig, 1909)
PETER HUMFREY

(1) Jacopo Bellini (*b* Venice, *c.* 1400; *d* Venice, between 26 Aug 1470 and 25 Nov 1471). Painter and draughtsman. His surviving work consists of some 20 paintings—mostly small-scale, intimate devotional pictures—and nearly 300 drawings, contained in two volumes (Paris, Louvre; London, BM). The drawings constitute a unique oeuvre for a 15th-century artist, both in regard to their number and their nature; most of them are finished, independent compositions. Most of Jacopo's large-scale picture cycles and important commissioned works have been destroyed. Known only through documentary evidence and contemporary sources, they are an indication of the high esteem in which he was held both in Venice and beyond.

I. Life and work. II. Working methods and technique. III. Critical reception and posthumous reputation.

I. Life and work.

1. Paintings. 2. Drawings.

1. PAINTINGS. Jacopo Bellini was the son of Nicoletto (Nicolò) Bellini, a Venetian pewterer, and his wife Franceschina. He was taught by Gentile da Fabriano, who lived in Venice between 1408 and 1413. In 1430 Jacopo signed a painting of the *Archangel Michael Defeating the Dragon* (ex-S Michele, Padua; untraced) as a *discipulus Gentili de Fabriano* and an inscription, formerly part of a fresco of the *Crucifixion* in Verona Cathedral (1436; destr. 1759) named Gentile da Fabriano as Jacopo's teacher. Vasari, also, stated that Jacopo was Gentile's pupil. Other indications of the two artists' close relationship are Marcantonio Michiel's description of a portrait of *Gentile da Fabriano* (untraced) by Jacopo that hung in the house of Pietro Bembo and the fact that one of Jacopo's sons was named Gentile.

Jacopo may have been in Gentile da Fabriano's workshop in the early 1420s when the latter was working in Florence. Two documents record that in 1423 one 'Jacobus de Venetiis', described as a 'member of the household and

pupil' of Gentile da Fabriano, was involved in court proceedings with the son of a Florentine citizen because of a fight. It is not universally accepted that the documents refer to Jacopo Bellini, since his father's name is given as Pietro. However, most scholars believe that they relate to him and that his father's name was wrongly recorded by the notary. If Jacopo did spend some time in Florence, he would have seen the work of Brunelleschi, Donatello and Masaccio and would have become familiar with a new way of making pictures based on scientific perspective, the observation of nature and the study of the Antique. His Venetian contemporaries, for example Antonio Vivarini and especially Michele Giambono, adhered throughout their lives to a retardatory, Gothic concept of art. Jacopo's true artistic contemporaries were not native Venetian painters, but the Tuscan masters who periodically visited Venice and Padua: Paolo Uccello, resident in Venice between 1425 and 1431, Filippo Lippi, documented in Padua in 1434, Leon Battista Alberti, in Venice in 1437, Andrea del Castagno, working in Venice in 1442 and Donatello, who worked in Padua from 1443 to 1453.

The will of Jacopo's father is dated 11 April 1424. Jacopo was appointed as one of the executors and described as being deeply in debt to his father. There is also a will dated 6 February 1429 (1428 Venetian style) drawn up by Jacopo's wife, Anna Rinversi, before the birth of her first child, as was the custom. Jacopo and Anna had four children, Nicolosia (who married Andrea Mantegna in 1453), Nicolò, Gentile and Giovanni. The order in which they were born has not been established.

That Jacopo was Gentile da Fabriano's pupil is clear from such surviving paintings from the early 1430s as the *Virgin and Child* (Bergamo, Gal. Accad. Carrara) and the *Virgin and Child* (Gazzada, Mus. Villa Cagnola). There is further evidence that his painting methods and treatment of drapery were modelled on Gentile da Fabriano in four fragments of a polyptych executed in tempera dating from between 1430 and 1435, and depicting *St Peter*, *St John the Evangelist*, *St Jerome* (Berlin, Gemäldegal.) and ?*St Lucy* (priv. col., see Zeri, p. 42). The saints are reminiscent of the statues on the tomb of *Doge Tommaso Mocenigo* (*d* 1423) in SS Giovanni e Paolo, Venice (Zeri). As in the sculpture, Jacopo's painted figures stand in round-arched shell niches. Bellini's efforts, albeit as yet based purely on trial and error, to create the illusion of depth through perspective are discernible in these paintings. The fanlike course of the ribs in the vaulting is varied in each niche and the perspective alters from figure to figure, as if the row of figures were observed from a fixed viewpoint (Christiansen).

Jacopo's first documented work is the *St Michael* (1430; ex-S Michele, Padua; untraced). It was valued by his contemporaries Michele Giambono and two other painters at 35 ducats. In 1436 Jacopo was again working on the mainland, painting the *Crucifixion* fresco (destr. 1759) in the chapel of S Niccolò, Verona Cathedral. Vasari reported that Jacopo portrayed himself among the crowd. The 18th-century Veronese painter Giambettino Cignaroli stated that Bishop Guido Memmo (*reg* 1409–38) who had commissioned the work and other clerics were included in the composition. Cignaroli praised the vividness of facial expression and gesture of the figures and lamented

its destruction 'on barbarous advice' (Bernasconi, 1869). The commission at Verona Cathedral brought Bellini into renewed contact with Antonio Pisanello who had collaborated with Gentile da Fabriano on frescoes in the Doge's Palace, Venice, and painted the fresco of *St George and the Princess* (1436–8) for the Pellegrini Chapel in S Anastasia, Verona. If this work is compared with drawings by Bellini dating from the 1430s, the extent of external and internal harmony expressed in the pictorial thinking of these two artists, still evident at that period and stemming from Gentile da Fabriano who taught them both, is astonishing. A surviving work, almost contemporary with the destroyed *Crucifixion* fresco, is the signed life-size canvas of the *Crucifixion* (Verona, Musei Civ.), which demonstrates the spiritually expressive power and nuance of Jacopo's work at that time. The small scene depicting *St Jerome* (*c.* 1440; Verona, Mus. Civ.; see colour pl. 1, X1) shows the saint in a landscape and is typical of a certain type of north Italian devotional painting of that date. In 1437 Jacopo Bellini was accepted into the Scuola Grande di S Giovanni Evangelista, Venice; later he was dean for the S Marco district.

In his book *De trigono balistario* (1440) the Venetian physician and natural scientist Giovanni Fontana (*c.* 1395–1455) mentioned a now lost treatise (*De arte pictoria*) he had written on the art of painting. As he explained in his *Liber de omnibus rebus naturalibus* (MS. 1454, published Venice, 1544), he had written it for Jacopo Bellini, whom he described as 'a distinguished Venetian painter'. Based on his observation from nature that light objects appear closer to the viewer than dark ones, Fontana in his treatise had drawn up rules for using light and dark colours in a painting so as to create three-dimensional effects on the surface. This suggests that Bellini was interested in resolving the problems of conveying depth not only by means of geometric perspective as the technique of the drawings in the Louvre in particular demonstrates, but also by the use of atmospheric perspective achieved through subtle gradation of colour.

On 26 August 1441 Niccolò III d'Este, Marchese of Ferrara, and his son Leonello, who succeeded to the title on the death of his father later that year, sent two bushels of corn to Jacopo in Venice. This gift was connected with Niccolò's commission to Jacopo to paint a portrait of *Lionello d'Este* (untraced) in competition with Pisanello. The Venetian notary and humanist Ulisse degli Aleotti (*fl* 1421, *d* 1488) wrote a sonnet describing how Pisanello had worked on Lionello's portrait for six months when Jacopo, whom he describes as 'a new Phidias in our blind world', arrived and how his faithful likeness of Lionello so appealed to Niccolò's fond paternal eye that he awarded the first prize to Jacopo Bellini rather than Pisanello. A comment made by the Ferrarese humanist Angelo Decembrio in his *De politia litteraria* (1450s) implied that Bellini's softer, more painterly style of portrayal was preferred to Pisanello's more penetrating, creative style with its stronger graphic emphasis. Pisanello's portrait of *Lionello d'Este* is probably the one now in the Galleria dell'Accademia Carrara, Bergamo.

Many of Bellini's portraits have disappeared. Girolamo Bologni da Treviso (1454–1517) extolled a portrait of *Laura* (untraced) in his possession in his poem entitled *In archetypa Laurae effigies in pictura Jacobi Bellini*; and Marcantonio Michiel, writing about the portrait of *Gentile da Fabriano* in the house of Pietro Bembo, also described a portrait of *General Bertoldo d'Este* (*d* 1463) and saw a portrait by Jacopo of the father of the philosopher *Leonico Tomeo* (1456–1531) at Tomeo's house in Padua. Jacopo's sole surviving portraits are the *Profile Portrait of a Man* in silverpoint (Paris, Louvre, fol. 22*r*) and a portrait of Leonello d'Este as donor in the *Madonna of Humility* (Paris, Louvre; see colour pl. 1, X2), the latter being further evidence of Bellini's connection with the Este at around the time of the competition. In the painting there is a mixture of progressive and traditional styles, which is a characteristic of Bellini's work as a whole. The *Madonna of Humility* as a picture type belongs to an earlier period. Jacopo's Virgin is similar in form and feature to those of the circle associated with Gentile da Fabriano. The disproportionate scale, firstly between the group with the Virgin and the donor and then between these figures and the landscape, also links the painting to the earlier style. The depiction of the landscape, however, shows some attempt to use perspective and there is indication of a new perception of nature in the precisely observed details used to recount the lives of the animals and the activities of man in the countryside. The half-length painting of the *Virgin and Child* (Florence, Uffizi) dates from about the same period as the *Madonna of Humility* and is linked with a drawing of the *Virgin and Child* (Paris, Louvre, fol. 68*r*). Both compositions are built up with iconic severity, revealing the influence of Byzantine art.

The *Annunciation* altarpiece in S Alessandro, Brescia (see fig. 1), is generally accepted as the work of Bellini. Notes of payments record the transportation of a *Nonziata* from Vicenza to Brescia in 1444, and most scholars believe this report refers to Jacopo's panel. A date in the early 1440s is possible, given the advanced way in which the picture is constructed with the help of a mathematical grid to suggest depth. The use of the rationally worked-out method of foreshortening to create perspective and convey depth gained ground in Jacopo's work around 1440 and replaced his earlier empirical method, as the development of the drawings in the Paris volume demonstrates. Surviving documents relating to a commission from the Servites at S Alessandro, Brescia, for an Annunciation scene seem to be open to various interpretations, and Zeri and Boskovits (1985) date Bellini's altar to *c.* 1428–30. There is evidence of payments for a *Nonziata* as early as 1432, though they were made to Fra Angelico. Humfrey (Florence, 1988) argued convincingly that the two payments recorded must relate to two different paintings. The amount paid to Fra Angelico was so little that the painting in question (untraced) can have been no more than a small devotional picture. It was stipulated that this picture should resemble the miraculous fresco of the *Annunciation* in SS Annunziata, Florence, venerated by the Servites. This would explain the undoubted similarities to Fra Angelico in Jacopo Bellini's *Annunciation* as conscious borrowings from Fra Angelico's picture and his Florentine method of conveying depth (Humfrey, Florence, 1988; Degenhart and Schmitt, 1990).

Compared to the main panels of Jacopo's *Annunciation*, where the excellence of the execution equals the colourful

1. Jacopo Bellini: *Annunciation*, tempera and gold on panel, main panels 2.19×0.98 m, early 1440s (Brescia, S Alessandro)

splendour of the fabrics and the angel's wings, the style of painting on the predella is less assured. A document of 1444 mentions payments 'alli maestri che fecero la predella della Nonziata', which confirms that it was executed by assistants and, presumably, only designed by Bellini. Jacopo's drawings offer many analogies with the five, only slightly larger, predella panels that depict scenes from the *Life of the Virgin*. These range from variations on the same themes to identical elements of composition (Degenhart and Schmitt, 1990).

Most scholars accept that Bellini, with Castagno and Giambono, worked on the cycle of mosaics in the Mascoli Chapel in S Marco, Venice, attributing the cartoon for the *Visitation* to him and dating it to the 1440s or possibly around 1450 (Merkel). The only dated work by Bellini is the *Virgin and Child* (1448; Milan, Brera) in which, unusually, mother and child are represented as a picture within a picture in an illusionistically painted frame. An inscription (replica of the original) running along the bottom edge of the painted frame names Jacopo Bellini and the year 1448.

The two currents in Bellini's art, the progressive and the traditional, are also evident in a group of later pictures of the same subject: the *Virgin and Child* (c. 1455; Lovere, Gal. Accad. B.A. Tadini), signed on the parapet, and the *Virgin and Child* (c. 1460; Venice, Accad., no. 582) are both severe in form and hieratically dignified, close in that respect to the paintings in Milan and Florence. Another

Virgin and Child (1460s; Venice, Accad., no. 835) anticipates the work of Giovanni Bellini in its tender and intimate mood. The *Virgin and Child* (1460–65; Los Angeles, CA, Co. Mus. A.), on the other hand, is modelled on a relief of the subject by Donatello and also uses compositional elements from the Byzantine tradition (Christiansen).

In 1452 Jacopo was commissioned to paint a large processional banner (destr.) for the Scuola di S Maria della Carità, Venice. In 1453 he received 20 ducats from the Scuola Grande di S Giovanni Evangelista, Venice, as a contribution towards the cost of his daughter Nicolosia's marriage to Andrea Mantegna. In 1457 he executed two works for S Pietro di Castello (the cathedral of Venice until 1807), a figure of the *Blessed Lorenzo Giustiniani* (1381–1456), the first patriarch of Venice (untraced), to go above his tomb in the church and an altarpiece (untraced) with three figures including *SS Peter and Paul*, intended for the great hall in the residence of the patriarch of Venice. In 1465 he received a final payment for paintings in the Sala of the Scuola Grande di S Giovanni Evangelista, Venice. According to Ridolfi, these depicted scenes from the New Testament (replaced 1594): the *Annunciation* and the *Birth of the Virgin* (Turin, Gal. Sabauda) and the *Marriage of the Virgin* and an *Epiphany* (New York, Stanley Moss priv. col.; see Collins, pp. 466–72). Jacopo Bellini's last recorded commission dates from 1466, when the Scuola di S Marco ordered two paintings depicting scenes from the *Passion* (destr. 1485).

2. DRAWINGS. In her will of 25 November 1471, Jacopo's widow, Anna Rinversi, bequeathed everything in her deceased husband's workshop to her son Gentile, including 'all his books of drawings', two of which have survived: one a volume on parchment (Paris, Louvre) and one on paper (London, BM), containing between them nearly 300 drawings in all. The drawings consist mainly of completed original compositions in which the artist, not bound by a commission or by iconographic convention, was free to investigate the creative problems that interested him. Jacopo's status and historical importance are better revealed in these drawings than in his surviving paintings; their unique quality is immediately clear from the history of the two volumes, which shows that from the 15th century they were regarded as objects of value to artists and collectors.

It is accepted that the parchment volume was presented by Gentile Bellini to the Ottoman sultan Mehmed II in Constantinople in 1479. When the volume was rediscovered in 1728 in Smyrna by Jean Guérin, the French agent employed by the King of France, Louis XV (reg 1715–74), its source was given as the Seraglio in Constantinople, and a 19th-century inscription on one of the folios (93r) gives the same information. After 1728 the volume again disappeared and only re-emerged in 1884 when it was bought by the Louvre. The volume of drawings in London is generally recognized as being the book bequeathed by Gentile Bellini in his will of 1507 to his brother Giovanni, on condition that Giovanni completed the work Gentile had begun for the Scuola Grande di S Marco. In 1530 the book of drawings was described by Marcantonio Michiel as being in the collection of Gabriele Vendramin in Venice,

and it then passed through the hands of various collectors until it was purchased by the British Museum in 1855.

The parchment volume in Paris is composed of 11 gatherings containing 93 parchment folios and 1 paper folio in a 15th-century leather binding. The folios are approximately 422 to 428 mm in height by 283 to 293 mm in width. The present sequence of the gatherings does not follow the original order. Bellini himself made changes within the order of the unbound gatherings, and other changes were made later so that the drawings are not arranged chronologically. In three gatherings Bellini reused older folios of parchment from a 14th-century Venetian pattern-book for materials, masking out the Trecento drawings with a chalk ground (Degenhart and Schmitt, 1980). Most of the drawings are in metalpoint, finished off in various shades of brown ink; the watercolour of an iris (fol. 56) is unique. Folio 93r contains an index of the drawings in the volume in 15th-century script. This is as informative on artistic aspects (drawing technique, methods of conveying space in architecture or landscape) as on the subject-matter, suggesting that the writer was himself an artist, possibly a member of Gentile Bellini's workshop, who compiled the index before the volume was presented to Sultan Mehmed II. Ten pages have gone missing from the volume since the index was compiled.

The London volume, in a 15th-century Venetian leather binding, contains 99 folios of paper, all with the same watermark. The folios are between 410 and 415 mm in height by 325 to 327 mm in width. All except three folios have metalpoint drawings on both sides. A few also use pen and brown ink or colour applied with a brush. Unlike the Paris volume where the position of individual gatherings has been altered, those in the London book were arranged in their present order from the beginning and Jacopo worked through the pages consecutively. Thus the chronological order has been retained.

If the question of the dating of the drawings is essential for their correct understanding and also important in determining whether they are by Jacopo himself, or in part by Gentile and Giovanni, it is crucial in assessing Jacopo's status as an artist. On the first page of the London volume Jacopo's name and the year 1430 are written in 15th-century script. This should not be regarded as the date of the drawings, which has to be decided on purely stylistic criteria in both books. This has led to divergences of view. Opinions fluctuate between accepting a short period in the years around 1450 for the genesis of the drawings (Ricci; Golubew; Testi; Röthlisberger; Scheller; Mariani Canova; Joost-Gaugier (1977, 1980)) or a long timespan, covering the whole of Bellini's career or at least extending over several decades (Fröhlich-Bum; Simon; Tietze-Conrat; Degenhart and Schmitt (1984, 1990)). On one point, however, there used to be agreement, that the London volume was earlier than the Paris one. Because of their supposedly sketch-like character, the drawings in London were thought to be preliminary studies for the final drawings in the Paris volume. From this assumption the picture emerged of an artist whose first ideas were progressive, but who in his final version always reverted to tradition. The contradictions were further heightened by suggestions that his sons Giovanni and Gentile or other workshop assistants might have contributed to the draw-

ings, or that they might have been drawn over at a later period. This led to negative assessments of Jacopo's work as a whole. Against this background, Degenhart and Schmitt (1984, 1990) convincingly demonstrated that the Paris volume is earlier than the London one. The Paris volume was produced between 1430 and 1455 and the London volume created in the following period that extended up to the end of Jacopo's life. Both are his own work.

Most pages in the two volumes depict a scene, usually Christian (see figs 2 and 3). However, in a few isolated cases Jacopo made a new departure in his choice of subject-matter, as in the compositions suggesting antiquity that feature hybrid mythological creatures (Paris, fols 36r, 39r; London, fol. 4r) and in the genre scenes depicting everyday life in the later London volume (fols 13v, 14r, 33v, 34r, 36v, 37r, 83v; see fig. 4). The setting for the event in the picture is most often an architectural vista, or perhaps a landscape. Studies of people or animals independent of background are in the minority, for the relationship between figures and space was Bellini's main preoccupation in the drawings. His concern for perspective can be demonstrated in his drawings from the beginning of the 1430s, and he was thus concerned with this problem before the early 1440s when he came under Alberti's influence. Bellini's drawings, especially those from his early period, are characterized not only by his interest in

2. Jacopo Bellini: *St John the Baptist Preaching*, 428×290 mm, *c.* 1430–55 (Paris, Musée du Louvre); from the Paris album of drawings on parchment, fol. 9

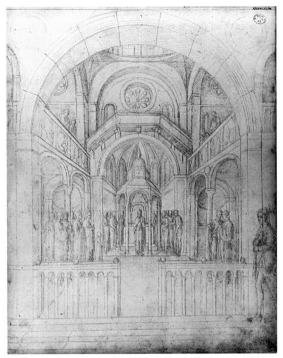

3. Jacopo Bellini: *Presentation of the Virgin*, metalpoint, 413×325 mm, after *c.* 1455 (London, British Museum); from the London album of drawings on paper, fol. 68*r*

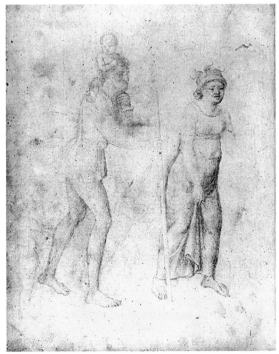

4. Jacopo Bellini: *Man and Woman with Child*, metalpoint, 413×325 mm, after *c.* 1455 (London, British Museum); from the London album of drawings on paper, fol. 33*v*

composition but also by a zest for narrative, although the essence of the action is not always immediately obvious. This is particularly true of the early drawings where the primary function of each figure and object in the picture is to define space and the demands posed by the perspectival organization of the picture affect their disposition more than the subject-matter of the picture.

Though few in number, the drawings relating to Classical antiquity represent an extremely important constituent of both volumes, both artistically and from the point of view of the development of Renaissance art. Just as his interest in relics from the past was wide-ranging—he studied architectural and sculptural monuments, statues and inscriptions from tombs and pictures on coins, his interest being caught by both the form and content of these objects—so his approach to reproducing them was varied. He ranged from the objective reproduction of antiquities to reinterpreting them in contemporary terms, especially in regard to the figural field (Schmitt).

Bellini's inexhaustible inventiveness served his desire to experiment, and in his compositions he not only elaborated picture forms that were innovative for Venetian art but also pointed to the future in the content of his pictures. There is a predominant element of fantasy in the early architectural vistas; features from Venetian architecture and earlier and contemporary forms of building are mixed up with antique motifs, pictures of coins and reliefs. Anticipating history, this kind of architectural conceit might even be called a *capriccio*. The more realistic architectural views from his later period in the London volume, on the other hand, have the character of townscapes. A long process of development relating to the representation of space and perspective, both as an artistic and a mathematical problem, portraiture as a formal and mental exercise, the observation of nature, and knowledge of antiquity from the historical and the creative points of view is mirrored in the drawings, taking us from the early Renaissance to the threshold of the High Renaissance (Degenhart and Schmitt, 1990).

II. Working methods and technique.

1. TECHNIQUE. An important peculiarity in the painting technique Jacopo employed in the Paris *Madonna of Humility* is the use of powdered gold in the Virgin's robes. This practice, borrowed from manuscript illumination, had already been adopted by Gentile da Fabriano and would subsequently be used by Giovanni Bellini and Mantegna. It occurs again in two later paintings of the *Virgin and Child* by Jacopo, one in Lovere (Gal. Accad. B.A. Tadini) and the other in Venice (Accad., no. 582). This stippling technique is also a feature of two works recently ascribed to Jacopo, a head and shoulders portrait of *St Bernardino* (New York, Dr and Mrs John C. Weber priv. col.; see Eisler, 1989, p. 69), thought to date from shortly after 1450 (Christiansen), and the *Virgin and Child* recently bought by the Los Angeles County Museum of Art, which has been dated between 1460 and 1465 (Christiansen).

A characteristic of Jacopo's working method evident in the London volume of drawings is that in making pictures he liked going back to earlier versions, whether in the Paris or London groups and developing them further in

different ways. Evidence of his development from the Paris volume of drawings to the London one is also to be found in the drawing technique. Considered in the sequence Paris–London, the two volumes provide a perfect illustration of two fundamental stages in the development of his drawing style. In the Paris volume there is a preponderance of meticulous metalpoint drawings finished off in pen and ink, which have a wealth of detail and represent a first stage that is rooted in the early Renaissance and comparable with Pisanello's work. The London volume, on the other hand, contains drawings that reveal an advanced stage of stylistic development, on a larger, broader scale, using a softer metalpoint. They should not be regarded as preparatory studies, but as finished works evincing great freedom of style. Apart from the unique watercolour of an iris (Paris, fol. 56r), all Jacopo's drawings, even those that appear to be drawn from nature, have gone through at least one and sometimes several preparatory stages before reaching their definitive formulation as end products in a process of constant refinement in drawing.

2. PROBLEMS OF COLLABORATION. In discussing Jacopo Bellini's late work, the question of his collaboration with his two sons Gentile and Giovanni plays an important role. A panel depicting *SS Anthony Abbot and Bernardino of Siena* (New York, priv. col.; see Christiansen, p. 175) was first attributed to Jacopo Bellini by Boskovits (1985). Degenhart and Schmitt (1990) are of the same opinion, while Volpe (quoted by Boskovits, 1985), Eisler (1985), Christiansen and Humfrey (1988) all regard the picture as a collaboration between Jacopo and his son Gentile. The subject led Eisler (1985), Boskovits (1986) and Christiansen to the conclusion that it might be part of the altar from the funerary chapel of the Condottiere Erasmo da Narni, known as Gattamelata (d 1443) in the Santo, Padua. There is evidence that Jacopo worked on this project with both of his sons. According to Polidoro (1590), all three painters signed the altarpiece, which was dated 1409 (MCCCCIX). The year was obviously wrongly transcribed and is generally corrected to 1459 (MCCCCLIX) or 1460 (MCCCCLX). If the New York panel is considered to be Jacopo Bellini's unaided work, then the participation of Gentile and Giovanni that can be inferred from the signature must relate to the other untraced sections of the Gattamelata Altar.

The form of the Gattamelata Altar as it can be deduced from this fragment is remarkable in regard to the history of altarpiece development. It can be reconstructed as a triptych and shows for the first time in Jacopo's work an attempt, inspired by Donatello and Mantegna, to create a composite altar as a compositional and spatial whole, in line with the ideas of the Renaissance (Humfrey, Florence, 1988). Other similar examples soon followed in the form of the four altarpieces dating from the early 1460s from S Maria della Carità, Venice (all Venice, Accad.), ascribed to Jacopo Bellini with the participation of his sons and studio assistants (Boskovits, 1986; Humfrey, Florence, 1988; Degenhart and Schmitt, 1990).

Three small predella panels depicting the *Adoration of the Magi* (Ferrara, Pin. N.), the *Crucifixion* (Venice, M. Correr) and *Christ in Limbo* (Padua, Mus. Civ.), which,

because they are similar in size and format, have long been recognized as belonging together, are 570 mm wide, like the New York picture. Eisler, Boskovits (1986) and Christiansen believe them to be the predella from the Gattamelata Chapel. This would vindicate the joint signature by the father and sons, as Giovanni's name has been repeatedly put forward as the author of some of the small panels (for the *Crucifixion* originally by Berenson and Pallucchini) or even for the whole predella (most recently by Boskovits, 1985; Eisler, 1985, and Christiansen). Degenhart and Schmitt (1990), on the other hand, think the three predella pictures are the work of Jacopo Bellini, whose drawings provide numerous analogies with all three compositions. They date the little panels to around 1450 and rule out any connection with the Gattamelata Altar. The altarpiece with seven saints (Matelica, Mus. Piersanti) is close to the small predella panels in its use of form and colour and consequently it, too, has been associated with Giovanni Bellini (Pallucchini and Eisler, 1985). It may date to shortly after 1450 because St Bernardino, who was canonized that year, is depicted on it. There are parallels for this work too in the volumes of drawings (Degenhart and Schmitt, 1990).

III. Critical reception and posthumous reputation.

The pioneering importance of Jacopo Bellini's art was immense. In his role as the founder of a family of artists, he was able to exercise direct influence on his sons Giovanni and Gentile and on his son-in-law Mantegna. He also had an impact on other representatives of the younger generation, such as Lazzaro Bastiani, Carlo Crivelli and Cima da Conegliano. But Bellini's art is more than just an important link in the chain of Venetian artistic tradition. It marks a radical change in direction. If his large compositional drawings are seen as works of art in their own right, he must be placed in the vanguard of Venetian art of the modern age. In the form, content and intellectual approach of his pictures he paved the way for developments leading to Giovanni Bellini, Giorgione and even Titian.

Historically, however, the high esteem in which Jacopo was held by his contemporaries and immediate successors did not last. He was quickly forgotten and for centuries suffered almost total neglect. The main cause of this was the early loss of monumental, publicly accessible works by him in Venice. If Marcantonio Michiel in his writings still spoke from living knowledge and his own observation, Vasari, when he came to write Bellini's life, could only give a hazy picture of the artist from the second-hand accounts provided by Venetian intermediaries. Nor did Ridolfi in his biography of Bellini add much to the information given by Vasari, his model.

After the eclipse of Jacopo's reputation in the 18th century—Luigi Lanzi, in his *Storia pittorica dell'Italia* (Bassano, 1795–6), remembered him only because of the reputation of his sons—the situation altered in the 19th century. A material and intellectual rediscovery was set in motion. In 1840 Gaye, who was then working for the Mantovani family, publicized the existence of the volume of drawings in Venice that was subsequently bought by the British Museum in 1855. The most sensational addition

to Bellini's oeuvre came with the reappearance of the volume on parchment that was bought by the Louvre in Paris in 1884. In 1871 Crowe and Cavalcaselle undertook the first just appraisal of Jacopo Bellini beyond the confines of regional art history. A wide range of critical writing followed in the wake of the rediscovered Louvre volume. Separate studies shed light on numerous facets of Bellini's creative work, though his high standing as an artist and his fundamental historical role were continually debated until the late 20th century when he received the recognition that is his due.

BIBLIOGRAPHY

EARLY SOURCES

M. Michiel: *Notizia d'opere di disegno* (MS. *c.* 1520–40); ed. G. Frizzoni (Bologna, 1888)

G. Vasari: *Vite* (1550, rev. 2/1568); ed. G. Milanesi (1878–85), iii, pp. 149–73

V. Polidoro: *Le religiose memorie nelle quali si tratta della chiesa gloriosa Sant'Antonio Confessore di Padova* (Venice, 1590)

C. Ridolfi: *Meraviglie* (1648); ed. D. von Hadeln (Berlin, 1914–24)

GENERAL WORKS

DBI; Thieme–Becker

J. A. Crowe and G. B. Cavalcaselle: *A History of Painting in North Italy*, 2 vols (London, 1871, rev. 2 by T. Borenius, 1912), pp. 100–17

A. Venturi: *Storia* (1901–40), VII/i, pp. 318–30

L. Venturi: *Le origini della pittura veneziana* (Venice, 1907)

L. Testi: *La storia della pittura veneziana, ii: Il divenire* (Bergamo, 1915)

R. van Marle: *Italian Schools* (1923–38)

H. Tietze and E.Tietze-Conrat: *The Drawings of the Venetian Painters in the 15th and 16th Centuries* (New York, 1944)

R. Pallucchini: *La pittura veneta del quattrocento: Il gotico internazionale e gli inizi del rinascimento* (Bologna, 1956)

B. Berenson: *Venetian School*, i (1957), pp. 37–8

R. W. Scheller: *A Survey of Medieval Model Books* (Haarlem, 1963)

P. Fortini Brown: *Venetian Narrative Painting in the Age of Carpaccio* (New Haven and London, 1988)

Gothic to Renaissance: European Painting, 1300–1600 (exh. cat. by P. Humfrey, London, P. & D. Colnaghi, 1988), pp. 18–26

MONOGRAPHS

C. Ricci: *Jacopo Bellini e i suoi libri di disegni*, 2 vols (Florence, 1908) [vol. i: Paris drawings; vol. ii: London drawings]

V. Golubew: *Die Skizzenbücher Jacopo Bellini*, 2 vols (Brussels, 1908–12)

V. Moschini: *Disegni di Jacopo Bellini* (Bergamo, 1943)

C. L. Joost-Gaugier: *Jacopo Bellini: Selected Drawings* (New York, 1980)

B. Degenhart and A. Schmitt: *Jacopo Bellini: Der Zeichnungsband des Louvre* (Munich, 1984; Eng. trans., New York, 1984)

C. Eisler: *The Genius of Jacopo Bellini: The Complete Paintings and Drawings* (New York and Cologne, 1989)

SPECIALIST STUDIES

Paintings

F. Zeri: 'Quattro tempere di Jacopo Bellini', *Diari di lavoro*, Quaderni di Emblemata, i (Bergamo, 1971), pp. 42–9

H. Collins: 'Major Narrative Paintings by Jacopo Bellini', *A. Bull.*, lxiv (1982), pp. 466–72

M. Boskovits: 'Per Jacopo Bellini pittore (postilla ad un colloquio)', *Paragone*, xxxvi/419 (1985), pp. 113–23

C. Eisler: '*Saints Anthony Abbot and Bernardino of Siena* Designed by Jacopo and Painted by Gentile Bellini', *A. Ven.*, xxxix (1985), pp. 32–40

K. Christiansen: 'Venetian Painting of the Early Quattrocento', *Apollo*, cxxv/3 (1987), pp. 166–77

P. Humfrey: *The Bellini, the Vivarini and the Beginnings of the Renaissance Altarpiece in Venice*, Florence, I Tatti (1988) [lecture]

——: *The Altarpiece in Renaissance Venice* (Newhaven and London, 1993)

Drawings

G. Gaye: 'Jacopo Bellini in seinen Handzeichnungen', *Schorn's Ksthl.* (1840), pp. 89–91, 93–5, 98–9, 101–2, 134–6, 138–9

E. Müntz: 'Jacopo Bellini et la Renaissance dans l'Italie septentrionale d'après le recueil récemment acquis par le Louvre', *Gaz. B.-A.*, n. s. 1, xxx (1884), pp. 346–55, 434–46

L. Fröhlich-Bum: 'Bemerkungen zu den Zeichnungen des Jacop Bellini und zu seiner Kunst', *Mitt. Ges. Vervielfält. Kst* (1916), pp. 41–56

C. de Mandach: 'Le Symbolisme dans les dessins de Jacopo Bellini', *Gaz. B.-A.*, n. s. 4 (1922), pp. 39–60

H. Simon: *Die Chronologie der Architektur- und Landschaftszeichnungen in den Skizzenbüchern des Jacopo Bellini* (Berlin, 1936)

M. Röthlisberger: 'Notes on the Drawing Books of Jacopo Bellini', *Burl. Mag.*, xcviii (1956), pp. 358–64

——: 'Nuovi aspetti dei disegni di Jacopo Bellini', *Crit. A.*, n. s. 3, ii (1956), pp. 84–8

G. Mariani Canova: 'Riflessioni su Jacopo Bellini e sul libro dei disegni del Louvre', *A. Ven.*, xxvi (1972), pp. 9–30

C. L. Joost-Gaugier: '"Subject or Nonsubject" in a Drawing by Jacopo Bellini', *Commentari*, xxiv (1973), pp. 148–53

——: 'The "Sketchbooks" of Jacopo Bellini Reconsidered', *Paragone*, xxv/297 (1974), pp. 24–41

B. Degenhart and A. Schmitt: *Corpus der italienischen Zeichnungen, 1300–1450*, II/i–iii (Berlin, 1980) [Venice; addenda to south and central Italy]

A. Schmitt: 'Antikenkopien und künstlerische Selbstverwirklichung in der Frührenaissance: Jacopo Bellini auf den Spuren römischer Epitaphien', *Akten des internationalen Symposions. Antikenzeichnung und Antikenstudium in Renaissance und Frühbarock: Coburg, 1986*, pp. 1–20

B. Degenhart and A. Schmitt: *Corpus der italienischen Zeichnungen, 1300–1450*, II/v–viii (Berlin, 1990) [Venice, Jacopo Bellini: this is an especially valuable work and has been crucial to the author as regards questions of chronology and attribution]

Other

F. Aglietti: 'Elogio storico di Jacopo e Giovanni Bellini', *Discorsi letti nella R. Accademia di Belle Arti di Venezia in occasione della distribuzione de' premi degli anni 1812, 1813, 1814, 1815*, i (Venice, 1815), pp. 19–80

C. Bernasconi: 'Cenni intorno la vita e le opere di Jacopo Bellini', *L'Adige*, 75–6 (1869), pp. 1–6

M. Röthlisberger: 'Studi su Jacopo Bellini', *Saggi & Mem. Stor. A.*, ii (1958–9), pp. 41–89

E. Merkel: 'Un problema di metodo: La *Dormitio Virginis* dei Mascoli', *A. Ven.*, xxvii (1973), pp. 65–70

C. L. Joost-Gaugier: 'Considerations Regarding Jacopo Bellini's Place in the Venetian Renaissance', *A. Ven.*, xxviii (1974), pp. 21–38

——: 'A Florentine Element in the Art of Jacopo Bellini', *Acta Hist. A. Acad. Sci. Hung.*, xxi (1975), pp. 359–70

——: 'Jacopo Bellini's Interest in Perspective and its Iconographical Significance', *Z. Kst*, xxviii (1975), pp. 1–28

——: 'The Tuscanization of Jacopo Bellini', *Acta Hist. A. Acad. Sci. Hung.*, xxiii (1977), pp. 95–112, 291–313

——: 'Jacopo Bellini and the Theatre of his Time', *Paragone*, xxviii/325 (1977), pp. 70–80

N. Gramaccini: 'Wie Jacopo Bellini Pisanello besiegte', *Idea: Jb. Hamburg. Ksthalle*, i (1982), pp. 27–53

M. Boskovits: 'Giovanni Bellini: Quelques suggestions sur ses débuts', *Rev. Louvre*, xxxvi (1986), pp. 386–93

URSULA LEHMANN-BROCKHAUS

(2) Gentile Bellini (*b* Venice, ?1429; *d* Venice, 23 Feb 1507). Painter and draughtsman, son of (1) Jacopo Bellini. An official painter of the Venetian Republic, he was a dominant figure in Venetian art for several decades in the latter half of the 15th century, known particularly for portraits and large narrative paintings in which the city and its inhabitants are depicted in great detail.

1. BEFORE 1479. Gentile is generally assumed to be the eldest son of (1) Jacopo Bellini and Anna Rinversi, on the basis of two wills made by his mother, but his date of birth and primogeniture are debated. Named after Jacopo's master, Gentile da Fabriano, he probably trained with his father, whose workshop he joined. Their earliest recorded collaborative work was an altarpiece for the Gattamelata Chapel in the Santo, Padua, dated 1460 and signed by Jacopo, Gentile and his brother (3) Giovanni Bellini. The altarpiece was long untraced, but a panel showing *SS Anthony Abbot and Bernardino of Siena* (New York, priv.

col.; see Christiansen, p. 175) has been identified (Eisler, fig. 1). Gentile also worked with his father on the scenes from the *Life of Christ* and the *Life of the Virgin* (Venice, Accad.) painted *c.* 1465 for the Scuola Grande di S Giovanni Evangelista in Venice. Influence from Paduan art, particularly the dry, linear style of Andrea Mantegna, Gentile's brother-in-law, is evident in portraits thought to date from Gentile's early years: *Doge Francesco Foscari* (Venice, Correr), *Francesco Petrarch* (Sarasota, FL, Ringling Mus. A.) and the *Portrait of a Young Man* (Isola Bella, Mus. Borromeo). This dry manner is also evident in an important early commission, the organ shutters with *SS Mark, Theodore, Jerome and Francis* (Venice, Mus. Dioc. S Apollonia) for S Marco, traditionally dated to 1464, in which the coffered arches and figures of SS Mark and Theodore reflect prototypes by Mantegna in his frescoes (most destr.) in the Eremitani, Padua.

Gentile's earliest securely dated independent work is a portrait of the first patriarch of Venice, *Lorenzo Giustiniani* (Venice, Accad.), painted for S Maria dell'Orto, Venice, signed and dated in 1465. The painting is in poor condition, but it shows the meticulous attention to detail that remained characteristic of his style. Other works probably from this early period include the *Portrait of a Prelate* (Feltre, Mus. Civ.), *SS Jerome and John the Baptist* (Trau Cathedral) and the *Virgin and Child with Two Donors* (Berlin, Gemäldegal.). The central figures in another work from this period, the *Pietà with SS Mark and Nicholas* (Venice, Doge's Pal.), are unusually expressive, and it has been suggested that they are based on a design by Giovanni Bellini. In 1466 Gentile was recorded working on paintings of the *Passion* that had been started by his father for the Sala Maggiore of the Scuola Grande di S Marco, Venice. These paintings (destr. by fire, 1485) contributed considerably to Gentile's reputation, which was further confirmed by the knighthood granted him by the Holy Roman Emperor Frederick III during a visit to Venice in 1469. This award may have been linked to a portrait of the Emperor by Gentile, although no such work has been identified. A reference to his knighthood is included in the signature of a picture probably painted shortly afterwards, the *Virgin and Child Enthroned* (London, N.G.), in which the decorative marble throne recalls similar settings by Mantegna. A letter of 1471 recommending a pupil for Gentile and Giovanni suggests that the two shared a workshop in this period and may have collaborated. A curious composition, *Cardinal Bessarion and Two Brothers of the Scuola della Carità Venerating the Relic* (Vienna, Ksthist. Mus.), was painted by Gentile in 1472 for the door of the tabernacle housing a relic of the True Cross given to the Scuola by the Cardinal.

The success of his paintings for the Scuola di S Marco led in 1474 to the most significant commission of Gentile's career, the redecoration of the Sala del Maggior Consiglio of the Doge's Palace in Venice, to replace the fresco scheme executed in 1415–20 by Gentile da Fabriano and Pisanello, which had deteriorated. He received no payment for this work, but was granted a lucrative brokerage (*sansaria*) at the Fondaco dei Tedeschi. The commission required him to paint each new doge, making him virtually the official painter of the Republic. It was decided to replace the fresco cycle with paintings in oil on canvas, a medium more suited to the Venetian climate. The new decorations, including portraits of the doges and 22 paintings showing legendary events from the *Life of Alexander III*, were destroyed by fire in 1577. The loss of this major work of Gentile's maturity, in addition to the destruction of the S Marco paintings, has made it difficult to reconstruct his development. A drawing of one scene survives, the *Doge Receiving a Sword* (London, BM), and copies of some of the portraits of doges, including *Niccolò Marcello* (reg 1473–4; London, N.G.), *Andrea Vendramin* (reg 1476–8; New York, Frick) and *Giovanni Mocenigo* (*c.* 1478; Venice, Correr). All three portraits are stylized profile likenesses, but the slightly later signed portrait of *Agostino Barbarigo* (Nuneham Park, Oxon), which is a three-quarter view, gives a better indication of Gentile's skill in conveying the individual character of a sitter. In 1476 Gentile is recorded designing a pulpit (untraced) for the Scuola Grande di S Marco, to be executed by Antonio Rizzo.

2. 1479 AND AFTER. The culmination of Gentile's role as an official portrait painter was his mission for the Signoria in 1479 to the court of the sultan Mehmed II in Constantinople, accompanied by Bartolomeo Bellano. Among the gifts he took there was a book of drawings by his father (Paris, Louvre). Works he is known to have executed in Constantinople include a view of Venice for the Sultan and portraits of members of the court; the Sultan's collection was sold soon after his death and few works have been identified. Gentile's portrait medal of the Sultan survives (G. F. Hill: *Corpus of Italian Medals of the Renaissance*, London, 1930, no. 432). A portrait of *Mehmed II* (London, N.G.) in a richly decorated fictive frame is inscribed with the name of Gentile and the date 25 November 1480, but it has been almost entirely repainted and may be a copy. A portrait of the *Sultan with a Youth* (Switzerland, priv. col.; see Meyer zu Capellen, fig. 10a) is also attributed to Gentile. One of his portraits of the Sultan was owned by Paolo Giovio, who published a woodcut version of it in his *Elogia bellica virtute virorum illustrium* (Florence, 1551). Other souvenirs of his stay in Constantinople include a decorative picture of a seated figure in a turban and patterned robe, *Young Man Reading* (Boston, MA, Isabella Stewart Gardner Mus.). Two exquisite autograph drawings of Turkish figures survive from this period (London, BM), as well as five copies of drawings by him (Frankfurt am Main, Städel. Kstinst. & Städt. Gal.; Paris, Louvre).

After his return to Venice, probably early in 1481, Gentile resumed work on the decoration of the Sala del Maggior Consiglio, with Giovanni and other artists who had continued the project in his absence. He was still occupied with the Sala decorations in 1493, when he was recorded working on a portrait of *Agostino Barbarigo* and a series of city views (all untraced) for Francesco II Gonzaga, 4th Marchese of Mantua. Also in this period he worked on the decoration of the Sala della Croce of the Scuola di S Giovanni Evangelista in Venice, supervising a team of artists that included Vittore Carpaccio, Lazzaro Bastiani, Giovanni Mansueti and Benedetto Diana. (A work commissioned from Perugino was not executed.) The decoration comprised eight paintings of scenes from the *Legend of the True Cross* (Venice, Accad.), of which

Gentile painted three: the *Procession of the True Cross in the Piazza S Marco* (1496; see colour pl. 1, X3), the *Miracle of the True Cross at the Bridge of S Lorenzo* (dated 1500; see fig. 1) and the *Miraculous Healing of Pietro de' Ludovici* (1501). The *Procession* shows the elaborate façade of S Marco with a perspectival view of the crowded piazza and a procession bearing the reliquary crossing the foreground. Although the composition is rigidly organized and dominated by orthogonals, the numerous buildings and figures are rendered in such detail that it lacks focus. Perhaps because its canalside setting is relatively intimate and irregular, the scene at S Lorenzo is more intriguing. A number of small boats and ghostly swimmers in white robes are shown attempting to rescue the precious relic from the water, watched by crowds along the banks and bridge. Some of its charm comes from such anecdotal elements as the child dangling from the bridge or the black servant preparing to jump into the water. There are identifiable figures in the crowd, including Caterina Cornaro, Queen of Cyprus, and her courtiers. Caterina Cornaro is also the subject of one of Gentile's best-known portraits (*c.* 1500; Budapest, Mus. F.A.; see fig. 2). Her distinctly plain face is carefully depicted, but more attention is devoted to her costume, of which every thread and bead is recorded with uniform, and tedious, meticulousness. A livelier portrait, the *Portrait of a Man with a Pair of Dividers* (London, N.G.), ascribed to Gentile and painted

around this date, was once thought to represent a mathematician, but it may be a portrait of Giovanni.

In his last years Gentile's productivity was reduced owing to ill-health. In 1504 the Scuola Grande di S Marco, of which he was an active member, engaged him for the decoration of their Albergo, a commission he had requested in 1492. He began an enormous painting of *St Mark Preaching in Alexandria* (Milan, Brera) and in 1505 presented a sketch for a second, of the *Martyrdom of St Mark*. Illness prevented him from finishing the *St Mark Preaching*, and at his request the picture was completed (1507) by Giovanni. The composition is similar to that of the *Procession in the Piazza S Marco*, a central view of a façade with a block of figures across the foreground, but its exotic setting is emphasized by the inclusion of a camel and a giraffe. Reflections of Mamluk architecture and costumes in the picture prompted the suggestion that Gentile may have visited Jerusalem during his stay in the eastern Mediterranean (Meyer zur Capellen). He included a self-portrait in the *St Mark Preaching*, wearing the gold chain presented to him by Mehmed II. Other likenesses of him also survive: a bronze portrait medal (*c.* 1490) by Vittore Gambello and two portrait drawings, one a *Self-portrait* (Berlin, Kupferstichkab.) and one attributed to Giovanni (Oxford, Christ Church Pict. Gal.).

Gentile's role as an official portrait painter and his major narrative paintings with their plethora of portraits

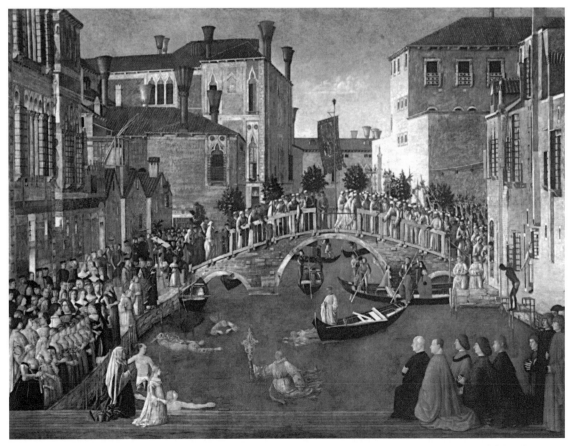

1. Gentile Bellini: *Miracle of the True Cross at the Bridge of S Lorenzo*, oil on canvas, 3.23×4.30 m, 1500 (Venice, Galleria dell'Accademia)

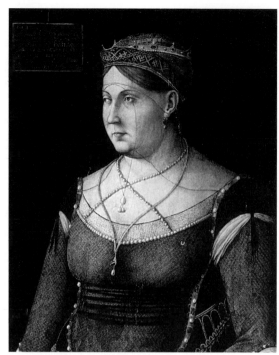

2. Gentile Bellini: *Caterina Cornaro, Queen of Cyprus*, oil on panel, 630×440 mm, *c.* 1500 (Budapest, Museum of Fine Arts)

and picturesque views of the city ensured the contemporary popularity of his work. His pictures continue to have an anecdotal appeal and are of interest as historical records, but the uniform emphasis on detail weakens the impact of his compositions. He was a capable and prolific practitioner of what has been termed the 'eye-witness' style of painting favoured in Venice in the 15th century, but his works lack the visual sophistication and expressive power of paintings by Giovanni and by Venetian artists of the next generation.

BIBLIOGRAPHY

DBI; Thieme–Becker

G. Vasari: *Vite* (1550, rev. 2/1568); ed. G. Milanesi (1878–85), iii, pp. 150–53, 166–8, 173, 177

L. Venturi: *Le origini della pittura veneziana* (Venice, 1907), pp. 325–45

J. A. Crowe and G. B. Cavalcaselle: *A History of Painting in North Italy* (London, 1912), i, pp. 118–38

A. Venturi: *Storia*, VII/iv (1915), pp. 213–54

H. Tietze and E. Tietze-Conrad: *The Drawings of the Venetian Painters* (New York, 1944)

R. Longhi: *Viatico per cinque secoli di pittura veneziana* (Florence, 1946)

M. Davies: *Catalogue of the Earlier Italian Schools in the National Gallery* (London, 1961)

C. Gilbert: 'The Development of Gentile Bellini's Portraiture', *A. Ven.*, xv (1961), pp. 33–8

F. Gibbons: 'New Evidence for the Birth Dates of Gentile and Giovanni Bellini', *A. Bull.*, xlv (1963), pp. 54–6

H. Collins: *Gentile Bellini* (PhD diss., U. Pittsburgh, PA, 1970; microfilm, Ann Arbor, 1976)

G. Gamulin: 'Contributi alla pittura del quattrocento', *A. Ven.*, xxxvii (1983), pp. 31–6

P. Fortini Brown: 'Painting and History in Renaissance Venice', *A. Hist.*, vii (1984), pp. 263–94

C. Eisler: '*Saints Anthony Abbot and Bernardino of Siena* Designed by Jacopo and Painted by Gentile Bellini', *A. Ven.*, xxxix (1985), pp. 32–40

P. Humfrey: 'The Life of St Mark Cycle in the Albergo of the Scuola Grande di San Marco in Venice in its Original Arrangement', *Z. Kst*, xlviii (1985), pp. 225–42

J. Meyer zur Capellen: *Gentile Bellini* (Stuttgart, 1985) [full bibliog.]

P. Humfrey: 'Gentile Bellini', *La pittura in Italia: Il quattrocento*, ed. F. Zeri (Milan, 1986, rev. 1987), ii, pp. 577–8

P. Fortini Brown: *Venetian Narrative Painting in the Age of Carpaccio* (New Haven and London, 1988); review by C. Hope, *NY Rev. Bks* (22 Dec 1988)

R. Tardito: 'Il restauro della Predica di San Marco in Alessandria d'Egitto di Gentile e Giovanni Bellini', *Pinacoteca di Brera* (Milan, 1988), pp. 258–66

E. Rodini: 'Describing Narrative in Gentile Bellini's *Procession in Piazza San Marco*', *A. Hist.*, xxi (March 1998), pp. 26–44

LUCINDA HAWKINS

(3) Giovanni Bellini [Giambellino] (*b* ?1431–6; *d* Venice, 29 Nov 1516). Painter and draughtsman, son of (1) Jacopo Bellini. Although the professional needs of his family background may have encouraged him to specialize at an early date in devotional painting, by the 1480s he had become a leading master in all types of painting practised in 15th-century Venice. Later, towards the end of his long life, he added the new genres of mythological painting and secular allegory to his repertory of subject-matter. His increasing dominance of Venetian art led to an enormous expansion of his workshop after *c.* 1490; and this provided the training-ground not only for his numerous shop-hands and imitators (generically known as Belliniani) but probably also for a number of major Venetian painters of the next generation.

Throughout his career, Giovanni showed an extraordinary capacity for absorbing a wide range of artistic influences, both from within Venetian tradition and from outside. He also oversaw a technical revolution in the art of painting, involving the gradual abandonment of the traditional Italian use of egg tempera in favour of the technique of oil painting pioneered in the Netherlands. It was thanks to Giovanni Bellini that the Venetian school of painting was transformed during the later 15th century from one mainly of local significance to one with an international reputation. He thus set the stage for the triumphs of Venetian painting in the 16th century and for the central contribution that Venice was to make to the history of European art.

I. Life and work. II. Style and development. III. Working methods and technique. IV. Posthumous reputation.

I. Life and work.

1. Biography. 2. Devotional works. 3. Narrative paintings. 4. Votive pictures and portraits. 5. 'Poetic' subjects. 6. Patronage.

1. BIOGRAPHY. Giovanni Bellini lived and died in Venice, where he was probably also born. His long career was outwardly uneventful, and he seems only once to have travelled outside the Veneto. It is generally accepted that he made an overland journey to the Marches some time in the 1470s, in connection with his commission to paint the large *Coronation of the Virgin* (Pesaro, Mus. Civ.) for the church of S Francesco there. On the other hand, there is no evidence that he ever visited Florence or Rome.

The date of his birth is unknown and has been much discussed. Vasari's report that Giovanni was older than his brother Gentile, and also that he was 90 when he died, has led some modern critics to place his birthdate as early as *c.* 1425. Since Jacopo's wife, Anna Rinversi, is known to have been pregnant for the first time in 1429, and since

she makes no mention of Giovanni in her last will of 1471, it has further been supposed that he was not her son and was illegitimate. However, as is now generally accepted, there is stronger contemporary evidence to believe that Gentile was in fact the elder brother, thus putting both assertions by Vasari in doubt and rendering the hypothesis of illegitimacy superfluous. Another common assumption, that Gentile was the child born of Anna in 1429, has recently been shaken by the confirmation of the existence of a third brother, Niccolò, who may well have been the child born in that year and the eldest of the three. In fact, Giovanni may have been born as late as *c.* 1435–6, especially if the very early *Crucifixion* (Venice, Correr) is accepted as part of Giovanni's contribution to Jacopo's now fragmentary Gattamelata Altarpiece of 1459–60.

Giovanni is first documented in 1459, when he was living in his own house in the parish of S Lio in Venice. By this date he must have been an independent master, although he continued to lend his father assistance during the 1460s. According to a late 16th-century source, the altarpiece in the Gattamelata Chapel in the Santo in Padua was signed with the names of Jacopo, Gentile and Giovanni Bellini (*see* (1), §II, 2 above); and according to Ridolfi (1648), the brothers worked with their father on a cycle representing the *Life of Christ* and the *Life of the Virgin* (destr.) for the Scuola di S Giovanni Evangelista, Venice, a work that is documented as having been completed in 1465. It seems likely, too, that the stylistically heterogenous set of four triptychs (Venice, Accad.) painted for the church of S Maria della Carità between 1460 and 1464 was commissioned not, as has often been assumed, from Giovanni (who is unlikely to have had his own team of assistants at this date), but from the well-established shop of Jacopo, who may well have made use of assistants, including both his sons (Robertson, 1968).

Giovanni's first major independent commission is likely to have been the *St Vincent Ferrer* polyptych (*c.* 1464–8; Venice, SS Giovanni e Paolo; see colour pl. 1, XI1). By the beginning of the 1470s he must have been regarded as the city's leading painter of altarpieces and smaller devotional works, and official recognition of his pre-eminent position in all branches of painting came in 1479 when he was appointed to work on the cycle of history paintings (destr. 1577) in the Doge's Palace.

During the 1480s and 1490s Giovanni lived in the parish of S Marina with his wife Ginevra (*d* before 1498), together with their son Alvise, who seems to have died soon afterwards. Giovanni is also known to have been a member of various confraternities, including the Scuola di S Cristoforo dei Mercanti and the Scuola Grande di S Marco. He seems to have been generous in his dealings with his professional colleagues: Dürer wrote in 1506 that of all the painters in Venice, Giovanni Bellini was the only one to treat him with courtesy and friendship; and according to Vasari, he was particularly known for the kindness he showed towards his many pupils.

He maintained his pre-eminent position among Venetian artists throughout his life, despite the artistic revolution created by Giorgione in the first decade of the 16th century; and when Giovanni died, the diarist Marin Sanudo wrote that 'despite his great age [he] still painted excellently' (*I diari*; Venice, 1879–1902).

Giovanni's likeness is known from an inscribed medal by Vittore Gambello, called Camelio (e.g. London, BM; Hill, 438), and from a related drawing attributed to Vittore Belliniano (Chantilly, Mus. Condé). On this basis, further portraits have been identified, including Titian's *Portrait of an Elderly Man* (*c.* 1511; Copenhagen, Stat. Mus. Kst, see Rapp). There also exists a portrait drawing by an anonymous artist of Giovanni Bellini on his deathbed (England, priv. col., see Fletcher, 1975, p. 23).

2. DEVOTIONAL WORKS. From the visual evidence, it is clear that Giovanni's earliest independent works consisted chiefly of small-scale panels for private devotion, a genre that remained characteristic throughout his career. Typical subjects are half-length representations of the Virgin and Child and of the Suffering Christ; full-length scenes from Christ's Passion, normally set in an extensive landscape; or representations of St Jerome in the wilderness. A demand for devotional images of this kind had originally been created by the import into Venice of large quantities of Byzantine icons, and it had recently been stimulated by the import from the Netherlands of small-scale religious panels, many of which would have shown landscape settings. Bellini's supreme ability to combine the various qualities of piety, pathos and verisimilitude typical of these imports, and to make them more immediate by rendering them in the formal language of the early Renaissance, must have guaranteed his own productions of this type an instant success. At an early date, too, perhaps already by the 1460s, Bellini's devotional images were apparently admired as much for their aesthetic as their religious qualities. A number of his Madonnas and Passion scenes are recorded in Venetian patrician art collections in the early 16th century by Marcantonio Michiel, alongside more profane works by members of the younger generation such as Giorgione and Titian. In a similar spirit, the Venetian government commissioned a *Virgin and Child* (untraced) from Bellini in 1515 to be sent to the sister of King Francis I of France (*reg* 1515–47) as a diplomatic gift (Bode, Gronau and Hadeln, 1911).

The qualities of calm dignity and spiritual depth found in the best of Bellini's small-scale devotional images also appear in the succession of church altarpieces that he produced throughout his career. The early *St Vincent Ferrer* polyptych of *c.* 1464–8 was followed by the *St Catherine of Siena* altarpiece (*c.* 1470; Venice, ex-SS Giovanni e Paolo, destr. 1867), the Pesaro *Coronation* (*c.* 1473), the S Giobbe Altarpiece (*c.* 1480; Venice, Accad.), the Frari Triptych (1488; Venice, S Maria Gloriosa dei Frari), the *Baptism of Christ* (*c.* 1502; Vicenza, S Corona; see colour pl. 1, XII1), the S Zaccaria Altarpiece (1505; Venice, S Zaccaria) and, finally, the S Giovanni Crisostomo Altarpiece (1513; Venice, S Giovanni Crisostomo). All are masterpieces, and they set the standards of quality and of innovative design against which all other Venetian altar paintings, and eventually altarpieces throughout Italy, came to be measured.

3. NARRATIVE PAINTINGS. Giovanni Bellini painted a scene (or scenes) from the *Life of St Jerome* (destr.) as part of a narrative cycle for the meeting-house of the Scuola di S Gerolamo. According to Ridolfi, this was dated

1464, and it therefore shows Giovanni as an exponent at an early date of a type of commission more normally associated with his brother Gentile. It often seems that Giovanni was less inclined towards narrative painting on canvas than to devotional painting on panel. He did not undertake any further scenes for the S Gerolamo cycle, which were later painted by Lazzaro Bastiani and Alvise Vivarini. He never executed the Old Testament scene for the Scuola di S Marco for which he signed a contract in 1470, and which was eventually painted in 1483 by Bartolommeo Montagna (destr. 1485). He only began his share of the work on the *Life of St Mark* cycle for the Scuola di S Marco after the death of Gentile in 1507. The nature of his contribution to the enormous canvas of *St Mark Preaching in Alexandria* (Milan, Brera) suggests that he was inspired more by fraternal loyalty than artistic commitment. On the other hand, from 1479, the date of Gentile's visit to Constantinople, Giovanni worked regularly on the cycle of scenes from Venetian history in the Sala del Maggior Consiglio in the Doge's Palace. He is recorded there in 1482–3, 1488, 1492, 1501, 1507 and 1515. His contribution to this cycle (destr. 1577), a major artistic complex, was described in some detail by Vasari, who admired it as much as any of Bellini's other works.

4. VOTIVE PICTURES AND PORTRAITS. Bellini and his assistants also must have undertaken a considerable amount of smaller works in the Doge's Palace, including numerous votive pictures, representing office-holders in the Venetian government presented to the Virgin by their patron saints. Most of these would have been destroyed in the fires of 1574 and 1577, but a fine surviving example is the *Votive Picture of Doge Agostino Barbarigo* (1488; Murano, S Pietro Martire; see fig. 1), which although

probably painted for the Sala dello Scudo in the palace was transferred after the donor's death to the convent of S Maria degli Angeli on Murano (Roeck). Another example, of lesser quality, but similar in compositional type, is the *Virgin and Child with SS Peter and Paul and Donors* (Baltimore, MD, Walters A.G.), originally hung in the offices of the Procuratia de Ultra.

In his work in the Doge's Palace, in the history cycle as well as in the votive pictures, Bellini was also required to make full use of his talents as a portrait painter. His earliest independent portraits, such as that of *Jörg Fugger* (1474; Pasadena, CA, Norton Simon Mus.), date from the mid-1470s and appear to represent a response to a growing taste for portraiture among Venetians, perhaps stimulated by a growing number of imports of portraits from the Netherlands and by the works of Antonello da Messina. Bellini's early portraits appear relatively informal and casual, but by the 1490s he placed increasing emphasis on the sitter's social status. Few sitters have been definitely identified, but it may be inferred from Vasari's comments on Bellini as a portrait painter, and also from the costumes, that most of them are members of the families that made up the ruling patriciate.

5. 'POETIC' SUBJECTS. Although the overwhelming majority of Bellini's works are religious in content, towards the end of his life he painted a handful of pictures with subjects based on Classical literature. Notable examples include the group of allegorical panels (Venice, Accad.), which apparently originally formed part of a piece of bedroom furniture, the *Woman (?Venus) at her Toilet* (1515; Vienna, Ksthist. Mus.) and the *Feast of the Gods* (1514; Washington, DC, N.G.A.), painted for Alfonso I d'Este, Duke of Ferrara. The mysterious and poetic

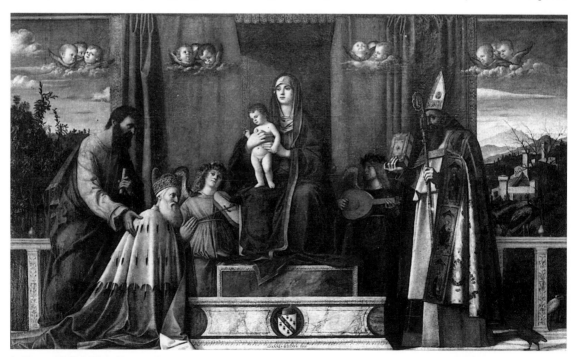

1. Giovanni Bellini: *Votive Picture of Doge Agostino Barbarigo*, oil on canvas, 2.0×3.2 m, 1488 (Murano, S Pietro Martire)

Drunkenness of Noah (*c.* 1513; Besançon, Mus. B.-A. & Archéol.) may also be regarded as belonging to this category. Although the elderly artist approached these works in a spirit of staid gravity somewhat at odds with their erotic and/or Bacchic content, their existence would probably not seem so surprising, were it not for our knowledge of a particularly well-documented episode, in which Alfonso's sister Isabella d'Este, Marchesa of Mantua, made persistent and ultimately unsuccessful efforts to persuade Bellini to contribute an allegorical picture for her own humanist-inspired *studiolo*.

Isabella first approached Bellini in 1496, in connection with her project to decorate her *studiolo* in the Palazzo Ducale in Mantua with works by the most famous artists in Italy. In 1501 Bellini apparently agreed to undertake one of the scenes and received one quarter of the fee in advance. Numerous letters between Isabella and two of her agents in Venice record the series of negotiations and changes of plan that took place during the next three years. First there were hagglings over the fee, then Bellini expressed dissatisfaction with the proposed subject. There can be little doubt that he felt uncomfortably constrained by the selfconsciously intellectual allegorical programme. Isabella agreed to let him depart from the detailed programme as long as he depicted a subject with an appropriately antique flavour. After further delays, Isabella tried to retrieve her original advance; but then, on the advice of her agents, she decided to settle for a small-scale religious subject that would be suitable for her bedroom rather than her *studiolo*. Finally a 'presepio', or *Nativity* (untraced), was delivered in the summer of 1504. Even then, Isabella did not abandon her original idea of having Bellini contribute to her *studiolo*, and on the encouragement of the poet Pietro Bembo, she reopened negotiations with the artist in 1505. A year later she seems finally to have lost patience with him, and the project was dropped.

The successful commission of the *Feast of the Gods* is much less well documented than the earlier abortive efforts of Isabella d'Este, and there has been much speculation about how this large pagan mythology came to be painted (Wind; Walker; Fehl). Alfonso I d'Este began preparing his own *studiolo* in the Castello in Ferrara around 1505; and after frontiers with Venice were reopened in 1513 after the war of Cambrai, it would have been natural for him to turn first to Bellini rather than to the younger, comparatively unknown Titian, who was later to play so important a role in the project. Bellini had already painted a traditional devotional subject for Alfonso in 1502, a half-length *St Dominic* (probably ex-Hickox priv. col., New York). It was probably also diplomatically advantageous for the Venetian government to exert pressure on its official painter to accede to Alfonso's request for a mythology.

6. PATRONAGE. A survey of the main types of commission undertaken by Bellini indicates that his clientele was mostly Venetian, and frequently of the highest social and political rank. From the time of his appointment to work in the Doge's Palace in 1479, he would have had opportunities for regular contact with prominent Venetian patricians, including the Doge himself; and in addition to the various government committees that supervised his official commissions, Bellini's clients are known to have included such individuals as Marco Zorzi, the donor of the altarpiece of the *Resurrection* (Berlin, Gemäldegal.), made for his chapel in S Michele in Isola, Zuan Michiel, the original owner of the *St Francis in Ecstasy* (New York, Frick; see Fletcher, 1972); and the three Pesaro brothers, donors of the Frari Triptych (Goffen, *Piety and Patronage*, 1986).

Another prominent social group for which Bellini worked extensively, although perhaps more in his earlier career than subsequently, were the *cittadini* (citizens), from whose ranks the members of the ruling committees of the *scuole* (confraternities) were drawn. The *scuole* commissioned not only narrative cycles for their meeting-houses, such as those at the Scuola di S Gerolamo and Scuola di S Marco, but also altarpieces for their chapels in Venetian churches. Thus, works of the highest art-historical importance such as the *St Vincent Ferrer* polyptych, the *St Catherine of Siena* altarpiece and probably also the S Giobbe Altarpiece (Goffen, 'Bellini, S Giobbe and Altar Egos', 1986) were respectively commissioned by *scuole* of the same name. The S Giovanni Crisostomo Altarpiece, too, was commissioned by the officers of the Scuola di S Marco, acting as executors of the will of a former member.

Perhaps because he found local commissions sufficiently attractive and lucrative, Bellini seems to have undertaken very little work for distant customers, especially compared with the rival shop of the Vivarini. The *Coronation of the Virgin* for Pesaro, and a *St Peter Martyr* (Bari, Pin. Prov.) painted for S Domenico, Monopoli in Apulia, are among the very few works he sent to towns on the Adriatic, traditionally a lively market for Venetian altarpieces. Even the immediate Venetian mainland seems to have held little attraction for him; and in this sense, his undertaking of the commission for even so large and important a work as the Vicenza *Baptism* may be seen as exceptional. As his international fame grew, so must the number of requests from outside customers; but Bellini's reluctance to satisfy them, especially if they involved types of commission to which he was not accustomed, is well illustrated by the episode with Isabella d'Este. He was similarly evasive in his reply to an invitation of 1497 by her husband, the Marchese Francesco Gonzaga, to provide him with a view of Paris as part of a projected series of views of famous cities.

II. Style and development.

During the course of his long career, Giovanni Bellini's style probably underwent greater changes than that of any other major painter of the 15th century. He was responsive to a whole succession of different influences and stimuli: the Byzantine and Gothic heritage of Venice; the innovative art of his father Jacopo and of his brother-in-law Andrea Mantegna; Netherlandish painting; the sculpture of Donatello in Padua and of Pietro Lombardo; the work of the Central Italian Piero della Francesca and of the Sicilian Antonello da Messina; and towards the end of his life, even the work of Giorgione, who was young enough to have been his grandson. Yet Bellini's own strongly marked personality is almost always evident, and his work is rarely confused with that of any of these other artists.

His adaptability may be regarded as a source of strength rather than as a sign of weakness, and in many cases he gave back as much as he borrowed. In the long run, it was Bellini's genius for harmoniously assimilating a wide range of artistic ideas that permitted the coming of age of the Venetian school of painting.

1. Early works, *c.* 1460–*c.* 1470. 2. Middle period, *c.* 1470–*c.* 1500. 3. Late works, *c.* 1500–1516.

1. EARLY WORKS, *c.* 1460–*c.* 1470. Bellini's early career is poorly documented, but critics are unanimous in regarding a signed panel of *St Jerome in the Wilderness* (U. Birmingham, Barber Inst.) as one of the artist's first independent works. The relationship of the slender, carefully delineated figure and of the rocky landscape to Jacopo's style as revealed in his albums of drawings is still very close, and it indicates that Giovanni had not long completed his apprenticeship. The *St Jerome* is also close stylistically to the longitudinal *Crucifixion* (Venice, Correr), a work that was traditionally regarded as Jacopo's, but which is now usually also seen as in part by Giovanni. On the assumption that Giovanni was born *c.* 1431 or earlier, critics have generally dated both panels *c.* 1445–50; but if the *Crucifixion* formed part of the predella of the Gattamelata Altarpiece (1459–60), the *St Jerome*—and the beginnings of Giovanni's independent career—must also date from around this time.

If the latter is true, Bellini's art must have developed rapidly in the immediately succeeding years. The earliest of his magnificent series of half-length Madonnas, such as the Lehman *Virgin and Child* and the Davis *Virgin and Child* (both New York, Met.), are evidently close in style and date to those parts of the Carità triptychs that may be attributed to Giovanni, such as the central figure of the triptych of the *Madonna* (*c.* 1460–64; Venice, Accad.). Both Virgins show a grandeur of conception and spiritual depth that signal Bellini's arrival at artistic maturity. The last traces of Jacopo's influence have been left behind; and as is apparent from the sculptural quality of the forms defined with sharp linear creases, and individual motifs such as the swag of fruit in the Lehman *Virgin and Child*, Giovanni's chief stylistic model was then the art of Mantegna. This is even more apparent in another probable work of the early 1460s, the *Agony in the Garden* (London, N.G.), the composition of which is closely based on Mantegna's own version of the subject (*c.* 1459–60; London, N.G.) and which shows comparable virtuoso displays of foreshortening. Typical of Bellini himself is the way in which the Mantegnesque structure is complemented by the painter's own direct observation of the details and effects of nature. This is apparent, above all, in the marvellously poetic treatment of the dawn light, which gently touches the hillsides and east-facing walls of the houses and *campanili* in the background. This is the first known evocation of dawn in Italian art, and it may owe much to Bellini's knowledge of Netherlandish painting. At the same time, it constitutes much more than a purely formal device, and with its suggestion of the Christian salvation that is to succeed the Agony, it is deeply expressive of the subject-matter.

Nowhere is Giovanni's highly charged Christian emotion more evident than in his various representations of Passion themes. An outstanding example from his early career, probably dating from the later 1460s, is the *Pietà* (Milan, Brera; see fig. 2), where the half-length format is adopted as a means of bringing the spectator into the closest possible contact with the suffering of Christ and the grief of his mother and St John. As in the contemporary *St Vincent Ferrer* polyptych, the Paduan element remains strong; and in addition to the incisive Mantegnesque contours, both the arrangement of the figures as if in relief and the expressive pathos seem to owe much to Donatello's bronze relief of the *Dead Christ Supported by Angels* in his altarpiece in the Santo, Padua. Again, this is combined with Netherlandish influences, in this case apparently that of Rogier van der Weyden (*c.* 1399–1464), whose *Lamentation* triptych in Ferrara (untraced) must similarly have combined harsh angular forms with an intense expression of bitter anguish. Typical of Bellini is the way in which the cold landscape and steely sky act as a foil and complement to the human drama in the foreground.

2. MIDDLE PERIOD, *c.* 1470–*c.* 1500. The technique of the Brera *Pietà* is still that of traditional tempera, and many of the characteristics of the medium—the hard, sculpted surfaces, for instance, and the sharp breaks in the modelling—are deliberately exploited to expressive effect. Soon after 1470, however, Bellini seems to have begun searching for a greater roundness of form and more softly blended tonal transitions, as if to break with the Paduan origins of his early style. He was apparently encouraged in this direction by an acquaintance with Piero della Francesca's work, perhaps made on the occasion of his putative visit to the Marches in connection with his commission to paint the Pesaro *Coronation of the Virgin* (Pesaro, Mus. Civ.). The figures in this great work are appreciably more three-dimensional than their counterparts in the Brera *Pietà*, and in a way characteristic of Piero, the cubic shapes of the throne are echoed by the towers in the landscape background. The pictorial space is conveyed with utter clarity, with the perspectively rendered floor-pattern providing a measure of the recession into depth; and in the geometrical subdivision of the surface, too, there is an harmonious sense of interval and proportion. With the calmness, simplicity and grandeur typical of Piero combined with Bellini's own warm and tender humanity, the picture presents a striking contrast with previous Venetian representations of the theme by such gothicizing painters as Jacobello del Fiore, Michele Giambono and Antonio Vivarini. In keeping with his search for volume, Bellini seems to be experimenting—apparently for the first time in a major work—with the oil medium; and although the frequently abrupt breaks in the modelling and the opacity of the shadows indicate that his command of the medium was still comparatively inexpert, the innovation was to be of crucial historical significance.

The date of the Pesaro *Coronation* is uncertain, and there has been much controversy about whether it precedes or postdates the documented visit to Venice by Antonello da Messina in 1475–6. The traditional view, based on Ridolfi, is that Bellini learnt the technique of oil painting directly from Antonello and that his first efforts in the medium must therefore date from after Antonello's

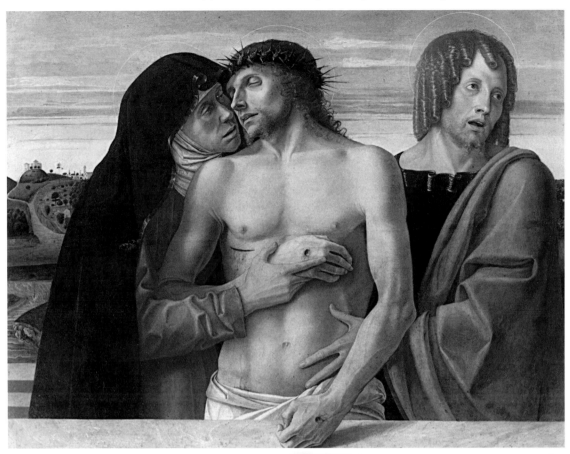

2. Giovanni Bellini: *Pietà*, tempera on panel, 0.86×1.07 m, *c.* 1467–8 (Milan, Pinacoteca di Brera)

visit, but various arguments may be put forward to modify such a view. There is the fact that Netherlandish panels, and perhaps also pictures by Antonello, had been imported into Venice for some years, and Bellini may have tried to imitate their technique on his own initiative. There is the strong possibility that Antonello himself paid an earlier visit to Venice, perhaps *c.* 1470. There is also the fact that Bellini's portrait of *Jörg Fugger* of 1474 is already painted in oils. It is perfectly possible, therefore—and perhaps for reasons of Bellini's internal chronology quite probable—that the *Coronation* was painted immediately before Antonello's documented visit. This is not to deny a strong element of poetic truth in Ridolfi's account, since the presence of Antonello in Venice in 1475–6 undoubtedly made a profound impression on Bellini, who might never have achieved a full mastery of the new medium without this direct personal contact at this moment in his career.

The main commission undertaken by Antonello in Venice was an altarpiece of the *Virgin and Child Enthroned with Saints* for S Cassiano. Although this work now survives only in a fragmentary form (Vienna, Ksthist. Mus.), it is clear that in its composition it originally bore a close resemblance to that of Bellini's *St Catherine of Siena* altarpiece in SS Giovanni e Paolo, of which an engraving (Francesco Zanotto, 1858) exists. There has been much discussion about the chronological priority of these two

works, but for many reasons there seems little doubt that Bellini's altarpiece, which was apparently executed in tempera, was painted earlier, perhaps *c.* 1470, and that Antonello imitated its arrangement. In some of his smaller devotional works, Antonello similarly adopted compositional formulae derived directly from Bellini. Equally, there can be little doubt that Bellini was consciously responding to the challenge of Antonello's S Cassiano Altarpiece when he came to paint his own large and imposing S Giobbe Altarpiece (Venice, Accad.; see fig. 3), a work that may be regarded as the central masterpiece of his career. The combination of a pyramidal figure group with a tall, originally arched picture field, largely occupied by a stately architectural setting, follows the same basic scheme as his own earlier *St Catherine of Siena* altarpiece, thus definitively establishing it as the model for innumerable other Venetian altarpieces of the Virgin and saints over the next decades, and finally rendering the older polyptych format obsolete.

A connection with Mantegna's S Zeno Triptych (completed 1459; Verona, S Zeno) is evident in the idea of illusionistically linking the forms of the painted architecture to those of the real stone frame (still in S Giobbe), so that the saints appear to be present in an actual chapel leading off the nave. This effect is even further enhanced by the close formal relationship between Bellini's painted

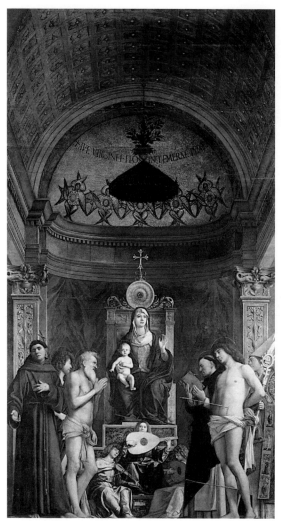

3. Giovanni Bellini: S Giobbe Altarpiece, oil on panel, 4.71×2.58 m, *c.* 1480 (Venice, Galleria dell'Accademia)

architecture and the frame on the one hand, and the real architecture of Pietro Lombardo's newly reconstructed church on the other. Mantegna's linearism has now largely disappeared and is replaced in the impressive nude figure of St Sebastian by a more fluent modelling that makes the figures of the Pesaro *Coronation* look faceted and wooden. The arrangement of the figures in a semicircle, echoing the concavity of the apse, has a similarly volumetric effect and again makes that of the *Coronation* look relief-like by contrast. Echoes of Donatello's Paduan work are present in the expressive pathos of St Francis, and the whole conception would have been unthinkable without a complete assimilation of Florentine perspective and anatomy; yet the effect is neither sculptural nor intellectual, but one of sensuous realism and gentle spirituality that is entirely Venetian. By achieving a complete command of a Netherlandish–Antonellesque evocation of surface texture, through which he was able to imitate the surface properties of marbles, brocades and glass tesserae, Bellini was able to provide an up-to-date and visually sophisticated version

of the traditional Venetian taste for material richness. In particular, the apsidal semi-dome, revetted in gleaming mosaic and decorated with Byzantine seraphim, would have irresistibly reminded Bellini's contemporaries of the interior of the state church of S Marco, with its combination of opulence and sanctity, majesty and mystery.

Paradoxically—for Bellini was the most innovative of all Venetian painters of the 15th century—there is a consciously archaic element in his art, perhaps also detectable in the iconic remoteness of the Virgin, which seems to reflect a deep awareness of the Byzantine heritage of Venetian painting and of its appropriateness to the artistic expression of things celestial. The colour is relatively subdued and remains subordinate to the representation of softly glowing light; Bellini's sense of the supernatural, which the more purely naturalistic Antonello lacked, was always to be conveyed, as here, by convincingly natural means; and it is precisely this combination of the real and otherworldly, the sensuous and the spiritual, the human and the divine, that constitutes one of the most moving characteristics of his art.

It was not only on the large scale of altar painting that Antonello's work acted as a stimulus to Bellini: in a relatively small work such as the *Transfiguration* (Naples, Capodimonte; see colour pl. 1, XI2), probably roughly contemporary with the S Giobbe Altarpiece, there is evidence of Antonello's influence as a landscape painter. As in the latter's *Crucifixion* of 1475 (Antwerp, Kon. Mus. S. Kst.), a work presumably painted in Venice, there is the Flemish device of the foreground plateau behind which the landscape drops away; there is a comparable richness of botanical and zoological detail, with the exquisitely precise rendering of the foreground plants and there is a comparable sense of luminosity, with jewel-like colours and radiant highlights. Compared to the Mantegnesque artificiality with which the landscape of the early *Agony in the Garden* was constructed, that of the *Transfiguration* is gentler and more natural-seeming, with the clouds in the sky correspondingly soft and fluffy. As in the S Giobbe Altarpiece, there is a sense of religious awe and mystery lacking in Antonello, conveyed here by the archaic stiffness of the figure group, with the figure of Christ appearing as flat and hieratic as a Byzantine Pantocrator. At the same time, there is a greater effect of formal, chromatic and spiritual unity between the figures and their surroundings than in Antonello, where the landscape has the character of an unrelated backdrop. For all his evident admiration of Antonello, therefore, Bellini remained his own master; and even works of his middle period, most close to Antonello, already contain the seeds of the highly personal style of his old age.

Neither the *Transfiguration* nor the S Giobbe Altarpiece are dated, and the question of dating of the S Giobbe Altarpiece within the ten-year span *c.* 1477–87 has given rise to much controversy. There seems to be a growing consensus that it must have been painted several years before the stylistically rather more advanced *Madonna degli Alberetti* (1487; Venice, Accad.) and the *Votive Picture of Doge Agostino Barbarigo* of 1488 (see fig. 1 above). A firm *terminus ante quem* of 1484 is, in fact, provided by Francesco Bonsignori's dated dal Bovo Altarpiece (Verona, Castelvecchio), in which the figure of St Onuphrius

constitutes a direct quotation of that of Job in the S Giobbe Altarpiece; some critics would also see an early *terminus ante* in Alvise Vivarini's *Sacra conversazione* (1480; Venice, Accad.) from S Francesco, Treviso.

The difficulties of charting Bellini's chronology remain considerable, however, not only because of the dearth of dated works before 1500, but also because his style sometimes seems to have varied according to the context or type of commission. Thus the Frari Triptych of the *Virgin and Child with Saints*, dated 1488, while also clearly postdating the S Giobbe Altarpiece, is surprisingly unlike the Barbarigo votive picture of the same year. In the Frari Triptych, relatively small in scale and painted on panel, Bellini adopted a relatively tight pictorial handling that serves to emphasize the roundness of the forms and to enhance the illusion of the presence of the figures, in a way that still recalls the manner of Antonello. In the votive picture, on the other hand, which like the large-scale decorations for the Doge's Palace is painted on canvas, the artist's handling is much broader, orthogonals into depth are suppressed, and the forms and colours are arranged to emphasize the decorative unity of the picture plane.

It would seem that Bellini was most active as a portrait painter in the 1480s and 1490s. The earliest dated example, the *Jörg Fugger* of 1474, although painted slightly in advance of Antonello's documented visit to Venice, certainly reflects knowledge of his portraits. Like Antonello, but in contrast to previous Venetian practice as exemplified by the profile portraits of his brother Gentile, Giovanni

adopted the three-quarter view characteristic of Netherlandish portraiture, but in contrast to Antonello's portraits, the sitter's gaze remains curiously abstracted and the forms have a decorative and linear quality that counteracts any effect of real physical presence. Bellini's later portraits, such as the *Portrait of a Man* (*c.* 1490; Washington, DC, N.G.A.), show a more emphatic realism, and the relationship with Netherlandish and Antonellesque prototypes is reinforced by the standard device of the marble parapet in the foreground. The averted glance and dignified bearing, which have the effect of limiting the expressive range of the work, are probably reflective of a Venetian sense of social decorum, as well as of Bellini's own temperament. For this reason, Bellini's portraits are not, on the whole, masterpieces on the level of his religious paintings. An exception to this generalization is provided by his greatest contribution to the genre, the superb *Doge Leonardo Loredan* (*c.* 1501; London, N.G.; see fig. 4), in which any expression of individual personality would have been out of place. Indeed, the very impersonality with which the sitter is represented equips him all the better to stand as a symbolic figurehead of the Venetian state, suggesting an ideal combination of wisdom and justice, enlightenment and severity, serenity and vigilance. Partly, perhaps, because of its function as a state icon, the portrait retains the assertive plasticity and textural differentiation of surfaces associated with the art of Antonello.

3. LATE WORKS, *c.* 1500–1516. By the turn of the 16th century Bellini had developed the characteristic atmospheric and planar style of his last years. This probably receives its first mature statement in the *Baptism* (*c.* 1500–02) for S Corona, Vicenza. Comparison with the *Transfiguration* of the 1480s shows that while the event is portrayed with the same typically Bellinesque combination of gentleness and gravity and is complemented by the highly evocative treatment of light and landscape, the artist has now subordinated spatial and intellectual logic to a more purely pictorial order. Instead of the winding paths and wedges of ground that in the earlier work led the eye step by step from foreground to distant background, the landscape is now conceived almost vertically, with no proper middle-ground, and it consists chiefly of large, luminous, interlocking planes. Whereas in the *Transfiguration* the draperies retained a sculptural quality, with sharp edges and deeply undercut folds arranged to convey round volume, they now appear as softer, warmer, broader patches of colour that spread across the picture surface and combine with the shapes and colours of the landscape to form a closely integrated decorative and atmospheric unity. Similar comparisons could be made between an Antonellesque example of the 1480s such as the *Virgin and Child with a Pomegranate* (London, N.G.) and a late picture such as the *Virgin and Child with SS John the Baptist and Mary Magdalene* (Venice, Accad.), in which, characteristic of Bellini's late Madonnas, the format is expanded laterally to include half-length saints at either side.

The altarpiece of S Zaccaria, Venice (1505; see colour pl. 1, XII2), like the S Giobbe Altarpiece of the 1480s, consists of a serene and meditative *Sacra conversazione*, in which the saints, reduced to four, and the single musician

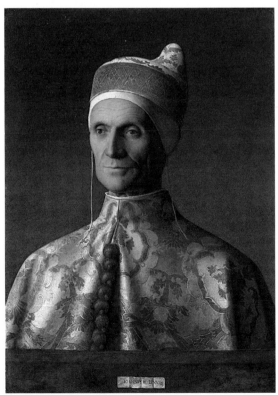

4. Giovanni Bellini: *Doge Leonardo Loredan*, oil on panel, 616×451 mm, *c.* 1501 (London, National Gallery)

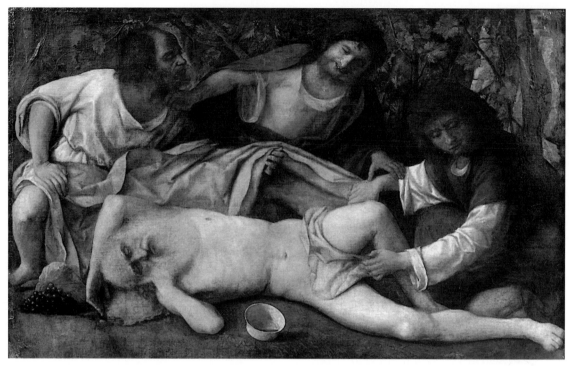

5. Giovanni Bellini: *Drunkenness of Noah*, oil on canvas, 1.03×1.57 m, *c*. 1514 (Besançon, Musée des Beaux-Arts et d'Archéologie)

angel are represented within a chapel-like architecture. Again the forms of the painted architecture are illusionistically linked to those of the real marble frame in a way that enhances the effect of spaciousness. However, the illusionism is less rigorously logical than in the S Giobbe Altarpiece—for example the viewpoint is unrealistically high—and the evocation of a sacred precinct, at once vividly present and seemingly palpable and yet more magical and elusive than everyday reality, is correspondingly more powerful than in the earlier work. In contrast to the carefully constructed and naturalistic solids of the S Giobbe Altarpiece, the soft, chromatically deeply saturated forms of the S Zaccaria Altarpiece appear to float weightlessly, as if to offer a version of reality transfigured by the presence of the divine.

Bellini's late style seems to have evolved naturally from his own previous work, partly perhaps as a result of his experience as a painter of large-scale mural decorations in the Doge's Palace; and although in its warmth of colour and softness of handling it shows certain analogies with the revolutionary style of Giorgione, Bellini is likely to have been the giver rather than the taker in the first instance. Even in his old age, and as the representative painter of the Venetian establishment, Bellini remained open to new ideas, as is apparent from his very last works such as the *Feast of the Gods* (1514), which was later radically altered by Titian, making it difficult to isolate Bellini's contribution in terms of pictorial handling. The *Drunkenness of Noah* (see fig. 5), probably of about the same date, seems to represent a strange and idiosyncratic contribution to the type of *poesia*, or poetic subject, made fashionable by Giorgione. The facial types of the figures, the glowing colour and deep shadows, and especially the

enigmatic mood, reveal Bellini's interest in the work of the younger master, and they provide impressive evidence of the octogenarian painter's inexhaustible capacity for self-renewal.

III. Working methods and technique.

1. Painting technique. 2. Drawings. 3. The workshop.

1. PAINTING TECHNIQUE. Giovanni Bellini constantly experimented with pictorial technique. Although not the first Italian painter to adopt the oil medium, he was responsible for establishing it as the norm in a major Italian school of painting and for extending its formal and expressive range in a way that was to be of the utmost importance for his 16th-century successors.

The changes that Bellini's technique underwent during the crucial middle period of his career may be illustrated by a comparison between two works that have recently undergone technical examination. In the *Blood of the Redeemer* (*c*. 1465; London, N.G.; see fig. 6), a work that is stylistically comparable to the *St Vincent Ferrer* altarpiece and the Brera *Pietà*, the artist employed the traditional Italian technique of egg tempera on a smoothly gessoed panel. The paint is applied thinly and evenly, with the colour planes adhering closely to the sharp contours established by the underdrawing; and infrared photography has revealed that the internal modelling of the forms was also indicated in places in the underdrawing by means of fine parallel hatchings (Braham, Wyld and Plesters, 1978). In the *Votive Picture of Doge Agostino Barbarigo* (see fig. 1 above), the position of the main forms was worked out carefully in advance, so that the red of the

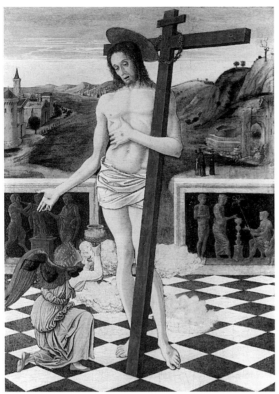

6. Giovanni Bellini: *Blood of the Redeemer*, tempera on panel, 470×343 mm, *c.* 1465 (London, National Gallery)

curtain, for example, is painted around the green cloth of honour and not underneath it, and similarly, the green is painted round the head of the Virgin and not underneath it (*La pala Barbarigo*, 1983). The technique is oil on thinly primed canvas, and Bellini's command of the oil medium is apparent in the greater tonal range of his colours and in the correspondingly greater subtlety of the modelling. His handling of paint is also broader and more expressive, with the minute, regular, almost metallic curls of the angel's hair in the earlier work replaced by the bold, broken, rhythmical touches that evoke rather than describe the hair of his later counterpart. The effect of atmospheric fusion between the forms and their surroundings is further assisted by the scarcely disguised roughness of the canvas support.

Although many of the technical procedures of the Barbarigo picture may be regarded as typical of Bellini's later career, his practice remained variable. His normal type of pictorial support remained panel rather than canvas, although sometimes, as in the *Virgin of the Meadow* (*c.* 1505; London, N.G.), the surface of the gesso ground is no longer made flawlessly smooth and white, but is deliberately roughened and given a warmer, brownish tone. Sometimes, especially apparently in the 1470s and 1480s, Bellini made very detailed underdrawings, with an elaborate system of hatching to indicate the modelling, as in the Booth *Virgin and Child* (Washington, DC, N.G.A.); later, as in the S Zaccaria Altarpiece (1505) and the Donà delle Rose *Pietà* (Venice, Accad.), his underdrawing becomes simple and sketchy, while the *Feast of the Gods* was

apparently painted without any underdrawing at all (see Bull and Plesters, pp. 58–9). From the mid-1470s he normally used oil as his principal medium, but recent tests have shown that by no means did he abandon egg tempera entirely and that he often continued to use it (as in the *Virgin of the Meadow*) for the lower paint layers, or to bind particular pigments. He also never lost the habits of the traditional tempera painter in the sense that he continued to apply paint in a limited number of thin layers, with little or no impasto and few *pentimenti*. The unfortunate corollary of Bellini's increasingly experimental approach to technique is that many of his later works tend to be much less well preserved than his earlier works executed according to well-tried traditional procedures.

2. DRAWINGS. Whether or not Bellini's pictures were painted over detailed underdrawings, they must have been preceded by separate drawings on paper, both of the composition as a whole and of individual details. Although a fair number of drawings in a recognizably Bellinesque style survive, few of them can be definitely identified as preparatory studies for known paintings. A rare exception is a pen-and-ink *Study of an Ox* (Florence, Uffizi), which corresponds closely to an animal in the background of the *Virgin of the Meadow* (Rearick). Other likely candidates include the *Head of St Anthony Abbot* (Windsor Castle, Berks, Royal Lib.) and the *St Sebastian* (London, BM), both of which are executed with the tip of the brush, with wash and white heightening, and which seem to correspond to their respective figures in the Carità triptychs; but in both cases the relationship is loose and has often been doubted.

Most other Bellinesque drawings fall into two categories: those considered to be of high artistic quality, but which do not correspond closely to known paintings; and those corresponding to known paintings, but which appear to have been made by some member of Bellini's shop, following either the painting or a lost drawing by the master. The problems surrounding the drawings in the first category are particularly contentious, since there is a good case for thinking that a high proportion of them, consisting of rapidly executed pen-and-ink sketches, mainly of Passion themes and standing saints, are not by Bellini at all, but by his brother-in-law Mantegna. Attributional doubts also cling to the handsome *Portrait of a Man* (Oxford, Christ Church Pict. Gal.), a highly finished study in black chalk, which has been plausibly seen as an analogy in drawing to the painted *Doge Leonardo Loredan* (Ames-Lewis, 1981), but which has also been attributed to Bonsignori and Mantegna.

Representative examples of the second category include a *Virgin and Child* (Florence, Uffizi; see Rearick) and a *Landscape with the Three Marys* (Milan, Ambrosiana), both of which are executed with the tip of the brush with wash and white heightening. The figure group in the first example appears in a *Virgin and Child with Four Saints and a Donor* (New York, Pierpont Morgan Lib.) and in at least 20 further painted variants (Heinemann); and the drawing may therefore be regarded as a *simile*, or carefully executed copy after a design by Bellini, made specifically as a guide for replicas to be painted by members of the workshop. Similarly, the motifs in the landscape drawing

recur in a number of pictures by Bellini's shop, and it is probably a chance survivor from a large stock of designs, based on nature studies by Bellini, and kept in the workshop for inserting into the background of paintings as and when the need arose. The existence of many more *simili* may be inferred from the frequent recurrence of particular motifs in the numerous works that issued from the Bellini studio. It is possible that *simile* drawings were also made on prepared panels rather than on paper, in which case a plausible candidate would be the technically unique panel, the *Pietà with the Three Marys and Disciples* (Florence, Uffizi). The function of this work, which is of high quality and obviously autograph, has been much discussed, with some critics regarding it as the underdrawing of an intended painting, and others unwilling to believe that even Bellini would have worked up a mere underdrawing to such a high degree of finish.

3. THE WORKSHOP. Although it seems unlikely that Bellini had his own assistants as early as 1460–64, the period of the Carità triptychs, the attribution by Marcantonio Michiel of the predella of a Bellini altarpiece of *c.* 1470 to the miniature painter Lauro Padovano suggests that by this date Bellini did employ the occasional collaborator on large-scale works. He certainly had assistants capable of producing variants on his designs by 1489, as is shown by a Bellinesque *Virgin and Child* (London, N.G.), signed in that year by Francesco Tacconi (*fl* 1458–1500).

Probably it was not until the 1490s that the enormous demand for works by Bellini led to the creation of one of the largest and best-organized workshops of 15th-century Italy. A short list of Belliniani, painters whose style remained closely dependent on that of the master, would include the following: Bartolomeo Veneto, Marco Bello (*fl* 1511), Francesco Bissolo, Cristoforo Caselli, Vincenzo Catena, Pietro Duia (*fl* 1520–29), Lattanzio da Rimini, Rocco Marconi, Marco Marziale, Filippo Mazzola, Girolamo Mocetto, Pier Maria Pennacchi, Pietro degli Ingannati, Andrea Previtali, Niccolò Rondinelli, Vincenzo dalle Destre, Vittore Belliniano and the various members of the Santacroce family. The diverse geographical origin of many of these painters—including Romagna (Lattanzio, Rondinelli), Parma (Caselli, Mazzola) and the province of Bergamo (Previtali, the Santacroce), as well as Venice and the immediate *terraferma*—attest to the international fame of the workshop. In addition to these lesser figures, a number of more important artists with their quite distinct style, such as Cima, Titian, Sebastiano del Piombo and Lorenzo Lotto, may also have begun their careers as pupils of Bellini.

Bellini's workshop, which was expanded in his later years to help him both to meet his commitments as a large-scale decorator in the Doge's Palace and to satisfy an apparently insatiable demand for panels for domestic devotion, was organized with an almost industrial efficiency. This fact has led to much controversy about how far the numerous surviving pictures painted in Bellini's late style are the work of the master and how far they are by his pupils. Our understanding of them has been greatly assisted by recent investigations of the way that Bellini's workshop was actually organized and of the ways in which responsibilities were delegated. So far, such investigations have been based chiefly on formal analysis of the works under normal viewing conditions (Gibbons, 1962, 1965), and it has not yet been possible systematically to verify the results thus obtained by scientific examination of the lower paint layers (but see Van Os and others, 1978).

The destruction of the Doge's Palace canvases makes it impossible to say how work on them was distributed between the master and his various assistants, but to judge from a surviving workshop altarpiece such as the *Assumption of the Virgin* (*c.* 1505; Murano, S Pietro Martire), it was Bellini's practice to use a single principal collaborator —in this case apparently Rocco Marconi—on each large-scale work. In other words, Bellini did not use a whole team of assistants on each work, and in contrast to the procedure later customary in Raphael's workshop, he did not employ specialists for particular sections, such as portraits or landscape. In smaller devotional works of a popular type, it has been suggested that Bellini would collaborate with a single assistant to produce a matrix version; and then the same assistant would go on to produce a number of copies and variants of the same composition (Gibbons, 1965). These were occasionally signed by the assistant, but more usually they are inscribed with Bellini's own name, as a kind of mark of authentication that it derived from his shop.

IV. Posthumous reputation.

When Bellini died, Marin Sanudo noted that he was considered to be 'the best of painters, whose fame is known throughout the world'; and nine years earlier, on the death of Gentile Bellini, the diarist had noted that Giovanni was 'the most excellent painter in Italy'. This was not just patriotic hyperbole: in 1506 Dürer wrote that despite his age, Giovanni was still the best of painters; and as early as the 1470s, the humanist Felice Feliciano of Verona had eulogized him as 'the most famous painter in the world'. Although within Gentile's lifetime, literary observers normally linked Giovanni's name with that of his brother, the more discriminating of them were beginning to compare Gentile unfavourably with Giovanni by the 1480s; and the superiority of the latter's talents must have been universally recognized by the 1490s.

Vasari in his *Vite* of the three Bellini acknowledged Giovanni as one of the great artists of his generation, praising the advances that he made in the art of painting and quoting from Ariosto's *Orlando furioso* (xxxiii), where he is mentioned together with Mantegna and Leonardo. For Vasari, however, Giovanni's artistic virtues were only relative, and in accordance with the evolutionary scheme of the *Vite*, he described Giovanni's style at the beginning of his *Vita* of Titian as 'arid, crude and laboured'. Similarly, Lodovico Dolce on the opening page of his *Aretino* (1557) selected Bellini as the ablest painter of his age, regarding him as 'a good and careful master . . . insofar as his period allowed'; but then declared him to have been completely outdistanced first by Giorgione, and then by Titian. With the significant exception of Marco Boschini (1664), in whom Bellini found an ardent champion, critics in the later 16th, 17th and 18th centuries remained guided by Dolce's assessment. Giovanni Bellini was the first great

painter of the Venetian school, his standing far higher than that of his Venetian contemporaries, many of whom were his pupils; but his art could not compare with the power and universality of that of the greatest of all Venetian painters, Titian.

Bellini's 'pre-Raphaelite' qualities of religious sincerity and loving attention to small-scale detail made a direct appeal to 19th-century critics such as John Ruskin (1819–1900), who once declared the Frari Triptych and the S Zaccaria Altarpiece to be the two best pictures in the world (*The Relations between Michelangelo and Tintoretto*, 1870–71). This revival of interest led to a closer investigation of Bellini's biography by Venetian archivists such as Paoletti and Molmenti and to the publication around 1900 of most of the known documents concerning the artist. This, in turn, provided a basis for the radical reassessment of his art, undertaken in particular by Longhi and Gronau. Longhi was concerned with reconstructing Bellini's poorly documented early career, reattributing to him misunderstood works such as the *St Vincent Ferrer* polyptych and insisting on the historical significance of major altarpieces such as the Pesaro *Coronation* for all Italian painting. Gronau was more concerned with the later career and with recognizing the qualities of many late works that had long been dismissed as the works of pupils. A new focus for these attributional and chronological questions was provided by the important monographic exhibition held in Venice in 1949. Since then, new questions have also begun to concern Bellini scholars, in particular those of iconography (Meiss, 1964), patronage and technique.

BIBLIOGRAPHY

EARLY SOURCES AND DOCUMENTS

M. A. Michiel: *Notizia d'opere di disegno* (MS., *c.* 1520–40), ed. G. Frizzoni (Bologna, 1884)

G. Vasari: *Vite* (1550, rev. 2/1568); ed. G. Milanesi (1878–85), iii, pp. 149–77

L. Dolce: *L'Aretino ovvero dialogo della pittura* (Venice, 1557; Eng. trans. and ed. M. Roskill as *Dolce's 'Aretino' and Venetian Art Theory of the Cinquecento*, New York, 1968)

F. Sansovino: *Venetia città nobilissima* (Venice, 1581; rev. G. Stringa, 1604; rev. G. Martinioni, 1663)

C. Ridolfi: *Meraviglie* (Venice, 1648); ed. D. von Hadeln (Berlin, 1914–24)

M. Boschini: *Le miniere della pittura* (Venice, 1664)

A. M. Zanetti: *Della pittura veneziana* (Venice, 1771)

G. B. Lorenzi: *Documenti per servire alla storia del Palazzo Ducale di Venezia* (Venice, 1868)

P. Molmenti: 'I pittori Bellini', *Archv. Ven.*, xxxvi (1888), pp. 219–34

P. Paoletti: *Documenti per servire alla storia della pittura veneziana nei secoli XV e XVI* (Padua, 1894–5)

W. Bode, G. Gronau and D. von Hadeln: *Archivalische Beiträge zur Geschichte der venezianischen Malerei aus dem Nachlass Gustav Ludwigs*, Italienische Forschungen, iv (Berlin, 1911)

D. Chambers: *Patrons and Artists in the Italian Renaissance* (London, 1970) [selection of documents in English translation]

C. Gilbert: *Italian Art, 1400–1500*, Sources & Doc. Hist. A. (Englewood Cliffs, 1980)

C. Brown: *Isabella d'Este and Lorenzo da Pavia: Documents for the History of Art and Culture in Renaissance Mantua* (Geneva, 1982)

GENERAL WORKS

DBI; *EWA*; Thieme–Becker

R. Longhi: 'Piero dei Franceschi e lo sviluppo della pittura veneziana', *Arte*, xvii (1914), pp. 198–222, 241–56

B. Berenson: *Venetian Painting in America* (London, 1916)

R. Longhi: *Viatico per cinque secoli di pittura veneziana* (Florence, 1946)

M. Davies: *The Earlier Italian Schools*, London, N.G. cat. (London, 1951, 2/1961)

J. Walker: *Bellini and Titian at Ferrara* (London, 1956)

S. Ringbom: 'Icon to Narrative: The Rise of the Dramatic Close-up in Fifteenth-century Devotional Painting', *Acta Acad. Abo.: Human.*, xxi (1965)

A. R. Turner: *The Vision of Landscape in Renaissance Italy* (Princeton, 1966)

J. Wilde: *Venetian Art from Bellini to Titian* (Oxford, 1974)

D. Goodgal: 'The Camerino of Alfonso I d'Este', *A. Hist.*, i (1978), pp. 162–90

R. Longhi: *Ricerche sulla pittura veneziana, 1946–1969* (Florence, 1978)

C. H. Smyth: 'Venice and the Emergence of the High Renaissance in Florence', *Florence and Venice: Comparisons and Relations* (Florence, 1979)

T. Pignatti, ed.: *Le scuole di Venezia* (Milan, 1981)

D. Rosand: *Painting in Cinquecento Venice* (New Haven, 1982)

L. Castelfranchi Vegas: *Italia e Fiandra nella pittura del quattrocento* (Milan, 1983)

M. Lucco: 'Venezia fra quattro e cinquecento', *Stor. A.*, v (1983), pp. 447–53

W. Wolters: *Der Bilderschmuck des Dogenpalastes* (Wiesbaden, 1983)

C. Eisler: '*Saints Anthony Abbot and Bernardino of Siena* Designed by Jacopo and Painted by Gentile Bellini', *A. Ven.*, xxxix (1985), pp. 32–40

P. Humfrey: 'The *Life of St Jerome* Cycle from the Scuola di San Gerolamo in Cannaregio', *A. Ven.*, xxxix (1985), pp. 41–6

R. Goffen: *Piety and Patronage in Renaissance Venice: Bellini, Titian and the Franciscans* (London and New Haven, 1986)

P. Humfrey: 'The Venetian Altarpiece of the Early Renaissance in the Light of Contemporary Business Practice', *Saggi & Mem. Stor. A.*, xv (1986), pp. 65–82

N. Huse and W. Wolters: *Venedig: Die Kunst der Renaissance* (Munich, 1986; Eng. trans., Chicago, 1990)

G. Muzzalini: 'Raphael and Venice: Giovanni Bellini, Dürer and Bosch', *Stud. Hist. A.*, xvii (1986), pp. 149–53

P. Brown: *Venetian Narrative Painting in the Age of Carpaccio* (New Haven, 1988)

P. Humfrey: 'Competitive Devotions: The Venetian *scuole piccole* as Donors of Altarpieces in the Years around 1500', *A. Bull.*, lxx (1988), pp. 401–23

M. Lucco: 'Venezia', *La pittura nel Veneto: Il quattrocento* (Milan, 1990), pp. 395–480

B. Roeck: *Arte per l'anima, arte per lo stato: Un doge del tardo quattrocento ed i segni delle immagini*, Quaderni del Centro Tedesco di Studi Veneziani, xl (Venice, 1991)

P. Humfrey: *The Altarpiece in Renaissance Venice* (New Haven and London, 1993)

MONOGRAPHS AND EXHIBITION CATALOGUES

R. Fry: *Giovanni Bellini* (London, 1900/*R* New York, 1995; intro. by D. A. Brown)

G. Gronau: *Die Spätwerke des Giovanni Bellini* (Strasbourg, 1928)

——: *Giovanni Bellini*, KdK (Stuttgart, 1930)

L. Dussler: *Giovanni Bellini* (Vienna, 1949)

Giovanni Bellini (exh. cat. by R. Pallucchini, Venice, Doge's Pal., 1949); review by R. Longhi in *Burl. Mag.*, xci (1949), pp. 274–83

R. Pallucchini: *Giovanni Bellini* (Milan, 1959)

F. Heinemann: *Giovanni Bellini e i Belliniani*, 2 vols (Venice, 1962)

K. Roberts: *Giovanni Bellini*, The Masters (London, 1967)

G. Robertson: *Giovanni Bellini* (Oxford, 1968) [bibliog. to 1964]

R. Ghiotto and T. Pignatti: *L'opera completa di Giovanni Bellini*, Class. A., xx (Milan, 1969)

N. Huse: *Studien zu Giovanni Bellini* (Berlin, 1972)

M. R. Valazzi, ed.: *La pala ricostituita: L'Incoronazione della Vergine e la cimasa vaticana di Giovanni Bellini* (Venice, 1988)

R. Goffen: *Giovanni Bellini* (New Haven and London, 1989)

F. Heinemann: *Giovanni Bellini e i Belliniani*, iii: *Supplemento e ampliamenti* (Hildesheim, 1991)

A. Tempestini: *Giovanni Bellini: Catalogo completo*, I gigli dell'arte (Florence, 1992)

——: *Giovanni Bellini* (New York, 1999)

TECHNIQUE, DRAWINGS AND WORKSHOP PRACTICE

H. Tietze and E. Tietze-Conrat: *The Drawings of the Venetian Painters of the 15th and 16th Centuries*, 2 vols (New York, 1944)

G. Fiocco: 'I disegni di Giambellino', *A. Ven.*, iii (1949), pp. 40–54

F. Gibbons: 'Giovanni Bellini and Rocco Marconi', *A. Bull.*, xliv (1962), pp. 127–31

——: 'Practices in Giovanni Bellini's Workshop', *Pantheon*, xxiii (1965), pp. 146–55

E. Packard: 'A Bellini Painting from the Procuratia de Ultra, Venice: An Exploration of its History and Technique', *J. Walters A. Gal.*, xxxiii–iv (1970–71), pp. 64–84

Tiziano e il disegno veneziano del suo tempo (exh. cat. by W. R. Rearick, Florence, Uffizi, 1976)

A. Braham, M. Wyld and J. Plesters: 'Bellini's *Blood of the Redeemer*', *N.G. Tech. Bull.*, ii (1978), pp. 11–24

Giorgione a Venezia (exh. cat., ed. A. Augusti Ruggeri; Venice, Accad., 1978) [for the Donà delle Rose Pietà]

La pala di Castelfranco Veneto (exh. cat., ed. L. Lazzarini; Castelfranco Veneto, 1978) [for the S Zaccaria altarpiece]

Proposte di restauro: Dipinti del primo '500 (exh. cat., Castelfranco Veneto, 1978) [for the Vicenza *Baptism*]

H. W. Van Os and others, eds: *The Early Venetian Paintings in Holland* (Maarssen, 1978)

F. Ames-Lewis: *Drawing in Early Renaissance Italy* (New Haven and London, 1981)

'La pala Barbarigo di Giovanni Bellini', *Quad. Sopr. Beni A. & Stor. Venezia*, iii (1983) [whole issue]

L. Lazzarini: 'Il colore nei pittori veneziani tra il 1480 e il 1580', *Boll. A.*, 6th ser., v (1983), suppl., pp. 135–44

Giovanni Bellini a Milano (exh. cat., Milan, Brera, 1986)

F. Ames-Lewis: 'Il disegno nella pratica di bottega del quattrocento', *La pittura nel Veneto: Il quattrocento*, ed. M. Lucco (Milan, 1990), pp. 657–85

D. Bull and J. Plesters: 'The *Feast of the Gods*: Conservation, Examination and Interpretation', *Stud. Hist. A.*, xl (1990)

D. Bull: '*Christ Crowned by Thorns* by Giovanni Bellini', *Nmus. Bull.*, xv/2 (1991), pp. 112–24

SPECIALIST STUDIES

G. Fogolari: 'Disegni per gioco e incunabili del Giambellino', *Dedalo*, xii (1932), pp. 360–90

E. Wind: *Bellini's 'Feast of the Gods'* (Cambridge, MA, 1948)

R. Gallo: 'I politici già nella cappella del coro di S M. della Carità', *A. Ven.*, iii (1949), pp. 136–40

A. Campana: 'Notizie sulla Pietà riminese di Giovanni Bellini', *Scritti di storia dell'arte in onore di Mario Salmi*, ii (Rome, 1962), pp. 406–27

F. Gibbons: 'New Evidence for the Birth-date of Gentile and Giovanni Bellini', *A. Bull.*, xlv (1963), pp. 54–8

E. Fahy: 'New Evidence for Dating Giovanni Bellini's *Coronation of the Virgin*', *A. Bull.*, xlvi (1964), pp. 216–18

M. Meiss: *Giovanni Bellini's 'St Francis' in the Frick Collection* (Princeton, 1964)

E. Hubala: '*Madonna mit Kind': Die Pala di S Giobbe* (Stuttgart, 1969)

J. Fletcher: 'Isabella d'Este and Giovanni Bellini's "Presepio"', *Burl. Mag.*, cxiii (1971), pp. 703–12

——: 'The Provenance of Bellini's Frick *St Francis*', *Burl. Mag.*, cxiv (1972), pp. 206–14

A. Smith: 'Dürer and Bellini, Apelles and Protogenes', *Burl. Mag.*, cxiv (1972), pp. 326–9

A. Smart: 'The *Speculum perfectionis* and Bellini's Frick *St Francis*', *Apollo*, xcvii (1973), pp. 470–76

P. Fehl: 'The Worship of Bacchus and Venus in Bellini's and Titian's Bacchanals for Alfonso d'Este', *Stud. Hist. A.*, vi (1974), pp. 37–95

J. Fletcher: 'Full of Grace', *The Sunday Times Magazine* (14 Sept 1975), pp. 17–29

R. Goffen: 'Icon and Vision: Giovanni Bellini's Half-length Madonnas', *A. Bull.*, lvii (1975), pp. 487–513

S. Delaney: 'The Iconography of Giovanni Bellini's *Sacred Allegory*', *A. Bull.*, lix (1977), pp. 331–5

F. Gibbons: 'Giovanni Bellini's Topographical Landscapes', *Studies in Late Medieval and Renaissance Painting in Honor of Millard Meiss* (New York, 1977), pp. 174–84

P. Humfrey: 'A Non-Bellini from the Church of the Carità in Venice', *Burl. Mag.*, cxix (1977), pp. 36–9

G. Knox: 'The Camerino of Federigo Corner', *A. Ven.*, xxxii (1978), pp. 79–84

C. Volpe: 'Per gli inizi di Giovanni Bellini', *A. Ven.*, xxxii (1978), pp. 56–60

Giorgione e la cultura veneta tra '400 e '500: Mito, allegoria, analisi iconologica. Atti del convegno, Rome, 1978

C. Joost-Gaugier: 'A Pair of Miniatures by a Panel Painter: The Earliest Works by Giovanni Bellini?', *Paragone*, xxx/357 (1979), pp. 48–71

M. Robertson: 'A Possible Classical Echo in Bellini', *Burl. Mag.*, cxxi (1979), pp. 650–53

J. Meyer zur Capellen: 'Die Bellini in der Scuola Grande di San Marco', *Z. Kstgesch.*, xliii (1980), pp. 7–11

A. Schulz: 'A Portrait of Giovanni Emo in the National Gallery of Art', *Stud. Hist. A.*, ix (1980), pp. 7–11

A. Conti: 'Giovanni Bellini fra Marco Zoppo e Antonello da Messina', *Antonello da Messina. Atti del Convegno di Studi: Messina, 1981*, pp. 275–303

M. Lattanzi: 'La pala di S Giovanni Crisostomo di Giovanni Bellini: Il soggetto, la committenza, il significato', *Artibus & Hist.*, iv (1981), pp. 29–38

J. Fleming: *From Bellini to Bonaventure: An Essay in Franciscan Exegesis* (Princeton, 1982)

H. Belting: *Giovanni Bellini Pietà* (Frankfurt, 1985)

R. Goffen: 'Bellini and the Altarpiece of S Vincenzo Ferrer', *Renaissance Studies in Honor of C. H. Smyth*, ii (Florence, 1985), pp. 277–85

M. Boskovits: 'Giovanni Bellini: Quelques suggestions sur ses débuts', *Rev. Louvre*, xxxvi (1986), pp. 386–93

R. Goffen: 'Bellini, S Giobbe and Altar Egos', *Artibus & Hist.*, xiv (1986), pp. 57–70

J. Benci and S. Stucky: 'Indagini sulla pala belliniana della Lamentazione', *Artibus & Hist.*, xv (1987), pp. 47–65

J. Rapp: 'Das Tizian-Porträt in Kopenhagen: Ein Bildnis des Giovanni Bellini', *Z. Kstgesch.*, l (1987), pp. 359–74

S. Sponza: 'Osservazioni sulle pale di San Giobbe e di San Zaccaria di Giovanni Bellini', *A. Ven.*, xli (1987), pp. 128–30

J. Fletcher: 'Harpies, Venus and Giovanni Bellini's Classical Mirror: Some Fifteenth-century Painters' Response to the Antique', *Riv. Archeol.*, suppl. 7 (1989), pp. 170–76

C. Wilson: 'Early Citations of Giovanni Bellini's Pesaro Altarpiece', *Burl. Mag.*, cxxxi (1989), pp. 847–9

J. Fletcher and D. Skipsey: 'Death in Venice: Giovanni Bellini and the Assassination of St Peter Martyr', *Apollo*, cxxxiii (1991), pp. 4–9

J. Fletcher: 'The Painter and the Poet: Giovanni Bellini's Portrait of Raffaelle Zovenzoni Rediscovered', *Apollo*, cxxxiv (1991), pp. 777–80

D. Arasse and others: 'Giovanni Bellini 1505/1515', *Venezia Cinquecento*, i/2 (1991) [whole issue]

A. F. Janson: 'The Meaning of the Landscape in Bellini's *St Francis in Ecstasy*', *Artibus & Hist.*, xv/30 (1994), pp. 41–54

M. Lucco and A. Pontani: 'Greek inscriptions on two Venetian Renaissance paintings', *J. Warb. & Court. Inst.*, lx (1997), pp. 111–29

PETER HUMFREY

(4) Leonardo Bellini (*fl* Venice, *c.* 1443–90). Illuminator and painter, nephew of (1) Jacopo Bellini. A contract of employment dated 23 August 1443, for two years apprenticeship with his maternal uncle Jacopo Bellini, has survived, and it is known that Leonardo lived with him from 1431 and, after the death of his natural father Paolo Remario, adopted Bellini's family name. He is also recorded as having been a witness at legal proceedings in Venice in 1469 and 1479 (Ludwig).

Leonardo's known paintings, all mixed media on panel, are the *Mocking of Christ* (*c.* 1445–50; Venice, Col. Cini, 6311), *St Ursula and Four Holy Women* (*c.* 1470; Venice, Accad., 188) and *Three Scenes from the Life of Drusiana* (*c.* 1480; Berchtesgaden, Schlossmus.). The principal work attributed to him consists of approximately 200 miniatures in a Hebrew manuscript known as the *Rothschild Miscellanea*, which contains 70 religious and secular texts on 473 sheets (*c.* 1470; Jerusalem, Israel Mus., MS. 180/51). His only authenticated works are the miniatures of the promission of a Doge, for which there is a record of payment dated December 1463. These can be identified as the *Oath of Office of Cristoforo Moro* (London, BL, Add. MS. 15816) (Moretti). Twenty-four further works have been attributed to Leonardo. Eight of these are dated in the text and were illuminated soon afterwards; hence Leonardo's career can be traced from the *Mocking of Christ* to *c.* 1457 when he worked on a Bible in two parts (Venice, Bib. N. Marciana, MS. Lat. I.16), to a second Bible, dated 1461 (Padua, Bib. Semin., MS. XXI), to the *Promission of Niccolò Marcello*

(1473; Venice, Correr, MS. III, 322), to 1476 with the *Mariegola of the Scuola dei Mascoli* (Venice, Mus. Dioc. S Apollonia, No. 32) and up to 1490 with the unfinished *Taccuinum sanitatis* (Vienna, Österreich. Nbib.).

The influence of Jacopo Bellini and Franco dei Russi is evident in Leonardo Bellini's works, in which he incorporated Renaissance elements and contemporary architectural forms together with a feeling for three-dimensional space. He also used a Ferrarese style of ornamentation with border medallions containing animals and half-figures. His work forms part of the revitalization of Venetian illumination after the stereotyped images of the first half of the 15th century.

BIBLIOGRAPHY

Thieme–Becker
G. Ludwig: 'Archivalische Beiträge zur Geschichte der venezianischen Kunst', *Aus dem Nachlass G. Ludwigs*, ed. W. Bode, G. Gronau and D. von Hadeln (Berlin, 1911), p. 168
L. Moretti: 'Di Leonardo Bellini, pittore e miniatore', *Paragone*, ix/99 (1958), p. 63, n. 1
G. Mariani Canova: 'Per Leonardo Bellini', *A. Ven.*, xxii (1968), pp. 9–20
U. Bauer-Eberhardt: 'Die Rothschild-Miscellanea in Jerusalem, Hauptwerk des Leonardo Bellini', *Pantheon*, xlii (1984), pp. 229–37
——: 'Lauro Padovano und Leonardo Bellini als Maler, Miniatoren und Zeichner', *Pantheon*, xlvii (1989), pp. 49–82
——: 'Miniature italiane in codici ebraici', *Atti del III convegno di storia della miniatura: Firenze, 1992*, pp. 425–37
The Painted Page: Italian Renaissance Book Illumination, 1450–1550 (exh. cat., ed. J. J. G. Alexander; London, RA, 1994)
U. Bauer-Eberhardt: 'Zur ferraresischen Buchmalerei unter Borso d'Este: Taddeo Crivelli, Giorgio d'Alemagna, Leonardo Bellini und Franco dei Russi', *Pantheon*, lv (1997), pp. 32–45

ULRIKE BAUER-EBERHARDT

Belliniano, Vittore [Vittore di Matteo] (*fl* 1507; *d* Venice, after 16 Aug 1529). Italian painter. His real name was Vittore di Matteo, but he seems to have assumed the name Belliniano after 1516 in honour of his dead master, Giovanni Bellini, and as a means of identifying himself as his artistic heir. On Bellini's recommendation, Vittore was commissioned in 1507 (together with Carpaccio) to complete the canvases in the Doge's Palace, Venice, left unfinished by Alvise Vivarini (destr. 1577) and in 1508 to serve on the committee to evaluate Giorgione's frescoes on the façade of the Fondaco dei Tedeschi. Vittore also completed the large canvas of the *Martyrdom of St Mark* for the Scuola di S Marco, Venice (Venice, Accad., on dep. Ospedale Civile), commissioned from Bellini in 1515 shortly before his death and signed by Vittore in 1526. Comparison of this with Vittore's other signed works, respectively dated 1518, 1521 and 1524, suggests that while Bellini probably designed the work, the execution must be mainly that of Vittore. Although his style closely followed that of his master, Vittore was also responsive to the romantic tonalism of Giorgione and to the more grandiose figure style of Titian; the somewhat inflated forms of a *Coronation of the Virgin* (1524) in the parish church, Spinea (Mestre), also suggest the influence of the early works of Pordenone. Vittore's other signed pictures, such as the *Portrait of a Man* (Bergamo, Gal. Accad. Carrara), together with the numerous portrait heads in the *Martyrdom of St Mark*, suggest that Vittore was particularly active as a portrait painter.

BIBLIOGRAPHY

Thieme–Becker
G. Ludwig: 'Archivalische Beiträge zur Geschichte der venezianischen Malerei', *Jb. Kön.-Preuss. Kstsamml.*, xxvi (1905), pp. 72–9 [docs]
B. Berenson: *Venetian School*, i (1957), p. 38
G. Fossaluzza: 'Vittore Belliniano, Fra Marco Pensaben e Giovan Girolamo Savoldo: La *Sacra conversazione* in S Niccolò a Treviso', *Stud. Trev.*, 4 (1985), pp. 39–88
P. Humfrey: 'The Bellinesque *Life of St Mark* Cycle for the Scuola Grande di San Marco in Venice in its Original Arrangement', *Z. Kstgesch.*, xlviii (1985), pp. 225–42
P. Fortini Brown: *Venetian Narrative Painting in the Age of Carpaccio* (London and New Haven, 1988)
G. Marin: 'Vittore Belliniano e Lorenzo Lotto', *Stud. Stor. A.* [Todi], v–vi (1994–5), pp. 185–91

PETER HUMFREY

Belluzzi [Bellucci], **Giovanni** [Giovan] **Battista** (*b* San Marino, 27 Sept 1506; *d* Pieve S Paolo, nr Pisa, 25 March 1554). Italian architect. He was the son of Bartolo di Simone Belluzzi, an important political figure in the Republic of San Marino. He spent his youth in commerce and at the age of 18 was sent by his father to Bologna, where he remained for two years. In 1535 he settled in Rome, entering the service of Ascanio Colonna, whom he followed to Naples to meet Charles V (*reg* 1519–56), Holy Roman Emperor. At the end of that year he returned to San Marino to marry a daughter of Girolamo Genga. From that time, without abandoning his business interests, he worked with his father-in-law, who was then employed by Francesco Maria I della Rovere, 4th Duke of Urbino, to enlarge the Villa Imperiale at San Bartolo, near Pesaro (for illustration *see* GENGA, (1)), and on other architectural projects for the state. In September 1538 Belluzzi worked with his father-in-law on the fortifications of Pesaro and at the same time began to study Vitruvius. In 1539 he went to Bologna with Bartolommeo Genga, Girolamo's son, to execute Girolamo's design for the façade of the church of S Petronio, which had never been built. In 1539–40 he designed and built houses and in the same period served as ambassador of the Republic of San Marino. In October 1543 he went to Florence, where he was engaged by Duke Cosimo I de' Medici to direct the building of the fortifications of San Casciano in Val di Pesa, near San Gimignano. In 1544 he worked on the defences of Pistoia, in collaboration with Nanni Unghero, designing the bastions of Porta al Borgo, Porta Fiorentina and the Fortezza di S Barbara. He built an imposing bastion in Pisa, as well as others at Castrocaro and Montepulciano and in Sansepolcro, where its pentagonal form resembled those of Pistoia.

In Florence Belluzzi supervised the modernization of the ramparts between Porta S Niccolò and Porta di S Miniato, where he built bastions to protect the monastic church of S Miniato al Monte. In the spring of 1548 he went to Elba, which had been ceded by Charles V to Duke Cosimo, who commissioned Belluzzi to plan a fortified city at Portoferraio to defend it against Barbary corsairs. The streets, which radiate from the rectangular Piazza d'Arme, are stepped because of the rising ground. In 1549 Belluzzi worked on the restoration of the walls of Barga, and again on the defences of Pistoia. In the same year he proposed to the Republic of San Marino the construction of a more modern defensive system planned by himself, but because he had served the Medici family his idea was not accepted. In the following years, after becoming chief Florentine military engineer, he worked in many places in the Duchy of Tuscany, including Camaiore, Mirandola,

Piombino and Empoli. In 1553, during the war between Florence and Siena, he secretly entered Siena while the city was under siege and designed its fortifications so as to facilitate its conquest. He continued to work on defences and entrenchments and the next year he was appointed Captain of Infantry. In this role, during the siege of the small fortress of Aiuola, Tuscany, he was fatally wounded.

Belluzzi was convinced that to create good defensive fortifications an architect had to understand military matters. He was the first to write a treatise on temporary defensive earthworks, in which he showed a remarkable competence, taking care to expound only what he knew directly through personal experience.

WRITINGS

P. Egidi, ed.: *Diario autobiografico (1535–1541)* (Naples, 1907)
Il trattato delle fortificazioni di terra (1545; Florence, Bib. Riccardiana, MS. 2587); ed. D. Lamberini in *Il disegno interrotto: Trattati medicei d'architettura* (Florence, 1980), pp. 375–513

BIBLIOGRAPHY

DBI
G. Vasari: *Vite* (1550, rev. 2/1568); ed. G. Milanesi (1878–85) vi, pp. 330–34
G. B. Belici: *Nuova inventione di fabricar fortezze* (Venice, 1598)
M. D'Ayala: 'Giovan Battista Bellucci', *Archv Stor. It.*, n. s. 2, xviii (1873), pp. 295–303
F. Balsimelli: *Giovanni Battista Belluzzi, detto 'Il Sanmarino'* (San Marino, 1928)
D. Lamberini: 'Giovanni Battista Belluzzi: Ingegnere militare e la fondazione di Portoferraio', *Cosmopolis Portoferraio Medicea secoli XVI–XVII: Mostra documentaria* (exh. cat., Portoferraio, Magazzini del Sale alla Linguella, 1981), pp. I1–I14
D. Lamberini: 'The Military Architecture of Giovanni Battista Belluzzi', *Fort*, xiv (1986), pp. 5–16
——: 'Funzione di disegni e rilievi delle fortificazioni nel cinquecento', *L'architettura militare veneta del cinquecento*, ed. R. Cevese, P. Marini, M. V. Pellizzari (Milan, 1988), pp. 48–61
N. Adams, D. Lamberini and S. Pepper: 'Un disegno di spionaggio cinquecentesco: Giovanni Battista Belluzzi e il rilievo delle difese di Siena ai tempi dell'assedio', *Mitt. Ksthist. Inst. Florenz*, xxii (1988), pp. 558–79

ADRIANO GHISETTI GIAVARINA

Beltraffio, Giovanni Antonio. *See* BOLTRAFFIO, GIOVANNI ANTONIO.

Bembo. Italian family of painters. At least nine artists with the name Bembo were active in Cremona between 1425 and the end of the 16th century. The two best known, (1) Bonifacio Bembo and (2) Benedetto Bembo, were the sons of Giovanni Bembo (*fl* 1425–49), a master who worked both in his home town and in Brescia. Another son, Andrea Bembo, also a painter, became a Brescian citizen in 1431, and a further member of the family, Ambrosio Bembo, is recorded in Cremona in 1450. (3) Giovan Francesco Bembo is thought to be the nephew of Bonifacio.

BIBLIOGRAPHY

M. Caffi: 'Di alcuni maestri di arte nel secolo XV in Milano poco noti o male indicati', *Archv Stor. Lombardo*, v (1878), pp. 82–106
C. Bonetti: 'I Bembo, pittori cremonesi', *Boll. Stor. Crem.*, i (1931), pp. 7–36
A. Puerari: *La Pinacoteca di Cremona* (Cremona, 1951)
G. Lonati: 'Cremonesi a Brescia nel secolo XV', *Boll. Stor. Crem.*, v (1953), pp. 157–72
S. B. Bistoletti: 'Documenti per i Bembo: Una bottega di pittori, una città ducale del quattrocento e gli Sforza', *A. Lombarda* (1987), pp. 155–81

(1) Bonifacio Bembo (*fl* 1447–78; *d* before 1482). In an undated letter Bonifacio recalled his support for Fran-cesco Sforza's cause in Reggio Emilia and Brescia during the conflict between Milan and Venice in 1447. By 1455 he was in the service of the Sforza family, although the exact nature of his work is not recorded. The following year he was called to Pavia to carry out a number of commissions, including touching up and repainting a hunting fresco dating from the time of the Viscontis, the previous rulers of Lombardy, in the castle's great hall. Work was slow and in 1458 the artist was ordered to take on assistants to complete the job more quickly.

Francesco Sforza was eager to emulate his predecessors and their artistic monuments. In the letter referred to above, Bembo mentioned that he had added two figures to a series of *baroni* in the Palazzo Visconti–Sforza in Milan. The frescoes have disappeared, but later writers recorded the signature and date *De Bembis de Cremona 1461*. Francesco and Bianca Maria Sforza also commissioned Bembo to produce original work. He provided an altarpiece, erected in commemoration of their wedding day, 25 October, the feast day of SS Daria and Grisante, for their chapel in S Agostino, Cremona. Bembo was paid in 1462 from tithes gathered in honour of the two saints, but in 1469 he was still owed money for the altarpiece. In 1467 he was paid for the high altarpiece of Cremona Cathedral along with the woodworker Pantaleone de Marchiis. This has recently been identified with the *Virgin and Child with Angels* (Cremona, Mus. Civ. Ala Ponzone). After the succession of Galeazzo Maria Sforza in March 1466, Bembo's work for the court increased. He was recalled to Pavia in 1468 and worked for three years on secular decorations, including scenes of the Duke and Duchess hunting, dining and performing official duties; he also undertook further retouching of the Visconti frescoes. He may have been involved in similar projects to fresco the Castello Sforzesco, Milan, between 1471 and 1474, but in August 1471 Bembo, who had returned to Cremona to answer persistent law suits, was told that he was no longer required in Pavia or anywhere else.

A year later, however, Bembo was again working for Galeazzo Maria alongside Leonardo Ponzoni of Cremona and Zanetto Bugatto on a chapel outside Vigevano, and in 1473 he directed the work in the newly built ducal chapel in the Castello Sforzesco. The frescoes of standing saints and the *Annunciation* along the walls as well as the *Resurrection* in the vault survive, although they have suffered from extensive restoration and repainting. Bembo's precise role here is difficult to assess; while he showed the Duke drawings for the chapel, several other artists, including Stefano de' Fedeli (*fl* 1472–81), who completed a sixth of the frescoes, worked either for or alongside him.

It was common practice in Lombardy to set up temporary teams of artists for such large-scale projects, and Bembo often worked with associates. In 1474 he collaborated with Giacomino Vincemala on a chapel in the church of S Maria da Caravaggio and with Vincenzo Foppa and Zanetto Bugatto on the polyptych designed to hold over 200 relics in Pavia. In 1476 he produced, with Foppa and Bugatto, a large cycle of 21 episodes from the *Life of Christ* for the church of S Giacomo fuori Pavia. After Galeazzo Maria Sforza's assassination in 1477, Bembo's work for the court practically ceased. He was still trying

to obtain payment for the chapels in Caravaggio and Vigevano many months after his patron's death. In 1482 his son Lodovico Bembo, also a painter, was recorded as 'filius quondam magistri Bonifacii'.

Despite considerable documentation, Bembo's oeuvre is difficult to assess. His only secure works are two badly damaged fresco portraits of *Francesco Sforza* and *Bianca Maria Sforza*, originally on pillars facing the altar in the chapel of SS Daria and Grisante in S Agostino, Cremona. Subsequently transferred to canvas and in ruinous condition, the works now hang inside the chapel. While the two kneeling figures have dry, severe profiles with little sense of weight or depth, the relatively well-preserved head of Francesco Sforza reveals the hand of a competent portrait painter. Details such as the mole on the Duke's cheek, the folds of his chin and the thin, pursed lips are carefully moulded with shadowy lines.

The earliest work attributed to the artist, the Cavalcabò Chapel in S Agostino, Cremona, has little in common with these portraits. Giovanna Cavalcabò paid for its decoration in 1447, stipulating that the work was to be completed within five years. Although there is no direct connection between Bonifacio and the chapel, his name has been associated with it since Wittgens's publication (1936). The Cavalcabò artist had a fine decorative style showing the influence of Michelino da Besozzo and the Zavattari brothers. The vault and apse of the chapel contain elaborate frescoes of the Evangelists, the coronation of Christ and the Virgin, and various saints, angels and figures representing theological virtues. Bright colours predominate and the doll-like figures are drawn with thin, curving lines. The hand at work here was prolific and influential. The same highly refined graphic style can be seen in numerous small-scale works such as the illuminated *History of Lancelot* (1449; Florence, Bib. N. Cent., cod. Palatina 556) and a series of ceiling panels of scenes from the Old Testament (Cremona, Mus. Civ. Ala Ponzone). The chapel of Bishop Carlo Pallavicino in Monticelli d'Ongina (Lodi) shows a similar method of working in fresco. Other related works include several sets of tarot cards (Milan, Brera; New Haven, CT, Yale U., Beinecke Lib; Bergamo, Gal. Accad. Carrara; New York, Pierpont Morgan Lib.).

Mulazzani (1981) attempted to reassess the works attributed to Bembo. Correctly noting that the Brera tarot cards were produced for Filippo Maria Sforza in the first half of the century, he suggested that they, and all other works related to the Cavalcabò Chapel, be given to the Master of the Visconti Tarocchi. The problem has been further complicated by the discovery of a small sketch, in this master's hand, on the cover of a Cremonese account book. One of the first payments recorded (9 April 1450) is to 'Magistro Ambroxo de Bembi'. Thus this body of highly stylized work may indeed be associated with this previously unknown member of the Bembo family. Characterizing Bonifacio's work becomes, therefore, increasingly problematic. Mulazzani assigned the triptych (Cremona, Mus. Civ. Ala Ponzone; Denver, CO, A. Mus.) reconstructed by Longhi (1928) to Bonifacio and centred the rest of the oeuvre on this. According to Mulazzani, Bonifacio was also responsible for the Castello Sforzesco Chapel and for the frescoes (1476) of the *Procession of the Magi* and the *Annunciation* in the Collegio Castiglione

Chapel, Pavia. But the Longhi Triptych, with scenes of the *Meeting of Joachim and Anna*, the *Adoration of the Magi* and the *Coronation of Christ and the Virgin*, is one of the most problematic pictures attributed to Bonifacio in both style and iconography. Mulazzani's assessment is based on Bandera's mistaken belief (1977) that the painting is the altarpiece produced for the chapel of SS Daria and Grisante in S Agostino and can, therefore, be dated to the early 1460s. However, the central scene is not the crowning of SS Daria and Grisante, but a peculiar Cremonese rendition of the dual coronation of the Virgin and Christ. This unusual iconography also appears in the Cavalcabò frescoes, as well as in the remains of a small portable triptych, attributed to Bembo (Avignon, Mus. Petit Pal.; see fig.). While the Longhi Triptych differs from the small-scale works, many common elements remain. The painting contains much of the Gothic elegance seen in other 15th-century Cremonese works although tempered with a greater sense of spatial depth and highly individualized portraiture.

The problem of identifying Bonifacio's work arises from the more general difficulties of the nature of Lombard patronage. The artist was probably popular with the Sforzas for his ability to imitate and repaint earlier works commissioned by the Viscontis. He usually worked with associates and a strong individual style was not encouraged. Bembo, Bugatto and Foppa were criticized by Galeazzo Maria Sforza for not fully integrating their separate manners in the frescoes in S Giacomo fuori Pavia. Cremona produced a flourishing school of 15th-century painters, most of whom are known only through written records. Bembo is the best documented of these artists, and the tendency to group these similar works under his name is understandable. But without further investigation, the traditional attributions to Bonifacio should be considered cautiously.

Bonifacio Bembo (attrib.): *Nativity* and *Coronation of Christ and the Virgin*, left- and right-hand panels from a triptych, each panel 690×350 mm, 15th century (Avignon, Musée du Petit Palais)

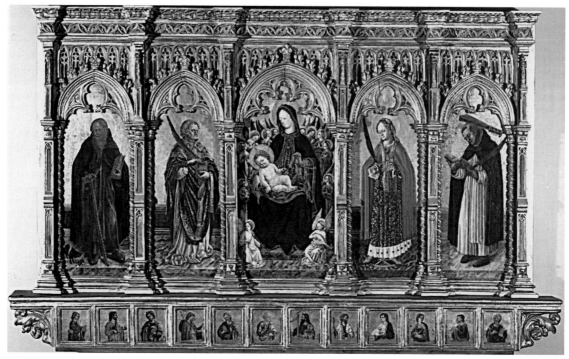

Benedetto Bembo: Torrechiara Polyptych (*Virgin and Child between SS Anthony Abbot, Nicodemus, Catherine of Alexandria and Peter Martyr*), tempera on panel, 1.2×2.3 m, 1462 (Milan, Castello Sforzesco)

BIBLIOGRAPHY

DBI

R. Longhi: 'La restituzione di un trittico d'arte cremonese circa il 1460 (Bonifacio Bembo)', *Pinacotheca*, ii (1928), pp. 79–87

F. Wittgens: 'Note ed aggiunte a Bonifacio Bembo', *Riv. A.*, xviii (1936), pp. 345–66

N. Rasmo: 'Il codice Palatino 556 e le sue illustrazioni', *Riv. A.*, xxi (1939), pp. 245–81

S. Bottari: 'I tarocchi di Castello Ursino e l'origine di Bonifacio Bembo', *Emporium*, lvii (1951), pp. 110–24

M. Salmi: 'Nota su Bonifacio Bembo', *Commentari*, iv (1953), pp. 7–15

F. Wittgens: 'Un dipinto ignoto di Bonifacio Bembo nel Museo di Worcester', *A. Lombarda*, i (1955), pp. 69–71

R. Longhi: 'Un cornice per Bonifacio Bembo', *Paragone*, lxxxvii (1957), pp. 3–13

F. Voltini: 'Tre tavolette di soffitto di Bonifacio Bembo', *Paragone*, lxxxvii (1957), pp. 54–6

L. Puppi: 'A proposito di Bonifacio Bembo e della sua bottega', *A. Lombarda*, iv (1959), pp. 245–51

A. C. Quintivalle: 'Un ciclo di affreschi di Bonifacio Bembo', *Crit. A.*, viii (1961), pp. 45–56

S. Bandera: 'Una aggiunta al maestro della Resurrezione della cappella del Collegio Castiglione di Pavia', *A. Ant. & Mod.*, vi (1963), pp. 321–2

G. Moakley: *The Tarot Cards Painted by Bonifacio Bembo* (New York, 1966)

A. C. Quintavalle: 'Gli affreschi di Bonifacio Bembo a Monticelli d'Ongina', *Boll. Stor. Piacent.*, lxviii (1973), pp. 129–33

S. Bandera: 'Persistente tardo-gotico a Cremona: Fra Nebridio e altri episodi', *Paragone*, cccxxiii (1977), pp. 34–72

G. Mulazzani: *I tarocchi viscontei e Bonifacio Bembo* (Milan, 1981)

M. Boskovits: 'Bottega dei Bembo [Ambrosio Bembo?]', *A. Lombarda*, (1988), pp. 176–7

L. Bellingeri and M. Tanzi: *Bonifacio Bembo della Cattedrale al Museo* (Brescia, 1992)

L'oro e la porpora: Le arti a Lodi nel tempo del vescovo Pallavicino (1456–1497) (exh. cat., ed. M. Marubbi; Lodi, S Cristoforo, 1998)

(2) Benedetto Bembo (*fl* 1462–89). Brother of (1) Bonifacio Bembo. Apart from the records of his presence in Cremona in 1464, 1478 and 1489, nothing is known about Benedetto Bembo's life. His major work is the large polyptych of the *Virgin and Child between SS Anthony Abbot, Nicodemus, Catherine of Alexandria and Peter Martyr* (Milan, Castello Sforzesco; see fig.) executed for the chapel of St Nicodemus in the Castello Rossi of Torrechiara, near Parma. It is inscribed *Benedictus Bembus ediit MCCCCLXII Mensis Mai* and has half-length busts of the Apostles in the predella panel below. The altarpiece is an elaborately carved, old-fashioned gold-backed polyptych. The figures are squat and heavy and Benedetto used layers of glaze to create wrinkled skin textures and drapery folds in a manner typical of Ferrarese painters. The large, heavy-lidded, almost squashed features reappear constantly throughout Benedetto's work. The Torrechiara Polyptych is very different from the earlier Cremonese style as represented by the Cavalcabò Chapel, but a fresco cycle in a small chapel in Monticelli d'Ongina, outside Cremona, which freely copies the figures of the four Evangelists in the Cavalcabò Chapel vault, has been convincingly attributed to Benedetto, along with the frescoes in and around the apse. The figure of the Virgin ascending into heaven on the far wall by the apse is comparable with the Torrechiara Virgin. The scenes from the *Life of St Bassiano* by the entrance are probably by an assistant.

Other works containing Benedetto's distinctive style are the central panel of a triptych representing the *Virgin and Child with a Kneeling Donor, SS George and Thomas Aquinas* (Cremona, Mus. Civ. Ala Ponzone) and a fresco fragment of the *Flight into Egypt* (Cremona, S Michele). The *Preaching of St John the Baptist* (New York, Kress Found.) attributed to Benedetto by Suida is probably by a related

master. As the Rossi family had connections with Cremona, and the Torrechiara Polyptych was painted for them, the frescoes in the Camera d'Oro of the castle in Torrechiara have also been attributed to Benedetto. But the frescoes celebrating the love of the patron Pier Maria Rossi and his mistress Bianca Maria Pellegrini show none of his characteristics (Woods-Marsden).

BIBLIOGRAPHY

DBI
M. Salmi: 'Un nuovo Benedetto Bembo', *Dedalo*, vii (1926–7), pp. 43–50
W. Suida: 'Zum Werk des Benedetto Bembo', *Belvedere*, xi (1932), pp. 33–5
F. Zeri: 'Due santi di Benedetto Bembo', *Paragone*, xvii (1951), pp. 32–5
M. L. Ferrari: 'Considerazioni Bembeschi ai margini di una lettura', *Paragone*, xlvii (1958), pp. 67–70
A. C. Quintavalle: 'Problemi Bembeschi a Monticelli d'Ongina', *Archv Stor. Lodi.*, xii (1964), pp. 10–17
M. L. Ferrari: 'Corollari Bembeschi', *Paragone*, ccliii (1971), pp. 54–69
R. Greci, M. di Giovanni Madruzza and G. Mulazzani: *Corti del rinascimento nella provincia di Parma* (Turin, 1981), pp. 139–52
J. Woods-Marsden: 'Pictorial Legitimation of Territorial Gains in Emilia: The Iconography of the Camera Peregrina Aurea in the Castle of Torrechiara', *Renaissance Studies in Honor of Craig Hugh Smyth*, ii (Florence, 1985), pp. 553–70
M. Boskovits: 'Benedetto Bembo', *Arte in Lombardia tra Gotico e Rinascimento* (Milan, 1988), pp. 18–23
S. Bandera Bistoletti: 'Benedetto Bembo', *Pittura a Cremona del Romanico al Settecento*, ed. M. Gregori (Milan, 1990), p. 237
M. Tanzi: 'Benedetto Bembo', *Museo d'arte antica del Castello Sforzesco* (Milan, 1997), pp. 114–20

E. S. WELCH

(3) Giovan Francesco [Gianfrancesco] **Bembo** [il Vetraio; Vetraro] (*fl* Cremona or Rome, ?*c.* 1480–1543). Nephew of (1) Bonifacio Bembo. He can be identified with the Giovan Francesco Vetraio mentioned by Vasari in the 1568 edition of the *Vite*, but very little is known of either his life or his works. He was presumably born in Cremona and trained in a local bottega. According to Vasari, he went to Rome to paint Pope Leo X's coat of arms on the façade of Cardinal Francesco Soderini's palazzo. This must have been done between 1513, the year of Leo X's election, and 1518, when Bembo is documented at Cremona for the decoration of the central nave of the cathedral. He was paid in December 1519 for the *Adoration of the Magi* and the *Presentation in the Temple* in the fifth bay on the left. In these frescoes, which form part of the vast cycle already begun by Boccaccio Boccaccino and to which Altobello Melone and Pordenone contributed shortly afterwards, Bembo left his first signature: BEMBUS INCIPIENS. Chronologically close to these frescoes was the altarpiece of the *Virgin and Child with SS Francis and Stephen*, of which only two fragments survive: the *Virgin and Child* (Cremona, Gal.) and a tondo with the head of *St Francis* (Gazzada, nr Varese, Cagnola priv. col.). An old photograph of the complete altarpiece, or an early copy of it, has been recovered. In 1967 Gregori published a portrait of a *Girl with a Dog* (ex-Wilton House, Wilts), which can be ascribed with certainty to Bembo and is datable to 1510–20. There is less agreement over the panel of the *Adoration of the Child* (Cremona Cathedral; see Tanzi and Mancinelli). In 1517 Bembo received payment for two paintings (untraced) for Cremona Cathedral. The next documentation is in 1524, when he signed the altarpiece of the *Virgin, Three Saints and a Donor* (Cremona, S Pietro al Po). The style of this work suggests that Bembo had made a second journey to Central Italy in order to keep up with artistic developments. There are several more mentions of him in Cremonese documents but none after 1543.

BIBLIOGRAPHY

G. Vasari: *Vite* (1550, rev. 2/1568); ed. G. Milanesi (1878–85), v, p. 147
A. Lamo: *Discorso intorno alla scoltura e pittura* (Cremona, 1584; rev. 1774), p. 26
M. Gregori: 'Altobello e Gianfrancesco Bembo', *Paragone*, viii/93 (1957), pp. 16–40
——: 'Giovan Francesco Bembo', *I Campi e la cultura artistica cremonese del cinquecento* (Cremona, 1985), pp. 101–8 [with earlier bibliog.]
F. Mancinelli: 'Bembo, Giovan Francesco', *La pittura in Italia: Il cinquecento*, ed. G. Briganti, ii (Milan, 1987, rev. 1988), p. 642
M. Tanzi: 'Riflessioni sulla attività di Altobello Melone dopo il 1520', *An. Bib. Stat. & Lib. Civ. Cremona*, xxxvii (1987), pp. 97–107
F. Frangi: 'Gianfrancesco Bembo', *Pittura a Cremona dal romanico al settecento*, ed. M. Gregori (Milan, 1990), pp. 255–7

MARCO CARMINATI

Bembo, Cardinal **Pietro** (*b* Venice, 20 May 1470; *d* Rome, 18 Jan 1547). Italian ecclesiastic, writer, collector and patron. His literary fame rests chiefly on his contributions to the development of Italian vernacular literature and to his revival of the Petrarchan style in poetry. Among his best-known works is *Gli Asolani* (written *c.* 1497; pubd 1505), which consists of Platonic dialogues on love. Born of a patrician family, he made several attempts to follow his father's distinguished political career before deciding to devote himself to literature. In 1492 he left Venice, going first to Messina, then Padua and Ferrara. For a time he was part of the cultivated circle of the della Rovere court in Urbino, where he was described by Baldassare Castiglione in *Il libro del cortegiano* (1528) as the archetypal humanist. After taking minor orders in 1508, he moved to Rome in 1512 and worked there as a papal secretary, together with Jacopo Sadoleto (1477–1547). On the death of Leo X in 1522, he retired to his villa at Padua and concentrated on his writing. He did not return to Rome until 1539, when he achieved his long-coveted elevation to the cardinalate. He remained there until his death.

The collection that Bembo assembled in his Paduan house reflected his humanist interests. According to Michiel, he owned several precious manuscripts, some small bronzes and numerous portraits of poets and friends. He also owned the Mensa Isiaca (Turin, Mus. Egizio), a large rectangular slab covered with hieroglyphic symbols, produced either in Alexandria at the end of the Hellenistic period or, possibly a little later, in Rome; this formed the basis for Western knowledge of hieroglyphics until Napoleon's invasion of Egypt. The paintings in his collection included Andrea Mantegna's *St Sebastian* (Venice, Ca' d'Oro) and *Circumcision* (Berlin, Bodemus.), as well as works by Hans Memling (*St John the Baptist*), Jacopo Bellini (portraits of *Gentile la Fabiano* and *Bertoldo*) and Giulio Campagnola (two 'quadretti'; all untraced). Apart from collecting portraits, however, Bembo seems to have had no special interest in the visual arts; indeed, in connection with his own output, Cellini commented on the cardinal's lack of understanding. Nonetheless, he numbered several artists among his friends, including Titian, Michelangelo and Raphael, and was also a friend and admirer of the architect Girolamo Genga, with whom he collaborated on devising inscriptions for the Villa

Imperiale at Pesaro. Bembo apparently met Raphael in Urbino *c.* 1506, when he had a miniature portrait painted (untraced). He was associated with another of Raphael's early commissions in 1507, when he acted as intermediary between Elisabetta Gonzaga, Duchess of Urbino, and a Camaldolese hermit, to whom she gave a small *Agony in the Garden* by Raphael (untraced). His friendship with the painter was renewed in Rome. In a letter of April 1516 he described an archaeological outing to Tivoli planned by himself and Raphael, with Castiglione and the humanists Andrea Navagero and Agostino Beazzano. Around this date Raphael painted a portrait of the latter two (Rome, Gal. Doria–Pamphili), which belonged to Bembo until 1538. In 1516 Bembo also declared his intention of having a second portrait by Raphael executed, but no record survives of an actual commission. The earliest surviving likeness of the writer is a medal of *c.* 1532 by Valerio Belli (e.g. Washington, DC, N.G.A.), to whom Bembo sold some hunting dogs. Another medal was made by Cellini (1537; Florence, Bargello). Immediately after he was made a cardinal, Bembo commissioned two portraits from Titian, one of which survives (Washington, DC, N.G.A.). A third portrait (?1545–6; Naples, Capodimonte) was possibly painted by Titian's son, Orazio Vecellio, although its ruined condition makes attribution difficult. Bembo was buried in Rome in S Maria sopra Minerva; a monument by Michele Sanmicheli with a bust (1547) by Danese Cattaneo was erected in the Santo in Padua.

BIBLIOGRAPHY

DBI

M. Michiel: MS. notes (1525–43; Venice, Bib. N. Marciana); ed. T. Frimmel as *Der Anonimo Morelliano (Marcantonio Michiel: Notizie d'opere del disegno)* (Vienna, 1888), pp. 20–22

B. Cellini: *Vita* (MS., *c.* 1558–67; ed. B. Maier (Florence, 1961), i, ch. xciv

A. Ferrajoli: 'Il ruolo della corte di Leone X', *Archv Soc. Romana Stor. Patria*, xxvii (1914), pp. 307–60, 453–84

G. Coggiola: 'Per l'iconografia di Pietro Bembo', *Atti Reale Ist. Ven. Sci., Lett. & A.*, lxxiv (1914–15), pp. 473–514

Raffaello in Vaticano (exh. cat., ed. F. Mancinelli; Rome, Vatican, Braccio di Carlo Magno, 1984), pp. 60–62

C. Raffini: *Marsilio Ficino, Pietro Bembo, Baldassare Castiglione: Philosophical Aesthetic and Political Approaches in Renaissance Platonism* (New York, 1998)

CLARE ROBERTSON

Benaglio [Benalius], Francesco [Francesco di Pietro della Biada] (*b c.* 1430; *d* Verona, ?1492). Italian painter. He adopted his professional name from a noble Bergamask family then living in Verona. His earliest documented work is the signed triptych of the *Virgin and Child Enthroned Adored by St Bernard with SS Peter, Paul, Francis, Jerome, Louis of Toulouse and Anthony of Padua* (1462; Verona, Castelvecchio), executed for S Bernardino, Verona. It is a relatively free copy after Mantegna's S Zeno Altarpiece (Verona, S Zeno), although much more decorative in the details and less secure in the spatial arrangement of the saints. Benaglio's name regularly appears in the Veronese tax records from 1465 to 1482. In 1475, he and a painter named Martino were condemned to four months in prison for painting obscene figures on the façade of the Palazzo Sagramoso. In 1476, he finished a fresco of *SS Bartholomew, Zeno, Jerome and Francis* (destr. 1738) in S Maria della Scala. In 1492, Benaglio's son Girolamo is listed as an orphan, indicating that his father must have died that year.

Other signed works by Benaglio include the *St Anthony* (Washington, DC, N.G.A.), the *Virgin and Child* (ex-Chalandon priv. col., Paris), the *Virgin and Child* (Washington, DC, N.G.A.) and the *Madonna del Ventaglio* (Verona, Castelvecchio). The signature on the *Virgin with Four Saints* (Rome, Pal. Venezia) appears to be false.

BIBLIOGRAPHY

DBI; Thieme–Becker

L. Simeoni: 'Una vendetta signorile nel '400 e il pittore Francesco Benaglio', *Nuo. Archv Veneto*, n.s. 2, v (1903), pp. 252–8

A. Venturi: *Storia* (1901–40), VII/iii (1914), pp. 441–6

E. Valvalà: 'Francesco Benaglio', *A. America*, xxi (1933), pp. 48–65

R. Longhi: 'Calepino veneziano: Una *Madonna* della cerchia di Piero della Francesca per il Veneto', *A. Veneta*, i (1947), pp. 86–9

R. Brenzoni: 'Sulla datazione dell'ancona di Francesco Benaglio nella Chiesa di San Bernardino di Verona', *Boll. A.*, xliii (1958), pp. 68–9

C. del Bravo: 'Sul seguito veronese di Andrea Mantegna', *Paragone*, xiii/147 (1962), pp. 53–60

KRISTEN LIPPINCOTT

Benavides, Marco Mantova (*b* Padua, 1489; *d* Padua, 2 April 1582). Italian jurist, collector and patron. He was the son of Giampietro Benavides, a famous physician, and studied law at the University in Padua, where he later taught for much of his life. Benavides was among a group of patrons who promoted a self–consciously Romanizing style in Padua during the 1540s. As governor of the city's Arca del Santo, he was able to assist such promising artists as Domenico Campagnola and Bartolomeo Ammanati, whom he introduced to an important circle of Roman patrons. Campagnola collaborated on the frescoes in the Sala dei Giganti in the Palazzo del Capitanio (*in situ*), a major decorative programme whose Roman syntax was novel in the Veneto, while Ammanati's tomb monument for Benavides (1546; Padua, Eremitani) introduced forms used by Michelangelo in the Medici tombs (Florence, S Lorenzo, New Sacristy; *see* MICHELANGELO, fig. 4 and colour pl. 2, V1). Benavides also commissioned a series of *all'antica* portrait medals from Giovanni da Cavino in 1540, and his own portrait was executed by his friend the medallist Jacob Zagar.

Benavides's passion for the visual arts, and for hermetic iconography, was expressed in a large and diverse collection kept from *c.* 1541 in his palazzo, adjacent to the Eremitani Church in Padua. The collection was rich in ancient and modern numismata and in fragments of stucco relics of Greek and Roman sculpture. It also included a variety of prints, drawings, paintings and sculpture, mostly by contemporary Paduan or Venetian artists. The nearly 100 portraits of jurists collected by Benavides were engraved and issued in two sets, the *Illustrium iureconsultorum imagines* (Rome, 1566) and the *Illustrium virorum iureconsultorum effigies, liber II* (Venice, 1570). Like Pietro Bembo and Paolo Giovio, Benavides regarded his palazzo and its contents as a museum, a gathering place for learned friends, but it was also a civic monument to its founder, a fact reflected in its splendid decoration. Campagnola and Gualtiero frescoed the interior with hieroglyphic imagery, scenes from Roman history and personifications. Ammanati also executed two works for the courtyard: a triumphal arch, executed in a vigorous Doric order with statues of *Jupiter* and *Apollo* (1547; *in situ*) and a colossal statue of *Hercules* (h. 6.4 m; *in situ*), intended to rival antique sculpture. The palazzo became one of the most celebrated

sites in the city, but the collection was largely dispersed, mostly after 1711, when the bronzes, coins and medals went to the Libreria Marciana and then to the Ca' d'Oro in Venice. The antiquities form the core of the archaeological museum of the Università degli Studi in Padua.

BIBLIOGRAPHY

L. Polacco: 'Il museo di Marco Mantova Benavides e la sua formazione', *Arte in Europa: Scritti di storia dell'arte in onore di Edoardo Arslan* (Milan, 1966)
I. Favaretto: 'Andrea Mantova Benavides: Inventario della antichità di casa Mantova Benavides, 1695', *Boll. Mus. Civ. Padova*, lxi (1972), pp. 35–164
C. Davis: *Medals of Marco Benavides by Jacob Zagar and Giovanni da Cavino*, Stud. Hist. A., 6 (1974), pp. 96–103
L. Puppi: 'L'innovamento tipologico del cinquecento', *Padova: Case e palazzi*, ed. L. Puppi and F. Zuliani (Vicenza, 1977), pp. 125–8
I. Favaretto: 'Marco Mantova Benavides tra libri, statue e monete: Un studio cinquecentesco', *Atti Ist. Ven. Sci., Lett. & A.*, 138 (1979–80), pp. 81–94
Marco Mantova Benavides: Il suo museo e la cultura padovana del cinquecento: Atti delle giornate di studio: 12 novembre nel IV centenario della morte (Padua, 1982)
E. Dwyer: 'Marco Mantova Benavides e i ritratti di giureconsulti illustri', *Boll. A.*, lxiv (1990), pp. 59–70
I. Favaretto: 'Ritratti all'antica nel Veneto in età rinascimentale: Il caso del "Nerone" Mantova Benavides', *Studi di archeologia della X regio in ricordo di Michele Tombolani*, ed. B. M. Scarfi (Rome, 1994), pp. 567–77
L. Beschi: 'L'impegno antiquario di Bartolomeo Ammannati', *Bartolomeo Ammannati, scultore e architetto (1511–1592)*, ed. N. Rosselli del Turco and F. Salvi (Florence, 1995), pp. 41–8
C. Lattanzi: 'L'attività giovanile di Bartolomeo Ammannati in Veneto', *Bartolomeo Ammannati, scultore e architetto (1511–1592)*, ed. N. Rosselli del Turco and F. Salvi (Florence, 1995), pp. 87–94
F. Ackermann: 'Die Perlmutternachbildung einer Medaille auf Marco Mantova Benavides in Basel', *Medal*, xxviii (Spring 1996), pp. 4–16

LINDA S. KLINGER

Bencivenni, Antonio (da Mercatello) (*b* ?Perugia; *fl* 1498; *d* Todi, March or April 1528). Italian wood-carver. He is first mentioned in 1498 in Perugia, where he had been for some time and where he may have been born. Between 1498 and 1500, Bencivenni was associated with Crispolto di Polto da Bettona (*fl* 1468–1512) on a few projects related to the construction of the choir-stalls in S Domenico, Perugia. He is last mentioned in Perugia in 1518, when he moved to Todi. During the next ten years in Todi, Bencivenni, with his son Sebastiano (*b c.* 1505), worked on several projects including doors for S Francesco, Montone, and the doors and choir-stalls of Todi Cathedral (including four reliefs of the *Virgin Annunciate, Gabriel, St Peter* and *St Paul*). Bencivenni was one of the finest wood-carvers of his generation. His sculptural style is decorative and richly refined, and his carving is precise and accurate in execution, recalling the linear style in flattened relief of Agostino di Duccio, but fuller and more robust. The sense of balance and equilibrium present in Bencivenni's carving appears to have been influenced by contemporary Umbrian painting, especially Pietro Perugino's lyrical classicism. It has been proposed that Perugino and Bencivenni collaborated on the Collegio del Cambio in Perugia. The wooden doors of the Cambio signed by Bencivenni may have been based on a programme supplied by Perugino, who was responsible for the building's interior decorative painting.

BIBLIOGRAPHY

DBI
C. Grondona: *Todi: Guida storica ed artistica* (Marsciano, 1962)

STEVEN BULE

Benedetto Bordon [Bordone]. *See* BORDON, BENEDETTO.

Benedetto da Rovezzano (*b* Canapale, nr Pistoia, 1474; *d* Vallombrosa, nr Florence, *c.* 1554). Italian sculptor, active also in England. The son of Bartolommeo de' Grazzini, Benedetto took his name from the town outside Florence where he owned a farm. His earliest known works are a marble singing-gallery of 1499 (Genoa, S Stefano) and the figures of *Louis, Duke of Orléans,* and his wife *Valentina Visconti* (1502; marble; Paris, St Denis), for the tomb of the Dukes of Orléans, which was commissioned from four artists by Louis XII (*reg* 1498–1515). In 1505 Benedetto went to Florence and began his most ambitious work, the marble sepulchre of *St Giovanni Gualberto* for Santa Trinita. Substantially completed by 1515, the monument was wrecked during the Siege of Florence in 1530; several surviving reliefs (Florence, S Salvi) demonstrate Benedetto's rather hard, linear figural style. In 1508 he completed ('rinettato') Michelangelo's bronze *David* (untraced). The tomb of *Piero Soderini* (marble; Florence, S Maria del Carmine; damaged and rebuilt in the 18th century) was finished by 1510, and the marble *St John the Evangelist* (Florence Cathedral) by 1513. Benedetto was in England by 1524, remaining until at least 1536. There he made a tomb with many bronze statuettes for Cardinal Wolsey, which Henry VIII (*reg* 1509–47) later claimed for himself (destr. 1646; marble, gilt bronze and touchstone; sarcophagus now part of Nelson's tomb in St Paul's Cathedral, London). In Florence again by 1543, Benedetto became blind some time later. The work generally considered to be his last, the Sernigiani Altar (Florence, Santa Trinita), inscribed 1552, was assembled from fragments of the *Gualberto* monument. According to Vasari, he died 'a few years' after 1550. An almost exact contemporary of Michelangelo, Benedetto continued an essentially 15th-century style well into the 16th century.

BIBLIOGRAPHY

Thieme–Becker
G. Vasari: *Vite* (1550, rev. 2/1568); ed. G. Milanesi (1878–85), iv, pp. 529–37
L. Tosi: 'Sculture inedite di Benedetto da Rovezzano', *Dedalo*, xi (1930–31), pp. 35–42
F. Luporini: *Benedetto da Rovezzano: Sculture e decorazioni a Firenze tra il 1490 e il 1520* (Milan, 1964)
M. Mitchell: 'Works of Art from Rome for Henry VIII', *J. Warb. & Court. Inst.*, xxxiv (1971), pp. 178–203
A. Luchs: 'A Relief by Benedetto da Rovezzano', *Mitt. Ksthist. Inst. Florenz*, xviii (1974), pp. 363–9

THOMAS MARTIN

Benedetto di Bindo [Zoppo] (*b* Castiglione di Valdorcia, nr Siena, ?1380–85; *d* Perugia, 19 Sept 1417). Italian painter. He may have been a pupil of Paolo di Giovanni Fei and was influenced by Taddeo di Bartolo in his early works. However, the strongest influence on his art was Simone Martini. He is first recorded on 20 November 1409, when he was paid by the Opera del Duomo, Siena. He had overall responsibility for the fresco decoration of the three chapels in the sacristy of Siena Cathedral (March 1411–March 1412), one of the most prestigious commissions in Siena at that date. There he worked with Gualtieri di Giovanni, Niccolò di Naldo and Giovanni di Bindino (*b* Siena, ?1380–85; *d* Siena, 9 Nov 1417), a group of painters

sometimes called the Masters of the Sacristy of Siena Cathedral. His work has a lively narrative style and uses forceful characterization in such scenes as the *Apparition of St Michael on Castel Sant'Angelo* in the chapel of the Reliquary. He also painted the reliquary cupboard (1412; Siena, Mus. Opera Duomo) for the sacristy. Between November 1415 and November 1416 he painted the frescoes in the chapel of SS Catherine and Peter Martyr in S Domenico, Perugia. Other works attributed to him include the fresco of the *Assumption of the Virgin* (Siena, S Niccolò del Carmine), the *Virgin and Child with SS Andrea and Onofrio* (Siena, Pin. N., 140), *St Lucy* (Minneapolis, MN, Inst. A.) and the *Annunciation* (New York, Cathedral of St John the Divine).

BIBLIOGRAPHY

P. Bacci: *Fonti e commenti per la storia dell'arte senese* (Siena, 1944), pp. 195–229
C. Brandi: *Quattrocentisti senesi* (Milan, 1949)
M. Boskovits: 'Su Niccolò di Buonaccorso, Benedetto di Bindo e la pittura senese del primo quattrocento', *Paragone*, xxxi/2 (1980), pp. 2–22
J. Mongellaz: 'A propos d'une fresque peu connue de la Cathédrale de Sienne', *An. Fond. Roberto Longhi*, i (1984), pp. 27–34
——: 'Reconsidération de la distribution des rôles à l'intérieur du groupe des Maîtres de la Sacristie de la Cathédrale de Sienne', *Paragone*, xxxvi/2 (1985), pp. 73–89

JACQUELINE MONGELLAZ

Benedetto di Leonardo. *See* MAIANO, (2).

Benozzo di Lese. *See* GOZZOLI, BENOZZO.

Benti, Donato (di Battista di Matteo) (*b* Florence, 1470; *d c.* 1537). Italian sculptor. The son of Giovanni Battista di Matteo, he was educated in Pisa. He was best known for his elaborate, fluid and well-composed style of decoration. He appears to have been less adept at carving figures, which is why his works are primarily reliefs, and most successful when highly decorative. Because of the similarity between his style and that of Lorenzo Stagi (*b* ?1455) and Stagio Stagi, and because of the lack of detailed documentation, distinguishing between the work of Benti and that of the Stagi is often difficult. The first documentary reference to his work dates from 1485, the year Pietrasanta came within the domain of Florence. There is mention that he worked with the 'Master of the Door' in the cathedral of S Martino in Pietrasanta.

For the next decade Benti was active in Pietrasanta, helping with the reinforcement of the city walls and gateway, as well as undertaking more work in the cathedral. The fortress of Pietrasanta was surrendered to the French king, Charles VIII (*reg* 1483–98), in 1498 and Benti left for Genoa, where in 1499 he collaborated with Benedetto da Rovezzano on the singing-gallery in S Stefano, a work commissioned by Abbot Lorenzo Fieschi. This consists of four marble slabs with carved reliefs of musical angels and on the sides the coat of arms of the Fieschi. Carlo Aru attributed the outer two slabs to Benti because the figures are slightly too large for the space. The gallery bears the inscription LAURENTII FLISCI JUSSU ET ERE DONATUS BENTI ET BENEDICTUS FLORENTINI DIVO STEPHANO PROTHOMARTIRI CHRISTI SCULPSERE ANNO A NATIVITATE DOMINI MCCCCLXXXXIX (By the order and with the gold of Lorenzo Flisci [sic], Donato Benti and

the Florentine Benedetto sculpted [this] for St Stephen protomartyr of Christ in the year 1499). The work was moved in 1639 and partially reconstructed.

In 1502 Benti, Michele d'Auria (*fl c.* 1466–*c.* 1502), Girolamo Viscardi and Benedetto were commissioned by the French king, Louis XII, to carve marble tombs for Louis, Duke of Orléans, his wife Valentina Visconti and their two sons. Carved in Italy, the monument was transported in 1504 by two of the artists to France, where it was installed in the Celestine Church (destr.) in Paris; it is not known for certain if Benti was one of the two who delivered the work. It was moved in 1816 to the abbey at Saint-Denis, where it remains *in situ*. There is a strong qualitative difference between the awkward rendering of the four figures of the deceased (attributed to d'Auria and Viscardi, and probably based on a French design), and the loose elegance of the 24 figures in niches along the bases of the sarcophagi. The latter, with their decorative touches, are attributed to Benedetto and Benti: the figures carved by Benti are considered to be slightly more rigid than those of Benedetto.

Benti returned in 1507 to Pietrasanta, where he received numerous commissions. In 1508 he worked on a marble pulpit for the cathedral. The upper pentagonal part consists of the Four Evangelists in relief with their respective attributes. This section is set on a pedestal richly decorated with angels' heads and ornamentation probably carved by Lorenzo Stagi. At this time Benti also carved a basin in a style similar to Stagi's. Now used as a stoup, the basin is inscribed A.D. MDVIII DONATUS BENTI FLORENTINUS FACTITABAT (In the year AD 1508 the Florentine Donato Benti was making [this]). It is documented that in 1509 Benti worked on the steeple of S Martino, as well as on the construction of S Maria di Porta (destr.). He received the initial commission, along with Nicolao di Matteo Civitali (1482–after 1560), for the sculpture in the baptistery of S Giovanni adjacent to the cathedral. He carved a font with an elegant frieze showing the *Victory of Neptune*, and possibly an unfinished statue of *St John the Baptist*. He received his full fee for the font posthumously: 1488 lire was paid to his son Battista Benti in 1540. He also carved angels on a tabernacle, for which Stagio Stagi later made pilasters (1522).

In 1513 Pietrasanta again came under the rule of Florence, and Benti was commissioned to carve the coat of arms of Leo X on the façade of S Martino. He also completed work on a column with a Florentine lion for the piazza in Pietrasanta (now in front of the Palazzo Pretorio). In 1518 he contracted with Michelangelo to act as supervisor for the quarrying and transportation of marble from Carrara and Seravezza, near Massa, for the façade of S Lorenzo and the tomb of *Julius II*. Michelangelo and Benti frequently exchanged correspondence concerning this project and developed a trustful working relationship. Michelangelo received two plans in 1519 for a church in Lucca, one of which was by Benti. From 1519 to 1520 Benti worked on the grand stairway leading up to S Martino, and at the same time was paid for more work on the steeple. He also completed additional work in the baptistry in 1525. From 1526 to 1528 he worked on the tabernacle of the high altar in S Agostino, Pietrasanta (now used in S Maria Assunta in Cardoso as a font). Together

with Stagio Stagi, he was contracted on 6 April 1529 to evaluate the altar of S Biago in Pisa Cathedral, which had been begun by Pandufo di Bernardo Fancelli (*d* 1526) and was later finished by Stagi. The last noted documentation of work by Benti was in 1531, when he was paid for more work on the steeple of S Martino: Stagio Stagi continued working on the steeple after Benti's death.

BIBLIOGRAPHY

Bénézit; *DBI*; Thieme–Becker

C. Aru: 'Notizie della Versilia', *L'Arte*, ix (1906), pp. 466, 468–9

——: 'Scultori della Versilia', *L'Arte*, xii (1909), pp. 271, 273–5

V. Venturi: *Storia*, x, pt 1 (1935), pp. 477–8, 480

A. Blunt: *Art and Architecture in France, 1500 to 1700*, Pelican Hist. A. (Harmondsworth, 1953, 4/1980/*R* 1982), pp. 36–7

G. Poggi, ed.: *Il carteggio di Michelangelo*, i, pp. 251, 334, 337–40, 343–4; iii, pp. 55–6 (Florence, 1965) [posth. edn, ed. P. Barrocchi and R. Ristori]

R. P. Ciardi, C. Casini and L. T. Tomasi: *Scultura a Pisa tra quattro e seicento* (Pisa, 1987), pp. 116, 157

ELIZABETH A. LISOT

Bentivoglio. Italian family of patrons. Originally from Viadagola, a village later absorbed into Granavolo, near Bologna, the family played a prominent role in Bolognese life from the 13th century to the 16th (*see* BOLOGNA). The first member of the family to assume political control was Giovanni I Bentivoglio (*b c.* 1358; *d* 30 June 1402), who was Signore of Bologna from March 1401 until his murder by supporters of the rival Visconti family. He had two sons: Ercole Bentivoglio (*d* 1424), a military adventurer and father of (1) Sante Bentivoglio; and Antongaleazzo Bentivoglio (1390–1435), a lecturer in law, who held power briefly in 1420 but was ultimately killed by papal officials. The monumental tomb to *Antongaleazzo Bentivoglio* (completed *c.* 1451) in S Giacomo Maggiore, Bologna, was begun by Jacopo della Quercia in a style traditionally used for university professors. Antongaleazzo's putative son Annibale Bentivoglio (*c.* 1413–45) led the revolt of Bologna against the papacy in 1438. He was a popular leader but he too was assassinated; the splendid equestrian monument to him (1458), also in S Giacomo Maggiore, is by a gothicizing follower of Donatello. The succession went to Sante Bentivoglio and in 1463 to Annibale's son (2) Giovanni II Bentivoglio. The family's ascendancy in Bologna ended when in November 1506 Pope Julius II drove Giovanni II and his relatives from the city; the Palazzo Bentivoglio (also known as the Palazzo Grande) with all its treasures was destroyed in May 1507. The main nucleus of the family found hospitable refuge in the fortified city of Ferrara, where (3) Cornelio I Bentivoglio became a leading member of the Este court; he was also responsible for commissioning the design of the Palazzo Bentivoglio (now Palazzo Comunale) at Gualtieri from Giovanni Battista Aleotti.

BIBLIOGRAPHY

DBI; *Enc. Spettacolo*

P. Litta: 'Bentivoglio di Bologna', *Famiglie celebri italiane*, xxxi (Milan, 1834)

A. Sorbelli: *I Bentivoglio signori di Bologna* (Rocca San Casciano, 1969)

F. Bocchi: *Il patrimonio bentivolesco alla metà dell'400* (Bologna, 1971)

A. de Benedictis: 'Dalla signoria bentivolesca al sovrano pontefice', *Storia illustrata di Bologna*, ii/1 (Bologna, 1988), p. 20

(1) Sante [Santi] **Bentivoglio** (*b* Poppi nel Casentino, 1424; *d* Bologna, 1 Oct 1463). He was an illegitimate child, brought up by his mother's family in the Tuscan countryside and unaware of the identity of his father, Ercole Bentivoglio. He was working in the wool guild in Poppi when a local lord, one of the few people who knew his origins, took him to Bologna and introduced him to Annibale Bentivoglio, who was struck by his resemblance to other members of the family. When Annibale was murdered in 1445, Sante was summoned from Florence to succeed him (Annibale's son (2) Giovanni II Bentivoglio being only two years old). Sante solemnly took leave of Cosimo I de' Medici, a scene represented in a fresco by Giorgio Vasari in the Salone del Cinquecento of the Palazzo Vecchio, Florence. Cosimo is reputed to have told Sante on this occasion that it was up to him to show whether he was the son of a draper or of the soldier Ercole Bentivoglio. Sante proved himself by becoming a judicious and popular leader. He brought administrative order, internal stability and solid alliances to Bologna, particularly through his agreement with Pope Nicholas V over the city's constitution, and through his marriage (1454) to 12-year-old Ginevra Sforza, daughter of the Signore of Pesaro and niece of Francesco II Sforza, Duke of Milan. Under Sante's rule, the appearance of the city changed, its Gothic aspect increasingly transformed by Renaissance architecture. He imported artists from Tuscany, notably the sculptor and architect PAGNO DI LAPO of Fiesole, who was commissioned to design the Palazzo Bentivoglio on a vast area of the city, previously occupied by vegetable gardens and huts, with its façade bordering the road to Viadagola. The foundations of the building were laid in 1460.

(2) Giovanni II Bentivoglio (*b* Bologna, 15 Feb 1443; *d* Milan, Feb 1508). Great-nephew of (1) Sante Bentivoglio. He was Signore of Bologna from 1463 to 1506 and gained recognition not only from the popes, beginning with Paul II, but from the Habsburg ruler Maximilian I (*reg* 1493–1517), Holy Roman Emperor from 1508. In May 1464 he married Ginevra, his predecessor's widow, who had given Sante two children and was to give Giovanni a dozen. By skilful political manoeuvres, he added greatly to his patrimony, and hence his revenues, and he completed the construction of the Palazzo Bentivoglio, which became a sumptuous court. He also gained from Maximilian the right to coin money (1494). The Bologna mint was still producing coins of a medieval type, either without names or with the insignia of the numerous popes who reigned during Giovanni's supremacy. Giovanni used his privilege to strike his own more 'modern' coins outside the mint, in gold, silver and copper, the largest bearing a splendid portrait created, according to a tradition originating with Vasari, by the painter Francesco Francia. Some superb medals of Giovanni II have also survived: in one, by Sperandio of Mantua, he is designated LIBERTATIS PRINCEPS, in other (anonymous) medals REI PUBLICAE CONSERVATOR.

Giovanni patronized the most renowned artists, inviting several from Ferrara, especially after the death of Duke Borso d'Este (1471). The family palazzo was richly embellished with statues and frescoes by Francia and the Ferrarese artists Francesco del Cossa and Lorenzo Costa (i). Important evidence of Giovanni's patronage, and that

of the wealthy citizens who wished to emulate him, remains in churches and in palazzi with long porticos of elegant round-arched arcades (*see* BOLOGNA, §I, 2), as well as in the family chapel in S Giacomo Maggiore and in the nearby oratory of S Cecilia. The chapel, through which Pagno introduced to Bologna the Florentine style of Filippo Brunelleschi, has a dedicatory inscription dated 1486. It was decorated mainly in the style of Costa with a mixture of sacred and profane motifs extolling the glory of the Bentivoglio family, together with portraits of Giovanni and his relatives: a worthy setting for the beautiful altarpiece by Francia, *Virgin Enthroned with Child, Saints and Two Angels* (*c.* 1494). The frescoes in S Cecilia, dating from the early years of the 16th century, illustrate the lives and martyrdoms of SS Cecilia and Valerian, and were painted by Francia, Costa and Aspertini (for illustration *see* ASPERTINI, AMICO). When the family fled from Bologna in 1506, Ginevra took refuge in Busseto, where she died in 1507; Giovanni lived for only a few months longer, in the Castello Sforzesco in Milan.

BIBLIOGRAPHY

G. Vasari: *Vite* (1550, rev. 2/1568); ed. G. Milanesi (1878–85), iii, p. 535

C. Volpe, ed.: *Il tempio di S Giacomo Maggiore in Bologna: Studi sulla storia e le opere d'arte* (Bologna, 1967) [incl. A. M. Matteucci: 'Le sculture', pp. 73–82; A. Ottani Cavina: 'La cappella Bentivoglio', pp. 117–31; D. Scaglietti: 'La cappella di S Cecilia', pp. 133–46]

GIORGIO TABARRONI

(3) Cornelio I Bentivoglio (*b* ?Ferrara, ?1519; *d* Ferrara, 26 May 1585). Son of (2) Giovanni II Bentivoglio. In the 1550s he was in France as a condottiere in the service of King Henry II (*reg* 1547–59). His return to Ferrara in 1559 coincided with the accession of Duke Alfonso II d'Este, who in 1560 appointed him Lieutenant-general of the state. In 1567 Alfonso granted him the fief of Gualtieri (near Reggio Emilia), which in 1575 was created a marquisate.

Cornelio's forceful personality and organizational ability in military and theatrical affairs made him one of the leading members of the Este court, for which he staged, for example, a spectacular joust in 1577. In 1582 a performance of Torquato Tasso's *Aminta* was given at Cornelio's palazzo in Ferrara (now Via Garibaldi, 90), a 15th-century building which he had remodelled in 1583. The façade, richly decorated with trophies, shields and statuary, was possibly designed by Pirro Ligorio but has been attributed to GIOVANNI BATTISTA ALEOTTI, on the development of whose career Cornelio exercised a considerable influence, both as supervisor of fortifications for the Este family and as a patron in his own right at Gualtieri. From the later 1570s Aleotti was employed at Gualtieri on land reclamation and on the design of the grand Palazzo Bentivoglio (now Palazzo Comunale), with its colonnaded piazza, an ambitious project that was continued after Cornelio's death by his sons Ippolito I Bentivoglio (*d* Modena, 1619) and (4) Enzo Bentivoglio.

BIBLIOGRAPHY

G. Campori: *Gli artisti italiani e stranieri negli stati estensi* (Modena, 1855)

D. R. Coffin: 'Some Architectural Drawings of Giovanni Battista Aleotti', *J. Soc. Archit. Hist.*, xxi (1962), p. 16

W. Barnes: 'The Bentivoglios of Gualtieri', *Country Life*, clxix (23 April 1981), pp. 1130–32

JANET SOUTHORN

Benvenuti, Giovanni Battista. *See* ORTOLANO.

Benvenuto di Giovanni (di Meo del Guasta) (*b* Siena, 13 Sept 1436; *d* Siena, after 1518). Italian painter. He was the son of a bricklayer and lived and worked in or near Siena all his life. He is first recorded working as an artist in 1453 when he was painting in the Siena Baptistery, probably with Vecchietta. In a tax return of 1465, Benvenuto declared himself to be without property or relations and to be living near the baptistery. The following year he married Jacopa di Tommaso da Cetona with whom he had seven children. They owned a vineyard, and Benvenuto served at least two terms in public office. Among his extant works, nine are signed and dated altarpieces, four are identifiable through documents and many others can be attributed to him on stylistic grounds. Their dates span 43 years, and they include panel paintings, frescoes, manuscripts and designs for the decorative pavement of Siena Cathedral.

Benvenuto was probably trained in Vecchietta's workshop, although stylistic affinities with Sano di Pietro suggest that he might also have worked for him. Benvenuto's early works show that he gathered inspiration from sources both in and outside Siena. The artistic tradition established by the 14th-century Sienese masters was frequently reinterpreted by subsequent generations of the city's artists; Benvenuto's imaginative archaistic use of Trecento motifs underlined the religious significance and civic associations of his art. The composition of his earliest known painting, an *Annunciation* (1466; Volterra, S Girolamo), is clearly inspired by Simone Martini's eloquent painting of the same subject (1333; Florence, Uffizi), while the two saints are stylistically close to Vecchietta's sculpture; the angel's face and bay wreath recall the angels in Sano di Pietro's early works, and the unearthly insubstantiality of the Virgin resembles the spectral figures of Sassetta.

The reciprocal influences between Benvenuto and his contemporaries Matteo di Giovanni, Francesco di Giorgio and Neroccio de' Landi in the last quarter of the 15th century were undoubtedly encouraged by their nearly concurrent commissions for choral miniatures, pavement designs and frescoes for Siena Cathedral. Elements of Umbrian and Florentine painting are also present in Benvenuto's oeuvre. The landscapes in the *Crucifixion* and *Resurrection* frescoes in the monastery of S Eugenio, Siena, are Umbrian in character; the wind-blown drapery of the angel in his *Annunciation* (1470; Sinalunga, S Bernardino) recalls Botticelli, and there are numerous references to Gentile da Fabriano's *Adoration of the Magi* (Florence, Uffizi; *see* GENTILE DA FABRIANO, fig. 3) in Benvenuto's painting of the same subject (Washington, DC, N.G.A.). This refined painting style was evolved through a process of borrowing and combining diverse motifs and ideas from a wide range of sources.

During the early 1480s Benvenuto's style changed considerably. In 1482 he was paid for a miniature of the *Donation of the Keys to St Peter* in the *Antiphonary of the Birth of St John the Baptist* (Siena, Bib. Piccolomini, MS. 15.Q.a.c. fol. 34*v*) for Siena Cathedral; other illuminations have been convincingly attributed to him but are not documented (Ciardi Duprè). At the cathedral Benvenuto

would have seen the miniatures by Liberale da Verona and Girolamo da Cremona, both of whom worked extensively on the same choirbooks from 1466 to 1476. In paintings executed after 1482, Benvenuto combined the vivid colours and crystalline light of Liberale and Girolamo, a deliberate distortion of space and anatomy derived from Vecchietta and Donatello and a growing fascination with the landscapes and detailed surface realism of northern European painting. The *Maestà* (Siena, S Domenico) and the *Ascension* (1491; Siena, Pin. N.; see fig.) illustrate his experiments with dizzying spatial distortions and his investigation of the psychological and decorative potential of gold, colour, light, landscape and perspective. These experiments produced intensely eerie visions of the celestial realm and its divine inhabitants.

Benvenuto's later works painted after 1500 retain the beautifully described and polished surfaces of his earlier paintings, but they are less imaginative and tend to repeat the same well-tried formulae. His only follower was his less gifted son, Girolamo, who collaborated with his father in many later works.

BIBLIOGRAPHY
E. Romagnoli: *Biographia cronologica de'bellartisti senesi, 1200–1800*, 13 vols (MS. Siena, Bib. Com. Intronati, 1835/*R* Florence, 1976), pp. 153–84
G. Milanesi: *Documenti per la storia dell'arte senese* (Siena, 1854–6), ii, pp. 334, 366, 378, 382, 387, 420; iii, pp. 40, 79
S. Borghesi and L. Banchi: *Nuovi documenti per la storia dell'arte senese* (Siena, 1898), pp. 226, 330, 350, 383
E. Jacobsen: *Das Quattrocento in Siena* (Strasbourg, 1908)
G. H. Edgell: *A History of Sienese Painting* (New York, 1932), pp. 251–5
R. van Marle: *Italian Schools* (1923–38), xvi, pp. 390–420
J. Pope-Hennessy: *Sienese Quattrocento Painting* (London, 1947), pp. 18–19, 30
C. Brandi: *Quattrocento senesi* (Milan, 1949), pp. 266–7
E. Sandberg Vavalà: *Sienese Studies* (Florence, 1952), pp. 337–9
B. Fredericksen and D. Davisson: *Benvenuto di Giovanni and Girolamo di Benvenuto: Their Altarpieces in the J. Paul Getty Museum and a Summary Catalogue of their Paintings in America* (Malibu, 1966)
B. Berenson: *Central and North Italian Schools* (1968), pp. 39–42
M. G. Ciardi Duprè: *I corali del Duomo di Siena* (Siena, 1972), pp. 20–21, 31, 44–5
M. C. Bandera: 'Variazioni ai cataloghi berensoniani di Benvenuto di Giovanni', *Scritti di storia dell'arte in onore di Ugo Procacci* (Milan, 1977), pp. 311–13
B. Cole: *Sienese Painting in the Age of the Renaissance* (Bloomington, 1985), pp. 122–8

CYNTHIA COTÉ

Beretta, Ludovico (*b* Brescia, 1518 or 1512; *d* Brescia, 1572). Italian architect. He operated until 1549 as a timber merchant in the village of Condino in the Val Giudicarie north-east of Brescia, where his brother Francesco Beretta was priest, and by 1550 he had begun repairs to Condino parish church. Beretta then won a competition to complete the Palazzo della Loggia (begun 1492), Brescia, and he was appointed Brescia's city architect on 4 December 1550, a position he held until his death. In this capacity he made a major contribution to the city's new square, the Piazza della Loggia; through private initiatives, he also made substantial improvements in the vicinity of the nearby Piazza di Mercato (formerly Piazza delle Erbe).

Beretta commenced work on the Palazzo della Loggia in 1553. His winning competition design, apparently recorded in a drawing by Andrea Palladio (London, RIBA, inv. X/15; see fig.), is known to have involved the addition of a third storey, but it was soon abandoned because of structural doubts. In the event, the building was completed under Beretta in accordance with the original 15th-century project but with a lavish crowning entablature designed by Jacopo Sansovino in 1554 and large rectangular upper windows designed by Palladio and Giovanni Antonio Rusconi in 1562. At the opposite, eastern end of the Piazza della Loggia Beretta in 1552 laid out a new approach road, the Strada Nuova (now Via Beccaria), which cuts through from close to the Piazza del Duomo and enters the square on its main axis some distance to the north of a mid-15th-century clock-tower, which was subsequently demolished. The road is lined on either side with a severe but ingeniously designed continuous façade, the lower storey of which is organized as an alternating sequence of large recessed arches accommodating shop fronts and broad piers pierced with further openings; this arrangement is similar to the lower storey of Palladio's Casa Civena (begun 1540), Vicenza, but is of greater elaboration and variation of surface relief. The piazza's existing eastern frontage, built by Pietro Maria Bagnadore *c.* 1595 but very possibly to Beretta's plan, was developed as a long two-storey range, with a ground-level arcaded loggia and an upper storey with pilasters framing windows and decorative panels.

In the Piazza di Mercato Beretta designed a long and imposing two-storey range (1558) for commercial use,

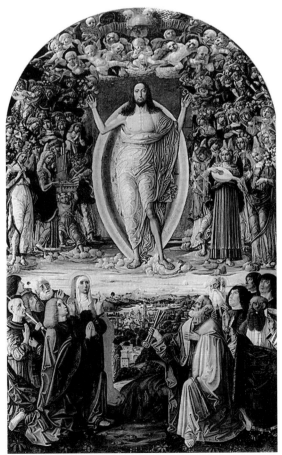

Benvenuto di Giovanni: *Ascension*, oil on panel, 3.97×2.45 m, 1491 (Siena, Pinacoteca Nazionale)

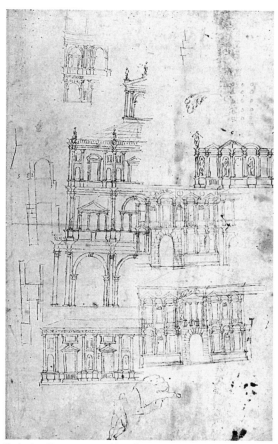

Ludovico Beretta: competition design (1550) for the Palazzo della Loggia, Brescia, begun 1553; drawing by Andrea Palladio (London, Royal Institute of British Architects)

comprising a rusticated arcade and an upper storey articulated with pilasters. In general format the design is similar to that of Sansovino's commercial Fabbriche Nuove (begun 1554) in Venice, but works by Palladio and Galeazzo Alessi are recalled in its details, particularly the order uniting two levels of rectangular windows and the way the triangular pediments over the main windows are broken to accommodate sculpted busts. Near the piazza Beretta also built *c.* 1559 the so-called Case del Gambero (mostly destr.); this had long three-storey frontages of sober and carefully regulated design, incorporating panels enlivened with frescoes by Lattanzio Gambara.

Beretta seems also to have worked extensively as a domestic architect, producing designs for a series of imposing and modern palaces in Brescia cast very much in the style of Sansovino and Palladio, the leading Venetian architects of his day. These city palaces fall into two distinct groups. Those of the first group, which tend to be relatively small, have their façades articulated with the orders. The Palazzo Uggeri–Ganassoni (?mid-1550s) has a lower order of Doric pilasters rising from tall pedestals to correspond with raised cellar windows, and an upper order of Ionic pilasters, also rising from tall pedestals to correspond with a continuous balcony formed upon the intervening cornice. The three-bay Palazzo Lana–Ghi-

della (*c.* 1560) is of a similar but more elaborate design: Doric pilasters below frame a rusticated portal arch and stacked windows to either side, while Ionic pilasters above are raised on pedestals framing windows of simple Palladian design with alternating pediments, the central one allotted a balcony. The three-bay Palazzo Dolzani–Masperi (undated), very possibly also by Beretta, is faced in stone and is an adaptation of a Venetian palace, with a three-storey elevation articulated with Doric, Ionic and Corinthian pilasters and crowned with a richly carved entablature closely modelled on that of Sansovino's Biblioteca Marciana, Venice; each of the central bays of the two upper storeys is treated as a Serliana.

The palaces of the second group, which are larger, have repetitious façades, unembellished with the orders, in the manner of Sangallo's Palazzo Farnese, Rome. The Palazzo Maggi (*c.* 1554), for example, has a lower tier of simple, square-headed windows interrupted by a sober portal with fluted Doric half-columns, and an upper tier of more elaborate windows beneath a bold cornice. The Palazzo Martinengo–Cesaresco dell'Aquilone (begun 1557) is similar in arrangement but with a spectacular arched portal, partly rusticated and partly ornamented with military spoils; this leads via a shallow three-bay vestibule into a majestic, seven-bay, rear-facing loggia with elaborate Doric detailing. On the palace's splendid rear elevation, the loggia's trabeated Doric colonnade is surmounted by an enclosed upper storey (fronting the main *salone*), which is articulated with Ionic pilasters; this arrangement echoes the façade of Palladio's Palazzo Chiericati, Vicenza, but has windows—again with alternating pediments—placed only in the three alternate bays. Beretta's other late works included the completion from 1560 of the prestigious S Maria dei Miracoli, Brescia; in 1566 he also prepared a design (untraced) for the proposed rebuilding of Brescia Cathedral, which in 1567 was admired by Palladio for its '*bella invenzione*'; the cathedral was eventually reconstructed to a project (1604) by Giovanni Battista Lantana (1581–1627).

DBI

BIBLIOGRAPHY

B. Zamboni: *Memorie intorno alle pubbliche fabbriche più insigni della città di Brescia* (Brescia, 1778)

G. Papaleoni: 'Nuovi documenti sul architetto … Ludovico Beretta', *Archv Stor. Lombardo*, xvii (1890), pp. 943–8

A. Peroni: 'Ludovico Beretta', *Storia di Brescia*, ed. G. Treccani degli Alfieri, ii (Brescia, 1963), pp. 851–62

D. Hemsoll: 'Bramante and the Palazzo della Loggia in Brescia', *A. Lombarda*, 86–7 (1988), pp. 167–79

DAVID HEMSOLL

Bergamaschi. *See under* BUON (ii).

Bergamasco, il. *See* CASTELLO, (1).

Bergamo [anc. Bergomum]. Italian city in Lombardy. It is situated on the Lombard plain *c.* 50 km north-east of Milan, at the entrance to the Brembana and Seriana valleys and below the first foothills of the Alps. The city is divided into two parts: upper Bergamo (*città alta*) and lower Bergamo (*città bassa*), the modern city; the upper part, crowning a steep hill (h. *c.* 360 m), retains its 16th-century circuit of walls and many fine early Renaissance buildings.

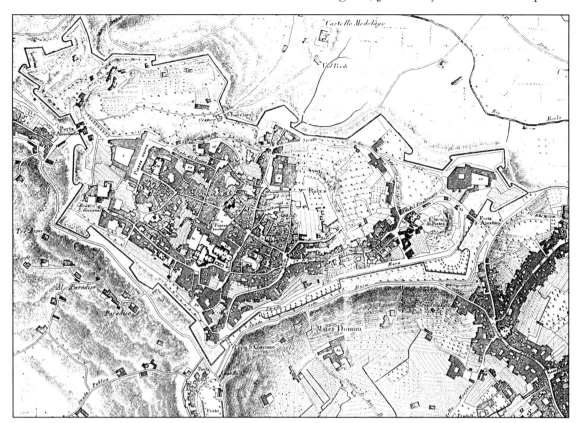

1. Bergamo, plan of the upper city; from an engraving by Giovanni Manzini, 1816

1. History and urban development. 2. Art life and organization.

1. HISTORY AND URBAN DEVELOPMENT. The importance of the Bergamo region emerged only after 1000 BC, when the Po Valley became a focus of commercial travel, especially where the Piedmontese trade routes crossed with those between the valleys and the plain. A pre-urban centre was created in the Etruscan period (6th–4th centuries BC), and under Roman rule Bergamo gained the status of citizenship granted to the centres of Cisalpine Gaul (49 BC). The free town (*municipium*) of Bergomum was established in 45 BC. It had a roughly rectangular perimeter (*c.* 600×400 m); the crossing of the *decumanus* (now Via Colleoni in the upper city) and the *cardo maximus* was the *compitum*, near the medieval Torre del Gombito. Traces of the Roman forum have been found, but most of the city's population must have settled outside the walls where the aqueduct, annual market, arena, sacred area and necropolis were all located. Near the necropolis was erected a column marking the place of martyrdom (AD 297) of St Alexander, the patron saint of the city (now outside S Alessandro in Colonna in the lower city).

Because of destruction in the 5th century AD, and after the siege and capture of the city (AD 894) by Arnolfo of Carinthia, the urban configuration of Bergamo in the high medieval period is difficult to establish. The fortifications followed the line of the Roman walls; to the west was Porta S Alessandro and, slightly to the north of it, outside the walls, was the ancient cathedral of S Alessandro (destr. 16th century); to the east and south were Porta S Andrea and Porta S Stefano, the latter facing the site of the fair of S Alessandro. The walls enclosed an area of *c.* 26 ha, which was not completely built up. Within them, on the site of a Roman temple adjacent to the forum, another cathedral, S Vincenzo (now S Alessandro), was built in the 8th century AD (rebuilt 13th, 15th and 17th centuries; dome and façade 19th century).

In 1098 Bishop Arnolfo began the process of constituting Bergamo as a free *comune*, its first consuls being elected in 1108. At the end of the 13th century Bergamo came under the control of the Visconti family of Milan. In 1331 construction began of the castle (Rocca) outside the walls to the east, which was completed (1336) by Azzo Visconti, Lord of Milan. Bernabò Visconti built the Cittadella (1355; later enlarged; now the Museo di Scienze Naturali and Museo Archeologico) in the western sector of the city, which was protected by a moat in place of the old Porta S Alessandro. In 1408 Bergamo fell into the hands of Pandolfo III Malatesta (1370–1427) and, after the battle of Maclodio (1428), was surrendered to Venice. Between 1430 and 1450 a new circuit of walls was built, enclosing the suburbs and linked with the medieval walls of the upper city. This period of Bergamò's development is portrayed in Marcantonio Michiel's *Descriptio* (1516).

One of the city's finest 15th-century buildings is the Colleoni Chapel (1472–6) at S Maria Maggiore (*see* §3 and fig. 2 below) commissioned by BARTOLOMEO COLLEONI, a condottiere in the service of the Venetian republic. New fortifications to the upper city, with polygonal bastions

and four gates (see fig. 1), were erected by the Venetians in 1561–80, obliterating the ancient cathedral of S Alessandro and cutting off the suburbs (which were reintegrated into the city only in the late 17th century).

BIBLIOGRAPHY

P. Pesenti: *Bergamo* (Bergamo, 1910)
L. Angelini: *Il volto di Bergamo nei secoli* (Bergamo, 1952)
B. Belotti: *Storia di Bergamo e dei bergamaschi*, i–iv (Bergamo, 1959)
L. Angelini: *Lo sviluppo urbanistico di Bergamo nei secoli: La progressiva configurazione della 'forma urbis'* (Bergamo, 1962)
T. Torri: *Piazza Vecchia in Bergamo* (Bergamo, 1964)
V. Zanella: *Bergamo città* (Bergamo, 1971)
A. Fumagalli: *Bergamo: Origini e vicende del centro antico* (Milan, 1981)
C. Mazzoleni, ed.: *Teoria del piano, Giovanni Astengo e il piano di Bergamo: Un caso paradigmatico* (Milan, 1983)
M. L. Scalvini and G. P. Calza: *Bergamo 1516, città e territorio nella 'Descriptio' di Marcantonio Michiel* (Padua, 1984)
R. Poggiani Keller, ed.: *Bergamo dalle origini all' altomedioevo: Documenti per un' archeologia urbana* (Modena, 1986)
M. L. Salvini, G. P. Calza and P. Finardi: *Bergamo* (Bari, 1987)

ROBERTO CORONEO

2. ART LIFE AND ORGANIZATION. The first real school of art in the city started in the 14th century. It was led by the masters of the Campionesi, a group of sculptors, master builders and stonecutters active in several parts of Italy and Switzerland from the mid-12th century to the late 14th. In Bergamo under Giovanni da Campione they built the Baptistery (1340; *see* §3 below), one of the small porches (1351) of S Maria Maggiore and an equestrian statue of *St Alexander* (1353; now in S Maria Maggiore) for the church of S Alessandro (destr.).

In the early 15th century the influence of Flemish painting began to spread, and this contributed to the development of a Bergamese school of painting in the second half of the century. One of the most notable sculptors active in Bergamo at this time was Giovanni Antonio Amadeo, who built the Colleoni Chapel at S Maria Maggiore (see fig. 2) and carved the tomb of *Bartolomeo Colleoni* (*see* AMADEO, GIOVANNI, ANTONIO, fig. 1). In 1476 Vicenzo Foppa painted a *Virgin and Saints* (now in Milan, Brera), a polyptych originally on the main altar of S Maria delle Grazie. This marked the beginning of a clearly defined local school of painting, which included such artists as Palma Vecchio, Andrea Previtali and Giovanni Cariani. In 1477 DONATO BRAMANTE went to Bergamo to work on the interior and exterior decoration of the Palazzo del Podestà (detached fragments in Bergamo, Pal. Ragione).

The artist who left the strongest impression on Bergamese painting, however, was Lorenzo Lotto, who lived in Bergamo in 1513–25. He was in close contact with the Venetian artistic circles dominated by Giovanni Bellini, and his arrival in Bergamo marked the beginning of a fertile period in his difficult life. He painted numerous works in Bergamo, including important altarpieces for the churches of S Stefano (1516), S Bernardino in Pignolo (1521; *see* LOTTO, LORENZO, fig. 2) and Santo Spirito (1521), as well as the frescoes of the *Life of St Barbara* (1524) in the Suardi family oratory. He also created the intarsia panels and covers of Old Testament stories (from 1523) for the choir of S Maria Maggiore. Lotto's ideas were developed in Bergamo through the late Mannerist language of Simone Peterzano and the classicism of

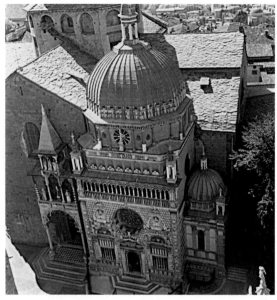

2. S Maria Maggiore, Bergamo, showing the north transept portal (1351) and the Colleoni Chapel (1472–6) by Giovanni Antonio Amadeo

Andrea Moroni. Later in the 16th century the city's artistic scene was dominated by the painter GIOVANNI BATTISTA MORONI, who worked almost exclusively in Bergamo in the 1550s and gave the local school of painting a clearly defined shape. He produced a number of portraits that bring out the character of his secular, bourgeois patrons, for example the *Portrait of a 29-year-old Nobleman* (1567; Bergamo, Gal. Accad. Carrara).

BIBLIOGRAPHY

T. M. Tassi: *Vite dei pittori, scultori e architetti bergamaschi* (Bergamo, 1793); ed. F. Mazzini, 2 vols (Milan, 1969)
P. Locatelli: *Illustri bergamaschi* (Bergamo, 1869)
R. Longhi: 'Dal Moroni al Ceruti', *Paragone*, iv/41 (1953)
M. Rosci: 'Storia dell'arte in Lombardia', *L'Italia* (Novara, 1987)

DANIELA CUCCIARI

Bergognone (da Fossano), Ambrogio (di Stefano) (*b* ?Milan, *c.* 1453; *d* Milan, 21 May 1523). Italian painter. His name first appears in a Milanese notarial act of 11 May 1472, as witness to a *procura ad causas* ('power of attorney') stipulated by the painter Melchiorre Lampugnano (*d c.* 1485–6). His presence in Lampugnano's home suggests that he was already active as a painter, perhaps professionally associated with the older artist either as an assistant or partner. In 1481 his name appears in the 'matricola' of Milanese painters. Nothing is known of Bergognone's training or activity before the late 1480s. Although it may be assumed, on the basis of stylistic evidence, that he met Vincenzo Foppa during this period, Foppa's influence is not strongly felt in such early works as the *Pietà* (probably *c.* early 1470s; Gazzada, Cagnola priv. col.). In the 1480s Foppa's example took on primary importance for Ambrogio: the small fresco of the *Virgin* in a lunette over a door in the south transept of the Certosa di Pavia, one of his first works there, makes direct reference to Foppa's *Madonna del Tappeto* (Milan, Brera) executed for S Maria

in Brera, Milan, in 1485, while other works of this period reflect Foppa's compositions and figure types. Much has also been said about the influence of 'northern' art on Bergognone, which, if it exists, is of Provençal rather than Netherlandish origin; it is possible that Bergognone, like Foppa, worked in Liguria, on the north-west coast of Italy, before beginning his activity at the Certosa.

In 1488 or 1489 Bergognone was commissioned by the abbot and member of the Roman curia Gerolamo Calagrani to execute an altarpiece depicting the *Virgin and Child with Saints* (Milan, Bib. Ambrosiana) for S Pietro in Ciel d'Oro, Pavia. By late 1488 he was employed at the Certosa di Pavia as what amounted to chief painter. In 1488–9 he painted the altarpiece depicting the *Virgin and Child with SS Peter and Paul* (centre panel, ex-Kaiser-Friedrich Mus., Berlin, ?destr. 1945; wings, Pavia, Mus. Certosa); in 1490 the *St Ambrogio* altarpiece, the *Crucifixion* (both Pavia, Mus. Certosa), and perhaps the altarpiece depicting the *Virgin and Child with SS Catherine of Siena and Catherine of Alexandria* (London, N.G.) and the *St Benedict* altarpiece (fragments Pavia, Mus. Certosa); in 1491 the *St Siro* altarpiece (Pavia, Mus. Certosa); and probably in 1493 the altarpiece depicting the *Virgin, Salvator mundi, the Doctors of the Church and the Four Evangelists* (Bergamo, Borromeo priv. col.; Pavia, Mus. Certosa). In 1492–4 he worked on frescoes in the apses of the north and south transepts and throughout the whole of the period produced several other altarpieces, now untraced or dispersed, and various small frescoes. These works for the Certosa have an overall silvery tonality unique to Ambrogio and are generally said to have been executed in his *maniera grigia* ('grey style'). The paintings from the 1490s are far less reliant on Foppa's example; it was during this period that Bergognone perfected an individual style—calm, rather melancholy, and ideally suited to the representation of religious subjects—that did not change greatly during the succeeding decades. The painting of *Christ Carrying the Cross with Carthusian Monks* (Pavia, Pin. Malaspina; see fig.) dates from this period. Behind the group of monks with their highly individualized faces masons at work on the façade of the Certosa may be seen.

By August 1495 Ambrogio was at work on frescoes of a series of saints commissioned by the Milanese church of S Maria presso S Satiro. In November 1497 the deputies of the church of the Incoronata at Lodi employed him and Antonio Raimondi (*d* late 1510s) to decorate the main chapel and to gild and colour the wooden altarpiece already installed there. This project was begun in May 1498 and completed by the end of August 1500. In 1505–6 he executed a polyptych commissioned by Francesco Osnago for S Giovanni Battista, Melegnano (only the centrepiece, the *Baptism*, survives; *in situ*). In 1506–7 he painted the great fresco of the *Coronation of the Virgin* in S Simpliciano, Milan, and in 1509 a large altarpiece of the *Pentecost* for Santo Spirito, Bergamo. Between 1500 and 1510 Ambrogio abandoned his *maniera grigia* in favour of a brighter palette. During this period a vague influence of Leonardo da Vinci, adapted entirely to Ambrogio's means of expression, became apparent. This can be seen especially in the four panels depicting scenes from the *Life of the*

Ambrogio Bergognone: *Christ Carrying the Cross with Carthusian Monks*, ?oil on canvas, 1.66×1.18 m, *c.* 1496 (Pavia, Pinacoteca Malaspina)

Virgin (Lodi, Incoronata) and the *Virgin and Child with the Infant St John and St Roch* (Milan, Brera).

In 1514 Bergognone was again at the Certosa di Pavia, occupied with frescoes for the newly renovated refectory. Documentary evidence suggests that Ambrogio executed his decorations for the chapter room of S Maria della Passione, Milan, in 1515. These decorations, partly in fresco and partly on panel, consist of figures of the Apostles standing in a fictive loggia, and of a vault frescoed with portraits of members of the Lateran Order and grotesques. Similar documentary evidence indicates a date of 1518 for the frescoes in the chapel of S Martin in S Pietro in Gessate, Milan. Ambrogio's last-known painting is the *Assumption of the Virgin* (1522; Milan, Brera), executed for the Olivetan monastery at Nerviano. While some of his late works, for example the small *Ecce homo* (Milan, Brera), are executed with considerable expressive power, towards the end of his life this power began to weaken: the Nerviano *Assumption*, though not without masterly passages, is on the whole a tired and mechanical reprise of earlier versions of the same subject.

Ambrogio's brother, Bernardino (*b* ?Milan, *c.* 1455–60; *d* Milan, *c.* 1524), assisted him in the execution of the transept frescoes at the Certosa di Pavia and also worked with him at Lodi and on the Melegnano Polyptych. In 1507, apparently independently, he frescoed the cloister of S Simpliciano, Milan. From October 1517 until August 1518, with Francesco da Niguarda (*c.* 1490/93–after 1550) and Battista Bossi (*fl c.* 1485), he gilded and painted the

figures made by the wood-carver Giovanni Pietro Gallarati for the *Altare arboris* ('Altar of the Tree') in Milan Cathedral. Although in his early years Bernardino's style probably resembled his brother's, his only dated work, the *St Roch* (1523; Milan, Brera), is more 'modern' than Ambrogio's paintings and is noticeably influenced by Bernardino Luini and other second-generation followers of Leonardo. A somewhat earlier work that may be attributed to him is a *Conversion of St Paul* (Isola Bella, Borromeo priv. col.).

BIBLIOGRAPHY

J. Shell: *Pinacoteca di Brera: Scuole lombarda e piemontese, 1300–1535* (Milan, 1988), pp. 85–9, 93–112, 409–13; nos 75–6, 81–7, 88, 197, 198 [with bibliog.]

Ambrogio Bergognone: Acquisizioni, scoperte e restauri (exh. cat. by P. C. Marani and J. Shell, Milan, Brera, 1989) [with bibliog.]

G. A. dell'Acqua and S. Coppa: *Bergognone* (Florence, 1991)

N. Righi: 'Une hypothese pour la reconstitution d'un retable du peintre lombard Ambrogio Bergognone (1453–1523)', *Rev. Louvre*, xlviii/2 (April 1998), pp. 31–41

JANICE SHELL

Bernardi, Giovanni (Desiderio) [Giovanni da Castel Bolognese] (*b* Castel Bolognese, 1494; *d* Faenza, 22 May 1553). Italian gem-engraver and medallist. He was first instructed as a gem-engraver by his father, the goldsmith Bernardo Bernardi (1463–1553). His earliest works, which dated from the three years he spent in Ferrara at the court of Alfonso I d'Este, were an engraving on crystal of the *Battle of La Bastia* and steel dies for struck medals representing *Alfonso d'Este* and *Christ Taken by the Multitude* (untraced; see Vasari). By 1530 Giovanni Bernardi was in Rome, where he worked for the cardinals Giovanni Salviati and Ippolito de' Medici. He was commissioned to produce a portrait of *Pope Clement VII* for the obverse of a medal struck with two different reverses: *Joseph Appearing to his Brothers* (e.g. Modena, Gal. & Mus. Estense; London, V&A) and the *Apostles Peter and Paul* (e.g. Milan, Castello Sforzesco; Paris, Bib. N.). For Clement VII he engraved on rock crystal the *Four Evangelists* (Naples, Capodimonte), a work that was much praised and admired; even Benvenuto Cellini, in his *Vita* (1532), called Bernardi 'molto valentuomo' ('a very able man'). For the coronation of Charles V (*reg* 1519–56) as Holy Roman Emperor in Bologna (24 Feb 1530), Bernardi presented him with a splendid gold medal bearing his portrait (silver version, Vienna, Ksthist. Mus.). This earned Bernardi a reward of 100 gold doblas and also an invitation to the court of Spain. He could not accept this because of commitments to the Pope, who rewarded him with the honorific title of Papal Mace-bearer. From 1534 until 1538 Bernardi held a post at the Papal Mint.

During these first years in Rome, Bernardi made other engravings on crystal for Cardinal Ippolito; surviving examples, skilfully adapted from drawings by Michelangelo (Windsor Castle, Berks, Royal Col.; London, BM), include various versions of *Tityus* (e.g. London, BM; *see* GEM-ENGRAVING, fig. 3) and the *Fall of Phaëthon* (e.g. *c.* 1533–5; Baltimore, MD, Walters A.G.; *see* fig.), which is inscribed IOVANES. There are also several plaquettes dispersed in numerous museums. Two further engraved gems may be attributed to Bernardi at this time, one on chalcedony with the portrait of *Cardinal Ippolito* and the other on jasper, the *Damned Soul* (both Florence, Pitti);

Giovanni Bernardi: *Fall of Phaëthon*, engraved rock crystal, 73×62 mm, *c.* 1533–5 (Baltimore, MD, Walters Art Gallery)

the latter is elaborated from a drawing by Michelangelo (Florence, Uffizi).

In 1535, on the death of Cardinal Ippolito, Bernardi entered the service of Cardinal Alessandro Farnese, for whom he executed many works, including a medal with a portrait of *Pope Paul III* (Milan, Castello Sforzesco). Through the writings of Antonio Francesco Gori, it has been possible to trace two exceptionally fine cameos, one a portrait of *Giovanni Baglioni* and the other that of *Margaret of Austria* (both Brit. Royal Col.); these were once in the collection of Joseph Smith, British consul at Venice from 1744 to 1760.

In 1539 Bernardi settled in Faenza, remaining there for the rest of his life except for the years 1541–5, when he was again in Rome, working at the Papal Mint as a master engraver. His most important works from 1539 onwards are documented in his letters to Cardinal Farnese (see Ronchini) and are also listed in detail by Vasari. These include two series of rock crystals depicting episodes from the *Life of Christ*: the first series (1539) engraved after drawings by Perino del Vaga (e.g. New York, Pierpont Morgan Lib.; Paris, Louvre); the second, representing the *Passion*, was completed in 1546–7. Of the rock crystals, 13 survive, mounted on a cross and on two silver-gilt candlesticks (all 1582; Rome, St Peter's, Treasury) commissioned for St Peter's, Rome, by Cardinal Farnese and made in 1570–80 by the goldsmith Gentile da Faenza. Four other engraved rock crystals are mounted on a 17th-century casket (Copenhagen, Nmus.); there are also a *Crucifixion* (Paris, Bib. N.), a *Christ before Pilate* (Baltimore, MD, Walters A.G.), an *Adoration of the Shepherds* (London, V&A) and *Christ Driving the Money-changers from the Temple* (Washington, DC, N.G.A.).

Six of Bernardi's most important rock crystals depicting mythological and historical themes are mounted on the

Farnese Casket (Naples, Capodimonte), which was made between 1548 and 1561 by the Florentine goldsmith Manno di Bastiano Sbarri (1536–76), a pupil of Cellini. Working from drawings by Perino del Vaga (Paris, Louvre; Chatsworth, Derbys), Bernardi engraved four of these crystals with scenes representing the *Battle of the Amazons*, the *Battle of the Centaurs and the Lapiths*, the *Triumph of Bacchus* and the *Kalydonian Boar Hunt*. The other two, of which the designer is unknown, show a *Naval Battle* and a *Chariot Race in the Circus*. A seventh engraved crystal, of the *Battle of Tunis* (New York, Met.), had been intended for the Farnese Casket but was not used.

Further works by Bernardi include an engraving on rock crystal of a *Cavalry Battle* (Baltimore, MD, Walters A.G.), which probably represents the Battle of Carignano, and a rock crystal tazza with engravings of the *Flood* and *Noah's Ark* (Florence, Pitti). Bernardi considered a rock crystal pax depicting the *Conversion of St Paul* (untraced) to be his greatest work (according to a letter to Cardinal Farnese of 25 December 1547). Among the most important gem-engravers of the first half of the 16th century, he is principally noted for the Farnese Casket, a masterpiece of Mannerist invention.

BIBLIOGRAPHY

G. Vasari: *Vite* (1550, rev. 2/1568); ed. G. Milanesi (1875–85), v, p. 371

A. F. Gori: *Dactyliotheca Smithiana* (Venice, 1767), i, p. 226; ii, p. 95, pls XCIX–C

A. Ronchini: 'Maestro Giovanni da Castel Bolognese', *Atti & Mem. RR. Deput. Stor. Patria Prov. Moden. & Parmen.*, iv (1868), pp. 1–28 [with Bernardi–Farnese letters; MS. of 1 letters, plus Ronchini's transcriptions of others in Parma, Archv Stato]

A. De Rinaldis: 'Il cofanetto farnesiano del Museo di Napoli', *Boll. A.: Min. Pub. Istruzione*, n. s., iii (1923–4), pp. 145–65

V. Sloman: 'Rock-crystals by Giovanni Bernardi', *Burl. Mag.*, xlviii (1926), pp. 9–23

E. Kris: 'Di alcune opere ignote di Giovanni dei Bernardi nel tesoro di San Pietro', *Dedalo*, ix (1928), pp. 97–111

V. Donati: *Pietre dure e medaglie del rinascimento: Giovanni da Castel Bolognese* (Ferrara, 1989)

La Collezione Farnese: Le arti decorative, Naples, Capodimonte (Naples, 1996)

P. Attwood: 'Giovanni Bernardi and the Question of Medal Attributions in Sixteenth-Century Italy', *Perspectives on the Renaissance Model*, ed. S. K. Scher (in preparation)

VALENTINO DONATI

Bernardino d'Antonio, Paolo di. *See* PAOLINO, FRA.

Bernardino da Parenzo [Parentino; Parenzano] (*b* Parenzo, Istria [now Poreč, Croatia], *c.* 1450; *d* ?Padua, *c.* 1500). Italian painter. He was born and probably also educated in Parenzo, Istria, where he studied antique inscriptions. From Parenzo he probably moved to the political and cultural capital of the region, Capodistria. Here, during what appears to have been a prolonged stay, he was able to study other inscriptions and to indulge his passion for antiquity. During this early period he may have been in contact with Giorgio Schiavone, possibly at Zara, as well as with other Dalmatian artists from the group around Francesco Squarcione, for example Marinello da Spalato (*fl* second half of the 15th century) (Billanovich, 1981).

Probably during the 1480s Bernardino moved to Italy. He lived in Mantua for several years, where he married and worked in the service of Francesco Gonzaga, 4th Marquese of Mantua (Brown). He left Mantua and spent a brief, undocumented period in Venice. He next went to Padua, where, between 1492 and 1496, he frescoed the Chiostro Grande of the monastery of S Giustina with scenes from the *Life of St Benedict*, scenes from the *Old and New Testaments* and grotesques (partially destr.; detached fragments in the monastery). Until the late 18th century, it was apparently still possible to read the signature *Opus Parentini* on the frescoes.

In 1496 Isabella d'Este, Marchesa of Mantua, invited Bernardino to return to Mantua, where he worked on the decoration of her *studiolo* in the Palazzo Ducale. Nothing is known of the character of this work. He subsequently returned to Padua to complete the S Giustina frescoes and probably died there around the turn of the century, leaving his work unfinished. In addition to the S Giustina frescoes Bernardino's only other signed work (*Bernardin Parençan pi[n]sit*) is a panel depicting *Christ Carrying the Cross with SS Augustine and Jerome* (Modena, Gal. & Mus. Estense). The date and place of execution of this work remain unknown (Billanovich, 1971).

Bernardino's love of antiquity and of inscriptions in particular, stimulated at an early stage by the Roman monuments of Istria, may also have been encouraged by indirect contact with the workshop of Squarcione and reinforced by later contact in Mantua with Andrea Mantegna. Bernardino may also have been familiar with the works of artists active in Bologna, such as Ercole de' Roberti and Francesco del Cossa (De Nicolò Salmazo). Bernardino da Parenzo was formerly confused with a monk of the same name who was born in Venice in 1437 and who died in the monastery of S Michele, Vicenza, in 1531.

BIBLIOGRAPHY

DBI

M. P. Billanovich: 'Una miniera di epigrafi e di antichità: Il chiostro maggiore di S Giustina a Padova', *Italia Med. & Uman.*, xii (1969), pp. 197–293

C. M. Brown: 'Little-known and Unpublished Documents Concerning Andrea Mantegna, Bernardino Parentino, Pietro Lombardo, Leonardo da Vinci and Filippo Benintendi (Part One)', *L'Arte*, vi (1969), pp. 140–64

M. P. Billanovich and G. Mizzon: 'Capodistria in éta romana e il pittore Bernardino Parenzano', *Italia Med. & Uman.*, xiv (1971), pp. 249–89

M. P. Billanovich: 'Bernardino da Parenzo pittore e Bernardino (Lorenzo) da Parenzo eremita', *Italia Med. & Uman.*, xxiv (1981), pp. 385–404

J. Bettini, ed.: *La galleria Estense di Modena: Guida illustrata* (Bologna, 1987), p. 67

A. De Nicolò Salmazo: *Bernardino da Parenzo: Un pittore 'antiquario' di fine quattro cento* (Padua, 1989) □

Bernardino del Castelletto (di Massa) (*fl* Massa and Lucca, 1481–90). Italian painter. He was documented in Massa in 1481, and in 1490 he signed and dated a panel of the *Virgin and Child with SS Sixtus and Peter* (Lucca, Villa Guinigi), made for the church of Pomezzana in Versilia. Stylistically it shows the influence of both Lombard and Tuscan painting. The same characteristics, blended with certain Lucchese traits, are present in the *Virgin and Child with Saints* (Lucca, S Pietro a Vico), which has been dated to the last years of the 15th century (Ferretti, 1975). It would seem that the painter moved from Massa to Lucca and adapted his style to local taste. A *Virgin and Child with Saints* (Massa, Archbishop's Chapel) is also attributed to Bernardino (Bertolini Cam-

petti). This attribution has yet to be proved; the painting was formerly attributed to the Master of St Anastasio (Ferretti, 1975), the author of two triptychs, both of the *Virgin and Child with Saints* (Valle di Serchio, parish church of S Anastasio; Valle di Serchio, church of Vallico di Sotto), the latter dated 1471.

BIBLIOGRAPHY

L. Bertolini Campetti: *Museo Nazionale di Villa Guinigi* (Lucca, 1968), pp. 167–8
M. Ferretti: 'Percorso lucchese', *An. Scu. Norm. Sup. Pisa*, n.s. 2, v/3 (1975), p. 1034
——: 'Di nuovo sul percorso lucchese', *An. Scu. Norm. Sup. Pisa*, n.s. 2, viii/3 (1978), p. 1242
M. Natale: 'Note sulle pittura lucchese alla fine del quattrocento', *Getty Mus. J.*, viii (1980), pp. 42–3

MAURIZIA TAZARTES

Bernardo delle Girandole. *See* BUONTALENTI, BERNARDO.

Bertani, Giovanni Battista (*b* Mantua, *c.* 1516; *d* Mantua, 2 April 1576). Italian architect, painter, sculptor and writer. He was educated in Mantua, was recorded as active 'for many years in Rome and elsewhere' and became known only when he was over 30, due to his design for the triumphal decorations set up in Mantua in January 1549 in honour of Philip (later Philip II of Spain), son of Emperor Charles V (*reg* 1519–58). The success of these decorations won for him the esteem of Cardinal Ercole Gonzaga, and he obtained the prestigious appointment of supervisor of the Cathedral Works (Opera del Duomo) and in May 1549 the title of Prefetto delle Fabbriche Ducali, a post that had remained vacant for almost three years following the deaths, in rapid succession, of Giulio Romano and Battista da Covo. The decree of appointment praises him as a 'supreme architect, excellent painter, refined sculptor', yet the only evidence of his youthful activity as a painter consists of an order (1531) to pay him for a fresco (destr. 1899) made to Giulio Romano's design on the façade of the Palazzina of Margherita Paleologa at Mantua; the early date of this order has given rise to discussion of Bertani's date of birth, which has been deduced from the Mantuan register of deaths.

In the cathedral, Bertani continued the radical transformation of the interior initiated by Giulio Romano in 1545. In the Palazzo Ducale he built a semicircular theatre with stepped seats, modelled on ancient Greek and Roman monuments. This construction—one of the earliest Renaissance examples of a permanent theatre—was destroyed by fire only a few decades later. Bertani's work was decisive in establishing the layout of a large part of the Palazzo. In the spacious rectangle of the Palazzo's Corte della Mostra, he developed in various stages the theme of rusticated architecture first introduced by Giulio Romano. On the long sides of the courtyard, Giulio Romano's vocabulary was given a new rhythm as a result of arches placed beside rectangular openings and framed by paired pilasters on the ground-floor, with spiral columns on the upper storey. The alternation generated by the semicircular arches and straight sections of entablature, which can be interpreted as a sequence of so-called Serlian or Palladian motifs, pervades the majority of Bertani's architectural work and underlines its scenographic nature.

Bertani soon came to the attention of architectural circles in other parts of Italy and, in 1551, was invited to participate in a competition for the design of the Rialto Bridge in Venice. His rapid rise within the hierarchy of the Gonzaga court and in Mantuan society finds its tangible expression in his own house in Mantua, built during the first half of the 1550s. The façade (see fig.) of this 'palazzo' (thus defined by Bertani) has on each side of the main entrance an Ionic column resting on a high pedestal and crowned with a fragment of entablature. On the right side the order is completely smooth, while on the left it is made up of sections in order to highlight the projections of the individual elements, which are also identified by inscriptions in Roman lapidary characters.

Bertani's house served as a manifesto of his theoretical ideas and was the forerunner of his treatise *Gli oscuri et dificili passi dell'opera ionica di Vitruvio . . .* (1558). This brief volume, complete with numerous illustrations, is dedicated to Cardinal Ercole, and the frontispiece is dominated by the mythical figure of *Hercules Killing the Hydra*, an engraving by Giorgio Ghisi after an idea by Bertani. The author's defence of the fundamental importance of Vitruvius is in contrast to the relativist and subjective approach that underlies the writing of art treatises in general in the second half of the 16th century. The problems to which Bertani principally devoted his attention are the methods for describing the volutes of the Ionic capital, the profiles of the columns, the various types of fluting and the proportional relationship of doorways. The most original passage on the Ionic order in Bertani's version describes the subdivision of the trunk of the pedestal into projecting bands, similar to those of the architrave, but such an interpretation has been firmly rejected by subsequent readers of Vitruvius.

The correspondence between theory and practice is a fundamental element of Bertani's approach; he cited as a concrete application of the Corinthian order the columns

Giovanni Battista Bertani: façade of the architect's house, Mantua, 1550–55

that supported the two organs in Mantua Cathedral. Yet such an approach did not prevent him from freely interpreting the Classical repertory, as at the church of S Barbara, erected within the confines of the Palazzo Ducale for Guglielmo Gonzaga, 3rd Duke of Mantua. The building work, which was undertaken in three successive stages, lasted from 1561 to 1572; a dramatic interlude occurred in 1568, when Bertani was subjected to the rigours of the Inquisition, imprisoned for several months, then obliged to take the oath of abjuration. This large church, with its flanking bell-tower and front portico, has a complex internal spatial organization. The presbytery is elevated over the crypt, itself divided into a rectangular and an oval area (the first instance of an oval plan in Mantuan architecture). A vertical caesura divides the long nave into two sections, each crowned with a light-filled dome rising from a square base, creating a centralized space. The orders are schematic and reduced almost to an abstract level. Bertani freed himself from the well-established Vitruvian models: he eliminated the bases, reduced the capitals to almost unrecognizable simulacra and varied the heights and proportional relationships of the pilaster strips. The structural function of the orders is subordinated to the rhythm of the cavities and panels, which in turn is emphasized by the multiple niches and blind fenestration. In some of the details, such as the niche on the campanile bearing the architect's name, the freedom of the classicizing vocabulary reaches extremes that have something in common with the tension and energy of Michelangelo's architecture, yet here appears frozen in the play of overlapping geometrical forms. Also at the Palazzo Ducale Bertani supervised the decoration of the summer apartments of the Mostra (e.g. the Loggia dei Frutti, 1561 and 1573) and enlarged Giulio Romano's Troy apartment together with the Galleria dei Marmi and the Sala di Mano.

The unnerving variations that Bertani introduced to Classical architecture in no way compromised his faith in the 'true and infallible style' of the 'worthy ancients', which he reaffirmed in 1570 in reply to a question put to him by Martino Bassi in relation to Milan Cathedral. In his brief declaration, Bertani alluded to his experiences in sculpture, of which there remains no material trace. His identity as a painter is equally vague, although his role as coordinator of altarpiece design for the cathedral and for S Barbara is confirmed by documents. Also documented is his intervention on a painting by Lorenzo Costa the younger, but this perhaps predates the composition and is therefore less binding than the designs that had been supplied by Giulio Romano.

Bertani's reception from contemporary critics was flattering (despite Vasari's reservations) and continuously lively in subsequent centuries. In the 19th century, however, his work was almost totally neglected, and in the 20th century too his intellectualizing inventions were often rejected. Bertani was nevertheless an architect who managed to free himself from the cumbersome heritage of Giulio Romano to take his own path within the context of Mannerist architecture.

WRITINGS
Gli oscuri et dificili passi dell'opera ionica di Vitruvio, di latino in volgare et alla chiara inteligentia tradotti, et con sue figure a luochi suoi (Mantua, 1558)

BIBLIOGRAPHY
DBI
G. Vasari: *Vite* (1550, rev. 2/1568); ed. G. Milanesi (1878–85), vi, pp. 487–9
M. Bassi: *Dispareri in materia d'architettura et perspettiva: Con pareri di eccellenti, et famosi architetti, che li risolvono* (Brescia, 1572), pp. 49–50
R. Toscano: *L'edificatione di Mantova* (Mantua, 1587), pp. 20–34
L. Coddè and P. Coddè: *Memorie biografiche dei pittori, scultori, architetti ed incisori mantovani* (Mantua, 1837/*R* Bologna, 1967), pp. 17–22
C. d'Arco: *Delle arti e degli artefici di Mantova* (Mantua, 1857/*R* Bologna, 1975), i, pp. 95–8
A. Barbacci: 'Il "cortile della Cavallerizza" nel Palazzo Ducale di Mantova', *Palladio*, iii (1939), pp. 63–76
C. Cottafavi: 'Ricerche e documenti sulla costruzione del Palazzo Ducale di Mantova dal secolo XIII al secolo XIX: Il cortile della Cavallerizza nel Palazzo Ducale di Mantova', *Atti & Mem. Reali Accad. N. Virgil.*, n. s., xxv (1939), pp. 171–90
E. Marani: 'Giovan Battista Bertani', *Mantova: Le arti* (Mantua, 1960–65), iii, pp. 3–70
C. Cottafavi: 'Saggi inediti su edifici della corte di Mantova: La fabbrica guglielmina in Corte Nuova', *Atti & Mem. Accad. N. Virgil. Mantova*, n. s., xxxiv (1963), pp. 19–32
F. Pellati: 'G. B. Bertani: Architetto, pittore, commentatore di Vitruvio', *Scritti di storia dell'arte in onore di Mario Salmi*, iii (Rome, 1963), pp. 31–8
T. Gozzi: 'La basilica palatina di Santa Barbara in Mantova', *Atti & Mem. Accad. N. Virgil. Mantova*, n. s., xlii (1974), pp. 3–91
C. Tellini Perina: '"Bertanus invenit": Considerazioni su alcuni aspetti della cultura figurativa del cinquecento a Mantova', *Ant. Viva*, xiii/4 (1974), pp. 17–29
T. Gozzi: 'Lorenzo Costa il Giovane', *Saggi & Mem. Stor. A.*, x (1976), pp. 33–62

□

Bertino, Giovanni di. *See* GIOVANNI DI BERTINO.

Berto di Giovanni (di Marco) (*fl* 1488; *d* before 14 Oct 1529). Italian painter. A pupil of Perugino, he was strongly influenced both by his teacher and by Raphael and his circle. He is first mentioned in documents in 1488 and again in 1495 when, with Sinibaldo Ibi, Eusebio da San Giorgio, Lattanzio di Giovanni (*d* 1534) and Lodovico di Angelo (1481–1522), he took a year's lease on a workshop near the Porta Eburnea, Perugia. In 1499 he was appointed treasurer of the painters' guild of Perugia, an office he again held in 1504, 1514 and 1522. In 1502, with Eusebio da San Giorgio and Nicolò da Cesena, he received payment for frescoes (destr.), which decorated the presbytery of Perugia Cathedral. In 1504 he painted a fresco of the *Virgin and Two Saints in a Landscape* in the Palazzo Conestabili, Perugia. A *Virgin and Child with Saints* painted in 1506–7 for S Franceso, Montone, strongly reveals the influence of Perugino, to whom it was mistakenly attributed by Vasari. Between 1508 and 1510 Berto and Sinibaldo Ibi executed a *Virgin and Child with Saints* for S Agostino, Perugia. In the following years Berto executed several minor commissions in Perugia. In 1516, on renewal of the contract between Raphael, himself and the monastery of Monteluce, Berto was engaged to work on the altar panels, which were to be completed by Raphael. The resulting predella panels, executed before 1525, depict four scenes from the *Life of the Virgin* (Perugia, G.N. Umbria). The strong colour contrasts set against a dark ground and the mannered character of the figures reveal his stylistic dependence on Giulio Romano and Giovanni Francesco Penni, who were responsible for completing the main panel after the death of Raphael in 1520. Berto's last recorded work was a plague banner, executed in 1526 in a retardataire style, for Perugia Cathedral.

BIBLIOGRAPHY

Thieme–Becker
J. A. Crowe and G. B. Cavalcaselle: *A New History of Painting in Italy* (London, 1866/*R* New York, 1980), pp. 339, 347–8, 365
W. Bombe: *Geschichte der Peruginer Malerei*, Italienische Forschungen, v (Berlin, 1912), pp. 95, 265, 270, 314
U. Gnoli: 'Berto di Giovanni', *Pittori e miniatori dell'Umbria* (Perugia, 1923)
F. Gualdi: 'Contributi a Berto di Giovanni pittore Perugino', *Commentari*, xii (1961), pp. 253–67
T. Henry: 'Berto di Giovanni at Montone', *Burl. Mag.*, cxxxviii/1118 (May 1996), pp. 32–58

SUSANNE KIEFHABER

Bertoia [Bertoja; Zanguidi], **Jacopo** (*b* Parma, 22 July 1544; *d* ?1573). Italian painter and draughtsman. His earliest known work, the fresco of the *Coronation of the Virgin* (1566) for the façade of the Palazzo Comunale, Parma, of which a fragment of the Virgin's head remains (detached, Parma, Pal. Com.), shows the influence of Parmigianino. Bertoia's only other documented paintings are frescoes depicting scenes from the *Passion* cycle in the oratory of S Lucia del Gonfalone, Rome, and biblical scenes in the Palazzo Farnese, Caprarola (all 1569–73), works that reflect his contact with the art of Raphael and with contemporary Roman Mannerism.

Bertoia devised the decorative scheme at the oratory of S Lucia del Gonfalone, where the ornamental architectural framework, derived from stage scenery, shows a dependence on similar work by Francesco Salviati. His figure style in the cycle is directly influenced by Raphael's frescoes in the Chigi Chapel, S Maria della Pace, Rome. Bertoia executed the first scene, the *Entry into Jerusalem*, and the accompanying frieze of prophets and sibyls above before July 1569, when he was summoned by Cardinal Alessandro Farnese to supervise the decoration of his villa at Caprarola. There, between July and October 1569, he completed the frescoes in the Sala d'Ercole (see fig.), left unfinished by Federico Zuccaro, and between 1569 and 1571 he painted the ceilings of the Sala dei Giudizi, the Sala della Penitenza and the Sala dei Sogni. He also began the Sala degli Angeli shortly before his death. His decoration closely follows the compositional patterns already set by the Zuccaro brothers and the complicated iconographical requirements of Farnese's literati. However, Bertoia's simplified compositions, more transparent colours and freely executed, elegantly elongated figures reflect his Parmese background. By July 1572 Bertoia had painted another prophet and sibyl frieze at the Gonfalone, above the fourth scene, and had possibly completed designs for the *Agony in the Garden* and the figure of *Solomon* before returning again to Caprarola. During his Roman years Bertoia and his équipe also painted the *Story of Aeneas* in the Palazzo Capodiferro (now Spada).

A contemporary Parmese chronicler, Angelo Maria di Edoari da Herba, related that Bertoia painted many 'extremely graceful works' in the Palazzo del Giardino, Parma, for his patron Ottavio Farnese, 2nd Duke of Parma and Piacenza. However, Bertoia's role in the decoration of the two exotic rooms, the Sala di Ariosto (or Sala di Orfeo) and the Sala di Boiardo (or Sala del Bacio), long considered his masterpieces, is unclear. These rooms were designed by the little-known Bolognese painter Girolamo Mirola (*d* 1570), who worked on them from 1562 until his

Jacopo Bertoia: *Peasants Dedicating a Temple to Hercules* (1569), fresco, in the Sala d'Ercole, Palazzo Farnese, Caprarola

death and may also have frescoed the fantastic palace of crystal columns with dancing and kissing figures in the Sala di Boiardo. Two other rooms, the Sala di Perseo and Sala di Paesaggio (*c.* 1571), can be attributed with some certainty to Bertoia, as their style accords with his documented frescoes in Rome. The Sala di Perseo reveals Bertoia's talent for complicated illusionistic effects and brilliant transparent coloration.

Bertoia was primarily a fresco painter. Works in Parma such as that in the Casa di Santa Croce were destroyed and the attributions of frescoes elsewhere, such as those in the Cappella Pepoli in S Domenico, Bologna, and the frescoes depicting episodes from the *History of the Rossi Family* in the *salone* at La Rocca, San Secondo Parmense, are disputed. His large graphic output includes both drawings and prints, but none of the latter has been identified. His known frescoes and drawings show him to have been an innovative decorator who combined Parmese elegance and illusionism with conservative Roman classicism.

BIBLIOGRAPHY

K. Oberhuber: 'Jacopo Bertoia im Oratorium von S. Lucia del Gonfalone in Rom', *Röm. Hist. Mitt.*, iii (1958–60), pp. 239–54
A. Ghidiglia Quintavalle: *Il Bertoja* (Milan, 1963)
L. W. Partridge: 'The Sala d'Ercole in the Villa Farnese at Caprarola', *A. Bull.*, liii (1971), pp. 467–86; liv (1972), pp. 50–62
D. De Grazia: 'Un capolavoro sconosciuto di Jacopo Bertoia nel Palazzo del Giardino di Parma', *Boll. A.*, lxxii/41 (1987), pp. 87–92
D. De Grazia and B. W. Meijer: 'Mirola and Bertoia in the Palazzo del Giardino, Parma', *A. Bull.*, lxix/3 (1987), pp. 395–406

D. De Grazia: *Bertoia, Mirola and the Farnese Court* (Bologna, 1991)

P. Rosenberg: '*Vénus découvrant Adonis*: Un Tableau inédit de Jacopo Bertoia', *Ars naturam adiuvans: Festschrift für Matthias Winner*, ed. V. V. Flemming and S. Schutze (Mainz, 1996), pp. 296–300

DIANE DE GRAZIA

Bertoldo di Giovanni (*b* ?Florence, *c.* 1430–?1440; *d* Poggio a Caiano, nr Florence, 28 Dec 1491). Italian sculptor and medallist. Throughout most of his career he was a member of Lorenzo the Magnificent's Florentine household and in his old age was put in charge of the academy that met in the Medici sculpture garden. Bertoldo's work contributed to the antique revival, and, in particular, he developed the genre of the bronze statuette, of which six examples by him survive. He also produced bronze reliefs and medals as well as working in other media. It is very likely that he is identifiable with one Bertoldo di Giovanni di Bertoldo, who was involved in a minor commercial transaction in 1463.

1. BRONZE RELIEFS AND MEDALS. According to Vasari, Bertoldo was a pupil of Donatello, responsible for chasing his master's late works, including the bronze reliefs for the pulpits in S Lorenzo. Writing to Lorenzo de' Medici on 29 July 1479, Bertoldo called himself a 'disciple of Donato', but the hypothesis that he might have designed some of the pulpit reliefs has been rightly denied by Bode (1925) and others.

The first work securely attributable to Bertoldo, dated 1469, is a medal of *Emperor Frederick III* (Hill, no. 912). Its reverse has an animated scene of Frederick knighting a group of men on the Ponte Sant'Angelo, Rome. It is possible that Bertoldo was in Rome during the Florentine embassy to the Emperor in 1468–9 and that this design was created then. The mission was headed by Filippo de' Medici (1426–74), Archbishop of Pisa; Bertoldo made a medal of him at this time (Hill, no. 914), with a *Last Judgement* on the reverse. Bertoldo's next and best-known medal commemorates the Pazzi Conspiracy of 1478 (Hill, no. 915). The busts of the brothers Giuliano de' Medici and Lorenzo the Magnificent, apparently derived from paintings by Botticelli, loom rather clumsily over the hectically thronged scenes of the assassination attempt in Florence Cathedral. The murder of Giuliano is shown on one side, while on the other Lorenzo is shown escaping. The literal depiction of scenes of such violence was unprecedented in medals of this date; Bertoldo, rather in the manner of a *cassone* painter, executed them with due regard for perspective and varied postures. A letter of 11 September 1478 from Fra Andrea Guacialoti, the medallist of Prato, to Lorenzo states that he cast four examples of a medal—presumably the Pazzi medal—after Bertoldo's 'first proof' and particularly remarks on the originality of Bertoldo's model, 'an immortal thing'. Bertoldo's active representation of events gives way to relatively bland Petrarchian scenes of triumph in three subsequent medals: the signed *Mehmed II* and one of the orator *Antonio Gratiadei*, both datable to the early 1480s, and one of a Venetian matron named *Letitia Sanuto* (Hill, nos 911, 913, 917). The figures are more elongated, stiffer and coarser.

A bronze *Battle* relief (*c.* 1480; Florence, Bargello) was mentioned by Vasari as a work by Bertoldo. Originally

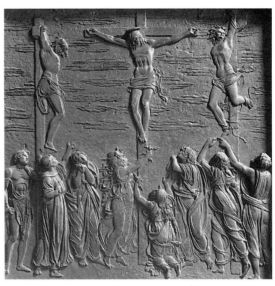

1. Bertoldo di Giovanni: *Crucifixion with SS Jerome and Francis*, bronze relief, 590×605 mm, *c.* 1478 (Florence, Museo Nazionale del Bargello)

installed over a fireplace in the Palazzo Medici, it is a reduced copy of an antique Roman battle sarcophagus in the Campo Santo, Pisa, and is often cited as a watershed in the history of antique revival. The sarcophagus has a hole in its centre, and in his version Bertoldo modelled this section afresh. Set amid the tumultuous scene of fighting nudes and horsemen is a rider wearing a winged helmet but wielding a club and girt by a lionskin, emblems that identify him as Hercules. The two Victories flanking the action are linear and elongated. The figures, freely adapted from the Pisan sarcophagus and others, have bony but well-formed physiognomies with angular gestures and small, regular facial features set in somewhat myopic expressions.

In the battle scene, Bertoldo followed his antique model by casting it in high relief. Elsewhere he showed a preference for low relief approaching *rilievo schiacciato*. The earliest exercises in this technique were probably a narrow frieze of the *Triumph of Silenus* (130×620 mm, Florence, Bargello), which bears *imprese* used by Piero I de' Medici (*d* 1469), and a plaque of the *Virgin and Child* with musical angels placed beneath an arch (Paris, Louvre).

Bertoldo's finest relief is the *Crucifixion with SS Jerome and Francis* (Florence, Bargello; see fig. 1) originally in the Palazzo Medici. Despite some naive efforts at foreshortening, there is authentic tragic grandeur in the spacing of the diaphanously costumed figures reminiscent of Botticelli and neo-Attic relief, and the chasing is masterly. In 1483–4 Bertoldo was in Padua, accompanied by an assistant. There he and Giovanni Fonduli made trial reliefs of Old Testament subjects for the Santo. Neither Bertoldo's *Jonah and the Whale* nor Fonduli's work found favour; indeed Bertoldo's *Jonah* was melted down and the metal given to Bartolomeo Bellano, who was commissioned to make ten of the reliefs that now decorate the choir.

2. BRONZE STATUETTES. Bertoldo's most significant contribution to Renaissance art was to the development

of the bronze statuette. Earlier sculptors, including Filarete and perhaps Donatello, as well as Antonio Pollaiuolo and Bellano, experimented with statuettes, often in imitation of the bronzes of Classical antiquity, but more of Bertoldo's statuettes survive than of any other early master, and there are further descriptions of other lost statuettes. A small bronze *Centaur* (untraced) was recorded in the Palazzo Medici inventory of 1492 as Bertoldo's work. His earliest statuettes are two gilt examples of a *Shieldbearer* (Vaduz, Samml. Liechtenstein; New York, Frick). Their stilted poses are comparable to figures on the *Frederick III* medal (1469). They probably accompanied the rustic *Hercules on Horseback* (Modena, Gal. & Mus. Estense). According to Lisner, there is a precedent for this highly unusual equestrian *Hercules*, and the one in Bertoldo's bronze *Battle* relief, in tapestries (untraced) at the court of Ercole I d'Este at Ferrara; a connection with the Ferrarese court, which formerly owned the *Hercules on Horseback*, can therefore be surmised. Bertoldo's preferred figural type, with urgent peering expressions, suits the primitive subjects admirably well. The nascent form of the *figura serpentinata*, already present in each *Shieldbearer*, became more pronounced in his subsequent statuettes, most of which represent nude (or semi-nude) males. He thus links the *figura serpentinata* developed by Donatello in the bronze angels of the font in the Siena Baptistery to the early 16th century when it became an important device.

The statuette of *St John the Baptist* (Paris, Louvre), sometimes ascribed to Vecchietta, probably dates from the 1470s. It is close in detail and in its mood of exaltation to Bertoldo's *Supplicant* (ex-Kaiser-Friedrich Mus., Berlin, destr.). The rather large *Apollo* (h. 437 mm; Florence, Bargello), shown playing a *lira da braccio*, is an unfinished cast with serious cracks, but Bertoldo treated it to a wealth of varied tooling before he abandoned it. Probably also dating from the 1470s, it was presented to the Medici by Stefano Lalli in 1556 when it was believed to be a Classical statuette.

The best known of Bertoldo's statuettes, *Bellerophon and Pegasus* (Vienna, Ksthist. Mus.; see fig. 2), can probably

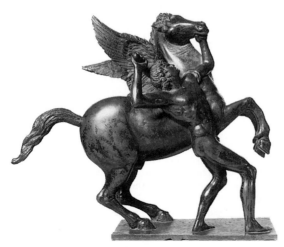

2. Bertoldo di Giovanni and Adriano Fiorentino: *Bellerophon and Pegasus*, bronze group, h. 325 mm, probably early 1480s (Vienna, Kunsthistorisches Museum)

be dated to the early 1480s. It is first recorded by Marcantonio Michiel in the possession of Alessandro Capella of Padua. It bears the joint signature of Bertoldo as modeller and Adriano Fiorentino as founder and is sometimes adduced as evidence of Bertoldo's reliance on the assistance of others. In fact, the cast is not as expertly chased as Bertoldo's other works, in which design and execution seem intimately bound together. The form of the nude Bellerophon is now relatively open and freeflowing. Adriano's own statuettes, though clearly evolved from Bertoldo's, are far less agile than this.

3. WORK IN OTHER MEDIA. In 1476 Bertoldo recorded the measurements of an unnamed church façade for Lorenzo de' Medici. In 1479 his letter to Lorenzo claims him to be skilled in architecture as well as sculpture. In 1485 he was commissioned to supply two gilded wooden angels for Florence Cathedral, but they seem never to have been finished. A much-discussed painted wooden statue of *St Jerome* (Faenza, Pin. Comunale) is also attributable to Bertoldo rather than to Donatello because of the technical device of grooving, which Bertoldo used in his bronzes, as well as its agreement with his anatomical and compositional habits.

Two substantial commissions that can be associated with Bertoldo are the glazed terracotta frieze on the façade of the Medici villa at Poggio a Caiano and a group of 12 stucco reliefs in the courtyard of the Florentine palazzo of Bartolomeo Scala, Chancellor of the Florentine Republic. Bertoldo's role in both may have been confined to supplying small-scale models. The Poggio a Caiano frieze was executed in the workshop of Andrea della Robbia. Bertoldo's style is especially detectable in details, such as the square-shouldered labourers who embody the Months in the fourth section. The programme of the whole is couched in terms of the divisions of Time but also alludes to Lorenzo de' Medici's role in ushering in a Golden Age. In the fifth and last section, Apollo–Lorenzo ascends by chariot into the stars. The low-relief style and format—white figures with golden-yellow accents against a blue ground—as well as specific motifs reveal Bertoldo's familiarity with the Medici collection of antique cameos. The frieze must owe much to Giuliano da Sangallo, the architect responsible for the villa, who had returned from Rome full of ideas about the role of the relief in Classical buildings. Sangallo was also the architect of Scala's palazzo, where the 12 grainy stucco courtyard scenes illustrate apologues devised by the owner, a statesman with humanist aspirations. The scenes are eccentric in their crowding (akin to the reverses of Bertoldo's last medals), in their strident directional axes, in their primeval clothespeg-shaped figure types and in grim embellishments such as apes' heads on the wheels of chariots. Parronchi argued that a jocular letter Bertoldo wrote to Lorenzo in 1479 refers to the making of these scenes. While the argument is unconvincing in its details, there is, nevertheless, a parallel between the scenes and the letter's tone of pessimistic sarcasm.

4. ASSOCIATION WITH THE MEDICI AND THE MEDICI ACADEMY. Documents amply testify to Bertoldo's connections with the Medici. Lorenzo di Medici

was tremendously upset when his familiar Bertoldo died, of quinsy. A notice of his death written the same day by Bartolommeo Dei emphasizes the closeness of his ties to Lorenzo, though perhaps exaggerating his stature:

> Bertoldo, a most worthy sculptor and capital manufacturer of medals, who always did worthy things with the Magnificent Lorenzo, died after two days at Poggio. The loss is great and he [Lorenzo] is very much affected, because there is not another in Tuscany nor perhaps in Italy with such noble intelligence and art in such things.

Vasari's account of Bertoldo acting as the 'guide and chief' of an academy established for promising Florentine artists in the *casino* of the garden of S Marco, a sinecure bestowed by Lorenzo on Bertoldo in his old age, is likely to be reliable (*see* FLORENCE, §V, 2). Chastel and Gombrich questioned this description of it, yet the prevalent notion of an academy in the 15th century would have been a place for informal colloquy rather than for organized tuition. The Medicean academy's sole curriculum seems to have been contemplation of the Antique. The most gifted student was Michelangelo, on whose early works the influence of Bertoldo can hardly be denied. In particular, the fragmentary marble *Youth*, lately rediscovered in the French Cultural Services of the French Embassy in New York and justly reclaimed by Brandt as a work of the novice Michelangelo refers unmistakably to Bertolodo's Bronze *Apollo*.

BIBLIOGRAPHY

DBI; Thieme–Becker

G. Vasari: *Vite* (1550, rev. 2/1568); ed. G. Milanesi (1878–85), ii, pp. 416, 423–5; iv, pp. 256–9; vi, p. 201; vii, pp. 141–2

T. Frimmel: 'Die Bellerophongruppe des Bertoldo', *Jb. Ksthist. Samml. Wien*, v (1887), pp. 90–96

W. von Bode: 'Bertoldo di Giovanni und seine Bronzebildwerke', *Jb. K. Preuss. Kstsamml.*, xvi (1895), pp. 143–59

K. Rohwaldt: *Bertoldo: Ein Beitrag zur Jugendentwicklung Michelangelos* (Berlin, 1896)

W. von Bode: *Die italienischen Bronzestatuetten der Renaissance*, 3 vols (Berlin, 1907–12); Eng. trans., 1 vol., ed. J. D. Draper (New York, 1980) [good illus.]

——: *Bertoldo und Lorenzo dei Medici: Die Kunstpolitik des Lorenzo il Magnifico im Spiegel der Werke seines Lieblingskünstlers Bertoldo di Giovanni* (Freiburg im Breisgau, 1925)

E. Jacobs: 'Die Mehemmed-Medaille des Bertoldo', *Jb. Preuss. Kstsamml.*, xlviii (1927), pp. 1–17

G. F. Hill: *Corpus* (1930), i, pp. 259–68; ii, pls 147, 149

A. Chastel: 'Vasari et la légende médicéenne: "L'Ecole du jardin de Saint Marc"', *Studi vasariani: Atti del Convegno internazionale per il IV centenario della prima edizione delle 'vite' del Vasari: Florence 1950*, pp. 159–67

E. H. Gombrich: 'The Early Medici as Patrons of Art', *Italian Renaissance Studies*, ed. E. F. Jacobs (London, 1960), pp. 309–11

J. Pope-Hennessy: *Italian Renaissance Sculpture* (London, 1963, rev. 3/1985), pp. 302–4

A. Parronchi: 'The Language of Humanism and the Language of Sculpture: Bertoldo as Illustrator of the *Apologi* of Bartolomeo Scala', *J. Warb. & Court. Inst.*, xxvii (1964), pp. 108–36

U. Middeldorf: 'On the Dilettante Sculptor', *Apollo*, cvii (1978), pp. 314–16

M. Lisner: 'Form und Sinngehalt von Michelangelos *Kentaurenschlacht* mit Notizen zu Bertoldo di Giovanni', *Mitt. Ksthist. Florenz*, xxiv (1980), pp. 299–344

S. Bardazzi and E. Castellani: *La villa medicea di Poggio a Caiano*, i (Prato, 1981), pp. 241–308 [colour plates of the frieze]

J. Cox-Rearick: *Dynasty and Destiny in Medici Art: Pontormo, Leo X and the Two Cosimos* (Princeton, 1984), pp. 63–86

G. Pollard: *Medaglie italiane del rinascimento nel Museo Nazionale del Bargello*, i (Florence, 1984), pp. 402–8

Italian Renaissance Sculpture in the Time of Donatello (exh. cat., entries by J. D. Draper; Detroit, MI, Inst. A., 1985), pp. 233–41 [full bibliog.]

J. D. Draper: *Bertoldo di Giovanni: Sculptor of the Medici Household* (Columbia and London, 1992) [appendix of documents and full bibliog.]

F. W. Kent: 'Bertoldo "sculptore" and Lorenzo de' Medici', *Burl. Mag.*, cxxxiv (1992), pp. 248–9

——: 'Bertoldo "sculptore" Again', *Burl. Mag.*, cxxxv (1993), pp. 629–30

J. D. Draper: 'Bertoldo di Giovanni di Bertoldo', *Burl. Mag.*, cxxxvi/1101 (1994), p. 834

K. Weil-Garris Brandt: 'A Marble in Manhattan: The Case for Michelangelo', *Burl. Mag.*, cxxxviii/1123 (Oct 1996), pp. 644–59

JAMES DAVID DRAPER

Bertucci. Italian family of painters. (1) Giovanni Battista Bertucci is known as *il vecchio* to distinguish him from his nephew Giovanni Battista Bertucci *il giovane* (*c.* 1540–1614), who worked on the decoration of the Vatican Loggia in Rome; Giovanni Battista *il vecchio*'s sons, Michele (1493–1520) and Raffaelle Bertucci (*b* 1496/1501), were also painters. Giovanni Battista *il vecchio* sometimes worked with his brother Girolamo Bertucci (*d* 1528), whose works have not been identified.

☐

(1) Giovanni Battista Bertucci *il vecchio* [Bracceschi; dei Pittori; Utili] (*fl* Faenza, 1495; *d* Faenza, April 1516). He has been confused since the late 19th century with the Florentine painter Biagio d'Antonio, who was in Faenza intermittently between 1476 and 1504. Bertucci is continuously documented in Faenza from 1495 and painted religious subject-matter only. His early works show the stylistic influence of Bernardino Pinturicchio, Pietro Perugino and Lorenzo Costa the elder, which is surprising, given that Bertucci is not documented as working outside Faenza and its environs.

Bertucci's first signed and dated work is a triptych (1506; Faenza, Pin. Com.) of the *Virgin and Child with St John the Baptist, SS Ippolito and Benedict* and *SS Romuald and Lawrence*, known as the Camaldolese Triptych and influenced by Perugino; it has been the basis for other attributions. A lunette of the *Coronation of the Virgin* (ex-Wittgenstein priv. col., Vienna) and the side panels of *St John the Baptist* and *St Catherine* (both Faenza, Pin. Com.) belong to a dismembered altarpiece of *c.* 1508 made for the Mengolini family chapel in S Caterina, Faenza. A *St John the Baptist* (*c.* 1508; Honolulu, HI, Acad. A.) shows the influence of the Florentine Piero di Cosimo, to whom it was previously erroneously attributed. In 1508 Bertucci, Sebastiano Scaletti (*fl* 1503–59) and Carlo Mengari (?1453–1528) were commissioned to decorate the ceiling of the library of the Dominican monastery in Faenza, for which they were still being paid in 1510. The same year Bertucci was commissioned to paint the façade of S Sebastiano, Faenza, of which fragments of the *Way to Calvary* and the *Deposition* have survived (Faenza, Pin. Com.). In 1511 he painted the *Virgin Enthroned with SS Bernard, John the Baptist, Celestine and Anthony of Padua* (Faenza, Pin. Com.) for Giacomo Cittadini.

In the paintings produced in the last five years of his life, Bertucci appears to have been influenced by Francesco Zaganelli, who in 1514 painted a *Baptism* (London, N.G.) for S Domenico, Faenza. Bertucci also softened his palette so that his late works are close to his Florentine contemporaries, particularly Francesco Granacci. In 1512 Clarice

Manfredi, a nun, commissioned from Bertucci an altarpiece for S Andrea in Faenza, of which some panels survive: a *Virgin and Child in Glory with Angels* (London, N.G.) and lateral panels of *St Thomas Aquinas* (ex-Lord Aldenham priv. col., sold 24 Feb 1937) and *St John the Evangelist* (sold Christie's, London, 9 July 1948). Other late works are the *Adoration of the Shepherds* and the *Adoration of the Magi* (both Faenza, Pin. Com.).

BIBLIOGRAPHY

DBI

L. Lanzi: *Storia pittorica della Italia*, iii (Bassano, 1795–6); ed. M. Capucci (Florence, 1968–74), p. 25

G. M. Valgimigli: *Dei pittori e degli artisti faentini de' secoli XV e XVI* (Faenza, 1871), pp. 19–24

F. Argnani: 'Una lunetta di G. B. Bertucci senior', *Rass. A.*, x (1901), p. 173

A. Messeri and A. Calzi: *Faenza nella storia e nell'arte* (Faenza, 1909)

C. Grigioni: 'È esistito il pittore faentino G. B. Utili?', *L'Arte*, xxx (1927), pp. 259–62

R. Buscaroli: *La pittura romagnola del quattrocento* (Faenza, 1931), pp. 281–96

C. Grigioni: *La pittura faentina dalle origini alla metà del cinquecento* (Faenza, 1935), pp. 276–330

Mostra di Melozzo e del quattrocento romagnolo (exh. cat. by R. Longhi and L. Becherucci, Forlì, Pal. Mus., 1938), pp. 95–6

A. Corbara: 'Un Bertucci di più e uno Zaganelli di meno', *Il Piccolo*[Faenza] (20 Feb 1949); also in *Gli artisti, la città: Studi sull'arte faentina di Antonio Corbara* (Bologna, 1986), pp. 174–5

M. Davies: *The Earlier Italian Schools*, London, N.G. cat. (London, 1951, 2/1961), pp. 232–7

E. Golfieri: *Pinacoteca di Faenza* (Faenza, 1964)

F. Zeri: 'Appunti sul Lindenau Museum di Altenburg', *Boll. A.*, xlix (1964), pp. 45–53

B. Fredericksen and F. Zeri: *Census of Pre-nineteenth Century Italian Paintings in North American Public Collections* (Cambridge, MA, 1972), pp. xxxi, 27

F. Zeri: 'Honolulu Academy of Art: Eight Centuries of Italian Art', *Apollo*, 1979, pp. 8–15

Gli artisti, la città: Studi sull'arte faentina di Antonio Corbara (Bologna, 1986)

La pittura in Italia: Il cinquecento (Milan, 1988), i, pp. 278, 286, 287; ii, p. 645 [with bibliog.]

ROBERTA BARTOLI

Besozzo, Leonardo (de' Molinari) da. *See* LEONARDO DA BESOZZO.

Besozzo, Michelino da. *See* MICHELINO DA BESOZZO.

Bevilacqua (i). Italian family of patrons. They are documented from the early 1200s in Verona, where their rise in fortune was related to their support of the della Scala (or Scaligeri) family (*reg* 1259–1387). In 1336 Francesco Bevilacqua (1304–68) received a gift of land near Montagnana for his services; he built a castle there and the settlement that grew up around it is still known as Bevilacqua. In 1381 his son Guglielmo Bevilacqua (1334–97) sought refuge with Gian Galeazzo Visconti, later 1st Duke of Milan, who subsequently became ruler of Verona (*reg* 1387–1402). The Bevilacqua family thus regained possession of its lands but following Visconti's death allied itself with Venice, which assumed control of Verona in 1516. At the splendid Palazzo Bevilacqua (1530), on the Corso Cavour, Verona (for illustration *see* VERONA), redeveloped by MICHELE SANMICHELI for Antonio Bevilacqua and his brother Gregorio, the architect took his inspiration from the nearby Roman gate, the Porta dei Borsari, to create one of his most successful works. The

building has a Mannerist façade exhibiting a complex interplay of decorative features. The Verona family later also included Count Mario Bevilacqua (1536–93), who graduated in law at Bologna; he was a man of wide culture who, besides collecting art and ancient sculpture, built up a library and a numismatic collection.

In Ferrara, where another branch of the Bevilacqua family was established, the Palazzo Bevilacqua (?1495) at Piazza Ariostea 11 has been attributed to Biagio Rossetti. It was first built by the Strozzi family and was acquired by the Bevilacqua in 1499. The front of the palazzo facing the piazza has a long ground-floor loggia with marble columns. After damage sustained in World War II, the building has been partly restored. Another Palazzo Bevilacqua lies on the Corso Biagio Rossetti. This was commissioned by Onofrio Bevilacqua (1598–1680) at the end of the 16th century and is one of the most beautiful buildings in Ferrara. Among the many other impressive palazzi formerly owned by the Bevilacqua family, the most notable is undoubtedly the Palazzo Bevilacqua (1484; acquired 1776) in Via D'Azeglio, Bologna. It is considered to be one of the finest palazzi in the city and, because of the prismatic cut of its masonry, was once known as the 'Palazzo dei Diamanti'. The building was begun by Nicolò Sanuti, Conte di La Poretta (*d* 1482), and finished by his widow Nicolosa. Subsequent damage to the fabric (especially in the interior) was repaired at the instance of Duca Lamberto Bevilacqua; accurate and scrupulous restorations were executed in 1907 and 1908 by A. Rubbiani (1848–1913) and the painter A. Casanova (1861–1948). The palazzo is currently lived in by members of the Bevilacqua family.

BIBLIOGRAPHY

P. Litta: *Bevilacqua di Verona*, Famiglie celebri italiane, lxxvi (Milan, 1852)

A. Rubbiani: *Il palazzo Bevilacqua in Bologna* (Milan, 1908)

M. Salmi: 'Rinascimento', *Enciclopedia universale dell'arte* Sansoni, xi (Venice, 1963)

B. Zevi: 'Sanmicheli', *Enciclopedia universale dell'arte* Sansoni, xii (Venice, 1964)

——: *Saper guardare l'urbanistica* (Turin, 1971), pp. 173–7 [Palazzo Bevilacqua in Piazza Ariostea, Ferrara]

A. Mezzetti and E. Mattaliano: *Indice ragionato de' pittori e scultori ferraresi di G. Baruffaldi* (Ferrara, 1980), pp. 133–4 [Palazzi in Ferrara; with comprehensive bibliography]

GIORGIO TABARRONI

Bevilacqua (ii). *See* SALIMBENI, VENTURA.

Biada, Francesco di Pietro della. *See* BENAGLIO, FRANCESCO.

Biagio, Vincenzo di. *See* CATENA, VINCENZO.

Biagio dalle Lame. *See* PUPINI, BIAGIO.

Biagio d'Antonio (Tucci) (*b* Florence, 1446; *d* Florence, 1 June 1516). Italian painter. He was previously confused with three other painters: Andrea Utili (*fl* 1481–96) of Faenza; 'Giovanni Battista Utili' (?1465–1516), whose second family name was Bertucci, also of Faenza; and Benedetto Ghirlandaio. His true identity was first documented by Grigioni, and Golfieri and Corbara then linked archival references to surviving paintings. Lightbown excluded the suggestion that he is the Biagio apprenticed

to Botticelli, who, according to Vasari, was the victim of a practical joke played by his master.

According to a *catasto* (land registry declaration), his surname was Tucci. An eclectic artist, he reflected the styles of many contemporary Tuscan painters, although his own slightly stiff and doll-like figure style is constant. He was trained in Florence and was first influenced by Fra Filippo Lippi, as is apparent in the *Nativity* (Dijon, Mus. B.-A.), then, around 1470, particularly by Verrocchio, as is evident in the *Virgin Adoring the Child* (Siena, Col. Chigi–Saracini). In 1476 Biagio was established as an independent painter and executed an *Adoration of the Child with Saints and Donors* for the Ragnoli family (ex-S Michele, Faenza; Tulsa, OK, Philbrook A. Cent.). This marks the beginning of his activity in Faenza, which lasted at least 30 years; he seems to have kept abreast of artistic developments in Florence, however, and also worked elsewhere in Italy. In 1481–2 he collaborated with Cosimo Rosselli in the Sistine Chapel, Rome, frescoing the background landscape scenes in the *Last Supper* and probably a large part of the *Crossing of the Red Sea*. On 5 October 1482 he signed a contract with Perugino to paint frescoes in the Sala dei Gigli in the Palazzo Vecchio, Florence. These were never executed and the commission passed to Domenico Ghirlandaio, who next became the most important influence on Biagio; the triptych of the *Virgin and Child Enthroned with Saints and Angels* (Faenza, Pin. Com.) for the Dominicans of Faenza, commissioned in 1483, shows Ghirlandaio's influence both in composition and in facial types. The *Annunciation* also dates from the 1480s, whereas the *Pietà* (all Faenza, Pin. Com.) may be linked to a deed of 1488. The artist favoured bright, crystalline colours and naturalistic detail derived ultimately from Flemish and German paintings. This is evident in the carpets of flowers, genre details and landscape backgrounds in his works.

In 1489 Biagio was paid to fresco a coat of arms (now repainted) in the chapel of Filippo Strozzi the elder in the church of Lecceto outside Florence. The beautiful altarpiece of the *Virgin and Child Enthroned with SS Francis and Mary Magdalene* (ex-S Pancrazio, Florence; San Casciano Val di Pesa, S Francesco) dates from the beginning of the 1490s, while the *Road to Calvary* (Paris, Louvre), with the rare iconographic theme of St Veronica and the veil, should probably be dated to the end of the decade, with the *Virgin and Child Enthroned with SS John the Baptist and Jerome* (Gambassi, near Florence, Prepositura dei SS Jacopo e Stefano). In 1504 Biagio was commissioned to paint the panel of the *Virgin and Child Enthroned with SS John the Evangelist and Anthony of Padua* (Faenza, Pin. Com.; see fig.), which shows the influence of Filippino Lippi, who, together with Piero di Cosimo, influenced Biagio's late work. It also shows his growing affinity with the painterly traditions of Romagna and Bologna. Many paintings of the Virgin and Child are attributed to Biagio and they variously show the influence of Antonello da Messina, of Flemish artists, of Lorenzo di Credi, and of Perugino, who affected his later, rather weak works.

Biagio also produced many *cassone* paintings, in which he combined an animated narrative vein with an almost courtly taste for the description of rich and highly coloured costumes and armour. The *cassone* with *Stories of the*

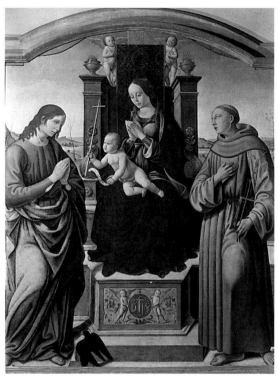

Biagio d'Antonio: *Virgin and Child Enthroned with SS John the Evangelist and Anthony of Padua*, tempera on panel, 1.73×1.46 m, 1504 (Faenza, Pinacoteca Comunale)

Argonauts (*c.* 1465; New York, Met.) is stylistically close to Pesellino, as is the pair of *cassoni* with *Stories of Lucretia* (*c.* 1465; Venice, Ca' d'Oro), but the *Meeting between Jason and Medea* (1487; Paris, Mus. A. Dec.) is painted with a greater sobriety. It has been suggested that Biagio may have been responsible for some of the miniatures of Federigo II da Montefeltro's Bible of 1478 (Rome, Vatican, Bib. Apostolica), but this is unproven.

BIBLIOGRAPHY

DBI

C. Grigioni: *La pittura faentina dalle origini alla metà del cinquecento* (Faenza, 1935), pp. 178, 194–219, 254, 297, 721–3

E. Golfieri and A. Corbara: 'Biagio d'Antonio pittore fiorentino in Faenza', *Atti & Mem. Accad. Fiorent. Sci. Morali: 'La Colombaria'*, i (1947), pp. 435–54

F. Zeri: 'Un riflesso di Antonello da Messina a Firenze', *Paragone*, ic (1958), pp. 16–21

E. Borsook: 'Documenti relativi alle cappelle di Lecceto e delle Selve di Filippo Strozzi', *Ant. Viva*, ix (1970), p. 4

E. Fahy: *Some Followers of Domenico Ghirlandaio* (New York, 1976), pp. 204–11

R. Lightbown: *Sandro Botticelli: Life and Work*, 2 vols (London, 1978)

M. Natale: *Museo Poldi Pezzoli: Dipinti* (Milan, 1982), pp. 156–7 [full bibliog.]

A. Conti: 'Andrea del Sarto e Becuccio Bicchieraio', *Prospettiva*, xxxiii–xxxvi (1983–4), p. 165, n. 4

E. Fahy: 'The Tornabuoni–Albizzi Panels', *Scritti in onore di Federico Zeri*, i (Milan, 1984), pp. 233–47

A. Angelini: *Collezione Chigi–Saracini: Sassetta e i pittori toscani tra XIII e XV secolo* (Siena, 1986), pp. 58–61

R. Bartoli: 'Biagio d'Antonio Tucci', *La pittura in Italia: Il quattrocento*, ii (Milan, 1987), pp. 583–4

——: 'Maestri e botteghe', *Pittura a Firenze alla fine del quattrocento* (Florence, 1992–3), pp. 73–4, 87, 243

ROBERTA BARTOLI

Bianco, Simone (*b* Loro Ciuffenna, before 1512; *d* Venice, after Dec 1553). Italian sculptor. He was the son of Nicolò Bianco, according to a will drawn up for Simone in 1547; the earliest reference to Simone occurs in a contract dated 6 June 1512 commissioning four marble reliefs of Old Testament scenes for the Scuola del Sacramento, Treviso Cathedral. He apparently did not complete the carvings. In 1532 the Venetian Marcantonio Michiel wrote of two marble sculptures (ex-Odoni priv. col., Venice), the first one of *Two Feet* executed completely in the round, the second of *Mars* carrying his helmet over one shoulder. Although these works have not been located, their description makes clear that they conformed to the antique type evident in Bianco's extant pieces. The artist also attracted the brief notice of Vasari, who mentioned him as a 'scultore fiorentino', although it was in Venice that Bianco settled and made his mark as a sculptor. In 1548 Pietro Aretino wrote to his friend Bianco, praising the artist's marble bust of Nicolò Molino's wife and noting that both Titian and Jacopo Sansovino concurred with his opinion that the portrait was delightful apart from a certain roughness in the treatment of the hair. This work is probably the bust attributed to Bianco now in the Staatliche Museen in Berlin. In fact all Bianco's identified works are marble and bronze portrait busts, sculpted *all'antica*. Inspired by but not copies of antique busts, these sculptures established Bianco firmly as a member of the humanist cultural milieu of 16th-century Venice. His affinity with the Classical world extended even to signing many of his busts in Greek letters as 'Simon Leukos Venetos Epoiei', identifying him as a Venetian artist. The number of portrait busts identified as being by Bianco remains rather small; many may still be in museum stores, mistaken for anonymous antique pieces.

The rediscovery of Bianco's work began *c.* 1880, when Louis Courajod, curator of Renaissance sculpture at the Louvre, identified two marble busts of Imperial Roman type portraying slightly over life-size men. Another bust attributed to Bianco appeared in a Parisian art dealer's store at about the same time, lending credence to the suggestion that some of Bianco's sculptures made their way to France via a Venetian merchant. The works demonstrate Bianco's talent as a portrait sculptor, although the names of his subjects remain unknown. The busts appear to represent not only contemporary Venetians but also figures from the Classical world. At least two images attributed to Bianco depict *Julius Caesar* (Berlin, Staatl. Mus., and Venice, Mus. Archeol.), each giving a slightly different interpretation of the ruler. Among the contemporary portraits is the marble bust of an anonymous man (see fig.), which clearly represents an individual of dignified grandeur and intelligence. While most of Bianco's artistic output depicted male figures, there exist four female portrait busts attributed to him, including the portrait of Molino's wife. Bianco's sculptures continued an archaizing tradition in Venice practised by Antonio Lombardo. They did not slavishly follow Lombardo's works, however, but rather reflected Bianco's absorption of elements of Venetian Cinquecento portrait painting. Neither was Bianco a mere imitator of the Antique: although he persisted in a style that appealed to a cultural élite long after it had been superseded in other artistic circles, he imprinted his own

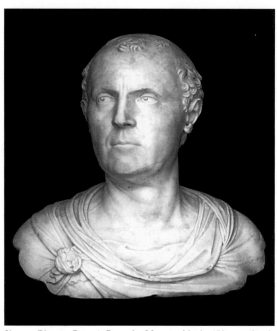

Simone Bianco: *Portrait Bust of a Man*, marble, h. 450 mm (Stockholm, Nationalmuseum)

artistic sensibility on the works, distinguishing them from genuine antique portrait sculptures. He inspired such followers as Francesco dei Sordi (*d c.* 1562), but none was able to match the refined imagery produced by Bianco.

BIBLIOGRAPHY

M. Michiel: *Notizia d'opere di disegno nella prima metà del secolo XVI* (MS., 1521–48); ed. J. Morelli (Bassano, 1800, rev. Bologna, 1884)
G. Vasari: *Vite* (1550), iii; ed. G. Milanesi (1878)
P. Aretino: *Lettere sull'arte* (1609); ed. F. Pertile and E. Camesasca, 3 vols (Milan, 1957–60)
L. Planiscig: 'Simon Bianco', *Belvedere*, v (1924), pp. 157–63
P. Meller: 'Marmi e bronzi di Simone Bianco', *Mitt. Ksthist. Inst. Florenz*, xxi (1977), pp. 199–210
U. Schlegel: 'Simone Bianco und die venezianische Malerei', *Mitt. Ksthist. Inst. Florenz*, xxiii (1979), pp. 187–96
I. Favaretto: 'Simone Bianco: Uno scultore del XVI secolo di fronte all'antica', *Numi. & Ant. Class.*, xiv (1985), pp. 405–22
U. Schlegel: 'Eine unbekannte Büste von Simone Bianco', *Antol. B.A.* (1990), pp. 148–52

ROBIN A. BRANSTATOR

Bibbiena, Bernardo [Dovizi, Bernardo] (*b* Bibbiena, nr Arezzo, 4 Aug 1470; *d* Rome, 9 Nov 1520). Italian cardinal and patron. He was from an obscure family and moved at an early age to Florence, where his elder brother Pietro was serving as secretary to Lorenzo de' Medici. Bernardo, too, entered Medici service and quickly became secretary to Cardinal Giovanni de' Medici, whom he served loyally and followed into exile in 1494. When Cardinal de' Medici was elected Pope Leo X in 1513, he made Bernardo treasurer general and then Cardinal. Generally known as Cardinal Bibbiena, from 1513 he lived in the Vatican Palace and during the first years of Leo's pontificate was the Pope's main adviser, even being called *alter papa*. Around 1515, however, his influence began to decline, as Leo increasingly relied on the advice of his cousin, Cardinal Giulio de' Medici (the future Clement VII). In 1516 Cardinal Bibbiena was sent as papal legate to the Holy

Roman Emperor, Maximilian I (*reg* 1493–1519), and in 1518 to Francis I (*reg* 1515–47). His influence further diminished as he showed increasing sympathy with the French. At the end of 1519 he returned to Rome, where he died the following year and was buried in S Maria d'Aracoeli.

In addition to his diplomatic skills, Cardinal Bibbiena was admired for his amiability and wit. He is represented as the leader in the discussion on humour in Baldassare Castiglione's *Il cortegiano* (Venice, 1528). A learned man well versed in the arts and literature, he corresponded with many prominent contemporaries. He was also active as an author, writing one of the first Italian comedies based on Classical models, *La calandria* (played first at Urbino, 1513). He was in contact with such artists as Michelangelo and Raphael, with whom he was on especially good terms. Bibbiena offered Raphael the hand of a relative, Maria (the marriage, however, never took place), and on Raphael's death in 1520 he inherited Raphael's house in Rome. A portrait of Bibbiena by or after Raphael is in Florence (Pitti). Raphael and his assistants decorated the *stufetta* (bathroom; 1516) and *loggetta* (1519) of Bibbiena's apartment in the Vatican. From Pietro Bembo's correspondence with the Cardinal, it appears that Bibbiena chose the subjects depicted, which were derived from Classical mythology and are mildly erotic. This, together with the sometimes coarse humour in *La calandria* and some of his letters, has given rise to an image of Bibbiena as a worldly man, unworthy of his office. Erotic scenes were not uncommon for bathroom decoration, however, and the humour of *La calandria* is paralleled in contemporary comedies.

BIBLIOGRAPHY

DBI

A. M. Bandini: *Il Bibbiena o sia il ministro di stato* (Livorno, 1758)
L. von Pastor: *Geschichte der Päpste* (Freiburg im Breisgau, 1886–1933), IV/i
G. L. Moncallero: *Il cardinale Bernardo Dovizi da Bibbiena umanista e diplomatico (1470–1520)* (Florence, 1953)
D. Redig de Campos: 'La stufetta del cardinale Bibbiena in Vaticano e il suo restauro', *Röm. Jb. Kstgesch.*, xx (1983), pp. 221–40

J. L. DE JONG

Bicci di Lorenzo (*b* Florence, 1373; *d* Florence, 6 May 1452). Italian painter and architect, son of LORENZO DI BICCI. He continued the workshop founded by his father. Though not attracted to the artistic ideals and innovations of the Renaissance, he developed the productive capacities of the workshop by inaugurating a remarkable series of partnerships and collaborations with other painters.

1. Life and work. 2. Style and workshop.

1. LIFE AND WORK.

(i) *To 1430.* Bicci's first artistic work was naturally done in the paternal workshop. No doubt because of the similarity between the names of father and son, Vasari assigned works to Lorenzo that were actually painted by Bicci. Moreover, he attributed to Lorenzo a second son, NERI DI BICCI, whereas Neri was in fact the only son of Bicci.

Between 1385 and 1408 Bicci enrolled in the Arte dei Medici e Speziali (Doctors' and Apothecaries' Guild), to which painters in Florence were required to belong. Over a period of nearly 40 years he produced a huge number of paintings inscribed with the year of production or recorded in documents. In his first dated work, a triptych of the *Annunciation with Saints* (1414; Porciana, nr Stia in Casentino, S Maria Assunta), the style is still reminiscent of the late 14th century, that is, the style learnt in his father's workshop, but with more attention paid to Gothic lines and modulations. The readiness of Bicci's workshop to take on any work connected with painting is recorded in an archive note dated 1416, when Bicci gilded chandeliers and benches for the Florentine charitable organization of the Compagnia Maggiore di S Maria del Bigallo.

In 1417 Bicci married Benedetta d'Amato d'Andrea Amati, with whom he had three daughters, Andrea, Maddalena and Gemma. The son who was to carry on the activity of the workshop, Neri di Bicci, was born in 1418. In that year Bicci seems to have begun a fruitful period of activity for the hospital complex of S Maria Nuova, Florence, which also employed him as an architect. He provided the *modelli* for the construction of the church of S Egidio, included within the old hospital building. In 1420 he frescoed the façade of the church with the *Consecration of St Egidio* (*in situ*), a composition that has often been cited as echoing Masaccio's *Festival of the Carmine* (untraced). In 1420–21, for the same church, Bicci painted an altarpiece (untraced) commissioned by Bartolommeo di Stefano of Poggibonsi, known as Ghezzo.

Bicci's pupil Stefano d'Antonio Vanni (?1407–1483) collaborated with him in his fresco painting. Much of his production was in this medium. In the first decade of the 15th century he had probably worked alongside his father in the monumental frescoed tabernacle known as the *Madonnone*. He painted frescoes (1421–*c*. 1425) for Ilarione de' Bardi in the Florentine church of S Lucia de' Magnoli. Of these, all that remain are small fragments, no longer clearly visible in the church.

A predella with scenes from the *Lives of the Saints* (Berlin, Gemäldegal.) is dated 1423, a significant year in the development of Bicci's style (see Paolucci). Influenced by Gentile da Fabriano, who was then in Florence painting the *Adoration of the Magi* (ex-Santa Trìnita, Florence; Florence, Uffizi) for Palla Strozzi, he introduced some strongly gothicizing elements, though Gentile's passages of shade and the richness of his materials and expression were very different from the precise backgrounds and bright colours of Bicci's painting. In 1423 Bicci also began the panel of the *Virgin and Child with Saints* (Empoli, Mus. S Andrea) for the church of the Collegiata, Empoli, commissioned by Simone da Spicchio. This work was finally paid for in 1426.

In 1424 Bicci was enrolled as a member of the Compagnia di S Luca. At the same time he continued to work in S Egidio, where he produced some statues of *Apostles* (untraced) and a terracotta relief of the *Coronation of the Virgin* (Florence, Arcisp. S Maria Nuo.; copy *in situ*). An altarpiece with the *Virgin and Child with Six Saints* for S Niccolò sopr'Arno, Florence (*in situ*), dates from 1425. In 1427 Bicci painted a fresco cycle (untraced) for Niccolò da Uzzano (1359–1431) in S Lucia de' Magnoli, Florence. Frescoes, documented in 1427, 1433 and 1441, for Santa Croce, Florence, are also untraced. From 1428 to 1432 he continued his fresco painting in S Marco, Florence, in

collaboration with Stefano d'Antonio Vanni, with whom he had formed an official partnership in 1426. This relationship continued until 1434 with the addition of another painter, Buonaiuto di Giovanni.

During this period countless commissions were received by Bicci's active workshop. In 1429 he executed frescoes in the Camaldolese Monastery, Florence, and in the same year he produced the panel with *SS Cosmas and Damian*, commissioned by Antonio Dalla Casa for Florence Cathedral. The altarpiece with the *Virgin and Child Enthroned with Four Saints* (Siena, Pin. N.) for the church of Vertine near Gaiole in Chianti dates from 1430, the date at one time inscribed on the fresco depicting the *Virgin and Child with SS Leonard and George* in the lunette over the Porta S Giorgio in the city wall of Florence.

(ii) 1430 and after. The influence of Gentile da Fabriano's painting, first evident in Bicci's work around the mid-1420s, re-emerged, at least superficially, in the Polyptych

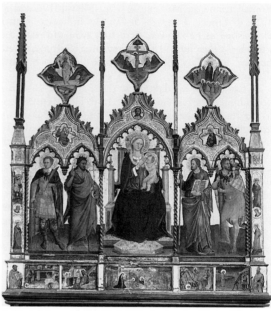

2. Bicci di Lorenzo and Neri di Bicci: triptych with the *Virgin and Child and SS Hippolytus, John the Baptist, James and Christopher*, 1435 (Bibbiena, SS Ippolito e Donato)

(1433; centre panels, Parma, G.N.; see fig. 1; side panels, Grottaferrata, Mus. Abbazia S Nilo, and New York, Met.) for the Benedictine convent of S Niccolò di Cafaggio (destr.), Florence. This was modelled almost slavishly on the Quaratesi polyptych (1425; dispersed), which Gentile painted for S Niccolò sopr'Arno, Florence. The frescoes with *Sacred Scenes* in the baptistery of S Martino a Gangalandi, near Lastra a Signa, are documented to 1433.

In 1434 in Santa Trìnita, Florence, Bicci worked with Stefano d'Antonio Vanni on the fresco decoration of the Compagni Chapel. The scenes of the *Slaying of the Brother* and the *Pardon of St John Gualberto* remain visible on the entrance arch; the altarpiece, also a product of the collaboration, is now in Westminster Abbey, London. Bicci's patrons thus also included some of the noble (or at least upper-class) families of Florence, as well as those from the surrounding countryside from whom he received a constant flow of commissions for altarpieces.

Bicci's son Neri has been credited with a role in the execution of the triptych showing the *Virgin and Child with SS Hippolytus, John the Baptist, James and Christopher* (1435; Bibbiena, SS Ippolito e Donato; see fig. 2). By the age of 20, Neri was managing the workshop alongside his father and his name began to appear in official documents next to that of Bicci. In this they repeated the procedure whereby Bicci had succeeded his father Lorenzo.

For the consecration (1435–6) of Florence Cathedral, Bicci was appointed, together with Lippo di Buono, Rossello di Jacopo Franchi and Giovanni dal Ponte, to decorate the chapels of the tribune with frescoes depicting the *Apostles* (*in situ*). This was a prestigious commission for the city's most important church and was entrusted to a stylistically homogeneous group of painters. The figures were repainted between 1439 and 1440 by Bicci himself, because the haste of the original execution led to their

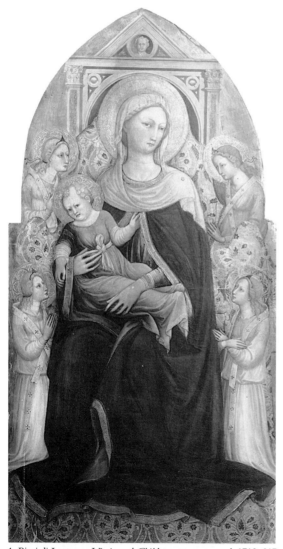

1. Bicci di Lorenzo: *Virgin and Child*, tempera on panel, 1710×817 mm, 1433 (Parma, Galleria Nazionale); central panel of an altarpiece for the Benedictine convent of S Niccolò di Cafaggio, Florence

deterioration. In 1437 he was again working at Santa Trinita, painting the altarpiece for the Scali Chapel (untraced). This had first been commissioned from Giovanni dal Ponte, who had left the work unfinished. On 7 June 1438 Bicci was a witness, with his son Neri, in a dispute between a gold-beater called Bastiano di Giovanni and Domenico di Giovanni Lapi. In 1439–40 Bicci received payment for the *trompe-l'oeil* funerary monument to *Luigi Marsili* (1342–94) frescoed on the right wall of the cathedral, although Neri appears to have played a large part in the execution of this work.

Bicci updated his style only with regard to decorative or accessory elements, inserting passages in classicizing taste into a repertory that depended essentially on the Gothic tradition. It is hard to say to what extent these elements were borrowed from the new Renaissance language and to what extent they were inherited from the tradition of ornamental expression going back to Giotto. In 1441, with a commission from the church of S Egidio at the Ospedale di S Maria Nuova, Florence, the 68-year-old Bicci was working alongside some of the most advanced painters of the day, Domenico Veneziano and Andrea del Castagno. By that time, however, his art had crystallized immutably and no great stimulus resulted to modify the compositional schemes that he repeated in so many works. His figures with their motionless features and his decorative repertory were favoured by many classes of patrons. This gave him a central role in the production of Florentine art and put him at the head of a workshop that employed many painters, albeit most were of modest standing.

From this point on, biographical information on Bicci becomes more scarce. In 1442 it was Neri who drew up the *catasto* (land registry declaration) in his father's name. There Bicci's age is given as 67; however, such inconsistencies are not rare in these declarations of income made by Florentine citizens to the government of the Republic. The workshop was evidently still operating in S Maria Nuova (works untraced), and receiving payments in 1443–6 and 1447. The altarpiece depicting *St Nicholas of Tolentino Protecting Empoli from the Plague* (Empoli, Mus. S Andrea) for the Augustinian church of S Stefano, Empoli, was completed on 5 October 1445.

Despite his age Bicci continued to receive commissions for important works: in Arezzo the Bacci family appointed him to fresco the main chapel of S Francesco, and he worked in the town sporadically from 1445 to 1447, when he was forced to leave Arezzo either because of an epidemic or because his own health was poor. In the angels of the triumphal arch, scholars have detected the less refined, more archaic style of Neri, who by that time seems to have been definitely in charge of the workshop. Yet another project, the fresco decoration of the Lenzi Chapel in the church of the Ognissanti, Florence, was commissioned by Bartolommeo Lenzi and begun by Bicci in 1446. It was completed in 1451 by Neri and other workshop collaborators.

In the *catasto* of 1446–7 Neri di Bicci, in his father's name, gave the address of the workshop as Via S Salvadore, in the district of Santo Spirito, declaring that it was bought from the abbot of the Camaldolese Monastery. Bicci's last *catasto* of 13 August 1451, drawn up as usual by Neri,

gives his age as 82, and that of his son as 31. Bicci, perhaps the most prolific and long-lived painter of the early 15th century, died the following year and was buried in S Maria del Carmine. It was not, however, the end of the workshop: this had been solidly managed, perhaps since the mid-1440s, by his son Neri, who expanded both its operative capacity and its range of activities.

Almost all of Bicci's most important works are documented. There are many others without documentation, including the frescoed tabernacle from Ponte a Greve, a suburb of Florence, depicting the *Virgin and Child* (Florence, Sopr. B.A. & Storici Col.); the altarpiece depicting the *Nativity* in the building known from 1551 as S Giovannino de' Cavalieri, Florence; the *Coronation of the Virgin* (ex-oratory of S Apollinare, Florence; Florence, Santa Trinita); the polyptych of the *Virgin and Child with Saints* in S Maria Cetica in the Pratomagno; a *Virgin and Child with St Catherine of Alexandria and Other Saints* frescoed in a private house, the Casa Bandinelli Gradi, Cerbaia, near San Casciano Val di Pesa; and the tabernacle with the *Virgin and Child Enthroned with Saints* at the Canto alla Cuculia in the district of Santo Spirito, Florence, near the church of S Maria del Carmine. All these works were painted after 1440.

2. STYLE AND WORKSHOP. Bicci's work retained coherence during his more than 40 years of documented activity. Indeed it became so distinctive, with the figures posed like cutouts against the gold backgrounds of the panels, and the thrones, tabernacles and chairs supported by little twisted columns decorated with rigid carved patterns or those inspired by Cosmati work, that the term Biccism is sometimes used in connection with the spread of his style (Frosinini). The extraordinary activity of Bicci's workshop required a large number of collaborators, with some of whom the master would on occasion go into partnership, as he did with Stefano d'Antonio Vanni and Buonaiuto di Giovanni. Other painters in the workshop were, from the 1420s, Masaccio's brother, Scheggia, Antonio di Maso, Marco da Montepulciano (with whom, according to Vasari, Bicci worked in Arezzo in S Bernardo) and Giovanni di Cristofano. During the 1440s he collaborated with Buono di Marco and Antonio di Lorenzo (*fl* 1391–*c*. 1440/50). The painter known as the Maestro di Signa left, in the church in Signa, frescoes whose formal characteristics are very close to those of Bicci. This anonymous artist worked in the town until the 1460s, and also painted numerous murals in both town and country churches. The tabernacle of the Canto alla Cuculia has also been assigned to him.

Although Bicci came into contact with the most important painters of the early 15th century, the figurative spirit of the Renaissance did not attract him even superficially, as it would later attract his son Neri. Nevertheless, his paintings were in great demand until the mid-century and not only in the countryside where outdated taste might be expected to linger on, but also in the city of Florence itself. Traditionalism, it would seem, was quite persistent, and Bicci its perfect, if unwitting, representative.

BIBLIOGRAPHY
Bolaffi; Colnaghi; *DBI*
G. Vasari: *Vite* (1550, rev. 2/1568); ed. G. Milanesi (1878–85), ii, pp. 49–60

O. Sirén: 'Di alcuni pittori fiorentini che subirono l'influenza di Lorenzo Monaco: Bicci di Lorenzo', *L'Arte*, vii (1904), pp. 345–8

G. Poggi: 'Gentile da Fabriano e Bicci di Lorenzo', *Riv. A.*, v (1907), pp. 86–8

R. Van Marle: *Italian Schools* (1923–38)

F. Zeri: 'Una precisazione su Bicci di Lorenzo', *Paragone*, 105 (1958), pp. 67–71

R. Caterina Proto Pisani: 'Tre casi d'intervento nel territorio toscano', *Boll. A.*, lxxii/6 (1984), pp. 3–6

C. Frosinini: 'Un contributo alla conoscenza della pittura tardogotica fiorentina: Bonaiuto di Giovanni', *Riv. A.*, xxxvii/4 (1984), pp. 107–31

——: 'Il trittico Compagni', *Scritti di storia dell'arte in onore di Roberto Salvini* (Florence, 1984), pp. 227–31

A. Padoa Rizzo and C. Frosinini: 'Stefano d'Antonio Vanni "dipintore" (1405–1483): Opere e documenti', *Ant. Viva*, xxiii/4–5 (1984), pp. 5–33

U. Procacci: 'Lettera a Roberto Salvini con vecchi ricordi e con alcune notizie su Lippo d'Andrea modesto pittore del primo quattrocento', *Scritti di storia dell'arte in onore di Roberto Salvini* (Florence, 1984), pp. 213–26

A. Paolucci: *Il Museo della Collegiata di S Andrea in Empoli* (Florence, 1985), pp. 62–3

C. Frosinini: 'Il passaggio di gestione in una bottega pittorica fiorentina del primo rinascimento: Lorenzo di Bicci e Bicci di Lorenzo', *Ant. Viva*, xxv/1 (1986), pp. 5–15

——: 'Il passaggio di gestione in una bottega fiorentina del primo '400: Bicci di Lorenzo e Neri di Bicci', *Ant. Viva*, xxvi/1 (1987), pp. 5–14

B. Santi: 'Pittura minore in S Trinita: Da Bicci di Lorenzo a Neri di Bicci', *La chiesa di S Trinita* (Florence, 1987), pp. 132–42

C. Frosinini: 'A proposito del "San Lorenzo" di Bicci di Lorenzo alla Galleria dell'Accademia', *Ant. Viva*, xxix/1 (1990), pp. 5–7

BRUNO SANTI

Bighordi [Bigordi]. *See* GHIRLANDAIO.

Bigio, Nanni di Baccio [Lippi, Giovanni] (*b* Florence, 1512–13; *d* Rome, Aug 1568). Italian architect and sculptor. He was the most productive member of an architectural family. His father, Baccio Bigio (Bartolomeo di Giovanni Lippi), was active in Florence in the early 16th century; his sons, Annibale Lippi (*fl* 1563–81) and Claudio Lippi, were active in Rome in the 1560s and 1570s. Nanni himself trained first as a sculptor in association with Raffaelo da Montelupo, enrolling in the Compagnia di S Luca in Florence in 1532. With Montelupo he travelled to Rome, where he entered the workshop of Lorenzo di Lodovico di Guglielmo Lotti (Lorenzetto), under whom he carved the first of two well-received copies (1532; marble; Rome, S Maria dell'Anima; and mid-1540s; Florence, Santo Spirito) of Michelangelo's early *Pietà* in St Peter's in Rome and the tomb effigy of *Clement VII* (1540; Rome, S Maria sopra Minerva).

About 1540 Nanni turned to architecture, finding employment with Lorenzetto on the fabric of St Peter's, then under the direction of Antonio da Sangallo the younger. He was active with the 'Setta Sangallesca' on projects for the Farnese family and their circle in Rome and Lazio. He learnt to build in the manner of Sangallo: plain walls with strengthened corners and weighty cornices, and repeated standard details. He developed a taste for the Doric order, columnar loggias, oculi and blind windows that would characterize his mature work. After the death of Sangallo in 1546, Nanni emerged as spokesman for the 'Setta', attacking Michelangelo's alteration of Sangallo's designs at St Peter's and the Palazzo Farnese, and thus commenced his independent career as a significant architect in the Sangallo tradition.

Nanni built fortifications, bridges and roads in Rome (1556–68), Fano (1559), Civitavecchia (1567) and Ostia (1568). Beginning with the Villa Rufina (now Villa Falconieri; 1548; rebuilt 1667–8), FRASCATI, he designed numerous villas and gardens, especially in Rome and Frascati. He also expanded and transformed a number of major palaces. His buildings are sober, practical and substantial; they display his taste for brick construction (he patented a brickmaking process in 1551), for making the principal floor and mezzanine into a single façade unit and for articulating wall-planes with string courses and rhythmic placing of the windows. This suited the tastes of a circle of important patrons, particularly Cardinal Giovanni Ricci of Montepulciano (1497–1574), for whom Nanni designed a Vatican apartment (1551–2); Palazzo Ricci (1550s), Montepulciano; Palazzo Ricci–Sacchetti (1552–7), Rome; the Villa Ricci (now Villa Vecchia; 1550s; rebuilt 1568–9; destr. and rebuilt 20th century), Frascati, and the Villa Ricci–Medici (1564–8), Rome. Other patrons included the Mattei family (Palazzo Mattei–Paganica (1540s), Rome; first projects for Il Gesù (1550), Rome), Julius III (Vatican apartment, 1551–2; Ponte S Maria, 1551; expansion of the Palazzo del Monte (1552), Monte Sansovino), the Salviati family (Palazzo Salviati alla Lungara (1556–68), Rome), Pius IV (exterior of the Porta del Popolo, Rome, 1562–5), Pius V (the Casaletto, 1566–7; S Martino degli Svizzeri (1568), Vatican) and Bernardino Cirillo (1500–75), for whom Nanni designed the Palazzo del Commendatore (1567–8), Rome, and a master-plan for the Ospedale di S Spirito (1567), Rome.

Ironically, Nanni is most generally remembered for his ill-fated Ponte S Maria, which collapsed in 1557, and for his hubristic but almost successful campaign (on grounds of structural expertise and economy) to supplant Michelangelo at St Peter's. (He was briefly appointed to supervise the basilica in 1563.) This earned him the ire of Vasari, who recorded incidents to cast Nanni in a bad light, thus misleading subsequent historians. The lack of information about his work is compounded by extensive alterations to most of his buildings, making stylistic analysis difficult.

BIBLIOGRAPHY

Thieme–Becker

G. Vasari: *Vite* (1550, rev. 2/1568); ed. G. Milanesi (1878–85), vii, pp. 234–5, 551–2

G. Giovannoni: *Antonio da Sangallo il Giovane* (Rome, 1959)

R. Wittkower: 'Nanni di Baccio Bigio and Michelangelo', *Festschrift Ulrich Middeldorf* (Berlin, 1968), pp. 248–62

C. Frommel: *Der römische Palastbau der Hochrenaissance* (Tübingen, 1973)

G. Andres: *The Villa Medici in Rome* (New York, 1976)

D. R. Coffin: *The Villa in the Life of Renaissance Rome* (Princeton, 1979)

La Villa Medici, Académie de France à Rome, ii (Rome, 1991)

GLENN M. ANDRES

Binasco, Francesco. *See* MASTERS, ANONYMOUS, AND MONOGRAMMISTS, §III: MASTER B.F.

Bindo, Benedetto di. *See* BENEDETTO DI BINDO.

Biondo, Flavio (*b* Forlì, 1392; *d* Rome, 4 June 1463). Italian scholar, writer and administrator. He trained as a notary—perhaps in Lombardy—and served as an administrator in various North Italian states, including for a time as secretary to the Venetian humanist and statesman Francesco Barbaro. In 1432 he became an apostolic notary

and shortly thereafter a papal secretary in the service of Eugenius IV (*reg* 1431–47). This appointment brought him into the mainstream of the humanist movement too late to acquire the literary graces apparent in the work of his contemporaries at the Curia, but an immense curiosity and the inspiration of Rome itself enabled him to take new and fertile directions in the study of history. His *Decades ab inclinatione imperii* (completed 1453), which filled a gap hitherto unperceived in historiography, is an objective account of the history of political power, from the fall of Rome to the flourishing Italian states of his own day. He was necessarily limited by the diverse aims and quality of his literary sources, but in putting the emphasis on human capacities, Biondo disengaged his narrative from his sources' concentration on the role of providence or fortune, which led them to promote moralizing or propagandistic points. The same unifying intent is found in his *Italia illustrata* (1453), a historical survey of the regions of Roman Italy (excluding the far south), which relates their ancient division to contemporary circumstances, covering such cultural features as eminent men of the distant and recent past, surviving ancient monuments and contemporary churches and libraries. The synoptic approach of these works, important in the long run, made little impression in the 15th century, where readier advancement was achieved through sponsored histories of states and princes.

More immediately influential was Biondo's handbook to the monuments of Rome. *Roma instaurata* (1446) was the first methodical reconstruction of the ancient city (although it also included notable modern buildings), arranged both topographically and by building type. Taking as a basis the map of the imperial urban areas, Biondo brought to bear on this work a wide range of ancient and medieval sources, tested against his own intimate knowledge of the remains. Personal examination of structures and the use of archaeological, epigraphic and even archival evidence led to the rejection of many current identifications, of the learned literature and of the legendary traditions enshrined in the medieval pilgrim's *Mirabilia*. When Biondo discusses the Theatre of Pompey, for example, a precise citation of Classical authors is followed by an almost successful attempt to locate it with reference to a recently found inscription. His careful handling of all accessible information and an eye for the significant made Biondo the true founder of the scientific study of antiquities, and his work remained unsurpassed in range and depth for a century. His last major work, *Roma triumphans*, comprised a systematic account of Roman public and private life and its development. Biondo was buried in the heart of Rome, at S Maria in Aracoeli on the Capitol.

WRITINGS
Roma instaurata (Rome, 1446)
Italia illustrata. Blondi Flavio Forliuensis de Roma instaurata (Rome, 1453, rev. Venice, 1503; 1470 edn London, BL); ed. J. Bremius, with comment. by R. Maffei (Turin, 1527)
Roma triumphans (n.p., n.d.)
Decades ab inclinatione imperii (Venice, 1483; London, BL)
Scritti inediti e rari di Biondo, Flavio (Rome, 1484; London, BL), ed. B. Nogara (Vatican City, 1927)

BIBLIOGRAPHY
DBI
R. Weiss: *The Renaissance Discovery of Classical Antiquity* (Oxford, 1969, rev. 1988)

M. C. DAVIES

Birago, Giovanni [Giovan] **Pietro** [Giampietrino] (*fl c.* 1471/4–1513). Italian illuminator and engraver. In 1894 he was tentatively associated with his principal work, the Hours of Bona Sforza (London, BL, Add. MSS 34294, 45722 and 62997), and became known as the Master of the Sforza Book of Hours or the Pseudo-Antonio da Monza; in 1956 he was conclusively identified by his signature PSBR IO PETR BIRAGVS FT on the frontispiece of a copy (Warsaw, N. Lib., Inc. F. 1347) of Giovanni Simonetta's life of Francesco Sforza, the *Sforziada*, published first in Latin and then in Italian translation at Milan in 1490.

Three choir-books from Brescia Cathedral dated *c.* 1471–4 (Brescia, Pin. Civ. Tosio-Martinengo, nos 22, 23 and 25) are the earliest known works signed by Birago. It has been suggested that he was active in Venice during the 1480s. Miniatures attributed to him appear in a Breviary of the Venetian Barozzo family, printed on parchment by Nicolas Jenson at Venice in 1481 (Vienna, Österreich. Nbib., Inc. 4. H 63), and in a Pontifical of the Hungarian Cardinal Johannes Vitéz of Veszprém (Rome, Vatican, Bib. Apostolica, MS. Ott. lat. 501). Birago also contributed two miniatures of *Apollo* to a small volume of Italian sonnets and songs (Wolfenbüttel, Herzog August Bib., Cod. 277 4 Extr.). By 1490 he was the leading illuminator at the Sforza court in Milan, and most of his important works are of around this date. The principal of these, the Hours of Bona Sforza, was executed for the mother of Duke Giangaleazzo Sforza (*reg* 1476–94). Unfinished at the Duke's premature death when Ludovico Sforza seized the duchy, the book accompanied Bona into retirement in her native Savoy in 1495. It was completed by Gerard Horenbout (1465–1541) in the Netherlands in 1519–21 for Margaret of Austria, widow of Bona's nephew. Birago participated in the decoration of a *Life of St Iosaphat* (Milan, Bib. N. Braidense, MS. AC XI, 37), also for Bona Sforza.

For Ludovico, Birago executed ornate illuminated frontispieces in a series of *de luxe* copies, printed on parchment, of the Italian translation of the *Sforziada*. Several copies survive: Ludovico's own copy (London, BL, Grenville MS. 7251); that presented to his nephew Giangaleazzo (Paris, Bib. N., Imp., rés., vél. 724); and the signed one in Warsaw, which was a gift to General Galeazzo da Sanseverino, who married Ludovico's illegitimate daughter Bianca in 1496. Nine fragments of the frontispiece of a fourth book (Florence, Uffizi) include one signed AVTORE IO PE BIRA. There is also a copy of the second Latin edition (1486) of the *Sforziada* with a frontispiece and a full-page miniature of *Francesco Sforza on Horseback* close to the style of Birago; this book (Florence, Bib. Riccardiana, ed. v. 428) was probably presented to Maximilian I (*reg* 1493–1519), Holy Roman Emperor, on his marriage to Ludovico's daughter Maria Bianca (1472–1510) in 1494. Maria Bianca may have owned the Wolfenbüttel volume of sonnets, which was in Germany by the beginning of the 16th century. Birago also contributed to the decoration of two books for Massimiliano Sforza, one of Ludovico's sons: a copy of Aelius Donatus's *Ars minor* and the *Liber Iesus* (both Milan, Bib. Trivulziana, Cods 2167 and 2163). He also executed a small Book of Hours (Venice, Fond. Cini, Bib., MS. 4) presented by Ludovico to Charles VIII

of France (*reg* 1483–98). About 1497 Birago illuminated a volume of biographies of French kings by Alberto Cattaneo of Piacenza (Paris, Bib. Arsenal, MS. 1096), destined for Charles VIII, but probably presented after his death to Louis XII (*reg* 1498–1515). In 1506, as Duke of Milan, Louis granted Birago a copyright. The artist was still alive on 6 April 1513, the date of an autograph letter.

Birago's workshop was responsible for the mutilated Hours of Francesco Maria Sforza (1491–4; London, BL, Add. MS. 63493), a Book of Hours probably for a Cremonese patron (Cambridge, U. Lib., Add. MS. 4104) and a decorated copy (London, BL, Add. MS. 21413) of Ludovico's marriage grant of 1494 to his wife, Beatrice d'Este. Six engravings of religious subjects, two of putti and a series of twelve upright ornamental panels, have also been attributed to Birago. One large woodcut records a lost Birago composition, probably also an engraving, but a recent attempt to add two small paintings to his oeuvre is unconvincing.

Like the classicizing details of architecture and armour in his work, Birago's predilection for landscapes composed of rocky heaps of striated boulders interspersed with formalized trees and distant buildings reveals his ultimate dependence on Mantegna, whose style had been introduced to Lombardy by Vincenzo Foppa in 1456. At the Sforza court Birago came into contact with Leonardo da Vinci, from whom he derived the technique of depicting hair as a mass of wiry curls. Grotesque facial types in the Bona Hours suggest a knowledge of Leonardo's celebrated caricatures. The equestrian figure of *Francesco Sforza* in Maximilian's *Sforziada* probably reflects Leonardo's lost plaster for the Sforza Monument, which was exhibited on the occasion of the Emperor's betrothal to Ludovico's daughter. Probably the most distinctive element in Birago's own repertory of figures is a particular sort of chubby putto, which frequently appears in miniatures and decorative borders.

Birago customarily employed a limited but distinguished colour range, composed primarily of deep blues and greens and dark reds, in both miniatures and borders. These colours are sometimes taken up in small pebbles scattered in the foreground of miniatures. Gold was employed sparingly, as often to suggest illumination as for decorative purposes. His full-page miniatures are bordered with simple, moulded gold frames, like those of panel paintings. Opening lines of prayers often appear in cartellini, which stand free within the pictorial space of miniatures or rest on their frames, like attached labels. In Birago's *Sforziada* frontispieces, the ornate borders surround the text with a superabundance of sphinxes, putti, mermaids, cornucopiae, vases and jewels, as well as arms, mottoes, imprese, portraits and political allegories. In the London *Sforziada*, the frontispiece text is transformed into the appearance of a pasted-down leaf of parchment, bending at the top under the weight of a putto who appears to lie on it. This perspectival capriciousness is in harmony with the witty and rich profusion of images that frames the page. As an ingenious response to the fundamental irreconcilability between the flat lines of text and the pictorial space of the miniatures, Birago's borders are comparable with the fictive architecture framing Mantegna's frescoes in the Camera Picta in the Palazzo Ducale, Mantua. Possibly

Birago's greatest achievement is his series of *Sforziada* frontispieces, which brings to life the last decade of Sforza Milan in a pageant of emblems and allegories.

BIBLIOGRAPHY

DBI

G. F. Warner: *Miniatures and Borders from the Book of Hours of Bona Sforza, Duchess of Milan, in the British Museum* (London, 1894)

J. C. Robinson: 'The Sforza Book of Hours', *Bibliographica*, i (1895), pp. 428–36

F. Malaguzzi Valeri: *La corte di Ludovico il Moro: La vita privata e l'arte a Milano nella seconda metà del quattrocento*, i (Milan, 1913), pp. 164, 450, 584; iii (Milan, 1917), pp. 157–75, 200, 225, 227

E. Calabi: 'Giovanni Pietro da Birago e i corali miniati dell'antica cattedrale di Brescia', *Crit. A.*, iii (1938), pp. 144–51

A. Cutolo: '*L' Officium Parvum Beatae Mariae Virginis' donato da Ludovico il Moro a Carlo VIII Re di Francia* (Milan, 1947)

E. Pellegrin: *La Bibliothèque des Visconti et des Sforza, ducs de Milan au XVe siècle* (Paris, 1955), pp. 364–5, 382, 396–7

B. Horodyski: 'Birago, miniaturiste des Sforza', *Scriptorium*, x (1956), pp. 251–5

Arte lombarda dai Visconti agli Sforza (exh. cat., Milan, Pal. Reale, 1958), pp. 141–5

A. Bertini: 'Un'ipotesi sull'attività pittorica di Giovan Pietro Birago', *Arte in Europa: Scritti di storia dell'arte in onore di Edoardo Arslan* (Milan, 1966), pp. 471–4

G. M. Canova: *La miniatura veneta del rinascimento, 1400–1500* (Venice, 1969), pp. 136–40

J. A. Levenson, K. Oberhuber and J. L. Sheehan: *Early Italian Engravings from the National Gallery of Art* (Washington, DC, 1973), pp. 272–80

J. J. G. Alexander: *Italian Renaissance Illumination* (London, 1977), pp. 96–103

G. Bologna: *Milano e gli Sforza Giangaleazzo Maria e Ludovico il Moro, 1476–1499* (Milan, 1983), pp. 71–5

A. C. de la Mare: 'Script and Manuscripts in Milan under the Sforzas', *Atti del Convegno internazionale: Milano dell'età di Ludovico il Moro: Milan, 1983*, pp. 399–407

T. Kren, ed.: *Renaissance Painting in Manuscripts* (New York and London, 1983), pp. 107–22

M. L. Evans: 'A Newly Discovered Leaf of *The Sforza Hours*', *BL J.*, xii/1 (1986), pp. 21–7

——: 'New Light on the *Sforziada* Frontispieces of Giovan Pietro Birago', *BL J.*, xiii/2 (1987), pp. 232–47

——: *The Sforza Hours* (London, 1992)

The Painted Page: Italian Renaissance Book Illumination, 1450–1550 (exh. cat., ed. J. J. G. Alexander; London, RA, 1994)

M. L. Evans and B. Brinkmann: *The Sforza Hours* (Lucerne, 1995) [facs. and commentary]

M. L. EVANS

Biringucci. Italian family of artists.

(1) Vannuccio [Vannoccio; Vanuccio] **Biringucci** (*b* Siena, 20 Oct 1480; *d* ?Rome, before 30 April 1539). Metallurgist and architect. He may have trained with his father, Paolo di Vannuccio Biringucci, who was a mason and a member of one of Siena's noble families. Biringucci was subject to conflicting pressures in the city's unstable political environment and he was exiled three times for sedition and conspiracy. In 1507 he travelled to Germany and North Italy, in 1517 to Rome, Naples and Sicily, and in 1526–9 to Germany and the Romagna. In 1524 he was given permission to manufacture saltpetre throughout Sienese territory. He went to Rome in 1536 and may have served as Master of the Papal Mint and artillery captain to Pope Paul III. He also served the Sienese Republic as an architect, designing arches (1513) for the triumphal entry of Bishop Gurgense, and succeeding Baldassare Peruzzi as architect to the republic and to the Cathedral Works (1535). His treatise, *De la pirotechnia* (1540), is one of the key works in the history of metallurgy, and covers the nature of ores and their location, the casting and fusing of

metals, and mining techniques. It also deals extensively with artillery and ammunition. The importance of the work lies in its accurate and careful description of metallurgical practice and in its reliance on experimentation and observation. It is the first printed work to cover the entire subject of metallurgy and it had a wide-ranging influence in western Europe and the New World.

WRITINGS

De la pirotechnia: Libri X (Venice, 1540); ed. C. S. Smith, Eng. trans. by M. T. Gnudi as *The Pirotechnia of Vannoccio Biringucci* (New York, 1943, rev. Cambridge, MA, 2/1959)

BIBLIOGRAPHY

E. Romagnoli: *Biografia cronologica de' bellartisti senesi, 1200–1800*, vi (Siena, 1835, rev. Florence, 2/1976), pp. 289–342

NICHOLAS ADAMS

(2) Oreste Vannocci Biringucci [Vannocci, Oreste; Vannoccio; Vanuccio] (*b* Siena, 1558; *d* Mantua, 8 July 1585). Architect, engineer and festival designer, grandson of (1) Vannuccio Biringucci. His father was the architect Oreste Vannocci. His early artistic contacts were in Rome and Florence, where he worked with Giovanni Giacomo della Porta and Bernardo Buontalenti. He was first noted as a translator of a commentary on Aristotle's *Mechanics* (Rome, 1582), and he later translated Heron of Alexander (1592; Siena, Bib. Com. Intronati, MS. L.VI.44). In 1583 he was appointed Prefetto delle Fabbriche to the Gonzaga court in Mantua, where he was primarily responsible for the design of festival decorations, such as those for the marriage of Vincenzo Gonzaga and Margherita Farnese in 1584. He coordinated the entire spectacle, including poetry, music and design.

Vannocci's importance rests on a small sketchbook (140×200 mm; Siena, Bib. Com. Intronati, MS. S.IV.1) of 149 folios. Entitled *Architettura, fortificazione e macchine di Oreste Vannocci*, it is a collection of drawings of buildings erected in Rome and Florence between 1540 and 1582. Included are copies of drawings by Jacopo Vignola—plans for Il Gesù in Rome and drawings after St Peter's—as well as drawings after Filippo Brunelleschi and the Antique. One important source was the Lille Sketchbook of Aristotele da Sangallo and Giovanni Battista da Sangallo. This work provides a record of various lost drawings and projects and is important for the method of presentation of the material. At times, Vannocci used a kind of comparative method (contemporary versus early Renaissance architecture). The manuscript was possibly to have formed part of an architectural treatise conceived on historical lines.

BIBLIOGRAPHY

E. Romagnoli: *Biografia cronologica de' bellartisti senesi, 1200–1800*, viii (Siena, 1835/*R* Florence, 1976), pp. 365–82

L. H. Heydenreich: 'Über Oreste Vannocci Biringucci', *Mitt. Ksthist. Inst. Florenz*, iii (1931), pp. 434–40

J. S. Ackerman and W. Lotz: 'Vignoliana', *Essays in Memory of Karl Lehmann*, i (Locust Valley, NY, 1964), pp. 1–24

G. Scaglia: *Francesco di Giorgio Checklist and History of Manuscripts and Drawings in Autographs and Copies from c. 1470 to 1687 and Renewed Copies* (Bethlehem, PA, 1992), pp. 136–9

NICHOLAS ADAMS

Bissolo [Bissuolo], **Francesco** (*b* ?Treviso, ?*c.* 1470–75; *d* Venice, 20 July 1554). Italian painter. At least eight signed works by Bissolo are known; one of the most important of these, the *Coronation of St Catherine of Siena* (1513; Venice, Accad.), is also documented with a contract. On this basis, a considerable number of other altarpieces and devotional half-lengths may be attributed to him with a reasonable degree of confidence. Bissolo is first recorded as an assistant of Giovanni Bellini at the Doge's Palace, Venice, in 1492, and his works demonstrate a stylistic dependence on his master throughout his long life (apparently spent entirely in Venice). Individual motifs are frequently borrowed directly from Bellini, as with the God the Father of the *Coronation*. Hallmarks of his own manner include a softness of modelling, tending towards formlessness, and a greater sentimentality of facial expression than usual in the work of Bellini's other followers.

In works that must belong to his later career, such as the *St Euphemia with Saints and a Donor* (Treviso Cathedral), Bissolo was evidently responding to the more advanced styles of younger contemporaries such as Paris Bordone and Bonifazio Veronese, without, however, abandoning the Bellinesque basis of his art. Bissolo was employed by distinguished men such as Pietro Barozzi, Bishop of Padua, and Bonino de' Bonini, printer and canon of Treviso Cathedral. Although as late as 1545 he enjoyed sufficient professional reputation to be asked to value a picture by Lorenzo Lotto, his rather low recorded fees confirm that his contemporaries did not overrate his essentially modest talents.

BIBLIOGRAPHY

DBI; Thieme–Becker

A. M. Zanetti: *Della pittura veneziana* (Venice, 1771), pp. 82–3

G. Ludwig: 'Archivalische Beiträge zur Geschichte der venezianischen Malerei', *Jb. Kön.-Preuss. Kstsamml.*, xxvi (1905), pp. 41–9 [docs]

L. Coletti: 'Intorno a Francesco Bissolo', *Boll. A.*, viii (1928–9), pp. 325–34

B. Berenson: *Venetian School* (1957), i, pp. 39–40

M. Palmegiano: 'Opere inedite di Francesco Bissolo', *A. Veneta*, xiii–xiv (1959–60), pp. 198–201

F. Heinemann: *Giovanni Bellini e i Belliniani*, i (Venice, 1962), pp. 90–97

L. Montobbio: 'Nuovi documenti su Francesco Bissolo', *Atti & Mem. Accad. Patavina Sci., Lett. & A.*, lxxxv (1972–3), pt iii, pp. 237–46

P. Carboni: 'La pala di Francesco Bissolo nel Duomo di Treviso', *A. Veneta*, xli (1987), pp. 128–30

P. Humfrey: 'Fra Bartolomeo, Venice and St Catherine of Siena', *Burl. Mag.*, cxxxii (1990), pp. 476–83

PETER HUMFREY

Bissone, Elia de. *See* GAGINI, (2).

Bissucio, Leonardo (de' Molinari) da. *See* LEONARDO DA BESOZZO.

Bisticci, Vespasiano da. *See* VESPASIANO DA BISTICCI.

Bitte [Bitti], **il.** *See* CAPORALI, (2).

Boccaccino [Boccacci]. Italian family of painters.

(1) Boccaccio Boccaccino (*b* Ferrara, before 1466; *d* Cremona, 1525). He is first recorded in 1493 in Genoa, where he contracted to paint the high altarpiece (untraced) for S Maria della Consolazione. In 1497 he was extracted from prison in Milan by the agent of Ercole I d'Este, Duke of Ferrara, and worked for the Duke in Ferrara until 1500. Perhaps as a consequence of having killed his common-law wife he then left, presumably for Venice, where he is

recorded as residing in 1505. A fresco in Cremona Cathedral is dated 1506, and Cremona was his principal workplace thereafter.

Boccaccio's early works (e.g. *Death of the Virgin*, Paris, Louvre; fragmentary frescoes from S Maria degli Angeli, Ferrara, now Ferrara, Pin. N.) show an uncertainty of orientation common to Ferrarese painters in the 1490s. Reminiscences of Ercole de' Roberti are overlaid, in different paintings, with elements from Lombard painting (especially Bramantino), Lorenzo Costa the elder and other Emilian artists, Perugino, Dürer's prints and the Bellinesque painters of Venice. In his most impressive early work, the *Road to Calvary* (London, N.G.), those elements are amalgamated into an expressive personal style.

Boccaccio's stay in Venice was decisive for his development. In his numerous Madonnas and *sacre conversazioni* (e.g. Venice, Correr; Boston, MA, Mus. F.A.) he appears as a highly resourceful convert to the contemporary style of Giovanni Bellini, emulating him in format, sentiment, in a harmonious but daringly variegated palette, and in the fluidly impressionistic rendering of landscape. He was also influenced by Benedetto Diana, Pier Maria Pennacchi and Giorgione at this time. Boccaccio's monumental altarpiece for S Zulian, Venice (*in situ*), reflects both Bellini's S Zaccaria Altarpiece in Venice (1505; *in situ*; see colour pl. 000) and Giorgione's Castelfranco Altarpiece (Castelfranco Cathedral; *see* GIORGIONE, fig. 6). Also from this Venetian period, though dated later by some, is the idyllic *Mystic Marriage of St Catherine* (Venice, Accad.), which exemplifies the translucent harmony of colour and magical delicacy in the evocation of landscape.

In 1506 Boccaccio frescoed the half-dome of the apse of Cremona Cathedral with a huge *Christ in Glory among Saints*, and for the next ten years he dominated painting in Cremona, working in the cathedral (the *Annunciation*; 1507) and other churches. Puerari suggested that he returned to Venice and Ferrara during this decade, and certain paintings such as the *Nativity* (Naples, Capodimonte) or the *Virgin with Shepherds* (Modena, Gal. & Mus. Estense) evince renewed contacts with the younger generation of Ferrarese painters: Ludovico Mazzolino, Ortolano and Garofalo. Vasari mentioned a trip to Rome, possibly in 1513–14, during which Boccaccio spoke slightingly of Michelangelo.

Between 1514 and 1518 Boccaccio painted eight large scenes (e.g. the *Birth of the Virgin*; see fig.) from the *Life of the Virgin* in the nave of Cremona Cathedral, initiating a fresco cycle continued by Altobello Melone, Gian Francesco Bembo, Girolamo Romanino and Pordenone. These, his most ambitious surviving works, combine panoramic Venetian landscapes, elaborate architectural scenography, startlingly vivid portraits and anecdotal episodes, restlessly swirling patterns of drapery and motion and, on occasion, classical fixity of composition into paradoxical but not incoherent wholes. Boccaccio's late altarpieces (e.g. the *Virgin Enthroned with Saints*, 1518; Cremona, Mus. Civ. Ala Ponzone) are quieter and more intensively atmospheric in effect, but they, too, show his responsiveness to German prints and to the work of his younger colleagues.

Boccaccio successfully assimilated a wide range of influences into a personal style that served as a point of

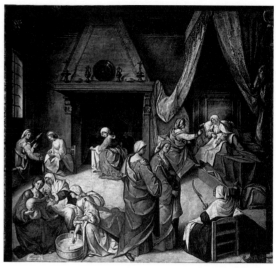

Boccaccio Boccaccino: *Birth of the Virgin*, fresco from the *Life of the Virgin* series (1514–18), Cremona Cathedral

departure for other painters. In Ferrara, Garofalo was apprenticed to him, and Boccaccio's adoption of a Venetian style *c.* 1500 was probably instrumental in the turning of a whole generation of Ferrarese painters (Garofalo, Mazzolino, Ortolano, Dosso Dossi) towards Venetian models. In Venice and Cremona his particular synthesis of Venetian and Lombard elements influenced Andrea Previtali, Romanino, Altobello Melone and Gian Francesco Bembo. After 1500 Boccaccio incorporated elements of Giorgione's style into his own, but, earlier, he may well have been among the Emilian artists to whom Giorgione looked when forming his art.

BIBLIOGRAPHY

DBI: 'Boccacci, Boccaccino'; Thieme–Becker
G. Vasari: *Vite* (1550, rev. 2/1568); ed. G. Milanesi (1878–85), iv, pp. 581–4; vi, pp. 459–60
G. B. Zaist: *Notizie storiche de' pittori, scultori, ed architetti cremonesi*, 2 vols, ed. A. M. Panni (Cremona, 1774/*R* 1976), i, pp. 63–90
C. Bonetti: *Note e appunti di storia cremonese* (Cremona, 1923), pp. 63–6
G. Gronau: 'Unveröffentlichte Bilder des Boccaccio Boccaccino', *Belvedere*, viii (1929), pp. 250–55
A. Puerari: *Boccaccino* (Milan, 1957) [standard monograph; chronology occasionally questionable]
M. Calvesi: 'Nuovi affreschi ferraresi dell'Oratorio della Concezione', *Boll. A.*, xliii (1958), pp. 141–238
S. Zamboni: 'Ludovico Mazzolino: Una primizia e altri inediti', *Prospettiva*, 15 (1978), pp. 53–72
E. Sambò: 'Per l'avvio di Ludovico Mazzolino', *Paragone*, 395 (1983), pp. 40–45
——: 'Sull'attività giovanile di Benvenuto Tisi da Garofalo', *Paragone*, 395 (1983), pp. 17–34
I Campi e la cultura artistica cremonese del cinquecento (exh. cat., ed. M. Gregori; Cremona, Mus. Civ. Ala Ponzone, 1985), pp. 51–63, 270–72, 457–8

FRANCIS L. RICHARDSON

(2) Camillo Boccaccino (*b* Cremona, 1504–5; *d* Cremona, 1546). Son of (1) Boccaccio Boccaccino. He probably received his initial training from his father, but was influenced at an early stage by Pordenone's Cremonese works, and also by Titian, whom he evidently came to know during his long sojourn in Venice (documented until 1525). His earliest known works show these influences

and that of contemporary Brescian painters. They include the *Virgin and Saints* altarpiece from S Maria del Cistello (1527; Prague, N.G., Šternberk Pal.), the imposing organ shutters of *David and Saul* from S Maria di Campagna in Piacenza (1530; Piacenza, Mus. Civ.) and the *Annunciation* (Piacenza, S Maria di Campagna), which was cut down to fit the church's apse. These works show a remarkable maturity and originality in the use of colour and chiaroscuro to create illusionistic effects.

Although Camillo Boccaccino produced very few paintings, several stylistic phases can be distinguished in his oeuvre. In 1532 he painted the altarpiece of the *Virgin and Child in Glory with SS Bartholomew, John the Baptist, Albert and Jerome*, formerly in S Bartolomeo, Cremona (Milan, Brera), a carefully constructed composition showing the influence of Pordenone, Raphael and Correggio. From 1535 to 1537 he frescoed the vault, semi-dome and entablature of the apse of S Sigismondo in Cremona with *Christ in Glory* and the *Four Evangelists*, biblical scenes and decorative friezes. While influenced by Correggio, Pordenone and Giulio Romano, the frescoes demonstrate the variety of Boccaccino's inventions and the novelty and boldness of some of his figurative solutions which inaugurated a new stylistic and decorative language in the Cremonese school of painting at this date.

During the 1530s Boccaccino moved stylistically closer to Parmigianino, with his extreme refinement, sinuously elegant forms and imaginative compositions; he was in close contact with Parmigianino, whose ideas he reinterpreted with originality, sometimes reaching his own eccentric solutions. These traits are evident in the altarpiece, commissioned in 1533 and probably painted in the late 1530s, for the altar of S Marta in Cremona Cathedral. It was never installed (at the artist's death it was still in his studio), but is known through an engraving by Niccolò Vicentino, numerous preparatory studies and some *bozzetti*. Camillo Boccaccino was a prolific and attractive draughtsman.

The frescoes of the *Resurrection of Lazarus* and *The Adultress* (1540) in the presbytery of S Sigismondo, Cremona, are notable for their bold use of colour and their disconcertingly novel Mannerist solutions. These stylistic tendencies were developed further in the frescoes of the *Life of the Virgin* painted in 1545 for S Sigismondo and in the altarpiece of the *Virgin and Child with St Michael and the Blessed Ambrogio Ansedoni* formerly in S Domenico (1544; Cremona, Mus. Civ. Ala Ponzone).

BIBLIOGRAPHY

DBI; Thieme–Becker

G. Vasari: *Vite* (1550, rev. 2/1568), ed. G. Milanesi (1878–85), iv, pp. 583–4

G. P. Lomazzo: *Idea del tempio della pittura* (Milan, 1590)

A. M. Panni: *Distinto rapporto delle dipinture che trovansi nelle chiese della città e sobborghi di Cremona* (Cremona, 1762)

G. B. Zaist: *Notizie istoriche de' pittori, scultori ed architetti cremonesi* (Cremona, 1774)

G. Aglio: *Le pitture e le sculture della città di Cremona* (Cremona, 1794)

F. Sacchi: *Notizie pittoriche cremonesi* (Cremona, 1872)

A. Venturi: *Storia* (1904–40, *R*/1966), IX, vi

M. Gregori: 'Traccia per Camillo Boccaccino', *Paragone*, iv/37 (1953), pp. 3–18

G. Bora: 'Note cremonesi, I: Camillo Boccaccino, le proposte', *Paragone*, xxv/295 (1974), pp. 40–70

I Campi e la cultura artistica cremonese del cinquecento (exh. cat., ed. M. Gregori; Cremona, Mus. Civ. Ala Ponzone, 1985)

I segni dell'arte. Il Cinquecento da Praga a Cremona (exh. cat., eds G. Bora and M. Zlatohlavek; Milan, 1997)

GIULIO BORA

Boccaccio, Giovanni (*b* ?nr Florence, 1313; *d* Certaldo, 21 Dec 1375). Italian writer. He was the natural child of an unknown mother and Boccaccino di Chellino, a merchant banker. At the age of 14 Boccaccio was sent to Naples and apprenticed to a Florentine counting house; subsequently he attended the University of Naples, where he studied canon law and met many of the city's leading scholars and humanists, including Paolo da Perugia, Andalo del Negro and Cina da Pistoia. Boccaccio's desire to pursue a literary career eventually supplanted all other interests. One of the most influential writers of the 14th century, he is now known primarily for his works in Italian, in particular the *Decameron*. During his lifetime, however, such works in Latin as *De claris mulieribus* (1361), *De casibus virorum illustrium* (1355–60) and the immensely influential encyclopedia *De genealogia deorum gentilium* (written 1350–60; revised 1371–4) were the major sources of his fame and were often the subject of manuscript and book illustrations, especially in the 15th century.

Boccaccio began the *Decameron* in 1350 and completed it *c*. 1353. In 1370 he revised it, and this second version exists in an autograph manuscript (Berlin, Staatsbib. Preuss. Kultbes., Hamilton MS. 90), which has both literary importance and artistic merit; it contains a series of 13 whimsical bust portraits ascribed to Boccaccio. These small sketches, executed in pen and watercolour, appear at the end of each quire and represent the work's major characters. Boccaccio was greatly influenced by Petrarch, whom he met in 1350, and by Dante, on whose life and works he delivered a series of lectures. Undeniably, the *Decameron* owes much to Dante. It is written in the vernacular, like the *Divine Comedy*, and comprises 100 tales, which contain references to many recognizable, contemporary individuals. The stories are drawn from a wide variety of sources, including the literature of France, Provence, Spain, the Near East, Byzantium and Italy. Throughout, the theme of love in all its guises predominates, but there are also tales of adventure and buffoonery.

Set in Florence in 1348 at the height of the Black Death, the story begins when seven young women and their three male companions decide to flee the disease-ridden city for a sojourn in the Tuscan countryside, filling their time with storytelling, singing and dancing. Six of the tales are concerned with contemporary Florentine artists. Giotto is the central character of VI.5, while the stories of VIII.3, 6 and 9, and IX.3 and 5 relate the scurrilous, fictional escapades of Buffalmacco (*fl c*. 1315–36), Bruno di Giovanni d'Olivieri (*fl* 1301–20) and the less talented Calandrino (Giovannozzo di Perino, *fl c*. 1301–18). Boccaccio's much-quoted comments regarding Giotto's fame, his humility, and the extraordinary illusionistic realism of his art were based on Pliny the elder's observations in *Natural History* XXXV (AD 77) on the genius of Classical art. Underlying the pranks of Buffalmacco and his colleagues is an equally serious allusion to the creative artist's power to reconstruct the world according to the dictates of his own imagination.

The *Decameron* soon attracted the interest of artists, as its concrete imagery and ribald humour afforded excellent

subjects for manuscript illumination as well as monumental art. The earliest extant illustrations are found in a late 14th-century Florentine manuscript (Paris, Bib. N., MS. it. 482). The work was translated into French by Laurent de Premierfait in 1414, under the title *Cent nouvelles*, and enjoyed a particular vogue in France and England. The first known illuminated manuscript of the French translation (Rome, Vatican, Bib. Apostolica, MS. Pal. lat. 1989) dates from the second decade of the 15th century. The *Decameron* achieved its greatest literary and artistic success during the 15th century and the early 16th, beginning with the first printed edition produced in Venice by Giovanni and Gregorio de' Gregoriis in 1492, which had 104 high-quality woodcuts (see fig.) executed by two artists; the illustrations were reused in the two later Venetian publications of 1498 and 1504. Subsequently such artists as Pesellino and Sandro Botticelli depicted stories from the *Decameron* on *cassoni* (see CASSONE, §1). The tale of patient Griselda (*Decameron* X) is one of the most popular subjects for illustration, as in the cycle of frescoes (probably 15th century) in the Castello Roccabianca near Parma, for example.

WRITINGS

Decameron (MS.; 1350–*c*. 1353); ed. D. Wallace (Cambridge, 1991)
V. Branca, ed.: *Tutte le opere de Giovanni Boccaccio*, 7 vols (Milan, 1964–92) [further five vols planned]

BIBLIOGRAPHY

G. von Terey: 'Boccaccio und die niederländische Malerei', *Z. Bild. Kst*, xxx (1919) [whole issue]
G. S. Purkis: 'A Bodleian Decameron', *Medium Aevum*, xix (1950), pp. 67–9
M. Meiss: 'The First Fully Illustrated Decameron', *Essays in the History of Art Presented to Rudolph Wittkower* (London, 1967), pp. 56–61
Omaggio a Giovanni Boccaccio degli artisti contemporanei (exh. cat., Certaldo, Pal. Pretorio, 1967)
M. Meiss: 'The Boucicault Master and Boccaccio', *Stud. Boccaccio*, v (1968), pp. 251–63
R. O'Gorman: 'Two Neglected Manuscripts of Laurent de Premierfait's *Decameron*', *Manuscripta*, xiii (1969), pp. 32–40
M. Ferrari: 'Dal Boccaccio illustrato al Boccaccio censurato', *Boccaccio in Europe. Proceedings of the Boccaccio Conference: Leuven, 1975*, pp. 111–34

The 'Brigata' Seated in a Garden, woodcut, frontispiece to Giovanni Boccaccio: *Decameron* (Venice, 1492) (Florence, Biblioteca Nazionale Centrale)

P. M. Gathercole: *Tension in Boccaccio: Boccaccio and the Fine Arts*, University of Mississippi Romance Monographs (Oxford, MS, 1975)
Boccace en France. De l'Humanisme à l'érotisme: VI centenario della morte del Boccaccio (exh. cat. by F. Avril and F. Callu, Paris, Bib. N., 1975)
F. B. Salvadori: 'L'incisione al servizio del Boccaccio nei secoli XV e XVI', *An. Scu. Norm. Sup. Pisa*, 3rd ser., vii/2 (1977), pp. 596–734
E. Callmann: 'The Growing Threat to Marital Bliss as Seen in Fifteenth-century Florentine Paintings', *Stud. Iconog.*, v (1979), pp. 73–92
V. Branca: 'Boccaccio illustratore del suo *Decameron* e la tradizione figurativa del suo capolavoro', *It. Q.*, xxi/79 (1980), pp. 5–10
——: *Boccaccio medievale e nuovi studi sul 'Decameron'* (Florence, 1981)
P. F. Watson: 'Gatherings of Artists: The Illustrators of a *Decameron* of 1427', *Text*, i (1981), pp. 147–56
M. Arese Simicik: 'Il ciclo profano degli affreschi di Roccabianca: Ipotesi per una interpretazione iconografica', *A. Lombarda*, 65 (1983), pp. 5–26
Tales Retold: Boccaccio's 'Decameron', 17th Century to 19th Century (exh. cat. by C. Gordon, Buxton, Mus. & A.G., 1983)
P. F. Watson: 'The Cement of Fiction: Giovanni Boccaccio and the Painters of Florence', *Mod. Lang. Notes*, xcix/1 (1984), pp. 43–65
V. Branca and others: 'Boccaccio visualizzato', *Stud. Boccaccio*, xv–xvi (1985–6) [whole issues]

JOAN ISOBEL FRIEDMAN

Boccardi, Giovanni (di Giuliano) [Boccardino the elder] (*b* Florence, 1460; *d* Florence, 1 March 1529). Italian illuminator. His activity is documented through Florentine records of payment by the Badia, the Opera del Duomo and the church of S Lorenzo. From payments dated 1477, 1479 and 1480, it appears that Boccardi was enrolled in the Compagnia della Purificazione e di S Zanobi. In 1480 he was an apprentice in the *bottega* of the bookseller Bastiano, but he may have begun working as early as 1475 in the *bottega* of Francesco di Antonio del Chierico.

Boccardi worked on Classical and humanist subjects as well as religious books. In 1485 he illuminated for a Book of Hours (Munich, Bayer. Staatsbib. Clm. 23639) a page that is particularly close to the work of Gherardo di Giovanni del Foro in the Netherlandish treatment of landscape and figures. Eight miniatures for the Psalter of S Egidio, dated 1486, are lost. In a Book of Hours illuminated by several artists (Attavante Attavanti, Mariano del Buono di Jacopo and Stefano Lunetti) for Lorenzo de' Medici's daughter-in-law Laudomia (1502; London, BL, Yates Thompson MS. 30), the use of the cameo is characteristic of Boccardi; its Classical iconography is sometimes abandoned in favour of a portrait. A Breviary (*c*. 1500; Paris, Bib. N., MS. lat. 6869) that Boccardi illuminated for an unidentified bishop reflects the strong influence of Domenico Ghirlandaio's *bottega* in its landscape vignettes, while the picturesque scenes from urban, suburban and country life are reminiscent of Gherardo. In 1512 the artist collaborated with Monte di Giovanni del Foro on a Choir-book (Florence, S Marco, MS. 542) for the Badia. Among his contributions to humanist codices for Matthias Corvinus, King of Hungary (*reg* 1458–90), is a Philostratus manuscript (Budapest, N. Széchényi Lib., Cod. lat. 417).

Boccardi's work shows a consistent interest in the Antique, using Classical motifs and decorative elements. His style before 1490 reflects close links with the del Foro *bottega*. Despite considerable enrichments, it is also recognizable in late documented works, showing affinities with the type of illustration typical of an ex-voto or of the predella of a panel painting: minuteness of detail, figures with faces narrowed towards the chin, astonished expressions and mannered attitudes.

BIBLIOGRAPHY
M. Levi d'Ancona: *Miniatura e miniatori a Firenze dal XIV al XVI secolo* (Florence, 1962), pp. 149–54
A. Garzelli: *Miniatura fiorentina del rinascimento, 1440–1525: Un primo censimento*, i (Florence, 1985), pp. 80–81, 341–6

PATRIZIA FERRETTI

Boccati (da Camerino), Giovanni (di Pier Matteo) (*b* Camerino, Marches, *c.* 1420; *d* after 1480). Italian painter. He was granted citizenship of Perugia in 1445, and it seems likely that he received at least part of his artistic training there. In 1447 he painted the *Madonna del pergolato* (*Virgin and Child with Saints*; Perugia, G.N. Umbria) for the Confraternità dei Disciplinati of S Domenico, Perugia. It is an eclectic work: the composition is based on altarpieces of the later 1430s by Fra Angelico (who was in Perugia in 1437) and Filippo Lippi; the Virgin's face is derived from Angelico, those of the Child, the saints and the angels from Lippi, while the pageantry of the predella, showing scenes from the *Passion of Christ*, may reflect the work of Domenico Veneziano, who had also been in Perugia in 1437. By 1448 Boccati was in Padua, but he may have been there earlier given the dominant influence of Filippo Lippi, who had worked there in the mid-1430s.

In 1451 Boccati left Camerino for Florence with the painter Giovanni Angelo di Antonio, also of Camerino. He may not have reached the city but have turned instead for Urbino, as at about this time he probably painted the frescoes (partly destr.) in the Appartamento dell'Iole, Palazzo Ducale, Urbino. The walls and vaults of the frescoed room, possibly originally an audience chamber, were covered with huge figures of heroes and soldiers, putti, coats of arms, medallions and damask hangings. In style the figures are similar to those of the *Madonna del pergolato*, and their monumentality perhaps reflects Boccati's recent stay in Padua.

By 1458 and again in 1462 he was in Camerino, where he appears to have remained until at least 1470. To this period belongs the Belforte Polyptych, with the *Virgin and Child with Saints* (Belforte sul Chienti, nr Camerino, S Eustachio), which is signed and dated 1468. This is a compartmentalized polyptych of the type produced by contemporary Venetian artists working in the Marches, such as Bartolomeo Vivarini and Carlo Crivelli. The gold ground and rich gold brocade of the Virgin's mantle are Venetian in origin, but the draperies and blonde light pervading the predella scenes recall Domenico Veneziano, and the physiognomy of the saints is reminiscent of Filippo Lippi. The figures of SS Eustace and Venanzio suggest that Boccati had been influenced by Mantegna's work in the Ovetari Chapel in the church of the Eremitani, Padua (*see* MANTEGNA, ANDREA, fig. 1).

The altarpiece of the *Virgin and Child with Saints* for the chapel of S Savino in Orvieto Cathedral (Budapest, Mus. F.A.) is signed and dated 1473. Stylistically, it is similar to the Belforte Polyptych, although the rendering of the draperies is more linear and the conception of the bodies underneath is less firm, leading to some flatness in the figures. The two surviving predella panels, showing scenes from the *Life of St Savino* (sold London, Sotheby's, 11 March 1964 and 24 March 1971), with their clothed but weightless figures and inaccurately constructed architecture, confirm this tendency. Boccati's last surviving

dated work, the *Pietà* (1479; Perugia, G.N. Umbria), is in poor condition; it has the same flat figures, but the lyrical mood and the clear light are still present. Boccati was last recorded in Perugia in 1480, when he was paid for two altarpieces (untraced).

BIBLIOGRAPHY
G. Vitalini-Sacconi: *La scuola camerinese* (Trieste, 1968), pp. 107–15
M. Bacci: 'Il punto su Giovanni Boccati', *Paragone*, xx (1969), no. 231, pp. 15–33; no. 233, pp. 3–21
P. Zampetti: *Giovanni Boccati* (Milan, 1971)
M. Cionini Visani: 'Un libro sul Boccati', *A. Ven.*, xxvii (1973), pp. 321–5
Urbino e le Marche, prima e dopo Raffaello (exh. cat., ed. M. G. Ciardi, D. dal Poggetto and P. dal Poggetto; Urbino, Pal. Ducale, 1983), pp. 35–9

JEANNETTE TOWEY

Bologna [Etrus. Felsina; anc. Rom. Bononia]. Northern Italian city and capital of the province of Emilia-Romagna. It lies in the north-eastern foothills of the Appenine range betwen the rivers Reno, Savena and Aposa and a system of canals, at the heart of a rich agricultural basin. Prominent since Roman times, the city straddles the Roman Via Emilia linking Rome and Ravenna, which formed the *decumanus maximus*, its main east–west street. The Roman street plan survives clearly in the central city. It has one of the oldest universities in Europe (founded 1088), famous as a centre of jurisprudence. The site's numerous waterways served the city's main industries, including production of silk, wool and hemp, which peaked during the Renaissance; the city was also known for its production of ceramics (*see* §III below). Architecturally Bologna is noted for its arcaded streets, and it largely retains the works of builders from the late 14th century to the 16th.

I. History and urban development. II. Art life and organization. III. Centre of ceramics production. IV. Buildings.

I. History and urban development.

1. Before *c.* 1400. 2. *c.* 1400–*c.* 1600.

1. BEFORE *c.* 1400. There is archaeological evidence of habitation from the Bronze and Iron ages and of necropolises indicating Villanovan settlement from *c.* 1050 to 500 BC. The Etruscans called the city Felsina; the Romans established a Latin colony there in 189 BC, which became Bononia, named after the Gallic Boii. In AD 53 a fire destroyed the city. Around 500 the Roman city was encircled by walls of selenite. Bologna came under Byzantine rule in the 6th century, before passing to the Lombards and then, in 765, to the Papacy. In the 10th century it became a free city. Between 1055 and 1070 the city boundaries were enlarged by a second circuit, and a century later the city was divided into four administrative quarters, and the wall became the circle of *torresotti* (gate towers) as habitations replaced original defensive functions.

An agreement among the local population in 1123 may mark the beginning of the Commune. Although conflicts with the Papacy caused Bologna to decline in the early 14th century, the re-establishment of an independent Comune in 1376 led to major civic improvements. The main city walls were built in the 13th and 14th centuries and lasted until the 19th century. The character of the medieval city is determined by its towers, its porticoes,

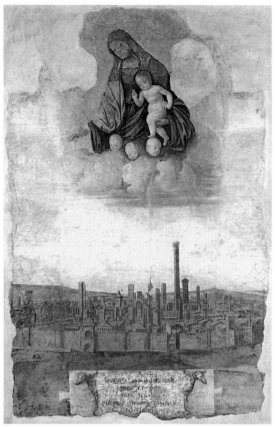

1. View of Bologna in the lower part of the *Madonna del Terremoto*
(1505), by Francesco Francia, fresco, Palazzo Comunale, Bologna

and by the russet and pink-toned local sandstone and red
brick and tile, which dominate the urban fabric. In the
early 14th century Bologna boasted more than 170 towers.
The highest, the Torre degli Asinelli (h. 97.5 m; 1109–10),
was joined to the contemporary Torre Garisenda in the
mid-14th century, the two towers representing the city in
frescoes (see fig. 1) and paintings from the 14th century
to the 17th. The city has 34 km of arcaded streets, an
amenity maintained by proprietors for the benefit of the
public.

2. *c.* 1400–*c.* 1600. Substantial growth during the
Renaissance period occurred during the rule of the Benti-
voglio in the 15th century, especially under Giovanni II
(1463–1506). Conspiracies against the ruling family led to
control by papal authority, sealed by the entry of Julius II
into the city in 1506. Following the Sack of Rome (1527),
Bologna became the second city of the Papal States. The
city's days of glory were in 1530, when it acted as host for
the coronation by Clement VII of Charles V (*reg* 1519–
56) as the Holy Roman Emperor. Papal ties were further
reinforced by Pius IV, who initiated an extensive scheme
of urban renewal, focused on the area in the vicinity of
the Piazza Maggiore. The see of Bologna was raised to an
archbishopric in 1582.

In the late 15th century the Bentivoglio began a far-
reaching programme of public works, paving streets,

building new porticoes and opening the Canal Naviglio to
Corticello. The most prominent of the Bentivoglio build-
ings was the family palace (destr. 1507), built from 1460
according to the designs of the Florentine Pagno di Lapo
Portigiani, with its residential tower and the loggia on the
Via S Donato near their church of S Giacomo Maggiore.
The Bentivoglio also supervised the transformation by
Aristotile Fieravanti (1415–?1485) of the Palazzo del
Podestà (begun 1201) into a Renaissance palace. Its huge
corner piers are appropriate to a centre of civic rule, with
its open loggia and grand hall providing easy access. A
Florentine style is more noticeable in the finely carved low
reliefs of S Giacomo Maggiore, a huge aisleless church
founded in 1267 and vaulted with four shallow domes in
1493; however, the loggia along the south front (1477–81)
is unmistakably Bolognese. From 1486 to 1496 the cloth-
makers' guild built an imposing headquarters opposite the
two towers; the decorative details of the Casa dei Drappieri
supposedly derived from the Palazzo Bentivoglio, which
owed much to Florentine precedents.

The private domain also expanded, particularly after the
fall of the Bentivoglio, when an assembly of prominent
citizens governed Bologna, and their palaces served as
ornaments to the city. Façades, salons and courtyards
often provided ceremonial backdrops for festivities and
receptions staged by the governing bodies. Whereas most
of these senatorial palaces were subsumed in the dominant
arcaded structure of the city, there are notable exceptions,
such as the Palazzo Fantuzzi (1517–32), by Andrea da
Formigine, with its heavy masonry and heraldic sculpture,
and the Palazzo Albergati (?1523; attrib. Baldassare Pe-
ruzzi), the irregular shape of which is determined by its
site.

2. Fountain of Neptune (1563) by Giambologna, Piazza Nettuno,
Bologna

Pope Pius IV contributed a development scheme around the Piazza Maggiore, with the Piazza Nettuno created for the view, from the Via Emilia, of the Fountain of Neptune (1563) by Giambologna (see fig. 2) within it. Balancing this square, opposite the unfinished transept of S Petronio (begun 1390), ANTONIO TERRIBILIA built the Palazzo Archiginnasio (1562–3), a single structure to unite all the university faculties. Few buildings are as indicative of the political and religious situation of the time as the Archiginnasio, the first structure specifically designed to accommodate the activities of the university, which, since its foundation, had prospered in makeshift quarters throughout the city. To complete the new design for the square, JACOPO VIGNOLA designed the Palazzo dei Banchi (1565–8), a masterpiece of classical stagecraft, to harmonize with the rest of the Piazza and to provide the type of urban backdrop familiar in the works of Sebastiano Serlio and Andrea Palladio. He was also responsible for a number of other projects in the city and had taken Bolognese citizenship in February 1549. In the last decades of the 16th century the completion of the façade of S Petronio constituted the principal architectural debate: 'Gothic' or 'modern' became a barometer for changing attitudes towards classicism. Vignola, Palladio and Terribilia, among others, submitted designs, continuing the controversy begun by Peruzzi and Giulio Romano in the first half of the century.

BIBLIOGRAPHY

L. Alberti: *Historie di Bologna*, i (Bologna, 1541/*R* 1979)
P. Lamo: *Graticola di Bologna* (Bologna, 1560); ed. G. Roversi (1977)
P. C. Ghirardacci: *Della historia di Bologna*, 3 vols (Bologna, 1596–1657)
G. Guidicini: *Case notabili della città di Bologna*, 5 vols (Bologna, 1868–73)
G. Gozzadini: *Delle torri gentilizie di Bologna* (Bologna, 1875)
F. Cavassa: *Le scuole dell'antico studio bolognese* (Milan, 1896)
F. Malaguzzi Valeri: *L'architettura a Bologna nel rinascimento* (Bologna, 1899)
L. Sighinolfi: *L'architettura bentivolesca in Bologna e il Palazzo del Podestà* (Bologna, 1909)
G. Zucchini: *Il Palazzo del Podestà di Bologna* (Bologna, 1912)
G. B. Comelli: *Piante e vedute della città di Bologna* (Bologna, 1914)
E. Sulze: 'Gli antichi portici di Bologna', *Atti & Mem. Regia Deput. Stor. Patria Prov. Romagna* (1928), pp. 305–411
G. Zucchini: *Edifici di Bologna: Repertorio bibliografico e iconografico*, 2 vols (Rome, 1931)
A. Foratti: *Aspetti dell'architettura bolognese della seconda metà del secolo XVI alla fine del seicento* (Bologna, 1932)
C. Ady: *The Bentivoglio of Bologna: A Study in Despotism* (London, 1937)
A. Raule: *Architetture bolognesi* (Bologna, 1952)
R. Renzi: *Bologna: Una città* (Bologna, 1960)
A. Emiliani, ed.: *Felsina, Bononia, Bologna* (Bologna, 1962)
G. Rivani: *Le torri di Bologna* (Bologna, 1966)
G. Cencetti: *Il Palazzo dei Notai in Bologna* (Bologna, 1969)
Bologna centro storico, Comune di Bologna (Bologna, 1970)
G. Cuppini: *I palazzi senatorii a Bologna: Architettura come immagine del potere* (Bologna, 1974)
A. Barbacci: *Monumenti di Bologna: Distruzioni e restauri* (Bologna, 1977)
P. L. Cervellati: *La nuova cultura delle città* (Milan, 1977)
A. Ferri and G. Roversi: *Storia di Bologna* (Bologna, 1978)
F. Bergonzoni: *Venti secoli di città: Note di storia urbanistica bolognesi* (Bologna, 1980)
M. Fanti: *La fabbrica di S. Petronio in Bologna dal XIV al XX secolo* (Rome, 1980)
G. Ricci: *Bologna* (Rome, 1980)
G. Roversi, ed.: *La Piazza Maggiore di Bologna* (Bologna, 1984)
——: *Palazzi e case nobili del 500 a Bologna* (Bologna, 1986)
G. Roversi, ed.: *L'Archiginnasio*, 2 vols (Bologna, 1988)
N. Miller: *Renaissance Bologna*, University of Kansas Humanistic Studies, lvi (New York, 1989)
F. Raffaelli: *Il Nettuno si racconta* (Bologna, 1989)
M. Fanti, ed.: *La chiese di Bologna* (Bologna, 1992)
H. W. Hubert: *Der Palazzo Comunale von Bologna, vom Palazzo della Biada zum Palatium Apostolicum* (Cologne, 1993)
M. Armaroli: *La Mercanzia di Bologna* (Bologna, 1995)
C. James: 'The Palazzo Bentivoglio in 1487', *Mitt. Ksthist. Inst. Florenz*, xli/1/2 (1997), pp. 188–96

<div align="right">NAOMI MILLER</div>

II. Art life and organization.

1. Before *c.* 1400. 2. After *c.* 1400.

1. BEFORE *c.* 1400. Traces of the Etruscan period in Bologna have been found (e.g. vases, bronzes and carved commemorative steles), but few from the Gallic Boii. The development of the University by the end of the 12th century gave the legal, medical and academic professions a central role in Bologna's economic and cultural growth. The immediate effect on the arts of the University, centred on the Benedictine abbey of S Procolo, was to lead the mendicant orders to set up schools and major churches. The presence of the University led *c.* 1250 to the development of the most important centre of medieval manuscript illumination south of the Alps. From 1350 most Bolognese artists worked mainly for local patrons. Until his death in 1399, Simone dei Crocefissi (*c.* 1330–99) dominated the profession, marrying the sister of the painter Dalmasio Scannabecchi (*fl* 1342–73) and living next door to his son. Simone was wealthy and a prominent citizen, becoming a member of the government in 1380. Lippo di Dalmasio (*d.c.* 1410) also held important civic offices up to the level of judge. Simone was a close friend of the illuminator Niccolò (*fl* 1349–1403) and probably trained his nephew Jacopo di Paolo, who became in turn one of the leading artists in the city. Although his own son Orazio was less prominent, his daughter married the leading artist active between 1410 and 1469, Michele di Matteo da Bologna (*fl* 1410–69). The dominance of this pair of families, together with the distinctive political and social character of the city, was probably responsible for the extreme conservatism of Bolognese art for much of the 15th century. In the late 14th century Bolognese painters were incorporated into the Società delle Quattro Arti: the four crafts (or guilds) were predominantly workers with leather and steel, the makers of sheaths, swords and knives, shield-makers and painters (together), and saddlers. Statutes, undated but known to be of the 1370s, are largely concerned with the control of apprentices and journeymen, the exclusion of non-members and non-citizens unless enrolled and the observation of feast-days; the statutes of 1382 exclude non-citizens, perhaps reflecting the closing of Bolognese art and the citizens after the populist revolt against papal authority in 1376.

The re-establishment of the Commune in 1376 appears to have been matched by repetitive commissions and overtly expressive imagery, as seen in Simone's versions of the *Coronation of the Virgin* (one version now Bologna, Pin. N., on dep. Budrio, Pin. Civ. Inzaghi). Most of the recorded and surviving art of the period from 1390 to 1420 was created for or frescoed within the basilica of S Petronio (commissioned by the Commune in 1390; *see* §IV, 2 below), including a lost model of the design in wood and card by Jacopo di Paolo in 1402. No rival source of patronage nor major Renaissance tradition was created

until Sante Bentivoglio established the Bentivoglio signory in Bologna during the 1450s.

BIBLIOGRAPHY

I. Supino: *L'arte nelle chiese di Bologna*, 2 vols (Bologna, 1932)
F. Filippini and G. Zucchini: *Miniatori e pittori a Bologna: Documenti del secolo XV* (Rome, 1968)
R. Gibbs: 'Two Families of Painters at Bologna in the Later Fourteenth Century', *Burl. Mag.*, cxxi (1979), pp. 560–68

ROBERT GIBBS

2. AFTER *c.* 1400. In 1401 Giovanni I Bentivoglio established his family's pre-eminence in Bologna, facilitating the rise of a new aristocracy, who shared with the merchant classes and humanist intellectuals an antiquarian and mythographical interest in collecting antiquities. In the early years the presence of foreign artists and works of art remained isolated episodes: Paolo Uccello's fresco the *Nativity* (Bologna, S Martino) dates from 1437; a large-scale polyptych (now Bologna, Pin. N.) by Bartolomeo and Antonio Vivarini arrived for the Certosa in 1450; Marco Zoppo returned from a period in Venice in 1461. Yet the culmination of a long era of Bentivoglio rule with Giovanni II (*see* BENTIVOGLIO, (2)), a godson of Lionello d'Este, Marchese of Ferrara, encouraged the influx of many artists from Ferrara, among them ERCOLE DE ROBERTI and FRANCESCO DEL COSSA. In the 1470s Bologna became an important artistic centre. Lorenzo Costa was the favoured artist of Giovanni II Bentivoglio, and he headed a busy studio, which carried out a series of important public commissions in Bolognese churches. At the turn of the 16th century local artists acquired similar prominence, and Costa, Francesco Francia and Amico Aspertini collaborated on a major commission of the period, the fresco cycle (1506) in the oratory of St Cecilia in S Giacomo Maggiore, funded by Giovanni II Bentivoglio (for illustration *see* ASPERTINI, AMICO). Sculptors were less prominent in Bologna, and the major figures were the Apulian NICCOLO DELL'ARCA, who rented a shop from the Fabbrica (Cathedral Works) of S Petronio in 1462, and the Tuscans FRANCESCO DI SIMONE FERRUCCI and Jacopo della Quercia (*see* JACOPO DELLA QUERCIA, fig. 4). Michelangelo stayed in the Bolognese house of Giovanni Francesco Aldrovandi in 1494, when he carved the small statues for the Arca di S Domenico.

With the fall of the Bentivoglio, their favoured artists fled, and in the 16th century, when Bologna was governed by papal legates, artistic links with Florence and Rome became increasingly important. In 1515 the arrival of Raphael's *St Cecilia* altarpiece (Bologna, Pin. N.) introduced a model of Roman classicism, and in the 1530s Giorgio Vasari and Francesco Salviati worked in the city. High churchmen decorated their palaces with frescoes of scenes from mythology and ancient history, such as those painted by Nicolo dell'Abate in the Palazzo Poggi (*see* ABATE, NICOLO DELL', fig. 1 and colour pl. 1, I1) and the Palazzo Torfanini (1548–52); by Prospero Fontana (who moved between Rome and Bologna) in the Palazzina della Viola (1550); and by Pellegrino Tibaldi in the Palazzo Poggi (*see* TIBALDI, PELLEGRINO, fig. 1 and colour pl. 2, XXXIII3). Cardinal Giovanni Poggi had met Tibaldi at the Roman court of Julius III, with which Bologna enjoyed a close relationship.

The Council of Trent held two sessions in Bologna, from 1547 to 1549; its demands for a clear and persuasive religious art were articulated by GABRIELE PALEOTTI, Bishop of Bologna from 1566, in his treatise *Discorso intorno alle immagini sacre e profane* (1582), which influenced the move away from Mannerist abstruseness of such Bolognese artists as Bartolomeo Cesi, Bartolomeo Passarotti and Prospero Fontana. Paleotti's ideal of truth to nature was supported by the naturalist Ulisse Aldrovandi (1522–1605), whose museum of natural history was visited by many artists. Most art of the period remained religious, but such artists as Passarotti and Lavinia Fontana also painted portraits and some genre scenes. In the studios of Denys Calvaert (*c.* 1540–1619), and of Passarotti, the study of prints by north European artists was popular. Artists became increasingly concerned to raise their social status and to establish painting as a liberal art and a profession. In 1569 painters separated from the Società delle Quattro Arti (*see* §I above), and they became associated with the Compagnia dei Bombasari. In 1600 the Compagnia de' Pittori separated from the Bombasari, and the painters were thus finally released from the old artisans' guilds.

BIBLIOGRAPHY

F. Malaguzzi Valeri: 'L'arte dei pittori a Bologna nel secolo XVI', *Archv Stor. A.*, 3 (1897), pp. 309–14
C. Dempsey: 'Some Observations on the Education of Artists in Florence and Bologna during the Later 16th Century', *A. Bull.*, (1980), pp. 552–69
A. Ghirardi: 'Per una lettura di due ritratti di famiglia di Bartolommeo Passerotti', *Itinerari: Contributi alla storia dell'arte in memoria di M. L. Ferrucci*, ii (Florence, 1981), pp. 57–65

ELENA DE LUCA

III. Centre of ceramics production.

The history of Bolognese ceramic manufacture remains somewhat unclear, due to the lack of documentary evidence; production is known to have been established, however, by the early 14th century. Clearly, it was well under way by the mid-16th century, when Cipriano Piccolpasso referred to the clay used by the city's artists in *I tre libri dell'arte del vasaio* (1556–9). In addition to the North Italian cities of Ferrara and Padua, Bologna was also a major centre for the production of lead-glazed, incised slipwares, the finest of which competed with the colourful tin-glazed earthenwares of Faenza and other maiolica centres for the luxury market. Signed and dated *sgraffito* pieces are extremely rare, and attribution is often difficult. However, excavations in Bologna have provided evidence for production there in the late 15th century and the 16th, patronized by such prominent local families as the Bentivoglio, whose arms appear on certain pieces (e.g. inkstand, *c.* 1500; London, V&A, cat. 1332). Among the best works are elaborate, large plates, tazze and modelled inkstands decorated with putti, figures of youths, portrait busts, animals and occasional genre, allegorical or religious scenes, bordered by patterns of stylized, Gothic-influenced leaves. The typical restrained palette is comprised of a whitish slip, through which a design was scratched to reveal the red earthenware beneath; the designs were then heightened with yellow, green, brown, purple and blue pigments and finally covered with a transparent glaze. Unlike the decoration of maiolica, which is characterized

by a painterly quality and complex colour range, incised slipwares rely on the linear directness of the artist's draughtsmanship for their effect. Maiolica was frequently imported into Bologna from Florence, Venice and Faenza. The tile-pavement (1487) in the Vaselli Chapel in the church of S Petronio, Bologna, for example, bears the name of the Faentine potter Petrus Andrea (*fl* 1493–1526). By 1595, however, maiolica workshops were established in Bologna and production of both types of wares continued.

BIBLIOGRAPHY

F. Malaguzzi Valeri: 'Su l'origine della fabbricazione delle maioliche a Bologna', *Faenza*, vi/2 (1918), pp. 25–6

W. B. Honey: 'Bologna Pottery of the Renaissance Period', *Burl. Mag.*, xlviii (1926), pp. 224–35

B. Rackham: *Catalogue of Italian Maiolica*, 2 vols (London, 1940, rev. 2/1970)

La ceramica graffita in Emilia-Romagna dal secolo XIV al secolo XIX (exh. cat., ed. G. Reggi; Modena, Pal. Musei, 1971)

WENDY M. WATSON

IV. Buildings.

1. S Domenico. 2. S Petronio.

1. S DOMENICO. Church dedicated by Innocent IV in 1251 to St Dominic. It has been enlarged several times, and the present interiors are the work of Carlo Francesco Dotti (1669–1759), who remodelled (1728–32) the church in the early 17th-century Bolognese style. It is notable chiefly as the home of the tomb of St Dominic, the Arca di S Domenico. St Dominic died in Bologna in 1221; in 1234 he was canonized, and *c.* 30 years later the Dominicans of S Domenico commissioned a tomb for their founder. The design of the tomb is generally credited to Nicola Pisano (*c.* 1220/5–1284), partly on stylistic grounds and partly on the evidence of a passage in the *Chronicle of the Convent of St Catherine in Pisa*, compiled *c.* 1400 but based on much earlier authorities, which refers to the body of St Dominic being placed in a tomb that had been sculpted by 'Nichole di Pisis'. The carving seems to have been under way by 1265, for at the General Chapter of the Dominicans held at Montpellier in that year, the friars recommended that funds should be allocated for the completion of the sepulchre.

The tomb no longer survives in its 13th-century form. The original shrine comprised a rectangular sarcophagus borne on caryatid figures. In 1411 it was relocated at the centre of the church, and later in the 15th century its originally flat top was modernized with the present pitched roof, and its statuary was supplemented with figures by Niccolò dell'Arca and Michelangelo. Probably at the same time, the caryatid supports were dispersed. Some of these have since been hypothetically identified in the archangels *Michael* and *Gabriel* in London (V&A); a statue of *Faith* in Paris (Louvre); a statue of three deacons holding liturgical objects in Florence (Bargello); and a similar group in Boston, MA (Mus. F.A.). Several attempts have been made to determine the original appearance of the shrine. Pope-Hennessy's reconstruction (1951), endorsed by Moskowitz (1987), would require two groups of three figures supporting the long sides of the sarcophagus (the two archangels and probably a third unidentified archangel on one side and the Louvre *Faith* and possibly two other

virtues on the other side). Along the central long axis would have been the two deacon groups in Florence and Boston. The sarcophagus is divided into six panels that recount significant events of St Dominic's life. On what is now the front are (i) *St Dominic Restoring Napoleone Orsini to Life after a Fall from his Horse* and (ii) the *Miracle of the Unburnt Books at Fanjeaux*; on the back, (iii) the *Profession and Vision of Reginald of St Gilles*, and (iv) the *Confirmation of the Dominican Order*; and on the short sides, (v) the *Apparition of SS Peter and Paul to Dominic* and *Dominic Sending his Followers out on their Mission*; and, (vi) *Dominic and his Disciples Fed by Angels*. The reliefs are separated from each other by statues. A *Virgin and Child* occupy a central position on the front; *Christ the Redeemer* is centrally located on the back; and the *Four Doctors of the Church* stand at the corners.

Compositionally, all of the reliefs show a single approach to space, suggesting the same designer. The figures are ranged in neatly organized rows that completely fill the frame. However, scholars have long recognized the diversity of handling in the actual carving. At least five different hands have been identified: Nicola Pisano; Arnolfo di Cambio (*fl* 1265–1302); Fra Guglielmo da Pisa (*c.* 1239–1312/3), who designed a pulpit in S Giovanni Fuorcivitas in Pistoia *c.* 1270; Lapo (1408–70); and an anonymous sculptor whom Gnudi (1948) christened the Fifth Master. This conforms perfectly with what is known about medieval sculptural practice, where groups of carvers were coordinated to work on large-scale commissions. The Arca di S Domenico, with its historiated sarcophagus carried on statuettes, became the model for other tombs. The commission for the shrine of *St Peter Martyr* in S Eustorgio in Milan requested specifically that it should be like the tomb of St Dominic in Bologna. Other comparable monuments are the shrine to *St Luke* (1316) in S Giustina, Padua, and the tomb of the *Beato Bertrando* (*c.* 1334–50) in Udine.

BIBLIOGRAPHY

C. Gnudi: *Nicola, Arnolfo, Lapo: L'arca di S Domenico in Bologna* (Florence, 1948)

J. Pope-Hennessy: 'The Arca of St Dominic: A Hypothesis', *Burl. Mag.*, xciii (1951), pp. 347–51; repr. in *Essays on Italian Sculpture*, (London, 1968), pp. 11–15

S. Bottari: *L'arca di S Domenico in Bologna* (Bologna, 1964)

A. F. Moskowitz: 'The Arca di San Domenico Caryatids: Support for a Hypothesis', *Source: Notes Hist. A.*, vi/3 (1987), pp. 1–6

B. Breveglieri: 'Le aree cimiteriali di San Domenico a Bologna nel medioevo: Ricostruzioni topografiche', *Atti & Mem. Regia Deput. Stor. Patria Prov. Romagna*, xlv (1994), pp. 165–234

BRENDAN CASSIDY

2. S PETRONIO. Bologna's votive and civic basilica located on the south side of the central Piazza Maggiore (see fig. 2 above) is dedicated to Bologna's patron saint. The Gothic-style church was erected by the Commune between 1390 and the third quarter of the 17th century. Although unfinished, it dominates the skyline and ranks among the largest ecclesiastical buildings in Italy (60 m wide, 132 m long, 44.27 m to the crowning of the vaults). Here Charles V was crowned Holy Roman Emperor by Clement VII in 1530. St Petronius was the eighth bishop of Bologna (*reg* AD 431–50). His cult was of minor importance until the later Middle Ages, when he began to be venerated as a rebuilder of the city, founder of Bologna

University—a popular but erroneous legend—and defender of communal liberty. By the mid-14th century he was the principal symbol of municipal patriotism, legitimizing local power and political autonomy against imperial and papal claims. On 1 January 1389 a popular government headed by artisans, merchants and intellectuals declared that a church be built in his name on the main civic square. A board of works, the Fabbricieri, was created, and the local master builder Antonio di Vincenzo (c. 1350–?1401/2) was appointed architect. In consultation with the head of the Servite Order, Andrea Manfredi da Faenza, the architect built an enormous model (destr. 1402) in wood and brick. The church was intended to be the largest in Christendom. For its site the city fathers expropriated and destroyed many houses and towers, as well as eight churches. The cornerstone was laid on 7 June 1390, and work proceeded southwards from the façade. In the course of the 15th century members of the ruling Bentivoglio family promoted uninterrupted construction: by 1401 the first two bays of the nave with a provisional apse, vaulted aisles and eight vaulted chapels (see fig. 3); by 1446 the third bay, a second apse, aisles and chapels; by 1450 the fourth bay, aisles and chapels; by 1462 the fifth bay, aisles and chapels; by 1469 a new apse at the fourth bay; in 1479 the founding of the final two of 22 chapels; and by 1492 a campanile. At the end of the 15th century the basilica had nearly reached its present configuration.

After Antonio di Vincenzo's large model was destroyed, Jacopo di Paolo prepared a small wood and paper model,

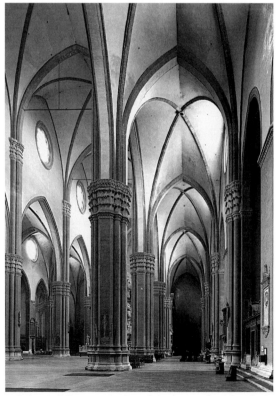

3. Bologna, S Petronio, interior of the nave and north aisle, by Antonio di Vincenzo, begun 1390

which has disappeared along with all graphic evidence of the architect's original intentions for the church as a whole. Modern reconstructions of the first plan have not been conclusive. From the contract for the large model it is known that the church was to have been 183 m long and 137 m wide at the transepts. Only the six-bay nave was built, but it makes clear that Antonio di Vincenzo was guided by Tuscan and Lombard precedents. The structure and dimensions of the nave and aisle bays were taken directly from Florence Cathedral, as was the general design of the piers. The inclusion of lateral chapels, two to each bay, was inspired by such monastic churches in and around Milan as S Maria del Carmine in Pavia. Yet what Antonio di Vincenzo envisioned beyond the nave, especially for the crossing, remains enigmatic.

From the early 16th century onwards, the Fabbricieri grappled with three major problems: laying out the crossing, transepts and choir; vaulting the nave; and decorating the façade. In each case they consistently sought stylistic congruity with the existing Gothic structure. In 1509–15 Arduino Arriguzzi (1460–1531) founded two piers for the crossing following a plan elaborated in a wooden model (c. 1513–16, Bologna, Mus. S Petronio). The model, often mistaken as representing the original 14th-century scheme, features deep, square transepts and a roundheaded choir ringed with chapels and an octagonal cupola on a high drum. Arriguzzi's project was soon abandoned, and all hope of completing S Petronio was effectively buried in 1563 with the erection of the Palazzo dell'Archiginnasio along the left flank of the church. Attention turned to covering the nave when Francesco Terribilia (see TERRIBILIA, (2)) vaulted the fifth bay (1587–9) to a height of c. 38 m. Terribilia's work was judged too low and was destroyed when the present quadripartite rib vaults were constructed over six metres higher along the entire nave (1646–58) by Girolamo Rainaldi. The choir was then closed by the present polygonal apse and vaulted. Illuminated by large windows in the nave, aisles and chapels, and articulated throughout by architectural members of buff sandstone and red brick against off-white walls, the vast and harmonious interior is remarkable above all for its spatial clarity.

The problem of the great façade (66 m wide, 51 m high) has never been fully resolved. The present marble socle goes back to Antonio di Vincenzo (1391–4), while Jacopo della Quercia decorated the Porta Magna with 10 marble relief scenes from Exodus on the flanking pilasters, 18 busts of *Prophets* on the jambs, five New Testament scenes on the lintel and statues of the *Virgin and Child* and *St Petronius* in the lunette (1425–30; see JACOPO DELLA QUERCIA, fig. 4). DOMENICO AIMO added the figure of *St Ambrose* (1510) to the lunette, above which Michelangelo installed his colossal bronze portrait statue of *Pope Julius II* (1506–8; destr. 1511). In 1518 Aimo drew up a masterplan for the façade (Bologna, Mus. S Petronio), which was followed for the decoration of the two existing lateral portals embellished with Old and New Testament scenes (1524–30). The marble reliefs were carved by teams of sculptors under the direction of Ercole Seccadenari (d 1540). The artists included Alfonso Lombardi, Amico Aspertini, Niccolò Tribolo, Girolamo da Treviso, Zaccaria Zacchi da Volterra (1473–1544) and Properzia de' Rossi.

The lunette over the left portal contains a figural tableau of the *Resurrection* (1527) by Lombardi, the lunette over the right portal the *Deposition* by Aspertini, Tribolo and Seccadenari. The pinnacles are adorned by reliefs (1567–9) by Giacomo Silla, Teodosio de' Rossi (*fl* 1560–1613) and Lazzaro Casario (*fl* 1568–88).

Dissatisfaction with Aimo's façade design induced the Fabbricieri to solicit outside opinions, some from leading architects who submitted their own original proposals for clothing the Gothic building. The majority of the surviving drawings are still preserved in the museum at S Petronio. Among them are three vivid and varied Gothic designs (1521–2) by Baldassarre Peruzzi, two austere projects by JACOPO VIGNOLA, architect to the basilica between 1543 and 1550, and a collaborative scheme (1545) by Giulio Romano and Cristoforo Lombardo. The debate continued: later 16th-century projects include those by Domenico Tibaldi (1571), Andrea Palladio (1572–9), who sought a purely classical solution, and Terribilia (1580).

BIBLIOGRAPHY

A. Gatti: *La fabbrica di S. Petronio: Indagini storiche* (Bologna, 1889) [doc.]

M. Fanti: *La fabbrica di S. Petronio in Bologna: Storia di un'istituzione* (Rome, 1980)

M. Fanti and others: *La Basilica di San Petronio in Bologna*, 2 vols (Bologna, 1983–4) [excellent illus.]

M. Fanti and Carlo De Angelis, eds: *Sesto centenario di fondazione della Basilica di San Petronio, 1390–1990: Documenti per una storia* (Bologna, 1990)

M. Fanti and D. Lenzi, eds: *Una basilica per una città: Sei secoli in San Petronio* (Bologna, 1994)

H. Smit: 'Tapestries for the Church of San Petronio in Bologna ca. 1500: Flemish Weavers Active in Italy', *Mitt. Ksthist. Inst. Florenz*, xxxix/2–3 (1995), pp. 185–208

RICHARD J. TUTTLE

Bologna, Giovanni. *See* GIAMBOLOGNA.

Bologna, il. *See* DOMENICO AIMO and TOMMASO VINCIDOR.

Boltraffio [Beltraffio], **Giovanni Antonio** (*b* Milan, *c.* 1467; *d* Milan, 15 June 1516). Italian painter and draughtsman. A pupil of Leonardo da Vinci, he was active mainly in Milan and was particularly noted as a portrait painter.

1. TRAINING AND WORKS BEFORE *c.* 1500. Boltraffio belonged to a noble Milanese family; he did not paint from financial necessity and did not pursue his career in a systematic way. His birth date is calculated from the inscription on his tomb (Milan, Castello Sforzesco; ex-S Paolo in Compito, destr. 1547). No signed painting by him survives, and the documentation records only three works of secure attribution and date and provides little biographical information. His reconstructed oeuvre has been expanded unduly by some writers and restricted too rigorously by others. Vasari stated that he trained with Leonardo; he is probably the 'Gian Antonio' mentioned by Leonardo in a note of 1491 (Paris, Bib. Inst. France, MS. C, fol. 15v), when Boltraffio was about 24. Some writers suggest that before he entered Leonardo's workshop Boltraffio had a phase of work influenced by Vincenzo Foppa and Bernardo Zenale, when he may have painted two panels with *Saints and Devotional Figures* (Milan, Castello Sforzesco). The execution is too crude,

however. According to Suida, they should be ascribed to a painter greatly influenced by him, whom Suida called the 'Pseudo-Boltraffio'.

Boltraffio's contract with Marco d'Oggiono, another pupil of Leonardo, for an altarpiece of the *Resurrection with SS Leonard and Lucy* (Berlin, Gemäldegal.) for the oratory of S Leonardo in S Giovanni sul Muro in Milan also dates from 1491 (Shell and Sironi). The work is the most secure example of Boltraffio's style in the 1490s. Marco was probably responsible for the entire upper part; Boltraffio painted the kneeling figures of the saints, in poses based on balanced oppositions. The finely painted surface and light shadows show the influence of Leonardo, to whom this altarpiece was once attributed. It was probably executed under Leonardo's supervision and perhaps even based on his drawings. Other works datable to the same years confirm Boltraffio's adherence to Leonardo's approach in his early period. The *Madonna of the Flower* (Milan, Mus. Poldi Pezzoli) is modelled on Leonardo's dynamic counterposition of movements; the *Portrait of a Lady* (Milan, Mattioli priv. col.) follows Leonardo's style in the *Portrait of a Musician* (Milan, Bib. Ambrosiana), although its dark background and pyramidal figure also recall the works of Antonello da Messina. In the *Madonna of the Bowl* (Budapest, Mus. F.A.) a new interest in Bramantino appears.

Early writers indicate that Leonardo often intervened in paintings begun by his pupils. This has led to doubts about the attribution to him of such works as the *Madonna Litta* (St Petersburg, Hermitage) and the *Belle Ferronnière* (Paris, Louvre; see colour pl. 1, XXXVI2), both of which have been linked to Boltraffio. The *Madonna Litta*, datable to the early 1490s, is undoubtedly from Leonardo's workshop; in fact it corresponds to autograph drawings by Leonardo, for instance the *Head of the Virgin* (Paris, Louvre). It is likely that Leonardo was responsible for the compositional scheme and that he intervened with corrections and alterations during its execution by a pupil (Brown, 1991). Although it has been proposed that this pupil was Marco d'Oggiono, the picture's many affinities with Boltraffio's style, and its indisputable technical excellence, suggest it may be his work. The *Belle Ferronnière* is now usually attributed to Leonardo alone, but the fact that writers have suggested intervention by Boltraffio in a work of such quality indicates how highly his work has been regarded.

Boltraffio was known for his skill as a portrait painter. In 1498, Isabella of Aragon (1470–1524), widow of Giangaleazzo Sforza, Duke of Milan (*reg* 1476–94), asked him to copy a portrait of her brother Ferrante (1469–96) in the Gonzaga collection in Mantua, and the poet Gerolamo Casio also praised his ability in that field, commenting that he 'made every man more handsome'. Certainly in his portraits, unlike painters in the Lombard realist tradition, he tended to idealize his subject. In the famous *Portrait of a Young Man* (Chatsworth, Derbys), the ambiguous beauty that Boltraffio conferred on the sitter (Casio, according to the inscription on the back) has led to the suggestion that the portrait is that of a woman. The identification of her as Costanza Bentivoglio (*c.* 1490–after 1525) of Bologna, from the initials C B on the cuff (Reggiani Rajna), however, has been generally rejected.

There are two other autograph versions of this work (Moscow, Pushkin Mus.; San Diego, Timken priv. col.). All three are linked to Boltraffio's friendship with Casio, who was responsible for his commission for an altarpiece in Bologna that Vasari dated from 1500 (see §2 below). Thus the portraits thought to be of Casio, including a fourth (Milan, Brera), should be dated around that time. Stylistically they are datable before 1500, both in their courtly tone and in their dependence on Leonardo's style in the *Portrait of a Musician*: this suggests that Boltraffio's relationship with Casio began before he went to Bologna.

Boltraffio also executed numerous drawings during the 1490s (Bora), mainly done with metalpoint on prepared paper (generally blue), a technique Leonardo introduced in Milan. These are distributed widely (e.g. Milan, Bib. Ambrosiana; Chatsworth, Derbys; Turin, Bib. Reale; Paris, Louvre; London, BM; Florence, Uffizi), although many attributions are uncertain.

2. WORKS AFTER *c.* 1500. Boltraffio later made drawings in coloured chalks or pastels, which can be dated after 1500, the year he painted the *Virgin and Child with SS John the Baptist and Sebastian and Two Donors* (Paris, Louvre; see fig. 1) for S Maria della Misericordia in Bologna, the altarpiece commissioned by the Casio family and mentioned by Vasari. The artist's time in Bologna gave him new interests that tempered his basic adherence to Leonardo: the Casio altarpiece is set in a luminous landscape with echoes of Pietro Perugino and Francesco Francia. His stay was short: in 1502 he was commissioned by the congregation of S Maria presso S Satiro in Milan to produce an altarpiece of *St Barbara* (Berlin, Gemäldegal.). The altarpiece combines the ideas developed in Bologna with a strong interest in Bramantino and Andrea Solario. It is related to a splendid charcoal and pastel drawing (Milan, Bib. Ambrosiana) that signals the change in Boltraffio's graphic style. The subject of another well-known drawing, *Portrait of a Young Man* (Milan, Bib. Ambrosiana), has been identified by some writers as Ferrante d'Aragona (Cogliati Arano, 1982). Boltraffio's permanent return to Milan is confirmed by a document of 1503, in which he is named among the experts appointed to judge models submitted for the door of the north transept (the Porta verso Compedo) of Milan Cathedral.

A fresco cycle commonly associated with Boltraffio is that depicting 26 figures of saints in fictive *oculi* in the loggia of S Maurizio al Monastero in Milan. Datable shortly after 1503, the cycle was worked on by various artists, some closer to Zenale and others to Boltraffio. It is unlikely, however, that Boltraffio ran a workshop, given his aristocratic origins and wealth. He may simply have provided models to be elaborated by other painters. Other figures of saints attributed to him include those frescoed in medallions in the Certosa di Pavia (transverse arches over the side aisles).

It was probably in the early 16th century that Boltraffio painted such portraits of very high quality as the *Lady in Grey* and the *Portrait of a Man* (both Isola Bella, Mus. Borromeo) and the *Portrait of a Man* (Florence, Uffizi), which show a renewal of his usual portrait formula. While the *Portrait of a Gentleman* (London, N.G.; see fig. 2) still follows the model of the profile against a dark background,

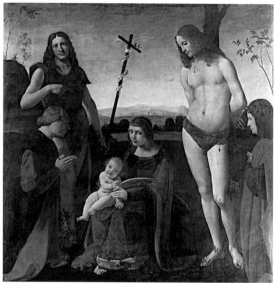

1. Giovanni Antonio Boltraffio: *Virgin and Child with SS John the Baptist and Sebastian and Two Donors*, oil on panel, 1.86×1.84 m, 1500 (Paris, Musée du Louvre)

derived from portrait medals, and the *Portrait of a Youth* (Berne, Kstmus.) has a composition reminiscent of the Casio portraits, in the later works the figure is depicted with broad forms against a light background; the contours are less distinct, and there is a keener sense of psychological introspection.

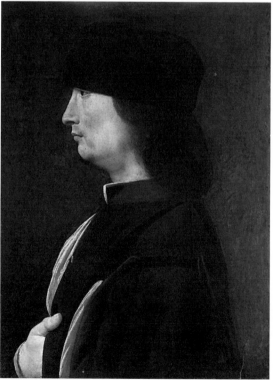

2. Giovanni Antonio Boltraffio: *Portrait of a Gentleman*, oil on panel, 565×425 mm, *c.* 1500 (London, National Gallery)

It has been suggested that Boltraffio made a journey to Rome before the end of 1506, when he might have painted the fresco of the *Virgin and Child with the Donor Francesco Cabañas* in S Onofrio. There is no documentation of such a journey, however, and the fresco was more probably painted by Cesare da Sesto. Leonardo mentioned Boltraffio in 1507 in a brief note on the back of a drawing (Windsor Castle, Berks, Royal Col., 19092v), an indication that their relationship continued. The identification of him as the Giovanni who accompanied Leonardo to Rome in 1513 is extremely unlikely, however. Boltraffio's works show none of the elements later adopted by those Lombard artists who were fascinated by the Roman cultural climate, and the antiquarian taste and the influences of Raphael and Michelangelo remained foreign to his art.

Boltraffio's last documented work, an altarpiece of the *Virgin and Child with SS John the Baptist, Sebastian and Donor* (Budapest, Mus. F.A.) for the da Ponte Chapel in Lodi Cathedral, was commissioned in 1508. The rocky landscape, the Child and the pointing gesture of St John the Baptist all derive from Leonardo's *Virgin of the Rocks* (London, N.G.; *see* LEONARDO DA VINCI, fig. 2). Thus Boltraffio reaffirmed his fidelity to his master and returned to the models he had used earlier. The St Sebastian recalls a prototype by Perugino, indicating that Boltraffio gathered ideas outside the Lombard tradition. It is significant, however, that during Leonardo's second Milanese period (1506–13) Boltraffio returned to his artistic roots. In the Lodi altarpiece only the application of paint lacks his usual refinement. The central motif recurs in the tondo of the *Virgin and Child* (Bergamo, Gal. Accad. Carrara).

It is difficult to reconstruct Boltraffio's activity after the Lodi altarpiece, although he is documented in 1509 and 1510 as living in the parish of S Paolo in Compito in Milan. He may have accepted only occasional commissions. Perhaps Leonardo's departure from Milan in 1513 left him with no incentive to paint. The catalogue of Boltraffio's works is far from definitive either for paintings or drawings. The works of the Pseudo-Boltraffio should be excluded. These are probably not by a single imitator but indicate a wider influence. A large altarpiece fragment with *Two Devotional Figures* (Milan, Brera), once considered essential to Boltraffio's catalogue, is now generally rejected (Fiorio).

BIBLIOGRAPHY

DBI
G. Casio: *Cronica* (Bologna, 1525)
G. Vasari: *Vite* (1550, rev. 2/1568); ed. G. Milanesi (1878–85), iv, p. 51
P. Lamo: *Graticola di Bologna* (Bologna, 1560/*R* 1844), p. 14
W. Suida: *Leonardo und sein Kreis* (Munich, 1929)
M. Reggiani Rajna: 'Un po' d'ordine fra tanti Casii', *Rinascimento*, ii (1951), pp. 337–83
L. Cogliati Arano: *Disegni di Leonardo e della sua cerchia alle Gallerie dell'Accademia* (Milan, 1980)
——: 'I disegni di Leonardo e della sua cerchia', *Leonardo all'Ambrosiana* (Milan, 1982), p. 92
M. T. Fiorio: *Leonardeschi in Lombardia* (Milan, 1982)
E. Rama: 'Un tentativo di rilettura della ritrattistica di Boltraffio tra quattrocento e cinquecento', *A. Lombarda*, 64 (1983), pp. 79–86
D. A. Brown: 'Leonardo and the Idealized Portrait in Milan', *A. Lombarda*, 67 (1983–4), pp. 102–16
O. Magnabosco: 'Un'ipotesi per la ritrattistica di Boltraffio', *A. Lombarda*, 73–5 (1985), pp. 45–50
G. Bora: 'Per un catalogo dei disegni dei Leonardeschi lombardi', *Rac. Vinc.*, xxii (1987), pp. 139–82
L. Cogliati Arano: 'Un Boltraffio inedito alla Biblioteca Ambrosiana', *Rac. Vinc.*, xxii (1987), pp. 61–9

M. T. Fiorio: 'Boltraffio', *Scuole lombarda e piemontese, 1300–1530*, Milan, Brera cat. (Milan, 1988), pp. 116–18, 415–19
L. Cogliati Arano: 'Un disegno del Boltraffio', *Arte Doc.*, iii (1989), pp. 128–9
J. Shell and G. Sironi: 'Giovanni Antonio Boltraffio and Marco d'Oggiono: The Berlin *Resurrection of Christ with Sts Leonard and Lucy*', *Rac. Vinc.*, xxiii (1989), pp. 119–54
D. A. Brown: 'The Master of the *Madonna Litta*', *Leonardeschi a Milano: Fortuna e collezionismo*, ed. M. T. Fiorio and P. C. Marani (Milan, 1991), pp. 25–34
V. Markova: 'Il *San Sebastiano* di Giovanni Antonio Boltraffio e alcuni disegni dell'area leonardesca', *Leonardeschi a Milano: Fortuna e collezionismo*, ed. M. T. Fiorio and P. C. Marani (Milan, 1991), pp. 100–107

MARIA TERESA FIORIO

Bomarzo, Sacro Bosco [Villa Orsini]. Italian estate below the hill town of Bomarzo, near Viterbo. The popular name derives from an inscription in the wood, which refers to it as a 'sacro bosco', an allusion to *Arcadia* (1504) by Jacopo Sannazaro. The Sacro Bosco, built for Pier Francesco ('Vicino') Orsini (*d* 1585) from *c*. 1552, was dedicated by him to his deceased wife, Giulia Farnese. Called a *boschetto* (little wood) by Orsini, the site is hilly with untouched terrain, although there are also level terraces and rectilinear enclosures. Much was done by 1564; sculpture was added during the 1570s, and work continued until Orsini's death in January 1585.

The original planting plan is unknown, and since the rediscovery of the site in the 1940s much has been replanted. The stream may have been dammed to form a lake in the areas of the present entrance and the path lined with heads (moved there in the modern restoration). The original entrance was probably near the Leaning House, the former location of the sphinxes, as their inscriptions address the entering visitor. The hypothesis of a formal garden contemporary with the Sacro Bosco on the hillside above must be rejected without further evidence.

The Sacro Bosco is filled with garden architecture and sculpture, some of which were originally fountains. Much of the architecture is in a classical style, although the principal structure, the tempietto dedicated to Giulia Farnese, imitates an Etruscan temple. The other major architectural works include the Leaning House (see fig.), dedicated to Cardinal Cristoforo Madruzzo, the theatre, inspired by the exedra of Bramante's Belvedere Court in the Vatican, Rome, and the *all'antica* nymphaeum adjacent to it. The sculpture is for the most part carved of volcanic outcroppings and is colossal in size; in late 1574 it was coloured. The sculpted figures are strikingly novel and enigmatic, although many belong to conventional categories of garden ornaments. The animals—common in 16th-century woods—include a stylized dragon fighting lions, a life-size African war elephant bearing a castle on its back and a soldier in its trunk, a giant tortoise supporting a statue of fame, an orc and the three-headed dog Cerberus. Other garden ornaments include a fountain of Pegasus, a river god, a sleeping nymph, a siren and grotesque heads; the giant grotesque head supporting a sphere with a castle on top and the colossal head called the *Mouth of Hell* are unparalleled, as are the seated female figure with a huge vase on her head and siren-like creatures holding an upended male figure at her back. Orsini was involved in the creation of the garden, which extended over a long period. Among the many architects whose names have

Bomarzo, Sacro Bosco, the Leaning House, from *c.* 1552

been suggested in connection with the site are Jacopo Vignola, Bartolomeo Ammanati and Pirro Ligorio. The colossal figures of the mid-1570s have been attributed to Simone Mosca Moschino.

A number of architectural and sculpted elements bear carved inscriptions, which during the modern restoration were painted over, some inaccurately. Sources have been noted in literary texts by such writers as Dante, Petrarch and Ariosto.

Many and widely different interpretations of the garden have been suggested, although its unusually personal character is widely agreed. The themes of history, time and artistic deception are evident in several feigned Etruscan funerary monuments as well as feigned evidence of destruction in the pseudo-Roman nymphaeum and the Leaning House. The Etruscan civilization—important to both regional and Orsini family history—is alluded to throughout. Sources have been uncovered for many of the ornaments, in Etruscan and Roman antiquities, engravings, emblems and woodcuts from the *Hypnerotomachia poliphili* (Venice, 1499) as well as influences from India, China and the New World. Disagreement remains about the significance and relationship of individual elements: some see a narrative development corresponding to Orsini's own biography or to such literary texts as Ariosto's *Orlando furioso* (1516, 1521, 1532), others a more general unifying theme in Vicino's devotion to his wife. The layout, diversity of ornaments and long period of creation instead suggest several overlapping themes including the pastoral ones of love and death.

BIBLIOGRAPHY

A. Bruschi: 'Il problema storico di Bomarzo', *Palladio*, xiii (1963), pp. 85–114

——: 'Nuovi dati documentari sulle opere orsiniane di Bomarzo', *Quad. Ist. Stor. Archit.*, 55–60 (1963), pp. 13–58

J. von Hennenberg: 'Bomarzo: Nuovi dati e un'interpretazione', *Stor. A.*, xiii (1972), pp. 43–55

J. Theurillat: *Les Mystères de Bomarzo et des jardins symboliques de la Renaissance* (Geneva, 1973)

L. Quartermaine: 'Vicino Orsini's Garden of Conceits', *It. Stud.*, xxxii (1977), pp. 68–85

E. G. Dotson: 'Shapes of Earth and Time in European Gardens', *A. J.* [New York], xlii (1982), pp. 210–16

M. J. Darnell and M. S. Weil: 'Il Sacro Bosco di Bomarzo: Its 16th-century Literary and Antiquarian Context', *J. Gdn Hist.*, iv (1984), pp. 1–91

H. Bredekamp: *Vicino Orsini und der heilige Wald von Bomarzo*, 2 vols (Worms, 1985)

J. B. Bury: 'Review Essay: Bomarzo Revisited', *J. Gdn Hist.*, v (1985), pp. 213–23

C. Lazzaro: *The Italian Renaissance Garden: From the Conventions of Planting, Design and Ornament to the Grand Gardens of Sixteenth-century Central Italy* (New Haven, 1990)

CLAUDIA LAZZARO

Bon. *See* BUON (i) and (ii).

Bonasone, Giulio (di Antonio) (*b* Bologna, *c.* 1510; *d* Bologna, after 1576). Italian printmaker and painter. He was a pupil of Lorenzo Sabbatini and evidently a late follower of Marcantonio Raimondi. He is now credited with 410 prints (almost all Rome, 1st. N. Graf.), as against Adam von Bartsch's attribution of 354. They include reproductive as well as original prints, and his independence of vision makes him one of the most interesting interpreters of his time. His activity in this field began *c.* 1531, as is indicated by the date on the Raphaelesque *St Cecilia* (B. 74). Parmigianino entrusted him with the copper engraving of his drawings, for example *Mercury and Minerva* (B. 168). While in Rome *c.* 1544–7 Bonasone interpreted works including Michelangelo's *Last Judgement* (B.80) and Raphael's *Toilet of Psyche* (B. 167). He often combined the techniques of etching and engraving in the same print.

In Bologna after *c.* 1547 Bonasone began his most important work, the illustration of the 155 symbols (B. 179–328) of the *Symbolicarum quaestionum de universo genere quas serio ludebat libri quinque* (Bologna, 1555) by Achille Bocchi (1488–1562), which show elements derived from Raphael, Michelangelo and Parmigianino, although they generally reproduce drawings (e.g. London, BM) by Prospero Fontana. The plates, first published in 1555, were completely retouched by Agostino Carracci (1557–1602) and reprinted in 1574. They are unique among contemporary illustrations of such emblems in that, instead of being subordinated to the text, they actually add meaning to it. After 1560 Bonasone achieved new effects and greater freedom in his etchings, such as the *Adoration of the Shepherds* (B. 39), and in works modelled on Titian, for example *Rest during the Flight into Egypt* (B. 67), in which he anticipated the refined solutions of his later years, for example in *St George* (B. 77), his last dated engraving.

BIBLIOGRAPHY

DBI

S. Ferrara and G. G. Bertela: *Incisori bolognesi ed emiliani del secolo XVI* (Bologna, 1975), nos 1–122

M. Cirillo: *Iulio Bonasone and the Sixteenth-century Italian Printmaking* (diss., U. Wisconsin, 1978)

S. Boorsch: *Italian Masters of the Sixteenth Century*, 29 [XV/2] of *The Illustrated Bartsch*, ed. W. Strauss (New York, 1982), pp. 9–157

S. Boorsch and J. T. Spike: *Italian Masters of the Sixteenth Century*, 28 [XV/1] of *The Illustrated Bartsch*, ed. W. Strauss (New York, 1985), pp. 205–351

STEFANIA MASSARI

Boncompagni. Italian family of patrons. Pietro Boncompagni (*d* 1404), a reader in civil law from 1378 to 1391, was buried in a tomb in S Martino, Bologna, where a Boncompagni family chapel, outstanding for its works of art, was completed in 1534. Its richly carved decoration is attributed to Amico Aspertini, and it features an *Adoration of the Magi* (1532) by Girolamo da Carpi on the wooden altar (attrib. Bartolomeo Ramenghi Bagnacavallo I). A great-grandson of Pietro Boncompagni, Cristoforo Boncompagni (1470–1546) was a draper and financier. He built a palazzo (1538–45) near the cathedral of S Pietro; its decorations were completed by his sons after his death. Giacomo Barozzi da Vignola may have contributed to this elegant and dignified structure. Restored in 1845, the palazzo, now called Palazzo Benelli, stands at Via del Monte 8. Interior restoration work began in 1980. Cristoforo Boncompagni's ten children included a son Ugo Boncompagni, who became GREGORY XIII.

BIBLIOGRAPHY

P. Litta: 'Boncompagni di Bologna', *Famiglie celebri italiane*, xxxv (Milan, 1836)

S. Mazzetti: *Repertorio di tutti i professori antichi e moderni della famosa Università del celebre Istituto delle Scienze di Bologna* (Bologna, 1847), p. 64

C. Ricci and G. Zucchini: *Guida di Bologna*, ed. A. Emiliani (Bologna, 1968), pp. 123, 145, 188

GIORGIO TABARRONI

Boncampagni, Ugo. *See* GREGORY XIII.

Bonfigli [Buonfigli], **Benedetto** (*b* Perugia, *c.* 1420; *d* Perugia, 8 July 1496). Italian painter. He was almost certainly trained in Perugia between 1430 and 1440, where a Late Gothic style was still dominant. Subsequently he was influenced by Fra Angelico, whose polyptych (Perugia, G.N. Umbria) for S Domenico, Perugia, was commissioned in 1437, and more importantly by Domenico Veneziano, who worked in that city *c.* 1438. The influence of Domenico Veneziano and of Gentile da Fabriano can be seen in Bonfigli's earliest surviving work, a polyptych (now dismembered), which had a central panel of the *Virgin and Child* (El Paso, TX, Mus. A.), shown against a densely wooded background, and *St Sebastian and a Bishop Saint* (Monserrat, Mus.) on one wing. Another wing (untraced) shows *St Bernardino of Siena* and *St Anthony Abbot*. Bonfigli is first documented on 7 March 1445, when he undertook to paint a *Virgin and Child with Two Angels* (untraced) for a chapel near S Pietro, Perugia. A votive fresco of *SS Catherine and Clement I* in S Cristoforo, Passignano, is dated 1446 and is very close to Bonfigli's style, but given its poor quality it should probably be attributed to one of his followers. It demonstrates, however, that by that date he was an established and imitated master.

An *Adoration of the Magi, and Christ on the Cross* (London, N.G.), which may either be a predella panel or a small altarpiece, and an *Adoration of the Child* (Florence,

I Tatti) both show the influence of Domenico Veneziano; both have been plausibly attributed to Bonfigli and dated *c.* 1450.

Early in 1450 Bonfigli was in Rome working in the Vatican Palace; he was paid a salary of seven ducats per month, the same as Benozzo Gozzoli, which indicates that he was highly regarded at the court of Pope Nicholas V. Unfortunately, all his work in the Vatican has been destroyed. On 2 December 1454 Bonfigli was back in Perugia, where he contracted to paint a series of frescoes in the Priors' Chapel of the Palazzo dei Priori. Although in a bad state of preservation, this is his greatest work. Bonfigli painted a *Crucifixion with SS Francis and Ercolano* (later completely repainted by Hendrik van den Broeck) and scenes from the *Life of St Louis of Toulouse*, the patron of the palace, both of which were valued for payment by Filippo Lippi on 11 September 1461. The scenes from the *Life of St Ercolano* occupied Bonfigli for the rest of his life. In addition to the influence of Fra Angelico, Domenico Veneziano and Filippo Lippi, Bonfigli apparently also studied the work of Piero della Francesca and possibly Mantegna's frescoes in the church of the Eremitani, Padua. Bonfigli set these animated, anecdotal scenes in contemporary views of Rome and Perugia, as in *Totila Laying Siege to Perugia* (Perugia, G.N. Umbria; see fig.), in which the city is represented with archaeological and documentary precision.

From 1450 to 1470 Bonfigli was at the height of his career. Also from this period are the *Annunciation with St Luke* (Perugia, G.N. Umbria), which shows the influence of Gozzoli, the exquisite small *Annunciation* (Madrid, Mus. Thyssen-Bornemisza) and the *Virgin and Four Saints* (Perugia, G.N. Umbria). In 1466 Bonfigli painted the altarpiece of the *Adoration of the Magi* with a predella of *Episodes from the Life of Christ and a Miracle of St Nicholas* (Perugia, G.N. Umbria) mentioned by Vasari. In this work Bonfigli confidently handled the depiction of space. The composition of the *Adoration* is derived from Gentile da Fabriano's altarpiece of the same subject (Florence, Uffizi; *see* GENTILE DA FABRIANO, fig. 3). Stylistically it is influenced by Fra Angelico and Domenico Veneziano as well as Fra Filippo Lippi and Netherlandish painting, which would confirm that Bonfigli had travelled to Florence and possibly elsewhere in Italy. In 1467-8 for the chapel of S Vincenzo in S Domenico, Perugia, Bonfigli painted the *Virgin and Child with Music-making Angels* (Perugia, G.N. Umbria).

Bonfigli specialized in a typically Perugian art form: *gonfaloni* (banners or standards painted on canvas or linen, carried by confraternities). The *gonfalone* of *St Bernard Interceding for the Citizens of Perugia* (1465; Perugia, G.N. Umbria) contains anecdotal scenes but is poorly composed; that of *Christ Hurling Thunderbolts on Perugia with the Virgin and Saints Interceding* (1472; Perugia, S Maria Nuova) and another of the *Virgin and Saints Interceding for Perugia* (1476; Perugia, S Fiorenzo) are both very beautiful and certainly autograph. The *gonfalone* of the *Madonna of Misericordia* (Perugia, S Francesco al Prato), made for the Cappella della Confraternità della SS Concezione, and two in the parish churches in the villages of Corciano (1472) and Civitella Benazzone, both near Perugia, are probably workshop productions made under

Benedetto Bonfigli: *Totila Laying Siege to Perugia*, detached fresco from the Priors' Chapel of the Palazzo dei Priori, Perugia, *c.* 1454–61 (Perugia, Galleria Nazionale dell'Umbria)

Bonfigli's supervision. A small *gonfalone* (Perugia, Carmine) appears to be by a competent follower.

It is open to doubt whether Bonfigli played any part in the production of the series of eight small panels illustrating *Miracles of St Bernard* (1473; Perugia, G.N. Umbria), which have some similarity with the St Bernard *gonfalone* of 1465. Certainly they were influenced by Antonio del Pollaiuolo, Andrea Verrocchio and the art of Urbino. The influence of these artists represented a decisive turning-point in Perugian painting of the 1470s, and Bonfigli, although he lived for another 20 years, never adapted to the new style.

Vasari wrote that Bonfigli was the most highly esteemed painter in Perugia before Perugino; certainly he was a superior artist to his collaborator Bartolomeo Caporali and other contemporary Perugian painters; however, his influence hardly extended beyond his pupils.

BIBLIOGRAPHY

DBI; Thieme–Becker

G. Vasari: *Vite* (1550, rev. 2/1568); ed. G. Milanesi (1878–85), iii, pp. 505–6

L. Pascoli: *Vite de' pittori, scultori ed architetti perugini* (Rome, 1732), pp. 21–3

A. Mariotti: *Lettere pittoriche perugine* (Perugia, 1788), pp. 129–42

J. A. Crowe and G. B. Cavalcaselle: *A New History of Painting in Italy*, i (London, 1864), pp. 138–60

E. Muntz: *Les Arts à la cour des papes*, i (Paris, 1878), p. 129

L. Manzoni: 'Commentario di Benedetto Buonfigli', *Boll. Deput. Stor. Patria Umbria*, vi (1900), pp. 289–316

A. Venturi: *Storia* (1901–40), pp. 538–44

W. Bombe: *Benedetto Buonfigli* (Berlin, 1904)

V. Ansidei: *Di un documento inedito su Benedetto Bonfigli* (Perugia, 1912)

W. Bombe: *Geschichte der Peruginer Malerei* (Berlin, 1912), pp. 96–113

E. Jacobsen: *Umbrische Malerei des vierzehnten, funfzehnten und sechzehnten Jahrhunderts* (Strasbourg, 1914), pp. 46–51

U. Gnoli: *Pittori e miniatori nell'Umbria* (Spoleto, 1923), pp. 58–62

R. van Marle: *Italian Schools* (1923–38), xiv, pp. 99–128

C. Gamba: *Pittura umbra del rinascimento* (Novara, 1949), pp. xviii–xix

F. Zeri: 'Appunti nell'Ermitage e nel Museo Pusckin', *Boll. A.*, iv/46 (1961), pp. 226–31

B. Berenson: *Central and North Italian Schools*, i (1968), p. 58

F. Santi: *Gonfaloni umbri del rinascimento* (Perugia, 1976), pp. 23–7

F. Zeri: 'An *Annunciation* by Benedetto Bonfigli', *Apollo*, cviii (1978), pp. 394–5

F. Santi: *Galleria Nazionale dell'Umbria: Dipinti, sculture e oggetti dei secoli XV–XVI* (Rome, 1985), pp. 40–53

B. Toscano: 'Pittura del quattrocento in Umbria', *La pittura in Italia: Il quattrocento* (Milan, 1987), pp. 367–8

F. Todini: *La pittura umbra: Dal duecento al primo cinquecento* (Milan, 1989)

F. F. Mancini: *Benedetto Bonfigli* (Perugia, 1992)

P. SCARPELLINI

Bonfratelli, Apollonio de' (*b* Capranica, *c.* 1500; *d* Rome, 1575). Italian illuminator. He almost certainly studied under Giulio Clovio in Rome and later worked at the papal court, probably from 1523 to 1572; his name is entered in the Archivio di Stato Romano for the year 1568–9. A detached leaf from a choir-book, now in a book of cuttings, some of which are signed (London, BL, Add. MS. 21412, fols 36–43), bears the date 1564 and an inscription stating that Bonfratelli was *miniator* (miniaturist) to the Apostolic Chamber under Pope Pius IV. Its fine miniature of the *Adoration of the Shepherds* shows some influence of Raphael, while the borders, decorated with a frieze of festoons and architectural motifs, have small figures in the style of Michelangelo. Other works attributed to Bonfratelli include a small miniature of *St Luke* (Philadelphia, PA, Free Lib., Lewis MS. M. 27:7) and a single leaf (New York, Pierpont Morgan Lib., MS. M. 270) composed of fragments including the *Four Evangelists* and the arms of Pope Gregory XIII, for whom the book was probably made. The attribution of the latter to Bonfratelli

has, however, been contested by Brown. Bonfratelli's work is characterized by a lively use of colour and a free compositional style. His borrowings (particularly in the marginal decorations) from contemporary trends in printed book designs show that he made attempts to modernize his repertory in the mid-16th century, at a time when manuscript illumination was already in decline.

BIBLIOGRAPHY

DBI; Thieme–Becker
J. W. Bradley: *A Dictionary of Miniaturists*, i (London, 1887), pp. 147–8
M. Harrsen and G. K. Boyce: *Italian Manuscripts in the Morgan Library* (New York, 1953), p. 58
T. J. Brown: 'Some Manuscript Fragments Illuminated for Pope Gregory XIII', *BM Q.*, xiii (1960–61), pp. 2–5
The Painted Page: Italian Renaissance Book Illumination, 1450–1550 (exh. cat., ed. J. J. G. Alexander; London, RA, 1994)
□

Bonifazio de' Pitati. *See* PITATI, BONIFAZIO DE'.

Bonis, Niccolo de' (*fl* 1574–92). Italian medallist. Although he worked in the papal mint from 1580 to 1592, virtually nothing is known about his life and career, which may say something about the relative unimportance of a die-engraver, a job that he is documented as having in 1591 ('*incisore della Zecca Romana*'). He seems to have moved with his brother, Emilio de' Bonis, from Venice to Rome and signed a medal in 1574 for the inauguration of the Collegio Germanico in Rome. Thereafter, virtually all of his medals were produced for his papal employers. According to Forrer, he struck medals for Gregory XIII (1572–85), Sixtus V (1585–90; five variants), Gregory XIV (1590–91; eight variants), Innocent IX (1591; seven variants) and Clement VIII (1592–1605; four variants). As was usually the case with papal commemorative medals, an official portrait of the pontiff was established, coupled with a series of reverses devoted to significant acts or events that occurred during that particular papacy. Such medals were invariably struck and were relatively monotonous and dry in technique and style. Nonetheless, the medals of de' Bonis do possess certain distinctive qualities. The portraits of Sixtus V, for example, are quite vigorous and capture the gruff features of this former peasant. The medal struck to commemorate the building of the Ponte Felice over the Tiber in the Borghetto section of Rome (1589; see Panvini Rosati, no. 140) has a portrait executed in fine detail and in higher relief than is usual with these pieces. The pontifical cope is rendered with great delicacy and extraordinary attention to exact description. Few of Niccolo's portraits attain the same level of characterization, although his depiction of draperies is always precise and sensitive. The reverses also show a similar technical facility, as in the interesting perspective view of the Piazza del Popolo on a medal of Sixtus V (1589; see Pollard, no. 671) or the graceful figure of *Abundance* on a medal of Gregory XIV (1590–91; see Pollard, no. 686).

BIBLIOGRAPHY

Forrer
F. Panvini Rosati: *Medaglie e placchette italiane dal rinascimento al XVIII secolo* (Rome, 1968), pp. 43–4
Roma resurgens: Papal Medals from the Age of the Baroque (exh. cat., ed. N. T. Whitman and J. L. Varriano; Ann Arbor, U. MI, Mus. A., 1983), pp. 39, 44–5, 48, 187

G. Pollard: *Italian Renaissance Medals in the Museo Nazionale del Bargello* (Florence, 1985), pp. 1156–8, 1170, 1175, 1189
STEPHEN K. SCHER

Bono, Michele. *See* GIAMBONO, MICHELE.

Bono da Ferrara (*fl* 1450–52). Italian painter. An artist of this name is documented working in Siena Cathedral in 1442 and 1461, but he cannot be identified with certainty as the painter mentioned in the payments registers of the d'Este family for 1450–52, who frescoed a loggia in the *delizia* of Migliaro for Borso d'Este, 1st Duke of Ferrara and Modena, and who worked in the houses at Casaglia and in the *studiolo* of the Palazzo di Belfiore (all these works are untraced). The latter was certainly the painter whose signature OPVS BONI appears on the large fresco of *St Christopher* (destr. 1944) in the Ovetari Chapel in the church of the Eremitani, Padua, for which he received payments on 24 and 30 July 1451. The *St Jerome* (ex-Gal. Costabili, Ferrara; London, N.G.), signed BONVS FERRARIENSIS PISANJ DISCIPVLVS ('Bono da Ferrara pupil of Pisanello'), may reasonably be assigned to Bono on the basis of technical analysis and probably pre-dates the Paduan work. The undeniable mark of Pisanello in the painting led Venturi and Longhi, among others, to reject the signature and assign the painting to Pisanello himself. This argument is supported by a contemporary statement by Guarino Veronese documenting a painting of *St Jerome* by Pisanello in Ferrara. It seems preferable, however, to accept the attribution to Bono at a period when he was still strongly influenced by his master. The untraced painting cited by Guarino probably provided the basis for Bono's compositional scheme. The Paduan fresco and the *Virgin and Child* (*c.* 1450–60; Budapest, Mus. F.A.) strongly recall the works of Mantegna, the major figure involved in the decoration of the Ovetari Chapel, and also demonstrate Bono's marked interest both in the new Tuscan ideas then circulating among north Italian painters, in particular Piero della Francesca, and, still more strongly, in the powerful monumentality of Andrea del Castagno.

BIBLIOGRAPHY

DBI
T. Borenius: 'Bono da Ferrara', *Burl. Mag.*, xxxv (1919), p. 179
A. Venturi: 'Del quadro attribuito a Bono da Ferrara nella Galleria Nazionale di Londra', *L'Arte*, xxv (1922), pp. 105–8
R. Longhi: *Officina ferrarese* (Rome, 1934, rev. 1956), pp. 15, 16, 20, 95
M. Davies: *The Earlier Italian Schools*, London, N.G. cat. (London, 1951, 2/1961/*R* 1986), pp. 93–5
□

Bononia. *See* BOLOGNA.

Bononia, Baveram de. *See* BAVIERA.

Bonsignori [Monsignori], **Francesco** (*b* Verona, *c.* 1460; *d* Caldiero, nr Verona, 2 July 1519). Italian painter. His father, Albertus Bonsignori, was reputedly an amateur painter; and besides Francesco, the oldest and most talented of his children, three other sons, including Bernardino (*c.* 1476–*c.* 1520) and Girolamo (*b c.* 1479), are also recorded as painters. Barely 20 paintings and fewer than a dozen drawings have been attributed to Francesco Bonsignori. Documents from his time at the Gonzaga

court in Mantua and Vasari's account of his life are the main sources for information on the artist.

Bonsignori's early career is the most fully documented period of his activity. His earliest signed work is a *Virgin and Child* (dated 1483; Verona, Castelvecchio), followed by the dal Bovo Altarpiece, depicting the *Virgin and Child Enthroned with Saints*, signed and dated 1484 (Verona, Castelvecchio), and the portrait of a *Venetian Senator* (London, N.G.), signed and dated 1487 (cartoon, Vienna, Albertina). The altarpiece depicting the *Virgin and Child Enthroned with Music-making Angels and SS George and Jerome* in the Banda Chapel, S Bernardino, Verona, is signed and dated 1488. Another altarpiece that was signed and dated 1488, depicting the *Virgin and Child Enthroned with SS Anthony of Egypt and Onofrio*, is known through a 19th-century copy (Florence, I Tatti). This group of works clearly indicates the characteristics and limitations of Bonsignori's art. Throughout his life he drew inspiration from other artists with regard to composition, form and colouring. His early models were Andrea Mantegna, Giovanni Bellini, Alvise Vivarini and Antonello da Messina. In spite of these identifiable influences, Bonsignori's style is unmistakably individual. His most successful genre is the devotional picture, where he is able to concentrate on the human figure. Because of this interest his portraits, too, are among his best works. Narrative details and landscape or architectural settings do not feature significantly in his paintings.

From 1492 Bonsignori was in Mantua in the service of the Gonzaga family, by whom he was employed as a portrait painter and in the decoration (destr.) of their palaces at Marmirolo and Gonzaga. In 1494 Francesco Gonzaga, 4th Marquese of Mantua, gave Bonsignori a piece of land in the Gonzaga region as a reward for his services as a painter. There is evidence from the same year that Bonsignori was then working on a portrait (untraced) of *Eleonora Gonzaga* (1493–1550). In 1495 Isabella d'Este, Marchessa of Mantua, planned to have her portrait painted by Bonsignori. This was delayed, however, by Francesco Gonzaga II's commission for a painting (untraced) to commemorate his victory as leader of the Italian states against Charles VIII, King of France (*reg* 1483–98), at Fornovo on 6 July 1495. In the autumn of 1495 Bonsignori travelled to the site of the battle with Francesco's court architect Bernardino Ghisolfi (*fl* 1483–1511) to make drawings of the area. A chalk drawing of *Francesco Gonzaga* (Dublin, N.G.), datable to *c.* 1500, is one of Bonsignori's most expressive portraits and one of the most sympathetic portrayals of the ruler. It supports Vasari's remark that the relation between Francesco Gonzaga and Bonsignori was warm and affectionate. The high quality of the drawing is also apparent in the discussion of its attribution: Mantegna and Giovanni Bellini have also been considered as authors of the work.

From 1495 there is no documentary mention of Bonsignori until *c.* 1506–7, when he executed the *Last Supper* (untraced) for the monastery of S Francesco de' Zoccolanti, Mantua. The profile drawing of the *Young Federico Gonzaga, 5th Marquese of Mantua* (Vienna, Albertina) is probably a study for the painting, in which Federico was shown kneeling in front of his father Francesco and being commended to Christ through the intercession of St Francis; opposite this group, St Bernard commended Cardinal Sigismondo Gonzaga (1469–1525) and Eleonora Gonzaga. The painting of *SS Louis and Francis with the Insignia of Christ* (ex-S Francesco de' Zoccolanti, Mantua; Milan, Brera) was probably produced at the same time as the *Last Supper*.

Portraits of Francesco's sister, *Elisabetta Gonzaga* (1471–1526) (Florence, Uffizi), and of *Emilia Pia di Montefeltro* (1471–1528) (Baltimore, MD, Mus. A.) were probably produced in 1509, when the two women were in Mantua. Bonsignori usually made monochrome copies of his portraits, according to Vasari, who saw the artist's collection of portrait drawings in the possession of his heirs in Mantua. This collection included portraits of Francesco Gonzaga's family for use as gifts to foreign rulers as well as portraits of *Francesco Sforza, Duke of Milan, Massimiliano Sforza, Duke of Milan, Andrea Mantegna* and others.

Christ Carrying the Cross (*c.* 1510; Mantua, Pal. Ducale) not only recalls Mantegna but also reveals, in its colour and mood, the influence of Lorenzo Costa the elder, who succeeded Mantegna as court painter to the Gonzagas in 1507. That this position was not given to Bonsignori, whose talent, along with his reliability and his compliance with the wishes of the Gonzaga family, had made him the most highly esteemed painter after Mantegna among the group of artists employed by the court, may be because Bonsignori—who, Vasari wrote, led a life of exemplary piety—probably did not participate in the passionate reverence for antiquity that pervaded life at the Mantuan court and thus was not equal to the artistic requirements of Isabella d'Este in particular.

Costa's use of form and colour had a decisive influence on Bonsignori's late style, as can be seen in the *St Sebastian* (1510–14; Curtatone, S Maria delle Grazie) and above all in the altarpiece depicting the *Virgin and Child in Glory with SS Blaise, Sebastian, Martial and Juliana* (1514–19) in SS Nazaro e Celso, Verona. In 1519 Bonsignori completed his last monumental work, an altarpiece depicting the *Adoration of the Blessed Osanna Andreasi* (Mantua, Pal. Ducale; see fig.). The nun is shown venerated by three Dominican nuns and two women in secular dress, one of whom, kneeling in the left foreground, can be identified as Isabella d'Este. A preparatory drawing for this figure (London, BM) shows the Marchessa dressed as a widow, indicating that the picture was completed after Federico Gonzaga's death on 29 March 1519. According to Vasari, Bonsignori died soon afterwards during a cure at Caldiero near Verona. The painting's old-fashioned compositional style provides a link with Bonsignori's first altarpiece of 1484. There are no landscape or architectural elements and no narrative details. The small group of pious women, probably all portraits, is the focus of attention. Bonsignori must have been familiar with the figure and facial features of the Blessed Osanna Andreasi (1449–1505), who had for decades been closely connected with the Gonzagas as a spiritual and political adviser. Thus in his final major work Bonsignori achieved a unique combination of the devotional picture and the portrait, genres that had from the beginning formed the twin focal-points of his work.

BIBLIOGRAPHY

DBI; Thieme–Becker

G. Vasari: *Vite* (1550, rev. 2/1568); ed. G. Milanesi (1878–85), v, pp. 299–307

Francesco Bonsignori: *Adoration of the Blessed Osanna Andreasi*, oil on canvas, 2.06×1.54 m, 1519 (Mantua, Palazzo Ducale)

B. dal Pozzo: *Le vite de' pittori, scultori e architetti veronesi* (Verona, 1718), pp. 18–22

D. Zannandreis: *Le vite dei pittori, scultori e architetti veronesi* (1831–34); ed. G. Biadego (Verona, 1891), pp. 250–54

C. D'Arco: *Delle arti e degli artefici di Mantova*, i (Mantua, 1857), pp. 56–9

C. Bernasconi: *Studi sopra la storia della pittura italiana dei secoli XIV e XV e della scuola pittorica veronese dai medj tempi fino a tutto il secolo XVIII* (Verona, 1864), pp. 250–54

G. Biadego: 'La Cappella di S Biagio nella chiesa dei SS Nazaro e Celso di Verona', *Nuovo Archv Ven.* (1906), pp. 123–4

L. Venturi: *Le origini della pittura veneta* (Venice, 1907), pp. 266–8

E. Tea: 'La famiglia Bonsignori', *Madonna Verona*, iv/13–16 (1910), pp. 130–40

A. L. Mayer: 'Francesco Bonsignori als Bildnismaler', *Pantheon*, iv (1929), pp. 345–55

R. Brenzoni: 'Su l'origine della famiglia di F. Bonsignori', *L'Arte*, lvii (1958), pp. 295–300; lviii (1959), pp. 225–8

C. Perina: 'Francesco Bonsignori', *Mantova: Le arti* (Mantua, 1961), ii, 1, pp. 367–72

U. B. Schmitt: 'Francesco Bonsignori', *Münchn. Jb. Bild. Kst* (1961), pp. 73–152

Andrea Mantegna (exh. cat., ed. G. Paccagnini; Mantua, Pal. Ducale, 1961), pp. 110–18

B. Berenson: *Central and North Italian Schools*, i (1968)

G. M. Sasso: *Venezia pittrice* (in preparation)

URSULA LEHMANN-BROCKHAUS

Bonvicino, Alessandro. *See* MORETTO.

Bonzagna [Bonzagni], **Gian Federigo** [Federigo Parmense] (*b* Parma, 1508; *d* after 1586). Italian medallist and goldsmith. His first signed medal was made in 1549 for Pope Paul III. Bonzagna is documented in 1554 working in the papal mint in Rome with his brother Gian Giacomo Bonzagna (1507–65) and Alessandro Cesati. He worked for the papal mint until 1575, when he prepared a medal for Pope Gregory XIII. He also worked in the mint at Parma, where he engraved the dies for medals of Pier Luigi Farnese, 1st Duke of Parma and Piacenza, Cardinal Alessandro Farnese and Ottavio Farnese, 2nd Duke of Parma and Piacenza. Bonzagna also executed medals for Cardinal Federico Cesi and, in 1560, Gian Battista di Collalto. In 1561 Bonzagna worked as a goldsmith with Cesati and Gian Alberto de' Rossi on a silver-gilt pax for Milan Cathedral. Bonzagna was one of the most prolific medallists of the 16th century. Because many of his medals were unsigned, it is difficult to distinguish his dies from those of Cesati. In some medals the obverse is by Bonzagna and the reverse by another artist. These were produced when several medals were restruck by Mazio in the 19th century. Bonzagna's work is varied and shows considerable technical accomplishment, but his style is cold and academic.

BIBLIOGRAPHY

Thieme–Becker

G. F. Hill: *Medals of the Renaissance* (Oxford, 1920, rev. London, 1978), pp. 91, 178, no. 240

G. F. Hill and J. G. Pollard: *Renaissance Medals from the Samuel H. Kress Collection at the National Gallery of Art* (London, 1967), p. 70

F. Panvini Rosati: *Medaglie e placchette italiane dal rinascimento al XVIII secolo* (Rome, 1968), pp. 39–42

J. G. Pollard: *Medaglie italiane del rinascimento nel Museo nazionale del Bargello* (Florence, 1984–5), ii, pp. 990–95, 1056–64, 1075–6, 1086–91; iii, pp. 1333–4

C. Johnson and R. Martini: *Milano, civiche raccolte numismatiche: Catalogo delle medaglie*, ii (Rome, 1988), pp. 93–144

FRANCO PANVINI ROSATI

Bordon [Bordone; Padovano], **Benedetto** (*fl* 1488; *d* Padua, Feb 1530). Italian illuminator, printmaker and writer. He is first mentioned in Padua as an illuminator in 1488. He has been identified as the Benedetto Padovano who signed the *Digestum novum* (BENEDI[CTI] PATAV[INI]; see fig.) and the Decretals of Pope Gregory IX (BE[NEDICTI] PA[TAVINI]), published by Jenson in Venice in 1477 and 1479 respectively (Gotha, Landesbib., Mon. Typ. 1477; Mon. Typ. 1479). Both incunabula were commissioned by the German book dealer Peter Ugelheimer, for whom Girolamo da Cremona also worked, probably shortly after 1483; the apparent dependence of Bordon's style on Girolamo, particularly in his early works, may suggest that the Gotha incunabula were decorated after that date, during the years in which Bordon is documented in Padua. In the same period he probably also illuminated two folios (Munich, Staatl. Graph. Samml., 40198 and 40140), a Book of Hours (Vienna, Österreich. Nbib., Cod. 1970) and a Cistercian Breviary (Oxford, Bodleian Lib., MS. Canon. Lit. 343).

In 1492 Bordon moved to Venice, where he was noted also for his work as a scholar and writer. In 1494 he edited an Italian translation of the Dialogues of Lucian of Samosato, illustrating the text himself. The book (Vienna, Österreich. Nbib., Inc. 4.G.27) bears the coat of arms of the Mocenigo family, and its decoration reflects Bordon's fresh response to Venetian painting, especially the work of Giovanni Battista Cima. Evidence of Bordon's work as an engraver survives in his 'book in which we speak of all the islands of the world', the *Isolario* (Venice, 1528); in 1504 he requested a licence to print a *Triumph of Caesar*. This had long been thought to be lost, but in the 1970s it

Benedetto Bordon: illumination from the *Digestum novum* (Venice, 1477) (Gotha, Landesbibliothek, Mon. Typ. 1477, *v* z.13, A.1.b)

was traced back through a 19th-century record to the *Triumph* traditionally attributed to the Alsatian woodcutter Jacobus Argentoratensis (Massing, 1990), with whom it is thought Benedetto may have collaborated on more than one work. Nevertheless, the impression that provided the evidence for this claim, which referred to Jacobus as the publisher, is untraced. It has been suggested that Bordon may be identified with the 'Classical Designer', who was responsible for a number of Venetian woodcuts in the 1490s.

A contract of 1523 records that Bordon undertook to decorate a Gospel Book and an Epistles for the Benedictine monastery of S Giustina in Padua. These have been identified as the manuscripts held respectively in Dublin (Chester Beatty Lib., MS. 107; signed BENEDETTO BORDONUS) and London (BL, Add. MS. 15815). Although they are years later than the Gotha incunabula, the works are homogeneous in style. This has supported Mariani Canova's emphasis on the identification of Bordon with Benedetto Padovano, which was accepted by the earliest critics but questioned by some later scholars, such as Levi D'Ancona (1967). The latter also attributed to Benedetto Padovano an Antiphonary (Padua, Mus. Civ., MSS C.M. 811–12) and other stylistically related works, including the Barozzi Missal (Padua, Bib. Capitolare, Inc. N. 260), but Mariani Canova has shown that these are the work of Antonio Maria da Villafora.

Bordon was the father of the humanist Giulio Cesare Scaligero, and he stands out as a truly eclectic personality with many interests, both literary and scientific. He was one of the principal masters of Paduan Renaissance illustration, strongly influenced by Mantegna but also open, in his mature years, to ideas from Venetian art and from contemporary Ferrarese illumination.

DBI

BIBLIOGRAPHY

R. Benson: *The Holford Collection: Dorchester House*, i (Oxford, 1929), pp. 32–3

M. Levi D'Ancona: 'Benedetto Padovano e Benedetto Bordone: Primo tentativo per un corpus di Benedetto Padovano', *Commentari*, xviii (1967), pp. 3–42

M. Billanovich: 'Benedetto Bordon e Giulio Cesare Scaligero', *Italia Med. & Uman.*, xi (1968), pp. 187–256

M. Levi D'Ancona: 'Precisazioni sulla miniatura veneta', *Commentari*, xxix (1968), pp. 268–72

G. Mariani Canova: 'Profilo di Benedetto Bordon miniatore padovano', *Atti Ist. Ven. Sci., Lett. & A.*, cxxvii (1968–9), pp. 99–121

J. J. G. Alexander and A. C. De La Mare: *The Italian Manuscripts in the Library of Major J. R. Abbey* (London, 1969), pp. 157–8

J. J. G. Alexander: 'Notes on some Veneto-Paduan Illuminated Books of the Renaissance', *A. Ven.*, xxiii (1969), p. 16

G. Mariani Canova: *La miniatura veneta del Rinascimento, 1450–1500* (Venice, 1969), pp. 68–74, 122–30

——: 'Manoscritti miniati veneti nelle biblioteche di Cambridge e Boston (Mass.)', *A. Ven.*, xxix (1975), pp. 97–104

U. Bauer Eberhardt: *Die italienischen Miniaturen des 13–16 Jahrhunderts* (Munich, 1984), pp. 26–7

J. M. Massing: '*The Triumph of Caesar* by Benedetto Bordon and Jacobus Argentoratensis: Its Iconography and Influence', *Prt Q.*, vii/1 (1990), pp. 2–21

The Painted Page: Italian Renaissance Book Illumination, 1450–1550 (exh. cat., ed. J. J. G. Alexander; London, RA; 1994)

H. K. Szepe: 'The Book as Companion, the Author as Friend: Aldine Octavos Illuminated by Benedetto Bordon', *Word & Image*, xi (Jan–March 1995), pp. 77–99

MILVIA BOLLATI

Bordone [Bordon], **Paris** (*b* Treviso, *bapt* 5 July 1500; *d* Venice, 19 Jan 1571). Italian painter and draughtsman. He is best known for his strikingly beautiful depictions of women, both in portraits and in cabinet paintings. He also excelled in rendering monumental architectural settings for narrative, both religious and secular, possibly initiating a genre that would find great currency during the mid-16th century, especially in Venice, France and the Netherlands. His favoured media were oil and fresco, the latter being used on both interiors and façades. Although he was not generally sought after by Venetian patrons during his career, as his art was eclipsed by that of Titian, Paolo Veronese and Jacopo Tintoretto, Bordone was regarded in the mid-16th century as an accomplished artist (Pino; Sansovino). He worked for the moneyed élite of North Italy and Bavaria, for the royalty of France and Poland, and had works commissioned to be sent to Spain and to Flanders.

Despite knowledge of the important patrons for whom he worked, the chronology of Bordone's oeuvre is by no means clear. Dating on stylistic grounds is confounded by the diverse sources on which he drew, ranging from the Emilian, Lombard and Venetian to the French and northern European, depending on the patron. Due to the ease with which prints circulated during Bordone's career, it is difficult to ascertain whether influences were derived at first hand or from printed images. Such difficulties in assigning dates are further exacerbated by his use of the

same figure study for numerous paintings evidently executed decades apart. Reliance on the testimony of Vasari, who interviewed Bordone in 1566, in conjunction with the extant documents, the few signed and dated paintings and, to a lesser extent, period fashion provides only a rough outline of his activity. Due to the lack of agreement among scholars regarding chronology, the following account is based mainly on the documentary evidence.

1. Training and early work in Venice, before 1538. 2. Middle period, 1538–*c.* 1550. 3. Late works, after *c.* 1550.

1. TRAINING AND EARLY WORK IN VENICE, BEFORE 1538. On the death of his father, Giovanni, in 1508, Paris moved with his mother, Angelica, to Venice. At school he excelled particularly in grammar and music and then entered the studio of Titian, probably in 1516. By 1518 he had become a master, although he had left Titian's studio prematurely, evidently due to Titian's hostility towards a student who so successfully imitated his style. The rift was apparently so great that Titian took for himself Bordone's first Venetian commission, the altarpiece (1523) of S Niccolò dei Frari. Giorgione's art also influenced Bordone early on, tempered by the example of other artists' work. Bordone's *The Lovers* (early 1520s; Milan, Brera; see colour pl. 1, XIII1), for example, exhibits a Giorgionesque mood and attendant psychology; the lovers emerge from the dark ground bathed in a soft light, while a third figure is relegated to relative obscurity in the darkness. The figural composition evidently draws on Tullio Lombardo's marble relief of 1510 of the same subject, as well as Titian's own *Lovers* (Florence, Casa Buonarroti), but Bordone added a third party. Typically he took a delight in texture and attention to detail, evident particularly in the sumptuous fabrics and gems and the soft, supple skin of figures that are imbued also with a Raphaelesque elegance and grace. The subject-matter itself looks forward to the conflation of portraiture and allegory that characterizes much of his mature work.

In Bordone's early religious paintings comparable artistic influences are evident. Giorgione's *Virgin and Child Enthroned with SS George and Francis* (*c.* 1500; Castelfranco Veneto, S Liberale; see GIORGIONE, fig. 6), executed for a condottiere (Tuzio Costanzo), provided Bordone with both a compositional and a stylistic guide for his *Virgin with SS Christopher and George* (*c.* 1524–6; Lovere, Gal. Accad. B.A. Tadini) for S Agostino, Crema, also commissioned by a condottiere, Giulio Manfron (*d* 1526). Typically, Bordone did not copy Giorgione slavishly; he enlivened the older master's composition in a manner evocative of both Titian and Pordenone, Titian's greatest rival in Venice. The figure of St George, a portrait of Giulio Manfron, stands in a relaxed but relatively static pose, while St Christopher, protector from violent deaths, such as Manfron was to suffer, emerges from the water with a forceful torsion reminiscent of Titian's and Pordenone's figures; the Virgin twists lest she let go of her son, recalling the sense of movement in Titian's figures of the Virgin; and the angels holding the cloth of honour evoke Raphael.

Bordone first achieved public recognition in 1534, when he won the competition of the Scuola Grande di S Marco

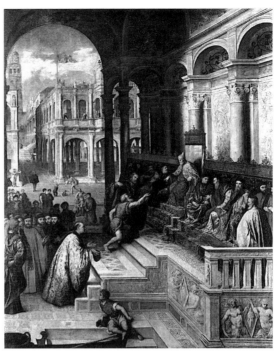

1. Paris Bordone: *Presentation of the Ring to the Doge*, oil on canvas, 3.7×3.0 m, 1534–5 (Venice, Galleria dell'Accademia)

to execute the *Presentation of the Ring to the Doge* (Venice, Accad.; see fig. 1). Nepotism may have played a part in his success; Zuan Alvise Bonrizzo, Guardian Grande of the Scuola in the 1530s, was his wife's uncle. With this painting Bordone reached artistic maturity; Vasari thought it the 'most beautiful and most noteworthy painting ever created by Paris'. The architecture is inspired by Books II and IV of his friend Sebastiano Serlio's unpublished treatise on architecture and follows a Venetian tradition of using detailed architectural backgrounds often not manifestly relevant to the narrative. It shows an ideal view of the renovations to the Doge's Palace and environs planned by Doge Andrea Gritti, who is represented as the 14th-century doge Pietro Gradenigo (*reg* 1289–1311), as well as a view of the tower of the Madonna dell'Orto, near where Bordone lived. Bordone's accomplished handling of the architecture may have prompted Titian's setting in the *Presentation of the Virgin* (1534–8; Venice, Accad.) of the Scuola Grande della Carità. No presentation drawing or modello survives for any painting by Bordone, although a sketch of a draped male figure seen from behind (Paris, priv. col., see Rearick in 1987 symposium, fig. 8) can be related to the *Presentation of the Ring*. Executed in black chalk, heightened with white, on blue paper, the artist's favoured method, the study relates to figures at the periphery of the canvas and exhibits the use of parallel hatching and the energetic touch that characterize much of Bordone's Titianesque draughtsmanship.

2. MIDDLE PERIOD, 1538–*c.* 1550. Success in the competition of 1534 did not lead to further important Venetian commissions for Bordone. In 1539 he lost a competition for a *Marriage of the Virgin* for the Scuola

Grande della Carità to another follower of Titian, Gian Pietro Silvio (*d* 1552). He had already begun to look elsewhere for patrons. He was absent from Venice from March 1538 until April 1539, and, according to Vasari, he travelled to Fontainebleau in 1538 to work at the court of Francis I (*reg* 1515–47), where he executed a large number of paintings including portraits of women. Among these commissions Vasari mentioned a cabinet picture of *Venus and Cupid* (perhaps Warsaw, N. Mus.) executed for the Duc de Guise (?Claude I, 1496–1550); and an *Ecce homo* (untraced) and *Jupiter with Io* for Cardinal de Lorraine (?Jean de Lorraine 1498–1550), generally identified as the signed but undated *Jupiter with Io* (Göteborg, Kstmus.; see fig. 2). The work exhibits Bordone's synthesis of the Venetian, Central Italian and French Mannerist sensibilities, probably inspired by such followers of Raphael as Luca Penni and Francesco Primaticcio, as well as the more Michelangelesque Rosso Fiorentino, who were also in the employ of the French king. The monumental figures of Jupiter and Io embrace amid the clouds, watched by Jupiter's eagle, while Juno rushes to the scene in her chariot. The soft, luminous flesh of the Brera *Lovers* is here given a more polished and pristine veneer, and the moody atmosphere, reminiscent of Giorgione, becomes a brighter, more refined ambience wholly in keeping with the courtly Mannerist style. Bordone's attention to detail and texture remains, but the glistening pearls on Io's tiara, her loosely flowing tresses (generally reserved for courtesans and maidens in 16th-century painting) and the delicacy and tactile quality of each fibre of her untied undergarment contribute to the preciosity and titillating nature of the scene.

On his return from France, Bordone embarked on an extensive fresco cycle for Santa Croce in Pialdier (Belluno) and continued to paint portraits, for which he was by this

time apparently well known. The portrait of *Jerome Krafft*, signed and dated 1540 (Paris, Louvre), together with evidence of Bordone's absence from Venice from November 1540 to April 1543, has been used to date the artist's trip to Bavaria. The documents presented by Fossaluzza (1982), however, suggest that the portrait was painted in Venice and that Bordone was in Milan during the early 1540s in the employ of Carlo da Rho (*d* 1552). In the chapel of S Jeronimo in S Maria presso S Celso, Milan, Bordone painted the altarpiece of a *Holy Family with St Jerome and Angels*, with a predella of a *Sleeping St Roch Visited by Angels* as well as a frescoed lunette representing *God the Father Surrounded by Angels*, works that exhibit his continuing debt to Titian. Bordone received payment for work on the chapel in July 1542, and by 1543 he is again documented in Venice. He seems to have remained in the Veneto until the autumn of 1548, although the possibility that in the interim he travelled to Augsburg cannot be discounted altogether. On 22 November 1548 he is documented in Milan, where he remained until *c.* 1550–51. At this time he worked again for Carlo da Rho and his consort, Paola Visconti, and executed a group of paintings with secular and religious subjects as well as portraits. The portrait of Carlo has not been identified, but that of *Paola Visconti* (ex-Pal. Real, Sintra) exhibits a new influence from the Lombard school, particularly of Moretto. A debt to Lorenzo Lotto, with whom Bordone had in 1548 been in contact in Venice, is also evident. The narrative paintings of this period continue to manifest Bordone's synthesis of the Venetian, Central Italian and French styles, especially of Raphael's school, and include *Venus and Mars under Vulcan's Net* (Berlin, Gemäldegal.) and its pendant, *Bathsheba Bathing* (Cologne, Wallraf-Richartz-Mus.), on the subject of adultery; a landscape with the *Holy Family and St John the Baptist* (Bonn, priv. col., see 1984 exh. cat., pl. 23), which, given the collocation of mythological and biblical subject-matter in the former pair, possibly formed a pendant to a pagan subject; as well as a nocturnal *Baptism of Christ* (Milan, Brera), possibly also a pendant to another unknown work. While in Milan, Bordone was also commissioned by Candiano, the Milanese physician to Mary, Queen of Hungary and Regent of the Netherlands (*reg* 1519–56), to execute a *St Mary Magdalene in the Desert with Angels* and a *Diana Bathing with Nymphs* (both untraced) as presents for the Queen. He also painted a number of Ovidian myths for the Marchese d'Astorga. These are thought to include a *Rape of Proserpina* (untraced), a *Rape of Europa* (Breda di Piave, Antonio Zangrando priv. col.) and a *Venus and Anchises* (Paris, Louvre). Bordone also seems to have painted a *Jupiter with a Nymph* for the King of Poland (either Sigismund I or II) at this time, or possibly slightly later, *c.* 1551–2, when he painted a portrait of the King's Veronese jeweller, *Gian Jacopo Caraglio* (Kraków, N. A. Cols) in Italy.

3. LATE WORKS, AFTER *c.* 1550. If Bordone did not go to Augsburg in the 1540s, he could not have travelled there until, at the earliest, December 1552. About 1550 he executed an extensive fresco cycle at S Simon di Vallada, Venice, which exhibits an influence of Leonardo and his Milanese school; in 1551 he painted an altarpiece of the

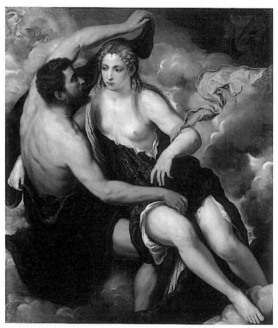

2. Paris Bordone: *Jupiter with Io*, oil on canvas, 1.36×1.18 m, *c.* 1538–40 or *c.* 1559 (Göteborg, Göteborgs Konstmuseum)

Sacred Mysteries for Treviso Cathedral, commissioned by Canon Andrea Salomon; he is documented as being in Treviso on 22–23 November 1552; and he executed several paintings, one on an extremely large scale, while in Bavaria at work for the Fugger family and an undocumented Prineri family, indicating a rather lengthy sojourn there. Garas dated the Bavarian stay to around 1550–60 and suggested that Bordone executed a series of six paintings for a room in the palace of one of his Bavarian patrons: a *Venus and Cupid* and its pendant, *Diana the Huntress with Nymphs* (both ex-Gemäldegal., Dresden); *Venus, Mars, Cupid and Victory* and *Mars Taking Cupid's Bow with Venus and Flora* (both Vienna, Ksthist. Mus.); *Apollo, Midas and Pan* (Dresden, Gemäldegal.) and an untraced panel with two unidentified female figures. The theme seems to concern love and marriage (e.g. Venus wears red, symbolizing love, and Victory holds the myrtle of marriage), yet the two figures of Mars differ substantially in age and appearance, suggesting either that there are problems in the reconstruction or that the paintings were intended to be viewed in pairs, rather than as a coherent programme. Vasari also mentioned that Bordone created a cabinet picture in the possession of the Cardinal of Augsburg, Otto Truchsess von Waldberg (1514–73), and 'a painting with all five orders of architecture' for the Prineri family, once identified as *Augustus and the Sibyl* (Moscow, Obraztsov Col., see Formicheva, 1971, fig. 45), but—given the French provenance of the latter work (traceable to the 17th century) and probable execution in France—now generally identified as the *Combat of Gladiators* (Vienna, Ksthist. Mus.) once attributed to Raphael's student Giulio Romano. For the *Combat* Bordone drew on Serlio once again, this time on Book III, but he accentuated the importance of the architecture by the use of diminutive figures; the painting probably has political overtones.

Of the many problems connected with the chronology of Bordone's works, the most contentious concerns a trip to the court of Francis II (*reg* 1559–60) at Fontainebleau in 1559. Federici (1803) found an encomium (untraced) written in 1559 by the Trevisan lawyer and humanist Prospero Aproino (*d* 1611) in honour of the departure of his city's most famed artist for France. Other peripheral documents have recently been used, with external evidence, to argue a case for a single French sojourn in 1559; for two French sojourns; and for a single trip in 1538. Were the trip to have occurred in 1559, then the *Venus and Cupid, Ecce homo, Jupiter with Io* and *Augustus and the Sibyl*, mentioned above, would all have to be dated some 20 years later than Vasari's testimony. Since documents reveal that from 1557–8 Bordone was at work on an altarpiece of the *Virgin Presenting St Dominic to the Saviour* (Milan, Brera), as well as a *Resurrection* and *Saints with Angels* (untraced) for the monastery of S Paolo in Treviso (destr. after 1810), and that in 1561 he was working for the monastery of Ognissanti in Treviso, then the possibility remains that in between Bordone was in France.

After 1560 Bordone worked at his Venetian studio, but his important commissions came from Treviso, not from Venice. This patronage derived from religious institutions, and, with the exception of portraits, he seems to have spent the remaining years of his life painting altarpieces

exhibiting a somewhat repetitive formal repertory, a tendency to which he was inclined throughout his life, given his habit of repeating figure studies from his own model-book. In the signed and dated *SS Lawrence, Jerome, Peter, John the Baptist and Sebastian* (1562; ex-S Lorenzo, Treviso; now Treviso Cathedral), he not only repeated figures within the same composition, but reduced them to virtual petrifaction.

BIBLIOGRAPHY

DBI; Thieme–Becker

P. Pino: *Dialogo di pittura* (Venice, 1548); ed. R. Pallucchini and A. Pallucchini (Venice, 1946)

G. Vasari: *Vite* (1550, rev. 2/1568); ed. G. Milanesi (1878–85), vii, pp. 461–6

F. Sansovino: *Delle cose notabili che sono in Venetia* (Venice, 1561)

D. M. Federici: *Memorie trevigiane sulle opere di disegno*, ii (Venice, 1803), pp. 41–5

M. Muraro: 'Un ciclo di affreschi di Paris Bordone', *A. Ven.*, ix (1955), pp. 80–85

G. M. Canova: 'I viaggi di Paris Bordone', *A. Ven.*, xv (1961), pp. 77–88

——: *Paris Bordon*, Profili & saggi di arte veneta, ii (Venice, 1964); review by C. Gould in *Burl. Mag.*, cvii (1965), p. 583

——: 'Nuove note a Paris Bordon', *A. Ven.*, xxii (1968), pp. 171–6

T. Formicheva: 'An Architectural Perspective by Paris Bordone', *Burl. Mag.*, xciii (1971), pp. 152–5

B. Klesse: 'Studien zu italienischen und französischen Gemälden des Wallraf-Richartz-Museums', *Wallraf-Richartz-Jb.*, xxxiv (1972), pp. 175–262

K. Prijatelj: 'Le opere di una collezione veneziana della fine del seicento a Dubrovnik (Ragusa)', *A. Ven.*, xxxiii (1979), pp. 167–8

G. Fossaluzza: 'Una *Sacra Famiglia* di Paris Bordon ritrovata', *A. Ven.*, xxxvi (1982), pp. 197–9

G. M. Canova: 'Precisazioni su Paris Bordon', *A. Ven.*, xxxviii (1984), pp. 132–6

Paris Bordon (exh. cat., ed. E. Manzato; Treviso, Pal. Trecento, 1984); review by L. L. Crosato in *Kunstchronik*, xxxviii/5 (May 1985), pp. 166–73

S. F. Lake: 'A Pounced Design in *David and Bathsheba* by Paris Bordone', *J. Walters A.G.*, xlii–xliii (1984–5), pp. 62–5

S. Béguin: 'Deux dessins inédits du Musée de Rennes', *Paragone*, xxxvi/419–23 (1985), pp. 180–83

E. Coda: 'Un inedito ciclo di affreschi di Paris Bordon nel Bellunese', *A. Ven.*, xxxix (1985), pp. 132–9

P. Humfrey: 'The Bellinesque *Life of St Mark* Cycle for the Scuola Grande di San Marco in Venice in its Original Arrangement', *Z. Kstgesch.*, xlviii (1985), pp. 225–44

Paris Bordon e il suo tempo: Atti del convegno internazionale di studi: Treviso, 1985 [esp. articles by K. Garas and W. Rearick]

M. Rogers: 'The Decorum of Women's Beauty: Trissino, Firenzuola, Luigini and the Representation of Women in Sixteenth-century Painting', *Ren. Stud.*, ii/1 (1988), pp. 47–88

S. Claut: 'Ancora a proposito di Paris Bordon', *Archv Stor. Belluno, Feltre & Cadore*, lxv/286 (Jan–March, 1994), pp. 20–24

CORINNE MANDEL

Borgherini, Pierfrancesco (*b* Florence, 4 April 1480; *d* Florence, 11 Nov 1558). Italian banker and patron. His main activities were in his family's Florentine banking business. His father, Salvi di Francesco Borgherini, presented him and Margherita Acciaiuoli on their marriage in 1515 with furnishings for their bedroom in the Palazzo Borgherini (now the Palazzo Rosselli del Turco) in the Borgo Ss Apostoli, Florence. These were produced by the workshop of Baccio d'Agnolo and were decorated with scenes by Andrea del Sarto (*Life of Joseph the Hebrew*, Florence, Pitti), Pontormo (London, N.G.), Bacchiacca (Rome, Gal. Borghese and London, N.G.) and Francesco Granacci (Florence, Uffizi; for illustration *see* GRANACCI, FRANCESCO), who also painted a *Trinity* (Berlin, Staatl. Museen, N. G.) that adorned the same room. The fireplace

by Baccio d'Agnolo is *in situ*; the richly carved chimney-piece by Benedetto di Rovezzano is in the Bargello, Florence.

Michelangelo became a client at the family bank's branch in Rome from 1515 and became a friend of Pierfrancesco, who requested a painting from him that was never executed. On Michelangelo's advice, he commissioned SEBASTIANO DEL PIOMBO to paint frescoes (1516–24) in the family chapel at S Pietro in Montorio, Rome. The family also employed del Sarto again: Pierfrancesco commissioned a *Virgin and Child* (Florence, Pitti) and his brother Giovanni Borgherini the *Holy Family with St John the Baptist* (New York, Met.) on the occasion of his marriage to Selvaggia Capponi in 1526. While no portrait of Pierfrancesco is known, one of *Giovanni Borgherini and his Tutor* (Washington, DC, N.G.A.) is attributed to the circle of Giorgione.

BIBLIOGRAPHY
DBI
G. Vasari: *Vite* (1550, rev. 2/1568), ed. G. Milanesi (1878–85), vi, pp. 261–2, 455
A. Braham: 'The Bed of Pierfrancesco Borgherini', *Burl. Mag.*, cxxi (1979), pp. 754–65
A. Cecchi: 'Storie di Giuseppe Ebreo', *Andrea del Sarto 1486–1530: Dipinti e disegni a Firenze* (exh. cat., ed. M. Chiarini; Milan, D'Angeli-Haeusler; Florence, Cent. Di, 1986), pp. 105–11 [with bibliog.]
ALESSANDRO CECCHI

Borghese, Michele. *See* CIAMPANTI, (1).

Borgia [Borja]. Spanish and Italian family of patrons. They claimed descent from the kings of Aragon but probably originated from the Aragonese town of Borja. In return for their loyal service against the Moors during the 13th-century conquest of Valencia, they received land in and around the town of Játiva, henceforth becoming influential members of the local nobility. The elections to the papacy of Alfonso Borgia as (1) Calixtus III (1455) and Rodrigo Borgia as (2) Alexander VI (1492) marked a further rise in the family fortunes. Through nepotism, the Borgias, among them Alexander's son, (3) Cesare Borgia, gained titles and possessions—both ecclesiastical and secular—in Italy, Spain and France. After the death of Alexander VI in 1503, the family was eclipsed but, as a consequence of skilful matrimonial alliances, including those of Alexander's daughter, (4) Lucrezia Borgia, survived within the Neapolitan, Ferrarese, Spanish and French nobility. Giovanni Battista Borgia, 3rd Prince of Squillace, built the village of Borgia on his southern Italian estates in 1547. In Spain, Maria Enríquez Borgia, widow of Alexander VI's son, Juan (Giovanni) Borgia, Duca di Gandía (?1474–97), embellished and endowed the collegiate church of Gandía and gave commissions to the Valencian sculptor Damián Forment and the Italian painter Paolo da San Leocadio, as well as initiating the family's patronage of the convent of the Poor Clares in Gandía. Later members of the family included Francisco Borja y Aragon (1510–72), who founded the city of S Francisco Borja, Mexico, and the National University of S Marcos (1551) in Lima, Peru.

BIBLIOGRAPHY
E. Bertaux: 'Monuments et souvenirs des Borgia dans le royaume de Valence', *Gaz. B.-A.*, xxxix/50 (1908), pp. 89–113, 198–220
M. Mallett: *The Borgias* (London, 1969)
DIANA NORMAN

(1) Pope **Calixtus III** [Alfonso Borgia] (*b* Játiva, 31 Dec 1378; elected 8 April 1455; *d* Rome, 6 Aug 1458). In Spain he patronized the Valencian painter Jacomart, from whom he commissioned a retable for the Colegiata in Játiva (1451–5; *in situ*), and initiated the construction of a chapel in Valencia Cathedral for the remains of St Louis of Toulouse (1430–86). During his pontificate Calixtus was obsessively preoccupied with organizing a crusade to recapture Constantinople, which had fallen to the Turks in May 1453. To this end he imposed taxes, sold gold- and silverwork and even rare bookbindings and halted the grandiose plan of his predecessor Nicholas V for the rebuilding of Rome. Humanists at the papal court criticized Calixtus for his apparent lack of interest in the arts, yet his passion for books was such that he himself made copies of manuscripts for his private library, while his accounts show large payments for bookbindings of velvet and silk and for plaques of gold and silver. He had an inventory made of the Latin manuscripts (both Rome, Vatican, Bib. Apostolica) collected and commissioned by Nicholas V, thus producing the first catalogue of the Vatican library. Calixtus also commissioned banners (untraced) for his galleys from painters and suits of armour (untraced) for his commanders from goldsmiths. He continued the programme of refurbishing Early Christian churches begun by Martin V (*reg* 1417–31), restoring the churches of SS Quattro Coronati, S Callisto, S Sebastiano, S Lorenzo fuori le Mura, S Prisca and the *sancta sanctorum* of the Lateran Palace. He also planned the present ceiling of S Maria Maggiore, which was installed by his nephew (2) Alexander VI.

BIBLIOGRAPHY
E. Muentz: *Les Arts à la cour des papes pendant le XVe et le XVIe siècle*, i (Paris, 1878), pp. 190–219
L. von Pastor: *Geschichte der Päpste seit dem Ausgang des Mittelalters*, i (Freiburg, 1885, 12/1955), pp. 655–794
S. Schueller-Piroli: *Die Borgia Päpste Kalixt III und Alexander VI* (Munich, 1980), pp. 13–82
HELLMUT WOHL

(2) Pope **Alexander VI** [Rodrigo Borgia] (*b* Játiva, nr Valencia, 1 Jan 1431; elected 11 Aug 1492; *d* Rome, 18 Aug 1503). Nephew of (1) Calixtus III. His patronage reflected his love of sumptuousness and pomp. As a cardinal, he built the palace opposite the Palazzo Piccolomini in the cathedral square at Pienza and the Palazzo Sforza Cesarini in Rome, which was his residence until his accession to the papacy and was compared to the Golden House of Nero. In 1473 he commissioned from Andrea Bregno for S Maria del Popolo a marble tabernacle, known as the Borgia Altar, that stood on the main altar of the church until the 17th century, when it was moved to the sacristy.

The reign of Alexander VI was governed by his vanity, sensuality and the promotion of his four illegitimate children, Juan, (3) Cesare, (4) Lucrezia and Gioffredo (*b* 1481/2). In 1501 he created Cesare Duke of Romagna, the largest province in the Papal States, and from then until the end of his reign pursued the aim of appropriating for his family the entire Papal States and all of central Italy. Enraged at the denunciations of papal corruption by the Florentine reformer Girolamo Savonarola, Alexander excommunicated him and had him tortured and burnt at the stake.

Next to the wing of Nicholas V (*reg* 1288–92) at the Vatican Palace, Alexander built the tower known as the Torre Borgia. It was completed in 1494 and contains two of the six rooms, the Sala delle Sibille and the Sala del Credo, of the Pope's private apartment, the Appartamento Borgia, that Bernardino Pinturicchio and his assistants decorated with frescoes between 1492 and 1495 (see ROME, §V, 14(iii)). The Appartamento Borgia, which was virtually unknown before it was restored and opened to the public in 1897, is the culminating example of the taste for ornamental richness and narrative detail in art commissioned by the papacy that began with Martin V's employment of Gentile da Fabriano. The most conspicuous traits of the five rooms that preserve the work of Pinturicchio and his collaborators are the liberal use of gold and jewelled decoration and the profusion of personal or family insignia, for example the double crown of Aragon, the device of Alexander formed by pennant-like flames and the heraldic Borgia bull.

The Sala delle Sibille and the Sala del Credo, embellished with lunettes containing, in one, paired sibyls and prophets and, in the other, paired prophets and apostles, are austere in comparison with the three rooms in the wing of Nicholas V. Alexander's study, the Sala delle Arti Liberali, with personifications of the Liberal Arts on elaborate thrones, is mainly the work of Pinturicchio's assistant, Antonio del Massaro (*fl* 1489–1509), known as il Pastura. The most sumptuous room, and Pinturicchio's masterpiece, is the Sala dei Santi. On its ceiling, emulating ceiling decorations in the Golden House of Nero, are ornamental compositions of the legends of Isis and Osiris and the Egyptian bull-god Apis, to whom Alexander's ancestry had been supposedly traced by one of the humanists at his court. In the grand mural of *St Catherine of Alexandria Disputing with Pagan Philosophers before the Emperor Maximian*, the Arch of Constantine in the background is surmounted by the Borgia-Apis bull, and in the *Resurrection* in the Sala dei Misteri della Fede, which was Alexander's private dining-room, a portrait of Alexander was inserted next to the figure of the Risen Christ. The patronage of Alexander VI established Pinturicchio, who had already served Alexander's predecessors Innocent VIII and Sixtus IV, as the pre-eminent painter at the Vatican during the last quarter of the 15th century.

In 1497 Alexander began the Palazzo della Sapienza, which until 1935 housed the University of Rome, and visited the site in 1499. He rebuilt the ancient Roman Porta Settimiana at the end of the Via della Lungara. At S Maria Maggiore he installed the coffered wooden ceiling that had been planned by his uncle (1) Calixtus III. It was completed in 1498 and is said to have been gilded with the first gold brought from the New World (see ROME, §V, 20). At the Castel Sant'Angelo, Alexander commissioned the architect Antonio da Sangallo (i) to design a new tower that stood until the reign of Urban VIII (1623–44), and a new entrance portal. Following an explosion in 1497, he commissioned Sangallo to rebuild the residential chambers of the Castel Sant'Angelo and had them decorated by Pinturicchio with frescoes of episodes from his pontificate (destr.).

In preparation for the papal jubilee of 1500, Alexander laid out the Via Alessandrina (now part of Via della Conciliazione) between the Castel Sant'Angelo and the Vatican Palace, parallel to the Borgo Sant'Angelo built by Sixtus IV for the jubilee of 1475 (see ROME, §II, 3). At St Peter's Alexander completed the Benediction loggia that had been begun by Pius II in 1461. It was destroyed in the early 17th century, when Carlo Maderno built the present façade of the basilica, but it appears in the background of Raphael's fresco of the *Fire in the Borgo* (see RAPHAEL, fig. 4) in the Vatican *stanze*.

BIBLIOGRAPHY

L. von Pastor: *Geschichte der Päpste seit dem Ausgang des Mittelalters*, iii (Freiburg, 1895, 11/1955), pp. 339–656
E. Muentz: *Les Arts à la cour des papes Innocent VIII, Alexandre VI, Pie III* (Paris, 1898), pp. 139–267
P. de Roo: *Materials for a History of Pope Alexander VI: His Relations and his Times* (Bruges, 1924)
O. Ferrara: *The Borgia Pope* (London, 1942)
G. Soranzo: *Studi intorno a papa Alessandro VI* (Milan, 1950)
F. Saxl: 'The Appartamento Borgia', *Lectures* (London, 1957), pp. 174–88
A. Parker: *At the Court of the Borgia* (London, 1963)
R. N. Parker: 'On the meaning of Pinturicchio's "Sala dei Santi"', *A. Hist.*, ii (1979), pp. 291–317
S. Schueller-Piroli: *Die Borgia Päpste Kalixt III und Alexander VI* (Munich, 1980), pp. 83–394
A. Capriotti: 'Umanisti nell'appartamento Borgia: Appunti per la sala delle arti liberali', *Strenna Romanisti* (1990), pp. 73–88

HELLMUT WOHL

(3) Cesare Borgia, Duca di Valentino (*b* Rome, Sept 1475; *d* Viana, Navarre, 12 March 1507). Son of (2) Alexander VI. He received a succession of ecclesiastical titles, culminating in his creation as cardinal on 20 September 1493. After the murder of his brother Juan, Duca di Gandía, in 1497, Cesare renounced his ecclesiastical titles and embarked on a secular career. He sought the patronage of Louis XII, King of France (*reg* 1498–1515), and acquired from him the title of Duca di Valentino and the hand of Charlotte d'Albret (1483–1514), sister of John III of Albret, King of Navarre. During Louis XII's campaign for Milan (1499), Cesare seized the chance to establish a feudal state for himself in Romagna. In a series of brilliant and ruthless campaigns, he captured many cities, which earned him the admiration of Niccolò Machiavelli (1469–1527) and formed the basis of his infamous reputation.

Although he was educated at the universities of Perugia and Pisa and was familiar with Renaissance humanist learning, Cesare's subsequent career, which was dominated by practical and military matters, left little time for scholarly pursuits. He nevertheless developed, consonant with his skills as a military leader, an abiding interest in architecture, particularly fortifications. Such interest is well illustrated by his employment of Leonardo da Vinci as his architect and engineer (1502–3). From Pavia on 18 August 1502 Cesare issued a patent that granted Leonardo free access to all the fortresses in his newly acquired possessions and gave the artist complete discretion to initiate improvements. During his period of employment Leonardo produced maps, urban plans—the finest of which is the map of *Imola* (Windsor Castle, Royal Lib.)—and designed a canal to connect Cesena with Porto Cesenatico, projections for systems of defence and a number of ingenious war machines. At this time Leonardo also sketched the head of *Cesare* from three angles (Turin, Bib. Reale). Cesare's entourage at this time also included the sculptor Pietro Torrigiano and the painter Bernardino Pinturicchio,

but neither artist appears to have completed any work for him.

Contemporary descriptions of the ceremonial entries staged by Cesare refer to lavish displays of jewels, livery, musical instruments and harnesses. Similarly, his marriage gifts to Charlotte d'Albret included elaborately crafted jewellery, tableware and linen. Cesare's predilection for such items must have resulted in his patronage of skilled jewellers and metalworkers capable of producing such artefacts as the parade sword made for him in 1498, decorated with Borgia emblems and scenes from the life of his namesake, Julius Caesar. Despite looting the priceless Montefeltro collection at Urbino, however, Cesare apparently took little aesthetic interest in its contents. His ill-health, the death of Alexander VI and the accession of his family's implacable enemy, Giuliano della Rovere, as Julius II, led finally to the loss of his Italian strongholds and his French fiefs and to his imprisonment in Spain. Escaping from Medina del Campo, he was killed in a skirmish while in the service of the King of Navarre.

BIBLIOGRAPHY
DBI
W. H. Woodward: *Cesare Borgia* (London, 1913)

(4) Lucrezia Borgia, Duchess of Ferrara (*b* Subiaco, 18 April 1480; *d* Ferrara, 24 June 1519). Daughter of (2) Alexander VI. While her father's ambitions for (3) Cesare focused on the Church and the accumulation of wealth, property and titles, Alexander concentrated on securing for Lucrezia a series of advantageous marriages. After several aborted betrothals, in 1493 she married Giovanni Sforza (*d* 1510), ruler of Pesaro, in order to consolidate an alliance between the Borgias and the Sforzas of Milan. When this alliance was no longer politically expedient, Lucrezia obtained a divorce (1497) on grounds of non-consummation and subsequently (1498) married Alfonso, Duca di Bisceglie, illegitimate son of Alfonso II, King of Naples. On 18 August 1500 Lucrezia's second husband was murdered by a henchman of Cesare, undoubtedly with the connivance of her brother. Despite her genuine grief at her husband's death, Lucrezia apparently acquiesced in again being a pawn in her family's dynastic plans and in 1502 duly married Alfonso I d'Este, the heir to the dukedom of Ferrara. She spent the rest of her life in Ferrara as Duchess, presiding over the court and bearing numerous children, only four of whom survived. She became increasingly pious, joining the Third Franciscan Order and founding the convent of S Bernardino in Ferrara (1510).

Although Lucrezia was not prominent amongst Renaissance women scholars and owned only a modest library of devotional texts, she nevertheless spoke a number of languages, wrote and composed poetry and, on the evidence of her surviving letters (examples, Milan, Bib. Ambrosiana), had a graceful epistolary style. The Ferrarese were also impressed by her skills as an embroiderer. As Governor of Spoleto and Nepi (1499) and the Vatican (1501) and as Duchess of Ferrara, she demonstrated her administrative abilities. While Duchessa di Bisceglie, she presided over a small literary coterie of poets and writers. In Ferrara she was able to extend her literary patronage to include Ercole Strozzi (*d* 1508) and Pietro Bembo, who dedicated his masterpiece the *Asolani* (1505) to her. As a Renaissance princess, Lucrezia enjoyed an annual income that enabled her to commission works from a number of artists and craftsmen. These generally took the form of rich textiles, jewellery and tableware. She also offered employment to the painters Garofalo, who decorated her apartments in the Castello Estense, Ferrara, with murals on courtly themes (destr.), and Bartolomeo Veneto, who in 1507 painted her a *Madonna and Child* in a gilded frame (untraced). Several portraits of Lucrezia have been identified, including one from the collection of Paolo Giovio (Como, Nessi priv. col.), probably derived from a lost original. There is insufficient proof that Pinturicchio used Lucrezia as a model for the youthful St Catherine in the *Disputation of St Catherine* (*c.* 1492; Rome, Vatican, Appartamento Borgia). Other portraits are those on three medals, the first probably a matrimonial medal with *Alfonso d'Este* on the reverse, the second, as *Duchess of Ferrara*, identical to a third with *Amor* on the reverse. It is not known whether any of these were commissioned by Lucrezia.

BIBLIOGRAPHY
M. Bellonci: *Lucrezia Borgia* (Milan, 1939); rev. as *Lucrezia Borgia: La sua vita e i suoi tempi* (Milan, 1960); Eng. trans., abridged, by B. Wall as *The Life and Times of Lucrezia Borgia* (New York, 1953)
A. De Hevesy: 'Bartolomeo Veneto et les portraits de Lucrèce Borgia', *A. Q.*, ii (1939), pp. 233–49
N. Rubinstein: *Lucrezia Borgia* (Rome, 1971)

DIANA NORMAN

Borgo, Cristofano dal. *See* GHERARDI, CRISTOFANO.

Borgo, Francesco del. *See* FRANCESCO DEL BORGO.

Botticelli, Sandro [Filipepi, Alessandro (di Mariano di Vanni)] (*b* Florence, 1444–5; *d* Florence, 17 May 1510). Italian painter and draughtsman. In his lifetime he was one of the most esteemed painters in Italy, enjoying the patronage of the leading families of Florence, in particular the Medici and their banking clients. He was summoned to take part in the decoration of the Sistine Chapel in Rome, was highly commended by diplomatic agents to Ludovico Sforza in Milan and Isabella d'Este in Mantua and also received enthusiastic praise from the famous mathematician Luca Pacioli and the humanist poet Ugolino Verino. By the time of his death, however, Botticelli's reputation was already waning. He was overshadowed first by the advent of what Vasari called the *maniera devota*, a new style by Perugino, Francesco Francia and the young Raphael, whose new and humanly affective sentiment, infused atmospheric effects and sweet colourism took Italy by storm; he was then eclipsed with the establishment immediately afterwards of the High Renaissance style, which Vasari called the 'modern manner', in the paintings of Michelangelo and the mature works of Raphael in the Vatican. From that time his name virtually disappeared until the reassessment of his reputation that gathered momentum in the 1890s (*see* §V below).

I. Life and work. II. Iconographical interpretation. III. Working methods and technique. IV. Character and personality. V. Posthumous reputation.

I. Life and work.

1. Training and early career, to *c.* 1478. 2. Years of maturity, *c.* 1478–90. 3. Late years, after 1490.

1. TRAINING AND EARLY CAREER, TO *c.* 1478. Botticelli (It.: 'a small wine cask'), a nickname taken from

that of his elder brother, was the son of a tanner. He may briefly have trained as a goldsmith, but soon entered the studio in Florence of Fra Filippo Lippi, who taught him painting. He is mentioned as an independent master in 1470 (though he doubtless arrived at this status earlier). The same year he executed his first securely dated painting, the justly famous *Fortitude* (Florence, Uffizi; see fig. 1), completing the series of *Seven Virtues* commissioned from Piero Pollaiuolo for the Hall of the Mercanzia (the magistracy governing the Florentine guilds) in the Palazzo della Signoria, Florence. In his earliest works he was distinctly affected by Lippi's homespun view of visible creation, but already this was transformed into a more refined and abstracted vision of the world.

In 1472 Botticelli joined the Compagnia di S Luca, the confraternity of Florentine painters, in the records of which Filippino Lippi, his late teacher's son, is named as his apprentice. On the feast of St Sebastian (20 January)

in 1474 Botticelli's *St Sebastian* (1473–4; Berlin, Gemäldegal.) was installed on a nave pillar in S Maria Maggiore, Florence. He was summoned to Pisa the same year to paint frescoes for the Camposanto, but instead worked for a time in the cathedral on a fresco of the *Assumption of the Virgin*, which he left incomplete. This no longer exists (destr. 1583), nor do the decorations that he made for the famous joust of Giuliano de' Medici (1453–78) in January 1475, including Giuliano's banner painted with an allegorical image of Minerva. Also lost is a fresco of the *Adoration of the Magi* painted in 1475 near the Porta della Catena of the Palazzo della Signoria, which was probably destroyed at the time of Vasari's 16th-century refurbishment. Three years later Botticelli painted over the Porta della Dogana a fresco of the Pazzi conspirators, who were hanged for the murder of Giuliano de' Medici, but this work was destroyed in 1494 when the Medici were expelled from Florence. Botticelli's portrait of *Giuliano de' Medici* (Washington, DC, N.G.A.) was apparently painted some time after the subject's murder.

2. YEARS OF MATURITY, *c.* 1478–90. More paintings are securely datable from the 1480s than from any other decade in Botticelli's career. In 1480 he painted a fresco of *St Augustine's Vision of the Death of St Jerome* (see colour pl. 1, XIV1) for the church of the Ognissanti, Florence, as a pendant to Ghirlandaio's fresco of *St Jerome* of the same year (both *in situ*). The following year he painted a fresco of the *Annunciation* (Florence, Uffizi) for the Ospedale di S Martino alla Scala, Florence, and later in 1481 he was summoned to Rome by Pope Sixtus IV, together with Ghirlandaio and Cosimo Rosselli, to join Perugino in decorating the walls of the recently completed Sistine Chapel. Botticelli painted the *Temptations of Christ* (see colour pl. 1, XIII2) on the right wall, devoted to scenes from the *Life of Christ*, and on the opposite wall, showing the *Life of Moses*, he painted *Moses and the Daughters of Jethro* and the *Punishment of Korah*; in addition he was responsible for a number of papal portraits in the register above.

By the autumn of 1482 Botticelli was back in Florence: in October, with Perugino, Ghirlandaio and Pollaiuolo, he was commissioned to decorate a portion of the Sala dei Gigli in the Palazzo della Signoria, but only Ghirlandaio's *St Zenobius* was executed (*in situ*). In 1483 Botticelli and his studio painted four *spalliera* panels, depicting the *Story of Nastagio degli Onesti* (Madrid, Prado (see colour pl. 1, XIV2); London, Watney priv. col., see Lightbown, 1989, pl. 52) from Boccaccio's *Decameron* (v.8), commissioned on the occasion of the marriage that year of Giannozzo Pucci (1460–97) and Lucrezia di Piero Bini. The following year he painted frescoes in Lorenzo de' Medici's villa at Spedaletto, near Volterra, and in August 1485 he was paid for the altarpiece of the *Virgin with SS John the Baptist and John the Evangelist* (Berlin, Gemäldegal.) for the Bardi Chapel in Santo Spirito, Florence. In 1489 he was commissioned to paint an *Annunciation* (Florence, Uffizi) for the Guardi Chapel in the church of Cestello (later S Maria Maddalena dei Pazzi) in Florence, and between 1488 and 1490 he painted the *Coronation of the Virgin* for the goldsmiths' chapel, dedicated to St Eligius, in S Marco, Florence.

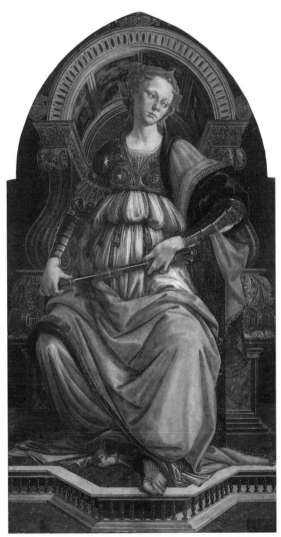

1. Sandro Botticelli: *Fortitude*, tempera on panel, 1.67×0.87 m, 1470 (Florence, Galleria degli Uffizi)

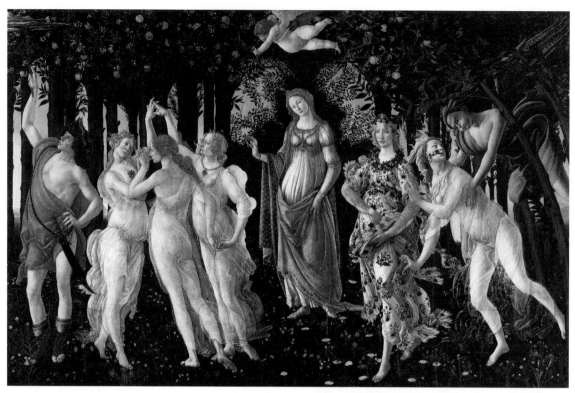

2. Sandro Botticelli: *Primavera*, tempera on panel, 2.03×3.14 m, *c.* 1478 (Florence, Galleria degli Uffizi)

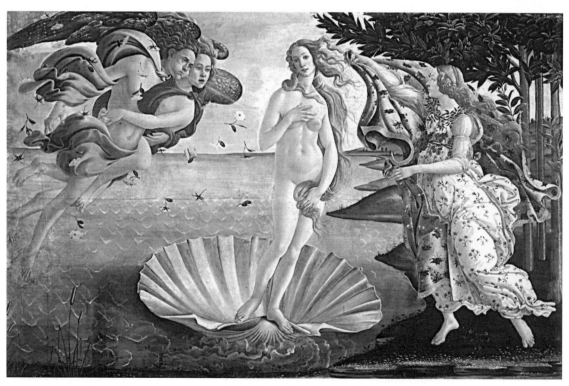

3. Sandro Botticelli: *Birth of Venus*, tempera on canvas, 1.72×2.78 m, *c.* 1484 (Florence, Galleria degli Uffizi)

From about 1478 to 1490, the period of Botticelli's greatest activity and the time he painted his famous mythologies, his art increasingly combined the characteristic features of a courtly style (with antecedents ultimately deriving from Angevin Late Gothic art of the previous century) with qualities learnt from the study and analysis of Classical prototypes. The effect of this assimilation—a style simultaneously *nuovo* and *antico*—is first apparent in the *Primavera* (*c.* 1478; Florence, Uffizi; see fig. 2) and reached a highpoint in the *Birth of Venus* (*c.* 1484; Florence, Uffizi; see fig. 3). It is also evident in such religious works as the Bardi Altarpiece, the *Lamentation* (Munich, Alte Pin.) and the great tondi (both Florence, Uffizi), known as the *Madonna of the Magnificat* (*Virgin and Child with Five Angels*) and the *Madonna of the Pomegranate* (*Virgin and Child with Six Angels*; see fig. 4). It appears in Botticelli's supple contours and the contrapposto poses, graceful proportions and balanced, natural movements of his figures, which respond to an invisible yet palpable rule of harmonic number. These figures are also very much of the Florentine present, for example the characters in the *Primavera* and *Pallas and the Centaur* (Florence, Uffizi), as well as those in the earlier *Adoration of the Magi* (1475–6; Florence, Uffizi) painted for the Lama Chapel in S Maria Novella, Florence, all appearing in the elaborate contemporary courtly and festival costumes worn in the religious and civic celebrations attending the feasts of St John the Baptist (one of the patron saints of Florence) and the Epiphany, or the jousts and tournaments ordained to celebrate the signing of peace treaties. Botticelli's paintings of the Virgin similarly approximate to a quasi-courtly ideal of antique grace clothed in the garments of the Florentine present.

3. LATE YEARS, AFTER 1490. The frescoes from the Villa Lemmi, near Florence, showing a *Youth Presented to the Liberal Arts* and a *Young Lady with Venus and the Graces* (both Paris, Louvre), were almost certainly done in 1491, the date of the second marriage of Lorenzo Tornabuoni, who owned the villa. Otherwise, the only securely dated picture from the last two decades of Botticelli's life is the *Mystic Nativity* (London, N.G.; see fig. 5), which the artist signed 'at the end of the year 1500', that is, according to the Gregorian calendar, early in 1501. Botticelli's production doubtless declined markedly in the last 15 years of his life, perhaps partly owing (as Vasari suggested) to his undertaking the immensely ambitious project of illustrating Dante's *Divine Comedy* in a luxurious illuminated manuscript for Lorenzo the Magnificent's cousin and former ward, Lorenzo di Pierfrancesco de' Medici, which was never completed.

However, there is a deeper crisis of style and expression discernible in Botticelli's later works, beginning with the *Calumny of Apelles* (1490s; Florence, Uffizi) and reaching a peak in such paintings as the *Mystic Nativity*, the *Mystic Crucifixion* (Cambridge, MA, Fogg), the *spalliera* panels with the *Story of Virginia* (Bergamo, Gal. Accad. Carrara) and the *Story of Lucretia* (Boston, MA, Isabella Stewart Gardner Mus.) and the four panels of the *Life and Miracles of St Zenobius* (London, N.G.; New York, Met.; and Dresden, Gemäldegal. Alte Meister). In such works Botticelli increasingly rejected the courtly, ornamented style of his early maturity in favour of a retrospective appeal to the simplicity and affective directness of an earlier generation of painters, who had been masters of an apparently unforced moral and religious sentiment. (From the time of the Counter-Reformation to the 19th century this *maniera devota* was nostalgically understood as a characteristic of the 'Primitives', that is the painters working before Raphael who were untouched by the sophistication and aesthetic selfconsciousness that first arose with the dawn of the High Renaissance.) Botticelli's extraordinary mastery of drawing and elastic contour became progressively simplified and economized, occasionally producing even a crudeness of effect; his colours, notably his greens, yellows and reds, became brighter and purer in hue; and the action of his profoundly felt dramas was staged in an abstract and otherworldly environment that is the imaginative counterpart to the simple backdrops designed for a mystery play. There is no artistic ornament conceived for its own sake, and all is calculated to enhance a single narrative and emotional effect.

In the light of the rapid development that occurred in Florentine painting during the last two decades of Botticelli's life, the retrospection of his late works is the more astounding and poignant, especially given the critical role played by his own earlier work in helping to form the new style then reaching its first perfection in the art of Leonardo da Vinci and Michelangelo. Both knew the older master, and Michelangelo's methods and techniques of painting as exemplified in the Doni Tondo (*Holy Family*, *c.* 1503; Florence, Uffizi; see colour pl. 2, IV3) are indeed unthinkable without the direct precedent of works such as Botticelli's *Coronation of the Virgin* for S Marco. Botticelli lived to see the achievement of Leonardo's unfinished *Adoration of the Magi* (1481; Florence, Uffizi) and Michelangelo's *David* (1504; Florence, Accad.; *see* ITALY, fig. 22), as well as the titanic competition of 1504 between the two in their battle-pieces for the Sala dei Cinquecento in the Palazzo della Signoria. By then his own art, by an effort of will, had abandoned a present he had helped to shape for the nostalgic values of an increasingly remote past—especially telling in this respect is the contrast of Leonardo's *Adoration of the Magi* with Botticelli's equally ambitious response in the preparation of a panel of the same subject (Florence, Uffizi), initiated some time after 1500 and also never completed. As Vasari said, Botticelli must have seemed a disappointed and sad relic of a bygone age.

II. Iconographical interpretation.

1. Mythological and allegorical works. 2. Religious works.

1. MYTHOLOGICAL AND ALLEGORICAL WORKS. In many respects Botticelli's art represents the maturation of the humanist conception of painting set forth in Alberti's *De pictura* (1436). (Alberti played a formative role in Lorenzo de' Medici's thinking about the arts, and his *De re aedificatoria* was first published, posthumously, in 1485 under Lorenzo's patronage, with a dedication by the humanist and poet Angelo Poliziano.) Botticelli, in such works as the *Primavera* and *Birth of Venus*, brought together the expressive content and forms of painting with those of the humanist poetic culture sponsored by Lorenzo, himself one of the most important vernacular poets of the century. Lorenzo's cultural programme was based

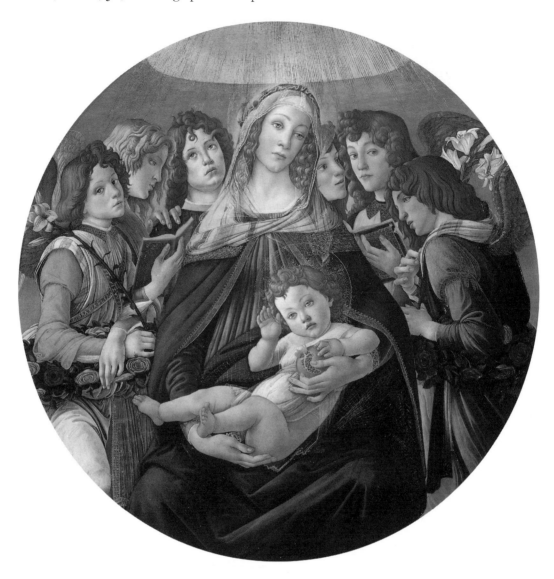

4. Sandro Botticelli: *Madonna of the Pomegranate*, tempera on panel, diam. 1.43 m, *c.* 1478–90 (Florence, Galleria degli Uffizi)

on an attempt to raise contemporary forms of expression to the level of the legacy of the ancients, through both critical and historical study and the artistic emulation of ancient and Tuscan models; he also intended the arts to be seen and heard to speak a perfect Latin in the vernacular tongue, a perfect Tuscan in the Latin. Botticelli's paintings of ancient myth, called poetic fable in the Renaissance, were unprecedented in conception and hence, like Poliziano's *Stanze. . .per la giostra di Giuliano de' Medici* (begun 1476, uncompleted) and Lorenzo's *Comento* to his own sonnets, to which they have often been compared, are of prime importance in understanding Renaissance culture at one of its most fertile turning-points. They directly exemplify Alberti's concept of poetic *inventio* in painting, an activity of the painter Alberti defined as not analogous to but identical with poetic thinking. As examples of *inventio*, Alberti cited Lucian of Samosata's description of the

Calumny of Apelles and Seneca's description of the Three Graces, the first of which was adapted by Botticelli for his own painting of the *Calumny of Apelles* and the second of which helped motivate the figures of the Graces in the *Primavera*.

(i) The 'Primavera'. (ii) The 'Birth of Venus'. (iii) 'Mars and Venus'. (iv) The 'Calumny of Apelles'.

(i) The 'Primavera'. The *Primavera* is the most important of all Botticelli's poetic inventions, not only as a supreme work of art and the earliest and most ambitious of them, but also for historiographic reasons. The quality of writing devoted to it since Warburg's initial study (1893) has ensured it a fundamental role in developing conceptions of the Renaissance. Warburg understood it in the context of the humanist revival and imitation of ancient poetry and also drew attention to parallels in sensibility and detail

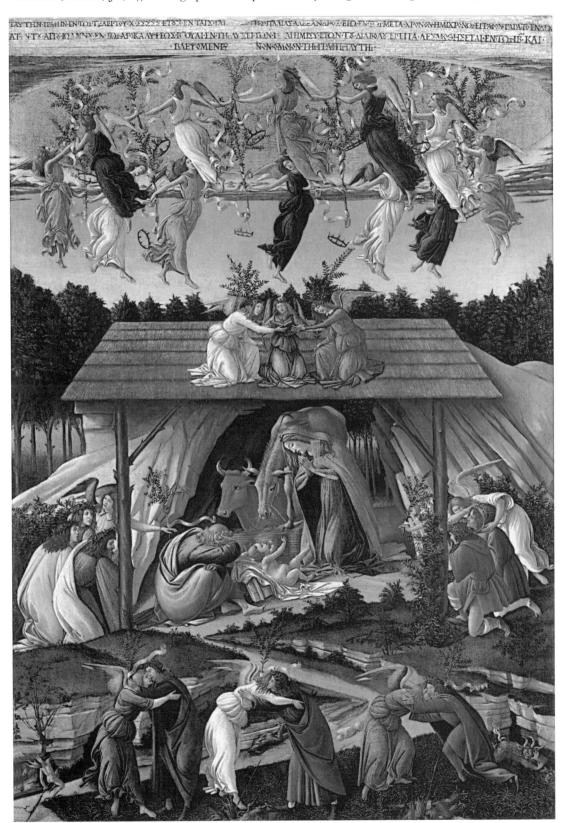

5. Sandro Botticelli: *Mystic Nativity*, tempera on canvas, 1085×749 mm, 1501 (London, National Gallery)

between Botticelli's imagery and contemporary vernacular poetry of love, especially Poliziano's *Stanze*. Since this poem mythologizes a contemporary event, the joust won by Lorenzo's brother Giuliano in 1475, the painting has also been considered a manifestation of the quasi-chivalric civic rituals celebrated in such tournaments, which were held to celebrate the conclusion of peace treaties. With the revival of interest in the social context of Renaissance art, it has been suggested that the *Primavera* was painted at the time of a Medici wedding to decorate the house of the couple, a hypothesis conceived in reaction to the dominant interpretation of the previous scholarly generation, which held that Botticelli's imagery expresses the Neo-Platonic philosophy of love as expounded by Marsilio Ficino. Though different interpretations vary in detail and emphasis, they nevertheless have a great deal in common: that the theme of the painting is by definition Love, denoted by Venus; and that the *Primavera* is a prime manifestation of the culture sponsored by Lorenzo de' Medici, the patron of both Poliziano and Ficino. The primary dispute has been whether the *Primavera* expresses the values of high culture, Latinate and remote, or whether it responds to those of a more popular culture as expressed in the decoration of private houses, in the celebration of marriages and in civic festivals and tournaments.

On the one hand, there is no question of the unprecedented philological skill that contributed to Botticelli's invention for the *Primavera*, which does not illustrate an episode from ancient myth or story but in true Albertian style expresses a new poetic idea based on material gathered from several ancient witnesses, including Lucretius, Ovid, Horace, Seneca and Columella. Botticelli's genre is thus established as a form of *carmen rusticum* or farmer's song. His invention is of the unfolding of the first spring of the world, the archetype for all new springs to follow, beginning with the rough blowing of the West Wind over the bare earth, depicted as Zephyr's rape of the nymph Chloris (see colour pl. 1, XV1), causing the earth to sprout forth, shown as the goddess Flora scattering the ground with flowers. The full ripeness of the season's regenerative fertility appears in Venus, the goddess of April, who stands in the centre attended by Cupid firing his flaming arrow, and spring draws to a close with the dance of the Three Graces and Mercury, the god of May, dispersing the last clouds in the sky with his caduceus. Mercury's identification with May is unique to the rustic calendar, organized according to the changing seasons of the farmer's year and followed before Julius Caesar's reform of the calendar based on calculation of the sun's movement. Mercury's appearance with the clothed and dancing Graces is also specifically archaic, as is the appearance of Venus, who is not nude and who assumes her primitive role as the *dea hortorum* (goddess of gardens). The invention is informed by genuine philological knowledge as well as a fine poetic instinct steeped in the study and imitation of ancient literary models, and this unique combination of qualities has led to the nearly universal consensus that it was devised by Poliziano.

On the other hand, despite the classically pure conception of the *Primavera*, Botticelli made no attempt to portray the gods in their ancient guises, showing them instead in contemporary vernacular costumes: Mercury wears a bur-

nished sallet and carries an elaborately worked and jewelled parade falchion as his sword; the Graces are clad in buttoned chemises adorned with beautiful brooches, the one worn by the right-hand Grace suspended from a braided rope of false hair used as a decorative embellishment and to bind an elaborate coiffure set off by a spectacular hair ornament attached to a string of pearls; Venus is shown in a gown decorated with gold appliqué, over which she wears a distinctly old-fashioned cape, from the hem of which hangs a densely clustered row of pearls; and finally Flora appears wearing a painted dress with gold-embroidered sleeves, tied fashionably across the forearm. The ancient gods are shown, in other words, as contemporary Florentines and, moreover, are dressed in quasi-theatrical costumes designed for masquerades of the sort that Vasari wrote were invented by Lorenzo de' Medici for civic festivals and tournaments. Their vernacular character is also expressed in the normative conventions to which Botticelli turned in imagining the individual beauties of the several goddesses. These are not Classical but instead follow patterns specific to the vernacular convention, describing the beauty of the poet's lady from the top of her head to the tip of the toe, praising her golden hair, broad and serene brow, perfectly arched black eyebrows, serious eyes and smiling mouth set with pearl-like teeth, cheeks of privet flushed with rose, breasts set like apples on her slightly bowed chest and every limb perfectly articulated. Here again the *Primavera* finds its closest parallels in the work of Poliziano, whose *Stanze*, exquisitely Latinate in allusions and formal language, detail and imagery, had been written in the vernacular and within vernacular conventions at Lorenzo's behest.

Vernacular poetry is by definition poetry about the present and about love, the object of which—the poet's lady—represents a particular ideal, whether it is the erotic and sensual lady of the troubadours, the Christ-like beatitude of Dante's Beatrice, or the more purely poetic ideal celebrated in Laura by Petrarch. It is clear that the ideal portrayed in the *Primavera* is none of these, but is instead an idea of love invested in Venus, Venus in her fully recovered and understood Classical meaning as the animating spirit of regenerative life in nature and Venus, too, as the spirit animating the revival taking place in the Florentine present. As a concept of love, she finds her place in the great tradition of Italian love poetry. Yet as also a new concept defined by her very antiquity, a truly classic idea of love in the world completely assimilated within the vernacular tradition, Venus also redefines the present. While it is true that Ficino's Neo-Platonic concept of love is not the same as that invested in the poetic lady of the troubadours or in Petrarch's Laura, it is also true that in the Venus of the *Primavera*, as also for the lady described in Lorenzo de' Medici's *Comento*, the poetic and Petrarchan lady is for the first time conceived as a principle of natural, divine perfectibility attainable in this world. She may therefore be legitimately understood in the context of Ficino's Neo-Platonism, bringing philosophy within the embrace of art, though not as the unitary expression of a single culture, high or low. Rather, the *Primavera* in its fullness, like Poliziano's *Stanze*, embodies an art that is at its purest and most refined, while at the same time it draws from the wellspring of contemporary experience and the

popular imagination as expressed in ballads and as enacted in the civic rituals of Florence.

(ii) The 'Birth of Venus'. As a new idea, the idea of love first given painted form in the *Primavera* naturally required a new style for its expression, the lineaments of which reached their full form in Botticelli's *Birth of Venus.* The subject is the same as in the *Primavera,* namely the springtime advent of Venus, with Zephyr carrying Chloris on the left, the roses generated by his warming breath falling to the earth, and Flora on the right, clad in her white dress painted with budding flowers and preparing to mantle the goddess with a fully flowered cloak. Here, however, Venus does not appear as the humble garden goddess she was for the primitive peoples but resplendently nude and in her Classical form, in fact so shown for the first time since antiquity. She is the fully conceived nature goddess of the Roman Empire, *Venus Genetrix* as hymned by Lucretius and as painted by Apelles in his famous *Venus Anadyomene* ('foam-born Venus'), which Ovid described as 'nuda Venus madidas exprimit imbre comas', and to which Botticelli alluded in the goddess's gesture of pressing her golden hair against her body. Though her individual features are still imagined in accordance with the normative Petrarchan conventions, namely dark and perfectly arched eyebrows, apple-like breasts and long golden tresses, these have been assimilated within a canon of beauty directly based on study of the ancient statue type of the *Venus pudica,* which gives a second meaning to Venus's gesture of modestly veiling her private parts. It is through such assimilation and refinement of the means of art, elevating the expressive potential of received traditions through the study and redeployment of ancient models, that Botticelli's art again finds its closest parallel with Poliziano's *Stanze,* at one and the same time *antico* and *nuovo,* perfectly Latin in a vernacular mode.

(iii) 'Mars and Venus'. Venus again makes her appearance, dressed as a Florentine nymph, in the *Mars and Venus (c. 1485;* London, N.G.; see fig. 6) but is here imagined in a darker guise. Though this painting too has been interpreted as possibly a marriage picture, or as a mildly erotic picture

of post-coital contentment, the image it presents has a more sinister character. The *satyriscus* (little satyr) blowing a conch is an image uniquely determined by two ancient scholia to Aratus's *Phaenomena,* published in Poliziano's *Miscellanea* (1489) and there interpreted as denoting panic terrors, empty phantasms inspiring fear (which is also the meaning of the *satyriscus* masking himself with Mars' helmet). *Phantasmata* are nightmare visions, and numerous ancient and Early Christian authorities, among them Augustine and Jerome, attested that satyrs and *satyrisci* were nightmare demons also known as *incubi,* which in their very nature especially provoked sexual terrors in the dreams of those bound in a state of sensual error and confusion. Mars in uneasy sleep is assailed by demons, who make lewd gestures towards Venus with their tongues and lift his jousting lance in order to poke a wasps' nest in the hollow of a tree against which his head rests and around which angry wasps are beginning to swarm. The idea of love here invested in Venus seems to be revealed, not in a positive celebration of the spirit animating natural life shown in the *Primavera* and *Birth of Venus* but as an empty sensual fantasy that disarms and torments the slumbering spirit of a once virile martial valour.

(iv) The 'Calumny of Apelles'. A similar pessimism can perhaps be discerned in Botticelli's *Calumny of Apelles,* a profoundly humanist work based on Lucian's rhetorical essay on Slander. The painting announces its theme of Slander by reference to a *koinos topos* (literary commonplace), Lucian's *ekphrasis* of an allegorical painting by Apelles in which Calumny, adorned by Treachery and Deceit, appears accusing Innocence before an ass-eared Judge whose heart is moved by her beauty and the blandishments of Ignorance and Suspicion, even as Repentance escorts Truth, too late, into the Judgement Hall. The genre of Botticelli's painting is determined by Lucian, whose essay is a virtuoso exercise in the rhetoric of display and whose subject is the power of rhetoric to make the heart love even that which is vile and putrid. The form given by Botticelli to the particular *topos* of Apelles' *Calumny* is calculated to provoke a further rhetorical response to the theme of Slander by setting the story in a

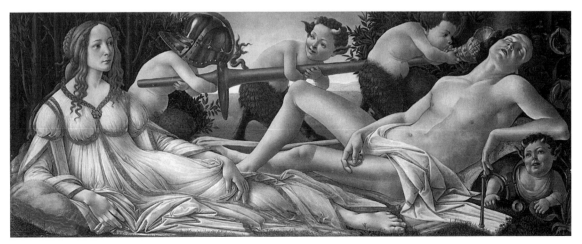

6. Sandro Botticelli: *Mars and Venus,* egg tempera on panel, 692×1734 mm, *c.* 1485 (London, National Gallery)

Judgement Hall richly ornamented with sculptures that supply other *topoi* variously drawn from ancient history (the Justice of Trajan), biblical narrative (Judith and Holofernes), ancient myth (Apollo and Daphne) and vernacular story (Nastagio degli Onesti). Strictly speaking, there is no 'right' or 'wrong' iconographical reading of his painting in the narrow sense, save for its injunction to the viewer to blame the demon Calumny, tricked out in the seductive rhetorical colours of Treachery and Deceit, and to praise naked Truth who has no need of artful adornment. This may be done in general and in particular, with reference to legendary and historical examples on the one hand or to real people and current events on the other. Underlying the theme of Slander is a genuine preoccupation with the fictive powers of art to move the heart, not only to love of the truth, but also to love of falsity and evil.

2. RELIGIOUS WORKS. The same lineaments of poetic beauty that characterize the protagonists of the *Primavera* and the *Birth of Venus* are also evident in Botticelli's depictions of the Virgin, saints and angels in such religious works as the St Barnabas Altarpiece, the Bardi Altarpiece and the great tondi of the *Madonna of the Magnificat* and the *Madonna of the Pomegranate*. In all of them the Virgin appears blonde and with black eyebrows arched in a perfect bow, her flesh tones painted in the perfect ivory and vermilion colours of the Petrarchan lady. The paradise created by the presence of the lady, a convention of love poetry spectacularly made visible in the garden setting of the *Primavera*, finds its poignantly evocative counterpart in the Bardi Altarpiece, which also embodies a new poetic invention on the religious theme of the Immaculate Conception, a subject then yet to be given its canonical formulation in the conventions of painting. The Virgin appears enthroned, with SS John the Baptist and John the Evangelist standing on either side, in a *hortus conclusus* (enclosed garden), a perfected earthly paradise ornamented with the plants that provide the biblical basis for her immaculacy: the rose of Jericho, the cedar of Lebanon, the olive and the lily. In such works too the Virgin is shown as a contemporary young Florentine woman, her chemise appearing in puffs at the sleeves, wearing luxurious transparent veils and her costume elaborately embroidered with gold at the hems.

The Dominican friar Girolamo Savonarola undoubtedly had such images in mind when he complained that the images in the churches of the Virgin, St Elizabeth and the Magdalene were painted like nymphs in the likenesses of the young women of Florence, thundering: 'You have made the Virgin appear dressed as a whore'. In his sermons he upbraided the young women of Florence for wearing such dress and castigated painters for representing them in sacred guise, urging everyone to burn their copies of the *Decameron* and all lascivious images. Savonarola's preaching in the 1490s had become highly apocalyptic in character, warning of the punishment to be visited on the city for its sins and of the impending end of the world, and his sermons increasingly adopted the eschatological methods of Joachim of Fiore who, in the 12th century, had been the first to interpret the book of the Apocalypse in the light of contemporary figures and events. Not long

after executing the *Calumny of Apelles*, Botticelli painted the *Mystic Crucifixion*, in which a view of Florence appears sparkling in the sunlight, a kind of new Jerusalem cleansed after suffering God's wrath, the *flagellum Dei* (scourge of God) imagined as fiery torches raining through a dark storm cloud retreating from the city.

The imagery of the *Mystic Nativity* was motivated by the same interpretative schemata that Savonarola had revived. The painting bears a Greek inscription identifying its subject as the Second Coming of Christ as foretold in the Revelation of St John and announcing Christ's coming in the year 1500 during the tribulations then afflicting the Italian peninsula. The inscription reads:

I, Alessandro, painted this picture at the end of the year 1500, in the troubles of Italy, in the half-time after the time, during the fulfilment of the 11th chapter of John, in the second woe of the Apocalypse, in the loosing of the devil for three and a half years. Afterward he shall be chained according to the 12th chapter and we shall see him [trodden down] as in this picture.

In the painting five devils are shown crushed in sliding crevasses opening up in the earth. In the foreground angels embrace three robed men crowned with the poet's bay, and two more angels bearing laurel branches stand to either side of the crib presenting five worshippers to the infant Christ, two of them clearly identifiable as shepherds and all of them similarly crowned with laurel. The three angels who kneel on the roof of the stable, dressed in red, white and green, are especially significant in the context of Joachimistic prophecy, as are the 12 angels bearing crowns and laurel branches, also dressed in red, white and green (the green a verdigris that has deteriorated to brown), who descend to earth in a golden circle of light. The colours are those traditionally assigned to Charity (red), Faith (white) and Hope (green), and it had been Joachim who identified the three realms, or stages, of the world with an Old Testament age of Hope, a New Testament age of Faith and a post-Apocalyptic age of Charity, or perfect Love, the future age initiated by the Second Coming of Christ. He named this as the age of the eternal Evangel (the book held by the central angel painted by Botticelli on the roof of the shed), when Hope and Faith would come together in perfect Charity, and he imagined that with the Second Coming of Christ and the expulsion of the devil from the world heaven would descend to earth and join with it, and men and angels would live together for a thousand years in a state of Christian love, until the end of the world in the day of the Last Judgement.

The Savonarolan image of the Second Coming painted in the *Mystic Nativity* is at the same time humanistically determined, as the wording of the inscription in Greek makes clear. The 12 angels bearing laurel branches and 12 crowns (an allusion to the 12-gated city of the Revelation of John, the new Jerusalem with a gate for each of the 12 tribes of Israel) strongly resemble the Florentine nymphs of Botticelli's mythological pictures, and the men embraced by angels appear as poets crowned with Laurentian no less than Petrarchan laurel. The concept of the painting, in other words, is as much indebted to the Medicean poets and humanists formerly supported by Lorenzo the Mag-

nificent, many of whom had become followers of Savonarola known as the Laurentians, as it is of the apocalyptic visions of the friar himself. An idea of Love originally personified as Venus, expressing a yearning for a lost age of perfection once attained by the ancients, has changed into a new idea of Love figured in Charity, expressing a yearning for an as yet unattained age of perfection. That these two different ideas of Love find their common ground in art, in the perfection of humanity through poetry, is also consistent within the work of a painter whose last years were spent in reading and illustrating the poetic theology of Dante and who, in Vasari's view, wasted his time commenting on it. However that may be, the *Mystic Nativity* is Botticelli's most ambitious late painting, conceived on the basis of a Dantean assimilation of theology into poetry.

III. Working methods and technique.

Since the 1980s Botticelli's panel paintings have been the subject of considerable scientific examination, with the result that a great deal is known about his technique. Botticelli was highly skilled and employed the same methods consistently throughout his career, but though conservative in his approach, he was not unwilling to vary the usual procedures to adopt recent innovations. This is most notable in his use of *tempera grassa*, a medium that was new to Italy, in which the egg yolk (the usual binder for tempera) was modified by the addition of oil to make the paint more transparent.

In many respects, however, Botticelli followed the traditional methods that had been perfected in the previous century and were described by Cennino Cennini in his *Libro dell'arte* of the 1390s. Like most Italian panels of the period, the support was poplar coated with gesso. On this the contours of the figures were established by a careful underdrawing in charcoal, done freehand without a cartoon, and the architectural features were indicated by incised lines made with a stylus. He then laid in the foundation colours, which varied according to the area of the finished painting: white lead, or the unprimed gesso, provided a base for the flesh tones, carbon black or malachite for the trees and landscape. Then—and here he departed from Cennini—he made a second preparatory drawing in black ink and wash applied with a brush, resetting the contours and giving his figures body and weight through modelling the lights and shadows. Many pentiments occur at this stage, notably in the placement of the hands and feet, indicating the importance to Botticelli of gestural expressiveness and graceful movement. Though these underdrawings are clearly defined—indeed virtually complete monochromes—they do not extend to broad areas of sky and landscape background, a phenomenon that recalls Leonardo's criticism of Botticelli for being indifferent to such things (see M. Kemp and M. Walker, *Leonardo on Painting*, New Haven and London, 1989, pp. 201–2).

Botticelli's pigments were of the finest, including malachite, verdigris (copper green), ultramarine, cinnabar, red, white and yellow lead, red lake and carbon black. Generally they were applied in thin, opaque layers known as 'scumbles', but the reds and dark greens were frequently glazed.

As the painting was built up, it gradually acquired a compact density, producing an exquisite, enamelled effect composed of infinite tonal gradations that create an extraordinary luminous subtlety, especially in areas representing reflected light. Unfortunately, many of his paintings have lost the fullness of their beauty with the passage of time, sometimes owing to abrasion or over-zealous restoration, sometimes to the tendency of colours to become more transparent or to change their nature over the years. Copper resinate, for example, which Botticelli employed extensively, turns from green to brown, resulting not only in an irreversible chromatic change but also in excessive contrast and loss of luministic gradation. An example appears in the green vestment worn by St Augustine in the S Marco *Coronation of the Virgin*, where the copper resinate glazed over malachite has permanently darkened, which flattens the voluminous effect of the garment. Another is in the *Primavera*, in which the bright white of the Graces' gowns is permanently out of balance with the darkened greenery behind.

Botticelli's technique is at its most refined in the rendering of the flesh tones, in which semi-transparent ochres, whites, cinnabars and red lakes are laid over one another in such minute brushstrokes as to render the gradations all but invisible. The faces of his women are exquisitely pale and porcelain-like, with the faintest pink blushes in the areas of the cheeks, nose and mouth, thus embodying the familiar Petrarchan metaphorical conventions. By contrast his infants and children are endowed with more intensely coloured, ruddier complexions made by cinnabar glazes and accents in red lake, while his men appear with darker flesh modelled from ochre applied over the black wash underdrawing, which sometimes remains visible and reinforces the more pronounced male bone structure and such features as the eye cavities. For gilding Botticelli often used finely powdered gold mixed with an adhesive and applied like any other colour. In the *Birth of Venus* and the *Madonna of the Magnificat*, for example, this gold paint, known as shell gold (*conchiglia*), was used to represent highlights in the hair, again rendering as literal the Petrarchan likening of the lady's tresses to spun gold. The decorative patterns of Venus's and Flora's costumes in the *Primavera* were also painted in shell gold, the gold being overpainted with red lake and black where the garments turn into the shadow. Similar effects appear throughout the whole of Botticelli's oeuvre. A further example of his illusionistic use of gold appears in the *Madonna of the Pomegranate*, in which the checked blanket beneath the infant Christ is rendered in malachite painted over gold leaf. Using a technique known as *sgraffito*, Botticelli then scratched through the green pigment to create the gold-checked pattern; in the areas of shadow the gold itself was scratched through to the underlying red bole.

As might be expected from the tensile line characterizing the figures in his paintings, Botticelli's drawings demonstrate that he was a superb draughtsman. Vasari indeed singled out Botticelli's drawings for the care and judgement the artist expended on them and said that because of their excellence they were greatly sought after by other artists. Undoubtedly many have perished because of frequent use by those artists, but exquisite examples survive (among

them a famous study for a Pallas). These show Botticelli's refined skill with chalk, pen and bistre, and also tempera, and his pioneering use of paper tinted with roses, violets, yellows and greys, which establish a middle value for figures, modelled up with whites in the light and down with darker colours and washes into the shadows. The Dante illustrations are unique in being executed only in outline (as Botticelli intended to colour them). They comprise 92 parchment sheets (divided between Berlin and the Vatican) illustrated on one side and with the text of an entire canto written on the other by Niccolò Mangona, who worked as a scribe in Florence between 1482 and 1503. The drawings vary greatly in completion, and some were never begun. They were initially scratched into the parchment, then overdrawn with slate and ink preparatory to being filled in with coloured inks. Some of the ink tracing is done with the utmost care, some is less advanced (and in places scratched out with a pin), and execution of the colouring did not progress very far.

In common with other painters of the time, Botticelli worked with craftsmen in other media, for example providing designs for ecclesiastical vestments and furnishings (examples in Sibiu, Brukenthal Mus.; Milan, Mus. Poldi Pezzoli). He painted decorations for Florentine civic celebrations, the most famous of which was the banner (destr.) carried by Giuliano de' Medici in his famous joust of 1475, and Vasari reported that he devised a new, more permanent method using coloured strips of cloth for realizing such images. He also worked closely with masters in the new art of engraving, supplying drawings for Baccio Baldini in particular, but the precise nature of his participation in this popular form of image-making, though certainly extensive, has yet to be established. The problem is complicated by the fact that his engravers were able to reproduce his characteristic style only superficially, as seen, for example, in the engravings after Botticelli's designs for Cristoforo Landino's edition (1481) of Dante's *Divine Comedy*.

IV. Character and personality.

In the first edition of the *Vite* (1550), Vasari cast Botticelli's biography as a kind of morality play, describing him as a quick-witted, high-spirited and worldly youth who won success quickly, only to decline with the turn of Fortune's wheel into inactivity, poverty and religious despair in old age. Mentally hyperactive and impatient in school, he was withdrawn early and apprenticed, his talent immediately becoming apparent. He enjoyed patronage from the most important Florentine families, in particular the Vespucci and the Medici, and Vasari emphasized his closeness to Lorenzo the Magnificent. Botticelli never married, instead preferring the companionship of his family, friends and workshop, which was quite large. Vasari also stressed the artist's sharp wit, his love of clever sayings and practical jokes, describing him as a person of sophistication who greatly admired people knowledgeable about art, but who lost precious time commenting on Dante and drawing illustrations for the *Divine Comedy*. According to Vasari, in later years he fell victim to melancholy and became a follower of Savonarola. Vasari softened this portrait in the second edition of the *Vite* (1568), in which he deleted his

moral judgement on Botticelli's decline and enriched his biography with additional factual and anecdotal detail, but the essential outline remains the same. Though his report of Botticelli's poverty and inactivity in the last 15 years of his life is to some degree exaggerated, the overall picture has not substantially altered.

Botticelli's links with the wider family of Lorenzo de' Medici were extensive, at least until Lorenzo's death in 1492 and the expulsion of the Medici two years later. There is reason to think that his first important commission, *Fortitude* (1470), was won through Lorenzo's influence, occasioning the breaking of the contract originally awarded to Pollaiuolo, and the *St Sebastian* (1473–4) may have been commissioned by Lorenzo himself. Botticelli is mentioned in Lorenzo's own comic poem *I beoni* ('The drinkers'; 1472–4). Poliziano, tutor to Lorenzo's son Piero, recorded three of Botticelli's jokes in his *Detti piacevoli* (1477–82). Two of them were repeated by the Anonimo Magliabecchiano (c. 1540), and the third is a quadruple play on words: 'Un bisticcio piacevole mi disse a questi dì Sandro di Botticello:—Questo vetro chi 'l votrà? Vo' tre, e io v'atrò!' ('The other day Sandro Botticelli told me a pleasing pun:—'Who'll empty this glass? You'll need three, and I'll help them!'). Poliziano has long been recognized as responsible for helping Botticelli with the inventions for some of his paintings of mythological subjects (*see* §III, 1 above). On a more extensive plane, the immersion in poetry that is implied by Vasari's statement that Botticelli 'commented on' Dante similarly finds expression in the inventions and interpretative decorum that inform his mythological paintings.

Botticelli's brother Simone is documented as a *piagnone*, or 'weeper', as Savonarola's followers were called, and Vasari was doubtless correct in reporting that Botticelli himself was 'extremely partisan to that sect'. The Greek inscription with which Botticelli signed and dated the *Mystic Nativity* clearly indicates a humanist point of departure and suggests that Botticelli, like the philosopher Giovanni Pico della Mirandola (1463–94) and many humanists formerly protected by Lorenzo de' Medici, had become moved by Savonarola's apocalyptic preaching after Lorenzo's death and in the face of the consequent turmoil that beset Florence and Italy.

V. Posthumous reputation.

Having been one of the most esteemed painters in Italy during his lifetime, Botticelli was soon eclipsed by the artists of the High Renaissance and long neglected thereafter. Despite occasional references to his art in such ultramontanist works as Alexis-François Rio's *De l'art chrétien* (1861–7), a fragmentary version of which was published in 1836, Botticelli's reputation did not enjoy a notable rise in critical esteem until the end of the 19th century; notwithstanding John Ruskin's moralistic—and ambiguous—treatment of him in the 1870s, it has been shown that, contrary to common supposition, neither the Nazarenes in Germany nor the Pre-Raphaelites in England were especially interested in him. Nevertheless, important paintings by Botticelli were gradually entering the great museums of Europe. The *St Sebastian* and the Bardi altarpiece, for example, went to Berlin in the 1820s and

Mars and Venus to the National Gallery in London in the 1860s, the decade in which the *Primavera* and *Birth of Venus* were also given prominent public display for the first time in the Galleria dell'Accademia in Florence. The Villa Lemmi frescoes were acquired by the Louvre, Paris, in the 1870s and three of the four *Nastagio degli Onesti* panels by the Prado, Madrid, at the end of the century. Museum acquisition and display were slightly in advance of public and critical response and in an important way laid the foundations for it.

The true revival of interest in Botticelli was the product of gradually developing 19th-century interest in the literary and political culture in Florence at the time of Lorenzo the Magnificent, and the concomitant rise in appreciation for the arts contemporary with him. William Roscoe's *Life of Lorenzo de' Medici* (London, 1796, rev. Heidelberg, 2/1825–6), which published many of his poems and those of his humanist contemporaries, Giosué Carducci's preface to his edition (1863) of Poliziano's *Stanze*, and numerous documentary and philological studies by Carducci's collaborator Isidoro del Lungo set high standards both of scholarship and sensibility. This sensibility found a response in Walter Pater's famous essay of 1873, and it was these works, and the literature to which they gave rise, that also set the tone for the earliest scholarly studies of Botticelli: in Germany with Warburg's dissertation (1893) on the *Primavera* and *Birth of Venus*, which inspired an entire school of art-historical research, and Ulmann's monograph (1893), the first devoted to him; and in the UK and USA with the Aesthetic Movement that stemmed from Pater and found its scholarly fruition in the work of Crowe (1886), Berenson (1896) and Horne (1908), whose monograph on Botticelli, dedicated to Pater, is perhaps the best that has ever been written on any Renaissance artist. The quality of Warburg's and Horne's work in particular ensured the centrality of Botticelli's achievement to subsequent evaluations of Renaissance art and culture. Investigation of the Neo-Platonic foundations to the Renaissance revival of antique forms, for example, especially as undertaken by Chastel, Wind and Panofsky, has in particular taken Botticelli's mythologies as a primary point of departure. Since the 1890s Botticelli's stature has been accorded the full critical and historical acknowledgement that is its due, and this will undoubtedly continue to be true in proportion as the stature of Renaissance culture in 15th-century Florence is itself acknowledged and valued.

BIBLIOGRAPHY

EARLY SOURCES

A. Poliziano: *Detti piacevoli* (MS., 1477–82); ed. T. Zanato (Rome, 1983)

A. Billi: *Il libro di Antonio Billi* (MS., c. 1481–1536; Florence, Bib. N.); ed. C. Frey (Berlin, 1892)

F. Albertini: *Memoriale di molte statue et picture sono nella inclyta ciptà di Florentia* (Florence, 1510); ed. O. Campa (Florence, 1932)

Il codice Magliabechiano (MS., c. 1540; Florence, Bib. N.); ed. C. Frey (Berlin, 1892)

G. Vasari: *Vite* (1550, rev. 2/1568); ed. G. Milanesi, iii (1878–85), pp. 309–331

V. Borghini: *Il riposo* (Florence, 1584)

F. Bocchi: *Le bellezze della città di Fiorenza* (Florence, 1591); rev. G. Cinelli (Florence, 1677)

GENERAL

J. A. Crowe and G. B. Cavalcaselle: *Storia della pittura italiana dal secolo II al secolo XVI* (Florence, 1894), vi, pp. 203–310

B. Berenson: *Florentine Painters of the Renaissance* (New York, 1896/R 1900, 1909)

R. van Marle: *Italian Schools*, xii (1931)

E. Wind: *Pagan Mysteries in the Renaissance* (London, 1958) [the most important and complete Neo-Platonic interpretation of Botticelli's mythological paintings]

A. Chastel: *Art et humanisme à Florence au temps de Laurent le Magnifique* (Paris, 1959, rev. 1982)

E. Panofsky: *Renaissance and Renascences in Western Art* (Stockholm, 1960/R New York, 1972)

L. D. Ettlinger: *The Sistine Chapel before Michelangelo: Religious Imagery and Papal Primacy* (Oxford, 1965)

R. Salvini and E. Camesasca: *La Cappella Sistina in Vaticano* (Milan, 1965)

M. Reeves: *The Influence of Prophecy in the Later Middle Ages: A Study in Joachimism* (Oxford, 1969)

D. Weinstein: *Savonarola and Florence: Prophecy and Patriotism in the Renaissance* (Princeton, 1970)

A. Garzelli: *Il ricamo nell'attività artistica di Pollaiuolo, Botticelli, e Bartolomeo di Giovanni* (Florence, 1973)

K. Langedijk: *The Portraits of the Medici, 15th–18th Centuries*, 3 vols (Florence, 1981–7)

S. Meltzoff: *Botticelli, Signorelli and Savonarola: Theologia, Poetica and Painting from Boccaccio to Poliziano* (Florence, 1987)

J.-M. Massing: *La Calomnie d'Apelle* (Strasbourg, 1990)

Botticelli's Witness: Changing Style in a Changing Florence (exh. cat. by L. Kanter, H. T. Goldfarb and J. Hawkins, Boston, MA, Isabella Stewart Gardner Mus., 1997)

MONOGRAPHS

W. Pater: 'Sandro Botticelli', *Studies in the History of the Renaissance* (London, 1873); rev. as *The Renaissance: Studies in Art and Poetry* (London, 1877, rev. 4/1893); ed. D. L. Hill (Berkeley, 1980)

H. Ulmann: *Sandro Botticelli* (Munich, 1893)

A. Warburg: *Botticellis 'Geburt der Venus' und 'Frühling': Eine Untersuchung über die Vorstellungen von der Antike in der italienischen Frührenaissance* (Hamburg and Leipzig, 1893); repr. in *Gesammelte Schriften* (Leipzig and Berlin, 1932), pp. 1–60; It. trans. in *La rinascita del paganesimo antico* (Florence, 1966), pp. 1–58

H. P. Horne: *Alessandro Filipepi Commonly Called Sandro Botticelli, Painter of Florence* (London, 1908/R Princeton, 1980, rev. Florence, 1986) [still fundamental, with documents and original texts of early biographers; 1986 edn contains Horne's previously unpubd notes]

J. Mesnil: *Sandro Botticelli* (Paris, 1938)

R. Salvini: *Tutta la pittura del Botticelli* (Milan, 1958) [complete illus]

G. C. Argan: *Botticelli* (Geneva, 1967)

G. Mandel: *L'opera completa del Botticelli* (Milan, 1967) [complete illus]

R. Lightbown: *Sandro Botticelli*, 2 vols (London, 1978); rev. as *Sandro Botticelli: Life and Work* (London, 1989)

U. Baldini: *Botticelli* (Florence, 1988)

N. Pons: *Botticelli: Catalogo completo* (Milan, 1989) [complete illus]

C. Caneva: *Botticelli: Catalogo completo* (Florence, 1990) [complete illus]

M. Togner: *Sandro Botticelli* (Brno, 1994)

SPECIALIST STUDIES

G. Poggi: 'La Giostra Medicea del 1475 e la "Pallade" del Botticelli', *L'Arte*, v (1902), pp. 71–7

J. Mesnil: 'Les Figures des Vertus de la Mercanzia: Piero del Pollaiuolo et Botticelli', *Misc. A.*, i (1903), pp. 43–6

——: 'Botticelli à Rome', *Riv. A.*, iii (1905), pp. 112–23

H. P. Horne: 'The *Last Communion of St Jerome* by Botticelli', *Bull. Met.*, x (1915), pp. 52–6, 72–5, 101–5

E. H. Gombrich: 'Botticelli's Mythologies: A Study in the Neoplatonic Symbolism of his Circle', *J. Warb. & Court. Inst.*, viii (1945), pp. 7–60; repr. in *Symbolic Images* (London, 1972), pp. 31–81

J. Pope-Hennessy: *Botticelli: The 'Nativity' in the National Gallery* (London, 1947)

P. Francastel: 'La Fête mythologique au Quattrocento: Expression littéraire et visualisation plastique', *Rev. Esthét.*, v (1952), pp. 376–410; repr. in *Oeuvres*, ii (Paris, 1965)

——: 'Un mito poetico y social del Quattrocento: La Primavera', *Torre*, v (1957), pp. 23–41; repr. in *Oeuvres*, ii (Paris, 1965)

M. Levey: 'Botticelli and Nineteenth-century England', *J. Warb. & Court. Inst.*, xxiii (1960), pp. 291–306

L. Donati: *Il Botticelli e le prime illustrazioni della Divina commedia* (Florence, 1962)

G. Walton: 'The Lucretia Panel in the Isabella Stewart Gardner Museum in Boston', *Essays in Honor of Walter Friedlaender* (New York, 1965), pp. 177–86

C. Dempsey: '*Mercurius Ver*: The Sources of Botticelli's *Primavera*', *J. Warb. & Court. Inst.*, xxxi (1968), pp. 251–73

W. Welliver: 'The Meaning and Purpose of Botticelli's *Court of Venus* and *Mars and Venus*', *A. Q.* [Detroit], xxxiii (1970), pp. 347–55

C. Dempsey: 'Botticelli's Three Graces', *J. Warb. & Court. Inst.*, xxxiv (1971), pp. 326–30

J. Shearman: 'The Collection of the Younger Branch of the Medici', *Burl. Mag.*, cxvii (1975), pp. 12–27

W. Smith: 'On the Original Location of the *Primavera*', *A. Bull.*, lvii (1975), pp. 31–40

K. Clark: *The Drawings by Botticelli for Dante's Divine Comedy, after the Originals in the Berlin Museums and the Vatican* (London, 1976)

R. Hatfield: *Botticelli's Uffizi 'Adoration': A Study in Pictorial Content* (Princeton, 1976)

M. Levi D'Ancona: *Botticelli's 'Primavera': A Botanical Interpretation Including Astrology, Alchemy and the Medici* (Florence, 1983)

U. Baldini and others: *La Primavera del Botticelli: Storia di un quadro e di un restauro* (Florence, 1984); Eng. trans. by M. Fitton as *Primavera: The Restoration of Botticelli's Masterpiece* (London, 1984)

E. Callmann: 'Botticelli's *Life of San Zenobius*', *A. Bull.*, lxvi (1984), pp. 492–5

P. Dreyer: 'Botticelli's Series of Engravings of "1481"', *Prt Q.*, i/2 (1984), pp. 111–15

——: *Dantes Divina Commedia mit den Illustrationen von Sandro Botticelli* (Zurich, 1986)

A. del Serra and others: '*La Nascita di Venere*' e '*l'Annunciazione*' del Botticelli restaurate, Florence, Uffizi, Studi e Ricerche, 4 (Florence, 1987)

R. Stapleford: 'Botticelli's *Portrait of a Young Man Holding a Trecento Medallion*', *Burl. Mag.*, cxxxix (1987), pp. 428–36

P. Dreyer: 'Raggio Sensale, Giuliano da Sangallo und Sandro Botticelli—Der Höllentrichter', *Jb. Berlin. Mus.*, xxix–xxx (1987–8), pp. 179–86

H. Bredekamp: *Botticelli 'Primavera': Florenz als Garten der Venus* (Frankfurt am Main, 1988)

S. Buske: *Sandro Botticelli, Weibliches Brustbildnis (Idealbildnis Simonetta Vespucci?)* (Frankfurt am Main, 1988)

'*L'Incoronazione della Vergine*' del Botticelli: Restauro e ricerche (exh. cat., ed. M. Ciatti; Florence, Uffizi, 1990)

C. Dempsey: *The Portrayal of Love: Botticelli's 'Primavera' and Florentine Humanist Culture at the Time of Lorenzo the Magnificent* (Princeton, 1992)

A. C. Blume: 'Botticelli's Family and Finances in the 1490s: Santa Maria Nuova and the San Marco Altarpiece', *Mitt. Ksthist. Inst. Florenz*, xxxviii/1 (1994), pp. 154–64

R. Stapleford: 'Intellect and Intuition in Botticelli's *Saint Augustine*', *A. Bull.*, lxxvi (March 1994), pp. 69–80

P. Barolsky: 'The Ethereal Voluptas of Botticelli', *Ksthist. Tidskr.*, lxiv/2 (1995), pp. 65–70

A. C. Blume: 'Giovanni de Bardi and Sandro Botticelli in Santo Spirito', *Jb. Berlin. Mus.*, xxxvii (1995), pp. 169–83

R. Hatfield: 'Botticelli's *Mystic Nativity*, Savonarola and the Millennium', *J. Warb. & Court. Inst.*, lviii (1995), pp. 88–114

R. J. M. Olson: 'An Old Mystery Solved: The 1487 Payment Document to Botticelli for a Tondo', *Mitt. Ksthist. Inst. Florenz*, xxxix/2/3 (1995), pp. 393–6

P. Barolsky and A. Barriault: 'Botticelli's *Primavera* and the Origins of the Elegaic in Italian Renaissance Painting', *Gaz. B.-A.*, cxxviii (Sept 1996), pp. 63–70

M. W. Kwakkelstein: 'Botticelli, Leonardo and a Morris Dance', *Print Q.*, xv/1 (March 1998), pp. 3–14

CHARLES DEMPSEY

Botticini, Francesco [Francesco di Giovanni di Domenico] (*b* Florence, 1446–7; *d* Florence, 16 Jan 1498). Italian painter. His father, Giovanni di Domenico di Piero, was a painter of playing cards. On 22 October 1459 Botticini was appointed as a salaried assistant in Neri di Bicci's thriving workshop at the relatively late age of about 13. This arrangement meant that Botticini could complete his training while at the same time gaining experience of a higher level than that available to him in his father's more modest workshop. Although his contract was drawn up for one year, he left his master on 24 July 1460, after only nine months. The fact that he was the son of an artisan

painter accounts for his being independent at so early an age and for his relatively brief apprenticeship. By 1469 he probably had his own workshop, since he is referred to in an arbitration document of that year as *dipintore*.

On 16 March 1471 Botticini joined the Compagnia dell'Arcangelo Raffaello, which at that time owed him for 'the painting of an angel Raphael'. This information provides concrete evidence for the attribution to Botticini of a panel with the *Three Archangels* (*c.* 1472; Florence, Uffizi; see fig.), which was painted for the company's altar in Santo Spirito. The frame was gilded by the painter Chimento di Piero on 13 March 1472.

The monumental *Tabernacle of the Sacrament* (Empoli, Mus. Dioc.) was commissioned for the high altar of the collegiate church of Empoli in March 1484 by the Compagnia Sant'Andrea della Veste Bianca. The work was to have been completed on 15 August 1486, but the terms of the contract were not honoured and it was installed only in 1491, when a committee of artists, including Domenico Ghirlandaio, Filippo di Giuliano, Neri di Bicci and Alesso Baldovinetti, appraised it. However, even at this date, the altarpiece was not complete, and on 10 August 1504 Botticini's son Raffaello (1477–after 1520) was commissioned to finish the work according to the terms of the original project (Poggi, 1905; Paolucci, 1985). In the side compartments that frame the central compartment with ciborium (now empty) are St Andrew, patron saint of the church and the company, and St John the Baptist, who points to the space in the centre where the Eucharist was kept. The predella is divided into three compartments with the *Last Supper* in the centre and the stories of the *Martyrdom of St Andrew* and the *Martyrdom of St John the Baptist* on either side. A large and sumptuously decorated wooden frame, beautifully carved and gilded, unites the various painted compartments.

The *Tabernacle of the Sacrament* ably combines the most important pictorial innovations that were being made by the foremost Florentine painters of the time, among them Verrocchio, Filippino Lippi, Perugino and Botticelli, whose influence became increasingly apparent in Botticini's work. It also reveals an interest in the various currents of Flemish painting that were well represented in Florence, ranging from the intimate and luminous works of Hans Memling (1430/40–94) to the monumental qualities of Hugo van der Goes (1440–82). Furthermore, the tabernacle shows close stylistic parallels with various works that Botticini painted for Empoli (Paolucci, 1985) and with other works that scholars, from Cavalcaselle and Milanesi onwards, have tentatively attributed to him. These include the *Tabernacle of St Sebastian* (*c.* 1476–80; Empoli, Mus. Dioc.), once in the chapel of S Sebastiano in the collegiate church at Empoli, where it framed a statue of the saint by Antonio Rossellino, and the two altarpieces painted for Santo Spirito in Florence: the Uffizi *Three Archangels* and *St Monica and Augustinian Nuns* (*c.* 1471; *in situ*). These works are among Botticini's best; they show him to have been sensitive to works produced by the Pollaiuolo workshop as well as a discerning follower of Botticelli, whose elegant sophistication he translated into more literal and concrete terms.

The two panels of the *Virgin and Child* and *St Augustine* (both Florence, Accademia) are of a similar high quality

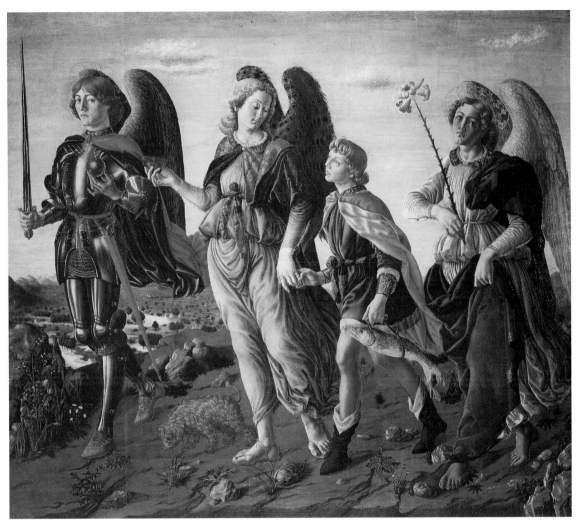

Francesco Botticini: *Three Archangels*, tempera on panel, 1.35×1.54 m, *c.* 1472 (Florence, Galleria degli Uffizi)

(Venturini, 1994), as is the *Virgin and Child with Saints* (1471; Paris, Jacquemart-André); the treatment of the figures in the last-mentioned, however, is more traditional and mechanical, contrasting greatly with the much freer handling of figures in the fervent *Virgin, St John the Baptist and Angels Adoring the Christ Child* (Modena, Gal. & Mus. Estense) and the *Crucifixion and Saints* (1475; ex-Kaiser-Friedrich Mus., Berlin; destr.). He carried out various works for Matteo Palmieri, a government official, writer and discerning patron of the arts. These include the *Assumption of the Virgin* (*c.* 1474–6; London, N.G.) with a portrait of Palmieri as donor and a panoramic view of Florence in the background, as well as some manuscript illuminations (Venturini, 1994). Botticini also seems to have prepared embroidery designs (Garzelli, 1973).

The altarpiece of *St Jerome in Penitence, with Saints and Donors* (*c.* 1484–91; ex-S Girolamo, Fiesole, now London, N.G.) is of particular iconographical interest: the four saints and the kneeling donors are shown worshipping a picture of St Jerome, which is placed in the centre of the panel in a scalloped frame. In this picture within a picture

St Jerome is on a larger scale than the donors and the musician angels. An imposing altarpiece of the *Virgin and Child Enthroned with Saints and Angels* (New York, Met.), already attributed to Botticini (Zeri, 1971), has been documented as his work (Roani Villani, 1988). It came from the altar of the Compagnia della Vergine in Fucecchio and dates from 1493. So far, no frescoes can be attributed to Botticini. He may have preferred to work on easel paintings and certainly won for himself a high degree of appreciation and success in that medium. His workshop was one of the most important of its day in the production of decorative, artisan-style works. An informative and complete monograph on the painter was published in 1994 by Lisa Venturini, who reconstructed a full and coherent corpus for the artist and clarified many dates.

BIBLIOGRAPHY

Colnaghi; *DBI*; Thieme–Becker

Neri di Bicci: *Le ricordanze, 1453–1475*, ed. B. Santi (Pisa, 1976), pp. 126–7, 333

G. Vasari: *Vite* (1550, rev. 2/1568), ed. G. Milanesi (1878–85), iv, pp. 245–7

G. B. Cavalcaselle and J. A. Crowe: *Storia della pittura in Italia dal secolo XII al secolo XVI*, 8 vols (Florence, 1875–98), vii, pp. 110–18

G. Milanesi: 'Documenti inediti', *Buonarroti*, xvii (1896), pp. 110, 137

G. Poggi: 'Della tavola di Francesco di Giovanni Botticini per la Compagnia di Sant'Andrea di Empoli', *Riv. A.*, iii (1905), pp. 258–64

P. Bacci: 'Una tavola sconosciuta con San Sebastiano di Francesco di Giovanni Botticini', *Boll. A.*, n.s. iv (1924–5), pp. 337–50

R. van Marle: *The Development of Italian Schools of Painting*, 19 vols (The Hague, 1931, 2/1970), xiii, pp. 390–427

M. Davies: *The Earlier Italian Schools*, London, N.G. cat. (London, 1951, 2/1961), pp. 118–27

B. Berenson: *Florentine School* (1963), p. 39

Arte in Valdelsa (exh. cat., ed. P. dal Poggetto; Certaldo, Pal. Pretorio, 1963), p. 60

L. Bellosi: 'Intorno ad Andrea del Castagno', *Paragone*, xviii/211 (1967), pp. 10–15

E. Fahy: 'Some Early Italian Pictures in the Gambier Parry Collection', *Burl. Mag.*, cix (1967), pp. 128–39

B. Berenson: *The Drawings of Florentine Painters*, 2 vols (Chicago, 1938, rev. 2/1969), i, p. 70; ii, p. 61

H. Friedman: 'Iconography of an Altarpiece by Botticini', *Bull. Met. Mus. A.*, xxviii (1969), pp. 1–17

F. Zeri and E. Gardner: *The Metropolitan Museum of Art, Italian Paintings: Florentine School* (New York, 1971), pp. 125–7

A. Garzelli: *Il ricamo nell'attività artistica di Pollaiuolo, Botticelli e Bartolomeo di Giovanni* (Florence, 1973), pp. 20–22

M. Boskovits: 'Una scheda e qualche suggerimento per un catalogo dei dipinti ai Tatti', *Ant. Viva*, xiv/2 (1975), pp. 9–21

M. Laclotte and E. Mognetti: *Avignon, Musée du Petit Palais: Peinture italienne* (Paris, 1976)

A. Padoa Rizzo: 'Per Francesco Botticini', *Ant. Viva*, xv/5 (1976), pp. 3–19

F. Petrucci: *Introduzione alla mostra fotografica di Antonio Rossellino* (Settignano, 1980), p. 40

A. Garzelli: *La miniatura fiorentina del quattrocento*, 2 vols (Florence, 1985), i, pp. 95–7

A. Paolucci: *Il Museo della Collegiata di Empoli* (Florence, 1985), pp. 114–24

A. Padoa Rizzo: 'Pittori e miniatori nella Firenze del quattrocento: In margine a un libro recente', *Ant. Viva*, xxv/5–6 (1986), pp. 5–15

R. Roani Villani: 'Relazione sulle pitture: Contributo alla conoscenza del patrimonio artistico della diocesi di S Miniato', *Erba d'Arno*, xxxii–xxxiii (1988), pp. 62–94

W. M. Griswold: 'Drawings by Francesco Botticini', *Master Drgs*, xxxii/2 (Summer 1994), pp. 151–4

L. Venturini: *Francesco Botticini* (Florence, 1994)

R. Bagemihl: 'Francesco Botticini's Palmieri Altarpiece', *Burl. Mag.*, cxxxviii/1118 (May 1996), pp. 308–14

ANNA PADOA RIZZO

Boulogne, Jean. *See* GIAMBOLOGNA.

Bozzato. *See* PONCHINO, GIAMBATTISTA.

Bracceschi, Giovanni Battista. *See* BERTUCCI, (1).

Braccesco, Carlo [Carlo da Milano] (*fl* Liguria, 1478–1501). Italian painter. He is first documented in 1478, when he executed the polyptych at Montegrazie, near Imperia; signed *Carolus Mediolanensis*, this large, three-tiered structure appears to be his only signed painting. An essentially Late Gothic, Lombard basis is agreed for this work, the complex sources of which also include Catalan and Venetian influences, the latter suggesting an affinity with such artists as Carlo Crivelli. Braccesco is also recorded (as Carlo da Milano) between 1481 and 1501 in a series of documents, mostly Genoese, relating to important commissions (all untraced). In 1481–2 he decorated the façade of the Palazzo delle Compere, Genoa, with a *St George on Horseback*. Between 1482 and 1484 he and Ambrogio de' Fiori produced four stained-glass windows for the chapel of S Sebastiano in Genoa Cathedral, then frescoed the walls, apse and exterior arch of the same

chapel. In 1484 he undertook to paint a polyptych depicting the *Assumption of the Virgin* for the Carmelites of S Maria degli Angeli. By 1492 he had probably executed a polyptych depicting the *Virgin and Child* for the unidentified locality of Belgandura. By 1494 he had completed a *Maestà* for the Commune of Levanto, and in that year or immediately afterwards he frescoed the chapel of the Nativity in the church of Nostra Signora del Monte, Genoa.

In 1497 Cristoforo della Torre, who had been commissioned to paint the organ case of Genoa Cathedral, arranged for Braccesco to paint six *Saints* on the shutters and a monochrome *Annunciation* on the outer face. In 1500 Braccesco may have participated in the decoration of the *caminata* (large hall) in the palazzo of Antonio Lomellini: Giacomo di Bartolomeo Serfolio and Leonoro dell' Aquila arranged for twelve medallions and four heraldic emblems to be painted on the frieze, either by Braccesco or by Stradioto. The document of 1501 refers to a commission to paint a polyptych of the *Assumption of the Virgin*, to be modelled on the one made by Giovanni Mazone for Baldassare Lomellini in S Teodoro, Genoa.

Braccesco's activity apart from his signed and documented works has been reconstructed on the basis of Longhi's attribution to him of an *Annunciation with Saints* (Paris, Louvre; see fig.), which is datable to shortly before 1495. It is a work of extraordinary quality, characterized by the successful grafting of Netherlandish and Mediterranean elements on to the most recent developments in Lombard painting. It seems, in turn, stylistically and chronologically related to *SS Erasmus and Jerome* and the *Holy Bishop and St Pantaleon* (both Levanto, S Andrea), fragments of painted cloth from a standard or altar curtain, in which the figures are set in a sunlit landscape reminiscent of the work of Nicolò Corso. If Longhi's attribution is accepted, the Louvre *Annunciation* would follow a now dispersed polyptych depicting *St Andrew*, painted by 1494, probably for the Commune of Levanto (main sections, untraced: ex-Herconway priv. col., London; ex-priv. col., Milan; predella panels: New York, Kress Found.; Venice, Ca' d'Oro; Avignon, Mus. Petit Pal.). A *Virgin and Child with Angels* (ex-Roerlich priv. col., New York) may also belong to the same polyptych, whose range of styles suggests an execution spread probably over several years. If the predella seems close to the works in Paris and Levanto, the principal elements, more clearly related to Vincenzo Foppa, seem still to be close to the central section of a polyptych at Borzone dated 1484. The stages following the Montegrazie Polyptych of 1478 are represented by a panel of unknown origin depicting *SS Vincent Ferrer and Peter Martyr* (untraced; see Boskovits, 1982) and by a *Virgin and Child with Angels* (Genoa, priv. col.). A Netherlandish influence is clearly seen in the detached fresco of the *Vision of St Dominic* (Genoa, S Maria di Castello), which is even more problematic in that it has been variously dated to *c.* 1470 (Boskovits) and after 1478 (most others).

The foregoing suggested chronology is not universally accepted, some scholars preferring a traditional attribution of the later paintings to the anonymous Master of the Louvre Annunciation. Arslan assigned to this artist the *St Andrew* polyptych and the Levanto fragments as well as

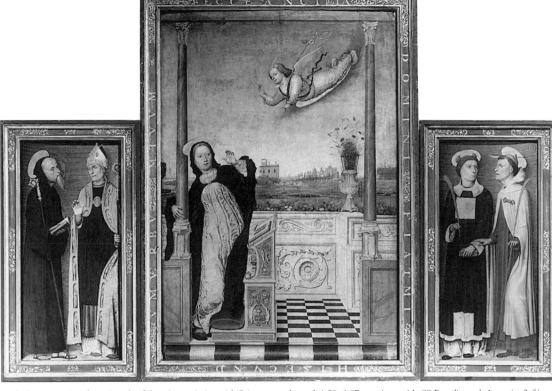

Carlo Braccesco (attrib.): triptych of the *Annunciation with Saints*, central panel, 1.58×1.07 m, wings with *SS Benedict and Augustine* (left) and *SS Stephen and Angelus* (right), 1.05×0.52 m, *c.* 1494 (Paris, Musée du Louvre)

the Louvre painting. Birolli and the *DBI* largely concur but restore the Levanto works to Braccesco.

BIBLIOGRAPHY

DBI

R. Longhi: *Carlo Braccesco* (Milan, 1942); also in *Lavori in Valpadana* (Florence, 1973), pp. 267–87

F. Zeri: 'Two Contributions to Lombard quattrocento Painting', *Burl. Mag.*, xcvii (1955), pp. 74–7; also in F. Zeri: *Giorno per giorno nella pittura* (Turin, 1988), pp. 329–31

E. Arslan: 'Il "Maestro dell'Annunciazione del Louvre" e Carlo Braccesco', *Scritti di storia dell'arte in onore di Mario Salmi*, ii (Rome, 1962), pp. 439–50

Z. Birolli: 'Il formarsi di un dialetto pittorico nella regione ligure-piemontese', *Boll. Soc. Piemont. Archeol. & B.A.*, xx (1966), pp. 115–25

G. V. Castelnovi: 'Il Quattro e il primo cinquecento', *La pittura a Genova e in Liguria dagli inizi al cinquecento*, ed. C. Bozzo Dufour, i (Genoa, 1970, rev. 1987), pp. 97–105, 145–7

M. Boskovits: 'Un Tableau inédit de Carlo Braccesco', *Rev. A.*, lvii (1982), pp. 77–8 [on *SS Vincent Ferrer and Peter Martyr*]

——: 'Nicolò Corso e gli altri: Spigolature di pittura lombardo-ligure di secondo quattrocento', *A. Crist.*, lxxv (1987), pp. 351–86 (368–79, 383–4)

P. Donati: 'Carlo Braccesco a Levanto', *A. Lombarda*, lxxxiii (1987), pp. 20–26

M. Natale: 'Pittura in Liguria nel quattrocento', *La pittura in Italia: Il quattrocento*, ed. F. Zeri (Milan, 1987), pp. 15–30 (21–4)

VITTORIO NATALE

Bracciolini, (Gian Francesco) Poggio (*b* Terranova, Tuscany, 11 February 1380; *d* Florence, 30 October 1459). Italian scholar, collector and writer. After notarial training in Florence, during which he came under the influence of the humanist Chancellor Coluccio Salutati (1331–1406),

Poggio worked as a papal bureaucrat from 1404 to 1453, with intermissions including a period in England (1418–23); he then became Florentine Chancellor himself (1453–6). The earlier part of his life was marked by discoveries of Latin texts hitherto unknown, including works of Lucretius, speeches of Cicero, Vitruvius' *On Architecture* and the complete works of Quintilian. He later issued histories and treatises on moral, social and scholarly questions.

In the opening years of the 15th century, Poggio was responsible, under the influence of Salutati and Niccolò Niccoli, for the first examples of a new, humanistic script based on Carolingian script and Roman inscriptions, the clarity and beauty of which led to it gradually replacing Gothic lettering in manuscripts and print. A collector of ancient inscriptions from his earliest days in Rome, Poggio was equally interested in the monuments of the city. Aided by texts he himself had found, as well as by inscriptions and close personal observation, he gave a nostalgic but precise account of urban topography in Book I of his *De varietate Fortunae* (1448; *see* ROME, §VII, 2), which overturned many traditional identifications. At his villa, in Fiesole, he installed antique statuary, inscriptions and coins collected for him from as far away as Greece; a passing comment in a letter to Niccoli shows Donatello approving one of his pieces. A silver reliquary bust commissioned by Poggio is now in New York (Met.).

WRITINGS

Opera (Strasbourg, 1511); ed. R. Fubini as *Opera Omnia*, 4 vols (Turin, 1964–9) [incl. *De varietate fortunae*]

BIBLIOGRAPHY

E. Walser: *Poggius Florentinus* (Berlin, 1914)

J. J. Rorimer: 'A Reliquary Bust Made for Poggio Bracciolini', *Bull. Met.*, xiv (1955–6), pp. 246–51

R. Weiss: *The Renaissance Discovery of Classical Antiquity* (Oxford, 1969, rev. 1988), pp. 59–60, 63–6, 147–9, 205

M. C. DAVIES

Bramante, Donato (*b* Monte Asdrualdo [now Fermignano, Marches], ?1443–4; *d* Rome, 11 April 1514). Italian architect, painter and engineer. His esteemed reputation as the father of High Renaissance architecture rests on a series of projects initiated towards the end of his life in Rome, including the enormous extension to the Vatican Palace and the new plans for the rebuilding of St Peter's. Although few of these buildings, even his masterpiece, the Tempietto, exist in the form in which they were conceived, it is still clear that they constituted a decisive departure from the traditions of the recent past. Due to his patron Pope Julius II taking full advantage of the opportunities presented, and through a profound re-evaluation of the heritage of Classical antiquity, Bramante achieved in these buildings a dignity and majesty quite new to Renaissance architecture. Already recognized by his contemporaries as a great innovator, Bramante had by far the most enduring and pervasive influence on the course of architecture throughout the 16th century.

I. Life and work. II. Critical reception and posthumous reputation.

I. Life and work.

1. Early life and training, to late 1470s. 2. Milan and Lombardy, late 1470s–1499. 3. Rome, 1500–14.

1. EARLY LIFE AND TRAINING, TO LATE 1470s. Bramante's place of birth—the small town of Monte Asdrualdo in the papal state of Urbino, where his father was a farmer—is certain, but his birth date can only be inferred from Vasari's assertion that Bramante was 70 when he died. According to Vasari, Bramante's father directed him to turn to painting once he had learnt to read, write and use the abacus; having abandoned his family's way of life, however, he was later excluded from his modest family inheritance. Possible clues about his artistic education can be gleaned from early sources: that he enjoyed most the works of the local painter Fra Carnevale and delighted in perspective and architecture (Vasari) or that he was a follower of Mantegna and Piero della Francesca (Saba da Castiglione). Whatever his actual training, he almost certainly acquired his early expertise as a painter and designer in Urbino, and this experience was partly to determine the course of his artistic career. At Urbino he would have become familiar with the splendid court and flourishing artistic community centred around Count (later Duke) Federigo da Montefeltro, which attracted such eminent figures as Leon Battista Alberti and Piero della Francesca. He would have witnessed at first hand the continuing construction of the ducal palace under Luciano Laurana and perhaps later under Francesco di Giorgio Martini, whose presence in Urbino is recorded in 1476. In addition, he would no doubt have come into contact with many of the artists and craftsmen who came to work on the palace decorations, not only from Florence and Central Italy but also from North Italy and beyond.

Bramante's future career as a painter and master of perspective must have been greatly stimulated by the work of Piero della Francesca and other artists and designers who worked at the palace. A specific example mentioned by Vasari is Fra Carnevale's altarpiece for S Maria della Bella, Urbino. This has sometimes been identified with the Barberini Panels (*c.* 1465–70; *Birth of the Virgin*, New York, Met.; *Presentation of the Virgin*, Boston, MA, Mus. F.A.), with their highly elaborate architectural backdrops of *all'antica* buildings painstakingly rendered in linear perspective (but *see* MASTERS, ANONYMOUS, AND MONOGRAMMISTS, §I: MASTER OF THE BARBERINI PANELS). More immediately comparable to Bramante's paintings, however, are the mural decorations at Loreto of his slightly older contemporary, Melozzo da Forlì, which, with their fictive architectural frameworks and bold foreshortenings, achieve startling and daring *trompe l'oeil* effects.

In Urbino, Bramante would also have had early exposure to avant-garde architectural taste under the motivating influences of Alberti and Laurana. The ducal palace itself, which so eloquently reveals the possibilities of architecture as a vehicle of aristocratic patronage, would have demonstrated to him how the new Renaissance style could be adapted, with a sufficiently well-organized workforce, to projects of colossal scale. There is no reason, however, to suppose that Bramante was involved in designs for the palace, although a number of late additions, notably the Temple of the Muses and the elaborately decorated Cappella del Perdono (1470s), both presumably built under Francesco di Giorgio, with their rich mouldings and elaborate terracotta barrel vaults are very close in spirit to some of Bramante's future Milanese projects.

Bramante probably left Urbino in 1472. He eventually moved north to Lombardy, where he undertook minor commissions 'in one city after the other' (Vasari). He finally settled in Milan, probably during the late 1470s, and the ascendancy of the brilliant court of Ludovico Sforza, Duke of Milan, who was a nephew of Federigo da Montefeltro's wife, Battista Sforza (*d* 1472), encouraged him to remain there for more than 20 years (*see* SFORZA, (5)).

2. MILAN AND LOMBARDY, LATE 1470s–1499.

(i) Painting. (ii) Architecture.

(i) *Painting.* The earliest work assigned to Bramante by Marcantonio Michiel was the fresco decoration commissioned in 1477 for the façade of the Palazzo del Podestà in Bergamo (detached fragments in Bergamo, Pal. Ragione). The design, executed with collaborators, consists of a band at the level of the *piano nobile* with pilasters separating the actual windows from fictive compartments housing seated figures of philosophers, the robustness and vitality of which recall the style of Melozzo. Later, in Milan, Bramante depicted 'the poet Ausonius . . . together with other coloured figures' (Lomazzo, IV.xiv) on a façade in the Piazza de' Mercanti. The one surviving painted façade design in Milan attributable to him is that of the Casa Fontana–Silvestri (date uncertain), a two-storey arrangement of columns and pilasters carrying entablatures with elaborately sculpted friezes, the lower providing the

platform for four *trompe l'oeil* bronze statues of allegorical figures.

More ambitious is the design attributed to him for the room decorations for the Casa Panigarola–Prinetti (1480s; substantial fragments in Milan, Brera). This consists of a series of niches that hold standing figures bearing arms, and a panel, formerly above the portal, depicting the philosophers Heraclitus (in tears) and Democritus (laughing). The figure style, especially the linear quality of the drapery, is reminiscent of Mantegna, as is the fanciful antiquarianism of the architectural design, for example the figurative frieze showing ancient rituals behind the two philosophers and the alternating sequence of paterae and striations, presumably inspired by a Doric frieze, that runs around the backs of the niches.

The most ambitious of Bramante's wall paintings is the so-called *Argus* (c. 1490–93) in the Cortile della Rocchetta of the Castello Sforzesco, Milan, which was painted for the Duke of Milan. The elegantly posed, semi-nude hero stands at the foot of a tunnel-like flight of steps upon a kind of balcony of striking illusionism, consisting of a pair of superimposed pedestals supported upon corbels, framing a recessed tondo of fictive bronze. The one panel painting usually thought to be by Bramante, on the authority of Lomazzo, is the distinguished half-length *Christ at the Column* (c. 1490; Milan, Brera), which reveals some familiarity with Venetian art in the clarity and colouristic variation of the skin tones and perhaps also with Ferrarese art in the sinuosity of the contours.

(ii) Architecture. In Milan, Bramante turned increasingly to architecture. According to Vasari, he resolved to do so when he first saw Milan's enormous cathedral. He may have already become involved in architectural projects during the early 1470s, perhaps playing some part in the designs for the remodelling of the Palazzo del Podestà in Bologna (attributed to Aristotele Fioravanti) and of the Loggia in Brescia (sometimes attributed to Tommaso Formenton), both of which are close to his Milanese works in style and architectural vocabulary. He may have hoped to displace his rivals in Milan and establish himself as ducal architect-in-chief, but this was not to be; as an outsider like his friend and contemporary Leonardo da Vinci, who lived there from c. 1483 to 1499, he received only a limited number of commissions from the Duke. He was also unable to circumvent the guild system that so effectively controlled the building trade in Milan, and most of his works were taken on as collaborations with local sculptor-architects, notably Giovanni Antonio Amadeo. Bramante certainly guided some of the most far-reaching projects of the period, however, and his expert opinion was sought in 1487–90 in connection with the crossing of Milan Cathedral (for which he proposed a Gothic design). He no doubt cultivated and maintained contact, both in Milan and on the lengthy trips he made to Florence and Rome in the 1490s, with other leading architects of the period, including Francesco di Giorgio, who inspected the cathedral in 1490, and Giuliano da Sangallo, who came to Milan in 1492.

(a) Early designs, S Maria presso S Satiro and Pavia Cathedral. (b) S Maria delle Grazie, S Ambrogio and Vigevano.

(a) Early designs, S Maria presso S Satiro and Pavia Cathedral. Bramante's increasing zest for architecture is apparent in his earliest documented work, the Prevedari engraving (signed; 1481; two surviving impressions in London, BM, and Milan, Perego priv. col.), commissioned by the painter Matteo Fedeli (*d* 1505) and engraved by Bernardo Prevedari, from whom its name is taken. The image lacks a conventional subject and depicts a monk who, unheeded by groups of bystanders, kneels before a candelabrum-column supporting a crucifix. The architectural setting, a large building meticulously delineated in oblique one-point perspective, is given unusual prominence and becomes in effect the main subject. The building is identifiable as pagan by its ruined condition and its elaborate *all'antica* ornament, including ritualistic friezes, centaurs and heads in roundels, the most conspicuous of which is turned to face away from the crucifix. The plan of the building is depicted as a domed Greek cross with groin-vaulted arms inscribed within a square. This derives ultimately from Byzantine models, such as S Marco in Venice, rather than from ancient Roman ones, although it conforms to a local Milanese tradition instituted by Antonio Filarete that was doubtless considered essentially antique. In elevation, the corner spaces are spanned by small arches supporting an entablature, which becomes the impost of larger arches of the arms; immediately above, another entablature provides the impost for the springing of the crossing vault. This system of interlocking arches suggests that Bramante was familiar with Brunelleschi's churches, but his design eschewed the latter's columns in favour of piers and pilasters, as in works by Alberti and Francesco di Giorgio, considerably enhancing its grandeur. Two sizes of pilasters are used, taller ones with elaborate Corinthian capitals for the arms of the cross and smaller pilaster-strips without capitals—a favourite motif of Francesco di Giorgio—for the subsidiary corner spaces.

The first major work built by Bramante, the pilgrimage church of S Maria presso S Satiro, Milan, is contemporary with the Prevedari engraving. Although a small chapel to house a miracle-working image of the Virgin was begun as early as 1478, Bramante's involvement is not documented until 1482, about when the chapel, parts of which can still be seen at the crossing when viewed from the Via del Falcone, was transformed into the present structure. Despite the building's unusual shape, the design was probably conceived as a whole. The church, attached to the small, round, 9th-century church of S Satiro (the exterior of which was refaced), is planned as a conventional Latin cross with aisled nave, domed crossing and three-bay transepts. However, the chancel arm was omitted because of the proximity of the Via del Falcone; instead there is a shallow niche, which, through the *trompe l'oeil* perspective design of its terracotta surface, achieves the striking illusion that it too is three full bays in extent (see fig. 1). The niche houses the image of the Virgin at the perspective focus above the altar, an arrangement resembling, albeit on a much larger scale, such objects as Desiderio da Settignano's Altar of the Sacrament (c. 1461; Florence, S Lorenzo). Two doors lead into the transepts from Via del Falcone to regulate the throngs of pilgrims.

Although the regularity of the plan of S Maria, especially the way in which the aisles continue into the transepts, has been likened to Brunelleschi's Santo Spirito in Florence, these features are also notable characteristics of

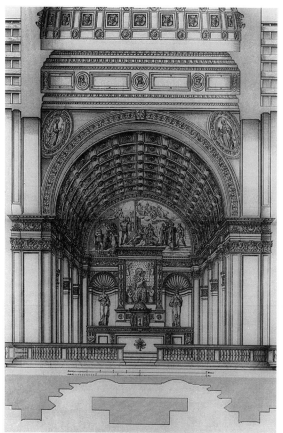

1. Donato Bramante: crossing of S Maria presso S Satiro, Milan, showing 'choir' painted in *trompe l'oeil* perspective, *c.* 1482

Milan Cathedral. The style and decoration of the architecture, however, are profoundly classical and quite without precedent in Milan. The closest parallel is Alberti's S Andrea (1470) in Mantua (*see* ALBERTI, LEON BATTISTA, figs 6–8), which probably inspired the use of monumental barrel vaults and arches on piers faced with two sizes of pilaster: the smaller supporting the side arches and the larger rising to the springing of the vault. The influence of Alberti may even extend to the darkness of the interior, which reflects an aesthetic for church design promoted in Alberti's *De re aedificatoria* (VII.xii). On the other hand, the elaborate coffering in the dome and barrel vaults as well as the elaborate detailing of the capitals and friezes, all richly crafted from gilded terracotta, are in keeping with the traditional Milanese fondness for ornamentation.

The façade of S Maria (covered over in the late 19th century) was never completed, but there is a long rear elevation on Via del Falcone, executed in exposed brick and terracotta. The Corinthian pilasters, paired at the corners, are here raised up on stacked pedestals and are taller than those inside, and the entablature, which has a very high and uncanonical panelled frieze, is interrupted by an even taller pilaster order that marks the crossing. At the intersection of the right transept and the nave is Bramante's remarkable octagonal sacristy. Apart from the octagonal sacristies at Loreto (see below), its most immediate model is local: the chapel of S Aquilino attached to

the Early Christian church of S Lorenzo, Milan, both of which were then believed to be antique. The lower storey of the interior of Bramante's sacristy has eight large niches that are alternately curved and rectangular, folded ornamental pilasters in the corners with exquisitely wrought stone Corinthian capitals, and an entablature with *all'antica* heads and reliefs in the tall frieze executed by Agostino Fonduli. A second storey is encircled by a gallery with two arched openings on each side; the lighting is from the vault above, a feature anticipated in the Prevedari engraving.

In 1488 Bramante became involved in the design of his most ambitious project in Lombardy, the rebuilding of Pavia Cathedral, where the Duke of Milan's brother, Cardinal Ascanio Sforza, was bishop. Although work had begun two years previously under Giovanni Antonio Amadeo, Bramante prepared a new design. Progress remained slow, and in 1497, by which time he took no further part, a revised project was prepared by Amadeo and Giovanni Giacomo Dolcebuono, and a model was commissioned (Pavia, Pin. Malaspina). The building, however, seems to be reasonably faithful to Bramante's design up to the height of the side chapels, since part of the exterior, including one of the eastern chapels, and most of the crypt had been completed by 1497. The layout is based on a Greek cross with an enormous octagonal crossing and aisles running along all four arms. He seems to have intended the entrance arm to be just four bays in length (of which three were eventually completed) so as to reach the Piazza del Duomo, although in Amadeo and Dolcebuono's model it is extended to eight bays, and the layout is thus changed to a Latin cross. Bramante may have also envisaged the octagonal sacristies positioned in the angles of the cross, the eastern pair of which were realized.

Precedents for the regularly organized plan at Pavia, which have close parallels in the contemporary drawings of Leonardo da Vinci, again include Milan Cathedral and S Lorenzo, Milan, which has an octagonal crossing similarly inscribed in a square and a dome supported on eight piers. By far the closest model for the plan, however, is the sanctuary church (1470) designed by Giuliano da Maiano at Loreto, which has an octagonal dome, aisled arms and octagonal sacristies in the corners (*see* LORETO, §II, 1(i)(a)). Bramante's responsibility for the awesome, stone-faced interior of Pavia Cathedral probably only extends as far as the order of Corinthian pilasters from which the aisle vaulting springs. Above this the design lacks the consistency and coherence of Bramante's other Milanese works. At one point an arcade is curiously sandwiched between an architrave and a cornice as though it were a giant frieze. Such oddities may be attributed to Amadeo and Dolcebuono, who may have effected substantial changes to the upper levels of the design. Bramante's low and austere crypt, with its arches and flattened vaults supported on pedestals, is the most uncompromising part of the building. The segmental vaults of the crypt's main apses, with radial ribs between arches, recall Brunelleschi's umbrella domes in Florence in the Old Sacristy (from 1419) of S Lorenzo and the Pazzi Chapel (designed 1420s) in Santa Croce, but they may have been derived from the Roman pumpkin domes visible at Hadrian's Villa (*c.* AD 125) at Tivoli.

(b) S Maria delle Grazie, S Ambrogio and Vigevano. The prestigious project for a new eastern end (*tribuna*) to the church of S Maria delle Grazie, Milan, was commissioned by the Duke as a mausoleum; work began on 29 March 1492. The basic design, attached to Guiniforte Solari's Late Gothic nave (1463), seems to have been Bramante's, although this has not been proved conclusively; if so, he must again have been working in conjunction with Amadeo and Dolcebuono, who are documented. The layout consists of an enormous square crossing crowned with a hemispherical dome, vast apses to left and right and a square chancel covered by a remarkable umbrella vault and with a further apse beyond (see fig. 2). Bramante's fascination with apsidal design, which characterizes virtually all his church designs from Pavia Cathedral onwards, may here have had specific funerary associations. The planning has similarities with the earlier ducal funerary church, the Certosa di Pavia (begun 1396), which has a crossing with three trilobed arms, but it is more closely related to Francesco di Giorgio Martini's S Bernardino (*c.* 1480–82) at Urbino (*see* FRANCESCO DI GIORGIO MARTINI, fig. 2), the trilobed funerary church designed for Federigo da Montefeltro, and ultimately to Brunelleschi's Old Sacristy (*see* BRUNELLESCHI, FILIPPO, fig. 2), which served as a Medici mausoleum. This last debt is also evident in the articulation of the crossing, with Corinthian pilasters folded around the corners, and the concentric archivolts, which have a memorable sequence of wheel-like tondi between them. Similarly conceived buildings, however, had already appeared in and around Milan, most notably the Portinari Chapel (before 1468) attached to S Eustorgio. At S Maria delle Grazie the design was adapted to truly

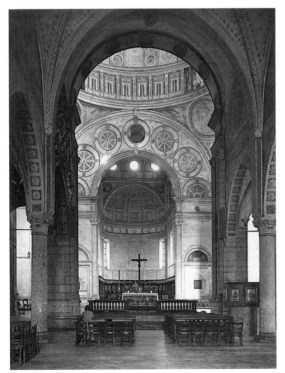

2. Donato Bramante: S Maria delle Grazie, Milan, begun 1492; interior looking east

monumental proportions. The overall coherence of the interior, which was executed largely in terracotta and stucco, nevertheless points to Bramante as the designer, as does the handling of such details as the raising of the pilasters on to pedestals and the placing of panels in the frieze, both of which recall the rear façade of S Maria presso S Satiro. The less coherent and more ornamental exterior, which was conceived as a series of superimposed storeys, seems much less characteristic of Bramante, and he may have played little part in its design.

Around 1492 the Duke of Milan commissioned Bramante to design the courtyard known as the Canonica at the Romanesque abbey church of S Ambrogio, Milan. The courtyard, of which only two incomplete sides were ever built, abuts the north wall of the church; its main axis is marked by a doorway into the building. On each side there are 11 arches, which, except at the centre, are supported on columns with Corinthian capitals. The central arch, twice as wide and almost twice as tall as the others, is supported on slender piers, each faced with a pilaster and raised on a tall pedestal. The columns next to the piers and those at the angles were made to resemble tree trunks. This motif, apart from being an emblem of the Duke, provides a learned antiquarian reference to the historical ancestry of the column as described by Vitruvius and illustrated by both Filarete and Francesco di Giorgio in their treatises. In 1497 Cardinal Ascanio Sforza commissioned Bramante to design a new monastic complex at S Ambrogio (executed mostly during the later 16th century). It is organized around a neighbouring pair of suitably restrained courtyards, descriptively known as the Doric and Ionic Cloisters. These are almost identical, with widely spaced columns carrying arches via entablature blocks and with tapering square-sectioned pillars at the angles, a type of support known to Francesco di Giorgio as a *colonna piramidale*. The corner pillars have Doric capitals even in the Ionic Cloister: the same combination also occurs in Giuliano da Sangallo's atrium (1491) at S Maria Maddalena dei Pazzi in Florence. The upper storeys in both cloisters have blind arches and a doubled rhythm of much shorter pilasters. Although typical of Lombard courtyard design, this arrangement closely resembles a drawing by Giuliano da Sangallo of the ruined Portico of Pompey in Rome and may well reflect an outlook of renewed antiquarianism (Rome, Vatican, Bib. Apostolica, MS lat. 4424).

In 1492–4, on the Duke's initiative, a new square was laid out in Vigevano, 12 km south-west of Milan. The work, which was carried out almost entirely to outline designs by Bramante, who was recorded there in 1492–6, involved the wholesale demolition of much of the old centre to create an open space extending more than 130 m from the façade of the cathedral—a size unprecedented in Lombardy—and the construction of new façades around three of the sides interrupted only at the dominant, towered entrance to the ducal castle towards the western end. Models for the scheme include the Piazza S Marco in Venice and the Renaissance Piazza della Loggia (*c.* 1485) in Brescia, as well as the ancient Forum Romanum as described by Vitruvius and Alberti, whose writings are echoed in an inscription on the castle tower. The façades, which have painted decorations (rest. 19th century), are of uniform design, with ground-level columned porticos

(as recommended by Vitruvius), an upper floor with arched windows and an attic. The bay sequence is broken, however, by two painted triumphal arches (only partly rest.), which mark the position of roadways and were almost certainly designed by Bramante. One, positioned near the centre of the short western end, is a single-arch design similar to the central arches of the S Ambrogio Canonica; in combination with framing pilasters at the upper level, the arrangement closely resembles a slightly earlier archway in the piazza at Brescia. The other arch, in the angle facing the castle tower, is a triple-arch design similar to the façade of Alberti's S Andrea (1472) in Mantua (*see* ALBERTI, LEON BATTISTA, fig. 8). As also in the Prevedari engraving, the capitals have bands of lattice decoration at their necks, no doubt to allude to the basket mentioned by Vitruvius in his account of the legendary origins of the Corinthian order (IV.i.g).

Bramante may have designed the Palazzo delle Dame in the castle complex at Vigevano, which has a colonnaded loggia above a massive arcaded basement, with recessed rims around the piers and arches similar to the arcades in Francesco di Giorgio's Urbino Cathedral (begun before 1482; altered 1789). He may also have been responsible for the façade of S Maria Nascente at nearby Abbiategrasso. This has a monumental arch set on two storeys of coupled columns and the whole inserted into one side of a pre-existing forecourt; it carries an inscription of 1497 but was completed only in the 17th century.

3. ROME, 1500–14.

(i) Early works and the Tempietto. (ii) Commissions for Pope Julius II. (iii) Non-papal late works.

(i) Early works and the Tempietto. In September 1499 Milan fell to the French, and the Duke was driven from power. Bramante left Lombardy and headed for Rome, arriving there, according to Vasari, just before the Holy Year of 1500. He soon received commissions from Pope Alexander VI to paint the papal arms over the main portal of S Giovanni in Laterano and to design two fountains, one in Trastevere (destr.), the other in the forecourt of St Peter's, fragments of which were reused by Carlo Maderno in 1614 for the fountain that now stands in the piazza's right-hand side. Vasari also claimed that Bramante was consulted in connection with a number of major buildings of the period, including the palace of Cardinal Raffaello Riario (now the Palazzo della Cancelleria; begun *c.* 1485; *see* ROME, §V, 6(i)), and that he actually made plans for the Palazzo Corneto (now Palazzo Giraud–Torlonia), a building of compact layout and restrained design but nonetheless a plausible attribution. Principally, however, he is described as devoting his time to the study and measurement of ancient buildings in Rome, Tivoli and further afield around Naples. This may indeed be true to judge from the remarkable increase in scale and monumentality and growing awareness of classical norms apparent in his architecture at this time.

Bramante fostered connections with those members of the papal circle with Spanish affiliations, such as Cardinal Oliviero Carafa, who supplied him with his first major Roman commission in 1500, the cloister at S Maria della Pace (completed 1504; see fig. 3). In some respects the

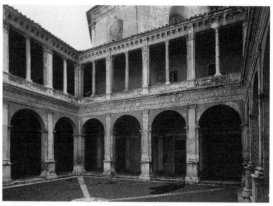

3. Donato Bramante: cloister of S Maria della Pace, Rome, completed 1504

design still relies on the formal vocabulary of his previous works: the pilasters on the courtyard side articulating the piers of the lower storey are raised upon pedestals, the subordinate pilaster-strips under the groin-vaulted arcades lack capitals, and the trabeated upper storey, which is not particularly tall, has a doubled rhythm. The design may also have taken into account recent architectural developments in Rome: the pier-arcade with attached order, although still most unexpected in a monastic cloister, appears earlier in the courtyard of the Palazzo Venezia (1464). Compared with contemporary Roman architecture, however, the cloister is much more rigorous in its geometry and the application of the orders. The square plan with four bays to each side is based on the module of a single bay measured from the centres of the pilasters, so that the pilasters in the corners appear only as thin fillets, as in Brunelleschi's Old Sacristy at S Lorenzo, Florence. The pilasters of the lower storey have Ionic capitals, the conventional choice for a cloister, and those above have Composite capitals, which complement the Ionic ones with their volutes; the additional supports between the piers at this level are slender columns with less ornamental Corinthian capitals. The corbels in the frieze above, which derive from the top storey of the Colosseum, add suitable weight to the terminal entablature.

It was probably about this time that Bramante received the commission for his epoch-making Tempietto, even though its style suggests that the design, which is undocumented, was substantially redrafted several years later. The date 1502 appears in an inscription in the crypt and refers either to the commission—transmitted by Cardinal Carvajal from Ferdinand II, King of Sicily and Aragón (*reg* 1479–1516), and Isabella, Queen of Castile and León—or to the actual beginning of work. The circular building (see fig. 4), which stands in a courtyard next to S Pietro in Montorio, serves as a shrine marking the supposed site of St Peter's crucifixion; at its very centre is the hole reputedly for the cross, exposed in the crypt and also visible through an opening in the paved floor above. Despite its tiny size, the Tempietto is majestically conceived. The shrine is encircled by a ring of sixteen Doric columns raised on three steps, with an entablature and balustrade above; the upper level has a drum and a dome with a crowning finial (altered in 1605). Under the colonnade, respondent pilas-

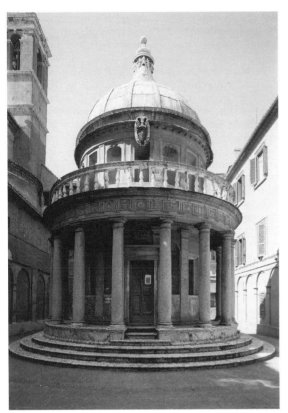

4. Donato Bramante: Tempietto, Rome, after 1502

and metopes, here carved with the instruments of the Christian liturgy, but also the earliest to conform in its proportions and the precise sequence of its constituent members to the Vitruvian canon. The Doric order itself was presumably selected according to Vitruvian rules of decorum for its suitable associations with the building's dedicatee, the strong and heroic St Peter. The adoption of respondent pilasters under the colonnade constitutes a departure from both Vitruvius and circular temple prototypes but helps emphasize the radial component to the design, which directs attention towards the hallowed site at the building's heart. An unexecuted scheme recorded in Serlio's treatise (Book III) to remodel the courtyard and enclose the building within a tall, circular cloister would have made this central focusing even more emphatic.

(ii) Commissions for Pope Julius II. Bramante's architectural ambitions were to be matched by those of Julius II, elected Pope on 31 October 1503 (*see* ROVERE, DELLA (i), (2)). Bramante had already been in contact with Julius's cousin Cardinal Raffaelle Riario, but he may have been recommended by Cardinal Ascanio Sforza, Julius's confidant and Bramante's former patron. Julius was quick to dispense with the services of his former architect, Giuliano da Sangallo, as he began to plan a number of magnificent projects in and around St Peter's and the Vatican, for which he assembled many of the leading artists of the period, including Michelangelo and Bramante, who was then aged about 60. It is even possible that Bramante assisted Michelangelo in the perspective and architectural framework of the Sistine Chapel ceiling (1508–12), which has some considerable similarities with the *Argus* in the Castello Sforzesco (*see* §2(i) above). Now established as, in effect, the official papal architect, Bramante embarked on a series of far-reaching projects that would rival even those of Roman emperors; for these he was well rewarded financially by Julius, who appointed him to the honorary office of *Piombo.*

(a) Vatican Palace. (b) St Peter's. (c) S Maria del Popolo and other work.

(a) Vatican Palace. The main adjunct to the Vatican Palace designed by Bramante is the colossal extension known as the Cortile del Belvedere, on which work began in the spring of 1505 (*see* ROME, §V, 14(iii)(a)). Although the design was modified by Pirro Ligorio before its completion (*c.* 1565) and altered by Domenico Fontana (1587–8), Bramante's scheme is faithfully recorded, most notably by Bernardino della Volpaia in the Codex Coner (London, Soane Mus.). The courtyard was intended to link the palace of Nicholas V to the Belvedere of Innocent VIII with its new sculpture court (completed 1506; remodelled 1773), situated more than 300 m to the north. The Cortile, arranged in three vast, ascending terraces, was designed to form a carefully considered composition, especially when viewed from the Pope's third-storey private apartment at the southern end. The long flanks of the Cortile house corridors and rise to roughly the same height, with three storeys for the lowest terrace and one storey for the top. A straight flight of steps once linked the lowest terrace, designed for use as a theatre, with the intermediate one, and a pair of transverse zigzag ramps to

ters frame windows alternating with niches and three portals (only one of which is original); panelled pilaster-strips around the drum frame a similar arrangement of openings. The interior also has Doric pilasters but with alternating narrow and wide bays, the ample niches in the wide bays for the portals (originally only one) and the altar.

In its basic design and function, Bramante's Tempietto can be related to structures built to house precious relics, such as Matteo Civitali's tempietto for the Volto Santo (1484) in S Martino, Lucca. Yet despite the externally expressed drum, with its arguably Christian associations, the design is conceived much more on the model of an ancient round peripteral temple. Temples of similar composition, with colonnades, attics and domes, appear in drawings by Francesco di Giorgio (Turin, Bib. Reale, Cod. Sal. fol. 84); Bramante's Tempietto, however, relies on a much more archaeologically informed knowledge of ancient prototypes, such as the Temple of Vesta (late 2nd century BC) by the Tiber and the so-called Temple of Portumnus near Ostia, which has an interior with niches and a crypt below.

The Tempietto also depends to an unprecedented degree on a new understanding of the rules set out by Vitruvius for temple design in general and for the Doric order in particular (III and IV). With exemplary dimensional rigour, the diameters of the interior and the colonnade, and the main elevational heights, are all based on the modular diameter of the columns. Moreover, the Tempietto's Doric order is not only the first Renaissance example to incorporate a proper Doric frieze with triglyphs

either side of a nymphaeum connected this level with the upper terrace. At the centre of the short northern end of the upper terrace, a broad single-storey semicircular exedra provided a fitting climax to the vista and gave access to the sculpture court (see colour pl. 1, XVI1). It was approached by a remarkable flight of concentric convex and concave steps, which thus combined the forwards and sideways movement of the steps and ramps below.

The Cortile's monumental conception depends, at least in part, on an archaeological awareness of ancient complexes in the vicinity of Rome. The terracing was probably inspired by the enormous Temple of Fortuna Primigenia complex at Palestrina, which also incorporates ramps and semicircular flights of steps; the exedra resembles that of one of the ancient bath complexes, and the covered corridors may have been based on such *cryptoportici* as those at Hadrian's Villa at Tivoli. The inventive elevations, however, are less immediately dependent on ancient precedent, although the Doric–Ionic–Corinthian sequence for the three-storey lower terrace, the first such occurrence in Renaissance architecture, derives ultimately from the Colosseum. This elevation has an arcaded lower storey with piers and attached Doric pilasters, a second storey with Ionic pilasters overlaid on half-pilasters and with pedimented windows flanked by niches, and an open top storey with Corinthian pilasters and smaller Doric columns between them supporting an unusual panel similar to those

at S Maria presso S Satiro; the single-storey elevation for the upper terrace also has Corinthian pilasters but with a triumphal-arch system of alternating wide and narrow bays.

Bramante also designed the spiral staircase-ramp, embellished with central supporting columns, in a tower near the sculpture court. Although the columns share a common spiral architrave, their capitals and proportions follow a sequence similar to that of the courtyard, which begins with a Tuscan order and is followed by a less robust Doric order, then progressively by more slender Ionic and Composite ones (see fig. 5). Vasari recognized a medieval precedent for the staircase in the 13th-century campanile of S Nicola at Pisa, but Palladio identified an internal staircase in the Porticus of Pompey as Bramante's model (I.xxviii). Bramante was also responsible for the Porta Julia, the external portal surrounded by massive blocks of rustication that leads into the Cortile's lower terrace, and for a wooden dome with an arcaded drum (1509; destr. 1523) on top of the nearby Borgia tower. Other designs by Bramante connected with the palace include the loggias of the neighbouring Cortile di S Damaso (begun by 1509; completed under Raphael), which has two storeys of arches with applied pilasters at first- and second-floor levels and a colonnaded storey at the top.

(b) St Peter's. On 18 April 1506 the foundation stone was laid for the first of the four enormous crossing piers of the new St Peter's (*see* ROME, V, 1(ii)(a)). Although little of Bramante's project for the church was actually realized, his plans formed the basis of all subsequent designs, including Michelangelo's. The impetus for the rebuilding of the venerated but dilapidated Early Christian basilica may have been provided by Julius's desire to find a suitable setting for the monumental tomb he commissioned from Michelangelo in 1505. Bramante's design, which was preferred to proposals submitted by Giuliano da Sangallo and Fra Giocondo, is represented on Caradosso's foundation medal (1506; e.g. London, BM), and the same design, apart from some minor deviations of detail, is recorded in a half-plan drawing known as the Parchment Plan (Florence, Uffizi, 1A; *see* ROME, fig. 5). The layout seems to have grown out of the ideas he had considered at Pavia Cathedral and S Maria delle Grazie, namely a domed Greek cross inscribed within a square and with apses on the main axes. It is here further elaborated with four subsidiary domes on the diagonals, where the Greek-cross arrangement is repeated on a smaller scale, and with four corner towers. The centre of the design corresponds fittingly with the revered tomb of St Peter, and the multi-domed layout recalls that of earlier sepulchral churches, such as S Marco, Venice; in other respects, the design can be related to the Early Christian S Lorenzo (*c.* AD 370), Milan, which has half-domes and corner towers. The arrangement of the crossing, however, although not so different from that in Pavia Cathedral, is a major innovation in church design, with diagonal chamfers to the massive crossing piers giving the dome a much greater diameter than the width of the arms.

In its enormous scale, Bramante's design for St Peter's was quite without precedent for a post-medieval church and relied heavily on ancient Roman bath complexes,

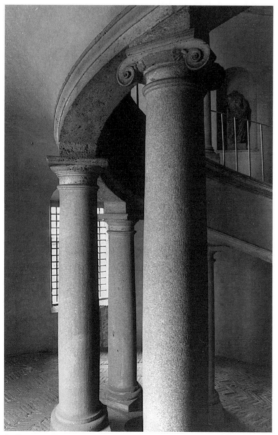

5. Donato Bramante: spiral staircase-ramp, Cortile del Belvedere, Rome, *c.* 1505

which seem to have inspired a wholly new approach to spatial planning. Whereas during the 15th century internal spaces were conceived as a product of designing walls, in St Peter's the walls were a product of designing spaces. Through this new approach, greatly aided by Bramante's revival of Roman brick-and-concrete construction, the massive vault-bearing walls took up the residual areas between neighbouring spaces and were hollowed out in a multitude of alcoves, arches and niches. Bramante's design for the dome, with its colonnaded drum resembling a circular temple and its crowning lantern, is known also from a plate in Serlio (Book III). In shape (hemispherical on the inside, stepped and dishlike on the outside) as well as in size (diam. 40.5 m when eventually realized), the design abandoned contemporary practice and was closely modelled instead on the Pantheon (diam. *c.* 43 m). The much greater overall size of St Peter's, however, compared with the Pantheon, was no doubt regarded as emblematic of the triumph of Christianity over ancient paganism and of the authority of papal rule.

The Parchment Plan design was, nevertheless, just one of many alternatives considered even as construction progressed. Other proposals included retaining the choir begun in 1452 under Nicholas V by Bernardo Rossellino, which Bramante completed, and adding ambulatories to the arms; there were even designs for a surrounding precinct. Bramante may also have been responsible for a Latin-cross scheme (Florence, Uffizi, 20A) intended to cover fully the hallowed site of the earlier basilica, which would have offered liturgical and ceremonial advantages and would have provided the building with a dominant façade lacking in the Parchment Plan design. No decision seems to have been made by Bramante's death, however, even though the crossing had been substantially completed up to the height of the drum, with piers and attached Corinthian pilasters using capitals copied from those inside the Pantheon. According to Vasari, Bramante intended the exterior to be Doric, and he certainly used this order for the outside of the 15th-century choir and the temporary stone shelter (1513; destr. 1592) over the site of St Peter's tomb. The latter's design, three bays with a paired order at either end, was similar to that of the Basilica Aemilia (179 BC) in the Forum Romanum.

(c) S Maria del Popolo and other work. Another church project in Rome commissioned from Bramante by Julius II was the extended choir for S Maria del Popolo (completed 1509), built to house the tombs of *Cardinal Ascanio Sforza* and *Cardinal Girolamo Basso della Rovere* (d 1507). The tombs are set below innovative Serlian windows either side of a square space covered by a saucer dome, approached from the pre-existing crossing through a barrel-vaulted bay, with another barrel-vaulted bay and apse beyond. The second barrel vault has coffering modelled on the entrance into the Pantheon, and the lowest coffer on the southern side is left open to make a window, an arrangement sometimes found in ancient *cryptoportici*. Apart from the saucer dome, frescoed by BERNARDINO PINTURICCHIO (*c.* 1510), the interior is remarkably stark, only articulated by plain pilaster-strips. It typifies the conception of true *all'antica* architecture that Bramante arrived at late in his career. The Pope then commissioned

Bramante to rebuild the church of SS Celso e Giuliano in Banchi (begun 1509; abandoned *c.* 1513; rebuilt after 1733); like a reduced version of St Peter's, this was planned as a domed Greek cross with four subsidiary domes and chamfered piers at the crossing. The interior was again very severe, simply articulated by plain pilaster-strips and corresponding ribs across the barrel-vaulted arms.

The Via Giulia, which runs close to the Tiber in a straight line towards the Vatican, was laid out by Bramante in 1507 as an important element in Julius's policy of renewing the fabric of the ancient city. In the following year Bramante started work on the enormous Palazzo dei Tribunali (abandoned 1511; most destr.), which was intended to bring together all the city's civil and ecclesiastical courts and to provide accommodation for the judges. The complex was to be arranged around a square courtyard with corner towers and a church, S Biagio della Pagnotta, projecting at the rear towards the Tiber. The layout is known principally from a drawing (Florence, Uffizi, 136A), which shows considerable similarities with the plans of the Cancelleria and other palaces for cardinals; the courtyard, with applied half-columns, recalls especially that of the Palazzo Venezia (begun 1455). Above all, it resembles Giuliano da Sangallo's scheme in the Codex Barberini (1488; Rome, Vatican, Bib. Apostolica, MS. lat. 4424) for a palace for the King of Naples. The four-storey main façade is known principally from the foundation medal of 1508 (e.g. Rome, Vatican, Medagliere), which shows a third tower at the centre rising in three battlemented stages to give a castle-like exterior resembling that of the Castello Sforzesco, Milan, and having similarities also with the mid-15th-century Palazzo dei Senatori, Rome. The lower level, a fragment of which survives, was rusticated with massive stone blocks and would have had openings for shops. The east end of S Biagio would, once again, have resembled the crossing of St Peter's combined with a two-bay nave as in the 15th-century church of S Maria della Pace.

Bramante designed several other works for Julius outside Rome. In 1508 he prepared designs to encase the Santa Casa, the house inside the sanctuary church at Loreto believed to be the Virgin's, in a lavish marble exterior (*see* LORETO, §II, 1(ii)(a) and fig. 3). The three-by-five-bay structure has Corinthian half-columns, associated by Vitruvius with maidenhood, arranged like a triumphal arch in narrow and wide bays. The half-columns are fluted, and all other available surfaces are decorated, incorporating a profusion of relief sculpture and statuary by Andrea Sansovino and others. Bramante also designed a very restrained, towered façade (unexecuted) for the church itself, recorded in a foundation medal of 1509 (e.g. Rome, Vatican, Medagliere), and a papal palace complex in the form of a monumental rectangular forecourt (1510; *see* LORETO, §II, 2 and fig. 1) that was realized in part, though with changes, under Sansovino and Antonio da Sangallo (ii). It has two-storey arcades with Doric and Ionic pilasters and defensive towers on the external angles. Elsewhere, it was almost certainly Bramante who designed the courtyard of the Rocca at Viterbo, with side-loggias of columns above piers (1506; later modified), and the fortress at Civitavecchia (1508), which has low bastions at the four corners and a large internal courtyard with

chamfered angles, similar to those in the earlier Belvedere statue court at the Vatican.

(iii) Non-papal late works. Bramante's Palazzo Caprini (*c.* 1510 ; also known as the House of Raphael, who bought it in 1517) was built in Rome for the apostolic protonotary Adriano de Caprinis. The building (subsequently remodelled) occupied a shallow site on the approaches to St Peter's; as was the custom in Rome, it had a row of shops at street level and living accommodation above. The design of the façade, best known from Antoine Lafréry's engraving (1549; see fig. 6), marked a watershed in palace design through the contrasting treatment of its two storeys, which accorded with their respective uses. The massive and ruggedly rusticated lower storey was treated as a five-bay arcade with openings for the main entrance and the four shops and with mezzanines for the shopkeepers' accommodation. The refined and elegant *piano nobile* above had pairs of Doric three-quarter columns, which stood on pedestals aligned with the piers below, supported a full Doric entablature and framed five pedimented windows with balustraded balconies. The design departed from previous façade arrangements in Rome, which were usually three storeys tall and had either plain stuccoed brickwork pierced by distinctive transom and mullion windows (e.g. Palace of Nicholas V in the Vatican and Palazzo Venezia) or orders of pilasters overlaid on rustication (e.g. Cancellaria or Palazzo Corneto), although, like the Palazzo Caprini, the order was usually omitted from the basement. It differed above all in its monumentality, having three-quarter columns rather than pilasters and a more pronounced rustication. The Palazzo Caprini façade may have been inspired to some extent by ancient temples or tombs with tall and massive substructures, although the direct influence of ancient prototypes is slight, being limited to the patterning of the stuccoed brick rustication and, in particular, to the design of the outer arches, which, with their inserted flat arches, closely resemble an ancient portal that formed part of the Temple of Romulus (now SS Cosma e Damiano) in the Forum Romanum. On the other hand, the underlying principles of Classical propriety, together with such Vitruvian details as placing the triglyphs at the extremities of the entablature, gave the façade a Classical spirit and authority that was new to Renaissance palaces.

The ruinous Nymphaeum outside Genazzano, attributed to Bramante by Frommel, was arguably designed for Cardinal Pompeo Colonna *c.* 1508–11, although the dating is far from certain. It was a recreational pavilion shelved into a hillside and used for viewing spectacles staged in and around a lake formed by damming a stream in the valley below. It had a three-bay, vaulted loggia at the front with apsed ends (an arrangement similar to that of Raphael's Villa Madama, begun *c.* 1518; *see* RAPHAEL, fig. 7); behind, on a slightly higher level, was a further three-bay area with a central apse, close to which was a domed octagonal bathhouse. The antiquarianism of the scheme, together with such motifs as the Serlian openings with roundels between concentric arches, seen also in S Maria delle Grazie, Milan (see fig. 2 above), support the attribution to Bramante. Other details, however, such as the nonstandard proportions of the Doric order, used throughout, seem inconsistent with his mature style.

II. Critical reception and posthumous reputation.

When Bramante died, a year after Julius, he received a magnificent funeral in St Peter's, where his body was

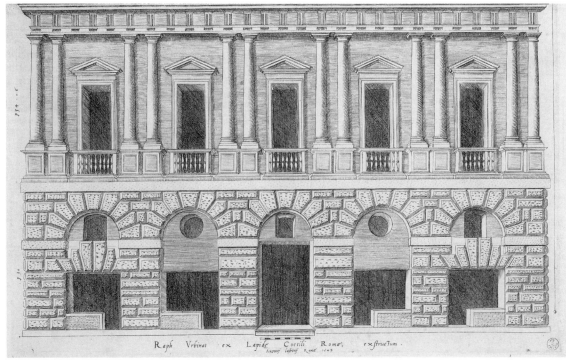

6. Donato Bramante: facade of the Palazzo Caprini, *c.* 1510; from an engraving by Antoine Lafréry, 1549

brought for burial. His contribution to architecture was quite apparent to his immediate followers, and it was they who established his enduring fame. An early and rather humorous portrait of the architect was presented by A. Guarna in his *Simia* (1516), but Bramante was also seen early on as having brought the art of architecture back to the standards of Classical antiquity, a view cogently expressed in Raphael's letter about the state of the arts addressed to Pope Leo X (*c.* 1516–18; Munich, Bayer. Staatsbib., cod. it. 37b), where architecture's recent advancement 'may be seen in the many beautiful buildings by Bramante'. Serlio, in Book III of his treatise, made a much more forthright claim when he specifically singled out Bramante as having 'revived the good architecture which had been buried until his time'. In so doing, Serlio consigned Bramante's contemporaries, including Giuliano da Sangallo and Fra Giocondo, to a lower league, and his legendary fame was thus crystallized. A similar estimation eventually formed the basis for a considerable elaboration by Vasari, who presented Bramante as the pioneering force in architecture for the third and final phase in the revival of the arts, and this view of Bramante as the father-figure of High Renaissance architecture has coloured all subsequent accounts of his career.

Many of Bramante's buildings and projects were recorded early, some even during the initial stages of construction as in the case of Bernardino della Volpaia's drawings in the Codex Coner. Although widely circulated through both drawings and foundation medals, Bramante's designs were transmitted most effectively by Serlio's treatise, which provides detailed descriptions and illustrations of most of his major Roman projects, including them in the book (III) that deals primarily with antiquities. Subsequently, in Palladio's *I quattro libri*, Bramante was to receive the unqualified accolade of being the only contemporary architect (apart from Palladio himself) to be illustrated, his Tempietto appearing as the only contemporary example in the final book on temples (IV. xvii).

The weighty and decorous style of classical architecture that Bramante was largely instrumental in establishing was enormously influential. Few subsequent architects remained untouched, for example, by the new approach to spatial planning that Bramante had introduced. The style enjoyed a continuing popularity in Rome and was brought to North Italy during the 1520s by his followers Giulio Romano, Michele Sanmicheli and Jacopo Sansovino, whence it was eventually disseminated throughout Europe. The fact that the style was by no means one of slavish revivalism in great part explains its success. Bramante was certainly attracted by Vitruvian orthodoxy, and this was an overriding concern in such buildings as the Tempietto, which became a modern classic. Yet he was also, as Vasari noted, attracted by the possibilities of invention: the Cortile del Belvedere, for example, was a most ingenious, evocative, but essentially modern reinterpretation of Classical themes, which fired the imagination of successors such as Raphael or Jacopo Vignola in the design of similar projects. Bramante's plans for St Peter's were to exert a profound influence on later church design. Michelangelo explicitly voiced a desire to return to Bramante's Greek-cross arrangement for St Peter's, and all the intervening redraftings of the plans were indebted to Bramante. Numerous other churches built in Italy during the 16th century were also inspired by his designs, and ultimately the idea of a great domed classical church became a standard throughout Europe. Similarly, the Palazzo Caprini became a source for subsequent palace designs, to the extent that many of the major palace façades of 16th-century Italy depend on it in some way; several, especially those of Sanmicheli, Sansovino and Palladio, are in effect creative variations. It is Bramante's influence on his immediate followers, and from them on posterity, rather than his own changed and disfigured buildings that finally holds the key to his deservedly great reputation.

BIBLIOGRAPHY

EARLY SOURCES

A. Guarna: *Simia* (MS., 1516; Milan, Bib. Trivulziana); ed. G. Nicodemi (Milan, 1943)

M. Michiel: *Notizia d'opere di disegno nella prima metà del secolo XVI* (MS.; 1521–43); ed. J. Morelli (Bassano, 1800; rev. Bologna, 1884)

S. Serlio: *Delle antichità* (Venice, 1540) [Book III of his treatise, fol. 64v of the 1619 edn]

G. Vasari: *Vite* (1550, rev. 2/1568); ed. G. Milanesi (1878–85), iv

Saba da Castiglione: *Ricordi* (Venice, 1554), iii, p. 138

A. Palladio: *I quattro libri dell'architettura* (Venice, 1570)

G. P. Lomazzo: *Trattato dell'arte della pittura* (Milan, 1584); ed. R. P. Ciardi in *Lomazzo: Scritti sull'arte*, 2 vols (Florence, 1973–4)

MONOGRAPHS

C. Baroni: *Bramante* (Bergamo, 1944)

G. Chierici: *Bramante* (Milan, 1954)

O. H. Förster: *Bramante* (Vienna and Munich, 1956)

G. Chierici: *Donato Bramante* (New York, 1960)

A. Bruschi: *Bramante architetto* (Bari, 1969)

Studi bramanteschi: Atti del congresso internazionale: Milano, Urbino, Roma, 1970

A. Bruschi: *Bramante* (Bari, 1973; Eng. trans., London, 1977)

H. A. Millon and V. M. Lampugnani, eds: *Renaissance from Brunelleschi to Michelangelo: The Representation of Architecture* (London, 1994)

URBINO AND MILAN

F. Malaguzzi-Valeri: *Bramante e Leonardo* (1915), ii of *La corte di Ludovico il Moro* (Milan, 1913–23)

A. Pica and P. Portaluppi: *Il gruppo monumentale di S. Maria delle Grazie* (Rome, 1938)

C. Baroni: *Documenti per la storia dell'architettura a Milano nel rinascimento e nel barocco*, i (Florence, 1940); ii (Rome, 1968)

P. Rotondi: *Il palazzo ducale di Urbino*, 2 vols (Urbino, 1950–51; Eng. trans., London, 1969)

W. Suida: *Bramante pittore e il Bramantino* (Milan, 1953)

F. Graf Wolff Metternich: 'Der Kupferstich Bernardos de Prevadari', *Röm. Jb. Kstgesch.*, xi (1967–8), pp. 9–97

A. Palestra: 'Cronologia e documentazione riguardante la costruzione della chiesa di S. Maria presso S. Satiro', *A. Lombarda*, 14 (1969), pp. 154–60

R. V. Schofield: 'A Drawing for S. Maria presso S. Satiro', *J. Warb. & Court. Inst.*, xxxix (1976), pp. 246–53

G. A. Dell'Acqua and G. Mulazzani: *Bramantino e Bramante pittore* (Milan, 1978)

La scultura decorativa del primo rinascimento: Atti del I convegno internazionale di studi: Pavia, 1980 [several interesting articles]

R. V. Schofield: 'Ludovico il Moro and Vigevano', *A. Lombarda*, 62 (1982), pp. 93–140

A. Palestra: *La Madonna miracolosa di S. Satiro, 1200 –c. 1983* (Milan, 1983)

L. Patetta: 'Bramante e la trasformazione della basilica di Sant' Ambrogio a Milano', *Boll. A.*, lxviii/21 (1983), pp. 49–74

S. Maria delle Grazie (Milan, 1983)

Bramante a Milano: Atti del congresso internazionale: Milano, 1986

R. V. Schofield: 'Florentine and Roman Elements in Bramante's Milanese Architecture', *Florence and Milan: Comparisons and Relationships*, i (Florence, 1989), pp. 201–22

C. D. Nesselrath: *Die Säulenordnungen bei Bramante* (Worms, 1990)

A. E. Werdehausen: *Bramante und das Kloster S. Ambroggio in Mailand* (Worms, 1990)

ROME

H. von Geymüller: *Les Projets primitifs pour Saint-Pierre* (Paris, 1875–80; German ed. Vienna, 1875–80)

K. Frey: 'Zur Baugeschichte des St. Peter', *Jb. Kön.-Preuss. Kstsamml.*, xxxi (1910), pp. 1–95; xxxiii (1913), pp. 1–153; xxxvii (1916), pp. 22–136 [CH]

D. Frey: *Bramante-Studien* (Vienna, 1915)

J. S. Ackerman: *The Cortile del Belvedere* (Rome, 1954)

F. Graf Wolff Metternich: 'Le Premier Projet pour St Pierre', *Studies in Western Art: Acts of the Twentieth International Congress of the History of Art: New York, 1961*, ii, pp. 70–81

——: 'Bramante's Chor der Peterskirche zu Rom', *Röm. Qschr.*, lviii (1963), pp. 271–91

G. De Angelis d'Ossat: 'Preludo romano del Bramante', *Palladio*, xvi (1966), pp. 92–124

S. Segui, C. Thoenes and L. Mortari: *SS Celso e Giuliano*, Le Chiese di Roma Illustrate (Rome, 1966)

L. H. Heydenreich: 'Bramante's "Ultima Maniera"', *Essays in the History of Architecture Presented to R. Wittkower* (London, 1967), pp. 60–63

C. L. Frommel: 'Bramante's "Ninfeo" in Genazzano', *Röm. Jb. Kstgesch.*, xii (1969), pp. 137–60

——: *Der römische Palastbau der Hochrenaissance* (Tübingen, 1971)

E. Bentivoglio and S. Valtieri: *S. Maria del Popolo a Roma* (Rome, 1976)

R. Tuttle: 'Julius II and Bramante in Bologna', *Le arti a Bologna e in Emilia dal XVI al XVIII secolo: Atti del XXIV Congresso internazionale di storia dell'arte: Bologna, 1979*, pp. 3–8

C. Robertson: 'Bramante, Michelangelo and the Sistine Ceiling', *J. Warb. & Court. Inst.*, xlix (1986), pp. 91–105

T. Carunchio: 'Il chiostro di S. Maria della Pace: Note e considerazioni', *Quad. Ist. Stor. Archit.*, 1–10 (1987), pp. 293–300

F. Graf Wolff Metternich and C. Thoenes: *Die frühen St.-Peter-Entwürfe, 1505–1514* (Tübingen, 1987)

A. Bruschi: 'Il contributo di Bramante alla definizione del palazzo rinascimentale romano', *Palazzo dal Rinascimento a oggi in Italia nel regno di Napoli in Calabria: Storia e attualità: Atti del convegno: Reggio Calabria, 1988*, pp. 55–72

F. Fagliari Zeni Buchicchio: 'La rocca del Bramante a Civitavecchia: Il cantiere e le maestranze da Giulio II a Paolo III', *Röm. Jb. Kstgesch.*, xxiii–xxiv (1988), pp. 275–383

H. W. Hubert: 'Il progetto della cupola del Bramante per la basilica di S Pietro', *L'église dans l'architecture de la Renaissance: Actes du colloque: Tours, 1990*, pp. 79–90

M. Wilson Jones: 'The Tempietto and the Roots of Coincidence', *Archit. Hist.*, xxxiii (1990), pp. 1–28

P. N. Pagliara: 'Una "non imitanda licentia" di Bramante nel dorico del coro S Pietro', *Architektur und Kunst im Abendland: Festschrift zur Vollendung des 65. Lebensjahres von Günter Urban*, ed. M. Jansen and K. Winands (Rome, 1992), pp. 83–9

M. C. Marzoni: 'Un capolavoro incompiuto: Il maestoso edificio apostolico', *Santuario di Loreto: Sette secoli di storia arte devozione*, ed. F. Grimaldi (Rome, 1994), pp. 155–64 [Palazzo Apostolico, Loreto]

J. M. Merz: 'Eine Bemerkung zu Bramantes St Peter-Plan Uffizien I A', *Z. Kstgesch.*, lvii/1 (1994), pp. 102–4

N. Riegel: 'Capella Ascanii: Coemiterium Julium: Zur Auftraggeberschaft des Chors von Santa Maria del Popolo in Rom', *Röm Jb. Bib. Hertz.*, xxx (1995), pp. 191–219

PAUL DAVIES, DAVID HEMSOLL

Bramantino [Suardi, Bartolomeo] (*b* ?Milan, *c.* 1465; *d* Milan, 1530). Italian painter and architect. He was one of the leading artists in Milan in the early 16th century. His early training as a goldsmith may indicate a relatively late start to his activity as a painter, and none of his work may be dated before 1490. The style of his early work parallels that of such followers of Vincenzo Foppa as Bernardino Butinone, Bernardo Zenale and Giovanni Donato da Montorfano. He assumed the name Bramantino very early in his career, indicating that he was in close contact with Donato Bramante, whose influence is uppermost in his early work.

Bramantino's earliest surviving painting is probably the *Virgin and Child* (Boston, MA, Mus. F.A.). It is an adaptation of a type of half-length Virgin with standing Christ Child well known in Milan. The linear emphasis and the dramatic treatment of light are aspects derived from Bramante's work. Bramantino stressed graphic quality in this picture, and throughout his early work he was considerably influenced by Andrea Mantegna and by the visual aspects of prints. His *Risen Christ* (Madrid, Mus. Thyssen–Bornemisza) derives from Bramante's *Christ at the Column* (*c.* 1490; Milan, Brera) but has a more precise musculature and a much harder use of line. The conception of the figure set against a rocky background, derived from Leonardo da Vinci's *Virgin of the Rocks* (versions, London, N.G.; Paris, Louvre; *see* LEONARDO DA VINCI, fig. 2 and colour pl. 1, XXXVII1), also indicates Bramantino's persistently eclectic nature.

Bramantino's interest in perspective and illusionism, also derived from Bramante, is evident in the *Pietà* fresco lunette from S Sepolcro, Milan (Milan, Ambrosiana), and in the *Adoration of the Shepherds* (Milan, Ambrosiana; *see* colour pl. 1, XVII1). A feature of all his earlier paintings is that they are idiosyncratic in their iconography. This is particularly apparent in *Philemon and Baucis* (Cologne, Wallraf-Richartz-Mus.), where he chose an unusual subject from Ovid's *Metamorphoses*, for which he had no prototype, and developed it by reference to the iconography of the Supper at Emmaus, exploring the Christian notion of the Eucharist in a Classical context. Similarly, in the *Adoration of the Magi* (*c.* 1500; London, N.G.; *see* fig.) he explored the significance of the Epiphany with references beyond the simple narrative. Here, typically, he controlled the broad iconographic reference with a masterful use of perspective and composition that gives the painting, despite its small scale, the aspect of a monumental altarpiece. The early work culminates in the series of 12 large tapestries of *The Months* (Milan, Castello Sforzesco), commissioned by Gian Giacomo Trivulzio and designed between 1501 and 1508. The scale of these works gave ample scope for the innovative treatment of subject and

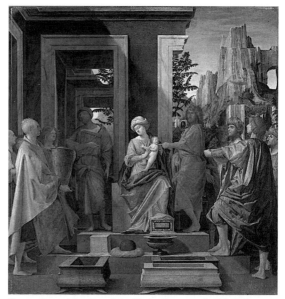

Bramantino: *Adoration of the Magi*, oil on panel, 570×550 mm, *c.* 1500 (London, National Gallery)

form. In particular, he added to traditional images of the months many references to antique works of art with which he seems to have been directly familiar. The style of the figures in the tapestries is more rounded and heavy and the composition more static; its counterpart is found in the *Virgin and Child with SS Ambrose and Michael* (Milan, Bib. Ambrosiana), which also may be dated to this period. This painting shows a greater competence in the use of oil and a softer treatment of form than in his earlier works.

Throughout much of 1508 Bramantino was in Rome, where he did work (destr.) in the papal apartments in the Vatican for Julius II. After his return to Milan, *c.* 1509, his prominence led to the receipt of a number of commissions. In 1519 he was a member of a committee advising on the construction of Milan Cathedral, and he was praised by Cesare di Lorenzo Cesariano in his edition of Vitruvius (Como, 1521). As a loyalist to the Sforza, in 1525 he was banished from Milan, though the same year he was appointed official architect and painter by Francesco Maria, the last Sforza Duke of Milan.

Bramantino's later work is principally religious, and its uniformity of style makes any precise chronology very difficult. In his largest picture, the *Crucifixion* (Milan, Brera), the subject is treated with great stillness, the paint is applied softly and the figures are constructed almost as patterns of flowing drapery. This picture is modelled on a characteristic Lombard formula, which was developed in quite a personal way by the inclusion of mysterious Classical architecture. The interest in the antique is a constant theme in his later work; in his altarpiece *Virgin and Child with Saints* (Florence, Pitti) the figures are statically arranged with an architectural background, recalling the reliefs from the period of Marcus Aurelius on the attic storey of the Arch of Constantine in Rome. Another late work, the *Flight into Egypt*, painted for the sanctuary of the Madonna del Sasso, Locarno (*in situ*), shows, less typically, his ability to depict landscape in an evocative and romantic way, indicating how at this stage he was affected by the example of Leonardo da Vinci.

Bramantino was also responsible for one architectural work, the funerary chapel of Gian Giacomo Trivulzio at S Nazaro Maggiore, Milan, designed in 1512. The chapel, which acts as a façade and vestibule to the church, combines various elements. It was developed from the pattern of such 15th-century chapels as the Portinari Chapel at S Eustorgio, Milan, and the Colleoni Chapel at Bergamo Cathedral, but the site gives it much greater prominence. The octagonal plan and extensive crypt are directly derived from antique examples, as was the projected portico, one of the first revivals of the temple front since antiquity. The plain style of the architecture, with its massive Tuscan order, is a departure from the highly ornamental style of Bramante and his contemporaries in Milan.

To an unusual degree, Bramantino's work encompasses the change in north Italian art from the graphic style of the 15th century to the more rounded, softer style of the 16th century. While he was a major figure in his lifetime, his work was relatively uninfluential. Much of his work is the product of his own rather tortuous design processes and theoretical interests. Throughout his career he dem-onstrated a considerable interest in architectural theory, the revival of the Antique and perspective, on which he wrote a treatise (parts preserved by Giovanni Paolo Lomazzo; see Suida).

BIBLIOGRAPHY

G. Fiocco: 'Il periodo romano di Bartolomeo Suardi detto il Bramantino', *L'Arte*, xvii (1914), pp. 24–40
C. Baroni: 'Leonardo, Bramantino ed il mausoleo di G. Giacomo Trivulzio', *Rac. Vinc.*, xv–xvi (1934–9), pp. 201–70
G. Hoogewerff: 'Documenti in parte inediti che riguardano Raffaello ed altri artisti contemporanei', *Rendi. Pont. Accad. Romana Archeol.*, 3rd ser., xxi (1945–6), pp. 253–68
W. Suida: *Bramante pittore e il Bramantino* (Milan, 1953)
M. Valsecchi: *Gli arazzi dei 'Mesi' del Bramantino* (Milan, 1968)
G. Mulazzani and G. A. dell'Acqua: *Bramantino e Bramante pittore: Opera completa* (Milan, 1978)
N. Forti Grazzini: *Gli arazzi dei 'Mesi' Trivulzio: Il committente, l'iconografia* (Milan, 1982)
C. Perogalli and G. B. Sannazzaro: 'Le architetture fortificate negli arazzi Trivulzio e nei dipinti del Bramantino', *Rass. Stud. & Not.*, x (1982), pp. 305–57
L. Cogliati Arano and G. Sironi: 'A proposito del Bramantino', *A. Lombarda*, 86–7 (1988), pp. 36–42

CHARLES ROBERTSON

Brambilla, Ambrogio (*fl* Rome, 1579–99). Italian printmaker and cartographer. Of Milanese origin, he is recorded first in Rome in 1579 as a member of the Congregazione dei Virtuosi al Pantheon, and he remained there at least until 1599, the date of his last work. In 1582 Brambilla produced a series of 135 small engravings of emperors from Julius Caesar to Rudolf II and in 1585 another series, of the popes to Sixtus V. His most successful works, however, were prints of scenographic reconstructions of antiquity such as the *Sepulchre of Lucius Septimius* (1582) and contemporary views of ancient and modern Rome, for example the *Belvedere del Vaticano* (1579) and the *Fireworks Display at Castel Sant'Angelo* (1579). Many of his prints depicting ancient monuments, produced after 1577, were included in the *Speculum Romanae magnificentiae* (see Hülsen). He also produced prints depicting popular games and street scenes (e.g. Rome, Calcografia N., no. 1179). In 1589 he engraved the *Last Judgement* after a relief sculpture in wax on slate by Giacomo Vivio based on Michelangelo's painting in the Sistine Chapel, Rome. Two unpublished engravings depict a *Perspective Map of Ancona* (1585) and a *View of the Catafalque for the Funeral of Cardinal Alessandro Farnese* (1589; both Milan, Castello Sforzesco). Later sources record Brambilla's activity as a poet, sculptor in bronze, painter and architect.

BIBLIOGRAPHY

DBI; Thieme–Becker
F. Ehrle: *Roma prima di Sisto V: La pianta di Roma di Pérac-Lafréry del 1577* (Rome, 1908)
C. Hülsen: 'Das *Speculum Romanae magnificentiae* des Antonio Lafréry', *Collectanea variae doctrinae Leoni S. Olschki bibliopolae Florentino sexagenario* (Munich, 1921), pp. 121–70
P. Arrigoni and A. Bertarelli: *Piante e vedute di Roma e del Lazio conservate nella raccolta delle stampe e dei disegni* (Milan, 1939)
O. A. P. Frutaz: *Le piante di Roma* (Roma, 1962)
L. Benevolo: *La città italiana nel rinascimento* (Milan, 1969), pp. 104–5
I ponti di Roma dalle collezioni del Gabinetto nazionale delle stampe (exh. cat., ed. M. Catelli Isola and E. Beltrane Quattrocchi; Rome, Villa Farnesina, 1975), pp. 33–5
F. Borroni: *Carte, piante e stampe storiche delle raccolte lafreriane della Biblioteca nazionale di Firenze* (Rome, 1980)

STEFANIA MASSARI

Brambilla, Francesco (i) (*fl* Milan, 1560; *d* 22 May 1570). Italian sculptor. He was first documented at Milan Cathedral on 3 August 1560, when he was commissioned to prepare ornamental work for the old organ and to finish it in collaboration with Martino da Vimercate (*fl* 1559–82). In 1565 Brambilla was commissioned to carve the eastern doorway of Milan Cathedral's transept; the doorway was not finished, but some reliefs from it survive in the chapel of the Madonna dell'Albero. On 7 August 1566 Brambilla was paid for the pedestal (*in situ*) for a statue of *Pope Pius IV* by Angelo Siciliano in the cathedral; it is a highly ornate work that demonstrates his love of vigorous plasticity and exuberant decorative sense. These qualities impressed even Giorgio Vasari on his visit to Milan in 1566: he described this work as being 'pierced with holes all over with a group of putti and stupendous foliage' and wrote that its creator was 'a very studious young man'. Such a description, referring to an artist who would be dead in four years, raises doubts about Vasari's judgement and poses the problem of whether the pedestal should not instead be attributed to FRANCESCO BRAMBILLA (ii), who was presumably younger, given that he died in 1599. (The same problem arises with a document of 16 May 1569 allowing Brambilla to work under the guidance of the Lombard sculptor Giovan Battista Rainoldi (*fl* mid-16th century), something that would make little sense if it referred to a mature artist.) It has been proposed (Bossaglia) that the two sculptors were one man, in which case the death of Francesco Brambilla in May 1570 refers to yet another unidentified person. In the face of such uncertainty, which may be resolved by the discovery of new documents, it may be prudent to work with the hypothesis of two sculptors with the same name.

BIBLIOGRAPHY

DBI; Thieme–Becker

G. Vasari: *Vite* (1550, rev. 2/1568); ed. G. Milanesi, vi (1881), pp. 480, 517

A. Venturi: *Storia*, x (1935), p. 702

R. Bossaglia: 'Scultura', *Il duomo di Milano*, ii (Milan, 1973)

M. T. Fiorio and A. P. Valerio: 'La scultura a Milano tra il 1535 e il 1565: Alcuni problemi', *Omaggio a Tiziano: La cultura artistica milanese nell'età di Carlo V* (Milan, 1977), pp. 130–31

MARIA TERESA FIORIO

Brambilla, Francesco (ii) (*fl* Milan, from 1570; *d* Milan, 1599). Italian sculptor. From documentary evidence chronicling his activity at Milan Cathedral from 1570 to 1599, it is possible to reconstruct his career, identify a phase (1572–86) of close collaboration with Pellegrino Tibaldi and conclude that Brambilla assumed the role of first sculptor of the cathedral. However, there is a possibility that he was the same person as FRANCESCO BRAMBILLA (i). From 1570 Francesco Brambilla (ii) participated in the programme of remodelling the interior of the cathedral instigated by Carlo Borromeo II, Archbishop of Milan. Collaborating with Tibaldi, who provided the designs, Brambilla prepared terracotta models for the wooden choir (*in situ*) of scenes from the *Life of St Ambrose* (one model, Milan, Mus. Duomo), for the statues (*in situ*) for the minor altars and for the marble enclosure (*in situ*) around the choir. In 1584 he delivered clay models for the reliquary bust of *St Tecla* (Milan Cathedral, chapterhouse sacristy). All these works are in a classicizing

style, evidently influenced by Michelangelo, characterized by the severe monumentality in which Tibaldi's influence can be discerned.

After Borromeo's death (1584) and Tibaldi's departure for Spain (1586), Brambilla continued his activity in Milan Cathedral and virtually assumed the role of overseer for the cathedral sculpture. His most engaging works belong to this phase of his career: the four energetic figures of the *Doctors of the Church* on the southern pulpit (*in situ*), the models (1589; Milan Cathedral) for which were cast in bronze by Giovanni Battista Busca in 1599. Brambilla's involvement in this work is documented by the inscription on the base of *St Augustine*: *Franciscus Brambilla formavit/ Io. Baptista Busca fundit MDIC* ('Francisco Brambilla modelled/Giovanni Battista Busca cast 1599); the attribution of the *Evangelists* on the north pulpit is based on documentation. Early sources also mention Brambilla working for the Certosa di Pavia, and for the churches of S Maria presso S Celso and S Sebastiano, Milan, but no further details are documented.

BIBLIOGRAPHY

G. Vasari: *Vite* (1550, rev. 2/1568); ed. G. Milanesi, vi (1881), pp. 480–517

R. Bossaglia: 'Scultura', *Il duomo di Milano*, ii (Milan, 1973)

M. Cinotti: 'Tesoro e arti minori', *Il duomo di Milano*, ii (Milan, 1973), pp. 265, 275–7, 280–81

R. Bossaglia and M. Cinotti: *Tesoro e Museo del duomo*, ii (Milan, 1978), pp. 11–13, 26

E. Brivio: *La scultura del duomo di Milano* (Milan, 1982), pp. 33–8

G. Anedi: 'Brambilla, Francesco jr.', *Il duomo di Milano: Dizionario storico, artistico e religioso* (Milan, 1986), pp. 106–8

MARIA TERESA FIORIO

Brancacci, Felice (di Michele) (*b* Florence, 1382; *d* Siena, 1449–55). Italian patron and diplomat. He was a member of a Florentine patrician family with interests in shipping. Between 1412 and 1433 he held various public offices and served the Florentine republic on diplomatic missions involving the supervision of military campaigns. In 1422–3 he was sent as ambassador to Cairo to secure commercial concessions for Florentine merchants. He favoured a close relationship between Florence and the papacy and in 1433 went to Rome on a diplomatic mission to offer the protection of Florence to Pope Eugene IV.

Felice's importance for the history of art rests on the presumption that he commissioned the frescoes (*c.* 1425–8) painted by MASOLINO and MASACCIO in the Brancacci Chapel in S Maria del Carmine, Florence. Although Felice was legal owner of the chapel from 1422 to 1434, no evidence links him directly to the two artists. The chapel was founded by his uncle, Pietro Brancacci (*d* 1366–7), whose son Antonio Brancacci made a bequest concerning it in his will dated 16 August 1383. The frescoes in the chapel remained unfinished when Masolino and Masaccio went to Rome, presumably at the beginning of 1428. Felice's second will of 5 September 1432 contains a provision that his heirs and executors were to undertake the completion of the decorations should they be unfinished at the time of his death. The frecoes, however, remained incomplete until they were finished by Filippino Lippi in the late 1480s. In 1434, when Cosimo de' Medici returned to Florence after a year's exile, Felice himself went into exile to Siena, compromised by suspicions of having plotted against the Medici.

BIBLIOGRAPHY

DBI

H. Brockhaus: 'Die Brancacci-Kapelle in Florenz', *Mitt. Ksthist. Inst. Florenz*, iii (1929–32), pp. 160–82

U. Procacci: 'Sulla cronologia delle opere di Masaccio e di Masolino tra il 1425 e il 1428', *Riv. A.*, xxviii (1953), pp. 16–31

P. Meller: 'La cappella Brancacci', *Acropoli*, 3 (1960–61), pp. 186–277

A. Molho: 'The Brancacci Chapel: Studies in its Iconography and History', *J. Warb. & Court. Inst.*, xl (1977), pp. 70–71, 74–81, 86–96

J. Beck: *Masaccio, the Documents* (Locust Valley, 1978), pp. 55–60

HELLMUT WOHL

Brandani, Federico (*b* Urbino, *c.* 1524–5; *d* Urbino, 20 Sept 1575). Italian stuccoist and sculptor. He enjoyed extensive patronage from the court of Guidobaldo II della Rovere, Duke of Urbino, for whom he modelled fireplaces and entire ceilings representing allegories of princely prerogative and aristocratic supremacy. This practice, unusual in Italy (where stucco was generally a decorative adjunct to fresco), may be partly explained by the fact that Guidobaldo did not retain a permanent court painter.

Between 1538 and 1541 Brandani was apprenticed in Urbino to Giovanni Maria di Casteldurante, a maiolica artist, but his earliest known work (*c.* 1551) is the luxuriant and overcrowded stucco ceiling, modelled with five relief scenes from the *Life of St Peter*, in the chapel of the Palazzo Corte Rossa, Fossombrone, near Urbino, for Cardinal Giulio della Rovere (1533–78). In 1552–3 Brandani made contributions to the stucco decoration at the Villa Giulia, Rome, modelling friezes, small roundels and grotesques in the rooms left and right of the entrance.

Brandani's first independent commission (*c.* 1559) was a ceiling at the Palazzo Ronca at Fabriano; this has boldly inventive strapwork, using elements from engravings by Enea Vico and from Book IV of Sebastiano Serlio's treatise on architecture. This ceiling is surpassed in intricacy only by the one he made (*c.* 1559) at Palazzo Tiranni, Cagli, near Urbino, which betrays an acquaintance with Lelio Orsi's decorative designs. In the Palazzetto Baviera, Senigallia (begun 1560), the reliefs of the Salone di Ercole and Salone di Troia are copied from drawings for maiolica by Battista Franco but those of the Salone della Repubblica Romana are of his own design, competently adapting elements from Polidoro da Caravaggio and Taddeo Zuccaro. Of Brandani's work at Castello di Montebello, near Urbino, four putti are particularly remarkable for their Mannerist sophistication.

Between 1567 and 1575 Brandani increasingly undertook religious commissions: in the relief of the *Beheading of St Catherine* (*c.* 1568) for the altar of S Caterina, Urbino, and again in his reliefs for S Maria Novella, Orciano (*c.* 1569), and the chapel of Guidobaldo II in the Palazzo Ducale, Urbino (*c.* 1570), he employed a forced expressiveness. From this he subsequently retreated under the influence of the *Decreta Concilii Urbini* of 1570, which required sacred imagery to excite feelings of piety in the onlooker.

Count Antonio II Brancaleone (*fl* 1556–98) of Piobbico, who had been enriched in 1570 by Turkish plunder, commissioned Brandani to rebuild the family church of S Stefanno, Finocchetto. Brandani's life-size statues of the *Apostles* and *Prophets* (1570–*c.* 1573) survived the destruction by earthquake of the building in 1781. They include *David* gazing upwards in ecstatic vision. In the slightly more than life-size relief of the *Crucifixion* (*c.* 1572–3) for the altar in the Bonamini Chapel, S Agostino, Pesaro, the emaciated Christ and the sorrowful Mary Magdalene are devised to induce a strong sense of repentance in the viewer. Brandani's *Adoration of the Shepherds* (1574) in the confraternity of S Giuseppe, Urbino, is a masterpiece of naturalism in which life-size figures in contemporary dress concentrate on the Child with individualized responses of delight.

BIBLIOGRAPHY

L. Pungileoni: 'Notizie istoriche di Federico Brandano', *G. Arcad. Roma*, xxxi (1826), pp. 361–79

L. Serra: *L'arte delle Marche: Il periodo del rinascimento* (Rome, 1934), ii, pp. 196–218

P. Hoffmann: 'Scultori e stuccatori a Villa Giulia', *Commentari*, no. 1 (1967), pp. 48–66

A. Antonelli: 'Contributi a Federico Brandani', *Not. Pal. Albani*, ii/1 (1973), pp. 43–9

L. Fontebuoni: 'Gli stucchi di Brandani', *I Brancaleoni e Piobbico* (Urbania, 1985), pp. 235–84

D. Sikorski: 'Il palazzo ducale di Urbino sotto Guidobaldo II (1538–74): Bartolomeo Genga, Filippo Terzi e Federico Brandani', *Il palazzo di Federico da Montefeltro: Restauri e ricerche*, ed. M. L. Polichetti (Urbino, 1985), pp. 67–90

——: *Brandani and his Patrons* (diss., U. London, Courtauld Inst., 1988)

——: 'Guidobaldo II e il palazzo di Pesaro', *Ric. Stor. Pesaro*, iii (1989)

DARIUS SIKORSKI

Brandini, Bartolomeo. *See* BANDINELLI, BACCIO.

Brazzacco. *See* PONCHINO, GIAMBATTISTA.

Brazzi. *See under* RUSTICI.

Bregno. Italian family of sculptors and architects. They were active in the 15th century and the early 16th. One of the most important and extensive family dynasties in Italian Renaissance sculpture, the Bregni came from the village of Righeggia, near Osteno on Lake Lugano. Active primarily in North Italy (Lombardy, Emilia, and the Veneto), a few Bregni also worked in central Italy. Several Bregno artists are documented, although the precise familial relationship between most of them is still unclear. The most important artists in the family were (1) Antonio Bregno I and his brother Paolo Bregno (*fl* Venice, *c.* 1425–*c.* 1460), (2) Andrea Bregno, (3) Giovanni Battista Bregno and (4) Lorenzo Bregno. Associated with Andrea Bregno were two of his brothers: Ambrogio Bregno (*d* before 1504) and Girolamo Bregno (*d* after 1504); a son Marcantonio Bregno; one Antonio Bregno II; and Domenico Bregno [il Brieno]. The last three assisted with various architectural projects during the 1470s and 1480s, although their roles are not specified. Other Bregni briefly mentioned in documents, and about whom little is known, include Antonio di Pietro Bregno, active for a while with Giovanni Battista Bregno in Venice in 1509, and Cristoforo di Ambrogio Bregno [Brignono], who is documented with his brother Giovanni Antonio Bregno in Ferrara in 1502.

DBI

BIBLIOGRAPHY

B. Cetti: 'Scultori comacini: I Bregno', *A. Crist.*, xx (1982), pp. 31–44

STEVEN BULE

(1) Antonio (di Giovanni) Bregno I (*fl* Venice, ?1425; *d* 1457). He is first mentioned with his brother Paolo

Bregno in 1777, the date of an engraving by Sebastiano Giammpiccoli of the tomb of *Doge Francesco Foscari* (*d* Nov 1457; see fig.) in S Maria dei Frari, Venice. The engraving carries the information that the tomb was 'designed and executed by the architect Paolo and the sculptor Antonio, the brothers Bregno of Como'. It would seem probable that this information was taken from a document then in the Foscari archive. The brothers presumably signed the document jointly. The designation of their professions as architect and sculptor respectively is likely to be an 18th-century anachronism; in the mid-15th century masons were not as specialized.

The Bregno brothers cannot positively be linked to any other commission, but they may have been active as masons at the Ca' d'Oro, Venice, in 1425, when an Antonio de Rigezzo da Como was working there with Matteo Raverti, and a Paolo was paid with him. In 1460 a mason named Paulo was a *proto* (overseer) at the Doge's Palace. It is tempting to identify him with Paolo Bregno and attribute to him the design of the second phase of the Foscari Arch in the courtyard of the Doge's Palace, which is stylistically very close to the Foscari Tomb. Markham Schulz (1978) has made the strongest case against the Foscari Tomb being the work of the Bregni and has attributed it, and a number of other sculptural works in Venice and Dalmatia, to NICCOLÒ FIORENTINO, a sculptor who is known to have worked in Trogir, Dalmatia, after 1467. The stylistic similarities between his documented works and the Foscari Tomb, however, would not appear to be sufficient to justify the attribution of the Foscari Tomb to Niccolò, nor should the 18th-century attribution be discounted.

The Foscari monument is a wall tomb surmounted by a gable with Christ blessing on the pinnacle, flanked by the figures of the Annunciation. Two pages stand on high half-columns and hold back the awning to display the recumbent figure of the Doge on his sarcophagus surrounded by personifications of virtues. The figure style of the tomb shows the influence of contemporary painting, particularly of the Paduan work of Andrea Mantegna, and

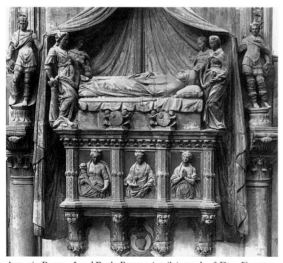

Antonio Bregno I and Paolo Bregno (attrib.): tomb of *Doge Francesco Foscari* (central part), marble, *c.* 1457 (Venice, S Maria dei Frari)

of Andrea del Castagno, who worked in Venice in the 1450s.

A group of sculptures in Venice, probably wrongly attributed to Antonio Rizzo at the start of his career, are stylistically close to the Foscari Tomb. They include the figures above the doorway of S Elena in Isola, the monument to *Orsato Giustiniani* (ex-S Andrea della Certosa, Venice; dispersed) and the figures above the doorway of S Maria dell'Orto. Of this group, the figure of *Fortitude* (*c.* 1442) on the Porta della Carta in the Doge's Palace seems to have much to recommend it as a product of the Bregno workshop (Planiscig). The *Annunciation* (London, V&A), which has also been attributed to the Bregno workshop, seems to be the work of the anonymous associate of Bartolomeo Buon, who in 1442–4 executed the portal of S Maria della Carità (now in the sacristy of S Maria della Salute, Venice).

BIBLIOGRAPHY

L. Planiscig: *Venezianische Bildhauer der Renaissance* (Vienna, 1921), pp. 30–37
G. Mariacher: 'Profilo di Antonio Rizzo', *A. Ven.*, ii (1948), pp. 67–84
——: 'New Light on Antonio Bregno', *Burl. Mag.*, xcii (1950), pp. 123–8
J. Pope-Hennessy: *Italian Renaissance Sculpture* (London, 1963, rev. Oxford, 3/1985), pp. 88, 331, 336–7
——: *Catalogue of Italian Sculpture in the Victoria and Albert Museum*, i (London, 1964), pp. 346–7
W. Wolters: *La scultura veneziana gotica, 1300–1460*, i (Milan, 1976), pp. 131–3, 292–4
A. Markham Schulz: *Niccolò di Giovanni Fiorentino and Venetian Sculpture of the Early Renaissance* (New York, 1978)
——: *Antonio Rizzo, Sculptor and Architect* (Princeton, 1983)

WOLFGANG WOLTERS

(2) Andrea (di Cristoforo) Bregno (*b* Osteno, nr Lugano, 1418; *d* Rome, Sept 1503). Nothing is known of Bregno's activity until his arrival in Rome in the 1460s, although his early works betray a Lombard training. During the pontificate of Sixtus IV he became the most popular and prolific sculptor of his day, with a large and well-organized bottega. He worked mainly on the decoration of tombs of prelates and dignitaries of the papal court. Bregno became famous in his lifetime and was mentioned, together with Verrocchio, by Giovanni Santi in *La vita e le geste di Federico di Montefeltro duca d'Urbino*, written between 1484 and 1487. The writer of a funeral epitaph actually compared him with Polykleitos (*c.* 450–415 BC). Bregno's work is characterized by great refinement and technical skill. Although he was often not particularly inventive, he was certainly a fine sculptor of grotesques and other forms of ornamentation. He soon fell under the influence of Tuscan models, probably as a result of his contact with Mino da Fiesole, with whom he worked in Rome. There his style became more classical and its design more compact, with precise references to antique sculpture: documents show that he possessed a collection of antique objects recovered from excavations. He was also a friend of Platina, who held him in high esteem, as he wrote in a letter to Lorenzo the Magnificent.

The earliest example of Bregno's Roman production is the relief of *Cardinal de Cusa* (*d* 1464) depicted with St Peter and an Angel, a fragment of a tomb (destr.) in S Pietro in Vincoli, in which one can see an affinity with the trend towards adopting medieval forms apparent in Roman sculpture of *c.* 1460. The funerary monument of

Cardinal L. d'Albret (*d* 1465) in S Maria d'Aracoeli already shows classicist sympathies. Almost contemporary are fragments of a ciborium for S Gregorio al Celio, which was mostly the work of Bregno's bottega. In 1466, with Giovanni Dalmata, he carved the tomb of *Cardinal Giacomo Tebaldi* in S Maria sopra Minerva, where the statue of *St Augustine* is undoubtedly his work. In 1473 Alessandro Borgia, later Pope Alexander VI, commissioned from Bregno a marble tabernacle, known as the Borgia Altar, located on the main altar of S Maria del Popolo until it was moved to the sacristy in the 17th century. In 1476–7, again with Dalmata, Andrea carved the tomb of *Cardinal Bartolomeo Roverella* in S Clemente, and in 1477 he also finished the tomb of *Cardinal Pietro Riario* (now Rome, SS Apostoli, Crypt). The design of this monument has also been attributed to Mino da Fiesole and Dalmata, but it appears to be the work of Bregno, since some of its architectural and decorative elements return later in such securely attributed works as the *Savelli* monument (1495–8) in S Maria d'Aracoeli. In the same years Bregno produced the tomb of *Cardinal Diego de Coca* (*d* 1477; see fig.) in S Maria sopra Minerva. In this reclining figure, which shows a fine plastic sense, Bregno revealed himself to be an exquisite decorative sculptor.

Other dated works by the artist are the monument to *Cardinal Cristoforo della Rovere and Cardinal Domenico della Rovere* (*d* 1479 and 1501 respectively) in S Maria del Popolo, on which Mino da Fiesole also worked, and the ciborium of S Martino al Cimino (1478), also in Rome. At the end of the 1470s Bregno worked with Dalmata and Mino da Fiesole on the internal transenna and the *cantoria* in the Sistine Chapel. After the departure from Rome of Dalmata and Mino da Fiesole, the supremacy in Rome of Bregno and his bottega was uncontested, while his fame as a sculptor spread all over Italy. Thus between 1481 and 1485, together with his assistants, he composed the Piccolomini Altar (signed and dated 1485) in Siena Cathedral, which was later embellished with sculptures (1501–4) by Michelangelo. Pursuing his intense interest in archaeology, in 1484 Bregno was already assisting in some excavations in Rome. In 1486 he worked on the monument to *Giovanni di Fuensalinda* (ex-S Giacomo degli Spagnoli, Rome; Rome, S Maria di Monserrato). Bregno also carved a shrine in the form of a tabernacle for the main altar of S Maria della Quercia in Viterbo. Between 1490 and 1495 he created a now dismembered altar (church of Boville Ernica; ex–Stroganoff col.; New York, Met.) for the Auditor of the Rota, Cardinal Guillermo de Pereirs, for whom he had also produced other works. His last documented works are the tabernacle of *Vannozza Cattanei* (1500–01) in S Maria del Popolo, and the tomb of *Pius II* (ex-St Peter's, Rome; Rome, S Pietro in Vincoli), which was mainly the work of the bottega. He probably also practised architecture, and some scholars attribute to him the façade of S Maria del Popolo, as well as a few elements in the Sistine Chapel.

BIBLIOGRAPHY

E. Muntz: *Les Arts à la cour des papes pendant les XVe et XVIe siècles*, i (Paris, 1878), pp. 89, 146, 200

A. Schmarsow: 'Maister Andrea', *Jb. Preuss. Kstsamml.*, iv (1883), pp. 18–31

E. Steinmann: 'Andrea Bregno Tätigkeith in Rom', *Jb. Preuss. Kstsamml.*, xx (1899), pp. 216–32

E. Lavagnino: 'Andrea Bregno e la sua bottega', *L'Arte*, xxvii (1924), pp. 247–63

H. Egger: 'Beiträge zur Andrea Bregno—Forschung', *Festschrift für J. van Schlosser* (Zurich, Leipzig and Vienna, 1927), pp. 122–36

E. Battisti: 'I comaschi a Roma', *Arte e artisti dei laghi lombardi*, i (Como, 1959), pp. 9, 20–29

G. S. Sciolla: 'Profilo di Andrea Bregno', *A. Lombarda*, 15 (1970), pp. 52–8

G. Santi: *La vita e le geste di Federico di Montefeltro duca d'Urbino* (Codice Vat. Ottob. Lat. 1305); ed. L. Michelini Tocci (Vatican City, 1985)

P. P. Bober and R. Rubinstein: *Renaissance Artists and Antique Sculpture: A Handbook of Sources* (New York, 1986)

GIOVANNA CASSESE

(3) Giovanni Battista [Giambattista] **(di Alberto** [di Roberto]**) Bregno** [Bregnon; de' Briani] (*b* 1467–77; *d* after 1518). Together with his brother (4) Lorenzo Bregno, he had a large workshop in Venice during the first years of the 16th century. Modern scholarship has elevated his status from that of a forgotten figure to that of one of the foremost Venetian sculptors of his generation. Nothing is known of his career before 1499, although many scholars consider it probable that he was trained in the workshop of Tullio Lombardo during the 1490s. His first documented commission was for the Beltiguoli Altar (1499–1503) in S Nicolò, Treviso. In 1502 Bregno received the commission to execute a low relief for the chapel of St Anthony in the basilica of il Santo, Padua. While he did not execute the work, receipt of this commission suggests

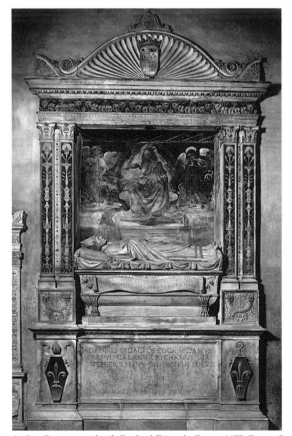

Andrea Bregno: tomb of *Cardinal Diego de Coca, c.* 1477 (Rome, S Maria sopra Minerva)

that he must already have achieved some degree of notoriety and maturity as a sculptor. A major obstacle to understanding Bregno's art is the problem of attribution —involving a small corpus of works—to Giovanni Battista or to Lorenzo, although this situation has been simplified by the efforts of scholars.

The most important commission in Bregno's brief career was the decoration of the chapel of the Holy Sacrament in Treviso Cathedral. In addition to executing the pavement and steps leading to the chapel (1504–8), Bregno was also commissioned to carve a *Risen Christ* (1506–8; see fig.), two *Adoring Angels* and a figure of *St Peter* (all completed by Dec 1509). Additional work for the chapel commissioned from Giovanni Battista was apparently completed by Lorenzo. Bregno's figures for Treviso demonstrate a lightness and delicate movement that recall the sculpture of the Lombardo family. The use of contrapposto in the *St Peter*, as well as the harmonious drapery patterns that successfully reveal underlying anatomy, indicate Bregno's interest in contemporary classiciz-

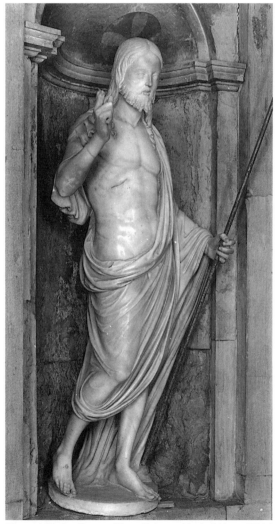

Giovanni Battista Bregno: *Risen Christ*, marble, h. 1.18 m, 1506–8 (Treviso Cathedral, chapel of the Holy Sacrament)

ing forms. The slightly slender figure of the *Risen Christ* is quite elegant and highly refined, and characteristically combines a classical contrapposto with a slight axial twist, attesting to Bregno's great technical skill as a marble carver and to his indebtedness to the Lombardo family and to Antonio Rizzo.

Two extant low reliefs by Bregno are an attributed *Visitation* (Treviso Cathedral) and a documented *St George Killing the Dragon* (Venice, monastery of S Giorgio Maggiore, dormitory façade), both of *c.* 1500. The *Visitation* is carved in a crisp style, somewhat akin to works by the Lombardi. The work is rich in surface-pattern, with subtle low-relief background details. The *St George* is quite different in approach and does not include the atmospheric qualities present in the *Visitation*. Both reliefs demonstrate a sense of movement, and the princess in the *St George* relief is remarkably expressive. Surface nuances in these works are achieved by a skilled use of the drill. Two elegant *Adoring Angels* (Venice, SS Giovanni e Paolo, and Berlin, Staatliche Museen Preussischer Kulturbesitz) are also attributed to Bregno and are indebted to earlier works by Tullio Lombardo, although Bregno was never overwhelmed by Lombardo's art to the point of losing his own artistic identity. The intricate articulation of the drapery is reminiscent of the inclination for animated surfaces and technical virtuosity commonly found in the art of Lombard sculptors. Bregno was neither highly innovative nor entirely up to date with the new styles of his contemporaries; his frequent reliance on the art of Pietro Lombardo and sculpture of the 1490s, rather than on the later—and more popular—softened, classicizing style of Tullio Lombardo, appears to have been unique for his period. As has been observed by Schulz, however, Bregno's achievement rests in being one of the last and finest technicians in marble of a 15th-century Venetian sculpture tradition.

BIBLIOGRAPHY
DBI
P. Paoletti: *L'Architettura e la scultura del rinascimento in Venezia* (Venice, 1893)
W. Steadman Sheard: *The Tomb of Doge Andrea Vendramin in Venice by Tullio Lombardo* (diss., New Haven, CT, Yale U., 1971)
A. M. Schulz: 'Giambattista Bregno', *Jb. Berlin. Mus.*, xxii (1980), pp. 173–202

STEVEN BULE

(4) Lorenzo (di Alberto) [di Roberto] **Bregno** (*b* Verona, 1475–85; *d* Venice, 4 Jan 1525). Brother of (3) Giovanni Battista Bregno. His career began in Treviso, in the workshop of Giovanni Battista. The first documentary information about him dates from 1506, when he was paid for an unidentified work for the chapel of the Holy Sacrament in Treviso Cathedral, where his brother had been working since 1504. Work began in 1507 on the urn of *SS Theonestus, Tabra and Tabrata* on the high altar of Treviso Cathedral. This sculpture had been commissioned in 1485 from Pietro Lombardo, but according to research it may be the earliest surviving work by Bregno. There is documentation, however, for Bregno's authorship of the *Four Evangelists* (1511–12) and the *St Paul* (1513) in the chapel of the Holy Sacrament. In these works, as indeed in the urn, there are clear references to the sculpture of Antonio Lombardo and Pietro Lombardo (especially *The Evangelists* in the Giustiniani Chapel in S Francesco della Vigna, Venice).

Other works of the period include the damaged altar of the *Holy Sepulchre* (not later than 1511) in the church of S Martino in Venice. In 1512 the artist produced three statues for an altar, later dismantled, in the Venetian church of S Marina; in the 19th century the *Magdalene* and the *St Catherine* were placed on the monument of *Doge Andrea Vendramin* in SS Giovanni e Paolo, while the statue of *St Marina* is at the Seminario Patriarcale. In 1515 Bregno executed sculptures for the altar of *St Sebastian* in the church of S Margherita in Treviso. These consist of a statue of the saint (now Treviso Cathedral) and a relief (now Budapest, Mus. F.A.), probably by an assistant.

During this period Bregno also produced the statues for various funerary monuments in Venice, including that of *Benedetto Pesaro* (S Maria dei Frari; the figure of *Mars* is by the Tuscan artist Baccio da Montelupo), as well as those of *Bartolomeo Bragadin* (SS Giovanni e Paolo) and

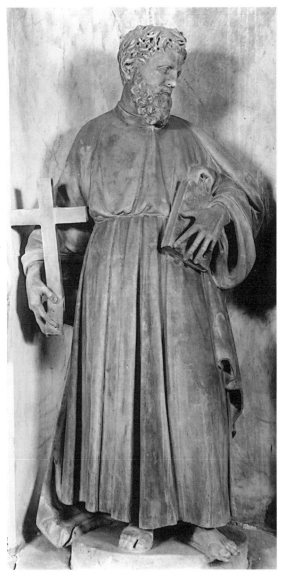

Lorenzo Bregno: *St Andrew*, 1524 (Venice, S Maria Mater Domini)

Lorenzo Gabriel, Bishop of Bergamo (Vienna, Österreich. Mus. Angewandte Kst). This last work was dismantled after the suppression of the oratory (1810), and the life-size statue of the bishop is now in Vienna. In 1514 Bregno obtained the commission for three statues (*St Leonard*, *St Eustace* and *St Christopher*) to decorate the altar of the chapel of S Leonardo in Cesena Cathedral; these were installed in February 1517. Like the preceding works, they appear stylistically related to the Lombardi. In fact there were continuing contacts between Bregno and the Lombardo workshop: in 1516 Bregno provided Tullio Lombardo with the marbles necessary for the work in the Zen Chapel of the basilica of S Marco in Venice. Two years later Bregno himself was called to S Marco to construct the altar of *The Cross* in the main apse behind the presbytery. He decorated this with small statues of *St Francis* and *St Anthony of Padua*, and with reliefs, although the bronze door is by Sansovino. The high altar at the church of S Maria dei Frari, the attribution of which is disputed by critics, dates from the same period, as does the funerary monument to *Bartolino da Terni* (signed) in the church of the Santa Trinità in Crema. The statues in the Scuola di S Rocco, recently attributed to Bregno, and one of *St John the Evangelist* (Berlin, Staatl. Museen, inv. 2928), can also be assigned to this period. In 1522 Bregno worked on the funerary monument to *Bertucci Lamberti* in Treviso Cathedral. He was active in the Venetian church of S Maria Mater Domini in 1524, producing the statues of *St Andrew* (see fig.) *St Peter* and *St Paul*, perhaps his best works, as they are least influenced by the academicism of the Lombardi. The other works in the church that are attributed to him were executed by his workshop after his death, with the help of the Paduan sculptor Antonio Minello.

DBI BIBLIOGRAPHY

C. Grigioni: 'Un'opera ignota di Lorenzo Bregno', *L'Arte*, xiii (1910), pp. 42–8
G. Mariacher: 'Problemi di scultura veneziana', *A. Ven.*, iii (1949), pp. 95–9
A. M. Schulz: 'Lorenzo Bregno', *Jb. Berlin. Mus.* (1984), pp. 143–79

FILIPPO PEDROCCO

Brescia [Lat. Brixia]. Italian city at the foot of the Alps in Lombardy. It was a notable Roman colony, an early centre of Christianity and a very prosperous city, as well as the focus of much artistic activity from the medieval period to modern times. The site was probably occupied by the Ligurians until the 4th century BC, and then by the Cenomani who were allied with Rome in 225 BC in the wars against other Celtic tribes. In 89 BC Brixia was granted Latin citizenship and in 49 BC Roman citizenship also. It soon converted to Christianity and in the 4th century AD became a bishopric. Although there are few traces of the early urban development, architectural continuity between Roman and medieval Brescia is demonstrated by the remains of the forum and the citadel on the hill of Cidnéo, north of the forum.

The city was ransacked in 452 by Attila and occupied in 562 by the Lombards, who made it the seat of a duchy. The first important new building was S Maria Maggiore (6th–7th centuries; destr.). Under the rule of Desiderius (*reg* 756–74) and his consort Ansa, Brescia enjoyed a

period of particular splendour and lively building activity. The city became a free commune at the beginning of the 12th century. It was captured by Emperor Frederick I in 1158 and became a member of the Lombard League in 1167. Later, torn apart by civil strife, it fell under the power of various rival factions: Ezzelino da Romano (1258), the Pallavicini, the Torriani, the Scaligeri (1316), the Angevins (1319), the Visconti and the Malatesta. The Visconti returned to power in 1421, but Brescia was finally ceded to Venice after the Battle of Maclodio in 1428. This was followed by a long period of peace and prosperity.

Between 1414 and 1419 Gentile da Fabriano worked on a fresco cycle (destr.) in the early 13th-century chapel of the Broletto or town hall, to a commission by Pandolfo III Malatesta (1370–1427). The artist's stay in Brescia may have played a part in the subsequent flowering of painting. Gentile's idiom was partly continued by Andrea Bembo, who worked in a Late Gothic court style characteristic of Lombardy. These and other artists were followed by Vincenzo Foppa, the first famous Brescian painter of the Renaissance and a dominant figure in the city's artistic life.

The architectural influences that followed the annexation by the Venetian Republic drastically altered Brescia's appearance. A new nucleus began to grow around the Loggia (1492–1575), a city palace constructed with the assistance of Jacopo Sansovino, Galeazzo Alessi and Andrea Palladio. The new religious buildings of the period include S Maria dei Miracoli (1487–1581), the original simple chapel that was extended to form a complex structure with refined decoration according to well-established Lombard formulae.

Another important project that continued throughout the second half of the 16th century was the reconstruction of the Castello, the major fortress on the hill of Cidnéo. The construction of the Duomo Nuovo (1604–1836) involved the most influential local architects. Giovan Battista Marchetti (1686–1758) was responsible for the design of the façade and Rodolfo Vantini (1791–1865) for the steep dome.

During the first half of the 16th century sculpture in Brescia, dominated by Maffeo Olivieri, was much less developed than painting, which reached the peak of its development; this period is well represented in the Pinacoteca Civica Tosio–Martinengo. The legacy of Foppa's luminosity and the innovative Venetian tonality represented in the city by Titian's polyptych of the *Resurrection* (1522) in SS Nazaro e Celso can be traced in works by the three principal painters, Giovanni Girolamo Savoldo, Gerolamo Romanino and Moretto, the last being the most highly regarded by the local patrons. The realism of the city's painters was taken up and continued by Giovanni Battista Moroni, and it constituted a prelude to the artistic Baroque revolution later brought about by Caravaggio (1571–1610).

BIBLIOGRAPHY
G. Treccani degli Alfieri, ed.: *Storia di Brescia*, 4 vols (Milan, 1963)
G. Panazza: *La Pinacoteca e i musei di Brescia* (Bergamo, 1968)
San Salvatore di Brescia: Materiali per un museo, i (exh. cat., ed. R. Bettinelli and I. Vettori; Brescia, S Salvatore, 1978)
L. Anelli and A. Fappani: *Santa Maria dei Miracoli* (Brescia, 1980)
M. Gregori and others, eds: *Pittura del cinquecento a Brescia* (Milan, 1986)
V. Guazzoni: 'La pittura del seicento nei territori di Bergamo e Brescia', *La pittura in Italia: Il seicento*, ed. C. Pirovano, i (Milan, 1988), pp. 104–22
V. Frati and others: *Brescia*, Le città nella storia d'Italia (Bari, 1989)
GIUSEPPE PINNA

Brescia, Giovanni Antonio da. *See* GIOVANNI ANTONIO DA BRESCIA.

Brescia, Fra Raffaello da. *See* RAFFAELLO DA BRESCIA, Fra.

Brescianino [Piccinelli, Andrea] (*b* Siena, *c.* 1487; *d* after 1525). Italian painter. He may have trained with Girolamo del Pacchia (1477–?1533), but is first documented at Siena working with Battista di Fruosino (*fl* 1457–?1507) in the Compagnia di San Gerolamo in 1507. Immediately after, in Florence, he came under the influence of Raphael, Fra Bartolommeo and Leonardo da Vinci. His *Virgin and Child with Two Saints* (*c.* 1510; Buonconvento, Mus. A. Sacra Val d'Arbia) shows this early influence from Florence both in colouring and close figure grouping. Apart from a short visit to Rome (*c.* 1516) to assist Baldassare Peruzzi with the decoration of the Villa Farnesina, most of his time was spent in Siena. Frequent contact with Florence is suggested by his style of painting after 1510 and he probably had a workshop there run by his brother Raffaello Piccinelli (*fl* 1506–45). Works of slightly later date, such as the *Three Virtues* (*c.* 1517–18; Siena, Pin. N.), demonstrate that Andrea del Sarto became a dominant influence. In the *Coronation of the Virgin* (*c.* 1520; Siena, SS Pietro e Paolo) colours and compositional ideas from del Sarto are combined with the local styles of Domenico Beccafumi and Girolamo del Pacchia. This altarpiece, with five predella panels depicting scenes from the *Life of Christ*, is one of his most substantial surviving works. He is last documented in 1525, in the confraternity of Florentine painters.

BIBLIOGRAPHY
A. Venturi: *Storia* (1901–40), ix/5, pp. 357–73
A. Salmi: *Il palazzo e la Collezione Chigi-Saracini* (Milan, 1967), pp. 107–15
N. Dacos: 'Peruzzi dalla Farnesina alla Cancelleria: Qualche proposta sulla bottega del pittore', *Baldassare Peruzzi, pittura, scena, architettura nel cinquecento* (Rome, 1987), pp. 469–90
Domenico Beccafumi e il suo tempo (exh. cat., ed. A. Bagnoli, R. Bartalini and M. Maccherini; Siena, Pin. N. and Pal. Pub. and elsewhere; 1990)

☐

Bresciano, il. *See* ANTICHI, PROSPERO.

Briani, Giovanni Battista (di Alberto) de'. *See* BREGNO, (3).

Briosco, Andrea. *See* RICCIO, ANDREA.

Briosco, Benedetto (*b* Milan, *c.* 1460; *d* ?Milan, after April 1514). Italian sculptor. The first notice of his activity dates from 1477, when he and his brother-in-law Francesco Cazzaniga were employed as sculptors on the monument to *Giovanni Borromeo and Vitaliano Borromeo* (Isola Bella, Palazzo Borromeo, chapel), which was executed for S Francesco Grande, Milan. By 1482 he had begun employment for the Fabbrica del Duomo (Cathedral Works) of Milan Cathedral and in 1483 was paid for carving a figure of *St Apollonia* (untraced). Although he was a master figure sculptor at the cathedral until the middle of 1485, the other work he did there remains unknown. During 1483–4 it is likely that he assisted

Francesco and Tommaso Cazzaniga in the execution of the tomb of *Cristoforo and Giacomo Antonio della Torre* (Milan, S Maria delle Grazie). In 1484 he and the Cazzaniga brothers began work on the tomb of *Pietro Francesco Visconti di Saliceto* destined for the Milanese church of S Maria del Carmine (destr.; reliefs in Cleveland, OH, Mus. A.; Kansas City, MO, Nelson-Atkins Mus. A.; and Washington, DC, N.G.A.; architectural elements in Paris, Louvre). This project was completed by Briosco and Tommaso Cazzaniga following Francesco Cazzaniga's death at the beginning of 1486. In the same year Benedetto and Tommaso were commissioned to finish the tomb of *Giovanni Francesco Brivio* (Milan, S Eustorgio), designed and begun by Francesco. Briosco's hand is virtually impossible to distinguish in these collaborative works.

In 1489 the Apostolic Prothonotary and ducal councillor Ambrogio Griffo engaged Briosco to execute his funerary monument, to be installed in the church of S Pietro in Gessate, Milan. This tomb, which in its original form consisted of an effigy mounted on a high rectangular sarcophagus, appears to be Briosco's first major independent work and represents a significant break with Lombard tradition; although its design may to some extent have been influenced by Giovanni Antonio Amadeo's tomb to *Medea Colleoni* (Bergamo, Colleoni Chapel; *see* AMADEO, GIOVANNI ANTONIO, fig. 1), it was free-standing and entirely secular in content. In 1490 Briosco returned to Milan Cathedral, where he was engaged to carve four life-size statues each year until he or his employers should cancel the arrangement. Although he worked at the cathedral until mid-1492, only a figure of *St Agnes* (Milan, Mus. Duomo) is documented from this period.

In July 1492 Briosco was hired by Amadeo as his assistant at the Certosa di Pavia and was probably at first chiefly occupied with decorations for the façade of the church. By 1494 or 1495 he was working there with Gian Cristoforo Romano on the monument to *Gian Galeazzo Visconti, 1st Duke of Milan* in the right transept. Briosco's signed statue of the *Virgin and Child* on the upper register of this monument is in the full Roman Classical style imported by Romano; at considerable variance with the *St Agnes*, it may well have been designed by Gian Cristoforo. Towards the end of the 1490s Amadeo and Briosco began work on the main portal of the church of the Certosa. Amadeo relinquished all responsibility for the façade in 1499, and the portal was completed by Briosco and assistants. The reliefs that encrust the portal have a liveliness and, at times, an almost foppish elegance that distinguishes them from Amadeo's more sober contribution.

In late 1495 Briosco undertook, on behalf of Giovannina Porro (*d* 1504), to complete the monument to her husband *Ambrosino Longignana* (Isola Bella, Pal. Borromeo, chapel), barely begun by Francesco Cazzaniga for the family chapel in S Pietro in Gessate, Milan; he probably executed most of it in 1496–8, although the commission had been entrusted to him some years earlier. Some elements may be related to the *Gian Galeazzo* monument, on which he was at work contemporaneously. In 1506 Briosco was engaged by officials of the church of S Tommaso, Cremona, to execute a large reliquary to house the remains of the martyr saints Peter and Marcellino.

Although work proceeded intermittently until 1513, the project was never finished; the reliefs carved by Briosco are installed in the recomposed monument in the crypt of Cremona Cathedral.

In 1508 Briosco and Antonio della Porta took over responsibility for the construction and decoration of the façade of the Certosa di Pavia. Benedetto was partially occupied with this project until at least 1513. In 1508 he began a profitable commercial association with Margarita de Foix, mother and guardian of the young marchese, Michelantonio di Saluzzo (1495–1528). At some time between 1508 and 1512 he executed the tomb (Saluzzo, S Giovanni) of *Lodovico II of Saluzzo* (1438–1504); his last major work, it is, in terms of its design, essentially a reprise of the *Griffo* monument. Much of the carving is the work of assistants, but the effigy, certainly autograph, is a figure of exceptional power and beauty. The latest notarial act in which Briosco is named is dated April 1514; he probably died shortly thereafter.

Briosco is a transitional figure. Formed in the Cazzaniga workshop and influenced by Amadeo, he nonetheless absorbed some of the lessons offered by Gian Cristoforo Romano, Cristoforo Solari and other sculptors of the younger generation. His son Francesco and his probable apprentice Agostino Busti emerged during the second decade of the 16th century as exponents of the 'modern', Romanizing style.

BIBLIOGRAPHY

R. Bossaglia: 'La scultura', *La Certosa di Pavia* (Milan, 1968), pp. 41–80
C. Mandelli: 'I primordi di Benedetto Briosco', *Crit. A.*, xix (1972), no. 124, pp. 41–57; no. 126, pp. 39–53
C. R. Morscheck: *Relief Sculpture for the Façade of the Certosa di Pavia, 1473–1499* (New York and London, 1978)
A. Roth: 'The Lombard Sculptor Benedetto Briosco: Works of the 1490s', *Burl. Mag.*, cxxii (1980), pp. 7–22
A. Viganò: 'Briosco, scultori', *Dizionario della chiesa ambrosiana*, i (Milan, 1987), pp. 507–9
M. Karpowicz: 'Benedetto Briosco we Wrocliawiu/Benedetto Briosco à Wroclaw', *Ikonotheka*, ix (1995), pp. 7–20

JANICE SHELL

Brixia. *See* BRESCIA.

Bronzino, Agnolo [Agniolo di Cosimo di Mariano Tori] (*b* Monticelli, nr Florence, 17 Nov 1503; *d* Florence, 23 Nov 1572). Italian painter and poet. He dominated Florentine painting from the 1530s to the 1560s. He was court artist to Cosimo I de' Medici, and his sophisticated Mannerist style and extraordinary technical ability were ideally suited to the needs and ideals of his ducal patron. He was a leading decorator, and his religious subjects and mythological scenes epitomize the grace of the high *maniera* style; his cool and highly disciplined portraits perfectly convey the atmosphere of the Medici court and of an intellectual élite.

1. Life and work. 2. Working methods and technique. 3. Critical reception and posthumous reputation.

1. LIFE AND WORK.

(i) Early work: Florence and Pesaro, 1522–40/45. (ii) Court artist to Duke Cosimo I de' Medici, 1539–60. (iii) Last works, after *c.* 1560.

(i) Early work: Florence and Pesaro, 1522–40/45. Bronzino was the pupil first of the conservative Raffaellino del

Garbo and then of Jacopo Pontormo, who portrayed him *c.* 1518 in the foreground of *Joseph in Egypt* (London, N.G.). Pontormo's Mannerist style was the major formative influence on Bronzino's art. He worked with Pontormo in 1523–6 in the cloister at the Certosa di Galluzzo, near Florence, where he painted lunettes (damaged) of the *Martyrdom of St Lawrence* (oil) and the *Man of Sorrows with Two Angels* (fresco). In 1526–8 he painted tondi of *St Luke* and *St Mark* for the pendentives of the vault opposite Pontormo's *Lamentation* in the Chapel Capponi in S Felicità, Florence (*see* PONTORMO, JACOPO DA, fig. 1). There are also a number of Pontormesque pictures (some collaborative; all of disputed attribution) from *c.* 1525–30: the *Virgin Enthroned with SS Jerome and Francis*, the *Legend of the Ten Thousand Martyrs* and *Pygmalion and Galatea* (all Florence, Uffizi); the *Madonna with St John* (Florence, Gal. Corsini); and the *Holy Family with St John* (after a drawing by Pontormo; St Petersburg, Hermitage). In the *Holy Family with SS Elizabeth and John* (Washington, DC, N.G.A.), the most successful of these works and long attributed to Pontormo, Bronzino attempted to accommodate his master's style, but his manner is less fluent, his vision more literal and his response to the subject-matter less sensitive.

Bronzino also painted works in a more individual style in the late 1520s: they include *St Benedict Tempted in the Wilderness* (fresco trans. to canvas; Florence, S Salvi), the *Dead Christ with the Virgin and the Magdalene* (Florence, Uffizi) and the *Noli me tangere* (destr. fresco, ex-S Girolamo delle Poverine, Florence).

In 1530 Bronzino went to Pesaro. There he worked, together with Raffaellino dal Colle, as an assistant on Girolamo Genga's fresco decoration of the Villa Imperiale, Pesaro, where Smyth (1956) has identified work by his hand. He came into contact with the classicism of the post-Raphael Roman school. Bronzino also painted for Guidobaldo II della Rovere a harpsichord cover of *Apollo and Marsyas*, which is strikingly Pontormesque in style (1531–2; St Petersburg, Hermitage); his portrait of *Guidobaldo* (1532; Florence, Pitti) is his first essay in the state portrait.

Bronzino returned in 1532 to Florence, where he painted a number of small altarpieces, which demonstrate a new individuality and independence of style. The surfaces of his panels are opaque and smooth in contrast to the transparency and luminous vibrancy of Pontormo's paintings; and his immobile forms are seen almost as elements of still-life, as opposed to the rhythmic fluidity of Pontormo's compositions. Among these pictures are *St Sebastian* (*c.* 1533; Madrid, Mus. Thyssen-Bornemisza), the *Adoration of the Shepherds* (*c.* 1539; Budapest, Mus. F.A.) and the *Virgin with SS Elizabeth and John* (*c.* 1540; London, N.G.). The major work of this group is the *Holy Family with St John* (*c.* 1540; Florence, Uffizi), painted for the Florentine aristocrat, poet and epigrammatist Bartolomeo Panciatichi (1507–72), wherein virtuoso draughtsmanship is joined with sculptural forms polished to enamel-like smoothness. These figures demonstrate Bronzino's penchant for antique sculpture, especially the Virgin, who is based on a Classical Venus. Later, but related stylistically, is the *Holy Family with SS Elizabeth and John* (*c.* 1545–50; Vienna, Ksthist. Mus.). If this work is the

second *Holy Family* mentioned by Vasari as painted for Panciatichi, as Smith (1982) suggested, it may date closer to 1540.

Bronzino also worked on decorative schemes and executed a number of works now lost, damaged or destroyed: lunettes with half-length figures of *Dante, Petrarch* and *Boccaccio* (1533–4) for a room in the house of Bartolomeo Bettini, the ruined *Pietà with Angels* (*c.* 1535–9; Mercatalle, S Casciano) in a tabernacle at the Villa of Matteo Strozzi and the allegorical fresco decorations (1535–43) at the Medici villas of Careggi and Castello, where he assisted Pontormo.

Bronzino achieved his greatest distinction in these years as a portrait painter, and by the early 1540s he had become the leading exponent in Florence. Examples of the early 1530s include the *Portrait of Lorenzo Lenzi* (Milan, Castello Sforzesco) and the *Portrait of a Man with a Lute* (Florence, Uffizi). *Andrea Doria as Neptune* (*c.* 1533; Milan, Brera; see colour pl. 1, XVII2), an unusual allegorical portrait resembling a painted sculpture, was made for Doria's friend, Paolo Giovio. More mature examples of Bronzino's *maniera* portraiture towards the mid-century are the portraits of the poet *Ugolino Martelli* (1540; Berlin, Gemäldegal.), the *Portrait of an Unknown Man* (*c.* 1540–45; New York, Met.), the *Portrait of a Woman with her Son* (*c.* 1540–46; Washington, DC, N.G.A.) and the pair of portraits of *Bartolomeo Panciatichi* (see colour pl. 1, XVII3) and his wife *Lucrezia Panciatichi* (both *c.* 1540; Florence, Uffizi). In these three-quarter-length frontal images Bronzino evolved a formula for aristocratic portraiture in which the emphasis is on the social or intellectual status of the sitter rather than on human communication. Elegance of design is combined with an objective detachment from the sitter, who, in turn, exhibits a masklike impenetrability. Elaborate, ambiguous and claustrophobic architectural settings set up a tension with the oppressive fixity of the images.

Many of Bronzino's portraits are of poets, musicians and men of letters. He was himself a poet, author of many sonnets, songs and burlesque rhymes; his first publication was *Del pennello* (1538). Bronzino was one of a small intellectual élite and a founder-member of the Accademia degli Umidi (later Fiorentina) in 1540. In 1547 (owing to new regulations) Bronzino and other artists were expelled from the academy, but he rejoined in 1566. In 1546 Benedetto Varchi, an eminent intellectual, asked a number of artists to express their views on the PARAGONE (debate) on the primacy of painting or sculpture. Bronzino's reply was published in Varchi's *Due lezioni* (1549). In 1537 he became a member of the painters' guild, the Compagnia di S Luca

(ii) Court artist to Duke Cosimo I de' Medici, 1539–60. In 1539 Bronzino contributed to the sumptuous decorations for Duke Cosimo's marriage to Eleonora of Toledo. This marked the beginning of a long period as court artist, a role that ensured his dominant position in Florentine painting until 1555, when ducal favour shifted increasingly to Giorgio Vasari.

(a) Figure paintings and designs for tapestries. Bronzino's first commission from the Duke was the decoration of a chapel for Duchess Eleonora (the Cappella di Eleonora),

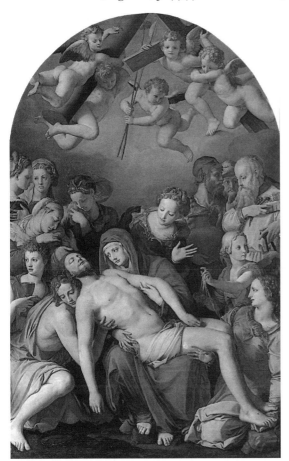

1. Agnolo Bronzino: *Lamentation*, oil on panel, 2.68×1.73 m, 1545 (Besançon, Musée des Beaux-Arts et d'Archéologie)

which is the major painted decorative ensemble of his career (1540–45; Florence, Pal. Vecchio). The vault of the chapel is frescoed with *St Michael*, *St John the Evangelist*, *St Jerome* and *St Francis*; on the walls are frescoes of stories of Moses (the *Brazen Serpent*, *Moses Striking the Rock and the Gathering of Manna* and the *Crossing of the Red Sea and Moses Appointing Joshua*). There Bronzino embraced an idealizing sculptural style suggesting the influence of the Antique and Michelangelo, which co-exists with passages of naturalism recalling his own earlier style. These frescoes—completely covering the walls of the small chapel (4 m sq.)—are one of the earliest examples of a characteristic type of *maniera* decoration in which all the wall surfaces are painted with complex, densely interwoven figural and decorative motifs, giving the impression of a jewelled ornament. The chapel's altarpiece of the *Lamentation* (1545; Besançon, Mus. B.-A. & Archéol.; see fig. 1), which was partly based on a lost drawing by Baccio Bandinelli, is one of the key religious paintings of the Florentine *maniera*. It represents Bronzino at the height of his powers. With its controlled line, gleaming marmoreal forms and lavish use of the expensive lapis lazuli paint, it is an opulent, precious object, even more jewel-like than the frescoes in which it was set. The altarpiece, justly called 'a most rare object' by Vasari, was sent by the Duke to

Cardinal Nicholas Granvelle (1484–1550) as a diplomatic gift. Bronzino's darker and more sombre replica of 1553 replaced it, and its original wings, *St John the Baptist* (Los Angeles, CA, Getty Mus.) and *St Cosmas* (untraced), were replaced in 1564 by Bronzino's *Annunciation*.

In the 1540s Bronzino made important designs for tapestries. His numerous tapestries designed for the ducal palace (1545–53) were executed by the Flemish weavers Giovanni Rost and Nicholas Karcher. The earliest series of tapestries (1545; all Florence, Pitti) included an *Abundance* (inv. no. 540), a *Primavera* (inv. no. 541) and the *Vindication of Innocence*. There followed his most important work in this medium: 16 cartoons for an ambitious series, on which he collaborated with Pontormo and Francesco Salviati, of the *Story of Joseph* (divided between Rome, Pal. Quirinale, and Florence, Pal. Vecchio), an allegory of the life and rule of Cosimo which was to hang in the Sala de' Dugento of the Palazzo Vecchio. In 1549 he designed the cartoon for the *Allegory with the Arms of the Medici and Toledo* (Florence, Pitti); and in 1555–7 cartoons followed for a tapestry series of the *Metamorphoses*, of which only *Apollo and Marsyas* survives (Parma, G.N.).

Bronzino also painted the famous allegory known as *Venus, Cupid, Folly and Time* (c. 1544–5; London, N.G.; see fig. 2) for the Duke, who gave it to François I, King of France (*reg* 1515–47), as a diplomatic gift. The work, stylistically the secular counterpart to the *Lamentation* in the Cappella di Eleonora, is Bronzino's masterpiece in the genre of mythological painting. It is an allegory of the Triumph of Venus, but the identity of some of its characters and the details of its iconography have been the subject of much debate. In these years Bronzino also worked for other Florentine patrons, mainly in the Medici

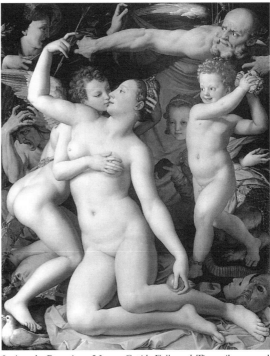

2. Agnolo Bronzino: *Venus, Cupid, Folly and Time*, oil on panel, 1.46×1.16 m, *c.* 1544–5 (London, National Gallery)

court circle. Two large altarpieces for major Florentine churches, both highly elaborate compositions of idealized nudes, continue the *'bella maniera'* of his religious works of the 1540s. The *Christ in Limbo* (1552; Florence, Mus. Opera Santa Croce) was painted for the chapel of Giovanni Zanchini in Santa Croce. It contains numerous portraits of Bronzino's friends in Florentine literary and artistic circles. The *Resurrection* (1552; Florence, SS Annunziata) was commissioned for the Cappella Guadagni. His mythological themes were developed in two further allegories of Venus: *Venus, Cupid, and Jealousy* (*c.* 1550; Budapest, Mus. F.A.), which is a simplified and less subtle variant on the *Venus, Cupid, Folly and Time* of 1544–5, and *Venus, Cupid, and a Satyr* (*c.* 1555; Venus' drapery added later; Rome, Gal. Colonna), painted for Alamanno Salviati. In 1557–8 he completed frescoes left unfinished at the death of Pontormo in 1556: *The Deluge*, the *Resurrection of the Dead* and the *Martyrdom of St Lawrence* in the choir of S Lorenzo (destr. 1738).

(b) Portraits. Bronzino was court portrait painter to Duke Cosimo, producing (with his workshop) dozens of portraits of the Duke, the Duchess Eleonora and their children Maria (*b* 1540), Francesco (*b* 1541), Isabella (*b* 1542), Giovanni (*b* 1543), Lucrezia (*b* 1545), Garzia (*b* 1547), Ferdinando (*b* 1549) and Pietro (*b* 1554). The state portraits of Cosimo are propagandist images of Medici rule, which combine an idealized type with a convincing surface realism. There are three Bronzino prototypes: a half-length portrait of *Cosimo in Armour* (1543; Florence, Uffizi; *see* FLORENCE, fig. 8), of which there is a three-quarter-length version painted for Paolo Giovio in 1544–5 (priv. col., see Simon, 1982, cat. A19a), a portrait of *Cosimo at Age Thirty-six* (1555–6; no extant original; a copy, ex-Gal. Erhardt, Berlin, is inscribed ANNI XXXVI; replica in Turin, Gal. Sabauda) and a portrait of *Grand Duke Cosimo* (1569; no extant original), painted in the year when he had been granted the title of Grand Duke of Tuscany. Bronzino also painted *Cosimo de' Medici as Orpheus* in 1539 (Philadelphia, PA, Mus. A.).

Bronzino's portraits of Duchess Eleonora are also of several types, which, like those of Cosimo, were often replicated. The earliest is a bust-length portrait (1543; Prague, N.G., Šternberk Pal.). In 1545 Bronzino painted the state portrait of *Eleonora of Toledo and her Son Giovanni* (Florence, Uffizi; see fig. 3). In this work, which is his most important Medici portrait and is technically a *tour de force*, the elaborate brocaded gown seems as much the subject of the portrait as Eleonora herself. He also painted Eleonora with Francesco (1549–50; workshop versions, Pisa, Mus. N. & Civ. S Matteo). As a pendant to the contemporaneous portrait of the Duke, Bronzino painted Eleonora in 1555–6 (no extant original; bust-length workshop version, Berlin, Gemäldegal.; three quarter-length workshop version, Washington, DC, N.G.A.).

The sequence of Bronzino's portraits of the Medici children begins with a posthumous portrait of Cosimo's illegitimate daughter Bia, who died in 1542 (Florence, Uffizi). In 1545 Bronzino painted *Giovanni with a Goldfinch* (Florence, Uffizi). There followed in 1551 portraits of Maria (Florence, Uffizi), Francesco (Florence, Uffizi), Giovanni (Oxford, Ashmolean) and Garzia (Lucca, Mus.

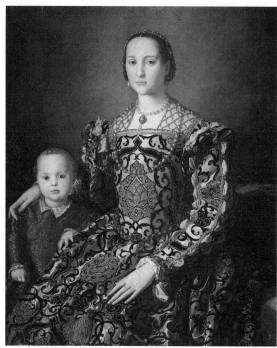

3. Agnolo Bronzino: *Eleonora of Toledo and her Son Giovanni*, oil on panel, 1.15×0.96 m, 1545 (Florence, Galleria degli Uffizi)

& Pin. N.). Giovanni was portrayed again *c.* 1552 (Bowood House, Wilts) and in 1560–62 he was represented by Bronzino as *St John the Baptist* (Rome, Gal. Borghese). Ferdinando was painted by Bronzino in 1559 (Lucca, Mus. & Pin. N.), and there is also a workshop portrait of Isabella (*c.* 1552; Stockholm, Nmus.).

According to Vasari, Bronzino also painted portraits of Cosimo's mother, Maria Salviati, and a dwarf–servant, Morgante. The unusual double-sided full-length portrait of the *Dwarf Morgante* (Florence, Uffizi; the front heavily repainted) was probably painted in response to Benedetto Varchi's *Paragone* and was completed before 1553.

During the 1540s Bronzino painted a few portraits of other sitters, which are stylistically related to his Medici portraits of this decade, although decidedly more individualistic. They include *Portrait of a Girl with a Missal* (*c.* 1545; Florence, Uffizi), the *Portrait of a Young Man with a Statuette* (*c.* 1545; Paris, Louvre), the portrait of Cosimo's general, *Stefano Colonna* (1546; Rome, Pal. Barberini) and the *Giannettino Doria* (1546–7; Rome, Gal. Doria–Pamphili). An impressive series of later portraits, dating from the 1550s, includes some of his masterpieces in the genre: the *Portrait of a Boy with a Statuette of Bacchus* (*c.* 1550; London, N.G.) and the magnificent *Ludovico Capponi* (*c.* 1550; New York, Frick; see fig. 4). In these works there is a new daring in colour, as in the bright pink of the curtain behind the boy, and Ludovico's black-and-white costume (the colours of the Capponi family arms) set against an acid green curtain. Other portraits of *c.* 1550–55 are: the *Portrait of an Unknown Woman* (Cleveland, OH, Mus. A., and Turin, Gal. Sabauda), the *Portrait of a Man with a Statuette of Venus* (Ottawa, N.G.), possibly a pendant to the Turin *Woman*, the *Portrait of a Youth with a Plumed*

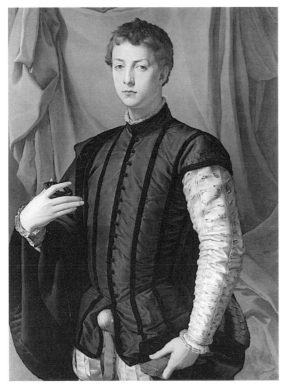

4. Agnolo Bronzino: *Ludovico Capponi*, oil on panel, 1.16×0.86 m, *c.* 1550 (New York, Frick Collection)

Cap (Kansas City, MO, Nelson–Atkins Mus. A.) and that of *Luca Martini* (Florence, Pitti). Bronzino's last major portrait, dating from *c.* 1560, is of the poet *Laura Battiferi* (Florence, Pal. Vecchio). The stylization of appearance and personality in the abstracting profile of his friend seems to carry *maniera* to an extreme.

(iii) Last works, after c. 1560. The *Noli me tangere* (1561; Paris, Louvre), which was painted for the Cappella Cavalcanti in Santo Spirito, is Bronzino's last purely *maniera* painting. In the 1560s his art was affected by the reaction against Mannerism in Italian painting. He seemed to renounce the beauty and artificiality of the *maniera* in paintings in which the rarefied abstraction of his earlier style gives way to a greater descriptiveness. In these works there is a new involvement of the spectator, which, as a response to a demand for narrative clarity, suggests the influence of the Counter-Reformation.

In the early 1560s Bronzino painted major altarpieces for Cosimo. The *Deposition from the Cross with Saints* (1561; Florence, Accad.) was commissioned for the convent of the Zoccolanti, Portoferraio (Elba), and the *Adoration of the Shepherds* (1564) was painted for the church of S Stefano dei Cavalieri, Pisa. His last commission from the Duke was the *Martyrdom of St Lawrence* (1565), an enormous Michelangelesque fresco which occupies a large section of the left nave wall of S Lorenzo, Florence. At about the same time he displayed his virtuosity in painting works of completely contrasting scales by executing a miniature-like (420×300 mm) *Pietà* on copper (Florence, Uffizi), probably for Cosimo's son, Francesco

I de' Medici. In 1565 he contributed to the wedding decorations for Francesco's marriage to Joanna of Austria, and in 1567 painted for him a small jewel-like work on copper, the *Allegory of Happiness* (Florence, Uffizi). Bronzino's final works were a *Pietà* for a pilaster in Santa Croce, Florence (*c.* 1569), and an altarpiece, the *Raising of the Daughter of Jairus* (*c.* 1571–2; Florence, S Maria Novella). This was mentioned by Borghini as Bronzino's last painting: probably completed with the assistance of his pupil Alessandro Allori, it strives for a new clarity of expression and gesture.

In 1572 Bronzino became consul of the Accademia del Disegno, in which he had been active since 1566; on his death he was buried in the church of S Cristoforo.

2. WORKING METHODS AND TECHNIQUE.

(i) Drawings. Bronzino's highly disciplined compositions and polished forms evolved through careful preparatory drawings; he was heir to the Florentine tradition of the most detailed preparation for a painting. However, he was not a prolific draughtsman, and only about 50 preparatory drawings have survived. In black (less often red) chalk, he investigated ideal form with a pure line less yielding than Pontormo's. He combined pen and wash with rich colouristic effect in finished composition drawings, such as a modello for the vault of the Cappella di Eleonora (*c.* 1540; Frankfurt am Main, Städel. Kstinst. & Städt. Gal.) in pen and wash with touches of white heightening on blue paper, and a drawing in the same medium for the borders of his tapestries (London, BM). He also made studies from life of individual figures, whose formal beauty suggests the influence of antique sculpture. However, two life studies for the Cappella di Eleonora, the *Young Man Seen from the Back* (Florence, Uffizi, 6704F), in black chalk on yellow paper, and a study for *St Michael* (Paris, Louvre, 6356), in black chalk on blue paper, reveal how even the most elaborate poses began with a study from nature. The later drawings are less softly lit and more schematic, the outlines are sharp and clear and the figures highly finished and precisely modelled.

(ii) Workshop practice. After 1548 Raffaello dal Colle assisted Bronzino with the tapestries; Lorenzo di Bastiano Zucchetti and Alessandro Allori assisted him in the border cartoons. Allori, Bronzino's ward and pupil, was his only real follower. He combined his master's idealizing, sculptural style with a personal inclination to naturalism. Santi di Tito, who may have been Bronzino's pupil, modelled his paintings after 1564 on Bronzino's, but later turned towards naturalism and luminism. Giovan Maria Butteri began as Bronzino's pupil but became a follower of Allori.

Bronzino's workshop produced many replicas and variants of his most famous Medici portraits. Among such works is a series of miniature historical portraits of the Medici, based on originals by Bronzino and other artists and inscribed with the names of the subjects (Florence, Uffizi). The set was begun in 1551, and by 1553 the portraits of Cosimo I, Lorenzo the Magnificent, Giuliano di Piero, Pope Leo X, Pope Clement VII, Lorenzo (Duke of Urbino) and Cosimo's children Maria, Francesco and Garzia (the children are after the Bronzino portraits of

1551 noted above) were finished. The remainder of the series was completed before 1568. The portrait of Duke Cosimo is by Bronzino himself, after the *Cosimo in Armour* of 1543.

3. CRITICAL RECEPTION AND POSTHUMOUS REPUTATION. During his lifetime Bronzino enjoyed a high reputation in the court circle of the Medici and among the intellectual élite of Florence. Vasari began his chapter on living artists with the life of Bronzino—'the most important and oldest'—and unconditionally praised Bronzino's works in painting and poetry. However, after Bronzino's death, it was Vasari's own more fluent variant on *maniera* that attracted the larger following; and when the general reaction against *maniera* set in after about 1580, Bronzino's reputation began to decline until, eventually, his place as the last major master of the Florentine Renaissance rested largely on his portraits. Only since World War II has Bronzino been recognized as the most sophisticated and technically accomplished Italian painter to embody the ideals of the *maniera*, the last great representative of the Florentine tradition of *disegno* and sculptural form. Only since 1979 have the later religious works begun to be rehabilitated.

Bronzino's reputation was spread through engravings: the Budapest *Adoration of the Shepherds* by Giorgio Ghisi (1553) and Giovanni Battista de Cavalieri (1565); the *Crossing of the Red Sea and Moses Appointing Joshua* by Hieronymous Cock (*c.* 1510–70); and the portrait of *Andrea Doria as Neptune* in Paolo Giovio's *Elogia virorum bellica virtute illustrium* (1577).

WRITINGS

F. Petrucci Nardelli, ed.: *Agnolo Bronzino: Rima in burla* (Rome, 1988)

BIBLIOGRAPHY

EARLY SOURCES

B. Varchi: *Due lezioni* (Florence, 1549)
G. Vasari: *Vite* (1550, rev. 2/1568); ed. G. Milanesi (1878–85), vii, pp. 593–605
R. Borghini: *Il riposo di Raffaello Borghini* (Florence, 1584); ed. M. Rosci, 2 vols (Milan, 1967)
J. W. Gaye: *Carteggio* (1839–40)
A. Furno: *La vita e le rime di Agnolo Bronzino* (Pistoia, 1902)

GENERAL WORKS

F. Goldschmidt: *Pontormo, Rosso, und Bronzino* (Leipzig, 1911)
Mostra di disegni dei fondatori dell'Accademia delle Arti del Disegno (exh. cat. by P. Barocchi and others, Florence, Uffizi, 1963) [entries on Bronzino by A. Forlani]
M. B. Hall: *Renovation and Counter-Reformation: Vasari and Duke Cosimo in Sta Maria Novella and Sta Croce, 1565–1577* (Oxford, 1979)
K. Langedijk: *The Portraits of the Medici: 15th to 18th Centuries*, 3 vols (Florence, 1981–7)
C. Adelson: 'Cosimo I de' Medici and the Foundation of Tapestry Production in Florence', *Firenze e la Toscana dei Medici nell'Europa del '500*, iii (Florence, 1983), pp. 900–24

MONOGRAPHS

H. Schulze: *Die Werke Angelo Bronzinos* (Strasbourg, 1911)
A. McComb: *Agnolo Bronzino, his Life and Works* (Cambridge, MA, 1928)
C. H. Smyth: *Bronzino Studies* (diss., Princeton U., NJ, 1955; 2 vols, Ann Arbor, 1956)
A. Emiliani: *Il Bronzino* (Busto Arsizio, 1960) [incl. an anthol. of his poetry]
——: *Bronzino*, Maestri Colore (Milan, 1966) [good colour pls]
M. Levey: *Bronzino*, The Masters, no. 82 (London, 1967) [good illus.]
C. H. Smyth: *Bronzino as Draughtsman* (Locust Valley, NY, 1971)
E. Baccheschi: *L'opera completa del Bronzino* (Milan, 1972) [good colour pls]
C. McCorquodale: *Bronzino* (New York, 1981) [bibliog. to 1980; colour pls]

SPECIALIST STUDIES

E. Panofsky: 'Father Time', *Studies in Iconology: Humanistic Themes in the Art of the Renaissance* (New York, 1944), pp. 69–94
C. H. Smyth: 'The Earliest Works of Bronzino', *A. Bull.*, xxxi (1949), pp. 184–211
D. Heikamp: 'Agnolo Bronzinos Kinderbildnisse aus dem Jahre 1551', *Mitt. Ksthist. Inst. Florenz*, vii (1955), pp. 133–8
J. Cox-Rearick: 'Some Early Drawings by Bronzino', *Master Drgs*, ii (1963), pp. 363–82
M. Levey: 'Sacred and Profane Significance in Two Paintings by Bronzino', *Studies in Renaissance and Baroque Art and Architecture Presented to Anthony Blunt on his 60th Birthday*, ed. M. Kitson and J. Shearman (London, 1967), pp. 30–33
J. Cox-Rearick: 'Les Dessins de Bronzino pour la Chapelle d'Eleonora au Palazzo Vecchio', *Rev. A.*, xiv (1971), pp. 7–22
K. W. Forster: 'Metaphors of Rule: Political Ideology and History in the Portraits of Cosimo I de' Medici', *Mitt. Ksthist. Inst. Florenz*, xv (1971), pp. 65–105
J. Beck: 'Bronzino nell'inventario mediceo del 1560', *Ant. Viva*, ii (1972), pp. 10–12
J. Cox-Rearick: 'Two Studies for Bronzino's Lost *Noli me tangere*', *Master Drgs*, xix (1981), pp. 289–93
G. Smith: 'Jealousy, Pleasure and Pain in the *Allegory of Venus and Cupid*', *Pantheon*, xxxix (1981), pp. 250–58
J. Cox-Rearick: 'Bronzino's *Young Woman with her Little Boy*', *Stud. Hist. A.*, xii (1982), pp. 67–79
R. B. Simon: *Bronzino's Portraits of Cosimo I de' Medici* (diss., New York, Columbia U., 1982; Ann Arbor, 1984)
G. Smith: 'Bronzino's *Holy Family* in Vienna: A Note on the Identity of its Patron', *Source*, ii (1982), pp. 21–5
R. W. Gaston: 'Iconography and Portraiture in Bronzino's *Christ in Limbo*', *Mitt. Ksthist. Inst. Florenz*, xxvii (1983), pp. 41–72
G. Smith: 'Bronzino's *Allegory of Happiness*', *A. Bull.*, lxvi (1984), pp. 390–99
R. B. Simon: 'Bronzino's *Cosimo I de' Medici as Orpheus*', *Bull.: Philadelphia Mus. A.*, lxxxi (1985), pp. 17–27
E. Pilliod: 'Bronzino's S Croce *Pietà*', *Burl. Mag.*, cxxxviii (1986), pp. 577–9
J. Cox-Rearick: 'Bronzino's *Crossing of the Red Sea and Moses Appointing Joshua*: Prolegomena to the Chapel of Eleonora di Toledo', *A. Bull.*, lxix (1987), pp. 44–67
——: 'A *Saint Sebastian* by Bronzino', *Burl. Mag.*, cxxix (1987), pp. 155–62
——: 'From Bandinelli to Bronzino: The Genesis of the *Lamentation* from the Cappella di Eleonora', *Mitt. Ksthist. Inst. Florenz*, xxxiii (1989), pp. 37–84
——: 'Deux dessins de Bronzino (1503–1572) découverts au Louvre', *Rev. Louvre*, 5–6 (1991), pp. 35–47
R. W. Gaston: 'Love's Sweet Poison: A New Reading of Bronzino's London *Allegory*', *I Tatti Stud.*, Essays in the Renaissance, 4 (1991), pp. 249–88
E. Pilliod: 'Le *Noli me tangere* de Bronzino et la décoration de la chapelle Cavalcanti de l'église Santo Spirito à Florence', *Rev. Louvre*, 5–6 (1991), pp. 33ff
——: 'Bronzino's Household', *Burl. Mag.*, cxxxiv (1992), pp. 92–100
J. Cox-Rearick: *Bronzino's Chapel for Eleonora di Toledo in the Palazzo Vecchio* (California, 1993); review by Y. Even in *16th C. J.*, xxvi/3 (1995), pp. 665–6
C. Plazzotta and L. Keith: 'Bronzino's *Allegory*: New Evidence of the Artist's Revisions', *Burl. Mag.*, cxli/1151 (1999), pp. 89–99

JANET COX-REARICK

Brugnoli. Italian family of architects and engineers. Alvise (Luigi) Brugnoli (*b* 1505–9; *d* Venice, 1560) specialized as a fortifications engineer and acted as executant architect for both Michele Sanmicheli and his nephew Giovanni Girolamo Sanmicheli (1513–58), whose sister Laura he married. From 1534 Alvise worked under Michele on Venetian fortifications, including those at Chiusa da Verona (1551) and Legnago (1554), and at Zara (now Zadar; 1534–50), Sebenico (now Šibenik; 1537–9) and Capodistria (now Koper; *c.* 1550) in Dalmatia. In Cyprus he assisted

Giovanni Girolamo in the construction of the governor's loggia at Famagusta (c. 1550).

Alvise's son, Bernardino Brugnoli (b 1538; d Venice, 16 March 1583), worked as a civil rather than military architect and was entrusted with the completion of many projects after the death of Michele Sanmicheli. According to Vasari, he was responsible for saving Sanmicheli's circular design for the church of the Madonna di Campagna (begun 1559) at San Michele Extra, near Verona, from being compromised by the 'miserliness' of the building commissioners. It seems, however, that he was not always so scrupulous in adhering to Sanmicheli's intentions: the window tabernacles (before 1579) of the campanile of S Giorgio in Braida, Verona, have pediments broken by the insertion of a ball on a pedestal, a feature wholly uncharacteristic of Sanmicheli's style. Brugnoli's design for the high altar there has paired Composite columns that support a pediment and the whole follows the curve of the church's apse, like the curved tabernacles in Sanmicheli's Pellegrini Chapel (begun 1527) in S Bernardino, Verona. In 1570 the Bishop of Reggio Emilia chose Bernardino's design for the completion of the cathedral façade, but it was never executed. Bernardino's career reached its zenith in 1580 when Andrea Palladio recommended him for the post of architect to the court of Guglielmo Gonzaga, 3rd Duke of Mantua.

BIBLIOGRAPHY

DBI [with full bibliog.]; Thieme–Becker

G. Vasari: *Vite* (1550, rev. 2/1568); ed. G. Milanesi (1878–85)

E. Langenskiöld: *Michele Sanmicheli: The Architect of Verona* (Uppsala, 1938)

PAUL DAVIES, DAVID HEMSOLL

Brunelleschi, Filippo (b Florence, 1377; d Florence, 16 April 1446). Italian architect and sculptor. He is traditionally regarded as the father of Renaissance architecture, who, in the words of Vasari, 'was sent by Heaven to invest architecture with new forms, after it had wandered astray for many centuries'. The 'new forms' were those of Classical antiquity, which Brunelleschi applied to such building types as churches and orphanages for which there were no ancient precedents. In these schemes he was the first since antiquity to make use of the Classical orders; at the same time he employed a proportional system of his own invention, in which all units were related to a simple module, the mathematical characteristics of which informed the entire structure. Brunelleschi worked almost exclusively in Florence, and many features link his architecture with the Romanesque—if not the Gothic—heritage of that city. Nevertheless, he was beyond question responsible for initiating the rediscovery of ancient Roman architecture. He understood its inherent principles and he employed them in an original manner for the building tasks of his own day.

I. Life and work. II. Influence and posthumous reputation.

I. Life and work.

Brunelleschi was the son of the notary Ser Brunellesco di Lippi, an official in the Florentine administration. Brunelleschi's schooling in the liberal arts was of the type that normally preceded training for one of the learned professions, but a gift for drawing led him instead to serve from 1398 as a journeyman in the silk-workers' guild (Por S Maria), which also controlled the craft of goldsmithing. Brunelleschi matriculated as a master goldsmith on 2 July 1404. Surviving work from this period includes silver figures of two *Prophets* (1398–1400) on the altar of S Jacopo, Pistoia Cathedral, and the gilded bronze panel depicting the *Sacrifice of Isaac* (1401; Florence, Bargello) that he submitted in the competition for the east doors of the Baptistery of Florence Cathedral; Brunelleschi's panel places Isaac at the centre of a scene of intense action, in which the main figures are depicted in profile. A wooden Crucifix (1.7×1.7 m, c. 1410–15) by Brunelleschi in the Gondi Chapel of S Maria Novella, Florence, was, according to an early 16th-century account, the outcome of a private competition with Donatello; a wooden Crucifix that has been attributed to the latter hangs in Santa Croce.

According to Brunelleschi's biographer, ANTONIO DI CIACCHERI MANETTI, after Lorenzo Ghiberti had won the competition (1401) for the Baptistery doors, the runners-up, Donatello and Brunelleschi, both left for Rome to study sculpture and architecture respectively. Brunelleschi, who, by family tradition, was a peripheral member of the Florentine political establishment, subsequently took up positions in local political circles, including service on the city council and on advisory committees on the great building works that characterized the emerging oligarchic state at the time and gave new form to the city (*see* FLORENCE, §I, 2). The account of Brunelleschi's visit to Rome is still disputed, but his involvement with Florentine building works and his studies of Classical and of Tuscan Romanesque architecture—exemplified not least in the classicizing details of the Baptistery—must have provided the foundations of his personal *all'antica* language of architectural details, and to his development c. 1413 of perspective construction and proportion systems. Brunelleschi's stepson, Buggiano, carved his funeral monument (1447–8; Florence Cathedral; *see* BUGGIANO and fig.).

1. Architecture. 2. Lost works, projects and attributions. 3. Urban planning.

1. ARCHITECTURE.

(i) Dome of Florence Cathedral. (ii) Ospedale degli Innocenti. (iii) Barbadori (Annunziata) Chapel, S Felicità. (iv) S Lorenzo. (v) Pazzi Chapel, Santa Croce. (vi) Palazzo di Parte Guelfa. (vii) Scolari Oratory, S Maria degli Angeli. (viii) Santo Spirito. (ix) Lantern and exedrae of Florence Cathedral.

(i) *Dome of Florence Cathedral.* Brunelleschi had been consulted on Florence Cathedral as early as 1404, when he was a member of an advisory commission on the construction of one of the buttresses of the northern tribune of the apse, but it was not until 1412 or 1413 that the octagonal opening of the drum was ready for spanning with a dome. In 1417 he was paid for drawings and by the time that a public competition was announced in 1418 for the solution of the problem of the dome, he had already become deeply involved. The wooden model (possibly that in Florence, Mus. Opera Duomo) on which the final scheme was based was submitted to the Cathedral Works as a collaborative effort of Ghiberti and Brunelleschi. Construction began in 1420 under their joint supervision,

but Brunelleschi—subsequently described as the 'inventor and governor'—soon took over and Ghiberti later withdrew or was dismissed. The great dome, which dominates the city of Florence, was completed in 1436 (*see* FLORENCE, fig. 1); its span makes it one of the greatest masonry domes ever built, and his success in its execution constituted the supreme building and engineering achievement of the 15th century.

The basic dimensions, form and curvature of the dome had been determined by 1367; Brunelleschi was constrained by specific guild legislation to accept the existing model, and there is no indication that he was in conflict with its predicated form. The major problem was that of spanning the 42-m opening of the octagonal drum, a space too wide to be bridged by traditional timber centering. Brunelleschi overcame this difficulty by distributing the stresses between eight major ribs, which spring from the angles of the octagon in continuation of the angle piers, and sixteen minor ribs in pairs between them (see fig. 1). The pitch of the inward-curving ribs was kept steep to prevent them from leaning too heavily on the light centering that was employed, while lateral support for the ribs is provided by interstitial binders or horizontal arches with stone, timber and iron tension chains, the whole so contrived as to be self-supporting as it rose, course by course. The statical formula is still a matter for scholarly debate, but a stability was achieved that made it possible to dispense with the massive and expensive falsework, the use of which had appeared unavoidable. The infill between the ribs and binders is of brick laid in a herringbone bond,

the dome being constructed with an outer and inner skin on the double-shell principle, the first instance of this usage; stairs between the skins lead up to the lantern.

Brunelleschi designed the scaffolding necessary for the construction work and also invented the hoisting equipment to haul up the building materials. Indeed the entire works, from the dome structure itself to the mechanical accessories used for erecting it, were devised by Brunelleschi himself and are the products of his own ingenuity. In this respect, and in his defence of his radical proposal to the cathedral authorities, he assumed a new status for the architect in relations with both patron and craftsmen, the latter being accorded only a subordinate role. The sources for his technological inspiration, apart from empirical observations and tests, are unclear. Whether or not he visited Rome, when he may have studied Roman construction methods, is still uncertain, but there were in any event no precedents in Rome for the dome of Florence Cathedral: for example, the solid, brick-faced concrete hemispherical dome of the Pantheon relies on mass instead of the sophisticated framework of Brunelleschi's dome.

(ii) Ospedale degli Innocenti. Brunelleschi's first opportunity to apply to a scheme of his own invention the insights he had gained from his studies of Classical and Tuscan Romanesque architecture had come in 1419. In that year his guild asked him to provide a design for an asylum for foundling children that it had undertaken to build. In response, Brunelleschi produced a drawing of a portico façade fronting the Piazza SS Annunziata. The plan of the complex (1419–24) reveals a new order and symmetry; the most revolutionary part of the building, however, is the façade (see colour pl. 1, XVI2), which was the first since antiquity to use the vocabulary of Classical Roman architecture and thus constitutes the first structure of the Renaissance. The loggia comprises an arcade of delicate Corinthian columns and wide semicircular arches supporting a deep entablature, with roundels in the spandrels of the arches. The arch faces are not triangular in section, as in a Gothic arch, but are lengths of curved architrave conforming to the profile of the lower part of a Corinthian entablature: in a word, they are classical archivolts. The square portico bays are roofed with a series of simple classical domes (sail vaults) instead of the traditional Gothic form of groined vaults; the domes are borne on the columns at the front and on corbels on the hospital wall at the rear. Corresponding to these bays at the *piano nobile* level of the façade, above the entablature, is a series of rectangular windows framed by moulded architraves and crowned by shallow pediments.

Although Brunelleschi used the stylistic components of ancient architecture at the Ospedale, he applied them to a building type unknown in antiquity and in a manner that differs from ancient usage: for example, the way that such broad arches are supported on such slender columns is as different from the colonnades of the Colosseum in Rome as from any Gothic arcade. The source in this instance was probably the Tuscan proto-Renaissance of the 11th and 12th centuries, as exemplified in S Miniato al Monte, Florence, which was then thought to be late Roman or Early Christian. The arcaded elevation of the Ospedale

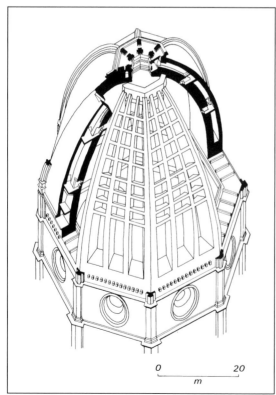

1. Filippo Brunelleschi: dome of Florence Cathedral, 1418–36; diagram showing construction

0 20
m

was subsequently imitated on two of the other sides of the Piazza SS Annunziata, namely *c.* 1518 at the Confraternità dei Servi opposite, and in 1599–1604 at the church of SS Annunziata at the north end of the square, although the impulse here was urbanistic rather than architectural.

(iii) Barbadori (Annunziata) Chapel, S Felicità. This structure (now known as the Capponi Chapel) is attributed to Brunelleschi by Manetti, who said he designed and executed it for the Barbadori family; late 20th-century research confirms that it was built between 1419 and 1423 by members of that family, and its origins go back to Bartolommeo di Gherardo Barbadori (*d* 1400 of plague). It is the first chapel on the right inside this aisleless church and is thus open in two directions with the help of a corner pier, which is faced with Corinthian pilasters. These support an entablature and flank a minor order of engaged Ionic columns carrying arches. A portico effect is thus created, recalling the loggia setting sometimes shown in depictions of the *Annunciation* (e.g. in S Maria Novella; mid-14th century); a similar scene may have been shown in the original fresco of the *Annunciation* (destr.) on the inner façade wall at S Felicità, which the Barbadori Chapel was intended to frame. The interior of the chapel is roofed by a dome (now truncated) on pendentives with roundels, while the mathematical imperatives of the new system of articulation defined by Brunelleschi are evident in the way that the pilasters in the internal corners are reduced almost to extinction. His design for the chapel served as a model for Michelozzo di Bartolomeo's tabernacle (*c.* 1448) in front of the miraculous image of the *Annunciation* at SS Annunziata, Florence.

(iv) S Lorenzo. The Old Sacristy at S Lorenzo was also begun by Brunelleschi in this immensely creative period of his life. The project was part of the reconstruction and enlargement of the church, which had been started, according to Manetti, in 1418 with a traditional design. The sacristy was commissioned in 1419 by Giovanni di Averardo de' Medici, probably influenced by his son Cosimo de' Medici; it was built quickly (1421–8), before the new church itself was constructed, and is thus usually considered as an independent structure. The Sacristy exemplifies the mathematical, modular proportioning system adopted by Brunelleschi, as well as his synthesis of Classical forms with innovations of his own devising. It is square in plan and forms a perfect cube in volume, covered by a classical hemispherical dome that is supported on ribs as a twelve-part umbrella dome.

The dome rests on deep pendentives, which lend a semicircular shape to the walls above the ornate entablature (see fig. 2); the latter divides the walls into two equal horizontal zones, the depth of the dome forming a third equal zone above. One of the sides of the cube is also divided into three; the central section opens into an altar space, square in plan and domed over pendentives, and the arch over the opening reflects the semicircular shape of the walls above. As at the Barbadori Chapel, these mathematically proportioned spaces created problems when it came to fitting in the classical articulation of pilasters, as can be seen in the reappearance of the evanescent strips of pilasters at the internal corners.

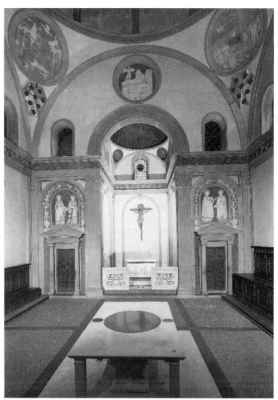

2. Filippo Brunelleschi: interior of the Old Sacristy (1419–28), S Lorenzo, Florence

Brunelleschi's Sacristy became the motive force for reconstructing the whole of S Lorenzo on Renaissance lines instead of traditional Gothic ones. At the instigation of Giovanni di Averardo de' Medici, the patron of the church, Brunelleschi established a scheme (*c.* 1421) for its overall transformation, but work soon lapsed and was not resumed until after 1434.

Brunelleschi's involvement probably ceased after completion of the Old Sacristy, and his supervision of the work was thus limited; the raw brickwork of the west front still lacks a façade, and even his responsibility for the design itself has been challenged in favour of Michelozzo (*see* FLORENCE, §IV, 5). Here it may be said that a simple system of mathematical proportioning informs the plan of S Lorenzo, the forerunner of all the systems—varying in complexity—that numberless Renaissance and Baroque buildings later exploited. The basic unit or module is the square of the crossing (see fig. 3a). This is repeated to form the transepts and choir; four such modules constitute the nave, while an aisle bay is a quarter of a module, as are the chapels grouped around the choir and transepts. In the angle between these chapels are the sacristies (the New Sacristy, 1519–33, was built by Michelangelo as a Mannerist variant of Brunelleschi's model). The nave chapels were originally intended to be square as well, but when construction resumed their dimensions were changed; at this time also the corner chapels were closed between nave aisle and transept, and the chapels at the ends of the transept were doubled. The overall effect of the proportioning

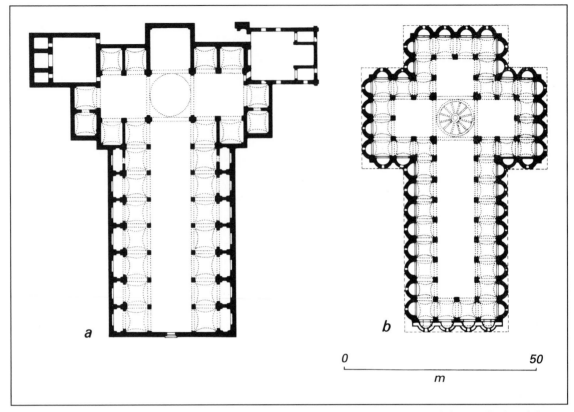

3. Filippo Brunelleschi: (a) plan of S Lorenzo, Florence (after 1434), showing the Old Sacristy (upper left) by Brunelleschi and the New Sacristy (upper right) by Michelangelo: (b) plan of Santo Spirito, Florence (begun 1436), showing proposed design of chapels at west front

system and the square module used promotes a feeling of serenity and order, even if the precise interrelationship between the parts is only registered subliminally (for illustration of interior *see* FLORENCE, fig. 12).

(v) Pazzi Chapel, Santa Croce. Brunelleschi's design for the chapter house in the cloister of Santa Croce was part of an extensive scheme of rebuilding following a dormitory fire in 1423. Patronage was assumed in 1429 by Andrea di Guglielmo Pazzi (1372–1445), whose family tombs were to be located in a crypt beneath the altar room; the building, generally known as the Pazzi Chapel, was intended to emulate the Old Sacristy at S Lorenzo. A formal commitment to the chapel was made in 1429, but Brunelleschi's design may have been elaborated by 1423–4. (It has recently been suggested by Tractenberg that the Pazzi Chapel is not by Brunelleschi but by Michelozzo di Bartolomeo, a theory that has not yet received universal acceptance.) It has many features in common with the Sacristy, including the character of the articulation, although the basic shape of the chamber is rectangular rather than square (see fig. 4a). There is, in fact, a square here, formed by the central bay of the building beneath a twelve-part umbrella dome, and it is flanked by narrow 'transeptal' bays marked off by Corinthian pilasters. The dome is supported on pendentives with roundels, like that in the Sacristy, resulting in deep curves in the upper parts of the walls and narrow, coffered barrel vaults over the

flanking bays. As at the Sacristy, the east wall is opened up in the centre to reveal a square altar room roofed by a frescoed dome and lit by a large stained-glass window in its far wall. The chapter hall itself is evenly lit by small round windows at the base of the dome, by its lantern-covered oculus and by four tall arched windows in the entrance wall; the latter are echoed in corresponding round-headed panels on the bays of the walls inside.

The front elevation of the Pazzi Chapel (see fig. 5) has a portico extending across its whole width and serving as a continuation of the surrounding cloisters. Its six Corinthian columns support a screen wall that is arched over the central bay and articulated with shallow rectangular panels and pilasters; an attic entablature runs across the top of the wall, above which the porch roof is raised on slender piers. The lateral passage of the portico is barrel-vaulted, with a shallow dome over the central bay; this central domed bay has its counterpart in the altar room on the same axis at the far side of the hall, while the flanking sections of the passage echo the flanking 'transeptal' bays inside.

Owing to the patron's reluctance to make funds available, the Pazzi Chapel was not built until 1442–c. 1465, after the death of Pazzi (who was buried in Santa Croce) and mostly after the death of Brunelleschi himself; after c. 1450 the work was probably supervised by the workshop of Bernardo Rossellino. Despite theories to the contrary, it is likely that the whole building as executed is substan-

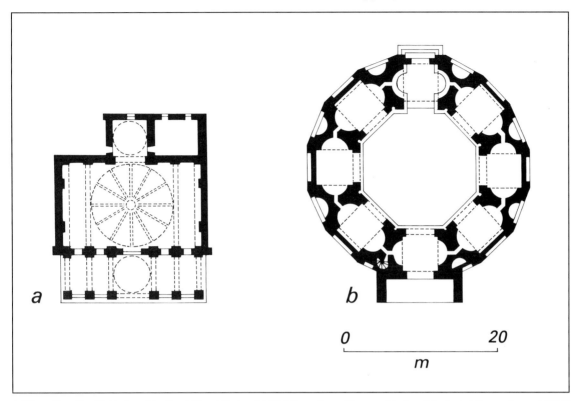

4. Filippo Brunelleschi: (a) plan of the Pazzi Chapel (designed 1420s), Santa Croce, Florence; (b) plan of the Scolari Oratory (begun 1434), S Maria degli Angeli, Florence

tially that projected by Brunelleschi, including the portico; instead of the executed central dome in the portico, however, he may have planned a sail vault, which would have obviated the raising of the existing porch roof to clear the dome. The completed work, with its subtle adjustment of details and striking contrasts, makes a powerful impression on the visitor. While its spatial organization is clearly expressed in the articulation of the walls and also in the pattern of the marble pavement, an impression of centrality is conveyed by the wider bays at the centre of each side of the room. At the same time, the architectural articulation, with classical pilasters, entablature, semicircular cornices and arches, is emphasized by the colouristic effect of these dark-grey stone elements against the plain white walls (see fig. 6). A similar contrast is provided by the coloured maiolica reliefs in the roundels of the walls (*see* ROBBIA, DELLA, (1), fig. 2); the four polychrome *Evangelists* in the pendentives may have been created by Brunelleschi. This effect was unprecedented, and it helped to promote the influence of the building on subsequent generations. This can be seen not only in such close copies as Giuliano da Sangallo's S Maria delle Carceri (from 1484; *see* SANGALLO, (1), fig. 1), Prato, or in such developments as the oblong room of Bramante's S Maria presso S Satiro (from 1478), Milan, but also in the way it demonstrated the potential of what Michelangelo later called 'the cheerful modern style'.

(vi) Palazzo di Parte Guelfa. This building, Brunelleschi's only extant palazzo, was designed as the assembly hall for the Guelph party, built above a vaulted lower storey to the east of the original palazzo constructed in the years after 1422. Such buildings, like the institutions they served, were modelled on those of the Florentine republic: the Palazzo del Podestà (now the Bargello) and the Palazzo della Signoria (now Palazzo Vecchio). Accommodation was typically centred on a large council hall flanked by administrative offices, all at first-floor level above a vaulted ground floor and accessible by narrow stairs, wholly or partly external for reasons of security. At the height of Guelph power in the 13th century, modest headquarters

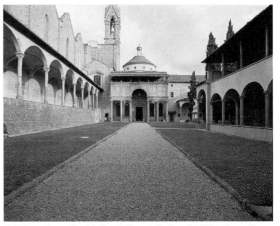

5. Filippo Brunelleschi: Pazzi Chapel (designed 1420s), Santa Croce, Florence

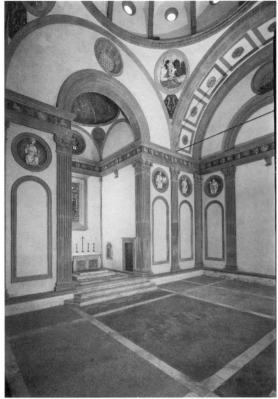

6. Filippo Brunelleschi: interior of the Pazzi Chapel (designed 1420s), Santa Croce, Florence

had sufficed the party; as it declined in influence, however, a building programme was instituted to double the size of its building in a final bid for consolidation of its power.

Brunelleschi's scheme for the assembly hall over the vaulted ground storey, to be joined to the original palazzo by a link block on the Via delle Terme, may have originally been made in the mid-1420s when the new connecting wing was being built. Work was interrupted during the wars with Milan and Lucca (1426–31) and the subsequent factional in-fighting. It was probably when work resumed in 1442 that Brunelleschi intervened with a project for a substantially larger hall in the new east wing, a project that meshed badly with the connecting wing and somewhat overwhelmed the ground-floor structure, but which assured much greater visibility (and hence prestige) for the building from the street. The rectangular hall is articulated on the long (east) wall by four tall, round-headed windows with profiled *all'antica* surrounds, each surmounted by a large circular window; two such units are also featured on the short (south) end. The external angles of the building are clasped by giant unfluted pilasters; these were left incomplete but were probably intended to have Corinthian capitals and an appropriate entablature. There is no central accent in this design, and, characteristically, the number of differentiated parts is reduced to the minimum. None of the internal décor was completed in Brunelleschi's lifetime, but the intention was to support the ceiling (probably coffered) on a classical entablature borne on pilasters between the windows. The existing interior pilas-

ters were executed before *c.* 1456 by Maso di Bartolommeo, an associate of Michelozzo. Work on the upper storey was ended in 1459 when Cosimo de' Medici decided on the permanent degradation of the old institution.

(vii) Scolari Oratory, S Maria degli Angeli. In his design for an oratory in the convent of S Maria degli Angeli, which was funded by the Scolari family and begun in 1434, Brunelleschi introduced yet another important innovation: the first centralized building of the Italian Renaissance (*see* ITALY, §II, 1). Central planning was traditionally confined to such building types as oratories or martyria, and it was for this reason that Brunelleschi chose a polygonal plan for the building. Centrality had been implicit in his designs for the Old Sacristy at S Lorenzo and the Pazzi Chapel, although not overtly expressed; the four major projects initiated during the last fifteen years of his life, however, all incorporate centralized symmetry in substance or in essence.

In 1437, three years after construction of the oratory began, the work was suspended and the building left uncompleted. A roof to protect the work was added in 1503, and in 1934 it was 'completed' according to a scheme by the architect Rodolfo Sabatini. Details of Brunelleschi's intentions, particularly with regard to the external elevations, thus derive from documentary sources (see *Filippo Brunelleschi: La sua opera e il suo tempo*, 1980, pp. 477–84). The building is planned as an octagon surrounded by a circle of eight chapels (see fig. 4b). Above the central space is a drum and dome supported on a ring of eight angular piers faced by fluted pilasters, probably Corinthian. This central space was intended to contain an altar and to be closed off from the laity by grilles; the monks would have entered from the convent through the eastern chapel, while the laity would have entered through a seven-bay portico on the western side, with access to the interconnected chapels through passageways in the piers. On the sixteen-sided exterior, blank panels alternate with niches set into the outer faces of the pier units.

The sculptural, three-dimensional form of the piers in S Maria degli Angeli gives this design a different character from Brunelleschi's Old Sacristy and Pazzi Chapel: instead of a space delineated by articulating elements, the spaces in the oratory appear to be moulded from the substance of the building. This is another characteristic of his mature work and is reflected in subsequent designs. A restrained classical vocabulary is used throughout the scheme, with a minimum number of differentiated units and identity of similar parts, but no exact equivalent is traceable to an ancient source, although the ruins of the Temple of Minerva Medica (early 4th century AD), Rome, exhibit a ring of peripheral 'chapels' around a polygonal centre. Many elements seem to be drawn from nearer sources: Florence Cathedral and Baptistery.

(viii) Santo Spirito. Brunelleschi's last great church was begun in 1436 but not finished until 1482, long after his death. It is in many ways similar to S Lorenzo, but without the constraints imposed by working on an existing building. Here he was able to resolve all the inconsistencies inherent in the project for S Lorenzo and, according to Manetti, the Santo Spirito design gave Brunelleschi the

most satisfaction. Although retaining the traditional Latin-cross layout required by the clergy, Santo Spirito displays powerful centralizing tendencies and an organic relationship between all of the parts (see fig. 3b; for illustration of the interior *see* RENAISSANCE, fig. 1).

The choir and transept arms around the umbrella-domed crossing are of identical dimensions, to which the aisle bays are proportionally related. A ring of identical colonnaded aisle bays (each roofed with a sail vault) and semicircular niched side chapels runs around the entire church—or would have done if Brunelleschi's design had been adhered to: Manetti states that they should have continued across the interior of the entrance front, where there would have been four doors, each opening into a small aisle bay, instead of the existing three. The ring of family chapels, all equal in form and nearly equivalent in prominence of position, made Santo Spirito a classic expression of the 14th-century Florentine ideal of rule by a patriciate of leading families of equivalent power and standing.

The proportions of Santo Spirito were also refined: the height of the nave arcade is the same as the clerestory above, instead of the 5:3 ratio in S Lorenzo, so that the aisle bays of Santo Spirito are half the height of the nave. In addition, the handling of the details reflects a more three-dimensional, sculptural approach, already seen at S Maria degli Angeli and here achieving a monumental, classical grandeur. Instead of flat pilasters flanking the entrances to the side chapels, as at S Lorenzo, for example, in Santo Spirito the equivalent features are half columns that act as responds to the columns in the nave. The semicircular form of the chapels themselves would have been expressed externally by an undulating wall if Brunelleschi's successors had not masked them with planar cladding. The form of the chapels also enabled Brunelleschi to resolve the awkward junction at the corners between the arms flanking the crossing: at Santo Spirito, identical chapels share a three-quarters engaged column at the corner, with the wall between the chapels reduced to a minimum. His perceived aim of achieving homogeneous lighting is satisfied by the careful disposition of windows: round-headed ones in the chapels and clerestory, roundels at the base of the dome, and an oculus at the top of the dome, covered by a lantern, which together ensured a proportional share of lighting throughout.

(ix) Lantern and exedrae of Florence Cathedral. Brunelleschi's chance to contribute his own, mature design approach to the cathedral complex came with the competition (1436) for a lantern to cap the completed dome. Brunelleschi's winning scheme reconciles the essentially Gothic form of the ribbed dome with the Renaissance form of the turret by linking them with a classicized version of flying buttresses (see fig. 7), which clearly express both a structural and an ornamental function. The eight buttresses visually continue the line of the dome ribs with a series of fluted piers, on top of which rest the outer ends of eight decorated volutes—an inversion of the Classical console. Each volute stretches over a pierced, shell-vaulted niche and leans its inner scroll against a Corinthian pilaster folded around the angle of the octagonal turret—a unique and newly invented way of handling

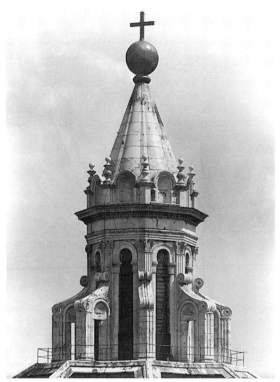

7. Filippo Brunelleschi: lantern (1436–67) of Florence Cathedral

8. Filippo Brunelleschi: semicircular exedra (designed 1439) at the base of the drum, Florence Cathedral

Classical details, never encountered in antiquity. In particular, Brunelleschi's innovative use of the Classical volute or scroll introduced one of the most popular elements of Renaissance architecture. The lantern turret is capped by a delicately moulded entablature, above which rises a stone spire made up of convex panels between pyramidally diminishing angle strips. A gilded ball and cross terminate the composition. The intended effect of this heavy, sculptural structure was to counter the centrifugal forces acting on the 6-m diameter ring at the apex of the dome, which tend to force the stone ribs apart. The lantern was executed (1446–67) under the direction of Michelozzo di Bartolomeo and Bernardo Rossellino.

Brunelleschi's final work at the cathedral, carried out towards the end of his life, was the construction of the exedrae (*tribune morte*) around the base of the drum. These were needed to take up the thrust of the dome on the four free sides of the octagonal substructure, namely the two between the choir and the transepts, and the two between the nave and the transepts. Polygonal exedrae in keeping with those of the choir and transepts had formed part of the original scheme, as embodied in the model of 1367. A revised form for these features was proposed in 1439 by Brunelleschi and accepted by the authorities, with the result that four early Renaissance terminal devices may be seen amid the late medieval complex (see fig. 8). The exedrae are semicircular drums articulated by five shell-vaulted niches, which are separated by pairs of engaged Corinthian columns—the first use of coupled columns in Renaissance architecture. They support a classical entablature beneath a conical tiled roof.

2. LOST WORKS, PROJECTS AND ATTRIBUTIONS. According to Manetti, Brunelleschi was involved with the construction of a house for his kinsman Apollonio Lapi on the Canto de' Ricci, Florence. The existing building there contains octagonal columns and masonry from the first half of the 15th century. Brunelleschi is also reported as having built a chapel for Schiatta Ridolfi in S Jacopo Oltrarno, which Manetti describes as being next to the main chapel, open on two sides (like the Barbadori Chapel) and covered with an umbrella dome. A Baroque reconstruction in 1709 destroyed any remains that may have existed. Other works discussed by Manetti include the office of the Ufficiali del Monte in the Palazzo della Signoria, still existing at the end of the 15th century, and a house in the Borgo San Jacopo, near the Ponte Vecchio, which was built for the Barbadori; remains of what was possibly the latter were destroyed in World War II.

Two perspective panels painted by Brunelleschi were also described by Manetti; they were included in the inventory of the Medici collection at the end of the 15th century but have long since disappeared. One of the panels showed a frontal view of the Baptistery, Florence, seen from the cathedral, which was intended as a graphic illustration of the proportional relationships between similar visual triangles at a scale of about 1:60. Whether the perspective was constructed according to the procedure described in Alberti's *Della pittura* is questionable. Brunelleschi, working inside the central portal of the cathedral, may have painted over the reflection of the building mirrored in the silvered back of the square panel described

by Manetti. The proper distance effect was achieved by looking through a hole in the back of the panel and viewing the painting reflected in a mirror held half an arm's length away. It was the correct illustration of the proportional principle, not the perspective illusion, that probably interested Brunelleschi. A second panel, showing the Palazzo della Signoria at an angle, cut out to be seen against real sky, had similar didactic purposes.

According to Vasari, Brunelleschi produced for Cosimo de' Medici a model for the Palazzo Medici, Florence, which was rejected as being too sumptuous (*see* PALAZZO); the palazzo as built was designed in 1444 by Michelozzo. Vasari also attributed three other buildings to Brunelleschi: the Palazzo Pitti and Palazzo Pazzi, Florence, and the Badia in Fiesole, though none of these attributions is universally accepted.

3. URBAN PLANNING. Brunelleschi and his patrons never lost sight of the importance of positioning their buildings in such a way as to assure maximum visibility at the longest possible distance. The Ospedale degli Innocenti faced on to the developing piazza in front of the Servite convent of SS Annunziata. The creation of a suitable piazza in front of S Lorenzo involved demolitions sanctioned by the Signoria in 1433. Brunelleschi's Parte Guelfa project was designed to make the largely hidden building more visible from the nearby main street, Via Por S Maria. The large square next to the oratory at S Maria degli Angeli would have allowed a view of the building from the main street of the Porta di Balla quarter, the Via de' Servi. At Santo Spirito, according to Manetti, Brunelleschi proposed to turn the façade of the church northwards and to create a great piazza extending to the present Via di Santo Spirito, or, possibly, down to the banks of the River Arno, so that travellers coming from Pisa could see the church as they passed on their way into the centre; the resistance of house owners in the quarter sufficed to quash this project, but the building was turned to face the Piazza Santo Spirito. This tendency reflects the spatial effect achieved by the design of such buildings as Santo Spirito, where the composition of repetitive, modular elements, enhanced by a sculptural richness, creates a remarkable visual perspective inside the building.

II. Influence and posthumous reputation.

Brunelleschi's reputation in his own lifetime was unmatched in Italy and has remained high ever since—although 30 years after his death it proved insufficient to ensure the adoption of his scheme for the west-front layout of Santo Spirito. His work exhibits three characteristic features that constituted a new approach to architectural composition: a tendency to reduce to a minimum the number of differentiated parts, as in the repetition of identical windows at the Palazzo di Parte Guelfa; homogeneity of lighting by allocating each part of a building a proportionately scaled window, achieved most notably at Santo Spirito; and a striving for the equivalence of parts, exemplified at the Pazzi Chapel, where a wider domed bay in the portico acts as a counterpart to the domed altar room, and the tall windows are echoed in wall panels. At the same time, many elements of Renaissance architecture

now taken for granted are also of his invention: the double-shell dome, the use of curved entablatures as arches over columns, volutes as a linking device, pendentives and coupled orders. The constant recurrence of these features, together with the revived concept of modular design that informs all subsequent architecture in the classical tradition, is testimony to Brunelleschi's influence, which was continued through the elaborations of his successors for the next four centuries.

Brunelleschi's diminishing position in Florentine politics after 1425, when he sat on its highest executive organ, the Priori, and the lack of private commissions in his work after *c*. 1430 indicates that his principal connections were probably with the older generation of Florentines in the more conservative, austere tradition of the 14th century, able to confront problems with a typical ingenuity and persistence. This reflects his architectural vision, which essentially updated the traditional Florentine building repertory with a highly restrained vocabulary—although an entirely novel one—derived from Classical antiquity. His own practical engineering bent ensured that his innovations were not stifled by an excessive devotion to the minutiae of Classical archaeology; instead they served to provide the stylistic guidelines for future generations of Renaissance and Baroque architects. If Alberti became the revolutionary architectural theorist of the early Renaissance, therefore, Brunelleschi remains the uncontested pioneer in the realm of practice, who succeeded, on the basis of his own observations, in reviving a system of architecture extinct for a thousand years and applying it to uses of which the Ancients had never dreamt.

BIBLIOGRAPHY

EARLY SOURCES

A. Manetti: *Vita di Filippo Brunelleschi* (MS. ?1480s; Florence, Bib. N. Cent., MS. II, ii, 325, fols 295*r*–312*v*); Eng. trans., ed. H. Saalman (University Park, PA, 1970)

P. Farulli: *Istoria cronologica del nobile ed antico monastero degli Angioli di Firenze del sacro ordine camaldolese, dal principio della sua fondazione fino al presente giorno* (Lucca, 1710)

G. Richa: *Notizie istoriche delle chiese fiorentine*, 10 vols (Florence, 1754–62)

GENERAL

H. Saalman: 'Early Renaissance Architectural Theory and Practice in Antonio Filarete's "Trattato di architettura"', *A. Bull.*, xli (1959), pp. 89–106

C. Elam: 'Lorenzo de' Medici and the Urban Development of Renaissance Florence', *A. Hist.*, i (1978), pp. 43–66

D. Kent: *The Rise of the Medici: Faction in Florence, 1426–1434* (Oxford, 1978)

A. Brown: 'Pierfrancesco de' Medici (1430–1476): A Radical Alternative to Elder Medicean Supremacy?', *J. Warb. & Court. Inst.*, xli (1979), pp. 81–7

D. F. Zervas: *The Parte Guelfa, Donatello and Brunelleschi* (Locust Valley, NY, 1987)

A. Bruschi: 'Religious Architecture in Renaissance Italy from Brunelleschi to Michelangelo', *Renaissance from Brunelleschi to Michelangelo: The Representation of Architecture*, ed. H. A. Millon and V. M. Lampugnani (London, 1994), pp. 122–81

H. A. Millon: 'Models in Renaissance Architecture', *Renaissance from Brunelleschi to Michelangelo: The Representation of Architecture*, ed. H. A. Millon and V. M. Lampugnani (London, 1994), pp. 19–73

MONOGRAPHS AND COLLECTIONS OF ESSAYS

H. Folnesicz: *Brunelleschi: Ein Beitrag zur Entwicklungsgeschichte der Frührenaissance-Architektur* (Vienna, 1915)

P. Ginori-Conti: *La basilica di S Lorenzo di Firenze e la famiglia Ginori* (Florence, 1940)

G. C. Argan: *Brunelleschi* (Milan, 1955/R 1978)

P. Sanpaolesi: *Brunelleschi* (Milan, 1962)

E. Luporini: *Brunelleschi: Forma e ragione* (Milan, 1964)

G. Morozzi and A. Piccini: *Il restauro dello Spedale di Santa Maria degli Innocenti, 1966–1970* (Florence, 1971)

I. Hyman: *Brunelleschi in Perspective* (Englewood Cliffs, NJ, 1974)

E. Battisti: *Filippo Brunelleschi* (Milan, 1976, rev. 1983)

G. Fanelli: *Brunelleschi* (Florence, 1977)

I. Hyman: *Fifteenth-century Florentine Studies: The Palazzo Medici and a Ledger for the Church of San Lorenzo* (New York and London, 1977)

C. Bozzoni and G. Carbonara: *Filippo Brunelleschi: Saggio di bibliografia*, 2 vols (Rome, 1977–8)

Filippo Brunelleschi: La sua opera e il suo tempo, 2 vols (Florence, 1977–80)

F. Borsi, G. Morolli and F. Quinterno: *Brunelleschiani* (Rome, 1979)

H. Klotz: *Die Frühwerke Brunelleschis und die mittelalterliche Tradition* (Berlin, 1979)

P. Roselli and O. Superchi: *L'edificazione della basilica di San Lorenzo* (Florence, 1980)

H. Saalman: *Filippo Brunelleschi: The Cupola of Santa Maria del Fiore* (London, 1980)

——: *Filippo Brunelleschi: The Buildings* (London, 1993)

SPECIALIST STUDIES

I. del Badia: 'Il vecchio palazzo della Parte Guelfa', *Bull. Assoc. Difesa Firenze Ant.*, iii (1902), pp. 63–74

C. von Fabriczy: 'Brunelleschiana: Urkunden und Forschungen zur Biographie des Meisters', *Jb. Kön.-Preuss. Kstsamml.*, xxviii (1907), pp. 1–84

L. H. Heydenreich: 'Spätwerke Brunelleschis', *J. Preuss. Kstsamml.*, lii (1931), pp. 1–28

G. Marchini: 'Un disegno di Giuliano da Sangallo riproducente l'alzato della rotonda degli Angeli', *Atti del 1. congresso di storia dell'architettura: 1936*, pp. 147–54

D. F. Nyberg: 'Brunelleschi's Use of Proportion in the Pazzi Chapel', *Marsyas*, vii (1957), pp. 1–7

H. Saalman: 'Filippo Brunelleschi: Capital Studies', *A. Bull.*, xl (1958), pp. 113–37

——: 'Further Notes on the Cappella Barbadori in S Felicità', *Burl. Mag.*, c (1958), pp. 270–74

G. Laschi, P. Roselli and P. A. Rossi: 'Indagini sulla Cappella dei Pazzi', *Commentari*, xiii (1962), pp. 24–41

H. Saalman: 'The Authorship of the Pazzi Palace', *A. Bull.*, xlvi (1964), pp. 388–94

M. Cardoso Mendes and G. Dallai: 'Nuove indagini sullo Spedale degli Innocenti a Firenze', *Commentari*, xvii (1966), pp. 83–106

L. Benevolo, S. Chieffi and G. Mezzetti: 'Indagine sul S Spirito di Brunelleschi', *Quad. Ist. Stor. Archit.*, xv (1968), pp. 1–52

P. Waddy: 'Brunelleschi's Design for S Maria degli Angeli in Florence', *Marsyas*, xv (1970–71), pp. 36–45

V. Hoffmann: 'Brunelleschis Architektursystem', *Architectura* [Munich], i (1971), pp. 54–71

A. Bruschi: 'Considerazioni sulla "maniera matura" del Brunelleschi: Con un'appendice sulla rotonda degli Angeli', *Palladio*, n. s., xxii (1972), pp. 89–126

V. Herzner: 'Zur Baugeschichte von San Lorenzo in Florenz', *Z. Kstgesch.*, xxxvii (1974), pp. 89–115

I. Hyman: 'Notes and Speculations on S Lorenzo, Palazzo Medici and an Urban Project by Brunelleschi', *J. Soc. Archit. Historians*, xxxiv (1975), pp. 98–120

G. Miarelli-Mariani: 'I disegni per la rotonda degli Angeli', *Ant. Viva*, xiv (1975), pp. 35–48

——: 'Il Tempio fiorentino degli Scolari: Ipotesi e notizie sopra una irrealizzata imagine brunelleschiana', *Palladio*, n. s., xxiii–xxv (1976), pp. 45–74

R. Mainstone: 'Brunelleschi's Dome', *Archit. Rev.* [London], clxii (1977), pp. 156–66

A. Molho: 'Three Documents Regarding Filippo Brunelleschi', *Burl. Mag.*, cxix (1977), pp. 851–2

H. Saalman: 'San Lorenzo: The 1434 Chapel Project', *Burl. Mag.*, cxx (1978), pp. 361–4

H. Burns: 'San Lorenzo in Florence before the Building of the New Sacristy: An Early Plan', *Mitt. Ksthist. Inst. Florenz*, xxiii (1979), pp. 145–53

C. Elam: 'The Site and the Early Building History of Michelangelo's New Sacristy', *Mitt. Ksthist. Inst. Florenz*, xxiii (1979), pp. 153–86

H. Saalman: 'Designing the Pazzi Chapel: The Problem of Metrical Analysis', *Architectura* [Munich], ix (1979), pp. 1–5

D. Carl: 'Die Kapelle Guidalotti-Mellini im Kreuzgang von S Croce: Ein Beitrag zur Baugeschichte', *Mitt. Ksthist. Inst. Florenz*, xxv (1981), pp. 203–30

C. R. Mack: 'Brunelleschi's Spedale degli Innocenti Rearticulated', *Architectura* [Munich], xi (1981), p. 130

J. Beck: 'Desiderio da Settignano (and Antonio del Pollaiuolo): Problems', *Mitt. Ksthist. Inst. Florenz*, xxviii (1984), pp. 203–24

H. Saalman: 'The New Sacristy of San Lorenzo before Michelangelo', *A. Bull.*, lxvii (1985), pp. 199–228

——: 'Form and Meaning at the Barbadori-Capponi Chapel in Santa Felicità', *Burl. Mag.*, cxxxi (1989), pp. 532–9

M. Kemp: *The Science of Art: Optical Themes in Western Art from Brunelleschi to Seurat* (New Haven and London, 1990)

A. Paolucci: 'Riflessi in uno specchio d'oro: La cupola di S Maria del Fiore nelle immagini del pittura', *Alla riscoperta di Piazza del Duomo in Firenze. iv. La Cupola di Santa Maria del Fiore*, ed. T. Verdon (Florence, 1995)

M. Trachtenberg: 'On Brunelleschi's Old Sacristy as Model for Early Renaissance Church Architecture', *L'église dans l'architecture de la Renaissance*, ed. J. Guillaume (Paris, 1995), pp. 9–39

——: 'Why the Pazzi Chapel is not by Brunelleschi', *Casabella*, lx (1996), pp. 58–77

——: 'Michelozzo and the Pazzi Chapel', *Casabella*, lxi (1997), pp. 56–75

——: 'Michelozzo architetto della Cappella Pazzi', *Michelozzo: Scultore e architetto (1396–1472)*, ed. G. Morolli (Florence, 1998), pp. 203–10

HAROLD MEEK

Brusasorci [Brusasorzi]. Italian family of painters. (1) Domenico Brusasorci was the son of a painter Agostino Riccio, by whom no works are known. Domenico's sons (2) Felice Brusasorci and Giovanni Battista (*b c.* 1544) and his daughter Cecilia (1549–after 1593) were also painters (dal Pozzo; Mantovanelli Stefani).

(1) Domenico Brusasorci [Domenico Riccio] (*b* Verona, *c.* 1515; *d* Verona, 30 March 1567). He probably began his training in his father's shop. Later he studied with Gian Francesco Caroto (Ridolfi, dal Pozzo). Most of Domenico Brusasorci's work was executed in Verona and the surrounding area, and in Vicenza. With Battista del Moro, Domenico belonged to the avant-garde of Veronese painters in the generation before Paolo Veronese.

Brusasorci's frescoes in the choir vault of S Stefano, Verona, painted after 1543, include a *Battle of an Angel and a Demon* that shows his appreciation of the sharply foreshortened figures in the choir vault of Verona Cathedral designed by Giulio Romano and executed by Torbido in 1534. The *Virgin and Child Enthroned with Saints* (Verona, Castelvecchio) and the fresco of *St Ursula and the Virgins* (Verona, Santa Trinità) include Parmigianinesque female figures. In 1552 Brusasorci painted an altarpiece of *St Margaret* for Mantua Cathedral; Battista dell'Angolo del Moro, Paolo Farinati and Paolo Veronese were commissioned to paint for the cathedral at the same time; artists were evidently selected for their modernity, and Brusasorci's *St Margaret*, with her precarious pose and elongated proportions, is an elegant statement of Mannerism.

Among Brusasorci's finest works are the fresco decorations of the Palazzo Fiorio della Seta (later Murari), Verona; the frieze of nymphs in *terra verde* from the façade that faced the River Adige survives (Verona, Castelvecchio). The graceful figures suggest a date in the early 1550s, close to the *St Margaret*. The fresco decoration of 1567 in the Bishop's Palace, Verona, features landscape views and portraits of the bishops of Verona. Brusasorci's abilities as a landscape painter were already demonstrated

in 1550 in the small panel paintings of landscapes with distant biblical scenes in the sacristy of S Maria in Organo, Verona.

BIBLIOGRAPHY

DBI; Thieme–Becker

G. Vasari: *Vite* (1550, rev. 2/1568); ed. G. Milanesi (1878–85), vi, pp. 366–8, 488

C. Ridolfi: *Meraviglie* (1648); ed. D. von Hadeln (1914–24), i, p. 298; ii, pp. 108–12

B. dal Pozzo: *Le vite de' pittori, scultori e architetti veronesi* (Verona, 1718), pp. 60–66, 75–6

G. da Re: 'Notizie sui Brusasorzi', *Madonna Verona*, iv (1910), pp. 1–14

R. Montini: 'Per un elenco delle opere di Domenico Brusasorzi', *Boll. Soc. Lett. Verona*, x (1934), pp. 43–8, 83–92

E. Arslan: 'Appunti su Domenico Brusasorzi e la sua cerchia', *Emporium*, cvi (1947), pp. 177–91

L. Crosato: *Gli affreschi nelle ville venete del cinquecento* (Treviso, 1962), pp. 42–3

B. Berenson: *Central and North Italian Schools*, i (London, 1968), pp. 67–9

G. Schweikhart: *Fassadenmalerei in Verona* (Munich, 1973), pp. 236–41

M. Mantovanelli Stefani: 'Una famiglia di artisti, i Brusasorzi: Chiaramenti e aggiunte', *Vita Veron.*, xxxi (1978), pp. 68–88

H. Sueur and others: *Disegni veronesi al Louvre 1500–1630* (exh. cat., Paris; Milan, 1993–4), pp. 82–93

D. Gisolfi: 'The School of Verona in American Collections', *Artibus & Hist.*, xxxiv (1996), pp. 177–91

(2) Felice Brusasorci (*b* Verona, 1539–40; *d* Verona, Feb 1605). Son of (1) Domenico Brusasorci. He was trained by his father in Verona. Felice may have visited Florence early in his career and was documented there in 1597, but most of his extant work is in Verona. His first known altarpiece, the *Virgin and Child Enthroned with Eight Female Saints* (dated 1566; Verona, Santa Trinità), has a polished finish that suggests he was influenced by Florentine Mannerists, whose elongated figures and artificial poses had been adopted earlier by Domenico. The altarpiece of the *Virgin in Glory with Three Archangels* (Verona, S Giorgio Maggiore) was probably executed before 1580; its tonality is lighter and the brushwork freer; the figures are elegantly elongated and fair. This painterly, soft version of Mannerism is evident in the contemporary *Annunciation* and *Four Saints* on the organ shutters of the church of the Madonna di Campagna at San Michele Extra, in the province of Verona, and also in the large *Finding of Moses* (1584; Verona, Castelvecchio). The *Flagellation of Christ* (*c.* 1596; San Michele Extra, Madonna di Campagna) has the same physical types and gestures but is transformed by a delicate luminism (Arslan).

The late works, dating from 1598–1600 onwards, approach a Baroque style and display a more intense religious feeling. In the Giusti Altarpiece of the *Virgin in Glory with Saints* (1598; Verona, S Anastasia) Felice used agitated gestures, although the figures' proportions are more normal, but in the *Christ and the Virgin Appearing to Franciscan Saints* (1600; Bolzano, Chiesa dei Cappuccini) this agitation is replaced by a more effective calm. Felice was locally celebrated for his refinement, delicacy of form and cool tones. He was the teacher of several Veronese Baroque painters, including Sante Creara (*c.* 1572–*c.* 1610–20), Alessandro Turchi (1578–1649), Pasquale Ottino (1578–1630) and Marcantonio Bassetti (1586–1630).

BIBLIOGRAPHY

DBI; Thieme–Becker

G. Vasari: *Vite* (1550, rev. 2/1568); ed. G. Milanesi (1878–85), v, p. 379

C. Ridolfi: *Meraviglie* (1648); ed. D. von Hadeln (1914–24), ii, pp. 123–6

B. dal Pozzo: *Le vite de' pittori, scultori e architetti veronesi* (Verona, 1718), pp. 72–5

G. da Re: 'Notizie sui Brusasorzi', *Madonna Verona*, iv (1910), pp. 1–14

E. Arslan: *Il concetto del luminismo e la pittura veneta barocca* (Milan, 1946), pp. 14–15

F. Zava: 'Profilo di Felice Brusasorzi', *A. Ven.*, xxi (1967), pp. 125–43

Cinquant'anni di pittura veronese, 1580–1630 (exh. cat. by L. Magagnato and others, Verona, Gran Guardia, 1974), pp. 51–78

P. Marini and others: *Disegni veronesi al Louvre 1500–1630* (exh. cat., Paris; Milan, 1993–4), pp. 145–51

L. Rognini: 'Nella cerchia dell'ultimo dei Brusasorzi: Giulio Cesare Cavalleri, L. Beriafino e Leonardo Melchiori, pittori', *Stud. stor.*, xlv (1995), pp. 173–94

DIANA GISOLFI

Brusis, Niccolò de. *See* NICCOLÒ PISANO.

Bugatto, Zanetto (*b* Milan, ?1433; *d* Pavia or Milan, 1476). Italian painter. He is one of the best-documented court portrait painters of the 15th century and worked for the Dukes of Milan for 15 years, producing numerous family likenesses on panel and in fresco. Bugatto's name appears in the account-books of Milan Cathedral in 1458 for minor work produced for a procession. His first commission for the court, a portrait of *Ippolita Sforza* (untraced), Francesco and Bianca Maria Sforza's eldest daughter, was undertaken in 1460. That year his patrons sent him to Brussels to study under Rogier van der Weyden (1399–1464). Bugatto remained in northern Europe for three years, but his relations with Rogier were not always ideal; the Milanese ambassador reported that Bugatto had left his master's studio and that the Dauphin, later Louis XI of France (*reg* 1461–83), had intervened to reconcile the two artists. Nonetheless, Rogier's influence must have been profound, and Bianca Maria wrote him a warm letter of thanks on Bugatto's return to Milan in 1463.

On the basis of this sojourn, Sterling has associated two pictures with Bugatto: a *Portrait of a Young Man* (Châteauroux, Mus. B.-A.) and the *Virgin with Symbols of the Passion* (Paris, priv. col., see Sterling, fig. 174), both of which combine Rogier-like characteristics with north Italian mannerisms. A small panel of *St Jerome* (Bergamo, Gal. Accad. Carrara) has also been connected, less convincingly, with this stay in northern Europe; it reproduces in colour the grisaille exterior of the Sforza Triptych (mid-1440s; Brussels, Mus. A. Anc.), a work commissioned by Alessandro Sforza and once considered to be by Rogier, but now usually attributed to Hans Memling (1430/40–94). None of these attributions has received wide support. In 1996 Syson argued, on the basis of a surviving coin designed by Bugatto, that the search for specifically Flemish influence was misleading. He convincingly identified a fragment of an altarpiece showing *Bona of Savoy and a Female Saint* (Milan, Cast. Sforzeco) with an altarpiece commissioned from Bugatto for the cathedral of Milan. This attribution has now attracted considerable support.

Bugatto's name appears frequently in Sforza correspondence after his return to Milan. The documents provide an excellent account of the services a court portrait painter was expected to undertake. He was sent to France in 1468 to portray Bona of Savoy, Galeazzo Maria Sforza's intended bride. Bugatto also profited from the trip by taking with him a double portrait of *Francesco and Galeazzo Maria Sforza* (untraced), which he sold to Louis XI. While in Milan, he designed coins and medals as well as easel portraits. In July 1471 Galeazzo Maria called him to Gonzaga, near Mantua, where he met Andrea Mantegna. The two artists returned together to Mantua, and Bugatto probably had a chance to study Mantegna's masterly portraits in the frescoes in the Camera degli Sposi in the Palazzo Ducale.

It is unclear whether Bugatto produced anything else apart from portraits. He often worked in association with other artists on larger commissions, but he may have specialized in the production of donor figures. In 1472 he collaborated with Bonifacio Bembo and Leonardo Ponzoni (*fl* 1472–7) on S Maria delle Grazie (destr.) outside Vigevano, where figures of the ducal family were frescoed along with religious scenes. In 1474 Bugatto joined with Bembo and Vincenzo Foppa to compete for a contract to paint a new chapel in the Castello Sforza in Pavia. Shortly before his death, he began working with these two painters on a large fresco cycle depicting scenes from the *Life of Christ* in the church of S Giacomo fuori Pavia.

When Bugatto died, Galeazzo Maria Sforza tried to obtain the services of Antonello da Messina as his new court portrait painter. There is no indication that Antonello moved to Milan or served Galeazzo Maria for the short period before the Duke was assassinated in December 1476. But his interest suggests that Bugatto's works may have had the same appeal as the Flemish-style portraits Antonello produced. With this in mind, scholars have attributed two other paintings with Flemish qualities to Bugatto: the *Virgin and Child* (Gazzada, Mus. Villa Cagnola) and the badly damaged portrait of *Galeazzo Maria Sforza* (see fig.). Each of these works is problematic.

Zanetto Bugatto (attrib.): *Galeazzo Maria Sforza*, 430×390 mm (Milan, Museo Civico di Milano)

BIBLIOGRAPHY

DBI

F. Malaguzzi Valeri: *I pittori lombardi del quattrocento* (Milan, 1902), pp. 125–36

P. Durrieu: 'Achat par le roi de France, Louis XI, d'un tableau du peintre milanais Zanetto Bugatto', *Chron. A. & Curiosité* (1904), pp. 231–2

F. Malaguzzi Valeri: 'Zanetto Bugatto', *Ant. Viva*, 11 (1911), pp. 193–5

——: 'Ancora di Zanetto Bugatto e de suoi soci', *Ant. Viva*, 12 (1912), p. 48

F. Bologna: 'Un *San Girolamo* lombardo del quattrocento', *Paragone*, xlix (1954), p. 49

F. Zeri: 'Un'aggiunta al problema della Madonna Cagnola', *Paragone*, xciii (1957), pp. 11–16

P. Wechser: 'Zanetto Bugatto e Rogier van der Weyden', *A. Q.* [Detroit], xxv (1962), pp. 209–13

C. Siracusano: 'Zanetto Bugatto?', *Antonello da Messina* (Rome, 1981), pp. 198–200

C. Sterling: 'A la recherche des oeuvres de Zanetto Bugatto: Une Nouvelle Piste', *Scritti di storia dell'arte in onore di Federico Zeri* (Florence, 1984), i, pp. 163–78

F Cavalieri: 'Osservazioni ed ipotesi per le ricerche sull'arte di Zanetto da Milano, pittore degli Sforza', *A. Lombarda*, xc–xci (1989), pp. 67–80

——: 'Osservazioni ad S. Ipotesi per le ricerche sull'arte di Zanetto da Milano, pittore degli Sforza', *A. Lombarda*, xc–xci (1989), pp. 67–80

——: 'Zanetto Bugatto and the Ducal Altarpiece in Milan Cathedral', *Burl. Mag.*, cxxxviii (Nov 1996), p. 754

L. Syson: 'Zanetto Bugatto, Court Portraitist in Sforza Milan', *Burl. Mag.*, cxxxviii (May 1996), pp. 300–08

F. Cavalieri: 'Zanetto Bugatto', *Museo d'Arte Antica del Castello Sforzesco* (Milan, 1997), pp. 13–28

C. E. Gilbert: 'The Two Italian Pupils of Rogier van der Weyden: Angelo Macagnino and Zanetto Bugatto', *A. Lombarda*, cxxii (1998), pp. 5–18

E. S. WELCH

Buggiano [Andrea di Lazzaro Cavalcanti] (*b* Borgo a Buggiano, Pistoia, 1412; *d* Florence, 21 Feb 1461/2). Italian decorator and sculptor. He was the son of Lazzaro Cavalcanti but was adopted at the age of seven by Filippo Brunelleschi and lived with him near S Michele Berteldi, where from an early age Brunelleschi put him to work at the cathedral in nearby Florence. As an apprentice he carved the marble cornices for the windows of the tribunes (1429). Two years later he worked on the sacristy chapel of Cosimo de' Medici (the Old Sacristy) in S Lorenzo, Florence, where he executed the marble altar, which is decorated with three panels, separated with marble semicolonettes, one of which includes figures of the *Virgin and Child*. In the same chapel he executed the tomb of Cosimo's father, *Giovanni di Averardo*, which takes the form of an antique sarcophagus decorated with garlands and groups of putti carrying scrolls. In 1433 Buggiano fled to Naples with his payment for this work, which had been withheld by Brunelleschi, and met up with some Florentine sculptors from the circle of Donatello. Through the intervention of Pope Eugene IV and Giovanna II, Queen of Naples, Brunelleschi resolved the matter within a year.

By 1438 Buggiano was back in Florence working on a marble lavabo in the Sagrestia delle Messe in the cathedral, a commission that had been given to Brunelleschi in 1432. This work, conceived as a Classical aedicula surrounding two putti in low relief sitting on a cushion and surmounted with a triangular pediment, was completed in 1440. In 1442 Buggiano began work on a similar marble lavabo for the Sagrestia dei Canonici of the cathedral. This version is more lively, both in its subject-matter and decoration, while the handling shows the influence of Donatello. In the same period, Buggiano carved other works in marble for the cathedral, including a tabernacle of *Corpus Christi*

(1443), eventually placed in the lateral tribune on the north side; the fluted columns and cornice of the altar of the SS Sacramento (1446), based on a design by Michelozzo di Bartolommeo and located in the same tribune; and the funerary monument to *Filippo Brunelleschi* (see fig.), consisting of a tondo containing his bust (1447–8). The features of the bust repeat those of the plaster death mask (Florence, Mus. Opera Duomo), which may have been made by Buggiano.

In 1443 Buggiano had begun to carve a circular marble pulpit for the church of S Maria Novella, Florence, based on a model by Brunelleschi and financed by the monk Andrea Rucellai. The pulpit, with its richly carved mouldings, betrays an element of ingenuity and repetition in the four panels depicting scenes of the Life of the Virgin; the work was completed in 1452, after much delay, and was assembled and evaluated by Antonio Rossellino and Desiderio da Settignano. Buggiano was also paid modest sums for unspecified work in S Lorenzo between 1445 and 1447. On Brunelleschi's death Buggiano inherited his entire estate, but offers of work diminished. His final documented work is an evaluation carried out for Luca della Robbia on the execution of the tomb of *Bishop Benozzo Federighi* (now in Florence, Santa Trìnita), following a dispute between della Robbia and his patron; Buggiano gave his full supoort to Luca's claims (1459).

Gaye suggested that Buggiano had also been an architect, but to date there is no documentary proof for this. In particular, the Oratory of the Madonna Piè di Piazza, Pescia (Pistoia), founded in 1447, and the Cardini Chapel in the church of S Francesco at Pescia, which is similar in appearance to the painted architecture of Masaccio's *Trinity* fresco (see colour pl. 2, III1) in the church of S Maria Novella, Florence, are attributed to him. Both buildings are judged to be immature and provincial creations, but are distinguished by virtue of being the first in the Renaissance style outside Florence. In addition, Schlegel (1957) attributed to Buggiano a contribution to Bru-

Buggiano: funerary monument to *Filippo Brunelleschi*, marble, 1447–8, Florence Cathedral

nelleschi's Barbadori Chapel in the church of S Felicità, because of certain inadequacies in the handling of the proportions and decorations, as well as work in the Carnesecchi Chapel in S Maria Maggiore and on the marble tabernacle in the church of S Ambrogio (*c.* 1433), all in Florence. Schlegel (1962) also attributed to him four stucco reliefs of the *Virgin and Child*, while Schöttmuller attributed to him two terracotta statues (all Berlin, Skulpgal.).

DBI
BIBLIOGRAPHY

G. Gaye: *Carteggio inedito d'artisti dei secoli XIV, XV, XVI*, i (Florence, 1839), p. 144
K. von Stegmann and H. F. von Geymüller: *Die Architektur der Renaissance in Toscana* (Munich, 1885–1907), i, pp. 3, 53, 61, 62; ii, p. 1
C. von Fabriczy: *Filippo Brunelleschi: Sein Leben und seine Werke* (Stuttgart, 1892)
G. Poggi: 'Il duomo di Firenze', *It. Forsch. Kstgesch.*, ii (1909), pp. 10, 12, 14, 18, 220
G. Calamari: *Andrea di Lazzaro Cavalcanti e la sua opera in Pescia* (Pescia, 1923)
F. Schöttmuller: *Die italienischen und spanischen Bildwerke der Renaissance und des Barock, i: Die Bildwerke in Stein, Holz, Ton u. Wachs*, Staatliche Museen zu Berlin, Bildwerke des Kaiser Friedrich-Museums (Berlin and Leipzig, 1933)
U. Schlegel: 'La Cappella Barbadori e l'architettura fiorentina del primo Rinascimento', *Riv. A.*, xxxii (1957), pp. 77–106
——: 'Vier Madonnen Reliefs des Andrea di Lazzaro gennant Buggiano', *Berlin. Mus: Ber. Staatl. Mus. Preuss. Kulthes.*, xii (1962), pp. 4–9
F. Borsi, G. Morolli and F. Quinterio: *Brunelleschiani* (Rome, 1979), pp. 25–33, 247–59
Atti del convegno su Andrea Cavalcanti detto 'Il Buggiano': Buggiano Castello, 1979

FRANCESCO QUINTERIO

Bugiardini, Giuliano (di Piero di Simone) (*b* Florence, 29 Jan 1475; *d* Florence, 17 Feb 1554). Italian painter and draughtsman. He trained in Florence in the workshop of Domenico Ghirlandaio. The influence of Ghirlandaio is apparent in his earliest known works, datable between *c.* 1495 and 1500, which include part of the altarpiece of the *Nativity* (Florence, Santa Croce) painted for the Castellani family. Apart from Ghirlandaio, his two most important early influences were Fra Bartolommeo and Mariotto Albertinelli. In 1503 Bugiardini joined the Compagnia di S Luca and began an association with Albertinelli that continued until 1509, when Albertinelli moved to the workshop of Fra Bartolommeo.

Bugiardini's paintings of the *Virgin and Child* (e.g. *c.* 1510; Kansas City, MO, Nelson–Atkins Mus. A.) show the influence of the balanced classical compositions executed by Raphael in Florence between 1504 and 1508 (e.g. the *Madonna of the Meadow*, 1505, Vienna, Ksthist. Mus., *see* RAPHAEL, fig. 3; *La Belle Jardinière*, 1507, Paris, Louvre). From Ghirlandaio's workshop and his study of antique sculpture in the Medici garden, Bugiardini would have known Michelangelo early in his career. Vasari mentioned Bugiardini as among the artists who went to Rome in 1508 to assist Michelangelo with the painting of the ceiling of the Sistine Chapel (Vatican) and who were almost immediately sent back to Florence. The influence of Franciabigio is clear in such works as the *Birth of John the Baptist* (1512; Stockholm U., Kstsaml.; autograph copy, Modena, Gal. & Mus. Estense) in which nature is not idealized, as compared to contemporary works in Rome. The signed and dated *Madonna della palma* (*Virgin and Child with the Infant John the Baptist*, 1520; Florence,

Uffizi) suggests his familiarity with such contemporary Roman paintings by Raphael and his workshop as the *Madonna of Divine Love* (Naples, Capodimonte) or the *Madonna of the Rose* (*c.* 1518; Madrid, Prado). The development of Bugiardini's mature style continued in the 1520s with such ambitious compositions as the *Virgin and Child with the Infant John the Baptist* (*c.* 1522; Leipzig, Mus. Bild. Kst).

Bugiardini was probably in Bologna *c.* 1523–5, where he began to return to the ideals of equilibrium and formal perfection that inspired him in his youth. The *Mystic Marriage of St Catherine* (*c.* 1525; Bologna, Pin. N.) is similar to many of Fra Bartolommeo's *Sacre conversazioni* (e.g. Paris, Louvre, *see* BARTOLOMMEO, FRA, fig. 3; Florence, Accad.) and also to Andrea del Sarto's *Mystic Marriage of St Catherine* (1512–13; Dresden, Gemäldegal. Alte Meister). The influence of Raphael and Fra Bartolommeo was revived in the *Martyrdom of St Catherine* (1530–40; Florence, S Maria Novella), which Bugiardini worked on intermittently for a decade, according to Vasari from drawings supplied by Michelangelo. The use of lucid and dense colours seems also to stem from Michelangelo and possibly from Agnolo Bronzino. In his most impressive surviving late work, the *Virgin and St Mary Magdalene with St John the Baptist* (*c.* 1540; New York, Met.), Bugiardini employed the style of Fra Bartolommeo with a new fluency and breadth of form derived from Michelangelo.

Many drawings once attributed to Bugiardini are now given to others. Several, however, can be linked to specific paintings, such as the delicate drawing of a woman's head (Paris, Louvre, 10965), probably a study for the *Virgin and Child* (*c.* 1523–5; Allentown PA, A. Mus.), also known as the Allentown *Madonna*.

BIBLIOGRAPHY

DBI; Thieme–Becker

G. Vasari: *Vite* (1550, rev. 2/1568); ed. G. Milanesi (1878–85), ii, pp. 214, 643; v, p. 25; vi, pp. 201–9, 211, 612–13; vii, pp. 175, 258
A. Venturi: 'Un disegno di Michelangelo e una tavola del Bugiardini', *L'Arte*, ii (1899), pp. 259–61
L. Dami: *Vita di Giuliano Bugiardini* (Florence, 1915)
O. Sirén: 'Alcuni quadri sconosciuti di Giuliano Bugiardini', *Dédalo*, iii (1926), pp. 773–83
E. Zahle: 'Bugiardini Caritas', *Kstmus. Årsskr.*, xix (1932), pp. 48–52
D. Redig de Campos: 'Das Porträt Michelangelos mit dem Turban von Giuliano Bugiardini', *Festschrift für Hubert von Einem zum 16. Februar 1965* (Berlin, 1965)
F. Zeri and E. E. Gardner: *The Metropolitan Museum of Art: Italian Painting: Florentine School* (London, 1971)
S. J. Freedberg: *Painting in Italy, 1500–1600*, Pelican Hist. A. (Harmondsworth, 2/1983), pp. 101, 238
L. Pagnotta: *Giuliano Bugiardini* (Milan, 1987)

□

Buglioni. Italian family of sculptors. Active in Florence and elsewhere in Italy from the late 15th century to the 16th, they were particularly noted for works in glazed terracotta. (1) Benedetto Buglioni worked with his brother Francesco Buglioni (1462–1520) and with another relative, (2) Santi Buglioni.

BIBLIOGRAPHY

A. Marquand: *Benedetto and Santi Buglioni* (Princeton, 1921/*R* New York, 1972)
G. Gentilini: *I Della Robbia: La scultura invetriata nel rinascimento* (Florence, 1992), pp. 390–449

(1) Benedetto Buglioni (*b* Florence, 1459/60; *d* Florence, 7 March 1521). The son of the sculptor Giovanni di

Bernardo (1429/30–*c.* 1510) and possibly a pupil of Andrea Verrocchio, he probably worked with Andrea della Robbia, whose glazing techniques he learnt. In the early 1480s he opened his own shop, producing works in the style of della Robbia, often with compositions after Verrocchio, Antonia Rossellino or Benedetto da Maiano. His first documented work dates from 1484: a relief of the *Descent into Limbo* (untraced) for SS Annunziata in Florence. From 1487 to 1490 he and his brother Francesco went to Perugia, where he executed for the cathedral the stone altar of the Holy Ring, of which only the busts of *Isaiah* and *David* are extant, and many works in glazed terracotta for the monastery of S Pietro dei Cassinesi, including a pulpit and a basin with *Christ and the Samaritans* (both *in situ*).

Among Buglioni's works from the 1490s are: the glazed altarpiece of the *Resurrection* (1490; Pistoia, Mus. Civ.) for Pistoia Cathedral; a frieze (*c.* 1493; London, V&A) for the main chapel of S Chiara in Florence; an altarpiece of the *Crucifixion* (1490–95; Radicofani, S Pietro); and the lunette with *St Mary of Egypt* (Florence, Mus. Opera Duomo). Also in this period he and his brother executed many projects for the sanctuary of S Cristina in Bolsena, rebuilt by order of Cardinal Giovanni de' Medici, notably the stone façade (1493–5), the effigy on the saint's tomb and an impressive tabernacle, the 'altar of St Christina'. The important decoration (1500) of the oratory of S Maria delle Grazie near Stia (Arezzo) was among many commissions from the Florentine prelate Leonardo Buonafede (*c.* 1450–1544). Buglioni was one of those appointed to decide the location of Michelangelo's *David* (Florence, Accad.) in 1504, probably the year he produced the glazed decoration (destr.) of the del Bianco Chapel in the Badia Fiorentina. From *c.* 1500 his workshop produced terracottas with naturalistic colourings, such as the *Virgin with SS Jerome and Nicholas of Bari* (1502; Amsterdam, Rijksmus.) and the *Virgin with SS John the Baptist and Anthony Abbot* (S Casciano, nr Florence, S Giovanni in Sugana). Probably *c.* 1510 he executed the *Coronation of the Virgin* over the portal of Ognissanti and the *St Lucy Adored by Angels* over the portal of S Lucia dei Magnoli (both Florence). His last documented work is the *Virgin with Child and Four Saints*, commissioned by Buonafede for S Michele at Badia Tedalda, Arezzo (*in situ*), for which he was paid in 1517. From 1510–20 he produced many polychrome altarpieces, for example the *Nativity* (Montaione, S Vivaldo) and the *Assumption* (Barga, S Elisabetta), the latest being the *Virgin and Saints* for S Miniato al Montanino near Figline (dated 1520; Florence, Mus. Osp. Innocenti).

BIBLIOGRAPHY

DBI; Thieme–Becker

F. T. Fagliasi Zeni Buchicchio: 'Santa Cristina a Bolsena e gli autori della sua facciata', *Stor. Archit.*, III/1–2 (1978), pp. 79–100

M. Moscini: *Il miracolo di Bolsena* (Bolsena, 1987), pp. 62, 157–61

F. Domestici: 'Il mecenatismo di Leonardo Buonafede per l'arredo del Santuario delle Grazie in Casentino', *Ant. Viva*, xxvii/3–4 (1988), pp. 35–40

G. Gentilini: *Sculture robbiane a Figline* (Florence, 1990), pp. 13, 37–8

(2) Santi (di Michele Viviano) Buglioni (*b* Florence, 20 Dec 1494; *d* Florence, 27 Nov 1576). Relative of (1) Benedetto Buglioni. He collaborated with Benedetto and inherited his workshop and name. He soon developed a more modern style than Benedetto, reflecting his interest in Mannerism. His hand can be seen in such workshop productions from 1510–20 as the altarpiece of S Giovanni in S Casciano Sugana and the lunette of the *Virgin with Child and Saints* (Arezzo, Badia Tedalda). His more independent works include the *Virgin and Child with Four Saints* (Antona, Massa, S Gimignano), the *Adoration of the Shepherds* (Chicago, IL, A. Inst.) and a lavabo (1520; Prato, S Niccolò da Tolentino). Payments to him are first recorded for a tabernacle with *Christ Blessing*, an altarpiece with the *Virgin of the Girdle*, and another with *SS Sebastian, Giuliano, Antonio Abate* and the *Annunciation* (all 1521–2) for Badia Tedalda, Arezzo (all *in situ*), works previously attributed to Benedetto. The polychrome altarpiece with *SS Peter and Paul Adoring the Eucharist* (mid-1520s; Greve in Chianti, S Maria a la Panca) shows his taste for elaborate Mannerist inventions. The compositional scheme of the painted terracotta *Lamentation* with a glazed frame (mid-1520s; Greve in Chianti, S Francesco) is repeated in the Franciscan churches of La Verna (*c.* 1532), S Salvatore al Monte in Florence, and the Osservanza in Siena. Among numerous monumental glazed altarpieces of the 1520s and 1530s are: the *Ecce agnus dei* (before 1529; Bibbiena, S Maria dal Sasso); two arched anconas of the *Noli me tangere* (both Florence, Bargello); and variants of the *Virgin with Saints* (Florence, Pal. Bardi di Vernio; Arezzo, Oratory of the Madonna del Ponte (1531); Vallombrosa Monastery). Lunettes include the *Annunciation* (before 1527; Florence, Compagnia della SS Annunziata) and the *Virgin with Child and SS Peter and Paul* (Florence, S Piero a Ponti).

Buglioni's best-known work is the glazed and painted terracotta frieze (1526–8) on the portico of the Ospedale del Ceppo in Pistoia. Commissioned by Leonardo Buonafede, it depicts the *Seven Works of Mercy* in scenes of great narrative effectiveness. After the plague of 1527, he was the only artist in Florence who knew the secret of della Robbia glazes. Also from this period is the important, animated ancona depicting the *Stigmata of St Francis* (Città di Castello, S Francesco). Buglioni worked with Michelangelo's pupil Niccolò Tribolo on the decorations for the wedding of Cosimo I, Duke of Florence, and Eleonora of Toledo in 1539 and on the pavement (1548–54) of the library at S Lorenzo, Florence. He also designed numerous pavements (1555–60) in the Palazzo Vecchio and in the Boboli Gardens, Florence. Works probably of the mid-16th century include the altarpiece of *Meeting of Mary and Joseph* (Florence, S Maria at Dicomano), the Virgin and Saints (after 1530; Carnertino, church of the Capuchins), the *Pietà* and the *Madonna della Cintola* (Villafranca, Lumigiana, S Francesco) and the *Annunciation* (Bevagna, SS Annunziata). He modelled portraits of Michelangelo for the latter's funeral ceremonies in Florence in 1564 and, in 1565, with Lorenzo Marignolli (*fl c.* 1542–65), he executed stucco decorations for the Palazzo Vecchio in Florence for the wedding of Francesco de' Medici, later Grand Duke of Tuscany, and Joanna of Austria.

BIBLIOGRAPHY

DBI

G. Vasari: *Vite* (1550, rev. 2/1568); ed. G. Milanesi (1878–85), ii, p. 184; iii, p. 376; vi, p. 88; ix, p. 40

E. Allegri and A. Cecchi: *Guida storica: Palazzo Vecchio e i Medici* (Florence, 1980)

F. Gurrieri and A. Amendola: *Il fregio robbiano dell'Ospedale del Ceppo a Pistoia* (Pistoia, 1982)
M. I. Catalano: *Il pavimento della Biblioteca Medicea Laurenziana* (Florence, 1992)

GIANCARLO GENTILINI

Buon [Bon] **(i).** Italian family of sculptors and architects. They were active in Venice from the late 14th century to the late 15th. Giovanni Buon (*b c.* 1360; *d* 1442) ran a large workshop in Venice, where his son (1) Bartolomeo Buon was probably trained. Father and son took on a number of joint commissions until Giovanni's death, but the latter's contribution seems to have been a minor one. Attributions to Giovanni and Bartolomeo are many and so diverse that no consensus has been reached on their oeuvre. A complete lack of secure attributions to Giovanni has meant that there is no reliable basis for a reconstruction and appraisal of his career. In Bartolomeo's case the documents are more numerous, with several relating directly to specific works, although these works often show irreconcilable differences of style and quality. This uncertainty has led to widely differing accounts of his career (e.g. Wolters, 1976; Markham Schulz, 1978).

(1) Bartolomeo Buon (*b c.* 1400–10; *d c.* 1464–7). He is first mentioned as a sculptor in 1425. In 1427 he produced figures for the well-head of the Cà d'Oro, a sumptuous Gothic palace (1424–31) built in Venice for Marino Contarini. In this early work the drapery of the allegories of the *Virtues* shows clear allusions to the portal of the Corner Chapel in S Maria Gloriosa dei Frari, a work by the Master of the Mascoli Altar (*see* VENICE, §IV, 3). In another early work, the *Annunciation* (Frankfurt am Main, Liebieghaus), there are references to one of the saints on the Mascoli Altar in S Marco, Venice. Agreement has not been reached on the attribution of the group of the *Judgement of Solomon*, situated on the north-west corner of the Doge's Palace (*see* VENICE, §IV, 4(i)). Probably created in the 1430s, it is considered by some scholars to be Bartolomeo's finest sculptural work and by others to be the creation of Nanni di Bartolo.

In the late 1430s Bartolomeo seems to have turned increasingly to architecture. In 1438 father and son took on the contract for the Porta della Carta, a monumental entrance to the Doge's Palace; Bartolomeo, who signed the portal after his father's death, was probably responsible for the design, which was entirely in the traditional style of mature Venetian Gothic. In 1441 the sculptural group *Justice* was set in place on top of the portal (see fig.); it is one of the few works almost unanimously attributed to Bartolomeo (like the portrait bust of *Doge Francesco Foscari*; Venice, Mus. Opera Pal.) and is an excellent example of his expressive, psychologically astute style. When the *Justice* was put in position, most of the figures were still missing, including the *Virtues* in the niches, although these were soon supplied, possibly by four collaborators. There are notable stylistic similarities in this group of the *Judgement of Solomon* to the figures (e.g. *St Francis*) attributed to Bartolomeo on the main portal of S Maria Gloriosa dei Frari (?1440s). During the 1440s Bartolomeo worked as an architect and sculptor at S Maria della Carità, where his tracery windows on the façade (destr.) were imitated by the anonymous architect of S

Bartolomeo Buon: Porta della Carta, Doge's Palace, Venice, *c.* 1438, with the sculptural group of the *Judgement of Solomon* to the right

Gregorio, Venice, as early as 1450. He was commissioned to carve the relief (now in the sacristy of S Maria della Salute) on the portal of the same church, for which he was paid in 1442–4, although it was executed by an assistant. The same is true of his commission to carve the Virgin for the loggia at Udine in 1448, and probably of the relief of the *Madonna of Mercy* on the portal of the Scuola Grande di S Maria della Misericordia (London, V&A; *see* VENICE, fig. 13), which is likely to have come from his workshop. Bartolomeo's portal for SS Giovanni e Paolo (1458; *see* VENICE, §IV, 2) and above all, his main architectural work, the Cà del Duca palace, are evidence that he was the founder of Renaissance architecture in Venice. Only fragments of the Cà del Duca were built, as work was suspended in 1461, but the rusticated plinth in Istrian stone, surmounted by panels of facet-cut masonry, imply a design that has completed the transition from Gothic to early Renaissance. Bartolomeo Buon was undoubtedly the most important sculptor–architect active in

Venice before the emergence of the sculptor Antonio Rizzo and the architect Mauro Codussi.

BIBLIOGRAPHY

Macmillan Enc. Architects; Thieme–Becker

P. Paoletti: *L'architettura e la scultura del rinascimento a Venezia* (Venice, 1893)

L. Planiscig: *Venezianische Bildhauer der Renaissance* (Vienna, 1921)

G. Fiocco: 'I Lamberti a Venezia, III: Imitatori e seguaci', *Dedalo*, viii (1927–8), pp. 432–58

L. Planiscig: 'Die Bildhauer Venedigs in der ersten Hälfte des Quattrocento', *Jb. Ksthist. Samml. Wien*, n. s. 4 (1930), pp. 47–120

G. Fogolari: 'Ancora di Bartolomeo Bon scultore veneziano', *L'Arte*, xxxv (1932), pp. 27–45

R. Gallo: 'L'architettura di transizione dal gotico al rinascimento e Bartolomeo Bon', *Atti Ist. Ven. Sci., Lett. & A.*, cxx (1961–2), pp. 187–204

E. Arslan: *Venezia gotica* (Milan, 1970); Eng. trans. by A. Engel as *Gothic Architecture in Venice* (London and New York, 1971)

W. Wolters: *La scultura veneziana gotica (1300–1460)* (Milan, 1976) [contains a list of attributions made to Giovanni and Bartolomeo Buon up to 1976]

A. Markham Schulz: 'The Sculpture of Giovanni and Bartolomeo Bon and their Workshop', *Trans. Amer. Philos. Soc.*, lxviii/3 (1978), pp. 1–81

D. Howard: *The Architectural History of Venice* (New York and London, 1980)

WOLFGANG WOLTERS

Buon [Bon] **(ii).** Italian family of architects and sculptors. The lives and careers of Bartolomeo Buon (*b* Bergamo, *c.* 1450; *d* Venice, ?1509) and Pietro Buon (*d* Venice, 15 March 1529) are closely linked, with many details remaining conjectural; it is almost certain, however, that Pietro was Bartolomeo's son. Much of the work traditionally ascribed to Bartolomeo, notably at the Scuola Grande di S Rocco, Venice, has been reattributed by modern scholars to Pietro. The Buons were strongly influenced by Mauro Codussi, to whom they may have been related, and Pietro may have been the latter's pupil. The Buons' style is also linked to the decorative tradition of Pietro Lombardo, which is characterized by refined low-relief decoration and the use of rare marbles set within stone panelling. Their nickname of 'i Bergamaschi' reflects their Lombard origins and serves to distinguish them from the earlier, Venetian Buon family (*see* BUON (i)). Also referred to sometimes as one of 'i Bergamaschi' is Guglielmo de' Grigi (*see* GRIGI, DE', (1)), who was also from Bergamo and worked with Pietro Buon in Venice.

The first record of Bartolomeo Buon in Venice is from 1485, as an employee of the Provveditori al Sal, a government agency responsible for funding state building works. His first important scheme was the church of S Rocco (begun 1489; consecrated 1508). However, only the apses and high altar have survived; the rest of the church was rebuilt in the 18th century. The apses are simple forms in the manner of Codussi, and records of the lost façade show that it too was a straightforward work in Codussi's style, although of awkward proportions. The remains of the portal survive (on the north wall), decorated with pilasters similar to Lombardo's style. The high altar is later and considerably richer, inset with rare marbles. It dates from *c.* 1520 and must therefore be the work of Pietro. The careers of the two artists in the 1490s are difficult to disentangle. In 1492 Bartolomeo, still employed by the Provveditori al Sal, was sent abroad for two years on government business, but he resumed the post on his return. This was followed by a second foreign mission in 1496, at which time Pietro seems to have replaced him as *proto* (chief surveyor or architect), perhaps initially on a temporary basis.

In 1505 a 'maistro Bon' was appointed to the most senior post of *proto* of the Procuracy of S Marco, responsible for all state buildings on and near the Piazza S Marco. This seems to have been Pietro, to whom several works around the piazza from 1510 to 1517 are thus attributable. They include supervision of the completion of the Torre dell'Orologio (begun 1496–1500), generally believed to have been designed by Mauro Codussi. Pietro was also responsible for reconstructing (1511–14) the uppermost stage of the campanile of S Marco, which had been badly damaged by lightning in 1489; there he broadly followed an initial design by Giorgio Spavento, who had died in 1509. His last work on the Piazza was the supervision of the rebuilding of the Procuratie Vecchie, the long structure on the north side of the Piazza built to house the apartments of the Procurators of S Marco. A few bays of the older Procuratie had been demolished earlier to make room for the Torre, but in 1513 reconstruction began on the remainder. It is likely that Pietro followed original designs by Codussi, although as *proto* he had considerable authority to modify or refine detailing, subject to government approval. The lower two storeys were complete by 1518, while the second floor was added by Guglielmo de' Grigi, again under Pietro's supervision; this was completed by 1525. The repetitive rhythm of the arcades echoes the earlier Byzantine structure, while the detailing appears to retain Codussi's refined sense of proportion.

Because none of these works represents an original design by Pietro, however, his own style cannot be clearly identified in them. It is only at the Scuola Grande di S Rocco (for illustration *see* SCARPAGNINO, ANTONIO) that his own character emerges with clarity. The foundation stone for the Scuola was laid in 1515, but construction took 50 years under a succession of *proti*, whose relationship with the Scuola was often strained and occasionally broken. Pietro was appointed (unpaid) *proto* in 1517 and remained in office for nine years; he was responsible for the ground-plan and notably for the characteristic ground-floor hall, as well as the lower order of the façade. This fine, rich work incorporates motifs in the style of Codussi, such as the paired windows (by then a little archaic) together with more florid elements derived from Pietro Lombardo, notably the complex entrance portal with its rich marbles. Work had been completed up to the first floor by 1524, when Pietro had a dispute with the Scuola and was summarily dismissed, to be replaced first by Sante Lombardo and then by Antonio Scarpagnino, who completed the first floor. Little is known of Pietro's last years.

Several other works in Venice have been attributed to either Pietro or Bartolomeo, all from the first two decades of the 16th century. One is the Palazzo Cappello Trevisan, a particularly richly decorated Lombard-style palace, also sometimes attributed to de' Grigi. Bartolomeo had served under Admiral Melchior Trevisan for two years, and the house was built for the latter's family. It may thus be the work of both the Buons and de' Grigi. The campanile of the Madonna dell'Orto has often been ascribed to the Buons, but with no documentary evidence. The style of

the Buons is difficult to classify. Pietro in particular seems to have been somewhat eclectic and in some ways characteristic of the later part of the first wave of Renaissance architects in Venice: more robust and less purely decorative than Pietro Lombardo, his work is more richly decorated and decorative than the purer forms of Codussi. He is thus best seen as a transitional figure, and although his work has a fairly strong architectural framework, its rather excessive richness prompted the next generation of architects in Venice to develop a more disciplined classicism.

BIBLIOGRAPHY
G. Soravia: *Le chiese di Venezia descritte e illustrate* (Venice, 1824)
E. A. Cicogna: *Delle iscrizioni veneziane*, 6 vols (Venice, 1824–53)
P. Paoletti: *L'architettura e la scultura del rinascimento in Venezia* (Venice, 1897)
A. Venturi: *Storia* (1901–40)
A. Mazzucato: *La Scuola Grande e la chiesa di S Rocco in Venezia* (Venice, 1953)
J. McAndrew: *Venetian Architecture of the Early Renaissance* (Cambridge, MA, and London, 1980)
S. Mariani: *Vita e opere dei proti Bon, Bartolomeo e Pietro* (diss., Venice, Ist. U. Archit., 1983)
M. Tafuri: *Venice and the Renaissance* (Cambridge, MA, and London, 1989)

RICHARD J. GOY

Buonaccorsi, Pietro. *See* PERINO DEL VAGA.

Buonarroti, Michelangelo. *See* MICHELANGELO.

Buonconsiglio, Giovanni [il Marescalco] (*b* Vicenza, ?1465–70; *d* Venice, ?1535–8). Italian painter. Probably apprenticed in Vicenza to Bartolommeo Montagna by 1484, he was influenced by many painters during his formative years. He is documented as having settled in Venice on 22 January 1495, where he may have revived a friendship with Cima da Conegliano, whom he may have known in Vicenza. The few works predating 1497 that have been identified as Buonconsiglio's are dominated by Lombard influences, the spatial and monumental qualities of Antonello da Messina and Mantegna being particularly evident, as well as the influence of Bramante. Among these early works are the signed *Pietà* (*c.* 1495; Vicenza, Mus. Civ. A. & Stor.; see fig.) and a related drawing depicting *Christ at the Column* (Paris, Louvre). Generally considered to be his masterpiece, the *Pietà* reaches a level of perfection he was never to surpass nor often even to approach (Borenius, p. 161). The awkward figure of Christ lies rigidly at an angle to the picture plane, receding into it at the left, with head and shoulders resting against the Virgin, who is seated on a low, natural stone bench. Balancing these figures are those of St John the Evangelist and Mary Magdalene, respectively standing and kneeling to the right of the picture's centre. Greys, blues and olives predominate, with the bright red of St John's mantle and the gold and green of Mary Magdalene's elaborate garments in sharp contrast. The landscape background of this early masterpiece shows that Buonconsiglio must have known Mantegna or Domenico Morone well; Bramante's influence is especially clear in the figure of St John. Also from this early period are the *Beheading of St Paul* (Vicenza, S Lorenzo) and a corresponding drawing of *A Soldier* (ex-Koenig Col., Haarlem), fresco fragments in Montagnana Cathedral, the *St Catherine of Alexandria* (Vicenza, Mus.

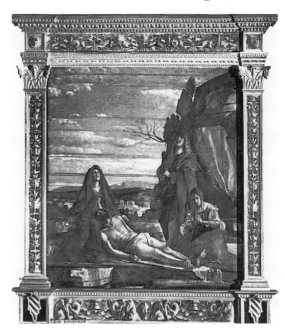

Giovanni Buonconsiglio: *Pietà*, tempera on panel, 1.77×1.60 m, *c.* 1495 (Vicenza, Museo Civico d'Arte e Storia)

Civ. A. & Stor.) and a monochrome frieze (Venice, Col. Cini). A fragment from an altarpiece, signed and dated 1497, depicting *SS Benedict, Tecla and Cosmas* (Venice, Accad.), shows the dominating influence of Giovanni Bellini.

Buonconsiglio's development in the first decade of the 16th century can be summarized by comparing two altarpieces with similar compositions: the large *Virgin and Child Enthroned with SS Paul, Peter, Dominic and Sebastian* (Vicenza, Mus. Civ. A. & Stor.) is signed and dated 1502; the *Virgin and Child Enthroned with Saints* (Montagnana Cathedral) dates from 1507. Both depict the Virgin and Child enthroned on a raised pedestal flanked by equal groups of saints, and, as was typically Venetian, the figures are placed in a church aedicule. The earlier painting owes a great deal to Giovanni Bellini: the figures of the Virgin and Child and SS Dominic and Sebastian, and the setting (a chapel covered in golden mosaics), are direct quotations from his S Giobbe altarpiece (Venice, Accad.). In the later painting, which shows Buonconsiglio having reached his maturity, the pedestal supporting the Virgin and Child has been lowered, resulting in a more nearly horizontal composition. Most impressive, however, is the difference in the structure and modelling of the figures in the two *sacre conversazioni*. In the earlier all surfaces are hard-edged and clearly differentiated, almost incised, while in the latter the figures, now more anatomically correct, are modelled with an almost *sfumato* technique. Buonconsiglio's *Virgin and Child with SS John the Baptist and Catherine* (*c.* 1508; Padua, Cassa di Risparmio) is notable for a landscape background that assimilates the influence of Dürer. Among Buonconsiglio's portraits is an impressive *Self-portrait* (*c.* 1500; Rome, Mus. Capitolino).

Another important group of paintings spans the years between 1510 and 1515; *St Sebastian with SS Lawrence and*

Roch (*c.* 1510; Venice, S Giacomo dell'Orio), the *Virgin and Child with SS Sebastian and Roch* (1511; Montagnana Cathedral) and *Christ the Redeemer with SS Jerome and George* (*c.* 1513; Venice, Spirito Santo). Although the last two paintings show a certain fatigue, passages of real beauty may be seen in the altarpiece of *St Catherine with the Archangel Raphael and Tobias and St Nicholas of Tolentino* (1513; Montagnana Cathedral), which takes Cima da Conegliano as a model. Buonconsiglio frescoed the apse and left transept wall in Montagnana Cathedral between *c.* 1511 and 1513 with, respectively, an *Assumption* (possibly derived from the apse painting by Melozzo da Forlì in Rome, SS Apostoli) and a *Circumcision*. Both survive *in situ*, although the *Circumcision* is in extremely poor condition. Buonconsiglio's latest significant works are the altarpiece of the *Virgin and Child Enthroned with SS John the Baptist and Stephen* (Warsaw, N. Mus.) and that for the church of St Peter in Montecchio Maggiore (1519), his last signed and dated work.

BIBLIOGRAPHY

Thieme–Becker
T. Borenius: *The Painters of Vicenza, 1480–1550* (London, 1909), pp. 155–204
R. Longhi: *Viatico per cinque secoli di pittura veneziana* (Florence, 1946), pp. 15, 60
G. Spettoli: 'Buonconsiglio: Due frammenti d'affresco', *Paragone*, i/2 (1950), pp. 58–60
F. Barbieri: *Museo civico di Vicenza: Dipinti e scultura dal XIV al XV secolo* (Venice, 1962), pp. 93–100
L. Puppi: 'Giovanni Buonconsiglio detto il Marescalco', *Riv. Ist. N. Archeol. & Stor. A.*, xiii–xiv (1964–5), pp. 297–374
R. Pallucchini: 'Una nuova opera del Marescalco', *A. Ven.*, xxvi (1973), pp. 31–8
V. Sgarbi: *Giovanni Buonconsiglio* (diss., U. Bologna, 1974)
F. Zeri: 'Il capitolo "bramantesco" di Giovanni Buonconsiglio', *Diari di lavoro 2* (Turin, 1976), pp. 58–70
V. Sgarbi: 'Le due culture di Giovanni Buonconsiglio', *Boll. A.*, lxv/7 (1980), pp. 31–64 [with full bibliog.]

ALEXANDRA HERZ

Buonconsiglio [Buon Consiglio; Trent; Trento] **Castle.** Vast monumental complex built between the north and east gates of the ancient city walls (*c.* 1200–20) of Trent, the capital of Trentino in Italy. It has three main nuclei: the Castelvecchio, the Magno Palazzo and the Giunta Albertiana. The oldest part, Castelvecchio, was built (1239–55) around the strong donjon, the Torre d'Augusto, by the Imperial Podestà of Trent, Sodegerio da Tito (*d* 1255), who took up office in 1238. Its function was predominantly military. In 1277 it passed to the Church and became the residence of the prince–bishop of Trent. In subsequent centuries a series of modifications and extensions have brought the castle to its present form (see fig.). Of fundamental importance were the works completed in 1475 by Giovanni Hinderbach (*d* 1486) with the aid of Venetian craftsmen, who built the Renaissance Gothic internal court with tiered open galleries and the small loggia on the third floor. At that time the walls of the upper loggia were frescoed with portraits of the bishops of Trent from the city's origin to the year 1000; the series was completed in the adjoining room with portraits of the

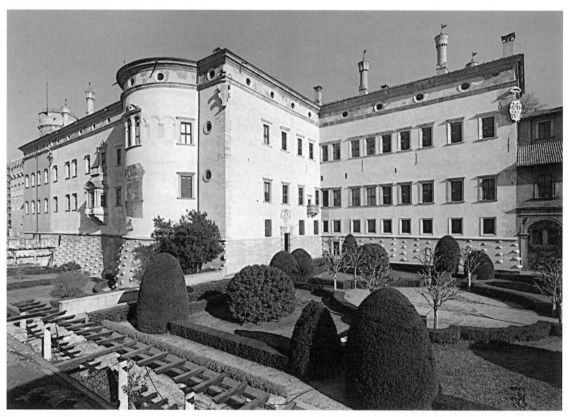

Buonconsiglio Castle, view from the south-west, showing the tower (completed 1475) by Giovanni Hinderbach incorporated into the Castel Nuovo ('Magno Palazzo'; 1528–36), and the top of the Torre d'Augusto (begun 1239) beyond, to the left

bishops since the millennium. The frescoed festoons (1476) on the outside of the galleries were the work of Bartolomeo Sacchetto of Verona. The appearance of the castle in the 15th century is known from a watercolour (1494; London, BM) by Albrecht Dürer (1471–1528).

Between 1528 and 1536 Bernhard von Cles (1485–1539; prince–bishop, 1514; cardinal, 1530) had the Castel Nuovo built beside the medieval structure; it was called the 'Magno Palazzo' by Pietro Andrea Mattioli. Cles was linked by close ties of loyalty to the Austrian monarchy, which considered the episcopal principality of Trent as the southern outpost of the empire. He chose to have his new residence built according to the dictates of Renaissance architecture, enriched by extensive decorations based on humanist themes, following the example of other Italian courts.

Documents provide the names of a few architects, including Lodovico Zaffran (*fl c.* 1527) and Alessio Longhi (*fl* 1522–50), as well as those of craftsmen who took part in the building of the palace under the careful guidance of Cles. It became a great Renaissance princely residence. The painters Gerolamo Romanino (*see* ROMANINO, GEROLAMO and fig.), Dosso Dossi, Battista Dossi, Marcello Fogolino, Matteo Fogolino (*fl* 1523–48) and Bartholomäus Dill Riemenschneider (*fl c.* 1525–50) worked on the decorations (damaged) from 1531, creating some of their masterpieces there. Sculptors included Vincenzo Grandi, Alessio Longhi and Zaccaria Zacchi.

BIBLIOGRAPHY

P. A. Mattioli: *Il Magno Palazzo del Cardinale di Trento* (Venice, 1539)

H. Semper: *Il Castello del Buon Consiglio a Trento: Documenti concernenti la fabbrica nel periodo closiano, 1527–1536* (Trent, 1914)

C. Ausserer and G. Gerola: *I documenti clesiani del Buonconsiglio*, ii of *Miscellanea veneto tridentina della regia deputazione di storia patria* (Venice, 1924)

G. Gerola: *Il Castello del Buonconsiglio e il Museo nazionale di Trento* (Rome, 1934)

N. Rasmo: *Il Castello del Buonconsiglio a Trento* (Rome, 1975, rev. Trent, 2/1982)

Bernardo Cles e l'arte del Rinascimento nel Trentino (exh. cat., ed. E. Chini and F. de Gramatica; Trent, Castello Buonconsiglio, 1985–6)

E. Chini: *Il Romanino a Trento: Gli affreschi nella loggia del Buonconsiglio* (Milan, 1988)

MARIA ANGELA MATTEVI

Buonfigli, Benedetto. *See* BONFIGLI, BENEDETTO.

Buono di Jacopo, Mariano del. *See* MARIANO DEL BUONO DI JACOPO.

Buontalenti, Bernardo [Bernardo delle Girandole] (*b* Florence, *c.* 1531; *d* Florence, 6 June 1608). Italian architect, engineer, designer, painter and inventor. He was one of the great Renaissance polymaths and was not only admired but also liked by his contemporaries. A friend of princes, he spent most of his life at the Tuscan court, but his influence stretched throughout Europe.

1. TRAINING AND EARLY WORK, BEFORE 1570. After his parents were drowned, he was brought up at the court of Cosimo I de' Medici. As an apprentice he trained first with Francesco Salviati, then with Agnolo Bronzino, Giorgio Vasari and finally Don Giulio Clovio. His education must have been broadly based, as he was appointed

tutor at the age of 15 to the future Francesco I de' Medici, to whom he taught not only drawing, colouring and perspective but also architecture and engineering. This was the beginning of a lifelong friendship, in which they shared a passionate interest in the natural sciences.

Buontalenti's earliest known work was a wooden crucifix (destr.) for the church of S Maria degli Angeli, Florence. On 1 February 1550 a document refers to his work as a pyrotechnist, from which he earned his nickname. In 1556 he was sent as a specialist adviser in engineering to Fernando Alvárez de Toledo, Duke of Alba, for whom he designed fortifications at Civetta del Trono. He also built the much-feared Florentine cannon nicknamed 'Scacciadiavoli' (destr.). In 1562–3, with Francesco de' Medici, he visited Madrid, where both men admired the oriental porcelain collection of Philip II of Spain (*reg* 1556–98). Buontalenti is credited with the creation of two soft-porcelain pieces (*c.* 1565) in Florence. He is also recorded as working in Madrid as a miniaturist, executing a number of portraits and paintings of the Virgin for the King.

Buontalenti's first recorded secular architectural work (1567) was the house for Bianca Capello, mistress and later wife of Francesco de' Medici. This was followed in 1569 by the commission for the villa and gardens at PRATOLINO, just outside Florence (now mostly destr.), to which a visit was almost obligatory for visitors to Tuscany. As a result, Pratolino had a major influence on European garden design and was studied through contemporary descriptions and engravings. The villa had evolved from ideas current at the time and discussed at the Medici court, and it epitomized Mannerist art. The villa's design was novel, anticipating Buontalenti's numerous experiments with the form over the following 20 years. The internal courtyard was omitted, the north and south façades were treated differently, and the central portion was raised considerably higher than the flanking wings. The vertical axis was emphasized by the two formal terraces leading down to the long avenue surrounded by the wild garden.

The letters of Benedetto Uguccioni (Florence, Archv Stat.), who supervised the building works, give an insight into Buontalenti's working methods. Work began on the villa before he had decided on the form of the main entrance, and this seems to have been a typical practice in later works. Two drawings for the doorway survive in the Uffizi, Florence. The garden was a combination of formal walks, punctuated with pools, grottoes and fountains, and wild groves dotted with architectural caprices. Here Buontalenti's skill as an engineer was particularly useful in transporting over five miles the huge amount of water needed to service the fountains. The six main grottoes were on two levels beneath the terraces by the house. The most admired was the Grotto of Galatea, with Galatea appearing on a golden shell pulled by dolphins, preceded by a Triton rising from the rocks blowing a trumpet.

2. ARCHITECTURAL WORK, AFTER 1570. Buontalenti's ability as an engineer continued to shape his career. During the 1570s he is recorded as working on the fortifications at various cities including Pisa, Siena, Prato (*c.* 1574) and Livorno (1576), where he was responsible for the design of the harbour that helped make Livorno

the second most important port in the Mediterranean by the end of the 16th century. He also constructed the canal (1573) between Livorno and Pisa.

Buontalenti's next major architectural commission was the Casino de' Medici (1574; now the Palazzo delle Corte d'Appello), again for Francesco de' Medici. It was built as a garden house opening on to an orchard, on the outskirts of Florence. The window arrangement is typical of Buontalenti's work, especially the elaborate detailing, where consoles flank carved shells and drapery swags beneath the ground-floor windows. However, the overall effect is of simplicity and harmony. His capricious spirit is evident in another work begun in 1574, the chancel of Santa Trinita (which has since been transferred to S Stefano). Here the steps of the chancel fan outwards like heavy folds of drapery from a pleat, contrasting with a very precise balustrade above.

On the death of Vasari in 1574, Buontalenti became chief architect to the Tuscan court. In this capacity he oversaw the conversion of the top floors of the Uffizi into the grand ducal art gallery. Around 1580 he designed the Tribuna in the Uffizi for the display of Francesco de' Medici's greatest art treasures. The room is octagonal with a diffused light issuing from windows in the drum, which in turn is reflected by the mother-of-pearl inlaid into the vault. He also completed the great grotto (see fig. 1) in the Boboli Gardens, Florence, adding the elaborate upper

storey, which incorporated natural rock formations and foliage framing the Medici coat of arms. The interior of the grotto (see colour pl. 1, XVIII1) housed Michelangelo's four *Slaves* (Florence, Accademia), which had recently been acquired by the Medici. They were set in the corners of the interior space amid roughly carved rocks, natural rock formations such as stalactites and frescoes of fantastic alpine landscapes by Bernardino Poccetti.

Buontalenti's major architectural works of the 1580s and 1590s include villas at Le Marignolle (1587), Castello (1592) and Artimino (1597), where in keeping with his working method at Pratolino he did not design the doors, chimney and fireplace until the first floor was complete. Like other Florentine villas of the time, these buildings were less grandiose and massive and had a neater, more controlled appearance than similar buildings in Rome, with smooth light surfaces ornamented with sparing dark patterns. Buontalenti's villas, however, have a stronger sense of volume than the typical Florentine villa. They are articulated more strongly using towers and loggias, and the windows are more definite elements in the patterning of wall surfaces. Buontalenti introduced more detail and a more inventive manner, as in the fantastic array of chimneys at the Villa Artimino, Signa. There is visual movement—often no more than the arrangement of windows, but this gives an air of vitality and lightness balancing the almost fortress-like architectural elements

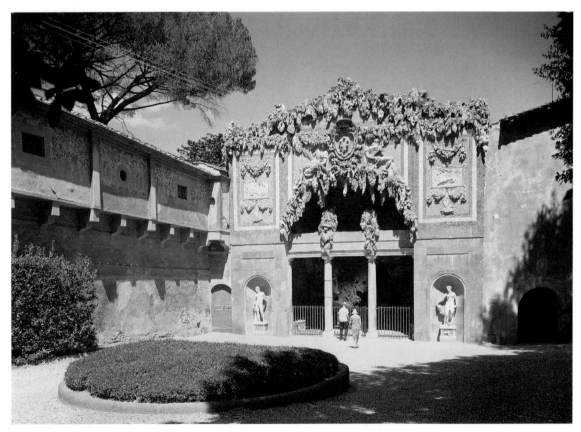

1. Bernardo Buontalenti: façade of the great grotto, Boboli Gardens, Florence (upper part by Buontalenti, from 1583; lower part by Giorgio Vasari, 1556–60)

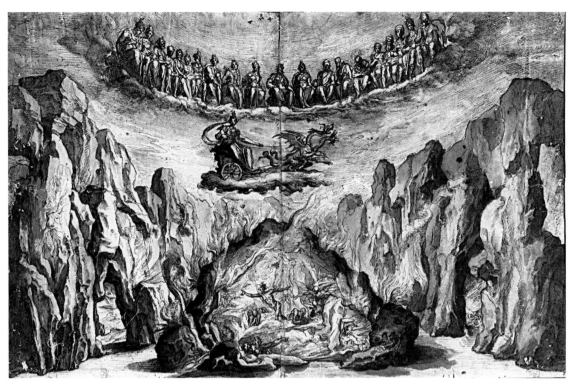

2. Bernardo Buontalenti: *Inferno*, design for the intermezzo of the *Music of Hell*, 1589 (Paris, Musée du Louvre)

—yet there is a strong overall sense of balance and order. Towards the end of his life, Buontalenti had two architectural failures: the façade of the cathedral and the Cappella dei Principi at the church of S Lorenzo, Florence. His proposed designs (Florence, Uffizi) were too inventive, and as a result of the consequent incoherence they remained unexecuted.

3. OTHER ACTIVITIES. In addition to his architectural achievements, Buontalenti excelled as a theatrical designer. His career in this area began with a period as assistant to Vasari; he is first mentioned in connection with the celebrations for the visit (1569) of Grand Duke Charles of Austria, when he was responsible for costumes transforming peasants into frogs. His skill as a designer was also required at state ceremonies such as baptisms and funerals, which in their lavishness attempted to bolster Medici claims as the rulers of Tuscany and as European powers. For the obsequies of Grand Duke Cosimo de' Medici, Buontalenti designed a stepped baldacchino laden with 3000 candles, for which the immediate precedent was the funeral in 1558 of Emperor Charles V (*reg* 1519–56) . However, such designs can be traced back to the funeral pyres of the Roman Empire, mentioned in Tommaso Porcecchi's treatise *Funerali antiche di diversi popoli et natione* (1574). Other elaborate settings were executed with just as much pomp and display, for example for such celebrations as the baptism of Filippo de' Medici in 1577. On that occasion the medieval interior of the Baptistery in Florence was ripped out and replaced by an elaborate double ramping staircase (destr.) leading to the tribune, where a new font and a platform of *pietra dura* for the

child were placed. For the same celebrations he designed a number of firework-breathing monsters.

In 1586 Buontalenti built the Teatro Mediceo (capacity 3000) on the top floor of the Uffizi. The inaugural performance was during the wedding festivities for Virginia de' Medici and Cesare d'Este, Duke of Modena. Contemporary accounts mention that he used bold colours for costumes and that he experimented with lighting, producing a more united and convincing effect than had previously been achieved. The audience was enthusiastic about the perspective view of Rome, which Buontalenti painted on a range of stage flats and backcloths, and which were viewed through a proscenium arch. In 1589, for the month-long celebration of the marriage of the Grand Duke Ferdinand I de' Medici to Christina of Lorraine, Buontalenti designed a series of intermezzi on fantastic, mythological and cosmological themes, in which music, dance and scenic effects were combined (see fig. 2). For his Great Naval Battle, another part of the same celebration, the entertainment began with an elaborate tournament in the courtyard of the Palazzo Pitti; when the guests returned from dinner they found the courtyard flooded and 18 galleons ready for a mock battle. The records for *Il rapimento di Cefalo* in 1600 describe it as having the most marvellous machines that had ever been seen and compared it to the spectacles of ancient Rome: Buontalenti apparently produced mountains that rose from the earth, flying Cupids, gods on clouds and elaborate sea scenes with leaping fish and whales.

Few of Buontalenti's paintings survive, although there is a *Self-portrait* (Florence, Pitti) and a miniature of the *Holy Family* (Florence, Uffizi). He was also known for his

skill with gemstones, and a lapis lazuli vase (*see* ITALY, fig. 35) designed by him is in the Palazzo Pitti, Florence.

BIBLIOGRAPHY

G. Vasari: *Vite* (1550, rev. 2/1568); ed. G. Milanesi (1878–85)
F. de' Vieri: *Delle maravigliose opere di Pratolino* (Florence, 1586)
R. Borghini: *Il riposo* (Florence, 1589), ii, pp. 26ff
F. Baldinucci: *Notizie* (1681–1728); ed. F. Ranalli (1845–7), ii, pp. 490–532
B. Sgrilli: *Descrizione della Regia Villa, fontane e fabbriche di Pratolino* (Florence, 1742)
V. Giovannozzi: 'La vita di Bernardo Buontalenti, scritta da Gherado Silvani', *Riv. A.*, xiv (1932), pp. 505–24
A. Colasanti: 'Una miniatura di Bernardo Buontalenti', *Miscellanea di storia dell'arte in onore di I. B. Supino* (1933)
V. Giovannozzi: 'Ricerche su Bernardo Buontalenti', *Riv. A.*, xv (1933), pp. 297–327
M. de Montaigne: *Journal de voyage à l'Italie par la Suisse et l'Allemagne en 1580–81*, ed. C. Dedeyan (Paris, 1946), pp. 185–6
L. Giori Montanelli: 'Giudizio sul Buontalenti architetto', *Quad. Ist. Stor. Archit.*, xxxl–xlviii (1961), pp. 207ff
W. Smith: 'Pratolino', *J. Soc. Archit. Hist.*, xx (1961), pp. 155–68
A. Nagler: *Theatre Festivals of the Medici* (London, 1964)
D. Heikamp: 'La Tribuna degli Uffizi: Come era nel cinquecento', *Ant. Viva*, iii (1964)
E. Borsook: 'Art and Politics at the Medici Court I: The Funeral of Cosimo I de' Medici', *Mitt. Ksthist. Inst. Florenz*, xii (1965), pp. 31–54
D. Heikamp: 'La grotta grande del Giardino di Boboli', *Ant. Viva*, iv (1965), pp. 27–43
E. Borsook: 'Art and Politics at the Medici Court II: The Baptism of Filippo de' Medici in 1577', *Mitt. Ksthist. Inst. Florenz*, xiii (1967), pp. 95–114
Mostra di disegno di Bernardo Buontalenti (exh. cat. by I. M. Botto, Florence, Uffizi, 1968)
N. Bemporad: 'Gli Uffizi e la scala buontalentiana', *L'Architettura*, xiv (1968), pp. 610–19
D. Heikamp: 'Pratolino suoi giorni splendidi', *Ant. Viva*, viii (1969), pp. 14–34
——: 'Il teatro medigeo degli Uffizi', *Boll. Cent. Int. Stud. Archit. Andrea Palladio*, xvi (1974), pp. 323–32
A. Fara: 'Le ville di Bernardo Buontalenti nel tardo rinascimento toscana', *Stor. A.* (1977)
——: *L'architettura delle ville buontalentiane attraverso i documenti*, *Citta, ville, fortezze della Toscana nel XVI secolo* (Florence, 1978)
——: *Buontalenti architettura e teatro* (Florence, 1979)

ALICE DUGDALE

Buonvisi Painter. *See under* FREDIANI, VINCENZO.

Busati, Andrea (*fl* Venice, 1503–28). Italian painter. None of the published documents provides any information about Busati's activity as a painter. He was a member of two of the Venetian *scuole grandi* and made his will in 1528. Three signed works are known; on one, a *Lamentation* (London, N.G.), the painter appears to call himself a pupil of Giovanni Bellini. A fourth painting, the *Virgin and Child with SS Peter and John the Baptist* (ex-Cavendish Beutinck priv. col.), apparently signed and dated 1522, has disappeared and it is not now possible to check the authenticity of the inscription. However, the stylistic evidence of the three extant works indicates that Busati was much more closely associated with Cima da Conegliano than with Giovanni Bellini. The *Lamentation* includes a landscape motif borrowed from the Bellini workshop, but its composition and figure types are based on Cima's *Lamentation* altarpiece (Modena, Gal. & Mus. Estense). Compared with Cima's figures, Busati's tend to be schematized, with pudgy faces and wooden draperies, and despite the somewhat pedantic accumulation of animals and buildings, his landscapes appear arid, without air or natural light. Similar stylistic features are present in a handful of unsigned works that may be reasonably attributed to Busati. Perhaps the best of them is a *Pietà* in the village church of San Pietro d'Orzio, near Bergamo. He probably also had a hand in a number of works attributed to Cima's workshop.

BIBLIOGRAPHY

DBI; Thieme–Becker
B. Cecchetti: 'Saggio di cognomi ed autografi di artisti in Venezia', *Archv Veneto*, xxxiii (1887), p. 402; xxxiv (1887), p. 205 [docs]
G. Ludwig: 'Archivalische Beiträge zur Geschichte der venezianischen Malerei', *Jb. Kön.-Preuss. Kstsamml.*, xxvi (1905), pp. 98–100
M. Davies: *The Earlier Italian Schools*, London, N.G. cat. (London, 1951, 2/1961/R 1986), pp. 129–32
S. Moschini Marconi: *Gallerie dell'Accademia di Venezia: Opere d'arte dei secoli XIV e XV* (Rome, 1955), pp. 95–6
B. Berenson: *Venetian School*, i (1957), p. 51
L. Coletti: *Cima da Conegliano* (Venice, 1959), pp. 67, 98
R. Pallucchini: 'Appunti alla mostra di Cima da Conegliano', *A. Veneta*, xvi (1962), p. 227
P. Zampetti: *A Dictionary of Venetian Painters*, ii (Leigh-on-Sea, 1970), p. 37
L. Menegazzi: *Cima da Conegliano* (Treviso, 1981)
P. Humfrey: *Cima da Conegliano* (Cambridge, 1983)

PETER HUMFREY

Busi, Giovanni de'. *See* CARIANI, GIOVANNI.

Busti, Agostino. *See* BAMBAIA.

Butinone, Bernardino (*b c.* 1450; *d* Treviglio, before 6 Nov 1510). Italian painter. He was the son of the painter Jacopo Butinone of Treviglio. His early activity is difficult to reconstruct. His training was probably based on the study of such painters as Andrea Mantegna, Cosimo Tura, Francesco del Cossa, from whom he learnt an expressive and refined style, and Vincenzo Foppa. The earliest works, probably from the early 1480s, include a panel of the *Crucifixion* (Rome, Pal. Barberini), the Pietà (destr.; formerly Berlin, Kaiser-Friedrich Mus.) and a series of 16 panels representing Biblical stories, today divided among museums and private collections, among which the *Circumcision* (Bergamo, Accad. Carrara), the *Adoration of the Shepherds* (London, N.G.), and the *Incredulity of Thomas* (Pavia, Pin. Malaspina), and the *Massacre of the Innocents* (Detroit, MI, Inst. A.). These small panels probably made up a portable altar similar to the later one with scenes from the *Life of Christ* (Milan, Castello Sforzesco). These works combine the influences of the Paduan school, in particular Francesco Squarcione, and above all of Mantegna. This is evident in the accentuated plasticity, and in the hard, sharp brushstrokes that refer also to the contemporary Lombard sculpture of Giovanni Antonio Amadeo, and of the Mantegazzas. The expressive vivacity and the refinement are also reminiscent of Francesco del Cossa, as revealed in the *Virgin and child with Angels* (Milan, Gallarati-Scotti priv. col.), probably originating at the church of S Maria delle Grazie in Milan. Butinone is documented in Milan, where he had a thriving studio, from 1484, probably the year he painted the triptych, signed, of the *Virgin and Child with SS Leonard and Bernardino of Siena* (Milan, Brera; see fig.), which reflects the realistic style of Foppa.

In 1485 Butinone and Bernardo Zenale signed a contract for the *St Martin* altarpiece (Treviglio, S Martino), for which Butinone probably painted the central section

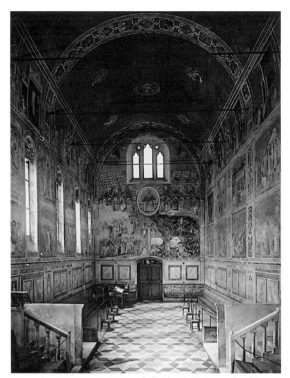

M. Gregori, ed.: *Pittura tra Adda e Serio: Lodi, Treviglio, Caravaggio, Crema* (Milan, 1987), pp. 163–6, 169–70

F. Zeri, ed.: *Pinacoteca di Brera: Scuole lombarda e piemontese, 1300–1500* (Milan, 1988), pp. 142–6

M. Gregori, ed.: *Pittura a Milano: Rinascimento e Manierismo* (Milan, 1998) pp. 196–7, 204–5, 212–3

ANNA MARIA FERRARI

Butteri, Giovanni Maria (*b* Florence, *c.* 1540; *d* Florence, 4 Oct 1606 or 1608). Italian painter. After he trained under Agnolo Bronzino (as did his brother, Cresci Butteri; *fl* 1551–89), in 1564 he entered the newly founded Accademia del Disegno in Florence, in which he was very active. He worked mainly in Florence and for the Medici on commissions for paintings, decorations for buildings and court occasions (many untraced); these included *Michelangelo the Poet with Apollo and the Muses* for the funeral of the artist (1564) and *Poets and Writers* for the wedding (1565) of Grand Duke Cosimo I de' Medici's son Francesco (later Francesco I de' Medici, Grand Duke of Tuscany) and Joanna of Austria (1547–78). For the Studiolo (Florence, Pal. Vecchio) of Francesco I de' Medici he painted (1570–71) *Aeneas Arriving in Italy* and the *Glassblowers' Workshop*. He worked on a number of commissions under the supervision of another Bronzino protégé, Alessandro Allori (*see* ALLORI, (1)), including decorations for the Villa Medici at Poggio a Caiano (1579–82), for the first corridor of the Galleria degli Uffizi (1581) in Florence and for the wedding of Grand Duke Ferdinand I de' Medici and Christine of Lorraine (1589), as well as cartoons (1590s) for the Arazzeria Medicea or tapestry works.

Numerous portraits by Butteri are documented: *Bianca Cappello* (Arezzo, Mus. Casa Vasari); the *Virgin and Child with Saints* (1575), which contains portraits of Eleonora de' Medici, Cosimo I de' Medici and their sons; and *Simone Corsi*, Luogotenente of the Accademia del Disegno (1596; both Florence, Depositi Gal.). Other works include the decoration (1578–81), with Allori, of the Palazzo Salviati in Florence (now the Banca Toscana), the *Christ and the Centurion* (Florence, Santa Maria del Carmine), the *Coronation of the Virgin* (Florence, Santo Spirito), six frescoes (begun 1582) in the large cloister of S Maria Novella, Florence, and paintings at the Badia of Passignano (1581; *in situ*), the *Miracle of St Giovanni Gualberto* and the *Trial of St Peter Igneus*. Butteri was a Tuscan Mannerist comparable to such other Bronzino followers as Allori. His paintings are characterized by bright diffused light, metallic colours and figures that show stylized forms and features deriving from Bronzino.

BIBLIOGRAPHY

Colnaghi; *DBI*; Thieme–Becker

G. Vasari: *Vite* (1550, rev. 2/1568); ed. G. Milanesi (1878–85), vi, p. 6; vii, pp. 305, 608; viii, p. 617

F. Baldinucci: *Notizie* (1681–1728); ed. F. Ranalli (1845–7), iii, pp. 500–01

D. E. Colnaghi: *Dictionary of Florentine Painters from the 13th to the 17th Centuries* (London, 1928/R Florence, 1986)

A. Schiavo: 'La Badia di San Michele Arcangelo a Passignano in Val di Pesa', *Benedictina*, viii (1954), p. 266

M. Collareta and K. Langedijk: 'Giovanni Maria Butteri', *Palazzo Vecchio: Committenza e collezionismo medicei, 1537–1610* (exh. cat., ed. C. Beltramo Ceppi and N. Conforto; Florence, Pal. Vecchio, 1980), pp. 289–90

A. Petrioli Tofani: 'Contributi allo studio degli apparati e delle feste medicee', *Firenze e la Toscana dei Medici nell'Europa del '500: Firenze, 1980,* ii, pp. 645–61

Bernardino Butinone: *Virgin and Child with SS Leonard and Bernardino of Siena*, oil on panel, 1.10×1.19 m, *c.* 1484 (Milan, Accademia di Belle Arti di Brera)

and the sections right of the upper row and right of the lower row, and most of the predella. The association with Zenale continued: in this period the two painters, possibly with Giovanni Donato da Montorfano, executed the frescoes of *Dominican Saints and Blesseds* in S Maria delle Grazie in Milan. Butinone, Zenale and other artists executed decorations (destr.) for the Sala della Balla in the Castello Sforzesco, Milan, in 1490, for the wedding of Ludovico Sforza and Beatrice d'Este. Probably from this period comes the *Virgin and Child with Angels and SS John the Baptist and Justine* (Isola Bella, Mus. Borromeo), in which the classical imprints reveal the influence of Bramante. Between 1493 and 1495 Butinone and Zenale frescoed (and signed) stories from the *Life of St Ambrose* in the Griffi chapel of S Pietro in Gessate, Milan. Early in the 16th century he frescoed (perhaps with collaborators) the stories from the *Life of St Mary Magdalene* in the church of the Camuzzago monastery at Bellusco (near Monza). According to sources from the 17th and 18th centuries, towards the end of his life he entered the Franciscan convent of the Annunziata in Treviglio and devoted his last years to the illumination of codices. His elegant and expressive style influenced Bramantino.

BIBLIOGRAPHY

DBI

Arte lombarda dai Visconti agli Sforza (exh. cat., Milan, Pal. Reale, 1958), pp. 147–50, 153–4 [entries by F. Mazzini]

F. Mazzini: *Affreschi lombardi del quattrocento* (Milan, 1965), pp. 473–6, 627–8

B. Berenson: *Central and North Italian Schools* (1968), i, pp. 69–72

Zenale e Leonardo: Tradizione e rinnovamento della pittura lombarda (exh. cat., Milan, Mus. Poldi Pezzoli, 1982), pp. 50–52, 150–51 [entries by M. Natale]

Il primato del disegno (exh. cat., ed. L. Berti; Florence, Pal. Strozzi, 1980), p. 92 [entry by M. Mosco]

M. Rinehart: 'A Document for the Studiolo of Francesco I', *Art, the Ape of Nature: Studies in Honor of H. W. Janson*, ed. M. Barasch, L. F. Sandler and P. Egan (New York, 1981), pp. 275–89

A. Cecchi: 'Invenzioni per quadri di don Vincenzo Borghini', *Paragone*, xxxiii/383–5 (1982), pp. 89–96

R. Scorza: 'A New Drawing for the Florentine "apparato" of 1565: Borghini, Butteri and the Tuscan Poets', *Burl. Mag.*, cxxvii (1985), pp. 887–90

B. Santi: 'Il dipinto della Madonna di Giovanni M. Butteri nela Propositura di Vaiano e il suo restauro', *Prato*, xxviii/71 (1987), pp. 72–5

From Studio to Studiolo: Florentine Draftsmanship under the First Medici Grand Dukes (essay K.-E. Barzman, exh. cat. ed. L. J. Feinberg; Oberlin Coll., OH, Allen Mem. A. Mus., 1991)

R. Scorza: 'Borghini, Butteri and Allori: A Further Drawing for the 1565 "Apparato"', *Burl. Mag.*, cxxxvii/1104 (March 1995), pp. 172–5

E. Terradura: 'Due opere di Giovanni Maria Butteri nella chiesa di San Salvatore a Vaiano', *Prato*, xxxvi/87 (Dec 1995), pp. 53–63

MILES L. CHAPPELL

C

Caballettus [de Cabaleto]**, Giovanni Battista.** *See* CAVALLETTO, GIOVANNI BATTISTA.

Caccavello, Annibale (*b* Naples, *c.* 1515; *d* after 22 March 1570). Italian sculptor. The son of a supplier of marble, he was one of the most important Neapolitan artists of the 16th century. His earliest work was probably executed in the workshop of Giovanni Marigliano, where he made the acquaintance of Giovan Domenico d'Auria (*see* AURIA, (1)), with whom he later formed a partnership and frequently collaborated. The marble statues of the *Risen Christ, St Nicholas of Bari, St Francis* and the two *Angels* on the tomb of *Sigismondo Sanseverino di Saponara* (Naples, SS Severino e Sossio) probably belong to this early period, as do many of the bas-reliefs depicting *Episodes in the Conquest of the Kingdom of Naples* on the base of the tomb of the Viceroy of Naples, *Don Pedro de Toledo* (Naples, S Giacomo degli Spagnoli). The relief depicting the *Conversion of St Paul* (1539; Naples, S Maria delle Grazie a Caponapoli) is documented as by Giovan Domenico d'Auria but sometimes attributed to Caccavello.

From 1547 to 1567 Caccavello kept a full diary of his career. The Tuscan Mannerism of Giovanni Angelo Montorsoli emerges in a number of works, for example certain parts of the monument to *Don Pedro de Toledo*, the decoration of the tomb of *Nicola Antonio Caracciolo, Marchese di Vico* (*c.* 1547; Naples, S Giovanni a Carbonara, Cappella Caracciolo di Vico), the relief depicting the *Virgin and Child in Glory with Souls in Purgatory* (1550; Capua, Mus. Prov. Campano), executed in collaboration with Giovan Domenico d'Auria, the tombs of *Odetto di Foix, Comte de Lautrec* and *Pietro Navarro* (1551; Naples, S Maria la Nova) and the tomb of *Alfonso Basurto* (1554; Naples, S Giacomo degli Spagnoli). In collaborating with d'Auria, Caccavello experimented with Mannerist decoration and forms of portrait iconography then unfamiliar but later used in 17th-century Neapolitan sculpture. In the tombs of *Hans Walter von Hiernheim* (1557; Naples, S Giacomo degli Spagnoli) and *Scipione Somma* (1557; Naples, S Giovanni a Carbonara) the emphasis on portraiture is subordinated to the decorative scheme. Caccavello's last works were mostly finished by his brother Desiato Caccavello and by another relative, Salvatore Caccavello.

WRITINGS
A. Filangieri di Candida, ed.: *Il diario di Annibale Caccavello, scultore napoletano del XVI secolo* (Naples, 1896)

BIBLIOGRAPHY
DBI; Thieme–Becker
O. Morisani: 'Giovanni Miriliano da Nola', *Archv Stor. Prov. Napolet.*, lxvi (1941), pp. 282–327 (319–25)
Sculture lignee nella Campania (exh. cat. by F. Bologna and R. Causa, Naples, Pal. Reale, 1950), pp. 74, 113, 159
O. Morisani: 'La scultura del cinquecento a Napoli', *Storia di Napoli*, V/ii, ed. E. Pontieri (Cava dei Tirreni, 1972), pp. 719–80 (763–70)
R. Pane: *Il rinascimento nell'Italia meridionale*, ii (Milan, 1977), pp. 127, 170, 189, 193, 194
F. Abbate: [review of G. Weise: *Studi sulla scultura napoletana del primo cinquecento* (Naples, 1977)], *Prospettiva*, 13 (1978), pp. 67–74
——: 'Un possibile episodio valdesiano a Napoli: La tomba di *Galeazzo Caracciolo* in San Giovanni a Carbonara', *Boll. A.*, 6th series, lxiv/2 (1979), pp. 97–102

For further bibliography *see* AURIA, D'.

RICCARDO LATTUADA

Caccini, Giovanni Battista (*b* Rome, 24 Oct 1556; *bur* Florence, 17 March 1613). Italian sculptor and architect. He was the pupil and assistant of Giovanni Antonio Dosio and probably moved with his master from Rome in November 1575 to Florence, where he spent the rest of his life. From Dosio he learnt the techniques of marble-carving, stucco and antique restoration and the principles of architecture, benefiting from Dosio's intense interest in Greek and Roman antiquity. He is recorded as spending much of his early career engaged in the restoration of antique statuary for the Medici (an archival notice of August 1578 also connects him with the Giambologna workshop in this respect), although he also produced significant original work during this time. He had his own workshop by the early 1590s, and his predominance as a sculptor in marble in Florence was assured when his principal rival in this medium, Pietro Francavilla, began to transfer his activities to Paris in 1601 (where he settled in 1605). The improved documentation of Caccini's work as an architect in recent years now confirms the importance of his contribution to the development of early 17th-century Florentine architecture.

1. SCULPTURE. The earliest archival reference to Caccini (recently discovered by Keutner) connecting him with the Giambologna workshop in 1578 suggests that he may have been drawn to Florence by the demand for skilled sculptors in marble to assist Francavilla with the execution of the Altar of Liberty (1577–9; Lucca S Martino). The very small number of independent works recorded by him before the early 1590s indicates that he served in both the Giambologna and Dosio workshops during this period and also explains Caccini's reproduction at this date not only of Giambologna's stylistic idiom but also of his models before they took their final form in bronze, as in the case of his statue of *Temperance* (*c.* 1578–

84; New York, Met; see fig. 1) for the Bishop of Marsia. In 1580 he received payments relating to the reclining tomb effigy of *St John Gualberto* (Passignano, Abbey of S Michele), which Natali has convincingly argued were for the restoration of the face and other parts of the original statue by Benedetto da Rovezzano. Caccini's statues of *St Bartholomew* and *St Zenobius* (*c.* 1580–85) for the Carnesecchi Chapel, S Maria Maggiore, Florence, and the *Temperance* were praised by Raffaele Borghini in 1584 as presaging an illustrious career, but no further independent works are known for the 1570s.

Caccini's main activity in his early years was the restoration of antique statuary (documented in the Medici

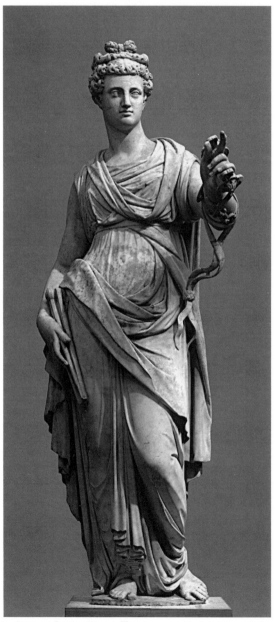

1. Giovanni Battista Caccini: *Temperance*, marble, h. 1.83m, *c.* 1578–84 (New York, Metropolitan Museum of Art)

archives between 1583 and 1590). Two of these documented restorations survive: an *Apollo Sauroktonos* and *Hercules and a Centaur* (both Florence, Uffizi); a further undocumented restoration of a *Bacchus and Faun* group (Florence, Uffizi) traditionally attributed to him has an intensity of expression unusual for Caccini and may have been executed at the time of his collaboration with Pietro Bernini in 1594.

Baldinucci recorded Caccini's industry as a portrait sculptor, and, though only a few can be securely identified, of which the *Baccio Valori* (1584; Florence, Bargello) is the earliest and best known, other recently attributed busts and reliefs, such as the *Roberto Pucci* (*c.* 1605–8); Florence, SS Annunziata), merit serious consideration. Early religious works, such as the *Christ* (1587) in Via de' Cerretani, Florence, also take the form of busts

On 8 May 1586 Caccini was elected a consul of the Accademia del Disegno. His contribution of papier mâché statues, including that of *St John Gualberto* (1588–9; Florence Cathedral) for the wedding festivities of Ferdinando I de' Medici, brought him court patronage, but he still remained in the shadow of Giambologna. In 1590 he obtained a commission for a marble statue of *St James the Greater* (1591) for Orvieto Cathedral (*in situ*). The statue demonstrates his virtuosity in the carving of marble, but Caccini could not challenge the predominance of Pietro Francavilla in this material in Florence and was unable to win a supervisory role in a major commission until the end of the 1590s. By 1593, however, he had enough work to open his own workshop. The works of the 1590s demonstrate a superlative technique and elegance of design but little originality. They are marked by a deeply mannered, intellectual approach that all but excluded reality. Caccini reduced Giambologna's drapery idiom to the simplified, almost relief-like planes of Dosio's style.

In 1592, on the occasion of the baptismal ceremonies of Prince Cosimo de' Medici (later Cosimo II), the Grand Duke of Tuscany's eldest son, Caccini made a terracotta modello of the kneeling figure of Charles V (*reg* 1519–56) for a marble group of the *Coronation of Charles V by Clement VII* for the Salone dei Cinquecento in the Palazzo Vecchio, Florence, but left incomplete. For the same occasion and site Caccini also provided a terracotta statue of *Francesco I de' Medici*. He executed both statues in marble between 1593 and 1594. His garden sculptures *Summer* and *Autumn* (*c.* 1592–3), commissioned by Alessandro Acciaioli, were later purchased by Ferdinando I to ornament the Ponte Santa Trinita (*in situ*) in 1608 for the wedding festivities of Prince Cosimo. Four of the undocumented garden figures in the Boboli Gardens in Florence have been attributed to Caccini: *Aesculapius and Hippolytus*, *Hygaeia* (*Autumn*), a female figure of *Summer* and a male figure of *Autumn*. It is likely that a further two, the *Young Jupiter* and *Flora*, are from his workshop.

In 1594 Caccini contracted to execute a relief of the *Trinity* for the façade of Santa Trinita, Florence, in collaboration with Pietro Bernini (1562–1629). He was also responsible for the statue of *St Alexis* on the same façade, (*c.* 1594–7). In 1593 he gained a commission for statues of *St John the Baptist*, *St Paul*, *St Peter* and *St Bruno* for Dosio's renovation of S Martino, Naples (all *in situ*), but did not begin work on them until 1609. These statues,

left unfinished at his death, were completed by Cosimo Fanzago in 1631. A statue of *Purity* (*Contemplative Life*) in the same church has also been attributed to Caccini. A lost work of these years, a marble bust of *Christ the Redeemer* formerly surmounting a tabernacle dedicated to the Benedetti family (1590s; Florence, S Maria Novella, nave), has recently been rediscovered on the London art market (see Keutner).

In 1597 Caccini was commissioned to provide reliefs for the bronze doors of Pisa Cathedral, designed by Raffaello Pagni (*fl* 1588–97). The project involved all the foremost sculptors in Tuscany, including Pietro Francavilla, Hans Reichle (1565/70–1642) and Pietro Tacca. Caccini was asked to provide 20 reliefs, more than any other sculptor, but his other commitments allowed him to model only four. A fifth relief, the *Assumption of the Virgin*, was modelled by a pupil after his design. For the frames Caccini designed and made wax models of figurines, emblem and motto reliefs, foliage, cartouches and architectural niches, for which he received payment between May 1599 and May 1600. Of a series of nine marble busts of saints in S Maria degli Angeli, Florence, begun by Francavilla in 1599, those of the *Blessed Michael* (1602), *St Boniface* and *St James the Greater* are signed by Caccini. Two more of this series, the *Christ* and the *Virgin*, have also been attributed to him.

Caccini's position in the vanguard of his profession was assured as Francavilla became increasingly active in France from 1601. The splendid high altar erected for Giovanni Battista Michelozzi in Santo Spirito, Florence, on which he worked from 1599 to 1613, is the fullest expression of Caccini's art and shows him to be as technically assured as Francavilla. Above the columns of the edifice enclosing the altar are four marble statues of *St Peter*, *St John the Baptist*, *St John the Evangelist* and *St Augustine*, all studio works. The niches of the ciborium contain four bronze statuettes of the Evangelists. The corners of the enclosing parapet support marble statues of the *Virgin*, *St John the Evangelist* and six angels bearing candelabra. According to early sources, of the four angels completed and installed before Caccini's death, the pair nearest the altar were executed by Gherardo Silvani, Caccini's principal assistant, after his master's models while the front pair are by Caccini himself. The rear two angels, the *Virgin* and the *Evangelist* were left unfinished at Caccini's death, and, though based on his designs, their style of execution indicates a later hand; they were installed in 1745. The *Baptist* above the altar is probably by Silvani.

Caccini's two angels bearing candelabra (designed by 1601; see fig. 2) appear to alight on their pedestals in a graceful gliding motion. Their design is based on that of Giambologna's angels (1599–1603) for Pisa Cathedral, although Caccini has a fundamentally new approach. Inspired by Giambologna's *Hope* (1579–80; Genoa, Grimaldi Chapel), Caccini invested the draperies with an expressive, fluttering motion, dramatically enhanced by the flickering play of light over abstracted patterns of deeply cut, sharp-edged curves that fall into triangular facets. Slim, tendril-like hands emerge from this brittle shell, while the angels' mobile features are exquisitely carved to imitate the waxy softness and subtle planes of youthful flesh, framed by streaming lines of thick hair.

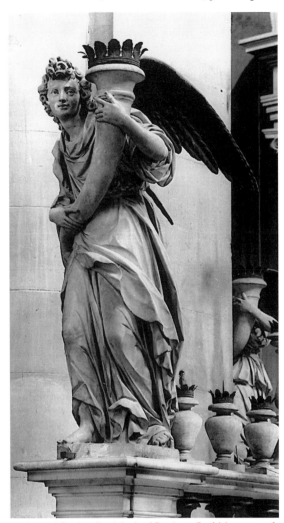

2. Giovanni Battista Caccini: *Angel Bearing a Candelabrum*, one of a pair from the high altar, marble, designed by 1601 (Florence, Santo Spirito)

Their expressions are of divine rapture, tempered by melancholy. These qualities of movement, dramatically expressive pictorial detail and poetic intensity anticipate aspects of the Baroque and illustrate the innovative artistic undercurrents at the turn of the 17th century, emerging concurrently in Rome in the works of Camillo Mariani, Nicolas Cordier (*c.* 1567–1612) and Francesco Mochi (1580–1654) and merging in the work of Gianlorenzo Bernini (1598–1610).

The imposing wall-tomb of *Antonio Peri* in SS Annunziata, Florence, completed in 1601, was also carried out by Caccini's studio. Despite conflicting traditions regarding the attribution of the statue of *St Peter* on this monument, and of the *St Paul* on the identical wall-tomb of *Caterina Pandolfini* opposite (1609), the quality of the former suggests that Caccini participated in its execution, while the latter was probably executed by Silvani after Caccini's model. The combination of technical brilliance and spiritual expression achieved by Caccini in his angels for Santo Spirito is also evident in his last completed

works, the statues of *St Agnes* and *St Lucy* (*c.* 1603–9; Florence, Santa Trìnita, Strozzi Chapel), which are undoubtedly by him.

2. ARCHITECTURE. Since the original edition of this article (written 12 years ago), important new research and analysis has illuminated this formerly neglected area of Caccini's practice. Cresti has called attention to the significance of his most important scheme, the high altar complex for Santo Spirito, for its introduction of a new rapport of chromatically enriched architecture and sculpture in an ensemble that redefines space by means of scenographic illusionism, to create a new autonomous 'via fiorentina' for Florentine architecture at the beginning of the 17th century. Despite the support of Grand Duke Ferdinando I, this process of experimentation in a novel and expressive formal language was a route followed only by Nigetti (1560/70–1648) in the Cappella dei Principi, and subsequent Florentine architectural practice remained routed in Buonalentian formulae. Caccini was therefore an envoy of an evolutionary phase that, although little understood at the time, was yet capable of transmitting impulses towards the Baroque into the Florentine ambience.

The first records of his work in this field concern his (rejected) designs for the projected renovations of the choir and sacristy of Pisa Cathedral in 1596. His earliest extant works are the elegant portico of SS Annunziata, Florence (1599–1601), which follows Michelozzo di Bartolomeo's design, and the sculptural and architectural additions that formed part of the renovation of the adjacent oratory of S Sebastiano (1597, 1601–8), commissioned by Roberto Pucci and completed by Silvani. Other architectural works include the renovation of the Strozzi Chapel in Santa Trìnita, Florence, and of the Inghirami Chapel (1607–15) in Volterra Cathedral, also completed by Silvani; the redesigning of the choir and vault of S Domenico, Fiesole (1603–6), and the supervising of the completion of Buontalenti's Palazzo Nonfinito, Florence (*c.* 1600–10), for which he had executed a richly detailed coat of arms *c.* 1592. He was also responsible for the ceiling stuccos of the reliquary chapel of S Giovanni Gualberto in Santa Trìnita (1593–4). The six herms of poets and humanists on the façade of the Palazzo Valori (now Palazzo Altoviti), Florence, completed before 1603, have also been attributed to him, while Morrogh assigned three architectural drawings (Florence, Uffizi) to Caccini.

3. INFLUENCE. In the field of marble sculpture Caccini established an alternative stylistic line of influence in Florence to that of Giambologna and his successors. None of Caccini's pupils was of sufficient calibre to exploit or develop the more innovative of their master's ideas, but in the succeeding generation the progressive styles of Domenico Pieratti (1600–56), Antonio Novelli (1600–62) and Bartolomeo Cennini (*c.* 1370–*c.* 1440) were formed in his school. Caccini also influenced Pietro Bernini (1562–1629) and Hans Reichle (*c.* 1565/70–1642), as is evident in the latter's works in Augsburg.

UNPUBLISHED SOURCES
London, Courtauld Inst., Conway Lib. [phot. by P. Ward-Jackson]

BIBLIOGRAPHY
DBI; Thieme–Becker
R. Borghini: *Il riposo* (Florence, 1584), p. 647
F. Baldinucci: *Notizie* (1681–1728); ed. F. Ranalli (1845–7)
A. Venturi: *Storia* (1901–40), X/iii, pp. 792–816
A. Grünwald: 'Über einige unechte Werke Michelangelos', *Münchn. Jb. Bild. Kst.*, v (1910), pp. 10–22, 68–70
E. Mandowski: 'Two Menelaus and Patroclus Replicas in Florence', *A. Bull.*, xxviii (1946), pp. 115–18
A. Morini: *Giovanni Caccini, scultore e architetto fiorentino* (diss., U. Florence, 1946)
J. Holderbaum: 'Surviving Colossal Sculpture for the Florentine Wedding Festivities of 1589', *J. Soc. Archit. Hist.*, xxvii (1968), pp. 210–11
J. K. Schmidt: 'Le statue per la facciata di S Maria del Fiore in occasione delle nozze di Ferdinando I', *Ant. Viva*, vii/5 (1968), pp. 43–53
——: *Studien zum statuarischen Werk des Giovanni Battista Caccini* (Cologne, 1971)
C. J. Valone: *Giovanni Antonio Dosio and his Patrons* (diss., Evanston, IL, Northwestern U., 1972), pp. 191, 204–7, 252, n. 99
Arte e storia in San Michele a San Salvi (exh. cat. by G. Gentilini and A. Natali, Florence, 1979), pp. 32–5
C. Caneva: *Il giardino di Boboli, Lo Studiolo* (Florence, 1982), p. 42, nos 38–9
A. D. Morogh: *The Early History of the Cappella de' Principi, Florence* (diss., U. London, 1983), pp. 120, 123–4, 136, 422, n. 3
M. I. Catalano: 'Scultori toscani a Napoli alla fine del cinquecento: Considerazioni e problemi', *Stor. A.*, 54 (1985), pp. 127–31
A. Brook: 'Mannerism, Transition and the Prelude to the Baroque: 17th-century Florentine Sculpture prior to Foggini', *Il seicento fiorentino Arte a Firenze*, ii
C. Caneva: 'Giovanni Battista Caccini', *Il seicento fiorentino: Arte a Firenze da Ferdinando I a Cosimo III* (exh. cat., Florence, Pal. Strozzi, 1986), iii, pp. 44–6
E. Andreatta and F. Quinterio: 'La Loggia dei Servi in Piazza SS Annunziata a Firenze', *Riv. A.*, xl, ser. 4, iv (1988), pp. 186, 219, 234
H. Keutner: 'Giovanni Caccini and the Rediscovered Bust of Christ', *Art at Auction, 1988–89*, London 1989, pp. 334–9
C Pizzorusso: *Boboli e altrove* (Florence, 1989)
C. Cresti: *L'Architettura del Seicento a Firenze*, (Rome, 1990), pp. 32–77
U. Muccini: *Il Salone dei Cinquecento in Palazzo Vecchio*, (Florence, 1990)
A. Natali: 'Giovanni Caccini "eccellente nel restaurare": Un'ipotesi di restituzione a Benedetto da Rovezzano', *Paragone*, xlii 499 (1991), pp. 3–14
S. Bellesi 'Nuove acquisizioni all scultura fiorentina della fine del cinquecento al Settecento', *Ant. Viva*, xxxi 5–6 (1992), pp. 37–8
S. Brusini: 'Un *Apollo musico* nella Firenze di Francesco I', *Ant. Viva*, xxxi/3 (1992), pp. 26–32
M. C. Fabbri: 'La sistemazione seicentesca dell'oratorio di San Sebastiano nella Santissima Annunziata', *Riv. A.*, xliv (1992), pp. 71–152
P. Bocci Pacini: 'Il Discobolo degli Uffizi', *Uffizi: Stud. & Ric.*, xiii (1994), pp. 22–26, 49–54
C. A. Luchinat: 'Il Cardinale Alessandro de' Medici e le arti: Qualche considerazione', *Paragone*, xlv (1994), pp. 134–40
Magnificenza alla corte dei Medici: Arte a Firenze alla fine del Cinquecento (exh. cat. by M. Daly Davis, Florence, Pal. Pitti, 1997), p. 60, nos 23–24
V. Saladino: 'Sculture antiche per la reggia di Pitti', *Magnificenza alla corte dei Medici: Arte a Firenze alla fine del Cinquecento* (exh. cat. by M. Daly Davis, Florence, Pal. Pitti, 1997), pp. 310–19

ANTHEA BROOK

Cafaggiolo Ceramic Factory. Italian ceramic factory. In 1498 a maiolica factory was established in the Medici villa of Cafaggiolo, in the Mugello near Florence, by the brothers Piero and Stefano SCHIAVON from Montelupo, a famous Tuscan centre of ceramics production. The factory was in production throughout the 16th century, and the products made for the grand dukes of Tuscany and other noble Florentine families reveal a remarkable pictorial zeal, which developed from decorative schemes influenced by the style of wares from Faenza, including *alla porcellana* (blue-and-white decoration inspired by Chinese porcelain) and grotesques and the rather showy and heraldic *istoriato* (narrative) scenes. Many of these

works are stamped or marked underneath with the words *in Chafagiollo* or *Chafaguotto* or sometimes stamped with the famous SP monogram, by tradition ascribed to the Fattorini family (e.g. jug with a portrait of Leo X, *c.* 1515; Faenza, Mus. Int. Cer.). The strong incentive of an important, rich clientele lasted for several decades. When it declined, however, the factory's production became increasingly mediocre during the 16th century and was finally supplanted by MONTELUPO, which was able to expand its production considerably in the 16th and 17th centuries. During the second half of the 16th century, after a period of intense activity to which the long lists of potters' names testify, only Jacopo di Stefano, Francesco di Stefano and Michele di Stefano were still active; Michele was working until at least 1599. From this point, however, the potters who had trained at Cafaggiolo seem to have transferred to other centres of production in the surrounding area.

BIBLIOGRAPHY

G. Guasti: *Di Cafaggiolo e d'altre fabbriche in Toscana* (Florence, 1902)
G. Cora: *Storia della maiolica di Firenze e del contado* (Florence, 1973)
G. Cora and A. Fanfani: *La maiolica di Cafaggiolo* (Florence, 1982)
Maioliche marcate di Cafaggiolo (exh. cat. by G. Cora and A. Fanfani, Florence, Bargello, 1987)
A. Alinari: 'Cafaggiolo in Mugello: Una bottega fuori contesto', *Ceramica toscana dal Medioevo al XVIII secolo*, ed. G. C. Bojani (Monte San Savino, 1990), pp. 134'45

CARMEN RAVANELLI GUIDOTTI

Calamelli, Virgiliotto [Virgilio] (*fl* Faenza, 1531; *d* Faenza, *c.* 1570). Italian potter. He was the son of Giovanni da Calamello, and there are plenty of documents relating to him, especially after 1540, when as a practising potter he went to sell his wares in Bologna. He was so successful that citizenship was conferred on him. In FAENZA his workshop was situated in the S Vitale quarter, where there were many other potteries during the 16th century. An inventory of 1556 (Grigioni, pp. 143–51) describes his economic position and the progress of his workshop. Apparently his was among the most well-established workshops in Faenza, able to produce huge table-services, including water jugs, salt-cellars, dishes and vases (e.g. vase with lion handles, *c.* 1550–60; Brunswick, Herzog Anton Ulrich-Mus.). In 1566, for health reasons, he handed his shop over to Leonardo Bettisi, known as Don Pino (*fl* 1564–89), also from Faenza. Calamelli is recognized as an important exponent of the *Compendiario* (sketchy) style, which was typical of the so-called *bianchi di Faenza* wares. His most important works were stamped with the monogram VR FA.

BIBLIOGRAPHY

C. Grigioni: 'Documenti: Serie faentina. I Calamelli maiolicari di Faenza', *Faenza*, xxii (1934), pp. 50–54, 88–90, 143–53
G. Gennari: 'Virgiliotto Calamelli e la sua bottega', *Faenza*, xlii (1956), pp. 57–60
C. Ravanelli Guidotti: *Faenza, Faïence: Bianchi di Faenza* (Ferrara, 1996), pp. 78–153
——: *Thesaurus di opere della tradizione di Faenza* (Faenza, 1998)

CARMEN RAVANELLI GUIDOTTI

Calcagni, Antonio (di Bernardino) (*b* Recanati, 18 Dec 1536; *d* Loreto, 9 Sept 1593). Italian sculptor and bronze-caster. Of noble birth, he showed a precocious drawing talent and at a young age was apprenticed to the sculptors Girolamo Lombardo and Aurelio Lombardo in Recanati.

He became a favoured student of Girolamo, learning to work bronze, silver, gold and terracotta. In 1574 he settled in Loreto, where he remained until his death. The foundry he owned with his brothers was renowned for the quality of its bronze-casting. Most of his early works were executed under his teachers' commissions, including a bronze baptismal font (destr.) for Penna Cathedral, Naples, and a fountain decoration (destr.) for the Doge's Palace, Venice. The bronze statue of *Gregory XIII* for Ascoli Piceno (destr. 1798; drawing, Ascoli Piceno, Mus. Dioc.), which Calcagni completed after Aurelio's death, established his reputation.

Calcagni's first independent work, a stucco *Virgin and Child*, was executed in 1574 for the Cavaliere Agostino Filago. This led to similar commissions from the religious community, such as figures of *Christ* for the Fraternità of Castelnuovo, and a figure of *Christ* and a silver *Crucifix* adorned with crystal for the Fraternità of Camerino. He also created a stone and bronze sepulchre for *Monsignor Francesco Alberici* (1574; bust only extant, Recanati, Mus. Dioc.), the bronze memorial to *Cavaliere Agostino Filago*, and a silver *Crucifix* and twelve *Apostles* (destr.) for Monsignor Casali, Governatore of Loreto. In this period Calcagni created perhaps his greatest work, the bust of the humanist *Annibal Caro* (London, V&A; see fig.), commissioned by his family in 1566. Dated either 1574 or between

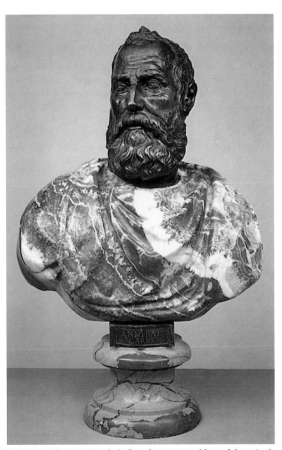

Antonio Calcagni: *Annibal Caro*, bronze, marble and breccia, h. 768mm, commissioned 1566 (London, Victoria and Albert Museum)

1566 and 1572, it was executed from a portrait of Caro by Jacopino del Conte and is a marvel of vitality and strength of character, of an immediacy belying its posthumous execution. Masterfully cast in bronze and fitted to a body of crimson breccia stained with white, it rests on a plinth of rich orange-red and white marble, with a *cartellino* of black marble. According to Pope-Hennessy, it is 'one of the masterpieces of bronze portraiture of the later 16th century'.

Calcagni's name is indissolubly linked with the basilica and the Santa Casa in Loreto (*see* LORETO, §II, 1), and most of his surviving work is there. The restriction of his activity to this relatively provincial area kept his reputation local. Works in the basilica include the oval relief of the *Crucifixion* with angels and doves, cast in 1578 for the Altar of the Pietà, and five bronze panels commissioned by Gregorio Massilla of San Ginesio for the chapel of the Pietà. These consist of a relief of the *Deposition* and relief portraits of Massilla, his wife and daughter and Antonio Rogato, cast in 1582.

Calcagni created two major works in bronze for the basilica. The first, the magnificent statue of *Sixtus V* for the piazza, was commissioned by the city in honour of the election of the Marchese Cardinal Peretti-Montalto as pope in 1585. Calcagni was awarded the commission over Girolamo Lombardo, whom he had succeeded as head of the Recanati school. The statue was rapidly executed, and installed by 1589. A seated figure, with arm raised in the act of benediction, the statue appears both beneficent and powerful. The pedestal is adorned with four small statues of *Charity*, *Peace*, *Faith* and *Justice* and two low reliefs of the *Entry into Jerusalem* and *Christ Driving the Money-changers from the Temple*. For its 'total perfection' he was awarded an additional 1300 scudi by the city. The second major work, the south door of the basilica, was commissioned 28 February 1590 by Cardinal Antonio Maria Gallo, Protector of Santa Casa, with the main door assigned to Antonio Lombardo, son of Girolamo, and the north door to Tiburzio Vergelli. Calcagni had executed the designs and terracotta models (Ancona, Mus. Dioc.) for the panels before his death. The door was completed by his students and inaugurated in 1600. Each of the two parts has five panels of scenes from the Old and New Testaments, ovals holding statues of the Prophets, and figures of the Virtues, putti, acantha flowers and fruit.

BIBLIOGRAPHY

DBI; Thieme–Becker

F. Baldinucci: *Notizie* (1681–1728); ed. F. Ranalli (1845–7), iii, pp. 101–24

A. Venturi: *Storia* (1901–40), x, pp. 721–34

G. Gennari: 'Un bassorilievo in terracotta di Antonio Calcagni da Recanati', *L'Arte*, xli (1938), pp. 298–300

J. Pope-Hennessy: 'Sculpture for the Victoria and Albert Museum', *Apollo*, lxxx (1964), pp. 458–65

——: 'Antonio Calcagni's Bust of Annibale Caro', *Arte in Europa: Scritti di storia dell'arte in onore di Edoardo Arslan*, 2 vols (Pavia, 1965–6), i, pp. 577–80; ii, pls 374–5; repr. in *V&A Mus. Bull.*, 3 (1967), pp. 13–17

F. Grimaldi and K. Sordi: *Scultori a Loreto: Fratelli Lombardi, Antonio Calcagni e Tiburzio Vergelli: Documenti* (Ancona, 1987), pp. 113–236, 297–308

——: *Pittori a Loreto: Committenze tra '500 e '600* (Ancona, 1988)

B. K. GRINDSTAFF

Caldara, Polidoro. *See* POLIDORO DA CARAVAGGIO.

Caliari. Italian family of painters. The most accomplished member of the family, Paolo Caliari, is better known as PAOLO VERONESE, from his birthplace. After his death in 1588, his workshop (*see* VERONESE, PAOLO, §II, 3) was run by his brother (1) Benedetto Caliari and his sons (2) Carlo Caliari and Gabriele Caliari (*b* Venice, 1568; *d* 1631), using the signature *Haeredes Pauli*. Only one signed work by Gabriele is known: an altarpiece of the *Virgin and St Anne* (Liettoli, parish church); its physical types are related to Veronese's but are rather awkward and heavy.

(1) Benedetto Caliari (*b* Verona, 1538; *d* Venice, 1598). In 1556, at age 18, he was recorded as the assistant of his elder brother, Paolo Veronese, decorating the ceiling (*in situ*; *see* VERONESE, PAOLO, §I, 2(i)) of the church of S Sebastiano, Venice, and it is thought that he was Veronese's principal collaborator at the Villa Barbaro at Maser (*c.* 1561; *see* VERONESE, PAOLO, §I, 3(i)), producing much of the illusionistic architecture there and some of the landscapes (*in situ*). Frescoes (*c.* 1564–77) in the Vescovado, Treviso (*in situ*), offer the first known instance of his independent work; the Sala there is an echo of the Sala Crociera at Maser, with landscape views seen through a painted arcade. Benedetto Caliari is attributed with the decoration of the Villa Corner–Piacentini, Sant'Andrea (*in situ*), with some of the frescoes (after 1575) of the Villa Giusti at Magnadola (*in situ*) and with easel paintings (late 1560s) of *St Peter Visiting St Agatha in Prison* (Murano, S Pietro) and the *Flight into Egypt* (Caen, Mus. B.-A.). He assisted Veronese with two commissions at the Doge's Palace, Venice (1574–82; *see* VERONESE, PAOLO, §I, 4(i)), and in 1575 he was in Padua, helping Veronese with the *Martyrdom of St Justine* (Padua, S Giustina), a work that clearly shows his hand. The *Birth of the Virgin* (1577; Venice, Accad., on dep. Venice, Gal. Farsetti), commissioned for the Scuola dei Mercanti, is one of the few paintings documented as designed and executed by Benedetto Caliari, the forms are heavy, strongly modelled versions of Veronese's types, and the hand is somewhat mechanical.

(2) Carlo [Carletto] **Caliari** (*b* Venice, 1567–70; *d* Venice, 1592–6). Nephew of (1) Benedetto Caliari and son of Paolo Veronese. As the most talented member of his father's workshop, he undoubtedly executed many works that are attributed to his father. Works that have been clearly isolated as Carlo's own are more precise and delicate, both technically and in the physical types; they lack Veronese's bravura, whether in the line and wash of a chiaroscuro drawing or in the richly layered pigments that make an embroidered drape. His early signed works show the influence of both his father and the Bassano family by whom he was trained. They include *Angelica and Medoro* (*c.* 1584; Padua, Barbieri priv. col.), which has a preciousness in the landscape and in details of foliage and coiffures that sets it apart from Veronese's work. The signed *Nativity* (*c.* 1588; Brescia, S Afra) combines narrative detail typical of the Bassano with morphological similarities to Veronese. There are similar characteristics in frescoes at the Villa Loredan, Sant'Urbano, Padua, that are assigned to Carlo by Crosato. Other signed paintings —the *Virgin in Glory with SS Margaret, Mary Magdalene*

and Frediano (c. 1588–90; Florence, Uffizi), *St Agnes* (Madrid, Prado) and the *Vanity* (London, priv. col.)—share facial type, a smooth finish and the somewhat mannered gestures also found in the attributed *St Catherine* (Florence, Pitti) and the attributed *Holy Family* (Princeton U., NJ, A. Mus.).

More closely resembling works by Veronese, and perhaps later, are the signed *St Augustine Giving the Rules of his Order to the Irregular Canons Lateran* (Venice, Accad.) and the *Virgin in Glory with Saints* (c. 1602; Venice, Fond. Cini; attributed to Carlo by Boschini). The signed *Resurrection of Lazarus* (Venice, Accad.) is rather refined, delicate and static, qualities also found in its preparatory drawing (Vienna, Albertina).

BIBLIOGRAPHY
Thieme–Becker
C. Ridolfi: *Meraviglie* (1648); ed. D. von Hadeln, i (1914–24), pp. 353–61
M. Boschini: *La carta del navegar pittoresca* (Venice, 1660), pp. 280, 435–9
——: *Le ricche miniere* (Venice, 1674), pp. 27, 50
B. dal Pozzo: *Le vite dei pittori, scultori e architetti veronesi* (Verona, 1718), pp. 114, 122
L. Coletti: 'I paesi di Paolo Veronese', *Dedalo*, vi (1925), pp. 404–10
L. Crosato: *Gli affreschi nelle ville venete del cinquecento* (Treviso, 1962), figs 109–20, 129–31
L. Crosato Larcher: 'Per Gabriele Caliari', *A. Ven.*, xviii (1964), pp. 174–5
——: 'Per Carletto Caliari', *A. Ven.*, xxi (1967), pp. 108–24
——: 'Note su Benedetto Caliari', *A. Ven.*, xxiii (1969), pp. 115–30
R. Brenzoni: *Dizionario di artisti veneti* (Florence, 1972), p. 67
T. Formiciova: 'Opere di allievi del Veronese nella collezione dell'Ermitage: Nuove attribuzioni', *A. Ven.*, xxxiii (1979), pp. 131–6
A. Cuozzo: 'Una inedita *Natività della Vergine* di Benedetto Caliari', *A. Ven.*, xxxiv (1985), pp. 145–6
L. Vertova: 'Su Matteo Verona, la bottega Caliari e Palma Giovine', *Ant. Viva*, xxiv (1985), pp. 58–66
C. Rigone: 'La bottega dei Caliari a Verona', *Veronese e Verona* (exh. cat., Verona, 1988), pp. 161–64
L. Crosato Larcher: 'La Bottega del Veronese', *Nuovi studi su Paolo Veronese: Convengo internazionale di studi: Venezia, 1988*, (Venice, 1990), pp. 256–64
D. Gisolfi 'The School of Verona in American Collections', *Art & Hist.*, xxxiv (1996), pp. 177–91

DIANA GISOLFI

Caliari, Paolo. *See* VERONESE, PAOLO.

Calixtus III, Pope. *See* BORGIA, (1).

Callisto da Lodi. *See* PIAZZA, (1).

Camelio [Camelius; Camelus]. *See* GAMBELLO, (2).

Camerino. *See under* VARANO.

Camerino, Arcangelo di Cola da. *See* ARCANGELO DI COLA DA CAMERINO.

Camerino, Giovanni Angelo di Antonio. *See under* MASTERS, ANONYMOUS, AND MONOGRAMMISTS, §I: MASTER OF THE BARBERINI PANELS.

Camerino, Girolamo di Giovanni da. *See* GIROLAMO DI GIOVANNI DA CAMERINO.

Campagnola. Italian family of draughtsmen, printmakers and painters. (1) Giulio Campagnola was the son of Girolamo Campagnola (1433/5–1522), a humanist scholar

and writer on art. Vasari mentioned a once-famous Latin letter by Girolamo describing the achievements of contemporary Paduan artists. (2) Domenico Campagnola was Giulio's adopted son, and the prints of both artists were important in spreading an awareness of Venetian landscape through Europe.

(1) Giulio Campagnola (*b* Padua, *c.* 1482; *d* Venice, after 1515). Contemporary humanists such as Matteo Bosso praised his precocious artistic gifts, his knowledge of Greek, Latin and Hebrew, and his skills as a musician, singer and lute-player. In 1497 his father sought to secure him a place at the court of Francesco II Gonzaga, 4th Marchese of Mantua, where it is possible that Giulio came into contact with Andrea Mantegna. By 1499 Giulio was at the Ferrarese court of Ercole I d'Este. His earliest engravings, datable between 1497 and 1506, were influenced by Mantegna and by Albrecht Dürer (1471–1528): for instance, in the *Ganymede and Zeus* (c. 1500–03; see Hind, no. 4) the figure style is indebted to Mantegna, while the rustic landscape is directly inspired by Dürer's *Virgin with the Monkey* (B. 42).

In 1507 Giulio was recorded in Venice, and his art from the period 1507–13 must be seen in the context of Venetian painting in the first decades of the 16th century. The dominant influence was the circle of Giorgione, and Giulio's engravings, such as the *Old Shepherd* (c. 1507–9; H 8), the *Astrologer* (1509; H 9), his only dated print, and the *Young Shepherd* (c. 1510–12; H 10), spread to a wider public an awareness of Giorgione's pastoral themes and arcane subjects as explored in such paintings as the *Three Philosophers* (c. 1508–10; Vienna, Ksthist. Mus.; *see* GIORGIONE, fig. 4). Giulio was evidently close to the humanist circles of the Veneto, and Marcantonio Michiel recorded ten miniatures on vellum by him in the house of the poet Pietro Bembo, one of which represented a 'nude woman, after Giorgione, reclining and viewed from behind'. This description recalls Giulio's engraving of *Venus Reclining in a Landscape* (c. 1510; H 13; see fig.), perhaps based on a lost painting by Giorgione, which is the most perfect example of his innovative stippling technique. The development from a purely linear treatment of form to an overall dotted surface of light and shade may be seen as an attempt to find a graphic equivalent to the tonal painting of Giorgione. It is not clear whether Giulio, in this or in other prints, collaborated directly with Giorgione (and later with Titian) or whether he made free interpretations of other artist's ideas.

In 1515 the celebrated Venetian printer Aldo Manuzio left instructions in his will that Giulio should cut the italic type he had invented. Giulio was himself probably dead by *c.* 1517, when his unfinished print *Shepherds in a Landscape* (H 6), which he had prepared in a delicate and poetic pen-and-brown-ink drawing (Paris, Louvre), was completed by Domenico Campagnola in a bolder style.

(2) Domenico Campagnola (*b* ?Venice, 1500; *d* Padua, 10 Dec 1564). Adopted son of (1) Giulio Campagnola. He was of German extraction and was apprenticed to Giulio in Venice *c.* 1507. A group of drawings of pastoral subjects, indebted to Giorgione and to Dürer, includes the slightly tentative *Landscape with Two Youths* (London, BM) and

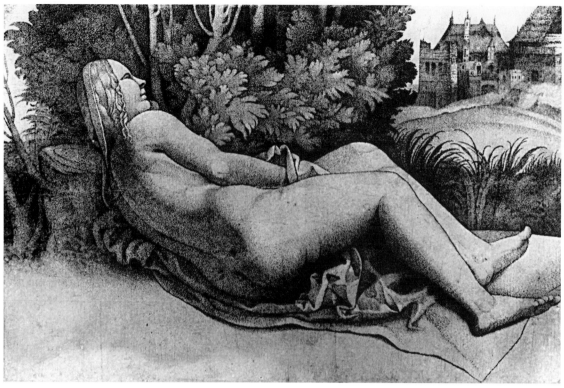

Giulio Campagnola: *Venus Reclining in a Landscape*, stipple engraving, 112×159 mm, *c.* 1510 (London, British Museum)

Landscape with Boy Fishing (Washington, DC, N.G.A.) and may be dated to his earliest years, perhaps before 1517. His independent career began in 1517–18 with a group of engravings and woodcuts that are largely independent of Giulio Campagnola but clearly indebted to the work of Titian. Indeed, the close correspondence between Domenico's work and Titian's has led to suggestions that Domenico was responsible for the forged Titian drawings (e.g. New York, Met.) taken from counterproofs of the master's woodcuts (see Dreyer; Byam Shaw). Domenico's own prints are executed in an unusually flowing and sketchy technique and include enigmatic, pastoral themes, such as the *Shepherd and Old Warrior* (1517; H 9), which recalls the moody poetry of Giorgione, and religious subjects, such as the *Assumption of the Virgin* (1517; H 3). This latter depends on Titian's painting of that subject (Venice, Frari), completed the following year, which suggests that Domenico had access to Titian's workshop. Domenico's main innovation was in the technique of the woodcut, and it is evident that he cut the blocks himself rather than relying on a professional cutter. The energy of the unusually bold *Vision of St Augustine* (1517; see 1976–7 exh. cat., no. 19) is indebted to such works as Titian's woodcut of *St Jerome*, cut by Ugo da Carpi (1976–7 exh. cat., no. 18).

Perhaps by 1520 Domenico had moved to Padua, where he became a leading painter, executing frescoes and easel paintings for churches and palaces. His fresco of *Joachim and Anna* (*c.* 1520; Padua, Scu. Carmine) is indebted to Titian, whose influence remains strong in such mature works as the *Virgin and Child Enthroned with Saints and*

a Donor (Prague, N.G., Šternberk Pal.). Here the asymmetrical composition and the high pedestal on which the Virgin sits are derived from Titian's *Pesaro Madonna* (Venice, Frari; see colour pl. 2, XXXV2), while the rich treatment of fabrics is close to the painting of Paolo Veronese.

However, in this period Domenico was most celebrated for his landscape drawings and woodcuts, which are deeply influenced by Titian's woodcuts, as in the *Landscape with Milkmaid* (*c.* 1520–25; see 1976–7 exh. cat.). In such woodcuts as *Landscape with a Wandering Family* (1535–40; see 1976–7 exh. cat., no. 28) and *Landscape with a Hurdy-gurdy Player and a Girl* (*c.* 1540; see 1976–7 exh. cat., no. 29) and in drawings such as *Landscape with a Dragon* (Vienna, Albertina) he created, with flowing, rhythmic strokes, decorative panoramic landscapes. The foregrounds are raised, and beyond extend vistas of twisting paths, castles, bridges and ruins, leading to the jagged peaks of distant mountains. Such works introduced a new speciality into Venetian art, and they were sought after by such cultivated collectors as Gabriele Vendramin and Marco di Mantova Benavides (Michiel). Hieronymous Cock (*c.* 1510–1570), Pieter Bruegel the elder (*c.* 1525/30–69), Hendrick Goltzius (1558–1617) and Peter Paul Rubens (1577–1640) are among the artists whose landscapes were influenced by Domenico's drawings and prints. This influence continued into the 18th century, when Antoine Watteau (1684–1721) copied Domenico's drawings.

BIBLIOGRAPHY

DBI [with bibliog.]

M. Bosso: *Familiares et secundae epistulae* (Mantua, 1498), pp. 75, 86, 211

G. Vasari: *Vite* (1550, rev. 2/1568); ed. G. Milanesi (1878–85), iii, pp. 225, 385, 634, 639

M. A. Michiel: *Notizie d'opere di disegno nella prima meta del secolo XVI, pubblicata e illustrata da D. Jacopo Morelli* (Bassano, 1800), pp. 19, 130 [Giulio]; (Bologna, 1884), pp. 23, 69 [Domenico]

P. Kristeller: *Giulio Campagnola Kupferstiche und Zeichnungen* (Berlin, 1907) [good illus.]

G. Fiocco: 'La giovanezza di Giulio Campagnola', *L'Arte*, xviii (1915), pp. 137–56

A. M. Hind: *Early Italian Engraving* (London, 1938–48), v, pp. 189–205, 207–15 [H]

H. Tietze and E. Tietze-Conrat: *The Drawings of Venetian Painters in the XVth and XVIth Centuries* (New York, 1944)

R. Colpi: 'Domenico Campagnola, nuove notizie biografiche e artistiche', *Boll. Mus. Civ. Padova*, xxxi–xliii (1952–4), pp. 81–111

Early Italian Engravings from the National Gallery of Art (exh. cat., ed. J. Levenson; Washington, DC, N.G.A., 1973), pp. 390–436

Titian and the Venetian Woodcut (exh. cat. by D. Rosand and M. Murano, Washington, DC, N.G.A.; Dallas, TX, Mus. F.A.; Detroit, MI, Inst. A.; 1976–7), pp. 120–39, 154–71

P. Dreyer: 'Tizianfälschungen des sechzehnten Jahrhunderts: Korrekturen zur Definition der Delineatio bei Tizian und Anmerkungen zur Datierung seiner Holzschnitte', *Pantheon*, xxxvii (1979), pp. 365–75

J. Byam Shaw: 'Titian's Drawings: A Summing up', *Apollo*, cxii (1980), pp. 386–91

M. J. Zucker: *Early Italian Masters* (1980), 25 [XIII/ii] of *The Illustrated Bartsch*, ed. W. Strauss (New York, 1978–), pp. 463–95 [Giulio]; pp. 497–516 [Domenico]

The Genius of Venice, 1500–1600 (exh. cat., ed. J. Martineau and C. Hope; London, RA, 1983–4), pp. 248–53 [drgs], pp. 310–15, 320–21, 324–8 [prts]

R. Cafritz, L. Gowing and D. Rosand: *Places of Delight* (London, 1989)

P. Holberton: 'Notes on Giulio Campagnola's Prints', *Prt Q.*, xiii (Dec 1996), pp. 397–400

□

Campanato, Pietro di Giovanni Battista [Pietro delle Campane] (*b* ?Venice, *c.* 1460; *d* Venice, 18 Oct 1542). Italian bronze-caster. During a period of revival in bronze-casting, he was trained in the workshop of Alvise Campanato in the parish of S Luca, Venice, establishing his own bronze foundry probably during the 1480s and becoming prominent as a caster of cannons. From 1504 to 1515, with Giovanni Alberghetti and Paolo di Matteo Savin, Campanato was involved in bronze-casting from models by Alessandro Leopardi, Tullio Lombardo and Antonio Lombardo for the chapel of Cardinal Zen in S Marco, Venice. The bronze statue of the *Virgin and Child* for this chapel by Antonio Lombardo (*see* LOMBARDO, §II(3)) bears the inscription PETRI IOANNIS CAMPANATI M.DXV. In 1521 Pietro also cast one of the bronze doors. Of his eighteen children, three were employed in his large workshop.

BIBLIOGRAPHY
Thieme–Becker
J. Pope-Hennessy: *Italian Renaissance Sculpture* (London, 1958, rev. New York, 1985), pp. 344–5

STEVEN BULE

Campi. Italian family of artists. From Cremona, they were active there and elsewhere in Italy from the late 15th century to the late 16th. Galeazzo Campi (*b* Cremona, *c.* 1477; *d* Cremona, 1536) and Sebastiano Campi (*fl* 1522–31), sons of Antonio Campi, were both painters who probably shared a workshop. Galeazzo's sons, (1) Giulio Campi and (2) Antonio Campi were painters and architects who collaborated on many decorative cycles in the mid-16th century. After Giulio's death, Antonio began to paint in a more naturalistic manner, and in this he was followed to some extent by his youngest brother, (3) Vincenzo

Campi, who had also almost certainly studied earlier with Giulio. The third generation of the Campi included Antonio's son, Claudio Campi, who signed his own name to his father's drawings.

BIBLIOGRAPHY
DBI
G. Vasari: *Vite* (1550, rev. 2/1568); ed. G. Milanesi (1878–85)
A. Perotti: *I pittori Campi da Cremona* (Milan, 1932)
I Campi e la cultura artistica cremonese del cinquecento (exh. cat., ed. M. Gregori; Cremona, Mus. Civ. Ala Ponzone, 1985)
I segni dell'arte. Il Cinquecento da Praga a Cremona (exh. cat., eds G. Bora and M. Zlatohlavek; Milan, 1997)
B. de Klerck: *Giulio, Antonio & Vincenzo Campi: schilderkunst en devotie in het zestiende – eeuwse Lombardije, 1565–1591* (Nijmegen, 1997)

(1) Giulio Campi (*b* Cremona, *c.* 1508; *d* 5 March 1573). Painter and architect. He probably trained with his father, Galeazzo Campi. His first signed and dated painting, the altarpiece of the *Virgin and Child with SS Nazarius and Celsus* (1527; Cremona, S Abbondio), shows the influence of the Brescian painting of Moretto and Romanino. His development was rapid, and within a few years he showed an interest in the art of Pordenone, Giulio Romano and Raphael. This is evident in two altarpieces, *Nativity with Saints* and *Virgin and Saints with a Marchese Stampa as Donor* (1530; both Milan, Brera), and in the frescoes (1530) in S Maria delle Grazie, Soncino. Apart from a few works of interest such as the *Game of Chess* (Turin, Mus. Civ. A. Ant.), in the 1530s Giulio concentrated on an important fresco cycle for S Agata, Cremona, with scenes from the *Life of St Agatha* (1537); and from 1539 to 1542 he decorated the two transepts of S Sigismondo, Cremona. The rich and varied style of these works, which combined elements from Mannerism and the work of Pordenone, influenced Cremonese painting in the following decades. In a major commission to decorate the whole of S Margherita, Cremona, which he also probably rebuilt (1547), he attained a high degree of sophistication and complexity. With his brother, (2) Antonio Campi, he then painted some canvases for the Palazzo della Loggia, Brescia, illustrating *Stories of Justice* (*in situ* and dispersed in Brescia, Pin. Civ. Tosio–Martinengo; Budapest, Mus. F.A.). He probably visited Rome in the mid-1550s; his subsequent decoration (1557) of the first bay of S Sigismondo, Cremona, with the *Pentecost* and two *Prophets* shows a new monumentality and daring illusionism. In the 1560s he painted a large *Crucifixion* for S Maria della Passione, Milan, an altarpiece with *SS Philip and James* (1565) for S Sigismondo, Cremona, and *St Lawrence* for Alba Cathedral (all *in situ*).

In his last years Giulio executed numerous works for Cremona Cathedral, including the vast organ shutters. These paintings show a gradual transition from complex compositions to simpler ones, reflecting the requirements of the Counter-Reformation. At his death, he left incomplete the decoration of the presbytery of S Maria di Campagna, Piacenza, and of S Abbondio, Cremona.

BIBLIOGRAPHY
S. Zamboni: 'Per Giulio Campi', *A. Ant. & Mod.*, x (1960), pp. 170–73
G. Bora: 'Note Cremonese, II: L'eredità di Camillo e i Campi', *Paragone*, 311 (1976), pp. 49–74
G. Godi and G. Cirillo: *Studi su Giulio Campi* (Milan, 1978)
G. Bora: 'Giulio e Antonio Campi architetti', *Per A. E. Popham* (Parma, 1981), pp. 21–41

M. Tanzi: 'Cremona 1560–1570: Novita sui Campi', *Boll. A.*, lxxix (Jan/Feb 1994), pp. 55–64

L. Cheney: 'The Cult of Saint Agatha', *Woman's A. J.*, xvii (Summer/Spring 1996), pp. 3–9

G. Gallina: 'Raffaello e Giulio Campi: Un legame inedito', *Grafica A.*, xxvi (April–June 1996), pp. 2–3

(2) Antonio Campi (*b* Cremona, 1523; *d* Cremona, Jan 1587). Painter, engraver, architect and writer, brother of (1) Giulio Campi. He probably trained with Giulio in a style tending towards Mannerism. His first signed and dated work, the *Virgin and Child with SS Jerome and Joseph, with Donor* (1546; Cremona, S Ilario), reflects the style of Camillo Boccaccino, himself inspired by Parmigianino, and the influence of Boccaccino on Antonio increased in the following years and is particularly marked in a series of chiaroscuro engravings (1547 to the early 1550s; e.g. *Adoration of the Magi*, 1547). Around 1547 Antonio collaborated with Giulio on frescoes in S Margherita, Cremona. Still working with Giulio, from 1549 he painted at least half of the eight canvases for the Palazzo della Loggia, Brescia, illustrating *Stories of Justice* (*in situ* and dispersed in Brescia, Pin. Civ. Tosio–Martinengo; Budapest, Mus. F.A.), and in 1557 he frescoed part of the first bay of S Sigismondo in Cremona.

Also in the 1550s Antonio worked on the decoration of two rooms in the Palazzo Pallavicini in Torre Pallavicina and possibly on its architectural plan. The decoration of the presbytery of S Paolo Converso, Milan, dates from before 1564. The rich and forceful Mannerist style of these works is also evident in the *Resurrection* (1560; Milan, S Maria presso S Celso) and is even more striking in the *Beheading of St John the Baptist* (1567), in the chapel of S Giovanni in S Sigismondo, Cremona, which was entirely decorated by Antonio over a period of almost 20 years.

During the 1560s Antonio veered between different styles: the *Pietà* (1566) in Cremona Cathedral is starkly devotional; the *Holy Family* (1567; Cremona, S Pietro al Po) conveys a sense of grandeur; and the *Sacra conversazione* (Milan, Brera) displays sumptuous elegance. Possibly because of his contact with the Archbishop of Milan, Carlo Borromeo (1538–84; canonized 1610), from the late 1560s Antonio's devotional subjects became more expressive. Examples include *Scenes from the Passion* (?1569; Paris, Louvre); frescoes of the *Three Marys at the Tomb* and a *Pietà* (Meda, near Milan, S Vittore); *St Jerome* (Madrid, Prado), painted for El Escorial; and the *Beheading of St John the Baptist* (1571; Milan, S Paolo Converso). In the *Adoration of the Shepherds* (1575; Crema, S Maria della Croce) the intimate devotional atmosphere is emphasized by the use of a nocturnal setting.

Apart from these experiments, Antonio's activity in the 1570s included works of such diverse character as his stately signed *Virgin with Saints* (1575), now part of the main altar of S Pietro al Po in Cremona; the mannered *St Sebastian* (1575; Milan, Castello Sforzesco); and the triptych of the *Assumption* (1577; Milan, S Marco), which recalls Brescian painting in its light and colour, as does the *Adoration of the Magi* (1579) in S Maurizio al Monastero Maggiore in Milan. He also completed the decoration of the transepts of S Pietro al Po in Cremona, with scenes from the *Life of St Peter* (1575–9). He then worked on important paintings in S Paolo Converso in Milan, including the *Adoration of the Shepherds* (1580; see colour pl. 1, XVIII2) and the *Martyrdom of St Lawrence*, both interesting for their strong naturalism, which anticipates Caravaggio (1571–1610).

From 1580 Campi served as architect for the Fabbrica del Duomo (Cathedral Works), Cremona, for which he also painted the fresco of the *Centurion Kneeling before Christ* for the apse (*in situ*). This fresco, commissioned in 1582, was probably completed after a journey to Rome, where Antonio is said to have worked in the Vatican and been made a *cavaliere aurato* in 1583 by Gregory XIII for his work as an architect. Campi's high standing in Cremona was confirmed with the publication of his important *Cremona fedelissima* in 1585, though a first incomplete edition had probably appeared in 1582. This is a history of the city illustrated with elaborate engravings.

Antonio Campi's last important paintings were done in Milan in the chapel of S Caterina in S Angelo (*in situ*). These are the *Martyrdom of St Catherine* (1583) and *St Catherine in Prison* (1584; see fig.); the former is characterized by formal devices and elaborate drapery, the latter by a masterly nocturnal play of light and shadow. A similar theatricality, although obtained here by the use of *sotto in sù* perspective, is found in the *Presentation in the Temple* (1586; ex-Milan, S Marco; Naples, S Francesco di Paola). Also in 1586, with his brother (3) Vincenzo Campi, Antonio began to paint the ceiling of S Paolo Converso, Milan. For this (*in situ*) he designed a false portico and an architectural backdrop by means of the *quadratura* devices for squaring up already used by Giulio Romano in Mantua and by his own brother, Giulio, in S Sigismondo, Cremona, and recently codified in the treatise by Jacopo Vignola, *Le due regole della prospettiva practica* (Rome, 1583). These advanced conceptions were probably sketched out by Antonio before his death and completed by his brother Vincenzo.

WRITINGS

Cremona fedelissima città e nobilissima colonia de' Romani . . . (Cremona, 1585)

BIBLIOGRAPHY

R. Longhi: 'Quesiti caravaggeschi, II: I precedenti', *Pinacotheca*, v–vi (1929), pp. 258–329

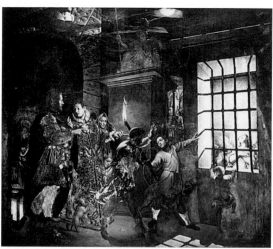

Antonio Campi: *St Catherine in Prison*, oil on canvas, 4.0×5.0 m, 1584 (Milan, S Angelo)

F. Bologna: 'Antonio Campi: La *Circoncisione* del 1586', *Paragone*, 41 (1953), pp. 46–51

R. Longhi: 'Un *San Sebastiano* di Antonio Campi', *Paragone*, lxxx/8 (1957), pp. 66–7

M. L. Ferrari: 'La "maniera de' Campi cremonesi" a Torre Pallavicina', *An. Scu. Norm. Sup. Pisa*, 3rd ser., iv/3 (1974), pp. 805–16

G. Bora: 'Note Cremonesi, II: L'eredità di Camillo e i Campi', *Paragone*, 327 (1977), pp. 54–88

——: 'Giulio e Antonio Campi architetti', *Per A. E. Popham* (Parma, 1981), pp. 21–41

(3) Vincenzo Campi (*b* Cremona, 1530–35; *d* Cremona, 1591). Painter, brother of (2) Antonio Campi. He trained in the family workshop in Cremona, absorbing from (1) Giulio Campi a formal and complex style of composition and from Antonio an expressive pathos. His earliest surviving works, which show little originality, were executed in the 1560s—altarpieces such as the *Deposition* (Cremona, SS Siro e Sepolcro) and the *Pietà* for S Facio in Cremona (Cremona, Osp. Nuovo). In the *Pietà* in the chapterhouse at Cremona Cathedral he attempted, through naturalism and illusionism, to express the new iconographical precepts of the Counter-Reformation. Similar and interesting paintings, which also show Vincenzo's characteristic sentimentality, are two versions of the *Pietà* (Bordolano, S Giacomo, and Cremona, Mus. Civ. Ala Ponzone). He worked in fresco on the *Prophets* (1573) on the nave arches in Cremona Cathedral.

In *Christ Being Nailed to the Cross* (1575; Pavia, Mus. Certosa) Vincenzo began to develop a richer and mellower palette to portray more naturalistic figures from contemporary life. The later *Christ Being Nailed to the Cross* (1577; Madrid, Prado), with its naturalistic motifs, which Cara-

vaggio (1571–1610) may have seen in his years in Lombardy, is similar in conception. At the same time Vincenzo was experimenting with his treatment of altarpieces, using simpler but more intense colour, as in the *Virgin in Glory with Saints* (1577; Cremona, S Maria Maddalena) and the *Trinity with SS Apollonia and Lucy* (1579; Busseto, Oratory of the Trinity). In the *Annunciation* (1581) in the oratory of S Maria Annunciata at Busseto, Vincenzo emphasized colour and chiaroscuro, almost certainly following recent developments in Venetian painting. In the same period he was influenced by such Flemish artists as Joachim Beuckelaer (*c.* 1534–*c.* 1574) and Pieter Aertsen (1507/8–1575) to paint humorous, naturalistic scenes with titles such as *Fishwives* and *Cooks* (e.g. series 1580–81; Kirchheim im Schwaben, Schloss Fugger), and *Fish Market* and *Fruit-seller* (*c.* 1580; Milan, Brera; see fig.).

Between 1586 and 1589, at first with his brother Antonio, and then on his own, Vincenzo worked on the ceiling frescoes of S Paolo Converso in Milan (*in situ*). These depict the *Ascension*, the *Assumption of the Virgin* and, theatrically framed in *trompe l'oeil* colonnades, the *Apostles*. One of his last works, *St Matthew with the Angel* (1588; Pavia, S Francesco Maggiore), shows an intensity of feeling and direct naturalism that anticipates Caravaggio.

BIBLIOGRAPHY

A. Venturi: *Storia* (1901–40), ix/6, pp. 887–900

A. Puerari: 'Due dipinti di Vincenzo Campi', *Paragone*, iv/37 (1953), pp. 41–5

S. Zamboni: 'Vincenzo Campi', *A. Ant. & Mod.*, xxx (1965), pp. 924–47

——: 'La cucina di S Sigismondo', *Atti & Mem. Accad. Clementina Bologna*, ix (1970), pp. 31–3

M. Gregori: 'Note su Vincenzo Campi, pittore di naturalia, e su alcuni precedente', *Paragone*, xlii/501 (1991), pp. 70–86

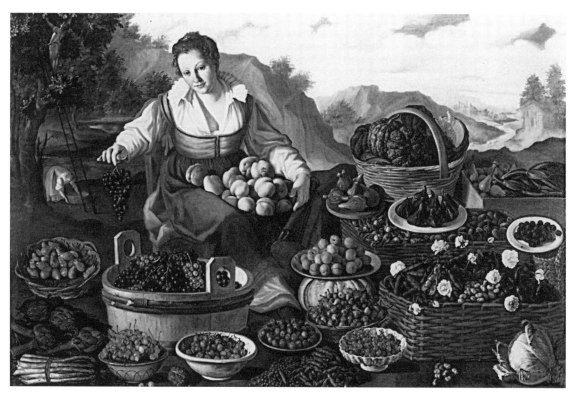

Vincenzo Campi: *Fruit-seller*, oil on canvas, 1.45 x 2.15 m, *c.* 1580 (Milan, Accademia di Belle Arti di Brera)

F. Paliaga and B. de Klerck: *Vincenzo Campi c. 1530–1591* (Soncino, 1997)

GIULIO BORA

Campi, Bernardino (*b* Cremona, 1522; *d* Reggio Emilia, 18 Aug 1591). Italian painter. He was almost certainly not related to the CAMPI family of artists from Cremona, although Claudio Campi, son of Antonio Campi (*see* CAMPI, (2)), married Bernardino's niece. The main source of information about Bernardino's life is Lamo's *Discorso* (1584). He trained in Cremona with his father, Pietro Campi, a goldsmith, with the painter Giulio Campi and then (after moving to Mantua) with Ippolito Costa. After his return to Cremona in 1541, Bernardino painted the *Assumption of the Virgin* (1542) for S Agata, and in S Sigismondo he executed frescoes (1546), including the *Prophets* in the nave. His work, always characterized by attention to detail, was influenced by Giulio Romano, Pordenone, Giulio Campi and especially by Camillo Boccaccino, with whom he seems to have collaborated from 1544.

Bernardino's fame grew during the 1550s, after he had moved to Milan, where he executed numerous works for the nobility (all untraced). Surviving altarpieces painted for Milanese churches in the 1560s include the *Transfiguration* (S Fedele) and the *Virgin with Saints* (1565; S Antonio), both executed with Carlo Urbino, and the *Crucifixion* (Florence, Fiesolana Abbey) for the Scuola dei Genovesi, Milan. After returning to Cremona, he painted the elegant altarpiece with *SS Cecilia and Catherine* (dated 1566) and the dome decorations (1570) for S Sigismondo. For Cremona Cathedral he produced a series of canvases and, for the apse, a fresco with the *Entry into Jerusalem* (1573).

Bernardino's work of the 1570s includes the *Pietà* (1574; Milan, Brera) and two altarpieces (1575) in S Maria della Croce at Crema. In 1582 he was in the service of Duke Vespasiano Gonzaga in Sabbioneta, where he carried out decorations for the Palazzo del Giardino (*in situ*); from 1587 to 1590 he was employed at Guastalla on decorations (destr.) in the palace of Ferrante Gonzaga. Bernardino's last documented paintings are the frescoes (1589) in the choir of S Prospero in Reggia Emilia.

DBI

BIBLIOGRAPHY

A. Lamo: *Discorso intorno alla scoltura, e pittura dove ragiona della vita, ed opere in molti luoghi . . . fatte dall'eccellentissimo cremonese M. Bernardino Campo* (Cremona, 1584)

G. B. Zaist: *Notizie istoriche de' pittori, scultori ed architetti cremonesi* (Cremona, 1774/*R* Cremona, 1975), pp. 186–214 [incl. Lamo]

F. Zeri: 'Bernardino Campi: Una *Crocifissione*', *Paragone*, iv/27 (1953), pp. 36–41

M. Di Giampaolo: 'Bernardino Campi a Sabbioneta e un'ipotesi per Carlo Urbino', *Antichità Viva*, xiv/3 (1975), pp. 30–38

G. Bora: 'Note cremonesi, II: L'eredità di Camillo e i Campi', *Paragone*, 327 (1977), pp. 54–88

I Campi e la cultura artistica cremonese del cinquecento (exh. cat., ed. M. Gregori; Cremona, Mus. Civ. Ala Ponzone, 1985)

M. Di Giampaolo: 'A Drawing by Bernardino Campi for the Badia Fiesolana *Crucifixion*', *Master Drgs*, xxxii (1994), pp. 380–82

A. Ghirardi: 'Per Bernardino Campi ritrattista', *Quad. Pal. Te*, i (1994), pp. 78–87

M. Tanzi: 'Cremona, 1560–1570: Novita sui Campi', *Boll. A.*, lxxix (1994), pp. 55–64

I segni dell'arte. Il Cinquecento da Praga a Cremona (exh. cat., eds G. Bora and M. Zlatohlavek; Milan, 1997)

GIULIO BORA

Canavesio, Giovanni (*b* Pinerolo, Piedmont; *fl* 1450–1500). Italian painter. He was registered in Pinerolo as a 'master painter' in 1450, but no early works by him are known. In 1472 he was commissioned in Albenga (Liguria) to paint a *Maestà* (untraced) for the church of Oristano in Sardinia, and from that date his career in western Liguria and the region of Nice is documented by signed and dated works. These include two important fresco cycles, that of the *Passion* and *Last Judgement* (1482) in S Bernardo, Pigna (Liguria), and that of the *Life of Christ* and the *Last Judgement* (1492) in Notre-Dame-des-Fontaines near La Brigue (Alpes Maritimes), as well as three large polyptychs, two of which depict the *Virgin and Child with Saints* (1491; Turin, Gal. Sabauda; and 1499, Verderio Superiore, nr Como, parish church, formerly in Pornassio, S Dalmazzo), while the third represents *St Michael* (1500; Pigna, S Michele). With Giovanni Baleison (*fl* 1481–4), Canavesio signed the frescoes in the chapel of St Sébastien, Saint-Etienne-de-Tinée (Alpes Maritimes).

Several other works are attributed to Canavesio, some of which are dated; among these are the heraldic decoration on the façade of the Bishop's Palace at Albenga (1477), the *Passion* frescoes in the chapel of Notre-Dame-des-Douleurs, Peillon (Alpes Maritimes), and the polyptychs of the *Virgin and Child* (Genoa, Pal. Bianco), of a *Dominican Saint* (either St Dominic or St Thomas Aquinas) in S Domenico, Taggia (Liguria), of *St Anthony of Padua* and of *St Bernardino*, both in Ste Rosalie, Lucéram (Alpes Maritimes), and of *St Christopher* (Florence, Banca Toscana). To these should be added the central figure of the polyptych of *St Biagio* (Pornassio, S Dalmazzo).

Canavesio's style is idiosyncratic, containing south Netherlandish elements and features from the schools of the Nice region and Provence, recognizable in the bright colours enhanced by strong lighting and also in the expressionistic traits derived from the figure style of north Piedmont. His activity in western Piedmont contributed to the formation of a style that combined characteristics from both Ligurian and Piedmontese painting, which survived until the mid-16th century in the work of local artists.

DBI

BIBLIOGRAPHY

M. Roques: *Les Peintures murales de sud-est de la France: XIIIe au XVIe siècle* (Paris, 1961), pp. 112–14, 341–52

G. V. Castelnovi: 'Il quattro e il primo cinquecento', *La pittura a Genova e in Liguria*, ed. E. Poleggi, i (Genoa, 1987), pp. 118–21, 151–2

GIOVANNA ROTONDI TERMINIELLO

Canneri [Canera; Caneri; Canerio; Carlerio], **Anselmo** (*b* Verona, 1522–34; *d* Verona, 1584–6). Italian painter. He was a pupil of Giovanni Caroto (Vasari) and worked mainly in Verona and the Veneto. He was one of a group of Veronese painters who often worked together, frequently on decorations for buildings by Michele Sanmicheli and Andrea Palladio, and was also an early collaborator of PAOLO VERONESE (see Gisolfi Pechukas, 1987 and 1988).

In 1551 Canneri worked with Veronese and Battista Zelotti on frescoes in Sanmicheli's Villa Soranzo (mostly destr. 1816) at Castelfranco. (Fragments by Canneri are at: Castelfranco Cathedral sacristy, two putti; Venice, Semin. Patriarcale, Gloria; Paris, Sambon Col., putto; Padua,

Favaretti Col., putto; priv. cols, *Rhetoric and Dialectic*, sold London, Christie's, 1962, and *Minerva between Geometry and Arithmetic*, sold Verona, Arte Antica, 1993; see Gisolfi Pechukas, 1987). Drawings by Canneri related to the Villa Soranzo fresco decorations are looser than those by Zelotti (see Gisolfi Pechukas, 1988, and Gisolfi, 1989–90). This was soon followed by collaboration with Bernardino India and Domenico Brusasorci on the decoration of Palladio's Palazzo Thiene, Vicenza (see Magagnato). Canneri's frescoes in both these schemes show flaccid physical types and clumsy foreshortening. The forms are, however, superficially close to those of Veronese while the colours are more muted and more diffusely lit than in contemporary examples by the latter. During the 1560s Canneri collaborated with Brusasorci, Paolo Farinati and Battista dell'Angolo del Moro in frescoing the exterior of the Palazzo Murari (later Bocca–Trezza) in Verona (see Schweikhart). Canneri's (damaged) frieze, representing emperors' busts and fallen warriors, is characterized by heavy forms.

Of three known altarpieces by Canneri for churches in Verona, two—the *Trinity with St Fermo and Another Saint* (ex-S Fermo) and the *Pentecost* (ex-SS Nazaro e Celso)—are untraced and the third, the *Circumcision* (1566; ex-S Zeno; Verona, Castelvecchio), is damaged, though not so much as to obscure the artist's now fuller forms and sensitive use of colour (for colour illustration see 1988 exh. cat.; see Gisolfi, 1989–90, for Zancon's engraving of the picture before its bisection). Later Canneri collaborated with Brusasorci and Farinati on a series of three oil paintings illustrating the *Life of Moses* for the Palazzo Ridolfi, Verona (see dal Pozzo and Corso). Figures in his severely damaged canvas of *Moses Affronting the Pharaoh* (1584; Verona, Castelvecchio) seem heavy and their finish is rather harsh. Yet the very same figure types in his smaller, better preserved *Finding of Moses* (Hagerstown, MD, Washington Co. Hist. Soc. Mus.) are more graceful and softer (see Gisolfi Pechukas, 1988).

BIBLIOGRAPHY

G. Vasari: *Vite* (1550, rev. 2/1568); ed. G. Milanesi (1878–85), v, pp. 290–91

B. dal Pozzo: *Le vite de' pittori, degli scrittori et architetti veronesi* (Verona, 1718), pp. 27, 255, 294

G. B. Lanceni: *Recreazione pittorica* (Verona, 1720), i, pp. 245, 303

D. Zannandreis: *Le vite dei pittori, scultori, ed architetti veronesi* (Verona, 1891), pp. 144–5

G. Corso: 'I. Nella quadreria di Luigi Ravignani una trilogia pittorica di Mosè di Felice Brusasorci, Anselmo Canerio e Paolo Farinati', *Madonna Verona*, xiv (1920), pp. 33–40

——: 'II. Note per la biografia del pittore Anselmo Canerio', *Madonna Verona*, xiv (1920), pp. 41–3

L. Magagnato: *Palazzo Thiene sede della Banco Populare di Verona* (Verona, 1966), pp. 81–7, 117–30

G. Schweikhart: *Fassadenmalerei in Verona* (Munich, 1973), p. 253, figs 226–9

Palladio e la maniera (exh. cat., ed. V. Sgarbi; Vicenza, S Corona, 1980), pp. 74–5

D. Gisolfi Pechukas: 'Veronese and his Collaborators at La Soranza', *Artibus & Hist.*, xv (1987), pp. 67–108

——: 'Paolo Veronese ed i suoi primi collaboratori', *Atti del convegno internazionale di studi e nel quatro centenario della morte di Paolo Veronese: Venezia, 1988*

Veronese e Verona (exh. cat., ed. S. Marinelli and others; Verona, Castelvecchio, 1988)

D. Gisolfi: '"L'anno veronesiano" and Some Early Questions about Early Veronese and his Circle', *A. Ven.*, xliii (1989–90), pp. 30–42

DIANA GISOLFI

Cantone, Bernardino (*b* Pieve di Balerna, nr Como, 1505; *d* Genoa, 1576–80). Italian architect, urban planner, surveyor and engineer. The son of a family of craftsmen, he arrived in Genoa in 1519 and enrolled in the guild of the Maestri Antelami Lombardi, completing his apprenticeship as a mason, architect and surveyor during the early 1520s. From around 1527 he took part in several projects to renovate and expand the medieval city, including the clearing of the Piazza Ferraria (now Piazza Matteotti). He played a key role in this phase of Genoese urban development (*see* GENOA, §1), firstly as architect to the Magistrates of the Padri del Comune (1531) and then as Architetto di Camera from 1546 until retirement in 1576. His early projects included the expansion of the eastern suburbs (1535–8) in conjunction with the modernization of Genoa's 14th-century fortifications; the enlargement of the Piazza Fossatello (1539–40) as a family enclave and marketplace; and the reconstruction of the Lanterna (1543), the beacon to ships at the harbour entrance.

In the same period Cantone built a palazzo (1542) for Nicola Cicala on the Piazza dell'Agnello in the early Renaissance style prevalent in Genoa during the first half of the 16th century. However, the arrival of Galeazzo Alessi to build the church of S Maria Assunta di Carignano (1549–1603) radically changed the predominant building style in Genoa to Roman High Renaissance. Alessi's designs were all closely supervised in construction by Cantone and other artists associated with the '*scuola di Carignano*'.

As Architetto di Camera, Cantone took charge of work on the Strada Nuova (1550–51, 1557–60), starting from Alessi's plan to create a monumental axial street on the northern fringe of the medieval city. He adapted Alessi's design, which was influenced by the Via Giulia (1508–11) in Rome, to the insular interests of the Genoese patriciate, creating, in a street closed at one end, an aristocratic residential neighbourhood for the élite families of bankers and merchants who built palaces there.

Cantone's mastery of Alessi's Roman style is evident in the Palazzo Pallavicino (1558–63; now Banco di Napoli), on the Strada Nuova, which he supervised according to Alessi's plans. This features a façade with a sophisticated Mannerist interplay of rusticated and dressed marble frames with grey *pietra di Promontorio* mouldings. Cantone also built the Palazzo Spinola (1558–66; now Banca d'America e d'Italia), with its more austere, tripartite façade decorated with painted Classical architecture, reliefs and figures. Both buildings continue the traditional Genoese atrium-staircase-loggia entrance and interior courtyard with the rich combinations of classical architecture, grotesque decoration and ceiling *quadro riportato* frescoes, characteristic of palaces by Alessi.

Cantone also collaborated with Giovanni Battista Castello on the Palazzo Spinola (now Doria, 1563–6, altered in the 17th century), the Palazzo Lomellino (now Podestà, 1563–5), both on the Strada Nuova, and the Palazzo Imperiale on the medieval Piazza di Campetto (1560). Cantone's Villa Lercari, 'la Semplicità', in S Pier d'Arena (1558–63, destr.), was particularly striking in its placement of a monumental building cube over a formal terraced garden, descending down to the sea with nymphaea and other garden structures. It contributed significantly to the

development of the suburban residence for which Genoa became famous during the Late Renaissance and Baroque eras.

BIBLIOGRAPHY

DBI

E. De Negri and others: *Il catalogo delle ville genovesi* (Genoa, 1967)
E. Poleggi: *Strada Nuova, una lottizzazione del cinquecento a Genova* (Genoa, 1968/*R* 1982)
Galeazzo Alessi e l'architettura del cinquecento. Atti del convegno internazionale di studi: Genova, 1974
I palazzi delle Strade Nuove (Genoa, 1986)
Le Strade Nuove (Genoa, 1986)
Le ville di Genova (Genoa, 1986)

GEORGE L. GORSE

Capalatitis, Giovanni Battista. *See* CAVALLETTO, GIOVANNI BATTISTA.

Caporali. Italian family of artists.

(1) Bartolomeo (di Segnolo) Caporali (*b* Perugia, *c.* 1420; *d* Perugia, *c.* 1505). Painter. He seems to have been working as a painter in Perugia by 1442 but is first documented on 24 December 1454, when he received payment for a *Pietà* and a *Maestà* (both untraced) executed for the shoemakers' guild in Perugia. In 1457–8 he was treasurer of the painters' guild, and in 1462 he was elected a civic prior for March and April. On 6 May 1467 he received payment, in Rome, for gilding the ceiling of S Marco. On 18 July of the same year he and Benedetto Bonfigli were paid by the merchant Lancillotto di Ludovico to execute a panel for the chapel of S Vincenzo in S Domenico, Perugia (untraced; unconvincingly associated with a reconstructed polyptych, Perugia, G.N. Umbria), and on 14 July the following year they received the balance due for their finished work.

Caporali's first extant work is the triptych depicting the *Virgin and Child Enthroned with Two Angels, a Sylvestrine Monk and a Lay Brother* executed for the Confraternita della Giustizia, Perugia (ex-S Mustiola, Perugia; Perugia, G.N. Umbria), sometimes attributed to Fiorenzo di Lorenzo. Several payments are recorded between October 1475 and April 1476 from the Confraternita di S Andrea, which commissioned the work, to Caporali and Sante d'Apollonio (*d* 1484), with whom he may have collaborated on a series of stylistically similar works, such as the *Virgin and Child with Angels* and *St Sebastian* (both Perugia, G.N. Umbria), a triptych (London, N.G.) and *St Eligius* and *St John the Baptist* (both Copenhagen, Thorvaldsens Mus.). Between 1477 and 1479 Caporali painted the *Adoration of the Shepherds* (Perugia, G.N. Umbria) for the convent in Monteluce, Perugia. In 1487 he signed and dated an altarpiece for the Cacciatori di Castiglione del Lago (fragments Perugia, G.N. Umbria; Udine, Mus. Civ., and Mentana, Zeri priv. col., see Gardner, pp. 47–9). On 26 November 1487 Evangelista di Francesco de' Rossi paid for a fresco, executed by Caporali, depicting the *Virgin and Child with SS Jerome and Anthony Abbot* (*in situ*) for the parish church of Rocchicciola, near Assisi. Another fresco, in S Francesco, Montone, depicting *St Anthony of Padua between St John the Baptist and the Archangel Raphael with Tobias*, commissioned by Bernardino Fortebraccio, is signed and dated 1491.

Caporali's style was derived primarily from Verrocchio and his followers and then modified through contacts with Umbrian artists younger than himself, such as Fiorenzo di Lorenzo, Perugino and Pinturicchio. Other works attributable to Caporali on stylistic grounds include a miniature depicting the *Porta Sant'Angelo* (1486; Vienna, Akad. Bild. Kst.) and two painted *gonfaloni* (1482; Montone, S Francesco; 1492; Civitella d'Arno, parish church). Among less secure attributions to Caporali are a series of works in the style of Benozzo Gozzoli and Bonfigli, sometimes dated to his early career (Bombe, Gnoli, Santi), and his participation in the *Tavolette di St Bernardino* (1473; Perugia, G.N. Umbria). Caporali's work as a miniaturist is unclear, but it is linked to the career of his brother Giapeco Caporali (*d* 1478), whose one certain work is a large, signed initial in the *Registro dei Consigli e Riformanze del Comune di Perugia* (1474; Perugia, Archv Stato).

BIBLIOGRAPHY

DBI

W. Bombe: *Geschichte der Peruginer Malerei* (Berlin, 1912)
U. Gnoli: *Pittori e miniatori nell'Umbria* (Spoleto, 1923), pp. 47–51, 348
C. Gamba: *Pittura umbra del rinascimento* (Novara, 1949), pp. xvi–xvii, xxiv–xxviii
F. Zeri: 'Appunti nell'Ermitage e nel Museo Pusckin', *Boll. A.*, iii (1961), pp. 219–36
F. Santi: *La nicchia di San Bernardino a Perugia* (Milan, 1963), p. 5
E. E. Gardner: 'I disegni di G. B. Cavalcaselle e la pala di Bartolomeo Caporali a Castaglione del Lago', *Quaderni d'Emblema*, ii (Bergamo, 1973)
——: *Galleria Nazionale dell'Umbria: Dipinti, sculture e oggetti de secoli XV–XVI* (Rome, 1985), pp. 51–9
B. Toscano: 'La pittura in Umbria nel 400', *La pittura in Italia: Il quattrocento*, ed. F. Zeri, 2 vols (Milan, 1987), p. 369
F. Todini: *La pittura umbra dal duecento al primo cinquecento* (Milan, 1989), i, pp. 49–52; ii, pp. 356–64
M. Bury: 'Bartolomeo Caporali: A New Document and its Implications', *Burl. Mag.*, cii (1990), pp. 469–75
P. Scarpellini: 'Bartolomeo Caporali', *Galleria Nazionale dell'Umbria. Dipinti, sculture e ceramiche: Studi e restauri* (Florence, 1994), pp. 235–8

P. SCARPELLINI

(2) Giovan Battista Caporali [il Bitte; il Bitti] (*b* Perugia, *c.* 1475; *d* Perugia, *c.* 1555). Painter, architect, illuminator and writer, son of (1) Bartolomeo Caporali. A follower of Perugino, he collaborated in 1503 with Bernardino Pinturicchio on the *Coronation of the Virgin* (Rome, Pin. Vaticana) for S Maria della Fratta, Umbertide. In 1508–9 he was in Rome, probably assisting Pinturicchio on the frescoes in S Maria del Popolo, and the influence of Raphael's works there can be seen in his fresco of *Christ Enthroned with Saints* (*c.* 1510; Cereseto, Parish church). His mature style is demonstrated in the *Adoration of the Shepherds* (*c.* 1519; Panicale, S Michele Arcangelo), the panel of the *Virgin and Child with Saints* (Perugia, G.N. Umbria) and frescoes including those in S Pietro, Perugia (1521), S Agostino, Montefalco (1522), and S Maria della Luce, Perugia (1532). In the 1520s he undertook a major architectural commission, a villa near Cortona, 'il Palazzone', for Cardinal Silvio Passerini. Caporali also executed some of the decoration of the interior, with Tommaso Bernabei Papacello (1500–59), including grisaille frescoes of mythological subjects. His writings included poetry (London, BM, C106.a.3) and an annotated Italian edition of Vitruvius's *De architectura*, essentially repeating Cesare Cesariano's translation of 1521. Among his illuminations is a signed portrait of *Pope Julius III* in

the *Annale decemvirale* of 1553 (Perugia, Bib. Augusta). He trained the architect Galeazzo Alessi, and his son Giulio Caporali (*fl* 1559–94) was a painter.

WRITINGS

Marcus Vitruvius Pollio, de architectura, con il suo comento et figure Vetruvio in volgar lingua raportato per M. Gianbatista Caporali di Perugia (Perugia, 1536)

BIBLIOGRAPHY

DBI

G. Vasari: *Vite* (1550, rev. 2/1568); ed. G. Milanesi (1878–85), iii, pp. 597, 696 [as 'Benedetto' Caporali]

B. Frescucci: *Il Palazzone* (Sondrio, 1965)

P. Scarpellini: 'Giovan Battista Caporali e la cultura artistica perugina', *Atti del XII Convegno di studi Umbri: Perugia, 1981*, pp. 22–79 [with bibliog.]

La pittura in Italia: Il cinquecento (Milan, 1988), ii, p. 666

☐

Capponi. Italian family of patrons, merchants and statesmen. From the 14th century the family was a powerful force in the political and economic life of Florence. A focus for their patronage was the family chapel in the church of Santo Spirito, Florence, which contains the sarcophagus (1458) of *Neri di Gino Capponi* (1388–1457) by Bernardo Rossellino. In 1521 Ludovico Capponi (*d* 1534), having pursued a banking career in Rome, returned to Florence and in 1525 bought the Annunziata Chapel (attributed to Brunelleschi) in the church of S Felicità. For it he commissioned from Pontormo, assisted by his pupil Bronzino, decorations (1525–8) that included an altarpiece of the *Lamentation* (*in situ*; see PONTORMO, JACOPO DA, fig. 2), which has subsequently been regarded as both Pontormo's masterpiece and a key work of Mannerism. Bronzino later executed a portrait (*c.* 1550; New York, Frick; see BRONZINO, AGNOLO, fig. 4) of Ludovico's son, also named Ludovico Capponi (1534–1614).

BIBLIOGRAPHY

DBI

G. Vasari: *Vite* (1550, rev. 2/1568); ed. G. Milanesi, iii (1878), p. 292; vi (1881), pp. 270–72

A. Pieraccini: *La famiglia Capponi di Firenze* (Pisa, 1882)

G. S. Cozzo: *I Codici Capponiani* (Rome, 1897)

JANET SOUTHORN

Capponi, Raffaelle de'. *See* RAFFAELLINO DEL GARBO.

Caprarola, Cola da. *See* COLA DA CAPRAROLA.

Caprarola, Villa [Palazzo] **Farnese.** Italian estate near Viterbo, *c.* 55 km north-west of Rome. It stands on a hilltop site overlooking the medieval village of Caprarola and was built for Cardinal Alessandro Farnese, grandson of Pope Paul III, by Jacopo Vignola and his successors from 1557 to 1583. The interior contains a series of frescoes that constitute one of the most important decorative cycles of the later 16th century. The lower gardens were built in 1557–83 to Vignola's designs, while the upper garden and casino (*palazzina*) were built *c.* 1584–6 to designs by Giacomo del Duca.

1. ARCHITECTURE AND DECORATION. The Villa Farnese was constructed on the foundations of a fortress begun *c.* 1521 for Pope Paul III by Antonio da Sangallo (ii) and Baldassare Peruzzi. This accounts for its unusual pentagonal plan with arrowhead bastions, although the circular courtyard at the centre of the structure was Vignola's own design. Vignola also designed the axial, terraced approach to the villa, with a straight road ascending from the village to an oval forecourt with a rusticated loggia facing a fish pond (filled in before 1600). The forecourt is embraced by two symmetrical semicircular horse-ramps rising to a second, larger, trapezoidal court, with staircases leading up to the villa itself (see fig.). These elements provide a magnificent spatial setting for the drafted masonry façade of the villa, articulated by two orders of pilasters in local volcanic stone. The design drew extensively on architecture at the Vatican in Rome, the seat of the patron's power: the tripartite, fortified façade with central loggia (originally open) recalls Innocent VIII's Villa Belvedere (1480s), while the double-ramped staircase in front of the villa and the triumphal-arch motif on the upper portico of the courtyard were derived from Bramante's Cortile del Belvedere (begun 1505; see colour pl. 1, XVI1). The contrast between the solid, massive lower storey and the flat, abstract, geometrical upper storeys, however, was characteristic of Vignola's own classicizing Mannerist style (for further discussion *see* VIGNOLA, JACOPO).

The ground floor and *piano nobile* of the villa were planned with two sets of summer apartments on the north side and two of winter apartments on the south, each with salon, antechamber, bedroom, dressing room and study. The basement housed service areas, while the small rooms in the top storeys housed staff and retainers. In one of the angles at the front of the building is a monumental two-storey spiral staircase; opposite is a guard room and circular armoury on the ground floor and a loggia and circular chapel on the *piano nobile* above.

The summer apartments were frescoed by Taddeo Zuccaro and Federico Zuccaro (*see* ZUCCARO), although the illusionistic architecture on the walls of the Sala di Giove and the vault of the armoury were designed by Vignola. After Taddeo's death (1566), Federico painted the Gabinetto dell'Ermatena, the circular chapel and part of the Sala d'Ercole, all on the *piano nobile*. He also painted

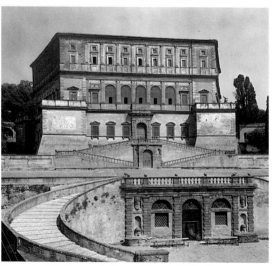

Caprarola, Villa Farnese, by Jacopo Vignola, 1557–83

the guard room and four rooms of the winter apartment on the ground floor (excluding the salon). Jacopo Bertoia completed the Sala d'Ercole (1569; for illustration *see* BERTOIA JACOPO, executed the vaults of the Stanze della Penitenza, dei Guidizi and dei Sogni in the winter apartment on the *piano nobile*, and began work on the Sala degli Angeli (also in the winter apartment) shortly before his death in 1572. About 1574–5 Giovanni de' Vecchi and his assistants painted the walls of the Sala degli Angeli and all of the Sala del Mappamondo (restored 1960s), which is decorated with maps of four continents, Italy and the Holy Land). The remaining frescoes, including the salon of the ground-floor winter apartment, the spiral staircase and the internal courtyard porticos, were supervised by Antonio Tempesta from 1579 to 1583.

The complex iconographical programme, glorifying the Farnese family and addressing major political, economic, spiritual and intellectual concerns of Cardinal Farnese, was worked out in consultation with the patron by such scholarly advisors as Onofrio Panvinio, who devised the scheme for the Sala dei Fasti Farnese; Paolo Manuzio (1512–74), the Venetian and Roman publisher; Annibal Caro, the humanist secretary to Cardinal Farnese; Cardinal Guglielmo Sirleto, the Vatican librarian, who wrote the programme for the Stanza della Penitenza; and perhaps also Fulvio Orsini, the Farnese librarian.

2. GARDENS. The two walled lower gardens of the Villa Farnese were laid out to Vignola's designs, in square parterres, with sculpture and fountains symbolizing the seasons and the regenerative cycles of nature. In the west garden—once linked by a pergola—are statues of *Autumn* and *Winter* and the Grotto of the Rain, a cave seemingly supported by six stucco satyrs with moisture dripping from the vault into a pond below. On the terrace above the grotto is the Fountain of Unicorns. The north garden contains statues of *Spring* and *Summer* and the Fountain of Venus, with Venus flanked by two satyrs. At the junction of the two gardens is the Fountain of the Shepherd; water was designed to cascade down a rustic hill from two satyrs or fauns at the top, over a shell held by two nude water deities, to two herms and two reclining river gods flanking a statue of *Mercury* as the good shepherd. The upper gardens and *casino* were laid out by Giacomo del Duca in the 1580s. He incorporated into the design terraces, fountains and sculpture. They are remarkable for the synthesis of natural and manmade elements.

BIBLIOGRAPHY

L. Sebastiani: *Descrizione e relazione istorica del nobilissimo e real palazzo di Caprarola* (Rome, 1741)
C. Trasmondo-Frangipani: *Descrizione storico-artistica del R. Palazzo di Caprarola* (Rome, 1869)
G. Balducci: *Il palazzo Farnese in Caprarola illustrato nella storia e nell'arte* (Rome, 1910)
F. Baumgart: 'La Caprarola di Ameto Orti', *Studi Romanzi*, xxv (1935), pp. 77–179
I. Faldi: *Gli affreschi del Palazzo Farnese di Caprarola* (Imola, 1962)
S. Benedetti: 'Sul Giardino Grande di Caprarola ed altre note', *Quad. Ist. Stor. Archit.*, xvi/91 (1969), pp. 1–44
G. Labrot: *Le Palais Farnèse de Caprarola: Essai de lecture* (Paris, 1970)
L. Partridge: 'Vignola and the Villa Farnese at Caprarola', *A. Bull.*, lii (1970), pp. 81–7
——: 'The Sala d'Ercole in the Villa Farnese at Caprarola', *A. Bull.*, liii (1971), pp. 267–86; liv (1972), pp. 50–62
——: 'Divinity and Dynasty at Caprarola: Perfect History in the Room of Farnese Deeds', *A. Bull.*, lx (1978), pp. 494–530
I. Faldi: *Il Palazzo Farnese di Caprarola* (Turin, 1981)
F. T. Fagliari Zeni Buchicchio: 'Giovanni Antonio Garzoni da Viggiu: L'architetto dei Farnese a Caprarola dopo il Vignola', *Bib. & Soc.*, vii–viii (1985–6), pp. 3–24
E. Polla: 'Anomalie costruttive e dimensionali nel Palazzo Farnese a Caprarola', *Saggi in onore di Guglielmo de Angelis d'Ossat*, ed. S. Benedetti and G. Miarelli Mariani (Rome, 1987), pp. 351–64
L. Partridge: *Caprarola, Palazzo Farnese, FMR* Grand Tour (Milan, 1988)
F. Matzner: *Vita activa und vita contemplativa: Formen und Funktionen eines antiken Dankmodells in der Staatsikonographie der italienischen Renaissance* (Frankfurt, Bern and New York, 1994)
I. Walter and others: *Casa Farnese: Caprarola, Roma, Piacenza, Parma* (Parma, 1994)
L. Partridge: 'Discourse of Asceticism in Bertoja's Room of Penitence in the Villa Farnese at Caprarola', *Mem. Amer. Acad. Rome*, xi (1995), pp. 145–74
——: 'The Room of the Maps at Caprarola, 1573–75', *A. Bull.*, lxxvii/3 (Sept 1995), pp. 413–44
P. Portoghesi, ed.: *Caprarola* (Rome, 1996)
C. Acidini Luchiat: *Taddeo e Federico Zuccari fratelli pittori del Cinquecento*, i (Rome, 1998), pp. 156–226
L. Partridge: 'Federico Zuccari at Caprarola, 1561–1569: The Documentary and Graphic Evidence', *Der Maler Federico Zuccari: Ein romischer Virtuoso von europaischem Ruhm. Akten des internationalen Kongresses der Bibliotheca Hertziana: Rom und Florenz, 1993*, Röm. Forsch. Hrg. Bib. Herziania, xxxii (Munich, 1999) pp. 157–82

LOREN PARTRIDGE

Capriani, Francesco. *See* VOLTERRA, FRANCESCO DA.

Caprino, Meo da. *See* MEO DA CAPRINO.

Capriolo, Domenico (di Bernardino) (*b* Venice, *c.* 1494; *d* Treviso, 8 Oct 1528). Italian painter. He moved *c.* 1517 from Venice to Treviso, where he is well documented (though there is little about his painting). In 1518–19 he married Camilla, daughter of the painter Pier Maria Pennacchi. A coherent body of work executed between 1518 and 1528 has been reconstructed. Capriolo's first secure work, the *Adoration of the Shepherds* (Treviso, Mus. Civ.), signed and dated 1518, has a formal structure reminiscent of the late style of Giovanni Bellini, with the broader chromatic range of Palma Vecchio and a crepuscular light that recalls the Venetian works of Giovanni Girolamo Savoldo or Giovanni da Asola (*fl* 1512–31). The *Assumption* in Treviso Cathedral, commissioned in 1520, shows, in its spiralling movement, the influence of the contemporary frescoes of Pordenone in the nearby Malchiostro Chapel. In the *Legend of the Doubting Midwife* (Treviso, Mus. Civ.), signed and dated 1524, the influence of Savoldo is greater than that of Palma. This is also apparent in the altarpiece of the parish church of Ponzano Veneto (Treviso), dated 1525.

The portrait of *Lelio Torelli* (Barnard Castle, Bowes Mus.), signed and dated 1528, Capriolo's last known work, seems by contrast to reflect local models of portraiture and lies somewhere between the styles of Sebastiano Florigerio and Bernardino Licinio. Other works assigned to Capriolo include: the altarpieces of the parish churches of Cavasagra and Spercenigo, near Treviso; the *Adoration of the Shepherds* in the sacristy of Serravalle Cathedral at Vittorio Veneto; a fragment of a *Nativity* (Venice, Mus. Correr); two paintings of the *Virgin and Child with Saints* (Bucharest, Mus. A.; Conegliano, Mus. Civ. Castello); and the *Portrait of a Musician* (Vienna, Ksthist. Mus.), previ-

ously attributed to Pordenone. Capriolo was murdered by his wife's stepfather, after years of litigation about her dowry.

BIBLIOGRAPHY

DBI; Thieme–Becker

M. Lucco: 'Domenico Capriolo', *Proposte di restauro: Dipinti del primo cinquecento nel Veneto* (Florence, 1978), pp. 97–100

G. Fossaluzza: 'Profilo di Domenico Capriolo', *A. Ven.*, xxxvii (1983), pp. 49–66

E. Manzato: 'Opere trevigiane di Domenico Capriolo', *Stud. Trevi.*, i (1984), pp. 85–93

M. Lucco: 'I pittori trevigiani e "l'effetto Malchiostro"', *Il Pordenone: Atti del Convegno internazionale di studio: Pordenone, 1985*, pp. 141–8

MAURO LUCCO

Caprotti, Gian Giacomo [Salaì] (*b* Oreno, nr Monza, *c.* 1480; *d* Milan, 19 Jan 1524). Italian painter. In 1490, aged 10, he joined the workshop of Leonardo da Vinci in Milan. In his notebooks Leonardo described him as a 'lying, obstinate, greedy thief' but also considered him an able pupil. He was nicknamed Salaì (or Salaino, the name of a demon) because of his lively and irascible character. He remained with Leonardo for about 30 years. In 1499 he accompanied him to Mantua, Venice and Florence. By 1505 he had achieved some fame as a painter; Alvise Ciocha, an agent of Isabella d'Este, Marchesa of Mantua, described him as 'very able for his years' and invited him to advise Pietro Perugino who was working for her. He accompanied Leonardo to Rome in 1513 and three years later to France, with Francesco Melzi.

In 1519, following his master's death, Salaì settled in Milan on property that Leonardo had bequeathed him. He died a violent death. An inventory of his possessions shows that he inherited many works by Leonardo, including the *Mona Lisa* (see colour pl. 1, XXXVI3) and the *Infant St John the Baptist* (both Paris, Louvre). No signed works by Caprotti are known; documents mention two paintings of the *Penitent St Jerome* (untraced) in the monastery of S Gerolamo in Milan. It is assumed that his work adheres closely to that of Leonardo. According to this hypothesis, two paintings representing the *Virgin and Child with St Anne* (Los Angeles, UCLA, Wight A. G.) and *St John the Baptist* (Milan, Ambrosiana), copies of paintings by Leonardo (both Paris, Louvre), have been attributed to him.

BIBLIOGRAPHY

J. P. Richter, ed.: *The Literary Works of Leonardo da Vinci*, ii (London, 1888, rev. 1970), pp. 363–5

W. Suida: *Leonardo und sein Kreis* (Munich, 1929), p. 306

J. Shell and G. Sironi: 'Salai and Leonardo's Legacy', *Burl. Mag.*, cxxxiii (1991), pp. 95–108 [good bibliog.]

——: "Gian Giacomo Caprotti, detto Salai' *I leonardeschi: L'eredità di Leonardo in Lombardia* (Milan, 1998) pp. 397–406

ANNA MARIA FERRARI

Caradosso [Foppa, Cristoforo] (*b* Mondonico, nr Pavia, *c.* 1452; *d* between 6 Dec 1526 and 1 April 1527). Italian goldsmith, coin- and gem-engraver, jeweller, medallist and dealer. Son of the goldsmith Gian Maffeo Foppa, from 1480 he served at the Milanese court with his father, eventually becoming personal goldsmith and jeweller to Ludovico Sforza (il Moro), Duke of Milan. In 1487 Caradosso was in Florence, where his appraisal of an antique cornelian was highly esteemed. He worked in Hungary in the service of King Matthias Corvinus (*reg* 1458–90), probably in August 1489; a later visit to the court was cut short by the King's death (1490). Between 1492 and 1497 Caradosso travelled to various Italian towns to buy jewels and other precious objects for Ludovico il Moro. He visited Rome, Viterbo and Florence early in 1496, when the Medici family's possessions were sold off after the expulsion of Piero de' Medici (1471–1503) from Florence.

After the fall of Ludovico il Moro in 1500, Caradosso remained for some years in Lombardy. In 1501 he was involved in negotiations to sell a number of marble busts and statues, presumably antique, to Ludovico Gonzaga, Bishop of Mantua; in 1503 he formed part of a committee to judge the plans for a door in Milan Cathedral; in 1505 he tried to persuade Isabella d'Este, Marchesa of Mantua, to buy a vase (untraced) he had made of 49 engraved crystals set in enamelled and gilt silver, but she rejected it because it was too big. He was in contact with the Mantuan court again in 1512 and in 1522–4.

Caradosso moved to Rome in 1505 and received a constant stream of commissions, from the popes from Julius II to Clement VII and from members of the papal court; he was also given a pension from the Camera Apostolica. In 1509 he was a founder-member of the Università degli Orefici (the goldsmiths' guild) in Rome. In 1526 he made a will in which several of his works are mentioned. Vasari stated that he portrayed Caradosso among the papal entourage in the fresco of the *Entry of Leo X into Florence* (Florence, Pal. Vecchio).

To his contemporaries, Caradosso was most famous as a jeweller. Although none of his jewellery works can be identified, his career can be traced from 1495 when he designed a gorget ('gorzarino') for Ludovico il Moro, until 1524, when he contracted to make a tabernacle for the Volto Santo in the Sancta Sanctorum in St Peter's, Rome; this was left unfinished at his death. His most famous work was a papal tiara made for Julius II in 1509–10 and recorded in a drawing (*c.* 1725; London, BM) by Francesco Bartoli (*c.* 1675–*c.* 1730). Caradosso also made a matching clasp for the Pope's cope; this was of sheet-gold and silver, with the Four Doctors of the Church grouped around a magnificent diamond. Cellini wrote that Caradosso was the finest craftsman of his day and described how he hammered gold and silver sheets finer than anyone else. Using this technique, he made hat badges, paxes, crucifixes and other decorative and functional objects. He made an inkwell for which John of Aragon was reputed to have offered 1500 gold pieces; Ambrogio Leone's description (*Dialogus de nobilitate rerum*, 1525) of this piece has led to the identification of numerous replicas of two of the reliefs that originally decorated it: the *Rape of Ganymede* and *Battle of the Lapiths and Centaurs* (specimens of both in Washington, DC, N.G.A.); other plaques have, consequently, also been attributed to Caradosso. He carved gemstones with such skill that they were mistaken for antique works. Lomazzo and Vasari reported that he made portrait medals of Gian Giacomo Trivulzio, Julius II and Bramante, and this has provided the basis for all the additional attributions made by modern writers, although none of his coins or medals is documented.

The attribution of the base of the *Calvary* of Matthias Corvinus (Esztergom, Mus. Christ.) to Caradosso would

seem to be correct on both historical and technical grounds, but other attributions, such as Pius IV's pax (Milan, Tesoro Duomo), are much more problematical. Lomazzo stated that a terracotta frieze of putti and heads (Milan, S Satiro) was by Caradosso, but it is documented as the work of Agostino Fonduli. Teseo Ambrogio (*Chaldaicam linguam*, Pavia, 1539, introduction, p. 182) described a bronze *Cupid* or *Apollo* (untraced) by Caradosso, his only recorded sculptural work.

BIBLIOGRAPHY
Thieme–Becker
P. Gauricus: *De sculptura* (1504); ed. and Fr. trans. by A. Chastel and R. Klein (Geneva, 1969), pp. 246, 263
G. Vasari: *Vite* (1550, rev. 2/1568); ed. G. Milanesi (1878–85), iii, p. 535; iv, p. 161
B. Cellini: *La vita* (MS., c. 1558–62), in *B. Cellini: Opere*, ed. O. Bacci (Florence, 1901), I, xxvi, xliii, liv
G. Lomazzo: *Trattato della pittura* (Milan, 1584), in *Lomazzo: Scritti sulle arti*, ed. R. P. Ciardi (Florence, 1973–4), i, p. 325; ii, pp. 287, 534, 549, 550
B. Cellini: *I trattati dell'oreficeria e della scultura*, ed. G. Milanesi (Florence, 1857), pp. 30–31, 72–5, 89–90, 95–6
A. Bertolotti: *Artisti lombardi a Roma nei secoli XV, XVI e XVII* (Milan, 1881), i, pp. 240–41, 258, 272–81; ii, pp. 274, 313
A. Luzio and R. Renier: 'Il lusso di Isabella d'Este. II. Gioielli e gemme', *Nuova Antol.*, xxxi/xiv (1896), pp. 294–324 [306–8]
A. Armand: *Les Médailleurs italiens des quinzième et seizième siècles* (Paris, 1883–87), i, pp. 107–12; ii, pp. 291–2; iii, pp. 34–44
E. Molinier: *Les Plaquettes*, i (Paris, 1886), pp. 99–108
E. Müntz: 'La Tiare pontificale du VIIIe au XVIe siècle', *Mém. Inst. Nat. Fr., Acad. Inscr. & B. Lett.*, xxxvi (1898), pp. 235–324 [303]
H. Thurston: 'Two Lost Masterpieces of the Goldsmith's Art', *Burl. Mag.*, viii (1905–6), pp. 37–43 [43]
F. Malaguzzi Valeri: *La corte di Lodovico il Moro* (Milan, 1913–23), iii, pp. 325–39
W. von Bode: 'Caradossos Plaketten und Bramantes Anteil daran', *Z. Numi.*, xxxiii (1922), pp. 145–55
J. Balogh: *Contributi alla storia delle relazioni d'arte e di cultura tra Milano e l'Ungheria* (Buda, 1928), pp. 63–4
G. F. Hill: *Corpus*, i (London, 1930), pp. 166–74
E. Schaffran: 'Mattia Corvino Re d'Ungheria ed i suoi rapporti col rinascimento italiano', *Riv. A.*, xv (1933), pp. 191–201 [193–4]
P. Bondioli: 'Per la biografia di Caradosso Foppa', *Archv Stor. Lombardo*, lxxv–lxxvi (1948–9), pp. 241–2
D. W. H. Schwarz: 'Eine Bildnisplakette des Gian Giacomo Trivulzio', *Jber.: Schweiz. Landesmus. Zürich*, lxvi (1957), pp. 39–47
C. G. Bulgari: *Argentieri, gemmari e orafi d'Italia: Roma*, i (Rome, 1958), p. 246
R. Weiss: 'The Medals of Pope Julius II (1503–1513)', *J. Warb. & Court. Inst.*, xxviii (1965), pp. 163–82 [169–79]
E. Steingräber: 'Lombardisches Maleremail um 1500', *Festschrift Wolfgang Braunfels* (Tübingen, 1977), pp. 371–87 [375–7]
Y. Hackenbroch: *Renaissance Jewellery* (Munich, 1979), pp. 17–22
J. Pope-Hennessy: 'The Italian Plaquette', *The Study and Criticism of Italian Sculpture* (Princeton, 1980), pp. 192–222 [204–6]
Natur und Antike in der Renaissance (exh. cat., Frankfurt am Main, Liebighaus, 1985), pp. 446–8

MARCO COLLARETA

Carafa. Italian family of patrons. Its origins are obscure, but by the 14th century it was one of the leading Neapolitan noble families, with an archbishop of Bari (Bartolomeo Carafa, *fl* 1325; *d* 16 March 1367) and prior of the Knights Hospitaller in Cyprus (Bartolomeo Carafa, *fl* 1378; *d* 1405) among its members. During the period of Aragonese rule in southern Italy (1442–1501), the Carafa extended their influence through military, administrative and diplomatic undertakings on behalf of the new rulers, thereby acquiring extensive feudal holdings in and around Naples that were consolidated and extended in later centuries. Apart from service as soldiers and statesmen, they also acquired pre-eminence in the Church, providing from the late 15th century onwards a veritable dynasty of archbishops of Naples, cardinals, including (1) Oliviero Carafa, and a pope, (2) Paul IV. There are Carafa monuments in Rome, but most are in Naples. Within the Seggio di Nido (one of the city's ancient city wards) are several Carafa palaces dating from the 15th and 16th centuries with later additions and restorations. The façade of the 15th-century Palazzo Carafa di Maddaloni, built by Diomede Carafa (1406–87), has the decorative stonework and classical ornament typical of the best of south Italian Renaissance architecture and once contained a remarkable collection of antique sculpture. As regards ecclesiastical patronage, the Carafa initially concentrated on the 14th-century Dominican church of S Domenico Maggiore at the heart of their family enclave. They contributed to the fabric of the priory and endowed the church with several chapels and tombs. While S Domenico continued in use as burial place for later generations of the Carafa, in 1497 (1) Cardinal Oliviero Carafa commissioned a funerary chapel in Naples Cathedral, where members of his immediate family were later buried.

BIBLIOGRAPHY
DBI
B. Aldimari: *Historia genealogica della famiglia Carafa*, 3 vols (Naples, 1691)
F. Scandone: 'I Carafa di Napoli', *Famiglie celebri italiane*, 2nd ser. (Turin, 1902–23), i, table 19

(1) Cardinal **Oliviero Carafa** (*b* Naples, 10 March 1430; *d* Rome, 20 Jan 1511). He studied civil and canon law at the universities of Perugia, Ferrara and Naples and was appointed Archbishop of Naples in 1458 by Pius II and vice-president of the Sacro Regio Consiglio (the supreme tribunal for the kingdom of Naples) by King Ferdinand I. With the latter's support, Carafa was made a cardinal by Paul II in 1467. His long experience and his abilities as a diplomat and jurist finally won him (1503) the supreme position within the College of Cardinals of Dean and Cardinal Bishop of Ostia. However, although thrice a powerful contender, he was never elected pope.

Carafa's will (1509) reveals his immense income from his many ecclesiastical benefices, and the few surviving documents concerning the financing of his artistic schemes suggest that he was willing to pay well above the standard fees. As Cardinal Protector of the Dominicans, he was a generous patron in several respects and contributed to the fabric of the principal Dominican church and priory in Rome, S Maria sopra Minerva. While his commission for a second cloister now remains in only a fragmentary state, his chapel at the end of the south transept of the church survives in much better condition, although its mural paintings, executed by Filippino Lippi between 1488 and 1493 (*see* LIPPI, (2)), have suffered a number of depredations, most notably those on the east wall, which was rebuilt in 1566 to install the tomb of *Pope Paul IV* (*see* (2) below). The paintings relate to the chapel's twin dedication to the Virgin Annunciate and to S Thomas Aquinas. On the altar wall is the *Assumption of the Virgin* and a fresco altarpiece of the *Annunciation with St Thomas Aquinas Presenting Cardinal Carafa to Mary*. On the west wall are two hagiographic scenes relating to Aquinas: the *Miracle of St Thomas* and the *Triumph of St Thomas*. In the vault

are four of the sibyls (one repainted in the 17th century). A tomb chamber (now concealed by the tomb of *Pope Paul IV*) contains a stuccoed and painted vault, embellished with Carafa emblems and attributed to Raffaellino del Garbo.

Although Carafa lived mainly in Rome, only occasionally visiting Naples, he acted as a patron to his family, especially deeming the archiepiscopal see to be his family's property and retaining control of the title by bestowing it on a succession of close relatives. Such considerations motivated his second and much larger chapel commission in the crypt of Naples Cathedral. Known popularly as the Succorpo, the chapel was built between 1497 and 1506 both as a funerary chapel for Carafa and his immediate family and as a reliquary chapel for St Januarius, patron saint of Naples. The saint's remains were rediscovered in 1480 at the abbey of Montevergine and, due to Carafa's efforts, translated to Naples in 1497 and placed in the Succorpo. The architectural design of the chapel is sometimes attributed to Bramante; the intricately carved marble relief work of the 12 altar niches lining the walls is more securely assigned to Tommaso Malvito (*fl* 1476–1508) and his workshop. There is no tomb, but a focal feature of the decorative scheme is a life-size carved statue of Carafa at prayer. Religious imagery is largely confined to the carved marble ceiling, where seven bishop saints of Naples are prominent. Elsewhere the ornament is overwhelmingly classical in detail and furnishes a vivid instance of Carafa's taste for the Antique.

Carafa also commissioned (*c*. 1508) from Perugino a high altarpiece for Naples Cathedral, the *Assumption of the Virgin with St Januarius and Cardinal Carafa* (*in situ*). As Cardinal Protector of the Canons Regular of the Lateran Congregation, he commissioned Bramante to design and supervise the building of the cloister at S Maria della Pace, Rome, as attested by the frieze inscription, which gives the date 1504 and names Carafa as the founder. Other evidence suggests that Carafa was also responsible for the construction of the adjacent convent. Other projects financed by Carafa (for which little or no physical evidence now survives) included the restoration and embellishment of the Roman churches of S Maria in Aracoeli and S Lorenzo fuori le Mura and the Neapolitan cemetery church of S Gennaro *extra moenia*. He also founded a hospital adjacent to S Gennaro.

Within the private sphere, Carafa built a villa in Rome on the site of the present Palazzo del Quirinale. A modest building, it contained a display of ancient funerary monuments inscribed with epigrams. This lost collection confirms his role as a patron of humanism, attested by dedications to him in numerous scholarly works and by his promotion of an annual literary festival that took place beside an antique sculpture nicknamed 'Pasquino', which Carafa set up on the street corner of his city residence, near Piazza Navona. While most of his commissions were religious, many of Carafa's artistic schemes were distinctive for their allusion to Classical prototypes: a striking instance of the influence of antiquity, even over ostensibly conservative Renaissance patrons.

BIBLIOGRAPHY

DBI

B. Chioccarello: *Antistitum praeclarissimae Neapolitanae ecclesiae catalogus* (Naples, 1643), pp. 286–309

F. Strazzullo: 'Il Card. Oliviero Carafa mecenate del rinascimento', *Atti Accad. Pontaniana*, n. s., xiv (1966), pp. 139–60

G. L. Geiger: *Filippino Lippi's Carafa Chapel: Renaissance Art in Rome* (Kirksville, MO, 1986)

D. Norman: 'The Succorpo in the Cathedral of Naples: "Empress of all Chapels"', *Z. Kstgesch.*, xlix (1986), pp. 323–56

——: 'The Library of Cardinal Oliviero Carafa', *Bk Colr*, xxxvi (1987), pp. 354–71, 471–90

——: 'In Imitation of Saint Thomas Aquinas: Art, Patronage and Liturgy within a Renaissance Chapel', *Ren. Stud.*, vii (1993), pp. 1–42

DIANA NORMAN

(2) Pope **Paul IV** [Gian Pietro Carafa] (*b* Sant'Angelo a Scala, nr Avellino, 28 June 1476; elected 1555; *d* Rome, 18 Aug 1559). After an exemplary life, first as a reform-minded bishop (1506), then as one of the founders of the Theatine Order (1524), he was elected pope at the age of 79. He was learned and interested in the arts but achieved comparatively little as a patron; his finances were limited, and he judged artists and the arts with the same severity that he showed in other affairs. Churches in Rome, such as S Maria Maggiore, were cleared of indecorous works of art, and in one case a painter was brought before the Inquisition for having made a Crucifix that was deemed unfitting. An *Index* of forbidden books was issued, and the Pope ordered Michelangelo to make his *Last Judgement* in the Sistine Chapel (see colour pl. 2, VII3) more modest. However, Michelangelo refused, and the Pope did not pursue the matter, being afraid of losing Michelangelo's services as architect of St Peter's. (Only after Michelangelo's death in 1564 was much of the nudity in the *Last Judgement* covered, by order of Pius IV.) It is symptomatic of his rule that such patrons as the cardinals Giovanni Ricci and Girolamo Capodiferro, whose recently finished palaces in Rome were being decorated, decided to leave the city.

In the Vatican Palace, Paul IV had the apartment of Julius III expanded and redecorated by Pietro Mongardini [Venale] (*fl* 1541–83), though no trace of the decoration survives. The loggia with scenes of the *Exploits of Hercules* by Taddeo Zuccaro was turned into a chapel by Giovanni Sallustio Peruzzi, who was then papal architect. Also in the Vatican Palace, Paul IV made alterations to the Sala dei Palafrenieri, which involved sacrificing frescoes by Raphael. In 1557 Pirro Ligorio, a fellow Neapolitan, was created architect to the Vatican Palace, where his most important commission was for a new *casino* in the Vatican gardens, which was finished in 1563 by Pius IV (see LIGORIO, PIRRO, fig. 1). In addition, Paul IV was concerned with the construction of St Peter's, bringing it explicitly to the attention of the cardinals on his deathbed, but he was never personally able to make a contribution of any importance to it. His tomb, designed by Ligorio, is in S Maria sopra Minerva.

BIBLIOGRAPHY

Ludwig, Freiherr von Pastor: *Geschichte der Päpste* (1886–9)

T. Torriani: *Una tragedia nel cinquecento romano: Paolo IV e i suoi nipoti* (Rome, 1951)

D. Redig de Campos: *I palazzi vaticani* (Bologna, 1967), pp. 140–46

J. L. DE JONG

Caraglio, Giovanni Jacopo (*b* Verona or Parma, *c*. 1500–05; *d* ?Kraków, 26 Aug 1565). Italian engraver, goldsmith and medallist, active also in Poland. He is first recorded in

1526 in the entourage of Marcantonio Raimondi in Rome. There the printer and publisher Baviera introduced him to Rosso Fiorentino, whose allegory *Fury* he engraved (B. 58). Caraglio continued to collaborate with Rosso and engraved several suites, such as the *Labours of Hercules* (B. 44–9), *Pagan Divinities in Niches* (B. 24–43) and *Loves of the Gods* (B.9–23; two after Rosso and eighteen after Perino del Vaga). After the Sack of Rome (1527), Caraglio took refuge in Venice, where he made engravings after Titian (B. 3, 64). His presence is recorded there until 1537.

By 1539 Caraglio was in Poland, probably at the recommendation of his friend Pietro Aretino, who had contacts in the court of Bona Sforza (1494–1557), wife of Sigismund I, King of Poland (*reg* 1506–48). By 1545 Caraglio entered the service of the King as goldsmith, medallist and engraver of hardstones. Surviving works include two signed intaglios (Paris, Bib. N.; New York, Met.), two medals (Padua, Mus. Civ.; Venice, Correr) and a cameo (Munich, Staatl. Münzsamml.). According to Vasari, he retired to Parma after the death of Sigismund I in 1548; other writers suggested he remained in Poland in the service of Sigismund II Augustus (*reg* 1548–72), who knighted him in 1552, an event probably commemorated in his portrait by Paris Bordone (Kraków, N. A. Cols).

Numbered with Agostino dei Musi and Marco Dente in the Roman school of engravers in the circle of Raimondi, Caraglio showed a greater freedom of line. With Rosso Fiorentino and Parmigianino, he discovered new modelling effects with subtler lighting and more animated forms, for example in his engraving of *Diogenes* (B. 61) and in the first state of the *Rape of the Sabine Women* (B. 63). His oeuvre comprises about 70 engravings (65 listed by Bartsch) on religious, mythological and allegorical themes after Rosso Fiorentino (almost half), Raphael, Perino del Vaga, Parmigianino, Titian, Giulio Romano and Baccio Bandinelli. He used various signatures: *Jacobus caralius Veronensis, Jacobus Veronensis* and *Jacobus Parmensis.*

BIBLIOGRAPHY
DBI
A. von Bartsch: *Le Peintre-graveur* (1803–21), XV/i, pp. 61–100 [B.]
J. D. Passavant: *Le Peintre-graveur* (Leipzig, 1860–64), vi, pp. 95–8
H. Zerner: 'Sur Giovanni Jacopo Caraglio', *Actes du XXIIe Congrès international d'histoire de l'art: Budapest, 1969*, pp. 691–5
S. Boorsch, J. T. Spike and M. C. Archer: *Italian Masters of the 16th Century* (1985), 28 [XV/i] of *The Illustrated Bartsch*, ed. W. Strauss (New York, 1978–)

FRANÇOISE JESTAZ

Caravaggio, Polidoro da. *See* POLIDORO DA CARAVAGGIO.

Cariani [de' Busi], Giovanni (*b* San Giovanni Bianco, nr Fuipiano al Brembo, *c.* 1485; *d* Venice, after 1547). Italian painter. He moved with his family *c.* 1505 to Venice, where he is first described as a painter in a Venetian document of 29 April 1509. His early style was deeply influenced by that of Sebastiano del Piombo rather than by that of Giorgione or Titian. This is evident in such paintings as *St Agatha* (Edinburgh, N.G.) and the *Sacra conversazione* (Venice, Accad.). Even the double *Portrait of Two Young Men* (Paris, Louvre) seems to be based on Sebastiano's portrait *Verdelot and Ubrecht* (untraced). After Sebastiano's departure for Rome (1511), Cariani became interested in

the work of Titian, creating a style close to that of his fellow Bergamesque, Palma Vecchio. This is demonstrated in a group of paintings that includes Cariani's first reliably dated work, the *Virgin and Child with Saints and Donors* (Bergamo, priv. col., see Pallucchini and Rossi, pl. I), which once bore the date 1514. Probably datable to the same period is *The Concert* (Warsaw, N. Mus.).

In 1517 Cariani was in Bergamo, where he was commissioned by the Scuola di S Giuseppe to paint an altarpiece, the *Virgin and Saints* (1517–18; Milan, Brera), for S Gottardo. This painting marked a definitive break with his Venetian style, in which his finest works were executed, and a turning towards a drier style featuring angular planes. It is a manner derived from Palma and Titian but more deeply rooted in a local tradition and not equal to that of Lorenzo Lotto, the most distinguished painter then active in Bergamo. Though less original than that of his earlier period, this is Cariani's most characteristic style. In 1519, still in Bergamo, Cariani signed and dated a portrait of *Seven Members of the Albani Family* (Bergamo, Roncalli priv. col., see 1983 exh. cat., p. 61) and in 1520 completed the *Virgin and Child with a Worshipper* and the *Resurrection* (both Milan, Brera), commissioned by Ottaviano Vimercati for S Pietro at Crema. Dating from the same period are the portraits of *Giovanni Benedetto Caravaggi* (Bergamo, Gal. Accad. Carrara) and *Giovan Antonio Caravaggi* (Ottawa, N.G.; see fig.).

Towards the end of 1523 Cariani returned to Venice, where much had changed; Titian now dominated the Venetian school. Cariani seems to have drawn closer to the style of Bonifazio Veronese and, possibly through the example of Giovanni Girolamo Savoldo, to have discovered the fascination of northern engravings. He also seems to have reconsidered the art of Lorenzo Lotto and Gerolamo Romanino. Such influences are apparent in the paintings of the *Road to Calvary* (Milan, Ambrosiana; Brescia, Pin. Civ. Tosio–Martinengo), in the *Visitation* (Vienna, Ksthist. Mus.) and in the so-called *Invention of the*

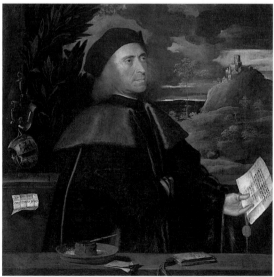

Giovanni Cariani: *Giovan Antonio Caravaggi*, oil on canvas, 935×937 mm, *c.* 1520 (Ottawa, National Gallery of Canada)

Cross (Bergamo, Gal. Accad. Carrara), dating from some years later.

Between 1528 and 1530 Cariano was again working in Bergamo, painting a triptych (Bergamo, Gal. Accad. Carrara, and Venice, priv. col.) for the church of Locatello. During the 1530s, in Venice, although he produced some distinguished works, such as *Lot and his Daughters* (Milan, Castello Sforzesco), which reflects the art of Bonifazio Veronese, his stylistic uncertainty became ever more evident, and his art increasingly provincial. In certain portraits of this period, such as the *Old Man of Nuremberg* (1536; Vienna, Ksthist. Mus.) and also in works such as the *Sacra conversazione* (London, N.G.), he came strikingly close to Bernardino Licinio. It seems likely, too, that he painted less, since few works painted between 1530 and 1547, when he is last documented, have been identified. However, in 1541, he was paid for an altarpiece of *St Roch* (destr.), executed for the Busi Chapel in SS Filippo e Giacomo, Fuipiano.

BIBLIOGRAPHY
DBI [with bibliog.]
M. A. Michiel: *Notizie d'opere di disegno* (*c.* 1534–40); ed. G. Frizzioni (Bologna, 1884), pp. 125, 138, 139, 144, 185
G. Mariacher: 'Giovanni Busi, detto Cariani', *Pittori bergamaschi dal XIII al XIX secolo: Il cinquecento*, i (Bergamo, 1975), pp. 247–313
R. Pallucchini and F. Rossi: *Giovanni Cariani* (Milan, 1983)
V. Sgarbi: '1518: Cariani a Ferrara e Dosso', *Paragone*, xxxiv/389 (1983), pp. 3–18
The Genius of Venice, 1500–1600 (exh. cat., ed. C. Hope and J. Martineau; London, RA, 1983), pp. 160–66
E. Safarik: 'Una monografia su Giovanni Cariani e un contributo alla conoscenza del suo primo periodo', *A. Ven.*, xxxviii (1984), pp. 230–32
F. Frangi: 'Giovanni Cariani', *La pittura in Italia: Il cinquecento*, ed. G. Briganti, 2 vols (Milan, 1987, rev. 1988), ii, pp. 667–8 [with bibliog.]
A. Ballarin: 'Giovanni Busi, Called Cariani', *Gothic to Renaissance: European Painting, 1300 to 1600*, ed. D. Garstang (London, 1988), pp. 27–32
F. Rossi: 'Cariani', *Pinacoteca di Brera: Scuola veneta* (Milan, 1990), pp. 406–19

MAURO LUCCO

Carlerio, Anselmo. *See* CANNERI, ANSELMO.

Carli, Raffaelle de'. *See* RAFFAELLINO DEL GARBO.

Carlo da Milano. *See* BRACCESCO, CARLO.

Carnevale [Carnovale], **Fra** [Bartolomeo di Giovanni Corradini] (*fl* Florence, 1445; *d* Urbino, 1484). Italian painter. On 28 November 1445 he was described as a pupil of Fra Filippo Lippi. He was active in his home town of Urbino by 1451, when he received payments on behalf of the syndics of S Domenico for the doorway and glazed terracotta lunette commissioned from Maso di Bartolommeo and Luca della Robbia in Florence. He was absolved from painting an altarpiece in 1456. From 1461 he was parish priest at San Cassiano di Cavallino, near Urbino, but he appears to have been active in Urbino, where in 1467 he received payments for an altarpiece of the *Birth of the Virgin* for S Maria della Bella. This was his most famous work, which Vasari said influenced Bramante. The picture was confiscated by Cardinal Antonio Barberini in 1631 and has been identified with two panels from his collection (New York, Met., and Boston, MA, Mus. F.A.). Carnevale is listed in a later *memoria* among the engineers

and architects of Federigo II da Montefeltro, Duke of Urbino.

See also MASTERS, ANONYMOUS, AND MONOGRAMMISTS, §I: MASTER OF THE BARBERINI PANELS.

BIBLIOGRAPHY
A. Schmarsow: *Melozzo da Forlì: Ein Beitrag zur Kunst und Kulturgeschichte Italiens im XV. Jahrhundert* (Berlin, 1886), pp. 361–2
K. Christiansen: 'For Fra Carnevale', *Apollo*, cix (1979), pp. 198–201
M. Strauss: *The Master of the Barberini Panels: Fra Carnevale* (diss., New York U., Inst. F. A., 1979)

KEITH CHRISTIANSEN

Carocci, Baverio de'. *See* BAVIERA.

Caroto. Italian family of painters, prominent in Verona during the first half of the 16th century. (1) Gian Francesco Caroto, who is the better known of the brothers on account of his greater productivity, travelled widely, and his work is noted for its eclecticism. His younger brother (2) Giovanni Caroto's development is, in contrast, gradual, conservative and based on local sources. Giovanni is also known for his drawings and woodcut illustrations of Roman antiquities in Verona. There are some disputed attributions between the two brothers, but these appear to derive from the mistaken assumption that works of lesser quality can be assigned to Giovanni. Fewer paintings can be assigned with confidence to him, but these are more consistent in quality than Gian Francesco's more numerous paintings. There appear to be only two clear instances of collaboration.

(1) Gian [Giovan] **Francesco Caroto** (*b* Verona, *c.* 1480; *d c.* 1555). According to Vasari, he was trained by Liberale da Verona, but there is no clear evidence of this in his earlier works. A chronological review of his securely attributed works reveals a series of identifiable influences, including Lorenzo Costa the elder, Leonardo and his followers, Raphael, Giulio Romano, Parmigianino and Correggio. Caroto's earliest known work is a *Virgin and Child* (Modena, Gal. & Mus. Estense), signed and dated 1501. It recalls more readily the sculptural qualities of Francesco Bonsignori than the linear emphasis of Liberale. A fresco depicting the *Annunciation* (1508; Verona, S Gerolamo) retains some of this sculpted sense, but the figure types are clearly influenced by Leonardo, probably the effect of a sojourn in Milan in 1507. The *Pietà* (Turin, Fontana priv. col., see Franco Fiorio, fig. 17), signed and dated 1515, resembles the style of Leonardo's Milanese followers. Lombard influence is also evident in the frescoes depicting *Tobias* and the canvas of *Three Angels* executed for the Spolverini Chapel, S Eufemia, Verona, variously dated between 1508 and 1520. A portrait of a *Red-headed Youth Holding a Drawing* (Verona, Castelvecchio) also belongs to this period.

A new phase revealing Central Italian influence is evident in the altarpiece depicting the *Virgin and Child with Four Saints* (1528; Verona, S Fermo Maggiore). Raphael's works and the presence of Giulio Romano in Mantua from 1524 seem to be the sources. In the *Raising of Lazarus* (1531; Verona, Pal. Vescovile), Caroto achieves a nice balance: the figures are classically proportioned, but their muscularity is not exaggerated; a view of the River

Adige provides a pleasingly lyrical setting. Six panels of landscapes viewed through illusionistic arched windows, decorating the choir-stalls in S Maria in Organo, Verona, are also datable to around 1530. *Christ Washing the Feet of the Disciples* (Verona, Castelvecchio) would seem to belong to the same period but is dated 1545–50 (dal Bravo; Franco Fiorio). Frescoes depicting scenes from the Old Testament (Verona Cathedral, nave) probably belong to the late 1530s. In the altarpiece depicting *St Ursula* (1545; Verona, S Giorgio in Braida) and *Christ Taking Leave of his Mother* (1546; Verona, S Bernardino, Avanzi Chapel), Gian Francesco's figures have acquired longer proportions and mannered poses. Some of Gian Francesco's works on canvas are executed in tempera (1987 exh. cat.). In the Villa del Bene, Volargne, decorated by the Caroto brothers and Domenico Brusasorci around 1551, the frescoes attributed to Gian Francesco include some extremely fine passages, such as the horn-blowing angel in scenes from the *Apocalypse* in the main hall. Gian Francesco's pupils included Domenico Brusasorci and Antonio Badile.

(2) Giovanni (Battista) Caroto (*b* Verona, 1488; *d* Verona, 1563–6). Brother of (1) Gian Francesco Caroto. His training is undocumented, and some writers have assumed that Giovanni studied with his brother. His work shows the influence of Girolamo dai Libri (1474–1555) and Francesco Morone. Giovanni's work moves from an early classical style that includes detailed representation of texture, fabric and landscape background to a fully High Renaissance style around 1530. His earliest extant work is probably the *Annunciation* on two canvases (Verona, S Giorgio in Braida), traditionally dated 1508 but possibly slightly later. It appears to refer both to Gian Francesco's contemporary fresco of the same subject (Verona, S Gerolamo) and to Leonardo's early *Annunciation* (Florence, Uffizi). Although the figures are somewhat stiff, the work shows Giovanni to be gifted and skilful. The depiction of the Virgin's luminous dress is masterful, and the attention to detail in the sunset and wintry landscape behind Gabriel recalls Netherlandish painting. Similar qualities recur in the *Virgin and Child Enthroned with SS Stephen and Martin* (signed and dated 1514; ex-S Giovanni in Fonte, Verona; Verona Cathedral). In the *Virgin and Child Enthroned with SS Peter and Paul* (1516; Verona, S Paolo, main altar) the detail in the landscape and the sharply illuminated, rich materials is reduced to achieve an immediate sense of unity and grandeur, fostered by the huge, barrel-vaulted setting and a more pervasive, even light.

The pair of canvases representing *St Paul* and *St George* (Verona, Castelvecchio) probably belong to the early 1520s. The figure types are more generalized, and detail is further reduced in the landscape background. Their cool afternoon light resembles that in earlier examples by Morone and Paolo Cavazzola. Giovanni's *Self-portrait with his Wife Placida* (1530; Verona, Castelvecchio), a fragment of high quality from an altarpiece formerly in the chapel of S Niccolò (S Maria in Organo)—which, according to Vasari, was frescoed by Gian Francesco and is an example of the brothers' collaboration—has great dignity and calm in its image of the praying couple: all stiffness and sharp

detail seen in earlier works have gone, and the cool light casts delicate, coloured shadows. Frescoes of the archangels *Michael* and *Gabriel* on the exterior of the Fontanelli Chapel, S Maria in Organo, also from 1530, likewise show mastery of a High Renaissance style. The angle at which the light falls is coordinated with the actual window to enhance the illusion that the sun is shining on the archangels in their *trompe l'oeil* niches.

Giovanni's activity as a student of antiquity may explain his smaller output in painting than his brother. In 1540 a series of his drawings of Verona's Roman remains—the only documented works by Giovanni from this decade—were printed as woodcut illustrations to the first, Latin, edition of Torello Saraina's *De origine et amplitudine civitatis Veronae*. They were published under his own name in 1560. These drawings show, in comparison with drawings of the same monuments by contemporaries, that Giovanni imaginatively 'restored' the antiquities, adding, for example, sculpted decorations on the Arco Leoni. The drawings for the 1546 vernacular edition (1546 edn and original drgs; Verona, Bib. Civ.) include a *Self-portrait* and a draped female niche figure, matronly and severe, labelled .GAVIA M.F. In the Villa del Bene, Volargne, where the Caroto brothers collaborated *c.* 1551, the room whose decoration is attributed to Giovanni has a striking monochrome frieze depicting animals, cornucopias, men and coats of arms. Below, six *trompe l'oeil* frescoes of biblical scenes appear as framed paintings with hooks and cast shadows (see fig.). Within this playful illusion, Giovanni's forms, illuminated by cool light, display their customary gravity and classical features.

The portrait of a *Young Benedictine Monk* (Verona, Castelvecchio) has variously been assigned both to Gian Francesco (Franco Fiorio) and to Giovanni (Baron). Its calm classicism, cool light and difference in handling in comparison with Gian Francesco's portrait of the *Red-headed Youth Holding a Drawing* (Verona, Castelvecchio) argue for the latter view. According to Vasari, Giovanni taught both Veronese and Anselmo Canneri.

PRINTS

De le antiquità de Verona con novi agointi da M. Zoane Caroto pittore (Verona, 1560)

BIBLIOGRAPHY

T. Saraina: *De origine et amplitudine civitatis Veronae* (Verona, 1540; vern. edn, 1546)

Giovanni Caroto: *Baptism* with illusionistic frame, shadow and hooks, detail from fresco (*c.* 1551), Villa del Bene, Volargne

G. Vasari: *Vite* (1550, rev. 2/1568); ed. G. Milanesi (1878–85)

B. dal Pozzo: *Le vite de' pittori, scultori e architetti veronesi* (Verona, 1718), pp. 25–7

G. Biermann: 'Die beiden Carotos in der Veroneser Malerei', *Kunstchronik*, iv (1903–4), pp. 7–20

L. Simeoni: 'Nuovi documenti sui Caroto', *L'Arte*, vii (1904), pp. 64–7

B. Baron: 'Giovanni Caroto I', *Burl. Mag.*, xviii (1910), pp. 41–4

——: 'Giovanni Caroto II', *Burl. Mag.*, xviii (1910), pp. 176–83

G. Trecca: 'Giovanni Caroto', *Madonna Verona*, iv/16 (1910), pp. 190–96

C. Garibotto: 'Affreschi di Giovanni Caroto in S Maria in Organo di Verona', *Madonna Verona*, xv/58–60 (1921), pp. 32–4

C. del Bravo: 'Per Giovan Francesco Caroto', *Paragone*, xv/173 (1964), pp. 3–16

M. T. Franco Fiorio: 'Appunti su Giovan Francesco Caroto', *A. Lombarda*, 11 (1966), pp. 33–42

P. Marchiori: 'Giovanni Caroto (cenni biografici)', *Vita Veron.*, xx (1967), pp. 94–6

——: 'Giovanni Caroto disegnatore', *Vita Veron.*, xx (1967), pp. 173–4

——: 'Giovanni Caroto pittore', *Vita Veron.*, xx (1967), pp. 340–44

M. T. Franco Fiorio: *Giovan Francesco Caroto* (Verona, 1971)

D. Gisolfi Pechukas: *The Youth of Veronese* (diss., U. Chicago, 1976), chaps ii and iii

Proposte e restauri (exh. cat., ed. S. Marinelli; Verona, Castelvecchio, 1987), pp. 128–40

G. Ericani: 'La stagione pre veronesiana e la pittura di paesaggio a Verona', *Veronese e Verona* (exh. cat., ed. S. Marinelli; Verona, Castelvecchio, 1988), pp. 7–15

W. Lotz: 'Sull'unità di misura nei disegni di architettura del Cinquecento', *Bol. Cent. Int. Stud. Archit. Andrea Palladio*, xii (1979), pp. 223–32

D. Gisolfi Pechukas: 'Two Oil Sketches and the Youth of Veronese', *A. Bull.*, lxiv (1982), pp. 388–413

M. Repeto Contaldo: 'Facciate affrescate in Piazza delle Erbe: casa Montanari e la Spezeria del Pano d'Oro', *Atti & Mem. Accad. Agric., Sci. & Lett. Verona*, 2 (1991–2), pp. 699–737

DIANA GISOLFI

Carpaccio. Italian family of painters. (1) Vittore Carpaccio was one of the most gifted painters in early Renaissance Venice. His artistic reputation far outweighs that of his two sons, Pietro Carpaccio (*fl c.* 1510–30) and (2) Benedetto Carpaccio, neither of whom remained in Venice. Presumably his principal pupils and assistants, they inherited a provincial, conservative and socially modest clientele from their father. Pietro was presumably the elder (since, according to Venetian custom, he was named after Vittore's father); he is first documented in Venice in 1513, but by 1526 he had set up shop in Udine. No certain works by him are known.

(1) Vittore Carpaccio [Carpathius; Carpatio; Scarpaza; Scharpaza; Scarpazza; Scarpatia] (*b* Venice, ?1460–6; *d* Venice, 1525–6). His name is associated above all with the cycles of lively and festive narrative paintings that he executed for several of the Venetian *scuole*, or devotional confraternities. He also seems to have enjoyed a considerable reputation as a portrait painter. While evidently owing much in both these fields to his older contemporaries, Gentile and Giovanni Bellini, Carpaccio quickly evolved a readily recognizable style of his own which is marked by a taste for decorative splendour and picturesque anecdote. His altarpieces and smaller devotional works are generally less successful, particularly after about 1510, when he seems to have suffered a crisis of confidence in the face of the radical innovations of younger artists such as Giorgione and Titian.

1. Life and commissions. 2. Work. 3. Working methods and technique. 4. Critical reception and posthumous reputation.

1. LIFE AND COMMISSIONS. Vittore was the son of Pietro Scarpazza, a Venetian furrier. A will made by his uncle in 1472 naming Vittore as a beneficiary has been used as evidence that the painter had reached the age of 15 by that date and therefore that he must have been born before 1457. But under Venetian law, a child could be named as a future, if not immediate, beneficiary of a testamentary bequest and the stylistic evidence of his work indicates that Vittore may have been born as late as 1465. This later birthdate is supported rather than contradicted by a document of 1486, which records him still living in his father's house.

Carpaccio's earliest dated work is the *Arrival of St Ursula at Cologne* (1490; Venice, Accad.), the first of nine canvases executed for the Scuola di S Orsola and depicting the life of the confraternity's patron saint (see colour pl. 1, XIX1). Other paintings in the cycle are dated 1491, 1493 and 1495. Almost certainly earlier than 1490 is the *Salvator Mundi with Four Apostles* (Florence, ex-Contini–Bonacossi priv. col.), in which the artist's signature uniquely appears in its Venetian form of 'Vetor Scarpazo'. The stylistic evidence of these and of other putative early works, some of them controversial attributions, provides the only source of knowledge of Carpaccio's artistic training and has been interpreted in a number of different ways. The traditional view that he was a pupil of the Bellini brothers was first challenged by Molmenti and Ludwig, who proposed Lazzaro Bastiani as his master. Emphasis has also been placed on the formative influences of Antonello da Messina, Ferrarese painting, Giovanni Bellini and Jacometto Veneziano. Gentile Bellini also seems a likely candidate, while the inclusion of Roman motifs in the St Ursula cycle, combined with apparent echoes of the art of Perugino, has led to speculation that Carpaccio paid an early visit to Rome (Zampetti, 1966 monograph).

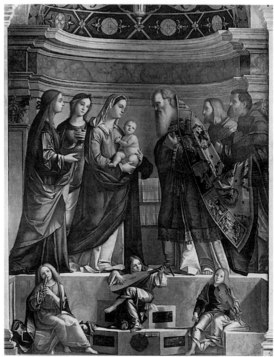

1. Vittore Carpaccio: *Presentation of Christ in the Temple*, oil on panel, 4.21×2.36 m, 1510 (Venice, Galleria dell'Accademia)

From the 1490s onwards, Carpaccio regularly inscribed his most important works with dates and signatures, and a number of documents also survive that refer to lost works and to other aspects of his professional career. In 1508 he served as a member of a committee convened to evaluate the recently completed frescoes by Giorgione on the Fondaco de' Tedeschi and in 1511 he corresponded with Francesco Gonzaga, Marchese di Mantua, in the hope of persuading him to buy a large canvas referred to as 'uno Jerusalem' (presumably a religious subject with a background townscape identifiable as that of Jerusalem). Among Carpaccio's most important dated altarpieces, most of which were painted in his later career, are St Thomas Aquinas Enthroned (1507; Stuttgart, Staatsgal.), the Presentation of Christ in the Temple (1510; Venice, Accad.; see fig. 1) and the Martyrdom of the Ten Thousand (1515; Venice, Accad.). These three works were all painted for churches in Venice; but from about 1510 Carpaccio worked increasingly for provincial customers, sending altarpieces to destinations such as Treviso, Capodistria (now Koper, Slovenia), Pirano (near Trieste), Brescia and Pozzale di Cadore in the Dolomites.

It has sometimes been suggested that Carpaccio was the preferred artist of a particular social or cultural group, such as the lunghi faction within the ruling Venetian patriciate (so-called because their families had held power for many generations), or of leading Venetian humanists and intellectuals. But a survey of all the artist's known employers shows that, on the contrary, he never enjoyed the consistent support of any one type of patron and that his association with the ruling classes was sporadic. For all his talents as a narrative painter, he worked only briefly on the great history cycle in the Sala del Maggior Consiglio in the Doge's Palace, assisting Giovanni Bellini in 1507. Perhaps even more surprisingly, he only ever painted one work for a scuola grande, contributing, in 1494, a canvas to the Miracles of the True Cross cycle for the Scuola Grande di S Giovanni Evangelista (Venice, Accad.; see fig. 2). On

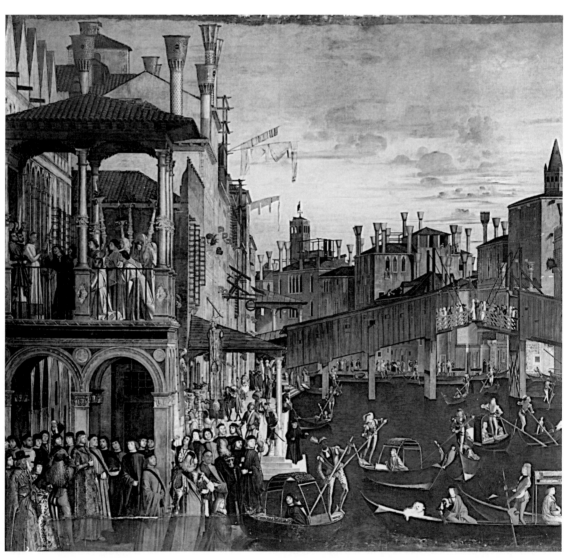

2. Vittore Carpaccio: Miracle at Rialto, oil on canvas, 3.65×3.89 m, 1494 (Venice, Galleria dell'Accademia)

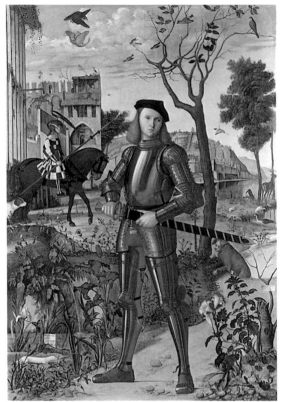

3. Vittore Carpaccio: *Portrait of a Young Knight*, oil on canvas, 218×152 mm, 1510 (Madrid, Mus. Thyssen-Bornemisza)

the Albanesi and S Stefano consisted chiefly of tradesmen, artisans, sailors and the like. The donors of Carpaccio's metropolitan altarpieces were of a similarly varied social standing, ranging from the patrician Sanuto family, to the citizen families of Ottoboni and Licinio, to a confraternity of artisans such as the Scuola dei Tessitori di Lana (wool-weavers). Beyond Venice, Carpaccio is known to have had contacts with members of princely families of the Italian mainland: the *Portrait of a Young Knight* (1510; Madrid, Mus. Thyssen-Bornemisza; see fig. 3) has been associated with the della Rovere of Urbino (or with the Aragonese dynasty at Naples). However, most of Carpaccio's mainland commissions came from clients of a much lower social status, such as the devotional confraternity in Udine who commissioned the *Blood of the Redeemer* (1496; Udine, Mus. Civ.), or the parish church of Grumello de' Zanchi near Bergamo (dismembered polyptych *in situ*).

2. WORK.

(i) Narrative cycles. The canvases painted in the mid-1490s for the Scuola di S Orsola already show Carpaccio at his best. In the largest of the series, the *Departure of St Ursula* (1495; Venice, Accad.; see fig. 4), the scene on the right is typically one of pageantry and ceremony, with gaily dressed figures set against a townscape teeming with incident. Although supposedly set in 4th-century Brittany, the scene is clearly meant to evoke the splendour of late 15th-century Venice, with marble-encrusted palaces rising from the waves, floating domes and bell-towers, ships at anchor, festive processions, displays of rich fabrics and shimmering reflections. In the scene on the left, set in pagan England, the backdrop is even more exotic. Here Carpaccio is known to have based his architectural designs on woodcuts showing views of buildings in the eastern Mediterranean, apparently with the intention of creating an appropriately outlandish setting. He is evidently in full command of the laws of geometric perspective and plots the recession into depth with logic and consistency; yet the effect of deep space is counteracted by the frieze-like treatment of the

at least two occasions he lost competitions for commissions held by the Scuola Grande della Carità to lesser artists. His four independent narrative cycles were all painted for *scuole piccole*; and although in the case of the Scuola di S Orsola at least some of the canvases were paid for and presumably also supervised by the patrician Loredan family, his employers at the *scuole* of the Schiavoni,

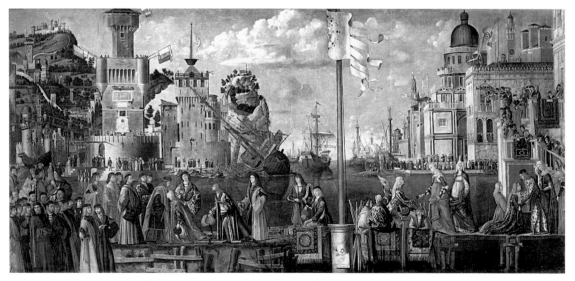

4. Vittore Carpaccio: *Departure of St Ursula*, oil on canvas, 2.80×6.11 m, 1495 (Venice, Galleria dell'Accademia)

figure composition, and especially by the highly decorative use of colour, which creates a pattern of reds and greens that decisively reasserts the picture plane.

By the 1490s such features were conventional in Venetian cyclical narrative painting, as was the group portrait in the lower left corner, which presumably represents the current office-holders in the confraternity. Important precedents for Carpaccio's approach to narrative painting were the cycle of Old Testament scenes painted in the 1460s and 1470s by various artists for the Scuola Grande di S Marco (destr. by fire in 1485), and the prestigious history cycle in the Doge's Palace (destr. by fire in 1577), with its many scenes of pageantry and of ambassadorial reception and departure. With the unfortunate loss of both these cycles, it is not easy to assess either the originality of Carpaccio's contribution to the type or his artistic relationship to its leading practitioner, Gentile Bellini. What does seem clear, however, is that the St Ursula cycle is characterized by a spirit of poetic fantasy that eluded the more soberly literal Gentile, and that with his feeling for the expressive qualities of light, Carpaccio had as much in common with Giovanni Bellini as with Gentile.

In the six or seven years during which Carpaccio was engaged on the St Ursula cycle, his art matured rapidly. In the *Arrival of St Ursula at Cologne* (1490; Venice, Accad.) the treatment of light and atmosphere is still comparatively primitive, and the ostentatious but naive use of perspective foreshortening recalls the work of Jacopo Bellini. In the *Reception of the Ambassadors* (c. 1496; Venice, Accad.) the balance between effects of spatial recession and flat decoration has become much more subtle and harmonious: virtuoso feats of *trompe l'oeil* illusionism in the foreground and effects of distance achieved through atmospheric softening do not disrupt the orderly pattern of shapes and colours whose arrangement reasserts the two-dimensional nature of the canvas.

The pictorial sophistication of the later St Ursula scenes is preserved in at least some of the canvases that Carpaccio painted for the Scuola di S Giorgio degli Schiavoni between 1502 and about 1508. This series, which today enjoys the distinction of being the only Venetian narrative cycle of the early Renaissance to survive in its original building, comprises four separate groups of scenes rather than a continuous narrative, as at the Scuola di S Orsola. The individual compositions are accordingly conceived less in a frieze-like than in a centripetal manner, while the narratives are treated with greater simplicity and clarity, particularly in the three scenes of the *Life of St Jerome*. In keeping with the smaller scale of the canvases, the mood is more intimate and the scene of *St Jerome Leading the Lion into the Monastery* (see colour pl. 1, XIX2) conveys a sense of humour all too rare in Italian Renaissance painting. The colour has become deeper and more glowing than in the St Ursula cycle, perhaps partly in response to the contemporary work of Giorgione, and this gives an appropriate warmth and richness to the exotic environment in the three scenes from the *Life of St George*. For information about Islamic buildings and costumes, Carpaccio drew extensively on woodcuts published in Bernhard von Breydenbach's account of his pilgrimage to the Holy Land (Mainz, 1486) as a means of lending his stories

verisimilitude, while at the same time freely rearranging his borrowings according to his own poetic invention.

The last of the Scuola degli Schiavoni series, *St Tryphonius Exorcizing the Demon* (c. 1507–8), shows a loss of inspiration compared with the St Jerome and St George scenes, appearing almost like a pastiche of the opening scenes of the St Ursula cycle. Comparable tendencies towards slack and mechanical draughtsmanship, hard and dull colour and self-repetition are already to be found in the six canvases of the Scuola degli Albanesi cycle (c. 1500–10; dispersed among Venice, Ca' d'Oro and Correr; Bergamo, Gal. Acad. Carrara; Milan, Brera). The explanation in both cases may be that Carpaccio was already making extensive use of workshop assistance. However, the decline in his art was not consistent from this time onwards, and all four of the canvases for the Scuola di S Stefano (1511–20; dispersed among Paris, Louvre; Berlin, Gemäldegal.; Milan, Brera; Stuttgart, Staatsgal.) are superior in invention and execution to those of the Albanesi. The *Stoning of St Stephen* (1520; Stuttgart, Staatsgal.) may even be interpreted as a brave attempt by the artist to revolutionize his style in accordance with 16th-century ideals: the figures are large in relation to the picture field and organized into more compact groups than in his earlier cycles, while the landscape is conceived in terms of loose and cursive rhythms rather than step-by-step spatial recession. But Carpaccio was only moderately successful in his attempt to modernize himself: his actors lack the mobile fluency and heroic dimension of the High Renaissance figure style, and their draperies are very stiff and angular. Furthermore, his art had largely lost the very qualities that made the earlier cycles so appealing: the picturesque details, the vividness of anecdote, the mood of festive gaiety. The *Stoning* is not only stylistically archaic for its date—by 1520 Titian had already completed his *Assumption of the Virgin* (Venice, S Maria Gloriosa dei Frari) and at least one of his mythologies for the Duke of Ferrara—but it also compares unfavourably with Carpaccio's own work of two or three decades earlier.

(ii) Devotional works and portraits. In the field of large-scale public works, Carpaccio's talents were undeniably best suited to narrative painting, and even at the height of his powers, he was much less successful as a painter of altarpieces. Models for his most ambitious works of this type would have been provided by the altarpieces of Giovanni Bellini, but Carpaccio lacked Bellini's ability to combine gentle dignity with calm grandeur. The wit and inventiveness with which the narrative scenes of St Ursula's life on earth are portrayed make the representation of her apotheosis in the accompanying altarpiece (1491; Venice, Accad.) appear dull and contrived by comparison; the figures seem artificially inflated rather than truly grandiose, and the symmetry of their grouping monotonous rather than impressively solemn. Carpaccio's metropolitan altarpieces of the first decade of the 16th century are somewhat more effective, but it is unfortunate that he received most of his altarpiece commissions in the last 15 years of his life, during the very period when his creative powers were in decline.

As a painter of devotional subjects, Carpaccio was much more comfortable when working on a relatively small scale

or on pictures intended for an informal, domestic setting. The *Virgin and Child with St John the Baptist* (Frankfurt am Main, Städel. Kstinst.) has an anecdotal charm that has much in common with the narrative cycles and constitutes a highly personal contribution to the well-established genre of the half-length Virgin and Child. In another vein, the *Meditation on the Passion of Christ* (New York, Met.) reveals an ability to communicate feelings of religious seriousness rarely found in his larger, more public works. This has been associated with the spiritual climate emanating from the circle of reforming clerics in Venice that centred around the personality of Paolo Giustinian (Perocco, 1960).

Carpaccio's devotional works vary in dimension, style and quality according to their subject-matter and typology, and probably also according to the type of client who commissioned them. They are consequently often very difficult to date, despite the fact that the comparatively large number of dated works by the artist ought to provide a clear chronological framework. The *Meditation on the Passion*, for example, is sometimes regarded as an early work of *c.* 1490 (Hartt, 1940; Lauts, 1962) and sometimes (and probably more plausibly) as a late work of *c.* 1510. Similarly, the polyptych in Zara (Zadar, S Anastasia) has been seen as early (Longhi, 1932, 1946; Pallucchini, 1961; Zampetti, 1966 monograph), middle (Pignatti, 1955; Perocco, 1960; Lauts, 1962), late (Tietze, 1944) and even as a work executed piecemeal in all three phases (Muraro, 1966).

Carpaccio's fame as a portrait painter is attested in general terms by Vasari, and more specifically by three separate contemporary sources, which refer to portraits by him of certain eminent men and women of letters. None of these can be identified with extant works of art, and most modern attributions remain controversial. Nevertheless, the number of individually characterized heads, including obvious group portraits, that appear in the narrative cycles (see fig. 4), together with a number of fine portrait drawings, make the testimony of the sources entirely credible. One of the characteristics most admired by the Tuscan poet Girolama Corsi Ramos in Carpaccio's portrait of her was that it made her 'seem about to speak'. In other words, the artist must have consciously departed from the characteristically reticent and timeless type of portraiture practised by Giovanni Bellini, and in this respect his portraits may have constituted an important link between those of Antonello da Messina and Giorgione. For most of his portraits Carpaccio would have adopted the standard bust-length, three-quarter view formula, but in the highly original *Portrait of a Young Knight* (see fig. 3 above) the figure is seen in full-length against a richly detailed landscape background. To account for this exceptional arrangement, it has been suggested that this was a posthumous portrait, in which the sitter is commemorated in the full-length pose often adopted for funerary effigies, especially for warriors (Goffen, 1983). In any case, Carpaccio deserves credit here for producing what is probably the first independent full-length portrait in Italian painting, a type that was later developed by Titian.

3. WORKING METHODS AND TECHNIQUE. Information about the composition and running of Carpaccio's workshop has to be inferred from visual and biographical evidence since there are no documents or early sources. The weaknesses of the Albanesi cycle suggest that by about 1500 Carpaccio employed at least one trained assistant in addition to the customary shop apprentice. The date is probably too early to allow an identification of this assistant with either of his sons, but it is normally assumed that they provided extensive assistance in the artist's later years.

Many of Carpaccio's works are executed on the traditional panel support, but to a greater extent than most of his contemporaries he also made frequent use of canvas, a support that only became normal in Venetian painting during the course of the 16th century. This was a direct consequence of his activity as a painter of narrative cycles, a context in which Jacopo and Gentile Bellini had already employed canvas for some decades. Carpaccio, however, was a pioneer in the use of canvas for altarpieces (as in the *Apotheosis of St Ursula*), and in exploiting its physical properties for new expressive ends. His priming is normally very thin, scarcely covering the rough weave, and his handling of the new medium of oil paint is often sketchy and suggestive. Bold touches of pure colour anticipate the pictorialism of Giorgione and Titian. While Carpaccio's technique lacked the careful, methodical craftsmanship of his contemporaries Giovanni Bellini and Cima, at its best it expressed a greater vivacity and spontaneity; at its worst it can look undisciplined and even incompetent. Analysis of the pigments has shown that Carpaccio moved from a relatively restricted palette in early works such as the St Ursula cycle to a much richer one in a latish work such as the *Presentation in the Temple* (1510; Venice, Accad.), perhaps with the aim of rivalling the chromatic effects of his younger contemporaries.

The comparative freedom of Carpaccio's pictorial technique was nevertheless combined with a traditional dependence on preliminary drawing as a means of working out his compositions and defining form. Scientific analysis has revealed sharp incisions into the gesso ground of architectural orthogonals and the outlines of figures. More drawings by Carpaccio survive than by any other Venetian painter before the later 16th century. Most of them can be related to paintings, and they appear to reflect all the main stages in the preparatory process, ranging from rapid, very free sketches corresponding to early compositional ideas, to more careful compositional studies in which effects of space and light are worked out, to detailed studies from life of individual figures and heads. In compositional studies, such as the preparatory drawing (London, BM) for *St Augustine in his Study* in the Scuola degli Schiavoni, Carpaccio reveals his essentially 15th-century habits of mind by concentrating on generating, by means of geometric perspective, a lucid three-dimensional space, into which his figure is later inserted. At the same time, by making frequent use of ink washes and of coloured (normally blue) papers, he used drawing in a characteristically Venetian fashion to suggest pictorial effects that would be fully realized only in the medium of paint.

In addition to their preparatory function, Carpaccio's drawings, especially the detailed figure studies, also served as records to be preserved in the workshop for use in subsequent commissions. This habit of reusing old designs

was shared by most of his contemporaries, including Giovanni Bellini, but after about 1510 Carpaccio tended to indulge in it excessively, and this certainly contributed towards the mechanical dullness that prevails in so many of his later works.

4. CRITICAL RECEPTION AND POSTHUMOUS REPUTATION. Despite the artistic decline of his later years, which must have been perfectly apparent to any discerning contemporary, Carpaccio was consistently regarded by subsequent generations as the most important of Giovanni Bellini's Venetian contemporaries. Daniele Barbaro speaks of him respectfully in his treatise on perspective (Daly Davis, 1980), and Vasari chose the biography of Carpaccio as the broad umbrella under which miscellaneous lesser north Italian painters of the 14th and 15th centuries could shelter. But for Vasari, followed by the main Venetian sources, Carpaccio himself stood very much in the shadow of the Bellini brothers, and it was not until the passionate reappraisal of his work by John Ruskin (1819–1900) in the 1860s that Carpaccio emerged as a fully autonomous artistic personality. Ruskin was attracted by the wealth of detail in Carpaccio's paintings, which he regarded as the outward manifestation of a touchingly sincere Christian reverence and sense of morality. In a characteristic overstatement he declared Carpaccio's message to be 'the sweetest, because the truest, of all that Venice was born to utter' (*Fors Clavigera*, Letter 71, 4 Oct 1876). Ruskin's often misplaced eloquence nonetheless aroused a greater general interest in the artist, and this in turn led to the detailed documentary study by Molmenti and Ludwig (1906), which provided the essential factual basis for all subsequent research. Molmenti and Ludwig shared the later 19th-century view of Carpaccio as essentially a genre painter, concerned with chronicling the people and events of his time; but, in the 1930s, critics of the Cubist generation such as Roberto Longhi and Giuseppe Fiocco emphasized the very different qualities that they saw as part of the heritage of Piero della Francesca and Antonello da Messina: crystalline perspectival space, reduction of forms to simple volumes rounded with light, clarity of formal structure, emotional impassiveness. A great variety of different approaches to Carpaccio were adopted by the many critics and historians who contributed to the discussion of his art at the time of, and immediately after, the comprehensive exhibition of his works held in the Doge's Palace in 1963.

(2) Benedetto Carpaccio (*fl c.* 1520–60). Son of (1) Vittore Carpaccio. The first documented references to Benedetto occur in 1530 and 1533 when he was still living in Venice, but by 1540 he had become a citizen of Capodistria (now Koper, Slovenia), where he apparently spent the rest of his life. A number of signed and dated altarpieces made for churches in Istria provide a fairly clear idea of his artistic personality: these include a *Coronation of the Virgin* (1537; Koper, Prov. Mus.), a *Virgin and Child with SS Justus and Sergius* (1540; Trieste, S Giusto) and a *Virgin and Child with SS George and Lucy* (1541; Pirano, nr Trieste, Municipio). These show Benedetto to have been an artist of greatly inferior talents who perpetuated an enfeebled 15th-century style up to the middle of the 16th century. After his father's death, he continued to produce paintings that were little more than assemblages based on existing motifs from the family stock of drawings. However, it is almost certainly thanks to their preservation by Benedetto that so many of Vittore Carpaccio's drawings, many of them of very high quality, have survived. Giovanni Bellini and Cima probably drew just as much as Carpaccio, but they lacked artistic heirs within their families, and it is likely that most of their drawings were lost soon after their deaths. Benedetto is last heard of in 1560, apparently having attained a position of considerable respectability in his adopted city.

BIBLIOGRAPHY

DBI; Thieme–Becker

EARLY SOURCES

G. Vasari: *Vite* (1550, rev. 2/1568); ed. G. Milanesi (1878–85), iii, pp. 627–42

F. Sansovino: *Venetia città nobilissima et singolare* (Venice, 1581, 2/1663)

C. Ridolfi: *Meraviglie* (1648); ed. D. von Hadeln (1914–24/*R* 1965)

M. Boschini: *Le miniere della pittura* (Venice, 1663)

A. M. Zanetti: *Della pittura veneziana e delle opere pubbliche de' veneziani maestri* (Venice, 1771)

G. A. Moschini: *Guida per la città di Venezia*, 2 vols (Venice, 1815)

GENERAL WORKS

J. Crowe and G. B. Cavalcaselle: *A History of Painting in North Italy* (London, 1871, rev. 2/1912)

J. Ruskin: *Fors Clavigera* (Orpington, 1871–87)

——: *St Mark's Rest* (Orpington, 1877–84)

L. Venturi: *Le origini della pittura veneziana* (Venice, 1907)

——: *Giorgione e il Giorgionismo* (Milan, 1913)

H. Tietze and E. Tietze-Conrat: *The Drawings of the Venetian Painters in the 15th and 16th Centuries*, 2 vols (New York, 1944)

R. Longhi: *Viatico per cinque secoli di pittura veneziana* (Florence, 1946)

B. Berenson: *Venetian School* (1957), i, pp. 56–9

M. Bonicatti: *Aspetti dell'umanesimo nella pittura veneta dal 1455 al 1515* (Rome, 1964)

A. Parronchi: 'La prospettiva a Venezia tra quattro e cinquecento', *Prospettiva*, 9 (1977), pp. 7–16

G. Bellavitis: 'La *Pala di Castelfranco*: Analisi prospettica', *Giorgione: Atti del convegno internazionale di studio per il 5to centenario della nascita: Venezia, 1979* [for technical analysis]

F. Ames-Lewis: *Drawing in Early Renaissance Italy* (London, 1981)

T. Pignatti, ed.: *Le scuole di Venezia* (Milan, 1981)

L. Lazzarini: 'Il colore nei pittori veneziani tra il 1480 e il 1580', *Boll. A.*, n. s. 6, 5 (1983), suppl., pp. 135–44

M. Lucco: 'Venezia fra quattro e cinquecento', *Storia dell'arte italiana*, ed. G. Bollati and P. Fossati, v (Turin, 1983), pp. 457–9

N. Huse and W. Wolters: *Venedig: Die Kunst der Renaissance* (Munich, 1986)

P. Fortini Brown: *Venetian Narrative Painting in the Age of Carpaccio* (London and New Haven, 1988)

MONOGRAPHS, EXHIBITION CATALOGUES, SYMPOSIA

P. Molmenti and G. Ludwig: *Vittore Carpaccio: La vita e le opere* (Milan, 1906; Eng. trans., 1907)

G. Fiocco: *Carpaccio* (Rome, 1931)

T. Pignatti: *Carpaccio* (Milan, 1955)

G. Perocco: *Carpaccio*, Tutta Pitt. (Milan, 1960)

R. Pallucchini: *I teleri del Carpaccio in San Giorgio degli Schiavoni* (Milan, 1961)

J. Lauts: *Carpaccio: Paintings and Drawings* (London, 1962) [cat. rais. and illus.]

Vittore Carpaccio (exh. cat., ed. P. Zampetti; Venice, Doge's Pal., 1963); review by G. Robertson in *Burl. Mag.*, cv (1963), pp. 385–90

M. Muraro: *Carpaccio* (Florence, 1966)

P. Zampetti: *Vittore Carpaccio* (Venice, 1966)

L'opera completa del Carpaccio, notes by G. Perocco, intro. M. Cancogni, Class. A. (Milan, 1967) [cat. and colour illus.]

G. Perocco: *Carpaccio: Le pitture alla Scuola di San Giorgio degli Schiavoni* (Treviso, 1975) [with Eng. trans.]

M. Serres: *Esthétiques sur Carpaccio* (Paris, 1975)

M. Muraro: *I disegni di Vittore Carpaccio* (Florence, 1977) [cat. and illus.]

V. Sgarbi: *Carpaccio* (Bologna, 1979)

F. Bardon: 'La Peinture narrative de Carpaccio dans le cycle de Ste Ursule', *Mem. Ist. Veneto Sci. Lett. & A.*, xxxix/4 (1985)

V. Sgarbi: *Carpaccio* (Paris, 1994); trans. by C. Bonnaont and F. Brun

A. Gentili: *Le Storie di Carpaccio. Venezia, i Turchi, gli Ebrei* (Rome, 1996)

SPECIALIST STUDIES

R. Fry: 'A Genre Painter and his Critics', *Q. Rev.* ccviii (1908), pp. 491–504

O. Böhm: 'The Calling of St Matthew, by Carpaccio', *Burl. Mag.*, xvi (1909–10), pp. 228–33

T. Hetzer: 'Tizian und Carpaccio', *Mhft. Kstwiss.*, vii (1914), pp. 317–22

R. Longhi: 'Per un catalogo del Carpaccio', *Vita A.*, iii (1932), pp. 4–13; also in *'Me pinxit' e quesiti caravaggeschi* (Florence, 1968), pp. 75–9

F. Hartt: 'Carpaccio's *Meditation on the Passion*', *A. Bull.*, xxii (1940), pp. 25–35

N. di Carpegna: 'Il restauro dei Carpaccio di S Giorgio degli Schiavoni', *A. Veneta*, i (1947), pp. 67–8

B. Maier: 'Benedetto Carpaccio', *Pagine Istria.*, iii (1950), p. 93

H. Roberts: 'St Augustine in *St Jerome's Study*: Carpaccio's Painting and its Legendary Source', *A. Bull.*, xli (1959), pp. 284–97

T. Pignatti: 'Rapporti fra il Cima ed il Carpaccio attorno al primo decennio del cinquecento', *Prov. Treviso*, v (1962), pp. 9–11

R. Gallo: 'La Scuola di S Orsola: I teleri del Carpaccio e le tombe di Gentile e Giovanni Bellini', *Boll. Mus. Civ. Venez.*, viii (1963), pp. 1–24

R. Weiss and V. Branca: 'Carpaccio e l'iconografia del più grande umanista veneziano (Ermolao Barbaro)', *A. Veneta*, xvii (1963), pp. 35–40

K. Ambrozic: 'Due dipinti di Vittore Carpaccio', *A. Veneta*, xviii (1964), pp. 162–4

W. Pokorny: 'Carpaccio's Alcyone Cycle', *Burl. Mag.*, cviii (1966), pp. 418–21

P. Zampetti: 'L'oriente del Carpaccio', *Venezia e l'oriente fra tardo medioevo e rinascimento*, ed. A. Pertusi (Florence, 1966), pp. 511–26

Z. Wazbinski: 'Portrait d'un amateur d'art de la Renaissance', *A. Veneta*, xxii (1968), pp. 21–9

M. Muraro: 'Vittore Carpaccio o il teatro in pittura', *Studi sul teatro veneto fra rinascimento ed età barocca*, ed. M. Muraro (Florence, 1971), pp. 7–19

G. Pochat: 'Bemerkungen zu Carpaccio und Mantegna', *Ksthist. Tidskr.*, xl (1971), pp. 99–106

J. Fletcher: 'Sources of Carpaccio in German Woodcuts', *Burl. Mag.*, cxv (1973), p. 599

V. Sgarbi: 'Vittore Carpaccio: Poetica e committenza', *Prospettiva*, xiv (1978), pp. 31–46

S. Vărzaru: 'Tre fonti letterarie riguardanti l'opera di Vittore Carpaccio', *Rev. Roum. Hist. A.* (Série Beaux-Arts), xv (1978), pp. 117–20

M. Daly Davis: 'Carpaccio and the Perspective of Regular Bodies', *La prospettiva rinascimentale*, ed. M. Dalai Emiliani, i (Florence, 1980), pp. 183–200

J. Bernasconi: 'The Dating of the Cycle of the Miracles of the Cross from the Scuola di San Giovanni Evangelista', *A. Veneta*, xxxv (1981), pp. 198–202

P. Reuterswärd: 'The Dog in the Humanist's Study', *Ksthist. Tidskr.*, 1 (1981), pp. 53–69

R. Goffen: 'Carpaccio's Portrait of a Young Knight: Identity and Meaning', *A. Veneta*, xxxvii (1983), pp. 37–48

M. Pedrocchi: 'La tavola con i Santi Giovanni Evangelista, Antonio Abate, Giacomo, Domenico, Lorenzo e Nicola di Bari dell'Accademia Carrara di Bergamo attribuita a Carpaccio', *Boll. A.*, n. s. 6, 5 (1983), suppl., pp. 145–50

A. Rona: 'Zur Identität von Carpaccios Ritter', *Pantheon*, xli (1983), pp. 295–302

D. Marshall: 'Carpaccio, St Stephen and the Topography of Jerusalem', *A. Bull.*, lxvi (1984), pp. 610–20

P. Scarpa: 'Disegni sconosciuti di Vettor Carpaccio', *Interpretazioni veneziani: Studi di storia dell'arte in onore di Michelangelo Muraro*, ed. D. Rosand (Venice, 1984), pp. 133–5

A. Gentili: 'Nuovi documenti e contesti per l'ultimo Carpaccio. I: *L'incontro di Gioacchino e Anna* per San Francesco di Treviso', *Artibus & Hist.*, vii/13 (1986), pp. 55–65

L. Zorzi: *Carpaccio e la rappresentazione di Sant'Orsola* (Turin, 1987)

A. Gentili: 'Nuovi documenti e contesti per l'ultimo Carpaccio. II: I teleri per la scuola di Santo Stefano in Venezia', *Artibus & Hist.*, ix/18 (1988), pp. 79–109

F. Polignano: 'Maliarde e Cortigiane: titolo per una *damnatio*. Le *Dame* di Vittore Carpaccio', *Venezia Cinquecento*, 2/3 (1992), pp. 5–23

Y. Szafran: 'Carpaccio's *Hunting on the Lagoon*: A New Perspective', *Burl. Mag.*, cxxxvii (March 1995), pp. 148–58

P. Dreyer: 'Bodies in the Trees: Carpaccio and the Genesis of a Woodcut of the 10,000 Martyrs', *Apollo*, cxlv (March 1997), pp. 45–7

H. Economopoulos: 'Prosopografia di un eroe: Giorgio Castriota Scanderbeg nel *Battesimo dei Seleniti* di Vittore Carpaccio', *Stor. A.*, lxxxix (1997), pp. 27–36

PETER HUMFREY

Carpi, Girolamo da [Sellari, Girolamo; Ferrara, Girolamo da] (*b* Ferrara, *c.* 1501; *d* Ferrara, ?1 Aug 1556). Italian painter, architect and stage designer. His father Tommaso (*fl* 1503–23) was a painter and decorator at the court of the Este in Ferrara, and Girolamo was trained in the workshop of Garofalo. He visited Rome in the early 1520s (Fioravanti Baraldi) and in 1525 was in Bologna, where he worked with Biagio Pupini and Giovanni Borghese on the decoration of the sacristy of S Michele in Bosco. Around this time (1525) he painted the altarpiece of the *Virgin Enthroned with Saints* (Dresden, Gemäldegal. Alte Meister; destr.) for S Biagio in Bologna.

From these early works onwards, da Carpi developed a pictorial language that combined the Ferrarese models of Garofalo and Dosso Dossi with the influence of such works by Raphael as the *St Cecilia* (Bologna, Pin. N.), which he saw in Bologna, the *Madonna of Foligno* (Rome, Pin. Vaticana) and the frescoes in the loggia of the Villa Farnesina in Rome. Da Carpi's *Adoration of the Magi* (*c.* 1528; Modena, Gal. & Mus. Estense) shows the influence of the cartoon (London, N.G.) on the same subject executed in Bologna *c.* 1523 by Baldassare Peruzzi for Conte Giovan Battista Bentivoglio. In 1530 da Carpi was again in Ferrara, where he worked with his father on the decoration of the cupola (destr.) and friezes in the nave of S Francesco. Some of the ideas in his *SS Catherine and Ursula* in S Francesco were clearly suggested by his meeting with Parmigianino in Bologna, *c.* 1527–30. Parmigianino's influence is strong also in the *Adoration of the Magi* (*c.* 1532; Bologna, S Martino), the *Mystic Marriage of St Catherine* (*c.* 1534; Bologna, S Salvatore) and the later *St Jerome* (Ferrara, S Paolo). In these works he combined the inspiration of Parmigianino with a monumental style derived from Giulio Romano.

Parmigianino's influence proved fundamental also for da Carpi's portrait painting, a field in which he was very active, according to Vasari. Important examples include the portraits of *Onofrio Bartolini Salimbeni* (1528–9; Florence, Pitti), *Cardinal Ippolito de' Medici and Monsignor Mario Bracci* (1532–3; London, N.G.; see fig.) and *Girolamo de' Vincenti* (1535; Naples, Capodimonte). Between 1531 and 1537 da Carpi settled in Ferrara, although he maintained close relations with patrons in Bologna. Around 1532–3, for S Francesco, Ferrara, he painted the altarpiece of the *Apparition of the Virgin* (Washington, DC, N.G.A.), which includes a portrait of the donor, Giulia Muzzarelli. This was his most mature work, in which he profited from his youthful study of Titian and Giulio Romano and his keen interest in the art of Correggio, which he saw in Modena and Parma (Vasari).

From 1536 da Carpi's relations with the Este court intensified. In 1537 his name first appeared in the accounts for frescoes painted (1537–41) in the Sala delle Vigne in the Este villa at Belriguardo (nr Ferrara), where he worked

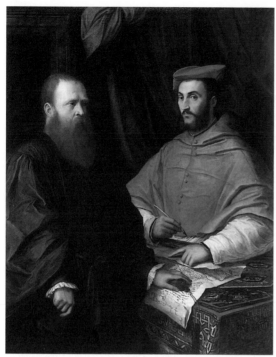

Girolamo da Carpi: *Cardinal Ippolito de' Medici and Monsignor Mario Bracci*, panel, 1.38×1.12 m, 1532–3 (London, National Gallery)

with Garofalo, Dossi, Camillo Filippi (*see* FILIPPI, (1)) and others. In this period he also worked on the construction of the Palazzo Naselli Crispi in Ferrara and on the decoration of other Este buildings including the Palazzo della 'Montagna di Sotto' or Montagnola (1541; destr.) and the villa at Copparo (1545), near Ferrara. In addition he created the sets for the tragedy *Orbecche* (1541) and the pastoral fable *Egle* (1545), both written by the humanist Giovan Battista Giraldi Cinzio. During the same years he painted several works on allegorical and mythological themes for Ercole II d'Este, including *Opportunity and Repentance* (1541), *Ganimede* (1541) and the *Venus on the Eridano* (1546; all Dresden, Gemäldegal. Alte Meister) for the 'camera del poggiolo' in the Castello Estense.

In 1549 da Carpi was called to Rome by Cardinal Ippolito II d'Este to work on the excavation of Hadrian's Villa at Tivoli and the arrangement of the gardens of the palace at Monte Cavallo, on the Quirinal Hill in Rome. His interest in antiquity is attested by his drawings (London, BM; Philadelphia, PA, Rosenbach Mus.; Turin, Bib. Reale). In 1550 he entered the service of Pope Julius III as architect in charge of modifications to the Villa Belvedere in the Vatican. After his return to Ferrara in 1553, he worked on the reconstruction of the Castello Estense, which was damaged by fire in 1554.

BIBLIOGRAPHY
G. Vasari: *Vite* (1550, rev. 2/1568); ed. G. Milanesi (1875–85)
F. Antal: 'Observations on Girolamo da Carpi', *A. Bull.*, xxx (1948), pp. 81–103
N. W. Canedy: 'Some Preparatory Drawings by Girolamo da Carpi', *Burl. Mag.*, cxii (1970), pp. 86–94
R. Roli: 'Quattro secoli di pittura', *San Michele in Bosco*, ed. R. Renzi (Bologna, 1971), pp. 204–9

N. W. Canedy: *The Roman Sketchbook of Girolamo da Carpi*, Stud. Warb. Inst., xxiv (London, 1976)
A. Mezzetti: *Girolamo da Ferrara detto da Carpi: L'opera pittorica* (Milan, 1977)
A. M. Fioravanti Baraldi: 'Girolamo Sellari detto da Carpi', *La pittura bolognese del '500*, ed. V. Fortunati Pierantonio (Bologna, 1986), pp. 209–35 [good bibliog.]
——: ' "Apollo, anchor che tu cantassi in rime . . .". Eros e Voluptas in alcuni disegni di Girolamo da Carpi, in Musei Ferraresi, 1985–1987', *Boll. Annu.*, xv (1988)
E. Sambo: 'Girolamo da Carpi/Girolamo Sellari', *La pittura in Italia: Il cinquecento*, ii (Milan, 1988), pp. 733–4
J. Bentini: 'La Sala delle vigne nella delizia di Belriguardo', *Atti & Mem. Accad. Clementina Bologna* (1996), pp. 9–37
J. Bentini: 'La Sala delle Vigne nella "delizia" di Belriguardo', *Arte a storia a Belriguardo: La Sala delle Vigne* (exh. cat. by C. Di Francesco, J. Bentini and A. Cavicchi, Ferrara, Belriguardo, 1997), pp.19–35

ANNA MARIA FIORAVANTI BARALDI

Carpi, Pio da. *See* PIO.

Carpi [Panico], Ugo da (*b* Carpi, *fl c.* 1502–32). Italian woodcutter. He trained as a type-founder and painter and *c.* 1509 moved to Venice, where he was employed for five or more years making woodcut book illustrations. Despite the menial nature of his work, which involved copying 15th-century designs, he broke with custom by signing his blocks. By 1515 he had secured an important commission from the Venetian publisher Bernardino Benalius to cut blocks for the *Sacrifice of Abraham*, (Passavant, VI, 223) a large black-and-white print on four joined sheets (Berlin, Altes Mus., 15.15). The composition is a pastiche of elements taken from Albrecht Dürer (1471–1528) and Titian and was designed perhaps by Ugo himself. Benalius sought a copyright for the print, and, probably under this influence, the following year Ugo sought the protection of the Venetian Senate for a colour-printing process he was now using, the chiaroscuro woodcut. He claimed to have invented the technique, although it was not this that was patented, as is often thought; rather he copyrighted all his chiaroscuro designs, past and future, doubtless due to the plagiarism of earlier works such as the *Sibyl Reading* (B. 89, 6). German chiaroscuro woodcuts, in fact, predate his by at least six years, and he probably encountered examples in Venice. Several of these employ three blocks, but Ugo began in the more usual two-block style. A series of three *Hercules* subjects (B. 133, 12; 117, 14, 15), printed with detailed black key-blocks over muted background blocks (usually blue), show his rapid progress towards more flexible line and more ingenious schemes of shading. He progressed to four blocks for his next print, the *Massacre of the Innocents* (B. 34, 8), a skilful interpretation of an engraving by Marcantonio Raimondi after Raphael (B. 34, 18).

Probably in late 1517 Ugo moved to Rome and sought work in the thriving print industry surrounding Raphael's studio. Nearly all his subsequent chiaroscuro prints, in three to five blocks, reflect the broad massing of colour areas found in the frescoes and monochrome paintings of Raphael's circle, as well as the planes of tone increasingly used by engravers to interpret them. Ugo's main contribution to the chiaroscuro woodcut, therefore, was stylistic: the abandonment of closed contours and linear cross-hatching in the key-block for strokes of emphasis and massed shadows, and in his tone-blocks the transformation

of shapes into flat planes and silhouettes. By 1518, the date of a copyright granted him by the Vatican, he was fully in control of his medium, as can be seen in such prints as *David Slaying Goliath* (B. 26, 8) and *Ananias Struck Dead* (B. 46, 27), and was acting as his own printer. Perhaps his most remarkable work, with its simple, stylized background, is *Aeneas Fleeing Troy with Anchises and Ascanius* (B. 104, 12), also dated 1518. Ugo must have begun work not long after this on woodcut typefaces for Lodovico Arrighi's *La operina di Lodovico Vicentino da imparare di scrivere littera cancellarescha* (Venice, 1522–3); in 1525, after a dispute with Arrighi, Ugo published another edition, with newly cut blocks. The same year he compiled, cut and published his *Thesauro de' scrittori*, a similar treatise on writing.

After the Sack of Rome in 1527, Ugo moved to Bologna, where, according to Vasari, he cut his masterpiece, the magnificent *Diogenes* (B. 100, 10; see colour pl. 1, XX1) after Parmigianino, or perhaps after Gian Jacopo Caraglio's engraving (B. 61) of the subject. Ugo's editions of his woodcuts are of high quality, usually printed in subdued graduated greens or blues, apart from the striking green and gold contrasts of the *Diogenes*. Numerous chiaroscuro woodcuts after Parmigianino and others have been attributed to him, despite their relatively superficial resemblance to his 14 documented works, and it is often assumed that he supervised a workshop.

WRITINGS

Thesauro de' scrittori (Venice, 1525); facs. edn with Eng. intro. by E. Potter (London, 1968)

BIBLIOGRAPHY

G. Vasari: *Vite* (1550, rev. 2/1568); ed. G. Milanesi (1878–85), pp. 420–21

A. von Bartsch: *Le Peintre-graveur* (1803–21), xii, [B.]

J. D. Passavant: *Le Peintre-graveur*, 6 vols (Leipzig, 1860–64)

L. Servolini: 'Ugo da Carpi', *Riv. A.*, xi (1929), pp. 174–94, 297–319

A. Petrucci: 'Di Ugo da Carpi e del chiaroscuro italiano', *Boll. A.*, xxvi (1932–3), pp. 277–81

W. Suida: 'Tizian, die beiden Campagnola u. Ugo da Carpi', *Crit. A.*, i/6 (1936), p. 285–88

P. Hofer: 'Variant Issues of the First Edition of Ludovico Arrighi Vicentino's "Operina"', *Calligraphy and Palaeography: Essays Presented to Alfred Fairbank on his 70th Birthday* (London, 1965)

L. Servolini: *Ugo da Carpi: I chiaroscuri e le altre opere* (Florence, 1977)

M. Zucker: *Early Italian Masters* (1980), 24 and 25 [XIII/i and XIII/ii] of *The Illustrated Bartsch*, ed. W. Strauss (New York, 1978–)

J. Johnson: 'Ugo da Carpi's Chiaroscuro Woodcuts', *Prt Colr/Conoscitore Stampe*, 57–8 (1982), pp. 2–87

D. Landau: 'Printmaking in Venice and the Veneto', *The Genius of Venice 1500–1600* (exh. cat., eds C. Hope and J. Martineau, London, RA, 1983), pp. 320–21, 333

B. Davis: *Mannerist Prints: International Style in the Sixteenth Century* (Los Angeles, 1988)

D. Landau and P. Parshall: *The Renaissance Print, 1470–1550* (New Haven and London, 1994)

JAN JOHNSON

Cartaro, Mario (*b* Viterbo; *fl* 1560; *d* Naples, 16 April 1620). Italian printmaker and cartographer. He was in Rome by 1560, the date of his first known engraving, the *Adoration of the Shepherds* (B. 2), after Heinrich Aldegrever (1502–1555/6). Bartsch recorded 28 prints by him, to which Passavant added a further 27. Mainly engravings, his works include *St Jerome* (B. 14), after Albrecht Dürer (1471–1528), *Christ Descending into Limbo* (B. 7), after Andrea Mantegna, the *Last Judgement* (B. 18), after Michelangelo, and a *Landscape* (B. 26), after Titian. Until 1577 Cartaro collaborated with the publisher Antoine Lafréry (1512–77), providing illustrations for the *Speculum Romanae magnificentiae*, a collection of plans and views issued between 1545 and 1577, and for *Le tavole moderne di geografia* (*c.* 1580). After this, he turned increasingly to the more profitable activity of print-selling. He spent his last years in Naples making drawings for printed maps of the kingdom of Naples (e.g. B. 27) with the help of the mathematician Niccolò Antonio Stelliola (1547–1623).

BIBLIOGRAPHY

DBI

A. von Bartsch: *Le Peintre-graveur* (1803–21), xv, pp. 520–32 [B.]

J. D. Passavant: *Le Peintre-graveur* (Leipzig, 1860–64), vi, pp. 157–61

S. Boorsch and J. T. Spike: *Italian Masters of the Sixteenth Century* (1986), 31 [XV/iv] of *The Illustrated Bartsch*, ed. W. Strauss (New York, 1978–)

FRANÇOISE JESTAZ

Cartoon. Drawing, sometimes coloured, made specifically as a pattern for a painting, textile or stained-glass panel. It is produced on the same scale as the final work and is usually fairly detailed. The transfer of the image works best if the drawing in the cartoon is of a linear nature and if the composition has crisp, clear outlines.

1. TECHNIQUE. In painting there are two methods of transferring a cartoon to the support, which may be a canvas, panel or wall. The first is similar to tracing. The back of the cartoon is rubbed over with chalk; the paper is attached to the support; and the main lines are drawn over with a stylus, thus transferring the chalk from the back of the cartoon to the new support. In the second method, which is called POUNCING, the main lines of the cartoon are pricked through with a needle or stylus, the size and closeness of the holes varying according to the detail in the drawing. Sometimes in order to preserve the drawn cartoon, a supplementary cartoon or *spolvero* is made by pricking through the original cartoon and a blank sheet of paper at the same time. The cartoon or supplementary cartoon is then laid flat against the support, and the pricked lines firmly dabbed with a muslin bag containing powdered charcoal. The charcoal dust penetrates the pounce bag and is forced through the holes in the cartoon on to the support beneath. Another method of transfer is to rub over the holes with a large stick of soft charcoal or red chalk and then to smear the medium through the holes and on to the support by using a finger.

When the cartoon is removed from the support, the original drawing is duplicated in a series of dots, which can be joined up to make a complete drawing using whatever instrument or medium the artist prefers. The original can be referred to if necessary to supply any details missing from the transfer. If a reversed image is required the *spolvero* is turned over before it is used. In surviving cartoons it is possible to tell which method was used for transfer from the prick marks or from the indentation of the lines.

2. HISTORY. Cartoons were used by illuminators, textile workers and stained-glass artists from the early medieval period, but their first appearance in painting occurs only in the second half of the 14th century. Cennini, writing *c.* 1390, gave detailed instructions for the execution of textile

patterns using a parchment cartoon, a procedure that has been verified in Tuscan panel paintings of the period. In the following century such artists as Piero della Francesca began to use cartoons for figure compositions, whereas previously they had been employed only for the repetition of decorative motifs.

From the late 15th century cartoons became an essential part of studio practice, particularly with the systematic working methods of such artists as Raphael (for illustration *see* POUNCING). For important areas of a painting, faces for example, auxiliary cartoons were made: outlines were pounced from the main cartoon on to a further sheet of paper, which was worked up in greater detail before transfer (see fig.). Since cartoons were used again and again, for copying whole compositions or for reproducing individual figures, they were considered valuable studio property. Cartoons by the greater artists were especially prized: those, for example, by Leonardo and Michelangelo for the Sala della Signoria in the Palazzo Vecchio, Florence (1504–5), were copied until they disintegrated. However, one cartoon by Leonardo does survive, the *Virgin and Child with SS John the Baptist and Anne* (black and white chalk on tinted paper, *c.* 1507–8; London, N.G.); although it seems to have been intended for a painting, it has not been pricked or incised.

In fresco painting cartoons were rarely used alone. Until the 16th century they were combined, to a greater or lesser extent, with *sinopia* underdrawing, and later they were employed in conjunction with freehand drawing, squaring up and other quick methods of transfer.

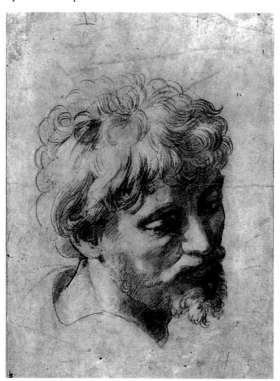

Auxiliary cartoon for the *Transfiguration* (1520) by Raphael: *Head of a Youthful Bearded Man Looking Downwards over his Right Shoulder* (detail), black chalk over pounced underdrawing, 375×278 mm (Chatsworth, Derbys)

In textile design cartoons have always been necessary. Silk-weavers used to work from full-colour cartoons that reproduced one section of the repeat, and embroiderers still pounce designs through to the ground fabric. In tapestry-weaving the cartoons were coloured (e.g. the series by Raphael depicting the *Missions of SS Peter and Paul*, *c.* 1514–17; British Royal Col., on loan to London, V&A; *see* RAPHAEL, fig. 5) until the 20th century, when outline drawings became more usual.

BIBLIOGRAPHY
C. Cennini: *Il libro dell'arte* (*c.* 1390); Eng. trans. and notes by D. V. Thompson jr as *The Craftsman's Handbook: 'Il libro dell'arte'* (New Haven, 1933/*R* New York, 1954), pp. 87, 111
G. Vasari: *Vite* (1550, rev. 2/1568); Eng. trans. by L. S. Maclehose, ed. G. B. Brown, as *Vasari on Technique* [intro. prefixed to the *Vite*] (London, 1907/*R* New York, 1960), pp. 213–15
J. Watrous: *The Craft of Old-Master Drawings* (Madison, 1957)
P. Goldman: *Looking at Drawings: A Guide to Technical Terms* (London, 1979)
P. Joannides: *The Drawings of Raphael, with a Complete Catalogue* (Oxford, 1983)
P. Mora, L. Mora and P. Philippot: *Conservation of Wall Paintings* (London, 1984)
Art in the Making: Italian Painting before 1400 (exh. cat. by D. Bomford and others, London, N.G., 1989–90), pp. 130–35
SHIRLEY MILLIDGE

Carucci, Jacopo. *See* PONTORMO, JACOPO DA.

Casanova, Antonio Maria. *See under* ANTONIO MARIA DA VILLAFORA.

Caselli [Castelli] **(da Parma), Cristoforo** [Temperelli; Temperello, il] (*b* Parma, *c.* 1460; *d* Parma, before 27 June 1521). Italian painter. He was the son of Giovanni di Cristoforo, who may also have been a painter. His style seems to have been based on a provincial Parmese version of Antonello da Messina's—which he could have learnt from Bartolomeo Montagna in Vicenza—and on that of Piero della Francesca. In 1488 Caselli was recorded in Venice, where he painted the organ shutters of the *Annunciation with SS Elijah and Albert* (destr.) for the church of the Carmine in 1489; also in 1489 he began to work with Giovanni Bellini, Alvise Vivarini, Lattanzio da Rimini and others on the painted decoration (destr. 1577) of the Sala del Maggior Consiglio in the Doge's Palace. There he presumably developed his individual narrative style, superficially close to Vittorio Carpaccio but fundamentally indebted to Giovanni Bellini. A triptych (1495; Venice, Semin. Patriarcale) of the *Virgin and Child with Two Saints*, a *Donor Bishop* and *God the Father* was made for S Cipriano, Murano. The *SS Francis and Louis of Toulouse with the Blessed Giovanni da Capestrano* (*c.* 1495; Baltimore, MD, Walters A.G.) and the *Virgin and Child* (sold London, Sotheby's, 7 April 1982) were also painted at this time.

In 1495 Caselli returned to Parma, where he undertook a series of important commissions, including the *Nativity with SS Peter and John the Baptist* (Castell'Arquato, S Maria, Mus.); this seems slightly earlier than the *Adoration of the Magi* (1499; Parma, S Giovanni Evangelista; see fig.), although it has been dated 1502 (Quintavalle; *DBI*). On 10 March 1496 he signed the contract to paint a large altarpiece of the *Virgin and Child with SS Hilary and John*

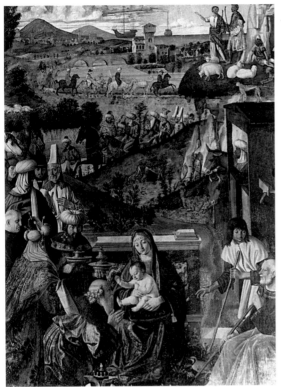

Cristoforo Caselli: *Adoration of the Magi*, oil on panel, 1.90×1.35 m, 1499 (Parma, S Giovanni Evangelista)

the Baptist and Angels for the Consorzio dei Vivi e dei Morti in Parma Cathedral (1499; Parma, G.N.). The large scale of the figures, the articulation of planes by means of architectural elements and the spaciousness of the scene would seem to be derived from a Lombard rather than a Venetian tradition, perhaps stemming from Donato Bramante. A synthesis of Venetian and Lombard traditions is evident in the *Adoration of the Magi* (ex-Nemes priv. col., Munich; see Berenson, 1957, i, pl. 527). Another signed work of *c.* 1499 is *St Peter Enthroned* in the parish church of Almenno San Bartolomeo (nr Bergamo), the central panel of a polyptych whose side panels show *SS Paul and James* and *SS Matthew and Sebastian* (both Detroit, MI, Inst. A.). The upper register of the polyptych consisted of three panels of *SS John the Baptist and Catherine*, the *Virgin and Child* and *Mary Magdalene and an Apostle* (all Bergamo, Gal. Accad. Carrara).

Between 1500 and 1507 Caselli was not recorded in Parma; he may have visited Venice again and seen Giovanni Bellini's S Zaccaria altarpiece (*in situ*). In 1507 he was back in Parma and painted *God the Father* in imitation mosaic in a semi-dome of the cathedral; it is obviously influenced by Giovanni Battista Cima, and Coletti suggested that it was derived from a drawing by that artist. The signed grisaille of the *Dead Christ between Two Angels* on the Montini Monument in Parma Cathedral probably dates from 1507, the year of Canon Montini's death. In the frieze decoration with scenes of sacrifice (Parma, S Giovanni Evangelista), formerly attributed to Giovanni Antonio da Parma, Caselli united elements from Bramante

with the late style of Giovanni Bellini. In 1515 he made armorial designs (destr.) for Giuliano de' Medici, Duc de Nemours, and designed those for Francis I, King of France (*reg* 1515–47), which were painted by Alessandro Araldi (1521; destr.).

BIBLIOGRAPHY

DBI; *Enc. It.*; Thieme–Becker

G. Vasari: *Vite* (1550, rev. 2/1568); ed. G. Milanesi (1878–85), vi, p. 485 [referred to as Castelli]

A. Venturi: *Storia* (1901–40), VII/iv, pp. 256, 604, 606–8, 616

J. A. Crowe and G. B. Cavalcaselle: *A History of Painting in North Italy* (London, 1912), i, p. 164; ii, pp. 300–02

B. Berenson: *Dipinti veneziani in America* (Milan, 1919), pp. 58–9

A. Venturi: *La pittura del quattrocento in Emilia* (Bologna, 1931), p. 74

E. Sandberg-Vavalà: 'Attribution to Cristoforo Caselli', *A. Amer.*, xx (1932), pp. 195–201

Catalogo della mostra parmense di dipinti noti ed ignoti dal XIV al XVII secolo (exh. cat. by A. Quintavalle, Parma, G.N., 1948), pp. 9–11

B. Berenson: *Venetian School* (1957), i, pp. 60–61

C. Coletti: *Cima da Conegliano* (Venice, 1959), pp. 57, 91

F. Heinemann: *Bellini e i Belliniani* (Venice, 1962), pp. 98–100

A. Quintavalle: 'Christoforo Caselli', *A. Emilia*, ii (1962), pp. 52–3

K. Rusk Shapley: *Paintings from the Samuel H. Kress Collection, Italian Schools, XV–XVI Century* (London, 1968), p. 61

F. Zeri: *Italian Paintings in the Walters Art Gallery*, i (Baltimore, 1976), pp. 274–80

C. Volpe: 'Una Madonna di Cristoforo Caselli e un prototipo di Piero per il Veneto', *Notizie da Palazzo Albani*, xii/1–2 (1983), pp. 34–7

MARIA CRISTINA CHIUSA

Cassai, Tommaso di Ser Giovanni di Mone. *See* MASACCIO.

Cassone [It.: 'chest']. Term used for large, lavishly decorated chests made in Italy from the 14th century to the end of the 16th. The word is an anachronism, taken from Vasari (2/1568, ed. G. Milanesi, 1878–85, ii, p. 148), the 15th-century term being *forziero*. Wealthy households needed many chests, but the ornate *cassoni*, painted and often combined with pastiglia decoration, were usually commissioned in pairs when a house was renovated for a newly married couple and were ordered, together with other furnishings, by the groom. Florence was the main centre of production, though *cassoni* were also produced in Siena and occasionally in the Veneto and elsewhere.

1. Painted. 2. Pastiglia. 3. Carved.

1. PAINTED.

(i) Florence. (ii) Siena. (iii) The Veneto.

(i) Florence. The earliest *cassoni* were simple structures with rounded lids, probably painted in solid colours, such as the red *cassone* in Giotto's *Annunciation to St Anne* (*c.* 1305; Padua, Arena Chapel). The earliest known chests with painted designs are all from the same shop (e.g. Florence, Mus. Pal. Davanzati, inv. mob. 162). Like the much more numerous contemporary chests with gilded low-relief in pastiglia (*see* §2 below), they have an all-over repeat pattern derived from textiles. They have been dated from the early 14th century to the early 15th, but the patterns of the decorative edges suggest they were made in Florence between 1360 and 1380.

Narrative, too, made a tentative appearance in *cassoni* at this time with allusions to the Garden of Love (London, V&A; Venice, Col. Cini). By the last quarter of the 14th century small painted scenes were routinely set into the

chests, but at first pastiglia decoration and story were given almost equal prominence (e.g. *Messer Torello and Saladin*; Florence, Bargello). Both the pastiglia relief and the painting were probably done in the same workshop, because the same gesso served as the base for the gilded framework as well as for the painted portion.

One anonymous Florentine artist active in the last quarter of the 14th century ran a large workshop that can be distinguished by its pastiglia decoration, its painting style and its subject-matter. He worked in a manner that ultimately derives from Bernardo Daddi (*fl c.* 1320–48), Andrea di Cione (1315/20–68; also known as Orcagna) and Andrea da Firenze (*fl* 1346–79), and he took much of his narrative from Boccaccio. In some cases the story was spread over both chests, as in that of *Messer Torello and Saladin* taken from the *Decameron* (x,9); several examples of the first part of the story survive (e.g. Florence, Bargello) but only one of the second part (Venice, Col. Cini). In other cases a chest displays stories that are complete, so that the pendant must have had a different cautionary tale illustrating the same theme.

The Late Gothic courtly style, introduced into Florence during the first decade of the 15th century, quickly made itself felt in the sphere of *cassoni* and continued to dominate the *cassone* market through the 1430s because its romanticism was ideally suited to marriage celebrations. The most common subjects were the Garden of Love and illustrations of novellas, such as Boccaccio's *Caccia di Diana* (Florentine, late 14th century; Florence, Mus. Stibbert) and *Ninfale fiesolano* (Brunswick, ME, Bowdoin Coll. Mus. A.). Others are tales of Classical heroines, such as Lucretia, which could have been taken from Boccaccio's *De claris mulieribus*. Familiar compositions were adapted for stories that had not previously been illustrated, but they conveyed didactic messages in much the same way as devotional narratives. The virtues expounded were, however, concerned with marriage, the family and civic duty rather than with religious faith.

Leading artists of the Late Gothic style painted *cassoni*, including Rossello di Jacopo Franchi, Lorenzo di Niccolò and the Master of the Bambino Vispo (believed by some to be Gherardo Starnina), who painted the *Battle of Saracens* (Altenburg, Staatl. Lindenau-Mus.). In the 1420s Francesco d'Antònio, Giovanni Toscani and Giovanni dal Ponte all produced *cassoni*. From 1420 onwards *cassoni* are mentioned frequently in Giovanni dal Ponte's tax declarations and records, including, after 1422, those of his partner, Smeraldo di Giovanni (*c.* 1365–after 1442). The *cassoni* that can be attributed to him all date from the 1430s, when, despite a preference for gold backgrounds, he had largely abandoned the Late Gothic style. A favourite subject of his was that of allegorical figures of the Seven Virtues with, on the pendant chest, the Seven Arts, each accompanied by one of its most famous exponents—Hercules with Fortitude, Tubalcain with Music etc (e.g. Madrid, Prado).

As the domestic sphere was not in the forefront of change, the shift from the Late Gothic style to that of the Renaissance occurred, as far as can be ascertained, only around 1440 for *cassoni*. By then it entailed the introduction of a new painting style, a new structural form and new subject-matter. The simple rectangular body of the chest was masked by elements taken from contemporary architecture—heavy, classical cornices, mouldings, volutes or

1. *Cassone* made for the Strozzi family with a panel of the *Conquest of Trebizond*, tempera, 0.39×1.25 m, from the workshop of Apollonio di Giovanni, Florence, 1461–5 (New York, Metropolitan Museum of Art)

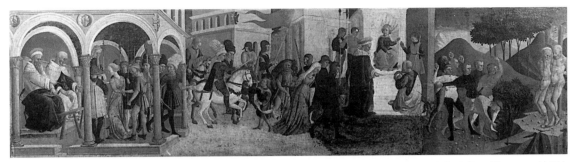

2. *Cassone* panel attributed to Domenico di Michelino: *Susanna and the Elders* (second part), tempera, 0.42×1.63 m, Florence, mid-15th century (Avignon, Musée du Petit Palais)

pilasters at the ends and all the vocabulary of Classical architectural ornament. Lids were flat, with the central section raised, as in the *cassone* with the *Conquest of Trebizond* (1461–5; New York, Met.; see fig. 1) from Apollonio di Giovanni's workshop. The chests also became much more massive in order to be in scale with the larger rooms of the new palaces. As it was easy to salvage the front panel, few complete *cassoni* from this period have survived, and most chests now in museums were made in the 19th century with 15th-century painted panels incorporated into them.

Although the older subjects were not completely discarded (e.g. ?Domenico di Michelino, *Susanna and the Elders*; Avignon, Mus. Petit Pal.; see fig. 2), from the 1450s the majority of panels depicted Classical subjects, most taken from Greek and Roman mythology or Roman history (for further illustration *see* APOLLONIO DI GIOVANNI). At first glance neither Virgil's *Aeneid* nor Roman battles and their victors' triumphs appear to celebrate marriage. However, for a society that traced its ancestry directly to ancient Rome, the deeds of these great men were intended to exhort the young citizen to live up to his glorious past and to serve Florence as selflessly as they had ancient Rome. Some subjects, such as the *Continence of Scipio* (e.g. attributed to the workshop of Apollonio di Giovanni; London, V&A; U. London, Courtauld Inst. Gals), in which the hero returns his beautiful prisoner untouched to her parents and betrothed, not only exemplify ancient heroism but also allude indirectly to the stresses of marriage and advocate generosity on the part of the husband.

All flat surfaces of a chest were painted, although the less prominent parts were usually left to assistants. Occasionally the *testate* (panels on the short ends of the chest) were decorated with narrative scenes, for example the *Judgement of Paris* (Glasgow, Burrell Col.) attributed to the Paris Master, but more usually there were only a few figures—mounted knights or putti—or coats of arms. The painting on the back of the chest, seen only when it was carried to the bride's new home, was cursory and often omitted several steps in the normal method of panel painting. The designs consisted mainly of large-scale textile patterns or imitation marble revetments (e.g. New York, Met.; Cincinnati, OH, A. Mus.). Textile patterns also adorned the tops of lids.

The insides of lids were more elaborately decorated. There are three types: a large-scale textile pattern that echoed the practice of lining the chests with cloth (Vasari); putti with coats of arms and/or flowers (e.g. Apollonio di Giovanni, *Two Heraldic Putti*; Bloomington, IN, U. A. Mus.); and a pair of reclining figures, a nude female in one lid and a youth, fully or partially clothed, in the other (e.g. Copenhagen, Stat. Mus. Kst). The putti holding garlands of red and white roses and/or arms refer to love and marriage, as do the pairs of reclining figures, though they are more difficult to interpret (e.g. ?Paolo Schiavo, *Reclining Venus with Cupid*; Los Angeles, CA, Getty Mus; see fig. 3). One youth is identified by inscription as Paris (Florence, Mus. Horne), and they may all depict ancient figures. The suggestion that they are meant to be the bride and groom is contrary to Renaissance ideas of propriety and love of allegory.

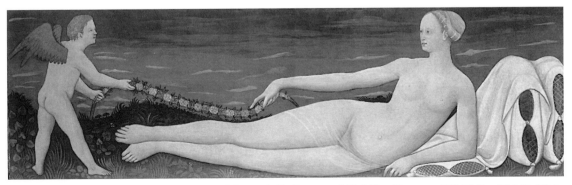

3. *Cassone* panel attributed to Paolo Schiavo: *Reclining Venus with Cupid*, tempera, 0.52×1.70 m, Florence, *c.* 1460 (Malibu, CA, J. Paul Getty Museum)

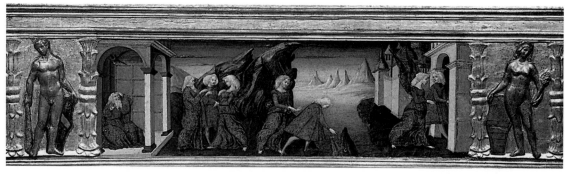

4. *Cassone* panel attributed to Liberale da Verona: *Tobias and the Angel*, tempera, 0.56×1.75 m, Siena, *c.* 1470 (Florence, private collection)

Cassoni were occasionally produced in the workshops of major artists. For instance, Domenico Veneziano provided a pair of *cassoni* for Marco Parenti in 1448 (untraced, see H. Wohl: *The Paintings of Domenico Veneziano*, New York, 1980, pp. 20–22, 198–200, 343–5), but there is little to support the idea that they were painted by the master himself; they were probably the work of assistants. Pesellino, however, painted some himself, favouring calmer topics such as Petrarchian triumphs (e.g. a pair in Boston, MA, Isabella Stewart Gardner Mus.). Apollonio di Giovanni and his prolific workshop specialized in secular work for private houses. Masaccio's brother, Scheggia, also painted cassoni, *deschi da porto*, *spalliere* and other domestic works (for illustration *see* SCHEGGIA).

The vast majority of *cassoni* defy attribution. This is not surprising because so many were left to lesser craftsmen, and most shops were neither so carefully supervised as Apollonio's nor insisted on consistency of production, as he did. Assistants may have moved from shop to shop frequently, adapting their manner to that of their current employer. Moreover, several assistants could work on a single panel. Most shops can, however, be characterized by their palette—particular colours and overall tonality—and by a body of specific motifs recurrently used. Each shop had a limited repertory of subjects and compositions, so that Schubring's system of classification (1915), based in good part on subject-matter, has considerable validity if not carried too far.

When narrative painting became more highly esteemed in the domestic setting, a picture's position on the front of the chest, virtually at floor level, became increasingly unsatisfactory. Hence, by the last third of the 15th century, pictures found a place on the wall of a room (*see* SPALLIERA), while painted *cassoni* were gradually replaced by chests decorated with reliefs or intarsia. By this date artists working for private clients painted both *cassoni* and *spalliere* with initially little distinction in their compositions, details or subjects. Jacopo del Sellaio, who introduced the story of Esther to the repertory (Paris, Louvre; Chantilly, Mus. Condé; Florence, Uffizi), seems to have divided his time equally between the two, but *cassoni* are much rarer in the oeuvre of such men as Biagio d'Antonio, Bartolomeo di Giovanni and the Master of Marradi (also known as the Apollini Sacrum Master). In the last two decades of the 15th century Roman battles and triumphs were illustrated less frequently, and scenes of justice were more common.

Throughout the 14th and 15th centuries more modest travel chests were also produced, variously called 'nuns'

coffers' or 'travel chests' because they occur in paintings of the Journey of the Magi or the Queen of Sheba, strapped one on each side of a horse. They are low, flat-topped coffers with a deeply curved front and flat backs that are painted with several large, alternating sections of coats of arms, devices and mottoes.

(ii) Siena. In Siena painted *cassoni* appeared in the second quarter of the 15th century. They were much rarer than in Florence and were not an essential element of the nuptial decor. The earlier of the two distinct types of *cassone*, generally dating from the mid-15th century, had two or three painted compartments, each wider than it was high, enclosed in broad, low-relief frames. Such panels are associated with Giovanni di Paolo, Domenico di Bartolo, Sano di Pietro, Pellegrino di Mariano (*fl* 1448; *d* 1492) and their circle. Attributions fluctuate widely because the pieces are not major works, and their execution was left largely to assistants who may have moved from shop to shop.

Although the choice of subjects and the dependence on antiquity are as great as with Florentine *cassoni*, the tone of Sienese examples is generally less fiercely didactic and more romantic. In the most archaic the figures are set into a complex architectural setting seen from a bird's-eye view. This revival of early 14th-century views is felicitous for pictures seen from above, as in Pellegrino di Mariano's *Story of Lucretia* (Avignon, Mus. Petit Pal.) and the *Journey of the Queen of Sheba* (New York, Met.). In his late works Pellegrino adopted the single scene of the *cassone* front then in vogue (e.g. the *Story of Hippo*; Baltimore, MD, Walters, A.G.). In other panels the architecture achieves a unified space that frames and encloses the composition, particularly when interiors are shown (e.g. pair illustrating the *Story of Joseph*; Sienese, *c.* 1450–75; Cambridge, Fitzwilliam).

The artists active from the 1460s to 1500 introduced a single, spatially unified picture, often flanked by shield bearers, either in pastiglia or painted, set between pairs of pilasters (e.g. *Tobias and the Angel*, attributed to Liberale da Verona; Florence, priv. col.; see fig. 4). The figures are much larger in scale, and the architecture is a heavy, rather visionary display of Renaissance forms and motifs. In continuous narratives, large rocks and trees or architectural elements separate the scenes. Most of these works are attributed to Francesco di Giorgio or Neroccio de' Landi, who shared a workshop from 1468–9 to 1475, when Francesco left Siena (e.g. the *Caccia di Diana*, Florence,

Mus. Stibbert). Neroccio continued the workshop into the 1490s and is known to have undertaken painting marble, wood and terracotta sculpture as well as chests, beds, chairs etc (G. Coor: *Neroccio de' Landi, 1447–1500*, Princeton, 1961, pp. 141–2). Quality and adherence to the shop's style vary widely, but assistants seem to have had models from which to work.

Liberale da Verona may also have been associated with Francesco di Giorgio's and Neroccio's shop (e.g. *Dido's Suicide*, London, N.G.; *Rape of Helen*, Paris, Louvre; *Rape of Europa*, Avignon, Mus. Petit Pal.). Other stylistically related panels are attributed to Guidoccio Cozzarelli (*Legend of Cloelia*; New York, Met.), the Stratonice Master, also identified with Michele Ciampanti (*Story of Stratonice and Antiochus*; San Marino, CA, Huntington Lib. & A.G.), and Girolamo da Cremona (*Chess Players*; New York, Met.).

(iii) The Veneto. In North Italy painted *cassoni* were rarely produced, except briefly in the Veneto *c.* 1490–1520. At that date the usual *cassone* decoration consisted of either three historiated rectangular compartments (e.g. North Italian school, *cassone* with scenes of *Lucretia and Mucius Scaevola*, U. London, Courtauld Inst., Gals; *cassone* with *Stories of Aeneas*, Chicago, IL, A. Inst.) or two tondi set into pastiglia work (e.g. *Tuccia and the Sieve* and *Duilius and his Wife*; Milan, Mus. Poldi Pezzoli). Most of these are poorly preserved, some completely effaced, and only a few were salvaged when damaged chests were discarded, such as the pair of tondi of the *Marriage of Antiochus and Stratonice* and the *Story of the Vestal Claudia* attributed to Bartolomeo Montagna (Oxford, Ashmolean). Verona was the main centre of production (e.g. *Perseus and Andromeda*; Venice, Col. Cini). Narrative subjects concerning heroines from ancient history or mythology abound, and the story of Atalanta was a favourite.

BIBLIOGRAPHY

GENERAL

A. Schiaparelli: *La casa fiorentina e i suoi arredi* (Florence, 1908, rev. 2/1983)

P. Schubring: *Cassoni, Truhen und Truhenbilder der italienischen Frührenaissance*, 2 vols (Leipzig, 1915, 2/1923) [suppl. to 1st edn, Leipzig, 1923]

——: 'Neugefundene Cassonebilder', *Z. Bild. Kst*, lix (1925–6), pp. 163–8

T. Borenius: 'Italian Cassone Paintings', *Apollo*, iii (1926), pp. 132–9

P. Schubring: 'New Cassone Panels', *Apollo*, iii (1926), pp. 250–7; v (1927), pp. 104–9, 154–9; viii (1928), pp. 177–83

T. Borenius: 'Some Italian Cassone Pictures', *Italienische Studien Paul Schubring zum 60. Geburtstag gewidmet* (Leipzig, 1929), pp. 1–9

P. Schubring: 'Neue Cassoni', *Belvedere*, viii (1929), pp. 176–9; ix (1930), pp. 1–3

——: 'New Cassoni Paintings', *A. America*, xviii (1929–30), pp. 228–35

G. Carandente: *I trionfi nel primo rinascimento* (Turin, 1963)

J. Cain: 'Les Cassoni', *Plaisirs France*, xxxi/326 (1965), pp. 36–43

J. Pope-Hennessy and K. Christiansen: 'Secular Painting in 15th-Century Tuscany: Birth Trays, Cassone Panels, and Portraits', *Bull. Met.*, xxxviii/1 (1980) [whole issue]

B. Witthoff: 'Marriage Rituals and Marriage Chests in Quattrocento Florence', *Artibus & Hist.*, iii (1982), pp. 43–59

L. Faenson and others: *Italian Cassoni from the Art Collections of the Soviet Museums* (Leningrad, 1983)

P. Thornton: 'Cassoni, forzieri, goffani and cassette', *Apollo*, cxx (1984), pp. 246–51

E. Callmann: 'Apollonio di Giovanni and Painting for the Early Renaissance Room', *Ant. Viva*, xxvii/3–4 (1988), pp. 5–18

A. Uguccioni: *Salomone e la regina di Saba. La pittura di cassone a Ferrara presenze nei musei americani* (Ferrara, 1988)

A. B. Barriault: 'The Abundant, Beautiful, Chaste and Wise: Domestic Painting of the Italian Renaissance in the Virginia Museum of Fine Arts', *A. VA*, xxx (1991), pp. 2–21

P. Thornton: *The Italian Renaissance Interior, 1400–1600* (New York, 1991)

Le temps revient. Il tempo si rinnova. Feste e spettacoli nella Firenze di Lorenzo il Magnifico (exh. cat., ed. P. Ventrone; Florence, Pal. Medici–Riccardi, 1992)

SPECIALIST STUDIES

W. Weisbach: 'Eine Darstellung der letzten deutschen Kaiserkrönung in Rom', *Z. Bild. Kst*, xxiv (1913), pp. 255–66

T. Borenius: 'Three Panels from the School of Pesellino', *Burl. Mag.*, xxxiii (1918), pp. 216–21

——: 'The Oldest Illustration of the Decameron Reconstructed', *Burl. Mag.*, xxxv (1919), p. 12

——: 'Unpublished Cassone Panels', *Burl. Mag.*, xl (1922), pp. 70–75, 131–2, 189–90; xli (1922), pp. 18–21, 104–9, 256–9

P. Schubring: ' "Aphrodite und Ares" Liebe: Ein Sieneser Cassone Bild aus dem 14. Jahrhundert', *Pantheon*, x (1932), pp. 298–300

W. Stechow: 'Marco del Buono and Apollonio di Giovanni, Cassoni Painters', *Bull. Allen Mem. A. Mus.*, i (1944), pp. 5–21

R. Carità: 'In margine alla mostra fiorentina "Lorenzo il Magnifico e le arti"', *Boll. A.*, xxxiii (1949), pp. 270–73

E. H. Gombrich: 'Apollonio di Giovanni: A Florentine Cassone Workshop Seen through the Eyes of a Humanist Poet', *J. Warb. & Court. Inst.*, xviii (1955), pp. 16–34; also in E. H. Gombrich: *Norm and Form* (London, 1966), pp. 11–28

A. Spychalska-Boczkowska: 'Diana with Meleagros and Actaeon: Some Remarks on a XV-century Italian Cassone', *Bull. Mus. N. Varsovie/ Biul. Muz. N. Warsaw.*, ix/2 (1968), pp. 29–37

B. B. Fredericksen: *The Cassone Paintings of Francesco di Giorgio* (Los Angeles, 1969)

P. F. Watson: 'Boccaccio's *Ninfale Fiesolano* in Early Florentine Cassone Painting', *J. Warb. & Court. Inst.*, xxxiv (1971), pp. 331–3

E. Callmann: *Apollonio di Giovanni* (Oxford, 1974)

——: 'An Apollonio di Giovanni for an Historic Marriage', *Burl. Mag.*, cxix (1977), pp. 174–81 [discusses lids]

D. DuBon: 'A Medici Cassone', *Bull. Philadelphia Mus. A.*, lxxiii/317 (1977), pp. 18–24 [discusses travel chests]

L. S. Malke: 'Contributo alle figurazioni dei trionfi e del canzoniere del Petrarca', *Commentari*, xxviii (1977), pp. 236–61

L. Vertova: 'Cupid and Psyche in Renaissance Painting before Raphael', *J. Warb. & Court. Inst.*, xlii (1977), pp. 104–21

E. Callmann: 'The Growing Threat to Marital Bliss as Seen in Fifteenth-century Florentine Paintings', *Stud. Iconog.*, v (1979), pp. 73–92

——: 'Triumphal Entry into Naples of Alfonso I', *Apollo*, cix (1979), pp. 24–31

P. F. Watson: *The Garden of Love in Tuscan Art of the Early Renaissance* (Philadelphia, 1979)

D. Cole: 'Renaissance Birth Salvers and the Richmond *Judgement of Solomon*', *Stud. Iconog.*, vii–viii (1981), pp. 157–74

E. Callmann: 'Romantic Proclivities on Some Venetian Cassoni', *Interpretazioni veneziane: Studi di storia dell'arte in onore di Michelangelo Muraro* (Venice, 1984), pp. 145–8

P. F. Watson: 'A Preliminary List of Subjects from Boccaccio in Italian Painting, 1400–1550', *Stud. Boccaccio*, xv (1985–6), pp. 149–66

M. Tazartes: 'Nouvelles perspectives sur la peinture lucquoise du quattrocento', *Rev. A.*, lxxv (1987), pp. 29–36 [identifies Stratonice Master as Michele Ciampanti]

E. Fahy: 'The Argonaut Master', *Gaz. B.-A.*, 3rd ser., cxiv (1989), pp. 285–300

M. Kemp and others: 'Paolo Uccello's "Hunt in the Forest"', *Burl. Mag.*, cxxxiii (1991), pp. 165–78

C. L. Baskins: 'Griselda, or the Renaissance Bride Stripped Bare by Her Bachelor in Tuscan Cassone Painting', *Stanford It. Rev.*, x/2 (1991–2), pp. 153–75

——: '*La Festa di Susanna*: Virtue on Trial in Renaissance Sacred Drama and Painted Wedding Chests', *A. Hist.*, xiv (1992), pp. 329–71

R. M. San Juan: 'Mythology, Women and Renaissance Private life: The Myth of Eurydice in Italian Furniture Painting', *A. Hist.*, XV (1992), pp. 127–45)

J. K. Morrison: 'Apollonio di Giovanni's *Aeneid* Cassoni and the Virgil Commentators', *Yale U. A.G. Bull.* (1992), pp. 27–47

J. Miziolek: *Soggetti classici sui cassoni fiorentini alla vigilia del rinasciemento* (Warsaw, 1996)

G. Hughes: *Renaissance Cassoni, Masterpieces of Early Italian Art: Painted Marriage Chests 1400–1550* (London, 1997)

E. Callmann: 'William Blundell Spence and the Transformation of Renaissance *Cassoni*', *Burl. Mag.*, cxli (1999), pp. 338–48

E. Callmann: 'Julius Caesar: Roman Virtue and Renaissance Marriage', *Register Kansas City Mus. A.* (in preparation) [written 1990]

2. PASTIGLIA. These wooden *cassoni*, decorated with reliefs in a very fine plaster, were made in Italy from the 14th century until well into the 16th. The wood was covered with several layers of plaster, first *gesso grosso* then *gesso sottile*, which could be modelled while still soft or carved, or high-relief elements could be moulded separately and then attached (*see* PASTIGLIA). The whole surface was then gilded, and on later examples details were also painted. Pastiglia is so brittle that extant *cassoni* are often heavily restored.

Most of the earliest works have overall patterns that cover the front and ends of the chest and consist of such single, repeated emblems as a lion, eagle or rosette, often set into a cordlike network, a design derived from textiles. These early pieces are thought to be Tuscan and have been variously dated from *c.* 1330 to 1425. Another early type, traditionally associated with Siena, has two or three large subdivisions with arms, devices and inscriptions. In Tuscany during the last quarter of the 14th century *cassoni* with three small painted scenes set into foliate pastiglia work came into use. Here pastiglia decoration and painting were given almost equal prominence and were both probably made in the same workshop. About the same time allegorical figures in quatrefoils were introduced, and this type of decoration continued throughout the first half of the 15th century, as seen in the *Four Cardinal Virtues* (*c.* 1400–25; Glens Falls, NY, Hyde Col.). Not much later, *cassoni* were decorated with simple, large-scale chivalric scenes or wedding processions (e.g. of mid-15th century; New York, Met.; see fig. 5) and show a strong dependence on contemporary sculpture. In Umbria and North Italy by the mid-15th century more complex narratives came into vogue, as in the *cassone* decorated with the *Story of Lucretia* (Perugia, G.N. Umbria). Figures are smaller, compositions crowded, and the continuous narrative is often separated by pilasters or arches. The relief is lower, and the images are closer to popular art and less influenced by monumental sculpture.

At the end of the 15th century a new type of pastiglia *cassone* was introduced in Florence: the form of the chest was similar to the earlier painted ones, but the pastiglia work was based on ancient sculpture. Many examples exist and show such figures as the Four Cardinal Virtues in classical garb, flanked by candelabra, centaurs and nereids. Roman candelabra appeared in Florentine art by the last quarter of the century, and the centaurs are best known from North Italian bronze caskets of *c.* 1500. The various examples of friezelike pairs of *cassoni* depicting the *Rape of Persephone* (Philadelphia, PA, Mus. A.) and *Demeter's Descent into Hades* (New York, Met.) imitate Roman sarcophagi and are from the same workshop. Concomitantly, high-relief, free-flowing foliate *cassoni* emerged (e.g. of *c.* 1490–*c.* 1515; Milan, Castello Sforzesco). During the early 16th century in the Veneto and possibly Lombardy, a low, often curved type of *cassone* evolved, which in structure closely resembled carved *cassoni* but was decorated with delicate, low-relief, classical ornament.

BIBLIOGRAPHY

C. Cennini: *Il libro dell'arte* (*c.* 1390); Eng. trans. and notes by D. V. Thompson jr as *The Craftsman's Handbook: 'Il libro dell'arte'* (New Haven, 1933/R New York, 1954)

W. von Bode: *Italienische Hausmöbel der Renaissance* (Leipzig, n.d.); Eng. trans. and rev. by M. E. Herrick (New York, 1921)

F. Schottmüller: *Furniture and Interior Decoration of the Italian Renaissance* (New York, 1921)

A. Pedrini: *Il mobilio* (Florence, 1948)

G. Schade: *Möbel der italienischen Renaissance* (East Berlin, 1964)

P. Thornton: 'I mobili italiani del Victoria and Albert Museum', *A. Illus.*, ii/19–21 (1969), pp. 76–87; iii/27–9 (1970), pp. 116–24

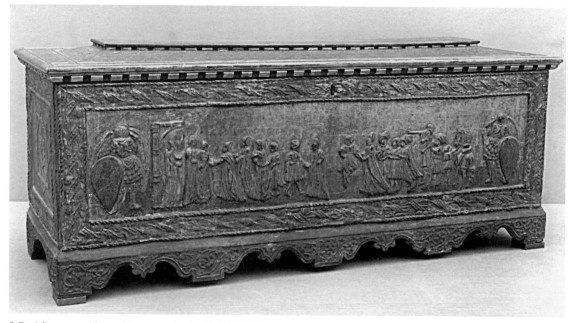

5. Pastiglia *cassone* with a wedding procession in relief, 705×1775×581 mm, Tuscany, mid-15th century (New York, Metropolitan Museum of Art)

Family Pride: The Italian Renaissance House and its Furnishings (exh. cat. by E. Callmann, Glens Falls, NY, Hyde Col., 1984)

For further bibliography *see* §1 above.

ELLEN CALLMANN

3. CARVED. During the Late Gothic period in North Italy *cassoni* were carved with tracery decoration on the front and sides. However, during the early 16th century carving began to supplant other forms of ornament as the main decorative treatment, and several drawings of designs have survived. *Cassoni* were normally of walnut and were given a simple polished finish (e.g. mid-16th century; London, V&A). In Tuscany and Rome, where the influence of antiquity was strongest, the rectangular forms imposed by the use of painted and intarsia panels were frequently discarded, and *cassoni* began to assume a wholly sculptural character. Lids were raised on bands of carved mouldings, while the bases were often bulbous and deeply fluted. The *cassone* was usually raised on lion-paw feet between which ran a scroll-carved apron. The main bodies of the grandest *cassoni* are carved with scrolling foliage or elaborate continuous scenes, broken sometimes by a cartouche painted with an armorial. Carvers were heavily influenced by the decoration of antique sarcophagi, and triumphal and mythological scenes were typical subjects. Carvers also responded to contemporary trends, and the influence of artists as diverse as Giulio Romano and Benvenuto Cellini is apparent in the attenuated figures and densely packed compositions. Gilding was sometimes used to highlight certain areas of carving and to form a background to the figures (e.g. walnut *cassone, c.* 1560; London, V&A; see fig. 6).

Carved *cassoni* continued to evolve during the 16th century. Whereas those of the late 15th century and early 16th had been flared towards the base, *cassoni* of the mid-16th century were often adapted to the waisted form of Roman sarcophagi, and the whole of the front might be gadrooned or fluted to emphasize its swollen contours, while the angles were often marked by curved herm figures (e.g. Florence, Bargello). *Cassoni* of simpler, rectangular form continued to be made in such northern areas as Lombardy, Piedmont and Venice, where French and German influence was important. In Venice carved ornament was often shallow and dense, resembling pastiglia. Later in the 16th century the influence of Jacopo Sansovino can be discerned in the use of elaborate strapwork designs. Large central panels were set between uprights, often carved with grotesques, and the *cassoni* were raised on feet carved as volutes. Even in Florence *cassoni* of severe architectural form, decorated only with panels outlined with crisp leaf mouldings, continued to be made. A particularly fine group of this type, carved with a distinctive volute motif at the angles, has been attributed to the workshop of Domenico del Tasso. In Bologna *cassoni* followed Florentine and Roman shapes, but continuous scenes were replaced by friezes carved with griffins, scrolling foliage and even bucrania. Later in the century Lombard chests resembled those of southern Germany and were given the dense architectural treatment familiar from the engravings of Jacob Guckeisen (*fl* 1590s).

BIBLIOGRAPHY

W. M. Odom: *A History of Italian Furniture from the Fourteenth to the Early Nineteenth Centuries*, 2 vols (New York, 1918–19, 2/1966–7)
M. Tinto: *Il mobile fiorentino* (Milan, 1929)
C. Alberici: *Il mobile lombardo* (Milan, 1969)
G. Lizzani: *Il mobile romano* (Milan, 1970)
L. Bandera: *Il mobile emiliano* (Milan, 1972)
A. González-Palacios: *Il tempio del gusto: Roma e il regno delle due Sicilie* (Milan, 1984)

J. W. TAYLOR

Castagno, Andrea del [Andrea di Bartolo di Simone di Bargiella; Andreino degli Impicchati] (*b* Castagno, before 1419; *d* Florence, *bur* 19 Aug 1457). Italian painter. He was the most influential 15th-century Florentine master, after Masaccio, of the realistic rendering of the figure and the representation of the human body as a three-dimensional solid by means of contours. By translating into the terms of painting the statues of the Florentine sculptors Nanni di Banco and Donatello, Castagno set Florentine painting on a course dominated by line (the Florentine tradition of *disegno*), the effect of relief and the sculptural depiction of the figure that became its distinctive trait throughout the Italian Renaissance, a trend that culminated in the art of Michelangelo.

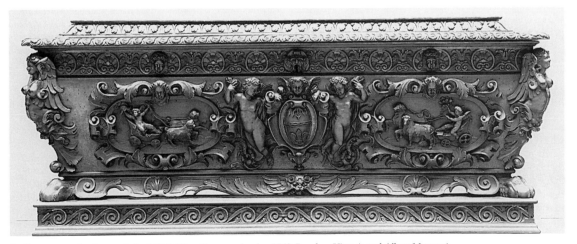

6. *Cassone*, carved walnut and gilt, 0.64×1.52 m, Roman school, *c.* 1560 (London, Victoria and Albert Museum)

1. Life and work. 2. Working methods and technique. 3. Critical reception and posthumous reputation.

1. LIFE AND WORK.

(i) Documented and accepted works. (ii) Lost works and doubtful attributions.

(i) Documented and accepted works.

(a) *c.* 1440–46. (b) 1447–8. (c) 1449–50. (d) 1451–7.

(a) c. 1440–46. His father was a farmer and owned land around Castagno, to the north-east of Florence. Andrea's name was included for the last time in his father's tax return in 1437, when he was at least 18. The story told by Vasari, that Andrea was found by Bernardetto de' Medici as a shepherd boy drawing animals on slabs of stone and was then apprenticed by Bernardetto to one of the leading masters in Florence, is merely a variation on a stereotype for the discovery of artistic talent that Vasari inherited from Classical antiquity. Two painters who have been proposed as Andrea's teachers are the minor Florentine masters Paolo Schiavo and Giovanni dal Ponte, but neither suggestion satisfactorily resolves the question of his training.

Andrea received his first commission from the Florentine Signoria, which, after the victory over Milan in 1440 at the Battle of Anghiari, condemned eight members of the Albizzi family who had gone over to the Milanese side as traitors and ordered that defamatory pictures of them hanging by one foot be painted on the exterior walls of the Palazzo del Podestà. The murals were erased in 1494, and the name of the artist is not recorded, but there can be little doubt that he was Andrea del Castagno: Giovanni Rucellai referred to him in his daybook as 'Andreino degli Impicchati' (of the hanged men), and he was still called that by Vasari.

The earliest surviving work by Andrea is probably a fresco of the *Crucifixion with the Virgin and SS John the Evangelist, Benedict, Romuald and Mary Magdalene* (now Florence, S Maria Nuova, Sala della Presidenza), painted for the eastern cloister of the Camaldolese monastery of S Maria degli Angeli in Florence. It is remarkable for its softly glowing colours, the classicizing architectural elements that frame the figures and a noble, restrained expression of grief, for which Castagno had a majestic precedent in Masaccio's *Trinity* (Florence, S Maria Novella; *see* MASACCIO, fig. 5 and colour pl. 2, III1). In the figure of the crucified Christ, Castagno followed the earlier wooden Crucifix by Brunelleschi (Florence, S Maria Novella), specifically in the hard and precise definition of the torso and the forward pitch of the head.

Andrea's earliest dated work is the fresco decoration in the apse of the chapel of S Tarasio in S Zaccaria, Venice, which he and the painter Francesco da Faenza signed and dated in August 1442. Cleaning in the 1950s confirmed that Andrea designed and in large part executed the figures in the seven compartments of the vault (*St John the Baptist*, the four *Evangelists*, *God the Father* and *St Zacharias*) and that the putti and the busts of prophets and saints on the soffit of the chancel arch are the work of assistants. The exact role of Francesco da Faenza is not clear. The figures show Andrea to have been a colourist of great originality

and a master of sculptural definition of the human form in the tradition of Masaccio. His principal sources of inspiration, however, were the statues of Donatello. In Venice, Castagno also designed elements in a mosaic of the *Death of the Virgin* on the vault of the Mascoli Chapel (Venice, S Marco): the two Apostles at the left, the recumbent Virgin, the seated figure of Christ in an aureole and perhaps the perspectival architectural background. Executed under the direction of the painter Michele Giambono, this mosaic, like the frescoes at S Tarasio, introduced the innovations of Florentine early 15th-century art into Venice. Its figures and those at S Tarasio have a stark presence, harsh realism and tragic dimension without precedent except in the work of Donatello. Andrea's third Venetian work may well have been the design of an undocumented lunette mosaic of *St Theodore with a Dragon* (Venice, S Marco, Sacrestia dei Canonici; see Hartt, 1959).

Andrea's first documented work in Florence is his monumental design of a *Lamentation* for one of the eight round stained-glass windows in the drum of the dome of Florence Cathedral, for which he and the stained-glass painter Bernardo di Francesco were paid on 26 February 1444. (Of the seven other windows, four were designed by Lorenzo Ghiberti, two by Paolo Uccello, and one by Donatello.)

On 30 May 1444 Andrea was admitted to the Arte dei Medici e Speziali (Florentine painters' guild). None of his documented commissions during the next two years has survived. On 30 April 1445 he received from the proconsuls of the guild of judges and notaries half the agreed price for a fresco portrait of *Leonardo Bruni* (*d* 8 March 1444), the Chancellor and historian of Florence, in the entrance of the Palazzo del Proconsolo. In 1446 there were two payments from the overseers of the cathedral: on 28 February for painting a Florentine lily and two putti above the organ, and on 19 December for a *Lamb of God* and for gilding the capitals on the organ case. On 30 March 1446 Andrea was paid for painting three *Virtues* in fresco above the seats in the audience hall of the Palazzo del Proconsolo.

According to Vasari, Andrea painted a second fresco at S Maria degli Angeli, in the cloister above the garden, and this has been identified with a badly damaged *Crucifixion with the Virgin and SS John the Evangelist, Benedict and Romuald* (Florence, S Apollonia, Refectory); stylistically this falls between the *Death of the Virgin* in the Mascoli Chapel and the later frescoes of 1447 at S Apollonia, Florence, and was probably executed *c.* 1445.

(b) 1447–8. In June 1445 Pope Eugenius IV granted permission to the nuns of the Florentine convent of S Apollonia to extend their buildings, and two years later the abbess hired Andrea to decorate the west wall of the convent's refectory with frescoes of the *Last Supper*, the *Resurrection*, the *Crucifixion* and the *Entombment*. Castagno worked on these from June to October 1447. The *Last Supper* (*see* RENAISSANCE, fig. 2) has been cleaned three times since 1952 and now appears with very nearly its original clarity of form and brilliance of colouring. It shows Andrea at the height of his powers. Jesus and the Apostles are seated along a table covered with a finely patterned

white tablecloth in a structure roofed with Tuscan tiles, its interior rendered with unprecedented sumptuousness. It is framed by grey stone pilasters ornamented with stylized palmette leaves. The ends of the wooden benches at either side are decorated with carved amphorae, framed by geometric intarsia patterns, and are surmounted by marble statues of winged sphinxes or harpies. A dark green cloth embroidered with a white and pink floral pattern hangs from a moulding at the level of the Apostles' heads. Along the sides six foreshortened coloured stone panels in moulded frames define the distance to the rear wall, where they continue in the form of six porphyry and veined marble squares. That distance, however, is not measurable. There is no common central point for the chamber's perspectival construction, and the chequerboard patterns on the floor and ceiling have been foreshortened in such a way that it is impossible to establish a viewing distance or a rate of spatial recession. The seemingly rational space is an ambiguous, mystical one in which the figures, logically at the far end of the room, appear in sharp detail at close range from whatever position in the refectory they are viewed.

In the cornelian field above Jesus, Judas and St Peter, the dark blue-green, reddish purple and golden orange tonalities of the six wall panels erupt dramatically in a surge of salmon pink, white, green and flamingo red. Two windows at the right of the painted room, the side from which light enters the actual refectory, are the source for the light that strikes the figures' hard, massively constructed heads and heavy, earth-coloured draperies: grey-brown, olive-green, tomato- or wine-red, grape-purple or lavender-blue. Draperies are carefully modelled and reinforced by the application of iridescent highlights and of impenetrable shadows in which black functions both as the absence or denial of light and as a colour in its own right. Colours are sometimes modelled not by a higher or lower value of themselves, but by another lighter or darker colour: green-blue by pink, crimson by purple, wine-red by blue. By virtue of Andrea's bold and original use of colour, modelling and contour, the relief of the figures rivals the statues of Donatello in power and starkness of sculptural form.

The three scenes from the *Passion* suffered badly from damp and were detached in 1953, revealing the *sinopie* beneath. These are sufficiently well preserved to testify to Andrea's power and incisiveness as a draughtsman on a monumental scale, qualities seen to similar advantage in the *sinopia* of the undocumented, badly damaged fresco of *Christ in the Tomb Supported by Two Angels*, from the lunette above a door of the cloister of S Apollonia (Florence, S Apollonia, Refectory).

Castagno's undocumented *Portrait of a Man* (Washington, DC, N.G.A.) may in fact be the bust of a saint from an altarpiece. It shares with the risen Christ in the *Resurrection* at S Apollonia the three-dimensional construction of the head, the level gaze and the frontal viewing position and was probably painted *c.* 1448.

(c) 1449–50. On 20 November 1449 Andrea received a commission from the rector of the church of S Miniato fra le Torri (destr.) for an altarpiece of the *Assumption of the Virgin with SS Miniato and Julian* (Berlin, Gemäldegal.;

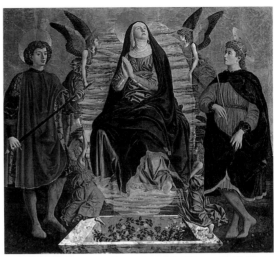

1. Andrea del Castagno: *Assumption of the Virgin with SS Miniato and Julian*, tempera on panel, 1.50×1.58 m, 1449–50 (Berlin, Gemäldegalerie)

see fig. 1), for which he was paid on 20 April 1450. The work's gilded background and its ornate quality, richness in colouring and sharpness of line and detail have been taken as evidence for a shift by the artist towards the so-called neo-Gothic style of the second half of the 15th century. This ornate quality, however, reflects a preference among patrons, both religious and secular, throughout the 15th century and should be interpreted as testimony of Andrea's ability to respond to his patron's wishes.

Sharpness of line and detail also characterize an undocumented painting of *David* on a leather shield (1449–50; Washington, DC, N.G.A.). The striding figure of the youthful hero has an antique prototype in one of the statues of the *Dioscuri* (Rome, Piazza del Quirinale), Roman copies of 5th-century BC originals that Andrea could have known from drawings, such as that by Pisanello (Milan, Bib. Ambrosiana, MS. 214, fol. 10*v*), in modelbooks.

A similar elegant quality appears on a monumental scale in the series of nine idealized portraits of *Famous Men and Women* (three Florentine military commanders, three famous women from Classical and biblical antiquity, Dante, Petrarch and Boccaccio) from a fresco cycle at the Villa Carducci in the Florentine suburb of Legnaia (now Florence, Uffizi; see fig. 2 and colour pl. 1, XXII). The work was commissioned by Filippo Carducci (*d* 28 July 1449) and completed before the villa was sold in 1451. With the figures standing in illusionistically rendered rectangular niches surmounted by a frieze with putti bearing garlands, the cycle, both in subject-matter and treatment, was a revival of secular Roman decoration as described by Vitruvius and advocated by Leon Battista Alberti in *De re aedificatoria* (1450). The frescoes were detached in 1850 and completely lost some of their colours.

(d) 1451–7. From January 1451 until September 1453 Andrea executed frescoes of the *Annunciation*, the *Presentation in the Temple* and the *Death of the Virgin* (praised by Vasari for the foreshortened figure of the Virgin) on

2. Andrea del Castagno: *Cumean Sibyl*, fresco from the series of *Famous Men and Women*, 2.45×1.65 m, from the Villa Carducci, Florence, 1449–51 (Florence, Galleria degli Uffizi)

3. Andrea del Castagno: the *Trinity Appearing to SS Jerome, Paula and Eustochium* (*c.* 1453–7), fresco, 3.00×1.79 m, Corboli Chapel, SS Annunziata, Florence

the east wall of the choir of S Egidio, the chapel of the hospital of S Maria Nuova, Florence. DOMENICO VENEZIANO had frescoed the west wall (1439–45). Andrea lived in the hospital and used a room there for a workshop during this time. All that survives of the paintings is a strip with feet, ends of draperies and pebbly terrain from the bottom of the *Death of the Virgin* (Florence, Pal. Congressi).

Between 1453 and his death, Andrea painted two frescoes in SS Annunziata, Florence: *St Julian Receiving Absolution from Christ* in the Gagliani Chapel and the *Trinity Appearing to SS Jerome, Paula and Eustochium* in the Corboli Chapel (see fig. 3). St Julian is Andrea's most majestic design; St Jerome, depicted as a penitent with a bared, bleeding chest and a skeletal head turned upwards toward a grim, foreshortened vision of the Trinity, is his most harrowing. The fresco's *sinopia* (uncovered 1967) shows a less harshly realistic, differently posed male saint who lacks attributes, but must be St Jerome because the name of the patron was Girolamo Corboli, and is represented without the Trinity.

On 14 October 1454 Andrea and six assistants were paid for 76 days' work in the Vatican Palace, Rome. The payment has been associated with architectural frescoes in a room known as the Biblioteca Graeca, but plans for converting the room into a library date to no earlier than

1471, following the accession of Pope Sixtus IV. In 1454 Andrea also received a payment for designing a large picture of the *Last Judgement* (ex-SS Annunziata, Florence; destr.) that was commissioned by Ludovico II Gonzaga, Marchese of Mantua, and executed on canvas by Alesso Baldovinetti. In 1455 Andrea painted a fresco of *Lazarus, Martha, Mary Magdalene and an Angel* (destr.) above the altar in the tomb chapel of Orlando de' Medici in SS Annunziata, and between 19 October 1455 and 1 March 1456 he was paid for a commemorative fresco in the form of an equestrian monument to *Niccolò da Tolentino* (Florence Cathedral; see fig. 4). He had represented this military commander, who served the Florentine Republic from 1427 until his death in 1434, once before, among the famous men and women at the Villa Carducci. The contract for the fresco in the cathedral specified that it was to be in the manner of the painted equestrian monument to *Sir John Hawkwood* that Paolo Uccello had painted there in 1436: in grisaille, simulating a sculptural monument (*see* UCCELLO, PAOLO, fig. 1). Andrea's mural was restored in 1524 by Lorenzo di Credi and again in the early 18th century. It was transferred to canvas in 1824. Andrea's last documented commission was a *Last Supper* (destr. after 1678) in the refectory of S Maria Nuova, for which he was paid on 10 May 1457.

(ii) Lost works and doubtful attributions. Vasari and other writers from the 16th to the 18th century attributed to Andrea numerous works that have not survived. The most intriguing of these is a nude figure of *Charity* over the

4. Andrea del Castagno: equestrian monument to *Niccolò da Tolentino* (1455–6), fresco, Florence Cathedral

portal of the Palazzo del Vicariato at Scarperia. The most influential was a fresco of the *Flagellation* in the second cloister of Santa Croce, Florence, which Vasari praised for its perspectival rendering of a cross-vaulted loggia. There are reflections of this composition in an engraving of the 1460s by a follower of Andrea known as the Master of the Vienna Passion (Hind, no. A.I.28), and in another of *c.* 1485–90 attributed to Francesco Rosselli (Hind, no. B.I.7).

Many works have been attributed to Andrea by modern scholars. According to the present writer, the *sinopia* of *SS Cosmas and Damian* for the Tabernacolo alle Mozzette at San Piero a Sieve, north-east of Florence, is by Paolo Schiavo; the detached, heavily restored fresco of the *Virgin and Child with SS Jerome and John the Baptist* from the Castello Trebbio (Florence, Pitti) is by an assistant of Andrea who also worked on the soffit of the chancel arch at S Tarasio; a *St Sebastian* (New York, Met.), predella panels of the *Last Supper* (Edinburgh, N.G.), the *Crucifixion* (London, N.G.) and the *Resurrection* (New York, Frick) are early works of Francesco Botticini; a triptych of the *Virgin and Child with Two Angels, SS Bridget and Michael* (Los Angeles, CA, Getty Mus.), known as the Poggibonsi Altarpiece, is by the Master of Pratovecchio; and a predella panel with the *Death of the Virgin* (New Haven, CT, Yale U.A.G.) is by Bernardino del Castelletto. The authorship of a diptych with portraits of two members of the Medici

family (Zurich, Landolthaus) is open to question. A pen-and-ink sketch of *Two Male Nudes* with the inscription *del Castagno* on the verso (Florence, Uffizi, 110E) is from the workshop of Antonio Pollaiuolo. A drawing of a *Head of a Man* (Florence, Uffizi, 250E) was adapted from Mantegna in the studio of Andrea del Verrocchio. The only drawing that has been convincingly attributed to Andrea is a *Profile Portrait of a Man* (Florence, Uffizi, 28E; see Hartt, 1956), customarily given to Paolo Uccello.

2. WORKING METHODS AND TECHNIQUE. Andrea del Castagno was the foremost exponent in his time of *disegno*, the Renaissance term for the definition of form through contour and modelling. In his *sinopie* as well as in his paintings, drawing assumes an importance in the realistic, three-dimensional rendering of form that it was to retain for Florentine artists throughout the Renaissance. He was the first artist whose work documents a change in the use of preparatory drawings in fresco painting. Earlier, drawings or *sinopie* were made directly on the wall, to be covered by areas of fresh plaster corresponding to a day's painting. Andrea's figure of Christ in the *sinopia* of the *Resurrection* at S Apollonia is indicated by little more than an outline of its overall shape. Punch marks along the contours of the painted figure reveal that the artist put the forms in place using cartoons the outlines of which were transferred to the wet plaster. These punch marks were then dusted in order to make them more clearly visible. Cartoons had not been employed earlier because paper was not produced in the requisite size and quantity until the mid-15th century. Although painters, including Andrea, continued to use the traditional *sinopia* method, it was inevitable that it should gradually yield to the greater accuracy, efficiency and manageability of the cartoon.

3. CRITICAL RECEPTION AND POSTHUMOUS REPUTATION. During the 15 years of his career Andrea's style evolved with remarkable single-mindedness towards a formidable command of the expressive and representational capabilities of *disegno*, culminating in the monumental, emotionally charged simplicity of the repentant St Julian and the relentless realism of the penitent St Jerome in SS Annunziata. Virtually no Florentine painter, from Giovanni di Francesco to Alesso Baldovinetti, Francesco Botticini or Cosimo Rosselli, was free from Andrea's influence. Of all his heirs, Antonio Pollaiuolo, Andrea del Verrocchio, Francesco del Cossa and Andrea Mantegna understood him best. But the most important of these was Verrocchio, who transmitted the lessons he himself learnt from Andrea to his pupils, who included Domenico Ghirlandaio, Perugino, Botticelli and Leonardo da Vinci.

Vasari praised Andrea for his mastery of *disegno* but censured his colouring as lacking the grace, harmony and sweetness for which he commended the artist's contemporary Domenico Veneziano. By the mid-16th century it was believed that Andrea murdered Domenico Veneziano out of envy while the two artists were working on the fresco decoration of S Egidio. Vasari repeated the legend, adding that the reason for Andrea's envy was the praise bestowed on Domenico for his mastery of the Netherlandish technique of oil painting. There is no evidence in Domenico Veneziano's paintings, however, that he used

oil as it was employed in the Netherlands, and Milanesi found documents proving that Domenico outlived Andrea by four years. Even after his exoneration, 19th-century critics from Cavalcaselle to Berenson regarded Andrea's realism as vulgar and brutal. In the 20th century, however, his taciturn, truculent figures came to be perceived as embodiments of dignity, sobriety and stoic restraint in the expression of human will, passion and conflict. Andrea's colours, too, have come to be recognized for their expressiveness and for their reinforcement of his figures' powerful three-dimensional presence.

BIBLIOGRAPHY

DBI: 'Andrea di Bartolo'; Thieme–Becker

SOURCES

G. Vasari: *Vite* (1550, rev. 2/1568); ed. G. Milanesi (1878–85), ii, pp. 667–89

G. Milanesi: 'Esame del racconto del Vasari circa la morte di Domenico Veneziano', *G. Stor. Archv Tosc.*, vi (1862), pp. 3–5

G. Poggi: 'Della data di nascita di Andrea del Castagno', *Riv. A.*, xi (1929), pp. 43–63

A. M. Hind: *Early Italian Engraving*, i (London, 1938)

R. G. Mather: 'Documents Mostly New Relating to Florentine Painters and Sculptors of the Fifteenth Century', *A. Bull.*, xxx (1948), pp. 28–9

A. M. Fortuna: 'Alcune note su Andrea del Castagno', *L'Arte*, lvii (1958), pp. 345–55

F. Hartt and G. Corti: 'Andrea del Castagno: Three Disputed Dates', *A. Bull.*, xlviii (1966), pp. 228–33

H. Wohl: *The Paintings of Domenico Veneziano, ca. 1410–1461* (New York, 1980), pp. 348–60

MONOGRAPHS

G. M. Richter: *Andrea dal Castagno* (Chicago, 1943)

A. M. Fortuna: *Andrea del Castagno* (Florence, 1957)

F. Russoli: *Andrea del Castagno*, Collezione Silvana (Milan, 1957)

M. Salmi: *Andrea del Castagno* (Novara, 1961); review by F. Hartt in *Ren. News*, xvii (1964), pp. 37–40

L. Berti: *Andrea del Castagno*, Diamanti A. (Florence, 1966)

M. Horster: *Andrea del Castagno* (Ithaca, 1980); review by E. Borsook in *Burl. Mag.*, cxxii (1980), pp. 839–40, and by H. Wohl in *A. Bull.*, lxiv (1982), pp. 145–50

SPECIALIST STUDIES

E. Schaeffer: 'Andrea del Castagno', *Das Museum* [Berlin], vii (1902), pp. 21–4

——: 'Über Andrea del Castagnos *Uomini famosi*', *Repert. Kstwiss.*, xxv (1902), pp. 170–77

O. H. Giglioli: 'L'arte di Andrea del Castagno', *Emporium*, xxi/122 (1905), pp. 114–41

H. Horne: 'Andrea del Castagno', *Burl. Mag.*, vii (1905), pp. 66–9, 222–33

G. Poggi: 'Degli affreschi di Andrea del Castagno nella cappella di San Giuliano della SS Annunziata', *Riv. A.*, iv (1906), pp. 24–9

G. Gamba: 'Una tavola di Andrea del Castagno', *Riv. A.*, viii (1910), pp. 25–8

R. Offner: 'The Unique Portrait by Andrea del Castagno', *A. America*, vii (1919), pp. 227–35

R. van Marle: *Italian Schools*, x (1923–38), pp. 335–93

F. Antal: 'Studien zur Gotik im Quattrocento', *Jb. Preuss. Kstsamml.*, xlvi (1925), pp. 3–16

G. Sinibaldi: 'Andrea del Castagno', *L'Arte*, xxxvi (1933), pp. 335–53

W. Deusch: 'Zur Entwicklung Andrea del Castagnos', *Pantheon*, xiv (1934), pp. 355–64

G. Pudelko: 'Two Portraits Ascribed to Andrea del Castagno', *Burl. Mag.*, xlviii (1936), pp. 235–42

M. Salmi: *Paolo Uccello, Andrea del Castagno, Domenico Veneziano* (Rome, 1936, rev. Milan, 2/1938)

G. M. Richter: 'The Beginnings of Andrea del Castagno', *A. America*, xxix (1941), pp. 177–99

M. Salmi: 'Contributi fiorentini alla storia dell'arte: Ricerche intorno a un perduto ciclo pittorico del rinascimento', *Atti & Mem. Accad. Fiorent. Sci. Morali 'La Colombaria'*, i (1943–6), pp. 421–53

——: 'Gli affreschi di Andrea del Castagno ritrovati', *Boll. A.*, xxxv (1950), pp. 295–306

M. Horster: 'Castagnos Fresken in Venedig und seine Werke der vierziger Jahre in Florenz', *Wallraf-Richartz-Jb.*, xv (1953), pp. 103–34

M. Salmi: 'Nuove rivelazioni su Andrea del Castagno', *Boll. A.*, xxxix (1954), pp. 25–42

Mostra di quattro maestri del primo rinascimento (exh. cat., Florence, Pal. Strozzi, 1954), pp. 129–50

M. Horster: 'Castagnos Florentiner Fresken, 1450–1457', *Wallraf-Richartz-Jb.*, xvii (1955), pp. 79–131

F. Hartt: 'A New Attribution for a Famous Drawing', *A. Q.* [Detroit], xix (1956), pp. 162–73

M. Salmi: 'Ancora di Andrea del Castagno dopo il restauro degli affreschi di San Zaccaria', *Boll. A.*, lxiii (1958), pp. 117–40

F. Hartt: 'The Earliest Works of Andrea del Castagno', *A. Bull.*, xli (1959), pp. 159–81, 227–36

M. Muraro: 'Domenico Veneziano at San Tarasio', *A. Bull.*, xli (1959), 151–8

A. M. Fortuna: 'Altre note su Andrea dal Castagno', *L'Arte*, xxvi (1961), pp. 165–76

B. Berenson: *Florentine School*, i (1963), pp. 46–7; ii, pls 749–64

L. Berti: 'Appunti su Andrea del Castagno a S Zaccaria', *Acropoli*, iii (1963), pp. 261–93

L. Bellosi: 'Intorno ad Andrea del Castagno', *Paragone*, xviii/211 (1967), pp. 3–18

C. Gilbert: 'The Renaissance Portrait', *Burl. Mag.*, cx (1968), p. 281

B. Degenhart and A. Schmitt: *Süd- und Mittelitalien*, i/2 of *Corpus der italienischen Zeichnungen, 1300–1450* (Berlin, 1968–), pp. 514–16

T. Yuen: 'The "Biblioteca Graeca": Castagno, Alberti and Ancient Sources', *Burl. Mag.*, cxii (1970), pp. 725–36

G. Daltrop: 'Zur Ueberlieferung und Restaurierung des Apollo vom Belvedere', *Rendi. Pont. Accad. Romana Archeol.*, xlviii (1975–6), pp. 128–31

M. Salmi: 'Un'ipotesi per Andrea del Castagno', *Commentari*, xxviii (1977), pp. 289–90

P. Meller: 'Two Drawings of the Quattrocento in the Uffizi: A Study in Stylistic Change', *Master Drgs*, xii (1978), pp. 261–79

L. Borgo: 'New Questions for Piero's *Flagellation*', *Burl. Mag.*, cxxi (1979), pp. 547–53

J. M. Dunn: 'Andrea del Castagno's *Famous Women*: One Sibyl and Two Queens', *Z. Kstgesch.*, lviii/3 (1995), pp. 359–80

M. Pelta: 'Expelled from Paradise and Put to Work: Recontextualizing Castagno's Adam and Eve', *J. Med. & Ren. Stud.*, xxv/1 (Winter 1995), pp. 73–87

HELLMUT WOHL

Castel Durante [now Urbania]. Italian centre of maiolica production. Situated near the Metauro River, the town was close to sources of raw materials and was in an excellent location for marketing its wares. Ceramics were manufactured in the town as early as the 14th century, and it was among the most prolific Italian centres of production for pottery during the first half of the 16th century. Its fine maiolica was remarked on by Vasari and by *Cipriano di Michele Piccolpasso* (1523/4–79), a native of Castel Durante and author of the treatise *I tre libri dell'arte del vasaio* (1557–9). Extensive interchange occurred between Durantine artists and those of Urbino, Gubbio, Pesaro and Faenza.

Among the most famous ceramics of Castel Durante were maiolica plates and jars decorated with candelabra, trophies, musical instruments, oak leaves and designs imitating Chinese porcelain. One important example is a bowl decorated with candelabra (1508; New York, Met.), with the arms of Pope Julius II and inscribed with the name GIOVANNI MARIA VASARO, either the painter or workshop owner. Other notable Durantine wares include pharmacy jars with imaginative, colourful grotesque designs. *Bella donna* dishes with idealized portraits of women and men were a popular product of the 1520s; attribution of these lyrical works to particular artists, including Nicola da Urbino (formerly identified as Nicolò Pellipario), remains unclear. The tradition of *istoriato* (narrative) wares developed in Castel Durante and Urbino in the 1520s and

1530s and was transferred to other areas by painters trained there. Some *istoriato* pieces were sent to Gubbio for the addition of its famous metallic lustre glazes. Among the identifiable painters of Castel Durante are Sebastiano di Marforio (*fl c.* 1509–41), the 'In Castel Durante Painter', an artist who created colourful narrative compositions in the mid-1520s, and Maestro Simone (*fl* 1550s–60s), whose name appears on pharmacy wares.

BIBLIOGRAPHY
C. D. E. Fortnum: *Maiolica* (Oxford, 1896), pp. 173–87
Italian Renaissance Maiolica in the William A. Clark Collection (exh. cat. by W. Watson, London, BM, 1986)
T. Wilson: *Ceramic Art of the Italian Renaissance* (London, 1987)

WENDY M. WATSON

Castelletto, Bernardino del. *See* BERNARDINO DEL CASTELLETTO.

Castello [Castelo]. Italian family of artists, also active in Spain. They specialized in elaborately conceived decorative schemes and received commissions from leading members of the Genoese nobility and Spanish monarchy. (1) Giovanni Battista Castello [il Bergamasco] was a painter, stuccoist and architect who worked in Genoa from *c.* 1540–41 to *c.* 1566–7 and thereafter in Spain until his death in 1569. His youngest son Fabrizio Castello (*c.* 1560–1617) was Pintor del Rey to Philip II, King of Spain (*reg* 1556–98), from 1584 and was chiefly engaged in the decoration of the Escorial.

(1) Giovanni Battista Castello [il Bergamasco] (*b* Gandino, nr Bergamo, *c.* 1509; *d* Madrid, 3 June 1569). Painter, stuccoist and architect. He was the son of Giovanni Maria Castello, who was also probably an artist. According to Soprani and other early sources, Castello arrived in Genoa *c.* 1540–41 as an assistant of Aurelio Busso, a painter from Cremona, to paint monochromatic façade decorations on palaces and villas of aristocratic patrons. Their painted classical reliefs for the rear garden façade of the Palazzo della Meridiana, which was begun *c.* 1540 by Cardinal Gerolamo and Giovanni Battista Grimaldi on the Salita S Francesco, include the *Labours of Hercules* and the *Battle of Lapiths and Centaurs*; these are among the best examples of Busso's Raphaelesque decorative style. Twentieth-century scholarship has placed Castello in the shadow of LUCA CAMBIASO, who is seen as the principal decorator to the *nobili vecchi* (the old noble families of Genoa) during the third quarter of the 16th century. However, Castello's career is even more crucial to the development of a distinctively Genoese High Renaissance decorative style between *c.* 1540 and 1575. Soprani reported that Tobia Pallavicino, a man of distinguished learning, took Castello under his protection and sent him to Rome during the 1540s to study painting, sculpture and architecture. While in Rome, Castello was influenced by such works as Raphael's loggia frescoes in the Villa Farnesina and Giulio Romano's decorations at the Villa Madama.

Castello first actually appears in Genoese documents in 1552 (Genoa, Archv Mun., Pal. Tursi), when he was elected Console dell'Arte dei Pittori. In 1558–60 Castello collaborated with Cambiaso in decorating Pallavicino's Villa delle Peschiere in Multedo with painted illusionistic architectural views and *all'antica* landscapes on the walls, recalling Baldassare Peruzzi's Sala delle Prospettive in the Villa Farnesina, Rome. Perseus, Apollo, Diana and other mythological gods appear with allegorical figures in grotesque compartment frames on the vaults of the first floor and ground floor. Concurrently (1558–61) Castello worked with Bernardino da Cantone in designing Pallavicino's palace on the Strada Nuova (now Via Garibaldi), the Palazzo Carrega Cataldi (now the Camera di Commercio) in Genoa. With its rusticated ground floor and fluted pilasters on the upper storeys, the façade parallels those of such Mannerist architects as Giulio Romano and Andrea Palladio. Castello linked the interior room sequence from the ground-floor vestibule to the double staircase and first-floor entertainment rooms with an intricate series of Mannerist grotesque paintings and tapestries (examples of Castello's tapestries, Genoa, Pal. Bianco). Other such elaborately decorated palaces include Castello's Palazzo Podestà on the Strada Nuova (*c.* 1563–5), designed for Nicolosio Lomellino, and the Palazzo Vincenzo Imperiale in Campetto (*c.* 1560–66). The façade of the Palazzo Podestà is decorated with antique trophies, swags and decorative elements. In the interior Castello created a particularly dramatic and innovative oval vestibule, encrusted with stucco decorations. This leads to a double staircase, ground-floor loggia and courtyard. The illusionistic vestibule vault is decorated with oval and circular medallions representing classical triumphal scenes in red clay, which contrast with the white stucco of the cartouche frames, garlands, trophies, draperies and seated *ignudi*. On the atrium walls are elegant term pilasters and niches.

Castello's activity also encompassed major religious commissions in Genoa. Together with Cambiaso, he supervised the architectural reordering and decoration (*c.* 1558–9) of the nave and side aisles of S Matteo. Castello complemented Cambiaso's fresco of the *Vocation of St Matthew* with sensuous oval stucco frames, supporting figures of angel-victories, terms, swags and grotesques. Around 1562 Castello worked at the Grimaldi Chapel in the church of S Francesco di Castelletto (destr.). His presbytery of SS Annunziata di Portoria (*c.* 1563, incomplete) included frescoes of *Christ in Judgement* and figures of the Four Evangelists. At the Lercari chapel (*c.* 1565–7, incomplete) in Genoa Cathedral he painted frescoes of the *Assumption* and the *Coronation of the Virgin*. According to Soprani, his inability to complete these commissions and the prescribed contractual penalties for delays resulted in personal debts, forcing the artist to flee to Spain (*c.* 1566–7) and the service of Philip II, King of Spain. However, through Pallavicino Castello had already received (*c.* 1564) a commission for designs for the Genoese palace of the Marqués di Santa Cruz a El Viso and two sarcophagi for Luis de Requensens. By 1567 he is documented in Spain as Philip's court architect and painter. His leadership of a workshop of architects, craftsmen, painters, sculptors, stuccoists and gilders strengthened the Late Renaissance–Mannerist tradition in Spain at a time of major court commissions. He contributed designs for the Escorial, which included a Genoese style double staircase. He also provided designs for the royal residences at El Pardo, Madrid, Segovia, Aranjuez and Toledo. His

decorative work focused on the Alcázar and Torre Nueva in Madrid (*c.* 1569, destr. 1748).

BIBLIOGRAPHY

DBI

R. Soprani: *Vite* (1674); enlarged, ed. C. G. Ratti, i (Genoa, 1768), 402–7

M. Labò: *G. B. Castello* (Rome, 1925)

E. Poleggi: *Strada Nuova: Una lottizzazione del cinquecento a Genova* (Genoa, 1968, 2/1972)

E. Gavazza: *La grande decorazione a Genova* (Genoa, 1974)

Galeazzo Alessi e l'architettura del cinquecento: Atti del Convegno internazionale di studi: Genova, 1974

C. Wilkinson: 'The Escorial and the Invention of the Imperial Staircase', *A. Bull.*, lvii (1975), pp. 65–90

G. Rosso del Brenna: 'Giovanni Battista Castello', *I pittori bergamaschi dal XIII al XIX secolo*, ii (Bergamo, 1976), pp. 377–488

C. B. Dufour and others: *La pittura a Genova e in Liguria dagli inizi al cinquecento* (Genoa, 1987)

L. Magnani: *Il tempio di Venere: Giardino e villa nella cultura genovese* (Genoa, 1987)

GEORGE L. GORSE

Castiglione, Baldassare [Baldesar], Conte (*b* Casatico, nr Mantua, 6 Dec 1478; *d* Toledo, 2 Feb 1529). Italian writer, humanist, diplomat and soldier. He was educated from 1490 to 1499 at the court of Ludovico Sforza, Duke of Milan, where he met Leonardo da Vinci and Giovanni Cristoforo Romano. He was in the service of Francesco II Gonzaga, 4th Marchese of Mantua, in 1499–1504, after which he was at the court of Urbino until 1516, serving first Guidobaldo I, Duke of Urbino, and afterwards his successor, Francesco-Maria I della Rovere. There he met Pietro Bembo, Ludovico da Canossa (1476–1532), Giuliano de' Medici, Duc de Nemours, and Raphael, with whom he developed a strong friendship.

In 1508 Castiglione began *Il libro del cortegiano*, for which he is best remembered. It was finished in 1518 and revised and published in 1528. In these fictitious dialogues, set in the palace rooms of Elisabetta Gonzaga, Duchess of Urbino, the courtiers, all historical persons, discuss the proper education for the ideal aristocrat. Castiglione dated the dialogues to 1506, when he was in fact in England representing Guidobaldo at the installation ceremony of the Order of the Garter. *Il libro del cortegiano* is divided into four books. In Book I, in the guise of Ludovico da Canossa, its interlocutor, Castiglione, expressed his views on sculpture and painting. He was aware that in his day the arts of drawing and painting were considered unsuitable for an aristocrat, but since in the ancient world painting had been deemed a worthy and necessary accomplishment of the nobility, he believed that the modern courtier ought to follow the example of the ancients by learning the art of drawing and acquiring a knowledge of painting. He considered drawing to be particularly useful in times of war because it provided the opportunity for rivers, bridges, citadels and fortresses to be recorded. He regarded painting as a source of pleasure since it enabled the courtier to judge the merits of ancient and modern art, enjoy the proportions of all living creatures and depict beautiful ladies for himself. Castiglione considered the art of his own times to be superior to that of the Middle Ages and thought painting a more noble art than sculpture on the grounds that it was capable of a greater fidelity to nature. He particularly appreciated technical virtuosity—foreshortening and perspective. In Book III, in the guise of Giuliano de' Medici, he advised the courtly lady to acquire a knowledge of painting and praised those women of antiquity who had excelled in the arts.

Castiglione was an informed collector and antiquary; while at Rome in 1513, he explored ancient sites with Pietro Bembo and Raphael, returning there for further investigations the following year while acting as the court of Urbino's ambassador. It was at this period that Raphael painted Castiglione's well-known portrait (*c.* 1514–15; Paris, Louvre; *see* RAPHAEL, fig. 8), which expresses the understated dignity of the accomplished courtier; Raphael had earlier borrowed his features for the portrait of Zoroaster in his frescoes of the *School of Athens* (*c.* 1510–11; Rome, Vatican, Stanza della Segnatura). Raphael trusted Castiglione's judgements on art, and in 1519 they collaborated in drawing up the report on ancient Rome that had been commissioned by Pope Leo X. Castiglione also acquired works of art for Isabella d'Este, Marchesa of Mantua, and Federico II Gonzaga, 5th Marchese of Mantua, in whose diplomatic service he was employed in 1519–24. From 1524, until his death he was papal nuncio at the Spanish court of the Holy Roman Emperor Charles V. The architect Giulio Romano, whom Castiglione had befriended and introduced to Federico Gonzaga, designed a stepped, pyramidal tomb for him in S Maria delle Grazie, near Mantua.

WRITINGS

Il libro del cortegiano (Venice, 1528); Eng. trans. by T. Hoby as *The Courtyer* (London, 1561) and by G. Bull as *The Book of the Courtier* (Harmondsworth, 1967)

A. P. Serassi, ed.: *Lettere*, 2 vols (Padua, 1769–71)

G. La Rocca, ed.: *Le Lettere*, 3 vols (Verona, 1978–)

BIBLIOGRAPHY

J. Cartwright: *Baldassare Castiglione, the Perfect Courtier: His Life and Letters, 1478–1529*, 2 vols (London, 1908)

R. Roeder: *The Man of the Renaissance. Four Lawgivers: Savonarola, Machiavelli, Castiglione, Aretino* (New York, 1933)

J. R. Woodhouse: *Baldesar Castiglione: A Reassessment of 'The Courtier'* (Edinburgh, 1978)

J. Shearman: 'Castiglione's Portrait of Raphael: Re–examination of Raphael's Letters', *Mitt. Ksthist. Inst. Florenz*, xxxviii (1994), pp. 69–97

C. Raffini: *Marsilio Ficino, Pietro Bembo, Baldassare Castiglione: Philosophical Aesthetic and Political Approaches in Renaissance Platonism* (New York, 1998)

DORIS FLETCHER

Cataneo, Pietro (*b c.* 1510; *d* after 1571). Italian architect, engineer, theorist and writer. He was the son of Giacopo Cataneo, a stationer from Novara. The earliest secure date for his activity (23 March 1533) occurs in his sketchbook (Florence, Uffizi, U 3275-3391 A), which has the general character of an exercise-book and hence of a youthful work. Virtually every drawing in it is copied from the treatises of Francesco di Giorgio Martini. The first 42 folios include drawings of ornaments and civil architecture from Francesco's codices Ashburnham (Florence, Bib. Laurenziana) and Saluzziano (Turin, Bib. Reale), while the remaining 64 folios contain drawings of fortifications and machines derived from the Codex Magliabechiano (Florence, Bib. N.). A peculiarity of the drawings of fortifications is their frequent juxtaposition with calligraphic exercises, the intention of which seems primarily decorative. It is as a 'scrittore' that Cataneo first appears in Sienese communal records in 1539, and also as 'computista', which looks forward to his first publication, *I primi due libri delle matematiche* (Venice, 1546).

Cataneo's interest in Francesco di Giorgio's theory and his work as a military engineer support the tradition that he trained under Baldassare Peruzzi. He first appears as an architect (1544), refortifying Orbetello (1544–50) and other forts on the Sienese coast in the wake of a Turkish raid. In 1548 he proposed building a new town at Orbetello, taking his cue from a letter of Claudio Tolomei in 1547, which suggested one on Monte Argentario. In 1552–3 Cataneo upgraded many fortifications, including Capalbio and Sinalunga, in preparation for the (ultimately unsuccessful) defence of Siena in 1554. The only other architectural works associated with Cataneo are the Palazzo Francesconi (now Coli; begun after 1527) and the church of S Giuseppe (1522–43), both in Siena. Peruzzi is said to have begun the palace and entrusted its completion to his pupil. The fact that in 1564 Cataneo arbitrated in a dispute over who should be paid for various works on the palace lends some weight to the attribution.

Cataneo's absence from the communal records during 1553 is possibly explained by a journey to Venice in connection with the publication of his treatise *I quattro primi libri di architettura* (Venice, 1554). It comprises four books, devoted respectively to the city and fortifications, building materials, churches and domestic architecture. Unlike earlier architectural treatises, it displays a lack of interest in antiquity. The first of the four books is the earliest published work on artillery defences, while the third, with its advocacy for churches of the Latin-cross plan in contrast to the central plans favoured by other theorists, anticipates Counter-Reformation thinking. Despite this semblance of originality, however, most of the ideas derive again from Francesco di Giorgio.

In 1567 the treatise was reissued with a further four books on the orders, water and baths, geometry and perspective. The first book gained a chapter on ancient Roman camps, and the third book eleven chapters on temples. The net effect was the dilution of the unantiquarian flavour of the 1554 version. Much of the new material is rather humdrum, but there are two points worth noting. The first is his method for achieving the effect of entasis on columns, enthusiastically taken up by Andrea Palladio in *I quattro libri* (Venice, 1570) and much simpler than that prescribed by Vitruvius. The second is the first accurate published interpretation of Vitruvius' description of *in antis* and prostyle temples. It seems improbable that Cataneo worked these out alone, but there is no clue as to his likely source. The lack of any reprint of Cataneo's treatise suggests that it found little favour, perhaps because it was not learned enough for the scholar, nor technical enough for architects, and lacked the attractive illustrations that gained Palladio and Serlio entrée to most gentlemen's libraries.

WRITINGS

I primi due libri delle matematiche (Venice, 1546, 3/1567)
I quattro primi libri di architettura (Venice, 1554/*R* Ridgewood, NJ, 1964)
L'architettura di Pietro Cataneo (Venice, 1567); ed. E. Bassi and P. Marini (Bologna, 1982)

BIBLIOGRAPHY

DBI
E. Romagnoli: *Biografia cronologica de' bellartisti senesi, 1200–1800*, vii (MS. 1835, facs. Florence, 1976), pp. 171–242
G. Milanesi: *Dell'edificazione d'una città sul Monte Argentario* (Florence, 1885)
A. Parronchi: 'Di un manoscritto attribuito a Francesco di Giorgio Martini', *Atti & Mem. Accad. Tosc. Sci. & Lett., 'La Colombaria'*, xxxi (1966), pp. 165–216
F. Secchi Tarugi: 'Aspetti del manierismo nell'architettura senese del cinquecento', *Palladio*, n. s. xvi (1966), pp. 103–30
M. Tafuri: *L'architettura del manierismo nel cinquecento europeo* (Rome, 1966)
C. Maltese: 'Il protomanierismo di Francesco di Giorgio Martini', *Stor. A.*, iv (1969), pp. 440–45
I. Campbell: *Pietro Cataneo: Architetto senese* (MA thesis, Norwich, U. E. Anglia, 1976)
S. Pepper and N. Adams: *Firearms and Fortifications* (Chicago and London, 1986)
G. Scaglia: *Francesco di Giorgio: Checklist and History of Manuscripts and Drawings* (Bethlehem, 1992), pp. 164–5, 235–6
R. Binaghi: 'Un manoscritto di Pietro Cataneo conservato agli Uffizi', *Dis. Archit.*, ix (April 1994), pp. 60–66

IAN CAMPBELL

Catena, Vincenzo [Vincenzo di Biagio] (*b* ?Venice, *c.* 1470–80; *d* Venice, Sept 1531). Italian painter. His paintings represent the perpetuation of the style of Giovanni Bellini into the second quarter of the 16th century. He made few concessions to the modern style that was being introduced to Venice by Titian, Palma Vecchio, Pordenone and others in the same period. This archaicizing tendency was shared by several minor Bellinesque painters of the period, including Pietro degli Ingannati, Pietro Duia, Francesco Bissolo, Vittore Belliniano and the Master of the Incredulity of St Thomas. Catena, together with Marco Basaiti, with whose works Catena's are sometimes confused, can be considered the most accomplished of these. Despite the fact that he counted several humanists in his circle, the extant repertory of his subjects is limited to religious themes, mainly Marian and including three altarpieces, and to male portraits. The latter, as Vasari observed, include several of his finest works.

Catena's earliest known work, a signed *Virgin and Saints* (*c.* 1500; Baltimore, MD, Walters A.G.), is a Bellinesque composition of half-length figures. The draperies and anatomy are stiff and hard, and the faces impassive. There is also a lack of psychological focus and physical movement. The borrowing and repetition of motifs from the Virgins of Giovanni Bellini dominated Catena's production at least until 1510. In a *Virgin and Saints* (*c.* 1502–4; Venice, Accad.) he reworked the Bellini workshop *Sacra conversazione* (Frankfurt am Main, Städel. Kstinst. & Städt. Gal.). Catena's *Virgin with SS Peter and Helen* (Dresden, Gemäldegal. Alte Meister) also copies a *Virgin and Child with Donor* by Bellini (London priv. col.), while Bellini's Frari Triptych provided Catena with the basis for his figure of St Peter. Through his study of the production of Giovanni Bellini and his workshop, Catena accomplished by 1510 a softer drapery style with a characteristic manner for the folds and a firm command of facial features, which continued, however, to be devoid of expression.

About 1506 Catena painted a small signed votive altarpiece for Doge Leonardo Loredan (Venice, Correr), indicating high-ranking notice of his work. About the same time Catena befriended Giorgione. An inscription on the back of Giorgione's *Laura* (Vienna, Ksthist. Mus.; see GIORGIONE, fig. 1), dated 1 June 1506, refers to Catena as Giorgione's colleague. The explanation may be that Catena had offered studio space to an indigent Giorgione and even introduced him to the circle of collectors that

was later to be chronicled by Marcantonio Michiel. Nevertheless Giorgione made no visible impression on Catena's art.

In the second decade of the 16th century Catena's paintings became less literally and more generically Bellinesque. A *Holy Family with Saints* (Berlin, Bodemus.) exemplifies this and includes a donor in profile who has tentatively been identified as the Ferrarese poet Lodovico Ariosto. That Catena moved in intellectual and aristocratic circles is borne out by documentary evidence and by his portraiture. Antonio di Marsilio (1486–1556), a successful civil servant and humanist, was named as executor of Catena's will in 1515. A codicil of 1518 added as executor the humanist scholar Giovanni Battista Egnazio (*c.* 1478–1553). Catena was mentioned in letters from Marcantonio Michiel (1520), Pietro Bembo (1525) and Giovanni Guidiccioni (1531). The last—the only occasion on which he is recorded outside Venice—reveals that Catena was in Rome in March 1531. Portraits datable to the 1520s of the humanist *Giangiorgio Trissino* (Paris, Louvre), who was later a patron of Palladio, and of *Doge Andrea Gritti* (London, N.G.), as well as portraits of the collectors *Francesco Zio* and *Giovanni Ram* (both untraced), indicate the extent of Catena's circle.

Between 1515 and 1520 Catena somewhat eclectically acknowledged recent developments in Venetian painting. In his *Christ Delivering the Keys of Heaven to St Peter* (Madrid, Prado) he twice made use of a shaded profile against a light background, a novel touch of drama taken from Cima da Conegliano. The same picture shows the influence of Sebastiano del Piombo (whose sister's marriage in 1527 Catena was to witness) and of Marco Basaiti. A lively and sharply individual signed *Portrait of a Man with a Book* (Vienna, Ksthist. Mus.) has been compared by Robertson (p. 53) to the portraiture of Raphael. A drawing from Raphael's studio inspired Catena's *Holy Family with St Anne* (*c.* 1520; two versions: ex-Earl of Mexborough priv. col.; Dresden, Gemäldegal. Alte Meister).

At the beginning of the 1520s Catena painted his masterpiece, *Christ Saving St Christina from Drowning*, for the church of S Maria Mater Domini, Venice (dated 1520 on frame; 1520–22; *in situ*; see fig.). This is the earliest example in Venice of a narrative altarpiece not drawn from the New Testament. The broadly Raphaelesque figure of Christ the Redeemer gazes down at the pyramidal and amply robed figure of St Christina. The composition is spacious, with a distant view over the lake of Bolsena, and monumental, with a tall tree uniting upper and lower parts. The painting shows Catena's strengths: the charmingly solicitous angels, the palette of pastel shades of green, blue and pink. It also shows his weaknesses: a lack of ability to suggest gravity and texture, the absence of drama through movement, gesture or expression and the failure of his only attempt to employ a turning contrapposto, in the clumsily draped Christ.

Catena's style settled down at this time with a coherent group of lingeringly Bellinesque depictions of the *Holy Family* and *sacre conversazioni*. Both the *Rest on the Flight into Egypt* (Ottawa, N.G.) and a *Virgin and Saints* (Messina, Mus. Reg.) use the motif of a Virgin and Child out of their original context so that the infant looks intently down-

Vincenzo Catena: *Christ Saving St Christina from Drowning*, oil on panel, 2.25×1.5 m, 1520–22 (Venice, S Maria Mater Domini)

wards at an absent donor figure. More successful was the *Adoration of the Shepherds* (New York, Met.), in which Catena responded to the landscape of Cima and specifically to the latter's altarpiece on the same theme in the church of S Maria dei Carmini, Venice (*c.* 1509–11). Two versions of the *Supper at Emmaus* (Bergamo, Gal. Accad. Carrara; ex-Contini–Bonacossi priv. col., Florence) revived a composition by Giovanni Bellini.

Catena's most accomplished later works were his portraits. These were helped by his careful attention to observed detail and inspired by Titian's development of this genre. In common with those already mentioned, the *Portrait of a Venetian Senator* (New York, Met.) successfully conveys a strong and individual personality. The *Judith* (*c.* 1530; Venice, Gal. Querini–Stampalia; see colour pl. 1, XXI3), though skilfully executed with a mastery of composition rare in Catena's work, lacks the invigorating element of his observation of and sympathy for his portrait sitters. In his mature masterpiece, the large *Holy Family with a Warrior Adoring the Infant Christ* (London, N.G.), Catena's considerable merits and limitations can again be comprehensively perceived despite the damage the picture has suffered. The atmosphere of reverie, the harmonious local colour and the pedantic, though charmingly observed, detail hark back to the opening of the 16th century and to the generation of Giovanni Bellini and Cima. Nevertheless the sense of the warrior's fervent devotion is owed to

Catena's assurance in manipulating the compositional structure and in particular to the metaphorical power of the contrast between the shaded profile of the warrior and the radiantly lit Virgin and Child.

Something of Catena's private life can be learnt from his several wills. He was a single man and relatively prosperous, thanks to some commercial activity, which may have been trade in spices. As a painter, therefore, he may have been a dilettante. He left no workshop to continue his production. Generously disposed towards the Venetian Scuola dei Pittori, he left them his residual estate in 1531, with which the guild was able to build a meeting hall at the church of S Sofia in 1532. Among his possessions was a *restelo*, a piece of furniture decorated with paintings by Giovanni Bellini, which have been plausibly identified with Bellini's *Five Allegories* (Venice, Accad.).

BIBLIOGRAPHY
DBI
G. Vasari: *Vite* (1550, rev. 2/1568); ed. G. Milanesi (1878–85), iii, p. 643
G. Ludwig: 'Archivalische Beiträge zur Geschichte der venezianischen Malerei', *Jb. Kön.-Preuss. Kstsamml.* (Suppl.), xxvi (1905), pp. 1–159 (esp. pp. 79–88)
G. Robertson: *Vincenzo Catena* (Edinburgh, 1954)

PHILIP RYLANDS

Cattaneo, Danese (*b* Colonnata, Carrara, *c.* 1509; *d* Padua, 1572). Italian sculptor. His family lived in the mountains of Carrara and was connected with the marble trade. Vasari placed him among the pupils of Sansovino before the Sack of Rome in 1527, and when his master moved to Venice, Cattaneo followed. His earliest surviving independent work is a statuette of *St Jerome*, made in competition with a *St Lawrence* (both Venice, S Salvatore) by Giacomo Fantoni in 1530. It is an accomplished semi-nude figure in the style of Sansovino, a style that Cattaneo sustained throughout his career. During the 1530s Cattaneo was briefly involved in the stucco ceiling decoration of the chapel of S Antonio in the Santo in Padua, and he also collaborated with Fantoni on Serlio's high altar for the church of the Madonna di Galliera in Bologna. Vasari (v, p. 91) credited him with a relief portrait of *Duke Alessandro de' Medici*, but this has not survived. Probably his first major surviving commission was for the marble statue of a *Sun God* (Venice, Pal. Pesaro, courtyard) for the Venetian mint, which Sansovino was rebuilding between 1537 and the mid-1540s. The statue probably dates from the later stages of this work. According to Vasari, it was one of three statues proposed by Cattaneo: a second, representing the *Moon*, would symbolize silver, while a third, unspecified, work would stand for copper. Only one statue was made, but the account illustrates Cattaneo's literary approach to his art, stimulated by his parallel interest in poetry. The *Sun God* is unconventional in its imagery, depicting a youthful male nude seated on a globe supported by mounds of gold. The figure's morphology recalls the work of Sansovino and Bartolomeo Ammanati, whose monument to *Marco Mantova Benavides* (finished 1546; Padua, Eremitani) evidently impressed Cattaneo.

Between 1543 and 1548 Cattaneo and Tiziano Minio (1517–52) were engaged on a project for bronze gates for the chapel of S Antonio in the Santo, but this was later abandoned. In the nave of the Santo, however, are two portrait busts by Cattaneo, of *Pietro Bembo* (1547) and *Alessandro Contarini* (*c.* 1553). The marble bust of Bembo was the focal-point of an imposing monument of which Palladio was probably the author, and its incisive characterization won the admiration of Aretino and Titian. Cattaneo had a flair for portraiture in both marble and bronze and helped to popularize the new type of *all'antica* portrait bust with a bell-like treatment of the torso. The bronze of *Lazzaro Bonamico* (1552; Bassano del Grappa, Mus. Civ.) and the *Portrait of a Man* (New York, Frick) are especially fine examples of Cattaneo's craftsmanship in bronze. Only the bust of *Gasparo Contarini* (*c.* 1563; Venice, S Maria dell'Orto) matches them in terms of technique and expressiveness. Cattaneo's ability to convey personality within a classicizing framework laid the foundation for the type of portraiture that was later taken up by Alessandro Vittoria.

In the 1540s and 1550s, Cattaneo frequently collaborated on Sansovino's major projects. In Venice he carved some figurative sculpture for Sansovino's Libreria Marciana and Loggetta, where the marble relief of *Venus Cyprica* is probably attributable to him. With Pietro da Salò, Cattaneo executed a telamon and a caryatid on the fireplaces (1553–4) designed by Sansovino for the Sala della Bussola and the Stanza dei Tre Capi of the Council of Ten in the Doge's Palace in Venice.

Cattaneo's most notable commissions during the 1550s and 1560s were in Verona: the commemorative marble statue of the physician and poet *Girolamo Fracastoro* (1555) now stands on top of an arch between the Piazza della Ragione and the Tribunale there and shows Fracastoro in a toga, the pose recalling Donatello's *St Mark* (Florence, Orsanmichele). More imposing is the Fregoso Altar (1565) in S Anastasia. Here Cattaneo's sculpture merges with his interest in recondite allegory: in coloured marbles, it adapts the form of a triumphal arch to the function of a combined tomb and altar dedicated to the Redeemer. The outer bays contain a statue of the deceased, the condottiere *Giano II Fregoso*, and a female allegorical figure of *Military Virtue*; they are accompanied by reliefs of *Minerva* and *Victory*, while the attic level has statues symbolizing *Fame* and *Eternity*. The central section forms an altar with a statue of *Christ the Redeemer* (see fig.), which is one of Cattaneo's greatest achievements: graceful in gesture and delicately poised, it echoes the lyrical quality of the sculpture Sansovino produced in Rome. The combination of sacred and profane themes drew criticism, and the sculptor felt defensive about it, according to Torquato Tasso.

The monument to *Doge Leonardo Loredan* in SS Giovanni e Paolo in Venice, commissioned from the architect Giovanni Girolamo Grapiglia (*fl* 1572–1621), is a more coherent and frankly secular work. Cattaneo was inspired by the format and allegorical statues of the Loggetta, introducing at the centre a tableau depicting the *War of the League of Cambrai*. Although the seated figure of the *Doge* was completed by Cattaneo's pupil Girolamo Campagna after 1604, the conception is faithful to the original design. Cattaneo's imaginative power enabled him to blend the traditions of the great 15th-century tombs of the doges with new iconography to create a fresh vocabulary for Venetian funerary monuments.

Throughout his career, Cattaneo had serious literary ambitions. He was a member of the circle of Paduan

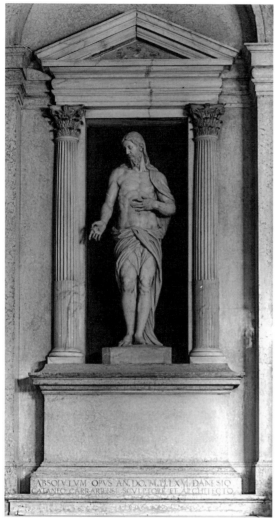

Danese Cattaneo: *Christ the Redeemer*, central statue of the Fregoso Altar, marble, 1565 (Verona, S Anastasia)

intellectuals centred on Pietro Bembo and Alvise Cornaro; he was especially close to Francesco Sansovino, who regarded him as a second father, and to Bernardo Tasso (1493–1569), the father of Torquato (who acknowledged Cattaneo as a source of encouragement and inspiration for his book *Gerusalemme liberata* of 1581). Cattaneo's chief poetic achievement was *L'amor di Marfisa*, published in Venice in 1562 with a dedication to Alberico Cybo Malaspina, Marchese di Carrara. In addition, he left two unpublished plays and a number of heroic poems (Rome, Vatican, Bib. Apostolica, MS.I.VI.238), which were gathered together by his grandson Niccolò, presumably for publication.

Towards the end of his career, Cattaneo began to receive greater recognition. On the recommendation of Vasari, he was elected a corresponding member of the Accademia del Disegno, Florence, in 1566. Cattaneo was on friendly terms with Vasari and became a chief source of information on artists of the Veneto for the second edition of the latter's *Vite*. Cattaneo's final major commis-sion came in 1572 when he was selected to carve the last marble relief, *St Anthony Raising the Youth in Lisbon*, for the chapel of S Antonio in the Santo: Cattaneo transferred his workshop to Padua but died towards the end of the year. His sculptural heir was the Veronese Girolamo Campagna, whom Cattaneo had made his apprentice during work on the Fregoso Altar. After completing the Loredan monument, Campagna won the competition to execute Cattaneo's relief for the Santo. Cattaneo combined a highly sophisticated skill as a sculptor with an outstanding ability to realize abstract ideas, although he never fully emerged from Sansovino's shadow. Had he concentrated all his talents in one field, he might, as Aretino noted, have surpassed his former master.

BIBLIOGRAPHY

G. Vasari: *Vite* (1550; rev. 2/1568); ed. G. Milanesi (1878–85), vii, pp. 522–6

T. Temanza: 'Vita di Danese Cattaneo', *Vite de più celebri architetti e scultori veneziani* (Venice, 1778); ed. L. Grassi (Milan, 1966), pp. 269–82

G. Campori: *Memorie biografiche degli scultori . . . di Carrara* (Modena, 1873), pp. 56–75

L. Planiscig: *Venezianische Bildhauer der Renaissance* (Vienna, 1921), pp. 411–32

E. Rigoni: 'Testamenti di tre scultori del cinquecento', *L'arte rinascimentale in Padova* (Padua, 1970), pp. 217–37

W. Timofiewitsch: 'Marginalien zur Grabmalskulptur des Danese Cattaneo', *A. Veneta*, xxxii (1978), pp. 230–37

H. Burns: 'Altare Fregoso', *Palladio e Verona* (exh. cat., ed. P. Marini; Verona, Pal. Gran Guardia, 1980), pp. 165–6

Giorgio Vasari (exh. cat., ed. C. Davis and others; Arezzo, Mus. Casa Vasari, 1981), pp. 227, 230–32, 295–6

B. Boucher and A. Radcliffe: 'Sculpture', *The Genius of Venice* (exh. cat., ed. J. Martineau and C. Hope; London, RA, 1983), pp. 361–2

M. Rossi: *La poesia scolpita: Danese Cattaneo nella Venezia del Cinquecento* (Lucca, 1995)

BRUCE BOUCHER

Cavalcanti, Andrea di Lazzaro. *See* BUGGIANO.

Cavalieri [de' Cavalleri; de Cavalleriis], **Giovanni Battista de'** (*b* Villa Lagarina, nr Trento, *c.* 1525; *d* Rome, 23 July 1601). Italian engraver, publisher and draughtsman. Active from 1559 in Rome, his repertories of engravings reflect the antiquarian interests of his patrons, high clergy of the Counter-Reformation Church. The *Antiquarum statuarum urbis Romae* provides the first systematic publication of engravings of antique statues in public and private, mostly clerical, collections in Rome. Printed between *c.* 1560 and 1594 in a series of small editions, its number of plates increased from 58 to 200. The representations of the statues are accurate, showing the degree of restoration. Latin captions give their names and locations, which in later editions reflect changes of address. Cavalieri's plates were also reprinted in the 17th century. Ashby described each standard edition by Cavalieri and his followers and tabled the plates of the various editions, including captions and present locations of the statues. Many extant copies vary from the standard editions, as customers chose loose plates to bind with a title-page (Gerlach, 1984), and copies not noted by Ashby contain prints from reworked and renumbered plates (Gerlach, 1989). Cavalieri also engraved and published Giovanni Antonio Dosio's 50 views of Roman architectural ruins (1569). His engravings of papal portraits with 230 plates in 1580 and Roman imperial portraits up to Rudolf II (*reg* 1576–1612) with 147 plates in 1583 were among his most influential publications

before his final work in 1593: books iii and iv of *Antiquarum statuarum*, the plates of which lack the clean style of the earlier editions.

WRITINGS
Antiquarum statuarum urbis Romae (Rome, [1560]–1594)
Urbis Romae aedificiorum illustrium (Rome, 1569)
Pontificium romanorum effigies opera et studio I. B. Cavallerijs collectae ac typis aeneis incisae (Rome, 1580)
Romanorum imperatorum effigies, cum elogiis ex diversis scriptoribus, studio Joh. Bapt. de Cavalleriis aeneis tabulis incisae (Rome, 1583; Italian edn, 1590)
Romanorum imperatorum effigies elogiis ex diversis scriptoribus per Thomam Treterum S Mariae Transtyberin canonicum collectis (Rome, 1583)
Omnium romanorum pontificum icones cum eorum vitis in compendium redactis. Opera J. B. Cavalleriis collectae et incisae (Rome, 1585)

BIBLIOGRAPHY
DBI
T. Ashby: 'Antiquae statuae urbis Romae', *Pap. Brit. Sch. Rome*, ix (1920), pp. 107–58
P. Gerlach: 'Eine Hand von Guglielmo della Porta? Cavalieri, Tetrode, Perret und der sogen. Antinous vom Belvedere', *De Arte et Libris. Festschrift Erasmus, 1934–1984* (Amsterdam, 1984), pp. 179–197
——: 'Ein *Antinous* des Guglielmo della Porta? Zum Datum einer Restaurierung des *Hermes-Andros* des Belvedere', *Städel-Jb.*, xii (1989), pp. 151–78
Archäologie der Antike 1500–1700 aus den Beständen der Herzog August Bibliothek (exh. cat. by M. Daly Davis, Wolfenbüttel, Herzog August Bib., 1994), pp. 122–4

RUTH OLITSKY RUBINSTEIN

Cavalletto [Caballettus; de Cabaleto; de Capalatitis; Chavaletto], **Giovanni Battista** (*fl* 1486–1523). Italian illuminator, painter and sculptor. He was principally active as an illuminator and ran a workshop of considerable repute in Bologna. In 1486 he collaborated with Martino da Modena (*fl* 1477–89) on the decoration of choir-books for S Petronio, Bologna, and this contact with Martino undoubtedly influenced his style. In 1509 and 1511 and then in 1522 and 1523 he and his collaborators received payments for the illumination of a number of choir-books for the same church (Bologna, Mus. S Petronio).

Cavalletto's only surviving signed and dated work is a full-page miniature of the *Coronation of the Virgin* (1523; Bologna, Mus. Civ. Med.), from the statute book of the guild of merchants and drapers of Bologna. The miniature, with the Virgin enthroned on a podium in a columned room, is strikingly monumental in its conception. Here, as in the best of Cavalletto's work as an illuminator, the marked influence of the Ferrara school fused with the traditional style of Bologna is apparent. Also attributed to Cavalletto are the frontispiece miniature of the statute book of the College of Jurists of Bologna representing the *Assumption of the Virgin* (1502; Bologna, Archv Stato), and the Office of Holy Week from the Lateran abbey of S Salvatore (Bologna, Mus. Civ. Med.). The elegant ornamental borders of these manuscripts may, however, be the work of Giovanni's son Scipione (*fl* 1516–26), who collaborated closely with him. Arslan has attributed to Cavalletto a number of painted works, including a triptych representing the *Virgin and Child with Saints* (Bologna, Mus. S Stefano). None of his sculptural works is known.

BIBLIOGRAPHY
DBI; Thieme–Becker
A. Masini: *Bologna perlustrata* (Bologna, 1666), p. 627
P. A. Orlandi: *Abecedario pittorico* (Bologna, 1704), p. 194
F. Malaguzzi Valeri: 'La collezione delle miniature nell'Archivio di Stato di Bologna', *Archv Stor. A.*, vii (1894), pp. 12–15
W. Arslan: 'Giovanni Battista Cavalletto', *Com. Bologna*, xviii (1931), no. 2, pp. 19–22; no. 8, pp. 3–5
The Painted Page: Italian Renaissance Book Illumination, 1450–1550 (exh. cat., ed. J. J. G. Alexander; London, RA, 1994)

□

Cavalli, Gian Marco (*b* Viadana, *c.* 1454; *d* after 1508). Italian medallist, sculptor and goldsmith. He was the son of a notary, Andrea Cavalli. First recorded as a goldsmith in June 1481, he executed the foot of a large tabernacle dedicated to the feast of Corpus Christi for Mantua Cathedral between 1483 and 1485 and a large Crucifix for the chapter house of the cathedral (1490–91); none of this work survives. In 1497 Cavalli probably began working for the Mantuan mint. The commissions from Ludovico Gonzaga, Bishop of Mantua, date from 1499 and 1501 (Rossi, 1888): a bronze statuette of the *Spinario* and four silver roundels with *Signs of the Zodiac*. Cavalli worked as a sculptor and medallist for the Gonzaga family from 1501 to 1505. He witnessed Andrea Mantegna's will on 1 March 1504 and the granting of Mantegna's funerary chapel in S Andrea, Mantua, on 11 August.

From March to June 1506 Cavalli is documented at the mint of the Holy Roman Emperor, Maximilian I (*reg* 1493–1519), at Hall, Tyrol. A testoon depicting *Maximilian I and Bianca Maria Sforza* has been attributed to Cavalli and linked by Schneider to a drawing in pen and ink and wash of *Two Heads and the Infant Christ* (Venice, Accad.) that was once attributed to Ambrogio de Predis. The testoon design was also cast in a larger format (e.g. Vienna, Ksthist. Mus., and Berlin, Bodemus.). Four medals made for Gianfrancesco Gonzaga, Lord of Rodigo, and four depicting Maximilian I and the Holy Roman Emperor Frederick III (*reg* 1452–93), as well as several coins depicting Gianfrancesco, are also attributed to Cavalli.

As a sculptor, he evidently executed a number of works after designs by other artists, including Antico. A bronze statuette of a nude female figure (New York, Frick) is associated with him. He may have cast the bronze busts of *Andrea Mantegna* (Mantua, S Andrea) and of the monk *Battista Spagnoli* (Mantua, Pal. Ducale), but evidence for his authorship of these works is inconclusive. Among several other works inconclusively given to him is the terracotta bust of *Gianfrancesco Gonzaga* (Mantua, Pal. Ducale), which is traditionally attributed to Giovanni Cristoforo Romano. Cavalli is last mentioned in the *Libro rosso* of the statutes of Viadana in 1508.

BIBLIOGRAPHY
DBI
U. Rossi: 'I medaglisti del rinascimento alla corte di Mantova, III: Gian Marco Cavalli', *Riv. It. Numi.*, i (1888), pp. 439–54
R. von Schneider: 'Di un medaglista anonimo mantovano dell'anno 1506', *Riv. It. Numi.*, iii (1890), pp. 101–18
U. Rossi: 'Gian Marco e Gian Battista Cavalli', *Riv. It. Numi.*, v (1892), pp. 481–6
P. Torelli: 'Gli argenti della cattedrale e Gian Marco Cavalli', *Atti & Mem. Accad. N. Virgil. Mantova*, n. s. (1925), pp. 310–27
G. F. Hill: *A Corpus of Italian Medals of the Renaissance* (London, 1930), pp. 61–3

ANDREA S. NORRIS

Cavalori, Mirabello (d'Antonio di Pacino) [Mirabello di Salincorno] (*b* 1535; *d* Florence, 27 Aug 1572). Italian painter. He was one of the founders of the Accademia del Disegno in Florence and worked on the academy's first

major projects: the decorations for Michelangelo's funeral in S Lorenzo (1564) and for Duke Francesco I de' Medici's wedding (1565) to Joanna of Austria. For Michelangelo's catafalque he collaborated with Girolamo Macchietti on a grisaille painting of *Lorenzo de' Medici Receiving Michelangelo* (untraced); for the Arch of Religion, a temporary structure erected along the route of Francesco I's wedding procession, Cavalori painted in monochrome *St Francis Founding the Retreat at Vernia and Receiving the Stigmata* (untraced).

According to Vasari, Cavalori was a successful portrait painter and executed at least two portraits of Francesco I (untraced). Surviving examples include the *Portrait of a Young Man Holding a Drawing* (c. 1568–9; Florence, Mus. Bardini) and the group portrait of the *Founders of the Confraternity of St Thomas Aquinas* (1568; Florence, Pitti), an austere and deliberately archaistic composition that reflects the intrusion of Counter-Reformation attitudes into Florentine art. Cavalori was also an extremely versatile artist. His *Pentecost* (c. 1567–8; Florence, Badia Fiorentina) recalls the High Renaissance in its clarity of exposition and spatial logic. Subsequently, he participated with Maso da San Friano, Francesco Morandini (1544–97) and Macchietti in a revival of the styles of Pontormo and Andrea del Sarto. The *Blessing of Isaac* (c. 1569; ex-priv. col., London, see 1991 exh. cat., fig. 19) shows a remarkable approximation of Pontormo's manner of the late 1520s. Elements from Pontormo and del Sarto can also be discerned in the two elegant and brilliantly coloured pictures Cavalori painted for the *studiolo* of Francesco I in the Palazzo Vecchio, the *Sacrifice of Lavinia* and the *Wool Factory* (c. 1570–72; both *in situ*). Unlike most of his Mannerist contemporaries, Cavalori emulated the masters he admired not so much by imitation of specific motifs but by truly understanding and simulating their ways of seeing and describing and by carrying their most advanced researches in the handling of light and space to the next logical stage. The comparative naturalism of these elements in the *Wool Factory* influenced both Macchietti and Santi di Tito (1536–1602) and thereby played a minor but consequential role in the formation of a Baroque style in Florence. Cavalori's last known work, *St Thomas of Villanueva Distributing Alms* (c. 1571–2; Scarperia, SS Jacopo e Filippo), probably a Medici commission, shows a retreat from this advanced position and a return to the subdued palette and grave Counter-Reformation tone of his portraits.

BIBLIOGRAPHY

G. Vasari: *Vite* (1550, rev. 2/1568); ed. G. Milanesi (1878–85), vii, p. 298
L. Marcucci: 'Appunti per Mirabello Cavalori disegnatore', *Riv. A.*, xxviii (1953), pp. 77–98
V. Pace: 'Contributi al catalogo di alcuni pittori dello studiolo di Francesco I', *Paragone*, xxiv (1973), pp. 69–84
M. Bacci: 'Alcune ipotesi su un quadro di una chiesa del Mugello', *Paragone*, xxx (1979), pp. 38–47
L. Feinberg: *The Works of Mirabello Cavalori* (diss., Cambridge, MA, Harvard U., 1986)
From Studio to Studiolo: Florentine Draftsmanship under the First Medici Grand Dukes (exh. cat. by L. Feinberg, Oberlin Coll., OH, Allen Mem. A. Mus., 1991)

LARRY J. FEINBERG

Cavazzola [Morando], **Paolo** (*b* Verona, 1486; *d* Verona, 1522). Italian painter. A pupil of Francesco Morone, he had a brief but productive career. Among his earlier works

is the large frescoed lunette of the *Annunciation* (1510) in the chapel of S Biagio, SS Nazaro e Celso, Verona (on cleaning of frescoes, see P. Cristani in dal Forno, 1989); the illusionism is dependent on the work of Giovanni Maria Falconetto and Domenico Morone, and the rather severe classical style is close to that of Francesco Morone. The half-length *Virgin and Child* (1508; Gazzada, Mus. Villa Cagnola) reveals a somewhat sculptural effect in the modelling. The series of canvases depicting scenes from the *Passion* (1517; Verona, Castelvecchio), designed to surround Francesco Morone's *Crucifixion* on the altar wall of the Cappella degli Avanzi in S Bernardino in Verona (copies *in situ*), is highly praised in early sources. In these paintings Cavazzola developed Francesco Morone's interest in depicting clear, cool daylight. The background landscape in the *Lamentation*, for example, includes a view of Verona with cool afternoon light reflecting off the walls of the Castel S Pietro.

There are two dated works of 1518: a *Portrait of a Man* (Dresden, Gemäldegal. Alte Meister) and a *Virgin and Child* (Milan, Mus. Poldi Pezzoli). Around the same time Cavazzola painted the *Virgin and Child with St John and an Angel* and *St Roch* (both London, N.G.), in which delicate shadows again show his study of light. The *Incredulity of Thomas* (c. 1518–19; Verona, Castelvecchio) is another good example of his mature work. The Sacco Altarpiece (c. 1522; ex-Cappella S Francesco, S Bernardino, Verona; Verona, Castelvecchio) is described by Vasari and dal Pozzo as Cavazzola's last work. This ambitious work depicts the *Virgin in Glory with SS Francis and Bernard*. The figures are placed above six other saints and a portrait bust of the donor, Caterina da Sacco. The forms are sharply modelled, and the whole is characterized by an intense clarity of light. The crozier and bishop's cope are executed with precise attention to detail. Cavazzola's palette departs from Francesco Morone's cool, bright colours in his liberal use of greys.

BIBLIOGRAPHY

G. Vasari: *Vite* (1550, rev. 2/1568); ed. G. Milanesi (1878–85), v, pp. 314–17
B. dal Pozzo: *Le vite de' pittori, scultori e architetti veronesi* (Verona, 1718), pp. 33–6
C. Gamba: 'Paolo Morando detto il Cavazzola', *Rass. A.*, v (1905), pp. 33–40
B. Berenson: *Central and North Italian Schools*, i (1968), pp. 83–4
C. Hornig: 'Paolo Cavazzola', *Maestri della pittura veronese*, ed. P. Brugnoli (Verona, 1974), pp. 193–200
——: *Cavazzola* (Munich, 1976)
L. Magagnato: *Progetto per un museo, II: Dipinti restaurati* (Verona, 1979), pp. 32–6
F. Bisogni: 'Il rittrato di Giulio Trivulzio del Cavazzola', *Renaissance Studies in Honour of Craig Hugh Smyth*, ii (Florence, 1985), pp. 37–47
P. Brugnoli, ed.: *Affreschi del rinascimento a Verona: Interventi di restauro* (Verona, 1987)
S. Marinelli: *Proposte e restauri* (Verona, 1987), pp. 109–13
F. dal Forno, ed.: *Cappella di San Brigio nella chiesa dei Santi Nazaro e Celso a Verona* (Verona, 1989)

DIANA GISOLFI

Cavino, Giovanni di Bartolommeo dal (*b* Padua, 16 May 1500; *d* Padua, 5 Sept 1570). Italian medallist and goldsmith. His entire career seems to have been spent in Padua, where he benefited from rich traditions of sculpture, bronze-casting, Classical studies and collecting. His artistic training appears to have been acquired in the

workshop of Andrea Riccio, who named Cavino as one of the executors of his will. Cavino worked in both bronze and gold and is documented as the author of a number of such ecclesiastical objects as candlesticks, censers and reliquaries; however, these works no longer exist. His fame derives in part from his having carved the dies for a series of struck pieces that imitated very closely ancient coins, particularly Roman sesterces. Such copies are now often found in cast versions, although many of the original dies are preserved in Paris (Bib. N., Cab. Médailles). Although it is not known whether Cavino's intention was to deceive, his imitations were so cleverly made that even the modern collector must beware of them. According to Gorini, they were produced between 1520 and *c.* 1532. The pieces, which are in fairly high relief with crisp details and a nervous, linear style, are mostly composed of portraits of Roman emperors and members of their families.

During this period and until *c.* 1565 Cavino also struck 34 portrait medals of contemporary Paduan notables, including a double portrait showing himself with the antiquarian *Alessandro Bassiano* (Washington, DC, N.G.A.). Although Hill dismissed Cavino with contempt, his work is not without merit. The style is delicate and incisive, the portraiture distinctly individualized and sensitive, and the compositions balanced. Such portraits as those of *Girolamo Cornaro, Giovanni Mels, Luca Salvioni* and *Cosimo Scapti* (all Washington, DC, N.G.A.) are particularly impressive. The lettering, however, is sometimes rather flimsy. The reverses, all based strongly on Classical sources and often not logically connected with the obverses, are graceful, as in the representation of a genius on several medals (Washington, DC, N.G.A.), or vigorous, as in the medal of *Goro Gualteruzzi*, with a scene of a woman attempting to restrain a lunging horse (Florence, Bargello).

BIBLIOGRAPHY

Forrer

R. H. Lawrence: *The Paduans: Medals by Giovanni Cavino* (New York, 1883/R Hewitt, 1964)

G. F. Hill: *Medals of the Renaissance* (London, 1920, rev. 1978), pp. 92–3

G. F. Hill and G. Pollard: *Renaissance Medals from the Samuel H. Kress Collection at the National Gallery of Art* (London, 1967), pp. 73–6

F. Cessi and B. Caon: *Giovanni da Cavino, medaglista padovano del Cinquecento* (Padua, 1969)

G. Pollard: *Italian Renaissance Medals in the Museo Nazionale del Bargello* (Florence, 1985), iii, pp. 1311–23

G. Gorini: 'New Studies on Giovanni da Cavino', *Stud. Hist. A.*, xxi (1987), pp. 45–54

The Currency of Fame: Portrait Medals of the Renaissance (exh. cat., ed. S. K. Scher; Washington, DC, N.G.A.; New York, Frick; 1994), pp. 182–5, 386–7

STEPHEN K. SCHER

Cazzaniga. Italian family of sculptors. Francesco Cazzaniga (*fl* Milan, 1467–86) and Tommaso Cazzaniga (*fl* Milan, 1481–1504) were the sons of Antonio Cazzaniga. From 1466 their family rented from the Solari a house in the parish of S Babila in Milan. Francesco was a stonecutter at Milan Cathedral between 1467 and 1473, while in 1481 Tommaso belonged to the society of the Quattro Incoronati, the association of cathedral stonecutters. The brothers frequently collaborated with their brother-in-law, Benedetto Briosco. In 1476–8 Francesco was among the sculptors who assisted Giovanni Antonio de Piatti (*d* 1479) on the tomb of *Giovanni Borromeo and Vitaliano Borromeo*

(ex-S Francesco Grande, Milan; now Isola Bella, Mus. Borromeo). In 1486 Tommaso and Briosco were contracted to finish the tomb, begun by Francesco, of *Giovanni Francesco Brivio* in S Eustorgio, Milan, agreeing to make it like the monument to the *della Torre Family* (*c.* 1483), which the Cazzanigas and Briosco had executed in S Maria delle Grazie, Milan.

Briosco, Francesco and Tommaso also created the tomb of *Pietro Francesco, Visconti di Saliceto* (*d* 1484) for S Maria del Carmine, Milan (reliefs in Cleveland, OH, Mus. A.; Kansas City, MO, Nelson–Atkins Mus. A.; and Washington, DC, N.G.A.; architectural elements in Paris, Louvre). Another collaboration between the Cazzaniga brothers and Briosco was the tomb of *Ambrosino Longignana* (*d* 1485) for S Pietro in Gessate, Milan (now Isola Bella, Mus. Borromeo). Tommaso worked at the Certosa di Pavia between 1496 and 1499, and in 1499 he became a salaried sculptor at Milan Cathedral. Most of the historical reliefs on the above-mentioned tombs, those on the tomb of *Pier Candido Decembrio* (*d* 1477) in S Ambrogio, Milan, and most of the portal of the sacristy of the lavabo at the Certosa, can be assigned to one leading executant, who was probably Tommaso.

BIBLIOGRAPHY

DBI; Thieme–Becker

F. Malaguzzi-Valeri: *Giovanni Antonio Amadeo: Scultore e architetto lombardo, 1447–1522* (Bergamo, 1904)

G. Treccani degli Alfieri, ed.: *Stor. Milano*, vii (Milan, 1956), pp. 725–31

C. Mandelli: 'I primordi di Benedetto Briosco', *Crit. A.*, xix/124 (1972), pp. 41–56; xix/126 (1973), pp. 39–52

U. Middeldorf: *Sculptures from the Samuel H. Kress Collection: European Schools, XIV–XIX Century* (London, 1976), pp. 54–7

A. Vigano: 'Il periodo milanese di Benedetto Briosco e i suoi rapporti con i cognati Francesco and Tommaso Cazzaniga: Nuove acquisizioni documentarie', *A. Lombarda*, 108/109 (1994), pp. 140–160

M. Natale, ed.: *I monumenti Borromei: scultura lombarda del Rinascimento* (Turin, 1997)

CHARLES R. MORSCHECK JR

Cedrini [Cedrino], **Marino (di Marco)** (*b* Venice, *fl* ?1458–76). Italian sculptor and architect. He was active in Romagna and the Marches, working in a transitional style between Gothic and Renaissance, influenced by Venetian taste. His first known work is the signed, but undated low stone relief depicting the *Lion of St Mark* (*c.* 1458–60) set into the brickwork over the entrance to the Rocca Brancaleone at Ravenna. In 1462 he was at Amandola, in the Marches, and was then called to the nearby town of Fermo to execute a commission (probably the Late Gothic mixtilinear arch that frames the entrance to the Euffreducci Chapel in the church of S Francesco). In 1465 he completed the door, in Istrian stone and Red Verona marble, of Forlì Cathedral (removed 1841; reconstructed with slight modifications in 1915 for the façade of the Carmelite church), the decorative style of which derives from Renaissance Tuscany. In 1468 he created a portal for the church of S Agostino, Amandola, which combines Romanesque and Late Gothic elements.

From 1471 Cedrini was in charge of the works for the basilica at Loreto, working on the walls of the south transept and on the nave; however, his contribution to the project, over a period of about five years, remains difficult to identify. In 1475, while in Ancona, he accepted a commission for the convent of S Francesco at Civitanova

Marche, where he probably built the campanile (Gianuizzi, 1913). An inscription at Fano claims that in 1476 he built a portico in that town (destr. 1591), possibly in front of the cathedral façade, and also describes him as the architect of the church at Loreto.

Cedrini's work is eclectic and sometimes conservative; Venturi compared it with that of the Tuscan Gothic wood-carving tradition. It does indeed relate to that style but also incorporates Renaissance elements and represents a fragmentary but significant contribution to the artistic production of the eastern part of the central regions of Italy in the 15th century.

BIBLIOGRAPHY

DBI; Thieme–Becker
J. A. Vogel: *De Ecclesiis Recinitensi et Lauretana commentarius historicus*, ii (Recanati, 1859)
G. Cantalamessa: 'Artisti ignoti nelle Marche: Marco Cedrino', *Archv Stor. A.*, i (1888), pp. 376–7
P. Gianuizzi: 'Documenti inediti sulla basilica loretana', *Archv Stor. A.*, i (1888), pp. 321–7, 364–9
A. Venturi: *Storia*, vi (1908), p. 20
C. Ricci: 'Per la storia della rocca di Ravenna: Il leone di Marco Cedrini', *Felix Ravenna*, i (1911), pp. 1–7
P. Gianuizzi: 'Marino di Marco Cedrino da Venezia: Ingegnere, architetto e scultore', *Boll. A.*, vii (1913), pp. 333–41
G. Gerola: 'Il portale di Marino Cedrini', *Felix Ravenna*, iv (1915), pp. 814–19
D. Tassotti: 'Ipotesi sui primitivi sviluppi del Santuario di Loreto', *Quad. Ist. Stor. Archit.*, xxiii (1976), pp. 47–70
G. Viroli: 'Il portale di Marino Cedrini già nel vecchio Duomo di Forlì: Il Leone di San Marco di Marino Cedrini nella Rocca Brancaleone a Ravenna', *Il monumento a Barbara Manfredi e la scultura del Rinascimento in Romagna* (exh. cat., ed. A. Colombi Ferretti and L. Prati; Forlì, Abbazia S Mercuriale, 1989), pp. 95–103

ADRIANO GHISETTI GIAVARINA

Cellini, Benvenuto (*b* Florence, 3 Nov 1500; *d* Florence, 13 Feb 1571). Italian goldsmith, medallist, sculptor and writer. He was one of the foremost Italian Mannerist artists of the 16th century, working in Rome for successive popes, in France for Francis I (*reg* 1515–47) and in Florence for Cosimo I de' Medici. Among his most famous works are the elaborate gold figural salt made for Francis I (Vienna, Ksthist. Mus.; see fig. 4 below) and the bronze statue of *Perseus* (Florence, Loggia Lanzi; see fig. 6 below). His *Vita* is among the most compelling autobiographies written by an artist and is generally considered to be an important work of Italian literature.

I. Life and work. II. Working methods and technique. III. Writings. IV. Character and personality. V. Critical reception and posthumous reputation.

I. Life and work.

1. Florence and Rome before the Sack, 1500–27. 2. From the Sack of Rome to the visit to France, 1527–40. 3. In the service of Francis I in France, 1540–45. 4. In the service of Cosimo I de' Medici in Florence, 1545–53. 5. Last years in Florence, 1553–71.

1. FLORENCE AND ROME BEFORE THE SACK, 1500–27. Cellini came from a middle-class Florentine family. His grandfather Andrea was a mason and his father Giovanni Cellini (1451–1528), who married Elisabetta Granacci in 1480, was a well-educated and expert carpenter who built the scaffolding put up to allow Leonardo da Vinci to paint the *Battle of Anghiari* (destr.) and who was a member of the committee responsible for choosing the

site for Michelangelo's statue of *David* (now Florence, Accad.; *see* ITALY, fig. 22). According to Benvenuto, his father was also capable of making complicated musical instruments and played the recorder, first in the service of the Medici and then for the Republic.

Cellini's father would have liked him to become a musician, but in 1513 Benvenuto entered the workshop of the goldsmith Michelangelo de' Brandini (1459–1528), father of the sculptor Baccio Bandinelli. In 1515 Cellini moved to the workshop of Antonio di Sandro di Paolo Giamberti, known as Marcone, but in 1516, following a brawl, he was banished from Florence and obliged to seek refuge in Siena. While there, he worked for the goldsmith Francesco Castoro, who was engaged on important works for the cathedral. Cellini returned to Florence later the same year but left again for Bologna, where he lodged in the house of the illuminator Scipione Cavaletti (*fl c.* 1516–26) and worked for a Jew called Graziadio. Cellini returned home six months later, but, following family disagreements, he moved in 1517 to Pisa and joined the workshop of the goldsmith Ulivieri della Chiostra. His stay in Pisa gave him the opportunity to study the antique sarcophagi in the Camposanto. Returning to Florence in 1518, he again worked for Marcone and then for Francesco Salimbeni. Above all, however, he made firm friends with Giovanni Francesco Lippi, who showed him sketchbooks (untraced) containing drawings after the antique made by his father, Filippino Lippi, during his stay in Rome.

Stimulated by these studies, Cellini moved to Rome in 1519 with his friend the wood-carver Battista di Marco del Tasso. There Cellini worked initially for the Piacentine goldsmith Fiorenzuola, making a silver salt (untraced) for an unnamed cardinal. This work was based on a famous porphyry sarcophagus standing in the Pantheon. Shortly afterwards he moved to the shop of the Milanese goldsmith Paolo Arsago (*fl* 1509–30). After the death of Leo X in 1521 and a temporary decline in artistic patronage during the short pontificate of Adrian VI, Cellini returned home to work for Salimbeni and then operated as an independent artist in a part of the workshop run by Giovanbattista Sogliani. In January 1523 Cellini was prosecuted for sodomy and towards the end of that year was obliged to flee to Rome following a violent brawl with members of the Guasconti family of goldsmiths.

On the way to Rome, Cellini learnt of the election of the Medici pope Clement VII, with whom his father was on good terms. When he reached Rome in early 1524, he entered the shop of the son of a papal goldsmith, Santi di Cola, which after the latter's death was directed by Lucagnolo da Jesi. There he produced for the Bishop of Salamanca two richly decorated candlesticks and a ceremonial ewer (all untraced); the latter, which was based on a design by the painter Giovanni Francesco Penni, is described in Cellini's *Trattato dell'oreficeria* (xxii) as being elaborately decorated with foliate and animal motifs.

Cellini then transferred himself to the workshop of the Milanese goldsmith Giovan Pietro della Tacca (1463–1552) and later in 1524, encouraged by the prestigious patrons who were seeking his work, finally opened his own independent studio. He received commissions from Cardinal Innocenzo Cibo (1491–1550) for a ceremonial ewer (untraced), similar in design but bigger than the

previous one, and from cardinals Francesco Cornaro, Niccolò Ridolfi and Giovanni Salviati. He also mounted jewels for Sulpizia Chigi and made a gold enseigne with a relief of *Leda and the Swan* (untraced) for the gonfaloniers of Rome. These were years of intense activity and great satisfaction for Cellini, marked by the opening of his own workshop, his study of the masterpieces of antiquity and of Michelangelo and Raphael, and the convivial company of the most promising young artists of his day, including Giulio Romano, Giovanni Francesco Penni, Rosso Fiorentino, Bacchiacca and Jacopo Sansovino, many of them former associates of Raphael: despite his repeated declarations in his autobiography that he was a follower of Michelangelo, it seems likely that Cellini's earliest works displayed a clear preference for the style evolved in the circle around Raphael. This era of splendid patronage and personal happiness was, however, brought to an end by the Sack of Rome by imperial troops in May 1527. It is almost certain that all of Cellini's early production in precious metals was lost at this time, probably melted down by the troops.

2. FROM THE SACK OF ROME TO THE VISIT TO FRANCE, 1527–40. Cellini left Rome for Florence in the summer of 1527, but an outbreak of plague forced him to move on quickly to Mantua, where he began working for the most important goldsmith in the city, Niccolò d'Asti. Through Giulio Romano, who had been in Mantua since 1524, he entered the service of the Gonzaga family, for whom he designed a reliquary (unexecuted) for a vial of the Precious Blood. He also made three seals (untraced), of which that for Cardinal Ercole Gonzaga (1528) is known from impressions in sealing wax on six manuscripts in the Curia Vescovile, Mantua (see Pope-Hennessy, 1985, pl. 19). The elliptical seal depicts the *Assumption of the Virgin* and is clearly based on Raphaelesque models, as is confirmed by Cellini's own drawing (Florence, Uffizi) made in the 1560s as a record of this early work.

In 1528 Cellini returned to Florence, where his father had died of the plague. He produced several emblematic enseignes: that depicting *Leda and the Swan* (untraced; see PH, pls 20–21), formerly in the collection of the Marchese Strozzi, Florence, may date from this time; it has been cautiously, though unconvincingly, attributed to Cellini. In 1529 the Siege of Florence caused Cellini to abandon the city for Rome. For five years he remained in the service of Clement VII, working on coin dies for the papal mint (in 1529 he was appointed Maestro delle Stampe, a post he held until January 1534), a famous morse or cope clasp (untraced; known from three watercolours of 1729 by Francesco Bartoli, London, BM; see PH, pls 22–4) and two silver gilt medals of exceptional quality (both medals, as well as the dies for them, Florence, Bargello). The two medals depict the Pope in profile bust format on the obverse. The reverse of one (1533–4) shows an allegory of *Peace Burning Weapons before the Temple of Janus*; the other (1534) represents *Moses Striking Water from the Rock* (see fig. 1). These are among Cellini's most successful works, demonstrating the virtuosity with which he created complex images in a limited space, effective both on a narrative level (*Moses*) and on a symbolic one (*Peace*). Above all, these works allowed Cellini to demonstrate his

1. Benvenuto Cellini: medal depicting *Clement VII* (obverse) and *Moses Striking Water from the Rock* (reverse), silver gilt, diam. 40 mm, 1534 (Florence, Museo Nazionale del Bargello)

skill as a portraitist, capable of rendering the personality—or at least the state of mind—of his sitters. As the seal for Ercole Gonzaga and the coin dies for Clement VII are known only from impressions (for coins see PH, pls 25–8), these medals are invaluable proof both of the stylistic maturity that Cellini had attained and of his success with one of the most important patrons of the day.

Despite this official recognition of Cellini's talent (in 1531 he also obtained the benefice of macebearer), his private life continued to be turbulent: in order to vindicate the violent death of his brother Cecchino, he in turn killed the assassin; in 1532, having attacked a notary, he was obliged to seek refuge in Naples, where the jeweller Domenico Fontana served as his guide to the ancient monuments of the area; and on 26 December 1534 he murdered the goldsmith Pompeo de' Capitaneis who, together with other companions, had spoken ill of Cellini at the papal court. Despite being pardoned by the newly elected Paul III, who guaranteed his safe conduct and commissioned a die (untraced) for a gold coin (e.g. London, BM), Cellini left Rome in 1535 to escape persecution by the Pope's illegitimate son, the powerful Pier Luigi Farnese. After a brief trip to Venice with the sculptor Niccolò Tribolo, Cellini returned to Florence and entered the service of Alessandro de' Medici, who made full use of Cellini's skill and ordered several coin dies (all 1535; untraced; for coins see PH, pls 35, 38–43). As a result of a dispute with Ottaviano de' Medici, the artist returned to Rome in 1536 and there made a gold and jewelled cover (untraced) for an illuminated prayerbook to be given by Paul III to Emperor Charles V (*reg* 1519–56). A portrait medal (untraced) made for Bartolomeo Valori also dates from this period; it was executed either in Florence or in Rome and was paid for in August 1536.

Cellini was restless and increasingly discontented with his situation and therefore decided to try his fortune in France. He travelled via Padua, where in 1537 he made a sketch model of a portrait medal for Cardinal Pietro Bembo. This was subsequently modified in execution: the obverse has a profile portrait of *Bembo*, the reverse an image of *Pegasus* (best example, in silver, Florence, Bargello). Later the same year Cellini reached Paris, but it is uncertain whether the fine, signed portrait medal *Francis I* (e.g. bronze, Florence, Bargello) dates from this time or from his second Paris visit. In Paris his erstwhile friend Rosso Fiorentino was not particularly encouraging; no further royal commissions were forthcoming, largely because France was preparing for its invasion of Italy. Cellini

did, however, make contact with an important patron who was to play a significant role in his future, Cardinal Ippolito d'Este. After a brief stop in Ferrara, he returned to Rome in December 1537, but on 16 October 1538 he was arrested and charged with having appropriated some jewels from the papal treasury that had been entrusted to him by Clement VII during the tragic days of the Sack. He was imprisoned in the Castel Sant'Angelo but managed to escape; he was rearrested and then set free permanently in November or December 1539, thanks to the intervention of Cardinal Ippolito, for whom he made an oval seal showing *St Ambrose Defeating the Aryans* and *St John the Baptist Preaching* (untraced; trial impression, in lead, Lyon, Mus. B.-A.). It is a work imbued with Mannerist characteristics, very close to the style of Perino del Vaga, and reveals the progress made by Cellini in little more than ten years in updating his own style from the late Raphaelesque vocabulary of the seal made for Ercole Gonzaga to one based on the most advanced experiments in Tuscan and Roman painting.

In 1540, on his way to France, Cellini followed Cardinal Ippolito to Ferrara. The accounts of Tommaso Mosti, the Cardinal's treasurer, document works executed there (all untraced) and Cellini writes of a silver bowl and jug which he made for Mosti, later given by Ippolito to Francis I. Commissions for three portraits probably also date from 1540: these were a portrait of *Ippolito d'Este* intended to be cast in bronze, a wax model of *Cardinal Benedetto Accolti*, and a relief of Ippolito's brother *Ercole II d'Este, Duke of Ferrara* carved in a tondo of black stone. Von Fabriczy (1903) attributed to Cellini a bronze medal depicting *Ercole II* (Weimar, Goethe-Nmus. Frauenplan); despite its high quality, it is inferior to other portraits by Cellini. After several months spent at Ferrara, Cellini arrived at Fontainebleau in the autumn of 1540.

3. IN THE SERVICE OF FRANCIS I IN FRANCE, 1540–45. In Paris, Francis I assigned the château of the Petit Nesle to Cellini as a residence and workshop; for the first time he was able to depend on the enthusiastic support of a generous patron with sufficient funds to finance his ambitious projects. After the death of Rosso Fiorentino in November 1540, Cellini found himself competing with another Italian, Francesco Primaticcio, but the court was firmly marked by Italian culture and he was not short of important commissions. During his second stay in France, Cellini worked simultaneously on a number of projects, but his determination to procure for himself so many prestigious contracts proved counterproductive: his critics were right in claiming that a much larger workshop would have been required for many years to complete all the projects he had undertaken. Cellini's restless and exalted mind constantly bred impractical ideas, and his ambition provoked friction with the other artists at the French court.

In November 1540 Francis I commissioned models for 12 life-size silver statues (six gods and six goddesses) to be used as candelabra around the royal table. This project occupied Cellini throughout his five years in Paris, yet only *Jupiter*, shown to the court in January 1545, was completed before his departure. The statue is lost, but it is possible that the *Jupiter* on the base of Cellini's statue of *Perseus*

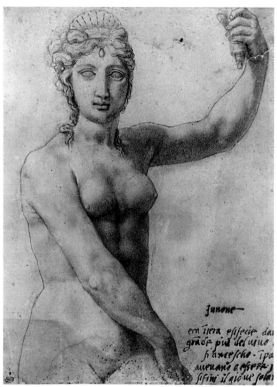

2. Benvenuto Cellini: *Juno*, drawing in black chalk, 247×186 mm, 1540–44 (Paris, Musée du Louvre)

(*see* §4(ii) below) reflects the model produced in France. A drawing by Cellini for the statue of *Juno* (Paris, Louvre; see fig. 2) survives, and a bronze statuette of the same subject (Paris, Stavros Niarchos priv. col., see PH, pls 53–4) has been plausibly attributed to him.

In 1542 Cellini designed and in part carried out the decoration of the Porte Dorée (not installed) at the royal château of Fontainebleau, built in 1538 by Gilles Le Breton as the principal entrance. The architectural ensemble consists of three superimposed arches (the doorway and two loggias) of awkward proportions. At the sides of the door there were to have been two monumental bronze satyrs with menacing expressions. The models were prepared but never cast. The appearance of one of the satyrs is known from a small bronze version (Los Angeles, CA, Getty Mus.; see fig. 3) and a drawing (Washington, DC, N.G.A., see PH, pl. 70), made by Cellini as a record after his return to Florence. The famous bronze relief of the *Nymph of Fontainebleau* (Paris, Louvre) was to have been placed above the entrance arch and was cast before 2 March 1543. This was Cellini's first encounter with the technique of bronze-casting on a large scale, and it is likely that it was in order to study the procedure that he produced two works subsequently presented to Francis I: a bronze bust of *Julius Caesar*, based on a small model he had brought with him from Rome, and the bronze *Head of a Young Girl* (both untraced). The *Nymph* relief is a work of Mannerist complexity and contrast: the languidly relaxed, nude body, whose elongated limbs have an almost abstract beauty, is set off by the intense realism of the

Despite the scepticism of Ippolito d'Este and his advisers that Cellini could complete this complex project, the enormous financial resources of the King and his confidence in Cellini resulted in its being finished in little more than two years; its completion was also aided by the fact that the wax model had been prepared in 1540, at the Cardinal's request, and that Cellini could rely on the support of numerous assistants (although he alluded to the latter in his autobiography, it is seldom adequately emphasized). His only major surviving goldsmith's work, it has an eclectic expressive vocabulary: the elegant figures of *Neptune* and *Earth* derive from Tusco-Roman Mannerism, which, in exactly this period, was influential on other talented goldsmiths in the circle around the Farnese family; by contrast, the opulence of the precious materials encrusted with tightly interwoven heraldic symbols, as well as the triumphal arch at the side of the figure of *Earth*, are clearly based on models from the Fontainebleau school. The personifications of *Morning*, *Day*, *Evening* and *Night* that decorate the base are, in turn, copies of the same sculptures by Michelangelo in the New Sacristy, S Lorenzo, Florence, works that Cellini knew well, having seen them during his visits to Florence, but before their installation on the sarcophagi of the tombs of *Lorenzo de' Medici* and *Giuliano de' Medici*. Having narrowly escaped being melted down in 1562, the salt was presented by Charles IX (*reg* 1560–74) in 1570 to Archduke Ferdinand of Austria, Count of Tyrol (*reg* 1564–95). It entered the collections at Schloss Ambras and, like so many of Cellini's works, was soon forgotten. It was not until 1819 that Alois Primisser, who was publishing a catalogue of the imperial collections, realized that the salt, which had been considered lost by Leopoldo Cicognara in 1816, had, in fact, survived intact at Ambras.

Before leaving France, Cellini embarked on another project that is fully described in the autobiography. In competition with Primaticcio he produced a model for a fountain at Fontainebleau in the centre of which was to stand a colossal statue of *Mars*, emblematic of Francis I. Allegorical statues of *Philosophy*, *Design*, *Music* and *Liberality* were intended to be placed at its base, on the corners

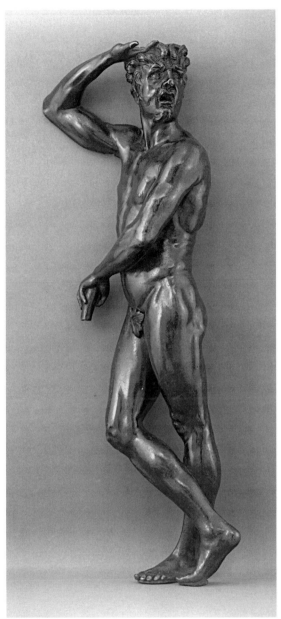

3. Benvenuto Cellini: *Satyr*, bronze, h. 560 mm, 1542–3 (Los Angeles, CA, J. Paul Getty Museum)

hounds and forest animals that surround her and by the rough animality of the satyrs designed to flank the entrance. The relief was never set up in its intended position but was reused by Philibert de L'Orme (1514–1570), together with the two female personifications of *Victory* (untraced; plaster casts, Paris, Louvre) designed for the spandrels, to decorate the entrance to the château of Anet, Eure-et-Loire.

Between the autumn of 1540 and the spring of 1543 Cellini executed what is probably the most famous work by a Renaissance goldsmith: the salt of Francis I (Vienna, Ksthist. Mus.; see fig. 4). The virtuosity of the composition in such a limited space (260×330 mm) is astonishing.

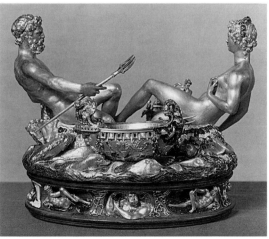

4. Benvenuto Cellini: salt of Francis I, gold and enamel, 260×330 mm, 1540–43 (Vienna, Kunsthistorisches Museum)

of a square basin, but this ambitious project never got past the planning stages: only the full-size clay, wood and plaster model (destr.) for the statue of *Mars* was realized in the courtyard of the Petit Nesle.

Cellini's stay in France was of fundamental importance to his career. It provided the opportunity for him to create his first sculptures, thus emancipating him from the status of goldsmith that restricted his talents. It also brought him into contact with a very stimulating artistic environment in which the refined style of the Fontainebleau school was being evolved and to which he was able to make a contribution. Although this was a period of personal happiness for Cellini and although he received the rare privilege of being made a French citizen, his quarrelsome nature continued to involve him in unpleasant episodes, and in July 1545 he was finally obliged to leave Paris following the slanderous accusation that he had stolen part of the silver that had been entrusted to him to make the King's candlesticks.

4. IN THE SERVICE OF COSIMO I DE' MEDICI IN FLORENCE, 1545–53. On his return to Florence, Cellini went to the villa of Poggio a Caiano to declare his allegiance to Duke Cosimo I, who must have received him favourably because a commission for a bronze statue of *Perseus* followed in August 1545. During the next 25 years, apart from brief visits elsewhere, Cellini was to remain in his native city. There he had to adapt himself to an uncongenial situation in which artistic patronage, including public commissions, was firmly controlled by the Duke and his closest supporters. After his bad experience with Francis I's favourite, Anne de Pisselieu, Duchesse d'Etampes, who had opposed his plans on a number of occasions, Cellini attempted, in an arrogant manner and without great success, to win over the powerful wife of Cosimo, Eleonora of Toledo. Nevertheless, the relentless opposition of the ducal bureaucracy succeeded in frustrating several of his plans. As Cellini tirelessly continued to submit to his patron ever new and more ambitious projects, the result was only to exasperate the cautious state administration. As the years went by, the number of unexecuted projects increased.

(i) Portrait busts, antique restorations and marble sculptures. The first decade of this new phase in Cellini's life was dominated by work on the statue of *Perseus*, but during this period he also produced several marble sculptures, both original works and ones based on antique fragments. He also created two important bronze portrait busts. In 1545 he began work on an over life-size bronze portrait bust of *Cosimo I* (Florence, Bargello) modelled from life. By October 1547 it had been cast, but the chasing and gilding were not completed before February 1548. The bust, which depicts the Duke in elaborately modelled Roman armour, is of superb workmanship. Cellini was vying with works from antiquity as well as with his principal rival in Florence, Bandinelli, but above all he sought to capture the disquieting personality of the sitter. The Duke, who viewed official portraits in terms of stereotypes, was incapable of appreciating the intimate, nervous image of himself that Cellini had created: the bust was kept in his

private apartments until in 1557 it was sent to Portoferraio on the island of Elba.

During the same period that he worked on the portrait of *Cosimo*, Cellini began a bronze bust of *Bindo Altoviti* (Boston, MA, Isabella Stewart Gardner Mus.; see fig. 5), a Florentine banker resident in Rome, who was an opponent of the Medici regime. The psychological tension and attention to detail suggest that the bust must have been modelled from life, but it is not clear if Cellini went to Rome to begin it or if a model was made during a visit by Altoviti to Florence. It is possible that the work was not completed until shortly after 1550, before Cellini went to Rome to visit Altoviti himself. As Pope-Hennessy (1985) pointed out, it is the only full-scale sculpture completed by Cellini that remains perfectly preserved.

The works that Cellini produced between 1545 and 1557 show an increasing interest in the art of antiquity. Although early on he had carefully studied the sarcophagi in the Camposanto at Pisa, as well as sites in Rome, the influence of antique prototypes is most evident in the sculptures of Cellini's middle age. This taste was, perhaps, stimulated by his activity as the Duke's restorer. In 1546 Cellini restored or remade the head, arms and feet of an 'antique bronze statuette', now in the Museo Archeologico, Florence. In 1548 he made a rearing bronze horse as a support for a small antique bronze of a rider, and the restoration of the well-known *Chimera d'Arezzo*, which is traditionally attributed to Cellini. Whatever the cause of this renewed interest in the Antique, many of Cellini's

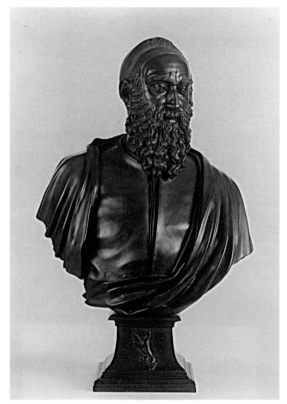

5. Benvenuto Cellini: *Bindo Altoviti*, bronze bust, h. 1.055 m, *c.* 1550 (Boston, MA, Isabella Stewart Gardner Museum)

PLATE I

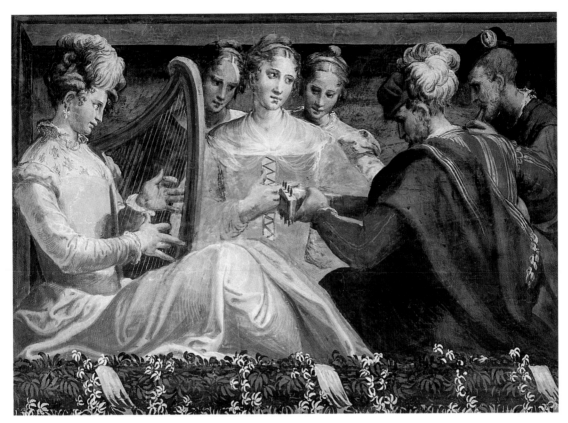

1. Nicolò dell'Abate: *Concert* (*c.* 1550; detail), frescoed frieze, Palazzo Poggi, Bologna

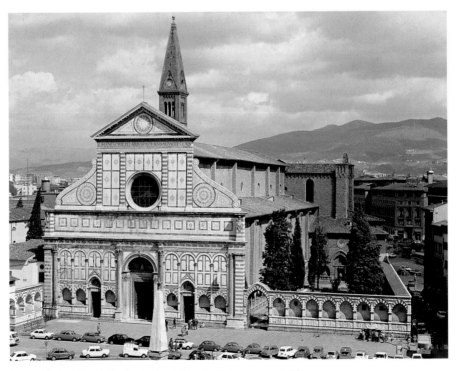

2. Leon Battista Alberti: façade of S Maria Novella, Florence, *c.* 1448–70

PLATE II

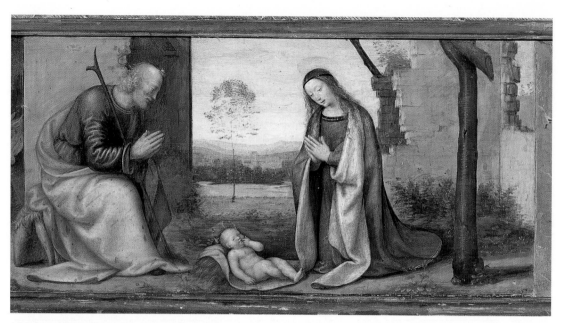

1. Mariotto Albertinelli: *Adoration of the Child*, oil on panel, 230×1500 mm, predella panel from the S Martino Altarpiece, 1503 (Florence, Galleria degli Uffizi)

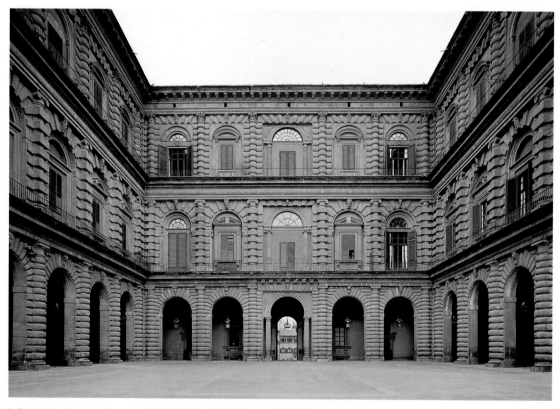

2. Bartolomeo Ammanati: courtyard of the Palazzo Pitti, Florence, 1560–77

PLATE III

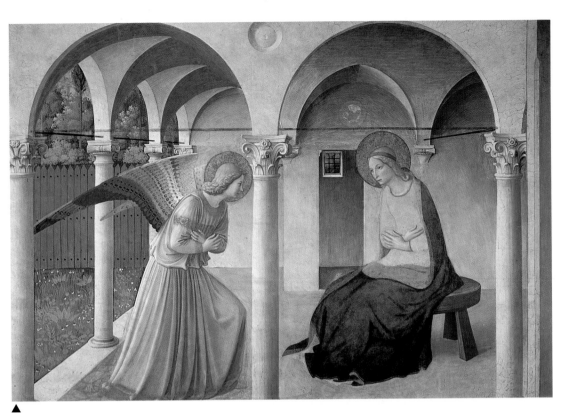

1. Fra Angelico: *Annunciation* (*c*. 1440–45), fresco,
north corridor, monastery of S Marco, Florence

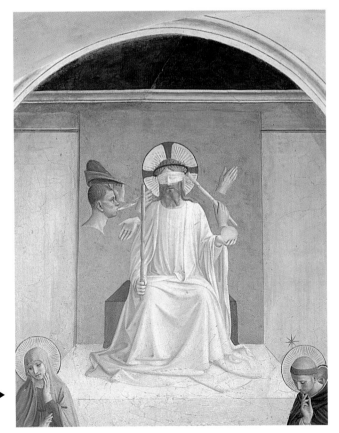

2. Fra Angelico: *Mocking of Christ* (*c*. 1440–45), fresco,
Cell 7, monastery of S Marco, Florence

PLATE IV

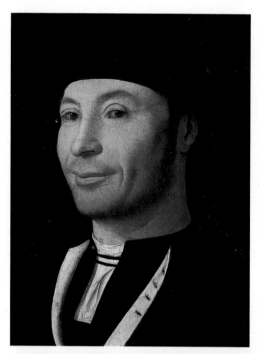

1. Antonello da Messina: *Pirate of Lipari*, oil on panel, 300×250 mm, late 1460s (Cefalù, Museo Mandralisca)

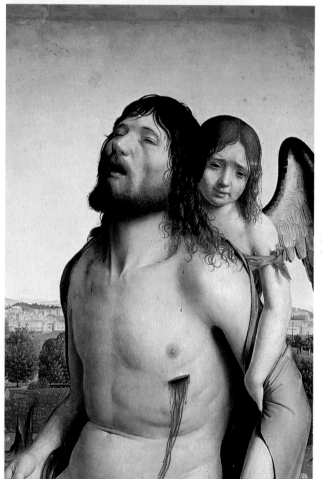

2. Antonello da Messina: *Pietà*, oil on panel, 740×510 mm, 1475–80 (Madrid, Museo del Prado)

PLATE V

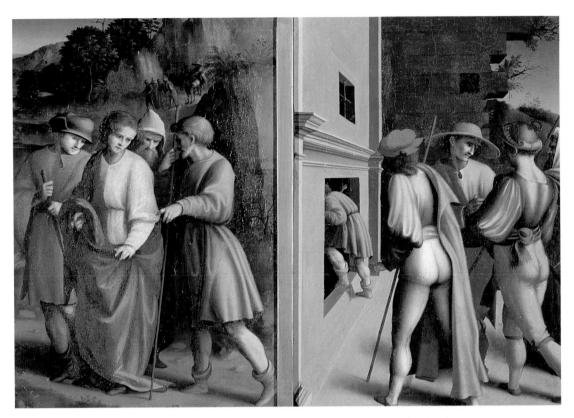

1. Bacchiacca: *Arrest of Joseph's Brothers* from the scenes from the *Life of Joseph*, *c.* 1517 (Rome, Galleria Borghese)

2. Alesso Baldovinetti: *Virgin and Child with Saints*, tempera on panel, 1.74×1.66 m, *c.* 1454 (Florence, Galleria degli Uffizi)

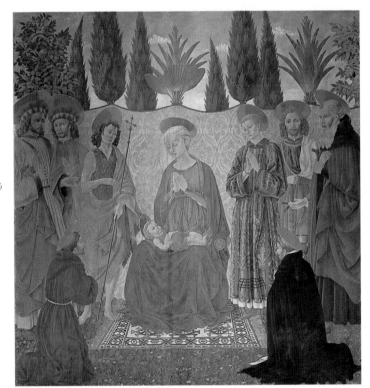

PLATE VI

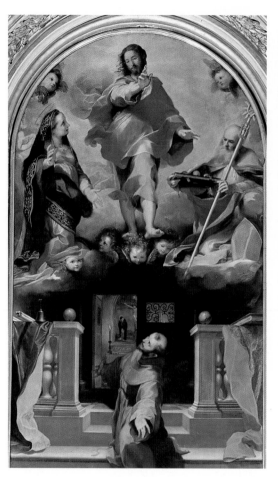

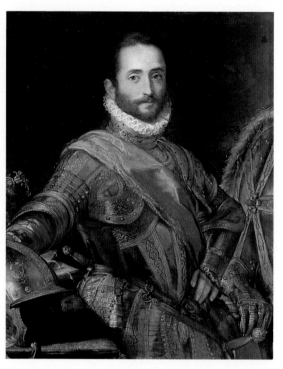

2. Federico Barocci: *Francesco Maria II della Rovere*, oil on canvas, 1130×930 mm, *c.* 1573 (Florence, Galleria degli Uffizi)

1. Federico Barocci: *'Il Perdono'* (Vision of St Francis), oil on canvas, 4.27×2.36 m, *c.* 1577 (Urbino, S Francesco)

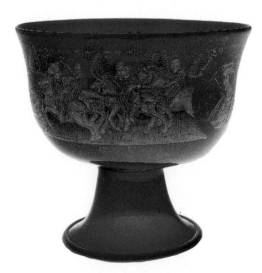

3. Barovier Cup, glass wedding goblet with enamel decoration, h. 180 mm, made in Venice (Murano), 1560–80 (Murano, Museo Vetrario)

PLATE VII

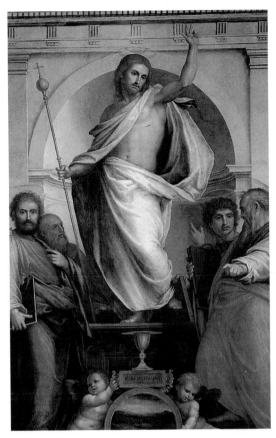

1. Fra Bartolommeo: *Christ and the Four Evangelists*, oil on canvas, 2.82×2.04 m, 1516 (Florence, Palazzo Pitti)

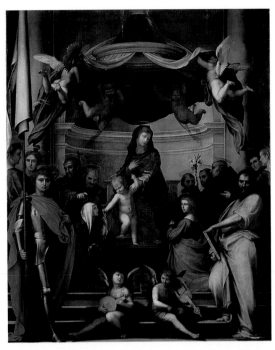

2. Fra Bartolommeo: *Mystic Marriage of St Catherine of Siena*, oil on panel, 3.51×2.67 m, 1512 (Paris, Musée du Louvre)

3. Marco Basaiti: *Virgin and Child with a Donor*, c. 1496–c.1500 (Venice, Museo Correr)

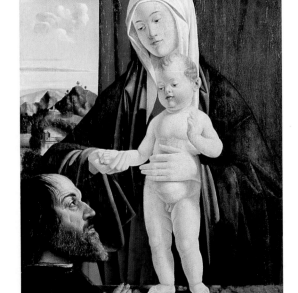

PLATE VIII

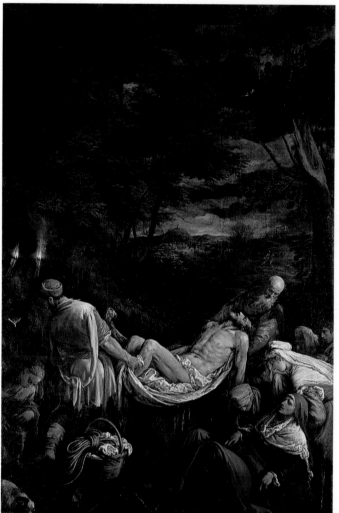

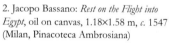

1. Jacopo Bassano: *Entombment*, oil on canvas, 2.7×1.8 m, 1574 (Padua, S Maria in Vanzo)

2. Jacopo Bassano: *Rest on the Flight into Egypt*, oil on canvas, 1.18×1.58 m, *c.* 1547 (Milan, Pinacoteca Ambrosiana)

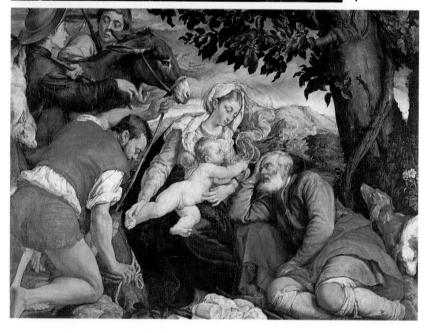

PLATE IX

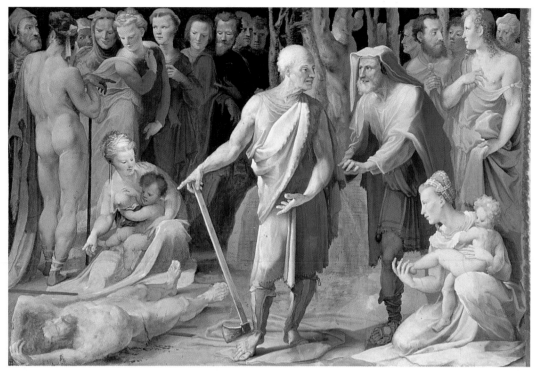

1. Domenico Beccafumi: *Posthumus Tiburtius has his Son Killed* (1529–32, 1535), ceiling fresco, Sala del Concistoro, Palazzo Pubblico, Siena

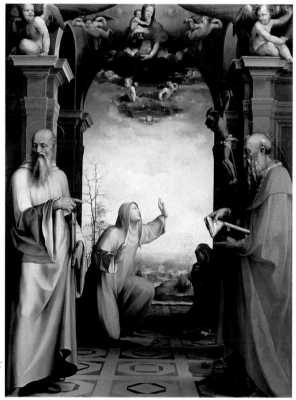

2. Domenico Beccafumi: *Stigmatization of St Catherine with SS Benedict and Jerome*, tempera and oil on panel, 2.12×1.62 m, 1514–15 (Siena, Pinacoteca Nazionale)

PLATE X

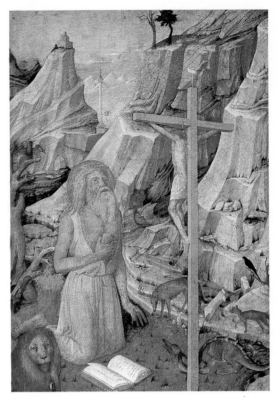 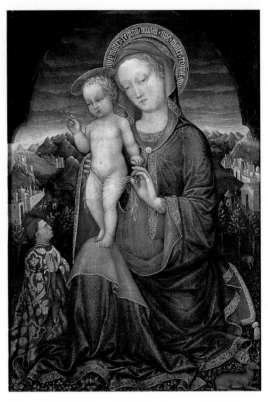

1. Jacopo Bellini: *St Jerome*, tempera on panel, 960×640 mm, *c.* 1440 (Verona, Musei Civici di Verona)

2. Jacopo Bellini: *Madonna of Humility*, oil on panel, 602×401 mm, *c.* 1430 (Paris, Musée du Louvre)

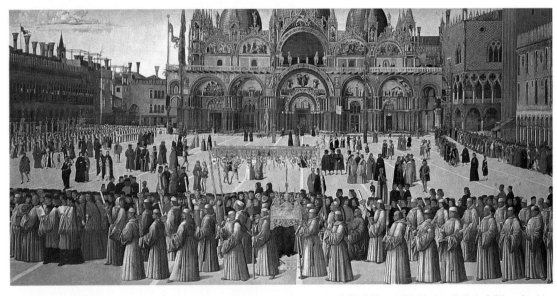

3. Gentile Bellini: *Procession of the True Cross in the Piazza S Marco*, tempera on canvas, 3.67×7.45 m, 1496 (Venice, Galleria dell'Accademia)

PLATE XI

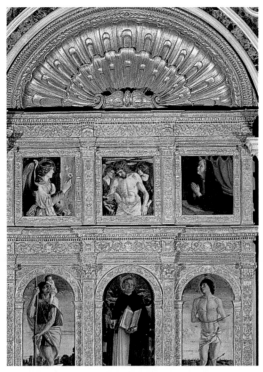

1. Giovanni Bellini: *St Vincent Ferrer* polyptych, tempera on panel, 720×670 mm, *c.* 1464–8 (Venice, SS Giovanni e Paolo)

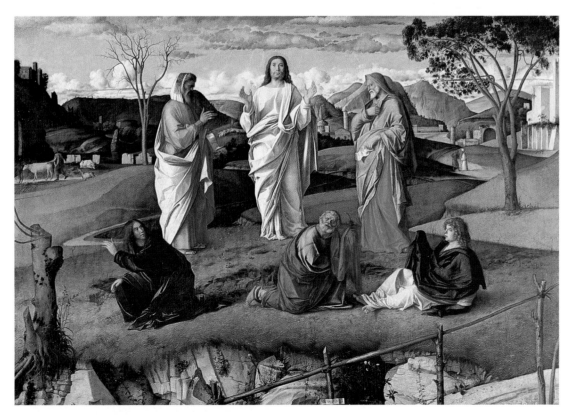

2. Giovanni Bellini: *Transfiguration*, oil on panel, 1.15×1.54 m, *c.* 1478–9 (Naples, Museo e Gallerie Nazionali di Capodimonte)

PLATE XII

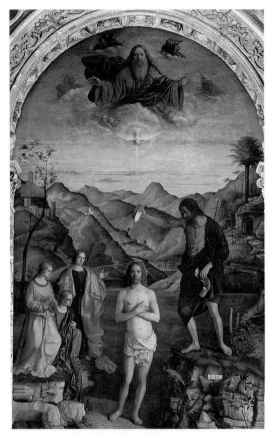

1. Giovanni Bellini: *Baptism of Christ*, oil on canvas, 4.00×2.63 m, *c.* 1502 (Vicenza, S Corona)

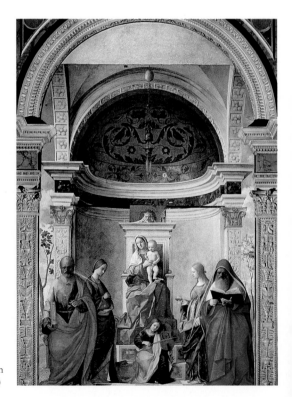

2. Giovanni Bellini: *Virgin and Child Enthroned with Four Saints*, oil on panel, transferred to canvas, 4.02×2.73 m, 1505 (Venice, S Zaccaria)

PLATE XIII

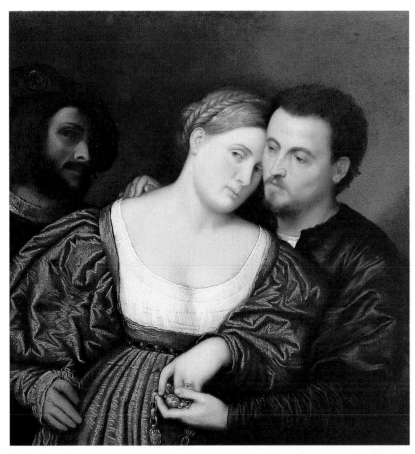

1. Paris Bordone: *The Lovers*, oil on canvas, 800×950 mm, early 1520s (Milan, Pinacoteca di Brera)

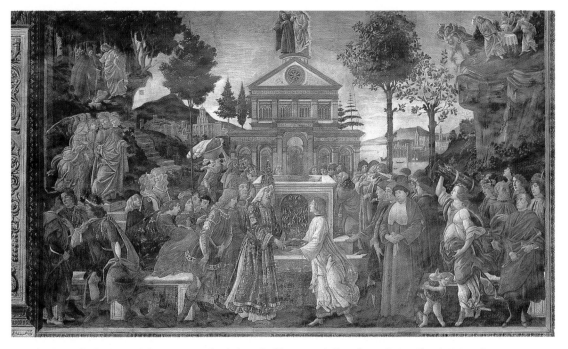

2. Sandro Botticelli: *Purification of the Leper* (1482; detail) from the *Temptations of Christ*, fresco, Sistine Chapel, Vatican, Rome

PLATE XIV

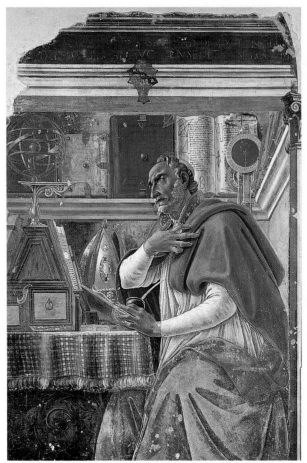

1. Sandro Botticelli: *St Augustine's Vision of the Death of St Jerome* (1480), fresco, church of the Ognissanti, Florence

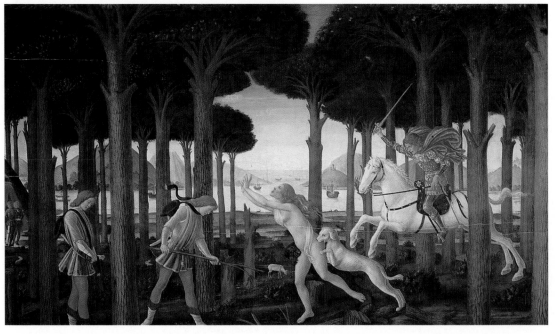

2. Sandro Botticelli: *spalliera* panel with the *Story of Nastagio degli Onesti*, oil on panel, 830×1380 mm, 1483 (Madrid, Museo del Prado)

PLATE XV

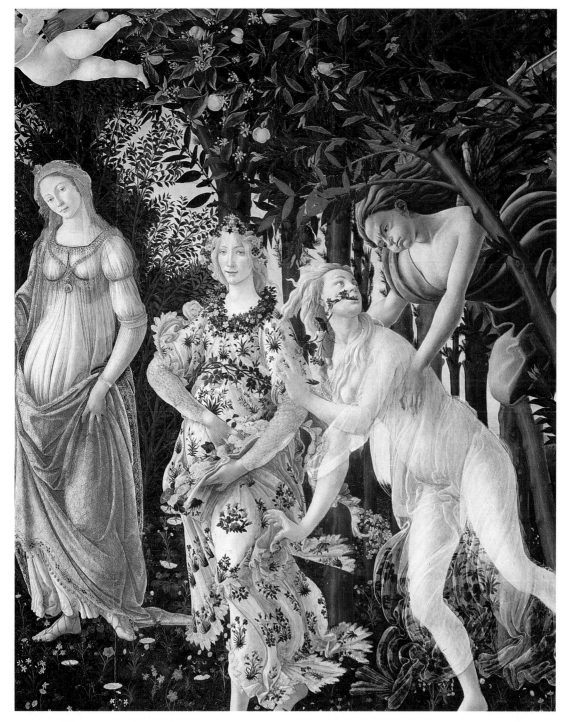

1. Sandro Botticelli: *Zephyr's Rape of the Nymph Chloris* (detail) from the *Primavera*, tempera on panel, 2.03×3.14 m, (whole panel), *c.* 1478 (Florence, Galleria degli Uffizi)

PLATE XVI

1. Donato Bramante: Cortile del Belvedere, Vatican, Rome, *c.* 1505

2. Filippo Brunelleschi: Ospedale degli Innocenti, Piazza SS Annunziata, Florence, begun *c.* 1419

PLATE XVII

1. Bramantino: *Adoration of the Shepherds*, tempera on panel, 860×850 mm, *c.* 1500, (Milan, Pinacoteca Ambrosiana)

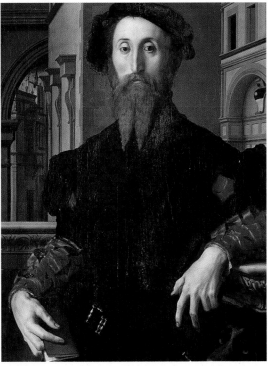

2. Agnolo Bronzino: *Andrea Doria as Neptune*, oil on canvas, 1150×530 mm, *c.* 1533 (Milan, Pinacoteca di Brera)

3. Agnolo Bronzino: *Bartolomeo Panciatichi*, oil and tempera on panel, 1040×850 mm, *c.* 1540 (Florence, Galleria degli Uffizi)

PLATE XVIII

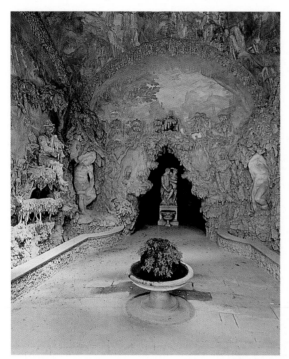

1. Bernardo Buontalenti: interior (from 1583) of the great grotto, Boboli Gardens, Florence

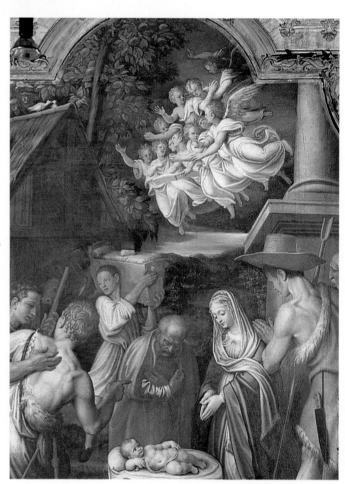

3. Antonio Campi: *Adoration of the Shepherds*, oil on canvas, 3.40×2.80 m, 1580 (Milan, S Paolo Converso)

PLATE XIX

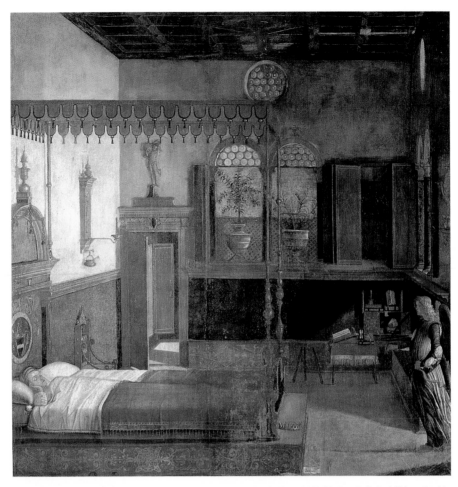

1. Vittore Carpaccio: *Dream of St Ursula*, tempera on canvas, 2.74×2.67 m, 1465 (Venice, Galleria dell'Accademia)

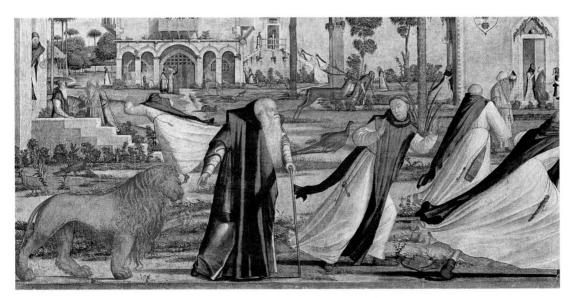

2. Vittore Carpaccio:: *St Jerome Leading the Lion into the Monastery*, oil on canvas, 1.41×1.21 m 1502–*c*.1508 (Venice, Scuola di S Giorgio degli Schiavoni)

PLATE XX

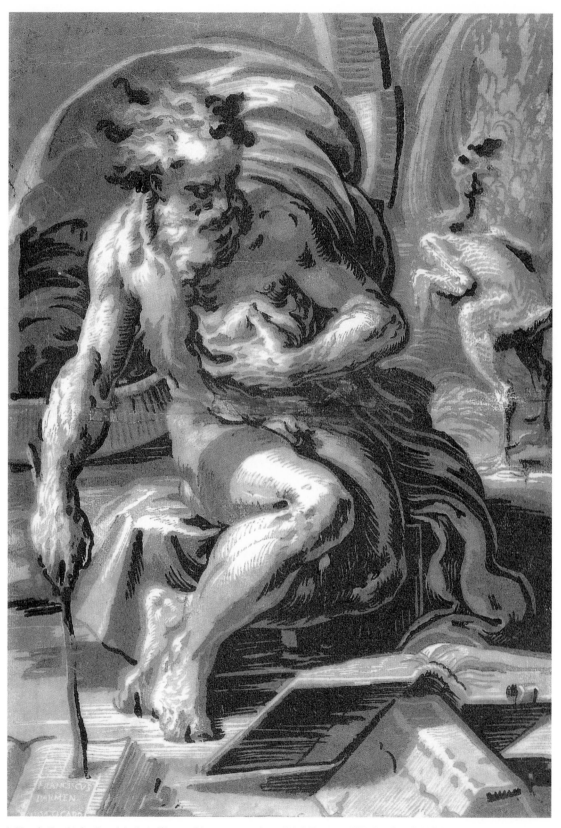

1. Ugo da Carpi (after Parmigianino): *Diogenes*, chiaroscuro woodcut, 484×347 mm, *c*. 1527 (London, British Museum)

PLATE XXI

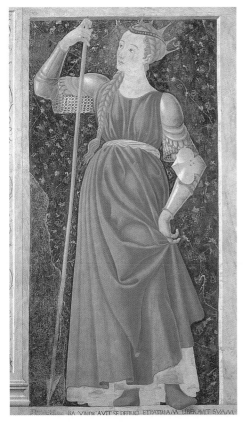

1. Andrea del Castagno: *Queen Tomyris*, fresco from the series of *Famous Men and Women*, from the Villa Carducci, Florence, 1449–51 (Florence, Galleria degli Uffizi)

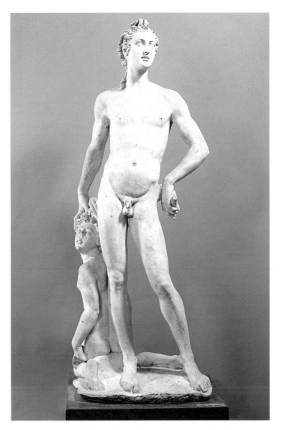

2. Benvenuto Cellini: *Apollo and Hyacinth*, marble, h. 1.91 m, 1548–57 (Florence, Museo Nazionale del Bargello)

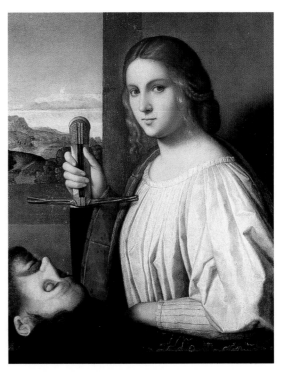

3. Vincenzo Catena: *Judith*, oil on panel, 820×650 mm, *c.* 1530 (Venice, Galleria Querini–Stampalia)

PLATE XXII

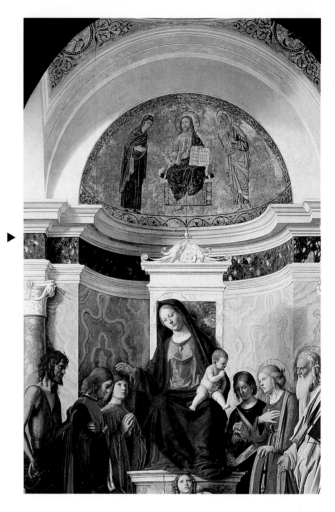

1. Cima da Conegliano: *Virgin and Child with SS John the Baptist, Cosmas, Damian, Apollonia, Catherine and John the Evangelist*, oil on panel, 2.08×1.25 m, *c.* 1506–8 (Parma, Galleria Nazionale)

2. Cima da Conegliano: *Bacchus and Ariadne*, oil on panel, 280×700 mm *c.* 1505–10 (Milan, Museo Poldi Pezzoli)

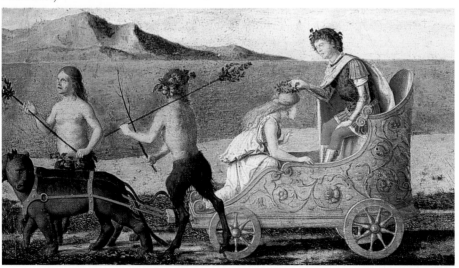

PLATE XXIII

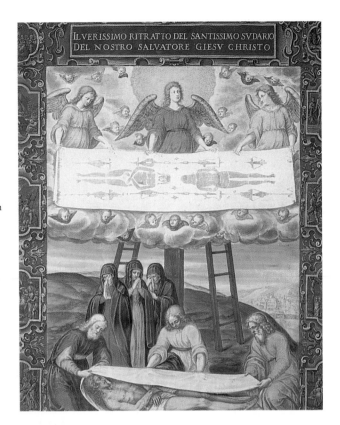

1. Giulio Clovio: *Holy Shroud*, tempera and watercolour on light canvas, 550×440 mm, (Turin, Galleria Sabauda)

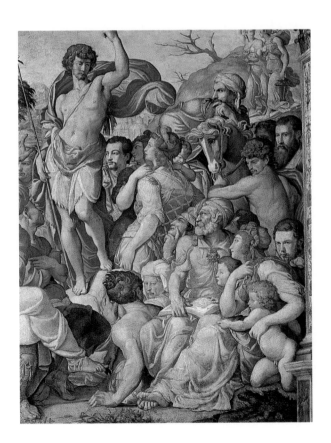

2. Jacopino del Conte: *Preaching of St John the Baptist* (1538), fresco, oratory of S Giovanni Decollato, Rome

PLATE XXIV

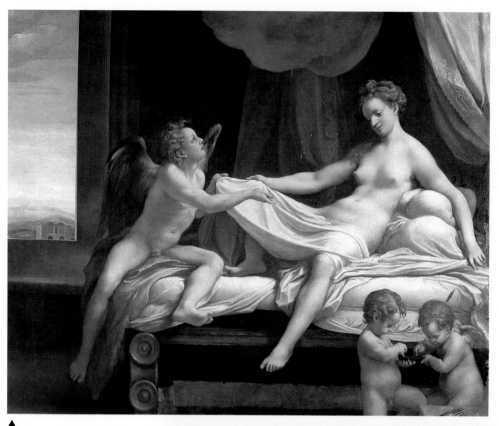

1. Correggio: *Danaë*, oil on
canvas, 1.61×1.93 m, *c.* 1532
(Rome, Galleria Borghese)

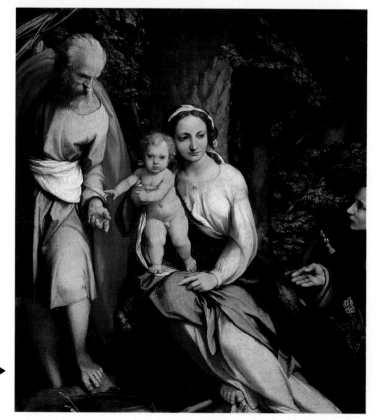

2. Correggio: *Rest on the Flight into
Egypt with St Francis*, oil on canvas,
1.23×1.06 m, 1520–21 (Florence,
Galleria degli Uffizi)

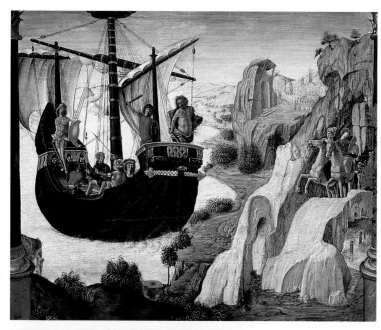

1. Lorenzo Costa (i): *The Argonauts*, tempera on panel, 470×580 mm, late 1480s (Padua, Museo Civico)

2. Francesco del Cossa: *St John the Baptist*, oil on panel, 1120×550 mm, 1473 (Milan, Pinacoteca di Brera)

3. Carlo Crivelli: *Madonna della candeletta*, tempera on panel, 2180×750 mm, early 1490s (Milan, Pinacoteca di Brera)

PLATE XXVI

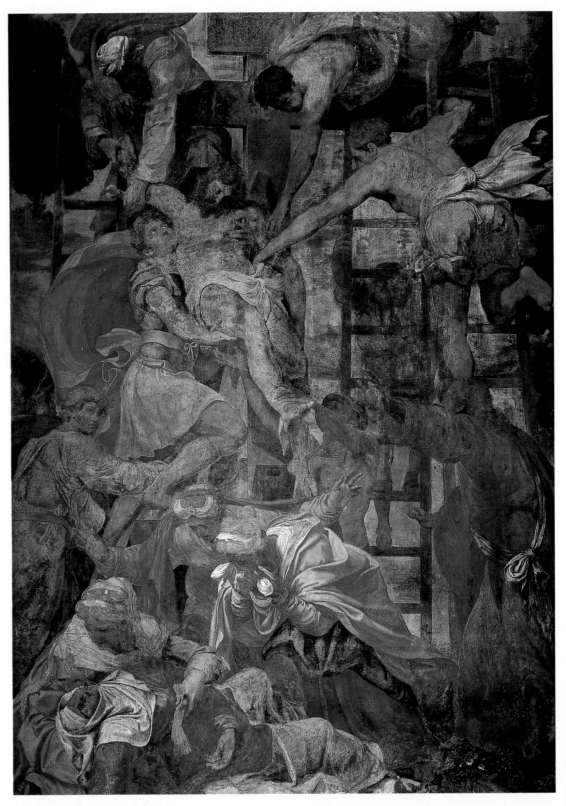

1. Daniele da Volterra: *Deposition* (*c.* 1545), fresco, Orsini Chapel, Trinità dei Monti, Rome

PLATE XXVII

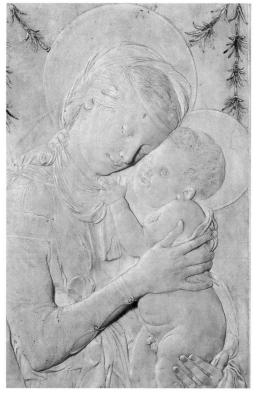

1. Vincenzo Danti: safe door for the personal quarters of Cosimo I de' Medici, bronze, 990×654 mm, 1560 (Florence, Museo Nazionale del Bargello)

2. Desiderio da Settignano: *Virgin and Child*, marble, h. 610 mm, ?late 1450s (Turin, Galleria Sabauda)

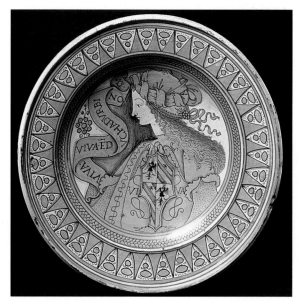

3. Deruta plate with arms of the Montefeltro family, maiolica, diam. 400 mm, before 1508 (Pesaro, Museo Ceramiche)

PLATE XXVIII

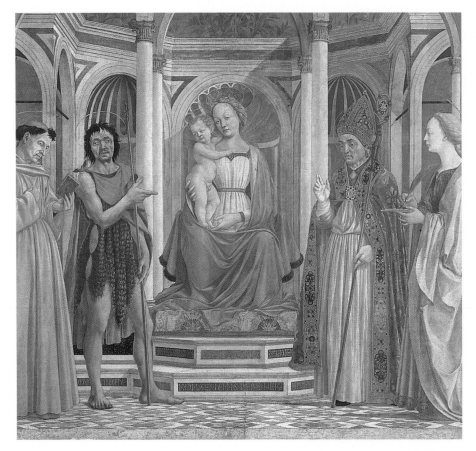

1. Domenico Veneziano: detail of the main panel of the *St Lucy* altarpiece, tempera on panel, 2.09×2.13 m (whole panel), mid-1440s (Florence, Galleria degli Uffizi)

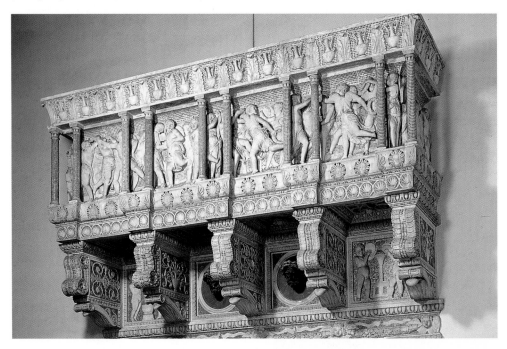

2. Donatello: *Singing Gallery (Cantoria)*, marble and mosaic inlay, 3.48×5.70 m, 1439 (Florence, Museo dell'Opera del Duomo)

PLATE XXIX

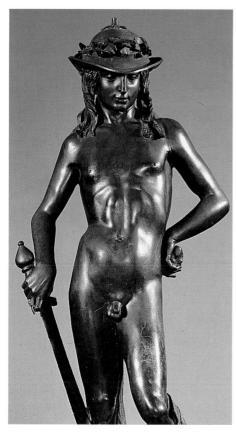

1. Donatello: *David*, bronze, h. 1.58 m, 1450s (Florence, Museo Nazionale del Bargello)

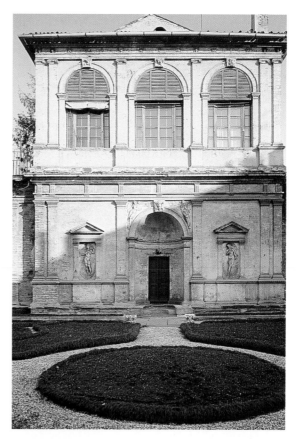

2. Giovanni Maria Falconetto: Odeo Cornaro, Padua, 1530

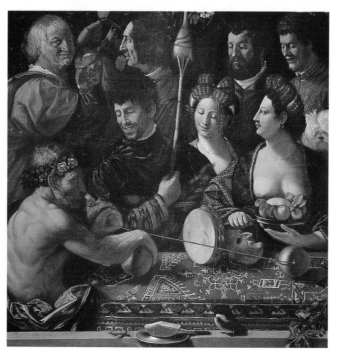

3. Dosso Dossi: *Stregoneria* ('Sorcery') or *Allegory of Hercules*, oil on canvas, 1.43×1.44 m, *c.* 1538 (Florence, Galleria degli Uffizi)

PLATE XXX

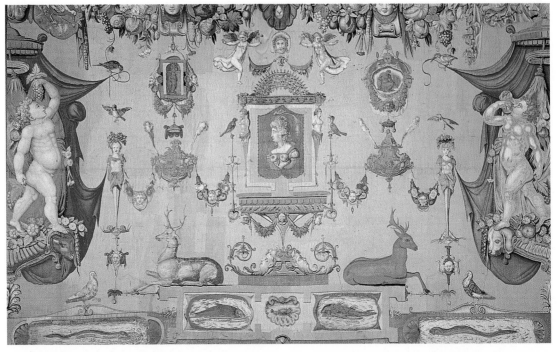

1. Florentine Arazzi tapestry with grotesques, 2.33×3.53 m (maximum dimensions), *c.* 1546–9 (Florence, Galleria degli Uffizi)

2. Orazio Fontana (workshop): maiolica dish with Raphaelesque decoration, diam. 665 mm, part of the table service made for the Duke of Urbino, 1565–71 (Florence, Museo Nazionale del Bargello)

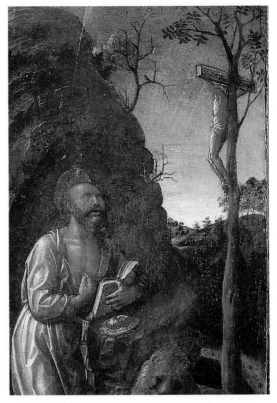

3. Vincenzo Foppa: *St Jerome*, tempera on panel, 460×310 mm, before 1460 (Bergamo, Accademia Carrara di Belle Arti)

PLATE XXXI

1. Francesco di Giorgio Martini: S Maria del Calcinaio, Cortona, begun 1485

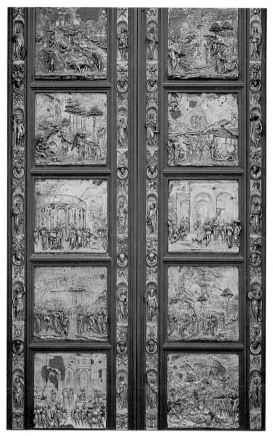

1. Lorenzo Ghiberti: *Gates of Paradise* (*c.* 1426–52), gilded bronze, Baptistery, Florence

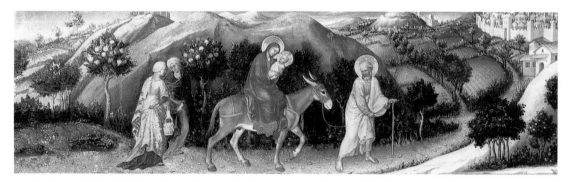

3. Gentile da Fabriano: *Flight into Egypt*, predella panel from the *Adoration of the Magi*, tempera on panel, 1.73×2.20 m, 1423 (Florence, Galleria degli Uffizi)

PLATE XXXII

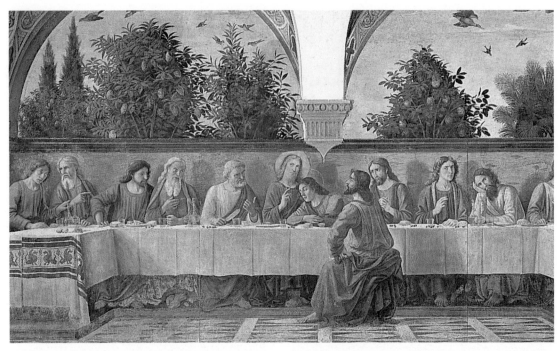

1. Domenico Ghirlandaio: *Last Supper* (1480), fresco, church of the Ognissanti, Florence

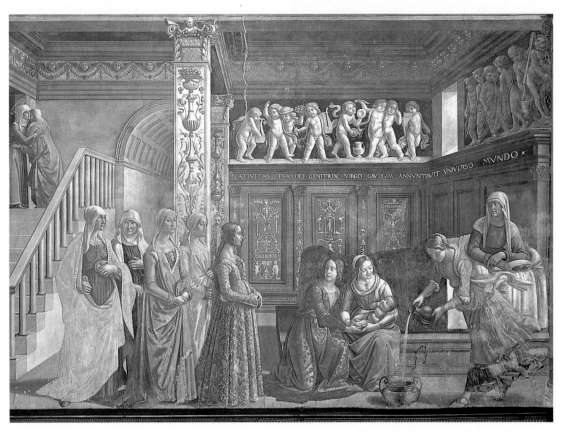

2. Domenico Ghirlandaio: *Birth of the Virgin* (1486–90), fresco, Tornabuoni Chapel, S Maria Novella, Florence

PLATE XXXIII

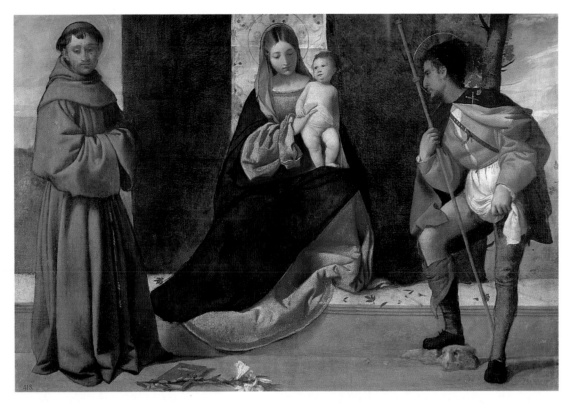

1. Giorgione (or ?Titian): *Virgin and Child with SS Roch and Anthony*, oil on canvas, 920×1330 mm, *c.* 1509 (Madrid, Museo del Prado)

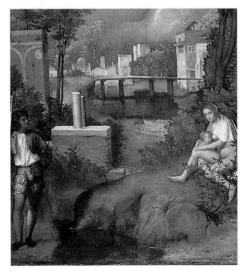

2. Giorgione: *The Tempest*, oil on canvas, 820×730 mm,
c. 1505 (Venice, Galleria dell'Accademia)

3. Giambologna: allegorical fountain of the *Apennines* (1570–80),
brick and volcanic lava, h. 11 m, Pratolino, near Florence

PLATE XXXIV

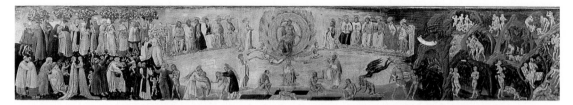

1. Giovanni di Paolo: *Last Judgement*, tempera on panel, 420×2530 mm, *c.* 1463 (Siena, Pinacoteca Nazionale)

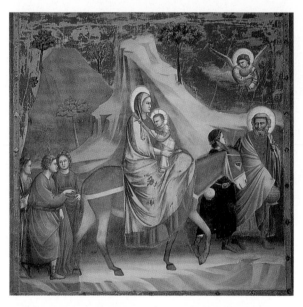

2. Giotto: *Flight into Egypt* (*c.* 1303–6), fresco, Arena Chapel, Padua

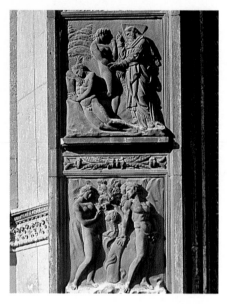

3. Jacopo della Quercia: relief panels with the story of *Adam and Eve* from the left side of the Porta Magna (1425–30), S Petronio, Bologna

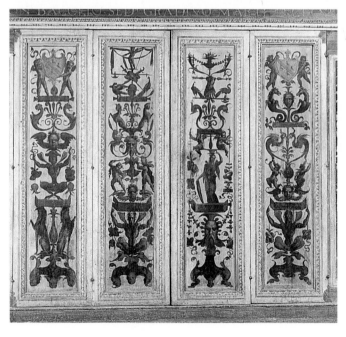

4. Italian Renaissance painted armoire, 2270×1800×580 mm, Siena, early 16th century (Florence, Palazzo Davanzati)

PLATE XXXV

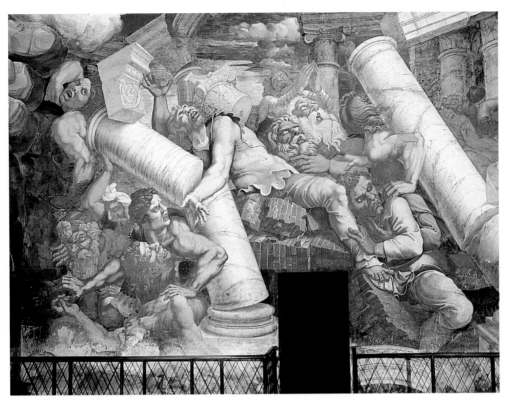

1. Guilio Romano: *Fall of the Giants*, (1532–4), fresco, Sala dei Giganti, Palazzo del Te, Mantua

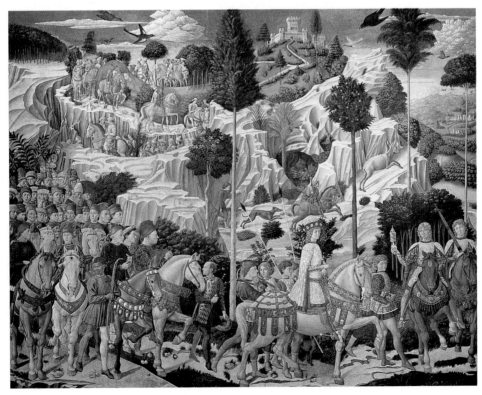

2. Benozzo Gozzoli: detail of one of the processions in the *Journey of the Magi*, (1459–61), fresco, Palazzo Medici–Riccardi, Florence

PLATE XXXVI

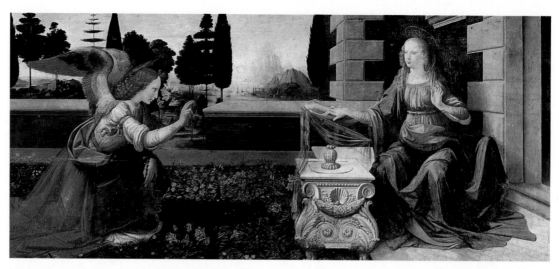

1. Leonardo da Vinci: *Annunciation*, oil and tempera on panel, 980×2170 mm, from the convent of Monte Oliveto, Florence, *c.* 1473 (Florence, Galleria degli Uffizi)

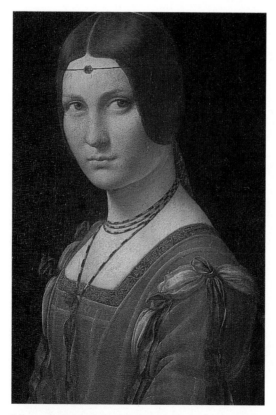

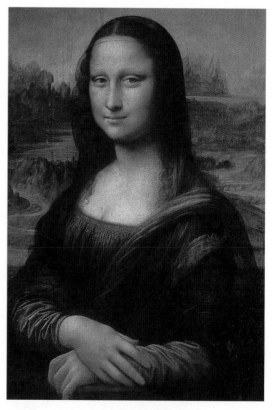

2. Leonardo da Vinci: *'La Belle Ferronnière'*, oil and tempera on panel, 630×450 mm, 1490s (Paris, Musée du Louvre)

3. Leonardo da Vinci: *'Mona Lisa'* oil and tempera on panel, 770×530 mm, *c.* 1500–03 (Paris, Musée du Louvre)

PLATE XXXVII

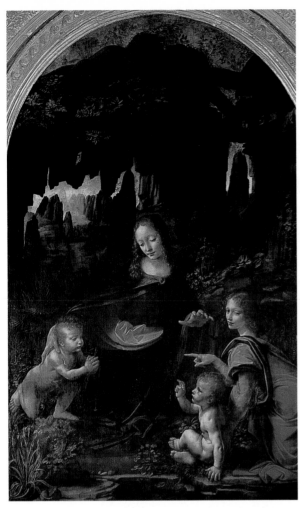

1. Leonardo da Vinci: *Virgin of the Rocks*, oil on panel, transferred to canvas, 1.97×1.20 m, begun 1483 (Paris, Musée du Louvre)

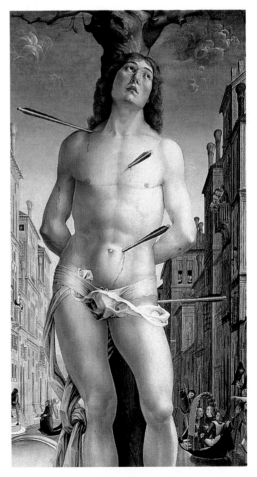

2. Liberale da Verona: *Martyrdom of St Sebastian*, panel, 1980×950 mm, late 1480s (Milan, Pinacoteca di Brera)

PLATE XXXVIII

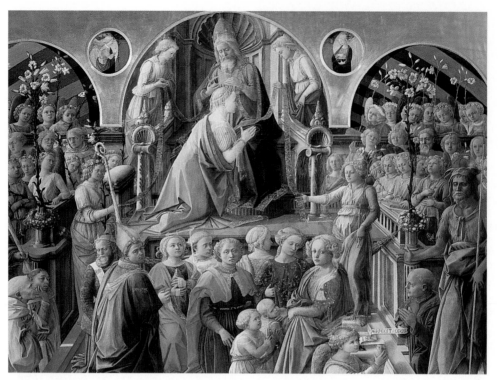

1. Filippo Lippi: *Coronation of the Virgin*, tempera on panel, 2.00×2.87 m, 1439–47 (Florence, Galleria degli Uffizi)

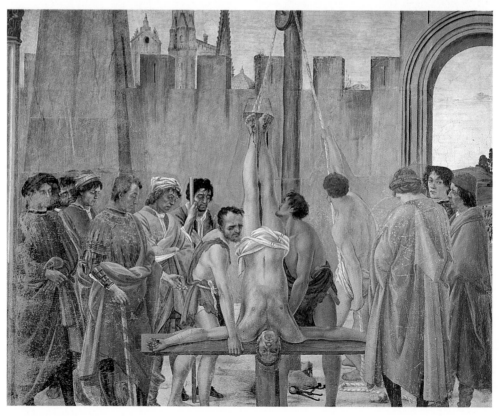

2. Filippino Lippi: *Crucifixion of St Peter* (*c.* 1485), fresco, Brancacci Chapel, S Maria del Carmine, Florence

PLATE XXXIX

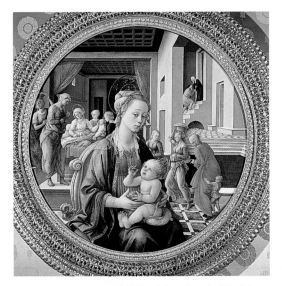

1. Filippo Lippi: *Virgin and Child with Scenes from the Life of the Virgin*, tempera on panel, diam. 1.35 m, 1452–3 (Florence, Palazzo Pitti)

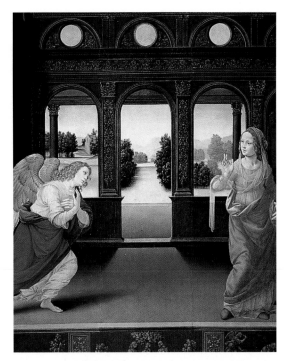

2. Lorenzo di Credi: *Annunciation*, oil on panel, 880×710 mm, late 1490s (Florence, Galleria degli Uffizi)

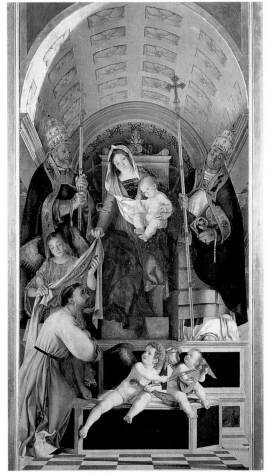

3. Lorenzo Lotto: *Virgin and Child with the Saints* (the Recanati Altarpiece), oil on panel, 2.27×1.08 m, completed 1508 (Recanati, Pinacoteca Civica)

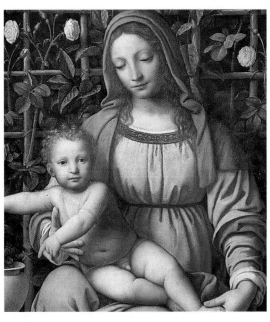

4. Bernardino Luini: *Virgin and Child of the Rose Garden*, panel, 630×700 mm (Milan, Pinacoteca di Brera)

PLATE XL

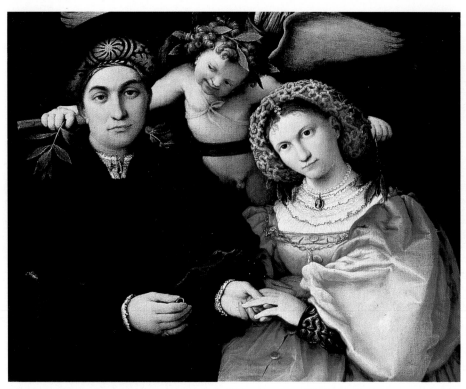

1. Lorenzo Lotto: *Messer Marsilio and his Wife*, oil on canvas, 710×840 mm, 1523 (Madrid, Museo del Prado)

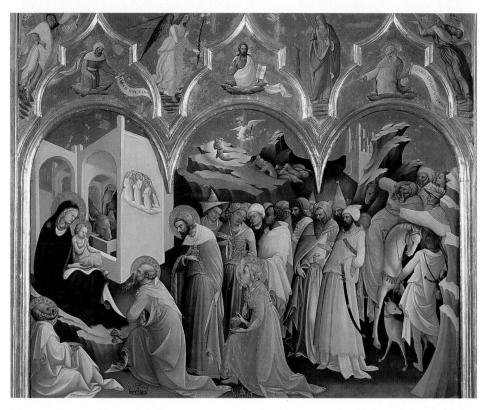

2. Lorenzo Monaco: *Adoration of the Magi*, tempera on panel, 1.15×1.70 m, early 1420s (Florence, Galleria degli Uffizi)

sculptures of the later 1540s and early 1550s, whether restorations of antique marble fragments or original works such as the bust of *Cosimo I* and the bronze relief of a *Saluki Dog* (1545–6; Florence, Bargello), were based on Classical prototypes. These prototypes were, however, translated into a Mannerist style that found its exact pictorial equivalent in the smooth forms favoured by Agnolo Bronzino.

After 1548 Cellini produced three marble statues of mythological subjects (all Florence, Bargello): the *Ganymede* (1548–50), which was constructed by adding head, arms, feet and a base with an eagle to an antique torso given to Cosimo I by Stefano Colonna (*d* 1548); the group of *Apollo and Hyacinth* (see colour pl. 1, XXI2); and the *Narcissus*, which was carved from a block of Greek marble that had been worn away by rainwater. The chronology of the *Apollo and Hyacinth* and the *Narcissus* (both original works) is unclear, but they were produced some time in the period 1548–57. They were undoubtedly inspired by Cellini's desire to prove himself in Florence as a marble sculptor and to challenge on his own ground the Duke's favourite sculptor, Bandinelli: the results are not altogether convincing. Even if the small *Ganymede* (h. *c.* 1 m) may be considered a successful re-interpretation of Jacopo Sansovino's *Bacchus* (Florence, Bargello), the (unfinished) *Apollo and Hyacinth* and the *Narcissus* cannot be included among Cellini's best works. It should, however, be remembered that the two statues were not rediscovered until 1940 (see Kriegbaum), having been exposed to the elements in the Boboli Gardens for nearly two centuries.

(ii) The 'Perseus' statue. Cellini's work in bronze is much more interesting than his work in marble, and this is clearly demonstrated by *Perseus with the Head of Medusa* (1545–53; Florence, Loggia Lanzi; see fig. 6). His posthumous fame is largely linked to this statue and to the passionate description of its casting that appears in the *Vita*; this account of its genesis makes it one of the best-documented sculptures of the Italian Renaissance. Unlike his work on a smaller scale, the *Perseus*, designed to be set up in the Piazza della Signoria between Michelangelo's *David* and Donatello's *Judith and Holofernes*, was from the outset, and remains, a public work. The ensemble consists of the figure of Perseus, standing triumphant and holding the head of Medusa aloft; the Gorgon's decapitated body lies on the base, which is raised on a marble pedestal, a kind of Mannerist reinterpretation of an antique altar. Out of the sides of the pedestal are hollowed four niches in which stand bronze statuettes of *Mercury, Danaë, Jupiter* and *Minerva*. There is also a rectangular, inset, bronze relief of *Perseus Freeing Andromeda* (all these subsidiary works now Florence, Bargello; replaced with copies). It formed part of a group of sculptures, which included the two works by Michelangelo and Donatello, as well as Bandinelli's marble group of *Hercules and Cacus* (see BANDINELLI, BACCIO, fig. 2), that were intended to symbolize Florentine civic pride. The symbolism of the *Perseus* is perhaps deliberately ambiguous: it can be taken as an *exemplum virtutis* or be read more narrowly as an emblem of the heroic leadership of Cosimo I and the beneficent protection of his government by the gods.

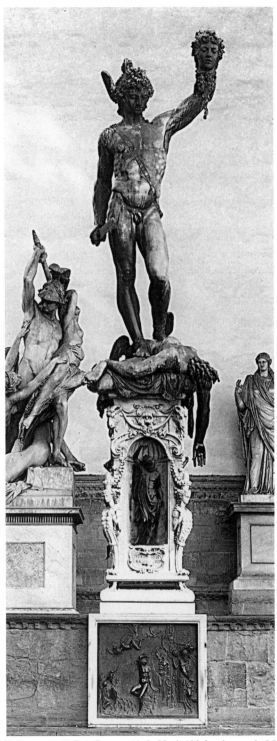

6. Benvenuto Cellini: *Perseus with the Head of Medusa*, bronze, h. 5.5 m, 1545–53 (Florence, Loggia dei Lanzi)

For Cosimo himself, the *Perseus* may also have had an additional significance as part of his selfconscious and patriotic Etruscan 'revival', since the pose of the hero bears a strong resemblance to an Etruscan bronze statuette

(*c.* 350 BC; Hamburg, Mus. Kst & Gew.). It has been argued plausibly that a bronze of this type must have been known to the Duke.

For Cellini, however, the *Perseus* represented, above all, the opportunity to show off to his colleagues his skills as a sculptor. His first large-scale works had been produced in France, and then Eleonora of Toledo had persisted in wanting to occupy him with goldsmith's work, but the commission for the *Perseus* finally gave him the chance to execute a prestigious public work with the additional advantage of it being in his own city. Cellini was well aware of the challenge that he was being invited to accept, and it is therefore not surprising that the bronze took him almost a decade to complete. He knew that the *Perseus* would have to measure up to the masterpieces of Michelangelo and Donatello, and it is not by chance that his group betrays a careful study of the great Florentine masters of the past (the influence of Leonardo and Donatello is particularly striking in the relief panel), but the opportunity to surpass Bandinelli freed him from all restraints and appealed to his sense of pride.

The wax model (Florence, Bargello) for the statue of Perseus and the body of Medusa was produced between August and October 1545, and the first payments for the erection of a workshop date from October of that year. Cellini then began a full-size plaster model of the figure of Perseus but, realizing that this method was too time-consuming, he then preferred to concentrate his efforts on the less complex figure of Medusa, which he prepared for casting by the lost-wax method. In 1546 payments for the workshop ceased since Cellini, accused of sodomy, had taken refuge for a time in Venice, where he met Jacopo Sansovino and Titian. On his return to Florence, Cellini cast the bust of *Cosimo I* and in May 1547 payments for *Perseus* resumed. During the summer the furnace was built and in June 1548 the figure of Medusa was cast in bronze. In December 1549 the figure of Perseus was cast, but it took almost four more years to clean and chase the bronze, which is signed and dated BENVENVTVS CELLINVS CIVIS FIORENT. FACIEBAT MDLIII. During these years Cellini was also working on the elaborately carved marble base with its four bronze statuettes and relief. It was originally intended to complete the group with a smaller bronze relief to be placed behind the statue, but this seems never to have got beyond the wax model (untraced), for the Duke was in a hurry to show the work to the public. The *Perseus* was transported to the Piazza in the summer of 1553 and, without having received its finishing touches, was unveiled in April the following year, provoking reactions of great enthusiasm and the writing of sonnets in its praise by Benedetto Varchi and Bronzino, among others.

5. LAST YEARS IN FLORENCE, 1553–71. The inauguration of the *Perseus* statue marked the climax of Cellini's artistic career. In the remaining 16 years of his life he completed only one important work. This chaotic period was characterized by arguments with the Medici administration over payment for works commissioned by the Duke, by his querulous petitions to Cosimo, by the birth of sons both legitimate and illegitimate and by scandals that ended in imprisonment. In 1556 he struck the

goldsmith Giovanni di Lorenzo Papi on the head and was imprisoned in the Stinche for more than two months; in February 1557 he was again charged with sodomy. Sentenced to four years' imprisonment, he was held under house arrest, and it was in these sad circumstances that he wrote his literary masterpiece, the *Vita* (*see* §III, 1 below).

During the 1550s the artistic environment in Florence underwent a radical change. Up to the time the *Perseus* was unveiled, Cellini's only serious rival had been Bandinelli, but already by 1553 Giorgio Vasari had returned to his native city and was destined to play a role of absolute dominion in the artistic field, particularly since he enjoyed the protection of Vincenzo Borghini, the influential prior of the Ospedale degli Innocenti. With the arrival in Florence of such sculptors as Bartolomeo Ammanati (1555), Giambologna (1556) and Vincenzo Danti (1557), the competition for Cellini, no longer in his prime, became unbearable.

After the success of the *Perseus*, relations with the Duke became strained. In his writings Cellini complained of Cosimo's meanness, but in reality it appears that the sculptor had appropriated a large quantity of bronze while working on the statue. For this reason Cellini was considered untrustworthy and from that moment on was relegated to the sidelines, pitied for his eccentricity and despised for his rebarbative character. During the 1560s he was nevertheless involved in several projects for Florence Cathedral: he undertook to execute reliefs for the choir, two pulpits intended to be decorated with bronze reliefs and a bronze relief of the *Creation of Adam* to be placed under the marble statue of *Adam* by Bandinelli. However, not one of these projects was completed or even taken past the model stage. Cellini's final masterpiece is thus the marble *Crucifix* (Madrid, Escorial), which was to have decorated his own tomb.

The *Crucifix* was made with the object of fulfilling a vow made by Cellini in 1539 during his imprisonment in the Castel Sant'Angelo but also as another attempt to demonstrate his mastery as a marble sculptor. In his will of 1555, it is recorded only as a small wax model. Cellini intended to translate it into marble but specified that should he die before doing so it was to be executed by the best sculptor available, on condition that this person was not a descendant or pupil of Bandinelli. It was to be placed in S Maria Novella, opposite Brunelleschi's *Crucifix*. The following year Cellini purchased the marble required for the work and, when he was imprisoned that same year, decided to undertake the carving himself with the help of Bernardino Pettirossi. In March 1557, in a petition to Cosimo, Cellini claimed that the work was almost complete and in November that year he bought the black marble to carve the cross; the figure of Christ is of white marble. The sculpture was not finally completed until 1562, the date carved as part of the inscription at the feet of Christ. At some point difficulties in finding a home for Cellini's tomb and a pressing need for money led him first to try to sell it and later to present it as a 'gift', for which he sent in a bill, to Cosimo I. Inevitably the matter of the *Crucifix* became confused with the other unconcluded business between the artist and the Duke—the payment of the balance for the portrait bust and the *Perseus*, and the gift (1561) of the house in which Cellini had lived since his

return to Florence. After laborious negotiations, Cosimo finally had the statue taken to the Palazzo Pitti in August 1565, although final payment was not made for the work until 1570. Five years after the artist's death, however, Grand Duke Francesco I de' Medici presented it to Philip II of Spain (*reg* 1556–98), who installed it in the monastery of S Lorenzo el Real in the Escorial, where it was rediscovered by Plon in 1882.

According to the *Vita*, while Cellini was completing the *Crucifix* he persuaded Cosimo I to organize a competition to prevent Bandinelli receiving the commission for the *Fountain of Neptune* in the Piazza della Signoria. It is more likely that the Duke yielded to similar pressure from Vasari. The hated Bandinelli died in 1560, and the fountain commission was passed to Ammanati, not to Cellini. The latter's models, including a full-size one, are untraced, but an anonymous small bronze statuette (Raleigh, NC Mus. A.) in all probability records his *Neptune* design.

At this point, Cellini's artistic career can be considered at an end. In 1564 he fell out with the organizers of Michelangelo's funeral over the lack of prominence given to sculpture in the complex programme of the ceremony, and during the 1560s he made a series of drawings (London, BM; Munich, Staatl. Graph. Samml.; Paris, Louvre) for the seal of the newly founded Accademia del Disegno. Cellini's known corpus of drawings comprises little over ten sheets: in addition to those already mentioned there are two drawings of nudes (Berlin, Altes Mus.) and one of the *Narcissus* in the Codex Resta (Milan, Ambrosiana). (The attributions proposed by Alexander Perrig in his book on Michelangelo are not convincing.) The 1560s were thus interspersed with abortive projects and sterile academic discussions concerning the relationship between painting and sculpture. Yet even this final phase of Cellini's career was not entirely unfruitful—in 1565 he began to write the treatises on goldsmithing and on sculpture that were printed at his own expense in 1568 with a dedication to Cardinal Ferdinando de' Medici (*see* §III, 2 below). His private life continued to be restless: in 1558, amid disputes and criminal proceedings, he received his first religious orders, only to renounce them two years later; in 1562 he married his housekeeper, the mother of some of his many children; and finally in 1568 he set up in business with the goldsmiths Antonio and Guido Gregori, an enterprise that proved profitable in many ways and helped to finance his passion for gambling.

In December 1570 Cellini made a will expressing the desire to be buried in SS Annunziata, and on 3 February 1571 he added a codicil leaving all the statues still in his workshop to Prince Francesco de' Medici, a decision that was a recognition of the new potential of private collections to transmit the artist's reputation to posterity.

II. Working methods and technique.

Like all great artists, Cellini was an inventor of new techniques of which—as can be seen from the autobiography and the treatises on goldsmithing and sculpture—he was particularly proud. After a lengthy training in the techniques of goldsmithing in a succession of workshops, he turned his skills to perfecting the production of dies for coins and medals. Some of Cellini's comments in the *Vita* may be the fruit of excessive arrogance, yet those on his own inventions are usually trustworthy: for example he correctly claimed to have been the first to reproduce a head on a coin in a foreshortened frontal view instead of the customary and simpler profile view. His talent was not, however, limited to purely formal innovations: when he made the medals for Clement VII, Cellini experimented with a mechanical method of impression (*Trattato dell'oreficeria*, xvii) that allowed him to strike numerous examples in brass without the image losing its original precision. As most of his goldsmith's work was destroyed, it is difficult to define his contribution to this field; nevertheless, his treatises are the principal source of information on the technical methods employed by the goldsmiths and sculptors of his time.

Cellini's contribution to the technique of bronze-casting was considerable, since the realization of the *Perseus* statue presented numerous technical problems due to its size and the exuberant richness of detail. These problems were resolved by adding a certain amount of tin to the bronze in order to render the alloy more fluid. Such a complex work required lengthy preparation: in the *Vita*, Cellini mentioned only one wax model, which is usually identified with the one (h. *c.* 700 mm) now in the Bargello, Florence, but the study of various compositions must have led him to take more than one of them to the model stage. After the relatively swift preparation of the definitive model, the original idea may have been further refined in a small bronze version (Florence, Bargello). However, this model is not recorded in Cellini's writings, and it is unclear what part the rare bronze statuettes by him played in his creative process—they may constitute, rather, a 'record' executed either during or immediately after the creation of the work itself. These preliminaries served to prepare a large model in plaster supported by an iron armature, an operation that occupied Cellini for more than a year. This system, however, proved ineffective and he decided to make a full-size model in clay and to follow more traditional methods, which were to be severely tested by the size of the intended cast. In the *Trattati*, Cellini gave a detailed description of the successive stages in the production of a bronze statue by the lost-wax method, but in the *Vita* he insisted on the fact that the method he followed 'was very different' to that employed 'by all other masters of the profession'. His account of the lengthy process of chasing and finishing a large bronze, a procedure that could last for several months or sometimes even years, highlights the complexity of sculptural production and the need for a large, organized workshop. Many pages of the *Vita* are dedicated to his assistants, and all Cellini's important works required a high degree of collaboration. Among his many assistants at various stages in his career were Ascanio de' Mari (1524–*c.* 1566) and Paolo Romano (*d* after 1552), who accompanied him on his second visit to France, Bernardino Mannellini, his principal assistant on the *Perseus* project, Battista di Domenico Lorenzi and Stoldo di Gino Lorenzi, the brothers Giampolo and Domenico Poggini and Francesco del Tadda, a pupil of Giovanni Angelo Montorsoli.

III. Writings.

1. THE 'VITA'. The fullest account of Cellini's remarkable career is presented through the filter of his own memory in an autobiography, the linguistic aspects of which are as audacious as many of the events of the sculptor's life. The *Vita di Benvenuto Cellini* has attracted an enthusiastic response from many generations of readers, even at times (as in the 18th and 19th centuries) when Cellini's art was neglected because Mannerism was regarded as degenerate.

The *Vita* was begun in 1558, or possibly in the previous year when Cellini was under house arrest. Although it was the result of his involuntary inactivity and the bitter experiences of his later years, Cellini nevertheless ennobled his memoirs by calling on the humanist belief that whoever had led an exceptional life should leave a record of it for posterity: he intended that the autobiography should act both as an *apologia* and as a further demonstration of his qualities as a universal man. As his relationship with Cosimo I grew increasingly tense, it became clear that the book would not be accepted for publication in his lifetime. The manuscript, largely dictated to an assistant, Michele di Goro Vestri, while Cellini worked on the *Crucifix*, was still incomplete in 1562, after which Cellini continued to work on it only spasmodically until 1566–7.

It has been claimed that the *Vita* should be classified as a novel. From the point of view of literary criticism, this judgement has something to offer. However, although Cellini's autobiography is selective and tendentious in its clever reconstruction of events (for example the numerous pro-Medici episodes with which the work is studded are told with one eye on the court of Cosimo I), it nevertheless remains a largely truthful document. Wherever it has been possible to test the events related in the *Vita* against other sources, Cellini's account has been verified. Indeed, in several cases, such as the sculptor's interrogation in the Castel Sant'Angelo in 1538, official documents confirm that he recorded even the tone of the conversations faithfully. Other passages, however, reveal that Cellini did not always heed the chronological sequence of events. For example in the section relating a discussion with Cosimo I, who had questioned the feasibility of casting the *Perseus* in bronze—a lively exchange that took place before 1549—Cellini's claimed answer is that, despite the Duke's scepticism, he had completed without problems the bronze portrait bust 'which has been sent to Elba'; yet Cosimo's portrait was not sent to Portoferraio until 1557, eight years after the supposed discussion.

The *Vita* should be read in the context of the tradition of biography and autobiography that is a feature of Italian humanism and a deeply rooted Florentine tradition, especially among artists. Yet the value and the particular success of Cellini's work are due primarily to the originality and immediacy of his style—the abundance of adjectives, the creation of neologisms, the concrete nature of his language and, above all, the facility for dialogue. Beyond its formal qualities and its engaging presentation of romanticized episodes, the *Vita* is also pleasing for its stylistic and thematic variety. The recurring subjects are numerous——man's relationship with nature and animals, passion, eroticism and family affections, the comedy of everyday events. Within this rich framework, there are two themes of particular importance: the oneiric and the erotic. The oneiric thread (dreams, visions, hallucinations and premonitions) gives the *Vita* a surprisingly modern aspect. The central theme of the *Vita* is, however, the concept of merit (*virtù*) triumphant over the blows dealt by fortune, a Renaissance *topos* that lends unity to Cellini's fragmentary text: the work is constructed on an all-pervading contrast—on the one hand the lively background of 16th-century society, peopled with characters who represent the antithesis of merit, and, on the other, the gigantic personality of Cellini himself. In comparing himself with this society, he nearly always emerges victor because, according to the words that he put in the mouth of Pope Paul III, 'men who are unique in their profession, like Benvenuto, should not be subject to the law'.

Among Cellini's contemporaries, Vasari, and consequently the entire Medici circle, were aware of the existence of his manuscript, but only a small élite, including Benedetto Varchi, had the privilege of reading it. Later the manuscript was believed lost, although several copies had been made during the 17th century. It enjoyed a limited circulation in manuscript copies among a few scholars, including Filippo Baldinucci, until Antonio Cocchi's edition (with a dedication to Richard Boyle, 3rd Earl of Burlington), was finally printed in Naples and published in Cologne in 1728. This edition was, however, based on an inaccurate transcription of the original manuscript. The first translation into English (1771), by Thomas Nugent, is from Cocchi; Goethe, in turn, based his German translation (1798) on Nugent. The original manuscript (Florence, Bib. Medicea–Laurenziana, Cod. Mediceo–Palatino 234.2) was rediscovered in 1805 and formed the basis of Francesco Tassi's fundamental edition (Florence, 1829). In the edition prepared by Brunone Bianchi (Florence, 1852), the *Vita* was subdivided for the first time into two parts and numerous chapters, an extremely rational structure and one that is familiar to the modern reader, but which does not reflect the form of the original manuscript. The most complete and erudite critical edition of the autobiography is that of Orazio Bacci (Florence, 1901).

2. THE 'TRATTATI' AND OTHER WRITINGS. One of the objectives of the *Vita* was to win back the trust of the court in order to gain further commissions from the Medici. Cellini stopped work on it between the end of 1566 and the beginning of the following year, probably because he hoped to have more success with a different type of publication. In 1565 he had begun the *Trattato dell'oreficeria* and the *Trattato della scultura*, presenting a combined manuscript copy of these to Francesco de' Medici on the occasion of his marriage that year. The two treatises, after having been revised and partially censored, in all probability by Gherardo Spini, a member of the Florentine Accademia, were published in Florence in 1568. In the printed version Cellini understandably suppressed passages likely to provoke Cosimo de' Medici, and his colourful, colloquial language was transformed into an academic literary style. In other words, the *Trattati* were purged of their polemic and autobiographical aspects and presented as a text of rules and recipes. The original

manuscript (Venice, Bib. N. Marciana) was rediscovered in 1776, but it was not until 1857 that Carlo Milanesi's reconstruction of the first version was published. The *Trattati* are, after the *Vita*, the most important source for information about technical aspects of Cellini's work.

In addition to the *Vita* and the *Trattati*, Cellini left a number of other writings on art—*Sopra l'arte del disegno*, *Della architettura*, *Sopra la differenza nata tra gli scultori e' pittori circa il luogo destro stato dato alla pittura nelle essequie del gran Michelagnolo Buonarroti* and the fragmentary *Sopra i principi e l' modo d'imparare l'arte del disegno*—as well as letters and 142 poems of mediocre quality, some on homosexual themes. These are published in the collected edition of Cellini's literary works by Maier (1968) and Ferrero (1971).

IV. Character and personality.

The *Vita* provides abundant information on Cellini's character and personality. He was a violent and quick-tempered man—one who, indeed, committed several murders—yet he was capable of tender affection for his family and displays of generosity towards his friends. Although he was self-centred and vain, he was a truly independent spirit, unconcerned with any kind of courtly behaviour. He has been widely stereotyped as an impenitent sodomite, and he was subjected to imprisonment several times as a result of his homosexual passions; yet the *Vita* also provides evidence of his frequent heterosexual relationships, although these sometimes tended towards the sadistic. In assessing his personality, care must be taken to avoid judgement on the basis of different moral standards: in the early decades of the 16th century bisexuality was a common phenomenon, while such crimes as theft or bankruptcy were severely punished, on occasion with heavier sentences than those inflicted on a murderer who could often claim to have acted out of honour.

The autobiography also provides information about Cellini's somewhat predictable reading matter, including the Bible (in Italian), Dante's *Divine Comedy*, Villani's *Chronicle*, the sermons of Savonarola and Vitruvius' *De architectura*. This list would have been familiar reading to a large number of middle-class Florentines, but Cellini probably drew his intellectual stimulus from the constant company he kept with the most important literary men of his time, including Benedetto Varchi, Pietro Bembo, Annibal Caro and Luigi Alamanni.

An important aspect of Cellini's personality, and one that has received little attention, was his love of collecting. The *Vita* describes antique cameos excavated in Rome and 'a book written in pen, copied from a work of the great Leonardo da Vinci' (for which he paid 15 gold scudi), comprising a treatise on sculpture, painting and architecture, as well as an essay on perspective. Yet the most surprising piece of information about Cellini's acquisitions is from Vasari, whose *Vita* of Michelangelo describes how 'pieces of the cartoons from the [Sistine] chapel, of the *ignudi* and the prophets, [were] brought [to Florence] by Benvenuto Cellini' (vii, p. 203).

V. Critical reception and posthumous reputation.

After the praise Cellini received from Vasari (2/1568), who described him as 'proud . . .most awesome . . .a person who unfortunately spoke his mind with his rulers', his fame depended for almost two centuries on the statue of *Perseus*, which is, in a sense, his only public work. Only some 50 years after the publication of the *Vita* (1728) was interest in his life and work revived. It is not difficult to understand this considering the misfortunes that befell his works: Cosimo I sent his own portrait bust to Portoferraio on the island of Elba, where it remained until 1781; the bust of *Bindo Altoviti* remained out of sight in the loggia of the family palace in Rome until the end of the 19th century; the salt of Francis I was not identified as Cellini's work until 1819; the *Nymph of Fontainebleau* was reattributed to Cellini by Cicognara in 1824, the Escorial *Crucifix* was traced by Plon in 1882 and finally the statues of *Apollo* and *Narcissus* were rediscovered in the Boboli Gardens as late as 1940. Thus Cellini's oeuvre was practically unknown between the 16th century and the 19th.

The change in critical attitudes towards Cellini began with the publication of the *Vita* in 1728 and by the essays in praise of it by Giuseppe Baretti in *La frusta letteraria* (Nov 1763–Jan 1764). From that moment on, his adventurous life was elevated to the level of myth. Cellini's paradigmatic status as representative Renaissance man and his hold on the Romantic imagination are reflected in Hector Berlioz's opera *Benvenuto Cellini* (1838). Inevitably, during the 19th century, commercial interests took advantage of this myth and the catalogue of Cellini's goldsmith's work grew progressively larger. However, during the second half of the century there was a serious attempt at rationalization: while some scholars pursued archival research in order to verify the accuracy of the facts related in the *Vita* (for example the numerous contributions by Bertolotti), others began to organize the catalogue. The inventories of Renaissance coins and medals by Armand (1879) and Heiss (1892) began to throw light on this area of the artist's activity; further important contributions were made by Hill (1911, 1917) and Pollard (1967, 1985). Plon's scrupulous and monumental monograph (1883), which gives an account of Cellini's career through an integration of the *Vita* with archival documents and also provides a *catalogue raisonné*, remains an indispensable tool. In 1901 Bacci published his impeccable critical edition of the *Vita*, and in 1907 Churchill compiled a bibliography that includes 234 titles. The renewed interest in Mannerist art in the second half of the 20th century was responsible not only for further scholarly publications, such as those of Calamandrei and Pope-Hennessy, but for a full appreciation among a wide public of Cellini's stature as an artist.

WRITINGS

'Vita'

A few pages of the original MS. (c. 1558–67; Florence, Bib. Medicea–Laurenziana, Cod. Mediceo-Palatino 234.2) are in Cellini's hand and a few others by an unidentified scribe; the rest was dictated to Michele di Goro Vestri. Since its first publication (1728) there have been many Italian editions, of which the most reliable are those of Bacci (1901) and Cordié (1960). The text has also been translated into many languages; the following selective list is focused on those into English.

A. Cocchi, ed.: *Vita di Benvenuto Cellini orefice e scultore fiorentino da lui medesimo scritta* (Cologne, 1728)

T. Nugent, trans.: *The Life of Benvenuto Cellini*, 2 vols (London, 1771)

J. W. von Goethe, trans.: *Benvenuto Cellini: Eine Geschichte des XVI. Jahrhunderts nach dem Italienischen*, 3 vols (Brunswick, 1798)

F. Tassi, ed.: *Vita di Benvenuto Cellini orefice e scultore fiorentino scritta di lui medesimo, restituita alla lezione originale sul manoscritto Poirot ora Laurenziano ed arrichita d'illustrazioni e documenti inediti*, 3 vols (Florence, 1829)

B. Bianchi, ed.: *La Vita* (Florence, 1852, rev. 2/1886)

J. A. Symonds, trans.: *The Life of Benvenuto Cellini*, 2 vols (London, 1887/R); abridged C. Hope and A. Nova as *The Autobiography of Benvenuto Cellini* (Oxford, 1983) [with notes and illus.]

O. Bacci, ed.: *Vita di Benvenuto Cellini: Testo critico con introduzione e note storiche* (Florence, 1901) [with a crit. list of earlier printed edns]

'trattati' and miscellaneous writings

The original MSS of the *Trattato dell'oreficeria* and the *Trattato della scultura* (both begun 1565; Venice, Bib. N. Marciana) were first published in 1568 in a revised version. The edition by Milanesi (1857) restores the original texts.

Due trattati, uno intorno alle otto principali arti dell'oreficeria, l'altro in materia dell'arte della scultura; dove si veggono infiniti segreti nel lavorar le figure di marmo, e nel gettarle di bronzo, Composti da M. Benvenuto Cellini, scultore fiorentino (Florence, 1568)

Due trattati di Benvenuto Cellini, scultore fiorentino, uno dell'oreficeria, l'altro della scultura (Florence, 1731)

C. Milanesi, ed.: *I trattati dell'oreficeria e della scultura di Benvenuto Cellini* (Florence, 1857, rev. 2/1893) [the standard edn; also includes Cellini's notes, letters and petitions, and the sonnets written by others to celebrate the inauguration of the *Perseus* statue]

C. R. Ashbee, trans.: *The Treatises of Benvenuto Cellini on Goldsmithing and Sculpture* (London, 1888/R New York, 1967)

collected editions

C. Cordié, ed.: *Opere di Baldassare Castiglione, Giovanni Della Casa, Benvenuto Cellini* (Milan and Naples, 1960) [*Vita, Trattati* and essays]

B. Maier, ed.: *Benvenuto Cellini: Opere* (Milan, 1968) [the most satisfactory collected edn of the *Vita, Trattati*, essays and poems]

G. G. Ferrero, ed.: *Opere di Benvenuto Cellini* (Turin, 1971, rev. 2/1980)

BIBLIOGRAPHY

DOCUMENTARY AND BIBLIOGRAPHICAL SOURCES

G. Vasari: *Vite* (1550, rev. 2/1568); ed. G. Milanesi (1878–85), vii, pp. 621–3

S. J. A. Churchill: 'Bibliografia celliniana', *La Bibliofilia*, ix (1907), pp. 173–7, 262–9

D. Heikamp: 'Nuovi documenti celliniani', *Riv. A.*, xxxiii (1958), pp. 36–8

P. Calamandrei: *Scritti e inediti celliniani*, ed. C. Cordié (Florence, 1971)

I. Lavin: 'The Sculptor's Last Will and Testament', *Allen Mem. A. Mus. Bull.*, xxxv/1–2 (1977–8), pp. 4–39

D. Weinstein: 'Benvenuto Cellini: Inediti', *Riv. A.*, vi (1990), pp. 213–25

See also 1984 exh. cat. below.

GENERAL

D. Heikamp: 'Rapporti fra accademici ed artisti nella Firenze del '500', *Il Vasari*, xv (1957), pp. 139–63

P. Barocchi, ed.: *Trattati d'arte del cinquecento*, 3 vols (Milan and Naples, 1960–62)

R. Wittkower and M. Wittkower: *Born under Saturn: The Character and Conduct of Artists: A Documented Study from Antiquity to the French Revolution* (New York, 1963)

K. W. Forster: 'Metaphors of Rule: Political Ideology and History in the Portraits of Cosimo I de' Medici', *Mitt. Ksthist. Inst. Florenz*, xv (1971), pp. 65–104

C. Dempsey: 'Some Observations on the Education of Artists in Florence and Bologna during the Later Sixteenth Century', *A. Bull.*, lii (1980), pp. 552–69

Palazzo Vecchio: Committenza e collezionismo medicei: Firenze e la Toscana dei Medici nell'Europa del cinquecento (exh. cat., ed. P. Barocchi; Florence, Pal. Vecchio, 1980)

Giorgio Vasari: Principi, letterati e artisti nelle carte di Giorgio Vasari (exh. cat. by L. Corti and others, Arezzo, Mus. Casa Vasari, 1981)

P. Barocchi: 'La storia della Galleria degli Uffizi e la storiografia artistica', *An. Scu. Norm. Sup. Pisa*, n. s. 2, xiii (1982), pp. 1411–523

A. Chastel: *The Sack of Rome* (Princeton, 1983)

J. Cox-Rearick: *Dynasty and Destiny in Medici Art: Pontormo, Leo X and the Two Cosimos* (Princeton, 1984)

K. Fittschen: 'Sul ruolo del ritratto antico nell'arte italiana', *I generi e i temi ritrovati*, ii of *Memoria dell' antico nell'arte italiana*, ed. S. Settis (Turin, 1985), pp. 381–412

G. Corti: 'Il Testamento di Zanobi Lastricati, scultore fiorentino del cinquecento', *Mitt. Ksthist. Inst. Florenz*, xxxii (1988), pp. 580–81

M. D. Carrol: 'The Erotics of Absolution: Rubens and the Mystification of Sexual Violence', *Representations* (1989), no. 25, pp. 3–30

T. Frangenberg: *Der Betrachter: Studien zur florentinischen Kunstliteratur des 16. Jahrhunderts* (Berlin, 1990)

J. Shearman: *Only Connect* (Princeton, 1992)

SPECIALIST STUDIES

A. Bertolotti: 'L'Atelier de Benvenuto Cellini', *Gaz. B.-A.*, xiii (1876), pp. 394–7

C. Davis: 'Benvenuto Cellini and the Scuola Fiorentina', *Bull.: NC Mus. A.*, 4 (1976), pp. 1–70

M. G. Ciardi Dupre dal Poggetto: 'Nuovo, ipotesi sed Cellini', S. Bertelli and G. Ramanus, eds, *Essays Presented to Myron P. Gilmore* (Florence, 1978) pp. 95–106

L. T. Hirte: 'Die Perseus-und-Medusa-Gruppe des Benvenuto Cellini in Florenz', *Jb. Berlin. Mus.*, 29 (1987/88), pp. 197–216

F. H. Jacobs: 'An Assessment of Contour Line: Vasari, Cellini and the Paragone', *Artibus & Hist.* (1988), no. 18, pp. 139–50

G. Baldini: 'Un ricordo del Cellini a Regio Emilia', *Mitt. Ksthist. Inst. Florenz*, xxxii (1988), pp. 554–6

MONOGRAPHS AND CATALOGUES

A. Bertolotti: *Benvenuto Cellini a Roma e gli orefici lombardi ed altri che lavorarono pei papi nella prima meta del secolo XVI* (Milan, 1881)

E. Plon: *Benvenuto Cellini, orfèvre, médailleur, sculpteur: Recherches sur sa vie, sur son oeuvre et sur les pièces qui lui sont attribuées*, 2 vols (Paris, 1883) [remains a fundamental work]

E. Camesasca: *Tutta l'opera del Cellini* (Milan, 1955)

C. Versini: 'Benvenuto Cellini, 1500–1571', *Cah. Acad. Auquetin*, xxiii (1976), pp. 33–71

S. Barbaglia: *L'opera completa del Cellini* (Milan, 1981) [cat. rais.]

Benvenuto Cellini: Opere non esposte e documenti notarili (exh. cat. by D. Trento, Florence, Bargello, 1984) [a re-exam. of works in the Bargello and of documents relating to the *Vita*, the *Trattati* and Cellini's finances]

J. Pope-Hennessy: *Cellini* (London, 1985) [reviewed by A. Radcliffe, *Burl. Mag.*, cxxx (1988), pp. 929–32] [PH]

I. Arnaldi: *La vita violenta di Benvenuto Cellini* (Rome, 1986)

SCULPTURE

F. Kriegbaum: 'Marmi di Benvenuto Cellini ritrovati', *L'Arte*, xliii (1940), pp. 5–25

J. Pope-Hennessy: 'A Sketch Model by Benvenuto Cellini', *Bull. V&A*, i (1965), pp. 5–9; also in *Essays on Italian Sculpture* (London and New York, 1968), pp. 141–4

W. Heil: 'A Rediscovered Marble Portrait of Cosimo I de' Medici by Cellini', *Burl. Mag.*, cix (1967), pp. 4–12

J. F. Hayward: 'A Newly Discovered Bronze Modello by Benvenuto Cellini', *Art at Auction: The Year at Sotheby's and Parke-Bernet, 1967–68* (New York, 1968), pp. 260–66

C. Avery: 'Benvenuto Cellini's Bust of Bindo Altoviti', *Connoisseur*, cxcviii (1978), pp. 62–72

M. G. Ciardi Dupré Dal Paggetto: 'Nuove ipotesi sul Cellini', *Essays Presented to M. P. Gilmore*, ii (Florence, 1978), pp. 95–106

J. Pope-Hennessy: 'A Bronze Satyr by Cellini', *Burl. Mag.*, cxxxiv (1982), pp. 406–12

K. Weil-Garris: 'On Pedestals: Michelangelo's *David*, Bandinelli's *Hercules and Cacus*, and the sculpture of the Piazza della Signoria', *Röm. Jb. Kstgesch.*, xx (1983), pp. 377–415

COINS AND MEDALS

A. Armand: *Les Médailleurs italiens des quinzième et seizième siècles*, i (Paris, 1879, rev. 2/1883), pp. 146–50

A. Heiss: *Les Médailleurs de la Renaissance*, viii (Paris, 1892), pp. 102–16

C. von Fabriczy: *Medaillen der italienischen Renaissance* (Leipzig, 1903; Eng. trans., London, 1904), pp. 143, 167, 183, 186, 204

G. F. Hill: 'Notes on Italian Medals—x', *Burl. Mag.*, xviii (1911), pp. 13–19

——: 'Notes on Italian Medals—xxvi', *Burl. Mag.*, xxxi (1917), pp. 211–17

——: *Medals of the Renaissance* (London, 1920, rev. 2/1978 by G. Pollard)

G. Pollard: *Renaissance Medals from the Samuel H. Kress Collection at the National Gallery of Art, Based on the Catalogue of Renaissance Medals in the Gustave Dreyfus Collection by G. F. Hill*, Washington, DC, N.G.A. cat. (London, 1967)

——: *Medaglie italiani nel Museo nazionale del Bargello*, Florence, Bargello cat. (Florence, 1985)

C. Avery: 'An *Assumption of the Virgin* by Benvenuto Cellini: A Gilt-bronze Seal in the Wernher Collection', *Apollo*, cxlix/443 (Jan 1999), pp. 34–9

DRAWINGS

Mostra di disegni dei fondatori dell'Accademia delle arti del disegno (exh. cat. by P. Barocchi, Florence, Uffizi, 1963)

Drawings from New York Collections, i: *The Italian Renaissance* (exh. cat. by J. Bean and F. Stampfle, New York, Met., 1965)

M. Winner: 'Federskizzen von Benvenuto Cellini', *Z. Kstgesch.*, xxxi (1968), pp. 293–304

L'Ecole de Fontainebleau (exh. cat., ed. S. Béguin; Paris, Grand Pal., 1972), pp. 51–2 [entry by C. Monbeig-Goguel]

Vasari et son temps (exh. cat. by C. Monbeig-Goguel, Paris, Louvre, 1972), pp. 45–6

Italienische Zeichnungen des 16. Jahrhunderts aus eigenem Besitz (exh. cat. by R. Harprath, Munich, Staatl. Graph. Samml., 1977), pp. 48–51

Il primato del disegno (exh. cat., ed. L. Berti; Florence, Pal. Strozzi, 1980), pp. 99–100

H. Keutner: 'Il disegno di un Narciso di Benvenuto Cellini', *Ant. Viva*, xxiv/1–3 (1985), pp. 45–9

N. Turner: *Florentine Drawings of the Sixteenth Century* (London, 1986), p. 163

Master Drawings from the Woodner Collection (exh. cat., ed. M. A. Stevens; New York, Met., 1990), no. 26 [entry by M. Miller and N. Turner]

L. A. Perrig: *Michelangelo's Drawings: the Science of Attribution* (New Haven and London, 1991)

LITERARY STUDIES

G. Baretti: *La frusta litteraria*, ed. by L. Piccioni, i (Bari, 1932), pp. 85–9, 203–4

B. Croce: 'Sul Cellini scrittore', *Poeti e scrittori del pieno e del tardo Rinascimento*, iii (Bari, 1945), pp. 168–70

B. Maier: *Umanità e stile di Benvenuto Cellini scrittore* (Milan, 1952) [extensive crit. analysis of the style and themes of the *Vita*]

M. L. Altieri Biagi: 'La *Vita* del Cellini: Temi, termini, sintagmi', *Atti del convegno Benvenuto Cellini artista e scrittore: Roma–Firenze, 1971*, pp. 61–163

C. Cases: 'Goethe traduttore del Cellini', *Atti di secondo convegno sui problemi della traduzione lettararia: 1974*, pp. 33–43

E. Koppen: 'Goethes "Benvenuto Cellini": Glanz und Elend einer Übersetzung', *Jb. Wien. Goethe-Ver.*, 81–3 (1977–9), pp. 247–62

D. S. Cervigni: *The 'Vita' of Benvenuto Cellini: Literary Tradition and Genre* (Ravenna, 1979)

G. Guntert: 'Skorpion und Salamander: Eine emblematische Deutung der Vita des Benvenuto Cellini', *Ren. Mitt.*, x (1986), pp. 49–66

ALESSANDRO NOVA

Cenni di Francesco di ser Cenni (*fl* 1369–1415). Italian painter. He was registered in the Arte dei Medici e Speziali, Florence, in March 1369. His only signed work is the fresco of 1410 in the chapel of the oratory of the Croce di Giorno attached to S Francesco, Volterra. However, dated works attributed to him suggest that his oeuvre was quite large and that stylistically he was of an eclectic nature. His early style is derived from that of the circle of the Orcagna; the signed and dated triptych of the *Virgin and Child with Saints* in the church of S Cristofano a Perticaia at Rignano sull'Arno (1370; *in situ*) shows, in its colouring and treatment of drapery, the influence of Nardo di Cione. Cenni distanced himself from his early Orcagnesque conception of form *c.* 1385–90 and, it has been suggested, may have had some connection with Giovanni del Biondo (Boskovits, 1968). The use of perspective to create depth in his compositions and his strong sense of narrative are apparent in such works as his fresco of the *Adoration of the Magi* (1383; Florence, S Donato in Polverosa). Here,

Cenni's taste for anecdote is evident, and the clothes of the attendant figures, painted with great attention to detail, are modelled on contemporary fashions. A sense of distance is created for the background scene of the *Annunciation to the Shepherds* by the use of monochromatic colours, a device he also employed at Volterra. The proportions of the figures are elongated and their features fine and elegant, and the drapery is boldly outlined. Cenni's gothicizing concept of form, his lively sense of colour and anecdotal qualities may be derived from manuscript illuminations. He worked as a manuscript illuminator and examples of his work are found among the products of the school of illuminators at the Camaldolese monastery of S Maria degli Angeli, Florence. Levi d'Ancona (1978) attributed a miniature of the *Resurrection* (Florence, Santa Croce, Corale D, fol. 3) to Cenni. From 1390 to 1393 Cenni lived in the quarter of S Giovanni in Florence. In the 1390s he was influenced by the Giottesque revival. The simplification of form is evident in the fresco *Virgin and Child with Saints* (1393; San Miniato, Pal. Com.); its well-balanced proportions are similar to those in the works of Taddeo Gaddi. The statuesque pose of the Virgin and the plasticity of the drapery are emphasized by uninterrupted heavy outlines.

In Cenni's late work, gothicizing elements are combined with conservative traits. This conflict is evident in the triptych of the *Virgin and Child with Saints* (*c.* 1400; Montalbino, S Giusto) and in the signed frescoes in Volterra (1410) depicting the *Legend of the True Cross* and scenes from the *Life of the Virgin* and the *Infancy of Christ*. Flattened figures are placed awkwardly before a receding background, attempts to depict movement—as in the *Theft of the Cross by King Chosroes*—are unconvincing and the crowded scenes seem strangely lifeless and motionless. Cenni, however, added little narrative episodes and genre-like motifs, and rendered landscapes and nature in great detail. The use of light colours and the draperies, boldly modelled through chiaroscuro effects, are also gothicizing in style. Cenni never became part of the more progressive stylistic movement represented in Florence by Lorenzo Monaco. His later pictures were all commissioned for places outside Florence. They include his *St Jerome* (San Miniato, Mus. Dioc. A. Sacra) painted for SS Jacopo e Lucia in San Miniato, dated to 1412 by documents. In composition and colouring the picture is related to the frescoes in Volterra; the figure of St Jerome is severely elongated and his hands unnaturally lengthened, a typical stylistic trait of Cenni's late work. In 1415 Cenni was registered in the Compagnia di S Luca in Florence and it is generally assumed that he died the same year.

BIBLIOGRAPHY

M. Levi d'Ancona: *Miniatura e miniatori a Firenze dal XIV al XVI secolo* (Florence, 1962)

M. Boskovits: 'Ein Vorläufer der spätgotischen Malerei in Florenz: Cenni di Francesco di ser Cenni', *Z. Kstgesch.*, xxxi (1968), pp. 273–92

——: *Pittura fiorentina alla vigilia del rinascimento, 1370–1400* (Florence, 1975)

M. Levi d'Ancona: 'Arte e politica: L'interdetto, gli Albizi e la miniatura fiorentina del tardo trecento', *La miniatura italiana in età romanica e gotica: Atti del I congresso di storia della miniatura italiana: Cortona, 1978*, pp. 461–87

Painting and Illumination in Early Renaissance Florence, 1300–1450 (exh. cat., New York, Met., 1994–5)

SUSANNE PFLEGER

Ceparelli, Silvio di fu Giovanni di Neri de'. *See* COSINI, SILVIO.

Cesare da Sesto (*b* Sesto Calende, 1477; *d* Milan, 27 July 1523). Italian painter and draughtsman. He was one of the most significant artists to emerge from Leonardo's circle in Milan, and his travels south of Rome helped to spread the ideas of the High Renaissance to painters in Naples and Sicily. As early as 1506 Cesare may have been in Rome, where he entered into a long working relationship with Baldassare Peruzzi. This probably began in S Onofrio, where a lunette depicting a strongly Leonardesque *Virgin and Child with a Donor* may be by him. By June 1508 Cesare was painting alongside Peruzzi in the Vatican Stanze of Julius II, specifically in the Pope's bedroom. Cesare possibly contributed to the 11 frescoes (Rome, Pin. Vaticana) that are thought to correspond to an *uccelliera* (aviary) painted by Peruzzi and described by Vasari. Peruzzi's team next worked in Ostia on the decoration of the Episcopio, the palace of Cardinal Raffaele Riario after his election as Bishop of Ostia in February 1511. Vasari described these frescoes as battle scenes *all'antica* and attributed them in part to Cesare. Giusti and Leone de Castris (1985) suggested that Cesare's introduction to Naples may have come around this time through Cardinal Oliviero Carafa. They attributed to Cesare a votive painting of *Christ and a Donor* (Naples, Capodimonte), in which the kneeling donor closely resembles other known representations of the Cardinal.

Twenty-four leaves from a sketchbook (New York, Pierpont Morgan Lib.) and some related sheets in other collections are mostly datable to Cesare's Roman period and reflect his interests during these formative years. The fluid, sensuous drawings depict grotesques and other antique motifs that parallel those used at Ostia. Other drawings after Raphael and Michelangelo feature images from both the Vatican Stanze and the Sistine Chapel. Lomazzo (1585) emphasized the importance of Raphael for Cesare, and the sketchbook contains many studies of Raphael's compositions, for example the Alba *Madonna* (*c.* 1511; Washington, DC, N.G.A.) and various figures from the narrative works.

Cesare's movements following this long stay in Rome are uncertain. Scholars believe either that he broke his sojourn in the south with a brief, but productive return to Milan or that he remained south of Rome for a prolonged, unbroken period and then returned permanently to Milan. According to the former view, the *Virgin and Child with SS John the Baptist and George* (San Francisco, CA, de Young Mem. Mus.), painted for the Genoese confraternity in S Domenico, Messina, is intimately related to Cesare's Roman work, including the sketchbook, and is thus probably datable to 1512–13. Similarly linked to the sketchbook and to motifs characteristic of the Roman stay is a group of works of Milanese provenance, the most important of which is the *Baptism* (Milan, Gallarati–Scotti priv. col.). The *Holy Family* (St Petersburg, Hermitage) and *Salome* (Vienna, Ksthist. Mus.) are presumed to date from an interim period in Lombardy.

In 1514 Cesare's devoted follower Gerolamo Aliprandi (*fl* 1514–*c.* 1523) is documented in Messina, which suggests that Cesare himself was also in the south by then. On 6

Cesare da Sesto: *St Roch*, central panel from the *St Roch* polyptych, tempera and oil on panel, 1400×655 mm, 1523 (Milan, Castello Sforzesco)

June 1514 Girolamo da Salerno was contracted to produce an altarpiece for the abbey of the Trinity, Cava dei Tirreni (Cava dei Tirreni, Mus. Badia SS Trinita). Cesare's participation in this polyptych, notably in the central panels depicting the *Baptism* and the *Virgin and Child in Glory*, is recorded in a payment made to him in March 1515 and in a letter from Girolamo sent to him in Naples in June 1515. While there Cesare painted a large *Adoration of the Magi* (untraced), said in Pietro Summonte's letter of 1524 to Marcantonio Michiel (see Fabriczy), to be in S Michele Arcangelo, Baiano. A relief of 1517 by Bartolomé Ordoñez in S Giovanni Carbonara, Naples, as well as slightly later works by Andrea da Salerno show the immediate impact

of Cesare's work. Another *Adoration of the Magi* (Naples, Capodimonte) was commissioned from Cesare for S Niccolò, Messina. The complexity and organic quality of this monumental work, especially when compared with the more static and additive nature of the first Sicilian painting for S Domenico, Messina, led scholars to infer a number of years and further travel between the two.

Some, however, remain unconvinced by this outline of his career (see 1986 exh. cat.) and argue that Cesare lived and worked for a number of years in Naples before moving on to Sicily. According to this view, the works of Milanese provenance date from the end of his career, after a definitive return to Milan. In this interpretation the elaborate Gallarati–Scotti *Baptism*, painted in collaboration with Cesare Bernazzano (*fl* first half of 16th century), a flower and landscape specialist, is dated after the scene of the same title in the Cava dei Tirreni Polyptych. The Morgan Library sketchbook is also interpreted more freely, the sketches assumed to have been in use throughout Cesare's later career rather than linked to the years immediately following his activity in Rome. Cesare's last significant work was an altarpiece painted for the confraternity of St Roch, Milan, depicting the *Virgin and Child with Saints* (Milan, Castello Sforzesco; Milan, Gallarati–Scotti priv. col.) with *St Roch* as the central panel of the polyptych (see fig.). This elaborate work was commissioned in January 1523 and was principally executed by Cesare himself although doubtless completed by his workshop. It testifies to Cesare's profound study of the artists whose works had impressed him in Milan and Central Italy, principally Leonardo and Raphael, and illustrates his highly personal fusion of their styles.

BIBLIOGRAPHY

DBI

G. P. Lomazzo: *Trattato dell'arte de la pittura* (Milan, 1584); ed. S. Del Monte (Rome, 1884)
——: *Idea del tempio della pittura* (Milan, 1590); ed. R. Klein (Florence, 1974)
C. von Fabriczy: 'Summonte's Brief an M. A. Michiel', *Repert. Kstwiss.*, xxx (1907), pp. 143–68
G. Frizzoni: 'Certain Studies by Cesare da Sesto in Relation to his Pictures', *Burl. Mag.*, xxvi (1915), pp. 187–94
L. Beltrami: *La commissione dell'ancona per la chiesa di S Rocco a Milano a Cesare da Sesto* (Milan, 1920)
G. Nicodemi: *L'opera e l'arte di Cesare da Sesto* (Milan, 1932)
F. Bologna: *Roviale spagnuolo e la pittura napoletana del cinquecento* (Naples, 1959)
Drawings from New York Collections, I: The Italian Renaissance (exh. cat. by J. Bean and F. Stampfle, New York, Met., 1965)
Capolavori d'arte lombarda: I Leonardeschi ai raggi 'x' (exh. cat., ed. M. Precerutti Gerberi and others; Milan, Castello Sforzesco, 1972)
M. V. Brugnoli: 'Baldassare Peruzzi nella chiesa di S Maria della Pace e l'uccelliera di Giulio II', *Boll. A.*, lviii (1973), pp. 113–23
S. Leone: 'Notizie su artisti ed opere d'arte del sec. xvi estratto dai registri di amministrazione della Badia di Cava', *Benedictina* (1977), pp. 333–81
C. L. Frommel: ' "Disegno" und Ausführung: Ergänzungen zu Baldassare Peruzzis figurale Oeuvre', *Kunst als Bedeutungsträger: Gedenkschrift für G. Bandmann* (Berlin, 1978), pp. 205–50
A. Perissa Torrini: 'Un'ipostesi per la "cona grande" di Cesare da Sesto per San Michele Arcangelo a Baiano', *Prospettiva* [Florence], 22 (1980), pp. 76–86
G. Borghini: 'Baldassare Peruzzi, Cesare da Sesto e altre presenze nell'episcopio di Raffaele Riario ad Ostia', *Quad. Pal. Venezia*, (1981), pp. 11–50
A. Perissa Torrini: 'Considerazioni su Cesare da Sesto nel periodo romano', *Boll. A.*, lxviii (1983), pp. 75–97
Leonardo e il Leonardismo a Napoli e a Roma (exh. cat., ed. A. Vezzozi; Naples, Capodimonte, 1983)
P. Giusti and P. Leone De Castris: *'Forestieri e regnicoli': La pittura moderna a Napoli nel primo cinquecento* (Naples, 1985)
Andrea da Salerno nel rinascimento meridionale (exh. cat., ed. G. Previtali; Padula, Mus. Archeol. Prov. Lucania Occident., 1986)
G. Agosti and V. Farinella: 'Qualche difficoltà nella carriera di Cesare da Sesto', *Prospettiva* [Florence], liii-lvi (1988–9), pp. 325–33

ANDREA BAYER

Cesariano [Ciserano], **Cesare** (*b* 1476–8; *d* Milan, 1543). Italian architect, theorist and painter. He was active mainly in Milan and is famous for publishing the first Italian translation, with commentary and illustrations, of Vitruvius (1521). The brief autobiography that this contains is also the principal source of information regarding Cesariano's own life, education and aims.

1. Early life and work, before 1521. 2. The *Di Lucio Vitruvio Pollione de Architectura* and late work, 1521 and after.

1. EARLY LIFE AND WORK, BEFORE 1521. Cesariano's date of birth has been disputed, but it is now thought to be 1476–8, following the documentation from the time of his father's death in 1482. In 1482 Cesariano was introduced to the court of Ludovico Sforza, Duke of Milan, where he came into contact with courtiers and artists and met Bramante, whom he named as his chief teacher. He doubtless observed the preparatory phases and building of S Maria presso S Satiro (*see* BRAMANTE, fig. 1), the only work by Bramante in Milan to which he refers specifically in his commentary on Vitruvius. He could not have followed Bramante's subsequent career, for he was forced to leave his home town *c*. 1492 after arguments with his mother, Elisabetta de Grittis, whom he called 'step-mother'. At the outset, he enjoyed modest financial assistance from Andrea Vimercati, the ducal chancellor and a former employee of his father. He was then introduced by the courtier Giovanni Simone Resta to the court of Ferrara, where he worked on theatrical productions for the Duke.

The exact chronology of Cesariano's presence in Ferrara is uncertain, but he mentions Duke Ercole I (*d* 1505). He may have visited the city more than once, working perhaps in the environs; in his commentary on Vitruvius he cites several towns in the locality as places that he had visited and with which he was familiar. It was at Ferrara, however, that Cesariano met Antonio Visconti, a former ambassador of the Duke Ludovico and a fervent student of philosophy, mathematics and cosmography, who retained him as an assistant to trace diagrams and scientific drawings. In 1500 Cesariano was married in Reggio Emilia, where he was recorded as a citizen in 1503. He worked on frescoes in the baptistery of St John the Evangelist and in the Palazzo del Podestà, but his stay there came to a dramatic end in 1507, when he had to flee after killing a man.

In 1508 Cesariano was in Parma, where he is referred to as 'Cesare of Reggio, the painter' in a contract for frescoes in the sacristy of the monastery of St John the Evangelist, which he executed between May and September 1508. The *Stories from the Bible* and *Virtues* that he painted there, complete with geometric surrounds and grotesque decorations, are the only surviving painted works that can be securely attributed to him; they demonstrate the high quality of his work as well as the application of the geometric discipline derived from Bra-

mante. Around 1509 Cesariano apparently returned to Milan, but he continued to work in other cities, if the attribution to him of the *Virgin and Child with SS Vittore, Sostene, Eufemia and Agnese* for S Eufemia in Piacenza 1512 is valid. His activity in Milan appears to have recommenced only in 1513, when he was taken into the service of Massimiliano Sforza, Duke of Milan. Cesariano executed 57 scenes for the decoration of the Council Chamber in Milan Cathedral, for which he and Vincenzo Foppa were paid on 26 November 1513.

As an architect, Cesariano worked during the same period on military installations for the Castello Sforza and its subsequent defence against Francis I of France (*reg* 1515–47). When the French invaded Milan in October 1515, Cesariano fled, taking with him nothing but his work on Vitruvius, which was then probably in an advanced state of preparation. In December 1513 Cesariano was paid for a new model and for the design of the atrium and the façade of S Maria presso S Celso, Milan, which had been begun by Giovanni Giacomo Dolcebuono and Giovanni Antonio Amadeo and completed on the basis of a model by Cristoforo Solari. However, only the external face of the portico, facing the cemetery of S Sisto, can be in any way connected with his design, which was modified after Bernardino Zenale succeeded him on the site. Even the attribution to Cesariano of the three drawings (Bianconi priv. col.) for the church now in Milan has been discredited. Among the other uncertain Milanese attributions of this period, that of the house (1515–23) for Tommaso Landriani is outstanding. It has a façade consisting of two superimposed Doric orders very close to the illustration on fol. 64*r* of Cesariano's edition of Vitruvius. Nevertheless, there are no unmistakable elements to justify this attribution either on the exterior or the interior. Cesariano is untraceable from 1515 to 1521 with the exception of his presence in Asti in 1518 for water engineering works related to the containment of the River Tanaro.

2. THE 'DI LUCIO VITRUVIO POLLIONE DE ARCHITECTURA' AND LATE WORK, 1521 AND AFTER. The *Di Lucio Vitruvio Pollione de Architectura* is certainly Cesariano's most significant work, for it gave birth to a new wave of classicism in Milan after Bramante. It was printed in Como by Gottardo da Ponte on 15 July 1521, the first published Italian translation of the Latin text, with marginal notes and 119 plates. The folio format of the volume allowed space for translation, commentary and illustrations all on the same page, with striking graphic effect and ease of reference. The translation can be considered accurate, complete and free of gross misinterpretations. There remain unresolved, however, numerous areas of interpretation fundamental to a complete understanding of Vitruvius that are cloaked in Latinisms. In addition to consulting earlier editions of Vitruvius' text, Cesariano used Fra Giovanni Giocondo's 1511 edition, and on the basis of this text he reorganized some of the work that he had already translated.

The commentary, in smaller print in the margin of the text, forms an encyclopaedic and meticulous appendix, through which Cesariano endeavoured to explain the choices of readings from the various versions of the text

and to amplify their meaning. His background approach appears to be close to the medieval and humanistic method of extracting from the text the salient points in order to create a collection of references necessary for the compilation of a personal system of cross-reference. It contains numerous quotations from Classical authors, including Aristotle and Pliny, as well as contemporary opinions. It is also clear that Cesariano was conversant with the works of such authors as Alberti, Filarete, F. Maria Grapaldo (*c.* 1454–1515) and Fra Giocondo, although these are never directly acknowledged. Furthermore, other authors whom he could not ignore, such as Francesco di Giorgio Martini, Leonardo and Luca Pacioli, are mentioned only fleetingly, while of the Milanese artists Vincenzo Foppa, Bernardino Butinone and Bernardino Zenale, the latter only is cited as a scholar of Vitruvius.

For his illustrations, Cesariano drew on Fra Giocondo's first illustrated edition of Vitruvius as an iconographic source, although he altered the terser and more formal solutions. He also included independent contributions, particularly in the case of illustrations for cities, temples and basilicas as well as for the explanation of individual architectural points. The greater realism of the illustrations and the care taken in defining details indicate that Cesariano considered this to be the most suitable area for amplifying the significance of the original text and for inserting elements from his own antiquarian architectural background, despite the fact that this was based on monuments far from Rome, a city that he appears never to have visited. His more unorthodox and modernist suggestions were linked to specific topics such as technical details, used as a pretext for illustrating city walls with contemporary defences or the ancient type of town house with its asymmetrical courtyard and only a partial colonnade.

The first group of innovative illustrations is that devoted to urban design, following the theme of Filarete's ideal city of Sforzinda. In fact, Cesariano abandoned the correct interpretation of *platea* as a broad street (as given by Giocondo in his reconstruction of the Vitruvian city on an orthogonal plan) and reinterpreted it to mean a piazza, deriving from it a radial city plan with eight major routes radiating from a central piazza. For the principal streets, however, Cesariano recommended laying out an irregular grid of canals and streets, reminiscent of the real Milan and perhaps also of the views of Alberti. The Vitruvian figure of the *homo ad quadratum* and *ad circulum* suggested by Fra Giocondo (for illustration *see* GIOCONDO, GIOVANNI) was also perfected by Cesariano with great graphical dexterity, drawing inspiration for the *homo ad circulum* from a drawing attributed by him to the Milanese artist Seganzone. In each case and for the first time Cesariano correctly represented supine man, although, as with Leonardo before him, his choice of the centre of the figure alternated between pubis and navel. The grid that divides up the space surrounding the *homo ad quadratum* is the basis from which, according to Cesariano, proportional modules are derived, or rather, those that he referred to as *euritmiate simmetrie* ('harmonious symmetries'), combining the two principles of Vitruvian thought in a single formula that he laid down as the basis of his conception of *all'antica* architecture.

Cesariano's interpretations of temples and houses are particularly original. The temples that are illustrated depict façades of a Lombard style with projections of orders that appear on the elevations as pilasters on solid walls, and thus derived from the temple *in antis* and prostyle. With regard to internal arrangements, he turned towards the Byzantine or neo-Byzantine tetrastyle form, which was common in contemporary Venetian architecture, and in the case of the peripteral temple he transformed the external colonnade into an internal one, in order to produce a church plan suited to Christian tradition and liturgy. For houses, Cesariano followed almost totally the sequence of illustrations used by Fra Giocondo, but with substantial and opportune corrections. He was the first to show clearly in his own graphic reconstruction the identity of the atrium and the *cavedium*, translating both as a courtyard. His interpretation, which corrects that of Fra Giocondo, was taken up again by Daniele Barbaro and Palladio for the Greek house, as well as by GALEAZZO ALESSI in the Palazzo Marino (1557; altered; partly destr. World War II) in Milan. Alessi may have been influenced by Giovan Battista Caporali (1476–1553), who began plagiarizing Cesariano's work in 1536 but only completed the first five books.

Cesariano's interpretation of the architectural orders is especially interesting, particularly in the plates that do not follow those of Fra Giocondo. The plate showing different orders of columns (see fig.) inaugurated a series of new variations on the theme, starting with Sebastiano Serlio and Jacopo Vignola. Only a few illustrations are derived from works by other authors, such as Franchino Gaffurio (1451–1522), Gianmaria Comense and Bernardo Granollachs, while the style of some of the imaginary illustrations can be traced to Giovanni Grueninger. Cesariano's influence was far-reaching, and his translation was taken up again in the vernacular edition of Vitruvius by Francesco Lutio Durantino (Venice, 1524) as well as in that of Caporali, while his illustrations often appeared in subsequent French, Spanish and German editions of Vitruvius.

On 11 April 1521 Agostino Gallo and Aloisio Pirovano undertook to finance the printing of 1300 copies of the volume and on 21 April to allow Cesariano the opportunity of inserting any necessary corrections. However, disagreements soon arose, probably because of the slowness and indecisiveness of the author, and Cesariano was prevented from carrying out any further amendments to his work beyond Book IX. He left Como, taking with him the remaining material of the book, but was apprehended, and all except a few plates that he managed to hide were taken from him by force. The completion of the commentary was assigned to Benedetto Giovio and Bono Mauro, while Cesariano returned to Milan to begin legal proceedings against the editors. His edition of Vitruvius can therefore be considered incomplete, as is borne out by his own handwritten notes in a now lost copy of the book (ex-Biblioteca Melziana, Milan). However, Cesariano's autograph manuscript for Books IX (chapters vii–ix) and X (chapters i–xii) has been discovered in Madrid by modern scholars (now in Madrid, Escorial). It contains 36 illustrations and can be used to identify how much of the text was missing and to assess the changes brought about by Cesariano himself in the final publication, given that only two of the illustrations contained in the manuscript match those in the published edition.

From 1524 Cesariano was registered with the college of engineers in Milan, and between 1525 and 1527 he was commissioned by the governor of Milan to furnish the Castello Sforza there with a tenaille projection from the main block (1525–7) facing the Carmine and the Borgo degli Ortolani. His work was subsequently superseded in 1546 by further fortification works. In July 1528 he finally obtained a favourable judgement in his case against his publishers and was awarded credit equal to one third of the value of the printed copies, for which a part of the assets of the Gallo family was confiscated. Although he had finally obtained the recognition that he deserved for his continual and impassioned practical work and study, in 1526 Cesariano failed in his application to succeed Zenale as architect to Milan Cathedral. In 1528, however, he was appointed imperial architect and in 1533 city architect. He was involved with the cathedral engineer Cristoforo Lombardo, Agostino Busti and Antonio Lonate on 29 April 1535 in judging the worth of the models prepared by Girolamo della Porta, and on 17 July 1537 in deciding on the model submitted for the *Porta verso compedo*, having himself presented a scheme in 1535 for a large doorway. Nothing has survived, however, of this, his last recorded work.

Cesare Cesariano: comparative table of the orders; engraving from his *Di Lucio Vitruvio Pollione de Architectura* (Como, 1521), fol. 62*r*

WRITINGS

Di Lucio Vitruvio Pollione de Architectura (Como, 1521); ed. F. Piel, with introduction by C. H. Krinsky (Munich, 1969)

Vitruvio: De Architectura, translato, commentato et affigurator da Caesare Caesariano (1521), ed. A. Brusci, A. Carugo and F. P. Fiore (Milan, 1981) [facs.]

BIBLIOGRAPHY

DBI; Thieme–Becker

C. Cantù: 'Cesare Cesariano', *Archv. Stor. Lombardo*, ii (1875), pp. 435–9

V. De Pagave: *Vita de Cesare Cesariano architetto Milanese*, ed. C. Casati (Milan, 1878)

L. Beltrami: 'Un disegno originale del progetto delle fortificazioni di Milano nella prima metà del secolo XVI', *Archv. Stor. Lombardo*, xvii/7 (1890), pp. 152–8

——: 'L'antica casa dei Landriani in Via Borgonuovo, Milano', *Rass. A.*, 2 (1902), 11–12, pp. 183–4

F. Malaguzzi Valeri: *La corte di Ludovico il Moro* (Milan, 1913–23)

F. Frigerio: *Il Vitruvio del Cesariano del 1521* (Como, 1934)

C. Baroni: 'Osservazioni su Cesare Cesariano', *Maso Finiguerra*, v/1–2 (1940), pp. 83–96

F. Leoni: 'Il Cesariano e l'architettura del Rinascimento in Lombardia', *A. Lombarda*, i (1955), pp. 90–97

P. Arrigoni: 'L'incisione rinascimentale milanese', *Stor. Milano*, viii (1957), pp. 691ff

E. Arslan: 'L'architettura lombarda del primo '500', *Stor. Milano*, viii (1957), pp. 534ff

A. G. Quintavalle: 'Un dipinto inedito di Cesariano a Piacenza', *Paragone*, ix/109 (1959), pp. 51–3

M. L. Ferrari: 'Zenale, Cesariano e Luini: Un arco di classicismo lombardo', *Paragone*, xviii/211 (1967), pp. 18–38

M. Lodinska-Kosinska: 'Quelques Remarques au sujet du dessin d'Antonio di Vicenzo et de la gravure de Cesare Cesariano', *Il duomo di Milano: Atti del Congresso Internazionale: Milan, 1968*, pp. 129–31

S. Wilinsky: 'Cesare Cesariano elogia la geometria architettonica della cattedrale di Milano', *Il duomo di Milano: Atti del Congresso Internazionale: Milan, 1968*, pp. 132–43

S. Gatti: 'L'attività milanese del Cesariano dal 1512–13 al 1519', *A. Lombarda*, xvi (1970), pp. 129–32

C. H. Krinsky: 'Cesariano and the Renaissance without Rome', *A. Lombarda*, xvi (1971), pp. 211–18

P. Verzone: 'Cesare Cesariano: Fonti e sviluppo dell'umanesimo in Lombardia', *A. Lombarda*, xviii (1973), pp. 129–32

L. Cervera Vera: 'Cesare Cesariano, 1483–1543: Traductor y comentarista de Vitruvio', *Academia: Bol. Real Acad. B.A. San Fernando*, xlvi/1 (1978), pp. 63–181

M. Tafuri: 'Cesare Cesariano e gli studi vitruviani del quattrocento', *Scritti rinascimentali di architettura* (Milan, 1978), pp. 387–467

F. P. Fiore: 'Cultura settentrionale e influssi albertiani nelle architetture vitruviane di Cesare Cesariano', *A. Lombarda*, lxiv/1 (1983), pp. 43–52

——: 'La traduzione vitruviana di Cesare Cesariano', *Roma: Centro ideale della cultura dell'antico nei secolo XV e XVI*, ed. S. Danesi Squarzina (Milan, 1986), pp. 458–66

S. Gatti: 'Nuovi documenti sull'ambiente familiare e la prima educazione di Cesare Cesariano', *A. Lombarda*, lxxxvi–vii/3–4 (1988), pp. 187–94

FRANCESCO PAOLO FIORE

Cesati, Alessandro [il Grechetto; il Greco] (*b* Cyprus; *fl* 1538–64). Italian medallist and gem-, cameo- and die-engraver. His father was Milanese and his mother Cypriot. At an early age he moved to Rome, where he was introduced by Annibale Caro into pontifical circles dominated by the Farnese family. As a result, he was appointed Incisore e Maestro delle Stampe at the papal mint, where he is documented in 1554 as having worked with Gian Federico Bonzagna, whose dies are difficult to distinguish from Cesati's. He remained at the mint until 1561 under Paul III and his successors, Julius III, Paul IV and Pius IV.

Cesati continued to receive commissions from other members of the Farnese family. His most famous medals include one of *Pier Luigi Farnese, 1st Duke of Parma* (*c.* 1546), one of *Alessandro Farnese* as Cardinal with *Apollo Shooting at Python* on the reverse (Florence, Bargello) and one of him when he became *Paul III*, with the reverse, so highly praised by Michelangelo (Vasari, *Vite*, 1568), depicting *The High Priest of Jerusalem Receiving Homage from Alexander the Great* (1547; Florence, Bargello). In 1550 Cesati contributed a jubilee medal for Julius III, known only from silver proofs (Florence, Bargello). Other medals include a series of classicizing heads of *Priam*, *Dido*,

Alexander the Great and *Augustus* (see Parkes Weber). From 1557 to 1559 he also worked for Ottavio Farnese at the reopened mint in Parma. After his departure from the papal mint, Cesati was summoned to Piedmont by Marguerite of France, the consort of Emanuel-Philibert of Savoy, for whom he made a medal with their portraits on obverse and reverse. The following year he completed a medal for Marguerite with a figure of *Minerva* on the reverse. Cesati's engraved gems include a portrait of *Henry II of France* (St Petersburg, Hermitage) in carnelian and a portrait of *Phocion* (London, BM). A cameo *Head of Augustus* (London, V&A) has been attributed to him. He returned to Cyprus after 1564.

BIBLIOGRAPHY

DBI

Vasari: *Vite* (1550, rev. 2/1568); ed. G. Milanesi (1878–85), vii, p. 284

F. Parkes Weber: 'Attribution of Medals of *Priam*, *Augustus* and *Alexander the Great* to a Medallist of Pope Paul III, Possibly Alessandro Cesati', *Numi. Chron.*, n. s. 2, xvii (1897), pp. 314–17

J. G. Pollard: *Italian Renaissance Medals in the Museo Nazionale del Bargello*, i (Florence, 1985), pp. 984–9

ANTONIA BOSTRÖM

Cesena, Peregrino da. See PEREGRINO DA CESENA.

Cesi. Italian family of collectors. The family, whose origins were in the Umbrian town of Cesi, settled in Rome in the 15th century. In the 16th century they were celebrated for the splendour of the Giardino dei Cesi, a sculpture garden at their palace at the foot of the Gianicolo. This was established by Cardinal Paolo Emilio Cesi (*b* Rome, 1481; *d* Rome, 5 Aug 1537), who adorned the garden with antique (and contemporary) statuary (see ROME, fig. 16). It was inherited by his brother Federico Cesi (*b* ?Rome, ?1 July 1500; *d* Rome, 28 Jan 1565), who became Cardinal in 1544 and who reorganized the garden and the palazzo so that it seemed like 'the entrance to Paradise' (Aldrovandi). He restored the statues and, above all, constructed an antique sculpture museum (destr. with the palazzo, 1940) with a Greek-cross plan, designed (1556–64) by GUIDETTO GUIDETTI and intended for small but precious pieces: it was one of the first buildings constructed purposely as a museum. Cardinal Federico also rebuilt S Caterina de' Funari to plans by Guidetti.

Before his election to the cardinalate in 1570, Federico's nephew, Cardinal Pier Donato Cesi (*b* Rome or Todi, 1522; *d* Rome, 29 Sept 1586), was Vice-legate at Bologna (1560), where he superintended and financed architectural and town-planning projects and pronounced on matters of artistic decorum. Among such projects were the Fountain of Neptune by Giambologna and the Archiginnasio. In 1584 he returned to Rome, where he assumed responsibility for the completion of S Maria della Vallicella. In the palazzo at Borgo Vecchio 165 (embellished by important artists) he established a museum of antiquities and art objects with a rich library.

BIBLIOGRAPHY

DBI

U. Aldrovandi: *Delle statue antiche che per tutta Roma in diversi luoghi et case si veggano*, in M. Lucio: *Le antichità della città di Roma* (Venice, 1556), pp. 115–315

P. Volpicelli: 'Ritrovamento dell'inventario degli oggetti appartenenti all'eredità di Federico Cesi', *Atti Accad. N. Lincei*, xiv (1866), pp. 203–5

D. Gnoli: 'Il giardino e l'antiquario del Cardinal Cesi', *Mitt. Ksr. Dt. Archäol. Inst.*, xx (1905), pp. 267–76

R. Lanciani: *Storia degli scavi di Roma e notizie intorno le collezioni romane di antichità*, iii (Rome, 1908), pp. 69, 260; iv (Rome, 1913), pp. 107–17

C. Hülsen: *Romische Antikengärten* (Heidelberg, 1917), pp. 1–42

E. Martinori: *Genealogia e cronistoria d'una grande famiglia umbro-romana: I Cesi*, ed. G. Gabrieli (Rome, 1931) [useful intro. and bibliog., incl. MS. sources]

M. Zocca: 'Il Palazzo Cesi in Borgo Vecchio', *Capitolium*, xii (1937), pp. 342–5

M. T. Buonadonna Russo: 'I Cesi e la Congregazione dell'Oratorio', *Archv Soc. Romana Stor. Patria*, xc (1967), pp. 101–55

M. Vander Meulen: 'Cardinal Cesi's Antique Sculpture Garden: Notes on a Painting by Hendrick Van Cleef III', *Burl. Mag*, cxvi (1974), pp. 14–24

Federico Cesi. Convegno celebrativo del IV centenario della nascita: Acquasparta, 1985

G. Gabrieli: *Federico Cesi, Linceo (1585–1630)* (Rome, 1987)

S. Eiche: 'On the Layout of the Cesi Palace and Gardens in the Vatican Borgo', *Mitt. Ksthist. Inst. Florenz*, xxxix (1995), pp. 258–81

DONATELLA L. SPARTI

Charles I, Duke of Savoy. *See under* SAVOY.

Chavaletto, Giovanni Battista. *See* CAVALLETTO, GIOVANNI BATTISTA.

Cherico, Francesco di Antonio del. *See* FRANCESCO DI ANTONIO DEL CHIERICO.

Chierico, Francesco di Antonio del. *See* FRANCESCO DI ANTONIO DEL CHIERICO.

Chigi, Agostino [il Magnifico] (*b* Siena, 29 Nov 1466; *d* Rome, 11 April 1520). Italian patron. He was recognized by his contemporaries as the wealthiest merchant and the most important banker in Europe and played a significant part in the social and artistic life of Rome during the Renaissance. As a patron, he favoured artists from his native Siena and in 1507 brought Sodoma to Rome. For his later projects, however, Agostino also employed non-Sienese artists and in 1511 brought Sebastiano del Piombo to Rome from Venice. Agostino Chigi was, with Pope Julius II and Pope Leo X, among Raphael's most important patrons.

Trained in Siena, Chigi moved in the 1480s to Rome, where, as an increasingly aggressive and successful financier, he became a powerful force in the financial world. The Roman branch of the Chigi bank was established in 1502 and at its point of greatest expansion had more than 100 offices in Italy and branches in Alexandria, Constantinople, Cairo, Lyon, London and Antwerp. It advanced loans to all the popes from Alexander VI to Leo X, as well as to the Borgia, the exiled Medici, the Venetian Republic, the British monarchy and others. Chigi's control of the papal monopoly on alum, mined at Tolfa, was a major source of his revenue. The height of his importance was during the pontificate of Julius II (*reg* 1503–13), when, for several years, he held the papal tiara in custody as security for loans to the papacy. He was granted the privilege of adding the papal family arms of della Rovere to his own, and Julius's patronage may have inspired his own impressive projects. He used his legendary wealth to cultivate his reputation as a patron of humanists, befriending Paolo Giovio, Pietro Bembo and Pietro Aretino. In 1515 Chigi founded a firm that printed the first Greek books to be published in Rome, notably an edition of Pindar.

Chigi's most important contribution to Italian Renaissance art is his villa (?1506–11; now the Villa Farnesina; *see* PERUZZI, BALDASSARE, fig. 1), in the suburbs of Rome, which was sold to the Farnese family in 1579. Designed as a Renaissance recreation of an ancient Roman villa, it housed Chigi's collection of antiquities, and the iconography of the pictorial decoration was based on the writings of ancient authors. Agostino held his renowned parties at this villa, to which the élite of Roman society were invited, and in 1519 was married by Pope Leo X there. The architect of the villa, Baldassare Peruzzi, also directed its decoration, although Chigi almost certainly selected the artists. The rather plain exterior was probably originally frescoed. Raphael conceived the fresco decoration of the loggia ceiling, which suggests an illusion of an open garden pergola with tapestries of the *Council of the Gods* and the *Wedding Banquet of Cupid and Psyche* (*c.* 1517–18) suspended overhead. In the side vaults are scenes from the legend of Psyche and representations of *amoretti* holding emblems of the gods; Raphael probably also intended that the lunettes of the loggia be frescoed. The execution was left largely to pupils, with various portions attributed to Giulio Romano, Giovanni da Udine, Raffaello dal Colle and Giovanni Francesco Penni. The Sala di Galatea, which like the loggia was also originally open to the garden, is decorated with Peruzzi's representation of the constellations of Chigi's horoscope accompanied by a personification of Fame trumpeting his glory. On the walls are Peruzzi's *Gigantic Head*, Sebastiano del Piombo's *Polyphemus* (*c.* 1511) and Raphael's *Galatea* (*c.* 1511; *see* colour pl. 2, XXII1), all portions of a cycle of the gods that was never completed, perhaps because the lower floor of the villa was subject to flooding. The Sala delle Prospettive above features illusionistic frescoes by Peruzzi (1516–17), and in Chigi's bedroom there are scenes from the life of Alexander the Great, including the *Marriage of Alexander and Roxana* (dated variously between 1509 and 1516) by Sodoma (*see* colour pl. 2, XXXII2), who also painted for Agostino a tondo featuring an allegory, *Love and Chastity* (1501–5; Paris, Louvre), and a *cassone* with the *Rape of the Sabine Women* (*c.* 1508; Rome, Pal. Barberini).

Chigi's burial chapel at S Maria del Popolo in Rome (1513–16), unfinished at the time of his death, was conceived as a complete complex—architecture, sculpture, mosaics—designed by Raphael. The mosaics in the dome, representing God the Father, angels and the seven planets, were executed by the Venetian Luigi da Pace in 1516 from cartoons by Raphael. Raphael also designed the pyramidal tombs in which Agostino and his brother Sigismondo (*d* 1526) were buried, though they were later redesigned and completed by Bernini. Lorenzo Lotti's bronze antependium and his marble figures of *Jonah* and *Elias* (both *in situ*) are based on designs by Raphael with pendants to these figures later added by Gianlorenzo Bernini (1598–1680). Additions ordered by the executors of Chigi's will include paintings by Sebastiano and Francesco Salviati. Agostino's commissions for his family chapel at S Maria della Pace included two bronze roundels by Lotti (now in the abbey of Chiaravalle, nr Ancona) after designs by Raphael and frescoes of *Four Sibyls* and *Four Prophets*

designed by Raphael (1514); the execution of the *Prophets* is attributed to Timoteo Viti. Raphael's designs for an altarpiece of the *Resurrection* have also been connected with this chapel.

BIBLIOGRAPHY
F. Saxl: *La fede astrologica di Agostino Chigi* (Rome, 1934)
C. L. Frommel: *Die Farnesina und Peruzzis architektonisches Frühwerk* (Berlin, 1961)
M. Hirst: 'The Chigi Chapel in S Maria della Pace', *J. Warb. & Court. Inst.*, xxiv (1961), pp. 161–85
J. Shearman: 'The Chigi Chapel in S Maria del Popolo', *J. Warb. & Court. Inst.*, xxiv (1961), pp. 129–60
C. L. Frommel: *B. Peruzzi als Maler und Zeichner* (Vienna and Munich, 1967–8)
W. Tosi, ed.: *Il magnifico Agostino Chigi* (Rome, 1970)
F. Gilbert: *The Pope, his Banker and Venice* (London, 1980)
M. Quinlan-McGrath: 'The Astrological Vault of the Villa Farnesina: Agostino Chigi's Rising Sign', *J. Warb. & Court. Inst.*, xlvii (1984), pp. 91–105
P. Morel: 'Priape à la Renaissance: Les Guirlandes de Giovanni da Udine à la Farnesine', *Rev. A.*, lxix (1985), pp. 13–28
I. D. Rowland: 'Render unto Caesar the Things which are Caesar's: Humanism and the Arts in the Patronage of Agostino Chigi', *Ren. Q.*, xxxix (1986), pp. 673–730
C. Magnusson: 'The Antique Sources of the Chigi Chapel', *Ksthist. Tidskr.*, lvi/4 (1987), pp. 136–9
——: 'Lorenzetto's Statue of Jonah, and the Chigi Chapel in S Maria del Popolo', *Ksthist. Tidskr.*, lvi/1 (1987), pp. 19–26
K. Lippincott: 'Two Astrological Ceilings Reconsidered: The Sala di Galatea in the Villa Farnesina and the Sala del Mappamondo at Caprarola', *J. Warb. & Court. Inst.*, liii (1990), pp. 185–207
M. Quinlan-McGrath: 'The Villa Farnesina: Time-Telling Conventions and Renaissance Astrological Practice', *J. Warb. & Court. Inst.*, lviii (1995), pp. 52–71

DAVID G. WILKINS

Chiulinovich, Juraj. *See* SCHIAVONE, GIORGIO.

Chusini, Silvio. *See* COSINI, SILVIO.

Ciaccheri Manetti, Antonio di. *See* MANETTI, ANTONIO DI CIACCHERI.

Ciampanti. Italian family of painters.

(1) Michele Ciampanti [Borghese] (*fl* 1470–1510). He is first documented in Lucca in 1470. In 1485 he was commissioned by Nicolao da Noceto to paint the vault of the chapel of S Regolo in Lucca Cathedral and to gild an altar carved by Matteo Civitali, also for the cathedral. In 1481 Ciampanti and Civitali had executed a polyptych for the church of S Romano, Lucca, and in 1486 Ciampanti, with Vincenzo Frediani, assessed Civitali's wooden *Pietà* (Lucca, Villa Guinigi). In 1492 Ciampanti was in Lucca, and in 1496 he was in Pietrasanta painting in the cathedral. He was in Lucca again from 1506 to 1510.

The triptych of the *Virgin and Child with SS John the Baptist, Vitus, Modestus and Peter* in SS Vito and Modesto, Montignoso, nr Massa, was commissioned from Ciampanti in 1482 (Tazartes, 1985). Stylistically it has the characteristics typical of a painter trained in Lucca at this time, influenced by Botticelli, Filippino Lippi and Ghirlandaio, all of whom worked for a time in Pisa or Lucca between *c*. 1474 and *c*. 1483. These characteristics are also found in works attributed to the Florentine period of the STRATONICE MASTER (*see* MASTERS, ANONYMOUS, AND MONOGRAMMISTS, §I): *St Sebastian* (untraced, see Bellosi, 1967), a *Virgin and Child with Angels* (ex-van Gelden priv.

col., Uccle, see Fahy, 1966, pl. 19) and the *Virgin and Child with an Angel* (ex-Lederer priv. col., Vienna, see Fahy, 1966, pl. 21). The Montignoso Triptych has previously been attributed to the Stratonice Master, and this has led to the supposition that Ciampanti painted some of the works previously given to the Master, particularly those strongly Lucchese in character. The works attributed to the Stratonice Master's early, Sienese period (1470–80), however, are difficult to reconcile with Ciampanti's oeuvre.

BIBLIOGRAPHY
Thieme–Becker
E. Fahy: 'Some Notes on the Stratonice Master', *Paragone*, xvii/197 (1966), pp. 17–28
L. Bellosi: 'Un *S Sebastiano* del Maestro di Stratonice', *Paragone*, xviii/207 (1967), pp. 62–3
M. Tazartes: 'Anagrafe lucchese, II. Michele Ciampanti: Il Maestro di Stratonice?', *Ric. Stor. A.*, xxvi (1985), pp. 18–27
——: 'Nouvelles perspectives sur la peinture lucquoise du quattrocento', *Rev. A.*, 75 (1987), pp. 29–36

(2) Ansano di Michele Ciampanti [Master of St Philip] (*fl* Lucca, 1498–1532). Son of (1) Michele Ciampanti. Natale (1980) isolated a group of paintings from the corpus formerly attributed to the Stratonice Master and gave them to the Master of St Philip, named after the location of the altarpiece of the *Virgin and Child with SS James and Philip* (Lucca, S Filippo). Subsequently it was discovered that the altarpiece was commissioned from Ansano di Michele Ciampanti on 29 August 1517 at a cost of 28 ducats; the painting was to be finished within four years (Baracchini and others, 1986). Stylistically the painting is transitional between the late 15th-century Lucchese style and that of Agostino Marti (*fl* 1520–26) and Zacchia the elder (*fl c*. 1500–after 1561). The fresco of the *Visitation* (Lucca, S Frediano; see Tazartes) and the panel of the *Virgin and Child with SS John the Baptist, Catherine, Lucy and Joseph* (Lucca, Villa Guinigi), both formerly attributed to the Master of the Lathrop Tondo, can also be given to Ciampanti.

BIBLIOGRAPHY
M. Natale: 'Note sulla pittura lucchese alla fine del quattrocento', *Getty Mus. J.*, viii (1980), pp. 56–61
M. Tazartes: 'Committenza popolare in S Frediano di Lucca, I', *Ric. Stor. A.*, xiii–xiv (1981), p. 118
C. Baracchini and others: 'Pittori a Lucca tra '400 e '500', *An. Scu. Nom. Sup. Pisa*, n.s. 2, xvi (1986), pp. 794–8
G. Concioni, C. Ferri, G. Chilarducci: *I pittori rinascimentali a Lucca* (Lucca, 1988), pp. 175–83

MAURIZIA TAZARTES

Cibo, Giovanni Battista. *See* INNOCENT VIII.

Ciccione, Andrea. *See under* ANDREA DA FIRENZE.

Cicognara, Antonio (*fl* 1480–?1500). Italian painter and illuminator. A *Virgin and Child* (Ferrara, Pin. N.), signed and dated *Antonii Cicognarii Pictura anno domini 1480*, shows him to have been an extremely feeble painter at that date. Longhi (1934) and Ruhmer (1957) proposed that Cicognara had played a substantial role in the decoration of the Salone dei Mesi in Palazzo Schifanoia, Ferrara, 11 years earlier, but this thesis seems unlikely and has not been generally accepted. His earliest certain work is as a miniaturist in Cremona, where he illuminated two Antiphonaries and a Psalter for the cathedral between 1482 and

1483. The miniature of *Isaiah* on fol. 3*r* of the Psalter (Cremona Cathedral, Cod. IV) is signed and dated 1483. He is also documented in Cremona on 17 December 1486 and 31 May 1487, painting in S Rocco and in the Ospedale della Pietà. In 1490 he signed and dated a *Virgin and Child with St Catherine of Alexandria and a Female Saint* (ex-Cologna and Speroni priv. col., Milan); in 1493 he signed and dated a *St Hyacinth* (destr.) painted on a pilaster in S Pantaleone, Cremona (Zaist, 1774). He was last recorded in Lodi in August 1500 with Jacopo de' Motti evaluating work by Ambrogio Bergognone in the sanctuary of the Incoronata.

Other paintings attributed to Cicognara include *St Catherine with an Adoring Nun* (Bergamo, Gal. Accad. Carrara) and the *Adoration of the Child with Two Angels* (Cremona, Pal. Com.). The attribution of six cards from the Visconti–Sforza tarot pack (New York, Pierpont Morgan Lib.; Bergamo, Gal. Accad. Carrara) is based primarily on faked documentary evidence (Novati, 1880, 1908; Gualazzini, 1931; Dummett, 1976).

BIBLIOGRAPHY
DBI
G. B. Zaist: *Notizie istoriche de' pittori, scultori ed architetti cremonesi* (Cremona, 1774), pp. 46–7
L. Cicognara: *Memorie spettanti alla storia della calcografia* (Prato, 1831), pp. 158–9, 329–56
F. Novati: 'La vita e le opere di Domenico Bordigallo', *Archv Veneto*, xix (1880), pp. 4–45
——: 'Per la storia delle carte da giuoco in Italia', *Libro & Stampe*, n. s. ii, 2–3 (1908), pp. 54–69
P. Toesca: *La pittura e miniatura nella Lombardia: Dai più antichi monumenti alla metà del '400* (Milan, 1912), pp. 526–7
U. Gualazzini: 'Contributo alla questione dragoniana', *Atti Reale Accad. Sci. Torino*, lxv (1931), p. 402
R. Longhi: *Officina ferrarese* (Rome, 1934); rev. in *Opere complete di Roberto Longhi*, v (Florence, 1956), pp. 37, 99–102
E. Sandberg Valvalà: 'Antonio Cicognara Again', *A. America*, xxv (1937), pp. 64–8
M. Gregori: 'Altobello, il Romanino e il cinquecento cremonese', *Paragone*, vi/69 (1955), p. 27, n. 12
E. Ruhmer: 'Nachträge zur Antonio Cicognara', *Pantheon*, xviii (1960), pp. 254–9
M. Dummett: 'A Note on Cicognara', *J. Playing Card Soc.*, ii/1 (1973), pp. 14–17
——: 'More about Antonio Cicognara', *J. Playing Card Soc.*, v/2 (1976), pp. 26–34
F. Zeri and F. Rossi: *La raccolta Morelli nell'Accademia Carrara* (Bergamo, 1986), pp. 172–4 (no. 61)
K. Lippincott: 'Gli affreschi del *Salone dei Mesi* e il problema dell' attribuzione', *Atlante di Schifanoia*, ed. R. Varese (Modena, 1989), pp. 111–39
L. Malaspina and A. Ricagni: 'Per Antonio Cicognara', *A. Crist.*, lxxxii/761 (March–April 1994), pp. 101–22
KRISTEN LIPPINCOTT

Cima da Conegliano(, Giovanni Battista) (*b* Conegliano, nr Treviso, ?1459–60; *d* Conegliano or Venice, Sept 1517 or 1518). Italian painter. He belonged to the generation between Giovanni Bellini and Giorgione and was one of the leading painters of early Renaissance Venice. His major works, several of which are signed, are almost all church altarpieces, usually depicting the Virgin and Child enthroned with saints; he also produced a large number of smaller half-length Madonnas. His autograph paintings are executed with great sensitivity and consummate craftsmanship. Fundamental to his artistic formation was the style that Bellini had evolved by the 1470s and 1480s; other important influences were Antonello da Messina and Alvise Vivarini. Although Cima was always capable of modest innovation, his style did not undergo any radical alteration during a career of some 30 years, and his response to the growing taste for Giorgionesque works from the early 16th century remained superficial. He seems to have maintained a sizeable workshop, but there is no evidence that he trained any major artist and he had little long-term influence on the course of Venetian painting.

Cima's work presents few serious problems either of attribution or dating. His style is readily recognizable and has rarely been confused with that of other major artists; the only real doubts relate to questions of workshop collaboration. A number of signed and dated works survives from all phases of his career, and several major works may be dated on external evidence. They show that Cima's style changed perceptibly but not radically, and although his later works show a certain softening of internal contours and a deeper and richer colour range, he remained largely impervious to the style that Bellini evolved after *c.* 1500.

1. Life and work. 2. Working methods and technique. 3. Critical reception and posthumous reputation.

1. LIFE AND WORK. Cima's name provides an accurate indication of his geographical and social origins: he came from a family of *cimatori* (cloth-shearers) in the small town of Conegliano on the Venetian mainland. He is first recorded in his father's tax returns in 1473, by which date he must have reached the age of 14. His entire career was spent in Venice, where he is first definitely recorded in 1492, but he maintained close links with his home town throughout his life, keeping a house there and later acquiring land in the area. This enduring contact with the Venetian *terra firma* may account for the important and distinctive part played by landscape in his art from early maturity onwards.

Cima may have served an apprenticeship with one of the painters active in Conegliano in the 1470s, but they were all provincial mediocrities, and he is likely to have gravitated to a more important centre by the early 1480s. Some critics have identified this as Vicenza, and his master as Bartolomeo Montagna, since Cima's earliest dated work, the *Virgin and Child with SS James and Jerome* (Vicenza, Mus. Civ. A. & Stor.), was painted for the church of S Bartolomeo, Vicenza, in 1489. But Cima would have reached the status of independent master long before then, and none of his works that appear to pre-date the Vicenza altarpiece reveals any response to the art of Montagna. The basis for Cima's own style is clearly that of Giovanni Bellini, and, whether or not he was trained in Bellini's studio, he must have been closely acquainted with Bellini's major works in Venice at an early stage in his career. Consistent with this supposition is the theory that Cima trained under Alvise Vivarini, for his earliest works contain echoes and near quotations from both artists. If Cima was resident in Venice by the early to mid-1480s, he may well be the 'magister Zambatista pictor' who is recorded as having sent a confraternity standard from Venice to Conegliano in 1486.

At the beginning of his career Cima's style more closely resembled relief sculpture than free-standing statuary. In

1. Cima da Conegliano: *St John the Baptist with SS Peter, Mark, Jerome and Paul*, oil on panel, 305×205 mm, *c.* 1493–5 (Venice, Madonna dell'Orto)

an early *Virgin and Child* (*c.* 1485–6; Philadelphia, PA, Mus. A.) the figures occupy a shallow space, the shadows are pale and the folds of drapery are treated more as an abstract pattern of lines than as a naturalistic representation of the fall of cloth. Similar features appear in an early altarpiece, the Olera Polyptych (*c.* 1486–8; Olera, Parish Church), in which the saints look slender and fragile, showing angularities of form that may derive from Alvise Vivarini.

Around this time Cima began to produce the first of the altarpieces that make up the main body of his work. The earliest examples were all painted for towns and villages in the Veneto—Oderzo (near Treviso) as well as Conegliano—and this region remained one of his most important sources of patronage. The earliest of his Venetian altarpieces show him already at the height of his powers. *St John the Baptist with SS Peter, Mark, Jerome and Paul* (*c.* 1493–5; Venice, Madonna dell'Orto; see fig. 1) well illustrates his main sources of inspiration. Its basic composition follows the principles laid down for *sacre conversazioni* by Giovanni Bellini in his altarpieces for SS Giovanni e Paolo (*c.* 1470; destr. 1867) and S Giobbe (*c.* 1480; Venice, Accad.; *see* BELLINI, (3), fig. 3). The picture field is a tall, round-topped rectangle, with the group of saints arranged symmetrically under vaulted architecture,

the forms of which are complemented by the real stone frame. The central saint, John the Baptist, is set slightly higher than his companions, with his head forming the apex of a compositional pyramid. The figures are disposed with a sense of easy spaciousness, their features, limbs and draperies modelled with crisp clarity in the sharply directed light. Cima's picture also has much in common with those of Bellini in its emotional tenor, the general mood one of calm meditation and gentle devotion. Characteristic of Cima himself is the rustic sturdiness of the figure types; and in contrast to Bellini's typically ecclesiastical interiors, Cima's architectural structure is ruinous, with vegetation encroaching into the open vault and a pleasant view of the Veneto countryside visible in the background. The formality and stability of Bellini prototypes is further reduced by the picturesque asymmetry of the architectural arrangement, which is presented obliquely, with the three columns on the right loosely balanced against the pier and tree on the left. Although the construction is somewhat improbable in functional terms, it is rendered delightful by the minute attention paid to the finely chiselled masonry, the variety of plants and flowers, and, above all, by the pervasive sense of fresh air and natural light.

Many of the same qualities are apparent in a characteristic *Virgin and Child* (*c.* 1495; Bologna, Pin. N.; see fig. 2), formerly in S Giovanni in Monte, Bologna. Again, Cima's starting-point is a formula established by Giovanni Bellini, with the Virgin seen in half-length behind a marble parapet, and a view of landscape behind. The painting also shows Cima's intelligent understanding of the formal problems that had preoccupied Bellini during his phase of active response to the art of Antonello da Messina during

2. Cima da Conegliano: *Virgin and Child*, tempera on panel, 710×480 mm, *c.* 1495 (Bologna, Pinacoteca Nazionale)

the 1470s and 1480s; the figures are conceived as two contrasting masses, and the volumetric quality of every shape is stressed by the carefully directed light. Also typical of Cima is the unaffected, countrified look of the figures, who lack the spiritual gravity of those of Bellini; and Bellini's customary back-cloth of honour, a regal symbol, is replaced by a landscape view agreeably reminiscent of the hilly countryside of Cima's homeland.

During the 1490s, when Giovanni Bellini was occupied largely with the decoration of the Doge's Palace, Cima became the leading exponent of altar painting in Venice. Even after the emergence c. 1505 of a younger and radically innovative generation that included Giorgione, Titian, Sebastiano del Piombo, Lorenzo Lotto and Palma Vecchio, Cima maintained his leading position and remained much in demand as a painter of devotional works. Among his largest and most imposing altarpieces are those painted for the Venetian churches of S Maria della Carità (c. 1499–1501; Venice, Accad.), Corpus Domini (c. 1505–6; Milan, Brera) and S Maria dei Carmini (c. 1509–11; *in situ*), all of which were commissioned by wealthy, though not noble, Venetian citizens closely involved in the devotional and charitable activities of the *scuole grandi*.

Although none of Cima's early altarpieces includes landscape background, the large-scale *Baptism* in S Giovanni in Bragora, Venice, is set in a landscape painted with complete confidence and mastery. This important commission for the church's high altarpiece was commissioned in 1492. The middle distance and background are filled with sharply focused natural detail and human incident: ducks on the river, sheep in the fields, boatmen and horsemen; yet these details are not obtrusive because they are imposed on to a compositional structure of perfect logic and clarity, which leads the eye gently backwards down the twisting river and up the hilly paths into the distant background. Together with the radiant light, these formal devices derive from works by Giovanni Bellini of the 1480s such as the *Ecstasy of St Francis* (New York, Frick) and the *Transfiguration* (Naples, Capodimonte; see colour pl. 1, XI2), but Cima succeeded in transforming them into something entirely his own.

During the 1490s Cima also worked for patrons in Emilia. The *Lamentation* (c. 1495–7; Modena, Gal. & Mus. Estense) once belonged to Alberto Pio (1475–1531), Lord of Carpi, near Modena, an ardent supporter of humanist learning and a regular visitor to Venice. Stylistic evidence indicates that this picture was soon followed by the first of three altarpieces that Cima painted for churches in Parma: the *Virgin and Child with SS Michael and Andrew* (c. 1496–8; Parma, G.N.), in which Cima used a particularly daring asymmetrical composition, moving the architecture entirely to one side and balancing it against a view of a distant hill city on the other. The figure of St Michael shows a refinement and sophistication that marks a departure from the rustic simplicity of the Madonna dell'Orto saints and that may reflect contact with the art of Pietro Perugino. If Cima did visit Parma in connection with this commission, he may have stopped in Bologna on the way and seen Perugino's *Virgin in Glory with Four Saints* (c. ?1496; Bologna, Pin. N.), painted for S Giovanni in Monte. Such an influence might also account for the novel effects of contrapposto in the work.

The twisting poses of the figures and the relaxed asymmetry of the composition are important precedents for the dynamically conceived altarpieces of Titian and Sebastiano del Piombo at the beginning of their careers. But Cima did not pursue his own innovations, and major works of the first decade of the 16th century such as the altarpiece from the Corpus Domini in Venice, *St Peter Martyr with SS Nicholas and Benedict* (c. 1505–6; Milan, Brera), reveal his essentially conservative temperament. Although the late afternoon pastoral landscape in the background has an elegiac quality that is rather different from the morning freshness of the earlier *Baptism* and that perhaps owes something to Giorgione, the architectural foreground is again entirely symmetrical, with the three saints correspondingly calm and static, themselves resembling architectural members. It is as if Cima were consciously renewing the springs of his art by turning back not just to the earlier Giovanni Bellini but to Antonello da Messina. Cima's early works show little direct influence from the pictures that Antonello had left in Venice during his visit of 1475–6, but the rigorous simplification of the head and robes of the central figure of St Peter Martyr and the geometric harmony of the composition seem to reflect a careful study of Antonello's great altarpiece for S Cassiano (1475–6; fragment in Vienna, Ksthist. Mus.).

The *Virgin and Child with SS John the Baptist, Cosmas, Damian, Apollonia, Catherine and John the Evangelist* (c. 1506–8; Parma, G.N.; see colour pl. 1, XXIII1) was commissioned by Canon Bartolomeo Montini for his funerary chapel in Parma Cathedral. Montini is of particular interest since he was closely related to two of the leading patrons of art in the city, the Marchese Scipione della Rosa and Scipione's sister-in-law, the abbess Giovanna da Piacenza, both early supporters of Correggio. There is some evidence to suggest that a pair of exquisite mythological tondi by Cima, *Endymion Asleep* (see fig. 3) and the *Judgement of Midas* (both c. 1505–10; Parma, G.N.), were also commissioned by a member of this circle. Cima

3. Cima da Conegliano: *Endymion Asleep*, oil on panel, diam. 240 mm, c. 1505–10 (Parma, Galleria Nazionale)

produced only a handful of works with mythological subjects, all of them on a small scale, and all apparently made to decorate *cassoni* or other items of furniture. They are important early examples of a genre that was to become closely associated with the great Venetian painters of the 16th century, especially as Cima's earliest examples, a pair of panels with scenes from the *Legend of Theseus* (*c.* 1495–7; Zurich, priv. col., and Milan, Brera, on dep. Milan, Mus. Poldi Pezzoli; see colour pl. 1, XXII2 and Humfrey, 1981), appear to pre-date the earliest examples by Giovanni Bellini and Giorgione. But by far the most numerous domestic pictures produced by Cima and his shop were half-length paintings of the Virgin and Child, with or without accompanying saints. Such pictures were clearly painted to meet a heavy popular demand for small panels with devotional subjects and often may have been sold on the open market.

The best of Cima's late works, for example the third of the Parma altarpieces, the *Virgin and Child with SS John the Baptist and Mary Magdalene* (*c.* 1511–13; Paris, Louvre; see fig. 4), similarly show only superficial concessions to modernity within a framework of intelligent conservatism. The landscape is lusher and more generalized than that of the *St Peter Martyr* altarpiece, the shadows deeper and the saints—a Giorgionesque Baptist and a Magdalene in the style of Palma Vecchio—move forward to adore the Child in a way that imparts a new fervour to the mood and a

new animation to the composition. But there remains a duality between the figures and their environment, and the literalism and dependence on linear perspective to create the illusion of space is still in the spirit of the 15th century. Forms are conceived additively rather than organically, and the attention to small-scale detail is, by 16th-century standards, pedantic. Yet Cima had not lost self-confidence, nor had he relaxed his high standards of craftsmanship; and, no less than are his more progressive works of the 1490s, the altarpiece is one of great serenity and beauty.

Documents relating to Cima's life are scarce: he was twice married and had eight children, none of whom followed their father's profession. In 1507–9 he was involved in a lawsuit over his *Incredulity of Thomas* (1502–4; London, N.G.), a large altarpiece painted for a flagellant community in Portogruaro. At a meeting of the painters' guild in 1511, Cima proposed that figure painters be accorded a status superior to that of decorative painters, but this was summarily dismissed. In 1514 he was living in an apartment in the Palazzo Corner Piscopia (later Loredan), near the Rialto Bridge in the parish of S Luca. It is not clear how often and how widely he travelled outside Venice; he may not always have accompanied his altarpieces to distant destinations in the Veneto, making use instead of Venice's well-developed systems of transport, but when establishing contact with important patrons like those in Parma, it seems likely that he made the journey in person. He certainly made frequent visits to Conegliano. A document relating to his death states that he was buried *alli fra menori* (in the church of the friars minor, i.e. Franciscans), which may refer to the Frari in Venice or to S Francesco in Conegliano.

2. WORKING METHODS AND TECHNIQUE. Cima's practice was based on that of Giovanni Bellini in matters of workshop procedure and pictorial technique, as well as of style. Almost without exception his pictures were painted on gesso-primed panels, and from early maturity onwards he used oil as his principal medium. It is evident from the quantity, and also from the rather variable quality, of surviving works in Cima's style that he made extensive use of workshop assistants. The identity of some of these, including Andrea Busati, Girolamo da Udine, Pasqualino Veneto and Anton Maria da Carpi (*fl* 1495), may be inferred from the occasional work inscribed with their signatures.

Cima's working methods are well illustrated by a small *Virgin and Child with SS Andrew and Peter* (Edinburgh, N.G.), which has survived in an unfinished state (see Plesters, 1985). The ground has been identified as true gesso, on top of which Cima made an underdrawing with the tip of the brush in black gall ink, carefully mapping out the entire composition. The internal modelling of the forms, in particular of the draperies, is rendered with finely detailed parallel hatching and shading. In some of the forms colour had not yet been applied; elsewhere the artist had begun to apply the paint, bound with linseed oil in a leanish mixture, in a series of thin, even layers kept strictly within the contours of the forms. None of the colour planes has a final paint layer, and hence they also lack the

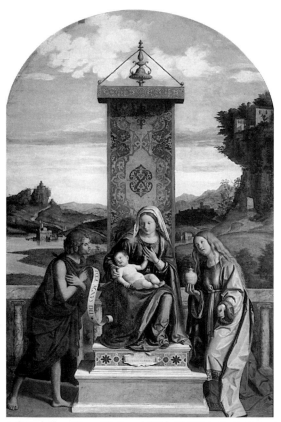

4. Cima da Conegliano: *Virgin and Child with SS John the Baptist and Mary Magdalene*, oil on panel, 1.68×1.1 m, *c.* 1511–13 (Paris, Musée du Louvre)

glazes and highlights that give the surfaces of objects in Cima's completed pictures their characteristic glow.

Cima's slow and deliberate method of painting, carefully following his detailed underdrawing, has more in common with traditional Italian tempera techniques than with the more flexible and spontaneous method of oil painting developed by Titian during Cima's lifetime. His works up to c. 1490 all seem to have been painted in tempera; thereafter he evidently combined both media in individual works. It is clear from the increasingly soft and fluent tonal transitions that appear in his works of the 1490s that by the end of the decade he had acquired full confidence in the use of the new oil medium.

Cima's dependence on underdrawings, which excluded all but the most minor pentiments in his paintings, indicates that each new project must have been preceded by numerous preparatory drawings on paper. Although no more than eight or nine of his drawings survive, they illustrate several different stages of the planning process, from the full-length *St Jerome* (Florence, Uffizi), a relatively sketchy study for the modelling of St Jerome's draperies in the Vicenza altarpiece of 1489, to the extremely detailed *Head of St Jerome* (London, BM), which seems to be an 'auxiliary' cartoon for the *Madonna of the Orange Tree* (c. 1496–8; Venice, Accad.). The drawing of an *Enthroned Bishop with Two Saints* (Windsor Castle, Berks, Royal Col.) represents a fully evolved compositional study. Drawings would also have played an important role in Cima's workshop as *ricordi* or visual records for later re-use or adaptation. The *Head of St Jerome* may itself be based on a *ricordo*, since a very similar head had already appeared in the Olera polyptych (c. 1486–8); it is typical of Cima's method that heads, figures and landscape motifs should make frequent reappearances in later works, sometimes after ten years or more. This habit of self-repetition, which was a useful expedient in meeting the popular demand for his works, was criticized by Vasari in relation to Cima's contemporary, Perugino; but on the whole Cima managed to avoid the obvious danger of monotony by the sheer skill and meticulous craftsmanship of his pictorial execution.

3. CRITICAL RECEPTION AND POSTHUMOUS REPUTATION. The large output of Cima's workshop, which did not decrease towards the end of his life, shows that his works were in high demand. Even after Giorgione's death, Cima continued to receive important metropolitan commissions such as that for the *Adoration of the Shepherds* (c. 1509–11; Venice, S Maria dei Carmini). His typical customers (members of the Venetian citizen class, devotional confraternities and mainland parishes), however, were more likely to have been attracted to his art for its devotional than for its purely aesthetic qualities. His solemn, meditative, humanly accessible saints, set within a harmonious architectural foreground against a peaceful sunlit landscape, evidently accorded well with a particular brand of contemporary religiosity. But for collectors and connoisseurs with more sophisticated and secular tastes, Cima's style must have begun to look old-fashioned soon after 1500. It is significant that Michiel's *Notizia* (c. 1520–40), a detailed account of Venetian art collections, does not record a single work by Cima, even

though numerous private homes must have possessed examples of his work.

By the mid-16th century 'Giovanni Battista da Conegliano' had become little more than a name attached to a handful of signed altarpieces in Venetian churches. Vasari included Cima in his life of 'Scarpazza' (Carpaccio), mentioning only the *St Peter Martyr* altarpiece in the church of Corpus Domini, and referring to him as a pupil of Giovanni Bellini. Vasari also provided the mistaken information that Cima died young, thus misleading critics for another three centuries. The mistake may, however, have been based on the astute visual observation that Cima followed Bellini's middle style, not his late one. The various Venetian sources of the 16th, 17th and 18th centuries all give Cima respectful but brief mention and sometimes confuse his works with those of Bellini.

Cima's reputation was revived in the 19th century, along with that of many of his contemporaries. He was a favourite painter of John Ruskin (1819–1900), whose *Modern Painters* (London, 1843) contains a lyrical passage about the plants in the Madonna dell'Orto altarpiece. The first serious and detailed study of Cima's art was made by Crowe and Cavalcaselle (1871). This was followed by Botteon's and Aliprandi's monograph (1893), which is likely to remain the fullest biographical account. A significant landmark for the wider appreciation of Cima's art was the ambitious exhibition held in Treviso in 1962. In 1977 the artist's birthplace became the headquarters of a society founded in his honour, the Fondazione Giovanni Battista Cima da Conegliano.

BIBLIOGRAPHY

DBI; Thieme–Becker

GENERAL WORKS

J. Crowe and G. B. Cavalcaselle: *A History of Painting in North Italy* (London, 1871, rev. 1912)

L. Venturi: *Le origini della pittura veneziana* (Venice, 1907)

P. Schubring: *Cassoni* (Leipzig, 1915, 2/1923)

A. Venturi: *Storia*, vii/4 (1915/*R* 1967), pp. 500–51

B. Berenson: *Venetian Painting in America* (New York, 1916)

H. Tietze and E. Tietze-Conrat: *The Drawings of the Venetian Painters in the 15th and 16th Centuries*, 2 vols (New York, 1944)

R. Longhi: *Viatico per cinque secoli di pittura veneziana* (Florence, 1946)

M. Davies: *The Earlier Italian Schools*, London, N.G. cat. (London, 1951, 2/1961/*R* 1986)

S. Moschini Marconi: *Opere d'arte dei secoli XIV e XV*, Venice, Accad. cat. (Rome, 1955)

B. Berenson: *Venetian School* (1957), pp. 64–8

M. Bonicatti: *Aspetti dell'umanesimo nella pittura veneta dal 1455 al 1515* (Rome, 1964)

M. Kemp: *Cima* (London, 1967)

H. W. van Os and others, eds: *The Early Venetian Paintings in Holland* (Maarssen, 1978)

M. Natale: *Musei e Gallerie di Milano: Museo Poldi Pezzoli, dipinti* (Milan, 1982)

M. Lucco: 'Venezia fra quattro e cinquecento', *Storia dell'arte italiana*, ed. G. Bollati and P. Fossati, v (Turin, 1983), p. 459

N. Huse and W. Wolters: *Venedig: Die Kunst der Renaissance* (Munich, 1986)

P. Humfrey: 'Competitive Devotions: The Venetian *Scuole piccole* as Donors of Altarpieces in the Years around 1500', *A. Bull.*, lxx (1988), pp. 401–23

——: *The Altarpiece in Renaissance Venice* (New Haven and London, 1993)

EARLY SOURCES

M. A. Michiel: *Notizia d'opere di disegno* (c. 1520–40); ed. G. Frizzoni (Bologna, 1884) [records S Maria della Carità altarpiece]

G. Vasari: *Vite* (1550, rev. 2/1568); ed. G. Milanesi (1878–85), iii, p. 645

F. Sansovino: *Venetia città nobilissima et singolare* (Venice, 1581, rev. 2/1663)

C. Ridolfi: *Meraviglie* (1648); ed. D. von Hadeln (1914–24/R 1965), i, pp. 76–7

M. Boschini: *Le minere della pittura* (Venice, 1663)

A. M. Zanetti: *Della pittura veneziana e delle opere pubbliche de' veneziani maestri* (Venice, 1771)

F. Malvolti: *Catalogo delle migliori pitture esistenti nella città e territorio di Conegliano* (1774); ed. L. Menegazzi (Treviso, 1964)

D. M. Federici: *Memorie trevigiane sulle opere di disegno*, 2 vols (Venice, 1803)

G. A. Moschini: *Guida per la città di Venezia*, 2 vols (Venice, 1815)

G. Caprin: *Istria nobilissima*, 2 vols (Trieste, 1904), p. 135 [documents for Capodistria altarpiece]

MONOGRAPHS, EXHIBITION CATALOGUES AND SYMPOSIA

V. Botteon and A. Aliprandi: *Ricerche intorno alla vita e alle opere di Giambattista Cima* (Conegliano, 1893/R Bologna, 1977)

R. Burckhardt: *Cima da Conegliano* (Leipzig, 1905)

L. Coletti: *Cima da Conegliano* (Venice, 1959)

Cima da Conegliano (exh. cat., ed. L. Menegazzi; Treviso, Pal. Trecento, 1962)

Prov. Treviso, v (1962) [issue dedicated to Cima]

S. Coltelacci, I. Reho and M. Lattanzi: 'Problemi di iconologia nelle immagini sacre: Venezia c. 1490–1510', *Giorgione e la cultura veneta tra '400 e '500; Atti del Convegno: Roma, 1978*, pp. 97–103

Giorgione a Venezia (exh. cat., Venice, Accad. Pitt. & Scul., 1978)

L. Menegazzi: *Cima da Conegliano* (Treviso, 1981)

P. Humfrey: *Cima da Conegliano* (Cambridge, 1983) [illustrations and documents]

Venezia cinquecento, iv/7–8 (Conegliano, 1993) [papers given at conference on Cima]

SPECIALIST STUDIES

V. Lasareff: 'Opere nuove o poco note di Cima da Conegliano', *A. Ven.*, xi (1957), pp. 39–52

J. Białostocki: '"Opus quinque dierum": Dürer's *Christ among the Doctors* and its Sources', *J. Warb. & Court. Inst.*, xxii (1959), pp. 17–34

A. C. Quintavalle: 'Cima da Conegliano e Parma', *Aurea Parma*, xliv (1960), pp. 27–30

A. Ballarin: 'Cima at Treviso', *Burl. Mag.*, civ (1962), pp. 483–6

R. Pallucchini: 'Appunti alla mostra di Cima da Conegliano', *A. Ven.*, xvi (1962), pp. 221–7

L. Vertova: 'The Cima Exhibition: A Festival at Treviso', *Apollo*, lxxvi (1962), pp. 716–19

I. Kühnel-Kunze: 'Ein Frühwerk von Cima', *A. Ven.*, xvii (1963), pp. 27–34

R. Marini: 'Cima e la sua problematica', *Emporium*, cxxxvii (1963), pp. 147–58

R. Grönwoldt: 'Studies of Italian Textiles II: Source Groups of Renaissance Orphreys of Venetian Origin', *Burl. Mag.*, cvii (1965), pp. 231–40

P. Humfrey: 'Cima da Conegliano at San Bartolomeo in Vicenza', *A. Ven.*, xxxi (1977), pp. 176–81

——: 'Cima da Conegliano and Alberto Pio', *Paragone*, xxix/341 (1978), pp. 86–97

——: 'Cima's Altarpiece in the Madonna dell'Orto', *A. Ven.*, xxxiii (1979), pp. 122–5

——: 'Cima da Conegliano, Sebastiano Mariani and Alvise Vivarini at the East End of S Giovanni in Bragora in Venice', *A. Bull.*, lxii (1980), pp. 350–63

——: 'Two Fragments from a Theseus *Cassone* by Cima', *Burl. Mag.*, cxxiii (1981), pp. 477–8

——: 'Cima da Conegliano a Parma', *Saggi & Mem. Stor. A.*, xiii (1982), pp. 35–46

J. Plesters: *Cima da Conegliano, the Virgin and Child with SS Andrew and Peter: Notes on the Examination of the Picture and Analysis of Samples* (typescript, Edinburgh, N.G., 1985)

M. Wyld and J. Dunkerton: 'The Transfer of Cima's *The Incredulity of St Thomas*', *N.G. Tech. Bull.*, ix (1985), pp. 38–59

Disegni veneti di collezioni olandesi (exh. cat., ed. B. Aikema and B. Meijer; Venice, Fond. Cini, 1985), pp. 32–3 [sheet by Cima in Rotterdam]

Master Prints: Fifteenth to Nineteenth Century (sale cat., ed. R. Bromberg; London, Colnaghi & Co., 1985), p. 49 [tentative attribution to Cima of engraving in Mantegna's style]

J. Dunkerton and A. Roy: 'The Technique and Restoration of Cima's *The Incredulity of S. Thomas*', *N.G. Tech. Bull.*, x (1986), pp. 4–27

P. Humfrey: 'Some Additions to the Cima Catalogue', *A. Ven.*, xl (1986), pp. 154–6

G. J. van der Sman: 'Uno studio iconologico sull' *Endimione dormiente* e sul *Giudizio di Mida* di Cima da Conegliano: Pittura, poesia e musica nel primo cinquecento', *Stor. A.*, 58 (1986), pp. 197–203

E. Martini: 'Di alcune opere di Cima da Conegliano', *Arte Doc.*, iv (1990), pp. 76–81

PETER HUMFREY

Cioli [Ciolli; Ciuli]. Italian family of sculptors.

(1) Simone (di Michele) Cioli [Simone da Settignano] (*b* Settignano, *c.* 1500; *d* Florence, 17 Aug 1572). According to Vasari, he was a pupil of Andrea Sansovino. His earliest documented activity is in Sansovino's workshop in Loreto in 1515–16, when he received payments in connection with the marble redecoration of the Santa Casa. He probably continued to work at Loreto until 1523, although he is not identified personally among Sansovino's many assistants. In 1525 he is documented working with Niccolò Tribolo and Girolamo da Treviso on reliefs for the smaller doors of S Petronio in Bologna and between 1527 and 1528 with Giovan Battista da Siena in the chapel of the Magi at Orvieto Cathedral. He again received payments at Loreto in 1533 (Vasari stated that he executed some of the putti on the spandrels of the doors in the Santa Casa, although this cannot be documented). Four years later he was selected by Antonio da Sangallo (ii), the new director of works at Loreto, to carve two *Prophets* for the Santa Cappella (the first prophet completed in 1538, the second in 1541); these have been identified as the two stiff and pedestrian figures now placed on the Porta Romana at Loreto (Weil Garris).

Simone is next recorded in Rome some 20 years later, collaborating with his son (2) Valerio Cioli on the restoration of antique sculpture in the collection of Ippolito II d'Este. From 1561 to 1564 father and son were in Florence, restoring antique sculpture in Cosimo I de' Medici's collection. In 1565 Simone was cited in Vincenzo Borghini's list of possible candidates to provide decorations for the marriage of Francesco I de' Medici, although no other evidence of his participation in this project survives.

BIBLIOGRAPHY

DBI

G. Vasari: *Vite* (1550, rev. 2/1568); ed. G. Milanesi (1878–85), iv, p. 523; v, p. 462; vi, pp. 302, 480

K. Weil Garris: *The Santa Casa di Loreto: Problems in Cinquecento Sculpture*, 2 vols (New York, 1977), p. 90

(2) Valerio (di Simone) Cioli (*b* Settignano, *c.* 1529; *d* Florence, 29 Dec 1599). Son of (1) Simone Cioli. After training with his father, he worked under Niccolò Tribolo at Cosimo I de' Medici's villa at Castello from *c.* 1544, when he may have produced the spirited bronze fountain figure *Satyr with a Flask* (Florence, Bargello), which was formerly at Castello. In 1548–9 he went to Rome, where he entered the workshop of Raffaello da Montelupo, a pupil of Michelangelo. No autograph work survives from this period, but his activity as a restorer of antique statues between 1554 and 1560 is well documented: he worked first for Giuliano Cesarini and then, together with his father, for Cardinal Ippolito II d'Este. The restoration of a colossal statue of *Rome* (Rome, Villa Medici), formerly at the Este villa of Monte Cavallo, has been attributed to Valerio. During this period he may also have restored and recarved the antique figure of *Narcissus* (London, V&A), which was attributed to Michelangelo during the 19th century.

Following Cosimo I's visit to Rome in 1561, when Valerio gave him a marble statue of *Venus* (untraced), he and his father were summoned to Florence to undertake the restoration of the Grand Duke's collection of Classical statuary. Other Medici commissions include the grotesque marble statue of the court dwarf *Morgante*, depicted nude and seated on the back of a tortoise, which was later adapted as a fountain (now called the *Fountain of Bacchus*, 1561–8; Florence, Boboli Gdns), and the more sympathetically characterized standing nude figure of the second court dwarf, *Pietro Barbino* (marble, life-size; Florence, Pitti). These popular images were produced as bronze statuettes, variously attributed to both Cioli and Giambologna (examples, Florence, Bargello).

For Michelangelo's funeral in 1564 in S Lorenzo in Florence, Valerio contributed an allegorical statue for the catafalque and the group *Christian Charity Subduing Vice* to the right of the high altar. The success of these led to his nomination to the Accademia del Disegno in the same year and to his selection as one of the sculptors to carve a statue for Michelangelo's tomb in Santa Croce: the pensive and solemnly classical seated marble figure of *Sculpture*, completed by 1573. In 1565 Valerio provided allegorical groups for the wedding decorations for the marriage of Francesco I de' Medici and Joanna of Austria, and in 1569 he was occupied on the figure of *St John*, completed by Giovanni Vincenzo Casali (1540–93), for the chapel of S Luca in the cloister of SS Annunziata. From 1574 Cioli was active at the Medici villa at Pratolino, where he produced a number of mediocre genre groups, including a colossal limestone figure of a *Laundress Wringing out Clothes*, a marble *Satyress Milking a Ewe* and a *Mower* (all untraced, but described by Borghini), which were apparently interesting for their narrative subject-matter and decorative qualities.

Valerio's activity outside the Medici circle includes his drily characterized marble bust of *Vincenzo Danti*, carved between 1578 and 1584 for the sculptor's tomb in S Domenico in Perugia, and the funerary monument (1580; destr.) commissioned by Antonio Guidi [Serguidi], secretary to Francesco I de' Medici, for the Guidi family chapel in the cathedral at Volterra. Around this time Valerio apparently returned to Rome, where he executed the funerary portrait of *Pietro Paolo Mignanelli* (*c.* 1583; Rome, S Maria della Pace) and a marble Crucifix for the chapel of the Cardinal of S Severina in S Giovanni in Laterano. For the decorations and *intermezzi* in honour of the marriage in 1589 of Ferdinando I and Christine of Lorraine, Cioli contributed a gilded statue of *Giovanni delle Bande Nere* and other papier-mâché sculptures.

During the last decade of his career Valerio was occupied on marble groups for the Boboli Gardens: the 'Lavacapo' (*Woman Washing a Boy's Hair*), from which water falls into a pool, a *Peasant Emptying Grapes into a Vat* and a *Peasant Hoeing* (all *in situ*). These are executed in a ponderous and stiff hand, perhaps due to the fact that they were completed only after Valerio's death in 1599 by his nephew, Giovan Simone di Bernardo (*c.* 1580–after 1617); they are stylistically far removed from the Mannerist elegance of Valerio's earlier works and rely on a humorous and naturalistic realism that heralds the genre groups of the next century.

BIBLIOGRAPHY

DBI

G. Vasari: *Vite* (1550, rev. 2/1568); ed. G. Milanesi (1878–85), vi, p. 478; vii, pp. 301, 317, 639; viii, p. 629

R. Borghini: *Il riposo* (Florence, 1584); ed. M. Rosci (Florence, 1967), pp. 523, 599

F. Gurrieri and J. Chatfield: *Boboli Gardens* (Florence, 1972), pp. 37–8, 49, 62–3

Giambologna (exh. cat., ed. C. Avery and A. Radcliffe; Edinburgh, Royal Scot. Mus.; and elsewhere; 1978), pp. 101–5

M. Daly Davis: 'La galleria di sculture antiche di Cosimo I a Palazzo Pitti', *Le arti del principato mediceo*, ed. C. Adelson (Florence, 1980), pp. 31–54

B. G. Fischer Thompson: *The Sculpture of Valerio Cioli, 1529–1599* (Ann Arbor, MI, 1980) [with further bibliog.]

ANTONIA BOSTRÖM

Cioni, Andrea di Michele di Francesco. *See* VERROCCHIO, ANDREA DEL.

Circignani, Niccolò. *See* POMARANCIO, NICCOLÒ.

Ciriaco d'Ancona [Ciriaco di Filippo de' Pizzicolli]. *See* CYRIAC OF ANCONA.

Ciserano, Cesare. *See* CESARIANO, CESARE.

Ciuffagni, Bernardo (di Piero di Bartol) (*b* Florence, 1385; *d* Florence, 1457). Italian sculptor. His name first appears on the rolls of Florence Cathedral in 1409. The following year he was commissioned to provide the seated figure of *St Matthew* (Florence, Mus. Opera Duomo) for the main portal of the cathedral, the other three evangelists having already been assigned to Nanni di Banco, Niccolò di Pietro Lamberti and Donatello. Completed in 1415, the *St Matthew* displays Ciuffagni's talent for eclecticism rather than originality, and records testify to a degree of suspicion on behalf of the other three sculptors at the newcomer's interest in their work. Ciuffagni continued to enjoy official favour in Florence, and widely attributed works include a prophet for the Porta della Mandorla (*c.* 1415), a statue of *Joshua* for the campanile façade (begun *c.* 1415–17, finished, probably by another artist, 1421; Florence, Mus. Opera Duomo) and a statue of *St Peter* for the Butchers' Guild at Orsanmichele (*c.* 1415; *in situ*). In 1415 Ciuffagni left Florence, most probably for Venice, where he is thought to have collaborated with Niccolò di Piero Lamberti and Piero di Niccolò Lamberti on the façade of S Marco, before returning to Florence in 1422. The Opera del Duomo (Cathedral Works) again provided work, in 1423 commissioning the statue of *Isaiah* for the campanile, which, though finished in 1427, was placed instead on the cathedral façade. Vasari's assertion that Ciuffagni worked on S Francesco, Rimini, repeats an earlier, unfounded tradition that has basis in neither stylistic nor documentary evidence. He appears to have ceased working in the late 1430s.

BIBLIOGRAPHY

H. W. Janson: *The Sculpture of Donatello*, 2 vols (Princeton, 1957)

M. Wundram: 'Donatello and Ciuffagni', *Z. Kstgesch.*, xxii (1959), pp. 85–101

C. Seymour jr: *Sculpture in Italy, 1400–1500*, Pelican Hist. A. (Harmondsworth, 1966)

JUDITH NESBITT

Ciuli. *See* CIOLI.

Civerchio, Vincenzo (*b* Crema, *c.* 1470; *d* Crema, *c.* 1544). Italian painter and sculptor. He was primarily active in Brescia and Crema, arriving in the former city around 1490. He was influenced by Vincenzo Foppa, with whom Vasari and Lomazzo confused him. In 1493 he was commissioned to paint frescoes (destr.) depicting the *Life of the Virgin* in the presbytery of the Old Cathedral, Brescia. Extant works from those years include the *Road to Calvary* and the *Deposition* (1490; Travagliato, SS Pietro e Paolo) and a polyptych depicting *St Nicholas of Tolentino* (1495; Brescia, Pin. Civ. Tosio–Martinengo) painted for S Barnaba, Brescia. Recent restoration has revealed that the left panel of *St Sebastian* was painted and signed by an artist who worked in the style of Leonardo and was active in Milan, Francesco Galli, called Francesco Napoletano (*d* 1501). Not only do these works show strong ties with Foppa and such Milanese artists as Bernardo Zenale but they also contain clear references both to German engravings, such as the *Road to Calvary* by Martin Schongauer (*c.* 1435/50–91) and to Leonardo. Civerchio's study of the austere, powerful works of Foppa is seen most strikingly in the *Pietà* (1504; Brescia, S Alessandro).

From 1507 Civerchio worked extensively for civic and ecclesiastical patrons in Crema. The municipal government commissioned important paintings, such as *St Mark between Justice and Temperance* (1507; confiscated by the French in 1509; untraced), and organ shutters depicting the *Annunciation* for the cathedral. These latter show an understanding of architectural perspective that bears out Marcantonio Michiel's description of Civerchio as 'painter, architect and perspectivist'.

In 1512 Civerchio is documented as living in Romano di Lombardia, north of Crema. His altarpiece, dated 1519, depicting *SS Sebastian, Roch and Christopher* (Crema, Cathedral), while still making reference to Foppa's late work, demonstrates Civerchio's characteristically incisive line and attention to landscape. Also in the cathedral Civerchio executed a fresco surrounding an early 15th-century frescoed image of the *Virgin* thought to be miraculous, commissioned in 1522. His major work from this decade is a polyptych of the *Virgin and Child with Saints* (1525; Palazzolo sull'Oglio, S Maria Assunta), in which allusions to the work of Lorenzo Lotto and Romanino show that Civerchio was well aware of the innovations of his younger contemporaries. Civerchio was active for the next 20 years: a number of altarpieces bear late dates, and numerous documents attest to his productivity. Several wood sculptures have traditionally been attributed to Civerchio, for example *St Pantaleon* (Crema, Cathedral), probably carved in the 1530s. A document of 1541 implies that Civerchio carved two angels for S Maria, Offanengo, that may be identifiable with two figures still in that church.

BIBLIOGRAPHY

DBI

G. Vasari: *Vite* (1550, rev. 2/1568); ed. G. Milanesi (1878–85)
[M. Michiel]: *Notizia d'opere di disegno* (1512–75); ed. J. Morelli (Bassano, 1800)
M. L. Ferrari: 'Lo pseudo Civerchio e Bernardo Zenale', *Paragone*, xi/127 (1960), pp. 34–69
——: 'Ritorno a Bernardo Zenale', *Paragone*, xiv/157 (1963), pp. 14–29
G. P. Lomazzo: 'Gli sognie raggionamenti', *Scritti sulle arti*, ed. R. P. Ciardi, 2 vols (Florence, 1973–5); i, pp. 1–240
——: 'Trattato dell'arte della pittura, scoltura et architettura', *Scritti sulle arti*, ed. R. P. Ciardi, 2 vols (Florence, 1973–5); ii, pp. 9–589
Il polittico di Civerchi in parrocchia di Santa Maria Assunta, Palazzolo sull'Oglio, 1782–1982: I duecento anni di vita della Parrocchiale (Palazzolo sull'Oglio, 1982)
M. Verga Bandirali: 'Nuovi documenti per Vincenzo Civerchio', *Insula Pulcheria*, xiii (1983), pp. 67–84
M. Marubbi: *Vincenzo Civerchio: Contributo alla cultura figurativa cremasca nel primo cinquecento* (Milan, 1986)
L. Baini and others: *La pittura in Lombardia: Il quattrocento* (Milan, 1993)

ANDREA BAYER

Civitali [Civitale], **Matteo (di Giovanni)** (*b* Lucca, 5 June 1436; *d* Lucca, 12 Oct 1501). Italian sculptor, painter, architect and engineer. He is generally considered the most important Tuscan marble sculptor working outside Florence during the second half of the 15th century; he is also documented as a painter, although no works have been attributed to him. Civitali's training and early years are undocumented, but it is likely that he worked in Antonio Rossellino's Florentine workshop during the 1460s. He is first mentioned in 1468, when he appraised Rossellino's tomb of *Filippo Lazzari* in Pistoia Cathedral. Stylistically Civitali's sculpture is related to the work of Donatello, Desiderio da Settignano, the Rossellino brothers, Mino da Fiesole and Benedetto da Maiano. Civitali's amalgam of sources is quite complex, yet his sculptures maintain an equilibrium more common to works of the early 15th century. He possessed a certain originality as a designer, and his sculpture demonstrates that he was a technician of considerable accomplishment.

Civitali's first documented work, the tomb of *Pietro da Noceto* (*d* 1467, tomb completed 1472; Lucca Cathedral; see fig.), is dependent on the humanist wall tombs, most notably Bernardo Rossellino's tomb of *Leonardo Bruni* (*c.* 1450; Florence, Santa Croce; for illustration *see* ROSSELLINO, (1)) and Antonio Rossellino's tomb of the *Cardinal of Portugal* (*c.* 1466; Florence, S Miniato al Monte). The eclectic nature of the tomb reflects Civitali's ability to borrow and synthesize from a variety of sources. Innovative details include a crisply carved frieze with garlands and griffins on the base and profile busts of the deceased and his son—who commissioned the tomb—placed in the lunette flanking the tondo of the *Virgin and Child*.

Civitali's most important patron was the Lucchese humanist and statesman Domenico Bertini (*c.* 1417–1506). Among the many works he commissioned are the altar of the Sacrament for Lucca Cathedral (1473–after 1476; angels *in situ*, tabernacle, London V&A), the tomb of *Domenico Bertini and Sveva Risaliti* (1479; Lucca Cathedral), a *Virgin and Child* (*c.* 1482; Lucca, S Michele in Foro), the chapel of the Volto Santo (1484; Lucca Cathedral) and the tomb of *St Romanus* (1490; Lucca, S Romano). The Bertini tomb is a simple arcosolium tomb, based on earlier Florentine models and Palaeo-Christian tombs, and includes a life-size bust of the deceased carved in a veristic style akin to that developed by Benedetto da Maiano. It is supported on two marble skulls and a marble iliac bone: references to death not commonly found in Italian Renaissance sculpture at this period. The tone of the tomb is more medieval than Renaissance, and the style appears rather austere and severe when compared to other monuments by Civitali and his contemporaries.

In the 1480s Civitali and his workshop worked on many projects, the most important of which were the altar tomb

and aesthetic only partly evolved from Civitali's earlier works and are characterized by pathos and subtly dramatic expressive faces. In particular, the figures of *St Elizabeth* and *St Zacharias* possess a quality of realism and emotion similar to contemporary Emilian sculpture.

Civitali demonstrated his talents as an architect and engineer in the bridge across the River Serchio at Moriano (1490), his fortifications at Lucca (1491) and the Palazzo Pretorio in Lucca, begun in 1494 but completed only after 1506, presumably by his son, Nicolao Civitali (*b* Lucca, *bapt* 25 April 1482; *d* Lucca, before 23 Dec 1560). While the overall design of this two-storey palace is derived from prototypes by Michelozzo and others and is probably Matteo's work, a substantial part of the ornamental details and execution should tentatively be credited to Nicolao: most notably the decoration around the upper-storey mullioned windows, and the open loggia and blind arches on the ground-floor—elements found in later buildings in Lucca attributed to Nicolao. Matteo's legacy as an architect is perhaps more evident in his large marble monuments in Lucca Cathedral. His strict use of symmetry and carefully calculated harmonious proportions reflect a sense of order similar to that in the architecture of Brunelleschi and Michelozzo. In addition to his many other activities, Matteo, with his brother Bartolomeo Civitali (*d c.* 1478), also established Lucca's first printing press in 1477.

By the late 1460s Matteo had established a large and active workshop in Lucca that, after his death, continued to operate until the last quarter of the 16th century. Matteo's son Nicolao assumed leadership of the workshop following Matteo's death; Matteo's nephew, Masseo di Bartolomeo Civitali (*d* Lucca, after 1511), was an accomplished wood-carver, responsible for the main doors on Lucca Cathedral and in 1498 carved a wooden baldacchino (destr.) for a marble pulpit by Matteo Civitali also in Lucca Cathedral. Masseo's brother, Vincenzo di Bartolomeo Civitali (*b* Lucca, before 1477), also worked in the shop; his only known work is a marble figure of *St Peter* (1505–6; Lucca, S Frediano). Lorenzo Stagi (1455–1506) was trained in the Civitali workshop and established his own modest dynasty of artists. Among Lorenzo's more important works are the high altar for Pietrasanta Cathedral and the marble choir in the Lucca Cathedral, on which he collaborated with Matteo Civitali. Matteo's grandson, Vincenzo di Nicolao Civitali (*b* Lucca, *bapt* 17 Dec 1523; *d* Lucca, June 1597) was active as an architect, engineer and sculptor in Lucca and Rome. Among his important works are the monument of *Bishop Guidiccioni* (1541–6) in S Francesco, Lucca, and the chapel of the Sacrament in Lucca Cathedral (1575–85).

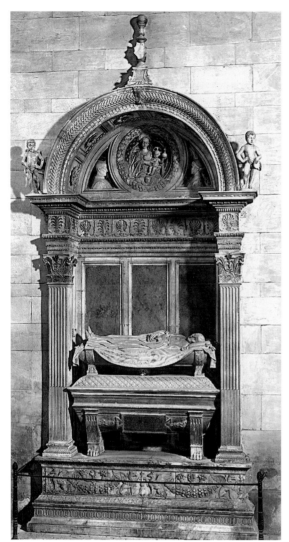

Matteo Civitali: tomb of *Pietro da Noceto*, marble, completed 1472 (Lucca Cathedral)

of *St Regulus* (1484; Lucca Cathedral) and the chapel of the Volto Santo. The *St Regulus* monument is based on the tomb of *Baldassare Coscia* (*c.* 1425; Florence Cathedral, Baptistery) by Donatello and Michelozzo; it includes some of Civitali's most ambitious carving, for example three life-size marble figures of saints and a delicately carved frieze that recalls the relief styles of Desiderio da Settignano and Jacopo della Quercia. The chapel of the Volto Santo is an elaborate octagonal structure that demonstrates Civitali's indebtedness to the architecture of Michelozzo and Brunelleschi. An elegant, semi-nude life-size statue of *St Sebastian*, set in an external niche, is derived from Antonio Rossellino's *St Sebastian* (*c.* 1475; Empoli, Collegiata) and also recalls Perugino's idealized youthful saints of the 1480s and 1490s.

The six life-size, free-standing statues (*Adam, Eve, St Elizabeth, St Zacharias, Isaiah* and *Habakkuk*) executed for the chapel of St John the Baptist in Genoa Cathedral are usually dated to 1496. They are infused with a spirit

BIBLIOGRAPHY

DBI; Thieme–Becker

G. Vasari: *Vite* (1550, rev. 2/1568); ed. G. Milanesi (1878–85), ii, pp. 119, 125–30

A. Mazzarosa: *Lezione intorno alle opere di scultura e d'architettura di Matteo Civitali* (Lucca, 1826)

E. Ridolfi: *L'arte in Lucca studiata nella sua cattedrale* (Lucca, 1882)

C. Yriarte: *Matteo Civitali: Sa Vie et son oeuvre* (Paris, 1886)

J. Pope-Hennessy: *Italian Renaissance Sculpture* (London, 1963, rev. Oxford, 3/1985), pp. 292–3

C. Baracchini and A. Caleca: *Il duomo di Lucca* (Lucca, 1972)

F. Negri Arnoldi: 'Matteo Civitali: Scultore lucchese', *Egemonia fiorentina ed autonomie locali nella Toscana nord-occidentale del primo rinascimento: Vita, arte, cultura: Atti del Settimo convegno internazionale: Pistoia, 1975*

U. Middeldorf: 'Quelques sculptures de la renaissance en Toscane occidentale', *Rev. A.* [Paris], xxvi (1977), pp. 7–26

F. Petrucci: *Matteo Civitali e Roma* (Florence, 1980)

S. Bule: *Matteo Civitali: Four Major Sculptural Programmes* (diss., Columbus, OH State U., 1987)

G. Concioni, C. Ferri and G. Ghilarducci: *I pittori rinascimentali a Lucca* (Lucca, 1988)

S. Bule: 'Nuovi documenti per Matteo Civitali', *Riv. A.*, xl (1988), pp. 357–67

——: 'Matteo Civitali's Statues for the Duomo of Genoa', *Verrocchio and Late Quattrocento Italian Sculpture*, ed. S. Bule, A. Darr and F. Superbi Giofreddi (Florence, 1992)

M. Harms: *Matteo Civitali, Bildhauer der Frührenaissance in Lucca* (Münster, 1995)

STEVEN BULE

Clement VII, Pope. *See* MEDICI, DE', (8).

Clemente, il. *See* SPANI, (2).

Clovio, Giulio [Giorgio; Klovic, Juraj] (*b* Grisone [Grizane], Croatia, 1498; *d* Rome, 3 Jan 1578). Italian painter and illuminator of Croatian birth. The most important illuminator of the 16th century, he was a 'Michelangelo of small works', according to Vasari. Many of his documented works are dispersed or untraced, and some attributions are controversial, but his secure oeuvre gives a clear idea of his stylistic influences and development. Although much of his inspiration came from Raphael and Michelangelo, he developed his own visual language, brilliantly translating their monumental forms for work on the smallest scale.

1. TRAINING AND WORK, TO 1540. Educated in his native Croatia, Clovio came to Italy at the age of 18 to study art. He began his training in Venice and spent several years there in the service of Cardinal Domenico Grimani and his nephew Marino Grimani. During this period he visited Rome, where he met Giulio Romano and studied with him. This stay in Rome, as well as his experience of the art collections of the Grimani, which included many works by northern artists, notably Albrecht Dürer (1471–1528), strongly influenced his artistic development. Around 1523 he left Venice to work at the court of the rulers of Bohemia and Hungary, Louis II (*reg* 1516–26) and Mary of Austria, the sister of Emperor Charles V (*reg* 1519–56). Works he executed there may include illustrations in a Missal (1525; Zagreb Cathedral, Treasury, no. 354) made for Simone Erdody, Bishop of Zagreb (appointed 10 Nov 1518; *d* 2 ?May/June 1543): leaves with scenes of the *Lives of the Virgin and Christ*, landscape medallions and richly decorated borders of putti with garlands. He is known to have painted a *Judgement of Paris* there and, for Queen Mary, a picture of the *Death of Lucretia* (both untraced). His stay ended with the Turkish invasion and the death of King Louis in 1526.

Clovio returned to Rome, where he was taken into the service of Cardinal Lorenzo Campeggi (1474–1539). He resumed contact with Giulio Romano and, according to Vasari, studied the works of Michelangelo. During the Sack of Rome the following year, he was taken prisoner by the troops of Charles V, a traumatic experience that led to his decision to join a monastery. On his release from prison, he moved to Mantua, where he entered the Benedictine abbey of S Ruffino, taking the name Giulio probably in honour of his teacher. He continued to paint

and when he moved to the monastery at Candiana, near Padua, he became acquainted with the illuminator Girolamo dai Libri of Verona. It has been suggested that he collaborated with Girolamo on a choir-book, of which one leaf (Windsor Castle, Royal Lib., no. 43) is signed with Clovio's name (Cionini Visani, 1971). The work includes two small compositions, one showing a figure of *St Theodore*, the other a *Cardinal, Nobleman and Priest*, possibly Clovio and Grimani. The vivid use of colour and elaborate decoration reflects Venetian, Paduan and Roman influences, in particular that of Mantegna and Raphael. In Padua, Clovio renewed his association with Grimani, and it was probably in this period that he executed the Grimani Evangeliary (Venice, Bib. N. Marciana, MS. lat. I. 103), with numerous illuminated initials and 12 illustrations depicting the *Evangelists* and scenes from the *Life of Christ*. The use of colour and the decorative motifs in this work again are Venetian in derivation, with elements from Roman and northern art.

With the help of Grimani, who had become a cardinal in 1527, Clovio obtained papal dispensation to leave the monastery, although he remained a priest. About 1534 he moved to Perugia, where Grimani was apostolic nunzio, and in 1536 he was given the benefice of S Bartolomeo, in nearby Castel Rigone. He remained in Perugia until 1538, and some of his finest works date from this period. In the Stuart de Rothesay Hours (London, BL, Add. MS. 20927), executed for Grimani, the four main compositions show *David Praying* (fol. 91*v*), the *Annunciation* (fol. 13*v*), the *Raising of Lazarus* (fol. 119*v*) and the *Crucifixion* (fol. 165*v*). Although the influence of Raphael and of Roman Mannerist art is detectable in these and smaller scenes, and in the grotesque decoration, it is integrated into Clovio's own mature style.

The illumination in the *Commentary on St Paul's Epistle to the Romans* (*c*. 1537–8; London, Soane Mus., vol. 143 [MS. 11]), probably also made for Grimani, similarly reveals his absorption and adaptation of Roman influences. The scene showing the *Conversion of St Paul* (see fig. 1) is clearly based on Raphael's design for the tapestry of that subject (Rome, Pin. Vaticana); the cartoon (destr.) was in Domenico Grimani's collection. References to Michelangelo include nude figures taken from those on the Sistine Chapel ceiling. Elements from Raphael and Michelangelo also appear in a manuscript executed from this period, the *Stanze* of the poet Eurialo d'Ascoli (Vienna, Albertina, MS. 2660). Given to the Emperor Charles V in honour of his victory over the Turks at Tunis in 1535, it includes a miniature of an eagle hovering over a female nude on a flaming pyre, possibly an allegorical reference to the Emperor as the defender of Christianity. A miniature on the title-page shows a circular building similar to Bramante's Tempietto in Rome (*see* BRAMANTE, DONATO, fig. 4). Mannerist tendencies are more pronounced in three detached leaves, also probably datable to this period, showing the *Three Virtues*, *St Paul Blinding Elymas* and *Christ Giving the Keys to St Peter* (all Paris, Louvre). A drawing for the latter survives (Windsor Castle, Royal Lib.). Clovio returned to Rome at the end of the 1530s.

2. IN THE SERVICE OF CARDINAL ALESSANDRO FARNESE, 1540–78. In 1540 Clovio entered the service of Cardinal Alessandro Farnese, a leading patron and

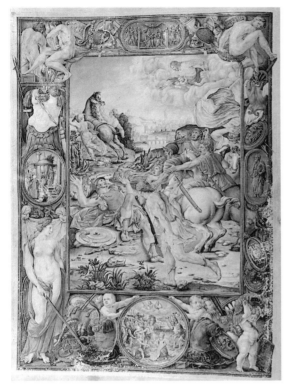

1. Giulio Clovio: *Conversion of St Paul*, 350×250 mm, miniature from the *Commentary on St Paul's Epistle to the Romans*, c. 1537–8 (London, Sir John Soane's Museum, vol. 143 [MS. 11], fol. 7v)

the Vatican, here with a greater Mannerist emphasis, probably derived from Parmigianino; the influence of Dürer also has been suggested (Cionini Visani, 1971).

Clovio accompanied Farnese to Florence in 1551 and remained there until 1553. For the Duke of Florence, Cosimo I de' Medici, he executed small paintings on parchment: a *Crucifixion with St Mary Magdalene* (Florence, Uffizi) and a *Pietà* (Florence, Uffizi; see fig. 2), in which the acid colours and cropped figures recall Tuscan Mannerism. He returned to Rome in 1553, when he probably executed the Towneley Lectionary (New York, Pub. Lib., MS. 91), also commissioned by Cardinal Farnese. The miniatures for this manuscript, which include a *Last Judgement* (now fol. 23v) and a dramatic *Resurrection* (fol. 16v), again exhibit a mixture of Roman influences but have a greater spiritual intensity, reflecting the Counter-Reformation. It has been suggested that they also show his interest in Flemish art and that Pieter Bruegel the elder (c. 1525/30–69), who was then in Italy, collaborated on the decoration of some of the borders (De Tolnay). In 1556 Clovio spent a period in Parma with the Cardinal's brother, Ottavio Farnese, Duke of Parma, and his wife Margaret of Austria, daughter of Charles V. According to Vasari, he executed a *Judith and Holofernes* for the Duchess and a pendant, *David and Goliath*, which she sent to her brother, Philip II, King of Spain (reg 1556–98). In 1557–8 Clovio was in Piacenza and in 1560 in Candiana.

In 1561 Clovio returned to Rome to the household of Cardinal Farnese in the Palazzo della Cancelleria. During

collector, who was the grandson of Pope Paul III. This association continued until Clovio's death, and he executed many commissions for Farnese. The work generally acknowledged as his masterpiece, the Book of Hours known as the Farnese Hours (New York, Pierpont Morgan Lib., MS. M. 69), was completed for the Cardinal in 1546. It contains 26 miniatures illustrating biblical scenes, including the *Death of Uriah the Hittite* (fol. 63v), the *Crossing of the Red Sea* (fol. 43v), the *Circumcision* (fol. 34v) and the *Flight into Egypt* (fol. 42v). Most of the miniatures are arranged in pairs, with Old and New Testament scenes on the facing leaves of an opening, reflecting the medieval typological tradition, in which events in the Old Testament prefigure those in the New. Unlike medieval miniatures, however, image and text are not integral; each scene is treated as a framed painting, with the text included as an inscription. The elaborate architectural borders are decorated with a witty assortment of fictive sculpture, putti and nude figures in poses recalling Michelangelo's Sistine ceiling *ignudi*. Clovio's figures are lively and graceful, with an appealing sensuality. Small scenes painted in black and white are also included, and other subsidiary scenes are represented on the plinths. The pages are crowded but masterfully composed, with subtle, harmonious colouring against a gold background. It is a monumental composition in miniature. Vasari described the volume in great detail, noting particularly the borders ornamented with nudes and grotesques, the figures 'smaller than ants', and 'most marvellous, a tangle of the names of saints'. Again there are reflections of Raphael's and Michelangelo's works in

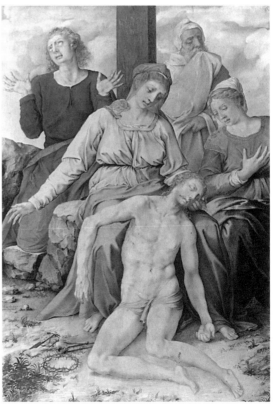

2. Giulio Clovio: *Pietà*, tempera on parchment, 375×250 mm, 1551–3 (Florence, Galleria degli Uffizi)

his periods of residence in Rome, Clovio had access to many important writers and artists and he became an influential figure in artistic life there. His friends included Michelangelo, Giorgio Vasari, Annibal Caro (1507–66) and Vittoria Colonna. He was an early supporter of El Greco (*c.* 1541–1614) and in 1570 persuaded Cardinal Farnese to give the young artist lodgings in the Palazzo. El Greco's striking portrait of *Clovio* (*c.* 1571; Naples, Capodimonte) shows him holding the Farnese Hours and indicating the miniature of the *Creation of the Sun and Moon*. Clovio's likeness, with those of Michelangelo and Raphael, is also included in El Greco's painting of *Christ Driving the Money-changers from the Temple* (Minneapolis, MN, Inst. A.). At least one *Self-portrait* by Clovio survives (Florence, Uffizi). Late works by him include three miniatures, the *Holy Family with a Knight*, the *Holy Family with St Elizabeth* and *David and Goliath* (Paris, Mus. Marmottan), in which his characteristic stylistic mix is used with less conviction. A return to a more classical mood is suggested by two paintings attributed to him: the *Holy Shroud* (see colour pl. 1, XXIII1) and four scenes of the *Passion* (Turin, Gal. Sabauda). Among his finest surviving drawings are the *Entombment* (Chicago, IL, A. Inst.) and the *Conversion of St Paul, Crucifixion* and *Lamentation* (all London, BM). Variants of the *Entombment, Conversion* and *Crucifixion* drawings were engraved by Cornelis Cort. Another drawing of the *Entombment* (Paris, Louvre) includes a cortège of Michelangelesque male nudes, and a number of drawings copied from Michelangelo also survive (Windsor Castle, Royal Lib.). Clovio was buried in S Pietro in Vincoli, Rome. An inventory made after his death indicates that his collection included works by Bruegel and Titian. His drawings were left to Cardinal Farnese.

BIBLIOGRAPHY

DBI; Thieme–Becker

G. Vasari: *Vite* (1550, rev. 2/1568); ed. G. Milanesi (1878–85), vii, pp. 439–50

W. Smith: 'Giulio Clovio and the *maniera di figure piccole*', *A. Bull.*, xlvi (1964), pp. 395–401

C. De Tolnay: 'Newly Discovered Miniatures by Pieter Bruegel the Elder', *Burl. Mag.*, cvii (1965), pp. 110–14

M. Levi d'Ancona: 'Un libro scritto e miniato da Giulio Clovio', *Miscellanea in onore di Lamberto Donati* (Florence, 1969), pp. 197–209

M. Cionini Visani: 'Un itinerario nel manierismo italiano: Giulio Clovio', *A. Ven.*, xxv (1971), pp. 119–44

A. N. L. Munby: *Connoisseurs and Medieval Miniatures, 1750–1850* (Oxford, 1972)

W. Smith: *The Farnese Hours* (New York, 1976) [facs.]

J. Harthan: *Books of Hours* (London, 1977)

F. Strazzullo: 'Giulio Clovio e il libro d'ore del card. Alessandro Farnese', *Atti Accad. Pontaniana*, xxvii (1978), pp. 141–53

M. Cionini Visani and G. Gamulin: *Giorgio Clovio: Miniaturist of the Renaissance* (New York, 1980)

S. Meloni Trkulja: 'Giulio Clovio', *Firenze e la Toscana dei Medici nell'Europa del cinquecento* (exh. cat., Florence, Pal. Vecchio, 1980), pp. 194–7

M. J. Cerney: *The Farnese Hours: A 16th-century Mirror* (diss. Columbus, OH State U., 1984; microfilm, Ann Arbor, 1985)

S. Tumidei: *La pittura in Italia: Il cinquecento*, ed. G. Briganti (Milan, 1987, rev. 1988), ii, pp. 681–2

C. Robertson: *Il Gran' Cardinale: The Artistic Patronage of Alessandro Farnese* (New Haven and London, 1992)

The Painted Page: Italian Renaissance Book Illumination, 1450–1550 (exh. cat., ed. J. J. G. Alexander; London, RA, 1994)

D. Laurenza: 'Un dessin de Giulio Clovio (1498–1578) d'après Michel Coxcie (1499–1592): De l'influence de Raphaël et de Michel-Ange sur des artistes de la génération de 1530', *Rev. Louvre*, xliii/3 (1994), pp. 30–35

LUCINDA HAWKINS

Codussi [Coducci], **Mauro** [Mauro di Codussis; Moretto da Bergamo; Moro di Martino] (*b* Lenna, nr Bergamo, *c.* 1440; *d* Venice, before 23 April 1504). Italian architect. Although trained as a stone mason and builder, he was one of the first masons in Venice to be referred to as *architectus*. He was the most accomplished and original architect of early Renaissance Venice. His style is characterized by a subtle blending of Venetian, Byzantine and Tuscan elements, refined by an apparent knowledge of the writings of Alberti. Although all his known buildings are in Venice, in 1477 and 1478 he visited Ravenna in connection with works at the Camaldolese abbey at Classe, and he also made several journeys to Istria and Verona to procure stone for his building works. He must therefore have known the antiquities of Verona and Pola, and perhaps also of Rimini, while the evidence of his buildings suggests that he probably had first-hand knowledge of Central Italian Renaissance architecture.

1. Life and work. 2. Reputation and influence.

1. LIFE AND WORK.

(i) Early career, to 1490. (ii) From 1490.

(i) Early career, to 1490. Codussi may have worked briefly in the Ravenna area, but the earliest record of his activity in Venice is in 1469, when he was named as the designer of the new abbey church of S Michele in Isola. Not only did this work establish his reputation in Venice, it also introduced him to a circle of educated and discriminating nobles who were to become his most supportive patrons. The community of Camaldolese hermits had already rebuilt their cloister and campanile when Codussi took over. Work on the new church may have started in 1468, and was certainly under way by the following spring. Despite many practical and financial problems the church was inaugurated in 1477; only the *barco* (raised monks' choir) and some decorative details remained outstanding. The history of the project is fully documented in a series of letters to the Abbot of S Michele, Pietro Donà, who was away at the sister house of Classe for the period concerned, from his deputy in Venice, Pietro Delfino (1444–1525). These letters vividly convey the monks' pride in their new church.

The design of S Michele introduced many new ideas into Venice, filtered through Codussi's sensitive appreciation of local traditions and materials. This was the first time that a church façade in the city had been completely faced in Istrian stone, an innovation taken up a century later by Palladio in his Venetian churches. The distinctive lobed profile would have reminded Venetians of the lunettes of S Marco and the trilobate façades of many of the lagoon's Gothic churches. Yet the design was also imbued with new ideas imported from Tuscany and the Marches: the façade (see fig. 1), for instance, recalls Alberti's church of S Francesco in Rimini, as depicted in Matteo de' Pasti's medal of the *Foundation of the Tempio Malatestiano* (1453–4; G. F. Hill: *Corpus* (1930), no. 167), while its rusticated lower order is reminiscent of Bernardo Rossellino's newly built Palazzo Piccolomini (1459–64), Pienza. The motif of bold Roman lettering in the frieze had been revived in Luciano Laurana's courtyard (begun

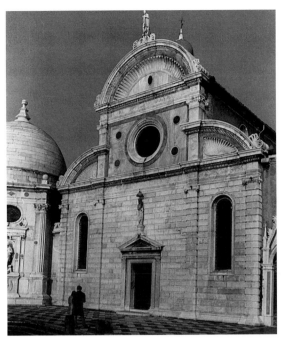

1. Mauro Codussi: façade of S Michele in Isola, Venice, begun 1469

1465) of the Palazzo Ducale, Urbino. The interior of S Michele is longitudinally planned in the monastic tradition, yet transformed into a centralized space by the placing of the choir gallery, as if in deference to Alberti's ideas. Delfino's letters show that the monks knew Alberti's *De re aedificatoria* (*c*. 1450), and they probably conveyed their interest to Codussi. The slight, but measurable, concavity of the façade of S Michele may perhaps suggest an interest in the problems raised by Albertian optics, comparable with that of several 15th-century painters, from Uccello to Leonardo, who had experimented with curved fields of vision. The superb quality of the details of the stonework, both inside and out, adds to the distinction of the church.

In 1482 Codussi received the commission to rebuild the campanile of the cathedral of S Pietro di Castello through the initiative of the Patriarch of Venice, Maffeo Gerardo, himself a Camaldolese monk. Codussi visited the quarries of Istria to choose stone for facing the new campanile, the first Venetian bell-tower to be clad entirely in Istrian stone. It was completed by 1490; with its gleaming white masonry, crisply cut cornices and delicate Brunelleschian shell-niches in the drum, Codussi's campanile remains a striking monument, although the crowning cupola was removed in 1670 when it became unsafe.

During the same years Codussi was also in charge of the completion of the church of S Zaccaria, a wealthy Benedictine nunnery with strong ducal connections. The abbess, Lucia Donà, was a relative of Pietro Donà, the Abbot of S Michele. In 1483 Codussi succeeded Antonio Gambello as *proto*, or chief architect, erecting the whole of the façade above the first cornice and the upper parts of the ambulatory and nave. His personal style is evident in the façade's overall whiteness, bold, lobed skyline and rhythmic disposition of horizontals and verticals (*see* ITALY, fig. 6).

(ii) From 1490.

(a) Parish churches. In his two parish churches, S Maria Formosa and S Giovanni Crisostomo, Codussi moved away from the eclecticism of his early projects towards a more specifically Byzantine style. There are various reasons for this shift. There was a general interest in Byzantine and Greek culture in late 15th-century Venice, a trend that has been linked to the fall of Constantinople to the Turks in 1453 and Venice's desire to take over as capital of the Byzantine world. The native Byzantine tradition in Venice also provided Codussi with the nearest available pre-Gothic stylistic models, just as Brunelleschi in Florence had often been inspired by the local Tuscan Romanesque. The Veneto-Byzantine Greek-cross plan was the traditional form for Venetian parish churches: only S Giacomo di Rialto (rebuilt 1601) preserves its original layout, but other examples survived in Codussi's time. He would no doubt have recognized that a local model would suit the aspirations and practical needs of Venetian parishes. It is also likely that, in both Codussi's parish churches, the need to reuse existing foundations encouraged the centrally planned design.

The new church of S Maria Formosa was begun in 1492 and was substantially complete by Codussi's death, apart from the two façades and campanile, which were erected later. The church underwent a series of alterations over the centuries and was severely bombed in World War I, but the interior still preserves the main lines of Codussi's design. The church has a broad, squarish plan with a central dome, long transepts and a slightly elongated nave, like the plan of S Marco, but the vaulting is more varied and explanatory. Codussi roofed the side aisles with a series of domes on pendentives, while the nave, aisles and chancel are groin vaulted, and the side chapels barrel vaulted. There is no carved decoration in the interior, apart from simple mouldings and cornices, as if to emphasize the purely spatial qualities of the architecture. The church was visited annually by the doge on the Feast of the Purification of the Virgin (2 February), and the interpenetrating spaces of the interior, with graceful biforate openings linking the side chapels, would have formed a dramatic setting for processions. The three swelling apses, which dominate the *campo* behind, are also perhaps suggestive of the church's dedication, because the meaning of the word *formosa*, beautiful, also carries a hint of plumpness.

With his second parish church, S Giovanni Crisostomo (begun 1497), Codussi was constrained by a more restricted budget and a very cramped site, but this inspired him to produce a brilliantly compact and cohesive design. Here the Greek-cross plan is based on the central crossing of S Marco, with its central dome, four smaller domes at the corners, and barrel-vaulted aisles and chapels. The main pilaster order, raised on high bases, is cut at about two-thirds of its height by a subsidiary cornice, which runs consistently around the building to articulate the lower arches. This logical, satisfying system produces a design of great clarity. The church was probably once much darker, for the triforate windows in the chancel appear to be a 17th-century alteration. The façade is a concise reworking of the façade design of S Michele in Isola, here in simple stuccoed brick, with Istrian stone

used only for the dressings. Detail is limited to the capitals of the giant pilaster order and the heavy projecting doorways, designed to attract attention in a narrow street.

(b) The Scuole Grandi. The great citizens' guilds, the Scuole Grandi, were among the wealthiest and most ambitious patrons in Renaissance Venice (*see* VENICE, §V, 2 and 3). Codussi's involvement with the Scuole began in 1490 when he took over as chief architect to the Scuola Grande di S Marco (*see* VENICE, fig. 11). The original building had been destroyed by fire in 1485, and reconstruction of the lower storey began as early as 1487. In 1489 Pietro Lombardo and Giovanni di Antonio Buora (1450–1513), two fellow Lombard masons, were put in charge of the rebuilding and erected the lower order of the façade. They were replaced by Codussi in 1490, who completed most of the façade, apart from some of the uppermost sculptural detail, before his dismissal (as an economy measure) in 1495. There is still much discussion over how much of the façade was designed by Codussi, but probably most of the upper order as well as the crowning lunettes were executed under his direction. This busy, colourful and decorative façade is not easily reconciled with Codussi's dignified, architectonic style, but one should not discount the possible influence of the Scuola official in charge of the project, Domenico di Piero, a jeweller with a taste for lavish, highly ornate architecture. The rolling lunettes across the skyline, at least, bear Codussi's personal imprint. He also executed a double-branched staircase (after 1490) alongside the main Scuola building, providing a grand processional route from the lower to the upper hall, as proposed by the Scuola in 1486. It was demolished in 1812, but was reconstructed in 1952 with some inaccuracies. The design was contrived so that the experience of mounting the stair was dramatically mirrored by the gradual appearance of the opposite flight, the barrel-vaulted ramps meeting at a sail-vaulted landing at the summit.

In 1495 the increasing competitiveness between the five *scuole grandi* led the Scuola Grande di S Giovanni Evangelista to commission from Codussi a double-branched staircase to rival that of S Marco. Here he was able to perfect the invention in a staircase of great subtlety and elegance. Widening imperceptibly towards the top, the stair is lit by large windows at each of the landings. The two flights meet beneath a dome carried on pendentives supported on coupled columns, the Istrian stone mouldings delicately patterned with small, staccato rosettes. At this point, beneath the pivoting form of the dome, the two mounting processions would join and turn together to enter the upper meeting hall.

(c) Palaces. Marco Zorzi, the patron of the Palazzo Zorzi, would have met Codussi when he paid for the building of the southern apse chapel of S Michele in Isola between 1475 and 1477. There is no other evidence for the attribution of his palace on the Rio di S Severo to Codussi, apart from stylistic affinities and the decorative restraint of the long canal façade, refacing an earlier structure behind and enabling Codussi to exploit his love of overall surface whiteness in the smooth Istrian stone. The centre of the façade is emphasized by the projecting

balustrades (the heavy balconies at the sides are later) and the rhythmic disposition of the central arched windows.

The patron of the Palazzo Lando (*c.* 1490; later Palazzo Corner–Spinelli) was probably Pietro Lando, who married a member of the Corner family in 1471. After he was widowed he entered the Church, eventually becoming Patriarch of Constantinople; he was thus one of Codussi's circle of patrons with ecclesiastical connections. No documentary proof exists to confirm the attribution to Codussi, but it is generally accepted on stylistic evidence alone. The palace passed to the Corner family in 1542. This was one of the earliest Venetian palaces to be completely faced in Istrian stone, and its location on the Grand Canal made it more conspicuous than the Palazzo Zorzi. The lower storey has crisp rustication like that on the façade of S Michele in Isola, and pilasters of decreasing height frame all three storeys. The attractive trilobate balconies of the *piano nobile* recall those of the Gothic Casa Pigafetta (*c.* 1480) in Vicenza as well as the north pulpit of S Marco in Venice. The biforate windows topped by tear-drop shaped oculi are an ingenious translation of Gothic language into Renaissance forms. In short, the palace moves tentatively but stylishly towards an overall classical articulation, within the strict formal limits of the Venetian Gothic palace tradition.

The Palazzo Loredan (later known as the Palazzo Vendramin–Calergi) is singled out by Francesco Sansovino in *Venetia città nobilissima . . .* (Venice, 1581) as one of the four finest in the city. The patron, Andrea di Nicolo Loredan (*d* 1513), was one of the main benefactors of S Michele in Isola, for which he was granted the use of the chancel for his family burial chapel. From this well-documented connection it would appear likely that he commissioned his palace from Codussi, for no other contemporary architect in Venice could have achieved so mature and coherent a design, of a classical sophistication unequalled anywhere in Italy at this time (see fig. 2). The palace does not appear in Jacopo de' Barbari's woodcut *View of Venice* (*c.* 1497–1500; original blocks in Venice, Correr; *see* VENICE, fig. 1) and was probably begun *c.* 1502, being complete certainly by the outbreak of the

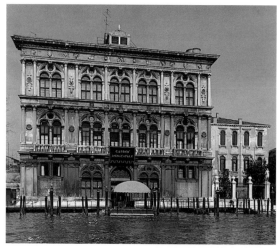

2. Mauro Codussi: façade of the Palazzo Loredan (later Palazzo Vendramin–Calergi), Venice, begun *c.* 1502

Cambrai Wars (1509–17). Here, for the first time, Codussi articulated the whole façade with the Classical orders, in an emphatic overall grid of horizontals and verticals. The three Corinthian orders are differentiated according to their function: pilasters on the prosaic water-storey, fluted half columns on the *piano nobile* and smooth half columns on the upper floor. The tear-drop shaped oculi of the Palazzo Lando are here superseded by more classical roundels over the large biforate windows. The decoration is restrained, grand, classical and carefully disposed to respect the overall articulation. Colour is used discreetly, in the form of exquisite, rare oriental marble inlays. The huge, crowning cornice was the first full Classical cornice to be seen in Venice. Here, at the climax of his career, Codussi fully grasped the logic of the Classical orders, reducing the wall surface to that of passive infilling. One can sympathize with the patron's wish to excuse his ostentation with the façade inscription 'NON NOBIS D[OMI]NE/NON NOBIS' ('Not unto us, O Lord, not unto us [but unto thy name give glory]'; Psalm 115:1).

2. REPUTATION AND INFLUENCE. Most of Codussi's patrons in Venice belonged to intellectual circles connected in various ways with his first employers, the Camaldolese monastery of S Michele in Isola. Despite his outstanding abilities, there is no record that he ever held any salaried office in either the Procuracy of S Marco or the Salt Office, the two bodies responsible for most of the public buildings in Venice. The audacity and intellectual rigour of his designs seem not to have appealed to the conservative Venetian oligarchy. Nonetheless, he probably supplied the design for the Torre dell'Orologio, the clock tower over the entrance to the Merceria, Venice's main shopping street, from Piazza S Marco. This tower, erected between 1496 and 1500 (the side wings were added soon afterwards), follows Alberti's recommendations for building a tower at, and placing an arch over, the point where the main street of a city meets the principal square. We have already seen that Codussi was probably acquainted with Alberti's writings. Hirthe's attempt to attribute the east wing of the Doge's Palace to Codussi is less convincing. This wing was erected under the direction of Antonio Rizzo after the fire of 1483. Its busy, highly ornate and almost chaotic design, with its mixture of Gothic and Renaissance forms, is not easily reconciled with Codussi's logical, economical and architectonic style.

Codussi was almost forgotten by the time Francesco Sansovino published his guide to Venice in 1581. The ravages of the Cambrai Wars stifled building in Venice to such an extent that Codussi left no direct followers apart from Giorgio Spavento (*d* 1509). Although Jacopo Sansovino and Palladio took up Codussi's ideas in their church designs, his name had already faded into obscurity. It was not until the 19th century that Pietro Paoletti assiduously scoured the documents of the period and reconstructed the oeuvre of this mysterious genius, working under several variants of his name. Whereas his fellow Lombard masons in Venice excelled in delicate *all'antica* ornament, lacy crestings, richly coloured marble inlays and finely carved arabesque reliefs alive with griffins, flora and fauna, Codussi alone knew how to organize spaces, to articulate walls and to make ornament the servant of architecture.

BIBLIOGRAPHY

P. Delphinus: *Petri Delphini . . . Epistolarum volumen . . .* (Venice, 1524); ed. R. Cessi and P. Sambin, *Annalium Venetorum pars quarta* (Venice, 1943)

P. Paoletti: *L'architettura e la scultura del rinascimento in Venezia*, 2 vols (Venice, 1893)

L. Olivato Puppi and L. Puppi: *Mauro Codussi* (Milan, 1977)

R. Lieberman: 'Venetian Church Architecture around 1500', *Boll. Cent. Int. Stud. Archit. Andrea Palladio*, xix (1977), pp. 35–48

J. McAndrew: *Venetian Architecture of the Early Renaissance* (Cambridge, MA, 1980)

R. Lieberman: *Renaissance Architecture in Venice, 1450–1540* (London, 1982)

P. L. Sohm: *The Scuola Grande di San Marco, 1437–1550: The Architecture of a Venetian Lay Confraternity* (New York, 1982)

T. Hirthe: 'Mauro Codussi als Architekt des Dogenpalastes', *A. Ven.*, xxxvi (1982), pp. 31–42

□

Coffering Coffering, or the insertion of an infill panel between the beams of a flat ceiling as a means of articulating the curved inner surfaces of a vault or dome, regained its Classical importance as a decorative feature during the Renaissance. Acting as a light mesh between a web of beams, coffering often retained its structural validity as its surface was stepped down in cantilevered slabs to reduce the size of the final panel, and even this stepping device was used to evolve decorative patterns. Thus the flat, recessed surface of the panel was separated from the structural beams by rolled mouldings in cyma recta, ovolo or egg-and-dart, and the central panel became a field for the carving or painting of circular patterns, often in the form of rosettes or other natural foliage. Coffering was a favourite device for painters to emphasize perspective recession and concentrate attention on a central feature in a painting as, for example, in Masaccio's *Trinity* (*c.* 1427) in S Maria Novella at Florence (see colour pl. 2, III1) and in Piero della Francesca's Montefeltro Altarpiece (Milan, Brera) of the mid-1470s (see colour pl. 2, XVI2).

Inspired by such Roman examples as the Pantheon, Leon Battista Alberti wrote that 'the ornaments of vaulted roofs, which consist in the forms of their panels or excavations, are in many places exceedingly handsome, and particularly in the Rotonda at Rome' (*De re aedificatoria* VII.xi). But, he complained, 'we have nowhere any instruction left us in writing how to make them'. This did not prevent him from using deep coffering in the vaulting of S Andrea (begun 1472) at Mantua, or many other Renaissance architects from following his example, as can be seen in the Pazzi Chapel (1442–*c.* 1465) and Michelangelo's dome of his New Sacristy (begun 1579) at S Lorenzo, both in Florence.

Sebastiano Serlio (*De architettura* III; 1540) illustrated the coffering in the vault of the Pantheon together with drawings showing the potential for intricate patterns which could be created to form coffering. Panels, though usually square, could be rectangular, octagonal or formed in a variety of shapes. In subsequent developments, mouldings were adjusted in profile to allow for foreshortening when seen from below. By the beginning of the 16th century elaborate decoration gave way to the use of a play of line on flat surfaces as, for example, on the vault of Donato Bramante's choir (completed 1509) of S Maria del Popolo in Rome, where the architect created a coffered vault with

a succession of plain, flat surfaces to delineate his fascination with proportional relationships. Thus it can be seen that, from the time of the Renaissance, coffering became an important device in both the decorative and the proportional exploitation of architectural and artistic surfaces.

BIBLIOGRAPHY

J. Q. Hughes and N. Lynton: *Renaissance Architecture* (London, 1962), p. 72

QUENTIN HUGHES

Cola da Camerino, Arcangelo di. *See* ARCANGELO DI COLA DA CAMERINO.

Cola (di Matteuccio) da Caprarola (*fl* 1494–1518). Italian architect. He is first mentioned working with Antonio da Sangallo (i) on the palace and fortifications of La Rocca at Civita Castellana (1494–1500) for Pope Alexander VI. Their brief included the restoration of masonry, carpentry and joinery but was primarily to update the fortifications in accordance with new theories; thus La Rocca was built as a pentagonal fortress. Similar work was carried out on the fortifications of Nepi, the contract for which survives (Rome, Vatican, Archv Segreto). It states that Cola was commissioned to execute the solaria and the roof of the palace and describes him as 'lignarius', suggesting that his speciality was woodwork.

Cola is next recorded on 7 October 1508 as receiving payment for the work on S Maria della Consolazione at Todi (*see* ITALY, fig. 9), where payments to him are recorded until 1512. These describe him first as 'muratore' and later as 'maestro di fabbrica', but not until 1510 is he referred to as architect. The church is centrally planned and can be regarded as a simplified version of Donato Bramante's designs for St Peter's, Rome, on which work had begun in 1506. A contract for 1509 specifies only three apses, leaving uncertainty as to whether the final form would be centralized or longitudinal, as happened with St Peter's.

The church is an architectural exercise in the use of basic geometrical forms. It consists of a large square space bordered by large semicircular chapels. These chapels are surmounted by half-domes, while a circular dome rises above the central space. In this combination of shapes the church is the closest in form to the writings of Alberti and the drawings of Leonardo and Bramante. It stands on an isolated elevated site, and the lucid grouping of its geometrical forms is continued upwards through the exterior elevations. The clarity of the design remains uncluttered, with the stairs and sacristy accommodated within the walls, thus retaining the pure simplicity of the internal and external shape. The clarity of the planning is heightened by the sparse decoration of the interior. *Pietra serena*, set against plain white walls, is employed to emphasize the geometrical units and to articulate the window and side altar aedicules along with the ribs of the domes. It seems likely, however, that the design for the church was by Bramante with Cola in charge of the building work, as the site architect. He may have been responsible for some of the internal detailing, which shows a knowledge of the centralized church of S Maria del Calcinaio (begun 1484) at Cortona by Francesco di Giorgio Martini.

Cola is next mentioned in a document from December 1512, as the architect in charge of the restoration of Foligno Cathedral. He is last recorded there on 14 December 1515 (docs, Foligno, Archv Episc.). The final record of Cola is in a Chigi family account-book for 22 March 1518, noting a pact for the building of the fortress at Porto Ercole.

BIBLIOGRAPHY

A. Rossi: 'Il secondo rinnovamento', *G. Erud. A.*, vi (1877), pp. 343–57
E. Muntz: 'Gli architetti Cola da Caprarola e Antonio di San Gallo il Vecchio a Nepi (1499)', *A. & Stor.* (1892), pp. 33ff
G. Clausse: *Les Sangallo* (Paris, 1902)
G. de Angelis Ossat: 'Sul tempio della Consolazione a Todi', *Boll. A.*, xli (1956), pp. 207–13
L. Heydenreich and W. Lotz: *Architecture in Italy, 1400–1600*, Pelican Hist. A. (Harmondsworth, 1974)

ALICE DUGDALE

Cola dell'Amatrice [Filotesio, Nicola] (*b* Amatrice, *c.* 1480; *d* Amatrice, after 31 Oct 1547). Italian architect, painter and engineer. He began his career as a painter, working probably in Latium and in the Abruzzi and the Marches. The first work that can definitely be ascribed to him, the polyptych with the *Virgin and Child with Saints* (the Piagge Polyptych, 1509; Ascoli Piceno, Pin. Civ.), was painted in Ascoli Piceno, where he was to spend much of his life. It has characteristics typical of painting from Umbria and Lazio and some affinities with the work of Carlo Crivelli, who was active in the same town in the late 15th century. The *Virgin and Child with Saints* (S Vittore Altarpiece, 1514; Ascoli Piceno, Mus. Dioc.) reflects an acquaintance with Raphael's Stanza della Segnatura (Rome, Vatican) and the Umbrian work of Luca Signorelli, influences that are also found in the *Assumption of the Virgin* (1515; Rome, Pin. Vaticana), *Christ Instituting the Sacrament of the Eucharist* (1517–19; Ascoli Piceno, Pin. Civ.) and the *Road to Calvary* (?1533; Ascoli Piceno, Pin. Civ.).

Cola's first architectural work was the rear façade (1518–20) of the Palazzo del Popolo in Ascoli Piceno, which echoes Raphael's Roman works, such as the Palazzo Bresciano and the Villa Madama. Cola probably went to Rome in 1512 to 1514, possibly in the suite of Alberto da Piacenza (*fl* 1501–16), an architect and hydraulics expert who had previously worked in Rome with Bramante and later worked at Ascoli Piceno. In 1523 Cola designed the side portal for S Pietro Martire in Ascoli Piceno, which was inspired by the pedimented tabernacles inside the Pantheon, Rome, while its Doric frieze is derived from Bramante's Tempietto at S Pietro in Montorio, Rome (*see* BRAMANTE, DONATO, fig. 4). In 1525, after another probable journey to Rome, Cola began his most important work, the façade of S Bernardino in L'Aquila. The lower order was built in 1525–7, and the upper two orders in 1540–42. Taking as his starting-point ideas from the designs of Giuliano da Sangallo and Raphael (as copied in an anonymous 16th-century drawing) for the façade of S Lorenzo in Florence (Tafuri, p. 167), Cola experimented with the application of superimposed orders to the square, flat-topped façade that is traditional in the Abruzzi and that had already been adopted for the façade of S Maria dell'Anima, Rome. The niches placed one above the other between the paired columns are also borrowed from Raphael, as is the treatment of the entablatures, which are

continuous in the lower order but project above the columns in the upper two orders. The Serlian window in the centre of the second order was added after 1703.

From 1525 Cola also worked on the façade of Ascoli Piceno Cathedral. The single giant order is inspired to some degree by Roman triumphal arches. Alongside the evident influence of Antonio da Sangallo the younger are certain liberties typical of Mannerist taste, such as Corinthian columns attached to Doric piers, and long volute corbels flanking a low window. The small church of S Maria della Carità (begun 1532), also in Ascoli Piceno, is more sedate. The interior takes the form of a rectangular space with niches between Corinthian pilasters similar to those on the façade. Between 1537 and 1539, Cola began building a dam at Norcia in order to create an artificial lake on the River Nera, but the dam collapsed and the project was abandoned. For Alessandro Vitelli, the local landowner, he began rebuilding the town of Amatrice (1540), which had been destroyed by the Spaniards in 1529, adapting the existing late medieval orthogonal layout to Renaissance theories of town planning.

In 1542 Cola worked as architect on the Rocca Paolina in Perugia with Antonio da Sangallo the younger and his cousin Bastiano da Sangallo. Also for Vitelli he painted in the Palazzo della Cannoniera in Città di Castello a cycle of frescoes (c. 1544) that shows the continuing influence of Raphael's painting. He then returned to Ascoli Piceno, where he left a design (untraced) for the main portal of the Palazzo del Popolo surmounted by a monument to Pope Paul III (1546); however, the work was executed according to a design by Francesco Ferrone.

Cola was one of the chief exponents of the classical language developed in Rome in the circle of Bramante and Raphael, but, as Vasari noted, because he worked outside the principal centres of the Renaissance the quality of his works was limited. Like Bramante, he constantly experimented with designs, but he only rarely succeeded in expressing his ideas in an effective and unified manner.

BIBLIOGRAPHY

Thieme–Becker: 'Amatrice, Cola dall' '

G. Vasari: *Vite* (1550, rev. 2/1568); ed. G. Milanesi (1878–85), v, pp. 213–15

A. Massimi: *Cola dell'Amatrice (Nicola Filotesio)* (Amatrice, 1939)

G. Fabiani: *Cola dell'Amatrice secondo i documenti ascolani* (Ascoli Piceno, 1952)

M. R. Valazzi: 'Nicola Filotesio detto Cola dell'Amatrice', *Lorenzo Lotto nelle Marche: Il suo tempo, il suo influsso* (exh. cat., ed. P. Dal Poggetto and P. Zampetti; Ancona, Gesù; S Francesco delle Scale; Loggia Mercanti; 1981), pp. 156–63

A. Ghisetti Giavarina: *Cola dell'Amatrice architetto e la sperimentazione classicistica del cinquecento* (Naples, 1982)

M. R. Valazzi: 'Nicola Filotesio detto Cola dell'Amatrice', *Urbino e le Marche prima e dopo Raffaello* (exh. cat., ed. M. Dupré Dal Poggetto and P. Dal Poggetto; Urbino, Pal. Ducale, 1983), pp. 346–54

M. Tafuri: 'Progetto per la facciata della chiesa di San Lorenzo, Firenze, 1515–1516', *Raffaello architetto* (exh. cat., ed. C. Frommel, S. Ray and M. Tafuri; Rome, Mus. Conserv., 1984), pp. 168–9

F. F. Mancini, ed.: *Pinacoteca comunale di Città di Castello: 1. Dipinti, Palazzo Vitelli alla Cannoniera* (Perugia, 1987), pp. 47–56, 58–66, 69–71, 84–112, 114–23

R. Cannatà and A. Ghisetti Giavarina: *Cola dell'Amatrice* (Florence, 1991)

ADRIANO GHISETTI GIAVARINA

Colantonio, Niccolò (Antonio) (*b* ?Naples, *c.* ?1420; *d* Naples, after 1460). Italian painter. A certain 'Cola de Neapoli' is documented in Rome in 1444, but he cannot be definitely identifed with Colantonio. The main source for the reconstruction of Colantonio's activity is Pietro Summonte's letter of 1524 to the Venetian Marcantonio Michiel on the history of the arts in the Kingdom of Naples. Despite the small number of undisputed works, scholars unanimously assign to Colantonio a primary role in the history of Neapolitan painting in the period of Aragonese rule between 1440 and 1470. In those years Naples was the capital of a vast realm and a centre of culture and art where many international styles came together.

Colantonio's artistic education probably took place in the fertile period of lively cultural ferment between 1438 and 1442, during the brief reign of René d'Anjou (1438–42). The Angevin ruler, a man of wide culture and a great patron in his French dominions, was probably accompanied in his Neapolitan sojourn by some of his foremost artists (*see* NAPLES, §2). Among these, it is thought, was the Master of the Aix Annunciation (*fl* 1442–5), who undoubtedly had a very strong influence on Colantonio. It has even been suggested that they were one and the same artist.

Colantonio's first work, mentioned in the early sources, is a panel depicting *St Jerome in his Study Removing the Thorn from the Lion's Paw* formerly in S Lorenzo, Naples (Naples, Capodimonte; see fig.). The upper section of the complex polyptych of which it formed part consisted of another panel by Colantonio, *St Francis of Assisi Giving the Rule to the First and Second Franciscan Orders* (Naples, Capodimonte). The altarpiece was flanked by two small pilasters, surmounted with niches in which were depicted *Ten Blessed Franciscans*, five on each side. Of these, eight have been found (Bologna, Morandi priv. col.; Florence, Fond. Longhi; ex-Moratilla priv. col., Paris; ex-Col. Cini, Venice). The entire altarpiece has to be read in terms of the Franciscans' ideological debate on poverty, which had been going on in Naples for over a century in S Lorenzo, for which the work was destined (Bologna). The painting celebrates the Franciscan orientation of St Bernardino of Siena (1380–1444). That it was commissioned by Alfonso of Aragon is clear both from the presence of his coats of arms and from the fact that he was among the first to

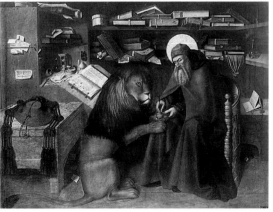

Niccolò Colantonio: *St Jerome in his Study Removing the Thorn from the Lion's Paw*, panel (Naples, Museo e Gallerie Nazionali di Capodimonte)

propose the canonization of Bernardino (1450). The iconographic complexity of the altarpiece is matched by its wide range of cultural and stylistic references. *St Jerome in his Study* clearly shows familiarity with the work of the Master of the Aix Annunciation and has a strong south Netherlandish–Provençal accent; *St Francis Giving the Rule* shows the influence of Jan van Eyck (*c.* 1395–1441) as well as Spanish and, in particular, Valencian features derived from Jacomart (*c.* 1411–61), a painter present in Alfonso's court between 1440 and 1451. The influence of Jean Fouquet (*c.* 1415/20–81) is evident in the *Blessed Franciscans*, probably the last parts of the altarpiece to be painted and attributed by some scholars to the young Antonello da Messina, who is known to have received his early training in Colantonio's workshop *c.* 1450. There are close similarities between these portraits of famous Franciscans and those of illustrious men depicted by Fouquet in his illuminations for the Cockrell Chronicle (now dispersed).

Colantonio was greatly interested in south Netherlandish art, especially that of Jan van Eyck, after whom he copied numerous works including a *St George* from an original that was in Naples in 1445 (both untraced). Around the middle of the 15th century a strong Netherlandish influence pervaded the whole of Neapolitan culture, and Alfonso of Aragon enriched his collection with works by van Eyck and Rogier van der Weyden. Derived from a prototype by van Eyck (e.g. New York, Met.) and attributed to Colantonio is a *Crucifixion* (Madrid, Mus. Thyssen-Bornemisza), which has also been attributed to Antonello da Messina (Sricchia Santoro, 1981–2). Colantonio is also thought to be the author of a *Deposition* (Naples, S Domenico Maggiore) based on Rogier van der Weyden's tapestries of scenes from the *Passion* (untraced), which decorated the 'Hall of Triumph' in the Castelnuovo, Naples. The *Deposition* also provides an interesting echo of the *Lamentation* (Brussels, Mus. A. Anc.) by Petrus Christus (*c.* 1410–75/6).

Colantonio's last work cited in early documents is the retable of *St Vincent Ferrer* (Naples, S Pietro Martire), commissioned around 1460 as an ex-voto by Queen Isabella Chiaromonte, wife of King Ferdinand I of Naples (*reg* 1458–94). In one of the predella panels she is depicted, in prayer with her children, as a votary of the Dominican saint (*can* 1456). This work shows a more profound and direct knowledge of the work of Jan van Eyck, Rogier van der Weyden and Petrus Christus. The organization of space, however, is different from the S Lorenzo polyptych. There is a more mature conception of perspective, deriving from Piero della Francesca, whose new ideas had been introduced in Naples by the Master of S Giovanni da Capestrano and developed in the studies of Antonello da Messina, who was already active as an independent artist in those years. Most scholars no longer attribute to Colantonio the *Portrait of a Man* (Cleveland, OH, Mus. A.), the *Annunciation* (Sorrento, Mus. Correale Terranova) or parts of the Strozzi Altarpiece (Naples, Capodimonte).

BIBLIOGRAPHY

DBI: Thieme–Becker

W. Rolfs: *Geschichte der Malerei Neapels* (Leipzig, 1910), pp. 87–95

F. Nicolini: *L'arte napoletana del rinascimento e la lettera di P. Summonte a M. A. Michiel* (Naples, 1925), pp. 160–63, 199–232

C. Aru: 'Colantonio ovvero il maestro dell'Annunciazione di Aix', *Dedalo*, xi (1931), pp. 1121–41

L. Demonts: 'Le Maître de l'Annonciation d'Aix et Colantonio', *Mélanges Hulin de Loo* (Brussels and Paris, 1931), pp. 123–7

C. Grigioni: 'Il primo documento d'archivio su Colantonio', *A. Figurativa*, iii (1947), p. 137

Les Primitifs méditerranéens (exh. cat., Bordeaux, Gal. B.-A., 1952), pp. 52–4

R. Longhi: 'Una crocifissione di Colantonio', *Paragone*, vi (1955), pp. 3–10

L. Castelfranchi Vegas: 'Intorno a un compianto del Cristo', *Paragone*, xx (1969), pp. 46–9

R. Pane: *Il rinascimento nell'Italia meridionale*, i (Milan, 1975), pp. 73–7

F. Bologna: *Napoli e le rotte mediterranee della pittura da Alfonso il Magnanimo a Ferdinando il Cattolico* (Naples, 1977), pp. 53–70

F. Sricchia Santoro: 'L'ambiente della formazione di Antonello: La cultura artistica a Napoli negli anni di Renato d'Angiò (1438–1442) e di Alfonso d'Aragona (1443–1458)', *Antonello da Messina* (exh. cat., Messina, Mus. Reg., 1981–2), pp. 61–72

——: *Antonello e l'Europa* (Milan, 1986), pp. 17–41

F. Navarro: 'La pittura a Napoli e nel meridione nel quattrocento', *La pittura in Italia nel quattrocento*, ii (Milan, 1988), pp. 446–73, 601–2

GIOVANNA CASSESE

Colle, Raffaello [Raffaellino] **(di Michelangelo di Luca) dal** (*b* Colle, nr Borgo San Sepolcro, *c.* 1490; *d* Borgo San Sepolcro, 17 Nov 1566). Italian painter. He is first documented on arrival in the Vatican workshop of Raphael in Rome in 1519, a connection that evidently fixed his style in the manner of the late Raphael and established him in a master–assistant relationship from which he never freed himself. For four years after Raphael's death in 1520 he continued in the workshop as Giulio Romano's chief assistant. Scholars have detected Raffaello's hand in the *Vision of Constantine* (1521) in the Sala di Costantino in the Vatican, as well as in some of the panels in the Vatican Logge (1518–19). He may also have worked in the Loggia di Psiche (1517–18) in the Villa Farnesina, Rome, with Giulio Romano and Giovanni Francesco Penni. Among his smaller commissions during this early period are several paintings of the *Virgin and Child* for which the Raphael workshop was so well known. The *Virgin and Child with the Infant St John* (1520s; Baltimore, MD, Walters A.G.) is a testament to Raffaello's Roman sojourn, its porcelain-like precision showing that he had fully mastered the beauty and elegance of Giulio Romano's Virgins. By 1527 Raffaello had returned to Borgo San Sepolcro where, according to Vasari, he offered refuge and hospitality to Rosso Fiorentino after the Sack of Rome in that year.

Between 1530 and 1532 Raffaello was working under Girolamo Genga for Francesco-Maria I della Rovere, Duke of Urbino, at the Villa Imperiale, Pesaro (*see* PESARO (i), §3). There Raffaello joined Agnolo Bronzino and Dosso Dossi, both of whom were involved in the decoration of the villa. Raffaello's contact with Bronzino and, earlier, with Rosso influenced his own style towards an elongation of the figures and an interest in poses of greater complexity, as the figures of the *Virtues* in the villa's Sala della Calunnia suggest. This stylistic development is similarly evident in roughly contemporary works such as the *Immaculate Conception with God the Father and Angels* (Mercatello sul Metauro, Collegiate Church) and the fresco cycle in the oratory of Corpus Domini, Urbania. In 1536 Vasari requested Raffaello's assistance with the temporary decoration of Florence for the grand entry of Emperor Charles V (*reg* 1519–56). In 1544–5 Raffaello again worked

with Vasari, in Naples at the refectory of Monte Oliveto, and in 1546 at the Palazzo della Cancelleria, Rome. At Bronzino's request he returned to Florence in 1548 to help with Grand Duke Cosimo I's commission for the tapestry cartoons for the Sala del Dugento in the Palazzo Vecchio. Raffaello has also been credited with a fresco cycle (1550–55) in the Palazzo Rondanini, Rome, and with a very mannered *Holy Family* (1563–4; Perugia, G.N. Umbria) commissioned by the Compagnia di S Agostino, Perugia.

Raffaello's flexibility in adapting to the stylistic demands of large artistic ventures may be what his better-known contemporaries admired in him and why he was so often called on to assist others. Unfortunately, his conformity has led to problems of attribution, magnified by the poor condition of the works. It is due to these factors that Raffaello's output has been considered provincial and uninteresting. Restorations have clarified some of these problems, however, and may succeed in launching a reappreciation of Raffaello's oeuvre. He is now considered to have been a principal figure in the dissemination of Raphael's late style throughout Umbria and the Marches.

BIBLIOGRAPHY

G. Vasari: *Vite* (1550, rev. 2/1568); ed. G. Milanesi (1878–85), v, pp. 163, 533, 556; vi, pp. 213, 214, 217, 227, 318
G. Sapori: 'Percorso di Raffaellino del Colle', *Annuario dell'Istituto di Storia dell'Arte dell'Università di Roma, 1974/5–1975/6* (Rome, 1976), pp. 167–92
F. Zeri: *Italian Paintings in the Walters Art Gallery*, 2 vols (Baltimore, 1976)
R. Keaveney: 'A Fresco Cycle by Raffaellino del Colle in the Palazzo Rondanini', *Antol. B. A.*, ii/5–8 (1978), p. 6
M. G. Ciardi Dupré Dal Poggetto and P. Dal Poggetto, eds: *Urbino e le Marche prima e dopo Raffaello* (Florence, 1983) [good colour pls; incl. restorations]
P. Verdier: 'Bramante's Belvedere and a Painting by Raffaello dal Colle in the Walters Art Gallery', *J. Walters A. G.*, xli (1983), pp. 45–58
C. L. C. Ewart Whitcombe: 'Raffaellino del Colle and Giulio Romano's *Holy Family with Saints* in Sta Maria dell'Anima', *Gaz. B.-A.*, n. s. 6, cxiv (1989), pp. 51-62

MARJORIE A. OCH

Colleoni, Bartolomeo (*b* Castello Solza, nr Bergamo, *c.* 1400; *d* Castello Malpaga, nr Bergamo, 2 Nov 1475). Italian condottiere and patron. He was born into the minor aristocracy of Bergamo and entered military life as a page in Piacenza, then served in Naples, Florence and, in 1431, in Venice under the orders of Francesco Bussone of Carmagnola (*c.* 1385–1432). From 1441 onwards he was a highly esteemed commander, who served Venice and Milan alternately until he was made General Captain in Venice in 1455. Henceforth he remained, except for a few short-lived engagements, in the service of Venice, which granted him important contracts and ceded him properties throughout the Bergamo region. Rich and powerful, he displayed his success and ensured his immortality through lavish patronage of the arts.

In 1456 Colleoni bought the castle of Malpaga and there created a splendid court at the heart of his landed property. He restored and enlarged the castle, probably employing Bartolomeo Gadio (1414–84), an architect from Cremona, to make it both a fortress that could house his soldiers and a luxurious dwelling fit, in 1474, to receive Christian I (1449–81), the King of Denmark and Norway. Frescoes of courtly scenes in the International Gothic style decorate the first floor; later, in the 16th century, scenes from Colleoni's life, including his reception of Christian I, were added. Colleoni also won fame by pious foundations: for example he had the Franciscan monastery of the Incoronata built at Martinengo. A fresco there (now Bergamo, Inst. Colleoni) represents him adoring Christ on the cross. In 1470 he decided to have his funerary chapel built on the site of the sacristy of S Maria Maggiore in Bergamo. The centrally planned chapel, a design new to Lombardy, was built by Giovanni Antonio Amadeo and the façade embellished with a lavish array of marble reliefs. Within is an elaborate tomb (*see* AMADEO, GIOVANNI ANTONIO, fig. 1) with seven marble figures (*in situ*) and a life-size equestrian effigy, originally of marble but replaced (1493) with a version in gilded wood. In 1842 the funerary monument of one of Colleoni's daughters, Medea, who died in 1470, was transferred there. This also was by Amadeo and originally stood in the sanctuary of S Maria della Basella near Urgnano (Bergamo).

Colleoni bequeathed his immense wealth to Venice in his will, on condition that a statue of him be erected in the Piazza S Marco. This was commissioned from Verrocchio, whose bronze equestrian statue was erected in 1494 (*see* VERROCCHIO, ANDREA DEL, fig. 4), not in the piazza, but in front of the Scuola di S Marco, beside the church of SS Giovanni e Paolo.

BIBLIOGRAPHY
DBI
C. Isermeyer: *Verrocchio und Leopardi: Das Reiterdenkmal des Colleoni* (Stuttgart, 1963)
A. Meli: *Bartolomeo Colleoni nel suo mausoleo* (Bergamo, 1966)
F. Piel: *La cappella Colleoni e il luogo pio della Pietà in Bergamo* (Bergamo, 1975)
V. Polli: *Il castello del Colleoni a Malpaga e i suoi affreschi* (Bergamo, 1975)
R. Signorini: 'Cristiano I in Italia', *Veltro: Riv. Civiltà It.*, xxv/1–3 (1981), pp. 23–58
J. Shell: 'The Mantegazza Brothers, Martino Benzoni and the Colleoni Tomb', *A. Lombarda*, c (1992), pp. 53–60
D. Erben: *Bartolomeo Colleoni: Die künstlerische Repräsentation eines Condottiere im Quattrocento* (Sigmaringen, 1996)

BERTRAND JESTAZ

Colonna. Italian family of patrons and collectors. The first important member of this ancient family was Oddone Colonna, who was elected (1) Pope Martin V in 1417. Re-establishing Rome as the seat of the papacy, he began various programmes of reconstruction and improvement. His nephew (2) Prospero Colonna pursued antiquarian interests as well as some modest collecting.

UNPUBLISHED SOURCES
Rome, Pal. Colonna, Archv Colonna [contains var. doc. relating to the fam., incl. the inv. of 1689]

BIBLIOGRAPHY
DBI
Catalogo dei quadri e pitture esistenti nel palazzo dell'Eccellentissima Casa Colonna (Rome, 1783)
T. Minardi: *Stima dei quadri della Galleria Colonna* (Rome, 1848)
L. Corti: *La Galleria Colonna* (Rome, 1937, rev. 1969)
P. Paschini: *I Colonna* (Rome, 1955)
E. Safarik with G. Milantori: *Catalogo sommario della Galleria Colonna in Roma*, 2 vols (Rome and Busto Arsizio, 1981)

(1) Pope Martin V [Oddone Colonna] (*b* Genazzano, nr Rome, 1368; *elected* 11 Nov 1417; *d* Rome, 20 Feb 1431). His election at the Council of Constance brought to an end the Great Schism in the Western Church (1378–

1417), and his entry into Rome on 28 September 1420 marked the first permanent return of the papacy to the Eternal City since Clement V (*reg* 1305–14) had moved the papal court to Avignon in March 1309. The most urgent task that faced the new pope was to restore the papacy's spiritual and temporal authority. He reorganized the papal state, which during the schism had fallen into chaos, refilled his treasury and enriched his family with lucrative estates in the papal territories. In Rome he carried out a vast programme of reconstructing ruined churches and public buildings, including the rehabilitation of the Vatican Palace (*see* ROME, §V, 1(iii)), for which he negotiated some of the finance with the Medici bank during his stay (26 Feb 1419–9 Sept 1420) in Florence. He also commissioned Lorenzo Ghiberti to make him a mitre with six golden figures and a jewelled button for his ceremonial cope.

After securing the peace and security of the papal state and of Rome, the Pope started to improve the look of the city. On 30 March 1425 he revived and placed under the control of the Curia the office of Supervisor of the Streets of Rome. His policy of urban and artistic renewal concentrated on those holy sites and antique monuments that attracted the greatest number of pilgrims and tourists, and on the routes between them. Among his first projects was the renovation of the lead roof tiles of the Pantheon, which in the 8th century had been renamed S Maria ad Martyres. He ordered the restoration and redecoration of the Castel Sant'Angelo, the Lateran Palace (*see* ROME, §V, 2), the Lateran Basilica (where he installed the present marble pavement and a new wooden ceiling), S Maria Maggiore, S Paolo fuori le Mura and the portico of St Peter's. At the Lateran Basilica he engaged Gentile da Fabriano, to whom payments are recorded from 28 January to 2 August 1427, to paint a fresco cycle (*see* GENTILE DA FABRIANO, §1(iii)) which, after the death of Gentile in that year, was continued by Pisanello. It was destroyed in the 17th century when the basilica was remodelled by Francesco Borromini. According to Bartolomeo Fazio's *De viris illustribus* (1456), Gentile began but did not complete one scene from the *Life of St John the Baptist* and painted five tabernacles with grisaille figures of Old Testament prophets in niches between the windows of the clerestory. A drawing (Berlin, Kupferstichkab..) of the fresco cycle prior to 1647 by a follower of Borromini shows the tabernacle with the prophet Jeremiah. In 1428 Martin commissioned a double-sided triptych for one of the four Colonna chapels in S Maria Maggiore from the Florentine painters Masolino da Panicale, who painted five of its panels, and Masaccio, who painted but did not complete one, and designed and began at least two others. At its centre were Masolino's *Foundation of S Maria Maggiore* (*see* MASOLINO, fig. 3) and *Assumption of the Virgin* (both Naples, Capodimonte); one set of side panels, with *SS Paul and Peter* and *SS John the Evangelist(?) and Martin* (both Philadelphia, PA, Mus. A.), were begun by Masaccio but in their present form were painted by Masolino; the other set was composed of Masolino's *Pope Liberius(?) and St Matthias* and Masaccio's unfinished *SS Jerome and John the Baptist* (both London, N.G.).

BIBLIOGRAPHY
R. W. Kennedy: 'The Contribution of Martin V to the Rebuilding of Rome', *The Renaissance Reconsidered* (Northampton, 1964), pp. 27–39
M. Meiss: 'The Altered Program of the Santa Maria Maggiore Altarpiece', *Studien zur toskanischen Kunst* (Munich, 1964), pp. 169–84
H. Wohl: 'Martin V and the Revival of the Arts in Rome', *Rome in the Renaissance* (Binghamton, 1982), pp. 171–83
——: 'Papal Patronage and the Language of Art: The Pontificates of Martin V, Eugene IV and Nicholas V', *Umanesimo a Roma nel quattrocento* (Rome, 1984), pp. 235–46
C. B. Strehlke and M. Tucker: 'The Santa Maria Maggiore Altarpiece: New Observations', *A. Crist.*, lxxv (1987), pp. 105–24

HELLMUT WOHL

(2) Cardinal **Prospero Colonna** (*b* Rome, *c.* 1400; *d* Rome, 1463). Nephew of (1) Martin V. He was secretly ordained cardinal in 1426 by his uncle. In 1427 he obtained the title of S Giorgio al Velabro, Rome. This was a period of economic and political advancement for the Colonna family, and they acquired several landed properties near Rome, including Rocca di Papa, Nettuno and Astura. In Rome the family had established its houses and fortifications on the slopes of the Quirinal. There, in 1440, Prospero organized and financed an archaeological excavation to recover the remains of the Temple of the Sun. In the climate of antiquarian fervour that pervaded Rome in that period, this initiative was highly praised. The humanist Flavio Biondo, recalling the episode in the first book of his *Roma instaurata*, compared Prospero to Maecenas and called him 'studiorum humanitatis apprime doctus cultorumque amantissimus'. Prospero was undoubtedly much interested in the study of the classics and in the nascent Roman humanist culture. Among his closest friends were Poggio Bracciolini, who dedicated to him the treatise *De avaritia*, and Lapo di Castiglionchio the younger (1405–38). He is also mentioned by Giorgio di Trebisonda (1395–1484) and by the Florentine Leonardo Dati (1407/8–1472) in the dedication of his tragedy *Hiempsal*. It appears that Prospero, on the strength of these interests, had established a large library; but all that is known with certainty is that he owned a 9th-century codex with the works of Ammianus Marcellinus (*d* after AD 391).

Prospero's interest in antiquity led to his supporting the recovery of a Roman ship in the lake of Nemi; he consulted Leon Battista Alberti on the construction of the machine for this operation. His antiquarian passion is attested by contemporary sources, on the basis of which he has been called the initiator of the collection of antiquities in Palazzo Colonna. In reality, however, only two statues can be securely attributed to his collection: the group of the *Three Graces*, found near his palazzo (Siena, Bib. Piccolomini) and the Belvedere *Torso* (Rome, Vatican, Mus. Pio-Clementino). The *Three Graces* appear in the Colonna house in a drawing (Munich, Staatl. Graph. Samml.) dating from the end of the 15th century. The statues passed to Cardinal Piccolomini probably on Prospero's death. His tomb is in the chapel of S Francesco in SS Apostoli, Rome.

DBI
L. Musso: 'Le antichità Colonna nei secoli XV e XVI', *La galleria Colonna in Roma: Scultura* (Rome and Busto Arsizio, 1990), pp. 13–14

FRANCESCA CAPPELLETTI

Colonna, Jacopo. *See* FANTONI, GIACOMO.

Colonna, Vittoria, Marchesa di Pescara (*b* ?Marino, ?1490; *d* Rome, Feb 1547). Italian writer. She was the granddaugh-

ter of Federigo II da Montefeltro, Duke of Urbino, and her accomplishments suggest that she received a strong humanist education. In 1509 she married Ferrante Francesco d'Avalos, the Marchese di Pescara, a soldier in the service of Emperor Charles V (*reg* 1519–56). Her husband died, disgraced, in 1525, suspected of plotting against the Emperor. After his death, Vittoria wrote sonnets to commemorate him and probably to vindicate his name. She continued to write poetry and was praised by Pietro Bembo and Baldassare Castiglione for her contribution to vernacular literature. From the 1520s she was involved with Catholic reformers, including Cardinal Reginald Pole (1500–58), whose beliefs emphasizing justification through faith and direct personal communion informed her spiritual sonnets.

In Rome in the late 1530s the Marchesa became a close friend of Michelangelo and introduced him to reformist circles. Their friendship is known from their correspondence as well as through such contemporary accounts as the *Diálogo da Pintura* by Francisco de Holanda (1517–84), which purports to record their conversations on art, especially its religious dimensions. Their correspondence often took the form of sonnets, and Michelangelo made several highly finished presentation drawings for her, including a *Pietà* (Boston, MA, Isabella Stewart Gardner Mus.), a *Crucifixion* (London, BM) and a *Christ and the Woman of Samaria* (untraced; engraving (*c.* 1540) by Nicolas Beatrizet), which seem to reflect reformist ideas. Their friendship strengthened the spiritual commitment of Michelangelo's later years and perhaps influenced his conception of the *Last Judgement* in the Sistine Chapel (Rome, Vatican, Sistine Chapel; see colour pl. 2, VII3). A portrait (1552–68; Florence, Uffizi) of *Vittoria Colonna* was painted by Cristofano dell'Altissimo; another thought to be of her (mid-16th century; Rome, Gal. Colonna) is by Bartolomeo Cancellieri. She is also portrayed on several medals (e.g. 1525–35; Vienna, Ksthist. Mus.).

BIBLIOGRAPHY

DBI

F. de Holanda: *Diálogo da Pintura* (Lisbon, 1548); Eng. trans. as *Four Dialogues on Painting* (London, 1928)

C. de Tolnay: *Michelangelo: The Final Period* (Princeton, 1960)

D. J. McAuliffe: 'Vittoria Colonna and Renaissance Poetics, Convention and Society', *Il Rinascimento: Aspetti e problemi attuali*, ed. V. Branca (Florence, 1982), pp. 531–42

V. Evangelidis: 'Michelangelo and Nicodemism', *A. Bull.*, lxxi (1989), pp. 58–66

S. Deswarte: 'Vittoria Colonna et Michel-Ange dans les Dialogues de Francisco de Holande', *Atti del congresso internazionale. Vittoria Colonna e Michelangelo: Ischia, 1990*

M. A. Och: *Vittoria Colonna: Art Patronage and Religious Reform in Sixteenth-century Rome* (PhD diss., Bryn Mawr Coll., PA, 1993)

MARJORIE A. OCH

Coltellini [Cortellini], **Michele di Luca dei** (*b* Ferrara, *c.* 1480; *d* after 1543). Italian painter. He was almost certainly trained within the circle of Ercole de' Roberti. His earliest works, two small panel paintings depicting *St Peter* and *St John the Baptist* (*c.* 1495–1500; ex-S Paolo, Ferrara; Bologna, Mus. S Stefano), which must originally have formed the side-panels of a polyptych, and the signed and dated *Death of the Virgin* (1502; Bologna, Pin. N.) are characterized by a harsh, archaicizing style that reveals the influence of northern art. The *Death of the Virgin* was inspired by

the engraving of the same subject (*c.* 1480; B. 33) by Martin Schongauer (*c.* 1435/50–91) and appears to express the sense of religious contrition felt by Coltellini, who was one of the lesser exponents of the religious fervour that characterized the final years of the dukedom of Ercole I d'Este, Duke of Ferrara, partly as a result of the influence of Girolamo Savonarola. Around this time Coltellini painted the polyptych with the *Virgin and Child Enthroned with Saints* (Ferrara, Pin. N.) and the *Circumcision* (Bergamo, Accad. Carrara B.A.), which may be a fragment of a larger painting. In the *Risen Christ with Four Saints* (Berlin, Staatl. Museen), signed and dated 1503, it is possible to detect the beginnings of his stylistic evolution towards Lorenzo Costa the elder.

Around 1505 Coltellini took part in the fresco decoration of the oratory of S Maria della Concezione, Ferrara (fragments Ferrara, Pin. N.). The altarpiece, dated 1506, depicting the *Virgin and Child Enthroned with Four Saints* (Baltimore, MD, Walters A.G.) reveals a radical change of style and the influence of the Bolognese works of Francesco Francia, Costa the elder and Perugino, suggesting a visit to Bologna shortly before 1506. The altarpiece depicting the *Virgin and Child with Eight Saints* (ex-S Maria in Vado, Ferrara; Ferrara, Pin. N.), possibly datable within the 1520s, shows the new influence of Domenico Panetti (*c.* 1460–before 1513) and Garofalo. The *Circumcision* dated 1516 (Berlin, Staatl. Museen) marks a return to his more typically detailed, northern-influenced style. Documents of 1520 and 1543 record his collaboration with his sons Alessandro, Galasso and Baldassarre, who were mask-makers.

BIBLIOGRAPHY

DBI; Thieme–Becker

A. von Bartsch: *Le Peintre-graveur* (1803–21) [B.]

A. Venturi: 'Maestri ferraresi del rinascimento', *L'Arte*, vi (1903), pp. 142–3

E. G. Gardner: *The Painters of the School of Ferrara* (London, 1911), pp. 134–5, 224–5

A. Venturi: *Storia*, VII/iii (1928), p. 934

R. Longhi: *Officina ferrarese* (Rome, 1934/R Florence, 1956)

M. Calvesi: 'Nuovi affreschi ferraresi dell'Oratorio della Concezione', *Boll. A.*, 4th ser., xxxix (1958), pp. 141–56, 309–28

A. Emiliani: *La Pinacoteca nazionale di Bologna* (Bologna, 1967), p. 194, no. 95

E. Riccomini: *La Pinacoteca nazionale di Ferrara* (Bologna, 1969), pp. 20, 53

S. Zamboni: *Pittori di Ercole I d'Este* (Milan, 1975), pp. 77–84

F. Zeri: *Italian Paintings in the Walters Art Gallery*, ii (Baltimore, 1976), pp. 366–7, no. 244

GIANVITTORIO DILLON

Compagno di Pesellino. *See* APOLLONIO DI GIOVANNI.

Condivi, Ascanio (*b* Ripatransone, nr Ascoli Piceno, 1525; *d* nr Ripatransone, 10 Dec 1574). Italian painter and writer. His work, unanimously considered mediocre, is now known through a few surviving religious paintings. He is known principally for his biography of Michelangelo. He moved to Rome *c.* 1545, where he established contact with Michelangelo and, in the early 1550s, wrote his *Vita di Michelagnolo Buonarroti* (1553). He probably wrote it directly under Michelangelo's influence. Everyday details abound, and Condivi's friendship with Michelangelo is stressed in order to contest certain aspects of Vasari's biography (1550) and to defend Michelangelo from hostile

allegations of his indifference to teaching, his arrogance, professional jealousy, avarice and homosexuality.

Michelangelo's influence is clear from the start, in the long and probably fictitious account of his genealogy, a matter of great concern to Michelangelo, which traces his ancestry as far as the Counts of Canossa. Condivi also stressed that since his adolescence his subject had enjoyed the esteem and friendship, of the papacy, royalty, the nobility and the world of letters. In similar vein, he excluded any possibility that Michelangelo could have been indebted to any other artist, omitting mention of the time Michelangelo spent in Ghirlandaio's studio and evading the subject of Michelangelo's debt to Bramante. This emphasis on Michelangelo's nobility and originality led to some historical distortions in an account that otherwise respected chronological accuracy. In the course of the *Vita*, Condivi described Michelangelo's principal works, adding iconographical commentaries that complement his praise for the artist's knowledge of perspective and architecture—which, he stressed, was based on a study of anatomy. A concluding series of anecdotes created a portrait of Michelangelo that conformed to the 16th-century criteria of artistic and moral excellence.

The *Vita* was distinguished by its literary qualities, which have often been attributed to the intervention of the erudite Annibale Caro (Battisti, Wilde). Few editions of the text appeared, but it exercised a considerable influence on Vasari, who used it extensively to rewrite his own biography of Michelangelo (in which he also corrected several contentious points). One edition of the *Vita*, annotated by a contemporary apparently close to Michelangelo, offered a final set of corrections to Condivi's account (Procacci). Above all, these notes shed light on the historical importance and nature of Condivi's difficult endeavour; writing the biography of an artist who was already the subject of myth and legend in his own lifetime. After the biography was published, in late summer 1553, Condivi returned to Ripatransone in 1554, where he married, undertook various civic responsibilities and devoted himself to painting. Among his works are a *Virgin and Child with Saints* (Florence, Casa Buonarroti), after a cartoon (London, BM) by Michelangelo, and a frescoed *Madonna del Carmine* (1569; Ripatransone, S Savino).

WRITINGS
Vita di Michelagnolo Buonarroti (Rome, 1553); ed. E. Spina Barelli (Milan, 1964; Eng. trans., Oxford, 1976)

BIBLIOGRAPHY
DBI [with bibliog. to 1967]
E. Battisti: 'Note su alcuni biografi di Michelangelo', *Scritti di storia dell'arte in onore di Lionello Venturi* (Rome, 1956), i, pp. 321–39
U. Procacci: 'Postille contemporanee in un esemplare della Vita di Michelangelo del Condivi', *Atti del convegno di studi michelangioleschi: Florence and Rome, 1964*, pp. 277–94
G. Settimo: *Ascanio Condivi biografo di Michelangelo* (Ascoli Piceno, 1975)
J. Wilde: *Michelangelo: Six Lectures* (Oxford, 1978), pp. 1–16

FRANÇOIS QUIVIGER

Conegliano, Cima da. *See* CIMA DA CONEGLIANO.

Consalvo, Giovanni di. *See* GIOVANNI DI CONSALVO.

Contarini. Italian family of patrons and collectors. They were one of the most ancient, powerful and wealthy of patrician families of Venice. Together with 11 other Venetian dynasties, they were an 'apostolic family' (i.e. present at the election of the first doge of Venice in AD 697). Over the centuries the Contarini family provided Venice with eight doges (one each in the 11th, 13th and 14th centuries and five in the 17th century) and numerous high-ranking officials. The genealogy of the *casada* (clan) is complex, with families belonging to about a dozen distinct branches, some of which were not directly related. Over the centuries, branches of the Contarini constructed approximately 25 palaces in Venice, although not all now bear the Contarini name. The most celebrated palace is the Ca' d'Oro (*c.* 1421), built for Marin Contarini (1386–1441), a member of the S Felice and S Sofia branch of the family. It was owned by the family for two generations.

During the 15th and 16th centuries a number of Contarini were distinguished and highly cultivated patrons and collectors. (1) Taddeo Contarini collected works by Giorgione; (2) Alessandro Contarini was a patron of Titian; (3) Jacopo Contarini was also a patron of Titian as well as Tintoretto and knew Palladio well; and (4) Federico Contarini was instrumental in forming the first public collection of antiquities. Caterina Contarini was a wealthy parishioner who donated 20 ducats towards the cost of the commission of Sebastiano del Piombo's high altarpiece for S Giovanni Crisostomo (1510–11; see colour pl. 2, XXXI2). She may have been actively involved in its inception as her name saint, Catherine, appears prominently in the painting. Antonio Contarini was a high-ranking prelate. After his election as patriarch of Venice (1508–24), he undertook extensive restoration of his cathedral of S Pietro di Castello, Venice. He also financed the decoration of five chapels: S Maria Maddalena (Treviso), S Antonio di Castello, S Salvatore and two others in S Pietro di Castello. The chapel of the Holy Cross in S Pietro was decorated with an altarpiece (1512; destr.) by Giovanni Mansueti. Contarini also commissioned an altarpiece by Carpaccio (completed 1522; destr.) and possibly Marco Basaiti's *St Peter Enthroned* (S Pietro, Venice) and *St George and the Dragon* (1520; Venice, Accad.; formerly S Pietro) for the same church. According to Sansovino (1581; ed. 1663), Girolamo Contarini commissioned an altarpiece of the *Transfiguration* for S Maria Mater Domini, Venice, from Francesco Bissolo (?1512; *in situ*). In 1527 Pietro Contarini requested in his will that four canvases by Giovanni Gerolamo Savoldo, depicting the *Flight into Egypt*, and a marble head of *St Sebastian* should be placed beside a marble *Virgin* on the altar in his chapel in SS Apostoli, Venice. For Tommaso Contarini (*d c.* 1578) Tintoretto painted the altarpiece of *St Agnes Reviving Licinio* (*c.* 1578–9; *in situ*) for the Contarini Chapel in the Madonna dell'Orto, Venice (*in situ*). And for Angelo Contarini he painted the *Birth of Christ* as an altarpiece for the family chapel in S Benedetto. According to Ridolfi (*Meraviglie* (1648); ed. D. von Hadeln (1914–24), ii, p. 225), Tintoretto's portrait of *Henry III of France* (untraced) was owned by the Contarini at San Samuele (*see* (3) below).

During the early 18th century, Bertucci Contarini (*d* 1712), the last of the Contarini delle Figure line, bequeathed his collection to the state: this comprised many manuscripts and books, which went to the Biblioteca Marciana, and various paintings, including Veronese's

Rape of Europa (*c.* 1580; Venice, Doge's Pal., Anticollegio), and in the early 19th century Alvise II Contarini (called Girolamo) bequeathed 184 paintings from his collection to the Accademia, including Giovanni Bellini's *Madonna of the Alberetti* (1487; Venice, Accad.), and his extensive library to the Biblioteca Marciana. The fine furniture carved by Andrea Brustolon for the Contarini was added to the collections of Teodoro Correr and is now housed in the Ca' Rezzonico.

BIBLIOGRAPHY

F. Sansovino: *Venetia città nobilissima et singolare* (Venice, 1581), ed. G. Martinioni (Venice, 1663)
M. Muraro: *Palazzo Contarini a San Beneto* (Venice, 1970)

(1) Taddeo Contarini (*b* Venice, *c.* 1466; *d* Venice, 11 Oct 1540). He acquired his wealth through trade and collected paintings. He was a patron of Giorgione, whose *Three Philosophers* (Vienna, Ksthist. Mus.; *see* GIORGIONE, fig. 4) and the *Birth of Paris* (destr.) he owned in 1525 (Michiel), in addition to works by Giovanni Bellini, Palma Vecchio and Gerolamo Romanino. He also owned a nocturne (destr.) by Giorgione, which Isabella d'Este was anxious to acquire (letter from Taddeo Albano to Isabella d'Este, 8 Nov 1510). Taddeo was a friend and neighbour of the noted patron Doge Gabriele Vendramin, to whom he became brother-in-law by his marriage (5 May 1495) to Vendramin's sister, Maria. Titian's evident familiarity with Bellini's *St Francis* (New York, Frick), which was owned at that time by Taddeo, suggests he may have visited Taddeo's home, the Palazzo Contarini on the Strada Nuova.

BIBLIOGRAPHY

M. Michiel: *Notizie d'opere di disegno* (MS., *c.* 1520–40); ed. G. Frizzoni (Bologna, 1884); Eng. trans. by P. Mussi, ed. G. C. Williamson as *The Anonimo* (London, 1903/*R* New York, 1969), pp. 102–5
D. Battilotti and M. T. Franco: 'Regesti dei Committenti e dei primi collezionisti di Giorgione', *Ant. Viva*, xvii/4–5 (1978), pp. 58–61
D. Battilotti and M. T. Franco: 'La committenza e il collezionismo privato', *Tempi di Giorgione*, ed. R. Maschio (Rome, 1994), pp. 204–29
S. Cohen: 'A New Perspective of Giorgione's *Three Philosophers*', *Gaz. B.-A.*, cxxvi/1520 (1995), pp. 53–64

(2) Alessandro Contarini (*b* Venice, 7 March 1486; *d* Padua, 16 March 1553). He had a long and successful naval career, becoming steward and captain general of the Venetian armed forces. On 28 June 1538 he was created *procurator* of S Marco. He was the recipient of Lodovico Dolce's evocative description (1554–5) of Titian's *Venus and Adonis* (Madrid, Prado) and also purchased from Titian the *Supper at Emmaus* (Brocklesby Park, Lincs), which he presented to the Signoria to be hung in the Chiesetta dei Pregardi in the Palazzo Ducale. Possible portraits include one attributed to Titian (or workshop) (Munich, Alte Pin.) and one by the Tintoretto workshop (Venice, Accad.). Contarini's grandiose funerary monument (*c.* 1553; Padua, S Antonio) was designed by Michele Sanmicheli and executed by Alessandro Vittoria, Pietro da Salo and Agostino Zoppo. The marble portrait bust of *Alessandro Contarini* is by Danese Cattaneo.

BIBLIOGRAPHY

M. W. Roskill: *Dolce's "Aretino" and Venetian Art Theory of the Cinquecento* (New York, 1968), pp. 212–17
Collezioni di antichità a Venezia nei secoli della Repubblica (exh. cat., ed. M. Zorzi; Venice, Bib. N. Marciana, 1988), p. 55

H. Ost: 'Tizian und Alessandro Contarini', *Wallraf-Richartz-Jb.*, lii (1991), pp. 91–104
G. Schweikhart: 'Ein unbekannter Entwurf für das Grabmal des Alessandro Contarini in S Antonio in Padua', *Wallraf-Richartz-Jb.*, lii (1991), pp. 317–19

(3) Jacopo [Giacomo; Jacomo] **Contarini** (*b* Cipro, 24 July 1536; *d* Venice, 4 Oct 1595). He became a senator in 1574 and, together with Alvise I Mocenigo, was requested to organize the festivities for the state reception of Henry III of France (*reg* 1574–89) into Venice. Jacopo commissioned a triumphal arch and loggia from Palladio, which was decorated by Tintoretto, Titian and Antonio Vassilacchi. Jacopo was one of a circle of Venetian patricians, including Daniele Barbaro and Leonardo Mocenigo (*b* ?1522), interested in science and architecture; Palladio was reputedly a regular visitor to his home, the Palazzo Contarini delle Figure at San Samuele. There, according to Francesco Sansovino, Jacopo housed his collection of manuscripts, mathematical and cosmographical instruments and a remarkable library. His art collection included paintings by Titian, Tintoretto, Jacopo Bassano and possibly Palma Giovane. No doubt because of his reputed scholarship, in 1577 Jacopo was requested to help devise an iconographic programme with scenes celebrating Venetian victories. These were meant to decorate the Sala del Maggior Consiglio, the Sala dello Scrutinio and doors of the Sala dell'Antipregadi in the Doge's Palace. Executed by Tintoretto and assistants, the cycle of paintings was to replace those destroyed by fire in 1577 (*see* VENICE, §IV, 4(ii)).

In 1580 Palladio bequeathed Jacopo a large number of drawings and, according to Paolo Gualdo's *Vita di Andrea Palladio* (Venice, 1617), a manuscript of his writings on antique architecture. Jacopo also advised on military architecture and the authorship of a treatise on fortifications (Modena, Bib. Estense, MS Gamma V. 4.I.(9)) has been attributed to him. After Palladio's death, Jacopo transferred his patronage to Vincenzo Scamozzi, who dedicated his *Discorso sopra le antichità di Roma* (Venice, 1582) to him. In the 18th century, via Jacopo's descendants, the remains of his library passed into the Biblioteca Marciana and the paintings into the possession of the Venetian state. Palladio's drawings found their way to England, possibly through the agents of Lord Burlington, and are now in the collection of the Royal Institute of British Architects, London.

BIBLIOGRAPHY

P. L. Rose: 'Jacomo Contarini (1536–1595): A Venetian Patron and Collector of Mathematical Instruments and Books', *Physis*, xviii/2 (1976), pp. 117–30
M. Tafuri: 'Daniele Barbaro, Andrea Palladio e Jacopo Contarini', *Venezia e il rinascimento: Religione, scienza, architettura* (Turin, 1985)
Collezione di antichità a Venezia nei secoli della Repubblica (exh. cat., ed. M. Zorzi; Venice, Bib. N. Marciana, 1988), pp. 57ff

(4) Federico [Federigo] **Contarini** (*b* Venice, 1538; *d* Venice, 21 Oct 1613). He had a successful political career, holding a series of government posts including the prestigious *procurator de supra* (1571) of S Marco. He was a cultivated dilettante and passionate collector of antiquities. The richness and diversity of his collection is testified to by contemporaries. An inventory (6 March 1609; Venice, Bib. Correr, MS. P.D./c N. 1267) itemizes marble statues,

Greek and Roman inscriptions, cameos, medals, paintings, mosaics and books as well as fossils, minerals and other curios. Like Cardinal Giovanni Grimani, Federico donated his collection to the Venetian Republic. The bequest, comprising 66 statues, 84 busts, as well as many coins, intaglios and bronze statuettes, formed part of what is today the Museo Archeologico in Venice. He also acquired works by contemporary artists, including Jacopo Sansovino's marble relief of the *Virgin and Child with Angels* (Venice, Ca' d'Oro), which he placed above the marble altar (*c.* 1585–95) that comprised his funerary monument in the church of the Zitelle (S Maria della Presentazione). Antonio Vassilacchi's altarpiece of the *Virgin and Child with St Francis and Federico Contarini* (destr.) surmounted this altar.

BIBLIOGRAPHY

M. Cortelazzo: 'L'Eredità di Federico Contarini: Gli inventari della collezione e degli oggetti domestici', *Boll. Ist. Stor. Soc. & Stat. Ven.*, iii (1961), pp. 221–57

G. Cozzi: 'Federico Contarini: Un antiquario veneziano tra rinascimento e controriforma', *Boll. Ist. Stor. Soc. & Stat. Ven.*, iii (1961), pp. 195–205

Collezioni di antichità a Venezia nei secoli della Repubblica (exh. cat., ed. M. Zorzi; Venice, Bib. N. Marciana, 1988), pp. 56ff

□

Conte, Jacopino del (*b* Florence, *c.* 1515; *d* Rome, 10 Jan 1598). Italian painter. A pupil of Andrea del Sarto (Vasari), he appears to have worked independently from around the time of del Sarto's death in 1530 and to have specialized at first in devotional works of moderate size. In such paintings as the *Virgin in the Clouds* (Berlin, Gemäldegal.), the *Holy Family* (New York, Met.; see fig.) and the *Virgin and Child* (Florence, Uffizi) he imposed a Michelangelesque monumentality and sculptural density on figure compositions that are reminiscent of the warm intimacy of del Sarto's Holy Families. This early style culminates in the *Virgin and Child with SS John the Baptist and Elizabeth* (Washington, DC, N.G.A.), the largest of his Florentine paintings in which the prominent figure of the Virgin in a rose-red gown dominates the sober domestic scene.

Del Conte settled in Rome by 1538, when he was a member of the Accademia di S Luca and resident in the parish of S Marcello. He collaborated with Leonardo da Pistoia (*fl* 1502; *d* after 1548) on an altarpiece (St Peter's, sacristy) for the Cappella dei Palafrenieri in old St Peter's, and *c.* 1538 he was commissioned by the Florentine Confraternity of the Misericordia to paint an *Annunciation to Zacharias* in their oratory of S Giovanni Decollato (*in situ*). The latter work, the first fresco in a cycle depicting the *Life of St John the Baptist*, reveals a continuing debt to Florentine sources. The composition is based on del Sarto's fresco of the same subject in the Chiostro dello Scalzo, Florence, and the statue in the background is based on Michelangelo's *David* (Florence, Bargello; *see* ITALY, fig. 22). The influence of Raphael's Roman works, especially his tapestry designs for the Sistine Chapel, is also reflected in the calculated gestures and highly controlled geometric ordering of the surface.

Del Conte's second fresco at the oratory, the *Preaching of St John the Baptist* (1538; *in situ*; see colour pl. 1, XXIII2), is even more closely allied with the Raphaelesque tradition, being based on a sketch (Vienna, Albertina) by

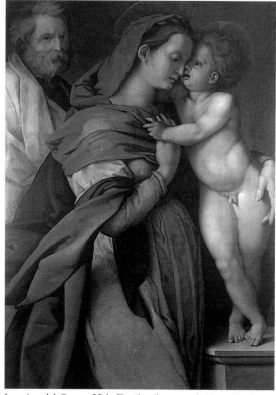

Jacopino del Conte: *Holy Family*, oil on panel, 1207×857 mm, *c.* 1530–35 (New York, Metropolitan Museum of Art)

Raphael's pupil Perino del Vaga, who had recently returned to Rome. In this second fresco (which is punctuated by a series of boldly realistic portraits, their insertion into the narrative suggesting a debt to Ridolfo Ghirlandaio), the austerity of del Conte's earlier style gave way to ornamental opulence, encouraged perhaps by rivalry with the Florentine artist Francesco Salviati, who was also active at the oratory. Del Conte continued to work at the oratory into the next decade, providing a design for the *Birth of St John the Baptist* (reproduced in an engraving by Giulio di Antonio Bonasone), which shows the influence of Baccio Bandinelli, and completing the *Baptism* (*in situ*) in 1541.

By the late 1530s Jacopino was also painting portraits, at first mainly of members of the Tuscan community in Rome, including *Michelangelo* (New York, Met.), *Antonio da Sangallo* (1542; Rome, Pal. Montecitorio) and *Roberto di Filippo di Filippo Strozzi* (Florence, Pal. Vecchio). In 1544–5 Paolo Giovio was endeavouring to obtain work from Jacopino for his collection, including a portrait of *Cardinal Jacopo Sadoleto*. During the 1540s, and especially after the death of Sebastiano del Piombo in 1547, del Conte became the favoured portrait artist of the Roman clergy and aristocracy. His portraits of *Marcello Cervini* (*Marcellus II*) and *Vittorio Farnese* (both Rome, Gal. Borghese), and that of *Paul III* (Rome, S Francesca Romana), reveal a severe monumentality.

In Rome, after Perino del Vaga's death in October 1547, del Conte inherited a commission for the decoration of the chapel of S Remigio, S Luigi dei Francesi, which he

shared with Girolamo Siciolante and Pellegrino Tibaldi. Del Conte was responsible for the painting of the *Battle of Tolbiac* on the right wall and the severe, didactic altarpiece, *St Remigius Converting the Franks*. At about the same time he painted the lunette frescoes in Cardinal Alessandro Farnese's chapel at the Palazzo della Cancelleria in Rome (*Gideon Destroying the Temple of Baal*; *Conversion of a Pagan Temple*; *Arrival of the Golden Age*; *Prophet and Sibyl*; all *in situ*), a project which may have been initially under the direction of Perino del Vaga. Apparently the Cardinal was displeased with del Conte's work, and the decoration of the lower walls was given to Salviati in the autumn of 1548.

Del Conte's religious paintings around the middle of the 16th century became increasingly sober and schematic. These include an altarpiece with a *Pietà* (completed by 1550; Chantilly, Mus. Condé) for the chapel of Bernardino Elvino (treasurer of Paul III) in S Maria del Popolo. In the 1550s del Conte returned to the oratory of S Giovanni Decollato to paint the *Deposition* (*in situ*) over the altar, a commission that Daniele da Volterra had failed to carry out in 1551. A *Magdalene* (Rome, S Giovanni in Laterano) and several versions of the *Holy Family* (e.g. Rome, Pal. Barberini) belong to this same cold, monumental phase of his style.

Remarkably little is known of del Conte's later paintings. Two, which Baglione said were his last public works, a *Pietà* and a *Stigmatization of St Francis* (Rome, Monastery of Corpus Christi) executed for the Capuchins of S Chiara al Quirinale, indicate that he repeated compositional formulae that he had developed around the middle of the 16th century. Most of his later work was probably in the field of portraiture. Baglione said that del Conte painted all the popes from Paul III to Clement VIII, ambassadors, ecclesiastics, military captains and members of the old baronial families, such as the Colonna and Orsini. In 1556 he was asked by the Jesuits to paint a portrait of the dying *Ignatius Loyola* (Rome, Casa Gen. Gesuiti). The image of austere authority and sober piety that he provided in works such as the *Portrait of a Man* (Rome, Gal. Spada) and the *Portrait of a Cardinal* (Vienna, Ksthist. Mus.) clearly satisfied Roman Counter-Reformation taste.

Jacopino del Conte enjoyed considerable honour in his later years. He received Roman citizenship in 1558, and in the same year Paolo Giordano Orsini granted him land and a house in Rome. Later he was three times cited as Consul of the Accademia di S Luca, Rome (1561, 1576, 1577); he was also a member of the Virtuosi al Pantheon and the confraternity of the SS Crocefisso at S Marcello.

AKL; *DBI*
BIBLIOGRAPHY
G. Vasari: *Vite* (1550, rev. 2/1568); ed. G. Milanesi (1878–85), v, pp. 58; vii, pp. 16, 31, 258
G. Baglione: *Vite* (1642); ed. V. Mariani (1935), pp. 75–6
F. Zeri: 'Salviati e Jacopino del Conte', *Proporzioni*, ii (1948), pp. 180–83
I. Hofmeister: 'A Portrait by Jacopino del Conte in the Borghese Gallery', *Marsyas*, vi (1950–52), pp. 35–41
F. Zeri: 'Intorno a Gerolamo Siciolante', *Boll. A.*, xxxvi (1951), pp. 139–49
——: *Pittura e controriforma: L'arte senza tempo di Scipione da Gaeta* (Turin, 1957)
J. von Henneberg: 'An Unknown Portrait of St Ignatius by Jacopino del Conte', *A. Bull.*, il (1967), pp. 140–42
I. H. Cheney: 'Notes on Jacopino del Conte', *A. Bull.*, lii (1970), pp. 32–40
C. von Holst: 'Florentiner Gemälde und Zeichnungen aus der Zeit von 1480 bis 1580: Kleine Beobachtungen und Ergänzungen', *Mitt. Ksthist. Inst. Florenz*, xv (1971), pp. 48–54
V. Pace: 'Osservazioni sull'attività giovanile di Jacopino del Conte', *Boll. A.*, lvii (1972), pp. 220–22
R. E. Keller: *Das Oratorium von San Giovanni Decollato* (Neuchâtel, 1976)
F. Zeri: 'Rividendo Jacopino del Conte', *Antol. Belle A.*, ii (1978), pp. 114–21
J. S. Weisz: 'Daniele da Volterra and the Oratory of S Giovanni Decollato', *Burl. Mag.*, cxxiii (1981), pp. 355–6
I. Cheney: 'A "Turkish" Portrait by Jacopino del Conte', *Source*, i (1982), pp. 17–20
J. S. Weisz: 'Salvation through Death: Jacopino del Conte's Altarpiece in the Oratory of S Giovanni Decollato in Rome', *A. Hist.*, vi (1983), pp. 395–405
S. J. Freedberg: 'Jacopino del Conte: An Early Masterpiece for the National Gallery of Art', *Stud. Hist. A.*, xviii (1985), pp. 59–65
P. Costamagna and A. Fabre: 'Di alcuni problemi della bottega di Andrea del Sarto', *Paragone*, 491 (1991), pp. 15–28
A. Vannugli: 'La *Pietà* di Jacopino del Conte per S Maria del Popolo: Dall'identificazione del quadro al riesame dell'autore', *Stor. A.*, lxxi (1991), pp. 59–93

IRIS CHENEY

Conti, Bernardino de' (*b c.* 1470; *d* after 1523). Italian painter. Son of a hitherto unknown painter, Baldassare, from Castelseprio, 'Bernardinus de Committibus' probably trained in Milan, where, on 16 February 1494, he obtained his first commission, for an altarpiece depicting the *Virgin and Child* (Milan, S Pietro in Gessate). Bernardino was probably a pupil of Ambrogio de Predis, judging by the similarly official quality of their portraits, and also their shared use of profile. His earliest portrait, completed 15 June 1496, depicts the infant duke *Francesco Sforza* (Rome, Pin. Vaticana). In the following years the portraiture to which he devoted himself was characterized by his use of uniform colour for the background, as in the *Portrait of a Musician* (ex-Crespi priv. col., Milan), painted in 1497, the year, probably, of the portrait of *Isabella of Aragon* (1471–1524; ex-Trotti priv. col., 1917). The *Portrait of a Prelate* (Berlin, Gemäldegal.) dates from 1499. Bernardino's fortunes did not change after the fall, that year, of Milan to the French, and in 1500 he executed a likeness of the new Governor of Milan, *Charles II d'Amboise*, which includes certain variations in the background colour and a balustrade in front of the figure. The *Portrait of a Gentleman* (Paris, Mus. Jacquemart-André) also dates from 1500, while the portrait of *Sisto della Rovere* (Berlin, ex-Pal. Kaiser Wilhelms I) was painted in 1501.

The portrait of *Castellano Trivulzio* at the age of 26 (New York, Brooklyn Mus. A.), dated 13 March 1505, introduces a new element to Bernardino's repertory: the portrayal of subjects with their head in profile, but with the bust shown frontally. The difficulties of this pose were resolved in the portrait of *Alvise Besozzi* (1506; Berlin, Bodemus.), where the sitter's body is shown at an angle, with the face aligned along the diagonals. The same technique appears in the *Portrait of a Young Man* and the *Portrait of a Lady Wearing a Coral Necklace* (both Isola Bella, Mus. Borromeo) and also in the *Portrait of a Man* (Philadelphia, PA, Mus. A.). The portrait of *Gian Giacomo Trivulzio in Armour* (1518; untraced) and the *Portrait of a Young Aristocrat* (Detroit, MI, Inst. A.) are both works of Bernardino's maturity.

Bernardino also produced religious paintings throughout his career, for example the signed and dated *Virgin*

Suckling the Infant Christ (1501; Bergamo, Gal. Accad. Carrara), which reflects the influence of Leonardo and, somewhat awkwardly, also reveals traces of south Netherlandish influence. Bernardino was prone to repeat the same compositional formula (e.g. Williamstown, MA, Williams Coll. Mus. A., and Verona, priv. col.). His later religious paintings are typified by the weak and poorly preserved *Virgin and Child with the Infant St John* (signed and dated 1522; Milan, Brera, replicated in another painting, dated 1523, ex-Potsdam).

BIBLIOGRAPHY

DBI
W. Suida: 'Leonardo da Vinci und seine Schule in Mailand', *Mhft. Kstwiss.*, xii/10–11 (1919), pp. 274–8
——: *Leonardo und sein Kreis* (Munich, 1929)
S. Gatti: 'Un'opera ritrovata di Bernardino dei Conti', *A. Lombarda*, 51 (1979), pp. 77–9
——: 'Un polittico torinese di Bernardino dei Conti: Documenti', *A. Lombarda*, 60 (1981), pp. 111–13
M. T. Fiorio: 'Per il ritratto lombardo: Bernardino de' Conti', *A. Lombarda*, 68–9 (1984), pp. 38–52
Disegni e dipinti leonardeschi dalle collezioni milanesi (exh. cat., Milan, Pal. Reale, 1987), pp. 131, 154–5
A. Porro: 'Proposte per il primo '500 lombardo: Alvise de Donati e Bernardino de' Conti', *A. Crist.*, xi–xii (1990), pp. 399–416

FRANCO MORO

Coppi, Giacomo [Jacopo del Meglio] (*b* Peretola, nr Florence, Sept 1523; *d* Florence, 1591). Italian painter. He entered the circle of Vasari as an already mature painter. Apart from the works of Vasari, he was influenced by the Mannerism of Jacopino del Conte (*c.* 1515–1598), Alessandro Allori and the Netherlandish elements in the work of Joannes Stradanus. While typically Coppi's figures adhere to Mannerist formulae—exaggeratedly elongated, artificially posed and locked into a space with multiple perspectives—his interest in physiognomic details, often verging on the grotesque, is highly individual. Except for a *Self-portrait* (Florence, Uffizi) and a *Pietà* (Florence, Banca Tosc.), both painted before 1570, all his known works belong to the 1570s. He was active uninterruptedly in Tuscany from 1570 to 1576. The two scenes painted between 1570 and 1573 for the *studiolo* of Francesco I de' Medici in the Palazzo Vecchio, Florence, the *Invention of Gunpowder* and the *Family of Darius before Alexander* (both *in situ*), mark the moment of Vasari's greatest influence on him. They were followed by the signed and dated *Sermon of St Vincent Ferrer* (1574; Florence, S Maria Novella) and the signed and dated *Ecce homo* (1576; Florence, Santa Croce). In 1576 Coppi moved to Rome where he executed his most ambitious works: the signed and dated frescoes depicting the *Legend of St Peter's Chains* and the *Angelic Concert* (1577; Rome, S Pietro in Vincoli). In 1579 he signed and dated the *Legend of the Crucifixion of Soria* (Bologna, S Salvatore), which shows the influence of Rosso Fiorentino and Jacopo Pontormo. The *Pentecost* (late 1570; Florence, S Niccolò sopr'Arno) is his last known work.

BIBLIOGRAPHY
DBI; Thieme–Becker
V. Pace: 'Contributi al catalogo di alcuni pittori dello studiolo di Francesco I', *Paragone*, xxiv/285 (1973), pp. 69–70
M. Rinehart: 'The Studiolo of Francesco I', *Art the Ape of Nature: Studies in Honor of H. W. Janson* (New York, 1981), pp. 275–89
S. Schaefer: 'The Invention of Gunpowder', *J. Warb. & Court. Inst.*, xliv (1981), pp. 209–11

C. Spada: 'Il miracolo del crocefisso di Beirut nella pala di Jacopo Coppi', *Il Carrobbio*, xv (1989), pp. 325–34

MARINA GAROFOLI

Cordiani. *See* SANGALLO, DA, (4) and (7).

Cori, Domenico di Niccolò dei. *See* DOMENICO DI NICCOLÒ.

Cornaro [Corner]. Italian family of nobles and patrons. Among the richest, most powerful and oldest of Venice's 'Apostolic' families, the Cornaro boasted four doges among its members, the first of whom was (1) Marco Cornaro. The best-known member of the family is (2) Caterina Cornaro, the dispossessed Queen of Cyprus; her knighted brother Giorgio Cornaro (1447–1527), a hero of the Wars of the League of Cambrai, established three of his sons as heads of independent branches: the Cornaro della Regina, named for their inheritance of the Queen's great Gothic palace (*c.* 1450–80; destr. 1723; rebuilt 1723–*c.* 1730) in the parish of San Cassiano; the Cornaro di Ca' Grande, whose palace (begun 1545) at San Maurizio was designed by Jacopo Sansovino; and the Cornaro di San Polo, whose palace (*c.* 1550) was by Michele Sanmicheli (*see* SANMICHELI, MICHELE, §1(ii)(a)).

These three distinct, but allied branches made the Cornaro uniquely powerful among Venetian families: their San Polo members included the three later doges as well as Cardinal Alvise Cornaro (1517–84), who commissioned a palace (1551–82) by Giacomo del Duca behind the Trevi Fountain, Rome.

Many of the Cornaro di Ca' Grande (who had a distinguished picture collection) were churchmen: Cardinal Francesco (*c.* 1476–1543) was the earliest prominent partisan at the papal court in defence of Michelangelo's *Last Judgement* (Rome, Vatican, Sistine Chapel; see colour pl. 2, VII3), commissioning a painted copy (1541; untraced) within two weeks of the fresco's unveiling. This branch of the family also commissioned a series of ponderous late Mannerist tombs (1570–84)—into one of which Queen Caterina's remains were transferred—by Bernardino Contino (*d c.* 1597) in the two transepts of S Salvatore, Venice.

Several members of the Cornaro della Regina were important patrons of architecture. The family funerary chapel (1483–9) at SS Apostoli, Venice, is one of the jewels of Venetian Renaissance architecture. Senator Girolamo Cornaro (*c.* 1485–1551), commander at Candia (Crete) and at Padua, ordered civic fortifications and, at Piombino Dese, a villa (*c.* 1545; destr. 18th century) from Sanmicheli; Giorgio (Zorzon) Cornaro (1517–71), a galley commander portrayed by Titian (1537; Omaha, NE, Joslyn A. Mus.), commissioned Palladio's magnificent Villa Cornaro (1551–3; *see* PALLADIO, ANDREA, fig. 4) at Piombino Dese. The Corner-Piscopia (a collateral line with a Byzantino-Gothic palace at Rialto, Venice, and so named in the 14th century for the vast sugar plantations granted them at Episkopi on Cyprus) built a richly floriated Gothic burial chapel (now baptistery, 1417–25), at S Maria Gloriosa dei Frari, Venice.

UNPUBLISHED SOURCES
Venice, Correr [archive of the Cornaro della Regina family, 15th–19th centuries]: MSS di Provenienze Diverse, schedario (partial modern inventory listings, by subjects), MSS Cicogna 3781 [Girolamo Priuli:

Cornaro biographies in *Pretiosi frutti del maggior consiglio della Serenissima Repubblica di Venezia*, i, fols 187*r*–207*v*]

BIBLIOGRAPHY
DBI
A. Berrutti: *Patriziato veneto: I Cornaro* (Turin, 1952) [sometimes unreliable]
D. Lewis: 'Freemasonic Imagery in a Venetian Fresco Cycle of 1716', *Hermeticism in the Renaissance*, ed. I. Merkel and A. G. Debus (London, 1988), pp. 366–99 [with bibliog. on earlier Cornaro collectors and patrons]

DOUGLAS LEWIS

(1) Marco Cornaro, Doge of Venice (*b* Venice, ?1284–6; *reg* 1365–8; *d* Venice, 13 Jan 1368). He was the first of the four Cornaro doges. His career was primarily political and military, his responsibilities ranging from that of Duke of Candia (Crete) in the 1340s, to ambassador to both Pope Clement VI and the Emperor Charles IV in the 1350s, to the important position as one of the representatives of the Venetian Republic's mission (1363) to congratulate Urban V on his election to the papacy in Avignon.

The pictorial decoration of the Sala del Maggior Consiglio in the reconstructed south wing of the Doge's Palace was begun in 1366; although the original paintings have either been destroyed or removed (*see* VENICE, §IV, 4(ii)), the hall's special combination of political and religious iconography was established during Cornaro's dogate. A fresco cycle of 22 scenes narrating the *Story of Doge Sebastiano Ziani* (*reg* 1172–8) mediating between the warring Frederick Barbarossa and Pope Alexander III was begun on the south, west and north walls; at least two of the paintings are attributed to GUARIENTO. A series of ducal portraits adorned the wall's upper borders. The east wall, before which sat the doge and his government, was frescoed by Guariento with the *Paradise* (1365–8; Venice, Doge's Pal., Sala dell'Armamento), which shows the *Coronation of the Virgin* among the elect; the *Angel Gabriel* and the *Virgin Annunciate* were each depicted in an aedicula on the wall's upper left and upper right corners. A surviving inscription on the *Paradise* reads MARCUS CORNARIUS DUX ET MILES FECIT FIERI HOC OPUS. Both the Republic's fame as an international power and its belief that the Virgin gave it favoured status were thus given explicit pictorial expression in Cornaro's reign. He was buried in SS Giovanni e Paolo, Venice, where a funeral monument, executed in part by Nino Pisano, was erected in the presbytery.

BIBLIOGRAPHY
E. Cicogna and others: *Storia dei dogi di Venezia* (Venice, 1857)
B. Cecchetti: 'Funerali e sepolture dei veneziani antichi', *Archv Ven.*, xxxiii (1887)
F. Flores D'Arcais: *Guariento* (Padua, 1974)
A. Da Mosto: *I dogi di Venezia nella vita pubblica e privata* (Florence, 1977)
U. Franzoi: *Storia e leggenda del Palazzo Ducale di Venezia* (Verona, 1982)
P. Fortini Brown: *Venetian Narrative Painting in the Age of Carpaccio* (New Haven and London, 1988)

WILLIAM L. BARCHAM

(2) Caterina Cornaro, Queen of Cyprus (*b* Venice, ?25 Nov 1454; *d* Venice, 10 July 1510). Descendant of (1) Marco Cornaro. She was the eldest of five daughters of the Venetian nobleman Marco Cornaro (1406–79) and Fiorenza Crispo, who was a granddaughter of Manuel III, Emperor of Trebizond (*reg* 1390–1417), and a princess of Byzantium. From the age of ten she attended a Benedictine convent school in Padua. In July 1468 she was married by proxy in Venice to King James II of Cyprus (1440–73; *reg* 1460–73), an associate of her father's brother, Andrea Cornaro (1412–73). In 1472 she embarked for Cyprus, where she was married and crowned Queen. Eight months later the King died, possibly poisoned by an agent of the Council of Ten. His son, born posthumously, died within a year, and the Queen was beset by a series of increasingly peremptory Venetian delegates and advisers. In February 1489 Caterina was forced to abdicate, and Cyprus was annexed by the Republic. Returning to Venice that year, she was allowed to retain her rank and titles and was granted life-time sovereignty of the city and territory of Asolo, a charming citadel on the foothills of the Dolomites. With a generous allowance and a large retinue, she took up residence in the castle at Asolo (ruined). For the next 20 years she presided there and in Venice over a court in exile—where she was visited by, among others, Maximilian I, Isabella d'Este, Sigismondo Pandolfo Malatesta, Guidobaldo I Montefeltro, Duke of Urbino, and Beatrice, wife of Ludovico Sforza.

There is a fine late portrait of Caterina in a panel painting by Gentile Bellini (*c*. 1500–05; Budapest, Mus. F.A.; *see* BELLINI, (2), fig. 2); a profile portrait (untraced), apparently also by Gentile, was copied by Albrecht Dürer in a drawing (1494–5; Bremen, Ksthalle). A baptismal font in Asolo Cathedral was commissioned by her in 1491 from Francesco Grazioli (1468–1536). Caterina's life at Asolo is hauntingly rendered by Pietro Bembo in his lyric dialogue on platonic love, *Gli Asolani* (*c*. 1495–8, pubd 1505), the greatest work linked to her court. The poets Luigi da Porto (1485–1529) and Andrea Navagero (1483–1529) were also associated with her circle; the same may have been true of Giorgione, who is said by Vasari to have painted her portrait (untraced) and whose early patron, Tuzio Costanzo, was the Queen's condottiere and associate for almost 40 years.

Perhaps the most pervasive influence of the court was architectural: Caterina's pleasure villa, the Barco della Regina (1491–2) at Altivole below Asolo, designed by Grazioli and executed by Pietro Lugato (1470–?1550), was a provincial evocation of Roman (as at Spalato), Byzantine and Near Eastern imperial estates. Its rectangular palace (destr. *c*. 1820) was approached on its long axis through a towered forecourt (destr. 1832) enclosed by arcaded and frescoed loggias (two of which, with an adjacent chapel and service rooms, remain; frescoes, *c*. 1495, attributed to Girolamo da Treviso (i)). This nucleus was surrounded by a walled and towered hunting preserve of more than 270 ha. The Barco was most precisely copied in a surviving Trevisan country palace for another ancient Venetian family with Eastern associations, the Castello Giustinian (1511–13) at Roncade by Tullio Lombardo; it also strongly influenced the regional High Renaissance paradigms of Jacopo Sansovino in the Villa Garzoni (*c*. 1539) at Pontecasale and Michele Sanmicheli in La Soranza (1539–41) near Treville, as well as numerous works by Andrea Palladio, beginning with the Villa Pisani (1542–4) at Bagnolo.

BIBLIOGRAPHY
DBI
H. R. F. Brown: 'Caterina Cornaro, Queen of Cyprus', *Studies in the History of Venice* (London, 1907/*R* New York, 1973; ed. B. Franklin), i, pp. 255–92

A. L. Zacchia-Rondinini: *Caterina Cornaro: Patrizia veneta, regina di Cipro* (Rome, 1938)

L. Puppi: 'Il "Barco" di Caterina Cornaro ad Altivole', *Prospettive*, xxv (1962), pp. 52–64

L. Comacchio: *Splendore di Asolo ai tempi della Regina Cornaro* (Castelfranco Veneto, 1969)

J. Anderson: 'Some New Documents Relating to Giorgione's "Castelfranco Altarpiece" and his Patron Tuzio Costanzo', *A. Ven.*, xxvii (1973), pp. 290–99

C. K. Lewis: *The Villa Giustinian at Roncade* (New York, 1977), pp. 98–166, 212–20, 270–87, pls 97–134 [Barco della Regina, its prototypes and parallels]

A. Chastel: 'Le Mirage d'Asolo', *A. Ven.*, xxxii (1978), pp. 100–05

DOUGLAS LEWIS

Cornaro [Corner], Alvise [Luigi] (*b* Venice, 1484; *d* Padua, 8 May 1566). Italian architectural theorist, patron, humanist and architect. Inheriting his uncle's estate in Padua, he combined the activities of a landowner with interests in literature, drama and architecture and became an important figure in the city's humanist circle, which included Giovanni Maria Falconetto, Andrea Palladio, Giangiorgio Trissino and Daniele Barbaro. He encouraged Falconetto, previously a painter, into architecture, visiting Rome with him in 1522 and commissioning him to design his first works of architecture: two garden structures at his palazzo (now Palazzo Giustiniani) in the Via del Santo, Padua, a loggia for theatrical performances (1524; see FALCONETTO, GIOVANNI MARIA, fig. 2) and the Odeon for musical performances (1530–33), both extant. The buildings derived from ancient Roman prototypes and followed their detailing closely; they formed a 'forum' in the courtyard. Although Cornaro may have helped in the design, it is more probable that his humanist interests influenced Falconetto. However, when Cornaro commissioned Falconetto to design the Villa dei Vescovi (now Villa Olcese, *c.* 1535–42) at Luvigliano he certainly shared in its design. The form and position of the villa, an arcaded structure on a rusticated base, recall Bramante's Cortile del Belvedere in the Vatican (begun 1505; see colour pl. 1, XVI1).

Cornaro was the author of a treatise on architecture (*c.* 1550–53) that addressed the domestic architecture of the common citizen rather than the aristocrat. He preferred functional and practical architecture to theoretical attitudes to aesthetics: *commoda* and *onestamente bella* to *bellissima et incommoda*. This attitude, unique among Renaissance architectural treatises, was derived more from the works of Roman engineers than from Vitruvius and Alberti. Cornaro's treatise had an influence on Palladio—the two met (1538–40) when Palladio visited Padua—and Cornaro's preference for unarticulated masses may be seen in Palladio's early villas, such as the Villa Godi, Lonedo (1537–42). As a supporter of the exploitation of the Venetian *terraferma*, Cornaro also wrote several treatises on agriculture and drainage in the Lagoon and proposed (*c.* 1560) the construction of a Roman theatre and an artificial hill surmounted by a temple in the basin of S Marco, apparently symbolizing the triumph of the *terraferma* over the sea. In his old age Cornaro's portrait (1560–65; Florence, Pitti) was painted by Jacopo Tintoretto. Through the marriage of his only daughter, he achieved his ambition to join the noble branch of the Cornaro family.

WRITINGS

Trattato di architettura (MS., *c.* 1550–53; Milan, Bib. Ambrosiana); ed. G. Fiocco in *Alvise Cornaro e i suoi trattati sull'architettura*, Atti dell'Accademia Nazionale dei Lincei, Memorie, iv (Rome, 1952); also in P. Barocchi, ed.: *Scritti dell'Arte del Cinquecento*, iii (Milan, 1977), pp. 3134–61

BIBLIOGRAPHY
DBI
G. Fiocco: *Alvise Cornaro: Il suo tempo e le sue opere*, Saggi & Stud. Stor. A., viii (Venice, 1965)

Alvise Cornaro e il suo tempo (exh. cat., ed. L. Puppi; Padua, Pal. Ragione, 1980)

E. Lippi: *Cornariana studi su Alvise Cornaro*, Biblioteca Veneta, i (Padua, 1983)

M. Tafuri: 'Un teatro, una "fontana del sil" e un "vago monticello": La riconfigurazione del bacino di S. Marco a Venezia di Alvise Cornaro', *Lotus Int.*, xliv (1984), pp. 40–51

□

Corona, Leonardo (*b* Murano, 1561; *d* Venice, 1605). Italian painter. He was first taught by his father, Michele Corona, an illuminator, and later entered the workshop of Master Rocco, a copyist of antique works, but the main influences on his development were the works of Titian, Veronese and Jacopo Tintoretto. Between 1577 and 1585 Corona painted three *grisailles* for the Sala del Maggior Consiglio in the Doge's Palace, Venice. These were rather clumsily modelled on the work of Veronese, but they nevertheless secured Corona the commission to decorate the walls of the same room with the story of the *Doge Enrico Dandolo* (destr.).

Corona's oil paintings depicting *Christ's Entry into Jerusalem* and *Christ before Caiaphas*, executed before 1585 for S Giuliano, Venice, clearly show the influence of Tintoretto in the crowds of figures and the dramatic use of chiaroscuro. His period of greatest activity was in the 1590s, when he worked in S Giovanni Elemosinario, Venice; his paintings there include a *Crucifixion*, the *Prayer in the Garden* and the *Resurrection*. In addition he painted a *Crucifixion* (Murano, Mus. Vetrario) for S Maria Formosa, Venice, and another *Crucifixion* for S Fantin, Venice. He also painted an altarpiece, *SS Onofrio and James* (Castelfranco Veneto, Cathedral) for the Scuola dei Tintori (the dyers' guild). His continuing interest in chiaroscuro and the effects of light, seen in these works, reached its culmination in the canvases for S Giovanni in Bragora, Venice, depicting the *Flagellation* and the *Crowning with Thorns*, and in his cycle for the Scuola di S Fantin (1600–05; Venice, Ateneo Veneto), depicting eight scenes from the *Passion* and two *Prophets*, in which the dramatic composition and the intense chiaroscuro that causes the strongly Mannerist figures to stand out against their gloomy background anticipate works of the mid-17th century.

BIBLIOGRAPHY
E. Manzato: 'Leonardo Corona da Murano', *A. Ven.*, xxix (1970), pp. 128–50

R. Pallucchini: *La pittura veneziana del seicento*, 2 vols (Milan, 1981), pp. 48–9

G. Nepi Scirè: 'Leonardo Corona', *Da Tiziano a El Greco: Per la storia del manierismo a Venezia, 1540–1590* (exh. cat., ed. R. Pallucchini; Venice, Doge's Pal., 1981), pp. 228–9

FILIPPO PEDROCCO

Corradi, Girolamo di Giovanni dei. *See* GIROLAMO DA CREMONA.

Correggio [Allegri, Antonio] (*b* Correggio, ?1489; *d* Correggio, 5 March 1534). Italian painter and draughtsman. Apart from his Venetian contemporaries, he was the most

important North Italian painter of the first half of the 16th century. His best-known works are the illusionistic frescoes in the domes of S Giovanni Evangelista and the cathedral in Parma, where he worked from 1520 to 1530. The combination of technical virtuosity and dramatic excitement in these works ensured their importance for later generations of artists. His altarpieces of the same period are equally original and ally intimacy of feeling with an ecstatic quality that seems to anticipate the Baroque. In his paintings of mythological subjects, especially those executed after his return to Correggio around 1530, he created images whose sensuality and abandon have been seen as foreshadowing the Rococo.

Vasari wrote that Correggio was timid and virtuous, that family responsibilities made him miserly and that he died from a fever after walking in the sun. He left no letters and, apart from Vasari's account, nothing is known of his character or personality beyond what can be deduced from his works. The story that he owned a manuscript of Bonaventura Berlinghieri's *Geographia*, as well as his use of a latinized form of Allegri (Laetus), and his naming of his son after the humanist Pomponius Laetus, all suggest that he was an educated man by the standards of painters in this period. The intelligence of his paintings supports this claim. Relatively unknown in his lifetime, Correggio was to have an enormous posthumous reputation. He was revered by Federico Barocci and the Carracci, and throughout the 17th and 18th centuries his reputation rivalled that of Raphael.

1. Life and work. 2. Working methods and technique. 3. Critical reception and posthumous reputation.

1. LIFE AND WORK.

(i) Training and early work, before 1520. (ii) Mature work, 1520 and after.

(i) Training and early work, before 1520. Correggio was born probably in 1489, rather than 1494 as has often been stated. His earliest years are difficult to reconstruct, and there is considerable disagreement about his first works. Whatever rudimentary lessons he may have learnt from his uncle, the painter Lorenzo Allegri (*d* 1527), or from the Modenese painter Francesco de' Bianchi Ferrari, his first real inspiration came from Andrea Mantegna. Correggio was about 16 when Mantegna died in 1506, and he could have known him. Mantegna's sons were not gifted artists, so it seems reasonable to look for Correggio's hand among the best productions of his school.

Some critics have assigned the *Evangelists* in the pendentives of the dome of the funerary chapel in S Andrea, Mantua, to Correggio, although they show almost no divergence from the style of Mantegna. Two frescoes, now detached, from the atrium of the same church (Mantua, Mus. Dioc.) are more convincingly attributed to him. These tondi of the *Entombment* and the *Holy Family* reveal a profound understanding of the dark pathos of Mantegna's final manner, but bring to it a softness of touch that is new. They are badly damaged, but a cartoon for the head of Mary Magdalene in the *Holy Family* (New York, Pierpont Morgan Lib.) shows that they are the work of a major artist. They may date from before 1510, and there is an autograph easel painting of the *Virgin and Child* (Washington, DC, N.G.A.) of the same period, the

attribution of which is also disputed. The first documentary link between Correggio and the city of Mantua dates from 1514, when he was commissioned to paint the organ shutters (untraced) for the nearby Benedictine abbey of San Benedetto Po.

The earliest extant documented work by Correggio is the *Virgin of St Francis* (1514–15; Dresden, Gemäldegal. Alte Meister; see fig. 1), but a considerable body of work clearly precedes it. Most are small-scale devotional paintings of the Virgin and Child or biblical episodes, and they suggest that his career was slow to develop. In addition to the influence of Mantegna, which Correggio never wholly repudiated, there are other inspirations. The distinctive smiling faces and *sfumato* of Leonardo da Vinci and his Milanese followers gain in importance, as do the bright enamelled colours of the Bolognese school, probably best known to Correggio through Lorenzo Costa (i), who succeeded Mantegna in Mantua as court painter to the Gonzaga. The most ambitious work of these years is a small altarpiece, the *Mystic Marriage of St Catherine* (Detroit, MI, Inst. A.). In it the figure of St John the Baptist is derived from a Leonardo invention, whereas the ideal profile of Catherine comes from Mantegna. This profile is also found in other works of the same period, notably a dramatic night scene of *Judith and Holofernes* (Strasbourg, Mus. B.-A.). Even in its damaged state, the painting's emerald greens and luminous oranges and reds stand out, and there is a glimpse of a landscape distinctly inspired by Albrecht Dürer (1471–1528). This feature is also found in an exquisitely preserved *Virgin and Child with the Infant Baptist* (Chicago, IL, A. Inst.), which dates from nearer the end of this brief period. Correggio's visual language remained resolutely Italian, but northern emotionalism, combined with a northern subject, is also found in the

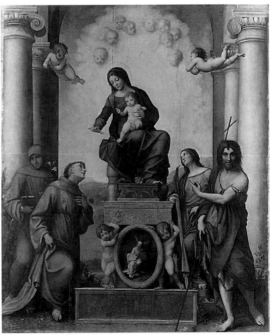

1. Correggio: *Virgin of St Francis*, oil on panel, 2.99×2.45 m, 1514–15 (Dresden, Gemäldegalerie Alte Meister)

painting of *Christ Taking Leave of his Mother* (London, N.G.).

The Dresden *Virgin of St Francis* (Dresden, Gemäldegal. Alte Meister) was painted for the high altar of S Francesco, the largest church in Correggio. Again in the figure types Correggio blended the very different worlds of Mantegna and Leonardo, but set them in Renaissance architecture of the sort found in Bolognese altarpieces. The correctness of Correggio's Ionic columns, compared with those of Francesco Francia and Costa, demonstrates how much better educated an artist he was. More important, the whole composition has a spaciousness and breadth that was unknown in North Italian altarpieces of this date, apart from examples from Venice. Some critics have been so struck by the similarities of style to Raphael's *Virgin of Foligno* (Rome, Pin. Vaticana), that they have assumed Correggio must have been to Rome by this date. In fact, the two artists responded independently to the achievements of Pietro Perugino, and Correggio did not travel to Rome until towards the end of the 1510s.

The *Virgin of St Francis* nevertheless marked a turning-point in Correggio's career, as can be seen in the contrast between the *Adoration of the Shepherds* and the *Adoration of the Magi* (both Milan, Brera). The former is much harder and more wooden, in spite of its beautiful landscape, whereas the latter is both more delicately painted and more elegantly composed. In the *Magi* he again quoted from Leonardo and Dürer, but the picture is in no sense merely an accumulation of influences. It must date from around 1516–17 and is thus roughly contemporary with Correggio's next major commission, the *Four Saints* (New York, Met.), executed for a private chapel in S Maria della Misericordia, Correggio. Although more freely painted than the *Virgin of St Francis*, this is not one of Correggio's best works. Another altarpiece, the *Virgin of Albinea* (1517–19), known only through copies (one in Parma, G.N.), suggests that this was not an easy time for the artist.

Correggio's fortunes changed, however, with his move to Parma, the nearest city of substance. He appears to have been summoned there to fresco the ceiling of a room in the Benedictine convent of S Paolo for the intellectual and independent Abbess Giovanna da Piacenza, probably on the advice of her cousin Scipione Montino della Rosa. It is generally assumed that around this time, 1518–19, Correggio went to Rome, and it is true that his works of the 1520s betray awareness of Michelangelo's frescoes on the ceiling of the Sistine Chapel (*see* ROME, fig. 9) and of Raphael's projects for the *Transfiguration* and the Sala di

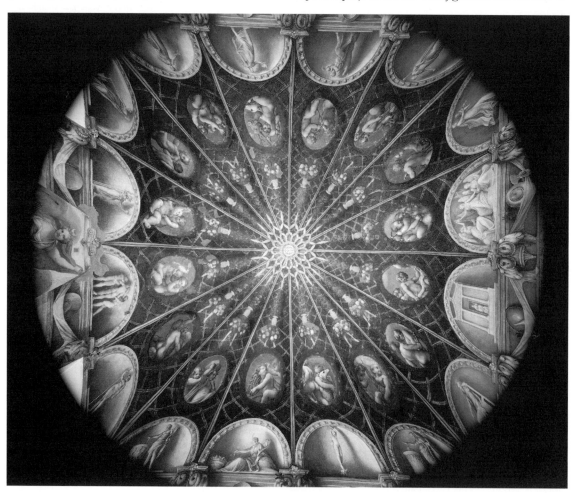

2. Correggio: frescoes (*c.* 1519), detail from the umbrella vault of the Camera di S Paolo, Convent of S Paolo, Parma

Costantino (both Rome, Vatican). In fact, Giovanna was in contact with Raphael's workshop in these years, as demonstrated by a painting by Giulio Romano (Parma, G.N.) for which a drawing by Raphael (Los Angeles, CA, Getty Mus.) survives. It is possible, therefore, that Giovanna, who was doubtless dissatisfied with the frescoes in the adjoining room by Alessandro Araldi (1460–1528), arranged for Correggio to go to Rome and gain access to Raphael and his circle.

The frescoes of the Camera di S Paolo (*in situ*) demonstrate a dramatic stylistic change, one that is likely to have followed the Rome journey. Over the fireplace is the figure of Diana, goddess of the moon, of the chase and of chastity, and a fitting, if pagan, *alter ego* for Giovanna, whose coat of arms of three crescents is prominently displayed in the centre of the ceiling. The umbrella vault, of 16 curved sections, is covered by a spectacular arbour, which is perforated by 16 ovals (see fig. 2). Through the ovals are glimpses of sky and exuberant putti, many displaying symbols of the chase. Below are 16 grisaille lunettes and an illusionistic sculpture frieze including rams'

heads, many with amusing, quizzical expressions. The lunettes are the most interesting part of the decoration. Many were based on antique Roman coins, as Affò recognized in the late 18th century when the convent, which had been in the hands of an enclosed order, became visitable. It is doubtful, however, that there was a comprehensive programme for these *all'antica* scenes. What they show clearly is Correggio's new confidence in representing the human body, whether draped or as here, for almost the first time in his work, nude. The alluring delicacy of the *Three Graces* and *Juno* in the lunettes hints at the delights of his later mythological paintings.

(ii) Mature work, 1520 and after.

(a) Frescoes. Correggio's patrons at San Benedetto Po and in S Paolo were Benedictines, and his next commission was for the Benedictines of S Giovanni Evangelista in Parma. Their church and cloisters were the newest, grandest monuments in the Renaissance style in the city, and they intended to cover them with frescoed decoration. It is generally agreed that Correggio first painted a modest

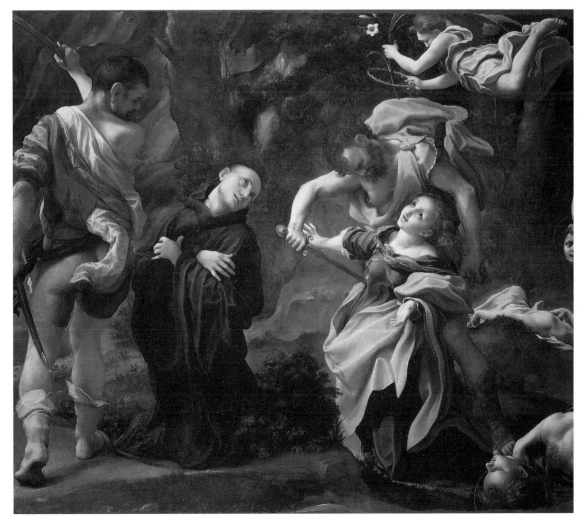

3. Correggio: *Martyrdom of SS Placidus and Flavia*, 1.57×1.82 m, *c.* 1522 (Parma, Galleria Nazionale)

lunette fresco of *St John the Evangelist* over the door leading from the church to the monastery and was then given the opportunity to produce works of far greater substance. By 1525 he had completed frescoes in the dome, the apse, the choir vault and frieze and—with assistants—the nave frieze.

Scholarly debate has centred on the chronology of the dome and apse, apparently settled in favour of the priority of the dome. This seems to have been executed between 1520 and 1522 and represents the *Vision of St John the Evangelist on Patmos* as described in the Book of Revelation. The saint is at the base of the dome, visible only from the choir steps, while above him the commanding figure of Christ is shown descending, ringed by the Apostles seated on clouds. These graceful but heroic figures, nude but for their flowing draperies, represent Correggio's synthesis of Michelangelo's Sistine Ceiling and Raphael's Vatican Stanze. Below them is a drum, with grisaille frescoes all but invisible from the ground; the oculi of the drum are the main, if insufficient, light source for the frescoes. Still lower are the pendentives, each of which contains an Evangelist and a Doctor of the Church engaged in intense theological debate. Finally, fictive bronze reliefs on the arches of the crossing represent Old Testament prophets and patriarchs. The dome, which was directly above the monks' enclosed wooden choir, was designed to be seen from many different points of view. The lay congregation would have had access to only one of them.

The apse fresco, the *Coronation of the Virgin*, was executed between 1522 and 1524. The subject was not an unusual one, but it had particular significance in Parma, whose principal patron saint was the Virgin and where it adorned the town seal. In addition to Christ and the Virgin, Correggio included the two St Johns and two Benedictines, probably St Benedict and St John, the first abbot of the monastery. When the choir was extended in 1587, the apse was destroyed, and the fresco was replaced by a full-scale copy by Cesare Aretusi; only the central part of the original survives (Parma, Bib. Palatina). What is lost, however, is the sense of a sequence of illusions originally conveyed by the two frescoes when they were adjacent. Although the composition of the apse is necessarily more conventional than that of the dome, it is unusual to find such an emphasis on depth and distance in a work of this sort.

Correggio's other frescoes in S Giovanni are relatively minor, with the main exception of the *Conversion of St Paul* and the *Healing of the Paralytic by SS Peter and John the Evangelist* on the entrance arch of the del Bono Chapel. Although probably executed by assistants, this scheme was designed by Correggio and is a clever variation on the theme of Michelangelo's decoration of the ceiling bays in the Sistine Chapel. Correggio also executed two remarkably bold compositions for the side walls of the chapel, the *Martyrdom of SS Placidus and Flavia* (see fig. 3) and the *Lamentation* (Parma, G.N.; copies *in situ*). Especially in the latter, he responded ingeniously to the problem of composing pictures that generally were seen from an oblique angle. Furthermore, in their ecstatic lingering over the pains and pleasures of death and martyrdom, both paintings clearly anticipate what was to become an almost morbid concern of the Counter-Reformation.

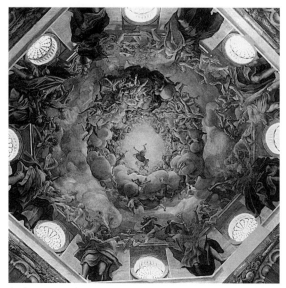

4. Correggio: *Assumption of the Virgin* (*c.* 1530), fresco, Parma Cathedral

In November 1522, as a result of the success of the newly completed dome, Correggio won the prime commission to fresco the dome, apse and choir vault of Parma Cathedral. The lesser parts of the vast decorative scheme were allotted to the young Parmigianino and others. In the event, Correggio completed only the dome and that not until 1530, after a delay occasioned both by the need to finish at S Giovanni and by the work required to make the dome ready for fresco painting. The dome of the cathedral is octagonal, and yet Correggio's finished fresco, the *Assumption of the Virgin* (see fig. 4), seems to be a soaring, seamless design. The spectator in the body of the church is conceived of as witnessing the Assumption from underneath. At the base of the dome is a fictive parapet pierced by real round windows. In front of it, on a ledge that is one of Correggio's greatest illusionistic triumphs, stand the Apostles in attitudes that convey the violence of their emotions. Beyond is the Virgin herself, almost swallowed up by the exultant throng of music-making angels and putti who carry her into the company of heaven. The patriarchs, headed by Adam, are to the left, the women with Eve to the right. The whole drama is moved away from the centre, so that the Virgin is more easily visible from the nave. In the centre of the dome is a plummeting figure generally identified as Christ. As the figure has no beard or stigmata and wears green and white, a colour combination not usually associated with Christ, it seems more likely that he is an angel.

The paintings on the squinches, which depict four of the patron saints of Parma (John the Baptist, Hilary, Bernard Uberti and Joseph), were designed and executed after 19 March 1528, the day St Joseph was included in their number. They are painted in an even more ethereal style than the dome, but the same spirit of delight inhabits them, especially conspicuous among the rejoicing angels. The dome ensemble, which was unprecedentedly daring as an illusion, should have represented the crowning achievement of Correggio's career, but there is some

evidence that it was a failure. An anecdote, which may be based on fact, relates that one of the canons called it 'a stew of frogs' legs'; certainly after 1530 Correggio received no further commissions in Parma.

In addition to these two colossal fresco commissions, Correggio also painted two smaller frescoes (both Parma, G.N.), which were saved when the buildings that housed them were destroyed in the late 16th century. The *Annunciation* was in SS Annunziata, the other, the *Virgin of the Steps*, adorned one of the city gates of Parma.

(b) Altarpieces and devotional works. It is impossible to make a division between the small devotional works of the late 1510s and those of the early 1520s. For one reason, Correggio often re-used drawings or cartoons, with the result that the same Child is found in the *Virgin and Child with the Infant John the Baptist* (Madrid, Prado) as in the *Holy Family with St Jerome* (London, Hampton Court, Royal Col.), and that the Hampton Court Virgin is also found in the *Holy Family with the Infant John the Baptist* (Orléans, Mus. B.-A.). What does become apparent is a gradual loosening of the brushstrokes and the use of a more substantial figure type, especially for the Virgin. The culmination of this development is the *Rest on the Flight into Egypt with St Francis* (1520–21; Florence, Uffizi; see colour pl. 1, XXIV2), painted for the Munari Chapel in S Francesco, Correggio, at a time when the artist's career was increasingly taking him to Parma. In it the Virgin and Child are seated conventionally in the centre of the composition, but the kneeling figure of St Francis and the standing Joseph produce a rising right-to-left diagonal.

For the rest of the 1520s Correggio divided his time between frescoes in summer (it was too cold in winter) and altarpieces and preparations the remainder of the year. He painted five altarpieces in this period, at least three of which seem to have followed the success of the S Giovanni dome. Two were for Parma, two for Modena and one for Reggio Emilia. Since he appears to have worked on more than one altarpiece at a time, it does not make sense to talk of a simple chronological sequence. Rather, each represents a highly individual response to a particular demand.

The first to be completed, the *Virgin of St Sebastian* (Dresden, Gemäldegal. Alte Meister), was inspired by an outbreak of plague in 1523. It must have been well advanced if not completed as early as 1524, for in that year Parmigianino went to Rome, where he painted his own similar composition, the *Virgin and Child with SS John the Baptist and Jerome* (London, N.G.). The motif of the Virgin in the clouds in Correggio's painting may have been suggested by local precedent, notably Dosso Dossi's *St Sebastian* altarpiece of 1521 in Modena Cathedral, but it was also suitable for an image in which a group of saints prays to the Virgin and Child to intercede. Correggio may have come into contact with the confraternity of St Sebastian in Modena, which commissioned the work, through his friend Francesco Grillenzoni, who was a member and for whom he painted the intimate *Mystic Marriage of St Catherine with St Sebastian* (Paris, Louvre) shortly afterwards. The *Virgin of St Jerome* (the '*Giorno*'; Parma, G.N.) was painted for the family chapel of Melchior

Bergonzi and Briseide Colla in S Antonio, Parma. It is a joyful representation of the Virgin, totally absorbed with her son, flanked by St Jerome, accompanied by an angel and presenting his translation of the Bible, and by Mary Magdalene anointing the Child's feet in anticipation of the service she will perform for her Saviour. Behind her an impish boy, possibly St John the Baptist, sniffs at her ointment vase. The atmosphere is relaxed but not frivolous.

This idyllic atmosphere is even more evident in the *Adoration of the Shepherds* (the '*Notte*'; Dresden, Gemäldegal. Alte Meister; see fig. 5), which was commissioned by Alberto Pratoneri in October 1522 for his family chapel in S Prospero, Reggio Emilia (the original frame is *in situ*), and which does not appear to have been delivered until 1530. Although night scenes were by no means unknown before this date and Correggio's own *Judith* (Strasbourg, Mus. B.-A.) and *Agony in the Garden* (London, Apsley House) are distinguished examples of the genre, his image of the Virgin basking in the radiance of her son caught the imagination of subsequent generations. All around her is turmoil and confusion, as angels come to worship, as the shepherds remove their caps and kneel, and as a maidservant, or midwife, recoils from the brightness of the light. In the murky background Joseph attends to the ass, in anticipation of the Flight into Egypt. The *Rest on the Return from Egypt* is the unusual subject of Correggio's next altarpiece, the *Madonna della scodella* (Parma, G.N.), painted for the chapel of the confraternity of St Joseph in S Sepolcro, Parma. Like the two preceding works, it was designed for a side chapel as opposed to a high altar

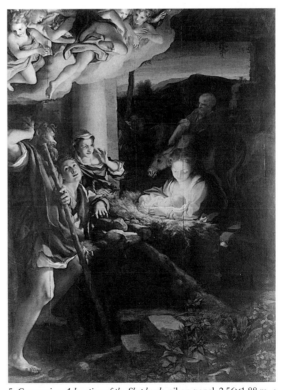

5. Correggio: *Adoration of the Shepherds*, oil on panel, 2.56×1.88 m, *c.* 1530 (Dresden, Gemäldegalerie Alte Meister)

and—even more plainly—is an asymmetrical composition based on a rising diagonal. Thus in these works Correggio introduced illusionism into the altarpiece in the same decade as Titian executed the Pesaro *Madonna* (*c.* 1522; Venice, S Maria Gloriosa dei Frari; see colour pl. 2, XXXV3).

Correggio's last altarpiece, the *Virgin of St George* (Dresden, Gemäldegal.), also appears to have been completed by 1530. Like the *Virgin of St Sebastian*, it was painted for a Modenese confraternity, in this case of St Peter Martyr as the high altarpiece of their oratory. It shows the Virgin and Child below a pergola based on the one in Mantegna's *Madonna of Victory* (1495–6; Paris, Louvre; *see* MANTEGNA, ANDREA, fig. 5) and flanked by SS John the Baptist, Gimignano, Peter Martyr and George. Often regarded as conservative by comparison with the three altarpieces that preceded it, it is arguably the most visually daring of them all, particularly the distortion of the figures and the way they crowd around the Virgin and Child. Correggio contracted for another altarpiece—possibly recorded in a drawing of *Four Saints* (Florence, Uffizi)—for the Panciroli family of Reggio. He also appears to have executed a triptych of *Christ, SS John the Baptist and Bartholomew* (untraced) for S Maria della Misericordia, Correggio; the middle part and left wing are known through copies (Rome, Pin. Vaticana; ex-J. C. Robinson priv. col., London, see Ekserdjian, 1988, fig. 33).

In the 1520s Correggio seems to have been so busy with large-scale frescoes and major altarpieces that he was obliged to cut down his production of small pictures for private devotion. His few surviving works of this type indicate that he always took considerable trouble over them. One of the earliest is the *Noli me tangere* (Madrid, Prado), painted for the Ercolani family of Bologna who also owned Raphael's *Vision of Ezekiel* (Florence, Pitti). Although almost large enough for a small altarpiece, it appears to have been a private image and is accordingly meticulously finished. The Christ recalls his counterpart in the London *Christ Taking Leave of his Mother*, whereas the Magdalene has all the blond opulence of her namesake in the Parma *Virgin of St Jerome*. Other paintings show the Virgin and Child, either alone or with other figures. They include the *Mystic Marriage of St Catherine* (Naples, Capodimonte), the Louvre *Mystic Marriage* mentioned above, the *Virgin of the Basket* (London, N.G.), the *Madonna del latte* (Budapest, Mus. F.A.) and the *Virgin Adoring the Child* (Florence, Uffizi). These paintings, which date from the first half of the 1520s, are characterized by a pronounced intimacy of emotion and playfulness between mother and child. This was already present in such works of 1510–20 as the *Zingarella* (Naples, Capodimonte), but is taken even further in these works. One of Correggio's greatest achievements was to convey this exchange on the large stage offered by the altarpiece. Correggio also produced paintings related to the passion of Christ, such as the *Agony in the Garden*, mentioned above, where Christ looks in vain for the weeping angel hovering so near him. Other examples are the *Ecce homo* (London, N.G.) and the *Veil of St Veronica* (Firle Place, E. Sussex). In the former the sources are clearly Netherlandish and German, but the pathos is peculiarly ripe and

Italian. In the latter the directness of the work makes it hard to remember that this is meant to be an image of an image. The *Veil* may well date after 1530, and Correggio's retreat from Parma, and its smooth flesh tones have much in common with the late mythological paintings.

(*c*) *Mythological paintings.* All Correggio's mythological and allegorical paintings, with the exception of the Camera di S Paolo, date from after 1520, and it is often implied that only the patronage of a court like that of the Gonzaga at Mantua could have inspired this kind of art. Yet early drawings by Correggio show an interest in this type of subject, and Parmigianino's *Cupid* (Vienna, Ksthist. Mus.; *see* PARMIGIANINO, fig. 4) was painted for a local Parmesan nobleman. Correggio's earliest surviving mythological paintings, *Mercury Instructing Cupid before Venus* (the '*School of Love*'; London, N.G.) and the *Venus and Cupid with a Satyr*, sometimes wrongly entitled *Jupiter and Antiope* (Paris, Louvre), are first documented in the Gonzaga collection only in 1627. Often considered as a pair, these two paintings are in fact very different in scale. The earlier of the two, the '*School of Love*', is considerably smaller. It shows Venus standing and Mercury seated teaching their son, Cupid, to read. The dappled warm light playing on the ample flesh gives an effect of considerable sensuality. This atmosphere is even more pronounced in the *Venus and Cupid with a Satyr*, in which the sleeping nude woman is unveiled for the viewer's delectation by a discreet but enchanted satyr.

Correggio's next works in this genre do in fact represent a pair. The *Allegory of Virtue* and *Allegory of Vice* (both Paris, Louvre) were executed for the second, larger *studiolo* of Isabella d'Este in the Palazzo Ducale at Mantua. They were designed to be seen next to paintings of *c.* 1500 by Mantegna, Perugino and Costa commissioned for the first *studiolo*, and Correggio employed the archaic tempera medium to produce an effect of bright primary colours. *Virtue*, for which two preparatory drawings and an unfinished oil *bozzetto* survive (ex-Suida–Manning priv. col., New York, see Popham, 1957, pl. civ; Paris, Louvre; Rome, Gal. Doria–Pamphili), is seated in triumph, crowned with the laurels and palm of victory by music-making genii, and flanked by personifications of the virtues and sciences. *Vice*, by contrast, includes fewer symbols. It shows a bearded man tormented by three women: one brandishes serpents, one blows a loud pipe in his ear, while the third flays him. In the foreground is a puckish boy holding a bunch of grapes, who appears to warn against the dangers of drink. This figure was added to the scheme after the highly finished preparatory drawing for the composition (London, BM).

Correggio's last mythological paintings were a series of the *Loves of Jupiter*, commissioned by Federico II Gonzaga, 5th Marchese of Mantua, as a present for Emperor Charles V. It is generally assumed that they were given to the Emperor on one of his visits to Mantua in 1530 or 1532, but there is no proof of this. They may have been completed later and simply sent to Spain; Correggio was never a fast worker, and four major canvases are likely to have taken him some time to complete. The paintings are in two pairs, the horizontal *Leda* and *Danaë*, and the vertical *Ganymede* and *Io*. The *Leda* (Berlin, Gemäldegal.)

was severely damaged in the 18th century by the son of the Regent of France. It was repainted, but not entirely accurately, judging from the copy in Madrid (Prado). The picture shows the arrival of the swan, the moment of coition and his departure, a narrative sequence common on *cassoni* of the previous century. Its pendant, the *Danaë* (Rome, Gal. Borghese; see colour pl. 1, XXIV1), shows the moment just prior to the act of love, when Jupiter, disguised as a cloud, hovers over the bed and the first drops of golden rain fall. Cupid draws aside Danaë's drapery, and she looks down at her body in wonder. In the *Ganymede* (Vienna, Ksthist. Mus.) the figure of the youth derives from an attendant angel from the squinch depicting St Bernard Uberti in Parma Cathedral, but the expression is subtly transformed. Jupiter appears as the ardent eagle, and there is an atmospheric landscape. The *Io* (Vienna, Ksthist. Mus.; see fig. 6) is a remarkable image: the god comes to the mortal concealed in a dark cloud, from which only his hand and face emerge; Io throws back her elaborately coiffed head in sheer delight. In all four pictures Correggio portrayed a slim, adolescent beauty and painted human flesh with extraordinary delicacy and smoothness of touch. They are among the most extraordinary mythological pictures ever painted, affirmations of human pleasure that are rivalled in this period only by the generally darker and more tragic visions of Titian.

2. WORKING METHODS AND TECHNIQUE. By comparison with many of his contemporaries, Correggio appears to have drawn relatively little, and then only when he had a specific end in mind. His drawings are of three main types. The largest group consists of studies in red chalk, often for individual figures or parts of compositions. These are generally meticulous, and it is reasonable to assume that they were executed after other drawings, which were lost or destroyed during the creative process. A sheet of studies for the *'Giorno'* (Oxford, Christ Church Pict. Gal.) shows how Correggio produced a palimpsest of red chalk lines and then drew over it with pen to clarify his thoughts. A different sort of drawing, sometimes on pink-washed paper, is also in red chalk and pen but with extremely thickly applied white heightening. The overall effect is far from linear, almost like an oil sketch. The finest example is a sheet in Cambridge (Fitzwilliam), probably a first idea for the *'Notte'*. The extant drawings suggest Correggio's great willingness to think about subject-matter and to make significant changes. The double-sided sheet of studies for the dome of Parma Cathedral (Oxford, Ashmolean) shows a far more timid composition for the base of the dome, with quite different iconography. In the earliest surviving study (Washington, DC, N.G.A.) for the *Madonna della scodella*, the Rest on the Flight, as opposed to the Return, is depicted. Most tellingly, the study for the *Virgin of St George* lacks the putti playing with the saint's armour in the foreground, a reference to the famous antique painting by Aetion of the *Wedding of Alexander and Roxane* (destr.), known in the Renaissance through Pliny's written description. Correggio is sometimes dismissed as a skilful but frivolous artist, unconcerned with subject-matter and devoted to the profanation of religious art: his drawings indicate that nothing could be further from the truth.

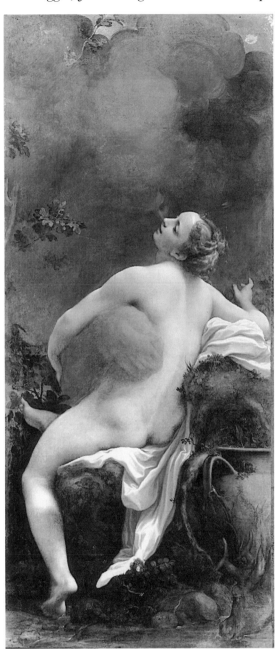

6. Correggio: *Io*, oil on canvas, 1670×710 mm, *c.* 1532 (Vienna, Kunsthistorisches Museum)

The vast majority of Correggio's easel paintings are on panel, although he sometimes used canvas, especially but not exclusively for mythological pictures. Some of his earlier paintings have completely different compositions underneath. The *Zingarella*, for example, is painted over a *Christ Carrying the Cross*, which is also known through a copy (Parma, priv. col., see Quintavalle, pl. 37). In other cases, such as *Christ Taking Leave of his Mother*, he turned a canvas upside down and started again. His tendency to make changes during the process of painting never wholly disappeared, as the adjustments to the *Ecce homo* prove.

This sort of freedom was not exercised only on cabinet pictures, however, because both the 'School of Love' and the *Danaë* have major pentiments, which alter the meaning of the images. In the former Venus looked down and Mercury out as opposed to the other way round, while in the latter Danaë looked across at Cupid, not down at her own body. These very significant alterations were at least as much psychological as formal in intention.

Correggio's fresco technique was extremely professional and polished. He seems to have used cartoons. There are fragments of cartoons for the S Andrea *Entombment* (New York, Pierpont Morgan Lib.), for the S Giovanni *Coronation of the Virgin* (Oxford, Christ Church Pict. Gal.) and probably for Parma Cathedral (Paris, Ecole N. Sup. B.-A.). There is, however, no evidence of pouncing on the frescoes themselves. The separation from its support of the central fragment of the S Giovanni *Coronation* fresco has revealed an underdrawing on the *intonaco* (Parma, Bib. Palatina), executed in a style that closely resembles Correggio's other drawings. His drawings also offer interesting insights into the problem of how he planned the dome of Parma Cathedral. The sheet of studies for the dome (Oxford, Ashmolean), taken in conjunction with a drawing in Frankfurt am Main (Städel. Kstinst. & Städt. Gal.), suggests that he devised the composition in the round, but took into account the octagonal shape of the dome so that the joins would not be marked. Popham (1957) suggested that Correggio suspended wax or clay models of figures from strings to study the *di sotto in sù* perspective. It is also probable that he made a small-scale model of the entire dome. Indegaay (1985) proposed that the cartoons for the dome fresco survive in Paris (Louvre), however these appear to be tracings of the originals, which were probably destroyed in the painting process.

3. CRITICAL RECEPTION AND POSTHUMOUS REPUTATION. In view of his suspicion of artists unconnected with Tuscany and Rome, Vasari's account of Correggio may be interpreted as extremely favourable. He recognized Correggio's importance as one of the pioneers of a new style in Lombardy and was particularly lavish in his praise of the artist's gifts as an illusionist and as a painter of hair. Correggio's reputation in the late 16th century, however, was due mainly to his influence on other painters. His effect on artists in Parma was profound, above all on Parmigianino, but also on Michelangelo Anselmi and Francesco Maria Rondani, and it spread to Camillo Boccaccino and the Campi in Cremona as well. It was Barocci's devotion to Correggio, especially obvious in his *Rest on the Flight* (Rome, Pin. Vaticana), which is based on the *Madonna della scodella*, and in his depictions of ecstatic saints, that had a formative role on the Carracci. Annibale Carracci transformed the Venus from the 'School of Love' into one of the attendants in his *Venus Adorned by the Graces* (c. 1594; Washington, DC, N.G.A.), and he was inspired by Correggio's *Lamentation* (Parma, G.N.) in his numerous treatments of the subject, but the influence was far more pervasive.

From the 17th century Correggio was revered with Raphael as one of the supreme Old Masters. This had enormous consequences in the work of such artists as Gianlorenzo Bernini (1598–1680), whose debt to Correg-gio ranged from the statue of *St Longinus* (Rome, St Peter's) inspired by the Parma Cathedral Apostles, to the figure of *Truth* (Rome, Gal. Borghese), which is based on the figure of Minerva in the *Allegory of Virtue* (Rome, Gal. Doria–Pamphili). Correggio's reputation was also extended by such 17th-century Italian writers as Filippo Baldinucci (1625–97) and Giovanni Pietro Bellori (1613–96). As a consequence, Correggio's works were avidly collected. The Este family of Modena were exceptionally insatiable and unscrupulous: they secretly replaced the *'Notte'* by a copy, the discovery of which caused a riot in Reggio Emilia. As a result, four important altarpieces by Correggio ultimately went to Dresden, where they were relatively inaccessible, a situation that may have contributed to the decline of his reputation.

In the 18th century Correggio continued to be emulated by artists as diverse as Antoine Watteau (1684–1721) in his *Nymph and Satyr* (Paris, Louvre) and Sir Joshua Reynolds (1723–92) in his *Garrick between Tragedy and Comedy* (priv. col., see *Reynolds* exh. cat.; Paris, Grand Pal.; London, RA; 1985–6, no. 42), and his works made Parma a standard stop on the Grand Tour. Anton Raphael Mengs (1728–79), who was to write an excellent monograph on the painter, was named after Correggio by his artist father. Critical opinion in the 19th century remained generally respectful, although John Ruskin (1819–1900) fulminated and Bernard Berenson (1865–1959) saw only frivolity, however irresistible. In the 20th century Correggio's reputation remained high among art historians, but declined among the general public. In 1957 Popham, in the introduction to his exemplary monograph on Correggio's drawings, placed him with Leonardo, Michelangelo, Raphael and Titian in 'the conventional quintette of great Renaissance artists'. It is regrettable that Correggio is the least known of the five.

BIBLIOGRAPHY

EARLY SOURCES

G. Vasari: *Vite* (1550, rev. 2/1568); ed. G. Milanesi (1878–85), iv, pp. 109–29, 457–529

DBI

GENERAL WORKS

A. E. Popham: *Artists Working in Parma in the Sixteenth Century*, London, BM cat., 2 vols (London, 1967)

B. Adorni and others: *L'abbazia benedettina di San Giovanni Evangelista a Parma* (Parma, 1979)

M. Dall'Acqua: *Correggio e il suo tempo* (Parma, 1984)

Correggio and his Legacy (exh. cat. by D. De Grazia, Washington, DC, N.G.A.; Parma, G.N.; 1984)

The Age of Correggio and the Carracci (exh. cat., Bologna, Pin. N.; Washington, DC, N.G.A.; New York, Met.; 1986–7)

MONOGRAPHS

C. G. Ratti: *Notizie storiche sincere intorno la vita e le opere del celebre pittore Antonio Allegri da Correggio* (Finale, 1781)

G. Tiraboschi: *Biblioteca modenese*, 6 vols (Modena, 1781–6) [includes a monograph on Correggio]

A. R. Mengs: *Opere*, 2 vols (Bassano, 1783) [includes a monograph on Correggio]

I. Affò: *Ragionamento sopra una stanza dipinta dal celeberrimo Antonio Allegri da Correggio nel Monastero di S. Paolo in Parma* (Parma, 1794, rev. Milan, 1988)

L. Pungileoni: *Memorie istoriche di Antonio Allegri detto il Correggio*, 3 vols (Parma, 1817–21)

C. Ricci: *Antonio Allegri da Correggio: His Life, his Friends, and his Time* (London, 1896)

A. Venturi: *Correggio* (Rome, 1926)

C. Ricci: *Correggio* (Rome, 1930)

R. Longhi: *Il Correggio e la Camera di San Paolo* (Genoa, 1956, rev. Milan, 1988)

A. E. Popham: *Correggio's Drawings* (London, 1957)

E. Panofsky: *The Iconography of Correggio's Camera di San Paolo* (London, 1961, rev. Milan, 1988)

M. Larkin: *The Early Work of Correggio* (diss., New York U., Inst. F.A., 1964)

A. C. Quintavalle: *Correggio: Opera completa* (Milan, 1970)

G. M. Toscano: *Nuovi studi sul Correggio* (Parma, 1974)

C. Gould: *The Paintings of Correggio* (London, 1976); review by J. Shearman in *Times Lit. Suppl.* (18 March 1977)

E. Battisti and others: *Come si fabbrica un paradiso* (Rome, 1981)

D. A. Brown: *The Young Correggio and his Leonardesque Sources* (New York and London, 1981)

G. Ercoli: *Arte e fortuna del Correggio* (Modena, 1981)

A. Muzzi: *Correggio e la congregazione cassinese* (Florence, 1981)

E. Riccómini, M. Indegaay and others: *La più bella di tutte: La cupola del Correggio nel Duomo di Parma* (Parma, 1985)

D. Ekserdjian: *The Altarpieces of Correggio* (diss., Courtauld Inst., U. London, 1988)

M. di Giampaolo and A. Muzzi: *Correggio: I disegni* (Turin, 1988)

P. Piva: *Correggio giovane e l'affresco ritrovato di San Benedetto in Polirone* (Turin, 1988)

M. Dall'Acqua and others: *Il Monastero di San Paolo* (Parma, 1990)

L. Fornari Schianchi and others: *Un miracolo d'arte senza esempio* (Parma, 1990) [on S Giovanni Evangelista cupola]

L. Fornari Schianchi: *Correggio* (Florence, 1994)

D. Ekserdjian: *Correggio* (New Haven, 1997)

SPECIALIST STUDIES

R. Hodge: 'Three Stages in the Genesis of Correggio's *Madonna della Scodella*', *Burl. Mag.*, cxv (1973), pp. 603–4

E. H. Gombrich: 'Topos and Topicality in Renaissance Art', *Annual Lecture of the Society for Renaissance Studies* (London, 1975)

J. Shearman: 'Correggio's Illusionism', *La prospettiva rinascimentale* (Florence, 1980), pp. 281–94

E. Kane: 'Correggio in San Giovanni Evangelista: Not Aaron but Jesse', *Burl. Mag.*, cxxiii (1981), pp. 155–9

D. Ekserdjian: 'Correggio in Parma Cathedral: Not Thomas, but Joseph', *Burl. Mag.*, cxxxviii (1986), pp. 412–15

K. Christiansen: [review of *Important Old Master Paintings and Discoveries of the Last Year* (exh. cat., New York, Piero Corsini, 1986)], *Burl. Mag.*, cxxix (1987), pp. 211–12

C. Gould: 'A Correggio Fresco Restored and a Fresh Light on the Young Parmigianino', *Gaz. B.-A.*, n. s. 5, cxvii (1991), pp. 226–32

C. Smith: *Correggio's Frescoes in Parma Cathedral* (Princeton, 1997)

P. Joannides: 'A Putto by Correggio', *Apollo*, cxlvii (Feb 1998), pp. 47–8

DAVID EKSERDJIAN

Correr. Italian family of patrons and collectors. One of the great noble families of Venice, they are documented from the 14th century. The family attained considerable power with the election of Angelo Correr as Pope Gregory XII (*reg* 1406–15), whose great nephew Gregorio Correr (*b* Venice, *c.* 1411; *d* Verona, 30 Nov 1464) was a patron of Mantegna. According to Agostini, Gregorio was the son of Giovanni di Filippo Correr, Procurator of S Marco, and Cecilia Contarini. Educated in Venice by the humanist Vittorino da Feltre, he subsequently spent two years at the Gonzaga household in Mantua. In 1443 he was created Apostolic Protonotary by Pope Eugenius IV (*reg* 1431–47) and was given the benefice of the Benedictine monastery of S Zeno, Verona, of which he became Abbot in 1445. He ordered the reconstruction of the basilica and commissioned the high altarpiece (1456–9; *see* MANTEGNA, ANDREA, §I, 1(iii)). He was elected Patriarch of Venice in 1464 but died before assuming office and was buried in the convent of San Giorgio in Alga. By 1568–9 the Correr family owned one of the four officially recognized private banks in Venice. Family property in Venice also included the 15th-century Palazzo Correr at S Fosca.

BIBLIOGRAPHY

E. Bassi: *Palazzi di Venezia* (Venice, 1976), pp. 460–63

F. G. Degli Agostini: *Notizie istorico-critiche intorno la vita, e le opere degli scrittori viniziani*, i (Venice, 1752), pp. 108–34

C. A. Riccio: *Gregorio Correr* (Pistoia, 1900)

L. Puppi: *Il trittico di Andrea Mantegna per la basilica di San Zeno Maggiore in Verona* (Verona, 1972), pp. 35–49

HELEN GEDDES

Corso, Nicolò (di Lombarduccio) (*b* Pieve di Vico, Corsica, *c.* 1446; *d* Genoa, 1513). Italian painter. He is first documented in Genoa in 1469, when he worked briefly with Giovanni dall'Acqua as a decorator of *cassone* panels. He is next mentioned in local records in 1478, in connection with the painting of civic and dogal emblems in Pietrasanta (Lucca). In 1484–5 he worked for a few months painting *cassone* panels and altarpieces in Alessandria, in the workshop of Giovanni Mazone. A *St Gregory* (Toledo, OH, Mus. A.) and a *St Nicholas* (untraced) formerly attributed to the Master of the Madonna Cagnola, identified by some critics as Zanetto Bugatto, are now thought to be among Corso's earliest works. These panels, with a *St Jerome* (priv. col., see Boskovits, p. 357), show an up-to-date knowledge of the painting of Vincenzo Foppa at the beginning of the 1460s, from the time of Foppa's first period of residence in Genoa. Their descriptive and illusionistic precision is clearly of south Netherlandish derivation; they are painted on a gilded ground and call to mind Mediterranean practice.

A similar Netherlandish and Provençal orientation, again comparable to the production of the Master of the Madonna Cagnola, appears in such later paintings as a dispersed triptych formerly in the monastery of S Gerolamo, Genova Quarto (Genoa, Mus. Accad. Ligustica B.A.; Philadelphia, PA, Johnson priv. col.) and a *Virgin and Child with Angels* (ex-Lanz priv. col., Amsterdam). An interest in the style of Carlo Braccesco appears to supplant the influence of Foppa. This can be seen especially in the landscape views that place these paintings around 1490–95, when Corso was documented as an oblate of the Benedictine monastery. In 1491 he was commissioned, with Francesco de' Ferrari of Pavia (*fl* 1476–93), to paint an altarpiece and frescoes for S Maria della Passione (destr.) and in 1491–2 to give a valuation, with David da Staglieno, of the della Rovere family polyptych painted by Mazone for the Sistine Chapel in Savona (Avignon, Mus. Petit Pal.).

For the monastery of S Maria delle Grazie, Portovenere (nr La Spezia), Corso painted frescoes, including a *Crucifixion* and a rich frieze: the saints depicted opposite one another in the roundels already anticipate the polished volume and the air of sweetness that are derived from Mazone and the new generation of Lombard painters active in Liguria; these same qualities characterize the now dispersed polyptych of *St Vincent Ferrer* (1501; Taggia, Dominican Convent; Genoa, Sopr. Beni A. & Stor. Liguria; Kraków, N.A. Cols). Rigid draperies and shimmering highlights of Netherlandish inspiration can nevertheless still be seen in the surviving parts of the wall paintings of the monastery of S Gerolamo, Genova Quarto, in whose refectory the date 1503 was once legible.

BIBLIOGRAPHY

L. Martini: 'Ricerche sul quattrocento ligure: Nicolò Corso tra lombardi e fiamminghi', *Prospettiva*, xxviii (1984), pp. 42–58

G. Rotondi Terminiello, ed.: *Nicolò Corso un pittore per gli Olivetani: Arte in Liguria alla fine del quattrocento* (Genoa, 1986)

M. Boskovits: 'Nicolò Corso e gli altri: Spigolature di pittura lombardo-ligure di secondo quattrocento', *A. Crist.*, lxxv (1987), pp. 351–87 (351–5; 374–6)

M. Natale: 'La pittura a Genova e in Liguria dagli inizi al cinquecento', *La pittura in Italia: Il quattrocento*, ed. F. Zeri, 2 vols (Milan, 1987), pp. 15–30 (21)

G. Algeri and A. De Floriani: *La pittura in Liguria: Il quattrocento* (Genoa, 1991), pp. 395–408, 519

VITTORIO NATALE

Corte, Niccolò da (*b* before 1507; *d* Granada, before 16 Jan 1552). Italian sculptor and mason, active also in Spain. His father was from Lake Lugano and da Corte probably received his training in the circle of Agostino Busti in Milan. It was no doubt here that he met Gian Giacomo della Porta, who was active in the Milan Cathedral stone masons' lodge. In 1528–9 da Corte was in Genoa and Savona. His first known work, the inscribed plaque and surrounding sculptural decoration above the portal of the Palazzo Andrea Doria, Genoa, was executed in 1528. From 1532 da Corte collaborated with della Porta on numerous commissions, such as the marble decoration in the Sala Grande of the Palazzo Ducale in Genoa. In 1534 he contracted a formal partnership with della Porta and his son Guglielmo della Porta, which lasted until 1537. The two most important pieces from this workshop are in Genoa Cathedral: the baldacchino in the chapel of S Giovanni Battista, which was commissioned by Filippo Doria *c.* 1530 and erected in 1532, and the funerary monument to *Giuliano Cybo, Bishop of Agrigento* (1533–7). On the baldacchino, the decorative elements and some of the prophet reliefs on the socles can be attributed to da Corte, and on the Cybo monument, the relief with *Fortitude and Justice*.

In 1536 da Corte was contracted to supply architectural elements for the palace of Alvaro de Bazán, Marqués de Santa Cruz, in Granada. He emigrated to Granada in 1537. In November 1537 he was paid for the figure of *Fame* on the south portal of the palace of Charles V (*reg* 1519–56) in the Alhambra. In 1538–9 he was working on the socle reliefs with war trophies, also on the south portal. His presence in Granada can be documented from 1545 until his death. From 1545 da Corte worked on the wall fountain in the Alhambra (*el pilar de Carlos V*). His last commission was the 'Mirador', a Venetian window in the palace of Charles V. Da Corte's greatest stylistic achievement is found in ornament and decoration, and even in his figural works the elegance of the drapery is more impressive than the expressive qualities.

BIBLIOGRAPHY

S. Varni: 'Delle opere di Gian Giacomo e Guglielmo della Porta e Niccolò da Corte in Genova', *Atti Soc. Ligure Stor. Patria*, iv (1866), pp. 35–78

F. Alizeri: *Notizie dei professori del disegno in Liguria dalle origini al secolo XVI*, v (Genoa, 1877)

E. Rosenthal: 'The Lombard Sculptor Niccolò da Corte in Granada from 1537–1552', *A.Q.* [Detroit], xxix (1966), pp. 208–44

——: 'Niccolò da Corte and the Portal of the Palace of Andrea Doria in Genoa', *Festschrift Ulrich Middeldorf* (Berlin, 1968), pp. 358–63

H.-W. Kruft and A. Roth: 'The della Porta Workshop in Genoa', *An. Scu. Norm. Sup. Pisa*, n. s. 3, iii (1973), pp. 893–954

E. Rosenthal: *The Palace of Charles V in Granada* (Princeton, 1985)

HANNO-WALTER KRUFT

Cortellini, Michele di Luca dei. *See* COLTELLINI, MICHELE DI LUCA DEI.

Cortese, Cristoforo (*fl* Venice, *c.* 1399–before 1445). Italian illuminator. A pivotal figure in early 15th-century Venetian manuscript illumination, he was first mentioned as a 'miniator' in the *Mariegola* (rule book) of the Scuola di S Caterina dei Sacchi, Venice (Venice, Correr, MS. IV, 118), written around the turn of the 15th century. A note indicating his paternity ('filio ser Marci') in a document of 1420 indicates that he was a brother of Franceschina, wife of Giovanni di Francia. The latter has been identified with Zanino di Pietro, a painter who influenced Cortese's style. In 1409 a Venetian document mentions a 'Christophorus de Cortisiis pictor', who may be the illuminator Cortese to whom the polyptych *Virgin and Child with Four Saints* in the parish church of Altidona, Ascoli Piceno, has been tentatively attributed. The polyptych is very close to the style of Zanino di Pietro and also to that of a diptych, with the *Crucifixion with SS Francis and ?Onofrio*, (Boston, Mus. F.A.). Other documents, dated 1420 and 1425, also mention the artist. In September 1425 Cortese was in Bologna, but in October he returned to Venice, where he is mentioned as still living in 1439.

Cortese's only documented work is the choir-book initial depicting the *Death of St Francis* (Paris, Mus. Marmottan), signed *Christophorus de Cortesiis venetus*. On the basis of this initial, scholars have created a corpus of similar illuminations, but dating remains problematic. Early 15th-century works such as the *Registrum omnium possessionum* (ex-Camaldolese monastery of S Mattia di Murano; Venice, Semin. Patriarcale, MS. Ba 956, 17) indicate that the illuminator had a late 14th-century Paduan training. In their Giottesque figures and in certain types of ornament, such as lush foliage and fantastic birds and flowers, they are close to the style of the Master of the Novella, an illuminator active in Padua at the end of the 14th century. The expressive qualities and lively narrative of Cortese's work recall both the style of Niccolò di Pietro and contemporary Bolognese illumination.

From around 1415 Cortese brought his style abreast of current developments by studying the works of Gentile da Fabriano, Pisanello and, especially, Michelino da Besozzo. In the figures and ornamentation of the copy of Valerius Maximus' *Factorum ac dictorum memorabilium libri* (1415; Rome, Vatican, Bib. Apostolica, MS. Urb. lat. 418, also known as *Memorabilia*) and other works, a new fluency of design, a new softness of modelling and a courtly, naturalistic style of decoration are evident. The colouring is splendid, based on pinks, greens and blues with brilliant flashes of white. In 1423 Cortese executed the Foscari *Ducale* (Treviso, Fellisent priv. col.). This work is stylistically very close to the signed *Death of St Francis*, which may date from the same period.

Cortese's most successful and productive period was probably the second half of the 1420s, when he illuminated a Gradual (Milan, Bib. N. Braidense, MS. A.B. XVII. 28) for the Camaldolese monks of S Michele di Murano. A familiarity with the Florentine Camaldolese choir-books by Silvestro dei Gherarducci (*d* 1399) and with the work of the Master of S Michele di Murano, a follower of Michelino who worked in Venice between 1418 and 1422 on a matching Gradual (Berlin, Kupferstichkab., MS. 78 F 1) for the same monastery, adds a new sense of spatial organization and stronger psychological characterization

to Cortese's work. Drawings for the tapestries for S Marco depicting scenes from the *Passion* (Venice, Mus. S Marco) have been tentatively attributed to this period.

These show the influence of German models, transmitted through imported prints. Such influence is also apparent in two series of woodcuts dating from the 1430s, showing scenes from the *Passion* (Berlin, Kupferstichkab.; Nuremberg, Ger. Nmus.). No further influences appear in Cortese's work after about 1430. His style becomes more cursive and attentive to surface values, with a few lapses of quality ascribable to the work of assistants. Cortese illuminated many religious, literary and Classical texts. He worked for religious orders, producing, for example, Graduals for the Certosa di S Andrea del Lido (Venice, Bib. N. Marciana, MS. lat. III, 18=2283; 2284; see fig.). He also worked for the feudal lords of the Po Valley, executing, for example, a *Vita Christi* (after 1433; Bologna, Bib. Com. Archiginnasio, MS. A 121; and Vienna, Österreich. Nbib., MS. 1379) for Ludolf of Saxony (*c.* 1295–1377). On stylistic grounds it is possible to attribute to Cortese the invention of a type of ornament with white *girari* (garlands)—antiquarian in type but reminiscent of the friezes of the Master of the Novella—which appear in a group of Venetian humanistic manuscripts of the 1430s (Rome, Vatican, Bib. Apostolica, *Dialoghi*, MS. Chig. D. VI. 97).

BIBLIOGRAPHY

P. Toesca: 'Quelques Miniatures vénétiennes du XIVe siècle', *Scriptorium*, i (1946–7), pp. 73–4

I. Chiappini Di Sorio: 'Documenti per Cristoforo Cortese', *A. Ven.*, xvii (1963), pp. 156–8

Cristoforo Cortese: initial from a Gradual of the Certosa di S Andrea del Lido (Venice, Biblioteca Nazionale Marciana, MS. lat. III, 18=2283, fol. 149*r*)

C. Huter: 'Cristoforo Cortese in the Bodleian Library', *Apollo*, cxi (1980), pp. 11–17

S. Cohen: 'Cristoforo Cortese Reconsidered', *A. Ven.*, xxxix (1985), pp. 22–31

M. Ferretti: 'Ritagli di Cristoforo Cortese', *Paragone*, xxxvi/419–23 (1985), pp. 92–6

G. Mariani Canova: 'Cristoforo Cortese', *Arte in Lombardia tra gotico e rinascimento* (exh. cat., Milan, Pal. Reale, 1988), pp. 230–39

——: 'Miniatura e pittura in età tardo gotica (1400–1440)', *La pittura nel Veneto: Il quattrocento*, ed. M. Lucco, i (Milan, 1989), pp. 193–222

FEDERICA TONIOLO

Cortona [Etrus. Curtun]. Italian hill city in Tuscany, 80 km south-east of Florence. Situated on a ridge overlooking the Valdichiana to the west and Lake Trasimeno to the south, the city is largely surrounded by Etruscan and medieval walls and is notable for its medieval and Renaissance buildings. Settlement on the site dates from the Villanovan period. Later an Etruscan stronghold and probably a member of the Etruscan League, Cortona became an ally of Rome after the defeat of the Etruscans in the late 4th century BC. In the Middle Ages Cortona had a tumultuous history of shifting alliances with Arezzo, Perugia, Siena and Florence. An independent commune in the 13th century, from 1409 the city came under Florentine rule for 250 years. Materially, it was protected from destruction by the mountainous nature of its site: the city was built on steep irregular terraces, and nearly all its many medieval buildings rest on giant, quadrangular Etruscan foundation blocks.

The Palazzo Comunale, Palazzo Casale, Palazzo del Popolo and several large family palazzi, including that of the Mancini–Sernini (see fig.), all have Renaissance façades, but their sides clearly reveal their medieval origins, and the Palazzo Comunale retains its 13th-century council chamber. The Renaissance additions to the Palazzo Casale reflect its function as the seat of the ruling Florentine commissioners. Many façades of both secular and religious buildings were redesigned and decorated by members of the Berrettini family, the most illustrious later member of which was Pietro da Cortona (1596–1669): Francesco and Giovanni Berrettini are credited with the mid-15th-century loggia added to the 13th-century hospital of S Maria della Misericordia.

The Museo Diocesano has paintings by Duccio and Pietro Lorenzetti and an *Annunciation* panel by Fra Angelico, dated *c.* 1432. The last is recorded as living in Cortona in 1438–9, and he also painted the small fresco of the *Virgin and Child with SS Dominic and Peter Martyr* (?1440) in S Domenico there. Luca Signorelli retired to his home town, both working in Cortona itself and painting a fresco of the *Baptism of Christ* (1521–3) in the chapel of the Palazzone, a villa outside the city that belonged to Cardinal Silvio Passerini (1470–1529), Bishop of Cortona and at one time governor of Florence for the Medici. With the aid of benefices granted by the two Medici popes, Passerini remodelled and decorated the cathedral as well as his urban residence, the 13th-century Palazzo del Popolo.

Outside the city walls are two important Renaissance churches. S Maria delle Grazie al Calcinaio, designed by FRANCESCO DI GIORGIO MARTINI, is a fine Brunelleschi-inspired church begun in 1485; S Maria Nuova, designed by Battista Infregliati in 1551 and completed by Giorgio

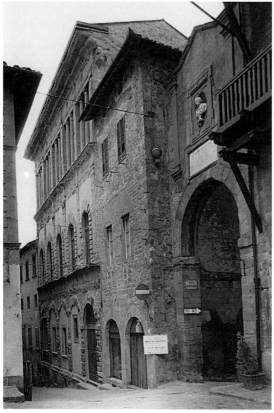

Cortona, Palazzo Mancini–Sernini, Renaissance façade (1533) on the Via Guelfa

Vasari, complements it on the other side of the mountain slope.

BIBLIOGRAPHY
P. Uccelli: *Storia di Cortona* (Arezzo, 1835)
A. della Cella: *Cortona antica* (Cortona, 1900)
G. Cataldi and others: *Cortona, struttura e storia* (Cortona, 1987)
A. Tafi: *Immagine di Cortona* (Cortona, 1989)
P. Holder: *Cortona in Context: The History and Architecture of an Italian Hilltown* (Clarksville, TN, 1992)

PHILANCY N. HOLDER

Cortona, Urbano da. *See* URBANO DA CORTONA.

Cosimo I, Grand Duke of Tuscany. *See* MEDICI, DE', (14).

Cosimo, Andrea di. *See* FELTRINI, ANDREA.

Cosimo, Piero di. *See* PIERO DI COSIMO.

Cosimo il Vecchio. *See* MEDICI, DE', (2).

Cosini [Chusini]**, Silvio** [Silvio da Fiesole; Silvio di fu Giovanni di Neri de' Ceparelli] (*b* Poggibonsi, *c.* 1495; *d* Milan, after 1547). Italian sculptor and stuccoist. Noted for his decorative work, trophies, masks and stucco ornaments, he was trained in the style of Michelangelo by Andrea Ferrucci in Florence. His first independent commission, the tomb of *Raffaelle Maffei* (*il Volterrano*) in S Lino at Volterra (1522), was arranged by Ferrucci. He usually worked with other artists, including his brother

Vincenzo (*b c.* 1505). In 1524 Ferrucci was commissioned to execute the monument to *Antonio Strozzi* in S Maria Novella, Florence, for which Cosini carved a relief of the *Virgin and Child.* His execution of the face recalls Ferrucci's technique, derived from Leonardo da Vinci. Also in this period Cosini executed the monument to *Ruggero Minerbetti* for the same church, in which Michelangelo's influence is especially apparent. Cosini's approach was elegant as well as humorous, and his skill as a carver enabled him to give marble a tender, flesh-like quality. His ability was recognized by Michelangelo, who employed him between 1524 and 1528 to execute decorative carvings, including trophies, for the Medici Chapel (Florence, S Lorenzo). His bizarre creations, especially the masks, contribute to the disquieting atmosphere of the chapel.

In 1528, because of the war, Cosini left Florence for Pisa. There he executed at least one of the two candelabra-bearing *Angels* for the cathedral (both 1528; *in situ*) and marble reliefs for an altar in the sacristy of the sanctuary at Montenero, near Livorno (1530). The *Angels* are in different styles, indicating a collaboration with Stagio Stagi or Niccolò Tribolo. The figure on the right has drapery that undulates to the floor in a manner typical of Cosini's work and is reminiscent of his *Virgin and Child* for the *Strozzi* tomb. During his stay in Pisa, according to Vasari, Cosini dissected a corpse for anatomical study and made himself a waistcoat of the flayed skin. He married in 1532 and remained in the Pisa region until 1542, although he made frequent trips to Orvieto, Genoa and Milan for work. After the death of his wife, he married again and moved to Genoa, where he worked with Perino del Vaga on the decoration of the palace of Andrea I Doria and executed a marble bust of *Emperor Charles V* (untraced). According to Alizeri, he did decorative carving for the cathedral and continued to work in and around Genoa after 1542. He is also mentioned repeatedly in documents of the architectural workshop of Milan Cathedral from 1543–4, where he executed a relief of the *Marriage of the Virgin* for the Albero Chapel.

BIBLIOGRAPHY
DBI; Thieme–Becker
G. Vasari: *Vite* (1550, rev. 2/1568); ed. G. Milanesi (1878–85), iv, pp. 481–4; v, p. 613; vi, p. 404
F. Alizeri: *Notizie dei professori del disegno in Liguria*, v (Genoa, 1877), pp. 196–310, 336–9, 348–51, 363
A. Venturi: *Storia* (1901–40), X/i, pp. 487–96
J. Pope-Hennessy and R. Lightbown: *Catalogue of Italian Sculpture in the Victoria and Albert Museum*, ii (London, 1964), pp. 447–8
M. Pizzo: 'Note in margine al volume di S. Blake McHam, "The Chapel of St. Anthony at the Santo and the Development of Venetian Renaissance Sculpture"', *Santo*, xxxiv/2–3 (May–Dec 1994), pp. 349–54

KATHRYN A. CHARLES

Cossa, Francesco del (*b* Ferrara, *c.* 1435; *d* Bologna, 1476–7). Italian painter. Together with Cosimo Tura and Ercole de' Roberti, he was one of the most important painters working in Ferrara and Bologna in the second half of the 15th century. With them he shared an expressive use of line and solidity of form, but he also had a gift for decorative and anecdotal scenes, most evident in the frescoes in the Palazzo Schifanoia, Ferrara.

1. TO 1470. The date of Cossa's birth must be deduced from information contained in two sets of documents

relating to his death. As the coda to two epigrams he dedicated to the painter, the Bolognese jurisconsult Lodovico Bolognini recorded that Cossa died at the age of forty-two years, two months and eight days. The date of Cossa's death can be inferred from epigrams and letters of 1477 exchanged between two Bolognese gentlemen, Angelo Michele Salimbeni and Sebastiano Aldrovandi, in which Cossa is described as not long dead. In combination, these documents allow one to place his birth around 1435. Cossa was born into an artistic family. His father, Cristoforo del Cossa, was a mason who had worked on the campanile of Ferrara Cathedral. His uncle Antonio del Cossa was also a mason who worked on several of the Este castles. Cossa's mother was Fiordelisa Mastria.

The earliest record of Cossa's artistic activities is a document of 11 September 1456, in which the Fabbrica (Cathedral Works) of Ferrara Cathedral paid him 3 lire 5 soldi for a work to be placed on the high altar. The interpretation of this document is problematic. Scalabrini transcribed the payment as for an altarpiece of 'a Pietà composed of three half-figures', while Cittadella read the document as specifying 'three half-figures of stone' (pietra). The fact that Cossa is described as a painter in the document lends support to Scalabrini's reading, but, coming as he did from a family of masons, Cossa's first work could easily have been a sculptural group. The work was destroyed in 1727, without its appearance being recorded. The possibility that Cossa might have been a practising sculptor is further supported by references in the letters and epigrams of Salimbeni and Aldrovandi: Salimbeni praised Cossa specifically as a sculptor, comparing him with Polykleitos and Phidias; Aldrovandi referred to him as a modern Skopas or Praxiteles. Following these indications, critics have attempted to attribute a number of sculptural works to Cossa, the most notable pieces being the decorative friezes of the portal of the Palazzo Schifanoia, Ferrara (see FERRARA, fig. 2), and the tomb slab of Domenico Garganelli (Bologna, Pin. N.). Cossa may have been both a painter and sculptor during his short career, but without secure knowledge of what his sculptural style might have been, any attributions should be accepted only tentatively.

On 29 November 1460, Cossa became an independent master. He is recorded in Bologna, acting as godfather at the baptism of Domenico Garganelli's son Ludovico on 17 December 1462. Between this date and 1469–70, Cossa's whereabouts are undocumented. He may have remained in Bologna until 1466–7, as he seems to have provided cartoons for a series of stained-glass windows executed by the brothers Jacopo Cabrini and Domenico Cabrini for the façade of S Giovanni in Monte. One of the windows from this complex (the arrangement of which was recorded by Marcello Oretti in 1783 before it was dismantled) is signed by the Cabrini brothers and dated 1467. Several of the windows are still in S Giovanni in Monte (a Virgin and Child Enthroned with Four Angels, a St John the Evangelist on Patmos and a panel depicting the coat of arms of the patron Annibale Gozzadini). Other fragments exist in Ferrara (Gal. Civ. A. Mod.) and in Costozza, Viterbo (Da Schio priv. col.). Certain compositional elements of the stained-glass designs have prompted some critics to include them in a later phase of Cossa's

career, perhaps as late as 1474 or 1475, suggesting that the complex of windows could be the result of two separate decorative campaigns. There are marked stylistic similarities, however, between the angels in the Virgin and Child window and those found in a painting universally accepted as Cossa's earliest extant work, the Virgin and Child with Angels (?1460–65; Washington, DC, N.G.A.; see fig. 1). Even if dated as early as 1467, the S Giovanni window designs would be the work of an artist who had practised for at least 11 years and therefore would say little about Cossa's training or early career.

In a letter of 25 March 1470, Cossa complained to Borso d'Este, Duke of Modena (later Duke of Ferrara), that he had been badly paid for the work he had recently completed in the Palazzo Schifanoia (see FERRARA, §4 and fig. 2). Claiming to have worked on his own to complete three panels on the wall next to the anteroom of the great hall, he grumbled at being paid at the rate of a mere 10 bolognini per foot, the same rate as the 'poorest apprentice painter' in Ferrara. The letter defines the three vertical panels on the east wall of the Salone dei Mesi in the Palazzo Schifanoia—the zodiacal months of Aries, Taurus and Gemini—as by Cossa's hand alone. Of his extant paintings, the Schifanoia frescoes are Cossa's masterpiece and the touchstone of his early style. They reveal an intriguing combination of a Pisanello-like accuracy in

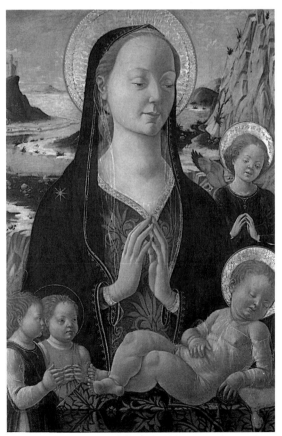

1. Francesco del Cossa: *Virgin and Child with Angels*, tempera on panel, 535×362 mm, ?1460–65 (Washington, DC, National Gallery of Art)

detail, a luminosity of colour reminiscent of Piero della Francesca and a prettiness in the features and bearing of the figures, which relates most closely to contemporary Florentine manuscript illumination. Since Cossa demonstrated such a uniformly high level of quality in invention, design and execution in the Salone dei Mesi, it can only reflect badly on the sensibilities of the patron that Cossa's pleas for recognition went unheard. Disillusioned by the Duke's response that he had been paid what he deserved, Cossa left Ferrara, never to return.

2. AFTER 1470. Cossa received 100 ducats in 1472 from the Confraternity of the church of S Maria del Baraccano, Bologna, for restoring and renovating its miraculous image, a fresco of the *Virgin and Child*, attributed to Lippo di Dalmasio, usually dated before 1401. Cossa added two standing, candelabrum-bearing angels, an architectural framework through which a distant landscape can be seen and the donor portraits of either Bente or Giovanni I Bentivoglio and his wife (*in situ*). Lamo records two additional figures of SS Catherine and Lucy (untraced). At the same time, or perhaps slightly earlier, Cossa was commissioned to paint an altarpiece for the church of the Convent of the Osservanza, Bologna. Longhi suggested that the *Annunciation* and its accompanying predella depicting the *Nativity with Dancing Shepherds* (Dresden, Gemäldegal. Alte Meister) formed the central section of the Osservanza altarpiece. He further proposed that *St Clare* and *St Catherine of Alexandria* (both Madrid, Mus. Thyssen-Bornemisza) might have been placed as pendants on the extreme outer edges of the altar's predella.

One of Cossa's major projects during 1473 was the triptych commissioned by Floriano Griffoni for his family chapel in S Petronio, Bologna. On 19 July 1473, Agostino de' Marchi da Crema, an *intarsiatore*, was paid for the frame of the elaborate altarpiece. Longhi's reconstruction of the altarpiece, based in part on suggestions first made by Crowe and Cavalcaselle, has been confirmed by the discovery of a drawing by the 18th-century Bolognese painter Stefano Orlandi (Benati, 1984 and 1985), who recorded the shape of the frame and the distribution of the panels. The central panel was *St Vincent Ferrer* (London, N.G.), to the right *St John the Baptist* (see colour pl. 1, XXV2) and to the left *St Peter* (both Milan, Brera) and above the central panel the tondo of the *Crucifixion* (Washington, DC, N.G.A.). Orlandi recorded two smaller panels with rounded tops, of *St Rosalia* and *St Paul*, placed above the panels of *St John the Baptist* and *St Peter*. Longhi suggested that the three-quarter-length *St Florian* and *St Lucy* (Washington, DC, N.G.A.) belong to this section of the polyptych. Above these half-length saints were two tondi representing the *Annunciation* (Gazzada, Mus. Villa Cagnola). The predella, composed of scenes from the *Life of St Vincent Ferrer* (Rome, Vatican, Pin.), is usually attributed in part or in whole to ERCOLE DE' ROBERTI. On 27 September 1473 Cossa was paid 2 lire 16 soldi for a cartoon representing *St Petronius*, to be executed by Agostino de' Marchi in intarsia for the choir-stalls of S Petronio. The *St Petronius*, as well as a *St Ambrose* also attributed to Cossa's design, are still *in situ*.

In 1472, Cossa had been commissioned by the judge Alberto de' Cattani and the notary Antonio degli Amorini to paint an altarpiece for the Palazzo della Mercanzia in the Foro dei Mercanti, Bologna. The *Virgin and Child with SS Petronius, John the Evangelist and a Donor* (Bologna, Pin. N.; see fig. 2) is signed and dated 1474. The painting shows Cossa entering a new stylistic phase in which the colours are more sombre and the figures weightier. One can only assume that his last work, for the Garganelli Chapel in S Pietro, Bologna (destr. 1606), was of a similar quality. Lamo described Cossa's part in the decoration of the Garganelli Chapel, stating that it comprised the Four Evangelists and Four Doctors of the Church seated in the cupola and several prophets in the vault. Above the entrance to the chapel was an *Annunciation* painted half life-size; all the other figures in the chapel were full scale.

In a document of 19 November 1476, Cossa's address was given in the Polirone di S Antonio quarter of Ferrara, although it was noted that the painter lived in Bologna. His comparatively early death was presumably a result of an outbreak of plague.

UNPUBLISHED SOURCES

Bologna, Bib. Com. Archiginnasio [MS. of M. Oretti: *Le pitture nelle chiese di Bologna* (1783)], pp. 265, 314

BIBLIOGRAPHY

EARLY SOURCES

G. Vasari: *Vite* (1550, rev. 2/1568); ed. G. Milanesi (1878–85), iii, pp. 131–44
P. Lamo: *Graticola di Bologna ossia descrizione delle pitture, sculture e architettura di detta città* (1560); ed. G. P. Cavazzoni Zanotti (Bologna, 1844), pp. 12, 31, 39
G. A. Scalabrini: *Memorie istoriche delle chiese di Ferrara e de' suoi borghi* (Ferrara, 1773)

GENERAL

Enc. It.; *EWA*; Thieme–Becker
G. Baruffaldi: *Vite de' pittori e scultori ferraresi*, ed. G. Boschini (Ferrara, 1844–6), i, pp. 92–5, 102–25, 132–48
L. N. Cittadella: *Documenti ed illustrazioni risguardanti la storia artistica ferrarese* (Ferrara, 1858)
——: *Notizie relative a Ferrara* (Ferrara, 1864), i, pp. 52, 118; ii, pp. 337–40
J. A. Crowe and G. B. Cavalcaselle: *History of Painting in North Italy*, i (London, 1871), pp. 522–5
A. Venturi: 'I primordi del rinascimento artistico a Ferrara', *Riv. Stor. It.*, i (1884), pp. 591–631
G. Campori: 'I pittori degli Estensi nel secolo XV', *Atti & Mem. RR. Deput. Stor. Patria Prov. Moden. & Parm.*, n.s. 3, iii (1885/*R* Modena, 1886), pp. 562–604
A. Venturi: 'L'arte a Ferrara nel periodo di Borso d'Este', *Riv. Stor. It.*, ii (1885), pp. 689–749
G. Frizzoni: 'Zur Wiederherstellung eines altferrarischen Altarwerkes', *Z. Bild. Kst*, xxiii (1888), pp. 299–302
G. Gruyer: *L'Art ferrarais à l'époque des princes d'Este*, ii (Paris, 1897), pp. 101–21
A. Venturi: *Storia* (1901–40/*R* 1967), VII/iii, pp. 570, 586–650, 656
——: 'Maestri ferraresi del rinascimento', *L'Arte*, vi (1903), pp. 133–46
E. G. Gardner: *The Painters of the School of Ferrara* (London, 1911), i, pp. 441–68; ii, pp. 101–21
R. Longhi: 'Officina ferrarese' (1934), 'Ampliamenti nell'officina ferrarese' (1940), and 'I nuovi ampliamenti' (1956), *Edizione delle opere complete*, v (Florence, 1956/*R* 1975), pp. 9–147, 151–215, 219–45
C. Padovani: *La critica d'arte e la pittura ferrarese* (Rovigo, 1945), pp. 489–533
B. Nicolson: *The Painters of Ferrara* (London, 1951), pp. 10, 12–14, 19, 20

MONOGRAPHS

S. Ortolani: *Cosmè Tura, Francesco del Cossa, Ercole de' Roberti* (Milan, 1941)
A. Neppi: *Francesco del Cossa* (Milan, 1958)

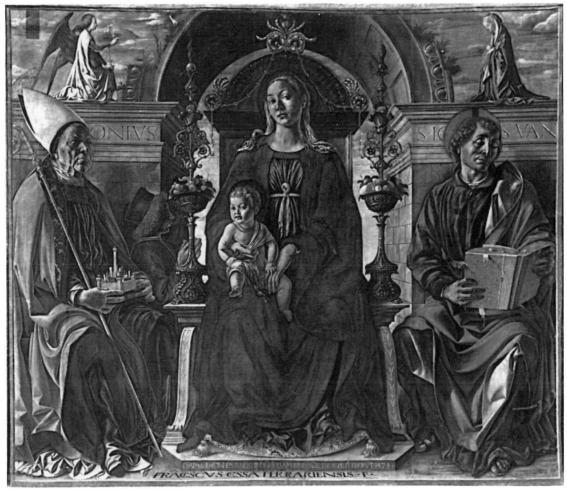

2. Francesco del Cossa: *Virgin and Child with SS Petronius, John the Evangelist and a Donor*, tempera on canvas, 2.27×2.66 m, 1474 (Bologna, Pinacoteca Nazionale)

E. Ruhmer: *Francesco del Cossa* (Munich, 1959)
V. Scassellati-Ricardi: *Cossa* (Milan, 1965)

SPECIALIST STUDIES

A. Venturi: 'Ein Brief des Francesco del Cossa', *Kunstfreund*, i/9 (1885), cols 129–34
I. Lermolieff [G. Morelli]: *Le opere dei maestri italiani nelle gallerie di Monaco, Dresden e Berlino* (Bologna, 1886), p. 108
A. Venturi: 'Les Arts à la cour de Ferrara: II. Francesco del Cossa', *Les Arts* [Paris], iv (1888), pp. 73–80, 96–101
L. Frati: 'La morte di Francesco del Cossa', *L'Arte*, iii (1900), pp. 300–02
F. Filippini: 'Francesco del Cossa scultore', *Boll. A.*, vii (1913), pp. 315–19
J. M. Perkins: 'La *Crocifissione* di Francesco del Cossa', *L'Arte*, xvii (1914), pp. 222–3
C. Ricci: 'Tarsie disegnate dal Cossa', *Boll. A.*, ix (1915), pp. 262–3
G. Zucchini: 'Le vetrate di San Giovanni in Monte di Bologna', *Boll. A.*, xi (1917), pp. 82–90
B. Berenson: 'A Ferrarese Marriage Salver in the Boston Museum of Fine Arts', *Essays in the Study of Science and Painting* (New York, 1918), pp. 57–80
G. Zucchini: 'La distruzione degli affreschi della Cappella Garganelli (S Pietro di Bologna)', *L'Arte*, xxiii (1920), pp. 275–8
A. L. Mayer: 'Two Unknown Panels by Cossa', *Burl. Mag.*, lvii (1930), p. 311
A. Venturi: 'Eine Madonna von Francesco del Cossa', *Pantheon*, v (1930), pp. 249–50
G. Zucchini: 'Avanzi di un affresco di Francesco del Cossa (opere d'arte inedite)', *Com. Bologna*, xxi (1934), pp. 16–18

E. Oriolo: 'La cappella maggiore del Baraccano', *Archiginnasio*, ix (1938), p. 439
H. Bodmer: 'Francesco Cossa', *Pantheon*, xxviii (1941), pp. 230–36
M. Meiss: 'Five Ferrarese Panels, 1: A Portrait by Cossa', *Burl. Mag.*, xciii (1951), pp. 69–70
L. Chiappini: 'Appunti sul pittore Francesco del Cossa e la sua famiglia', *Atti & Mem. Deput. Ferrarese Stor. Patria*, n.s., xiv (1955), pp. 107–20
M. Salmi: 'Echi della pittura nella miniatura ferrarese del rinascimento', *Commentarii* (1958), pp. 94–8
C. Volpe: 'Tre vetrate ferraresi e il rinascimento a Bologna', *A. Ant. & Mod.*, i (1958), pp. 23–37
E. Ruhmer: 'Ein Madonnabild nach Francesco del Cossa', *Pantheon*, xxii (1964), pp. 73–80
P. Meller: 'Drawings by Francesco Cossa in the Uffizi', *Master Drgs* (1965), pp. 3–20
B. W. Meijer: 'Esempi del comico figurativo nel rinascimento lombardo', *A. Lombarda*, xvi (1971), pp. 259–66
C. M. Rosenberg: 'Francesco del Cossa's Letter Reconsidered', *Mus. Ferrar.: Boll. Annu.*, v–vi (1975–6), pp. 11–15
'Un affresco di Francesco del Cossa nella chiesa di San Martino a Bologna', *Inf. Ist. Beni A. Cult. Nat. Reg. Emilia-Romagna*, ii (1977), pp. 7–8
D. Benati: 'Il polittico Griffoni', *La basilica di San Petronio in Bologna*, ii (Bologna, 1984), pp. 156–74
——: 'Per la ricomposizione del polittico Griffoni', *Da Borso a Cesare d'Este: La scuola di Ferrara, 1450–1682* (Ferrara, 1985), pp. 172–5
F. Varignana: 'Francesco del Cossa: Le vetrate di S Giovanni in Monte', *Tre artisti nella Bologna dei Bentivoglio* (Bologna, 1985), pp. 5–113

KRISTEN LIPPINCOTT

Costa. Italian family of painters. (1) Lorenzo Costa (i) was one of the leading artists of the school of Ferrara. His work is a link between the Late Gothic style of Cosimo Tura and that of the High Renaissance. His son (2) Ippolito Costa spent ten years as an artist at the Gonzaga court in Mantua. (3) Lorenzo Costa (ii) was probably the son of Ippolito and, except for a period in Rome, spent most of his career in Mantua, particularly working on decorations in the Palazzo Ducale.

(1) Lorenzo (di Ottavio) Costa (i) (*b* Ferrara, *c.* 1460; *d* Mantua, 5 March 1535). He was the son of a painter, Giovanni Battista (?)Costa, and he received his early training in the studio of Ercole de' Roberti in Ferrara. Probably in the early 1480s he moved to Bologna, where he became the favoured artist of Giovanni II Bentivoglio (*see* BENTIVOGLIO, (2)). Major commissions for Bolognese churches suggest that at one time he was the most sought-after artist in Bologna.

Costa's early works were identified only in the 20th century, mainly by Roberto Longhi. Tracing his early activity is difficult, as there are no surviving signed or documented works before 1488, the date of the *Family of Giovanni II Bentivoglio Kneeling before the Virgin* (Bologna, S Giacomo Maggiore). On the basis of this altarpiece, Longhi attributed to Costa a group of paintings in a style similarly strongly linked to Ercole, including the paintings depicting *Scenes of the Argonauts* (dispersed; see colour pl. 1, XXV1) and the beautiful altarpiece of the *Virgin and Child with Saints* (ex-Berlin, Kaiser-Friedrich Mus., destr.) from S Maria delle Rondini, Bologna. Longhi's reconstruction showed strong links between Costa's early paintings and his later documented works. It also confirmed his attention to Classical sources, particularly evident in the *St Jerome* altarpiece in the Castelli Chapel, S Petronio, Bologna. This painting was probably executed some time after 1484, the date of Baldassare Castelli's will. Its attribution to Costa dates from Vasari, but other artists have been proposed, including Ercole. The resemblance of the *St Jerome* to the style of Ercole is, rather, an indication of Costa's increasing skill in this period. Following the example of Ercole, Francesco del Cossa and Cosimo Tura, Costa's adherence to the restrained form of classicism practised locally gained him the patronage of Giovanni II Bentivoglio. For Giovanni he provided decorations (from 1483) for the new palace (destr. 1502) and tempera paintings (1488; destr.) in the Bentivoglio Chapel of S Giacomo Maggiore, Bologna. Ercole's influence is still apparent in Costa's frescoes depicting the *Triumph of Death* and the *Triumph of Glory* (1488–90), also for the Bentivoglio Chapel. Giovanni subsequently invited him to participate in the decoration of the oratory of S Cecilia, S Giacomo Maggiore, Bologna, for which he painted frescoes of the *Conversion of St Valerian* and the *Charity of St Cecilia* in 1505–6.

Other works were undertaken by Costa in that fruitful period at the end of the century; for the Gozzadini family he designed the window of *St John on Patmos* (*c.* 1490; Bologna, S Giovanni in Monte). From 1491 he worked with Francesco Francia in the Vaselli Chapel in S Petronio, Bologna, where he painted 12 *Apostles* and the *Annunciation*. His last work for S Petronio was the great altarpiece

(1492) in the Rossi Chapel depicting the *Virgin and Child Enthroned with SS Sebastian, James, Jerome and George* (see fig.) with, in the lunette, three *Angelic Musicians*. Also from 1492 is the *Concert* (London, N.G.). This depicts three singers in a style close to that of the Bentivoglio Altarpiece and antedates similar Venetian scenes. The signed altarpiece the *Virgin and Child with SS Petronius and Tella* (Bologna, Pin. N.) is dated 1496, and the altarpiece *Virgin and Child Enthroned with Saints* for the Ghedini family (Bologna, S Giovanni in Monte) is from 1497. The pronounced formality of the Ghedini Altarpiece may be a result of Costa's exposure to Tuscan and Umbrian art, particularly that of Perugino and Filippino Lippi, during a journey to Florence in the 1490s (Longhi). In 1499 Costa was in Ferrara painting decorations (destr.) in the choir of the cathedral, and this may be the date of the Pala Strozzi, the *Virgin and Child with SS William of Aquitaine and John the Baptist* (London, N.G.). The *Nativity* (London, N.G.), also painted about this time, is close in style to the signed and dated predella of the *Epiphany* (1499; Milan, Brera).

Costa's works from between 1502 and 1505 include *St Peter Enthroned with SS Francis and Domenic* (Bologna, Pin. N.), the *Pietà* (Berlin, Gemäldegal.) and the *Virgin and Child with SS Peter, Philip, John the Evangelist and John the Baptist* (London, N.G.). In 1504 Isabella d'Este, Marchesa of Mantua, commissioned Costa to paint the *Allegory* (1504–6; Paris, Louvre) for her *studiolo*. With the end of Bentivoglio rule in Bologna in 1506, Costa moved

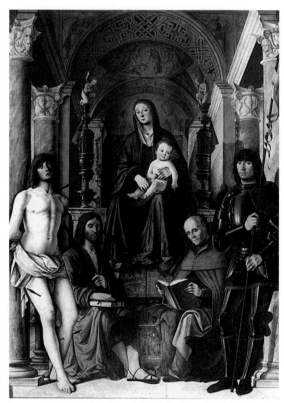

Lorenzo Costa (i): *Virgin and Child Enthroned with SS Sebastian, James, Jerome and George*, 1492 (Bologna, S Petronio)

to Mantua, where he succeeded Andrea Mantegna as court painter to the Gonzagas. Subsequently, probably in 1511, he completed the *Reign of Comus* (Paris, Louvre), begun by Mantegna for the *studiolo* but left unfinished at his death (1506). From 1507 to 1512 Costa worked with Francesco Bonsignori on the decorations of the palace of S Sebastiano (destr. 1630), Mantua. He painted numerous portraits, in both Bologna and Mantua; surviving examples include the *Woman with a Lap Dog* (London, Hampton Court, Royal Col.), sometimes identified with untraced, documented portraits (1508) of Isabella d'Este and her daughter, Eleonora, and *Battista Fiera* (London, N.G.), the Mantuan poet and physician.

Among Costa's late works are the *Venus* (*c.* 1518; Budapest, N.G.), probably painted for Francis I, King of France (*reg* 1515–47), the signed altarpiece *St Anthony of Padua with SS Ursula and Catherine* (*c.* 1518; New York, Met.), painted for S Nicolò, Carpi, and the *Investiture of Federico Gonzaga as a Captain of the Church* (1522; Prague, N. Mus.). His last known work, the *Virgin Enthroned with Saints* (Mantua, S Andrea), is signed and dated 1525.

BIBLIOGRAPHY

Bolaffi; *DBI*

G. Vasari: *Vite* (1550, rev. 2/1568); ed. G. Milanesi (1878–85), iii, p. 131

E. Cabassi: *Notizie degli artisti carpigiani con le aggiunte . . . d'altri artisti dello stato di Modena* (1784); ed. A. Gariuti (Modena, 1986)

G. Campori: *Gli artisti italiani e stranieri negli stati estensi* (Modena, 1855)

R. Longhi: *Officina ferrarese* (Florence, 1956)

R. Varese: *Lorenzo Costa* (Milan, 1967)

C. Volpe, ed.: *Il Tempio di San Giacomo in Bologna: Studi sulla storia e le opere d'arte* (Bologna, 1967), pp. 117–31, 136–46

B. Berenson: *Central and North Italian Schools* (1968)

P. Venturoli: 'Lorenzo Costa', *Stor. A.*, i–ii (1969), pp. 161–8

B. B. Frederiksen and F. Zeri: *Census of Pre-19th Century Italian Paintings in North American Public Collections* (Cambridge, MA, 1972)

D. Benati: 'Da Lorenzo Costa a Francesco Francia', *La Basilica di San Petronio in Bologna* (Bologna, 1983), pp. 174–94

M. Lucco: 'Lorenzo Costa', *La pittura in Italia: Il quattrocento*, 2 vols, ed. F. Zeri (Milan, 1986, rev. 2/1987), i, pp. 604–5

E. Landi: 'Lorenzo Costa', *Arte emiliana: Dalle raccolte storiche al nuovo collezionismo*, ed. G. Manni, E. Negro and M. Pirondini (Modena, 1989), p. 32

E. Negro: 'Lorenzo Costa', *Arte emiliana: Dalle raccolte storiche al nuovo collezionismo*, ed. G. Manni, E. Negro and M. Pirondini (Modena, 1989), p. 32

(2) Ippolito Costa (*b* Bologna or Mantua, 1506; *d* Mantua, 8 Nov 1561). Son of (1) Lorenzo Costa. From 1529 to 1539 he is documented among the artists of the Gonzaga court in Mantua. The style of his earliest known work, the *Virgin and Child with Three Saints* (1531; Milan, Mus. Poldi Pezzoli), painted for a member of the Gonzaga family, recalls works by his father and Girolamo da Carpi, who may have been his teachers. A similar approach is evident in the *Virgin and Child Enthroned with SS Benedict and John the Evangelist* (Gonzaga, S Benedetto), while his mature works are clearly influenced by Giulio Romano and Tuscan–Roman Mannerism. These include *St Agatha* (1552; Mantua Cathedral) and the *Deposition* (Mantua, S Gervasio), which are comparable to contemporary examples by his pupil Bernardino Campi. His documented portrait of *Bishop Ippolito Capilupi* and *Margherita Paleologa*, wife of Federico II Gonzaga, are untraced.

BIBLIOGRAPHY

DBI; Thieme–Becker

F. Russoli: *La Pinacoteca Poldi Pezzoli* (Milan, 1955)

Mantova: Le arti, iii (Mantua, 1965) [entries by E. Marani, C. Perina]

La pittura in Italia: Il cinquecento, ed. G. Briganti, ii (Milan, 1988), pp. 687–8 [entry by C. Tellini Perina]

(3) Lorenzo Costa (ii) (*b* Mantua, 1537; *d* Mantua, 1583). Probably the son of (2) Ippolito Costa. It is likely that his early training was with his father in Mantua in the period after the death (1546) of Giulio Romano, when the architect Giovanni Battista Bertani was a major influence. Three of Lorenzo's paintings are mentioned in a document dated 1560; in 1561 he was paid for a banner (untraced) for the chapter house of Mantua Cathedral. From 1561 to 1564 he was in Rome, where he worked at the Vatican with Federico Zuccaro on decorations for the Borgia tower, the tribunal of the Ruota, the Belvedere and the Casino of Pius IV. In 1564 he was still in Rome, painting a series of papal portraits for Alfonso Gonzaga of Novellara. In this period he became acquainted with Bertani, with whom he worked on altarpieces for S Barbara in Mantua; he received payments between 1569 and 1572 for the *Baptism of Constantine* and the *Martyrdom of St Adrian*, based on drawings by Bertani.

Lorenzo's work in the apartments of Guglielmo Gonzaga, Duke of Mantua, in the Corte Nuova and Corte Vecchia of the Palazzo Ducale, Mantua, is documented from 1569 to 1581. In the Corte Nuova, Aldrovandi (*c.* 1575) mentioned the Camera di Nettuno, decorated with fish by Costa. Other works in the Corte Nuova included decorations (mainly destr.) in the Camera di Giove, the Camera di Apollo, the Loggie dei Frutti and the Sala di Manto (1574), decorated with episodes from the mythical history of the city. He may also have painted battle scenes for the Sala dei Capitani, which probably correspond to two drawings in London (BM). The lunettes (badly damaged) in the Camera delle Virtù and a few fragments in a small chapel can be convincingly attributed to Costa (Bazzotti and Berzaghi). Guglielmo's apartment in the Corte Vecchia was largely redecorated in the 18th century, but the ceiling decorations in the Sala dello Zodiaco (formerly Stanza dei Cani) survive; its frieze is now in the Sala del Crogiuolo (Berzaghi).

While Lorenzo was in Rome, he learnt from the paintings of Federico Zuccaro, Taddeo Zuccaro and Federico Barocci, whose influence is apparent in the works done after his return to Mantua. In addition to the documented altarpieces for the basilica of S Barbara are wall paintings in the Cappella della Preziosissima Sangue in S Andrea in Mantua; the altarpiece of *St Helena and the Cross* in SS Fabiano e Sebastiano, San Martino dell'Argine; the *Supper in the House of the Pharisees* in the parish church of Boccadiganda, Mantua; the *Preaching of St John the Baptist* in S Leonardo; the *Martyrdom of St Laurence* in S Maria delle Grazie, Mantua; and the *Miracle of the Multiplication of the Loaves* in S Barnaba, Mantua.

BIBLIOGRAPHY

DBI [full bibliog.]

U. Aldrovandi: *Itineraria Mantuae* (*c.* 1575)

R. Berzaghi: 'La Corte Vecchia del duca Guglielmo, tracce e memorie', *Quad. Pal. Te*, iii (1985), pp. 43–64

U. Bazzotti and R. Berzaghi: 'Degli Dei la memoria, e degli Heroi, Palazzo Ducale, l'appartamento di Guglielmo Gonzaga', *Corte Nuova* (Mantua, 1986)

P. Carpeggiani and C. Tellini Perina: *S Andrea in Mantova: Un tempio per la città del principe* (Mantua, 1987), pp. 40, 42, 130

C. P. Tellini: 'L. Costa il Giovane ad vocem', *La pittura del cinquecento: Dizionario biografico degli artisti* (Milan, 1989), p. 688

<div align="right">MARIA CRISTINA CHIUSA</div>

Costanzo, Marco (di) (*fl c.* 1450–1500). Italian painter. He was a Syracusan whose identity was established by an inscription and date (no longer legible) on a panel of *St Jerome* (Syracuse Cathedral, Sacristy), painted for S Girolamo fuori le Mura. His relationship with his fellow Sicilian Antonello da Messina is not clear; it has been suggested that they were students together in Naples, but it seems more likely that Costanzo was influenced by Antonello in the 1470s than that they shared a common background in the 1440s. The *St Jerome* is strongly Netherlandish in character, ultimately reflecting a prototype by Jan van Eyck (*c.* 1395–1441). Di Marzo read the date as 1468 and considered the painting to be an advanced work for a provincial artist, both in its use of perspective and its subtle lighting effect. Longhi suggested that the date had been mistranscribed, and a date of *c.* 1480 is generally accepted. If dated *c.* 1480, it is possible for some details, such as the carved prie-dieu, oriental rug and illusionistic corbel, to be credited to the influence of Antonello's *Annunciation* (1474; Syracuse, Pal. Bellomo).

A group of small panels of the Apostles and *Christ the Redeemer* (originally numbering 13) (Syracuse Cathedral, Sacristy) have been associated with Costanzo. The fluidity and sense of atmosphere recall Antonello, and there are also echoes of Central Italian art (Melozzo da Forlì, Luca Signorelli and the Spaniard Pedro Berruguete (*c.* 1450–*c.* 1500), who worked at Urbino). At least two of the panels in the series (*St John the Evangelist* and the *Redeemer*) are by other hands and have been reasonably attributed to Salvo d'Antonio and Jacobello d'Antonio respectively. This would suggest that Costanzo was directly associated with Antonello's workshop in Messina in the decade after the master's death in 1479, when first Jacobello d'Antonio, Antonello's son, then probably Salvo d'Antonio, his nephew, ran the bottega.

In 1500 Costanzo was commissioned by the Confraternity of Santo Spirito to paint a *Crucifixion* and a *Pietà* (both untraced) and to renovate their *gonfalone* (untraced). A *Trinity between SS James and Stephen* dated 1495 (Syracuse, Pal. Bellomo), painted for Santo Spirito, is attributed to him and, although retouched, probably preserves the original composition. Bottari noted a Spanish influence in this work and described Costanzo as a Sicilian Berruguete.

BIBLIOGRAPHY
G. Di Marzo: *Delle belle arti in Sicilia*, iii (Palermo, 1862), p. 107
S. Bottari: 'Un pittore siciliano del quattrocento, Marco Costanzo', *Boll. A.*, xxxvi (1951), pp. 124–9
Antonello e la pittura del '400 in Sicilia (exh. cat., ed. G. Vigni and G. Carandente; Messina, Pal. Comunale, 1953), pp. 75–7
R. Longhi: 'Frammento siciliano', *Paragone*, iv/43 (1953), pp. 31–44 (38)
S. Bottari: *La pittura del quattrocento in Sicilia* (Messina and Florence, 1954), pp. 44–6, 62–83
Antonello da Messina (exh. cat., ed. A. Marabottini and F. Sricchia Santoro; Messina, Mus. Reg., 1981), pp. 219–22
F. Sricchia Santoro: *Antonello e l'Europa* (Milan, 1986), pp. 143–8

<div align="right">JOANNE WRIGHT</div>

Costanzo da Ferrara [Costanzo de Moysis; Costanzo Lombardo] (*b* Venice, *c.* 1450; *d* ?Naples, after 1524). Italian medallist and painter. It is generally believed that he is the painter also known as Costanzo Lombardo, recorded in Naples *c.* 1484, and Costanzo de Moysis, described as a painter from Venice and recorded painting in Naples in 1483 and frescoing the *Story of the Prince of Rossano* (destr.) in the Villa Duchesca in 1488 (Strazzullo). Most of the information about him comes from a letter dated 24 August 1485 from Battista Bendidio, the Ferrarese envoy in Naples, to Ercole d'Este, Duke of Ferrara. Bendidio mentioned that Costanzo had lived for a considerable time in Ferrara and married a Ferrarese woman. He also reported that when Sultan Mehmed II of Turkey (*reg* 1444–6 and 1451–81) had requested that a painter be sent to Istanbul to paint his portrait, King Ferdinand I of Naples (*reg* 1458–94) had dispatched Costanzo, who stayed there several years and was knighted by the Sultan. Babinger (1967) suggested that he could have left Naples for Istanbul in spring 1478, about a year before Gentile Bellini went to the Turkish court.

No painted portrait of Mehmed II by Costanzo has been positively identified, but two medals of the Sultan are by his hand; both are signed and one is dated 1481. The undated medal (unique copy, Washington, DC, N.G.A.) is far more refined in technique than the dated medal and probably the earlier of the two, dating from about 1478–9 (Hill and Pollard). Vasari believed the medals were by Pisanello, and the powerful profile portraits, by far the best that survive of the Turkish conqueror, and the spirited equestrian portraits on the reverses owe much to Pisanello. After the Sultan's death on 3 May 1481, Costanzo returned to Naples, and in 1485, on the commission of Bendidio, he painted a portrait of *Ferrante d'Este* (untraced), son of Ercole d'Este. He was recorded again at the Neapolitan court in 1492, and Pietro Summonte, in a letter of 1524 from Naples to Marcantonio Michiel in Venice, reported that Costanzo was still alive. Raby (1987) attributed three watercolour drawings to Costanzo that were previously given to Gentile Bellini: a *Seated Scribe* (Boston, MA, Isabella Stewart Gardner Mus.), a *Seated Solak* and a *Seated Turkish Woman* (both London, BM).

BIBLIOGRAPHY
DBI; Thieme–Becker: 'Costanzo'; 'Moysis, Costanzo de'
A. Armand: *Les Médailleurs italiens*, i (Paris, 2/1883–7), pp. 78–9
G. Gruyer: *L'Art ferrarais*, i (Paris, 1897), p. 651
C. von Fabriczy: 'Summontes Brief an M. A. Michiel', *Rep. Kstwiss.*, xxx (1907), pp. 149–59
J. von Karabacek: *Abendländische Künstler zu Konstantinopel im XV. und XVI. Jhdt, I: Italienische Künstler am Hofe Muhammeds II des Eroberers, 1451–1481* (Vienna, 1918)
G. Habich: *Die Medaillen der italienischen Renaissance* (Stuttgart and Berlin, 1922), p. 52
G. F. Hill: *Corpus*, i (1930), p. 80
B. Gray: 'Two Portraits of Mehmet II', *Burl. Mag.*, lxi (1932), pp. 4–6
F. Babinger: *Mehmed der Eroberer und seine Zeit* (Munich, 1953; rev. Eng. trans., Princeton, NJ, 1978), pp. 380–81, 388, 505–6
F. Babinger: 'Un ritratto ignorato di *Maometto II*, opera di Gentile Bellini', *A. Veneta*, xv (1961), pp. 25–32
G. F. Hill and G. Pollard: *Renaissance Medals from the Samuel H. Kress Collection at the National Gallery of Art* (London, 1967), no. 102
F. Strazzullo: 'Lavori eseguiti in Castelcapuano nell'anno 1488', *Napoli Nob.*, xiv (1975), pp. 143–9
M. Andaloro: 'Costanzo da Ferrara: Gli anni a Costantinopoli alla corte di Maometto II', *Stor. A.*, xii (1980), pp. 185–212
G. Pollard: *Medaglie italiane del rinascimento: Museo Nazionale del Bargello*, i (Florence, 1985), p. 183
J. Raby: 'Pride and Prejudice: Mehmed the Conqueror and the Italian Portrait Medal', *Stud. Hist. A.*, xxi (1987), pp. 171–94

——: 'Constanzo da Ferrara', *The Currency of Fame: Portrait Medals of the Renaissance*, ed. S. K. Scher (New York, 1994), pp. 87–90

<div align="right">MARK M. SALTON</div>

Cotignola, Francesco da. *See* ZAGANELLI, FRANCESCO.

Covo, Battista da (*b* ?Mantua, *c.* 1486; *d* Mantua, 17 Nov 1546). Italian architect and designer. He is first recorded in Mantua in 1522, when he was working on the new apartments in the Reggia dei Gonzaga (Palazzo Ducale) of Isabella d'Este, Marchesa of Mantua. Her rooms, located on the ground-floor of the Corte Vecchia, look out over a small secret garden with walls articulated by Ionic half columns. This garden has traditionally been attributed to Covo, but modern historians have expressed doubt. Nevertheless, Covo's presence on the site during the building of Isabella's apartments, as well as the trust repeatedly expressed in him by the Marchesa, are well documented. In 1524 he presented a project (unrealized) for the abbey church of S Benedetto in Polirone.

After 1524, following the transfer of Giulio Romano to the court of Federico II Gonzaga, 5th Marchese (later 1st Duke) of Mantua, Covo was put in charge of the construction of the buildings designed by Giulio, including the Palazzo del Te and Mantua Cathedral. In the early 1530s Covo worked for Isabella d'Este on the remodelling of the castle of Solarolo (destr.) in Romagna. In 1546, after Giulio's death, Covo received the prestigious title of Prefect of the Ducal Buildings, but his untimely death only a few days later prevented him from taking up his new post. Ducal decrees, an elegant inscription (Mantua, S Andrea) and the praise of Bernardo Cles, Bishop of Trent, all compliment Covo on his ability as a designer. It is unlikely, however, that he had many opportunities for the practical application of his talent. The lack of firm examples for comparison makes it difficult to support the hypothesis of an attribution to Covo of a variety of projects, including the restoration of the church of S Maria del Gradaro (rest. and remod., 20th century), Mantua, or the remodelling of the rustic sanctuary of the church of the Madonna della Comuna at Ostiglia, near Mantua.

BIBLIOGRAPHY

DBI

L. Negri: 'Giovanni Battista Covo, l'architetto di Isabella d'Este', *Riv. A.*, xxix (1954), pp. 55–96

E. Marani: *Mantova: Le arti*, ii (Mantua, 1960–65), pp. 179–84

H. Burns: 'The Gonzaga and Renaissance Architecture', *Splendours of the Gonzaga* (exh. cat., ed. D. Chambers and J. Martineau; London, V&A, 1981) pp. 27–38

A. Belluzzi: 'Battista Covo, Giulio Romano e Gerolamo Mazzola Bedoli a San Benedetto in Polirone', *Dal Correggio a Giulio Romano: La committenza di Gregorio Cortese* (exh. cat., ed. P. Piva and E. Del Canto; San Benedetto Po, 1989), pp. 119–31

<div align="right">□</div>

Cozzarelli. Italian family of artists.

(1) Guidoccio (di Giovanni) Cozzarelli (*b* Siena, 1450; *d* Siena, 1516–17). Painter and illuminator. He trained in the workshop of Matteo di Giovanni, with whom he was associated from about 1470 to 1483 and with whom he is often confused. Early illuminations for the Antiphonals of Siena Cathedral (*c.* 1480; Siena, Bib. Piccolomini, 6F, 15Q, 26R) and a number of securely attributed paintings demonstrate Guidoccio's develop-

ment of a fine, distinctive style that reflects Tuscan and northern European as well as Sienese influences. A scene from an Antiphonal depicting a *Religious Ceremony* (Siena, Bib. Piccolomini), a fragment of an altarpiece depicting the *Annunciation* and the *Journey to Bethlehem* (Coral Gables, FL, U. Miami, Lowe A. Mus.) and a *cassone* panel depicting the *Legend of Cloelia* (New York, Met.) all combine masses of rusticated and Classical architectural structures into perspective vistas. The dense cityscapes are played off against open sky and landscape, while porticos, gateways and vaulted spaces form the stage on which tactile and sprightly figures re-enact religious drama or ancient legends. In the *Baptism of Christ with SS Jerome and Augustine* (1470; Sinalunga, S Bernardino) the deep, panoramic landscape and triad of angels suggest Umbrian influences. A connection with Piero della Francesca through Matteo di Giovanni is possible.

Guidoccio's familiarity with contemporary trends in architecture and painting and his fashionable interest in the exploitation of antique subject-matter suggest points of contact with Francesco di Giorgio Martini and another member of his own family, the sculptor (2) Giacomo Cozzarelli, who accompanied Francesco di Giorgio to Urbino around 1476–8. Guidoccio produced manuscript copies of Francesco di Giorgio's architectural texts (Turin, Bib. Reale, C.14B; Florence, Bib. N. Cent., C. Palat. 767), and it has been suggested that he was responsible for colouring Giacomo Cozzarelli's terracotta *Lamentation* group (Siena, Chiesa dell'Osservanza). In accordance with common practice, Guidoccio also produced numerous traditional images of the Virgin and Child. By the end of the 15th century in Siena, his workshop produced the majority of secular cupboards and *cassone* panels depicting scenes from Classical mythology.

BIBLIOGRAPHY

R. van Marle: *Italian Schools* (1923–38)

B. Berenson: *Central and North Italian Schools* (1968), ii, pp. 97–101

G. Scaglia: 'Autour de Francesco di Giorgio Martini, ingénieur et dessinateur', *Rev. A.*, xlviii (1980), pp. 7–25

M. Ciatti: 'I costumi e i tessuti: Proposte di lettura', *Restauro di una terracotta del quattrocento: Il' Compianto di Giacomo Cozzarelli* (exh. cat. ed. A. M. Giusti; Florence, Mus. Opificio Pietre Dure, 1984), pp. 115–39

Painting in Renaissance Siena, 1420–1500 (exh. cat. by K. Christiansen, L. Kanter and C. B. Strehlke, New York, Met., 1988), pp. 282–5

<div align="right">VIRGINIA ANNE BONITO</div>

(2) Giacomo [Jacopo] Cozzarelli (*b* Siena, 20 Nov 1453; *d* Siena, 25 March 1515). Sculptor, painter and architect. His brother, Battista Cozzarelli (*b* 1483), was a goldsmith: his relationship to (1) Guidoccio Cozzarelli is unclear. His own activity began with the painting of *cassoni* and processional chariots and extended to sculpture and architecture. His direct contact with Francesco di Giorgio Martini is first documented in October 1471 in connection with the Ospedale di S Maria della Scala in Siena. Giacomo followed Francesco to Urbino around 1476, and in 1477, in his tax return to Siena, declared that he was in Urbino 'to paint'. In 1488 he stated in another tax return: 'I have been in Urbino with Francesco di Giorgio di Martino, and I have been already 10 years' (Bacci). No evidence of Giacomo's work in Urbino has been found and the attributions to him of decorative works in the Palazzo

Ducale are not entirely convincing. In 1489 he collaborated with Francesco di Giorgio, with whom he had returned to Siena just after 1488, on the production of two large bronze *Angels* (Siena Cathedral), which, together with another two (*in situ*) by Giovanni di Stefano, were placed at the sides of the main altar. In 1490 Giacomo supervised the casting of Francesco's *Angels* (see Fumi), and from 1491 to 1495 he cast cannon for the Siena commune.

Cozzarelli's work is not easily distinguished from that of Francesco di Giorgio, for whom he may have painted panels and perhaps also illustrated pages of his architectural treatise. Cozzarelli successfully followed Francesco's dynamic interpretation in his sculptural works, accentuating the popular character of the figures also through the technique of polychrome terracotta. The most notable example of this is his group of seven statues comprising the very expressive *Lamentation* in the Petrucci Chapel (1498; Siena, Osservanza; see fig.) connected with Francesco di Giorgio and his *Pietà* di Querciagrona. With Francesco, Giacomo probably worked also on the *Virgin and Child* (Torrita di Siena, church of S Leonard in Montefollonico). Among the numerous other Sienese works latterly attributed to him are the *St Lucia* (S Niccolò e Lucia) and the *St Margherita* (Santi Matteo e Margherita ai Tufi), while the monochrome terracotta of *St Sigismund* (completed 1507; Siena, Carmine), the tomb plaque of

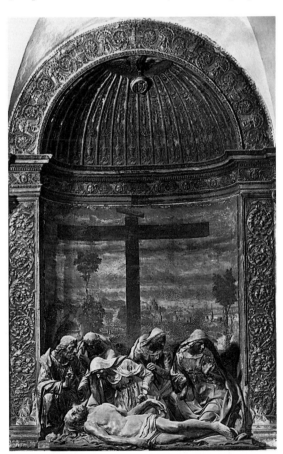

Giacomo Cozzarelli: *Lamentation*, polychrome terracotta group, 1498 (Siena, church of the Osservanza, Petrucci Chapel)

Giovan Battista Tondi (Siena, Ospedale S Maria della Scala) and the polychrome wooden statue of *St Vincent Ferrer* (completed 1512; Siena, Santo Spirito) may be considered to be among his most mature and independent works. In 1505–6 he was working on bronze statues (unexecuted) of the twelve Apostles, designed for Siena Cathedral by Francesco di Giorgio.

The distinction between the two artists is similarly unclear with regard to some architectural works in Siena, in particular the church of the Osservanza, which Francesco may have planned in 1476. From 1495 Giacomo also directed new fortifications in Montepulciano, where Francesco made a tour of inspection in 1496. Both S Sebastiano in Valle Piatta, begun around 1493, and Villa Chigi (1496–1505) at Le Volte were probably designed by Francesco, but were probably more likely continued by Baldassarre Peruzzi rather than by Cozzarelli. Certain simplifications introduced into the architectural language of Francesco di Giorgio make it seem more plausible that Cozzarelli designed the church of Santo Spirito, Siena, rebuilt between 1498 and 1504. Cozzarelli was employed by the commune in 1508, when he began the church of S Maria Maddalena (destr. 1526) outside Porta Tufi. In the same year the Palazzo del Magnifico, the massive residence commissioned by Pandolfo Petrucci and situated opposite the Baptistery in Siena, was being completed by Giacomo. This house, which again echoes Francesco di Giorgio's architectural solutions, was partly altered after the sack and ruin following Petrucci's death (1512), but Cozzarelli's bronze fittings (*bracciali* and *portatorce*) are preserved on the exterior.

BIBLIOGRAPHY

DBI

P. Bacci: 'Commentarii dell'arte senese: I. Il pittore, scultore e architetto Iacopo Cozzarelli e la sua permanenza in Urbino con Francesco di Giorgio Martini dal 1478 al 1488; II. I due "angioletti" di bronzo (1489–1490) per l'altare del Duomo di Siena', *Bull. Sen. Stor. Patria*, n.s., iii (1932), pp. 97–112

L. Bersano: 'L'arte di Giacomo Cozzarelli', *Bull. Sen. Stor. Patria*, lxiv (1957), pp. 109–42

A. Cecchi: 'Giacomo Cozzarelli (Siena, 1453–1516): Bracciali', *Mostra di opere d'arte restaurate nelle provincie di Siena e Grosseto*, ii (Genoa, 1981), pp. 128–31

F. Fumi: 'Nuovi documenti per gli angeli dell'altar maggiore del Duomo di Siena', *Prospettiva*, xxvi (1981), pp. 9–25

Restauro di una terracotta del quattrocento: Il 'Compianto' di Giacomo Cozzarelli (exh. cat., ed. A. M. Giusti; Florence, Mus. Opificio Pietre Dure, 1984)

A. Ferrari, R. Valentini and M. Vivi: 'Il Palazzo del Magnifico a Siena', *Bull. Sen. Stor. Patria*, xcii (1985), pp. 107–53

C. Sisi: 'Giacomo Cozzarelli', *Domenico Beccafumi e il suo tempo* (Milan, 1990), pp. 540–47

A. Bagnoli: 'Gli angeli dell'altare del Duomo e la scultura a Siena alla fine del secolo', *Francesco di Giorgio e il rinascimento a Siena, 1450–1500*, ed. L. Bellosi (Milan, 1993), pp. 414–19

F. Cantatore: 'Opere bronzee', *Francesco di Giorgio architetto*, ed. F. P. Fiore and M. Tafuri (Milan, 1993), pp. 326–8

FRANCESCO PAOLO FIORE

Credi, Lorenzo di. *See* LORENZO DI CREDI.

Cremona. Italian city in Lombardy, capital of the province of Cremona. Situated on the River Po about 80 km southeast of Milan, the city is famous for its medieval and Renaissance buildings and also for a school of painting that flourished there in the 16th century. The original Gallic settlement at Cremona became a Roman colony in

218 BC, its commercial and strategic importance assured by its position on the Po. The street pattern in the town centre, around the Piazza del Comune, still retains the grid layout of the original Roman nucleus. During the Byzantine period the city expanded to the north, around the present Piazza Garibaldi, to accommodate a military garrison. The city re-emerged in 1098 as one of the Lombard city states, acquiring a circuit of walls that remained unaltered until the 19th century.

Cremona's first artistic flowering followed its establishment as a free *comune*, recognized in 1114 by Henry V, Holy Roman Emperor (*reg* 1106–25). In 1334 Cremona was taken by the Visconti family of Milan, passing to the Sforza family in 1441 on the marriage of Bianca Maria Visconti to Francesco I Sforza (later Duke of Milan). Sforza patronage favoured the development of architecture and the arts in the city for the next century, until 1535 when Cremona came under the domination of the Spanish rulers of Milan. After 1619 it suffered an economic depression from which it never recovered.

In 1452 work began on the construction of the Ospedale Maggiore, the plan of which probably derives from Filarete's Ospedale Maggiore in Milan. In 1463 Bianca Maria founded a new church at the abbey of S Sigismondo, *c.* 2.5 km to the east of Cremona, to commemorate her marriage there. The measured articulation of space that characterizes this building has led to suggestions that Filarete may have been involved in its design.

A striking feature of 15th-century architecture in Cremona is the use of terracotta, both as polychrome decoration with plaster and stone inserts, and as tiles stamped with Classical motifs used to outline arches, cornices and friezes, for example the terracotta work by Rinaldo de Staulis (*fl* 1450–94) in the Palazzo Fodri (1488–1500) by Guglielmo de Lera. At this time the city was the Po Valley's main centre of production for moulded terracotta tiles, while the building trade was dominated by a few families, including the de Lera (*fl* early 16th century) and DATTARO (*c.* 1550–80) families. Several important Renaissance buildings often classified as 'Bramantesque' were also erected in Cremona. They include the Palazzo Raimondi (*c.* 1496), by a local group of architects led by the building's owner, ELISEO RAIMONDI, who were devoted to the study of Vitruvius; the Cappella di Cristo Risorto (1502) in front of S Luca, attributed to Bernardino de Lera, which reveals the influence of Giovanni di Domenico Battaggio, a Lombard follower of Bramante; and the cloisters of S Pietro al Po (begun 1505) by Cristoforo Solari (*see* SOLARI (i), (5)) and S Abbondio (*c.* 1511) by Bernardino de Lera, which were based on Roman models.

In painting, the rapid increase in commissions under the Sforza led to the decline of small family workshops, such as that of the BEMBO, in favour of corporate institutions: the Paratico dei Pittori was founded in 1470. In the 16th century painting in Cremona was distinguished for its openness to outside influences, for example from Bologna, Ferrara, the Veneto, Central Italy and Umbria, and also from Germany and Flanders. Rich inspiration and the use of brilliant colour characterize the Cremona school of painting, which for more than a century produced first-class artists, including Boccaccio Boccaccino (*see* BOCCACCINO, (1)), ALTOBELLO MELONE, Sofonisba Anguissola (*see* ANGUISSOLA, (2)) and members of the CAMPI family; many works by these and other artists can be seen in the cathedral and other churches in the city.

Cremona's art collections are displayed in the Museo Civico Ala Ponzone in the Palazzo Affaitati (probably built *c.* 1560 by Giuseppe DATTARO), which also houses the cathedral treasury. Other works are exhibited in the Palazzo del Comune. The city's consciousness of its artistic heritage was celebrated in writings, from Antonio Campi's *Cremona fedelissima* (1585) to the guides and biographies written by local scholars between the 17th and 19th centuries.

BIBLIOGRAPHY

Boll. Stor. Cremon. (1931–)
An. Bib. Stat. & Lib. Civ. Cremona (1948–)
L. Grassi: 'Gli Sforza e l'architettura del ducato', *Gli Sforza a Milano* (Milan, 1978), pp. 183–262
A. Piva, ed.: *Palazzo Affaitati a Cremona: Il nuovo Museo Civico* (Milan, 1984)
I Campi e la cultura artistica cremonese del cinquecento (exh. cat., ed. M. Gregori; Cremona, 1985) [detailed bibliog.]
B. Adorni and M. Tafuri: 'Il chiostro del convento di Sant'Abbondio a Cremona: Un'interpretazione eccentrica del modello bramantesco del belvedere', *A. Lombarda*, lxxix (1986), pp. 85–98
S. Bandera Bistoletti: 'Documenti per i Bembo: Una bottega di pittori, una città ducale del quattrocento e gli Sforza', *A. Lombarda*, lxxx/lxxxii (1987), pp. 155–81

STEFANO DELLA TORRE

Cremona, Girolamo da. *See* GIROLAMO DA CREMONA.

Cremona, Nebridio da. *See* NEBRIDIO DA CREMONA.

Crescione. *See* CRISCUOLO.

Crevalcore, Antonio da. *See* ANTONIO DA CREVALCORE.

Criscuolo [Crescione]. Italian family of painters. They were active in Naples and southern Italy in the 16th century. (1) Giovan Angelo Criscuolo is recorded as a notary who later turned to painting as a minor exponent of Mannerism. His brother (2) Giovan Filippo Criscuolo painted in a style derived from the followers of Raphael and Perino del Vaga. A number of paintings in the style associated with Giovan Filippo's workshop have been attributed to Mariangela Criscuolo (*fl c.* 1550–*c.* 1580), who was probably his daughter.

(1) Giovan Angelo Criscuolo (*b* Naples, ?1500–10; *d* Naples, after 1577). He is documented as a notary between 1536 and 1560, but, according to de Dominici, Criscuolo abandoned that profession and spent five years in the workshop of Marco Pino, who later helped him obtain his first public commission, the signed and dated *Adoration of the Magi* (1562; untraced, but described by early Neapolitan sources) for S Luigi di Palazzo, Naples (destr.).

Criscuolo's earliest work, the *Stoning of St Stephen* (Naples, Capodimonte), commissioned in 1558, is executed in the Mannerist style of Pino, but later works such as the *Annunciation* (1567; Aversa, Seminario), *St Jerome* (1572; Naples, church of Montecalvario) and the *Assumption of the Virgin* (*c.* 1577; Naples, S Giacomo degli Spagnoli) reveal the delicate manner of the Neapolitan painters Silvestro Buono (*fl* 1575–82) and Giovan Bernardo Lama (1508–79). In the *Annunciation* Criscuolo

appears to have been influenced by the Flemish devotional tradition in his handling of facial expressions and in the delicacy of the features. The *St Jerome*, on the other hand, is closer to Lama's style, especially in the working of the landscape, an aspect that is also important in such works as the S Giacomo *Assumption* and the *Nativity* (Naples, S Paolo Maggiore). In the context of mid-16th-century Neapolitan painting, Criscuolo was a painter of secondary importance, whose work falls within the Mannerist tradition, a style that later adapted itself in Naples to suit the requirements of the Counter-Reformation.

BIBLIOGRAPHY

DBI; Thieme–Becker

C. D'Engenio: *Napoli sacra* (Naples, 1624)

G. C. Capaccio: *Il forestiero* (Naples, 1634)

F. de Petri: *Historia napoletana* (Naples, 1634)

B. de Dominici: *Vite* (1742–5), ii, pp. 154–62

G. Previtali: *La pittura del cinquecento a Napoli e nel Vicereame* (Turin, 1978), pp. 73, 90

(2) Giovan Filippo Criscuolo (*fl c.* 1529–61). Brother of (1) Giovan Angelo Criscuolo. The main influence during his formative years in Naples was Lombard art, especially Bramantino, and he was associated with the workshop of Andrea Sabatini. Works of this early period include a *St Andrew* (1529; Naples, Capodimonte) and *St Dominic* (Naples, S Domenico Maggiore). From the 1530s he was active in the region of Gaeta. His first important cycle comprises 19 panels with scenes from the *Life of the Virgin* and the *Life of Christ* (signed and dated 1531) in the Grotta d'Oro at SS Annunziata, Gaeta. These reflect Lombard influence and the styles of Sabatini and Polidoro da Caravaggio, who was in Naples in 1527. References to Tuscan painting also support the account that he went to Rome and saw works by Raphael and followers of Perino del Vaga (de Dominici). A contemporary altarpiece (Ausonia, S Maria del Piano; dispersed) was crowned with a lunette of the *Death of the Virgin* and the *Assumption of the Virgin* (*in situ*), a theme to which he returned (e.g. Budapest, Mus. F.A.; 1534, Fondi, S Maria Assunta; Lipari Cathedral). A large altarpiece (1540; Vallo della Lucania, Mus. Dioc.; disassembled) reflects Spanish taste in its division into many compartments; the central panel is a copy of Raphael's *Madonna of the Fish* (1513–14; Madrid, Prado), which was then in S Domenico Maggiore, Naples. The style developed in these altarpieces remained substantially unchanged in the altarpiece of *SS Sebastian and Mary Magdalene* (Ravello Cathedral) and the triptych with the *Nativity* (1545; Naples, Capodimonte). His late works, such as the scenes from the *Life of Christ* (Naples, S Paolo Maggiore), are pervaded with the eccentric manner of Polidoro and Perino.

BIBLIOGRAPHY

B. de Dominici: *Vite* (1742–5), ii, pp. 174ff

P. Leone de Castris: 'Giovan Filippo Criscuolo', *Andrea da Salerno nel rinascimento meridionale* (exh. cat., ed. G. Previtali; Padula, Certosa di S Lorenzo, 1986), pp. 229–33

——: 'La pittura del cinquecento nell'Italia meridionale', *La pittura in Italia: Il cinquecento*, ed. G. Briganti (Milan, 1987), pp. 480–81, 689–90

GENNARO TOSCANO

Cristofano dal Borgo. *See* GHERARDI, CRISTOFANO.

Cristofano dell'Altissimo. *See* ALTISSIMO, CRISTOFANO DELL'.

Cristofano di Michele Martini. *See* ROBETTA.

Cristoforo di Geremia (*fl* 1456–76). Italian medallist, goldsmith and metalworker. Originally from Mantua, he worked most of his life in Rome. In the capacity of metalworker, he repaired the antique Roman statue of *Marcus Aurelius* (Rome, Piazza del Campidoglio) in 1468. He is known to have visited Florence in 1462 and was making jewellery for Borso d'Este, Duke of Ferrara, in 1466.

Cristoforo went to Rome in 1456 and seems first to have been employed by Lodovico Scarampi Mezzarota, Cardinal of S Lorenzo and Patriarch of Aquileia (*d* 1465). An unsigned medal with a forceful portrait of this cleric is usually attributed to the artist (Hill, *Corpus*, no. 756). He then entered the papal service and in 1469 received payment for medals of *Paul II* to be buried in the foundations of the Palazzo Venezia, Rome. None of the many surviving medals of this pope, who was an enthusiastic collector of ancient coins, bears Cristoforo's signature. Nonetheless, a large number of medals of Paul II have been attributed to him (Hill, nos 759–74). Although they follow the normal serial production of papal medals, the portraiture has the strength and individuality of Scarampi's medal.

Cristoforo signed two of his medals. The first, which was probably cast around 1458, shows a splendid bust of *Alfonso V of Aragon, King of Naples* (Hill, no. 754) and is related to Pisanello's medals of the same subject (Hill, nos 41–3). The reverse shows Alfonso enthroned and crowned by Bellona and Mars. Although the composition is crowded within the confines of the medal, the suggestion of three-dimensionality achieved through the placement of the figures on a three-quarter axis in depth, and the rich modelling of the bodies of Mars and Alfonso, combine with the draperies of Bellona to create an impressive relief.

The second signed medal, *c.* 1468, is of *Constantine the Great* and, as an imaginary portrait, is rather less impressive (Hill, no. 755). The reverse shows the dignified figures of the Emperor and the Church clasping hands and demonstrates Cristoforo's ability to give monumentality to his figures. Two further medals are attributed to the artist: *Cardinal Guillaume d'Estouteville, Bishop of Ostia* (London, V&A; Hill, no. 757) and *Paolo Dotti of Padua* (Hill, no. 758). The simple and effective reverse of the latter, showing the figure of Constantia, was copied by Andrea Guacialoti for his medals of *Sixtus IV* (Hill, no. 751) and *Alfonso of Calabria* (Hill, no. 752).

Cristoforo di Geremia's influence was considerable; Hill called him the founder of the Roman school of medallists. The medallist Lysippus the younger was his nephew, who, together with Guacialoti and possibly Niccolò di Forzore Spinelli, borrowed figures and compositions from Cristoforo.

BIBLIOGRAPHY

Forrer

G. F. Hill: *Medals of the Renaissance* (London, 1920); rev. and enlarged by G. Pollard (London, 1978), pp. 68–70

——: *Corpus*, i (1930), pp. 195–201

G. Pollard: *Italian Renaissance Medals in the Museo Nazionale del Bargello*, i (Florence, 1984), pp. 314–26

J. Woods-Marsden: 'Art and Political Identity in Fifteenth-century Naples: Pisanello, Cristoforo di Geremia, and King Alfonso's Imperial Fanta-

sies', *Art and Politics in Late Medieval and Early Renaissance Italy, 1250–1500*, ed. C. M. Rosenberg (London, 1990), pp. 11–37
The Currency of Fame: Portrait Medals of the Renaissance (exh. cat., ed. S. K. Scher; Washington, DC, N.G.A.; New York, Frick; 1994), pp. 119–120, 381

STEPHEN K. SCHER

Crivelli. Italian family of painters. The most eminent member of the family was (1) Carlo Crivelli. His brother (2) Vittore Crivelli also attained distinction as a painter. Their father Jacopo (*fl* Venice, 1444–9) and Vittore's son Giacomo (*fl* Fermo, 1496–1502) were also painters; no works by them are known to survive. Documentation concerning a third brother, Ridolfo (*fl c.* 1487), who may have been a painter, was apparently known to 19th-century authorities; nothing substantiating this figure has come to light.

I. Family members. II. Workshop organization. III. Critical reception and posthumous reputation.

I. Family members.

(1) Carlo (Giovanni) Crivelli (*b* ?Venice, ?1430–35; *d* Ascoli Piceno, before 3 Sept 1495). He produced many large, multi-partite altarpieces in which his highly charged, emotional use of line, delight in detail, decoration and citric colours, often set against a gold ground, convey an intensity of expression unequalled elsewhere in Italy. His mastery of perspective was also used for dramatic impact. As he worked in isolation in the Marches, his style had only local influence. In the 19th century, however, he was one of the most collected of 15th-century Italian painters.

1. Life and work. 2. Technique and style.

1. LIFE AND WORK.

(i) Training and early work, before 1465. On 7 March 1457 a legal suit was brought against Crivelli in Venice for having committed adultery with the wife of a sailor; he was fined and sentenced to six months' imprisonment. Since the proceedings of the trial refer to him as an independent painter, and he is known to have died in 1495, it has been estimated that he was born in the early 1430s, presumably in Venice. Although he always signed himself as a Venetian, no later document mentions him in Venice.

Crivelli presumably learnt the rudiments of painting from his father, Jacopo, who was active in the S Moisè district of Venice in the 1440s. It is assumed that Carlo was then apprenticed to some figure of greater distinction early in life. Ridolfi (1648) claimed that he was a pupil of Jacobello del Fiore; but Jacobello died in 1439, so this must be discounted. Crowe and Cavalcaselle (1871) suggested that Giambono was his master, emphasizing the taste both artists share for lavish costumes and intricate textile patterns. Davies (1972) and others proposed that Crivelli was connected with the Vivarini workshop, since works by him from the 1470s share many characteristics with earlier Vivarini workshop paintings in their treatment of figure types.

Crivelli soon came under the influence of the school of Squarcione at Padua. This is evident not so much from stylistic affinities with Squarcione himself, but with his pupils, including Mantegna, Marco Zoppo and Giorgio

Schiavone. Schiavone's work *c.* 1460 shows many connections with Crivelli's early style, especially in figure types and characterization, and Zampetti (1961) conjectured that the two may have emigrated to Dalmatia together. This would help to explain how Crivelli was often able to draw on sources from regions in which he is not known to have worked. Squarcione possessed a considerable and diverse collection of drawings for the purpose of teaching, and when Schiavone left Squarcione's workshop he took with him 19 of these drawings, which may have become available to Crivelli during his Dalmatian period. One of these drawings showed 'certain nudes by Pollaiuolo', and this possibly provided the model for the nude figures in the *Martyrdom of St Sebastian* from the predella of Crivelli's Odoni Altarpiece (*c.* 1491; London, N.G.).

Most of these early influences on Crivelli's style may be seen in one of only two signed works datable before his time in the Marches, the *Virgin and Child* (*c.* 1460; Verona, Castelvecchio; see fig. 1), originally from S Lorenzo in Venice. Like many of his paintings, this is iconographically a complicated work, combining two disconnected themes, the infancy and the Passion of Christ. The Virgin stands behind a parapet on which seven minute children, perhaps representing Holy Innocents, present instruments of the Passion to the Child. Behind the Virgin, a cloth of honour and a swag of fruit hang from a curious classicizing structure. Here, as elsewhere in Crivelli's work, fruits and

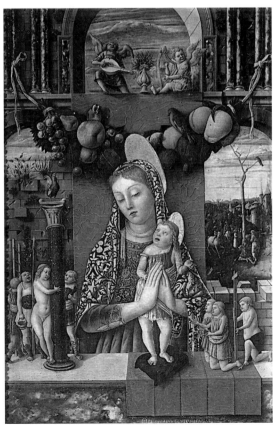

1. Carlo Crivelli: *Virgin and Child*, oil on panel, 710×480 mm, *c.* 1460 (Verona, Museo Civico di Castelvecchio)

similar objects are not used merely in a decorative manner, but also serve a symbolic function, enhancing the devotional significance of the image. To the right, an arch frames a view of the outskirts of a city, in the middle ground the episode of Peter cutting off the ear of Malchus is enacted, and in the distance the Crucifixion takes place. Van Marle (1923–38, xviii) related the painting to works by Giambono, but Paduan elements are much more prominent: swags and parapets are frequently found in works by Squarcione's pupils, where they are used to construct the spatial context. Mantegna's influence is particularly evident in details such as the raven perched in a defoliated tree, the angel foreshortened from below and the dilapidated wall, here used to mark off the middle ground. All of these features have possible parallels in Mantegna's *Agony in the Garden* (London, N.G.)

Possibly of greater significance for his later work than any one of these influences is Crivelli's dependence on aspects of the work of Jacopo Bellini, in whose workshop he may well have received some training. In the picture at Verona the Virgin's facial type and expression correspond with works by Jacopo such as the *Virgin and Child* (Florence, Uffizi), while the treatment of the landscape and the extraordinary perspectival arrangement echo types found in Jacopo's sketchbooks. Several of Crivelli's narrative scenes depend on compositions known from Jacopo's drawings.

(ii) Mature work, 1465 and after. By 1465 Crivelli was living in Zara in Dalmatia (now Zadar, Croatia), then a province of the Venetian Republic. A document dated 11 September 1465 refers to him as a master painter from Venice and a citizen of Zara, indicating that he had been resident there for some time. By 1468 he was working at Fermo in the Marches on his earliest dated work, the Massa Fermana Altarpiece (on dep. Urbino, Pal. Ducale), a small polyptych commissioned by a local patron. Interesting comparisons may be made between this altarpiece and the four triptychs painted in the 1460s for S Maria della Carità, Venice, which have been attributed to the studio of Jacopo Bellini. Crivelli was also familiar with the early work of Giovanni Bellini, who probably contributed to the Carità triptychs. Giovanni's early representations of the Pietà furnished Crivelli with ideas on which his own highly emotional Pietà compositions are based. It is likely that Crivelli maintained some contact with Giovanni in later life.

In 1469 Crivelli executed two more altarpieces at Fermo, one for the parish church at Porto San Giorgio (dispersed) and the other for the Franciscan church at Macerata, of which only a fragment survives (Macerata, Pin. & Mus. Com.). These works established him as a major artist in the Marches. By the end of his career most of the larger towns in the region could boast examples of his work in their principal churches. He achieved his success by satisfying a demand from local ecclesiastics and members of the minor nobility for religious panel paintings, chiefly altarpieces, which could attract attention through devotional appeal and a dazzling display of decorative effects.

Between 1468 and 1473 Crivelli completed no fewer than eight altarpieces, each one showing greater confidence in technique and stylistic refinement. In these works he

developed the distinctive characteristics for which his work is most admired, seen to advantage in the polyptych of 1473 in the cathedral of S Emidio, Ascoli Piceno, one of his few altarpieces to remain intact, retaining its original Gothic frame. Like several of Crivelli's early altarpieces, this is an ancona in three tiers, the principal tier showing in separate compartments the Virgin and Child surrounded by four saints. Although this was an old-fashioned format, he gave it new relevance by imbuing the figures with a compelling vitality, as in the *Pietà* depicted in the central panel at the top of the polyptych (see fig. 2).

Crivelli perhaps continued to be based in Fermo for the next few years. Works dating from the early 1470s, such as the polyptych from S Francesco at Montefiore dell'Aso (dispersed), were destined for churches in the vicinity. By 1483 he had settled in Ascoli Piceno, the largest city in the southern Marches, where local prosperity probably guaranteed superior commissions. The earliest work (untraced) that he seems to have executed in the city was in 1471 for the church of S Gregorio. From 1473 until 1488 his presence in the city is frequently recorded. In June 1478 he bought a house near the cathedral. Documents dating from this year and from 1487 explicitly refer to Carlo Crivelli as a citizen of Ascoli; however, he also received commissions from outlying towns, suggesting a fairly peripatetic life.

Ascoli lay just north of the kingdom of Naples, but was under the Pope's sovereignty. In 1482 Sixtus IV granted the city the right of self-government in return for acknowledgement of his suzerainty. The city celebrated the event by instituting an annual procession held on the feast of the Annunciation, when news of the agreement reached the city. A phrase was coined, *Libertas ecclesiastica* ('Freedom under the Church'), to describe the arrangement. This is inscribed on two commemorative paintings, both

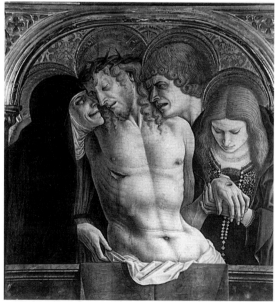

2. Carlo Crivelli: *Pietà*, central panel from the top of a polyptych, tempera on panel, 610×640 mm, 1473 (Ascoli Piceno, Cathedral of S Emidio)

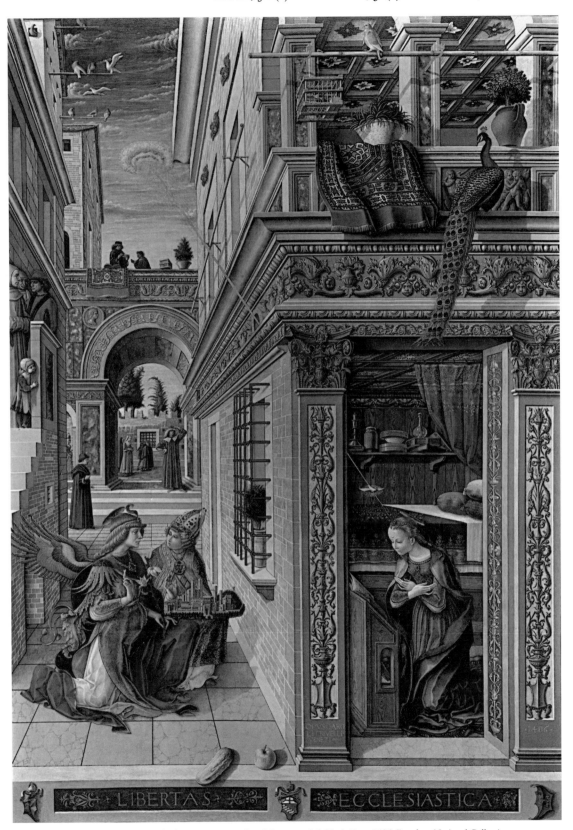

3. Carlo Crivelli: *Annunciation*, egg and oil on canvas, transferred from panel, 2.07×1.47 m, 1486 (London, National Gallery)

depicting the *Annunciation*: one is by Crivelli's follower Pietro Alemanno (1484; Ascoli Piceno, Pin. Civ.); the other is one of Crivelli's most sumptuous and powerful compositions and his largest work devoted to a biblical narrative (1486; London, N.G.; see fig. 3). Painted for SS Annunziata, the church where the procession ended, it is notable for its spectacular perspectival scheme, based on a composition in Jacopo Bellini's sketchbook, and is Crivelli's most ambitious attempt at integrating figures and architectural setting. Its use of extra-narrative elements, such as citizens dressed in contemporary costumes and St Emygdius, patron saint of Ascoli, indicates that the work was intended to have special significance for the people of Ascoli.

Rushforth (1900) conjectured that Crivelli may have been involved in political events. In 1490 the anti-papal party gained control in Ascoli, and Neapolitan forces took command. In April 1490 Prince Ferrante of Capua, the future King of Naples, knighted Crivelli at Francavilla. He is also referred to as the Prince's *familiaris* (companion), an honour unlikely to be connected with recognition of artistic distinction—there being no evidence that Ferrante commissioned anything from him—but rather with some service to do with the surrender of the city. Furthermore, it seems significant that Crivelli appears not to have returned to Ascoli until 1495, the year of his death.

During the last five years of Crivelli's life he accepted commissions from towns in the northern Marches, such as Fabriano and Camerino. In most of these works he added the title *miles* (knight) to his signature. On one panel, the *Madonna della candeletta* (Milan, Brera; see colour pl. 1, XXV3), part of a large altarpiece from Camerino Cathedral and possibly his last completed work, his signature is followed by another title, *Eques aureatus*, perhaps indicating that he had been granted a still greater honour. The enormous cost of his late works is confirmed by an inscription on the Becchetti Altarpiece (1491; London, N.G.), referring to the considerable expense that the patron incurred in ordering it. His last dated work, the *Coronation of the Virgin with Saints* surmounted by a *Pietà* (1493; Milan, Brera; see fig. 4), originally from S Francesco at Fabriano, is one of only three altarpieces by Crivelli for which records of contracts have survived. On 9 February 1493 he committed himself to completing this commission within two years at a cost of 250 ducats; the altarpiece was delivered in August 1494. The speed of the work suggests that Crivelli ran an exceptionally efficient workshop. Its form was certainly influenced by Giovanni Bellini's altarpiece painted for Pesaro in the 1470s; this originally consisted of a large *Coronation of the Virgin* (Pesaro, Mus. Civ.) surmounted by a panel of the *Pietà* (Rome, Pin. Vaticana). The expressive interlacing of hands in Bellini's *Pietà* was exploited in Crivelli's late works, particularly in the *Pietà* of 1493.

2. TECHNIQUE AND STYLE. Crivelli is often treated as an isolated figure, worthy of attention on account of his unmistakable style and fanciful sense of decoration, but standing apart from the main developments in Italian art because his oeuvre, which is exclusively religious, shows little evidence of concern with the prevailing interests of Renaissance artists. The choice of Ascoli as a

base for his operations cut him off from major centres of artistic activity, and consequently several aspects of his work seem old-fashioned by comparison with contemporary painting in Venice or Florence. Unlike many Venetian artists, he never took up oil by itself as a medium, always employing tempera on panel. He also favoured devices such as raised gesso-work to heighten the three-dimensional effects of such details as saints' attributes, gold backgrounds and pieces of coloured glass to simulate jewels, all of which had fallen out of use in Venice soon after he settled in the Marches. Nonetheless, from a technical standpoint he was a highly accomplished artist, bringing traditional techniques to a new peak of refinement. His palette is especially notable, expertise in the handling of pigments being evident from the wide range of rich and brilliant colours he brought to his work.

Crivelli's very individual style is characterized by vigorous draughtsmanship, bold modelling and great attention to such naturalistic details as veins and wrinkles. Each figure is carefully worked out so that no pose or gesture is repeated, a variety emphasized by the use of a wide range of vivid, almost garish colours. But it is the inclination to exaggerate form, sometimes to the point of contortion, yet always with expressive results, that makes these figures memorable. This tendency towards exaggeration may have been deliberately developed to satisfy the devotional needs of the Dominicans and Franciscans, Carlo's major patrons,

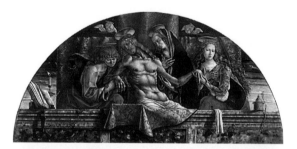

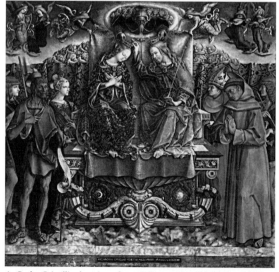

4. Carlo Crivelli: altarpiece from S Francesco, Fabriano, with *Pietà* lunette (1.28×2.41 m) above the *Coronation of the Virgin with Saints* (2.25×2.55 m), tempera on panel, 1493 (Milan, Pinacoteca di Brera)

who advocated the use of striking images as an aid to devotion. However, the immediate source for this kind of treatment of the figure was probably Donatello's altarpiece in Il Santo at Padua (*in situ*), which had a profound effect on many artists of Crivelli's generation, including some who shared these qualities of exaggeration, for instance Cosimo Tura.

Although in his later career Crivelli adopted the Renaissance type of altarpiece, integrating the principal figures into a single space as in the Odoni Altarpiece (London, N.G.), his figure style remained remarkably consistent. The tendency to exaggerate, however, gradually became more prominent, some figures appearing neurotic, even hysterical. Ornamental qualities were also developed further, perhaps inspired by contemporary schemes of architectural decoration in the Palazzo Ducale at Urbino. While it is clear that the major developments in Italian art had little effect on Crivelli's later work, it is sometimes possible to detect isolated new influences. Still-life details in the *Annunciation*, for example, suggest familiarity with Flemish paintings, available to him at Urbino, and the musician angels in the *Coronation of the Virgin* may owe something to Melozzo da Forlì, whose work of the 1480s at Loreto was accessible to him.

(2) Vittore [Vittorio] **Crivelli** (*b* Venice, 1444–9; *d* Fermo, after 10 Nov 1501). Brother of (1) Carlo Crivelli. Like Carlo, Vittore always signed himself as a Venetian. He followed his brother to Zara, where he is documented from 1465. He probably spent some time in Carlo's workshop, although there is only one surviving collaborative work, a polyptych for the church of S Martino at Montesanmartino (*in situ*). In 1469 Vittore took on a pupil in Zara whom he agreed to train for eight years. In 1476 he bought a house there. By 1481 he had moved to the Marches. In that year he signed a contract to paint a polyptych with the *Virgin Enthroned with Saints* (Rome, Pin. Vaticana) for the church of the Madonna di Loreto in Montelparo, and from the same year also dates a polyptych painted for S Francesco in Fermo (Philadelphia, PA, Mus. A.).

Vittore settled in Fermo, where he spent most of the rest of his life, apparently in comfortable circumstances. He was first mentioned as an inhabitant of the city in 1489. From this period there survives a series of signed works, mostly depicting the Virgin and Child, a small number of which are dated, including two further polyptychs for churches in Montesanmartino, one of 1489 (S Maria del Pozzo) and the other of 1490 (S Martino). In August 1501 he received a commission for an altarpiece (destr.) destined for S Francesco at Osimo for which he was to be paid 200 ducats, slightly less than Carlo received for his altarpiece of 1493, but an indication that Vittore was similarly held in high esteem. In November 1501 Vittore was paid an advance of 55 ducats for this work, but he must have died not long afterwards, because the following year his son Giacomo Crivelli asked Antonio Solario to finish the altarpiece, which was completed in 1506.

Vittore's last dated work, a *Virgin and Child* (1501; Paris, Louvre), indicates how little his style changed from works dated 20 years earlier. His oeuvre, which is variable

in quality, may be seen at its best in the early polyptych painted for S Francesco in Fermo, now dismembered (Philadelphia, PA, Mus. A.). The high quality of this work was recognized during his lifetime, since a contract of 1491 cites it as an exemplar. In the central panel, a *Virgin and Child Enthroned with Angels*, many features, such as the symbolic use of fruit and flowers and the lavish decorative effects, are clearly borrowed from Carlo. A certain angularity in the figure style is also derived from his brother, but without such expressive results. The draughtsmanship, though at times good, is never as powerful as in Carlo's work, and his figures tend to lack vitality. Colours are also more subdued, and in Vittore's work linear qualities tend to be more pronounced than in Carlo's, since his technique of modelling in tempera is less refined. However, while many of Vittore's figures are simply lightweight adaptations of his brother's types, his own compositions have a sweetness and charm that gives them a character of their own. Such features as flushed pink cheeks, languid expressions and small, delicate hands also help to make his best work immensely appealing.

II. Workshop organization.

The scale of Carlo Crivelli's later works and the degree to which they make use of routine but time-consuming techniques, such as details in relief, punched gold backgrounds and stencilling, suggest that he ran a large workshop, members of which continued employing his stylistic traits long after his death. One follower, the Austrian Pietro Alemanno, actually signed himself on one occasion as a disciple of Carlo, though he was probably never formally a pupil. Carlo's closest and most successful adherent was his brother (2) Vittore Crivelli. Although the two collaborated on only one occasion, on the large polyptych for the church of S Martino at Montesanmartino (*in situ*), Vittore's style is heavily indebted to his brother's, so it is likely that he spent a period in Carlo's shop, perhaps in the early 1460s. The efficiency of the workshop is suggested by the speed with which the commission for the *Coronation of the Virgin* (1493; Milan, Brera) was completed (*see* §I(2)1 above).

III. Critical reception and posthumous reputation.

The large number of commissions that the Crivelli brothers undertook and the enormous prices they could command suggest that both artists enjoyed considerable reputations, although they remained unknown beyond the region of their activity. Their works particularly suited the devotional aims of local religious orders, probably the most significant patrons in the Marches, and, perhaps because of their attractive decorative effects, they were also favoured by the minor nobility. However, there is little evidence that their work was acceptable to patrons in larger cultural centres used to more cosmopolitan tastes. This is perhaps one reason why Giovanni Santi did not mention either Carlo or Vittore in the list of notable artists of his time included in his rhymed chronicle, even though he undoubtedly knew Carlo's work. Neither did Vasari mention them, possibly because he was unfamiliar with their region, but more likely because he considered their achievement

insignificant to his notion of the progress of art. It would be wrong to assume from this silence, however, that they were totally forgotten. Some brief 16th-century references have come to light, and several 17th-century sources cite Carlo, notably the historians of Venetian painting Ridolfi (1648) and Boschini (1664), both of whom mentioned lost works by him in Venice; in the Marches, the historian Andreantonelli (1676) made a record of his knighthood. In a history of Montefeltro, Guerrini (1667) described a panel by Carlo at Carpegna.

In the 18th century historians of Ascoli mention Carlo enthusiastically, and he is included in Lanzi's history of Italian painting (1795–6). In the 19th century, however, Carlo's works were neglected and many dispersed. This was due in part to the suppression of convents for which they had been painted, and more particularly to Napoleon's Italian campaigns, resulting in numerous Marchigian paintings being removed to the Brera, Milan, which still possesses one of the largest collections of Carlo's works. Many other works by him were taken to Rome; some are now in the Vatican. By 1801 Cardinal Zelata possessed 13 panels by Carlo. These later (1852–c. 1866) belonged to Prince Anatoly Demidov (1812–70), who formed them into a composite altarpiece, the Demidoff Altarpiece (London, N.G.) for his villa near Florence. In 1823 the *Virgin and Child* from this ensemble was reproduced in Seroux d'Agincourt's *Histoire de l'art*, and this seems to have provoked interest in Carlo's works among collectors, particularly in England. As a result of the popularity of his work with wealthy Englishmen in the 19th century, the National Gallery, London, has one of the finest collections of his paintings, including the *Annunciation* of 1486 and the Demidoff Altarpiece, both acquired in the 1860s. By the end of the 19th century demand for Carlo's paintings was such that works were reaching very high prices. One altarpiece (Berlin, Gemäldegal.), which sold for 920 guineas in 1849, reached 7000 guineas at a sale in 1892. To satisfy the market for Carlo's works, many polyptychs were dismantled for sale as individual panels; by using antiquarian descriptions and old inventories, later scholars succeeded in reconstructing the original arrangements of these polyptychs.

BIBLIOGRAPHY

EARLY SOURCES AND DOCUMENTS

C. Ridolfi: *Le meraviglie dell'arte* (Venice, 1648); ed. D. von Hadeln, i (Berlin, 1914)

M. Boschini: *Le miniere della pittura veneziana* (Venice, 1664), p. 186

P. A. Guerrini: *La Carpegna abbellita e il Montefeltro illustrato*, i (Urbino, 1667)

S. Andreantonelli: *Breve ristretto della storia di Ascoli* (Ascoli Piceno, 1676)

T. Lazzari: *Ascoli in prospettiva, colle sue più singolari pitture, sculture e architetture* (Ascoli Piceno, [1724])

B. Orsini: *Descrizione delle pitture, sculture, architetture . . . della insigne città di Ascoli* (Perugia, 1790)

A. L. Lanzi: *Storia pittorica dell'Italia* (Bassano, 1795–6, 3/1809)

A. Ricci: *Memorie storiche delle arti e degli artisti della Marca di Ancona*, i (Macerata, 1834)

G. Cantalamessa: 'Artisti veneti nelle Marche', *Nuova Antol.*, xli (1892), pp. 401–31

R. Sassi: 'Arte e storia fra le rovine di un antico tempio francescano', *Rass. March.*, v (1927), p. 348

G. Fabiani: *Ascoli nel quattrocento*, 2 vols (Ascoli Piceno, 1950–51)

P. Zampetti: 'Carlo Crivelli a Zara', *A. Ven.*, xiii-xiv (1960), pp. 227–8

L. Dania: 'Nuovi documenti sui Crivelli', *Appennino Camerte* (31 Jan 1970), p. 3

GENERAL WORKS

DBI; Thieme–Becker

J. A. Crowe and G. B. Cavalcaselle: *History of Painting in North Italy* (London, 1871); ed. T. Borenius, i (London, 1912)

R. van Marle: *Italian Schools*, xviii (1923–38), pp. 3, 32, 42, 44, 48, 50, 65, 81, 88, 97

F. M. Godfrey: *Early Venetian Painters, 1415–1495* (London, 1954)

L. Dania: *La pittura a Fermo e nel suo circondario* (Fermo, 1968)

MONOGRAPHS AND CATALOGUES

G. Rushforth: *Carlo Crivelli* (London, 1900, rev. 2/1910)

F. Drey: *Carlo Crivelli und seine Schule* (Munich, 1927)

A. Bovero: *Tutta la pittura del Crivelli* (Milan, 1961)

P. Zampetti: *Carlo Crivelli* (Milan, 1961) [the principal monograph]

Crivelli e i crivelleschi (exh. cat., ed. P. Zampetti; Venice, Doge's Pal., 1961)

L. Murray: *Carlo Crivelli* (London, 1966)

M. Davies: *Carlo Crivelli* (London, 1972)

S. Di Provvido: *La pittura di Vittore Crivelli* (L'Aquila, 1972)

A. Bovero: *L'opera completa del Crivelli*, Class. A. (Milan, 1975)

P. Zampetti: *Carlo Crivelli* (Fermo, 1986)

SPECIALIST STUDIES

C. Grigioni: 'Notizie biografiche ed artistiche intorno a Vittorio e Giacomo Crivelli', *Rass. Bibliog. A. It.*, ix (1906), pp. 109–19

H. Friedmann: 'The Symbolism of Crivelli's *Madonna and Child Enthroned with Donor*', *Gaz. B.-A.*, 6th ser., xxxii (1947), pp. 65–72

P. Zampetti: 'Un politico poco noto di Carlo e Vittore Crivelli', *Boll. A.*, xxxvi (1951), pp. 130–38

F. Zeri: 'Cinque schede per Carlo Crivelli', *A. Ant. & Mod.*, iii (1961), pp. 158–76

J. F. Omelia: 'Addenda to a Recent Reconstruction of the Demidoff Altarpiece', *Marsyas*, xi (1962–4), pp. 10–24

S. Legouix: 'Vittore Crivelli's Altar-piece from the Vinci Collection', *Burl. Mag.*, cxvii (1975), pp. 98–102

G. Crocetti: 'Vittore Crivelli e l'intagliatore Maestro Giovanni di Stefano da Montelparo', *Not. Pal. Albani*, v/2 (1976), pp. 17–28

F. V. Lombardi: 'Un capolavoro di Carlo Crivelli e la sua origine', *Antol. B. A.*, iii/9–12 (1979), pp. 43–7

L'Annunciazione di Carlo Crivelli ad Ascoli (exh. cat by G. Gagliardi; Ascoli Piceno, Pin. Civ. 1996)

S. Papetti: 'Venetian Gold: Crivelli's Polyptych in Ascoli Cathedral', *F.M.R. Mag.*, xci (April/May 1998), pp. 17–38

THOMAS TOLLEY

Crivelli, Taddeo [Taddeo da Ferrara] (*fl* 1451; *d* Bologna, by 1479). Italian illuminator and painter. Bertoni hypothesized a Lombard origin for the artist on orthographic grounds, and Crivelli's style seems to support this, although at least 20 years of his working life were spent in Ferrara. The earliest surviving document concerning Crivelli is his personal account book for 1451–7 (Modena, Archv Stor.). Ljuba Eleen (*DBI*) calculated that during this period Crivelli was engaged in more than 100 projects. In carrying out these commissions, he employed a sizeable shop of apprentices and assistants, including Cristoforo Mainardi (*fl* 1454) and Jacopo Filippo d'Argenta. In 1452 Crivelli contracted to illuminate 'uno trato sopra lo evangelio di san zoane che fe santo agostino' for Novello Malatesta. This has been identified with a copy of St Augustine's *Sermons on the Gospel of St John* (Cesena, Bib. Malatestiana, MS. D.III.3).

In 1455 Crivelli received his most important commission, and until 1461, with Franco dei Russi, he was responsible for the illumination of the Bible of Borso d'Este (Modena, Bib. Estense, MS. V.G. 12–3, lat. 422–3). A final summary payment indicates that he was responsible for the execution of $42\frac{1}{2}$ gatherings (quinternions) out of a total of 60. His style can best be seen in the double-folio incipit for Genesis (I, fols 5*v*–6*r*) and the single-page incipits for Psalms (I, fol. 214*r*) and Ecclesiastes (I, fol. 280*v*). Figures are small, with spindly legs and

rather large heads with fine features. Costumes tend to be aristocratic, possibly reflecting the patron's taste for luxury. The interest in line visible in details of drapery, golden goffered clouds and wavelike rocks suggests a Lombard background. Architectural spaces, though fragile in appearance, display a grasp of artificial perspective. Colours tend to be opaque and saturated.

In 1467 Crivelli was commissioned to illuminate a copy of Boccaccio's *Decameron* for Teofilo Calcagnini (1441–88), a member of Borso's court. This is generally acknowledged to be a manuscript in Oxford (Bodleian Lib., MS. Holkham misc. 49; see fig.), with miniatures demonstrating the same courtly style as Crivelli's illuminations in the Bible of Borso d'Este. The last reference to Crivelli in the Este accounts of 1472 records the redemption of eight quinternions of a Breviary that he had pawned in Ferrara. This suggests a hasty and perhaps ignominious exit from the city where his commissions may well have diminished with the death of Borso in 1471. Nonetheless, Crivelli is generally acknowledged as one of the founders of the Ferrarese school of illumination. Bertoni published a letter that indicated that Crivelli also executed larger-scale paintings for Borso, but none has been identified.

Crivelli was recorded in Bologna in 1473, when he and Domenico Pagliarolo (*fl* 1471–97) were commissioned to illuminate a Gradual for the monks of S Procolo. In the same year Crivelli contracted to decorate maps and nautical charts. He may also have been engaged in the production of the first printed maps in Bologna, though the evidence for this is slight. In 1476 he contracted with the clerics of S Petronio for work on a new set of choir-books for the church and, with Bornio de' Bianchi, to illuminate an *Hours of the Virgin*. Some historians have discerned Crivelli's hand in a portion of a Gradual (Bologna, Mus. S Petronio, MS. Cor. III), a manuscript completed by Martino da Modena (*fl* 1477–89). A document of 1479 refers to Crivelli as deceased.

BIBLIOGRAPHY

DBI

H. J. Hermann: 'Zur Geschichte der Miniaturmalerei am Hofe der Este in Ferrara', *Jb. Ksthist. Samml. Allhöch. Ksrhaus.*, xxi (1900), pp. 121–271; It. trans. with new material as *La miniatura estense* (Modena, 1994)

G. Bertoni: *Il maggiore miniatore della Bibbia di Borso d'Este 'Taddeo Crivelli'* (Modena, 1925)

M. Salmi: *Pittura e miniatura a Ferrara nel primo rinascimento* (Milan, 1961)

G. M. Canova: 'La committenza dei codici miniati alla corte estense al tempo di Leonello e di Borso', *Muse e il principe: Arte di corte nel Rinascimento padanao: Saggi* (exh. cat., Milan, Mus. Poldi Pezzoli, 1991), pp. 87–117

F. Toniolo: 'Taddeo Crivelli: Il maggior miniatore della Bibbia di Borso d'Este: A Fifteenth-century Illuminated Manuscript from Ferrara', *Boll. A.*, lxxx (1995), pp. 159–80

U. Bauer-Eberhardt: 'Zur ferraresischen Buchmalerei unter Borso d'Este: Taddeo Crivelli, Giorgio d'Alemagna, Leonardo Bellini und Franco dei Russi', *Pantheon*, lv (1997), pp. 32–45

La miniature a Ferrara: Dal tempo di Cosme Tura all'eredita di Ercole de' Roberti (exh. cat., Ferrara, Pal. Schifanoia, 1998)

CHARLES M. ROSENBERG

Croce, Baldassarre (*b* Bologna, 1553–8; *d* Rome, 8 Nov 1628). Italian painter. He is first recorded in 1575 in Bologna, where he trained in the local Mannerist style of such painters as Lorenzo Sabatini, Orazio Sammachini, Pellegrino Tibaldi and Denys Calvaert (*c*. 1540–1619). During the papacy of Gregory XIII he went to Rome and worked at the Vatican on the decoration of the Cortile di S Damaso (1576–7), under the supervision of Sabatini, and on that of the Galleria delle Carte Geografiche (1580–83), under Girolamo Muziano and Cesare Nebbia. In Rome, Croce became a member of the Accademia di S Luca (1581) and of the Virtuosi al Pantheon (1584). His fresco for the oratory of the Crocifisso there, the *Approval of the Statutes* (*c*. 1583), reflects the Roman Mannerist style of Federico Zuccaro. He executed frescoes (1583–4) in S Giacomo degli Spagnoli, Rome, and took part in projects of Sixtus V, including the decoration (1586–9) of the Scala Santa, Rome, where his style is close to Bolognese Mannerism, but with echoes of Muziano, via Nebbia (Scavizzi).

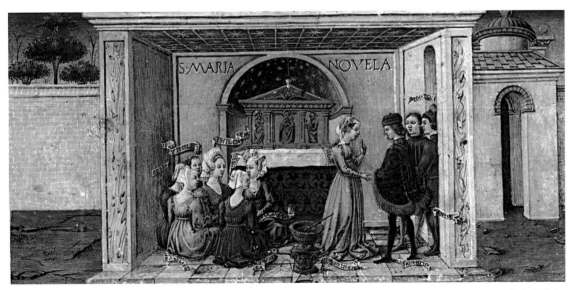

Taddeo Crivelli: *Ten Protagonists Meet in S Maria Novella*, 80×169 mm, miniature from Boccaccio: *Decameron*, begun 1467 (Oxford, Bodleian Library, MS. Holkham misc. 49, fol. 5*r*)

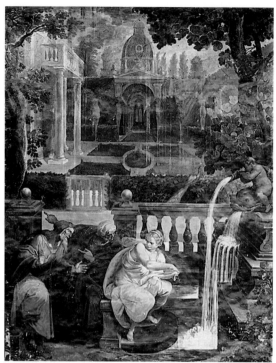

Baldassarre Croce: *Susanna and the Elders* (1598–1600), fresco, S Susanna, Rome

In 1592 he completed the decoration of the Sala Regia in the Palazzo Comunale, Viterbo: he painted the six scenes as fictive tapestries within an elaborate architectonic border, including festoons, portrait medallions, putti and niches with historical figures. Two of his frescoes, the *Cruxifixion* and the *Pietà* (both 1593), in the central nave of S Maria Maggiore, Rome, show the influence of Zuccaro and Muziano, especially in the draperies.

Generally considered his most important works are his frescoes in S Susanna, Rome, commissioned by Cardinal Girolamo Rusticucci: the *Martyrdom of St Gabino* in the apse (1595) and the scenes from the *Life of St Susanna* in the nave (1588–1600; see fig.) show close links with the theatrical scenery of the oratory of the Gonfalone, Rome. The *Christ Crowned with Thorns* (1594; Rome, S Prassede, main nave), the frescoes (1599) in the chapel of S Francesco di Assisi, Il Gesù, Rome, as well as the later frescoes in S Maria degli Angeli at Assisi and his probable participation in the decoration of S Cesareo, Rome, indicate that Croce reached the peak of his success at the end of the 16th century and the beginning of the 17th.

BIBLIOGRAPHY

AKL; DBI; Thieme–Becker

G. Scavizzi: 'Gli affreschi della Scala Santa ed alcune aggiunte per il tardo manierismo romano', *Boll. A.*, xlv (1960), pp. 111–22, 325–35, fig. 9

J. von Henneberg: *L'oratorio dell'Arciconfraternità del SS Crocifisso di Roma* (Rome, 1974), pp. 79–83, fig. 28

C. Strinati: *Quadri romani tra '500 e '600: Opere restaurate e da restaurare* (Rome, 1979), pp. 10, 12, 14–17

——: 'Roma nell'anno 1600: Studio di pittura', *Ric. Stor. A.*, x (1980), pp. 26, 45, n. 29

M. C. Abromson: *Painting in Rome during the Papacy of Clemente VIII* (New York, 1981)

Roma di Sisto V (exh. cat., ed. M. L. Madonna; Rome, Pal. Venezia, 1993) [exh. pamphlet & subsqent book]

ANTONIO VANNUGLI

Cronaca [Simone di Tomaso del Pollaiuolo] (*b* Florence, 30 Oct 1457; *d* Florence, 27 Sept 1508). Italian architect and mason. He trained as a stone-carver and seems to have spent his early years (*c.* 1475–85) in Rome after a sodomy charge. According to Vasari, his nickname (literally 'the Chronicle') was derived from his study of antiquity and his skill in recounting 'the marvels of Rome' on his return to Florence. In 1486 Cronaca matriculated as a stonecutter in the Florentine Guild of Stonecutters and Woodworkers (Arte dei Maestri di Pietra e Legname), by which time he was already married to the daughter of the builder Jacopo Rosselli, who worked on the early stages of the Palazzo Strozzi and who may have introduced him to Filippo Strozzi I.

Cronaca's first documented activity was in the workshop of Florence Cathedral, but in February 1490, six months after work began on the Palazzo Strozzi, Cronaca was engaged by Strozzi as chief stonecutter, assuming the role of Capomaestro (chief architect) from 1497 until work on the first phase stopped in 1504. He was paid 36 florins per annum to supervise quarrying, stone-carving and construction, supplying models and designs when required. Giuliano da Sangallo's wooden model (1489; Florence, Pal. Strozzi) established the basic plan (bilaterally symmetrical to provide houses for Strozzi's sons from his two marriages) and the three-storey rusticated façade. In execution, vaulting on the first floor greatly increased the height of the building and necessitated the steep stairs disparaged by Vasari. Certainly designed by Cronaca are the upper levels of the courtyard and the exterior cornice. The latter is the most impressive constructed in the 15th century, both for its assimilation of an accurately observed ancient prototype (from the Forum of Nerva, Rome) and for the intricate constructional geometry that keys in its enormous weight. The superb courtyard is three bays wide and five deep, and on the ground floor it is relatively conventional, with arches carried on Composite columns in the manner of the Palazzo Medici. On the first floor the system changes to one of arches and plain piers, originally open loggias at front and back, and closed at the sides by rectangular cross-mullioned windows with oculi above. The top storey remains open, with slender Composite columns on high pedestals linked by a balustrade. Although the sequence lacks real coherence, it gives a convincing impression of tight organization through the use of robustly articulated elements and strong projections.

From 1495 to 1497 Cronaca was joint chief architect of the Hall of the Great Council in the Palazzo della Signoria (now Palazzo Vecchio) for the new republican assembly. This was the most important civic architectural project in Florence after the expulsion of the Medici in 1494. Here Cronaca helped to supervise construction of the enormous wooden roof, the carpentry of which Vasari admired and reused when the Hall was raised and transformed (1563–5) into the Salone del Cinquecento. Traces of Cronaca's windows are visible on the exterior of the Hall. From 1495 until his death, Cronaca was Capomaestro at Florence Cathedral. The cathedral works in these years were minor, largely confined to the construction of marble altars, the paving of the choir and general repairs: Cronaca's conscience therefore impelled him to negotiate a reduction in

his salary in 1502. As cathedral architect, he also designed a house (1503–4) for Michelangelo and collaborated with Giuliano da Sangallo and Baccio d'Agnolo on the model (1507) for the arcaded gallery of the cupola. In 1504 he and Antonio da Sangallo (i) were entrusted with the design and construction of the plinth for Michelangelo's *David* (1504; *see* ITALY, fig. 22).

Vasari also attributes to Cronaca the design of S Salvatore al Monte (*c.* 1490–1504; see fig.), the observant Franciscan church next to S Miniato: its powerfully simple handling accords well with his style, and in 1504 Cronaca was officially elected architect of the Calimala (Cloth Merchants' Guild), which undertook the construction of the church. He is also described as having consistently advised the guild about architectural matters before that date. The plan of S Salvatore, with its single, flat-roofed nave, interconnecting side-chapels and friars' choir behind the altar, is of a type favoured by the observant orders and influential in the next century (cf. Sansovino's S Francesco alla Vigna, Venice). Of particular interest is the square Nerli Chapel to the right of the choir, which, with its groin vault supported by four columns in the corners, makes direct reference to the early Christian church of S Salvatore at Spoleto, much studied as an antiquity by Renaissance architects. On the exterior, S Salvatore has a Tuscan simplicity expressive of the reforming nature of the observant Franciscans, adorned only by the tabernacle windows at clerestory level with alternating triangular and segmental pediments, refined from the Florentine Baptis-

tery. These appear again on the interior, which is fully articulated with a two-storey superimposed Tuscan Doric order of pilasters, with fluted capitals. The nave is dominated by the chancel arch, its tough, wide mouldings enlivened by the Calimala eagle at the apex. The energetic simplicity of the brown stone detailing belies its actual sophistication: characteristic are the keystone brackets of the nave chapels, which incorporate the knotted cord of the Franciscan order.

Undocumented works attributed to Cronaca since the 19th century include the Palazzo Corsi (now Museo Horne) and the Palazzo Guadagni (1503–6) built for the Dei family, the splendidly severe façade of which became characteristic of 16th-century Florentine town houses (e.g. the early palaces of Baccio d'Agnolo). Cronaca's known allegiance to Savonarola, and his association with the Hall of the Great Council, make it tempting to see his soberly robust forms as an expression of Savonarolan piety. Vasari's characterization of Cronaca as 'a good imitator of antiquity, an observer of the rules of Vitruvius and the works of Brunelleschi' is borne out by his few surviving drawings, which show him studying a strikingly Brunelleschian range of buildings, including the Baptistery and SS Apostoli in Florence and such celebrated Roman structures as the Pantheon, Septizodium and the Castel Sant'Angelo (which was miniaturized to compose a chimney-piece in the Palazzo Strozzi). Along with Giuliano da Sangallo, Cronaca was a key influence on the early architecture of Michelangelo.

Cronaca: S Salvatore al Monte, Florence, *c.* 1490–1504

UNPUBLISHED SOURCES

Berlin, Kupferstichkab. [drgs]
Florence, Uffizi [drgs]
Montreal, Cent. Can. Archit. [drgs]

BIBLIOGRAPHY

Thieme–Becker

G. Vasari: *Vite* (1550, rev. 2/1568); ed. G. Milanesi (1878–85)
H. von Geymüller and C. von Stegmann: *Die Architektur der Renaissance in Toskana*, iv (Munich, 1885)
C. von Fabriczy: 'Simone del Pollaiuolo, il Cronaca', *Jb. Kön.-Preuss. Kstsamml.*, xxvii (1906) [suppl.], pp. 45–69
G. Marchini: 'Il Cronaca', *Riv. A.*, xxiii (1941), pp. 99–136
L. Grassi: 'Disegni inediti di Simone del Pollaiuolo', *Palladio*, vii (1943), pp. 14–22
R. Goldthwaite: 'The Building of the Strozzi Palace: The Construction Industry in Renaissance Florence', *Studies in Medieval and Renaissance History*, x (1973), pp. 99–194
A.-I. M. Radice: *Il Cronaca: A Fifteenth-century Florentine Architect* (PhD diss., U. NC, Chapel Hill, 1976) [useful annotated bibliog.]
L. P. Najemy: 'The First Observant Church of S Salvatore al Monte in Florence', *Mitt. Ksthist. Inst. Florenz*, xxiii (1979), pp. 273–96
A. Nesselrath: 'I libri di disegni di antichità: Tentativo di una tipologia', *Memorie dell'antico nell'arte italiana*, iii, ed. S. Settis (Turin, 1986), pp. 89–147

CAROLINE ELAM

Crucifix. Cross with a figure of the crucified Christ. Throughout its history, the form of the painted and sculpted Crucifix varied widely in size, material and function, ranging from a small, portable object of private devotion to a monumental work, usually for liturgical use. This article focuses on the larger sculpted Crucifixes, predominantly for ecclesiastical use, since painted Crucifixes, which were widespread in Italy from the early 12th century to the late 14th, were rare in the Renaissance period. Only isolated examples after *c.* 1400 are known.

1. Introduction. 2. Sculpted.

1. INTRODUCTION. Christ's Crucifixion was not depicted in the first centuries of Christianity; the earliest surviving examples are Italian and date from the 5th century AD. The Crucifix as an independent art form developed somewhat later. Although chiefly a Western phenomenon, its iconography was closely related to that of the Crucifixion in Byzantine art. Christ was initially shown as if he were alive, with his head and body erect and eyes wide open. There is evidence that in some early Crucifixions he was shown naked; however, while this may be more accurate historically, from the 5th century he was almost invariably shown wearing either an ankle-length tunic (*colobium*) or, later, a loincloth (*perizoma*). The shift from depicting a living to a dead Christ in Byzantine Crucifixions dates from the second half of the 8th century.

Early scenes of the Crucifixion were often flanked by other scenes and figures, for example the Virgin and St John the Evangelist were often shown (from the end of the 6th century) and the thieves, the sponge-bearer, the lance-bearer and the soldiers casting lots were also represented from early on. Such symbolically significant images were often included in crucifixes. The beginning of the compositional division into left and right sides and the pairing of figures so that the positive are always to Christ's right dates from this period. In the 9th century other symbolic images such as Ecclesia and Synagoga, a dead serpent or Adam's skull at the foot of the Cross were also included. From the 13th century artists usually emphasized Christ's suffering on the Cross; furthermore, from the mid-13th century the number of nails was often reduced from four to three by placing one foot over the other, and this powerfully affected the hanging, buckled posture of Christ's body. At about the same time the Virgin began to be depicted fainting at the foot of the Cross, sometimes with a sword piercing her breast, as prophesied by Simeon. These changes were connected with a more intimate and emotional piety inspired by the writings of St Bernard and St Francis and later also by the 14th-century mystics.

BIBLIOGRAPHY

RDK

F. Cabrol and H. Leclerq: *Dictionnaire d'archéologie chrétienne et de liturgie*, iii (Paris, 1913)
L. Réau: *Iconographie de l'art chrétien*, ii (Paris, 1957)
C. E. Pocknee: *Cross and Crucifix* (London, 1962)
G. Schiller: *Ikonographie der christlichen Kunst*, 4 vols (Gütersloh, 1966–80; Eng. trans., London, 1972)
E. Dinkler: *Signum crucis* (Tübingen, 1967)
R. Schneider Berrenberg: *Kreuz, Kruzifix: Eine Bibliographie* (Munich, 1973)

CATHERINE OAKES

2. SCULPTED. Florentine sculptors of the Renaissance created southern Europe's first major sculpture in the round on the theme of the Crucifix. Although the condemnation of three-dimensional sculpture by the Council of Nicea (AD 787) governed only branches of the Eastern Orthodox Church, until the Renaissance it had the effect of also discouraging the development of such religious sculpture in Italy. In northern Europe the sculpted Crucifix followed in the tradition of Carolingian and Ottonian art, which treated the dead figure of Christ differently from the Eastern tradition. In Germany during the Renaissance the established tradition of Late Gothic limewood sculpture developed in the crucifix a heightened expression of human emotion.

In Italy in the early 15th century Donatello and Brunelleschi carved strikingly different life-size polychrome wooden Crucifixes (the attribution to Donatello, however, has been questioned). The difference between the 'Donatello' Crucifix (1.78×1.73 m, *c.* 1410–15; Florence, Santa Croce) and the Brunelleschi Crucifix (*c.* 1410–15; Florence, S Maria Novella; see fig.) is partly captured in the criticism attributed to Brunelleschi by Vasari, that Donatello's Christ resembled a peasant; the dark skin and the muscular chest and limbs of Donatello's Christ contrast with the white skin and thin limbs and torso of Brunelleschi's version. While in both the head hangs towards the right, it is bowed more deeply in Brunelleschi's rendering, which presents the legs also turned towards the right. Donatello's Christ confronts the viewer, while Brunelleschi's Christ turns slightly away and invites attention without engaging the viewer in a dialogue. There is power in each Christ; but it is a power of life in Donatello's and of death in Brunelleschi's. A much later sculpture by Donatello, a bronze Crucifix (1441–9; Padua, S Antonio), contains the substantial legs of his earlier work, but they turn towards the right, and the head bows more deeply in that direction, as in Brunelleschi's sculpture. The earliest Donatello work is in keeping with the frontality of the Eastern Church's images, reminding the viewer of other face-to-face encounters, such as receiving the Host from a priest. Brunelleschi's Crucifix and Donatello's later Crucifix reject this frontal

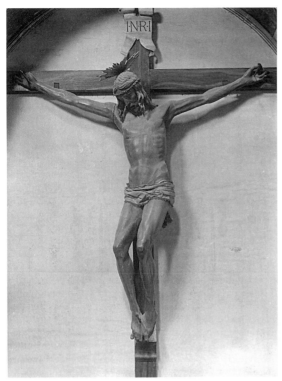

Crucifix by Brunelleschi, polychrome wood, figure 1.7×1.7 m, *c.* 1410–15 (Florence, S Maria Novella)

view in favour of a detached perspective. The influence of Brunelleschi's form of the crucifix is evident in many later sculptures.

The sculpted figure of the crucified Christ usually included a loincloth, which might be part of the sculpture itself or a separate piece of fabric. Brunelleschi intended his Crucifix to have such a fabric loincloth, and so did not sculpt details in the genital area. However, the leading theologians of the early Christian Church, including St Augustine, were certain that Christ had died totally naked, for that was a feature of the customary Roman mode of crucifixion, as well as being theologically appropriate to express Christ's innocence. While the influence of the Eastern Church had tended towards a clothed Christ on the Cross, the followers of St Francis of Assisi had once again affirmed Christ's nakedness, in order to assert not only the humanity of Christ but also an affinity between Christ and the poor. All of these interpretations may be seen in the nakedness of a Crucifix attributed to Michelangelo (polychrome wood, 1.35×1.35 m, *c.* 1492–4; Florence, Casa Buonarroti). In this sculpture Christ is depicted with an adolescent body, conveying a minimal sense of suffering; the small wound in the side appears nearly healed. The lithe body has often been compared to the idealization in Donatello's bronze *David* (1450s; Florence, Bargello; see colour pl. 1, XXIX1). In the wooden Crucifix the head hangs to the right, as is customary; but the legs turn towards the left, giving Christ a dancing movement.

BIBLIOGRAPHY
H. W. Janson: *The Sculpture of Donatello* (Princeton, 1957/*R* 1963)
G. Andres, T. Hunisak and A. Turner: *The Art of Florence*, 2 vols (New York, 1988)

DOUG ADAMS

Ćulinović, Juraj. *See* SCHIAVONE, GIORGIO.

Cungi, Leonardo (*b* Borgo San Sepolcro; *fl* 1540s; *d* Rome, June 1569). Italian painter and draughtsman. Vasari mentioned him among the painters who decorated the Vatican Belvedere in the 1560s. This was an important collaborative project involving Pirro Ligorio, Taddeo and Federico Zuccaro, Federico Barocci and Santi di Tito and may be the work for which Cungi received a payment from the papal datary in 1566. In 1569 Cungi was asked to complete the ceiling gilding in the nave of S Giovanni in Laterano for Pope Pius IV, a project first assigned to Daniele da Volterra. Cungi died before the commission was completed, and it was undertaken by Cesare Trapasso (*fl* 1570s).

Vasari recognized a drawing by Cungi of Michelangelo's fresco of the *Last Judgement* in the Sistine Chapel (see colour pl. 2, VII3) in the collection of Perino del Vaga at Perino's death in 1547. According to Giovanni Battista Armenini, the drawing would have formed part of Perino's collection of drawings sold by his daughter to the Mantuan antiquary and collector Jacopo Strada in 1566. Vasari assembled other designs by Cungi in his *Libro dei disegni*. A number of Cungi's drawings of the *Last Judgement* and of Michelangelo's Pauline Chapel frescoes survives (Florence, Uffizi), as do several other sheets (Cleveland, OH, Mus. A.; Paris, Louvre). The draughtsmanship is characterized by figures with blank eyes and scalloped outlines for hands and feet. The use of a loose, ornamental line for interior modelling often results in lyre-shaped abdomens, and short, widely spaced parallel strokes are used for shading. Cungi's brother, Giovanni Battista Congi (*fl* 1539–46), was also a painter.

BIBLIOGRAPHY
Thieme–Becker
G. Vasari: *Vite* (1550, rev. 2/1568); ed. G. Milanesi (1878–85)
G. B. Armenini: *De' veri precetti della pittura* (Ravenna, 1587/*R* New York, 1971); Eng. trans. and ed. E. Olszewski (New York, 1977), pp. 134–7
B. Berenson: *Drawings of the Florentine Painters*, 3 vols (Chicago, 1938)
The Draughtsman's Eye: Late Italian Renaissance Schools and Styles (exh. cat. by E. J. Olszewski, Cleveland, OH, Mus. A., 1979), pp. 68–70

EDWARD J. OLSZEWSKI

Cyriac of Ancona [Ciriaco d'Ancona; Ciriaco di Filippo de' Pizzicolli] (*b* Ancona, 1391; *d* Cremona, ?1455). Italian traveller and antiquarian. A self-educated merchant and occasional papal diplomatic agent, he played a central role in the rediscovery of the ancient world during the 15th century, travelling extensively in Italy, Greece and the Near East between 1412 and 1449. He learnt Latin and Greek and became the first great amateur classicist, as well as the undisputed father of modern archaeology and epigraphy. His explorations in Greece and the Levant resulted in the recovery of a number of manuscripts by ancient authors, though his most important contributions to the study of ancient art were his detailed notes on the antiquities he observed during his travels. Among the monuments of greatest interest to him were the antiquities of Athens, where he drew the Parthenon, the Philopappos Monument and the Temple of Olympian Zeus when it had 21 columns. He also recorded the Temple of Artemis at Didyma in Turkey before it was toppled by an earth-

quake, the ruins of Kyzikos on the Sea of Marmara, Hagia Sophia in Istanbul and the monuments of ancient Egypt. He devoted himself as well to searching for and recording the antiquities of Italy, assembling a substantial corpus of drawings of ancient monuments and inscriptions. His relatively analytical and precise approach to antiquity sets him apart from late medieval tradition, especially in regard to the exactness with which he copied inscriptions. While he made use of historical texts, Cyriac preferred to study monuments and inscriptions directly, thus laying the foundations of the antiquarian approach to antiquity that became standard in the following centuries.

Cyriac's notebooks are invaluable for their descriptions and drawings of monuments that have since been lost or damaged. Among the few extant autograph texts are his descriptions and drawings of Athenian antiquities, especially the Parthenon (see fig.), of which his is the earliest surviving drawing. Nonetheless, much of his material has survived in the form of copies, for his work was already admired and imitated by the second half of the 15th century, shortly after his death. Among those who read and copied his manuscripts and imitated his cultural

Cyriac of Ancona (attrib.): earliest surviving drawing of the west front of the Parthenon, silverpoint, 1436–7 (Berlin, Deutsche Staatsbibliothek, Cod. Berolinensis Hamiltonianus 254, fol. 85r)

attitudes were Felice Feliciano (1433–79) and Giovanni Marcanova (d 1467). These men journeyed with Samuele da Tradate and Andrea Mantegna to search for antiquities on Lake Garda—a famous episode clearly reflecting Cyriac's interests that inspired Feliciano's compilation of inscriptions for Mantegna. This line of antiquarian and epigraphic research led, in North Italy and especially in the Veneto, to that climate of admiration for and recording of ancient monuments that later found expression in the *Hypnerotomachia Poliphili* (1499) by the Dominican monk Francesco Colonna of Venice.

In addition to his records of ancient monuments, Cyriac is known for his description of smaller objects and for his own collections. He probably bought and sold ancient coins, and he was often in Venice, where collectable antiques circulated before this interest developed elsewhere. He certainly owned various small artefacts, such as a head of Medusa and an engraved gem depicting the monster Scilla. He also had casts made from these objects, which he presented to friends such as Teodoro Gaza.

Cyriac knew many of the most important political and cultural figures of the age, such as the Giustiniani family, who ruled the island of Chios, and Pope Eugenius IV, whom he lobbied for a crusade against the Turks in order to prevent further defilement of the antiquities under their control. He was also for a time companion to Sultan Mehmed II (*reg* 1444–6) and may have entered Constantinople (now Istanbul) with him when it fell to the Turks in 1453. Other acquaintances included Ambrogio Traversari and the humanist NICCOLÒ NICCOLI. To Cyriac we also owe some important information on the 15th-century figurative cycle begun for the Marchese of Ferrara, Lionello d'Este, in 1447; Cyriac saw two of the paintings before the cycle was complete.

BIBLIOGRAPHY

A. Momigliano: 'Ancient History and the Antiquarian', *J. Warb. & Court. Inst.*, xiii (1950), pp. 285–315
B. Ashmole: 'Cyriacus of Ancona and the Temple of Hadrian at Cyzicus', *J. Warb. & Court. Inst.*, xix (1956), pp. 179–91
A. Campana: 'Giannozzo Manetti, Ciriaco, e l'Arco di Traiano ad Ancona', *Italia Med. & Uman.*, iii (1959), pp. 484–504
E. W. Bodnar: *Cyriacus of Ancona and Athens* (Brussels, 1960)
C. Mitchell: 'Ex libris Kiriaci Anconitani', *Italia Med. & Uman.*, v (1962), pp. 283–99
R. Weiss: *The Renaissance Discovery of Classical Antiquity* (Oxford, 1969)
A. Campana: 'Ciriaco d'Ancona e Lorenzo Valla sull'iscrizione greca del Tempio dei Dioscuri a Napoli', *Archeol. Class.*, xxv–xxvi (1973–4), pp. 85–102
E. W. Bodnar and C. Mitchell: 'Cyriacus of Ancona's Journeys in the Propontis and Aegean, 1444–1445', *Mem. Amer. Philos. Soc.*, cxii (1976) [whole issue]
J. Colin: *Cyriaque d'Ancône* (Paris, 1982)
M. Manfredini: 'Ciriaco d'Ancona e l'epitaffio per i Corinzi a Salamina', *An. Scu. Norm. Sup. Pisa*, 3rd ser., xiii (1983), pp. 1003–5
C. R. Chiarlo: '"Gli frammenti della sancta antiquitate": Studi antiquari e produzione delle immagini da Ciriaco d'Ancona a Francesco Colonna', *Memoria dell'antico nell'arte italiana*, i (Turin, 1984), pp. 271–303
K. A. Neuhausen: 'Cyriacus und die Nereiden: Ein Auftritt des Chors der antiken Meernymphen in der Renaissance', *Rhein. Philol.*, cxxvii (1984), pp. 174–92
C. A. Smith: 'Cyriacus of Ancona's Seven Drawings of Haghia Sophia', *A. Bull.*, 69 (1987), pp. 16–32

CARLO ROBERTO CHIARLO

D

Dadda, Francesco del. *See* FERRUCCI, (3).

Dall'Abacco, Antonio. *See* LABACCO, ANTONIO.

Daniele da Volterra [Ricciarelli, Daniele] (*b* Volterra, 1509; *d* Rome, 4 April 1566). Italian painter, stuccoist and sculptor. Much of the fascination of his career resides in the development of his style from provincial origins to a highly sophisticated manner, combining the most accomplished elements of the art of Michelangelo, Raphael and their Mannerist followers in a distinctive and highly original way. He provided an influential model for numerous later artists in Rome.

The only work to survive from Daniele's early career is a fresco, a political allegory of *Justice*, painted shortly after 1530 for the Palazzo dei Priori in Volterra (now detached, Volterra, Pin. Com.). It reflects the pervasive influence of Sodoma, with whom he is presumed to have studied in Siena. Badly damaged and overpainted, it is a generally clumsy work, demonstrating an inadequate grasp of foreshortening; it exhibits the *difficultà* of manner noted by Vasari.

It is not known exactly when Daniele travelled to Rome, but it is now generally assumed that his initial work there on the villa of Cardinal Agostino Trivulzio at Salone, outside the city, was begun after 1535. Only one portion of this work remains: a loggia decoration consisting of frescoes of gladiatorial games, landscapes and grotesques, as well as stuccowork. The style is decidedly that of the Sienese-born Baldassare Peruzzi, who designed the villa, and with whom Daniele is also thought to have trained. The connection with Peruzzi may well have led to Daniele's involvement here.

Daniele's first work in Rome to show both independence of mind and maturity of style is the frieze decoration depicting scenes from the *Life of Fabius Maximus*, in the *salone* of the Palazzo Massimo alle Colonne, Rome, which was probably started in the late 1530s. The format of the decoration still owes much to Peruzzi (here again the designer of the building) and the earliest scenes recall Daniele's Sienese background and study of works by Peruzzi, Sodoma and Domenico Beccafumi. The more ambitious scenes show the influence of Raphael's biblical frescoes, Michelangelo's muscular figures on the Sistine Chapel ceiling and Sebastiano del Piombo's work. The rhythmical complexity of the most accomplished painting suggests the influence of Perino del Vaga, at work elsewhere in the palace during the late 1530s, when this project is presumed to have begun.

Daniele was characteristically a slow worker, and the development of his style towards Roman Mannerism probably reflects work over a period of several years into the early 1540s. Especially notable in this decoration is the interplay between the dynamic and suave rhythms of the surface design, and the bold spatial excavations, similar to effects in the works of Daniele's rival, Francesco Salviati. Another example of this transitional phase of Daniele's career is the austere *Holy Family with St John the Baptist* (late 1530s; Rome, Pal. Doria–Pamphili). Details of still-tentative drawing and of fracture and touch all echo Sienese precedents, but the composition is derived from Raphael's *Madonna della Rosa* (Madrid, Prado), revised in a manner emphatically reminiscent of the geometric shaping of Michelangelo's *Delphic Sibyl* on the ceiling of the Sistine Chapel (see colour pl. 2, VI1).

During the 1540s Daniele's major work was the decoration of the Orsini Chapel in Trinità dei Monti, Rome, including scenes from the *Legend of the True Cross* (destr.) and his most famous work, the *Deposition* (*c.* 1545; *in situ*; see colour pl. 1, XXVI1). Though this fresco is badly damaged, it still reveals the powerful influence of Michelangelo's sculptural style and of particular motifs derived from his drawings. It was also indebted to paintings of the same subject by Rosso Fiorentino (1521; Volterra, Pin. Com.; *see* ROSSO, FIORENTINO, fig. 1) and Sodoma (*c.* 1500; Siena, Pin. N.). A number of drawings survive that give insight into Daniele's slow, deliberate labour and the growth of his conception towards the monumentality, grandiloquence and immediacy of his religious drama. Its influential combination of Michelangelo's *terribilità* with a Raphaelesque grace of design derived from Perino affected artists as diverse as Federico Barocci and Tintoretto and reverberated well into the next century.

During the same decade Daniele worked in the shadow of Perino on various works in Rome. He added the figures of *St Matthew* and *St Luke* to the fresco cycle in the chapel of the Crucifixion in S Marcello, which had been begun by Perino before the sack of Rome in 1527. He assisted Perino in the decoration of the Sala Regia in the Vatican for Pope Paul III and took over the project when Perino died in 1547, continuing it until the Pope's death in 1549, when work was disrupted. In the late 1540s he executed a brilliant frieze decoration in the Palazzo Farnese, illustrating scenes from the *Life of Bacchus*, adorned with highly imaginative grotesques in the manner of both Peruzzi and

Perino. Closely related to these decorations is Daniele's work in the Vatican in the Stanza della Cleopatra, begun for Pope Julius III in 1550.

The final phase of Daniele's career was dominated by his decoration of the Rovere Chapel in Trinità dei Monti. Executed largely in the early 1550s, the work may have dragged on over several years (Vasari). In the *Assumption of the Virgin* and the *Presentation of the Virgin* (see fig.), particularly, the artist employed bold and indeed stunning forms of illusionism derived from the examples of Raphael and Peruzzi. The figures are decidedly Michelangelesque, some having large, swollen volumes that betray the manner of Sebastiano del Piombo as well. Daniele was assisted on this project by a number of artists, mostly from the circle of Perino, including Pellegrino Tibaldi, Marco Pino, Gaspar Becerra (1520–68), Giovanni Paolo Rossetti (*d* 1586) and Michele Alberti. This phase of his work is closely paralleled by the grand and imposing *Virgin and Child with St John and Female Saint* (*c.* 1548–50; Siena, d'Elci priv. col., see Barolsky, fig. 48).

Another important commission from Daniele's last years, executed with considerable help from assistants, was the decoration of the Ricci Chapel in S Pietro in Montorio, Rome. This was begun *c.* 1555 but not completed until 1568, two years after his death. The scheme included, on the vault, scenes from the *Life of St John the Baptist* and, flanking the altarpiece of the *Baptism*, statues of *St Peter* and *St Paul* to his design. It emulated the decoration of the del Monte Chapel opposite by the Florentines Vasari and Bartolomeo Ammanati. Daniele was similarly influenced by Florentine Mannerism in other works, for example in the paintings he made for Giovanni della Casa during the 1550s. Although these works, including the *David and Goliath* now in Fontainebleau,

are generally derived from drawings by Michelangelo, their polish and finish are close to the manner of Vasari and Salviati.

At the very end of his life Daniele was called on by Pope Paul IV—in the new, stricter spirit of the Counter-Reformation—to overpaint the more obviously 'shameful parts' of the nudes in Michelangelo's *Last Judgement* in the Sistine Chapel (see colour pl. 2, VII3), a commission that has somewhat clouded his reputation. His finest works, however, are brilliant in invention, bold in illusionism and frequently distinguished by exquisite draughtsmanship and artificial, metallic colouring.

BIBLIOGRAPHY
G. Vasari: *Vite* (1550, rev. 2/1568); ed. G. Milanesi (1878–85)
S. Levie: *Der Maler Daniele da Volterra, 1509–1566* (Cologne, 1962)
F. Sricchia Santoro: 'Daniele da Volterra', *Paragone*, ccxiii (1967), pp. 3–34
P. Barolsky: *Daniele da Volterra: A Catalogue Raisonné* (New York and London, 1979)
T. Pugliatti: *Giulio Mazzoni e la decorazione a Roma nella cerchia di Daniele da Volterra* (Rome, 1984)
P. Joannides: 'Drawings by Francesco Salviati and Daniele da Volterra: Additions and Subtractions', *Master Drgs*, xxxii/3 (Autumn 1994), pp. 230–51
A. Zezza: 'Tra Perin del Vaga e Daniele da Volterra: Alcune proposte, e qualche conferma, per Marco Pino a Roma', *Prospettiva*, lxxiii–lxxiv (Jan–April 1994), pp. 144–58
A. Bostrom: 'Daniele da Volterra and the Equestrian Monument to Henry II of France', *Burl. Mag.*, cxxxvii/1113 (Dec 1995), pp. 809–20
PAUL BAROLSKY

Danti. Italian family of artists, scientists and writers. The members of the Danti family (originally the Rainaldi: the name was changed out of admiration for Dante Alighieri) are said to have pursued artistic and literary careers over several generations. Theodora Danti (*fl* early 16th century) was a painter and a pupil of Perugino (Pascoli, pp. 75–9). Like several other family members, she was also distinguished for her love of astronomy and mathematics and for making scientific instruments. Theodora's brother Giulio Danti (1500–75), an architect, goldsmith and metalcaster, was the father of (1) Vincenzio Danti, a leading Florentine Mannerist sculptor, and one of the most distinguished sculptors in 16th-century Italy. Vincenzio also wrote a celebrated treatise on proportion. His younger brother (2) Ignazio Danti, a mapmaker and mathematician, was heir to all his family's manuscripts, none of which is known to have survived. A third brother, Gerolamo Danti (1547–80), was a goldsmith and painter, who frescoed the sacristy of S Pietro in Perugia with scenes from the *Acts of the Apostles*.

(1) Vincenzio [Vincenzo] **Danti** (*b* Perugia, 1530; *d* Perugia, 26 May 1576). Sculptor, architect and writer.

1. LIFE AND WORK. Danti was probably trained by his father, Giulio Danti, and was enrolled in the Perugian guild of goldsmiths in 1548. Pascoli wrote that Danti studied grammar and rhetoric and was sent while still a youth to Rome, where he studied anatomy with Michelangelo and Daniele da Volterra. There is a certain circumstantial plausibility to this account, since Michelangelo was studying anatomy in the late 1540s with Realdo Colombo, the rival of Andreas Vesalius. Even peripheral contact with such circles, which also included Juan de Valverde,

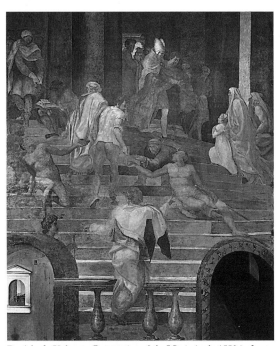

Daniele da Volterra: *Presentation of the Virgin* (early 1550s), fresco, Rovere Chapel, Trinità dei Monti, Rome

whose *Historia del cuerpo humano* (1556) is connected with Danti's later treatise, might explain the beginnings of Danti's interest in the theory and practice of anatomy.

Danti's first commission was the bronze seated statue of *Julius III* (1553–5) outside Perugia Cathedral. It is an exuberantly ornate and ambitious work and shows the impact of Guglielmo della Porta's tomb of *Paul III* in St Peter's, Rome, underway at the same time. Danti's remarkable low-relief style is already fully evident in the allegorical figures encrusting the Pope's vestments.

By 1557 Danti had moved from Perugia to Florence, where he spent most of his short career. Things began auspiciously with a commission for the bronze group *Hercules and Antaeus* to complete Niccolò Tribolo's Fountain of Hercules (*c.* 1550) at the Medici villa at Castello (for illustration *see* TRIBOLO, NICCOLÒ). Opportunity turned to disaster when Danti miscast the group three times. After this failure, he worked at humbler projects in Giorgio Vasari's redecoration of the Palazzo Vecchio. He may also have been associated with Baccio Bandinelli during his first years in Florence, which would have given him the opportunity to learn to carve marble. Bandinelli died in 1560, during the competition for the Fountain of Neptune in the Piazza della Signoria, in which Danti was a participant. In 1561, shortly after this competition, Danti carved his group *Honour Triumphant over Falsehood* (Florence, Bargello; see fig.) for Cosimo I de' Medici's chamberlain, the fellow Perugian Sforza Almeni. This is one of the finest works of 16th-century Italian sculpture and Danti's best work in marble. It is often used to reconstruct missing figures for Michelangelo's tomb of *Julius II*, but, beyond its psychomachic theme, the sculpture bears little relation to Michelangelo's. It is probably not far from Danti's model (untraced) for the Fountain of Neptune and records his assimilation of the styles of Bandinelli and Benvenuto Cellini, and perhaps also that of the paintings of Agnolo Bronzino.

While establishing his reputation as a sculptor in marble, Danti continued to work in bronze. The large relief of *Moses and the Brazen Serpent* (Florence, Bargello), cast in two parts, was completed in late 1559 and may have been associated with the decorations of the Palazzo Vecchio, or with a failed project to make bronze reliefs a part of Bandinelli's choir in Florence Cathedral. Whatever its original destination, the *Brazen Serpent* panel displays a freedom and variety in the treatment of relief, together with a lightness of hand and attenuation of form comparable to the best drawings of Florentine Mannerist artists. In 1560 Danti cast the safe door (Florence, Bargello; see colour pl. 1, XXVII1) for the personal quarters of Cosimo I as part of Vasari's continuing transformation of the Palazzo Vecchio.

The *Honour* group having established his credentials, Danti began a series of marble commissions that occupied him through the next decade. Between 1562 and 1566 he worked at the monument to *Carlo de' Medici* in the cathedral at Prato. This is a stiff reprise of the composition of Michelangelo's *Madonna* in Onze Lieve Vrouw, Bruges, accompanied by two more supple putti and a delicate low relief portrait of *Carlo de' Medici* (*d* 1492). In 1564 Danti began the Medici coat of arms with allegories of *Equity* and *Rigour* and a commanding portrait of *Cosimo I* for the

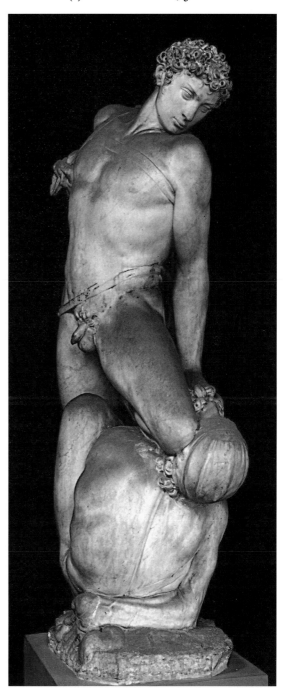

Vincenzio Danti: *Honour Triumphant over Falsehood*, marble, h. 1.9 m, 1561 (Florence, Museo Nazionale del Bargello)

entrance of Vasari's Uffizi. The svelte reclining allegories are still in place, but the large seated allegorical portrait of *Cosimo I* that was to have topped the group ended up as a fountain in the Boboli Gardens. Danti's second attempt, the standing, strongly idealized portrait of *Cosimo I as Augustus* (Florence, Bargello), must have been carved in the early 1570s and was replaced about 10 years later by the present much more straightforward portrait by Giambologna.

During the late 1560s Danti also carved the standing *Virgin and Child* (Florence, Santa Croce), a group outstanding both for its Mannerist abstraction of form, line and surface and for its apparent archaism. Danti in fact seems to have specialized in imitating earlier styles: his portrait of *Carlo de' Medici* recalls 15th-century relief; in the late 1560s he completed Andrea Sansovino's *Baptism* group over the east portal of the Baptistery of Florence Cathedral, and the monument to *Giovanni da Salerno* in S Maria Novella is the most extreme of all his essays in the duplication of earlier styles.

Danti was closely connected to the Florentine Accademia del Disegno from the time of its foundation in 1563. He served as an officer in the Accademia and contributed works to its various enterprises. He was involved in the planning of the funeral of Michelangelo in 1564, for which he made an allegorical painting, *Fame Triumphant over Death and Time*, and a sculpture, *Genius Overcoming Ignorance*. Danti modelled an equestrian portrait of *Cosimo I* for the wedding decorations of Francesco I de' Medici and Joanna of Austria in 1565 and made a statue of *St Luke* for the Accademia's Cappella di S Luca in the SS Annunziata in 1571, the only one of these works to survive.

During his final years in Florence, Danti returned to bronze sculpture on a monumental scale, completing the *Beheading of St John the Baptist* group over the south portal of the Baptistery in 1571. This is one of the masterpieces of what can properly be called Mannerist sculpture and combines Danti's virtuosity and inventive mastery of modelling in wax with the restrained statement of volume of his works in marble. In the same late period, and in a similar vein, he also cast the small bronze statue *Venus Anadyomene* for the *studiolo* of Francesco I in the Palazzo Vecchio.

In 1572 Danti made an oval plan (untraced) for the church of the Escorial for Philip II (*reg* 1556–98) and was invited to Spain. Just when his career seemed to be ascending, however, he returned to Perugia, where he married. While in Florence, Danti had worked from time to time in Perugia, and on 20 July 1573 he was appointed architect of his native city. He helped establish the Perugian Accademia del Disegno, to which he donated casts of Michelangelo's statues the *Four Times of Day* in the Medici Chapel, S Lorenzo, Florence.

2. WRITINGS. Danti became a member of the literary Accademia Fiorentina in September 1565. In April 1567 he dated the dedication to Cosimo I of *Il primo libro del trattato delle perfette proporzioni* . . . This was to have been the theoretical introduction to an unrealized work of 15 books, an encyclopedic presentation of the arts of design centring on human anatomy. The importance given to human anatomy itself relates Danti's scheme to the art of Michelangelo, to the authority of which he repeatedly appealed. Danti argued from a distinction between what he called portraying (*ritrarre*) and imitation (*imitare*). The first of these is the simple copying of appearances, an option rejected on the generally Neo-Platonic grounds that actual things are almost always imperfect. Therefore it is necessary to have recourse to higher knowledge, to imitate. Danti's distinction between *ritrarre* and *imitare*

parallels that between history and poetry made in Aristotle's *Poetics*, just coming into the full flood of its influence after its translation in 1548. Poetry is general and philosophical, history is particular, and the arts of design, like poetry, are properly grounded in philosophical understanding. This higher understanding can be attained either by imitating works judged to be perfect or by discerning the ends nature intended to achieve in bringing imperfect individual things into existence. All things inanimate and animate are in a more or less perfect proportion to the end discernible in them. In animals the end is local movement, the evident activity of the soul. The highest form of animal movement is human movement, which is free and rational. Beautiful forms are those fully suited to their ends, and these should be imagined and imitated by the artist. Danti's 'perfect proportion' is thus continuous with the teleological explanation basic to speculation on anatomy from Aristotle and Galen through the Renaissance. Danti's deep knowledge of anatomy is certain. He claimed to have performed 83 dissections in preparation for his book, and he obtained several cadavers between 1567 and 1570. Michelangelo's art may be imitated, in short, because it displays a perfect knowledge of anatomy and therefore a grasp of the nature of things concentrated in the microcosmic human soul. The academician Danti thus avoided the anti-canonical side of Michelangelo's poetic art in favour of its philosophical and teachable side. It was perhaps during Danti's last years in Perugia that he wrote the apparently now untraced autobiography in *terza rima* and the lives of the modern sculptors attributed to him by Pascoli (pp. 143, 293).

WRITINGS

Il primo libro del trattato delle perfette proporzioni di tutte le cose che imitare e ritrarre si possano con l'arte del disegno (Florence, 1567), repr. with a critical commentary in P. Barrocchi, ed.: *Trattati d'arte del cinquecento fra Manierismo e Controriforma* (Bari, 1960), pp. 207–69

BIBLIOGRAPHY

DBI; Thieme–Becker
G. Vasari: *Vite* (1550, rev. 2/1568); ed. G. Milanesi, vii (1881), pp. 630–33
L. Pascoli: *Le vite de' pittori, scultori ed architetti perugini* (Rome, 1732), pp. 75–9, 137–43
J. Pope-Hennessy: *Italian High Renaissance and Baroque Sculpture* (1963, rev. 3/1986), iii of *Introduction to Italian Sculpture* (Oxford, 1955–63), pp. 377–80
S. Rossi: 'Il *Trattato delle perfette proporzioni* e l'incidenza della *Poetica* sulle teorie artistiche del secondo cinquecento', *Stor. A.*, xiv (1972), pp. 127–47
D. Summers: *The Sculpture of Vincenzio Danti* (New York and London, 1979)
——: *Michelangelo and the Language of Art* (Princeton, 1981)
M. Daly Davis: 'Beyond the "Primo Libro" of Vincenzo Danti's *Trattato delle perfette proporzioni*', *Mitt. Ksthist. Inst. Florenz*, xxvi/1 (1982), pp. 63–89
G. B. Fidanza: *Vincenzo Danti, 1530–1576* (Florence, 1996)

DAVID SUMMERS

(2) Ignazio [Egnazio] Danti (*b* Perugia, 1536; *d* Alstri, nr Rome, 1586). Mapmaker, mathematician, architect and instrument-maker, brother of (1) Vincenzio Danti. He entered the Dominican Order in 1555. In 1562 Cosimo de' Medici, to whom he had probably been presented by Vincenzio, commissioned him to paint a set of maps of the world on the doors of the cabinets in the Guardaroba of the Palazzo Vecchio, Florence, and to create a large

terrestrial globe (the largest now in existence, which was finished in 1567 and stands in the centre of the room). So well satisfied was Cosimo that he won permission from the Dominicans for Ignazio to live in his palace. In the early 1570s Ignazio was engaged on astronomical research and was a member of Pope Gregory XIII's commission to reform the calendar. He became increasingly interested in perspective and in 1573 published the *Prospettiva di Euclide*, together with the previously unpublished *Prospettiva di Eliodoro Larisseo*, an annotated translation that includes a description of the camera obscura and of a method of correcting images by using mirrors.

Francesco I de' Medici dismissed Danti from his court, and he moved to Bologna, where he became Professor of Mathematics from 1576 to 1584. He was the architect of a chapel in S Domenico, Bologna, and painted maps in the Palazzo del Podestà. In 1577 he went to Perugia to draw a map of the city and its environs; this was published in Rome in 1580 and by order of the Pope was later extended to cover the entire Papal States. In 1578 he filled a sketchbook (Bologna, Bib. Com. Archiginnasio, Gozzadini col.; pubd 1867) with drawings of the villas, castles and churches around Bologna. Gregory XIII called him to Rome in 1580 to work on the final stages of the calendar reform and in the same year commissioned him to paint maps of the various regions of Italy, in thirty-two large panels and eight smaller ones in the Galleria delle Carte Geografiche in the Vatican. This work was finished in 1583, and in the same year Danti published Jacopo Vignola's *Le due regole della prospettiva pratica*, to which he added a long and learned commentary and a biography of Vignola; this became his best-known and most influential work and suggests the interrelationship between the interest in perspective of painters and mathematicians in this period. In November 1583 he was called to Rome by Pope Sixtus V to advise on the restoration of the Porto Claudio at Fiumicino, and to work with Domenico Fontana on transferring the Vatican obelisk from the former Circus of Nero, south of St Peter's, to the centre of St Peter's Square.

BIBLIOGRAPHY

S. Mazzetti: *Repertorio di tutti i professori ecc.* (Bologna, 1847), p. 110
P. Riccardi: *Biblioteca matematica italiana* (Modena, 1870–76)
M. Fanti: *Ville, castelli e chiese bolognesi da un libro di disegni del cinquecento* (Bologna, 1967)
M. L. Bonelli: 'Danti, Egnazio (Pellegrino Rainaldi)', *Dictionary of Scientific Biography*, ed. C. C. Gillespie, iii (New York, 1971), pp. 558–9
G. Roversi: 'Il patrimonio fondiario dei Tanari a Gággio Montano e nel Belvedere', *Strenna Stor. Bologn.*, xxiv (1974), pp. 260–62

GIORGIO TABARRONI

Dario da Pordenone. *See* DARIO DA TREVISO.

Dario (di Giovanni) da Treviso [Dario da Pordenone] (*fl* 1440; *d* before 1498). Italian painter. Described in a Paduan document of 1440 as *pictor vagabundus* (itinerant painter), he is also mentioned as being employed in the workshop of Francesco Squarcione. Still in Padua, he next moved on to work in the shop of the Milanese artist Pietro Maggi. Around 1448 he moved to Treviso, where in 1455 he married Ginevra Ziliolo, daughter of an otherwise unknown painter whose workshop he inherited. He is subsequently recorded in Treviso, Asolo, Bassano, Cone-

gliano and Serravalle, working mainly as a fresco painter. In two of his early works, the *Crucifixion* (fresco; Treviso, Mus. Civ. Bailo) and another *Crucifixion* (fresco, 1453; Treviso, S Francesco), the influence of Squarcione and of Dario's Ferrarese background—this latter already seen in the painter's earlier *St Christopher* (panel; Venice, Ca' d'Oro)—acquires softer tones. Similar tendencies are evident in the *Madonna of Humility* (1459; Asolo, Mus. Civ.), while in the fresco cycle in S Gottardo, Asolo, painted over several years, particular characteristics emerge, as, for example, in the *St Blaise*, where clear affinities with the school of Paolo Uccello can be seen. In other parts of the decoration Late Gothic elements are evident. The Tuscan tendencies disappear in such later works as the dated *Virgin and Child* (1492; Asolo Cathedral), where the linear, decorative manner of his early education can be discerned, fixed within a figurative repertory destined to be of great influence in the Treviso area as far as Friuli and recognizable in such works as the *Virgin and Child with Saints* (fresco; Schio, S Francesco).

BIBLIOGRAPHY

G. Vasari: *Vite* (1550, rev. 2/1568); ed. G. Milanesi (1878–85), iii, p. 358
J. A. Crowe and G. B. Cavalcaselle: *A History of Painting in North Italy*, ii (London, 1871, rev. 1912), pp. 54–8
G. B. Cavalcaselle: *La pittura friulana del rinascimento* (Friuli, 1876, rev. Vicenza, 1973)
G. Gerola: 'Dario pittore', *Miscellanea di studi in onore di A. Ortis*, ii (Trieste, 1910), pp. 871–87
I. Furlan: 'Dario da Pordenone', *Noncello*, xxviii (1969), pp. 3–32
——: 'Dario da Pordenone', *Dopo Mantegna: Arte a Padova e nel territorio nei secoli XV e XVI* (exh. cat., Padua, Pal. Ragione, 1976), p. 27
M. Boskovits: 'Ricerche su Francesco Squarcione', *Paragone*, xxviii/325 (1977), pp. 40–70

UGO RUGGERI

Dattaro. Italian family of architects. Francesco Dattaro (*d* ?1585) and his son Giuseppe Dattaro (*d* ?Guastalla, *c.* 1619), both of whom acquired the nickname Pizzafuoco, were from Cremona, where most of their few attributable works are situated. Francesco's career is the more prominent and more securely documented. At Cremona Cathedral he was responsible for the chapel of the Sacrament and the chapel of the Assumption (*c.* 1556), both elaborate sculptural works of an almost Baroque character. He also designed the more restrained and classical altar of St Michael in the cathedral. His work is more sculptural and decorative than architectural, although the Palazzo Pagliari (1566) in Cremona is usually attributed to him. It is a substantial building, the façades of which are crowded with Mannerist detail. Particularly notable are the ornate window pediments, the various forms of rustication and the small blind windows to the *piano nobile*. The interior is much simpler.

Francesco was closely associated with Vincenzo Campi, who in turn collaborated with Giulio Romano on the Palazzo del Te for the Gonzaga court at Mantua. Giulio may well have been the source for much of Francesco's own Mannerist detailing. Giuseppe's style is similar to that of his father, and the monumental Palazzo Affaitati (1561; later Palazzo Ugolani Dati; now the Museo Civico Ala Ponzone) in Cremona is probably his work. It is similar in character to the Palazzo Pagliari although rather more austere and Florentine in appearance, particularly in its principal façade. In 1583 Giuseppe left Cremona to enter

the service of Ferdinand II Gonzaga (*d* 1630) and went to Guastalla to work on his palace; he seems to have spent some years in the service of the Gonzaga.

BIBLIOGRAPHY

A. Haupt: *Architettura dei palazzi dell'Italia settentrionale e della Toscana dal sec. XIII al sec. XVII*, 3 vols (Milan and Rome, n.d.)
G. B. Zaist: *Notizie istoriche de' pittori, scultori ed architetti cremonesi* (Cremona, 1875)
A. Venturi: *Storia* (1901–40)
A. Perotti: *I pittori Campi da Cremona* (Milan, 1932)
M. Tafuri: *L'architettura del manierismo nel cinquecento italiano* (Rome, 1966)
A. Smart: *The Renaissance and Mannerism in Italy* (London, 1971)

□

Deferrari, Defendente. *See* FERRARI, DEFENDENTE.

Dei, Pietro di Antonio. *See* BARTOLOMEO DELLA GATTA.

Delamayne, John. *See* MAIANO, DA, (3).

Delitio, Andrea (*fl* Abruzzo, *c.* 1440–80). Italian painter. His career has been reconstructed on the basis of his one surviving signed and dated work, a gigantic image of *St Christopher* (1473) on the façade of S Maria Maggiore in Guardiagrele. He is known to have painted frescoes in 1450 for S Francesco in Sulmona and two panels for S Maria Maggiore in 1463 and 1467 (all untraced). On the basis of the *St Christopher*, he has been credited with a cycle of frescoes on the *Life of the Virgin* (*c.* 1480; Atri Cathedral), two frescoes of the *Virgin and Child* (L'Aquila, S Amico; Sulmona, Pal. Sanità), a diptych of the *Crucifixion* and *Virgin and Child with a Saint* (L'Aquila, Mus. N. Abruzzo) and a triptych of the *Virgin and Saints* (Baltimore, MD, Mus. A.). In these works Delitio appears as a Late Gothic provincial master, rather backward by comparison with painters working in the large cities, his style characterized by linear, swirling folds of drapery and landscape backgrounds of stylized mountains crowned with castles. More modern Renaissance elements are evident in the plasticity of his figures and in some experimentation with fragile perspective structures. The latter feature led some scholars to conjecture that he may have been in Florence *c.* 1440–50, in contact with such first-generation Renaissance painters as Fra Filippo Lippi and Paolo Uccello. In those years the last of the painters who developed in the Late Gothic period were still active, for example Masolino da Panicale, who was once thought to have painted the *Annunciation* from the Lehman collection (New York, Met.) that is now attributed to Delitio.

BIBLIOGRAPHY

E. Carli: 'Per la pittura del '400 in Abruzzo', *Riv. Ist. N. Archeol. & Stor. A.*, ix/1–3 (1942), pp. 164–211
F. Bologna: 'Andrea Delitio', *Paragone*, i/5 (1950), pp. 44–50
G. Romano: 'A. Delitio', *Petit Larousse de la peinture*, i (Paris, 1979), pp. 450–51

MINA BACCI

Dellaurana, Luciano. *See* LAURANA, LUCIANO.

Delli, Dello (di Niccolò) (*b* Florence, *c.* 1404; *d* Spain). Italian painter and sculptor, active also in Spain. Nothing is known of his training in painting and sculpture. Vasari attributed to him the terracotta *Coronation of the Virgin* in the tympanum of a portal at S Maria Nuova, Florence; in 1424 Bicci di Lorenzo was paid for painting the figures. Stylistically it is related to Ghiberti's figural forms. Vasari also indicated that Dello was responsible for paintings on furniture, although no attributable examples survive. In 1424 Dello moved to Siena with his father Niccolò, who had been exiled from Florence for having failed in his role of civil guardian of the Rocca di Montecerro by surrendering it to Filippo Maria Visconti, Duke of Milan. In 1425 Dello was commissioned to make a figure of a man in bronze to strike the bell in the Torre del Mangia of the Palazzo Pubblico of Siena, but he seems to have left the city before carrying out the work.

In 1427 Dello moved with his father and his brother Sansone to Venice, where he stayed until 1433. This has led to the suggestion that he may have worked in Uccello's workshop both in the Veneto and also later in Florence in the Chiostro Verde, S Maria Novella. In 1433 he enrolled in the Arte dei Medici e degli Speziali in Florence, which would suggest that he was active as a painter in Florence; however, in the same year he left for Spain with his brother Sansone. His career as a painter in Spain was apparently enormously successful, and by 1446 he was negotiating to be knighted. He returned to his native city in 1447, was knighted in 1448 and seems to have left again for Spain. No documented works survive from Dello's career in Spain, although a long painted rotulus, or scroll, is recorded depicting the *Battle of Higuezuela* in 1431; this painting was reportedly signed *Dello eques florentinus*, which would place it after 1448. Paintings attributed to Dello in Salamanca Cathedral are actually by his brother Niccolò. The date of Dello's death is unknown.

BIBLIOGRAPHY

F. Quilliet: *Le arti italiane in Ispagna* (Rome, 1825)
G. Milanesi: *Documenti per la storia dell'arte senese*, ii (Siena, 1854), p. 290, no. 204n
M. Gómez Moreno: 'Maestre Nicolao Florentino y sus obras en Salamanca', *Archv Esp. A. & Arqueol.*, iv (1928), pp. 1–24
G. Fiocco: 'Dello Delli, scultore', *Riv. A.*, xi (1929), pp. 25–42
M. Salmi: 'Un'opera giovanile di Dello Delli', *Riv. A.*, i (1929), pp. 104–10
G. Gronau: 'Il primo soggiorno di Dello Delli in Spagna', *Riv. A.*, xiv (1932), pp. 385–6
G. Pudelko: 'The Minor Masters of the Chiostro Verde', *A. Bull.*, xvii (1935), pp. 71–89
U. Middeldorf: 'Dello Delli and *The Man of Sorrows* in the Victoria and Albert Museum', *Burl. Mag.*, lxxviii (1941), pp. 71–8
J. Rubio: 'Alfons El Magnanim, Rei de Napols, I Daniel Florentino, Leonardo da Bisuccio I Donatello', *Misc. Puig & Cadafalch*, i (1947), pp. 25–35
G. Fiocco: 'Il mito di Dello Delli', *Arte in Europa: Scritti di storia dell'arte in onore di Edoardo Arslan* (Milan, 1966), pp. 341–9
A. Condorelli: 'Precisazioni su Dello Delli e su Nicola Fiorentino', *Commentari*, xix (1968), pp. 197–211
M. Lisner: 'Intorno al Crocifisso di Donatello in Santa Croce', *Donatello e il suo tempo* (Florence, 1968), pp. 122–5
A. Parronchi: 'Probabili aggiunte a Dello Delli scultore', *Cron. Archeol. & Stor. A.*, viii (1969), pp. 103–10
J. Beck: 'Masaccio's Early Career as a Sculptor', *A. Bull.*, xii (1971), pp. 177–95
E. Casalini: 'Un *Calvario* a fresco per la *Pietà* di Dello Delli', *La SS Annunziata di Firenze* (Florence, 1971), pp. 11–24
R. Lunardi: *Arte e storia in Santa Maria Novella* (Florence, 1983)
B. Borngässer: 'Die Apsisdekoration der alten Kathedrale zu Salamanca und die Gebrüder Delli aus Florenz', *Mitt. Ksthist. Inst. Florenz*, xxxi (1987), pp. 237–90

JOHN T. PAOLETTI

Demayanns [Demyans], **John.** *See* MAIANO, DA, (3).

Demio [de Mio; Fratina; Fratini; Fratino; Visentin], **Giovanni** (*b* Schio, *c.* 1510; *d* ?Cosenza, *c.* 1570). Italian painter and mosaicist. He is first recorded in 1537 collaborating with Vincenzo Bianchini (1517–63) on mosaic work in S Marco, Venice, and he also worked as a mosaicist in 1538 and 1539 in the Camposanto, Pisa. In the *Martyrdom of St Lawrence* (Torrebelvicino, Vicenza, parish church), possibly an early work, his style reflects not only the Tuscan Mannerism of Giorgio Vasari and Francesco Salviati, both of whom Demio had probably met in Venice in 1542, when he was still working at S Marco, but also the Tusco–Roman manifestation of the style as seen in the work of Salviati, Jacopino del Conte, Pirro Ligorio and Battista Franco in the oratory of S Giovanni Decollato, Rome.

Demio was called to Milan by the Marchese del Vasto, and there he executed some frescoes (formerly attributed to Simone Peterzano) and an altarpiece depicting the *Crucifixion* in the Sauli Chapel, S Maria delle Grazie. These works are closely modelled on the style of Giulio Romano, both directly and as interpreted by Maarten van Heemskerck, and seem also to reflect the influence of Paris Bordone. Demio next travelled to Naples, perhaps at the request of Vasari, whose *Presentation in the Temple* (Naples, S Anna dei Lombardi) he copied, with certain variations, for the parish church at Maiori. Around 1550 he executed some frescoes for the Villa Thiene, Quinto Vicentino, commissioned by Palladio, who regarded him as a 'man of very fine talent'. In 1556 he painted three allegorical tondi in the Libreria Marciana, Venice, which again show strong links with Romano and also with Giulio Clovio. His patrons, the Grimani family, recommended him to the authorities of Orvieto Cathedral for the task of restoring the mosaics on the façade, but he soon returned to the Veneto, where in 1558 he executed two altarpieces for S Maria in Vanzo, Padua.

Demio subsequently travelled to Central Italy, where he probably worked on the *Last Judgement* (Farfa Abbey, near Rieti) that was signed in 1561 by Hendrik van den Broeck (*c.* 1530–97), with whom he later collaborated in Rome. In 1570 he was working at Cosenza. Even in his late works, Demio adhered to the Mannerist tradition, albeit interpreted in a highly personal way and within the context of the Netherlandish influences then prevailing in Rome.

BIBLIOGRAPHY

G. Guglielmi: 'Profilo di Giovanni Demio', *A. Ven.*, xx (1966), pp. 98–111

G. Bora: 'Giovanni Demio', *Kalòs*, ii (1971), pp. 17–23

——: 'La cultura figurativa a Milano, 1535–1565', *Omaggio a Tiziano: La cultura artistica milanese nell'età di Carlo V* (exh. cat., Milan, Pal. Reale, 1977), pp. 45–54

P. L. De' Vecchi: 'Nota su alcuni dipinti di artisti veneti per committenti milanesi', ibid., pp. 55–58

G. Previtali: *La pittura del cinquecento a Napoli e nel vicereame* (Turin, 1978)

V. Scarbi: 'Aspetti della maniera nel Veneto', *Paragone*, xxxi/369 (1980), pp. 65–80

——: *Palladio e la maniera: I pittori vicentini del cinquecento e i collaboratori del Palladio* (Venice, 1980)

——: 'Giovanni Demio', *Da Tiziano a El Greco: Per la storia del manierismo a Venezia, 1540–1590* (exh. cat., Venice, Doge's Pal., 1981), pp. 123–9

UGO RUGGERI

Demyans, John. *See* MAIANO, DA, (3).

Dente [da Ravenna], **Marco** (*b* Ravenna; *d* Rome, 1527). Italian engraver. He was active in Rome during the early 16th century. Some early writers confused him with Silvestro da Ravenna, and his family name was unknown until its rediscovery by Zani. He studied with Marcantonio Raimondi and was strongly influenced by the latter's style. He often collaborated with Agostino Veneziano, another Marcantonio student who also had some influence on Dente's work. Dente was evidently born in Ravenna, although his birth date is undocumented. His earliest signed and dated print is inscribed 1515, suggesting that he was active from *c.* 1510 and was probably born in the late 15th century. He was killed in the Sack of Rome in 1527.

Dente produced over 60 reproductive engravings, primarily after works by Raphael and his circle and after the Antique. Occasionally he made engravings after other artists, such as the *Massacre of the Innocents* (1520–21; B. 21) after Baccio Bandinelli. He engraved several copies after Marcantonio prints that were based on Raphael designs. Two examples of this, the *Massacre of the Innocents* (B. 20) and *Judgement of Paris* (B. 246), were considered by Bartsch to be among Dente's best works. Other engravings may derive directly from Raphael drawings, such as the *Venus Wounded by the Rose's Thorn* (B. 321). Dente's only print to include an inscription with his full name (MARCVS RAVENAS), rather than a monogram, is his engraving after the *Laokoon* (B. 353), which shows the antique statue before its restoration.

BIBLIOGRAPHY

G. Vasari: *Vite* (1550, rev. 2/1568); ed. G. Milanesi (1878–85)

G. Gori Gandellini: *Notizie istoriche degli'intagliatori*, iii (Siena, 1771), pp. 144–5; xii (Siena, 1818), pp. 233–42

K. H. Heinecken: *Dictionnaire des artistes dont nous avons des estampes avec une notice detaillée de leurs ouvrages gravés* (Leipzig, 1778–90), i, pp. 642ff

P. Zani: *Enciclopedia metodica critico-ragionata delle belle arti* (Parma, 1820), ii, part 5, p. 327

G. K. Nagler: *Neues allgemeines Kunstler-Lexikon oder Nachrichten von dem Leben und den Werken der Maler, Bildhauer, Baumeister* (Munich, 1835–52), xiv, pp. 6–27

——: *Die Monogrammisten* (Munich and Leipzig, 1858–1920), ii, no. 2373; iv, no. 3468; v, no. 265

K. Oberhuber: *Die Kunst der Graphik II: Renaissance in Italien 16. Jahrhundert* (Vienna, 1966), pp. 107–9

S. Ferrara and G. Gaeta Bertelà: *Incisori bolognesi ed emiliani del sec. XVI* (Bologna, 1975), nos 175–226

K. Oberhuber, ed.: *The Works of Marcantonio Raimondi and of his School (1978)*, 26 [XIV/i] and 27 [XIV/ii] of *The Illustrated Bartsch* (New York, 1978–) [B.]

BABETTE BOHN

Denti, Girolamo (*b* ?Venice, *c.* 1510; *d* ?Venice *c.* 1572). Italian painter. He was in Titian's workshop, probably from about 1520, and became his most prominent assistant, signing himself *di Tiziano*. His fame is based mainly on two paintings traditionally ascribed to him: the *Four Seasons* (Paris, priv. col.) and the *Holy Family with Donors* (Dresden, Gemäldegal. Alte Meister), both executed between 1540 and 1550. In the early 1530s he painted a *Virgin and Child Enthroned with Saints* for Ceneda Cathedral, and about ten years later he sent another altarpiece of that subject (Monópoli, Vescovado) to Apulia. A portrait of the *Two Pesaro Brothers* (1540s; United Kingdom, priv. col., see 1983 exh. cat., no. 120), once assigned to Titian, belongs to the same period, as does *SS Andrew, Sebastian and Roch* (Mel, nr Belluno, parish church) and *SS Mark, Leonard and Francis* (Ancona, Pin. Com.).

In 1557 Denti received the commission for the official portrait of *Doge Lorenzo Priuli* (sold London, Sotheby's, 28 April 1971) and for the huge *Annunciation* (1557–61; Venice, Accad., on dep. Mason Vicentino) in the Scuola della Carità in Venice, the companion piece to Titian's *Presentation of the Virgin* (Venice, Accad.). The *Annunciation* is a theatrical work, recalling perhaps his documented activity as a scene painter, and reveals various influences, from Andrea Palladio to Raphael and Lorenzo Lotto. Denti's sensitivity to the works of Paris Bordone is seen in the *Virgin and Child with Saints* (1559; Venice, Accad.), once in Belluno. The clear reference to the style of Schiavone in these paintings suggests assigning to Dente also the *SS Caterina and Veneranda* (Torcello, Mus. Torcello). Among other works of the favourite collaborator of Titian, one can also consider the *Madonna and Child with Two Angels* for the church of Pilastrello at Lendinara, and a *Sacra conversazione* (Vienna, priv. col.), thought by Benesch to be a late work of Lorenzo Lotto. Between 1560 and 1570 Denti reached the height of his career, narrowly missing a commission from Philip II, King of Spain (*reg* 1556–98), to paint a copy of Titian's *Martyrdom of St Lawrence* (Madrid, Escorial). He is last mentioned in 1566, when he may have been the main executant, with Marco Vecellio and Emanuele d'Augusta, of the frescoes (destr.) after Titian's cartoons in the arch-diaconal church of Pieve di Cadore.

BIBLIOGRAPHY

G. Vasari: *Vite* (1550, rev. 2/1568); ed. G. Milanesi (1878–85), vii, p. 468

M. R. Fisher: *Titian's Assistants during the Later Years* (New York, 1977), pp. 31–42

F. Heinemann: 'La bottega di Tiziano', *Tiziano e Venezia*, ed. N. Pozza (Vicenza, 1980), pp. 434–5

D. Rosand: *Painting in Cinquecento Venice: Titian, Veronese, Tintoretto* (New Haven and London, 1982)

The Genius of Venice, 1500–1600 (exh. cat., ed. J. Martineau and C. Hope; London, RA, 1983)

S. Claut: 'All'ombra di Tiziano', *Ant. Viva*, 5–6 (1986), pp. 16–29

——: 'Feltre e Belluno', *La pittura nel Veneto. Il Cinquecento*, ed. M. Lucco, ii (Milan, 1998), p. 727

SERGIO CLAUT

Dentone, il. *See* RUBINO, GIOVANNI.

Dermyans, John. *See* MAIANO, DA, (3).

Deruta. Italian centre of maiolica production. It was the main centre of pottery production in Umbria during the Renaissance. A document of 1358 records the sale of ceramic wares to the convent of S Francesco in nearby Assisi, although potteries probably existed in Deruta even earlier. Between *c.* 1490 and 1550 production increased in quantity and quality, and plain and decorated wares were supplied to a wide market (*see* ITALY, fig. 28). By the early 16th century 30 to 40 kilns were in operation, of which only three or four used the metallic gold and red lustres for which Deruta and Gubbio are renowned. As in Gubbio, lustres were applied to local wares and to those brought from such other centres of production as Urbino for this specialized finish. In addition to lustred ceramics, quantities of polychrome maiolica were produced, the predominant colours of which are yellow, orange and blue (see colour pl. 1, XXVII3).

The tin-glazed earthenware produced at Deruta in the 16th century was noted for a conservatism and consistency, both in style and shape, which was probably engendered by its geographical isolation. The large, deep dishes, known as *piatti da pompa*, painted with idealized portraits of women or men set within formalized floral and geometric borders (e.g. of *c.* 1500–40; London, BM), were particularly popular. Other common subjects for these dishes were images of SS Francis, Jerome and Rocco, the Virgin, angels, equestrian figures or scenes based on local fables, allegories or proverbs. Products from Deruta of this period also include polychrome drug jars decorated with complex floral and grotesque designs, moulded plates with relief patterns and *istoriato* wares with religious, historical, literary or mythological subjects.

Giacomo Mancini (*fl c.* 1540–60; known as 'El Frate') was the most notable Deruta *istoriato* painter and one of the few who signed his works. His dated pieces were made between 1541, when he came to Deruta from Urbino, and 1545, although it is likely that he was responsible for some important tile pavements of the 1560s. His work, typified by a signed plate with the subject of *Alexander and Roxanne* (*c.* 1540–50; Paris, Petit Pal.), is characterized by a stylized linearity and somewhat awkward spatial conception.

BIBLIOGRAPHY

L. De-Mauri: *Le maioliche di Deruta* (Milan, 1924)

C. Fiocco and G. Gherardi: 'Contributo allo studio della ceramica derutese', *Faenza*, lxix (1983), pp. 90–93

Ceramiche umbre dal medioevo allo storicismo, i (Faenza, 1988)

WENDY M. WATSON

Desiderio da Firenze (*b* Florence; *fl* 1532–45). Italian sculptor and bronze-founder. He probably trained in Padua and Florence, and he worked extensively in Padua until at least 1545. He was noted for his bronze sculptures, and his workshop produced such decorative objects as inkwells and candlesticks. It is difficult to establish the attributions of these small bronze pieces, but it is certain that Desiderio created the bronze voting urn (1532–3; Padua, Mus. Civ.; see fig.) commissioned by the Maggior Consiglio of the Comune of Padua. Payments to him are documented in 1532–3. The style of the tripartite bronze urn, which combines Florentine clarity with hints of Venetian models, seems more indebted to Andrea Verrocchio than, as has been suggested, to Andrea Riccio. On the three-faced base there are putti bearing the Comune's coat of arms; the upper sections display an intricate arrangement of motifs, including lions of St Mark, dolphins, *grotteschi* and garlands. The urn is considered to be one of the best poured bronzes of 16th-century Padua.

In 1537 Pietro Bembo recommended Desiderio for the commission to execute the cover for the baptismal font in S Marco in Venice (*in situ*), for which the contract was signed in 1545. He collaborated with the Paduan sculptor Tiziano Minio (*c.* 1511–52), but their specific roles are not known, and Desiderio may have functioned solely as the founder. According to Planiscig, although Desiderio distinguished himself as a bronze-founder, he became sufficiently original as a sculptor to move beyond the essentially 15th-century style of Riccio. Stylistic analysis of his work is complicated by problems of attribution. Venetian influence came from both Riccio and Jacopo Sansovino, but

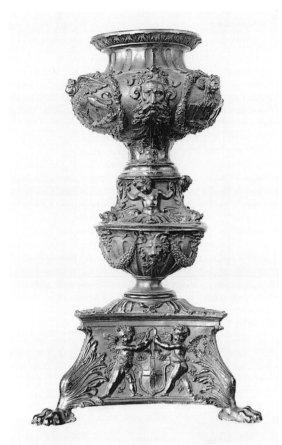

Desiderio da Firenze: *voting urn*, bronze, partly gilt, h. 510 mm, 1532–3 (Padua, Museo Civico)

his Tuscan links remained strong, and the influence of Verrocchio should not be discounted.

BIBLIOGRAPHY
L. Planiscig: 'Desiderio da Firenze: Dokumente und Hypothesen', *Z. Bild. Kst*, lxiv (1930–31), pp. 70–78
W. Wixom: *Renaissance Bronzes from Ohio Collections* (exh. cat., Cleveland, OH, Mus. A., 1975)
A. Radcliffe: 'Desiderio da Firenze', *The Genius of Venice, 1500–1600* (exh. cat., ed. J. Martineau and C. Hope; London, RA, 1983)
J. Carrington: 'A New Look at Desiderio da Firenze and the Paduan Voting Urn', *Boll. Mus. Civ. Padova* lxxiii (1984), pp. 105–45
D. Banzato and F. Pellegrini: *Bronzi e placchete dei Musei Civici di Padova*, (Padua, 1989) □

Desiderio da Settignano (*b* Settignano, nr Florence, 1429–32; *d* Florence, *bur* 16 Jan 1464). Italian sculptor. His career lasted only about 12 years, but during that time he produced some of the most delicate and intimate sculptural works of mid-15th-century Florence. There are problems of dating and attribution even with his partially documented works, and records survive of several unidentifiable commissions; consequently, it is difficult to chart the course of his stylistic development, and the reliefs and portrait busts attributed to him are grouped around two works: the tomb of *Carlo Marsuppini* (Florence, Santa Croce) and the sacrament tabernacle (Florence, S Lorenzo).

1. Life and work. 2. Workshop.

1. LIFE AND WORK. He was the son of Bartolommeo di Francesco, described after 1451 as a stone-carver. His two elder brothers, Francesco (*b* 1413) and Geri (*b* 1424), were stone masons, in whose guild, the Arte dei Maestri di Pietro e Legname, Francesco matriculated in 1447 and Geri in 1451. At that date Desiderio was too young to join the guild independently. He finally matriculated in 1453 and in the same year, with Antonio Rossellino, assessed Buggiano's pulpit in S Maria Novella, Florence. His initial training was probably with members of his family, but it is possible that he was associated with Donatello at an early stage of his career, since Vasari stated that the frieze of terracotta putti heads on the façade of the Pazzi Chapel, Santa Croce, was the joint work of Donatello and Desiderio. There is also a constant reflection in Desiderio's oeuvre of Donatello's sculpture, particularly in technique. It has been proposed that he was an assistant in Bernardo Rossellino's shop (Markham, 1963), but Desiderio's exuberant decorative detail on, for example, the *Marsuppini* tomb, is closer in spirit to Donatello than the drier, more severe handling of Bernardo Rossellino. According to Vasari, Desiderio made a marble base (untraced) decorated with harpies and bronze swags for Donatello's bronze *David* (Florence, Bargello; see colour pl. 1, XXIX1); however, an attempt to identify the base, which presumably would have been commissioned in the 1450s, with the lavabo in the sacristy of S Lorenzo (Passavant, 1981) is not convincing. In November 1453 Desiderio was ordered to make 12 'heads' for Giovanni de' Medici's study, for which he was paid in 1455. These have been associated with reliefs of the *Heads of the Roman Caesars* such as, for instance, *Julius Caesar* (Paris, Louvre) and with several profile heads of emperors in marble copied after Desiderio (Middeldorf, 1979). In 1455 Desiderio was also paid for a Madonna, in 1456 for two basins and a mantelpiece and in 1458 for 'heads'; none of these works has been identified.

The tomb of *Carlo Marsuppini* (see fig. 1), Desiderio's only monumental work, is described by Vasari in Desiderio's *Vita*. Marsuppini (*d* 1453) had been State Chancellor of Florence, and presumably his tomb was begun soon after his death, but, assuming Desiderio was accepting other commissions during its execution, it may not have been finished until 1460. It is placed in the nave of Santa Croce, across from Bernardo Rossellino's tomb of *Leonardo Bruni* (*d* 1444; for illustration *see* ROSSELLINO, (1)). Bruni was Marsuppini's predecessor as Chancellor and both men were noted humanists. Desiderio's tomb deliberately echoes that of Rossellino in both design and ornament. Both tombs are framed by an arch and have the effigy of the dead man placed on an elaborate bier over an inscribed sarcophagus, both have a relief of the *Virgin and Child* in a lunette above the effigy and youthful angels carrying garlands above the gable. The effigy of Marsuppini is more steeply tilted on the bier, making the portrait more visible, and the free-standing, shield-bearing putti who flank the base of the arch are not present in the *Bruni* tomb; they act as intermediaries between the observers' space and that of the monument, as do the youths with their striding poses on the entablature, whose garlands fall outside the confines of the architectural framework.

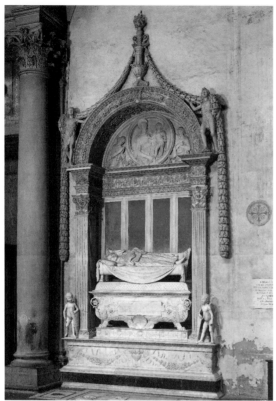

1. Desiderio da Settignano: marble tomb of *Carlo Marsuppini*, originally partly gilt and painted, *c.* 1453–60 (Florence, Santa Croce)

Similarly, in the tondo of the *Virgin and Child*, the haloes and drapery break beyond the carved frame. Desiderio used softer forms in the sphinxes at the base and in the acanthus leaf that serves as a keystone of the arch. Compared with the *Bruni* tomb, decoration takes precedence over architectural structure. Filarete praised Desiderio's skill in decorative carving. Desiderio had a facility for finishing surfaces and creating an effect of palpable life in his faces; this verisimilitude would have been enhanced by the colour with which the monument was originally decorated; traces of gilding, green paint on the drapery and porphyry red on the panelling remain. Although the participation of assistants is evident in several details, and early sources claimed that Verrocchio was involved in the execution, the high quality of the carving suggests that Desiderio was responsible for much of it. The tomb slab of Carlo Marsuppini's father, Gregorio, placed directly before his son's monument, may be the work of Desiderio's shop (Pines).

Several works have been attributed to Desiderio on the grounds of their similarity to the *Marsuppini* tomb. The marble relief of the *Virgin and Child*, known as the Foulc *Madonna* (*c.* 1455–60; Philadelphia, PA, Mus. A.), originally from the hospital of S Maria Nuova, Florence, is close to the tondo of the *Virgin and Child* on the tomb. The low relief is, in terms of composition and expressive power, one of Desiderio's best works. The relief of the *Virgin and Child* (Turin, Gal. Sabauda; see colour pl. 1, XXVII2) is accepted as an autograph early work; another relief of

the same subject known as the Pantiatichi *Madonna* (*c.* 1461–4; Florence, Bargello) is also universally accepted. Other reliefs of the same subject that have not been so accepted include the Dudley *Madonna* (London, V&A; see Pope-Hennessy, 1964, Strom, 1984) and the Beauregard *Madonna* (Los Angeles, CA, Getty Mus.). The latter appears to be closer to the work of either Domenico Rossellino or Francesco di Simone Ferrucci, both skilled imitators of Desiderio.

Even more contentious is the attribution of a group of female portrait busts to Desiderio, none of which has been universally accepted as his work. Vasari mentioned a portrait bust by him of Marietta Strozzi in the Palazzo Strozzi, and a marble head was listed in a Medici inventory, but neither has been positively identified. The *Portrait of a Lady*, sometimes called *Marietta Strozzi* (Berlin, Skulpgal.), has been attributed by Pope-Hennessy (1958) to Antonio Rossellino; a presumed portrait of *Simonetta Vespucci* (Washington, DC, N.G.A.) has been tentatively connected with Verrocchio (Middeldorf). Another female bust (Florence, Bargello) seems to have the strongest stylistic relationship with Desiderio's extant work (Pope-Hennessy, 1985), although it has been rejected by Markham (1963).

Other problematic works attributed to Desiderio include the group of small heads that may represent the Christ Child or the Infant St John, or may possibly be portraits of children. Of the three most frequently discussed—the Mellon *Christ Child*, the Kress bust (both Washington, DC, N.G.A.) and the *Laughing Boy* (Vienna, Ksthist. Mus.)—the Vienna bust seems most likely to be autograph. The attribution of another infant's head (Florence, priv. col., see Negri-Arnoldi, 1967) is not convincing. Three marble reliefs in this genre seem likely to be autograph: the *Youthful St John the Baptist* (Florence, Bargello; see fig. 2) with an unusual three-quarter view of the profile, presumed to be an early work; the *Youthful Hero* (Paris, Mus. Jacquemart-André), which resembles the Bargello relief in the treatment of the hair and the facial expression and features but is probably slightly later; and the tondo of the *Infant Christ and the Infant St John*, known as the Arconati–Visconti Tondo (Paris, Louvre), which, although sometimes dated *c.* 1453–5 (see 1985 exh. cat.), may be dated in the 1460s, given the similarity of the children's faces to those in the sacrament tabernacle of S Lorenzo.

The tabernacle is the central work of Desiderio's later career. A document refers to its installation in 1461, but a letter written to Francesco Sforza, Duke of Milan, in February 1462 explains that the sculptor was 'occupied and will be for a long time on a certain work in San Lorenzo', which implies that it was not finished. It is conceivable that the letter refers to some other work for the church; alternatively it might suggest that not all the elements of the tabernacle were installed simultaneously. The tabernacle's original location and configuration are unknown: it has been moved at least three times since its initial installation and its present arrangement is unlikely to be as it was originally. It has been suggested that it first formed part of the high altar (Beck) and that the supporting members only were installed at first (Spencer), although this last hypothesis seems unlikely; more probably the

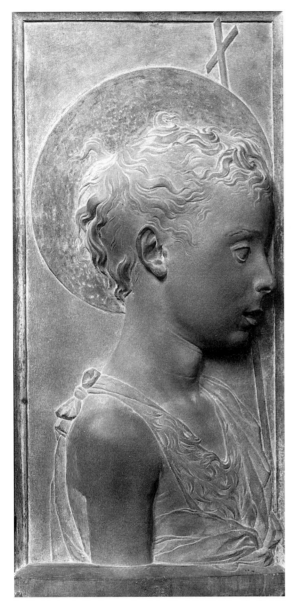

2. Desiderio da Settignano (attrib.): *Youthful St John the Baptist*, marble relief, 500×240 mm (Florence, Museo Nazionale del Bargello)

tabernacle and its architectonic surround were positioned first and the free-standing elements were added later. The attribution to Desiderio of some of the sculptural elements has been questioned. Albertini (1510) said that the *Blessing Christ Child* that crowns the altar was replaced by a copy by Baccio da Montelupo before 1500.

Attempts have been made to identify Desiderio's original figure with a *Christ Child* (Cleveland, OH, Mus. A.), and the figure *in situ* has been given to Baccio (Verdier, 1983). A more likely suggestion is that a faithful copy of the S Lorenzo *Christ Child* (Paris, Louvre) is Baccio's version (Gaborit, 1987), and that the *Christ Child* in S Lorenzo is Desiderio's work. The central relief has been attributed to an anonymous assistant of Brunelleschi working from his master's design (Parronchi, 1980), but

the central relief with its steep perspectival rendering of a vaulted interior and its delicacy and decorative elaboration is compatible with Desiderio's certain works and with a date in the second half of the 15th century. The half-length relief of the *Lamentation over Christ* forming the lower half of the tabernacle, with the outlines of the figures deeply undercut, is stylistically distinct from the sculptor's other late work and has led to the suggestion that it is not by Desiderio at all (Cardellini, 1962), although iconographically it is appropriate for an altar dedicated to the sacrament. Finally, it is unclear if all the elements were intended to form part of a wall tabernacle or were part of a free-standing altar. A wall tabernacle was probably intended: not only was it a common solution at this date, but the perspective of the central relief would work best in this context. A group of late 15th-century drawings (London, V&A; Florence, Uffizi) with various solutions for the arrangement of a wall tabernacle have been associated with Desiderio (Kurz).

In Desiderio's later reliefs he employed an increasingly sophisticated *relievo schiacciato* technique. *St Jerome in the Wilderness* (Washington, DC, N.G.A.), exhibiting the influence of Donatello both in technique and in the dramatic presentation of the subject, is his only extant narrative composition (an untraced narrative relief by Desiderio with 'fauns and other figures' was listed in the Medici inventory in 1492). Only three large-scale, free-standing figures can be connected with the sculptor. The Martelli *Youthful St John the Baptist* (Florence, Bargello), notable for the extreme shallowness of its carving and delicacy of expression, was once attributed to Donatello, but it can be given to Desiderio on stylistic grounds and on the strength of a documented connection between Desiderio and the Martelli family (Beck). The polychromed wooden statue of *St Mary Magdalene* (Florence, Santa Trinita) was, according to Vasari, started by Desiderio and finished by Benedetto da Maiano; it also shows the influence of Donatello, as does a wooden crucifix from the convent at Bosco ai Frati, also formerly given to Donatello but now attributed to Desiderio (Lisner, 1970). These works have been dated to Desiderio's early period, but instead seem to be the products of his last years, that is during the 1460s, when both he and Donatello were working on different projects in S Lorenzo. In 1461 Desiderio submitted a design (untraced) in competition for the chapel of the Madonna della Tavola in Orvieto Cathedral, and in 1463 he was paid for a death mask made in connection with the tomb of the *Cardinal of Portugal* executed by the Rossellino brothers in S Miniato al Monte, Florence. He was buried in S Pier Maggiore, Florence.

2. WORKSHOP. It is assumed that Desiderio's brothers, Francesco and Geri, were active in Desiderio's workshop. Geri shared a house and shop with Desiderio from 1456 until 1461, at which point Desiderio gained control of the shop, though both brothers probably continued to work there. Although it has been suggested that Geri's contribution to works produced by the shop can be identified, it may be that he strove to imitate his more famous brother's style and never developed one of his own. Contemporary sources say that Verrocchio worked on the *Marsuppini* tomb, and his hand has been identified in

elements of the S Lorenzo tabernacle (Seymour, 1966), but if he did work in Desiderio's shop, it was probably only for a few years at the end of the work for Santa Croce. Vasari claimed that Desiderio was Mino da Fiesole's master, but this is patently impossible in terms of date. The work of Francesco di Simone Ferrucci shares some qualities with that of Desiderio, but he was also influenced by other sculptors. It is possible that the majority of regular assistants in the shop came from Settignano, Desiderio's place of birth.

There are numerous contemporary versions in stucco and terracotta of Desiderio's reliefs of the Virgin and Child. Francesco Sforza, Duke of Milan, attempted to obtain such a work in 1462, which suggests that they were renowned. Neri di Bicci, in his *Ricordanze*, refers to colouring works by Desiderio made of stucco and marble (Middeldorf, 1978), and this practice may have continued after Desiderio's death. Marble replicas of devotional reliefs seem to have been produced in the workshop both during his lifetime and, probably, later. This would explain the many small-scale works in marble tentatively attributed to Desiderio.

BIBLIOGRAPHY
EARLY SOURCES AND DOCUMENTS

Filarete: *Trattato di architettura* (MS., *c.* 1460–64); trans. J. Spencer (New Haven, 1965), pp. 170, 258, 284, 391

Neri di Bicci: *Le ricordanze* (MS., 1453–75); ed. B. Santi (Pisa, 1976)

F. Albertini: *Memoriale di molte statue e pitture della città di Firenze* (Florence, 1510); ed. L. Mussini (Florence, 1863), p. 11

G. Vasari: *Vite* (1550, rev. 2/1568); ed. G. Milanesi (1878–85), ii, p. 483; iii, pp. 107–12

G. Richa: *Notizie istoriche delle chiese fiorentine divise nei suoi quartieri* (Florence, 1754–62), i, p. 90; v, p. 28

C. Kennedy: 'Documenti inediti su Desiderio da Settignano e la sua famiglia', *Riv. A.*, 2nd ser., ii (1930), pp. 243–91

R. Mather: 'Documents, Mostly New, Relating to Florentine Painters and Sculptors of the Fifteenth Century', *A. Bull.*, xxx (1948), pp. 20–66

G. Corti and F. Hartt: 'New Documents Concerning Donatello, Luca and Andrea della Robbia, Desiderio, Mino, Uccello, Pollaiuolo, Filippo Lippi, Baldovinetti and others', *A. Bull.*, xliv (1962), pp. 155–67

I. Cardellini: 'Desiderio e i documenti', *Crit. A.*, ix/53–4 (1962), pp. 110–12

J. R. Spencer: 'Francesco Sforza and Desiderio da Settignano: Two New Documents', *A. Lombarda*, xiii/1 (1968), pp. 131–3

J. Beck: 'Desiderio da Settignano (and Antonio del Pollaiuolo): Problems', *Mitt. Ksthist. Inst. Florenz*, xxviii (1984), pp. 203–24

GENERAL

Thieme–Becker

A. Venturi: *Storia* (1901–40), vi, pp. 410–28

F. Burger: *Geschichte des florentinischen Grabmals von der ältesten Zeiten bis Michelangelo* (Strasbourg, 1904)

J. Pope-Hennessy: *Italian Renaissance Sculpture* (London, 1958, rev. Oxford, 3/1986), pp. 29–30, 37–8, 49–50, 283–7, 355–6

C. Seymour jr: *Sculpture in Italy, 1400–1500*, Pelican Hist. A. (Harmondsworth, 1966), pp. 139–43, 149

M. Lisner: *Holzkruzifixe in Florenz und in der Toskana von der Zeit um 1300 bis zum frühen Cinquecento* (Munich, 1970), pp. 73–4

J. Schuyler: *Florentine Busts: Sculptured Portraiture in the Fifteenth Century* (diss., New York, Columbia U., 1976)

Italian Renaissance Sculpture in the Time of Donatello (exh. cat., ed. A. Darr and G. Bonsanti; Detroit, MI, Inst. A., 1985); also as *Donatello e i suoi: Scultura fiorentina del primo rinascimento* (Florence, Forte Belvedere, 1986)

La Maddalena tra sacro e profano (exh. cat., ed. M. Mosco, Florence, Pitti, 1986)

A. V. Coonin: 'New Documents concerning Desiderio da Settignano and Annalena Malatesta', *Burl. Mag.*, cxxxvii/1113 (1995), pp. 792–9

——: 'Portrait Busts of Children in Quattrocento Florence', *Met. Mus. J.*, xxx (1995), pp. 61–71

MONOGRAPHS

C. da Prato: *Desiderio da Settignano e diverse opere sue* (Florence, 1890)

L. Planiscig: *Desiderio da Settignano* (Vienna, 1942)

M. Cardellini: *Desiderio da Settignano* (Milan, 1962); rev. by A. Markham in *A. Bull.*, xlv (1963), pp. 35–45, and by F. Negri-Arnoldi in *Paragone*, xv/171 (1964), pp. 69–73

SPECIALIST STUDIES

P. Giordani: 'La rappresentazione del "Genietto" in Desiderio da Settignano', *Rass. A.*, viii (1908), pp. 151–4

C. Kennedy: *The Tomb of Carlo Marsuppini by Desiderio da Settignano and Assistants* (Northampton, MA, 1928)

——: *The Tabernacle of the Sacrament by Desiderio* (Northampton, MA, 1929)

——: *Magdalen and Sculptures in Relief by Desiderio da Settignano and Associates* (Northampton, MA, 1929)

L. Becherucci: 'Un angelo di Desiderio da Settignano', *L'Arte*, xxxv (1932), pp. 153–60

W. R. Valentiner: 'Leonardo and Desiderio', *Burl. Mag.*, lxi (1932), pp. 53–61

W. Paatz: 'Vergessene Nachrichten über einige Hauptwerke der Florentiner Quattrocento-Skulptur', *Mitt. Ksthist. Inst. Florenz*, ix/2–3 (1932–4), pp. 140–41

L. Planiscig: 'Di alcune opere falsamente attribuite a Donatello', *Phoebus*, ii (1948–9), pp. 55–9

——: 'Santa Maria Maddalena di Desiderio da Settignano', *A. Medit.*, iii (1949), pp. 5–11

O. Kurz: 'A Group of Florentine Drawings for an Altar', *J. Warb. & Court. Inst.*, xviii (1955), pp. 35–53

M. Lisner: 'Die Büste des Heiligen Laurentius in der alten Sakristei von S Lorenzo: Ein Beitrag zu Desiderio da Settignano', *Z. Kstgesch.*, xii (1958), pp. 51–70

G. Laschi, P. Roselli and P. Rossi: 'Indagini sulla Cappella dei Pazzi', *Commentari*, xiii/1 (1962), pp. 24–41

A. Markham: 'Desiderio da Settignano and the Workshop of Bernardo Rossellino', *A. Bull.*, xlv (1963), pp. 35–45

F. Negri-Arnoldi: 'Un Desiderio da Settignano vero (e uno falso)', *Paragone*, xv/175 (1964), pp. 69–73

J. Pope-Hennessy: *Catalogue of Italian Sculpture in the Victoria and Albert Museum* (London, 1964)

A. Parronchi: 'Sulla collocazione originaria del Tabernacolo di Desiderio da Settignano', *Cron. Archeol. & Stor. A.*, iv (1965), pp. 130–40

F. Negri-Arnoldi: 'Un marmo autentico di Desiderio all'origine di un falso Antonio Rossellino', *Paragone*, xviii/209 (1967), pp. 23–6

U. Schlegel: 'Zu Donatello und Desiderio da Settignano: Beobachtungen zur physiognomischen Gestaltung im Quattrocento', *Jb. Berlin. Mus.*, ix (1967), pp. 135–55

R. Wittkower: 'Desiderio da Settignano's *St. Jerome in the Desert*', *Stud. Hist. A.*, iv (1971–2), pp. 7–37

C. Avery: 'The Beauregard Madonna: A Forgotten Masterpiece by Desiderio da Settignano', *Connoisseur*, cxciii/777 (1976), pp. 186–95

A. Parronchi: 'Tabernacolo brunelleschiano', *Prospettiva*, ix (1977), pp. 55–6

U. Middeldorf: 'Some Florentine Painted Madonna Reliefs', *Collaboration in Italian Renaissance Art*, ed. W. S. Sheard and J. Paoletti (New Haven, 1978), pp. 77–90

——: 'Die Zwölf Caesaren von Desiderio da Settignano', *Mitt. Ksthist. Inst. Florenz*, xxiii (1979), pp. 297–312

A. Parronchi: 'Un tabernacolo brunelleschiano', *Filippo Brunelleschi: La sua opera e il suo tempo* (Florence, 1980), pp. 239–55

G. Passavant: 'Beobachtungen am Lavabo von San Lorenzo in Florenz', *Pantheon*, xxxix (1981), pp. 33–50

G. C. Vines: *Desiderio da Settignano* (diss., Charlottesville, U. VA, 1981)

M. Godby: 'The "Boni Chimney-piece" in the Victoria and Albert Museum: A Fifteenth-century Domestic Cenotaph', *A. & Libris*, xxvii (1982), pp. 4–17

V. Herzner: 'David Florentinus', *Jb. Berlin. Mus.*, xxiv (1982), pp. 107–19

D. Strom: 'Desiderio and the Madonna Relief in Quattrocento Florence', *Pantheon*, xl (1982), pp. 130–35

P. Verdier: 'Il putto ignoto: A Marble Statue of Christ in Quest of a Father', *Bull. Cleveland Mus. A.*, lxx/7 (1983), pp. 303–11

D. Strom: 'A New Look at the Mellon Christ Child in the National Gallery of Art', *Ant. Viva*, xxii/3 (1983), pp. 9–12

——: 'A New Identity for the Dudley Madonna and Child in the Victoria and Albert Museum', *Ant. Viva*, xxiii/4–5 (1984), pp. 37–41

D. S. Pines: *The Tomb Slabs of Santa Croce: A New 'Sepoltuario'* (diss., New York, Columbia U., 1985)

J. R. Gaborit: 'Desiderio da Settignano, Baccio da Montelupo et le "Bambino" de San Lorenzo', *Hommage à Hubert Landais* (Paris, 1987), pp. 97–103

C. Avery: 'A Fascinating Enigma: The *Dudley Madonna*, Desiderio or Donatello?', *A. Q.*[London] (1998), pp. 46–9

SHELLEY E. ZURAW

Destre, Vincenzo dalle [Vincenzo da Treviso] (*b* ?Treviso, *fl* from 1488; *d* before 1543). Italian painter. He was a pupil of Girolamo da Treviso the elder and in 1495 collaborated with Giovanni Bellini in the Sala del Maggior Consiglio of the Doge's Palace, Venice. In the same city he was connected with the Scuola di S Giovanni Evangelista and the Scuola di S Maria della Misericordia and enrolled as a member of the painters' guild (*fraglia*). Two of his paintings, both signed (Padua, Mus. Civ.; Venice, Correr), are based on Bellini's *Presentation in the Temple*. The two versions differ from each other only in the figure of the woman on the left. In the version in Venice she is derived, as is the figure of St Joseph, from Bellini's grisaille depicting the *Lamentation* (Florence, Uffizi). In the painting in Padua, on the other hand, she appears to be based on a type of Virgin that was first introduced by Bellini and also used early in his career by Rocco Marconi. Two altarpieces have been assigned to Vincenzo: the *Virgin and Child Enthroned with SS Andrew and Liberalis* (Treviso, Mus. Civ.) and *St Erasmus Enthroned between SS John the Baptist and Sebastian* (1503; Treviso, S Leonardo; figures of Virgin and Child added later in 16th century), and he may also have executed the *Virgin and Child* (sold Munich, J. Böhler, 1 and 2 June 1937, lot 1653), which derives from a prototype by Bellini in which the Virgin is flanked by SS John the Baptist and Elizabeth (two versions; Frankfurt am Main, Städel. Kstinst & Städt. Gal.; Urbino, Pal. Ducale).

BIBLIOGRAPHY

Thieme–Becker

G. Mariacher: *Il Museo Correr di Venezia: Dipinti dal XIV al XVI secolo* (Venice, 1957), pp. 229–30

F. Heinemann: *Giovanni Bellini e i Belliniani*, 2 vols (Venice, 1962)

L. Gargan: 'Lorenzo Lotto e gli ambienti umanistici trevigiani fra quattro e cinquecento', *Lorenzo Lotto a Treviso: Ricerche e restauri* (exh. cat., Treviso, S Nicolo, 1980), pp. 1–10

M. C. Rossi: 'Il pittore trevigiano Vincenzo dai Destri: Documenti e proposte', *Atti Ist. Ven. Sci., Lett. & A.*, cxlv (1986–7), pp. 281–300

D. Banzato: *La quadreria Emo Capodilista* (exh. cat., Padua, 1988), pp. 51, n.12

ANCHISE TEMPESTINI

Diamante (di Feo), Fra (*b* Terranuova, Val d'Arno, *c.* 1430; *d* after 1492). Italian painter. He was brought up in the Carmelite convent in Prato and first worked as *garzone* for the Carmelite painter Fra Filippo Lippi. On 17 July 1447 he was paid for gilding a temporary predella for Lippi's *Coronation of the Virgin* (Florence, Uffizi; see colour pl. 1, XXXVIII1). At Prato he assisted Lippi on his fresco cycle in the choir of the parish church (now the cathedral) between 1452 and 1466. In July 1460 Diamante received payment on Lippi's behalf for the latter's completion of Pesellino's *Trinity with Saints* (London, N.G.), and in the same month he is recorded as a Vallombrosan monk. At this time he probably executed the frescoes of *St John Gualbertus* and *St Albert of Trapani* beside the window of the choir of Prato Cathedral.

In 1463 Diamante was imprisoned in Florence for an undisclosed crime. His absence from Prato coincided with a halt on Lippi's fresco project, and in January 1464 the *comune* of Prato implored the Archbishop of Florence to grant Fra Diamante's release. Work on Lippi's frescoes recommenced in March, apparently without Diamante, and the next mention of him there is in October 1465. But on 18 November he received 15 florins for his work on the final scene in Lippi's cycle, either the *Celebration of the Relics of St Stephen* or the *Feast of Herod*.

Diamante was appointed to Lippi's former post as chaplain of the Augustinian convent of S Margherita, Prato, in 1466. By the spring of 1467 he had probably joined Fra Filippo at Spoleto to assist him with the fresco decoration of the cathedral choir. On Lippi's death in October 1469, Diamante was appointed guardian of his son, Filippino Lippi, and commissioned to complete the frescoes in Spoleto Cathedral. His final payment was made in February 1470. Of a total payment of 697 ducats for the cycle, Diamante received 137, almost a fifth. His share in the work was thus considerable. The *Coronation of the Virgin*, probably the first scene to be painted, and finished at least by the end of 1468, is largely by Lippi, while the other scenes—the *Annunciation*, *Death of the Virgin* and *Nativity*—increasingly show the presence of assistants working from Lippi's designs. The *Nativity* was certainly not executed by Lippi. It was painted by the same hand responsible for another *Nativity* panel (Paris, Louvre; no. 1343). Since the latter came from S Margherita in Prato, where Fra Diamante was chaplain from 1466 onwards, it is tempting to attribute this work and the execution of the *Nativity* fresco at Spoleto to Diamante, as Oertel and other critics have done.

In May 1468 and the spring of 1469, Diamante made two short trips to Rome, where he painted a work of which the location, date and subject are unknown. Whatever it was, the method of its payment caused him frequent legal problems. By May 1470 he returned to Prato, where he painted a fresco portrait of the *podestà* (destr.). In 1472 he was a member of the Compagnia di S Luca, the artists' confraternity in Florence, and lived in the Vallombrosan convent of San Pancrazio. In 1483 he was prior of S Pietro di Gello, near Volterra, and in 1489, at the command of the Vallombrosan abbot of S Salvi, Florence, he was again imprisoned in that city. Fra Diamante is last mentioned in 1492. Although he was Fra Filippo Lippi's assistant and, later, collaborator for 22 years, no surviving painting can be firmly attributed to him. The problem of his oeuvre involves the question of Lippi's workshop in Prato, still a highly complex issue.

BIBLIOGRAPHY

DBI

M. Pittaluga: 'Fra Diamante collaboratore di Fra Filippo Lippi', *Riv. A.*, xxiii (1941), pp. 19–71

——: 'Note sulla bottega di Filippo Lippi', *Arte*, xliv (1941), pp. 20–37, 67–81

R. Oertel: *Fra Filippo Lippi* (Vienna, 1942), p. 51

M. Pittaluga: *Filippo Lippi* (Florence, 1949), p. 184

B. Berenson: *Florentine School* (1963), pp. 58–9

E. Borsook: 'Fra Filippo Lippi and the Murals for Prato Cathedral', *Mitt. Ksthist. Inst. Florenz*, xix (1975), pp. 1–148

G. Marchini: *Filippo Lippi* (Milan, 1975), pp. 168–9, 215

E. Borsook: 'Cults and Imagery at Sant'Ambrogio in Florence', *Mitt. Ksthist. Inst. Florenz*, xxv (1981), pp. 147–202

Additional information was supplied by Eve Borsook.

ELIOT W. ROWLANDS

Diana [Rusconi]**, Benedetto** (*b c.* 1460; *d* Venice, 9 Feb 1525). Italian painter. In 1482 he was listed as a painter on

the rolls of the Scuola della Carità in Venice; in 1485 his wife and his mother made a joint will. On this basis, his birth is usually placed *c.* 1460 but may be somewhat earlier. He is thought to have been a pupil of Lazzaro Bastiani. In 1485–6 he completed a fresco of *The Flood* begun by Bartolomeo Montagna for the Scuola Grande di S Marco in Venice. The influence of Montagna, Bastiani and Giovanni Bellini is evident in Diana's first surviving painting, a *Virgin and Child Enthroned between Two Saints and Donors* (Venice, Ca' d'Oro), commissioned in 1487 for the Venetian Mint by its magistrates. Its colour is characteristic of his work: a pale, luminous tonality achieved by the subtle gradation and relation of unsaturated cool hues. In terms of light and volume it is radically sophisticated: space is conceived as no less a presence than the forms it separates; and there is a calculated play of geometrically conceived forms: squat against slim, dense against ethereal. The background shows an astonishing mastery of the optical effects of a summer landscape seen through haze and of buildings reduced to geometry by light and shadow.

In the absence of other dated works, the chronology of Diana's work is conjectural. Paintings that show a close study of Antonello da Messina's work probably date from the 1490s. The half-length *Christ Blessing* (London, N.G.) revises Antonello's painting of the same subject (1465; London, N.G.) with reference to Alvise Vivarini and Cima, retaining Antonello's solid-geometric abstraction of forms but intensifying their lighting. A small *Standing Christ* (Modena, Gal. & Mus. Estense) has a deep landscape, reminiscent of Jan van Eyck (*c.* 1395–1441), which achieves a standard of execution hardly below Antonello's own. A polyptych of the *Virgin and Child Enthroned with Saints* (Cremona, Mus. Civ. Ponzone) must also date from the 1490s. At first glance it seems Bellinesque, but the figures are so abstracted as to be geometric integers; those of the main register are marooned on a vast sunlit terrace, which continues across the three panels, while far behind them flows a beautiful and subtly integrated landscape, its details realized mostly in values of colour and light. Colour is low-key and carefully calibrated as in the Ca' d'Oro picture, but warmer.

Shortly after 1500 Diana, Gentile Bellini and Carpaccio each painted a large narrative canvas for the Scuola Grande di S Giovanni Evangelista's series of the *Miracles of the True Cross* (Venice, Accad.). Diana's painting of the *Miraculous Cure of the Son of Ser Alvise Finetti* illustrates for the first time the weightier figures and idiosyncratic faces of his later style. These recur in, for instance, a group of singular predella paintings (ex-Longhi priv. col., Florence; Washington, DC, N.G.A.) and a series of *sacre conversazioni* (e.g. Coral Gables, FL, U. Miami, Lowe A. Mus.; three in Venice, Accad.), in which massive figures are set before or within spacious, geometrically simplified landscapes and all things are linked by the play of silvery light and shadow. They attain a 16th-century monumentality, despite the quirkiness of detail that allies them with such artists as Jacopo de' Barbari and Lorenzo Lotto.

In 1505 Diana and Bastiani were commissioned to paint three giant standards for S Marco 'according to Diana's design' and in 1507 Diana won a competition to paint the standard (*gonfalone*) of the Scuola della Carità in Venice,

beating Carpaccio. In 1512 he became president of the painters' guild.

In the paintings of his last ten or fifteen years Diana attempted to keep pace with younger artists such as Cariani and Pordenone, while retaining his formidable individuality. A monumental *Assumption* (Crema, S Maria della Croce) seems to adapt architectural elements from Pordenone and to take on some of his eccentric dynamism, but its spectacular colour and its figure style are Diana's own. Still more extraordinary is the large *Madonna Enthroned with Saints* from the church of S Maria dei Servi in Venice (Venice, Accad.): facial types recall Pordenone, but Diana alone is responsible for the sleek geometry of the architecture, the subtle perfection of lighting, and the beauty and refinement of the silvery colour.

Diana, admired by 16th- and 17th-century writers, has since sometimes been grouped mistakenly with Giovanni Bellini's followers. Like Bastiani, but on a higher level of quality, Diana represented a 'third force' in late 15th-century Venetian painting, independent both of the Bellini and Vivarini workshops. As such, he was important for other individualists at the turn of the century, notably Pier Maria Pennacchi, Marco Basaiti, and Lotto. His greatest contribution, however, lies in the originality, sophistication and perfection of his own paintings as formal entities.

BIBLIOGRAPHY

Thieme–Becker

M. Michiel: *Notizie d'opere di disegno* (MS. 16th century); ed. J. Morelli (Bassano, 1800, rev. Bologna, 1884); Eng. trans. of 2nd edn, ed. G. Williamson (London, 1903/*R* New York, 1969), pp. 24, 87

G. Vasari: *Vite* (1550, rev. 2/1568); ed. G. Milanesi (1878–85), iii, pp. 628, 650

C. Ridolfi: *Meraviglie* (1648); ed. D. von Hadeln (1914–24/*R* 1965), pp. 41–2

M. Boschini: *Le ricche miniere della pittura veneziana* (Venice, 1674)

A. Zanetti: *Della pittura veneziana* (Venice, 1771), pp. 70–71

G. Ludwig: 'Archivalische Beiträge zur Geschichte der venezianischen Malerei', *Jb. Kön.-Preuss. Kstsamml.*, xxvi (1905), suppl., pp. 56–61 [essential docs]

R. van Marle: *Italian Schools* (1923–38), xviii, pp. 406–18 [unperceptive but useful]

B. Berenson: *Venetian School* (1957), i, pp. 73–4, pl. 376–83

A. Paolucci: 'Benedetto Diana', *Paragone*, cxcix (1966), pp. 3–20 [excellent article]

FRANCIS L. RICHARDSON

Disegno e colore. Controversy that developed in Italy in the 16th century over the relative merits of design or drawing (It. *disegno*) and colour (*colore*). It was fundamentally a debate over whether the value of a painting lay in the idea originating in the artist's mind (the invention), which was explored through drawings made prior to the painting's execution, or in the more lifelike imitation of nature, achieved through colour and the process of painting itself.

The *disegno e colore* debate focused on the rivalry between the two dominant traditions of 16th-century Italian painting, Central Italian and Venetian. Central Italian, especially Florentine, painting depended on drawing and on the use of preparatory studies and cartoons, and the depiction of the human figure was the supreme test of an artist's skill; Venetian painters built up their pictures directly on the canvas, creating a more spontaneous and expressive art. The difference between the two approaches was formulated in the writings of Giorgio Vasari (*see* VASARI, (1)) and LODOVICO DOLCE. The first edition of Vasari's *Vite*

(1550), while showing some enthusiasm for Venetian art and paying tribute to Titian at the end of the life of Giorgione, was nonetheless written to proclaim the superiority of the Florentine school and of Michelangelo. The Venetian Dolce's *Dialogo della pittura* (1557) rejected this view, defending the Venetian tradition and exalting Titian above both Raphael and Michelangelo. Dolce's definition of the three parts of painting—*disegno, invenzione* and *colorire*—was the traditional one and had been expressed slightly earlier by the Venetian PAOLO PINO, in his *Dialogo della pittura* (Venice, 1548). Dolce defined *disegno* as 'the form with which the painter presents his material', while *colorito* was equated with nature's diversity and variety. He praised Titian's closeness to nature and the vitality of his forms, which depended on his use of colour. In this power to suggest life lay colouring's claim to supremacy; 'And certainly colouring is so important and compelling that, when the painter produces a good imitation of the tones and softness of flesh, and the rightful characteristics of any object there may be, he makes his paintings seem alive.' In the 1568 edition of the *Vite*, Vasari was more critical of Venetian art than previously. He gave an expanded theoretical definition of *disegno*, which he called the 'father of the three arts', and defined *disegno*, which derives from the intellect, as an idea of the forms of nature. This idea found objective expression through the artist's hands, or drawing; thus *disegno* is a 'manifest expression and embodiment of the concept which he has in his mind'. Titian is censured for his lack of *disegno*. Vasari described a visit he had made with Michelangelo to Titian's studio, where Michelangelo is reported as lamenting that 'in Venice they did not learn to draw well from the beginning, and that those painters did not pursue their studies with more method. . . .if Titian had been assisted by art and design as much as he was by nature . . .then no one could achieve more or work better'. Vasari's severest criticism was reserved for Tintoretto, whose freedom of touch seemed to him both extravagant and capricious.

Proponents of *disegno* were concerned to stress its intellectual aspects, underlining its theoretical rather than its manual or practical character and proposing that painting should be elevated to the status of a liberal art, on a level with poetry. These intellectual aspects are stressed in the works of the late Mannerist writers Paolo Lomazzo and Federico Zuccaro. In his *Trattato dell'arte della pittura* (Milan, 1584) and *Idea del tempio della pittura* (Milan, 1590), Lomazzo imbued *disegno* with an almost spiritual quality, equating it with *eurythmia* or proportion, providing a fundamental framework for the work of art. Yet he was also concerned to reconcile it with *colore* and so urged artists to learn from the different perfections of great artists. In 1584 he wrote of the dangers of limiting oneself to a single artist's example and claimed that the best procedure was for the painter to form his own style by selecting and combining the most beautiful aspects of the great masters. In the *Idea* (p. 60) he gave a concrete example of this precept by describing his idea of a perfect pair of pictures: Adam drawn by Michelangelo and coloured by Titian, and Eve drawn by Raphael and coloured by Correggio. In the writings of Zuccaro, Neo-Platonic elements dominate; he envisaged *disegno* as equivalent to the 'idea' in the artist's mind, derived from God, and

distinguished between *disegno interno* (the ordering faculty of the artist) and *disegno esterno* (the actual linear outline; see Blunt, 1940, p. 141, n. 1).

BIBLIOGRAPHY

GENERAL
M. Kemp: *The Science of Art* (London, 1990), pp. 274ff
F. Gage: *Colour and Culture* (London, 1993), pp. 117ff

ITALY
G. Vasari: *Vite* (1550; rev. 2/1568); ed. G. Milanesi (1878–85)
L. Dolce: *Dialogo della pittura* (Venice, 1557); ed. M. Roskill (New York, 1968)
G. Mancini: *Considerazioni sulla pittura* (MS., 1617–21); ed. A. Marucchi (Rome, 1956)
A. F. Blunt: *Artistic Theory in Italy, 1450–1600* (Oxford, 1940)
D. Rosand: 'The Crisis of the Venetian Renaissance Tradition', *L'Arte*, 11–12 (1970), pp. 6–12

CLAIRE PACE

Doceno, il. *See* GHERARDI, CRISTOFANO.

Dolce, Ludovico (*b* Venice, 1508; *d* Venice, 1568). Italian writer, critic and dramatist. He belonged to a noble but impoverished Venetian family. Dolce studied in Padua and became a versatile writer, typical of his times, who took his material from the works of others, with adaptations and quotations often bordering on plagiarism. He became an 'editorial consultant', working mainly for the Venetian publisher Giolito de' Ferrari, for whom he edited many contemporary works as well as translations of the classics by Virgil, Horace and Cicero. He wrote five comedies, a few tragedies, poems and treatises and a few biographies of illustrious persons, such as the Emperor Charles V (*reg* 1519–56). Most of these were superficial works, written to gain fame and money; but they demonstrate a response to a new interest in public cultural debate.

Thus it was natural for Dolce to take an interest in the problems of the fine arts. From about 1540 the two most celebrated artistic capitals of Italy, Florence and Venice, debated the merits of their rival traditions, of DISEGNO E COLORE. Many Venetian artists travelled to Rome, and Giorgio Vasari visited Venice in 1541, with other Tuscan artists. The Tuscan writer Pietro Aretino lived in Venice from 1527, and became a supporter of the Venetian school, admiring Titian even more than Michelangelo. Dolce was in close contact with Aretino, especially between 1535 and 1545; they exchanged letters, and Dolce dedicated writings to him and published his works. Dolce's interest in painting is first mentioned in a letter he wrote to Paolo Crivelli (Pino, 1574) on 10 March 1545: when Aretino was condemning the immorality of Michelangelo's *Last Judgement* in the Sistine Chapel (see colour pl. 2, VII3), Dolce expressed admiration for the Tuscan master and some reservations about Venetian painting, except for Titian. Nevertheless in a letter to Gasparo Ballini (post-1550, as it shows a knowledge of Vasari's *Vite*, first published in that year; *Lettere*, 1559), he vigorously repeated Aretino's unfavourable opinion of Michelangelo, expressing a preference for Raphael and again for Titian. Around 1554 in his last artistic letter, to the collector Alessandro Contarini, he wrote a long eulogy of Titian's painting *Venus and Adonis* (1551–4; Madrid, Prado), which he praised for its naturalism and sweetness of feeling.

Dolce's masterpiece of art criticism (and perhaps his only published work on that subject) is the *Dialogo della pittura* (1557), titled in memory of Aretino, who had died the previous year. This work is polemical advocacy, inspired by Aretino, of the Venetian school, which was also supported in Paolo Pino's *Dialogo di pittura* (1548), against the superiority of the Florentine tradition set out in Vasari's *Vite* (1550). In it Dolce also defended the rights of the educated layman against the specialized technical knowledge of professional painters. The structure of this dialogue has some elements in common with that of Pino: the defence of the Venetian school, based on colour and naturalism; the recognition of the antiquity of painting and the view that it was superior to sculpture; and the importance of drawing. There are, however, considerable differences, and the historical significance of Dolce's work is different, because of the moment when it was written. It is certainly a celebration of Titian, the incomparable master of colour and leader of the Venetian school of art (and Vasari drew on it in the 1568 edition of the *Vite*), but it follows a complex line which also includes an enthusiastic discussion of Raphael, as a learned painter and the upholder of the classical doctrine of *ut pictura poësis*. To the professional painter, Vasari, Dolce opposed a criterion of value for painting which is closer to rhetoric: and the three parts of painting, *invention*, *drawing* and *colour*, correspond exactly to the *inventio*, *dispositio* and *elocutio* of rhetorical theory.

Vasari was also the champion of Florentine Mannerism. Dolce contrasted the balance and harmony of Raphael, close to the naturalism of Venetian art, with the Mannerist excesses of Michelangelo. He condemned Michelangelo not only for his overriding interest in the drawing of the nude but also for the excessive virtuoso display of his skill in foreshortening. Dolce was selective in his arguments, though, and even in the case of Titian concentrated on his mature work; he could not accept the Mannerist paintings of Titian's late years.

WRITINGS

La poetica d'Horatio (Venice, 1536)

Dialogo della pittura intitolato l'Aretino (Venice, 1557); ed. P. Barocchi as *Trattati d'arte del cinquecento tra manierismo e controriforma* (Bari, 1960), i, p. 34 [critical bibliog. on Dolce], pp. 143, 206 [commentary]

Lettere di diversi eccellentissimi huomini, ed. Dolce (Venice, 1559/*R* in Bottari-Ticozzi: *Raccolta* (1822–5), v, p. 166

Dialogo nel quale si ragiona della qualità, diversità e proprietà dei colori (Venice, 1564)

BIBLIOGRAPHY

B. Pino: *Della nuova scielta di lettere* (Venice, 1574), ii, pp. 194, 196, 200, 323

E. Cicogna: 'Memoria intorno la vita e gli scritti di M. L. D. letterato veneziano del secolo XVI', *Memorie dell'I. R. Istituto veneto di scienze, lettere ed arti*, xi (Venice, 1862), pp. 93–207

M. L. Gengaro: *Orientamenti della critica d'arte nel rinascimento cinquecentesco* (Milan/Messina, 1941), pp. 110–52

M. W. Roskill: *Dolce's Aretino and Venetian Art Theory of the Cinquecento* (New York, 1968) [text and trans. of *Dialogo della pittura* and letters to Ballini and Contarini]

F. Bernabei: 'Tiziano e Ludovico Dolce', *Tiziano e il manierismo europeo: Atti del convegno alla Fondazione Cini di Venezia, Civiltà veneziana saggi n. 24: Firenze, 1978*, pp. 307–37

D. R. E. Wright: 'Structure and Significance in Dolce's L'Aretino', *J. Aesth. & A. Crit.*, xlv (1987), pp. 273–83

FRANCO BERNABEI

Dolcebuono, Giovanni [Gian] **Giacomo** (*fl* Milan, 1465; *d* Aug 1504). Italian sculptor and architect. In 1465 he witnessed a document at the offices of the Fabbrica (Cathedral Works) of Milan Cathedral together with Francesco Solari and Giovanni Antonio Amadeo, Dolcebuono's lifelong associate. All three were living in the parish of S Martini in Compedo, the neighbourhood of the Solari family of sculptors and architects, which suggests that Amadeo and Dolcebuono may have been trained by them. Dolcebuono's association with the Solari is confirmed by a document of 1467, in which Guiniforte Solari, then architect to the Fabbrica, and Giovanni Solari, Guiniforte's father and formerly an architect to the Fabbrica, hired Dolcebuono as a journeyman labourer for two years. By 1479 he was a member of the Scuola dei Quattro Coronati, the society of stonecutters at the Fabbrica. In 1472 he was paid for measuring for and designing the altar of St Joseph at the respectable rate of ten soldi per day. Documents of 1473 refer to his working on a *maestà* for the church of S Celso.

Another document from 1473 shows Dolcebuono entering an agreement with Amadeo, Lazzaro Palazzi (*fl* 1464–1508), Giovanni Antonio Piatti (*d* 1479), and Angelo da Lecco (*fl* 1458–1505) to collaborate on the façade of the Certosa di Pavia (*see* PAVIA, §2), should any of them receive the commission (which Amadeo subsequently did), and also to work together on other projects in Milan and elsewhere. A 17th-century manuscript attributed to Matteo Valerio says that starting in 1491 Amadeo undertook to execute the façade of the Certosa, and that the design of the façade was the work of Dolcebuono and the painter Ambrogio Bergognone. This agreement, together with many other documents demonstrating Dolcebuono's prolonged association with Amadeo, makes it difficult to distinguish his work from that of Amadeo. That Dolcebuono was a master sculptor is proved by an apprenticeship document of 1474 in which he promises to teach his apprentice 'arte lapicide et a talio et a figuris. . .'. Dolcebuono continued to work for the Fabbrica throughout the 1470s, and from 1489 he also worked at the church of the Incoronata in Lodi. Between 1490, when he and Amadeo were chosen by the Fabbrica of Milan Cathedral as engineers to finish the lantern, and his death, surviving documents usually mention the two as collaborators. In 1490 they were associated with Francesco di Giorgio Martini as architects of the lantern.

It is probable that Dolcebuono and Amadeo collaborated with Bramante on the construction of the lantern of S Maria delle Grazie, Milan, in the 1490s. Between 1491 and 1494 Dolcebuono was architect to S Maria presso S Celso, Milan, providing columns and terracottas for the sanctuary. In 1493 it was decided to replace Dolcebuono at S Maria presso S Celso with Cristoforo Solari, but in 1494 he was replaced instead by Amadeo. In 1497 and 1498, however, Dolcebuono and Amadeo worked together as engineers on the lantern of S Maria presso S Celso, on Pavia Cathedral and on the lantern of Milan Cathedral. In 1501 Dolcebuono was still active as an architect at S Maria presso S Celso. In 1503 he and Amadeo made a wooden model for the Porta verso Compedo of Milan Cathedral. On 12 August 1504 Dolcebuono and Amadeo, as architects to the Fabbrica, evaluated stone for the doorway, but Dolcebuono was dead by September. No sculpture has been attributed to Dolcebuono, and his association with

Amadeo makes it difficult to define his individual architectural style. Nevertheless, the general style in which he worked is defined by the projects with which he was involved, which form the major architectural monuments of the Lombard Renaissance.

BIBLIOGRAPHY
Thieme–Becker
G. L. Calvi: *Notizie sulla vita e sulle opere dei principali architetti scultori e pittori che fiorirono in Milano durante il governo dei Visconti e degli Sforza*, ii (Milan, 1865), pp. 175–90
C. Baroni: *Documenti per la storia dell'architettura a Milano nel rinascimento e nel barocco*, i (Florence, 1940)
G. Borlini: 'Gian Giacomo Dolcebuono', *Rendi. Reale Ist. Lombard. Sci. & Lett.*, lxxvii (1954), pp. 53–71
M. L. Rizzardi: 'La Chiesa di San Maurizio in Milano non è opera del Dolcebuono', *Ist. Lombard. Sci. & Lett., Cl. Lett., Sci. Mor. & Polit.: Rendi.*, lxxxix–xc (1956), pp. 582–6
G. Borlini: 'The Façade of the Certosa di Pavia', *A. Bull.*, xlv/4 (1963), pp. 323–36
R. V. Schofield: 'Bramante and Amadeo at Santa Maria delle Grazie in Milan', *A. Lombarda*, 78 (1987), pp. 41–58
R. V. Schofield, J. Shell and G. Sironi: *Giovanni Antonio Amadeo: Documents/I documenti* (Como, 1989)

CHARLES R. MORSCHECK JR

Domenico Battaggio, Giovanni di. *See* BATTAGGIO, GIOVANNI DI DOMENICO.

Domenico di Bartolo (Ghezzi) (*b* Asciano, Siena, *c.* 1400; *d* Siena, before 1445). Italian painter. His few surviving works show that he played a pivotal role in the movement from Gothic painting to the Renaissance style in Siena during the 15th century. He is first documented in 1420, as an apprentice on an unidentified project for Siena Cathedral, and his name appears near the end of the *Ruolo dei pittori*, the list of the painters' guild compiled from 1428.

Inferences about Domenico's artistic education are suggested by the first work securely assignable to him, a small panel of the *Virgin and Child Enthroned with SS Peter and Paul* (Washington, DC, N.G.A.). This shows an early awareness of Florentine art of the 1420s and complete familiarity with the new artistic language of the Renaissance. The architectural setting, in classical style, is apparently inspired by the new conception of the altarpiece as a *sacra conversazione*, favoured by Fra Angelico at the beginning of the 1420s. The Virgin, housed in a shell niche, is crowned with a garland held by putti reminiscent of Donatello. She sits firmly and solemnly on a marble throne, holding the muscular child. The composition is a free variation on a model by Masaccio, whose early work, like Domenico's, shares many features with the sculpture of Luca della Robbia. Another Florentine element, apparently derived from Paolo Uccello, is the halo with star points, also used by Domenico in later works. The strongly Florentine orientation of this early work refutes the theory that he was trained by Taddeo di Bartolo, who Vasari believed was his uncle. According to Vasari, Domenico worked in Florence, executing two important paintings (untraced): an *Annunciation* for Santa Trinita and the main altarpiece of S Maria del Carmine, both *c.* 1436. This corroborates the stylistic evidence of the panel in Washington and confirms his familiarity with Masaccio's frescoes in the Carmine.

It is possible that in the early 1420s Domenico painted within the Sienese Gothic tradition, although no such work is known. The panel fragment of the *Virgin and Child Enthroned* (Princeton U., NJ, A. Mus.), which has been connected with the Carmine commission (Strehlke, see 1988 exh. cat.), cannot be dated before the early 1430s, shortly before his first signed and dated painting, the *Madonna of Humility* (1433; Siena, Pin. N.; see fig.). This is Domenico's masterpiece and one of the highpoints of 15th-century Sienese painting, a beautifully balanced composition combining refined expression and broad cultural references. Probably commissioned by Cardinal Antonio Casini or Bishop Carlo Bartoli, it represents a synthesis of Domenico's Florentine influences, including those of Uccello, Masaccio and Donatello. Its dynamic sculptural quality and simulated low-relief effects make it one of the earliest translations of Donatello's sculptural style into painting, contemporary with those of Florentine artists. Fra Filippo Lippi indicated a similar interest in his early *Madonna of Humility* (Milan, Castello Sforzesco). Domenico's study of Luca Della Robbia is evident in the background angels in his *Madonna of Humility*: they recall the earliest parts of Luca's *Singing Gallery* (Cantaria) made for Florence Cathedral (1432–8, probably completed *c.* 1434;

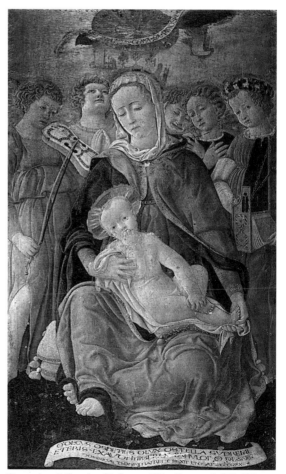

Domenico di Bartolo: *Madonna of Humility*, panel, 930×595 mm, 1433 (Siena, Pinacoteca Nazionale)

see ROBBIA, DELLA, (1), fig. 1). The extraordinary range of greens, pinks and blues shows a Sienese sense of colour, heightened by a clear light that recalls Domenico Veneziano. The date of the work, in fact, suggests that it preceded Veneziano, who began painting around the mid-1430s and whose training seems to have been Florentine. A link between the two artists is also suggested by a comparison between Domenico's *Virgin and Child* (1437; Philadelphia, PA, Mus. A.) and Veneziano's *Virgin and Child* (Bucharest, N. Mus. A.), both of which have as a background a rose garden seen in perspective. The elegant inscription on the Siena panel is one of the first examples of the humanist revival of Roman majuscule script; its precedent, in Siena, was probably the inscription on Donatello's tomb of *Bishop Giovanni Pecci* (*d* 1426) in Siena Cathedral.

It may have been Donatello's Sienese works, produced in the late 1420s, that inspired Domenico to broaden his artistic education in Florence. He must have returned to Siena before April 1433, however, as according to documents he drew from life the Holy Roman Emperor Sigismund (*reg* 1410–37), who was in Siena until that date. The portrait was reinterpreted in the marble pavement of Siena Cathedral the following year. The Princeton panel fragment of the *Virgin and Child Enthroned*, identified by Strehlke with the Carmine panel, may also date from the first half of the 1430s. Again it shows his profound stylistic interest in Florentine art: the monumental throne, shown in perspective from below, is clearly inspired by Masaccio's painting of the subject (London, N.G.; *see* MASACCIO, fig. 1) for the Pisan Carmelites; the central group also recalls Masaccio's solutions, rather than the sculptural quality of Jacopo Della Quercia.

From 1435 to 1440 Domenico frescoed scenes from the *Lives of the Four Patron Saints of Siena* in the sacristy of the cathedral; only a small fragment survives. He seemed to turn away from Florentine interests in the altarpiece (Perugia, G.N. Umbria) painted in 1438 for S Giuliana, Perugia, which reflects traditional Gothic solutions. From 1440 to 1444 he executed one of his most significant works, a series of frescoes in the pilgrims' hostel in the Ospedale di S Maria della Scala, Siena, commissioned by its rector Giovanni Buzzichelli. The cycle, painted according to a secular humanistic programme, illustrates the daily life and history of the hospital. Three of the scenes were commissioned from another artist familiar with the new Renaissance taste, Vecchietta, but only one scene survives. Domenico was assigned five scenes: three with episodes of everyday life and two with events from the history of the hospital (*see* SIENA, §III, 2 and fig. 3). These scenes are filled with minutely painted details, which tend to fragment the narrative. Domenico's last commission was the fresco of the *Coronation of the Virgin* in the Cancelleria di Biccherna (now Sala della Giunta) in the Palazzo Pubblico of Siena. He painted the four angel heads at the top, but work was interrupted, probably by his death, and the fresco was completed by Sano di Pietro in 1445.

BIBLIOGRAPHY
G. Vasari: *Vite* (1550, rev. 2/1568); ed. G. Milanesi (1878–85), ii, pp. 40–42
G. Milanesi: *Documenti per la storia dell'arte senese*, 3 vols (Siena, 1854–6), i, p. 49; ii, pp. 161–2, 171–3
R. Wagner: *Domenico di Bartolo Ghezzi* (Göttingen, 1898)
C. Brandi: *Quattrocentisti senesi* (Milan, 1949), pp. 105–20, n. 70–79
R. Longhi: 'Fatti di Masolino e di Masaccio', *Opera completa*, viii/1 (Florence, 1956/*R* 1975), pp. 43–4, n. 28
E. Carli: *I pittori senesi* (Milan, 1971), pp. 28–9
C. B. Strehlke: 'La *Madonna dell'Umiltà* di Domenico di Bartolo e San Bernardino', *A. Crist.*, 705 (1984), pp. 381–90
D. Gallavotti Cavallero: *Lo spedale di Santa Maria della Scala in Siena: Vicende di una committenza artistica* (Pisa, 1986), pp. 160–72, n. 105–57
F. Zeri, ed.: *La pittura in Italia: Il quattrocento* (Milan, 1987), i, pp. 316–18; ii, pp. 618–19 [entry by C. Alessi]
Painting in Renaissance Siena, 1420–1500 (exh. cat. by K. Christiansen, L. B. Konter and C. B. Strehlke, New York, Met., 1988)
P. Tottiti: *La Pinacoteca Nazionale di Siena* (Genoa, 1990), pp. 245–7
Una scuola per Piero: Luce, colore e prospettiva nella formazione fiorentina di Piero della Francesca (exh. cat., ed. L. Bellosi; Florence, Uffizi, 1992) [entry by G. Damiani]

GIOVANNA DAMIANI

Domenico di Michelino [Domenico di Francesco] (*b* ?1417; *d* Florence, 18 April 1491). Italian painter. He took his name from his teacher, a carver in bone and ivory named Michelino. He was elected to the Compagnia di S Luca in 1442 and joined the Arte dei Medici e degli Speziali on 26 October 1444. In 1459 he received payment from Lorenzo Pucci for a processional banner (untraced) for a confraternity based in S Francesco, Cortona. Four years later he was paid for some figures of saints (untraced) for a cupboard belonging to the Compagnia di S Maria della Purificazione e di S Zanobi, a Florentine confraternity of which he had been a member since 1445.

Domenico's only surviving documented work is the painting of *Dante Reading from the 'Divine Comedy'* (see fig.) in the north aisle of Florence Cathedral, where Lenten readings from the *Divine Comedy* had been held since at least 1432. On 30 January 1465 Domenico was charged by the *operai* of the cathedral to execute a painting of the poet within six months for the sum of 100 lire. The figure of Dante was based on a modello supplied by Alesso Baldovinetti. On 19 June 1465 Baldovinetti and Neri di Bicci appraised the work and declared that since Domenico had added so many details of his own invention, he should receive the sum of 155 lire.

Ciaranfi assembled a homogeneous group of paintings close to the *Dante* in style. Additions were proposed by Offner. These works form a consistent, sometimes repetitive corpus, although Berenson assigned several of them to Giusto di Andrea. Berenson suggested that a *Last Judgement* (ex-Kaiser-Friedrich Mus., Berlin; destr.) was begun by Giusto's father, Andrea di Giusto, and completed by Domenico di Michelino with an assistant. This work was dated 1456 and was commissioned for the Villani Chapel in S Benedetto fuori Porta Pinti, Florence. The design was heavily dependent on Fra Angelico, who according to Vasari (ii, p. 522) was Domenico's master, although this theory is unlikely. It is probable that the design of the *Last Judgement* can be attributed to Andrea di Giusto, who may have also painted the spandrels; Domenico appears to be responsible for the rest of the painting (for further attributed work *see* CASSONE, fig. 3).

Other influences are apparent in the *Virgin and Child with Six Saints* (San Giovanni Valdarno, S Maria delle Grazie), where the use of colour, the milky tonality and the drapery style of the figure of St Anthony Abbot are strongly reminiscent of Filippo Lippi, while the bright,

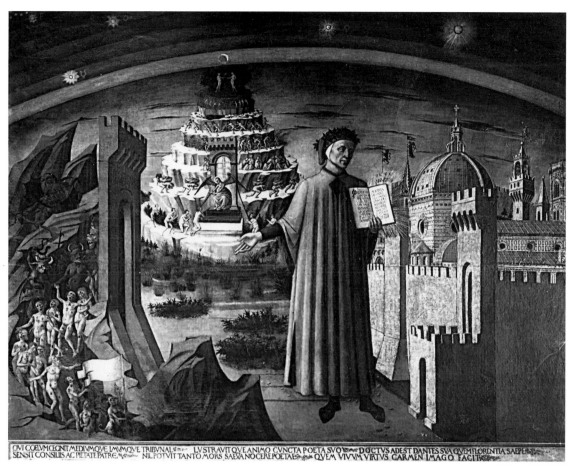

Domenico di Michelino: *Dante Reading from the 'Divine Comedy'*, tempera on linen, 1465 (Florence Cathedral)

broad-cheeked faces recall Pesellino. This work, although attributed to Giusto di Andrea by Berenson, was given to Domenico by Ciaranfi and Offner. Domenico also appears to have collaborated with Benozzo Gozzoli on the framing elements for Gozzoli's altarpiece for the Compagnia di S Maria della Purificazione (1461; London, N.G.). Each painted a pilaster enclosing three saints (Florence, Accad. B.A. & Liceo A.). A group of paintings (*c.* 1440–53) by Domenico's workshop have been ascribed by several critics to an anonymous artist dubbed the Master of the Buckingham Palace Madonna.

BIBLIOGRAPHY
G. Vasari: *Vite* (1550, rev. 2/1568); ed. G. Milanesi (1878–85)
A. M. Ciaranfi: 'Domenico di Michelino', *Dedalo*, vi (1925–6), pp. 522–38
R. Altrocchi: 'Michelino's *Dante*', *Speculum*, vi (1931), pp. 15–59
R. Offner: 'The "Mostra del Tesoro di Firenze Sacra"', *Burl. Mag.*, lxiii (1933), p. 174, n. 27
R. W. Kennedy: *Alesso Baldovinetti* (New Haven, CT, 1938), pp. 133–4
W. Cohn: 'Notizie storiche intorno ad alcune tavole fiorentine del '300 e '400', *Riv. A.*, xxxi (1956), pp. 43–5
B. Berenson: *Florentine School*, ii (1963), pp. 5, 60–61, 92–3
J. Shearman: *The Early Italian Pictures in the Collection of Her Majesty the Queen* (Cambridge, 1983), pp. 235–6

ELIOT W. ROWLANDS

Domenico di Niccolò [dei Cori; Spinelli] (*b* Siena, *c.* 1363; *d* Siena, *c.* 1453). Italian sculptor, designer and architect. He is known primarily for the large number of carved and polychromed wood statuettes of the Virgin, Virgin and Child, Christ and saints that he produced throughout his career for churches in and around Siena. The works attributed to his early career (*c.* 1395–1400) are characterized by broad, architectonic forms, suggestive of Nicola Pisano; however, such elements were superseded *c.* 1414 by an elegance of gesture and expressive drama that marked the beginnings of Domenico's mature gothicizing style. His rekindling of the Gothic spirit is strongly evident in the *Mourning Virgin* and the *Mourning St John* executed for Siena Cathedral (1414–15; Siena, S Pietro a Ovile; restored 1923). These 'Dolenti' reveal a new emotionalism and suggest a direct rapport with Sienese painting of the early 15th century. Around the same time Domenico executed intarsia choir-stalls for the new chapel in the Palazzo Pubblico, Siena (1415–*c.* 1428). His exceptional skill in this intricate and complex art form brought him high praise and the appellation 'dei cori'. The intarsie consist chiefly of decorative geometric designs and small scenes illustrating verses from the Credo, such as 'Descendit de coelis' and 'Et ascendit in coelum'. Their abstract, calligraphic quality is pronounced, and their sophisticated expressiveness is comparable to that of the 'Dolenti'. The *Risen Christ* (1442) made for the Ospedale di S Maria della Scala (Siena, Col. Chigi–Saracini) is one of his last known works and perhaps his most powerful. From at least 1394

Domenico was employed in various capacities by the Opera del Duomo in Siena; in 1402 he became a master of the cathedral's fabric and in 1413 was promoted to *capomaestro*.

BIBLIOGRAPHY

G. Previtali: 'Domenico "dei cori" e Lorenzo Vecchietta: Necessità di una revisione', *Stor. A.*, 38–40 (1980), pp. 141–4
A. Bagnoli: 'Domenico di Niccolò "dei cori"', *Scultura dipinta: Maestri di legname e pittori a Siena, 1250–1450* (exh. cat., ed. A. Bagnoli and R. Bartalini; Siena, Pin. N., 1987), pp. 104–32

□

Domenico di Paris (*b* Padua; *fl c.* 1443–1501). Italian sculptor, bronze-caster and wood-carver. A pupil and son-in-law of NICCOLÒ BARONCELLI, he followed his master from Padua to Ferrara. That he was called 'Domenico del Cavallo' in later documents attests to his considerable role in the making of the bronze equestrian monument to *Niccolò III d'Este, Marchese of Ferrara* (destr. 1796), which was begun by Baroncelli in 1443 and dedicated on 2 June 1451. After Baroncelli's death (1453), Domenico was head of the workshop and was paid in 1454, 1456 and 1457 for the monument to *Borso d'Este, Duke of Ferrara* (destr. 1796), begun by Baroncelli in 1451. In 1466 he completed the life-size bronze statues of *St George* and *St Maurelius* begun by Baroncelli for the high altar of Ferrara Cathedral; he also executed two marble lions for the high altar (all *in situ*). On 3 April 1467 he undertook to execute reliefs to cover the ceilings of upper rooms in the Palazzo Schifanoia, Ferrara. Although the contract makes no mention of the walls, the elaborate polychromed stucco decorations on the walls of the antechamber are universally given to him and Bongiovanni di Geminiano. Based on similarities to the putti and the figures of Virtues in the antechamber, two terracotta reliefs of the *Virgin Adoring the Christ Child* (Berlin, Bodemus.; Berlin, Gal. Goldschmidt–Wallerstein) have been attributed to him. Neither of these works can be identified with a terracotta altarpiece with figures in relief for which he was paid in 1466.

Domenico's other documented works have been destroyed. They included two large bronze candlesticks (1461), a lead *Hercules* (1472), wood-carvings made with other artists for a sumptuous carriage in 1473, some work in 1490 in connection with a marriage chest painted for Isabella d'Este, models for vases executed in 1492 and 60 wooden roses carved in 1501 for the oratory of the Confraternità delle Morte in Ferrara. On 21 January 1492 and 24 December 1493 he was paid for a wooden model for the summit of the cathedral campanile, and in 1493 he cast various components for the third storey.

BIBLIOGRAPHY

Thieme–Becker
A. Frizzi: *Memorie per la storia di Ferrara* (Ferrara, 1791–1809), iv, pp. 8, 24
G. Antonelli: 'Appendice', *Memorie originali italiane riguardanti le belle arti* by M. Gualandi, iv (Bologna, 1843), pp. 36–41, 48
V. N. Pietrucci: *Biografia degli artisti padovani* (Padua, 1858/*R* Bologna, 1970), p. 215
L. N. Cittadella: *Notizie relative a Ferrara per la maggior parte inedite ricavate da documenti ed illustrate*, i (Ferrara, 1864), pp. 46, 100–02, 416, 419–22, 578, 668, 704
G. Gruyer: 'La Sculpture à Ferrare', *Gaz. B.-A.*, n. s. 3, vi (1891), pp. 177–203 (188, 191–2)
——: *L'Art ferrarais à l'époque des princes d'Este* (Paris, 1897), i, pp. 297, 316–7, 423, 516; ii, p. 489

A. Venturi: 'Miscellanea: Una scultura di Domenico di Paris padovano', *L'Arte*, vii (1904), pp. 158–9
G. Agnelli: 'I monumenti di Niccolò III e Borso d'Este in Ferrara', *Atti & Mem. Deput. Ferrar. Stor. Patria*, xxiii (1918), pp. 1–32
L. Dussler: 'An Unknown Sculpture by Domenico di Paris', *Burl. Mag.*, xlvii (1926), pp. 301–2
P. Schubring: 'Zwei Madonnenreliefs von Giovanni da Pisa und Domenico Paris', *Der Cicerone*, xviii (1926), pp. 566–8 (567)
G. Medri: *La scultura a Ferrara* (Rovigo, 1957), pp. 51–3
C. M. Rosenberg: *Art in Ferrara during the Reign of Borso d'Este (1450–1471): A Study in Court Patronage* (diss., Ann Arbor, U. MI, 1974), pp. 65, 177–82
——: 'The Iconography of the "Sala degli Stucchi" in the Palazzo Schifanoia in Ferrara', *A. Bull.*, lxi (1979), pp. 377–84 (378)

JILL E. CARRINGTON

Domenico Veneziano [Domenico di Bartolomeo da Venezia] (*fl* 1438; *d* Florence, *bur* 15 May 1461). Italian painter. Venetian by birth or descent, he was one of the founders of Renaissance painting in Florence in the first half of the 15th century and the most enigmatic. His training (north Italian or Florentine), the chronology of his few surviving works (his only documented fresco cycle has perished and there is only one major altarpiece) and his relationship to contemporary painters, sculptors and theorists (particularly Alberti) have been debated; they cannot, given the shortage of evidence, be resolved satisfactorily. Yet, despite these difficulties, Domenico's altarpiece for S Lucia de' Magnoli in Florence (the *St Lucy* altarpiece; main panel in Florence, Uffizi; see fig. 2 and colour pl. 1, XXVIII1), with its ambitious architectural setting, acutely described figures and its pale colours bathed in a convincing outdoor light, would alone assure him a central place in the history of Renaissance art.

1. Life and work. 2. Working methods and technique. 3. Relationship to contemporaries and influence.

1. LIFE AND WORK.

(i) Early works, to mid-1440s. (ii) *St Lucy* altarpiece, mid-1440s. (iii) Other late works, mid-1440s and after.

(i) Early works, to mid-1440s. Although Domenico is mentioned by such contemporaries as Filarete (*Trattato dell'architettura*, *c.* 1461–2; see Wohl, 1980, p. 349) and Alamano Rinuccini (dedicatory epistle to the Latin translation of Philostratus' *Life of Apollonius*, 1473; see Wohl, 1980, pp. 349–50), he is, surprisingly, omitted from Cristoforo Landino's commentary of Dante of 1480 with its characterization of the work of Masaccio, Filippo Lippi, Andrea del Castagno, Paolo Uccello and Fra Angelico. Vasari's biography of Domenico is subordinate to the life of Andrea del Castagno and contains a considerable amount of bad information: Domenico is credited with having introduced the practice of oil painting into Florence and his fresco of *SS John the Baptist and Francis* (Florence, Mus. Opera Santa Croce) is ascribed to Castagno, whom Vasari erroneously claimed had murdered Domenico (*see* CASTAGNO, ANDREA DEL).

The first document relating to Domenico is a letter he wrote from Perugia in 1438 to Piero de' Medici, then in Ferrara. The letter attests to Domenico's presence in Central Italy by that date and confirms his activity in Perugia (where Vasari records a cycle of frescoes of unspecified subject in the Baglioni Palace, destr. 1540). It also reveals a familiarity with events in Florence that

suggests some prior activity in the city. Domenico expresses his hope to obtain the commission for a major altarpiece he understands Cosimo de' Medici is contemplating (usually identified as Fra Angelico's high altarpiece for S Marco; Florence, Mus. S Marco). He is also aware that Filippo Lippi is already engaged on an altarpiece, commissioned on 8 March 1437 for Santo Spirito (the Barbadori Altarpiece; Paris, Louvre; *see* LIPPI, (1), fig. 1). The letter contains orthographic peculiarities characteristic of both Venice and Florence (Wohl, 1980; Beck), further suggesting that by 1438 at the latest Domenico had assimilated Florentine habits. No special importance can be attached to Domenico's use of 'da Venezia' or 'Veneziano' until his death; this was common practice among those whose birthplace or citizenship differed from the city or region in which they worked, and it is, in consequence, idle to speculate when and under what circumstances Domenico arrived in Central Italy. Although an apprenticeship to Gentile da Fabriano or to Pisanello is not impossible, his work is, from the outset, decisively Florentine, not Venetian, in its concerns.

Any interpretation of Domenico's career relies on the chronology assigned to his surviving paintings, none of which is documented. No consensus has been reached (the most thorough and convincing chronology is that of Wohl, 1980). A guiding principle is Domenico's increasing command of the use of perspective for pictorial and narrative effects and greater subtlety in physiognomic description. On this basis, one may accept Vasari's assertion that the much damaged fresco of the *Virgin and Child Enthroned* (London, N.G.) for an exterior tabernacle from the Canto de' Carnesecchi in Florence is his earliest work. Characteristically, the ovoid head of the Virgin, the tooled gold leaf of her brocade dress and the pale flesh tints, the accomplished foreshortening of God the Father and the dove and the accentuated perspective of the throne (the vanishing point is in the lap of the Virgin), have their closest parallel in the work of Masolino, not in Gentile da Fabriano or Pisanello. It is conceivable that Domenico worked with Masolino in Rome between 1428 and 1433 (the throne recalls the work of the Cosmati workshop in Rome) or at Castiglione d'Olona, west of Milan, *c.* 1433–5, and this could partly explain the penchant Domenico shared with Masolino for perspective as a means both of suggesting depth and of generating abstract surface patterns. The relatively primitive perspective structure of the Carnesecchi Tabernacle, with its tunnelling effect at the expense of the figures, would accord with a date in the early 1430s.

The next reasonably datable work is a *Virgin and Child* (Bucharest, Mus. A.). The more massive proportions of the Virgin, the active pose of the Christ Child (dependent on Donatello's dancing putti on the *Singing Gallery (Cantoria)* of 1433–9 for Florence Cathedral; now Florence, Mus. Opera Duomo) and the use of a highly focused light find an analogy in Filippo Lippi's *Virgin and Child* known as the Tarquinia *Madonna* (1437; Rome, Pal. Barberini), while the preference for geometric clarity in the design and details such as the rhythmic disposition of the fingers of the Virgin's hands provide a precedent for Piero della Francesca's *Madonna of Mercy* (Sansepolcro, Pin.). Piero is mentioned in 1439 as Domenico's assistant in a payment

for the lost fresco cycle in the choir of S Egidio, Florence, and the *Virgin and Child* in Bucharest establishes the importance of this training. Some of the same traits characterize the roughly contemporary tondo of the *Adoration of the Magi* (Berlin, Gemäldegal.; *see* fig. 1), the astonishing landscape of which is the basis for that in Piero's *Baptism* (London, N.G.; *see* PIERO DELLA FRANCESCA, fig. 1). The origins of that landscape style (North Italian or, more probably, Flemish) have been debated (see especially Zeri), but there is general agreement that its remarkable perspective structure, with a vanishing-point separate from that of the foreground scene, depends on Donatello's stucco tondo relief of *St John on Patmos* (probably completed by 1443) in the Old Sacristy of S Lorenzo, Florence. The application of perspective to landscape painting was as innovative as the acute, descriptive technique with which the background details are represented and had a notable impact on Piero della Francesca. Domenico's tondo has sometimes been identified with an item in a Medici inventory of 1497 (Pudelko; Wohl, 1980), and it has been argued that the commission came from Piero de' Medici and involved Medici portraits and devices (Ames-Lewis), but the inventory names Pesello (i.e. Pesellino) as the artist and gives different dimensions from those of the painting in Berlin.

Part of the importance of the *Virgin and Child* in Bucharest and the *Adoration of the Magi* in Berlin derives from the fact that they were painted shortly before or contemporary with Domenico's lost frescoes on the west wall of the choir of S Egidio, which were begun in 1439 and appear to have been largely completed by 1443, although there is an additional payment in June 1445. One scene was completed by Alesso Baldovinetti in 1461; Wohl (1980) attempted to demonstrate that Domenico completed only the sinopia for this, but as he was paid more than Andrea del Castagno for three companion scenes on the opposite wall, this analysis is likely to be incorrect.

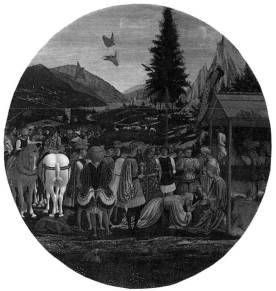

1. Domenico Veneziano: *Adoration of the Magi*, tempera on panel, diam. 840 mm, *c.* 1439–41 (Berlin, Gemäldegalerie)

Vasari recorded the subjects and general character of the scenes, of which a few fragments were salvaged in 1938. They showed, from top to bottom, the *Meeting at the Golden Gate*, the *Birth of the Virgin* and the *Marriage of the Virgin* and were conspicuous for their elaborate architectural settings and profuse details, such as a child beating the door with a hammer in the *Birth of the Virgin* and a dwarf in the *Marriage of the Virgin*. The composition for the *Marriage of the Virgin* is probably reflected in a small panel of the same subject (Florence, I Tatti; Meiss), in which the architecture of the open courtyard, with a straight entablature supported by columns, prefigures a feature of Alberti's architecture also found in the work of Piero della Francesca.

(ii) 'St Lucy' altarpiece, mid-1440s. This altarpiece (main panel, Florence, Uffizi, see fig. 2 and colour pl. 1, XXVIII1; predella panels, Washington, DC, N.G.A.; Berlin, Gemäldegal.; Cambridge, Fitzwilliam, see fig. 3 below), painted for the high altar of the small church of S Lucia de' Magnoli, probably dates from the mid-1440s and is roughly contemporary with Fra Angelico's S Marco Altarpiece (Florence, Mus. S Marco) and Filippo Lippi's *Coronation of the Virgin* (Florence, Uffizi; see colour pl. 1, XXXVIII1) for S Ambrogio. Like those two works, it marks the climax of early Renaissance painting in Florence. No earlier 15th-century altarpiece, and few later ones, employ such an ambitious architectural setting (Verga's suggestion that Piero della Francesca was involved in the design is highly improbable). In the S Marco Altarpiece architecture serves as a screen between a projected, geometric patterned carpet and the distant landscape, and in Filippo Lippi's *Coronation of the Virgin* the complicated, stepped, box-like space compromises a profusion of decorative detail and a superabundance of figures, but in the *St Lucy* altarpiece architecture both defines the space and articulates the figural content.

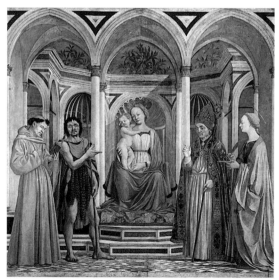

2. Domenico Veneziano: main panel of the *St Lucy* altarpiece, tempera on panel, 2.09×2.16 m, mid-1440s (Florence, Galleria degli Uffizi)

The four saints (Francis, John the Baptist, Zenobius and Lucy) occupy a foreground defined by an inlaid pavement and a raised arcade beneath which sit the Virgin and Child. The arcade also divides the picture surface vertically into three parts—as in a Gothic triptych—and behind the arcade is a pentagonal exedra comprising three shell niches and two vaulted bays, above which are visible a blue sky and three orange trees (Marian symbols). The notion that this inventive scheme could have been evolved without recourse to some sort of preliminary ground-plan drawings (Wohl, 1980, argues for the use of a surface grid that should not, however, be confused with the *velo* device recommended by Alberti for studying foreshortening of individual objects) is contradicted by the analyses of Verga, Battisti and Welliver, who have recreated the layout of the architecture. The resulting impression is of the apse of an open-roofed church viewed through a raised rood screen, or *tramezzo*. The reference to ecclesiastical architecture, with the Virgin/Ecclesia at its focus, is unquestionably intentional. It recurs, notably, in Filippo Lippi's contemporary *Annunciation* (Munich, Alte Pin.; *see* LIPPI, (1), fig. 2) and, significantly, receives its most complete statement in Piero della Francesca's altarpiece of the *Virgin and Child Enthroned with Saints and Federigo da Montefeltro* (Milan, Brera; see colour pl. 2, XVI2). The polychromatic inlaid details of the architecture relate to a well-established Tuscan tradition also used by Alberti, and the design of the exedra seems to reflect Brunelleschi's tribunes for Florence Cathedral. The pointed arches of the arcade have parallels in contemporary Florentine architecture and were necessitated by the fact that the spans of the arcade are narrower than those of the exedra (Welliver).

The unusually low viewing-point (in the lap of the Virgin) has been seen as contradicting Alberti's recommendations, but it was determined by the approximate height of a viewer standing before the altar in the church and expresses Alberti's intention that perspective be used to create a fictive extension of the viewer's space (this idea was later developed by Mantegna). Likewise, the light source coincides with the primary source of illumination in the church (the 45° angle at which it falls also enhances the geometric clarity of the composition). The inventive use of perspective as a factor of design applies also to the five narrative panels of the predella, each of which originally had a fictive moulding enhancing Alberti's concept of painting as a window. In the idyllic *Annunciation* (Cambridge, Fitzwilliam; *see* ITALY, fig. 14) the perspective structure is normative: the horizon is level with the Virgin's head and the vanishing-point is located on what was originally the vertical axis (the angle of the shadow was, like the perspective of the pavement, determined by a visible incision). In the *Martyrdom of St Lucy* (Berlin, Gemäldegal.) the vanishing-point coincides with the focus of the action, emphasized by the orthogonals, one of which is described by the sceptre of the governor ordering the execution. In the *Miracle of St Zenobius* (Cambridge, Fitzwilliam; see fig. 3) the focus of the perspective is off-centre and organizes the receding buildings into two sets of converging diagonals that generate a sensation of heightened drama to the story, enacted in a shallow area across the foreground. The source for this unusually free

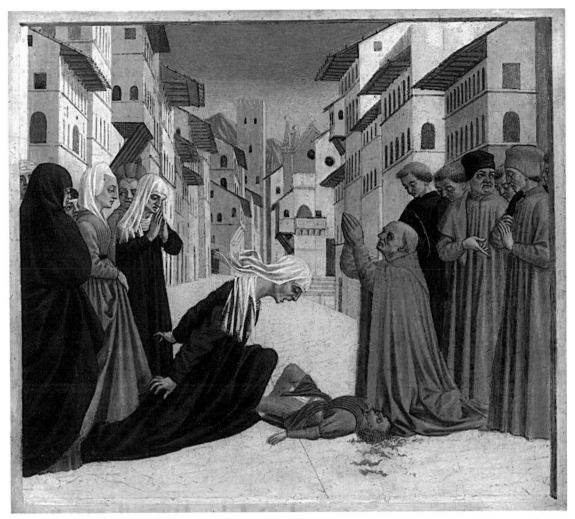

3. Domenico Veneziano: *Miracle of St Zenobius*, predella panel of the *St Lucy* altarpiece, tempera on panel, 286×325 mm, mid-1440s (Cambridge, Fitzwilliam Museum)

and imaginative use of perspective as a narrative device is, again, Donatello's relief sculpture.

The iconography of the altarpiece seems, on the whole, unexceptional, although it has been the subject of an elaborate exegesis, and the inscription on the steps (an invocation to the Virgin) has been thought to camouflage a variety of erudite meanings (Wohl, 1980; Welliver). The blond tonality of the altarpiece and the innovative description of light have been commented on by numerous critics (see especially Pudelko) and mark a shift from the more saturated colour and dense shadows of Domenico's earlier work. Interestingly, the same shift is observable in Piero della Francesca's *Baptism* (London, N.G.) and *St Jerome* (1450; Berlin, Gemäldegal.); Domenico was employed in Arezzo in 1450 (Dabell) and may be responsible for this shift in Piero's work. (Vasari also records that the two artists worked together in Loreto, but this cannot be verified.)

(iii) Other late works, mid-1440s and after. Documents relating to Domenico's life after 1445 are remarkably

uninformative. In 1447–8 he painted two chests (untraced) for the marriage of Marco Parenti to Caterina Strozzi; an idea of their appearance may be gleaned from the *desco da parto* (birth tray) illustrating the *Triumph of Fame* (1449; New York, Hist. Soc.) for Lorenzo de' Medici (the Magnificent), the design of which Domenico Veneziano may have been responsible for, although the execution is due to Giovanni di ser Giovanni, known as Scheggia. In 1454 Domenico was nominated, together with Filippo Lippi and Fra Angelico, to evaluate the work of Benedetto Bonfigli in the Palazzo de' Priori in Perugia, and three years later, with Filippo Lippi, he evaluated Pesellino's *Trinity* (London, N.G.); these references confirm his central position in Florence.

Only three works may be connected with the last 16 years of Domenico's life. A *Virgin and Child* (Washington, DC, N.G.A.) is, perhaps, slightly later than the *St Lucy* altarpiece and marks an increased refinement of figure type and colour harmonies. Another *Virgin and Child* (Florence, I Tatti) is sometimes considered an early work, but its sophisticated design and decorative use of gold leaf

are paralleled in Florentine art of the mid-15th century. In a detached fresco of *SS John the Baptist and Francis* (Florence, Mus. Opera Santa Croce; see fig. 4), originally on the *tramezzo* of Santa Croce, Domenico reached new depths of expressiveness. The fresco also reveals his continued concern with perspective to achieve an effect of immediacy and urgency (the saints are shown *di sotto in sù* and from the right, in accordance with the natural viewing-point in the church).

A number of other works from these years may be presumed lost, but it is doubtful that Domenico's level of production was great; his work is the product of a slow, deliberate process, again similar to that of Piero della Francesca. In the letter of 1438 he estimated it would take Filippo Lippi five years to complete the altarpiece on which Lippi was employed, and this may be taken as indicative of his own rate of production. Moreover, allowance must be made for the possibility of an extensive career outside Florence: his name occurs in few Florentine documents; it is not known when (or if) he joined the painters' guild, though his name does occur in the records of the Compagnia di S Luca, and only in 1455 is there a record of his lease of a house in Florence.

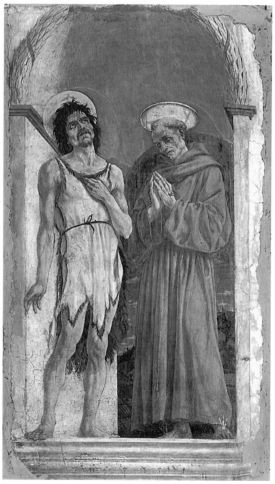

4. Domenico Veneziano: *SS John the Baptist and Francis* (*c.* 1445–61), fresco, Florence, Museo dell'Opera di Santa Croce

2. WORKING METHODS AND TECHNIQUE. Vasari claimed that Domenico learnt the technique of oil painting in Venice from Antonello da Messina and introduced it to Florentine painters, most notably in his destroyed murals in S Egidio. The first half of this claim is clearly incorrect and derives from Vasari's misconception of Venetian painting in general and his classification of Domenico as a Venetian artist. There is a payment for linseed oil in 1441 for use on the murals in S Egidio, but Wohl (1980) has convincingly argued that this oil was used not as a principal medium but as a binder in adding details *a secco*, a technique recorded by Cennino Cennini. There has been no scientific analysis of the medium employed by Domenico in his panel paintings, which, however, have the appearance of being executed in tempera. Nonetheless, Piero della Francesca's use of an oil or oil-like medium in his earliest documented work, commissioned in 1445, the *Madonna of Mercy* in Sansepolcro, suggests that his master may have had some awareness of the technique.

Domenico's use of full-scale cartoons in designing his paintings is of primary importance for the subsequent history of Florentine painting. This can be demonstrated in his fresco of *SS John the Baptist and Francis* for Santa Croce and in the *Virgin and Child* in Washington, in both of which *spolveri* are visible. These are among the earliest examples of a technique also employed by Andrea del Castagno and Piero della Francesca, who may well be indebted to Domenico for it. The use of cartoons was obviously due to Domenico's deep concern for details and his desire to plan all aspects of a composition prior to painting. Concomitant was his concern with perspective and the point from which the works would be viewed. The one surviving sinopia for the murals at S Egidio establishes that, like Uccello, Domenico began work by defining the space in which the figural action would take place. The accomplished complexity of the *St Lucy* altarpiece would have been impossible without the aid of cartoons and the mastery of perspective, both of which are central to subsequent Renaissance art in Florence.

It is clear that sculpture in general played a significant role in Domenico's art: the importance of Donatello's reliefs in the Old Sacristy of S Lorenzo has already been noted. Domenico's frescoed figure of *St John the Baptist* would scarcely be conceivable without the example of Donatello's wooden statue of *St Mary Magdalene* for the Florence Baptistery (Florence, Mus. Opera Duomo; *see* DONATELLO, fig. 5), and the composition of the Virgin and Child in the *St Lucy* altarpiece is in many respects a painted counterpart to Luca della Robbia's terracotta tondo on Orsanmichele. This interest extended to antique sculpture as well: the pose of the young St John the Baptist in the predella panel (Washington, DC, N.G.A.) from the *St Lucy* altarpiece seems to derive from a Roman sarcophagus showing Hercules in combat with Diomedes (Wohl, 1980), and his almost Hellenic beauty—he is the most beautifully painted male nude of the first half of the 15th century—possibly reflects a familarity with antique bronze statuettes. Each of these interests, however, was subservient to Domenico's refined sensibility and his apparent conception of painting as an intellectual endeavour rather than a craft.

3. RELATIONSHIP TO CONTEMPORARIES AND
INFLUENCE. The relationship of Domenico Veneziano's
work to that of his presumed pupil, Piero della Francesca,
has been discussed briefly above, but it should be empha-
sized that this extended from figure types and colour in
Piero's early paintings to the use of perspective both as a
device of pictorial composition and as a means of describ-
ing space. In the case of Piero, Alberti can be shown to
have played a crucial role in these concerns, and it is
probable that he had a direct impact on Domenico as well,
possibly in 1434–6, when he was in Florence as part of
the papal retinue and composed his treatise on painting,
or between 1439 and 1443. It is even conceivable that the
shift in style documented by the *St Lucy* altarpiece may
owe something to Alberti. Given the sparse evidence,
however, it is almost impossible to gauge the extent of
Alberti's influence, though an eloquent attempt has been
made by Longhi to relate Domenico's work to ideas in *De
pictura* (1435).

Vasari's portrayal of Domenico as a gentleman–painter
('amiable, he sang and liked to play the lute') is probably
based not on fact but on his view of Venetian painters in
general (the characterization is curiously like that of
Giorgione). The fact that Vasari coupled the lives of
Domenico and Andrea del Castagno in a single biography
seems, on the other hand, well-grounded. Domenico has
been ascribed a collaborative role in Castagno's fresco
cycle in S Tarasio, Venice, which is dated 1442 (Muraro),
and although this has been denied (most emphatically by
Zeri), it is not impossible: the figure of St John the
Evangelist is painted in a manner closely resembling that
of Domenico. In 1451 Castagno was commissioned to
fresco three scenes opposite Domenico's in S Egidio, and
his late work reveals a refinement of colour and sensitivity
to landscape and light that unquestionably derive from
Domenico. (However, Hartt's erroneous attribution to
Domenico of the *sinopia* for Castagno's *St Jerome* in the
SS Annunziata is based on a misunderstanding of its
function as a preliminary design done without the aid of a
cartoon.) It is worth noting that in the 16th century
Domenico's fresco of *SS John the Baptist and Francis* in
Santa Croce passed as the work of Castagno or Antonio
del Pollaiuolo. The attribution to Pollaiuolo emphasizes
the importance of Domenico's unequalled powers of
description among his contemporaries, as does the con-
fusion of Pollaiuolo's *Portrait of a Lady* (Berlin, Gemäl-
degal.) as a work of Domenico's (the only two portraits
that may reasonably be attributed to Domenico are those
of *Matteo Olivieri* and *Michele Olivieri*, Washington, DC,
N.G.A.; Norfolk, VA, Chrysler Mus.; both poorly pre-
served). The most direct influence was that exerted on
Alesso Baldovinetti, whose work is in many respects an
academic corruption of Domenico's.

Domenico's influence extended well beyond Florence.
Zeri has convincingly argued that Domenico di Bartolo's
frescoes in the Ospedale della Scala, Siena, and Benedetto
Bonfigli's in the Cappella de' Priori, Perugia, derive to
some extent from those of Domenico in Perugia and
Florence. Zeri has also demonstrated Giovanni Boccati's
dependence on Domenico's landscape style. The Master
of the Barberini Panels, who, like Boccati, was from the
Marches, was among Domenico's most faithful imitators

and to a degree so also was the Sienese artist Vecchietta.
Interestingly, it is impossible to establish any certain
influence of Domenico on Venetian art, underscoring his
role as a Central Italian artist.

BIBLIOGRAPHY

G. Vasari: *Vite* (1550, rev. 2/1568); ed. G. Milanesi (1878–85), ii, pp. 667–
89
G. Pudelko: 'Studien über Domenico Veneziano', *Mitt. Ksthist. Inst.
Florenz*, iv (1932–4), pp. 145–200
M. Salmi: *Paolo Uccello, Andrea del Castagno, Domenico Veneziano* (Rome,
1936)
A. Busuioceanu: 'Una nuova Madonna di Domenico Veneziano', *L' arte*,
n. s., viii (1937), pp. 3–15
R. W. Kennedy: *Alesso Baldovinetti: A Critical and Historical Study* (New
Haven and London, 1938)
R. Longhi: 'Il Maestro di Pratovecchio', *Paragone*, 35 (1952), pp. 10–30
M. Muraro: 'Domenico Veneziano at San Tarasio', *A. Bull.*, xxix (1959),
pp. 151–8
M. Meiss: 'Contributions to Two Elusive Masters', *Burl. Mag.*, ciii (1961),
pp. 57–61
F. Zeri: *Due dipinti, la filologia e un nome* (Turin, 1961)
D. Gioseffi: 'Domenico Veneziano: L'esordio masaccesco e la tavola con
i SS Girolamo e Giovanni Battista della National Gallery di Londra',
Emporium, cxxxv (1962), pp. 51–72
C. Shell: 'Domenico Veneziano, Two Clues', *Festschrift Ulrich Middeldorf*
(Berlin, 1968), pp. 150–54
F. Hartt: *The History of Italian Renaissance Art* (New York, 1969), p. 226
M. Hall: 'The *Tramezzo* in S Croce, Florence and Domenico Veneziano's
Fresco', *Burl. Mag.*, cxii (1970), pp. 797–9
E. Battisti: 'Mantegna come prospettico', *A. Lombarda*, xvi (1971), pp.
104–7
H. Wohl: 'Domenico Veneziano Studies: The Sant'Egidio and Parenti
Documents', *Burl. Mag.*, cxiii (1971), pp. 635–40
W. Welliver: 'The Symbolic Architecture of Domenico Veneziano and
Piero della Francesca', *A. Q.*, xxxvi (1973), pp. 1–30
C. Verga: 'Un pavimento di Piero?', *Crit. A.*, xlii (1977), pp. 100–15
F. Ames-Lewis: 'Domenico Veneziano and the Medici', *Jb. Berlin. Mus.*,
xxi (1979), pp. 67–90
J. Beck: 'Was Domenico Veneziano Really *Veneziano*?', *A. News*, lxxix/
10 (Dec 1980), pp. 168–9
H. Wohl: *The Paintings of Domenico Veneziano, ca. 1410–1461: A Study
in Florentine Art of the Early Renaissance* (New York, 1980); review by
K. Christiansen in *Apollo*, cxiv/233 (1981), pp. 66–7
F. Dabell: 'Domenico Veneziano in Arezzo and the Problem of Vasari's
Painter Ancestor', *Burl. Mag.*, cxxvii (1985), pp. 29–32
*Una scuola per Piero: Luce, colore e prospettiva nella formazione fiorentina di
Piero della Francesca* (exh. cat. by L. Bellosi, Florence, Uffizi, 1992–3)
A. De Marchi: 'Domenico Veneziano alla mostra degli Uffizi: Appunti e
verifiche', *Kermes*, vii/20 (May–Aug 1994), pp. 30–40

KEITH CHRISTIANSEN

Donatello [Donato di Niccolo di Betto Bardi] (*b* Florence,
1386 or 1387; *d* Florence, 13 Dec 1466). Italian sculptor.
He was the most imaginative and versatile Florentine
sculptor of the early Renaissance, famous for his rendering
of human character and for his dramatic narratives. He
achieved these ends by studying ancient Roman sculpture
and amalgamating its ideas with an acute and sympathetic
observation of everyday life. Together with Alberti, Bru-
nelleschi, Masaccio and Uccello, Donatello created the
Italian Renaissance style, which he introduced to Rome,
Siena and Padua at various stages of his career. He was
long-lived and prolific: between 1401 and 1461 there are
400 documentary references to him, some for nearly every
year. However, there is no contemporary biography, and
the earliest account, in Vasari's *Vite* (1550), is confused.

I. Life and work. II. Working methods and technique. III. Character and
personality. IV. Critical reception and posthumous reputation.

I. Life and work.

1. Training and early work, before 1409. 2. Florence, Pisa and Rome, 1409–42. 3. Padua, 1443–53. 4. Old age, 1454–66.

1. TRAINING AND EARLY WORK, BEFORE 1409. The earliest record of Donatello's artistic career is his apprenticeship to Lorenzo Ghiberti between 1404 and 1407, when the latter was engaged in preparing the models for the bronze reliefs on the north doors of the Baptistery in Florence (*see* GHIBERTI, (1), fig. 1). This would have given him a grounding in Late Gothic style design as practised by Ghiberti and in the techniques of modelling in wax and clay, in preparation for casting in bronze. However, Ghiberti was not a marble-carver and Donatello must have acquired this skill elsewhere, probably in the flourishing workshops of Florence Cathedral, where his earliest documented sculptures, two small marble statues of *Prophets* for the Porta della Mandorla (1406), are found. Two years later, in 1408, Donatello was commissioned to carve a full-size marble statue of *David* (Florence, Bargello) to crown one of the cathedral buttresses. This was his first major statue and took several years to carve. It was never erected on the buttress but was acquired in 1416 by the City Council of Florence for display as a civic emblem in the Palazzo della Signoria—a sign of their early recognition of Donatello's talent. It was painted, gilded and set on a pedestal inlaid with mosaic and must have looked highly ornamental. This would have appealed to the then current taste for Late Gothic art. All traces of colour are now lost and the statue looks rather bland. Its most remarkable feature is the head of Goliath lying at David's feet: it is carved with great assurance and reveals the young sculptor's genuinely Renaissance interest in an ancient Roman type of mature, bearded head.

Also in 1408, Donatello was the youngest of four sculptors to receive a commission to carve an over life-size seated figure of an Evangelist for each of the four niches flanking the great western portal of Florence Cathedral (*see* FLORENCE, §IV, 1(i)(b)). His *St John the Evangelist* (Florence, Mus. Opera Duomo; see fig. 1) took until 1415 to finish, perhaps because he chose to pioneer a new style of maximum realism and psychological impact. The broad swathes of drapery in the Evangelist's toga serve as a foil for the enlarged, relaxed hands and the noble, bearded head. Donatello also deliberately distorted the proportions of the figure in order to compensate for the effects of foreshortening, when it was seen from below by passers-by—a most sophisticated device. The torso is unnaturally elongated and looks unstable when seen straight on (as in many of the standard photographs), but it has a solid pyramidal appearance when a lower viewpoint is adopted, corresponding with that of an observer when the statue was in its original niche. Giovanni Pisano had made the heads of his *Prophets* (after *c.* 1284) for the façade of Siena Cathedral jut forward pronouncedly, to make them more visible from below, but he did not adjust their proportions. Donatello was acutely conscious of the settings of all his statues, and this may be counted as a Renaissance tendency. According to Vasari, Donatello is also supposed at this early stage of his career to have carved and painted a wooden Crucifix for Santa Croce,

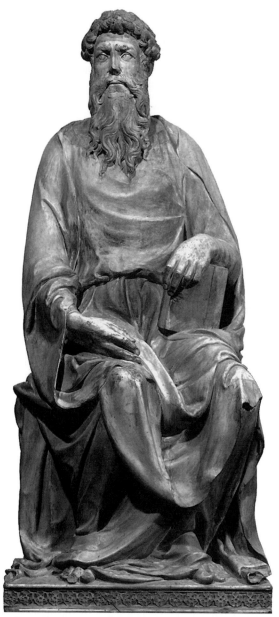

1. Donatello: *St John the Evangelist*, marble, h. 2.10 m, completed 1415 (Florence, Museo dell'Opera del Duomo)

Florence (*in situ*), but its attribution is no longer universally accepted.

2. FLORENCE, PISA AND ROME, 1409–42.

(i) Statutary and portraiture. (ii) Narrative reliefs.

(i) Statuary and portraiture. In 1411, while still at work on the *St John*, Donatello was commissioned by the Arte dei Linaioli (Linen Drapers' Guild) to carve a different Evangelist, this time standing, for their niche on the guildhall of Orsanmichele. The ponderation of the resultant statue of *St Mark* (marble, 1411–13; *in situ*), which gives him an air of authority, is derived from ancient Roman figures of senators: the weight-bearing leg is emphasized by parallel

folds of drapery (like the flutes on a Classical column) and is clearly differentiated from the relaxed leg, only the knee of which can be seen through the thick wrinkles of the toga. The saint stands on a cushion, a totally unrealistic idea, but one that permitted Donatello to indicate the weight of the figure by the indentations made by the feet. The cushion may also have referred to the products of the textile guild that commissioned the statue. A radical contrast in style may be remarked between Donatello's completely Renaissance *St Mark* and Ghiberti's contemporaneous, but still very Gothic, bronze statue of *St John the Baptist* (1412) in a niche near by.

Soon afterwards, perhaps around 1414, the Arte dei Corazzai (Guild of Armourers) ordered from Donatello a marble statue for Orsanmichele of their patron, *St George* (Florence, Bargello; *see* FLORENCE, fig. 11), a knight in armour and thus an advertisement for their wares. This has always been one of Donatello's most admired statues. The sculptor overcame a difficult problem, for the unyielding metal plates of armour did not permit him to express the potential movements of the limbs and body inside. Donatello could only use the pose to hint at them: *St George* is balanced expectantly on the balls of his feet. Otherwise Donatello could express emotion only in the face and the hands, protruding from the armour. In the clenched right-hand fist a hole indicates that the knight once held a weapon, probably a sword fashioned in gilt-metal, as it would have been impossible to carve out of marble. 'In the head', Vasari wrote, 'there may be seen the beauty of youth, courage and valour in arms, and a proud and terrible ardour; and there is a marvellous suggestion of life bursting out of the stone.'

The success of the statues of *St Mark* and *St George* encouraged the Guelph party to commission from Donatello a yet more ambitious one of their patron, *St Louis of Toulouse*. The statue (*c.* 1418–22; Florence, Mus. Opera Santa Croce) is in gilded bronze, the most glamorous—and the most expensive—sculptural material. To meet this complex technical challenge, Donatello called on the expert assistance of Michelozzo, an experienced metallurgist, who until then had been working with Ghiberti. The crinkly drapery of the voluminous cope gives vivacity to what might otherwise have been a rather bland figure of a youthful bishop: the figure was to be so large that, for technical reasons, the cope had to be modelled, and then cast and gilded, in several separate sections. This must have inspired the artist to give it a life of its own. The gloves, mitre and crozier—even the face—were also made separately and fixed together over an iron armature inside the figure. The brightly gilded masterpiece was installed in a Brunelleschian, Renaissance niche on Orsanmichele in 1422.

Late in 1415 Donatello began work on two life-size marble statues of *Prophets*—*Jeremiah* and *Habakkuk*—for some niches high on Giotto's Campanile. (The originals, grimy and weathered by centuries of exposure, are now in the Museo dell'Opera del Duomo and have been replaced with modern copies on the Campanile; *see* FLORENCE, fig. 10.) These statues were the earliest of a whole series, the execution of which lasted until the end of the mid-1430s; for the sake of speed, some were carved in collaboration with other sculptors. They were to be seen high above

eye-level, so their features and drapery had to be boldly chiselled, yet their movements were constricted by the narrow lancet shapes of the pre-existing niches. Donatello met this challenge by adapting the plastic forms of drapery that he had had to model in wax or clay for his *St Louis* to the different medium of marble; gnarled hands and wizened faces—some quite hideous, but all the more moving—express the pathos of these Old Testament prophets, whose messages were rarely heeded. Their heads look like portraits. They are clearly indebted to ancient Roman ancestor busts and statues but are further enlivened by Donatello's fertile imagination and minute observation of his fellow men.

Donatello's interest in ancient Roman busts is demonstrated by a gilt-bronze reliquary for the head of the Early Christian martyr *St Rossore* (Pisa, Mus. N. S Matteo), a relic that reached the friars of Ognissanti in Florence in 1422. St Rossore (also known as St Lussorio or Lussurgiu) was a soldier who was beheaded under the Roman emperor Diocletian; thus Donatello's choice of the classic bust form used by the Romans to commemorate their ancestors was particularly appropriate. This form had survived in the Middle Ages as a container for head relics, but the faces had tended to be purely symbolic. Donatello, on the contrary, endowed his saint with lifelike, though imaginary, features and, with its knitted brow, an expression of intense anxiety appropriate to a victim of execution. This is the first datable example of a revival of the Roman type of realistic bust.

Two other undated and undocumented busts are generally associated with Donatello: one in bronze, like the *St Rossore*, shows a handsome youth in Classical guise, with a cameo (the original of which was owned by the Medici) around his neck (Florence, Bargello; see colour pl. 2, IX4). It is very like the bronze statue of *David* (Florence, Bargello) that the sculptor produced later in his career for Cosimo I de' Medici and has similar, Neo-Platonic overtones (*see* §4 below). The other bust, modelled in terracotta and realistically painted (Florence, Bargello), represents the patrician *Niccolò da Uzzano* (1359–1431). Its identification and attribution, though sometimes doubted, have been affirmed by a recent cleaning, which revealed the high quality of its modelling and painting (see fig. 2). It remains uncertain whether Donatello portrayed the sitter from the life, or after his death, using a mask cast from the face and then revitalized by retouching the clay before it finally set. In either case, this is probably the earliest true portrait bust of the Renaissance, predating by a considerable number of years that of *Piero de' Medici* by Mino da Fiesole (1453; Florence, Bargello; see colour pl. 2, VIII2), often claimed as the first. It is more likely that the credit for such a significant re-invention should go to an artist of greater calibre than Mino and occur at a date earlier than the middle of the century, by which time the Renaissance was well under way.

Portraiture was also Donatello's major personal contribution to a commission that he undertook *c.* 1424 jointly with Michelozzo (by then his business partner): the monumental tomb of *Baldassarre Coscia, the Anti-Pope John XXIII* (*d* 1419; Florence, Baptistery). Donatello himself must have been responsible for the ennobled rendering of the fleshy, care-worn face and complex

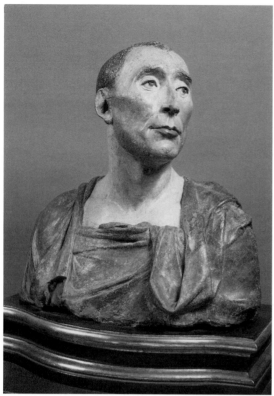

2. Donatello: *Niccolò da Uzzano*, painted terracotta, h. 460 mm, ?1430s (Florence, Muzeo Nazionale del Bargello)

drapery of the effigy, which was cast, like the *St Louis*, in bronze and then gilded. The design of the wall monument, which was inserted between two of the Roman columns supporting the Baptistery, is an early manifestation of Renaissance architecture and is probably joint work, for Michelozzo was the more architecturally minded (though Donatello's personal involvement with architecture dates back to 1419, when he submitted an unsuccessful model to the competition for the cupola of Florence Cathedral). The carving of the marble components of the Anti-Pope's tomb was delegated to their assistants. The harmonious composition of the various elements, such as the effigy on

a bier, the sarcophagus, the Virgin and Child in the lunette above and the division of the background into panels, were to inspire all the major 15th-century tomb monuments in Tuscany and Rome, which have collectively been called 'the humanist tomb' (Pope-Hennessy). Donatello was thus involved in yet another major innovation in Renaissance sculpture and architecture.

(ii) Narrative reliefs. Once he had mastered the art of modelling scenes in relief in Ghiberti's workshop, Donatello applied this knowledge to a variety of minor commissions, for example some gilded decorative friezes in the old houses of the Medici, mentioned by Vasari; and probably some renderings of the Virgin and Child, which were a prerequisite of every lady's bedroom and a staple product of sculptors' workshops. It is not until 1417, however, that there is a documentary reference to a relief in a public place, one showing *St George and the Dragon* (Florence, Bargello), which was carved in marble on the lintel at the foot of the niche for his statue of *St George* on Orsanmichele. It is the first manifestation of Donatello's interest in a form of extremely shallow relief-carving (It. *rilievo schiacciato*: 'flattened-out relief') that was more closely allied to graphic art than to sculpture (*see* §II below). Years of weathering have disguised the original subtlety of carving of the relief, but the receding hills and wind-battered trees in the background can still be made out. Straightforward linear perspective was also used to imply depth in the blind arcade at the right.

The next datable marble panel, the *Assumption of the Virgin* (Naples, S Angelo a Nilo), is on the tomb of *Cardinal Rinaldo Brancacci* (d 1427), which was carved by Donatello and Michelozzo at Pisa and sent to Naples (*see* MICHELOZZO DI BARTOLOMEO, fig. 1). In it Donatello flattened the relief of all the figures, even the centrally enthroned Virgin, whose notionally projecting knees he had to swing sideways.

While in Pisa, Donatello was in close contact with the painter Masaccio: their work from *c.* 1426—notably several Madonnas—reflects mutual influences. Most Masaccio-esque of all Donatello's shallow reliefs is the lovely marble panel (London, V&A; see fig. 3) combining two quite distinct episodes from the New Testament, the *Ascension* and *Christ Giving the Keys to St Peter*. Though it was

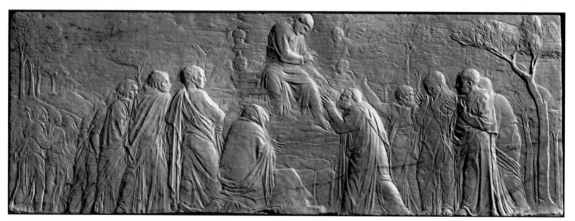

3. Donatello: *Ascension* with *Christ Giving the Keys to St Peter*, marble, 410×1145 mm, 1420s (London, Victoria and Albert Museum)

recorded in 1492 in an inventory of Lorenzo the Magnificent's effects in the Palazzo Medici, its earlier history is unknown. It is generally dated in the 1420s because it is composed in a way redolent of Masaccio's fresco of the *Tribute Money* in the Brancacci Chapel (*see* MASACCIO, fig. 6), with a half circle of Apostles surrounding the Saviour. Both the sculpture and the fresco are populated by the same deeply serious figures, impressively modelled and individually characterized. In contrast with the usual, idealized renderings of the Virgin, which portray her still youthful, untainted by sin, Donatello dared to show her as a wizened old peasant woman with coarse hands, as she might really have looked when her son was about the age of 30. The heads of the Apostles, especially of St Peter, are dexterously gouged out of the marble on a tiny scale with amazing confidence and freedom. Distant walled cities, hilltops and receding rows of trees are scratched into the rear planes so deftly that their very sketchiness helps to suggest distance, creating an effect that is termed 'aerial' perspective (as distinct from linear means).

Of several other marble reliefs in the same technique attributed to Donatello, the most interesting is the *Feast of Herod* (Lille, Mus. B.-A.). Its subject is the same as in Donatello's earliest documented bronze relief (1423–5), made for the parapet of the font in the baptistery of Siena Cathedral, but the treatment is very different. The marble relief is remarkable for its complicated architectural setting: Herod's vast palace is laid out correctly in perspective across the surface of the marble panel, but the principal episode is diminished in both scale and impact. The size of the figures in the foreground—one third of the height of the total field—and several other technical features correspond closely with Alberti's instructions for creating an ideal picture, and this seems to be a deliberate demonstration on Donatello's part of how this theory could be put into practice. In the Sienese bronze panel, the drama is witnessed in close focus owing to Donatello's use of a viewpoint for his perspectival scheme that is closer and higher than normal. The principal characters are large and few in number, so that their expressions can be clearly seen. The sequence of arcades, arranged one behind another towards the background, creates an effect of great space, and it is there that the earlier episode of the actual beheading is depicted.

Donatello continued to be much involved with relief-carvings in the 1430s: a sacramental tabernacle in St Peter's, Rome, its architecture peopled by angels and framing a scene of the *Entombment* (*c.* 1432); an external pulpit with panels of dancing putti for Prato Cathedral (commissioned in 1428, but delayed until 1438); and a *Singing Gallery* (*Cantoria*) for Florence Cathedral (1433–9; see colour pl. 1, XXVII2). The latter was to correspond with one already commissioned from Luca della Robbia (1431; *see* ROBBIA, DELLA, (1) fig. 1), while Donatello and Michelozzo had been away in Rome. Luca had chosen logically to illustrate the verses of Psalm 150 with a series of closed compositions of child-musicians or dancers on panels separated by pilasters, with the relevant verses of the psalm incised above and below. In the pulpit for Prato Cathedral, Donatello had used a similar scheme of panels divided by pilasters, but by cutting off from view some of the limbs of his infant dancers, he suggested that they

were dancing in a continuous row behind the architecture. For the Florence *Cantoria*, he pursued this concept further, and the putti are carved on two long slabs of marble, performing two continuous dances in a circle, physically behind the series of free-standing paired colonnettes that articulate the structure. Background and colonnettes are encrusted with mosaic *tesserae* to provide a colourful foil for the frieze of dancers in plain white marble. No such specific theme as Luca's is depicted, but Donatello was probably trying to convey an ecstatic dance of the souls of the innocent in paradise.

Similar in its architectural ornament to the *Singing Gallery*—and also ensconced in the wall of a building—is the *Tabernacle of the Annunciation* in Santa Croce, Florence. It is undocumented but formed the altarpiece of a former side chapel belonging to the Cavalcanti family. Carved in deep relief out of grey sandstone (*pietra serena*, a favourite Tuscan building stone), it shows the two participants at life size and almost in the round, as in a *tableau vivant*, on a tiny stage behind a proscenium arch. For the sake of clarity, the ornamental details of the architecture and Mary's bedchamber are picked out in gilding, and the scene is enlivened by two pairs of mischievous infants teetering on the cornice above.

Following Brunelleschi's completion of the Old Sacristy at S Lorenzo for the Medici in 1429, and probably after the return of these patrons from a brief exile in 1433, Donatello created a series of vigorously modelled and brightly painted reliefs in the eight great roundels on its walls and pendentives (*see* BRUNELLESCHI, FILIPPO, fig. 2, as well as in two lunettes over the doorways flanking its chancel. There are no documents for them, nor for the twin pairs of bronze doors, but since from 1433 until 1443 the sculptor was living and working in an old inn owned by the Medici, for which he was asked only a nominal rent, perhaps his work on their family mausoleum in S Lorenzo was taken for granted and his expenses met out of petty cash. On the walls the four *Evangelists*, accompanied by their symbolic beasts, are seen in their studies, as though through portholes. Donatello typically refused to idealize these humble folk of the New Testament, showing them instead as haggard old men, deeply absorbed in the effort of penning their gospels. They are incongruously shown seated on ornamental thrones and with desks covered with Renaissance details.

On the pendentive roundels the theme was four episodes from the *Life of St John the Evangelist*. Here Donatello exploited all that he had learnt about creating the illusion of perspective, either by linear or 'aerial' means. Several of the participants are shown only in part, as though cut off by the circumference of the roundel, a bold device that implies that the scenes continue beyond the spectator's field of vision: this gives an effect of 'photographic immediacy' to the miraculous dramas. The extraordinary freedom with which the figures are modelled bespeaks a truly great artist at the height of his creative powers. It calls to mind late 19th- or early 20th-century sculptors such as Degas, Rodin or Epstein, all of whom enjoyed the feeling of life that is conveyed by quick, spontaneous modelling, the building up of an image out of ductile materials and the refraining from any attempt at finish, which would have tended to deaden the effect.

Donatello also saw the potential for casting such rough images into bronze. The doors in the Old Sacristy are decorated with pairs of saintly figures in earnest discussion or meditation, and these are only the beginning of a crescendo of production of narrative reliefs: for the high altar in the basilica of S Antonio, Padua (*see* §3 below); for the west doors of Siena Cathedral (never cast); and for the twin pulpits in the nave of S Lorenzo, Florence, produced at the end of Donatello's life (*see* §4 below).

3. PADUA, 1443–53. In 1443 Donatello left Florence for Padua, where he stayed for a decade. His first commission was for a life-size bronze Crucifix (1441–9) for the rood screen in the basilica of S Antonio (the Santo): he modelled a strongly muscled, but idealized mature male body, departing from Gothic prototypes, which had tended to stress the physical anguish of the crucifixion. Shortly afterwards, a bequest enabled the friars to project a new high altar: regrettably Donatello's architectural and sculptural masterpiece was dismantled a century later, but the bronze statuary survives and the general scheme seems to be reflected in the composition of Mantegna's S Zeno Altarpiece (Verona, S Zeno). Beneath an open tabernacle of ornamental, classicizing form, with eight columns and a curved pediment with volutes at either end, were disposed seven life-size bronze statues. A central *Virgin and Child* (in an unusual pose recalling local, Byzantine art) was flanked in a *sacra conversazione* by six patron saints, including SS Anthony and Francis. They were modelled and cast with freedom, and not highly finished, as they would never have been visible close to or in a clear light. At the level of the predella of a normal painted altarpiece were inserted four rectangular, panoramic relief scenes of the *Miracles of St Anthony*. In front of imaginatively conceived, Roman architectural backgrounds, interior or exterior (their details picked out with gilding), Donatello mustered groups of amazed bystanders round the principal actions of the saint and those immediately involved, in a way reminiscent of a modern stage director. Between these four narratives were interspersed twelve panels with charming *Musician Angels*, and four with the *Symbols of the Evangelists* and one of the *Dead Christ*, while on the back of the structure of the altar was a great relief of the *Entombment*, carved in stone and inlaid with mosaic and glazed coloured strips. Here Donatello's dramatic powers were unleashed in figures of frenzied holy women bewailing the event. Full documentation allows this major project to be followed step by step, giving an insight into the wide delegation of tasks to which Donatello had to resort in order to push work forward to completion by 1450.

Donatello's other important Paduan commission, of a very different kind, was the creation of a bronze equestrian monument (1447–53) to Erasmo da Narni (1370–1443), known as *Gattamelata*, a deceased captain-general of the Venetian army (see fig. 4). This is the earliest surviving equestrian statue from the Renaissance. It was a revival of an ancient Roman type known at the time principally from the *Marcus Aurelius* in Rome. To support the great weight of the thickly cast bodies of horse and rider on only four legs was a great technical achievement: Donatello would have liked to have had one forehoof raised free, as in his ancient prototype (as well as in the *Horses* on S Marco,

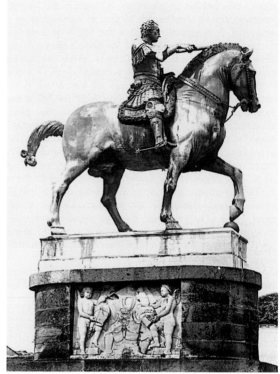

4. Donatello: equestrian monument to *Gattamelata*, bronze on marble and stone base, h. 3.4 m, 1447–53 (Padua, Piazza del Santo)

Venice, which were much nearer to Padua), but he did not dare. Instead he fell back on the device of propping it up by a cannon ball conveniently lying on the field of battle. The General is brilliantly portrayed and idealized as a heroic man of action, using a close-cropped Roman hairstyle and the Classical type of light war-horse. Details on his armour also recall antiquity, though the long broadsword and cannon ball reflect contemporary warfare. This was an image that inspired Verrocchio, challenged Leonardo da Vinci and, ultimately, in the work of Giambologna 150 years later, spread to all the great squares of Europe, as a symbol appropriate for monarchs. The end of Donatello's stay in Padua was marred by disputes with several of his patrons over completion of his work and payment. He was much in demand elsewhere, but, in order to return to his native city, he turned down invitations from the Gonzaga in Mantua, the Este in Modena and King Alfonso I of Naples.

4. OLD AGE, 1454–66. By 1454 Donatello was renting a house and shop on the Piazza del Duomo in Florence. Possibly Cosimo de' Medici had prevailed on Donatello to return, as his great new palace was nearing completion and needed some major sculptural decoration. Donatello was by then nearly 70 years old and becoming infirm, though his spirit and imagination were unbowed. He was ill in 1456, for his doctor, Giovanni Chellini (of whom there is a marble portrait bust by Antonio Rossellino, 1456; London, V&A), received in lieu of a fee an unusual bronze roundel of the *Virgin and Child with Angels* (London, V&A). Even so, the sculptor made substantial

purchases of materials for casting bronze statuary, one example of which was the impassioned figure of *St John the Baptist* for a chapel in Siena Cathedral (*in situ*). The following year Donatello actually moved to Siena in order to work on a side chapel and on some bronze doors for the cathedral. From his stay there only a large marble roundel of the *Virgin and Child* over the Porta del Perdono of the cathedral, finished by assistants, survives: panels modelled in wax on wood made in preparation for casting into bronze for the doors were abandoned, and, disheartened, their author returned to Florence.

In 1459 Donatello must have begun several major commissions for his favourite patron, Cosimo de' Medici. Most enigmatic both in treatment and in dating—for it is absolutely undocumented—is the nearly nude bronze *David* (Florence, Bargello; see colour pl. 1, XXIX1), which stood on an ornamental pedestal in the centre of the newly built courtyard of the Medici palace (some scholars prefer to date the statue to before Donatello's Paduan sojourn). It was at the centre of a complex intellectual scheme comprising eight of the great marble medallions that decorate the walls of the courtyard, above the arcade. These are enlargements of important antique gems, most of which were owned by the Medici, but their meaning is obscure. It has been suggested that the nudity and sensuousness of the boy David, as well as some surprising details of his costume, none of which is derived from the biblical story, may result from a Neo-Platonic philosophical interpretation of David as an allegory of heavenly love (Ames-Lewis). (Cosimo was the founder of the Neo-Platonic Academy in Florence.) Donatello's other commission for the palace, this time for a fountain in the back garden, was a more easily explicable group, also on an Old Testament theme, *Judith Slaying Holofernes* (Florence, Piazza della Signoria; *see* ITALY, fig. 18). It is an allegory of Humility triumphing over Pride, as is known from a lost, but recorded, inscription.

The last work for Cosimo is a series of bronze panels depicting the *Passion of Christ* and the *Martyrdom of St Lawrence* for the twin pulpits in the nave of the Medici parish church at S Lorenzo. One is dated June 1465. They are grimly realistic, abandoning all traditional restraints and the usual tendency towards idealization, glossing over the full horror of some episodes. The original wax modelling must have been vigorous and passionate: in the dramatic bronze narratives that resulted, it seems as if Donatello was so emotionally involved that he attacked the cold metal surfaces of the scenes with a savagery resulting from his personal empathy with the sufferings of the saviour. Work does not seem to have been finished at the time of Donatello's death (1466), and several hands can be traced in the chasing. Surprisingly, in view of the artist's fame, the panels were not installed on the pulpits until the 16th century: perhaps they were too avant-garde for mid-15th-century taste, which was more attuned to the suave, but less demanding, narrative style of Ghiberti's *Gates of Paradise* doors on the Baptistery (installed in 1452; see colour pl. 1, XXXI2).

This constitutes the work of Donatello's old age, apart from an undocumented painted wood statue of *St Mary Magdalene* (Florence, Mus. Opera Duomo; see fig. 5 below), which is usually held to be a late work because of its overwrought, emotional effect. Such reasoning is no longer entirely acceptable, for a very similar, painted wooden statue of the haggard *St John the Baptist* (Venice, S Maria Gloriosa dei Frari), produced by Donatello for a chapel of the Florentine community in Venice, has been found, after cleaning, to be dated 1438. Perhaps it was carved at the behest of the Medici, as a thank-offering for hospitality that they had received during their brief exile there in 1433. So the sculptor was capable of such horrifically gripping imagery far earlier in his career than had previously been supposed: it was not confined to his old age.

II. Working methods and technique.

Donatello is remarkable for the sheer range of materials in which he worked: he turned his hand with equal facility, apparently, to modelling in clay, stucco or wax (nothing survives in wax, but casts from wax models in terracotta and bronze do); and to finishing bronze in the cold metal (though he did not do his own casting, but delegated it, as was normal, to specialist foundries, some of which are recorded). He carved marble and grey Tuscan sandstone (the *macigno* or so-called *pietra serena*), as well as wood, which he then painted, probably himself, to enhance its naturalistic appearance. In the *Madonna dei Cordai* (Florence, Mus. Bardini) Donatello used a curious technique of jigsawing the contours of a Virgin and Child out of wood and applying it to a flat background, then modelling the figures over it in a composition material. He filled the background with pretence *tesserae* of gilt leather to resemble mosaic (which he also used in reality on the Prato pulpit and the *Cantoria*) and painted and varnished the whole. He also designed, but did not execute, a stained-glass window for the drum of Florence Cathedral (*Coronation of the Virgin*; *in situ*) and, perhaps in collaboration with a member of the Barovier family of Murano, planned to make casts in glass from the reverse of the bronze roundel that he eventually gave to Dr Chellini (London, V&A).

Donatello's principal technical innovation was in the field of relief-carving. Apparently in the late 1410s and early 1420s he devised a method of carving—almost drawing—a scene in very shallow relief, the technique known as *rilievo schiacciato*. Within a depth of about 10 to 20 mm, the sculptor conveyed a much greater imaginary depth by means of only very slight indentations on the surface of the marble. The contours of the figures were drawn in with the corner of a chisel and crystals of marble whittled away round the edges to leave in relief the volumes of the bodily forms. The planes of the various figures were compressed in depth, unlike the standard Roman or medieval technique, where they had been left standing out, half or more in the round, in front of a flat background. Donatello's technique allowed the forms to merge into the background more fluently, so that a spatial continuum was suggested, as in a painting.

In the marble relief of the *Assumption* of 1427 Donatello invented stylized forms—almost like stratified slate—to indicate thickly massed cirrus clouds, between which angels are visible in a tumbling mass of limbs swooping through the air, as though swimming in the sea. This bold

5. Donatello: *St Mary Magdalene*, polychrome and gilt wood, h. 1.88 m, ?*c.* 1456–60 (Florence, Museo dell'Opera del Duomo)

and economical use of a lifetime's repertory of forms and motifs to indicate his intensity of feeling towards his Christian subject. Donatello could also render purity and beauty with supreme ease, for instance when depicting the Virgin (e.g. in the *Annunciation* or in his several reliefs showing her with the baby Jesus) or indeed the boy *David*. Such images were in tune with the optimistic styles of Ghiberti or Luca della Robbia, which were extremely popular in the worldly, mercantile centre that was Florence.

Where Donatello excelled, however, and where he was perhaps too demanding for his contemporaries, was in his rendering of drama and pathos, nearly always in a Christian context. The gaunt, painted wood statues of *St John the Baptist* (1438; Venice, S Maria Gloriosa dei Frari) and *St Mary Magdalene* (?*c.* 1456–60; Florence, Mus. Opera Duomo; see fig. 5), as well as his bronze *St John* for Siena Cathedral, border on the horrific and are deliberately shocking to a casual observer. The choice of wood may reflect a wish to relate these figures to the Gothic tradition of wood-carving in Germany and the alpine regions, where it was always used expressively. The intense empathy that Donatello manifested with his chosen subjects, whether carved in wood or marble or cast in bronze (see fig. 6), is deeply moving and is still much appreciated, despite the general loss of religious belief in modern society. The very humanity of such works retains its appeal across six centuries. But even if Donatello's expressiveness is all his own, to some extent he was drawing on an earlier Tuscan Gothic tradition of fiercely dramatic narrative founded by Giovanni Pisano, who, where necessary, as in the *Massacre*

illusion may once have been heightened by touches of colour and gilding, as was normal in marble sculpture at that time. This kind of 'aerial' perspective was even more subtle than the use of architectural settings to provide linear means of suggesting recession through the newly discovered rules of geometrical perspective. In the larger fields of the roundels in the Old Sacristy at S Lorenzo, Donatello laid out the architectural settings with ruler and set square in the damp stucco, and then cut back the material with spatulas to indicate successive, receding planes: the spaces thus suggested were then populated with figures at various scales literally added on top. They had to be modelled around projecting nail-heads to help them adhere to the perilously inward-sloping background.

It was by exploiting linear perspective that Donatello was able to achieve a still more gripping effect of realism than his predecessors. In his reliefs, after he had initially mastered the techniques of shallow-carving or modelling, stylistic development is to be noted chiefly in the increased elaboration of groups of *dramatis personae* and in the boldness of movement. As his technique became accomplished and his self-confidence grew, the modelling became freer and more 'impressionistic'—even 'expressionistic' on occasions, when the apparent roughness of execution reflects the emotional violence of the subject. In the series of *Passion* reliefs (Florence, S Lorenzo) made at the end of his life, lack of finish seems not to betray loss of control due to old age, nor yet interruption by death, but rather a supremely confident

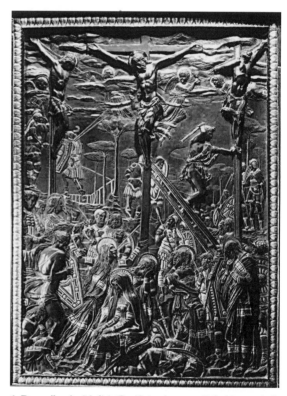

6. Donatello: the Medici *Crucifixion*, bronze relief with parcel gilt, 930×700 mm, 1454–6 (Florence, Museo Nazionale del Bargello)

of the Innocents (*c.* 1300; Pistoia, S Andrea), did not flinch from inflicting the full horror of the event on the spectator.

As was normal practice in the early 15th century, Donatello entered into working partnerships, either informally (as with Brunelleschi on occasions, and later with Nanni di Bartolo for several of the *Prophets* for the Campanile; for illustration *see* NANNI DI BARTOLO) or formally (as with Michelozzo in the mid-1420s for the co-production of tombs). He also employed assistants, though their names are not always recorded: lesser sculptors such as the bronze specialist Maso di Bartolomeo and the marble-carver Pagno di Lapo Portigiani (1408–70) moved in and out of his orbit. Vespasiano da Bisticci, in his *Vita* of Cosimo *il vecchio* de' Medici, talked of the banker making a weekly allowance to the sculptor 'enough for him and four assistants', and perhaps this was the average number of personnel in Donatello's Florentine workshop. The most informative series of archival documents about his working methods is that concerning the production during the 1440s of the high altar in S Antonio, Padua, where Donatello functioned as an impresario, managing a large team engaged on various aspects or component parts of the vast sculptural undertaking. Giovanni da Pisa, Niccolò Pizzolo, Urbano da Cortona and, ultimately, Bartolomeo Bellano are the best known of his assistants.

III. Character and personality.

Donatello left no writings or correspondence and may have been virtually illiterate, which would have been normal in the humble background from which he came: his father was a wool-carder and had been involved in the Ciompi Revolt in 1378, even being briefly exiled for murdering someone in street violence. The sculptor seems to have taken a perverse pride in his 'working class' origins, and his affections for the Medici may have stemmed from their being non-noble and their espousal of the popular, democratic cause. Presumably Donatello acquired his knowledge of the Bible and ancient mythology by word of mouth, especially from the Neo-platonic philosophers whom Cosimo also patronized.

In 1525 Donatello's character was described by Summonte as 'rough and very straightforward' ('rozo e semplicissimo'), which seems a fair summary. He did not aspire to a more 'gentlemanly' role in society, unlike his ex-master and rival Lorenzo Ghiberti, who associated himself with the literary side of humanism by penning his *Commentarii*. Also in contrast to Ghiberti, who vaingloriously included his self-portrait on both pairs of doors for the Florentine Baptistery (one showing him wearing the *mazzocchio*, the turban-like headgear of a Florentine gentleman), Donatello showed a complete lack of attention to his own appearance, as was remarked on twice by contemporaries. Manetti, in his biography of Brunelleschi, in which he described their joint, early visit to Rome, wrote:

> Neither of them had family problems since they had neither wife nor children, there or elsewhere. Neither of them paid much attention to what they ate and drank or how they were dressed or where they lived, as long as they were able to satisfy themselves by seeing and measuring.

This was corroborated by Vespasiano da Bisticci in his life of Cosimo:

> Since Donatello did not dress as Cosimo would have liked him to, Cosimo gave him a red cloak with a hood, and a gown under the cloak, and dressed him all afresh. One morning of a feast day he sent it all to him to make him wear it. Donatello did, once or twice, and then he put it aside and did not want to wear it any more, for it seemed too dandified for him.

Donatello was evidently a popular figure in Florence, notorious for making sarcastic, and occasionally coarse, remarks. He even featured as a speaking character in a miracle play written during his lifetime, called *Nebuchadnezzar, King of Babylon*. His delays on producing the pulpit for Prato are referred to in passing, as though they were a well-known scandal. A number of catch-phrases originating from his lips were recorded in a 16th-century anthology of more or less scurrilous tales. Some are difficult to interpret today, but the general tone is of tight-lipped, Tuscan humour, deriving from someone who was evidently renowned for his eccentricity and sharp wit. Vasari recorded various unkind remarks made to, or about, fellow artists, for example to Paolo Uccello: it is hard to tell if they were meant to be hurtful or merely sarcastically humorous. Vasari also noted the sculptor in frustration crudely swearing at his statue of *Habakkuk*: 'Favella, favella, che ti venga il caccasangue' ('Speak, speak, or may you get bloody shit!').

Donatello was frequently obstreperous with his patrons, particularly bodies of churchmen from outside Florence, for instance the unfortunate Cathedral Works of Prato, who had legitimate cause for complaint over his irresponsible attitude and dilatoriness in fulfilling his contractual obligations to them. Having tried to encourage him by some seasonal presents, ultimately they resorted to asking Cosimo de' Medici to intervene on their behalf. Duke Ludovico Gonzaga used the same expedient in 1458, when he was trying to get the sculptor to finish some work for which he had made models several years earlier: in the exchange of correspondence Ludovico called Donatello 'very tricky' ('molto intricato') and admitted that he 'had a mind made up in such a way that if he does not come, one cannot entertain any hope of it, even if one pesters him'. This is an extraordinary admission from a grand patron dealing with an artist, then normally regarded as a mere artisan. Clearly Donatello was an exception to any rule.

If Donatello's behaviour with his patrons was exceptional, so too was the perceptive generosity of Cosimo, who seems to have recognized the artist's sheer genius and been prepared to put up with his stubbornness and impertinence. Besides living nearly rent-free for a whole decade (1434–43) in an old inn that Cosimo had bought for eventual demolition to make way for his grand new palace, according to Vespasiano da Bisticci, in the sculptor's old age, when work was hard to find, Cosimo gave him commissions deliberately in order to keep him busy and paid him by banker's order on a weekly basis. This background accounts for the complete absence of documents for payment and hence firm dates for any of Donatello's work for the Medici. Cosimo also arranged in

his will that the sculptor should be looked after by his heir, Piero I (the Gouty), and given accommodation and a pension in his old age, and should eventually be buried beside him in the family vault beneath S Lorenzo. This came to pass and was an extraordinary honour.

IV. Critical reception and posthumous reputation.

Donatello's reputation was made within his own lifetime and has remained high ever since, though with a mild waxing and waning of popularity according to the taste of successive centuries. He was counted as a friend by Cosimo de' Medici and by Alberti, who in his *De pictura* (1436) listed him directly after Brunelleschi as 'this our very great friend' ('quel nostro amicissimo Donato scultore') and before Ghiberti, Luca della Robbia and Masaccio. Barto-lomeo Fazio included him in his *De viris illustribus* (1456) as 'excelling for his talent and no less for his technique; he is well known for his sculpture in bronze and marble, because he succeeds in giving life to the faces of his figures, and in this respect he shares the glory of the masters of antiquity'. In the same year his medical doctor Chellini noted that he was a 'singular and principal master in making figures of bronze and wood and terracotta'. A note of criticism of some of Donatello's more irrationally exaggerated figures on the bronze doors of the Old Sacristy was sounded by the architect–sculptor Filarete in his *Trattato d'architettura* (1461–4), who preferred a degree of decorum: apostles should behave like apostles and not like fencers.

In 1481 Cristoforo Landino (*Apologia*) praised the late sculptor highly:

> Donato the sculptor is to be numbered among the men of old, admirable as he is for his compositions and his variety, and his ability with great lifelikeness to arrange and place his figures, all of which appear to be in motion. He was a great copyist of antiquity and also understood about perspective.

Amid general posthumous praise, there were occasion-ally subjective, though partially justifiable, criticisms. For instance, the Mannerist sculptor Baccio Bandinelli wrote in 1547 that when Donatello made the bronze pulpits for S Lorenzo he was 'so old that his eyesight was not up to judging them properly, nor to giving them a beautiful finish, and even though they are a good invention, he never made an uglier work'. The apparent lack of finish was also criticized by Michelangelo (according to Condivi, 1553), who admired Donatello in other respects. Vasari (1568) was at pains to flatter his own patron, the Grand Duke Cosimo I, by stressing the enlightened patronage that Donatello had enjoyed from his collateral ancestor and namesake, Cosimo *il vecchio*. He also published an elegant literary conceit of Vincenzo Borghini's that drew a parallel between Donatello and Michelangelo: 'Either the spirit of Donatello works in Michelangelo; or Michel-angelo's one worked beforehand in Donatello.' However, Vasari's *Vita* of Donatello contains more than average distortions and is confusing to a modern reader because it is based not on a chronological approach so much as on a topographical one, probably because it was derived from an earlier guidebook to Florence. Certain statues such as *St Mark* (admired by Michelangelo) and *St George* (praised

by Vasari) have always remained relatively popular, while others, sometimes owing to their removal around the city, became dissociated from his name, for example the *St Louis*, which, amazingly, was recognized only in the early 20th century.

Centenaries of the sculptor's birth and death have been potent stimuli to reassessment in the past two centuries. That in 1886–7 was celebrated partly because it happened to coincide with the completion of the Gothic Revival façade of Florence Cathedral. It was permanently com-memorated—as was the fashion at the time—with bronze portraits and inscriptions, one mounted on the north aisle of Santa Croce, the Pantheon of Florence; another on the façade of one of the several studios he used near the cathedral; and a third on a tomb in the Renaissance style (1896; complete with a bronze effigy) by Dario Guidotti (*fl* 1892–1900) and Raffaello Romanelli (*b* 1856) in the Martelli Chapel of S Lorenzo. A pioneering exhibition was mounted in the Museo del Bargello, Florence, and a number of grandiloquent speeches by eminent professors were published as pamphlets.

The beginning of modern art-historical literature on Donatello in Italian (Milanesi, 1887) was soon followed by major monographs in German (Semper and von Tschudi, both in 1887; Schottmüller, 1904; Schubring, 1907; Kauffmann, 1935). In England Lord Balcarres addressed the subject in 1903, to be closely followed by Maud Cruttwell in 1911, both giving very respectable 'overviews' for the educated, Anglo-Saxon general reader. In 1941 a well-illustrated Phaidon Press monograph by Goldscheider appeared. The major monograph on the artist is by H. W. Janson, incorporating the notes and photographs of Jeno Lanyi. It has gone through several editions since 1957 and consists of an exhaustive and invaluable catalogue raisonné, but without a discursive biography. The latter was supplied by a *de luxe* volume by Hartt, with new photographs by Finn (1973). Bennett and Wilkins (1984) published a volume of extended scholarly essays on various aspects of the sculptor's activity.

The quincentenary of Donatello's death, in 1966, gave rise to an international congress, the acts of which were published in 1968, and renewed interest was kindled by the rediscovery in England of the bronze roundel given in 1456 to Dr Chellini (see Radcliffe and Avery, 1976), which resulted in a number of essays addressing the question of Donatello's reliefs of the Madonna. The sixth centenary of the sculptor's birth, in 1986, occasioned a loan exhibi-tion of sculpture at the Detroit Institute of Arts and the Forte di Belvedere in Florence, as well as one in the Bargello, drawn solely from its own collection, with accompanying catalogues (see 1985 and 1985–6 exh. cats) and conferences (see 'Donatello Studien', 1989). Also coinciding with these centenary celebrations were the publication in Italian of a volume of new photographs and catalogue entries (Pope-Hennessy, Ragioneri and Perugi, 1985) and an introductory biography (Avery, 1986). A spate of booklets and articles has since appeared, notably on some of the sculptures that were restored as a result of the sixth centenary.

BIBLIOGRAPHY
EARLY SOURCES
L. B. Alberti: *De pictura* (MS., 1436); ed. C. Grayson: *Opera volgari* (Bari, 1973), iii, p. 7

G. Chellini: *Libro debitori, creditori e ricordanze* (MS., 1456); ed. A. De Maddalena: 'Les Archives Saminiati: De l'économie à l'histoire de l'art', *An., Econ., Soc., Civilis.*, xiv (1955), pp. 738–44

B. Facio: *De viris illustribus* (MS., 1456); ed. L. Mehus (Florence, 1745); Eng. trans. in M. Baxandall: 'Bartholomaeus Facius on Painting: A Fifteenth-century Manuscript of *De viris illustribus*', *J. Warb. & Court. Inst.*, xxvii (1964), pp. 90–107 [106–7]

A. Averulino [Filarete]: *Trattato d'architettura* (MS., 1461–4); ed. A. M. Finoli and L. Grassi (Milan, 1972), pp. 658–9

A. Manetti: *Vita di Filippo Brunelleschi* (MS., *c.* 1480); ed. D. De Robertis and G. Tanturli (Milan, 1976), pp. 67–9, 109–10

C. Landino: *Apologia* (MS., 1481); repr. in *Dante con l'esposizione di Cristoforo Landino e di Alessandro Vellutello* (Venice, 1564)

Vespasiano da Bisticci: *Le vite* (MS., ?1493); ed. A. Greco (Florence, 1970), ii, pp. 193–4

P. Summonte: letter to Marcantonio Michiel (MS., 1525); ed. F. Nicolini: *L'arte napoletana del rinascimento e la lettera di Pietro Summonte a Marcantonio Michiel* (Naples, 1925)

B. Bandinelli: letter to Cosimo I de' Medici (MS., 7 Dec 1547); ed. G. Bottari and S. Ticozzi: *Raccolta di lettere sulla pittura, scultura ed architettura*, ii (Milan, 1822), p. 72

G. Vasari: *Vite* (1550, rev. 2/1568); ed. G. Milanesi (1878–85), ii, pp. 395–426

A. Condivi: *Vita di Michelangelo Buonarroti* (Rome, 1553)

GENERAL

W. Bode: *Florentine Sculptors of the Renaissance* (London, 1928)

J. Pope-Hennessy: *Italian Renaissance Sculpture* (London, 1958, rev. 3/New York, 1985)

——: *Catalogue of Italian Sculpture in the Victoria and Albert Museum* (London, 1964)

——: *Essays on Italian Sculpture* (London, 1968)

C. Avery: *Florentine Renaissance Sculpture* (London, 1970)

MONOGRAPHS

G. Milanesi: *Catalogo delle opere di Donatello* (Florence, 1887)

H. Semper: *Donatellos Leben und Werke* (Innsbruck, 1887)

H. von Tschudi: 'Donatello e la critica moderna', *Riv. Stor. It.*, iv/2 (1887), pp. 193–228

Lord Balcarres: *Donatello* (London and New York, 1903)

F. Schottmuller: *Donatello* (Munich, 1904)

P. Schubring: *Donatello*, Klass. Kst Gesamtausgaben (Stuttgart and Leipzig, 1907)

M. Cruttwell: *Donatello* (London, 1911)

H. Kauffmann: *Donatello* (Berlin, 1935)

L. Goldscheider: *Donatello: Complete Phaidon Edition* (London, 1941)

H. W. Janson: *The Sculpture of Donatello* (Princeton, 1957, rev. 2/1963)

G. Castelfranco: *Donatello* (Milan, 1963)

L. Grassi: *All the Sculpture of Donatello* (London, 1964)

F. Hartt and D. Finn: *Donatello: Prophet of Modern Vision* (New York, 1973, 2/London, 1974)

A. Parronchi: *Donatello e il potere* (Florence, 1980)

M. Greenhalgh: *Donatello and his Sources* (London, 1982)

B. A. Bennett and D. G. Wilkins: *Donatello* (Oxford, 1984)

J. Pope-Hennessy, G. Ragioneri and L. Perugi: *Donatello* (Florence, 1985)

C. Avery: *L'invenzione dell'umano: Introduzione a Donatello* (Florence, 1986)

E. Settesoldi: *Donatello and the Opera del Duomo in Florence* (Florence, 1986)

M. Trudzinsky: *Beobachtungen zu Donatellos Antikenrezeption* (Berlin, 1986)

G. Morolli: *Donatello: Immagini di architettura* (Florence, 1987)

C. Avery: *Donatello: Catalogo completo delle opere* (Florence, 1987)

J. Pope-Hennessy: *Donatello Sculptor* (London, Paris and New York, 1993)

A. Rosenauer: *Donatello* (Milan, 1993)

C. Avery: *Donatello: An Introduction* (New York, 1994)

A. Calore: *Contributi Donatelliani* (Padua, 1996)

EXHIBITION CATALOGUES AND CONGRESSES

Donatello e il suo tempo: Atti dell'VIII Convegno internazionale di studi sul rinascimento: Firenze, 1966

Italian Renaissance Sculpture in the Time of Donatello (exh. cat., ed. A. P. Darr; Detroit, MI, Inst. A., 1985); It. edn as *Donatello e i suoi: Scultura fiorentina del primo rinascimento* (ed. A. P. Darr and G. Bonsanti; Florence, Forte Belvedere, 1986)

Omaggio a Donatello (exh. cat. by P. Barocchi and others, Florence, Bargello, 1985)

'Donatello Studien', *It. Forsch. Kstgesch.*, 3rd ser., xvi (1989)

SPECIALIST STUDIES

F. Ames-Lewis: 'Donatello's Bronze *David* Reconsidered', *A. Hist.*, ii/2 (1974), pp. 140–55

J. Pope-Hennessy: 'The Medici *Crucifixion* of Donatello', *Apollo*, ci (1975), pp. 82–7; repr. in J. Pope-Hennessy: *The Study and Criticism of Italian Sculpture* (Princeton, 1980), pp. 119–28

M. L. Dunkleman: *Donatello's Influence on Italian Renaissance Painting* (diss., New York U., Inst. F.A., 1976)

J. Pope-Hennessy: 'The Madonna Reliefs of Donatello', *Apollo*, ciii (1976), pp. 172–91; repr. in J. Pope-Hennessy: *The Study and Criticism of Italian Sculpture* (Princeton, 1980), pp. 71–105

A. Radcliffe and C. Avery: 'The Chellini *Madonna* by Donatello', *Burl. Mag.*, cxviii (1976), pp. 377–87

V. Herzner: 'Regesti donatelliani', *Riv. Ist. N. Archeol. & Stor. A.*, ii (1979), pp. 169–228

C. Avery: 'Donatello's Madonnas Reconsidered', *Apollo*, cxxiv (1986), pp. 174–82

C. Elam and others: 'Donatello at Close Range', *Burl. Mag.*, cxxix (1987), special suppl., pp. 1–52

L. Dolcini: *Donatello e il restauro della 'Giuditta'* (Florence, 1988)

C. Avery: 'Donatello's Madonnas Revisted', *Donatello-Studien, Italienische Forschungen* (Munich, 1989), pp. 219–34

A. Jolly: *Madonnas by Donatello and his Circle* (diss., Cambridge, U. Cambridge, 1992)

C. Sperling: 'Donatello's Bronze *David* and the Demands of Medici Politics', *Burl. Mag.*, cxxxiv (1992), pp. 218–24

C. Avery: 'Donatello's Marble Narrative Reliefs', *Atti della giornata di studio: Le vie del marmo: Aspetti della produzione e della diffusione dei manufatti marmorei tra Quattrocento e Cinquecento: Pietrasanta, 1992*, pp. 7–16

A. Butterfield: 'Documents for the Pulpits of San Lorenzo', *Mitt. Ksthist. Inst. Florenz*, xxxviii/1 (1994), pp. 147–53

G. Gentilini: 'Sedici cherubini', *Artista* (1994), pp. 28–43

G. A. Johnson: *In the Eye of the Beholder: Donatello's Sculpture in the Life of Renaissance Italy* (diss., Cambridge, MA, Harvard U., 1994)

S. L. Smith: 'A Nude Judith from Padua and the Reception of Donatello's Bronze David', *Comitatus*, xxv (1994), pp. 59–80

C. Avery: 'Donatello and the Medici', *The Early Medici and their Artists*, ed. F. Ames-Lewis (London, 1995), pp. 71–106

W. S. A. Dale: 'Donatello's Chellini Madonna: "Speculum sine macula"', *Apollo*, cxli/397 (March 1995), pp. 3–9

G. A. Johnson: 'Activating the Effigy: Donatello's Pecci Tomb in Siena Cathedral, Italy', *A. Bull.*, lxxvii/3 (Sept 1995), pp. 445–59

C. Dempsey: 'Donatello's Spiritelli', *Ars naturam adiuvans: Festschrift für Matthias Winner*, ed. V. V. Flemming and S. Schutze (Mainz, 1996), pp. 50–61

C. Fulton: 'Present at the Inception: Donatello and the Origins of Sixteenth-century Mannerism: The Influence of Donatello's 1515 Pulpit Reliefs on Florentine Painters', *Z. Kstgesch.*, lx/2 (1997), pp. 166–99

G. A. Johnson: 'The Original Placement of Donatello's Bronze Crucifix in the Santo in Padua', *Burl. Mag.*, cxxxix (1997), pp. 860–62

C. Avery: 'Donatello: Rough and Simple in Everything but his Sculpture', *Sculp. Rev.*, xlvi/3 (1998), pp. 9–13

——: 'A Fascinating Enigma: The *Dudley Madonna*, Desiderio or Donatello?', *A. Q.*[London] (1998), pp. 46–9

CHARLES AVERY

Donato de' Bardi. *See* BARDI (i), (1).

Doni, Agnolo (*b* Florence, 29 Aug 1474; *d* Florence, 5 Jan 1539). Italian merchant and patron. He came from a family of dyers and enrolled in the Arte della Lana (Clothmakers' Guild) in 1488. He made a considerable fortune from the cloth trade; the status he attained is reflected in his marriage in 1504 to the Florentine noblewoman Maddalena Strozzi. The couple took up residence in the house that Agnolo had had built. According to Vasari, Morte da Feltro decorated the wedding chests (untraced) for the furnishings for the marital bedroom, built by the del Tasso workshop. The del Tasso shop also probably made the elaborate painted and gilded frame, designed by Michelangelo, for the painting he executed

for Agnolo, the Doni Tondo, *Holy Family with St John the Baptist* (1506; Florence, Uffizi; see colour pl. 2, IV3).

In the same year, Agnolo commissioned portraits of himself and his wife from Raphael (Florence, Pitti). Vasari reported that Agnolo collected antique art as well as modern works; he probably bought Donatello's *Amor Atys* (Florence, Bargello), a work once thought to be antique, which remained in the possession of the Doni family until 1778. Agnolo's collection, which was visited by artists and connoisseurs, was further enriched in 1516 by the addition of the *Holy Family with St John* (Rome, Pal. Barberini) by Fra Bartolommeo.

BIBLIOGRAPHY

G. Vasari: *Vite* (1550, rev. 2/1568); ed. G. Milanesi, iv (1879), p. 325; viii (1881), pp. 158–9

A. Cecchi: 'Agnolo e Maddalena Doni committenti di Raffaello', *Studi su Raffaello. Atti del congresso internazionale di studi: Urbino and Florence, 1984*, pp. 429–39

ALESSANDRO CECCHI

Donzello [Donzelli]. Italian family of painters. (1) Pietro del Donzello and (2) Ippolito del Donzello were the sons of a messenger for the city administration (*donzello dell' Signoria*) in Florence. They are both documented in a Florentine *catasto* (land registry declaration) of 1480 and were not of Neapolitan origin, as is often stated erroneously.

BIBLIOGRAPHY

Thieme–Becker

(1) Pietro del Donzello (*b* Florence, 1452; *d* Florence, 24 Feb 1509). He is first mentioned in the 1480 *catasto*. He was a pupil of Giusto di Andrea and worked mainly as a craftsman, painting standards and shields. His earliest documented work is a standard with an allegorical figure of *Lombardy* (1483; untraced) for the Sala dell'Udienza in the Palazzo della Signoria, Florence. In 1488 he may have been in Naples working on the decoration at Poggio Reale (*see* (2) below). He is also known to have painted standards and shields for the Opera del Duomo between 1503 and 1507, and benches for the refectory of the Ospedale di S Matteo in 1506. His only documented paintings were made for Florence, a *Crucifixion with Two Angels* (1506; untraced) for the Ospedale di S Matteo and an *Annunciation* (*in situ*) for one of the Frescobaldi chapels in Santo Spirito. The latter suggests that he was a modest, graceful follower of the style of Domenico Ghirlandaio and Lorenzo di Credi.

BIBLIOGRAPHY

M. Bori: 'L'annunciazione di Pietro del Donzello in una cappella Frescobaldi nella chiesa di Santo Spirito', *Riv. A.*, iv (1906), pp. 117–23

E. Fahy: *Some Followers of Domenico Ghirlandaio* (New York and London, 1976), pp. 41–2, 187, 220–21

MINA BACCI

(2) Ippolito del Donzello (*b* ?Florence, *c.* 1456; *d* Florence or Naples, 1494). Brother of (1) Pietro del Donzello. He trained with Neri di Bicci *c.* 1469–73 in Florence and is documented there in 1485. He went to Naples, probably in 1488, at the request of Guiliano da Maiano (*see* MAIANO, DA, (1)) to work on the decoration of the villa at Poggio Reale (from 1487; destr. late 18th century), which Giuliano had designed for the Duke of Calabria (later Alfonso II, King of Naples). Ippolito's

frescoes there (destr.) included a battle scene and numerous portraits. Many works in Naples are assigned to him, but none is secure.

BIBLIOGRAPHY

G. Vasari: *Vite* (1550, rev. 2/1568); ed. G. Milanesi (1878–85), ii, pp. 70, 470, 474–5, 485–6

□

Door. Movable closure of an entranceway to a building or room. The symbolic significance of the door has provided many opportunities for artistic decoration and attracted the attention of many major artists.

The medieval tradition of covering doors with bronze reliefs was continued in the Renaissance only in Italy. In 1401, when Lorenzo Ghiberti won the competition to make the second set of doors for the Baptistery in Florence, he exactly followed the pattern used by Andrea Pisano (*c.* 1295–1348/9) 70 years earlier; in contrast to Pisano's rapid progress, however, Ghiberti's north doors took a quarter of a century to finish (1403–24; *see* GHIBERTI, (1), fig. 2). This may have been due partly to outside factors, such as finance, but also Ghiberti's designs for the New Testament story are distinctly more complex and sophisticated, introducing as they did numerous Renaissance motifs. When Ghiberti was commissioned to make the third and last pair of doors (1425–52), he was able to persuade his patrons to abandon the cramped Gothic design in favour of ten large, square panels, which would permit a freer rendering of settings and backgrounds and a more modern and painterly approach. Conversely, it meant that each panel had to rely on the medieval tradition of 'continuous narration' to incorporate several episodes that were actually diverse in time into one great scene as though they were simultaneous: for example, the first panel gave the whole story of the Creation and Fall of Man. They were completely gilded, conspicuously advertising the affluence of the patron guild. So glamorous were they, and so suave was Ghiberti's figure style, that Michelangelo called them, aptly, the 'Gates of Paradise', a poetic name that has remained in common use (see colour pl. 1, XXXI2). The original panels (Florence, Mus. Opera Duomo) have been cleaned and replaced by modern casts.

Probably in the 1430s, Donatello contributed two pairs of bronze doors in the Old Sacristy of S Lorenzo, Florence, with hyperactive pairs of Apostles or martyrs in square fields against neutral backgrounds. These were followed by a commission (1437) to produce two larger pairs for the two sacristies of Florence Cathedral, but Donatello failed to deliver these, and in 1446 a new contract was drawn up with his associates Michelozzo di Bartolomeo and Maso di Bartolommeo, as well as Luca della Robbia, for one pair for the north sacristy. These were not completed until 1469. Luca played the major role and predictably created a series of ten panels that were blander than anything that Donatello would have designed: the four *Evangelists* and four *Fathers of the Church* were shown calmly writing or teaching, with the *Virgin and Child* next to *St John the Baptist* completing the sequence at the top. Heads project from the intersections of the frame, following the example of Ghiberti, and three are thought to be portraits of the sculptors involved.

In Rome, meanwhile, the architect–sculptor Filarete, aided by Simone Ghini, had been furnishing an enormous

pair of bronze doors, with some gilding and enamelling, for the main portal of Old St Peter's (*c*. 1433–45). Installed in the new basilica, they are impressive for sheer size and exuberance of ornament, which includes, for example, inhabited scrolls of acanthus with medallion portraits on the frame (*see* FILARETE, fig. 1). The four rectangular panels with large figures of *Christ* and the *Virgin Enthroned*, *St Paul* and *St Peter* with Eugene IV, the papal donor, at his feet are, however, rather disappointing aesthetically in comparison with the contemporary doors made in Florence, for Filarete's gifts of composition and drapery were limited; if anything they seem to reflect an admiration for the hieratic figures on Early Christian ivory consular diptychs and, possibly, Byzantine bronze doors. More interesting are the two square panels at eye-level showing the *Decapitation of St Paul* and the *Crucifixion of*

St Peter. Here Filarete managed lively narratives, with interesting historical references, for example to the Council of Ferrara in 1439, as well as a proud self-portrait and inscription.

In the next generation (*c*. 1475) the example of Filarete's narratives, packed with anecdote, was followed by Guglielmo Monaco, an artillery founder, in his doors for the gateway of the Castel Nuovo in Naples (now in the Palazzo Reale). He depicted the recent victories of Ferrante I of Aragon over Jean d'Anjou in minute detail in four large, square fields, with an upper pair forming a lunette when closed. The junctions of the frame are marked with medallions with heraldic devices and the artist's self-portrait and signature. What might have been a spectacular exercise in narrative relief by Donatello in his late, 'expressionist' style, challenging Ghiberti's ideal serenity, a pair of bronze doors for the western portal of Siena Cathedral, for which he made models in 1457–9, came to nought. There survives no record of the subject or design, unless they are reflected in the reliefs cast a few years later for the left-hand pulpit (*c*. 1465) in S Lorenzo, Florence. During the High Renaissance in Italy only one bronze door was made, the concave one by Jacopo Sansovino for the sacristy in S Marco, Venice (see fig.). With only two large, square narrative panels (*Entombment* and *Resurrection*), a frame broad enough to contain niches with statuettes of Evangelists, and portrait busts projecting from the junctions, Sansovino's reliance on the *Gates of Paradise* is manifest: indeed it is a tribute to that masterwork of the early Renaissance. In 1565 several sculptors contributed to the temporary doors made out of ephemeral materials for Florence Cathedral on the occasion of the nuptials of Prince Francesco de' Medici (later Francesco I, Grand Duke of Tuscany). Of these, only Giambologna's *Adoration of the Shepherds* survives (gilt stucco, Fiesole, Mus. Bandini).

BIBLIOGRAPHY

E. Rumler: *Portes modernes: Architecture, ferronnerie, sculpture* (Paris, *c*. 1910)
A. Pettorelli: *Il bronzo e il rame nell'arte decorativa italiana* (Milan, 1926)
K. Clark and D. Finn: *The Florence Baptistery Doors* (London, 1980)
F. Grimaldi and K. Sordi: *Scultori a Loreto: Fratelli Lombardi, Antonio Calcagni e Tiburzio Vergelli*
M. Scalini: 'La Porte bronzée', *L'arte italiana del bronzo* (Busto Arsizio, 1988), pp. 17–29

CHARLES AVERY

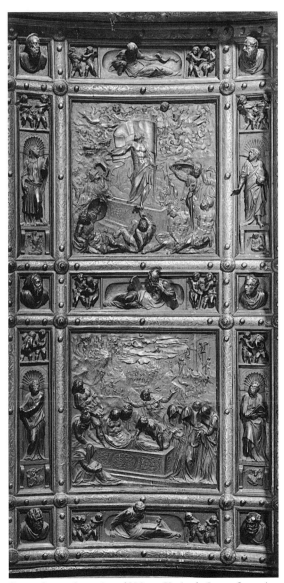

Bronze door to the sacristy of S Marco, Venice, by Jacopo Sansovino, *c*. 2.16×1.17 m, commissioned 1546, installed 1572

Doria. Italian family of patricians, soldiers, seamen, patrons and collectors. First documented in 1089, the family resided initially in Genoa and became prominent in its government. From the start Doria art patronage had a strong element of self-celebration, evident from the inscriptions in the family church of S Matteo (founded 1125; rebuilt 1278). Among the Doria family's many branches, the Doria of Dolceacqua, in the province of Imperia, counted among its members the renowned seaman-statesman (1) Andrea I Doria, who built the Palazzo Doria (now Palazzo Doria–Pamphili) in Fassolo, west of Genoa. With the advent of the Counter-Reformation, the Doria family played an active role in promoting the establishment of reformed religious orders in Genoa. In 1583 Nicolò Doria (1539–94) founded the monastery of S Anna for the Barefoot Carmelites, while (2) Giovanni Andrea I Doria and his wife Zenobia del Carretto sponsored the installa-

tion of the Trinitarians in the church of S Benedetto (1593).

BIBLIOGRAPHY

DBI
C. Fusero: *I Doria* (Varese, 1973)

LORENZA ROSSI

(1) Andrea I Doria (*b* Oneglia, Imperia, 30 Nov 1466; *d* Genoa, 25 Nov 1560). Admiral and patron. He was the most important political, military and economic figure in Genoa during the 16th century. At the age of 18 he left his native city and lived in some of the most important centres of the Italian Renaissance (Rome, Urbino and Naples). Once he had become an admiral, he associated with the heads of the major European powers of the time—the papacy, France and the Holy Roman Empire—and it was through these contacts that he acquired the well-informed and innovative knowledge of art that enabled him to become one of the major Italian patrons of his period. He settled in Genoa in 1527 and, shortly after his marriage to Peretta Usodimare, accomplished his longheld plan to build a noble residence in Fassolo, to the west of the city (for illustration *see* GENOA).

The decoration and furnishings of the Palazzo Doria (now Doria–Pamphili) are proof of his advanced and cosmopolitan taste. Perino del Vaga was entrusted with supervising the entire work, from construction to decoration, which employed him from 1528 to early 1533. It is assumed that the building was completely finished when Emperor Charles V (*reg* 1519–56) was a guest there in 1533. Perino paid particular attention to the design of the first floor and the apartments of the newlyweds. The southern façade of the palazzo, as was the custom in Genoa at the time, was frescoed—by Perino, Domenico Beccafumi and Pordenone. Plans for decorating the northern façade, however, remained as designs (Amsterdam, Rijksmus.; Chantilly, Mus. Condé). The frescoes followed Roman contemporary taste, depicting Classical subjects that referred allusively to the patron's successful career. This self-celebratory iconographic programme reached its height in the dome of the drawing-room of Doria's apartment, with a fresco depicting *Jove Hurling Thunderbolts at the Giants* (see colour pl. 2, XIV1). By identifying himself with Jupiter, an allegorical subject used by the Emperor himself, Andrea Doria clearly showed the level of his self-esteem. In line with the most up-to-date European trends, he decorated the walls of his palazzo with tapestries, woven directly in Flanders from cartoons by Perino del Vaga, their subjects relating to the frescoes in the rooms where they were to be hung.

Between 1543 and 1557 Andrea Doria entrusted two sculptors, Giovanni Angelo Montorsoli and Silvio Cosini, the latter already working in Fassolo, with the decorative restoration of S Matteo, Genoa, his family church. The presbytery and the crypt where the Admiral was to be buried were decorated in distinctly Renaissance style, again with self-glorifying images. Such iconography is less evident in the decoration of the nave by Giovanni Battista Castello (i) and Luca Cambiaso, but this work is believed to have been done for the same patron. There are two portraits of Andrea Doria in the Palazzo Doria–Pamphili, one (1526) by Sebastiano del Piombo (*see* SEBASTIANO

DEL PIOMBO, fig. 4) and the other by Bronzino, which is actually a copy of the original (*?c.* 1533; Milan, Brera).

BIBLIOGRAPHY

A. Merli and L. T. Belgrano: 'Il palazzo del Principe d'Oria a Fassolo in Genova', *Atti Soc. Ligure Stor. Patria*, x (1874) [engrs; whole issue]
E. Parma Armani: 'Il palazzo del Principe Andrea Doria a Fassolo in Genova', *L'Arte*, x (1970), pp. 12–63
E. Grendi: 'Andrea Doria, uomo del rinascimento', *Atti Soc. Ligure Stor. Patria*, xciii (1979)
G. L. Gorse: *The Villa Doria in Fassolo, Genoa* (diss. Providence, RI, Brown U., 1980)
P. Boccardo: *Andrea Doria e le arti* (Rome, 1989)

MATILDE FASSIO

(2) Giovanni Andrea [Gian Andrea] **I Doria** (*b* Genoa, 6 Feb 1539/40; *d* Genoa, 2 Feb 1606). Admiral and patron, nephew and adopted son of (1) Andrea Doria I. On Andrea I's death, he took up residence at the Palazzo Doria at Fassolo. In 1575, after a period of civil strife, he was awarded the title of Conservatore della Libertà della Patria, and subsequently pride in his civic role, and the devout spirituality of his wife, Zenobia del Carretto, determined the nature of his patronage. He was involved in extending the Palazzo Doria, and adorning it with works of art, from 1565 until his last years. After 1575 the architecture was directed by Giovanni Ponzello; Lazzaro Calvi (1502–?1607) painted frescoes celebrating the Doria family; five chapels where Mass could be celebrated were constructed within the palazzo. The garden was embellished by Marcello Sparzo (*fl* 1565–1606), a stuccoist from Urbino, whose works included a statue of *Jupiter* (1586). In 1589 Doria acquired 12 marble heads of emperors for the southern part of the garden; Taddeo (*d* 1613), Giuseppe and Battista Carlone produced the Fountain of Neptune (1599–1601) for the lower garden. Works of art for the interior included 60 portraits of famous men, bought in Rome in 1591. The stuccowork in four of the rooms in the eastern part is by Sparzo (1599). The church of S Benedetto, adjacent to the palazzo, was rebuilt by Ponzello in 1592, and an altarpiece created by Andrea Semino's sons, Giulio Cesare and Alessandro. Benedetto Brandimarte (*fl* 1588–92), who had been summoned from Lucca in 1581, painted an *Annunciation* (untraced) and organ shutters (*in situ*).

Giovanni Andrea also employed Ponzello to build the Palazzo Doria at Loano (1574–8; now Palazzo Comunale) and the church of S Agostino there (1588–96), for which Sparzo created stucco statues of the *Four Evangelists, Gabriel* and the *Annunciation*; Giovanni Battista Paggi painted an altarpiece, the *Martyrdom of St Andrew* (*c.* 1590); the Semino brothers painted the *Baptism* (1590), and Benedetto Brandimarte the *Nativity* and the *Assumption of the Virgin* (dated 1592). At Pegli, a suburb of Genoa, Giovanni Andrea employed (1592) Andrea Ceresola (il Vannone; *fl* 1575–1619) to supervise the aggrandisement of the Villa Doria–Centurione; Lazzaro Tavarone (*c.* 1556–1641) was commissioned to paint mythological frescoes. Ceresola also constructed the church of Nostra Signora delle Grazie at Pegli, for which Paggi and Andrea Semino created altarpieces.

Giovanni Andrea was Admiral of the Spanish fleet in the Mediterranean, and he sent paintings by Genoese and Tuscan artists to King Philip II (*reg* 1556–98). He also sent

Luca Cambiaso (1583) and Benedetto Brandimarte to work at the Spanish court. Marcantonio Calvi, grandson of Lazzaro Calvi (1502–1607), was sent to Venice to acquire paintings by Titian, Veronese and Andrea del Sarto, which were presented to Philip II on behalf of the Admiral.

BIBLIOGRAPHY

R. Bracco: *Il principe Giannandrea Doria* (Genoa, 1960)

L. Magnani: 'Committenza e arte sacra a Genova dopo il concilio di Trento: Materiali di ricerca', *Stud. Stor. A.*, v (1983–5), pp. 133–84

LORENZA ROSSI

Dosio, Giovanni Antonio [Giovannantonio] (*b* San Gimignano, 1533; *d* Naples, 1609). Italian sculptor, architect, draughtsman, antiquarian, engineer and decorator. He began his career as a goldsmith and engraver. He arrived in Rome in 1548 and the next year entered the workshop of the sculptor and architect Raffaele da Montelupo, where he worked mostly on wall decorations for mausoleums. Around this time he carved a statue of *Hope* for the tomb of *Giulio del Vecchio* in SS Apostoli, Rome. Between 1552 and 1564 he was in close contact with Michelangelo, and he may have participated with Guglielmo della Porta in the reconstruction of S Silvestro al Quirinale, Rome. Della Porta and Dosio associated with the artistic circle around the Carafa family, for whom they may have planned a chapel. In 1561 Dosio was working as a sculptor and stuccoist for the patrician Torquato de' Conti. Other sculptural work in Rome includes a funerary monument with posthumous portrait bust for the poet *Annibal Caro* (1567–70) and another to *Giovanni Pacini* (1567–8; both S Lorenzo in Damaso).

During his early years in Rome, Dosio's approach to architecture was eclectic, as can be seen from his numerous drawings, datable between 1556 and 1576 (Florence, Uffizi). These range from engineering drawings that follow Vitruvius or are clearly inspired by sources such as Francesco di Giorgio Martini, Giuliano da Sangallo and Baldassare Peruzzi to studies of Michelangelo's sculpture and architecture, for example in connection with the tomb of Pope Julius II and the Medici Chapel and façade of S Lorenzo, Florence. These drawings have proved valuable sources for studying the Roman architectural works of Bramante, Raphael and Michelangelo. The drawings Dosio also made for prints dealt with various architectural themes: church façades, centrally planned churches and semi-fortified villas (*see* VILLA, §2). In the latter he sought a synthesis between the closed, defensive geometry of closely spaced bastions and the open fluidity of country dwellings. Rather than the singularly defensive solutions deriving from Michelangelo, they evoke the compositional experiments of Jacopo Vignola at the Villa Farnese, Caprarola, where in his later career Dosio planned the sunken gardens (1580–83).

Dosio entered the world of antiquarian culture as an illustrator of Roman antiquities. He is remarkable among the Tuscan Mannerists for his vast philological and antiquarian study of ancient monuments, a study motivated not so much by any clear plan of semantic codification as by an inexhaustible encyclopedic curiosity. Though he did not belong to the Accademia della Virtù, founded in Rome in 1542 to promote the knowledge of Vitruvius and

Roman architecture, his work accords with its principles. Many of his accurately executed reliefs are pervaded by a limpid atmospheric quality, and tonal modelling is used only to give realistic emphasis to the volumes of buildings. Dosio was one of the first artists to experiment with the genre of the Veduta, realizing that attractive perspectives and archaeological precision were greatly appreciated in the flourishing Roman antique market for which he worked. Bernardo Gamucci used some of Dosio's drawings in *Le antichità di Roma* (1565), and Giovanni Battista de' Cavalieri included Dosio's 50 views of Roman architectural ruins in his collection of engravings, *Urbis Romae aedificiorum illustrium* (1569). Dosio acted as an intermediary for Niccolò Gaddi in the latter's purchases of antique works of art and made drawings of funerary cippi for the Mantuan antiquarian Jacopo Strada. His correspondence with Gaddi (1574) mentions plans for a treatise on architecture, but this was never successfully realized.

From 1576 to 1590 Dosio worked mainly in Florence, where he had assisted Bartolomeo Ammannati at the Medici villa at l'Ambrogiana (1574), and in 1575–6 rebuilt the Gaddi Chapel in S Maria Novella; he received increasingly prestigious appointments in the city. He proposed a setting for Donatello's altar in Il Santo, Padua (?1579), and built a palazzo for Filippo Giacomini (now the Palazzo Giacomini–Larderel) with a façade in the classical style (1580). On the invitation of Cardinal Alessandro de' Medici, he planned the façade of the Archbishop's palace in the Piazza S Giovanni (1582, partially executed). Revisiting Rome the same year, he supervised the completion of the plans by Antonio da Sangallo (ii) for S Maria di Monserrato. In 1585 he began work on the Niccolini Chapel in Santa Croce, Florence. In 1586 he took part in a competition organized by Francesco I de' Medici, Grand Duke of Tuscany, for the façade of the cathedral (model Florence, Opera del Duomo) and another competition connected with the Medici Chapel in S Lorenzo. He was one of the main designers of the decorations for the wedding (1589) of Ferdinand I de' Medici and Christine of Lorraine, arranging the *apparati* for the Ponte alla Carraia and for the Palazzo Vecchio, where he produced an architectural pastiche reminiscent of Pirro Ligorio's bizarre scenographic imagination, freely exploiting his erudition in his design for a temporary façade for the cathedral.

After 1590 Dosio worked in Naples, where, in 1591, he was paid as an engineer of the royal court and had numerous supervisory duties. He made one return visit to Rome, remodelling the Palazzo Medici (now Palazzo Madama) with Lodovico Cigoli (1559–1613). Between 1601 and 1603 he supervised work in the Neapolitan church of the Girolamini. At the Certosa di S Martino from 1590 he worked on an extension, plans for side chapels and the cloister and a puteal, all of which were completed by Giovanni Giacomo di Conforto (c. 1569–1631) and Cosimo Fanzago (1591–1678). In Naples, Dosio was active in the field of church interior design, producing the tabernacles (1598) in the Brancaccio Chapel in the cathedral and supervising the works in Il Gesù Nuovo (1605). He died while he was modernizing the convent.

Dosio oscillated between classicism and Mannerism. His work shows sensitivity to the composure and equilib-

rium of Raphael and Peruzzi and a critical and attentive observation of Michelangelo's manner, although he could not recognize his innovative importance.

BIBLIOGRAPHY

V. Daddi Giovannozzi: 'Il palazzetto Giacomini–Larderel del Dosio', *Riv. A.*, xvii (1935), pp. 209–10
L. Wachler: 'Giovannantonio Dosio', *Röm. Jb. Kstgesch.*, iv (1940), pp. 143–251
V. Daddi Giovannozzi: 'Di alcune incisioni dell'apparato per le nozze di Ferdinando de' Medici e Cristina di Lorena', *Riv. A.*, xxii (1940), pp. 85–100
E. Luporini: 'Formazione, cultura e stile di Giovannantonio Dosio', *Studi in onore di Matteo Marangoni*, ed. C. L. Ragghianti (Florence, 1957), pp. 224–37
——: 'Un libro di disegni di Giovanni Antonio Dosio', *Crit. A.*, iv/24 (1957), pp. 442–67
F. Borsi and others, eds: *Roma antica e i disegni di architettura agli Uffizi* (Rome, 1976) [with list of writings by Dosio and bibliog.]
C. Bertocci and C. Davis: 'A Leaf from the Scholz Scrapbook', *Met. Mus. J.*, xii (1977), pp. 93–100
C. Przyborowski: *Die Ausstattung der Fürstenkapelle an der Basilika von San Lorenzo in Florenz: Versuch einer Rekonstruktion* (Würzburg, 1982)
G. Tedeschi Grisanti: '*Dis manibus, pili, epitaffi e altre cose antiche*: Un codice inedito di disegni di Giovannantonio Dosio', *Boll. A.*, n. s. 5, lxviii/2 (1983), pp. 69–102
R. Pane: 'Dosio e Fanzago', *Napoli Nob.*, xxii/5–6 (1983), pp. 161–7
M. I. Catalano: 'Per Giovanni Antonio Dosio a Napoli: Il puteale del chiostro grande nella Certosa di San Martino', *Stor. A.*, 50 (1984), pp. 35–41
G. Galletti: '"Se amerai di gareggiare con la vaghissima ritondità del cielo...: Il giardino a pianta centrale fra manierismo e barocco', *Giardino delle muse: Arti e artifici nel barocco europeo: Pietrasanta, 1993*, pp. 39–60

ANTONIO MANNO

Dossi. Italian family of painters. (1) Dosso Dossi and his less talented younger brother (2) Battista Dossi were the leading painters at the court of Ferrara under Alfonso I d'Este and Ercole II d'Este. Most of their documented work for the court was ephemeral in character and is now lost. It included frescoes for the various ducal residences; designs for tapestries, theatre sets, festival decorations, banners, coins and tableware; the decoration and varnishing of carriages and barges. However, there survives a considerable number of easel paintings attributable to the brothers, either singly or in collaboration; and a relatively high proportion of these are allegorical or mythological in content, in a way that clearly reflects the wider cultural interests of the Ferrarese court. Although responsive to a wide range of outside influences, the most important of which were probably those of Giorgione in Venice and Raphael in Rome, Dosso was an artist of great originality with a strong feeling for effects of light and of glowing colour, and for the poetic quality of landscape. He also had an unusually marked sense of humour and often displays a mock-heroic irony akin to that of his fellow employee at the Ferrarese court, the great poet Lodovico Ariosto (1475–1533). Battista is a much lesser figure, and most of his career was spent in the shadow of his brother.

(1) Dosso Dossi [Giovanni Francesco di Niccolò di Luteri] (*b* Tramuschio (Mirandola), *c.* 1486; *d* Ferrara, 1541–2). According to Vasari, Dosso was a close contemporary as well as a compatriot of Ariosto. Longhi (1934) was the first to challenge this implied birthdate in the 1470s; and on the basis of his reconstruction of Dosso's early career, he argued that the painter must have been at least 10 to 15 years younger that Ariosto. According to a

recently discovered legal document (Giovannini, 1992), Dosso had reached the majority age of 25 by June 1512; from this it may be deduced that he was born some time before June 1487. According to another recently discovered document (Franceschini, 1995), at the likely time of Dosso's birth his father was living in the small principality of Mirandola, on the borders of Mantua and Ferrara. The nickname 'Dosso', by which he was always known in his lifetime, derives from the name of a small family property nearby; Battista was generally known as 'Battista del Dosso', or 'Battista Dossi'. On the basis of this usage, subsequent Ferrarese historians mistakenly came to believe that 'Dossi' was the brothers' family name.

1. EARLIER WORKS, TO *c.* 1522. The earliest record of Dosso's activity as a painter dates from April 1512, when he was paid for painting 'a large picture with eleven figures' for the palazzo of S Sebastiano in Mantua. This work is almost certainly now lost, but the document lends some credence to the report by Vasari that Dosso was a pupil of Lorenzo Costa, court painter at Mantua from 1507. On the other hand, Dosso's early style has nothing in common with that of Costa, and any relationship is likely to have been shortlived. Much more essential to his artistic formation was the work of Giorgione, and it is reasonable to assume that Dosso had already spent time in Venice, perhaps under Gonzaga sponsorship, in the immediately preceding years. Further documents published by Franceschini (1995) show that Dosso had settled in Ferrara by the summer of 1513, when he received payments, together with his collaborator Garofalo, for the huge polyptych (Ferrara, Pin. N.) painted for the ducal counsellor Antonio Costabili. By the following year Dosso had entered the service of Duke Alfonso, for whom he undertook several journeys to Venice between 1516 and 1519, and also to Florence in 1517 and Mantua in 1519. But Dosso was never tied exclusively to the Duke, and between 1518 and 1521 he painted the *Virgin and Child in Glory Escorted by SS Lawrence and James with SS John the Baptist, Sebastian and Jerome* for Modena Cathedral (*in situ*), the first of at least three important altarpieces commissioned by Modenese patrons (documents Giovannini, 1988 and 1992).

The study of Dosso's early career, up to the time of the obviously mature altarpiece for Modena Cathedral, remains an area of lively critical debate. Until recently, there was almost unanimous acceptance of the view of the early Dosso put forward by Longhi (1927, 1934). According to this view, the painter began with a provincially Titianesque manner, represented by such pictures as the *Holy Family with St John and Two Donors* (Philadelphia, PA, Mus. A.); he then progressed around 1516–17 to a more freely experimental manner, based on Giorgione, with such pictures as the *Three Ages of Man* (New York, Met.; see fig. 1); and finally arrived at the more disciplined and classicising style represented by the Modena altarpiece. Some adherents to this view have further suggested that a picture representing *Bathers* (Rome, Castel Sant'Angelo), already related by Longhi to his early group, is identical with the documented work painted in Mantua in 1512.

Longhi's entire reconstruction has been thrown into doubt, however, by the revelation that Dosso was em-

1. Dosso Dossi: *Three Ages of Man*, oil on canvas, 775×1118mm, *c.* 1514–15 (New York, Metropolitan Museum of Art)

ployed on the Costabili Polyptych—a work previously dated on stylistic grounds to the mid-1520s or later—as early as 1513. Some scholars have responded to the new documents by questioning their relevance and have hypothesized that, although begun *c.* 1513, the polyptych was only completed, or was extensively reworked, a decade later. But it seems more reasonable to accept the parts of the polyptych attributable to Dosso—most notably the highly romantic figure of St George, with his glinting armour emerging from deep shadows, and the broadly executed, poetically evocative landscape—as a reliable guide to his early style. In this case, the group of early pictures assembled by Longhi cannot be by Dosso; instead, Dosso's other early, explicitly Giorgionesque works would include the New York *Three Ages of Man*, with its dominant landscape, and the half-length pendants, *St John the Baptist* (Florence, Pitti) and *St George* (Los Angeles, Getty Mus.).

With its fashionably dressed figures swamped by the lush, superabundant vegetation, the *Three Ages of Man* also apparently reflects Dosso's response to prints by German artists such as Albrecht Altdorfer (*c.* 1480–1538); and German inspiration is even more evident in the explicitly genre-like *Standard-bearer* (*c.* 1515–16; Allentown, PA, A. Mus.). Meanwhile, Dosso took his engagement with Venetian painting a stage further in the magically poetic *Melissa* (*c.* 1515–16; Rome, Gal. Borghese), in which the opulence of colour and texture clearly reflects his contact with Titian, who made repeated visits to Ferrara throughout the decade 1516–26.

2. LATER WORKS, *c.* 1522–42. A Venetian warmth of colour and atmospheric softness of surface remain fundamental to the Modena altarpiece of 1518–21. But the muscular nudity of the three principal saints, with their foreshortened limbs, also indicates a new interest in the art of High Renaissance Rome: of the mature Raphael, and in particular, of Michelangelo. Before the recent discovery of documents relating to the commission, the picture was thought to date from 1522, the date of the installation; and some scholars inferred that Dosso must have made a trip to Rome *c.* 1520. In fact, he may have made the trip much earlier, *c.* 1513; and the change of stylistic direction towards the end of the decade may instead reflect the documented arrival in Ferrara of two full-scale cartoons by Raphael, in 1517 and 1518, and the growing interest in Michelangelo around this time among North Italian painters generally.

Dosso's stylistic development in the 1520s and early 1530s is somewhat easier to trace than in the previous decade, thanks to the existence of a greater number of works of art that are documented or datable on external evidence. In 1524–6 he received payments for painting a circular panel for the ceiling of one of the ducal apartments, the Camera del Pozzuolo, fragments of which—the *Man Embracing a Woman* (London, N.G.) and the *Page with a Basket of Flowers* (Florence, Longhi priv. col.; see Gibbons, fig. 25)—survive. In 1527 he undertook the commission for the *Four Fathers of the Church* altarpiece (ex-Gemäldegal. Alte Meister, Dresden; destr.) for Modena Cathedral

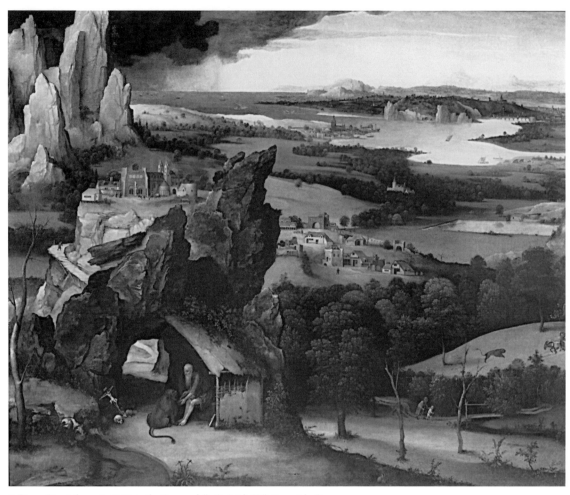

2. Dosso Dossi: fresco (*c.* 1530) in the Camera delle Cariatidi, Villa Imperiale, Pesaro

(Cremonini, 1997). The date 1527 is also given in an inscription formerly mounted below the della Sale Altarpiece, *SS John the Evangelist and Bartholomew* (1527; Rome, Pal. Barberini), in Ferrara Cathedral. His frescoes at the Villa Imperiale, Persaro, commissioned by the Duchess of Urbino, almost certainly date from the summer of 1530 (Smyth in *Dosso's Fate*, 1998); in the Sala delle Cariatidi there he painted maidens transformed into leafy caryatids who support a fictive pergola and frame an enchantingly fresh illusionistic landscape (see fig. 2). From September 1531 to June 1532 Dosso is recorded, together with Battista, painting frescoes for Cardinal-bishop Bernardo Cles (1485–1539) in the Castello del Buonconsiglio, Trent. The witty and festive decorations at Pesaro and Trent are all that remain of Dosso's extensive activity as a fresco painter, practised for the most part in the various ducal residences in and around Ferrara.

The documented works of the 1520s, together with undocumented masterpieces such as the *Jupiter, Mercury and Virtue* (*c.* 1523–4; Vienna, Ksthist. Mus.), the *Apollo* (*c.* 1524; Rome, Gal. Borghese) and the *Mytholgocial Allegory* (*c.* 1529–32; Los Angeles, Getty Mus.; see fig. 3), show that Dosso's Central Italian interests were further stimulated by the arrival in 1524 at the nearby court of

Mantua of Raphael's principal pupil, Giulio Romano. The effect of Giulio is particularly evident in Dosso's new attention to plastic firmness of form, to precision of detail, and perhaps also in the extensive background landscape of the *Mythological Allegory*, with its view of a distant city by the edge of the sea. At the same time, this panoramic approach to landscape, so different from that revealed in earlier works such as the *Three Ages of Man*, probably owes much to imported pictures of the Antwerp school, by such painters as Joachim Patinir (*c.* 1480–before 1524). Several of Dosso's most beautiful and ambitious works datable to this decade, including the *Jupiter* and *Mythological Allegory*, also serve to illustrate the difficulties of interpretation often presented by the artist's subject-matter. Apparently mixing mythological with allegorical figures, such works appear to reflect the involvement of a court humanist in drawing up a programme that often seems to take a perverse delight in giving old stories a new twist, or in giving traditional figures new attributes, so that they are no longer unambiguously recognizable.

Among the works known to date from the last decade of Dosso's life are the *St Michael and the Assumption of the Virgin* (Parma, G.N.), documented to 1533–4, the *SS John the Baptist and George* (Milan, Brera), datable on external

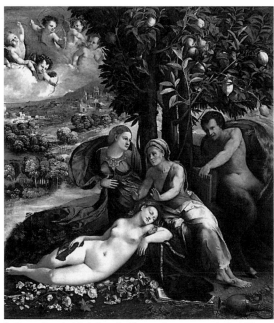

3. Dosso Dossi: *Mythological Allegory*, oil on canvas, 1.60×1.32 m, *c.* 1529–32 (Los Angeles, CA, J. Paul Getty Museum)

circumstantial evidence to the later 1530s, and the *St Michael* (Dresden, Gemäldegal. Alte Meister), for which he was paid (together with Battista) in 1540. These recorded dates confirm that stylistically related works such as the *Allegory of Fortune* (*c.* 1535–8; Los Angeles, Getty Mus.) and the so-called *Stregoneria*, probably in fact an *Allegory of Hercules* (*c.* 1538; Florence, Uffizi; see colour pl. 1, XXIX3), date from this late phase of the painter's career. But any consideration of the later Dosso is complicated by the fact that after *c.* 1530 he worked in regular collaboration with Battista, so that even a documented picture such as the Parma *St Michael*, for which payments were made to Dosso alone, cannot be regarded as purely autograph.

3. WORKING METHODS AND POSTHUMOUS REPUTATION. Dosso placed a much higher priority on rich and varied pictorial effects than on formal structure and draughtsmanship. Numerous pentiments revealed by x-radiographs of the *Mythological Allegory* show that, even at his most Raphaelesque or Giuliesque, Dosso followed the example of Giorgione, dispensing with preparatory drawings and sketching his design straight on to the canvas. Only a very small number of drawings can be associated with his style, and even these may be by Battista rather than his elder brother.

As early as the 1520s Dosso's originality as a landscape painter was admired by the humanist Paolo Giovio, who implicitly compared him with the antique painter Ludius, who, according to Pliny (Natural History, XXXV), similarly specialized in scenes in which rustic figures were subordinate to an extensive landscape. While echoing this praise for Dosso's speciality, Vasari had little enthusiasm for his art in general; and for Vasari, Dosso's tendency towards the bizarre and preference for expressive colour

over careful draughtsmanship meant that he lacked a true sense of style, or *maniera*. As fellow Emilians reacting against the Mannerism of which Vasari was a typical exponent, the Carracci family may have been more sympathetic to his robust vitality. Yet for them too Dosso must have seemed too undisciplined and idiosyncratic, and lacking in a classical sense of beauty. The ascendancy of Bologna in Emilian painting in the later 16th century, and the political degradation of Ferrara after 1598, when many of Dosso's works, above all his frescoes, were lost, prevented his art from having the impact on the 17th century that it might otherwise have had.

(2) Battista Dossi [Battista di Niccolò di Luteri] (*d* Ferrara, 1548). Brother of (1) Dosso Dossi. He spent almost his entire career in the service of the court at Ferrara, where his name first occurs in the ducal accounts in 1517, and frequently collaborated with his brother. From 1517 he may have worked in Rome in Raphael's workshop, where he is mentioned in a letter of 1520 from the Duke's agent in Rome (Campori). In August 1520, four months after Raphael's death, Battista is documented back in Ferrara. He is likely to have only just graduated as a master at this time; this supposition is confirmed by a document of 1521 relating to Dosso's altarpiece for Modena Cathedral, in which Battista is mistakenly called Dosso's son, implying that Battista was much younger than his brother. He collaborated with Dosso on the frescoes in the Villa Imperiale in Pesaro (*c.* 1530) and in 1531–2 again worked with his brother on the frescoes in Trent Castle. In 1533 he was commissioned to paint a *Deposition* for the Confraternity of the Cross in S Francesco Faenza (untraced), for which both brothers were paid in 1536. In the same year his name is recorded as the principal author of a *Nativity with Saints and Donors* (Modena, Gal. & Mus. Estense), commissioned by Duke Alfonso for Modena Cathedral; and in 1540 he was paid, together with Dosso, for the two canvases, *St Michael* and *St George* (both Dresden, Gemäldegal. Alte Meister).

In these years the career of Battista, who evidently performed best under the guidance of Dosso, is obscured by that of his brother. It is not always easy to identify the extent and nature of his contribution even in those works in which he is known to have had a hand. The Modena *Nativity*, for example, is often reasonably regarded as a key-work for defining Battista's own style; yet while the clearly drawn composition and elaborately posed figures may indeed be interpreted as still reflecting his early experience in Raphael's workshop, the dramatically conceived background landscape suggests that Dosso was also involved in the design and execution of the picture. A clearer idea of Battista's independent artistic personality emerges from a number of works documented to the years between Dosso's death in 1542 and Battista's own in 1548; these include the *Justice* and the *Hour Leading forth the Horses of Apollo* (both 1544; Dresden, Gemäldegal. Alte Meister). The depiction of Justice is prosaic, the details of her costume pedantically literal and the entire figure completely unintegrated with the background landscape. But is should be emphasized that, like his brother before him, Battista in these years was the head of a busy workshop, involved in the usual round of court commis-

sions; and even these documented late works can, therefore, scarcely be regarded as autograph.

BIBLIOGRAPHY

G. Vasari: *Vite* (1550, rev. 2/1568); ed. G. Milanesi (1878–85), v, pp. 96–101

P. Giovio: *Fragmentum trium dialogorum Pauli Jovii espiscopi Nucevini*; repr. in G. Tiraboschi: *Storia della letteratura italiana* (Florence, 1812), vii/4, p. 1722

G. Baruffaldi: *Vite de' pittori e scultori ferraresi (1697–1722)*, ed. G. Boschini (Ferrara, 1844), i, pp. 239–93

G. Campori: *Notizie inedite di Raffaello d'Urbino* (Modena, 1863), p. 29

R. Longhi: 'Un problema di cinquecento ferrarese (Dosso giovine)', *Vita artistica*, ii (1927), pp. 31–5; also in *Opere complete di Roberto Longhi*, ii (Florence, 1967)

——: *Officina ferrarese* (Florence, 1934); also in *Opere complete di Roberto Longhi*, v (Florence, 1968)

E. H. Gombrich: 'Renaissance Artistic Theory and the Development of Landscape Painting', *Gaz. B.-A.*, n. s. 5, xli (1953), pp. 335–60; repr. in *Norm and Form: Studies in the Art of the Renaissance* (London, 1966)

M. G. Antonelli Trenti: 'Notizie e precisazioni sul Dosso giovane', *A. Ant. & Mod.*, xxviii (1964), pp. 404–15

P. Dreyer: 'Die Entwicklung des jungen Dosso: ein Beitrag zur Chronologie der Jugendwerke des Meisters bis zum Jahre 1522', *Pantheon*, xxii (1964), pp. 220–32, 363–75; 23, 22–30

A. Mezzetti: *Il Dosso e Battista ferraresi* (Ferrara, 1965) [cat., register of doc., bibliog. and pl., some colour]

F. Gibbons: *Dosso and Battista Dossi: Court Painters at Ferrara* (Princeton, 1968) [cat., register of doc., bibliog. and pl.]; review by M. Calvesi in *Stor. A.*, 1–2 (1969), pp. 168–74

S. Freedberg: *Painting in Italy, 1500–1600* (Harmondsworth, 1971)

C. Volpe: 'Dosso: Segnalazioni e proposte per il suo itinerario', *Paragone*, xxv/293 (1974), pp. 20–28

A. Braham and J. Dunkerton: 'Fragments of a Ceiling Decoration by Dosso Dossi', *N.G. Tech. Bull.*, v (1981), pp. 27–37

C. Volpe: 'Una pala d'altare del giovane Dosso', *Paragone*, xxxiii/383–5 (1982), pp. 3–14

F. Trinchieri Camiz: 'Due quadri "musicali" del Dosso', *Frescobaldi e il suo Tempo* (exh. cat., Ferrara, Pin. N., 1983), pp. 85–91

The Age of Correggio and the Carracci (exh. cat., Bologna, Pin. N.; Washington, DC, N.G.A.; New York, Met.; 1986–7)

C. Giovannini: 'Notizie inedite sull'altare di S. Sebastiano e sul presepio del Begarelli nel Duomo di Modena', *Il Duomo e la Torre di Modena*, ed. O. Baracchi and C. Giovannini (Modena, 1988), pp. 207–26

——: 'Nuovi documenti su Dosso', *Prospettiva*, 68 (1992), pp. 57–60

T. Frangenberg: 'A Lost Decoration by the Dossi brothers in Trent', *Z. Kstgesch.*, lvi (1993), pp. 18–37

——: 'Decorum in the *Magno Palazzo* in Trent', *Renaissance Stud.*, vii (1993), pp. 352–78

A. Ballarin: *Dosso Dossi: La Pittura a Ferrara negli Anni del Ducato di Alfonso I*, 2 vols (Cittadella, 1994–5) (cat. by V. Romani, register of doc. by A. Pattanaro, and pl., many in colour)

C. Del Bravo: 'L'Equicola e il Dosso', *Artibus & Hist.*, xxx (1994), pp. 71–82

A. Franceschini: 'Dosso Dossi, Benvenuto da Garofalo, e il politico Costabili a Ferrara', *Paragone*, 543–5 (1995), pp. 110–15

S. Tumidei: 'Dosso (e Battista) al Buonconsiglio', *Il Castello del Buonconsiglio*, ed. E. Castelnuovo (Trento, 1996), ii, pp. 131–57

C. Cremonini: 'La pala dell'*Immacolata Concezione* di Dosso Dossi nel Duomo di Modena: un contributo per la cronologia', *Dialoghi di Storia dell'Arte*, iv–v (1997), pp. 350–54

P. Humfrey and M. Lucco: 'Dosso Dossi in 1513: A Reassessment of the Artist's Early Works and Influences', *Apollo* cxlvii/432 (1998), pp. 22–30

P. Humfrey: 'Dosso Dossi et la peinture de retables', *Rev. A.*, cxix (1998), pp. 9–20

Dosso Dossi: Court Painter in Renaissance Ferrara (exh. cat. by P. Humfrey and M. Lucco, Ferrara, Pin. N.; New York, Met.; Los Angeles, Getty Mus.; 1998–9)

L. Ciammitti, S. Ostrow and S. Settis, eds.: *Dosso's Fate: Painting and Court Culture in Renaissance Italy* (Los Angeles, 1998) [papers of two conferences]

L. Ciammitti, ed.: *Garofalo e Dosso: Richerche sul Polittico Costabili* (Venice, 1998)

PETER HUMFREY

Dovizi, Bernardo da. *See* BIBBIENA, BERNARDO.

Duca. Italian family of artists. Of Sicilian origin, they were active in Central Italy, mainly in Rome, in the second half of the 16th century.

(1) Giacomo [Jacopo] del Duca (*b* Cefalù, *c.* 1520; *d* Cefalù, 9 July 1604). Sculptor, architect, bronze-caster and garden designer. He trained in Sicily with Antonello Gaggini and then in Rome with Michelangelo, whom he met through his uncle, Antonio del Duca, Capellano di S Maria di Loreto. He became one of Michelangelo's principal assistants and continued to work for him until Michelangelo's death in 1564. He also worked independently before that date; his marble relief for the abbey of S Bartolomeo di Campagna (now Trisulti; *in situ*) was begun before 1561.

In 1562–3 Giacomo assisted Michelangelo on a new gate to Rome, the Porta Pia, commissioned by Pope Pius IV, for which he executed the winged figures above the main arch, as well as the mask on the keystone. Also in this period he worked with Michelangelo on S Maria degli Angeli, Rome, commissioned by Pius IV and built on the remains of the ancient Baths of Diocletian. The project was promoted by Antonio del Duca, who had first petitioned the papacy about it in 1541. Preliminary proposals were made by Antonio da Sangallo (ii), but in 1559 the commission was given to Michelangelo. Work began in 1562 and continued under Giacomo's supervision after Michelangelo's death. Giacomo completed the cupola over the entrance vestibule and the marble flooring, but the exact extent of his contribution is difficult to determine. (The church was remodelled in the mid-18th century by Luigi Vanvitelli.) Giacomo executed a large bronze tabernacle (begun 1565; now Naples, Capodimonte) for the church from Michelangelo's design. His work in the late 1560s probably included the monastic buildings adjacent to S Maria degli Angeli. The design of the colonnades in the large cloister, with Doric columns supporting simple semicircular arches, is particularly refined. One of his most significant works of the 1570s is the monument to *Elena Savelli* in S Giovanni in Laterano, Rome (moved but *in situ*), in which the legacy of Michelangelo is revealed in the interpenetration of architectural elements. The bronze sculpture, set in marble, includes circular reliefs and the bust of Savelli. In 1574 Giacomo was commissioned by Pope Gregory XIII to design the Porta S Giovanni, Rome. In the form of an antique triumphal arch, perhaps based on a sketch by Michelangelo, it shows Giacomo's assured use of his mentor's vocabulary. Particularly notable are the great rusticated blocks radiating from the arch, giving the whole an effect of depth and power.

Two important ecclesiastical commissions for Giacomo date from the mid-1570s. S Maria di Loreto, Rome, had been begun by Donato Bramante *c.* 1507 and continued by Sangallo. Built on a restricted site, to a centralized plan, it has a square base and an octagonal drum with a prominent cupola; the small chancel projects at the rear. The lower parts of the church and the principal façade to the south were complete when work restarted under Giacomo, after 1573. The detailing of the body of the church is restrained, but Giacomo's cupola is a powerful work, with strongly moulded ribs and circular windows in bold, simple frames; it displays his inheritance from

Michelangelo in a context too refined for the strength of its forms. The complex lantern, with its pinnacles and colonettes, is too elaborate for the bold expression of the dome (see fig.). His designs for the flanking façades broadly respect Sangallo's principal elevation. From *c.* 1573 Giacomo remodelled S Maria in Trivio, Rome, a small, aisleless, rectangular church on an extremely restricted site. The façade (1575) is attractive and well-proportioned, although some of the Mannerist details are over contrived and awkward. The small entrance portal is particularly complex, with a curved, broken pediment inserted in a triangular one. The doors are flanked by curious narrow modillions.

Other work by Giacomo in the 1570s includes a large tabernacle commissioned by Philip II (*reg* 1556–98) for S Lorenzo at the Escorial in Spain (not completed) and the wall surrounding the gardens on the Palatine Hill, the Horti Farnesiani, Rome. Around 1572 he entered the service of Paolo Giordano Orsini (*d* 1585), for whom he designed a garden at Bracciano and possibly worked at the Villa Orsini, Bomarzo, as well as remodelling the presbytery of S Giovanni Battista, Campagnano. In 1582 Giacomo travelled to Innsbruck at the invitation of Archduke Ferdinand, Count of the Tyrol (1529–95), who wanted him to cast the bronze statue for the tomb of *Maximilian I* in the Hofkirche. Giacomo refused, and the work was later undertaken by his brother (2) Lodovico del Duca.

The most significant work designed by Giacomo in the 1580s was the upper gardens and *palazzina* of the Villa Farnese at Caprarola. The complex, including terraces, fountains and sculpture, is remarkable for its synthesis of natural and manmade elements. In 1585 he remodelled SS Quirico and Giulitta, Rome, and parts of the Villa Rivaldi (Rome; partially destr.) for Cardinal Alessandro Farnese. The following year he completed the remodelling of Villa Mattei (altered) on Monte Celio, Rome, for Ciriaco Mattei. His details can be identified on the lower façade, and there is a strongly moulded cornice, characteristic of his style, on the first floor. Also in 1586 he executed the Mattei Chapel in S Maria in Aracoeli (altered), Rome, notable for its stuccowork and coffered ceiling.

By 1592 Giacomo had returned to Sicily as chief architect of Messina, where his work included the tribune of S Giovanni di Malta and the Cappella del SS Sacramento in the cathedral. Despite later alterations, the chapel shows his characteristic inventiveness in the rich interrelationship of architecture and sculpture, one that anticipates the Baroque. According to Baglione, Giacomo was also a poet.

BIBLIOGRAPHY

DBI; Thieme–Becker

G. Vasari: *Vite* (1550, rev. 2/1568); ed. G. Milanesi (1878–85), vii, p. 261

G. Baglione: *Vite* (1642); ed. V. Mariani (1935), p. 54

A. Bertolotti: 'Alcuni artisti siciliani a Roma nei secolo XVI e XVII', *Archv Stor. Sicil.*, 2nd ser., iv (1879), pp. 6–10, 14

E. Lavagnino: 'Jacopo del Duca, architettore del popolo romano', *Capitolium*, x (1931), pp. 203–8

F. Basile: *Studi sull'architettura di Sicilia: La corrente michelangiolesca* (Rome, 1942), pp. 81–109

S. Benedetti: *S Maria in Loreto* (Rome, 1968)

——: 'Sul giardino grande di Caprarola', *Quad. Ist. Stor. Archit.*, 91–6 (1969), pp. 3–46

H. Geiss: 'Studien zur Farnese Villa am Palatin', *Röm. Jb. Kstgesch.*, xiii (1971), pp. 215–20

S. Benedetti: *Giacomo Del Duca e l'architettura del cinquecento* (Rome, 1973)

A. Schiavo: 'Il michelangiolesco tabernacolo di Jacopo del Duca', *Stud. Romani*, xxi/2 (1973), pp. 215–20

S. Benedetti: 'Addizioni a Giacomo Del Duca', *Quad. Ist. Stor. Archit.*, 1–10 (1987), pp. 245–60

(2) Lodovico del Duca (*b* ?Cefalù; *fl* 1551–1601). Bronze-caster, brother of (1) Giacomo del Duca. The earliest record of his activity, a letter from Giorgio Vasari of June 1551 referring to bronze heads cast by Lodovico for the Palazzo Ridolfi, Florence, suggests his career was established by that date. In the early 1570s he participated in casting the bronze sculpture for the monument to *Elena Savelli* (Rome, S Giovanni in Laterano) designed by his brother Giacomo. Also in collaboration with his brother he cast the bronze rays surrounding an emblem designed by Bartolomeo Ammanati for the main façade of Il Gesù, Rome. In 1583 Lodovico was invited by Archduke Ferdinand, Count of the Tyrol (1529–95), to Innsbruck to undertake the project refused by Giacomo, the casting from the model by Alexander Colin (*c.* 1526–1612) of the statue of *Maximilian I* (*d* 1519) for his tomb in the Hofkirche. The statue, for which Lodovico was paid in 1584, was his first large-scale work. During his stay in Innsbruck he also worked for the ducal court of Bavaria.

After his return to Rome, Lodovico received many commissions during the papacy of Sixtus V. From 1586 to 1590 he worked with Bastiano Torrigiani, head of the papal foundry, on a bronze-gilt tabernacle for the presbytery chapel in S Maria Maggiore, probably from a model by Andrea Riccio and Andrea Soncino. The tabernacle, in the form of a temple and decorated with figures reminiscent of Michelangelo, was cast by Lodovico, the four

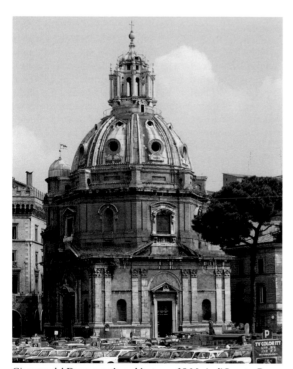

Giacomo del Duca: cupola and lantern of S Maria di Loreto, Rome, after 1573

supporting angels by Torrigiani. In 1586 Lodovico was among many bronze-casters who worked under Domenico Fontana on the erection of the obelisk in the piazza of St Peter's, Rome. With Torrigiani he cast the four lions supporting the obelisk from models by Prospero Antichi and Francesco da Pietrasanta (*fl* late 16th century). He cast another group of four lions by the same artists and Gregorio de Rossi (1570–1637/43) for the obelisk at S Giovanni in Laterano. For a member of the Savelli family he executed a bronze-gilt Crucifix (1592) for the altar then dedicated to S Ignazio in Il Gesù, Rome. He was paid for other work in S Giovanni in Laterano in 1598, probably relating to the decoration of the Cappella del SS Sacramento.

Lodovico was also employed to evaluate works by others. In 1600 he was cited by Orazio Censore as an assessor of works in S Giovanni in Laterano; also in that year he went to Loreto to assess the work of Antonio Calcagni in the Cappella della Pietà. In addition to large commissions, Lodovico also cast small bronzes from antique models, including the copy (Florence, Bargello; see fig.) of the equestrian statue of *Marcus Aurelius* (Rome, Capitoline Hill). A small bronze plaque, a *Pietà* (Messina, Mus. Reg.), has been attributed to him (Accascina). He is last recorded in 1601, receiving four plaster models from S Maria di Loreto in Rome.

BIBLIOGRAPHY

DBI; Thieme–Becker

G. Vasari: *Vite* (1550, rev. 2/1568); ed. G. Milanesi (1878–85), viii, p. 297

G. Baglione: *Vite* (1642); ed. V. Mariani (1935), p. 51

A. Bertolotti: *Artisti bolognesi, ferraresi. . .in Roma nei secolo XV, XVI e XVII* (Bologna, 1884), pp. 78, 81, 185–6

J. Hirn: *Erzherzog Ferdinand II. von Tirol: Geschichte seiner Regierung und seiner Länder*, i (Innsbruck, 1885), pp. 375, 390

W. von Bode: *Die italienischen Bildwerke der Renaissance und des Barock*, ii (Berlin and Leipzig, 1930), p. 43

S. Benedetti: *Giacomo Del Duca e l'architettura del cinquecento* (Rome, 1973), pp. 75, 362

M. Accascina: *Oreficeria di Sicilia dal XII al XIX secolo* (Palermo, 1974), p. 230

E. Egg: *Die Hofkirche in Innsbruck* (Innsbruck, 1974), p. 40

F. Grimaldi and K. Sordi: *Scultori a Loreto* (Ancona, 1987), pp. 125, 181

□

Duccio, Agostino di. *See* AGOSTINO DI DUCCIO.

Durantino, Francesco (*fl c.* 1543–54). Italian ceramics painter. He was first active in Urbino, where he is recorded as working in the workshop of Guido di Merlino from 1543. His early signed and dated works include a dish painted with a scene showing *Martius Coriolanus and his Mother* (1544; London, BM) and a fragment (1546; Stockholm, Nmus.) illustrating the *Death of Polixena* and bearing the monogram and sign of Urbino. Stylistically very similar

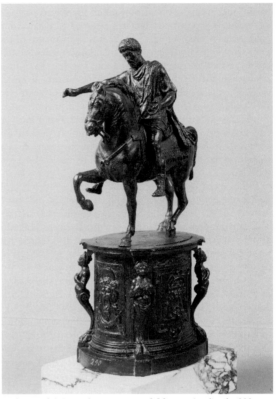

Lodovico del Duca: bronze copy of *Marcus Aurelius*, h. 380 mm, 1580–82 (Florence, Museo Nazionale del Bargello)

to these are plates and dishes illustrating biblical and mythological scenes, dating from 1542 to 1547 (examples in Brunswick, Herzog Anton Ulrich-Mus.; London, V&A; Edinburgh, Royal Mus. Scotland; Pesaro, Mus. Civ.). In 1547 he took over a kiln in Monte Bagnolo, near Perugia. Certain large vessels, decorated both inside and out, have been attributed to this period (examples in Florence, Bargello, and London, V&A), as have albarelli and flasks. His work is characterized by a strong palette of blues, yellows, oranges and greens and lightly marked contours. His compositions were inspired by printed sources including the illustrated version of Livy's *History of Rome* (Venice, 1498).

BIBLIOGRAPHY

J. Lessmann: *Herzog Anton Ulrich–Museum Braunschweig: Italienische Majolika* (Brunswick, 1979)

G. Papagni: *La maiolica del rinascimento in Casteldurante, Urbino e Pesaro: Da Pellipario ed i Fontana ai Patanazzi* (Fano, 1980)

T. Wilson: 'The Origins of the Maiolica Collections of the British Museum, 1851–5', *Faenza*, lxxi (1985), pp. 68–81

LUCIANA ARBACE

E

Eleanora of Toledo. *See* MEDICI, DE, (15).

Elia de Bissone. *See* GAGINI, (2).

Emanuel-Philibert, 10th Duke of Savoy. *See under* SAVOY.

Embriachi [Ubriachi]. Italian family of entrepreneurs and carvers. The precise location and the organization of the workshop is unknown, although *c*. 1431 there was evidently a workshop in Venice, in the area of S Luca, where various members of the family are recorded. The family had links with Florence until the end of the 15th century, particularly with the church of S Maria Novella, where Baldassare Embriachi was recorded as a benefactor, and where his descendant Lorenzo d'Antonio di Messer Manfredi degli Embriachi was buried in 1483.

The workshop completed a number of prestigious commissions for patrons in north Italy and Burgundy and is known also for its production of domestic objects, which were mass-produced in numbers comparable with 14th-century Nottingham alabasters. In choosing Venice as a centre for production, the workshop profited from the existing casket and altarpiece industries and employed the skills of local workers specializing in *certosina* (inlay of stained woods, bone and horn). Articles were sold as stock items, carved in the readily available material, bone (usually horse or ox), and embellished with inlaid woods.

The earliest documented member of the family workshop was Baldassare di Simone d'Aliotto degli Embriachi (*fl c*. 1390–1409), a Florentine of Genoese extraction. He was an entrepreneur and manager of a large workshop of bone-carvers but is unlikely to have been a practising craftsman. He is recorded as a dealer in jewels trading in Spain, France and England, and he also served as the political and banking agent (*cambiatore*) for Giangaleazzo Visconti, Duke of Milan, in Venice. Between 1400 and 1409 the Prior of the Certosa di Pavia made final payments to Baldassare for a large carved bone triptych with scenes from the *Life of the Virgin*, the *Legend of the Three Magi* and the *Life of Christ* (Pavia, Certosa, Sacrestia Vecchia; see fig.) and two coffers (now dismantled; New York, Met.); the latter are decorated with carved bone plaques depicting the seated *Virtues* and scenes from *Pyramus and Thisbe*, the *Story of Mattabruna* and other mythological subjects.

Other large triptychs can be attributed to this workshop by stylistic comparison with the Pavia altarpiece. They are

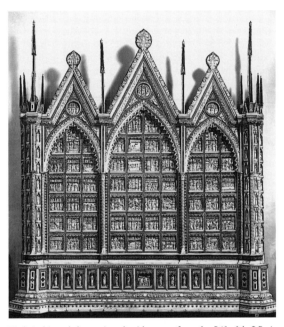

Embriachi workshop: triptych with scenes from the *Life of the Virgin*, the *Legend of the Three Magi* and the *Life of Christ*, bone and inlaid wood, h. 2.60 m, *c*. 1400–09 (Pavia, Certosa, Sacrestia Vecchia)

two altarpieces (the so-called *Oratoires des Duchesses de Bourgogne*; now much restored, Paris, Mus. Cluny) depicting scenes from the *Life of Christ* and the *Life of St John the Baptist*, which were donated in 1393 by Philip the Bold, Duke of Burgundy (1342–1404), to the Charterhouse of Champmol. A triptych (Paris, Louvre) with similar subjects and donor portraits of *Jean, Duc de Berry*, and his wife, *Jeanne de Boulogne*, was donated to the abbey of Poissy in 1408 or 1409, and a triptych with scenes of the *Lives of Christ and SS John the Baptist and John the Evangelist* (*c*. 1400–10; New York, Met.), formerly in the abbey of Cluny, can also be attributed on stylistic grounds. All are examples of the most elaborate works produced by the workshop and were intended for public display in the institutions with which the patrons had close associations. The compositions are carved in small convex panels of bone (h. *c*. 50–100 mm) and are framed by rich *certosina* work. The multiple panels are arranged in a horizontal narrative sequence within the three arched divisions of each triptych. The carving is uniformly low relief, partly

dictated by the convex profile of the material itself, with little attempt to illustrate form or depth, and architectural settings are arranged with buildings and figures piled up in friezelike compositions. Intricately carved pinnacles and crockets on the frames, borders of angels, and the figures of saints and prophets in niches recall the ornate frames of 14th-century Venetian polyptychs.

The workshop also made caskets, which were produced as bridal gifts to hold jewels or documents. Scenes from mythology (such as the legends of Jason and Paris) and chivalric romances (such as Lancelot du Lac) decorate the sides and are drawn from north Italian and French illuminated manuscripts. The caskets were produced in rectangular, octagonal and hexagonal formats, with domed lids often decorated with panels depicting the Virtues. The earliest documented piece from the workshop is a small casket (*c.* 1375–80) in the chapel of St Sigismund in Prague Cathedral. The best examples retain traces of gilding and polychromy, such as the casket with scenes from the *Legend of Paris* (*c.* 1400–25; ex-Ste-Chapelle, Paris; London, V&A). Mirrors, game-boards and other domestic objects produced by the workshop are all decorated in the typical combination of carved bone and inlay. The workshop also produced portable house-altars for domestic use, and these diptychs and triptychs vary considerably in size and quality. They were made to the requirements of the prospective purchaser, who would select the saints and religious scenes for inclusion on the wings and central panels, as for example an altarpiece with scenes from the *Life of Christ* (*c.* 1400–25; Turin, Mus. Civ. A. Ant.).

Though never rivalling the elegance of 14th-century French ivory carvings, the finest works of the Embriachi workshop depend on French models and iconography, although the more crudely carved and naive depiction of figures and architecture retains a wholly Italian charm.

Under Baldassare's son Benedetto (legitimized in 1389), who was an authority on glass mosaic and maiolica glazing, the workshop continued to operate in Venice until *c.* 1420. Another branch of the family (all described as ivoryworkers) is recorded in Venice in 1431, when the three sons of an Antonio Ubriachi (*d c.* 1431), Geronimo (*fl* 1431), Domenico (*fl* 1431) and Lorenzo (*c.* 1400–83), with the help of the Florentine ambassador Giuliano Davanzati, liquidated the contents of the workshop of their father and his brother Giovanni (*fl* 1400–33). It is also probable that other north Italian workshops were producing articles based on their models for a considerable period after 1430. A sufficient number of forgeries exist in public and private collections and on the art market to suggest that Italian and Tyrolese workshops continued to produce altarpieces, caskets and other domestic items in the Embriachi style well into the 19th century.

BIBLIOGRAPHY

D. Sant'Ambrogio: 'Il trittico in dente d'ippopotamo e le due arche o cofani d'avorio della Certosa di Pavia', *Archv Stor. Lombardo*, xxii (1895), pp. 417–68
——: 'Il grande trittico d'osso scolpito dell'abbazia di Poissy', *Archv Stor. A.*, ix (1896), pp. 288–305
L. Beltrami: *Storia documentata della Certosa di Pavia* (Milan, 1896)
H. Semper: 'Über ein italienisches Beintriptychon des XIV. Jahrhunderts im Ferdinandeum und diesem verwandte Kunstwerke', *Z. Ferdinandeums, Tirol & Vorarlberg*, iii, 40 (1896), pp. 145–78, figs vi–viii
J. von Schlosser: 'Die Werkstatt der Embriachi in Venedig', *Jb. Allhöch. Kr.*, xx (1899), pp. 220–82
Medioevo e produzione artistica di serie: Smalti di Limoges e avori gotici in Campania (exh. cat., ed. P. Giusti and P. Leone de Castris; Naples, Mus. N. Cer., 1981–2), pp. 49–54, 118–43
G. A. Dell'Acqua: *Embriachi: Il trittico di Pavia* (Milan, 1982) [excellent pls]
K. Benda: 'Časná Embriachiovská truhlička 2. Kaple Sr. Zikmunda ve Svatovítském Chrámv' [An early Embriachi chest from the second chapel of St Sigmund in St Vitus Cathedral], *Umění*, xxxv (1987), pp. 483–9
A. Boström: *Catalogue of the Embriachi and Other Northern Italian Workshops in the Victoria and Albert Museum* (in preparation)

ANTONIA BOSTRÖM

Enzola, Gianfrancesco (di Luca) (*b* Parma, *fl* 1455–78). Italian goldsmith and medallist. He is recorded in Parma between 1467 and 1471 and was master of the mint in Ferrara in 1472–3 under Ercole d'Este, Duke of Ferrara. Although no coins with his signature have been identified, it is quite likely that he engraved dies for some of the Duke's coins of Ferrara and Reggio, in particular a number of fine portrait pieces, including those of his principal patrons, *Francesco Sforza, Duke of Milan, Cecco Ordelaffi of Forlì, Taddeo Menfredi of Faenza* and *Pier Maria Rossi of Berceto*. Many of his early medals (1455–71) are struck from engraved dies and are small, but only a few struck examples survive; most known specimens are cast from struck originals. In later years he changed his method and in 1474–5 produced a splendid series of large cast medals of *Costanzo Sforza, Lord of Pesaro*. One of these is dedicated to the memory of Costanzo's father, Alessandro Sforza, who is portrayed on the reverse. The other reverse types eulogize Costanzo's military prowess but suffer from over-elaboration of detail. Characteristic is the representation of the castle of Pesaro with its pinnacled towers fully manned, many windows, drawbridge and gateway surmounted by a coat of arms. Of his largest medal (92 mm), of *Federigo da Montefeltro*, only an impression in leather is extant (Rome, Vatican, Bib. Apostolica).

Most of Enzola's medals are dated (1455–78) and signed (IOHANNIS FRANCISCI (ENZOLAE) PARMENSIS OPVS, with various abbreviations). His cast medals carry the legend on a raised band, possibly produced by impressing a lettered metal ring into the mould. Other works by Enzola include several signed and unsigned plaquettes, the *Virgin Enthroned*, the *Martyrdom of St Sebastian*, *St Jerome, St George, Child on a Lion* and a *Horseman Attacked by Three Lions*, as well as a signed seal of Parma. Other unsigned, but stylistically similar seals (e.g. of *Lorenzo Rovorella* and *Niccolò Perotto*) have also been attributed to him.

BIBLIOGRAPHY

Forrer; Thieme–Becker

A. Armand: *Les Médailleurs italiens* (Paris, 1879, rev. 2/1883–7), i, pp. 43–6; iii, p. 7
J. Friedländer: *Die italienischen Schaumünzen des 15. Jahrhunderts, 1430–1530* (Berlin, 1882), pp. 115–20
E. Molinier: *Les Bronzes de la Renaissance: Les Plaquettes, catalogue raisonné* (Paris, 1886), i, p. 60; ii, p. 199
G. F. Hill: *Medals of the Renaissance* (London, 1920; rev. and enlarged by G. Pollard, 1978), pp. 29, 54
G. Habich: *Die Medaillen der italienischen Renaissance* (Stuttgart, 1922), pp. 78–9
H. Nussbaum: 'Fürstenporträts auf italienischen Münzen des Quattrocento', *Z. Numi.*, xxxv (1925), pp. 145–92
G. F. Hill: *Corpus* (1930), i, pp. 70–74
J. Pope-Hennessy: *Renaissance Bronzes from the Samuel H. Kress Collection in the National Gallery of Art* (London, 1965), nos 62–8

G. F. Hill and G. Pollard: *Renaissance Medals from the Samuel H. Kress Collection in the National Gallery of Art* (London, 1967), pp. 22–3

G. Pollard: *Medaglie italiane del rinascimento*, Florence, Bargello cat., i (Florence, 1985), pp. 159–67

MARK M. SALTON

Ercolano, Pietro di Galeotto di. *See* PIETRO DI GALEOTTO.

Ercole de' Roberti [Ercole de' Grandi]. *See* ROBERTI, ERCOLE DE'.

Erri [degli Erri; Herri; de Ler; del R]. Italian family of painters. The family comprised several generations of painters, of whom the most important were the brothers Angelo [Agnolo] Erri (*fl* Modena, 1442–97) and Bartolomeo Erri (*fl* Modena, 1450–79), who worked together. It has proved impossible to distinguish the hand of each in individual works, most of which were commissioned from both of them and probably executed in collaboration.

The Erri brothers' tripartite altarpiece depicting the *Coronation of the Virgin with Saints* and scenes from the *Life of St John the Baptist* (1462–6; Modena, Gal. Estense) contains Late Gothic narrative elements organized according to a rationale that is wholly Renaissance. This can be attributed both to their familiarity with Ferrarese culture and to their free elaboration of Tuscan elements, drawn from the tradition of Domenico Veneziano. Through comparison with that altarpiece, the brothers have been attributed with the altar frontal depicting scenes from the *Life of St Thomas* (after 1466; ex-S Domenico, Modena), of which only eight fragments have survived (Washington, DC, N.G.A.; San Francisco, CA, M. H. de Young Mem. Mus.; New Haven, CT, Yale U. A.G.; New York, Christie's Int.; Brno, Morav. Gal.; several priv. cols).

Perhaps another member of the Erri family, if not Angelo and Bartolomeo, worked on the earliest of the three altar frontals for the church of S Domenico, Modena, this one depicting the *Life of St Peter the Martyr* (*c.* 1450; Parma, G.N.). In 1467 Bartolomeo Erri was commissioned to paint an altarpiece for S Domenico's main altar; in 1480 it was still unfinished, and in 1710 it was removed from the altar and dismantled. All that is known to survive is a fragment depicting the *Virgin Enthroned* and part of the main panel, depicting the *Virgin and Saints* (Strasbourg, Mus. B.-A.), and one of the sections of the predella depicting a *Miracle of St Dominic* (New York, Met.). Compared with the earlier works, the style is more developed and characterized by the geometricizing of the forms and a clearer and stronger illumination of the figures; this indicates a reference to Piero della Francesca.

During the 1480s the Erri brothers worked on the third altar frontal for S Domenico, this one depicting the *Life of St Vincent Ferrer* (Modena, Semin. Vesc.; Vienna, Ksthist. Mus.; Oxford, Ashmolean). The whole composition is governed by an absolute obedience to the laws of visual perspective, but the individual elements display an exceptional narrative wealth, with extremely convincing realistic details, particularly in the representation of contemporary Modena.

BIBLIOGRAPHY

A. Venturi: 'L'Oratorio dell'Ospedale della Morte', *Atti & Mem. R. R. Deput. Stor. Patria Prov. Modern. & Parm.*, iii (1885), pp. 245–77

A. M. Chiodi: 'Bartolomeo degli Erri e i polittici domenicani', *Commentari*, ii (1951), pp. 17–25

D. Benati: *La bottega degli Erri e la pittura del rinascimento a Modena* (Modena, 1988)

DANIELE BENATI

Este. Italian dynasty of rulers, patrons and collectors (see fig.). Azzo I d'Este was Lord of Ferrara from 1209 to 1212, but the family's power in the city became firmly established only in 1242, when Azzo II d'Este, 2nd Marchese of Ferrara (*reg* 1215–22; 1240–64), defeated the Ghibelline faction with Venetian help. Modena came under Este control in 1288 and (2) Niccolò III d'Este added Reggio and other cities to the family's territories, (4) Borso d'Este becoming 1st Duke of Ferrara, Modena and Reggio. FERRARA was governed by the Este until 1598, when it was annexed by the papacy. The Este court at Ferrara was one of the most notable in North Italy, commissioning works from and attracting numerous important artists, musicians and writers. Especially outstanding among the Este as patrons and collectors were (6) Isabella d'Este and (8) Alfonso I d'Este.

BIBLIOGRAPHY

L. Chiappini: *Gli Estensi* (Milan, 1967)

(1) Niccolò II d'Este, 10th Marchese of Ferrara (*b* Ferrara, 1331; *reg* 1361–88; *d* Ferrara, 1388). He was the son of Marchese Obizzo III d'Este (*d* 1352) and Lippa di Jacopo Ariosti of Bologna. He was known as 'lo Zoppo' (the Lame) because of his infirmity caused by gout. In 1362 he married Verde della Scala, sister of Cangrande II della Scala of Verona. Niccolò's court attracted poets and humanists; Francesco Petrarch was a guest in 1370 and Benvenuto da Imola, a friend of Petrarch and pupil of Boccaccio, dedicated his commentary on Dante's *Divine Comedy* to Niccolò. Niccolò's main undertaking as a patron was to improve Ferrara's civic centre and defences. He employed, in 1385, the military architect Bartolino da Novara (*fl* 1368) to construct a fortified castle within the city, borrowing 25,000 ducats from his neighbour and ally Francesco I Gonzaga of Mantua to finance the project. The Castello di S Michele, now known as the Castello Vecchio or Estense (*see* FERRARA, fig. 1), although still ostensibly a medieval fortification, was the first great monument of Renaissance architecture in Ferrara. Niccolò's other projects included paving the main piazza and streets, building a new customs house, erecting a bell tower for the Palazzo della Ragione and fortifying the suburbs, thus transforming Ferrara into an attractive urban centre. The eminent Paduan humanist Giovanni Conversino da Ravenna praised Niccolò's civic improvements in his *Dragmalogia de eligibili vitae genere* (Paris, Bib. N., MS. Lat. 6494; Venice, Fond. Querini–Stampalia, MS. IX, II), which was written in 1405 after Niccolò's death.

BIBLIOGRAPHY

L. Chiappini: *Gli Estensi* (Milan, 1967), pp. 68–73

W. L. Gundersheimer: *Ferrara: The Style of a Renaissance Despotism* (Princeton, 1973)

J. E. Law: 'Popular Unrest in Ferrara in 1385', *Il rinascimento a Ferrara e i suoi orizzonti europei*, ed. J. Salmons and W. Moretti (Cardiff and Ravenna, 1984), pp. 41–60

HELEN GEDDES

(2) Niccolò III d'Este, 12th Marchese of Ferrara (*b* Ferrara, 1383; *reg* 1393–1441; *d* Milan, 26 Dec 1441).

484

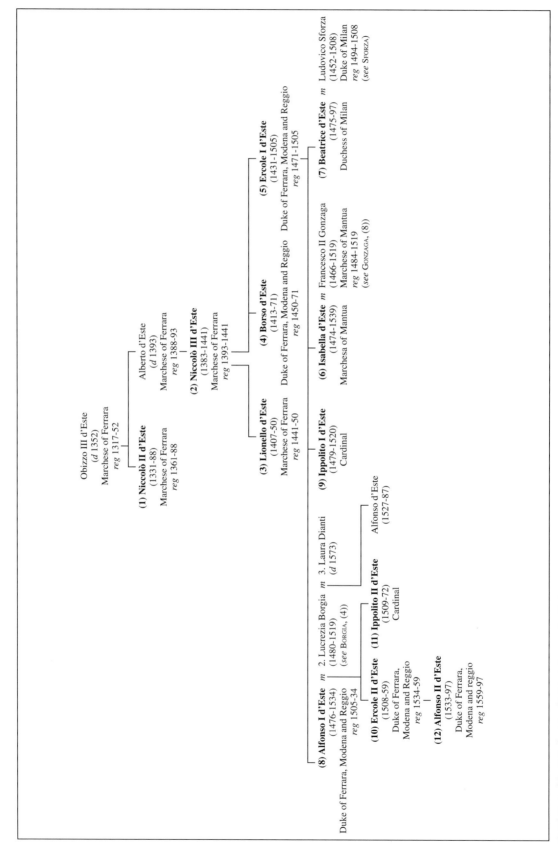

Obizzo III d'Este
(d 1352)
Marchese of Ferrara
reg 1317-52

Alberto d'Este
(d 1393)
Marchese of Ferrara
reg 1388-93

(1) Niccolò II d'Este
(1331-88)
Marchese of Ferrara
reg 1361-88

(2) Niccolò III d'Este
(1383-1441)
Marchese of Ferrara
reg 1393-1441

(3) Lionello d'Este
(1407-50)
Marchese of Ferrara
reg 1441-50

(4) Borso d'Este
(1413-71)
Duke of Ferrara, Modena and Reggio
reg 1450-71

(5) Ercole I d'Este
(1431-1505)
Duke of Ferrara, Modena and Reggio
reg 1471-1505

(6) Isabella d'Este
(1474-1539)
Marchesa of Mantua

m Francesco II Gonzaga
(1466-1519)
Marchese of Mantua
reg 1484-1519
(see GONZAGA, (8))

(7) Beatrice d'Este
(1475-97)
Duchess of Milan

m Ludovico Sforza
(1452-1508)
Duke of Milan
reg 1494-1508
(see SFORZA)

(9) Ippolito I d'Este
(1479-1520)
Cardinal

(8) Alfonso I d'Este
(1476-1534)
Duke of Ferrara, Modena and Reggio
reg 1505-34

m 2. Lucrezia Borgia
(1480-1519)
(see BORGIA, (4))

3. Laura Dianti
(d 1573)

Alfonso d'Este
(1527-87)

(11) Ippolito II d'Este
(1509-72)
Cardinal

(10) Ercole II d'Este
(1508-59)
Duke of Ferrara,
Modena and Reggio
reg 1534-59

(12) Alfonso II d'Este
(1533-97)
Duke of Ferrara,
Modena and reggio
reg 1559-97

Family tree of the Este dynasty of rulers, patrons and collectors

Nephew of (1) Niccolò II d'Este. He became ruler before his tenth birthday, and over the years he added Modena, Rovigo, Reggio and other smaller cities to the Este territorial holdings. Politically astute and praised for his commitment to learning, he could also be cruel and implacable. He made distant pilgrimages to Jerusalem, Vienne (south of Lyon) and Loreto; when at SS Annunziata in Florence, he gave (1435) a large wax relief that represented him on horseback. In 1429 he invited the humanist Guarino da Verona to teach at the University of Ferrara, bringing fame to that institution.

Niccolò ordered the completion of the Castello Estense in Ferrara, initiated the first phase (1412) of the cathedral's campanile, commissioned the Este rural retreat of Belriguardo (1435; largely destr.), c. 15 km north-east of Ferrara, frescoes and amenities at the Palazzo Schifanoia, Ferrara, and continued construction of the villa of Belfiore (begun by Alberto d'Este; destr.), Ferrara, as well as adding to it the Dominican church of S Maria degli Angeli (destr.). For the latter he ordered a terracotta pala (1440–41) for the main altar from Michele da Firenze, while in the narthex was his equestrian statue made of polychromed cloth and wax (destr. 1484). Niccolò III had a sizeable library, including illuminated manuscripts. In 1400 Jacopo di Cassola (*fl* 1400–30) produced for him a copy of Caesar's *De bello Galico* (Modena, Bib. Estense, MS. Lat. 421) with miniatures by Paduan illuminators. A more important commission was the Bible (1434; Rome, Vatican, Bib. Apostolica, MS. Barb. Lat. 613) with decoration by Belbello da Pavia. Amadio da Milano (*fl* 1437–83) and Sperandio were Niccolò's goldsmiths and medallists, and a medal of Niccolò is attributed to the former (e.g. c. 1432; Ferrara, Mus. Civ. A. Ant. Pal. Schifanoia; Modena, Gal. & Mus. Estense). From 1419 Giacomo da Sancino (Sagramoro; *d* 1456/7) was the painter most closely connected to Niccolò's service. Other noted painters at his court were Antonio Alberti and the Master of Palazzo Pendaglia. When the Marchese hosted the abortive Council of Churches in 1438, Pisanello was on hand executing portraits of his children (*see* PISANELLO, fig. 4), but when the artist competed (1441) with Jacopo Bellini to portray his elder son (3) Lionello d'Este, Niccolò III favoured Bellini (*see* (3) below).

Niccolò also sought northern European art; an altarpiece of the *Passion*, made in Nottingham alabaster (Ferrara, Mus. Civ. A. Ant. Pal. Schifanoia) is thought to originate from an Estean oratory of his time. In 1433–41 two Brabantine sculptors, Arrigo [Henri] di Brabante and Guillaume di Brabante (both *fl* 1431–41), were commissioned to carve stone altarpieces in S Francesco, Ferrara, and elaborate ornaments for the cathedral sacristy. An alabaster head of *John the Baptist* (c. 1435; Modena, Gal. & Mus. Estense) is by a Brabantine sculptor, the Master of the Rimini Crucifixion (*fl* 1430–42). Jean Fouquet (c. 1415/20–c. 1481) executed a portrait of Niccolò's jester, *Gonella* (c. 1440; Vienna, Ksthist. Mus.), and from 1436 the Flemish weavers Jacomo de Flandria de Angelo and Pietro di Andrea di Fiandra (both *fl* 1436–41) were employed by Niccolò III.

BIBLIOGRAPHY
A. Venturi: 'I primordi del rinascimento artistico a Ferrara', *Riv. Stor. It.*, i (1884), pp. 591–631

O. Pächt: 'Die Autorschaft des Gonella-Bildnisses', *Jb. Ksthist. Samml. Wien*, lxx (1974), pp. 39–88
N. Gramaccini: 'Wie Jacopo Bellini Pisanello besiegte: Der Ferrareser Wettbewerb von 1441', *Idea: Jb. Hamburg Ksthalle*, i (1982), pp. 27–31
P. de Winter: *Renaissance Sculpture in Ferrara* (Ferrara, 1999)
PATRICK M. DE WINTER

(3) Lionello d'Este, 13th Marchese of Ferrara (*b* Ferrara, 21 Sept 1407; *reg* 1441–50; *d* Ferrara, 1 Oct 1450). Son of (2) Niccolò III d'Este. During his brief rule he used the revenue from family properties and taxes to give lavish support to art and scholarship. His interest, which had developed under the influence of the humanist Guarino da Verona, who came to Ferrara in 1429, and the condottiere Braccio Fortebraccio (1368–1424), was genuine and discriminating. He established Ferrara as a virtually unrivalled centre for humanism. A reliable guide to cultural life in Ferrara at this time is given in the *De politia litteraria* (extant MS. 1462) of Angelo Decembrio (?1413/22–after 1466), a dialogue on scholarly, literary and artistic topics, set in Lionello's court. The Marchese appears from this to have favoured poetry and drama above the other arts.

Lionello's portrait was painted in 1441 by Pisanello (Bergamo, Accad. Carrara B.A.) and Jacopo Bellini (possibly the *Virgin and Child with Lionello d'Este*; Paris, Louvre), and in 1449 by Piero della Francesca and Andrea Mantegna (both untraced). Pisanello painted a view of the country villa of Belriguardo (destr.), as well as producing various medals, including five small pieces (?1443) and a superb example to commemorate Lionello's marriage in 1444. The villa of Belfiore (destr.) was frescoed with a decorative cycle of the *Muses* by Angelo del Macagnino and enriched with intarsie by Cristoforo Canozzi da Lendinara (*fl* 1454–91), Lorenzo Canozzi da Lendinara (*fl* 1434–77) and Arduino da Baisio (*fl* 1406–c. 1454). A triptych of the *Lamentation* (untraced) by Rogier van der Weyden (c. 1399–1464) is recorded there in 1449. Alberti, held in high esteem by Lionello, was asked to judge the bronze equestrian monument to *Niccolò III d'Este* (1444; destr. 1796) by Antonio di Cristoforo (a pupil of Donatello) and NICCOLÒ BARONCELLI. Alberti also advised on the designs for the pedestal of the Arco del Cavallo and the campanile of Ferrara Cathedral. Lionello continued his father's policy of improving and extending fortifications within the Este territory, and furthered Niccolò's projects for the church and villa at Belfiore and the villas at Cappara, Migliaro and Belriguardo.

BIBLIOGRAPHY
G. Pardi: *Lionello d'Este* (Bologna, 1904)
G. Bertoni: *Guarino da Verona fra letterati e cortigiani a Ferrara, 1429–60* (Geneva, 1921)
M. Baxandall: 'A Dialogue on Art from the Court of Leonello d'Este: Angelo Decembrio's *De politia litteraria* pars LXVIII', *J. Warb. & Court. Inst.*, xxvi (1963), pp. 304–26
W. L. Gundersheimer: *Ferrara: The Style of a Renaissance Despotism* (Princeton, 1973), pp. 92–126, 229–71
GORDON MARSHALL BEAMISH

(4) Borso d'Este, 1st Duke of Ferrara, Modena and Reggio (*b* Ferrara, 1413; *reg* 1450–71; *d* Ferrara, 20 Aug 1471). Son of (2) Niccolò III d'Este. He held many important mercenary military commands from 1430 to 1450. His art partronage was strategic, pragmatic, centralizing and intimate. Unlike his brother (3) Lionello d'Este,

he had only a rudimentary education and little empathy with the thought and literature of the ancient world. His main interest was the development of the Ferrarese state, and his control of the terms in which he wished to be seen by contemporaries and by posterity was absolute. Artists and scholars to him were functionaries, concerned with propaganda and entertainment, undeserving of special consideration, and arts and letters were tools of propaganda, which, shrewdly manipulated, would produce his image as a powerful, just, pious and magnanimous ruler. Borso returned to Ferrara in 1445 to assist Lionello in the administration of the Este territories. In 1452 he was invested as Duke of Modena and Reggio by the Holy Roman Emperor, Frederick III. The vital difference between Borso and his brother as patrons was revealed at this point. On becoming Marchese, Lionello's first act had been to reform the University of Ferrara; Borso's was to replace the coinage. Thus his presence was seen and felt intimately throughout Ferrarese territory.

The humanists Baptista Guarini (1458–1505), son of Guarino da Verona, and Ludovico Carbone (1435–82) received Borso's support. Their literary style—articulate, eloquent and unoriginal—suited him. Baptista was equally important as a diplomat. Carbone recorded court life in his orations and verse; his translation of Sallust's *Catilinarian* reveals an interest in Republican Roman history and indicates the important role of the vernacular at court. Borso knew no Latin; unlike Lionello, he did not attempt to write sonnets or give orations in Latin. Books were valuable as enhancers of his image. The Bible of Borso d'Este (Modena, Bib. Estense, MS. V.G. 12–13, lat. 422–3; for illustration *see* GIORGIO D'ALEMAGNA) required eight years to complete and ensured work for illuminators and miniaturists. Yet by 1468 the number of books held in Borso's library had declined to 148 compared with the 276 possessed during the reign of Niccolò III.

Borso's desire for flattery gave rise to an intensification of antiquarian researches on Ferrara and the Este territories. Pellegrino Prisciani (1435–1518), humanist, astrologer, antiquarian and historian, was engaged on this and skilfully combined courtly diplomacy with a thorough approach to the subject-matter. It was probably Prisciani who devised the programme for the frescoes of the Palazzo Schifanoia, Ferrara. In this complex work, painted by Cosimo Tura, Francesco del Cossa (*see* FERRARA, fig. 2), Antonio Cicognara and Baldassare d'Este, Borso was portrayed as dispensing sound justice in the presence of the gods and the people. A bronze statue of *Borso d'Este* enthroned (destr. 1796) was completed by Giovanni Baroncelli in 1453–4 and stood outside the Palazzo della Ragione, Ferrara.

In January 1471 Borso attempted to build an artificial mountain at Monte Santo, an unpopular and futile project. On 14 August 1471 he was invested as Duke of Ferrara by Pope Paul II, a mere six days before his death and characteristically magnificent funeral.

BIBLIOGRAPHY
G. Pardi: 'Borso d'Este, Duca di Ferrara', *Stud. Stor.*, xv–xvi (1906–7)
W. L. Gundersheimer: *Ferrara: The Style of a Renaissance Despotism* (Princeton, 1973), pp. 127–72, 229–71
GORDON MARSHALL BEAMISH

(5) Ercole I d'Este, Marchese of Este, 2nd Duke of Ferrara, Modena and Reggio (*b* Ferrara, 26 Oct 1431; *reg* 1471–1505; *d* Ferrara, 25 Jan 1505). Son of (2) Niccolò III d'Este. From 1445 to 1463 he served as Lieutenant-General under three successive rulers of Naples: Alfonso, Ferdinand and John of Anjou. Borso d'Este recalled him to Ferrara to assist in governing the Este territories and made him ruler of Modena. He was a shrewd and effective statesman, and his experience of the Neapolitan court had influenced his vision of his role and power. He was also compelled by virtue of his position to maintain a grand public image. To this end he held lavish parties and ceremonies and was a generous patron—of the theatre, of literature, music (Josquin Desprez wrote two masses for him), and of the visual arts. His leading court painter from 1486 was ERCOLE DE' ROBERTI, who received a generous salary and considerable encouragement from the Duke, who may have taken an active part in planning the iconography of the decorations for the Sala di Psyche, Palazzo di Belriguardo (destr.), which Ercole painted in the 1490s (Gundersheimer, 1976).

A pious man, Duke Ercole encouraged the illumination of devotional books and initiated a vast amount of church building and redecoration, most of which has not survived. Of equal importance was the Herculean Addition, the extension of Ferrara (*see* FERRARA, §1) carried out under his patronage in the 1490s. Biagio Rossetti, who also designed the churches of S Francesco (1494–1515) and S Maria in Vado (1495–6; *see* ROSSETTI, BIAGIO, fig. 2), was the architect. His best-known work is the Palazzo dei Diamanti, Ferrara (begun 1493; remodelled 1565; *see* ROSSETTI, BIAGIO, fig. 1).

There are portraits of Ercole I d'Este on three medals struck by Baldassare d'Este in 1472 and on medals (1473) by Sperandio, who also made two marble relief portrait busts (*c.* 1475; one Paris, Louvre). Dosso Dossi's painted portrait (Modena, Gal. & Mus. Estense) conveys the image of majesty that Ercole desired.

BIBLIOGRAPHY
E. G. Gardner: *Dukes and Poets in Ferrara* (London, 1904)
W. L. Gundersheimer, ed.: *Art and Life at the Court of Ercole d'Este* (Geneva, 1972)
W. L. Gundersheimer: *Ferrara: The Style of a Renaissance Despotism* (Princeton, 1973), pp. 173–271
——: 'The Patronage of Ercole I d'Este', *J. Med. & Ren. Stud.*, xi (1976), pp. 1–18
C. Benocci: 'I sistemi simbolici dei giardini delle ville D'Este a Roma e a Tivoli', *Duco Ercole I e il suo architetto Biagio Rossetti: Architettura e città nella Padania tra Quattro e Cinquecento* (Rome, 1995), pp. 39–46
E. Guidoni: 'Continuità e innovazione nel piano dell'addizione erculea', *Duco Ercole I e il suo architetto Biagio Rossetti: Architettura e città nella Padania tra Quattro e Cinquecento* (Rome, 1995), pp. 27–37
G. Lopez: 'Un cavallo di Troia per Milano', *Achad. Leonardi Vinci: J. Leonardo Stud. & Bibliog. Vinciana*, viii (1995), pp. 194–6
R. Shepherd: 'Giovanni Sabadino degli Arienti, Ercole I d'Este and the Decoration of the Italian Renaissance Court', *Ren. Stud.*, ix/1 (1995), pp. 18–57
M. Licht: 'Elysium: A Prelude to Renaissance Theatre', *Ren. Q.*, xlix/1 (Spring 1996), pp. 1–29
T. Tuohy: *Herculean Ferrara: Ercole d'Este (1471–1505) and the Invention of a Ducal Captial* (Cambridge, 1996)
GORDON MARSHALL BEAMISH

(6) Isabella d'Este, Marchesa of Mantua (*b* Ferrara, 18 May 1474; *d* Mantua, 13 Feb 1539). Daughter of (5) Ercole I d'Este. She was brought up in the cultivated atmosphere of her parents' court at Ferrara, where she studied with tutors, including the humanist scholars Giovanni Battista Guarino and Mario Equicola. Her intelli-

gence was particularly noted by the envoys sent to assess her by Francesco II Gonzaga, Marchese of Mantua (*see* GONZAGA, (7)), whom she married in 1490, when she was 16. Her private quarters in Mantua were in the tower of the Castello di S Giorgio, part of the complex of buildings which make up the Ducal Palace. The apartment included her first STUDIOLO and the cave-like *grotta* beneath, which housed her collection of antiquities. Her fame as a patron is due to the decorations she commissioned for her *studiolo*, a set of paintings of Classical and allegorical subjects, rather than the religious works associated with other female patrons. She commissioned the first picture from a painter particularly sympathetic to classical subjects, her husband's court artist, Andrea Mantegna, who executed the great *Parnassus* (begun 1495/6, completed 1497; Paris, Louvre; see colour pl. 2, II3) for her. Mantegna's second painting for the *studiolo, Pallas Expelling the Vices from the Garden of Virtue* (*c*. 1499–1502; Paris, Louvre), was only completed several years later (*see* MANTEGNA, ANDREA, §I, 2(ii)). In the interim, perhaps because of Mantegna's delays, she decided to seek works from the best painters in Italy. Leonardo da Vinci refused, but he did draw her portrait (Paris, Louvre; see fig.) when he visited Mantua in 1499. Giovanni Lorenzo Bellini failed to produce the requested work, objecting to the complex literary programmes she devised with the help of the Mantuan poet Paride Ceresara. Negotiations with Perugino in Florence continued over a period of ten years, and more than 70 of the letters survive (Mantua, Archv Stato) as well as a contract for the work (Florence, Archv Stato). Her instructions to him included not only a

detailed programme for the picture but also a drawing and an admonition not to add anything of his own invention. The lack of narrative clarity in the painting Perugino finally produced, the *Battle between Love and Chastity* (1503–5; Paris, Louvre), may reflect its difficult gestation. By about 1504, Isabella seems to have begun to treat the *studiolo* paintings as a frieze on the theme of Virtue and Vice, through which her own virtue could be emphasized by association. She turned to a Ferrarese painter, Lorenzo Costa (i), who executed the *Triumph of Poetry* or *Coronation of a Lady* (1505; Paris, Louvre), in which the central figure is probably Isabella. Costa was appointed court painter at Mantua after the death of Mantegna in 1506 and his second work for her, the *Comus* or *Triumph of Music* (Paris, Louvre), was produced only in 1510–11, completing the decoration of the first *studiolo*.

In 1522, a few years after the death of her husband, Isabella moved to the Corte Vecchia of the Palazzo Ducale. Her new quarters included a walled garden and a second *grotta* and *studiolo* with space for an additional two pictures. The new Marchese, her son Federico II Gonzaga (*see* GONZAGA, (8)), preferred works of an overtly erotic character, particularly those of Titian and Correggio, and his taste may have influenced his mother's. Titian painted a flagrantly flattering portrait of Isabella in 1529 (Vienna, Ksthist. Mus.), and about this time she commissioned Correggio to execute the two additional paintings for the second *studiolo*. The playful sensuality of Correggio's pictures, the *Allegory of Vice* and *Allegory of Virtue* (both *c*. 1531; Paris, Louvre; *see* CORREGGIO, §1(iv)), is a curious contrast to the moralizing tone of the earlier *studiolo* paintings. The decorations of the second *studiolo* included a marble doorway (*c*. 1523) by Tullio Lombardo, marquetry panelling (Mantua, Mus. Pal. Ducale) and cabinets housing her library of over 200 volumes.

Isabella's other abiding passion, her collection of antique and Classical art, is virtually without precedent for a woman of her rank. The inventory (Mantua, Archv Stato, Archv Gonzaga, b. 400) of her second *grotta* and other rooms made in 1542, three years after her death, lists 1620 items, mainly coins and medals but also 72 vessels and 46 engraved gems. She built her collection with the help of agents throughout Italy and expert advisers, including Mantegna, Jacopo Sansovino and Gian Cristoforo Romano. Romano, who executed her gold portrait medal (Vienna, Ksthist. Mus.; for illustration *see* GIAN CRISTOFORO ROMANO), probably designed the elaborate marble doorframe in her second *grotta*. One of her early acquisitions (1501) was a Hellenistic marble relief with two dancing satyrs (Mantua, Mus. Ducale). Her ambitions as a collector were restricted by lack of funds, although in 1506 she paid a significant sum for an onyx vase, traditionally identified with a cameo vase now in Brunswick (Herzog Anton Ulrich-Mus.). Also in 1506 she bargained with the dying Mantegna to obtain his treasured Roman marble bust of the *Empress Faustina*, often identified (probably incorrectly) with the bust in the Palazzo Ducale in Mantua. Other antique busts included one of *Octavian* (untraced), admired in 1572 by Gerolamo Garimberto. Many works were acquired as gifts. Cesare Borgia gave her an antique *Venus* as well as an *all'antica Cupid* by Michelangelo (untraced), which he had appropriated from

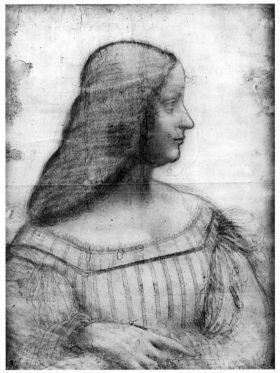

Isabella d'Este by Leonardo da Vinci, black and red chalk, pastel highlights, 630×460 mm, 1499 (Paris, Musée du Louvre)

her Montefeltro relations. She displayed Michelangelo's marble figure with another *Cupid* (untraced) attributed to Praxiteles, acquired through Pope Julius II. In 1515 she acquired part of the collection of antiquities of the recently deceased Galeazzo Sforza of Pesaro (*fl* 1497; *d* 1515). Her son Federico II presented her with a marble Roman relief of *Proserpina in Hades* (Mantua, Pal. Ducale) in 1524, which was given to him by Pope Adrian VI. She owned various antique bronze heads and busts and commissioned contemporary works to complement them: bronze statuettes from Antico, including the *Hercules* and *Antaeus* (Vienna, Ksthist. Mus.). The decoration of the first *grotta* included an elaborate marquetry ceiling (*in situ*) by the Mantuan brothers Antonio and Piero Mola. Isabella's collection and apartments were much visited in her lifetime and were noted in numerous 16th-century guidebooks. Her example inspired the famous *camerino* of her younger brother Alfonso I d'Este, Duke of Ferrara (*see* (8) below) and the Camera del Costo in Federico II's Palazzo di S Sebastiano. Her sons Federico II, Ercole and Ferrante (*see* GONZAGA, (9) and (10)) also became notable patrons.

BIBLIOGRAPHY

J. Cartwright: *Isabella d'Este*, 2 vols (London and New York, 1903; 2/1932)

M. Biachedi, ed.: *La figura e l'opera di Alessandro Luzio* (San Severino, 1957) [includes Luzio's extensive and important publications on Isabella d'Este]

E. Verheyen: *The Paintings in the Studiolo of Isabella d'Este at Mantua* (New York, 1971)

Lo Studiolo d'Isabella d'Este (exh. cat., ed. S. Béguin; Paris, Louvre, 1975)

C. M. Brown and A. Lorenzoni: 'The Grotta of Isabella d'Este', *Gaz. B.-A.*, 6th per., lxxxix (1977), pp. 155–71; xci (1978), pp. 72–82

Splendours of the Gonzaga (exh. cat., ed. D. Chambers and J. Martineau; London, V&A, 1981) [entries by C. Elam and J. Fletcher]

C. M. Brown: *La grotta di Isabella d'Este: Un simbolo di continuità dinastica per i duchi di Mantova* (Mantua, 1985)

Isabella d'Este, Fürstin und Mäzenatin der Renaissance (exh. cat., ed. S. Ferino Pagden; Vienna, Ksthist. Mus., 1994)

——: 'Isabella d'Este's Apartments in the Corte Vecchia at the Palazzo Ducale in Mantua', *The Court of Gonzaga in the Age of Andrea Mantegna, 1450–1550*, ed. R. Oresko and C. Mozzarelli, Biblioteca del cinquecento (in preparation)

C. M. Brown: '"Purché la sia cosa che representi antiquità": Isabella d'Este Gonzaga e il mondo greco-romano', *Isabella d'Este, i luoghi del collezionismo* (exh. cat., Mantua, Pal. Ducale, 1995), pp. 70–89

A. Cole: *Virtue and Magnificence: Art of the Italian Renaissance Courts* (New York, 1995)

Isabella d'Este, i luoghi del collezionismo (exh. cat., Mantua, Pal. Ducale, 1995)

CLIFFORD M. BROWN

(7) Beatrice d'Este, Duchess of Milan (*b* Naples, 29 June 1475; *d* Milan, 2 Jan 1497). Daughter of (5) Ercole I d'Este. In 1491 she married Ludovico Sforza ('il Moro'), Duke of Milan. Her forceful and resolute personality was astutely expressed through an affable approach to peers and employees, and was manifest in the splendour of her clothes and jewels and in the numerous poets and musicians of her court. Her support for the applied arts included the commissioning of superb musical instruments from Atalante Migliorotti and Lorenzo Gusnasco di Pavia. Especially noteworthy is the clavichord made by the latter in 1494. This was coveted, and eventually acquired, by (6) Isabella d'Este after Beatrice's death. As far as the fine arts are concerned, GIAN CRISTOFORO ROMANO made a marble bust of her (1490; Paris, Louvre), as strikingly objective as that he created in terracotta of *Francesco II*

Gonzaga (*c*. 1498; Mantua, Pal. Ducale). Both Beatrice and Ludovico were enthusiasts for the theatre and had one built in Milan, providing employment for courtiers, writers and scenographers. After Beatrice's death, Ludovico commissioned Christoforo Solari to create a sepulchral monument in her honour. Although the monument was never finished, Solari's marble effigies of Beatrice and Ludovico have survived (for illustration *see* SOLARI, (5)).

BIBLIOGRAPHY

J. Cartwright: *Beatrice d'Este, Duchess of Milan, 1475–97: A Study of the Renaissance* (London, 1905/R Milan, 1938)

R. de la Sizeranne: *Béatrice d'Este et sa cour* (Paris, 1920; London and New York, 1924)

Le muse e il principe: Arte di corte nel rinascimento padano (exh. cat., Milan, Mus. Poldi Pezzoli, 1991)

GORDON MARSHALL BEAMISH

(8) Alfonso I d'Este, 3rd Duke of Ferrara, Modena and Reggio (*b* Ferrara, 21 July 1476; *reg* 1505–34; *d* Ferrara, 31 Oct 1534). Son of (5) Ercole I d'Este. In 1502 he married Lucrezia Borgia (*see* BORGIA, (4)) and became a ruler of notable military and diplomatic ability. His chief claim to fame as patron was his employment of the poet Lodovico Ariosto, but he also patronized some of the outstanding artists of his day. His most important artistic commissions involved the decoration of his rooms in the so-called Via Coperta, the block linking the Palazzo del Corte (now Palazzo Comunale) with the Castello Estense in Ferrara, which he enlarged. No trace of the original decoration survives *in situ*, and the precise disposition and content of the rooms, which were later known as the Camerini Dorati and the Camerini d'Alabastro, remain matters of controversy. The two Camerini d'Alabastro contained marble reliefs (*c*. 1507–15) by Antonio Lombardo, of which the largest surviving group is in St Petersburg (Hermitage). These reliefs include panels with grotesque decoration as well as large figurative compositions featuring pagan deities.

One of the Camerini d'Alabastro also contained a series of paintings of pagan subjects. The earliest of these was the *Feast of the Gods* (Washington, DC, N.G.A.), completed by Giovanni Bellini in 1514 and subsequently repainted first by Dosso Dossi and again by Titian. Also in 1514 Alfonso seems to have commissioned a *Triumph of Bacchus* from Raphael; this was never completed, nor was a second painting ordered later, a *Hunt of Meleager*. In 1516 Fra Bartolommeo was in Ferrara and was then apparently given a commission for a *Worship of Venus*, a subject taken from the *Imagines* of Philostratos Lemnios. After his death in 1517, the commission was transferred to Titian, whose picture (Madrid, Prado; *see* TITIAN, fig. 3) was finished in 1519. A second work by Titian, *Bacchus and Ariadne* (London, N.G.; *see* TITIAN, fig. 4), based on a passage of Catullus (84–54 BC), was painted between 1520 and 1523, and a third, *Bacchanal of the Andrians* (Madrid, Prado; *see* TITIAN, fig. 5), again after Philostratos Lemnios, was finished in 1524 or 1525. The same room also contained a frieze of subjects from the *Aeneid* by Dosso Dossi (1518–22; surviving sections, Washington, DC, N.G.A.; U. Birmingham, Barber Inst.; Ottawa, N.G.), and a larger mythological composition that can no longer be identified.

Alfonso's model for this group of paintings seems to have been the ensemble of pictures by Pietro Perugino, Andrea Mantegna and others owned by his sister, (6) Isabella d'Este, in Mantua; but unlike those examples, Alfonso's pictures were without edifying content. His intention was evidently to assemble a group of masterpieces by the foremost Italian painters of the day, emulating the picture galleries of Classical antiquity. The pictures themselves seem not to have been easily accessible in the 16th century, but after their removal to Rome by Cardinal Pietro Aldobrandini in 1598, Titian's bacchanals in particular were immensely influential; there is a copy (Stockholm, Nmus.) by Peter Paul Rubens (1577–1640) and one (Edinburgh, N.G.) that has been attributed to Nicolas Poussin (1594–1665).

Alfonso also commissioned from Titian the *Tribute Money* (?1516; Dresden, Gemäldegal. Alte Meister), which was almost certainly displayed on the door of a coin cabinet, a portrait of himself (copy in New York, Met.), and one of his mistress *Laura de' Dianti* (*c.* 1527; Kreuzlingen, Heinz Kisters). In addition he is known to have received two other works from Raphael as gifts, the cartoons (untraced) for the *St Michael* and for the portrait of *Joanna of Aragon* (both 1518; Paris, Louvre). Alfonso also commissioned a painting from Michelangelo in 1512, shortly after having inspected the ceiling of the Sistine Chapel from the scaffolding; but this was never delivered. Four years earlier he had acquired the bronze head of *Julius II* (untraced), the only part of Michelangelo's statue of the Pope in Bologna to have been preserved. Alfonso also obtained the bronze used for the rest of the figure, from which he made a large cannon. Besides seeking works by artists living outside Ferrara, Alfonso employed Dosso Dossi and Battista Dossi on a regular basis, though little of their work for him can be identified; the most important examples are some ceiling panels from the Camerini Dorati (Modena, Gal. & Mus. Estense, and elsewhere). Another artist in his service was the decorative painter Tommaso Sellari (1470–1545). A complete account of Alfonso's energetic and informed artistic patronage cannot be provided, because of the dispersal of the d'Este collection and the incomplete preservation of his archive.

For further illustration see SPINELLI, (3).

BIBLIOGRAPHY
G. Vasari: *Vite* (1550, rev. 2/1568); ed. G. Milanesi (1878–85), vii, pp. 172, 194–5, 199–202
A. Luzio: 'Federico Gonzaga ostaggio di Giulio II', *Archv Soc. Romana Stor. Patria*, ix (1886), pp. 540–41
L. Venturi: 'Saggio sulle opere d'arte italiana a Pietroburgo: II—La scultura', *L'Arte*, xv (1912), pp. 305–13
A. Mezzetti: *Il Dosso e Battista ferraresi* (Milan, 1965), pp. 57–64
C. Hope: 'The "Camerini d'Alabastro" of Alfonso d'Este', *Burl. Mag.*, cxiii (1971), pp. 641–50, 712–21
A. Mezzetti: *Girolamo da Ferrara detto da Carpi* (Milan, 1977), pp. 51–54
G. Cavalli-Björkman, ed.: *Bacchanals by Titian and Rubens*, Nmus. Skrser., 10 (Stockholm, 1987) [articles on the Camerini d'Alabastro, with bibliog.]
J. Shearman: 'Alfonso d'Este's Camerino', *Il se rendit à Italie: Etudes offertes à André Chastel* (Rome, 1987), pp. 209–30
D. Bull and J. Plesters: *'The Feast of the Gods': Conservation, Examination and Interpretation*, Stud. Hist. A., 40 (Washington, 1990)
A. Colantuono: *'Dies Alcyoniae*: The Invention of Bellini's *Feast of the Gods'*, A. Bull., lxxiii (1991), pp. 237–56
CHARLES HOPE

(9) Cardinal **Ippolito I d'Este** (*b* Ferrara, 20 Nov 1479; *d* Ferrara, 2 Sept 1520). Son of (5) Ercole I d'Este. Destined from birth for an ecclesiastical career, he was named Archbishop of Esztergom at the age of seven through the influence of his aunt, Beatrice of Aragon, wife of King Matthias Corvinus of Hungary (*reg* 1458–90). In 1487 Ercole de' Roberti was paid for a painting possibly executed for Ippolito, whom he may have accompanied on a journey to Hungary soon afterwards. Ten years after being appointed archbishop, Ippolito was made apostolic legate and cardinal by Pope Alexander VI. Exchanging Esztergom for the more lucrative seat of Eger, he soon accumulated further benefices: the archbishopric of Milan (which he later renounced), and the bishoprics of Ferrara, Modena, Narbonne and Capua, while also being Abbot of Pomposa, Tellonica and S Faustino. He lived in a princely manner, and, adept in military affairs, sank part of the Venetian fleet in 1509. An epicurean and collector of antique sculpture, he protected Antonio Elia (*fl* 1502–15), a Ferrarese gem-engraver who, while living in his palace in Rome, made copies of antiques, notably the *Laokoon* (Rome, Vatican, Mus. Pio-Clementino). The Cardinal's offices were sought in the expansion of his brother Duke Alfonso I d'Este's collection of antiquities. Tommaso da Carpi (*fl* 1503–23) worked in Ippolito's villas at Ro, Codigoro and Sabioncello, and painted cases for his firearms and musical instruments. Ippolito surrounded himself with men of letters; Ludovico Ariosto wrote *Orlando furioso* while in his service but declined to follow the Cardinal to Hungary in 1517.

BIBLIOGRAPHY
A. Frizzi: *Memorie per la storia di Ferrara*, iv (Ferrara, 1848)
A. Venturi: *La Regia Galleria Estense in Modena* (Modena, 1882)
G. Gruyer: *L'Art ferrarais à l'époque des princes d'Este*, 2 vols (Paris, 1897)
PATRICK M. DE WINTER

(10) Ercole II d'Este, 4th Duke of Ferrara, Modena and Reggio (*b* Ferrara, 4 April 1508; *reg* 1534–59; *d* Ferrara, 5 Oct 1559). Son of (8) Alfonso I d'Este. He steered a prudent political course, strengthening relations with the papacy that had been strained as a result of the support of Calvinism by his wife Renée, the daughter of King Louis XII of France (*reg* 1498–1515), whom he married in 1528. He also was an avid collector. Among his acquisitions were ancient reliefs (Bacchic scenes; now Modena, Gal. & Mus. Estense), antique coins and many gems, some carved by Luigi Anichini (?1500–10–after 1559). In 1536 the Duke founded a tapestry workshop in Ferrara, employing weavers from Brussels, including Nicolas Karcher (*d* 1562), Giovanni Karcher (*fl* 1517–62) and Jan Rost (*fl* 1535). Among sets woven (fragments Paris, Louvre) were the *Labours of Hercules*, episodes from Ovid's *Metamorphoses* after cartoons by Battista Dossi, and Estean heraldry after Camillo Filippi. While Leonardo da Brescia (*d* 1598) furnished models for scenes with panoramas of Este cities and fortresses, Giulio Romano, who came to Ferrara in 1535 at the ducal behest, provided drawings (Paris, Louvre) for scenes for the *Fall of the Giants* based on his work at the Palazzo del Te in Mantua. Giulio also made architectural drawings in connection with the rebuilding of Ferrara's Palazzo di Corte that had been damaged by fire in 1532. Ercole was also an important patron of sculpture;

over 40 pieces graced the *studio di marmo* and *adorato* in the Castel Vecchio, Ferrara. In 1536 he commissioned a sculpture (untraced) from Antonio Begarelli, and in 1540 Benvenuto Cellini executed in Ferrara a medal of Ercole, with the personification of Peace on its reverse (untraced). The trenchant personality of Duchess Renée is captured in a medal (Florence, Bargello) by Pastorino Pastorini (1508–92), while Leone Leoni executed a portrait of the ruler in silver (untraced). In 1550, on ducal commission, Jacopo Sansovino began an over life-size statue of Hercules, one of the numerous manifestations of the Duke's infatuation with his Classical namesake. Originally destined for the Porta Ercolea of Modena's newly built walls, Ercole subsequently had it brought to Brescello, which he intended to transform into a model city and where the statue stands in the main square. In 1552 Alessandro Vittoria sent a sketch (untraced) for a bust of the Duke, while Prospero Spani produced a relief depicting him in profile (Modena, Gal. & Mus. Estense).

Ercole employed the preeminent painters of his dukedoms for the decoration of his various residences. In 1535–6 Dosso Dossi was overseer of the decoration of the Camera di Corte and he then painted *Hercules and the Pygmies* (Graz, Steiermärk. Landesmus.) in which the hero bears the features of the Duke. On Ercole's commission Dosso and his brother Battista in 1540 produced large canvasses among which *St George and the Dragon* and *St Michael Overcoming Satan* (Dresden, Gemäldegal. Alte Meister) are based on prototypes of Raphael. Tommaso da Carpi (*fl* 1503–37) and Garofalo executed wall paintings with heraldic subjects and battle scenes. Tommaso's son Girolamo da Carpi became principal court painter, producing a full-length portrait of the Duke in armour, a probable portrait of the Duchess (Frankfurt am Main, Städel. Kstinst. & Städt. Gal.), and wall paintings with the 16 Este rulers of Ferrara (1544–7), the *Labours of Hercules* and other themes. He and Battista Dossi also produced canvases, notably those for the Stanze Nuove in the Via Coperta that unite the older and newer parts of the castle. Moreover, Girolamo's role was expanded to that of general overseer. He designed the *giardino pensile* (hanging garden) above the battlements of the Castello Estense and was in charge of the numerous additions made to the Este *delizie* (suburban villas set amidst pergolas, grottoes, labyrinths, and involved waterworks), most particularly those of Belriguardo, Montagnana and Belvedere. From 1545 Lucas Cornelisz. was landscape painter for the Duke, notably producing a series views of the *delizie*. He was succeeded in 1554 by Guglielmo Boides, and a year later by Leonardo da Brescia. By 1553 Ercole had taken 'Patience' as his personal emblem. He commissioned a Camera della Pazienza within the Castello Estense in Ferrara, arrayed with large paintings by Girolamo da Carpi and Camillo Filippi (now Dresden and Modena, Gal. & Mus. Estense) and his bust on a socle carved by Spani with an image of Patience (Modena, Gal. & Mus. Estense). Pompeo Leoni's medal of the Duke of 1554 bore the same imagery. Ercole also saw to the expansion of Ferrara's fortifications and to the upkeep of his artillery. He had in his service Annibale Borgognoni (*fl* 1537–68), who in 1556 cast a large double culverin, known as *La regina*, bearing the ducal arms (destr., recorded in line drawings by Sardi). A bronze

mortar (Washington, DC, N.G.A.), on which are depicted the *Four Ages of Man*, bears the Duke's arms within the collar of the French Order of St Michael, which Ercole was granted in 1554. It is probably by Antonio Gentili da Faenza, and was produced in Rome.

BIBLIOGRAPHY

Documenti inediti per servire alla storia dei musei d'Italia, Ministero della Pubblica Istruzione, Direzione generale Antichità e Belle Arti, ii (Florence, 1878)
L. Chiappini: *Gli Estensi* (Varese, 1967)
A. Mezzetti: *Girolamo da Ferrara detto da Carpi* (Ferrara, 1977)
J. Bentini: 'La Sala delle Vigne nella "delizia" di Belriguardo', *Atti & Mem. Accad. Clementina Bologna*, n.s. xxxv–xxxvi (1995–6), pp. 9–37
Dosso Dossi: Court Painter in Renaissance Ferrara (exh. cat., ed. A. Bayer; New York, Met., 1998)
P. de Winter: *Renaissance Sculpture in Ferrara* (Ferrara, 1999)

PATRICK M. DE WINTER

(11) Cardinal **Ippolito II d'Este** (*b* Ferrara, 25 Aug 1509; *d* Tivoli, 2 Dec 1572). Son of (8) Alfonso I d'Este. At the age of ten he was already Archbishop of Milan, his uncle, (9) Cardinal Ippolito I d'Este, having renounced the title. He later held archbishoprics in Lyon, Autun, Auch, Orléans and Morienne and was proclaimed cardinal by Pope Paul III on 5 March 1539, partly through the efforts of the French king Francis I (*reg* 1515–47). On several occasions Ippolito was forwarded, unsuccessfully, by the French as papal candidate. Paul IV, however, banished Ippolito from Rome in 1555 on account of his simony, and confiscated the governorship of Tivoli from him. This was restored to him on the accession of Pius IV in 1559. Ippolito's most important mission was as *legato a latere* on behalf of Pius IV in the latter's dealings with Catherine de' Medici from 1561 to 1563, at the time of religious disorders in France. His diplomatic skill and personal contacts ensured some success. In 1566 Ippolito's nephew, (12) Alfonso II d'Este, departed for Hungary to fight the Turks and entrusted the duchy of Ferrara to Ippolito.

Throughout his life, Ippolito shared the Este love of display, which revealed itself in his enthusiastic patronage of the arts, especially music and architecture: for example, he engaged Pirro Ligorio to excavate Hadrian's Villa and to build the sumptuous Villa d'Este at Tivoli (for illustration *see* TIVOLI and LIGORIA, PIRRO, fig. 2). Although Ippolito bought property at Tivoli as early as 1550 for the purpose of laying out the spectacular gardens there, it was not until his return from exile that substantial work was undertaken. Ippolito also enjoyed a fine residence at Monte Cavallo in Rome, where he amassed an almost unrivalled collection of antique sculptures, to be seen by private admirers. This palace also had fine gardens, designed by Girolamo da Carpi, whom Ippolito had summoned to Rome in 1549.

BIBLIOGRAPHY
F. Brioschi: *Villa d'Este* (Rome, 1902)
V. Pacifici: *Ippolito II d'Este*, 2 vols (Tivoli, 1920–23)
C. Marcova: 'Ippolito II, Arcivescovo di Milano', *Mem. Stor. Dioc. Milano*, xi (1959)

GORDON MARSHALL BEAMISH

(12) Alfonso II d'Este, 5th Duke of Ferrara, Modena and Reggio (*b* Ferrara, 28 Nov 1533; *reg* 1559–97; *d* Ferrara, 27 Oct 1597). Son of (10) Ercole II d'Este. Having

spent the years from 1552 to 1559 at the French court, once he succeeded to the Este territories his desire to outshine the Medici made him a generous patron of the arts. His court was maintained in great splendour, renowned for virtuosic theatrical productions and for the Duke's patronage of poets (Torquato Tasso and Giovanni Battista Guarini among them), musicians and makers of musical instruments. A richly decorated harp (Modena, Gal. & Mus. Estense) was made for him in Rome in 1581 by Giovan Battista Giacomelli and subsequently inlaid in Ferrara (1587) by the Ferrarese Giulio Marescotti.

As a collector, Alfonso II took a particular interest in antiquities, often buying up entire studios formed by earlier collectors in Brescia, Bologna and Parma. In 1563 Enea Vico was appointed curator of these collections, and after his death (1567) PIRRO LIGORIO, who worked in various capacities for the Duke. At the start of Alfonso's reign, Leonardo da Brescia (*d* 1598) was commissioned to fresco in grisaille the inner court of the Castello Estense, Ferrara, with images of over 200 Este forebears. The project was short-lived (1559–60) but was resumed in *c.* 1577 by Ludovico Settevechi (*c.* 1520–*c.* 1590) under the direction of Ligorio, who made preparatory drawings. By this time Ferrara had suffered the earthquake of 1570 and much rebuilding, renovating and redecoration was in progress. Settevechi also assisted Sebastiano Filippi II, Alfonso's principal court painter, in decorating the Salone dei Giochi in the Castello Estense with colourful sporting scenes (*c.* 1574; *in situ*). There are various other decorative frescoes in the Castello by Filippi, all done after 1570. Another painter who worked for the court was Giuseppe Mazzuoli (il Bastarolo; *c.* 1536–89), who was commissioned by Alfonso's second wife, Barbara of Austria (*d* 1572), to paint two altarpieces.

As for Alfonso's patronage of sculpture, Prospero Spani was employed by the Duke episodically; he carved a statue of *Alfonso d'Este as Hercules* (Modena, Gal. & Mus. Estense) and also created large figures of *Hercules* and *Marco Emilio Lepito* for the façade of the Palazzo Estense in Modena (both *in situ*). Orazio Grillenzoni (*d* 1592), painter and sculptor, produced a bust for the *gran sala* of the same palazzo. A small bronze bust of *Alfonso II*, known in several casts (e.g. Modena, Gal. & Mus. Estense), portraying him in armour shortly after his accession, was probably made in Milan and not by Hubert Gerhard, to whom it has sometimes been attributed. Francesco Casella (*fl* 1585–1610) was awarded the major sculptural commissions of Alfonso's late years. He was in Ferrara by 1591, working on the ducal chapel and on the long-delayed tomb of *Barbara of Austria* in the Gesù, Ferrara. The tomb was probably designed by GIOVANNI BATTISTA ALEOTTI, who in 1575 became architect to Alfonso II, in succession to Galasso Alghisi, and helped restore the buildings of Ferrara after the earthquake of 1570. The architect ALESSANDRO BALBAS also worked for the Duke from 1574 and was notably responsible for the large tribune (1590–94) in the chapel of the Presiosissimo Sangue in the transept of S Maria in Vado.

BIBLIOGRAPHY

G. Medri: 'La scultura a Ferrara', *Atti & Mem. Deput. Ferrar. Stor. Patria*, xvii (1957) [whole issue]

Bastianino e la pittura a Ferrara nel secondo cinquecento (exh. cat., Ferrara, Pin. N., 1985)

J. Bentini and L. Spezzaferro, eds: *L'impresa di Alfonso II: Saggi e documenti sulla produzione artistica a Ferrara nel secondo cinquecento* (Bologna, 1987)

L. Spezzaferro: 'Perché per molti segni sempre si conoscono le cose...: per la situazione del lavoro artistico nella Ferrara di Alfonso II', *Classicismo: Medioevo, Rinascimento, Barocco: Atti del Colloquio Cesare Gnudi* (Bologna, 1993), pp. 139–69

P. de Winter: *Renaissance Sculpture in Ferrara* (Ferrara, 1999)

PATRICK M. DE WINTER

Este, Baldassare d'. *See* BALDASSARE D'ESTE.

Eusebio (di Jacopo di Cristoforo) da San Giorgio (*b* Perugia, between 1465 and 1470; *d* Perugia, after 1539). Italian painter and sculptor. The son of an apothecary, he was a pupil of Perugino. His work reveals the influence not only of the young Raphael but also of Bernardino Pinturicchio, who often employed him as his journeyman. In 1493 Eusebio received payment from the monastery of S Pietro, Perugia, for a panel (untraced) depicting *St Benedict*. He was treasurer of the Perugian painters' guild for the first term of 1494, and in 1496 he took a year's lease on a workshop in the parish of S Maria del Mercato, Perugia, with Berto di Giovanni, Sinibaldo Ibi, Lattanzio di Giovanni (*fl* 1484; *d* 1534) and Lodovico di Angelo (*fl* 1481–1522). His earliest surviving work of importance is the *Adoration of the Magi* (Perugia, G.N. Umbria) executed for the Oddi Chapel in S Agostino, Perugia. The year MDV or MDVI is inscribed on the hem of the Virgin's robe. The crowded procession of figures and the gentle, finely drawn landscape with the characteristic arched rock testify strongly to the influence of Pinturicchio. Subsequently, in company with Matteo Balducci (*fl* 1509–54), Giovan Battista Caporali and Giovanni di Francesco Ciambella (*fl* 1495–1510), Eusebio assisted Pinturicchio with the frescoes (1502–8) for the Piccolomini Library, Siena Cathedral.

Pinturicchio's influence continued in Eusebio's frescoes depicting *St Francis Preaching* and the *Stigmatization of St Francis* for the cloisters of S Damiano, near Assisi, and in the altarpiece executed for S Andrea, Spello (*in situ*). The contract of March 1507 for the Spello painting stated that Eusebio was to receive 100 gold ducats for a representation of the *Virgin and Child with the Infant St John the Baptist and Four Standing Saints*. Pinturicchio executed the preparatory drawing and was bound by the contract to paint the heads himself. He also promised to produce designs for the predella. In 1508 Eusebio was commissioned by the Baglione family to paint an *Adoration of the Magi* for S Pietro dei Cassinensi, Perugia. In this work the influence of Raphael, his contemporary under Perugino, is evident as well as his debt to Pinturicchio. In the *Virgin of the Masts* (Perugia, G.N. Umbria), painted for the oratory of the confraternity of St Benedict, the overall disposition of the figures recalls Raphael's *Virgin and Child Enthroned with SS John the Baptist and Nicholas of Bari* (1505; London, N.G.). One of Eusebio's finest panels, comparable in quality to the Spello altarpiece, is the *Virgin and Child with SS Anthony of Padua, John the Evangelist, Andrew and Nicholas of Tolentino*, painted for S Francesco, Matélica, near Fabriano, with scenes from the *Miracle of St Anthony* on the predella.

Eusebio was also active as a sculptor, though he was less prolific in this medium. In 1525 he executed a relief

of *St Roch*. In 1530 he made two candlesticks in the form of angels for the high altar of the confraternity of St Benedict, Perugia, and a figure of *St Roch* for Guido di Meo d'Antonia. Eusebio always preserved his links with Perugia. In 1516, 1526 and 1537 he was again treasurer of the Perugian painters' guild, and in 1509 he held the office of prior. In 1527 he was a member of the 100-man authority that was elected for each district of Perugia. He is last documented, gravely ill, in 1538. As he is not entered in the register of deaths for Perugia, it can be presumed that he died after 1539. Eusebio ranks next to Raphael as the most important representative of the Perugian school of painting as it developed after Perugino and Pinturicchio.

BIBLIOGRAPHY

Thieme–Becker

J. A. Crowe and G. B. Cavalcaselle: *A New History of Painting in Italy* (London, 1866/*R* New York, 1980), pp. 241–3, 339–41

W. Bombe: 'Geschichte der Peruginer Malerei', *It. Forsch. Kstgesch.*, v (1912), pp. 234–5, 238–9

C. Ricci: *Pintoricchio* (Perugia, 1912), pp. 299–303

E. Jacobsen: *Umbrische Malerei* (Strasbourg, 1914), pp. 123–33

G. Urbini: *Arte umbra* (Rome, 1925/*R* 1974), pp. 55–121

SUSANNE KIEFHABER

Evangelista da Reggio, Fra (*b* Reggio Emilia, *c.* 1440; *d* before 15 Jan 1495). Italian scribe, illuminator and Franciscan friar. Between 1477 and 1487 he wrote three, and partially decorated six, large Antiphonaries for the cathedral of Ferrara (Ferrara, Mus. Duomo). In a series of eleven Antiphonaries and six Graduals commissioned in 1490 for the convent of S Francesco, Brescia (Brescia, Pin. Civ. Tosio–Martinengo, MSS 1–17), he illuminated initials as well as border decoration. In both enterprises Fra Evangelista probably had a controlling hand and used JACOPO FILIPPO D'ARGENTA as a close collaborator. Attributions of cuttings in Berlin (Kupferstichkab.) and a miniature with *St Jerome* (Cleveland, OH, Mus. A.) are inconclusive.

Fra Evangelista emulated the styles of Guglielmo Giraldi, Martino da Modena and Jacopo Filippo d'Argenta, all three active on the two series of choir-books. Like most contemporary painters in Ferrara, he was greatly influenced by the works of Cosimo Tura. His own style is characterized by a geometrically structured, balanced page layout that includes strong acanthus decoration bound within frames, and wooded or rocky scenes with large figures draped in bulky garments and with smallish heads. When working directly with Jacopo Filippo d'Argenta (best exemplified in Ferrara, Mus. Duomo, MS. Corale VI), he tended to be more inventive, his acanthus leaves stylishly framing medallions.

BIBLIOGRAPHY

H. J. Hermann: 'Zur Geschichte der Miniaturmalerei am Hofe der Este in Ferrara', *Jb. Ksthist. Samml. Allhöch. Ksrhaus.*, xxi (1900), pp. 117–271

M. Salmi: *Pittura e miniatura a Ferrara nel primo rinascimento* (Milan, 1961)

PATRICK M. DE WINTER

Evangelista di Pian di Meleto (*b* Pian de Meleto, nr Urbino, *c.* 1460; *d* Urbino, 18 Jan 1549). Italian painter. He is first documented in 1483 as a 'pupil of Giovanni Santi of Urbino', and he later worked for Timoteo Viti. He received commissions for chalices, candelabra, epitaphs and other similar work (untraced), sharing the more prestigious commissions with other artists. For example, he was named with Ottaviano Prassede (*c.* 1480–*c.* 1537) in connection with the decoration of the chapel of the Holy Sacrament in Urbino Cathedral (*in situ*) and as Raphael's assistant in executing the altarpiece of *St Nicholas of Tolentino* (1501; Paris, Louvre; Naples, Capodimonte; Brescia, Pin. Civ. Tosio–Martinengo) for the church of S Agostino in Città di Castello, commissioned in 1500. Although some works formerly accredited to Evangelista are now indisputably attributed to Giovanni Santi, he is still attributed with an oil-on-panel *Virgin and Child Enthroned with Saints* and frescoes depicting *Christ Crucified between SS Lawrence, Roch and Sebastian* (all Sassocorvaro, Pal. Com.) and *Christ Crucified with the Virgin and SS John the Evangelist and Mary Magdalene* (Pian di Meleto, parish church).

BIBLIOGRAPHY

A. Venturi: *Storia* (1901–40), VII/ii, pp. 188–221

E. Scatassa: 'Evangelista di Pian di Meleto', *Rass. Bibliog. A. It.*, vi (1903), pp. 110–21

L. Calzini: 'Raffaello ed Evangelista di Pian di Meleto', *Rass. Bibliog. A. It.*, xii/10–11 (1909), pp. 145–51

P. Zampetti: *L'arte marchigiana del '400* (Milan, 1969), p. 230

——: 'Per Raffaello', *Not. Pal. Albani*, xi/1–2 (1982), pp. 47–62

F. Martelli: *Giovanni Santi e la sua scuola* (Rimini, 1984), pp. 51–4

F

Fabriano, Antonio da. *See* ANTONIO DA FABRIANO.

Fabriano, Gentile da. *See* GENTILE DA FABRIANO.

Faccioli, Girolamo. *See under* MASTERS, ANONYMOUS, AND MONOGRAMMISTS, §III: MASTER H.F.E.

Facio [Fazio], Bartolomeo (*b* La Spezia, nr Genoa, before 1410; *d* Naples, Nov 1457). Italian humanist and writer. From a family of Ligurian notaries, he received his early education at Verona with Guarino Guarini (1624–83) in the early 1420s and at the end of the decade studied Greek at Florence. After holding various minor positions in Genoa and Lucca, he was appointed official Genoese envoy to Naples in 1443 and 1444, entering the service of King Alfonso of Naples (*reg* 1435–58) the following year. At Naples, where he remained for the rest of his life, he obtained the highly paid position of Royal Historiographer and served as tutor to Prince Ferrante.

Among Facio's works are treatises on happiness and the dignity of man and translations of Isocrates and Arrian. He is best known for his historical writings, in particular *De rebus gestis ab Alphonso primo libri X* (1455) and *De viris illustribus* (1456), a collection of 92 brief lives of contemporary figures, classified according to their professions. He included Leon Battista Alberti in the category of orators and referred to his *De pictura* and *De re aedificatoria*. The section of *De viris illustribus* devoted to painters and sculptors probably reflects the artistic taste and standards of the Neapolitan court, as well as Facio's own knowledge of Tuscan and Venetian art. It is introduced by a comparison of literature and art, based on Horace's *Ars poetica* and the *Prooemium* by Philostratus the younger to the *Imagines*. Importing a number of rhetorical terms into his discussion of art, Facio placed the highest value in painting, as in poetry, on the vivid and lifelike representation not only of external, physical traits but also, and more importantly, of interior feelings and character. It was primarily on the basis of their ability to convey emotional expressiveness that he judged what he considered to be the four outstanding painters of his day: Gentile da Fabriano, Jan van Eyck (*c.* 1395–1441), Pisanello and Rogier van der Weyden (*c.* 1399–1464).

Among the paintings of Gentile da Fabriano, Facio singled out the *Adoration of the Magi* painted for Santa Trinita, Florence (Florence, Uffizi; *see* GENTILE DA FABRIANO, fig. 3), the fresco of the *Virgin and Child* in Orvieto Cathedral painted in 1425 and an unidentified painting of *Pope Martin V and Ten Cardinals*, whose images he claimed 'seem to differ in no respect from the living'. His account of Jan van Eyck provides important evidence for the popularity of this Flemish artist in 15th-century Italy. He particularly admired van Eyck's illusionistic realism, as seen in the *St Jerome* panel of the Lomellini Triptych (untraced), then in the private apartments of King Alfonso, and a painting of women bathing (untraced), in which the artist used the reflection from a mirror to spectacular effect. Facio praised Pisanello's naturalistic depiction of horses and other animals, his powerful portrayal of *St Jerome* (untraced) and his medals of King Alfonso, Filippo Maria Visconti and other Italian princes. In his life of Rogier van der Weyden, Facio described paintings and tapestries (all untraced), which particularly impressed him on account of their realistic but decorous rendering of emotion and character.

Facio gave biographies of three sculptors: Lorenzo Ghiberti and his son Vittorio, mentioning the bronze *Gates of Paradise* for the Florentine Baptistery (see colour pl. 1, XXXI2), and Donatello, who, he said, approached the ancients in his ability to turn marble into living faces and exhibited equally marvellous workmanship in his bronze equestrian statue of *Gattamelata* in Padua (*see* DONATELLO, fig. 4).

WRITINGS
De viris illustribus (MS. 1456); ed. L. Mehus (Florence, 1745); partial Eng. trans. in M. Baxandall: 'Bartholomaeus Facius on Painting: A Fifteenth-century Manuscript of *De viris illustribus*', *J. Warb. & Court. Inst.*, xxvii (1964), pp. 90–107

BIBLIOGRAPHY
R. Weiss: 'Jan van Eyck and the Italians', *It. Stud.*, xi (1956), pp. 1–15
P. O. Kristeller: 'The Humanist Bartolomeo Facio and his Unknown Correspondence', *From the Renaissance to the Counter-Reformation: Essays in Honor of Garrett Mattingly* (New York, 1965), pp. 56–74
C. Marchiori: *Bartolomeo Facio tra letteratura e vita* (Milan, 1971)

JILL KRAYE

Faenza. Italian centre of maiolica production. It is one of the most famous centres of Italian maiolica production and from the 17th century lent its name to this particular category of ceramics made throughout Europe ('faience'). Ceramic production in Faenza is referred to in records and documents dating from as early as the 14th century. Early products are solid and heavy in shape and decorated with rather frugal, severe ornamentation, mostly in brown and green. For this reason they are generally considered 'archaic' medieval products.

Only during the 15th century did the production of ceramics in Faenza begin to develop a specifically individ-

ual style. Faenza maiolica was technically more refined than that produced in other centres and incorporated a rich, varied palette. In particular the decoration was enriched with fashionable subjects, including Gothic–Moorish motifs, coats of arms, heraldic devices and portraits of *belle donne* painted on *coppe amatorie* (love dishes). These features remained during the 16th century when the *istoriato* (narrative) genre was often combined with *berettino* (blue) glaze decoration, with grotesques and arabesques (e.g. plaque, *c.* 1525–30; London, BM).

From the mid-16th century Faenza was involved in the development of the so-called *bianchi di Faenza* (white ware). In this period skilful craftsmen and such heads of workshops as Francesco Mezzarisa, Virgiliotto Calamelli and Leonardo Bettisi (*fl* 1570–80) created relief surfaces, which became increasingly Baroque in style and were covered with a thick, white glaze onto which they applied a sparse, sketchy form of decoration known as *compendiaria* (e.g. pierced dish, *c.* 1550–70; London, BM).

BIBLIOGRAPHY

F. Argnani: *Il rinascimento delle ceramiche maiolicate in Faenza* (Faenza, 1898)
G. Liverani: 'La rivoluzione dei bianchi nella maiolica di Faenza', *Faenza*, xliv (1958), pp. 27–32
E. Golfieri: 'Il cenacolo della Fabbrica Ferniani e i pittori di genere a Faenza', *Faenza*, liii (1967), p. 58

CARMEN RAVANELLI GUIDOTTI

Faenza, Antonio Gentili [Gentile] **da** (*b* Faenza, 1519; *d* Rome, 29 Oct 1609). Italian goldsmith. He was the son of Pietro Gentili, a goldsmith. By *c.* 1549 he was active in Rome and by 1552 he had entered the goldsmiths' guild as a master craftsman, holding several offices during his lifetime. His fame enabled him to move in high circles. Records indicate that he executed various works in gold for the Medici, pieces ranging from vases and lamps to keys and bedwarmers. It was for Cardinal Alessandro Farnese that Antonio created his acknowledged masterpiece, consisting of two silver-gilt candlesticks and a cross (1582; Rome, St Peter's, Treasury), for which he received 13,000 scudi. The objects, which contain rock-crystal tondi by Giovanni Bernardi and inlay work of lapis lazuli, were then donated by the Cardinal to St Peter's. Antonio signed the work, yet authorities have often attributed it to Benvenuto Cellini or Michelangelo, among others.

Part of the difficulty in identifying Antonio's work is the confusion caused by his habit of borrowing motifs from other artists, especially those employing a style similar to that of Michelangelo. This practice was highlighted when the 90-year-old goldsmith testified in an inheritance lawsuit brought by Guglielmo della Porta's son, Teodoro della Porta, regarding casts and models missing from his father's workshop. During testimony Antonio stated that he owned and used casts by Michelangelo and others. His adoption of others' designs in his pieces, a common practice among 16th-century goldsmiths, did not hinder his versatility. In 1580 he fashioned a miniature gold bust of the armoured *Emperor Augustus* on a small agate base (h. 210 mm; Florence, Pitti). In 1584 he became an assayer for the papal mint. Antonio also created a silver book cover for Cardinal Farnese's Book of Hours (1600; New York, Pierpont Morgan Lib.). The richly decorated cover portrays the *Annunciation* bordered by a pattern of cher-

ubim heads and acanthus leaves. Famous in his own day, Antonio's influence extended to 18th-century France and England, where the candlesticks in St Peter's inspired such figures as Jean-Louis Prieur (1732/6–95), Matthew Boulton (1728–1809) and Josiah Wedgwood I (1730–95) to incorporate elements of Antonio's masterpiece in their own works.

BIBLIOGRAPHY

G. Baglione: *Vite* (1649); ed. V. Mariani (1935)
A. Bertolotti: *Artisti bolognesi, ferraresi ed alcuni altri* (Bologna, 1885)
W. Volbach: 'Antonio Gentili da Faenza and the Large Candlesticks in the Treasury of St Peter's', *Burl. Mag.*, xc (1948), pp. 281–6
H. Honour: *Goldsmiths and Silversmiths* (New York, 1971)
A. Chadour: *Antonio Gentili und der Altarsatz von St Peter* (diss., Münster, Westfäl. Wilhelms-U., 1980)
A. Chadour: 'Der Altarsatz des Antonio Gentili in St Peter zu Dom', *Wallraf-Richartz-Jb.*, xliii (1982), pp. 133–98

ROBIN A. BRANSTATOR

Falconetto, Giovanni Maria (*b* Verona, 1468; *d* Padua, 1535). Italian painter and architect. He was one of the foremost painters working in the Renaissance style in Verona in the early 16th century and is notable for his employment of antique themes. His later architectural works are an important feature of the city of Padua. His work prepared the architectural climate for the large-scale shift of interest to antiquity, which reached a climax in the next generation of architects in northern Italy, especially in the work of Andrea Palladio.

1. Verona, before 1517. 2. Padua, 1517–35.

1. VERONA, BEFORE 1517. According to Vasari, Giovanni Maria Falconetto's father Jacopo Falconetto (1396–1472), also a painter, was his first teacher, although Michiel (more plausibly) named Melozzo da Forlì as his teacher. During a long stay in Rome, Falconetto seems to have come into close contact with Bernardino Pinturicchio. In his painted work North Italian influences are mingled with Central Italian and Roman elements from the late 15th century.

The earliest work securely attributed to Falconetto is the painting of the chapel of S Biagio (1497–99) in the church of S Nazaro, Verona. The two spandrels on the right wall are signed by Falconetto. Several other painters were involved in the decoration of the chapel, including Domenico Morone, Zuane Giacomo (*c.* 1444–1502), Francesco Morando, Paolo (Morando) Cavazzola and Girolamo Mocetto. The design for the decoration of the dome and drum of the chapel, and the painted architectural articulation, are probably by Falconetto. The painted pillars, architraves and coffered arches below the dome, the column-embellished drum and the dome itself make the chapel one of the most important works of Renaissance architecture in Verona. The details of the painted architecture and the figural decoration show that by this date Falconetto already had extensive knowledge of Roman architecture and sculpture. The frieze with Tritons and nereids, and other small chiaroscuro scenes, incorporate reliefs in an antique style, which Falconetto can have seen only in Rome. Vasari's statement that Falconetto spent 12 years in Rome in his youth would appear to be confirmed by such early work.

In 1498 Falconetto married Elena di Provalo, a weaver's daughter from Verona. In the early 1500s he produced further wall decoration in the form of painted architecture around two chapels, the Cappella Calcasoli and the Cappella Emilei in the southern aisle of Verona Cathedral. Falconetto made use of motifs from Roman triumphal arches, filling the painted niches and false architectural spaces with figures. Above the Cappella Calcasoli he incorporated on two tablets his signature and date in the manner of Roman inscriptions. This style of decoration had parallels in the local tradition of decorating chapels with sculptural or painted frames, evident in other chapels in the cathedral and those in the church of S Anastasia, Verona, but Falconetto's repertory of forms and proportions reveals an influence of Roman architecture greater than that of any other artist. For the cathedral at Trento, in collaboration with his brother Tommaso Falconetto, he painted in 1507–8 organ shutters depicting *SS Peter and Paul* when closed and the *Annunciation* when open (now in Trento, S Maria Maggiore). Here, too, Falconetto made numerous allusions to ancient Roman architecture.

In the following years Falconetto decorated several houses in Verona with frescoes. Those on the façade of the Casa Trevisani–Lonardi on the Vicolo S Marco in Foro are partly preserved and show numerous illusionistic reliefs painted in stone colour against a colourful background between painted pilasters and friezes. Almost all the illustrations can be traced back to Roman reliefs, such as those found on sarcophagi, on the Arch of Constantine or Trajan's Column. Sacrificial and hunting scenes, illustrations of battles and triumphs, as well as such mythological scenes as the *Rape of Proserpine* and *Daedalus and Pasiphae*, were shown in the individual picture panels. The preference for Classical themes and images affected even the details of the decoration of the house. His paintings (destr.) at the Palazzo Sanbonifazj–Tedeschi in the Via Scala were equally fine. Falconetto also executed the frescoes on the Palazzo Franchini in the Via Emilei. Only parts of the frieze below the eaves have survived, revealing sacrificial, triumphal and cavalry scenes. The frieze in the Casa Vignola is a well-preserved example of his interior fresco style. It also incorporates copies and variations of ancient reliefs, repeated in laterally inverted form and grouped symmetrically around coats of arms.

During the occupation of Verona in 1509–17 by the troops of Maximilian I, the Holy Roman Emperor (*reg* 1493–1519), Falconetto painted the east wall of the small church of S Giorgetto, of which only the lunette decoration has survived. The patrons were two counsellors of the Emperor, and they are both portrayed as donors. The lunette decoration depicts an allegory of the Annunciation. Many Marian themes, including the *Unicorn Hunt*, the *Hortus conclusus*, the *Porta clausa* and *Moses and the Burning Bush*, show that Falconetto must have had an exact model from northern Europe, where such pictures were widely disseminated. The closest parallels are to be found in a contemporary Swiss tapestry of the *Hortus conclusus* (Zurich, Schweiz. Landesmus.). Falconetto's panel picture from the church of the Santa Trinità, depicting *Augustus and the Sibyl* (now Verona, Castelvecchio; see fig. 1), may also be from this period. The figures and setting are strongly influenced by Classical antiquity. Several architec-

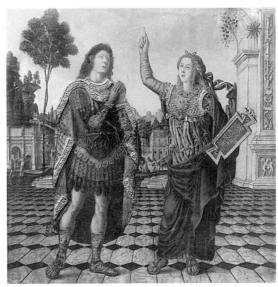

1. Giovanni Maria Falconetto: *Augustus and the Sibyl*, tempera on panel, 1.52×1.53 m, ?*c.* 1509–17 (Verona, Museo Civico di Castelvecchio)

tural ruins in the painting can be joined together to form a *frons scenae*, which has parallels in contemporary theatre illustration. Falconetto omits a complete *frons scenae*, however, in favour of a 'perspective stage'. From this picture it is apparent that he had detailed knowledge of contemporary work on the Vitruvian and the modern perspective stage. This knowledge played an important part in his later works for Alvise Cornaro (*see* §2 below).

About 1515 the canons Francesco Maffei and Girolamo Maffei had a chapel built in Verona Cathedral, in which Falconetto painted a *Resurrection* in the upper lunette. He incorporated painted arcaded arches with *all'antica* coffers in the existing Gothic architecture. Vasari refers to the work in the Maffei Chapel, adding that Falconetto himself recognized his limitations as a painter.

2. PADUA, 1517–35. As a supporter of the imperial party, Falconetto was forced to leave Verona in 1517 when the Venetians returned. According to Vasari, he first went to Trento, although no works by Falconetto from this period have been traced there. The frescoes in the Palazzo d'Arco in Mantua, however, were probably produced soon after 1517. Falconetto divided the four walls of a room (9.7×15.4 m) on the first floor into 12 compartments (one compartment destr. through the later addition of a fireplace). These display a broad spectrum of Classical allusions with rich architectural articulation and diverse figural scenes. The pictures show typical occupations of the calendar months along with the mythological stories of the associated signs of the zodiac. For the figures Falconetto drew on ancient reliefs and statues, on such contemporary works as that by Andrea Riccio, and even on the prints of Lucas van Leyden. The chamber is one of the most important surviving frescoed rooms of the early 16th century in northern Italy, demonstrating more clearly than almost any other the predilection of the period for Classical themes and forms.

At the beginning of the 1520s Falconetto seems to have come to the notice of ALVISE CORNARO, who was in the process of transforming his house in Padua, with an extensive garden, into a splendid estate on the Classical pattern. Michiel related that Falconetto painted the chapel and the staircase in Cornaro's house, which suggests that Falconetto first worked as a painter for Cornaro and became an architect in his circle at a later date. Falconetto's first architectural work in Padua was the loggia (1524; see fig. 2) in the courtyard of the Cornaro house (now the Palazzo Giustiniani). The architrave is inscribed and dated. The building originally had a single storey and served as a *frons scenae* at theatrical performances, for example of works by Angelo Beolco (called Ruzzante). It consists of five arcaded bays divided by Tuscan semi-columns, which support a richly decorated frieze. The central bay projects slightly and has carved figures of Victories in the spandrels. The upper storey is architecturally more reticent. The central and terminal bays have shallow, rectangular, pedimented niches, which frame statues of Classical figures, including Apollo, appropriate to the theatrical use of the loggia. A few years later the courtyard was extended by a further building—the so-called Odeo (1530; see colour pl. 1, XXIX2)—which was built to Cornaro's own plans, although Falconetto, along with other artists, can be assumed to have been involved in the decoration, which includes lavish stucco and fresco work comparable to that in the Villa Madama, Rome.

Although in 1529 and 1531 Falconetto is mentioned in the registers and the estimates of Verona, works from this period cannot be traced there. In the same period in Padua he had a rich architectural output, including numerous civic buildings. The Porta S Giovanni is signed and dated 1528 and combines motifs of the Classical triumphal arch with the function of a city gate. The Porta Savonarola followed in 1530, making still greater use of Classical motifs. The ground-plan presents a variation on the Classical idea of an octagonal room with niches in the diagonal sides, as used in the Odeo Cornaro. On the outer façades there are stone tondi copied from analogous pieces on the Porta Aurea in Ravenna, showing busts of the *Four Seasons*.

About 1530 Falconetto was commissioned by the Consiglio of the city of Padua to reshape the upper floor of the Monte di Pietà on the Piazza del Duomo. Falconetto's articulation of the façade with pilasters, socles, window pediments and entablatures reveals an intensive study of Classical and contemporary Roman architecture. In the same year he was put in charge of work on the Loggia del Consiglio, which had been planned since 1496 and was built to a design by Annibale Magi da Bassano (*d* 1504). In 1531–2 the main entrance to the Palazzo del Capitanio, the seat of the Venetian governor on the Piazza dei Signori, Padua, was rebuilt to a design by Falconetto. It is an enlarged version of the central bay of the Loggia Cornaro, with the addition of paired Tuscan semi-columns.

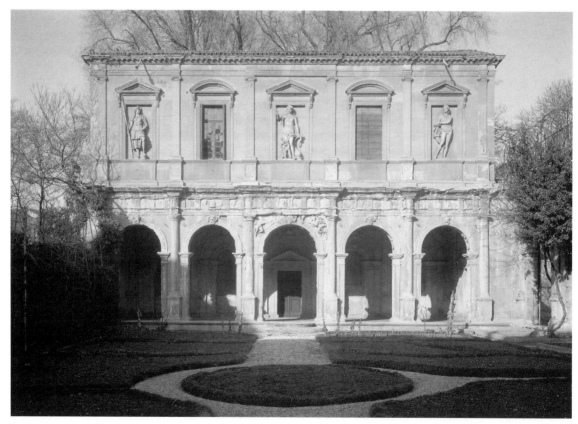

2. Giovanni Maria Falconetto: loggia of the Cornaro house (now Palazzo Giustiniani), Padua, 1524

Instead of an antique frieze the architrave bears the inscription of the Doge of Venice, Andrea Gritti, and also the insignia of the two administrators Badoer and Moro, who represented Venice in Padua from 1531 to 1532. The entrance is thus a visible sign of Venetian sovereignty next door to the Loggia del Consiglio, in which the local Paduan assembly met. The portal recalls the form of the triumphal arch, while particular motifs, for example the double columns, allude to such Classical buildings as the Arch of the Sergius family at Pula.

Falconetto's advice was also sought outside Padua in this period. In 1532 the Scuola Grande della Misericordia in Venice commissioned him to design a new building for the Scuola, planned since 1505 and already partly constructed. In 1533 Falconetto was commissioned to complete the Cappella del Santo in the Basilica di S Antonio, Padua. He designed a lavish stucco ceiling, based on Roman models and making particular use of motifs from the Domus Aurea.

Only a small part of Falconetto's undoubtedly large output of drawings has so far been identified. The inventory of his legacy of 9 January 1535 mentions a portfolio of preparatory drawings for paintings. In addition, some drawings are mentioned separately, probably the ones of ancient monuments (London, BM, 1911-10-18-1; and Vienna, Albertina, 13247-8). The numerous attributions of drawings to Falconetto by G. Zorzi cannot be substantiated. Of his designs for frescoes or panel paintings, only one of *St Peter* (Verona, Mus. Miniscalchi Erizzo) has survived. More numerous are the drawings that are reproductions or variations of ancient illustrations. Designs for tombs or altars are among the most interesting works, especially the careful design for a monument on which many bronze figures and reliefs were to be mounted (Paris, Louvre, RF 1075). Also from Falconetto's last years is the large design for an altar and tomb monument (Florence, Uffizi, UA2194), attributed to him by Burns (1980 exh. cat.; see *Palladio e Verona*).

BIBLIOGRAPHY

M. Michiel: *Notizia d'opere del disegno* (MS.; *c.* 1520–40); ed. P. Barocchi in *Scritte d'arte del cinquecento*, iii (Milan, 1977), pp. 2867–8
G. Vasari: *Vite* (1550, rev. 2/1568); ed. G. Milanesi (1878–85), v, pp. 318–26
G. Biadego: 'La cappella di S Biagio nella chiesa SS Nazaro e Celso di Verona', *Nuovo Archv. Ven.*, xi (1906), pp. 91–134
E. Lovarini: 'L'eredità di Gian Maria Falconetto', *Boll. Mus. Civ. Padova*, n. s., i (1925), pp. 122–32
G. Fiocco: 'Le architetture di Giovanni Maria Falconetto', *Dedalo*, xi (1931), pp. 1203–14
R. Brenzoni: 'Nuovi dati d'archivio su G. M. Falconetto, pittore e architetto, detto il Rosso da San Zeno e i due Ridolfi plasticatori', *Atti Ist. Ven. Sci., Lett. & A.*, ii (1953), pp. 269–95
R. Wyss: 'Vier Hortus-conclusus-Darstellungen im schweizerischen Landesmuseum', *Z. Schweiz. Altertknd.*, xx (1960), p. 113
T. Buddensieg: 'Die Ziege Amalthea von Riccio und Falconetto', *Jb. Berlin. Mus.*, v (1963), pp. 121–50
W. Wolters: 'Tiziano Minio als Stukkator im "Odeo Cornaro" zu Padua: Ein Beitrag zu Tiziano Minios Frühwerk: Der Anteil des Giovanni Maria Falconetto', *Pantheon*, xxi (1963), pp. 20–28, 222–30
G. Zorzi: 'Gli antichi archi veronesi nei disegni palladiani di Verona e di Londra attribuiti a G. M. Falconetto', *Atti & Mem. Accad. Agric., Sci. & Lett. Verona* (1965), pp. 169–91
——: 'Le filigrane dei disegni palladiani delle antichità e alcune attribuzioni a G. M. Falconetto', *Atti Ist. Ven. Sci., Lett. & A.*, (1964), pp. 303–42
G. Schweikhart: 'Studien zum Werk des Giovanni Maria Falconetto', *Boll. Mus. Civ. Padova*, lvii (1968), pp. 17–67
T. Buddensieg and G. Schweikhart: 'Falconetto als Zeichner', *Z. Kstgesch.*, xxxiii (1970), pp. 21–40
F. E. Keller: 'Alvise Cornaro zitiert die Villa des Marcus Terentius Varro in Cassino', *L'Arte*, xiv (1971), pp. 29–53
G. Schweikhart: *Fassadenmalerei in Verona: Vom 14. bis zum 20. Jahrhundert* (Munich, 1973), pp. 215–18
——: 'Giovanni Maria Falconetto', *Maestri della pittura veronese* (Verona, 1974), pp. 123–32
——: 'Antike Meerwesen in einem Fries der Casa Vignola in Verona: Ein unbekanntes Werk des Giovanni Maria Falconetto', *A. Ven.*, xxix (1975), pp. 127–33
P. Carpeggiani: 'Giovanni Maria Falconetto: Temi ed eventi di una nuova architettura civile', *Padova, case e palazzi*, ed. L. Puppi and F. Zuliani (Vicenza, 1977), pp. 71–99
L. Venier: 'Falconetto: Astrologia e cultura antiquaria', *Piranesi e la cultura antiquaria: Atti del convegno: Rome 1979*, pp. 111–21
Palladio e Verona (exh. cat. by P. Marini, Verona, 1980), p. 99
R. Signorini: 'Due fonti iconografiche di affreschi mantovani: La conversione di S Paolo di Luca di Leida e due dettagli della sala dello zodiaco in Palazzo d'Arco a Mantova', *Civiltà Mant.*, n. s. ii (1984), pp. 9–11
G. Schweikhart: 'Un artista veronese di fronte all'antico: Gli affreschi zodiacali del Falconetto a Mantova', *Roma e l'antico nell'arte e nella cultura del cinquecento*, ed. M. Fagiolo (Rome, 1985), pp. 461–88
P. Brugnoli: *La cattedrale di Verona nelle sue vicende edilizie dal secolo IV al secolo XVI* (Verona, 1987)
'La casa Trevisani–Lonardi', *Affreschi del rinascimento a Verona: Interventi di restauro*, ed. P. Brugnoli (Verona, 1987), pp. 15–53
R. Signorini: *Lo zodiaco di Palazzo d'Arco in Mantova* (Mantua, 1987)
L. Capodieci and C. Ilari: 'I segreti del tempo: Prime considerazioni sullo Zodiaco di palazzo d'Arco a Mantova', *Stor. A.*, lxxxvii (1996), pp. 141–67

GUNTER SCHWEIKHART

Falier, Antonio [Antonio da Negroponte] (*fl* Venice, second half of the 15th century). Painter of Greek origin, active in Italy. In a document of 3 March 1469, Jacopo Bellini nominated his attorney, Alvise Sagundino, Chancellor of the captain of the Venetian fleet, to recover money owed to him by 'Antonio Falirio, painter, resident of Negroponte', threatening the latter with legal proceedings if he failed to pay. Jacopo's death (1470–71) and the fall of Negroponte to the Turks in 1470 make it likely that no further action was taken. Two other documents, one a Venetian missive sent to Crete that mentions a 'frate Antonio da Negroponte' (7 June 1497) and the other a will made by Antonio da Negroponte in Venice (24 July 1449), presumably refer to the same person.

It seems possible to identify this painter with the author of an altarpiece of the *Virgin and Child Enthroned with Angels* painted for the Morosini Chapel in S Francesco della Vigna, Venice (*in situ*) and signed *Frater Antonius de Nigroponto pincsit*. It is a bizarre painting, combining highly decorative Gothic elements derived from Pisanello and Jacopo Bellini with Renaissance elements derived from Antonio Vivarini and Squarcione's Paduan school. The former include carefully painted birds, flowers and fruit, while the latter is evident in the elaborate canopied throne decorated with fictive relief panels. The composition may have influenced Bartolomeo Vivarini's *Virgin and Child Enthroned with SS Augustine, Roch, Louis of Toulouse and Nicholas of Bari* (Naples, Capodimonte), dated 1465, and consequently Antonio's altarpiece has been tentatively dated slightly earlier. It is his only known work.

BIBLIOGRAPHY

DBI; *Enc. It*: 'Antonio da Negroponte'
B. Cecchetti: 'Saggio di cognomi ed autografi di artisti in Venezia: Secc. XIV–XVII', *Ateneo Veneto*, 17 (1887), p. 209
P. Paoletti: *Raccolta di documenti inediti per servire alla storia della pittura veneziana nei secoli XV e XVI*, i: *I Bellini* (Padua, 1894), pp. 10–11

L. Venturi: *Le origini della pittura veneziana, 1300–1500* (Venice, 1907), pp. 94–7

L. Testi: *Storia della pittura veneziana*, ii: *Il divenire* (Bergamo, 1915), pp. 547–51

M. Cattapan: 'Nuovi documenti riguardanti pittori cretesi dal 1300 al 1500', *Atti del 2° convegno internazionale di studi cretesi: Athens, 1968*, iii, pp. 35–6

E. Merkel: 'Una ricerca per frate Antonio Falier da Negroponte, pittore girovago', *Quad. Sopr. Beni A. & Stor. Venezia*, 7 (1979), pp. 45–56

ETTORE MERKEL

Falloppi, Giovanni di Pietro. *See* GIOVANNI DA MODENA.

Fancelli, Luca (*b* Settignano, *c.* 1430; *d* after 1494). Italian architect and sculptor. He trained as a stonecutter but was involved more with architecture than sculpture. Several contradictory references by Vasari relate to Fancelli's early career and attribute to him the construction of the Palazzo Pitti, the tribune of SS Annunziata and other Florentine buildings designed by Brunelleschi and Alberti. Vasari's proposal, however, lacks documentary confirmation, since Fancelli moved *c.* 1450 to Mantua, where he entered the service of Ludovico II Gonzaga, 2nd Marchese of Mantua. While there, he supervised the construction of Alberti's churches of S Sebastiano (from 1460) and S Andrea (from 1472); his personal contribution to these buildings, especially S Andrea, which was begun only shortly before Alberti's death, should not be underestimated.

For approximately 35 years Fancelli supervised building work for the Gonzaga family, including improvements to the castle at Mantua, numerous country residences, fortresses and even the construction of the Marchese's Bucentaur, a luxurious river vessel. During the 1450s Fancelli was responsible for Revere, the Gonzagas' fortified palace on a rectangular plan, which was not completed. The military allusions are limited to the vertical emphasis of the corner towers, the outward slope of the socle and the blind crenellation of the roofline. The paired columns of the open loggia of the courtyard have bases and capitals in the Gothic tradition. The main entrance has classical qualities, with fluted Corinthian pilasters, trabeation in the form of an antique frieze, and a triangular pediment in strong relief. The rectangular windows surrounded by denticulated frames are characteristic of Fancelli's work. Many of his buildings have been destroyed or radically transformed. Certain of his characteristic features, however, such as blind crenellation and denticulated window-frames, are found on little-documented buildings, such as the Palazzo Pastore built for Francesco Secco at San Martino Gusnago. Fancelli's influence is also evident in the reconstruction (early 1470s) of the medieval Palazzo del Podestà, Mantua, although the project was supervised by the engineer Giovanni Antonio d'Arezzo.

Fancelli's career as a sculptor is difficult to define. He is generally credited with the sculptural embellishment of the buildings on which he collaborated, such as the entrance and a fireplace in the Revere castle, the transennae on the façade of S Sebastiano, the fireplace in the Camera del Sole of the Ducal Palace at Mantua, but these designs are more probably attributable to Mantegna or Alberti. In 1482 he produced a design for the funerary monument to Ludovico's wife, Barbara of Brandenburg (*d* 1481), but

this was rejected in favour of a model by Mantegna. In the early 1480s Federico I Gonzaga, 3rd Marchese of Mantua, offered Fancelli his most prestigious commission: to design a monumental new palace within the confines of the Mantuan court. The Nova Domus differed from Fancelli's other palace designs with the introduction of superimposed architectural orders, although the corner towers were retained and opened up into roof terraces. After the death of Federico Gonzaga (1484), the palace remained unfinished (the façade towards the lake is largely the result of 20th-century restoration), and Fancelli's fortunes at the Mantuan court rapidly declined.

During the following decade, Fancelli left Mantua on several occasions to take up prestigious, but temporary commissions. In 1487 he spent some time in Milan studying the structural problem of the cathedral's lantern and evaluating the solutions put forward by Leonardo, Bramante and other famous architects. Subsequently, thanks to the intervention of Lorenzo de' Medici, he was appointed superintendent of the dome of Florence Cathedral. As an architect, he achieved an original synthesis of elements, some Florentine in origin, as well as archaeological references and themes traditional to the Po region, from which he created compositional solutions that were widely diffused and contributed to the establishment of Mantua's civic image during the second half of the 15th century.

WRITINGS

C. Vasić Vatovec, ed.: *Luca Fancelli, architetto: Epistolario gonzaghesco* (Florence, 1979)

BIBLIOGRAPHY

G. Vasari: *Vite* (1550, rev. 2/1568); ed. G. Milanesi (1878–85), ii, pp. 373, 545–6

W. Braghirolli: 'Luca Fancelli: Scultore, architetto e idraulico del secolo XV', *Archv Stor. Lombardo*, iii (1876), pp. 610–38

E. Marani: 'Luca Fancelli', *Dall'inizio del secolo XV. alla metà del XVI.*, ed. E. Marani and C. Perina (1961), ii/2 of *Mantova* (Mantua, 1958–65), pp. 63–115

C. Perina: 'L'attività scultoria di Luca Fancelli', *Dall'inizio del secolo XV. alla metà del XVI.*, ed. E. Marani and C. Perina (1961), ii/2 of *Mantova* (Mantua, 1958–65), pp. 511–16

M. Salmi: 'La "Domus Nova" dei Gonzaga', *Arte, pensiero e cultura a Mantova nel primo rinascimento in rapporto con la Toscana e con il Veneto: Atti del VI convegno internazionale di studi sul rinascimento: Firenze, Venezia, Mantova, 1961*, pp. 15–21

C. Cottafavi: 'Saggi inediti su edifici della corte di Mantova: La Nova Domus', *Atti & Mem. Accad. N. Virgil. Mantova*, n. s., xxxiv (1963), pp. 8–18

P. Carpeggiani: 'Luca Fancelli architetto civile nel contado mantovano: Ipotesi e proposte', *Civiltà Mant.*, 20 (1969), pp. 87–114

——: *Il palazzo gonzaghesco di Revere* (Mantua, 1974)

C. Vasić Vatovec: 'La villa di Rusciano', *Filippo Brunelleschi: La sua opera e il suo tempo: Firenze, 1977*, pp. 663–7

A. Calzona: *Mantova città dell'Alberti: Il San Sebastiano: Tomba, tempio, cosmo* (Parma, 1979)

M. Palvarini Gobio Casali: 'La "Ghirardina" di Motteggiana ovvero la "casa di Saviola" del marchese Ludovico II Gonzaga', *Civiltà Mant.*, n. s., 8 (1985), pp. 37–57; 11 (1986), pp. 5–34

A. Belluzzi: *Chiese a pianta centrale di Giuliano da Sangallo, Lorenzo il Magnifico e il suo mondo: Convegno internazionale di studi: Florence, 1992*, pp. 385–406

□

Fano, Giovanni da. *See* GIOVANNI DA FANO.

Fantoni, Giacomo [Colonna, Jacopo] (*fl* Venice, *c.* 1530; *d* Bologna, *c.* 1543). Italian sculptor. He was the son of a sculptor from Bergamo, Venturino Fantoni (*fl c.* 1517; *d c.* 1524). Vasari and Francesco Sansovino mention him as

a disciple of Jacopo Sansovino, and his earliest surviving work, a statuette of *St Lawrence* (1530) made in competition with a *St Jerome* by Danese Cattaneo (both Venice, S Salvatore), is a modest work showing the influence of Sansovino. His other surviving Venetian work, *Christ Showing his Wounds*, made for the now destroyed Santa Croce, Venice (*c.* 1535; Venice, Ca' d'Oro), is a more accomplished performance in the same vein. Fantoni made an equestrian statue probably also dating from the 1530s for S Marina in Venice, as well as figures of *St Dorothy*, *St Lucy* and *St Catherine* (all destr.) for S Giovanni Novo.

In 1532 Fantoni was engaged on relief decoration for the Scuola di S Rocco, and by 1533 he had completed two stucco figures of *St Anthony of Padua* and *St Daniel* for the façade of the chapel of St Anthony in the basilica of S Antonio (the Santo) in Padua. He probably gained this commission through the influence of Sansovino, on whose *Virgin and Child* for Verona Cathedral Fantoni based the *St Daniel*. Sansovino introduced Fantoni to the circle of the humanist Alvise Cornaro in Padua, for whom he created three colossal stucco figures of *Minerva*, *Venus* and *Diana* (all destr.) as well as smaller figures such as a terracotta nude *Mars* (destr.) based on the antique bronze *Spinario* (Rome, Mus. Conserv.). By 1536 Fantoni had moved to Forlì, where he provided decorations for the chapel of the Conception in S Mercuria, and at the end of the decade he was engaged on the marble decoration of the high altar of the church of the Madonna di Galliera in Bologna, a composition designed by Serlio, on which Niccolò Tribolo and Danese Cattaneo also collaborated.

BIBLIOGRAPHY

G. Vasari: *Vite* (1550, rev. 2/1568); ed. G. Milanesi (1878–85)

A. Venturi: *Storia* (1901–40)

R. Bossaglia, ed.: *I Fantoni, quattro secoli di bottega di scultura in Europa* (Vicenza, 1978), pp. 74–5

S. Wilk: 'La decorazione cinquecentesca della cappella dell'Arca di S Antonio', *Le sculture del Santo di Padova*, ed. G. Lorenzoni (Vicenza, 1984), pp. 119, 159, 162

For further bibliography see SANSOVINO, JACOPO.

BRUCE BOUCHER

Fantuzzi, Antonio (*b* ?Bologna; *fl* Fontainebleau, 1537–50). Italian painter and printmaker. He was one of Francesco Primaticcio's main assistants at Fontainebleau. Although no painted work or drawing by him can be identified, he is recorded as having designed some of the grotesques for the vault of the Galerie d'Ulysse. From 1542 to 1545 he was one of the principal etchers of the Fontainebleau school, producing more than 100 etchings in that short time. Around 1542–3 he reproduced many drawings by Giulio Romano and Rosso Fiorentino, recording many of the latter's compositions for the palace of Francis I (*reg* 1515–47). Because he always worked from preparatory drawings rather than from the frescoes themselves, Fantuzzi's etchings are an invaluable source of information about lost drawings by Rosso. Later he worked from Primaticcio's designs, especially his drawings after antique statues. While Fantuzzi's earlier etchings are violent in their handling and light effects (e.g. his etching after Rosso's *The Sacrifice*; see Zerner (1969), no. 27), his *maniera* later became more careful and softer (e.g. *Apollo and Marsyas*, after Parmigianino; see Zerner (1969), no.

77). Fantuzzi has often been mistakenly identified with Antonio da Trento.

BIBLIOGRAPHY

F. Zava-Boccazzi: *Antonio da Trento, incisore* (Trent, 1962)

H. Zerner: 'L'Eau-forte à Fontainebleau: Le Rôle de Fantuzzi', *A. France*, iv (1964), pp. 70–85

——: *École de Fontainebleau: Gravures* (Paris, 1969)

Rosso Fiorentino (exh. cat. by E. Carroll, Washington, DC, N.G.A., 1987)

HENRI ZERNER

Farinati [Farinato], **Paolo** (*b* Verona, 1524; *d* Verona, 1606). Italian painter and draughtsman. He was the son of a painter, Giambattista, but probably trained in the workshop of Nicola Giolfino (Vasari). His earliest documented painting, *St Martin and the Beggar* (1552; Mantua Cathedral), was commissioned by Cardinal Ercole Gonzaga along with works by Battista dell'Angolo del Moro, Veronese and Domenico Brusasorci for Mantua Cathedral, newly restored by Giulio Romano. As is evident in his chiaroscuro and figure types, Farinati had absorbed certain Mannerist influences from the frescoes of scenes from the *Life of the Virgin* (1534) in the choir of Verona Cathedral, executed by Francesco Torbido to Giulio's design. Giolfino's eccentric style would also have encouraged Farinati to emphasize line over colour and to restrict his palette to rather opaque greys, browns, mauve and rust. His two-canvas *Massacre of the Innocents* (1556; Verona, S Maria in Organo) displays the muscular figures, sharp foreshortenings and posed attitudes of Mannerism and has a more polished finish than his earlier work. Its strong, plastic qualities are also evident in *Christ Walking on the Water* and the *Supper of St Gregory* (1558) in the choir of the same church. These characteristics are united with a more defined architectural space, derived from Veronese, in his *Ecce homo* (1562; Verona, Castelvecchio). In 1566 Farinati painted two frescoes—one of *Elijah Ascending into Heaven*, the other (damaged) of uncertain subject—on the walls flanking Veronese's altarpiece in the Cappella Marogna, S Paolo, Verona. His use of somewhat brighter colours is probably due to the influence of Veronese. Farinati's mythological and allegorical frescoes in the Palazzo Giuliari, Verona, were completed before he began his journal in 1573. Around 1575 he executed the cycle of canvases and frescoes depicting the *Lives of SS Nazarius and Celsus* in the choir of SS Nazaro e Celso, Verona. While his altarpiece of *SS Francis and Nicholas* (1588; Verona, S Paolo) is among the more colourful, his style did not change radically. His late works include the *Miracle of the Loaves and Fishes* (1603; Verona, S Giorgio in Braida). Drawings form a significant part of Farinati's oeuvre, especially his numerous chiaroscuro drawings on tinted paper, which were often used as modelli (e.g. New York, Met.; Paris, Louvre; Vienna, Albertina; Washington, DC, N.G.A.).

WRITINGS

Giornale, 1573–1606 (Verona, Archv Stato, MS. Comune, n. 604); ed. L. Puppi (Florence, 1965)

BIBLIOGRAPHY

G. Vasari: *Vite* (1550, rev. 2/1568); ed. G. Milanesi (1878–85), vi, pp. 374–5

C. Ridolfi: *Meraviglie* (1648); ed. D. von Hadeln (1914–24), ii, pp. 127–34

B. dal Pozzo: *Le vite de' pittori, degli scultori et architetti veronesi* (Verona, 1718), pp. 122–9

L. Simeoni: 'Il giornale del pittore Paolo Farinati', *Madonna Verona*, i (1907), pp. 123–9; ii (1908), pp. 49–53, 90–101, 130–40; iii (1909), pp. 125–30, 151–70, 222–7

G. Fiocco: 'Paolo Veronese und Farinati', *Jb. Ksthist. Samml. Wien*, i (1926), pp. 123–36

U. G. Tessari: *S Tomaso C., S Paolo, S Fermo Minore* (Verona, 1955)

F. dal Forno: *Paolo Farinati, 1524–1606* (Verona, 1965)

B. Berenson: *Central and North Italian Schools* (1968), pp. 124–7

D. DeGrazia Bohlin: 'Paolo Farinati in the Palazzo Giuliari: Frescoes and Preparatory Drawings', *Master Drgs*, xx (1982), pp. 347–69, pls 1–11

G. Baldissin Molli: 'Paolo Farinati e gli affreschi della chiesa dei Santi Nazaro e Celso a Verona', *A. Ven.*, xxxviii (1984), pp. 31–45

——: 'Qualche riflessione su un quadro poco noto e un disegno inedito di Paolo Farinato', *A. Ven.*, xxxix (1985), pp. 47–54

S. Marinelli: 'Paolo Farinato a Palazzo Stoppi', *Venezia A.*, vii (1993), pp. 67–72

Disegni veronesi al Louvre 1500–1630 (exh. cat., ed. P. Marini and others; Paris, Louvre; Verona, Castelvecchio, 1993–4), pp. 98–135

G. Peretti: 'Due inediti fregi veronesi de soggetto imperiale', *Quad. Pal. Te*, i (1994), pp. 52–69

F. Arduini: 'Due inediti paragoni', *Labyrinthos*, xiv/278 (1995), pp. 203–17

G. Baldissin Molli: 'L'iconografia di San Giacinto in due dipinti veronesi e un aggiunta all'Orbetto', *A. Crist.*, lxxxiii/767 (March–April 1995), pp. 119–29

DIANA GISOLFI

Farnese. Italian family of rulers, ecclesiastics, patrons and collectors. The family originated in Lazio, possessing much territory in the region of Lake Bolsena. During the 13th and 14th centuries they distinguished themselves chiefly as civic leaders in Orvieto and as condottieri, usually in the service of the papacy. They became prominent in Rome under Martin V, who made Ranuccio Farnese (*d c.* 1450) a senator in 1417. In 1435 Ranuccio was made Gonfalonier of the Church by Eugenius IV, and his service was rewarded with grants of land in Lazio. The family entered the Roman aristocracy when Ranuccio's son Pier Luigi Farnese married Giovanna Caetani. From this union was born Alessandro Farnese (*see* (1) below), who later became Pope Paul III and was the true founder of the family's fortunes. During the 15 years of his pontificate (1534–49) he pursued an energetic policy of nepotism to make the Farnese one of the leading families of Europe. His son (2) Pier Luigi Farnese was made papal Gonfalonier, created Duke of Castro in 1537 and Duke of the newly created duchy of Parma (*see* PARMA, §I) and PIACENZA in 1545. Paul's eldest grandson, (3) Alessandro Farnese, was made a cardinal (1534) and Vice-Chancellor of the Church (1535) and showered with lucrative benefices. Alessandro's younger brother (4) Ranuccio I Farnese was also made a cardinal (1545). Important dynastic marriages were arranged for Paul's other two grandsons: in 1538 Ottavio Farnese (1525–86) married the illegitimate daughter of Emperor Charles V (*reg* 1519–56), Margaret of Austria (Alessandro de' Medici's widow), while in 1552 Orazio Farnese (*c.* 1531–53) married Diane de Valois, illegitimate daughter of the French king Henry II (*reg* 1547–59). Paul III was a patron on a lavish scale, a family tradition that was continued by Alessandro and Ranuccio.

BIBLIOGRAPHY
F. de Navenne: *Rome, le Palais Farnèse et les Farnèse* (Paris, 1914)

——: *Rome et le Palais Farnèse pendant les trois derniers siècles* (Paris, 1923)

G. Drei: *I Farnese* (Rome, 1954)

E. Nasalli Rocca: *I Farnese* (Milan, 1969)

F. da Mareto, ed.: *Bibliografia generale delle antiche provincie parmensi* (Parma, 1974) [full bibliog.]

Le Palais Farnèse, Ecole française de Rome (Rome, 1981)

A. Viscogliosi: 'Gli orti farnesiani: Cento anni di trasformazioni, 1537–1635', *Orti farnesiani sul Palatino* (Rome, 1990), pp. 299–339

I Farnese: arte e collezionismo (exh. cat., eds L. Fornari Schianchi and N. Spinosa; Colorno, Pal. Ducale; Naples, Capidomente; Munich, Haus Kst., 1995)

L. Fornari Schianchi, ed.: *I Farnese: arte e collezionismo: studi* (Milan, 1995)

CLARE ROBERTSON

(1) Pope Paul III [Alessandro Farnese] (*b* Canino, nr Viterbo, 29 Feb 1468; elected 1534; *d* Rome, 10 Nov 1549). He received a humanist education at the University of Pisa and at the court of Lorenzo de' Medici (the Magnificent), where he came into contact with such leading scholars as Angelo Poliziano, Marsilio Ficino, Pico della Mirandola, Cristoforo Landino and probably with the young Michelangelo. In 1491 he entered the curia in Rome as an apostolic notary and in 1493 was made a cardinal by the Borgia pope, Alexander VI, who was said to have had Alessandro's sister, Giulia Farnese, as one of his mistresses. Cardinal Farnese's career prospered; he accumulated 16 bishoprics and finally realized his ambition to become pope in 1534. Despite a licentious past, which had produced at least four illegitimate children, he worked devotedly and with the skill of a consummate politician to repair the devastations of the Sack of Rome (1527) and to overcome problems caused by the Reformation.

In this context, Michelangelo's *Last Judgement* (see colour pl. 2, VII3) on the altar wall of the Sistine Chapel (commissioned by Clement VII but executed under Paul III and completed in 1541) was of extreme iconographic and spiritual importance. Perhaps the most important event during Paul III's early reign was the triumphal entry into Rome of Emperor Charles V (*reg* 1519–56) on 5 April 1536 in the wake of his African campaigns. This provided the pretext for repairing the damages of the Sack, as well as for an ambitious urban restructuring of the city with new axial thoroughfares (*see* ROME, §II, 2). Many churches were destroyed to create processional routes and to expose to view important monuments of antiquity. The special temporary decorations (triumphal arches etc) were executed to a sophisticated programme based on the triumphs of the Emperor as the Defender of the Faith and, as the route approached the Vatican palace, on the glories of the papacy. Baldassare Peruzzi was initially in charge of artistic supervision, and after his death (6 Jan 1536) was succeeded by Antonio da Sangallo the younger. The Emperor's itinerary carefully omitted a visit to the Capitoline Hill, which had not yet felt the effects of the urban renewal programme and, moreover, was the city's most important political centre. Paul's own patronage was soon to extend to this area: in January 1538, at the Pope's insistence, Michelangelo transferred the ancient equestrian monument of *Marcus Aurelius* from the Lateran to the Capitol, where its central placement provided the nucleus for the development of the Piazza del Campidoglio, one of the most spectacular and influential urban schemes of the 16th century (*see* MICHELANGELO, §I, 4 AND fig. 9).

From 1540 Paul stressed the papal presence on the Capitol by his villa near Aracoeli, designed by JACOPO MELEGHINO and connected by a walkway to one of his favourite residences, the Palazzo di S Marco (now Palazzo di Venezia). The gardens had select views over some of the remains of Republican and Imperial Rome, and the

complex therefore indicated a re-assertion of papal authority after the disaster of the Sack. In a similar vein, and again anticipating the triumph of papal authority during the Baroque, Paul developed an entire area in the Campus Martius around the Campo dei Fiori. Here he built the Palazzo Farnese (*see* ROME, §V, 7). He had already started on the construction, with Sangallo as architect, in 1514–15 while still a cardinal (*see* SANGALLO, DA (4), fig. 2). After Farnese's accession to the papacy, plans were created on a grander scale to include the great atrium, whose 12 main columns are ancient spoils of great quality. The Via dei Baullari, begun by Leo X, was completed to connect the new palace with the Campo dei Fiori, the Massimi palaces and the main papal processional routes. On the death of Sangallo in 1546, the commission was transferred to the 71-year-old Michelangelo. His changes to the façade included a more dynamic emphasis to the central axis, a raised upper floor and a massive cornice, *c*. 3 m deep, which gave the palace a more overpowering appearance and made it a prototype for many future palaces in Rome and elsewhere (*see* MICHELANGELO, §I, 4 AND fig. 10). Michelangelo wanted to create a grand vista involving a bridge across the Tiber to connect with the Farnese gardens on the other side, but nothing came of this. The third important architect was Giacomo della Porta, who abandoned the rear façade in favour of the present loggia. Other commissions in palace architecture for which Paul III was responsible include the palace at Gradoli (1517–26) in northern Lazio, designed by Sangallo, and the Palazzo Farnese at Capodimonte (both decorated with frescoes), the 'tempietti' on the Bisentina island in Lake Bolsena, the development of the Palazzo del Drago in Bolsena (under Simone Mosca and Raffaello da Montelupo, 1542–5) and, above all, the villa at Caprarola, begun (1520–21) by Sangallo and Baldassare Peruzzi and completed (1559–73) after the Pope's death by JACOPO VIGNOLA (for illustration *see* CAPRAROLA, VILLA FARNESE).

It was Pope Paul III who appointed Michelangelo architect-in-charge of the new St Peter's after the death of Sangallo (1546). Michelangelo rejected much of Sangallo's design (based on having a nave) and returned again to a central plan, which developed Bramante's original project (*see* MICHELANGELO, §I, 4 and ROME, §V, 1(ii)(d) AND fig. 6). He also designed the dome, but the proportions he devised were altered later by Domenico Fontana in order to give the structure added height and therefore better visibility from the Piazza S Pietro. By that time a longitudinal section with a massive nave had again been adopted. Paul III also commissioned Michelangelo's last frescoes, the *Crucifixion of St Peter* and the *Conversion of Saul* (1542–50; Rome, Vatican, Pauline Chapel; *see* MICHELANGELO, fig. 6). These images of suffering and conversion are fully in the spirit of the Counter-Reformation and make few concessions to conventional aesthetic tradition (*see* MICHELANGELO, §I, 2). Their themes, featuring the patron saints of Rome—Peter, Christ's appointed successor, and Paul, who convened the first council of the Christian Church—represent a further acclamation of papal authority. Another outstanding expression of the inviolability of papal authority was the replacement of the angel on the summit of the Castel Sant'Angelo (destroyed in the Sack

of Rome) with a new one (1544) by Montelupo. Tiberio Crispi (1497–1566), papal castellan of the Castel Sant'Angelo (1542–5), commissioned Raffaello da Montelupo (*see* MONTELUPO, (2)) to build a series of new apartments and other rooms for Paul III in the fortress. These were decorated (from 1545) by Perino del Vaga, including the vast Sala Paolina, for which he executed an elaborate fresco scheme (for illustration *see* PERINO DEL VAGA).

Paul III also strengthened the military defences in Rome and the papal states. His costly fortifications of Rome concentrated on the left side of the Tiber and on the Aventine. The fortifications on the right side of the Tiber, at the Vatican and the 'borgo', were the work of Sangallo and Meleghino; Michelangelo completed the Belvedere bastion in 1548. Paul had already (in 1536) fortified Ancona and Civitavecchia against the Ottoman threat, and after the 'Salt War' in 1540 against Perugia, which crushed the power of the Colonna clan, he erected the formidable Rocca Paolina (designed by Sangallo) above that city. The most famous portrait of Paul III is that by Titian: *Pope Paul III with his Grandsons* (1546; Naples, Capodimonte). The two had first met in Bologna in 1543, when Titian made his earliest portrait of the Pope (Naples, Capodimonte; *see* TITIAN, fig. 10). Paul III's tomb in St Peter's, with his image in bronze, is by Guglielmo della Porta (*see* PORTA, DELLA, (3)).

BIBLIOGRAPHY

C. Capasso: *Paolo III, 1534–1549*, 2 vols (Messina, 1924)
W. Friedensburg: *Kaiser Karl V und Papst Paul III, 1534–1549* (Leipzig, 1932)
W. H. Edwards: *Paul der Dritte, oder der geistliche Gegenreformation* (Leipzig, 1933)
R. Harprath: *Papst Paul III als Alexander der Grosse: Das Freskenprogram —der Sala Paolina in der Engelsburg* (Berlin and New York, 1978)
Gli affreschi di Paolo III a Castel Sant' Angelo: Progetto ed esecuzione, 2 vols (exh. cat., ed. F. M. Aliberti Gaudioso and others; Rome, Castel S Angelo, 1982)
C. M. Brown: 'The Farnese Family and the Barbara Gonzaga Collection of Antique Cameos', *J. Hist. Col.*, vi/2 (1994), pp. 145–51
R. Harprath: 'Marco Pino e il ciclo di Alessandro Magno nel Castel Sant'Angelo a Roma', *Umanesimo a Siena: Letteratura, arti figurative, musica*, ed. E. Cioni and D. Fausti (Siena, 1994), pp. 437–52
TILL R. VERELLEN

(2) Pier Luigi Farnese, 1st Duke of Parma and Piacenza (*b* Rome, 19 Nov 1503; *d* Piacenza, 10 Sept 1547). Son of (1) Paul III. He became a professional soldier at an early age and in 1528 fought in Italy as an ally of Emperor Charles V (*reg* 1519–56) against the papal forces, to the embarrassment of his father. Nonetheless, after his election as pope, Paul III pardoned Pier Luigi and made him papal Gonfalonier (1537). Pier Luigi's violent character has generally obscured the fact that he was an energetic and adventurous patron, often favouring young and relatively unknown artists rather than those patronized by his father. Most of his architectural commissions were for military projects. Paul III granted him the duchy of Castro in 1537, and Pier Luigi undertook extensive fortifications both there and at Nepi, employing his father's architect, Antonio da Sangallo the younger. In both locations he also commissioned much domestic architecture: at Castro, indeed, a complete town was built, which was destroyed in 1649 during the Second War of Castro. He employed Francesco Salviati as his court painter

during the 1530s and early 1540s. Salviati designed a set of tapestries illustrating the *Life of Alexander the Great*, one of which, *Alexander Sacrificing*, survives (Naples, Capodimonte). Salviati also frescoed a bathroom at Nepi and designed temporary decorations for the Duke's entry into Castro in 1543. A portrait of Pier Luigi, long attributed to Titian but now thought to be by Salviati, is in the Palazzo Reale, Naples. Another portrait, probably by Titian (Naples, Capodimonte), is greatly damaged. In 1545 Pier Luigi employed Girolamo Siciolante as court painter, but only one of the works painted for him, a *Virgin and Child with Saints* (1545; Parma, G.N.), can be identified. In the same year Paul III made Pier Luigi Duke of Parma and Piacenza, whereupon he started planning major building projects for both towns. However, these plans were abruptly curtailed when he was murdered in Piacenza.

BIBLIOGRAPHY

I. Affò: *Vita di Pier Luigi Farnese* (Milan, 1821)
I. Cheney: *Francesco Salviati (1510–1563)* (diss, U. New York, 1963), pp. 42–3
H. Giess: 'Die Stadt Castro und die Pläne von Antonio da Sangallo den Jüngeren', *Röm. Jb. Kstgesch.*, xvii (1978), pp. 47–88; xix (1981), pp. 85–140

(3) Cardinal **Alessandro Farnese** (*b* Valentano, nr Viterbo, 7 Oct 1520; *d* 2 March 1589). Son of (2) Pier Luigi Farnese. He was the most important private patron of mid-16th century Rome. He entered the Church very young and was made a cardinal at the age of 14 by his grandfather, Pope Paul III, although he was not ordained as a priest until 1564. In 1535 he was made Vice-Chancellor of the Church for life and was showered with lucrative benefices. Even after the death of Paul III in 1549, he remained one of Rome's most powerful men, and his enormous wealth enabled him to commission an immense number of artistic projects, including the Villa Farnese at Caprarola and the church of Il Gesù in Rome. His earliest artistic experience was gained acting as an intermediary between Paul III and his artists: for example, conveying Paul's instructions and receiving reports from Antonio da Sangallo the younger and JACOPO MELEGHINO about the fortification of Rome and additions to the Vatican palaces. During the 1540s he began to commission works of art for himself. Paolo Giovio introduced Giorgio Vasari to Cardinal Alessandro and arranged for him to paint a *Justice* (1543; Naples, Capodimonte) for the Cardinal. In 1546 Vasari frescoed the Sala dei Cento Giorni in the Palazzo della Cancelleria (*see* ROME, §V, 23(ii)) with a cycle glorifying Paul III's achievements, the programme for which was devised by Giovio. Also in 1546 Alessandro suggested that Vasari should help Giovio to compile biographies of artists, and Giovio, in turn, suggested that Vasari should do this on his own. In the same year Titian was invited to Rome to paint portraits of members of the Farnese family, including the unfinished *Pope Paul III with his Grandsons*; he also painted the *Danäe* (both Naples, Capodimonte). Francesco Salviati, who had already worked as Pier Luigi's court painter, decorated (1548) the Cardinal's private chapel in the Cancelleria, the Cappella del Pallio, and painted a *Virgin and Child with Two Angels* for his titular church, S Lorenzo in Damaso, Rome. ANNIBAL CARO, who had also earlier worked for Pier

Luigi, became Alessandro's secretary and chief artistic adviser on Pier Luigi's death.

Alessandro was particularly interested in the minor arts, and many of his early commissions were for engraved gems by Giovanni Bernardi, medals by Alessandro Cesati and miniatures by GIULIO CLOVIO, including the celebrated Book of Hours (*c.* 1540–46; New York, Pierpont Morgan Lib., MS. M. 69). Among his most important commissions was for the Farnese Casket (Naples, Capodimonte), executed between 1543 and 1561, in which six crystals engraved by Bernardi, some after designs by Perino del Vaga, were set in a silver-gilt frame by Manno Sbarri (1536–76).

In 1558 Alessandro commissioned JACOPO VIGNOLA to convert the pentagonal fortress at Caprarola, begun by Baldassare Peruzzi and Sangallo, into a sumptuous villa; Vignola did this with conspicuous success, creating what was thereafter known as the VILLA FARNESE, CAPRAROLA. It was Vignola's first project for his major patron and involved extensive remodelling of the town to provide a suitably grand approach road. From *c.* 1561 Taddeo Zuccaro decorated the interior with an elaborate and sophisticated series of images described by Caro (see colour pl. 2, XL1), who devised some of the programmes, as 'suitable to the place and out of the ordinary'. On Taddeo's death in 1566, the work was taken over by his brother, Federico Zuccaro, who worked there until his dismissal in 1569. The remaining apartment was frescoed by Jacopo Bertoia (for illustration *see* BERTOIA, JACOPO), Giovanni de' Vecchi and Raffaellino da Reggio (1550–78), following programmes by various advisers, including Fulvio Orsini and Onofrio Panvinio. The Villa Farnese also had fine gardens designed by Vignola and Giacomo del Duca and containing a *palazzina* by the latter. Alessandro also owned extensive gardens in Rome: the Palatine Hill was transformed into the Orti Farnesiani by Vignola and later by del Duca. He was given the Villa Madama by the Medici family in 1555 and housed some of his antique sculpture there; and he bought the Villa Farnesina from the heirs of Agostino Chigi, planning to revive Michelangelo's scheme to connect it to the Palazzo Farnese with a bridge across the Tiber.

After the conclusion of the Council of Trent in 1564, religious commissions became far more significant in Cardinal Farnese's patronage. The reasons for the change were several: there was great papal pressure on cardinals at this period to reform and refurbish their religious foundations, but Alessandro was also anxious to forward his ambitions to become pope himself. Furthermore, he became closely involved with the Jesuit Order around this date. In 1568 he commissioned from Vignola designs for a new church for the order: Il Gesù (*see* ROME, figs 13–14). The façade and cupola were designed by Giacomo della Porta, who succeeded Vignola as Alessandro's architect. This was the largest church to be built in Rome since the Sack of 1527, and it became an influential model of the Counter-Reformation church (*see* ROME, §V, 3). Throughout the project Alessandro was eager to impose his own architectural ideas on the Jesuits, often against their wishes. He also commissioned the decoration of the cupola and drum with frescoes by Andrea Lilio and Giovanni de' Vecchi (destr. during the 17th century). His

extensive programme of religious patronage also included refurbishing S Lorenzo in Damaso, for which he commissioned a new altarpiece, the *Martyrdom of St Lawrence*, from Taddeo Zuccaro (completed by Federico Zuccaro), and frescoes (destr.) from de' Vecchi, Niccolò Pomarancio and Giovanni Cesari. He restored the abbeys of Grottaferrata and Farfa and the cathedral at Monreale. After the death of his brother (4) Cardinal Ranuccio I Farnese in 1565, he substantially assisted the Arciconfraternità del SS Crocefisso di S Marcello, Rome, in the construction of the façade of their oratory and the piazza in front. He apparently also contributed to the oratory of the Gonfalone, Rome, where his coat of arms features on a wooden ceiling. His last major religious commission was the building of S Maria Scala Coeli (1581–4), Rome, designed by della Porta, with mosaic decoration by de' Vecchi.

Alessandro inherited the Palazzo Farnese on Ranuccio's death but continued to live in the Cancelleria. This circumstance, and his commitment to several costly commissions, explains his reluctance to complete the building of the palace, although the rear section was finally finished in accordance with designs by della Porta in 1589. The palace housed the vast family collection of paintings and antique sculpture, including Gianfrancesco Ponni's *Madonna del Divin Amore* (Naples, Capodimonte), El Greco's *Christ Healing the Blind Man* (Parma, G.N.), the Farnese *Hercules*, Farnese *Flora* and Farnese *Atlas* (all Naples, Mus. Archeol. N.). Artists were occasionally allowed to make copies of works in the collection, and friends seem to have had access, but the palace was inhabited only by a few familiars such as Fulvio Orsini and Giulio Clovio.

As a patron, Alessandro was particularly interested in architecture and was well-versed in the technicalities of this art and able to influence the ultimate appearance of a project to a considerable degree. This was demonstrated by his intervention over the Il Gesù plans, which resulted in the decision to build the church with a single nave, to have a vault rather than a wooden ceiling and to orientate the building so that it could have a piazza in front of it. He apparently took much less interest in painting, and it is difficult to discern any particular stylistic preferences in his choice of artists. Rather, he delegated much responsibility for both the selection of subject-matter and even of painter to advisers such as Caro and Orsini. It is largely their taste that is revealed in the surviving Farnese commissions for paintings.

BIBLIOGRAPHY

C. Trasmondo Frangipane: *Memorie sulla vita e i fatti del Cardinal Alessandro Farnese* (Rome, 1876)

F. Zeri: *Pittura e controriforma* (Turin, 1957), pp. 44–61

C. Riebesell: *Die Sammlung des Kardinal Alessandro Farnese: Ein 'studio' für Künstler und Gelehrte* (Weinheim, 1989)

C. Robertson: *Il Gran Cardinale: The Artistic Patronage of Alessandro Farnese* (New Haven and London, 1992)

P. Tosini: 'Rivedendo Giovanni de'Vecchi: Nuovi dipinti, documenti e precisazioni', *Stor. A.*, lxxxii (1994), pp. 303–47

C. Adini Luchinat: *Taddeo e Federico Zuccari: fratelli pittori del Cinquecento* (Milan, 1998), ch. 8

(4) Cardinal Ranuccio I Farnese (*b* Rome, 11 Aug 1530; *d* Parma, 28 Oct 1565). Son of (2) Pier Luigi Farnese. Like his elder brother, (3) Cardinal Alessandro Farnese, he entered the Church at an early age and was made Prior of the Knights of Malta and Archbishop of Naples before becoming a cardinal in 1545. The magnificence of Alessandro's artistic patronage has somewhat overshadowed the achievements of the short-lived Ranuccio. Their patronage was, moreover, intertwined since they frequently commissioned work from the same artists, and after Ranuccio's death Alessandro took over several of his ecclesiastical commissions. Ranuccio visited Venice in 1542, where Titian painted the magnificent portrait of him wearing the cloak of the Knights of Malta (Washington, DC, N.G.A.). In 1544 he commissioned Giorgio Vasari, who had already worked for Alessandro, to paint a pair of organ-shutters for Naples Cathedral (*in situ*). They show *Paul III among the Patron Saints of Naples* and a *Nativity with Cardinal Ranuccio Farnese and his Entourage*. Francesco Salviati, who had worked for both Pier Luigi and Alessandro, was commissioned to paint a fresco cycle in the *salotto* (Sala dei Fasti Farnesiani) of the Palazzo Farnese, depicting scenes from the Farnese family history (*see* SALVIATI, FRANCESCO, fig. 4). Possibly the artist was chosen in this case by Annibale Caro, then Ranuccio's secretary. Salviati may also have painted a portrait of Ranuccio: a sheet survives with sketches of both him and Caro (Venice, Accad.).

At Salviati's death in 1563, the *salotto* was incomplete, and the commission for the remaining two walls was awarded to Taddeo Zuccaro, who was simultaneously working at Alessandro's villa at Caprarola. In 1561 Ranuccio also commissioned a *Last Judgement* from Hendrik van den Broeck (*c*. 1530–97) for Farfa Abbey, which was one of his benefices. Although he purchased a villa at Frascati in 1562 from Cardinal Giovanni Ricci of Montepulciano (1497–1574), he effected few changes there before his death. The young Cardinal was protector of the Arciconfraternità del SS Crocefisso di S Marcello, Rome, at the time when they began building their oratory in 1562, later completed under Alessandro's patronage. Ranuccio was buried in the family mausoleum on Isola Bisentina, Lake Bolsena. Alessandro later had Giacomo della Porta erect a monument to him in S Giovanni in Laterano (the Lateran basilica), Rome.

BIBLIOGRAPHY

P. Litta: *Famiglie celebri italiani* (Milan, 1819–83), x, pl. xii

C. Pietrangeli and C. d'Onofrio: *Abbazie del Lazio* (Rome, 1971), p. 163

Fasolo, Giovanni Antonio (*b* Mandello del Lario, 1530; *d* Vicenza, 23 Aug 1572). Italian painter. Of Lombard origin, he was initially a pupil of Paolo Veronese and subsequently had a short, but successful career as a fresco and portrait painter in and around Vicenza. In 1551–2 he collaborated with Battista Zelotti and Veronese on frescoes for the Castello Porto–Colleoni, Thiene. Scenes such as the *Meeting of Sophonisba and Massinissa* are executed in the style of Veronese, but with a noticeably harder and drier edge and lacking Veronese's rich luminosity and effortless control of space. In 1555–6 Fasolo was employed as a minor assistant to Veronese at S Sebastiano, Venice, but emerged in his own right towards the end of the decade (1557–61), when he began producing stage designs for the Accademia Olimpica, Vicenza. In the 1560s he executed frescoes at several country villas: at the Villa Roberto (Brugine, nr Padua; *c*. 1564–5), the Villa Campiglia

(Albettone, nr Vicenza; *c.* 1565–7) and the Villa Caldogno (Caldogno, nr Vicenza; *c.* 1568–70). These last (e.g. the *Stolen Embrace*) are characterized by their contemporary air and informality, reproducing on a large scale the naturalistic tendencies—a possible Lombard inheritance—that underpin his style and become increasingly apparent in his portraiture.

In the companion portraits of *Paola Gualdo Bonanome with her Daughters Laura and Virginia* and *Giuseppe Gualdo with his Sons Paolo Emilio and Paolo* (*c.* 1566–7; Vicenza, Mus. Civ. A. & Stor.), Fasolo's most original works, penetrating individualization is combined with Veronese's firmness of structure, but the twisting, elongated forms of the sitters with their delicately spread fingers also demonstrate Fasolo's increasing interest in the stylizations of Parmigianino's *maniera*. Fasolo also produced altarpieces, for example the *Virgin of the Rosary* (*c.* 1570; Vicenza, Mus. Civ. A. & Stor.), although these typically lack the strength of his portraits and frescoes.

BIBLIOGRAPHY

G. Zorzi: 'Giovanni Antonio Fasolo pittore lombardo-veneto emulo di Paolo Veronese', *A. Lombarda*, vi (1961), pp. 206–26

L. Crosato: *Gli affreschi nelle ville venete del cinquecento* (Treviso, 1962), pp. 77–8

R. Pallucchini: 'Giambattista Zelotti e Giovanni Antonio Fasolo', *Boll. Cent. Int. Stud. Archit. Andrea Palladio*, x (1968), pp. 203–28

P. Boccardo: 'Per il catalogo di Palazzo Rosso: Quattro ritratti del Cinquecento', *Boll. Mus. Civ. Gen.*, xvi/47–9 (Jan–Dec 1994), pp. 41–50

TOM NICHOLS

Fattore, il. *See* PENNI, (1).

Fattorini. *See* SCHIAVON.

Fazio, Bartolomeo. *See* FACIO, BARTOLOMEO.

Federighi, Antonio (*b* ?1420; *d* Siena, 15 Jan 1483). Italian sculptor and architect. He served as *capomaestro* of the cathedral workshop in Siena for three decades (1450–81). During this period he was involved in almost every major public artistic enterprise undertaken in the city, which was revitalized following the election (1458) of Aeneas Silvius Piccolomini, a Sienese, as Pope Pius II. First mentioned as an apprentice in the cathedral workshop, Federighi was employed by Jacopo della Quercia in 1438 just before the latter's death. This brief association with della Quercia was crucial to the development of Federighi's robust, classicizing style.

In 1444 Federighi played a minor role in carving the tomb of *Bishop Carlo Bartoli* (Siena Cathedral) designed by Pietro del Minella (1391–1458). In 1445 he was paid for work on the chapel of S Ansano at Castelvecchio; this was probably limited to the design of four windows and a doorway (Mantura). In May 1451 Federighi received his first independent commission to create a marble intarsia for the exterior pavement of the central portal of the Sienese Baptistery. In September of the same year he was commissioned to carve three statues of saints for the Loggia di Mercanzia (Loggia di San Paolo), Siena, but the monies advanced to him were withdrawn in 1453, when he failed to deliver the figures within the specified time. From 1451 to 1456 Federighi served as *capomaestro* of

Orvieto Cathedral, which, no doubt, contributed to his failure to fulfil his Sienese obligations. He contributed some work to the cathedral façade, including the addition of niches to the topmost edge of the rose window, and designed a holy water basin for the interior. A statue mentioned in the documents cannot be identified, as has been customary, with the *Sibyl* on the left flank of the cathedral.

Federighi returned to Siena in 1457, lured, perhaps, by a more lucrative contract for the Loggia di Mercanzia, the decoration of which had remained dormant in his absence. In March 1457 his statue of *St Peter* (untraced) was already installed in a niche on the first pier of the Loggia. A second, documented, figure of *St Ansano* (*c.* 1458–9), on the adjacent pier, is reminiscent of della Quercia's *Angel Gabriel* (San Gimignano, Collegiata). The treatment of the massive tubular folds of S Ansano's robe recalls della Quercia's handling of the garments of the saints in the Trenta Altarpiece (Lucca, S Frediano). The figure of *St Vittore* (*c.* 1457–8; see fig.) on the third pier is less subtle but more dramatic; barely contained within the niche, the warrior saint gazes defiantly into the distance. The intensity of his expression is accentuated by the straining tendons of his neck and the exaggerated folds of his voluminous mantle. In spirit, the saint is reminiscent of Donatello's *St George* (Florence, Orsanmichele; see FLORENCE, fig. 11). Donatello was in Siena at this time (1457–61) and was offered the commission to carve a statue of *St Bernardino* (unexecuted) for the same Loggia.

A marble bench (*c.* 1459–64; *in situ*) for the Loggia, ornamented with reliefs of ancient Roman heroes on the front and the nursing she-wolf with her human charges on the reverse, has also been attributed to Federighi. The heavy foliated carving of the *all'antica* garlands demonstrates the sculptor's assimilation of both classical form and technique.

In 1459 Federighi was paid for a marble intarsia of the *Parable of the Blind* for the pavement of the choir of Siena Cathedral. The following year he began work on the Loggia del Papa, Siena (*c.* 1460–62), for Pius II. The small, three-bay loggia is exceptional for its lack of sculptural detail. The Pope's sister, Caterina, selected Federighi to work on the Palazzo Piccolomini, Siena (1462–3). It was probably designed by Bernardo Rossellino, with Federighi assuming a largely supervisory role. Federighi also executed the tomb monument to *Vittoria Fortiguerra and Silvius Piccolomini* (Siena, S Francesco, destr. 1655), the parents of the Pope. Pius composed the Latin epitaph located below the half-length posthumous portraits for which Federighi was paid in 1460.

Two holy water basins (Siena Cathedral), described as newly made in an inventory of 1467, are also attributed to Federighi. They resemble antique candelabra and are richly decorated with lush garlands, palmettes, sphinxes and dolphins. They combine antique motifs with contemporary fantasy; the four bound, nude figures ornamenting the neck of one of the basins are sometimes cited as the modest precursors of Michelangelo's *Slaves* (Paris, Louvre; Florence, Accad.; *see* MICHELANGELO, fig. 3) for the tomb of *Julius II*. A marble statuette of *Bacchus* (Siena, Monte dei Paschi) is related to the heroic, struggling nudes on the basin. All exhibit the same widespread stance, sinewy

In 1468 Federighi was involved in the construction of the upper storey of the chapel of the Campo, Siena. He designed the intarsia panel depicting the *Seven Ages of Man* for the cathedral (Siena, Mus. Opera Duomo) in 1475. In 1480 he was appointed supervisor of the water pipes that service the fountains of Siena. Federighi's increased civic responsibilities and absences due to illness meant that he spent less time in the cathedral workshop, and he was relieved of his duties as *capomaestro* in 1481. His last commission was to design a marble intarsia of the *Erythraean Sibyl* (1481–2) for the south aisle of the cathedral. An octagonal font for the chapel of S Giovanni Battista (Siena Cathedral) can no longer be regarded as an autograph work since the chapel was constructed after 1482. Various wooden sculptures, including the statuettes of *St Ambrose* and *St Augustine* and the larger *St Nicholas of Bari* (all Siena, Pal. Pub.), have been attributed to Federighi, but none of these figures is stylistically consistent with the sculptor's marble works.

BIBLIOGRAPHY

Thieme–Becker

G. Milanesi: *Documenti per la storia dell'arte senese*, 3 vols (Siena, 1854–6)

A. Schmarsow: 'Antonio Federighi de' Tolomei, ein sienesischer Bildhauer des Quattrocento', *Repert. Kstwiss.*, xii (1889), pp. 277–99

R. H. H. Cust: *The Pavement Masters of Siena, 1369–1562* (London, 1901)

P. Schubring: *Die Plastik Sienas im Quattrocento* (Berlin, 1907)

E. Carli: *La scultura lignea senese* (Milan and Florence, 1951)

B. Mantura: 'Contributo ad Antonio Federighi', *Commentari*, xix (1968), pp. 98–110

C. Del Bravo: *Scultura senese del quattrocento* (Florence, 1970)

A. Bagnoli: 'Antonio Federighi', *Jacopo della Quercia nell'arte del suo tempo* (Florence, 1975), pp. 294–305

J. T. Paoletti: 'Antonio Federighi: A Documentary Re-evaluation', *Jb. Berlin. Mus.*, xvii (1975), pp. 87–143

E. Carli: *Il Duomo di Siena* (Genoa, 1979)

——: *Gli scultori senesi* (Milan, 1980)

E. Richter: *The Sculpture of Antonio Federighi* (diss., Columbia U., New York, 1984)

L. Martini: 'Antonio Federighi', *Donatello e i suoi* (Florence, 1986), pp. 221–4

M. Masini, P. Rosa and B. Santi: 'Il restauro del pancale di A. Federighi, 1463 ca., nella Loggia della Marcanzia a Siena', *Kermes*, viii/23 (May–Aug 1995), pp. 20–27

ELINOR M. RICHTER

Federigo Parmense. *See* BONZAGNA, GIAN FEDERIGO.

Fei, Alessandro (di Vincenzio) [Barbiere, Alessandro del] (*b* Florence, ?1538–43; *d* ?Florence, 1592). Italian painter. As a youth he was an apprentice in the workshops of the Florentine painters Ridolfo Ghirlandaio and Pierfrancesco Foschi. From 1564 he was enrolled at the Accademia del Disegno in Florence, and in 1565 he began to work for Giorgio Vasari, painting a series of canvases for the decoration of the Salone del Cinquecento (Florence, Pal. Vecchio). Fei collaborated with Maso da San Friano, whose work in S Pietro in Gattolino, Florence, is linked stylistically to Fei's *Virgin Suckling the Infant Christ with Two Angels* of 1568. Around 1570 he painted one of his most famous works, the *Goldsmith's Workshop*, in the *studiolo* of Grand Duke Francesco I de' Medici in the Palazzo Vecchio (*in situ*), in which Tuscan late Mannerism is combined with an almost Flemish attention to narrative detail. In 1571, following Vasari, he was in Rome, where he worked in the Vatican on the papal chapels in the Torre Pio.

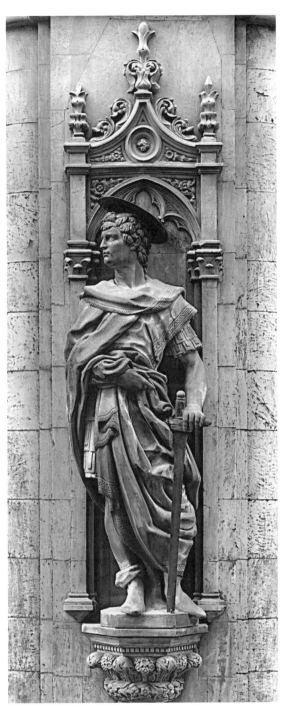

Antonio Federighi: *St Vittore*, marble, *c.* 1457–8 (Siena, Loggia di Mercanzia)

limbs, locked knees, ample pelvises and broad, muscular shoulders. The modelling of the *Bacchus* is, however, considerably softer as befits his inebriated, self-indulgent state. This faunlike creature, perhaps the first sculptural image of Bacchus since antiquity, represents a further development of Federighi's assimilation of the Classical vocabulary.

After Fei's return to Florence, he worked at Santa Croce, where he painted the signed and dated *Flagellation* (1575; *in situ*), which shows a mixture of Tuscan and Roman influences, particularly from the Zuccaro brothers. Other paintings from this period are the fresco for the great cloister of S Maria Novella, Florence, the *Annunciation* of S Nicolò Oltrarno and the *Virgin and Saints* in S Maria delle Grazie, Pistoia. In 1585 he painted four canvases of *Christ and the Apostles* for S Giovannino degli Scolopi, Florence. A year later he was commissioned by Lorenzo de' Medici to do his portrait. The *Virgin of the Rosary* (Vicchio di Mugello, S Giovanni Battista) and *S Pancrazio* (Valdelsa, parish church of S Pancrazio) are also from this period. In 1589 he collaborated on the festive decorations for the wedding of the Grand Duke Ferdinand I de' Medici and Christine of Lorraine. According to Borghini and Baldinucci (confirmed by Susinno), Fei spent some time in Messina, producing a cycle of 12 painted stone tiles set in the mosaic of the *Virgin of the Ciambretta* (Messina, S Gregorio). Following this, five stone tiles painted with scenes from the *Life of the Virgin* (*c.* 1582; Messina, Mus. Reg.) have been attributed to Fei.

BIBLIOGRAPHY

G. Vasari: *Vite* (1550, rev. 2/1568); ed. G. Milanesi (1878–85), vii, pp. 620–21

R. Borghini: *Il riposo* (1584); ed. M. Rosci (Milan, 1967), pp. 632–7

F. Baldinucci: *Notizie* (1681–1728); ed. F. Ranalli (1845–7), rev. P. Barocchi (Florence, 1974), iii, pp. 527–8

F. Susinno: *Le vite de' pittori messinesi* (MS.; 1724); ed. V. Martinelli (Florence, 1960), p. 94

A. M. P. Tofani: 'Firenze e la Toscana dei Medici nell'Europa del cinquecento', *Il primato del disegno* (exh. cat., ed. L. Berti; Florence, Pal. Strozzi, 1980), p. 111

F. Campagna Cicala: 'Presenze fiorentine a Messina nella seconda metà del cinquecento', *Quad. Ist. Stor. A. Med. & Mod.*, 9–10 (1985–6), pp. 21–37

GIOVANNA FAMA

Fei, Paolo di Giovanni. *See* PAOLO DI GIOVANNI FEI.

Felice, Matteo [Mazzeo] (*fl* 1467–93). Italian illuminator. He commanded a sizeable patronage at the Aragonese court and among religious institutions of the Kingdom of Naples–Sicily. His colourful miniatures are eclectic with characteristic boldly outlined, childlike figures. He apparently trained with Cola Rapicano, and such manuscripts as Albertus Magnus's *Summa* (U. Valencia, Bib., MS. 820) seem to have been cooperative ventures by the two men. The earliest record concerning a manuscript that Felice illuminated independently is a payment in 1467 for a volume combining Boethius's *Consolation of Philosophy* and Vergerio's *De ingenuis moribus* (Rome, Vatican, Bib. Apostolica, MS. Pal. lat. 1470). Here he adopted the white intertwined vine-scroll borders that had become the trademark of Gioacchino de Gigantibus de Rottenburg, who was active in Naples at the same time.

Felice, to a greater degree than Rapicano, sought his own style in Catalan versions of south Netherlandish modes that Lleonard Crespi, Alfonso di Cordova (*fl c.* 1442–58) and others had developed, creating miniatures with open, luminous landscapes inhabited by many figures. His borders are constructed of short, symmetrical flower sprigs in which nestle putti, fauna and medallions. Single initials are enlivened with delicately painted vine-scrolls.

Most appealing among his many works is a series of Books of Hours: that made for Isabella di Chiaromonte (Cambridge, MA, Harvard U., Houghton Lib., MS. Typ. 463), for her son Alfonso when Duca di Calabria (London, V&A, MS. 2397) and a third now in Trieste (priv. col.). As accomplished are a Breviary (U. Valencia, Bib., MS. 662) and a Psalter (New York, Pub. Lib., Spencer MS. 130). Felice also contributed six miniatures to the Codex of S Marta (Naples, Archv Stato, MS. 99.C. I.) and decorated a number of theological and Classical texts, such as Duns Scotus's *Commentaries* (Berlin, Staatsbib. Preuss. Kultbes., MS. 52), St Thomas Aquinas's Commentary on the book of Isaiah (Paris, Bib. N., MSS lat. 495 and 674) and works of Plato (London, BL, Harley MS. 3481).

BIBLIOGRAPHY

T. De Marinis: *La biblioteca napoletana dei re d'Aragona*, 4 vols (Milan, 1947–52); *Supplement*, 2 vols (Verona, 1969) [with additions by J. Ruysschaert]

——: 'Codici miniati a Napoli da Matteo Felice nel secolo XV', *Contributi alla storia del libro italiano: Miscellanea in onore di Lamberto Donati* (Florence, 1969), pp. 96–103

A. Daneu Lattanzi: 'Di alcuni codici miniati attribuibili a Matteo Felice e bottega (e di qualche altro codice della scuola napoletana del quattrocento)', *La Bibliofilia*, lxxv (1973), pp. 1–43

A. Putaturo Murano: *Miniature napoletane del rinascimento* (Naples, 1973)

G. Toscano: 'Tre miniatori rinascimentali a Napoli, Roma e Ferrara: Matteo Felice, un miniatore al servizio dei Re d'Aragona di Napoli', *Boll. A.*, lxxx (Sept–Dec 1995), pp. 87–118

PATRICK M. DE WINTER

Felix V, Pope. *See under* SAVOY.

Felsina. *See* BOLOGNA.

Feltre, Morto da. *See under* LUZZO, LORENZO.

Feltrini, Andrea (di Giovanni di Lorenzo) [Andrea di Cosimo] (*b* Florence, 1477; *d* 12 May 1548). Italian painter. Vasari noted that Andrea was a student of Cosimo Rosselli and then of Lorenzo Luzzo, whose names he appended to his own. Through the latter, who arrived in Florence from Rome *c.* 1505, he became aware of the archaeological classicism dominant in Rome from at least the 1480s. He mastered the vocabulary of Classical motifs, especially the grotesques inspired by examples in the newly excavated Domus Aurea, and Vasari credited him with the idea of using them in *sgraffito* decorations of palace façades, which brought him fame among his contemporaries. He was much in demand in Florence to decorate houses in what was believed to be the fashion of imperial Rome, and the façades of the Palazzo Lanfredini (1515) and Palazzo Sertini (1515–20), both now restored, indicate the extremes to which Classical motifs were developed in Florence. Andrea was also in demand by his fellow artists: in 1515, for example, he collaborated with Ridolfo Ghirlandaio and Jacopo Pontormo on the decoration of the Cappella dei Papi in S Maria Novella, Florence. The grotesques on the walls and vault can be attributed to Andrea and, perhaps, the *all'antica* organization of the latter. For the execution of these large projects, he formed a partnership with Mariotto di Francesco and Raffaello di Biagio, who assisted him in his later years in the preparation of decorations for festivals and Medici weddings.

BIBLIOGRAPHY

G. Vasari: *Vite* (1550, rev. 2/1568); ed. G. Milanesi (1878–85), v, pp. 201–10

C. Thiem and G. Thiem: 'Andrea di Cosimo Feltrini und die Groteskendekoration der Florentiner Hochrenaissance', *Z. Kstgesch.*, xxiv (1961), pp. 1–39

——: *Toskanische Fassaden-Dekoration in Sgraffito und Fresko: 14. bis 17. Jahrhundert* (Munich, 1964), pp. 31–3

J. Cox-Rearick: *Dynasty and Destiny in Medici Art: Pontormo, Leo X and Two Cosimos* (Princeton, 1984)

MARJORIE A. OCH

Ferdinando I, Grand Duke of Tuscany. *See* MEDICI, DE', (17).

Fermo da Caravaggio. *See* GHISONI, FERMO.

Ferrara. Italian city in Emilia-Romagna, situated on the delta of the River Po. It was the centre of a flourishing court under the Este family from the 13th century to the 16th (*see* ESTE). A noted example of early Renaissance urban planning, it was also the centre of a distinctive school of painting and of tapestry-weaving. The city is divided into two distinct sections, medieval to the south and Renaissance to the north.

1. History and urban development. 2. Art life and organization. 3. Centre of tapestry production. 4. Palazzo Schifanoia

1. HISTORY AND URBAN DEVELOPMENT.

(i) Introduction. Ferrara lies on the left bank of a subsidiary channel running south from the Po, known as the Po di Ferrara, at the point where this divides into the Po di Volano and the Po di Primaro. The city originated on the right bank within this divide, centred on the cathedral of S Giorgio, built in the 7th century AD (altered). In 986 Ferrara was placed under the rule of Tedaldo, Count of Modena and Canossa (988–1012), son of Emperor Otto I, who built Castel Tedaldo (destr. 1608) on the left bank. In 1106 the relics of the city's patron saints, George and Maurelius, Bishop of Voghenza and Ferrara (*d* 644), were brought to the cathedral. After the death of Matilda of Canossa in 1115, Ferrara became a free comune, and the centre of the city was transferred to the left bank of the river.

Ferrara was a centre of strife between the Guelph (papal) and Ghibelline (imperial) factions, but from 1242, when Azzo II (*reg* 1215–22; 1240–64) established control of the city with Venetian help, it was ruled by the Este family, who remained in power until 1598. A Venetian representative, Visdomino, was retained there. Ferrara was papal territory, but the Este family were made papal vicars, subject to the payment of the *census vicariatus*. Alberto (*reg* 1361–93) obtained other privileges after a pilgrimage to Rome in 1391, commemorated by a statue and inscription on the cathedral façade. He also founded the university.

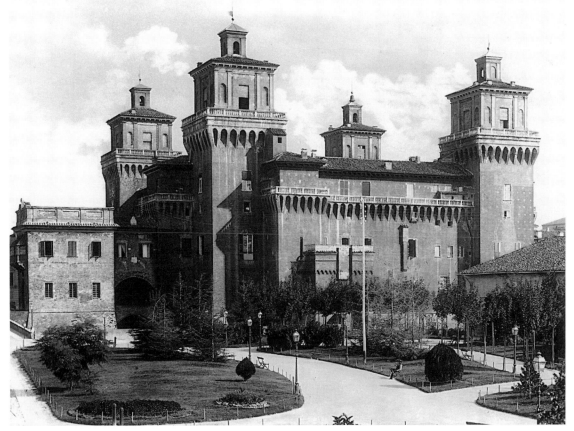

1. Ferrara, Castello Estense, begun 1385; the towers were modified in 1570

In the long period of peace under Alberto's heir, his young son Niccolò III (*reg* 1393–1441), the city achieved international importance, the ecumenical Council of Ferrara in 1438 providing the most significant testimony to Niccolò's reputation as a mediator. The Este family retained and increased their power and prestige through a mixture of political astuteness and advantageous marriages, but the disastrous war with Venice waged from 1482 to 1484 by Ercole I (*reg* 1471–1505) and Ercole's subsequent intrigues to regain lost territory were partly responsible for encouraging the invasion of Italy by the French king Charles VIII (*reg* 1483–98). Francophile policies were continued by Alfonso I (*reg* 1505–34), and the Calvinist sympathies of Renée of France (1510–75), wife of Ercole II (*reg* 1534–59), created further discord between the increasingly powerful papacy and the Este family. After the death without a legitimate heir of Alfonso II (*reg* 1559–97), the troops of Pope Clement VIII occupied Ferrara.

(ii) Este patronage. The first important Este building was the Palazzo del Corte (now the Palazzo Comunale), begun by Azzo II in 1242 at the west end of the Piazza Maggiore facing the cathedral. In 1283 the Torre de Rigobello (destr. 1593), a clock-tower facing down the square, was built by Obizzo I (*reg* 1264–93). In 1385 Niccolo II (*reg* 1361–88) founded the large, imposing moated fortress (Castello Vecchio or Estense; see fig. 1) that still dominates the city, on what was then its northern edge. The castle was linked to the Corte by a corridor, the Via Coperta, in 1471 (raised 1499), and the two formed the focus of court life until the Este family left Ferrara, although Alberto rebuilt Castel Tedaldo and Niccolò III built the Castello Nuovo (1425–35, destr. 1562) on the riverbank downstream. It was in the Corte that Pope Eugenius IV was entertained during the Council of Ferrara.

Alberto built the Palazzo Schifanoia (*see* §4 below) south-east of the city centre and the villa of Belfiore to the north. Belfiore was continued by Niccolò III, who added near by the church and monastery of S Maria degli Angeli. Both buildings were linked to the city by a poplar-lined avenue (Via dei Pioppini, Via degli Angeli, Corso Vittorio Emanuele, Corso Ercole d'Este). Niccolò III also built the most famous Este *delizia* (palace), the great villa of Belriguardo (destr.) *c.* 15 km south-east of Ferrara.

Under Leonello (*reg* 1441–50) the first elements of architectural decoration in the new Renaissance style were introduced in the *volta del Cavallo*, an arch to support Niccolò Baroncelli's bronze equestrian statue of *Niccolò III*, begun in 1443 (destr. 1796). This pedestal has been attributed to Leon Battista Alberti, who judged the competition for the statue, but there is no documentary foundation for this claim, nor for the claim that he designed the cathedral bell-tower (1451–1596), which was continued by Borso d'Este. Borso extended the city by enclosing an area to the east, the Addizione Borsiana, but his most important building was the Certosa (1452–61) to the north-east, parts of which have been incorporated into the city cemetery. A richly decorated palace was also built there for his own use.

In the late 15th century under Ercole I, Ferrara was transformed and enlarged. In preparation for his marriage in 1473 a series of balconies, one adorned with medallions representing the *Twelve Caesars*, was added to the Torre de Rigobello to provide better viewpoints in the main square. A raised platform supported by a columnar arcade was built along the side of the cathedral. For the first 20 years of his rule Ercole concentrated on the Corte, which by the time of his death had been transformed into a worthy ducal residence by his architects Pietro de Benvenuti (*fl* 1458–84) and Biagio Rossetti. The Corte included the Cortile Grande, with an external staircase built in 1479 by Benvenuti; the court chapel, which possessed one of the finest choirs in Europe; and a garden court overlooked by guest rooms and the duke's private apartments and studio. The private rooms were connected by the Camere Dorate, a series of gilded state rooms (built 1479–81), to the Sala Grande (50×16 m), where the most important court festivals and theatrical entertainments were held. Beneath the Sala Grande was an arcade of 25 columns with shops, but they were both destroyed by fire in 1532, only a fragment surviving. The Sala dalle Commedie was the first purpose-built Renaissance theatre (1503), but Ercole died before it was finished. In the Castello Vecchio apartments were prepared for the duchess (1477), who had a garden to the north across the moat, with a pavilion surmounted by a statue of *Hercules*. This survived until 1655, when it was cleared away to allow the Via degli Angeli to extend to the castle moat, but it was described in detail by Ercole's eulogist Giovanni Sabadino degli Arienti (*d* 1510). In the town Rossetti also began the Palazzo di Lodovico il Moro (now the Museo Nazionale Archeologico), which he left unfinished in 1503, with a fine arcaded cortile.

In 1492 Ercole and Rossetti began the extension north of the city, later known as the Addizione Erculea. A defensive moat was dug to enclose the Certosa, S Maria degli Angeli, Belfiore and the Barco, the ducal hunting park, all of which had been damaged in the war with Venice. A circuit of walls was begun (completed by Alfonso I and his successors). Rossetti built the first part of the walls and is generally credited with the overall plan of the Addizione, but it was done in consultation with Ercole, who took a close personal interest in all his projects. Some of the roads in the Addizione already existed, but the layout of the straight, wide streets and the Piazza Nuova (now the Piazza Ariostea), surrounded by arcaded palaces, was an important advance in town planning. Some of the palaces located on the principal crossroads survive, notably the Palazzo dei Diamanti (begun 1493 by Rossetti, remodelled 1565; damaged 1943; *see* ROSSETTI, BIAGIO, fig. 1), which is atypically faced in marble (diamond-shaped blocks) rather than brick. Particularly pious towards the end of his life, Ercole founded fourteen new monasteries or churches and contributed to the cost of nine others, but not all survive. S Francesco (1227) was partly rebuilt by Rossetti in 1494 (*see* ROSSETTI, BIAGGIO, fig. 2) and its bell-tower added in 1605.

Ferrara's population, estimated at *c.* 38,000 in 1500, did not expand to fill the new extension. After disastrous earthquakes in 1570 resources were concentrated on repairing damage, including the raising of Castello Vecchio by Alessandro Balbi. Giovanni Battista Aleotti refaced the Palazzo Bentivoglio with stone rustication, scrolls and

trophies, and between 1579 and 1594 he and Balbi added a fourth storey to the cathedral bell-tower. Under the rule of the papal legates from 1598, the only substantial building work was the pentagonal fortress built in 1608, including the site of the Castel Tedaldo (moat filled in 1858, fortress destr. 1859) by Aleotti, who also added a floor to the Palazzo del Ragione in 1603 and in 1610 designed a new façade for the Palazzo del Paradiso, an Este palace of 1391 that was the seat of the university from 1586 until 1962.

BIBLIOGRAPHY

G. Sabadino degli Arienti: *De triumphis religionis* [*c.* 1500]; ed. W. Gundersheimer as *Art and Life at the Court of Ercole I d'Este* (Geneva, 1972)

A. Frizzi: *Memorie riguardanti per la storia di Ferrara*, 4 vols (Ferrara, 1791–1809/*R* 1848)

F. Bonasera: *Forma veteris urbis Ferrariae* (Florence, 1965)

L. Chiappini: *Gli Estensi* (Varese, 1967)

B. Zevi: *Biagio Rossetti* (Turin, 1970)

W. Gundersheimer: *Ferrara: The Style of a Renaissance Despotism* (Princeton, 1972)

C. M. Rosenberg: 'The Erculean Addition to Ferrara: Contemporary Reactions and Pragmatic Considerations', *Acta: Conference on the Early Renaissance: Binghamton, NY, 1978*, pp. 51–3

F. Bocchi: 'La "Terranova" da campagna a città', *La corte e lo spazio: Ferrara Estense*, i (Rome, 1982), pp. 167–92

T. J. Tuohy: *Studies in Domestic Expenditure at the Court of Ferrara, 1451–1505: Artistic Patronage and Princely Magnificence* (diss., U. London, 1982), pp. 257–63 [palace reconstruction]

P. Ravenna: *Le Mura di Ferrara* (Modena, 1985)

T. J. Tuohy: *Herculean Ferrara, Ercole d'Este (1471–1505) and the Invention of a Ducal Capital* (Cambridge, 1996)

C. M. Rosenberg: *The Este Monuments and Urban Development in Renaissance Ferrara* (Cambridge, 1997)

2. ART LIFE AND ORGANIZATION. Most Ferrarese art production was centred on the Este court. The large numbers of religious paintings produced to decorate the churches, many of which had been built by the Este family, were, however, often commissioned by patrons not directly involved with the court, and as religious art has survived better than court art, an imbalance has been created. The great period of Ferrarese art production coincided with the Este ascendancy in the 15th and 16th centuries.

Obizzo I (*reg* 1264–93) suppressed the guilds in 1287, and no important painter emerged in the 14th century. Antonio Alberti depicted scenes from the Council of Ferrara in the Palazzo del Paradiso after 1438, and other painters working for the Este family in the mid-15th century included Rogier van der Weyden (*c.* 1399–1464), Piero della Francesca, Jacopo Bellini and PISANELLO, whose portraits and medals provide the most evocative images of the court of Leonello d'Este. The first important painter of Ferrara was COSIMO TURA, who can be considered as the founder of the school of Ferrara. His most important followers were FRANCESCO DEL COSSA and ERCOLE DE' ROBERTI, although they both produced some of their most important work in Bologna, as did Lorenzo Costa (i). Lodovico Mazzolino specialized in highly detailed, small-scale paintings, but the influence of manuscript illumination was characteristic of the early Ferrarese school, and even large paintings were very detailed. Influenced by Ercole I's penitential mood, Ferrarese art at the end of the 15th century suffered a fallow period, represented by the bleak images of Michele di Luca dei Coltellini, Gian Francesco de' Maineri and Domenico Panetti (1460–1512).

In the early 16th century Ferrara was renowned for artillery personally produced by Alfonso I. The duchy was under constant threat, and the Duke was unable to indulge in serious artistic patronage until after the death of Pope Julius II in 1513. Then he commissioned mythological scenes for his rooms in the Via Coperta from Giovanni Bellini (*Feast of the Gods*, 1514; Washington, DC, N.G.A.) and Titian (*Bacchus and Ariadne*, 1523; London, N.G.; *see* TITIAN, fig. 4) in Venice, and the main influences on 16th-century Ferrarese painting became the Venetians, notably Giorgione, and Raphael. The most significant painters of the time include Battista and Dosso Dossi, GAROFALO, Ortolano, GIROLAMO DA CARPI, Giuseppe Mazzuoli, Camillo Filippi and his son Sebastiano II, and SCARSELLINO, whose works survive in many churches, including S Paolo, S Domenico and S Francesco. The Ferrarese school came to a triumphant conclusion with the elegant large-scale works of Carlo Bononi (e.g. S Maria in Vado).

A court environment required particular services of painters. The Salone dei Mesi painted by Cossa and others in the Palazzo Schifanoia (*see* §4 below) depicting activities at the court of Borso d'Este is the only surviving example of a common type of decoration. Many rooms at Belfiore and Belriguardo were painted with courtly scenes (destr.). The production of dynastic and courtly images of record was an important task of court painters. The complex astrological programme of the Salone dei Mesi may have been unusual, but Ferrara was an important centre for the production of tarot cards. Ephemeral work was also required of painters. Theatrical performances were a regular feature of Ferrarese court life after 1487, and Dosso Dossi painted scenery for the plays of Ludovico Ariosto, de' Roberti designed triumphal arches, Tura painted tournament costumes, Carpi painted carriages, and many painters were involved in the decoration of *bucintori*, the state barges that navigated the Po, as well as marriage chests, bridal beds and cradles. Carnival masks from Ferrara were much in demand in Milan and Rome. Ferrara's reputation as a centre for theatrical performance reached new heights after the 1560s, when Cornelio Bentivoglio I (*see* BENTIVOGLIO, (3)) staged ever more spectacular jousts and musical dramas, which were continued by his son Enzo.

Sculptors were also required to produce ephemera for state visits or weddings, but the normal sculptural material was terracotta, as in the rest of Emilia, and life-size, free-standing groups, particularly of the *Lamentation*, were common; Ludovico de Castellani (*fl* 1456–1505) and Alfonso Lombardi both made such groups. Terracotta or cast stucco were used in interior decoration: the Sala degli Stucchi in the Palazzo Schifanoia is the only surviving example, but Tura's chapel at Belriguardo and a room at the Palazzo della Certosa (both destr.) had similar rich decoration. Although the equestrian statue of *Niccolò III* (1443–51) by the Florentine NICCOLÒ BARONCELLI and his assistant DOMENICO DI PARIS, the first bronze equestrian statue of the Renaissance, was destroyed in 1796 together with another bronze statue of *Borso d'Este* (1454), an over life-size bronze *Crucifixion* group by these sculptors survives in the cathedral. Alfonso Lombardi worked in terracotta and marble, mostly in Bologna. Antonio

Lombardo of Venice carved the finest marble reliefs in Ferrara, which were perhaps intended for Alfonso I's 'camerino di alabastro' (1506–16; Florence, Bargello; St Petersburg, Hermitage).

Wood inlay (intarsia) and carving (intaglio) was provided by Arduino da Baisio (*fl* 1406–53) and the brothers Christoforo Canozzi da Lendinara (*d* 1491) and Lorenzo Canozzi da Lendinara (*d* 1477), who decorated *studioli* for Leonello and Borso d'Este. Stefano de Donabona (*fl* 1472–1503) made inlaid doors for Ercole I and carved the architectural elements of the Camere Dorate. Tapestry was an important element of palace decoration, and most Ferrarese painters furnished designs (*patroni; see* §3 below). Under Borso, Ferrara was an important centre for manuscript illumination, and his Bible (1455–61; Modena, Bib. Estense, MS. V.G. 12–13, lat. 422–3) was one of the most expensive books produced in Italy. Illuminators included Taddeo Crivelli, Franco dei Russi and Guglielmo Giraldi. Ferrarese art is widely dispersed. In 1598 Cardinal Pietro Aldobrandini removed many paintings to Rome, and Cesare d'Este removed most of the collections to Modena. In 1746 Augustus III of Poland (*reg* 1733–63) acquired many of the best Este pictures (Dresden, Gemäldegal. Alte Meister). During the Napoleonic period most religious institutions were suppressed and their paintings gathered together to form the nucleus of the Pinacoteca Nazionale in the Palazzo dei Diamanti.

BIBLIOGRAPHY

G. Baruffaldi: *Vite de' pittori e scultori ferraresi* [*c.* 1697–1722]; ed. G. Boschini, 2 vols (Ferrara, 1844–6)

G. Campori: 'I miniatori degli Estensi', *Atti & Mem. RR. Deput. Stor. Patria Prov. Moden. & Parm.*, vi (1872), pp. 142–274

——: 'L'arazzeria Estense', *Atti & Mem. RR. Deput. Stor. Patria Prov. Moden. & Parm.*, viii (1876), pp. 415–80

A. Venturi: 'I primordi del rinascimento artistico a Ferrara', *Riv. Stor. It.*, i (1884), pp. 591–631

G. Campori: *Gli artisti italiani e stranieri negli stati Estensi* (Modena, 1885)

A. Venturi: 'L'arte ferrarese nel periodo di Borso d'Este', *Riv. Stor. It.*, ii (1885), pp. 689–749

——: 'L'arte ferrarese nel periodo di Ercole d'Este', *Atti & Mem. Regia Deput. Stor. Patria Prov. Romagna*, n. s. 2, vi (1888), pp. 350–422; vii (1889), pp. 368–412

G. Gruyer: *L'Art ferrarais à l'époque des princes d'Este*, 2 vols (Paris, 1897)

E. G. Gardner: *The Painters of the School of Ferrara* (London, 1911)

La pittura ferrarese del rinascimento (exh. cat., Ferrara, Pin. N., 1933)

R. Longhi, ed.: *Officina ferrarese* (Rome, 1934)

A. Venturi, ed.: *La bibbia di Borso d'Este* (Milan, 1937)

S. Zamboni: *Pittori di Ercole I d'Este* (Milan, 1975)

J. Manca: *The Art of Ercole de' Roberti* (Cambridge, 1992)

A Ballarin: *Dosso Dossi: la pittura a Ferrara negli anni del Ducate di Alfonso I*, 2 vols (Padua, 1994–5)

S. J. Campbell: *Cosmè Tura of Ferrara: Style, Politics and the Renaissance City, 1450–1495* (New Haven, 1997)

P. Humfrey and M. Lucco: *Dosso Dossi: Court Painter in Renaissance Ferrara* (exh. cat., ed. A. Bayer; Ferrara, Pin N.: New York, Met.; Los Angeles, Getty Mus., 1998–9)

THOMAS TUOHY

3. CENTRE OF TAPESTRY PRODUCTION. The collection of northern European tapestries owned by the Este family was already large by 1436, when the family began to follow the lead of the Gonzaga in Mantua in hiring French and Flemish master weavers to care for them, to weave new tapestries and to act as liaisons with northern workshops for larger commissions. Tapestry patronage varied in tenor with political events and with each succeeding ruler. The first Flemish weavers were hired under Niccolò III d'Este, Marchese of Ferrara, who had bought many prestigious northern sets. Jacomo de Flandria de Angelo (*fl* 1436) is the first mentioned, hired apparently to repair tapestries. He was joined by another master, Pietro di Andrea di Fiandra (*fl* 1441–71), in 1441. Rinaldo Boteram (pseud. di Gualtieri; *fl* 1438–81) from Brussels, one of the most famous northern weavers in Italy during the 15th century, may have already worked for Niccolò before he set up shop in Siena in 1438.

It was apparently Niccolò's son, Leonello d'Este, however, who first encouraged the weaving of new tapestries in the city on a large scale. In 1444, probably because of the rich tapestry displays planned for his second marriage to Maria of Aragon, Leonello not only bought and borrowed many sets but also attracted many master weavers including Boteram, who, although he moved to Mantua in 1448, continued to serve as a go-between for court orders of larger tapestries from the north for over 30 years. Another important master, Livinus Gilii de Burgis (*fl* 1444–after 1473), also arrived in 1444 and worked in Ferrara, except for a short period in Florence (1455–7), until he went to Milan in 1463; he returned briefly to Ferrara in 1473. None of the tapestries woven in Ferrara for Leonello or the many more woven for his successor, Borso d'Este, has survived, but documents indicate that most were small pieces such as altar frontals, bench-backs and bed covers and hangings, often of precious materials and from cartoons by the city's finest painters, particularly Cosimo Tura. The Paris master Renaud de Maincourt (pseud. Rainaldo de Man Curta; *fl* 1451–7) was in Ferrara briefly in 1457, the year another French weaver, Rubinetto di Francia (*fl* 1457–84), began working there. Giovanni Lattres of Arras (*fl* 1461–7; *d* by 1471) is also documented mainly in Ferrara, except for a brief stay in Venice between 1462 and 1464. Giovanni Mille (*fl* 1464–5) and Rinaldo Grue (*fl* 1464–71), two weavers from Tournai (now in Belgium), arrived in Ferrara in 1464; in 1470 Rigo d'Alemagna (*fl* 1470–74) arrived and was most active under Borso's successor, Ercole I d'Este. The only 15th-century Ferrarese tapestries to survive are two versions of a *Pietà* (*c.* 1475–6; Lugano, Col. Thyssen–Bornemisza, and Cleveland, OH, Mus. A.) woven by Rubinetto di Francia from a cartoon by Tura, which illustrate the high quality of both design and weaving that must have characterized Ferrarese production in this period.

During the later rule of Ercole I and under the great painting patron Alfonso I d'Este, there was a hiatus in Ferrarese tapestry production, until it was revived under Ercole II d'Este. The brothers Giovanni Karcher (*fl* 1517–62) and Nicolas Karcher (*d* 1562) had possibly been active in Ferrara by 1517, mainly repairing tapestries. In 1536 Ercole II sent Nicolas to Brussels to recruit eight weavers, including Jan Rost (*fl* 1535–1564), to establish a proper court factory. Another northern weaver, Gerardo Slot (*fl* 1537–42), is documented working independently at the court at this time. Ercole began commissioning ambitious sets of large tapestries from these masters as an integral part of his extensive redecorating programme for his palace and other residences. Among those who painted the cartoons were the Dossi brothers, Giulio Romano, Girolamo da Carpi, Leonardo da Brescia (*fl* 1544; *d* 1598) and Garofalo. Only a few of these tapestries survive,

including the remains of the five *Metamorphoses* (*c.* 1544–5; two tapestries, Paris, Louvre; fragments, priv. cols) after cartoons by Battista Dossi, and seven *Pergoline* (*c.* 1556–9; one tapestry and two fragments, Paris, Mus. A. Déc.) from cartoons by Leonardo da Brescia. A series of eight *Stories of SS George and Maurelius* woven by Karcher's workshop for Ferrara Cathedral from cartoons (1550–53) by Garofalo, Camillo Filippi and Luca d'Olanda (*fl* 1536–54) is *in situ*.

During the reign of Alfonso II d'Este, tapestry production again declined. Giovanni Karcher's son Luigi Karcher (*d* 1580), who was a painter as well as a weaver, inherited the Karcher workshop in 1562. His major surviving work is a tapestry of the *Marriage of the Virgin* from a cartoon by Camillo Filippi and his son Sebastiano Filippi II for the *Life of the Virgin* cycle in Como Cathedral (1569–70; *in situ*). After Luigi's death, tapestry weaving effectively ended in Ferrara.

BIBLIOGRAPHY

G. Campori: *L'arazzeria Estense* (Modena, 1876/*R* Sala Bolognese, 1980)

A. Venturi: 'Le arti minori a Ferrara nella fine del sec. XV: L'arazzeria', *L'Arte*, xii (1909), pp. 207–10

M. Viale Ferrero: *Arazzi italiani del cinquecento* (Milan, 1963), pp. 18–22, 45, 50–51

C. Adelson: 'The Decoration of Palazzo Vecchio in Tapestry: The *Joseph* Cycle and Other Precedents for Vasari's Decorative Campaigns', *Atti del convegno Vasariano: Arezzo, 1981*, pp. 170–73

N. Forti Grazzini: *L'arazzo ferrarese* (Milan, 1982); review by C. Adelson in *Burl. Mag.*, cxxvii (1985), pp. 307–8

Arazzi del cinquecento a Como (exh. cat., ed. N. Forti Grazzini; Como, Cathedral, 1986), pp. 57–60

CANDACE J. ADELSON

4. Palazzo Schifanoia. The palazzo, located in the south-eastern section of Ferrara just within the Renaissance city walls, owes its present shape to four separate building campaigns undertaken by members of the Este family. According to the Ferrarese chronicler Ugo Caleffini, the palazzo first built by Alberto V in 1385 was a small, single-storey edifice. In 1391, Alberto enlarged the building to twice its original length and by a third of its depth. He also connected it internally to an adjoining building on the eastern side, raised the main floor to accommodate a sunken cellar and added a large loggia to the back of the palazzo at the western end. A general idea of the composition of the rooms is conveyed through an inventory of the palazzo's contents made in 1436. The rooms were named after their decoration: 'deli alifanti, dele donzeli et cimeri, di san zorzo, dale pigne and dale rode' (elephants, maidens and crests, St George, pines and wheels).

Borso d'Este began extensive remodelling of the palazzo some time after 1465. The earliest document is dated 28 February 1468, and building work appears to have been finished by the end of 1469. He added a *piano nobile* at the second-storey level (above the former main floor), extended a staircase from the garden to the new *piano nobile*, added an elaborate marble doorframe to the main entrance and repainted the decorative geometric frescoes on the façade of the building. Three of the rooms decorated for Borso are still extant: the Sala degli Stemmi, the Sala degli Stucchi and the Salone dei Mesi.

In 1493 Ercole I enlarged the palazzo to the east and transformed its 'medieval' appearance by replacing the

merloned roofline with an oversized, classically inspired terracotta cornice. Until the late 16th century the Palazzo Schifanoia was used by the Este family both as a suburban retreat and as a lodging house for important visitors. In 1438, during the Council of Ferrara, Demetrius (*d* 1460), brother of Emperor John VII Palaiologos (*reg* 1425–48), was housed there; in 1468 three of the Sforza brothers stayed there, and in 1471 the Venetian ambassador and his family were placed there. In 1482, however, Cardinal Francesco Gonzaga wrote to his *camerario*, Giovan Francesco Strata, saying that he preferred not to be put up at the Schifanoia because it was a long way from the centre and stuffy in winter. In 1538, the palazzo became the residence of the retired Archbishop of Ravenna, Cardinal Benedetto Accolti.

The internal decoration of the Palazzo Schifanoia has suffered greatly through neglect, abuse and inexpert restorations carried out early in the 19th century. The Sala degli Stemmi contains remains of a series of frescoed medallions with the Este coat of arms and the personal imprese of Borso d'Este. Most of the frescoes have disappeared, but the massive and highly elaborate stucco frieze (*c.* 2.5 m high) containing six sculpted, polychrome, nearly life-size, seated figures of the *Virtues* set within shallow niches has survived. The decoration was begun by Domenico di Paris and Bongiovanni di Geminiano some time after April 1467 and was finished before the end of 1469. The room was apparently used as an audience chamber. It has been suggested that Borso d'Este, when seated on his throne in this room, would have been seen as the embodiment of the missing virtue of Justice.

The Salone dei Mesi, although severely damaged and with little more than half of the frescoes surviving, is the major monument of 15th-century Ferrarese art. The room measures 24×11×7.5 m. The walls are divided by painted grisaille pilasters into eighteen sections. Six sections are frescoed with jousting scenes and cityscapes; the remaining twelve are dedicated to the months of the year; hence the name of the room. They run chronologically anti-clockwise and are divided into three horizontally superimposed zones. The upper section of each panel illustrates the triumphal procession of the pagan god or goddess of the month following the list provided by the ancient Roman astrological poet Marcus Manilius (*Astronomica*, ii, 439–47). The pictorial models for these gods were drawn primarily from the text and illustrations of the late medieval mythographic handbooks. The middle zone shows the zodiacal sign of each month surrounded by three astrological demi-gods, called decans after their function of dividing the 30° of each astrological month into three segments of 10°. The representation of the decan-gods were probably drawn from a contemporary manuscript containing a severely edited and textually contaminated version of the Latin translation of Abu Ma'shar's *Introductorium in astronomiam*, made by Hermannus Dalmata. The lowest zone of the panels contains scenes of daily life at the court of Borso d'Este.

Two contemporary documents mention the decoration of the Salone dei Mesi: the first is a letter to Borso d'Este from Francesco del Cossa dated 25 March 1470, in which he identifies himself as the author of the three panels on the eastern wall (the zodiacal months of Aries, Taurus and

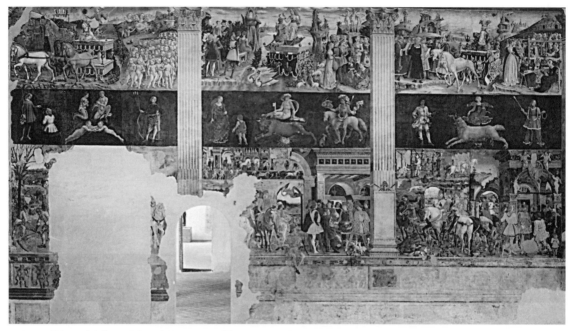

2. Ferrara, Palazzo Schifanoia, Salone dei Mesi, *Aries, Taurus, Gemini,* frescoes on the eastern wall by Francesco del Cossa, before 1470

Gemini; see fig. 2); this also provides a *terminus ante quem* for the *salone*. The second is a payment for work done before 16 September 1473 to Baldassare d'Este for having 'touched up' 36 portrait busts of the Duke. The authorship of the other frescoes in the *salone* has remained the subject of fierce debate: proposed candidates include Ercole de' Roberti, Antonio Cicognara, Cosimo Tura, Ettore d'Antonio de' Bonacossi (*d* 1522), the Master of the Occhi Spalancati, the Master of the Occhi Ammiccanti, the Master of Ercole and the mysterious 'Vicino da Ferrara'.

BIBLIOGRAPHY

F. Avventi: *Descrizione dei dipinti di Cosimo Tura detto Cosmè ultimamente scoperti nel Palazzo Schifanoia in Ferrara nell'anno 1840* (Bologna, 1840)
A. Venturi: 'Gli affreschi del Palazzo di Schifanoia in Ferrara secondo recenti pubblicazioni e nuove ricerche', *Atti & Mem. Reale Deput. Stor. Patria Prov. Romagna*, 3rd ser., iii (1885), pp. 381–414
——: 'Ein Brief des Francesco del Cossa', *Kunstfreund*, ix (1885), pp. 129–34
A. Warburg: 'Italienische Kunst und internationale Astrologie im Palazzo Schifanoia zu Ferrara', *L'Italia e l'arte straniera. Atti del X Congresso internazionale di storia dell'arte: Roma, 1912*, pp. 178–93
G. Bargellesi: *Palazzo Schifanoia: Gli affreschi nel Salone dei Mesi in Ferrara* (Bergamo, 1945)
P. d'Ancona: *I mesi di Schifanoia in Ferrara: Con una notizia sul restauro di Cesare Gnudi* (Milan, 1954)
R. Longhi: *Opere complete di Roberto Longhi*, v (Florence, 1956), pp. 37–9, 48–51, 99–102, 137–8, 182–4
C. Rosenberg: 'Francesco del Cossa's Letter Reconsidered', *Mus. Ferrar.: Boll. Annu.*, v/vi (1975–6), pp. 11–15
S. Macioce: 'La *Borsiade* di Tito Vespasiano Strozzi e la "Sala dei Mesi" di Palazzo Schifanoia', *Annu. Ist. Stor. A.*, n. s. 2 (1982–3), pp. 3–13
K. Lippincott: *The Frescoes of the Salone dei Mesi in the Palazzo Schifanoia in Ferrara: Style, Iconography and Cultural Context* (diss., U. Chicago, 1987)
R. Varese, ed: *Atlante di Schifanoia* (Modena, 1989)
K. Lippincott: 'The Iconography of the Salone dei Mesi and the Study of Latin Grammar in Fifteenth-century Ferrara', *La Corte di Ferrara e il suo mecenatismo, 1441–1598*, ed. M. Pade, L. Waage Petersen and D. Quarta (Modena, 1990), pp. 93–109
A. M. Visser Travagli: '*Palazzo Schifanoia a Ferrara e la palazzina Marfisa a Ferrara* (Milan, 1991)
K. Lippincott: 'Gli dei-decani del Salone dei Mesi di Palazzo Schifanoia', *Alla corte degli Estensi: Filosofia, arte e cultura a Ferrara nei secoli XV e XVI: Atti del convegno internazionale di studi: Ferrara, 1992* ed. M. Bertozzi, pp. 181–97

KRISTEN LIPPINCOTT

Ferrara, Costanzo da. *See* COSTANZO DA FERRARA.

Ferrara, Girolamo da. *See* CARPI, GIROLAMO DA.

Ferrari [de Ferrari; Deferrari], **Defendente** (*b* Chivasso, nr Turin; *fl* Piedmont, *c.* 1500–35). Italian painter. It has been established through connoisseurship that he trained in the workshop of GIOVANNI MARTINO SPANZOTTI, who, after his move to Chivasso *c.* 1502, dominated painting in western Piedmont for some 30 years. Many of the works previously thought to have been by Spanzotti are now attributed to Defendente. The polyptych of the *Virgin and Child with Saints* (*c.* 1505; Biella, S Sebastiano) is clearly deeply indebted to Spanzotti, yet Defendente's *Virgin Enthroned with Saints* (1505–7; Turin Cathedral), which is surrounded by 18 small panels depicting legends of SS Crispin and Crispianus, shows that he was also influenced by the highly ornamental qualities of Late Gothic art, a northern European style that persisted in the area around Turin into the early years of the 16th century. Defendente's elaboration of that style is again apparent in his nocturnal *Nativity* (before 1508; Cambridge, MA, Fogg), and it can also be seen in a succeeding group that includes a *Nativity* (1510; Turin, Mus. Civ. A. Ant.) that is almost a miniature version of the earlier one.

It is harder to trace consistent traits in Defendente's art between *c.* 1508 and 1530. His triptych depicting a *Nativity with Saints* (1511; Avigliana, S Giovanni) was followed by a *Christ among the Doctors* (Turin, Mus. Civ. A. Ant.; a copy by Giovanni Battista Giovenone provides a *terminus*

ante quem of 1513) and another group of works is closely similar in style. These paintings, while still reflecting Defendente's earlier work, indicate a response to the new art of the Renaissance. The spacious landscape background of the *Baptism* (1508–13; Turin Cathedral) suggests Central Italian influence. This confluence of Gothic traditions and Renaissance art can also be seen in the *Assumption of the Virgin*, painted for the Confraternity of the Holy Shroud at Cirié, near Turin. An inscription on the predella indicates who commissioned it and when it was painted: *Hoc opus feceru[n]t fieri mercatores lanor[um] Ciricaci 1516.*

Around 1520, a particularly fruitful period, Defendente painted the beautiful *Nativity* (1518; Riggisberg, Abegg–Stift.) and the *Penitent St Jerome* (1520; see fig.), which is distinguished by its nocturnal landscape. In these years he appears to have concentrated mainly on small works, searching for an emotional intensity that does not feature in his large altarpieces. The harsh elements in his style were abandoned in favour of more fluid brushstrokes and the creation of soft, dense highlights. This explains the disparity between works such as the delightful small triptych portraying the *Adoration of the Magi* at the centre and the *Nativity* and *Deposition* on either side (1523; Turin, Gal. Sabauda) and the large *Adoration*, perhaps of slightly later date, that repeats the composition, enriching it with elaborate Renaissance architecture. In 1523 Defendente also provided drawings for the choir-stalls in S Gerolamo at Biella.

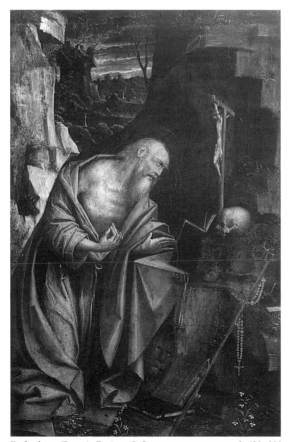

Defendente Ferrari: *Penitent St Jerome*, tempera on panel, 430×280 mm, 1520 (Turin, Museo Civico d'Arte Antica)

In the following years Defendente was equally prolific, though few of the works from this period can be securely dated. It seems that his workshop expanded and he himself repeated earlier compositions. In 1526 he made two replicas of subjects painted many years earlier: a copy (1526; Amsterdam, Rijksmus.) of Raphael's *Orléans Madonna* (Chantilly, Mus. Condé) and a *Christ among the Doctors* (1526; Stuttgart, Württemberg. Landesmus.). Spanzotti too had treated these subjects: his *Christ among the Doctors* was painted before 1513 (Turin, Mus. Civ. A. Ant.); his copy of the *Orléans Madonna* (Baltimore, MD, Walters A.G.) is not dated.

Defendente's paintings of the late 1520s seem to reveal the presence of a very skilful assistant, called the 'Pseudo-Giovenone' by Romano (1970). The most convincing example of their collaboration is the *Virgin and Child with St Anne* (1528; Amsterdam, Rijksmus.). Another of Defendente's late works, a monumental winged polyptych depicting the *Adoration of the Child with Saints* (1531; Ranvuso, nr Turin, S Antonio), is supported by a document of 1530, which refers to the work's artist having been commissioned to provide this for the community at Moncalieri. Despite its late date the work does not introduce any new stylistic elements and indeed seems less subtle, refined and aristocratic in style than Defendente's earlier works. He continued to work until at least 1535, the date that appears on the *Virgin Enthroned between SS Crispin and Crispinianus* (Avigliana, Turin, S Giovanni).

BIBLIOGRAPHY

A. M. Brizio: *La pittura in Piemonte dall'età romanica al cinquecento* (Turin, 1942), pp. 45–64, 195–201

B. Berenson: *Italian Pictures of the Renaissance: Central Italian and North Italian Schools*, 3 vols (London, 1968), pp. 101–6

G. Romano: *Casalesi del cinquecento: L'avvento del manierismo in una città padana* (Turin, 1970), pp. 11–12

——: 'Orientamenti della pittura casalese da G. M. Spanzotti alla fine del cinquecento', *Quarto congresso di antichità e d'arte della Società Piemontese d'Archeologia e Belle Arti: Casale Monferrato, 1974*, pp. 289–98

Soprintendenza alle gallerie e alle opere d'arte del Piemonte: Recuperi e nuove acquisizioni (exh. cat., ed. G. Romano; Turin, Gal. Sabauda, 1975)

Opere d'arte a Vercelli e nella sua provincia: Recuperi e restauri, 1968–1976 (exh. cat., ed. F. Mazzini; Vercelli, Mus. Civ. Borgogna, 1976), pp. 23–4, 134–5

RICCARDO PASSONI

Ferrari, Eusebio (*fl* Vercelli, 1508; *d* after 18 Sept 1526). Italian painter and ?architect. He is first documented in Gaudenzio Ferrari's commission for the polyptych depicting scenes from the *Life of St Anne*, for which he agreed to act as guarantor; although this suggests that he was already a mature artist, his style was based on the new elements introduced by Gaudenzio Ferrari, later the leading artist in Vercelli. This can be seen in Eusebio Ferrari's *Adoration of the Child Jesus* (1505–10; priv. col.), created at the same time as his frescoed grotesques in the Palazzo Verga at Vercelli. On a trip to Rome (*c.* 1505) Gaudenzio Ferrari encountered the style formulated in Central Italy by Perugino and others and was possibly accompanied by Eusebio. Eusebio's greatest work, his triptych of the *Adoration of the Child Jesus with Saints* (?*c.* 1519; Mainz, Altertmus. & Gemäldegal.), shows traces of a greater familiarity with the Lombard style of art, with Bramantino and the works created by Pedro Fernández in the Po Valley but also with the style of painting introduced by Leonardo da Vinci. Ferrari did not achieve so much in his

Virgin and Child with Saints (1519; Turin, Museo Civ. A. Ant.) or the *Mystic Marriage of St Catherine* (1520s; Turin, Gal. Sabauda). Eusabio Ferrari has been postulated (Romano) as the architect of the church of S Sebastiano at Biella, one of the most important examples of Piedmontese architecture and clearly influenced by Bramante.

BIBLIOGRAPHY

G. Romano: 'Eusebio Ferrari e gli affreschi cinquecenteschi di Palazzo Verga a Vercelli', *Prospettiva* [Florence], 33–6 (1983–4), pp. 135–44

Ferrari, Gaudenzio (*b* Valduggia, nr Vercelli, 1475–80; *d* Milan, 3 Jan 1546). Italian painter and sculptor. He probably received his training at Varallo at the beginning of the 1490s, a lively period in the town's artistic life, when extensive works were being carried out at the sacromonte. His master was Gian Stefano Scotto (*fl* 1508), none of whose works has as yet been identified but who, judging from the early work of his pupil, may have been influenced by Lombard artists. Gaudenzio's early works, such as a painting on panel of the *Crucifixion* (Varallo, Mus. Civ. Pietro Calderini), were influenced by the poetic art of Bramantino and by the North Italian classicizing style of the Milanese painter Bernardo Zenale. His early, but self-assured, *Angel of the Annunciation* (*c*. 1500; Vercelli, Mus. Civ. Borgogna), painted for the convent of the Grazie, Vercelli, suggests that these sources were soon enriched by his response to the tender Renaissance style of Pietro Perugino (active at the Certosa di Pavia, 1496–9). Gaudenzio is also recorded at Vercelli in the first known documentary reference to him, the contract for a polyptych commissioned by the Confraternity of St Anna in 1508, with Eusebio Ferrari acting as guarantor. There remain four paintings of scenes from the *Life of St Anne and God the Father* (Turin, Gal. Sabauda) and two of the *Annunciation* (London, N.G.). In these works Gaudenzio's style is more controlled, possibly as a result of a journey to Central Italy in *c*. 1505.

In 1513 Gaudenzio painted a cycle of frescoes showing scenes from the *Passion* on the dividing wall of S Maria delle Grazie, Varallo. Giovanni Martino Spanzotti had painted a similar cycle in S Bernardino, Ivrea, a century earlier. The frescoes are rich in strikingly realistic detail and convey emotion with passionate intensity; here Gaudenzio created new forms to express human emotions and attitudes. In the second decade of the 16th century he painted a series of great polyptychs in the area around Novara. A polyptych at Arona shows, in the upper register, *God Blessing SS Ambrose and Felinus, Jerome and Gratianus* and, in the lower, the *Nativity with SS Catherine and Barbara, Gaudentius and Peter Martyr*, with *Christ and the Apostles* on the predella (1511; Arona, S Maria). An altar (1514–21) in the church of S Gaudenzio, Novara, shows a *Nativity* in the upper register with a divided *Annunciation* to either side of it and a *Virgin and Child with Saints* below, flanked by *SS Peter and John the Baptist* and *Agabus and Paul*. The predella is devoted to *Legends of St Gaudentius*. In the second altar Gaudenzio conveys emotion with ease and grace, predominantly through rich and emotionally expressive colour.

It is harder to trace Gaudenzio's career over the next decade. By 1517 work had resumed on the chapels of the sacromonte at Varallo, where between *c*. 1520 and 1526

he was responsible for such masterpieces as the chapel of the Crucifixion (XXXVIII) and the chapel of the Adoration of the Magi (V). He combined painting with life-size statues of polychrome terracotta and created a radically new rendering of scenes from the Passion. The sculptures, which are startlingly realistic, are arranged as though on a stage and blend with illusionistic and dramatically expressive frescoes. At the same time Gaudenzio started painting and gilding the great wooden altarpiece created by Giovanni Angelo del Mayno for the sanctuary of the Assumption at Morbegno, with scenes from the *Life of the Virgin and Christ*. The beautiful polyptych of the *Holy Sacrament* (Isola Bella, Mus. Borromeo) must have been painted by 1531.

Gaudenzio's work was done over a wide geographical area, but it was at Vercelli that he achieved his greatest success. Between 1529 and 1532 he painted an altar, the *Virgin of the Oranges*, and frescoed scenes from the *Life of Mary Magdalene*, a *Crucifixion* (see fig.) and scenes from the *Life of the Virgin* in the church of S Cristoforo, Vercelli. The powerful *Crucifixion*, or the harmonious and spirited *Assumption of the Virgin*, demonstrate Gaudenzio's high level of achievement in portraying sacred subjects. The psychological power of the protagonists is remarkable, as successful here as in his smaller paintings.

At this point Gaudenzio began working more regularly in Lombardy, starting with his ethereal, visionary frescoes of *Angel Musicians* (1534–6) for the dome of the sanctuary of S Maria delle Grazie at Saronno, where he succeeded the recently deceased Bernardino Luini. The contract was drawn up in Milan, where Gaudenzio lived from 1539 until his death and where he opened a workshop that carried out the city's main private commissions. In the frescoes at Saronno, and in his later work in Milan, Gaudenzio's art took a new direction; he placed greater emphasis on a more theatrical language of gesture and expression, and he drew closer to the prevailing style of Milanese Mannerism. This emphasis on drama is developed in works such as the *Martyrdom of St Catherine* (Milan, Brera) and the frescoes for S Maria della Pace, now transferred on to canvas, depicting scenes from the *Life of St Anne* and scenes from the *Life of the Virgin* (1545; Milan, Brera), which are among the most impressive works of his final years. Gaudenzio was an influential artist and a series of cartoons (Turin, Accademia) suggests the existence of a school of artists who kept his style alive throughout the rest of the century.

BIBLIOGRAPHY

G. P. Lomazzo: *Trattato de l'arte della pittura* (Milan, 1584)

Mostra di Gaudenzio Ferrari (exh. cat., ed. A. M. Brizio and others; Vercelli, Mus. Borgogna, 1956)

G. Testori: *Il gran teatro montano: Saggi su Gaudenzio Ferrari* (Milan, 1965)

V. Viale: *Gaudenzio Ferrari* (Turin, 1969)

C. Debiaggi: 'Nuovi apporti e alcune precisazioni sulla scultura lignea di Gaudenzio', *Studi gaudenziani* (Biella, 1977), pp. 9–28

Gaudenzio Ferrari e la sua scuola: I. Cartoni cinquecenteschi dell'Accademia Albertina (exh. cat., ed. G. Romano; Turin, Accad. Albertina, 1982)

F. M. Ferro: 'Gaudenzio a Romagnano Sésia', *Paragone*, xxxiv/401–3 (1983), pp. 72–80

G. Romano: 'Eusebio Ferrari e gli affreschi cinquecenteschi di Palazzo Verga a Vercelli', *Prospettiva*, xxxiii–xxxvi (1983–4), pp. 135–44

F. M. Ferro: 'Un'ancona milanese di Gaudenzio', *Paragone*, xxxvi/419–23 (1985), pp. 157–63

G. Romano: 'Gerolamo Giovenone, Gaudenzio Ferrari e gli inizi di Bernardino Lanino: Testimonianze d'archivio e documenti figurativi',

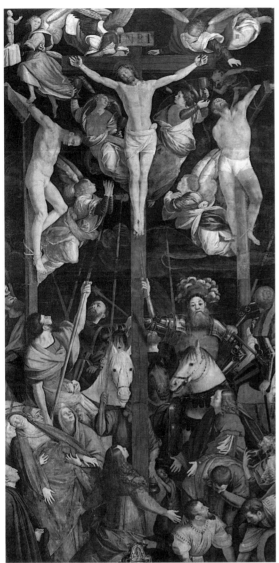

Gaudenzio Ferrari: *Crucifixion*, fresco, 1529–32 (Vercelli, S Cristoforo)

Bernardino Lanino e il cinquecento a Vercelli, ed. G. Romano (Turin, 1986), pp. 13–62

L. Lazzaroni and others: *Il concerto degli angeli: Gaudenzio Ferrari e la cupola del Santuario di Saronno* ([Milan],1994)

A. Nova: 'Popular Art in Renaissance Italy: Early Response to the Holy Mountain at Varallo', *Reframing the Renaissance: Visual Culture in Europe and Latin America, 1450–1650*, ed. C. Farago (New Haven and London, 1995), pp. 112–26, 319–21

RICCARDO PASSONI

Ferreri, Marco [Ferrari d'Antonio d'Agrate]. *See* AGRATE, MARCO D'.

Ferrini, Benedetto [Benedetto da Firenze] (*fl* 1453; *d* Bellinzona [now Switzerland], 1 Oct 1479). Italian architect and military engineer. He was one of the first architects in 15th-century Milan to abandon Gothic forms and to introduce elements of the Florentine Renaissance. Although his activity in the service of the dukes of Milan, Francesco Sforza (*see* SFORZA, (1)) and Galeazzo Maria Sforza, is confirmed by numerous documents, very few buildings survive that can be ascribed to Ferrini. In 1461, he was sent to Venice to work on the palace bought by Francesco Sforza, but the attribution to Ferrini of the façade fragment of the so-called Ca' del Duca at Venice can no longer be sustained. His name has, however, been more securely linked with parts of Milan Castle, which he converted (1472–6) into a residence equipped for the requirements of a Renaissance prince. There, he worked on the Corte Ducale with its extensive apartments, and he designed a courtyard arcade with flanking pilasters in the Florentine manner. He was responsible for planning the entire decoration of the Cappella Ducale, and he worked on the Rocchetta, which was used as the state treasury.

In 1471 Ferrini designed and built the Cappella dei Sette Santi in Milan Cathedral, but it has not been identified. Two years later he built the choir of S Maria del Monte at Sacro Monte di Varese (Lombardy), with three apses set out in trefoil plan and a crossing articulated by pilasters supporting an entablature. Documents show that he worked on many ducal castles, including Abbiategrasso (1469), Vigevano (1471), Villanova di Cassolnovo (1472) and Soncino (1473; all in Lombardy), and on the fortifications at Savona in Liguria (1472), but the majority of these either cannot be identified or are lost. A surviving example of Ferrini's military architecture is the Rocca di Sasso Corbaro (1479) in Bellinzona (Switzerland), a castle distinguished by its unusual geometric plan.

BIBLIOGRAPHY

E. Motta: 'I castelli di Bellinzona sotto il dominio degli Sforza', *Boll. Svizzera It.* (1890), pp. 181–219

J. R. Spencer: 'The Ca' del Duca in Venice and Benedetto Ferrini', *J. Soc. Archit. Hist.*, xxix (1970), pp. 3–8

M. Verga Bandirali: 'Documenti per Benedetto Ferrini ingegnere ducale sforzesco, 1453–1479', *A. Lombarda*, 60 (1981), pp. 49–102

L. Patetta: *L'architettura del quattrocento a Milano* (Milan, 1987)

O. Morisi: 'La ristrutturazione sforzesca della basilica di S Maria del Monte di Varese', *Sacri monti: Devozione, arte e cultura della controriforma*, ed. L. Vaccaro and F. Ricardi (Milan, 1992), pp. 357–70

L. Giordano: 'Milano e l'Italia nord-occidentale', *Storia dell'architettura italiana: Il Quattrocento*, ed. F. P. Fiore (Milan, 1998), pp. 166–99

A. E. WERDEHAUSEN

Ferrucci. Italian family of artists. Its members came from Fiesole and were active in Tuscany and elsewhere in Italy from the 15th century to the 17th. The most distinguished were the sculptor (1) Francesco di Simone Ferrucci, the sculptor and architect (2) Andrea di Piero Ferrucci and the sculptor (3) Francesco Ferrucci. Francesco di Simone was an eclectic artist who never developed a stable style of his own. He was an accomplished stone-carver and elegant decorator but lacked a sure grasp of figure construction. A skilful carver, Andrea di Piero's speciality lay in large marble complexes combining architecture, statues and reliefs. As an architect he worked on Florence Cathedral, of which he was *capomaestro* from 1512 until his death. Francesco devoted himself to porphyry-carving, mostly working for the Medici family.

BIBLIOGRAPHY

Thieme–Becker

C. von Fabriczy: 'Die Bildhauerfamilie aus Fiesole', *Jb. Kön.-Preuss. Kstsamml.*, xxix (1908), suppl., pp. 1–28 [doc.]

(1) Francesco di Simone Ferrucci [Fiesolano; da Fiesole] (*b* Fiesole, 1437; *d* Florence, 24 March 1493).

Sculptor. Francesco was probably trained by his father, Simone di Nanni Ferrucci (*b* 1402), and was decisively influenced by Desiderio da Settignano and Andrea del Verrocchio. Vasari named him among the pupils of Verrocchio, and it is possible that in the 1470s he assisted the master. He matriculated in the Arte dei Maestri di Pietra e di Legname, the Florentine sculptors' guild, in 1463 and established a workshop in Florence in 1466. By 1470, when he first submitted a *catasto* (land registry declaration), he was married and owned a house in Florence. He does not mention that house in his 1480 *catasto*, but lists another, purchased in 1474. Sometime between 1470 and 1480 he also acquired land near Pistoia.

Between 1460 and 1466 Francesco was employed making decorative carvings for the Badia at Fiesole, and from 1467 to 1478 he worked with his brother Bernardo Ferrucci (*b* 1447) at the convent of SS Annunziata, Florence, where they carved a marble cover for the tomb of Saracino Pucci (1469; untraced). No work by Francesco or Bernardo can be identified at SS Annunziata, but two doorframes in the transept of the Badia at Fiesole and possibly the design of a lavabo in the vestibule of the sacristy of the same church, for the carving of which Gregorio di Lorenzo received payment in 1461, can be attributed to Francesco. The doorframes in the Badia follow closely the decorative repertory and the figural types of Desiderio da Settignano.

Other documents record payments to Francesco for the execution of a holy water stoup (1466) for S Maria in Peretola, near Florence (*in situ*); the carving of the tomb of *Lemmo Balducci* (fragments, Florence, S Egidio) for the hospital of S Matteo, Florence (probably 1471–2), of which Balducci was the founder, and five columns for an altar in the hospital (1472); the execution of an indeterminable work for Prato Cathedral (1476); architectural carving in S Petronio, Bologna (1480); the delivery of a Holy Sacrament tabernacle that he made for the Sisters of S Maria di Monteluce, outside Perugia (1483; *in situ*); and the execution of a marble ciborium on commission from Cardinal Carlo de' Medici for Prato Cathedral (1487). In 1491 Francesco submitted a design (untraced) for the façade of Florence Cathedral, and in 1491 and 1492 he purchased marble from the Cathedral Works. Of the recorded projects, only the holy water stoup at Peretola and the Holy Sacrament tabernacle at Monteluce remain intact. The latter shows Francesco borrowing from both Desiderio da Settignano (the figure of the *Blessing Christ Child* is based on one that Desiderio made in the 1460s for his sacramental tabernacle in S Lorenzo, Florence) and Verrocchio (the paired angels elaborate Verrocchio types, as seen especially in the monument to *Cardinal Niccolò Forteguerri*, started in 1476–7; Pistoia Cathedral). Of the tomb of *Balducci* (disassembled and transferred in 1785 to S Egidio) only a profile portrait of the deceased, a garland frieze and the base with two lion heads and coupled balusters in low relief, survive. The ciborium for Prato Cathedral (dismembered 1638) is also fragmentary, the principal piece being a *Blessing Christ Child* (Prato, Mus. Opera Duomo).

A single signed work by Francesco exists: the marble tomb of *Alessandro Tartagni* (?1477–80; Bologna, S Domenico; see fig.), who died in 1477. This demonstrates

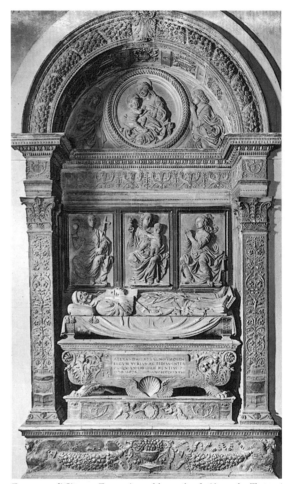

Francesco di Simone Ferrucci: marble tomb of *Alessandro Tartagni*, *c*. 1477–80 (Bologna, S Domenico)

that by the late 1470s Francesco's figure and drapery style had changed markedly under the influence of Verrocchio. The seated figures of *Virtues* in the middle zone, with their inflated drapery, are clearly inspired by Verrocchio's style of that period (i.e. late 1470s), although the form of the decorative vocabulary of the monument, in particular the sarcophagus, derive from Desiderio's tomb of *Carlo Marsuppini* (1453–60; Florence, Santa Croce). Vasari mentions a tomb of *Pietro Minerbetti* (*d* 1482) in S Pancrazio, Florence, of which only a marble relief of two angels holding the arms of the Minerbetti family (Detroit, MI, Inst. A.) survives.

A marble relief of a birth and death scene (Florence, Bargello) has been attributed to Francesco but is usually associated with Verrocchio's workshop. Whether the relief belonged to the tomb of *Francesca Tornabuoni* (*d* 1473), as is claimed on the strength of a statement by Vasari in his *Vite* of Verrocchio and Ghirlandaio, and how much Verrocchio had to do with its design are uncertain. But the relief bears the carving method seen in Francesco's portrait of *Balducci* and monument of *Tartagni*, and it may have been executed by him or under his direct supervision. Among other attributions to Francesco, the most notable are the tombs of *Barbara Manfredi* (*d* 1466; Forlì, S

Mercuriale); *Vianesio Albergati the elder*, (*c.* 1481; Bologna, S Francesco); *Gian Francesco Oliva* (*d* 1478) and his wife, *Marsibilia Trinci* (*d* 1485), both in the convent of S Francesco at Montefiorentino, Province of Pesaro (probably 1485 or shortly after); and three marble reliefs of the *Virgin and Child* (Raleigh, NC Mus. A; London, V&A; Kansas City, MO, Nelson–Atkins Mus. A.). A drawing in Stockholm (Nmus.) is probably a study by Francesco for the *Tartagni* monument before its final design was decided; several designs for altars (London, V&A; Florence, Uffizi; Paris, Louvre) are attributed to him; and a group of sheets (divided between museums in Berlin, Chantilly, Dijon, Hamburg, London, New York and Paris), for the most part of about the same size and nearly all with sketches on both sides, once known as the 'Verrocchio Sketchbook', is generally regarded as from a sketchbook by Francesco and his workshop. Many of these sheets have inscriptions (of *ricordi*, drafts of letters, or accounts, not evidently related to the sketches), and three have dates (1487 and 1488); varying in style and quality, with certain motifs repeated frequently, the sketches suggest the probable intervention of apprentices or assistants drawing from workshop models.

BIBLIOGRAPHY

G. Vasari: *Vite* (1550, rev. 2/1568); ed. G. Milanesi (1878–85)

A. Venturi: 'Francesco di Simone Fiesolano', *Archv. Stor. A.*, v (1892), pp. 371–86

G. Gronau: 'Das sogenannte Skizzenbuch des Verrocchio', *Jb. Kön.-Preuss. Kstsamml.*, xvii (1896), pp. 65–72

A. E. Popham and P. Pouncey: *Italian Drawings in the Department of Prints and Drawings in the British Museum: The Fourteenth and Fifteenth Centuries*, i (London, 1950), pp. 38–40

J. Pope-Hennessy: *Catalogue of Italian Sculpture in the Victoria and Albert Museum*, i (London, 1964), pp. 170–76

C. Seymour jr: *Sculpture in Italy, 1400–1500*, Pelican Hist. A. (Harmondsworth, 1966), pp. 149, 152–3

U. Middeldorf: *Sculptures from the Samuel H. Kress Collection: European Schools, XIV–XIX Century* (London, 1976), pp. 30–31

P. G. Pasini: 'La cappella dei conti Oliva', *Il Convento di Montefiorentino: Atti del convegno, 29 agosto 1979* (Studi Montefeltrani–Serie Atti dei Convegni, II) (San Leo, 1982), pp. 97–125

Italian Renaissance Sculpture in the Time of Donatello (exh. cat., ed. A. P. Darr; Detroit, MI, Inst. A., 1985), pp. 213–17

Il monumento a Barbara Manfredi e la scultura del Rinascimento in Romagna (exh. cat. ed. A. Colombi-Ferretti and L. Prati; Bologna, 1989)

D. R. Schrader: 'A Marble Relief by Francesco di Simone Ferrucci in the Virginia Museum Collection', *A. VA*, xxix (1990), pp. 22–7

S. S. Wolohojian: 'Francesco di Simone Ferrucci's Fogg *Virgin and Child* and the Martini Chapel in S Giobbe, Venice', *Burl. Mag.*, cxxxix (1997), pp. 867–9

DARIO A. COVI

(2) Andrea di Piero (di Marco) Ferrucci [da Fiesole] (*b* Fiesole, 1465; *d* Florence, after 25 Oct 1526). Sculptor and architect, first cousin once removed of (1) Francesco di Simone Ferrucci. According to Vasari, he learnt the rudiments of his art from Francesco and completed his training under Michele Maini from Fiesole, of whom nothing else is known. His style was rooted in the realistic tradition of the late 15th century. As he matured it was modified, but only slightly, by the classical trends of the 16th century. Vasari claimed that Andrea worked in the church of the Innocenti at Imola and later in Naples and Rome, but this cannot be substantiated. He was in Naples in 1487, according to his father's *portata dell'estimo*. He may have lived there for several years, possibly engaged on different projects for King Ferdinand I (*reg* 1458–94)

through his promotion by the King's architect and military engineer, Antonio di Giorgio Marchesi (1451–1522) from Settignano, whose daughter he married; but the only certain work he made for Naples, a marble altar (destr. 1757) for the Brancacci Chapel in S Maria Annunziata, was paid for much later, in 1508. Although Andrea is documented as temporarily in residence at Naples in June 1508, by that time he was already in the service of the Opera (Cathedral Works) of Florence Cathedral, and it appears that all his documented works, whether for patrons in Tuscany or elsewhere, were executed in Florence.

The earliest of his documented works are a marble altarpiece with a ciborium for Fiesole Cathedral (*in situ*), commissioned from him in 1488 but not completed until 1492–3, and a marble baptismal font for Pistoia Cathedral (*in situ*), which he executed in 1497–9 with the assistance of Jacopo d'Andrea del Maza, possibly after designs by Benedetto da Maiano. Benedetto had originally been engaged to do the work but died (1497) before he could carry it through. The centrepiece, a life-size *Baptism* in high relief, owes nothing to Benedetto, however, and is one of Andrea's most important surviving sculptures. Also probably from the 1490s, but undocumented, are a marble ciborium and a large marble altarpiece of the *Crucifixion* (both London, V&A; see fig.), which before 1859 were in the former convent of S Girolamo, outside Fiesole. Andrea specialized in large marble altar complexes, combining architecture, statues and reliefs. His model for these appears to have been Andrea Sansovino's Corbinelli Altarpiece (*c.* 1486) in Santo Spirito, Florence, with its tripartite division, in the manner of a triumphal arch, with

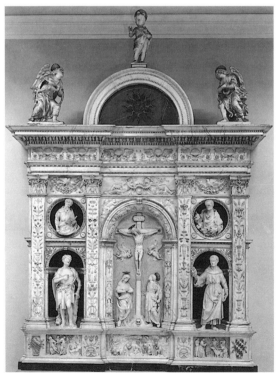

Andrea di Piero Ferrucci: altarpiece of the *Crucifixion*, marble, h. 3.66 m, probably 1490s (London, Victoria and Albert Museum)

statues in niches in the main zone, and narrative reliefs above and below.

From at least 1508 Andrea was employed by the Opera of Florence Cathedral, from which, in 1512, he purchased a house in the Borgo Pinti and which, on 16 December 1512, appointed him *capomaestro* of the cathedral, an office he held until the end of his life. In 1508 he was engaged to work on the balustrade for one of the eight sides of the drum of the cupola; in 1512–13 he executed an over life-size marble statue of *St Andrew* for one of the tribune piers. This figure, with its exaggerated pose and awkward proportions, reveals an insecure knowledge of the structure of the human body but an attentiveness to texture and detail in the treatment of hair and flesh. In the handling of the drapery Andrea achieved impressive pictorial effects, emphasizing the softness and texture of the fabric. These bear out Vasari's description of Andrea's art as the outgrowth of a skill acquired through the carving of foliage and aided by a sense of judgement derived from the study of nature, but without the benefit of a sound grounding in drawing.

In 1514 Andrea was commissioned to make a statue of *St Peter* for another tribune pier, though he failed to execute the work and the commission was transferred to Baccio Bandinelli. In 1519 Andrea was engaged on a major project outside Tuscany: a marble altarpiece commissioned by Tamás Bakócz, Cardinal and Archbishop of Esztergom in Hungary, for the Cardinal's chapel in Esztergom Cathedral (*in situ*). This has been much mutilated: three statues that originally stood in niches in the middle zone have disappeared, and two of them have been replaced with modern statues. Other sculptures (mainly a relief of the *Annunciation*, reliefs of the *Evangelists* and a portrait of the kneeling *Cardinal Bakócz*) have been restored.

In 1521–2 Andrea was again working in Florence Cathedral, carving the life-size marble commemorative bust of *Marsilio Ficino* for a wall niche next to the Porta dei Canonici. In 1522 he also executed the marble bust of the Florentine chancellor, *Marcello Virgilio Adriani*, for his cenotaph (Florence, S Francesco al Monte alle Croci). In 1524 he was commissioned by Antonia Vespucci to design the tomb of her husband, *Antonio Strozzi*, for S Maria Novella, the execution of which he left to his pupils Silvio Cosini, who carved the statue of the Virgin, and Tommaso di Pietro Boscoli (1503–74), who carved the two angels. On 29 March 1524 Michelangelo engaged Andrea as *capomaestro* of S Lorenzo, to direct the work on the tombs in the Medici Chapel. Among other undocumented works by Andrea are a life-size wooden *Crucifix* in S Felicità, Florence, and a smaller one in S Maria Primerana, Fiesole (probably early works), and two marble *Angels* bearing candelabra, installed in Volterra Cathedral, flanking the reliquary tomb (1522) of *St Octavian*.

BIBLIOGRAPHY

G. Vasari: *Vite* (1550, rev. 2/1568); ed. G. Milanesi (1878–85), iv, pp. 475–86
A. Venturi: *Storia* (1901–40), x/1, pp. 179–87
P. Bacci: 'Documenti su Benedetto da Maiano e Andrea da Fiesole relativi al 'fonte battesimale' del duomo di Pistoia', *Riv. A.*, ii (1904), pp. 271–84
J. Balogh: 'La cappella Bakócz di Esztergom', *Acta Hist. A. Acad. Sci. Hung.*, iii (1956), pp. 1–98 (70, 133–5)
J. Pope-Hennessy: *Catalogue of Italian Sculpture in the Victoria and Albert Museum*, i (London, 1964), pp. 179–82
E. Apfelstadt: 'Andrea Ferrucci's *Crucifixion* Altarpiece in the Victoria and Albert Museum', *Burl. Mag.*, cxxxv (1993), pp. 807–17

DARIO A. COVI

(3) Francesco [Cecco] **(di Giovanni) Ferrucci (i)** [del Dadda; di Taddeo; del Tadda] (*b* Fiesole or Florence, 1497; *d* Florence, 29 May 1585). Sculptor, great nephew of (1) Francesco di Simone Ferrucci. The son of the stone-carver Giovanni Ferrucci (*b* 1461), he was trained in the family workshop in Fiesole. Under the patronage of Grand Duke Cosimo I de' Medici, he was instructed in the virtually lost art of porphyry-carving and is renowned for commissions in this medium that came almost exclusively from the Medici family. Throughout his career he was also active as an architectural and ornamental carver in Florence, Carrara, Loreto and Naples.

In 1555, following a design by Giorgio Vasari, Ferrucci carved the porphyry fountain, surmounted by Andrea del Verrocchio's bronze *Putto with Dolphin*, for the courtyard of the Palazzo Vecchio, Florence. In 1560 he signed a porphyry relief of the *Head of Christ* (Prague, Rudolphinum); several versions of this composition exist, and a *Head of the Virgin* (untraced) may have been its pendant. The *Christ* provides the stylistic comparison against which a large porphyry portrait relief of *Cosimo I de' Medici* (after 1569; London, V&A) is attributed to him, and this is the finest of his portrait reliefs. Further portraits of *Cosimo I* and his wife, *Eleanore of Toledo*, and a signed *Cosimo il vecchio* (all Florence, Pal. Medici–Riccardi) may be those described by Vasari; another group of reliefs of other members of the Medici family (Florence, Bargello) are attributed to him, but their inferior carving suggests that they are probably workshop productions. He is reported to have sculpted two portraits of *Girolamo Savonarola*, one in the round (both untraced), and he carved the tomb of *Giovanni Francesco Vegio* (*d* 1554) in the Camposanto in Pisa.

Between *c.* 1570 and 1581, with assistance from his son Romolo Ferrucci (*d* 1621), Ferrucci carved the porphyry statue of *Justice* surmounting the antique granite column erected in 1566 in the Piazza Santa Trinita, Florence, to commemorate Cosimo I's victory over Republican exiles at the Battle of Montemurlo (1537). The work received a mixed critical reception, despite the considerable technical achievement of carving the monumental figure. A number of heads of *Alexander the Great* (Florence, Uffizi; Bargello; Mus. Opificio Pietre Dure) have been associated with his workshop. His own porphyry *Self-portrait* for his tomb in S Girolamo in Fiesole (transferred 1854 to Fiesole Cathedral) was carved in 1576.

BIBLIOGRAPHY
Thieme–Becker

G. Vasari: *Vite* (1550, rev. 2/1568); ed. G. Milanesi (1878–85), iv, pp. 475–87
D. Di Castro Moscati: 'The Revival of the Working of Porphyry in Sixteenth-century Florence', *Apollo*, cxxvi (1987), pp. 242–8

ANTONIA BOSTRÖM

Fesulis, Andrea de. *See* ANDREA DA FIESOLE.

Fiamberti, Tommaso (*fl* 1498; *d* Cesena, between 7 Sept 1524 and 21 Jan 1525). Italian sculptor. Originally from Campione, Lake Lugano, he was mainly active in Cesena,

where he is first documented in 1498. Commissions there for marble statues for the cathedral (1510) and for a chapel entrance arch at S Francesco (1513) apparently went unexecuted. His one certain independent work is the signed funerary monument of *Luffo Numai* (1509; Ravenna, S Francesco). This work of architectural and decorative sculpture, with polychrome stone inlay and rich classical *rinceau* decoration in high relief, suggests familiarity with Pietro Lombardo's work in Venice. Pilasters carved in the same style testify to Fiamberti's role in an earlier documented monument to *Luffo Numai* (1502; Forlì, S Maria dei Servi, also called S Pellegrino), in which he collaborated with a fellow Lombard, Giovanni Ricci (1440/50–after 1523), his partner from *c.* 1498 to 1508. The precise division of labour in this monument, however, remains controversial. The Forlì monument has formed the basis for many attributions of figural reliefs to Fiamberti, as well as for his identification (De Nicola) as the MASTER OF THE MARBLE MADONNAS (*see* MASTERS, ANONYMOUS, AND MONOGRAMMISTS, §I), but subsequent scholarship has cast doubt on these attributions, and the full range of Fiamberti's style remains problematical.

BIBLIOGRAPHY

Thieme–Becker

G. De Nicola: 'Tommaso Fiamberti: Il Maestro delle Madonne di Marmo', *Rass. A.*, ix (1922), pp. 73–81

J. Balogh: 'Uno sconosciuto scultore italiano presso il Re Mattia Corvino', *Riv. A.*, xv (1933), pp. 272–97

J. Pope-Hennessy: *Catalogue of Italian Sculpture in the Victoria and Albert Museum*, i (London, 1964), pp. 151–2

U. Middeldorf: 'An *Ecce homo* by the Master of the Marble Madonnas', *Album Amicorum J. G. van Gelder* (The Hague, 1973), pp. 234–6

G. Viroli: *La Pinacoteca Civica di Forlì* (Forlì, 1980), pp. 48–9

G. Gentilini: entry in *La Misericordia di Firenze: Archivio e raccolta d'arte* (Florence, 1981), cat. 58, pp. 248–9

ALISON LUCHS

Ficino, Marsilio (*b* Figline Valdarno, nr Florence, 19 Oct 1433; *d* Florence, 1499). Italian philosopher and writer. After studying the humanistic disciplines, medicine and philosophy in Florence, he embarked on the study of Platonism, sponsored by Cosimo de' Medici and later Lorenzo. He translated the complete works of Plato into Latin (published 1484) and also wrote elaborate commentaries on some of the dialogues. His interpretation of Plato was Neo-Platonic, heavily based on Plotinus, whose *Enneads* he also translated and commented upon. Always concerned to stress the compatibility of Platonism with Christianity, in 1473 he became a priest. The 'Platonic Academy', which he led and inspired, was not a formal institution but rather a circle of friends who shared a common enthusiasm for Platonic philosophy.

As a Platonist, Ficino distrusted the plastic arts because they belonged to the ephemeral world of appearances rather than to the eternal and unchangeable realm of ideas. Nonetheless, he regarded the artist as a symbol of man's creative power and of his ability to transcend and perfect the natural world (*Theologia platonica*, XIII.iii; see Chastel). This conception both reflected and contributed to the increased dignity accorded to artists in the Renaissance.

In his Latin commentary on Plato's *Symposium* (1469), Ficino explained his concept of beauty as a reflection of the divine splendour in the created world and expounded his doctrine of love as a means of rising to the suprasensible

world of ideas and ultimately attaining union with God. These notions, usually in a watered-down version, reached a wide popular audience in the 16th century and can be found in vernacular lyric poetry, as well as in many artistic and literary treatises. Michelangelo was in contact with Ficino and his circle in his youth and used many of the philosopher's ideas about beauty, love and divine frenzy in his poetry. Giovanni Paolo Lomazzo's *Idea del tempio della pittura* (1590) also reflects the influence of Ficino's account of beauty in his *Symposium* commentary.

Gombrich drew attention to the fact that Ficino was a friend and correspondent of Lorenzo di Pierfrancesco de' Medici, a patron of Botticelli and owner of the *Primavera* (Florence, Uffizi; *see* BOTTICELLI, SANDRO, fig. 2), and claimed that the main theme of the painting was a visual realization of the philosophical ideas expressed in a letter from Ficino to Lorenzo (*Opera*, vol. i, p. 805), in which he used Venus as a symbol of the virtue of *humanitas* (civilization and culture). Panofsky and Saxl argued that Ficino's discussion of melancholy (*De vita*, I.v, vi; III.ii, xi, xii, xxii) was one of the sources for the engraving *Melencolia I* by Albrecht Dürer (1471–1528).

Ficino is depicted, together with Cristoforo Landino and Angelo Poliziano, in the foreground of Domenico Ghirlandaio's *Zachariah in the Temple* (Florence, S Maria Novella). Vasari recorded (*Vite*, 2/1568, ed. G. Milanesi (1878–85), vol. iii, p. 49) that there was another portrait of Ficino in Benozzo Gozzoli's *Meeting of the Queen of Sheba and King Solomon* (Pisa, Camposanto), but due to the poor condition of the fresco, he is no longer identifiable.

WRITINGS

Commentarium in Convivium Platonis, de amore, in Plato: *Opera omnia* (Florence, 1469; Fr. trans., Paris, 1956; Eng. trans., Columbia, MO, 1944, rev. Dallas, 2/1985)

Opera omnia, 2 vols (Basle, 1576/R Turin, 1962)

BIBLIOGRAPHY

E. Panofsky and F. Saxl: *Dürers 'Melencolia I': Eine Quellen- und Typengeschichtliche Untersuchung* (Leipzig, 1923), pp. 32–54, 104–20

P. O. Kristeller: *The Philosophy of Marsilio Ficino* (New York, 1943/R Gloucester, MA, 1964)

E. H. Gombrich: 'Botticelli's Mythologies: A Study in the Neo-Platonic Symbolism of his Circle', *J. Warb. & Court. Inst.*, viii (1945), pp. 7–60; rev. in E. H. Gombrich: *Symbolic Images: Studies in the Art of the Renaissance* (London, 1972, 3/1985), pp. 31–81

A. Chastel: *Marsile Ficin et l'art* (Geneva, 1954/R 1975 [with bibliog. suppl.])

Il lume del sole: Marsilio Ficino medico dell'anima (exh. cat., Figline Valdarno, Vecchio Pal. Com., 1984)

P. O. Kristeller: 'Marsilio Ficino and his Work after Five Hundred Years', *Marsilio Ficino e il ritorno di Platone*, ed. G. C. Garfagnini, i (Florence, 1986), pp. 15–196 [with bibliog.]

J. Hawkins: 'Cosimo de' Medici and the Platonic Academy', *J. Warb. & Court. Inst.*, liii (1990), pp. 144–62

C. Raffini: *Marsilio Ficino, Pietro Bembo, Baldassare Castiglione: Philosophical, Aesthetic and Political Approaches in Renaissance Platonism* (New York, 1998)

JILL KRAYE

Fieravanti, Aristotele di. *See* FIORAVANTI, ARISTOTELE.

Fiesole, Andrea da. *See* ANDREA DA FIESOLE.

Fiesole, Mino da. *See* MINO DA FIESOLE.

Fiesole, Silvio da. *See* COSINI, SILVIO.

Figino, (Giovan) Ambrogio (*b* Milan, 1548; *d* Milan, 11 Oct 1608). Italian painter and draughtsman. A pupil of Giovanni Paolo Lomazzo, he was one of the most important artists working in Milan during the second half of the 16th century. His career, however, is poorly documented. His chief achievement, both in quantity and quality, was as a draughtsman, but he was also a very able portrait painter, highly popular with the nobility. His earliest known work is in fact a portrait of *Angelo Dannona*, signed and dated 1570 (sold London, Christie's, 28 June 1974, lot 61). The courtly style of his portraits is evident in two other surviving works: *Lucio Foppa* (*c.* 1585; Milan, Brera), shown in a noble and dignified pose, proudly attired in elegant shining armour against a dark background, and the *Portrait of a Member of the Cavalcabò Family* (*c.* 1580; Rome, Pal. Venezia). Here the subject is depicted in a half-length pose, turned three-quarters towards the right, his hand boldly placed on his hip. His gaze is deep and penetrating, his attitude courtly. Figino's portraiture received praise from illustrious contemporaries such as Torquato Tasso and Giambattista Marino and other less well-known poets, including Gregorio Comanini, Gherardo Borgogni and Giuliano Goselini. However, most of his documented portraits are untraced.

Apart from his lifelong interest in portraiture, Figino's other interests are documented by about 430 sheets of drawings. The most important collections of these are in the Galleria dell'Accademia, Venice (162 sheets), the Royal Collection, Windsor Castle (118 sheets), and the Pierpont Morgan Library, New York (19 sheets). Through this prolific and eclectic production, Figino's development can be followed from his first anatomical studies to his last agitated compositions. The early work includes studies after Leonardo and anatomical drawings done in the workshop of Lomazzo, who owned many of Leonardo's drawings. Around 1576–7 Figino travelled to Rome, where he diligently copied the work of Raphael and Michelangelo's Sistine Chapel ceiling and *Last Judgement* (see ROME, fig. and colour pls 2, V2 and 2, VII3). He also sketched the antique statues in the courtyard of the Belvedere del Vaticano, especially the *Apollo Belvedere*, the Belvedere *Torso* and the Belvedere *Antinous* (all Rome, Vatican, Mus. Pio-Clementino). Other drawings by Figino include studies for heads and portraits, figures, mythological subjects and preparatory sketches for paintings. Outstanding in the last category are a great number of small sketches, often on both *recto* and *verso*, that are rich in variations and pentimenti, for example studies for *St Sebastian* (see fig.). Twenty or thirty of these may appear on the same sheet, crowded together and almost overlapping, documenting the genesis and construction of Figino's compositions.

About 15 of the drawings in this group are sketches for paintings in Milanese churches: the *Agony in the Garden* (Milan, S Maria Passione), *St Matthew and the Angel* (Milan, S Raffaele) and the *Virgin and Child Crushing the Serpent* (Milan, S Antonio Abate), all datable to *c.* 1586. Although executed in a severe style, the paintings are calm and balanced, containing strong echoes of Raphael and Michelangelo. In the *Virgin and Child with St John the Evangelist and the Archangel Michael* (*c.* 1588; Milan, Brera), the approach is cooler and more intellectual. This is still more evident in the *St Ambrose on Horseback* (1590; Milan,

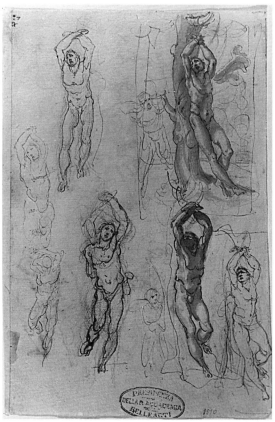

Ambrogio Figino: studies for *St Sebastian*, pen and brown ink, 213×143 mm, *c.* 1586 (Venice, Galleria dell'Accademia)

Castello Sforzesco), with its air of arrested drama and violence. The horse is frozen in a sudden rearing motion that slows and obstructs the furious rush of the punitive cavalcade.

In June 1590, at the peak of his career, Figino was commissioned to paint the shutters of the new organ in Milan Cathedral. These were completed in 1595. Two of the panels, depicting the *Resurrection* and the *Crossing of the Red Sea*, were destroyed during World War II but can be reconstructed from surviving photographs and from Figino's preparatory studies. The *Nativity* and another *Crossing of the Red Sea* are, however, still *in situ*. The signed and dated *Jupiter and the Heifer* (1599; Pavia, Pin. Malaspina), painted for the Holy Roman Emperor Rudolf II (*reg* 1576–1612), shows a marked Mannerist refinement. The elegant figure of Juno recalls the work of Francesco Salviati, while that of Jupiter shows the influence of Pellegrino Tibaldi. Figino's secular works include the new genre of still-life (e.g. the *Still-life with Peaches*, *c.* 1596; Bergamo, Lorenzelli priv. col., see Ciardi, 1968, p. 225) and reveal a timely study of the recent experiments by Vincenzo Campi and Fede Galizia.

Figino's last phase was characterized by the crowded and heavy compositions of the *Birth of the Virgin* (Milan, S Antonio Abate), the *Pietà* and scenes from the *Life of St Benedict* (Milan, S Vittore al Corpo) and the *St George* (Rho, Santuario della Madonna dei Miracoli), all *c.* 1603–

5. Finally, the *Coronation of the Virgin* (*c.* 1605) on the ceiling of S Vittore al Corpo, surrounded by rich gold and white stucco decoration, is the only known example of Figino's work as a fresco painter. In 1605 Figino moved to Turin, where he enjoyed continued success and directed works on the Grande Galleria of the Palazzo Reale of Charles-Emanuel I. His works in Turin remain untraced. He returned suddenly to Milan shortly before his death.

BIBLIOGRAPHY

R. Longhi: 'Ambrogio Figino e due citazioni al Caravaggio', *Paragone*, v/55 (1954), pp. 36–8

A. E. Popham: 'On a Book of Drawings by Ambrogio Figino', *Bib. Humanisme & Ren.*, 20 (1958), pp. 266–76

R. P. Ciardi: 'Giovan Ambrogio Figino e la cultura artistica milanese tra il 1550 e il 1580', *A. Lombarda*, vii (1962), pp. 73–84

J. H. Turnure: 'The Late Style of Ambrogio Figino', *A. Bull.*, xlvii/1 (1965), pp. 35–55

R. Longhi: 'Anche Ambrogio Figino sulla soglia della "natura morta"', *Paragone*, xviii/209 (1967), pp. 18–22

R. P. Ciardi: *Giovane Ambrogio Figino* (Florence, 1968)

P. Pouncey: 'Studies by Figino for his St Matthew Altarpiece', *Master Drgs* (1968), pp. 253–4

R. P. Ciardi: 'Addenda Figiniana', *A. Lombarda*, xvi (1971), pp. 267–74

M. L. Gatti Perer: 'Un ciclo inedito di disegni per la Beatificazione di Alessandro Sauli', *A. Lombarda*, xix/40 (1974), pp. 9–86

S. Coppa: 'Due opere di Ambrogio Figino in una donazione del 1637', *A. Lombarda*, 47–8 (1977), pp. 143–4

A. Perissa Torrini: 'Tre disegni inediti di Giovan Ambrogio Figino', *Prospettiva*, 40 (1985), pp. 75–81

——: *Galleria dell'Accademia di Venezia: Disegni del Figino* (1987), iv of *Catalogo dei disegni antichi* (Milan)

——: 'Da Leonardo a Canaletto', *Canaletto Disegni: Galleria dell'Accademia* (exh. cat., Venice, Accad., 1999), pp. 176–85

ANNALISA PERISSA TORRINI

Filarete [Antonio di Pietro Averlino] (*b c.* 1400; *d c.* 1469). Italian sculptor, architect and theorist. According to Vasari, he trained in the studio of Lorenzo Ghiberti, but he developed a personal style that was relatively independent of Florentine influence. His *Trattato di architettura* was the first Renaissance architectural treatise to be written in vernacular Italian and illustrated with drawings and was an important work in the development of Renaissance architectural theory.

1. Sculpture. 2. Architectural works. 3. The *Trattato di architettura*.

1. SCULPTURE. Filarete is first recorded in 1433 in Rome, where he attended the coronation of the Emperor Sigismund (*reg* 1410–37). Presumably the same year he was commissioned by Pope Eugenius IV to design and execute the bronze door of the main porch of the old St Peter's (inscribed and dated, 1445). The unsettled political conditions during the pontificate of Eugenius IV (1431–47) and the depiction of events during 1438–42 in the small, friezelike reliefs have led to the supposition (Spencer, 1978) that Filarete was not continuously engaged on the door and at one point was given a change of programme. The two wings of the door each consist of three rectangular fields of different size with large figures (see fig. 1); between these are smaller figural friezes. Pope Paul V later removed the doors (1619) to the central porch of the new St Peter's, where narrow rectangular fields were added above and below. The figures portrayed in the main fields are: Christ enthroned giving his blessing (top left); Mary enthroned (top right); St Paul (middle left); St Peter with Eugenius IV kneeling at his feet being given the keys

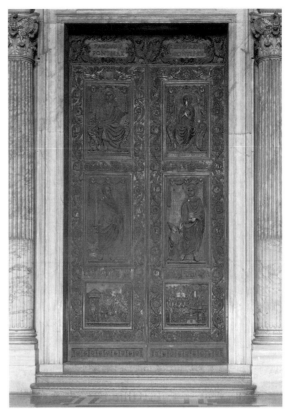

1. Filarete: bronze doors (*c.* 1433–45), St Peter's, Rome

(middle right); the martyrdom of St Paul (bottom left); and the martyrdom of St Peter (bottom right). The small friezelike figures in the relief between the main fields portray events from the pontificate of Eugenius IV. Antique and contemporary portraits, mythological scenes and animals are inserted in the acanthus tendrils.

The juxtaposition of Classical and Early Christian elements is a remarkable feature of the door, which is one of the earliest examples of Roman Renaissance sculpture. The division of the door into fields of different sizes, for example, departs from traditional medieval practice and also differs from Ghiberti's doors in the Baptistery at Florence, following instead such Classical models as the bronze doors of the Pantheon. At the same time, the combination of large seated figures with more detailed scenes on a significantly smaller scale reveals links with Early Christian diptychs of the time of the Consulate (Seymour). The scheme is intended to portray the primacy of the Roman Catholic Church and the Papacy, with its seat in Rome, in both its spiritual and temporal aspect. Indeed the Roman Church is depicted as the legitimate successor to the Roman Empire. The iconography of Christ, Mary, Peter and Paul in the principal fields follows Early Christian traditions, while the depiction of the crucifixion of St Peter on a mountain between two pyramids, the Castel Sant'Angelo and a tree, shows a mixture of various medieval and contemporary interpretations of the tradition of the crucifixion 'inter duas metas'. Stylistically the influence of the Classical world is visible

not in the treatment of perspective (as in Ghiberti and Donatello), but in such detailed motifs as the disciples' clothing, the architecture and topographical reconstructions of the city of Rome, the acanthus tendrils and the profiles of Caesar and mythological scenes taken from Ovid's *Metamorphoses*.

During his time in Rome, Filarete also produced the statue of *A Rider* (inlaid with bronze, gold and enamel, 380×360×145 mm, signed, *c.* 1440–45; Dresden, Skulpsamml.), which was a copy of the equestrian statue of *Marcus Aurelius*. This is the earliest surviving small Renaissance bronze and the earliest known copy of an ancient sculpture. In 1448 Filarete was accused of stealing relics and had to flee Rome; the *Trattato* implies that he spent 1449 in Venice. In the same year he was commissioned by the town of Bassano del Grappa to execute a processional cross (silver on wood, plated with gold leaf, 490×370 mm, 1449; Bassano del Grappa, Mus. Civ.) recalling 14th-century prototypes and clearly showing the influence of Ghiberti. A signed plaque with an allegorical scene (bronze, 855×135 mm; St Petersburg, Hermitage) also dates from *c.* 1450. Later sculptural works include a statuette of *Hector on Horseback* (bronze, 255×255×125 mm, 1456; Madrid, Mus. Arqueol. N.) and a plaque with his *Self-portrait* (bronze, 88×67 mm, *c.* 1460; Milan, Mus. Civ. Milano).

2. ARCHITECTURAL WORKS. In 1451 Filarete accepted an invitation from Duke Francesco Sforza (*see* SFORZA, (1)) to move to Milan, where he started a new career as architect and architectural theorist. He stayed in Milan until 1465, his most important work there being the Ospedale Maggiore, commissioned by Sforza in 1456 with the object of uniting the city's many small hospitals into a single complex. After recurrent difficulties with the hospital management, local building workers and perhaps also with Sforza himself, Filarete resigned his post as building superintendent in 1465, when only a small part of the project had been completed. His successors, Guiniforte Solari (1429–81) and later Giovanni Antonio Amadeo, continued the construction but with a partial change of design. Further alterations in the 17th and 18th centuries mean that the only parts of the present building built to Filarete's design are the south cross-shaped hall with its four courts and accompanying façades. However, in his *Trattato*, Filarete gave detailed information about his project (see fig. 2). His planned layout was completely axio-symmetrical: two large, cruciform halls, each embraced by four small courts, would have flanked a central court, with a church in the middle. The cruciform halls were to contain the beds, located according to the patients' illness and sex, all with a direct view of the altar, which was to stand under the domed crossing of the four arms.

The cruciform layout of the beds and the excellent ventilation and drainage system meant that the Ospedale Maggiore was the most advanced hospital of the age, for both organization and hygiene. Its design was immediately imitated in other cities of North Italy, and subsequently throughout Europe. The origins of this type of hospital have been variously explained. To what extent the hospitals at Florence and Siena, which Filarete studied at the request of his patron in 1456, before he started planning, can have served as models not only for the technical and organizational aspects, but also for the architectural design, is still a disputed question. It is nevertheless certain that Filarete was not the first to apply the cruciform layout, which had already appeared in Pavia (1449). Foster has argued that the type evolved under Pope Nicholas V and then developed into the hospitals of Pavia and Mantua (Luca Fancelli). Leverotti and Patetta refer to a document indicating that Filarete's design was influenced by a hospital project initiated by Cosimo de' Medici, which is attributed to Alberti or Bernardo Rossellino. Quadflieg on the other hand, traces the cruciform hall back to Islamic hospitals. Baini recently recognized that the long and narrow hospital wards in Siena and Florence constituted an important architectural forerunner to the cruciform type layout as seen in Lombardy. This cruciform layout then reached its most complete form in Filarete's Milanese building. The Ospedale Maggiore marks a turning-point in 15th-century Lombard architecture for here, for the first time, an architectural vocabulary is used that is influenced by the Florentine Renaissance, for example in the columned arcades of the courts and façades.

Another important commission Filarete received was for the new cathedral (1455–7) at Bergamo. However, due to extensive rebuilding in the 17th century, the only record of his work is a drawing in the *Trattato*: it shows an aisleless church with side chapels and a dominant cupola over the crossing flanked by four pointed towers. Francesco Sforza also recommended Filarete for appointment as building superintendent for the two largest schemes in Milan, the cathedral works and the Castello Sforzesco.

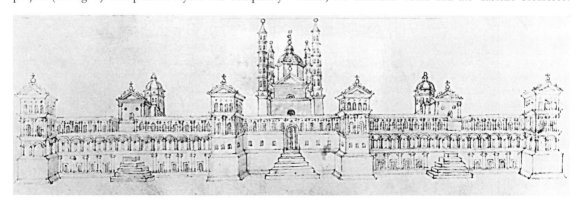

2. Filarete: façade of the Ospedale Maggiore, Milan, commissioned 1456; drawing from his *Trattato di architettura* (1461–4)

However, Filarete immediately withdrew from these latter projects following disagreements with local artists. After a dispute with Sforza, Filarete left Milan *c.* 1465 and moved back to Florence, where he was received into Piero de' Medici's circle.

3. THE 'TRATTATO DI ARCHITETTURA'. During his time in the service of Francesco Sforza, Filarete wrote his *Trattato di architettura* (1461–4), which remained unpublished until the late 19th century. Filarete's original manuscript has been lost, but several copies have survived. Of these it is generally agreed that the Codex Magliabechianus copy (Florence, Bib. N. Cent., MS. ii. i. 140) is the closest to Filarete's original. Although the treatise was first dedicated to Francesco Sforza, a further, reworked copy was produced for Piero de' Medici, with the addition of a key chapter in praise of the Medici family as patrons. The *Trattato* is substantially different in both spirit and form from the Classical prototype of Vitruvius and from Alberti's *De re aedificatoria* (1452). It is written as a court dialogue between the architect and his patron, and it contains a novelistic account of a town being founded by a rich prince.

Filarete's most significant contribution to Renaissance architectural theory lies in his remarks on the origin of architecture and its anthropomorphic proportions, planning stage method and finally in his project for the ideal town of Sforzinda. Like Vitruvius, Filarete traced the origin of architecture to primordial dwellings, but he gave the analysis a Christian slant by identifying Adam as the first architect. As the prototype of humanity, Adam is also seen as originating the proportions of columns. The proportions of the vertical supports in the first human habitation, which were subsequently developed into columns, therefore already correspond to those of the human body, and the anthropomorphic proportions of architecture are established in the first human dwelling. The human head becomes the basic unit for all measurements; starting from three average human sizes, Filarete develops the doctrine of the three orders of architecture (Doric, Ionic and Corinthian), exactly inverting that of Vitruvius: the Doric column is nine, the Ionic seven and the Corinthian eight heads high. Filarete is concerned only with a difference in proportion between the individual orders, not with any difference in detailing, as occurs in Vitruvius and Alberti. In his accompanying illustrations the Vitruvian descriptions of the form of capitals are interchanged. Filarete follows Vitruvius in deriving the basic geometrical units, the circle and square, from the proportions of the human body. Thanks to Filarete and subsequently Francesco di Giorgio Martini (MSS *c.* 1470–80), anthropomorphism, and its attendant doctrine of proportion as an integral part of architectural theory, were thus given more importance than at any time since Vitruvius.

Filarete's differentiation between the three stages of planning was significant for subsequent architectural practice in the Renaissance. The first stage, the 'congetto' or 'disegno in di grosso' (the sketch-plan), is followed by the 'disegno proporzionato' (the scale drawings squared up by the use of coordinate grids); finally, there is the 'disegno rilevato' or 'modello' (the wooden scale model illustrating the scheme). Above all, the gridded scale drawing, which for the first time set out the design and the completed building in a firmly defined dimensional relationship in all its parts, constituted an important innovation. The emphasis on theoretical design, and its clear definition in relation to the execution of a building, associates Filarete, like Alberti, with a higher social status for the architect, who is now seen as a humanistic scientist and courtier.

The relationship of the architect to his princely patron is another dominant theme in the treatise, especially evident in the description of the founding of Sforzinda, the first ideal town of the Renaissance to be planned and illustrated in detail. In Filarete's narrative, shortly after building is started, a Golden Book is found with a description in Greek of the city's ancient predecessor, which the prince then orders to be reconstructed. Sforzinda is planned as an octagonal central town with a radial network of streets, in the middle of which is the principal square with the cathedral, the Palazzo Signorile and adjoining markets. Two further squares with public and commercial buildings adjoin the central square. The parish churches and monastery churches are placed in the main thoroughfares. Filarete gives no specific location for the many other individual buildings mentioned. Following Vitruvius and Alberti he divides the various buildings, descriptions and plans of which form a substantial part of the account of Sforzinda, into public and private constructions; the former are then subdivided into religious and secular. Filarete also makes a further historical distinction between contemporary and ancient buildings. The designs for both groups are fantastic and utopian in form and style and are in marked contrast to contemporary built architecture. Against the background of the still medieval architecture of 15th-century Milan there is a sense of a continuous polemic against Gothic architecture and its pointed arches, which Filarete sets against the good architecture of antiquity that serves as a model for the buildings of Sforzinda.

WRITINGS

J. R. Spencer, ed.: *Filarete, Treatise on Architecture: Being the Treatise by Antonio di Piero Averlino, Known as Filarete*, 2 vols (New Haven, 1965)
A. M. Finoli and L. Grassi, eds: *Filarete: Trattato di architettura*, 2 vols (Milan, 1972)

BIBLIOGRAPHY
GENERAL

W. von Oettingen: *Über das Leben und die Werke des A. Averlino genannt Filarete* (Leipzig, 1888)
M. Lazzaroni and A. Munoz: *Filarete scultore e architetto del secolo XV* (Rome, 1908)
'Il Filarete: Atti del corso di specializzazione "Antonio Averlino detto il Filarete"', *A. Lombarda*, xii (1973)

SCULPTURE

V. Rakint: 'Une Plaquette du Filarete au Musée de l'Ermitage', *Gaz. B.-A.*, lxvi (1924), pp. 157–66
H. Keutner: '*Hektor zu Pferde*: Eine Bronzestatuette von Antonio Averlino Filarete', *Studien zur toskanischen Kunst: Festschrift für Ludwig H. Heydenreich* (Munich, 1963), pp. 139–56
U. Nilgen: 'Filaretes Bronzetür von St Peter: Zur Interpretation von Bild und Rahmen', *Actas del XXIII Congreso internacional de historia del arte, Granada, 1973*, iii, pp. 569–85
C. Seymour: 'Some Reflections on Filarete's Use of Antique Visual Sources', *A. Lombarda*, xxxviii–xxxix (1973), pp. 36–47
C. Lord: 'Solar Imagery in Filarete's Doors to Saint Peter's', *Gaz. B.-A.*, lxxxvii (1976), pp. 143–50
J. R. Spencer: 'Filarete's Bronze Doors at St Peter's: A Cooperative Project with Complications of Chronology and Technique', *Collaboration in*

Italian Renaissance Art, ed. J. T. Paoletti and W. S. Sheard (New Haven, 1978), pp. 33–57

——: 'Filarete the Medallist of the Roman Emperors', *A. Bull.*, xli/4 (1979), pp. 550–61

N. Gramaccini: 'Die Umwertung der Antike: Zur Rezeption des Marc Aurel', *Mittelalter und Renaissance, Natur und Antike* (exh. cat., Frankfurt am Main, Liebieghaus, 1985–6), pp. 51–83

R. Coppel: 'A Newly-discovered Signature and Date for Filarete's *Hector*', *Burl. Mag.*, 129 (1987), pp. 802–10

E. Parlato: 'Il gusto all'antica di Filarete scultore', *Da Pisanello alla nascita dei Musei Capitolini: L'Antico a Roma alla vigilia del Rinascimento* (exh. cat., Rome, Mus. Capitolino, 1988), pp. 115–34

P. Cannata: 'Le placchette del Filarete', *Stud. Hist. A.*, 22 (1989), pp. 35–53

ARCHITECTURE AND ARCHITECTURAL THEORY

L. Firpo: *La città ideale del Filarete* (Turin, 1954)

P. Tigler: *Die Architekturtheorie des Filarete* (Berlin, 1963)

J. Onians: 'Alberti and Filarete: A Study in their Sources', *J. Warb. & Court. Inst.*, xxxiv (1971), pp. 96–114

L. Grassi: *Lo 'Spedale dei Poveri' del Filarete: Storia e restauro* (Milan, 1972)

S. Lang: 'Sforzinda, Filarete and Filelfo', *J. Warb. & Court. Inst.* (1972), pp. 391–7

P. Foster: 'Per il disegno dell'Ospedale Maggiore di Milano', *A. Lombarda*, xviii (1973), pp. 1–22

H. Saalman: 'Early Renaissance Architectural Theory and Practice in Antonio Filarete's *Trattato di Architettura*', *A. Bull.*, xli/1 (1979), pp. 89–106

L. Giordano: 'Il trattato del Filarete e l'architettura lombarda', *Les Traités d'architecture de la Renaissance. Actes du colloque: Tours, 1981*, pp. 115–28

F. Leverotti: 'Ricerche sulle origini dell'Ospedale Maggiore di Milano', *Archv Stor. Lombarda*, 10th ser., vi (1981), pp. 77–113

E. Quadflieg: *Filaretes Ospedale Maggiore in Mailand: Zur Rezeption islamischen Hospitalwesens in der italienischen Frührenaissance* (Cologne, 1981)

M. Rossi: 'I contributi del Filarete e dei Solari alla ricerca di una soluzione del duomo di Milano', *A. Lombarda*, lx (1981), pp. 15–23

L. Patetta: *L'architettura del quattrocento a Milano* (Milan, 1987)

F. Bologna: 'Un passo del Libro de architectura di Antonio Filarete e l'Arco trionfale di Alfonso d'Aragona a Napoli', *Riv. Ist. N. Archeol. & Stor. A.*, xvii (1994), pp. 191–222

L. Oppio: 'La casa della virtù e del vizio del Filarete e le allegorie vinciane del piacere e dispiacere', *Achad. Leonardi Vinci: J. Leonardo Stud. & Bibliog. Vinciana*, viii (1995), pp. 190–93

P. Pierotti and M. L. Testi Cristiani: 'Le origini dell'urbanistica moderna', *Crit. A.*, lviii/2 (June 1995), pp. 74–9

L. Baini: 'Ipotesi sull'origine della tipologia cruciforme per gli ospedali del XV secolo', *Processi accumulativi, forme e funzioni: Saggi sull'architettura lombarda del Quattrocento*, ed. L. Giordano (Florence, 1996), pp. 59–102

L. Giordano: 'Milano e l'Italia nord occidentale', *Storia dell'architettura italiana: Il Quattrocento*, ed. F. P. Fiore (Milan, 1998), pp. 166–99

——: 'On Filarete's *Libro architettonico*', *Architectural Treatises of the Renaissance*, ed. V. Hart and P. Hicks (New Haven and London, 1998), pp. 51–65

A. E. WERDEHAUSEN

Filipepi, Alessandro. *See* BOTTICELLI, SANDRO.

Filippi. Italian family of painters. Its members were active mainly in Ferrara in the 16th century. Sebastiano Filippi I (*b* Lendinara; *d* Ferrara, 19 Dec 1523) was the father of (1) Camillo Filippi, who was the father of (2) Sebastiano Filippi II and Cesare Filippi (*b* Ferrara, 1536; *d* 1602).

(1) Camillo Filippi (*b* Ferrara, *c.* 1500; *d* Ferrara, 1574). He was trained by Battista Dossi and Girolamo da Carpi. In 1537 he collaborated with the latter on the decoration of the Delizia di Voghiera, a project on which he was also joined by Garofalo, who strongly influenced him, and Biagio Pupini. His early *Baptism* (Rovigo, Accad. Concordi) shows the influence of both Battista Dossi and Garofalo, but the inspiration derived from the former is

undermined by a stale and rigid adherence to the ideals expressed by Raphael. In the 1540s Filippi was engaged in a series of decorative projects with Girolamo da Carpi, at the Castello Estense, Ferrara (1541), in the Residenza della Montagnola, Copparo (1545; destr.), and again at the Castello Estense, Ferrara (1548). In 1550 he painted the altarpiece depicting the *Resurrection with Saints* (ex-S Barnaba, Ferrara; fragments in Ferrara, Pin. N.). The predella depicts the *Beheading of Pope Sixtus II* (priv. col.) and was formerly attributed to Camillo's son Cesare, as was the altarpiece. Displaying a typically diluted classicism, it is modelled on scenes in the contemporary series of cartoons for the tapestries in Ferrara Cathedral depicting scenes from the *Lives of SS George and Maurelius*, created in collaboration with Garofalo.

Together with Girolamo da Carpi, Camillo painted frescoes of *Muses* in the Palazzo Fabiani Freguglia, Ferrara. The sedate classicism that characterizes the frescoes executed with da Carpi is enlivened in the *Adoration of the Magi* (1560s; Polesine, nr Ferrara, convent of S Antonio), painted after his son Sebastiano's return from Rome around 1553, as can be deduced from the stylistic debt it owes not only to Girolamo da Carpi and Garofalo but also to Sebastiano. The influence of Michelangelo, which is apparent in the figure types of the *Annunciation* (Ferrara, S Maria in Vado), again stems from his link with Sebastiano, although Camillo's adaptations also take account of the style of Vasari, Girolamo Siciolante and Francesco Salviati, recent works by whom were to be found in Bologna.

BIBLIOGRAPHY

Thieme–Becker

A. Mezzetti: *Dosso e Battista ferraresi* (Ferrara, 1965)

——: *Girolamo da Ferrara detto da Carpi* (Ferrara, 1977)

J. Bentini: 'Precisazioni sulla pittura a Ferrara nell'età di Alfonso II', *L'impresa di Alfonso II: Saggi e documenti sulla produzione artistica a Ferrara nel secondo cinquecento*, ed. J. Bentini and L. Spezzaferro (Bologna, 1987), pp. 71–136

(2) Sebastiano Filippi II [il Bastianino] (*b* Ferrara, *c.* 1532; *d* Ferrara, 23 Aug 1602). Son of (1) Camillo Filippi. He was trained by his father in a classical style linked to Battista Dossi and Dosso Dossi and Garofalo. Sebastiano collaborated with his father on such works as the *Adoration of the Magi* (*c.* 1560; Modena, Gal. & Mus. Estense), in which the group to the right depicting the Holy Family can be attributed to him. The *Virgin in Glory with SS Peter and Paul* (Vigarano Pieve, parish church), possibly an earlier work, is still closely linked to Battista Dossi's Raphaelesque style but tempered by Sebastiano's contacts with Girolamo da Carpi.

Sebastiano's decoration of the Palazzina di Marfisa, Ferrara, begun in 1559, shows the influence of grotesque painting and the classicism of Girolamo da Carpi, with echoes of Michelangelo and Parmigianino. His *St Jerome* (Ferrara, church of the Madonnina) recalls particularly Michelangelo's *Jeremiah* on the ceiling of the Sistine Chapel (Rome, Vatican). In a series of small paintings datable to the 1570s, such as the *Nativity of the Virgin*, *Adoration of the Shepherds* and the *Assumption* (all Ferrara, Pin. N.), a new feeling of warmth gently modulates the influences from Michelangelo, Parmigianino and Raphael. Sebastiano's *Virgin and Child in Glory with SS Barbara and*

Catherine (Ferrara Cathedral), from the same period, was inspired by Raphael's *St Cecilia* (Bologna, Pin. N.) but also displays structural similarities with the work of Ortolano, Dosso Dossi and Girolamo da Carpi. In the *Annunciation* (Ferrara, Pin. N.) the more recent model of Pellegrino Tibaldi is used to modify ideas derived from Michelangelo.

Around 1565 Sebastiano went to Rome, where he was deeply impressed by Michelangelo's paintings in the Sistine Chapel. The resulting change in his painting can be seen in the *Last Judgement*, painted for S Cristoforo della Certosa, Ferrara, by comparing it with its companion piece, the *Transfiguration* (both Milan, Brera, on loan to Rovello Porro, parish church), which he painted with his father; this reveals the difference in quality between the two artists. In the tempera paintings of the *Prophets* and *Archangels* that surround the two altarpieces (both after 1570) in S Cristoforo della Certosa, Ferrara, the underlying Michelangelesque quality is strengthened by elements derived from Tibaldi and Dosso Dossi, recalling the latter's decorations in the Magno Palazzo of the Castello del Buonconsiglio, Trent. These paintings by Sebastiano show a new awareness of colour, which is even more marked in his *St Christopher*, also in the Certosa. Based on Titian's *St Christopher* (Venice, Doge's Pal.), it demonstrates the indefinite contours and painterly handling of Titian's late works.

The frescoes of allegorical subjects in the Castello Estense at Ferrara, datable to after the earthquake of 1570, are in a more emphatically Mannerist style, probably as a result of Sebastiano's familiarity with Giulio Romano's decoration of the Palazzo del Te, Mantua. In subsequent works, however, the tendency towards the dissolution of form becomes increasingly apparent. Sebastiano's great fresco of the *Last Judgement* (1577–80; Ferrara Cathedral) is a dramatic reinterpretation of Michelangelo's prototype (see colour pl. 2, VII3), dissolving the shapes in a misty atmosphere. Other works from his later period continue this trend, immersing Michelangelo's sculptural forms in the liquid, melting colour of Titian's late paintings to achieve the extraordinary 'unfinished' quality of such works as the *Resurrection* and *Annunciation* (both Ferrara, S Paolo), painted after 1590. The strikingly modern effect he obtained by manipulating the paint with his fingers (a method favoured also by Titian) influenced 17th-century Venetian artists, including Girolamo Forabosco and Sebastiano Mazzoni.

BIBLIOGRAPHY

G. Baruffaldi: *Vite de' pittori e scultori ferraresi* (Ferrara, *c.* 1697–1722); ed. G. Boschini (Ferrara, 1844–6)

G. Gruyer: *L'Art ferrarais à l'époque des princes d'Este* (Paris, 1897)

C. Savonuzzi: 'Sebastiano Filippi detto il Bastianino', *A. Figurative*, iii/1–4 (1947), pp. 85–94

F. Arcangeli: *Il Bastianino* (Ferrara, 1963)

G. Frabetti: *Manieristi a Ferrara* (Ferrara, 1972)

———: *L'autunno dei manieristi a Ferrara* (Ferrara, 1978)

M. A. Novelli: 'Dipinti ferraresi nei depositi dell'Alte Pinakothek di Monaco', *Cultura figurativa ferrarese tra XV e XVI secolo: In memoria di Giacomo Bargellesi* (Venice, 1981)

Bastianino e la pittura a Ferrara nel secondo '500 (exh. cat., ed. J. Bentini; Ferrara, Gal. Civ. A. Mod., 1985)

J. Bentini: 'Precisazioni sulla pittura a Ferrara nell'età di Alfonso II', *L'impresa di Alfonso II: Saggi e documenti sulla produzione artistica a Ferrara nel secondo cinquecento*, ed. J. Bentini and L. Spezzaferro (Bologna, 1987), pp. 71–136

UGO RUGGERI

Filippo di Matteo Torelli. *See* TORELLI, FILIPPO DI MATTEO.

Filotesio, Nicola. *See* COLA DELL'AMATRICE.

Finiguerra, Maso [Tommaso] (*b* Florence, March 1426; *d* Florence, *bur* 24 Aug 1464). Italian goldsmith, niellist and draughtsman. Son of the goldsmith Antonio, he trained under his father and possibly under Lorenzo Ghiberti, but he was soon established as an independent master. A sulphur cast made by Finiguerra was recorded in 1449, and in 1452 he was paid for a pax decorated with enamel and niello for the Florentine Baptistery. In 1456 he enrolled as a goldsmith in the Arte della Seta, and in 1457 he entered into partnership with Piero di Bartolomeo Sali. Between 1457 and 1462 he and his partner made a pair of candlesticks for S Jacopo, Pistoia, and from 1461 to 1464 he received payments from Cino di Filippo Rinuccini for jewellery and objects made of gold. Before February 1464 he designed five figures, whose heads were painted by Alesso Baldovinetti, for two intarsia panels for the north sacristy in Florence Cathedral. These panels, showing the *Annunciation* and *St Zenobius between SS Eugenio and Crescenzo*, were executed by his brother-in-law, Giuliano da Maiano. Maso left 14 volumes of drawings, various sulphur casts and some sketches, over which his heirs held protracted disputes.

Finiguerra was already famous in the 15th century, when he was praised as a goldsmith, niellist and master draughtsman. Vasari recorded that Maso 'drew much and very well', but Cellini stated that he always used Antonio Pollaiuolo's designs. Cellini's testimony has been used to deny Maso any real artistic ability, but documentary evidence has reinforced Vasari's judgement. Reconstruction of Finiguerra's oeuvre must begin with his only documented work, the designs for the intarsia panels in the north sacristy. It has been convincingly suggested that he was responsible for designing Giuliano da Maiano's intarsia of the *Annunciation*, formerly on a door of the abbey at Fiesole (Berlin, Tiergarten, Kstgewmus.). The close stylistic connection between these intarsia works and the niello of the *Coronation of the Virgin* on a pax (1452; Florence, Bargello; see fig.) formerly in the Baptistery confirms that this niello must have been the principal decoration of the pax for which Maso was paid in 1452. The *Coronation* is a masterpiece of refinement, in which Maso was clearly influenced by Fra Filippo Lippi's ornate style. Because of this, Maso has been credited with many nielli in Lippi's style, known through sulphur casts or paper impressions and noteworthy for their high artistic quality and wide range of subject-matter (e.g. Paris, Louvre; London, BM). A niello of the *Crucifixion* (Florence, Bargello) is stylistically close to the earliest group of these nielli and can be dated before the *Coronation* because of its debt to Ghiberti. The numerous copies of a later niello of the *Crucifixion* (Washington, DC, N.G.A.), which shows Pollaiuolo's influence, prove that Maso's works were very popular.

The successive influences of Ghiberti, Fra Filippo Lippi and Pollaiuolo can also be traced in the drawings that have been attributed to Finiguerra since Vasari's day; these are probably the works mentioned in the artist's will. Most are

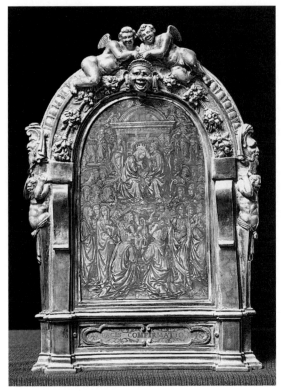

Maso Finiguerra: *Coronation of the Virgin*, niello on silver pax, 1452 (Florence, Museo Nazionale del Bargello)

figure studies (Florence, Uffizi), but there are also some larger and more animated compositions such as *The Flood* (Hamburg, Ksthalle) and *Moses on Mt Sinai* (London, BM), which were made into prints in the 15th century. Most of the drawings were executed by tracing the outline in pen and delicately shading with the brush, a technique that produced effects similar to those of niello. The Colvin Chronicle (London, BM) cannot be considered Maso's work, although its author must have had access to his drawings.

Vasari attributed the invention of engraving to Finiguerra. He claimed that this technique originated in Maso's habit of checking his work as it progressed by taking sulphur casts from the nielli and then paper impressions from the casts. This is supported by the fact that besides the niello of the *Coronation of the Virgin*, there are also two sulphur casts (London, BM; Paris, Louvre) and a paper impression (Paris, Bib. N.). This, however, does not imply that Maso engraved metal plates with the exclusive aim of producing prints.

BIBLIOGRAPHY

Thieme–Becker
G. Vasari: *Vite* (1550, rev. 2/1568); ed. G. Milanesi (1878–85), iii, p. 287
O. H. Giglioli: 'Maso Finiguerra', *Miscellanea di storia dell'arte in onore di Igino Benvenuto Supino* (Florence, 1933), pp. 375–95
A. M. Hind: *Nielli. . .in the British Museum* (London, 1936), pp. 9–13
A. Blum: *Les Nielles du Quattrocento* (Paris, 1950), pp. 11–14
J. Goldsmith Phillips: *Early Florentine Designers and Engravers* (Cambridge, MA, 1955), pp. 3–56
E. Möller: 'Maso Finiguerra', *Bib. Humanisme & Ren.*, xxi (1959), pp. 185–9
B. Degenhart and A. Schmitt: *Corpus der italienischen Zeichnungen, 1300–1450*, i (Berlin, 1968), pp. 599–618, 662–5

Early Italian Engravings from the National Gallery of Art (exh. cat. by J. Levenson, K. Oberhuber and J. Sheehan, Washington, DC, N.G.A., 1973), pp. 1–11
K. Oberhuber: 'Vasari e il mito di Maso Finiguerra', *Il Vasari storiografo ed artista. Atti del congresso internazionale nel IV centenario della morte: Firenze, 1974*, pp. 383–93
D. Carl: 'Documenti inediti su Maso Finiguerra e la sua famiglia', *An. Scu. Norm. Sup. U. Pisa*, xiii/2 (1983), pp. 507–54
M. Haines: *La sacrestia delle messe nel duomo di Firenze* (Florence, 1983), pp. 165–75
Disegni italiani del tempo di Donatello (exh. cat. by L. Bellosi and A. Angelini, Florence, Uffizi, 1986), pp. 10, 72–111
M. Collareta and A. Capitanio, eds: *Oreficeria sacra italiana*, Florence, Bargello cat. (Florence, 1990)
L. Whitaker: 'Maso Finiguerra, Baccio Baldini and the Florentine Picture Chronicle', *Florentine Drawing at the Time of Lorenzo the Magnificent: Papers from a Colloquium held at the Villa Spelman: Florence, 1992*, pp. 181–96
A. Wright: 'Antonio Pollaiuolo, "maestro di disegno"', *Florentine Drawing at the Time of Lorenzo the Magnificent: Papers from a Colloquium held at the Villa Spelman: Florence, 1992*, pp. 131–46
G. Galli: 'La rivista Maso Finiguerra', *Grafica A.*, xx (1994), pp. 14–15
L. Melli: *Maso Finiguerra: I disegni* (Florence, 1995)

MARCO COLLARETA

Fioravanti [di Fieravanti], **Aristotele** [Aristotile da Bologna] (*b* Bologna, 1415–20; *d* Moscow, 1485–6). Italian engineer and architect, active also in Russia. The son of a local mason, Fieravante di Ridolfo (*c.* 1390–1430), Aristotele initially worked as a goldsmith. He secured notoriety as an engineer in 1455 first for transporting the campanile known as the Torre della Mangione (destr. 1825) of S Maria del Tempio, Bologna, to a new site 18 m away, then for straightening the leaning campanile (destr. 18th century) of S Biagio, Cento, and finally for straightening the leaning campanile of S Angelo, Venice, which collapsed directly afterwards. In 1458 he moved with his family from Bologna to Milan, where he entered the service of Francesco I Sforza, Duke of Milan. After being sent to Mantua in 1459 to straighten another tower, he worked for the Duke as a hydraulic engineer, repairing a canal near Parma (from 1459) and constructing others near Cremona (from 1460) as well as one (from 1462) from the River Crostolo (between Parma and Reggio Emilia). He also worked as a military engineer inspecting fortifications, in which capacity he is mentioned in Filarete's *Trattato di architettura* (1461–4). Fioravanti returned to Bologna in 1464, and in the following year he was appointed the city architect and engineer. In 1467 he was invited by Matthias Corvinus to Hungary (*reg* 1458–90) to prepare defences against the Turks, and he is reputed to have built a bridge over the Danube. In 1471 he visited Rome in order to transport the Vatican obelisk to the square in front of Old St Peter's, a task abandoned almost immediately at Pope Paul II's death. (The project was eventually undertaken by Domenico Fontana in 1586.)

Fioravanti returned to Bologna, where he was almost certainly involved in the design of the new façade of the Palazzo del Podestà. A model is said to have been prepared in 1472, but execution was delayed until 1484–94 and conducted by Francesco Fucci di Dozza (*fl* 1478–94) and Marsilio Infrangipani (*fl* 1469–1517). The façade, one of the most innovative and overtly *all'antica* designs of the 15th century, faces S Petronio and dominates Bologna's main square. It is organized as two storeys: a massive ground storey arcade rusticated with faceted masonry

(each block embellished with a rosette) and articulated with Corinthian half columns, and an upper storey set back to allow for a balcony arranged with round-arched windows and ornamental Corinthian pilasters. The immediate model for the façade, which recalls such imperial prototypes as the Colosseum, was undoubtedly the Benediction Loggia (early 1460s; destr.) in front of Old St Peter's, Rome, which was still under construction when Fioravanti was called to Rome in 1471. In 1475 Fioravanti left his family in Bologna and moved to Moscow, where he spent the rest of his career.

BIBLIOGRAPHY
L. Beltrami: *Vita di Aristotile da Bologna* (Bologna, 1912)
V. Snegiryov: *Aristotel' Fioravanti i perestroyka moskovskogo Kremlya* [Aristotele Fioravanti and the reconstruction of the Moscow Kremlin] (Moscow, 1935)
C. De Angelis and P. Nanelli: 'La facciata del Palazzo del Podestà a Bologna', *A. Lombarda*, 44–5 (1976), pp. 79–82
S. Tugnoli Pattaro: 'Le opere bolognesi di A. Fioravanti', *A. Lombarda*, 44–5 (1976), pp. 35–70

DAVID HEMSOLL

Fiore, Jacobello del. *See* JACOBELLO DEL FIORE.

Fiorentino, Rosso. *See* ROSSO FIORENTINO.

Fiorenzo di Lorenzo (di Cecco di Pascolo) (*b* Perugia, *c.* 1445; *d* Perugia, early Feb 1522). Italian painter and architect. The earliest reliable document to mention him is dated 20 May 1463, when he was appointed in place of his father, Lorenzo di Cecco, to vote for the Capitano del Popolo. Between 1463 and 1469 his name appears on the register of painters of Perugia. In 1470 he was treasurer of the painters' guild, and in 1472 he was elected its prior for November–December. On 9 December that year the Sylvestrine monks of S Maria Nuova, Perugia, commissioned him to paint a double-sided polyptych (Perugia, G.N. Umbria) for the main altar of their church; he did not complete it until 1493. From the tenor of the contract and the substantial sum agreed—225 ducats—it appears that Fiorenzo was then considered the best of the young painters working in Perugia. In 1476, while the plague was becoming increasingly rampant, he painted a fresco of the *Madonna of Mercy* (Perugia, G.N. Umbria; see fig.) for the hospital of S Egidio (destr.), Perugia. Originally signed and dated, the work is badly damaged but remains of fundamental importance for understanding the art of Fiorenzo's early maturity. While its subject is characteristic of local plague banners, its style is directly related to Florentine art of the same period, for example in its use of the perspective device of square paving stones. Other elements recall the ambience of the Rossellini brothers and Andrea del Verrocchio, especially the motif of the angels flying overhead.

In the following years Fiorenzo executed numerous works in Perugia. Evidently in very comfortable economic circumstances, he played an important role in the political and administrative life of the city. In 1487 he signed and dated the painted decoration of the wooden niche for S Francesco al Prato (Perugia, G.N. Umbria), which probably once held a statue of the saint. The lunette depicts the *Virgin and Child* surrounded by cherubim and two angels. On the lateral piers are *SS Peter and Paul*, and in small

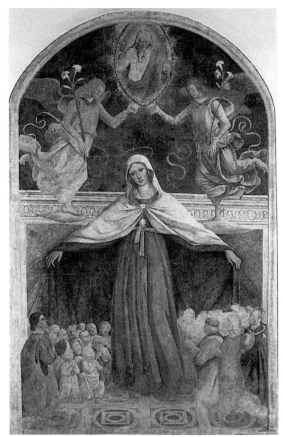

Fiorenzo di Lorenzo: *Madonna of Mercy*, detached fresco, 2.90×1.85 m, 1476 (Perugia, Galleria Nazionale dell'Umbria)

tondi in the predella are *St Bonaventure*, *St Anthony of Padua*, *St Bernardino* and *St Louis of Toulouse*. Various ornamental motifs, some in relief, appear inside the niche and on the side walls. Stylistically this work shows Fiorenzo's interest in the art of Antoniazzo Romano (in the monumentality of the poses) and also of Bernardino Pinturicchio; his own style is quite recognizable, however, through a certain dryness of the contour and through his fastidious manner of painting entirely with the tip of the brush, which suggests that he had close connections with the art of illumination.

The same characteristics can be seen in Fiorenzo's polyptych for S Maria Nuova, which departs considerably from the commission of 1472, eventually being executed between 1487 and 1493. For a fee of 130 florins, the new contract stipulated a single unified surface, with the *Virgin and Child* to be painted on the central panel, *St Peter*, *St Benedict*, *John the Evangelist* and the *Blessed Paolo Bigazzini* on the sides, the *Annunciation with Saints* on the pilasters and the *Eternal Father with Saints* in the cusps. This work confirms the stylistic tendencies apparent in the niche, but while forms reminiscent of Antoniazzo and echoes of the style of the so-called Master of the Gardner Annunciation (now identified as Piermatteo d'Amelia) prevail in the central part, the side panels—perhaps the last to be painted—show very clear signs of the influence of Pietro Perugino.

These three works, plus a frescoed *Crucifixion* for S Maria di Monteluce, Perugia, documented to 1491 but so heavily repainted as to be almost illegible, are all that can be reliably assigned to Fiorenzo. None of his other securely documented works survives, and several of the attributions to him remain unsubstantiated. Works that can be most reasonably assigned to him on the basis of stylistic comparisons include the *Virgin and Child with St Jerome* (Boston, MA, Isabella Stewart Gardner Mus.); a fresco of the *Crucifixion with Saints* (1492; Montelabbate, S Maria); a fresco of the *Virgin and Child and the Mystic Marriage of St Catherine* (1498; ex-S Giorgio dei Tessitori, Perugia; Perugia, G.N. Umbria); three panels depicting SS *Digna and Emerita, St Anthony Abbot* and *St Catherine* (Perugia, G.N. Umbria); *St Peter* (Hannover, Niedersächs. Landesmus.); the *Wounded Christ and the Chalice* (Perugia, Fratticciola Selvatica priv. col.); and *St Sebastian with a Donor* (Aix-en-Provence, Mus. Granet).

The *Virgin and Child* (Paris, Mus. Jacquemart-André), strongly reminiscent of Verrocchio and usually assigned to the young Perugino, may belong to Fiorenzo's career before 1476. Some of the *tavolette* depicting miracles of S Bernardino (1475; Perugia, G.N. Umbria), especially the scenes of the *Resurrection of the Stillborn Child* and the *Captain of Tornano Attacked by Cut-throats and Restored by the Saint*, show notable points of contact with the almost caricature-like figures in the step of the niche for S Francesco al Prato. The triptych of *Justice* (Perugia, G.N. Umbria), painted for the Confraternity of S Andrea, Perugia, has been reattributed, on documentary evidence, to Bartolomeo Caporali and Sante di Apollonio del Celandro (*d* 1486).

Fiorenzo's activity as an architect has been little studied. In 1490 he prepared a drawing (ex-Perugia, Osp. Misericordia) in two separate parts for the windows, festoons, cornices and fireplaces in the *piano nobile* of the building (now the Palazzo dell'Università Vecchia, Perugia), which a bull of Pope Sixtus IV designated as the seat of the *studium*. Two stonecutters, Mariotto di Pace and Bartoccio di Paolo, were engaged to execute the individual parts. In 1491 a payment to Fiorenzo was recorded for the design of letters carved into the architrave of the building's transomed, double-lighted windows. Fiorenzo therefore played a role in the planning of those stylistic details that characterize one of the most important Renaissance buildings in Perugia. From the study of these details considerable correspondences in taste emerge, not only with the *tavolette* of S Bernardino, but also with some contemporary *palazzi* in Pienza and Rome, for example the Palazzo Venezia. Another building in Perugia with the same type of window, the house owned by the Cavalieri di Malta at the end of Via dei Priori (now Via S Francesco), was restored in 1484.

Fiorenzo di Lorenzo was a figure of major importance in the panorama of Perugian art between 1470 and 1490. He strongly influenced the painting and manuscript illumination of the years just before Perugino's style acquired predominance. Research remains to be done on Fiorenzo's relationships with other artists of the time, notably Bartolomeo Caporali, Pietro di Galeotto di Ercolano, Sante di Apollonio, Ludovico di Angelo Mattioli (*fl* 1481–1522), Niccolò del Priore (*fl* 1470–1501) and Orlando Merlini (*fl*

1501–10). His brother Bernardino (*fl* 1484–1511) was also a painter and possibly also his collaborator.

BIBLIOGRAPHY

B. Orsini: *Guida al forestiere per l'augusta città di Perugia* (Perugia, 1784), p. 312
A. Mariotti: *Lettere pittoriche perugine* (Perugia, 1788), pp. 80–82, 210, 230
S. Siepi: *Descrizione topologica–istorica della città di Perugia* (Perugia, 1822), p. 792
C. F. von Rumohr: *Italienische Forschungen* (Berlin, 1827), pp. 320–24
M. Guardabassi: *Indice–guida dei monumenti pagani e cristiani riguardanti l'istoria e l'arte esistenti nella provincia dell'Umbria* (Perugia, 1872), pp. 216–29
G. B. Cavalcaselle and J. A. Crowe: *Storia della pittura in Italia*, ix (Florence, 1902), pp. 143–58
J. C. Graham: *The Problem of Fiorenzo di Lorenzo* (Rome, 1903)
S. Weber: *Fiorenzo di Lorenzo* (Strasbourg, 1904)
W. Bombe: *Geschichte der Peruginer Malerei* (Berlin, 1912), pp. 122–43
A. Venturi: *Storia*, vii/2 (Milan, 1913), pp. 567–85
U. Gnoli: *Pittori e miniatori dell'Umbria* (Spoleto, 1923), pp. 112–17
R. van Marle: *Italian Schools*, xiv (1933), pp. 122–43
F. Zeri: 'Il Maestro dell'Annunciazione Gardner', *Boll. A.*, xxxviii (1953), pp. 125–7, 233
F. Santi: *La Galleria Nazionale dell'Umbria: Dipinti, sculture ed oggetti dei secoli XV–XVI* (Rome, 1985), pp. 65–76
F. Todini: *La pittura umbra: Dal duecento al primo cinquecento* (Milan, 1989), i, pp. 67–9; ii, pp. 478–89
M. Bury: 'Bartolomeo Caporali: A New Document and its Implications', *Burl. Mag.*, cxxxii (1990), pp. 469–75

P. SCARPELLINI

Firenze, Desiderio da. *See* DESIDERIO DA FIRENZE.

Firenze, Michele da. *See* MICHELE DA FIRENZE.

Florence [It. Firenze]. Italian city and capital of Tuscany. Situated on the banks of the River Arno *c.* 85 km east of Pisa and *c.* 230 km north of Rome, the city lies in a basin surrounded by low hills. Florence is renowned as a centre of Italian art and architecture and for its role in the development of Renaissance art in the 15th century, particularly under the patronage of the Medici family.

I. History and urban development. II. Art life and organization. III. Centre of production. IV. Buildings. V. Institutions.

I. History and urban development.

1. Introduction. 2. *c.* 1283–1530. 3. 1531 and after.

1. INTRODUCTION. The plain of the River Arno was first settled in the Neolithic era. In the 5th century BC the Etruscans established a settlement, not on the plain but on the nearby hill of Fiesole. A Roman colony, Florentia, was subsequently founded by Julius Caesar in the mid-1st century BC on the northern bank of the River Arno near its junction with the Mugnone.

By the 2nd century AD the flourishing colony had a population of *c.* 10,000, and by the 4th century the inhabited area extended north of the walls to the present Piazza S Lorenzo, where the city's first Christian basilica, S Lorenzo, was consecrated as its cathedral by St Ambrose in AD 393.

As successive Gothic invasions wracked Tuscany in the 5th and 6th centuries, the settlement at Florence suffered demographic and economic decline. In the mid-6th century the Byzantine defenders of Florence built new fortifications enclosing a nucleus only about half the size of the Roman town, with massive Roman monuments used

as defensive strongpoints linked by barricades. Towards the end of the 6th century, however, the settlement fell to the Lombards, becoming part of the Lombardic Duchy of Tuscany centred at Lucca. During Lombard domination in the 7th and 8th centuries, the principal highway to Rome bypassed Florence, further contributing to its decline.

Tuscany became a Frankish province *c.* 775, and the Carolingian era marked the tentative beginnings of urban revival. A growing population and increasing prosperity in Florence were certainly among the motives for new city walls, probably constructed in the late 8th century or the early 9th. This circuit re-established the Roman perimeter on the east and west and incorporated a wedge of new settlement to the south. The Roman bridge over the Arno, destroyed during the Gothic invasions, was rebuilt, facilitating trade. Florence became the administrative centre of its county in 854. By the beginning of the 11th century Florence had become an important trading centre for the fertile valleys of Tuscany; its population was then around 5000.

In 1115 Florence achieved *de facto* self-government with the establishment of a *comune* (confirmed by the Holy Roman Emperor in 1183), which protected the interests of the merchants who were by then developing the cloth industry, trade and money-lending activities that later brought such wealth to the city. Many aristocratic family clans took up residence in the city at this time; within its walls they built defensible family enclaves, threaded by narrow alleys and enclosing minuscule piazzas. At the beginning of the 13th century, when the population had reached around 30,000, government by a Podestà (governing magistrate) replaced the *comune*, and the first guilds were formed. At this time also there began a century of bitter political rivalries and feuds between the Guelph faction (who supported the papal cause) and the Ghibellines (who supported the Holy Roman Emperor). The city was characterized by dozens of fortified family enclave towers: by some estimates, 200 or more such towers, mostly packed densely within the Carolingian walls, had been constructed by the mid-13th century. Despite the continual disruptions to urban life caused by the factional disputes, however, trade and industry continued to flourish, and during a brief period of popular government ('Primo Popolo'; 1250–60), which enforced reductions in the height of towers, the first monumental civic building in Florence was constructed: the Palazzo del Popolo (now known as the Bargello and housing the Museo Nazionale), built for the Capitano del Popolo, commander of the civic militia.

Expansion of the city continued, with settlements growing up ribbon-like along the highways outside the city gates. Magnets for further development were provided by the churches built in large open areas outside the city walls by the newly arrived mendicant orders: around 1220 the Dominicans acquired the church of S Maria Novella in the western suburbs and began a long rebuilding campaign *c.* 1246, receiving communal subsidies to create public piazzas in front of each succeeding structure; the Franciscans established themselves at Santa Croce east of the city walls, building a modest church *c.* 1225 but by 1294/5 beginning construction of an enormous new church facing

a large piazza; the Servites built a church (1250) to the north-east of the city walls that later became SS Annunziata; and on the southern side of the river (the Oltrarno) the Augustinians founded Santo Spirito (1250; rebuilt 15th century), and the Carmelites built S Maria del Carmine (1268; mostly rebuilt 1782) on the fringes of the built-up area (they too received government aid in creating piazzas). The growing importance of the Oltrarno as an integral part of the city led to the construction of three additional bridges: Ponte alla Carraia (1220), Ponte alle Grazie (1237) and Ponte Santa Trìnita (1252).

By the mid-13th century the Florentine cloth industry was producing for markets all over Europe, and merchants were involved in a huge commercial and banking network; the city's gold florin, first minted at about this time, became the standard currency in Europe. Florence also began to extend her control over much of the surrounding territory, annexing smaller adjacent city states. The increasing wealth and power of the city was reflected in the layout of many new streets, both inside and outside the city walls on both sides of the river; for example, while there had previously been little order in the urban sprawl except for the central grid of the old Roman town, the straight and relatively wide swaths of the Via Maggio and Via dei Servi, both dating from the mid-13th century, exemplify new criteria of order and regularity in urban planning. The new streets in turn provided opportunities for further development, and construction of modest housing was fostered by many ecclesiastical institutions, which subdivided their lands into building lots (*casolaria*) typically no more than 5 or 6 m wide along the street. The *casolare* thus became the principal module of development outside the 12th-century walls.

BIBLIOGRAPHY

R. Davidsohn: *Forschungen zur Geschichte von Florenz*, 4 vols (Berlin, 1896–1908)
——: *Geschichte von Florenz*, 4 vols (Berlin, 1896–1927; Ital. trans., 8 vols, 1957–68)
F. Schevill: *History of Florence* (New York, 1936); rev. as *Medieval and Renaissance Florence*, 2 vols (New York, 1963)
W. Paatz and E. Paatz: *Kirchen* (1940–54)
G. Maetzke: *Florentia* (Rome, 1941)
——G. Maetzke: 'Ricerche sulla topografia fiorentina nel periodo delle guerre goto-bizantine', *Rendi. Accad. N. Lincei, Cl. Sci. Mor., Stor. & Filol.*, 8th ser., iii (1948), pp. 97–112
W. Braunfels: *Mittelalterliche Stadtbaukunst in der Toskana* (Berlin, 1953)
U. Procacci: 'L'aspetto urbano di Firenze dai tempi di Cacciaguida a quelli di Dante', *Enciclopedia Dantesca*, ii (Rome, 1970), pp. 913–20
G. Fanelli: *Firenze: Architettura e città*, 2 vols (Florence, 1973) [vol. 2 contains numerous diagrams, maps, plans, photographs]
F. Sznura: *L'espansione urbana di Firenze nel dugento* (Florence, 1975)

PAULA SPILNER

2. *c.* 1283–1530. Following war with Siena and continual struggles between Guelphs and Ghibellines, a second popular government ('Secondo Popolo') was set up in 1283 by the guilds. With the realization that once again extramural expansion had rendered Florence's fortifications obsolete, yet another circuit of walls was planned (begun 1299; completed 1333). This circuit enclosed all the monasteries and a huge area five times the size of that within the walls built in the 12th-century, but the dramatic population decline of the 14th century meant that it was centuries before the new zone was fully developed. Construction was also begun on a new cathedral in 1296, and

a new government building, the Palazzo dei Priori, the seat of the leaders of the guilds, was begun in 1299, symbolizing the civic values of the new political order in which the nobility were banned from holding office. By 1300 Florence was among the five largest cities in Europe, with a population of *c.* 100,000.

The 14th century, however, was a period of turmoil for Florence. A fire in 1304 destroyed hundreds of houses; there was famine in 1315–17; the Arno flooded in 1333, causing enormous damage; and the plague reached the city in 1348, resulting in a 60% decline in the population. These events led to acute difficulties in building works, including the slowing of progress on earlier projects, such as the Gothic churches of S Maria Novella and Santa Croce (consecrated 1443). Nevertheless the two principal hubs of the city became more clearly defined at this time as work continued on the new cathedral and government buildings. Much of the new cathedral (see fig. 1) by Arnolfo di Cambio (*fl* 1265) had been completed by 1331 when relics presumed to be of the first bishop, St Zenobius (*d c.* 390), were found, and it was decided to extend the work to create a much larger church, for which the wool-merchants' guild (Arte della Lana) assumed responsibility. Work was initially concentrated on the campanile, begun by Giotto in 1334, and then continued on the cathedral (from 1355) by Francesco Talenti (1300/10–69).

Meanwhile a civic hub was being developed around the fortress-like Palazzo dei Priori (now Palazzo Vecchio; *see* §IV, 8 and fig. 7 below), which stands on part of the site of the old Roman theatre and was first completed in 1302 but enlarged later in the century on an irregular, trapezoidal plan. It immediately became the administrative and political centre of the city. At the same time the adjacent piazza (now Piazza della Signoria) began to be opened up specifically as a civic square, with no market functions; it was enlarged several times and was paved in the mid-14th century. In 1359 the Loggia della Mercanzia was built at the east end of the piazza to dispense justice over trade and guild matters. A few years later the Loggia dei Pisani was built on the west side and the Loggia dei Lanzi (or Loggia della Signoria; 1376–81) on the south side. The latter was built for ceremonial use by the Priori, and its arcade of semicircular arches anticipates Renaissance forms. The mint was built behind it and the whole area devoted to the agencies of the State.

The street linking the cathedral and the Palazzo dei Priori, the Via de' Calzaiuoli, which follows one of the old Roman roads, became the chief civic axis of the city. Along it, on the site of the old church of S Michele in Orto, was built the Orsanmichele (1336–1404; *see* §IV, 2 below). This was a new grain market with two large, superimposed vaulted halls over an arcaded ground-floor,

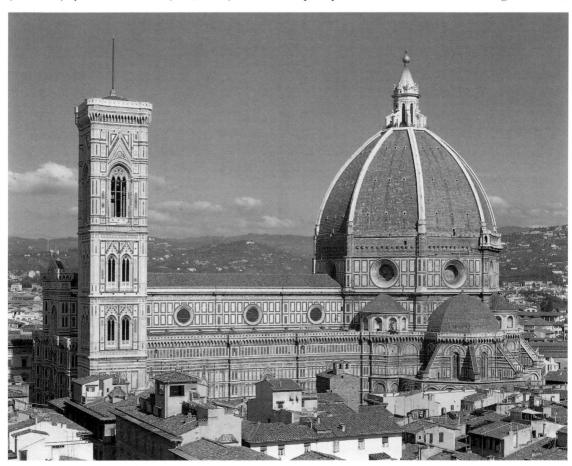

1. Florence Cathedral, begun *c.* 1294; dome by Filippo Brunelleschi, 1420–36

which by 1381 had been enclosed to form a sanctuary; this became an oratory for the trade guilds, all of whom had been involved in the project. The guilds were also important as founders and benefactors of hospitals. The cloth-merchants' guild (Calimala) built the hospital of Bonifazio, and the bankers' guild (Cambio) built the hospital of S Matteo; somewhat later the silk-workers' guild (Por S Maria) founded the Ospedale degli Innocenti (1419). Many such works were begun as a result of the 1348 plague.

Political and economic difficulties continued to occur during the period. The Florentine economy suffered a crisis in the 1340s when two of the most important banking families, the Peruzzi and the Bardi, became bankrupt; and the brief rule of Walter de Brienne, Duke of Athens, elected as Signore (1342–3), was ended by popular insurrection. Nevertheless the city's administrative structure was reorganized in 1343; instead of six *sestieri*, the new circuit of walls enclosed four *quartieri*, each subdivided into four smaller *gonfaloni*. Strong controls were also exerted by the city government over many aspects of development, chiefly as a reaction against acute congestion in the medieval nucleus. For example, the large zone enclosed by the new walls was to be developed in a rational manner, with broader, straighter streets: the original Roman grid, by then much modified by later encroachments, was considered the ideal model. A broadly radial pattern of new roads was established from the centre towards the city gates, together with a few major cross-axes, thus forming a roughly rectangular grid pattern with large areas of open space remaining. Existing open spaces were also enlarged, particularly in front of Santo Spirito, Santa Croce and S Maria Novella, where an important new public square was formed. Some streets in the old centre were also widened and jetties removed, while the process of paving continued throughout the central areas. Attempts were also made to impose greater discipline on new development by the alignment of façades and controls over facing materials and window types and sizes. Maximum heights were stipulated for new buildings, and the *comune* had the power compulsorily to demolish dangerous older structures, such as some of the fortress-towers. In 1349 a new agency, the Ufficiali delle Cinque Cose, took responsibility for most public works, including bridges, water supply, civic buildings and the city walls.

By 1400 three zones were clearly identifiable in the urban layout of Florence. The first was the original, densely developed core, irregularly superimposed on the Roman grid, with many fortified towers but with open space limited to the Piazza del Duomo and the Piazza della Signoria. The second zone included the area immediately surrounding the centre, originally just beyond the walls; this was also densely developed but with some squares, gardens and orchards. The third zone included the most recently enclosed areas beyond, developed only along the older radial routes and backed by large areas of gardens and orchards. The Oltrarno formed a small, compact zone south of the river, with some development along the Roman road; by this time there were four bridges linking it with the city centre.

Political unrest in the latter part of the 14th century, largely between the wealthy *borghesi* and the poorer artisans, culminated in the Ciompi revolt of 1378, when the wool-carders demanded the right to form a guild; this resulted briefly in direct popular representation in government. In 1382, however, a small number of wealthy merchant families succeeded in forming an oligarchic government, finally diminishing the political power of the guilds after nearly a century of dominance. By the beginning of the 15th century the population had recovered to *c.* 60,000; Arezzo was annexed in 1384, and in 1406 Florence conquered Pisa, signalling the final defeat of the Ghibellines and giving Florence control of an important seaport and extended opportunities for trade throughout the Mediterranean and to the Levant.

In the early 1400s the Medici family began the final stage of its rise to power. One of the wealthiest families in Florence and one of the few to survive the banking crisis of the 1340s, the Medici were among the first Florentines to patronize the arts and humanist learning. At the same time, however, they were active supporters of the guilds and opponents of the oligarchy. Cosimo de' Medici (il Vecchio) was exiled in 1433 but returned to popular acclaim in 1434 to become unofficial ruler as Lord of Florence ('Pater Patriae'). Medici patronage was a dominant factor in the development of Florence as the birthplace and cultural centre of the Italian Renaissance (*see* §II below).

The 15th century was marked by the complete reconfiguration of the medieval city of Florence as it became a centre of great wealth and power. In particular, the work of FILIPPO BRUNELLESCHI between 1418 and 1446 marked a decisive period in the development of both architecture and urban design. Brunelleschi's rational, structural approach was visionary, even revolutionary, by comparison with the earlier urban interventions of Giotto and Arnolfo, and it reached an unprecedented scale in the construction of the magnificent dome of the cathedral, built in 1420–36 (*see* §IV, 1(i)(a) below and BRUNELLESCHI, FILIPPO, figs 1,7 and 8). Quite different from any other tall structure in Florence, whether campanile or fortified tower, the dome dominated the entire city, acted as its symbol and asserted the power of its spiritual heart. Set in the middle of the urban fabric, the cathedral is best seen from a distance; the only important axial view within the city is from Via de' Servi, at the far end of which Brunelleschi laid out Piazza SS Annunziata to terminate the vista.

Brunelleschi's work at the Ospedale degli Innocenti (begun *c.* 1419) in that piazza is another masterpiece of the early Renaissance, its colonnade of semicircular arches developing forms seen earlier in the Loggia dei Lanzi but here made an essential part of the urban fabric (see colour pl. 1, XVI2). Piazza SS Annunziata can be considered the first modern Florentine square. Topographical principles of design are equally clear at the Palazzo Pitti (*see* §IV, 9(i) below and colour pl. 1, II2), which was built on a prominent terrace south of the Arno, with its façade aligned to the tower of Santo Spirito; probably begun *c.* 1457 it was built on an imposing scale by LUCA DI BONACCORSO PITTI as a demonstration of his wealth and power. The square created in front of it was the first in Florence to be related to a private house rather than a public building.

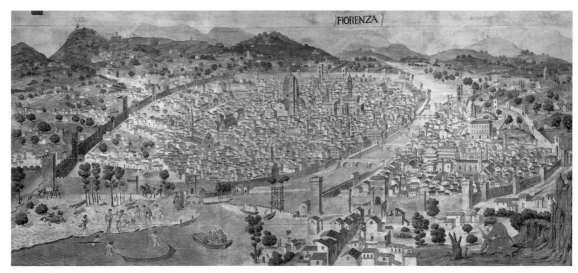

2. *Florence*, 'Pianta della Catena' view of the city, woodcut, attributed to Francesco Rosselli, 588×1315 mm, *c.* 1472 (Berlin, Kupferstichkabinett)

Under Medici rule, particularly that of Cosimo il Vecchio (*reg* 1434–64), public building activity began to lose importance to the private sector. Particular architects became associated with individual patrons, for example MICHELOZZO DI BARTOLOMEO with the Medici and LEON BATTISTA ALBERTI with the Rucellai, who were second only to the Medici in wealth and influence, and a great age of palazzo building among the banking and merchant families began. The STROZZI built the finest such palace in the city (begun *c.* 1489), in the heart of the old quarter, designed and executed by Benedetto da Maiano, Giuliano da Sangallo and Cronaca; the Palazzo Strozzi (*see* ITALY, fig. 5) is grandiose, severe and monumental and was loosely based on the Palazzo dei Priori. Others included the Palazzo Medici (1444–60; now Palazzo Medici–Riccardi; *see* PALAZZO, fig. 1, and MICHELOZZO DI BARTOLOMEO, fig. 3), built on the Via Larga (now Via Cavour) by Michelozzo; the Palazzo Rucellai (begun *c.* 1453), built to a design by Alberti (*see* ALBERTI, LEON BATTISTA, fig. 2); the Palazzo Antinori, perhaps by Giuliano da Sangallo; and the Palazzo Corsi by Michelozzo. These palaces transformed the districts immediately surrounding the old city centre, directly reflecting the wealth of the oligarchical clans that ruled the city. Because the banks and businesses of their owners remained in the medieval core of the city, they also marked the first separation between places of work and residence; the latter represented a new concept of the private palace as a self-contained entity. Their forbidding public façades contrast sharply with the light, refined design of their courtyards—private inner worlds surrounded by colonnades and loggias.

In the same period some families began to build villas in the *contado*, the surrounding countryside. Most active again were the Medici, who eventually owned more than a dozen such houses (*see* §5 below); the most notable is Poggio a Caiano, rebuilt by Giuliano da Sangallo for Lorenzo the Magnificent in the mid-1480s (*see* POGGIO A CAIANO, VILLA MEDICI).

The *de facto* rule of Lorenzo the Magnificent (1469–92; *see* MEDICI, DE', (5)) marked the apogee of building activity

by the families of Florence, which also included the patronage of churches. The Medici, for example, had earlier funded rebuilding work at S Lorenzo by Brunelleschi, his Old Sacristy (1419–28; *see* BRUNELLESCHI, FILIPPO, fig 2) being one of the earliest and purest monuments of the Renaissance (*see* §IV, 5 below). Later work at S Lorenzo by Michelozzo (and, subsequently, Michelangelo; see below) was also funded by the Medici, to the extent that it effectively became their own church. Medici patronage of nearby S Marco (built after 1452 by Michelozzo), where Cosimo il Vecchio had established the first public library in Europe (*see* MEDICI, DE', (2); MICHELOZZO DI BARTOLOMEO, fig. 2), made this zone of the city the Medici quarter. Other notable church projects of the period included Santo Spirito, begun by Brunelleschi in 1436 and completed in 1483 (*see* RENAISSANCE, fig. 1; BRUNELLESCHI, FILIPPO, §I,1(viii) and fig. 3b), and major alterations to SS Annunziata, begun 1444 by Michelozzo and completed by Alberti *c.* 1470. The city centre was profoundly changed by these projects; it acquired a new, monumental character, much of which remains, particularly around the medieval nucleus. As a patron of all the arts, Lorenzo de' Medici was outstanding—although not unique—in stimulating the atmosphere for such extraordinary creative activity.

The Renaissance concept of the city and interest in its further beautification were also stimulated by progress in printing techniques, which, for the first time, allowed images of the city to be accurately committed to paper. The first important view was by Pietro del Massario (1469), while the well-known 'Pianta della Catena' view of *c.* 1472 (see fig. 2) is the first detailed attempt to portray the city within its natural context; it is no coincidence that the cathedral dome is shown precisely in the centre. The view represents a new way of seeing and understanding the urban form. Equally characteristic of an increasing sense of civic pride and cultural superiority are the minutely detailed descriptions of the city's wonders produced at about this time by such writers as Benedetto Dei.

Lorenzo de' Medici, whom the Pazzi family tried to assassinate in 1478, had his son Giovanni de' Medici made

a cardinal at the age of 13 in 1489 (later Pope Leo X; *see* MEDICI, DE', (7)); the Medici bank failed before Lorenzo's death in 1492, however, and in 1494 his son Piero il Fatuo (1472–1503) was forced to leave Florence after secretly surrendering the city to the French. A new republican government was set up, but in 1512 the Medici regained power. During the next few years they consolidated some of the urban projects of the previous century, establishing the Palazzo Medici as a rival to the Palazzo della Signoria (Palazzo dei Priori) as the city's seat of power. The Via Larga, on which the Palazzo Medici was situated, formed a direct continuation of the Via de' Calzaiuoli, the main urban axis, thus linking the Palazzo della Signoria, the cathedral and the Medici power-base in a single, direct line. In 1516–20 Antonio da Sangallo (*see* SANGALLO, (2)) completed the Piazza SS Annunziata—largely a Medici creation—with the Loggia dei Servi opposite Brunelleschi's loggia. Michelangelo enriched S Lorenzo, the Medici church, with the New Sacristy (begun 1519), which became the Medici funerary chapel, and with the Biblioteca Laurenziana (begun *c.* 1524; *see* MICHELANGELO fig. 8), which housed the family's collection of manuscripts (*see* §IV, 5 below).

In 1529, after another brief republican interregnum, Florence was besieged by imperial forces; Michelangelo took charge of the fortifications and built a complex of new defences around S Miniato al Monte as well as extensive works to strengthen the city walls to the north. The siege lasted ten months and resulted in great destruction inside the city walls and in the surrounding area. Supported by both the Emperor and the Medici pope Clement VII (*see* MEDICI, DE' (8)), the Medici finally returned to Florence in 1530, beginning 200 years of hereditary rule by the family.

3. 1531 AND AFTER. The rule of the unpopular Alessandro de' Medici (*reg* 1531–7), who was given the title Duke of Florence by the Emperor, was a period of political uncertainty in Florence, and few building works were undertaken. The construction of the huge Fortezza da Basso (1533–5) on the north-west flank of the city walls was symptomatic of the era: it was built not to defend the city from external aggression but as a base from which internal dissent could be crushed. Under Cosimo I (*reg* 1537–74; *see* MEDICI, DE', (14)), however, the introduction of policies for the reconstruction of Tuscan sovereignty transformed the city into the seat of an economically and culturally flourishing dukedom. Building works at this time were undertaken chiefly to serve the Medici court rather than the city as a whole, in order to enhance and consolidate further their political and cultural power. The period is thus characterized essentially by works of order: the rebuilding of Ponte Santa Trinita, the restoration of the Ponte Vecchio and the construction of the Uffizi.

Until 1540 the Medici had continued to reside at the family palace on Via Larga (now Villa Cavour), but in that year Cosimo I moved them into the Palazzo dei Priori, which became known as the Palazzo Ducale and was extensively remodelled by Giorgio Vasari (*see* §IV, 8 below). In 1550 they moved again, this time to the Palazzo Pitti across the Arno, which Eleonora de' Medici, wife of Cosimo I, had bought. As a result of these moves, several important urban works were undertaken that had a profound effect on the city centre. The Palazzo Pitti was enlarged (*see* §IV, 9 below) and became the focus of the courtly life of the capital, but the need for easy communication with the Palazzo Ducale (henceforth known as the Palazzo Vecchio) and the proliferation of bureaucracy led to the building of the Uffizi (from 1559; *see* §IV, 10 below) to house many government departments; this was one of the first buildings in Florence to be conceived as a piece of urban design (see fig. 3). Vasari, who became court architect, then also built the long Corridoio Vasariano connecting the Uffizi and the Palazzo Vecchio with the Ponte Vecchio and thence to the Palazzo Pitti, providing a secure, direct link between these two new poles of power. The whole focus of government in the city had thus altered, with nuclei on each side of the Arno.

Cosimo I also instigated many other works dedicated to enhancing the city's grandeur as a Medici fiefdom. Columns were erected in the piazzas of S Marco, Santa Trinita and S Felice; the Via Maggio and Via Tornabuoni were widened and resurfaced; and the rebuilding of Ponte Santa Trinita (*c.* 1570) by Bartolomeo Ammanati created, together with the Via Maggio, another significant link between the old city centre and the newly important districts of the Oltrarno. New loggias were erected at important points in the city's fabric: the Loggia del Pesce by Vasari in the Mercato Vecchio, later moved to Piazza dei Ciompi; the Loggia del Mercato Nuovo (1547–51); and, later, the loggias of the Grana and S Maria Nuova. In 1571 the Jewish Ghetto, which had only two gates and was restricted by curfew, was formally established in a city block just north of the Mercato Vecchio. Consolidation of Medici power was also necessary well beyond the city walls; a programme of fortifications was undertaken in many dependent towns, including Pisa and Arezzo; Livorno was also restructured to become Florence's chief port on the Mediterranean. Wars with Siena, particularly in 1526, had necessitated works to Florence's own defences, especially across the Arno, but final victory over Siena in the period 1555–9 confirmed the Medici as absolute rulers of all Tuscany, and they were made Grand Dukes of Tuscany by the Emperor in 1569. Only Lucca remained as an independent city state.

Little work on churches was undertaken during the reign of Cosimo I, although the Jesuits arrived in Florence in 1546. Within existing churches, a new wave of austerity led to the removal of several choirs and the obliteration of some medieval wall paintings. Private palace building was chiefly confined to works by Cosimo's own courtiers and the favourites of his son Francesco de' Medici (later Francesco I). Examples are the palaces of the Grifoni, the Ramirez de Montalvo and the Almeni families. A new building type began to appear in the form of terraced houses for artisans, reflecting a new interest by the wealthy in land development, not only of their country estates but also within the city walls.

The courtly nature of Medici rule continued with Francesco I (*reg* 1574–87; *see* MEDICI, DE', (16); there was a renewed interest in the decorative frescoing of wall surfaces, such as that on the palazzo of Bianca Cappello, second wife of Francesco I, and a tendency towards highly Mannerist detailing after the style of Michelangelo and

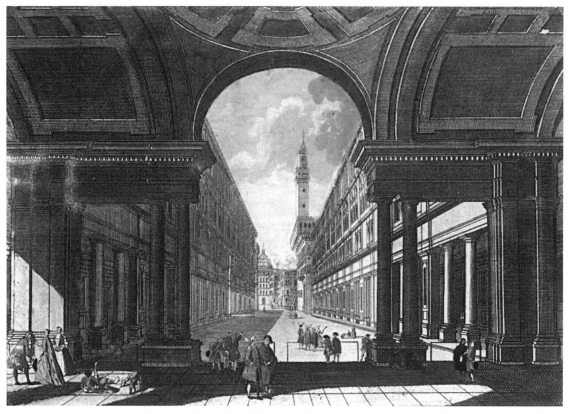

3. Florence, courtyard of the Uffizi, by Giorgio Vasari, from 1560, with the Palazzo Vecchio and the dome of the cathedral beyond; depicted in a steel engraving by Giuseppe Vasi after a drawing by Giuseppe Zocchi

Giulio Romano, with a parallel indulgence in capriccios in the form of gardens and grottoes. The reign of Ferdinando I (*reg* 1587–1609; *see* MEDICI, DE', (17)) is notable chiefly for the many important works of art commissioned for the Uffizi, but during this period Bernardo Buontalenti completed the Forte di Belvedere (1590–1600) above the Boboli Gardens at the Palazzo Pitti, built around the small villa at the highest point in the city. The villa had loggias on both principal façades to take advantage of views over the city and its southern hills. Few public works were necessary in this period. The Boboli Gardens were extended (*see* §IV, 9(iii) below and colour pl. 1, XVIII1), and new villas were built in the *contado* as part of a general reorganization of Medici lands. In 1599 Giusto Utens (*d c.* 1609) made a pictorial record of all 14 Medici villas (Florence, Mus. Firenze com'era; see fig. 14 below); in addition to the Pitti and Poggio a Caiano villas, the most important were at PRATOLINO, La Peggio and Castello.

In the city itself, many older, medieval houses were modernized, often remodelled internally and refaced externally. Churches, too, were refurbished, often to provide space for a proliferation of private chapels. A new urban equilibrium was established within the city walls as the population stabilized at about 60,000 at the end of the 16th century. Much of the area enclosed by the walls remained undeveloped, with many gardens and orchards behind a narrow ribbon of housing along the radial routes. Stefano Bonsignori's depiction (Florence, Mus. Firenze

com'era) of the city in 1584, a highly detailed aerial view based on a combination of axonometric and perspective projections, represents the record of a scientific age of enquiry and objectivity.

BIBLIOGRAPHY

F. L. del Migliore: *Firenze città nobilissima illustrata* (Florence, 1684)
E. Mazzanti and others: *Studi storici sul centro di Firenze* (Florence, 1889)
G. Conti: *Firenze dai Medici ai Lorena: Storia, cronaca aneddotica, costumi* (Florence, 1909)
A. Mori and G. Boffito: *Firenze nelle vedute e nelle piante: Studio storico, topografico, cartografico* (Florence, 1926)
Stradario storico e amministrativo della città e del comune di Firenze (Florence, 1929)
W. Paatz and E. Paatz: *Kirchen* (1940–54)
M. Lopes Pegna: *Firenze dalle origini al medioevo* (Florence, 1962)
E. Detti: *Firenze scomparsa* (Florence, 1970)
M. Bucci and R. Bencini: *Palazzi di Firenze*, 4 vols (Florence, 1971–3)
L. Ginori Lisci: *I palazzi di Firenze nella storia e nell'arte* (Florence, 1972)
F. Borsi: *Firenze del cinquecento* (Rome, 1974)
A. Busignani and R. Bencini: *Le chiese di Firenze* (Florence, 1974–)
L. Benevolo: *Storia della città* (Rome and Bari, 1976)
J. R. Hale: *Florence and the Medici: The Pattern of Control* (London and New York, 1977)
La città del Brunelleschi (Florence, 1979)
G. Fanelli: *Firenze: La città nella storia d'Italia* (Rome and Bari, 1980) [comprehensive and well illustrated]

For further bibliography *see* §IV below.

RICHARD J. GOY

II. Art life and organization.

1. Before *c.* 1530. 2. *c.* 1530 and after.

1. BEFORE *c.* 1530. The art of Florence developed from the earliest distinctive Tuscan art, which was pro-

duced in the 13th century in Pisa and Lucca. The sculptor Nicola Pisano (*c.* 1220/25–84) demonstrated an understanding of Classical forms in the mid-13th century, and his son Giovanni Pisano carried into the Tuscan vernacular the latest developments of Gothic sculpture, creating figures of unprecedented naturalism. A similar sense of naturalism was evident in the work of Giotto. In his narrative wall paintings, especially the frescoes (*c.* 1320) commissioned by the powerful banking families of the BARDI and Peruzzi for their chapels in Santa Croce, figures painted with dimension and monumentality are given dramatic expression. They exist within a naturalistic space, itself conceived with an awareness of the pattern created by forms across the surface of a picture (*see* GIOTTO, §I, 3(ii) and figs 7 and 8). An approach similar to Giotto's is evident in the work of his contemporaries. These artists established the major preoccupations of Florentine painters in the centuries to come. Their attention to naturalism was encouraged by the subjects commissioned in the 14th century for churches of the Franciscan and Dominican orders, including Santa Croce and S Maria Novella. Depictions of people, places and events of only a few generations earlier, together with accessible representations of familiar stories, were commissioned for the large churches built for preaching to the laity of the expanding towns. While some scenes were based on traditional compositions, others, especially those concerning the orders' founders and early saints, had no precedent and gave artists scope for invention.

From the 13th century in churches throughout Florence, as in other Tuscan cities, there was an increased demand for religious panel painting, especially for the decoration of altars. The reasons for the emergence of the altarpiece are not clear; from the first decades of the 14th century, however, elaborate, multi-panelled structures with complicated carved wooden frames were produced by the most innovative Tuscan painters and woodworkers, directly influencing Florentine painting until the mid-15th century. Contracts show that clients often had a woodwork shape in mind when they employed a painter, and that they discussed with painters the holy figures to be depicted in the main panels of the work. The subject-matter of the narrative scenes, called 'stories' in the documents, that were to appear in the predella panels, is rarely mentioned in contracts and may have been left to the discretion of the painter.

Many of the earliest altarpieces for Florentine churches were made by artists from Florence's arch-rival, Siena; political differences did not prevent patrons in either city from employing painters from the other for major commissions. The Sienese artist Ugolino di Nerio (*fl* 1317), for example, was commissioned in the 1320s to paint a large work for the high altar of Santa Croce; it may have been the earliest polyptych produced for a Florentine altar. The guilds, presumably aware of the beneficial stimulation of outside talent, made it easy for foreign artists to work in Florence. Sculptors belonged to their own guild, which had minor status; by 1316, painters were members of the major Arte dei Medici e Speziali. Guilds themselves became important patrons of art. From the early 14th century certain major guilds undertook the upkeep and embellishment of particular religious buildings, and all the

guilds were involved in the restoration and decoration of Orsanmichele (see fig. 4; *see also* §IV, 2 below).

The taste for naturalism developed by the earliest Florentine painters waned in the third quarter of the 14th century, possibly in response to the plague in mid-century, but a renewed interest in Classical sources and naturalistic form emerged in the late 14th century and the early 15th. POGGIO BRACCIOLINI and a small group of Florentine humanists discovered in monasteries works by Cicero and other Classical authors that had been ignored for centuries (*see* HUMANISM, §1), and they developed a new script and style of book decoration specifically for use in reproducing Classical texts.

The funding of large public projects by the civic authorities gave particular scope to sculptors, and in the first few decades of the 15th century DONATELLO, Lorenzo Ghiberti (*see* GHIBERTI, (1)) and NANNI DI BANCO created figures for the façades of the cathedral, the Loggia della Signoria (now Loggia dei Lanzi), Orsanmichele and the Baptistery that combine Classical simplicity and monumentality of form with naturalistic pose and modelling (see figs 10 and 11 below). The sculpture, much of which was just above street level, influenced painters, architects and other artists.

Gentile da Fabriano cultivated a sumptuous naturalism, manifested in Florence in the altarpiece of the *Adoration of the Magi* (1423; Florence, Uffizi), painted for Palla Strozzi (*see* GENTILE DA FABRIANO, fig. 3; *see also* STROZZI, (1)). MASACCIO reanimated Giotto's monumental figures with a dramatic realism and, employing mathematical perspective, placed them in a convincing pictorial space. Filippo Brunelleschi created a new, classical architectural style (*see* §I, 2 above); LEON BATTISTA ALBERTI codified the artists' achievements in his theoretical treatise *De pictura* (1435); and Florence was established as the foremost centre of Renaissance culture in the 15th century.

Linear perspective, first demonstrated by Brunelleschi, revolutionized the treatment of space, and Florentine artists made creative use of the new technique. In the second third of the 15th century, Florentine artists of note—Lorenzo Ghiberti, Fra Angelico, Filippo Lippi, Paolo Uccello, Luca della Robbia, Domenico Veneziano and Andrea del Castagno—explored its possibilities, setting their figures in an environment that seemed to extend the real space of the viewer. In the final third of the century such artists as Antonio Pollaiuolo and Piero Pollaiuolo, Perugino, Sandro Botticelli, Filippino Lippi and Domenico Ghirlandaio created compositions in which elegant figures inhabited a space often defined by Classical monuments and physically bound on both frescoes and

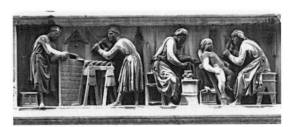

4. Florence, Orsanmichele, relief attributed to Nanni di Banco: *Sculptors at Work*, marble, early 15th century

panels by decorative surrounds based on antique forms. These surrounds were developed in the mid-15th century as a new form of altarpiece structure reflecting the widespread interest in the Antique. Gothic woodwork forms were eschewed in favour of Classical architectural elements. The new altarpieces were usually smaller than polyptychs and were composed of a rectilinear main panel over a predella; some were topped by pieces in the shape of a half tondo, but many surrounds consisted only of a simple architrave supported by columns. It is likely that sculptor-woodworkers were as influential as painters and their clients in developing the form. The earliest surviving antique-style carved surround is that made around 1432 for Fra Angelico's *Annunciation* altarpiece for S Domenico, Cortona (Cortona, Mus. Dioc.); an earlier painted surround can be seen in Masaccio's *'Trinity'* fresco (*c.* 1427) in S Maria Novella (see colour pl. 2, III1).

While there was no special artists' quarter in Florence, artistic methods were handed down in workshops in which master artists trained apprentices, who, together with other assistants, aided the master with projects. A clear account of workshop techniques and modes of operation is given in *Il libro dell'arte* (*c.* 1390) by Cennino Cennini (*c.* 1370–1440). Since Cennini was a pupil of Agnolo Gaddi (*fl* 1369), who was the son of Giotto's assistant Taddeo Gaddi (*fl* mid-1320s), the handbook can be taken to report the methods used in Giotto's shop and is a measure of the persistence of the tradition. The methods Cennini described, and the recipes he recorded, were employed into the 16th century. Workshop organization varied, however. The size of a shop depended on the personality and business requirements of individual artists, and the number of people employed might depend on the number and type of projects undertaken. Painting frescoes, for example, often required more assistance than the production of panels or altarpieces, and master painters were commonly required to transfer themselves, their assistants and their materials to a work site, often while retaining the main workshop in Florence.

The workshop tradition might have engendered stultified, conservative art, but in Florence that was not the case. The city's artists maintained a high degree of originality, and clients seem to have valued innovation. Giorgio Vasari (*see* VASARI, (1)) notes that the spirit of competition was important in the development of the best Florentine artists; in his account of the life of Perugino, he records that painters were spurred to creativity by a combination of critical attention, their natural industry and their eagerness for glory and honour. Originality is evident not only in style but also in the innovative use of materials, such as Luca della Robbia's use of glazed terracotta for sculpture, and in the organization of shops that offered diverse services. The workshop of ANDREA DEL VERROCCHIO, for example, produced sculpture in stone, bronze, silver and terracotta as well as panel paintings, and the absence of paintings that can be securely attributed to him suggests that he left an important part of the execution of panels to assistants. The POLLAIUOLO brothers were famous into the 16th century as masters of the skill most admired in Florence—design—and they were particularly praised for it by Benvenuto Cellini. Their workshop produced sculpture, goldsmiths' work and painting in all media, as well as

designs for embroidery, drawings and at least one print clearly for the use of other artists.

While Florentine workshops were usually competitive and individualistic, some projects required collaboration, and some artists specialized in cooperative work. MICHELOZZO DI BARTOLOMEO advised Ghiberti on bronze-casting and established a formal partnership with Donatello for the production of marble sculpture before becoming the chief architect of the Medici family. MASOLINO and Masaccio worked together on the frescoes in the Brancacci Chapel in S Maria del Carmine (*c.* 1427; see fig. 5 and colour pls 2, II2–2, IV2), imaginatively unifying their different styles. Documents record that the projects for the sculptural decoration of the façades of the cathedral and the newly constructed Loggia della Signoria involved the joint efforts of painters, who designed the statues and reliefs, and sculptors, who realized the plans in stone. The chapel of the Cardinal of Portugal (second half of 15th century) in S Miniato al Monte is the supreme example of a successful collaboration by a large group of artists (see fig. 6; *see also* §IV, 7 below).

By the mid-15th century, the dominant mode of patronage had changed from corporate to personal, largely through the Medici family's expression of its power and immense wealth through patronage of the arts. The extent of Cosimo de' Medici's commissions, for example at S Lorenzo and S Marco, rivalled that of even the richest guilds (*see* MEDICI, DE', (2)). His son Piero commissioned works in painting and sculpture (*see* MEDICI, DE', (3)), and both men were responsible for the establishment of Florence as a centre of manuscript illumination (*see* VESPASIANO DA BISTICCI). Other patrons, mainly Medici

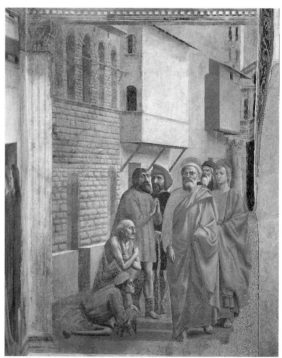

5. Florence, S Maria del Carmine, Brancacci Chapel, fresco by Masaccio: *St Peter Healing with his Shadow, c.* 1427

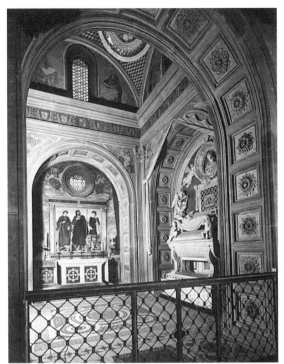

6. Florence, S Miniato al Monte, Cardinal of Portugal's Chapel, second half of the 15th century

supporters, followed suit on a smaller scale; Giovanni Rucellai employed Alberti to design his palace (begun *c.* 1453; *see* ALBERTI, LEON BATTISTA, fig.2), family chapel (1464–7; *see* ALBERTI, LEON BATTISTA, fig.3) in S Pancrazio and the façade (*c.* 1458–70) of S Maria Novella (see fig. 13 below).

In the last quarter of the 15th century, Lorenzo the Magnificent styled himself more overtly as a prince, and his control of artistic life was unprecedented (*see* MEDICI, DE', (5)), although he acted personally as a collector rather than a commissioner of new work. The frescoes (*c.* 1478) by Domenico Ghirlandaio of scenes from the *Life of St Francis* in the Sassetti Chapel in Santa Trìnita illustrate the new conditions; included among a large number of prominent portraits of the family is one showing Lorenzo himself standing next to FRANCESCO SASSETTI, manager of the Medici banking empire from 1463 (*see* ITALY, §XII and fig. 39).

The work of Florentine artists was highly regarded, and this is reflected in the payment they received for their work. Between 1400 and 1500 most painters trained in Florence seem to have been able to command higher fees than artists trained elsewhere. Lorenzo was thus able to use them as tools in his diplomacy, for example in securing a cardinalcy for his son Giovanni de' Medici, the future Pope Leo X. By the early 16th century, however, while Florentine artists continued to be in demand, those trained in other cities were equally sought after and well paid.

At the end of the 15th century, turbulent economic, political and social conditions and the preaching of GIROLAMO SAVONAROLA severely affected private patronage. The expulsion of the Medici family in 1494 led

to the re-establishment of the republic, which initiated projects promoting the new regime, centred on the Palazzo della Signoria (now Palazzo Vecchio; see fig. 7). Michelangelo was commissioned in 1501 to complete the colossal statue of *David* (Florence, Accad.), a traditional symbol of Florentine liberty (*see* MICHELANGELO, §I, 3; *see also* ITALY, fig. 22). Andrea Sansovino and Fra Bartolommeo were also hired, as were Leonardo and Michelangelo, who were commissioned to produce large frescoes of the *Battle of Anghiari* and the *Battle of Cascina* respectively. The frescoes (destr.) were never completed, but the cartoons of both were widely admired and strongly influenced contemporary Florentines. In the first decade of the 16th century, private patronage was revived on a more pious, sober note, as seen in the series of Madonnas painted by the newly arrived Umbrian artist, Raphael, and in the altarpieces of Fra Bartolommeo and ANDREA DEL SARTO. In the work of these artists extraneous details were eliminated, and monumental figures were represented in calm, balanced compositions that, together with contemporary achievements in Rome, came to be seen as defining a kind of classical perfection. With the return of the Medici in 1512, the sculptural and architectural embellishment of S Lorenzo was revived, principally under Michelangelo. At the same time, younger Florentine painters, chiefly ROSSO FIORENTINO and PONTORMO, began to develop particular aspects of High Renaissance style, contributing to the eclectic variety of styles now known as Mannerism.

BIBLIOGRAPHY

C. Cennini: *Il libro dell'arte* (MS.; *c.* 1390); trans. and notes by D. V. Thompson jr (New Haven, 1933/*R* New York, 1960)
L. B. Alberti: *De pictura* (MS.; 1435); ed. G. Papini (Lanciano, 1913)
N. di Bicci: *Le ricordanze* (MSS; 1453–75); ed. B. Santi (Pisa, 1976)
G. Vasari: *Vite* (1550, rev. 2/1568); ed. G. Milanesi (1878–85)
B. Cellini: *Trattato dell'oreficeria* and *Trattato della scultura* (MSS; begun 1565); ed. G. Milanesi (Florence, 1857)
P. Bacci: *Documenti toscani per la storia dell'arte,* ii (Florence, 1912)
H. Lerner-Lehmkuhl: *Zur Struktur und Geschichte des florentinischen Kunstmarktes im 15. Jahrhundert* (diss., U. Munich, 1936)
M. Wackernagel: *Der Lebensraum des Künstlers in der florentinischen Renaissance* (Leipzig, 1938; Eng. trans., Princeton, 1981)
R. Lopez: 'Hard Times and Investment in Culture', *The Renaissance: A Symposium,* ed. W. Ferguson (New York, 1953)

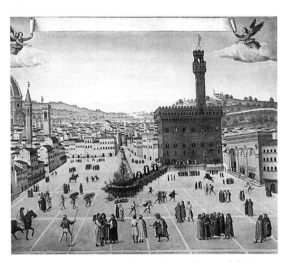

7. Florence, Palazzo Vecchio, begun 1299, and Piazza della Signoria; from the *Death of Savonarola, c.* 1500 (Florence, Museo di S Marco)

E. H. Gombrich: 'The Early Medici as Patrons of Art', *Italian Renaissance Studies*, ed. E. F. Jacob (London, 1960)

H. Hager: *Die Anfänge des italienischen Altarbildes: Untersuchungen zur Entstehungsgeschichte des toskanischen Hochaltarretabels* (Munich, 1962)

C. Gardner von Teuffel: *Studies of the Tuscan Altarpiece in the Fourteenth and Early Fifteenth Centuries* (diss., U. London, Courtauld Inst., 1974)

A. Thomas: *The Workshop Procedure of Fifteenth-century Florentine Artists* (diss., U. London, Courtauld Inst., 1976)

C. Gardner von Teuffel: 'The Buttressed Altarpiece: A Forgotten Aspect of Tuscan Fourteenth-century Altarpiece Design', *Jb. Berlin. Mus.*, xxi (1979), pp. 21–65

E. Skaug: 'Punch-marks—What Are they Worth? Problems of Tuscan Workshop Interrelationships in the Mid-fourteenth Century: The Ovile Master and Giovanni da Milano', *La pittura nel XIV e XV secolo. Il contributo dell'analisi tecnica alla storia dell'arte. Atti del XXIV congresso internazionale di storia dell'arte: Bologna, 1982*, iii, pp. 253–82

P. Burke: *The Italian Renaissance: Culture and Society in Italy* (Princeton, 1986)

F. W. Kent and P. Simons, eds: *Patronage, Art and Society in Renaissance Italy* (Oxford, 1987)

C. Hope: 'Altarpieces and the Requirements of Patrons', *Christianity and the Renaissance: Images and Religious Imagination in the Quattrocento*, ed. T. Verdon and J. Henderson (Syracuse, 1990)

B. Kempers: *Painting, Power and Patronage: The Rise of the Professional Artist in the Italian Renaissance* (London, 1992)

R. A. Goldthwaite: *Wealth and the Demand for Art in Italy* (London, 1993)

E. Borsook and F. Superbi Gioffredi: *Italian Altarpieces, 1250–1550: Function and Design* (Oxford, 1994)

M. Hollingsworth: *Patronage in Renaissance Italy* (London, 1994)

M. O'Malley: *The Business of Art: Contracts and Payment Documents for 14th- and 15th-century Altarpieces and Frescoes* (diss., U. London, 1994)

Florentine Drawing at the time of Lorenzo the Magnificent: Papers from a Colloquium held at the Villa Spelman: Florence, 1992

D. Norman, ed.: *Siena, Florence and Padua: Art, Society and Religion, 1280–1400* (New Haven and London, 1995)

R. Scorza: 'Borghini and the Florentine Academies', *Italian Academies of the Sixteenth Century*, ed. D. S. Chambers and F. Quiviger (London, 1995), pp. 137–63

Painting and Illumination in Early Renaissance Florence, 1300–1450 (exh. cat., New York, Met., 1995)

G. Gentilini: 'La scultura fiorentina in terracotta del Rinascimento: Tecniche e tipologie', *Scultura in terracotta: Tecniche e conservazione*, ed. M. G. Vaccari (Florence, 1996), pp. 64–103

MICHELLE O'MALLEY, CHRISTOPHER POKE

2. *c*. 1530 and after. The events that led to the siege of 1529–30 and Alessandro de' Medici's appointment as Duke of Florence brought about a profound political, economic and cultural crisis in the city. Many emigrated, including Michelangelo in 1534, and the city's intellectual and artistic circles were dispersed. Alessandro was too concerned with securing his political position to occupy himself with matters of culture, but his successor, Cosimo I, introduced policies to promote the cultural and artistic prestige of Florence and Tuscany that soon gained considerable public support (*see* MEDICI, DE', (14)). The political and cultural organizations that emerged during this period, including the Accademia Fiorentina (founded 1542) and the Accademia del Disegno (founded 1563; *see* §V, 1 below), were to survive until the end of the Medici era. The celebrations in June 1539 for the marriage of Cosimo I and Eleonora, daughter of Pedro de Toledo, Viceroy of Naples (1484–1553), were evidence of improving political stability in Florence.

The success of Medici propaganda was manifested by the return (1553) of emigré writers, such as BENEDETTO VARCHI, and artists, including BACCIO BANDINELLI, BENVENUTO CELLINI (1545), BARTOLOMEO AMMANATI and Giorgio Vasari (*see* VASARI, (1)). The members of the Accademia Fiorentina, especially Varchi, were responsible

for the elaboration of theories that were to have great influence on the development of linguistics, literature and visual arts in Florence and throughout Tuscany. The most active individual in the implementation of Medici cultural policy, however, was Vasari, who was appointed court architect and painter in 1554. In the next two decades he consolidated his position through important architectural projects, including the reconstruction and decoration of the Palazzo Vecchio into a representative residence for the head of state and the artistic supervision of the decorative work at the wedding in 1565 of the future Francesco I and Joanna of Austria (1547–78).

Medici propaganda achieved its triumphs not only as a result of its military successes but also through its many public foundations. In addition to the Accademia Fiorentina and Accademia del Disegno, various court manufacturing establishments were founded to produce, for example, tapestries (the Arazzeria Medicea, 1554; *see* §III, 3 below) and crystal glass (1569), and a foundry for light castings was modernized in 1556. The Biblioteca Laurenziana was opened to the public in 1571, and Cosimo established the basis of the Medici museum, creating an antiquities collection (1561–2) in the Palazzo Pitti that was independent of the rich collections at the Guardaroba in the Palazzo Vecchio; he also anticipated the building of the gallery at the Uffizi (*see* ITALY, §XIV, 2). Artists active during the early part of his reign included JACOPO DA PONTORMO, whose figurative compositions, especially the *Last Judgement* (1546–56; destr. 1742) in the choir of S Lorenzo, were inspired by the work of Michelangelo, and AGNOLO BRONZINO, who was court portrait painter to Cosimo I (see fig. 8) and, with Vasari, was one of the founders of the Accademia del Disegno.

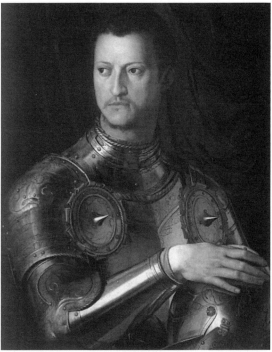

8. *Cosimo I in Armour* by Agnolo Bronzino, oil on canvas, 710×570 mm, 1543 (Florence, Galleria degli Uffizi)

The reign of Francesco I (*reg* 1574–87; *see* MEDICI, DE',
(16)) was marked by the development of goldsmithing,
porcelain (*see* §III, 1 below) and crystal glass manufacture,
for which Bernardo Buontalenti built the Casino de' Medici
(1574; now the Palazzo della Corte d'Appello) in Piazza S
Marco. Francesco's extensive collection of antiques, small
bronzes, natural objects and watercolours depicting nature
was originally housed at the *studiolo* (1570–73) in the
Palazzo Vecchio (*see* STUDIOLO, fig. 2) and then in the
Tribuna (*c.* 1580), an octagonal rotunda in the Uffizi.
Numerous travellers, including Michel de Montaigne
(1533–92), who visited in 1580, marvelled at the splendid
gardens (1573–80; destr.) designed by Buontalenti for the
Medici villa at Pratolino. The spectacles staged in the
Teatro Mediceo, built in 1586 by Buontalenti on the top
floor of the Uffizi, were influential in the development of
opera. At the end of Francesco's reign, Giambologna
produced a bronze equestrian statue of *Grand Duke
Cosimo I* (1587–93), which was placed in the Piazza della
Signoria outside the Palazzo Vecchio (*see* GIAMBOLOGNA,
fig. 5); it was replicated shortly afterwards in a version of
Francesco I (1608) in Piazza SS Annunziata.

The Medici court was not the only stimulus in Florentine
culture, however. Various brotherhoods and associations,
both religious and lay, were highly active, and many
individuals also collected and commissioned works of art.
BERNARDO VECCHIETTI, for example, amassed an inter-
esting collection after 1552 at his villa, Il Riposo, near
Florence. This included drawings, cartoons and many
models by Giambologna, whom Vecchietti sponsored
between 1552 and 1566. He also organized an artists'
workshop to provide for his own commissions. Niccolò
Gaddi (*see* GADDI (2)) created a Galleria in which, as well
as his collection of Italian and Dutch landscape drawings
and watercolours of nature studies by Jacopo Ligozzi
(1547–1627), there were workshops specializing in the
coloured stone used in the decoration of his ancestral
chapel (1575–6) in S Maria Novella. Il Riposo and the
Galleria were meeting-places for art lovers and tourists
alike.

The Medici court's role as the impetus for the city's
cultural life was consolidated during the reign of Ferdi-
nando I (*see* MEDICI, DE', (17)). Under a decree of 1588,
all the court workshops were transferred to the Uffizi
building and joined together in one uniform institution as
the Galleria dei Lavori. In 1604 a workshop later known
as the Opificio delle Pietre Dure (*see* §III, 2 below) was
created within the framework of the Galleria, partly to
meet the building requirements of the Cappella dei Principi
in S Lorenzo (*see* §IV, 5 below), and it achieved interna-
tional prominence in this craft. The studios of Giambol-
ogna and Jacques Bylivert (1550–1603) were associated
with the Galleria. Meanwhile, the sumptuous banquets
that took place in 1600 during the marriage celebrations
of Marie de' Medici and Henry IV, King of France (*reg*
1589–1610), surpassed all the Medici's previous spectacles.

BIBLIOGRAPHY
J. Pope-Hennessy: *Italian High Renaissance and Baroque Sculpture* (London,
 1963, rev. 3/1986)
E. Borsook: 'Art and Politics at the Medici Court: I. The Funeral of
 Cosimo de' Medici', *Mitt. Ksthist. Inst. Florenz,* xii (1965), pp. 31–54
L. Berti: *Il principe dello studiolo: Francesco I e la fine del rinascimento
 fiorentino* (Florence, 1967)
W. Prinz: *Die Sammlung der Selbstbildnisse in der Uffizien* (Berlin, 1971)
M. D. Davis: 'La galleria di sculture antiche di Cosimo I a Palazzo Pitti',
 Le arti del principato mediceo (Florence, 1980), pp. 31–54
C. W. Fock: 'Francesco I e Ferdinando I: I mecenati di pietre dure', *Le
 arti del principato mediceo* (Florence, 1980), pp. 317–63
Il primato del disegno (exh. cat., Florence, Pal. Strozzi, 1980)
Theater Art of the Medici (exh. cat. by A. R. Blumenthal, Hannover, NH,
 Dartmouth Coll., Hopkins Cent. A.G., 1980)
K. Langedijk: *The Portraits of the Medici, 15th–18th Centuries,* 3 vols
 (Florence, 1981–7)
F. Haskell and N. Penny: *Taste and the Antique: The Lure of Classical
 Sculpture, 1500–1900* (New Haven and London, 1982)
D. Heikamp: 'La galleria degli Uffizi descritta e disegnata', *Uffizi: Quattro
 secoli di una galleria. Atti del convegno internazionale di studi: Firenze,
 1982,* ii, 461–88
Z. Waźbiński: *L'Accademia medicea del disegno a Firenze nel cinquecento:
 Idea e istituzione* (Florence, 1987)
 Z. WAŹBIŃSKI

III. Centre of production.

1. Porcelain. 2. Hardstones. 3. Tapestry.

1. PORCELAIN. A porcelain factory was in operation
in the vicinity of the Palazzo Pitti during the reign of
Grand Duke Francesco I. According to Vasari's *Vite,* it is
believed to have originated *c.* 1565 with experiments by
the court architect Bernardo Buontalenti. Production was
first mentioned in 1575. The body employed was a soft-
paste porcelain not unlike pottery from Iznik in Turkey
and it possibly resulted from advice said to have been
provided by a Levantine. Only 57 pieces of Medici
porcelain have been recorded, and all but three, which are
polychrome, are painted in underglaze blue of variable
colour and control. Three main types of decoration were
employed: grotesque ornament derived from Italian maiol-
ica, particularly the Raphaelesque type associated with the
workshops of the Fontana and Patanazzi families in
Urbino (*see* URBINO, §3); motifs borrowed from 15th-
century as well as contemporary Chinese porcelains; and
Ottoman styles based on 16th-century Iznik pottery.
Forms derived from maiolica, metalwares and lapidary
work included simple, deep dishes, but more typical were
ewers, flasks (e.g. one of 1575–87; Paris, Louvre; *see also*
ITALY, fig. 30) and cruets. Factory workmen included
Flaminio Fontana (*fl* 1573–8) and Pier Maria da Faenza *fl*
1580–89). Most pieces are marked with the dome of the
cathedral of S Maria del Fiore and the letter F in underglaze
blue. Production appears to have ended with Francesco's
death (1587), but the presence in Florence in 1589 of the
potter Niccolò Sistì (*fl c.* 1577–*c.* 1619) and the record in
1613 of porcelain tokens decorated with the Medici arms
indicate continued, unofficial activity.

BIBLIOGRAPHY
Baron Davillier: *Les Origines de la porcelaine en Europe* (Paris, 1882)
G. Liverani: *Catalogo delle porcellane dei Medici* (Faenza, 1936)
J. Lessmann: 'Polychromes Medici-Porzellan', *Pantheon,* xxxiv (1976), pp.
 280–87
G. Cora and A. Fanfani: *La porcellana dei Medici* (Milan, 1986)
 CLARE LE CORBEILLER

2. HARDSTONES. Francesco I also created a fashion
for mosaics and intaglio works in hardstones and, taking
a personal interest in experimentation with materials and
techniques, fostered their production in Florence. In 1572
the Milanese brothers Ambrogio Caroni (*d* 1611) and
Stefano Caroni (*d* 1611) moved to Florence, followed by

Giorgio Gaffurri, the head of a Milanese workshop specializing in the engraving of rock crystal and pietre dure. Designed by such court-approved artists as Bernardo Buontalenti, sophisticated vases were decorated with gold and enamel work by the Florentine and north European goldsmiths whom Francesco I had gathered in the Casino de' Medici in Piazza S Marco, his private residence. Intarsia and pietre dure mosaics made at this time are mainly geometric in composition and give maximum prominence to the assortment of precious materials.

At the Galleria dei Lavori founded by Ferdinando I in 1588 (see §II, 2 above), the most prominent activity was the production of pietre dure. A predilection for ornamental and figurative themes prevailed, and the resulting mosaics are sophisticated examples of the use of hardstones to create 'stone paintings'. An opportunity to develop this technique was provided by the decoration of the Cappella dei Principi in S Lorenzo (see §IV, 5 below), a mausoleum with hardstone cladding and, at its centre, a small temple entirely in pietre dure with trimmings of precious metal. This work began under Ferdinando I in 1580–90 and continued for many years without being finished. The numerous craftsmen employed on the project executed the pietre dure mosaics following polychrome cartoons provided by such painters as Lodovico Cigoli (1559–1613), Bernardino Poccetti and Jacopo Ligozzi. Fully rounded statuettes, composed of various polychrome elements of pietre dure (Florence, Pitti) were also created for the chapel. This singular genre of 'mosaic sculpture', first produced in Florence at the end of the 16th century with the rock-crystal aedicula containing *Christ and the Woman of Samaria* (Vienna, Ksthist. Mus.), continued to be practised in the Florentine workshop alongside the other speciality of pietre dure mosaic.

BIBLIOGRAPHY

A. Zobi: *Notizie storiche sull'origine e progressi dei lavori di commesso in pietre dure che si eseguiscono nell'I. e R. Stabilimento di Firenze* (Florence, 2/1853)

F. Rossi: *La pittura di pietra* (Florence, 1967)

A. M. Giusti, P. Mazzoni and A. Pampaloni Martelli: *Il Museo dell'opificio delle pietre dure a Firenze* (Milan, 1978)

U. Baldini, A. M. Giusti and A. Pampaloni Martelli: *La Cappella dei Principi e le pietre dure a Firenze* (Milan, 1979)

A. Gonzalez-Palacios: *Mosaici e pietre dure*, ii (Milan, 1981)

——: *Il Tempio del Gusto: Il Granducato di Toscana e gli stati settentrionali*, 2 vols (Milan, 1986)

Splendori di pietre dure: L'arte di corte nella Firenze dei Granduchi (exh. cat., ed. A. M. Giusti; Florence, Pitti, 1988–9)

A. M. Giusti: *Pietre Dure: Hardstones in Furniture and Decoration* (London, 1992)

A. Gonzalez-Palacios: *Il gusto dei principi*, 2 vols (Milan, 1993)

ANNAMARIA GIUSTI

3. TAPESTRY.

(i) Before 1554. (ii) 1554–c. 1600.

(i) Before 1554. During the 15th century tapestries were imported into Florence from weavers and dealers in the south Netherlands and northern France. The major agent was the Medici Bank, the Bruges branch of which bought, commissioned or handled financial arrangements for tapestries. No tapestries traded through the Medici Bank, however, can be positively identified; a Netherlandish *verdure* with the Medici arms (Cleveland, OH, Mus. A.)

was commissioned later, probably between c. 1513 and 1537.

At least two workshops of peripatetic northern tapestry-weavers are known to have been in operation in Florence at this time. Livinus Gilii de Burgis, primarily employed by the Este family in Ferrara, was permitted to weave enormous figured tapestries for the *ringhiera* of Florence's Palazzo Vecchio between 1455 and 1457, which were based on cartoons by Neri di Bicci and Vittorio Ghiberti. Between 1476 and 1480 the south Netherlandish master Giovanni di Giovanni produced works for Florence Cathedral. Little or nothing, however, remains of this production; a very small *Annunciation* (New York, Met.) is attributed to an early 16th-century Florentine workshop.

In 1545 Duke Cosimo I arranged for Jan Rost (*fl* 1535–64) and Nicolas Karcher (*d* 1562), two south Netherlandish master weavers, to establish workshops in Florence. Unlike his political rival Ercole II d'Este, who employed a workshop almost exclusively for his personal needs, Cosimo hoped to turn Florence into a centre of production for this luxury industry. He therefore assisted the workshops both economically and materially but stipulated in contracts (1546; Rost's renewed 1549; Karcher's renewed 1550) that they had to teach local apprentices the Netherlandish low-warp weaving technique and that their new equipment would revert to the Duke if they left Florence. Constant ducal orders were promised to supplement private commissions. In 1549 the weaver Francesco di Pacino (*fl* 1549) was also involved in the production of tapestries for the Duke.

Between 1546 and the end of 1553, 120 tapestries were woven in Florence for Cosimo I: 44 (42 extant) narrative pieces with fine sett and materials, including much silk and many metallic threads; and 76 (all destr.) heraldic covers of coarser wool and *filaticcio* (silk from broken cocoons), sometimes used for pack animals or carriages. The cartoons for the fine tapestries, which were mainly for the Palazzo Vecchio, were made by major Florentine painters. At first Cosimo asked AGNOLO BRONZINO to provide cartoons for three trial *portières* (1545–6; Florence, Sopr. B.A. & Storici Col.) for Rost and FRANCESCO SALVIATI to provide cartoons both for Karcher's trial altar tapestry of the *Lamentation* (1546) and for his *Ecce homo* (1547–9; both Florence, Uffizi). At the same time, Cosimo divided larger sets between the two weavers; a twenty-piece *Story of Joseph* series (1546–53; Florence, Sopr. B.A. & Storici Col.; Rome, Pal. Quirinale) from sixteen cartoons by Bronzino, three by Jacopo Pontormo and one by Salviati (see fig. 9), and ten *Grotesque 'spalliere'* (1546–?50; Florence, Sopr. B.A. & Storici Col., six on dep. London, It. Embassy) after Bacchiacca. Karcher wove a Moresque table carpet (Poggio a Caiano, Mus. Villa Medicea), from designs perhaps by Bronzino, and two additions (untraced) to a south Netherlandish *Story of Tobias* set owned by Cosimo I. Two *portières* of an *Allegory with the Medici–Toledo Arms* (1549–?50; Florence, Pitti), from cartoons by Benedetto Pagni da Pescia, were begun under Francesco di Pacino, but the second had to be completed in Karcher's workshop.

Salviati designed many private commissions in this period, including Karcher's *Resurrection* altar tapestry (c. 1546; Florence, Uffizi) for Benedetto Accolti, Cardinal of

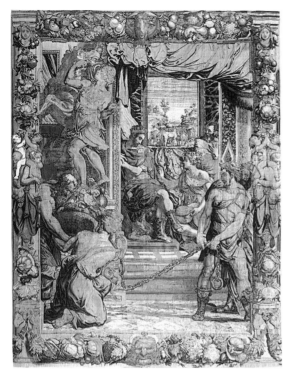

9. Tapestry of *Joseph Explaining Pharoah's Dream of the Seven Fat and Seven Lean Kine*, wool, silk and metallic threads, 5.70×4.46 m; design and cartoon by Francesco Salviati, made in the workshop of Nicolas Karcher, Florence, 1548 (Florence, Soprintendenza per i Beni Artistici e Storici)

Ravenna, and Rost's *Meeting of Dante and Virgil* (*c*. 1547–9; Minneapolis, MN, Inst. A.; *see* ITALY, fig. 37). Nearly all the tapestries from this period are outstanding and distinguished by rich, innovative borders. The borders designed by Bronzino for the *Joseph* series are an Italian monumentalization of popular south Netherlandish garland models, but Bronzino's and Salviati's other border designs were inspired by such diverse sources as architecture, picture frames, East Asian carpets and the framing devices, combining cartouches and figures, of prints disseminated by the first Fontainebleau school in the 1540s (see colour pl. 1, XXX1). By the 1550s a distinctive and enduring Florentine approach to tapestry borders had developed, characterized by deft balancing of large, often crowded forms, strong plasticity—often working out from an architectonic framework with punctuating cartouches——and considerable visual humour. Although the Medici family had weavers at their service, they also continued to buy some south Netherlandish tapestries throughout the 16th century.

(ii) 1554–c. 1600. In 1554 Cosimo I used the equipment left by Karcher for a new, private ducal factory—now referred to as the Arazzeria Medicea. The reasons for this were doubtless both financial (the costly campaign against Siena combined with the famous masters' high fees) and practical (the slow production of truly fine tapestries compared with the numerous palaces and villas Cosimo had to decorate). At the new factory less complex designs

with coarser sett and materials were executed, which lowered the cost and accelerated the rate of production. There were two workshops, headed by Benedetto di Michele Squilli (*fl* 1555–88) and Bastiano Sconditi (*fl* 1555–68).

Bronzino continued to design cartoons until 1557, but the temperament of the court architect and painter Giorgio Vasari was better suited to the increased pace projected by the Duke. After executing a few designs and possibly cartoons to accompany frescoed decorations in the Palazzo Vecchio, Vasari incorporated the production of tapestry cartoons into his workshop's well-organized decorating procedures. The Flemish painter JOANNES STRADANUS so excelled at this art that he soon became the official cartoonist for the workshops, designing his own compositions: for the Palazzo Vecchio they were biblical, historical and mythological (examples in Florence, Sopr. B.A. & Storici Col.; London, V&A; Paris, Mobilier N.); for rooms in the Villa Medici at Poggio a Caiano he designed 40 *Hunts* (1567–77; examples in Florence, Sopr. B.A. & Storici Col.; Pisa, Mus. N. S. Matteo; Siena, Pal. Reale); for Bianca Cappello, second wife of Francesco I, Grand Duke of Tuscany, he collaborated with Domenico d'Antonio Buti (*c*. 1550–90) on cartoons for five *Grotesques* (1572 and 1578; three, Paris, Mus. A. Déc.). Stradanus's cartoons are notable for their close observation of nature and characterizing detail and a keen sense of both decoration and humour. From late 1558 to 1574, the only set apparently woven for the Medici that was not designed by Stradanus was the *History of Florence* (1564; three, Florence, Sopr. B.A. & Storici Col.) for the Sala di Gualdrada in the Palazzo Vecchio from cartoons by Friedrich Sustris (*c*. 1540–99).

In 1575, the year after Cosimo I's death, Alessandro Allori (1535–1607), a favourite painter of Francesco I who had worked on tapestry cartoons under Bronzino, became the official cartoonist at the Arazzeria Medicea. Allori was nearly as prolific as Stradanus, although his static figures and compositions are not as imaginative and humorous. His border designs follow Stradanus's in layout but are more formally structured. When Stradanus left Florence temporarily in 1576, Allori continued the *Hunts* for the Villa Medici. Allori's designs were, however, mainly for the Palazzo Pitti in Florence: mythological series included *Latona, Centaurs, Niobe, Phaëthon* and *The Seasons* (examples in Florence, Sopr. B.A. & Storici Col.). During this period more outside commissions were executed by the Arazzeria Medicea, and Allori's workshop painted cartoons for tapestries for the church of S Maria Maggiore in Bergamo (e.g. *Life of the Virgin*, 1582–6; *in situ*) and for the cathedral in Como. On Squilli's death (1588), Guasparri di Bartolomeo Papini (*d* 1621) became head weaver. After the succession (1587) of Ferdinando I, Grand Duke of Tuscany, who had been a cardinal, religious tapestries became more popular: Allori designed overdoors depicting the *Life of Christ* (1598–1600) and a *Passion* series (1592–1616; both Florence, Sopr. B.A. & Storici Col.) in collaboration with Lodovico Cigoli.

BIBLIOGRAPHY

C. Conti: *Ricerche storiche sull'arte degli arazzi in Firenze* (Florence, 1875/R 1983)

C. Rigoni: *Catalogo della R. Galleria degli arazzi* (Florence and Rome, 1884)

G. Poggi: 'La giostra medicea del 1475 e la "Pallade" del Botticelli', *L'Arte*, v (1902), pp. 71–7

J. A. F. Orbaan: *Stradanus te Florence* (Rotterdam, 1903)

A. Schiaparelli: *La casa fiorentina e i suoi arredi nei secoli XIV e XV* (Florence, 1908/*R* with suppl., 1983)

D. Heikamp: 'Arazzi a soggetto profano su cartoni di Alessandro Allori', *Riv. A.*, xxxi (1956), pp. 105–55

——: 'La Manufacture de tapisserie des Médicis', *L'Oeil*, 164–5 (1968), pp. 22–31

——: 'Giovanni Stradanos Bildteppiche für den Palazzo Vecchio mit Darstellungen aus dem Leben der älteren Medici', *Mitt. Ksthist. Inst. Florenz*, xiv (1969), pp. 183–200

——: 'Die Arazzeria Medicea im 16. Jahrhundert: Neue Studien', *Münchn. Jb. Bild. Kst*, ser. 3, xxx (1969), pp. 33–74

A. Frezza: 'Influenze fiamminghe e originalità fiorentina nella storia dell'arazzeria medicea', *Rubens e Firenze* (Florence, 1979), pp. 229–48

D. Heikamp: 'Unbekannte Medici-Bildteppiche in Siena', *Pantheon*, xxxviii/4 (1979), pp. 376–82

C. Adelson: 'Bachiacca, Salviati, and the Decoration of the Sala dell'Udienza in Palazzo Vecchio', *Le arti del principato mediceo* (Florence, 1980), pp. 141–400

——: 'Cosimo I de' Medici and the Foundation of Tapestry Production in Florence', *Firenze e la Toscana dei Medici nell'Europa del Cinquecento*, 3 vols (Florence, 1980), pp. 899–924

C. Adelson, A. Frezza and G. G. Bertelà: 'Arazzi', *Palazzo Vecchio: Committenza e collezionismo mediceo* (exh. cat., ed. P. Barocchi; Florence, Pal. Vecchio, 1980), pp. 43–116

C. Adelson: 'The Decoration of Palazzo Vecchio in Tapestry: The *Joseph* Cycle and Other Precedents for Vasari's Decorative Campaigns', *Atti del convegno vasariano: Arezzo, 1981*, pp. 145–77

C. Adelson: 'Florentine and Flemish Tapestries in Giovio's Collection', *Atti del convegno: Paolo Giovio, il rinascimento e la memoria: Como, 1983*, pp. 239–81

——: 'Three Florentine Grotesques in the Musée des Arts Décoratifs, Paris', *Bull. Liaison Cent. Int. Etud. Textiles Anc.*, lix–lx/1–2 (1984), pp. 54–60

——: 'Documents for the Foundation of Tapestry Weaving under Cosimo I de' Medici', *Renaissance Studies in Honor of Craig Hugh Smyth*, ed. A. Morrogh, ii (Florence, 1985), pp. 3–17

Gli arazzi della Sala dei Duecento: Studi per il restauro (exh. cat., Florence, Pal. Vecchio, 1985)

L. Meoni: 'Gli arazzieri delle "Storie della Creazione" medicee', *Boll. A.*, ser. 6, lviii (1989), pp. 57–66

C. Adelson: *The Tapestry Patronage of Cosimo I de' Medici: 1545–1553* (diss., New York U., 1990)

C. Adelson and R. Landini: 'The "Persian" Carpet in Charles Le Brun's *July* Was a 16th-century Florentine Table Tapestry', *Bull. Liaison Cent. Int. Etud. Textiles Anc.*, lxviii (1990), pp. 53–68

C. Adelson: *European Tapestry in the Minneapolis Institute of Arts* (Minneapolis, 1992)

——: 'On Benedetto Pagni da Pescia and Two Florentine Tapestries: The Allegorical "portiere" with the Medici–Toledo Arms', *Kunst des Cinquecento in der Toskana*, ed. M. Kämmerer (Munich, 1992), pp. 186–96

N. Forti Grazzini: *Il patrimonio artistico del Quirinale: Gli arazzi*, i (Rome and Milan, 1994), pp. 16–78

C. Adelson: *Francesco Salviati (1510–1563) o la Bella Maniera* (exh. cat., Rome, Villa Medici; Paris, Louvre; 1998), pp. 284–9, 292–305

L. Meoni: *Gli arazzi nei musei fiorentini* (Florence, 1998)

CANDACE J. ADELSON

IV. Buildings.

1. Cathedral buildings. 2. Orsanmichele. 3. SS Annunziata. 4. Santa Croce. 5. S Lorenzo. 6. S Maria Novella. 7. S Miniato al Monte. 8. Palazzo Vecchio. 9. Palazzo Pitti. 10. Uffizi.

1. CATHEDRAL BUILDINGS. Florence Cathedral (Duomo), whose great dome dominates the city, the tall campanile at its south-west corner, which balances the dome, and the Baptistery to the west—all set in the Piazza del Duomo in the centre of the city—form a remarkable group of polychrome marble buildings that demonstrates the traditions of Florentine art from the Romanesque period to the Renaissance. The immense programme of work on the cathedral in the 14th century and first half of the 15th was coordinated by the Opera del Duomo (Cathedral Works), which initiated the most prestigious artistic projects of the period. Many of the original works from the buildings, as well as models and equipment used in the planning and construction of the dome, are exhibited in the Museo dell'Opera del Duomo, which is on the site of the cathedral masons' workshops.

(i) Cathedral. (ii) Baptistery. (iii) Campanile. (iv) Cathedral Works.

(i) Cathedral. Originally dedicated to S Reparata, the cathedral was rededicated to S Maria del Fiore in 1412. For many, it represents the beginning of the Renaissance period, with its soaring dome designed and executed in part by Filippo Brunelleschi, reflecting a rebirth of interest in Classical forms and methods of construction (see fig. 1 above).

(a) Architecture. (b) Sculpture. (c) Painting. (d) Stained glass. (e) Furnishings.

(a) Architecture. Excavations have shown that the first cathedral of Florence, probably dating from the 4th or early 5th century AD, was reconstructed in the 8th or 9th century and modified in the 11th, when the presbytery was raised over a large crypt, which contained a number of spolia. Shortly after 1294 work on a new cathedral was planned (begun 1296), and the old one was finally demolished in 1375. Responsibility for the new construction initially rested with the Florentine *comune* and the Bishop and Chapter.

The first master of the new cathedral was Arnolfo di Cambio, who died *c.* 1302. The extent to which his scheme was followed has been debated, but excavations indicate that he began work at the west and east ends simultaneously and that an eastern octagon was planned from the start. His church would have been shorter than the present building, however, and was probably intended to have a timber roof, with a wider central nave and relatively narrow aisles.

In 1331, when the presumed relics of St Zenobius (*d c.* 390), traditionally the first bishop of Florence, were found under the old crypt, it was decided to enlarge the original rebuilding project and to enlist financial help from all the major guilds, with the wool-merchants' guild (Arte della Lana) assuming control. Work was suspended in 1334, however, while the campanile was built (*see* §(iii)(a) below), but a fresco of *c.* 1342 (Florence, Mus. Bigallo) shows that the façade was by then partially built and that several bays of the aisle walls had been completed, presumably to Arnolfo's design.

Work resumed in 1355 under a new Master of Works, Francesco Talenti (1300/10–69), who made a wooden model (destr.) in May of that year in connection with defects in the chapels and windows of the cathedral. The old plans were modified in 1357 in order to accommodate the enlarged new project, and the first nave pier was founded; reference to a dome was also made for the first time, although Arnolfo's scheme probably incorporated such a feature. Discussions over the proportions of the cathedral, the form of the clerestory windows and of the

drum that was to support the great dome, and whether the nave should have three or four bays, continued for a decade, and various designs were prepared before a definitive brick model (destr. 1421) was approved in 1368. Andrea da Firenze (*fl* 1346), one of the committee members involved in these discussions, was at the same time decorating the Spanish Chapel at S Maria Novella, and his fresco there of the *Church Triumphant* depicts a vast building and dome very similar to the cathedral as finally built.

Between 1384 and 1410, the octagonal piers were built, the tribunes vaulted and the drum begun. A competition held in 1418 to decide the construction technique of the dome was won by Brunelleschi (with Lorenzo Ghiberti), with a proposal that avoided centering; one wooden model attributed to him survives (Florence, Mus. Opera Duomo). Brunelleschi then took sole control of the work, and the dome was completed in 1436; the lantern was built to Brunelleschi's design by Michelozzo di Bartolomeo and Bernardo Rossellino between 1446 and 1467. Apart from some exterior surfaces that still reveal the original brickwork beneath the marble casing, particularly at the base of the dome, the cathedral fabric was finally finished in the 19th century when a new Gothic-style façade was added (1871–87) by Emilio De Fabris (1807–83) to replace the original, incomplete work that was dismantled in 1587.

The completed building has a rib-vaulted nave of four bays (square in the main vessel, rectangular in the aisles); this leads to an eastern octagon the width of the nave, which is surrounded by three tribunes of identical design, each opening into five rectangular chapels. The church thus combines two Early Christian building types, the basilica and the centralized martyrium. The Gothic nave has features in common with such Florentine churches as S Maria Novella (begun *c.* 1246) and Santa Croce (begun *c.* 1294; *see* §§6 and 4 below). The widely spaced main arcade is surmounted by a corbelled walkway that runs around the vault springers, continuing into the octagon, and the clerestory (like the drum of the dome) is pierced by oculi; the architectural elements are articulated in grey limestone. The octagonal, pointed dome is composed of two shells of herringbone brickwork, a Roman-derived technique that served to spread the weight evenly as the height increased. The shells are connected and strengthened by stone ribs; those at the angles concentrate the load on to the supporting piers, so that the dome can also be read as a cloister vault. Brunelleschi's exedrae, which buttress the drum on its four free faces, are articulated by deep, shell-topped niches and coupled half-columns, while the lantern incorporates classical consoles, which also function as buttresses (for further discussion and illustrations *see* BRUNELLESCHI, FILIPPO, §I, 1(i) and (ix) and figs 1, 7 and 8).

BIBLIOGRAPHY

C. Guasti: *La cupola di Santa Maria del Fiore* (Florence, 1857)
——: *Santa Maria del Fiore: La costruzione della chiesa e del campanile* (Florence, 1887)
H. Saalman: 'Santa Maria del Fiore, 1294–1418', *A. Bull.*, xlvi (1964), pp. 471–500
G. Kreytenberg: *Der Dom zu Florenz: Untersuchungen zur Baugeschichte im 14. Jahrhundert* (Berlin, 1974)
G. Morozzi, F. Toker and J. Hermann: *Santa Reparata: L'antica cattedrale fiorentina* (Florence, 1974) [excav. reports]
F. Toker: 'Excavations below the Cathedral of Florence, 1965–1974', *Gesta*, xiv (1975), pp. 17–36
H. Saalman: *Filippo Brunelleschi: The Cupola of Santa Maria del Fiore* (London, 1980)
C. Pietramellara: *S Maria del Fiore a Firenze: I tre progetti* (Florence, 1984)
G. Rocchi and others: *S Maria del Fiore* (Milan, 1988)
T. Benton: 'The Design of Siena and Florence Domes', *Siena, Florence and Padua: Art, Society and Religion, 1280–1400*, ed. D. Norman, ii (New Haven and London, 1995), pp. 129–43
T. Verdon, ed.: *La cupola di Santa Maria del Fiore*, iv of *Alla riscoperta di Piazza del Duomo in Firenze* (Florence, 1995)
T. Verdon, ed.: *La facciata di Santa Maria del Fiore*, v of *Alla riscoperta di Piazza del Duomo in Firenze* (Florence, 1995)
L. A. Waldman: 'Florence Cathedral in the Early Trecento: The Provisional High Altar and Choir of the Canonica', *Mitt. Ksthist. Inst. Florenz*, xl (1996), pp. 267–86

ANABEL THOMAS

(b) Sculpture. The new cathedral offered numerous opportunities for sculptural decoration on the exterior wall coverings, portals, finials and west façade, as well as the decoration of chapels and other interior spaces with altarpieces, free-standing monuments and single figures. Local painters played an important part in producing designs for sculpture, much of which was subsequently carried out by artists more skilled in carving marble, the main material used in the decoration of the complex. The exterior of the cathedral is distinguished by its use of local stone: white marble from Carrara, green from Prato and pink from Maremma. For reasons of preservation, many of the original furnishings and sculptural decoration from both the interior and exterior of the fabric are now housed in the Museo dell'Opera del Duomo.

The involvement of established Florentine workshops of the early 14th century in the first period of sculptural decoration on the cathedral exterior is particularly evident on the Porta del Campanile (south façade), where the date November 1310 appears on the *Annunciation*. The figure sculpture of the west façade was begun under the direction of Arnolfo di Cambio and continued in successive campaigns through the 14th and 15th centuries; but only a third of the façade was completed by 1587 when it was dismantled, and the sculpture removed to the interior of the cathedral or dispersed to surrounding palaces and gardens. A 16th-century drawing (Florence, Mus. Opera Duomo) by Bernardino Poccetti, literary descriptions and a fresco of *c.* 1342 (Florence, Mus. Bigallo) have enabled the main lines of the scheme to be reconstructed, although the details are disputed.

In contrast to the façade of Siena Cathedral (begun *c.* 1285), the façade sculpture at Florence Cathedral was subordinated to the architecture, with figures set in niches and around the portals in a coherent iconographic scheme. In the central tympanum was a seated *Virgin and Child*, probably flanked by *St Reparata* and *St Zenobius* and *Angels* (all Florence, Mus. Opera Duomo), with the reclining *Virgin of the Nativity* (Florence, Mus. Opera Duomo) in the left tympanum and the *Death of the Virgin* (ex-Kaiser Friedrich Mus, Berlin; destr.) in the right; in a niche in the upper part of the façade was a statue of *Pope Boniface VII* (Florence, Mus. Opera Duomo). All these figures belong to the first campaign. After a break, work resumed in 1362; sculpture from this new phase (all Florence, Mus. Opera Duomo) includes a series of *Apostles* (1388) for the embrasures of the central portal; *Martyrs* and *Doctors of*

the Church (1390s), including *SS Augustine and Gregory* by Niccolò di Piero Lamberti; a *St Barnabas* (1395) by Giovanni d'Ambrogio and four *Evangelists* for the niches between the portals. The last, executed from 1408–15 by Donatello (*see* DONATELLO fig. 1), NANNI DI BANCO, Bernardo Ciuffagni and Niccolò di Piero Lamberti (for illustration *see* LAMBERTI), illustrate changing styles in sculpture in Florence at the beginning of the 15th century. In 1415–16 Donatello also made a giant figure in white terracotta (untraced) for the upper part of the façade.

Such masters as GIOVANNI D'AMBROGIO, Niccolò di Piero Lamberti, Nanni di Banco and Donatello contributed to the Porta della Mandorla on the north side of the cathedral, begun in 1391 and completed *c.* 1423. The door surrounds, executed in the first phase, include musician angels in hexagons and the *Labours of Hercules* set among rich classicizing foliate decoration. The archivolts, with reliefs of angels holding scrolls, belong to the second phase, from 1404. The fine gable relief of the *Assumption of the Virgin* in a mandorla (1414–21) by Nanni di Banco is flanked by two low-relief heads of a prophet and prophetess and by small statues of prophets on the pinnacles, the former documented and the latter attributed to Donatello. Near by, on the buttress of the north tribune, stood life-size marble statues of *Isaiah* by Nanni di Banco (now inside the cathedral) and *David* by Donatello (Florence, Bargello), both commissioned in 1408.

In the interior of the cathedral there is much fine marble work, including the tomb of *Bishop Antonio d'Orso* (*d* 1320) by Tino di Camaino (*c.* 1280–1337), the Renaissance lavabos in the sacristies (*c.* 1438–40 and 1442–5) by Buggiano and the *Apostles* on the piers of the octagon, executed by various masters in the 16th century; but the marble singing galleries (*cantorie*), carved by Donatello and Luca della Robbia during the 1430s and originally set up over the sacristy doors (now Florence, Mus. Opera Duomo), are the most notable pieces from the later period of decoration (*see* colour pl. 2, XXIV2 and ROBBIA, DELLA, (1), fig. 1). The central octagonal choir, beneath the dome, was executed by BACCIO BANDINELLI from 1547 and completed by Giovanni Bandini.

For further discussion *see* §(e) below.

BIBLIOGRAPHY

G. Poggi: *Il duomo di Firenze: Documenti sulla decorazione della chiesa e del campanile tratti dall'archivio dell'opera*, 2 vols (Berlin, 1909/R Florence, 1988)
C. Seymour: 'The Younger Masters of the First Campaign of the Porta della Mandorla, 1391–1397', *A. Bull.*, xli (1959), pp. 1–17
R. Munman: 'The Evangelists for the Cathedral of Florence: A Renaissance Arrangement Recovered', *A. Bull.*, lxii (1980), pp. 207–17
J. Pope-Hennessy: *Luca della Robbia* (London, 1980)
M. Greenhalgh: *Donatello and his Sources* (London, 1982)
B. A. Bennett and D. Wilkins: *Donatello* (Oxford, 1984)
G. Gentilini: *I della Robbia: La scultura invetriata nel rinascimento* (Florence, 1992)
J. W. Pope-Hennessy: *Donatello: Sculptor* (London, Paris and New York, 1993)
C. Avery: *Donatello: An Introduction* (New York, 1994)
E. Oy-Marra: *Florentiner Ehrengrabmäler der Frührenaissance* (Berlin, 1994)
A. Calore: *Contributi Donatelliani* (Padua, 1996)

ANABEL THOMAS

(c) Painting. Many artists, both foreign and Tuscan, produced paintings for the new cathedral as well as designs for sculpture and stained glass (*see* §(d) below). Although the original interior decoration is much altered, a number of paintings on panel and in fresco still remain on the walls and above the altar tables of the cathedral interior. The most significant of these are Domenico di Michelino's painting in tempera on linen of *Dante Reading from the 'Divine Comedy'* (1465; for illustration *see* DOMENICO DI MICHELINO), the painted images of saints by Bernardo Daddi, Bicci di Lorenzo and Poppi, the *St Blaise Enthroned* (1408) by Rossello di Jacopo Franchi and the *St Joseph* altarpiece by Lorenzo di Credi. A number of fine paintings from the 15th and 16th centuries hang in the old sacristy (Sagrestia dei Canonici). The walls of the north sacristy (Sagrestia delle Messe) are covered with elaborate, inlaid intarsia work thought to have been designed by, among others, Alesso Baldovinetti.

A number of illusionistic funeral monuments were painted in fresco. These include the two equestrian monuments to *Sir John Hawkwood* (1436) and *Niccolò da Tolentino* (1455–6), painted by Uccello and Andrea del Castagno respectively (*see* UCCELLO, PAOLO, fig. 1, and ANDREA DEL CASTAGNO, fig. 4). Uccello also painted the heads of prophets (1443) around the clock face on the interior of the façade. The inside of the dome, although no doubt originally planned by Brunelleschi to remain unpainted, was frescoed in 1573–4 by Giorgio Vasari and in 1578–9 by Federico Zuccaro, together with their workshops, with scenes from the *Last Judgement*.

BIBLIOGRAPHY

G. Poggi: *Il duomo di Firenze: Documenti sulla decorazione della chiesa e del campanile tratti dall'archivio dell'opera*, 2 vols (Berlin, 1909/R Florence, 1988)
M. Meiss: 'An Early Altarpiece from the Cathedral of Florence', *Bull. Met.*, n. s., xii (1954), pp. 302–17

ANABEL THOMAS

(d) Stained glass. The main windows of the cathedral date from the first half of the 15th century and combine the Renaissance style with traditional Gothic glazing techniques. Lorenzo Ghiberti designed the three oculi on the west front, with the *Assumption of the Virgin* (*c.* 1404) flanked by *St Lawrence* (1412) and *St Stephen* (1412). The eight oculi around the dome were designed by a remarkable combination of talents from 1438 to 1445: Donatello provided the *Coronation of the Virgin* and Paolo Uccello the *Nativity*, *Resurrection* and *Annunciation* (untraced), distinguished by pure colours and naturalism. Andrea del Castagno's *Deposition* is monumental and sculptural, while Ghiberti's mature style is seen in his *Presentation in the Temple*, *Agony in the Garden* and *Ascension*. Ghiberti completed the nave (the earliest four windows of which were made in 1394 by Antonio da Pisa) and apse with a unified design of tiers of prophets and saints under canopies, characterized by majestic scale and strong colours and imbued with great spirituality.

BIBLIOGRAPHY

A. Lane: 'Florentine Painted Glass and the Practice of Design', *Burl. Mag.*, xci (1949), pp. 43–8
G. Marchini: *Italian Stained Glass Windows* (London, 1957), pp. 43–52
L. Lee, G. Seddon and F. Stephens: *Stained Glass* (London, 1976), pp. 118–21

CAROLA HICKS

(e) Furnishings. Although the simple and solemn interior of the cathedral is devoid of superfluous ornament, it

contains a variety of furnishings. Most notable are the sculptural artefacts at the east end. They include, in the central apse, Luca della Robbia's two free-standing *Kneeling Angels Holding Candlesticks* (1448) in enamelled terracotta above the altar and Lorenzo Ghiberti's shrine of *St Zenobius* with four low reliefs in bronze beneath it (1432–42; *see* GHIBERTI, (1), §I, 1(iv)). Over the north and south sacristies are Luca della Robbia's two large lunettes of the *Resurrection* (1443–4) and *Ascension* (1446–51) in enamelled terracotta. The bronze doors (1446–75) of the north sacristy, the result of a collaboration between Michelozzo di Bartolomeo, Luca della Robbia and Maso di Bartolommeo, are decorated with ten reliefs, each framed by four heads of prophets.

The most important among the free-standing marble statues to be seen in the aisles are those originally designated for the old façade of the cathedral, notably Nanni di Banco's *Isaiah* (1408) and Bernardo Ciuffagni's *Isaiah* (completed 1427) in the south aisle. Among the marble busts commemorating famous philosophers and artists, also in the south aisle, are those of *Marsilio Ficino* (1521) by Andrea di Piero Ferrucci, *Giotto* (1490) by Benedetto da Maiano and *Filippo Brunelleschi* (1447–8) by Buggiano (for illustration *see* BUGGIANO). Brunelleschi was the only Florentine artist granted the honour of burial in the cathedral. Of special interest are Paolo Toscanelli's huge gnomon (1475) for solar observations, set in the pavement of the left apse, and the huge clock on the west wall above the central entrance. The latter shows the 24 hours of the day anticlockwise, beginning and ending at the bottom. It operates according to the '*hora italica*' system prevalent in Italy until the 18th century.

See also §(b) above.

BIBLIOGRAPHY
F. Bocchi: *Le bellezze di Firenze* (Florence, 1591)

YAEL EVEN

(ii) Baptistery. Most famous for its three sets of bronze doors (*see* §(c) below), the octagonal Baptistery is the oldest extant building in Florence. According to medieval Florentine tradition, it was a Roman temple of Mars and was dedicated to St John the Baptist in the early 4th century AD. The date of the present building is controversial, but it is now thought likely that it is a 6th- or 7th-century structure, although it has also been attributed to the 11th century: there was a consecration in 1059.

In 1329 the Arte di Calimala (the cloth-merchants' guild, who were in charge of the Baptistery), abandoning an earlier plan to cover the wooden doors of the Baptistery with metal plates, decided to install new doors cast in bronze (now on the south side). Documents identify the designer as Andrea Pisano (*c.* 1295–1348/9). The doors, installed in 1336, were cast by the lost-wax process, with fire-gilt figures, background details and decorative motifs. The 28 rectangular fields contain reliefs, each within a quatrefoil frame, illustrating scenes from the *Life of St John the Baptist* and, in the lowest two rows, seated *Virtues*. In them Andrea succeeded in translating the narrative power of Giotto's paintings into sculpture. The reliefs reveal the influence of northern Gothic art but also hint at the sculptor's future assimilation of the classical style in his work on the campanile (*see* §(iii)(b) below).

In 1401 a competition was announced for a second set of bronze doors. The two finalists were Lorenzo Ghiberti and Filippo Brunelleschi; both entries, illustrating the *Sacrifice of Isaac*, are extant (Florence, Bargello; *see* GHIBERTI, (1), fig. 1). Ghiberti won the competition and was commissioned in 1403 to design doors with New Testament scenes. Installed in 1424 on the east side, these followed the scheme of the earlier doors, having twenty narratives and eight seated figures within quatrefoils (*see* GHIBERTI, (1), fig. 2). The enframing lattice is considerably richer than that of Pisano's doors, and the compositions are more closely coordinated with the quatrefoils.

In 1425 Ghiberti received the commission for the final set of doors. The Gothic quatrefoil and the distinction between the dark background and the gilt figures were this time abandoned; in contrast, the new doors had ten large, squarish, totally gilded reliefs, each containing several related Old Testament episodes. Through gilding, the use of Albertian perspective (*see* ALBERTI, LEON BATTISTA, §II, 1) and gradation of relief (diminishing as forms recede), Ghiberti achieved a convincing illusion of spatial depth and narrative continuity. The doors (completed 1452; see colour pl. 1, XXXI2) made such a strong impression on the artist's contemporaries that his earlier set was transferred to the north entrance and the new doors were installed on the east façade, facing the cathedral. According to Vasari, Michelangelo, in a play on the word *paradiso* (the area between a baptistery and a cathedral façade), claimed that Ghiberti's doors were worthy to be the 'Gates of Paradise'.

BIBLIOGRAPHY
I. Falk: *Studien zu Andrea Pisano* (Hamburg, 1940)
I. Falk and J. Lanyi: 'The Genesis of Andrea Pisano's Bronze Doors', *A. Bull.*, xxv (1943), pp. 132–53
R. Krautheimer: *Lorenzo Ghiberti*, 2 vols (Princeton, 1970)
B. Bearzi: 'La tecnica usata dal Ghiberti per le porte del battistero', *Lorenzo Ghiberti nel suo tempo. Atti del convegno internazionale di studi: Firenze, 1978*, i, pp. 219–22
U. Baldini, ed.: *Metodo e scienza: Operatività e ricerca nel restauro* (Florence, 1982), pp. 168–206 [cleaning and restoration of Gates of Paradise]
M. Burresi, ed.: *Andrea, Nino e Tommaso, scultori pisani* (Milan, 1983)
G. Kreytenberg: *Andrea Pisano und die toskanische Skulptur des vierzehnten Jahrhunderts* (Munich, 1984)
A. Moskowitz: *The Sculpture of Andrea and Nino Pisano* (Cambridge, 1986)

ANITA F. MOSKOWITZ

(iii) Campanile. The campanile, or bell-tower, of Florence Cathedral (see fig. 1 above) was begun shortly after Giotto was elected Master of Works in April 1334. He died in 1337, but a design attributed to him survives (Siena, Mus. Opera Duomo). It shows a tower crowned by an octagonal spire, with window lights increasing in number from bottom to top and no statue niches; only the lowest zone corresponds to the completed tower. Work was continued during the 1340s by Andrea Pisano and finished in the late 1350s by Francesco Talenti, who increased the height of the storeys, thus enhancing the elegance and lightness of the structure; he also added a flat-topped belfry. The campanile is 84 m high and, like the cathedral, is faced in white, green and pink marble. It is square in plan with octagonal corner buttresses and is divided into horizontal zones: the lower ones are decorated with reliefs and statues, while the upper and slightly narrower part of the tower is pierced on each of its four sides, first by two

storeys of twin, two-light openings and, finally, in its uppermost storey, by a single great tripartite window.

The programme for the sculpture of the campanile may well have been designed by Giotto before his death in 1337. It seems likely that the greater part of the early sculptural work was carried out under Andrea Pisano (*c.* 1295–1348/9), who was referred to as *capomaestro* (head of building works) in 1340. He does not appear in documents after 1342, the date of the Compagnia del Bigallo fresco (Florence, Mus. Bigallo), which shows the campanile partially built and the lower part faced in marble.

All the original sculpture is now in the Museo dell'Opera del Duomo, having been replaced on the campanile by replicas (see fig. 10). The six-sided reliefs of the lower storeys combine a number of narrative scenes and single figures to form a complex allegorical cycle, continuing and developing the one planned for the façade of the cathedral, the theme of which was the redemption of mankind through the intercession of the Virgin. The programme of the campanile illustrates the prophecy of redemption, represented by figures of sibyls, prophets and patriarchs, and man's preparation for life after death through his existence on earth, beginning with the *Creation of Adam and Eve* and continuing in personifications of the *Planets, Virtues, Liberal Arts* and *Seven Sacraments*. It is significant that the relief showing *Sculpture* suggests a new act of creation. The first sculptures to be completed were those on the south side, which faces towards the Via de' Calzaiuoli. The last work by Andrea Pisano was probably the scene of *Navigation* on the east side, although some scholars attribute some of the *Liberal Arts* to him. Luca

della Robbia completed the series of *Liberal Arts* during the 1430s (*see* ROBBIA, DELLA, (1)).

Reference to the statues that were to be placed in niches above the reliefs was first made in 1415, when Bernardo Ciuffagni was allocated a figure of *Joshua*. This statue was reallocated to Donatello (*see* DONATELLO, §I) and finally completed by Nanni di Bartolo in 1420. Donatello completed two other figures during this period and collaborated with Nanni on the completion of the *Abraham and Isaac*, which was finished in 1421. In the early 1420s Donatello was working on three other statues, one of them being the *Zuccone*, which he was probably finishing during the 1430s after a brief absence in Siena. Some statues were repositioned in 1464 to make way for figures by Donatello and Nanni di Bartolo, and this resulted in some confusion over identification at a later date.

BIBLIOGRAPHY
A. Nardini: *Il campanile di Santa Maria del Fiore* (Florence, 1885)
G. Poggi: *Il duomo di Firenze: Documenti sulla decorazione della chiesa e del campanile tratti dall'archivio dell'opera*, 2 vols (Berlin, 1909/R Florence, 1988)
M. Trachtenberg: *The Campanile of Florence Cathedral* (New York, 1971)
A. Moskowitz: 'Trecento Classicism and the Campanile Hexagons', *Gesta*, xxii (1983), pp. 49–65

ANABEL THOMAS

(iv) Cathedral Works. The decision in 1294 to build the new cathedral resulted in the establishment of the Opera del Duomo to oversee the cathedral works. It was funded largely by public monies and, until the advent of Medici patronage in the 15th century, it initiated and directed the most numerous, prestigious and challenging architectural

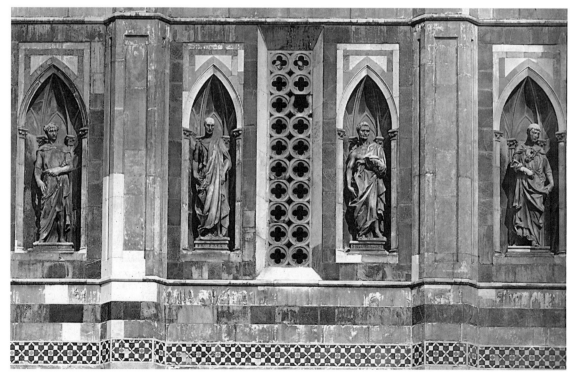

10. Florence, cathedral campanile, west side showing replicas of statues by Donatello, 1420s and 1430s; originals now in Florence, Museo dell'Opera del Duomo

and sculptural enterprises in and around Florence. Its members, the Operai, who all belonged to the Florentine Arte della Lana (wool-merchants' guild) after 1331, supervised not only the Cathedral Works but also the work on the Loggia della Signoria (now Loggia dei Lanzi), the new wall around the Stinche prison, the papal apartment at S Maria Novella and the fortification of settlements in the Arno valley.

The scope of the programmes of work at the cathedral was enormous. During the first half of the 15th century alone, countless statues, stained-glass windows, altars, two singing galleries (*cantorie*) and a set of bronze doors were commissioned, and the dome was constructed. Elected treasurers and notaries, a foreman and many skilled sculptors, glaziers, goldsmiths and painters were employed. Most projects were conceived as collaborative ventures. The four seated marble figures of *Evangelists* intended to flank the central entrance, for example (*see* §1(i)(b) above), were carved by Niccolò di Piero Lamberti, Nanni di Banco, Donatello and Bernardo Ciuffagni in seven years (1408–15; Florence, Mus. Opera Duomo). The dome, initially conceived with the enforced cooperation of Brunelleschi and Ghiberti, took 16 years to build (1420–36).

In order that such collaborations should hasten production and minimize costs, competition between potential or actual rivals was promoted. Luca Della Robbia (*see* ROBBIA, DELLA, (1)) and Donatello (*see* DONATELLO, §I), working together on the altar of St Paul (1439) or independently on the two singing galleries (1431–9; Florence, Mus. Opera Duomo; *see* ROBBIA, DELLA, (1), fig. 1 and colour pl. 2, XXIV2), vied for individual recognition. The allocation of equal stipends (but with bonuses for special accomplishments) further stimulated artists to excel, as did frequent evaluations of work in progress, sometimes announced as renewed contests. Ghiberti, who had designed cartoons for the stained glass of the façade and tribunes (1404–1420s), had to compete, once unsuccessfully, for the windows in the drum (designed 1443). Brunelleschi, whose model for the dome had been officially accepted (1420), had to submit further proposals for several sections of it (1423; 1425–26; 1436). This policy of reassessment and, if necessary, modification, enabled the Operai to control the workforce and to invite public opinion or even participation.

Since the primary goal was productivity, unity of style was sometimes sacrificed in the interest of speed. The Porta della Mandorla (1391–*c.* 1423) was assigned to artists of widely variable talent who were paid by the unit of carved marble. This same pragmatism is reflected in the use of an hour-glass to record the workers' presence on site and in the rule that those working above ground must not descend more than once a day. Yet the Opera del Duomo played a key role in civic patronage for over a century and commissioned many works that are fundamental to the early Italian Renaissance.

BIBLIOGRAPHY

C. Seymour: 'The Younger Masters of the First Campaign of the Porta della Mandorla', *A. Bull.*, xli (1959), pp. 1–17

L. Becherucci and G. Brunetti: *Il Museo dell'Opera del Duomo a Firenze* (Florence, 1969)

Y. Even: 'The Sacristy Portals: Cooperation at the Florentine Cathedral', *Source: Notes Hist. A.*, vi (1987), pp. 7–13

——: 'Divide and Conquer: The Autocratic Patronage of the Opera del Duomo', *Source: Notes Hist. A.*, vii (1989), pp. 1–6

——: 'Lorenzo Ghiberti and Filippo Brunelleschi Reconsidered: Forced Alliances between Lifelong Adversaries', *Fides & Hist.*, xxii (1990), pp. 38–46

For further bibliography see entries on individual artists.

YAEL EVEN

2. ORSANMICHELE. Standing on the Via de' Calzaiuoli, midway between the ecclesiastical centre (the cathedral and Baptistery) and the secular centre (the Palazzo Vecchio and Piazza della Signoria), the church of Orsanmichele, a converted grain hall, marks the site where the nuns of S Michele originally had their convent and garden. There is a reference to the church of S Michele in Orto as early as the 9th century. The early history of the site shows that it assumed a number of different functions, both civic and ecclesiastical. The nuns ran a flourishing wool shop there, renowned both within and outside Florence, and during the late 12th century the building was used as a meeting-place for the governmental bodies that emerged during the early years of the *comune*. Churches were frequently used in this way before the erection of such new government buildings as the Bargello (originally the Palazzo del Popolo) and the Palazzo Vecchio. The dual character of Orsanmichele continued throughout the Gothic and Renaissance periods.

During the first half of the 13th century the convent gradually fell into a state of disrepair, and it was demolished in 1240 to make way for a market-square where grain was sold. Some 40 years later a loggia was built to house the grain market, perhaps to the design of Arnolfo di Cambio (*fl* 1265), and a painted image of the *Virgin* was set up on one of the interior pilasters. A company of singers known as the Laudesi was formed in 1291 to chant in front of this holy image, which from an early stage was renowned for performing miracles. Orsanmichele consequently became a pilgrimage site, a function that sometimes conflicted with the market. In June 1304 a fire destroyed the whole loggia, and although the image of the *Virgin* survived and was retrieved to be venerated once more in a temporary wooden shelter, it was only in 1336 that a decision was taken by the Signoria to rebuild the old loggia. The new building was to serve both as a grain market and as a place of worship. The Arte della Lana (wool-workers' guild) was originally entrusted with sole responsibility for rebuilding the loggia, but it was later agreed that all the guilds should share this task. The architect is not documented. Vasari believed it to have been Taddeo Gaddi (*fl* mid-1320s), working to a design by Arnolfo di Cambio; according to others Francesco Talenti (1300/10–69), Neri di Fioravante (*fl* 1340–84) and Benci di Cione (*d* 1388) were responsible. It is known, however, that Andrea di Cione (1315/20–68) was commissioned to make the marble tabernacle inside (completed 1359/60) and that Bernardo Daddi (*fl c.* 1320–48) was commissioned by the Laudesi in 1347 to produce a new painting of the *Virgin* and that this was placed within Andrea's tabernacle.

The sandstone exterior of the building clearly reflects the interior arrangement: three great rectangular spaces superimposed one upon another. The massive arches of

the original ground-floor arcade, still visible despite having been filled in (see below), are typical of 13th-century and early 14th-century civic architecture in Italy. The ground-floor space was divided into two naves by two large, load-bearing piers, but the upper storeys were undivided, making them ideal for the storage and distribution of grain. By the time of the completion of the second storey in 1361, the Signoria had already determined to transfer the grain market elsewhere and to concentrate on the religious aspect of the site, but despite this the upper storeys were used for the grain trade until well into the 16th century, when Cosimo I decided to convert them to archives. The upper storeys subsequently housed the Società Dantesca, but a narrow staircase within the pier on the north-west corner of the building testifies to the original use, as does a corn-chute on one of the piers on the north side.

In the second half of the 14th century Simone Talenti (1330/35–83) was entrusted with the embellishment of the existing loggia arcade, at first leaving the spaces open with low parapets, allowing passers-by to see the holy image inside. By 1381, however, Talenti's delicate tracery in the upper part of the arches had been incorporated into a curtain wall, entirely filling in all but four of the spaces and turning the open loggia of the grain market into an enclosed place of devotion.

During the 14th-century work, a decision was made to decorate the exterior pilasters with large-scale statuary. It was not, however, until 1404, when the new building was completed, that the Signoria issued a firm decree to the guilds that the exterior niches should be completed. Seven major guilds and five of the fourteen minor ones were allotted niches. They were charged with financing and supervising the production of tabernacles and figures of their patron saints, in bronze for the major guilds and marble for the minor ones, which were to be finished within the space of ten years. The guilds that were not represented on the exterior were entrusted with tabernacles inside the church. This resulted in a period of activity lasting not ten, but twenty years, during which such leading sculptors as Donatello, Ghiberti, Nanni di Banco (see fig. 5 above) and Niccolò di Piero Lamberti (*see* LAMBERTI, (1)) were entrusted with the decoration of individual guild niches. Competition between guilds and between individual artists engendered a highly creative, experimental and progressive series of works that significantly broadened the expressive scope of early Renaissance sculpture.

The most important figures are *St Mark* (1411–13; for the linen-drapers' guild), *St George* (*c.* 1414; for the armourers' guild; Florence, Bargello; see fig. 11) and the gilded bronze *St Louis of Toulouse* (*c.* 1418–22; Florence, Mus. Opera Santa Croce), all by Donatello (*see* DONATELLO, §I); *St John the Baptist* (*c.* 1412–16), *St Matthew* (1419; *see* GHIBERTI, (1), fig. 3) and *St Stephen* (1425–9; for the wool-workers' guild), all cast in bronze by Lorenzo Ghiberti; and *St Philip*, *Four Crowned Saints* (for illustration *see* NANNI DI BANCO) and *St Eligius*, all of disputed date, by Nanni di Banco. The tabernacles were also decorated with low reliefs that are themselves important in the development of early Renaissance sculpture, for example *St George and the Dragon* (*c.* 1416–17) by Donatello. In practice the church of Orsanmichele became

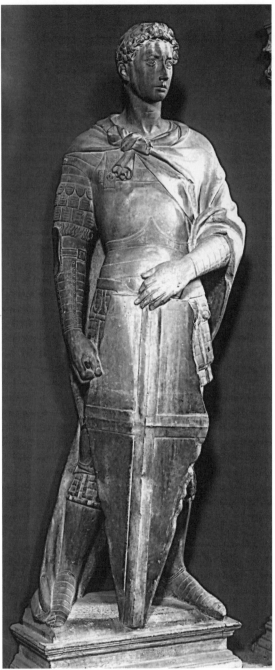

11. Florence, Orsanmichele, niche figure of *St George* by Donatello, marble, *c.* 1414 (Florence, Museo Nazionale del Bargello)

the guild church of Florence and thus a powerful architectural statement in the context of the city's medieval and Renaissance history.

BIBLIOGRAPHY

P. Bargellini: *Orsanmichele a Firenze* (Milan, 1969)
A. Busignani and R. Bencini: *Quartiere di S Croce* (1982), iii of *Le chiese di Firenze* (Florence, 1974–)
G. Kreytenberg: 'Orsan Michele und die Florentiner Architektur um 1300', *Mitt. Ksthist. Inst. Florenz*, xxvii (1983), pp. 171–92

H. B. J. Maginnis and A. Ladis: 'Sculpture's Pictorial Presence: Reflections on the Tabernacle of Orsanmichele', *Stud. Stor. A.* [Todi], v–vi (1994–5), pp. 41–54

W. Tresidder: 'Lorenzo Ghiberti and the Frame of Gentile da Fabriano's *Adoration of the Magi*', *Source*, xiv/4 (Summer 1995), pp. 8–13

D. Finiello Zervas: *Orsanmichele a Firenze* (Modena, *c*.1996)

ANABEL THOMAS

3. SS ANNUNZIATA. In 1250 the small church of S Maria dei Servi was erected by the new Florentine mendicant order of Servites just outside the city walls at Cafaggio near the Porta Balla. The church, which became known as SS Annunziata after the miraculous image of the *Annunciation* frescoed on its interior rear wall, was soon the site of a celebrated cult devoted to the Virgin. The ever-growing popularity of this image necessitated a series of new building campaigns, the most substantial of which occurred in 1264 and 1384. The 14th-century church was based on a typical basilican plan with a nave and two aisles divided by octagonal piers. Like Santa Croce, it had a T-shaped transept and a free-standing monastic choir in the centre of the crossing behind a monumental screen *tramezzo* or road screen.

The appearance of SS Annunziata was radically altered from 1444 by a series of major renovations initially planned and executed by Michelozzo. An Early Christian-style atrium (Chiostrino dei Voti) was constructed in front of the church and a marble tabernacle erected before the *Annunciation*. Transverse walls were placed between the nave piers and the outer walls, thereby transforming the aisles into a series of side chapels, and a large centralized addition with seven radiating chapels known as the tribune was built behind the high altar (for further discussion and plan of the church *see* MICHELOZZO DI BARTOLOMEO, §§1(ii), 3(ii) and fig. 4). At the same time the *tramezzo* was dismantled, and a new circular choir, based on the one in the cathedral, was located within the tribune. Michelozzo was a conservative architect who drew heavily from both the Gothic tradition and Brunelleschi's newer Renaissance idiom. Like Brunelleschi's work, SS Annunziata was built using the traditional Florentine materials of *pietra serena* (dark-grey stone) and white plaster.

Michelozzo's elaborate building campaign was conceived under the aegis of the Medici family. Piero de' Medici was directly responsible for the tabernacle and its accompanying chapel, but he probably offered additional advice on the overall plan, the selection of the architect and the recruitment of other patrons for the newly formed chapels. Altogether, fourteen new patrons were needed: seven for the chapels of the nave and seven for the chapels encircling the tribune. As insufficient funds had been raised to complete the tribune, in 1449 Cosimo de' Medici and the prior of the monastery suggested to Ludovico II Gonzaga, 2nd Marchese of Mantua, that he finance its construction and that of the new choir. Ludovico finally agreed to bequeath to the church part of the military salary owed him by the Florentine community.

In 1455 construction of the tribune was halted at cornice level; it was resumed (1459–60) under the direction of Antonio di Ciaccheri Manetti, but the only progress made was the reinforcing of the pre-existing piers. Another ten years passed before continuation of the tribune was even considered. This time Ludovico Gonzaga intervened and

assumed complete financial responsibility in exchange for the exclusive rights to the tribune and all of its chapels, and control over the artistic plans. He turned the project over (*c*. 1470) to Leon Battista Alberti, who modified Michelozzo's design by adding two additional radiating chapels, opening a grand triumphal arch between the nave and tribune, and covering the latter with a drum and dome patterned after ancient Roman mausolea. The loggia in front of the church was erected (1599–1604) by Giovanni Battista Caccini to Michelozzo's design, complementing the adjacent early Renaissance Ospedale degli Innocenti by Brunelleschi (see colour pl. 1, XVI2).

Early frescoes in the church include two (1453–7) by Andrea del Castagno in the north aisle chapels (*see* CASTAGNO, ANDREA DEL, §1(iv) and fig. 3); a series in the Chiostrino, including a *Nativity* (1462) by ALESSO BALDOVINETTI; the *Birth of the Virgin* (1513–14; see colour pl. 1, V2) by ANDREA DEL SARTO, who is buried in the church; the *Marriage of the Virgin* (1513) by FRANCIABIGIO; the *Visitation* (1516) by PONTORMO; and the *Assumption of the Virgin* (1517) by Rosso Fiorentino. Leonardo's cartoon of the *Virgin and Child with SS Anne and John the Baptist* (London, N.G.) was formerly displayed on the church's high altar, and Perugino's *Virgin and Child with Saints*, now in a side chapel, was once on the high altar. In the 1580s the eastern chapel of the tribune was reconstructed by Giambologna as his own tomb, with fine bronze reliefs.

BIBLIOGRAPHY

P. Tonini: *Il santuario della Santissima Annunziata di Firenze* (Florence, 1876)

L. Heydenreich: 'Die Tribuna der SS Annunziata in Florenz', *Mitt. Ksthist. Inst. Florenz*, iii (1932), pp. 268–85

W. Lotz: 'Michelozzos Umbau der SS Annunziata in Florenz', *Mitt. Ksthist. Inst. Florenz*, v (1937–40), pp. 402–22

L. M. Bulman: *Artistic Patronage at SS Annunziata, 1440–c. 1520* (diss., U. London, 1971)

H. Teubner: 'Das Langhaus der SS Annunziata in Florenz', *Mitt. Ksthist. Inst. Florenz*, xxii (1978), pp. 27–60

B. L. Brown: 'The Patronage and Building History of the Tribuna of SS Annunziata in Florence: A Reappraisal in Light of New Documentation', *Mitt. Ksthist. Inst. Florenz*, xxv (1981), pp. 59–146

C. Elam: 'Lorenzo's Architectural and Urban Policies', *Lorenzo il Magnifico e il suo mondo: Convegno internazionale: Florence, 1992* (Florence, 1994), pp. 357–84

E. M. Casalini: *Michelozzo di Bartolomeo e L'Annunziata di Firenze* (Florence, 1995)

B. L. Brown: 'Choir and Altar Placement: A Quattrocento Dilemma', *Machiavelli Stud.*, v (1996), pp. 147–81

BEVERLY LOUISE BROWN

4. SANTA CROCE. The church of Santa Croce was originally established as a Florentine place of worship for the Franciscan Order by St Francis of Assisi at the beginning of the second decade of the 13th century. Building work on a modest fabric, remains of which are still visible under the existing pavement of the nave, was probably carried out before the saint's death in 1226. This first building thus pre-dated by a couple of decades the important Gothic reconstruction work carried out at the Dominican church of S Maria Novella on the other side of the city (*see* §6 below).

As a result of the rapid growth of the Franciscan Order during the 13th century, a second church was begun in 1252, and this in turn was probably incorporated into the enormous new project begun in 1294 or 1295. Work on

the new fabric progressed slowly, and the nave was not finished until the end of the 14th century. The church was finally consecrated in the presence of Pope Eugenius IV (*reg* 1431–47) in 1443 (although the Gothic-style façade was added only in 1857–63 by Niccola Matas). The Piazza Santa Croce, provided to allow open-air preaching to the large congregations attracted to the order, remains one of Florence's most popular urban spaces.

In the 15th century several notable architects worked at Santa Croce. The classically inspired Renaissance Pazzi Chapel (built 1442–*c.* 1465), traditionally thought to be by Brunelleschi (*see* BRUNELLESCHI, FILIPPO, §I, 1(v) and figs 4, 5 and 6) although it has also been recently been attributed to Michelozzo di Bartolomeo, contrasts very obviously with the first Gothic cloister on the south side, while a second, gracefully arched Renaissance cloister in *pietra serena* has been variously attributed to Brunelleschi and members of the Rossellino and da Maiano workshops. The Medici Chapel (1440s) at the end of the south transept was commissioned from Michelozzo by Cosimo de' Medici (*see* MICHELOZZO DI BARTOLOMEO, §3). Later, in the 16th century, the church underwent modernization when, in 1565–6, Giorgio Vasari removed the monks' choir or Ponte on the orders of Cosimo I and refurbished the existing side chapels, inserting the funerary monument to his contemporary Michelangelo.

In addition to Michelangelo, many great Italian writers, artists, musicians, historians and politicians were buried or commemorated in the church, among them Ghiberti, Galileo Galilei and Niccolò Machiavelli. Others include Leonardo Bruni (1369–1444), whose tomb (1444–51) was carved by Bernardo Rossellino, Francesco Nori (*d* 1478), whose tomb is by Antonio Rossellino (for illustrations *see* ROSSELLINO, (1) and (2)), and Carlo Marsuppini (1398–1453), with a tomb (*c.* 1453–60) by Desiderio da Settignano (*see* DESIDERIO DA SETTIGNANO, fig. 1). Other important sculptural works include the *Tabernacle of the Annunciation* by Donatello (*see* DONATELLO, §I, 2(ii)) and the marble pulpit (completed 1485) by Benedetto da Maiano (for discussion and illustration *see* MAIANO, DA, (2), §1). There are also many important early frescoes and paintings in Santa Croce. Giotto painted those in the Bardi Chapel and the Peruzzi Chapel (both *c.* 1320; *see* GIOTTO, figs 7 and 8) and the polyptych in the Baroncelli Chapel.

BIBLIOGRAPHY
W. Paatz and E. Paatz: *Kirchen* (1940–54)
R. Sciamannini: *La basilica di S Croce* (Florence, 1955)
J. White: *Art and Architecture in Italy, 1250 to 1400*, Pelican Hist. A. (Harmondsworth, 1966)
A. Busignani and R. Bencini: *Quartiere di S Croce* (1982), iii of *Le chiese di Firenze* (Florence, 1974–)
J. C. Long: 'Salvation through Meditation: The Tomb Frescoes in the Holy Confessors Chapel at Santa Croce in Florence', *Gesta*, xxxiv/1 (1995), pp. 77–88
ANABEL THOMAS

5. S LORENZO. The titular church of the Medici family, S Lorenzo is regarded by many as the quintessential Renaissance church. The rebuilding of the old Romanesque church of S Lorenzo, originally consecrated by St Ambrose in the 4th century, was largely carried out in the 15th century, with additions in the 16th and 17th. The Signoria gave permission for the enlargement of the existing church in 1418, and it has been argued that church officials were persuaded that the fabric should be extended in order to accommodate chapels for such families of standing as the Neroni, Ginori, Rondinelli, della Stufa, Nelli and Ciai. Although Filippo Brunelleschi was traditionally associated with the design of the new church, he is now thought to have designed only the Old Sacristy in the north-west corner, commissioned by Giovanni di Averardo de' Medici and the first part of the new fabric to be erected. The rest of the rebuilding work may have been conceived on the basis of his designs, but it is now thought more likely to have been carried out under the influence of such followers as Michelozzo (see discussion below).

Brunelleschi's Old Sacristy was commissioned in 1419 and mostly completed a decade later. Conceived as a cube surmounted by a hemispherical umbrella dome, with three small chapels—the central one open—ranged along one wall, the interior is regulated and articulated by a system of arches and roundels that interact with voids and flat surfaces (*see* BRUNELLESCHI, FILIPPO, §1(iv) and figs 2 and 3a). The void of the arched entrance to the small central chapel, which opens off the main space of the sacristy and has its own comparable square plan and dome, is balanced by the proportions and divisions of the opposite altar wall. The windows and wall articulation of the chapel in turn reflect the overall pattern of decoration in the sacristy, where a series of round-headed rectangular windows in the upper walls and open round windows in the dome is balanced by arched wall niches and decorated roundels set into the walls. A heavily defined entablature horizontally divides the wall surfaces of both sacristy and chapel.

The Old Sacristy is decorated with terracotta roundels of cherubs (*c.* 1433–43) by Donatello, who was responsible for much of the sacristy's decoration, including terracotta reliefs of the *Life of St John the Evangelist* (*c.* 1433–43), the chapel's titular saint, which are set in the pendentives beneath the main dome, and the bronze doors surmounted by terracotta reliefs either side of the small central chapel (*see* DONATELLO, §I, 2(ii)). The sacristy was designed as the funerary chapel of Giovanni di Averardo de' Medici, and at his death in 1429 his sons Cosimo de' Medici and Lorenzo de' Medici (1395–1440) contributed a considerable amount of money to S Lorenzo in order that masses should be said for his soul in the sacristy. The completion of this early phase of rebuilding thus clearly anticipated the leading role assumed by the Medici at S Lorenzo.

By the mid-1430s a programme apparently existed for the uniform development of shallow chapels that were to follow the design of those already constructed in the sacristy and the adjoining transept. Cosimo was exiled from Florence in 1433–4, but a document dated June 1434 shows that a number of other individuals were interested in the continuation of building work at S Lorenzo, perhaps motivated by Cosimo's exile, since his absence would have weakened the Medici power base at the church. The 1434 document is particularly significant in that it makes no mention of Brunelleschi. Neither is he mentioned in relation to a decision by the Signoria the previous year to enlarge the piazza in front of S Lorenzo, nor in slightly later building accounts. It seems likely, therefore, that although Brunelleschi was clearly involved

in the early stages of rebuilding and possibly even submitted a plan for the overall design, he was not the guiding influence in the overall execution of the church, where building work continued long after his death in 1446; it is now argued that Michelozzo, the architect favoured by the Medici family during the mid-15th century, probably played a leading part in its completion.

It was not until 1442 that the Medici intervened once more in the continuation of building work at S Lorenzo. In that year Cosimo was involved in financial transactions with the Chapter in which it was agreed that he should have patronage over the entire transept of the new church, including the choir and high altar as well as the part of the remodelled fabric that included the remains of the old Romanesque church. The new church of S Lorenzo, designed on a Latin-cross plan and completed in the 1460s, reflects Renaissance preoccupations with balance and harmony. The exterior was never finished, but the rough façade clearly reflects the internal arrangement of a high central nave flanked by lower aisles and side chapels. Blind arcading on the lower level of the exterior measures out the dimensions of these internal chapels (which are exactly half the area of the square, domed aisle bays) while repeating the harmonious rhythms of aisle and nave arcading. The east end has a square central crossing, square choir and transepts, and square chapels grouped around the transepts.

The interior (see fig. 12) is articulated by bands of *pietra serena* stone that clearly define and demarcate the upper

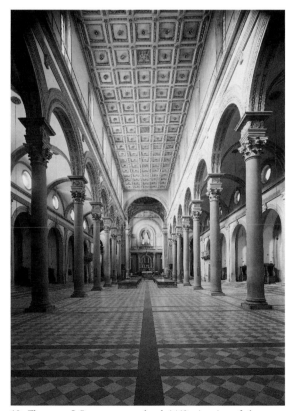

12. Florence, S Lorenzo, completed 1460s, interior of the nave looking east

clerestory level as well as tracing the semicircular arches of the nave arcade, resting on classically inspired Corinthian columns. The bands of *pietra serena* reinforce the underlying 2:1 ratio that governs the proportions of both plan and elevation, the basic module being one side of the crossing square, to which the dimensions of choir, nave, aisles and chapels are related. Michelozzo's involvement in the work is supported by the architectural style of such details as the capitals in the nave and by the apparent decision to change the original undulating exterior chapel profiles to straight walls. It is significant that when in 1436 Brunelleschi submitted his design for Santo Spirito, the other great Florentine Renaissance church of the 15th century, it featured a series of curves on the exterior, reflecting the internal chapels.

Cosimo de' Medici was buried in S Lorenzo in 1464, his tomb designed by Verrocchio (1465–7). The Chapter subsequently gave his son Piero de' Medici permission to allocate those chapels that were still to be finished on the north side of the church to any citizens of his choice outside the Medici family. They were completed during the following two decades. By the last quarter of the 15th century the responsibility for the fabric and decoration of S Lorenzo lay firmly in the hands of the Medici and their supporters.

Medici patronage continued well into the 16th century, when Michelangelo was commissioned to design the façade (1516; unexecuted), the New Sacristy (1519–34; see colour pl. 2, V1) and the Biblioteca Laurenziana (begun *c.* 1524; *see* MICHELANGELO, §I, 4). The wooden model of the façade (1517; Florence, Casa Buonarroti) shows that Michelangelo was concerned with maintaining the unity of the existing church exterior. His design envisaged the continuation of the horizontal cornice bands and blind arcading still visible on the right nave, aisle and chapel exterior walls. The project remained unexecuted, however, when his attention was diverted to the New Sacristy, a funerary chapel for the Medici at the north-east corner of the church, which is regarded as one of the first and finest examples of Mannerism. It has been argued that the conservatism of Michelangelo's patrons, the Medici popes Leo X and Clement VII, demanded that the ground-plan should closely reflect that of Brunelleschi's Old Sacristy at the other end of the transept, but the agitated articulation of the internal walls marks a radical departure from the classical serenity of Brunelleschi's style. The Biblioteca Laurenziana, intended to house the family's collection of manuscripts, has an unconventional high vestibule dominated by a huge staircase (*see* MICHELANGELO, fig. 8), and a long, low reading-room. Work began in the mid-1520s under the patronage of Clement VII (*see* MEDICI, DE', (9)); like that on the New Sacristy, however, it was interrupted by the Medici family's exile in 1527 and again by Michelangelo's own permanent move to Rome in 1534. Building work at both sites was carried on by Giorgio Vasari and Bartolomeo Ammanati during the 1550s.

The most important furnishings are the two pulpits by Donatello and his pupils (*c.* 1465–6; *see* DONATELLO, §I, 4). In the opening between the Old Sacristy and the adjoining chapel is the double tomb of *Piero I and Giovanni de' Medici* (1472) by Verrocchio (*see* VERROCCHIO, ANDREA DEL, fig. 2). The New Sacristy contains the

important tombs of *Giuliano de' Medici, Duke of Nemours* (see colour pl. 2, V1) and *Lorenzo de' Medici, Duke of Urbino* (the 'Capitani') by Michelangelo (1524–34; *see* MICHELANGELO, §I, 3 and fig. 5). Notable paintings include the *Annunciation* (*c.* 1439) by Fra Filippo Lippi (*see* LIPPI, (1), §I, 2).

BIBLIOGRAPHY

P. G. Conti: *La basilica di San Lorenzo* (Florence, 1940)

V. Herzner: 'Zur Baugeschichte von San Lorenzo in Florenz', *Z. Kstgesch.*, xxxvi (1974), pp. 89–115

I. Hyman: 'Notes and Speculations on S Lorenzo, Palazzo Medici and an Urban Project by Brunelleschi', *J. Soc. Archit. Historians*, xxxiv (1975), pp. 98–120

——: *15th-century Florentine Studies: The Palazzo Medici and a Ledger for the Church of San Lorenzo* (New York, 1976)

J. Ruda: 'A 1434 Building Programme for S Lorenzo in Florence', *Burl. Mag.*, cxx (1978), pp. 358–61

F. B. Saalman: 'S Lorenzo: The 1434 Chapel Project', *Burl. Mag.*, cxx (1978), pp. 361–4

H. Burns: 'S Lorenzo in Florence before the Building of the New Sacristy: An Early Plan', *Mitt. Ksthist. Inst. Florenz*, xxiii (1979), pp. 145–54

C. Elam: 'The Site and Early Building History of Michelangelo's New Sacristy', *Mitt. Ksthist. Inst. Florenz*, xxiii (1979), pp. 155–86

P. Roselli and O. Superchi: *L'edificazione della basilica di San Lorenzo* (Florence, 1980)

U. Baldini and B. Nardini: *Il complesso monumentale di San Lorenzo* (Florence, 1984)

M. Trachtenberg: 'On Brunelleschi's Old Sacristy as Model for Early Renaissance Church Architecture', *L'église dans l'architecture de la Renaissance: Actes du colloque: Tours 1990*, (Paris, 1995), pp. 9–39

C. Elam: 'Cosimo de Medici and San Lorenzo', *Cosimo 'Il Vecchio' de' Medici (1389–1464)*, ed. F. Ames-Lewis (Oxford 1992)

G. Morolli and P. Ruschi, eds: *San Lorenzo, 393–1993: L'architettura: Le vicende della fabbrica* (Florence, 1993)

ANABEL THOMAS

6. S MARIA NOVELLA. The Dominican church of S Maria Novella was built on the site of a 10th-century chapel and of a later Romanesque church dedicated to S Maria delle Vigne (1094). St Dominic was in Bologna in 1219 and from there founded the Dominican convent in Florence, acquiring the church of S Maria delle Vigne. It is not known when work was first begun on the new Gothic structure, although Dominican friars were documented as directing work there in 1246, and references had been made a few years earlier to the enlargement of the square to the east of the church. There was another burst of activity at the end of the 13th century, a new model for the church being mentioned in 1277. The main structure was completed in 1360 by Jacopo Talenti (1330/35–1383), who was Master of Works between 1333 and his death in 1362. There is considerable controversy over the dating of various parts of the church, such as the Strozzi Chapel at the end of the left transept, which has been dated both to the 13th century and the mid-1340s.

Numerous changes were made to the fabric after the main building activity during the Gothic period, notably the addition of the classically inspired Renaissance façade (*c.* 1458–70; see fig. 13) by Alberti for Giovanni Rucellai (*see* ALBERTI, LEON BATTISTA, §III, 2(ii)(b)), with its green-and-white geometrical patterning and Rucellai imprese, mathematical proportions and innovative scroll forms, which were widely copied. Radical alterations were made to the aisle and transept chapels by Vasari in the 16th century, and the original deep choir-screen in the northern half of the nave, with integral chapels, known as the Ponte, was also removed at this time. As at Santa Croce, parts of

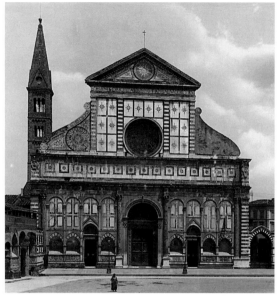

13. Florence, S Maria Novella; lower part of façade before *c.* 1360, upper part by Leon Battista Alberti, *c.* 1458–70

the conventual complex underwent changes of use that were closely linked with the history of the Medici family. The convent chapter-room, now better known as the Spanish Chapel, which opens off the north side of the Chiostro Verde, was originally erected by Talenti in the mid-14th century not only for use by the friars of S Maria Novella but also as a central council chamber for all Dominicans in the province. Two centuries later, with the marriage of Eleonora of Toledo to Cosimo I de' Medici in 1539, a special dispensation was made for the chapter house to be used as a place of worship for the growing Spanish community in Florence. Its fresco decoration (1365; *see* ANDREA DA FIRENZE) still bears witness, however, to its original purpose.

The church contains some notable works of art, among the earliest being the ceiling frescoes of *c.* 1270 and a Crucifix (*c.* 1300) by Giotto (*see* GIOTTO, §I, 3(iii) and fig. 10). Masaccio's *Trinity* (*c.* 1427; see colour pl. 2, III1) in the left aisle is remarkable for its early use of perspective (*see* MASACCIO, §I, 2(i)). In the choir is the important Tornabuoni fresco cycle (1485–90) by Ghirlandaio (*see* GHIRLANDAIO, (1), §I, 2(i)(b), colour pl. 1, XXXII2 and ITALY, fig. 13); and the chapel of Filippo Strozzi, which contains his tomb (1491–5) by Benedetto da Maiano, has a fresco cycle (completed 1502) by Filippino Lippi (*see* LIPPI, (2), §1(iv) and fig. 4). The frescoes (after 1447) in the Chiostro Verde were painted by Paolo Uccello in *terra verde*, which, along with earlier *terra verde* frescoes, gave the cloister its name (*see* UCCELLO, PAOLO, fig. 2). Other furnishings include a marble pulpit (1443–52) by Buggiano and a wooden Crucifix (*c.* 1410–15) by Brunelleschi in the Gondi Chapel.

BIBLIOGRAPHY

G. Kiesow: 'Die gotische Südfassade von S Maria Novella in Florenz', *Z. Kstgesch.*, (1962), pp. 1ff

J. White: *Art and Architecture in Italy, 1250–1400*, Pelican Hist. A. (Harmondsworth, 1966)

K. G. Arthur: 'The Strozzi Chapel: Notes on the Building History of Sta Maria Novella', *A. Bull.*, lxv/3 (1983), pp. 367–86

A. M. Adorisio: 'Una precisazione sulla facciata gotica di Santa Maria Novella', *Ant. Viva*, xxvii/2 (1988), pp. 32–5

R. G. Kecks: *Ghirlandaio: Catalogo completo* (Florence, 1995)

ANABEL THOMAS

7. S MINIATO AL MONTE. S Miniato is one of the oldest Benedictine churches in Tuscany. It stands on a hill south of the River Arno overlooking Florence and is not far from Piazzale Michelangelo. St Miniato was martyred in AD 250 during the persecutions of Emperor Decius (*reg* 249–51), and the origins of the church are traceable to early Carolingian times: in 783 Charlemagne donated several properties to the abbey of S Miniato for the repose of the soul of his bride Hildegarde. Later documents refer to a new construction, initiated by the Florentine bishop Hildebrand and supported financially by the Holy Roman Emperor Henry II and his wife Kunigunde. It was consecrated by Hildebrand on 27 April 1018. The only remains of this building are a few stretches of wall near the crypt and probably some reused capitals. In the second half of the 11th century it was radically restructured in its present form: the recently built monastic complex is referred to in a decree (*c.* 1062) of Emperor Henry IV (*reg* 1065–1104). It was not until the following century, however, that the work was completed.

Additions were made during the Renaissance. The chapel of the Crucifix in the centre of the nave, in front of the entrance to the crypt, was commissioned in 1447–8 by Piero de' Medici, probably from Michelozzo, to hold the Crucifix of St John Gualberto, a Florentine nobleman. Its design, with a barrel vault supported on columns, shows a clear stylistic continuity with the architecture of the surrounding church. The so-called chapel of the Cardinal of Portugal (see fig. 6 above) is entered through a large coffered arch in the north aisle of the church. This monument is particularly representative of Florentine art of the second half of the 15th century, harmoniously combining architecture, sculpture and painting. The chapel was commissioned by King Alfonso V of Portugal (*reg* 1438–61) in memory of his nephew James of Lusitania, Cardinal and Archbishop of Lisbon, who died in Florence on 15 December 1459. Its architecture, inspired by Brunelleschi, is attributed to Antonio di Ciaccheri Manetti, who was undoubtedly responsible for the inlaid pavement. The vault decoration is one of the masterpieces of Luca della Robbia, perhaps assisted by his brother Andrea. ALESSO BALDOVINETTI painted the lunettes and pendentives, but his major work is the panel painting of the *Annunciation* (1466–7), set in the recess under the arch of the left wall above the marble episcopal throne. On the opposite wall is the funeral monument of James of Lusitania, sculpted by Antonio Rossellino in 1461. This work is similar in plan to the monument to *Leonardo Bruni* executed in Santa Croce by Bernardo Rossellino (for illustration *see* ROSELLINO, (1)), with the additional motif of marble curtains and, most notably, two graceful angels that prefigure those of Verrocchio's monument to *Cardinal Niccolò Forteguerri* in Pistoia Cathedral. On the end wall, over the altar, is a copy of a panel painting, now in the Uffizi, of *SS Vincent, James and Eustace* by Antonio and Piero Pollaiuolo.

BIBLIOGRAPHY

F. Tarani: *La basilica di S Miniato al Monte* (Florence, 1909)

M. Salmi: 'Arte romanica fiorentina', *Arte*, xvii (1914), pp. 265–80, 369–78

L. Dami: 'La basilica di S Miniato al Monte', *Boll. A.* (1915), pp. 216–44

M. Salmi: *L'architettura romanica in Toscana* (Milan, 1926)

H. Beenken: 'Die Florentiner Inkrustationsarchitektur des XI. Jahrhunderts', *Z. Bild. Kst*, lx (1926–7), pp. 221–30, 245–55

E. Anthony: *Early Florentine Architecture and Decoration* (Cambridge, 1927)

W. Horn: 'Romanesque Churches in Florence: A Study in their Chronology and Stylistic Development', *A. Bull.*, xxv (1943), pp. 112–31

W. Paatz and E. Paatz: *Kirchen*, iv (1952), pp. 211–94

P. Bargellini: *San Miniato al Monte: Kunst und Geschichte* (Florence, 1957)

F. Hartt, G. Corti and C. Kennedy: *The Chapel of the Cardinal of Portugal (1434–1459) at San Miniato in Florence* (Philadelphia, 1964)

P. Sanpaolesi: 'Sulla cronologia dell'architettura romanica fiorentina', *Studi di storia dell'arte in onore di Valerio Mariani* (Naples 1972), pp. 57–65

A. Busignani and R. Bencini: *Le chiese di Firenze*, i (Florence, 1974), pp. 217–58

B. Santi: *S Miniato* (Florence, 1976)

L. Zeppegno: *Le chiese di Firenze* (Rome, 1976), pp. 140–51

I. Moretti and R. Stopani: *La Toscana* (1982), v of *Italia Romanica*, 6 vols (Milan, 1978–84), pp. 119–25

M. C. Mendez Atanazio: *A arte em Florença no séc: XV e a capela do cardeal de Portugal* (Lisbon, 1983)

F. Pratesi: *La splendida basilica di San Miniato a Firenze: Il Rinascimento inizia da qui* (Florence, 1995)

MARIO D'ONOFRIO

8. PALAZZO VECCHIO. Originally known as the Palazzo dei Priori and later as the Palazzo della Signoria and Palazzo Ducale, the 13th-century Palazzo Vecchio was built to house the Priori, the leaders of the guilds, following the establishment of the popular government in 1283. The site was probably chosen because of its proximity to their previous meeting-place, the church of S Piero Scheraggio (destr. 16th century). The new palace was an architectural statement of the new political order that followed the resolution of the fierce fighting between the Guelph and Ghibelline factions in the city (*see* §I, 2 above). Construction involved the demolition of a number of buildings formerly belonging to such families of the defeated Ghibelline faction as the Uberti and the Foraboschi, and the subsequent trapezoidal plan of the palace and its skewed façade largely resulted from the piecemeal acquisition of the building site. As the foundations were being laid in 1299, further houses in the vicinity were acquired and demolished in order to create a great piazza to the north that would balance the open space on the west resulting from the levelling of the Uberti property. This occasional balancing of spaces continued throughout the first half of the 14th century, and as late as 1349 the decision was taken to demolish the church of S Romolo to the west of the palace in order to improve the square. The bell-tower (known as the *vacca* or 'cow') of the palace, which was considerably higher than the original Foraboschi tower on the same site, was a powerful symbol of the new government; it tolled warnings in times of unrest or danger and called citizens together to discuss matters of communal interest.

The Palazzo Vecchio (still the town hall of Florence) set the pattern for Central Italian civic architecture during the 14th century. Its battlemented upper profile (see fig. 8 above), with deeply recessed supporting brackets decorated with the coats of arms of the Florentine *comune*, was typical of the fortification of secular buildings from the

time of the free *comuni*. Warring factions within the early *comuni* often made it necessary for members of government to install themselves behind battlements and sturdy walls, with internal council chambers safely raised above the level of surrounding streets and squares. The Loggia dei Lanzi opposite the palace, erected during the late 14th century (*see* §I, 3(i) above) and originally known as the Loggia dei Priori or Loggia della Signoria, was used for public government ceremonies. Government officials often congregated on the raised platform (*aringhiera*) in front of the Palazzo Vecchio to hear public proclamations declaimed from the loggia. This structure therefore served as an open-air adjunct to the main government building.

The palace subsequently underwent many changes, both internally and externally. In the 15th century, when it was known as the Palazzo della Signoria, Michelozzo was charged with shoring up the internal courtyard and fortifying the tower, both of which were in danger of imminent collapse; the present courtyard is very different from the 13th-century original, where thick columns with bases and capitals in *pietra serena* lined each side. Michelozzo also carried out extensive alterations to many of the external windows and a number of the internal rooms. Some parts nevertheless remain in their earlier form, notably the ground-floor Sala d'Arme, with groin vaults supported by octagonal pilasters. In 1495, after the expulsion of the Medici, an enormous hall (later remodelled as the Salone del Cinquecento; see colour pl. 2, XXXVII3) was built by Cronaca for meetings of the new legislative body (Consiglio Maggiore) until its dissolution in 1530. Decorative schemes of the 15th century include the magnificent ceiling (1476–81) by Giuliano da Maiano and Benedetto da Maiano and frescoes (1482–4) by Ghirlandaio (*see* GHIRLANDAIO, (1), §I, 2(i)(b)) in the Sala dei Gigli; and intarsia work (1475–80) by Francione in the Sala dell'Udienza, where Francesco Salviati later produced important wall paintings (1543–5; *see* SALVIATI, FRANCESCO, fig. 2).

Between 1540 and 1550 the palace was used as the official residence of Cosimo I de' Medici and was called the Palazzo Ducale; during this period the Cappella di Eleonora was decorated by AGNOLO BRONZINO, court artist until 1555. The building became known as the Palazzo Vecchio only after Cosimo transferred his principal place of residence to the Palazzo Pitti on the other side of the River Arno in 1550 (*see* §9(i) below). Thereafter the Palazzo Vecchio was used only for government business.

A particularly grandiose and ornate internal reconstruction was carried out under the direction of Vasari in 1555–72. Vasari decorated the courtyard in which Michelozzo had worked, designed and built the nearby great staircase rising to the Salone del Cinquecento, and planned an elaborate series of decorative schemes for the palace. The internal rooms reflect the individual tastes of various members of the Medici family: for example the *studiolo* of Cosimo's son Francesco I celebrates his interest in alchemy and the natural sciences (*see* MEDICI, DE', (16); for illustration *see* NALDINI, GIOVAN BATTISTA; *see also* STUDIOLO, fig. 2). Some of the schemes celebrate the triumphs of war and peace, the most splendid being in the Salone del Cinquecento, for which Vasari and his many

collaborators painted 39 panels (1563–5) celebrating the power and glory of the Medici (*see* VASARI, GIORGIO, §I, 3(ii) and fig. 5 and colour pl. 2, XXXVII3; for further illustration *see also* MEDICI, DE', (14)). Thus, although it was conceived as a monument to a democratic government, the Palazzo Vecchio now bears witness to the power of Florence's best-known rulers, the Medici.

BIBLIOGRAPHY

G. Gargani: *Dell'antico Palazzo della Signoria fiorentina durante la repubblica* (Florence, 1872)

C. von Stegmann and H. von Geymuller: *The Architecture of the Renaissance in Tuscany* (Nuremberg, 1885)

A. Gotti: *Storia del Palazzo Vecchio in Firenze* (Florence, 1889)

J. White: *Art and Architecture in Italy, 1250–1400*, Pelican Hist. A. (Harmondsworth, 1966)

J. Paul: *Der Palazzo Vecchio in Florenz: Ursprung und Bedeutung seiner Form* (Florence, 1969)

G. Orlandi: *Il Palazzo Vecchio di Firenze* (Florence, 1977)

J. Cox-Rearick: *Bronzino's Chapel of Eleonora in the Palazzo Vecchio* (Berkeley, 1993)

R. Starn and L. Partridge: *Acts of Power: Three Halls of State in Italy, 1300–1600* (Berkeley, 1993)

A. M. Bernacchioni: 'Alcune precizioni su un perduto ciclo di Uomini illustri in Palazzo Vecchio', *Paragone*, xlv/529–33 (March–July 1994), pp. 17–22

A. Cecchi: 'Diario del palagio dei signori dalla Prima alla Seconda Repubblica (1494–1530)', *La difficile eredità: Architettura a Firenze dalla Repubblica al assedio*, ed. M. Dezzi Bardeschi (Florence, 1994), pp. 72–86

P. Corrias: 'Don Vincezio Borghini e l'iconologia del potere alla corte di Cosimo I e di Francesco I de' Medici', *Stor. A.*, 81 (1994), pp. 169–81

C. Cunningham: 'For the Honour and Beauty of the City: The Design of Town Halls', *Siena, Florence and Padua: Art, Society and Religion, 1280–1400*, ed. D. Norman, ii (New Haven and London, 1995), pp. 29–53

N. Rubinstein: *The Palazzo Vecchio, 1290–1532: Government, Architecture and Imagery in the Civic Palace of the Florentine Republic* (Oxford, 1995)

M. Hegarty: 'Laurentian Patronage in the Palazzo Vecchio: The Frescoes of the Sala dei Gigli', *A. Bull.*, lxxviii/2 (June 1996), pp. 264–85

M. Trachtenberg: *Dominion of the Eye: Urbanism, Art and Power in Early Modern Florence* (Cambridge and New York, 1997)

ANABEL THOMAS

9. PALAZZO PITTI. One of the largest palaces in Florence, the Palazzo Pitti is laid out on the slopes of the Boboli Hill, south of the Arno. It now houses the Galleria Palatina, the Galleria d'Arte Moderna, the Museo degli Argenti and other collections.

(i) Architecture. The palace was commissioned by LUCA PITTI, who had owned the site (known as the Bogole) from as early as 1418. It was probably begun *c.* 1457 and was certainly well advanced by 1469 when the Pitti family was already installed. By the latter date, however, Luca Pitti had fallen from official favour, and the building work seems to have been interrupted; it was certainly halted by Pitti's death in 1472. It has been suggested that Brunelleschi produced the original design, consisting of seven bays with three large ground-floor openings and heavy rustication on each of its three levels, which appears on the predella of an altarpiece (Florence, Uffizi) from Santo Spirito by Alessandro Allori (1535–1607). The Palazzo Pitti has traditionally been linked with the great new palace built for the Medici family in Via Larga (now Via Cavour) in 1444–60. Brunelleschi's plan for the latter was rejected in favour of the less grandiose project put forward by Michelozzo, but he may have subsequently offered similar designs to Luca Pitti. The architect responsible for the actual construction of the Palazzo Pitti is unknown,

although some attempts have been made to identify him with Luca Fancelli.

In 1550 the palace was bought from the Pitti family by Eleonora de' Medici, wife of Cosimo I, and it became the residence of the main branch of the Medici family; it was connected with the Palazzo Vecchio and Uffizi by the Corridoio Vasariano in 1565 (see §10 below). In 1560 Bartolomeo Ammanati was given instructions to enlarge the building and construct a courtyard (see AMMANATI, BARTOLOMEO, §2 and colour pl. 1, II2). He broke away from the contained classicism of the earlier building and, under the Mannerist influence of such contemporaries as Michelangelo and Jacopo Vignola, introduced curiously shaped windows, broken arches and a variety of rustication. At the same time the surrounding land was developed to form one of the first great Italian gardens (see §(iii) below). The garden façade of the palace was arranged as an open loggia on the first floor, giving a magnificent view over the grounds. The palace was substantially altered under later members of the Medici family.

BIBLIOGRAPHY

F. Morandini: 'Palazzo Pitti: La sua costruzione e i successivi ingrandimenti', Commentari, i–ii (1965), pp. 35–46
P. Sanpaolesi: 'Il Palazzo Pitti e gli architetti fiorentini della discendenza brunelleschiana', Festschrift Ulrich Middledorf (Berlin, 1968), pp. 124–35
L. Ginori Lisci: I palazzi di Firenze nella storia e nell'arte, 2 vols (Florence, 1972)
M. Bucci and R. Bencini: Palazzi di Firenze, iv (Florence, 1973)
ANABEL THOMAS

(ii) Decoration. The decoration of the palace began under Ferdinand I de' Medici during the last years of the 16th century. The first part to be decorated was the right wing, which had been constructed by Ammanati for Cosimo I. At the beginning of the 17th century much work took place under Bernardino Poccetti, who painted the impressive *Battle of Bona and Prevesa* (c. 1608) in the Sala di Bona, as well as a series of grotesques inspired by the Antique in the small courtyard. A number of other late Mannerist artists, including Lodovico Cigoli (1559–1613), Cristofano Allori (1535–1607), Giovanni da San Giovanni (1592–1636) and Baldassare Franceschini (1611–90), took part in and continued the massive scheme of decoration begun by Poccetti—much of it glorifying the Medici.

BIBLIOGRAPHY

K. A. Piacenti: 'The Summer Apartment of the Grand Dukes', Apollo, cvi (1977), pp. 190–97
ANABEL THOMAS

(iii) Boboli Gardens. The gardens of the Palazzo Pitti were designed on several levels with wild and cultivated vegetation, pools and fountains. They comprise two principal sections, the original one commissioned by Cosimo I de' Medici. In 1550 Niccolò Tribolo designed the waterworks and the basic lines of the central axis, which extends behind the Palazzo Pitti up to the Forte di Belvedere. After 1560 Bartolomeo Ammanati linked the palace and the garden by a courtyard and ramp. Bernardo Buontalenti created the fanciful tripartite great grotto (Grotto Grande) between 1583 and 1585 (see BUONTALENTI, BERNARDO, fig. 1 and colour pl. 1, XVIII1); this contains frescoes by Bernardino Poccetti, a figure of *Venus* (c. 1565) by Giambologna and *Helen and Paris* sculpted by Vincenzo

de' Rossi (1558–60; for illustration see ROSSI, VINCENZO DE'). On the exterior of the grotto is a group of *Adam and Eve* by Baccio Bandinelli, whose statue of *God the Father*, intended for the high altar of Florence Cathedral, was transformed into a figure of *Jupiter* and set in an adjacent rose garden. The Grotticina di Madama (c. 1584) contains marble goats by Giovanni Fancelli (fl 1568–86). The stone amphitheatre (1599) was built against the natural hollow of the rising hillside and was the site of many court festivities. Above the amphitheatre is the Neptune Fountain (1565–8) by Stoldo di Gino Lorenzi.

When the *barco* (park) of Francesco I de' Medici at Pratolino was redesigned, many of the statues were sent to the Boboli Gardens. Tribolo's original design can be studied in one of 14 lunettes depicting the Medici villas in and around Florence (see fig. 14) by Giusto Utens (d before 19 April 1609). Despite minor planting changes and the reorganization of statues, the gardens remain largely intact, thus presenting a rare, extant example of a late Renaissance garden on this scale.

BIBLIOGRAPHY

G. Cambiagi: Descrizione dell'imperiale giardino di Boboli (Florence, 1757)
F. M. Soldini: Descrizione del giardino di Boboli (Florence, 1789)
F.Inghirami: Description de l'imp. et r. palais Pitti et du r. jardin de Boboli (Fiesole, 1832)
D. Heikamp: 'La grotta grande del giardino di Boboli', Ant. viva, iv (1965)
J. Chatfield and F. Gurrieri: Boboli Gardens (Florence, 1972)
Boboli 90. Transactions of the International Conference on the Protection and Use of the Garden: Florence, 1989
JUDITH CHATFIELD

10. UFFIZI. The Palazzo degli Uffizi houses the greatest collection of Florentine art and the State archives of Tuscany. Cosimo I de' Medici in 1559 commissioned the court architect, Giorgio Vasari, to design the palace, intending that it should house the public offices of the State—hence the name Uffizi, meaning offices (see VASARI, (1), §I, 3(iii) and fig. 3 above). By 1564 the part adjoining the Palazzo Vecchio was complete, and in 1565 Cosimo instructed Vasari to build the private passageway known as the Corridoio Vasariano linking the Palazzo Vecchio and Uffizi to the new Medici residence, the Palazzo Pitti on the far side of the River Arno. This was completed in a record five months. Vasari employed considerable engineering skill in overcoming the difficulties of building on

14. Florence, Boboli Gardens, begun c. 1550; depicted in lunette by Giusto Utens, tempera on canvas, 1.45×2.40 m, 1599–1602 (Florence, Museo di Firenze com'era)

sandy, unstable ground close to the river. He used iron to reinforce the building, which allowed him to insert large and frequent apertures, and he incorporated remains of the 11th-century Romanesque church of S Piero Scheraggio.

When Vasari died in 1574, the supervision of the work passed to BERNARDO BUONTALENTI and Alfonso di Santi Parigi (*d* 1590). The building was completed soon after 1580. Francesco I de' Medici (*see* MEDICI, DE', (16)) had the second storey of the palace remodelled to display the works of art belonging to the Medici family. Buontalenti completed the design of the Galleria and designed the Tribuna, the octagonal domed hall where the works of greatest value were kept. He also built the unusual side entrance known as the Porta delle Suppliche (*c.* 1580) and the theatre in the eastern part of the palace, where the Gabinetto dei Disegni is housed today.

The Uffizi occupies a U-shaped site between the Palazzo Vecchio and the Lungarno. Two long, narrow wings stand on either side of a narrow piazza and are linked by a short façade on the river-front, which is opened in a Venetian window on the ground-floor. The two wings are composed of long arcades supporting three upper storeys, and the façade is divided into regular units of three bays. Vasari's design elegantly frames and enhances the view both to the Palazzo Vecchio and to the river. The palace is built in Fossato stone, similar to the *pietra serena* that was used for many Florentine buildings. The Uffizi was the largest building project in Florence of its period and the first Florentine building to be conceived as a piece of urban design. Modelled on Michelangelo's Biblioteca Laurenziana at San Lorenzo, it was intended as a faithful return to the principles of ancient architecture. It was also the first building designed as a museum, and its series of long, well-lit, interconnecting galleries served as a prototype for many subsequent museums and galleries.

See also ITALY, §XIV, 2.

BIBLIOGRAPHY
Uffizi: Quattro secoli di una galleria. Atti del convegno internazionale di studi: Firenze, 1982
L. Berti, ed.: *Gli Uffizi: Storie e collezione* (Florence, 1983)
A. Godoli: 'L'Ammannati e gli Uffizi', *Bartolomeo Ammannati, scultore e architetto (1511–1592)*, ed. N. Rosselli del Turco and F. Salvi (Florence, 1995), pp. 147–53

SARAH MORGAN

V. Institutions.

1. Accademia del Disegno. 2. Medici Academy.

1. ACCADEMIA DEL DISEGNO. The Accademia was based on the Compagnia di S Luca (founded 1349), an association of artists of a religious character, and was constituted in 1563 largely at the instigation of Giorgio Vasari. Its numbers increased in 1571 when more artists broke away from the Arte dei Medici e Speziali (founded 13th century) and the masons' guild (founded 1236). The enlarged institution became the sole officially recognized professional body representing Florentine artists, and the school of art. In its final legal form, established in 1585, it comprised the Compagnia and the Accademia *sensu stricto*, and it was administered on behalf of the court by a Luogotenente (lieutenant) drawn from a distinguished Florentine family. (The Accademia survived in this form

until it was replaced in 1784 by the Accademia di Belle Arti, founded by Leopold, Grand Duke of Tuscany.)

The term 'academy' had been used formerly by Italian artists to describe their schools of art or their intellectual attitudes. Vasari extended its meaning to the whole Florentine scene (*see* §2 below). The new institution was modelled on the Accademia Fiorentina, which had been founded in 1542 through the transformation of the Accademia degli Umidi (1540) into an official institution. After consultation with Florentine artists, including Agnolo Bronzino and Giovanni Angelo Montòrsoli, and members of the court, Vasari announced his plan on 24 May 1562 during the consecration of the chapel of St Luke in SS Annunziata, which Montòrsoli had offered to the artists of Florence. The Accademia's constitution, which was approved by the court on 13 January 1563, was shaped by VINCENZO BORGHINI, Prior of the Ospedale degli Innocenti (see fig. 15). For the first two years he acted as the Luogotenente, after which he continued to serve as the chief adviser on iconography. The Accademia's prestige in Florence was considerably enhanced by its organization of the memorial ceremony (14 July 1564) in honour of Michelangelo in S Lorenzo and the completion of extensive decorations for the Medici court, including the modernization of S Maria Novella and Santa Croce (1564–75), and the decorations for the wedding in 1565 of the future Francesco I and Joanna of Austria (1547–78).

Vasari's greatest success was the acquisition, with Cosimo I's support, of premises at the Cistercian monastery (destr.) in Borgo Pinti. The Accademia's school was housed there from 1568 to 1627, and lectures on mathematics and geometry were given as early as 1569 (*see* ITALY, §XVI, 2); the earliest surviving accounts date, however, from the first half of the 17th century. Young people learnt to draw by copying works of art and studying models from life. Exhibitions were staged at the monastery annually on 18 October, the feast of St Luke, the patron saint of artists. The theoretical principles on which the school was founded were discussed in its statutes, in *I tre primi libri*

15. *Presentation of the Statutes of the Accademia del Disegno by Vincenzo Borghini to Cosimo I de' Medici* (1609) by Bernardino Poccetti, fresco, Museo dell'Ospedale degli Innocenti, Florence

...intorno agl'ornamenti che convengono a tutte le fabbriche che l'architettura compone (1568; Venice, Bib. N. Marciana, MS. It. IV, 38) by Gherardo Spini and in Francesco Bocchi's *Eccellenza della statua del San Giorgio di Donatello* (Florence, 1584), which was dedicated to the Accademia.

BIBLIOGRAPHY

G. Ticciati: *Notizie dell'Accademia del Disegno della città di Firenze dalla sua fondazione fino all'anno 1739* (MS.; London, BL, Ashburnham MS. 1035); ed. P. Fanfani in *Spigolatura michelangiolesca* (Pistoia, 1876), pp. 193–307
F. Boroni Salvadori: 'Le esposizioni d'arte a Firenze dal 1674 al 1767', *Mitt. Ksthist. Inst. Florenz*, xviii/1 (1974), pp. 1–166
T. Reynolds: *The Accademia del Disegno in Florence: Its Formation and Early Years* (diss., New York, Columbia U., 1974; microfilm, Ann Arbor, 1974)
The Twilight of the Medici: Late Baroque Art in Florence, 1670–1743 (exh. cat., ed. S. F. Rossen; Detroit, MI, Inst. A.; Florence, Pitti; 1974), pp. 19–24 [article by K. Lankheit]
C. Acidini: *Il disegno interrotto* (Florence 1980), pp. 13–183
C. Dempsey: 'Some Observations on the Education of Artists in Florence and Bologna during the Later Sixteenth Century', *A. Bull.*, lxii (1980), pp. 552–69
A. Hughes: 'An Academy for Doing: the Accademia del Disegno, the Guilds and the Principate in Sixteenth-century Florence', *Oxford A. J.*, ix/1 (1986), pp. 3–10
B. Laschke: 'Montorsolis Entwürfe für das Siegel der Accademia del Disegno in Florenz', *Mitt. Ksthist. Inst. Florenz*, xxxi/2–3 (1987), pp. 292–402
Z. Waźbiński: *L'Accademia Medicea del Disegno a Firenze nel cinquecento: Idea e istituzione*, 2 vols (Florence, 1987)

Z. WAŹBIŃSKI

2. MEDICI ACADEMY. Lorenzo the Magnificent developed lands at the Piazza S Marco (lands that his grandsire Cosimo had begun assembling in the 1450s, as Elam demonstrated) into a retreat with reception rooms as well as pleasant grounds. By 1480 the property was well-enough developed to show the Cardinal of Aragon its library and garden. Accounts by Benedetto Varchi and Vasari state that it was 'filled with antique and modern sculptures, in such a way that the loggia, the paths and all the rooms were adorned with good antique figures of marble, with paintings...from the hands of the best masters' (Vasari). According to them, young artists and aristocrats, including Michelangelo, were placed in the care of BERTOLDO DI GIOVANNI to study the examples of ancient art, forming a 'school and academy' that Pevsner defined as working to the 'first modern method'. As Bertoldo and Lorenzo died in 1491 and 1492 respectively, their involvement in the project would have been brief. The garden's contents were sacked in 1494 by French troops under Charles VIII (*reg* 1483–98).

Vasari's account, which appears only in the second edition (1568) of his *Vite*, has been questioned by some scholars, especially Chastel, noting that the inclusion of Niccolò Soggi (*c.* 1480–*c.* 1552), Lorenzo di Credi and Andrea Sansovino appears to be inaccurate. Chastel claimed that Vasari's description, which may be seen as a symbolic grafting of Domenico Ghirlandaio's pupils on to the Verrocchio workshop, was political in purpose, intended to create a prototype for the newly founded Accademia del Disegno (*see* §1 above) and to help secure the support of Cosimo I.

There is supporting evidence, however, for the existence of an educational instrument as described by Vasari and Varchi. As early as 1427 the humanist Poggio Bracciolini

had used 'academy' precisely in the context of a villa containing sculptures that provided a place for contemplation. Vasari continued to understand the same meaning. His writings show a fair knowledge of Bertoldo, whose chief contribution was to instruct Michelangelo in ways of looking at antique relief sculpture, as may be seen by a comparison of the former's *Battle* relief (Florence, Bargello) and the latter's *Battle of the Centaurs* (1492; Florence, Casa Buonarroti). Michelangelo's continued access to a Medici garden, whether at Piazza S Marco or in the Palazzo Medici, is indicated by a letter of 1494 to Adriano Fiorentino from his brother Amadeo with news of Michelangelo's escape 'from the garden'. Leonardo appears to have taken the idea of 'academy' to Milan, as the phrase 'Academia Leonardi Vinci' was applied to his workshop's knot-engravings. Pomponius Gauricus and Baccio Bandinelli were other early users of the term in an artistic context: Agostino dei Musi's engraving of 1531 shows Bandinelli and his 'academy' studying sculpture intently in a manner consistent with Vasari. The stress on the aristocratic nature of the enterprise by Vasari concurs with the belief of Leonardo and Bandinelli in the exalted calling of the artistic profession.

BIBLIOGRAPHY

G. Vasari: *Vite* (1550, rev. 2/1568); ed. G. Milanesi (1878–85), iv, pp. 256–9; vi, p. 201; vii, pp. 141–2
B. Varchi: *Orazione funerale di Benedetto Varchi fatta e recitata da lui pubblicamente nell'esequie di Michelagnolo Buonarroti* (Florence, 1564), pp. 21–2
K. Frey: *Michelangiolo Buonarroti: Quellen und Forschungen zu seiner Geschichte und Kunst* (Berlin, 1907), ii, pp. 45, 62–3
N. Pevsner: *Academies of Art, Past and Present* (Cambridge, 1940), pp. 1–66
A. Chastel: 'Vasari et la légende médicéenne: L'Ecole du jardin de Saint-Marc', *Studi vasariani. Atti del convegno internazionale per il IV centenario delle 'Vite' del Vasari: Firenze, 1950*, pp. 159–67
C. Elam: 'Il palazzo nel contesto della città', *Il Palazzo Medici–Riccardi di Firenze*, ed. G. Cherubini and G. Fanelli (Florence, 1990), pp. 44–57
J. D. Draper: *Bertoldo di Giovanni: Sculptor of the Medici Household* (Columbia, MO, and London, 1992)
IL GIARDINO DI SAN MARCO: MAESTRI E COMPAGNI DEL GIOVANE MICHELANGELO (exh. cat., ed. P. Barrocchi; Florence, Casa Buonarroti, 1992)

JAMES DAVID DRAPER

Florence, Dukes of. *See* MEDICI, DE'.

Florentia, Rafaelle de. *See* RAFFAELLINO DEL GARBO.

Florigerio, Sebastiano [Sebastiano di Giacomo di Bologna da Conegliano] (*b* Conegliano, *c.* 1510; *d* Udine, between 1550 and 1564). Italian painter. According to Vasari, who mentioned him as Bastiano Florigorio, he was a pupil of Pellegrino da San Daniele. He is documented in Pellegrino's shop from 1523 and married his daughter in 1527. His earliest surviving paintings are the *Virgin and Child with SS Anne, Roch and Sebastian* and the lunette of *St John the Evangelist with SS Francis and Anthony* (both Venice, Accad.) from the altarpiece executed in 1524–5 for S Francesco, Conegliano. A large painting of the *Virgin and Child with SS George and John the Baptist* (1529; Udine, S Giorgio), probably his best known work, is closer to the style of Pordenone than to that of Pellegrino. From *c.* 1529 until 1533 he was in Padua, where he frescoed a *Pietà* (destr.) for the main altar of S Bovo and painted an altarpiece with the central panel depicting the *Pietà* (Ro-

vigo, Accad. Concordi), the side panels *St Sebastian* and *St Roch* (both Padua, Mus. Civ.) and a predella of three panels: *SS Anthony and Prosdocimus* (Pordenone, priv. col.), signed and dated 1533, *St Daniel* (Venice, Calligaris priv. col.) and *St Justine* (untraced). The altarpiece was reassembled for the exhibition *Dopo Mantegna, Arte padovana e nel territorio nei secoli XV e XVI* (Padua, Pal. Ragione; 1976). He also executed frescoes (destr.) in the portico of the Palazzo del Capitano in Padua. Between 1538 and 1543 he was in Cividale. In 1543 he returned to Udine, where he probably remained until his death. Vasari attributed to him the portrait of *Raffaello Grassi* (Florence, Uffizi).

BIBLIOGRAPHY

G. Vasari: *Vite* (1550; rev. 2/1568); ed. G. Milanesi (1878–85), v, pp. 108–9

R. Marini: *Sebastiano Florigerio* (Udine, 1956)

M. Cosmacini: *Sebastiano Florigerio* (diss., U. Trieste, 1971)

G. Briganti, ed.: *La pittura in Italia: Il cinquecento* (Milan, 1988), p. 716

LUCA LEONCINI

Fogolino, Marcello (*b* Vicenza, between 1483 and 1488; *d* after 1548). Italian painter and printmaker. The son of Francisco, a painter from Friuli, he was trained in Vicenza, in the workshop of Bartolomeo Montagna. Although he was in Venice between *c.* 1508 and 1516, it was Montagna's retardataire style belonging to the 15th century that proved the decisive influence in Fogolino's early works, for example the *Virgin and Child with Saints* (*c.* 1513–15; The Hague, Mauritshuis). Between 1521 and 1524 he worked in Friuli, where his *St Francis with SS Daniel and John the Baptist* (*c.* 1522; Pordenone Cathedral), with its asymmetrical arrangement and bulky, powerfully modelled figure types, shows him responding quickly to Pordenone's dynamic style.

In 1527 Fogolino and his brother Matteo were banished from Venetian territory for their complicity in a murder. They settled in Trent until they were reprieved by the Venetians. Fogolino won extensive court patronage in Trent. At the Castel Buonconsiglio he collaborated with Girolamo Romanino and Giovanni Dosso on a fresco cycle (1531–2) for Prince–Bishop Bernard von Cles (1485–1539), and he was later involved in the production of triumphal decorations for the visits in 1536 and 1541 respectively of King Ferdinand (*reg* 1526–62) and his elder brother, Emperor Charles V (*reg* 1519–56). Fogolino's work from this period continues to reflect his earlier formative experiences of Montagna and Pordenone, but it is modified by the influence of contemporary Roman artists increasingly apparent in the styles of Romanino and Dosso. In 1547 he executed frescoes depicting scenes from the *Life of Moses* for the Palazzo Vescovile, Ascoli Piceno. Fogolino also made a small number of refined drypoint engravings, for example the *Woman and Child beside a Classical Building* (Amsterdam, Rijksmus.). He is last recorded in Trent in 1548.

BIBLIOGRAPHY

L. Puppi: *Marcello Fogolino pittore e incisore* (Trent, 1966) [incl. full bibliog.]

F. Barbieri: *Pittori di Vicenza, 1480–1520* (Vicenza, 1981)

TOM NICHOLS

Folchetti, Stefano (*b* San Ginesio; *fl* 1492–1513). Italian painter. The *Virgin and Child with Saints* (San Ginesio,

Mus. Pin. Gentili) and the fresco of the *Madonna and Child* in SS Rosario, Amandola, both dated 1492, are his earliest known works. In 1494 he painted the *Virgin and Child with a Donor* (Urbisaglia, S Maria di Brusciano). The *Virgin and Child between the Blessed Liberatus da Loro and St Francis* (San Ginesio, Mus. Pin. Gentili) is datable within the 1490s. His painting basically reflects the style of Carlo Crivelli, probably transmitted through the influence of Crivelli's brother Vittore. Facial expressions tend to be accentuated in a grotesque manner, in keeping with Late Gothic decorative taste, which is also apparent in the costumes, especially in the conspicuous use of gold. His work is also influenced by the Sanseverino school, especially Lorenzo d'Alessandro (*c.* 1440–1503).

Within the limits of Crivelli's style, Folchetti pursued an interest in abstract, at times archaic, decorative patterning. The potentially expressive and dynamic forces of the lines are, however, tempered by a tendency to fall into a mechanical repetition of geometric formulae. In the *Virgin and Child* (1506; San Ginesio, S Gregorio) a growing interest in rendering volume signals a break from the hitherto rigorous attention to surface patterning, but the latter aspect prevails in Folchetti's fresco of the *Madonna and Child* in S Maria, Ronzano. In Urbisaglia the artist is represented by a *Pietà* (Chiesa della Maestà) and a triptych depicting the *Mystic Marriage of St Catherine with SS Peter and Lawrence* (1507; Collegiata di S Lorenzo), and in the Municipio, Sarnano, by a *Crucifixion* dated 1513. Other works by Folchetti can be found in Amandola, San Ginesio, Recanati Cathedral and Philadelphia, PA (Mus. A).

BIBLIOGRAPHY

P. Zampetti: *La pittura marchigiana da Gentile a Raffaello* (Venice, 1970), pp. 192–200

Lorenzo Lotto nelle Marche: Il suo tempo, il suo influsso (exh. cat., ed. P. dal Poggetto and P. Zampetti; Ancona, Il Gesu; S Francesco alle Scale; Loggia Mercanti; 1981)

Documenti dell'Abruzzo Teramano, i (Rome, 1983), pp. 359–60

MARIO ALBERTO PAVONE

Foligno, Niccolò da. *See* NICCOLÒ DA FOLIGNO.

Fonduli [Fondulo]. Italian family of artists. (1) Giovanni Paulo Fonduli was probably the son of Fondulino de Fonduliis (*fl c.* 1444–9), a goldsmith and sculptor whose family had long-established ties with the district of Crema. Giovanni's brother Bartolomeo Fonduli (*fl* Vicenza, 1471– 1505) also practised as a goldsmith. (2) Agostino Fonduli, son of Giovanni, was an architect as well as a sculptor, working throughout Lombardy and collaborating with Bramante in Milan. □

(1) Giovanni Paulo Fonduli [Fondulli, Fundulli, Fondulio; Giovanni da Crema, Giovanni da Cremona] (*fl* second half of 15th century). Sculptor. A contract dated 29 November 1469, written by Fonduli himself, has survived, stipulating the execution of three *all'antica* terracotta altarpieces for a church to be built in the Castello at Este. From Fonduli's handwriting and Venetian dialect, it can be deduced that he had had some education and that he had probably worked outside of Crema, in Padua. In a later contract of 3 March 1484, Fonduli agreed to

create a bronze relief for the Paduan church of Il Santo. Terni de Gregory suggested that the relief may be extant in the church but attributed to another artist. Bronze was the medium preferred by Fonduli. His best-known work (also attributed to the MASTER 10.FF; *see* MASTERS, ANONYMOUS, AND MONOGRAMMISTS, §III), the bronze, partially gilded *Seated Goddess* (h. 204 mm; London, Wallace), signed 'OPUS IO/CRE', demonstrates his knowledge of antique sculpture. Based on an original ancient statue of *Andromeda* (Naples, Mus. Archeol. N.), it has been compared with Andrea Riccio's later images of female figures. In this work Fonduli combined naturalism with a characteristically Venetian taste for luxuriant forms, in order to create an image of the partially draped nude goddess that vies with the best of Riccio.

Attributions of Fonduli's sculptures to Riccio are fairly common. The stylistic similarities between the two artists, combined with Fonduli's anticipation of the freer sculptural forms of the 16th century, suggest that he was the younger artist and perhaps Riccio's student. The multitude of variants on Fonduli's name may include the initials IO.F.F. (implying the Latin form of his name 'Johannes Fondulini Fondulus') found on several bronze Paduan plaquettes, for example the *Allegorical Scene* (h. 32 mm; London, V&A) and one set as a sword pommel (h. 76 mm; London, Wallace). Each plaquette reflects knowledge of the goldsmith's art, a knowledge Fonduli acquired in his father's workshop.

BIBLIOGRAPHY
W. Bode: *Die italienischen Bronzestatuetten der Renaissance* (Berlin, 1907)
W. Terni de Gregory: 'Giovanni da Crema and his "Seated Goddess"', *Burl. Mag.*, xcii (1950), pp. 158–61

ROBIN A. BRANSTATOR

(2) Agostino Fonduli [de' Fondulis; de Fondutis] [il Padovano] (*fl*1483; *d*Crema, 1522). Sculptor and architect, son of (1) Giovanni Paulo Fonduli. He trained with his father in the Paduan circles of the followers of Donatello. In 1483 Agostino was in Milan, where he worked on the naturalistically painted terracotta *Pietà* group of 14 figures for the church of S Maria presso S Satiro, a work that was inspired both by Paduan Late Gothic naturalism and by the classicism of Andrea Mantegna. He also undertook a bust and panels for the lower frieze of the octagonal sacristy. These works, in which he was subjected to the artistic judgement of Bramante, are evidence of a well-matured Renaissance style. In 1484–6, together with his brother-in-law Giovanni di Domenico Battagio, Agostino worked on the Palazzo Landi (now Palazzo dei Tribunali) at Piacenza, producing busts and other decorations. In 1499 he was given the commission for the ceilings and other decoration for the Vimercati house (destr.), Crema, and he was present in 1501 for the valuation of the sculptural works executed for the façade of Crema Cathedral; his collaboration in the decoration of the Palazzo Fodri may also be associated with this visit.

During 1502 Fonduli probably worked on a series of ten statues intended for the church of S Maria presso S Celso, Milan. In Crema again in 1510 he was commissioned to produce a tomb for the church of S Maddalena e Santo Spirito. The eight statues for this may perhaps be identified with those now in the parish church of S Martino at

Palazzo Pignano, near Pandino, in which Paduan naturalism and the influence of Mantegna are combined with a classicism that derives from Bramante. Although inspired by Bramante, the architectural structure of S Maddalena e Santo Spirito (completed 1523) is also attributed to Fonduli, as are S Maria della Misericordia (1513–16) and SS Giacomo e Filippo (1517–51; rest. 1925), both in Castelleone (Cremona). Fonduli was the only Lombard sculptor collaborating with Bramante in Milan who could assure Bramante of a proper classical training. While remaining faithful to Bramante's teaching, as shown in his use of decoration in strict keeping with the architecture, he was able to provide an easy sense of balance in his personal interpretation of the monumentality that is typical of the Lombard sculptural tradition.

BIBLIOGRAPHY
M. Bandirali: 'Scheda per Agostino Fondulo scultore', *A. Lombarda*, iii/1 (1958), pp. 29–44
M. L. Ferrari: 'Il raggio di Bramante nel territorio cremonese: Contributi ad Agostino de Fonduli', *Studi bramanteschi: Atti del Congresso internazionale: Milan, Urbino and Rome, 1970*, pp. 223–32
S. Bandera Bistoletti: 'La "Pieta" di Agostino de' Fonduli in S Satiro nell'occasione del suo restauro', *A. Lombarda*, 86–7 (1988), pp. 71–82
M. Verga Bandirali: 'Contributo all ricostruzione di una fase cremasca nel percorso di Agostino Fondulo', *A. Lombarda*, 92–3 (1990), pp. 63–75

ADRIANO GHISETTI GIAVARINA

Fongario [da Fonghaia], **Bernardino**. *See* FUNGAI, BERNARDINO.

Font [Lat. *fons*: 'spring']. Object in which, or by which, baptism, the Christian rite of initiation, is practised. Evolving modes of liturgical practice, most notably the adoption of infant baptism, resulted in widely varying physical forms and positioning within the church.

1. Introduction. 2. Renaissance.

1. INTRODUCTION. John the Baptist baptized people in the River Jordan, washing them clean of sin. Jesus, however, told his followers that they must be reborn through baptism: 'except a man be born of water and of the Spirit, he cannot enter into the kingdom of God' (John 3:5). Christian baptism is thus a ritual dying and rebirth as a new person, entering the tomb of death (or the womb, for the second time) and being resurrected to a new life, sharing in the experiences of Christ, who himself suffered death but was reborn. The font, therefore, is an item of liturgical furniture, but it is also a physical symbol, embodying the ideas of death and rebirth. Some of the earliest fonts that have been identified were shaped like a coffin or tomb; others, being circular, approximated more to the womb. The numbers six and eight are found in early baptismal architecture, in the shape of either the font or the baptistery that housed it; occasionally hexagonal and octagonal structures are combined. These represent the sixth and eighth days, on which Christ died (Friday) and was then reborn (Sunday), providing the source of the baptismal candidate's ultimate hope. Some large, round cistern fonts are a reminder that such symbols are not peculiar to Christianity but can be found in the Cauldron of Rebirth of Celtic myth. Many Italian baptisteries are octagonal, and in Gothic art, both medieval and modern revivals, fonts are frequently eight-sided. Some Christian

traditions have long employed small bowls, perhaps raised on a column, for infant or adult baptism, while others immerse adult candidates in large tanks, set beneath the floor.

BIBLIOGRAPHY

J. G. Davies: *The Architectural Setting of Baptism* (London, 1962)

A. Eljenholm Nichols: *Seeable Signs: The Iconography of the Seven Sacraments, 1350–1544* (Woodbridge, 1995)

JOHN THOMAS

2. RENAISSANCE. In Italy in the late 14th century it was still customary to place the font, usually a monolithic basin, with or without a pedestal, within a baptistery. In the early 15th century, however, a new type of font developed that was to become very popular in Italy in the following century and co-exist with the traditional type. This so-called Renaissance font is approached by a flight of steps, at the top of which is a polygonal, square or round basin, supported on a pedestal and covered by a lid. The side of the basin and the lid are usually ornamented.

The most influential design in the type's development was the new font (1416–31) for the Siena Baptistery, on which Lorenzo Ghiberti was commissioned to advise, with decoration by Ghiberti (*see* GHIBERTI, (1), fig. 4), Donatello, Jacopo della Quercia and others. This was innovative in its structure, with a lidless basin and a tabernacle, and in its combination of bronze and marble. The hexagonal basin bears six gilded bronze reliefs of the *Life of St John the Baptist*, separated by six free-standing bronze *Virtues* set in shallow marble niches. Gold and azure blue enamelled friezes and inscriptions decorate the rim of the basin and the steps. A cluster of columns in the middle of the basin supports the hexagonal marble tabernacle, which is fashioned after Florentine models. On five sides there is the figure of an *Apostle*, set within a niche, while on the sixth there is a small door, behind which are stored the baptismal ointments. Putti crown the corners of the tabernacle, and above these rise columns supporting a statue of *St John the Baptist*.

Elements of this new type were to appear in new commissions and as additions to existing fonts. In Massa Marittima Cathedral, for example, the font (1267) comprised a single block of marble (2.73×2.40×0.98 m), with reliefs by Giroldo da Como, to which was added a tabernacle (1447) by Pagno di Lapo and Giovanni Rossellino (1417–*c*. 1496). Among the most important fonts with a tabernacle standing within the basin are the travertine font (1460) in the crypt of Pienza Cathedral, made by the school of Bernardo Rossellino; that made before 1484 by the workshop of Antonio Federighi for the chapel of S Giovanni Battista in Siena Cathedral; and the font (1502) made by Andrea Sansovino for the baptistery of Volterra Cathedral, which bears reliefs of *Hope, Faith, Justice, Charity* and the *Baptism*.

BIBLIOGRAPHY

P. Saintenoy: *Prolégomènes à l'étude de la filation des formes des fonts baptismaux depuis les baptistères jusqu'au 16e siècle* (Brussels, 1892)

J. C. Wall: *Porches and Fonts* (London, 1912)

E. T. Green: *Baptismal Fonts Classified and Illustrated* (London, 1928)

R. Bauerreisz: *Fons sacer* (Munich, 1949)

H. Caspary: *Das Sakramentstabernakel in Italien bis zum Konzil von Trient: Gestalt, Ikonographie und Symbolik, kultische Funktion* (diss., Munich, Ludwig-Maximilians-U., 1964)

J. T. Paoletti: *The Siena Baptistry Font: A Study of an Early Renaissance Collaboration Program, 1416–1434* (New York and London, 1979)

IRIS KOCKELBERGH

Fontana (i). Italian family of potters. The workshop founder, Guido Durantino (*d c*. 1576), was established as a potter in Urbino by 1519 and by 1553 had adopted the name Fontana. His three sons, Nicolo Fontana (*d* 1565), Camillo Fontana (*d* 1589) and Orazio Fontana (*c*. 1510–76), also took part in the business, as did Nicolo's son Flaminio Fontana (*fl* after 1576). The workshop was one of the most influential in the area during the 16th century.

Guido Durantino has been described as 'an artist of somewhat elusive personality' (Mallet), and it is still not certain whether as head of the workshop he confined his activities to the administration shop or was also a painter. The products of his studio include works dated between 1528 and 1542 and two important armorial services (both *c*. 1535) made for the Constable of France, Anne de Montmorency, and Cardinal Antoine Duprat; there are also indications that Guido's shop received commissions from Guidobaldo II, Duke of Urbino. Nicola di Gabriele Sbraghe (formerly incorrectly identified as Nicolò Pellipario; *see* URBINO, NICOLA DA) was one of at least six painters whose hand can be identified among the marked works from the Fontana shop, and it was here that Nicola painted his famous plate (1528; Florence, Bargello) depicting *St Cecilia*. The workshop maintained consistently high, if diverse, artistic and technical levels, producing *istoriato* (*see* URBINO, fig. 2) and white-ground grotesque wares, as well as plain white ceramics and fired and unfired utilitarian items. The grotesque wares of the Patanazzi family provided some competition for the Fontana workshop, and it can be difficult to differentiate between the products of the two shops between *c*. 1570 and 1585. Orazio Fontana probably began his career in his father's shop as a painter of *istoriato* wares, although his fame is attributable more to the appearance of his monogram on a number of pieces than to his talent as an artist. Seven pieces (including one formerly in Berlin, Schloss Charlottenburg; destr.) bear dates between 1541 and 1544 along with his monogram. The Berlin plate (inscribed 5 Nov 1542) typified Orazio's lively style, which has been described as 'far from impeccable and sometimes downright careless' (Mallet). His later career was highlighted by his service as master potter to the Duke of Savoy in 1564, a year before he established his own workshop in Urbino and provided maiolica to the Medici court in Florence (see colour pl. 1, XXX2). Flaminio Fontana, the son of Nicolo, carried on the family business until the late 16th century. He was involved with the Medicis' attempt to duplicate true East Asian porcelain and spent time in Florence supervising firings of the 'Medici porcelain' between 1573 and 1578.

BIBLIOGRAPHY

B. Rackham: 'The Maiolica Painter Guido Durantino', *Burl. Mag.*, lxxvii (1940), pp. 182–8

G. Liverani: 'Un piatto a Montpellier marcato da Orazio Fontana ed altri ancora', *Faenza*, xliii (1957), pp. 131–4

J. V. G. Mallet: 'In bottega di Maestro Guido Durantino in Urbino', *Burl. Mag.*, cxxix (1987), pp. 284–98

J. G. Romano: 'Ipotesi su un piatto per l'arcivescovo Iñigo Avalos Aragona nella sua permanenza a Torino (1563–1564)', *Stud. Piemont.*, xxi/1 (March 1992), pp. 139–43

WENDY M. WATSON

Fontana (ii). Italian family of painters and draughtsmen. They were active mostly in Bologna and Rome. (1) Prospero Fontana was a leading Bolognese exponent of Mannerism. (2) Lavinia Fontana, his daughter and pupil, was the first woman artist to have commissions for large-scale and public works as well as portraiture.

(1) Prospero Fontana (*b* Bologna, 1512; *d* Bologna, 1597). He trained with Innocenzo da Imola, a follower of Raphael, and early in his career assisted the Mannerist painter Perino del Vaga on the decoration of the Palazzo Doria in Genoa. His contact with Mannerist artists continued during his years as an assistant to Giorgio Vasari on projects in Rome and Florence. Despite this exposure to progressive influences, he continued to paint in an essentially conservative style in this period, as in the *Transfiguration with Saints* (1545; Bologna, S Domenico). From 1548 he moved between Rome and Bologna: in 1550 he executed frescoes of scenes from the *Life of Constantine* in the Palazzina della Viola, Bologna (*in situ*); in 1550–51 he supervised the decorations of the Vatican Belvedere, Rome, for Pope Julius III; and in 1551 he executed frescoes of *Virtues* and *Gods* in the Palazzo Bocchi, Bologna.

Early in 1553 Prospero was again in Rome, where he worked with Taddeo Zuccaro on the decorations (destr.) of the Villa Giulia. During this final period in Rome he also executed decorations for the loggia of the Palazzo di Firenze (*in situ*) for Balduino del Monte, brother of Julius III. Around 1560 he worked briefly with Primaticcio at Fontainebleau in France. His first convincing use of a Mannerist style occurs in such works of this period as the *Disputation of St Catherine* (*c.* 1560; Bologna, Madonna del Baraccano). He assisted Vasari again in 1563–5 on the decorations of the Palazzo Vecchio in Florence, and in 1565 he was admitted to the Florentine Accademia del Disegno. He followed the Mannerist style of Vasari until he settled in Bologna in the 1570s. There he responded to the appeals of Cardinal Gabriele Paleotti for artists to provide clear and persuasive religious works in keeping with the suggestions of the Council of Trent. The use of descriptive naturalism and convincing expression characterizes his late style, as in *St Alessio Distributing Alms* (1576; Bologna, S Giacomo Maggiore). His last important public commission dates from the late 1570s, when he contributed decorations for the rebuilt apse of S Pietro, Bologna (*in situ*). Although he continued to paint in the 1590s, Prospero failed to respond to the reform of Bolognese painting instigated by the Carracci family.

BIBLIOGRAPHY
Thieme–Becker
The Age of Correggio and the Carracci (exh. cat., Washington, DC, N.G.A.; New York, Met.; Bologna, Pin. N.; 1986), pp. 136–40
V. Fortunati Pietrantonio: *La pittura bolognese del '500* (Bologna, 1986)

(2) Lavinia Fontana (*b* Bologna, *bapt* 24 Aug 1552; *d* Rome, 11 Aug 1614). Daughter of (1) Prospero Fontana. She was trained by her father and followed his Mannerist style. Her first recorded works, which date from 1575, were small paintings for private devotion, such as the *Holy Family* (Dresden, Gemäldegal.). By 1577 she had become established as a portrait painter in Bologna. Works of this

date include the *Self-portrait at the Harpsichord* (Rome, Gal. Accad. S Luca) and the portrait of *Senator Orsini* (Bordeaux, Mus. B.-A.). Her portrait style reflects the formality of Central Italian models as well as the naturalistic tendencies of the North Italian tradition. The elegantly costumed Orsini is shown seated at a table, with a suite of rooms opening behind him, a setting recalling such Florentine portraits of the 1530s as Agnolo Bronzino's *Bartolommeo Panciatichi* (Florence, Uffizi; see colour pl. 1, XVII3). Lavinia used a similar setting for other portraits, including the *Gozzadini Family* (1584; Bologna, Pin. N.). Female sitters are also shown in elaborate dress, with particular attention paid to details of embroidery and jewels, and they are often accompanied by small dogs (e.g. Baltimore, Walters A.G.; Florence, Pitti). In naturalism and treatment of detail her portraits are comparable with those of her famous North Italian predecessor, Sofonisba Anguissola (e.g. *Portrait of a Woman*, 1557; Berlin, Gemäldegal.).

Although best known for her portraits, Lavinia also painted mythological and religious subjects, one of her most accomplished being the *Noli me tangere* (1581; Florence, Uffizi; see fig.). The simplicity of the composition and its soft light and muted golden colours show the influence of Correggio's painting of the same subject (1520s; Madrid, Prado), which was then in Bologna. Her incorporation of qualities typical of Correggio's work was unusual among Bolognese artists at this date, before their introduction by Annibale Carracci (1560–1609). Her first documented public commission was in 1584, for the *Assumption of the Virgin with SS Peter Crisologus and Cassian* (Imola, Pin. Civ.), a work full of Venetian colour and light. In 1589 she painted another major altarpiece,

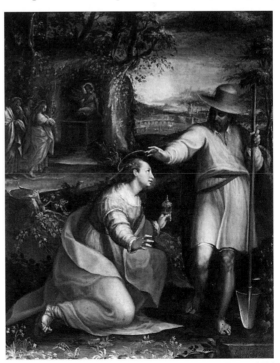

Lavinia Fontana: *Noli me tangere*, oil on canvas, 810×650 mm, 1581 (Florence, Galleria degli Uffizi)

the *Holy Family with the Sleeping Christ Child* for the monastery of S Lorenzo at the Escorial, Madrid (*in situ*), in a High Renaissance classical style reminiscent of Sebastiano del Piombo. Her response to progressive developments in Bolognese painting was tempered by her training in the Mannerist style of her father, and the tension between the two modes is evident in such works of the 1590s as the *Assumption of the Virgin* (Pieve di Cento, parish church) and the *Consecration to the Virgin* (Marseilles, Mus. B.-A.). The elaborate *Visit of the Queen of Sheba to Solomon* (Dublin, N.G.) may also date from this period.

Lavinia's work was introduced to Rome about 1600 with the *Vision of St Hyacinth* (Rome, S Sabina), commissioned by Girolamo Bernerio, Cardinal of Ascoli. The success of this painting and the prospect of important new patrons probably prompted her move there in 1603, the year she received her most important public commission, for a large altarpiece depicting the *Martyrdom of St Stephen* (destr. 1823) for the basilica of S Paolo fuori le Mura, Rome. The painting is recorded in an engraving of 1611 by Jacques Callot (see J. Lieure: *Jacques Callot*, i, Paris, 1924, no. 33). No major public commissions followed this, though she continued to work as a portrait painter in Rome (e.g. *Head of a Young Man*, Rome, Gal. Borghese). Among her last works are the full-length figures of *SS Cecilia, Catherine, Clare and Agnes* for the pilasters of the high altar of S Maria della Pace, Rome (*in situ*). These were commissioned by Gaspare Rivaldi, whose portrait by Lavinia is also in the church. One of the last of the Late Mannerist painters, Lavinia was not a stylistic innovator, but the range of subject-matter and format and the number of works she produced is significant; hers is the largest extant body of work by a woman artist active before 1700. She had 11 children from her marriage in 1577 to Gian Paolo Zappi, a minor artist who had studied with her father and became her agent.

BIBLIOGRAPHY
Thieme–Becker
R. Galli: *Lavinia Fontana, pittrice, 1552–1614* (Imola, 1940)
Women Artists, 1550–1950 (exh. cat. by L. Nochlin and A. Sutherland Harris; Los Angeles, CA, Co. Mus. A.; Austin, U. TX A. Mus.; Pittsburgh, PA, Carnegie; New York, Brooklyn Mus.; 1976–7)
E. Tufts: 'Lavinia Fontana, Bolognese Humanist', *Le arti a Bologna e in Emilia dal XVI al XVII secole/Receuils d'actes des Congrès internationaux d'histoire de l'art: Bologna, 1982*, pp. 129–34
V. Fortunati Pietrantonio: *La pittura bolognese del '500* (Bologna, 1986), pp. 727–75
The Age of Correggio and the Carracci (exh. cat. Washington, DC, N.G.A.; New York, Met.; Bologna, Pin. N.; 1986), pp. 132–5
M. T. Cantaro: *Lavinia Fontana bolognese* (Milan, 1989) [with full bibliog.]
V. Fortunati, ed.: *Lavinia Fontana (1552–1614)* (Milan, 1994)
C. P. Murphy: 'Lavinia Fontana and le dame della città: Understanding Female Artistic Patronage in Late Sixteenth-century Bologna', *Ren. Stud.*, x/2 (June 1996), pp. 190–208

□

Fontana, Annibale (*b* Milan, 1540; *d* Milan, 1587). Italian medallist, hardstone-engraver and sculptor. During the first half of his career, before 1570, he concentrated on making medals and on rock crystal engraving. From 1570 he turned increasingly to sculpture, especially that (from 1574) for the decoration of S Maria presso S Celso in Milan.

1. BEFORE 1570. He came from a family of Swiss origin, from Ticino, and was active mainly in Milan.

According to Giovanni Paolo Lomazzo, his great friend, Fontana in his early career was active mainly making medals and engraving on rock crystal and hardstones (pietre dure). Based on references in Lomazzo, portrait medals of *Ferdinando Francesco D'Avalos* and *Lomazzo* (both Milan, Castello Sforzesco) have been attributed to Fontana. The latter, which dates from 1560–61, shows Lomazzo presented to Prudence and Fortune on the reverse. The medal dedicated to Avalos, who was Governor of Milan from 1560, is more elaborate and of higher quality. It has been suggested (Rossi) that it reflects Bernardino Campi's painted portrait (untraced) of Avalos done in 1562, a possible *post quem* date for the medal. A medal of the philosopher *Ottaviano Ferrari* (Milan, Castello Sforzesco) with a bust of Aristotle on the reverse, also of this period, is ascribed to Fontana on the basis of a passage in a speech by the writer Francesco Cicereio (1521–96). The status and occupations of the subjects of these medals indicate that Fontana was in contact with patrons of high rank and with the intellectual circles of Milan. This is confirmed by his membership of the Accademia della Val di Blenio, also mentioned by Lomazzo. Stylistically, the three medals derive from Leone Leoni and Jacopo da Trezzo I, and these influences continued in his work.

In addition to the three documented medals, there are four signed examples, probably also early (1557–60). The inscription ANN (Annibale) appears on the medal of the banker *Tommaso Marino* (Bergamo, Gal. Accad. Carrara), which is among Fontana's securely identified early works. This was probably made *c*. 1557, when Marino is documented in Milan. The date is supported by the fact that the medal is based on the portrait of Marino included in the *Crucifixion* (Fiesole, Badia), painted by Bernardino Campi in the 1550s. A medal of *Cristoforo Madruzzo* (Milan, Castello Sforzesco), Bishop of Trent and Governor of Milan in 1556–7, is also signed ANN. The style of the portrait resembles that of the documented medals, while the reverse, of a type used in medals by other artists, may derive from existing plaques or medals. The inscription to Madruzzo as 'restorer of the state of Milan' indicates that it was executed in or before 1557. This medal is stylistically related to a silver medal of *Consalvo di Cordova* (Bergamo, Gal. Accad. Carrara), signed ANNIBAL, with a battle scene on the reverse, probably made in 1558–60. A silver medal of the condottiere *Giovan Battista Castaldi* (Milan, Castello Sforzesco), signed ANIB, once attributed to Annibale Borgognone (*fl* 1537–68), has been assigned to Fontana on the basis of stylistic affinities with the Ferrari and Consalvo di Cordova medals (Valerio, 1977).

Fontana's rock crystal engravings were in great demand by aristocratic patrons. Seven plaques with biblical scenes, engraved *c*. 1569 for Albert V, Duke of Bavaria (1550–79), were set in the ebony Albertine casket (Munich, Residenz). An oval crystal vase engraved with the *Story of Jason* and another with *Stories of Bacchus* (both Munich, Residenz) are attributed to Fontana (Heinz-Wied). He also seems to have provided designs for crystal engravings by the Saracchi brothers, including a rock crystal flask (Dresden, Grünes Gewölbe) for which there is a drawing by Fontana (Milan, Bib. Ambrosiana). The numerous crystal engravings attributed to Fontana are distinguished by a

masterly use of space, with active figures showing the influence of Michelangelo mediated through that of Leoni.

2. 1570 AND AFTER. The first reference to Fontana as a marble sculptor dates from 1570, when he is documented in Palermo in connection with a valuation of reliefs by Vincenzo Gaggini (1527–95) for the portal of the cathedral there. His presence in Palermo is important evidence of his contact with the Gaggini family workshop and also supports the hypothesis that he visited Rome and saw work there by followers of Michelangelo, particularly Guglielmo della Porta.

Fontana returned to Milan by 1572 and two years later entered the service of the Fabbrica (Church Works) of S Maria presso S Celso. All his known work as a sculptor was made for this church and is well documented in its archives. He collaborated with Stoldo di Gino Lorenzi on the façade of the church. The quality of this work indicates that he was already experienced in the field of large-scale sculpture, although no earlier example by him is known. His first two statues for the façade were the prophets *Isaiah* and *Jeremiah* (1575–6), for the niches of the upper order. The formal language of these works confirms the influence of Leoni and also of Pellegrino Tibaldi, and the severe devotional style clearly reflects the dictates of the Counter-Reformation. The statues of *Sibyls* (1577–9) reclining on the tympanum of the main portal, which have deep-cut drapery and expressive faces, derive from Michelangelo and della Porta. Fontana's collaboration with Lorenzi, who continued the tradition of the Florentine followers of Michelangelo, may have drawn him away from capricious Manneristic features towards a severe classicism that was sometimes academic in character.

From 1580 to 1583 Fontana executed three large reliefs for the façade: the *Adoration of the Shepherds*, the *Presentation at the Temple* and the *Marriage at Cana*. A terracotta model for the *Adoration* relief survives (Washington, DC, N.G.A.; see fig. 1). The compositions have a vertical emphasis, with monumental figures in paired poses clearly derived from Michelangelo. Fontana next executed statues of the *Assumption of the Virgin* and two *Angels* for the pinnacle. The contract of 1583 specified four angels, two praying and two singing. Only the latter were carved by him, however; the praying angels were completed to his design after his death by Milano Vimercati (*fl* 1577–93). Two wax models for the *Angels* (Cleveland, OH, Mus. A.; Los Angeles, CA., Co. Mus. A.) are rare surviving 16th-century examples in perishable material. The statue of the *Assumption* (see fig. 2), completed in 1584, remained on the pinnacle until 1620, when it was replaced with a copy by Andrea Prevosti (*fl* 1624–63). Fontana's statue, which was intended to be seen from far below, rising into open space in a whirling movement, is behind the main altar, where it conveys at least some sense of his grandiose vision. The *Assumption* also reflects a figure by Michelangelo, that of *Rachel* on the tomb of *Julius II* (Rome, S Pietro in Vincoli).

Fontana also worked on statues for the interior of the church, including *St John the Evangelist* (1583–7) for a niche to the right of the main altar and an *Assumption of the Virgin* (1583–6) for the altar of the Vergine dei Miracoli. In this second version of the *Assumption* the ascending

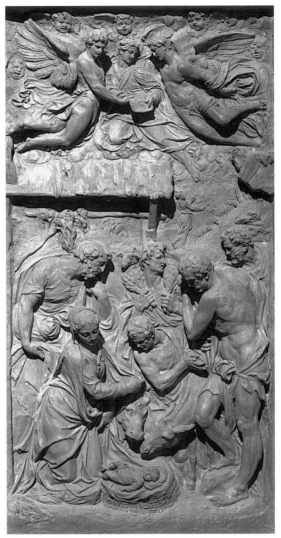

1. Annibale Fontana: *Adoration of the Shepherds*, terracotta model, 1.09×0.57 m, *c.* 1580 (Washington, DC, National Gallery of Art)

movement is accentuated, and there is a more dramatic treatment of drapery and gesture. Most notably, it is not on a plinth but poised on a cloud, apparently suspended in space, a bold solution that anticipates the ecstatic sacred images of Baroque sculpture. For the same altar in 1583 Fontana was commissioned to make two silver plaques, of the *Birth of the Virgin* and the *Death of the Virgin*. Terracotta models for both survive, as well as a series of preparatory drawings (Milan, Bib. Ambrosiana). Only the *Birth of the Virgin* was executed by Fontana; the *Death of the Virgin* was completed from his model after his death by Francesco Brambilla.

From 1574, when he joined its Fabbrica, Fontana's only documented work is for S Maria presso S Celso. The bronze decorations on the façade are no longer ascribed to him, however. Also rejected is the attribution to him of the bronze candelabras in the Certosa di Pavia, although he is documented at the Certosa in 1580, and drawings for the sacristy cupboards have been assigned to him

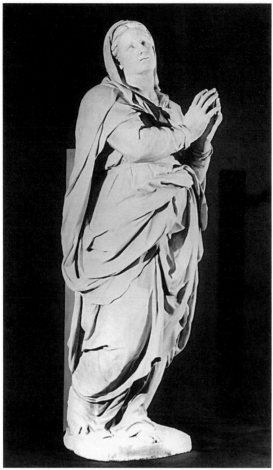

2. Annibale Fontana: *Assumption of the Virgin*, marble, 1584 (Milan, S Maria presso S Celso)

(Bossaglia). The attribution to Fontana of the monument to *Bishop Malombra* (Milan, S Angelo), proposed by Vigezzi, has found no support.

BIBLIOGRAPHY

Thieme–Becker

G. P. Lomazzo: *Trattato dell'arte della pittura, scultura e architettura* (Milan, 1584); ed. R. P. Ciardi (Florence, 1974)

——: *Rime* (Milan, 1587)

P. Morigia: *La nobiltà di Milano* (Milan, 1595; rev. 2/1619), pp. 471–2

P. P. Bosca: *De origine et statu Bibliothecae Ambrosianae* (Milan, 1672)

A. Venturi: *Storia* (1901–40), X/iii, pp. 466–82

E. Kris: *Meister und Meisterwerke der Steinschneidekunst in der italienische Renaissance* (Vienna, 1929)

S. Vigezzi: *La scultura lombarda nel cinquecento* (Milan, 1929)

E. Kris: 'Materialen zur Biographie des Annibale Fontana und zur Kunsttopographie der Kirche S Maria presso S Celso in Mailand', *Mitt. Ksthist. Inst. Florenz*, iii (1930), pp. 201–53

C. Baroni: 'Problemi di scultura manieristica lombarda', *Arti: Rass. Bimest. A. Ant. & Mod.*, v (1943), pp. 180–90

J. Pope-Hennessy: *Italian Renaissance Sculpture* (London, 1958), pp. 408–9

E. Spina Barelli: 'Disegni lombardi inediti nella Biblioteca Ambrosiana', *Vita e pensiero* (Milan, 1966)

R. Bossaglia: 'La scultura', *La Certosa di Pavia* (Milan, 1968), p. 68

O. Raggio: 'Alessandro Algardi e gli stucchi di Villa Pamphili', *Paragone*, 251 (1971), pp. 3–38

B. Heinz-Wied: 'Studi sull'arte della scultura in pietra dura durante il rinascimento: I fratelli Saracchi', *Ant. viva* (1973), pp. 37–58

A. P. Valerio: 'Annibale Fontana e il paliotto della Vergine dei Miracoli in Santa Maria presso San Celso', *Paragone*, 279 (1973), pp. 32–53

——: 'Annibale Fontana', *Il seicento lombardo* (exh. cat., Milan, Pal. Reale, 1973), pp. 15–16

——: 'La medaglia a Milano, 1535–1565', *Omaggio a Tiziano* (exh. cat., Milan, Pal. Reale, 1977), pp. 132–51

F. Rossi: 'Medaglie', *I campi e la cultura artistica cremonese del cinquecento* (exh. cat., ed. M. Gregori; Cremona, Mus. Civ. Ala Ponzone, 1985), pp. 358–62

P. M. de Winter: 'Recent Accessions of Italian Renaissance Decorative Arts', *Bull. Cleveland Mus. A.*, lxxiii/4 (1986), pp. 163–9

Dizionario della chiesa ambrosiana, ii (Milan, 1988), pp. 1248–50 [entry by S. Gavazzi]

B. Agosti: 'Contributo su Annibale Fontana', *Prospettiva*, lxxviii (April 1995), pp. 70–74

K. A. Piacenti: 'The Use of Cameos in the Mounts of Sixteenth-century Milanese Pietre Dure Vases', *Stud. Hist. A.*, liv (1997), pp. 126–35

MARIA TERESA FIORIO

Fonte, Jacopo della. *See* JACOPO DELLA QUERCIA.

Foppa, Cristoforo. *See* CARADOSSO.

Foppa, Vincenzo (*b* Bagnolo, nr Brescia, 1427–30; *d* Brescia, 1515–16). Italian painter and architect. He spent most of his painting career at Pavia, where he was patronized by the ruling Sforza family, the Dukes of Milan. Although many of his frescoes have been destroyed, his work in this medium prompted Filarete to name him among the greatest painters of his time, the only Lombard to be so honoured. Foppa also worked at Genoa and Savona, but he spent most of his later years working at Brescia.

1. BEFORE 1480. He was the son of Giovanni Sandrino, a tailor from Bagnolo. Although it is not known where he trained, his early style has prompted suggestions that he may have visited Padua, Venice or Verona. In the *Virgin and Child with Angel Musicians* (Florence, I Tatti), probably his earliest work, the squat, compact figures of the angels appear alongside the more elegant, curvilinear figure of the Virgin, whose Gothic qualities may derive from the work of Stefano da Verona or Michelino da Besozzo. The silver-grey flesh tones remained characteristic of Foppa's painting throughout his career. However, in his first signed and dated work, the *Crucifixion* (1456; Bergamo, Accad. Carrara B.A.), such Gothic features have disappeared. The skilled use of perspective and the classical triumphal arch framing the scene are comparable to the work of Jacopo Bellini, Andrea Mantegna or Giovanni Donato da Montorfano. Other early works are the *Virgin and Child* (*c.* 1450; Milan, Castello Sforzesco), the *Dead Christ Supported by an Angel* (Milan, priv. col., see Torriti, p. 112) and the signed panel of *St Jerome* (Bergamo, Accad. Carrara B.A.; see colour pl. 1, XXX3). It has also been suggested, with less plausibility, that he may have provided cartoons for a series of stained-glass windows in Milan Cathedral, executed during the 1450s by Niccolò da Varallo (*b* 1420).

Foppa was in Pavia by 1458, having probably arrived there several years earlier. Although no record of his first works for the court at Pavia survive, he must have made a good impression. In June 1461, while he was working for the priors of Genoa Cathedral in the chapel of S Giovanni Battista, the Milanese duke Francesco Sforza

intervened on Foppa's behalf, asking the priors to treat him with greater respect. The chapel was left unfinished when Foppa returned to Pavia in 1462 and was completed by him only in 1471.

Most of Foppa's documented works of the 1460s, including a signed and dated altarpiece (1462) for the church of the Carmine in Pavia, are lost. Natale (1982) suggested that two panels of *St Paul* and *St Siro* (Minneapolis, MN, Inst. A.) may have come from this altarpiece. Foppa also executed frescoes of prophets (destr.) in the great cloister of the Certosa di Pavia and an altarpiece (untraced) for S Maria delle Grazie in Monza, commissioned by Galeazzo Maria Sforza in 1466.

In 1463 Francesco Sforza summoned Foppa to Milan with the promise of work. According to Filarete, Foppa frescoed the courtyard of the Medici Bank in Milan with the *Story of the Emperor Trajan*, along with portraits of Roman emperors and members of the Sforza family. Only a fragment of a *Young Boy Reading Cicero* (*c.* 1465; London, Wallace) survives from this fresco cycle. Two drawings of the *Justice of Trajan* (Berlin, Kupferstichkab.; Oxford, Ashmolean) have been tentatively associated with the project, but the Berlin drawing is pricked for direct transfer, and it seems more likely that it was made for a small panel painting.

The fresco cycle of the *Life of St Peter Martyr* in the Portinari Chapel in S Eustorgio, Milan, was commissioned in the late 1460s by Pigello Portinari (*d* 1468), the representative of the Medici Bank in Milan. Despite the absence of documentation to confirm Foppa's hand in this work, the stylistic attribution is long-standing, and the connection between the artist and the patron is known to have been close. The frescoes demonstrate Foppa's ability to deal with perspective and architectural space on a large scale. The scene of *St Peter Martyr's Miracle at Narni* (see fig. 1) is set obliquely beneath a receding brick arch, with a miscellany of architectural motifs such as staircases, niches and crenellated walls behind the figures. The adjoining episode of the *Martyrdom of St Peter* takes place in an expansive landscape of forest, lake and mountains.

In 1467 Foppa asked Portinari for a letter of recommendation to Bianca Maria Sforza, Duchess of Milan, in order that he be accorded the rights and privileges of a citizen of Pavia and be permitted to buy property in the city. This was granted, and in 1468 he was made a member of the household of Galeazzo Maria Sforza, the new Duke of Milan. Despite this new status, he received little employment from the Duke before 1474. In 1469 he tried to obtain the commission to decorate the Camposanto in Pisa, but the task had already been assigned to Benozzo Gozzoli. By 1471 he was back in Genoa to complete the unfinished work in the cathedral, for which he received a further ten ducats.

Foppa probably returned to Brescia the following year, since a signed altarpiece dated 1472 was recorded by the 17th-century writer Bernardino Faini as having been in S Maria Maddalena in Brescia. He was back in Milan by July 1473, however, where he appraised the work of Stefano de Fedeli (*fl* 1472–81) in the ducal chapel of the Castello di Porta Giovia.

During the mid- to late 1470s Foppa worked in collaboration with the court artists Bonifacio Bembo and Za-

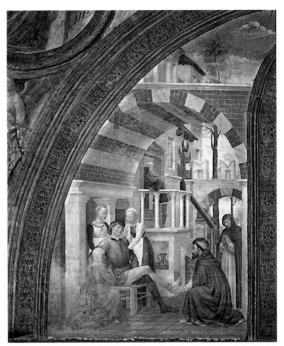

1. Vincenzo Foppa: *St Peter Martyr's Miracle at Narni* (*c.* 1468), fresco, Portinari Chapel, S Eustorgio, Milan

netto Bugatto on several major projects in Pavia for Galeazzo Maria Sforza. In 1474 they agreed to provide an immense wooden altarpiece for the castle, which was to contain 200 holy relics and be decorated with appropriate images of saints. The work had to be halted after the Duke's murder in December 1476. It has been suggested that the panel of *SS Agnes and Catherine* (Baltimore, MD, Walters A.G.), in which the figures stand in a loggia-like architectural setting, may have formed part of this work. In 1476, at the request of the Pavian noblewoman Zaccarina Beccaria, the artists agreed to paint a rood screen (destr.) for the Franciscan church of S Giacomo fuori Pavia. The screen was to include 21 scenes from the life of Christ. Evidently there was a problem of integrating the artists' various styles, since the patron complained that the painters' work was not uniform.

Various devotional works have been dated to the second half of the 1470s. They include the half-length *Virgin and Child with an Apple* (Berlin, Gemäldegal.), the *Virgin and Child with a Book* (Milan, Castello Sforzesco), the *Virgin and Child* (Florence, I Tatti) and a signed *Adoration of the Christ Child* (ex-Fisher priv. col., Detroit; see Wittgens, pl. 68). The most impressive, however, is a polyptych (*c.* 1476; Milan, Brera), including the *Virgin and Child with Saints*, that was originally painted for the high altar in S Maria delle Grazie, Bergamo. It was dismantled in the 19th century and reconstructed, with incorrect additions, at the beginning of the 20th. In it, Foppa's style appears as a curious mixture: the old-fashioned gold ground behind the saints in the upper tier is replaced lower down by landscapes and innovative spatial and architectural designs, suggesting that while Foppa experimented with new styles, he was still willing to accommodate conservative Milanese tastes. Between 1477 and 1509 Foppa received payments

for the decoration of the Averoldi Chapel in S Maria del Carmine, Brescia, for which he executed images of the *Evangelists* and the *Doctors of the Church*.

2. FROM 1480. During the early 1480s Foppa was working in Pavia. The Bottigella Altarpiece (Pavia, Pin. Malaspina), in which Silvestro Bottigella and his wife are shown kneeling before the enthroned Virgin, was probably executed before 1486. The continuing popularity of his traditional images of the Virgin and Child standing before a curtain or landscape is testified by the group of paintings of this subject dating from the 1480s (Milan, Mus. Poldi Pezzoli; New York, Met., see fig. 2; Philadelphia, PA, Johnson priv. col.; Florence, Uffizi). A detached fresco of the *Virgin and Child with SS John the Baptist and John the Evangelist* (Milan, Castello Sforzesco) from S Maria di Brera is dated 1485.

Also dating from this decade are various works representing St Sebastian, a subject perfectly suited to Foppa's ability to portray human anatomy. Among these are the detached fresco (Milan, Brera) from S Maria di Brera, Milan, and a wooden panel (Milan, Castello Sforzesco), in which the saint is shown in a contrapposto pose bound to an antique column, with the surrounding archers poised in such a way as to display a wide variety of musculature and movements. A small panel of *St Sebastian* (Florence, I Tatti), often attributed to Foppa, has been variously dated to the 1450s and the 1480s, although its colouring and hazily defined figures are uncharacteristic of Foppa's style.

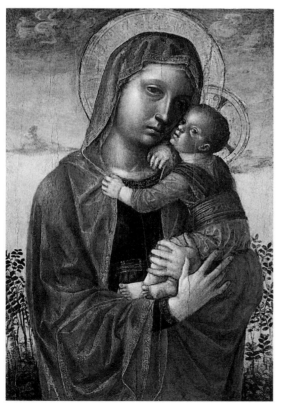

2. Vincenzo Foppa: *Virgin and Child*, tempera and gold on panel, 438×324 mm, 1480s (New York, Metropolitan Museum of Art)

Foppa had returned to Genoa by the end of the 1480s. In 1488 his associate Bertolino della Canonica was paid 15 lire on his behalf for figures of the martyrdom of St Sebastian for the altar of the Guild of St Sebastian, Genoa. In February 1489 Foppa was paid for an altarpiece (destr.) in the Doria Chapel in the Certosa di Rivarola outside Genoa. A surviving but ruined polyptych of the *Virgin and Child with Saints and a Donor* (Savona, Pin. Civ.) includes the name of the patron, Manfredi de Fornari, and the date 9 April 1489. The most important work produced during this stay in Liguria is the much damaged altarpiece for the oratory of S Maria di Castello, Savona (*in situ*), commissioned by Giuliano della Rovere (later Julius II) at a cost of 18,000 gold scudi. Although the three-tiered polyptych, which includes carved wooden figures in niches, was designed by Foppa in its entirety, he did not complete the work and had to be threatened with imprisonment before it was finally finished in August 1490. The figure of St John the Evangelist is signed by the local artist Louis Bréa.

In 1487 Foppa agreed to paint a chapel in S Piero in Gessate, Milan, for Ambrogio Griffi. The patron, an important member of the Sforza court, asked the Duke of Milan, Ludovico Sforza (il Moro), to write to the authorities in Brescia and request that Foppa be persuaded to fulfil his contract. Despite this pressure, however, Foppa never even began work in the Griffi Chapel, which was eventually decorated by Bernardo Zenale and Bernardino Butinone.

Foppa seems to have decided to settle in Brescia permanently from 1489. In that year the city council granted him a yearly allowance of 100 lire on the condition that he would practise his art within the town. The agreement names him as an architect as well as a painter. In 1490 the grant was ratified, and Foppa was asked to fresco the newly built Loggetta in the main square of the town.

By May 1495, when the council decided to discontinue Foppa's salary, he may have already returned to Pavia. Documents from July 1497 to 1499 concern his work on an altarpiece (untraced) for S Maria Gualtieri, Pavia, in association with Giovanni Siro Cattaneo da Bermano (*fl* 1499–1506). Other paintings from this late period include the *Virgin and Child with SS Faustina and Giovita* (Brescia, Pin. Civ. Tosio–Martinengo), a portrait of *Francesco Brivio* (Milan, Mus. Poldi Pezzoli), the signed *Pietà* (ex-Kaiser-Friedrich Mus., Berlin, destr.), the *Adoration of the Magi* (London, N.G.), the *Annunciation* (Isola Bella, Mus. Borromeo) and *SS Bernardino and Anthony of Padua* (Washington, DC, N.G.A.). In the early 1500s Foppa was back in Brescia, and in 1514 he executed a double-sided banner (Brescia, Pin. Civ. Tosio–Martinengo) for the town of Orzinuovi outside Brescia. On one side is depicted the *Virgin and Child with SS Catherine and Bernardino* and on the other *SS Roch, Sebastian and George*.

BIBLIOGRAPHY

A. Filarete: *Tratatto di architettura* (1451–64); ed. A. M. Finoli and L. Grassi, 2 vols (Milan, 1972)

M. Caffi: 'Vincenzo Foppa da Brescia, pittore ed architetto', *Archv Stor. Lombardo*, v (1878), pp. 96–106

C. J. Ffoulkes and R. Maiocchi: *Vincenzo Foppa of Brescia, Founder of the Lombard School: His Life and Works* (London, 1909)

W. Suida: 'Studien zur lombardische Malerei des XV. Jahrhunderts', *Sonderabdruck aus den Monatsheften für Kunstwissenschaft* (Leipzig, 1909), pp. 477–783

——: 'Two Unknown Pictures by Vincenzo Foppa', *Burl. Mag.*, xlv (1924), pp. 210–11

R. Henniker-Heaton: 'An Unpublished Picture by Vincenzo Foppa', *A. Amer.*, xii (1925), pp. 196–9

A. Venturi: 'Anconetta di Vincenzo Foppa', *Arte*, xxxvii (1934), pp. 76–7

K. T. Parker: 'Vincenzo Foppa', *Old Master Drgs*, xiii (1938), pp. 6–8

F. Wittgens: *Vincenzo Foppa* (Milan, 1949)

E. K. Waterhouse: 'The Fresco by Vincenzo Foppa in the Wallace Collection', *Burl. Mag.*, xcii (1950), p. 177

S. Bottari: 'Una tavola di Vincenzo Foppa', *Commentari*, ii (1951), pp. 201–2

E. Sandberg-Vavalà: 'Vincenzo Foppa', *Burl. Mag.*, xciii (1951), pp. 134–5

C. Ragghianti: 'Il Foppa e le vetrerie del duomo di Milano', *Crit. A.*, vi (1954), pp. 520–43

——: 'Postilla foppesca', *Crit. A.*, ix (1955), pp. 285–92

P. Rotondi: *Vincenzo Foppa in Santa Maria di Castello a Savona* (Genoa, 1958)

E. Arslan: 'Vincenzo Foppa', *Storia di Brescia* (Brescia, 1963), ii, pp. 929–48

R. Cipriani, G. A. dell'Aqua and F. Russoli: *La Cappella Portinari in S Eustorgio a Milano* (Milan, 1963)

P. Torriti: 'Contributo a Vincenzo Foppa', *A. Lombarda*, viii (1963), pp. 112–13

S. Matalon: *Vincenzo Foppa* (Milan, 1965)

M. Delai Emiliani: 'Per la prospettiva "padana": Foppa revisitato', *A. Lombarda*, xvi (1971), pp. 117–36

G. Frangi: *Foppa: Lo stendardo di Orzinuovi* (Brescia, 1977)

J. Gitlin Bernstein: 'Science and Eschatology in the Portinari Chapel', *A. Lombarda*, n. s., xxvi/60 (1981), pp. 33–40

M. Natale: 'Vincenzo Foppa: San Siro; San Paolo', *Zenale e Leonardo: Tradizione e rinnovamento della pittura lombarda* (exh. cat., Milan, Mus. Poldi Pezzoli, 1982), pp. 90–93

A. Nova: 'I tramezzi in Lombardia fra XV e XVI secolo: Scene della Passione e devozione francescana', *Il francescanesimo in Lombardia: Storia e arte* (Milan, 1983), pp. 197–215

G. Scotti: 'Alcune ipotesi di lettura per gli affreschi della Cappella Portinari alla luce degli scritti di S Antonino vescovo di Firenze', *A. Lombarda*, n. s., xxviii/64 (1983), pp. 65–78

E. Samuels Welch: 'New Documents for Vincenzo Foppa', *Burl. Mag.*, cxxvii (1985), pp. 296–300

M. Medica: 'Quattro tavole per un polittico di Vincenzo Foppa', *Paragone*, 431–3 (1986), pp. 11–17

M. Gregori and others: *Pittura del cinquecento a Brescia* (Milan, 1986)

La pittura in Lombardia: Il Quattrocento (Milan, 1993)

M. Marubbi: 'Un perduto polittico del Foppa per la Pieve di Soncino', *A. Lombarda*, 108–9 (1994), pp. 161–3

M. G. Balzarini: *Vincenzo Foppa: La formazione e l'attività giovanile* (Florence, 1996)

——: *Vincenzo Foppa* (Milan, 1997)

Museo d'arte antica del Castello Sforzesco (Milan, 1997)

E. S. WELCH

Fora, del. Italian family of artists. The sculptor Giovanni (or Nanni) Miniato (1398–1479), a collaborator of Donatello, had three sons who were active in Florence as artists: Bartolomeo di Giovanni (di Miniato) del Fora (1442–94), (1) Gherardo di Giovanni (di Miniato) del Fora and (2) Monte di Giovanni (di Miniato) del Fora. The three brothers maintained a book workshop together from 1465 and continued to work together until 1476, when Bartolomeo left, seemingly for financial reasons. Since Gherardo and Monte often collaborated, their work is sometimes difficult to distinguish with complete confidence. Both were familiar with contemporary painting, but they had different interests. Gherardo was sensitive to an ordered arrangement of figures in space; he preferred his portraits to be inscrutable, and he liked to reproduce contemporary Florentine architecture faithfully. Monte's urban views, by comparison, were more imaginative and his portraits more expressive.

BIBLIOGRAPHY

G. Vasari: *Vite* (1550, rev. 2/1568); ed. G. Milanesi (1878–85)

E. Muntz: *La Bibliothèque de Mathias Corvin* (Paris, 1899)

P. d'Ancona: *La miniatura fiorentina dall'XI al XVI secolo*, 2 vols (Florence, 1914)

G. S. Martini: 'La bottega di un cartolaio fiorentino nella seconda metà del 400', *La Bibliofilia*, lviii (1956), supplement, pp. 5–82

M. Levi d'Ancona: *Miniatura e miniatori a Firenze dal XIV al XVI secolo* (Florence, 1962)

A. Garzelli: *La Bibbia di Federico da Montefeltro: Un'officina libraria fiorentina, 1477–1478* (Rome, 1977)

——: 'Arte del Libro d'Ore e committenza medicea, 1485–1536', *Atti del i congresso nazionale di storia dell'arte: Roma, 1978*, pp. 475–99

——: 'Sulla fortuna del Gerolamo mediceo del van Eyck nell'arte fiorentina del quattrocento', *Studi in onore di Roberto Salvini* (Florence, 1984), pp. 347–53

——: *Miniature fiorentine del rinascimento: Un primo censimento*, i–ii (Florence, 1985)

All'ombra del lauro: Documenti librari della cultura in età laurenziana (exh. cat., ed. A. Lenzuni; Florence, Bib. Medicea–Laurenziana, 1992)

Maestri e botteghe: Pittura a Firenze alla fine del quattrocento (exh. cat., Florence, Pal. Strozzi, 1993), pp. 106–8

(1) Gherardo di Giovanni (di Miniato) del Fora (*b* Florence, 1445; *d* Florence, 1497). Illuminator and painter. He was active from the early 1460s as an illuminator and also painted panels and frescoes; his large-scale work can be attributed only through a systematic analysis of the illumination that has been assigned to him by scholars in the 20th century. With his brothers he maintained a workshop (see Martini, 1956), from which the principal religious and secular institutions of Florence commissioned illustrated books. Gherardo lived for many years as a lay brother in S Marco; he had literary and musical interests and frequented the bottegas of the most prestigious painters, from Bartolomeo della Gatta to Leonardo da Vinci. The salient characteristics of Gherardo's work in manuscripts, and sometimes in printed books, include the introduction of the Antique; an interest in portraiture and the peculiarities of architecture and landscape; the study of colour and light; the early introduction of Netherlandish elements in landscapes; and innovations in the layout of the page. He also introduced an unusual type of border, elegantly decorated *all'antica* with cameos, grotesques, mythological figures and candelabra drawn from engravings and sculpture. Other sculptural motifs include the tondo, reminiscent of Donatello, and the festoons with fruit and flowers in the style of the della Robbia family.

In works in which Gherardo collaborated with his brother (2) Monte di Giovanni del Fora, there is often a problem of identification, as in the refined iconography of the Bible (1488; Florence, Bib. Medicea–Laurenziana, MS. Plut. 17.15) illuminated for Matthias Corvinus (*reg* 1458–90). Gherardo's style is defined on the basis of the *Death of St Peter Martyr* (fol. 127) in the manuscript (Florence, Bargello, MS. 68) made for the Ospedale di of S Maria Nuova, for which he was paid on 3 March 1477. Gherardo's background landscapes contain echoes of Netherlandish painting, with new uses of light and colour that often reflected ideas introduced by Leonardo. Among Gherardo's works in printed books, the most important is the copy of Pliny's *Natural History* (Oxford, Bodleian Lib., MS. Douce 310), illuminated for Filippo Strozzi and containing three important portraits of *King Ferdinand II*, a *Man with his Son* (in the incipit of the preface) and

Cristoforo Landino (in the proem). In the borders are such mythological scenes as the *Triumph of Bacchus, Bacchus and Ariadne on Naxos, Mercury* and *Putti.* In Livy's *History of Rome* XXI–XXX (*c.* 1479; U. Valencia, Bib., MS. 763) are more representations of Bacchus and, on the frontispiece, two splendid studies of candelabra with Classical masks and festoons. In the *Works of Homer* (printed 1488; Naples, Bib. N., SQ XXIII K 22), folio 244 is decorated with cameos; while the firm lines and clear transition from light to dark in the full-page *Portrait of a Young Man* (fol. 2*v*) reveal a sympathetic interest in the style of Piero della Francesca. The last phase of Gherardo's taste for the Antique is represented in the extraordinary copy of Petrarch's *Trionfi* (Baltimore, MD, Walters A.G., MS. W.755), where the scenes are enclosed by forms that suggest worked gold. Particularly striking is the *Triumph of Death*, with an image of *Laura on her Deathbed with Bystanders* (fol. 30) in an architectural setting decorated with Classical low reliefs. A copy of Aratus' *Phaenomena* (Florence, Bib. Medicea–Laurenziana, MS. 89 sup. 43) contains depictions of themes closely linked with the text, prompting comparison with the painting of the *Combat of Love and Chastity* (London, N.G.).

Gherardo's large-format religious projects were undertaken for Florentine churches and convents. In a group of choir-books (Florence, S Lorenzo) Gherardo executed some of the miniatures: the large *Martyrdom of St Lawrence* (corale K, fol. 45), with its images of Castel Sant' Angelo and the Torre delle Milizie, is notable. The exquisite arrangement of groups of bystanders and the background views of Florence, Pisa and Rome demonstrate Gherardo's skills. More of his religious miniatures are found in a Franciscan Breviary (London, BL, Add. MS. 29735), where the *Adoration of the Magi* (fol. 28*v*) and the *Invention of the True Cross* (fol. 127) are treated like sketches for a large painting. Another large work, produced with Monte, is the Missal for S Maria del Fiore (*c.* 1494), in which Gherardo depicted elaborate mythological figures in the borders of folio 8. One of his last large-format illustrations is the incipit page of Nicholas of Lyra's *Postilla* (1494–6; 7 vols; Lisbon, Arquiv. N.), commissioned by Manuel I of Portugal: here again, in *Pope Damasus I Receiving the Vulgate from St Jerome*, a Classical atmosphere is evoked by the image of the Colosseum. The sketchy style of the miniature recalls Gherardo's fresco of *Pope Martin V Conferring Privileges on the ospedale di S Maria Nuova* (1474; Florence, S Egidio).

Among the many Books of Hours to which Gherardo contributed, a notable example is the Book of Hours (Munich, Bayer. Staatsbib., Clm. 23639) commissioned by Lorenzo de' Medici. Its production was organized by Gherardo, who painted the most important scenes (other contributors included Francesco Rosselli and Giovanni Boccardi). Gherardo executed the *Deposition*, the *Raising of Lazarus* and *David Praying* in a painterly manner; this is the highest-quality manuscript of those he painted for Lorenzo de' Medici. The Psalter (Cambridge, Fitzwilliam, Add. MS. 37–1970), commissioned by another member of the Medici family, is outstanding for the elegantly coloured pages and the candelabra. In their compositional innovations and their renderings of architecture and land-

scape, these small masterpieces recall the very greatest masters of Renaissance painting.

BIBLIOGRAPHY

F. Zeri: 'I frammenti di un celebre *Trionfi della Castità*', *Diari di lavoro*, i (Bergamo, 1971), pp. 56–65
G. Bologna: *Miniature italiane della Biblioteca Trivulziana* (Milan, 1974)
M. Haines: 'Il principio di mirabilissime cose: I mosaici per la volta della cappella di San Zanobi', *La difficile eredità: Architettura a Firenze dalla Repubblica all'assedio*, ed. M. Dezzi Bardeschi (Florence, 1994), pp. 38–55

ANNAROSA GARZELLI

(2) Monte di Giovanni (di Miniato) del Fora (*b* Florence, 1448; *d* between 3 Nov 1532 and 6 March 1533). Illuminator, painter and mosaicist, brother of (1) Gherardo di Giovanni del Fora. His extensive activity as a painter, mainly on panel, has yet to be reconstructed. A mosaic portrait of *St Zenobius* (1504; Florence, Mus. Opera Duomo) demonstrates his ability as a mosaicist; this is also mentioned in documents. His career began during the 1460s in a book workshop, collaborating with his two brothers. In Florence, Monte received commissions from the most prestigious religious orders (the cathedral, S Giovanni, the canons of S Lorenzo, the convents of S Marco and SS Annunziata, the Ospedale degli Innocenti, the Arcispedale di S Maria Nuova) and the most eminent families (the Medici, the Strozzi and Camillo Maria Vitelli); outside Florence he produced miniatures of high quality and great originality for the Primacy of Pisa and Aosta Cathedral and for the greatest European sovereigns, including Manuel I of Portugal (*reg* 1495–1521) and the King of Hungary, Matthias Corvinus (*reg* 1458–90).

The influence of many painters can be seen in Monte's miniatures. From the late works of Fra Filippo Lippi, who introduced him to the study of drapery, he learnt the use of hatching and a certain softness in the application of paint. From contemporary Netherlandish art he learnt such compositional solutions as the device of a picture within a picture. In his range of Classical and mythological themes, grotesques, cameos and themes from literary works on antique subjects, he was a precursor of Filippino Lippi. Among the most important features of Monte's work are the vast range of learned iconographic references, both religious and secular, and the innovative incorporation of references to the patron of the work. In short, Monte's illumination is characterized by its exuberant imagery, rich invention, sophisticated intellectual play and extremely versatile brushwork.

With Gherardo he illuminated the Missal of S Egidio (Florence, Bargello, MS. 67) for S Maria Nuova. This manuscript has been dated (Levi d'Ancona, 1962) to 1474–6, although this date is not without problems. The *Annunciation* (fol. 5*r*, partly by Gherardo) and the *Lamentation* (fol. 150*v*) are rich in innovations: studies of drapery and anatomy, a new use of colour and complex, imaginative Classical landscapes and urban vistas; in the borders are tondi with monochrome low reliefs recalling the work of Donatello. Among the manuscripts that Monte and Gherardo illuminated for Matthias Corvinus is a large Bible (Florence, Bib. Medicea–Laurenziana, MS. Plut. 15.17). The opening miniature (fol. 2*v*) shows *David Praying*, with related episodes including *Young David Gathering Stones from the Stream*, in which the image of David is reflected

in the water like that of Narcissus gazing at his reflection. There are also portraits of three sovereigns, *Matthias Corvinus, Charles VIII* (reg 1483–98) and an unidentified king. On the facing folio is a *Battle between Jews and Philistines* (fol. 3r). The borders of both pages are rich in iconographic details alluding to Matthias and in Classical references. Monte also dedicated a work by Didymus (the *Liber de spiritu sancto*, 1488; New York, Pierpont Morgan Lib., MS. 496) to Matthias Corvinus. The composition, including a portrait of *Matthias Corvinus and his Wife* (fol. 2r), is conceived as a great altar decorated with Classical low reliefs (e.g. *Apollo at the Castalia Spring* and *Apollo and Marsyas*) and other symbols of military, artistic and civic virtues referring to the King.

In 1496 Camillo Maria Vitelli commissioned the copy of Ptolemy's *Cosmographia* (Florence, Bib. N. Cent., MS. XIII.16), which has borders packed with Classical armoury, cameos and motifs partly taken from the ceiling of the Domus Aurea, Rome, extolling the military virtues of the client. A significant example of a type of coloured page introduced by Monte is found in the collection of musical texts by various authors (Florence, Bib. N. Cent., MS. Banco Rari 229), with a portrait of the musician *Johannes Martini* against a ruby-red background. In a copy of Nicholas of Lyra's *Postilla* (1494–6; Lisbon, Arquiv. N.), made for Manuel I of Portugal, Monte represented large architectural–sculptural structures, a large aedicula with portraits of *Matthias Corvinus*, wearing spectacles, and *Charles VIII of France*. Monochrome paintings with Classical subjects in the borders and elements derived from the Domus Aurea, are interspersed with religious subjects. Nicolò Valori's *Life of Lorenzo* (Florence, Bib. Medicea–Laurenziana, MS. Plut. 61.3) was illuminated for Lorenzo de' Medici; it includes a *View of Florence* and a tiny portrait of *Lorenzo* in the right border of the incipit page.

Florence Cathedral and S Giovanni were among Monte's ecclesiastical clients. His finest works include a Missal (Florence, Bib. Medicea–Laurenziana, MS. Edili 109), which Zanobi Moschini finished writing in 1493, in which Monte and Gherardo produced the miniature of the *Crucifixion with the Virgin and St John the Baptist* and a predella with the *Lamentation*; both these works show strong links with Jan van Eyck (c. 1395–1441). The group of works produced in collaboration with Gherardo during the 1490s includes a manuscript (Florence, Bib. Medicea–Laurenziana, MS. Edili 109) written in 1493 and illuminated in 1494, in which the *Annunciation* (fol. 8) repeats the scheme of Monte's panel painting (Modena, Mus. Stor. & A. Med. & Mod.) on the same subject but with greater articulation of the spatial setting.

Documents reveal that from the 1490s to the end of his long career, Monte worked on a series of choir-books (damaged 1966; Florence, Mus. Opera Duomo). The enormous historiated initials include religious scenes and vigorous portraits. Here, Monte's mature style is characterized by a persistent interest in Netherlandish formulae and a growing attraction to the monumental compositions of Domenico Ghirlandaio. The sumptuous Missal (Rome, Vatican, Bib. Apostolica, Barb. Lat. 610) for the Baptistery of Florence was illuminated in 1510. Its pages (380×270 mm) contain a *St John the Baptist Enthroned*, above a

Dance of Salome. Of great interest for its use of a picture within a picture is the *Last Supper* (fol. 185). Among the miniatures executed for Florence Cathedral (all Florence, Mus. Opera Duomo) in the first quarter of the 16th century are the *Adam and Eve in the Garden of Eden* (MS. D, fol. 2v), the *Baptism*, with portraits of contemporaries (MS. C 11, fol. 4), the *Annunciation* (MS. S, fol. 54), the *Nativity* (MS. S, fol. 114) and the *Marriage at Cana* (MS. C, fol. 71), with a view of Piazza S Marco, Florence, at sunset. Both with and without Gherardo, Monte illustrated Books of Hours for important weddings, in which he introduced structural and thematic ideas previously unknown in the repertories of other illuminators.

BIBLIOGRAPHY
A. Garzelli: 'Codici miniati della Biblioteca Laurenziana', *Crit. A.* (1975), 143, pp. 19–38; 144, pp. 25–40
——: 'Rogier van der Weyden, Hugo van der Goes, Filippo Lippi nella pagina di Monte', *Scritti in memoria di Mario Rotili* (Naples, 1984)
ANNAROSA GARZELLI

Forlì, Ansuino da. *See* ANSUINO DA FORLÌ.

Forlì, Melozzo da. *See* MELOZZO DA FORLÌ.

Formenton, Tommaso (*b* Vicenza, *c.* 1428; *d* 1492). Italian architect. The son of a local carpenter and presumably trained in the same profession, in 1467 he was appointed engineer to the city of Vicenza. Here, from 1481, he supervised the construction of loggia arcades (destr.; rebuilt by Palladio from 1549) around the city's Palazzo della Ragione (known as the Basilica), and he remained in charge of operations until 1491, when the work was almost complete. The design is known from early descriptions and images and from a few surviving fragments and remaining physical evidence. The two storeys of groin-vaulted loggia arcades, faced in pink and white stone and crowned with ornamental merlons, were built around three external sides of the existing palace, an enormous Late Gothic building (*c.* 1450–60; Domenico da Venezia) with an assembly hall covered by a vast keel roof occupying the entire upper storey. Formenton's design was evidently inspired by the Palazzo della Ragione in nearby Padua, a building of similar shape and size that had been fronted with new loggia arcades after 1420, although it was adapted to suit the Vicenza building's layout and Gothic style. The lower storey was arranged with broad round arches carried on squat columns, their spacing adjusted to accord with the unavoidable irregularities of the central building and the space restrictions of the site, while the upper storey was arranged with pointed arches in a doubled rhythm to match the windows of the assembly hall. Work was completed in 1494, but the loggias partly collapsed in 1496, soon after the installation of a staircase (1495–6), and were not rebuilt to the same design.

In 1484 Formenton was mentioned by the council of Brescia as 'architectus optimus' and as the designer of a new communal palace there, for which he personally delivered a large, spectacular model in 1489. The design is apparently lost. The existing palace, the magnificent Palazzo della Loggia (begun 1492), built in a radically classical style related to the works of Alberti in Mantua and the

early works of Bramante in Milan, with massive arcades and applied orders, seems to have been based on an earlier design and is perhaps a development of an original project that had been commissioned in 1467. Formenton's scheme, which would have been very different in style, was presumably requested as a belated alternative and was perhaps intended for one of the other sites around the same piazza that were under consideration in 1489.

BIBLIOGRAPHY

B. Zamboni: *Memorie intorno alle pubbliche fabbriche più insigni della città di Brescia* (Brescia, 1778)
A. Magrini: 'Intorno Tommaso Formenton ingegnere vicentino nel secolo XV', *Archv Ven.*, iii (1872), pp. 38–59; iv (1872), pp. 37–58
G. G. Zorzi: 'Contribuzioni alla storia dell'arte vicentina nei secoli XV e XVI', *Miscellanea di storia veneto-tridentina delle reale deputazione veneto-tridentina di storia patria*, ii (Venice, 1926), pp. 1–330
F. Barbieri: *Corpus palladianum II: La basilica palladiana di Vicenza* (Vicenza, 1968), pp. 28–32
D. Hemsoll: 'Bramante and the Palazzo della Loggia in Brescia', *A. Lombarda*, 86–7 (1988), pp. 167–79
G. Lupo: 'Platea magna communis Brixiae, 1433–1509', *La piazza, la chiesa, il parco*, ed. M. Tafuri (Milan, 1991), pp. 56–95

DAVID HEMSOLL

Fornovo, Giovanni Battista (*b* Parma, 2 Dec 1530; *d* 20 Nov 1585). Italian architect. He was in the service of Cardinal Alessandro Farnese from at least 1558, and worked with Jacopo Vignola on the Villa Farnese at Caprarola until 1562, when he was called to Piacenza to supervise the building of Vignola's Palazzo Farnese. Fornovo then entered the service of Ottavio Farnese, 2nd Duke of Parma and Piacenza, in which he remained for the rest of his life; he was, however, relieved of responsibility for the Palazzo Farnese in 1564. Fornovo's principal works were undertaken in Parma, where he designed the church of S Quintino (*c.* 1560), a longitudinal, aisleless church that demonstrates some of the characteristics of his work: an emphasis on verticality and an almost Gothic sense of structure in the lively outline of its external walls.

Fornovo's most important church, SS Annunziata, Parma, was begun in 1566; the dome was built from 1626 by Girolamo Rainaldi, then court architect, but closely followed Fornovo's design. The façade of SS Annunziata has an extremely tall, three-storey arched portico, articulated with orders, in a reworking of Alberti's S Andrea (begun 1470), Mantua (*see* ALBERTI, LEON BATTISTA, fig. 8); it is topped with an attic and pediment. The plan, based on a modified lateral oval, comprises two semicircular apses covered by ribbed semi-domes, with a rectangular, barrel-vaulted central space between. Five semicircular chapels radiate from each apse, creating an exceptional sense of centrifugal movement around the central core of the building. Externally, the convex projections of the chapels are balanced by concave walls above, set between tall buttresses; the resultant effect anticipates the Baroque plasticity of the drum of S Andrea delle Fratte (1653–65), Rome, by Francesco Borromini (1559–1667). There are also echoes of the Romanesque in the rows of niches on the exterior chapel walls, which contrast with niched windows below and are derived from the work of Giulio Romano. The adjacent large Observantine cloister was begun at the same time as the church but was not completed until 1688. Fornovo may also have been involved in urban improvements in Parma in 1566, for which a drawing survives (Parma, Archv Stato).

BIBLIOGRAPHY

F. da Parma: *Memorie istoriche delle chiese e dei conventi dei frati minori dell'osservante, e riformata provincia di Bologna*, ii (Parma, 1760)
I. Affò: *Ricerche . . . intorno la chiesa, il convento, e la fabbrica della SS Annunziata di Parma* (Parma, 1796)
W. Lotz: 'Die ovalen Kirchenräume des Cinquecento', *Röm. Jb. Kstgesch.*, vii (1955), pp. 7–99
B. Adorni: 'SS Annunziata in Parma: Architetto G. B. Fornovo', *Archit.: Cron. & Stor.*, xv/5 (1969), pp. 332–41
——: *L'architettura farnesiana a Parma, 1545–1630* (Parma, 1974), pp. 48, 104–15
——: 'Parma Rinascimentale e Barocca', *Parma/la città storica*, ed. V. Banzola (Parma, 1978), pp. 174–84
——: *L'architettura farnesiana a Piacenza, 1545–1600* (Parma, 1982), pp. 54, 196
——: 'Complessità strutturale e novità linguistiche: la Santissima Annunziata a Parma.1566–1632', *I Farnese, arte e collezionismo/Studi*, ed. L. Fornari Schianchi (Milan, 1995), pp. 174–81
——: 'Echi medievali nelle chiese di Giovan Battista Fornovo (Parma 1530–1585)', *Presenze medievali nell'architettura di età moderna e contemporanea*, ed. G. Simoncini (Milan, 1997), pp. 121–25

BRUNO ADORNI

Foscari, Francesco, Doge of Venice (*b* Egypt, 1373/4; *reg* 15 April 1423–23 Oct 1457; *d* 1 Nov 1457). Venetian ruler and patron. He was the longest serving doge in the history of Venice. His reign was a period of constant warfare, during which Venice consolidated her hold on her mainland possessions and acquired further territory. His only surviving son, Jacopo Foscari (*c.* 1415-57), a celebrated humanist, was three times disgraced for alleged corruption. After his son's final banishment and death, Francesco was persuaded by a group of hostile nobles to abdicate. He died a week later and was given a full ducal burial in the church of S Maria Gloriosa dei Frari, Venice. His tomb monument (for illustration *see* BREGNO, (1)) in the same church, executed by members of the Bregno family, was erected at the instigation of his grandson Nicolò Foscari, probably in the 1480s. Its mixture of Gothic and Renaissance elements echoes the transitional character of public art and architecture during his reign.

Foscari was a popular doge, whose fondness for pageantry, jousts and tournaments gave his reign a spectacular, courtly air. A new wing of the Doge's Palace was begun in 1424, facing the Piazzetta and continuing the design of the 14th-century frontage on the Bacino di S Marco (*see* VENICE, §IV, 4(i)). The red and white diaper pattern on the upper walls may have been added in Foscari's time. The culmination of the Piazzetta extension was the new entrance to the palace, the monumental, extravagantly carved, Gothic Porta della Carta, commissioned in 1438 from Giovanni and Bartolomeo Buon (for illustration *see* BUON (i), (1)), but revealing the influence of Michelozzo di Bartolomeo in the form of its gable. The Porta della Carta led into a covered passageway, also begun in 1438, flanked on its south side by a staircase, the Scala Foscara (completed 1453; destr. *c.* 1603), which is known from an engraving by Cesare Vecellio in his *Habiti antichi e moderni* (Venice, 1590). The eastward end of the new entrance passage was framed by a grand triumphal arch, now the lower storey of the so-called Arco Foscari, although originally it probably consisted only of a heavy round-arched opening in red and white striped marble,

surmounted by a balustrade, with the Foscari arms in the spandrels. A similar arch is depicted in a mosaic of the *Death of the Virgin* (*c.* 1430–51) in the vault of the chapel of the Madonna dei Mascoli in S Marco, Venice.

About 1452 Doge Foscari began an enormous family palace, the Ca' Foscari, on a conspicuous bend in the Grand Canal, Venice. Although the building is emphatically Gothic in style, with borrowings from the Doge's Palace, the enthusiasm for humanist scholarship in Venice during his reign is suggested by such decorative features as the *all'antica* putti bearing the Foscari arms over the second-floor windows. A strikingly realistic portrait bust of *Foscari* in his old age, formerly part of the kneeling effigy (destr. 1797) on the Porta della Carta, is housed in the Doge's Palace. His likeness is also recorded in a fine ducal portrait (Venice, Correr), attributed to Lazzaro Bastiani.

BIBLIOGRAPHY

M. Sanudo the younger: *De origine, situ et magistratibus urbis Venetae, ovvero la città di Venezia (1493–1530)*; ed. A. Caracciolo Aricò (Milan, 1980)
A. da Mosto: *I dogi di Venezia nella vita pubblica e privata* (Milan, 1960), pp. 162–74
H. Trevor Roper: 'Doge Francesco Foscari', *The Horizon Book of the Renaissance*, ed. J. H. Plumb (London, 1961), pp. 273–80; also in *Renaissance Essays* (London, 1985), pp. 1–12
D. Pincus: *The Arco Foscari: The Building of a Triumphal Gateway in Fifteenth Century Venice* (New York and London, 1976)
A. Markham Schulz: 'The Sculpture of Giovanni and Bartolomeo Bon and their Workshop', *Trans. Amer. Philos. Soc.*, lxviii/3 (1978), pp. 1–81
S. Romano, ed.: *La Porta della Carta: I restauri* (Venice, 1979)
U. Franzoi, T. Pignatti and W. Wolters: *Il Palazzo Ducale di Venezia* (Treviso, 1990)

☐

Francesca, Piero della. *See* PIERO DELLA FRANCESCA.

Francesco I, Grand Duke of Tuscany. *See* MEDICI, DE', (16).

Francesco, Domenico di. *See* DOMENICO DI MICHELINO.

Francesco, Giovanni di. *See* GIOVANNI DA PISA (i).

Francesco da Cotignola. *See* ZAGANELLI, FRANCESCO.

Francesco d'Antonio (di Bartolommeo) (*b* Florence, before 1393; *d* Florence, after 1433). Italian painter. He was a minor Florentine master whose work follows the shift in Florentine painting from the style of Lorenzo Monaco through that of Gentile da Fabriano, Masaccio and Masolino in the 1420s to that of Fra Angelico at the beginning of the 1430s. His artistic personality was differentiated by Longhi from that of an artist now identified as Masaccio's brother Giovanni di Ser Giovanni, called SCHEGGIA.

Francesco enrolled in the Arte dei Medici e Speziali in 1409 and was recorded as a member of the Medici e Speziali guild on 21 November 1429. His earlier phase is represented by his only signed and dated work, a triptych with the *Virgin and Child and Two Saints* (1415; Cambridge, Fitzwilliam), and by the signed frescoes (*c.* 1420) of the *Annunciation* and the *Coronation of the Virgin* in S

Francesco at Figline Valdarno. These paintings confirm Vasari's statement that Francesco, whom he referred to as 'Francesco Fiorentino', was apprenticed to Lorenzo Monaco. In the next phase of Francesco's stylistic development, his manner is closer to the Late Gothic style as exemplified by Gentile da Fabriano and is evident in *Virgin and Child* (London, N.G.) and *St Ansano* (Florence, S Niccolò sopr'Arno). His later, broader and more realistic style, perhaps reflecting the influence of Masaccio transmitted through Masolino, is seen in four organ shutters (Florence, Accad. Dis.) with the *Evangelists* on one side and singing angels on the other, which he delivered to Orsanmichele in 1429, a fresco of the *Virgin and Child with Two Saints* (Montemarciano, S Giovanni Valdarno, Oratory of the Madonna delle Grazie), a *Virgin and Child with Four Saints* (Florence, tabernacle in Piazza S Maria Novella), a dossal (Florence, Sopr. Gal.) commissioned after 1427 by Bernardo Quaratesi for S Niccolò sopr'Arno in Florence, the perspective composition of the *Healing of the Lunatic Boy* (Philadelphia, PA, Mus. A.), reminiscent of the circle of Masaccio and sometimes attributed to Masaccio himself, and the Rinieri Altarpiece of the *Virgin and Child with SS Jerome and John the Baptist* (Avignon, Mus. Petit Pal.). This last was executed at the beginning of the 1430s and shows movement towards Fra Angelico typical of many painters like Francesco who were associated with the Late Gothic current.

BIBLIOGRAPHY

G. Vasari: *Vite* (1550, rev. 2/1568); ed. G. Milanesi (1878–85)
O. Sirén: *Don Lorenzo Monaco* (Strasbourg, 1905), pp. 162–3
M. Salmi: 'Francesco d'Antonio fiorentino', *Riv. A.*, xi (1929), pp. 1–24
G. Gronau: 'Francesco d'Antonio pittore fiorentino', *Riv. A.*, xiv (1932), pp. 382–5
R. Longhi: 'Fatti di Masolino e di Masaccio', *Crit. A.*, v (1940), pp. 186–7
F. Zeri: 'Note su quadri italiani all'estero', *Boll. A.*, xxxiv (1949), pp. 22–6
L. Berti: 'Note brevi su inediti toscani', *Boll. A.*, xxxvii (1952), pp. 175–7
C. Shell: 'Francesco d'Antonio and Masaccio', *A. Bull.*, xlvii (1965), pp. 465–9
The Great Age of Fresco (New York, 1968), pp. 122–5
R. Freemantle: *Florentine Gothic Painters* (London, 1975), pp. 425–32
J. Beck: 'Una prospettiva . . .di mano di Masaccio', *Studies in Late Medieval and Renaissance Painting in Honor of Millard Meiss* (New York, 1977), pp. 48–53
——: *Masaccio: The documents* (New York, 1978), p. 51
E. Biag: *Francesco d'Antonio* (diss., U. Siena, 1983)
E. Rice: 'St Jerome's Vision of the Trinity: An Iconographical Note', *Burl. Mag.*, cxxv (1983), pp. 151–5
E. Biag: 'Francesco d'Antonia di Bartolommeo', *La Maddalena tra sacro e profano: Da Giotto de Chirico* (exh. cat., ed. M. Mosco; Florence, Pitti, 1986), pp. 47–8
F. Ciani Passeri: 'La Madonna Assunta di Loppiano di Francesco d'Antonio', *O.P.D.*, iii (1988), pp. 102–7

CECILIA FROSININI, HELLMUT WOHL

Francesco d'Antonio (Zacchi) da Viterbo [il Balletta] (*b* ?Viterbo, *c.* 1407; *d* ?Viterbo, before 1476). Italian painter. His workshop was at his home in Piazza S Maria Nuova, Viterbo, where he is documented as active between 1430 and 1464. Two polyptychs form the stylistic core of his attributed oeuvre. The first, signed and dated 1441 and depicting the *Virgin and Child Enthroned with Saints*, was painted for S Giovanni in Zoccoli, Viterbo, the second, signed only and depicting the *Virgin and Child Enthroned with SS Rose and Catherine of Alexandria*, for S Rosa, Viterbo. On the evidence of the dated work, Volpe

recognized Francesco as the contemporary, rather than the son of the painter Antonio da Viterbo (*fl c.* 1450–*c.* 1480). Untouched by the advent of the Renaissance, his compositions remain firmly entrenched within the traditions of the Gothic style and display great affinity with the Late Gothic painting of Pisa and, especially, Siena. His early work reflects the enduring influence of Bartolo di Fredi (*fl* 1353–1410) and Taddeo di Bartolo (1362/3–1422), both active generations before Francesco himself. From them he adopted not only the parallel alignment of his figures with the picture plane but also the sumptuous tooling of their clothing and the conical and tubular cascades of their lavish drapery. This trend in Francesco's oeuvre reaches its first climax in the triptych depicting *Christ Enthroned*, formerly in S Maria Maggiore, now in S Lorenzo, Tuscania. The later polyptychs in S Giovanni in Zoccoli, Viterbo, and S Rosa, Viterbo, show a reduction in the effusive drapery of their saints and a relaxation of the consistently parallel alignment of the figures with the picture plane. Facial features take on a new distinctiveness, and richly coloured garments are preferred. In the use of these devices they bear remarkable resemblance to the works of Ottaviano Nelli, but are closest to the style of the Sienese painters Luca di Tommé (*fl* 1356–89) and Turino di Vanni (1348–1438). In the predella scenes of the S Giovanni in Zoccoli Polyptych, which include scenes from the *Life of St John the Evangelist*, the animated, almost playful narrative style is fully consistent with the language of the waning Late Gothic style as employed by Nelli and Jacopo Salimbeni (*fl* 1416–27).

In Francesco's later works, after the middle of the 15th century, a new tendency towards the dramatic emerges. In the fresco of the *Crucifixion* (Viterbo, S Maria Nuova, chapel of S Ambrogio) the Virgin and St John the Evangelist grieve passionately over the dead Christ. Their anguished faces and dramatic gestures clearly reflect similar treatments of the subject by Matteo Giovanetti (*c.* 1300–68/9) and Salimbeni. In 1464 Francesco was commissioned to paint and gild a coat of arms for Pope Calixtus III for the Castello of Viterbo. Other works include a fresco depicting the *Virgin and Child Enthroned with a Goldfinch* (ex-S Maria in Gradi, Viterbo; Viterbo, Mus. Civ.), a fresco of the *Virgin and Child Enthroned* (Tuscania, S Biagio) and a panel depicting *St Ambrose* (Viterbo, S Ambrogio). Attributed works are in the Walters Art Gallery, Baltimore, MD, and S Maria Poggio, Viterbo. Francesco's son Gabriele (*fl* 1473–83) was also a painter.

BIBLIOGRAPHY

G. Signorelli: 'I più antichi pittori viterbesi', *Boll. Mun., Viterbo* (Oct 1934), pp. 6ff
La pittura viterbese (exh. cat., ed. I. Faldi and L. Mortari; Viterbo, Mus. Civ., 1954); review by F. Zeri, *Boll. A.*, xl (1955), pp. 85–91
C. Volpe: 'Una ricerca su Antonio da Viterbo', *Paragone*, xxii/253 (1971), pp. 44–52
F. Zeri: *Italian Paintings in the Walters Art Gallery* (Baltimore, 1976)
A. M. Corbo: 'Documenti: Chiese ed artisti viterbesi nella prima metà del sec. XV', *Commentari*, n. s. xxviii/1–3 (1977), pp. 162–71
A. M. Pedrocchi: 'Francesco d'Antonio Zacchi, detto il Balletta', *Il quattrocento a Viterbo* (exh. cat., ed. R. Cannatà and C. Strinati; Viterbo, Mus. Civ., 1983), pp. 137–46
A. Sibrilli: 'Il Balletta, Francesco d'Antonio Zacchi', *La pittura in Italia: Il quattrocento*, ed. F. Zeri, ii, (Turin, 1987), pp. 570–71

JOHANNES TRIPPS

Francesco de' Franceschi (*b* ?1425; *fl* 1443–68). Italian painter. His most important known work is the 12-part polyptych of *St Peter* (1447; Padua, Mus. Civ.), formerly in S Pietro, Padua. The largest panel, *St Peter Enthroned*, shows the saint in full papal regalia. In smaller flanking panels are standing figures of *St Christopher*, *St Paul* and *St John the Baptist*, as well as the *Archangel Michael*, depicted trampling the demon. In yet smaller panels, perhaps originally placed above, are half-length figures of *St Francis*, *St Mary Magdalene*, *St Clare* (*?Scholastica*) and *St Prosdocimo* (*?Benedict*). The top panel, a *Crucifixion*, is flanked by the two narrowest panels, both of an *Angel Praying*. The polyptych was long attributed to Antonio Vivarini and Bartolomeo Vivarini, or Michele Giambono, but in 1904 Moschetti proved that it was painted by Francesco, whose name once appeared on its frame.

While the polyptych of *St Peter* is Francesco's only securely dated and attributed work, Fiocco's attribution to him of the *St Mamas* panels is convincing. The cult of this martyr was particularly popular in Lombardy. There are seven known panels, the largest of which is of *St Mamas and the Lion*, with the flanking *Angel Gabriel* and *Virgin Annunciate* (all Verona, Castelvecchio); the others are in Venice (Correr) and New Haven, CT (Yale U. A.G.). Fiocco considered them much inferior to the work of Giambono; while Francesco's perspective had advanced somewhat beyond Giambono, Fiocco noted that he could not depict expression. He believed the *St Mamas* panels to be from a *cassone*, but Sandberg-Vavalà (1927) identified them as parts of a polyptych. She also wrote more favourably of the painter, whom she found a poor draughtsman but a 'vigorous colourist', whose rendering of drapery was 'large and plastic' and who was 'careful and rich in his ornament'. She pointed out that in contrast to Giambono, whose figures have 'little tactile reality', those of Francesco, if uncouth in form, suggest mass and volume. Unlike that of Antonio Vivarini, Francesco's drapery is 'settling down to the restraint and plasticity of the early Renaissance'. Giambono's drapery, by contrast, is 'characteristic of the most flowery virtuosity of the Gothic movement'. In her further research (1940) Sandberg-Vavalà added to his oeuvre two panels depicting full-length, standing figures of *Mary Magdalene* and *St Catherine* (both Oxford, Ashmolean). Of other attributions to Francesco she accepted only the *Virgin and Child* (Venice, Ca' d'Oro) and the panels of *St Catherine*, *St Clare*, *St Mary Magdalene* and *St Lucy* (all Budapest, Mus. F.A.).

BIBLIOGRAPHY
Thieme–Becker

A. Moschetti: 'Un'ancona di Francesco de' Franceschi pittore veneziano del secolo XV', *Boll. Mus. Civ. Padova*, vii/4 (1904), pp. 70–77
G. Fiocco: 'Due Madonne di Michele Giambono', *Dédalo*, v (1924), pp. 443–55
E. Sandberg-Vavalà: 'Michele Giambono and Francesco dei Franceschi', *Burl. Mag.*, li (1927), pp. 215–21
——: 'Additions to Francesco de' Franceschi', *Burl. Mag.*, lxxvi (1940), pp. 155–6
I capolavori dei musei veneti (exh. cat. by R. Pallucchini, Venice, Correr, 1946), pp. 45–8
G. Mariacher: *Il Museo Correr di Venezia: Dipinti dal XIV al XVI secolo* (Venice, 1957), pp. 80–81
C. Seymour jr, ed.: *Early Italian Paintings in the Yale University Art Gallery: A Catalogue* (New Haven, 1970), pp. 242–3

ALEXANDRA HERZ

Francesco del Borgo [Francesco del Cereo di Borgo San Sepolcro] (*b* Borgo San Sepolcro, Tuscany; *d* Rome, 1468).

Italian architect, illuminator and papal functionary. He is first mentioned in 1450 as a member of the financial staff of the Apostolic Chamber and of the secret treasury of Nicholas V, and he rose quickly through the levels of the financial bureaucracy at the papal court. He is known to have illustrated manuscripts of Latin translations of Archimedes, Euclid, Ptolemy and Muhammad al-Qazwini [Kazwini], some of which were decorated at his behest in 1457–8. Mixing in humanist circles at the court, Francesco may have been taught architecture and engineering by Leon Battista Alberti.

Alberti may also have recommended Francesco to Pius II, who commissioned him to design the benediction loggia in front of St Peter's and the reshaping of the Piazza S Pietro. Francesco planned to replace the temporary wooden pulpit in front of the old atrium, from which the earlier popes had blessed the crowd, by a two-storey marble loggia of eleven bays. Its elevation recalled the exterior of Roman theatres. Instead of half columns, however, antique marble shafts articulated the arcades. It was the first faithful imitation of Roman Imperial architecture and the first forum building *all'antica* erected since antiquity, and it was probably inspired by Alberti's *De re aedificatoria* (1452). In contrast with the formal Tuscan language of Bernardo Rossellino's contemporary piazza in Pienza, Francesco's loggia marks the beginning of an autonomous Roman Renaissance, the architectual expression of the new imperial aspirations of the papacy. Work on the loggia was continued until *c.* 1510 but was never finished, and the structure was destroyed in 1600. Other works that Francesco probably designed for Pius II are the surviving tabernacle near Ponte Milvio in Rome on the spot where Pius received the skull of St Andrew in 1462; a chapel in the outer left aisle of Old St Peter's with a two-storey tabernacle for the skull of St Andrew; and the fortress of Tivoli (1461–2).

In 1465 Francesco received a commission from Pius's successor, Paul II, to enlarge the palace that Paul had begun while Cardinal Piccolomini; it became the new papal residence (now the Palazzo Venezia). Although Superintendent of the Works, Francesco's exact role is uncertain, but by the time of his death the irregularly shaped 9th-century basilica of S Marco incorporated in the south side of the Palazzo Venezia had been transformed into a symmetrical church, featuring columns that supported vaulted aisles, semicircular chapels, transepts ending in exedrae, an elevation articulated in the nave by half columns and, in the aisles, by pilasters, and a rich coffered ceiling roofed with gilded lead tiles. For the old portico, a two-storey benediction loggia was substituted; it had only three bays but was similar to the one Francesco built for Pius II at St Peter's. In front of the S Marco loggia a regular piazza was laid out, one side of which was defined by the new Palazzetto Venezia (dismantled 1911 and re-erected further west). This was a hanging garden for the Pope, surrounded by porticos. The tripartite entablatures in both storeys and the exquisite proportions of the sober exterior are all attributable to Francesco. The Palazzetto was incorporated in the east wing of the papal palace; new halls of enormous size were added, together with a vestibule containing a coffered barrel vault and staircases. The huge corner tower was built after Francesco's death,

and the two large portals and fragmentary courtyard date from after Paul II's death.

Francesco's activities as a financial expert and architect are documented in a well-preserved series of account-books for the papacy. As an architect, his achievement lies between Alberti's revival of Roman Imperial architecture and the more conservative language of Michelozzo di Bartolomeo and Bernardo Rossellino. Francesco's use of antique prototypes and his somewhat abstract detailing are a result of the influence of the humanist circles in Rome. His many followers dominated Roman architecture for the next decades and were superseded only by Donato Bramante's arrival in 1499.

BIBLIOGRAPHY

E. Müntz: *Les Arts à la cour des papes pendant le XVe et la XVIe siècle*, ii (Paris, 1879), pp. 23–4
I. P. Dengel, M. Dvořák and H. Egger: *Der Palazzo Venezia in Rom* (Vienna, 1909)
G. Zippel: 'Paolo II e l'arte', *L'Arte*, xiii (1910), pp. 241–58
I. P. Dengel: *Palast und Basilika San Marco in Rom* (Rome, 1913)
G. Zippel: 'Ricordi romani dei Cavalieri di Rodi', *Archv Soc. Romana Stor. Patria*, xliv (1921), pp. 169–205
P. Tomei: *L'architettura a Roma nel quattrocento* (Rome, 1942), pp. 72–3
R. Olitsky Rubinstein: 'Pius II's Piazza S Pietro and St Andrew's Head', *Essays in the History of Architecture Presented to Rudolf Wittkower* (London, 1967), pp. 22–3
J. Ruysschaert: *Enea Silvio Piccolomini Papa Pio II* (Siena, 1968), p. 263
A. Spotti Tantillo: 'Inventari inediti di interesse libario', *Archv Soc. Romana Stor. Patria*, xcviii (1975), pp. 77–94
Palazzo Venezia: Paolo II e le fabbriche di S Marco (exh. cat. by M. L. Casanova Uccella, Rome, Pal. Venezia, 1980)
C. L. Frommel: *Der Palazzo Venezia in Rom* (Opladen, 1982)
——: 'Francesco del Borgo: Architekt Pius' II. und Pauls II. Teil I', *Röm. Jb. Kstgesch.*, xx (1983), pp. 107–54
——: 'Francesco del Borgo: Architekt Pius' II. und Pauls II. Teil II', *Röm. Jb. Kstgesch.*, xxi (1984), pp. 71–164
J. R. Banker: 'Piero della Francesco, il fratello Don Francesco de Benedetto e Francesco dal Borgo', *Prospettiva* [Florence], 68 (1992), pp. 54-6
CHRISTOPH LUITPOLD FROMMEL

Francesco del Cossa. *See* COSSA, FRANCESCO DEL.

Francesco di Antonio del Chierico [Cherico] (*b* 1433; *d* 27 Oct 1484). Italian illuminator and goldsmith. The creator of some of the liveliest miniatures of the 15th century, his manuscripts are rich in stylistic innovation and thematic invention, sometimes elaborated in a very limited space. He worked for the most important patrons in Italy and abroad, beginning his artistic career under Cosimo il Vecchio and Piero I de' Medici, and continuing it under Lorenzo the Magnificent. Vespasiano da Bisticci was his contact with patrons outside Florence, who included Federigo II da Montefeltro, Ferdinand I, King of Naples, Louis XI of France (*reg* 1461–83) and Matthias Corvinus, King of Hungary (*reg* 1458–90). Francesco decorated texts of all kinds—literary, historical, scientific, religious—and of all sizes, from small Books of Hours to huge choir-books. Amid this variety of subjects his studies of the human figure and his introduction of portraits was innovative; he also established his own approach to landscape, with results similar to those of Antonio Pollaiuolo. His inventions, however, were reserved for privately commissioned books of small size. He created a new kind of book illustration and interpretation with his miniatures for Petrarch's *Triumphs* and *Apollo and Daphne*, the latter almost all in the form of drawings or tinted drawings (e.g.

Rome, Vatican, Bib. Apostolica, MS. Chigi L. IV 114, fol. 10*r*, Venice, Bib. N. Marciana, MS. it. IX. 431, fol. 9*r*, and Boston, MA, Pub. Lib., MS. C 4269B, fol. 1*r*, all with variants). For the works of Ptolemy and Pliny he invented the image of the humanist in his study (e.g. Naples, Bib. N., MS. V. A. 3 and Vienna, Österreich. Nbib., Cod. lat. 2).

Francesco's miniatures show a subtle understanding of the Antique, acquired through an interpretation of Classical texts and through his knowledge of, for example, ancient cameos and sarcophagi. All his work shows an experimental, anti-academic approach. Even the borders of his decorated pages show a high level of creativity: in the innumerable putti, the arrangements of flowers and elegant candelabra. A concentration of bizarre details and innovative images appears in the Book of Hours of Lorenzo the Magnificent and Clarice Orsini (Holkham Hall, Norfolk, MS. 41), with its astrological apparatus linked with dates significant for the patrons, in a Breviary and Pontifical (Florence, Bib. Medicea–Laurenziana, MSS Plut.17.28 and 23.1) and in a Petrarch manuscript (Florence, Bib. Riccardiana, MS. 1108). His manner of drawing is vibrant, his colouring light, sometimes using an expressive sketchy technique with watercolour (e.g. the Florence Pontificale).

Francesco is documented from 1452 as a goldsmith and was enrolled as a lifelong member of the Compagnia di S Paolo in Florence. This activity has not been reconstructed, but there is evidence of it in the high quality of his drawings, visible in unfinished miniatures. His many works are documented from 1456, the date of his first extant Petrarch manuscript (Paris, Bib. N., MS. ital. 545). In 1457 he began work on Bishop Donato Medici's project for choir-books for Pistoia Cathedral, with collaborators executing the minor decoration. Francesco's work includes the *Exorcism of St Zeno* (Pistoia, Pal. Vesc., Corale L, fol. cxliii*r*).

Francesco's work for Piero de' Medici began in 1458 with his miniatures for Pliny's *Natural History* (Florence, Bib. Medicea–Laurenziana, MS. Plut. 82.3). Here he introduced the theme of *Two Young Lovers*, with mythological figures in the borders (fol. 4*r*). In another manuscript (Florence, Bib. Medicea–Laurenziana, MS. Plut. 82.4), illustrated by Ser Ricciardo di Nanni, Francesco illuminated the title page and signed in Greek. His signature appears again in Piero's Plutarch (Florence, Bib. Medicea–Laurenziana, MSS Plut. 65.26–7), with a miniature of *Theseus and the Minotaur in the Labyrinth* (fol. 2*r*). Extraordinarily rich in miniatures is the Breviary (Florence, Bib. Medicea–Laurenziana, MS. Plut. 17.28) with subtle details in homage to Lorenzo de' Medici. Francesco's most important Petrarch manuscript (Paris, Bib. N. MS. ital. 548) has a rare theme of a *Shipwreck* (fol. 1*v*)—an allegory alluding to Lorenzo, who commissioned it. The iconography of the other miniatures follows that of the 1456 Petrarch; the same designs were to return enriched in other Petrarch *Triumphs* (e.g. Milan, Castello Sforzesco, MS. 905).

The miniatures for the choir-books of the Badia of Fiesole (Florence, S Lorenzo, Archv Capitolare, B 201, C 202, D 203, E 204, F 205, H 207, I 208, K 209), to which he contributed from 1461, had the financial support of Cosimo il Vecchio. The large size of these volumes offered scope for original experimentation comparable to that enjoyed by painters in other media. This is demonstrated especially in the *St Michael and the Dragon* (K 209, fol. 46*r*), *David and Goliath* (F 205, fol. 1*r*), *Tobias and the Angel* (F 205, fol. 92*r*) and the *Birth of John the Baptist* (H 207, fol. 76*r*). In these miniatures a new vocabulary of imagery and a new artistic vision, enhanced by literary and theological experience were created: for example in the *Three Marys at the Tomb* (E 204, fol. 2*v*), or in the *Communion of the Apostles* (fol. 169*r*), where the arrangement of the figures and the biblical scenes are similar to the drawing and painting of Antonio Pollaiuolo.

The next set of choir-books Francesco illustrated was for Florence Cathedral (Florence, Bib. Medicea–Laurenziana, MSS Edili 148–51). This grandiose project, originally assigned to Zanobi Strozzi, was begun in 1463 but not completed until 1474. It was carried out by a whole workshop, which included such painters as Cosimo Rosselli and Domenico Ghirlandaio, as well as such young illuminators as Attavante Attavanti and the Master of the Hamilton Xenophon. Here Francesco's miniatures all have a monumental quality, both in the figures and the landscapes, whose luminosity is reminiscent of Domenico Veneziano's work. In these choir-books the narration extends to the tondi in the borders. Among the most important miniatures are the *Baptism* (MS. Edili 148, fol. 15*r*), the *Martyrdom of St Reparata* (MS. Edili 150, fol. 56*v*), with its Verrocchio-like touches, the bold perspective foreshortening of the *Nativity* (MS. Edili 150, fol. 72*v*) and a *Procession* (MS. Edili 149, fol. 75*r*), with its effective group portraits. His other numerous works for important religious orders include the choir-books for the Opera dell'Annunziata (1471–2).

Francesco's collaboration with other painters (e.g. Domenico and Davide Ghirlandaio) reached its high-point in the Bible for Federigo da Montefeltro (1477–8; Rome, Vatican, Bib. Apostolica, MSS Urb. lat. 1–2). This work shows further interest in the human figure in motion, as well as in landscape and antiquity, with compositional inventions in the frames of the tondi (e.g. scenes from *Genesis*). The copies by Francesco Rosselli in the Origen manuscript (Modena, Bib. Estense, MS. lat. 458) suggest a direct connection with the drawings of Francesco del Chierico. Among Francesco's light-filled scenes are the scene from *Exodus* (MS. Urb. lat. 1, fol. 27*r*; see fig.), the *Tobias and the Angel* (MS. Urb. lat. 1, fol. 213*v*), and *Judith Killing Holofernes* (MS. Urb. lat. 1, fol. 218*r*). Vespasiano da Bisticci, who served as agent for the court at Urbino, procured a precious library for the Duke, which included such works by Francesco as the *De varietate fortune* (Rome, Vatican, Bib. Apostolica, MS. Urb. lat. 224), with putti playing at the foot of the page and the portrait of *Poggio Bracciolini* (fol. 2*r*), the *Disputationes Camaldulenses* (Rome, Vatican, Bib. Apostolica, MS. Urb. lat. 508) with a full-page portrait of *Federigo da Montefeltro with Landino* (single leaf), and the great *Vision of St Bernard* (Rome, Vatican, Bib. Apostolica, MS. Urb. lat. 93, fol. 7*v*).

The most recent critical studies on Francesco have revealed his authorship of numerous works that D'Ancona had assigned to Francesco Rosselli, an artist who as an illuminator owes much to Francesco del Chierico's work.

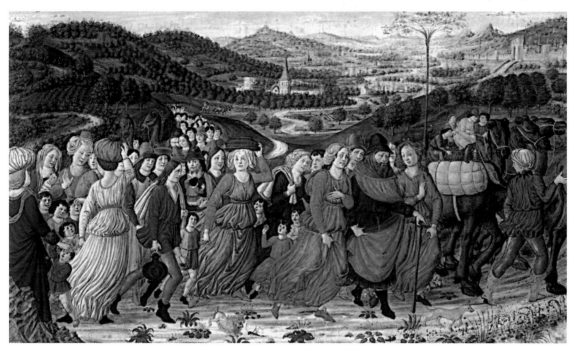

Francesco di Antonio del Chierico: *Exodus*; miniature from the Urbino Bible, 275×178 mm, 1477–8 (Rome, Vatican, Biblioteca Apostolica, MS. Urb. lat. 1, fol. 27*r*)

The latter also had a profound influence on the development of Attavante and the Master of the Hamilton Xenophon, as well as on such other lesser-known artists as the Master of the Decads and Bartolomeo di Domenico di Guido.

BIBLIOGRAPHY
G. Vasari: *Vite* (1550, rev. 2/1568); ed. G. Milanesi (1878–85)
P. D'Ancona: *La miniatura fiorentina dall'XI al XVI secolo*, 2 vols (Florence, 1914)
S. De Ricci: *A Handlist of Manuscripts in the Library of the Earl of Leicester at Holkham Hall* (Oxford, 1932)
P. R. Taucci: 'I corali miniati della SS Annunziata a Firenze', *Studi Stor. Ordine Servi Maria*, i (1933), pp. 150–53
M. Levi D'Ancona: *Miniatura e miniatori a Firenze dal XIV al XVI secolo* (Florence, 1962)
J. J. G. Alexander and A. C. De La Mare: *The Italian Manuscripts in the Library of Major J. R. Abbey* (London, 1969)
A. Garzelli: 'Antico e Nuovo Testamento nei codici miniati della Biblioteca Laurenziana: I e II', *Crit. A.*, 143–4 (1975), pp. 19–38, 25–41
——: *La bibbia di Federico da Montefeltro: Un'officina libraria fiorentina, 1477–1478* (Rome, 1977)
——: 'Zanobi Strozzi, Francesco di Antonio del Chierico e un raro tema astrologico nel libro d'ore', *Renaissance Studies in Honor of Craig Hugh Smyth*, ii (Florence, 1985), pp. 237–44
——: *Miniature fiorentine del Rinascimento: Un primo censimento*, 2 vols (Florence, 1985)
——: 'Note su artisti nell'orbita dei primi Medici: Individuazione e congetture dai libri di pagamento della Badia Fiesolana, 1440–1485', *Stud. Medi.*, xxvi (1985), pp. 435–64
——: 'I miniatori fiorentini di Federico da Montefeltro', *Atti del convegno: Federico di Montefeltro: Lo stato, le arti, la cultura: Roma, 1986*
M. Levi D'Ancona: 'Appunti d'archivio: L'anagrafe di Francesco di Antonio del Chierico', *Miniatura*, (1988), pp. 145–7
The Painted Page: Italian Renaissance Book Illumination, 1450–1550 (exh. cat., ed. J. J. G. Alexander; London, RA, 1994)

ANNAROSA GARZELLI

Francesco di Bartolomeo Alfei. *See* ALFEI, FRANCESCO DI BARTOLOMEO.

Francesco (Maurizio) di Giorgio Martini (Pollaiolo) [Francesco di Giorgio] (*b* Siena, *bapt* 23 Sept 1439; *d* Siena, *bur* 29 Nov 1501). Italian architect, engineer, painter, illuminator, sculptor, medallist, theorist and writer. He was the most outstanding artistic personality from Siena in the second half of the 15th century. His activities as a diplomat led to his employment at the courts of Naples, Milan and Urbino, as well as in Siena, and while most of his paintings and miniatures date from before 1475, by the 1480s and 1490s he was among the leading architects in Italy. He was particularly renowned for his work as a military architect, notably for his involvement in the development of the Bastion, which formed the basis of post-medieval fortifications. His subsequent palace and church architecture was influential in spreading the Urbino style, which he renewed with reference to the architecture of Leon Battista Alberti but giving emphasis to the purism of smooth surfaces. His theoretical works, which include the first important Western writings on military engineering, were not published until modern times but were keenly studied in manuscript, by Leonardo da Vinci among others; they foreshadowed a number of developments that came to fruition in the 16th century (*see* BALDASSARE PERUZZI and SEBASTIANO SERLIO).

1. Architecture. 2. Painting and drawing. 3. Sculpture.

1. ARCHITECTURE.

(i) Buildings and projects. (ii) Theory and writings.

(i) Buildings and projects. In Francesco di Giorgio's baptismal record his grandfather's occupation is given as a poultry farmer, which explains the traditional account of his rise from a humble background to become a great

artist whom Vasari considered second only to Brunelleschi in establishing Renaissance architecture. Research has shown, however, that Francesco's father was a civil servant in the commune of Siena, and through him Francesco was able to meet Mariano Taccola, a Sienese notary and student of mechanics. As a boy Francesco had access to Taccola's library, from which he drew both technical knowledge and inspiration, as demonstrated by the *Codicetto* (Rome, Vatican, Bib. Apostolica, MS. Urb. lat. 1757), a small book full of notes and drawings taken from Taccola's books. Francesco was possibly apprenticed to the painter Francesco di Bartolomeo Alfei, and his first documented payment as an independent artist was in 1464.

Although there is no documentary evidence that Francesco studied under Vecchietta, both are known to have been present in 1470–72 at the Ospedale della Scala, where Francesco worked as a painter and where he is also thought to have given advice on the hospital's new church, S Maria della Scala (*see* SIENA, §III, 2). Francesco's first professional involvement with building was in the field of civil engineering: in 1469 he was appointed, along with Paolo d'Andrea, as Operaio dei Bottini (conduit master) for Siena. This was an important post, as the two men undertook to increase by a third the city's water supply, which was delivered through long subterranean conduits (*bottini*). Francesco continued to work on the construction and maintenance of the conduits for most of his life, accumulating much experience of hydraulics and construction. In 1472 he was replaced by Berto d'Antonio, but in 1492 he was again in charge of the works, assisted by Berto's sons. As there is no evidence that Francesco took part in the rebuilding of Pienza, this work on the conduits appears to have been his most important formative experience in architecture and engineering in his Sienese training.

The only architectural work that can be attributed to Francesco in Siena before he went to Urbino is the church of the Osservanza, begun just outside the city in 1474 and improved, possibly by himself, in 1476. Although its plan, with an aisleless nave, sail vaults, dome and choir, displays Florentine accents and is a type that never recurs in Francesco's later work, the simplification of the parts and the use of a broken entablature over the pilasters between the side chapels, which so often characterized his later architecture, suggest that Francesco not only completed the church but also actually planned it. If so, he might previously have been called to Urbino by the Franciscan Observants, for whom he completed the friary of S Bernardino (see below).

Francesco may have met Federigo da Montefeltro (Count and from 1474 Duke of Urbino; *reg* 1444–82) and been invited to Urbino as early as 1472, after leaving his post as Operaio dei Bottini in Siena. He was possibly involved in the construction of the new fortress at Volterra, which Federigo built with the Florentines after his victorious siege of the city. On becoming Duke of Urbino in 1474, Federigo needed an architect to replace Luciano Laurana (who had left for Naples in 1472) and to complete his palace and build the cathedral and fortresses. Having broken off his partnership with the painter Neroccio de' Landi in 1475, Francesco was certainly living in Urbino from at least 1476, and by May 1477 he was already in the

full confidence of the Duke and the Duke's close friend, Ottaviano Ubaldini. He represented them in negotiating some contracts in Gubbio, one of which cites him as the designer of decorations for a room that was being built in the Palazzo Ducale there, perhaps the *studiolo* emulating that in Urbino. Another document mentions him as planner and director of works on the ravelin of Costacciaro. At about this time Francesco produced the *Opusculum* (London, BL, Harley MS. 3281, Cod. 197 *b* 21). This codex, without text except for the dedication to Federigo, was illustrated with drawings of machines and fortresses; Francesco may have presented it to the Duke on his arrival in Urbino, with the aim of promoting his engineering talents. In November 1477 Francesco declared himself resident in Urbino in the service of Federigo, and in 1478 he was accredited by two letters of Federigo for diplomatic missions at Siena.

Military architecture was prominent among Francesco's first documented works for Federigo. In particular, the ravelin of Costacciaro, with its angular form, met the new need for an architecture that could withstand gunfire and could be defended by grazing fire. It shows similarities to the ravelin of Volterra. The contemporary fortress of Sassocorvaro is only apparently far removed from this choice of new defensive forms. On the town side it survives in its original, circular form, but on the other side a casemate built by Francesco in the new pointed form was replaced by a rampart between two towers probably in the 18th century (see fig. 1). An important element of the Sassocorvaro fortress is the quadrangular courtyard with arches on piers, which already shows clearly the simplified, concise architectural language Francesco later developed in Urbino.

Francesco's most important works in Urbino were the completion of the Palazzo Ducale, the new cathedral, the church and cloister of S Bernardino and the convent of S Chiara. The loss of most of the city archives has made secure attributions and datings impossible. In the palace, which Vasari wrongly attributed entirely to Francesco, he completed what had already been started by Laurana, probably beginning with the courtyard, where he set the inscription in honour of Duke Federigo into friezes on the ground and first floors. In addition, it seems that Francesco added the Giardino Pensile garden terrace together with the adjacent wing that connects the main range (north wing) of the palace with the Castellare (a building abutting the cathedral; *see* URBINO, §4 and figs 3

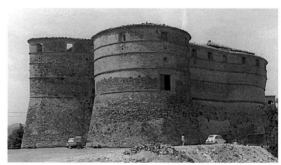

1. Francesco di Giorgio Martini: fortress of Sassocorvaro, begun 1476–8; with partial 18th-century remodelling

and 4). He built a spiral ramp towards the garden in the connecting wing and installed a complex system of service rooms and catchment chambers in the basement. This included Federigo's antique-style bathroom in the western part of the main range, between the towers and below the Cappella del Perdono and the Tempietto delle Muse (both possibly to his own design) on the ground-floor. The bathroom comprises a series of small rooms on various levels unified by a simple architectural order, an interesting example of Francesco's ability to link irregular spaces in a coherent way. Some decorative elements inside the palace are also attributable to Francesco. These include the design of an intarsia panel of the *studiolo* (1476), depicting a squirrel against the background of an arch flanked by pilasters, which recalls Francesco's portal leading from the ramp to the garden terrace (*see* STUDIOLO, fig. 1).

Francesco's ability to create unity from diverse elements is also shown by his design of the palace's 'Facciata ad Ali', which, together with the cathedral, forms a square closed on three sides and open towards the city. In this case Francesco used a more ornate architectural vocabulary. On the ground-floor he set the doors and windows in flat rusticated stone between large pilasters, with a base in the form of a bench, its back decorated with a frieze of the *Arts of War*. The large first-floor windows, probably designed by Laurana, are not aligned with the doors below; this was a novel and disconcerting feature, but it resolved the problems of design unity created by the asymmetrical main elevation of the palace facing the city. The attribution

to Francesco of the wing with arches on pilasters facing the Cortile del Pasquino remains uncertain. Francesco also built the Data, a long stable block for, at most, 300 horses to the west of the palace, and he constructed a bastion with a large spiral ramp inside (rest. 1977 by Giancarlo De Carlo) that gave access to the Data from the level of the palace and controlled the walls that extended to the Mercatale, a market square at the foot of the hill.

From *c*. 1480–81 Francesco built the new cathedral, on the site of the previous one opposite the palace. Compared with the ornate language of the palace façade, Francesco's solutions for the cathedral were simplified and austere. The sides of the nave show links with forms used by Alberti on the side of S Francesco, Rimini, and the still incomplete façade has elements of Alberti's design for S Andrea, Mantua, which was then under construction (*see* ALBERTI, LEON BATTISTA, fig. 8). After the earthquake of 1781, the church was restored by Giuseppe Valadier and others, who changed the architectural decoration but retained the main structure. From his survey drawings (1789), Francesco's church appears to have had a nave covered by a barrel vault on arches supported by piers without bases, aisles, projecting transepts and a large choir flanked by two chapels. Light was admitted mainly through the dome, which stood on an octagonal drum; the perimeter walls had curved chapels, where they are framed like the ends of the transepts by arches similar to the one Francesco designed for the palace *studiolo*. The unity of the whole was ensured by a pair of entablatures that

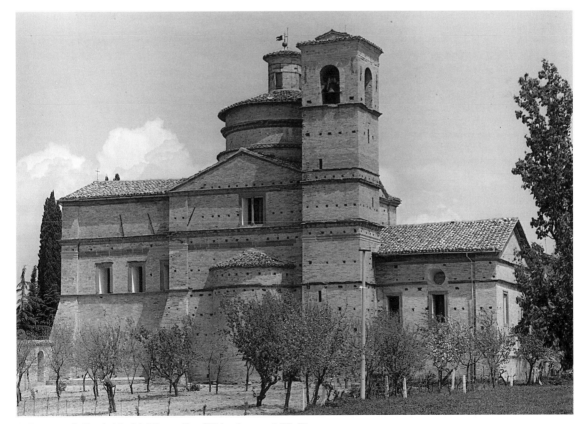

2. Francesco di Giorgio Martini: S Bernardino, Urbino, begun *c*. 1480–82

encircled the whole interior, matched (as far as can be reconstructed) by external entablatures at the same height.

Francesco's architectural language was characterized by clearly defined volumes made up of plane surfaces, with horizontal articulation encircling the structure without interruption and thus unifying the whole. This was derived not only from his Sienese training and Romanesque tradition but also from his own interpretation of ancient architecture. This original interpretation, close to the reality of the ruins then visible in Rome and elsewhere in Italy, was also expressed in his other church at Urbino, S Bernardino, which he began c. 1480–82. Together with its cloister, it was built to complete the friary of the Franciscan Observants and to form Federigo's mausoleum, where indeed he was later buried. Set on a hill facing the city, the church had an aisleless nave ending in a wider square space with four columns at the corners supporting the dome, as in an ancient mausoleum. The solid volume, lined by string courses and entablatures inside and out, is ornamented with columns, windows in the nave with alternating segmental and triangular pediments (then a very new feature) and a trabeated portal with dolphin capitals (see fig. 2).

Also around 1482–3 Francesco must have begun work on the convent of S Chiara, Urbino, commissioned by Elisabetta, Federigo's daughter and the widow of Roberto Malatesta. The church is situated on a slope and gives on to S Bernardino with a two-storey elevation flanked by porticoed wings. Here, too, the arches on pilasters echo the simplified motif of the order continued up to the entablature above. This seems to be the first appearance of the winged façade, and it served as a model for Pope Innocent VIII's Belvedere (1484–92) at the Vatican (see ROME, §V, 1(iii)). The convent church, built on a circular plan and surmounted by a dome, was not altered in its basic form by 17th-century modifications.

The Palazzo Ducale at Gubbio, donated by the city in 1480 to Duke Federigo, was probably also designed by Francesco, who was there for several years from 1477. The Gubbio palace is modelled on that at Urbino, but it is built on substantial earlier structures, incorporating an ancient square for the courtyard and using the medieval Palazzo della Guardia as the main body of the lower section. For this reason it is full of asymmetries, most visibly in the courtyard. The latter has four unequal sides, three of them porticoed with arches on columns and one with a series of hanging arches. The corners are similar to those at Urbino but adapted to follow the trapezoidal form of the courtyard and emphasized by the different widths of the pilasters that make up the main order, showing a very different conception from that of Laurana. The palace at Gubbio also repeats the urban scale of the palace at Urbino, allowing for the different context, as the Gubbio palace housed the municipal waterworks and was linked via an open space to the adjacent castle keep, which was renovated from 1480 in the latest defensive style. In view of the chronology as well as the architectural features, it is likely that this, too, was the work of Francesco di Giorgio, as was the ravelin at the Porta del Marmoreo, built downhill from 1486.

Francesco worked on numerous fortifications in other parts of the duchy of Montefeltro, and he discussed some of them in the *Trattati*, where he illustrated the castles of Sassofeltrio, Tavoleto and Serra S Abbondio (all c. 1478–86; destr.), that of Cagli (c. 1480–85; partly destr.), and two built between 1483 and 1490 or later for Giovanni della Rovere: Mondavio (incomplete but in good condition) and Mondolfo (destr. 1864–95). Modernizations of the castles of S Leo and Fossombrone can also be attributed to Francesco as they reflect the defensive criteria he expounded and the forms he used. Although Francesco probably remained constantly in Urbino in the first years of his employment by Federigo, he was still interested in Sienese projects.

In the years following Federigo's death in 1482 Francesco was able to accept fairly large commissions elsewhere. One of these was for the church of S Maria del Calcinaio at Cortona, in which he was invited to participate by Luca Signorelli, who went to see Francesco in Gubbio on 17 June 1484. The first stone of the church was laid in 1485, and the building followed the drawing and the wooden model for which Francesco was paid in 1484. The church corresponds well to some of the drawings in Francesco's *Trattati*. It has a barrel-vaulted, aisleless nave and an octagonal dome (built in 1508 by the Florentine Pietro di Domenico di Norbo) on squinches over the crossing (see fig. 3). The essence of the design is revealed in the semicircular chapels set in the thickness of the walls at ground-level and in the aedicule windows on the first floor, framed by superimposed orders with pilaster strips below and separated by a narrow string course from pilasters above. This corresponds with the exterior design (see colour pl. 1, XXXI) in both elevation and plan, so

3. Francesco di Giorgio Martini: S Maria del Calcinaio, Cortona, interior looking east, begun 1485

that the divisions of the external surface are visibly unequal. Francesco thus gave priority to architectural consistency based on structural rather than visual regularity. This was also clearly conveyed through the use of *pietra serena* for the orders on the white plastered walls of the interior, which, together with the proportions and the variety of capitals and cornices, makes the church a fine example of Francesco's mature architecture.

Francesco is thought to have been in Naples in 1484, although there is no documentation to confirm this. Although in 1485 the Sienese commune began asking him to return to his native city and appointed him to help repair the bridge at Maciareto, he was still evidently involved with projects in Urbino, near which in 1486 he bought a farm with a house at Villa Rancitelli. In the same year the contract was signed to build the Palazzo della Signoria at Jesi, following the model designed by Francesco and carved in wood by Domenico d'Antonio Indivini. This is a three-storey, isolated and compact building, with a rectangular plan incorporating a courtyard, a tower and a large hall with a vault on central piers at ground-floor level, over which on the first floor is the great meeting-hall. The courtyard is rather small, with arcaded loggias on piers on the ground-floor and arches on columns on the second; these, however, were built after the design of Andrea Sansovino, who in 1519 was summoned to complete it. The exterior features large Guelph windows (but lacking the lower mullion) on the first and second floors. This building represents a revival of the traditional type of the medieval Tuscan and Umbrian town hall. Its features, severe and yet modern, recall the spare language formerly used by Francesco in Urbino. Links have also been suggested with the inner ground-floor loggia of the Palazzo degli Anziani in Ancona, also attributed to Francesco, but the documentary evidence to confirm this is incomplete.

It was around this time that Francesco returned to Siena, where in 1487 he completed the bridge at Maciareto. He was appointed to design the fortress at Casole d'Elsa and to survey the territory between Chianciano and Montepulciano to settle a border dispute between the two communes. At the same time, however, Federigo's successor Guidobaldo I (*reg* 1482–1508) still referred to Francesco as 'his' architect. His return to Siena was confirmed in 1488, when he was engaged on projects for the city, but his assistant Giacomo Cozzarelli was still in Urbino, and in January 1489 Francesco again wrote home from Gubbio to give news of political events and troop movements.

In 1490 a new period began in Francesco's life. After returning to Siena, he was sought for projects and consultations all over Italy. At the request of Galeazzo Maria Sforza, he went to Milan in June 1490 to prepare a scheme for the lantern of the cathedral (together with Giovanni Antonio Amadeo and Giovanni Giacomo Dolcebuono), and in the same month he was in Pavia with Leonardo da Vinci for a consultation concerning the construction of the cathedral. The journey was important from the point of view of exchanges with Milanese architects, especially Bramante and Leonardo. That November he designed fortresses with Virginio Orsini at Campagnano and Bracciano and in Abruzzo. In January 1491 he was in Florence, where he entered the competition held by Lorenzo the Magnificent, Lord of Florence (*reg* 1469–92), for the cathedral façade. After visiting Naples in early 1491, he returned to Siena, but in 1492 he was again in Naples, where he spent between six and eight months before being recalled to Siena to repair the dam on the River Bruna. He spent the whole of 1495 in Naples and was again back there in 1497 to plan the new outer defences (modified 16th century; destr.) of the Castelnuovo, in polygonal form with towers at the corners, which were begun in 1494 and continued by his assistant Antonio Marchesi da Settignano (1451–1522). Francesco probably also worked on the new west walls of the city and on a new fortress at Castel Sant'Elmo, which was subsequently built (1537–46) in a different form by Pedro Luís Scrivá. He also participated in inspections for the Kingdom of Naples, while the fortresses of Otranto, Gallipoli and Taranto, as well as the modernization of that at Monte Sant'Angelo, are probably linked with his designs, as are numerous other fortifications in the region (Ortona, Matera).

Even during the years when Francesco was documented in Naples, he continued his activity in Siena, especially in the field of military architecture. In 1491 he was called to Sesta della Berardenga and to Cerreto Ciampoli to build fortifications (destr.), as well as to Lucca to work on the city's defences. In 1493 he was in Castelluccio di Montepulciano to inspect the model for the fortress; he was there again in 1496 and 1498, to demolish a bridge and a fort. In 1499 he was again in Urbino, and in 1500 he gave advice on buttressing the dome of S Maria di Loreto, and he perhaps designed the aqueduct and new fortifications in Loreto (built 1518–21). No civic architecture by Francesco is documented in Siena during his last years, but the design (*c.* 1492) of a new building for the Sapienza and two important buildings ascribed to his followers were probably planned by him. The church of S Sebastiano in Vallepiatta, begun after 1493, was built on a Greek-cross plan with apses at the sides and ends of the arms. The Villa Chigi at Le Volte, near Siena, was built (*c.* 1496–1505) with projecting wings, a form that was later used by Baldassare Peruzzi in Agostino Chigi's villa (1505–11; now the Villa Farnesina) in Rome (*see* PERUZZI, BALDASSARE, fig. 1).

(ii) Theory and writings. The *Trattati* is the title conventionally given to Francesco di Giorgio's collected writings, comprising essays on the role of the architect in relation to the new Renaissance interests in techniques and ancient buildings, studied through ruins and literary sources. The text is illustrated with numerous drawings and clear examples of architecture and machines. The *Trattati* have remained in manuscript form, surviving in several versions in different codices: the text was written by copyists, while the drawings are at least partly by Francesco's hand. Only Francesco's translation of Vitruvius in the Magliabechiano Codex (Florence, Bib. N. Cent., MS. Magl. II.I. 141, pt 2) is entirely autograph, but this has only seven folios with drawings. The Saluzziano Codex (Turin, Bib. Reale, MS. Saluzziano 148, pt 1) contains numerous autograph corrections by Francesco and a section on antique monuments connected with his survey drawings (Florence, Uffizi, MS. 318–37A).

Various hypotheses have been suggested to explain the work's complex evolution, and various dates have been proposed for the different versions. After the first main studies (Promis, 1841; Salmi, 1947; Maltese, 1969), the codices produced directly by Francesco were subdivided into two groups, the first (datable to before 1486) comprising the Laurenziano Codex (Florence, Bib. Medicea–Laurenziana, MS. Ashburnham 361) and the Saluzziano Codex, and the second (datable to 1485–92) consisting of the Siena Codex (Siena, Bib. Com. Intronati, MS. S. IV.4) and the Magliabechiano (pt 1). Maltese dated the *editio princeps* of Vitruvius's *On Architecture* by the philologist Sulpicio da Veroli to 1486 and placed it between the two groups. This chronology was generally accepted, although still the subject of discussion among scholars, but, following a re-examination of the material by Mussini (1991), it appears that the first group of codices dates from around 1487–9, although many parts incorporated in it had been prepared and collected by Francesco over many years previously. Thus, Francesco's treatises were put in order only after, and not before, his experiences as an architect, and he was able to work on the successive versions only after returning to Siena (?after 1496).

The first version of the *Trattati* begins with the programme of the new military architecture, which called for fortresses built low to the ground, with defences based on the broken perimeter, to permit flanking with the use of firearms, and on the moat. The latter was to be defended by embrasures set low in the castle walls and by covered gun stations inserted in the counterscarp. Francesco favoured sharp-angled walls facing the enemy, although in many cases these were protected by towers at the corners. This, together with the anthropomorphic fortress and the rhomboid type, which he considered perfect, represents the pentagonal form of bastion that influenced military architecture for many centuries (and which Francesco was credited with inventing by early 19th-century authors). This form, which he used more properly in ravelins and advanced bulwarks, can be considered a geometric rationalization of experiments tried in embryonic form in the fortresses of Fano (1439–45) and Cesena (1452–66) built by Matteo Nuti. Above all, Francesco laid great stress in his writings on the necessity of adapting to the conditions of the site and taking advantage of its defensive possibilities, sometimes using concentric circles of walls and detached forward defences.

The order of topics changes in the second version of the *Trattati*, in which a broad range of religious and civic architecture, subdivided by types is presented. Following Alberti, the civic architecture is classified according to the social standing of the intended occupant. The drawings, detailed and original, offer multiple solutions for each theme and are full of rich and realistic architectural invention, ready for further elaboration into final designs. They include drawings that have been linked to projects realized and knowledge accumulated by Francesco after 1490. The part of the *Trattati* devoted to the architectural orders is also set out in an original way. Despite its shortcomings, which include the insistent application of anthropomorphism and some misunderstandings, it was considered sufficiently up to date to be almost plagiarized by Luca Pacioli in *De divina proportione* (Venice, 1509).

The treatises are supplemented with drawings of civil and military machines, which are often based on Francesco's early notes from Taccola's books. Francesco continued his activities until his death, which explains why his last architectural projects and the final reorganization of his treatises were interrupted. As late as 1501 he is documented as making a tour of inspection of Sienese defences.

FRANCESCO PAOLO FIORE

2. PAINTING AND DRAWING. Francesco di Giorgio is generally thought to have studied with the painter and sculptor Vecchietta, although this is undocumented. The dating and even the attribution of several of his paintings and manuscript miniatures is controversial. Probably dating from the early 1460s are three *cassone* panels with scenes from the Old Testament: *Joseph Sold into Slavery*, *Joseph and Potiphar's Wife* and *Susanna and the Elders* (all Siena, Pin. N.). In style these are close to the work of Vecchietta, as is the *cassone* front showing the *Triumph of Chastity* (Los Angeles, CA, Getty Mus.). Numerous other *cassoni* (e.g. Florence, Mus. Stibbert; London, V&A; New York, Met.) dating from the end of the 1460s show Francesco's interest in narrative and are early examples of a renewed interest in antiquity in Siena. This tendency can also be seen in the fragment of a headboard illustrating an episode from the *Story of Psyche* (c. 1465; Florence, I Tatti)—not the *Rape of Helen*, as previously supposed. All these paintings reveal the artist's taste for the classically inspired representation of architecture and cities. The painted book cover of records of the Sienese Biccherna, depicting the *Virgin of the Earthquake* (1467–8; Siena, Archv Stato, inv. 51), is also close to the fabulous and still 'courtly' style of Vecchietta (generally attributed to Francesco, this painting is also credited by Angelini in Bellosi, 1993 exh. cat., no. 51, to an assistant, 'Fiduciario di Francesco', representing one of his earliest works). Datable soon after (c. 1473–4) is the so-called *Bianca e Siena* (Florence, Bib. N. Cent., MS. Palatino 211, fol. 1r), which also has characteristic city views, based on real places but interpreted in terms of Classical antiquity.

Francesco's first securely dated works are a group of miniatures in dated manuscripts. The earliest extant miniature represents an *Allegory of Chastity* accompanied by an illustration of the *Three Labours of Hercules*, in a manuscript of Albertus Magnus's *De animabilis* (Siena, Mus. Castelli, inv. 3, fol. 1r), which is dated 1463. Although it has been considered contemporary with the manuscript, the miniature may date to c. 1470 (Neerman, see 1982 exh. cat.). Other miniatures of around this date include the *Allegory of Theology* in a manuscript dated 1466, *Alphonsi summi theologi ordine S Augustini* (Siena, Mus. Castelli) and a *Nativity* in an initial from an Antiphonal (Chiusi Cathedral, Cod. B, fol. 3r). Payments for the Antiphonal were made to Lorenzo Rosselli (b 1390) between 1458 and 1461, although Francesco's work may have been executed later, perhaps completing illumination left unfinished by Rosselli. During this early period, Francesco came into contact with Liberale da Verona (in Siena from 1467) and with Girolamo da Cremona (in Siena from 1470) and was strongly influenced by them. Indeed, certain drawings and paintings have been variously attributed to one or all three of these artists; for instance the panel with *Youths* (Flor-

ence, I Tatti) has been attributed by Berenson, Weller and Pope-Hennessy (1947) to Francesco, but is believed by Zeri (1950) to be by Girolamo, and by Longhi and Laclotte to be by Liberale. The latter's influence can be seen in the first important large-scale work by Francesco (probably assisted by a pupil; see De Marchi in Bellosi, 1993 exh. cat., no. 56), the *Coronation of the Virgin* (1472–4; Siena, Pin. N.) and, above all, in the gable representing *God the Father*. The style is elaborate, but overburdened and contrived, the composition derived from a niello engraving (Florence, Bargello), which in its turn is derived from a drawing attributable to Maso Finiguerra or Pollaiuolo. The work reveals Francesco's attempt to incorporate innovations from contemporary Florentine painting, particularly the work of Verrocchio. For example, the figures are monumental and brought into the foreground, and there is also an attempt to soften the linear quality typical of Sienese painting. This may reflect the influence of Botticelli, although since Botticelli was still young the reverse is also possible (Yuen).

Close in date to the *Coronation* is a large detached fresco of *Fidelity* (Los Angeles, CA, Norton Simon A. Found.). Conceived as an illuminated page, the painting shows not only the rhythmic qualities of Botticelli but also signs of the influence of Neroccio de' Landi, who moved in the same artistic circles as Francesco from 1469 and worked with him until 1474. Various paintings of the Virgin, paralleling works by Filippino Lippi and Giovanni Boccati, date from this period, for instance two panels of the *Virgin and Child* (Siena, Pin. N., and ex-Pini priv. col., Bologna), the latter attributed to Francesco by Pope-Hennessy (1939) but ascribed by Longhi to 'someone close to Boccati'. Other versions of the *Virgin and Child* (e.g. Avignon, Mus. Petit Pal.; Madrid, Mus. Thyssen-Bornemisza; Coral Gables, FL, U. Miami, Lowe Art Gal.) are more archaizing in style and probably earlier. After 1475 Francesco's style became more naturalistic, both in terms of human form and in the use of light. This is evident in his only signed work, a *Nativity* (*c.* 1475–6; Siena, Pin. N.) from the monastery at Monte Oliveto; serene and sentimental, its typology is Verrocchian.

From 1477 to 1487, Francesco was in Urbino, working at the court of Federigo da Montefeltro. Vasari cited a medal by Francesco of *Duke Federigo I*, which has been convincingly identified with a surviving medallion portrait (*c.* 1478; London, BM). Another portrait of the Duke appears in a manuscript (Rome, Vatican, Bib. Apostolica, MS. Urb. lat. 508, fol. 1*v*), together with a painting once believed to be the only known self-portrait of Francesco (the miniature is now attributed to Botticelli, and the subject is identified with Cristoforo Landini; see Bellosi, 1993 exh. cat., fig. 88). After his stay in Urbino, Francesco's pictorial style underwent a further transformation, with his figures becoming increasingly 'abstract', almost symbolic, if not 'proto-Mannerist', anticipating the *figura serpentinata* of the 16th century. This is evident, for example, in the figure drawings that accompany the second version (*c.* 1495) of Francesco's *Trattati* (see §1(ii) above). The stereometric figure drawings (whose autography has been questioned), quite different from the more naturalistic ones in the first version of the treatise, combine the legacy of Urbino's perspective culture and that of Piero

della Francesca with the lofty concept of the 'science of drawing', the perfect equal of the other liberal arts, arithmetic and geometry; it is here that the artist's most significant contribution to the Italian Renaissance is evident.

The attribution of some late painted works to Francesco is controversial. The grisaille frescoes of *c.* 1490–94, uncovered in the Bichi Chapel in S Agostino, Siena, have in the past been attributed to him. Their execution and style, however, argues against this, particularly since they were painted at a time when Francesco was often absent from Siena and, as with some of his sculptural works (*see* §3 below), had to leave the execution of certain of his works to his pupils. Another work that has been removed from Francesco's oeuvre is the *Disrobing of Christ* (Siena, Pin. N.), which is probably the work of a later follower, *c.* 1500–03 (Seidel, 1979), of Baldassare Peruzzi (Frommel) or of 'Fiduciario di Francesco' (S. Santoro in Bellosi, 1993 exh. cat., no. 108).

3. SCULPTURE. There is little stylistic link between Francesco's paintings and sculpture, the latter being gen-

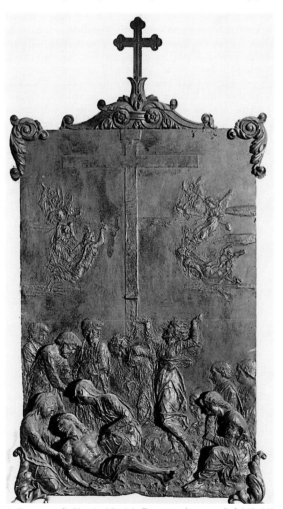

4. Francesco di Giorgio Martini: *Deposition*, bronze relief, 860×750 mm, 1474–7 (Venice, S Maria del Carmine)

erally far more sophisticated. He worked in wood, bronze and terracotta, and he also made medallions and plaquettes; there is some evidence that he also worked in stone (e.g. *Virgin and Child*, Berlin, Staatl. Museen Preuss. Kultbes.; see Bagnoli in Bellosi, 1993 exh. cat., no. 25). His first securely datable sculpture is a life-size wooden polychrome figure of *St John the Baptist* (1464; Siena, Mus. Opera Duomo), made for the Compagnia di S Giovanni Battista della Morte, and evidently influenced by Donatello, who worked in Siena from 1457 to 1461.

No other sculptural work of Francesco's can be positively dated before *c.* 1474. While in Urbino, Francesco produced the bronze relief of the *Deposition* (Venice, S Maria del Carmine; see fig. 4), originally from the oratory of Santa Croce in Urbino, and which can be firmly dated between 1474 and 1477. This relief, formerly attributed to Leonardo, reveals a lively concern for the rendering of forms by using light and shadow and suggests the influence of Donatello, even if only indirectly (Schubring, 1907; Pope-Hennessy, 1985; Luchs). More straightforward references to Donatello's work emerge in Francesco's bas-relief of the *Flagellation* (Perugia, G.N. Umbria), also formerly attributed to Leonardo as well as to Verrocchio and Bertoldo di Giovanni and almost certainly executed in Urbino around 1480–85 (only Del Bravo dates it to 1490–95). It is remarkable for the extremely skilful perspectival rendering of buildings, and for its rough finish, which gives the material a delicate quality and creates fine effects of light: this is one of the masterpieces of Renaissance sculpture, drawing directly on Classical art in a highly dramatic way, as already evident in the slightly earlier Venice *Deposition*. The great painting representing the *Nativity* (*c.* 1495; Siena, S Domenico) belongs to this late period of activity, and it is consistent stylistically with the two great bronze *Angels* in Siena Cathedral, with their undulating motion and light-filled modelling. These two *Angels*, which document Francesco's late style so well, are dated 1489–92, and documents indicate that they were cast under the direction of Francesco's pupil Giacomo Cozzarelli (*see* COZZARELLI, (2)).

PIETRO C. MARANI

UNPUBLISHED DRAWINGS
London, BL, Harley MS. 3281, Cod. 197 *b* 21 [*Opusculum*]

WRITINGS
Il Codice Ashburnham 361 della Biblioteca Medicea Laurenziana di Firenze: Trattato di architettura de Francesco di Giorgio Martini (MS.; *c.* 1490); ed. P. C. Marani, 2 vols (Florence, 1979)

Trattato di architettura civile e militare di Francesco di Giorgio Martini, architetto senese del secolo XV (MS.; *c.* 1490); ed. C. Promis, 3 vols (Turin, 1841)

Francesco di Giorgio Martini: Trattati di architettura ingegneria e arte militare (MS.; *c.* 1490–1500); ed. C. Maltese, 2 vols (Milan, 1967)

G. Scaglia, ed.: *Il 'Vitruvio Magliabechiano' di Francesco di Giorgio Martini* (Florence, 1985)

L. Michelini Tocci, ed.: *Das Skizzenbuch des Francesco di Giorgio Martini, Vat. Urb. lat. 1757* (Zurich, 1989)

BIBLIOGRAPHY
EARLY SOURCES
G. Santi: *La vita e le geste di Federico di Montefeltro, Duca d'Urbino* (MS.; *c.* 1492); ed. L. Michelini Tocci, ii (Rome, 1985), pp. 418, 419, 424, 670, 675, 742

G. Vasari: *Vite* (1550, rev. 2/1568), ed. G. Milanesi (1878–85), iii, pp. 69–79

MONOGRAPHS
A. S. Weller: *Francesco di Giorgio, 1439–1501* (Chicago, 1943)

R. Papini: *Francesco di Giorgio, architetto*, 3 vols (Florence, 1946)

C. Maltese: *Francesco di Giorgio*, I Maestri della Scultura (Milan, 1966)

P. Rotondi: *Francesco di Giorgio nel Palazzo Ducale di Urbino* (Novilara, 1970)

R. Todelano: *Francesco di Giorgio Martini: Pittore e scultore* (Milan, 1987)

F. P. Fiore and M. Tafuri, eds: *Francesco di Giorgio, architetto* (Milan, 1993–4)

ARCHITECTURE AND ENGINEERING
C. Promis: *Biografie di ingegneri militari italiani dal secolo XV alla metà del XVIII* (Turin, 1874)

W. Lotz: 'Eine Deinokratesdarstellung des Francesco di Giorgio', *Mitt. Ksthist. Inst. Florenz*, v (1937–40), pp. 428–33

C. Maltese: 'Opere e soggiorni urbinati di Francesco di Giorgio', *Studi artistici urbinati* (Urbino, 1949), pp. 57–83

P. Rotondi: 'Contributi urbinati a Francesco di Giorgio', *Studi artistici urbinati* (Urbino, 1949), pp. 85–135

M. Salmi: 'Il Palazzo Ducale di Urbino e Francesco di Giorgio', *Studi artistici urbinati* (Urbino, 1949), pp. 9–55

P. Sanpaolesi: 'Aspetti dell'architettura del'400 a Siena e Francesco di Giorgio', *Studi artistici urbinati* (Urbino, 1949), pp. 137–68

P. Rotondi: *Il Palazzo Ducale di Urbino*, i–ii (Urbino, 1950–51)

G. H. Fehring: *Studien über die Kirchenbauten des Francesco di Giorgio* (Würzburg, 1956)

C. Maltese: 'L'attività di Francesco di Giorgio Martini, architetto militare nelle Marche attraverso il suo "Trattato"', *Atti del XI congresso di storia dell'architettura: Marche, 1957*, pp. 281–328

M. Dezzi Bardeschi: 'Le rocche di Francesco di Giorgio nel ducato di Urbino', *Castellum*, viii (1968), pp. 97–140

P. Marconi: 'Una chiave per l'interpretazione dell'urbanistica rinascimentale: La cittadella come microcosmo', *Quad. Ist. Stor. Archit.*, 85–90 (1968), pp. 53–94

G. H. Hersey: *Alfonso II and the Artistic Renewal of Naples, 1485–1495* (New Haven and London, 1969)

H. Burns: 'Progetti di Francesco di Giorgio per i conventi di S Bernardino e Santa Chiara di Urbino', *Atti del congresso internazionale. Studi Bramanteschi: Milano, Urbino, Roma, 1970*, pp. 293–311

P. Rotondi: *Francesco di Giorgio nel Palazzo Ducale di Urbino* (Novilara, 1970)

M. Dezzi Bardeschi: 'L'architettura militare del '400 nelle Marche con particolare riguardo all'opera di Francesco di Giorgio', *Stud. Maceratesi*, 9 (1975), pp. 137–49

R. Pane: *Il rinascimento nell'Italia meridionale*, i, ii (Milan, 1975–7)

G. Martines: 'Il Palazzo Ducale di Gubbio: Un brano sepolto della città medievale, un'ipotesi per Francesco di Giorgio', *Ric. Stor. A.*, 6 (1977), pp. 89–110

A. Bruschi: 'Pareri sul tiburio del duomo di Milano: Leonardo, Bramante, Francesco di Giorgio', *Scritti rinascimentali di architettura* (Milan, 1978), pp. 320–86

G. Martines: 'Francesco di Giorgio a Gubbio in tre documenti d'archivio rinvenuti e trascritti da Pier Luigi Menichetti', *Ric. Stor. A.*, 11 (1980), pp. 67–9

P. C. Marani: 'Leonardo, Francesco di Giorgio e il tiburio del duomo di Milano', *A. Lombarda*, 62 [1982], pp. 81–92

——: 'A Reworking by Baldassarre Peruzzi of Francesco di Giorgio's Plan of a Villa', *J. Soc. Archit. Historians*, xli/3 (1982), pp. 181–8

F. P. Fiore: 'Francesco di Giorgio e il rivellino "acuto" di Costacciaro', *Quad. Ist. Stor. Archit.*, n. s., 1–10 (1983–7), pp. 197–208

D. Gallavotti Cavallero: 'Francesco di Giorgio di Martino, architetto, ingegnere, scultore, pittore, bronzista per la SS Annunziata di Siena', *Paragone*, xxxvi/427 (1985), pp. 46–56

M. Agostinelli and F. Mariano: *Francesco di Giorgio e il Palazzo della Signoria di Jesi* (Jesi, 1986)

F. P. Fiore: 'Francesco di Giorgio a Gubbio', *Federico di Montefeltro: Le arti* (Rome, 1986), pp. 151–70

——: 'Francesco di Giorgio e le origini della nuova architettura militare', *L'architettura militare veneta del cinquecento* (Milan, 1988), pp. 62–75

——: 'Le residenze ducali di Urbino e Gubbio: "Città in forma di palazzo"', *Archit. Stor. & Doc.*, 1–2 (1989), pp. 5–34

R. Schofield: 'Amadeo, Bramante and Leonardo and the Tiburio of Milan Cathedral', *Achad. Leonardi Vinci: J. Leonardo Stud. & Bibliog. Vinciana*, ii (1989), pp. 68–100

M. S. A. Dechert: 'The Military Architecture of Francesco di Giorgio in Southern Italy', *J. Soc. Archit. Historians*, xlix/2 (1990), pp. 161–80

P. C. Marani: 'Francesco di Giorgio a Milano e a Pavia: Consequenze ed ipotesi', *Prima di Leonardo: Cultura delle macchine a Siena nel rinascimento* (Milan, 1991), pp. 93–104

P. Matracchi: *La chiesa di S Maria delle Grazie al Calcinaio presso Cortona e l'opera di Francesco di Giorgio* (Cortona, 1991)

M. Mussini: *Il trattato di Francesco di Giorgio Martini e Leonardo: Il Codice Estense restituito* (Parma, 1991)

I. Moretti: 'Aspetti dell'architettura militare nella Valtiberina toscana all fine del Medioevo', *Valtiberina, Lorenzo e i Medici*, ed. G. Renzi (Florence, 1995), pp. 249–63

THEORY

E. Berti: 'Un manoscritto di Pietro Cataneo agli Uffizi e un codice di Francesco di Giorgio Martini', *Belvedere*, vii (1925), pp. 100–03

P. Fontana: 'I codici di Francesco di Giorgio Martini e di Mariano di Iacomo detto il Taccola', *XVIe Congrès international d'histoire de l'art 1936: Résumés des communications présentées en section. Actes du Congrès: Berne, 1936*, i, pp. 102–5

H. Millon: 'The Architectural Theory of Francesco di Giorgio', *A. Bull.*, xl (1958), pp. 257–61

L. Reti: 'Francesco di Giorgio Martini's Treatises on Engineering and its Plagiarists', *Technol. & Cult.*, iv/3 (1963), pp. 287–98

P. Marconi, F. P. Fiore, G. Muratore and E. Valeriani: *La città come forma simbolica: Studi sulla teoria dell'architettura nel rinascimento* (Rome, 1973)

L. Reti, ed.: *Leonardo da Vinci: I codici di Madrid* (Florence, 1974)

R. J. Betts: 'On the Chronology of Francesco di Giorgio's Treatises: New Evidence from an Unpublished Manuscript', *J. Soc. Archit. Historians*, xxxvi/1 (1977), pp. 3–14

S. Pepper and Q. Huges: 'Fortification in Late 15th-century Italy: The Treatise of Francesco di Giorgio Martini', *Brit. Archaeol. Rep., Suppl. Ser.*, 41 (1978), pp. 541–60

R. Feuer-Tóth: 'Un Traité italien du XVe siècle dans le Codex Zichy de Budapest', *Actes du colloque. Les Traités d'architecture de la Renaissance: Tours, 1981*, pp. 99–113

L. Lowic: 'The Meaning and Significance of the Human Analogy in Francesco di Giorgio's *Trattato*', *J. Soc. Archit. Historians*, xlii (1983), pp. 360–70

F. P. Fiore: 'La traduzione da Vitruvio di Francesco di Giorgio: Note ad una parziale trascrizione', *Archit. Stor. & Doc.*, 1 (1985), pp. 7–30

C. Kolb: 'The Francesco di Giorgio Material in the Zichy Codex', *J. Soc. Archit. Historians*, xlvii/2 (1988), pp. 132–59

M. Mussini: *Il 'Trattato' di Francesco di Giorgio Martini e Leonardo: Il Codice Estense restituito* (Parma, 1991)

G. Scaglia: *Francesco di Giorgio: Checklist and History of Manuscripts and Drawings in Autographs and Copies, from c. 1470 to 1687, and Renewed Copies, 1764–1839* (Bethlehem, London and Toronto, 1992); review by P. C. Marani in *Burl. Mag.*, cxxxvi/1101 (1994), pp. 845–6

DRAWINGS

C. Gamba: 'A proposito di alcuni disegni del Louvre', *Rass. A.*, ix/3 (1909), pp. 37–40

C. Brandi: 'Disegni inediti di Francesco di Giorgio', *Arte*, xxxvii (1934), pp. 45–57

B. Degenhart: 'Francesco di Giorgios Entwicklung als Zeichner', *Z. Kstgesch.*, iv (1935), pp. 103–26

——: 'Unbekannte Zeichnungen Francescos di Giorgio', *Z. Kstgesch.*, viii (1939), pp. 117–50

M. Salmi: 'Disegni di Francesco di Giorgio nella collezione Chigi Saracini', *Quad. Accad. Chigiana*, ix (1947), pp. 7–45

A. E. Popham and P. M. R. Pouncey: *Italian Drawings in the Department of Prints and Drawings in the British Museum, XIV–XV Centuries* (London, 1950), pp. 32–8

T. Buddensieg: 'Die Konstantinsbasilika in einer Zeichnung Francescos di Giorgio und der Marmorkolossos Kostantins des Grossen', *Münch. Jb. Bild. Kst*, xiii (1962), pp. 37–48

L. Michelini Tocci: 'Disegni e appunti autografi di Francesco di Giorgio in un codice del Taccola', *Scritti di storia dell'arte in onore di Mario Salmi* (Rome, 1962), ii, pp. 203–12

A. Forlani Tempesti: *Disegni italiani della Collezione Santarelli, sec. XV–XVII* (Florence, 1967)

C. L. Ragghianti: 'Note ai disegni di Francesco di Giorgio', *Crit. A.*, xiv/89 (1967), pp. 38–53

C. Maltese: 'Il protomanierismo di Francesco di Giorgio Martini', *Stor. A.*, iv (1969), pp. 440–46

F. P. Fiore: *Città e macchine del'400 nei disegni di Francesco di Giorgio Martini* (Florence, 1978)

E. Beltrame Quattrocchi: *Disegni toscani e umbri del primo rinascimento dalle collezioni del Gabinetto Nazionale delle Stampe* (Rome, 1979)

C. H. Ericsson: *Roman Architecture Expressed in Sketches by Francesco di Giorgio Martini: Studies in Imperial Roman and Early Christian Architecture* (Helsinki, 1980)

G. Scaglia: 'Autour de Francesco di Giorgio Martini ingénieur et dessinateur', *Rev. A.*, xlviii (1980), pp. 7–25

A. Parronchi, ed.: *Baldassarre Peruzzi: Trattato di architettura militare* (Florence, 1982)

S. Szabo: *Masterpieces of Italian Drawing in the Robert Lehman Collection, the Metropolitan Museum of Art*, no. 14 (New York, 1983)

M. Morresi: 'Francesco di Giorgio e Bramante: Osservazioni su alcuni disegni degli Uffizi e della Laurenziana', *Atti del convegno. Il disegno di architettura: Milano, 1988*, pp. 117–24

G. Scaglia: *Francesco di Giorgio: Checklist and History of Manuscripts and Drawings in Autographs and Copies, from c. 1470 to 1687, and Renewed Copies, 1764–1839* (Bethlehem, London and Toronto, 1992)

P. C. Marani: 'L'Amadeo e Francesco di Giorgio Martini', *Atti del convegno: Giovanni Antonio Amadeo: Scultura e architettura del suo tempo. Milano, 1993*

PAINTING

P. Schubring: *Cassoni: Truhen und Truhenbilder der italienischen Frühenrenaissance* (Leipzig, 1915), nos 462–7

A. McComb: 'The Life and Works of Francesco di Giorgio', *A. Stud.* (1924), pp. 3–32

A. Venturi: 'Per Francesco di Giorgio Martini', *Arte*, xxviii–xxx (1930), pp. 51–8

J. Pope-Hennessy: 'Francesco di Giorgio Martini, Neroccio: Two Madonnas and an Altarpiece', *Burl. Mag.*, lxxv (1939), pp. 229–35

——: *Sienese Quattrocento Painting* (Oxford, 1947)

C. Brandi: *Quattrocentisti senese* (Milan, 1949)

F. Zeri: 'Una pala d'altare di Gerolamo da Cremona', *Boll. A.*, xxxv (1950), p. 39

E. Carli: *La pittura senese* (Milan, 1955)

M. Laclotte: *De Giotto à Bellini* (Paris, 1956)

R. Longhi: 'Un familiare del Boccati', *Paragone*, xiii/153 (1962), pp. 60–64

F. Russoli: *La raccolta Berenson* (Milan, 1962)

F. Zeri: 'Un intervento su Francesco di Giorgio Martini', *Boll. A.*, xlix (1964), pp. 41–4

T. Yuen: 'New Aspects of Botticelli's Late Works: A Suggestion for the Dating of the Dante Illustrations and Francesco di Giorgio's Influence', *Marsyas*, xii (1966), pp. 22–33

C. L. Frommel: 'Baldasarre Peruzzi als Maler und Zeichner', *Röm. Jb. Kstgesch.*, xi (1967–8)

B. Berenson: *Central and North Italian Schools*, i (1968), pp. 140–41

B. Fredericksen: *The Cassone Painting of Francesco di Giorgio* (Los Angeles, 1969)

M. Salmi: 'Una precisazione su Francesco di Giorgio', *Commentari*, xxii/4 (1971), pp. 335–6

F. Bisogni: 'Risarcimento del *Ratto di Elena* di Francesco di Giorgio', *Prospettiva*, vii (1976), pp. 44–6

P. Torriti: *La Pinacoteca Nazionale di Siena: I dipinti dal XII al XV secolo* (Genoa, 1977)

M. Seidel: 'Die Fresken des Francesco di Giorgio in S Agostino in Siena', *Mitt. Ksthist. Inst. Florenz*, xxiii (1979), pp. 3–108

L. Vertova: 'Cupid and Psyche in Renaissance Painting before Raphael', *J. Warb. & Court. Inst.*, xlii (1979), pp. 104–21

Mostra di opere d'arte restaurate nelle province di Siena e Grosseto (exh. cat. by M. Seidel, Siena, Pin. N., 1979), pp. 152–9

Codici liturgici miniati dei Benedettini in Toscana (exh. cat., Florence, Cent. Incon. Certosa, 1982), pp. 269–83 [contribution by G. Neerman]

A. Garzelli: 'Un'inedita allegoria di Francesco di Giorgio Martini', *Paragone*, xxxvi/427 (1985), pp. 124–34

J. Pope-Hennessy: [review of P. Anselm Riedl and M. Seidel: *Die Kirchen von Siena* (Munich, 1984)], *Burl. Mag.*, cxviii (1986), pp. 512–13

Renaissance Painting in Siena (exh. cat. by K. Christiansen, L. Kanter and C. Strehlke, New York, Met., 1988), pp. 326–27

Francesco di Giorgio e il rinascimento a Siena, 1450–1500 (exh. cat., ed. L. Bellosi; Siena, S Agostino, 1993), pp. 19–89, 284–9, 290–316, 420–86

SCULPTURE

P. Schubring: *Plastik Sienas im quattrocento* (Berlin, 1907)

G. F. Hartlaub: 'Zur Würdigung des Francesco di Giorgio als Maler und Bildhauer', *Pantheon*, xxv (1940), pp. 87–92

J. Pope-Hennessy: *Italian Renaissance Sculpture* (London, 1955, rev. Oxford, 3/1985), pp. 61–3, 246, 307–9

G. Eimer: 'Francesco di Giorgios Fassadenfries am Herzogpalast zu Urbino', *Festschrift Ulrich Middeldorf*, i (Berlin, 1968), pp. 187–98

C. Del Bravo: *Scultura senese del quattrocento* (Florence, 1970)

E. Carli: *Scultori senesi* (Milan, 1980)

F. Fumi: 'Nuovi documenti per gli angeli dell'altar maggiore del duomo di Siena', *Prospettiva*, xxvi (1981), pp. 9–25

G. Bernini Pezzini: *Il fregio dell'arte della guerra nel Palazzo Ducale di Urbino: Catalogo dei rilievi*, Urbino, Pal. Ducale cat. (Rome, 1985)

A. Luchs: 'Francesco di Giorgio Martini', *Donatello e i suoi: Scultura fiorentina del primo rinascimento* (exh. cat., ed. A. Phipps Darr and G. Bonsanti; Florence, Forte Belvedere, 1986), pp. 225–9

A. Tonnesmann: 'Le palais ducal d'Urbino: Humanisme et réalité sociale', *Architecture et vie sociale: L'organisation intérieure des grandes demeures à la fin du Moyen Age et à la Renaissance: Actes du colloque: Tours, 1988*, pp. 137–53

N. Penny: 'Non-finito in Italian Fifteenth-century Bronze Sculpture', *Antol. B.A.*, 48–51 (1994), pp. 11–15

M. Seidel: 'A colloquio con l'antichità: Il giovane Francesco di Giorgio e la scultura romana', *Umanesimo a Siena: Letteratura, arti figurative, musica*, ed. E. Cioni and D. Fausti (Siena, 1994), pp. 285–309

F. PAOLO FIORE, PIETRO C. MARANI

Francesco di Giovanni di Domenico. *See* BOTTICINI, FRANCESCO.

Francesco di Pietro della Biada. *See* BENAGLIO, FRANCESCO.

Francesco di Stefano. *See* PESELLINO.

Francesco di Valdambrino (*fl* 1401; *d* Siena, 20 Aug 1435). Italian sculptor. He is best known as the friend and occasional collaborator of Jacopo della Quercia in Lucca and Siena, but he already had a considerable reputation before his association with della Quercia. In 1401 Francesco was invited to participate in the competition for the second set of bronze doors for the Florentine Baptistery together with Lorenzo Ghiberti, Filippo Brunelleschi, Niccolò di Piero Lamberti, Niccolò d'Arezzo, Simone da Colle and Jacopo della Quercia. His first dated work is a polychromed wooden statue of the standing *Virgin and Child* (1403), in S Andrea, Palaia (Burresi). Both the delicate *Virgin and Child* and the rigidly iconic *St Peter* (Montalcino, Mus. Dioc. A. Sacra) are in the Late Gothic style then current in Pisa and show the influence of Nino Pisano (*fl* 1334–60s) in particular.

Francesco was in Lucca in 1405–7, when Jacopo della Quercia was carving the tomb of *Ilaria del Carretto* (Lucca Cathedral; *see* JACOPO DELLA QUERCIA, fig. 2) with its classicizing frieze of putti carrying garlands. Francesco is believed to have executed the frieze on the north side of the sarcophagus, where the figures are less robust and less spatially ambitious (although Freytag has suggested the frieze is the work of Matteo Civitali's workshop). Francesco may also have contributed to the design of the colossal heads on the exterior of the cathedral. A statue of *St Nicholas of Tolentino* (Lucca, S Maria Corteolandini) has also been attributed to Francesco (Paoli).

By 1409 Francesco had returned to Siena, where he is documented carving four wooden statues of the city's patron saints. Three bust-length fragments of *St Vittorio*, *St Savino* and *St Crescenzio* (all Siena, Mus. Opera Duomo) survive, and they reveal an artist with a refined and sensitive manner best seen in the delicate treatment of the facial features. Francesco helped Jacopo della Quercia to buy marble for the Loggia di Mercanzia (Loggia di San Paolo), Siena, and it has also been suggested that he contributed to the decoration of the Fonte Gaia; the *Rhea Silvia* (*c.* 1416–18) has been attributed to him. He may have also aided della Quercia in his capacity as the official (1409–

22) in charge of the water pipes that service the fountains of Siena. Francesco held several political offices including *gonfaloniere* and *consigliere* (1411 and 1412) and was elected to the Priore in 1415 and 1435.

Although Francesco was a capable marble worker, his best works are polychromed wooden sculptures, a medium that enjoyed a considerable vogue among Sienese sculptors. *St Stephen* (Empoli, Mus. S Andrea) and *St Ansano* (Lucca, SS Simone e Guida) are both depicted as pensive, introspective figures. A number of wooden Annunciation groups have been attributed to Francesco (San Quirico, S Maria in Vitaleta; Munich, Bayer. Nmus.; Amsterdam, Rijksmus.); the most accomplished in the emotional interaction of the figures and their fluid linear rhythms and grace are the *Virgin Annunciate* and the *Angel Gabriel* (Asciano, Mus. A. Sacra). It has been suggested that an equestrian statue of *St Ansano* (San Cassiano in Controne, Pieve) was either a collaborative work between Jacopo della Quercia (horse) and Francesco (saint; see Freytag) or the work of della Quercia alone (Middeldorf). A date of the mid-1420s (Del Bravo) seems more plausible than the traditional dating of 1406–7.

BIBLIOGRAPHY

Thieme–Becker

G. Milanesi: *Documenti per la storia dell'arte senese*, 3 vols (Siena, 1854–6)

P. Bacci: *Francesco di Valdambrino: Emulo del Ghiberti* (Siena, 1936)

C. L. Ragghianti: 'Su Francesco di Valdambrino', *Crit. A.*, iii (1938), pp. 136–43

E. Carli: *Scultura lignea senese* (Milan, 1951)

C. Del Bravo: *Scultura senese del quattrocento* (Florence, 1970)

C. Freytag: 'Beiträge zum Werk des Francesco di Valdambrino', *Pantheon*, xxix (1971), pp. 363–78

A. Bagnoli: 'Francesco di Valdambrino', *Jacopo della Quercia nell'arte del suo tempo* (Florence, 1975), pp. 120–35

U. Middeldorf: 'Due problemi quereschi', *Jacopo della Quercia fra gotico e rinascimento* (Florence, 1977), pp. 147–9

E. Carli: *Gli scultori senesi* (Milan, 1980)

M. Paoli: 'Un nuova opera documentata di Francesco di Valdambrino', *Paragone*, xxxii (1981), pp. 66–77

M. Burresi: 'Incrementi di Francesco di Valdambrino', *Crit. A.*, 4th ser., l/6 (1985), pp. 49–59

B. Montuschi Simboli: 'La quattrocentesca Madonna di Croce Coperta a Lugo', *Romagna A. & Stor.*, xv/44 (1995), pp. 5–14

ELINOR M. RICHTER

Franchi, Rossello di Jacopo (*b* ?Florence, 1377; *d* Florence, 10 Aug 1456). Italian painter and illuminator. He was possibly a pupil of Mariotto di Nardo, matriculating in the Guild of St Luke in 1424. He filed a joint tax return with his brother Giunta di Jacopo (*b* 1379) in 1427 in which he claimed that he was not practising his art since he had 'nothing to do'. He was documented in 1429 as involved in illumination. In 1433 he painted 12 figures of *Apostles* for Florence Cathedral with Bicci di Lorenzo and Lippo di Corso (1357–1404). He worked with Ventura di Moro (*fl* 1416–56) on scenes from the *Life of St Peter Martyr* (1445–6; Florence, Mus. Bigallo). Franchi's dated works include *St Blaise Enthroned* (1408; Florence Cathedral), the *Coronation of the Virgin* (1420; Florence, Accad. B.A. & Liceo A.) and the signed and dated *Coronation of the Virgin* (1439; Siena, Pin. N.), the last showing an interesting iconographical development with the figures of Christ and the Virgin seated as if in a tomb. He was typical of many of the prolific artists of the early 15th century catering for the Florentine art market in producing compositions based on those of the better-known masters

of his day. His style is close to that of Bicci di Lorenzo and Lorenzo Monaco, although his drapery is slightly more agitated and he does not carry through Monaco's sophisticated treatment of space. His quite strongly modelled figures are often set against flat, decorated backgrounds that negate their plasticity. However, the strongly illusionistic frescoes of a *Male Saint* and *St Lucy* (both Florence, S Miniato al Monte) are more powerful.

BIBLIOGRAPHY
C. Pini and G. Milanesi: *La scrittura di artisti italiani (sec. XIV–XVII): Riprodotta on la topografia da Carlo Pini e correda di notizie da Gaetano Milanesi* (Florence, 1876)
U. Procacci: 'Di Jacopo di Antonio e delle compagnie di pittori del corso degli Adimari nel XV secolo', *Riv. A.*, xxxv (1960), pp. 3–70 (52 n. 99)
B. Berenson: *Central and North Italian Schools* (1968)
R. Fremantle: *Florentine Gothic Painters from Giotto to Masaccio: A Guide to Painting in and near Florence, 1300 to 1450* (London, 1975)
F. Petrucci: 'Franchi, Rossello di Jacopo', *La pittura in Italia: Il Quattrocento*, ii (Milan, 1987), pp. 627–8

ANABEL THOMAS

Francia [Raibolini]. Italian family of painters and goldsmiths. They worked mainly in and near Bologna. (1) Francesco Francia was the son of a carpenter. He had two sons, (2) Giacomo Francia and Giulio Francia (*b* Bologna, 20 Aug 1487; *d* Bologna, 22 Jan 1545).

(1) Francesco Francia [Raibolini] [il Francia] (*b* Bologna, *c.* 1450; *d* Bologna, 1517). He turned to painting *c.* 1485, and his first works already testify to the considerable technical accomplishment and gentle religious sensibility that remained constants of his art. His major surviving paintings are altarpieces, mostly images of the Virgin and saints, initially done for Bologna and later for nearby centres, notably Parma, Modena, Ferrara and Lucca. He also painted many small-scale devotional works and a few portraits. The apocryphal anecdote reported by Vasari that Francia died on seeing Raphael's altarpiece of *St Cecilia* (Bologna, Pin. N.) is emblematic of the change in taste that suddenly made his art—like that of Perugino——look old-fashioned.

1. Before 1500. 2. 1500–06. 3. After 1506.

1. BEFORE 1500. Francia trained as a jeweller and goldsmith. Unlike other 15th-century artists who trained as goldsmiths, such as Ghiberti and Verrocchio, he did not use this craft apprenticeship simply as a step towards artistic work of higher status. He signed his pictures *Aurifex* (goldsmith) to the last and frequently served as an officer of the goldsmiths' guild. He was also in charge of the Bolognese mint under the Bentivoglio family and later under Pope Julius II. A number of coins designed by him survive, as do niello paxes of the *Crucifixion* (*c.* 1488–90) and the *Resurrection* (*c.* 1500; both Bologna, Pin. N.), which are adorned with the coats of arms of prominent families and appear to commemorate marriages. The *Crucifixion* was probably a wedding present from Giovanni II Bentivoglio to his bride, Ginevra Sforza; the *Resurrection* must date from *c.* 1481, the year Bartolomeo Felicini married Dorotea Ringhieri. A third silver pax (untraced) was executed at immense expense for Giovanni Sforza and his wife, Lucrezia Borgia.

In his generally well-informed account of Francia's life, Vasari stated that his first painting was the altarpiece of the *Virgin and Child* (main panel and *Pietà*, Bologna, Pin. N.; *Nativity*, Glasgow A.G. & Mus.; *Baptism*, Lisbon, Fund. Gulbenkian; *St Francis*, London, Colnaghi's) painted in 1490 for the chapel of Bartolomeo Felicini in S Maria della Misericordia, near Bologna. However, stylistic evidence suggests this is not the case, and the work is now dated 1494. (The picture was retouched and the figures of SS Proculus and Monica added, possibly by (2) Giacomo Francia.) A sharper, more chiselled style is evident in three small-scale paintings, which may be earlier. All appear to have belonged to the Bolognese humanist Bartolomeo Bianchini (*b c.* 1480; *d* before 1528). The first, the *Crucifixion with SS John the Evangelist and Jerome* (Bologna, Pal. Com.), shows a high degree of influence from the work of Ercole de' Roberti and perhaps that of Francesco del Cossa but is already highly personal in style. Since Francia's paintings were praised by Angelo Michele Salimbeni (*Epitalamii pro nupitali . . .*, Bologna, Bib. U., MS. no. 1491) as early as 1487, a date of *c.* 1485 is plausible. The portrait of *Bartolomeo Bianchini* (see fig. 1) and the *Holy Family* (Berlin, Gemäldegal. Alte Meister) inscribed with Bianchini's name, which may have formed a diptych, cannot be significantly later in date. They reveal the same precision of modelling in the figures and a surface almost like enamel; as with Francia's use of oil paint, which is noted by Vasari, this suggests awareness of northern painting.

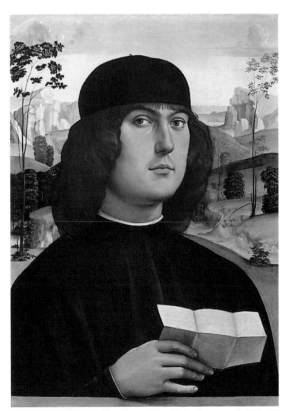

1. Francesco Francia: *Bartolomeo Bianchini*, oil on panel, 565×405 mm, *c.* 1485 (London, National Gallery)

Francia painted another altarpiece, the *Virgin Enthroned with Child, Saints and Two Angels*, *c.* 1494 for the chapel of Giovanni II Bentivoglio in S Giacomo Maggiore, Bologna (*in situ*). Close in style to the works of Lorenzo Costa (i), who executed frescoes for the chapel, it shows Francia's taste for sweet characterization and balanced composition within a classicizing—but not authentically classical—setting, into which the figures are tightly crowded. The altarpiece of the *Virgin and Child with SS Paul, Francis and the Infant John the Baptist* (Bologna, Pin. N.), which was commissioned by Giovanni Battista Scappi for S Maria della Misericordia, Bologna, must date from soon after 1494; Francia also painted a portrait of *Evangelista Scappi* (Florence, Uffizi). Another Bentivoglio commission of about this date was the *Adoration of the Child* (1498–9; Bologna, Pin. N.) for the high altar of the Misericordia, which originally had Costa's *Adoration of the Magi* (Milan, Brera) as its predella. It depicts the Virgin kneeling and flanked by St Augustine and the patron, Anton Galeazzo Bentivoglio (1472–1525). The standing shepherd sporting a laurel wreath is probably Anton Galeazzo's brother, Alessandro, a poet. A later, simplified version of the composition (Forlì, Pin. Civ.) was painted for Francia's friend Paolo Zambeccari, for whom he also executed frescoes in his palace in Bologna and a *Virgin and Child with St Francis*, dated 1503 (all untraced). The *Virgin and Child with Saints* (Bologna, Pin. N.) for the Manzuoli Chapel in the Misericordia, which shows a more open prospect than its precursors, probably also dates from the last years of the 15th century.

One of Francia's most important commissions for the Bentivoglio, his frescoes for the family palace in Bologna, were destroyed (1507) at the time of their fall. Vasari, who cannot have seen the frescoes, describes a fictive bronze *Disputation of Philosophers* and a *Judith and Holofernes*. A drawing on vellum of *Judith* (best version, New York, Pierpont Morgan Lib.), clearly inspired by Andrea Mantegna's treatments of the theme, may be related, but it does not seem to be for a many-figured composition such as Vasari described. Rather, like a number of mythological and allegorical sheets by Francia (New York, Pierpont Morgan Lib.; Oxford, Ashmolean; Vienna, Albertina) and Mantegna's drawing of *Judith* (1491; Florence, Uffizi), it was probably intended as a work of art in its own right. A fresco fragment (Bologna, Pin. N.) from the site of the Bentivoglio palace supports a date *c.* 1495–1500 for the decoration.

2. 1500–06. Francia's style around 1500 is displayed in the *Virgin and Child with SS Lawrence and Francis* (1500; St Petersburg, Hermitage), with its charming angel musicians. It was painted for the Calcina family as the high altarpiece of S Lorenzo, Bologna. Perugino's *Virgin and Child with Saints* (Bologna, Pin. N.) must have arrived in S Giovanni in Monte around this time, although Francia probably already knew of Perugino's art, since their styles are especially close in this period. Also signed and dated 1500 is the high altarpiece (Bologna, Pin. N.) for SS Annunziata. It portrays an unusually static Virgin Annunciate receiving the swooping Angel Gabriel's salutation, while above, in a mandorla, is the figure of the Christ Child holding a cross. The Virgin is flanked by SS Francis

and Bernardino and SS John the Evangelist and George. The scale of the figures is more monumental than before, and there is a new expansiveness. A variant of the central motif occurs in another altarpiece, the *Virgin with SS Jerome and John the Baptist* (Bologna, Pin. N.), originally in S Girolomo de Miramonte, Bologna. The *St Roch* (see fig. 2), for the Compagnia dei Morti, Bologna, is more animated, but the expressive language is still confined to the hand raised in supplication and the eyes rolled heavenwards. A votive fresco in the Palazzo Comunale, Bologna, dated 1505, the *Madonna del Terremoto*, shows the Virgin hovering over a topographically accurate view of the city (*see* BOLOGNA, fig. 1).

Before their fall, the Bentivoglio helped to fund frescoes for the oratory of S Cecilia, next to their parish church, S Giacomo Maggiore. The most prominent local artists of the period were involved, notably Lorenzo Costa (i) and Amico Aspertini, and each appears to have contributed two frescoes (for illustration *see* ASPERTINI, AMICO: Francia painted the *Marriage of St Cecilia* and the *Burial of St Cecilia c.* 1504–6. The figure of St Cecilia in the *Burial* is based on the figure of Christ in Mantegna's engraving of the *Entombment*, but Francia's approach to narrative is otherwise understated and undramatic. This is equally apparent in such works as the altarpiece of the *Baptism of Christ* (1509) and the predella panel of the *Adoration of the Magi* (after 1500; both Dresden, Gemäldegal. Alte Meister). At this time Francia continued to work predominantly for Bolognese patrons, but his fame had spread,

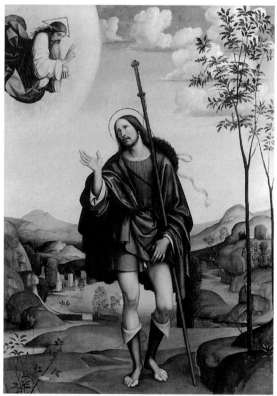

2. Francesco Francia: *St Roch*, tempera on panel, 2.17×1.50 m, 1502 (New York, Metropolitan Museum of Art)

and he was in demand elsewhere for both secular and ecclesiastical commissions. Isabella d'Este was unsuccessful in persuading him to produce a painting for her *studiolo* in the Palazzo Ducale at Mantua. One of his paintings of *Lucretia* (three versions, Dresden, Gemäldegal. Alte Meister; Dublin, N.G.; York, C.A.G.) may be that recorded by Vasari as commissioned for Francesco Maria I della Rovere, Duke of Urbino. For the same patron he also executed a pair of saddles (untraced) representing a *Forest Fire*, which, as described by Vasari, seem uncannily similar to Piero di Cosimo's *Forest Fire* (Oxford, Ashmolean). Francia's *Annunciation* (Milan, Brera) is documented as in progress in the will of Antonio de Grado of 23 August 1505. Commissions for such private devotional works were increasingly important in the final decade of Francia's career.

3. AFTER 1506. With the overthrow of the Bentivoglio in 1506, Francia was obliged to seek work outside Bologna. Vasari noted three altarpieces he painted soon afterwards for Modena. The *Virgin and Child with Saints* (ex-Kaiser-Friedrich Mus., Berlin, destr.), however, was signed and dated 1504, and the *Annunciation with St Albert* (Chantilly, Mus. Condé) is not dated; so only the *Baptism* (1509; Dresden, Gemäldegal. Alte Meister) is definitely dated after the fall of the Bentivoglio. (A fourth Modenese commission is the *Madonna of the Rose-hedge*; Munich, Alte Pin.) The *Annunciation* has a Carmelite connection, as do the *Baptism* (London, Hampton Court, Royal Col.) and the *Entombment with St Hilarion* (Turin, Gal. Sabauda).

Francia's other important monastic patrons were the Benedictines of the Congregation of S Giustina, Parma. According to Vasari, his first commission for them was the *Lamentation* (Parma, G.N.) for S Giovanni Evangelista, Parma, allegedly once dated 1510, followed by a *Virgin with Saints* (untraced) for their house in Reggio Emilia and finally by the *Circumcision* (Cesena, Madonna del Monte). The Reggio Emilia altarpiece may be the *Virgin and Child with the Infant John the Baptist and Benedictine Saints* (1515; Parma, G.N.), which must have been painted for a Benedictine church. It is often suggested that (2) Giacomo Francia and Giulio Francia collaborated on this altarpiece and other late works. These include the *All Saints* (Ferrara Cathedral) and two altarpieces for Lucca, an *Immaculate Conception* based on one by Vincenzo Frediani (1502–3; Lucca, Villa Giunigi) and the *Virgin and Child with St Anne and Saints* (London, N.G.). In addition to these commissions, Francia continued to be in demand in his native Bologna. This is evidenced by such works as the portrait of Isabella d'Este's son, *Federico Gonzaga* (1510; New York, Met.), painted in Bologna while the boy was *en route* to Rome as a papal hostage. If the portrait of *Bishop Altobello Averoldi* (Washington, DC, N.G.A.) dates from 1513, when the sitter served his second term as governor and vice legate of Bologna, it reveals Francia's sustained high reputation. After Francia's death, his sons continued the family business but do not appear to have felt bound to complete paintings he left unfinished. The fascinating hybrid, the *Presentation of the Virgin* (Rome, Pal. Barberini), bears an inscription stating that what Francia left unfinished was completed by Bartolomeo Passarotti.

BIBLIOGRAPHY

G. Vasari: *Vite* (1550, rev. 2/1568); ed. G. Milanesi (1878–85), iii, pp. 533–64
C. G. Malvasia: *Felsina pittrice* (1678); ed. G. Zanotti (1841)
J. A. Calvi: *Memorie della vita e delle opere di Francesco Raibolini detto il Francia* (Bologna, 1812)
G. C. Williamson: *Francesco Raibolini, Called Francia* (London, 1901)
M. Carmichael: *Francia's Masterpiece* (London, 1909)
G. Lipparini: *Francesco Francia* (Bergamo, 1913)
B. Berenson: *Central and North Italian Schools* (1968)
R. Rossi Manaresi and J. Bentini: 'The Felicini Altarpiece by Francesco Francia: Contribution of Technical Analyses to the Solution of a Chronological Problem', *Atti del XXIV Congresso Internazionale di Storia dell'Arte: Bologna, 1979*, pp. 395–409
J. Cartwright: *Mantegna and Francia* (London, 1981), pp. 63–114
Leonardo: Il Codice Hammer e la Mappa di Imola presentati da Carlo Pedretti—Arte e scienza a Bologna in Emilia e Romagna nel primo cinquecento (exh. cat., Bologna, Pal. Podestà, 1985)
C. Dempsey: 'Malvasia and the Problem of the Early Raphael and Bologna', *Stud. Hist. A.*, xvii (1986), pp. 57–70
S. Stagni: 'Francesco Francia', *Pittura bolognese del cinquecento*, ed. V. Fortunati Pietrantonio, i (Bologna, 1986), pp. 1–28
Bologna e l'umanesimo, 1490–1510 (exh. cat., ed. M. Faietti and K. Oberhuber; Bologna, Pin. N., 1988)
Colnaghi Master Paintings, 1400–1850 (exh. cat., London, Colnaghi's, 1991), pp. 24–7, no. 5

DAVID EKSERDJIAN

(2) Giacomo Francia [Raibolini] (*b* Bologna, *c.* 1486; *d* Bologna, 3 Jan 1557). Son of (1) Francesco Francia. He was trained by his father in painting and goldsmithing. In 1517, the year of his father's death, he and his brother, Giulio, assumed responsibility for the family business and together executed many altarpieces, identifiable by the initials (I I) of their latinized names (Iacobus and Iulius). Giacomo's earliest known work is the *Virgin in Glory with SS Peter, Mary Magdalene, Francis, Martha and Six Nuns* (after 1515; Bologna, Pin. N.). In this painting, as in the *SS Jerome, Margaret and Francis* (1518; Madrid, Prado) and the *Nativity* (1519; Parma, S Giovanni Evangelista), both dated and signed by both brothers, there appear, in addition to the influence of their father, echoes of the monumental style of Raphael.

In the early 1520s Giacomo painted, again in collaboration with Giulio, the *Deposition* (Bologna, Pin. N.), the *Crucifixion* (Bologna, S Stefano) and *God the Father with Angels* (Bologna, S Petronio). During this period Giacomo probably went to Florence and perhaps to Rome. He was also influenced by contemporary Ferrarese painting, especially in the imaginary landscape backgrounds to several of his works from this period, such as the *Virgin and Child with SS Paul, Mary Magdalene and the Infant John the Baptist* (Bologna, Pin. N.) and *St Michael with SS Dominic and Francis* (Bologna, S Domenico). The Ferrarese influence is also evident in works from the same period executed with his brother. The fresco depicting the *Nativity* (Bologna, SS Vitale e Agricola) also dates from this period. With these works of the 1520s Giacomo reached his full artistic maturity.

Another altarpiece signed by both brothers, depicting *St Frediano with SS James, Lucy, Ursula and a Blessed Person* (*c.* 1530; Bologna, Pin. N.), repeats the compositional structure of Raphael's *St Cecilia in Ecstasy* (Bologna, Pin. N.) and conveys a certain severity in the powerful monumentality of the figures. The same grandiose modelling characterizes a slightly later work, by Giacomo alone, the *Virgin and Child with the Infant St John the Baptist, SS*

Francis, Dominic, Mary Magdalene and Agnes (Berlin, Gemäldegal.), but here the greater elegance of the elongated figures with their balanced, graceful movements was inspired by the refined style of Parmigianino, who was in Bologna from 1527 to 1530. It is significant that at this point Giacomo abandoned the Ferrarese landscapes typical of his works of the early 1520s.

A banner depicting the *Virgin and Child with SS Sebastian, Joseph and the Infant St John the Baptist* (1535; Fuipiano, near Bergamo, parish church) concludes the experimental phase when Giacomo was open to the influence of the dominant artistic trends. Thereafter he limited himself to the reworking of old-fashioned and well-used designs and forms, probably as a consequence of the spread of the difficult Mannerist style. He produced compositionally repetitive works (e.g. *Virgin and Child with SS Gervasio, Protasio, Catherine, Justine and Four Nuns*, 1544; Milan, S Maria di Piazza) based on the centralized Raphaelesque type, combined with an archaizing return to the style of his father. A document of 8 October 1545 records Giacomo as a member of the council of the Compagnia delle Quattro Arti.

Among Giacomo's late works are the *Nativity* (1551; Bologna, S Cristina). In addition to large altarpieces, Giacomo also executed numerous smaller panels for private female convents. Compositionally, these are conventional works that reflect the religious requirements of the patrons. Two of the best examples are the tondo depicting the *Virgin and Child with the Infant St John the Baptist* (Baltimore, MD, Walters A.G.; see fig.) and the *Virgin and Child with SS Lawrence and Gregory* (Philadelphia, PA, Mus. A.). Though a prolific artist, many of his works have been destroyed or lost and are known only from documentary sources.

BIBLIOGRAPHY

Thieme–Becker
G. Vasari: *Vite* (1550; rev. 2/1568); ed. G. Milanesi (1878–85)
C. C. Malvasia: *Felsina pittrice* (1678); ed. G. Zanotti (1841)
——: *Le pitture di Bologna* (Bologna, 1686); ed. A. Emiliani (Bologna, 1969)
A. Venturi: *Storia* (1901–40), VII/iii, pp. 952–73
E. Jacobsen: 'I seguaci del Francia e del Costa in Bologna', *L'Arte*, viii (1905), pp. 81–93
A. Emiliani: *La Pinacoteca Nazionale di Bologna* (Bologna, 1967)
N. Roio: 'Giacomo e Giulio Raibolini detti i Francia', *Pittura bolognese del cinquecento*, ed. V. Fortunati Pietrantonio, i (Bologna, 1986), pp. 29–57

NICOSETTA ROIO

Franciabigio [Francesco di Cristofano Giudicis] (*b* Florence, 30 Jan 1484; *d* Florence, 14 Jan 1525). Italian painter. The son of a Milanese linen-weaver, he had completed his apprenticeship, in Florence, by 18 October 1504. His earliest documented works, for example a *Pietà* (1506) for S Pancrazio, Florence, have not survived. According to Vasari, Franciabigio trained with Mariotto Albertinelli, in whose last work, the signed and dated *Crucifixion* (1506; Florence, Certosa del Galluzzo, Pin.), he painted the angels (Shearman). In December 1508 the names of Franciabigio and Andrea del Sarto, who sometime between autumn 1506 and 1509 set up a joint workshop, were entered in the registration book of the Arte de' Medici e Speziali, to which painters were required to belong. The *Portrait of a Young Man* (Paris, Louvre) dates from this period. The work, which was later enlarged, shows the subject half-length, leaning pensively against a balustrade, with strong areas of shadow around the eyes. This is the first in a series of male portraits typical of Franciabigio: the subjects, each of whom wears a hat, are mostly placed in front of a landscape, with their gaze fixed meditatively or piercingly on the onlooker.

The religious works from this period, such as the *Virgin and Child* (1509; Rome, Pal. Barberini), also show a movement away from the style of Albertinelli and Raffaellino del Garbo and begin to reveal instead the influence of Leonardo, Michelangelo and, especially, Raphael. Yet Franciabigio's connection with Andrea del Sarto was the determining factor in his career. When in 1509 it was del Sarto who received the commission to complete the fresco cycle in the atrium of SS Annunziata, Florence, their relationship altered significantly. They had been regarded as equals, but thereafter del Sarto developed into the more successful and also the more innovative painter, and Franciabigio, who had begun to absorb elements from del Sarto's style, remained in his shadow.

Around 1511 del Sarto and Franciabigio's joint workshop moved to the vicinity of SS Annunziata, and many young artists were associated with it. Franciabigio nonetheless trained two of his brothers, among others, in a separate workshop. In 1513 he finally received a commission for a fresco in the atrium of SS Annunziata, the *Marriage of the Virgin*. In this work he had to compete directly with del Sarto's creations. Vasari described how the affair took a disastrous course when Franciabigio damaged sections of his finished fresco, including the Virgin's face. The monumental conception of the work was new in Florentine art. The temple vestibule in the background, a Classical triumphal arch, takes up half the surface of the painting, but Franciabigio failed to relate it satisfactorily to the figure groups in the foreground. The overall appearance of the work has led to the assumption that Franciabigio was in Rome shortly before (*c.* 1511–12).

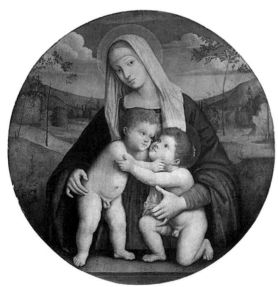

Giacomo Francia: *Virgin and Child with the Infant St John the Baptist*, oil on panel, diam. 880 mm, 1540s (Baltimore, MD, Walters Art Gallery)

The *Portrait of a Young Man* (*c.* 1513; Detroit, MI, Inst. A.), signed with initials, reinforces this supposition. The subject looks back over his shoulder at the onlooker, a pose that by 1513 was already very popular. Perfected by Giorgione in Venice, it had been brought to Raphael in Rome via Sebastiano del Piombo. The signed and dated *Portrait of a Young Man* (1514; Florence, Uffizi) and the *Portrait of a Knight of St John* (London, N.G.) are very similar in terms of composition. The subject of the latter may be Giulio de' Medici, later Pope Clement VII, and the work can be connected with a commission from the Maltese sisters of S Giovanni della Calza, Florence, whose abbess was also a Medici. For the refectory of this convent, Franciabigio painted a *Last Supper* (1514), whose illusionistic windows depicting views of the convent's surroundings are an interesting feature. In the signed and dated panel depicting the *Virgin Enthroned with St John the Baptist and Job* (1516; Florence, Uffizi), the figure of St John, according to Vasari, is a self-portrait by Franciabigio. This panel is very close to del Sarto's style.

From 1515 Franciabigio executed several pictures of the Virgin that echo his own early work, for example the *Madonna del Pozzo* (*c.* 1517–18; Florence, Accad. B.A. & Liceo A.). In 1518–19, with del Sarto away in France, Franciabigio executed two grisailles for the Florentine Chiostro dello Scalzo. He may, however, have followed pre-existent designs for these. He carried out several commissions for the Medici after their return to Florence from exile in 1513. The last of these was for decorations to celebrate the marriage in 1518 of Lorenzo de' Medici, Duke of Urbino. When Pope Leo X arranged for the magnificent interior decoration of Poggio a Caiano, the villa his father Lorenzo the Magnificent had bought in 1479, Franciabigio was employed to decorate the ceiling in the *salone* in collaboration with the stuccoist Andrea Feltrini. Franciabigio followed this with a fresco of the *Triumph of Cicero* (*c.* 1520–21), one of his major works, a theme related to Medici rule and one well suited to exploit his inclinations towards drama and rhetoric.

Franciabigio had probably made a second visit to Rome *c.* 1519 in connection with this commission. At any rate, the portrait of *Jacopo Cennini* (London, Hampton Court, Royal Col.; see fig.), signed with a monogram, is contemporary with the frescoes at Poggio a Caiano and shows the influence of Roman portraiture of the period. The sitter was identified by Vasari as a steward of the Medici, and the picture itself offers several pointers to this, notably the coat of arms, the keys and the laurel. The broken laurel stem probably alludes to the deaths of Giuliano de' Medici, Duc de Nemours (1516), and Lorenzo, Duke of Urbino (1519), which suggests a date of composition after May 1519. The steward, shown in a neglected state with an open collar, pauses at the beginning of a new line and looks out of the picture with a worried expression.

The *Story of Bathsheba* (1523; Dresden, Gemäldegal. Alte Meister) is Franciabigio's best-known late work. The main point of interest resides in the unusual bathing scene. The bath is shown as a baptismal font, which fits with the pose of the serving girl to the right of Bathsheba. The daring pose of the figure on the left at the edge of the fountain recalls Michelangelo's *Ignudi* and the prophet Jonah from the Sistine Chapel ceiling (see colour pl. 2,

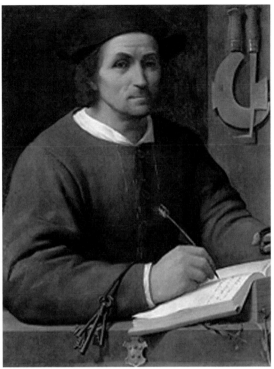

Franciabigio: *Jacopo Cennini*, oil on panel, 650×489 mm, *c.* 1520 (London, Hampton Court, Royal Collection)

VI2). Franciabigio's last work, according to Vasari, was a *Noli me tangere* (before 1525; Florence, Mus. Horne) frescoed for the house of a friend who was a linen-weaver. After this, Vasari stated, he died of an illness brought on by plague fever.

BIBLIOGRAPHY

Thieme–Becker

G. Vasari: *Vite* (1550, rev. 2/1568); ed. G. Milanesi (1878–85), v, pp. 189–200

S. J. Freedberg: *Andrea del Sarto*, 2 vols (Cambridge, MA, 1963)

J. Shearman: *Andrea del Sarto*, 2 vols (Oxford, 1965)

B. Berenson: *Central and North Italian Schools* (1968)

M. Winner: 'Cosimo il Vecchio als Cicero: Humanistisches in Franciabigios Fresko zu Poggio a Caiano', *Z. Kstgesch.*, xxxiii/4 (1970), pp. 261–97

S. Regan McKillop: *Franciabigio* (Berkeley, Los Angeles and London, 1974)

L. Pagnotta: 'Franciabigio', *La pittura in Italia: Il cinquecento*, ed. F. Zeri, ii (Milan, 1987) [lists pubns since 1974]

S. Padovani: 'Andrea dell Sarto: Ipotesi per gli inizi', *A. Crist.*, lxxii (1988), pp. 197–216

ANDREW JOHN MARTIN

Francione [Francesco di Giovanni] (*b* 1428; *d* Florence, 25 July 1495). Italian carpenter and architect. Most of his work was in Florence or on Florentine territory, although he may have worked on the tomb of *Pope Calixtus III* (*reg* 1455–8) at St Peter's, Rome. He was responsible for intarsia decorations for interiors such as Pisa Cathedral (1461–74), where he also worked on the coffered ceilings (destr. 1595) and the audience chamber in the Palazzo Vecchio, Florence (1475–80).

Francione also made architectural models (all untraced). Vasari mentioned one for the villa at Poggio a Caiano, which was ultimately built (*c.* 1483) to a design by Francione's pupil Giuliano da Sangallo. Francione also

made a model of SS Flora and Lucilla (1470), Arezzo, with Giuliano da Maiano and one for the competition for the façade of Florence Cathedral (1491). His model (1493) for the vaulting in the vestibule of Santo Spirito, Florence, was done to the design of Giuliano da Sangallo and Cronaca. As a military architect, Francione contributed to the development of the bastion. He served at the sack of Volterra (1472) and was subsequently responsible for rebuilding sections of the fortress, where his large, low, round bastions show an early architectural response to cannon. He was later active as military architect at Pietrasanta (1484–5), Sarzana (1487) and Sarzanello (1492–5), where he mixed round and polygonal bastions.

Francione's workshop on the Via de' Servi, Florence, was a training ground for some of the most important architects, engineers and woodworkers of the time. Among his pupils and collaborators were Giuliano and Antonio da Sangallo (i), Baccio Pontelli, Baccio d'Agnolo, La Cecca (1447–c. 1488) and Giuliano and Benedetto da Maiano.

BIBLIOGRAPHY

Thieme–Becker

G. Marchini: *Giuliano da Sangallo*, 2 vols (Florence, 1942)

P. Voit: 'Una bottega in Via dei Servi', *Acta Hist. A. Acad. Sci. Hung.*, vii (1961), pp. 197–228

J. R. Hale: 'The Early Development of the Bastion: An Italian Chronology c. 1450–c. 1534', *Europe in the Late Middle Ages*, ed. J. R. Hale, J. R. L. Highfield and B. Smalley (London, 1965), pp. 466–94

D. Lamberini: 'Architetti e architettura militare per il Magnifico', *Lorenzo il Magnifico e il suo mondo: Convegno internazionale di studi: Florence, 1992*, pp. 407–25

NICHOLAS ADAMS

Franco, (Giovanni) Battista [Baptista Veneziano; il Semolei] (*b* Venice, ?1510; *d* Venice, 1561). Italian painter, printmaker and draughtsman. Giorgio Vasari, who knew Franco well and who is the chief source for his life, claimed that Franco was born in 1498; however, later writers placed his birth in 1510, and the latter date seems more likely. Although Venetian by birth, by the age of 20 Franco was in Rome, where he devoted himself to making drawings after the Antique and particularly after the works of Michelangelo; he was one of the first to copy the frescoes in the Sistine Chapel. At this date he invariably worked in pen and made no original drawings. However, he subsequently made his own, more spontaneous studies, such as the *Man in a Cloak* (*c.* 1557–61; London, BM), in pen and wash over black chalk, and a total of about 100 drawings by his hand are now known. He also made many prints, often combining etching with engraving, as in *St Jerome* (*c.* 1554), printed from an enormous single plate (872×480 mm), showing an energetic, muscular saint at his devotions. Luigi Lanzi claimed that Franco was the master of Federico Barocci.

Franco first started to paint when Raffaelle da Montelupo secured him a commission to paint decorations on the Ponte Sant'Angelo for the triumphal entry of Emperor Charles V (*reg* 1519–56) into Rome on 5 April 1536. At the same time he frescoed the Porta San Sebastiano with scenes of ancient Roman history in grisaille. Later the same month he travelled to Florence to work on decorations for the Emperor's entry there; he also collaborated with Vasari on the decoration of Palazzo Medici for the arrival of Margaret of Austria, the future wife of Duke Alessandro de' Medici, in June 1536. While making draw-

ings after Michelangelo's Medici tombs in S Lorenzo, Florence, he met Bartolomeo Ammanati, who later housed Franco and Bartolommeo della Gatta at Urbino.

After Duke Alessandro's assassination (1537), his successor, Cosimo de' Medici, made Franco his personal painter and commissioned him to paint a triple portrait of *Pope Clement VII, Cardinal Ippolito de' Medici and Duke Alessandro de' Medici* (untraced). Franco based the likenesses on portraits by Sebastiano del Piombo, Titian and Jacopo Pontormo respectively (Vasari). He also made a painted copy (Florence, Casa Buonarroti) after Michelangelo's cartoon of *Noli me tangere* (untraced), then in the Medici collection. Also for Cosimo he painted the *Allegory of the Battle of Montemurlo* (Florence, Pitti), a badly organized composition, with figures directly copied from Michelangelo's design of the *Rape of Ganymede*. In June of 1539 he decorated a triumphal arch (destr.) at the Porta al Prato, Florence, for the wedding of the Duke to Eleonora of Toledo. Together with Ridolfo Ghirlandaio and Michele Tosini, he frescoed the cloister of the Madonna delle Vertighe near Monte Sansavino in the Valdichiana with scenes from the *Life of St Joseph* in grisaille.

By 1541 Franco was back in Rome, where he copied Michelangelo's *Last Judgement* (see colour pl. 2, VII3) soon after its unveiling in October. He also frescoed the loggia of the palace (destr.) of Cardinal Francesco Cornaro. His fresco of the *Arrest of St John the Baptist* (*c.* 1541–5) in S Giovanni Decollato, Rome, was described by Vasari as ill-proportioned and badly coloured. It is composed of elements taken from Michelangelo's works combined without thought of context or dramatic significance.

In 1545–6 Franco frescoed the vault of the choir of Urbino Cathedral with the *Assumption of the Virgin* (destr.); the work disappointed Guidobaldo II della Rovere, Duke of Urbino, because it failed to equal the quality of Franco's preparatory drawings, and he delayed its payment. Thinking Franco's skills were better suited to working on a small scale, the Duke commissioned him to make designs for maiolica produced at Casteldurante; a typical example is a plate with *Moses Striking the Rock* (London, V&A).

On 15 September 1547, Franco was commissioned to paint 14 small panels of scenes from the *Life of Christ* for Osimo Cathedral; although heavily dependent on Michelangelo, he tried to create dramatic effects through his use of light. In early 1548, Franco made decorations for the entry into Urbino of Guidobaldo and Vittoria Farnese after their wedding (Feb 1548); he then painted a Raphaelesque altarpiece of the *Virgin and Child with Saints* for S Venanzio, Fabriano (*in situ*); after returning to Rome with Ammanati, *c.* 1549, he painted scenery for the company of actors of the poet Giovanni Andrea dell'Anguillara. In 1550, with Girolamo Siciolante, he decorated the façade of the palace of Cardinal Federico Cesi with the coat of arms of Julius III (destr.); the same year he painted a fresco cycle of scenes from the *Life of the Virgin*, figures of prophets and sibyls, and the *Crucifixion* in S Maria sopra Minerva.

After another period in Urbino, Franco returned to his native Venice, probably *c.* 1552, certainly by 1554. There he rapidly assimilated Venetian techniques in his use of light and colour, while retaining something of the monu-

mental figure style of Michelangelo. Although Vasari considered Franco to be an important exponent of Roman *disegno* in Venice, his influence on local painters was not very strong. The altarpiece of the *Baptism* (see fig.) was painted for the family chapel of Ermolao Barbaro, the Patriarch of Aquileia, in S Francesco della Vigna. The large scale of the figures and their rhetorical gestures still owe something to Michelangelo, but the use of line is less harsh than in his earlier works; in two preliminary drawings (both Edinburgh, N.G.) he used a soft chiaroscuro to create light effects. Several other Venetian works, including a *Virgin and Child* in S Giobbe, have been lost.

Franco also did decorative painting in Venice: he painted the stuccowork designed by Alessandro Vittoria on the Scala d'Oro (destr.) in the Doge's Palace; and for the Libreria Marciana from 1556 onwards, he painted ceiling tondi of allegorical subjects and two *Philosophers* on the walls, for which the British Museum *Man in a Cloak* may have been a study. He also painted 48 panels on the ceiling of the Sala dell'Estate (destr.) of the Fondaco dei Tedeschi (6 preserved, Venice, Correr) and the Sala delle Mariegole in the Procuratie Nuove. A lunette in the *salone* of the Palazzo Grimani at S Maria Formosa is also attributed to him. Finally, he decorated several buildings designed by Andrea Palladio, including the Palazzo Chiericati, Vicenza,

and the Villa Malcontenta. His last work, like the Villa Malcontenta left unfinished at his death, was the decoration of the Grimani Chapel in S Francesco della Vigna, Venice, for the patriarch Giovanni Grimani; there he frescoed the vault with Virtues and angels in geometric compartments divided by elaborate stucco decoration, a selfconsciously Roman, classicizing work. The decoration was completed by Federico Zuccaro.

BIBLIOGRAPHY

Bolaffi; Thieme–Becker

G. Vasari: *Vite* (1550, rev. 2/1568); ed. G. Milanesi (1878–85), vi, p. 571

B. Berenson: *The Drawings of the Florentine Painters*, 2 vols (London, 1903, rev. 2/Chicago, 1938)

M. Pittaluga: *L'incisione italiana nel cinquecento* (Milan, 1930)

W. R. Rearick: 'Battista Franco and the Grimani Chapel', *Saggi & Mem. Stor. A.*, ii (1958–9), pp. 105–39

N. Ivanoff: 'La Scala d'Oro del Palazzo Ducale di Venezia', *Crit. A.*, viii (1961), pp. 27–41

L. S. Richards: 'Drawings by Battista Franco', *Bull. Cleveland Mus. A.* (1965), pp. 107–12

S. J. Freedberg: *Painting in Italy, 1500–1600*, Pelican Hist. A. (Harmondsworth, 1971, rev. 2/1983), pp. 484–6, 494, 539, 632, 714

L. Grumiero Salomoni: 'Battista Franco nelle Marche', *A. Ven.*, xxvi (1972), pp. 237–45

J. Lessman: 'Battista Franco disegnatore di maioliche', *Faenza*, ii (1976), pp. 27ff

H. Zerner: *Italian Artists of the Sixteenth Century: Palma, Rota, School of Fontainebleau*, 33 [XVI/ii] of *The Illustrated Bartsch*, ed. W. Strauss (New York, 1978–9), pp. 156–258

Palladio e la Maniera (exh. cat. by V. Sgarbi, Vicenza, S Corona, 1980)

J. A. Gere and P. Pouncey: *Italian Drawings in the Department of Prints and Drawings in the British Museum: Artists Working in Rome, c. 1550 to c. 1640*, London, BM cat., 2 vols (London, 1983), pp. 80–94

R. P. Baudille: 'Disegni di Battista Franco per incisioni', *A. Doc.*, viii (1994), pp. 89–100

——: 'Disegni di Battista Franco per opera marchigiane', *Disegni marchigiani dal cinquecento al settecento. Atti del convegno: Il disegno antico nelle Marche e dalle Marche: Monte San Giusto, 1992*, pp. 31–41

G. J. Van der Smann: 'Il percorso stilistico di Battista Franco incisore: Elementi per una ricostruzione', *A. Doc.*, viii (1994), pp. 101–14

C. Monbeig Goguel: 'Battista Franco et l'heritage de Rosso', *Pontormo e Rosso*, ed. R. P. Ciardi and A. Natali (Venice, 1996), pp. 17–58

A. C. Lauder: 'Un nuovo disegno di Battista Franco per il *Battesimo di Cristo* della cappella Barbaro', *A. Ven.*, l (1997), pp. 98–107

——: 'Absorption and Interpretation: Michelangelo through the Eyes of a Venetian Follower, Battista Franco', *Michelangelo and his Influence: Challenge and Response* (in preparation)

MARIA SICA

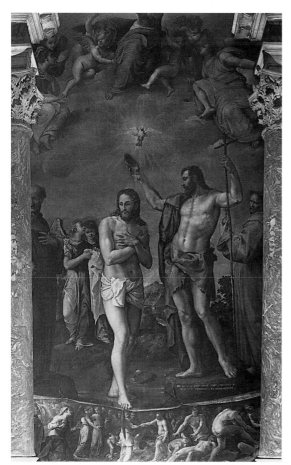

Battista Franco: *Baptism*, oil on panel, 3.4×1.9 m, *c.* 1555 (Venice, S Francesco della Vigna)

Franco dei Russi [Rossi] (*b* ?Mantua; *fl c.* 1453–82). Italian illuminator. Although he may have been in Ferrara as early as 1453, he is first unambiguously recorded in 1455, in the contract for the sumptuously decorated Bible of Borso d'Este (1455–61; Modena, Bib. Estense, MS. V.G. 12, lat. 422–3). Este court records refer to Franco 'da Mantova', but it is not obvious where he received his earliest training. His early style, in the Bible illuminations, reveals a certain courtly quality and naturalism of detail associated with a Lombard background, but these characteristics are tempered by a degree of sobriety. Figures tend to be large-scale, their heavy garments falling in long, straight patterns or gathered into broader, broken folds. Landscapes are schematic and airless, often marked by relatively dense foliage and wavelike hills. His palette is cool and opaque.

It is generally agreed that Franco left Ferrara early in the 1460s to work in the Veneto, where he remained until 1471 or 1472. During this decade his style changed decisively, taking on the humanistic tone, crispness of

figural definition, colour saturation and hardness of landscape forms typical of Andrea Mantegna. While working in the Veneto, Franco may also have played a role in the development of the architectural frontispiece. This motif appears in a copy of Bernardo Bembo's *Oratio gratulatoria* for Doge Cristoforo Moro (London, BL, Add. MS. 14787, fol. 6*v*). Autograph images that most clearly define Franco's style in the 1460s and very early 1470s include a cutting representing the triumph of a scholar or humanist (London, BL, Add. MS. 20916, fol. 1*v*) and the frontispiece of a copy of the Bible in Italian printed in Venice in 1471 by Vindelinus de Spira (Wolfenbüttel, Herzog August Bib., Cod. Slg 151, 2°, vol. i, fol. 1*v*).

In the early 1470s Franco moved to Urbino; he has been identified as the illuminator 'maestro francho da ferara' recorded as a member of the household of Federigo II da Montefeltro in a list prepared after the Duke's death in 1482. Franco was probably one of the illuminators of a copy of Dante's *Divine Comedy* executed for Federigo between 1474 and 1482 (Rome, Vatican, Bib. Apostolica, MS. Urb. Lat. 365).

BIBLIOGRAPHY

M. Bonicatti: 'Aspetti dell'illustrazione del libro nell'ambiente padovano del secondo "400"', *Riv. A.*, xxxii (1957), pp. 107–49
M. Levi D'Ancona: 'Contributi al problema di Franco dei Russi', *Commentari*, xi (1960), pp. 33–45
G. Mariani Canova: *La miniatura veneta del rinascimento, 1450–1500* (Venice, 1969)
G. M. Canova: 'La comittenza dei codici miniati alla corte estense al tempo di Leonello e di Borso', *Muse e il principe: Arte di corte nel rinascimento padano* (exh. cat., Milan, Mus. Poldi Pezzoli, 1991), pp. 87–117
H. J. Hermann: *La miniatura estense* (Modena, 1994)
The Painted Page: Italian Renaissance Book Illumination, 1450–1550 (exh. cat., ed. J. J. G. Alexander; London, RA, 1994)
F. Toniolo: 'Taddeo Crivelli: Il maggior miniatore della Bibbia di Borso d'Este: A Fifteenth-century Illuminated Manuscript from Ferrara', *Boll. A.*, lxxx (1995), pp. 159–80
U. Bauer-Eberhardt: 'Zur ferraresischen Buchmalerei unter Borso d'Este: Taddeo Crivelli, Giorgio d'Alemagna, Leonardo Bellini und Franco dei Russi', *Pantheon*, lv (1997), pp. 32–45
La miniature a Ferrara: Dal tempo di Cosme Tura all'eredità di Ercole de' Roberti (exh. cat., Ferrara, Pal. Schifanoia, 1998)

CHARLES M. ROSENBERG

Francucci, Innocenzo. *See* INNOCENZO DA IMOLA.

Frascati. Italian hill town near the ancient settlement of Tusculum, about 21.5 km south-east of Rome, noted for its many fine villas. Tusculum was an ancient town in the Alban Hills occupied by the Romans in 381 BC. Towards the end of the Republican period, the vicinity of Tusculum was the site of numerous villas of famous Romans, including Cato, Lucullus and Cicero; the latter's *Tusculan Disputations* is set at his villa there. Tusculum was destroyed in 1191 under Pope Celestine III, and Frascati, set below it at the foot of the Alban Hills, subsequently became the favourite location for *villeggiatura* or country living for the urban Romans.

In 1537, during the reign of Pope Paul III, the papacy re-acquired feudal rights to the territory of Tusculum from the Colonna family. From 1538 to 1545 the papal architect Jacopo Melighino renovated the walls, piazzas and streets of Frascati, and in 1549 the Pope issued a medal inscribed *Tuscolo rest[ituto]* in honour of the renovation. As a result of Paul III's enjoyment of summer stays at Frascati, having visited it every year since the spring of 1536, his courtiers soon emulated him, buying or renting country houses or vineyards there. In May 1548 Monsignor Alessandro Rufini, Bishop of Melfi, bought land where he built the Villa Rufina, also commemorated on the papal medal of 1549. The building, designed by Nanni di Baccio Bigio, was originally designed as a symmetrical, four-tower structure with loggias on the ground floor between the corner towers on two sides. The loggia on the north side looked out over the flat plain of the Campagna below the hillside with a magnificent distant view of Rome. This siting is typical of later villas in the area.

Soon after 1551 Nanni began another, more modest villa, the Villa Ricci (later Villa Tusculana), east of the town for Cardinal Giovanni Ricci of Montepulciano (1497–1574). Cardinal Ranuccio Farnese began in 1560 to purchase land near the Villa Ricci and in 1562 added the villa itself to his holdings with the intention of developing a large estate there. Meanwhile, in 1560 Pier Antonio Contugi, physician to Pius IV, acquired land west of the Villa Rufina and erected a small villa, Villa Contugi, which later became the nucleus of the splendid Villa Aldobrandini. Similarly, Annibal Caro in 1563 bought land west of Frascati that he claimed was the site of the ancient Roman villa of Lucullus. There Caro built a small *casino*, the Caravilla (later Villa Torlonia), and personally laid out a small ornamental garden.

Bishop Rufini sold the Villa Rufina in 1563 to the Cenci family and in the following year began a new *casino* on land given to his family just above his former residence. It was named the Villa Rufinella and was acquired in 1581 by Cardinal Guido Ferreri. The scarcity of water that plagued all these villas during the 16th century is illustrated by the violent reaction of Ferreri's neighbour, Paolo Sforza, to the small fountains Ferreri created for his gardens. Convinced that Ferreri had diverted water from the Sforza holdings, Sforza ordered that the Ferreri fountains be destroyed. Gregory XIII resolved the argument by ordering Sforza to restore the fountains under the threat of a heavy fine.

A more expansive building campaign began at Frascati following the purchase in 1567 by Cardinal Marcus Sitticus Altemps (1533–95), nephew of Pius IV, of the Villa Ricci. Jacopo Vignola enlarged the old villa in 1569, more than doubling its interior space by giving it a large central salon flanked by two smaller identical apartments. It was renamed the Villa Tusculana and was regularly visited by Gregory XIII. In order to provide increased accommodation for the papal entourage, Cardinal Altemps acquired more land above his villa and employed Martino I Longhi to erect a larger villa (1573–4). It was named Mondragone in honour of the Pope, whose coat of arms featured a dragon. The new building, like the earlier ones, faced north with a distant prospect of Rome from the terraces in front of it. The interior repeated Vignola's arrangement at the Villa Tusculana, with a large central salon—in this case, two storeys in height—flanked by two apartments, one on the east side for the Pope and another on the west for the Cardinal, each with its own private garden. Altemps also had a small palace, called the Retirata, built in 1574–9 behind the Villa Mondragone for his son. Gregory XIII visited the Villa Mondragone every year of his reign except the last, between four and twelve times a year.

BIBLIOGRAPHY

R. Lanciani: 'La riedificazione di Frascati per opera di Paolo III', *Archv Soc. Roman. Stor. Patria*, xvi (1893), pp. 517–22

F. Grossi-Gondi: *La villa dei Quintili e la villa di Mondragone* (Rome, 1901)

G. M. Andres: 'Cardinal Giovanni Ricci: The Builder from Montepulciano', *Il pensiero italiano del rinascimento e il tempo nostro: Atti del V convegno internazionale del centro di studi umanistici: Firenze, 1970*, pp. 306–8

I. Belli-Barsali and M. G. Branchetti: *Ville della campagna romana* (Milan, 1975)

D. R. Coffin: *The Villa in the Life of Renaissance Rome* (Princeton, 1979)

A. Tantillo Mignosi: *Villa e paese* (Rome, 1980)

M. Valenti: *Via Tuscolana* (Rome, 1995)

DAVID R. COFFIN

Fratina [Fratino], Giovanni. See DEMIO, GIOVANNI.

Frederici, Paolo di Giovanni. See PAOLO DI GIOVANNI FEI.

Frediani, Vincenzo (di Antonio) [Master of the Immaculate Conception] (*fl* Lucca, 1481–1505). Italian painter. The discovery of the contract for a large painting of the *Immaculate Conception* (Tazartes, 1987) has identified Frediani as the painter of a group of paintings formerly attributed to the Master of the Immaculate Conception (Symeonides). He was probably trained in Lucca but in the 1480s fell under the influence of Ghirlandaio, Filippino Lippi and Botticelli. In 1481 he painted an altarpiece (untraced) for the Lucchese merchant Paolo di Serfederigi for his altar in S Agostino, Lucca. The *Virgin and Child Enthroned with SS Nicholas, Dominic, Vincent, Peter Martyr and Two Angels* (ex-Kaiser-Friedrich-Mus., Berlin; destr.) was ordered by Domenico del Voglia in 1482 for his chapel in S Romano, Lucca, and finished before 1485. This painting was previously attributed to another anonymous master, the Buonvisi Painter, and it is possible that other paintings attributed to that Master may be the work of Frediani.

In the 1490s Frediani had an important workshop in Lucca. The *Virgin and Child with Saints* (Lucca, S Eustachio di Montignoso) is dated 1495, and in 1496 he executed paintings (untraced) in the Palazzo degli Anziani, Lucca. The *Virgin and Child with SS Peter and Andrew* (church of Tempagnano di Lunata) and frescoes and an altarpiece for the chapel of the Tertiary Franciscans (Lucca, S Francesco; both destr.) all dated from 1497. In 1502 the Tertiary Franciscans ordered a second, large, altarpiece of the *Immaculate Conception* (Lucca, Villa Guinigi) for S Francesco, Lucca. It was finished in 1503. Its complex iconography, a remarkable piece of Franciscan propaganda, was stipulated in the contract. The *Coronation of the Virgin with Saints* (Lucca, Villa Guinigi), formerly in S Lorenzo ai Servi, almost certainly dates from the same period. The large altarpiece of the *Death and Assumption of the Virgin* (San Maria a Colle, nr Lucca, parish church), dating from the beginning of the 16th century, is stylistically close to Michelangelo di Pietro. In 1505 Frediani started to paint a *Virgin and Child* for S Gennaro at Capannori which was left unfinished at his death and completed by Ranieri di Leonardo da Pisa.

BIBLIOGRAPHY

S. Symeonides: 'An Altarpiece by the Lucchese Master of the Immaculate Conception', *Marsyas*, viii (1957–9), pp. 55–65

E. Fahy: 'A Lucchese Follower of Filippino Lippi', *Paragone*, clxxxv (1965), p. 16

M. Ferretti: 'Percorso lucchese', *An. Scu. Norm. Sup. Pisa*, n.s. 2, v/3 (1975), pp. 1041–3

——: 'Di nuovo sul percorso lucchese', *An. Scu. Norm. Sup. Pisa*, n.s. 2, viii/3 (1978), pp. 1245–7

M. Natale: 'Note sulla pittura lucchese alla fine del quattrocento', *Getty Mus. J.*, viii (1980), pp. 49–51

M. Tazartes: 'Anagrafe lucchese, i: Vincenzo di Antonio Frediani "pictor de Luca": Il Maestro dell'Immacolata Concezione', *Ric. Stor. A.*, xxvi (1985), pp. 4–17

——: 'Nouvelles perspectives sur la peinture lucquoise du quattrocento', *Rev. A.*, lxxv (1987), pp. 29–36

C. Baracchini and others: 'Pittori a Lucca tra '400 e '500', *An. Scu. Norm. Sup. Pisa*, n.s. 2, xvi (1986), pp. 743–824

MAURIZIA TAZARTES

Fresco. Wall painting technique in which pigments are dissolved in water only and then applied to fresh, wet lime plaster (the *intonaco*). As the wall dries, the calcium hydroxide of the plaster combines with carbon dioxide in the atmosphere to form calcium carbonate. During this process the pigments become an integral part of the wall, forming a fine, transparent, vitreous layer on its surface. Fresco is particularly vulnerable to damp and for this reason is suitable only for dry climates.

Fresco painting was technically demanding and was usually carried out on a large scale, so the painter had to be accurate in drawing up his composition and capable of organizing a team of skilled hands, from the masons to the assistant painters who were assigned the less important parts of the work.

1. PREPARATION OF THE WALL. The wall was first carefully brushed and dampened. A layer of coarse plaster with a rough finish (the *arriccio*) was then applied. This could be done several years before the *intonaco*, though if the *arriccio* was old it had to be well brushed and wetted before the *intonaco* was applied. Usually the painting was carried out on the *intonaco*. The plaster of the various layers was composed of slaked lime and an inert filler, such as sand, ground marble or pozzolana (a baked clay of volcanic origin). The proportions were the same for the *arriccio* and the *intonaco*, although for the *arriccio* the aggregate, or filler, was coarse grained, while for the *intonaco* it was fine grained. There were two standard mixes: strong or fat mortar, which was composed of one part lime to two parts filler and tended to crack as it dried, and lean mortar, which had one part lime to three of filler. If a lean mortar contained pozzolana, the proportion could be one part lime to 1.75–2 parts pozzolana. The lime is obtained by firing calcareous rocks, composed largely of calcium carbonate ($CaCo_3$), at a temperature of 850–900 °C. By adding water to the resulting quicklime (CaO), slaked lime (calcium hydroxide, $Ca(OH)_2$) was obtained.

Good slaked lime underwent a long maturing process in vats or pits covered with water—the Romans allowed their lime to mature for at least three years. Microcrystalline limestones produced lean lime, which required less water in its manufacture, while cryptocrystalline or compact limestones produced fat lime, which required more water. The sand (silicon dioxide) had to be sharp sand obtained from a quarry or river, not from the seashore, where it contains salt; the individual grains had to be angular, not rounded, to encourage bonding with the lime. Pozzolana

is found as a natural rock in the regions surrounding Rome and Naples. Violet or black in colour, it produced a compact plaster superior to that obtained from sand or ground marble.

The appearance of the finished fresco depended on the way in which the *intonaco* was applied. Until the 15th century it was worked with a trowel to obtain an almost smooth surface, while from the 16th century, in an attempt to emulate painting on canvas, a rougher texture was created by working up the surface with short strokes of a brush.

2. LAYING OUT AND TRANSFERRING THE COMPOSITION. The vertical, horizontal and diagonal lines of the composition were laid out on the *arriccio* with cords pulled tight and pressed hard against the plaster. The rest of the composition was sketched out in charcoal, which enabled the artist to make corrections as necessary. The definitive design, the SINOPIA, was brushed in and served as a guide for the final execution of the painting. The whole composition was drawn full scale on a CARTOON, which was cut up into sections of varying sizes so the painting could be done piecemeal (*see* §4 below). As each section of the *intonaco* was applied, the design was transferred from the cartoon by POUNCING (see fig. 1) or by running a stylus over the outlines. (In the 14th century the design was transferred by pouncing and then painted in yellow ochre, so the artist could make any necessary adjustments before proceeding.) The lines of painted

1. Fresco of the *Fire in the Borgo* (1517) by followers of Raphael, Stanza dell'Incendio, Vatican, Rome; detail showing pouncing

frames and architectural forms were often incised directly on to the plaster without a cartoon, with the aid of compasses, rulers, set squares and cords pulled taut.

3. PIGMENTS. The range of colours for fresco was restricted to those that could withstand the alkaline action of the lime. Other colours could be used *a secco*, but a good fresco painter used secco colours as little as possible, since they were less durable. Fresco colours included vine black, black earth, ivory black; red ochres (particularly those rich in haematite), cinnabar (which is mixed with white to give a pink flesh colour); yellow ochre, yellow earth, Naples yellow, green earth, umber, raw and burnt sienna; *bianco sangiovanni*; and finally, smalt. All the other traditional colours, including ultramarine, azurite, malachite and erinite, were not suitable for fresco and were therefore applied *a secco*.

The pigments had to be finely ground in water. They could not be mixed on the palette because in drying they altered in tone and intensity and so could not be easily repeated. Instead, the whole range of colours in their various tonal gradations was prepared in advance in sufficient quantities to complete the composition. The colours were then kept in jars of water called *mestiche*. While the work was in progress the colours for each *giornata* (*see* §4 below) were taken from the jars as necessary.

4. APPLICATION OF THE PIGMENTS. The composition was divided into sections that could be worked in one day, called *pontate* or *giornate*. *Pontate* were used in Roman, Byzantine and 13th-century frescoes; they followed the arrangement of the scaffolding (It.: *ponteggio*), so were rectangular in shape and usually fairly large. *Giornate* were occasionally used in Roman murals but only became widespread from the 13th century. They followed outlines in the composition and so were irregular in shape; they were usually applied from top to bottom and from left to right.

Once the design or guidelines of a *giornata* had been traced, work could begin on the painting and could continue for several hours, depending on the climate and the season. The best time to begin painting was two or three hours after the laying down of the *intonaco*; conditions for work were optimum for at least two hours, after which the plaster began to form its crust of calcium carbonate. Work then became increasingly difficult, and the results correspondingly disappointing as the pigment was no longer absorbed. If the plaster was sprayed with water, work could continue for another hour, but during this stage only liquid colours could be used. Finally, when those colours that are mixed with the white pigment *bianco sangiovanni* began to dry and turn whitish in an irregular fashion, work had to cease, and the unpainted plaster was removed with an oblique cut (see fig. 2). This was the moment when highlights were applied, an operation that required experience and dexterity because colours with a green or black base became lighter as they dried, while those containing iron oxides became darker.

Any areas that could not be painted in fresco were done later, when the composition was completely finished and the plaster thoroughly dry. These included colours incom-

2. Fresco of the *Fire in the Borgo* (1517) by followers of Raphael, Stanza dell'Incendio, Vatican, Rome; detail, in raking light, showing the plaster sliced away at the edge of a *giornata*

patible with fresco and figurative motifs that overlapped several *giornate* (lances, festoons, ribbons etc). This operation was carried out *a secco* with pigments bound in adhesive. For each colour, a complementary undercoat was prepared *a fresco*: white for the blues, with shadows in yellow ochre for drapery, and black, red ochre or grey–blue for monochrome backgrounds. Metal leaf enamel —either gold or tin glazed with yellow to imitate gold—was also applied *a secco*, most frequently for armour and decorative motifs. Some gold areas, such as haloes or crowns, may have been raised in relief with a doughy mortar (not too moist) worked with a spatula, a mixture of flour and varnish worked with the tip of a paint brush or a mixture of warm beeswax and resin.

Fresco required no protective or enhancing finish like the varnish that was applied to canvas or panel paintings. Indeed, this would have prevented the formation of the transparent, glassy layer of calcium carbonate that gives fresco painting its characteristic force and beauty, as well as its resilience. Easily subject to decay or change, the organic substances in any such varnish would have compromised both the appearance and the preservation of the painting.

BIBLIOGRAPHY
EARLY SOURCES
C. Cennini: *Il libro dell'arte* (*c.* 1390); Eng. trans. and notes by D. V. Thompson jr as *The Craftsman's Handbook: 'Il libro dell'arte'* (New Haven, 1933/*R* New York, 1954)
G. Vasari: *Vite* (1550, rev. 2/1568); ed. G. Milanesi (1878–85)
G. B. Armenini: *De' veri precetti della pittura* (Ravenna, 1587)
A. Pozzo: 'Breve istruttione per dipingere a fresco', *Prospettiva de' pittori ed architetti* (Rome, 1692)

SPECIALIST STUDIES
R. La Montagne St Hubert: *The Art of Fresco Painting* (Paris, 1923)
R. Mayer: *The Artist's Handbook* (New York, 1940, rev. 4/1982/*R* London, 1987)
Frescoes from Florence (exh. cat. by V. Procacci and others, London, Hayward Gal., 1969)
U. Procacci and L. Guarnieri: *Come nasce un affresco* (Florence, 1975)
G. Botticelli: *Tecnica e restauro delle pitture murali* (Florence, 1980)
G. Ronchetti: *Pittura murale* (Milan, 1983)
E. Borsook and F. Superbi Gioffredi, eds: *Tecnica e stile*, 2 vols (Milan, 1986)

GIANLUIGI COLALUCCI

Friano, Maso da San. *See* SAN FRIANO, MASO DA.

Fruosino, Bartolomeo di. *See* BARTOLOMEO DI FRUOSINO.

Fungai [Fongario; da Fonghaia; Fungari]**, Bernardino** (Cristofano di Nicholo d'Antonio di Pietro) (*b* Siena, *bapt* 14 Sept 1460; *d* Siena, 1516). Italian painter. He is recorded in 1482 as Benvenuto di Giovanni's *garzone* at work on the monochrome frescoes decorating the drum of the cupola of Siena Cathedral. Most scholars have accepted Benvenuto as Fungai's teacher but stress the greater influence of Matteo di Giovanni; other proposals have included Giovanni di Paolo and, following the reattribution of paintings traditionally ascribed to Giacomo Pacchiarotti, Pietro Orioli. Fungai depended heavily on the preceding generation of Sienese painters and was considerably influenced by the contemporary activity of Pietro Perugino, Luca Signorelli and Bernardino Pinturicchio in and around Siena. His works are characterized by the docility of the figures, a keen decorative sensibility in the use of colour and the treatment of drapery and landscape, and a pleasantly engaging narrative skill. Although identification of works from his early career is problematic, a sizeable oeuvre has been ascribed on the basis of a signed and dated altarpiece executed for S Niccolò al Carmine depicting the *Virgin and Child Enthroned with SS Sebastian, Jerome, Nicholas and Anthony of Padua* (1512; Siena, Pin. N.).

Fungai's style first appears definitively in the *Stigmatization of St Catherine of Siena* (completed by Nov 1497; Siena, S Caterina in Fontebranda). The lunetted panel is dominated by the elongated figure of the saint kneeling at the left with brightly lit palms, face upturned towards a crucifix at the right. Above, a half-length Virgin and Child accompanied by saints and angels witness the miracle. The foreground sanctuary opens entirely on to a panorama of graceful buildings, gentle hills and tall, feathery trees that lead to an extensive sea defined by a blue-toned, undulating coastline and enlivened with small boats. This landscape, with its Umbrian influences, persists as a key element throughout Fungai's repertory. The contrast between the solid, hard-edged and hieratic figures in the lunette and the small background and predella figures with dancelike poses and freely moving, sketchy drapery is also typical. The apogee of this hieratic style is the *Coronation of the Virgin* (completed 1501; Siena, S Maria dei Servi). The aggrandized central figures and static, formally ranked saints and angels fill the plane. Bright, cool tones prevail.

Four scenes from the *Legend of St Clement* (Strasbourg, Mus. B.-A.; York, C.A.G.) may have formed part of the predella. Lyrical landscape and narrative charm similarly characterize Fungai's decorative, secular panels, notably in his stories of Scipio Africanus (ex-Agnew's, London; St Petersburg, Hermitage) and of a young woman pushed overboard from a ship and rescued from the water (Houston, TX, Mus. F.A.), the latter possibly depicting the *Beloved of Enalus Sacrificed to Poseidon and Spared* (see Wilson). Fungai's fascination with landscape and study of Pinturicchio are paramount in the altarpiece of 1512. His later works, for example the *Assumption* (Siena, Pin. A.), tend to be dry and overtly eclectic.

Fungai may have used an oil technique in the 1512 altarpiece to create fluid passages that anticipate Domenico Beccafumi (see Cole). Fungai's abundant use of gold is noteworthy in sumptuous damasks and in painted areas incised to reveal gilding. Commissioned in 1494 to decorate ceremonial banners with gold and azure and in 1499 to gild the organ case for the cathedral, he may have had a reputation for his adept handling of expensive materials. Other works attributed to him include frescoes (Siena, Monte Paschi and Ist. Sordomuti) and devotional panels (London, N.G.; Siena, Pin. N.).

Judging the altarpieces still in Siena, early scholars disparaged Fungai for a perceived lack of originality and for succumbing to Umbrian influences. His reputation rose with the attribution of other works (see Perkins, Berenson, Borenius), especially the narrative paintings on *cassone* and *spalliera* panels (publicized by Schubring). Bacci published Romagnoli's fundamental text and all documents, establishing the date and Fungai's connection with the S Maria dei Servi *Coronation*. Refinement of attribution (anticipated by Vertova) and a full reassessment of chronology (attempted only by van Marle) are in order.

BIBLIOGRAPHY

Thieme–Becker

G. Vasari: *Vite* (1550, rev. 2/1568); ed. G. Milanesi (1878–85), vi, p. 416

F. M. Perkins: 'Alcuni dipinti senesi sconosciuti o inediti', *Rass. A.*, xiii (1913), pp. 121–6

P. Schubring: *Cassoni* (Leipzig, 1915), pls CXXIV–CCXV

T. Borenius: 'Unpublished Cassone Panels: III', *Burl. Mag.*, xl (1922), pp. 189–90

B. Berenson: 'Quadri senza casa: Il quattrocento senese II', *Dedalo*, ii (1931), pp. 735–67

F. M. Perkins: 'Pitture senesi poco conosciute', *La Diana*, vii (1932), pp. 179–94, 236–46

A. Venturi: *Storia*, x (1932), pp. 319–30

R. van Marle: *Italian Schools*, xvi (1937), pp. 465–85

P. Bacci: *Bernardino Fungai pittore senese (1460–1516)* (Siena, 1947)

E. Carli: 'Dipinti senesi nel museo Houston', *Ant. Viva*, ii/4 (1963), pp. 15–25

B. Berenson: *Central and North Italian Schools* (1968), i, pp. 149–52; ii, pls 927–40

L. Vertova: 'Il Maestro della Pala Bagatti Valsecchi', *Ant. Viva*, viii/1 (1969), pp. 3–14

P. Torriti: *La Pinacoteca Nazionale di Siena: I dipinti dal XV al XVIII secolo* (Genoa, 1981), nos 431–41

L. Vertova: 'Cicli senesi di virtù: Inediti di Andrea di Niccolò e del Maestro di Griselda', *Scritti di storia dell'arte in onore di Federico Zeri* (Milan, 1984), pp. 200–12

B. Cole: *Sienese Painting in the Age of the Renaissance* (Bloomington, 1985), pp. 142–4

Painting in Renaissance Siena, 1420–1500 (exh. cat., ed. K. Christiansen, L. Kanter and C. Strehlke; New York, Met., 1988), pp. 352–9

C. C. Wilson: 'Bernardino Fungai and a Theme of Human Sacrifice', *Ant. Viva*, xxxiv/1–2 (1995), pp. 29–42

——: *Italian Paintings, XIV–XVI Centuries, in the Museum of Fine Arts, Houston* (Houston and London, 1996), pp. 256–63

CAROLYN C. WILSON

Fusina, Andrea da (*fl* 1486; *d* Milan, 1526). Italian sculptor and mason. In 1486 he entered Giovanni Antonio Amadeo's workshop at the Certosa di Pavia, and in 1506 he went with Amadeo on one of his visits to work at Milan Cathedral. He was commissioned in 1495 by the Ospedale Maggiore in Milan to execute the marble tomb of *Daniele Birago, Archbishop of Mitilene* and his brother *Francesco Birago* (completed *c.* 1500; Milan, S Maria della Passione), which depicts Daniele Birago guarded by four putti, reclining on his funeral bier, supported on two sarcophagi placed in tiers. An exuberant example of Lombard classical decorative ornament, it illustrates his debt to the repertory of decoration he would have learnt at Pavia. In 1497 he was paid for a figure for Milan Cathedral, which has been identified as the *Judas Maccabeus*, whose pose and antique armour suggest that Fusina was familiar with the Lombardo family's works in Venice and Padua. A figure of the *Magdalene* (Milan Cathedral) may be the one that Lomazzo recorded that Fusina made for the cathedral; the overtly classicizing personification suggests that it formed a pendant to the *Judas Maccabeus*.

In 1508 Fusina requested permission from the workshop of Milan Cathedral to go to Rome and Loreto. By February 1510 he had returned to Milan as architect at the cathedral, although later that year he was working at the Certosa di Pavia. He also started work on the tomb of *Bassiano da Ponte* (completed 1517; Lodi Cathedral), an austere design in which da Ponte is shown reclining on his side, his head resting on his hand, a device used by several Lombard sculptors at this period. For the tomb (1519; Milan, Castello Sforzesco; formerly S Maria della Pace) of *Bishop Battista Bagarotti* (?1437–1522), Fusina reverted to an earlier Lombard style, with the sarcophagus and bier supported on bulging candelabra columns and characterization of the figure secondary to decorative detail, which is executed in deeply undercut relief. A number of undocumented works are attributed to him, including a relief of *Francis I* (*reg* 1515–47) of France (Milan, Castello Sforzesco; see Malaguzzi-Valeri), the tomb of *Stefano Varisio* (1521; Monza Cathedral) and several epitaphs in Milanese churches.

BIBLIOGRAPHY

G. P. Lomazzo: *Trattato dell'arte della pittura* (Milan, 1584)

F. Malaguzzi-Valeri: 'Note sulla scultura lombarda del rinascimento: Il Caradosso e il Fusina', *Rass. A.*, v (1905), pp. 169–73

S. Vigezzi: *La scultura lombarda nel cinquecento* (Milan, 1929), pp. 47–55

A. Pettorelli: 'Il monumento del vescovo Bagaroto', *Boll. Stor. Piacent.*, iii (1933), pp. 97–101

G. Agosti: *Bambaia e il classicismo lombardo* (Turin, 1990), pp. 173–94

ANTONIA BOSTRÖM

G

Gaddi. Italian family of patrons and collectors.

(1) Giovanni de' Gaddi (*b* Florence, 1493; *d* Rome, 19 Oct 1542). The son of Taddeo Gaddi and Antonia Altoviti, he was a prominent member of his family and is given ample attention by Vasari and Cellini. Throughout his life, he sponsored artists and writers, and in his houses in Rome and Florence he collected works of art and rare books. He spent his youth in Florence, where he lived in the Palazzo Gaddi, which stands adjacent to the Piazza di Madonna. In these Florentine years, according to Vasari, he was friendly with Jacopo Sansovino, Niccolò Tribolo, Giovanni Francesco Rustici and Andrea del Sarto, all of whom produced important works of art for him (e.g. the *Madonna and Child* by Andrea del Sarto; Rome, Gal. Borghese). Gaddi moved to Rome in 1525 and became clerk of the chamber to Pope Clement VII. He continued his patronage of Sansovino, collecting his terracotta models and perhaps commissioning him to build the palazzo that stands in Via del Banco di Santo Spirito. He was also friendly with Sebastiano del Piombo, Michelangelo and Benvenuto Cellini. He collected antiques and, according to Vasari, owned some antique pieces that had belonged to Ghiberti, including the relief sculpture of *Amor and Psyche*, known as the *Bed of Polycletus* (untraced). His interests were literary as well as artistic. Annibal Caro was his secretary in Rome for many years, and other poets and writers also found hospitality in his house. It was thanks to his interest that Machiavelli's *Il principe* (1513) and *Discorsi* (1513–21) were published in Rome.

BIBLIOGRAPHY
G. Vasari: *Vite* (1550, rev. 2/1568); ed. G. Milanesi (1878–85)
B. Cellini: *La Vita* (1558–66); ed. P. d'Ancona (Milan, 1925)
P. Litta: *Famiglie celebri italiane* (Florence, 1862), ii, pp. 83–4
A. G. Mansuelli: 'Il torso Gaddi nella Galleria degli Uffizi', *Boll. A.*, xliii (1958), pp. 1–11

(2) Niccolò Gaddi (*b* Florence, 12 Oct 1537; *d* Florence, 14 June 1591). Nephew of (1) Giovanni de' Gaddi. He was the son of Sinibaldo Gaddi and Lucrezia Strozzi, and he was one of the most important collectors in Florence in the second half of the 16th century. He was close to the Medici and held important political posts as Ambassador to Ferrara in 1569 and as part of the entourage of Eleonora de' Medici on her bridal journey to Mantua in 1584. His collection, which he kept in the Florentine palazzo in Via del Giglio, is known through a detailed inventory. It reflected the artistic and scientific interests

of the court of Francesco I de' Medici, being a mixture of *naturalia* and *artificialia* typical of late 16th-century collections. In addition to works of art, antiques and natural curiosities, Gaddi collected a rich library and a vast collection of drawings, five volumes (bought in 1574) being from Giorgio Vasari's collection (*see* VASARI, (1), §IV). Before that time, drawings had not been greatly esteemed by collectors.

To increase his collection and his botanical garden, Gaddi corresponded with many artists and dealers, not only on his own behalf but also on that of Francesco I de' Medici. Early sources often praise him not only for his collection but also for having commissioned the Gaddi Chapel in S Maria Novella in Florence, which was designed by Giovanni Antonio Dosio (1575–6); Giovanni Bandini made marble relief panels of the *Presentation of the Virgin* and the *Marriage of the Virgin* for the chapel in the 1570s and Alessandro Allori painted the frescoes of the dome. Gaddi was in constant contact with this artist and in fact may himself have been an amateur architect. In 1579 he was appointed lieutenant of the Accademia dell'Arte e Disegno. He was a friend of Federico Zuccaro and contributed to the polemics over the frescoes for the dome of Florence Cathedral. With his death, the Gaddi family became extinct, and Niccolò's collections were inherited by his Pitti nephews.

BIBLIOGRAPHY
G. de' Ricci: *Il priorista* (Florence, 1595)
S. Ammirato: 'Lettera al Cardinal Ferdinando de' Medici', *Opuscoli* (Florence, 1637–42), ii, pp. 55–7
J. Gaddi: 'Elogio di Niccolò Gaddi', *Elogi storici in versi e in prosa* (Florence, 1639), p. 271
G. G. Bottari and S. Ticozzi: *Raccolta di lettere sulla pittura, scultura e architettura* (Milan, 1822), iii, pp. 262–327
C. Valone: 'A Note on the Collection of Niccolò Gaddi', *Crit. A.*, xlii (1977), pp. 151–207
C. Acidini Luchinat: 'Niccolò Gaddi collezionista e dilettante del Cinquecento', *Paragone*, xxxi (1980), no. 359–61, pp. 141–75

DONATELLA PEGAZZANO

Gaetano, il. *See* PULZONE, SCIPIONE.

Gagini [Gaggini; Gazini; Gazzini]. Italian family of sculptors, masons and architects. One branch of the family, which came from Bissone, Ticino, was active in Genoa from the 15th century. (1) Domenico Gagini initially worked there, as did his nephew (2) Elia Gagini and their relation (3) Giovanni Gagini. In the early 16th century Giovanni's brother (4) Pace Gagini collaborated with Antonio della Porta (*see* PORTA, DELLA, (1)), his and

Giovanni's uncle, on work that included French and Spanish commissions. The Gagini workshop was organized along medieval lines: they produced works in collaboration, combining the skills of mason and sculptor. Their work was chiefly of a decorative and ornamental nature, figurative sculpture being of secondary importance. They remained active in Genoa until the 19th century.

Domenico, one of the most innovative members of the family, settled in Sicily between 1458 and 1463 and founded a separate branch that remained active until the 17th century. Domenico's son (5) Antonello Gagini was an outstanding sculptor: later generations, including Antonello's son Fazio Gagini (1520–67), merely copied earlier designs and produced derivative works. So far, it has only been possible to reconstruct the genealogy of the Sicilian branch of the family.

BIBLIOGRAPHY

Thieme–Becker

F. Alizeri: *Notizie dei professori del disegno in Liguria dalle origini al secolo XVI*, iv (Genoa, 1876)

G. di Marzo: *I Gagini e la scultura in Sicilia nei secoli XV e XVI*, 2 vols (Palermo, 1880–83)

A. Venturi: *Storia* (Milan, 1901–40), vi

L. A. Cervetto: *I Gaggini da Bissone: Loro opere in Genova ed altrove* (Milan, 1903)

H.-W. Kruft: *Domenico Gagini und seine Werkstatt* (Munich, 1972)

——: *Antonello Gagini und seine Söhne* (Munich, 1980)

(1) Domenico Gagini (*b* Bissone, *c.* 1425–30; *d* Palermo, 29–30 Sept 1492). Filarete referred to a 'Domenico from the lake of Lugano, disciple of Pippo di Ser Brunelleschi' (*Trattato di architettura*, Milan, 1461–4), and it seems probable that Domenico was apprenticed to Brunelleschi, although there is no documentary evidence. As a sculptor, Domenico was most influenced by Donatello. Domenico's first major commission was the façade of the chapel of S Giovanni Battista in Genoa Cathedral, on which he worked from 1448 until 1456–7 (see fig.). This façade is reminiscent of the porch of the Pazzi Chapel in Florence and also reflects a knowledge of Donatello's work. Stylistically, however, it remains a product of the Lombard early Renaissance decorative style; probably many Lombard assistants were involved. Other works by Domenico that date from *c.* 1455 include an overdoor relief of *St John the Baptist in the Wilderness* (Lawrence, U. KS, Spencer Mus. A.), a statuette of the *Virgin and Child* (ex-Staatl. Museen, Berlin; destr.) and another statuette of the *Virgin and Child* in the sacristy of Torcello Cathedral.

Domenico was first recorded in Naples in January 1458. With Isaia da Pisa, Antonio Chellino (*fl* 1446–60), Pietro di Martino da Milano, Francesco Laurana and Paolo Romano, he undertook to complete the triumphal arch of the Castelnuovo. Only the group of wind-players to the far right of the triumphal frieze and the figure of *Temperance* on the upper tier can be ascribed to him. The lively procession of musicians is deeply undercut, with some figures carved almost in the round. Of the four *Virtues* set in niches, *Temperance* is the most graceful. Her head is inclined, and her cloak is arranged in a diagonal sweep falling heavily over her feet. While in Naples, Domenico also produced a portal with a double-sided overdoor relief in the Sala dei Baroni at the Castelnuovo (largely destr. 1919) and a recess containing a statuette of the *Virgin and Child* (Naples, Capodimonte) in the former sacristy of the

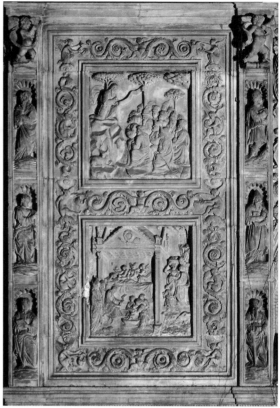

Domenico Gagini: panels showing the *Life of St John the Baptist*, marble, 1448–56/7 (Genoa Cathedral, Chapel of S Giovanni Battista)

chapel of St Barbara in the Castelnuovo. The relief of the *Adoration of the Christ Child* (Washington, DC, N.G.A.) probably also dates from this period. Stylistically, all these works show a fluidity of line more characteristic of painting than of sculpture.

Shortly after the death of Alfonso of Aragon in 1458, Domenico seems to have moved to Sicily, although he was first documented there in 1463. His first work there was probably the restoration of the 12th-century mosaics in the Cappella Palatina in Palermo. In 1463 Pietro Speciale, at that time Praetor of Palermo, commissioned him to make a tomb for his son Antonio. The recumbent figure, in S Francesco d'Assisi, Palermo, was rediscovered in 1948 (there is some controversy about whether to ascribe the work to Domenico or to Francesco Laurana). He was probably commissioned at the same time to make the portrait bust of *Pietro Speciale* dated 1468 (Palermo, Pal. Speciale–Raffadali). From 1463 Domenico carried out several commissions in Palermo and for patrons in other parts of Sicily and in Mallorca. In 1465 he paid a brief visit to Genoa on business. Thereafter he appears never to have left Sicily.

Works of a particularly high quality include *St Julian* (*c.* 1463; Salemi, Chiesa Madre); an allegorical overdoor relief of *Ferdinand of Aragon Enthroned* (after 1473; Los Angeles, CA, Co. Mus. A.); the reliquary of *Gandolfo da Binesco* (1482; Polizzi Generosa, Chiesa Madre); the tomb of *Bishop Giovanni Montaperto* (*d* 1485) in Mazara del Vallo

Cathedral; and the monument to *Panormus* (the base of which is probably by Gabriele di Battista; Palermo, Municipio). These examples show how Domenico's agitated but elegant style, in which he breaks down the contours, gradually lost its vigour. While in Sicily, Domenico left an increasing amount of work to his studio assistants, with a consequent fall in the artistic standard. Much of the work became stereotyped, and his studio continued to reproduce a number of items, such as Madonnas, in a standardized manner—even after the artist's death.

Domenico also traded in sugar and owned a property business. In 1487 he was a leading signatory among the *marmorarii* and *fabricatores* of Palermo when they petitioned for independent legal status.

BIBLIOGRAPHY
S. Bottari: 'Per Domenico Gagini', *Riv. A.*, xvii (1935), pp. 77–85
W. R. Valentiner: 'The Early Development of Domenico Gagini', *Burl. Mag.*, lxxvi (1940), pp. 76–87
S. Bottari: 'Nuovi studi su Domenico Gagini', *Siculorum Gymnasium*, n. s., ii (1949), pp. 324–30
M. Accascina: 'Sculptores habitatores Panormi', *Riv. Ist. N. Archeol. & Stor. A.*, n. s., viii (1950), pp. 269–313
——: 'Aggiunte a Domenico Gagini', *Boll. A.*, xliv (1959), pp. 19–29
E. Arslan, ed.: *Architetti e scultori del quattrocento* (Como, 1959), i of Arte e artisti dei laghi lombardi
S. Bottari: 'Un'opera di Francesco Laurana', *Boll. A.*, xlv (1960), pp. 213–16
F. Meli: 'Francesco Laurana o Domenico Gagini?', *Nuovi quaderni del Meridione*, iii (1965), pp. 305–15
B. Patera: 'Sull'attività di Francesco Laurana in Sicilia', *Annali del Liceo Classico 'G. Garibaldi' di Palermo*, ii (1965), pp. 526–50
M. Donato: *Domenico Gagini nel periodo pre-siciliano* (Acireale, 1968)
M. Accasiana: 'Inediti di scultura del rinascimento in Sicilia', *Mitt. Ksthist. Inst. Florenz*, xiv (1970), pp. 251–96
H.-W. Kruft: 'Die Madonna von Trapani und ihre Kopien', *Mitt. Ksthist. Inst. Florenz*, xiv (1970), pp. 297–320
——: 'La cappella di San Giovanni Battista nel duomo di Genova', *Ant. Viva*, ix/4 (1970), pp. 33–50
G. L. Hersey: *The Aragonese Arch at Naples, 1443–1475* (New Haven, 1973)
H.-W. Kruft and M. Malmanger: 'Der Triumphbogen Alfonsos in Neapel', *Acta Archaeol. & A. Historiam Pertinentia*, vi (1975), pp. 213–305
H.-W. Kruft and F. Negri Arnoldi: 'Postille a Domenico Gagini', *Boll. A.*, lx (1975), pp. 242–4
F. Negri Arnoldi: 'Revisione di Domenico Gagini', *Boll. A.*, lx (1975), pp. 18–29
B. Patera: 'Scultura di rinascimento in Sicilia', *Stor. A.*, 24/25 (1975), pp. 151–8
R. Pane: *Il rinascimento nell'Italia meridionale*, ii (Milan, 1977), pp. 302–7

(2) Elia Gagini [Elia de Bissone] (*fl* 1441–89). Nephew of (1) Domenico Gagini. He has often been confused with other sculptors called Elia (such as Elia di Bartolomeo da Ponte Lombardo, active in Città di Castello). No works can be securely attributed to him. In 1441, and again between 1450 and 1454, he worked on the Loggia Comunale in Udine. On 8 March 1457 he was named as Domenico Gagini's representative for work undertaken and accounts due in connection with the chapel of S Giovanni Battista in Genoa Cathedral. It is not clear how much he contributed to the chapel's façade. In 1465 Domenico Gagini took a six-year lease on a house in Genoa for his nephew Elia. In 1472 Elia undertook to make a number of columns and transport them to Seville. In 1478 he paid rent on a studio in Genoa. In 1512 a report compiled by Romerio da Campione (*fl* 1508–19) mentions the late Elia Gagini's contributions to the decoration of a chapel of the Madonna delle Rose in S

Maria di Castello, Genoa, but it is impossible to identify surviving fragments in this church with the chapel decorations.

BIBLIOGRAPHY
L. Filippini: 'Elia Gaggini da Bissone', *L'Arte*, xi (1908), pp. 17–29
C. Someda: 'Architetti e lapicidi lombardi in Friuli nei secoli XV e XVI', *Architetti e scultori del quattrocento*, ed. E. Arslan, i (Como, 1959), pp. 309–42, i of Arte e artisti dei laghi lombardi
H.-W. Kruft: 'La cappella di San Giovanni Battista nel duomo di Genova', *Ant. Viva*, ix/4 (1970), pp. 33–50

(3) Giovanni Gagini (*fl* Genoa, 1449–1514; *d* Mendrisio, *c.* 1517). Relation of (2) Elia Gagini. He was the son of Beltrame Gagini (*d* before 1476). His earliest surviving work is the rose window in S Michele, Pigna, Liguria, which is inscribed and dated 1450. Giovanni's later architectural works continue to show the influence of the Lombard Late Gothic style, already clearly apparent here. In 1451–2 Giovanni and Leonardo Riccomanno (*fl* 1431; *d* after 1472) jointly executed a portal in the sacristy of S Maria di Castello, Genoa. In 1457 Giovanni was commissioned to make the portal of the Palazzo Doria–Quartara, Genoa. The ornamental doorframe supports a rectangular marble overdoor relief of *St George and the Dragon*. The scene is flanked by two shield-bearing soldiers, reverses from a single design. This portal establishes the design for the decoratively unified Genoese portal type. *St George and the Dragon* became the principal and most important theme for Genoese portals during the 1450s and 1460s, partly because of the old devotion to St George in Genoa and partly due to the Banco di S Giorgio, to which the city owed its economic prosperity. Other Genoese portals by Giovanni or his studio are those in the Palazzo Brancaleone Grillo, where he may also have helped construct the courtyard, and at the Palazzo Valdettaro–Fieschi. There are also two overdoor reliefs in the Victoria and Albert Museum, London. In 1487–8 he delivered overdoor reliefs of *St George* to Lerici, Liguria, and to Bastia, Corsica. Other reliefs produced in his studio found their way to Chios. Characteristic of all these works is an ornamental, decorative style that betrays little individuality. In 1461 Giovanni was in charge of the construction of the Ponte S Zita, Genoa.

In 1465, when Giovanni was in Genoa, Domenico Gagini declared himself in Giovanni's debt for deliveries of marble. In the same year Giovanni was commissioned by Matteo Fieschi and Giacomo Fieschi to decorate their family chapel in Genoa Cathedral: the tomb of *Cardinal Giorgio Fieschi* (*d* 1461) and the entrance arch still survive. In 1475 Giovanni and Michele d'Aria (*fl* 1446–1502) were commissioned by Francesco Spinola to construct a marble fountain and a marble screen adorned with angels for the chapel of S Vincenzo in S Domenico, Genoa. In 1488 Giovanni agreed to build a chapel in S Maria delle Vigne, Genoa, and to decorate it. Neither work survives. In 1504 Giovanni authorized his nephew Antonio Barosino to collect outstanding debts, especially from his brothers Antonio Gagini (*fl* 1504; *d* between 1526 and 1532) and (4) Pace Gagini. In 1506 he acquired from Bernardo Forno da Campione a stock of marble and *pietra nera* (slate). From 1507 Giovanni lived in Mendrisio, and a votive relief in the cloister of the Servite monastery in Mendrisio is dated 1514. In 1517 he made his will.

SKL
BIBLIOGRAPHY

E. Gavazza: 'Ricerche sull'attività dei Gagini architetti a Genova', *Architetti e scultori del quattrocento*, ed. E. Arslan (Como, 1959), pp. 173–84, i of Arte e artisti dei laghi lombardi

J. Pope-Hennessy and R. Lightbown: *Catalogue of Italian Sculpture in the Victoria and Albert Museum*, i (London, 1964), pp. 386–91

H.-W. Kruft: *Portali genovesi del rinascimento* (Florence, 1971)

E. Poleggi: *Santa Maria di Castello e il romanico a Genova* (Genoa, 1973), p. 141

H.-W. Kruft: 'Alcuni portali genovesi del rinascimento fuori Genova', *Ant. Viva*, xvii/6 (1978), pp. 31–5

(4) Pace [Pasio] **Gagini** (*fl* 1493–1521). Brother of (3) Giovanni Gagini. Pace was trained in the masons' lodge at the Certosa di Pavia. Initially he worked for his uncle Antonio della Porta (*see* PORTA, DELLA, (1)) as a *piccatore lapidum*. On 6 November 1493 he signed a four-year contract with his uncle Antonio to work as a *scultor et magister figurarum marmoris*. Pace's collaboration and partnership with his uncle lasted until 1513. In 1501 Francesco Lomellini commissioned them to construct a family chapel in S Teodoro, Genoa. After the church's destruction in 1870, the altar retable, depicting the *Adoration of the Christ Child*, and the monument to Lomellini were incorporated into the present church. In 1504 Pace undertook to supply two marble columns for the main doorway of the monastery church of the Certosa di Pavia. Before 1513 Pace and della Porta worked on the right-hand tabernacle in the choir of the Certosa, which had probably been commissioned from Francesco Briosco (*fl* 1500–11) in 1511.

From 1506 Gagini and della Porta undertook a number of commissions for France, including a fountain (dismantled 1759) for the château of Gaillon, near Rouen, which is recorded in a drawing (*c*. 1575; London, BM) and engraving by Jacques Androuet Du Cerceau the elder (*c*. 1515–85), and the tomb of *Raoul de Lannoy and Jeanne de Poix* in the parish church of Folleville, Picardy, on which the recumbent effigy of *Raoul de Lannoy*, the French Governor of Genoa, bears Pace's signature. The tomb relief of mourning putti, attributable to Pace alone, shows a classical influence. A statuette of the *Virgin and Child*, which both della Porta and Pace signed, is in the parish church of Ruisseauville, Pas-de-Calais. In 1508 both sculptors were paid for the seated figure of *Francesco Lomellini* in the Palazzo S Giorgio, Genoa, although only Pace signed the work. In all these works, Pace's individual style is hard to define, since the sculptor always collaborated with his uncle.

In 1520 Pace and Girolamo Viscardi, among others, signed a petition addressed to the municipality of Genoa asking for the sculptors to be released from their dependence on the *antelami* and given separate legal status. On 1 April 1521 Pace appointed the sculptor Francesco de' Brocchi to be his representative in Genoa. This is probably connected with his departure for Seville. In 1520 Pace seems to have been commissioned by Don Fadrique de Henríquez de Ribera to make the tomb of his mother, Doña Catalina Ribera. No documentary record for this commission exists. The tomb, which Pace signed, was erected in the charterhouse of Seville and is now in the university church. It consists of two arches raised on a high base, the outer supported on piers, the inner on highly decorated columns, with niches containing figures of saints. The recess is decorated with rectangular reliefs of *Christ in Limbo* and *Christ Carrying the Cross* beneath a lunette of the *Adoration of the Shepherds*. The recumbent effigy lies on a bier supported by winged, sphinx-like figures. The tomb combines classical details, such as flying victories and putti, with the surface decoration typical of Lombard sculpture. The design follows the pattern of a typical 15th-century Roman tomb set into a wall, such as the tomb of *Paul II* (ex-St Peter's, Rome; fragments Rome, Grotte Vaticane, and Paris, Louvre) by Giovanni Dalmata and Mino da Fiesole. Pace himself can only have been responsible for a small part of its execution.

Pace Gagini is important in the dissemination of Lombard Renaissance sculpture into France and Spain. His style is very difficult to isolate since it is bound up with traditional studio methods then current in Genoa.

BIBLIOGRAPHY

C. Justi: 'Lombardische Bildwerke in Spanien', *Jb. Kön.-Preuss. Kstsamml.*, xiii (1892), pp. 3–22, 68–90 [repr. in C. Justi: *Miscellaneen aus drei Jahrhunderten spanischen Kunstlebens*, i (Berlin, 1908)]

C. Magenta: *La Certosa di Pavia* (Milan, 1897)

L. Beltrami: 'Pasio Gaggini di Bissone alla Certosa di Pavia', *Rass. A.*, iv (1904), pp. 26–8

——: 'Le opere di Pasio Gaggini in Francia', *Rass. A.*, iv (1904), pp. 58–62

R. Maiocchi: *Codice diplomatico artistico di Pavia dall'anno 1330 all'anno 1550*, 2 vols (Pavia, 1937–49)

R. Bossaglia: 'La scultura', *La Certosa di Pavia* (Milan, 1968), pp. 39–80

H.-W. Kruft: 'Antonio della Porta genannt Tamagnino', *Pantheon*, xxviii (1970), pp. 401–14

——: 'Genuesische Skulpturen der Renaissance in Frankreich', *Actes du XXII congrès international d'histoire de l'art: Budapest, 1972*, pp. 697–704

——: 'Pace Gagini and the Sepulchres of the Ribera in Seville', *Actas del XXIII congreso internacional de historia del arte: Granada, 1977*, pp. 327–38

C. R. Morschek jr: *Relief Sculpture for the Façade of the Certosa di Pavia, 1473–1499* (New York, 1978)

(5) Antonello [Antonio] **Gagini** (*b* Palermo, 1478–9; *d* Palermo, between 31 March and 22 April 1536). Son of (1) Domenico Gagini. He was the leading representative of the Sicilian branch of the family. He was trained as a sculptor in the studio of his father. Between 1504 and 1506 he appears to have been in Calabria and Rome, where he briefly worked as Michelangelo's assistant on the tomb of *Julius II* (relief on the left-hand socle of the *Rachel* niche, S Pietro in Vincoli). His early work shows the influence of Francesco Laurana, Michelangelo and Andrea Sansovino. Antonello built up a large studio, and for decades he was able to monopolize all the major sculptural commissions in Sicily and, to some extent, Calabria. However, the large scale of his studio led to artistic and stylistic stagnation. Antonello's work as an architect still needs further research.

From 1498 to 1508 Antonello based his studio in Messina and produced statues of the Virgin and Child, altar retables and tombs. In 1507 he received his most important commission: to provide sculptures for the chancel of Palermo Cathedral. Work went on until 1574, long after his death. This, one of the largest ensembles of sculptures produced in the Renaissance, was arranged on two levels, with pilaster strips dividing the 42 statues, reliefs and friezes. The whole ensemble combines both

Italian and Spanish stylistic and compositional elements. While the cathedral was being restructured along classical lines (1781–1801), the ensemble was broken up, but most of the figures survive (the figures of *Christ* and the *Apostles* are on the altar in the chancel), and it has been possible to reconstruct it in a drawing (Kruft, 1980). In some of these figures Antonello achieved a simple monumentality.

Antonello undertook many commissions for Sicily, Calabria and Malta, some of which he had to delegate to other studios. He worked mainly in marble, but sometimes also in a mixture of plaster and a papier mâché (*mistura*), terracotta and bronze. Other works of especially high quality include a marble arch and altar retable (1503–17; Palermo, S Zita); *St John the Baptist* (1521–2; Castelvetrano, S Giovanni Battista); the *Annunciation* (1525; Erice, Mus. Civ. Cordici); the altar retable of *St George* (1526; Palermo, S Francesco d'Assisi); and the tomb of *Antonio Scirotta* (*c.* 1527; Palermo, S Zita). Stylistically, Antonello's works are striking both for their high degree of technical expertise and for a sentimentality of expression that gives them common appeal. He was highly respected and from 1517 was consul of the sculptors' guild of Palermo. Antonello also had dealings in agriculture and trade, and he acquired numerous properties. Artistically and socially he appears to have identified himself with the artisan milieu in which he moved.

Antonello's five sons, Giandomenico (*b* 1503; *fl* until 1560), Antonino (*b* before 1514; *fl* until 1574), Giacomo (1517–98), Fazio (1520–67) and (Giovan) Vincenzo (1527–95), were also sculptors. They were all employed in their father's large workshop. Although they never achieved Antonello's high standard, each son developed a fairly individual style, and the following pieces can be attributed thus: a marble arch by Antonello, Antonino, Giandomenico and Giacomo (1531–9; Trapani, Santuario della SS Annunziata); the *Transfiguration* by Antonino (*c.* 1537; Mazaro del Vallo Cathedral); and the reliefs on the arch of the Cappella del Crocifisso (1557–65; Palermo Cathedral) by Fazio and Vincenzo. This last was dismantled in the 18th century, but there is a sketched reconstruction in Kruft (1979, 1980).

BIBLIOGRAPHY

V. Auria: *Il Gagino redivivo, o'vero notitia della vita, ed opere d'Antonio Gagino* (Palermo, 1698)

A. Gallo: *Elogio storico di Antonio Gagini* (Palermo, 1860)

F. Meli: *Matteo Carnilivari e l'architettura del quattro- e cinquecento a Palermo* (Rome, 1958)

V. Regina: *Antonello Gagini e sculture cinquecentesche in Alcamo* (Palermo, 1969)

H.-W. Kruft: 'Die Cappella del Crocifisso im Dom von Palermo: Ein Rekonstruktion', *Pantheon*, xxxvii (1979), pp. 37–45

——: *Antonello Gagini und seine Söhne* (Munich, 1980)

G. Bresc-Bautier: 'Deux statues attribuées a Antonino Gagini, acquises a Palerme par Nelie Andre', *Gaz. B.-A.*, cxxv (1995), pp. 149–54

V. Segreti: 'Un capolavoro di Antonello Gagini nella storia e nella religiosità amanteane', *Calabria Lett.*, xliii/13 (1995), pp. 48–50

HANNO-WALTER KRUFT

Galeotti, Pietro Paolo [Romano] (*b* Monte Rotondo, nr Rome, 1520; *d* Florence, 19 Sept 1584). Italian medallist, goldsmith and sculptor. The son of Pietro di Francesco, he was brought to Florence at a young age by Benvenuto Cellini, who described in his *Vita* how he found Galeotti in Rome in 1528. Galeotti accompanied Cellini to Ferrara and Paris in 1540 and worked in his Paris workshop with Ascanio de' Mari (*d* 1566) in the Château du Petit-Nesle in 1548–9. He settled in Florence around 1552 and entered into the service of the Mint. He became a Florentine citizen in 1560. A payment to him from Cellini is recorded in January 1552, for chasing done on Cellini's *Perseus*. A sonnet of 1555 by the historian and critic Benedetto Varchi (*I Sonetti*, Venice, 1555, i, 252) describes Galeotti as an equal rival of Domenico Poggini, another medallist also employed by the Mint. Briefly in 1575, Galeotti appears to have been an assistant engraver at the Papal Mint in Rome, taking the place of Lodovico Leoni (1542–1612).

Galeotti's extant oeuvre comprises around 80 medals, many bearing his signature PPR, or PETRVS PAVLVS ROM, or a derivative. Eight are dated, between 1552 and 1570, the earliest depicting *Cardinal Madruzzo* (1512–87). In addition to Florence, his sitters came from Genoa, Milan, Turin and north of the Alps, but his best-known work was a series of medals depicting Cosimo I de' Medici (*see* MEDICI, DE', (14)) and his accomplishments (such as the building of the Florentine aqueducts, or the Uffizi), both before and after 1569, when Cosimo became 1st Grand Duke of Tuscany. The same bust is featured on both early and late medals and derives from Poggini's medals of 1561, but the inscription, COS.MED.MAGNVS.DVX. ETRVRIAE (Cosimo de' Medici, Grand Duke of Tuscany), on the later examples identifies Cosimo's heightened importance. Vasari praised the series, describing the medals, particularly in regard to the portrait, as graceful and beautiful. As with Galeotti's works in general, they are classicizing in style and probably reflect the Roman coins in Cosimo's extensive collection.

Only one monumental work by Galeotti is known, a bronze bust, *all'antica*, of *Ottavio Farnese*, 2nd Duke of Parma and Piacenza, signed P PAV.ROM.F (London, Cyril Humphris Gal., summer 1990, no. 17). The work, which recalls Cellini's bronze bust of *Cosimo I* (Florence, Bargello), was one of two instances when Galeotti portrayed Farnese, the other being a medal, which also depicted the Duke's wife, Margaret of Austria (1522–86).

BIBLIOGRAPHY

Thieme–Becker

G. Vasari: *Vite* (1550, rev. 2/1568); ed. G. Milanesi (1878–85), v, p. 390; vi, p. 251; vii, p. 542–3

B. Cellini: *Vita di Benvenuto Cellini* . . . (Cologne, 1728; Eng. trans., Oxford, 1949), pp. 150, 152, 165

L. Forrer: *Biographical Dictionary of Medallists* (London, 1904–16), ii, pp. 190–94

C. Johnson: 'Cosimo I de' Medici e la sua "Storia metallica" nelle medaglie di Pietro Paolo Galeotti', *Medaglia*, xii (1976), pp. 14–46

D. Myers: 'Pietro Paolo Galeotti, Called Romano', *The Currency of Fame: Portrait Medals of the Renaissance* (exh. cat., ed. S. K. Scher; New York, Frick, and Washington, DC, N.G.A.,1994), pp. 164–5

DONALD MYERS

Galli, Jacopo (*d* Rome, 1505). Italian banker and patron. He was from a noble family in Rome, prominent in banking and as civic officials, and received a humanist education. He formed a collection of antiquities, which was arranged in the garden of the Casa Galli (destr.), near the Palazzo della Cancelleria, Rome. In 1496, probably through his friend Cardinal Raffaele Riario, he met Michelangelo, who was on his first visit to Rome. Michelangelo came to live in Galli's house, and Galli bought his

first large-scale sculpture, the marble *Bacchus* (1496; Florence, Bargello). The *Bacchus* was displayed in the garden of the Casa Galli, where it was recorded in a drawing of 1536 (Berlin, Kupferstichkab.) by Maarten van Heemskerck (1498–1574) and in a description *c.* 1550 by Ulisse Aldrovandi, until its purchase in 1571–2 by Francesco I de' Medici, Grand Duke of Tuscany. Galli is documented as owning a standing marble *Cupid*, or *Apollo*, by Michelangelo (untraced, though possibly to be identified as that in New York, French Embassy Cult. Bldg). He also supervised the contract of 27 August 1498 between Michelangelo and Jean Bilhères de Lagraulas (or Villiers di Fezensac; *d* 1499), Cardinal of S Sabina, Rome, for the *Pietà* (Rome, Vatican, St Peter's). As the sculptor's guarantor, Galli stated in the contract that the work would be the most beautiful marble statue in Rome.

BIBLIOGRAPHY

U. Aldrovandi: Le statue antiche di Roma (MS.; *c.* 1550); as an app. to L. Mauro: *Le antichità della città di Roma* (Venice, 1556)

G. Vasari: *Vite* (1550, rev. 2/1568); ed. G. Milanesi (1878–85), vii, pp. 149–50

K. Frey: *Michelangelo Buonarroti* (Berlin, 1907), pp. 285–330, passim

A. Condivi: *Vita di Michelangiolo*, ed. A. Maraini (Florence, 1926), pp. 28–9

C. de Tolnay: *The Youth of Michelangelo* (Princeton, 1943), pp. 142–50

K. Weil-Garris Brandt: 'A Marble in Manhattan: The Case for Michelangelo', *Burl. Mag.*, cxxxviii (1996), pp. 644–9.

——: 'More on Michelangelo and the Manhattan Marble', *Burl. Mag.*, cxxxix (1997), pp. 400–04

JANET SOUTHORN

Gallucci, Nicola [Nicola da Guardiagrele] (*b c.* 1395; *d* before 1462). Italian goldsmith and sculptor. He was active in Guardiagrele in the Abruzzi region, which was an area celebrated since ancient times for the work of its goldsmiths. It is probable that he was trained in the workshop of his father, Andrea Gallucci, who was also a goldsmith and sculptor. The earliest of Nicola's many documented and securely attributed works is a monstrance (1413; Francavilla al Mare, S Maria Maggiore), which, like all his early works, is in the Late Gothic style. Some of his works reflect Tuscan influence, in particular that of Lorenzo Ghiberti. This is already apparent in a cross (1431; Guardiagrele, S Maria Maggiore), but is particularly marked in his altar frontal (1448; Teramo Cathedral) with scenes from the *Life of Christ*, some of which are based directly on those of Ghiberti's north doors of 1403–24 (Florence, Baptistery; *see* GHIBERTI (1), fig. 1).

The *Annunciation* (Florence, Bargello) attributed to Nicola and his bust of *St Giustino* (Chieti Cathedral) are examples of Nicola's activity as a goldsmith–sculptor, but it was his crosses that earned him renown. According to Chini, Nicola made the one destined for S Maria, Paganica, in his workshop in Guardiagrele, but he then had to take it to L'Aquila at his own expense in order to have it assayed and marked. Nicola's processional crosses are of the standard 15th-century type, common also in southern Italy. They are made of silver sheets that are chased, embossed and attached to a wooden support; they are often decorated along the edges with small copper balls. The figures were made to commission and are sometimes quite complex iconographically, and characterized by a great variety of pose and a refinement of execution: for example the *Christ* on the fine cross (L'Aquila, Mus. N.

Abruzzo) and the finely carved figures of the gilded silver cross (Rome, S Giovanni in Laterano). They were normally cast separately and then fixed to the terminals of the cross and to the *suppedaneum* on the reverse, or placed at the base of the crucifix, often specifically requested by the patron. The crosses would be fixed on to a processional staff by means of a spherical fitting that could be altered to make the crosses free-standing.

BIBLIOGRAPHY

Enc. It.; Thieme–Becker

M. Chini: 'Documenti relativi all'arte nobile dell'argento in Aquila', *Rivista abruzzese* (1913)

E. Matiocco: 'L'oreficeria medioevale abruzzese', *Abruzzo*, vi/2 (1968), pp. 361–403

ANGELA CATELLO

Gambara, Lattanzio (*b* Brescia, 1530; *d* Brescia, 18 March 1574). Italian painter. It is generally agreed that he received his early training with Giulio Campi in Cremona, where he developed his style, derived from Lombard and Emilian Mannerism. In 1549 Gambara returned to Brescia, where he became an assistant to Gerolamo Romanino and married the latter's daughter in 1556. During the 1550s he collaborated with Romanino on the fresco cycles in the Averoldi and Bargnani palaces in Brescia, where he made some accommodation in his style to Romanino's, though demonstrating his innate eclecticism. His first important independent commissions were the façade frescoes (*c.* 1557) on the Case del Gambero (Brescia). Here, Gambara fused the decorative elegance of Parmigianino and Camillo Boccaccino with the Michelangelesque qualities of Giulio Romano and Pordenone. He was a prolific fresco painter and draughtsman, and after Romanino's death in 1560 he became the leading artist in Brescia. In 1561 he frescoed four scenes from the *Apocalypse* in the Palazzo Broletto in Brescia (destr.), which reflected strongly the influence of Giulio Romano. This is true also of his *Nativity* (*c.* 1561–8; Brescia, SS Faustino e Giovità), where an academic dryness begins to appear. From 1567 to 1573 Gambara was engaged in frescoing the nave arcade and internal façade of Parma Cathedral together with the Cremonese painter Bernardino Gatti. These frescoes, as well as the contemporary frescoes in Cremona Cathedral, are in a turgid Mannerist style, filled with large figures and complicated foreshortening. He died while executing the vault frescoes in S Lorenzo, Brescia.

BIBLIOGRAPHY

Thieme–Becker

G. Vasari: *Vite* (1550, rev. 2/1568), ed. G. Milanesi (1878–85), vi, pp. 491, 498, 506

F. Nicoli Cristiani: *Della vita e delle pitture di Lattanzio Gambara* (Brescia, 1807)

S. Fenaroli: *Dizionario degli artisti bresciani* (Brescia, 1877)

A. Venturi: *Storia* (1901–40), ix, pp. 323–34

M. L. Ferrari: *Il Romanino* (Milan, 1961)

L. Crosato: *Gli affreschi nelle ville venete del cinquecento* (Treviso, 1962)

G. Treccani degli Alfieri, ed.: *La Storia di Brescia*, iii (Brescia, 1963–4)

Mostra di Girolamo Romanino (exh. cat., ed. G. Panazza; Brescia, Duomo Vecchio, 1965)

G. Godi: 'Anselmi, Sojaro, Gambara, Bedoli: Nuovi disegni per una corretta attribuzione degli affreschi in Steccata', *Parma A.*, viii (1976), pp. 55–79

G. Vezzoli and P. V. Begni-Redona: *Lattanzio Gambara, pittore* (Brescia, 1978)

M. Di Giampaolo: 'Lattanzio Gambara, pittore', *Prospettiva*, xviii (1979), pp. 57–9

C. S. Cook: 'The Lost Last Works by Romanino and Gambara', *A. Lombarda*, 70–71 (1984), pp. 159–67
——: 'The Collaboration of Romanino and Gambara through Documents and Drawings', *A. Ven.*, xxxviii (1984), pp. 186–92
M. Gregori, ed.: *Pittura del Cinquecento a Brescia* (Milan, 1986)

<div align="right">CATHY S. COOK</div>

Gambello. Italian family of artists.

(1) Antonio (di Marco) Gambello (*fl* 1458; *d* Venice, 1481). Architect and sculptor. His documented work is limited to one important building, the wealthy monastic church of S Zaccaria, Venice, to which he was appointed *proto* (chief architect) in 1458, and with which he was closely associated until his death (*see* ITALY, fig. 6). S Zaccaria holds a pivotal position between Gothic and Renaissance architecture in Venice, although the church was unfinished on Gambello's death and was completed by Mauro Codussi between 1483 and *c.* 1490. Gambello's progress was delayed by frequent journeys abroad at the behest of the Venetian government, to design and inspect fortifications. He was firstly responsible for extensive alterations to the earlier, Gothic church of S Zaccaria, parts of which were incorporated into the new structure. These alterations are all in a late, purely Gothic style. Gambello's new church has a spacious three-bay nave terminating at the east end in an ambulatory with radiating chapels, the only example in the city before Baldassare Longhena's nave (begun 1631) at S Maria della Salute. The apse contains an unusual, but harmonious mixture of Gothic and Renaissance motifs, some partly the work of assistants after his death. Gambello was also responsible for the stylobate of the façade, again continued by assistants before Codussi was appointed to complete the building. Often claimed as the work of Gambello, although undocumented, is the land-gate (completed 1460) to the Venetian Arsenal, a complex early Renaissance work, loosely based on the Roman Arch of the Sergii at Pula (Croatia), then a Venetian colony. In detail immature, the land-gate is notable for its classical, rather than Lombard Renaissance, origins. Gambello is also associated with S Giobbe, Venice, although the chancel, choir and chapels are attributable to Pietro Lombardo.

BIBLIOGRAPHY
P. Paoletti: *L'architettura e la scultura del rinascimento in Venezia*, 2 vols (Venice, 1897)
A. Angelini: *Le opere in Venezia di Mauro Codussi* (Milan, 1945)
E. Arslan: *Venezia gotica* (Milan, 1970)
L. O. Puppi and L. Puppi: *Mauro Codussi: L'opera completa* (Milan, 1977)
J. McAndrew: *Venetian Architecture of the Early Renaissance* (Cambridge, MA, and London, 1980)

<div align="right">□</div>

(2) Vittore [Vittorio] **Gambello** [Camelio; Camelius; Camelus] (*b* Venice, 1455 or 1460; *d* Venice, 1537). Medallist and sculptor, son of (1) Antonio Gambello. He studied drawing under Giovanni Bellini. The earliest references to him document his employment as *maestro della stampe* at the Venetian Mint in 1484. He perfected a method for stamping medals in high relief rather than casting them in sand or by the lost-wax process; this allowed the easier production of medals in larger editions. While certain scholars (Armand and Fabriczy) include 13 medals—8 cast and 5 stamped—in their accounts of Gambello's production, others list 11 or 12. The hypothesis that medals signed *Moderni* or *Moderno* might be attributed to Gambello has been abandoned for stylistic reasons. His style has been criticized (Fabriczy and Hill) for its lifeless academicism. It has also been argued (Fabriczy) that his designs display an incomplete knowledge of Greek reliefs and Classical principles, and that although he initially practised a vigorous naturalism, his later work involved less distinctive modelling and weaker compositions. However, Foville claimed that Gambello successfully modernized antique forms for 16th-century taste.

Gambello's earliest medal (1482 or 1484) has a portrait of Pope Sixtus IV wearing the traditional papal tiara and cape, while the reverse depicts the enthroned Pope surrounded by a cardinal and other persons. Around 1490 he produced portrait medals of *Gentile Bellini* and *Giovanni Bellini*. His most successful medal has been considered to be that of *Pope Julius II*, which has a bust in profile of the Pope, while the reverse depicts Christ enthroned, delivering the papal keys to the kneeling St Peter. The justification of papal authority is a common theme of Gambello's portrait medals, most of which have a relevant allegorical or Classical scene on the reverse. He also executed a medal with a *Self-portrait* (1508), inscribed *Camelio*. From 1515 to 1517 Gambello worked as a die-engraver at the Papal Mint, as a result of his expertise in the process of stamping medals. Moreover, he still held his position at the Venetian Mint at the time of his last appearance in official records in 1523. Gambello's work also included large-scale sculptures: among those that have been attributed to him are the marble statues of Apostles and other saints in the old choir of S Stefano, Venice, later moved to the presbytery.

BIBLIOGRAPHY
Thieme–Becker
V. Lazari: *Notizia delle opere d'arte e d'antichità della raccolta Correr di Venezia* (Venice, 1859), pp. 181–3
A. Armand: *Les Médailleurs italiens* (Paris, 1883–7), i, pp. 114–17
C. von Fabriczy: *Medaillen der italienischen renaissance* (Leipzig, 1903); Eng. trans. as *Italian Medals* (London, 1904), pp. 56, 78–9, 186
J. de Foville: 'Médailleurs de la Renaissance: Camelio', *Rev. A. Anc. & Mod.*, xxxii (1912), pp. 274–88
G. F. Hill: *Portrait Medals of Italian Artists of the Renaissance* (London, 1912), pp. 13, 14, 38–9, 43–4

<div align="right">WILLIAM L. ANTHES JR</div>

Gamberelli. *See* ROSSELLINO.

Garbo, Raffaellino del. *See* RAFFAELLINO DEL GARBO.

Garden. Relatively small space of ground, usually out of doors, distinguished from the surrounding terrain by some boundary or by its internal organization or by both. A combination of architectural (or hard) and natural (or soft) materials is deployed in gardens for a variety of reasons —practical, social, spiritual, aesthetic—all of which are explicit or implicit expressions of the culture that created them. A garden is the most sophisticated expression of a society's relationship with space and nature.

I. Introduction. II. Development in Italy.

I. Introduction.

1. General. 2. Iconography and phenomenology. 3. 'Three natures': gardens, cultural landscapes and wilderness. 4. Treatises and theoretical writings.

1. GENERAL. Local cultural circumstances determine many aspects of the garden's form and meaning, including

the proportion of hard to soft elements, the relationship of gardens to adjacent buildings or the larger landscape and the specific or unconscious motives for its creation. To the extent that a garden depends on natural materials, it is at best ever-changing (even with human care and attention) or at worst destined from its inception for delapidation and ruin. Given this fundamental contribution of time to the garden, it exists in and takes its special character from four dimensions, unlike most art forms. Almost all the great civilizations of the world have prized gardens and practised what has come to be termed landscape architecture, often deeming those who worked in this medium as much artists as designers, technicians or gardeners.

The full scope and history of Western gardens as art, design and technology were sketched out in the late 17th century by John Evelyn (1620–1706) as a contents list for his unfinished magnum opus, the *Elysium Britannicum* (MS. Oxford, Christ Church College, Lib.). Evelyn began by considering the four elements and especially the constitution of the earth; his treatise continues by reviewing in detail all the horticultural skills and tools required by the gardener to manage the natural elements, the structures by which garden space is created and subdivided (terraces, allees, groves etc) and the devices with which it is

diversified and decorated (waterworks, grottoes, pavilions, arbours, topiary work, knots, parterres etc). He proposed also to treat of 'Hortulan Entertainments, Divine, Moral, and Natural, to shew the riches, beauty, wonder, plenty, delight and universal use of a Garden', these being what might be called the metaphysical as opposed to the physical aspects of a garden. Evelyn's agenda for the study of princely or royal gardens has been followed piecemeal ever since. This emphasis on élite examples is perhaps inevitable, since they have always displayed the most complex and sophisticated garden art; it is this type, moreover, that generally survives. The impulse to create gardens, however, has never been exclusively patrician. Popular or vernacular gardens have always existed, though their transience and the fact that they have usually elicited little contemporary commentary mean that the materials for their study are sparse. Vernacular gardens have acquired a fresh esteem in modern society, in the allotment or victory garden and in the vogue for community garden projects. Their study and that of middle-class gardening extend significantly an understanding of the impulses, forms and significances of high garden art.

2. ICONOGRAPHY AND PHENOMENOLOGY. One of the most frequent, largely art-historical approaches to

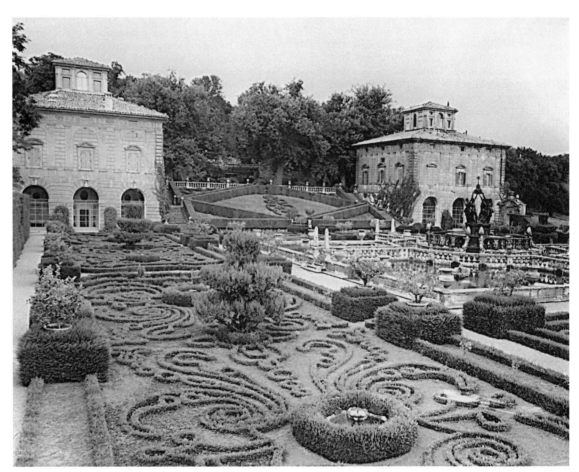

1. Gardens of the Villa Lante, Bagnaia, attributed to Jacopo Vignola, 1568–78

gardens has been to consider the iconography of aristocratic examples and the patronage system that brought them into being. Some Renaissance and Renaissance-influenced gardens had elaborate programmes or at least clusters of imagery; the most elaborated of these are at the Villa d'Este at Tivoli (for illustration *see* TIVOLI) and the VILLA LANTE, BAGNAIA (see fig. 1). The most frequent impulse of such programmes is ideological, usually a display of the owner's power whereby the skills of technology and art are united with the resources of nature to create a quasi-mythical place. Such achievements may be signalled (as at the Villa d'Este and the Villa Lante) by statues of Pegasus, whose hoof, striking Mt Parnassus, released the Helicon spring, or Hercules, one of whose labours was to steal golden apples from the legendary Garden of the Hesperides, the relocation of which is implied by Hercules' presence in a real one. Gardens may also announce themes without formulating them as programmes, and the articulation of these in garden terms probably outnumbers occasions on which iconographic programmes occur.

3. 'THREE NATURES': GARDENS, CULTURAL LANDSCAPES AND WILDERNESS. Italian Renaissance humanists called gardens a 'third nature' incorporating both nature and art. This referred to Cicero's definition of a second nature as one altered by man for utilitarian purposes—the fields, villages, roads, harbours, bridges etc, of what has become known as the cultural landscape. By implication, Cicero also defined a first nature: a primal, unmediated wilderness. Gardens take their place and are best studied in this hierarchy of three natures. The scale of human intervention in the first nature increases in the transition from second to third natures; there is more elaboration, more planning, more art, design and technology within gardens than, for example, within fields or orchards. Furthermore, the garden itself tends to allude to the other natures. By direct imitation, idealization, recreation or even simply by contrast, gardens define themselves and establish their own meaning by comparison with the other two natures.

Sometimes gardens are created directly out of the first nature or wilderness. Sometimes, rather than stark juxtapositions to a surrounding wilderness, gardens are an elaboration of a cultural landscape of terraced agrarian land, fields and orchards. This may best be seen in the series of lunettes by Giusto Utens (*d* before 19 April 1609) depicting Medici villas in and around Florence at the end of the 16th century (1599–1602; Florence, Mus. Firenze com'era; *see* FLORENCE, fig. 14 and VILLA, fig. 1); Florence, Sopr. B. A. & Storici Col.). Besides spaces for hunting, farming, growing fruit and vines, there are more sophisticated enclosures and geometrical elaborations of orchards and flower beds; with the introduction of pergolas, waterworks, statuary, grottoes and pavilions in some properties, a triumphant vision of garden art was created. Gardens distinguish themselves from both wilderness and cultural landscapes either by their boundaries or by their more elaborate decoration and concentration of effects or by both.

The etymology of words for garden confirms their essential characteristic of enclosure. The enclosed area is visibly different from the surrounding land by virtue of the

extent, scope and variety of its elaboration and decoration. These effects may be vegetal or architectural, including sculptural and hydraulic. They may be concentrated and massed, as if to represent the fullness of the world outside (e.g. lush herbaceous borders or the profusion of architectural and sculptural elements at Stowe and the Villa Orsini, Bomarzo (for illustration *see* BOMARZO, SACRO BOSCO), or the fountains at the Villa d'Este). The effect may also be minimal or reduced, as if a garden's art consisted in stripping nature of accidents and mere contingency.

4. TREATISES AND THEORETICAL WRITINGS. Many early garden features may survive to be studied *in situ*, even though modified in form; changes in gardens wrought by time or human alterations are a fundamental aspect of their existence. Records of garden art, design and technology survive as well in treatises and theoretical handbooks, which are invaluable to the historian as records of a given culture's garden theories and practices. Such treatises have almost invariably and not surprisingly been produced at moments when gardens became prominent in a given culture, when the establishment of gardens was pervasive enough to be celebrated and recorded, or codified so that others could imitate their designs. Such literary texts as the *Hypnerotomachia Poliphili* of 1499, though in fact a narrative composition, exercised a wide influence over European garden design during the Renaissance, largely through the illustrations, which were made available in its different language editions, of garden knots

2. Knot garden; woodcut from *Hypnerotomachia Poliphili* (Venice, 1499)

(see fig. 2), labyrinths, trelliswork, arbours, fountains and even ruins in the landscape.

BIBLIOGRAPHY

EWA: 'Landscape architecture'
G. Sitwell: *An Essay on the Making of Gardens* (London, 1909)
M. L. Gothein: *A History of Garden Art*, 2 vols (Jena, 1914; Eng. trans., London, 1928/*R* New York, 1979)
D. Coffin: *The Villa d'Este at Tivoli* (Princeton, 1960)
C. Thacker: *The History of Gardens* (London, 1979)
J. B. Jackson: 'Gardens to Decipher and Gardens to Admire', *The Necessity for Ruins and other Topics* (Amherst, MA, 1980)
D. Mignani: *Le ville medicee di Giusto Utens* (Florence, 1980)
'Current Bibliography of Garden History', *J. Gdn Hist.*, iii–iv (1983), pp. 347–81
A. van Erp-Houtepen: 'The Etymological Origins of the Garden', *J. Gdn Hist.*, vi (1986), pp. 227–31
G. Jellicoe and S. Jellicoe, eds: *The Oxford Companion to Gardens* (Oxford and New York, 1986)
C. W. Moore, W. J. Mitchell and W. Turnbull jr: *The Poetics of Gardens* (Cambridge, MA, 1989)
M. Francis and R. T. Hester jr, eds: *The Meaning of Gardens* (Cambridge, MA, 1990)
C. Lazzaro: *The Italian Renaissance Garden: From the Conventions of Planting, Design and Ornament to the Grand Gardens of Sixteenth-century Italy* (New Haven and London, 1990)
J. Dixon Hunt: *Gardens: Theory, Practice, History* (London, 1992)
J. Dixon Hunt, ed.: *The Oxford Book of Garden Verse* (Oxford, 1992)
Garden History: Issues, Approaches, Methods: Dumbarton Oaks Colloquium on the History of Landscape Architecture, xiii: Washington, DC, 1992
J. Goody: *The Culture of Flowers* (Cambridge, 1993)
The Vernacular Garden: Dumbarton Oaks Colloquium on the History of Landscape Architecture, XIV: Washington, DC, 1986
J. Dixon Hunt: *Greater Perfections* (London, 1999)

JOHN DIXON HUNT

II. Development in Italy.

1. Early Renaissance. 2. Late Renaissance.

1. EARLY RENAISSANCE. Despite some continuities with the medieval garden, Italian attitudes to the making of gardens show substantial changes from the mid-15th century onwards. These changes are closely associated with HUMANISM, the primarily literary movement, originating in Tuscany, which sought to recover the admired qualities of ancient Greece and Rome. For many of humanism's dominant figures garden-making and the great project of a Renaissance were profoundly connected; its ideas came to influence other Italian provincial cultures (as well as those of northern European countries).

(i) *Classical and humanist background.* Some Classical elements of garden design, such as the Roman peristyle garden, which influenced the monastery cloister, had survived the Middle Ages. This continuity extended into the Renaissance with monasteries serving as the nuclei of such estates as the Villa d'Este at Tivoli. The connection between monasteries and ancient villas was recognized in the Middle Ages and contributed to an understanding of Classical gardening that was not confined to monasteries; the Emperor Frederick II (*reg* 1212–50) excavated Roman villas and created sophisticated gardens in imitation. This response to classically inspired gardens culminated in the first half of the 15th century in the creation of the gardens of Poggio Reale, Naples. The splendour of Neapolitan gardens, with their sculpture, water features, architectural organization and horticultural riches led Charles VIII of France (*reg* 1483–98) to take the Neapolitan gardener

Pacello da Mercogliano (*d* 1534) back with him to France (1495), where he probably worked at Amboise, Gaillon and Blois.

The most important sources for early Renaissance gardens were, however, descriptions of life in Roman villas, Roman horticultural manuals and accounts of the Greek sense of the sacredness of groves and woods, as expressed in Classical texts recently discovered or made available through humanist scholarship. These stimulated a new idea of the garden as composing, with the house and the landscape, a unified ensemble. The power of the descriptions of Classical villas lay in the vision they presented of the life of cultured men in ancient times. The villa expressed an ideal, summed up in the word *villegiatura*, of healthy mental and physical life, in contact with the natural world while retaining proper commitment to city and society.

The works of Virgil, Pliny the younger and Vitruvius were particularly influential in forming this ideal, along with the frequently reprinted *Res rustica scriptores*, collections of Classical writings on rural subjects, first printed in Venice in 1470. Included were works by Columella, Varro, Cato and Palladius, some of them authors central to Classical literature. Their prominence, and the place of garden-related material in their works, reinforced the association between the love of antiquity and the love of gardens. Ancient descriptions of villas and gardens were conveniently suggestive and non-prescriptive. Even with the additional evidence of the remains of Roman villas, some above ground and others being excavated, the information available was insufficiently clear to force sterile repetition; it rather offered a repertory of elements for designed landscapes, fostering creative imitation.

The writings of Leon Battista Alberti both stimulated the desire to imitate the Roman ideal and provided a summary of villa features. He based his instructions on studies of the surviving evidence of Classical architecture, both texts and buildings, and on archaeological exploration. His principal contribution was *De re aedificatoria libri X* (printed in 1485, but circulating from 1452). Although such writers as Antonio Filarete (*Trattato d'architettura*, 1461–4) and Francesco di Giorgio Martini (*Trattato di architettura civile e militare*, 1486–92) extended and altered the thrust of Alberti's treatise and provided more detailed guidance, he remained supremely important as interpreter of the architecture and gardening of the ancient world. Alberti stressed the mixed character of the ideal dwelling, citing Cicero, Terence and Martial in support of his vision of *utilità* and *comodità*. He also emphasized the advantages of a hillside site, enabling owner and guests to enjoy views and fresh air, and he suggested features to provide shade in summer and shelter in winter, and to blur the distinction between house, garden and wider landscape.

(ii) *Villas and their gardens.* Early Renaissance villas show an immediate response to Alberti's theories. The Villa Medici at Fiesole (1458–61; see fig. 3) and other houses placed on natural or artificial elevations used their situations to offer views that extended the garden into the landscape; the terraced gardens that descended from them increasingly seized opportunities to incorporate variety through changes of level. Within the house, representa-

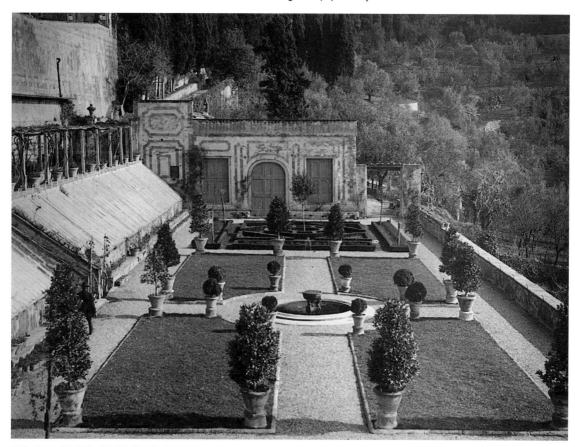

3. Garden of the Villa Medici, Fiesole, 1458–61

tions of gardens and landscapes connected interior and exterior, as did vistas. Loggias, garden rooms, pergolas and the medieval *hortus conclusus* ('enclosed' or 'secret garden'), now integrated into the overall design, exhibited the interpenetration of house and garden, also incorporating orchards and vineyards. Classically inspired restraint ensured that the design of each terrace remained simple: commonly a quartered rectangular pattern of beds with a water feature, usually a fountain, at the centre, and perhaps incorporating statues, grottoes and watercourses. The gardener's resources included evergreens for topiary in the Roman manner and exotic plants. Axial organization increasingly dominated the overall design, following Alberti's recommendation and its implementation at the Villa Quaracchi in Florence (before 1459), designed perhaps by him or his colleague Bernardo Rossellino; there the arrangement continued beyond the road dividing the estate to lead the eye from the slightly elevated house, through the garden with its *hortus conclusus*, and through the landscape to the banks of the Arno.

Within this new garden setting, the owner and his guests engaged in the cultivation of the human mind, most famously in Cosimo de' Medici's Villa Medici at Careggi, where the remodelling of house and garden was again inspired by Alberti's works, being intended as the setting for study and conversation. Although little survives of the garden at Careggi, it is clear that Cosimo asked Michelozzo

di Bartolomeo to reconstruct both house and garden in imitation of a Roman villa. In style and spirit, the garden shows a remarkable advance on Michelozzo's work at the Medici villa of Il Trebbio, near Cafaggiolo (1451), which, with its detached walled garden, remained essentially medieval in concept. The garden at Careggi was dominated by evergreens—bay, box, cypress and myrtle—permitting the imitation of Roman topiary. Following the advice of Pliny the younger and others, the west side of the villa was adorned with a double loggia, for summer shade and winter warmth. The garden was regarded as the philosopher's Helicon (a phrase used by Petrarch), philosophical debate being associated with gardens, in emulation of Plato's Academy.

Following ancient Roman practice, gardens also contained statues, since the creation and contemplation of visual art was important to villa life. The collection of Lorenzo the Magnificent fostered the formation of the 'garden school' in Florence, where Michelangelo gained his first knowledge of antique statuary. With their combination of natural and artificial elements, and their owners' heightened awareness of both nature and art, gardens frequently formed a meditation on the relationships between human and universal creativity, and embodied increasingly a witty competition between the two.

(iii) The villa and the town. Although many of the early Renaissance gardens were associated with rural life, they

were nevertheless dominated by awareness of the town. Thus the Medici villas around Florence were recreative departures from the city, not permanent alternatives. Alberti taught that the supreme commodiousness of the villa depended on its simultaneous relationships with town and country. Other, more troublesome ambiguities stemmed from the fact that the early Renaissance villas were constructed mainly for rulers and princes. The tensions are recognizable in the palace and garden created by Aeneas Silvius Piccolomini in Corsignano, his birth-place, which he renamed Pienza, immediately after his election to the papacy as Pius II in 1458. Piccolomini was a distinguished humanist, and the garden of the Palazzo Piccolomini (see fig. 4), which was the work of, among others, Alberti and Rossellino, was, at first sight, that of a scholar–statesman, rather than that of a Renaissance pope. Facing away from the city and launched out on a manmade terrace, it appeared to be the garden of a rural villa, encouraging the eye to range over the peaceful agricultural landscape far below. The garden and the landscape beyond were overlooked by a supremely elegant triple loggia, full of light and air, and without any thought of defence. But the Palazzo Piccolomini's other façades, which faced the town, were closed and dominating, their towering walls permitting only the occasional glimpse of the palace's courtyard and, distantly, the garden beyond. The garden had additional ranges of meaning in relation to the town: the Palazzo Piccolomini's dominance of Pienza was the expression of the prince's dominance, and the *hortus conclusus* a political statement, by virtue of its possession of a privacy the palace simultaneously denied to others. The garden, surrounded by pergolas, was the prince's privileged viewing place, from which he watched, concealed, the labours of his subjects. Thus the garden expressed both recreation and involvement. The hanging gardens at Pienza were not the enclosed, inward-looking

courtyards of the cloister or peristyle garden, but the eye's avenues into the world beyond. However, the Palazzo Piccolomini displayed the instability of the humanist garden, resulting from incompatibility between the republican ideal that inspired it and the reality in the service of which the Albertian villas were created. Both Alberti and Rossellino had also been on the architectural staff of Nicholas V, the last great builder pope; both had used their understanding of Classical culture in the service of autocracy.

BIBLIOGRAPHY

A. Filarete: *Trattato d'architettura* (Florence, 1461–4)
Columella, Varro, Cato, Palladius and others: *Res rustica scriptores* (Venice, 1470)
L. B. Alberti: *De re aedificatoria libri X* (Florence, 1485); Eng. trans. as *On the Art of Building in Ten Books* (Boston and London, 1988)
F. di Giorgio Martini: *Trattato di architettura civile e militare* (Florence, 1486–92)
B. Taegio: *La villa* (Milan, 1559)
A. F. Doni: *Le ville* (Bologna, 1566)
D. Coffin: *The Villa D'Este at Tivoli* (Princeton, 1960)
A. Perosa, ed.: *Giovanni Rucellai ed il suo Zibaldone*, Stud. Warb. Inst., 2 vols (London, 1960)
G. Masson: *Italian Gardens* (London, 1961/R 1966)
D. Coffin, ed.: *The Italian Garden* (Washington, DC, 1972)
H. Acton: *The Villas of Tuscany* (London, 1973, rev. 1984)
T. Comito: *The Idea of the Garden in the Renaissance* (New Brunswick, 1977)
J. Dixon Hunt: *Garden and Grove: The Italian Renaissance Garden in the English Imagination, 1600–1750* (London, 1986)
J. S. Ackerman: *The Villa: Form and Ideology in Country Houses* (Princeton, 1990)
C. Lazzaro: *The Italian Renaissance Garden: From the Conventions of Planting, Design and Ornament to the Grand Gardens of Sixteenth-century Italy* (New Haven and London, 1990)
M. Mosser and G. Teyssot, eds: *The History of Garden Design: The Western Tradition from the Renaissance to the Present Day* (London, 1991)
J. Dixon Hunt, ed.: *The Italian Garden: Art, Design and Culture* (Cambridge, 1995)

MICHAEL LESLIE

2. LATE RENAISSANCE. The gardens in Italy from the mid-16th century for which the greatest traces survive are the aristocratic gardens in which the land was significantly altered, architectural structures were built and water was brought in by aqueduct and prominently displayed in sculpted fountains. Although in virtually all extant gardens the planting has been altered, considerable evidence from contemporary views, descriptions and documents allows the reconstruction of their former appearance.

(i) General characteristics. (ii) Historical development.

(i) General characteristics.

(a) Design. The modern term 'formal' has come to denote a characteristic aspect of Italian gardens, as distinct from the landscape and Picturesque English gardens of the 18th century. Notwithstanding the modern distinction, Italian gardens were described by their contemporaries as an interaction of art and nature in which nature was ordered by art: geometry was the basis of their designs. Bilateral symmetry governed the relationship of the geometric units, while both terrain and plant materials were regularized and ordered. Trees were planted in rows, compartments defined by hedges, avenues covered with pergolas and large areas separated by walls. Trees and shrubs were clipped and shaped into topiary, labyrinths and theatres of greenery. However, the Italian garden of

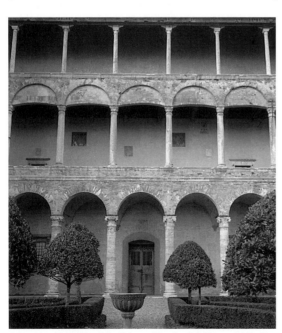

4. Loggia and garden of the Palazzo Piccolomini, Pienza, 1460–62

the period was not characterized solely by its so-called formal aspect or ordered nature. The geometric garden included a planted *bosco*; this had a counterpart in the park, which contained areas of unaltered terrain and freely growing trees. The wild aspect of nature was also given expression within the garden through rustic ornaments, such as fountains and grottoes, which imitated nature's own by the use of such natural materials in rough form as pebbles or shells.

(b) *Origins*. Underlying these aspects of Italian gardens was a conscious and persistent relationship to Classical antiquity, which provided the model for the ordering of plant materials, the vocabulary of architectural and decorative forms and the terracing of the land with massive retaining walls, architectural frontispieces, staircases and ramps. Antiquity provided the subjects and styles of garden sculpture, and the myths about nature that they expressed. The aqueducts and hydraulics that brought water to fountains, as well as the automata and water tricks, were all inspired by the desire to outdo the ancients. Classical antiquity, in particular the heritage of ancient Rome known through literature, letters and surviving ruins, informed every aspect of the Italian garden. Ancient Rome was in a sense a living presence, stimulating invention, not, as in later gardens, a distant culture that was simply one among many represented in garden ornaments for their associative value.

(c) *Use for display*. Like palaces and villas, grand gardens expressed their owners' magnificence, conveying status, power and wealth. This was achieved through terracing, architecture, sculpture and fountains, as well as exotic and expensive planting and labour-intensive garden ornaments, such as pergolas and topiary. Water was a most important expression of magnificence, since it was often acquired at great expense. Gardens formed a significant aspect of the building campaigns of rulers: in the 15th century the Este in Ferrara and the Aragonese dukes in Naples, and in the 16th century the Medici in Tuscany. In Rome and the Papal States gardens were created by popes and cardinals. The Borromeo family, which transformed a rocky island into the flourishing garden of Isola Bella, had long been feudal lords in that region. Where no single family or ruler had authority over the land, the wealthy and politically powerful built gardens, an example in Genoa being Andrea Doria, founder of the Genoese Republic. All manner of distinguished guests, including kings and emperors, were entertained in these gardens. At the Boboli in Florence, the U-shaped garden behind the Pitti Palace, begun by Duke Cosimo de' Medici in 1550, was later transformed into an amphitheatre built of stone in 1637 and became the site of extravagant court entertainment. The semicircular theatre form, whether made of stone or greenery, became a popular garden feature; some were actually used as theatres.

Views and detailed descriptions of grand gardens served to make their magnificence known far and wide. A description, written *c*. 1571, of the garden created by Cardinal Ippolito d'Este II, governor of Tivoli, was sent to Emperor Maximilian II; another (1611) of the villa at Frascati belonging to Pietro Aldobrandini, nephew of Pope Clement VIII, was addressed to Charles-Emanuel I of Savoy. Many views of gardens were produced, among the most famous being the 14 lunettes of Medici villas (Florence, Mus. Firenze com'era; *see* FLORENCE, fig. 14 and VILLA, fig. 1) painted in 1599–1602 by Giusto Utens (*d* before 19 April 1609) and originally hung in the palace at Artimino. Most of the grand gardens were recorded in prints; in the 16th century these were single engravings, such as that by Etienne Dupérac (1525–1601) of the *Villa d'Este at Tivoli* (1573; for illustration *see* TIVOLI).

(d) *Planting*. Despite regional and chronological differences, the plant materials in Italian gardens throughout this period consisted, in varying proportions, of herbs and flowers, fruit trees and larger trees, many of them evergreen. At the Villa d'Este, as in many other gardens, the three conventional plant materials ascended the hillside: herbs and flowers, together with a few fruit trees, were on the lowest terrace, with grapevines and smaller trees on the intermediate slope, and a dense *bosco* above. Important criteria in garden planting were the variety of plants within the three categories, and the inclusion of rare and exotic specimens. From the early 16th century new plants were being imported from the Middle East, America, Africa and Asia. This influx prompted the creation of the first botanic garden in Europe, the Orto Botanico in Padua (1545), for the scientific study of plants. A late 17th-century inventory of the Villa Barbarigo at Valsanzibio reveals that the basic categories of plants remained constant from earlier periods, but their number and variety had much expanded. Among the 226 flowers, the hyacinth, rose, violet, ranunculus, tulip and carnation had been favourites since the 16th century. The 233 fruit trees included the traditional citrus, peach, pear, plum, cherry, nut and fig trees in numerous varieties.

(ii) *Historical development*. Gardens were composed of regular units or compartments, which represent the ordered cosmos in microcosm. Circles and squares, being considered the most perfect geometric figures, dominated the design of gardens, as in Raphael's design for the garden of the Villa Madama in Rome (*c*. 1518), the Orto Botanico in Padua and the Medici estate at Petraia (1590s). Views of 16th-century gardens emphasized the order, as in Dupérac's engraving of the Villa d'Este, which was designed by Pirro Ligorio from *c*. 1560; in it the steeply sloping site and architectural elements were subordinated to the regular units. The Giardino Giusti in Verona, created in the 1560s or 1570s, retains most of the original nine square compartments, which end at the base of a sheer cliff, with a balcony at the summit overlooking the garden. Like other Renaissance gardens, the Giusti garden is finite and measurable.

Since much of the topography of Italy is hilly, gardens were frequently laid out on hillside sites. They were regularized by terracing, with supporting walls and connecting staircases, inspired by descriptions of ancient villas and visible archaeological remains. These architectural gardens were furnished with a variety of inventions suggested by Classical gardens, but over time the relationship between natural and architectural elements changed significantly. At the Este garden at Tivoli and the VILLA

LANTE, BAGNAIA (1568–78), attributed to Vignola (see fig. 1 above), as well as at the Genoese gardens of the Palazzo Doria (now Doria–Pamphili, 1540s) by Giovanni Angelo Montorsoli and Galeazzo Alessi's Villa Imperiale–Scassi (1560s), each terrace forms a large garden, in some cases square, balanced but not dominated by the succession of architectural features that mark the central axis. Also new in these 16th-century terraced gardens were architectural fountains and water chains. The great fountains at Tivoli—the Fountain of the Dragon (*see* LIGORIO, PIRRO, fig. 2), the Oval Fountain and the Water Organ—were the backdrop for dramatic water displays in which the water was manipulated in a number of ways: formed into cascades, shot up in high jets and arcs and used to power booming and singing hydraulic devices. Another part of the Classical tradition in Italian gardens were the omnipresent water tricks.

The sculpture and sculpted fountains prominent in 16th-century gardens were also derived from Classical precedents and provided the repertory of garden ornament for the next two centuries. Much of the imagery refers to the natural world through mythological figures, such as Neptune, Venus, Ceres and satyrs, or through personified rivers and mountains. Pastoral literature inspired the representation of shepherds and shepherdesses with their sheep and goats, and of peasants with hoes and wine barrels. Sculpted animals appropriately populated the *boschi* or grottoes, as at the Villa Medici at Castello, where the interior of the grotto, covered in natural stalactites, has three niches filled with animal figures of every sort. The rustic was given metaphoric expression in the large grotesque heads that also appeared in gardens at this period, most dramatically at the Giardino Giusti in Verona and the Sacro Bosco or Villa Orsini, Bomarzo (*see* BOMARZO, SACRO BOSCO). By contrast with such artifice, some 16th-century estates were designed as parks. Like the park of the Villa Lante at Bagnaia adjacent to the geometric garden, these were planted principally with trees and did not have either compartments or terracing. The *barco* (park) of Francesco I de' Medici at Pratolino, which is known in its original state only from a painting by Utens (Florence, Mus. Firenze com'era), was densely planted with trees, predominantly fir, and ornamented with water channels, grottoes, statues, automata and Giambologna's colossal figure of *Appennino* (see colour pl. 1, XXXIII3).

BIBLIOGRAPHY

C. A. Platt: *Italian Gardens* (1884/*R* London, 1993)
D. Coffin: *The Villa d'Este at Tivoli* (Princeton, 1960)
G. Masson: *Italian Gardens* (London, 1961/*R* 1966)
C. D'Onofrio: *La Villa Aldobrandini di Frascati* (Rome, 1963)
I. Belli Barsali: *Ville di Roma* (Milan, 1970, rev. 1983)
E. B. MacDougall: *The Villa Mattei and the Development of the Roman Garden Style* (diss., Cambridge, MA, Harvard U., 1970)
D. Coffin, ed.: *The Italian Garden* (Washington, DC, 1972)
S. Langé: *Ville della provincia di Milano* (Milan, 1972)
E. B. MacDougall, ed.: *Fons Sapientiae: Renaissance Garden Fountains* (Washington, DC, 1978)
I. Belli Barsali: *Ville e committenti dello stato di Lucca* (Lucca, 1979)
D. Coffin: *The Villa in the Life of Renaissance Rome* (Princeton, 1979)
M. Fagiolo: *Natura e artificio: L'ordine rustico, le fontane, gli automi nella cultura del Manierismo europeo* (Rome, 1979)
M. Pellegri: *Colorno: Villa Ducale* (Parma, 1981)
G. Ragionieri, ed.: *Il giardino storico italiano: Problemi di indagine, fonti letterarie e storiche* (Florence, 1981)

L. Puppi: 'The Giardino Barbarigo at Valsanzibio', *J. Gdn Hist.*, iii (1983), pp. 281–300
F. Borsi and G. Pampaloni: *Ville e giardini* (Novara, 1984)
S. Langé and F. Vitali: *Ville nella provincia di Varese* (Milan, 1984)
M. Azzi Visentini: *L'Orto botanico di Padova e il giardino del rinascimento* (Milan, 1984)
G. L. Gorse: 'The Villa of Andrea Doria in Genoa: Architecture, Gardens and Suburban Setting', *J. Soc. Archit. Historians*, xliv (1985), pp. 18–36
E. B. MacDougall: 'Imitation and Invention: Language and Decoration in Roman Renaissance Gardens', *J. Gdn Hist.*, v (1985), pp. 119–34
L. Magnani: ' "L'uso d'ornare i fonti": Galeazzo Alessi and the Construction of Grottoes in Genoese Gardens', *J. Gdn Hist.*, v (1985), pp. 135–53
J. Dixon Hunt: *Garden and Grove: The Italian Renaissance Garden in the English Imagination, 1600–1750* (London, 1986)
V. Vercelloni, ed.: *Il giardino a Milano, per pochi e per tutti, 1288–1945* (Milan, 1986)
L. Magnani: *Il tempio di Venere: Giardino e villa nella cultura genovese* (Genoa, 1987)
J. Chatfield: *A Tour of Italian Gardens* (London and New York, 1988)
A. Tagliolini: *Storia del giardino italiano: Gli artisti, l'invenzione, le forme dall'antichità al XIX secolo* (Florence, 1988)
M. Azzi Visentini, ed.: *Il giardino veneto: Dal tardo medioevo al novecento* (Milan, 1988)
C. Lazzaro: *The Italian Renaissance Garden: From the Conventions of Planting, Design and Ornament to the Grand Gardens of Sixteenth-century Central Italy* (New Haven and London, 1990)
H. Mosser and G. Teyssot: *L'architettura dei giardini d'Occidente: Dal rinascimento al novecento* (Milan, 1990); Eng. trans. as *The Architecture of Western Gardens: A Design History from the Renaissance to the Present Day* (Cambridge, MA, 1991)
J. Dixon Hunt, ed. *The Italian Garden: Art, Design and Culture* (Cambridge, 1995)

CLAUDIA LAZZARO

Garimberto, Gerolamo (*b* Parma, 1506; *d* Rome, 1575). Italian bishop, antiquarian and collector. He went to Rome some time before 1527, serving as a canon of St Peter's and as vicar of S Giovanni in Laterano (where his mortuary monument remains) before being made Bishop of Gallese by Pius IV in 1562. By this date he had published five books, the first of which, *De reggimenti pubblici delle città*, appeared in 1544. In 1550 Ulisse Aldrovandi recommended his readers to the antiquarian collection 'nella camera di messer Hierolimo Garimberto' in the Palazzo Gaddi on Monte Citorio.

In 1562 Garimberto helped to evaluate the antiquities that Paolo Bufalo offered to Cardinal Alessandro Farnese. He also served as archaeological adviser to Cesare Gonzaga, Lord of Guastalla, and to his cousin Guglielmo Gonzaga, 3rd Duke of Mantua. The extensive correspondence (1562–73) with the former and the letters written to the latter in 1572–3 provide a highly readable source of information on the contemporary Roman antiquities market and on Garimberto's relations with such other antiquarians and dealers as Alessandro de' Grandi (*d* after 1590) and Vincenzo and Giovanni Antonio Stampa (active in Rome 1550–80). His own collection of antiquities is documented in detailed inventories of 1567 and 1576 sent to Albert V, Duke of Bavaria (*reg* 1550–79), in anticipation of a possible sale. Several of the works described can be related to engravings of items 'in Museo Garimberti', shown in books 3–4 of Giovanni Battista de' Cavalieri's *Antiquarum statuarum urbis Romae* (1594), and of these some can be identified with extant works as, for example, the *Infant Hercules Wrestling with Snakes* (Turin, Mus. Civ. A. Ant.), the acquisition of which is mentioned in the correspondence with Cesare Gonzaga. The same source documents the major purchase of his career, the collection

of the Milanese merchant Francesco Lisca (*d* 1564/5), which he bought in 1565.

In 1572 Garimberto wrote to Cesare Gonzaga describing his library of over 2000 books, arranged according to subject and interspersed with busts of many of the authors, his gallery displaying figurines and imperial heads and his loggia containing 'statove grande del naturale' (i.e. life-size statues). He was not the most learned member of the contemporary Roman intelligentsia, but his aspirations were typical and are unusually well documented.

BIBLIOGRAPHY

I. Affò and A. Pezzani: *Memorie degli scrittori e letterati parmigiani*, 7 vols (Parma, 1789–1833), iv, pp. 135–44; vi, pp. 542–7

P. P. Bober: 'Francesco Lisca's Collection of Antiquities: Footnote to a New Edition of Aldrovandi', *Essays in the History of Art*, ii of *Essays Presented to Rudolf Wittkower on his 65th Birthday*, ed. D. Fraser, H. Hibbard and M. J. Lewine (London, 1967), pp. 119–22

C. M. Brown: 'Major and Minor Collections of Antiquities in Documents of the Later 16th Century', *A. Bull.*, lxvi/2 (1984), pp. 496–507

——: 'Paintings and Antiquities from the Roman Collection of Bishop Gerolamo Garimberto Offered to Duke Albrecht Vth of Bavaria in 1576', *Xenia*, x (1985), pp. 55–70

C. Riebesell: *Die Sammlung des Kardinal Alessandro Farnese* (Weinheim, 1989)

C. M. Brown: *Cesare Gonzaga and Gerolamo Garimberto: Two Renaissance Collectors of Greco-Roman Art* (New York and London, 1993)

C. M. BROWN

Garofalo [Tisi, Benvenuto] (*b* Ferrara, 1481; *d* Ferrara, 1559). Italian painter. Active mainly in Ferrara and the district around the Po Delta, he was one of the most outstanding figures in Emilian classicism during the first half of the 16th century. In 1497 Garofalo's father paid Boccaccio Boccaccino to teach his son the rudiments of painting. Garofalo's first works were directly influenced by the Cremonese painter, to whom they were formerly even attributed. They consist of a series of small paintings depicting the *Virgin and Child*. The example in the Ca' d'Oro in Venice must have been Garofalo's first painting and reveals not only the lessons learnt from Boccaccino, but also signs of the influence of Domenico Panetti (*c.* 1460–before 1513), traditionally recorded as his first master. Another *Virgin and Child* (Assisi, Perkins priv. col.) shows signs of the early influence of Lorenzo Costa the elder, while the example in the Nationalmuseum, Copenhagen, shows a similarity with the early works of his contemporary, Lodovico Mazzolino.

A particularly important project in Ferrara during the earliest years of the 16th century, involving numerous highly skilled artists, was the fresco decoration of the oratory of the Concezione. The frescoes (Ferrara, Pin. N.) represent a significant development in the city's art. Garofalo's hand has been identified in the *Presentation in the Temple*, in which he reveals a familiarity not only with local art, but also with the high-points of Bolognese classicism, whose greatest exponents were Francesco Francia and Lorenzo Costa the elder. Around 1505, Garofalo's works show a close familiarity with artistic developments in Bologna, in particular the mature style of Costa and the decoration in 1505–6, by Francesco Francia, Costa, Aspertini and others, of the oratory of S Cecilia in S Giacomo Maggiore (for illustration *see* ASPERTINI, AMICO). Garofalo's *Virgin Enthroned between SS Martin and Rosalia* (Florence, Uffizi), created for Codigoro Cathedral, should be seen within this context, whereas the small altarpiece for the Arcivescovado, Ferrara, although executed at the same time, shows early, if faint, signs of the influence of Venetian painting of the period.

In 1506 Garofalo received payments for work done in the apartments of Lucrezia Borgia in the Palazzo di Schifanoia, Ferrara, and it was probably at this time that he executed the strikingly illusionistic figures of musicians on the ceiling of the Aula Costabiliana in the Palazzo di Ludovico il Moro. This important scheme reveals a complex variety of different visual influences, especially the Mantuan work of Mantegna, the clearest stylistic prototype for the work. It also reveals a more highly evolved sense of perspective, derived from Lombard art, in which Garofalo may well have been influenced by the presence in Ferrara of Cesare di Lorenzo Cesariano. Garofalo's paintings began to reflect a number of qualities reminiscent of the work of Giorgione, and it is possible that he travelled to Venice. This influence can be clearly seen in a series of small paintings, a *Nativity* (Ferrara, Pin. N.) and two versions of the *Adoration of the Magi* (Berlin, Staatl. Museen Preuss. Kultbes.; Krakow, N. Mus.), which reveal first-hand knowledge of such works by Giorgione as the *Adoration of the Magi* (London, N.G.). In the large painting created for the Este family depicting *Neptune and Minerva* (1512; Dresden, Gemäldegal.) Garofalo turned his attention to the classicism of Giorgione's final years, as exemplified by the latter's *Female Nude* on the façade of the Fondaco dei Tedeschi, Venice, while still retaining an interest in Mantegna's final style.

Between executing the *Neptune and Minerva* and the large *Nativity* (Ferrara, Pin. N.), which can be dated to July 1513, it is possible that Garofalo went to Rome, since the latter painting and also the *Virgin and Child between SS Lazarus and Job* (Ferrara, Pin. N.) from the same year clearly display a familiarity with the new classicism of Raphael, which is still absent from the Dresden painting. This new element was to form the basis of Garofalo's output over a long period, starting with a direct allusion to Raphael's Aldobrandini *Madonna* in his Suxena Altarpiece (Ferrara, Pin. N.; see fig.), executed for Santo Spirito, Ferrara.

As Garofalo's style became more complex and grandiose and enriched with Classical allusions, his vein of originality seemed to exhaust itself. His activities were, nonetheless, marked by an impressive series of commissions, ranging from a *Virgin with Saints* (1517; London, N.G.), executed for S Guglielmo, Ferrara, to the *Massacre of the Innocents* (1519; Ferrara, Pin. N.) for S Francesco, Ferrara, and in 1519–20, the decoration of two rooms in the Palazzo del Seminario, Ferrara, in which he revived the layout of the ceiling of the Palazzo di Ludovico il Moro, accentuating the perspective arrangement, but weighing it down with excessive ornamentation. In the meantime, documents record Girolamo da Carpi among his collaborators, while Garofalo himself produced a vast number of altarpieces for the main churches in Ferrara. After the large and iconographically complex fresco of 1523, depicting the *Old and New Testament* (Ferrara, Pin. N.) for the refectory of S Andrea, Ferrara, and the polyptych executed for the same church in collaboration with Dosso Dossi, he completed such other works as the

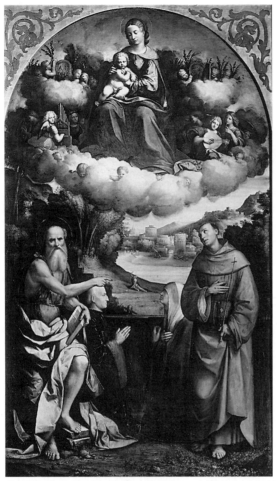

Garofalo: *Madonna of the Clouds with SS Jerome and Francis of Assisi and Two Members of the Suxena Family* (Suxena Altarpiece), oil on panel, 2.46×1.46 m, 1514 (Ferrara, Pinacoteca Nazionale)

Deposition (1527; Milan, Brera) and the *Raising of Lazarus* (1534; Ferrara, Pin. N.), all of which mark a phase in which Garofalo was impressed by the work of Michelangelo.

In 1537 and 1541 in the company of Battista Dossi, Camillo Filippi and Girolamo da Carpi, Garofalo worked on the decoration of the Este villas of Belriguardo and La Montagnola (both destr.). The faded frescoes executed in 1543 in the church of the Ospedale di Rubiera, commissioned by the Sacrati family, are extant, albeit in poor condition. Despite serious problems with his vision, resulting in total blindness in 1550, Garofalo continued his prolific output throughout the 1540s, executing such works as an altarpiece for S Salvatore, Bologna (1542) and a fresco of the *Last Supper* (1544; Ferrara, Pin. N.). His last dated painting is the *Annunciation* (1550; Milan, Brera).

BIBLIOGRAPHY
Thieme–Becker
E. Sambo: 'Sull'attività giovanile di Benvenuto Tisi da Garofalo', *Paragone*, xxxiv/395 (1983), pp. 19–34 [with bibliog.]
V. Sgarbi: 'Testimonianze inedite del Raffaellismo in Emilia: "Garofalo, Gerolamo da Carpi e Battista Dossi a Belriguardo"', *Studi su Raffaello. Atti del congresso internazionale di studi: Urbino and Florence, 1984*, pp. 596–60
J. Manca: 'Two Copies after a *Massacre of the Innocents* by Ercole de' Roberti', *Master Drgs*, xxv/2 (1987), pp. 143–6
A. M. Fioravanti Baraldi: *Il Garofalo: Benvenuto Tisi, pittore (c.1476–1559): Catalogo generale* (Rimini, 1993); review by A. Pattanaro in *Prospettiva*, lxxix (1995), pp. 39–53
A. Pattanaro: 'Garofalo e Cesariano in Palazzo Costabili a Ferrara', *Prospettiva*, lxxiii–lxxiv (1994), pp. 97–110

MARCO TANZI

Gasparo Padovano (*fl* Rome, 1483–5). Italian illuminator. He is mentioned as an illuminator, with Bartolomeo Sanvito, in Rome, in the will (1483) of Cardinal Francesco Gonzaga. In 1485 he was in Rome in the service of the Neapolitan cardinal Giovanni d'Aragona (1456–85). He can be identified with the Gasparo Romano mentioned by Pietro Summonte in a letter of 20 March 1524 to Marcantonio Michiel as the illuminator 'al garbo antiquo' (in the antique manner) of a copy of Pliny (untraced) for Giovanni d'Aragona. The same source stated that Gasparo was also an architect and that his style was copied by Giovanni Todeschino (*fl* Naples, 1487–1500).

There are no documented works by Gasparo. His Paduan origin, his presence in Rome and his relationship with Sanvito make it likely that he was one of the illuminators who propagated in Rome the antiquarian, classicizing style that originated in Padua and the Veneto region (*see* VENICE §III, 1). Scholars have tentatively identified Gasparo with two anonymous illuminators, the Master of the Berlin St Jerome (Berlin, Kupferstichkab., MS. 78 D. 13) and the Master of the Vatican Homer (Rome, Vatican, Bib. Apostolica, MS. Vat. gr. 1626). In both cases the artists, who are presumed to have come from the Veneto region, worked during the 1480s and 1490s on commissions from Giovanni d'Aragona as well as those mentioned above. The manuscripts of the Master of the Vatican Homer have also been attributed to Sanvito or Lauro Padovano. Those of the St Jerome master, on the other hand, for example a copy of Ovid's *Metamorphoses* (Paris, Bib. N., MS. lat. 8016), have recently been ascribed to the Master of the London Pliny (London, BL, MS. IC. 19662). These works influenced manuscript illumination in Naples and might, therefore, have been executed by Gasparo. Decorated with architectural frontispieces and antiquarian motifs of gems, pearls and cameos, they are characterized by refined metallic tones based on blues, mauves and gold.

BIBLIOGRAPHY
J. J. G. Alexander: 'Notes on Some Veneto-Paduan Illuminated Books of the Renaissance', *A. Ven.*, xxiii (1969), pp. 9–20
J. Ruysschaert: 'Miniaturistes "romains" à Naples', *La biblioteca napoletana dei re d'Aragona: Supplemento*, ed. T. de Marinis, i (Verona, 1969), pp. 263–74
A. Putaturo Murano: 'Ipotesi per Gasparo Romano miniatore degli Aragonesi', *Archv. Stor. Prov. Napoletane*, xiv (1975–6), pp. 95–100
L. Armstrong: *Renaissance Miniature Painters and Classical Imagery: The Master of the Putti and his Venetian Workshop* (London, 1981), pp. 40–49
The Painted Page: Italian Renaissance Book Illumination, 1450–1550 (exh. cat., ed. J. J. G. Alexander; London, RA, 1994)

FEDERICA TONIOLO

Gatta, Bartolomeo della. *See* BARTOLOMEO DELLA GATTA.

Gatti, Bernardino [il Soiaro] (*b* ?Pavia, *c.* 1495; *d* Cremona, 1576). Italian painter. In some documents he is said to have come from Pavia. His first documented work, the

Resurrection (1529; Cremona Cathedral), shows that he had a thorough knowledge of Correggio's work and of the classicizing manner of Raphael and Giulio Romano. Correggio's influence became increasingly apparent, although it was blended with Lombard archaisms, as in the *Virgin of the Rosary* (1531; Pavia Cathedral) and in the *Resurrection with the Virgin and St John the Baptist* and the *Last Supper* (1534–5; both Vigevano Cathedral). In the frescoes of *St George and the Dragon* and scenes from the *Life of the Virgin* (1543; both Piacenza, S Maria di Campagna) he tried to refine his style further, still drawing on Giulio and Correggio but achieving only a somewhat bloodless sentimentality. This is evident in the *Crucifixion* (Piacenza, Municipio).

From 1549 Gatti worked in Cremona. He painted the fresco of the *Ascension* on the vault of S Sigismondo that year, and in S Pietro al Po a large fresco of the *Miracle of the Loaves and Fishes* (1552), notable for its vividly naturalistic portraits. For the same church he also painted the *Nativity* (*in situ*), one of his most successful works. From 1560 to 1572 he worked on the prestigious commission for the decoration of the cupola of S Maria della Steccata, Parma; this included the *Assumption of the Virgin*, the *Annunciation* and figures of the Apostles. He still drew inspiration from Correggio, although transmuted into stiff and often awkward formulae. He painted the *Annunciation* in S Sigismondo, Cremona, but the monumental canvas of the *Assumption of the Virgin* for the high altar of Cremona Cathedral, a wooden work, was left unfinished at his death.

BIBLIOGRAPHY

A. M. Panni: *Distinto rapporto delle dipinture che trovansi nelle chiese della città e sobborghi di Cremona* (Cremona, 1762)

G. B. Zaist: *Notizie istoriche de' pittori, scultori ed architetti cremonesi* (Cremona, 1774)

G. Aglio: *Le pitture e le sculture della città di Cremona* (Cremona, 1794)

L. Lanzi: *Storia pittorica della Italia* (Bassano, 1795–6)

G. Picenardi: *Nuova guida di Cremona per gli amatori dell'arti del disegno* (Cremona, 1820)

E. Schweitzer: 'La scuola pittorica cremonese', *L'Arte*, iii (1900), pp. 41–71

R. Longhi: 'Quesiti caravaggeschi, ii: I precedenti', *Pinacotheca*, 5–6 (1929), pp. 97–144; repr. in '*Me pinxit' e quesiti caravaggeschi* (Florence, 1968)

A. Venturi: *Storia* (1933), ix/6, pp. 812–24

A. C. Quintavalle: 'Un appunto sulla cultura di Bernardino Gatti', *A. Ant. & Mod.*, vii (1959), pp. 433–6

M. Di Giampaolo: 'Disegni di Bernardino Gatti', *Antol. B. A.*, iv (1977), pp. 333–8

I Campi e la cultura artistica cremonese del cinquecento (exh. cat., ed. M. Gregori; Cremona, Mus. Civ. Ponzone, 1985), pp. 145–51

J. Biscontin: 'Antique Candelabra in Frescoes by Bernardino Gatti and a Drawing by Giulio Romano', *J. Warb. & Court. Inst.*, lvii (1994), pp. 264–9

GIULIO BORA

Gazini [Gazzini]. *See* GAGINI.

Gem-engraving. Engraved gems are gemstones, whether quartzes or the harder, more precious stones, either engraved in intaglio, as for seals, or cut in cameo to give a raised relief image. In a wider sense gem-engraving encompasses shell cameos and moulded, glass-paste imitations of engraved gems.

1. History. 2. Collections and museums.

1. HISTORY. The earliest important examples of post-medieval glyptics date from Valois France, but it was in Renaissance and Mannerist Italy that, under the stimulus of a growing passion for collecting ancient gems, the revived craft reached an artistic perfection unrivalled since antiquity. Craftsmen practising in such related occupations as seal-engraving, coin-die cutting and as medallists set up as gem-engravers in North Italian cities and in Rome, which was to dominate gem-engraving until the decline of the craft in the 19th century.

(i) 1400–*c.* 1500. (ii) *c.* 1500–1600.

*(i) 1400–*c. *1500.* In Italy gem-engraving, influenced by Classical models, arose in various Italian cities in the wake of humanist learning and collecting of antiquities. Knowledge of ancient gems was disseminated through plaster casts and bronze plaquettes; the excitement they aroused among artists is evident in their influence on sculptures by Donatello and his followers; they are reproduced in paintings and drawings by Botticelli, Giovanni Bellini and Veronese, and on the reverses of medals. They also stimulated contemporary gem-engravers to produce work in the Classical tradition; the techniques of engraving on stone were influenced by learning from Byzantine refugees and from Burgundian craftsmen. They employed the traditional quartzes (hardstones): for intaglio, pale chalcedony, cornelian and sard; for cameo, mostly two- or three-layer agates, for example onyx and sardonyx, and varieties of chalcedony and jasper. They also engraved on lapis lazuli and occasionally on the harder gemstones, such as sapphire or ruby.

Turquoise was a particular favourite of Isabella d'Este, Marchesa of Mantua, who commissioned gems from

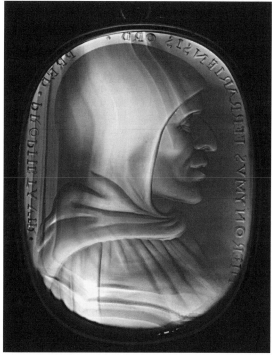

1. Cornelian intaglio of *Girolamo Savonarola* by Giovanni delle Corniole, 327×415 mm, *c.* 1500 (Florence, Palazzo Pitti, Museo degli Argenti)

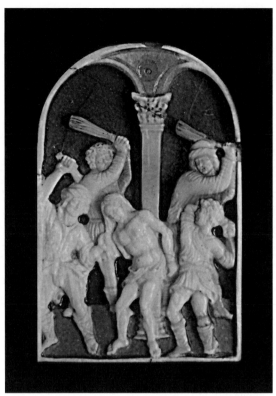

2. Onyx cameo, *Christ at the Column*, 65×42 mm, North Italian, *c.* 1500 (Vienna, Kunsthistorisches Museum, Kunstkammer)

Francesco Anichini in Venice, already a noted centre for the craft. In 1477 Lorenzo de' Medici, the Magnificent, brought the medallist Pietro de' Neri Razzanti [Petroceni] (1425–after 1480) to Florence to teach gem-engraving, and in Milan Domenico dei Cammei (*d* 1508) engraved a portrait of *Ludovico il Moro* (Florence, Pitti; St Petersburg, Hermitage, attrib.; *see also* §II below). Remarkably naturalistic portraits of old men (London, BM; Vienna, Ksthist. Mus.) were also produced in Milan. Rome attracted artists to the Papal Mint and court: a cornelian intaglio portrait of *Pope Paul II* (1470; Florence, Pitti) by Giuliano di Scipione (*fl c.* 1470) is the earliest preserved Italian gem by a named engraver. Three other gems (Naples, Mus. Archeol. N.) once owned by the Pope, later in the collection of Lorenzo de' Medici, and variants (e.g. Paris, Bib. N., Cab. Médailles) of the ancient *Apollo and Marsyas* gem (Naples, Mus. Archeol. N.) are by unknown contemporary artists. A cameo portrait of *Lorenzo* (Florence, Pitti), probably posthumous, has been attributed to the earliest engraver mentioned by Vasari, Giovanni delle Corniole [Giovanni delle Opere] (1470–*c.* 1516), whose cornelian intaglio of *Girolamo Savonarola* (see fig. 1) was acquired *c.* 1568 by Cosimo I de' Medici, Grand Duke of Tuscany. The noble, idealizing style of these busts—very different from Milanese naturalism—reveals the influence of Classical portraiture. Besides motifs from the Antique, biblical subjects were engraved in styles closely related to those of the major arts of the period (e.g. *Annunciation*; St Petersburg, Hermitage; *Christ at the Column*, *c.* 1500; see fig. 2). The work of PIER MARIA SERBALDI DA PESCIA is

imbued with the Classical spirit that he absorbed in the circle of Lorenzo. Serbaldi distinguished himself by working in the exceedingly hard porphyry (e.g. dies for a portrait medal of *Pope Leo X*, Florence, Pitti; Paris, Louvre). A cornelian intaglio representing a many-figured *Bacchanal* (Paris, Bib. N., Cab. Médailles), which in subsequent centuries was one of the most admired and copied stones, has been ascribed to Serbaldi.

(ii) c. 1500–1600. After the restoration of the Medici in 1527, Florence once again exercised important patronage; portraits of the assassinated *Alessandro de' Medici* (cameo; Florence, Pitti; rock crystal intaglio; Paris, Bib. N., Cab. Médailles) are ascribed to Domenico di Polo (1480–1547), who engraved a magnificent standing *Hercules* for Grand Duke Cosimo I's seal (Florence, Bargello). Much of the busy trade in gems continued through Venice, where Francesco Anichini remained revered as the leading glyptic artist until his death in 1526. Chalcedony cameo busts of women (e.g. *Cleopatra*; Vienna, Ksthist. Mus.) show the influence of the work of the sculptor Tullio Lombardo (*see* LOMBARDO, (2)); similar busts, almost or entirely in the round, appear in hyacinth, for example *Lucretia* (Florence, Pitti).

Antique motifs and Classical styles continued to dominate the work of gem-engravers, who also drew on contemporary graphics and plaquettes, which were themselves influenced by Classical art, for models of frieze-like processions and sacrifices, triumphs and bacchanals, hunts and cavalry battles; portraits and contemporary scenes were also depicted in antique mode, for example the confronted *Cosimo I and Eleonora de' Medici* and the *Triumph of Philip II* (both Florence, Pitti) by Domenico Compagni (*fl c.* 1550–86). Matteo del Nassaro (*d* 1547/8) from Verona, who studied in Rome with his compatriot Nicolò Avanzi (1500–*c.* 1550) was an admired gem-engraver of the first half of the century; in 1515 Matteo left Italy to work in France for Francis I (*reg* 1515–47). Even his reputation, however, was surpassed by that of the prolific VALERIO BELLI. Belli was renowned for his large, reverse intaglio rock crystal plaques, designed to be seen through the polished surface, for example those forming the casket (1530–32; Florence, Pitti; *see* ITALY, fig. 33) with scenes of the *Passion* commissioned by Pope Clement VII. His mature work in gems was widely disseminated through reproduction in plaquettes (examples in Florence, Bargello), as was that of his younger rival GIOVANNI BERNARDI, who worked chiefly in Rome, a master of the struck medal as well as of gem-engraving. Bernardi's technique of reverse intaglio resembled that of Belli, but his style is related to contemporary Mannerist art; a rock crystal intaglio of *Tityus* (see fig. 3) is based on a drawing by Michelangelo. Bernardi's work exercised great influence on the newly fashionable vessels in rock crystal and hardstones created in Milan (*see* MILAN, §III), where, under the settled rule of the Spanish Habsburgs, dynasties of craftsmen were established.

A different direction is indicated by the smaller-scale work of Alessandro Cesati. Active in Rome during the mid-16th century, he was employed by the Mint and is reputed to have been a skilful forger of ancient coins; his

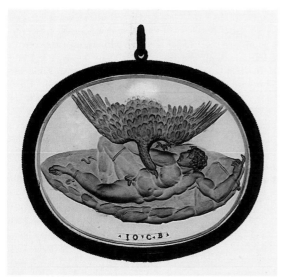

3. Rock crystal intaglio of *Tityus* by Giovanni Bernardi, l. 60 mm, 16th century (London, British Museum)

cameos are distinguished by a virtuoso technique in extremely low relief, for example a portrait of *Henry II* of France (*reg* 1547–59) in cornelian (St Petersburg, Hermitage).

An exceptionally important commission for Rome was the State Cameo (1565–72; Florence, Pitti) created by Giovanni Antonio de' Rossi for Cosimo I. It was designed to emulate Classical models and depicts the Duke surrounded by his wife and children.

For jewellery, the more colourful and more immediately 'readable' cameos began to be preferred over intaglios, their contrasting layers making a splendid show in badges or pendants, sumptuously mounted in gold, enamel and precious stones (examples of original settings in Vienna, Ksthist. Mus.). As emblems of dynastic power, often destined for gifts, cameo portraits of rulers and their consorts assumed great importance. In addition to portraits in the antique style (e.g. onyx cameo of *Cosimo I* by ?Domenico Poggini; Florence, Pitti), sitters were also shown in contemporary armour or costume, with minutely detailed dress, hairstyles and jewels (e.g. ?*Alfonso II, Duke of Ferrara, and Lucrezia de' Medici*; Paris, Bib. N., Cab. Médailles).

Even more striking, naturalistic effects were achieved in *commesso* cameos, in which differently coloured hardstones were placed in mosaic with enamelled gold and gems to render flesh-tones and costume; in the cameo of *Cleopatra* (Vienna, Ksthist. Mus.) a diamond is used to imitate a mirror. Ottavio Miseroni developed this genre further by adopting a relief mosaic, which he employed for portraits, both real and ideal (e.g. *Lady with a Feather Fan*; Vienna, Ksthist. Mus.), for pagan allegorical figures, and for Christian devotional gems (e.g. *Madonna*; Vienna, Schatzkam.). In *cameos ornés*, details of jewellery are rendered in applied pearls and brilliants, most strikingly on heads of negroes and Moors, their images cut in the dark surface layer of onyx or sardonyx (e.g. *Diana as a Negress*; Vienna, Ksthist. Mus.; *Negro King*; Paris, Bib. N., Cab. Médailles); ideal heads of *Roman Emperors*, some-

times in series of the *Twelve Caesars*, similarly exploit the crisply defined strata of the stones. Another favourite motif consisted of half figures of nude women, for example *Lucretia* (*c.* 1560–70; Vienna, Ksthist. Mus.) by Jacopo da Trezzo I. Sculpture, plaquettes and prints provided the models for narrative subjects: Francesco Tortorino (*d* before 1595) depicted a cavalry battle after a motif from the Arch of Titus in Rome; his scenes in high relief——*Marcus Curtius at the Bridge*, the *Generosity of Scipio* (attrib.; both Vienna, Ksthist. Mus.) and other subjects from Roman history—were frequently repeated, as they were on plaquettes; earlier intaglios by Valerio Belli were also translated into cameo. Brightly coloured jaspers cut in high relief depicting birds or animals (e.g. St Petersburg, Hermitage) were the speciality of the workshop of Giovanni Antonio Masnago (*fl* late 16th century); minute figures in highly elaborate landscapes and architectural settings, representing Classical or biblical scenes after prints by Etienne Delaune (*c.* 1519–83), were engraved by Giovanni Antonio's son Alessandro Masnago (*fl c.* 1575–1612) on polychrome jaspers and agates, as in the *Rape of Proserpina* (Vienna, Ksthist. Mus.); greatly prized by Rudolf II (*reg* 1516–1612), many are preserved in elaborate mounts (Vienna, Ksthist. Mus.) by Andreas Osenbruck (*fl* 1612–22) and Hans Vermeyen (*d* 1606). Cameos were also employed profusely in a subsidiary role to decorate such gold objects as cups, caskets, mirrors, candelabra and even arms; here one finds ancient and imposing modern cameos intermingled with such hasty and insignificant work as small portrait heads, busts of women with exposed breasts, and roughly cut intaglios of pseudo-Classical heads and figures in cornelian and lapis lazuli. At the end of the century large oval plaques of transparent banded and mottled agates were cursorily engraved in intaglio with Classical figures, often cupids, in a landscape (e.g. Vienna, Ksthist. Mus.; Florence, Pitti).

BIBLIOGRAPHY

AKL; *DBI*; Forrer; Thieme–Becker

G. Vasari: *Vite* (1550, rev. 2/1568); ed. G. Milanesi (1878–85)

A. P. Giulianelli: *Memorie degli intagliatori moderni in pietre dure, cammei, e gioje, dal sec. XV fino al sec. XVIII* (Livorno, 1753)

H. Rollett: 'Glyptik', *Geschichte der technischen Künste*, ed. B. Bucher, i (Stuttgart, 1857), pp. 271–356

C. D. Fortnum: *Notes on Some of the Antique and Renaissance Gems and Jewels in Her Majesty's Collection at Windsor Castle* (London, 1876)

E. Müntz: *Les Arts à la cour des Papes pendant le 15e et 16e siècle*, i (Paris, 1878)

O. M. Dalton: *Catalogue of Engraved Gems of the Post-Classical Periods in the British Museum* (London, 1915)

H. Gebhart: *Gemmen und Kameen* (Berlin, 1925)

V. Slomarin: 'Rock Crystals by Giovanni Bernardi', *Burl. Mag.* (Jan 1926), pp. 9–22

F. Eichler and E. Kris: *Die Kameen im Kunsthistorischen Museum* (Vienna, 1927)

E. Kris: 'Di alcune opere ignote di Giovanni dei Bernardi nel Tesoro di San Pietro', *Dedalo*, ix (1928), pp. 97–111

——: *Meister und Meisterwerke der Steinschneidekunst in der italienischen Renaissance*, 2 vols (Vienna, 1929)

R. Righetti: *Incisori di gemme e cammei in Roma dal rinascimento all'ottocento* (Rome, 1952)

C. G. Bulgari: *Argentari gemmari e orafi d'Italia—Roma*, 3 vols (Rome, 1958–66)

C. Piacenti Aschengreen [K. Aschengreen Piacenti]: *Il Museo degli Argenti a Firenze* (Milan, 1968)

A. Ballerin 'Valerio Belli e la glittica nel Cinquecento', *Il gusto e la moda nel Cinquecento vicentino a veneto* (exh. cat., Vicenza, Pal. Chiericati, 1973)

J. Kagan: *Western European Cameos in the Hermitage Collection* (Leningrad, 1973)

M. A. McCrory: 'Cammei a intagli', *Firenze e la Toscana dei Medici nell' Europa del Cinquecento: Palazzo Vecchio: Commitenza e collezionismo medicei* (exh. cat., Florence, Pal. Vecchio, 1980), pp. 143–56

D. Chambers: *A Renaissance Cardinal and his Worldly Goods: The Will and Inventory of Francesco Gonzaga (1444–1483)* (London, 1982)

M. A. McCrory: 'Renaissance Shell Cameos from the Carrand Collection of the Museo Nazionale del Bargello', *Burl. Mag.*, cxxx (1988), pp. 412–26

C. Robertson: '*Il Grand Cardinale': Alessandro Farnese, Patron of the Arts* (New Haven and London, 1992), pp. 36–45

G. Seidmann *Portrait Cameos: Aspects of their History and Function, Cameos in Context*, ed. M. Henig and M. Vickers (Oxford and Houlton, 1993)

E. Zweirlein-Diehl: 'Antikeisierende Gemmen des 16–18 Jahrhunderts', *PACT*, xxxiii (1993), pp. 373–403

C. Gasparri: *Le gemme Farnese* (Naples, 1994)

G. Tassinari: 'Valerio Belli, Giovanni Bernardi e un gruppo di intagli non antichi', *Bull. Ant. Besch., lxxi (1996), pp. 161–95*

K. Achengreen Piacenti: 'The Use of Cameos in the Mounts of Sixteenth Century *Pietre Dure* Vases', *Engraved Gems: Survivals and Revivals*, ed. C. M. Brown (Washington, DC, 1997), pp. 158–79

M. A. McCrory: 'The Symbolism of Stones: Engraved Gems at the Medici Ducal Court (1537–1609)', *Engraved Gems: Survivals and Revivals*, ed. C. M. Brown (Washington, DC, 1997), pp. 158–79

D. Thornton: 'Valerio Belli and after: Renaissance Gems in the British Museum', *Jewel Stud.*, viii (1998), pp. 11–20

2. COLLECTIONS AND MUSEUMS. In Italy Petrarch was one of the earliest humanists to collect gems; in the 15th century Pietro Barbo (later Pope Paul II) owned 821, including the Tazza Farnese (Naples, Mus. Archeol. N.), which, with others from his collection, was later in the possession of Lorenzo de' Medici, who had the letters LAV. R. MED. engraved on many of them (dispersed; the majority in Naples, Mus. Archeol. N.). Outstanding collectors *c.* 1500 in Italy were Cardinal Domenico Grimani (collection in Venice, Mus. Archeol.) and Isabella d'Este, Marchesa of Mantua, who owned the great jugate cameo admired by Rubens, later called the *Cameo Gonzaga* (probably that in St Petersburg, Hermitage), and the Roman Imperial onyx known as the *Mantuan Vase* (Brunswick, Herzog Anton Ulrich-Mus.). In the 16th century Cosimo I, Grand Duke of Tuscany, and the later Medici re-established a collection in Florence (Pitti); the scholar Fulvio Orsini bequeathed his important collection (Naples, Mus. Archeol. N.) to Cardinal Odoardo Farnese.

BIBLIOGRAPHY

C. Piacenti Aschengreen: *Il Museo degli Argenti a Firenze* (Milan, 1968), pp. 11–26

Il tesoro di Lorenzo il Magnifico: Le gemme (exh. cat. by N. Dacos, A. Giuliano and U. Pannuti, Florence, Pal. Medici–Riccardi, 1972)

M. van der Meulen: *Petrus Paulus Rubens Antiquarius: Collector and Copyist of Antique Gems* (Alphen aan de Rijn, 1975)

GERTRUD SEIDMANN

Genga. Italian family of artists.

(1) Girolamo Genga (*b* Urbino or surroundings, 1476; *d* La Valle, nr Urbino, 11 or 31 July 1551). Painter and architect. Vasari stated that he was first apprenticed to Luca Signorelli, probably when the latter went to Urbino in 1494. From *c.* 1498 until 1501 he was active in Pietro Perugino's workshop, where he probably met Raphael. He later went to Florence, remaining there for some years, according to Vasari, before going to Siena, though the sequence of his movements between 1501 and *c.* 1513 is

disputed. His career is unlikely to have followed the neat progression implied by Vasari, and it is more reasonable to consider the artist as relatively mobile, moving between different artistic centres.

In 1504 Girolamo Genga is documented working with Timoteo Viti on a fresco cycle of the *Life of St Martin* (destr. 1793) and an altarpiece of *SS Thomas Becket and Martin Venerated by Bishop Arrivabene and Duke Guidobaldo da Montefeltro* (Urbino, Pal. Ducale) for the chapel of St Martin in Urbino Cathedral. The following year they were both paid for painting and gilding a tabernacle (destr.) for the cathedral. In 1507 they shared a commission to paint a silk standard for the *comune* of Urbino, and in 1508 Genga was entrusted with the decorations for the funeral of Duke Guidobaldo I da Montefeltro. Towards the end of 1509 Genga and Viti designed the triumphal arches and other ephemeral decorations for the festivities celebrating the entry into Urbino of Leonora Gonzaga (*d* 1550), consort of Francesco Maria I della Rovere, 4th Duke of Urbino.

Genga's work in the Palazzo Petrucci, Siena, where he painted alongside Bernardino Pinturicchio and Signorelli, has been dated to 1509, although some scholars suggest a date as early as 1498 or place the project in the years 1503–12. Genga is most frequently linked with the two frescoes (now detached) of the *Ransoming of Prisoners* and *Aeneas' Flight from Troy* (Siena, Pin. N.). He is documented in Siena in 1510, and this date is also assigned to the *Transfiguration* (Siena, Mus. Opera Duomo), painted as a cover for the cathedral organ, in which the influences of Sodoma and Girolamo del Pacchia (1477–1533) are more apparent than those of his earlier teachers.

Genga's name has been linked with the decorations for the inaugural performance of *Calandria* (1506) by Cardinal Bernardo Bibbiena in Urbino on 6 February 1513, as described in a letter by Baldassare Castiglione and an anonymous 16th-century manuscript (Rome, Vatican, Bib. Apostolica, MS. Urb. Lat. 490), but neither source names the artist responsible. Since no traces of the sets have survived, and considering Castiglione's reference to his own role as overseer and director of the enterprise, it is difficult to accept the attribution to Genga without question, although both Serlio and Vasari wrote of his talents in designing theatre sets.

In September 1513 Genga was commissioned by the Augustinian Order in Cesena to paint the altarpiece of the *Dispute on the Immaculate Conception* (Milan, Brera), signing the contract *gironimo da urbino pictore in fiorenza*. He executed the work in Cesena and received the first payment in 1516, by which date he was a resident there. The altarpiece was installed in S Agostino in 1520. It reflects the influence of Raphael, but more particularly of Michelangelo. A painting of the *Dispute on Original Sin* (Berlin, Bodemus.), stylistically similar to the Cesena Altarpiece, is dated *c.* 1515. In 1518 Genga collaborated with Viti on a fresco cycle of the *Assumption of the Virgin* (destr. 1793) in the church of S Francesco, Forlì. Before 1520 he was commissioned by Agostino Chigi to paint an altarpiece of the *Resurrection* for the oratory of S Caterina da Siena in the Via Giulia, Rome (*in situ*). Its dependence on Raphael's *Transfiguration* (Rome, Pin. Vaticana) is clearly visible

Girolamo Genga: Villa Imperiale, Colle San Bartolo, near Pesaro (1530s)

(Colombi Ferretti). It is likely that Genga was in Rome in 1520–21.

In August 1522 Genga was invited to Urbino by Francesco Maria I della Rovere to become court artist and architect. During his earliest years in the Duke's service he spent much time in Rome drawing antiquities and acquiring precious building materials, such as columns and slabs of ancient marble and coloured stone. For most of the 1520s his work was limited to the restoration and modernization of the two principal ducal palaces, at Pesaro and Urbino, and the Duchess's residence at Fossombrone. Between c. 1529 and 1532 he was commissioned by the Duchess to plan and oversee a fresco cycle in eight rooms in the Sforza Villa Imperiale (see PESARO (i), §3). The Duchess also commissioned him to design his first architectural project, a new villa on a difficult hill site further up the Colle San Bartolo (1530s; see fig.). For Francesco Maria I he restored the Barchetto (destr.), a park located inside the town walls of Pesaro near the Porta Rimini, where, according to Vasari, he designed a small house built to simulate a ruin.

Genga's last major building was S Giovanni Battista, Pesaro, begun in 1543 and continued after his death by his son, (2) Bartolommeo Genga. The Latin-cross plan, with an octagonal choir, barrel-vaulted nave and side chapels, was clearly influenced by Francesco di Giorgio Martini, Donato Bramante and Baldassare Peruzzi. Certain architectural details of the unfinished façade, such as the shallow pilasters, recall those of the earlier Villa Imperiale.

(2) Bartolommeo [Bartolomeo] **Genga** (b Cesena, 1518; d Malta, July 1558). Architect, son of (1) Girolamo Genga. According to Vasari, he was apprenticed to his father at the age of 18. Around 1538 he was sent from Pesaro to Florence to continue his studies in drawing and painting. While there, he came under the influence of Vasari and Bartolomeo Ammanati, two of the leading exponents of Tuscan Mannerism. When he returned to Pesaro three years later, his father decided that he showed more skill in architecture than in painting. Accordingly, Girolamo instructed him in perspective and sent him to Rome to measure antiquities. On his return to the Duchy of Urbino (c. 1545), he became the principal military architect to Guidobaldo II della Rovere, Duke of Urbino, who took him on one of his missions for the Republic of Venice, to draw fortifications. Vasari specifically refers to the fortress of S Felice, Verona, where work is documented as under way between late 1546 and 1547. Ferdinand I of Austria, King of Bohemia (reg 1526–62), saw work executed by Genga in Lombardy and tried to engage his services but was unsuccessful. Back in Pesaro, in 1548, Bartolommeo prepared a model for the port, but his project was abandoned, probably for lack of funds. His renown as a military engineer spread quickly. Around 1550, while in Rome with the Duke, he made drawings for the fortification of the Vatican Borgo. Also at this time, the Genoese tried to commission him to work on their defence system, but the Duke refused to give his architect leave of absence.

Bartolommeo's activity was not restricted to military projects. In January 1548 he had been in charge of the decorations honouring the arrival in Urbino of Vittoria Farnese, Duke Guidobaldo's second wife. Not much later, he began a major restoration and modernization of the Palazzo Ducale in Pesaro. He enlarged the 15th-century courtyard, installing an entrance portal with access to the principal staircase, the source for which can be found in the central bay of Giovanni Maria Falconetto's Loggia Cornaro in Padua (1524). Despite its more vertical lines, the Pesaro door closely reflects Falconetto's scheme, even including the two *Victories* in the spandrels. Bartolommeo also designed three rooms on the first floor of the palazzo that are remarkable for their ornate ceilings, the elaborate forms of which could have been inspired by his father's ceilings in the Villa Imperiale, though Bartolommeo's designs surpass them in intricacy. He built another apartment of four rooms, which is mentioned by Vasari as the Duke's apartment, in the wing overlooking the Corso.

Bartolommeo succeeded his father as chief ducal architect in 1551 and supervised the continuation of S Giovanni Battista, although the façade was not completed. In the Palazzo Ducale at Urbino he built the suite of rooms on the second floor (1554–7), over the 15th-century apartment of Iole, that served as the Duke's private quarters. In March 1558 he arrived at Malta to design the fortifications of the island and two new cities, one of the few commissions he was allowed to accept outside Urbino, but managed to prepare only one urban design and drawings for some of the buildings.

BIBLIOGRAPHY

B. Castiglione: *Le lettere* (early 16th century); ed. G. La Rocca (Verona, 1978)

S. Serlio: *Il secondo libro di prospettiva* (Paris, 1545); ed. G. D. Scamozzi (Vicenza, 1618), fol. 47v

G. Vasari: *Vite* (1550, rev. 2/1568); ed. G. Milanesi (1875–85), vi, pp. 315–40

F. Milizia: *Memorie degli architetti antichi e moderni*, i (Bassano, 1785), p. 177

B. Patzak: *Die Villa Imperiale in Pesaro* (Leipzig, 1908)

G. Gronau: *Documenti artistici urbinati* (Florence, [1936])

A. M. Petrioli Tofani: 'La *Resurrezione* del Genga in S Caterina a Strada Giulia', *Paragone*, xv (1964), no. 177, pp. 48–58

———: 'Per Girolamo Genga', *Paragone*, xx (1969), no. 229, pp. 18–36; no. 231, pp. 39–56

A. Pinelli and O. Rossi: *Genga architetto* (Rome, 1971)

M. Groblewski: *Die Kirche San Giovanni Battista in Pesaro von Girolamo Genga* (diss., U. Regensburg, 1976)

F. Ruffini: *Teatri prima del teatro* (Rome, 1983)

A. Colombi Ferretti: *Girolamo Genga e l'altare di S Agostino a Cesena* (Bologna, 1985)

D. J. Sikorsky: 'Il Palazzo Ducale di Urbino sotto Guidobaldo II (1538–74): Bartolomeo Genga, Filippo Terzi e Federico Brandani', *Il Palazzo di Federico da Montefeltro: Restauri e ricerche* (exh. cat., ed. M. L. Polichetti; Urbino, Pal. Ducale, 1985), pp. 67–90

S. Eiche: 'La corte di Pesaro dalle case malatestiane alla residenza roveresca', *La Corte di Pesaro*, ed. M. R. Valazzi (Modena, 1986), pp. 13–55

A. Fucili Bartolucci: 'Architettura e plastica ornamentale nell'età roveresca dal Genga al Brandini', *Arte e cultura nella provincia di Pesaro e Urbino*, ed. F. Battistelli (Venice, 1986), pp. 281–92

S. Eiche: 'Girolamo Genga the Architect: An Inquiry into his Background', *Mitt. Ksthist. Inst. Florenz*, xxxv (1991), pp. 317–23

——: 'Prologue to the Villa Imperiale Frescoes', *Not. Pal. Albani.*, xx (1991), pp. 99–119

——: 'Fossombrone, Part I: Unknown Drawings and Documents for the *Corte* of Leonora Gonzaga, and her son, Giulio della Rovere', *Stud. Stor. A.*, ii (1991), pp. 103–28

A. Morandotti: 'Gerolamo Genga negli anni della pala di Sant'Agostino a Cesena', *Stud. Stor. A.*, iv (1993), pp. 275–90

F. Todini: 'Una *Sacra Famiglia* di Gerolamo Genga', *Stud. Stor. A.*, iv (1993), pp. 291–4

SABINE EICHE

Genoa [anc. Genua; It. Genova]. Italian city, capital of Liguria. It lies on the shores of the Gulf of Genoa in the north-west of Italy, its urban area extending up into the surrounding hills. Genoa is the most important port in Italy and one of the largest in the Mediterranean. Its historic importance as a maritime power, which rivalled that of Venice by the 14th century, is reflected in the city's rich medieval and Renaissance architecture, notably the palaces of its great maritime families. Genoa also became a noted centre of production, particularly of silk and ceramics.

1. History and urban development. 2. Art life and organization. 3. Centre of production.

1. HISTORY AND URBAN DEVELOPMENT. With origins perhaps in the 6th century BC, a Ligurian trading settlement was established at Genoa, which subsequently allied itself with Rome in the 3rd century BC; although destroyed by the Carthaginians (205 BC), it was quickly rebuilt. The outline of the first settlement can be seen on the slopes of the Collina di Castello. The remains of the Ligurian site to the north of the Castello probably indicate the limits of pre-Roman habitation. It is likely, however, that the summit of the hill constituted the principal urban area even in Roman and Byzantine times. After the collapse of the Roman Empire, Genoa was ruled successively by the Goths, Byzantines, Lombards and Franks. The medieval city finally took shape in the period between construction of the first and second city walls (AD 864–1161). The 9th-century walls took in the lower inhabited areas (*civitas*) and the higher (*castrum*) areas of Castello on the northern side of the town, in which direction subsequent major urban growth developed. The arrival of the relics of S Remo in the walled city between 889 and 916 and the transfer of the cathedral from the country church of S Siro to S Lorenzo (987) resulted in the development in the city's Castello quarter of an active canonical community. A new Romanesque cathedral was consecrated in 1118 (modified later; rest. 1934). S Siro and the Benedictine abbey of S Stefano (façade 13th–14th century) then became the focal-points of suburban colonization encouraged by the Church in the 10th and 11th centuries.

After the establishment (1009) of the 'Compagna Communis' for the emancipation of the *comunes* from imperial and ecclesiastical power, control of Genoa was disputed between powerful local families, notably the SPINOLA, Grimaldi, DORIA and Fieschi, who subsequently became important patrons. The city's rise to maritime power began when, together with Pisa, it acquired the islands of Sardinia and Corsica from the Saracens in 1070. It then took full advantage of the Crusades to develop trade with the East, consolidating its influence with a colony at Byzantium (1204) and, having defeated its rival Pisa in 1284, gaining a monopoly over trade between the Russian empire, Turkey and Egypt. Genoa's mercantile success resulted in enormous demographic and urban expansion. The Ripa Maris (sea-wall), the long colonnade along the port, was begun in 1133 and completed by Giovanni Boccanegra with the Palazzo del Mare (1160) and the new walls (1155–61), which encompassed the quarters of Borgo and the fort of Castelletto. The nobility, engaged in commerce, resided in those quarters sheltered by the Ripa, whereas the monastic orders occupied the few free areas within the city walls. By the end of the 13th century, medieval Genoa had attained its definitive form. In the 14th century the joint claims of Genoa and Pisa on the Greek island of Tenedos (now Bozcaada, Turkey) drew them into conflict with Venice in the Wars of Chioggia (1378–81), from which Genoa emerged defeated. Attempts to arrest the resulting political and commercial decline of the city led to the formation (1407) of the sole trading company, the Casa di S Giorgio, but this was unable to halt its loss of control of trade to the East, which fell to the Turks and Venetians. Protected at first by France and then by the Visconti and Sforza families, Genoa came under the domination of Francis I of France (*reg* 1515–47) in 1527. A year later it was liberated from the French by Andrea Doria I, one of the greatest of its naval leaders, and by the intervention of Spain, to which the city remained closely linked for the next two centuries.

The revival on a grand scale of Genoese urban politics took place in the 1530s, when the city became a financial centre. While the city walls were being reconstructed (1536), an extraordinary series of noble suburban villas was begun, including the Palazzo Doria (now Doria–Pamphili), built for Andrea Doria I at Fassolo (see fig.); from 1528 many artists from both Florence and Rome were employed at the palazzo, which became a model through which the High Renaissance was introduced to Liguria (*see* §2 below; for further discussion *see* DORIA, (1)). Other villas were built by Galeazzo Alessi, one of the most important architects working in Genoa in the 16th century: these include the Villa Giustiniani (1548; renamed Villa Cambiaso; *see* ALESSI, GALEAZZO, fig. 1) and Villa Pallavicino (*c.* 1555; also known as the Villa delle Peschiere; *see* VILLA, fig. 3). The cubic spatial form of the villas is also seen in Alessi's church of S Maria Assunta (1552–1603; *see* ALESSI, GALEAZZO, fig. 2), his masterpiece, which is perched high up on the hill of Carignano, dominating the southern part of Genoa.

Genoa, Palazzo Doria (now Doria–Pamphili), Fassolo, begun *c.* 1528; photographed before damage in World War II

Among the most distinguished urban projects of the 16th century was the creation of the Strada Nuova (1550–58; now Via Garibaldi), instigated by the Grimaldi family in an effort to clean up the area around Castelletto, which was occupied by a public brothel. The Strada Nuova was known as Via Aurea for the magnificence of its buildings, including the Palazzo Doria–Tursi (begun 1565; now Palazzo del Municipio), designed originally for Nicolò Grimaldi by the PONZELLO brothers and executed by Giovanni Lurago (*see* LURAGO , (1)); the Palazzo Podestà (*c.* 1563–5) by Giovanni Battista Castello (*see* CASTELLO , (1)); and the Palazzo Bianco (*c.* 1565; enlarged after 1711) by Giovanni Orsolino (*d* 1597) and Domenico Ponzello.

BIBLIOGRAPHY

E. De Negri and others: *Catalogo delle ville genovesi* (Genoa, 1967)
T. O. De Negri: *Storia di Genova* (Milan, 1968)
P. Torriti: *Tesori di Strada Nuova: La Via Aurea dei genovesi* (Genoa, 1970)
L. Grossi Bianchi and E. Poleggi: *Una città portuale nel medioevo: Genova nei secoli X–XVI* (Genoa, 1979)
E. Poleggi and P. Cevini: *Genova* (Rome and Bari, 1981)
C. Arvigo Spalla: 'La Darsena di Genova: I documenti d'archivio e la costruzione della carta della stratificazione storica degli edifici e degli spazi', *Disegni d'archivio negli studi di storia dell'architettura: Naples, 1991*, pp. 182–5
G. L. Gorse: 'A Classical Stage for the Old Nobility: The Strada Nuova and Sixteenth-century Genoa', *A. Bull.*, lxxix (1997), pp. 301–27

GIUSEPPE PINNA

2. ART LIFE AND ORGANIZATION. During the 14th century, the Genoese preferred to commission works by important Tuscan artists: Giovanni Pisano (*c.* 1245/50–1319), for example, created the tomb of *Margaret of Luxembourg* (part in Genoa, Mus. S Agostino; statue in Genoa, Pal. Spinola), who died in Genoa in 1311. During the 15th century, architectural sculpture was virtually monopolized by Lombard artists, although Tuscan sculptors were also still employed. The same situation prevailed in painting: from the end of the 13th century to the middle of the 14th Tuscan painters who were influenced by Cimabue (*c.* 1240–1302) or Pisan and Sienese–Avignon painters worked in Genoa alongside Byzantine or Byzantine-influenced artists. The first Ligurian painters did begin

to make an appearance at this time, albeit heavily influenced by Tuscan art. During the 15th century, however, painting was almost completely controlled by Lombard artists.

In 1528, after consolidating his power, Andrea Doria I summoned PERINO DEL VAGA to Genoa and, with him, several painters and sculptors from both Rome and Florence to work at the Fassolo workshop, the painters executing an iconographic scheme depicting Classical subject-matter and intended to express Doria's achievements and public recognition (see colour pl. 2, XIV1). The arrival of these artists, including Giovanni Angelo Montorsoli and Baccio Bandinelli, brought High Renaissance art to Genoa, which underwent a total transformation. Many trading and banking families followed Doria's example and commissioned villas and lavishly decorated new town houses. The influx of artists from the most artistically advanced Italian cities continued throughout the century, but from the 1550s the presence was also felt of Genoese artists educated outside the city, who were familiar with the latest artistic developments. A particularly important figure in this respect was the painter LUCA CAMBIASO, who, after studying in Rome, worked in Genoa; he contributed to the modernization of Genoese painting and decoration and introduced Italian Mannerism to the city.

BIBLIOGRAPHY

E. Gavazza: *La grande decorazione a Genoa* (Genoa, 1974)
La pittura a Genova e in Liguria, 2 vols (Genoa, 1987)
La scultura a Genova e in Liguria, 3 vols (Genoa, 1987–9)
P. Boccaro: *Andrea Doria e le arti* (Rome, 1989)
G. Algeri and A. De Floriani: *La pittura in Liguria: Il quattrocento* (Genoa, 1991)
E. Castelnuovo, ed.: *Niveo de marmore: L'uso artistico del marmo di Carrara dall'XI al XV secolo* (Genoa, 1992)

ANNA DAGNINO

3. CENTRE OF PRODUCTION.

(i) Silk. The trade in silk fabrics and the raw materials for their production has been an important part of the Genoese economy since the Middle Ages. At first Genoa served as a centre of distribution for woven-silk products. There is evidence, however, of local production, of significant quality and quantity, from the mid-13th century. At the beginning of the 14th century numerous weavers exiled from Lucca arrived in Genoa to teach their craft. The arrival of these craftsmen, who were technically advanced and artistically autonomous, substantially increased production in Genoa. The silk-workers, who for over a century had belonged to the Corporazione dei Merciai, acquired their own statutes in 1432.

In the 16th century, partly because of the Turkish threat, which reduced trade with the Near East, the Genoese transferred their investments from foreign trade to the local silk industry. Whereas in Milan participation in the silk trade was prohibited to noblemen, in Genoa it was taken up by members of such important families as the Grillo, Spinola, di Negro and Grimaldi. Silk manufacturers imported raw silk from the Near East and Messina and from other areas in Italy such as Calabria, Lombardy and Piedmont and then employed specialized workers in small, family workshops to carry out the various operations of spinning, dyeing, spooling and weaving. Relations between

the entrepreneur and the different categories of workers were regulated by statutes, which tended to prohibit the weavers from practising their trade independently: they were allowed a limited number of looms and had to remain within the city walls. The quality of the product was maintained by rigidly fixed technical specifications; this also served as a protection against frauds and falsifications. The Consiglio dell'Arte della Seta and its consuls formed a real magistrature in the Republic, which indicates their economic and political power.

Genoese fabrics were widely appreciated in the other Italian and European states; particular specialities were plain and decorated velvets, satins and damasks. Black Genoese velvet was considered incomparable for softness and lustre and was favoured by the European nobility for their clothes; women preferred the crimson damask, of a delicate pinkish tone, which was never successfully imitated, and the precious gold and silver lamé fabrics that can still be seen in the splendid later portraits by Anthony van Dyck (1599–1641).

BIBLIOGRAPHY

Antiche stoffe genovesi (exh. cat. by G. Morazzoni, Genoa, Teat. Carlo Felice, 1941)

P. Massa: 'L'arte genovese della seta nella normativa del XVe del XVI secolo', *Atti Soc. Ligure Stor. Patria*, x/1 (1970)

——: *Un'impresa serice genovese della primametà del cinquecento* (Milan, 1974)

——: *La 'fabbrica' dei velluti genovesi: Da Genova a Zoagli* (Genoa and Zoagli, 1981)

ELENA PARMA

(ii) Ceramics. Production of ceramics is documented in Genoa from the Middle Ages. A few jugs from that period, decorated with a dark-green lead glaze incised through to an ochre ground, are extant. These utilitarian, domestic vessels were recovered from archaeological excavations. There are numerous documents referring to 15th-century workshops, which produced items decorated with painted or incised motifs, often in blue on a pale ground. At that time there was also a considerable production of *laggioni*, tiles decorated in a Moorish style in imitation of those imported from Valencia in Spain. In 1528 the manufacture of maiolica became important in Genoa. Production was similar to that of potteries in the Marches and Faenza, due in part to Francesco da Pesaro and Francesco da Camerino from Faenza, who founded the first workshop in the city. They produced tableware and vases with light-blue grounds decorated with calligraphy, grotesques, arabesques or chinoiseries. After the death (1580) of Bartolomeo da Pesaro, son of Francesco, the workshop was taken over by his son-in-law Giovan Antonio Cagnola, who continued to produce fairly high-quality wares.

BIBLIOGRAPHY

F. Marzinot: *Ceramica e ceramisti di Liguria* (Genoa, 1979)

LUCIANA ARBACE

Gentile (di Niccolò di Massio) da Fabriano (*b* Fabriano, *c.* 1385; *d* Rome, before 14 Oct 1427). Italian painter and draughtsman. He was the most important Italian representative of the elaborate Late Gothic style of painting that dominated European painting around 1400. He was a consummate master of naturalistic rendering, narrative invention and detail, and ornamental refinement.

He introduced a new relationship between painting and nature through the depiction of three-dimensional space and the representation of natural lighting. This relationship, established at the same time but in much more radical form by Masaccio, was central to the art of the Renaissance.

1. Life and autograph work. 2. Attributions. 3. Working methods and technique. 4. Influence, critical reception and posthumous reputation.

1. LIFE AND AUTOGRAPH WORK.

(i) Fabriano, Venice and Brescia, c. 1385–1420. Fabriano, the artist's birthplace, in the Marches, is roughly halfway between Perugia and Ancona. Although his grandfather, father and uncle served there as officials of various civic and religious organizations, Gentile's early life and apprenticeship are not documented. The first record of him is a payment of 27 July 1408 for a panel (untraced) that Gentile was to paint for Francesco Amadi in Venice. Before his departure for Venice the artist painted a *Virgin and Child* (Perugia, G.N. Umbria) for S Domenico at Perugia, and a *Virgin and Child with SS Nicholas, Catherine of Alexandria and a Donor* (Berlin, Gemäldegal.) for S Niccolò, Fabriano (see fig. 1). Stylistically, both panels are dependent on Lombard illuminated miniatures and on a group of works, datable *c.* 1405 to *c.* 1410, by the itinerant Venetian painter Zanino di Pietro, and may be dated between *c.* 1406 and 1408, the year in which Gentile arrived in Venice.

There he was inscribed in the Scuola di S Cristoforo dei Mercanti, and, according to 16th- and 17th-century guidebooks to Venice, he painted panels for the churches of S Felice, S Giuliano and S Sofia. In 1409 and 1411 the Maggior Consiglio voted funds to repair a cycle of narrative frescoes in the Sala del Maggior Consiglio in the Doge's

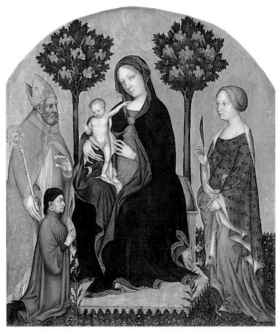

1. Gentile da Fabriano: *Virgin and Child with SS Nicholas, Catherine of Alexandria and a Donor*, tempera on panel, 1.31×1.13 m, *c.* 1406–8 (Berlin, Gemäldegalerie)

Palace, begun 1366–7 by Guariento, which depicted the struggle between Pope Alexander III and the Emperor Frederick Barbarossa (*reg* 1152–90) at Venice and the role of Doge Sebastiano Ziani in securing a papal victory. According to Bartolommeo Fazio, Gentile executed the scene of the naval battle between the Venetians and Barbarossa. Francesco Sansovino reported that Gentile's reputation was such that for this work he was paid the extravagant fee of a ducat a day and that he dressed in open sleeves like a nobleman.

In Venice, Gentile met the Lombard painter and illuminator Michelino da Besozzo, who was there in 1410, and was influenced by his refined, languorous, rhythmically sophisticated style. They probably collaborated, with Pisanello and Jacobello, on the decoration of the Sala del Maggior Consiglio (frescoes destr. 1557). The most important work from Gentile's five years in Venice is the Valle Romita Altarpiece, a polyptych with the *Coronation of the Virgin* (see fig. 2) flanked by *SS Jerome, Francis, Mary Magdalene* and *Dominic* and scenes from the lives of the saints (Milan, Brera). In the sophistication of its colouring, the attention to naturalistic detail and the fluid curvilinear shapes of the design, it is Gentile's first masterpiece. It was probably commissioned by Chiavello Chiavelli (*d* 1412), Lord of Fabriano, who in 1405 bought and rebuilt the monastery of S Maria di Valdisasso, near Fabriano, and who, while in the service of the Venetian Republic, may have contracted Gentile to paint the altarpiece for the new church. Because of the stylistic dependence of the work on Michelino da Besozzo, it is unlikely that it was executed before 1410. Other autograph works from this period are a badly damaged *Virgin and Child* (New York, Met.), a heavily repainted *Virgin and Child* (Ferrara, Pin. N.) and two small panels of *St Peter* and *St Paul* (Florence, I Tatti).

In May 1413 Pandolfo Malatesta, Lord of Fano, Bergamo and Brescia and commander of Venetian forces, was awarded Venetian citizenship and a house on the Grand Canal in recognition of his victory over a Hungarian army led by the Florentine condottiere Pippo Spano. Later that year Pandolfo must have appointed Gentile his court artist, for by January 1414 Gentile had moved to Brescia, where for the next five years he worked on the fresco decoration of the chapel of the Broletto, or court house, of which fragments have recently been recovered. In *De laudibus Brixiae oratio* (1458), Umbertino Posculo recorded that one of its scenes showed St George slaying the dragon. Gentile's lost composition is perhaps reflected in a painting of *St George and the Dragon* by a Brescian artist (*c*. 1450–75; Brescia, Pin. Civ. Tosi–Martinengo) and may have had as its model a relief (Cesena, Bib. Malatestiana) carved by a Venetian sculptor for Andrea Malatesta (*d* 1416). In November 1418 Gentile painted a panel for Pandolfo as a gift for Pope Martin V, then in Mantua, but who had passed through Brescia in October on his way from his election at the Council of Constance to Rome. On 18 September 1419 Gentile requested a letter of safe conduct for eight people and eight horses in order to join the Pope (who resided in Florence from 26 February 1419 until 9 September 1420) and left Brescia on 22 September.

(ii) Florence and Siena, 1420–27. In March and April 1420 Gentile petitioned for exemption from taxes and debts in

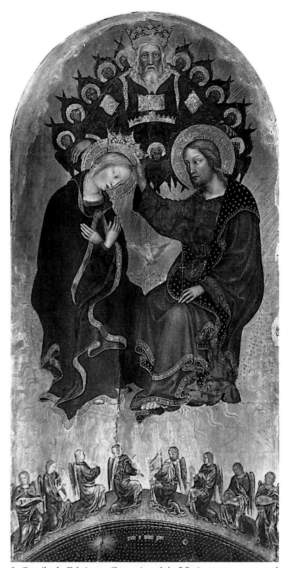

2. Gentile da Fabriano: *Coronation of the Virgin*, tempera on panel, 1.78×0.79 m, *c*. 1410 (Milan, Accademia di Belle Arti di Brera)

Fabriano and declared that he wished to live, work and die on his native soil. But between 6 August and 24 October of that year he paid the equivalent of a year's rent for a house in Florence, which suggests that he had settled there before his visit to Fabriano. It was during this visit that he probably received the commission for a double-sided processional standard with the *Coronation of the Virgin* (Los Angeles, CA, Getty Mus.) on one side and the *Stigmatization of St Francis* (Italy, priv. col., see Christiansen, 1982, colour pl. B) on the other. The two images are very different in conception. The *Coronation of the Virgin* and a roughly contemporary *Virgin and Child* (Washington, DC, N.G.A.) reveal a move away from the gothicizing delicacy of Gentile's earlier work towards the solidity of form and rich surface tooling of 14th-century Florentine painting. The *Stigmatization of St Francis* shows a much more important development, not only in Gentile's style

but also in early 15th-century painting, in the interpretation of the divine light emanating in golden rays from the vision of the crucifix as natural light by which the scene is illuminated.

Gentile's first signed work is an altarpiece of the *Adoration of the Magi* (the Strozzi Altarpiece; Florence, Uffizi; see fig. 3). Its main panel is one of the grandest pictures of the early 15th century and had a more lasting influence on Italian Renaissance painting than any other work of its time. It was completed in May 1423 and had been commissioned for the sacristy of Santa Trìnita by Palla Strozzi, who had built the sacristy as a private chapel for the Strozzi family after the death of his father Onofrio in 1418. The artist's growing mastery of naturalistic illumination and the three-dimensional construction of figures are accompanied, especially in the predella panels of the *Nativity*, the *Flight into Egypt* (both Florence, Uffizi) and the *Presentation in the Temple* (Paris, Louvre), by perspectival coherence and the suggestion of atmosphere in the rendering of pictorial space. For these accomplishments Gentile was indebted to Donatello's innovations in relief sculpture, which he was the first artist to translate into painting.

The main panel of the Strozzi Altarpiece is divided into a crowded foreground, in which the three Magi adoring the child on the left and their retinue of grooms and horses on the right are seen from close up, and a background with three scenes from the journey of the Magi, seen from far away, under the three arches of the frame. By virtue of the consistency of illumination and tonality throughout the composition, the viewer has the illusion of continuous space. The source of illumination in both background and foreground is the star that leads the Magi to their destination. In the left arch they see it in a golden sky above the sea; in the central arch, wider and higher than the

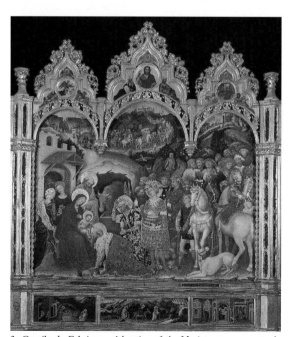

3. Gentile da Fabriano: *Adoration of the Magi*, tempera on panel, 3.00×2.83 m, 1423 (Florence, Galleria degli Uffizi)

arches at the sides, they ride with their retinue through fields and hedges, loosely described in an ebbing light with delicately applied shadows, to the castellated town of Jerusalem; and on the right they are about to enter the gate of Bethlehem. In the foreground the star has come to rest above the Holy Family, where it serves as one of the light sources for the array of figures, horses and other animals. The figure style has little in common with the rhythmic contours, smooth, hard surfaces and bright, clear colours of contemporary Florentine painting. Shapes are conceived not as silhouettes but as bodies or masses in space and light, with loosely rendered and sensitively differentiated surfaces and muted colours. The figures, especially those of the Magi, are lit up by stamped and richly tooled patterns of gold leaf.

Gentile's novel conception of design, light, colour and space is even more clearly in evidence in the predella. In the *Nativity* three sources of light—the moon for the sky, the angel above the hills for the shepherds and the Christ Child for the foreground—are interwoven to form the first convincingly realistic night scene in Renaissance art. In the *Flight into Egypt* (see colour pl. 1, XXXI3) gilding on the ground and on the side of the hills behind the figures registers the light of the rising sun, represented as a rounded gilt disk, while the more neutral lighting of the fields and the walled town evoke the cool of morning where the sun has not yet reached.

The *Adoration of the Magi* may also have a humanist meaning. One of the inheritances of the Renaissance from the Middle Ages was the belief that chivalry had been founded in Classical antiquity. The depiction in the *Adoration of the Magi* of a resplendent world of chivalry brought to life for the Renaissance imagination a vision of the ideal world of antiquity that it so passionately sought to recapture.

Gentile's influence on his contemporaries, particularly on Masolino da Panicale, and the number of commissions he now received suggest that in 1423 he was the leading painter of Florence. A small *Virgin and Child* (Pisa, Mus. N. S Matteo) and an altarpiece of the *Virgin and Child with SS Julian and Lawrence* (New York, Frick), important for the consistency in the illumination of the figures, probably date from that year. Perhaps dating from a year later are a fragment of a *Virgin and Child* (Florence, I Tatti) and a signed *Virgin and Child* (New Haven, CT, Yale U. A.G.) in which the figures, set against a foliated background (a motif introduced by Gentile into Florentine painting) and surrounded by a window frame, are seen from below.

In May 1425 Gentile completed a polyptych (now dispersed) commissioned by the Quaratesi family for the high altar of S Niccolò sopr'Arno that consisted of a *Virgin and Child with Angels* (London, Hampton Court, Royal Col., on loan to London, N.G.), *SS Mary Magdalene, Nicholas, John the Baptist and George* (Florence, Uffizi) and five predella panels (four in Rome, Vatican, Pin., one in Washington, DC, N.G.A.; see fig. 4). Vasari considered this altarpiece to be the best work by Gentile that he had seen, and it served as a model for Fra Angelico and Domenico Veneziano as well as Bicci di Lorenzo and other minor masters. Its central panel is Gentile's masterpiece in subtlety of lighting, tonal balance and the depiction

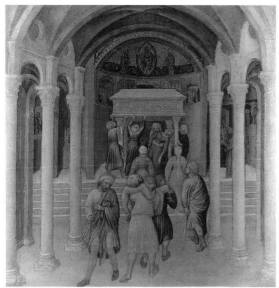

4. Gentile da Fabriano: *Pilgrims at the Tomb of St Nicholas*, tempera on panel, 350×360 mm, 1425 (Washington, DC, National Gallery of Art)

of three-dimensional form through the control of values of light and dark.

From 22 June to September 1425 Gentile rented a house in Siena and painted a polyptych with the *Virgin and Child with SS John the Baptist, Peter, Paul and Christopher* (destr., last recorded in the 18th century) for the guild of notaries; this was placed beneath a baldacchino on the outside of the guild's palazzo in the Piazza del Campo. Its influence on Sienese painting can be gauged by the naturalism, spatial arrangement of narrative compositions and rich surface texture that appear in the works of Giovanni di Paolo and Sassetta after 1426. Gentile interrupted his work in Siena in order to paint a fresco of the *Virgin and Child* in the south aisle of Orvieto Cathedral, arriving in Orvieto on 25 August 1425. Since its restoration and the removal of drastic overpainting, the 'Maestà', as it was called, has emerged as one of his most monumental designs and, technically and colouristically, one of his most delicate works (Christiansen, 1989). The Sienese chronicler Sigismondo Tizio recorded in the *Historiarum Senensium* (Siena, Bib. Com. Intronati) that Gentile returned from Orvieto to Siena to finish the polyptych for the notaries' guild.

(iii) Rome, 1427. On completion of the work in Siena, Gentile went to Rome, where from 28 January 1427 he received payments for the fresco decoration of S Giovanni in Laterano, the first major pictorial cycle commissioned by Pope Martin V after his return to the city in 1420. The last payment is dated 2 August 1427, and on 14 October Gentile is referred to as having died. The frescoes were completed by Pisanello and were destroyed in the 17th century. According to Fazio, Gentile began, but did not finish, one scene from the *Life of St John the Baptist*, and painted five tabernacles with grisaille figures of Old Testament prophets in niches between the windows of the clerestory. A drawing of the fresco cycle before 1647

by a follower of Borromini (Berlin, Kstbib. & Mus.) shows the tabernacle with the prophet Jeremiah. Christiansen (1982) has associated a fresco fragment, tentatively identified as a *Head of David* (Rome, Vatican, Mus. Pio-Crist.), with the prophets at S Giovanni in Laterano. This association is questionable, however, because the head is not in grisaille but coloured. Fazio also refers to a panel by Gentile in S Giovanni in Laterano of Martin V and ten cardinals, and Vasari reports that Gentile painted a *Virgin and Child with SS Benedict and Joseph* above the tomb of Cardinal Adimari in S Francesca Romana. A *Virgin and Child* (Velletri, Mus. Capitolare) from SS Cosma e Damiano in Rome and a small, heavily repainted *Stoning of St Stephen* (Vienna, Ksthist. Mus.), which shows Gentile's adventurous compositional skills in the crescent-shaped spatial arrangement of the figures, date from his last two years.

2. ATTRIBUTIONS. There are grounds for the attribution to Gentile of a group of drawings after Roman sarcophagi and other reliefs (Florence, Uffizi, 3S; Milan, Bib. Ambrosiana, 214F, fols. 13r and 15r; Oxford, Ashmolean, 41v; Paris, Ecole N. Sup. B.-A., 2342; Paris, Louvre, 2397v; Rotterdam, Mus. Boymans–van Beuningen, I.523) that were originally part of a sketchbook begun in Gentile's workshop in Rome and continued after his death in the studio of Pisanello. They are stylistically consistent with the posing and rendering of figures in the predellas of the *Adoration of the Magi* and the Quaratesi Altarpiece, and their importance as the first preserved series of systematic studies of the Antique is a reflection of Gentile's interest in Classical art. Testimony for this is his employment of antique prototypes ranging from Roman sarcophagi to reliefs on the Arch of Constantine in the *Adoration of the Magi* and the Quaratesi Altarpiece.

According to the present writer, among paintings attributed to Gentile on the grounds of quality and style, a *Virgin and Child with Angels* (Athens, N.G.) is by Zanino di Pietro; a *St Michael* (Boston, MA, Mus. F.A.) is by the Marchigian painter Pellegrino (di Giovanni) di Antonio (*d* 1437); a dossal with five panels commissioned by Bernardo Quaratesi for S Niccolò sopr'Arno (on dep. Florence, Pitti) is the work of Francesco d'Antonio; a *Nativity* (Malibu, CA, Getty Mus.) was designed and painted by an assistant in Gentile's workshop during the last few years of his stay in Florence; and a watercolour on parchment of a *Maiden* (Paris, Louvre, 20693) is by an anonymous Lombard artist *c.* 1400. Two drawings in pen and ink on parchment associated with Gentile—one with a *Seated Woman* on the recto and *St Paul* on the verso (Berlin, Kupferstichkab., Kd. Z.5164), the other with *Two Apostles* on the recto and a drapery study on the verso (Edinburgh, N.G., D.2259)—share stylistic characteristics with figures in the Valle Romita Altarpiece, but it is an open question whether they are by Gentile, by followers, or are copies after him.

3. WORKING METHODS AND TECHNIQUE. Gentile's works reveal a sharp and sensitive eye, but they also show that, in conformity with contemporary artistic practice, he worked not directly from nature, but rather from studies from nature in model-books such as the drawings after

the Antique in his own Roman sketchbook. The dog in the right foreground of the *Adoration of the Magi*, for example, has been traced to a Tuscan model-book of *c.* 1400 (Paris, Louvre, 759–760, fol. 6*r*). The frontally foreshortened crouching figure removing the spurs from the left foot of the standing Magus reverts to a 14th-century model-book. The identical motif was employed in the figure of the prostrate Holofernes in a fresco from S Andrea in Ferrara, the *Triumph of St Augustine* (Ferrara, Pin. N.) by an Emilian painter of the second half of the 14th century. Gentile's panel paintings and his one surviving fresco display both mastery and delight in the employment of colours and materials described in the early 15th-century painting manual *Il libro dell'arte* by Cennino Cennini.

4. INFLUENCE, CRITICAL RECEPTION AND POSTHUMOUS REPUTATION. During the two decades of Gentile's career his style underwent astonishing and far-reaching changes. In his early works the study of nature was subordinated to, and served as an embellishment for, the medieval conception of art as timeless and symbolic. The exploration of space and of light and shade in his mature paintings reflects the Renaissance notion, first formulated by Alberti in *De pictura* (1435), that painting represents its objects as they are seen in nature. From the late 15th century until the mid-20th Masaccio alone was credited with the introduction of space and of light and shade into Renaissance painting, while Gentile was perceived as the consummate master of the Late Gothic style. Although the view of Gentile as a progressive artist is no longer contested, his relationship to Masaccio remains controversial, largely because of unresolved problems in the chronology of Masaccio's works. Two painters whom Gentile demonstrably influenced were Jacopo Bellini, who was one of his apprentices at the time of the *Adoration of the Magi*, and Domenico Veneziano, who was probably a member of his workshop in Florence as well as in Rome.

Bartolommeo Fazio elevated Gentile above all Italian painters of his time, not only because of his virtuosity but also because the ornate, naturalistically descriptive style of paintings such as the *Adoration of the Magi* was the pictorial style preferred by humanists. It was also what they admired most in the art of antiquity. The earliest and clearest articulation of this humanist taste is found in the writings of the Greek-born Manuel Chrysoloras (1350–1415), who came to Florence in 1397 at the invitation of Palla Strozzi. He was also his patron's teacher, and Palla's choice of Gentile for the altarpiece of his family chapel was one of the fruits of that teaching.

At the end of the 16th century Francesco Bocchi wrote in his guidebook to Florence, *Le bellezze della città di Firenze* (1591), that Gentile's *Adoration* 'is held in reverence like a work of antiquity and because it proceeds from the first painter in whom was born the wonderful style which is today in flower'. The association of the *Adoration of the Magi* with the Renaissance revival of antiquity challenges the view first articulated by Alberti that identifies the founding of this revival with Brunelleschi, Donatello, Ghiberti, Masaccio and Luca della Robbia. It also raises the question of the relationship between these artists' approach to the Antique and that of Gentile. Another

challenge to traditional views in Bocchi's text is his perception of a connection between Gentile's style and the *maniera* style of his own time.

BIBLIOGRAPHY

EWA; Thieme–Becker

SOURCES

B. Fazio: *De viris illustribus* (1456) in M. Baxandall: 'Bartholomaeus Facius on painting', *J. Warb. & Court. Inst.* xxvii (1964), pp. 90–107 (100–101)

G. Vasari: *Vite* (1550, rev. 2/1568); ed. G. Milanesi (1878–85), iii, pp. 5–33

F. Sansovino: *Venetia, città nobilissima et singolare* (Venice, 1581)

A. Venturi: *Gentile da Fabriano e il Pisanello* (Florence, 1896), pp. 1–19

R. Sassi: 'La famiglia di Gentile da Fabriano', *Rass. March.*, ii (1923), pp. 21–8

——: 'Altri appunti su la famiglia de Gentile da Fabriano', *Rass. March.*, vi (1928), pp. 259–67

D. Davisson: 'New Documents on Gentile da Fabriano's Residence in Florence, 1420–1422', *Burl. Mag.*, cxxii (1980), pp. 759–63

GENERAL WORKS

G. Poggi: *La cappella e la tomba di Onofrio Strozzi nella chiesa di Santa Trìnita (1419–1423)* (Florence, 1903)

R. van Marle: *Italian Schools* (1923–38), viii, pp. 1–53

H. Siebenhüner: *Über den Kolorismus der Frührenaissance* (Schramberg, 1935), pp. 45–50

R. Longhi: 'Fatti di Masolino e di Masaccio', *Crit. A.*, (1940), pp. 189–91

B. Degenhart and A. Schmitt: *Süd- und Mittelitalien*, 4 vols (1969–), i of *Corpus der italienischen Handzeichnungen, 1300–1450* (Berlin, 1969–), i/2, pp. 334–45, 639–44

F. Hartt: *History of Italian Renaissance Art* (Englewood Cliffs, 1969, rev. 2/1979), pp. 188–92

D. Davisson: 'The Iconology of the S Trinita Sacristy, 1418–35: A Study of the Private and Public Functions of Religious Art in the Early Quattrocento', *A. Bull.*, lvii (1975), pp. 315–35

H. Wohl: *The Paintings of Domenico Veneziano, ca. 1410–1461: A Study in Florentine Art of the Early Renaissance* (New York, 1980), pp. 7–9

——: 'The Revival of the Arts in Rome under Martin V', *Rome in the Renaissance* (Binghamton, 1983), pp. 171–83

MONOGRAPHS

A. Colasanti: *Gentile da Fabriano* (Bergamo, 1909)

B. Molajoli: *Gentile da Fabriano* (Fabriano, 1927)

L. Grassi: *Tutta la pittura di Gentile da Fabriano* (Milan, 1953)

L. Bellosi: *Gentile da Fabriano*, Collezione Silvana (Milan, 1966)

E. Micheletti: *L'opera completa di Gentile da Fabriano*, Class. A. (Milan, 1976)

K. Christiansen: *Gentile da Fabriano* (Ithaca, 1982) [includes source material]; review by H. Wohl in *A. Bull.*, lxvi (1984), pp. 522–7

SPECIALIST STUDIES

A. Ricci: *Elogio del pittore Gentile da Fabriano* (Macerata, 1829)

H. Horne: 'The Quaratesi Altarpiece by Gentile da Fabriano', *Burl. Mag.*, vi (1904–5), pp. 470–74

A. Colasanti: 'Un quadro inedito di Gentile da Fabriano', *Boll. A.*, i (1907), pp. 19–20

L. Venturi: 'Un quadro di Gentile da Fabriano a Velletri', *Boll. A.*, vii (1913), pp. 73–5

R. Sassi: 'Arte a storia fra le rovine d'un antico tempio francescano', *Rass. March.*, v (1927), pp. 331–51

R. Longhi: 'Me pinxit: Un S Michele Arcangelo di Gentile da Fabriano', *Pinacotheca*, i (1928), pp. 71–5

R. Sassi: 'Gentile nella vita fabrianese del suo tempo', *Gentile da Fabriano: Boll. Mens. Celeb. Centen.*, vi (1928), pp. 7–13, 33–8

B. Molajoli: 'Bibliografia di Gentile da Fabriano', *Boll. Reale Ist. Archaeol. & Stor. A.*, iii (1929), pp. 102–7

A. L. Mayer: 'Zum Problem Gentile da Fabriano', *Pantheon*, xi (1933), pp. 41–6

E. Lavignino: 'Un affresco di Gentile da Fabriano a Roma', *A. Figurativa*, i (1940), pp. 40–48

W. Suida: 'Two Unpublished Paintings by Gentile da Fabriano', *A. Q.* [Detroit], iii (1940), pp. 348–52

L. Grassi: 'Considerazioni intorno al polittico Quaratesi', *Paragone*, 15 (1951), pp. 23–30

E. Micheletti: 'Qualche induzione sugli affreschi di Gentile da Fabriano a Venezia', *Riv. A.*, xxviii (1953), pp. 115–20

C. Sterling: 'Un Tableau inédit de Gentile da Fabriano', *Paragone*, 101 (1958), pp. 26–33

C. Volpe: 'Due frammenti di Gentile da Fabriano', *Paragone*, 101 (1958), pp. 53–5

B. Degenhart and A. Schmitt: 'Gentile da Fabriano in Rom und die Anfänge des Antikenstudiums', *Münchn. Jb. Bild. Kst*, xi (1960), pp. 59–151

C. Huter: *The Veneto and the Art of Gentile da Fabriano* (diss., U. London, 1966)

B. Davidson: 'Gentile da Fabriano's *Madonna and Child with Saints*', *ARTnews*, lxviii (1969), pp. 24–7, 57–60

C. Huter: 'Gentile da Fabriano and the Madonna of Humility', *A. Ven.*, xxiv (1970), pp. 26–34

B. Davidson: 'Tradition and Innovation: Gentile da Fabriano and Hans Memling', *Apollo*, xciii (1971), pp. 378–85

F. Rossi: 'Ipotesi per Gentile da Fabriano a Brescia', *Not. Pal. Albani*, ii/1 (1973), pp. 11–22

C. Brandi: 'A Gentile da Fabriano at Athens', *Burl. Mag.*, cxx (1978), pp. 385–6

K. Christiansen: 'The *Coronation of the Virgin* by Gentile da Fabriano', *Getty Mus. J.*, 6–7 (1978–9), pp. 1–12

R. Panczenko: 'Gentile da Fabriano and Classical Antiquity', *A. & Hist.*, ii (1980), pp. 9–27

L. Analli: 'Ricognizione sulla presenza bresciana di Gentile da Fabriano dal 1414 al 1419', *A. Lombarda*, 76/77 (1986), pp. 31–54

K. Christiansen: 'Revising the Renaissance: "Il Gentile Disvelato"', *Burl. Mag.*, cxxxi (1989), pp. 539–41

L. Riccetti: '"Dolci per Gentile": New Documents for Gentile da Fabriano's *Maestà* at Orvieto', *Burl. Mag.*, cxxxi (1989), pp. 541–2

W. Tresidder: 'Lorenzo Ghiberti and the Frame of Gentile da Fabriano's *Adoration of the Magi*', *Source*, xiv/4 (1995), pp. 8–13

HELLMUT WOHL

Gentili, Antonio (*b* Faenza, 1519; *d* Rome, 29 Oct 1609). Italian goldsmith and engraver. After moving to Rome in 1549–50, he was first elected consul of the goldsmiths' guild in 1563 and, after 1584, assayer for the Papal Mint. His workshop executed important commissions for the Farnese family, among which survive a cross and two monumental candlesticks (1570–82; Rome, St Peter's); Cardinal Alessandro Farnese paid 13,000 scudi for these items and presented them to St Peter's, Rome, to be placed on the high altar. In this ensemble, one of the most important of late 16th-century Italian silver, Gentili combines technical expertise with a mastery of the plastic modelling of putti, nudes and caryatids, inspired by the work of Michelangelo. These figures appear in the miniature architectural structures that form the stems of the candlesticks. In the late 17th century the silversmith Carlo Spagna (*fl* 1680) created a triangular base for these pieces, commissioned by Cardinal Francesco Barberini and with volutes framing a scroll with a bee, the symbol of the Cardinal. A fine set of knife, fork and spoon (New York, Met.), the handles of which are chased with various elements from his decorative repertory, has been attributed to Gentili on the basis of a design (New York, Met.) for a similar spoon, signed *Antonio di Faenza*.

For bibliography *see* ITALY, §IX, 1.

ANGELA CATELLO

Geremia, Cristoforo di. *See* CRISTOFORO DI GEREMIA.

Gerolamo di Giovanni Pennacchi. *See under* GIROLAMO DA TREVISO (i).

Gherardi, Cristofano [Cristofano dal Borgo; il Doceno] (*b* Borgo San Sepolcro, 26 Nov 1508; *d* Florence, 4 April 1556). Italian painter. In 1529, after studying with Raffaello dal Colle, he went to Florence, where he became one of Vasari's most steadfast followers. His figurative training provided him with a minute, analytical language, which he often grafted on to Vasari's compositional schemes to produce an effect of refined elegance. His works bear the stamp of the Tuscan–Roman Mannerism of Giulio Romano, Perino del Vaga and Francesco Salviati, not to mention its originators Michelangelo and Raphael. The first work he completed under Vasari was the *sgraffito* decoration, in 1534–5, of the garden façade of the Palazzo Vitelli alla Cannoniera, Città di Castello. In 1537, accused of plotting against the Medici, he was exiled from Florence. In the following years, in collaboration with Raffaello dal Colle and Dono Doni (*d* 1575), he executed the frescoes (destr.) of the Rocca Paolina, Perugia. Between 1537 and 1554 he produced the important cycle of mythological paintings for the Castello Bufalini, San Giustino, and between 1539 and 1542 he and Stefano Veltroni (*fl* 1536–51) painted the frescoes of grotesques and views of the principal Olivetan monasteries in the refectory of the Convent of Monte Oliveto, San Michele in Bosco.

In 1546, after a period in Rome and Naples, Gherardi again worked with Vasari, on 18 panels depicting scenes from the *Old and New Testaments*, the *Four Evangelists* and the *Doctors of the Church* for the sacristy of S Giovanni Carbonara, Naples. In 1554 he was pardoned by Cosimo I de' Medici and was able to return to Florence. There, alongside Vasari, he began his last work, the frescoes (1555–9) depicting allegorical and mythological subjects in the Quartiere degli Elementi, Palazzo Vecchio. These, however, remained incomplete after Gherardi's sudden death.

BIBLIOGRAPHY
Thieme–Becker

G. Vasari: *Vite* (1550, rev. 2/1568); ed. G. Milanesi (1878–85)

P. Barocchi: *Complementi al Vasari pittore* (Florence, 1964), pp. 269–77

C. Monbeig Goguel: 'Gherardi senza Vasari', *A. Illus.*, v/48 (1972), pp. 130–41

A. Ronen: 'Palazzo Vitelli alla Cannoniera: The Decoration on the Staircase', *Commentari*, n. s., xxvi/1–2 (1975), pp. 56–88

——: 'The Pagan Gods: A Fresco Cycle by Cristofano Gherardi in the Castello Bufalini, San Giustino (II)', *Ant. Viva*, xvii/6 (1978), pp. 19–30

S. Béguin: 'Pour Cristofano Gherardi', *Giorgio Vasari tra decorazione e storiografia artistica. Convegno di Studi: Arezzo, 1981*, pp. 409–15

A. Ronen: 'Prometheus Creating the First Man: Drawings by Cristofano Gherardi and Cherubino Alberti', *Jb. Zentinst. Kstgesch.*, 5/6 (1989/90), pp. 245–52

——: 'Gherardi's Frescoes in the Apollo Room in the Castello Butalini: Their Sources and Iconography', *Stor. A.*, lxxviii (1993), pp. 129–55

MARINA GAROFOLI

Gherardo di Giovanni del Fora. *See* FORA, DEL, (1).

Ghiberti. Italian family of artists. (1) Lorenzo Ghiberti was the leading bronze-caster in Florence in the early 15th century and the head of a highly influential workshop, which became a kind of academy of Florentine art. He was renowned both for his monumental bronze sculptures and for his development of a new type of pictorial low relief, which culminated in the panels of the *Gates of Paradise* for the Baptistery, Florence (see colour pl. 1, XXXI2). About 1415 Lorenzo married Marsilia, the 16-year-old daughter of a wool-carder; their two sons, Tommaso Ghiberti (*b c.* 1417; *d* after 1455) and (2) Vittorio

Ghiberti I both worked in Lorenzo's studio, although Tommaso is not mentioned in the documents after 1447. In 1443 Tommaso collaborated with another of Lorenzo's assistants on the execution of the tabernacle for Michelozzo's *Baptist* (Florence, Mus. Opera Duomo) on the silver altar of the Baptistery. In Lorenzo's last years Vittorio played an increasingly important role as his partner. Vittorio's son, (3) Buonaccorso Ghiberti, was an artist and engineer whose *zibaldone* (sketchbook-notebook) includes numerous architectural and technical plans. Buonaccorso's son Vittorio Ghiberti II (*b* Florence, 3 Sept 1501; *d* Ascoli Piceno, 1542) was active as a sculptor, painter and architect.

(1) Lorenzo (di Cione) Ghiberti (*b* Florence, 1378; *d* Florence, 1 Dec 1455). Bronze-caster, sculptor, goldsmith, draughtsman, architect and writer. He was the most celebrated bronze-caster and goldsmith in early 15th-century Florence, and his many-sided activity makes him the first great representative of the universal artist of the Renaissance. His richly decorative and elegant art, which reached its most brilliant expression in the *Gates of Paradise* (Florence, Baptistery), did not break dramatically with the tradition of Late Gothic, yet Ghiberti was undoubtedly one of the great creative personalities of early Renaissance art; no contemporary artist had so deep an influence on the art and sculpture of later times. His art, in which idealism and realism are fused, reflects the discovery of Classical art as truly as the realism of Donatello, and to label Ghiberti a traditionalist is to define the Renaissance art of the early 15th century one-sidedly in terms of increased realism. His competition relief of the *Sacrifice of Isaac* (1401; Florence, Bargello) determined the development of low relief not only in the 15th century but through the stylistic periods of Mannerism and Baroque, and up until the work of Auguste Rodin (1840–1917) in the 19th century. Ghiberti's writings, *I commentarii*, which include his autobiography, established him as the first modern historian of the fine arts, and bear witness to his ideal of humanistic education and culture. He was wealthier than most of his contemporary artists, and he owned considerable land and securities.

I. Life and work. II. Working methods and technique.

I. Life and work.

Lorenzo's father, Cione Paltami Ghiberti, was the son of a notary but seems to have been a somewhat dissolute character. In 1370 he married Mona Fiore, the daughter of a farm labourer, at Pelago, near Florence, but they soon separated and she went to live with Bartolo di Michele (*d* 1422), known as Bartoluccio, whom she married when Cione Paltami died (1406). Bartoluccio taught Lorenzo the goldsmith's art (Lorenzo became a master of the goldsmith's guild in 1409) and was evidently close to his stepson, who variously signed his name as Lorenzo di Bartolo, Lorenzo di Bartoluccio or Lorenzo di Bartolo Michele. Their close relationship is further demonstrated by their collaboration, until Bartolo's death, on the making of the bronze doors (now the north doors) of the Baptistery in Florence (see fig. 1 below).

According to Ghiberti's autobiography, written towards the end of his life, he left Florence in 1400 in the company of an eminent (but unnamed) painter to enter the service of Lord Malatesta of Pesaro, for whom he and his companion painted a room. He returned to Florence on hearing of a competition that was to be held for the design of bronze doors for the Baptistery, and his success in this competition determined the course of his professional life. He is thus best known to posterity as a sculptor, most notably of the Baptistery doors, but his career also included work as an architect, goldsmith and painter, apart from his significant contribution as a writer.

1. Sculpture. 2. Architecture, painting and goldsmith's work. 3. Writings.

1. SCULPTURE.

(i) The north doors of the Baptistery, Florence, 1400–24. (ii) Bronzes for Orsanmichele, Florence and the Siena reliefs, 1413–27. (iii) The *Gates of Paradise* for the Baptistery, Florence, 1426–52. (iv) Other works, from 1425.

(i) The north doors of the Baptistery, Florence, 1400–24. In announcing a competition (winter 1400–01) to design doors for the Baptistery, the Arte di Calimala (Cloth-dealers' and refiners' guild) sought to fulfil a project that had been in abeyance since Andrea Pisano (*c.* 1295–1348/9) had completed a set of bronze doors (1336; *in situ*), at which time the intention had been to adorn the two remaining portals in a similar way (*see* FLORENCE, §IV, 1(ii)). Ghiberti's autobiography gives a vivid account of the competition. Seven artists took part in the final stages: the conservative artists Simone da Colle (*fl c.* 1401), Niccolò di Luca Spinelli (1397–1477), Francesco di Valdambrino and Niccolò di Piero Lamberti and three protagonists of a newer style: Ghiberti, Brunelleschi and Jacopo della Quercia. The prescribed task was a relief depicting the *Sacrifice of Isaac*. Evidently the jury laid down precise specifications, since the connection of the sacrifice scene with a group of servants waiting at the foot of the mountain is not part of the iconographical tradition. Vasari supposed that the theme was chosen for its variety of motifs: single figures and groups, nude and clothed figures, an animal and, above all, a landscape setting. Of the reliefs submitted, only those of Ghiberti (see fig. 1) and Brunelleschi have survived (Florence, Bargello). Both are bronze, partly gilded and measure 465×400 mm (including frame). Ghiberti's is the earliest work securely attributed to him. Artistically the two panels could not be more different. Brunelleschi divided the plaque into two tiers, one above the other, with the figures placed alongside or above one another in the pictorial field. The parts are linked together by the action, which embraces every detail of the scene. Ghiberti's version, on the other hand, gives an impression of unity and of objective calm. Unity is achieved by the incorporation of all parts of the design in a single landscape and by the treatment of space: the figure of the servant, below left, and the angel, upper right, which seems to fly in obliquely from the depth of the scene, form the two extremities of a diagonal that contains in itself the nucleus of a pictorial development of the relief ground. Ghiberti was less interested in a powerful representation of the event than in achieving aesthetic perfection in each detail and in the whole, an endeavour that resulted in some figures of great beauty, such as the naked Isaac or the servant turning away from the spectator, who was to

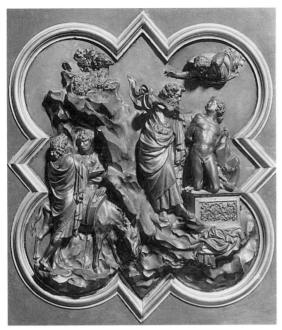

1. Lorenzo Ghiberti: *Sacrifice of Isaac*, bronze, partly gilded, 465 x 400 mm (including frame), *c.* 1401 (Florence, Museo Nazionale del Bargello)

reliefs a year for a fee of 200 gold florins, a stricter agreement was drawn up on 1 June 1407: he was to accept no other commissions without the consent of the consuls of the Arte di Calimala, and must work on the door full-time. On 19 April 1424 the doors were completed (see fig. 2) and set up in the main portal of the Baptistery, opposite the cathedral façade, replacing Andrea Pisano's doors, which were removed to the west portal.

The plan of the doors was similar to that of Pisano's, consisting of 28 reliefs in seven horizontal rows of four, each framed in a diamond-shaped quatrefoil. The events read from left to right, extending over both wings of the door, and from the bottom upwards. The two bottom rows represent the Latin fathers of the church (*St Augustine*, *St Jerome*, *St Gregory* and *St Ambrose*) and seated figures of the *Four Evangelists*. The third row begins the narrative of the *Life of Christ* from the *Annunciation* to *Pentecost*, in an order different from that of Pisano's portal. The panels are divided by latticework enriched by varied floral ornament and by individual medallion heads. As in Andrea Pisano's portal, the figures, architecture and landscape details are gilded and gleam against the dark background. Ghiberti signed his work OPUS LAURENTII FLORENTINI above the scenes of the *Nativity* and the *Adoration of the Magi*; the head above-left of the signature may be presumed to be a self-portrait, that above-right to be (2) Vittorio Ghiberti I.

inspire Verrocchio, two generations later, in his group of the *Incredulity of St Thomas* (*c.* 1466–83; Florence, Orsan-michele; *see* VERROCCHIO, ANDREA DEL, fig. 1). Yet in their relation to antiquity Brunelleschi's and Ghiberti's works are close. In neither case is ancient art a constituent feature of the design; rather, antique forms are used as 'quotations', for example in the variation on the *Spinario* (Rome, Mus. Conserv.) in the right-hand servant in Brunelleschi's work, or Ghiberti's Isaac, which probably derives from a Roman torso. It is profitless to compare the two reliefs from the point of view of 'modernity'. Brunelleschi's expressive realism and Ghiberti's idealized forms both represent basic attitudes that remained constant in the development of art in the early 15th century. The 'pictorial' treatment of a unified relief space was perhaps the more modern solution at the time and was to develop into the more markedly pictorial reliefs of the *Gates of Paradise*. The jury were doubtless also influenced by Ghiberti's technical superiority. His relief, unlike that of Brunelleschi, was cast in one piece, apart perhaps from the figure of Isaac, which may have been cast separately; he therefore required less material and incurred less expense. The 'palm of victory' was awarded to him 'by all the experts, and by all those who had competed with me'.

It is not known when, or why, the decision was taken to substitute New for Old Testament themes. A source of 1402 or 1403 (Krautheimer and Krautheimer-Hess, 1956, Document 33), which cannot be dated more precisely, records this change of programme, and that the 'story of Abraham' (the competition relief) was to be gilded and kept for a later door. The contract between the Arte di Calimala and Ghiberti for the execution of the doors was signed on 25 November 1403. As Ghiberti did not keep to the original terms, by which he was to deliver three

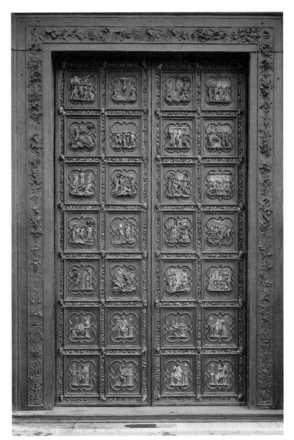

2. Lorenzo Ghiberti: partially gilded bronze doors (1403–24), north side of the Baptistery, Florence

Ghiberti worked on the doors for over 20 years, and the reliefs illustrate the evolution of his style. Initially he worked in Pisano's manner, with the figures powerfully modelled yet firmly linked to the background, and the relief ground functioning as a neutral closing-off surface (e.g. the *Annunciation*). In line, more or less, with the chronology of the narrative, he progressively departed from this practice, the figures becoming less attached to the background and appearing to be almost in the round (the *Temptation in the Wilderness*, *Christ Driving the Money-changers from the Temple*, the *Flagellation*, *Christ before Pilate*). At the same time there is a developing sense of the organic structure of bodies in motion. The relief space is extended towards the spectator and the ground gradually put to 'pictorial' effect. Increasingly more delicate gradations of the height of the relief, and perspectival constructions, make the landscape or architecture seem to extend into the background far beyond the limit set by the quatrefoil framing. The ground is transformed from a closing-off surface into a 'picture' of optically indefinite depth (*Christ among the Doctors*, the *Baptism*, the *Entry into Jerusalem*, the *Capture*). The consequences of this development are seen even in apparently trivial details, such as the changing design of the brackets beneath the scenes that have an architectural setting. While in the *Annunciation* Ghiberti started out with the clearly defined architectonic form of Pisano's brackets, gradually he filled the underside of the front stage with plants and rocks so that the extent of the projection can no longer be seen. In general, the reliefs that were probably executed latest, including *Christ before Pilate* and *Pentecost*, show a tension between high and low relief that almost transcends the quatrefoil framework. If, despite stylistic variation, the door as a whole makes a comparatively unified impression, there are probably two main reasons for this: first, the highly decorative quatrefoil frames did not permit further development of the background, and, second, Ghiberti deliberately refrained from making too radical a break with his initial concept of the relief so as to avoid a disturbing lack of harmony. Between 1423 and 1426 Ghiberti worked on the bronze jambs and lintel that frame the door; these are decorated with a varied array of flowers, fruits and tiny animals. The reliefs of the inner jamb introduce a new type of very shallow relief and an elegant stylization of natural forms.

(ii) Bronzes for Orsanmichele and the Siena reliefs, 1413–27. While work was proceeding on the bronze doors, Ghiberti undertook various other commissions. The years between 1413 and 1427 were years of rapidly growing fame and prosperity. In 1423 he was enrolled in the painters' guild, and on 20 December 1426 in the stone masons' guild. Some of his work took him outside Florence; he went to Siena, and in 1424 to Venice to avoid the plague that had broken out in Florence. In *I commentarii* he mentioned a visit to Rome, which may have taken place between 1425 and 1430.

In 1413 Ghiberti was working on an over life-size bronze statue of *St John the Baptist* for the Arte di Calimala, to be placed on the east side of the guild hall of Orsanmichele, Florence (*in situ*). The casting began on 1 December 1414. The signature on the hem of the saint's cloak reads LAURENTIUS GHIBERTUS MCCCCXIV, the date probably referring to the completion of the model. Documents confirm that the niche architecture is entirely by Albizzo di Piero (*fl* 1411). This statue is of great historical importance. It is the first monumental bronze figure of modern times and is thus an extraordinary technical achievement. Above all, it represents a stage of the Late Gothic style that is without parallel in early 15th-century Florentine sculpture. The saint is enveloped in voluminous swirling drapery with deep folds and furrows. The multiple curves and undulations, frequently moving counter to one another along the axis, give the figure its prevailing line and produce a graceful, almost dancing, effect that is in delightful contrast to its material weight. The heritage of Late Gothic, then in its last stages, is unmistakable; some features are reminiscent of types of sculpture, such as the 'Beautiful Madonnas', from north of the Alps. However, there is a clear departure from the medieval type of draped figure. Far from neglecting the articulation of the body underneath the ample robe, Ghiberti succeeded in creating an impression of the body and its clothing as two largely independent layers of equal importance. The nearest comparable approach to the treatment of figures is to be found in his reliefs of the *Adoration of the Magi* and *Christ among the Doctors* on the doors of the Baptistery, both probably executed at a fairly early stage. (This would confirm the evidence that work on the bronze doors was slow to start.)

By *c.* 1415 Ghiberti was recognized as the best Florentine sculptor in bronze. On 21 July 1419 the wealthy Arte di Zecca (Money-changers' guild), responsible for the west side of Orsanmichele, commissioned from him an over life-size bronze statue of *St Matthew* (see fig. 3). A detailed contract was drawn up on 26 August and gave Ghiberti the permission (which he did not use) to cast the figure in two parts, the head and the remainder. The statue was to be about the same size as that of *St John the Baptist* and to be completed within three years. The date *1420* on the hem of the saint's cloak is probably that of the preparation of the model; Ghiberti received his final payment on 6 March 1423. The design of the niche in which the statue stands can also be regarded as Ghiberti's work: in a contract dated 2 May 1422 the masons Jacopo di Corso (*b c.* 1382) and Giovanni di Niccolò were directed to execute the niche in accordance with Ghiberti's drawing and instructions. Although some basic motifs are repeated from the statue of *St John*—a wide horizontal fold in front of the hip, a long furrow extending from the left hip to the right foot, cascades of drapery by the leg that takes the weight, and the modelling of the hair—nonetheless *St Matthew*, with its approach to antique contrapposto, represents a new stage in Ghiberti's development. The garment is no longer an equal partner of the body; it is less voluminous and serves to articulate the saint's pose and attitude. Compared to the strict frontality of St John, St Matthew's body is slightly turned on its axis, giving an effect of movement. Here Ghiberti was making use of impressions from Donatello (*St Mark*, 1411–13; Florence, Orsanmichele) and Nanni di Banco (*Four Crowned Saints*, *c.* 1416; Florence, Orsanmichele; for illustration *see* NANNI DI BANCO). The niche is the only piece of monumental architecture known to be by Ghiberti. Its shallowness was

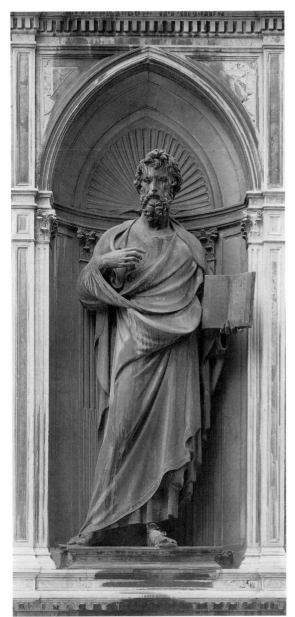

3. Lorenzo Ghiberti: *St Matthew* (1419–22), bronze, over life-size, west side of Orsanmichele, Florence

modelling of the figure. The same tension is present between high and low relief as in the later panels of the bronze doors of the Baptistery. The statuesque appearance of *St Matthew* can also be compared with figures in what are thought to be late reliefs in the bronze doors: the figure seen from behind in *Christ before Pilate* or that of Christ in the *Road to Calvary*.

Two reliefs for the font of the Baptistery in Siena (*St John the Baptist before Herod* and the *Baptism*, fire-gilded bronze, each 790×790 mm; *in situ*; see fig. 4) suggest the development of Ghiberti's art. In spite of ample documentary evidence, the complex history of the commission presents some difficulties. In June or July 1416 Ghiberti was paid the cost of travelling to Siena, where he advised on the erection of the font. He visited Siena twice more, and on 21 May 1417 was commissioned to execute two bronze reliefs within 10 to 20 months. He did not keep to this timetable, and the reliefs were still unfinished in 1425. A document of 16 April 1425 states that he was working personally on one of them, while the other was in the hands of Giuliano di ser Andrea (*fl* 1403–27). Only on 15 November 1427 was the cost of sending the two bronze reliefs to Siena refunded. The Siena reliefs differ from the later panels of the bronze door in the strong emphasis placed on the background, whether it represents an interior space as in *St John the Baptist before Herod*, or a heavenly scene with clouds and angels as in the *Baptism*. But there are also notable differences between the two Siena reliefs, which foreshadow a decisive turn in Ghiberti's artistic development after 1425. Whereas the scene depicting St John and Herod is dominated by the three-dimensional figures in the foreground, in the *Baptism* only the four principal figures are in high relief, the rest of the relief being shallow. Accordingly the actual depth of the space in front of the figures in the latter is not great, and appears even less because of its steepness. We may suppose that the model for the relief of *St John before Herod* is contemporary with the last panels of the bronze doors,

dictated by the architecture of the church (the steps leading to the upper storey are located inside the corner pillar), but presumably Ghiberti's design was hardly affected by this limitation. The antique composite capitals articulate the figure's shoulders; the cornice between the vertical and vaulted parts of the niche marks the junction of the head and body; the fluted pilasters at the back confirm the lateral contours of the body; the shell-like ornament of the vaulting may be taken as suggesting a halo. In contrast to the earlier statues at Orsanmichele, the figure and architecture are closely related to each other; the niche, however, does not enclose the statue but acts rather as a frame, its flatness contrasting with the three-dimensional

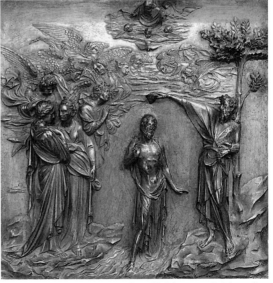

4. Lorenzo Ghiberti: *Baptism*, fire-gilded bronze relief for a font, 790×790 mm, *c.* 1416–27 (Siena, Baptistery)

while the *Baptism* dates from 1426–7 at the earliest. In addition, it seems probable that different hands were involved in the execution of the two reliefs. Despite its delicacy of detail, *St John the Baptist before Herod* is not of the same quality as the *Baptism* or the late panels of the bronze doors. The abrupt termination of the architecture on the right gives an unbalanced effect; the figures are unusually elongated; the individual forms of the palace are more delicate than in any other background architecture by Ghiberti; and the slight perspectival distortions are also unexpected, in comparison with the exemplary relief of *Christ before Pilate* on the bronze doors. This could be a largely independent work by Giuliano di ser Andrea. In the *Baptism*, on the other hand, Ghiberti accomplished the harmonization of the picture planes and the gradation of modelling that were characteristic of his latest reliefs.

(iii) The 'Gates of Paradise' for the Baptistery, Florence, c. 1426–52. Ghiberti was now at the peak of his fame, and he received the most important commission of his career. Evidently impressed by the doors he had just completed (2 Jan 1425), the Arte di Calimala entrusted him with a commission for a third pair of doors for the Baptistery (see colour pl. 1, XXXI2). In the same year Leonardo Bruni suggested a scheme (Krautheimer and Krautheimer-Hess, 1956, Document 52), similar to that of the two older doors, for twenty-eight reliefs in seven rows of four each, depicting eight prophets and twenty Old Testament episodes. It may be supposed that the reliefs were intended to be enclosed within quatrefoils and that the competition relief of the *Sacrifice of Isaac* (1401) was to be incorporated. However, this plan was abandoned—it is not known why or when, nor at whose direction it was changed. As finally executed, the door is divided into ten large, nearly square panels, each illustrating a number of episodes and set within borders richly decorated with small figures and heads. The outer frame is ornamented with leaves, birds and animals. The programme must have been decided on soon after the commission was awarded, as the ten scenes were already rough cast by 4 April 1436 (or possibly 1437). Ghiberti wrote in his autobiography: 'I was given a free hand to execute [the doors] in whatever way I thought best.' This was presumably more than mere rhetoric. When he received the commission, Ghiberti was working on the two reliefs for the font at Siena. Evidently he used these to convince his patrons that a larger format, free from the constraint of the decorative framework, was better suited to narrative scenes. It is certainly not by chance that the dimensions of the Siena reliefs are almost exactly the same as those of the *Gates of Paradise* or that gilt covers the whole surface of these panels. There are signs of a new self-confidence on the artist's part, as he began to free himself from craft constraints, and of a corresponding change in the relationship between artist and patron. The ten reliefs were completed by 7 August 1447 and the following years devoted to the framing; the gilding was completed on 16 June 1452. On 13 July 1452 the consuls of the Arte di Calimala decided that the new doors would replace Ghiberti's first set in the main portal of the Baptistery, and the earlier doors would be reinstalled on the northern side. The new doors were to adorn the main entrance 'stante la sua bellezza'. This is the first

recorded occasion on which 'beauty' is referred to as a purely aesthetic category, independent of the subject of a work. That two portals adorned with eminently suitable themes for a Baptistery (the *Life of St John the Baptist* on those by Pisano) or for the main entrance to any church (the *Life of Christ*) should give place to a set of Old Testament scenes is remarkable, and indicates that artistic merit was beginning to be rated higher than content. It also provides evidence to support the conjecture that the artistic perfection of Ghiberti's competition relief had swayed the jury's decision in 1401. This second set of bronze doors has become known in art history as the *Gates of Paradise*. Vasari reported that Michelangelo thought the door worthy to adorn the entrance to Paradise, but the name may have referred to the relief of *Genesis*, which was especially admired, judging by the frequency with which its individual motifs were borrowed in subsequent painting. A third possible explanation for the name is that there may formerly have been a parvis between the cathedral and the Baptistery.

At first sight, Ghiberti's two sets of doors seem, both as a whole and in detail, to represent opposed functions: the older door gives the impression of shutting out, while the *Gates of Paradise*, in which the small quatrefoil reliefs have given place to large panels resembling spacious pictures, rather suggest an entrance through the wall. But it may be doubted that there was in fact a break in Ghiberti's artistic development, as is so often stated; rather that the new conception of the *Gates of Paradise* was a logical evolution of the old. *Christ before Pilate* in the old door and *Jacob and Esau* in the new have many similarities. In both cases we find the illusionistic treatment of the ground as a space extending far into the picture; the tension between high and low relief, with many gradations; the almost three-dimensional handling of the foreground, and the mobility of the figures. Admittedly, the new format of the reliefs provided an opportunity for the flowering of these tendencies. The new problems of design that con-

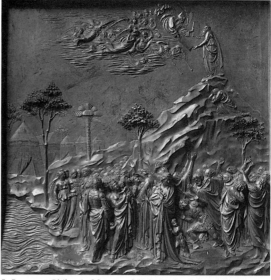

5. Lorenzo Ghiberti: *Moses on Mt Sinai*, detail from the Gates of Paradise (*c.* 1426–52), gilded bronze, Baptistery, Florence

6. Lorenzo Ghiberti: self-portrait on the *Gates of Paradise* (*c.* 1426–52), gilded bronze, Baptistery, Florence

fronted Ghiberti in the *Gates of Paradise* were chiefly those of uniting several scenes within ordered compositions and organizing the relief space in continuously connected layers. Here, too, Ghiberti's style evolves continuously throughout the sequence of panels, from *Jacob and Esau* and *Cain and Abel*, through *Genesis* and *Moses on Mt Sinai* (see fig. 5), to *David and Goliath* and *Solomon and the Queen of Sheba*. The front stage is increasingly reduced, while the background receives increasing emphasis, with a growing preference for shallow relief. Correspondingly, there is a slight diminution of scale in the foreground figures. This combination of sculptural and pictorial techniques tends to resolve the tension between high and low relief and thus unify the ensemble. The medallion heads in the borders marking the corners of the reliefs show more individuality than those in the older door and reflect Ghiberti's interest in Classical art. The statuettes of Old Testament figures beside the reliefs belong to the incunabula of the genre of small bronzes. The floral ornamentation reveals a direct perception of nature that had a far-reaching effect on 15th-century sculpture and painting. With justified pride, Ghiberti added after his signature above the second row of reliefs: MIRA ARTE FABRICATUM. The two medallion heads on the central framing strip at the level of this inscription are, on the left, Ghiberti himself (see fig. 6) and, on the right, his son Vittorio.

(iv) Other works, from 1425. During the execution of the *Gates of Paradise*, Ghiberti received a number of presti-

gious commissions. On 2 April 1425 the Arte di Lana (Wool guild) decided to replace their marble statue of *St Stephen* at Orsanmichele, which dated from 1340, with a bronze figure and a new tabernacle; clearly they did not wish to be outdone by the rich guilds of the Calimala and Zecca. Ghiberti received the commission in that year, and the statue, originally partly gilded, remains *in situ* on the west side of Orsanmichele. The model for the statue was completed on 5 August 1427, and the whole work, including gilding, on 1 February 1429. Critics have generally been reserved in their praise of *St Stephen*. It is true that the statue does not represent any further progress in Ghiberti's move towards 'modern' contrapposto, begun in his *St Matthew*. As in the statue of *St John the Baptist*, the pose and movement are chiefly expressed in the soft undulations of the voluminous garment. However, the unity of composition is much more emphasized than in the statue of *St John*, and the sensitive modelling of the head, perhaps influenced by that of Donatello's *St Louis* (Florence, Mus. Opera Santa Croce), is unsurpassed by any other of Ghiberti's works.

Between 1425 and 1427 Ghiberti executed the bronze tomb slab of *Leonardo Dati* (*d* 1425), general of the Dominican Order (Florence, S Maria Novella), the head of which may have been worked from a death-mask. The bronze shrine of *SS Protus, Hyacinth and Nemesius* (Florence, Bargello), commissioned by Cosimo and Lorenzo de' Medici, was installed in S Maria degli Angeli in 1428. It was broken up during the Napoleonic period and subsequently reassembled, except for the base (an inscription on which was recorded by Vasari), which remains untraced. The front, with two hovering angels supporting a wreathed medallion, combines high and low relief in the style of the early parts of the *Gates of Paradise*. The composition may be derived from antique sarcophagi. The most important of the commissions executed by Ghiberti during his work on the *Gates of Paradise* was the bronze shrine of *St Zenobius* (Florence Cathedral), commissioned by the Arte di Lana. The contract of March 1432 specified the precise size, materials and weight, and laid down that the work should be finished by April 1435. In fact it took a whole decade. Bronze for the casting of two reliefs was paid for on 22 October 1434. It is unlikely that the models for the side panels were completed by then, as a new contract of April 1439 refers to those panels as having only just been begun. Ghiberti received the final payment for the work on 30 August 1442. The scene of the *Miracle of the Servant* (left narrow side) was probably completed first. As in the later panels of the *Gates of Paradise*, the front stage is minimal and slopes rapidly upwards to the vertical relief plane. The figures are in low relief; the ensemble is highly compact. These features appear even more strongly on the opposite relief, showing the *Miracle of the Ox-cart*. The final stage of the development is seen in the reliefs on the two long sides. The plaque on the side that is away from the spectator depicts *Angels Bearing a Wreath*, with the groups of angels shown in varying degrees of relief, from high to very shallow. The tension between high and low relief that distinguished the shrine of 1428 is here resolved. The main relief, on the side that faces the spectator, shows the *Miracle of the Strozzi Boy*, and in this the relief projects immediately from the front edge. Even

the nearest rows of figures are tied in with the ground to a greater extent than in the late reliefs of the *Gates of Paradise*. The composition combines lively freedom in individual figures with the strict regularity that characterizes Ghiberti's late style. This brief sketch of Ghiberti's relief technique is also borne out by the gilt-bronze shutter showing *God the Father*, cast in 1450 (probably with much workshop assistance) for Bernardo Rossellino's marble tabernacle (Florence, S Egidio). A large bronze relief of the *Assumption of the Virgin* (Sant'Angelo in Vado, S Maria dei Servi), occasionally attributed to Ghiberti, is now regarded as the work, under his influence, of a master from the Marches.

In the late 1440s Ghiberti gradually retired from business. Tax returns from 1427, 1431, 1433, 1442 and 1447 show him as owning houses and land to an increasing extent, and he made a will in November 1455. In 1442 he acquired a manor house, and in 1452 the Calimala paid him and Vittorio for the *Gates of Paradise* by giving them the workshop and house where the doors had been cast.

2. ARCHITECTURE, PAINTING AND GOLDSMITH'S WORK. Knowledge of Ghiberti's work as an architect is patchy. In 1406–8 he was already advising on the construction of Florence Cathedral. A document of September 1418 indicates that he employed four assistants to produce a model for the dome, which was submitted on 13 December together with models by other masters. On 11 August and 3 October 1419 he was paid for preparing models of the dome, one being made of small bricks. The final competition between Brunelleschi and Ghiberti for the construction of the dome evidently took place at the end of March or beginning of April 1420. On 16 April of that year Ghiberti, Brunelleschi and the master mason Battista d'Antonio (*fl* 1420–39) were appointed to supervise the construction, each being paid 3 gold florins a month. On 24 April 1420 Ghiberti and Brunelleschi received another 10 gold florins for a model of the dome, apparently their joint work. In the following years Ghiberti remained associated with the work, on the same monthly salary. From 4 April 1426 onwards Brunelleschi received 100 gold florins a year for full-time work on the dome, while Ghiberti's fee for part-time work remained at 36 gold florins a year. The last payment to Ghiberti in this connection was not made until 30 June 1436. What part he had in its final design and technical construction is not clear, though the relatively large amount paid to him over 16 years suggests that it was more than a merely advisory function. He himself writes in his autobiography: 'And especially in the building of the dome Filippo [Brunelleschi] and I were competitors for 18 years at the same salary; thus we executed the said dome.' On 14 August 1436, in competition with Brunelleschi and others, Ghiberti submitted a model for a lantern for the dome; nothing is known of its design. Other attributions remain hypothetical: the only indications we have of his architectural style are the niche for the statue of *St Matthew* at Orsanmichele, which employs a composite style of antique and Late Gothic elements, the tabernacle (Florence, Mus. S Marco) designed in 1432 for an altar for the Arte di Linaiuoli (Linen-workers' guild), and the architectural settings of the reliefs. On this basis he may, however, be considered the probable designer of the portal of the Strozzi Chapel (1423–4) in Santa Trìnita, Florence, with its slender fluted shafts decorated with foliate garlands and of the façade of the sacristy (1417–24) of that church. This is all the more likely since, on 4 January 1420, Ghiberti was appointed a supervisor of the wood-carving work in the Strozzi Chapel, so that there is evidence of his connection with the church.

Ghiberti's ascertainable work as a painter is confined to the design of important stained-glass windows: he supplied (probably in 1404) a cartoon of the *Assumption* for the central rose window in the cathedral façade, and in 1412 designs for the flanking windows, representing *St Stephen* and *St Lawrence*. On 4 April 1424 he was paid for two designs for windows in the first bay of the cathedral, representing *Joachim Expelled from the Temple* and the *Death of the Virgin*. In October 1436 he received a final payment for designs for four windows in the St Zenobius Chapel of the cathedral choir. Finally, he designed three of the round windows in the drum of the cathedral dome: on 7 December 1443 he was paid for the *Presentation in the Temple* and on 11 September received final payments for *Christ on the Mount of Olives* and the *Ascension*. Judging by its stylistic affinity to these windows, and also according to Vasari, the façade window of the *Crucifixion* in Santa Croce, Florence, was also designed by Ghiberti, probably *c.* 1450.

There is no evidence of Ghiberti's work as a goldsmith, beyond what is stated in his autobiography and referred to in documents. In 1417 he supplied a design for two silver candlesticks for Orsanmichele; in 1419 he designed a mitre for Pope Martin V during the latter's stay in Florence (both untraced). In 1428 he set, for Cosimo de' Medici, an antique cornelian engraved with the *Flaying of Marsyas*, and in ?1441 he made a mitre (untraced) for Pope Eugenius IV.

Ghiberti's work has hardly been touched by problems of attribution. There has been dispute as to the authorship of a drawing comprising studies for a *Flagellation* (Vienna, Albertina). It is probably not a sketch for the relief on the first set of bronze doors, but a late 15th-century work. The statuettes of *St Andrew* and *St Francis* on a reliquary containing St Andrew's arm (Città di Castello, Pin. Com.) are derived, certainly, from figures on the first bronze doors but are hardly by Ghiberti's own hand. It may be doubted whether the angels on the silver-gilt reliquary of St James (Pistoia, Mus. Cap.) are from Ghiberti's workshop.

3. WRITINGS. Ghiberti's *I commentarii*, which are divided into three books, were begun *c.* 1447 and remained incomplete at his death. They are outstanding among 15th-century writings on art, both in their ambition to discuss the development of art from antiquity to modern times and in their humanistic belief in the supremacy of ancient art. Book 1 deals with the art of Classical antiquity, drawing widely on the writings of Vitruvius and Pliny. It stresses the perfection of ancient art and the importance to the sculptor of a knowledge of both the liberal arts and theoretical sciences. Ghiberti admired ancient art, as Pliny had done, for its naturalism, and there is a long section, derived from Pliny, on ancient bronze statuary and its

origins in clay modelling. Book 2, the most fascinating section, contains a history of modern art, from its death in the Dark Ages to its resurrection by Giotto, who 'abandoned the crudeness of the Greeks and rose to be the most excellent painter in Etruria' (see GIOTTO, §I, 2(ii)). Ghiberti then outlined the history of Florentine and Sienese painting and sculpture in the 13th and 14th centuries, with a new emphasis on style rather than anecdote. He particularly praised Sienese painters, above all Ambrogio Lorenzetti, who had created naturalistic settings, and to whom his own art was indebted. The book culminates in an account of his life, the earliest example of an artist's autobiography, which is primarily a chronological list of his works. The third book is a discussion of the sciences necessary to a sculptor, including optics, anatomy and, inspired by Vitruvius, the theory of human proportion.

II. Working methods and technique.

Ghiberti had superb technical gifts, and his workshop became the training-ground for a generation of Florentine artists. The two sets of bronze doors for the Baptistery in Florence, the north doors and the *Gates of Paradise*, were cast by the lost-wax process. For the reliefs of the north doors, Ghiberti made separate wax models for the figures and for the ground plaque with setting. The frame, and the 28 reliefs, were cast separately; the reliefs are therefore hollow sheets, although some of the most three-dimensional figures, such as the Christ in the *Crucifixion*, were cast separately. There followed the longer process of chasing the reliefs. Ghiberti's second contract, of 1407, stipulates that he was himself to execute the wax models and to carry out the chasing of the cast 'particularly on those parts which require the greatest perfection, like hair, nudes and so forth'. That this, his first main work, took proportionately much longer to complete than had the bronze doors of Andrea Pisano, has often been explained by Ghiberti's meticulousness, or by his simultaneously working on other prestigious commissions. However, Bruno Bearzi's technical investigations since World War II have disproved these suppositions. Andrea Pisano's reliefs were cast by experts from Venice, a city where the classical tradition of bronze-casting remained alive; their rough casts were of high quality, and the chasing therefore relatively easy. In the early 15th century the situation was different, and Ghiberti had to rediscover the lost-wax process. The rough casts of his reliefs were coarse, and the chasing and polishing were lengthy and laborious; Bearzi actually speaks in this connection of 'sculpture in bronze'. In the later panels Ghiberti began to use a shallower relief, and Donatello's concept of *rilievo schiacciato* was probably inspired by this. In 1423 the decision was taken to fire-gild the doors (Poggi, 1948). The gilding highlights the heads, figures and settings, creating a rich contrast with the dark bronze of the background. For the *Gates of Paradise* the panels were cast in one piece and fire-gilded; but here the gilding, as in the Siena reliefs, covers the entire surface, creating a delicate play of light and shade. Again much of the effect of the doors depends on the high quality of the chasing, which occupied 27 years, and which is particularly evident in *Cain and Abel*

and *Isaac*. In these panels, too, the technical device of shallow relief finds its richest expression.

St John the Baptist on the Orsanmichele, the first monumental bronze figure of modern times, was an extraordinary technical achievement. The figure was cast as a single piece, and the difficulties of casting necessitated laborious polishing and chasing, including incisions in the drapery up to a depth of 50 mm. The statue is distinguished by the extraordinary detail and decorative beauty of the chasing of the hair, beard and goatskin. The casting of the over life-size bronze statue of *St Matthew* was only partly successful, and certain parts had to be recast. There is no evidence as to which these were, nor can it be discerned from the figure; conceivably it was the open book of the Gospel and the right hand, held away from the body. A coloured drawing (Paris, Louvre) associated with the third Orsanmichele statue, that of *St Stephen*, was probably made in the workshop, at Ghiberti's direction, to give the patron an idea of the work. The intention, shown in the drawing, to introduce antique elements into the Late Gothic niche, was not carried out.

Documentary sources have revealed much evidence about Ghiberti's studio, the progress of his works, his assistants and business practices. The initial contract for the north door of the Baptistery stipulated that he was to work with Bartolo di Michele and might employ other masters if he wished. By 1407, when the second, more stringent, contract was drawn up, Ghiberti already had a workshop of considerable size; a document, not precisely dated, in the Spoglie Strozziane (extracts from the papers of the Arte di Calimala, transcribed in Krautheimer and Krautheimer-Hess) lists 11 assistants, including Giuliano di ser Andrea and Donatello. A second document, of after 1407, gives 25 names, although we must assume that changes were frequent. Among others, Bernardo Ciuffagni and Paolo Uccello worked in Ghiberti's shop for a time (c. 1420), as did Michelozzo di Bartolomeo. Michelozzo is also mentioned in 1422, in connection with the casting of the *St Matthew*. Many assistants are also listed during the period when the *Gates of Paradise* were being made. In 1437, in addition to Michelozzo, there is Ghiberti's son, Vittorio, and three unnamed goldsmiths. In 1443 Ghiberti's son, Tommaso, was active in his father's workshop. On 24 January 1444 Benozzo Gozzoli was engaged to work on the new door. In the late years Vittorio played an increasingly dominant role.

The influence of this workshop, which brought together goldsmiths, sculptors, painters and bronze-casters, was widespread, and Ghiberti's art was further disseminated by the help he himself described giving to 'many painters, sculptors and stonecarvers' for whom he 'made very many models in wax and clay'. In short, although Ghiberti's proud boast that 'Few works of importance were made in our city that were not designed or devised by my hand' contains an element of rhetoric, it is also a just claim to a creative versatility that sets him apart from all other artists of his generation.

WRITINGS
J. von Schlosser, ed.: *Lorenzo Ghibertis Denkwürdigkeiten (I commentarii)*, 2 vols (Berlin, 1912)

BIBLIOGRAPHY
SOURCES
G. Vasari: *Vite* (1550, rev. 2/1568); ed. G. Milanesi (1878–85)
G. Guasti: *Santa Maria del Fiore* (Florence, 1887)

A. Doren: *Das Aktenbuch für Ghibertis Matthäusstatue an Or San Michele zu Florenz*, It. Forsch. Ksthist. Inst. I (Berlin, 1906)

G. Poggi: *Il Duomo di Firenze*, It. Forsch. Ksthist. Inst. II (Berlin, 1909)

MONOGRAPHS AND EXHIBITION CATALOGUES

L. Planiscig: *Lorenzo Ghiberti* (Vienna, 1940, rev. Florence, 1949)

J. von Schlosser: *Leben und Meinungen des florentinischen Bildners Lorenzo Ghiberti* (Basle, 1941)

L. Goldscheider: *Ghiberti* (London, 1949)

R. Krautheimer and T. Krautheimer-Hess: *Lorenzo Ghiberti* (Princeton, 1956, rev. 3/1982)

G. Brunetti: *Ghiberti* (Florence, 1966)

G. Marchini: *Ghiberti architetto* (Florence, 1978)

M. Wundram: 'Lorenzo Ghiberti', *Neue Zurich. Ztg*, ccxxxix (1978)

Lorenzo Ghiberti: Materia e ragionamenti (exh. cat., Florence, Accad. and Mus. S Marco, 1978)

SPECIALIST STUDIES
Specific works

F. Gregori and T. Patch: *La porta principale del Battistero di Firenze* (Florence, 1773)

A. Schmarsow: 'Ghibertis Kompositionsgesetze an der Nordtür des Florentiner Baptisteriums', *Abh. Philol.-Hist. Kl. Kön. Sächs. Ges. Wiss.*, xviii/4 (1879)

H. Kauffmann: 'Eine Ghiberti-Zeichnung im Louvre', *Jb. Kön.-Preuss. Kstsamml.*, l (1929), pp. 1–10

W. Lotz: *Der Taufbrunnen des Baptisteriums zu Siena* (Berlin, 1948)

G. Poggi: 'La ripulitura delle porte del Battistero fiorentino', *Boll. A.*, xxxiii (1948), pp. 244–57

B. Albrecht: *Die erste Tür Lorenzo Ghibertis am Florentiner Baptisterium* (diss., U. Heidelberg, 1950)

R. Salvini: *Lorenzo Ghiberti: Le Porte del Paradiso* (Milan, 1956)

M. Wundram: *Ghiberti-Paradiestür* (Stuttgart, 1963)

G. von Österreich: *Die Rundfenster des Lorenzo Ghiberti* (diss., U. Fribourg, 1965)

R. Krautheimer: *Ghiberti's Bronze Doors* (Princeton, 1971)

U. Mielke: 'Zum Programm der Paradiestür', *Z. Kstgesch.*, xxxiv (1971), pp. 115–34

D. F. Zervas: 'Ghiberti's *St Matthew* Ensemble at Or San Michele: Symbolism in Proportion', *A. Bull.*, lviii (1976), pp. 36–44

B. Bearzi: 'La tecnica usata dal Ghiberti per le porte del Battistero', *Lorenzo Ghiberti nel suo tempo: Atti del Convegno Internazionale: Firenze, 1980*

M. Haines: 'Il principio di mirabilissime cose: I mosaici per la volta della cappella di San Zanobi', *La difficile eredità: Architettura a Firenze dalla Repubblica all'assedio*, ed. M. Dezzi Bardeschi (Florence, 1994), pp. 38–55

Other

H. Brockhaus: *Forschungen über Florentiner Kunstwerke* (Leipzig, 1902)

J. von Schlosser: 'Über einige Antiken Ghibertis', *Jb. Ksthist. Samml. Allhöch. Ksrhaus.*, xxiv (1903), pp. 125–59

W. Bode: 'Lorenzo Ghiberti als führender Meister unter den Florentiner Tonbildnern der ersten Hälfte des Quattrocento', *Jb. Kön.-Preuss. Kstsamml.*, xxxv (1914), pp. 71–89

G. Sinibaldi: 'Come Lorenzo Ghiberti sentisse Giotto e Ambrogio Lorenzetti', *L'Arte*, xxxi (1928), pp. 80–82

H. Gollob: *Ghibertis künstlerischer Werdegang* (Strasbourg, 1929)

R. Krautheimer: 'Ghibertiana', *Burl. Mag.*, lxxi/413 (1937), pp. 68–80

W. R. Valentiner: 'Donatello and Ghiberti', *A.Q.* [Detroit], iii (1940), pp. 182–214

R. Krautheimer: 'Ghiberti and Master Gusmin', *A. Bull.*, xxix/1 (1947), pp. 25–35

M. Wundram: *Die künstlerische Entwicklung im Reliefstil Lorenzo Ghibertis* (diss., U. Göttingen, 1952)

U. Middeldorf: 'L'Angelico e la scultura', *Rinascimento*, vi/2 (1955), pp. 179–94

M. Salmi: 'Lorenzo Ghiberti e la pittura', *Scritti in onore di Lionello Venturi* (Rome, 1956), i, pp. 223–7

M. Wundram: 'Albizzo di Piero: Studien zur Bauplastik von Or San Michele in Florenz', *Das Werk des Künstlers: Festschrift für H. Schrade*, ed. H. Segers (Stuttgart, 1960), pp. 161–76

G. Marchini: 'Ghiberti "ante litteram"', *Boll. A.*, l/3–4 (1965), pp. 181–93

U. Middeldorf: 'Additions to Lorenzo Ghiberti's Work', *Burl. Mag.*, cxiii/815 (1971), pp. 72–9

D. F. Zervas: *System of Design and Proportion Used by Ghiberti, Donatello and Michelozzo in their Large-scale Sculpture-architectural Ensembles* (diss., Baltimore, MD, John Hopkins U., 1973)

S. Euler-Künsemüller: *Bildgestalt und Erzählung: Zum frühen Reliefwerk Lorenzo Ghibertis* (Frankfurt am Main and Berne, 1980)

B. Nagel: *Lorenzo Ghiberti und die Malerei der Renaissance* (Frankfurt am Main, Berne and New York, 1987)

W. Tresidder: 'Lorenzo Ghiberti and the Frame of Gentile da Fabriano's *Adoration of the Magi*', *Source*, xiv/4 (1995), pp. 8–13

L. Bartoli: 'Rewriting History: Vasari's Life of Lorenzo Ghiberti: Why Vasari Classified Ghiberti as a Painter', *Word & Image*, xiii (1997), pp. 245–52

C. Elam: 'Florence Cathedral: Works and Days', *Burl. Mag.*, cxxxix (1997), p. 443

(2) Vittorio Ghiberti I (*b* Florence 1418 or 1419; *d* Florence 1496). Bronze-caster and sculptor, son of (1) Lorenzo Ghiberti. His birthdate is given differently on two of Lorenzo's tax declarations (9 July 1427 and 26 Jan 1431). He no doubt served his apprenticeship in his father's workshop. In 1437 he is mentioned as assistant to his father on the *Gates of Paradise* at the handsome salary of 100 gold florins per annum. In the ensuing years he seems to have become his father's partner. On 24 January 1444 he signed, on the latter's behalf, the contract engaging Benozzo Gozzoli as an assistant; and from 1451 he is always mentioned together with his father in the documents relating to final work on the doors. His head is portrayed next to his father's, on the right-hand central framing strip of the *Gates of Paradise* at the level of the inscription (*see* (1) above). On 12 February 1453 Lorenzo and Vittorio received the commission for the bronze frame of Andrea Pisano's door, which Vittorio apparently executed himself. It was completed between 1462 and 1464, and payments for it are recorded only after Lorenzo's death, the first being in April 1456. Although Vittorio lived until 1496, nothing is known of further works by him. His personal style can be judged only by the frame of the Pisano door. The floral details stand out boldly from the relief ground, and the softer modelling of the *Gates of Paradise*, for instance, gives way to pointed, angular forms. The figures of Adam and Eve are distinguished by elongation and an emphasis on anatomical detail rather than regard for the general effect. Beauty of line gives place to affectation and refinement.

MANFRED WUNDRAM

(3) Buonaccorso (di Vittorio) Ghiberti (*b* Florence, 10 Dec 1451; *d* Florence, 16 July 1516). Engineer and draughtsman, son of (2) Vittorio Ghiberti. He was involved in artillery-making in 1487 and 1495, and in 1504 he helped to move Michelangelo's *David* (*see* ITALY, fig. 22) from the workshop to its place in front of the Signoria. His signed *zibaldone* of 220 folios (Florence, Bib. N. Cent., MS. Banco Rari 229) was begun in the 1470s. Its contents fall into two groups. The first contains drawings and texts copied from his grandfather Lorenzo's notebooks. These include: extracts from Vitruvius translated into Italian; copies of illustrations from a Late Antique Vitruvius; festival apparatus and hoists, cranes and tools invented and designed by Filippo Brunelleschi; notes on metallurgy and on foundry methods for casting and repairing bells; and sundry records of building material prices and payments to workmen. The second category comprises drawings arranged at random, dating from between *c.* 1470 and *c.* 1500. The subject-matter of these drawings ranges from tombs, equestrian statues and candelabra to architectural

subjects such as church façades, Roman capitals and entablatures, a series of 13 fantasy buildings *all'antica* and the Marzocco Tower in Livorno. Of the numerous drawings of machinery and equipment, many are copied from Roberto Valturio's *De rei militari* (Verona, 1483) or are related to those of Francesco di Giorgio (hoists, cranes, trebuchets and scaling ladders, as well as a mechanism for hauling obelisks). The *zibaldone* passed into the hands of Cosimo Bartoli, as did Lorenzo's *I commentarii*, and perhaps other notebooks from Lorenzo's *scriptorio* that Buonaccorso had inherited in 1455. This type of sketch-book–notebook was common in artists' workshops but survives intact only rarely.

BIBLIOGRAPHY

R. Corwegh: 'Der Verfasser des kleinen Kodex Ghiberti', *Mitt. Ksthist. Inst. Florenz*, i (1911), pp. 156–67
G. Scaglia: 'Drawings of Brunelleschi's Mechanical Inventions for the Construction of the Cupola', *Marsyas*, x (1960–61), pp. 45–68
——: 'Drawings of Machines for Architecture from the Early Quattrocento in Italy', *J. Soc. Archit. Historians*, xxv/2 (1966), pp. 90–114
——: 'Fantasy Architecture of *Roma antica*', *A. Lombardo*, xv (1970), pp. 9–24
——: 'A Miscellany of Bronze Works and Texts in the *Zibaldone* of Buonaccorso Ghiberti', *Proc. Amer. Philos. Soc.*, cxx/6 (1976), pp. 485–513
——: 'La Torre del Marzocco a Livorno in un disegno di Buonaccorso Ghiberti', *Lorenzo Ghiberti nel suo tempo. Atti del convegno internazionale di studi: Firenze, 1978*, pp. 463–80
——: 'A Translation of Vitruvius and Copies of Late Antique Drawings in Buonaccorso Ghiberti's *Zibaldone*', *Trans. Amer. Philos. Soc.*, lxix/1 (1979), pp. 3–30

GUSTINA SCAGLIA

Ghirlandaio [Bighordi, Bigordi; del Ghirlandaio, Ghirlandajo, Grillandai]. Italian family of artists. (1) Domenico Ghirlandaio and (2) Davide Ghirlandaio are first mentioned in the 1457 Florence tax declaration (*catasto*) of their grandfather Currado di Doffo Bigordi and stated to be nine and six years old respectively. Their brother (3) Benedetto Ghirlandaio is recorded as ten years old in the tax declaration of 1470. Their father Tommaso (*b* 1422) had three other children, and the extended family lived near S Lorenzo on the Via dell'Ariento, Florence. They also owned a small farm near San Martino a Scandicci, outside Florence, which was worked by a labourer and produced a modest yield of grain and wine. The tax declarations of 1470, 1480 and 1498 reveal a prosperous family of artisans and small businessmen.

In 1457 the family was probably engaged in trading crafted goods, including leather and cloth. The tax declaration of 1457 lists Currado as a toll-collector, while two of his three sons, Antonio (*b c.* 1418) and Tommaso, had a shop dealing in small quantities of silk and related objects (*setaiuoli a minuto*). In the 1480 tax declaration, Tommaso, who seems to have expanded the business, is listed as a *sensale* (general broker). There is no evidence that he worked as a goldsmith, although Vasari, the major source for information on the family, credited him with making silver votives and lamps (untraced) for SS Annunziata, Florence. Vasari attributed the family surname to Tommaso's invention of hair ornaments by this name. Again, this is unlikely, although Tommaso may have been involved in trading these items, as one Nicholo delle Grillande, who is documented as producing such ornaments, is listed as a debtor to the family in 1457. Tommaso

is briefly listed as 'del Ghirlandaio' in 1452 and 1453, but Domenico had adopted the name by 1472, when he is listed in the *Libro rosso* of the Compagnia di S Luca as 'Domenicho di Tomaso del Grilandaio dipintore'. Davide is first mentioned with the name in 1476, in records of payments for work at the Badia, Passignano, and documents throughout their careers regularly refer to the brothers as 'del Ghirlandaio'. The name's permanence was acknowledged in the fresco depicting the *Birth of the Virgin* (1486–90; Florence, S Maria Novella), where the names BIGHORDI and GRILLANDAI are inscribed in gilded letters on the wood panelling behind St Anne's bed.

Like their slightly older contemporaries, Andrea Verrocchio and the Pollaiuolo brothers, the Ghirlandaio family worked in several different media. This, and the ability to collaborate with artisans of varying specialities, was fundamental to the nature of their art, which successfully perpetuated the craft tradition of the 15th century. Domenico was by far the most important and talented member of the family. Apart from a few minor individual commissions, Davide's role appears to have been to assist his brother in their busy workshop, as did BASTIANO MAINARDI, who married their sister Alessandra (*b c.* 1475) in 1494. Benedetto pursued an independent career in France, returning to Florence about the time of Domenico's death. Domenico's son (4) Ridolfo Ghirlandaio, although not as successful in business, remained active until 1542. His style alternates between moments of great originality, built on an awareness of Fra Bartolommeo, Andrea del Sarto and, above all, Raphael, and an innate conservatism reflecting his long association with his uncle Davide Ghirlandaio.

(1) Domenico Ghirlandaio (*b* Florence, 1448–9; *d* Florence, 11 Jan 1494). Painter, mosaicist and possibly goldsmith. He was head of one of the most active workshops in late 15th-century Florence. He developed a style of religious narrative that blended the contemporary with the historical in a way that updated the basic tenets of early Renaissance art. Domenico's documented material situation—prosperous, land-owning—conflicts with Vasari's description of him as unconcerned with wealth and business, and he emerges as an enterprising, versatile craftsman, the artisan and bourgeois nature of his life making him perfectly suited to satisfying the tastes and aspirations of his patrons. He was called to Rome in 1481 to work in the Sistine Chapel, and throughout the 1480s he received prestigious fresco commissions, culminating in 1485 with that to decorate the Tornabuoni Chapel in S Maria Novella, Florence. Many panel paintings, either autograph or workshop productions, were also produced at this time. He received no major fresco commissions after completing the work in S Maria Novella in 1490, but several projects for mosaic decoration date from this period.

I. Life and work. II. Working methods and technique.

I. Life and work.

1. Training and early works, before c. 1470. 2. c. 1470 and after.

1. TRAINING AND EARLY WORKS, BEFORE *c.* 1470. Domenico was admitted to the Compagnia di S Paolo on

12 May 1470. The matriculation book states that he 'sta all'orafo', that is, he was apprenticed to, or was practising as, a goldsmith. Vasari stated that Domenico was trained in his father's profession as a goldsmith; although probably mistaken about Tommaso's trade, he seems to have been correct about Domenico's. Payments made to Domenico in 1481 for designing and gilding candlesticks (untraced) for Florence Cathedral and in 1486 for the valuation of a silver censer (untraced) made by Andrea di Leonardo di Pavolo for Santa Trinita, Florence, indicate some competence in goldsmithing. Vasari's statement that Domenico was a pupil of Alesso Baldovinetti appears to be supported by the *Memoriale* (1513; Florence, Bib. N. Cent., Cod. Baldovinetti, no. 244) of Francesco Baldovinetti, Alesso's fourth cousin, although this reference is ambiguous.

No securely documented works by Domenico exist before 1475, but many frescoes and panel paintings can be attributed to his first years on stylistic grounds. One of his earliest independent works is a fresco in S Andrea a Brozzi, near Florence, depicting the *Baptism* in the lunette and below, between painted pilasters and simulated marble slabs, the *Virgin and Child Enthroned with SS Sebastian and Julian.* The scenes reveal the various components of Ghirlandaio's early style. The lower scene is modelled on Antonio and Piero Pollaiuolo's panel of *SS James, Vincent and Eustace* (1467) for the Cardinal of Portugal's Chapel in S Miniato al Monte, Florence. The format of figures standing on a narrow, paved terrace before a balustrade with glimpses of a panoramic landscape was reworked by Ghirlandaio into a *sacra conversazione*, introducing a shell niche to emphasize the Virgin and Child and clarifying the relationships between the figures. The style points clearly to another early and influential source, Verrocchio, whose nearly contemporary *Virgin and Child* (*c.* 1468; Berlin, Gemäldegal., 108) is recalled in the facial types and draperies, the strong light and the compacted mass of figures. The drive towards a rectilinear ordering of the composition and the unity of real and depicted space is strikingly apparent in the Brozzi paintings; these qualities emerge repeatedly in his paintings in a manner unequalled in Verrocchio's contemporary work.

The composition for the *Baptism* is often thought to have been modelled on Verrocchio's *Baptism* (*c.* 1475–85; ex-S Salvi, Florence; Florence, Uffizi; *see* VERROCCHIO, ANDREA DEL, fig. 5) but is closer in format and detail to a niello engraving (before 1464; Paris, Louvre) attributed to Maso Finiguerra. The pose of Ghirlandaio's St John is also close to Baldovinetti's early panel for the silver chest of SS Annunziata (*c.* 1449; Florence, Mus. S Marco), and the arrangement of the attendant angels on the left is reminiscent of Antonio Pollaiuolo's reliquary cross (1457; Florence, Mus. Opera Duomo) for the Florentine Baptistery. It is therefore possible that Ghirlandaio's composition precedes rather than derives from that of Verrocchio, or is at least indebted to a common source. The figure style of the *Baptism*, however, is similar to that of the *Virgin and Saints* below and shows an awareness of Verrocchio's style generally, if not the S Salvi picture in particular.

In the *Baptism*, Ghirlandaio's cautiously creative approach to his models suggests that, in spite of a bias towards Verrocchio, his artistic temperament had already been formed. While these early scenes show that he was aware of the latest developments in Florentine art, they also reveal the possible lingering influence of early training with Baldovinetti, perhaps between 1460 and 1468, thus vindicating Vasari's assertion. Ghirlandaio's figures recall Baldovinetti in their simplified contours and schematized modelling. The Brozzi *Virgin* shares with Baldovinetti's contemporary works, such as the figures (1466) in the Cardinal of Portugal's Chapel or the *Trinity* panel and fresco fragments (early 1470s) from Santa Trìnita, Florence, a tautness of outline and slenderness of figure that separate them from the aggressive plasticity and incisive drawing of Verrocchio's contemporary work. A date of *c.* 1468–70 may be assigned to the Brozzi fresco, a period that appears also to coincide with Ghirlandaio's closest involvement with Verrocchio's workshop.

Ghirlandaio could not have absorbed his capacity for clear spatial organization and balanced figural arrangement solely from Baldovinetti, and neither Verrocchio nor Antonio Pollaiuolo seems to be the source of this aspect of his work. It is possible that Ghirlandaio looked for inspiration to the tradition of intarsia work. He may have designed the figures of *SS Peter and Paul* for the entrance arch in the north sacristy of Florence Cathedral, for which Finiguerra and Baldovinetti provided designs and Giuliano da Maiano created the architectural settings and ornament. This may be Ghirlandaio's first link with the da Maiano family, with whom he collaborated throughout his career, and might also explain the source for this distinctive component of his style. He has also been attributed with the design of an *Annunciation* intarsia, part of a large cupboard formerly in S Maria Primerana, Fiesole. This is similar to his early drawing of the *Annunciation* (Florence, Uffizi) and recalls Finiguerra's design in the north sacristy of Florence Cathedral. Ghirlandaio's few early drawings, such as the pen sketch for the *Annunciation* intarsia and the slightly later cartoon for the Ognissanti *Pietà* (Florence, Uffizi; *see* §2(i)(a) below), declare even more clearly than his early paintings his debt to the classical strain in early 15th-century Florentine art, especially to Masaccio and Donatello, and to its later adherents, such as Verrocchio.

2. *c.* 1470 AND AFTER.

(i) Frescoes. (ii) Panel paintings. (iii) Illumination and mosaics.

(i) Frescoes.

(a) Early maturity, c. 1470–c. 1480. In the 1470s Ghirlandaio's work is marked by increasingly large and schematized plastic forms occupying ample, fully articulated space. The incisive drawing of his earliest works, influenced by Verrocchio, is also simplified. The hallmarks of his style, visible even in the Brozzi frescoes—clear, rectilinear spatial order, block-like plastic form and sculpturesque rendering of light and texture—remain unchanged.

The frescoes over the Vespucci altar on the right wall of the nave in the church of the Ognissanti are probably Ghirlandaio's first major work. They are dated on stylistic grounds to 1470–71, although external evidence is often cited to place them a year or two later, and are a marked advance over the Brozzi frescoes. In the lunette of the *Madonna of Mercy*, in particular, the masterfully foreshortened group of members of the Vespucci family gathered

under the Virgin's protective cloak shows that Finiguerra's designs in the cathedral sacristy had been profitably studied. In the *Pietà* below, on the other hand, a Netherlandish prototype has been less successfully assimilated, and this, with the last-minute inclusion of the portrait head second from the left, results in a less harmonious composition.

The frescoes depicting *SS Barbara, Jerome and Anthony Abbot* in S Andrea, Cercina, north of Florence, were probably executed about 1473. Here Ghirlandaio successfully resolved the challenge of working in the curving apse of the south aisle and achieved the harmonious blend of painted and real space characteristic of his work. The north sacristy in the cathedral is a conspicuous precedent for the arrangement of figures in a barrel vault, with St Barbara flanked by figures in small niches, but his adaptation allows for both the isolation of the single figures and their unification by the architectural frame and the site. In these frescoes his figures have become more elongated, and draperies articulate volume with a new clarity and conviction.

Ghirlandaio's earliest documented works are the eight lunette frescoes with busts of the *Church Fathers* and *Classical Philosophers* (1475–6) in the Biblioteca Latina (now Biblioteca Apostolica) in the Vatican Palace, Rome. Such a prestigious commission, the occasion for his first

trip to Rome, suggests that he had already achieved some reputation. Although Davide seems to have been chiefly responsible for the execution, the design was undoubtedly Domenico's. Neither the illusionistic conception nor the use of painted architecture to forge the link between real and depicted space is new to his art, but the total effect nonetheless reveals the impact of Roman illusionistic wall decoration. The decorative vocabulary takes on a new richness and an explicitly classical note, as seen, for example, in the urns flanking the figures, the fruit and flower garlands that frame the lunettes and the painted acanthus friezes below. The figures, for example *St Jerome*, are broader-shouldered than those at Cercina but are deprived of commensurate weight and plasticity by the weak execution. Far from changing his stylistic development, contact with the Roman tradition reinforced the tendencies inherent in his own style. Some of his figures may owe their new monumental ambition to the influence of Melozzo da Forlì, then active in Rome.

Domenico had returned to Florence by spring 1476. His first new commission was to fresco the *Last Supper* in the refectory of the Badia, Passignano. Painted in collaboration with Davide between June and September 1476, it was his largest work to date. Its general format is clearly indebted to Andrea Castagno's version of the subject (1447; Florence, Cenacolo S Apollonia), but the painting

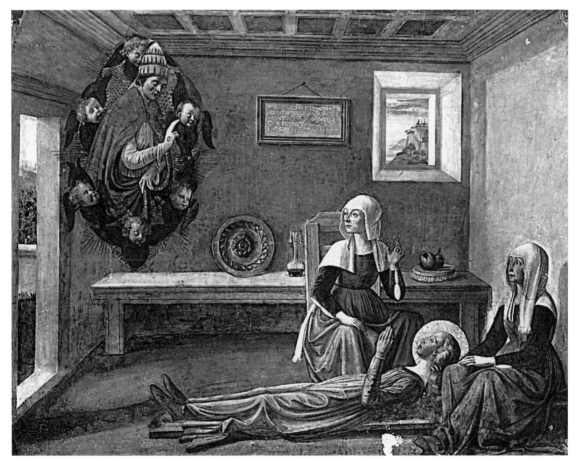

1. Domenico Ghirlandaio: *Vision of St Fina* (*c.* 1477–8), fresco, chapel of St Fina, Collegiata Pieve, San Gimignano

is linked more explicitly to the actual space of the room, thereby creating a more compelling effect of depth and atmosphere. The monumental effects of the Vatican Library busts are further developed in the figures, whose grave yet animated faces have taken on greater mass than those in his earliest works and assume normal proportions.

Ghirlandaio's first monumental fresco cycle was executed in the chapel of St Fina in the Collegiata Pieve, San Gimignano. A payment on 30 November 1477 probably refers to work in the chapel, and the style of the frescoes confirms the date of *c.* 1477–8. The *Evangelists* in the vault, the *Church Fathers* in the lunettes and the half-length figures of prophets in the spandrels above the altar and entrance arch display greater mass and movement than the Passignano Apostles. The basic components of his narrative style are clearly visible in the scenes below. On the right, the *Vision of St Fina* (see fig. 1) recalls the work at Passignano in its general composition, yet the free disposition of the figures, the atmospheric unity and glimpses of lush landscape through the door and window lend the space a more fluid and unified character. The figures assume calm, understated poses in harmony with the simple domestic interior, but their plasticity is none-theless sure and convincing, and the drapery takes on a new fluidity. The self-contained space of the *Vision* scene is a perfectly calculated field for the depicted event. The figures, elegantly disposed in the uncluttered room, display seemly surprise and awe at the saint's vision, while sunshine steals through the window and door as a natural counter-part to the divine apparition. In the *Funeral of St Fina*, the rich, classical ornamentation of the massive, semi-domed apse records the impact of Ghirlandaio's Roman sojourn. The huge structure articulates the space, and the broad figural arrangement, rich in secondary incident, comple-ments the outward embrace of the curving apse. Individual figures turn and gesture with a new expansiveness. Faces, too, show a typological maturity beyond even those at Passignano. The portraits of the three men at the right display a new, incisive drawing style and richness of description beyond the early Vespucci family portraits at the Ognissanti. As in the *Vision* scene, the atmospheric effects and the tall towers of the cityscape glimpsed beyond lend the whole a new breadth and airiness.

Unlike the doll-like stage-sets of Benozzo Gozzoli's frescoes (1463–5) in nearby S Agostino (*see* GOZZOLI, BENOZZO, fig. 2), Ghirlandaio's architecture creates an ample field for narrative action. Truncated at the top, the structure in the *Funeral* towers over the figures and implies space beyond the frame. He also integrated the scene into the actual space of the chapel by harmonizing his painted architecture in mass and decorative detail with Giuliano da Maiano's architecture. The interpolation of invented architecture with identifiable landscape or city views is a familiar device in Ghirlandaio's later works. Similarly, the mingling of portraits and invented figures became a hallmark of his style. While none of the elements present in the S Fina frescoes is new to narrative painting, his synthesis is innovative, and the tone of the work, grave yet celebratory, is distinctively his.

Two further frescoes in the Ognissanti, Florence, both dated 1480, mark Ghirlandaio's stylistic maturity. While *St Jerome* demonstrates his ability to describe objects and surfaces in detail, the *Last Supper* (see colour pl. 1, XXXII1) shows his conquest of figural mass and clear spatial organization: its integration of depicted with actual space is the culmination of his researches throughout the 1470s. At about this time he also painted the frescoes reportedly of the *Life of the Virgin* and *Life of St John the Baptist* (both destr.) that decorated the tomb of *Francesca Tornabuoni* in S Maria sopra Minerva, Rome. Francesca, wife of the prominent Florentine citizen Giovanni Tor-nabuoni, had died on 23 September 1477, and the tomb by Verrocchio and frescoes by Ghirlandaio were produced some time after. This was his first commission from the Tornabuoni family, who were to become his most impor-tant patrons, and it was the first casting of the themes that he later treated in S Maria Novella, Florence (*see* §(ii) below).

(b) Mature works, c. 1480–90. The prestigious fresco commissions that Ghirlandaio received during the 1480s confirmed his stature as one of the foremost painters in Florence. In 1481–2, with Perugino, Botticelli and Cosimo Rosselli, he was working in Rome, called there to execute the figures of popes and Old and New Testament scenes in the newly constructed chapel of Sixtus IV (the Sistine Chapel) in the Vatican Palace (*see* ROME, §V, 1(iii)(b)). He painted the *Calling of SS Peter and Andrew* for a fee of 250 ducats, as well as the *Resurrection* (repainted) on the entrance wall and a large number of standing popes. Although the Sistine Chapel frescoes were probably planned by Perugino, their format and style were informed by Florentine conventions and were entirely compatible with the narrative style seen in Ghirlandaio's earlier works. The commission enabled him to work on an extended cycle of frescoes and on a monumental scale. The sump-tuousness of the paintings, especially the extensive use of gold, was to reappear in his future works.

Between 17 September 1482 and 7 April 1484 Ghirlan-daio, newly returned from Rome, received payments for frescoes in the Sala dell'Orologio (Sala dei Gigli) of the Palazzo della Signoria, Florence. Botticelli, Perugino and Piero Pollaiuolo were also commissioned to work there, but only Domenico completed his contribution, creating his most monumental decorative scheme thus far: an entire wall was used to depict a painted triumphal arch, through the central arch of which, under a star-studded vault, can be seen an enthroned St Zenobius, patron saint of Florence, flanked by two deacons. To left and right, standing on a painted ledge above an actual door and window, sculpturesque figures of Roman heroes are sil-houetted against the sky. The richness of the painted architectural detail, harmonizing with Giuliano da Maiano's frieze and ceiling and Benedetto da Maiano's sculpted doorway, as well as explicitly Roman details taken from coins and sculpture, mark a new phase in the early Renaissance use of Classical themes and motifs.

The frescoes depicting the *Life of St Francis* (*see* ITALY, figs 30 and 39) in the chapel of Francesco Sassetti in Santa Trinita, Florence, were probably commissioned in 1478–9 but executed considerably later. By April 1478 Sassetti had begun negotiations to acquire the rights to the chapel, and before May 1479 Ghirlandaio had executed some drawings. The different worlds of the sacred, the antique

and the contemporary are given equal weight in these frescoes, and this skilful blend produced the finest display of his mature style so far.

Ghirlandaio's most monumental and last significant fresco cycle is of scenes from the *Life of the Virgin* and *Life of St John the Baptist*, which Giovanni Tornabuoni commissioned for the family chapel in S Maria Novella, Florence, on 1 September 1485, just as Ghirlandaio was finishing the Sassetti Chapel in Santa Trinita (dedicated on Christmas Day 1485). The project eventually included designs for an altarpiece and stained-glass windows. The contract, extraordinarily detailed and providing for the patron's control over every facet of the design and execution, stipulated that work was to begin in May 1486 and be completed by May 1490. A further document of 7 April 1489 extended the deadline by a year, although not all of this was needed as the frescoes were finished and the chapel dedicated in December 1490. The frescoes are on a grander scale than those in the Sassetti Chapel and once more achieve a synthesis of sacred narrative with personal history. The best-known example of this is the scene depicting the *Birth of the Virgin*, in which Ludovica Tornabuoni (see colour pl. 1, XXXII2), daughter of the patron, leads a group of women on a formal visit to the newly delivered St Anne, who reclines in a comfortable contemporary Florentine interior. The rich imagery of the Tornabuoni frescoes (Simons, 1987) is the crowning achievement of Ghirlandaio's career.

Other important frescoes by Ghirlandaio are known only from documentary sources or survive in fragmentary condition. The only occasion on which he is documented as working directly for the Medici was when, with Perugino, Botticelli and Filippino Lippi, he decorated Lorenzo de' Medici's villa at Spedaletto, near Volterra, executing a fresco of *Vulcan's Forge* (still extant mid-19th century). He also worked on frescoes (destr.) for the chapel of Giovanni Tornabuoni's Villa Lemmi, Chiasso Macerelli, and at the church of Cestello, Florence.

(ii) Panel paintings. The earliest of Ghirlandaio's altarpieces, the *Virgin and Child with SS Peter, Clement, Sebastian and Paul* (*c.* 1473–4; Lucca Cathedral), is similar in format to the early fresco at Brozzi (*see* §1 above), but both figures and space are carefully orchestrated to emphasize depth and introduce variety. In spite of his efforts, the tooled gold curtain and patterned carpet reinforce a two-dimensional effect. The light and colour are delicately handled, the latter warm and harmonious. The contrasts of complementary colours, especially red and green, seen also at Brozzi and in the Vespucci altar frescoes in the Ognissanti, are suffused in a golden glow.

In December 1478 Ghirlandaio was paid for work in Pisa. The two altarpieces of the *Virgin and Child with Saints* (both Pisa, Mus. N. S Matteo) are probably not the works to which the payments refer, although they were almost certainly painted at this time. The better-preserved panel, with figures of SS Elizabeth, Stephen, Rose and an unidentified saint, is largely by Domenico, while the other appears to be by Davide. The autograph panel testifies to Domenico's awareness of contemporary stylistic developments. The central figural composition recalls Leonardo's *Virgin and Child with a Vase of Flowers* (Munich,

Alte Pin.), but Domenico does not imitate the rich handling of light and texture that is so striking in Leonardo's picture. Significantly, Domenico was not abreast of Leonardo's latest innovations, which broke decisively with Quattrocento precedents: by *c.* 1480 Leonardo had completed the Benois *Madonna and Child* (St Petersburg, Hermitage), while the pen-and-ink studies of the *Virgin and Child with a Cat* (London, BM; *see* LEONARDO DA VINCI, fig. 8) were probably made soon after. Ghirlandaio was instinctively drawn to Leonardo's less mature composition, which is more in harmony with his own style and temperament.

The altarpiece of the *Virgin and Child with Saints* (ex-S Giusto fuori le Mura, Florence; church destr. 1529, altarpiece now Florence, Uffizi) is documented from 1485 but was probably finished soon after the Pisan works. It is the last of the important undocumented or undated early works, and its similarity to the later Ognissanti frescoes confirms a date of 1479–80. The work was influenced by the Pistoia Cathedral altarpiece, which was commissioned from Verrocchio between 1474 and 1479 but remained unfinished in 1485. Whereas the latter is characterized by understatement, Ghirlandaio's altarpiece is explicit, with figures carefully and clearly ordered in space, and with balanced placing of strong local colour to provide unity and emphasize surface design. Light lends atmospheric unity without obscuring volume, colour or his characteristic precision of surfaces and forms. Of the many portraits by Ghirlandaio and his workshop, the *Portrait of an Old Man and a Boy* (Paris, Louvre), probably dating from *c.* 1490, best exemplifies Ghirlandaio's portrait style. The old man's facial deformity—carefully studied in a preparatory drawing (*c.* 1490; Stockholm, Nmus.; see fig. 4 below)—contrasts with the child's smooth visage, yet the fondness of their embrace binds them together.

While fully engaged as a fresco painter until near the end of his career, the remarkable number of panel paintings executed by Ghirlandaio and his workshop (*see* §II, 2 below) testifies to the secure commercial success of their business. In addition to frescoing the walls of the Sassetti Chapel in Santa Trinita, he was commissioned to execute the altarpiece of the *Adoration of the Shepherds* (see fig. 2), with its prominent Classical sarcophagus and triumphal arch. Its iconography was probably devised by the humanist Bartolomeo della Fonte (1445–1513). The *Adoration* is entirely autograph and shows Domenico's characteristic skill in synthesizing many sources of inspiration, including Classical sculpture, the monumental frescoes of the Sistine Chapel and Flemish painting: the figures of the shepherds reflect the influence of the Portinari Altarpiece (the *Adoration of the Shepherds*, late 1470s; Florence, Uffizi) by Hugo van der Goes (1440–82) which had arrived in Florence in 1483.

On 23 October 1485 Ghirlandaio was commissioned to paint a panel, within 30 months, for the chapel in the Ospedale degli Innocenti, Florence. The panel, depicting the *Adoration of the Magi* (Florence, Gal. Osp. Innocenti), was not completed until March 1489. The predella, originally part of his commission, was reallocated on 30 July 1488 to BARTOLOMEO DI GIOVANNI, who also painted the *Massacre of the Innocents* in the panel's background.

Several dated panels survive from the later 1480s and 1490s. The tondo of the *Adoration of the Magi* (1487;

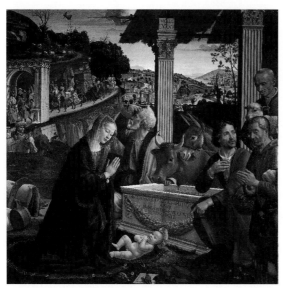

2. Domenico Ghirlandaio: *Adoration of the Shepherds*, tempera on panel, 1.67×1.67 m, 1485 (Florence, Santa Trinita, Sassetti Chapel)

Florence, Uffizi) was painted for Giovanni Tornabuoni and listed in the inventory of his palazzo, while the portrait of *Giovanna degli Albizzi Tornabuoni* (1488; Madrid, Mus. Thyssen–Bornemisza) was inventoried in the possession of her husband, Lorenzo Tornabuoni. The double-sided altarpiece, flanked by saints in shell niches, for the Tornabuoni Chapel in S Maria Novella was probably commissioned in 1487 or 1488; it was removed and dismembered in the 19th century. The front central panel of the *Virgin and Child in Glory with Saints* (Munich, Alte Pin.; with two side panels, *St Lawrence* and *St Peter Martyr*) is largely autograph. The rear panel of the *Resurrection* (Berlin, Bodemus.) is a workshop production. Vasari's statement that the altarpiece was finished after the artist's death is substantially correct, as recently discovered records indicate that the altarpiece was installed in the chapel in May 1494, four months after Ghirlandaio's death. Numerous other panels, made either for Florence or near by, such as the *Visitation* (1491; Paris, Louvre), or for provincial customers, for example the *Coronation of the Virgin* (1484–6; Narni, Pin. Com.) and *Christ in Glory* (1492; Volterra, Pin. Com.), reveal varying degrees of workshop intervention.

(iii) Illumination and mosaics. Domenico was primarily a painter, but documentary evidence, and some extant works, show that he also worked in other media. His earliest dated work may be an illumination of the *Invention of the True Cross*, inscribed *Domenico Corradi* and dated 1473 (Rome, Vatican, Bib. Apostolica, MS. Ross. 1192, *c.* 16). He is recorded in 1470 as being connected with goldsmithing (*see* §1 above), a profession that often overlapped with that of the illuminator, and his brother (3) Benedetto was also active in the 1470s as an illuminator. Facial and drapery details correspond well with Ghirlandaio's autograph early work, and there is a similar handling of figural and spatial relationships.

Ghirlandaio's activity as a mosaicist reflects the renewed interest in this art, apparently fostered by Lorenzo de' Medici. Vasari stressed the permanence of the medium, and its antique associations undoubtedly added to its prestige. In December 1486 Ghirlandaio evaluated Baldovinetti's restoration of the mosaics in the Florentine Baptistery. The first recorded mosaic commission to Domenico and his workshop was in 1489 for the Porta della Mandorla of Florence Cathedral and was completed by 22 April 1490. Although he received no major fresco commissions during the 1490s, his workshop is frequently recorded in connection with mosaic work. In 1491 Domenico, Davide, Botticelli, Monte di Giovanni (di Miniato) del Foro and his brother Gherardo di Giovanni (di Miniato) del Foro were commissioned to execute mosaics (most destr.) for the vault of the chapel of St Zenobius in Florence Cathedral. Payments are also documented for restoration work at the cathedrals of Pisa (1492–3) and Pistoia (1493–4; apse destr. 1620).

II. Working methods and technique.

1. TECHNIQUE. The corpus of Ghirlandaio's drawings is unusually rich and varied for a 15th-century artist. Their survival provides a relatively complete view of his working method, from his first designs to his finished works. He certainly began with small-scale sketches of whole compositions. Exactly which of his surviving drawings represent preliminary ideas is debated. The sketch (London, BM) for the *Birth of the Virgin* in S Maria Novella is probably a first sketch. Including both figures and architecture, its consistent graphic style and multiple pentiments fix the basic elements of the composition. He used intermediary sketches of figures, singly and in groups, to establish the relationship of the figures and their poses and costumes, as, for example, in the drawing (London, BM; see fig. 3) for the *Naming of the Baptist*, also for S Maria Novella.

More detailed studies of faces (see fig. 4) and costumes also survive. Once individual details had been resolved, he probably made another drawing of the whole composition, fixing the perspective design, reintegrating the figures into the architectural setting and unifying the lighting. This stage is perhaps represented by the drawing (Berlin, Kupferstichkab.) for the *Confirmation of the Rule* in the Sassetti Chapel. At this point the transition to the actual surface to be painted was made. In his earlier works it is unlikely that he made a full-scale cartoon of the whole surface to be painted, but he may well have adopted this method as his frescoes became larger and more complex in the 1480s. He used cartoons in conjunction with *sinopie*, and the latter, except for the earliest instance at Brozzi, themselves show dependence on cartoons. In the absence of surviving cartoons or visible *sinopie* for the great fresco cycles of the 1480s, however, the procedure he followed in his mature works remains uncertain.

Most of Ghirlandaio's frescoes are executed largely in *buon fresco*, with passages of secco and gilding on the *intonaco* and on raised wax decoration. His contemporaries recognized his sound technique, and inspection of the frescoes confirms their remarkable durability. Technical

examination of his frescoes in the Sassetti and Tornabuoni chapels shows the consistency of his technique. The pattern of *giornate* is regular, starting from the upper left and proceeding down the wall. Architectural elements were generally positioned either by snapping a cord or by scoring the *intonaco* directly with a straight edge. Figures were either transferred from full-scale cartoons by pouncing or by incising the major lines of the cartoons. In the latter parts of the decoration of S Maria Novella he seems to have preferred the incising method, perhaps for its greater speed and efficiency.

Individual figures were executed with great variety of stroke and technique; sometimes underpainting and drawing remain visible. Frequently the figure was sketched on the *intonaco* in red pigment, and underpainting, to adumbrate the lighting, was brushed in before the final, top layers of pigment were laid down. These top layers, especially for the most prominent figures, were often composed of a web of strokes, using white and light pigments in the highlights and tiny, reddish-brown strokes to indicate features. Such descriptive details as hair are often deftly indicated with an almost impastoed freedom of touch. Frequently tell-tale dots of dust are visible, indicating the use of a cartoon. Drapery, on the other hand, was painted more freely, with large sweeps of the brush. Frequently the contours indicated by the incised cartoon are ignored by last-minute improvisations. This varying technique for different parts is registered in the pattern of *giornate*: frequently one or two heads make up

4. Domenico Ghirlandaio: study for the *Portrait of and Old Man and a Boy*, silverpoint heightened with white, on pink prepared paper, 320 x 295 mm, *c.* 1490 (Stockholm, Nationalmuseum)

one *giornata*, indicating the care with which these were painted, while *giornate* for drapery are larger and those for landscape and architecture are larger still.

Ghirlandaio's tempera technique was similar to that used in his frescoes. He always worked on prepared panels with a mixture of tempera and oil. Incisions visible in the

3. Domenico Ghirlandaio: study for the *Naming of the Baptist*, pen and brown ink, 185×263 mm, *c.* 1486–90 (London, British Museum)

gesso made with the aid of a straight edge or other device indicate the adumbration of the general composition. While skin tones and the broad modelling of drapery were laid in over an underdrawing on the gesso, descriptive details and highlights were meticulously executed in tempera with the tip of the brush. He seems to have varied this technique only once, using tempera with an unusually large mixture of oil in his undated altarpiece of the *Virgin and Child with Saints* (Florence, Uffizi), but the isolation of this technical experiment indicates the fundamental suitability of his usual technique to his aesthetic ends.

Ghirlandaio's drawings reveal a rich variety of techniques, ranging from pen-and-ink studies and metalpoint drawings highlighted with white on coloured prepared papers (see fig. 4), to brush drawings in tempera on linen; the latter technique was particularly associated with Leonardo but was certainly used by several artists associated with Verrocchio's shop. This variety corresponds to the different function of the drawings, from planning whole compositions to studying the play of light on the edge of a drapery fold. The drawings demonstrate, as does his painting technique, Ghirlandaio's sure command of the materials of his craft.

2. WORKSHOP ORGANIZATION. Much speculation has centred on the organization of Domenico's workshop and his participation in the works created in it. The long list of artists cited by Vasari as being trained in his shop (including Michelangelo) and the obvious variation in quality in some of the works associated with his name, has led to endless conjecture over attributions. Few convincing identifications of assistants' hands have been made. Examination of the S Maria Novella frescoes suggests that at most four hands were at work in the major scenes, even in the uppermost, least visible parts.

Vasari credited Domenico's brother Davide and Bastiano Mainardi with a large role in the workshop's production. In the contract with Giovanni Tornabuoni for the frescoes in the choir of S Maria Novella, both the sequence in which Domenico and Davide are named and the manner in which they are described imply a secondary position for Davide. Moreover, payment was made exclusively to Domenico. The contract of 1490 between Domenico and Davide and the Franciscan friars of S Francesco di Palco, near Prato, specifies that Domenico was to design the saints and colour the faces, a stipulation found in several surviving contracts. Other documents, while not specifying the division of labour, provide clues as to how this was done. The payments listed in Platina's register in the Vatican, for example, suggest that, although Domenico was given the commission, he did not supervise it to completion. Only the first payment was made to Domenico, while subsequent payments were made to Davide. Similarly, five of the payments made to the brothers for the *Last Supper* at Passignano were to Davide alone, compared with two to Domenico and two to both brothers. In other payments, Domenico is even less involved, although on occasion Davide is not mentioned at all. It is clear that the degree of collaboration between the brothers varied greatly. At times Davide seems to have been only an adjunct to his brother, yet even when he did assume a more active role he remained subordinate to

Domenico. Probably Davide's role (and the size and composition of Domenico's workshop) expanded and contracted to suit the current workload. While the independent style of Mainardi is somewhat clearer owing to the survival of early paintings by him in S Agostino, San Gimignano, details of his participation in Ghirlandaio's workshop remain obscure. That contracts were made solely with Domenico for work that clearly included workshop participation (e.g. the Sistine Chapel) is not surprising. Unless he clearly stipulated otherwise, a patron would be satisfied with any painting or fresco issuing from Domenico's workshop, in the knowledge that the formal contract ensured that Domenico was legally responsible for the quality of the final work, including the competence of assistants. Throughout the 1480s Domenico was extraordinarily busy with large commissions, yet after 1490 there is evidence of only smaller projects.

For further illustrations *see* SPALLIERA, fig. 1

DBI; EWA

BIBLIOGRAPHY

EARLY SOURCES

G. Vasari: *Vite* (1550, rev. 2/1568); ed. G. Milanesi (1878–85), iii, pp. 253–83; vi, pp. 531–40

L. Landucci: *Diario fiorentino dal 1480 al 1516* [MS; Florence, Bib. Marucelliana]; ed. I. del Badia (Florence, 1883; Eng. trans., London, 1927)

G. Milanesi: Documenti inediti dell'arte toscana dal XII al XVI secolo', *Buonarroti*, n. s. 2, ii (1887), pp. 335–8

G. Bruscoli: '*L'Adorazione dei Magi*': Tavola di Domenico Ghirlandaio nella *chiesa dello Spedale degli Innocenti* (Florence, 1902)

C. von Fabriczy: 'Aus dem Gedenkenbuch Francesco Baldovinettis', *Repert. Kstwiss.*, xxviii (1905), pp. 540–45

J. Mesnil: 'Portata al catasto dell'avo e del padre di Domenico Ghirlandaio', *Riv. A.*, iv (1906), pp. 64–6

R. G. Mather: 'Documents Mostly New Relating to Florentine Painters and Sculptors of the Renaissance', *A. Bull.*, xxx (1948), pp. 47–9

H. Glasser: *Artists' Contracts of the Early Renaissance* (New York, 1977)

GENERAL WORKS

J. A. Crowe and G. B. Cavalcaselle: *A New History of Painting in Italy, from the Second to the Sixteenth Century* (London, 1864–6); ed. E. Hutton (London, 1909), ii, pp. 441–71

A. Venturi: *Storia*, vii/1 (1911), pp. 713–70

R. van Marle: *Italian Schools*, xiii (1931), pp. 1–268

E. Borsook: *The Mural Painters of Tuscany* (London, 1960, rev. Oxford, 1980)

B. Berenson: *Florentine School* (1963), i, pp. 71–7; ii, pls 954–98

MONOGRAPHS

E. Steinmann: *Ghirlandaio* (Bielefeld and Leipzig, 1897)

G. S. Davies: *Ghirlandaio* (London, 1908)

P. E. Küppers: *Die Tafelbilder des Domenico Ghirlandajo* (Strasbourg, 1916)

J. Lauts: *Ghirlandaio* (Vienna, 1943)

M. Chiarini: *Ghirlandaio* (Milan, 1966)

E. Micheletti: *Domenico Ghirlandaio* (Florence, 1990)

R. G. Kecks: *Ghirlandaio: Catalogo completo* (Florence, 1995)

DRAWINGS

H. Egger: *Codex Escurialensis: Ein Skizzenbuch aus der Werkstatt Domenico Ghirlandaios*, 2 vols (Vienna, 1906/R 1975)

F. Ames-Lewis: 'Drapery "Pattern"-drawings in Ghirlandaio's Workshop and Ghirlandaio's Early Apprenticeship', *A. Bull.*, lxiii (1981), pp. 49–62

J. Cadogan: 'Linen Drapery Studies by Verrocchio, Leonardo and Ghirlandaio', *Z. Kstgesch.*, xliii (1983), pp. 367–400

——: 'Reconsidering Some New Aspects of Ghirlandaio's Drawings', *A. Bull.*, lxv (1983), pp. 274–90

——: 'Observations of Ghirlandaio's Method of Composition', *Master Drgs*, xxii (1984), pp. 159–72

——: 'Drawings for Frescoes: Ghirlandaio's Technique', *Drawings Defined*, ed. K. Oberhuber and T. Felker (New York, 1987), pp. 63–76

J. K. Cadogan: 'Domenico Ghirlandaio in Santa Maria Novella: Invention and Execution', *Florentine Drawing at the time of Lorenzo the Magnificent:*

Papers from a Colloquium held at the Villa Spelman: Florence, 1992, pp. 63–72

C. Fischer: Ghirlandaio and the Origins of Cross-Hatching, *Florentine Drawing at the time of Lorenzo the Magnificent: Papers from a Colloquium held at the Villa Spelman: Florence, 1992*, pp. 245–53

SPECIALIST STUDIES

J. Mesnil: 'L'Influence flamande chez Domenico Ghirlandaio', *Rev. A. Anc. & Mod.*, xxix (1911), pp. 59–85

B. Berenson: 'Nova Ghirlandajana', *L'Arte*, xxxvi (1933), pp. 165–84

C. L. Ragghianti: 'La giovinezza e lo svolgimento artistico di Domenico Ghirlandaio', *L'Arte*, vi (1935), pp. 167–98, 341–73

N. Dacos: 'Ghirlandaio et l'antique', *Bull. Inst. Hist. Belge Rome*, xxxiv (1962), pp. 419–53

M. Levi d'Ancona: 'Una miniatura firmata di Domenico Ghirlandaio e un'altra qui attribuita a Benedetto Ghirlandaio', *Scritti di storia dell'arte in onore di Mario Salmi*, ii (Rome, 1962), pp. 339–61

E. Borsook and J. Offerhaus: *Francesco Sassetti and Ghirlandaio at Santa Trinita, Florence: History and Legend in a Renaissance Chapel* (Doornspijk, 1981)

P. Porcar: 'La Cappella Sassetti in S Trinita a Firenze: Osservazioni sull'iconografia', *Ant. Viva*, xxiii (1984), pp. 26–36

A. Garzelli: 'Problemi del Ghirlandaio nella cappella di Santa Fina: Il ciclo figurativo nella cupola e i probabili disegni', *Ant. Viva*, xxiv (1985), pp. 11–25

P. Simons: 'Patronage in the Tornaquinci Chapel, Santa Maria Novella, Florence', *Patronage, Art and Society in Renaissance Italy*, ed. F. W. Kent and P. Simons (Oxford, 1987), pp. 221–50

C. Danti and G. Ruffa: 'Osservazioni sugli affreschi di Domenico Ghirlandaio nella chiesa di Santa Maria Novella in Firenze', *Le pitture murali*, ed. C. Danti, M. Matteini and A. Moles (Florence, 1990), pp. 39–58

O. Sveva-Barberis: 'Domenico Ghirlandaio: Le splendeur restauree', *B.-A. Mag.*, cxxxix (1995), p. 19

P. Nuttall: 'Domenico Ghirlandaio and Northern Art', *Apollo*, cxliii/412 (1996), pp. 16–22

J. de Lancey: 'Before Michelangelo: Colour Usage in Domenico Ghirlandaio and Filippino Lippi', *Apollo*, cxlv (1997), pp. 15–23

JEAN K. CADOGAN

(2) Davide Ghirlandaio (*b* Florence, 14 March 1452; *d* Florence, 11 April 1525). Painter and mosaicist, brother of (1) Domenico Ghirlandaio. Most of his professional career was linked to that of his brother. His date of birth is recorded in the baptismal records of Florence Cathedral, and in 1472 he is listed with Domenico in the *Libro rosso* of the Compagnia di S Luca. On 3 January 1472 he was admitted to the Compagnia di S Paolo. His collaboration with Domenico is documented from 1480, when he is listed in his father's tax declaration as being 29 years old and described as Domenico's '*aiuto*', but a precise definition of his role as assistant is unclear. Suggestions range from considering him a financial adviser (the source of which is an anecdote in Vasari) to an alter ego of his brother. His participation in Domenico's painting commissions is well documented (*see* (1) above), but a clear view of his own early style is impossible to establish owing to the lack of independent commissions documented to him. The earliest such commission, a panel of *St Lucy and a Donor* (1494; Florence, S Maria Novella), shows a style that differs from Domenico's largely in terms of its inferior quality. Both figure and drapery style show Domenico's imprint, but the drawing and modelling are both simpler and stiffer. Vasari recorded other works by Davide, including a fresco of the *Crucifixion with Saints* (Florence, formerly Cenacolo S Apollonia), the facial types, drapery and figure styles of which show similarities with the S Maria Novella *St Lucy*.

The most numerous of Davide's documented commissions were in mosaic and included the façades of Orvieto and Siena cathedrals (1491–3 and 1493 respectively; both mosaics destr.). The mosaic of the *Virgin and Child Enthroned with Two Angels* (Ecouen, Mus. Ren.) was formerly signed and dated 1496 (see Chastel). Vasari also mentioned work in stained glass and mosaic for Montaione in Valdelsa. In stained glass Davide's only documented commission (1495; destr.) was for the tribune of Pisa Cathedral.

After Domenico's death, Davide took over commissions from his brother's workshop, including the high altar for S Maria Novella and an altarpiece depicting *SS Vincent Ferrer, Sebastian and Roch* (Rimini, Pin. Com. & Mus. Civ.), commissioned by Elisabetta da Rimini. He also took in Domenico's children and trained his eleven-year-old nephew (4) Ridolfo, who rapidly became an important member of Davide's shop. Davide made his will in 1513: most of his comfortable estate was left to his wife and, having no children of his own, his sisters, nephews and nieces.

BIBLIOGRAPHY

G. de Francovich: 'David Ghirlandaio', *Dedalo*, xi (1930–31), pp. 65–88, 133–51

A. Chastel: 'Une Mosaïque florentine du XVe siècle', *Rev. des A.*, 2 (1958), pp. 97–101

JEAN K. CADOGAN

(3) Benedetto Ghirlandaio (*b* Florence, 1458–9; *d* Florence, 17 July 1497). Painter, brother of (1) Domenico Ghirlandaio and (2) Davide Ghirlandaio. His birthdate is deduced from his father's 1469 tax declaration, in which he is stated to be ten years old. The 1480 declaration says that Benedetto, now 22 years old, had given up working as an illuminator owing to trouble with his eyesight. He was admitted to the Compagnia di S Paolo on 29 January 1479 and accompanied his brothers to Rome in 1481–2. According to Vasari, Benedetto spent many years in France, and documents confirm his presence there by the autumn of 1486. The one painting reasonably attributable to him is a panel of the *Nativity* (Aigueperse, Notre-Dame), formerly inscribed with his name and an illegible date. The panel is painted in a thoroughly Frenchified version of Domenico Ghirlandaio's style, in which the thin, stiffly drawn forms, reminiscent of Davide's rather than Domenico's work, are clad in a veneer of Flemish detail. Benedetto returned to Florence about the time of Domenico's death. His participation in the decoration of the Tornabuoni Chapel in S Maria Novella, Florence, often posited, is therefore impossible.

BIBLIOGRAPHY

G. de Francovich: 'Benedetto Ghirlandaio', *Dedalo*, vi (1925–6), pp. 708–39

JEAN K. CADOGAN

(4) Ridolfo Ghirlandaio (*b* Florence, 4 Feb 1483; *d* 6 Jan 1561). Painter, son of (1) Domenico Ghirlandaio. He probably learnt his craft from his father and remained with his uncle (2) Davide Ghirlandaio when the latter took over the workshop in 1494. Ridolfo's first documented work is the *Virgin of the Sacred Girdle* (1509; Prato Cathedral), which was commissioned in 1507 from Davide and Ridolfo but probably mostly painted by the latter. The upper part still shows Domenico's influence, whereas the lower section reflects, somewhat clumsily, the more modern style of Fra Bartolommeo, with whom Ridolfo studied,

according to Vasari. An interest in Piero di Cosimo is also apparent in the use of light and the sometimes disquieting landscapes of the earlier works that may be attributed to Ridolfo with certainty. This is particularly evident in *SS Peter and Paul* (Florence, Pitti), commissioned from Davide in 1503 but attributable to Ridolfo on the basis of style, the *Virgin and Child between SS Francis and Mary Magdalene* (1503; Florence, Accad.) and the *Coronation of the Virgin* (1504; Paris, Louvre), which was inspired by Domenico's altarpiece of the same subject (1484–6; Narni, Pin. Com.). Another very interesting work that may be dated to the first decade of the 16th century is the *Procession to Calvary* (London, N.G.; see fig.), which shows signs of Ridolfo's study of Leonardo's lost cartoon of the *Battle of Anghiari*.

Ridolfo's training also included links with Raphael during the latter's stay in Florence (1504–8). Vasari related that they became friends and that Raphael entrusted Ridolfo with the completion ('the blue robe') of one of his paintings, identified by Milanesi as *La Belle Jardinière* (Virgin and Child with the infant St John; Paris, Louvre). Some of Ridolfo's portraits, such as the *Portrait of a Woman* (Florence, Pitti), also show stylistic evidence for the link with Raphael.

Ridolfo returned to a conservative formula in the *Adoration of the Shepherds* (Budapest, Mus. F.A.), signed and dated 1510, and thereafter alternated between this style and one of great originality. This perhaps reflects the general crisis in Florentine painting, in which light should be viewed his frescoes, begun in 1514 and ornamented by Andrea Feltrini, for the Cappella della Signoria in the Palazzo Vecchio, Florence. On several occasions Ridolfo was appointed painter for the workshop of Florence Cathedral. In 1515 he was given an official commission to decorate the Cappella dei Papi in the convent of S Maria Novella, Florence, assisted by Feltrini and the young JACOPO DA PONTORMO. The *Miracle of St Zenobius* and

Translation of the Body of St Zenobius (both Florence, Cenacolo Andrea del Sarto S Salvi) were painted in 1517 for the saint's confraternity and were designed to flank Mariotto Albertinelli's *Annunciation* (completed 1510; Florence, Accad.; *see* ALBERTINELLI, MARIOTTO, fig. 2). They are among Ridolfo's greatest achievements and demonstrate his ability to create evocative, theatrical scenes. This talent was also used in commissions for festive decorations, such as those for the wedding of Lorenzo de' Medici, Duke of Urbino, in 1518. The *Pietà between Two Saints* (1521; Colle di Val d'Elsa, S Agostino) marked a return to the solemnity of Fra Bartolommeo and Andrea del Sarto. About this time Ridolfo began working with his gifted pupil Michele Tosini, collaborating on a series of altarpieces listed by Vasari, including the *Virgin, St Anne and Other Saints* (Florence, Santo Spirito) and the *Virgin and Child with Four Saints* (Florence, S Felice). These works are of uneven quality, probably owing to commercial pressures.

Ridolfo's activities during his final decades were progressively reduced by gout. His paintings included a portrait of *Cosimo I as a Young Man* (1531; Florence, Pal. Vecchio) and the grotesque decorations (1542) in the Camera Verde of the Palazzo Vecchio. His last fresco, the *Last Supper* (1543) in the refectory of S Maria degli Angeli, Florence, is a rather feeble tribute to that by Andrea del Sarto (1526–7; Florence, convent of S Salvi, refectory; *see* SARTO, ANDREA DEL, fig. 4).

BIBLIOGRAPHY

DBI: 'Bigordi, Ridolfo'

G. Vasari: *Vite* (1550, rev. 2/1568); ed. G. Milanesi (1878–85), iv, p. 328; vi, pp. 531–48

E. Maggini: *Un classicista fiorentino: Ridolfo Ghirlandaio* (Florence, 1968)

S. Meloni Trkulja: 'Ridolfo del Ghirlandaio', *Il primato del disegno* (exh. cat., ed. L. Berti; Florence, Pal. Strozzi, 1980), p. 186

A. Brown: 'A Contract for Ridolfo Ghirlandaio's "Pietà" in S Agostino, Colle Val d'Elsa', *Burl. Mag.*, cxxx (1988), pp. 692–3

W. M. Griswold: 'Early Drawings by Ridolfo Ghirlandaio', *Master Drgs*, xxvii (1989), pp. 215–22

D. Franklin: 'Ridolfo Ghirlandaio's Altar-pieces for Leonardo Buonafé and the Hospital of S Maria Nuova in Florence', *Burl. Mag.*, cxxxv (1993), pp. 4–16

——: 'Towards a New Chronology for Ridolfo Ghirlandaio and Michele Tosini', *Burl. Mag.*, cxl/1144 (1998), pp. 445–55

ANDREA MUZZI

Ghirlandaio, Michele di Ridolfo del. *See* TOSINI, MICHELE.

Ghisi. Italian family of artists. (1) Giorgio Ghisi was the most important reproductive engraver of the generation following Marcantonio Raimondi. His brother (2) Teodoro Ghisi spent most of his life in Mantua working as a painter and had a particular interest in the study of nature.

(1) Giorgio Ghisi (*b* Mantua, 1520; *d* Mantua, 15 Dec 1582). Engraver and damascener. His teacher was probably Giovanni Battista Scultori, after whose designs and in whose style he engraved two *Scenes from the Trojan War* (see 1985 cat. rais., nos 7 and 8). His six earliest prints, from the early 1540s or before, are after designs by Giulio Romano. They are lightly engraved in rather flat perspective, the figures often silhouetted against dark backgrounds, the shading lines not necessarily defining volume,

Ridolfo Ghirlandaio: *Procession to Calvary*, oil on canvas, transferred from panel, 1.66×1.62 m, *c.* 1504–10 (London, National Gallery)

and with an effect of intense flickering light, in the style of Scultori. Ghisi is recorded as being with Giovanni Battista Bertani in Rome during the reign of Pope Paul III (1534–49). There he may have met Antoine Lafréry, who published four of his engravings during the 1540s, and many others throughout his life. Probably after his return from Rome, he made an engraving on ten separate plates after Michelangelo's *Last Judgement* (Rome, Vatican, Sistine Chapel; see colour pl. 2, VII3), his model probably being a drawing by Marcello Venusti.

Around 1550 Ghisi travelled to Antwerp, where he made five large engravings for the publisher Hieronymus Cock (*c.* 1510–70) at his publishing house, Aux Quatre Vents. Two of these, the *School of Athens* (1985 cat. rai. 11) and the *Disputation on the Holy Sacrament* (1985 cat. rai. 13), were after Raphael's frescoes in the Stanza della Segnatura of the Vatican (*see* ITALY, fig. 15) and introduced these great works of the Italian High Renaissance to northern Europe for the first time in large-scale reproductions of high quality (Riggs). These engravings show a growing mastery of the medium, with shading lines following the contours of the forms, and more substantial figures.

Ghisi was in Paris from *c.* 1556 until at least 1567. He worked after designs by Luca Penni, then in Paris, and after several of Primaticcio's designs at Fontainebleau, as well as after Perino del Vaga, Polidoro da Caravaggio, Giulio Romano and Bertani. Here he achieved his mature style, producing densely engraved and richly embellished compositions, filling backgrounds and blank spaces with his own designs of flora, townscapes and landscapes. In 1559–60 he became one of the first printmakers to be granted a French royal privilege for single plates. In Paris he produced his most famous print, the *Allegory of Life* (formerly called the *Dream of Raphael*, 1561; 1985 cat. rai. 28), an enigmatic, compelling image, large, dark and dreamlike, complex and crowded with figures, animals, monsters, plants and water.

After 1567 Ghisi returned to Mantua, where he produced two highly ornamental scenes (*c.* 1570; 1985 cat. rai. 42–3) after drawings by his brother (2) Teodoro Ghisi, the equally ornamental *Cupid and Psyche* (1573–7; 1985 cat. rais. 50) after Giulio Romano, and the set of six large and imposing *Prophets* and *Sibyls* (1985 cat. rai. 44–9) after Michelangelo's frescoes in the Sistine Chapel (see colour pl. 2, V2). From *c.* 1575 all but one of his works were of religious subjects. The exception was his engraving (1985 cat. rai. 58) of the Farnese *Hercules* (Naples, Capodimonte). The religious works, five of them published by Lafrery in 1575, vary a great deal in quality; but the *Flight into Egypt* (1985 cat. rai. 59), apparently dated 1578, shows that his control remained undiminished.

Towards the end of his life, Giorgio was employed by the Gonzaga family as keeper of jewels and precious metals and overseer of work on the Gonzaga wardrobes. As a damascener, he is known by only two signed pieces, a richly embossed and damascened parade shield (London, BM), dated 1554, when he was probably in Antwerp, and a dagger hilt (1570; Budapest, N. Mus.).

BIBLIOGRAPHY

G. B. Bertani: *Gli oscuri e dificili passi del'opera ionica di Vitruvio* (Mantua, 1558), leaf Ev*r*

C. d'Arco: *Di cinque valenti incisori mantovani del secolo XVI e delle stampe da loro operate* (Mantua, 1840), pp. 97–116

C. Huelsen: 'Das Speculum Romanae Magnificentiae des Antonio Lafreri', *Collectanea Variae Doctrinae Leoni S. Olschi* (Munich, 1921), pp. 121–70

H. Zerner: 'Ghisi et la gravure maniériste à Mantoue', *L'Oeil*, lxxx (1962), pp. 26–32, 76

P.-J. Mariette: 'Catalogue de l'oeuvre gravé des Ghisi', ed. J. Adhémar, *Nouv. Est.*, ix (1963), pp. 367–85

T. Riggs: *Hieronymus Cock: Printmaker and Publisher* (New York, 1977)

Incisori mantovani del '500—Giovan Battista, Adamo, Diana Scultori e Giorgio Ghisi—dalle collezioni del Gabinetto Nazionale delle Stampe e della Calcografia Nazionale (exh. cat. by S. Massari, Rome, Calcografia N., 1980–81)

G. Albricci: 'Il *Sogno di Raffaello* di Giorgio Ghisi', *A. Cristiana*, lxxi (1983), pp. 215–22

S. Boorsch, M. Lewis and R. E. Lewis: *The Engravings of Giorgio Ghisi* (New York, 1985) [cat. rais.; all prints illustrated]

S. Boorsch and J. Spike, eds: *Italian Masters of the Sixteenth Century (1986)*, 31 [xv/iv] of *The Illustrated Bartsch*, ed. W. Strauss (New York, 1978–)

MICHAL LEWIS

(2) Teodoro Ghisi (*b* Mantua, 1536; *d* 1601). Painter, draughtsman, illustrator and naturalist, brother of (1) Giorgio Ghisi. He was custodian of the Palazzo del Te, Mantua, where his natural history collection attracted a visit in 1571 from Ulisse Aldrovandi, for whom he executed some animal paintings, including those of two parrots. At around the same time he created the designs for Giorgio's engravings of *Venus and Adonis* and *Angelica and Medoro*. In 1576 he and Giorgio acquired a house in Mantua, where Teodoro worked for Guglielmo Gonzaga, 3rd Duke of Mantua, and Vincenzo I, 4th Duke of Mantua. Between 1579 and 1581 he contributed to the decoration of the Galleria dei Mesi in the Palazzo Ducale and probably worked with Lorenzo Costa the younger in the Sala dello Zodiaco. Around 1579 he executed the *Visitation* for the cathedral at Carpi, and in 1586–7 he worked in the Palazzo di Goito (destr.). From 1587 to 1590 he was court painter to Guglielmo Gonzaga's brother-in-law Archduke Charles II of Austria (1564–90), in Seckau and Graz, where he painted the altarpiece *Symbolum apostolorum* (1588; Graz, Alte Gal.), showing the *Creation of Eve*, surrounded by depictions of articles of the Nicene Creed. He received a life pension from the Archduke in 1589 but returned to Mantua in 1590. There he and Ippolito Andreasi (1548–1608) decorated the cathedral for Bishop Francesco Gonzaga, with frescoes that accorded with the dictates of the Counter-Reformation. The evangelists' animal symbols attest to Teodoro's continuing interest in nature. He indulged this further in his illustrations for Pietro Candido Decembrio's *De animantium naturis* (Rome, Vatican, Bib. Apostolica, MS. Urb. lat. 276), combining his flamboyantly Mannerist palette with many illustrations from Conrad Gessner's *Historiae Animalium* (Zurich, 1551–87), and in other instances working from life.

BIBLIOGRAPHY

Thieme–Becker

A. Neviani: 'Di uno sconosciuto naturofilo italiano della seconda metà del cinquecento', *Atti della Pontificia Accademia delle Scienze, Nuovi Lincei: Rome, 1933*, pp. 358–62

C. Tellini Perina: 'Teodoro Ghisi: L'immagine fra maniera e controriforma', *La scienza a corte: Collezionismo eclettico natura e immagine a Mantova fra rinascimento e Manierismo* (exh. cat. by D. A. Franchini and others, Rome, 1979), pp. 239–68

——: 'Per il catalogo di Teodoro Ghisi', *A. Lombarda*, n. s., 58–9 (1981), pp. 47–51

C. M. Pyle: *Das Tierbuch des Petrus Candidus: Codex Urbinas Latinus 276: Eine Einführung*, Codices e Vaticanis selecti (Zurich, 1984), pp. 77–105

——: 'Some Late Sixteenth-century Depictions of the Aurochs (*Bos primigenius* Bojanus, extinct 1627): New evidence from Vatican MS. Urb. lat. 276', *Archv Nat. Hist.*, 21 (1994), pp. 275–88

——: 'The Art and Science of Renaissance Natural History: Thomas of Cantimpré, Pier Candido Decembrio, Conrad Gessner and Teodoro Ghisi in Vatican Library MS urb. lat. 276', *Viator*, xxvii (1996), pp. 265–321

CYNTHIA M. PYLE

Ghislieri, Michele. *See* PIUS V.

Ghisoni, Fermo (di Stefano) [Fermo da Caravaggio] (*b* Caravaggio, *c.* 1505; *d* Mantua, 1575). Italian painter. He trained with Lorenzo Costa the elder and worked under Giulio Romano in Mantua on the decoration of the Palazzo del Te (payments for the Sala di Psiche and the Sala dei Giganti between 1527 and 1534), in the Palazzo Ducale on the apartment built for Margherita Paleologo (1534) and in the Corte Nuova (Sala di Troia; 1538). Vasari mentioned him as one of the ablest executors of Giulio's designs. Works assigned to him on the basis of style include the *Virgin and Child with Saints* (Mantua, Mus. Dioc.) and three paintings for S Benedetto in Polirone (1538–42; two *in situ*, one, Mantua, church of Ognissanti). Although compared with the inventions of Giulio, these works reflect a lack of originality typical of Mantuan painting in this period, their simplified and less anti-classical style reflects the patrons' requirements. Ghisoni was in Venice in 1545 and probably in Rome the following year. On his return to Mantua, he painted altarpieces of *St Lucy* and *St John the Evangelist* (both 1552; Mantua Cathedral) for Cardinal Ercole Gonzaga. He was influenced by Mannerist ideas in this period through his collaboration with Gerolamo Mazzola Bedoli on the *Adoration of the Shepherds* (Paris, Louvre) for S Benedetto in Polirone. He worked for Ferrante Gonzaga, Prince of Guastella, and in the 1560s painted a series of portraits for the *studiolo* of Ferrante's son Cesare (Vasari). He also executed the altarpiece of the *Crucifixion* for S Andrea, Mantua. His last work, the organ shutters with the *Annunciation* and *SS Peter and Barbara* (Mantua, S Barbara), shows the influence of Giovanni Battista Bertani in the use of perspective and realistic detail.

BIBLIOGRAPHY

G. Vasari: *Vite* (1550, rev. 2/1568); ed. G. Milanesi (1878–86), vi, pp. 487–9

R. Berzaghi: 'Committenze del cinquecento: La pittura', *I secoli di Polirone*, i (San Benedetto, 1981), pp. 295–311

M. Tanzi: 'Fermo Ghisoni', *Pittura tra Adda e Serio*, ed. M. Gregori (Milan, 1987), pp. 238–9

R. Berzaghi: 'Fermo Ghisoni', *Pittura a Mantova dal Romanico al settecento*, ed. M. Gregori (Milan, 1989), pp. 240–41

Giulio Romano (exh. cat. by A. Belluzzi, K. Forster, H. Burns and others, Mantua, Mus. Civ. Pal. Te, and Pal. Ducale, 1989)

MATILDE AMATURO

Giacomo, Scilla. *See* LONGHI, SILLA.

Giambellino. *See* BELLINI, (3).

Giamberti. *See under* SANGALLO, DA.

Giambologna [Bologna, Giovanni; Boulogne, Jean] (*b* Douai, 1529; *d* Florence, 1608). Flemish sculptor, active in Italy. Born and trained in Flanders, he travelled to Italy in 1550 to study the masterpieces of Classical and Renaissance sculpture. On his way home, he visited Florence (*c.* 1552) and was persuaded to settle there under the patronage of the Medici dukes, eventually becoming their court sculptor.

As a sculptor, Giambologna grafted an understanding of the formal aspect of Michelangelo's statuary on to a thorough reappraisal of Greco-Roman sculpture, as it was being daily revealed in new excavations. Particularly influential were the ambitious representations of figures and groups in violent movement, and the technical finesse of late Hellenistic work, most of which had not been available to earlier generations (e.g. the Farnese *Bull*; Naples, Mus. Archeol. N.; excavated in 1546).

For half a century Giambologna dominated Florentine sculpture, carving an ever more impressive series of statue groups in marble: *Samson Slaying a Philistine* (1560–62), *Florence Triumphant over Pisa* (1563–75), the *Rape of a Sabine* (1582), *Hercules Slaying a Centaur* (1595–1600). In addition, Giambologna produced several extraordinary bronze statues, *Bacchus* (before 1562), *Mercury* (*c.* 1565) and *Neptune* (1566), culminating in his equestrian monument to *Cosimo I, Grand Duke of Tuscany* (1587–93). The last was copied shortly afterwards for the kings of France and Spain.

By *c.* 1570 Giambologna had become the most influential sculptor in Europe; apart from the fame that his monumental statues in Florence inevitably brought, his style was disseminated in the form of small bronze reproductions of his masterworks, or statuettes, which he composed independently as elegant ornaments for the interior. These were used by the Medici as diplomatic gifts for friendly heads of state, and were also eagerly purchased by European collectors as examples of sophisticated Florentine design. They were especially favoured in Germany and the Low Countries and were prominently illustrated in paintings of fashionable gallery interiors there.

Another important way in which Giambologna's reputation and style spread was through the movement of his pupils and assistants. Many of them, like himself, were from the Low Countries; travelling to Italy, they worked for a while in his studio in Florence (which became something of an international entrepôt) and then returned homewards, sometimes with a recommendation from him to a particular patron in the north of Europe.

For compositional subtlety, sensuous tactile values and sheer technical virtuosity, Giambologna's work is virtually unequalled in any period or country.

I. Life and work. II. Working methods and technique. III. Character and personality. IV. Critical reception and posthumous reputation.

I. *Life and work.*

1. Background and early study. 2. Statues, statue groups and fountains. 3. Statuettes. 4. Narrative reliefs. 5. Equestrian monuments. 6. Architecture and ornament.

1. BACKGROUND AND EARLY STUDY. Giambologna began his training as an apprentice to Jacques Du Broeucq (*c.* 1505–84), a notable Flemish sculptor who at the time

was engaged in carving the rood screen (c. 1544) for Ste Waudru, Mons, a major monument in the history of sculpture in Flanders. It was an ornamental edifice made colourful by the use of alabaster for the statues and narrative reliefs, and black touchstone for the architectural elements. It was demolished later, but the sculptural components were disposed around the abbey and are easily visible. Giambologna would have learnt from Du Broeucq how to compose figures and carve the relatively soft alabaster. He would also have gained an initial enthusiasm for the Italianate style, which Du Broeucq had developed after visiting Italy, and the inspiration to visit Rome himself, after the rood loft at Ste Waudru was completed in 1550. Also at this time he would inevitably have become familiar with the work of the local wood-carvers, who produced great retables in oak with numerous figures, and with that of the brass-founders of Dinant. The fine casting techniques of 'Dinanderie', as their products are generically called, may have inspired Giambologna later in life, when he began to produce bronze statues and statuettes serially.

By the mid-16th century a journey to Rome had become a fashionable necessity for any aspiring young artist from northern Europe, and Giambologna assiduously studied ancient sculpture there for two years from 1550, making models in wax and clay. One of these he showed to the elderly Michelangelo, who criticized it for having too high a finish, before the fundamental pose had been thoroughly worked out. This lesson was never forgotten, and Giambologna became an assiduous maker of models, of which many have survived.

Giambologna began his journey home to Flanders (1552) by going north to Florence, where he could see more masterpieces of the 15th century and study Michelangelo's work better than in Rome. A rich and perspicacious patron of the arts, BERNARDO VECCHIETTI, offered him accommodation and financial support if he would prolong his stay in Florence. Before long Vecchietti introduced him to the Medici, who ruled the city. Thus it was that Giambologna settled down to make his career in Florence, shortly afterwards becoming a court sculptor.

2. STATUES, STATUE GROUPS AND FOUNTAINS. Uncertainty surrounds the identification of a marble *Venus*, which he carved for his patron Vecchietti, but its success aroused the interest of Prince Francesco de' Medici (later Grand Duke of Tuscany; *reg* 1574–87), who gave him a coat of arms to execute for a recently completed building (1558/9) and, from 1561, provided him with a monthly salary. An early commission by Giambologna for the Medici was the casting of a bronze figure of Florence for the Fountain of the Labyrinth at the Villa di Castello (now in Villa La Petraia, near Florence), from a model that had been left unfinished at the death in 1550 of a previous court sculptor, Niccolò Tribolo. The motif of the girl wringing out her hair is mentioned by Vasari in his description of the model that Tribolo had made, and it is not impossible that Giambologna merely reproduced this model in bronze rather than invent the sophisticated and attractive composition, as has usually been claimed. The spiral axis and contrast of rounded curves and sharp angles formed by the elbows and knees, which were to be the

hallmark of his treatment of compositions involving a single figure (e.g. *Apollo* and *Astrology* statuettes), may thus be derived ultimately from a study of Tribolo's work. Certainly Giambologna would have taken note of the light-hearted, and sometimes grotesque, figures by Tribolo and his associate Pierino da Vinci in the gardens, grottoes and fountains of Il Castello, as well as similar work in the Boboli Gardens. Early in the 1560s he modelled and cast two (or possibly three) *Fishing Boys* (Florence, Bargello) for a small fountain in the gardens of the Casino Mediceo, near S Marco, Florence. These were inspired by Michelangelo's mischievous painted putti on the ceiling of the Sistine Chapel, Rome, and by Guglielmo della Porta's baby angels on his monument to *Pope Paul III* (c. 1550; Rome, St Peter's).

In 1560 a commission for a Fountain of Neptune for the Piazza della Signoria, Florence, which had previously been allocated to Baccio Bandinelli, fell vacant on his death. A competition was held to decide which of the available sculptors should receive the commission. Bartolomeo Ammanati won (see AMMANATI, BARTOLOMEO, fig. 2), through influence at the Medici court and the support of Michelangelo from Rome, but the young Giambologna's full-size model (destr.) was highly praised by another great sculptor, Leone Leoni, in a letter to none other than Michelangelo.

In view of this achievement, Giambologna received his first major commission from Prince Francesco de' Medici, for an over life-size group in marble depicting *Samson Slaying a Philistine* (1560–62; London, V&A; see ITALY, fig. 23). The subject and treatment were derived from a project of Michelangelo's from the 1520s involving *Samson and Two Philistines*; this got no further than the stage of a model and is known only from a series of bronze aftercasts (e.g. Florence, Bargello, sometimes attributed to Pierino da Vinci). These bronzes represent the stage of Michelangelo's compositional thinking that immediately followed the *Victory* (c. 1530/33; Florence, Pal. Vecchio), when he was engaged on an abortive project for a free-standing group to match his own earlier *David* (1501–4; Florence, Accad.; see ITALY, fig. 22). Francesco's and Giambologna's intention was therefore to render in marble (as originally intended) what might have been Michelangelo's most magnificent sculptural composition, embodying as it did all his theoretical ideals: a pyramidal or conical volume, with a flame-like contour to suggest movement, and three figures unified in action. Giambologna created a distinct variation on the theme, however, by removing the third, dead, figure from the base, thus enabling him to pierce the lower part of the pyramidal block of marble with a series of interstices, which penetrate daringly into and through the depths of the block. The technical problems involved in excavating the marble to this extent were enormous, but Giambologna welcomed the opportunity of demonstrating his virtuosity, in imitation of such Hellenistic groups as the Farnese *Bull* (Naples, Mus. Archeol. N.), which he had seen in Rome.

Later (1569–70) Giambologna created an oddly shaped basin, with monsters supporting it, for a fountain that he crowned with his earlier group of *Samson*. It is quadrilobed in plan, with four great fungus-like protrusions instead of the normal circular basin; bronze monkeys cavorted in

niches below. His most important later fountain, carved in marble, was designed for the piazza in front of the Pitti Palace and later erected on the axis of the Boboli Garden behind, only to be moved early in the 17th century to its present site on the Isolotto, near the Porta Romana. The finial was a great marble figure of *Neptune*, probably reflecting his early model made in connection with the competition for the Fountain of Neptune for Piazza della Signoria. The original marble statue is now preserved in the Bargello. Lower down the stem are perched three crouching river-gods holding upturned urns, which pour water, above a huge granite tazza, which had been the raison d'être of the commission. This represented the ocean, which was believed in those days to surround the earth, and so the complex is called the Fountain of the Ocean to distinguish it from the several other fountains of Neptune.

Three years after the competition for the Fountain of Neptune in Florence, the authorities in Bologna approached Giambologna to make a statue of *Neptune* and many subsidiary figures and ornaments for a fountain designed by Tommaso Laureti that they were erecting in the centre of their city. The young sculptor's full powers seem to have been released in the making of this Fountain of Neptune (completed 1566), perhaps because the artistic milieu of Bologna was less competitive than that of Florence. He was able to give rein to his imagination and sure sense of composition in the mighty figure of *Neptune* itself, with its energetic pose and sharp turn of the head. At the feet of Neptune are four boys struggling with dolphins, which spout water, interspersed with grotesquely puffing heads of childlike wind-gods, also spouting water. At the four corners of the pedestal below are four sensuous figures of Sirens, with bulbous curving fishy tails for legs, expressing water from their full breasts into the basin below. In between are many grotesque masks and shells articulating the several smaller basins.

During his stay in Bologna, Giambologna produced the earliest of several versions of a flying figure of *Mercury*, which has become his most celebrated statue. It was sent to Maximilian II, Holy Roman Emperor (*reg* 1564–76), by Francesco I de' Medici as a gift, in preparation for his marriage to Margherita of Austria. A version of similar size in the Museo Nazionale del Bargello, Florence, is a later cast (1580), which has never left Italy, but Maximilian's *Mercury* must have been almost identical, to judge from its correspondence with a small bronze statuette in Bologna, which probably reflects Giambologna's initial wax sketch-model. The origins of the beautiful, balanced pose may be found in bronzes of the 15th century by Antonio del Pollaiuolo and Andrea del Verrocchio, as well as in the statuette of *Mercury* on the base of Benvenuto Cellini's statue of *Perseus with the Head of Medusa* (1545–53; Florence, Loggia Lanzi; *see* CELLINI, BENVENUTO, fig. 6), and on the reverse of a medal by Leone Leoni. Giambologna's superior control of the means of suggesting movement through the lithe pose and taut musculature, however, gives his figure a feeling almost of flight, which has often been emulated but never surpassed.

While Giambologna was engaged on the Bolognese projects, two events occurred that conspired to suggest to the Medici the next major marble sculpture that they

required him to create. The death of Michelangelo in 1564 led to their being given by his heir the nearly finished group of *Victory* that had remained locked up in his studio ever since he had left Florence in 1534. Furthermore, the wedding of Prince Francesco de' Medici to Joanna of Austria in the following year required grandiose decorations for the Palazzo Vecchio, Florence. The idea was thus conceived of commissioning Giambologna to create an allegorical group as a pair to Michelangelo's *Victory*; its subject was to be politically relevant, *Florence Triumphant over Pisa*. Giambologna was thereby led to reconsider the problem of uniting two figures in an action group, which Michelangelo had tackled in the 1520s as part of his scheme for the tomb of *Pope Julius II* (Rome, S Pietro in Vincoli). Virtually all the sculptors of the mid-16th century

1. Giambologna: *Florence Triumphant over Pisa*, terracotta modello, h. 380 mm, 1565 (London, Victoria and Albert Museum)

had tried their hand at this challenging type of composition, and Giambologna's creative powers were therefore being put to a severe test. A tiny preliminary model in wax and a larger one in terracotta (both London, V&A; see fig. 1) show his first thoughts on the subject, while a full-scale working model in plaster (Florence, Accad.) was ready in time to be painted white to resemble marble and exhibited at the wedding. A marble version (Florence, Bargello) was carved considerably later (1575), and then largely by his assistant, Pietro Francavilla. The original little wax model is wonderfully spontaneous, its elongated proportions corresponding with those of Michelangelo's *Victory*, which it had to match. Its destination against a wall in the Salone del Cinquecento meant that it would be seen only from the front and sides, but its axis was arranged spirally, within a block of marble of pyramidal shape, like the *Victory*.

Not truly a fountain, but presiding over a pond, into which the main figure appears to press water from a fish, is Giambologna's most extraordinary creation, an allegory of the *Apennines* (in the shape of a crouching, hoary old man; 1570–80), made for the gardens of the Grand-Ducal Villa Demidoff (destr.) at Pratolino, near Florence (see colour pl. 1, XXXIII3). This is a colossal edifice, which was designed to look as though it were carved out of the living rock, but was actually constructed out of brick and volcanic lava over an iron armature. It is so big that there are chambers in its torso, with window-slits through which people could mysteriously hail other visitors, causing fright and mirth. It is thus a characteristic product of the age of Mannerism.

Giambologna's third great marble group, the *Rape of a Sabine* (1582; Florence, Loggia Lanzi; see fig. 2), represented the climax of his career as a figure sculptor, combining three figures into a cohesive group, an idea that had obsessed Michelangelo without his ever having been permitted to realize it in marble. Giambologna's first thoughts are embodied in a bronze group with a standing man and a woman raised in his arms, which he produced in 1579 for Ottavio Farnese, 2nd Duke of Parma and Piacenza (*reg* 1550–86). 'The subject', wrote Giambologna to this patron, 'was chosen to give scope to the knowledge and a study of art', suggesting that it was a conceptual rather than a narrative composition. Giambologna's contemporaries subsequently compelled him to identify the particular episode that was shown in the full-scale marble sculpture, by supplying a bronze relief with an unambiguous narrative to go below it, to act as a sort of visual label.

The development from a group of two to one with three figures is plotted in preliminary wax models (London, V&A). The three figures are linked psychologically by the directions of their glances, as well as formally by the arrangement of their limbs and bodies. The spiral composition means that the group cannot be fully comprehended from any single viewpoint. Technically, the sculpture is a masterpiece of virtuosity, pushing to its furthest limits the technique of undercutting, which Giambologna had observed in Hellenistic carving, and the use of which distinguishes his work so sharply from Michelangelo's.

In 1584 Giovanni Paolo Lomazzo published his *Trattato dell'arte de la pittura* (Milan), in which he wrote:

Michelangelo once gave this advice . . . one should always make the figure pyramidal serpentine and multiplied by one, two or three . . . A figure has its highest grace and eloquence when it is seen in movement . . . And to represent it thus there is no better form than that of a flame, because it is the most mobile of all forms and is conical. If a figure has this form it will be very beautiful . . . the figure should resemble the letter S.

Published a year after the unveiling of Giambologna's masterpiece, the *Rape of a Sabine*, Lomazzo's criteria of excellence in figure composition apply with uncanny exactness to the style of Giambologna. Michelangelo's ideas had obviously been current in artistic circles long before they were set in print, and Giambologna must have been familiar with them from the outset of his career in Italy. Indeed, when one reviews his total production it seems that he may have set out deliberately and methodically to achieve the effects recommended by Michelangelo and contemporary theorists. The series of monumental

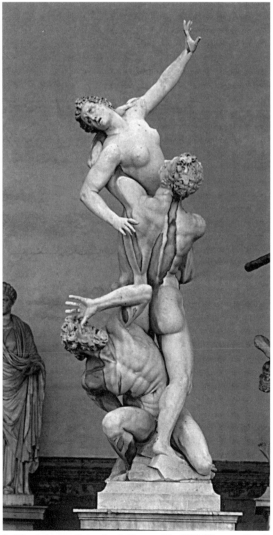

2. Giambologna: *Rape of a Sabine*, marble, 1582 (Florence, Loggia dei Lanzi)

marble sculptures that span his career are the embodiment of Michelangelo's proposal that a figure may be multiplied by one, two or three.

3. STATUETTES. There are few points of reference in the enormous production of statuettes by Giambologna and his principal assistant in bronze making, Antonio Susini (*see* SUSINI, (1)). Many were original, small compositions rather than reductions from his full-scale statues (as might have been expected). There are nearly 100 models directly associable with him on stylistic grounds, but by no means all are documented. The use of piece-moulds permitted the reproduction of a given original model in some quantity. Furthermore, moulds could be taken from an existing statuette, so that it could be copied too. Individual casts are therefore difficult to date. Only a dozen statuettes bear signatures and none has a date inscribed. Descriptions in inventories are often too generalized to enable identification of particular models, let alone individual examples. There are, however, two lists, drawn up after Giambologna's death, that purport to contain the authentic compositions, and broadly speaking they correspond, but give a total of some 20 models only, which falls far short of the actual number known.

Probably the earliest major statuette is the *Mercury* (*c.* 1565; Bologna, Mus. Civ.; see fig. 3), apparently cast from Giambologna's wax sketch model for the monumental statue (1563) destined for the Università degli Studi, Bologna. The next important statuette, and one of the few that is dated by documents, is the *Apollo* (1572–5; Florence, Pal. Vecchio) that was Giambologna's contribution to a series of eight gods or goddesses by different sculptors made to decorate niches in the walls of the private *studiolo* cabinet of Francesco I de' Medici. This *Apollo* is a serpentine composition inspired by Michelangelo and his follower Tribolo, with a mellifluous interplay of curves in the contours of torso and thighs, contrasted with zigzag lines created by bent knees and elbows. The climax of this type of composition is the gilt *Astrology* (early to mid-1570s; Vienna, Ksthist. Mus.), which represents a mirror image of the *Apollo*, adapted to a female body; as these figures are revolved, there is a subtle merging of angular and curved forms, which gives a highly sophisticated progression of views.

For most of his male figures in action, notably his statuette of *Mars* (*c.* 1565–70; priv. col., see Avery, 1987) and an entire series of the *Labours of Hercules* (*c.* 1577–after 1590), Giambologna resorted to open poses, with limbs centrifugally penetrating the space around the figures, in a way that exploited the tensile strength of bronze. Another amusing sideline was a series of genre figures of country folk: *The Fowler*, *The Shepherd*, *The Bagpiper* (all *c.* 1580–1600) and *The Duck-girl* (1574; priv. col.). Apart from the human figure, Giambologna's repertory included animals, particularly horses walking or rearing, individual bulls and groups showing them attacked by lions, as well as centaurs in combat with Hercules, or the *Centaur Nessus Abducting Deianeira* (*c.* 1576; Rome, Gal. Colonna). A further extension of Giambologna's repertory in bronze was a commission in 1567 for a series of life-size—and extremely life-like—figures of birds (e.g. *Turkey* (see fig. 4), *Eagle*, *Owl*; all Florence, Bargello) to decorate a grotto

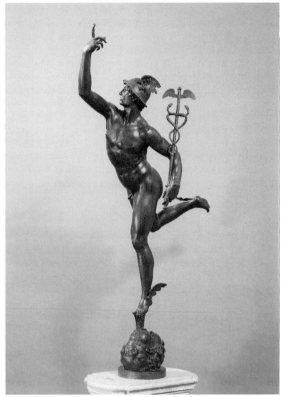

3. Giambologna: *Mercury*, bronze, *c.* 1565 (Bologna, Museo Civico)

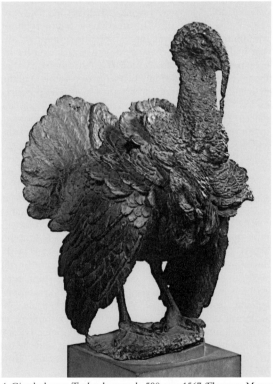

4. Giambologna: *Turkey*, bronze, h. 590 mm, 1567 (Florence, Museo Nazionale del Bargello)

at the Medicean Villa di Castello. For these he invented an 'impressionistic' rendering in the original wax of plumage, which was faithfully translated by skilful casting into the final bronze versions. He treated similarly the fur of some *Monkeys* (*c.* 1570; Aranjuez, Jard. Príncipe), which he made to go in niches under the fountain basin that he carved as a mounting for his earlier marble group of *Samson*. Giambologna's vivacious and sympathetic studies of birds and animals, from the life, pointed the way for the French school of 'animaliers' in the 19th century.

4. NARRATIVE RELIEFS. By 1580 the Counter-Reformation movement in the Roman Catholic church was having an impact on the art world. Giambologna, hitherto a sculptor of pagan themes, had to evolve a clear relief style for depicting religious narrative. A skilful amalgam of Italian quattrocento precedents and contemporary relief style in his native Flanders resulted in the successful cycles of bronze panels showing the *Passion* (1585–7; Genoa, U. Studi) for the Grimaldi Chapel, Genoa, and those showing the *Life of St Anthony* (1581–7; Florence, S Marco). Under his aegis a cycle of *Passion* reliefs (1590) was supplied for the church of the Holy Sepulchre, Jerusalem, and later a number of pupils collaborated on the three pairs of bronze doors (*c.* 1600) for the western façade of Pisa Cathedral. He also created three historical reliefs for the base of his equestrian statue of *Cosimo I* (see below).

Giambologna developed a highly logical relief style, which owed more to Donatello in its rendering of perspective than to his immediate predecessors, Baccio Bandinelli and Benvenuto Cellini, whose fascination with Mannerist surface patterns had militated against clarity. He used architectural settings in perspective to establish a sense of space, and the figures are grouped in distinct blocks within them, related to the various elements of their surroundings. They are often dramatically separated by vistas, which plunge into space. The narrative is thus set out in a clear and comprehensible fashion, showing clear links with the compositions of panels in the oak retables that Giambologna recalled from the days of his youth in Flanders, or more recent ones that he might have known from drawings brought from Flanders by apprentices (e.g. the reliefs of Cornelis Floris (*c.* 1513/4–1575) on his rood loft in Tournai Cathedral).

5. EQUESTRIAN MONUMENTS. Having achieved by the 1580s a complete mastery of the human form, Giambologna turned to the subject that had fascinated the ancient Greeks and Romans almost as much, the horse. He addressed the subject with a scientific approach derived from anatomical dissections culminating in a large bronze model of a *Flayed Horse* (U. Edinburgh, Talbot Rice Gal., Torrie Col.). This enabled him to create his masterpiece in bronze, the equestrian statue of *Cosimo I, Grand Duke of Tuscany* (1587–93; Florence, Piazza della Signoria; see fig. 5). It was an immediate success and was replicated on the much reduced scale of statuettes, with a variety of different riders, ranging from the *Grand Duke Ferdinando I* (1600; Vaduz, Samml. Lichtenstein) to the *Emperor Rudolf II* (*c.* 1600; Stockholm, Nmus.) and *Henry IV, King of France* (*c.* 1600–04; Dijon, Mus. B.-A.). A full-size variant showing Ferdinando himself was commissioned

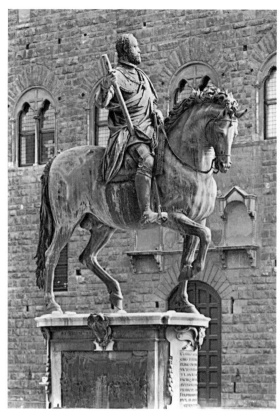

5. Giambologna: *Cosimo I, Grand Duke of Tuscany*, bronze, 1587–93, Piazza della Signoria, Florence

shortly afterwards for Piazza SS Annunziata (1601–8); others followed for the kings of France and Spain.

Giambologna was responding to the challenge of antiquity (*Marcus Aurelius*, Rome, Piazza del Campidoglio; *Horses*, Venice, S Marco) and of the Renaissance (Donatello: *Gattamelata*, Padua, Piazza S Antonio, *see* DONATELLO, fig. 4; Verrocchio: *Colleoni*, Venice, Piazza SS Giovanni e Paolo, *see* VERROCCHIO, ANDREA DEL, fig. 4). He would also have been aware of Leonardo da Vinci's abortive projects for equestrian monuments in Milan, and of a great bronze horse in Rome, cast by Daniele da Volterra from a design by Michelangelo, which was still awaiting a rider (later exported to Paris and destroyed in the French Revolution). His chosen model of horse was compact and rotund, with a short body and well-rounded rump, its contours enlivened by the raised front hoof and wildly curling mane, as well as by the sinuous tail. The lively character and alertness of the beast are conveyed by its swollen veins, rolling eyes and pricked-up ears.

After the equestrian monument had been unveiled, to great public acclaim, Giambologna set to work on his last autograph marble carving, which also had an equine component, for it depicted *Hercules Slaying a Centaur* (1595–1600; Florence, Loggia Lanzi). It originally stood on a street corner and was set high on a pedestal, which conditioned the way in which it was to be viewed—it must have looked more imposing than it does in its present location. The vigorous torsions of the bodies of victor and victim, the compressed springing of the horse-body and

the excited thrashing of the tail (which is daringly undercut) build up a highly dramatic composition. Indeed, it was a proto-Baroque sculpture that was to be influential on Gianlorenzo Bernini (1598–1680).

6. ARCHITECTURE AND ORNAMENT. In his most imposing painted portrait by Francavilla (c. 1570; priv. col., on loan to Edinburgh, N.G.), Giambologna chose to have himself portrayed as an architect, seated in polite apparel at a table, with a pair of dividers poised on a plan; his sculptural activity is alluded to only in the background, in a vignette of his studio with large models seen through a doorway or internal window. The more gentlemanly pursuit was traditionally held in higher social and intellectual esteem, but in Giambologna's case the pretension was based on solid achievement, which has, however, been overshadowed subsequently by his sculptural prowess.

The dual role had been normal since the later Middle Ages and Renaissance, as sculpture was so closely allied to the building that it was used to decorate, and the example of Michelangelo was sufficient to stimulate an artist with the worldly ambition of Giambologna. His principal projects were the town palace in Florence and nearby country seat—the Villa Il Riposo—of his patron Vecchietti; the Grimaldi Chapel in Genoa; the Salviati Chapel in S Marco, Florence; and his own funeral chapel in SS Annunziata, Florence. All show a distinct, personal style of Mannerist architecture, evolved from the work of Vasari, Bartolomeo Ammanati and ultimately Michelangelo. Smaller projects included a wooden model for the façade of Florence Cathedral, the Altar of Liberty (1579) in Lucca Cathedral, and altars or tombs elsewhere. Other insights may be gained by an examination of the architectural settings and background vistas of his narrative reliefs (see §4 above).

Giambologna's role in creating the 'auricular' style of semi-abstract but organic-looking ornament should not be underestimated: the basin and pedestal of the fountain of *Samson Slaying a Philistine* are the classic example (see §2 above), but other fascinating forms appear in bases, pedestals and mouldings throughout his career, providing a repertory on which his successors were to draw.

II. Working methods and technique.

1. Sketch-models. 2. Studio organization. 3. Patrons, collectors and connoisseurs.

1. SKETCH-MODELS. More sketch-models (*bozzetti*) for sculptures by Giambologna have survived than by any other Renaissance artist. Like many sculptors—although unlike Michelangelo—he seems to have preferred to invent his compositions in three-dimensional form from the outset, instead of resorting to the standard two-dimensional approach of a graphic artist. The few drawings by him are not exploratory, but depict in a fairly finished state whole projects, such as fountains or the design of a chapel. By examining the evidence that the models (mostly London, V&A) provide, and reading contemporary accounts of the technique and use of models written by Cellini, Vasari and Raffaelle Borghini, it is possible to reconstruct Giambologna's working procedure.

For his statue of *Florence Triumphant over Pisa* all the stages survive (London, V&A; Florence, Accad.). He began with tiny models of wax, which he built up round an armature of iron wire or a nail, demarcating the volumes and establishing the form ('disegno'). The anatomical forms are usually attenuated and 'mannered' at this stage. Such models are about 100–200 mm high. Subsequently they were 'fleshed out', a process that began at the next stage, in clay: a model of 400–500 mm high (about a Florentine *braccio*) was built up, with more naturalistic proportions, giving an accurate idea of the general appearance of the final statue. If necessary, small separate studies of such details as heads might be made to refine the expressions. An excitingly direct and rapid technique of modelling distinguishes most of Giambologna's terracottas, although there are also a few highly finished ones, for presentation to his patrons. From the terracotta, a full-scale model (*modello grande*) was then produced in clay by a process of enlargement, probably using some mechanical aids, such as a grid system in three dimensions, to permit accurate enlargement. Two such full-scale models—whitewashed over—survive, for *Florence Triumphant over Pisa* (see §I, 2 above) and the *Rape of a Sabine* (both Florence, Accad.).

For the narrative reliefs that Giambologna cast in bronze in later life, he used a carpenter's approach: he made a backboard out of planks of wood, and then nailed to it a wedge-shaped board at the bottom, to create the illusion of a floor, sloping up and backwards towards a vanishing point. Over this construction he spread a thin layer of red wax, into which he inscribed the details of an architectural setting, building forward from it colonnades and other forms where desired, or cutting away the wax to reveal the wood behind to indicate the furthest distance. Then, around a few projecting nail-heads to help the wax adhere and hold together, he peopled this stage with tightly massed groups of bystanders, often with strongly projecting figures, almost in the round, standing out at either side to close the composition effectively. A protagonist, for example Christ, would be placed at a focal point, carefully emphasized by the architectural setting, or divided from an opponent by a distant vista plunging into the background. The distance would often be emphasized, even exaggerated, by the small size of mysterious observers seen fleetingly in the architectural background.

From such original wood and wax models, for example those for the *Passion* reliefs of the Grimaldi Chapel, Genoa (c. 1580; London, V&A; see fig. 6; Brisbane, Queensland A.G.), assistants would make piece-moulds in plaster, which could be safely removed without damaging the master-model, and then reassembled, creating a hollow, negative image into which molten wax could be poured to produce a separate model for use in the foundry (which would then be melted down in the process of lost-wax casting).

Giambologna's models, of which he was justifiably proud, have survived despite their inherent fragility because not only he, but also his contemporaries, preserved and displayed them as works of art in their own right, either in special cabinets or on shelves or brackets round the walls. It was a phenomenon of the High Renaissance and afterwards that artists' sketches or models were

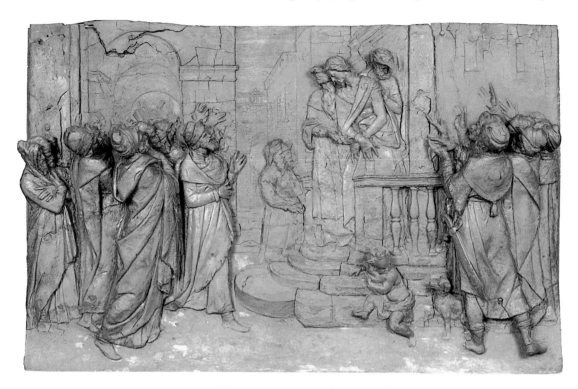

6. Giambologna: *Ecce homo*, wax modello for a relief from the *Passion* series in the Grimaldi Chapel, Genoa, 483×737 mm, *c.* 1580 (London, Victoria and Albert Museum)

considered prime examples of their creative genius. They were sometimes preferred for their very spontaneity to the finished works that evolved from them, for the latter might become deadened by too laborious a working up. This was especially true of sculpture, for which the necessary technical processes of carving or casting are exhausting and lengthy, and often involved other hands.

2. STUDIO ORGANIZATION.

(i) Marble sculpture. It was standard practice in the Italian Renaissance, as in most other periods and places, for a sculptor to delegate work to more or less skilled assistants and apprentices. Men at the quarries would hew blocks to roughly the dimensions and shape required (some drawings by Michelangelo have survived, showing blocks needed for the statues in the New Sacristy, Florence): the larger the statue, the greater the need to reduce the bulk and weight of the block before transport began, to save effort and hence expense, and to reduce the risk of breakage. The blocks were slid down the precipitous slopes from the quarries of Carrara or Pietrasanta on sleds, with the help of ropes, rollers and levers; put on board ship to travel by water as near as possible to their destination; and then loaded on to ox-carts (or specially constructed wheeled crates) for delivery to the sculptor's studio (this was best undertaken in the spring, to take advantage of high water in the River Arno and cooler weather).

Once in the studio, the block would be set up near the full-scale model, so that measurements could be trans-ferred and constantly checked throughout the carving, which might take months, sometimes even several years. Masons (*scarpellini*) roughed out the general shape of the figure(s) and then the sculptor and his foreman would take over to remove the final superfluous 'layers' of marble and reveal the statue as it had been envisaged in the model (or, on occasion, vary it as they chose, or according to necessity, if hidden flaws appearing in the block forced a change of design, or a slip of the chisel accidentally cut off too much marble).

The younger and/or poorer the sculptor, the more of the laborious hewing out he would have to undertake in person, both to gain experience and to save having to pay assistants; skilled labour was relatively cheap, however, and so could be afforded quite early in a normal career. Some information about Giambologna's situation can be gleaned from archival documents. As early as 1560, at an early point in his career, he enjoyed the help of Carlo di Cesare 'del Palagnio' (1540–98), when making the huge clay model of *Neptune* in the competition for the fountain figure in Florence. For the huge amount of carving involved in the four statues and subsidiary components on his Fountain of the Ocean, he employed in 1574–5 Jacopo di Zanobi Piccardi and his son Andrea di Zanobi Piccardi (both active *c.* 1574–1600), who were skilled carvers from the quarry town of Rovezzano. Jacopo later helped to install the statues on the Altar of Liberty in Lucca Cathedral, and thereafter on occasion selected and paid for various blocks of marble for Giambologna at Carrara (e.g. in 1595 for *Hercules and the Centaur*). Piccardi

had an independent standing and was employed by other sculptors too. Through his good offices, Giambologna's most important apprentice and eventual successor as court sculptor to the Medici, Pietro Tacca of Carrara, was introduced to the Florentine studio in 1592.

Before Tacca, Giambologna's principal associate had been PIETRO FRANCAVILLA, a fellow Franco-Fleming who had been born in Cambrai in 1548. He trained principally under a wood-carver in Innsbruck and then went to Florence c. 1570, with a letter of introduction to Giambologna, but was free to conduct business on his own account too. However most of his 'independent' statues betray compositional ideas from Giambologna. He signed several statues jointly, having been responsible for carving them in marble from models by Giambologna: *Grand Duke Ferdinando I* (1594; Pisa and Arezzo); *Grand Duke Cosimo I* (1595; Pisa, Piazza dei Cavalieri); and *St Matthew* (1599; Orvieto, Mus. Opera Duomo). When Francavilla left for Paris in 1601, Tacca was ready to assume his role as foreman of the elderly Giambologna's studio.

(ii) Bronze-casting. Giambologna was quick to exploit the additional scope for statues with limbs outflung in dramatic movement that was offered by the tensile strength of bronze, as opposed to the fragility and weight of marble, which militated against such compositions. Furthermore, strength and stability could be increased by a firm armature of iron running up inside the hollow castings. He must have been aware of the formidable array of brass sculpture and ornament produced in the Meuse Valley around Dinant in his native country; even Cellini praised the excellence of the foundrymen of Liège above all others. He could not have learnt the technology, however, for sculptors were in a different trade guild and demarcation lines were strict.

When Giambologna arrived in Italy, he would have noted the former glories of the bronze sculpture of the Quattrocento and perhaps registered surprise that Michelangelo did not, after his early days, work in the medium, exclusively preferring marble. Soon after Giambologna's arrival in Florence he saw Cellini unveil his monumental group in bronze of *Perseus with the Head of Medusa (see* §I, 2 above) and was doubtless inspired to emulate it, as well as the statuettes and narrative relief in bronze that were set below it. Cellini was a goldsmith by training and therefore expert in foundry work, but Giambologna had no such advantage. Among his earliest statues, however, are several in bronze, for example *Bacchus* and *Mercury*; it is probable that he subcontracted their casting, as was normal practice. He also used bronze to preserve many of his original wax sketches and subsequently to reproduce them in some numbers, for sale as figurines and larger statuettes; exactly where and by whom they were produced is not recorded.

The first components of the Fountain of Neptune for Bologna were cast in Florence by Zanobi Portigiani while his son Fra Domenico Portigiani (1536–1601) produced most of the statues and reliefs (1581–7) for the Salviati Chapel in S Marco, Florence, and some reliefs for Jerusalem. To cast the equestrian statue of *Cosimo I*, Giovanni Alberghetti, a professional artillery founder, was employed, in view of the enormity and political importance of the

task; this particular commission is correspondingly well documented. For smaller casting jobs, sometimes in precious metal, professional goldsmiths were employed, and in 1581 one of these, Antonio Susini, was hired on the orders of Jacopo Salviati to help finish and polish the bronzes for his chapel. Susini was to become Giambologna's most important assistant in the serial production of bronze statuettes to satisfy the demands of collectors. He evolved a distinctive personal style, consisting of great precision in details, such as the irises and pupils of the eye, or the nails of fingers and toes, as well as the curls of hair and the channelled folds of drapery. Susini eventually set up independently but was allowed the use of Giambologna's models, and on one occasion the master even purchased a finely finished cast from him. Susini also produced some of his own models, but they were usually indebted to Giambologna's, sometimes simply being on a different scale, or a mirror-image. Several of the foreign journeymen who stayed for a while in the studio also gained experience by cleaning and finishing bronzes: for example, Adriaen de Vries (c. 1545–1626) was first documented as helping to cast two crucifixes (1581), later becoming independent and gradually evolving a freer style of modelling that was all his own. He was Giambologna's follower as favourite sculptor of Rudolf II, Holy Roman Emperor (*reg* 1576–1612), in Prague. Hans Reichle (c. 1565/70–1642) was also a member of Giambologna's workshop between 1588 and 1595 and afterwards took his style north to Munich.

Giambologna's earlier, initialled, or otherwise documented, statuettes were frequently unique, or nearly so (for replicas of them appeared only later, with the arrival of Susini). They may be assumed to be 'autograph' (i.e. all his own work), apart from the purely technical foundry process: the original wax model was by the master (it was probably actually consumed in the lost-wax casting), and the bronze, when cold, was then finished personally by Giambologna. A statuette of *Mars* (priv. col.) initialled 'I.B' under one foot is a good example. Its 'painterly' surface and waxy-looking details of hair, fingers, toes etc, reflect the appearance of the original wax model, almost down to the marks of the sculptor's fingers. Many other casts exist, however, and some can be associated on stylistic criteria with Antonio Susini. Others, which differ minutely, may be the work of other craftsmen: there is one documented case, after Giambologna's death, of bronze statuettes by Giambologna himself and by Susini being borrowed back from their owner by Pietro Tacca, to reproduce in bronze as a Medicean diplomatic gift for the Prince of Wales (1611).

In some cases even the name of Giambologna actually inscribed on an item seems not to be a signature in the usual sense, as a guarantee that he actually finished it, but rather a statement of his authorship of the initial model and, presumably, his approval of the particular cast. It was added to satisfy a foreign patron, who wanted to be reassured that he had got 'the real thing', and was not being fobbed off with a 'copy'. There are therefore grave problems, which can be resolved only by connoisseurship, in the study of bronze statuettes made from Giambologna's designs.

3. PATRONS, COLLECTORS AND CONNOISSEURS. Giambologna's earliest and lifelong patron was Bernardo Vecchietti, a prominent banker and courtier, who acted as a personal adviser and friend of Francesco I de' Medici. Vecchietti apparently spotted the talent of the young Flemish émigré when he arrived in Florence c. 1551, and offered him lodging and subsistence. This perspicacious—even if self-interested—generosity secured for Florence and the Medici the services of a man who was to become the major sculptor in Europe during the second half of the century. Vecchietti also collected the sculptor's sketch-models avidly, thereby setting a new fashion and guaranteeing their preservation for posterity. Other models were kept by the Medici, by a master mason with whom Giambologna occasionally worked, by such aristocratic patrons as the Gondi and Salviati, and by the artist himself.

While successive Medici Grand Dukes, Cosimo I, Francesco I and Ferdinando I, were his greatest patrons, Giambologna also worked for the Holy Roman Emperors Maximilian II (reg 1564–76) and Rudolf II (who granted him a coat of arms) and the popes (one of whom knighted him). Several other prominent nobles, Italian, German and Austrian, coveted his services, notably the Duke of Urbino, the Dukes Albert V (reg 1550–79) and William V of Bavaria (reg 1579–98) and the Electors Augustus I (reg 1553–86) and Christian I of Saxony (reg 1586–91). At the height of his career Giambologna and his assistants produced equestrian monuments for the kings of France and Spain and were solicited for one from as far afield as England, by King James I (reg 1603–25). Indeed, Henry, Prince of Wales, and King Charles I (reg 1625–49) were avid collectors of his bronzes, as later were the French king Louis XIV (reg 1643–1715) and his courtiers, André Le Nôtre (1613–1700) and Cardinal Richelieu (1585–1642).

The English have always been excited by the Italianate elegance and bravura of Giambologna's work. Charles I and George Villiers, 1st Duke of Buckingham (1592–1628), imported in 1623 the only major monumental marble ever to have left Italy, *Samson Slaying a Philistine*, which eventually reached the Victoria and Albert Museum, London, in 1956. That museum has also gradually acquired, from the date of its foundation in 1852, the finest collection of sketch-models in the world. Many of these reached England much earlier, during the age of the Grand Tour, with the noted connoisseur William Locke (1732–1810) of Norbury Park. His collection (sold anonymously at Christie's, London, in 1775) included many models, and these passed successively through the hands of such artist–admirers as the sculptor Joseph Nollekens (1737–1823)—whose style, especially in his small terracotta models, was visibly influenced by them—and Thomas Lawrence (1769–1830).

III. Character and personality.

Details of the character and private life of Giambologna are scanty, as he confided little to paper apart from business. Unlike Michelangelo, he had few intellectual, spiritual or philosophical pretensions and was not given to theorizing about his art. He was barely literate and never mastered Italian properly. Instead, he strove for perfection in composition and technique. His business-like approach—quite the opposite of that of the neurotic genius Michelangelo—endeared him to his princely patrons, who received the works they had ordered finished and on time. He was by temperament ideally suited to the role of court sculptor that he rapidly assumed under the Medici. He affected to be unconcerned about money and to care only for glory, by which he meant rivalling the reputation of Michelangelo.

He coveted signs of official recognition, such as the gentleman's coat of arms he was awarded by Emperor Rudolph II in 1588, and, towards the end of his career, he solicited, and ultimately received (1599), a knighthood from the pope. He immediately modelled a self-portrait bust with the cross of the Knights of Christ proudly emblazoned on his tunic; its size was miniature, presumably to indicate a certain modesty. Three casts are known (Amsterdam, Rijksmus.; Dijon, Mus. B; Florence, priv. col. of the late Sir John Pope-Hennessy), so his image was presumably distributed to patrons and friends.

Giambologna must have been a good and inspiring teacher to have attracted over the years so many young sculptors of various nationalities to study under and to work for him. He must have been self-disciplined and well organized to run his large establishment, and to supervise the simultaneous production of so much marble sculpture and bronze casting.

IV. Critical reception and posthumous reputation.

Giambologna was accorded a brief biography in the second edition of Vasari's *Vite* (1568), under the heading of the Accademici del Desegno (members of the recently founded Grand-Ducal Academy of Design). Vasari qualified him as a 'truly exceptional young man' and enumerated his works to date; he also mentioned that Vecchietti and others were collecting his models. In 1584 Raffaelle Borghini, in his book about the arts *Il Riposo* (the title of which is taken from the name of Vecchietti's suburban villa, where the discussions it recounts took place), gave a fuller biography than Vasari had done, probably because he benefited from verbatim information from the sculptor, the protégé of Vecchietti. An illuminating passage about the technique of making models for sculpture is also included. A century later, in 1688, Filippo Baldinucci (1625–97) published a complete biography, subsuming the earlier, partial ones and adding detail from reliable sources and from the Medicean archives. It gives more anecdotes and passes occasional shrewd judgements. Baldinucci also printed an invaluable list of the authentic models produced as bronze statuettes.

The bronze statuettes disseminated all over Europe by the 17th century spread Giambologna's fame everywhere: plaster casts appeared in many artists' studios, especially in his native Flanders, and they were studied by painters, as well as sculptors, as part of their artistic education.

Giambologna's work remained popular and his masterpieces were remarked on in most guidebooks and tourists' accounts of Florence (e.g. John Evelyn's *Diaries*). In 1752 Joshua Reynolds (1723–92) visited his former workshop (the Grand-Ducal sculpture studio, by then much less active) and praised the original full-scale models for the

Fountain of the Ocean, hazarding the remark: 'I think him greater than M. Angelo and I believe it would be a difficult thing to determine who was the greatest [sic] sculptor'. Within 20 years of Reynolds's high praise William Locke was recorded as possessing 'among a goodly number of original models by several old masters, many in wax and clay by Giambologna, most of which came from the celebrated collection of Bernardo Vecchietti'. When Locke's collection was put up for sale at Christie's, London, in 1775, the greatest artists of the day vied to possess them, including the sculptor Nollekens, for obvious reasons, and, interestingly, Richard Cosway (1742–1821), Benjamin West (1738–1820) and Thomas Lawrence. Evidently, Reynolds's enthusiasm sufficed to give the models and their creator a fresh allure for the English, which they have retained ever since, due to their final gathering together in the Victoria and Albert Museum, London.

During the early 19th century, under the influence of Neo-classicism, the work of Giambologna waned in popularity, apart from certain compositions such as the *Mercury*, which (paired with a variety of modern female partners) was continually reproduced, as an ornament for the domestic interior (so potent is its imagery that it continued to be used in the 20th century in a variety of contexts concerning rapid communication: on some air-mail postage stamps of Australia in the 1930s; on the cap-badge of the Royal Signals Regiment of the British army; and as the symbol of Interflora); or his *Rape of a Sabine*, which was available for purchase as a tourist souvenir in various materials, such as alabaster or *verde di Prato* marble, complete with the relief on its base.

The reappraisal of Giambologna in the 20th century was motivated by civic pride in his native city of Douai, long since part of France: Desjardins published a luxury monograph in 1883, with much new documentation from the archives of Florence. The next stride forward, half a century later, was the doctoral thesis by Gramberg (1928; pubd 1936) charting Giambologna's early career, which is still somewhat speculative. The major contribution was post-war, in a well-researched monograph (including a catalogue raisonné) based on her doctoral thesis by Elisabeth Dhanens (1956). Another doctoral thesis, by Holderbaum (1959; pubd 1983), concentrated on elucidating the origins and appeal of Giambologna's style. An exhibition of the bronze statuettes, as nearly complete as proved possible, was held in Edinburgh, London and Vienna in 1978–9, and its catalogue remains the standard work on that vital aspect of his oeuvre. A fully illustrated survey of the current state of knowledge on Giambologna was published by Avery in 1987.

BIBLIOGRAPHY

EARLY SOURCES

G. Vasari: *Vite* (1550, rev. 2/1568); ed. G. Milanesi (1878–85)
R. Borghini: *Il Riposo* (Florence, 1584), pp. 585–9; facs., ed. M. Rossi (Milan, 1967), 2 vols
F. Baldinucci: *Notizie* (1681–1728); ed. F. Ranalli (1845–7)

GENERAL

B. Wiles: *The Fountains of Florentine Sculptors and their Followers from Donatello to Bernini* (Cambridge, MA, 1933)
H. Keutner: 'Über die Entstehung und die Formen des Standbildes im Cinquecento', *Münchn. Jb. Bild. Kst*, n. s. 2, viii (1956), pp. 159ff
J. Pope-Hennessy: *Italian High Renaissance and Baroque Sculpture* (London, 1963)

J. Pope-Hennessy with R. Lightbown: *Catalogue of Italian Sculpture in the Victoria and Albert Museum* (London, 1964)
L. Berti: *Il principe dello studiolo* (Florence, 1967)
C. Avery: *Florentine Renaissance Sculpture* (London and New York, 1970)
K. J. Watson: *Pietro Tacca, Successor to Giovanni Bologna: The First Twenty-five Years in the Borgo Pinto Studio, 1592–1617* (diss., University Park, PA State U., 1973)
V. L. Bush: *Colossal Sculpture of the Cinquecento, from Michelangelo to Giovanni Bologna* (New York and London, 1976)
K. Langedijk: *The Portraits of the Medici, 15th–18th Centuries* (Florence, 1980)
C. Avery: *Studies in European Sculpture, I* (London, 1981)
M. Bury: 'Bernardo Vecchietti, Patron of Giambologna', *I Tatti Stud.*, I (1985), pp. 13–56
C. Avery: *Studies in European Sculpture, II* (London, 1987)

MONOGRAPHS

A. Desjardins: *La Vie et l'oeuvre de Jean Boulogne, d'après les manuscrits inédits recueillis par Foucques de Vagnonville* (Paris, 1883)
W. Gramberg: *Giovanni Bologna: Eine Untersuchung über die Werke seiner Wanderjahre* (Berlin, 1936)
E. Dhanens: *Jean Boulogne, Giovanni Bologna Fiammingo* (Brussels, 1956); review by H. Keutner in *Kunstchronik*, xi (1958), pp. 325–38
J. Holderbaum: *The Sculptor Giovanni Bologna* (New York and London, 1983)
C. Avery: *Giambologna: The Complete Sculpture* (Oxford, 1987)

SPECIALIST STUDIES

Marble statues and models

H. Keutner: 'Il San Matteo nel Duomo di Orvieto: Il modello e l'opera eseguita', *Boll. Ist. Stor. A. Orviet.*, xi (1955)
J. Pope-Hennessy: 'A New Work by Giovanni Bologna', *V&A Mus. Bull.*, 2 (1966), pp. 75–7
——: 'Giovanni Bologna and the Marble Statues of the Grand-Duke Ferdinando I', *Burl. Mag.*, cxii (1970), pp. 304–7
D. Heikamp: 'Scultura e politica: Le statue della Sala Grande di Palazzo Vecchio', *Le arti del Principato Mediceo* (Florence, 1980), pp. 201–54
——: 'The Grotto of the Fata Morgana and Giambologna's Marble *Gorgon*', *Ant. Viva*, xx/3 (1981), pp. 12ff.
M. Campbell: 'Observations on the Salone dei Cinquecento in the Time of Duke Cosimo I de' Medici, 1540–74', *Firenze e la Toscana dei Medici nell'Europa del 500* (Florence, 1983)
M. Baker: '"A Peece of Wondrous Art": Giambologna's *Samson and a Philistine* and its Later Copies', *Antol. B.A.*, n. s., 23–4 (1984), pp. 62–71
M. P. Mezzatesta: 'Giambologna's "Altar of Liberty" in Lucca: Civic Patriotism and the Counter-Reformation', *Antol. B.A.*, n. s., 23–4 (1984), pp. 5–19
L'Appennino del Giambologna (exh. cat., ed. A. Venzzosi; Pratolino, Villa Demidoff, 1985; rev. 1990)
C. Acidini Luchinat: *Fiorenza in villa* (Florence, 1987)
H. Keutner: 'Die *Bathsheba* des Giovanni Bologna', *J. Paul Getty Mus. J.*, xv (1987), pp. 139–50
C. Acidini Luchinat: *Risveglio di un colosso* (Florence, 1988)
A. Standati, ed.: *Risveglio di un colosso* (Florence, 1988)
C. Avery: 'Giambologna's *Julius Caesar*: The Rediscovery of a Masterpiece', *Art and Tradition: Masterpieces of Important Provenances* (exh. cat., Munich, Konrad O. Bernheimer, 1989), pp. 46–65, 108–9
M. Cambell: 'Giambologna's Oceanus Fountain: Identifications and Interpretations', *Boboli 90: Atti del convegno internazionale di studi per la salvaguardia e la valorizzazione del Giardino: Florence, 1989*, pp. 89–106
C. Avery: 'When is a "Giambologna" not a "Giambologna"?', *Apollo*, cxxxi/340 (1990), pp. 391–400
M. Bury: 'Giambologna's *Fata Morgana* Rediscovered', *Apollo*, cxxxi/336 (1990), pp. 96–100
G. Gentilini: 'Jean Boulogne detto Giambologna - Pan', *Per la storia della scultura: Materiali inediti e poco noti* (exh. cat. ed. M. Ferretti, Turin, 1992), pp. 71–91
C. Avery: 'Bathsheba (Psyche?)', *Daniel Katz Ltd XXV, 1968–1993*, ed. P. Laverack (London, 1993), pp. 22–5
Giambologna's Cesarini Venus (exh. cat. by A. Radcliffe, Washington, DC, N.G.A., 1993–4)
A. Radcliffe: 'Giambologna's *Venus* for Giangiorgio Cesarini: A Recantation', *Ant. B.A.*, n.s. 52–5 (1996), pp. 60–72 [special issue: *La scultura: Studi in onore di Andrew Ciechanowiecki*]
M. T. Colomo: 'La Grotta di Fattuccia e la statua della *Fata Morgana* di Giambologna', *Magnificenza alla Corte dei Medici: Arte a Firenze alla*

fine del Cinquecento (exh. cat., Florence, Mus. Argenti and Pitti, 1997), pp. 426–9

C. Avery: 'The Ford Giambolognas', *Walpole Soc.*, lx, Ford I (1998), p. 74

Bronzes: general

W. Bode: *The Italian Bronze Statuettes of the Renaissance* (London, 1908–12, rev. New York, 1980)

J. Mann: *Sculpture*, London, Wallace cat. (London, 1931)

H. Weihrauch: *Die Bildwerke in Bronze und in anderen Metallen*, Munich, Bayer. Nmus. (Munich, 1956)

Italian Bronze Statuettes (exh. cat., ACGB; Amsterdam, Rijksmus.; Florence, Pal. Strozzi; 1961–2)

H. Weihrauch: *Europäische Bronzestatuetten* (Brunswick, 1967)

M. Campbell and G. Corti: 'A Comment on Prince Francesco de' Medici's Refusal to Loan Giovanni Bologna to the Queen of France', *Burl. Mag.*, cxv (1973), pp. 507–12

K. Watson and C. Avery: 'Medici and Stuart: A Grand Ducal Gift of "Giovanni Bologna" Bronzes for Henry, Prince of Wales (1612)', *Burl. Mag.*, cxv (1973), pp. 493–507

R. Bauer and H. Haupt: 'Das Kunstkammerinventar Kaiser Rudolfs II, 1607–1611', *Jb. Ksthist. Samml. Wien*, lxxii (1976)

Giambologna, Sculptor to the Medici, 1529–1608 (exh. cat., ed. C. Avery and A. Radcliffe; ACGB, 1978); review by J. Montagu in *Burl. Mag.*, cxx (1978), pp. 690–94

Giambologna, 1529–1608: Ein Wendepunkt der europäischen Plastik (exh. cat., ed. C. Avery, A. Radcliffe and M. Leithe-Jasper; Vienna, Ksthist. Mus., 1978)

B. Jestaz: 'A propos de Jean Bologne', *Rev. A.*, 46 (1979), pp. 75–82

Firenze e la Toscana dei Medici nell'Europa del cinquecento, Il Primato del disegno (exh. cat., Council of Europe exh., Florence, 1980)

Liechtenstein: The Princely Collections (exh. cat., New York, Met., 1985)

Die Bronzen fürstlichen Sammlung Liechtenstein (exh. cat., Frankfurt am Main, Liebieghaus, 1986)

Renaissance Master Bronzes from the Collection of the Kunsthistorisches Museum, Vienna (exh. cat. by M. Leithe-Jasper, Washington, DC, Smithsonian Inst., 1986)

Il seicento fiorentino: Arte a Firenze da Ferdinando I a Cosimo III (exh. cat., ed. G. Guidi and D. Marcucci; Florence, 1986), pp. 422–8, nos 4.1–4.6

Prag um 1600: Kunst und Kultur am Hofe Kaiser Rudolfs II (exh. cat., Vienna, Ksthist. Mus., 1988), pp. 127–49

H. Keutner: 'Appendice: Bronzi moderni', *Catalogo della Galleria Colonna in Roma: Sculture* (Rome, 1990), pp. 277–304

L. O. Larsson: *European Bronzes, 1450–1700* (Stockholm, 1992)

"Von allen Seiten Schön": Bronzen der Renaissance und des Barock (exh. cat., Berlin, Staatl. Museen Preuss. Kultbes., 1995), nos 108–23

Magnificenza alla corte dei Medici: Arte a Firenze alla fine del Cinquecento (exh. cat., Florence, Mus. Argenti and Pitti, 1997)

Giambologna: An Exhibition of Sculpture by the Master and his Followers from the Collection of Michael Hall, Esq. (exh. cat. by C. Avery, New York, Salander-O'Reilly Gals, 1998)

Bronzes: complexes or individual examples

J. del Badia: *Cosimo de' Medici modellata da Giovanni Bologna e fusa da Giovanni Alberghetti: Documenti inediti* (Florence, 1868)

F. Kriegbaum: 'Ein Bronzepaliotto von Giovanni Bologna in Jerusalem', *Jb. Preuss. Kstsamml.*, xlvii (1927), pp. 43–52

H. Keutner: 'Die Tabernakelstatuetten der Certosa zu Florenz', *Mitt. Ksthist. Inst. Florenz*, v (1955), pp. 139–44

——: 'Der Giardino Pensile der Loggia dei Lanzi und seine Fontane', *Kunstgeschichtliche Studien für Hans Kauffmann* (Berlin, 1956), pp. 240–50

——: 'Two Bronze Statuettes of the Late Renaissance', *Register* [Lawrence, U. KS], i (1957), pp. 117ff

A. Ronen: 'Portigiani's Bronze 'Ornamento' in the Church of the Holy Sepulchre, Jerusalem', *Mitt. Ksthist. Inst. Florenz*, xiv (1970), pp. 415–42

G. Corti: 'Two Early Seventeenth Century Inventories Involving Giambologna', *Burl. Mag.*, cxviii (1976), pp. 629–34

R. Tuttle: 'Per l'iconografia della fontana del Nettuno', *Il Carrobbio*, iii (1977), pp. 437–45

M. W. Gibbons and G. Corti: 'Documents Concerning Giambologna's Equestrian Monument of Cosimo I, a Bronze Crucifix and the Marble Centaur', *Burl. Mag.*, cxx (1978), pp. 508–10

B. Jestaz: 'La Statuette de *La Fortune* de Jean Bologne', *Rev. Louvre* (1978), pp. 48–52

A. F. Radcliffe: 'Giambologna's Twelve Labours of Hercules', *Connoisseur* (Sept 1978), pp. 12–19

C. M. Brown: 'Giambologna Documents in the Correspondence Files of Duke Vincenzo Gonzaga in the Mantua State Archives, *Burl. Mag.*, cxxiv (1982), pp. 29–31

M. Bury: 'The Grimaldi Chapel of Giambologna in San Francesco di Castelletto, Genoa', *Mitt. Ksthist. Inst. Florenz*, xxvi (1982), pp. 85–128

C. W. Fock: 'The Original Silver Casts of Giambologna's Labours of Hercules', *Studien zum europäischen Kunsthandwerk, Festschrift Yvonne Hachenbroch* (Munich, 1983), pp. 141–5

M. W. Gibbons: *Giambologna's Grimaldi Chapel: A Study in Counter-Reformatory Iconography and Style* (New York, 1984)

A. Lefebure: 'Un singe en bronze de Jean Bologne', *Rev. Louvre*, 3 (1984), pp. 184–8

H. Keutner: *Giambologna e il Mercurio volante*, Florence, Bargello cat. (Florence, 1984)

O. Raggio: 'Bust of Grand Duke Francesco I de' Medici', *Notable Acquisitions, 1983–84*, New York, Met. cat. (New York, 1985)

M. E. Flack: *Giambologna's Cappella di Sant'Antonio for the Salviati Family: An Ensemble of Architecture, Sculpture and Painting* (New York and London, 1986)

C. Acidini Luchinat, ed.: *Fiorenza in Villa* (Florence, 1987)

C. Avery: 'Giambologna's *Horse and Rider*', *SMI Rev.*, 17 (1993), pp. 19–27

S. Eiche: 'Giambologna's *Neptune Fountain* in Bologna: Newly-discovered Letters from 1565', *Mitt. Ksthist. Inst. Florenz*, xxxviii/2–3 (1994), pp. 428–9

F. Vossilla: 'Storia d'una fontana: Il *Bacco* del Giambologna in Borgo San Jacopo, Florence, *Mitt. Ksthist. Inst. Florenz*, xxxviii/1 (1994), pp. 130–46

M. W. Gibbons: *Giambologna: Narrator of the Catholic Reformation* (Berkeley, Los Angeles and London, 1995)

B. Jestaz: 'Le Livre Journal de la fabrique de al chapelle Salviati à Saint-Marc de Florence (1579–1594)', *Bib. Ecole Hautes Etud.*, ccci (1995) [whole issue]

C. Avery: '*Mercury*: A Flight of the Renaissance Imagination', *Sculp. Rev.*, xliv/1 (1996), pp. 15–17

CHARLES AVERY

Giambono [Bono; Zambono], **Michele** [Michele di Taddeo di Giovanni Bono] (*b* Venice, *c.* 1400; *d* Venice, *c.* 1462). Italian painter. He was heir to the Late Gothic style as practised in Venice, and his art represents the most complete development of that style by a Venetian painter. He was seemingly not interested in the forms of antique art and did not seek the kind of verisimilitude practised by such fully Renaissance artists as Giovanni Bellini. His style remained Gothic, as did his vision, but he created unusual combinations of images that anticipate the novel kind of subject-matter later used by Giovanni Bellini. Until the mid-19th century he was known primarily for his designs for the mosaics in the Mascoli Chapel, S Marco, Venice, but he is now also recognized as an accomplished panel painter.

1. Life and work. 2. Working methods and technique.

1. LIFE AND WORK. Giambono may have belonged to a family of artists living in Treviso at the end of the 14th century and could have received his training in that workshop. He was, however, a Venetian, as the extant signatures on his works attest. He is first documented in Venice in November 1420, when he was already established as a painter and living in the parish of S Angelo. In 1422 he joined the Scuola di S Giovanni Evangelista.

Giambono must have enjoyed a considerable personal and professional reputation, for on a number of occasions he was called on to evaluate works by his contemporaries. In April 1430, for example, he and two other artists judged a painting of *St Michael* (untraced) that Jacopo Bellini had made for the church of S Michele, Padua, to be worth 35

gold ducats; in the summer and autumn of 1453 he took part in the arbitration between Donatello and the son of Gattamelata concerning the price to be paid to the sculptor for his equestrian monument to *Gattamelata* outside the Santo, Padua (*see* DONATELLO, fig. 4).

One of Giambono's earliest surviving works is the *Man of Sorrows with St Francis* of the 1420s (New York, Met.), and his first major known altarpiece is the polyptych of the *Virgin and Child with Saints* (*c.* 1430; Fano, Pin. Civ. & Mus. Malatestiano). In this work his style is fully developed; the figures seem to float above the ground on which they are meant to stand, and there is very little suggestion of anatomical structure beneath the drapery.

In 1440 the city of San Daniele di Friuli and the church of S Michele there jointly commissioned Giambono and Paolo Amadeo, a woodcarver, to make a partially carved and partially painted altarpiece, as well as two candelabra for acolytes and two angels to be placed above the altar. For these objects the two artists were to receive 95 gold ducats, but they were required to deliver the works at their own cost and risk, thus substantially reducing their net wages. The sole surviving portions of this altarpiece may be the *St Michael Archangel* (Florence, I Tatti) and the *Virgin and Child Enthroned* (Venice, Ca' d'Oro). The *St Michael* is one of Giambono's best works. The rhythmical, undulating curves of the angel's dalmatic and the thin, translucent veils of crimson paint with which it is depicted unite to lend the image a luminous, shimmering quality; the opaque cerulean blue of the background perfectly harmonizes with the rich crimson and deep old gold of the dalmatic, creating a mellow effect. Giambono's fascination with line is evident in many other paintings, for instance the *Male Saint* (*c.* 1440; Oxford, Ashmolean; see fig. 1), in which he employed patterns borrowed from 15th-century Venetian textiles, such as brocades and damasks. These patterns, derived from vegetal forms, are highly abstracted and stylized. The *Male Saint* is probably the central panel from a dismembered polyptych to which *St Gregory the Great*, *St Augustine* and the *Man of Sorrows* (all Padua, Mus. Civ.) may also have belonged.

Giambono's success as an artist parallels that of Lorenzo Monaco in Florence and lies largely, but not exclusively, in his enhancement and accentuation of the decorative and rhythmical elements of the Late Gothic style, never allowing facial expression to overshadow the decorative elements. He derived his facial types from works by Gentile da Fabriano and Pisanello, both of whom worked in Venice for short periods during the first quarter of the 15th century. In conceiving the faces of his mature male figures, as in the *Man of Sorrows* (*c.* 1440; Padua, Mus. Civ.), he generally followed a formula in which the eyes are set wide apart, emphasizing the bridge of the nose, with the brow stereotypically furrowed into sections and the mouth turned down at the corners and almost always slightly open. Nevertheless, it is likely that at some time he studied human heads and faces and then typified them according to received formulae.

Another feature of Giambono's style is his careful depiction of nature. In the *Virgin and Child Enthroned* (*c.* 1445; Budapest, Mus. F.A.) the vegetation is treated with attention and is used to create abstract patterns. In two panels dating from the 1450s, both of the *Virgin and Child*

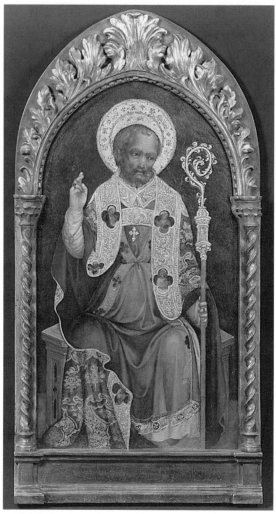

1. Michele Giambono: *Male Saint*, tempera on panel, 825×455 mm, *c.* 1440 (Oxford, Ashmolean Museum)

(Rome, Pal. Barberini, see fig. 2; and Venice, Correr), birds are drawn with an uncommon accuracy of detail. The *Virgin and Child* in Rome shows a balance between the decorative, natural and expressive elements of his style: the bold pattern of the background cloth of honour is played against the delicate patterns of the haloes and of the border of the Virgin's mantle; these patterns are, in turn, relieved by the relatively unbroken colours of the Virgin's mantle, the cloth over her head and that in which the Child is wrapped. At the centre of the panel, emerging from the rhythmical nexus, are the faces of the Virgin and Child, both imbued with an expression of seraphic joy. Giambono never tried to fuse these disparate elements as did true Renaissance artists; rather he sought their harmonious co-existence.

Giambono was probably himself not a mosaicist, but he was responsible for the designs of several of the scenes from the *Life of the Virgin* on the vault of the Mascoli Chapel in S Marco, Venice. Since the 16th century these mosaics have been cleaned and restored on several occasions, but Giambono's contribution to them can still be

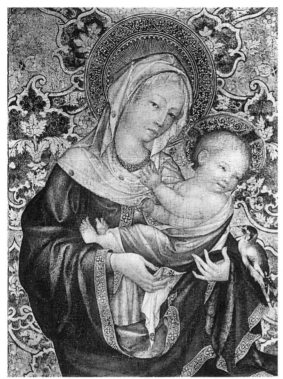

2. Michele Giambono: *Virgin and Child*, tempera on panel, 570×390 mm, 1455 (Rome, Palazzo Barberini)

identified. He designed the *Birth of the Virgin*, the *Presentation of the Virgin in the Temple* and the *Annunciation* (on the altar wall) as well as the decorative borders and the three tondi with the *Virgin and Child*, *David* and *Isaiah* at the top of the vault. He also designed the figures in the *Visitation*, but not the architecture, and the nine disciples at the foot of the Virgin's bier in the *Death of the Virgin*; the rest of the figures, and perhaps the architecture, were drawn by Andrea del Castagno, who was in Venice in 1442–3. The mosaics were probably executed between *c.* 1443 and *c.* 1450.

Certain documents provide a glimpse of the kind of demands Giambono's patrons made on him. In May 1447 Giovanni di ser Francesco, a syndic and proctor of the church of S Agnese, Venice, commissioned him to make a painting (untraced) for the high altar, which was to be similar in form, fabrication, decoration and framing to the *Coronation of the Virgin* of 1444 by Giovanni d'Alemagna and Antonio Vivarini in the Ognissanti Chapel of S Pantaleone, Venice (*in situ*). Giambono was to finish the painting before Easter 1448, or, unless illness prevented its completion, he would forfeit 30 of the 130 ducats he was to be paid. He was also to make his painting wider than the original (by *c.* 300 mm). Two weeks later he subcontracted with Francesco Moranzone for the frame of the altarpiece, which was to be of the same quality as the original. The altarpiece may be recorded in a drawing (London, BL, MS. Add. 41600, fol. 90 *v*) by an anonymous 15th-century artist. It has been proposed that the *Coronation of the Virgin* (Venice, Accad.), formerly attributed to Giambono, is the work of Antonio Vivarini and

Giovanni d'Alemagna and not the work intended for S Agnese (Land, 1977).

Although Giambono's style was influenced throughout his career by the art of his contemporaries, his figures share certain general characteristics with late 14th-century art in Venice. The melancholic expression of his figures, as in, for example, the *St James* polyptych (*c.* 1455; Venice, Accad.), is similar to the expression of the figures in altarpieces by Lorenzo Veneziano and in the sculptural group on the iconostasis in S Marco by Jacobello and Pierpaolo dalle Masegne. His use of richly patterned drapery parallels Lorenzo's employment of the same device, just as the graceful, delicately curving lines of the forms find an echo in the figures by the dalle Masegne brothers. Because Giambono's style is basically linear, his figures are always relatively flat in appearance, the result of his emphasis on contour. Indeed, the contours of his forms were of such interest to him that his figures, such as those in the *St James* polyptych, tend to be first discerned almost as silhouettes against a gold-leaf background.

In one of Giambono's late and most successful works, the *St Chrysogonus* (*c.* 1460; Venice, S Trovaso), linear pattern is masterfully wedded to the composition as a whole. The complex swirls of the saint's banner and his cape as it unfurls behind him suggest a centripetal movement around the centre of the composition. Indeed the movement that might be expected from a figure on horseback is not conveyed by the horse itself, but by the pattern of flying cloth and the strong diagonal thrust of the saint's lance. Naturalism is confined to the depiction of the details of horse and vegetation but is not a principle of vision informing every aspect of the painting.

Giambono may have been the teacher of Giovanni d'Alemagna, who in 1433, before he became the partner of Antonio Vivarini, seems to have painted the fresco of the *Annunciation* around the Cortesia Sarego monument in S Anastasia, Verona. This fresco has been attributed to Giambono, but the attribution is far from unanimous. He seems also to have influenced Carlo Crivelli, whose penchant for intricate patterns and elegant line is close to Giambono's.

Giambono made significant contributions to Venetian iconography by inventing novel combinations of conventional images in his paintings. His *Man of Sorrows with St Francis* of the 1420s (New York, Met.) is an early example of his innovations in the treatment of Franciscan subject-matter, in which the theme of the saint's stigmatization is fused with that of a Pietà. In his only extant narrative panel, the *Stigmatization of St Francis* (*c.* 1440; Venice, Col. Cini), the saint's vision on Mt Alverna is connected to the theme of the Man of Sorrows. Both of these panels express in new ways the likeness between the stigmatized saint and the crucified Christ described by some of St Francis's biographers. Another example is the *Veil of Veronica* (*c.* 1450; Pavia, Pin. Malaspina), in which the head of Christ is slightly tilted to one side and his eyes are half-closed, both features that are found in traditional images of the Man of Sorrows. Giambono thus presented Christ both as the Holy Face miraculously imprinted on Veronica's cloth and as the Man of Sorrows, thereby enriching the traditional allusion of the sudarium to the Passion.

Vasari did not mention Giambono, but Francesco Sansovino in his guide to Venice (1581) noted two altarpieces in S Alvise, one on the high altar and the other in the chapel of S Agostino.

2. WORKING METHODS AND TECHNIQUE. Giambono seems to have employed the same procedure in creating his paintings throughout his career. First, he made a preparatory drawing, seemingly done with a pen or small brush and ink, on the white gesso ground of the panel. Then, over these preliminary preparations for the figure, he would put on layers of translucent colours, so that in the *St James* polyptych, for example, the underdrawing is visible through the paint, which presumably is tempera. His backgrounds are always either cerulean blue (probably lapis lazuli) or gold leaf, which in some panels is punched to create a geometrical pattern. Occasionally he also used flat gold leaf in the drapery of his figures, painting over it with thin paint to create a textile pattern. His drapery, particularly the borders of copes on his ecclesiastical figures, is sometimes decorated with raised and gilded gesso, and other objects, such as books and keys, are embossed and covered with gold leaf, both practices that give his works a tactile quality like that of a low relief. Throughout his career he employed two separate colour schemes, one predominantly crimson and cerulean blue, as in the panels of *?St Gregory the Great* and *?St Augustine* (both *c.* 1440; Padua, Mus. Civ.), and the other comprising bright pink, orange, green, blue, yellow, red and lavender, as in the *St Peter* (*c.* 1440; Washington, DC, N.G.A.).

There are no known drawings on paper certainly by Giambono, but he was fundamentally a draughtsman, not only because he began his paintings with a drawing, but also because one of the most aesthetically pleasing features of his paintings is the expressiveness of his line, which at its best is spontaneous and vivacious, qualities usually found only in drawings on paper.

BIBLIOGRAPHY

Thieme–Becker: 'Bono, Michele di Taddeo'
F. Sansovino: *Venetia città nobilissima et singolare* (Venice, 1562), fol. 62r
J. A. Crowe and G. B. Cavalcaselle: *A History of Painting in North Italy* (London, 1871, rev. by T. Borenius, 2/1912), pp. 12–15
E. Sandberg-Vavalà: 'Michele Giambono and Francesco dei Franceschi', *Burl. Mag.*, li (1927), pp. 215–21
——: 'The Reconstruction of a Polyptych by Michele Giambono', *J. Warb. & Court. Inst.*, x (1947), pp. 20–26
B. Berenson: *Venetian School* (1957), i, pp. 82–3
M. Muraro: 'The Statues of the Venetian *Arti* and the Mosaics of the Mascoli Chapel', *A. Bull.*, xliii (1961), pp. 260–74 [discusses dating of mosaics]
E. Packard: 'The Madonna of Humility', *Bull. Walters A.G.*, xvii/3 (1964), n.p. [with x-ray and ultraviolet photographs showing underdrawing]
N. Land: *Michele Giambono* (diss., Charlottesville, U. VA, 1974)
——: 'Michele Giambono's *Coronation of the Virgin* for S Agnese in Venice: A New Proposal', *Burl. Mag.*, cxix (1977), pp. 167–74 [discusses drawing after lost original]
C. Pesaro: 'Per un catalogo di Michele Giambono', *Atti Ist. Ven. Sci., Lett. & A.*, cxxxvi (1977–8), p. 29 [surveys all documents]
N. Land: 'Two Panels by Michele Giambono and Some Observations on St Francis and the Man of Sorrows in Fifteenth-century Venetian Painting', *Stud. Iconog.*, vi (1980), pp. 29–41
——: 'A New Proposal for Michele Giambono's Altarpiece for S Michele in S Daniele in Friuli', *Pantheon*, iv (1981), pp. 304–10
——: 'A New Panel by Michele Giambono and a Reconstructed Altarpiece', *Apollo*, cxix (1984), pp. 150–65
P. Humfrey: 'The Venetian Altarpiece of the Early Renaissance in the Light of Contemporary Business Practice', *Saggi & Mem. Stor. A.*, xv (1986), pp. 67–82
N. Land: 'Michele Giambono, Cennino Cennini and *Fantasia*', *Ksthist. Tidskr.*, lv (1986), pp. 47–53 [artist's work evaluated in relation to art theory]

NORMAN E. LAND

Giampetrino, il. *See* RIZZOLI, GIOVANNI PIETRO.

Gian [Giovanni] **Cristoforo Romano** (*b* Rome, *c.* 1465; *d* Loreto, 31 May 1512). Italian sculptor and medallist. He was the son of Isaia da Pisa. Some scholars have followed Vasari in suggesting that he was trained by his father or by Paolo Romano, but Isaia stopped work and Paolo died too early to have had any significant influence on him. It is likely that he studied with Andrea Bregno, who worked in Rome from 1446 to 1506. He may have been in Urbino before 1482, working at the Palazzo Ducale with the Lombard master Ambrogio d'Antonio Barocci. Several doorframes in the palazzo have been attributed to him. He then probably went to the Este court at Ferrara. In 1490 he carved a portrait bust of *Beatrice d'Este* (Paris, Louvre), the daughter of Ercole I d'Este, Duke of Ferrara, for her betrothal to Ludovico Sforza, Duke of Milan. The attribution of this bust derives from a letter of 12 June 1491 from Isabella d'Este, requesting that Ludovico send Gian Cristoforo, who had done Beatrice's portrait, to Mantua to work for her. The bust is inscribed with the imprese of a sieve surrounded by a diamond ring. The sieve was a symbol of Ludovico, the diamond of Ercole; entwined they suggest marriage and the hope of fertility. This bust is the sculpture most securely attributed to Gian Cristoforo and, with his medals, provides the basis for the assessment of his style.

In 1491 Gian Cristoforo went to Milan, probably in the wedding entourage of Beatrice d'Este. In that year he began work on his major surviving commission, the tomb of *Giangaleazzo Visconti, 1st Duke of Milan* at the Certosa di Pavia (*see* PAVIA, §2). Despite ample documentation and Gian Cristoforo's signature carved on the front, it has not been possible to distinguish his work on the tomb from that of his collaborators: it is likely that he assigned most of the carving to other sculptors, particularly Benedetto Briosco. Similarly it seems that Gian Cristoforo supervised, either personally or in letters, the many other monumental sculptures and portraits attributed to him.

After the completion of the *Visconti* tomb and the death of Beatrice d'Este, Gian Cristoforo left Milan for the court of Isabella d'Este in Mantua, arriving in September 1497. Several Mantuan works, including a marble doorframe for Isabella (between her second *studiolo* and her grotta) and a terracotta bust of her husband *Francesco II, 4th Marchese of Mantua Gonzaga* (*c.* 1498; Mantua, Pal. Ducale), have been attributed to him. Also from this period is the tomb of *Pier Francesco Trecchi* (Cremona, S Agata), which was designed for S Vincenzo, Cremona. He was in Venice in 1503 and possibly in Rhodes before this.

In 1505 Gian Cristoforo was back in Milan, staying at the house of the doctor and anatomist Marc'Antonio della Torre. His letters to Isabella d'Este refer to designs for the tomb of *Osanna Andreasi* (destr. ?1797), which she had commissioned for S Domenico, Mantua. Also in 1505 he was called to Rome by Pope Julius II. Letters from Isabella indicate that he was to act as her agent in seeking antiquities in Rome. Although letters refer to sculpture of

this period, only medals have been securely identified. Three medals by him are noted in a letter of 1507 from Giacomo d'Atri, Mantuan ambassador to Naples, to Isabella d'Este in Mantua. These depict *Isabella d'Este* (gold, *c.* 1498; Vienna, Ksthist. Mus.; see fig.), which is set in a gold frame with enamel and diamonds that spell her name, *Isabella of Aragon* (e.g. London, BM) and *Pope Julius II* (e.g. London, BM).

Between 1507 and 1510 Gian Cristoforo travelled to Urbino, Naples and possibly Mantua and Fossombrone. In December 1510 he was in Loreto and by March 1511 he was working on the Santa Casa there, a project that seems to have occupied him until his death. No work on the Santa Casa has been identified as his, and indications are that he worked on the architecture of the church rather than the Santa Casa itself (Weil-Garris). Gian Cristoforo is further documented as a courtier, musician, antiquary, poet and writer on literature and art. This wide range of activities, as well as his travels and periods of illness (probably syphilis), might account for his small output.

BIBLIOGRAPHY

Thieme–Becker: 'Romano, Giovanni Cristoforo'
G. Vasari: *Vite* (1550, rev. 2/1568); ed. G. Milanesi (1878–85), ii, p. 650
A. Venturi: 'Gian Cristoforo Romano', *Archv Stor. A.*, i (1888), pp. 49–59, 107–18, 148–58
A. Bartolotti: *Figuli, fonditore e scultori in relazione con la corte di Mantova nei secoli XV, XVI, XVII* (Milan, 1890)
A. Luzio and R. Renier: 'Delle relazione di Isabella d'Este Gonzaga con Ludovico e Beatrice Sforza', *Archv Stor. Lombardo*, II/vii (1890), pp. 74–119, 346–399, 619–674
G. de Nicola: 'Falsificazione di documenti per la storia dell'arte romana,' *Repert. für Kstwiss.* xxxii (1909), pp. 55–60
A. Venturi: 'Gli studi su Gian Cristoforo Romano, scultore', *Atti del I. Congresso nazionale di studi romani: Roma, 1929*, pp. 553–9
G. F. Hill: *A Corpus of Italian Medals of the Renaissance before Cellini* (London, 1930)
C. Brown: 'Gleanings from the Gonzaga Documents in Mantua: Gian Cristoforo Romano and Andrea Mantegna', *Mitt. Ksthist. Inst. Florenz*, xvii (1973), pp. 153–9

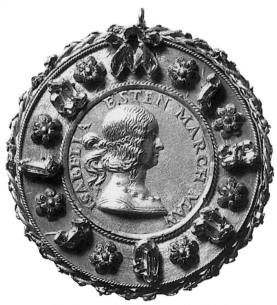

Gian Cristoforo Romano: *Isabella d'Este*, gold medal, diam. 89 mm, *c.* 1498 (Vienna, Kunsthistorisches Museum)

A. S. Norris: *The Tomb of Gian Galeazzo Visconti at the Certosa di Pavia* (diss., New York U., 1977)
K. Weil-Garris: *The Santa Casa di Loreto: Problems in Cinquecento Sculpture* (New York, 1977)
A. Nova: 'Dall'arca alle esequie: Aspetti della scultura a Cremona nel XVI secolo', *I campi e la cultura artistica cremonese del cinquecento* (Milan, 1985), pp. 409–30
A. S. Norris: 'Gian Cristoforo Romano: The Courtier as Medalist', *Stud. Hist. A.*, xxi (1987), pp. 131–41

ANDREA S. NORRIS

Giannotti, Tommaso. *See* RANGONE, TOMMASO.

Giocondo (da Verona), Fra Giovanni (*b* Verona, 1433; *d* Rome, 1 July 1515). Italian engineer, architect, epigraphist and scholar. He was much sought after for his technical skills, particularly his expertise in hydraulics and military engineering, while his wide-ranging interests in archaeology, theology, urban planning and philology earned him the regard of his contemporaries; Vasari described him as 'un uomo rarissimo ed universale'. He was almost certainly a Franciscan friar, but it is not known where he acquired his architectural training. Given his lifelong and profound study of Classical architecture and inscriptions, Vasari's assertion that he spent time in Rome as a youth is plausible. One of his earliest endeavours was to compile a collection of Latin inscriptions. The first version (1478–*c.* 1489), which included drawings and was dedicated to Lorenzo de' Medici, became an important and much-copied reference work; it was also a major source for the *Corpus inscriptionum latinarum*, the principal 19th-century compilation. A fine copy survives (Rome, Vatican, Bib. Apostolica, MS. Vat. lat. 10228), transcribed by Giocondo's friend and sometime collaborator, the eminent Paduan calligrapher, Bartolomeo Sanvito.

The first secure documentary reference to Giocondo is in 1489 when he was paid for inspecting the ancient ruins at Pozzuoli with the poet and art collector Jacopo Sannazaro (1455–1530). While working for the Duke of Calabria (later Alfonso II, King of Naples), Giocondo made trips to examine the remains of ancient buildings in Naples and its environs (e.g. Castel Mola, now Formia; Gaëta) and was probably consulted on other projects, including, perhaps, the planning of the city (see Hamberg). According to Pietro Summonte (letter 20 March 1524), Fra Giocondo acted as architect-in-chief for over two years supervising the completion of the villa of Poggio Reale (begun 1487; destr.) after the death (1490) of Giuliano da Maiano. On 30 June 1492 Giocondo was paid by the Neapolitan treasury for 126 drawings on paper (copies possibly preserved in Florence, Uffizi) to illustrate two manuscripts (untraced) of treatises by Francesco di Giorgio Martini, 'uno darchitectura et altro dartigliaria et cose appartenenti a guerra'. This contact with the work of Francesco di Giorgio is significant, given Giocondo's subsequent interest in Vitruvius.

As a result of the deteriorating political situation, Giocondo left Naples and in May 1495 entered Paris in the retinue of Charles VIII, King of France (*reg* 1483–98). In 1498 he was described as 'deviseur des bastiments' to the King; he later also worked for Louis XII (*reg* 1498–1515). He may have been involved in the construction of the Pont Notre-Dame (1500–05) and, according to Leonardo da Vinci (undated note, Paris, Inst. France, MS. K.,

fol. 100r), Giocondo also made hydraulic apparatus for the fountains at the château of Blois. During his stay in Paris, he gave a series of illustrated public lectures on Vitruvius' treatise *On Architecture*; this legacy of interest in Vitruvius was developed in France, most notably by the French humanist Guillaume Budé.

A document of 5 June 1506 records that Giocondo was in Venice employed as Chief Architect to the Council of Ten. In this capacity and as a hydraulics expert, he was involved in a number of projects in the Veneto and made a tour of inspection of several towns of the Venetian terra firma. He submitted proposals (unexecuted) for the re-building of the old Rialto Bridge (destr. 1514) and its immediate vicinity. His ambitious scheme is described in detail by Vasari who claimed to have seen a drawing of the project. Giocondo was employed c. 1506 on the systemization of the Brentella Canal, designed to prevent the Venetian canals silting up; he also planned the land reclamation surrounding the Villa Barco (1491–2; destr. c. 1820), Altivole, and was asked to prepare a scheme for regulating the waters of the Bacchiglione, near Limena. While in Venice, Giocondo edited a number of Classical texts for his friend the publisher Aldo Manuzio, to whom he presented a manuscript of the letters of Pliny the younger. In 1509 Giocondo worked on the fortifications of Padua and in 1509–11 on those of Treviso. For the latter he is traditionally thought to have designed the fortified city walls (completed 1513) with bastions and rounded, projecting gun platforms.

In 1511 Giocondo's definitive edition of Vitruvius' *On Architecture* was published by the printer Giovanni Taccino and dedicated to Pope Julius II. The text, the earliest version to be illustrated, was accompanied by 136 of Giocondo's own woodcuts (see fig.); although crudely executed, they are clear in conception and *all'antica* in character. Giocondo was the first to comprehend properly the various types of peripteral temple classified by Vitruvius and to publish in full the Greek epigrams in Book VIII. Giocondo's knowledge as an archaeologist, his active interest in Classical architecture and his meticulous philological approach resulted in a substantial contribution to the understanding of the corrupted text, which subsequently became highly influential. In addition, he emphasized the treatise's practical application, aiming to make its contents relevant to contemporary architects and engineers by including, for example, a glossary of terms to clarify Vitruvius' technical terminology. Reprinted in 1513 in a smaller format with Sextus Julius Frontinus' *De aquaeductibus urbis Romae* and an additional four illustrations, the book was this time dedicated to Giuliano de' Medici. Antonio da Sangallo the younger owned a copy of the second edition, and both Raphael and Cesare Cesariano consulted it when producing their own versions of the work. Other writings include an undated fragment, in Italian, of a treatise on epigraphic alphabets, *Fragmenta de literis* (Munich, Bayer. Staatsbib., Cod. it. 37c, fols 90–97v), partly written in Giocondo's own hand. He intended it to be an exhaustive survey, serving as a practical handbook for stonecutters, architects and calligraphers. Despite his advanced years, Giocondo was invited by Pope Leo X to Rome and on 1 November 1514 was appointed architect at St Peter's, together with Raphael and Giuliano da Sangallo. During this period, he is also documented in Venice (5 March 1514), still involved with plans for the Rialto.

Several buildings have been attributed to Giocondo, although there is no documentation to support this: most notably the Loggia del Consiglio (1493), Verona; the design of the Villa Barco, Altivole, of which only a loggia survives; and the Fondaco dei Tedeschi, Venice; his name is also associated with the Pontano Chapel (1492), Naples. There survive autograph drawings of architectural studies and geometric constructions (e.g. Venice, Bib. N. Marciana, MS. lat. XIV.171; Florence, Bib. Medicea–Laurenziana, MS. Plut. 29.43) and further, attributed drawings (Florence, Uffizi; St Petersburg, Hermitage, Album B). Despite these attributions, the surviving evidence implies that Giocondo acted more as a technical adviser rather than as an architect concerned with design.

WRITINGS

ed.: *M. Vitruvius, per iucundum solito castigatior factus, cum figuris et tabula, ut iam legi et intellegi possit* (Venice, 1511, rev. 1513)

BIBLIOGRAPHY

G. Vasari: *Vite* (1550, rev. 2/1558); ed. G. Milanesi (1878–85), v, pp. 261–73

R. Brenzoni: *Fra Giovanni Giocondo Veronese, Verona 1435–Roma 1515* (Florence, 1960)

L. A. Ciapponi: 'Appunti per una biografia di Giovanni Giocondo da Verona', *Italia Med. & Uman.*, iv (1961), pp. 131–58

P. G. Hamberg: 'Vitruvius, Fra Giocondo and the City Plan of Naples', *Acta Archaeol.* [Copenhagen], xxxvi (1965), pp. 105–25

M. Muraro: 'Fra' Giocondo da Verona e l'arte fiorentina', *Florence and Venice: Comparisons and Relations: Acts of Two Conferences at Villa I Tatti: Florence, 1976–7*, ii, pp. 337–9

P. N. Pagliara: 'Una fonte di illustrazioni del Vitruvio di Fra Giocondo', *Ric. Stor. A.*, vi (1977), pp. 113–20

L. A. Ciapponi: 'A Fragmentary Treatise on Epigraphic Alphabets by Fra Giocondo da Verona', *Ren. Q.*, xxxii/1 (1979), pp. 18–40

——: 'Fra Giocondo da Verona and his Edition of Vitruvius', *J. Warb. & Court. Inst.*, xlvii (1984), pp. 72–90

V. Fontana: 'Fra' Giocondo e l'antico', *Antonio da Sangallo il Giovane, la vita e l'opera: Atti del XXII congresso di storia dell'architettura: Roma, 1986*, pp. 423–4

——: *Fra Giovanni Giocondo architetto, 1433–c. 1515* (Vicenza, 1988)

Giovanni Giocondo: *Vitruvian Man*, woodcut, 1511

——: 'Fra' Giovanni Giocondo a Venezia, 1506–1514', *Venezia A.*, ii (1988), pp. 24–30

HELEN GEDDES

Giolfino, Nicola [Niccolò] (*b* Verona, 1476; *d* Verona, 1555). Italian painter. Born into a family of sculptors active in Verona during the 15th and 16th centuries, he was the son of Nicolò Giolfino (*b c.* 1450). He was trained in the workshop of Liberale da Verona along with Gian Francesco Caroto, and his earlier works, such as the altarpiece depicting the *Pentecost* (1518; Verona, S Anastasia), show a linear quality and hard surface compared to that of his master.

Giolfino's importance as a fresco painter is established in his decoration, between 1512 and 1522, of the chapel of S Francesco, S Bernardino, Verona, where, in an attempt to reproduce consistent illusionism, he skilfully used scenographic techniques to organize complex episodes of the *Life of St Francis*. In the (damaged) scene of *St Francis Renouncing his Inheritance*, the architecture is used to create a foreground stage, and a view of the River Adige to the upper left conveys a sense of spaciousness. In Giolfino's frescoes depicting scenes from the *Old Testament* in S Maria in Organo, Verona, dating from the 1530s, the forms are smoother and more intensely coloured than in earlier works.

The Cappella degli Avanzi, S Bernardino, contains several important works in oil by Giolfino. On the upper left wall are a *Resurrection, Christ before Pilate* and *Christ Nailed to the Cross*. All have rather slender, static forms and appear to be earlier than his *Arrest of Christ* (1546) on the lower right, with its more powerful, muscular forms and heightened activity. Giolfino began with an eccentric yet conservative style, still related to Late Gothic art, with slender forms and agitated draperies. His mature work is characterized by more robust, active forms and an intensity of colour that seems to favour malachite greens and vermilion. Giolfino was probably the teacher of Paolo Farinati.

BIBLIOGRAPHY
G. Vasari: *Vite* (1550, rev. 2/1568); ed. G. Milanesi (1878–85)
C. Ridolfi: *Meraviglie* (1648); ed. D. von Hadeln (1914–24)
B. dal Pozzo: *Le vite de' pittori, scultori e architetti veronesi* (Verona, 1718), pp. 58–9
A. Avena: 'Le origini dei Giolfino', *Madonna Verona*, v/1 (1911), p. 49
M. Repetto: 'Profilo di Nicola Giolfino', *A. Ven.*, xvii (1963), pp. 51–63
B. Berenson: *Central and North Italian Schools* (1968), i, pp. 170–72
M. Repetto: 'Nicola Giolfino', *Maestri della pittura veronese*, ed. P. Brugnoli (Verona, 1974), pp. 153–60
D. Gisolfi Pechukas: *The Youth of Veronese* (diss. U. Chicago, 1996)
M. Repetto Contaldo: 'Novità e precisioni su Nicola Giolfino', *A. Ven.*, xxx (1976), pp. 73–80
P. Brugnoli: *Affreschi del rinascimento a Verona: Interventi di restauro* (Verona, 1987)
M. Repetto: *Nicola Giolfino* (Verona, 1990)

DIANA GISOLFI

Giorgio da Gubbio. *See* ANDREOLI, GEORGIO.

Giorgio d'Alemagna (*d* between 12 Feb and 9 March 1479). Italian illuminator, probably of German descent. He is documented from 1441 to 1462 in the Este court at Ferrara, working first under Lionello d'Este, Marchese di Ferrara, and then Borso d'Este. He was granted citizenship of Ferrara in 1462. His earliest documented works were executed in Ferrara, where in 1445–8 he participated in

the decoration of a Breviary for Lionello d'Este (sold London, Christie's, 8 Dec 1958, lot 190, p. 32; later dismembered). His illuminations for a Missal for Borso d'Este (Modena, Bib. Estense, MS. lat. 239), executed between 1449 and 1457, include that of the *Crucifixion* (fol. 146*r*; see fig.). In 1453 he decorated the *Spagna in Rima* (Ferrara, Civ. Bib. Ariostea, MS. Cl.II 132). The stylistic relationship between this work, the Missal and the Breviary is problematic. Some scholars attribute only the *Spagna in Rima* to Giorgio, assigning the other works to an anonymous Master of the Missal of Borso d'Este. In Lionello's Breviary (for example the folios sold London, Sotheby's, 25 April 1983, lot 133, p. 199) Giorgio worked in a Late Gothic Emilian style similar to that of the anonymous frescoes at Vignola painted for Niccolò III d'Este. After 1450 his style took on Renaissance characteristics. In the Missal, Giorgio showed familiarity with the art of Francesco Squarcione and Donatello as transmitted through the work of Michele Pannonio, then active in Ferrara. He also knew the work of Piero della Francesca, who in 1451 was in Rimini and later in Ferrara. Giorgio's stylistic vocabulary recalls that of his contemporary Taddeo Crivelli and also the early works of Cosimo Tura. Giorgio's illuminations are of remarkably high quality; the drawing is clear and lively, with Late Gothic rhythms that give a dynamic quality to the figures and an intense expressiveness to the faces. The landscapes are characteristically fantastic: full of pointed rocks, hills and coloured stones, within a fine, carefully worked out colour scheme.

The stylistic connection with Crivelli and Tura is supported by documents that mention Giorgio as a painter.

Giorgio d'Alemagna (attrib.): *Crucifixion*, 280×220 mm, illumination from the Missal of Borso d'Este, 1449–57 (Modena, Biblioteca Estense, MS. lat. 239, fol. 146*r*)

In 1452 he painted panels with scenes of the *Passion* for a reliquary gilded by Cosimo. One of the panels may be the *Crucifixion* (Dublin, N.G.). In 1459 he contributed to the Bible of Borso d'Este (Modena, Bib. Estense, MS. lat. 429), executed in 1455–61 principally by Crivelli and Franco dei Russi. Gathering Z in the first volume (fols 212–221*v*) can be attributed to Giorgio because of its resemblance to the style of his son Martino da Modena (*fl* 1477–89), who was also an illuminator, and because of its stylistic resemblance to some initials in a copy of Virgil's *Works* (Paris, Bib. N., MS. lat. 7939A) executed by Giorgio between 1458 and 1459. In these works Giorgio approaches the style of Guglielmo Giraldi, another illuminator active in Ferrara during this time.

Many of Giorgio d'Alemagna's documented works are untraced. The illuminations in Giovanni Bianchini's *Tabulae astrologiae* (Ferrara, Civ. Bib. Ariostea, MS. Cl.I No. 147), which are close to the style of the Missal but with a courtly language reminiscent of Flemish illumination, have been tentatively attributed to him. During the 1460s and 1470s Giorgio d'Alemagna appears to have participated in the decoration of another Missal (Milan, Castello Sforzesco, MS. 2165). Between 1473 and 1476 he executed some illuminations (untraced) for the choir-books of Modena Cathedral. He is credited with a single folio (fol. 212*S*) depicting *St John the Evangelist* in the Cini Foundation, Venice, and the Albergati Bible (New Haven, CT, Yale U., Bienecke Lib., MS. 407) has also been attributed to him.

BIBLIOGRAPHY

H. J. Hermann: 'Zur Geschichte der Miniaturmalerei am Hofe der Este in Ferrara', *Jb. Ksthist. Samml. Allhöch. Ksrhaus.*, xxi (1900), pp. 117–271

G. Bertoni: *Il maggior miniatore della Bibbia di Borso d'Este 'Taddeo Crivelli'* (Modena, 1925)

M. Boskovits: 'Ferrarese Painting about 1450: Some New Arguments', *Burl. Mag.*, cxx (1978), pp. 370–85

Corali miniati del quattrocento nella Biblioteca Malatestiana (exh. cat., ed. P. Lucchi; Cesena, Bib. Malatestiana, 1989)

Le Muse e il principe: Arte di corte nel rinascimento paolano (exh. cat., Milan, Mus. Poldi Pezzoli, 1991)

F. Toniolo: 'I miniatori estensi', *La miniatura estense*, ed. H. J. Hermann (Modena, 1994), pp. 207–54

The Painted Page: Italian Renaissance Book Illumination, 1450–1550 (exh. cat., ed. J. J. G. Alexander; London, RA, 1994)

U. Bauer-Eberhardt: 'Zur ferraresischen Buchmalerei unter Borso d'Este: Taddeo Crivelli, Giorgio d'Alemagna, Leonardo Bellini und Franco dei Russi', *Pantheon*, lv (1997), pp. 32–45

FEDERICA TONIOLO

Giorgione [Zorzi da Castelfranco; Zorzon] (*b* Castelfranco Veneto, ?1477–8; *d* Venice, before 7 Nov 1510). Italian painter. He is generally and justifiably regarded as the founder of Venetian painting of the 16th century. Within a brief career of no more than 15 years he created a radically innovative style based on a novel pictorial technique, which provided the starting-point for the art of Titian, the dominant personality of the 16th century in Venice. Although he apparently enjoyed a certain fame as a painter of external frescoes, Giorgione specialized above all in relatively small-scale pictures, painted for private use in the home. A high proportion of his subjects were drawn from, or inspired by, mythology and secular literature. Landscape played an important role in many of his compositions, and particular attention was

1. Giorgione: *Laura*, oil on canvas glued to panel, 410×336 mm, 1506 (Vienna, Kunsthistorisches Museum)

often paid to the representation of storms, sunsets and other such natural phenomena. Giorgione was evidently also prized as a painter of portraits, many of them 'fancy' portraits, or views in close-up of the kind of poetic or mythological figure also seen in his narratives. His exploitation of a taste for such works within a circle of aesthetically sophisticated Venetian patricians in turn provided the context for the creation of an entirely novel range of pictorial images.

The extreme difficulty experienced by even the earliest commentators on Giorgione's art in interpreting much of his subject-matter is matched by equally severe problems of chronology and attribution, to the extent that the artist's name has become virtually synonymous with mystery. The difficulties surrounding his work are due in part to the brevity of his career and to the almost complete lack of documented commissions; but to a large extent, too, they are inherent in the peculiar character of his art, which typically tends towards poetic suggestiveness rather than the explicit statement and seeks to evoke a mood rather than to present a clear narrative.

The situation is further complicated by Giorgione's very success in capturing the imagination of his contemporaries, since even in his lifetime his manner was imitated and adapted by his younger colleagues, with the result that the outlines of Giorgione's own personality had become blurred within a few decades of his death. Any modern attempt to interpret his art and to compile a catalogue of his surviving autograph works is bound, therefore, to be more than usually subjective; and experience has shown that it stands little or no chance of gaining universal critical acceptance. What is not in doubt, however, is Giorgione's greatness as an

2. Giorgione: *Portrait of a Man*, oil on panel, 299×266 mm (San Diego, CA, San Diego Museum of Art)

artist; and few critics would dissent from the view that the handful of works that make up his uncontested oeuvre are to be numbered among the most hauntingly beautiful paintings of the Italian Renaissance.

I. Life and work. II. Working methods and technique. III. Critical reception and posthumous reputation.

I. Life and work.

1. Documentary evidence and early sources. 2. Style, attribution, chronology. 3. Interpretation of meaning. 4. Giorgione and his public.

1. DOCUMENTARY EVIDENCE AND EARLY SOURCES. In view of the proverbial mystery surrounding Giorgione's life and work, any discussion of his art must begin by taking careful stock of the information that may reasonably be inferred from contemporary inscriptions and documents and from the earliest written sources. These may be summarized as follows:

(i) Inscriptions. No works by Giorgione are signed, but two carry apparently contemporary inscriptions on their backs that both confirm their authorship and provide dates: the *Laura* (Vienna, Ksthist. Mus.; see fig. 1), dated 1506, and the *Portrait of a Man* (San Diego, CA, Mus. A.; see fig. 2). The date on the latter has been read by Pignatti (1969) as 1510, but the last two digits are badly abraded, and 1506 is equally possible.

(ii) Documents. Only two pairs of documents referring to Giorgione in his lifetime are known; a third pair dates from immediately after his death. All of them call him Zorzi (Venetian for Giorgio) da Castelfranco, thereby also naming his birthplace.

(a) Between August 1507 and January 1508 Giorgione painted a canvas for the Sala dell'Udienza (audience chamber) in the Doge's Palace, Venice. This work was almost certainly destroyed in one of the fires that gutted the palace in 1574 and 1577.

(b) In December 1508 Giorgione was paid for his recently completed fresco decoration of the façade of the Fondaco de' Tedeschi, the German warehouse next to the Rialto Bridge, Venice. By the 18th century the frescoes had faded badly; by the early 20th century a single, barely legible fragment of a *Female Nude* remained (detached 1937; Venice, Ca' d'Oro). Some idea of Giorgione's decorations may be gained from early descriptions by Vasari and others and from a series of engravings of individual figures (including the one corresponding to the surviving *Female Nude*) made in the 18th century by Anton Maria Zanetti (1706–78).

(c) In October 1510 the Marchesa of Mantua, Isabella d'Este, wrote to her agent in Venice asking him to acquire for her a picture of a night scene ('una nocte') by Giorgione. The agent replied that the artist had recently died of the plague; neither of the two night scenes known to him was available for purchase, and nor indeed were any other works by the artist. No surviving night scene by Giorgione is known.

(d) In March 1508 the silk merchant Jacopo di Zuanne was permitted by the Scuola di S Rocco to commission an altarpiece for a small chapel dedicated to the Cross in the church of S Rocco (Anderson, 1977). The work is identifiable with the *Christ Carrying the Cross* (Venice, Scu. Grande S Rocco), which must, therefore, date from 1508–9 (1509 being the recorded date of a dedicatory inscription). It is also frequently attributed to Titian, but the evidence both of the sources and of scientific examination tends to support an attribution to Giorgione.

(iii) Sources.

(a) Michiel. The *Notizie* (notebooks) of the Venetian patrician and connoisseur Marcantonio Michiel, compiled between 1521 and 1543, and containing descriptions of the most important private art collections in Venice, provide the most detailed and reliable source of information on the work of Giorgione. Three works listed by Michiel as by Giorgione are certainly identifiable with existing pictures: *The Tempest* (Venice, Accad.; see colour pl. 1, XXXIII2); the *Boy with an Arrow* (Vienna, Ksthist. Mus.) and the *Three Philosophers* (Vienna, Ksthist. Mus.; see fig. 3). Michiel added that the last painting was completed by Sebastiano del Piombo. A fourth work, the *Sleeping Venus* (Dresden, Gemäldegal. Alte Meister; see fig. 4), is generally identified with a picture attributed by Michiel to Giorgione, but of which he said that a figure of Cupid (now overpainted) and the landscape were completed by Titian; a minority of critics, however, attribute the work in its entirety to Titian. Greater doubts attach to the identification of a number of other works listed by Michiel, while several more are evidently lost. One of these, however, a *Finding (or Birth?) of Paris*, is recorded in an engraving of 1658 by David Teniers (1582–1649);

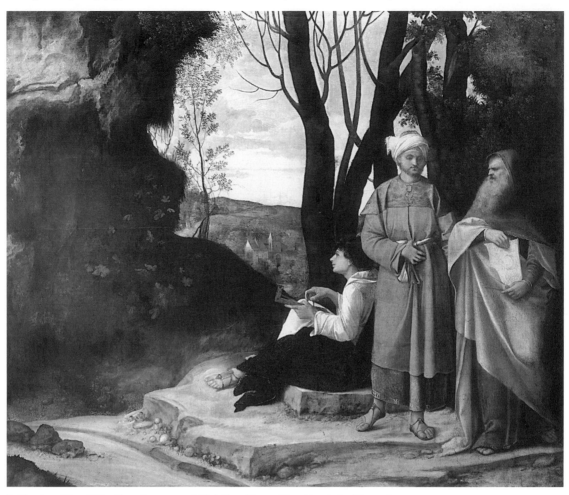

3. Giorgione: *Three Philosophers*, oil on canvas, 1.23×1.44 m (Vienna, Kunsthistorisches Museum)

and since Michiel specifies that this was an early work, the engraving provides a useful point of reference for other putative early works. In connection with another lost work, a *St James*, Michiel implies that he thought that the S Rocco *Christ Carrying the Cross* (see above) was by Giorgione.

Michiel's notes are chiefly of value for the guidance they provide on attributions to Giorgione, but they have also been used as a key to interpreting his subject-matter. Michiel is frequently vague about what Giorgione's pictures are supposed to represent, and it has sometimes been assumed—probably incorrectly—that this vagueness reflects a lack of clear intention of the part of the artist himself.

(b) Inventory of the collection of Domenico Grimani, 1528. This includes a *Self-portrait of Giorgione as David with the Head of Goliath*. The work is recorded in an engraving of 1650 by Wenceslaus Hollar (1607–77); a surviving painted fragment (Brunswick, Herzog Anton Ulrich-Mus.) is sometimes regarded as Giorgione's original, and sometimes as a copy. The reference to 'Zorzon' in the inventory provides the earliest known instance of the use of the nickname by which the artist has subsequently always been known.

(c) Vasari. The earliest biography of Giorgione was included in the first edition of Vasari's *Vite* (1550). It provides the generally accepted information that the artist was born in 1477 or 1478. A twin theme of the revised version of the biography in the second edition (1568) is that Giorgione was the first exponent of the *maniera moderna* in Venice, and that he formulated this under the direct inspiration of Leonardo da Vinci. Although the latter claim has often been dismissed as an example of Vasari's Tuscan chauvinism, and it is true that he does not properly explain how Giorgione came to know the art of Leonardo, the visual evidence tends to support the author's claim—despite the fact that his first-hand knowledge of Giorgione's works was evidently quite limited. Vasari did not, for instance, have access to the private collections described by Michiel, and two of the public works he described in the greatest detail—the high altarpiece of S Giovanni Crisostomo (*in situ*) and the *Storm at Sea* in the Scuola di S Marco (now Ospedale Civile; *in situ*)—he later (1568) gave to Sebastiano del Piombo and to Palma

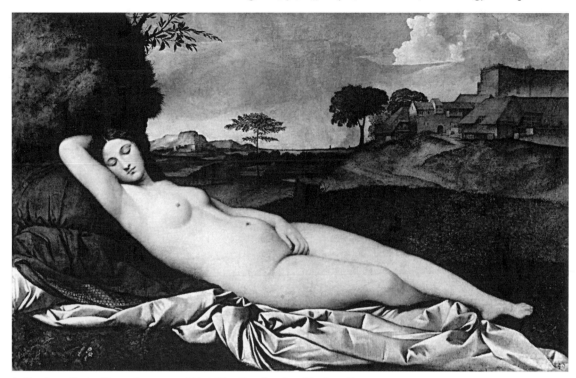

4. Giorgione: *Sleeping Venus*, oil on canvas, 1.09×1.75 m (Dresden, Gemäldegalerie Alte Meister)

Vecchio respectively. Although some scholars still hold that Giorgione was responsible at least for the design of these works, the documentary and circumstantial evidence tends to vindicate Vasari's change of mind in both cases. In the case of a third work discussed in detail, the S Rocco *Christ*, Vasari significantly retained his earlier attribution to Giorgione (although he inconsistently also gave it to Titian in his *Life of Titian*). Vasari also provided full accounts of the documented Fondaco de' Tedeschi frescoes and of another painted façade (untraced); and he lists a number of portraits by Giorgione, including the *Self-portrait as David*, and others that are no longer identifiable, including one of *Caterina Cornaro*, the ex-Queen of Cyprus.

(d) *Inventories of the Vendramin collection, 1567–9 and 1601 (see Ravà, 1920; Anderson, 1979b).* In addition to *The Tempest* already described by Michiel, these include the picture of an old woman identifiable as *La Vecchia* (Venice, Accad.) as a work by Giorgione. Another possible identification is *The Concert* (formerly called *Samson*) in the Mattioli private collection, Milan (see Ballarin, 1993 exh. cat.).

(e) *Ridolfi.* By the end of the 16th century, all first-hand memory of Giorgione had faded, and accounts of his life and work were increasingly coloured by myth. In his biography of Giorgione, Ridolfi (1648) listed no less than 66 attributions, very few of which had any basis in reality; a notable exception is the altarpiece that is still in the cathedral of Giorgione's home town of Castelfranco, the *Virgin Enthroned with SS George and Francis* (the Castel-franco Altarpiece; see fig. 5), a work unanimously accepted by modern criticism. Ridolfi may also have been correct in ascribing to Giorgione a number of further Venetian façade decorations, none of which survive.

2. STYLE, ATTRIBUTION, CHRONOLOGY.

(i) The problems. (ii) Building an oeuvre. (iii) Artistic achievement.

(i) *The problems.* If the severest criteria of attribution are adopted—that is to say, the acceptance of only those surviving works documented by early inscriptions or in contemporary sources—only four works, *The Tempest*, the *Boy with an Arrow*, the *Laura* and the *Portrait of a Man* in San Diego, can be said to qualify with a reasonable degree of certainty as wholly by Giorgione. Of the other certainly identifiable works listed by Michiel, the *Three Philosophers* and the Dresden *Venus* were described as having been completed by Sebastiano and Titian respectively, while his reference to the S Rocco *Christ Carrying the Cross* leaves room for doubt as to whether he was talking about the original or a pupil's copy.

The condition of these works is extremely variable. The *Laura* and the S Rocco *Christ*, for example, have each been severely abraded, and the former has been cut down by as much as a third at the bottom. On the other hand, the recent cleaning of the so-called *Three Ages of Man* (Florence, Pitti) seems to have laid to rest previous critical doubts about its quality, and hence its attribution to Giorgione (Lucco, 1989 exh. cat.). There also exists a handful of other undocumented works, including the *Judith* (St Petersburg, Hermitage), the Castelfranco Altar-piece and the *Portrait of a Young Man* (Berlin, Gemälde-

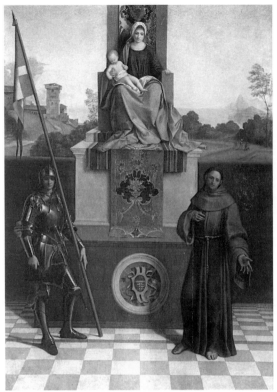

5. Giorgione: *Virgin Enthroned with SS George and Francis* (the Castelfranco Altarpiece), tempera on panel, 2.00×1.52 m (Castelfranco Veneto, S Liberale)

gal.), which virtually every modern critic agrees to be by Giorgione.

The basis for a chronology of Giorgione's work is equally insecure. Only the *Laura*, a relatively uninformative picture, bears a date; and a previously accepted dating of the Castelfranco Altarpiece to *c*. 1504, by reference to the tombstone of Matteo Costanzo, son of the probable patron of the work, has been shown to be undependable (Anderson, 1973). The loss of the documented painting for the Doge's Palace and the frescoes for the Fondaco de' Tedeschi (completed in 1508) present a particularly severe problem, since there is no secure alternative evidence of Giorgione's handling of large and complex figural compositions in the last three years of his life. The remaining fragment from the Fondaco provides little guidance, while the useful 18th-century engravings by Anton Maria Zanetti inevitably transpose Giorgione's originals with respect to medium, scale and Zanetti's own style.

When we realize that the early careers of Titian and Sebastiano, the other two leading painters to participate in the stylistic revolution of the period 1500–10, are even less well authenticated, it is easy to see why the attribution and chronology of works from this decade have provided so much room for dispute. Dogmatic assertions of attribution and dating are to be distrusted. The best the historian can accomplish is to recognize that a number of more-or-less internally consistent models for Giorgione's career can be constructed, and to accept with due qualification the model that sits least uncomfortably with the

evidence. It is unfortunate that the most consistent model(s) for Giorgione's oeuvre can cause difficulties for the construction of similar models for Titian, Sebastiano and their lesser contemporaries. If Giorgionesque works of major quality are ousted from the canon of Giorgione's paintings, for instance the *Concert champêtre* (Paris, Louvre; see colour pl. 2, XXXVI3), they need to be located satisfactorily within the careers of another master.

(ii) Building an oeuvre. The *Laura* of 1506 (see fig. 1 above), particularly as reconstructed on the basis of its depiction by David Teniers II in one of his interior views, the *Painting Gallery of Archduke Leopold William* (Madrid, Prado), demonstrates an amplitude of figure style and emotional subtlety that place Giorgione's style firmly within the characteristics of High Renaissance portraiture as pioneered by Leonardo and Raphael. The handling of the oil medium, allowing for the surface damage, exhibits delicate freedom and warm colourism. The selectively applied highlights are composed from thin ribbons and points of impasto, while the modelling of the flesh on the canvas support is achieved with broken touches of paint that tend to dissolve the linear boundaries of forms and permit a subdued radiance of light in the shaded areas. The San Diego *Portrait of a Man* (see fig. 2 above) similarly illustrates Giorgione's interest in exploiting the suggestive qualities of oil paint in such a way that the play of light on forms is evoked through painterly means. This effect is particularly apparent in the economical streaks of impasto that describe the man's untidy bunches of hair.

The evocation of light on surfaces through varied paint handling is also apparent in the Castelfranco Altarpiece (see fig. 5). The 'grainy' treatment of the lit and shaded areas of the Virgin's flesh—conveying a scattered radiance of colour—is contrasted with separate blobs of impasto in the strong highlights of the gold brocade and with the absorbent, matt quality of her green dress. However, such effects are achieved in a less fluent manner than in the *Laura*, and the medium has been identified as the relatively old-fashioned tempera. The figure style also displays a less developed technique than the *Laura* or the engravings after the Fondaco frescoes. The figures possess a delicate, almost 15th-century air, and the composition is assembled from a series of discrete units. Although the orthogonal lines of the perspective construction focus with fair precision on a single vanishing point (Castelfranco, 1955), the point lies at an improbably high position, and the deeper horizontal intervals of the tile pattern are erratically placed. There is no indication in Giorgione's other works that he was particularly concerned with accurate control of perspectival structures or with other aspects of correct *disegno* in the manner of Raphael and the Central Italian painters.

If Vasari was right in placing Giorgione's birthdate in 1477–8, his career is likely to have begun in the mid-1490s; in which case the manifestly early Castelfranco Altarpiece is likely to date from *c*. 1500 or even earlier. Often associated with this work are the *Holy Family* (Washington, DC, N.G.A.) and the *Adoration of the Magi* (London, N.G.), both of which exhibit the same virtues and defects. The suggestive delicacy of handling and colouristic delights foreshadow the later works, while the articulation of the

figures, insecurities of structure and assertive description of drapery folds provide unevenness of pictorial effect. Probable early portraits include the beguilingly romantic *Young Man* in Berlin and the youthful *Francesco Maria della Rovere* (Vienna, Ksthist. Mus.; see Ballarin, 1993 exh. cat.). More marginal attributions in this early period are the *Virgin and Child* in the Ashmolean Museum, Oxford (also occasionally, but improbably, dated later in his career; or else identified, and perhaps more plausibly, as the earliest surviving painting by Sebastiano); the *Judgement of Solomon* and the *Trial of Moses* (both Florence, Uffizi), closely related paintings that share many of the characteristics of 'early Giorgione' but are full of stylistic inconsistencies. The range of the inconsistencies in paint handling, figure type and facial expression (within each picture and between them) is so great as to make it difficult to assign them to one artist. They may be eclectic compilations of Giorgionesque motifs by one or more imitators of Giorgione's earlier style.

The most substantial and developed of the paintings which can be reconciled with the *Holy Family* and *Adoration of the Magi* is the Allendale *Adoration of the Shepherds* (Washington, DC, N.G.A.). Although it may have been subject to later additions (?the angels' heads), the refined sentimentality of the figures and meandering pastoral delights of the landscape represent a generally credible step in Giorgione's development. A further step may be represented by the *Judith* in the Hermitage, first attributed to Giorgione only in the 19th century but now almost universally accepted. Although some internal inconsistencies in handling and structure remain, they are subordinated to a colouristic and atmospheric unity that is characteristic of his mature work.

In March 1500 Leonardo is known to have paid a brief visit to Venice. Although Giorgione may well have already been acquainted with his work, the personal presence of Leonardo in the city seems to have made a strong impact on the Venetian, and two of his works that most explicitly approach Leonardo's style—the Vienna *Boy with an Arrow* and the Pitti *Three Ages of Man*—may probably best be dated to around this time. In both pictures, the half-length figures emerge from a dark background, with their forms softened by an unprecedentedly soft *sfumato*; while the latter—actually representing a musical subject—includes a contrast of physiognomic types that is strongly reminiscent of Leonardo.

Perhaps dating from an intermediate phase between these works and the *Laura* of 1506 are the crucial reference points of *The Tempest* (see colour pl. 1, XXXIII2) and the *Three Philosophers* (see fig. 3 above). Once allowance has been made for differences in figure scale and condition, *The Tempest* can probably be most readily aligned with the style of the *Laura*. The handling of paint in the flesh, foliage and architectural detail retains some of the characteristics of the Castelfranco Altarpiece. However, recent interpretations of the allegorical meaning of *The Tempest* have relied on a date no earlier than 1509. The small size of the work makes comparison with the Fondaco frescoes a hazardous undertaking, but the relatively simple and awkwardly articulated poses in *The Tempest* are difficult to reconcile with the phase of his career following his experiments with complex postures on a large scale in 1508.

Whether we date *The Tempest* to *c.* 1505–6 or 1509 makes a radical difference to our model of the final phase of his career. If the earlier date is accepted, the way is open for a 'late' style that could include such works as the *Concert champêtre* and the *Virgin and Child with SS Roch and Anthony* (Madrid, Prado; see colour pl. 1, XXXIII1); or, according to an alternative model, the Mattioli *Concert* and the *Two Singers* (Rome, Gal. Borghese). A late date for *The Tempest* leaves little room for any of these pictures and, indeed, presents considerable problems with respect to the San Diego *Portrait*, the S Rocco *Christ* and the generally attributed *La Vecchia*. On balance, it seems that fewer problems are created by a rather earlier dating for *The Tempest*.

It might seem obvious that the paintings apparently completed by Sebastiano and Titian, the *Three Philosophers* and *Sleeping Venus* (see fig. 4 above), would be late works, left unfinished on Giorgione's death. However, a late date for Giorgione's part in the *Three Philosophers* is difficult to sustain, since the relatively simple poses seem to belong to his work before the Fondaco frescoes. The element in this picture that speaks most clearly of Sebastiano's vision is the seated figure, in which the attempt to describe the structure of facial features and hands appears to belong more with his concept of form. The *Venus*, by comparison, can be reconciled with the surviving fragment of the Fondaco decoration and represents a figure style of considerable rhythmic sophistication. The landscape in this latter picture may be regarded as characteristically Titianesque (even if one does not accept the minority attribution of the whole work to Titian), and it is possible that the rather waxy folds of the white cloth were also contributed by the younger master.

If *La Vecchia* joins the S Rocco *Christ* in the last two years of Giorgione's life, his 'late' style may be characterized as exploiting a highly individual form of suggestive realism. In this he may have been responding both to the works painted by Albrecht Dürer (1471–1528) on his second visit to Venice and to the increased Venetian awareness of Central Italian art, as reflected at this time in Sebastiano's work. The directness of Giorgione's 'late realism' is, however, more apparent than actual. He remains resolutely attached to the inference of form through a painterly evocation of light and colour. The descriptive *La Vecchia* is a partial exception to this rule, but it is a subject that makes specific, descriptive demands and may be one of his most direct responses to Dürer's paintings.

If the problematic *Concert champêtre* (see colour pl. 2, XXXVI3) is indeed by Giorgione, it too must belong to the last phase of his brief career. Many critics—perhaps the majority of present-day authorities—prefer to see this picture as an early work by Titian; and indeed, there are numerous points of stylistic contact with the documented frescoes in the Scuola del Santo, Padua, of 1510–11 and with several other works universally attributed to him. Such critics argue that none of Giorgione's extant pictures show a comparable complexity of figure composition or dominance of the figures over their landscape surroundings. But dealing with an artist of such genuinely revolu-

tionary qualities as Giorgione, the historian is extremely unwise to draw rigid boundaries round the possible parameters of his style; and on balance, it seems more reasonable to side with those critics who see the pervasively poetic mood of the *Concert champêtre* as intrinsic to Giorgione's own artistic personality and foreign to the more extrovert Titian. In either case, the picture may be regarded as the most advanced and complex manifestation of the traits apparent in *The Tempest* and the Fondaco fresco, and as a seminal work in the Giorgionesque revolution in form, colour, meaning and expression.

(iii) Artistic achievement. It would also be misleading to allow the historical problems of reconstructing Giorgione's career to obscure the quality and nature of the revolution that he led during the first decade of the century. Giorgione took the first steps in the realization of the potential for oil paint to be handled in a manner that did not suppress its qualities as paint. Rather, he used varied paint application to evoke a coherent visual world of light and colour. He inaugurated a tradition of painterly colour that could stand as an alternative to the Florentine tradition in general and Leonardo's system of light and shade in particular. Although Vasari attributed Giorgione's 'soft-focus' effects to Leonardo's influence, the Venetian achieved his qualities quite differently. Instead of the systematic veiling of colour and form found in Leonardo's paintings, Giorgione used broken touches in the highlights and radiant, even hot, tones in the shadows to achieve a suggestive impression of the elusiveness of light and colour in the natural world. The pictorial unity achieved through paint and colour was placed in the service of a new form of unity between man and nature. The encyclopedic rapture for exquisitely painted natural detail that characterized Giovanni Bellini's *St Francis in Ecstasy* (c. 1480; New York, Frick) has given way to a sense in which the figures and landscape belong together—in the same atmosphere, the same light and within a single, credible scene, rather than as an aggregate of separate observations.

These forms of unity were essential in Giorgione's new forms of expression. The small, enigmatic, poetic pictures, which have always been regarded as most archetypally Giorgionesque, rely for their effect on the deliberate subversion of explicit narrative or overt symbolism in favour of a prevailing mood. His paintings were clearly made to appeal to what may be called a romantic sensibility. The ability of his (?predominantly young) patrons to attune themselves to the romantic mood is likely to have been more important to both artist and patron than any more literal meanings that the paintings may have possessed.

3. INTERPRETATION OF MEANING. The problems of reading the content of Giorgione's pictures extend beyond the obvious question of finding textual keys to their narrative or symbolism. In some instances we cannot even be sure what kind of interpretative key we require. In the extreme case of *The Tempest*, the work has been variously interpreted as a mythology (e.g. 'The Infancy of Paris', Richter, 1937), as a religious painting (e.g. 'The Legend of St Theodore', de Grummond, 1972), as an allegory of Virtues (Wind, 1969), as referring to events in

Venetian history (Howard, 1985, and Kaplan, 1986) and as a free poetic invention with no preconceived subject.

It cannot be doubted that Giorgione possessed an unusual attitude to subject-matter. Even the apparently straightforward Castelfranco Altarpiece departs from the norms in the illogicality of its architectural setting, its prominent pastoral features, the uncanonical colour scheme and the languorous romanticism of the saints. Even when his various frescoes on the façades of Venetian houses and palaces were still plainly visible, early commentators such as Vasari found them difficult to interpret; it is clear, nevertheless, that their iconography was based on a range of mythological and literary sources similar to that of his cabinet paintings. In these smaller-scale, private paintings his treatment of subject-matter often appears to be almost wilfully subversive. The picture called by Michiel the *Birth of Paris*, for example (untraced but reliably recorded in a copy by David Teniers II), has been called by others the *Finding of Paris*, but actually it corresponds precisely to neither incident in Paris's infancy. Rather it works a free pastoral variation on the theme of Paris as a baby in nature, accompanied by the two shepherds, an elderly flute-player, a scantily-dressed woman and other figures indulging in rural dalliance. It is a fantasia around the theme, much in the manner of a musical fantasia or improvised poem.

Giorgione's pictures of single, half-length or bust-length figures are equally original. He seems to have invented the romantic image of androgynous boys in the possible guise of cupid or shepherd (e.g. the Vienna *Boy with an Arrow*). Novel formats for portraits include those showing the sitter with his back to the viewer, as in the *Man in Armour* (Vienna, Ksthist. Mus.), and/or accompanied by a secondary figure, such as a page. There is no precedent for his *Self-portrait with the Head of Goliath*, with its enigmatic combination of introspective melancholy and outward challenge. The two paintings that present the severest problems of interpretation are the *Three Philosophers* and *The Tempest*. It is disconcerting that Michiel, who almost certainly had direct access to the original patrons of some of Giorgione's pictures, should provide such limited clues. The former painting is described as 'philosophers in a landscape, two standing and one sitting who contemplates the rays of the sun with that rock executed so miraculously', and the latter as 'the small landscape on canvas with the storm, with the gypsy and soldier'.

The *Three Philosophers* (see fig. 3 above) was to be found in the house of Taddeo Contarini, who also owned Bellini's *St Francis in Ecstasy*. Although Bellini's picture may have entered Contarini's collection after Giorgione's death, it is tempting to view Giorgione's painting as a homage to (and ?criticism of) the *St Francis*. In any event, a comparison assists in interpreting the subject of Giorgione's work. Bellini's painting is deeply involved with light: the brilliant natural light of the landscape and the burst of divine light that attracts the saint's rapture. Giorgione's seated philosopher similarly seems to be the privileged witness to a directional shaft of light from the top left of the picture. Given Giorgione's oblique treatment of standard subjects, it becomes feasible to interpret the figures as the three biblical Magi who are about to embark on the first steps towards their mission.

The meaning of *The Tempest* (see colour pl. 1, XXXIII2) is one of the *causes célèbres* of art history. The problems have only been exacerbated by the evidence of the X-ray examination (Morassi, 1939), which showed Giorgione's remarkably free approach to the setting-up of the subject: a seated female nude was revealed to lie beneath the standing male figure on the lower left-hand side. The main recent tendencies in interpretation have been to approach *The Tempest* as an allegory, either in pure terms or as applied to contemporary events. Wind's allegorical interpretation would have us see two virtues—*fortezza* (Strength, symbolized by the broken columns) and *carità* (Charity, suckling a child)—under threat from the vagaries of *fortuna* (Fortune as a storm, in terms of the shared meaning of the word). The political interpretations broadly accept this approach but additionally identify the buildings as making reference to a specific city. Kaplan (1986) identifies the small, barely discernible heraldic motifs on the buildings as the Venetian lion and the Paduan *carro* (the largely obsolete heraldic device of a carriage used by the da Carrara rulers) and accordingly reads the whole composition as an allegory of the recapture of Padua from imperial troops in 1509. Even by Giorgione's standards, these heraldic motifs are so hidden and the *carro* so recondite a motif as to cast doubt on whether the whole meaning of the picture could hinge on their being noticed.

In the face of such arcane complexities, the return by Settis (1978) to an interpretation of the work as a relatively straightforward episode from the Old Testament, or by Büttner (1986) as a mythology (Ceres and Iasion), have an obvious appeal. Yet no literal interpretation of this kind has ever won general acceptance, and perhaps the most satisfactory way of approaching *The Tempest* and similar Giorgionesque pictures is to regard them as poems in paint, or *poesie*. That is to say, the painter and his public regarded them as visual analogues to poetry and as sharing much of poetry's generic content (pastoral, amatory, mythological etc.). Further, while the painting might evoke, or allude to, a particular text or range of texts, it was not intended as a precise textual illustration. On the contrary, the task of the painter, like that of the writer, was to create a new, and ultimately autonomous, poetic invention (Anderson).

4. GIORGIONE AND HIS PUBLIC. The private, domestic nature of Giorgione's art, and the difficulty of his subject-matter, implies that he was supported by a type of patronage very different from that traditional in late 15th-century Venice, which was devoted to large-scale religious works and, on a more intimate scale, to Madonnas and other half-length devotional subjects. Vasari's remark that Giorgione began his career by painting Madonnas and portraits—pictures of a type associated with Giovanni Bellini—before moving on to his more original subjects seems inherently plausible; so, too, is Ridolfi's information that in his early career Giorgione decorated pieces of furniture with mythological themes drawn from Ovid, furniture-painting being the one context in which older painters such as Bellini and Cima had previously represented secular subjects.

It appears that Giorgione began by painting relatively conventional small-scale works for an existing market and then developed a radically novel range of subject-matter as a taste for his art grew among collectors. His portraits, with their emphasis on private thoughts and emotions rather than public image, evidently struck an increasingly sympathetic chord with a new generation of Venetians. Michiel provides the names of the collectors who owned pictures by Giorgione in the 1520s and 1530s, and modern research has succeeded in unearthing a certain amount of information about some of them. Giovanni Ram, for example, who owned the *Boy with an Arrow*, was a Catalan merchant and also owned pictures by Titian, Rogier van der Weyden (1399–1464) and Jan van Scorel (1495–1562); while Andrea Odoni, who owned an untraced *St Jerome in a Moonlit Landscape* by Giorgione, and whose portrait by Lorenzo Lotto is now at Hampton Court, England (*see* LOTTO, LORENZO, fig. 3), was a connoisseur and antiquary from a wealthy mercantile family of Milanese origin. But it is not clear how many of such collectors actually commissioned their works from Giorgione: thus, while Ram may have, Odoni certainly did not. The only collector in Michiel's list whom we know definitely to have had direct contact with Giorgione was the original owner of the *Three Philosophers* and the *Finding of Paris*, Taddeo Contarini, since he is mentioned in the correspondence of Isabella d'Este in 1510 as the owner of a night-piece by the artist. Settis (1978) was almost certainly correct to identify him as Taddeo di Niccolò Contarini (1466–1540), a wealthy patrician merchant and the brother-in-law of another early owner of pictures by Giorgione, Gabriele Vendramin (1484-1552). Vendramin was the owner of a thriving soap-works as well as of an important art collection that included *The Tempest* and *La Vecchia*; and although still young at the time of Giogione's death, it may well be that he, too, was a direct employer of Giorgione.

The identification of such individuals has obvious relevance for the interpretation of Giorgione's subject-matter; too little, however, is known of the cultural and intellectual interests even of Contarini and Vendramin to permit definite conclusions to be drawn in this connection. Some critics have claimed that they were steeped in humanist learning, and that they are likely to have encouraged a type of art that was self consciously recondite, incorporating complex philosophical ideas that would have been comprehensible only to an intellectual élite. Other critics, however, have pointed out that they were not in the first place academics but merchants and administrators, and that they are more likely to have regarded their collections as an undemanding source of pleasure and of relaxation from the cares of business.

The only other direct employer of Giorgione about whom some information is known is Tuzio Costanzo, the donor of the Castelfranco Altarpiece. Costanzo was a Sicilian *condottiere*, who entered the service of Queen Caterina Cornaro in Cyprus and then accompanied her to her court in exile at Asolo, not far from Giorgione's birthplace in the Veneto. Since Vasari mentions that Giorgione painted a portrait of the ex-Queen, and also that he possessed musical accomplishments much in demand at social gatherings, several critics have inferred that the painter was in close contact with the court at Asolo, and also therefore with the various poets and

intellectuals who met there, including the celebrated Pietro Bembo and others associated with the currently fashionable vogue for pastoral poetry. The prominence of landscape in so many of Giorgione's works, and their characteristic mood of mystery and poetry, have thus often come to be interpreted as painted equivalents of such contemporary literary successes as Jacopo Sannazaro's *Arcadia* (Wittkower, 1963). Yet here again, Giorgione's supposed contacts with the literary circle at Asolo are by no means proved, and other critics consider that the mood of Arcadian nostalgia, which does indeed appear in certain Venetian paintings of the period, is actually foreign or peripheral to the central works of Giorgione's maturity. Such critics point out that Bembo's collection in Padua, which is also described by Michiel, did not contain any works attributed to Giorgione himself.

II. Working methods and technique.

With his concentration on small-scale works with subjects that closely reflected the personal interests of particular clients, Giorgione had no need of a large-scale, well-organized workshop of the kind run by Giovanni Bellini and later by Titian. It is possible, in fact, that he had no direct pupils at all, and that he only employed assistants in the context of fresco painting. Even so, Titian seems to have been employed at the Fondaco de' Tedeschi as an independent master rather than as an assistant; and Michiel's remark that Titian was responsible for completing the *Sleeping Venus* (see fig. 4 above) should probably be interpreted as meaning that he did so after Giorgione's death rather than as a pupil in his shop.

The highly personal and innovative character of Giorgione's pictorial technique was not, in any case, one that would easily have lent itself to the use of studio assistants. In his *Life of Titian*, Vasari correctly identifies the essence of Giorgione's technical revolution as a method of creating form directly out of colour, dispensing with preparatory drawings on paper. This is in complete contrast to the traditional method as practised in Venice by Giovanni Bellini, where the exact position of every major form had been carefully worked out in the preliminary design, and the paint was then applied methodically in thin, flat layers, with the colour planes remaining strictly within their predetermined contours. Bellini had made use of the newly introduced oil medium to achieve a greater luminosity of colour and a greater softness of tonal transition; but it was Giorgione who first realized the full versatility and malleability of the medium, applying the paint unevenly and expressively, making the forms seem to emerge out of, and to fuse with, one another, thus evolving his composition in the very process of pictorial execution. Although Giorgione sometimes used the traditional panel support, particularly in apparently early works such as the Castelfranco Altarpiece (see fig. 5 above) and the St Petersburg *Judith*, he increasingly turned to canvas, with its comparatively rough, textured surface, as the natural complement to his expressive brushwork and impastoed highlights.

Many aspects of Giorgione's innovative technique are evident to the naked eye, but our knowledge of it has been considerably expanded by the scientific tests made on a number of his pictures during the course of the last half-century. X-ray photographs have proved to be particularly informative, since by penetrating the upper paint layers, they have revealed the artist's often quite radical changes of mind (pentiments) during the course of execution. An exceptionally dramatic case is that of *The Tempest* (see colour pl. 1, XXXIII2), with the revelation that a female nude had been replaced by a standing male figure (*see* §I, 3 above). But other, more recently developed methods of analysis, such as infra-red photography and the study of paint layers in cross-section, have revealed new information about Giorgione's technique that is hardly less relevant to the broader problems of chronology, attribution and meaning. Tests on the Castelfranco Altarpiece undertaken in 1978, for example, have shown that in many aspects of its technique (including the use of tempera) it remains a comparatively traditional work and hence is likely to have preceded the much more radically experimental *Tempest*; while the tendencies in the latter towards a freer and more direct application of paint, and towards a more restricted palette, are taken further in *La Vecchia*, suggesting that this may be even later in date. *La Vecchia* is very close technically to the S Rocco *Christ*, a work that is often attributed to Titian but which lacks the much more complicated pictorial structure and extraordinarily wide colour range of an undisputed early work by Titian such as the *St Mark Enthroned* (Venice, S Maria della Salute; see Lazzarini, 1978 exh. cat.).

However, the technical evidence regarding dating and attribution is rarely conclusive and is just as open to differing interpretations as traditional methods of stylistic analysis. Scientific investigation of the *Concert champêtre*, a notoriously problematic work, has merely fuelled the controversy about whether it is by Giorgione, Titian or by the two artists in collaboration. Equally controversial is the interpretation of Giorgione's intentions regarding his subject-matter on the basis of pentiments revealed by X-rays. Thus, for some critics the replacement of a female nude with a clothed male in *The Tempest* proves that Giorgione approached his subjects in a spirit of pure fantasy; while for others the female nude is merely an earlier version of the gypsy figure that the painter subsequently decided to place on the right of the composition.

In view of Giorgione's technical procedures, it is only to be expected that drawings by him should be extremely rare. The only universally accepted example is a *?Shepherd in a Landscape* (Rotterdam, Mus. Boymans–van Beuningen); the recent revelation that the city walls in the background do not represent, as was previously thought, the artist's home town of Castelfranco, but rather Montagnana, does not seem to have shaken confidence in the attribution. The drawing, which is not connected with any known picture, is executed in red chalk, a medium that lends itself perfectly to the kind of suggestive *sfumato* also found in Giorgione's handling of paint. A number of other drawings have also been attributed to Giorgione with varying degrees of plausibility; and it has also been suggested that certain engravings by Giulio Campagnola and Marcantonio Raimondi are based on designs by Giorgione (Oberhuber in Levenson, Oberhuber and Sheehan, 1973; Oberhuber, 1993 exh. cat.). But the whole field of Venetian drawing and engraving in the early decades of

the 16th century is highly problematic; and the suggestion, which also carries implications for the study of Giorgione's chronology, remains controversial.

III. Critical reception and posthumous reputation.

Giorgione's impact on Venetian painting was sudden and profound. Although his work may have been little known outside an inner circle of connoisseurs as late as *c.* 1507, it was so highly prized by the time of his death in 1510 that Isabella d'Este in Mantua was unable to acquire a single example of it. For a brief spell between *c.* 1508 and the definitive emergence of Titian *c.* 1516 as the new artistic leader, Giorgione's influence dominated Venetian painting. Not only were Venice-based painters such as Sebastiano del Piombo, Lorenzo Lotto, Palma Vecchio, Giovanni Cariani and Paris Bordone all deeply influenced by his example, but so too were other North Italians, such as the Brescian Giovanni Girolamo Savoldo and the Ferrarese Dosso Dossi. The most important of the Giorgioneschi was Titian himself, of whom Vasari observed that he succeeded in imitating the manner of Giorgione so well that it was often difficult to distinguish their hands. The truth of the remark is borne out by the lively controversy that still surrounds the attribution of such works as the *Concert champêtre*. Even after the superficial aspects of Giorgionism had disappeared from Titian's work, such as the treatment of themes connected with music, poetry and love, more fundamental aspects remained, such as the new painterly freedom of technique; and through Titian they became a vital force in the wider European tradition.

Giorgione was already recognized as one of the great painters of modern times in Baldassare Castiglione's *Il libro del cortegiano* (1528), where he is listed together with Leonardo, Raphael, Mantegna and Michelangelo. He appears in similarly exalted company in Paolo Pino's *Dialogo di pittura* (1548), where he is presented as the hero of Venetian pictorialism, practising a style of dazzling verisimilitude. It is again this aspect of Giorgione that received the highest praise from Vasari, who, although disapproving of his method of painting without drawing, regarded the innovative softness and suggestiveness of his handling as admirably natural; and Vasari paid him the high compliment of placing his Life close to the beginning of Part III of the *Vite*, between those of the other great pioneers of the *maniera moderna*, Leonardo and Correggio. Vasari also provided some of the basic ingredients of the 'myth of Giorgione' by describing him as a person of gentle and courteous manners, fond of social gatherings where his talents as a singer and lutenist were much in demand, and whose love of a lady brought him to his premature grave. Carlo Ridolfi (1648), while as a fellow-Venetian intent on defending Giorgione from Vasari's Tuscan-inspired strictures on his technique, took over and elaborated on the romantic aspect of the Giorgione legend, portraying him as a poet of the paint brush, who re-created in his pictures an Ovidian Golden Age, with happy men and women dallying among pleasant pastures and shady groves. Consistent with this alluring image is the attribution of the *Concert champêtre* to Giorgione in the earliest certain

mention of this picture, in the inventory made by Jean-Baptiste-Pierre Le Brun (1748–1813) of the collection of Louis XIV (*reg* 1643–1715) in the later 17th century.

Giorgione and the mystery associated with him was predictably a subject of the deepest fascination to the 19th-century Age of Romanticism. Lord Byron was instrumental in having the *Judgement of Solomon* (Kingston Lacy, Dorset, NT) brought to England—a work now almost universally attributed to Sebastiano del Piombo but which was authoritatively listed by Ridolfi as by Giorgione. John Ruskin (1819–1900), closely identifying Giorgione with the spirit of Venice itself, made him a hero of Book V of *Modern Painters* (1860)—without, however, knowing a single example of his work. The climax of this romantic, intuitive approach is marked by Walter Pater's essay 'The School of Giorgione' (1877), a poetic evocation of the spirit of Giorgionism, in which Giorgione's art is made the basis for the famous dictum of the Aesthetic Movement that 'all art constantly aspires towards the condition of music'. Yet even before Pater had written his essay, a new approach to the artist had begun to take shape, founded on more objective criteria. Michiel's *Notizie* had been rediscovered and published as early as 1800, and during the course of the 19th century several of the most important pictures attributed to Giorgione by Michiel, including *The Tempest*, came to public attention for the first time. The process of stripping away the layers of legend accumulated over centuries, and of attempting to establish an authentic corpus, was begun by J. A. Crowe and Giovanni Battista Cavalcaselle (1871), who now reattributed the *Concert champêtre* to Sebastiano del Piombo and replaced it with *The Tempest* and the *Three Philosophers* as the essential touchstones for all attributions to Giorgione. Their approach was continued by Giovanni Morelli, who first reidentified the Dresden *Venus* (1880) and who made a number of convincing new attributions on the basis of this radically revised image of Giorgione's art.

Giorgione studies in the earlier part of this century were characterized mainly by disputes between 'expansionist' critics such as Ludwig Justi (1908), who was able to reconcile a rather large number of works with the newly redefined image of the artist, and the 'contractionist' critics such as Tancred Borenius (editor of Crowe and Cavalcaselle, 1912) and Louis Hourticq (1919), who were unable to accept more than the canonical handful. The severe problems of interpretation posed by Giorgione's pictures also divided critics into a quite different pair of opposing camps, according to whether they agreed with Pater in viewing them as purely lyrical utterances, analogous to music, without any literary subject (Venturi, 1913), or whether, on the contrary, they regarded them as dense with learned allusions, the meaning of which would become clear once the right key was found (Ferriguto, 1933; Wind, 1969).

The considerable amount of scholarly discussion generated by the celebrations of the fifth centenary of Giorgione's birth in 1978 showed that these debates are far from settled. Indeed, new archival research on the artist's patrons and new methods of scientific investigation of his pictures have in many ways made the problems even more complex. Another result of the centenary year

was to throw into relief another growing dichotomy in Giorgione studies, this time relating to an assessment of his place in the history of art, and of the very nature of his creative achievement. One view, perhaps best represented by an essay by Rudolf Wittkower (1963), and tending to be shared by northern European and American scholars, takes an Arcadian view of Giorgione and retains a certain sympathy for the romantic interpretation of Walter Pater. According to this view, Giorgione is a painter of poetic, dream-like idylls that evoke a bittersweet nostalgia for a far-off Golden Age; artistically he is the forerunner of Claude (1604/5–82) and Watteau (1684–1721). His most characteristic work is the Dresden *Venus*, and even if the *Concert champêtre* is not actually by him, it is a perfect specimen of the Giorgionesque spirit. Against this view is one developed by Roberto Longhi during the 1930s, and now shared by the overwhelming majority of Italian scholars, which insists that the *Concert champêtre* is entirely characteristic of the 'chromatic classicism' of the early Titian and has nothing whatever to do with Giorgione. Returning to Vasari, Longhi (1946) dismissed as fanciful the stories of lutes and love and concentrated instead on Vasari's praise of Giorgione's verisimilitude. For Longhi, Giorgione's greatness lay in a powerful naturalism, which led not to Claude and Watteau but through Lombard painting to Caravaggio (1571–1610) and Velázquez (1599–1660).

In 1978 (conferences at Castelfranco and Venice) Carlo Volpe expanded upon and reinforced Longhi's interpretation, referring to the *Self-portrait as David*, with its melancholy expressiveness and the gruesome trophy of the decapitated head, to the shadowy, introverted San Diego *Portrait of a Man*, to the veristic *La Vecchia*, and to the Pitti *Three Ages of Man* as all central to a proper understanding of the artist. Similarly Alessandro Ballarin (at Castelfranco in 1978 and in 1993 exh. cat.) has redefined the character of Giorgione's late work by insisting on the correctness of Longhi's attributions to the master of the Borghese *Singers* and the Mattioli *Concert*. There is clearly much in this view that the opposing camp does not properly take into account; few critics would deny, for instance, that a fundamental work such as *The Tempest* is characterized rather by brooding disquiet than by idyllic serenity. Yet the Longhian view is equally one-sided and chooses to ignore the gentle languor of the equally fundamental Dresden *Venus*, which, somewhat perversely, it tends to attribute to Titian. Giorgione's artistic personality thus remains far from clearly defined, even after a century of investigation by modern art-historical methods. But it is perhaps a measure of his range and greatness, as well as of his expressive ambiguity, that his work should have given rise to such diverse but creative interpretations by other artists in the past and by historians in the present.

BIBLIOGRAPHY

EARLY SOURCES

M. A. Michiel: Venice, Bib. N. Marciana, Ital. XI 67 (7351), pub. as *Notizia d'opere di disegno nella prima metà del secolo XVI* (MS.; 1521–43); *Notizie d'opere di disegno* (MS.; *c.* 1520–40); ed. G. Frizzoni (Bologna, 1884); Eng. trans. by P. Mussi, ed. G. C. Williamson as *The Anonimo* (London, 1903/R New York, 1969)

P. Pino: *Dialogo di pittura* (Venice, 1548); ed. R. Pallucchini and A. Pallucchini (Venice, 1946)

G. Vasari: *Vite* (1550, rev. 2/1568); ed. G. Milanesi (1878–85), iv, pp. 91–100 [*Giorgione*]; vii, pp. 425–8 [intro. to *Life of Titian*]

C. Ridolfi: *Meraviglie* (1648); ed. D. von Hadeln (1914–24)

M. Boschini: *Le miniere della pittura veneziana* (Venice, 1664)

A. M. Zanetti: *Della pittura veneziana* (Venice, 1771)

GENERAL

J. A. Crowe and G. B. Cavalcaselle: *A History of Painting in North Italy* (London, 1871, rev. T. Borenius, 1912)

W. Pater: *The Renaissance: Studies in Art and Poetry* (London, 1877, rev. 4/1893; ed. D. L. Hill, Berkeley, 1980) [incl. 'The School of Giorgione' of 1877]

I. Lermolieff [G. Morelli]: *Die Werke italienischer Meister in den Galerien von München, Dresden und Berlin* (Leipzig, 1880)

L. Hourticq: *La Jeunesse de Titien* (Paris, 1919)

H. Tietze and E. Tietze-Conrat: *The Drawings of the Venetian Painters in the 15th and 16th Centuries*, 2 vols (New York, 1944)

R. Longhi: *Viatico per cinque secoli di pittura veneziana* (Florence, 1946)

K. Clark: *Landscape into Art* (London, 1947)

C. Gilbert: 'On Subject and Not-subject in Italian Pictures', *A. Bull.*, xxxiv (1952), pp. 202–16

E. H. Gombrich: 'The Renaissance Artistic Theory and the Development of Landscape Painting', *Gaz. B.-A.*, xli (1953), pp. 335–60; also in E. H. Gombrich: *Norm and Form* (London, 1966), pp. 107–21

A. R. Turner: *The Vision of Landscape in Renaissance Italy* (Princeton, 1966)

S. Freedberg: *Painting in Italy, 1500–1600*, Pelican Hist. A. (Harmondsworth, 1971)

J. Levenson, K. Oberhuber and J. Sheehan: *Early Italian Engravings from the National Gallery of Art* (Washington, DC, 1973)

T. Pignatti: 'The Relationship between German and Venetian Painting in the Late Quattrocento and Early Cinquecento', *Renaissance Venice*, ed. J. Hale (London, 1973), pp. 244–73

J. Wilde: *Venetian Art from Bellini to Titian* (London, 1974)

D. Rosand: *Painting in Cinquecento Venice* (New Haven, 1982)

L. Lazzarini: 'Il colore nei pittori veneziani tra il 1480 e il 1580', *Bull. A.*, 6th ser., no. 5 (1983), suppl., pp. 135–44

M. Lucco: 'Venezia fra quattro e cinquecento', *Storia dell'arte italiana*, v (1983), pp. 447–77

J. Shearman: *The Early Italian Pictures in the Collection of Her Majesty the Queen* (Cambridge, 1983) [attrib. of Hampton Court *Shepherd* to Titian]

N. Huse and W. Wolters: *Venedig: Die Kunst der Renaissance* (Munich, 1986); Eng. trans. as *The Art of Renaissance Venice* (Chicago, 1990)

M. Lucco: 'La pittura a Venezia nel primo cinquecento', 'La pittura nelle provincie di Treviso e Belluno', *La pittura in Italia: Il cinquecento*, 2 vols, ed. G. Briganti (Milan, 1987, rev. 1988), i, pp. 149–70, 197–218

H. Wethey: *Titian and his Drawings* (Princeton, 1988)

P. Humfrey: *Painting in Renaissance Venice* (New Haven and London, 1995)

MONOGRAPHS, EXHIBITION CATALOGUES, SYMPOSIA, COLLECTIONS OF ESSAYS

C. Justi: *Giorgione* (Berlin, 1908)

L. Venturi: *Giorgione e il Giorgionismo* (Milan, 1913)

A. Ferriguto: *Attraverso i misteri di Giorgione* (Castelfranco, 1933)

G. M. Richter: *Giorgione da Castelfranco* (Chicago, 1937) [with cat., illus., doc. and bibliog. to 1936]

Giorgione e i giorgioneschi (exh. cat. by P. Zampetti, Venice, Accad., 1955); review by G. Robertson in *Burl. Mag.*, xcviii (1956), pp. 272–7

V. Lilli and P. Zampetti: *Giorgione*, Class. A., xvi (Milan, 1968) [with cat. and illus., many in colour]

E. Wind: *Giorgione's 'Tempesta'* (Oxford, 1969)

T. Pignatti: *Giorgione* (Venice, 1969, rev. 1978; Eng. trans. 1971) [with cat., doc., bibliog. and illus., some in colour]

Giorgione a Venezia (exh. cat. by A. A. Ruggeri, Venice, Accad., 1977)

Ant. Viva, xvii/4–5 (1978) [issue devoted to Giorgione]

L. Mucchi: *Caratteri radiografici della pittura di Giorgione* (Florence, 1978)

S. Settis: *La Tempesta interpretata* (Turin, 1978); Eng. trans. as *Giorgione's 'Tempest': Interpreting the Hidden Subject* (Chicago, 1990)

La Pala del Castelfranco (exh. cat. by L. Lazzarini, Castelfranco Veneto, Casa Giorgione, 1978)

Giorgione: Atti del convegno internazionale di studio per il 5 centenario della nascita: Castelfranco Veneto, 1978

Giorgione e la cultura veneta tra '400 e '500: Atti del convegno: Roma, 1978

Giorgione e l'umanesimo veneziano: Atti del convegno: Venezia, 1978

R. C. Cafritz, L. Gowing and D. Rosand: *Places of Delight: The Pastoral Landscape* (Washington, DC, 1988)

A. Parronchi: *Giorgione e Raffaello* ([Bologna], 1989)

'Le tre età dell'uomo' della Galleria Palatina (exh. cat., Florence, Pitti, 1989)

Leonardo and Venice (exh. cat., ed. P. Parlavecchia; Venice, Pal. Grassi, 1992)

Le Siècle de Titien (exh. cat., Paris, Grand Pal., 1993)

R. Maschio: Tempi di Giorgione (Rome, 1994)

M. Lucco: Giorgione (Milan, 1995)

J. Anderson: Giorgione: The Painter of "Poetic Brevity" (Paris, 1997)

SPECIALIST STUDIES

C. Ravà: 'Il camerino delle anticaglie di Gabriele Vendramin', Nuovo Archv Ven., n. s., xxxix (1920), pp. 155–81 [1567–9 inventory of Vendramin collection]

P. Paschini: 'Le collezioni archeologiche dei prelati Grimani del cinquecento', Rendi. Pont. Accad. Romana Archeol. (1926–7), pp. 149–90

J. Wilde: 'Röntgenaufnahmen der Drei Philosophen Giorgiones und der Zigeunermadonna Tizians', Jb. Ksthist. Samml. Wien, vi (1932), pp. 141–54

A. Morassi: 'Esame radiografico della Tempesta', Arti: Rass. Bimest. A. Ant. & Mod., i (1939), pp. 567–70

C. Gamba: 'Il mio Giorgione', A. Ven., viii (1954), pp. 172–7

G. Castelfranco: 'Note su Giorgione', Boll. A., xl (1955), p. 298

H. Ruhemann: 'The Cleaning and Restoration of the Glasgow Giorgione', Burl. Mag., xcvii (1955), pp. 278–82

R. Wittkower: 'L'Arcadia e il giorgionismo', Umanesimo europeo e umanesimo veneziano (Florence, 1963); Eng. trans. as 'Giorgione and Arcady', Idea and Image (London, 1978), pp. 161–73

N. T. de Grummond: 'Giorgione's Tempest: The Legend of St Theodore', L'Arte, xviii–xx (1972), pp. 5–53

J. Anderson: 'Some New Documents Relating to Giorgione's Castelfranco Altarpiece and his Patron Tuzio Costanzo', A. Ven., xxvii (1973), pp. 290–99

T. Fomiciova: 'The History of Giorgione's Judith and its Restoration', Burl. Mag., cxv (1973), pp. 417–20

M. Muraro: 'The Political Interpretation of Giorgione's Frescoes on the Fondaco de' Tedeschi', Gaz. B.-A., lxxxvi (1975), pp. 117–84

T. Pignatti: 'Il paggio di Giorgione', Pantheon, xxxiii (1975), pp. 314–18

J. Anderson: 'Giorgione, Titian and the Sleeping Venus', Tiziano e Venezia: Convegno internazionale di studi: Venezia, 1976, pp. 337–42

——: 'The Christ Carrying the Cross in San Rocco: Its Commission and Miraculous History', A. Ven., xxxi (1977), pp. 186–8

R. Salvini: 'Leonardo, i fiamminghi e la cronologia di Giorgione', A. Ven., xxxii (1978), pp. 92–9

J. Anderson: 'L'Année Giorgione', Rev. A., xliii (1979), pp. 83–90

——: 'A Further Inventory of Gabriele Vendramin's Collection', Burl. Mag., cxxi (1979), pp. 639–50

C. Cohen: 'Pordenone not Giorgione', Burl. Mag., cxxii (1980), pp. 601–7

C. Hornig: 'Unterzeichnungen Giorgiones', Pantheon, xxxviii (1980), pp. 46–9

M. L. Krumrine: 'Alcune osservazioni sulle radiografie del Concerto campestre', Ant. Viva, xx/3 (1981), pp. 5–9

F. Benzi: 'Un disegno di Giorgione a Londra e il Concerto campestre del Louvre', A. Ven., xxxvi (1982), pp. 183–7

A. Ballarin: 'Giorgione e la Compagnia degli Amici: Il "Doppio Ritratto" Ludovisi', Storia dell'arte italiana, v (1983), pp. 479–541

W. S. Sheard: 'Giorgione's Tempesta: External vs. Internal Texts', Italian Culture, iv (1983), pp. 145–58

D. Howard: 'Giorgione's Tempesta and Titian's Assunta in the Context of the Cambrai Wars', A. Hist., viii (1985), pp. 271–89

F. Büttner: 'Die Geburt des Reichtums und der Neid der Götter: Neue Überlegungen zu Giorgiones Tempesta', Münchn. Jb. Bild. Kst, xxxvii (1986), pp. 113–30

P. Kaplan: 'The Storm of War: The Paduan Key to Giorgione's Tempesta', A. Hist., ix (1986), pp. 405–27

C. Hornig: Giorgiones Spätwerk (Munich, 1987)

J. Hale: 'Michiel and the Tempesta: The Soldier in a Landscape as a Motif in Venetian Painting', Florence and Italy: Renaissance Studies in Honour of Nicolai Rubinstein, ed. P. Denley and C. Elam (London, 1988), pp. 405–18

W. S. Sheard: 'Giorgione's Portrait Inventions c. 1500: Transfixing the Viewer', Reconsidering the Renaissance, ed. M. A. di Cesare (Binghamton, NY, 1992), pp. 141–76

P. Holberton: 'Varieties of Giorgionismo', New Interpretations of Venetian Renaissance Painting, ed. F. Ames-Lewis (London, 1994), pp. 31–41

D. Lettieri: 'Landscape and Lyricism in Giorgione's Tempesta', Artibus & Hist., xv/30 (1994), pp. 55–70

S. Cohen: 'A New Perspective on Giorgione's Three Philosophers', Gaz. B.-A., cxxvi/1520 (1995), pp. 53–64

A. W. G. Poseq: 'The Tempest Again: Giorgione's "Ingegno"', Ksthist. Tidskr., lxv/1 (1996), pp. 19–26

PETER HUMFREY, MARTIN KEMP

Giotto (di Bondone) (b ?Vespignano, nr Florence, 1267–75; d Florence, 8 Jan 1337). Italian painter and designer. In his own time and place he had an unrivalled reputation as the best painter and as an innovator, superior to all his predecessors, and he became the first post-Classical artist whose fame extended beyond his lifetime and usual residence. This was partly the consequence of the rich literary culture of two of the cities where he worked, Padua and Florence. Writing on art in Florence was pioneered by gifted authors and, although not quite art criticism, it involved the comparison of local artists in terms of quality. The most famous single appreciation is found in Dante's verses (Purgatory x) of 1315 or earlier. Exemplifying the transience of fame, first with poets and manuscript illuminators, Dante then remarked that the fame of Cimabue (fl 1272), who had supposed himself to be the leader in painting, had now been displaced by Giotto. Ironically, this text was one factor that forestalled the similar eclipse of Giotto's fame, which was clearly implied by the poet. About the same date, Giotto's unique status was suggested by his inclusion, unprecedented for an artist, in a world chronicle (c. 1312–13) by Riccobaldo Ferrarese (see §I, 2(i) below). The artist's name first became synonymous with 'the best painting' in a poem by the Florentine Cecco d'Ascoli (d 1327) and, more subtly, in several observations by Petrarch (for comments from Boccaccio onwards see §III below).

I. Life and work. II. Working methods and technique. III. Critical reception and posthumous reputation.

I. Life and work.

The basis on which Giotto's life is reconstructed and works are attributed to him is provided by the combined information derived from administrative documents and early literary and historical sources. Discussion of these will be followed by that of the works themselves.

1. Documents. 2. Early commentators. 3. Works.

1. DOCUMENTS. Most of the documents concerning Giotto are mundane reports about property transfers, which are more numerous than those for any other contemporary artist and reflect his financial success (see Previtali). Legal records cite Giotto as 'of' Vespignano, a village c. 20 km north of Florence, and name his father as Bondone. Giotto's death on 8 January 1337 (1336 in the Florentine calendar system) was reported by the contemporary chronicler Giovanni Villani. In 1373 the chronicle was rewritten and expanded by Antonio Pucci, who gave Giotto's age at death as 70. This statement is the main basis for the consensus about his birth in 1266, although it has also been placed ten years earlier (Ragghianti) or later (Brandi, 1969, based on Vasari). Several records narrow the possibilities. Giotto must have been an established adult when first recorded on 25–6 May 1301 as a house owner. A witness to this document, Martino di

Bondone, quite possibly Giotto's brother, is not recorded later, but in 1295 he had been documented in arrangements for his future wife's dowry, suggesting his early adulthood. Giotto's father died before 8 December 1313, when Giotto is described as the emancipated (legally independent) son of the late Bondone, but probably after 1311 when the term 'late' is not used. Bondone must have lived to an advanced age for the period and become a father at an unusually early age for Giotto to have been born *c.* 1267–8; an even earlier birthdate would call for very unlikely cases. A document of 15 September 1318 records Giotto's emancipated son, Francesco, as his father's business agent, assigning land to his sister, Donna Bice, while she was a member of the third order of St Dominic; they were thus both adults. Even if in 1318 the emancipated Francesco was only 21, Giotto is unlikely to have been born any later than the mid-1270s, and an earlier date is more probable. Pucci's statement about Giotto's age at his death should not be valued simply because it is the earliest account we have; the age of 70 it provides may represent merely a rounded-up estimate, more common then than now. In 1376 Benvenuto da Imola, the commentator on Dante, wrote that Giotto was 'still rather young' when he painted the Arena Chapel in Padua (*c.* 1305; see fig. 1). If he defined the term as Dante did, that would mean under 35, thus suggesting a birthdate of 1270 or later. In 1568 Vasari wrote that Giotto died at 60, and this has been the basis on which some scholars have suggested a birthdate of 1276. The statement is, however, unsupported and might even be a slip for 70. The consideration of all these documents together seems to indicate 1267–75 for Giotto's birthdate, and more likely the earlier years of this period.

Following the Florentine document of 1301, other sources record Giotto's presence in Padua, Assisi, Florence, Rome, Naples and Milan. The first of these, dating from 1303–6, concern the Arena Chapel in Padua (*see* §3(i) below). Property owned by Giotto in Florence is mentioned in 1305 and 1307, without implying his presence in the city. On 4 January 1309 a citizen in Assisi paid a debt owed by himself and Giotto, reasonably suggesting the artist's previous stay there. In Florence records show Giotto present on 23 December 1311 and then in 1312, 1313, 1314, 1315, and again in 1320 and 1325. Most concern minor business, but of particular interest is a will of 15 June 1312 in which money was left to light a lamp under a crucifix in S Maria Novella by 'the superior painter Giotto', and to do the same under a painting in the Dominican church at Prato 'which the said' testator 'had painted by the notable painter Giotto di Bondone of Florence'. The latter clause, often overlooked since the work is lost, gives weight to the writer's attribution of the former work to Giotto; it is generally identified as the *Crucifix* still in the church (*see* §3(iii) below). On 12 November 1312 Giotto rented out a loom (*telarium francigenum*, not a painter's stretcher), suggesting his varied business activity. His appointment on 8 December 1313 of an agent in Rome to recover property he had left there, including beds, confirms that he had worked there before. In 1320 he is listed with other painters in the Arte dei Medici e Speziali.

There survive for the period 1328–33 numerous records of Giotto's work for the Angevin court in Naples. Giotto was paid a salary on 8 December 1328, 5 August 1329 and 2 January 1330; on 20 January 1330 Robert, King of Naples (*reg* 1309–43), granted him the title *familiare*. On 20 May 1331 he was paid for expenses incurred between September 1329 and the end of January 1330 for materials, including gold, gesso and ass's leather, used while painting the King's Chapel in the Castelnuovo, and a panel, executed at home. The money also covered salaries paid by Giotto to other 'masters', both painters and 'servants'. The King's last payments were in 1332 and 1333. Back in Florence, on 12 April 1334 the city council named Giotto Chief of Works for the cathedral, city walls, fortifications and other projects, on the grounds that he was the best master in the world and so should be retained in the city. Villani reported that the cathedral campanile was begun on 18 July 1334, but he also noted that the government sent Giotto to Milan to serve its ruler, Azzo Visconti (*see* VISCONTI, (1)), a journey from which he returned to die on 8 January 1337. A record in Florence of 15 September 1335 may precede the trip to Milan or mark a temporary visit home during it. Posthumous records include the 1361 entry in the obit book of Old St Peter's, Rome, which states that Cardinal Giacomo Gaetani Stefaneschi had paid a large amount for the high altarpiece and for the façade mosaic, called the 'Navicella', and that Giotto was the artist. Boccaccio's *Decameron* (*c.* 1353) provides an anecdote of Giotto coming to Florence by horse from his native region where he had been inspecting his property. This is consistent with the many other records of his seven children, nearly all concerning land they owned in that region, and contributes to our understanding of Giotto's private life.

2. EARLY COMMENTATORS. There are normally three bases on which works are attributed to an artist of this period: signatures, contractual documents and early written sources. The evidence for Giotto is unusual. Three paintings are agreed to bear his signature, but two (and sometimes the third) are usually rejected and attributed to distinct members of his workshop, an indication that signed works cannot be used as the criterion for his oeuvre (*see* §II, 1 below). The sole documents of a contractual nature concern two lost panels (the Prato one of 1312 and the Naples one of 1330; see §1 above) and the Naples Castelnuovo chapel frescoes, the minor surviving fragments of which are also always regarded as by assistants. Thus all the works that form the basis for our knowledge of Giotto's work (before the addition of stylistically similar attributions) emerge from early written sources. These are not always reliable, especially in the case of a famous artist who attracts hopeful attributions very quickly. Nevertheless, there is consistency among the reports and among works cited in them, which show a single style.

(i) Written sources, to *c.* 1450. (ii) Ghiberti's *I Commentarii.*

(i) *Written sources, to c. 1450.* The earliest reports chiefly refer to Padua. About *c.* 1313 Francesco da Barberino, an allegorical poet, praised Giotto for his image of *Envy* in the Arena Chapel. About 1312–13 the chronicler Ric-

cobaldo included in his *Compendium Romanae historiae* a short paragraph on Giotto, reporting his 'admired' works in Franciscan churches in Assisi, Rimini and Padua, and also those in the Arena Chapel in Padua and in the town's civic palace, the Palazzo della Ragione. With the exception of Rimini, all these places are found in other early reports. The three locations in Padua recur in local reports: the chronicler Giovanni da None (*d* 1346) described the vault of the civic palace as having zodiacal imagery by Giotto; Benvenuto da Imola, the commentator on Dante, reported the work in the Arena Chapel; and in 1447 the local chronicler Michele Savonarola (*c.* 1385–1464) included the Arena Chapel and the Franciscan church, Il Santo, specifying that Giotto's work was in the chapter house (he omitted the civic palace, which had burnt in 1420). As a visitor, Ghiberti also discussed these two monuments (*see* §(ii) below). Early Florentine reports are surprisingly thin: apart from the will of 1312 concerning the crucifix in S Maria Novella (*see* §1 above), there is only Giovanni Villani's mention of the supervision of the cathedral and work on its campanile. Villani's report in 1340 that in 1335 Giotto was sent to work for the ruler of Milan may helpfully be combined with a report, also of 1335, by the Milanese chronicler Galvanno Fiamma (or Flamma) of paintings in the Palazzo di Azzone Visconti (destr.) on the theme of Worldly Glory, although Giotto is not named. The link is confirmed later by Ghiberti's report that Giotto painted a *Worldly Glory*, although in this case no location is given (*see* §(ii) below). The early reports about Rome are those noted in the obit book of 1361 (*see* §1 above).

A commentary on Dante of 1334, the so-called 'Ottimo', shows marked consistency with all these reports in stating that Giotto's main works were in Florence, Padua, Rome, Naples and Avignon. Of places cited earlier, only Riccobaldo's references to Assisi and Rimini are omitted, quite possibly because this commentator's knowledge did not reach back to Giotto's youth. On the other hand, Avignon first appears here, and 15th-century sources suggest that works by Giotto were sent to the papal court there, which would be plausible, but the matter can be taken no further. Boccaccio, with a special interest in secular imagery, described paintings of *Worldly Glory*, the *Zodiac* and *Loves of Men of Antiquity*, the last-named in a royal hall (possibly to be identified with the Great Hall or Sala dei Baroni of the Castelnuovo in Naples), with remarks that seem to assign them to Giotto. The latter cycle reappears in two other written reports: an anonymous sonnet sequence describing it in detail, but without Giotto's name, and Ghiberti's *I Commentarii*, which names Giotto but provides no details. Petrarch praised Giotto's work in the Castelnuovo chapel of St Barbara in Naples and a *Virgin and Child*, otherwise unknown, which he owned himself, a gift from a Florentine friend (*see* PETRARCH, FRANCESCO). A single report (*c.* 1395) by an anonymous commentator on Dante of works in Bologna has no clear links to known paintings. Around the same time, however, Filippo Villani included in his lives of famous Florentines—the *Liber de origine Florentiae et eisdem famosis civibus*—a short biography of Giotto, the first time a painter had been included in such a work. The author was defensive

on the point and emphasized Giotto's significance in painting the portrait of Dante in an altarpiece for the Palazzo del Podestà (now the Bargello, Florence), which is never otherwise reported. Besides that he cited only the *Navicella*, allowing the inference that it was Giotto's most famous work, a status confirmed by Alberti, who mentioned it in his *De pictura* (1435) as the only example of modern art, along with many others from antiquity.

(ii) Ghiberti's 'I Commentarii'. A significant change of approach appears in Ghiberti's *I Commentarii*, begun *c.* 1447 but surely based on notes collected over his lifetime. His autobiography, the first by an artist, is prefaced by a survey of Florentine and other artists from Cimabue onwards. In the account of Giotto his list of 40 works is astonishing, both in comparison with the few works cited by earlier writers and with any list in this period of any artist's works.

(a) The canon. Several factors make Ghiberti's canon resemble a catalogue raisonné in completeness and reliability: the 40 works, which include several large fresco cycles, might plausibly comprise most of what Giotto achieved; it has no incorrect attributions (Bellosi, 1974); and of works previously mentioned, it omits only one that can be assumed to have been of major scale and that had been cited with any specificity—work in S Francesco, Rimini—which is also omitted by all other accounts after 1312. Excluded from the list are the already destroyed *Zodiac* cycle in the Palazzo della Ragione, Padua, the generic allusions to work in Avignon and Bologna, and three apparently small panels, the documented ones of Prato and Naples and Petrarch's *Virgin and Child*, along with two of the three signed works, which all other sources also omit.

Furthermore, Ghiberti named at least nine and perhaps all of the ten works previously cited that had received relatively exact identifications and that were major in scale: the two surviving works in Padua; the two from Old St Peter's, Rome; the Naples chapel; the 'lower part', as he puts it, of S Francesco, Assisi; the *Worldly Glory*, cited without location probably because already lost; and, in Florence, the cathedral campanile and the S Maria Novella *Crucifix*. He also cites the tenth, the Bargello Altarpiece, if we take his allusion to 'the Bargello Chapel' to include it as well as the frescoes there, not previously recorded. (This assumes an emendation, plausible if not allowed for in the scholarship, of the writer's Castel dell'Ovo to Castelnuovo for the chapel cited in Naples; otherwise, Ghiberti omitted that well-known chapel and cited a work otherwise never noted.)

Hence the list of 40 works includes 31 not named before. Of these, five are located outside Florence: the work from S Maria degli Angeli in Assisi, the cycle of *Famous Men* in the Great Hall of the Castelnuovo, Naples (perhaps the same that Boccaccio had glancingly noted as a cycle of the *Loves of Men of Antiquity*), the frescoes at St Peter's, Rome, and a crucifix and panel from S Maria sopra Minerva, also in Rome. The works in Florence, the essential basis for our knowledge of Giotto's work there, include two more at S Maria Novella, two at S Giorgio sulla Costa, two at the Palazzo di Parte Guelfa, two at the

Bargello (the chapel frescoes and the *Commune Cheated*), eight at the church of Ognissanti, three in the Badia, eight in Santa Croce (four frescoed chapels and four altarpieces), and the drawings for the campanile sculpture. Of the 40 references, 38 are quite specific, only two merely noting 'other works' in the same buildings with others and so precluding identification (the Palazzo di Parte Guelfa and S Maria Novella).

Of equal importance, over half the works cited survive, contrary to the impression often given (e.g. Oertel) that Giotto is known only through a small fraction of his output. Three works survive only in copies: one, the Bargello *Commune Cheated*, in differing and thus problematic copies (perhaps the best one in a relief sculpture on the tomb of Bishop Tarlati in Arezzo); a second, *Worldly Glory*, in three very consistent copies (in illustrations in two manuscripts of Petrarch's *De viris illustribus*, Paris, Bib. N.; and one in Darmstadt, Hess. Landes- & Hochschbib.; see Gilbert, 1977); and a third, design drawings for the campanile sculpture, surviving in the sculpture itself (Florence, Mus. Opera Duomo; *see* FLORENCE, §IV, 1(iii)). Two more works survive only in small fragments: the frescoes of the Badia chapel of St Mary Magdalene and those of the chapel in the Castelnuovo, Naples. One work survives in a combination of fragments and many consistent copies: the *Navicella* (fragments, Boville Ernica, S Pietro Ispano; Rome, Grotte Vaticane). The other survivals, however, are complete or nearly so: the Arena Chapel, including its *Crucifix* (Padua, Mus. Civ.); the frescoes at S Francesco, Assisi, regardless of which cycle there Ghiberti meant; the Stefaneschi Altarpiece (Rome, Pin. Vaticana) from Old St Peter's, Rome; the Badia Altarpiece (*Virgin and Child with Saints*; Florence, Uffizi); the Bardi and Peruzzi frescoes at Santa Croce, Florence (*see* §3(ii) below); the signed *Coronation of the Virgin* from the Baroncelli Chapel of the same church (*see* §II, 1 below); three works from the church of Ognissanti, the *Crucifix* (*in situ*), the *Madonna* (Florence, Uffizi; *see* §3(ii) below) and the *Death of the Virgin* (Berlin, Gemäldegal.); the S Giorgio sulla Costa *Virgin and Child* (Florence, Museo Diocesano); the Bargello Chapel; the S Maria Novella *Crucifix* (*in situ; see* §3(iii) below) and the campanile sculptures.

Three more surviving works may or may not be identified with ones named by Ghiberti. A second of the four Santa Croce altarpieces he listed may be the one in Raleigh (Raleigh, NC Mus. A.) with *St John the Baptist* and *St John the Evangelist*, which would match the dedication of the Peruzzi Chapel to those two saints. The main doubt cited, that this is a shop work, does not seem relevant to this question (*see* §(b) below). Often overlooked are the fragmentary workshop frescoes (rest.) in the chapter house of Il Santo, Padua, attributed to Giotto by Michele Savonarola in 1447 and perhaps by Riccobaldo in 1313, which may be identifiable with those Ghiberti cites as 'at the Franciscans'. The objection that Riccobaldo's citation of 'the church' could not allude to these works in the adjacent friary perhaps seeks an unlikely specificity from him, the more so since his text simply refers to the Franciscan churches of three towns, except that one manuscript places Giotto's work in a 'chapel outside S Antonio' in Padua (Hankey). The chapter house shares a connecting door with the church sacristy, and no work by

Giotto within the church building was known to the alert Savonarola, so the chapter house frescoes seem very likely to be the work cited by the other two commentators.

The third uncertain case is Giotto's altarpiece, now dispersed among various museums, comprising the *Virgin and Child* (variously dated 1315–30; Washington, DC, N.G.A.), *St Stephen* (Florence, Mus. Horne), *St Lawrence* and *St John the Evangelist* (Chaalis, Mus. Abbaye) and a lost figure. As suggested by Schmarsow, even when aware only of the *St Stephen* panel, this could be identified as the third of the four Santa Croce altarpieces cited by Ghiberti, since it would have been appropriate for the chapel dedicated to SS Lawrence and Stephen (Pulci–Beraldi Chapel). The chapel's frescoes of those saints' martyrdoms by Giotto's pupil, Bernardo Daddi (*fl c.* 1320–48), of before *c.* 1330, recall the situation in the Baroncelli Chapel in the same church, where the signed altarpiece by Giotto's workshop accompanies frescoes by another of Giotto's pupils, Taddeo Gaddi (*d* 1366), of around the same time; pupils may have inherited commissions when the master went to Naples in 1328. If this dispersed altarpiece, generally agreed to be at least in part by Giotto's own hand, is not on Ghiberti's list, it would be almost the only surviving large-scale work he omitted, so it seems plausible that it is one of those he named. That consideration apparently supported earlier proposals (Longhi and others) to identify this work with another entry on Ghiberti's list, the Badia Altarpiece (now firmly identified in another way with the painting in the Uffizi; see above), or else with still another, the Peruzzi Chapel altarpiece, because the dispersed work includes one *St John the Evangelist* and might have included the other. However, the Raleigh altarpiece, with both saints John, fits the Peruzzi dedication as well, if not better, just as the dispersed altarpiece fits the Pulci Chapel.

(b) *Critical significance.* The great value of Ghiberti's list is that, apart from the Arena Chapel, he was the first to cite all the works of Giotto on which is based our chief image today of the artist: the Ognissanti *Madonna* and the Bardi and Peruzzi chapels' frescoes, followed probably by the Berlin *Death of the Virgin* as the next most important. (The *Madonna* had been attributed to Giotto before Ghiberti, in a manuscript document of 1418, but this would not have established the attribution.) The fewer works on his list that are now lost may be considered of proportionately less importance in Giotto's achievement since a number were smaller, simpler and repetitive images (two more crucifixes, a half-length *Virgin and Child* and another with two saints). In Giotto's secular work, however, loss outweighs survival since no original is preserved: two major works cannot be reconstructed (the Palazzo di Parte Guelfa fresco and the *Famous Men* of Naples), while three others are known only in copies—the *Commune Cheated*, the *Worldly Glory*, and the zodiacal frescoes from the civic palace (Palazzo della Ragione) in Padua, lost before Ghiberti made his list. There survives only the cathedral campanile sculpture, with its partial inclusion of secular figures.

Ghiberti's canon is helpful only if it is understood that his idea of a work by Giotto included work of his shop, for example the Ognissanti *Crucifix*, unanimously attrib-

uted to workshop hands. Ghiberti stated that all forty works were 'made' by Giotto, yet just six were 'by his hand'. There is thus a large group of works by him but not by his hand, a reflection of contemporary business patterns. Hence, in discussions on the difference between master and shop the wrong criteria have been applied, and Ghiberti's statements have been interpreted as false attributions and thus unreliable. Of perhaps even greater importance in judging Ghiberti is the fact that not a single work attributed to Giotto after Ghiberti has obtained full acceptance. This is a natural result both of the broad coverage of Ghiberti's work and of the loss of a live critical tradition after more than a century. After him, no new attributions were even attempted until Vasari in 1550, and some of his attributions can be proved to be false. This is the case with the work Vasari described in most detail, a fresco cycle of the life of S Michelina, the subject of which died later than Giotto. The fact that these frescoes are lost has made them little considered by scholars, who have thus ignored this strong evidence for Vasari's unreliability in attributing works. This needs to be emphasized, especially when considering whether to accept Vasari's most famous novelty, his identification of Giotto's work at S Francesco, Assisi, as being the cycle in the Upper Church of the *Legend of St Francis* (*see* §3(iii) below).

3. WORKS. The discussion that follows will focus on the two most critical areas concerning Giotto's work: the Arena Chapel, Padua, on which all other attributions to this artist are based, and the frescoes of S Francesco at Assisi. Giotto's major works in Florence are also discussed here; for paintings attributed to his workshop *see* §II, 1 below.

(i) The Arena Chapel and early works. (ii) Major Florentine paintings. (iii) Assisi and related works. (iv) Stylistic sources.

(i) The Arena Chapel and early works. Giotto's frescoes in the Arena Chapel (Cappella degli Scrovegni) at Padua comprise his earliest work of known date and that on which our idea of his art is chiefly based. Generally agreed to be dated to *c.* 1305, further research has shown that the work may be dated no earlier than 1303, when the building was evidently under construction (for details of the building and its dating *see* PADUA, §4), and no later than 1306, when a set of six choir-books for Padua Cathedral (now Padua, Bib. Capitolare), which contain copies from some of Giotto's scenes, was begun; they include a copy of the *Lamentation* fresco, one of the last to be painted since it is low on the wall. The view that the frescoes might be as late as 1310 (Gnudi) is supported by the fact (Borsook) that in 1306 the choir-book project was still in progress with only two of the six volumes (A15, A16) completed, though the remainder had been partly done. The few miniatures in the first two volumes that show the same scenes as Giotto's paintings do not echo his designs, and the first to copy him are more than midway through the third volume. This would be significant only if it were further argued that before that point work on the set of books was interrupted for four years or more, implausible in general and more so since the work was being done at the cathedral. Further, a phrase of the 1306 document,

wrongly transcribed in publication, shows that the set had then continued beyond volume two ('alia vero pars non est ligata neque completa'). On the assumption that the work went on normally, 1306 is firm as the latest date for the originals that were copied in the choir-book.

Calculated by the *giornate* (seams between different days' work; *see* §II, 2 below), the frescoes were painted in 852 days, some of them of course the simultaneous work of assistants painting, for example, decorative borders, but the work surely took most of the years 1304–5, apart from days with temperatures below freezing, when fresco work is not practical (and preparatory drawing might be done). Giotto's painting (see fig. 1) covers the whole vault and walls of the nave (but excluding the small choir): the entrance wall (193 days) with the *Last Judgement*; the vault (88 days) with 33 small figures in medallions and ornamental bands; the long south (245 days) and north (250) walls with narrative scenes; and the choir arch with the *Annunciation* (76 days, plus the panel painting of *God the Father* inserted at the top). The arrangement with the large *Last Judgement* on the entrance wall, as at Torcello Cathedral, and long narrative biblical sequence on the sides, as at S Angelo in Formis (nr Naples), reflects the Italian version of Byzantine church decoration. The large, immobile imagery of the *Judgement* is made less dominant, however, notably by reducing most of its figures to the size of those on the narrative walls; the Apostles, somewhat larger, lead to the central larger figure of Christ, whose isolation renders him less overwhelming. Giotto also rejected the hierarchical scaling of Gothic imagery, such as is found in cathedral portals, which often focused on the Last Judgement and always gave the narrative a minor

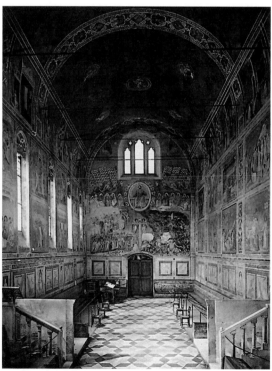

1. Giotto: frescoes (1303–6), Arena Chapel, Padua; view to the west

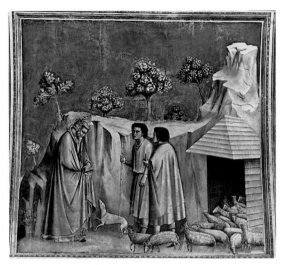

2. Giotto: *Joachim and the Shepherds* (1303–6), fresco, Arena Chapel, Padua

role. Although Giotto favoured Western models in most respects, here he was influenced by the greater concern with narrative action evident in Byzantine art, and he went even further to make it the vehicle of his message. The 'story' became the artist's chief material, as Alberti defined it a century later for Giotto's heirs in Florence.

On the two lateral walls, the three tiers of scenes for the most part neatly cover six sections of the narrative: at the top the *Life of Joachim and Anna* on one side, and the *Life of the Virgin* on the other; in the middle the *Infancy of Christ* on one side (see colour pl. 1, XXXIV2 for an illustration of the *Flight into Egypt*), his *Ministry* and *Miracles* on the other; at the bottom both sides have scenes of the *Passion*. The *Passion*, however, beginning on the middle level, thus diminishes the emphasis on the *Miracles*, just as in the Church's liturgical year. Thus *Infancy* and *Passion* dominate. The lack of emphasis on the *Miracles* (in contrast with Duccio's contemporary work) and the added attention to the Virgin and her parents, a rare element, are evidence of Giotto's most basic novelty: the attention to the human condition rather than to the supernatural. Christ emerges not from a diagrammatic Tree of Jesse but from a warm extended family; his ancestry and Old Testament analogues are not abolished but are removed to the small vault and wall medallions (see below).

In the cycle of the *Life of the Virgin* the events of her wedding are extended over four scenes only moments apart, three of which have the same architectural setting; this is Giotto's only use of a device adopted by Duccio for several *Passion* sequences. The fourth scene, the Virgin's return to her parents' house after the wedding, is a rare image and emphasizes her virginity. The detailed story of the Virgin's parents begins with Joachim's expulsion from the temple because of his childlessness and ends with his return and reunion with his wife, Anna, at the city gate, which is a metaphoric image of the conception of their daughter, as the Annunciation is of Christ's. Most of this narrative echoes the text of Jacopo da Voragine's *Golden Legend* and has clear moral messages.

An exception is the second scene, showing the grieving Joachim arriving in the mountains (see fig. 2), which bears little relation to that text, apart from the short phrase 'and he went to his shepherds'. It seems to carry little doctrinal weight, but it has been reasonably viewed as a statement of purely human values by Giotto and has been a favourite example by which to expound his artistic procedures. As in Byzantine painting, there is less naturalism here in the landscape than in the figures. A dramatic scene is created by showing the interaction of a few sharply individualized figures, like a tableau in a play. The paint surface is treated in an innovative fashion, with soft effects of flesh and cloth in gradually shifting light and shade, suggesting the roundness of organic bodies. Joachim is slightly larger than the secondary figures, the shepherds, and his form more solidly shown as a single, unarticulated unit, which emphasizes his greater physical and dramatic weight. His lowered head, merging into his body and suggesting grief, is noted by the shepherds, who also observe one another, giving the scene weight and moment and ultimately its resulting humanity. A more formal and less affective tone is found in a few scenes with a strong tradition of symbolic meaning, for example the *Baptism* and the *Crucifixion*. Among the *Passion* scenes, the well-known *Betrayal of Christ* and the *Lamentation* (see figs 3 and 4) also present the interaction of a few figures at a point of stress.

Giotto's involvement with the physical and human is striking when faced with inevitable references to the supernatural, and he tended to evade such references. In the *Raising of Lazarus*, one of only two miracle scenes included, Lazarus is depicted still dead, eyes fixed with centred pupils, contrary to Giotto's practice, thus without implying the suspension of the laws of nature. (The follower of Giotto who painted this scene in Assisi, in the Magdalene Chapel, reverted to the traditional gazing eyes.) The same considerations prompted Giotto's solution to depicting flying angels and the Christ of the Ascension, which he reduced to half-figures trailing off below the waist into cloudy forms. This may have been influenced by Giotto's portrayal of a natural phenomenon, Halley's comet of 1301, which is shown in its first accurate representation, with its tail, as the star guiding the Magi. His inventive imagery for the allegorical figures of *Virtues* and *Vices* on the dado level of the walls may reflect similar preoccupations. These are represented not as real people but as monochrome sculptures in grisaille (see fig. 5), inspired by the pulpits of Nicola and Giovanni Pisano, which include series of allegorical figures on their lowest levels. At the same time Giotto's figures physically embody or enact their virtues, rather than symbolizing them with attributes.

The *Last Judgement*, often considered a 'relative failure' (Battisti), charts its hierarchy of figures not through relative size but in a clearly diagrammatic way. The damned in Hell are a notable exception, caricatured as tiny figures in their vivid tortures, but they are so crudely executed that Giotto is usually thought not to have had a part in their design or execution. Among them, the larger figure of *Satan* shows in his mask-like frontality that he is not part of the physical human world. This frontality is also seen in the large *Virgin* of the vault, where she is is shown as

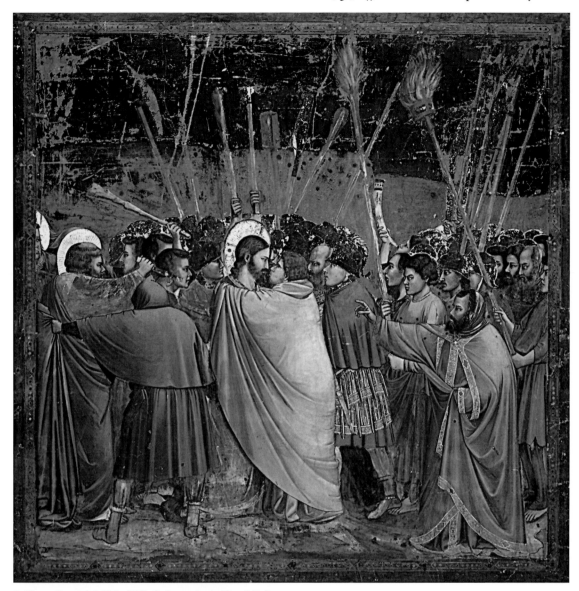

3. Giotto: *Betrayal of Christ* (1303–6), fresco, Arena Chapel, Padua

Queen of Heaven. The small medallions in the frames between scenes all present in very reduced, almost vestigial form, imagery that had played a leading role in earlier Gothic cycles. The most interesting are those adjacent to ten of the scenes of the *Life of Christ*, showing analogous events from the Old Testament or elsewhere, such as *Moses Receiving the Tablets of the Law*, adjacent to the *Pentecost*, in which the Holy Spirit descends on the Apostles. The juxtaposition of Old and New Testament scenes is limited to the two lower tiers of the windowless wall, perhaps suggesting that this was a device used to fill extra space. In addition, there are busts of saints: on the top tier the *Twelve Apostles* with eight others whose identical attributes link them with the thirty-three heads in the vault, together representing the forty generations of the ancestors of Christ from *Abraham* (at the top of the choir arch), with *Christ* himself. At the ends on the lower

two tiers are four female saints, the *Four Evangelists* and *Four Doctors of the Church*.

Two works are stylistically placed earlier than the Arena Chapel. One is the S Maria Novella *Crucifix* (*in situ*), although this applies only to the central figure; it will be discussed in connection with the Assisi problem (*see* §(iii) below), to which its side figures are closely linked. The other is the *Virgin and Child* in S Giorgio sulla Costa, Florence, also linked to Assisi as it is stylistically related to the *Virgin* on the entrance wall there. It has the same simple massiveness as Giotto's later *Virgin* panels, if a more linear contour, but does not show the metallic surfaces evident in the Assisi paintings. The S Giorgio *Virgin* may either be the earliest work by Giotto's own hand, or the later work of a more conservative workshop assistant echoing Giotto's Ognissanti *Madonna* (*see* §(ii) below).

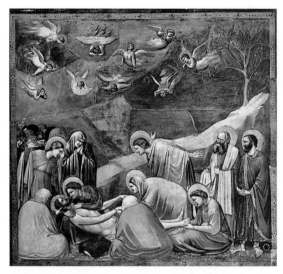

4. Giotto: *Lamentation* (1303–6), fresco, Arena Chapel, Padua

(ii) Major Florentine paintings. The *Madonna* (Florence, Uffizi; see fig. 6), from the church of Ognissanti, is generally dated to *c.* 1310. Giotto's version updated the type of colossal enthroned Virgin altarpiece produced by Cimabue (e.g. Santa Trinita *Madonna*; Florence, Uffizi) and Duccio (*fl* 1278) (e.g. Rucellai *Madonna*; Florence, Uffizi). The modelling of the figure is like that in the Arena Chapel, but here the lack of motion, appropriate to an icon, almost excludes emotional interrelations between figures and adds to the effect of dominating weight; some emotion is suggested by the intense gaze of the angels towards the Virgin. The visibility of figures through the arcaded sides of the throne, a device inspired by Duccio, emphasizes the human figures and the secondary role of the architecture, and also looks forward to the use of space developed in later works. The most notable of the later *Virgin and Child* panels (Washington, DC, N.G.A.) also focuses on human, rather than supernatural, elements, with the Child using all his fingers to grasp one of his mother's instead of blessing, suggesting physical attachment and dependency while also depicting proportionate scale.

At Santa Croce the two surviving cycles of frescoes are in the chapels of the Bardi and Peruzzi families, respectively devoted to seven scenes of the *Life of St Francis* (one outside over the entrance arch; see fig. 7) and to three scenes each of the *Life of St John the Baptist* (see fig. 8) and the *Life of John the Evangelist*. Both cycles have been assigned widely divergent dates anywhere between the Arena Chapel frescoes (1303–6) and Giotto's trip to Naples (1328–33). Each has been considered earlier than the other on the basis of subjective views of Giotto's stylistic evolution. Since St Louis of Toulouse, represented in the Bardi Chapel, was canonized in 1317, the chapel is often held to be necessarily later, although it was not uncommon for uncanonized saints to be depicted. If a date around 1320 is most often favoured for the Bardi paintings, the date for the Peruzzi works ranges from much earlier (*c.* 1313; Previtali) to much later (Borsook). The most notable difference between the two works is

technical, the Peruzzi paintings being executed on dry plaster (secco), while in the Bardi Chapel the fresco technique on wet plaster was used (*buon fresco*). Why secco painting should have been selected has been little discussed: it might be because *buon fresco* cannot be executed in freezing weather and was generally not scheduled for the winter; the busy artist might have been able to include it in his schedule only by making use of that season. That would also permit a dating of the two chapels in the same years, which has been argued on the grounds that they share the same internal stylistic evolution from top to bottom (Gilbert, 1968). It is generally agreed that, compared to the Arena Chapel frescoes, both cycles in Santa Croce show greater emphasis on the representation of space, independent of the figures, which all occupy well-proportioned buildings. The inclusion of crowd scenes,

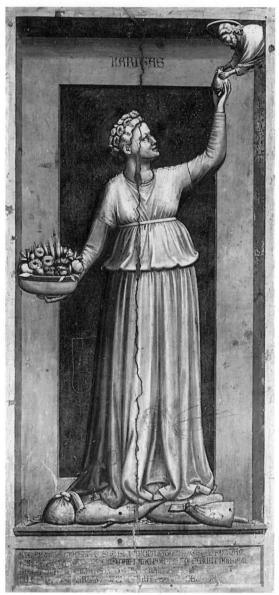

5. Giotto: *Allegory of Charity* (1303–6), fresco, Arena Chapel, Padua

with several examples of public chorus-like responses to the hero's dramatic gesture, are possible because of the larger expanses of wall in Santa Croce. Sometimes they are set in everyday contexts, such as a monastery courtyard or a public square, and sometimes indoors with fewer figures and the space divided in two, a motif borrowed from Duccio.

(iii) Assisi and related works. The most controversial question about Giotto is whether or not he painted, as first stated by Vasari, the 28 scenes of the *Legend of St Francis* running around the two sides and one end of the Upper Church of S Francesco, Assisi. In the literature on Giotto this matter dominates. Scholarship is divided into two camps, although there has been some degree of compromise towards intermediate positions.

(a) The Assisi debate. (b) The *Isaac* scenes and the S Maria Novella *Crucifix*.

(a) The Assisi debate. The early sources from Riccobaldo onwards agree that Giotto painted in S Francesco at Assisi. Its omission from 'Ottimo's' reliable list of 1334 of the places where Giotto worked should not be overlooked (as it often is), but it is not strong evidence against the attribution. After a visit to Assisi in 1459, Pope Pius II, in a very rare reference by him to an artist, spoke of the 'double church, one over the other', adorned with paintings by Giotto, 'known as the greatest painter of his time'; this suggests that Giotto's presence was locally renowned. The first more precise report is Ghiberti's, which states that Giotto painted 'almost all the part below' in the basilica (*I Commentarii*, ii). If Ghiberti meant the Lower Church, he

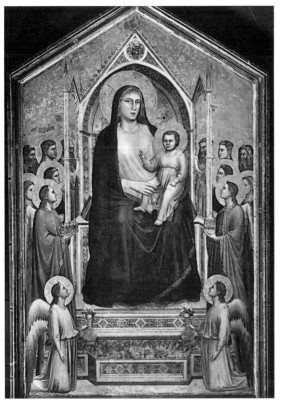

6. Giotto: Ognissanti *Madonna*, tempera on panel, 3.25×2.04 m, *c.* 1310 (Florence, Galleria degli Uffizi)

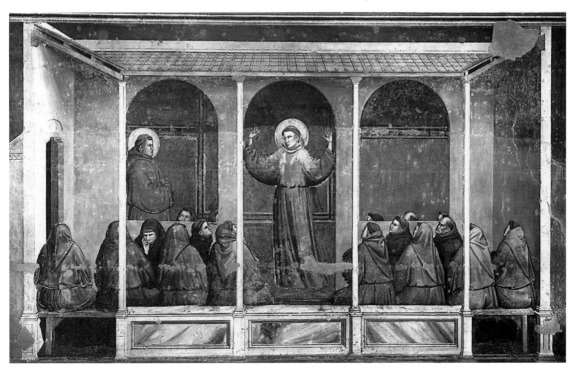

7. Giotto: *Apparition of St Francis at Arles* (*c.* 1320), fresco, Bardi Chapel, Santa Croce, Florence

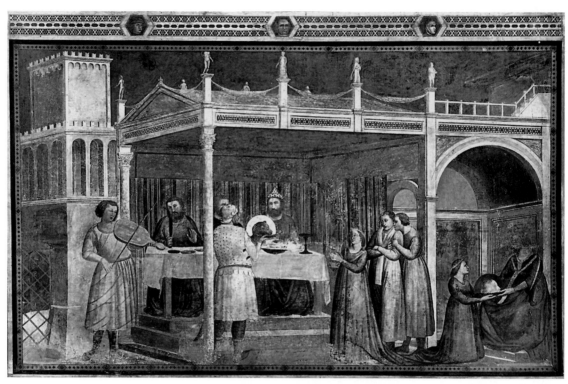

8. Giotto: *Feast of Herod* (*c.* 1320), mural *a secco*, Peruzzi Chapel, Santa Croce, Florence; scene from the *Life of St John the Baptist* cycle

would have intended the four cycles there that are, by general agreement, attributed to Giotto's workshop (those in the crossing, the north (right) transept, the S Nicola Chapel and the Magdalene Chapel). These cycles can be reasonably treated as 'almost all' of the painting there, especially if primitive or provincial painting is discounted. If, however, Ghiberti meant the lower wall area of the Upper Church, this would indicate the *St Francis* cycle and exclude the Lower Church. While some Italian scholars argue that the meaning 'lower church' for 'the part below' is not possible linguistically (Gnudi), others (Supino) have adopted that meaning. Gnudi further proposed to exclude the Lower Church from consideration on the grounds that all the Giotto workshop painting there is later than 1313, the year by which Riccobaldo had already cited work by Giotto in the church; however, since Gnudi's publication, the S Nicola Chapel, very close in style to the Arena Chapel, has been firmly dated to no later than 1307 (Meiss).

Vasari's support for Giotto's authorship of the *St Francis* cycle is agreed to be of limited significance, but until the 19th century it was not challenged; similarly, the cycle was unrivalled as the main visible representative of this famous artist's work since the *Navicella* mosaic was mostly destroyed, the Santa Croce frescoes whitewashed in the later 18th century, after long being hard to make out as their condition deteriorated, and the Arena Chapel privately owned and only locally known. Thus Vasari's statement, made glancingly in the first edition of his *Vite* in 1550 and with precision in the 1568 edition, received wide acceptance. Following doubts by some 19th-century scholars, it was forcefully opposed in the early 20th century by

Rintelen and Offner in particular. Some of their arguments, such as the much later dating proposed by Rintelen and Offner's 'idealizing' description of the stylistic qualities, have been abandoned. The principal remaining objection to the attribution was well defined by Bellosi: this is the difference between the Assisi cycle's 'incisive and almost metallic' drawing style and surface texture and the 'soft and fluid' approach in the undisputed Arena Chapel frescoes. For some, such factors differ too much for the works to be by the same master, while others counter that the dates of the two cycles may be far enough apart to account for the differences. Gnudi (1956), in particular, argued that the Arena Chapel frescoes were executed *c.* 1310, explicitly commenting in a footnote that this would 'better explain' the dissimilarity in style to Assisi. The recently discovered reference (no later than 1310) to Giotto (Thomann, 1991) by the notable science writer in Padua, Pietro d'Abano, also might just fit this date. In his commentary on the pseudo-Aristotelian work *Problems* he answers the question 'why do images of people exist' by saying that they show an individual's character especially when by an artist 'such as Giotto', who is able to represent them 'in all respects'. This strikingly suggests the people in the Arena scenes. Since Gnudi, the firmer evidence from the Padua choir-books, supporting the traditional 1304–5 date for the Arena Chapel paintings (*see* §(i) above), renders the differences in style from Assisi difficult to explain. The most logical surrebuttal by Bellosi (1985) was to infer an earlier date for the Assisi work than the 1295 plus usually accepted, in 1291–2. The evidence for this revision—costume details and influence on other works—does not seem completely reliable; none of the other

work is firmly dated, and Brandi in response noted the long persistence of costume types. To hypothesize both early dating and Giotto's authorship involves other difficulties (see below) and the date has not generally been adopted. The one remaining, if daring, stance for those advocating Giotto's work at Assisi is that taken by Previtali, who stated that the cycles could be by the same hand even if only about three years apart.

As a compromise, the supporters for Giotto's authorship of the *St Francis* cycle have shifted ground and, following earlier tentative suggestions, proposed that most of the cycle is by Giotto's assistants and unlike the Arena Chapel, which is agreed to be autograph for that reason. This is in addition to the wide agreement to attribute the last three scenes in Assisi (XXVI–XXVIII), and probably scene I as well, to a distinct artist, frequently identified as the St Cecilia Master (*fl* 1290–), whether or not the latter was working under Giotto's general direction. Gnudi (1956) has proposed that only scenes II–VII are 'fully autograph' (see fig. 9), VIII–XIX only partly so, and those from XX onwards completely independent of Giotto. There is wide acceptance for the artist of scenes XX–XXV as a distinct personality, sometimes called the Master of the Obsequies of St Francis or the Master of the Funeral Rites, from a theme recurrent in his scenes. In these scenes Giotto's ideas, having been 'interpreted in a personal way' (Gnudi), cannot be seen even as to general layout. From scene XIII onwards other assistants' ideas are 'dominant', although according to Gnudi they 'respect Giotto's ideas'. For Previtali, Giotto was always present but was forced 'for some reason to speed up' and so grouped his assistants in two teams working simultaneously. One assistant first appeared in scene VI, a second 'Sienizing' one in scene

XI, where he is 'almost autonomous', while scenes XIII and XVIII–XXII are by an assistant Previtali named the 'Worst Helper'; the last scenes show 'almost independent' work by the artist usually, but for Previtali wrongly, called the St Cecilia Master. These writers do not, however, specify how different tasks were distributed within each more or less collaborative scene; Bellosi suggested such assignments in his captions, indicating that at Assisi about a tenth of the work is by Giotto himself, in comparison with half at Padua (all but minor details) and more than that in works of Cimabue and others mentioned as comparable. This leaves the argument that the strong collaborative role for assistants in the *St Francis* cycle reflects standard 'medieval' practice with little support. Furthermore, for the work to be by Giotto with a crew using his style, it would have to be dated at a time after Giotto was an established master, a conclusion hard to reconcile with a date in his early youth.

Both opposing groups have thus naturally sought firmer bases for dating the series. Those supporting Giotto's authorship of the *St Francis* frescoes have pointed to the image in scene I of the local Torre del Comune, which lacks the top storey added in 1305, and hence must have been painted earlier. Other examples of inaccuracies in the representation of buildings, however, make this line of argument dubious. The most convincing evidence of the date by which the Assisi cycle must have been painted is the existence of a copy dated 1307 of scene XIX, the *Stigmatization of St Francis*, in an altarpiece (Boston, MA, Isabella Stewart Gardner Mus.) by Giuliano da Rimini. Those who think the cycle is reatively late and too close to the Arena Chapel cycle to be by the same artists, cite motifs that occur frequently in the Arena Chapel and only once at Assisi, which would suggest that the latter is a later copy; the combination of a boy shown in lost profile with another onlooker has often been used as such an example.

(b) The 'Isaac' scenes and the S Maria Novella 'Crucifix'. An intermediate position has been taken by some who do not support Giotto's authorship of the *St Francis* cycle, by attributing to him some of the upper tier of frescoes of biblical scenes on the same walls (ignoring Ghiberti's reference), especially the two scenes representing the aged Isaac, *Isaac Blessing Jacob* and *Isaac and Esau*. Suggested by some 19th-century writers, this attribution was more influentially proposed by Meiss. Although the drawing style is not like that in the Arena Chapel frescoes, and is as sharp and metallic as the *St Francis* cycle, the simplicity of the intense drama is compatible with the approach at Padua and has suggested to some that this is the young Giotto working *c.* 1290–95. The *St Francis* cycle would then be by the master's assistants, cruder executants of his drawing style, overseen by him while he painted above. It is thus argued that the *Isaac* scenes are of such high quality that if they are not by Giotto, he cannot be held to be the stylistic innovator as is always supposed. This assumes, however, that the work, in a style that probably would have emerged *c.* 1290, is itself to be given this date rather than allowing for later work by the same artist retaining his same style. In the latter case the work could reflect, rather than anticipate, the Arena Chapel in its dramatic force.

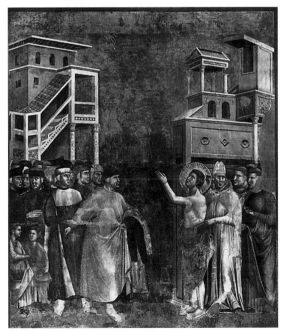

9. Giotto (attrib.): *St Francis Renouncing his Worldly Goods* (first quarter of the 14th century), fresco, Upper Church, S Francesco, Assisi

The attribution to Giotto of the *Isaac* scenes seems strongly supported by the similarity of the S Maria Novella *Crucifix* (*in situ*; see fig. 10), attributed to Giotto in the early sources. On the other hand, some (Toesca and others) have seen in it the work of two hands, a view occasionally rejected (Bonsanti, 1988) but most often overlooked. The heads of *St John* and the *Virgin* at the terminals are by the same hand as the *Isaac* scenes, while the central *Christ* matches the softer modelling of the mature Giotto; the usual arrangement of an assistant painting the less important figures would readily apply here. This implies that the painter of the *Isaac* frescoes was an assistant to Giotto, an older one who had not been trained in his shop. In the frescoes he could well have used Giotto's designs, which would account for the brilliance of their dramatic composition. He would have headed a large team of artists at Assisi, whose relationship to Giotto varied.

A date for the Assisi work beginning in 1304 (copies of the Arena Chapel figures like the boys in profile) and before 1307 (dated copy of the Assisi *Stigmatization*) would be consistent with the commission by the Franciscan official in charge to 1304, Giovanni da Murrovalle. It would also suggest that Giotto, busy at the Arena Chapel, handed over the Assisi work to his associates. A remarkable support for this argument is Vasari's attribution of the S Maria Novella *Crucifix* to two hands, the only such instance in his *Vita* of Giotto. It is often held that such statements about minor artists are more credible than attributions to great ones, the more so in this case since Vasari's informants about the second artist he names,

Puccio Capanna (*fl* 1341–7), were descendants of this artist in Assisi, who said that their forefather had come from Florence to live there. It could then be plausible that Puccio visited Assisi to supervise the frescoes. However, the historical Puccio Capanna has now been firmly identified as the hand responsible for the frescoes of the following generation that Longhi labelled Stefano Fiorentino (*fl c.* 1347), a pupil of Giotto. Yet since Vasari frequently included errors, especially of the wrong generation or date, in data that were otherwise well based, it would be consistent if the Capanna family's claim that their painter ancestor helped on the *Crucifix* were true of a generation earlier than Puccio, thus making the Isaac Master 'Capana Senior'.

(iv) Stylistic sources. Praise of Giotto began by claiming that he was not indebted to his predecessors; his naturalism was contrasted with the Byzantine 'Greek manner' of Cimabue, with whom he is traditionally thought to have trained. The notion of a rigid, lifeless Byzantine art, however, has been challenged, and such works as Cimabue's Assisi *Crucifixion* fresco have been shown to stress similar dramatic human concerns to those found in Giotto's work; differences occur in the drawing of the figures, where Byzantine conventions are rejected by Giotto and a more naturalistic style, much influenced by French Gothic sculpture and Classical Roman work, is adopted. The dramatic Macedonian style of 13th-century Byzantine art has been added to this range. A major precursor of Giotto's soft modelling of figures, and of his fresco technique, is the work of Pietro Cavallini (*c.* 1240–*c.* 1330) in Rome. His art, greatly influenced by Early Christian styles, is characterized by tranquil, statuesque figures. Giotto's work is thus a synthesis of Cavallini's painting qualities and Cimabue's dramatic narrative style.

Although the difference of medium has sometimes argued against the idea that the great Tuscan sculptors of the 13th century anticipated Giotto's work, the classical body forms of Nicola Pisano (*c.* 1220/25–before 1284), as well as Giovanni Pisano's great dramatic compositions of passion and crisis, were certainly major stimuli. Giotto's most intimate source may be in work of the less prominent Arnolfo di Cambio (*fl* 1265), who was active in Florence in Giotto's youth, and whose style reveals a greater emphasis on simple mass. Favoured Giotto motifs anticipated by Arnolfo are the figure leaning forward attentively with powerful shoulders in a tightly pulled robe, for example in the small Perugia Fountain (five figures, Perugia, G.N. Umbria), and the contrast within one work of a frontal icon and a mobile narrative group, as found in the lunette of Florence Cathedral façade (destr.), which recurs in Giotto's *Navicella*.

II. Working methods and technique.

1. WORKSHOP. The loss of Giotto's large, late works in Naples and Milan is the more regrettable as they evidently differed from those that survive, since some were of secular subject-matter and others involved large, unified schemes. Allegorical subjects with frontal protagonists seem to have been more prominent than in earlier works; the large allegorical cycle of the Florence campanile

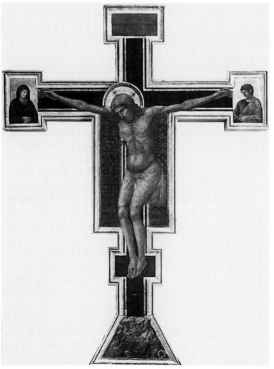

10. Giotto and his workshop: *Crucifix*, tempera on panel, 5.78×4.06 m, *c.* 1300 (Florence, S Maria Novella)

provides some indication of this phase. Giotto was by this stage a famous master, a status that may account for two works of *c.* 1330 with his signature, which were, however, painted by his assistants: the Baroncelli Chapel *Coronation of the Virgin* (Santa Croce, *in situ*; *God the Father* panel; San Diego, CA, F.A. Gal.); the *Virgin and Child with Saints* (Bologna, Pin. N.). Only one earlier signature is known, on the *Stigmatization of St Francis* (Paris, Louvre) usually dated *c.* 1300, which was previously (and may have been originally) at S Francesco, Pisa. It is striking, therefore, that Riccobaldo's report of 1312 on Giotto's work, emphasizing Franciscan work in various cities, does not name Pisa; he is sometimes believed to have obtained his information at a Franciscan conclave in 1310, and he is generally held to have been so well informed that the cities he named were in the order in which Giotto visited them to work. The omission of Pisa is thus incompatible with the picture's attribution to Giotto or his shop, unless the value of Riccobaldo's whole text is questioned, or, more plausibly, the painting is dated later, after he wrote; the inclusion in it of copies of Assisi scenes would fit this hypothesis well and strengthen the case for shop execution.

The two other signed works are both inscribed as by 'magister' Giotto, not a usual form for any artist's signature, particularly notable in the light of Boccaccio's comment that Giotto 'refused to be called Master'. The term would thus imply Giotto's assistants and probably indicates that the works were produced when he was away in Naples. The earliest biography of Giotto, by Filippo Villani in 1395, commented on Giotto's influence on several pupils, Taddeo Gaddi, Maso di Banco and Stefano Fiorentino, all of whom became leading painters of Florence in their time. Their styles are distinct in a way that the style of the workshop painting in Giotto's oeuvre is not. Nevertheless, it has conventionally been held that these artists did not break new ground but only recycled some aspects of their teacher's work, thus only underlining his greatness and continuing influence; some attempts have been made to qualify this view.

2. TECHNIQUE. Giotto's only known mosaic, the *Navicella* (*Christ Walking on the Waves*), survives only in fragments and was quite probably executed to his design by a specialist. All his other work is in fresco or secco on plaster walls, or in tempera on panel, unless the relief sculptures of the campanile, evidently based on his drawings, are included. The fresco technique, in which small areas of plaster were painted while still wet, was new in Giotto's time. Cimabue and others had applied the thin coat of plaster all at once to the whole wall, which normally dried long before the painting was complete, often resulting in the later loss of paint. Cavallini, just before Giotto, is perhaps responsible for making advances in the technique by applying wet plaster in areas small enough to be painted in one day. This assured very durable results, and also left the slight seams between patches of different days' work (*giornate*). These *giornate*, easily visible in Giotto's work, differ greatly in size depending on the complexity of what was being painted, and might range from the head of a protagonist to several spectators, or even the upper half of a fresco consisting of sky. Study of these has permitted the count of the days required to paint

the Arena Chapel frescoes, recorded above. The most interesting findings about Giotto's technique are the absence of true fresco on wet plaster in the Peruzzi frescoes, and a large revision in one of the Arena Chapel frescoes, *Christ Driving the Money-changers from the Temple*; the revision has partly peeled off, as the bonding to a previous coat of pigment is less secure. This seems to have been a rare case. Until further research is done, the most useful clues to Giotto's technique are the instructions in the handbook of Cennino Cennini, who was trained by a pupil of Taddeo Gaddi.

III. Critical reception and posthumous reputation.

Giotto's reputation after his death did not decline. In Boccaccio's *Decameron* Giotto is introduced as a character and defined as the first painter not only to revive art after many centuries when it had been lost but also to imitate nature well enough to deceive. This formula, of Classical derivation, is the first to give Giotto a role in the broad history of art and was one that persisted. In 15th-century Florence Ghiberti perceived Giotto again as an innovator who had replaced the 'Greek' (i.e. Byzantine) manner of Cimabue by studying nature (*see also* §I, 3(iv) above). Alberti in 1435 offered the first close analysis of a work in such a way as to suggest its appeal: he described the different gestures and poses of the figures in the *Navicella*, and how these evoke aspects of fear. In the late 15th century Leonardo da Vinci's only note on past artists states that Giotto was admirable because he followed nature but criticizes his followers until Masaccio, who similarly returned to nature. Here Giotto is admired and yet is superseded by later progress, a viewpoint enforced by Vasari's *Vite* of 1550. In this Giotto is portrayed as the great master of the first of the three ages, succeeded and improved by Masaccio and then by Leonardo. Thus Giotto had become interesting only as a historical pioneer, a position he retained for the next several centuries (see Baccheschi). Simultaneously, serious criticism took the form of the destruction of major works, the *Navicella* and the four whitewashed fresco cycles in Santa Croce, only two of which were recovered in the 19th century.

Giotto's status began to benefit *c.* 1800 from historicism in general (e.g. in the writings of Johann David Passavant, 1820, who called him unsurpassed) and, more practically, from Italian political nationalism. The first removal of whitewash, *c.* 1841, was from the Bargello Chapel frescoes, but only because they included a portrait of Dante. Nevertheless, this stimulated similar restoration programmes at the Bardi and Peruzzi chapels, and in 1880, after a long campaign, the Arena Chapel became public property. Such developments became the basis for Giotto's renewed reputation, most obviously in the essays of John Ruskin (1819–1900) on the Arena Chapel and Santa Croce cycles. Giotto was once again seen as a great master who embodied principles that interested critics; thus in the 1890s Berenson found him the ideal creator of 'life-enhancing' tactile values, which made him compatible with emerging formalism and with the era of Paul Cézanne (1839–1906). Occasional reflections of Giotto, as in the works of Paul Gauguin (1848–1903) and Diego Rivera (1886–1957), are conveyed with simplified shapes that

express the high value of a simpler society, indicating a continuing trace of the notion of Giotto as belonging to a more primitive culture. More broadly, probably most 20th-century artists (other than those who eschew any consciousness of the high culture of past Western civilization) treat with great respect Giotto's formal skills as a modeller and his capacity to communicate the human condition, although generally his interest in narrative drama and religion hold little interest. A typical comment is that of Henry Moore (1898–1986), who on a visit to Italy found little sculpture to admire but said that the 'sculpture' of Giotto compensated by its greatness.

BIBLIOGRAPHY

EARLY SOURCES

Riccobaldo Ferrarese: *Compendium Romanae historiae* (written *c.* 1312–13); ed. A. T. Hankey (Rome, 1984)
G. Boccaccio: *The Decameron* (written *c.* 1353); Eng. trans. by G. H. McWilliam (Harmondsworth, 1972)
C. Cennini: *Il libro dell'arte* (written 1390s; publd Rome, 1821); Eng. trans., ed. D. Thompson (New Haven, 1935)
G. Vasari: *Vite* (1550, rev. 2/1568); ed. G. Milanesi (1878–85)
L. Ghiberti: *Commentarii* (1912)

GENERAL

J. Crowe and G. B. Cavalcaselle: *A History of Painting in Italy* (London, 1854)
J. Ruskin: *Mornings in Florence* (London, 1875)
B. Berenson: *The Florentine Painters of the Renaissance* (New York, 1896/R 1909)
P. Toesca: *La pittura fiorentina del trecento* (Verona, 1929)
Pittura italiana del duecento e del trecento (exh. cat. by G. Brunetti and G. Sinibaldi, Florence, Uffizi, 1937)
P. Toesca: *Il trecento* (Turin, 1951), pp. 442–99
R. Oertel: *Die Frühzeit der italienischen Malerei* (Cologne, 1953; Eng. trans., London, 1968)
E. Borsook: *The Mural Painters of Tuscany* (London, 1960; rev. Oxford, 2/1980)
J. Lafontaine-Dosogne: *Iconographie de l'enfance de la Vierge dans l'empire byzantin et en occident*, ii (Brussels, 1965)
L. Bellosi: *Buffalmacco o il trionfo della morte* (Turin, 1974)
P. Hills: *The Light of Early Italian Painting* (New Haven, 1987)

MONOGRAPHS

H. Thode: *Giotto* (Leipzig, 1899)
F. Perkins: *Giotto* (London, 1902)
F. Rintelen: *Giotto und die Giotto-Apokryphen* (Munich, 1912)
O. Sirén: *Giotto and Some of his Followers* (London, 1917)
I. Supino: *Giotto* (Florence, 1920)
R. Salvini: *Giotto: Bibliografia* (Rome, 1938)
T. Hetzer: *Giotto* (Frankfurt, 1941)
G. Gnudi: *Giotto* (Milan, 1956)
E. Battisti: *Giotto* (Geneva, 1960)
D. Gioseffi: *Giotto architetto* (Milan, 1963)
E. Baccheschi: *L'opera completa di Giotto* (Milan, 1966; Eng. trans., 1969)
G. Previtali: *Giotto e la sua bottega* (Milan, 1967, rev. 1974) [most complete set of docs]
Giotto e il suo tempo. Atti del congresso internazionale per la celebrazione del VII centenario della nascita di Giotto: Assisi, Padova, Firenze, 1967
F. Bologna: *Novità su Giotto* (Turin, 1969)
R. Salvini and C. de Benedictis: *Giotto: Bibliografia*, ii (Rome, 1973) [up to 1970, with addenda of items before 1938 missed in vol. i; incl. 1307 doc.]
L. Schneider, ed: *Giotto in Perspective* (Englewood Cliffs, 1974) [col. of important stud. by various authors]
B. Cole: *Giotto and Florentine Painting* (New York, 1976)
L. Bellosi: *La pecora di Giotto* (Turin, 1985)
G. Bonsanti: *Giotto* (Padua, 1988)

PADUA

J. Ruskin: *Giotto and his Works in Padua* (London, 1854)
U. Schlegel: 'Zum Bildprogramm in der Arenakapelle', *Z. Kstgesch.*, xx (1957), pp. 125–46
W. Euler: *Die Architekturdarstellung in der Arena-Kapelle* (Berne, 1967)
J. H. Stubblebine: *Giotto: The Arena Chapel Frescoes* (New York, 1969)

C. Bellinati: 'La cappella di Giotto all'Arena a le miniature dell'antifornario "giottesco" della cattedrale', *Da Giotto a Mantegna* (exh. cat., ed. L. Grossato; Padua, Pal. Ragione, 1974)
D. Giunta: 'Appunti sull'iconografia della storia della Vergine nella cappella degli Scrovegni', *Riv. Istituto nazionale d'archeologia e storia dell'arte*, xxiii/xxiv (1974–5), pp. 79–139
Boll. A., lxiii (1978) [issue ded. to stud. on the conservation of the Arena Chapel, Padua]
M. Lisner: 'Farbgebung und Farbikonographie in Giottos Arenafresken', *Mitt. Ksthist. Inst. Florenz*, xxix (1985), pp. 1–78
G. Basile: *The Arena Chapel Frescoes* (London, 1993)

ASSISI

R. Offner: 'Giotto, non-Giotto', *Burl. Mag.*, lxxiv (1939), pp. 259–68; lxxv (1939), pp. 96–113
R. Longhi: 'Stefano Florentino', *Paragone*, 13 (1951), pp. 18–40
R. Fisher: 'Assisi, Padua, and the Boy in the Tree', *A. Bull.*, xxxviii (1956), pp. 47–52
J. White: 'The Date of the Legend of St Francis at Assisi', *Burl. Mag.*, xcviii (1956), pp. 344–51
M. Meiss: *Giotto and Assisi* (New York, 1960)
G. Palumbo, ed.: *Giotto e i giotteschi in Assisi* (Rome, 1969)
A. Smart: *The Assisi Problem and the Art of Giotto* (Oxford, 1971)
V. Martinelli: 'Un documento per Giotto ad Assisi', *Stor. A.*, xix (1973), pp. 193–210
H. Belting: *Die Oberkirche von San Francesco in Assisi* (Berlin, 1977)
E. Battisti: 'Body Language nel ciclo di San Francesco di Assisi', *Roma anno 1300. Atti della IV settimana di storia dell'arte medievale dell' Università di Roma 'La Sapienza': Roma, 1980*, pp. 675–88
L. Bellosi: 'La barba di San Francesco', *Prospettiva*, xxii (1980), pp. 11–34
H. Belting: 'Assisi e Roma', *Roma anno 1300. Atti della IV settimana di storia dell'arte medievale dell'Università di Roma 'La Sapienza': Roma, 1980*, pp. 93–101
G. Bonsanti: 'Giotto nella cappella di S Nicola', *Roma anno 1300. Atti della IV settimana di storia dell'arte medievale dell'Università di Roma 'La Sapienza': Roma, 1980*, pp. 199–209
I. Hueck: 'Il Cardinale Napoleone Orsini e la cappella di S Nicola nella basilica francescana ad Assisi', *Roma anno 1300. Atti della IV settimana di storia dell'arte medievale dell'Università di Roma 'La Sapienza': Roma, 1980*, pp. 187–98
L. Schwartz: *The Fresco Decoration of the Magdalen Chapel in St Francis at Assisi* (diss., Bloomington, IN U., 1980)
D. Schönau: 'The Vele of Assisi', *Meded. Ned. Hist. Inst. Rome*, 44–5 (1983), pp. 99–109
J. H. Stubblebine: *Assisi and the Rise of Vernacular Art* (New York, 1985)

SPECIALIST STUDIES

J. Gy-Wilde: 'Giotto-Studien', *Jb. Ksthist. Samml. Wien.*, vii (1930), pp. 45–94
A. Schmarsow: 'Zur Masolino-Masaccio Forschung', *Kstchron. & Kstlit.*, n. s., lxiv (1930/31), pp. 1–3, n. 1
U. Procacci: 'La patria di Giotto', *A Giotto il suo Mugello* (Borgo San Lorenzo, 1937, rev. Florence, 1967), pp. 2–5 [incl. 1301 and 1305 docs]
W. Päseler: 'Giottos Navicella und ihr spätantikes Vorbild', *Röm. Jb. Kstgesch.*, v (1941), pp. 51–162
R. Oertel: 'Wende der Giotto-Forschung', *Kstgesch.*, ii (1943–4), pp. 1–27
R. Longhi: 'Giudizio sul dugento', *Proporzioni*, ii (1949), pp. 52–4
C. Mitchell: 'The Lateran Fresco of Boniface VIII', *J. Warb. & Court. Inst.*, xiv (1951), pp. 1–6
P. Murray: 'Notes on some Early Giotto Sources', *J. Warb. & Court. Inst.*, xvi (1953), pp. 58–80
C. Ragghianti: 'Inizio di Leonardo', *Crit. A.*, n. s., i (1954), pp. 1–18
C. Brandi: 'Giotto recuperato a San Giovanni Laterano', *Scritti in onore di Lionello Venturi* (Rome, 1956), pp. 55–85
F. Zeri: 'Due appunti su Giotto', *Paragone*, 85 (1957), pp. 75–87
C. Gnudi: 'Il passo di Riccobaldo Ferrarese relativo a Giotto', *Studies Dedicated to William Suida* (London, 1959), pp. 26–30
U. Procacci: 'La tavola di Giotto della chiesa della Badia', *Scritti in onore di Mario Salmi* (Rome, 1962), pp. 9–45
A. Romanini: 'Giotto e l'architettura gotica in alta Italia', *Boll. A.*, l (1965), pp. 160–80
L. Tintori and E. Borsook: *Giotto: La cappella Peruzzi* (Turin, 1965)
C. Gilbert: 'L'ordine cronologico degli affreschi Bardi e Peruzzi', *Boll. A.*, liii (1968), pp. 192–7
C. Brandi: 'Percorso di Giotto', *Crit. A.*, xvi (1969), pp. 3–80
M. Trachtenberg: *The Campanile of Florence Cathedral* (New York, 1971)
C. Gilbert: 'Cecco d'Ascoli e la pittura di Giotto', *Commentari*, xxiv (1973), pp. 19–25

J. Gardner: 'The Stefaneschi Altarpiece: A Reconstruction', *J. Warb. & Court. Inst.*, xxxvii (1974), pp. 57–103

C. Gilbert: 'The Fresco by Giotto in Milan', *A. Lombarda*, n.s., 47–8 (1977), pp. 31–72

I. Hueck: 'Giotto und die Proportion', *Festschrift W. Braunfels* (Tübingen, 1977), pp. 143–55

G. Kreytenberg: 'Der Campanile von Giotto', *Mitt. Ksthist. Inst. Florenz*, xxii (1978), pp. 147–84

R. Olson: 'Giotto's Portrait of Halley's Comet', *Sci. American*, ccxl (1979), pp. 160–70

J. Gardner: 'The Louvre Stigmatization and the Problem of the Narrative Altarpiece', *Z. Kstgesch.*, xlv (1982), pp. 217–47

M. Zucker: 'Figure and Frame in the Paintings of Giotto', *Source: Notes Hist. A.*, i/4 (1982), pp. 1–5

A. T. Hankey: 'Riccobaldo of Ferrara and Giotto: An Update', *J. Warb. & Court. Inst.*, liv (1991), p. 244

J. Thomann: 'Pietro d'Abano on Giotto', *J. Warb. & Court. Inst.*, liv (1991), pp. 238–44

Uffizi, Stud. & Ric., viii (1992) [issue ded. to the stud. on the Ognissanti Madonna]

CREIGHTON E. GILBERT

Giovanni, Antonio di Agostino di ser. *See* ANTONIO DA FABRIANO.

Giovanni, Apollonio di. *See* APOLLONIO DI GIOVANNI.

Giovanni, Bartolomeo di. *See* BARTOLOMEO DI GIOVANNI.

Giovanni, Benvenuto di. *See* BENVENUTO DI GIOVANNI.

Giovanni, Berto di. *See* BERTO DI GIOVANNI.

Giovanni, Bertoldo di. *See* BERTOLDO DI GIOVANNI.

Giovanni, Gualtieri di. *See* GUALTIERI DI GIOVANNI.

Giovanni, Matteo di. *See* MATTEO DI GIOVANNI.

Giovanni, Mino di. *See* MINO DA FIESOLE.

Giovanni Agostino da Lodi [Pseudo-Boccaccino] (*fl c.* 1467–1524/5). Italian painter and draughtsman. The identification of a particular hand has resulted in the removal of a group of paintings from those formerly attributed to Boccaccio Boccaccino of Cremona (whence the name 'Pseudo-Boccaccino'). This resulted from the discovery of the signature of Giovanni Agostino da Lodi on a small panel painting of *SS Peter and John* (*c.* 1495; Milan, Brera) and was confirmed by another on a drawing, *Allegory of Prudence* (sold New York, Sotheby's, 16 Jan 1986, lot 36). These works suggest that he was an intermediary between the perspective art of Lombardy during the last decade of the 15th century and the Venetian style of Giovanni Bellini, Giorgione and the other painters of their circle. A lengthy stay in Venice is attested by a payment made in 1504 and by the presence of important paintings in the Veneto, such as the *Virgin and Child Enthroned with Four Saints* (Murano, S Pietro Martire), *Christ Washing the Feet of the Disciples* (1500; Venice, Accad.) and the *Virgin and Child with SS Roch and Nicholas* (Bribano, S Nicola), in which his style was enriched by elements inspired by Albrecht Dürer (1471–1528). His career thus appears to have run parallel with Gerolamo Romanino, Altobello Melone and those artists whose works reveal a fusion of Milanese, Venetian and northern European influences. After returning to Lombardy, Giovanni Agostino da Lodi executed paintings at Gerenzano (*in situ*), in the Certosa di Pavia (*in situ*; thus confirming his importance in contemporary Lombard art) and for S Maria della Pace, Milan (now in Milan, Brera).

BIBLIOGRAPHY
A. Puerari: *Boccaccino* (Milan, 1957)

M. Lucco and M. Natale: *Cena in Emmaus: Giovanni Agostino da Lodi* (Milan, 1988)

F. Moro: 'Giovanni Agostino da Lodi ovvero l'Agostino di Bramantino: Appunti per un unico percorso', *Paragone*, xl (1989), no. 473, pp. 23–61

MARCO TANZI

Giovanni Angelo di Antonio da Camerino. *See under* MASTERS, ANONYMOUS, AND MONOGRAMMISTS, §I: MASTER OF THE BARBERINI PANELS.

Giovanni Antonio da Brescia (*b* ?Brescia, *c.* 1460; *d* ?Rome, *c.* 1520). Italian engraver. His career can be traced through 27 engravings with his signature (usually IO.AN.B or IO.AN.BX) and many others attributed to him. He appears to have begun work in the circle of Andrea Mantegna, and a number of engravings of the Mantegna school are generally assigned to him, including three prints after Mantegna's *Triumph of Caesar* (B.17b, 18b, 19b) and a version of the *Four Dancing Ladies* (B. 29b). This early phase probably ended about 1506, when the school dispersed after the death of Mantegna. A transition period is suggested by a group of prints that demonstrate the technical conventions of Mantegna with stylistic influence from the work of Benedetto Montagna: *Nativity* (B. 4); *Virgin and Child* (B. 9); *St Barbara* (B. 12); and *Justice* (B. 27; see fig.). In the *Virgin and Child* the view of a distant landscape may have been inspired by the engravings of Albrecht Dürer (1471–1528), which arrived in North Italy in this period. Giovanni Antonio executed four copies of Dürer's engraving of the *Satyr Family* (1505), one dated 1507 (B. 39).

Evidence of Giovanni Antonio's arrival in Rome is provided by two works in which he reverted to his early style. The first, of uncertain attribution, is a portrait of *Pope Leo X* (B. 35), which cannot have been executed before 1513, when his papacy began. The second engraving, signed IO.AN.BRIXIAS, a *Venus* (B. 22), according to the inscription, represents a statue that had recently been discovered in Rome. The figure and draperies recall his earlier works, but the technique of the landscape is close to that of Dürer, although it is probably derived from an engraving by Marcantonio Raimondi, who absorbed Dürer's style. The *Venus* landscape is the first manifestation of Marcantonio's influence on Giovanni Antonio, which continued throughout the rest of his career. In 1516 Giovanni Antonio produced the latest of his signed and dated engravings (B. 25), one of a series of four illustrations from Virgil's *Aeneid* (B. 23–6), copied from four designs engraved on a single plate by Marcantonio. In his later works his technique became more disciplined, as can be seen from a group of engravings probably produced *c.* 1515–20 (B.1–3, 7, 16, 29). Two of these are based on works by other artists that can be dated: the *Abraham and Melchizedek* (B.1), derived from a fresco by Raphael in the

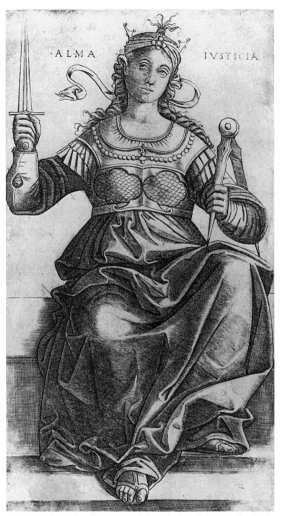

Giovanni Antonio da Brescia (after Andrea Mantegna): *Justice*, engraving, 317×170 mm, *c.* 1507 (London, British Museum)

Vatican *Loggie*, completed in 1519; and the *Discovery of Joseph's Cup* (B. 2), after a drawing by Baldassare Peruzzi of *c.* 1520 (London, BM). These are his latest known works.

BIBLIOGRAPHY

Thieme–Becker

A. M. Hind: *Early Italian Engraving: A Critical Catalogue with Complete Reproduction of All the Prints Described*, v (London, 1948), pp. 33–54

J. A. Levenson, K. Oberhuber and J. L. Sheehan: *Early Italian Engravings from the National Gallery of Art* (Washington, DC, 1973), pp. 235–64

M. J. Zucker: *Early Italian Masters (1980), Commentary* (1984), 25 [XIII/ii] of *The Illustrated Bartsch*, ed. W. L. Strauss (New York, 1978) [B.]

J. M. Gonzalez de Zarate: 'Una breve nota sobre la fachada da la Universidad de Salamanca', *Homenaje al profesor Martín González* (Valladolid, 1995), pp. 625–30

□

Giovanni Cristoforo Romano. *See* GIAN CRISTOFORO ROMANO.

Giovanni da Castel Bolognese. *See* BERNARDI, GIOVANNI.

Giovanni [di Bartolo Bettini] **da Fano** (*fl c.* 1450–70). Italian illuminator. In 1462 he is recorded in Rimini living in the house of Francesco Antonio degli Atti, brother-in-law of Sigismondo Pandolfo Malatesta, ruler of Rimini, at whose court he was active. Giovanni illustrated copies of Basinio de' Basini's *Hesperides* (1449–57), an epic poem portraying Malatesta engaged in a struggle against Alfonso I, King of Naples and Sicily, for the domination of Italy. Presentation manuscripts (e.g. Paris, Bib. Arsenal, MS. 630; Oxford, Bodleian Lib., MS. Canon. Class. lat. 81; Rome, Vatican, Bib. Apostolica, MS. lat. 6043) were lavished by Malatesta on his allies. These codices include between 19 and 22 coloured drawings, with variations between copies, which are remarkable for their immediacy; one, for example, depicts a fortress by moonlight, another the Tempio Malatestiano under construction. Some scenes are within illusionistic marble frames. Two of the compositions bear the inscription OP. IOANNIS PICTORIS FANESTRIS. Giovanni also illustrated, with pen drawings, copies of Roberto Valturio's *De re militari*, which dealt with war machines and strategy while exalting Malatesta. This treatise, begun soon after 1449–50, was completed by 1461 when Matteo de' Pasti was sent to Constantinople with a presentation copy for the Ottoman ruler, Muhammad II (*reg* 1272–1302). Francesco Sforza, Duke of Milan, also received an exemplum with an accompanying letter, dated 9 June 1464, from Bishop Angelo Geraldini, specifying that the illustrator involved in the production of this series was from Fano. Several other Riminese manuscripts of the *De re militari* are extant (e.g. 1462; Rome, Vatican, Bib. Apostolica, MS. Urb. lat. 281; 1463; Paris, Bib. N., MS. lat. 7236; 1465; Modena, Bib. Estense, MS. lat. 447; 1466; Venice, Bib. N. Marciana, MS. lat. VIII. 29; 1470; Milan, Bib. Ambrosiana, MS. F. 150. sup.).

BIBLIOGRAPHY

C. Ricci: *Il Tempio malatestiano*, 2 vols (Milan and Rome, 1925)

——: 'Di un codice malatestiano della *Esperide* di Basinio', *Accad. & Bib. Italia*, i/5–6 (1928), pp. 20–48

E. Rodakiewicz: 'The "editio princeps" of Roberto Valturio *De re militari* in Relation to the Dresden and Munich Manuscripts', *Maso Finiguerra*, v (1940), pp. 14–81

O. Pächt: 'Giovanni da Fano's Illustrations for Basinio's Epos *Hesperis*', *Stud. Romagn.*, ii (1951), pp. 91–103 [app. by A. Campana]

S. Nicolini: 'Alcune note su codici Riminesi e malatestiani', *Stud. Romagn.*, xxxix (1988), pp. 17–39

The Painted Page: Italian Renaissance Book Illumination, 1450–1550 (exh. cat., ed. J.J.G. Alexander; London, RA, 1994)

PATRICK M. DE WINTER

Giovanni da Fiesole, Fra. *See* ANGELICO, FRA.

Giovanni d'Alesso d'Antonio. *See* UNGHERO, NANNI.

Giovanni dal Ponte [Giovanni di Marco] (*b* Florence, 1385; *d* Florence, 1437–8). Italian painter. He was reputed to have been a student of Spinello Aretino. He acquired the name dal Ponte due to the location of his studio at Santo Stefano a Ponte, Florence. He joined the Arte dei Medici e degli Speziali in 1410 and the Compagnia di S Luca in 1413. Outstanding debts brought him a prison sentence in 1424, but he still owed money to a carpenter three years later. By the late 1420s he had opened his own studio and formed a partnership with the painter Smeraldo di Giovanni (*c.* 1365–after 1442). Giovanni dal Ponte's varied and prolific production, which continued until his death, included fresco cycles, panels and the decoration

of small objects. A number of allegorical panel paintings and *cassoni* are attributed to him. The animated, stylized figures in the *Seven Liberal Arts* (1435; Madrid, Prado) are shown in a garden dotted with naturalistic flowers and plants. His early work shows the impact of the Late Gothic style. The composition of the *Coronation of the Virgin* (?1420; Chantilly, Mus. Condé) recalls the famous altarpiece of the same subject (1413; Florence, Uffizi) by Lorenzo Monaco, while the treatment of drapery suggests the influence of Lorenzo Ghiberti's sculpture. Giovanni assimilated the discoveries of his contemporaries. In the *Virgin and Child with Angels* (c. 1427–8; Cambridge, Fitzwilliam, 551) the bulky figures derive from Masaccio. However, his late *Virgin and Child with Angels* (c. 1434–5; San Francisco, CA, de Young Mem. Mus.) shows a return to a decorative, linear style.

See also CASSONE, §1.

BIBLIOGRAPHY

C. H. Shell: *Giovanni dal Ponte and the Problem of Other Lesser Contemporaries of Masaccio* (diss., Cambridge, MA, Harvard U., 1958)

B. Berenson: *Florentine School*, i (1963), pp. 90–92

F. Guidi: 'Per una nuova cronologia di Giovanni di Marco', *Paragone*, xix/223 (1968), pp. 27–46

——: 'Ancora su Giovanni di Marco', *Paragone*, xxi/239 (1970), pp. 11–23

C. Shell: 'Two Triptychs by Giovanni dal Ponte', *A. Bull.*, liv (1972), pp. 41–6

C. Mack: 'A Carpenter's *catasto* with Information on Masaccio, Giovanni dal Ponte, Antonio di Domenico, and Others', *Mitt. Ksthist. Inst. Florenz*, xxiv (1980), pp. 366–8

F. G. Bruscoli: 'Una tavola di Giovanni di Marco da San Donato a Porrona', *Scritti di storia dell'arte in onore di Federico Zeri*, ed. M. Natale, i (Milan, 1984), pp. 60–67

C. Frosinini: 'Proposte per Giovanni dal Ponte e Neri di Bicci: Due affreschi funerari del Duomo di Firenze', *Mitt. Ksthist. Inst. Florenz*, xxxiv (1990), pp. 123–38

EUNICE D. HOWE

Giovanni d'Ambrogio, Pietro di. *See* PIETRO DI GIOVANNI D'AMBROGIO.

Giovanni da Modena [Giovanni di Pietro Falloppi] (*fl* 1409; *d* before 1455). Italian painter. He is first recorded in Bologna in 1409; the following year he was paid for the hangings for an important funeral in S Francesco, Bologna. His major surviving work is the fresco decoration of the Bolognini Chapel in S Petronio, Bologna, commissioned in Bartolomeo Bolognini's will of 1408. It is attributed to Giovanni on the basis of his later work (1420–21) in the neighbouring chapel of S Abbondio. Bolognini stipulated that there should be a *Paradise*, in which Giovanni shows rows of saints seated on benches, contemplating the Coronation of the Virgin, an *Inferno* 'as horrible as possible' and a *Journey of the Magi*. On the altar wall Giovanni, assisted by Jacopo di Paolo (who painted the altarpiece and stained glass), depicted the *Legend of St Petronius*, bishop and protector of Bologna. The fresco of the installation of a bishop (perhaps Giovanni di Michele of Bologna, *reg* 1412–17) by the anti-pope John XXIII suggests a dating of c. 1412–20. The *Petronius* scenes are set against details of Bologna's townscape; the embarkation and papal scenes recall illuminations of Bolognese shipping law and canon law manuscripts respectively. The hollow-cheeked faces and dark shadows probably show the influence and assistance of Jacopo di Paolo. The *Departure*

of Petronius reflects Giotto's *Visitation* (Padua, Scrovegni Chapel), though this echo may be via Tomaso da Modena, another likely influence on Giovanni. Volpe has shown a similarity between the *Inferno* scene and those of the Master of the Brussels Initials. But the architectural style, the rocky gorges, the pinks and greens and the long oval faces with dreamy eyes show that Giovanni's style was above all adapted from Agnolo Gaddi's, adding an International Gothic interest in the fashionable, lavish and exotic that was probably fuelled by contact with the art of the Visconti court and with foreign visitors in Bologna. Such details as pointed Hungarian hats, baggy-brimmed boots, extravagantly curled beards and a jester wearing bells appear alongside stewards driving flies from camels. The panels of *SS Cosmas and Damian* (Berlin, Gemäldegal.) can be closely associated with these frescoes in date and style.

The frescoes of 1420–21 in the chapel of S Abbondio in S Petronio, Bologna, show two mystic *Crucifixions*: one of Christ on a tree between Adam and Eve, prophets, the Virgin and saints (see fig.), and the other on a cross, the arms of which crown a personification of the Church on one side and stab a personification of the Synagogue on the other (an anti-Semitism aimed at locally established Jewish colonies). The *Crucifixions* are set in foliate Venetian arches above an illusionistic colonnade framing shields of the aldermen of Bologna. In these scenes Giovanni's style becomes broader and more angular. The intensified drama is particularly evident in the faces of the Virgin and St John in a Crucifix of the same period from S Francesco, Bologna (Bologna, Pin. N.), in which Christ's face is hidden by a striking frontal foreshortening. A slightly later work, the *Stigmatization of St Francis with Three Saints* (Florence, Fond. Longhi) again shows Giovanni's fashion-consciousness. Several frescoes in the aisles of S Petronio, Bologna, and frescoes of the *Madonna* in S Giovanni al Monte and S Maria dei Servi, Bologna, belong to the 1420s to 1430s, while a dismembered polyptych (Bologna, Com-

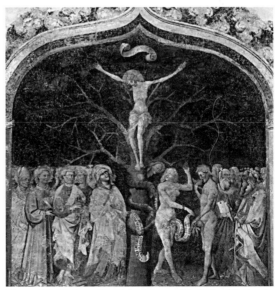

Giovanni da Modena: *Crucifixion: Mystery of the Fall and Redemption of Man* (1420–21), fresco, chapel of S Abbondio, S Petronio, Bologna

pagnia Lombardi; Ferrara, Pin. N.) shows the much bolder, coarser style of the 1440s.

Giovanni is last recorded painting a canvas of S Bernardino of Siena, commissioned in 1451 (Bologna, Pin. N.), and the decorations of the chapel of S Bernardino in S Francesco, Bologna, dated 1455–6. The scenes of the saint's life are shown in perspectival niches around the central image of S Bernardino, whose wizened features suit Giovanni's angular style ideally.

BIBLIOGRAPHY

R. Longhi: *Officina ferrarese* (Rome, 1934, rev. 3/1975)
S. Bottari: *La pittura in Emilia nella prima metà del '400*, ed. C. Volpe (Bologna, 1958)
L. Castelfranchi Vegas: *International Gothic Art in Italy* (London, 1968)
F. Filippini and G. Zucchini: *Miniatori e pittori a Bologna: Documenti del secolo XV* (Rome, 1968)
R. Longhi: *Lavori in Valpadana* (Florence, 1973)
S. Padovani: 'Materiale per la storia della pittura ferrarese nel primo quattrocento', *Ant. Viva*, xiii (1974), pp. 3–21 (3–5)
C. Volpe: 'La pittura gotica: Da Lippo di Dalmasio a Giovanni da Modena', *La basilica di S Petronio* (Bologna, 1983), pp. 213–94
P. Montiani Bensi and M. R. Montiani Bensi: 'L'iconografia della *Croce vivente* in ambito emiliano e ferrarese', *Mus. Ferrar.: Boll. Annu.*, 13–14 (1985), pp. 161–82
I. Kloten: *Wandmalerei im grossen Kirchenschisma: Die Capella Bolognini in San Petronio zu Bologna* (Heidelberg, 1986)
R. D'Amico and R. Grandi, eds: *Il cantiere di San Petronio* (Bologna, 1987)
Il tempo di Nicolò III: Gli affreschi del Castello di Vignola e la pittura tardogotica nei domini estensi (exh. cat., ed. D. Benati; Vignola, Rocca, 1988)
J. Baschet: *Les Justices de l'au-delà* (Rome, 1993), pp.363–404, 639–41

ROBERT GIBBS

Giovanni da Napoli. *See* MARIGLIANO, GIOVANNI.

Giovanni da Nola. *See* MARIGLIANO, GIOVANNI.

Giovanni (di Giuliano) da Oriolo (*b* Oriolo, nr Faenza; *d* Faenza, before 24 Sept 1474). Italian painter. His oeuvre is known through one painting, the signed profile portrait of *Lionello d'Este* (London, N.G.). Stylistically similar to Pisanello's *Portrait of Lionello d'Este* (*c.* 1441; Bergamo, Gal. Accad. Carrara), Giovanni's painting probably dates to the same period or slightly later. There is a payment to 'Magistro Johanni de Faventia' dated 21 June 1447, which may refer to the portrait. He returned to Faenza in 1449 and soon after was commissioned to paint portraits of Astorgio II Manfredi's two daughters, Elisabetta and Barbara (untraced). He is recorded as court painter in Faenza and is described as 'pictor publicus' and 'magister' in 1461. In 1452, 'Marcius' is given as his second name; later the family name Savoretti appears. He is said to be dead in a document of 24 September 1474. Giovanni di Giuliano da Oriolo should not be confused with his compatriot Giovanni (di Andrea) da Riolo (*fl* 1433), nor with Giovanni Pietro da Oriolo, who painted in Asolo.

BIBLIOGRAPHY

G. Ludwig: 'Archivalische Beiträge zur Geschichte der venezianischen Malerei', *Jb. Kön.-Preuss. Ktssamml.*, xxvi (1905), p. 157 [suppl.]
G. Ballardini: *Giovanni da Oriolo pittore faentino del '400* (Florence, 1911)
R. Buscaroli: *La pittura romagnola del quattrocento* (Faenza, 1931), pp. 61, 71–5, 255
A. Venturi: *Storia* (1901–40), VII/i, p. 268
M. Davies: *The Earlier Italian Schools*, London, N.G. cat. (London, 1951, 2/1961/R 1986)

KRISTEN LIPPINCOTT

Giovanni (di Pietro) da Pisa (i) (*fl* 1401–23). Italian painter. He is first documented in 1401 in Genoa, where he became Deputy of the Painters' Guild in 1415. Two signed works by him are extant: a triptych depicting the *Virgin and Child with SS John the Baptist and Anthony Abbot* (1423; San Simeon, CA, Hearst Found.) and a polyptych depicting the *Virgin and Child with Four Saints* (Barcelona, Mus. A. Catalunya). Whereas the former shows close contacts with the art of the many Pisan painters, for example Turino di Vanni (1348–1438) present in Genoa between 1410 and 1420, the latter shows a stronger influence of Taddeo di Bartolo (1362/3–1422), active in Liguria between 1393 and 1398, and is probably therefore the earlier work. Close to the Barcelona *Virgin and Child*, but considered slightly earlier, is a polyptych partially reconstructed by Algeri from dispersed panels (e.g. Genoa, S Fede; Pavia, Pin. Malaspina). Giovanni's first known work has been identified as the polyptych fragment depicting *Four Saints* (Portoria, nr Genoa, convent of the Annunziata), where the Pisan influences of his formative years blend with Ligurian elements derived from Barnaba da Modena (*fl* 1361–83) and Taddeo. Algeri proposed the attribution to Giovanni of the polyptych depicting *St Lawrence with Four Saints* (Moneglia, S. Giorgio) because of its similarities with the Portoria panel.

BIBLIOGRAPHY

F. R. Pesenti: 'Un apporto emiliano e la situazione figurativa locale', *La pittura a Genova e in Liguria dagli inizi al cinquecento*, i (Genoa, 1970, rev. 1987), pp. 65–6, 70
M. Migliorini: 'Persistenze pisano–senesi nella pittura genovese del primo quattrocento: Un inedito di Giovanni di Pietro da Pisa', *Stud. Stor. A.*, ii (1978–9), pp. 97–103
E. Rossetti Brezzi: 'Nuove indicazioni sulla pittura ligure–piemontese tra '300 e '400', *Ric. Stor. A.*, ix (1978–9), pp. 13–24
M. Natale: 'Pittura in Liguria nel quattrocento', *La pittura in Italia: Il quattrocento*, ed. F. Zeri, i (Milan, 1987), pp. 15–20 (15–16)
G. Algeri: 'Nuove proposte per Giovanni da Pisa', *Boll. A.*, xlvii (1988), pp. 35–48

VITTORIO NATALE

Giovanni da Pisa (ii) [Giovanni di Francesco] (*fl* 1444; *d* ?Venice, *c.* 1460). Italian sculptor. In a document of February 1447 he is named as a member of Donatello's Paduan workshop, where he apparently worked between 1444 and 1449, engaged on the high altar in Il Santo together with Donatello's other assistants, Niccolò Pizzolo, Urbano da Cortona, Antonio Chellini (*fl* 1446; *d* after 1464) and Francesco del Valente (*fl* 1447). Though his role is not specified, Giovanni probably assisted in the modelling and casting of the bronzes and later may also have assisted on Donatello's pulpits in S Lorenzo, Florence. On 8 July 1447 Giovanni was paid for work on the terracotta altar in the Ovetari Chapel of the church of the Eremitani, Padua. Although Michiel attributed the altarpiece to Giovanni, the design and execution are evidently the work of Pizzolo, from whom the altarpiece was commissioned, and Giovanni's role was minor. Puppi suggested that he made a small-scale model of the altarpiece. Also attributed to Giovanni, probably erroneously, are three reliefs of the *Virgin and Child* (Padua, Eremitani, Ovetari Chapel, included in terracotta altar; Padua, S Giustina; Venice, S Maria Mater Domini), all of which are indebted to Donatello.

BIBLIOGRAPHY

Thieme–Becker

M. A. Michiel: *Notizia d'opera del disegno* (MS. before 1552); ed. T. Frimmel as *Der anonimo morelliano* (Vienna, 1888), p. 26

A. Venturi: *Storia* (1901–40), vi, pp. 332, 448–50

A. Cotton and R. Walker: 'Minor Arts of the Renaissance in the Museo Cristiano', *A. Bull.*, xvii (1935), pp. 118–62

L. Puppi: *La chiesa degli Eremitani a Padova*, ii (Vicenza, 1970), pp. 79–80

Da Giotto a Mantegna (exh. cat., ed. L. Grossato; Padua, Pal. Ragione, 1974), no. 96

STEVEN BULE

Giovanni da Udine [Nanni, Giovanni; Ricamatori, Giovanni dei] (*b* Udine, 27 Oct 1487; *d* Rome, 1564). Italian stuccoist, painter, draughtsman and architect. In 1502 he was apprenticed to Giovanni Martini (also called Giovanni da Udine; *d* 1535), a painter in Udine, and subsequently he may have studied with Giorgione in Venice. According to Vasari, armed with a letter of introduction to Baldassare Castiglione, he decided to go to Rome to seek work with Raphael. He joined Raphael's workshop, where he may have learnt techniques of still-life painting from a Netherlandish colleague. The musical instruments in Raphael's *St Cecilia* altarpiece (1516; Bologna, Pin. N.) are often attributed to Giovanni.

In Rome, Giovanni da Udine was particularly inspired by the decoration of ancient buildings. Excavations revealed rooms then underground (thus called *grotte*) with a style of painted and plastered decoration incorporating foliated scrolls, naturalistic animals and plants and fantastic figures and architecture (hence called *grotteschi*; *see* GROTESQUE). Such motifs had been copied before in Rome (notably by Bernardino Pinturicchio), but it was Raphael, probably with the assistance of Giovanni, who created the first decorative scheme entirely composed of them in the bathroom (*stufetta*) of Cardinal Bernardo Bibbiena (1516; Rome, Vatican Pal.; see fig.). That scheme

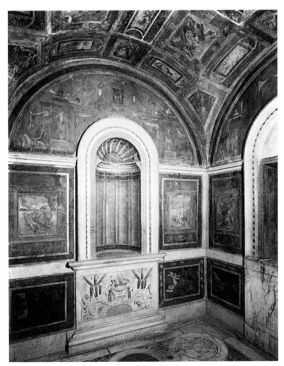

Giovanni da Udine: fresco decoration (1516) in the bathroom (*stufetta*) of Cardinal Bernardo Bibbiena, Vatican Palace, Rome

was entirely painted. At about this time a formula for re-creating the Romans' rock-hard plaster, capable of reproducing minute details, was devised, almost certainly by Giovanni, probably using marble dust and chips of travertine stone. Thus when Raphael and his assistants began decorating the 13 bays of the first of the great Logge of the Vatican Palace (1517–19), Giovanni was able to contribute figured frames and other details in stucco to the scheme, as well as painted grotesques on the pilasters and walls, with a delicate freshness at least partly due to his inclusion of tempera in the fresco medium. Vasari described Giovanni's work on the Loggia as 'the finest painting ever seen by mortal eye'.

During this period Giovanni was also involved in Raphael's decoration of the villa of Agostino Chigi (1517–18; Rome, Villa Farnesina). In the villa's Loggia of Cupid and Psyche, Giovanni painted festoons of flowers and fruit on the walls, decorative features on the ceiling and grotesques above the windows. In his grotesques he both copied and transformed Roman models and also showed considerable powers of invention. These are evident in the more conventional scheme in the Vatican on which he and Polidoro da Caravaggio collaborated for the ceiling of the corridor below Raphael's Loggia for Leo X (1518–19). In 1520 Giovanni became involved in the decoration of the Villa Madama, Rome, which Raphael had begun some years earlier for Cardinal Giulio de' Medici; on Raphael's death the same year, Giovanni was put in charge of the work, together with Raphael's senior assistant, Giulio Romano. This collaboration was fraught with difficulties, which were the talk of the papal court, but it resulted in the most harmonious decorative treatment of any Renaissance villa. In the garden loggia, which is all that remains of what was built of the project, Raphael's magnificent architecture is sumptuously enriched by its stucco skin of small-scale Classical ornament, more architectonic and sculptural than grotesque (*see* RAPHAEL, fig. 9). The painted decoration of the vault does contain grotesques, as well as small scenes and fields of pure ornament, and the vigorous colouring reflects the taste of Giulio Romano, but this does not detract from the remarkable beauty of the whole, which is the only Renaissance interior fully to reflect the grandeur of Imperial Rome. (Giovanni is also credited with the design of an Elephant Fountain (untraced) in the gardens, *c.* 1526.)

In 1522, during the artistic drought of the pontificate of Adrian VI (*reg* 1521–3), Giovanni left Rome for Udine. The accession of Giulio de' Medici as Clement VII the following year led him to return; it may have been on this journey that he decorated a room (destr.) in the Palazzo Medici, Florence. Again in the Vatican, he collaborated with Perino del Vaga on the ceiling decoration of the Sala dei Pontefici, with celestial motifs and the Medici arms (*c.* 1521; *in situ*). This sojourn was terminated by the Sack of Rome in 1527. On his return to Udine, he designed the campanile in the Piazza Contarena (1527; now Piazza Vittorio Emanuele). In 1531 he was summoned back to Rome by Clement VII to decorate a chapel in St Peter's and was then sent to work on Medici projects in Florence.

In 1532 Giovanni began work on the stucco decoration for Michelangelo's Medici Chapel in S Lorenzo, Florence, but the project was never completed. It was probably at

this time that he designed the stained-glass windows with exquisite grotesques in the Laurentian Library (Florence, Bib. Medicea–Laurenziana), attached to the monastery of S Lorenzo. In 1534, when Clement VII died, Giovanni returned to Udine, where he married and eventually had 12 sons. In 1537 he began to decorate a room in the Palazzo Grimani, Venice, for the brothers Giovanni and Vettor Grimani, with *Myths of Diana* in his most elegant stuccowork; in 1540, in another room of the palace, he created an elaborate stucco framework for painted *Myths of Apollo* by Francesco Salviati (all *in situ*).

Over the next decade Giovanni was involved in various unrealized public projects in Udine, where in 1552 he secured an official architectural position. In 1560 he was summoned back to Rome by Pius IV, to undertake the decoration of one of the new Vatican Logge with grotesques and Medici arms. He died while engaged on this work and is buried in the Pantheon.

BIBLIOGRAPHY
Thieme–Becker: 'Udine, Giovanni de'
G. Vasari: *Vite* (1550, rev. 2/1568); ed. G. Milanesi (1878–85), vi
A. Venturi: *Storia* (1901–40), vii/4, ix/2, xi/1
H. Voss: *Die Malerei der Spätrenaissance in Rom*, i (Berlin, 1920)
S. J. Freedberg: *Painting in Italy, 1500–1600*, Pelican Hist. A. (Harmondsworth, 1971)
R. Redig de Campos: 'La stufetta del cardinale Bibbiena in Vaticano', *Röm. Jb. Kstgesch.*, xx (1983), pp. 221–40
E. Bartolini: *Giovanni da Udine* (Udine, 1987)
G. C. Custoza: *Giovanni da Udine: La tecnica della decorazione a stucco alla romana nel Friuli del XVI secolo* (Prato, 1996)

Giovanni da Verona, Fra (*b* ?Verona; *fl* 1476; *d* ?Verona, 1525–6). Italian intarsia artist. He entered the Olivetan Order at Monte Oliveto Maggiore near Siena in 1476, and after ordination (1477–9) he was sent to the monastery of S Giorgio, Ferrara, where he learnt the art of wood inlay from Fra Sebastiano da Rovigno, called 'Schiavone'. Giovanni then worked as a wood-carver in Perugia (1480–84). The first large project of which substantial traces survive is the choir of S Maria in Organo, Verona, where he decorated the lectern, candelabrum and choir-stalls with architectural motifs, still-lifes, figures of saints and a *Crucifixion* (1494–9). In this work he can already be seen moving away from the Venetian and Ferrarese intarsia tradition in which he was trained towards solutions that are softer and more classical in line. Between 1502 and 1504 he worked on the great choir complex at Monte Oliveto Maggiore (now divided between the abbey church and Siena Cathedral), the intarsia panels of which, featuring birds, fountains, diverse objects and views of Siena, represent the high point of his creativity and skill.

Between 1506 and 1510 Giovanni divided his time between Naples and Fondi. He produced intarsia work for the choir of S Anna dei Lombardi, Naples, where he showed a keen interest in architectural motifs. One of the choir-stalls exhibits a view of Donato Bramante's Tempietto (1502) at S Pietro in Montorio (*see* BRAMANTE, DONATO, fig. 4), Rome. He also produced the seat backs (*c.* 1513) for the Stanza della Segnatura in the Vatican Palace, and the communicating door between it and the Stanza di Eliodoro. Except for the door (heavily rest.), his work was removed in the mid-16th century by Pope Paul III. Giovanni's intarsia work in the choir of S Maria fuori Porta Tifi, Siena, later dismantled and partly transferred to Monte Oliveto, shows that he adopted the expressive language of Roman classicist painters. His last work was on the wardrobes (1519) in the sacristy of S Maria in Organo, Verona, and the choir-stalls (1523) of Villanova del Sillaro Abbey, near Milan (now in Lodi Cathedral).

BIBLIOGRAPHY
Thieme–Becker
P. Lugano: 'Di fra Giovanni da Verona, maestro di intaglio e di tarsia e della sua scuola', *Bull. Sen. Stor. Patria*, xii (1905), pp. 147–61
M. Ferretti: 'I maestri della prospettiva', *Situazioni momenti indagini: Forme e modelli*, ed. F. Zeri, Storia dell'arte Italiana, 11 (Turin, 1982)

MARCO CARMINATI

Giovanni dell'Opera. *See* BANDINI, GIOVANNI.

Giovanni di Bertino (*b* first half of the 15th century; *d* ?Florence, *c.* 1471). Italian stone mason and decorator. He was the son of Bertino di Piero, a Florentine stone mason who in 1412 had executed the doors of Orsanmichele, Florence. Giovanni's brother, Piero, was in Carrara in 1442, working for Filippo Brunelleschi, and was in charge of the preparation of marble sections for the lantern of Florence Cathedral. Some time later, Giovanni was employed to finish some of the capitals on the columns of the nave in S Lorenzo, Florence (1448), although specific carvings by him have not been identified. In April 1454 Giovanni was in charge of the decoration of the church beside the Ospedale del Ceppo at Pistoia, where he was described as *disegnatore*. Both this project and S Lorenzo were works by Michelozzo di Bartolomeo. From around 1457 Giovanni worked on the façade designed by Leon Battista Alberti for S Maria Novella, Florence (*see* FLORENCE, fig. 13). The work was commissioned by the Arte del Cambio (Bankers' guild) and Giovanni Rucellai, the latter recording in his account book works of art in his private collection by Giovanni. The portal, executed by him, incorporated rich decorations of inlay and low reliefs featuring emblems of the Rucellai and Medici families along with relief carvings of fruit, ribbons and spirals. The beauty of the work established Giovanni's fame in his own lifetime and was recorded by Fra Domenico da Corella in his poem, *Teotocon* (1464–9). Among Giovanni's late works are some corbel capitals of the Composite order carved in *pietra serena* for S Bartolomeo at Monteoliveto near Florence (1469). Giovanni's name is listed in the registers of the Arte del Maestri di Pietra e Legname (Stone and Woodworkers' guild) until 1471.

BIBLIOGRAPHY
Thieme–Becker
F. Mandelli, ed.: *Nuova raccolta d'opuscoli scientifici e filologici*, xix (Venice, 1770), p. 455 [includes the *Teotocon* by Fra Domenico da Corella]
G. Mancini: *Vita di Leon Battista Alberti* (Florence, 1882, rev. 2/1911), pp. 460–61
I. Hyman: *Fifteenth Century Florentine Studies: The Palazzo Medici and a Ledger for the Church of San Lorenzo* (diss., New York U., 1968), pp. 385–6
L. Gai: 'Interventi rinascimentali nello Spedale del Ceppo', *Contributi per la storia dello Spedale del Ceppo di Pistoia* (Pistoia, 1977), pp. 108, 124

FRANCESCO QUINTERIO

Giovanni di Bicci. *See* MEDICI, DE', (1).

Giovanni di Consalvo [Master of the Chiostro degli Aranci] (*fl* Florence, *c.* 1436–9). Italian painter of Portu-

guese or Spanish descent. He was probably the author of ten scenes from the *Life of St Benedict*, frescoed in the lunettes of the upper loggia of the cloister (called the Chiostro degli Aranci) of the Badia, a Benedictine abbey in Florence which is attributed to the Florentine architect and sculptor Bernardo Rossellino, and which was completed in 1437. The scenes are arranged along two walls so that they seem to take place beneath the loggia; the lunettes are divided from each other by fictive painted fluted pilasters. The fourth scene in the sequence was damaged and replaced by a fresco of *St Benedict in the Wilderness* by Agnolo Bronzino. Beneath the lunettes runs a decorative wainscoting set in an illusionistic architecture, with busts of Benedictine saints set in tondi. A Latin inscription, painted between the scenes and the frieze, describes the scenes and names the saints. Two extra lunettes of scenes from the *Life of the Longobard King Totila* are of mediocre quality and are by another hand, although dating from only shortly after the scenes of *St Benedict*. In 1956, and again in 1978, the frescoes were restored and the *sinopie* revealed (the frescoes and the *sinopie* are both displayed at the Badia).

The only document that connects the frescoes to Giovanni di Consalvo, by whom no other works are known, records that he was reimbursed for money spent on painting materials between May 1436 and April 1438 while working at the Badia (see Gordalina, 1994, p. 75). Other documents (found by G. Poggi; see Salmi, 2/1938) record that payments were made to the 'painter who is painting the cloister' but do not name him. The dates accord well with the small scale of the cycle, with the style of the paintings and with the fact that the building of the cloister had only recently been completed. Another document names Fra Macario Chonverso, a Benedictine monk at the Badia, who, in October 1439, had been taught to paint at S Domenico, Fiesole, near Florence, where Fra Angelico was working. Salmi attributed the lunette scenes of *St Benedict* to Fra Macario on the grounds that only he could have been influenced by Fra Angelico; to Consalvo he attributed only the frieze of saints, which he described as provincial and slightly Flemish in character. However, since the restoration, it is obvious that the saints and the lunettes are by the same hand. It is possible that Fra Macario was responsible for the scenes of *Totila*, although they do not show the influence of Fra Angelico. Berenson attributed the *St Benedict* scenes to the Master of the Castello Nativity, but this seems unlikely both from a chronological and a stylistic point of view. An argument in favour of Giovanni di Consalvo's authorship is the fact that at the time the cloister was frescoed another Portuguese, Gomez Ferreira da Silva, was prior of the Badia (Battelli) and that in 1435 a "Joane Consalvii di Portoghalia" is mentioned at a meeting of the monks of the Dominican convent in Fiesole (Orlandi, 1959–60, pp. 37–9 & 137).

By framing the scenes and the wainscoting with painted pilasters, the painter created a perspectival framework that echoes the loggia in which they are set. The same device was used by Masolino and Masaccio at the Brancacci Chapel (Florence, S Maria del Carmine). The artist was evidently aware of Filippo Brunelleschi's principles of perspectival construction and, in the *Miracle of the Poisoned Bread* (see fig.), made use of Paolo Uccello's virtuoso system of construction. The decorative frieze beneath the scenes is also close to Uccello's illusionist techniques and similar to that in the chapel of the Assumption, Prato Cathedral, attributed either to Uccello or his close follower, the Prato Master. However, the figures retain Gothic elements and the architecture is not always perspectively correct. The buildings in the scenes of *St Benedict Leaving Norcia*, *The Young Monk Tempted by the Devil* and *St Benedict Breaking the Glass of Poisoned Wine* are curiously eclectic in character and recall Pisanello's and Gentile da Fabriano's imaginary Late Gothic city views, but they also possess exotic elements, probably of Iberian origin. Such architectural forms can also be found in Fra Angelico's predella panels (1433–6) for the Linaioli Tabernacle (*see* ANGELICO, FRA, fig. 3) and in the view of a city in the background of his *Deposition* (both Florence, Mus. S Marco). Certainly the strongest influence is that of Fra Angelico: Berti (1968 exh. cat.) suggested that the Badia artist collaborated on the predella with scenes from the *Life of St Nicholas* (Rome, Vatican, Pin.) from a polyptych by Fra Angelico of 1437. Other documents state that a 'Giovanni di Portogallo' was among the most important disciples of Fra Angelico in 1435 (Berti, 1968 exh. cat.). This suggests that the Badia artist's style was formed at S Domenico: the simplification of the architecture, the compositional system and the landscapes with large sickle-shaped rocks all recall Angelico's work. The simplified forms of the figures and their juxtaposition to each other also show his influence, as does the rational use of light (e.g. the still-life on the table in *St Benedict Taking the Habit and Adopting the Hermit's Life*). The scene of the *Miracle of the Broken Sieve* may even be derived from a lost painting by Fra Angelico and foreshadows the scenes in his frescoes in the chapel of Nicholas V (Rome, Vatican; *see* ANGELICO, FRA fig. 6) of almost 20 years later. The architecture has much in common with that of Michelozzo di Bartolomeo—the mullioned windows in the frescoes are similar to those at S Marco—and the church façade in the *Miracle of the Wine* recalls that of Michelozzo's church of S Marco.

The Badia painter was also influenced by other Florentine masters. Salmi (*Masaccio*, Milan, 2/1947, p. 163) noticed an echo of Masaccio in the figure of St Benedict who is signalling silence in the lunette above the door leading to the Chiostro degli Aranci. Vasari attributed the fresco to Fra Angelico (2/1568, ed. G. Milanesi, 1878–85, ii, pp. 513–14), but stylistically it must be the work of Giovanni di Consalvo (Chiarini, 1963). In the scene of the *Miracle of the Wine* he seems to have absorbed the jovial spirit of Filippo Lippi's fresco of the *Scene of Carmelite Rule* (Florence, S Maria del Carmine). The landscapes are an important element in the scenes and are used to emphasize their mood. The horizon is generally high, either creating a foreshortened effect or a bird's eye view; spatial depth is emphasized both by architectural elements and by the atmospheric use of light evident where the blue paint (painted *a secco* over a red undercoat) still survives. Finally, some of the faces achieve the status of real portraits. All these traits would seem to confirm the complex cultural and stylistic background of this painter who synthesized Florentine and Flemish elements. At-

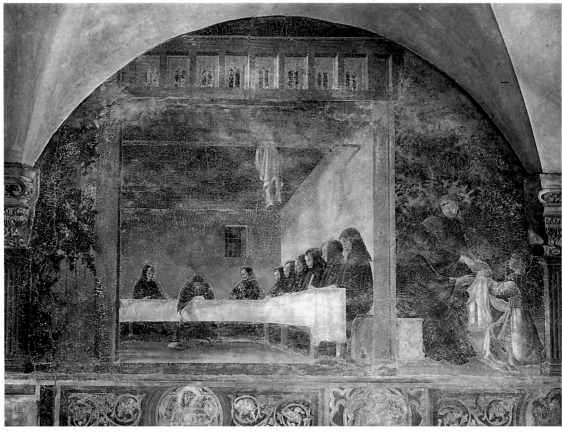

Giovanni di Consalvo: *Miracle of the Poisoned Bread* (1436–9), fresco, 2.18×3.06 m, Chiostro degli Aranci, the Badia, Florence

tempts to attribute further works to him have been unconvincing. These include a painting of the *Marriage of the Virgin* (Florence, I Tatti; see Meiss, 1961) and three small panels of saints, one of *St Lawrence* (Baltimore, MD, Walters A.G.; called School of Tuscany; attributed to Battista di Gerio by Boskovits, see F. Zeri: *Italian Paintings in the Walters Art Gallery*, Baltimore, 1976, i, no. 93) and the other two of *St John the Baptist* and an unidentified saint (both sold London, Sotheby's, 26 March 1969, lot 128).

BIBLIOGRAPHY
Colnaghi
A. Neumayer: 'Die Fresken im "Chiostro degli Aranci" der Badia fiorentina', *Jb. Preuss. Kstsamml.*, xlviii (1927), pp. 25–42
B. Berenson: *Italian Pictures of the Renaissance* (Oxford, 1932), p. 343
M. Salmi: *Paolo Uccello, Andrea del Castagno, Domenico Veneziano* (Rome, 1936, rev. Milan, 2/1938), pp. 18–19, 139
G. Battelli: *L'abate Dom Gomez Ferreira da Silva e i Portoghesi a Firenze nella prima metà del quattrocento: Relazioni storiche fra l'Italia e il Portogallo* (Rome, 1940), p. 149
R. Longhi: 'Il Maestro di Pratovecchio', *Paragone*, iii/35 (1952), pp. 12, 20, 30 (n. 3), 34 (n. 13)
Mostra di affreschi staccati (exh. cat., ed. U. Baldini and L. Berti; Florence, Forte Belvedere, 1957), pp. 68–70
M. Salmi: *Il Beato Angelico* (Spoleto, 1958), pp. 67, 126
IIa mostra di affreschi staccati (exh. cat., ed. U. Baldini and L. Berti; Florence, Forte Belvedere, 1958), pp. 41–4
E. Borsook: *The Mural Painters of Tuscany* (London, 1960, rev. Oxford, 2/1980), pp. 80, 84, n. 20
M. Chiarini: 'Di un maestro "elusivo" e di un contributo', *A. Ant. & Mod.* (1961) pp. 134–8 [issue dedicated to Longhi]
M. Meiss: 'Contributions to Two Elusive Masters', *Burl. Mag.*, ciii (1961), p. 57
M. Chiarini: 'Il Maestro del Chiostro degli Aranci: Giovanni di Consalvo, Portoghese', *Proporzioni*, iv (1963), pp. 1–24
The Great Age of Fresco: Giotto to Pontormo (exh. cat. by M. Meiss and L. Berti, New York, Met., 1968), pp. 150–55
N. Rosenberg Henderson: 'Reflections on the Cloister degli Aranci', *A. Q.*, xxxii (1969), pp. 393–410
E. Sestan, M. Adriano and A. Guidotti: *La Badia Fiorentina* (Florence, 1982), pp. 120, 139–40, n. 218–23 [A. Guidotti]

MARCO CHIARINI

Giovanni di Domenico Battaggio. *See* BATTAGGIO, GIOVANNI DI DOMENICO.

Giovanni di Francesco (del Cervelliera) (i) [Master of the Carrand Triptych] (*b* Florence, 1412; *d* Florence, 28 Sept 1459). Italian painter. His date of birth is deduced from an entry in the *catasto* (land registry declaration) of 1435, in which the artist gave his age as 23 (Levi d'Ancona). Toesca first identified Giovanni di Francesco as the author of a group of works previously attributed to the Master of the Carrand Triptych (Weisbach), who was named after the triptych formerly in the Carrand collection, of the *Virgin and Child with SS Francis, John the Baptist, Nicholas and Peter* (Florence, Bargello), from S Nicolò, Florence. The scenes from the *Life of St Nicholas* (Florence, Casa Buonarroti) probably formed the predella. The identification was based on a document relating to a payment for the fresco of *God the Father with the Holy Innocents* over the door of the church of the Ospedale degli Innocenti, Florence (1458–9; *in situ*).

On the basis of a document of 1439, Fredericksen identified Giovanni di Francesco as the author of a triptych painted for the nuns of the Convento del Paradiso at Pian di Ripoli, near Florence, the earliest notice of his activity as a painter. Fredericksen proposed that the Paradiso Triptych could be identified as the *Virgin and Child with SS Bridget and Michael*, known as the Poggibonsi Altarpiece (Los Angeles, CA, Getty Mus.), ascribed by Longhi to the anonymous MASTER OF PRATOVECCHIO (*see* MASTERS, ANONYMOUS, AND MONOGRAMMISTS, §I). He accordingly suggested that the Master's work should be given to Giovanni di Francesco; however, this view is difficult to sustain given the stylistic disparity of the two groups of paintings, and the hypothesis has not been generally accepted (Laghi, Bacarelli).

The document of 1439 reveals that Giovanni di Francesco was the nephew of the painter Giuliano di Jacopo Lorino and the cousin of another painter, Jacopo di Antonio. Vasari claimed that the two cousins were both pupils of Andrea del Castagno, but this should be discounted as Castagno was ten years younger than Giovanni di Francesco. Giovanni probably received his training *c.* 1430. He does not appear in any of the numerous documents relating to his uncle, but this does not exclude the possibility that he was active in his workshop in a minor capacity.

Stylistically, Giovanni di Francesco's early paintings, for instance the *Nativity* (Berea Coll., KY), appear to be derived from Uccello's work of the 1440s, such as the stained-glass window of the same subject in Florence Cathedral. They are also close to the frescoes in the chapel of the Assumption in Prato Cathedral (1435–6), and to the fresco of the *Nativity* (before 1437; Bologna, S Martino) attributed to Uccello (see C. Volpe: 'Paolo Uccello a Bologna', *Paragone*, xxi/365, 1980, pp. 3–28). From Uccello, Giovanni di Francesco absorbed a fascination with perspective, a taste for linear definition, a marked sense of form and a predilection for intense facial expressions, qualities evident in the Carrand triptych and in the *Crucifixion* in S Andrea a Brozzi, near Florence.

In 1450 Giovanni di Francesco was owed the considerable sum of 40 florins by Filippo Lippi for his contribution to a collaborative work (untraced). The two painters worked together again in 1455 (Marchini). Lippi's influence on Giovanni is particularly evident in two predella panels, one of the *Adoration of the Magi* (Montpellier, Mus. Fabre) and the other of *SS James and Anthony Abbot Blessing a Donor* (Dijon, Mus. B.-A.). The latter panel formed part of a dismembered triptych comprising the *Virgin and Child* (Florence, Uffizi, Contini–Bonacossi col.), *St Anthony Abbot* (Milan, Pin. Ambrosiana) and *St James* (Lyon, Mus. B.-A.).

An altar frontal of *St Biagio*, dated January 1453 (NS 1454), was painted for S Biagio at Petriolo, near Florence, where the painter's family owned land. Both this work and the *St Anthony of Padua* (Berlin, Gemäldegal.) display an affinity with Castagno's *Assumption of the Virgin with SS Miniato and Julian* (1449–50; Berlin, Gemäldegal.; *see* ANDREA DEL CASTAGNO, fig. 1) and his frescoes from the Villa Carducci (Florence, Uffizi). It is possible that Giovanni di Francesco may have worked with Castagno on a similar basis during the time he was collaborating

with Lippi, and this may have been the reason that Vasari believed he was Castagno's pupil. Giovanni di Francesco was also influenced by Domenico Veneziano and, to a certain extent, by Piero della Francesca (Longhi). This is evident in his taste for minutely detailed decorative elements in the Flemish style and in the luminosity of his colours, qualities present in the Carrand Triptych. Uccello's influence is still present in his late works such as the Innocenti lunette and the *terra verde* frescoes in the loggia of the Palazzo Rucellai, Florence, depicting biblical stories (Salvini); the latter were probably left unfinished at the artist's death and were completed by Pier Francesco Fiorentino.

Giovanni di Francesco also produced works of a more artisan quality, such as the *Virgin and Child with Saints* (Philadelphia, PA, Mus. A.) and a frame decorated with prophets holding scrolls (Berlin, Kaiser-Friedrich Mus., destr.). *Portrait of a Lady in Profile* (New York, Met.), showing the influence of Lippi, has also been attributed to him. A different interpretation of some aspects of the activity of Giovanni di Francesco was given by Luciano Bellosi in the 1990 exhibition in Florence.

BIBLIOGRAPHY

G. Vasari: *Vite* (1550, rev. 2/1568), ed. G. Milanesi (1878–85), ii, p. 682
W. Weisbach: 'Der Meister des Carrand Triptychon', *Jb. Preuss. Kstsamml.*, xxii (1901), pp. 45–8
P. Toesca: 'Il pittore del trittico Carrand: Giovanni di Francesco', *Rass. A.*, xvii (1917), pp. 1–14
R. Longhi: 'Ricerche su Giovanni di Francesco', *Pinacotheca*, i (1928), pp. 34–48
V. Giovannozzi: 'Note su Giovanni di Francesco', *Riv. A.*, xvi (1934), pp. 334–65
R. Kennedy: *Alesso Baldovinetti* (New Haven, 1938), p. 215
R. Longhi: 'Il Maestro di Pratovecchio', *Paragone*, iii/35 (1952), pp. 10–37
M. Levi d'Ancona: *Miniatura e miniatori a Firenze dal XIV al XVI secolo* (Florence, 1962), pp. 144–6
B. Berenson: *Florentine School* (London, 1963), i, pp. 87–8
F. R. Shapley: *Paintings from the Samuel H. Kress Collection: Italian Schools, XIII–XV Century* (London, 1966), p. 104
F. Zeri and E. Gardner: *Italian Paintings: Florentine School* (exh. cat., New York, Met., 1971), p. 113
B. Fredericksen: *Giovanni di Francesco and the Master of Pratovecchio* (Malibu, 1974)
G. Marchini: *Filippo Lippi* (Milan, 1975)
——: 'Una curiosità sul Lippi', *Archv Stor. Pratese*, 51 (1975), pp. 171–5
M. Horster: *Andrea del Castagno* (London, 1980), pp. 198–9
R. Salvini: 'The Frescoes in the Altana of the Rucellai Palace', *Giovanni Rucellai e il suo zibaldone, II: A Florentine Patrician and his Palace*, Studies of the Warburg Institute (London, 1981), pp. 241–52
A. Laghi: 'Giovanni di Francesco, trittico Carrand', *San Niccolò Oltrarno: la chiesa, una famiglia di antiquari* (Florence, 1982), pp. 63–5
[G. Bacarelli and others]: *Il 'Paradiso' in Pian di Ripoli* (Florence, 1985), p. 100
Disegni Italiani del tempo di Donatello (exh. cat., ed. A. Angelini; Florence, Uffizi, 1986), pp. 32–3
Pittura di luce: Giovanni di Francesco e l'arte fiorentina di metà Quattrocento (exh. cat., ed. L. Bellosi; Florence, Casa Buonarroti, 1990)

ANNA PADOA RIZZO

Giovanni di Francesco (ii). *See* GIOVANNI DA PISA (ii).

Giovanni di Gherardo da Prato (*b* Prato, nr Florence, 1360; *d* Prato, *c.* 1442). Italian poet and architect. He received his education in the liberal arts at the University of Padua, specializing in optics with Biagio Pelacani. He frequented the cultivated circles of Florentine society as well as lively clubs (*brigate*) such as the Burchiello, where

he participated in collective poetry writing. For the *Geta e Birria* (1413–25) his co-authors included Filippo Brunelleschi. In September 1414 Giovanni was appointed Capitano di Orsanmichele. In May 1417 he was invited by the Reformatori dello Studio to hold the annual Dante lectures. In 1420 he is recorded in the second group of superintendents for the construction of the dome of Florence Cathedral. In this period the relationship between Giovanni and Brunelleschi underwent a change, which was reflected in a defamatory sonnet, *O forte fonda e nizza di ignoranza*, against Brunelleschi who had patented a costly but impractical riverboat for transporting marble on the River Arno. In 1425 Giovanni was paid by the Opera del Duomo (Cathedral Works) for several drawings and a model of the dome. From these, a parchment with three drawings survives (Florence, Archv Stato) together with two reports in which he criticized the incorrect angulation of the rows of bricks in the dome. Giovanni insisted on the need to pierce additional windows in the dome. He advocated three on each side of the octagonal drum, beneath the incurvature. While this would have provided additional light it would have weakened the structure of the dome. In 1425, the Dante lectures having been abolished by Florence, Giovanni retired with his sister to his villa at Prato, where he wrote the novel *Il paradiso degli Alberti* (c. 1426).

WRITINGS

Il paradiso degli Alberti (c. 1426); ed. A. Wesselofsky, 2 vols (Bologna, 1867)

BIBLIOGRAPHY

Thieme–Becker
C. Guasti: 'Un disegno di Gio di Gherardo da Prato, poeta e architetto concernente alla cupola di Santa Maria del Fiore', *Belle arti: Opuscoli descrittivi e biografici* (Florence, 1874), pp. 107–28
H. Saalman: 'Giovanni di Gherardo da Prato's Design Concerning the Cupola of S Maria del Fiore in Florence', *J. Soc. Archit. Hist.*, xviii (1959), pp. 11–20
F. D. Prager and G. Scaglia: *Brunelleschi: Studies of his Technology and Inventions* (Cambridge, MA, and London, 1970), p. 152
E. Battisti: *Filippo Brunelleschi* (Milan, 1976), pp. 324–7, 365
G. Tanturli: 'I rapporti del Brunelleschi con gli ambienti letterari fiorentini', *Proceedings of the conference, Filippo Brunelleschi, la sua opera e il suo tempo: Florence, 1977*, pp. 125–44
H. Saalman: *Filippo Brunelleschi: The Cupola of Santa Maria del Fiore* (London, 1980)
C. Vecce: 'Tomi schiavoneschi', *Achad. Leonardi Vinci: J. Leonardo Stud. & Bibliog. Vinciana*, viii (1995), pp. 184–6

FRANCESCO QUINTERIO

Giovanni di Marco. *See under* GIOVANNI DAL PONTE.

Giovanni di Nicolò (da) Barbagelata. *See* BARBAGELATA, GIOVANNI DI NICOLÒ.

Giovanni di Paolo (di Grazia) (*b* Siena, *c.* 1399; *d* Siena, 1482). Italian painter and illuminator. With Sassetta and Domenico di Bartolo, he was one of the greatest Sienese painters of the 15th century. He created a lyrical figural style capable of conveying both exaltation and pathos.

1. TO 1430. Giovanni was born probably towards the end of the 14th century, as he was given significant commissions as early as 1420. His training is not recorded, but certain influences can be inferred. An early contact with Lombard culture is suggested by a document showing that on 5 September 1417 he received a payment from Fra Niccolò Galgani (*d* 1424), librarian of S Domenico, Siena, for miniatures in a Book of Hours (untraced) for the wife of Cristoforo Castiglione (1345–1425). Castiglione, a Milanese professor of law at Pavia, was from 1400 to 1404 a member of the supervising board of works of Milan Cathedral. He and his wife lived in Siena *c.* 1415–19, and it is possible that they introduced Giovanni to Lombard book illumination. Throughout his career Giovanni executed book illuminations as well as panel paintings. In 1420 he received payments for two paintings (untraced): one, of an unknown subject, was for the Sienese convent of S Domenico; and the other, of the *Blessed Catherine of Siena*, was ordered by Franceschino Castiglione, probably the son of Cristoforo, for the monastery of S Marta in Siena. These were works of some importance, which suggests he was already an established artist. The first work securely attributed to him is a box with a panel painting of the *Triumph of Venus* (Paris, Louvre), dated 1421. An exquisite and rare work in good condition, it shows his early interest in the refined, subtle style of Paolo di Giovanni Fei and has echoes of Paduan art, especially in the box's elegant border of deer and wild boar.

In the early 1420s Giovanni painted the first of four altarpieces for S Domenico, Siena: the panel with *Christ Suffering and Triumphant* (Siena, Pin. N.). This was probably for the altar commissioned by the Bishop of Grosseto, Francesco Bellanti, whose coat of arms is on the back. The Pecci Altarpiece (dispersed) for S Domenico is signed and dated 1426. Its central panel, the *Virgin and Child with Angel Musicians* (see fig. 1), is in the parish church of Castelnuovo Berardenga near Siena; two of the side panels, *St John the Baptist* and *St Dominic*, are in Siena (Pin. N.), and four of the five predella sections, representing the *Passion of Christ*, are in the Walters Art Gallery (Baltimore, MD). The fifth, central section of the predella, with the *Crucifixion*, is in Altenburg (Staatl. Lindenau-Mus.). This is the first work in which Giovanni's poetic figurative style is fully defined. Also from this period is the *St Jerome* (Siena, Pin. N.). In these paintings Giovanni shows a strong (if idiosyncratic) adherence to the Late Gothic tradition, with its sinuous lines and decorative details. Also apparent is his interest in the forms used by such earlier artists as Taddeo di Bartolo (1362/3–1422) (already evident in the Pecci Altarpiece), or the sculptor Domenico di Niccolò.

At this early stage Giovanni's work shows no interest in art outside Siena, especially in the new developments in Florence. Rather, his attention seems to have been directed to the great Sienese models of the early 14th century, from Simone Martini (1284–1344) to Ambrogio Lorenzetti, and to the expression of his own particular view of reality. He had an intense, fertile imagination and a highly individual way of using line—nervous and impetuous—which boldly distorted and abstracted natural forms. In his later works this became impressionistic and grotesque, negating all earthly beauty. Although he does not seem to have absorbed Florentine spatial and compositional innovations, Giovanni was clearly attracted by the precious new style introduced to Siena in 1425 by Gentile da Fabriano in his polyptych (untraced) for the guild of notaries. The influence of Gentile is already evident in the Pecci Altarpiece, in such motifs as the garlands worn by the angels

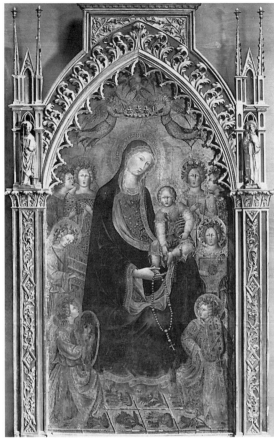

1. Giovanni di Paolo: *Virgin and Child with Angel Musicians*, central panel of the Pecci Altarpiece, egg tempera on panel, 1700×830 mm, 1426 (Castelnuovo Berardenga, parish church)

This work shows the first signs of Sassetta's influence, with a tendency towards monumentality of form and compactness of composition that can also be seen in other works datable to the mid-1440s, when Giovanni collaborated with Sano di Pietro on a panel (untraced) for the Compagnia di S Francesco. The influence of Sassetta also appears in the *Crucifix* of S Pietro Ovile, the *Crucifixion* in the hermitage of S Leonardo al Lago (his only fresco) and the Antiphonal (Siena, Bib. Com. Intronati, MS. G.I.8) made for the convent of Lecceto. The Antiphonal, and other illuminations Giovanni executed for Lecceto, including three miniatures for a Gradual in the same series (MS. H.I.2), mark a period of intense creativity. The scenes are rendered with great immediacy and narrative conciseness, and are richly adorned with anthropomorphic initials and luxuriant foliage. The elegant Gothic line, with none of the agitated quality of the earlier works, has a strong flowing rhythm that does not detract from the expressive intensity.

From the 1440s Giovanni, who had reached maturity artistically, created numerous fine works, many dated. Typically, he returned to themes he had used earlier, for which he devised imaginative new solutions. He also depicted narrative subjects that were seldom, if ever, treated in Sienese art, including scenes from the lives of SS Catherine of Siena, Ansanus, John the Baptist, Clare and Galganus, as well as the passages from Dante already mentioned. In 1445 he painted the *Coronation of the Virgin* (Siena, S Andrea; signed and dated); he returned to this subject, perhaps a decade later, to produce another, splendid version (New York, Met.).

Between 1447 and 1449 Giovanni executed an important commission for the guild of the Pizzicaiuoli, an altarpiece for S Maria della Scala, Siena. The central panel, which depicts the *Presentation in the Temple* (Siena, Pin.

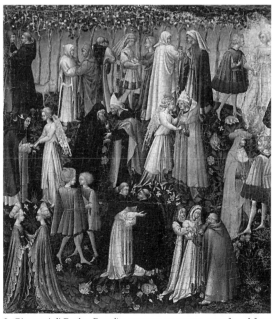

2. Giovanni di Paolo: *Paradise*, tempera on canvas, transferred from panel, 469×406 mm, *c.* 1440 (New York, Metropolitan Museum of Art

and the garden carpet at the Virgin's feet. Gentile's art is first reflected strongly in the Branchini Altarpiece (Pasadena, CA, Norton Simon Mus.), painted for S Domenico in 1427, and it remained an important element in Giovanni's figurative language until after the 1460s, even in periods when he drew ideas from other artists.

2. 1430–50. Giovanni's interest in Gentile is clear in the predella of the Fondi Altarpiece for S Francesco, Siena, and in the *Madonna della Misericordia* for the Servite church there (both painted in 1436). It is still apparent in his wonderful illustrations (1438–44) for Dante's *Divine Comedy* (London, BM), and in the paintings of *Paradise* (see fig. 2) and the *Creation, and the Expulsion from Paradise* (both New York, Met.). These small panels, with two of the artist's most evocative narrative scenes, are undisputed masterpieces of 15th-century Sienese painting. They may have belonged to the predella of the Guelfi Altarpiece, the last he painted for S Domenico, and dubiously identified with a *Virgin and Child with Saints* (Florence, Uffizi), signed and dated 1445.

Having joined the Sienese painters' guild, the Ruolo dei pittori, in 1428, Giovanni became its *rettore* in 1441. The *Crucifixion* (Siena, Pin. N.) for a cloister chapel of the church of the Osservanza in Siena was painted in 1440.

N.), reflects Ambrogio Lorenzetti's treatment of the subject, then visible in Siena Cathedral (*see* LORENZETTI, (2), fig. 2), as well as motifs and gestures from Gentile da Fabriano's predella panel on the same theme (1423; Paris, Louvre). The original arrangement of this polyptych is still debated. Other panels (dispersed) include ten scenes from the *Life of St Catherine* (Cleveland, OH, Mus. A.; Detroit, MI, Inst. A; New York, Met.), the *Crucifixion* (Utrecht, Catharijneconvent), and several images of Sienese saints. Some writers suggest that the *St Catherine* scenes were not part of the original structure but were added later, after her canonization.

3. FROM 1450. In the 1450s Giovanni's style seems to show a stronger influence of Sassetta, with more clearly defined volumes and spatial relations. These features are already evident in the architectural backgrounds of his most ambitious narrative cycle, the scenes from the *Life of St John the Baptist*. The 12 panels, of which 11 survive (Chicago, IL, A. Inst.; Münster, Westfäl. Landesmus.; New York, Met.; Avignon, Mus. Pet. Pal.; Pasadena, CA, Norton Simon Mus.) were originally arranged in four vertical rows, perhaps as part of a cabinet (*custodia*) housing a sacred object or reliquary. They were painted on both sides; traces of an *Annunciation* are discernible on the back of the first panel, the *Annunciation to Zacharias*. A closer adherence to the style of Sassetta is apparent in the *St Nicholas* altarpiece (Siena, Pin. N.), dated 1453. The imposing central figure contrasts with the slender saints at the sides, and all the figures are depicted with conciseness of gesture, strong verticality in the drapery, and severe dignity of expression. His interest in Sassetta proved fertile, and around 1450–55 he produced some of his greatest works, including the altarpiece the *Virgin and Child with SS Peter Damian, Thomas, Clare and Ursula* (Siena, Pin. N.), and perhaps four predella panels with scenes from the *Life of St Clare* (Berlin, Gemäldegal.; Houston, TX, Mus. F.A.; New Haven, CT, Yale U. A.G.). The silvery sheen of the surface, the purity of line, and the severe nobility of the figures are particularly beautiful in these paintings. References to Sassetta are no longer evident in the altarpiece Giovanni painted in 1463 for Pius II's new cathedral in Pienza (*in situ*). Although by this date his skill had begun to decline, he was still capable of producing such fine works as the *Last Judgement* (Siena, Pin. N.; see colour pl. 1, XXXIV1). This wonderful painting, with its pure Sienese flavour, seems to sum up his experiences, from the Late Gothic style of Gentile da Fabriano to the Renaissance art of Fra Angelico, who painted a similar sequence (Florence, Mus. S Marco). The figure of Christ the judge anticipates the gesture of Christ in the *Last Judgement* (Rome, Vatican, Sistine Chapel; see colour pl. 2, VII3) painted by Michelangelo, who may have known it through a fresco (untraced) by Masaccio. The small figures appear to be surrounded by a silvery radiance, and the whole composition, notably a gorgeous Paradise strewn with flowers and golden fruits, is superimposed on a drawing of exceptional purity and elegance. In his final phase of activity, in which workshop intervention is prominent, Giovanni was still able to create the imaginative and original colouring of the predella of the San Galgano Altarpiece (*c.* 1470; Siena, Pin. N.). The altarpiece for S

Silvestro di Staggia (Siena, Pin. N.), once signed and dated 1475, is his last documented work.

BIBLIOGRAPHY

E. Romagnoli: *Biografia cronologica de' bellartisti senesi* (Siena, *c.* 1835/*R* Florence, 1976), iv, pp. 309–30
G. Milanesi: *Documenti per la storia dell'arte senese* (Siena, 1854), i, p. 48; ii, pp. 241–2, 301, 340, 372, 389
G. Borghesi and L. Banchi: *Nuovi documenti per la storia dell'arte senese* (Siena, 1898), pp. 135–6, 182–3, 233
A. Venturi: *Storia* (1901–40), VII/i, pp. 498–501
R. Van Marle: *The Development of the Italian Schools of Painting*, ix (The Hague, 1927), pp. 390–465
J. Pope Hennessy: *Giovanni di Paolo, 1403–1483* (London, 1937)
P. Bacci: 'Documenti e commenti per la storia dell'arte', *Le Arti*, i (1941), pp. 3–39
C. Brandi: *Giovanni di Paolo* (Florence, 1947)
E. Carli: *I pittori senesi* (Milan, 1971), p. 27
M. Meiss: 'A New Panel by Giovanni di Paolo from his Altarpiece of the Baptist', *Burl. Mag.*, cxvi (1974), pp. 73–7
Il gotico a Siena (exh. cat. by G. Chelazzi Dini and others, Siena, Pal. Pub.; 1982), pp. 358–71
La pittura in Italia: Il quattrocento (Milan, 1987), i, pp. 316–25; ii, p. 643
Painting in Renaissance Siena, 1420–1500 (exh. cat. by K. Christiansen, L. B.Kantor and C. B. Strehlke, New York, Met., 1988–9), pp. 168–242
C. B. Strehlke and others: *La pittura senese nel rinascimento* (Milan, 1989), pp. 182–256
P. Torriti: *La pinacoteca nazionale di Siena* (Genoa, 1990), pp. 215–43
A. Ladis: 'Sources and Resources: The Lost Sketchbooks of Giovanni di Paolo', *Craft of Art: Originality and Industry in the Italian Renaissance and Baroque Workshop*, ed. A. Ladis, C. Wood and W. U. Eiland (Athens, GA, 1995), pp. 48–85

GIOVANNA DAMIANI

Giovanni di Pietro (i). *See* GIOVANNI DA PISA (i).

Giovanni [Nanni] **di Pietro (di Giovanni) (ii)** (*b c.* 1403; *fl* 1439–68; *d* before May 1479). Italian painter. He was the brother of VECCHIETTA, who, along with MATTEO DI GIOVANNI, influenced his style. Giovanni di Pietro is first documented in 1452 collaborating with the much younger Matteo in gilding a statue by Jacopo della Quercia for Siena Cathedral. Giovanni and Matteo had a formal partnership and the following year are recorded as sharing living quarters. It is difficult to reconstruct Giovanni's activities before the period of his partnership with Matteo. In 1439 the Ospedale di S Maria della Scala, Siena, paid a certain 'Nanni di Pietro', perhaps Giovanni, for frescoes (destr.) for the 'Pellegrinaio di mezzo'. Other collaborative projects with Matteo include the decoration (1454) of the organ shutters in Siena Cathedral and, with Matteo and a team of other artists, the decoration (1457) of the chapel of S Bernadino in the same cathedral.

In 1463 Giovanni was paid for a tabernacle and a predella painting for the Compagnia di S Ansona (fragments in Esztergom, Mus. Christ.; Merion Station, PA, Barnes Found.; Florence, Uffizi; and London, N.G.). Although the altarpiece is usually attributed entirely to Matteo, Giovanni's hand can now be recognized in those parts (all Sansepolcro, Mus. Civ.) that once surrounded Piero della Francesca's *Baptism* (London, N.G.; *see* PIERO DELLA FRANCESCA, fig. 1). Three surviving predella panels with scenes from the *Life of the Virgin* from another collaborative effort by Matteo and Giovanni, the altarpiece of the *Annunciation with SS John the Baptist and Bernardino* (Siena, S Pietro Ovile; still largely *in situ*), are considered Giovanni's masterpieces. These comprise the *Birth of the Virgin* (Paris, Louvre), the *Virgin Returning to the House*

of her Parents and the *Marriage of the Virgin* (both Philadelphia, PA, Mus. A.); a fourth scene, the *Presentation of the Virgin in the Temple*, is lost. As well as the predella scenes, Giovanni is thought to have painted the central *Annunciation* (copied after Simone Martini) and the pinnacle with the *Crucifixion*. The two lateral panels of *St Bernardino* and *St John the Baptist*, attributed to the so-called Master of the Ovile Annunciation in 1947 by Pope-Hennessy, are probably by Matteo, as are the pinnacles of the half-length saints, *St Paul* and *St Peter*.

BIBLIOGRAPHY

R. van Marle: *Italian Schools* (1923–38), ix and xvi

Edgell: *A History of Sienese Painting* (New York, 1932)

J. Pope-Hennessy: *Sienese Quattrocento Painting* (London and Oxford, 1947), p. 29, pls 50–53

C. B. Strehlke: 'Sienese Painting in the Johnson Collection', *Paragone*, xxxvi/427 (1985), pp. 3–15

Painting in Renaissance Siena, 1420–1500 (exh. cat. by K. Christiansen, L. B. Kanter and C. B. Strehlke, New York, Met., 1988–9), pp. 264–9, nos 45a, 45b and 46

S. J. TURNER

Giovanni di ser Giovanni Guidi. *See* SCHEGGIA.

Giovanni di Stefano (*b* Siena, *bapt* 20 June 1443; *d* Siena, before 1506). Italian bronze-caster, sculptor and engineer. He was the son of the painter SASSETTA. In 1466 he worked together with the goldsmith Francesco di Antonio di Francesco (*fl* 1440–80) on a silver reliquary for the head of St Catherine of Siena (untraced); by that date he was referred to as a sculptor. In 1477 Federigo II da Montefeltro, Duke of Urbino, wrote to the governors of Siena commending Giovanni's work for him as a military engineer. In 1481–2 Giovanni made the marble intarsia of the *Cumaean Sibyl* for the pavement of Siena Cathedral. Giovanni's only marble statue, the elegant if somewhat mannered *St Ansanus*, made for the chapel of St John the Baptist in the cathedral (*in situ*), must date from after the construction of the chapel in 1482. By the mid-1480s Giovanni had moved to Rome, where he worked on the tomb of *Cardinal Pietro Foscari* (*d* 1485) in S Maria del Popolo. Originally the tomb was free-standing; now only the marble base and bronze recumbent figure survive. The figure is refined and delicate, with an emphasis on surface pattern; the base incorporates antique motifs. The attribution to Giovanni of the two bronze candle-bearing angels for the high altar of Siena Cathedral (*in situ*) is open to question, and they would appear to be the work of two different hands. Giovanni di Stefano was involved in a legal dispute with his assistants in Siena in 1498 for which Urbano da Cortona acted as one of the arbitrators. At that date, Giovanni was in charge of a workshop of stone-carvers, not bronze-casters.

BIBLIOGRAPHY

Thieme–Becker

G. Milanesi: *Documenti per la storia dell'arte senese* (Siena, 1854–6), ii, pp. 274, 280, 332, 335, 362, 378, 415, 458–9, 464; iii, pp. 70, 290

F. E. Bandini-Piccolomini: 'L'urna della testa di Santa Caterina', *Misc. Stor. Sen.*, i (1893), pp. 168–9

R. H. H. Cust: *The Pavement Masters of Siena, 1369–1562* (London, 1901)

P. Schubring: *Das Plastik Sienas im Quattrocento* (Berlin, 1907)

A. Monferini: 'Il ciborio lateranese e Giovanni di Stefano', *Commentari*, xiii (1962), pp. 182–212

C. Del Bravo: *Scultura senese del quattrocento* (Florence, 1970), p. 87; review by C. Freytag in *Pantheon*, xxx (1972), pp. 249–50 and by J. Paoletti in *A.Q.* [Detroit], xxxvi (1973), p. 105

M. Kühlenthal: 'Das Grabmal Pietro Foscaris in S Maria del Popolo in Rom, ein Werk des Giovanni di Stefano', *Mitt. Ksthist. Inst. Florenz*, xxvi (1982), pp. 47–62

JOHN T. PAOLETTI

Giovanni di Turino. *See under* TURINO DI SANO.

Giovanni Francesco da Rimini (*b* Rimini, ?*c*. 1420; *d* Bologna, 1470). Italian painter. He was first mentioned in the statutes of the painters' guild of Padua in 1441 and 1442. Documents of 1442 and 1444 show that he had connections with Francesco Squarcione and was already established as an independent painter. He was recorded in Bologna from 1459 to 1470. There he executed a painting of the *Virgin and Child* (Bologna, Mus. S Domenico) for the Pepoli Chapel, S Domenico, signed and dated 1459, and a *Virgin and Child with Two Angels*, signed and dated 1461 (London, N.G.). From 1459 until 1464 he was engaged in the decoration (destr.) of the tribune of S Petronio, Bologna; around that time he was also commissioned, with Tommaso Garelli, to fresco the S Brigida Chapel in S Petronio, a commission that appears not to have been carried out. All his other Bolognese works are lost (Filippini and Zucchini).

On the basis of the two signed and dated paintings, Ricci reconstructed Giovanni Francesco's oeuvre. The chronology of the works is problematic. The fact that he was in Padua at the beginning of the 1440s makes it likely that, after an initial training in Rimini, he worked around Padua and the Veneto in the circle of Jacopo Bellini, Antonio Vivarini and Giovanni d'Alemagna. The influence of these painters is evident in the series of 12 scenes from the *Life of the Virgin* (Paris, Louvre; formerly attributed to the school of Gentile da Fabriano), to which the two panels of the *Annunciation* (Columbus, OH, Mus. A.) belong. This is also true of the *Nativity* (Paris, Louvre), two paintings of the *Adoration of the Christ Child* (Le Mans, Mus. Tessé; Atlanta, GA, High Mus. A.), the tondo of *God the Father with Angels* (ex-Cook col., see *Burl. Mag.*, cxviii (1976), p. 657, fig. 32) and the *Pietà* (Hannover, Niedersächs. Landesmus.). All these works date from between 1441 and 1450. Giovanni Francesco increasingly borrowed motifs from Squarcione and Mantegna, as well as from the Florentine artists working in the Veneto, including Uccello, Castagno, Donatello and, in particular, Filippo Lippi. The possibility that Giovanni Francesco lived in Florence for a while is strengthened not only by the apparent influence of Florentine art on his work after 1450 but by the provenance of the panel of *St Vincent Ferrer* (Florence, Accad.), painted for the convent of the nuns of S Domenico del Maglio, near Florence. Two predella panels with a *Miracle of St Nicholas* (Paris, Louvre) and a *Miracle of St James* (Rome, Pin. Vaticana) are painted with a more rigorous sense of space compared with his Paduan work, and with a sureness of style that may have been acquired from direct contact with Filippo Lippi, Alesso Baldovinetti, Pesellino and Giovanni di Francesco.

Attributed works dating from Giovanni Francesco's Bolognese period (1459–70) include the *Adoration of the Christ Child* (Bologna, Pin. N.), the *Baptism of Christ* (Rome, Blumenstihl priv. col.) and the *Miracle of St Dominic* (Pesaro, Mus. Civ.). It has been suggested that he may

have spent the years 1464–70 in Umbria and the Marches because several of his works are in or from that region. These include the large triptych of the *Virgin and Child with SS Jerome and Francis* (Perugia, G.N. Umbria), the *Virgin and Child* (Ljubljana, N.G.), the *Virgin and Child* (S Benedetto del Tronto, Brancadoro priv. col.) and the *Virgin and Child* (Baltimore, MD, Walters A.G.). These works have, however, been dated by Zeri (1976) to the early 1450s.

BIBLIOGRAPHY

Bolaffi; Thieme–Becker
C. Ricci: 'Giovanni Francesco da Rimini', *Rass. A.*, ii (1902), pp. 134–5
——: 'Ancora di Giovanni Francesco da Rimini', *Rass. A.*, iii (1903), pp. 69–70
M. Logan Berenson: 'Ancora di Giovanni Francesco da Rimini', *Rass. A.*, vii (1907), pp. 53–4
G. Fiocco: 'I pittori marchigiani a Padova nella prima metà del quattrocento', *Atti Ist. Veneto Sci., Lett. & A.*, ii (1932), pp. 1359–70
M. Urzi: 'I pittori registrati negli statuti della Fraglia Padovana dell'anno 1441', *Archv Ven.*, xii (1932), pp. 212, 223
B. Berenson: *Central and North Italian Schools* (1968), i, pp. 183–4
F. Filippini and G. Zucchini: *Miniatori e pittori a Bologna* (Rome, 1968), pp. 89–90
S. Padovani: 'Un contributo alla cultura padovana del primo rinascimento: Giovan Francesco da Rimini', *Paragone*, xxii/259 (1971), pp. 3–31 [with bibliog.]
C. Joost-Gaugier: 'A Contribution to the Paduan Style of Giovanni Francesco da Rimini', *Ant. Viva*, 3 (1973), pp. 7–12
F. Zeri: *Italian Paintings in the Walters Art Gallery*, i (Baltimore, 1976), pp. 207–8
——: *Tuji slikarji od. 14 do. 20 stoletja* (Ljubljana, 1983), pp. 100–01

SERENA PADOVANI

Giovanni (di Francesco) Toscani. *See* TOSCANI, GIOVANNI.

Giovanni Zenone da Vaprio (*fl* Milan, 1430–6). Italian painter and illuminator. He was one of a large family of painters and illuminators working in Milan in the 15th century. He appears frequently in the registers of the building works of the city's cathedral and as a creditor of the influential Borromeo family. First recorded in 1430 as the painter of two altarpieces for the cathedral, he is mentioned again in 1433 and 1444 for the gilding of sculpture and in 1442, 1446 and 1448 for further paintings. None of these works survives.

In 1445 and 1446 Giovanni was paid by Vitaliano Borromeo for the illumination of family *imprese*. However, Cipriani has suggested that these payments were for a group of decorated diplomas (Milan, Trivulziana) granted to the Borromeo family in 1445, and on this basis says that the designs may be by the much better-known Master of the Vitae Imperatorum. A miniature of Filippo Maria Visconti in Galessio da Correggio's *Historia Angliae* (Paris, Bib. N., MS. lat. 6041) has also been connected with Giovanni. Less convincing are the attempts to identify da Vaprio as the Master of the 'Giuochi Borromeo', a mid-15th-century painter of a fresco cycle of courtly games in the Palazzo Borromeo in Milan. Although Giovanni appears with great frequency in the family registers, the sums are always small amounts of money, which probably indicate a continuous flow of minor decorative commissions.

BIBLIOGRAPHY

Annali della Fabbrica del Duomo, appendix 2 (Milan, 1885), pp. 25, 29, 31, 37, 40, 43, 52, 61, 65–7, 69, 222
G. Biscaro: 'Note di storia dell'arte e della cultura a Milano dai libri mastri Borromeo, 1427–1478', *Archv Stor. Lombardo*, xvi (1914), pp. 71, 108
R. Cipriani: 'Giovanni da Vaprio', *Paragone*, lxxxvii (1957), pp. 47–53
G. Consoli: *I giuochi Borromeo ed il Pisanello* (Milan, 1966)

E. S. WELCH

Giovenone, Giovanni [Giovan] **Battista** (*b* Vercelli, *c.* 1525; *d* Vercelli, 1573). Italian painter. He probably trained in the workshop of his father, Pietro, a wood-carver who was the brother of a painter, Gerolamo Giovenone (*c.* 1490–1555). His work is documented from 1546, the date on the earliest of his two certain paintings, the *Martyrdom of St Agatha* in SS Quirico e Giulitta in Trivero Matrice (Vercelli), which he signed with Francesco di Gattinara. This schematic composition is painted in a somewhat archaic style. The second secure work, which is of much higher quality, is the *Mystic Marriage of St Catherine* (Vercelli, Mus. Civ. Borgogna), signed and dated 1547, painted for S Francesco, Vercelli. It reflects the influence of Gaudenzio Ferrari, one of his principal models, and is a variation of Ferrari's painting of the same subject in Novara Cathedral. The figure of St Lawrence is almost certainly a portrait, and the background landscape, with a play of light among the trees, shows a sensitive use of colour. A drawing (Turin, Accad. Albertina, 357) linked to this painting by Griseri has been attributed to Gerolamo Giovenone (see 1982 exh. cat.).

The *Virgin and Child with SS John the Baptist and Anthony and a Supplicant* in SS Quirico e Giulitta in Trivero Matrice was ascribed to Giovanni Battista by Sciolla on the basis of a payment recorded in 1548 for two altarpieces, of which one has been identified as his *Martyrdom of St Agatha*. This attribution was rejected by Ghisotti, however, who proposed to add to his oeuvre a drawing of *St Dorothy Presenting a Supplicant* (Turin, Accad. Albertina), formerly attributed to Ferrari. Documents dated later than his secure works indicate that Giovenone also worked as a *plasticatore*, carving small wooden reliefs. Apart from Ferrari, Giovanni Battista was influenced by Gerolamo Giovenone, Bernardino Lanino (*c.* 1512–83) and Ottaviano Cane (1495–1576), whose daughter he married. There is a certain dryness in his modelling, especially of drapery, but he is notable for his sensitivity to light and colour, and for his interest in landscape and portraiture.

BIBLIOGRAPHY

A. Griseri: 'I Gaudenziani', *Gaudenzio Ferrari* (exh. cat., Vercelli, Mus. Civ. Borgogna, 1956), pp. 138–9
G. C. Sciolla: *Il biellese dal medioevo all'ottocento* (Turin, 1980), p. 156
S. Ghisotti: 'Giovan Battista Giovenone', *Gaudenzio Ferrari e la sua scuola* (exh. cat., ed. G. Romano; Turin, Accad. Albertina, 1982), pp. 123–8

FRANCESCA CAPPELLETTI

Giovio, Paolo (*b* Como, April 1483; *d* Florence, 11 Dec 1552). Italian historian, physician, humanist and collector. He belonged to the Zanobi, one of the oldest and most prominent families in Como, and was devoted to his cultural patrimony, especially to Como's great historians, the elder and younger Pliny. His guardian and mentor was his elder brother, Benedetto Giovio (1471–*c.* 1545), a prominent civic figure, local historian and antiquarian who, among other projects, was involved with Cesare Cesariano on the translation and annotation of Vitruvius' *De architectura* (Como, 1521). In compliance with his

brother's wishes, Paolo trained as a physician in Pavia and Padua (1498–1507), studying with Marc'antonio della Torre and Pietro Pomponazzi. The university environment of Lombardy and the Veneto exposed him to contact with artistic enterprises of the early 16th century and with those who promoted them. For instance, della Torre apparently collaborated with Leonardo da Vinci on an illustrated anatomical text during Giovio's studentship.

By 1512 Giovio was in Rome, as physician to Pope Julius II; he later became physician to Clement VII and Paul III, being rewarded in due course with the bishopric of Nucera. He began to devote himself to the writing of history, taking advantage of his position at the centre of cultural and political affairs. In 1514 Pope Leo X appointed him to the faculty of the university, pleased with a piece he had written on contemporary Italy; the piece was later published as part of Giovio's two-volume *Historiarum sui temporis* (Florence, 1551–2). He remained at the papal court for most of his career, moving among the great political and intellectual figures of the day and becoming a member of the Accademia della Virtù and the Accademia degli Intronati. Besides chronicling current affairs, he wrote medical texts, an influential dialogue on imprese (Rome, 1555) and numerous biographies, including the first of Michelangelo, Raphael and Leonardo. These were initially published in G. Tiraboschi's *Storia della letteratura italiana* (Parma, 1772–82).

Giovio collaborated with artists over the designs for three large-scale decorative projects, including one of the most important fresco cycles of 16th-century Florentine art: the historical allegories alluding to the family history of the Medici, executed by Andrea del Sarto, Franciabigio and Pontormo in the *salone* of the Villa Medici at Poggio a Caiano (begun 1520). He also provided designs for the façade of Tommaso di Cambi's palazzo in Naples (*c.* 1540), depicting the virtues and deeds of the Emperor Charles V (*reg* 1519–56), and a programme for Giorgio Vasari's frescoes (1546) celebrating Pope Paul III in the Sala dei Cento Giorni of the Palazzo della Cancelleria in Rome. Giovio served in an advisory capacity to the Fabbrica (Cathedral Works) of St Peter's (1535–41) and to that of Milan Cathedral. In addition he designed imprese and devices for his patrons, wrote with admirable sensitivity on the styles of some contemporary artists (e.g. his perceptive appreciation of Dosso Dossi's landscape painting) and acted as an intermediary between artists and potential patrons. In particular he was also responsible for launching Vasari's career in Rome and encouraging him to undertake the writing of his *Vite*. He then edited the work and arranged for its publication in Florence.

The only major artistic ventures Giovio undertook on his own behalf were the formation of his celebrated portrait collection and the building of a villa-museum in Borgovico, north of Como. He probably started collecting portraits after his arrival in Rome; by the time of his death, the collection was singular by virtue of its size and content. It comprised over 400 portraits of illustrious and infamous Europeans, past and contemporary, and a number of subjects from the dynasties of the Near and Middle East, and elsewhere. They were probably mostly acquired, as was then common, in return for services rendered to patrons and acquaintances. They tended to be workshop reproductions of varying quality, but the collection nonetheless won great renown. Giovio's villa was built in 1537–8 in anticipation of his retirement, near the site of Pliny the elder's villa, La Commedia. It was Vitruvian in style, lavishly decorated and dedicated to Pliny's memory; it became Giovio's summer retreat and the setting for most of his collection. After his death, the building and its contents remained largely intact until 1569, when the first of several serious floods occurred. What was left undamaged was gradually dispersed, and the building was demolished in 1615. The portraits are known today from painted copies made for Cosimo I de' Medici (Florence, Uffizi), Federico Borromeo (Milan, Ambrosiana) and Ferdinand of Tyrol (*reg* 1564–95) (Innsbruck, Schloss Ambras); also from the woodcuts by Tobias Stimmer (1539–84) illustrating editions of Giovio's *Elogia virorum bellica virtute illustrium veris imaginibus* and *Elogia veris clarorum virorum imaginibus* (Basle, 1575 and 1577 respectively) and Nicolaus Reusner's *Icones sivé imagines vivae literis claris* (Basle, 1589). Giovio's *Elogia* were written in his later years to embellish his portrait collection, commemorating in words the deeds and characters of the subjects of the paintings. It was a project that admirably reflected his interest in art as it related to history.

Giovio's position at the court of Paul III weakened in the 1540s as a result of his perceived allegiance to the policies of Charles V. He reconsolidated his position with the Medici, aided in this by the fact that Cosimo I was just then trying to bring the finest artists and intellectuals to Florence. Hence Cosimo became Giovio's last patron, overseeing the completion and publication of his most important writings. He also arranged Giovio's funeral, honouring him with an elaborate ceremony and burial in S Lorenzo, Florence. A commemorative statue, which now stands at the foot of the stairs to the Biblioteca Laurenziana, Florence, was made by Francesco da Sangallo in 1560.

WRITINGS

Elogia veris clarorum virorum imaginibus apposita quae in Musaeo Comi spectantur (Venice, 1546); It. trans. by L. Domenichi as *Le iscrittioni poste sotto le vere imagini degli uomini famosi le quali a Como nel Museo si veggiono* (Florence, 1552)

Elogia virorum bellica virtute illustrium veris imaginibus (Florence, 1551); It. trans. by L. Domenichi as *Gli elogi: Vite brevemente scritte d'huomini illustri di guerra, antichi e moderni* (Florence, 1554)

Dialogo dell'imprese militari e amorose di Paolo Giovio Vescovo di Nucera (Rome, 1555)

G. G. Ferraro, ed.: *Pauli Iovii opera: Epistolarum*, 2 vols (Rome, 1956–8)

R. Meregazzi, ed.: *Pauli Iovii opera: Gli elogi degli uomini illustri (letterati, artisti, uomini d'arme)* (Rome, 1972) [reprints Latin editions of 1546 and 1551]

M. L. Doglio, ed.: *Dialogo dell'imprese militari e amorose* (Rome, 1978)

BIBLIOGRAPHY

G. B. Giovio: *Elogi italiani*, ed. A. Rubbi (Venice, 1778–84), v; viii, pp. 7–107; xi

F. Fossati: 'Il Museo Gioviano e i ritratti di Cristoforo Colombo', *Period. Soc. Stor. Prov. & Ant. Dioc. Como*, ix (1892), pp. 87–104

K. Frey, ed.: *Il codice magliabechiano* (Berlin, 1892), pp. lxii–lxxix

E. Müntz: 'Le Musée de Paul Jove: Contribution pour servir à l'iconographie du moyen âge et de la renaissance', *Mém. Acad. Inscr. & B.-Lett.*, xxxvi/2 (1898), pp. 249–343

A. Luzio: 'Il Museo Gioviano descritto da A. F. Doni', *Archv Stor. Lombardo*, xxviii (1901), pp. 143–50

L. Rovelli: *L'opera storica ed artistica di Paolo Giovio: Il museo di ritratti* (Como, 1928)

E. Zanolari: *L'erudizione storica di un patrizio comasco del sec. xviii* (Sondrio, 1950)

P. O. Rave: 'Paolo Giovio und die Bildnisvitenbücher des Humanismus', *Jb. Berlin. Mus.*, i (1959), pp. 119–54

——: 'Das Museo Giovio zu Como', *Misc. Bib. Hertz.* (1961), pp. 275–84

T. C. P. Zimmerman: 'Paolo Giovio and the Evolution of Renaissance Art Criticism', *Cultural Aspects of the Italian Renaissance: Essays in Honor of Paul Oskar Kristeller*, ed. C. Clough (Manchester, 1976), pp. 406–24

M. Gianoncelli: *L'antico museo di Paolo Giovio in Borgovico* (Como, 1977)

Z. Waźbiński: 'Musaeum Paolo Giovio w Como: Jego geneza i znaczenie' [The Paolo Giovio Museum in Como: its origins and significance], *Acta U. Nicolai Copernici*, xc (1979), pp. 115–44

Atti del convegno Paolo Giovio: Il Rinascimento e la memoria: Como, 1983

R. Pavoni: 'Paolo Giovio, et son musée de portraits à propos d'une exposition', *Gaz. B.-A.*, n. s. 5, cv (1985), pp. 109–16

L. Klinger, L. Raby and J. Raby : 'A Portrait of Two Ottoman Corsairs from the Collection of Paolo Giovio', *Atti del primo simposio internazionale sull'arte veneziana e l'arte islamica. Venezia e l'Oriente Vicino: Venezia, 1986*, in *Ateneo Ven.*, ix (1989), pp. 47-59

L. S. Klinger: *The Portrait Collection of Paolo Giovio* (diss., Princeton U., NJ, 1990)

T. C. P. Zimmerman: *Paolo Giovio: The Historian and the Crises of Sixteenth-century Italy* (Princeton, 1995)

LINDA S. KLINGER

Giraldi [del Magro], **Guglielmo** (*fl* 1445–89). Italian illuminator. The son of a tailor, Giovanni, he is documented continuously in Ferrara from 1445 to 1477. With Taddeo Crivelli, he was the favourite illuminator of Borso d'Este, Duke of Ferrara, and one of the most important Ferrarese personalities in Renaissance book decoration. He was also active in Urbino, where in 1480 he is recorded working for Federigo II da Montefeltro, Duke of Urbino. Many documented works by Giraldi remain untraced.

Giraldi's early style is known from signed miniatures in the copy of Aulus Gellius's *Noctes Atticae* (Milan, Bib. Ambrosiana, Cod. Scotti; see fig.) made in Bologna in 1448. Late Gothic stylistic elements persist in the frontispiece miniature, characterized by the hooked folds of the drapery and the expressiveness of the faces. The bright light and chromatic range are Giraldi's additions and are close to Florentine techniques, especially those of Domenico Veneziano. Scholarship is divided as to whether the spatial construction, which is realistic but perspectively inaccurate, reveals the influence of Paolo Uccello or Piero della Francesca.

Through his study of Piero della Francesca and his contact at the Este court with the painter Cosimo Tura, Giraldi reached full stylistic maturity in the 1450s. In this period he illuminated the only surviving folio of Borso d'Este's Breviary (1454–9), now the frontispiece of the Book of Hours of Louis of Savoy (Paris, Bib. N., MS. lat. 9473), and a copy of Virgil made in 1458 (Paris, Bib. N., MS. lat. 7939 A). The historiated initials and monochrome vignettes that Giraldi contributed to this volume are regarded as his finest work.

Giraldi's style reveals numerous borrowings from Tura in its elongated figures in contorted poses, the tortuous drapery and the rocky landscapes. It is characterized by a highly skilful rendering of space achieved through meticulous perspectival draughtsmanship and a way of modulating light by the use of colour that he probably learnt from Piero della Francesca. The strong pinks and deep blues and greens are typical, as is the almost classical sense of measure and balance that distinguish his style from that of Crivelli.

Some miniatures in the Bible of Borso d'Este (Modena, Bib. Estense, MS. V. G. 12–13, lat. 422–3) may be

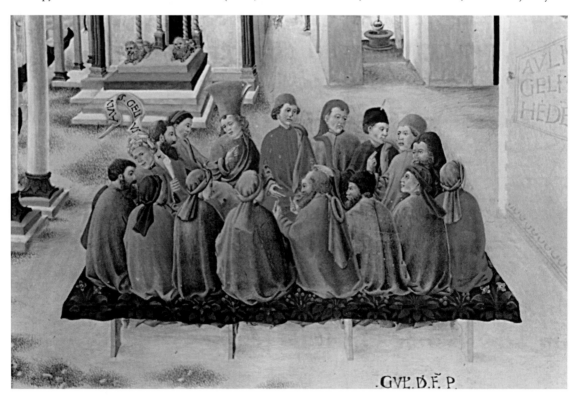

Guglielmo Giraldi: detail of miniature from Aulus Gellius's *Noctes Atticae*, 1448 (Milan, Biblioteca Ambrosiana, Cod. Scotti)

attributed to Giraldi on stylistic grounds (e.g. vol. ii, fols 106*r*–113*v*). The high quality of his work is apparent in the four volumes of another Bible commissioned by Borso d'Este for the Certosa di Ferrara (*c.* 1462–76), and in the choir-books for the same monastery (both Ferrara, Mus. Civ. A. Ant. Pal. Schifanoia). The first, autograph, volume of the Bible contains miniatures that in terms of their size, quality and chromatic splendour are really small paintings, also interesting for their naturalistic friezes with architectural inserts. The inferior quality of the second and third volumes indicates the presence of assistants, who executed the entire fourth volume and also worked on the choir-books. A Psalter and a Hymnal for Ferrara Cathedral (1472; Ferrara, Mus. Duomo) are documented as the work of Giraldi. On stylistic grounds, various other works have been attributed to him: a copy of Plautus (Madrid, Bib. N., MS. Vit., 22.5), executed for the Gonzaga family; the *Trattato del ben governare* (Milan, Castello Sforzesco, MS. 86), which is stylistically closer to Crivelli; and the *Libro del Salvatore* (Modena, Bib. Estense, MS. it. 353), which was produced by assistants.

After 1477 Giraldi's name no longer appears in Ferrara, and he was probably employed in Urbino, where he participated in the decoration of a copy of Dante's *Divine Comedy* (*c.* 1480; Rome, Vatican, Bib. Apostolica, MS. Urb. lat. 365). The style of this manuscript differs from that of the first volume of the Certosa Bible only in its closer connection with the work of Francesco del Cossa, an influence that is already visible in Giraldi's late Ferrara works. Among Giraldi's followers was his nephew Alessandro Leoni, who, in 1475, collaborated with him on a Psalter (Modena, Bib. Estense, MS. lat. 990).

BIBLIOGRAPHY

F. Hermanin: 'Le miniature ferraresi della Biblioteca Vaticana', *L'Arte*, iii (1900), pp. 341–73

H. J. Hermann: 'Zur Geschichte der Miniaturmalerei am Hofe der Este in Ferrara', *Jb. Ksthist. Samml. Allhöch. Ksrhaus.*, xxi (1900), pp. 117–271

G. Bertoni: *Il maggior miniatore della Bibbia di Borso d'Este 'Taddeo Crivelli'* (Modena, 1925)

M. Bonicatti: 'Contributo al Giraldi', *Commentari*, viii (1957), pp. 195–210

M. Salmi: *Pittura e miniatura a Ferrara nel primo rinascimento* (Milan, 1961)

Dix siècles d'enluminure italienne (VI–XVI siècles) (exh. cat., ed. F. Avril, Y. Zaluska and others; Paris, Bib. N., 1984)

Le muse e il Principe: Arte di corte nel rinascimento padano (exh. cat., Milan, Mus. Poldi Pezzoli, 1991) [notes by F. Avril]

The Painted Page: Italian Renaissance Book Illumination, 1450–1550 (exh. cat., ed. J. J. G. Alexander; London, RA, and New York, Pierpont Morgan Lib. 1994–5)

FEDERICA TONIOLO

Girolamo da Cremona [Girolamo di Giovanni dei Corradi] (*fl* 1451–83). Italian illuminator and painter. He probably trained in the circle of Francesco Squarcione in Padua. It is possible that Girolamo is the Gerolamo Padovano described as illuminating manuscripts for S Maria Nuova, Florence, in Vasari's *Vita* of Bartolomeo della Gatta. Girolamo's first known works are an historiated initial P showing the *Baptism of Constantine* (1451; Paris, Mus. Marmottan) and a letter M inscribed *Ieronimus. F.* with *St Catherine before Maxentius* (London, V&A, MS. 1184), both probably excised from the same Antiphonal. The style of these compositions is eclectic and includes figures with little articulation that appear to derive from Antonio Vivarini's types, combined with studied spatial effects probably learnt from Donatello's main altar at the basilica of S Antonio, Padua. A subsequent but near contemporary work possibly by Girolamo is the miniature of *St Maurice* in the *Life and Passion of St Maurice* (1452/3; Paris, Bib. Arsenal, MS. 940, fol. 34*v*), commissioned by Jacopo Marcello as a gift for René I, 4th Duke of Anjou. Girolamo's fame soon spread beyond Padua and he was summoned to Ferrara to contribute miniatures (formerly assigned to Marco di Giovanni dell'Avogaro; *fl* 1449–76) to the Bible of Borso d'Este (Modena, Bib. Estense, MS. V. G. 12–13, lat. 422–3) produced between July 1455 and December 1461. During his activity in the Estense capital, Girolamo was influenced by the stage-like settings and abstracted backgrounds of Jacopo Bellini, who had been the painter favoured by Leonello d'Este, Marchese of Ferrara.

In 1461 Girolamo moved to Mantua, where, on the recommendation of Mantegna, he completed by 1466 a lavish Missal (Mantua, Mus. Dioc.) for Barbara of Hohenzollern, Marchesa of Mantua (1422–81), which had been started by Belbello da Pavia in a pristine Gothic style. The work was reassigned to Girolamo in spite of Belbello's entreaties and offer to complete the volume without compensation. Girolamo's close contact with Mantegna was apparently crucial in his obtaining the commission, and the illuminator's work in the Missal demonstrates Mantegna's growing influence on his development. In a letter written in 1461 as Girolamo was hired, the patroness praised his work as that of a young (*un zovene*), talented illuminator, from which it may be inferred that the artist was then probably in his twenties. In Mantua, Girolamo's style matured and became crisply descriptive in the rendering of sculptural forms, even in such details as rock formations and foreground pebbles; but he also adopted Belbello's brilliant palette in an artful and sophisticated manner. Probably dating to 1461–3, and thus of his Mantuan period, are the miniatures he produced along with Franco dei Russi and Jacopo da Mantova (*fl* 1460–65) in an Antiphonal (London, Soc. Antiqua., MS. 456, fols 1*r*, 19*v*, 27*v*) for the church of SS Cosma e Damiano (destr. 1587), originally adjacent to the Mantuan palace. In the miniature of the *Martyrdom of the Saints*, the low vantage-point and the steep foreshortening reflect the influence of Mantegna's Ovetari Chapel frescoes (mostly destr. 1944) in the Eremitani, Padua.

Girolamo's Mantuan output demonstrates his excellent craftsmanship in the rendering of a calm, ordered world composed of well-delineated, metallic-like forms and static, svelte figures clad in pleated draperies with long tubular folds, and with small, roundish heads marked by high curved foreheads, wide-bridged noses, and receding chins. The tonalities in his often repetitive compositions are judiciously juxtaposed to maximize the effect of opulence. Also characteristic are his borders, which are enlivened by numerous and illusionistically modelled representations of rubies, amethysts, cameos and other gems enhanced by involved goldsmithswork and gilt chiaroscuro scrolls, as well as prominent shadow-casting pearls. His framed compositions are surrounded by bevelled borders adapted from panel painting.

In 1466 both Girolamo and Mantegna are recorded in Florence. Girolamo subsequently went to Siena, where he

was intermittently active from February 1470 until 1474, illustrating choir-books with large historiated initials and borders in collaboration with LIBERALE DA VERONA and Venturino Mercanti da Milano (*fl* 1467–79), for both the monastery of Monte Oliveto Maggiore outside Siena and Siena Cathedral. Girolamo's contribution to the former is in *Corale* M (1472; Chiusi, Mus. Cattedrale), and for the latter in a number of Graduals and Antiphonals (Siena, Bib. Piccolomini, MSS 16.1, 17.2, 18.3, 19.4, 23.8, 28.12, 3.C, 10.L, 12.N). Other works datable to this period are initials I and R showing an *Angel Blowing a Trumpet* and the *Resurrected Christ* (fol. 199*r*; see fig.), respectively in an Antiphonal (Cleveland, OH, Mus. A., Acc. 30.661) and a cutting from a Psalter of an initial O (or D) with *God the Father Enthroned* (New Haven, CT, Yale U.A.G., Acc. 1954.7.2). The miniatures Girolamo produced in Siena are compositionally his most complex and stylistically his most dynamic. He played an essential role in introducing such Sienese artists as Benvenuto di Giovanni to a sympathetic, innovative style that combined skilful coloration with clear drawing in a finely descriptive technique. Furthermore, he introduced North Italian architectural motifs to the Sienese school.

Between 1473 and early 1475 Girolamo was also in Florence, participating with Gherardo di Giovanni da Miniato (1444/5–97) and Mariano del Buono di Jacopo on the illustration of a manuscript (Florence, Bargello, MS. 68), copied in 1473 and intended for the Camaldolese hospital of S Maria Nuova. During this period he also produced the illustrations in a manuscript of Pseudo-Lull's *Trattato di alchimia* (Florence, Bib. N. Cent., MS. Banco Rari 52). In 1475 the peripatetic Girolamo is mentioned in two letters from Benedetto Capperello to Lucrezia

Girolamo da Cremona: *Resurrected Christ*, cutting from an Antiphonal, ink, tempera and gold on parchment, 559×432mm, *c.* 1470–80 (Cleveland, OH, Cleveland Museum of Art, Acc. 30.661, fol. 199*r*)

de'Medici as active in Venice and working on a Missal for her. Three sets of cuttings are cited as having been excised from the Missal (untraced): border decoration with deer, a roundel with deer and an initial C showing a *Priest Celebrating Mass* (Philadelphia, PA, Free Lib., Lewis MS. 27:27–29); a miniature (affixed to a cradled panel) of the *Deposition* (New York, Met., Acc. 49.7.8); and two miniatures, the *Epiphany* and *Presentation in the Temple* (Paris, Wildenstein priv. col.). Also of Girolamo's Venetian period are the first part (up to fol. 180*v*) of a remarkable Carthusian Breviary (Oxford, Bodleian Lib., MS. Canon. Liturg. 410) with large architectural motifs, and a Cluniac Psalter (Oxford, Bodleian Lib., MS. Liturg. 72) with impressive gold scrolls enlivened with fauna. Other manuscript illumination attributed to Girolamo, which appears to belong to his late period in Venice, is in a Breviary for the Certosa di Montello (Treviso, Bib. Com., MS. 888), a religious treatise *Theologica mistica* produced for a nun (Venice, Bib. N. Marciana, MS. it. I. 61), and a miniature of the *Crucifixion* (ex-Eugene Schweitzer priv. col., Berlin).

The bulk of Girolamo's late work seems to have been devoted to the illustration of incunabula for Venetian book publishers. Occasional single copies of texts printed on parchment and destined for bibliophiles had miniatures added by Girolamo. He produced frontispieces for volumes printed by Nicolas Jenson: Eusebius's *De evangelica praeparatione* (1470; London, BM, Inc. IB 1912); Gratian's *Decretals* (1474; London, BM, Inc. IC 19678); St Augustine's *City of God* (1475; New York, Pierpont Morgan Lib., ChL 760); another *Decretals* (1477; Gotha, Forschbib.); and Plutarch's *Lives* (1478; vol. I: Paris, Bib. N., Vélins 700; vol. II: New York, Pierpont Morgan Lib., ChL 767). His work in these large volumes consists of rich acanthus borders in which are lodged pearls, precious stones in mounts, and medallions with deer and water fowl at rest or in flight, similar to those in the Cluniac Psalter. The last known productions of this artist are two outstanding frontispieces and some 19 large initials, each enlivened with a bust or cameo within a setting, executed for an edition of Aristotle's *Works*, printed in two volumes in 1483 by Andrea dei Torresani d'Asola and Bartolomeo de Blavis (New York, Pierpont Morgan Lib., ChL 907). Here Girolamo, in a softened and more luminous style, probably engendered by contact with Venetian artists, created especially spectacular *trompe l'oeil* effects. In the first frontispiece, images are shown as if through torn blank areas of the page, while in the second, the text appears like a tapestry, tied to the façade of a Renaissance palace from which Aristotle, Averroës and their followers glance out, with deer, playful satyrs and putti below. These ornamental inventions were subsequently imitated by Venetian illuminators.

Of the several panel paintings once attributed to Girolamo (e.g. in the cathedrals at Viterbo and Arsola, and in S Francesca Romana and the Palazzo Venezia, Rome) all, save a rather bland *Annunciation* (Siena, Pin. N., no. 309) and perhaps a *Virgin and Child with Angels* (Perugia, G.N. Umbria), have been reattributed by post-1950 scholarship to Liberale da Verona. In miniature painting, the individual work of the two artists is at times just as difficult to distinguish, as they seem to have made a concerted effort to converge towards a uniform style on the choir-books

in Siena, in fact cooperating in numerous instances on the same miniature (e.g. Siena, Bib. Piccolomini, MS. 16.1, fol. 23*v*), with Girolamo's style influencing Liberale's freer, nervous manner, but benefiting in turn from the latter's creative compositions. Girolamo's sense of monumentality and space transformed the scope of book illumination from subordinate decoration into a form closer to small panel paintings; he is thus justly considered outstanding among North Italian illuminators of the period.

BIBLIOGRAPHY

G. Vasari: *Vite* (1550, rev. 2/1568); ed. G. Milanesi, iv (1878–85), pp. 584–5

M. Salmi: 'Girolamo da Cremona miniatore e pittore', *Boll. A.*, n. s. 1, i (1922–3), pp. 385–404, 461–78

M. Levi D'Ancona: 'Postille a Girolamo da Cremona', *Studi di bibliografia e storia in onore di Tammaro De Marinis*, iii (Verona, 1964), pp. 45–104

B. Berenson: *Central Italian and North Italian Schools* (1968), i, pp. 189–93; ii, pls 866–75, 877–8

M. Levi D'Ancona: *The Wildenstein Collection of Illuminations: The Lombard School* (Florence, 1970)

M. G. Ciardi-Dupré: *I corali del Duomo di Siena* (Milan, 1972)

F. Bisogni: 'Liberale o Girolamo?', *A. Illus.*, vi (1973), nos 55–6, pp. 400–08

M. Righetti: 'Indagine su Gerolamo da Cremona miniatore', *A. Lombarda*, 41 (1974), pp. 32–42

H. J. Eberhardt: *Die Miniaturen von Liberale da Verona, Girolamo da Cremona und Venturino da Milano in den Chorbüchern des Doms von Siena: Dokumentation, Attribution, Chronologie* (Munich, 1983)

Painting in Renaissance Siena, 1420–1500 (exh. cat., ed. K. Christiansen, L. B. Kanter and C. Brandon Strehlke; New York, Met., 1988–9) [entries by K. Christiansen]

F. Toniolo, ed.: *La miniatura estense* (Modena, 1994)

PATRICK M. DE WINTER

Girolamo da Sermoneta. *See* SICIOLANTE, GIROLAMO.

Girolamo [Gerolamo] **da Treviso** [*il vecchio*] **(i)** (*fl* Treviso, *c.* 1475–97). Italian painter. The identity of this painter is uncertain. A group of paintings produced in Treviso between *c.* 1475 and 1497 are signed *Hieronymus Tarvisio*; several of them are also dated. Documents show that there were two painters who might have used this signature, both active in Treviso at the same time, both of whom died in 1497. They are Girolamo di Bartolomeo Strazzarolo da Aviano (documented 1476; *d* between 29 May and 26 Oct 1497) and Gerolamo di Giovanni Pennacchi (1455–before 15 May 1497), the elder brother of the painter Pier Maria Pennacchi. Unfortunately, no extant painting is securely documented as the work of either man. Because an inscription on the back of *St Jerome in the Wilderness* (Bergamo, priv. col., see Zocca, p. 389) says that it was painted in Padua, and Girolamo Pennacchi stated in his will of 17 July 1496 that he had previously worked in Padua, the oeuvre has been ascribed to him; conversely, it has also been given to Girolamo Strazzarolo da Aviano, because in September 1496 he was given a barrel of wine in payment at Paese, near Treviso, where an altarpiece of *St Martin and the Beggar* (*in situ*), signed *Girolamo da Treviso*, is dated 1496: it is assumed that the wine was in part payment for the painting. Federici, followed by Coletti and Nepi Scirè, identified the artist as Girolamo Strazzarolo da Aviano; Biscaro, Paoletti and Ludwig and Zocca claimed he was Girolamo Pennacchi; Fiocco and Longhi divided the oeuvre between the two men.

The works are in a Paduan, Mantegnesque style; the earliest appears to be the *St Jerome in the Wilderness*, signed and dated 1475. A panel of the *Death of the Virgin* (1478; Treviso, Cassa di Risparmio), a *Pietà* (Lovere, Gal. Accad. B.A. Tadini) and a *Dead Christ with Angels* (Milan, Brera) are in the same tempera technique and the same Mantegnesque style.

After 1480 the artist veered towards a style that imitates Alvise Vivarini; to this period belong two paintings of the *Virgin and Child* (Budapest, Mus. F.A.; Portland, OR, A. Mus.) and a panel fragment of the head of St Anthony Abbot (Treviso, Mus. Civ. Bailo). The signed and dated *Virgin and Child Enthroned with SS Sebastian and Roch*, known as the Pala del Fiore (1487; Treviso Cathedral), shows the influence of Bartolommeo Montagna. Thereafter the artist apparently reverted to a more retardataire style evident in the lunette of the *Transfiguration* (Venice, Accad.), part of a destroyed altarpiece of 1488 (the only painting ascribed by Fiocco to Strazzarolo da Aviano; the rest he gave to Pennacchi); the same stylistic development is visible in the *Virgin and Child with Four Saints*, called the Pala di Collalto (1494; Venice, Accad.), an altarpiece (Treviso Cathedral) from San Vigilio, near Montebelluna, and the *St Martin and the Beggar*, signed and dated 1496.

BIBLIOGRAPHY

D. M. Federici: *Memorie trevigiane sulle opere di disegno. . .*, i (Venice, 1803)

L. Crico: *Lettere sulle belle arti trevigiane* (Treviso, 1833)

J. A. Crowe and G. B. Cavalcaselle: *A History of Painting in North Italy*, ii (London, 1871, rev. 2/1912, ed. T. Borenius)

G. Biscaro: 'Note e documenti per servire alla storia delle arti trevigiane', *Culture & Lavoro* (1897)

P. Paoletti and G. Ludwig: 'Neue Beiträge zur Geschichte der venezianischen Malerei', *Repert. Kstwissen.* (1899)

G. Fiocco: 'Pier Maria Pennacchi', *Riv. Regio Ist. Archeol. & Stor. A.* (1929)

E. Zocca: 'Girolamo da Treviso il vecchio', *Boll. A.*, xxv (1931–2), pp. 388–97

R. Longhi: *Viatico per cinque secoli di pittura veneziana* (Florence, 1946)

L. Coletti: *Pittura veneta del quattrocento* (Novara, 1953)

G. Nepi Scirè: 'Appunti e chiarimenti su Gerolamo da Treviso il vecchio (Gerolamo Aviano o Gerolamo Pennacchi?)', *Not. Pal. Albani*, iii (1973), pp. 27–39 [with documents]

MAURO LUCCO

Girolamo (di Tommaso) da Treviso [*il giovane*] **(ii)** (*b* Treviso, *c.* 1498; *d* Boulogne-sur-Mer, 1544). Italian painter, draughtsman, sculptor and military engineer. He is first documented in 1523 in Bologna but had probably arrived there *c.* 1520. Between 1515 and 1520 he produced an engraving (initialled) of *Susanna and the Elders* and a series of drawings that were engraved by Francesco de Nanto, depicting scenes from the *Life of Christ*. A series of paintings, some of them initialled, were attributed to him by Coletti and this attribution is now generally accepted. The group includes two small canvases (transferred from panels that were initialled HIRTV) representing *Isaac Blessing Jacob* and *Hagar and the Angel* (both Rouen, Mus. B.-A.), the monogrammed *Sleeping Venus* (*c.* 1520–29; Rome, Gal. Borghese; see fig.), which contains an echo of Marcantonio Raimondi's so-called *Dream of Raphael* (B. 274, 359), the initialled *Female Nude* (Vienna, Ksthist. Mus.), derived from a drawing by Raphael (London, BM) that was engraved by Raimondi (B. 234, 311), the *Holy Family with Simeon* (Ca' Morosini, parish church), the *Noli me tangere* (Bologna, S Giovanni in Monte) and the *Christ*

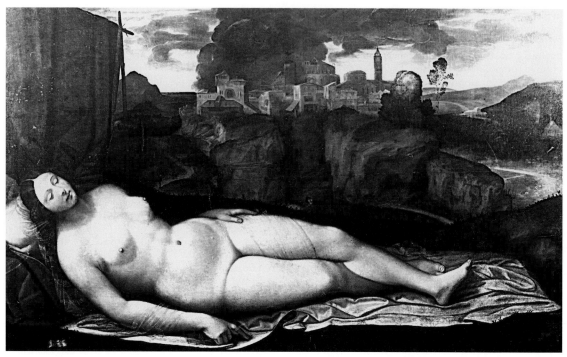

Girolamo da Treviso (ii): *Sleeping Venus*, oil on canvas, 1.30×2.12 m, *c.* 1520–29 (Rome, Galleria Borghese)

in Limbo (Munich, Alte Pin.). These would be early works but they already show that Girolamo's Venetian style was modified by his response to the classicizing art of Emilia, and particularly by the work of Giacomo Francia and Marcantonio Raimondi, who united the classicism of Raphael with the fantasies of northern European engravers.

In 1524 Girolamo collaborated in the sculptural decoration of the right-hand portal on the façade of S Petronio in Bologna, carving marble reliefs of *Jacob's Sons Presenting him with Joseph's Bloodstained Garment* and the *Cup Found in Benjamin's Sack*. Between the end of 1525 and May 1526 he made eight signed grisaille wall paintings in oil, depicting *Miracles of St Anthony of Padua* in the Guidotti Chapel of the same church. In 1527–8, according to Vasari, he frescoed the façade of the Casa Doria in Genoa, and immediately afterwards may have been involved in the decoration of the Palazzo del Te in Mantua with Giulio Romano (Mancini). In Venice in 1531–2 he provided an altarpiece (untraced) for S Salvatore and painted frescoes on the façade of the house of Andrea Odoni, the antiquarian and collector whose portrait was painted by Lorenzo Lotto (London, Hampton Court, Royal Col.).

In 1533, in Faenza, Girolamo decorated the apse of the church of the Commenda with a beautiful fresco, the central part showing the *Virgin and Child Enthroned with SS John and Catherine of Alexandria, with Mary Magdalene Presenting the Donor*. The *sinopia* shows that the artist originally planned to have four saints beside the throne of Mary. Two sheets of preparatory drawings have survived (Florence, Uffizi). These and the painting itself show a matured style in which Girolamo re-elaborates stylistic devices and formulae found in the work of Correggio,

Parmigianino, Bartolomeo Ramenghi Bagnacavallo and Garofalo.

According to Vasari, Girolamo also took part in the decoration of the Magno Palazzo commissioned by Bishop Bernardo Clesio (1485–1539) in the castello of Buonconsiglio in Trent, but there is no other documentary evidence for this. Sometime between 1529 and 1538 the artist produced the fresco, now fragmentary, in the oratory of S Sebastiano at Castelbolognese (Ravenna), the *Adoration of the Magi* (London, N.G.) from a cartoon by Baldassare Peruzzi for the Bentivoglio family, and, for S Salvatore, Bologna, the *Presentation of the Virgin with St Thomas of Canterbury* (*in situ*), which is strongly influenced by the Venetian paintings of Sebastiano del Piombo. This painting, for which there is also a preparatory drawing (Florence, Uffizi), was executed for the English students' chapel, a commission that probably led to the invitation from King Henry VIII (*reg* 1509–47) for the artist to work at the English court as a military engineer. While in Britain, he produced the satirical grisaille of the *Evangelists Stoning the Pope* (London, Hampton Court, Royal Col.), and the anti-papal and anti-imperial drawing of the *Triumph of Death over Church and State* (sold London, Christie's, 23 June 1970, lot 52). Vasari reported that Girolamo was killed by a cannon shot while the English were besieging Boulogne-sur-Mer.

BIBLIOGRAPHY

G. Vasari: *Vite* (1550); ed. L. Bellosi and A. Rossi (Turin, 1986), pp. 687, 762–4, 867

——: *Vite* (1568); ed. P. della Pergola, L. Grassi and G. Previtali (Milan, 1962–6), iv, pp. 264, 403–10; v, pp. 358, 360, 395; viii, p. 218

I. B. Supino: *Le sculture delle porte di S Petronio in Bologna* (Florence, 1914), pp. 37, 41, 47–51, 64

L. Coletti: 'Gerolamo da Treviso il Giovane', *Crit. A.*, i (1935–6), pp. 172–80

P. Pouncey: 'Girolamo da Treviso in the Service of Henry VIII', *Burl. Mag.*, xcv (1953), pp. 208–11

K. Oberhuber: *Marcantonio Raimondi*, 26 [XIV/i], 27 [XIV/ii] of *The Illustrated Bartsch*, ed. W. L. Strauss (New York, 1978) [B.]

The Genius of Venice, 1500–1600 (exh. cat., ed. J. Martineau and C. Hope; London, RA, 1983), pp. 172–3

A. Tempestini: 'Contributo a Girolamo da Treviso il giovane', *Mus. Ferrar.: Boll. Annu.* (1983–4), pp. 111–18

P. Casadio: 'Un affresco di Girolamo da Treviso il giovane a Faenza', *Il Pordenone. Atti del convegno internazionale di studio: Pordenone, 1985*, pp. 209–15

A. Speziali: 'Girolamo da Treviso', *Pittori bolognesi del cinquecento*, ed. V. Fortunati Pierantonio (Casalecchio di Reno, 1986), i, pp. 147–83 [excellent bibliog. and pls]

V. Mancini: 'Un insospettato collaboratore di Giulio Romano a Palazzo del Te: Girolamo da Treviso', *Paragone*, xxxviii/453 (1987), pp. 3–21

A. Tempestini: 'Un *Cristo al limbo* di Girolamo da Treviso il giovane (1498–1544)', *Ant. Viva*, xxviii/2–3 (1989), pp. 15–18

J. Winkelmann: 'Proposte per alcuni disegni bolognesi del '500', *Da Leonardo a Rembrandt: Disegni della Biblioteca Reale di Torino: Atti del convegno internazionale di studi: Turin, 1990*, pp. 167–76

ANCHISE TEMPESTINI

Girolamo da Udine (*fl* 1506–12). Italian painter. Girolamo's only authenticated surviving work is a *Coronation of the Virgin with SS John the Baptist and John the Evangelist* (ex-S Francesco dell'Ospedale, Udine; Udine, Mus. Civ.) signed *Opus ieronimi Utinensis*. He is almost certainly the same Girolamo, son of Bernardino da Verona (1463–1528), who signed a contract to paint a chapel in SS Biagio e Giusto in Lestizza, near Udine, in March 1511 and who died the following year. Attempts to associate him with a document of 1539 have been shown to be mistaken. Girolamo must have been resident for most of his career in Venice, since the style of the *Coronation* is very close to that of Cima da Conegliano. The fairly literal borrowing of the figure of the Baptist from its counterpart in Cima's *Rest on the Flight to Egypt* (c. 1495–8; Lisbon, Mus. Gulbenkian) suggests a date of about 1500 for the *Coronation* and confirms that Girolamo had access to the contents of Cima's workshop. Another work in the style of Cima that is generally attributed to Girolamo is an *Adoration of the Shepherds* (Worcester, MA, A. Mus.), in which the stylization of the draperies and the timid little figures with button-like eyes bear a close resemblance to the figure types in the *Coronation*. Girolamo may have been responsible for several other variants on designs by Cima; he also seems occasionally to have collaborated with his compatriot Giovanni Martini da Udine (*fl* 1497–1535), for example on the lunette (Udine, Mus. Civ.) of Giovanni's documented *St Ursula* altarpiece of 1503–7.

BIBLIOGRAPHY

Thieme–Becker

V. Joppi: 'Contributo quarto ed ultimo alla storia dell'arte nel Friuli', *Misc. Stor. Ven.*, n.s. 2, xii A (1894), p. 24

G. M. Richter: 'Italian Pictures in Scandinavian Collections', *Apollo*, xix (1934), pp. 128–9

B. Berenson: *Venetian School* (1957), p. 90

M. Levi d'Ancona: *The Iconography of the Immaculate Conception in the Middle Ages and Early Renaissance* (New York, 1957), p. 31

L. Coletti: *Cima da Conegliano* (Venice, 1959), p. 66

Prima mostra del restauro (exh. cat., ed. A. Rizzi; Udine, Castello, Salone Parlamento, 1963), pp. 70–71

L. Lanzi: *Storia pittorica dell'Italia*, ed. M. Capucci (Florence, 1968), ii, p. 63

P. Zampetti: *A Dictionary of Venetian Painters* (Leigh-on-Sea, 1970), i, pp. 56–7

F. Zeri: *Italian Paintings in the Walters Art Gallery* (Baltimore, 1976), i, pp. 258–9

A. Tempestini: *Martino da Udine detto Pellegrino da San Daniele* (Udine, 1979)

——: 'Tre schede venete', *Itinerari*, i (1979), p. 78

L. Menegazzi: *Cima da Conegliano* (Treviso, 1981)

P. Humfrey: *Cima da Conegliano* (Cambridge, 1983)

PETER HUMFREY

Girolamo del Crocifissaio. *See* MACCHIETTI, GIROLAMO.

Girolamo [Gerolamo] di Bartolomeo Strazzarolo da Aviano. *See under* GIROLAMO DA TREVISO (i).

Girolamo di Giovanni da Camerino (*fl* 1449–73). Italian painter. His first known painting is a fresco, dated 1449, of the *Virgin and Child with SS Anthony of Padua and Anthony Abbot* (Camerino, Mus. Pin. Civ.). The influence of Piero della Francesca, who was active in Urbino during the late 1440s, is evident in the fresco's dramatic play of light and the geometric simplicity of its figures. On 21 November 1450 Girolamo entered the painters' guild in Padua. His hand was identified by Longhi in the frescoes of *St Christopher and the King* (destr. 1944) in the Ovetari Chapel in the Eremitani, Padua. His arrival in the city just after the death of Giovanni d'Alemagna and the withdrawal of Antonio Vivarini from the contract to decorate the chapel suggests that Girolamo went to Padua in order to apply for the new commission.

The *Annunciation* and *Pietà* (Camerino, Mus. Pin. Civ.), executed shortly after Girolamo's return to Camerino, show the influence of Mantegna's use of architectural perspective: the interior of the Virgin's chamber in Girolamo's *Annunciation* is clearly inspired by Mantegna's work in the Ovetari Chapel (*see* MANTEGNA, ANDREA, fig. 1). The figure of the Angel Gabriel, on the other hand, is derived from the Paduan works of Filippo Lippi, who had worked in Padua around 1434.

Girolamo's art shows little stylistic development since he was by nature an eclectic. His work has been compared with that of Giovanni Boccati, also from Camerino, and Berenson even suggested that Girolamo studied with Boccati, but this seems unlikely since they were of the same generation. Girolamo's last dated work is a large polyptych of the *Virgin and Child with Saints* (1473; Montesanmartino, nr Macerata, Madonna del Pozzo). Works by him continue to be discovered in the Marches.

BIBLIOGRAPHY

B. Berenson: 'Gerolamo di Giovanni da Camerino', *Ant. Viva*, vii (1907), pp. 129–35

R. Longhi: 'Lettere pittoriche: Roberto Longhi a Giuseppe Fiocco', *Vita Artistica*, i (1926), pp. 127–39 (136)

L. Serra: 'Girolamo di Giovanni da Camerino', *Rass. March.*, viii (1929–30), pp. 246–68

F. Zeri: *Due dipinti, la filologia e un nome* (Turin, 1961), pp. 74–80

P. Zampetti: *La pittura marchigiana del '400* (Milan, 1969), pp. 90–95 [with catalogue of works]

A. Paolucci: 'Per Girolamo di Giovanni da Camerino', *Paragone*, xxi/239 (1970), pp. 23–41

P. Zampetti: *Dalle origini al primo rinascimento*, i of *Pittura nelle Marche* (Florence, 1988), pp. 389–93, 398–9

ELIOT W. ROWLANDS

Girolamo di Romano. *See* ROMANINO, GEROLAMO.

Giudicis, Francesco di Cristofano. *See* FRANCIABIGIO.

Giuliano, Duc de Nemours. *See* MEDICI, DE', (9).

Giuliano, Giovanni di. *See* GIOVANNI DA ORIOLO.

Giuliano d'Arrigo. *See* PESELLO.

Giulio Romano [Pippi] (*b* Rome, ?1499; *d* Mantua, 1 Nov 1546). Italian painter and architect. He was trained by Raphael, who became his friend and protector, and he developed into an artist of consequence in the third decade of the 16th century. His authority derived from his artistic lineage, attunement to the needs of courtly patrons and a style that blended modern sensibilities with the forms of Classical art. His greatest achievements were the monumental fresco programmes and architectural projects that he conceived and oversaw. Giulio's contemporaries particularly praised the facility and inventiveness of his drawing, a view upheld by 20th-century writers. Most of his career was spent in Mantua, as court artist for Federico II Gonzaga, 5th Marchese and 1st Duke of Mantua (*reg* 1519–40). The Palazzo del Te, designed for Federico, is a *tour de force* of Mannerist architecture and decoration. Giulio's Mantuan workshop was modelled on the organizational structure of Raphael's; it did not, however, generate the sort of independent and highly skilled artist that Giulio himself exemplified.

I. Life and work. II. Working methods and technique.

I. Life and work.

1. In Raphael's workshop, to 1520. 2. Works following the death of Raphael, 1520–24. 3. Works for Federico Gonzaga, 1524–40. 4. Other projects of the 1530s and 1540s.

1. IN RAPHAEL'S WORKSHOP, TO 1520.

(i) Artistic formation. Vasari provided the earliest information about Giulio's beginnings as an artist. This account indicates that he began his apprenticeship as a boy, but then it jumps to a description of him already working at a responsible level, as an assistant to Raphael in the Stanze (papal apartments) in the Vatican. Vasari's remarks firmly set the origins of Giulio's art within Raphael's workshop as it carried out the decoration of the papal apartments from 1509 to 1517, but they leave unclear the particulars of his first steps within that milieu. His early development is difficult to trace in detail since it took place during the production of these monumental projects. His artistic formation, then, can be discussed convincingly only within the context of a workshop system, where the sum of individual efforts was intended to add up to the idea of the master. The more efficient and successful the result, the less is the likelihood that the work of individual hands can be identified. A more promising path for the investigation of Giulio's early development is to explore the indications provided in Vasari's biography of him; this is an authoritative source, since Vasari knew Giulio and interviewed him on at least one occasion. His account records instances of collaboration between Raphael and Giulio, both as a method of teaching and as a business practice, and also points to aspects of the division of labour in Raphael's organization. Such remarks provide the clearest guidance for a consideration of Giulio's earliest

work, which, however, cannot be isolated as a distinct corpus.

(ii) The Stanze. Chronologically, Vasari posited Giulio's first significant participation as Raphael's assistant to the decoration of the third room, the Stanza dell'Incendio in the papal apartments (completed by 1517), identified by its scene of the *Fire in the Borgo* (*see* RAPHAEL, fig. 4). He described Giulio's painting there as extensive, noting particularly the dado with a fictive relief of bronze figures flanked by grisaille elements. Singled out for description and praise, the dado must have been a milestone in Giulio's apprenticeship. He later provided Marcantonio Raimondi with drawings of the dado figures, which the engraver used as the basis for a series of prints. Giulio's involvement in the transfer of these drawings into prints can be taken as further evidence that he had a significant role in the production of this part of the room's decoration. It is reasonable to assume that during work in the Stanza dell'Incendio, Giulio, who was about 17, would have been supervised in the painting of the narrative scenes, executing the master's designs, but allowed more autonomy in carrying out the ornamental dado. While the use of fictive sculpture was an established tradition in fresco painting —and certainly Giulio was adhering to a given programme —it is notable that experimenting with the representational possibilities of the medium was a concern that continued in his later work. As a novice fresco painter, he also must have delighted in the opportunity to explore ideas used by Michelangelo in the Sistine Chapel (Rome, Vatican), with its compelling display of multiple levels of fiction in the bronze and grisaille figures.

(iii) The Loggia of Leo X. Giulio's development in the composition of figural groups can also be studied in the series of narrative scenes from biblical subjects in the Loggia of Leo X (Rome, Vatican). This is the other grand project that Vasari cited, with particular praise of Giulio's abilities, as an arena of major activity during the artist's years of apprenticeship. Payments made directly to the assistants of Raphael in 1518 and 1519 record not only the dates of the work but also that it was a collaborative effort of the workshop. A significant site, contiguous to the Stanze, the Loggia was intended to be part of a monumental façade for the Vatican Palace. Its decoration demonstrated Raphael's ability to conceive a highly synthetic decorative ensemble and to orchestrate its realization through a startlingly large number of assistants. Although there is no general agreement about the attribution of specific portions of the Loggia to Giulio, this should not prevent recognition of its seminal influence on the artist's genesis. Both for the successful blending of antique and modern idioms and for the strategic employment of specialized assistants, the decorative campaign for the Loggia was the model for Giulio's career as a court artist.

In the complex programme of the Loggia, the arches are covered with elaborate stuccowork and the intervening walls with whimsical motifs in the Classical grotesque manner, while the vaults bear Old Testament scenes. According to Vasari, labour was divided into two main categories, with two protagonists: Giovanni da Udine for the stuccowork, and Giulio Romano for the figural scenes.

Vasari's life of Raphael also indicates that Giulio's responsibilities as the chief assistant for the paintings mimicked Raphael's own with regard to the entire shop: he functioned more as a creative manager than as a simple executant of the images. Giulio's supervision of the realization of the biblical episodes indicates his place in the hierarchy of the shop, and it is clear that after Raphael's death Giulio was recognized as a key figure among all the workshop collaborators and assistants for the production of narrative scenes of epic character. His later success in realizing vast fresco cycles, including intricate decorative elements, attests to his close study of the overall strategy of Raphael's handling of complex commissions.

(iv) Easel paintings. In addition to his participation in large-scale fresco projects, Giulio also collaborated with Raphael on numerous easel paintings. His collaboration was always anonymous, however, as a member of the shop, and uncertainty about attribution also surrounds this aspect of his earliest output. The question is vexing since it is known that he was substantially involved in some commissions, yet his precise contribution cannot be established. With this in mind, it is interesting to consider the portrait of *Joanna of Aragon* (Paris, Louvre), completed in 1518. Vasari noted this as one of the works commissioned by Leo X and presented by Cardinal Bernardo Bibbiena to the King of France from Raphael, who completed them with the aid of Giulio. The portrait received enthusiastic response for its elegant presentation of the sitter, to the extent that copies were made and the preparatory studies were in demand by collectors. When he sent one such study to Alfonso I d'Este, Duke of Ferrara, Raphael let it be known that the drawing was by a pupil without, however, naming him. Raphael thus retained the authorship but denied the execution. This is the most useful way to understand Giulio's professional circumstances at this time, when he had extensive autonomy in production but lacked an individual artistic identity. It is generally accepted that Giulio painted the portrait of *Joanna* (most persuasively argued by Joannides). The composition departs from Raphael's practice of concentration on a figure placed close to the viewer's space and is more discursive in presentation. The detachment of the figure from the viewer, spatially and psychologically, is reinforced by the artifice of her gestures and her impassive expression. The summary handling of the subject's delicate features, with detail and visual excitement lavished on her costume and surroundings, is an approach echoed in Giulio's later style. The construction of a complex spatial setting, including areas of deeper space with secondary figures, is another compositional strategy employed by Giulio in later works. The composition, probably worked out by Giulio under Raphael's tutelage, became an influential portrait type, of which many Mannerist variations were made. Perhaps due to the concentration on rendering Joanna's material splendour, the figure itself lacks volume, and there is some dissonance between its form and the space it inhabits; these are possible indications that it is the work of a young artist, struggling with an ambitious and innovative format.

A mature treatment of a similar scheme can be seen in Giulio's portrait of *?Isabella d'Este* (London, Hampton Court, Royal Col.). Here the tentative explorations of the earlier work are codified: the flowing forms of the sitter's gown have become a major pictorial motif, engulfing the foreground with dynamic patterns, and the bulk of the figure convincingly anchors it in the surrounding, compartmentalized space.

As Giulio's talents developed under the pressure of Raphael's work, he quickly achieved the skill required to carry out autonomous commissions and the prestige necessary to receive them. However, it is not clear whether he was at liberty to accept independent employment during Raphael's lifetime. This question is suggested by a major work, the *Stoning of St Stephen* (Genoa, S Stefano), painted by Giulio between 1519 and 1521. The future Datary of Pope Clement VII, Giovanni Matteo Giberti (1495–1543), commissioned the altarpiece to decorate the church, for which he had just received a benefice. Giberti was a close friend of Giulio, as well as a powerful presence in the papal court, reasons that may have been enough for a breach of protocol. Certainly Giberti wanted to obtain as quickly as possible a work intended to mark an addition to his stature. When the benefice was pronounced in 1519, Raphael himself was engaged on a major Medici commission, the *Transfiguration* (Rome, Pin. Vaticana), and was therefore not available. It is compelling to imagine that Giberti had Giulio in mind from the start; whether he approached him directly or through Raphael is uncertain. On the basis of a drawing, however, it has been suggested (Ferino Pagden, 1989 exh. cat.) that the commission was given first to Raphael and passed to Giulio after the former's death in 1520.

The composition of the *St Stephen* altarpiece emulates the bipartite division of Raphael's *Transfiguration* and shares the motif of a prominent seated figure in the left foreground, gesticulating towards the central action. The striking array of antique structures in the background is, however, a strong statement of Giulio's own fantasia. His particular blend of imaginative reconstruction and recognizable elements from ancient ruins was designed so that the viewer could delight in the exoticism of a colossal stage-set while discerning its origins in such monuments as the Market of Trajan, the Milvian Bridge and Trajan's Column. The drama of the first martyrdom found a particular response in Giulio's sensibilities. He depicted with brio the straining muscles, violent expressions and agitation of the group of ruffians throwing rocks, and accentuated the action through an emphatic pattern of light effects. Vasari called it most beautiful in composition, invention and grace, never outdone by Giulio himself.

2. WORKS FOLLOWING THE DEATH OF RAPHAEL, 1520–24.

(i) Sala di Costantino. (ii) Villa Madama. (iii) Villa Lante. (iv) Palazzo Stati Maccarani. (v) Fugger Altarpiece.

(i) Sala di Costantino. Raphael's death in 1520 caused a scramble among artists ambitious to capture his lapsed commissions and disappointed patrons. Giulio's ascendancy was not guaranteed. He was, in official terms, the inheritor of Raphael's shop in partnership with Giovan Francesco Penni, but the successful running of the shop depended on convincing the buyers of the continued quality of the product. His first great battle to prove

himself as Raphael's replacement was with Sebastiano del Piombo for the decoration of the Sala di Costantino in the Vatican. The dispute, initiated in the summer of 1520, was complicated by Michelangelo's shadowy participation on behalf of Sebastiano. The competition between the two camps was for artistic primacy in the court of Leo X. The Pope eventually awarded the commission to Raphael's shop, which claimed to have Raphael's drawings for the project, a claim that proved decisive, if not necessarily true. Nevertheless, scaffolding had been erected for the preparation of the walls as early as 1519, and it has been argued persuasively that Raphael conceived the underlying scheme for the frescoes, with its alternations between fictive tapestries and illusionistic architectural spaces articulated by massive thrones (Quednau). It is unclear how far the work progressed during the two years before the death of Leo X. When it was resumed after the brief papacy of Adrian VI (1522–3), the project was under the direction of Giulio, who saw it to completion in 1524. In addition to consolidating his artistic pre-eminence at the papal court, work on the Sala di Costantino gave Giulio the satisfaction of supervising the completion of the decoration of the papal apartments, the site of his own beginnings as an artist.

The two frescoes in the room that most clearly expand the lessons of Raphael's interest in classical form and motifs are the *Adlocutio* (Vision of Constantine) and the *Battle of the Milvian Bridge*. In the presentation of these scenes of Constantine's military exploits, Giulio drew heavily on imagery from Trajan's Column (AD 113; Rome, Foro di Traiano). The archaeological nature of Giulio's borrowings was noted with approval by Vasari. The armour of Giulio's soldiers is copied from that of their ancient counterparts; the image of Constantine on a rearing horse, triumphant in battle, echoes the relief depicting the Trajanic period in the Arch of Constantine (AD 315; Rome, Foro Romano). Giulio's knowledge and assimilation of ancient pictorial vocabulary reinvented the Roman past for the papal court, replacing the more monumental and abstract vision of Raphael. In contrast to Raphael, Giulio delighted in introducing spirited witticisms and distracting detail into even the most monumental compositions. Thus a vividly painted dwarf is prominent in the serious *Adlocutio*, and part of the visual pleasure of the *Battle* is to pick out the incidental episodes of struggle and defeat, of bellicose encounters. In this great fresco cycle, the first to be dominated by Giulio's control, the artist shows his sensibilities to be elaborative and excursive. He achieves an overall effect and grandeur that compensates for any weaknesses in individual passages.

(ii) Villa Madama. In addition to the extensive programme for the decoration of the last of the Vatican Stanze, a major architectural project of Raphael's passed to Giulio for completion. Giulio's training in architecture was probably analogous to that in painting: he assisted Raphael at levels of increasing responsibility, gaining mastery while performing the tasks allotted to him. Since Raphael was appointed architect to the pope in 1514, Giulio's apprenticeship in this arena must date from his earliest years under Raphael's tutelage. As with painting, his first steps as an architect are indistinguishable in the works of his master, and similar questions of authorship arise. Thus for the luxurious residence later known as the Villa Madama, built for Cardinal Giulio de' Medici, the future pope Clement VII, Raphael developed the plan with such accomplished collaborators as Antonio da Sangallo the younger, aided by assistants, notably Giulio, in measures that it is impossible to quantify with certainty. With Raphael's death, Giulio's mounting prestige was such that the Cardinal gave the commission to him. It has been argued that the plan was conceived by Giulio independently, which suggests he was integral to the project from the start, working closely with Raphael during the initial stages (Frommel, 1989 exh. cat.).

The projected structure was to be built on a colossal scale, with a courtyard at its core, thus imitating ancient Roman prototypes. Unusual for the Renaissance, the courtyard was to be circular, with adjoining vestibules, one opening on to a grandiose loggia overlooking a garden. Notably, the project also included the construction of an outdoor theatre on a sloping hillside, in the ancient manner. Although only a portion of the vast complex was completed under Giulio's efforts, the results were stunning, both for their invention and richness of effect. The two principal façades, for example, were designed asymmetrically, with the small stretch of wall on the garden façade both dissolved and continued by the articulation of the adjoining, monumental loggia. Although in this instance rooted in Raphael's project, similar unexpected juxtapositions were an important element in Giulio's later architectural work in Mantua. The loggia of the villa (*see* RAPHAEL, fig. 9) was richly decorated *all'antica* in stucco and fresco by Giulio himself and Giovanni da Udine, reminiscent in its components and visual effect of the splendour of the Vatican Loggia (*see also* GIOVANNI DA UDINE, and fig.). Progress on the decoration of the villa almost foundered at one point due to the constant battle of wills between Giulio and Giovanni da Udine, and the Cardinal despaired of negotiating peace between the two 'cervelli fantastichi'. One aspect of Raphael's genius was the smooth implementation of collaborative effort, and it became clear that despite its collective talent, the workshop could not survive without him.

(iii) Villa Lante. In addition to the completion of Raphael's unfulfilled commissions, Giulio immediately received independent architectural assignments. In 1520–21 he had the opportunity to capitalize on the fashion for classical suburban villas, which the Villa Madama had helped to create, when Baldassare Turini commissioned a residence (now known as the Villa Lante) on the Janiculum Hill. The setting suggested a classical conceit: it was the site of a villa thought to be owned by the Roman writer Martial (*c.* AD 40–104; Frommel, 1989 exh. cat.), a link that Turini wanted to celebrate. Giulio's capacity to enunciate modern building language through an antique vocabulary gave him perfect credentials for Turini's task. (His role in the design of the villa is controversial; it has been suggested that the project was begun by Raphael (D. Coffin: *The Villa in the Life of Renaissance Rome*, Princeton, 1979, p. 262).) The design acknowledged the building's ancient predecessor by following the outline of its ruins and the loggia (later enclosed) on its extant foundations (Frommel, 1989 exh.

cat.). The details of the structure, however, were not calculated to conform to the Roman canon. The villa is high and narrow, with vertical continuity stressed in the placement of the orders, which are delicately scaled and without massive projection. The pristine Doric order of the ground-floor is surmounted by elegantly shallow Ionic pilasters, whose volutes swell only slightly from the surface of the wall. The lightness conveyed by the dainty proportions of the orders is apparent also in the simplified entablature—just an architrave and cornice—and is continued in the tall, narrow arches of the loggia. The canonic orders here begin to be treated visually as independent from their structural purposes, and this liberation offered the architect new expressive possibilities.

(iv) Palazzo Stati Maccarani. Following the Villa Lante, *c.* 1522–3 Giulio took up the commission from a Roman patrician, Cristoforo Stati, to construct an urban palazzo facing the Piazza S Eustachio. In contrast to the villa commissions with their concern for beauty of setting and explicit ancient prototypes, here Giulio was faced with the conversion of the site of several smaller houses into one unified structure, with the inclusion of income-producing shops at the street-level. The resulting Palazzo Stati Maccarani (now the Palazzo Di Brazzà) is a massive three-storey building surrounding an interior courtyard, with

five bays composing its principal façade (see fig. 1). The shops on the ground-floor are marked with dynamic, rusticated keystones and voussoirs that burst out in the shape of a fan over the flat-arched entrances. The energy that explodes from the expansive forms and rusticated blocks of the lowest floor leads into a much more restrained *piano nobile*, with its paired pilasters and shallow aediculae framing the windows in stately niches. In the uppermost floor the vigorous physicality that sweeps the ground-level has become completely enervated; even the doubled pilasters, here without architraves, bases and pedestals, almost sink into the wall, merely echoing the articulation of the façade below. The refined effect of the third storey is that of a ghostly grid, in very low relief.

The Palazzo Stati Maccarani provides a clear measure of the rapidity with which Giulio came into his own in architectural design. Although essentially the palazzo fits into the line of development pioneered by Donato Bramante and developed by Raphael, Giulio's variation establishes a different dialogue among the architectural forms, animates them with the tension of contrast and provides a kind of commentary on architectural practice by calling attention to it through the manipulation of its vocabulary.

(v) Fugger Altarpiece. In the aftermath of Raphael's death, Giulio also executed independent commissions for easel

1. Giulio Romano: Palazzo Stati Maccarani (now Palazzo Di Brazzà), Rome, *c.* 1522–3

paintings, a format that he used extensively during his apprenticeship, but seldom later. A major work of his last years in Rome is an altarpiece, the *Holy Family with SS James, John the Baptist and Mark* (Rome, S Maria dell' Anima; see fig. 2), commissioned by the German banker Jakob Fugger II (1459–1525), perhaps *c.* 1522.

Although the subject is traditional, commemorating both the client's patron saint and that of the chapel, the arrangement of the figures is somewhat surprising. The saints seem to move in and out of the foreground and middle ground at various angles to the emphatically asymmetrical placement of the Virgin and Child. The asymmetry is accentuated by the twisting pose of the Virgin, who is out of alignment with the front of her draped throne. A striking pattern of deep shadows and metallic lights complicates even further the strange balance of this spatial organization. Giulio's penchant for visual digression appears in the detailed architectural fantasy of the background, in which is depicted the curious motif of an old woman holding a distaff and a hen and chicks. The luminous openness of this structure provides a foil for the intensity of the crowded foreground of the painting; its free play with the architectural forms of antiquity was later realized in three dimensions when Giulio constructed the Palazzo del Te in Mantua.

3. WORKS FOR FEDERICO GONZAGA, 1524–40.

(i) Move to Mantua and appointment as court artist. (ii) Palazzo del Te. (iii) Palazzo Ducale.

(i) Move to Mantua and appointment as court artist. As Giulio's reputation grew in the years after the death of Raphael, competition for his services increased. From at least 1522, serious efforts were made by the ruler of Mantua, Federico II Gonzaga, 5th Marchese and 1st Duke (*see* GONZAGA, (8)), to lure the artist from Rome to his court in northern Italy. The negotiations were conducted through the Mantuan ambassador, Baldassare Castiglione, who persuaded Giulio to leave Rome in the autumn of 1524. Giulio's universal training must have been a compelling factor in the court appointment, but it is clear that his talent as an architect was Federico's first concern. Even before he moved to Mantua, Federico had commissioned him to make a model for an expansion of a villa (destr.) in the Gonzaga holdings at Marmirolo. The success of this work led to Federico's redoubled efforts to secure the artist's residency in his court. In Mantua, Giulio's ascendancy was swift but not automatic; during the first two years he established himself with credibility but without fanfare, and proved the quality and range of his capacities.

A sequence of documents attests to Giulio's rapid rise in official standing. In a series of declarations Federico honoured him with citizenship and special privileges, awarded him a house and appointed him Superior General of the Gonzaga buildings for the entire Mantuan state; further declarations bestow benefices and grant tax exemptions. In November 1526 a climax was reached when Giulio received the title of Superior of the Streets, with attendant possibilities for further income and powers of management. Thus Federico publicly established the terms for an extremely close working relationship with his court artist, one that endured throughout his lifetime. Federico

and Giulio were close in age, shared fundamental aspects in their cultural formation and had highly compatible aesthetic sensibilities, all of which contributed to one of the most fruitful patronage partnerships in the Renaissance. Giulio's work for Federico included everything from designs for silverware to directing the renovation and construction of buildings. He oversaw projects for urban renewal, advised on engineering problems, produced stage sets for court entertainments and devised and managed the execution of elaborate fresco programmes. None of Federico's needs was too trivial to command Giulio's attention or too grandiose to exhaust the artist's invention.

(ii) Palazzo del Te. The first sustained project that Giulio carried out for his patron was the transformation of a utilitarian structure on an island site known as the Te into a sumptuous setting for leisure activity and courtly entertainment. The Isola del Te, just outside the city, housed stables for the prized breed of Gonzaga horses; the production of a luxury commodity was thus at the core of the programme for a pleasure villa. The project developed gradually, from a modest villa incorporating extant structures into a palazzo embellished with increasingly imposing architectural forms to keep pace with the architect's fertile imagination and the patron's increasing rank within the politics of the Holy Roman Empire (Forster and Tuttle, 1971). Again there was a close match between Giulio's preferred approach, composite and incremental both in conceptualization and process, and his patron's escalating

2. Giulio Romano: *Holy Family with SS James, John the Baptist and Mark* (the Fugger altarpiece), oil on canvas, ?*c.* 1522 (Rome, S Maria dell' Anima)

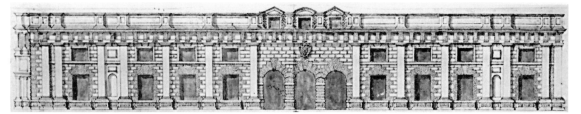

3. Giulio Romano: north façade of the Palazzo del Te, Mantua; pen and brown ink drawing by Ippolito Andreasi, 182×842 mm, *c.* 1567–8 (Düsseldorf, Kunstmuseum im Ehrenhof)

ambitions, backed by resources that came in spurts. Construction and decoration of the Palazzo del Te took place over about a decade, from the mid-1520s with several interruptions.

The Palazzo del Te is in the shape of a square, with four wings, each cut by a loggia, assembled around an open courtyard. This imposingly large central space originally held a labyrinth, which was both decorative and symbolic, as the labyrinth was a Gonzaga emblem. The exterior of the palace is low and compact, with massive rusticated blocks and Doric pilasters as the controlling forms.

On both the north façade (see fig. 3) and west façade, the pilasters extend past the ground-floor through the mezzanine level, so becoming linked visually. These façades are highly textured, with differing thicknesses of the rusticated elements, as well as varying protrusions of the pilasters, their podia and bases, the keystones and voussoirs and the horizontal bands and friezes. The most monumental exterior is the east façade, with its majestic, triple-arched loggia that originally overlooked reflecting pools and an expanse of garden. The courtyard façades continue the themes introduced on the northern and western

exteriors, but with a more vigorous projection: the pilasters have swelled into engaged columns, and the entablatures are heavy and deep. Motifs of movement create a cultivated dissonance; keystones jut upwards to split the pediments, and sections of the frieze drop out of register, taking with them slabs of the architrave below. These motifs have been interpreted as manifestations of artistic *Angst* or Mannerist neurosis, but they are more properly seen as a sophisticated dialogue with the Classical canon and as expressive forms meant to embellish the architecture. Moreover, in the context of Giulio's stylistic development, many elements of the Palazzo del Te's energy and whimsy were tentatively explored in the Palazzo Stati Maccarani and other early works.

The interior plan of the palazzo is determined by four blocks of apartments on the ground level, separated by loggias. These suites, which were elaborately decorated, were destined for Federico's private use or for the pleasure of his guests. Giulio marshalled imagery from a spirited variety of sources: Classical texts in the Sala di Ovidio; astrological texts in the Sala dei Venti; imperial splendour in the Sala degli Stucchi and the Sala di Cesare. In one vast hall Giulio used a subject appropriate to the site; the walls

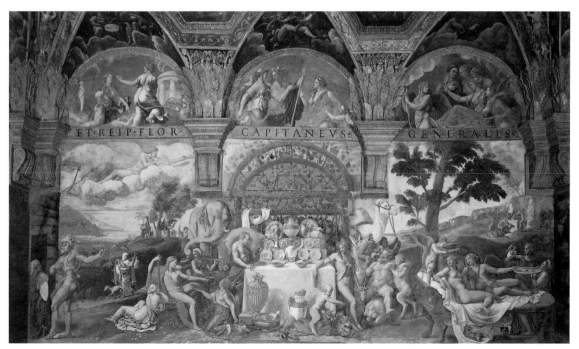

4. Giulio Romano: *Wedding Feast of Cupid and Psyche* (1528), fresco, Sala di Psiche, Palazzo del Te, Mantua

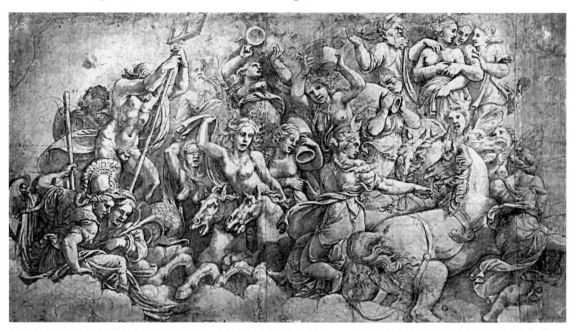

5. Giulio Romano: *Study of Olympian Deities*, pen and brown ink, brush and brown wash, heightened with white, over black chalk, 502×920 mm, for the Sala dei Giganti, Palazzo del Te, 1532–4 (Paris, Musée du Louvre)

are decorated with frescoes of Federico's favourite horses, studied from life.

The equine portraits, set in front of landscapes, alternate with fictive niches with statues of Olympian deities, an ensemble indicating the ruling presences on the Isola del Te. The diversity of subject-matter and the plethora of decorative ideas give the rooms marvellously different characters and attest to Giulio's delight in sheer inventiveness.

Two rooms are particularly impressive: the Sala di Psiche and the Sala dei Giganti. Mythological eroticism lies behind the story of Psyche's tribulations at the hands of Venus. In the room dedicated to the unfolding of her story, Giulio created an environment sparkling with colour and elaborately embellished, with the ceiling compartmentalized into octagons, lozenges and squares, each holding a panel painted with an episode of the narrative. Related or analogous stories appear on the walls in fresco (see fig. 4), with an emphasis on the erotic in both theme and presentation. The Sala di Psiche was evidently a showpiece; the images display much virtuosity in their compositions and conception, while an inscription along the walls records Federico as the proprietor and augurs his enjoyment of leisure hours.

The conspicuous enjoyment of relaxation is also a theme in the Sala dei Giganti (see fig. 5; and colour pl. 1, XXXV1). This was conceived as a show of ingenuity in its fabrication and decoration. The subject of Jupiter's victory over the rebel giants is presented as a threat to the viewer's well-being, as the painted lightning bolts hurled from the ceiling appear to destroy the very structure of the supporting walls.

The theatrical result was surely intended to rival the degree of illusionism and the viewer's complicity in its game in Mantegna's Cameri degli Sposi in the Gonzaga's urban palazzo (see colour pl. 2, I1). In its original presentation the decoration of the Sala dei Giganti was completely continuous, so that ceiling, walls, floor and closed doors coalesced into one collapsing environment. Giulio ensured that the spectral fantasy attained maximum effect by constructing the room as an echo chamber, with a fireplace (since walled over) providing an eerie, flickering effect. Part of one of the later stages of decoration in the Te, the Sala dei Giganti shows Giulio sufficiently confident and autonomous to unleash a highly individualized fantasy for the amusement of his patron.

(iii) Palazzo Ducale. The playfulness indulged in the decorations of the Palazzo del Te was licensed by its function as a suburban villa, used for relaxation and the passing of leisure hours. When faced with the task of coordinating new construction and embellishment within the core of the Gonzaga's urban residence, Giulio eschewed the currents of eroticism and frivolity and turned instead to themes of history, militarism and courtly decorum. The result was the formation of an elegant state apartment, a coherent unit of reception halls, smaller, intimate spaces and loggias, ensconced within the enormous complex of structures that together formed the Palazzo Ducale. The work was carried out over three years, from 1536 to the end of 1538, with several significant breaks. Giulio again had full artistic control over all aspects of the project, carefully monitored by his patron. As in all of his projects for Federico, Giulio had to contend with severe restrictions on the site itself, limited resources and urgent deadlines for completion. With inventiveness that both incorporated and transcended the considerable restraints, he realized a suite of rooms that became a paradigm for 16th-century courtly environments.

In its most formal and stately aspects, the Appartamento di Troia (named after the subject-matter of its major room)

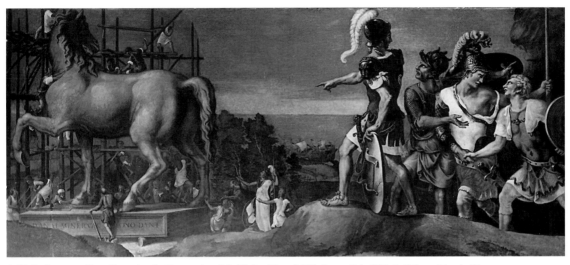

6. Giulio Romano: *Sinon Overseeing the Construction of the Trojan Horse* (1538), fresco, Sala di Troia, Palazzo Ducale, Mantua

culminated in a reception hall bound by a monumental loggia. The loggia, like most of these Renaissance structures, has been enclosed to form a gallery. In its original form it was airy and grandiose, with a series of dignified arches that opened on to a vast courtyard. The walls of the Loggia dei Marmi, as its name indicates, incorporated niches that held marble statues and stuccos, either antique or replicas fabricated in Giulio's shop. From this loggia one entered the Sala di Troia, a formal stateroom with frescoes on all the walls and around the ceiling, depicting epic, Homeric subjects (see fig. 6). The style is classicizing in its grandeur and in its content, appropriate to the dynastic function of the room. With the exception of the Sala dei Cavalli, conceived similarly to that in the Palazzo del Te, the other spaces in the apartment are much smaller in scale and private in nature. Their decoration, like that of the Palazzo del Te, shows delight in a variety of materials and formats and is uniformly courtly in motif, with imagery of birds and hunting falcons, or elegant ensembles punctuated by antique busts.

The decoration of the Appartamento Ducale was of such consequence that collaborators of the highest calibre were involved. Taking up one of the practices of Raphael that he was otherwise not disposed to follow, Giulio engaged a distinguished colleague for the project. For the Room of the Caesars, Titian provided 11 portraits of Roman emperors, on canvas, while Giulio painted the twelfth portrait and furnished the setting for them. The disposition of the entire room, with the allegorical fresco on the ceiling, stuccoed frames, niches, grotesque ornament, as well as narrative panels complementary to the portraits, was created to act as foil for Titian's contribution. That Giulio's more illustrious colleague commanded special consideration is clear from the correspondence about the paintings that was sent directly from Federico himself.

4. OTHER PROJECTS OF THE 1530S AND 1540S. Giulio's impressive position in Mantua was acquired at the cost of severe restrictions in the commissions that could be carried out for patrons other than the Gonzaga. His incumbency in Federico's court implied his constant availability; it also identified him completely with his lord, so that his services became a political benefice that Federico could generously bestow or vengefully withhold. Even an old friend of high standing could not presume upon the employment of Giulio, as Giovanni Matteo Giberti discovered in 1534. Giberti, the patron and close friend of Giulio's Roman years, was at this time the Bishop of Verona, and he requested the decoration of the apse of his cathedral. Although Giulio was not allowed the liberty to carry out the commission, he devised the composition and furnished drawings for an *Assumption of the Virgin*, which was then painted by a local artist, Francesco Torbido (*in situ*).

The fireworks of Giulio's design, analogous to the illusionism and high drama of the contemporary Sala dei Giganti, are not rendered in Torbido's translation. The idea, however, was masterful. Giulio envisioned a redefinition of the actual apse through a simulated structure of a coffered half dome, whose supporting cornice is surmounted by a balustrade. This forms the precarious setting in which the Twelve Apostles react to the vision of the Virgin's sudden movement towards the heavens. Clouds with angels in agitated motion rupture the coffered surface of the vault, and the apostles tumble and gesticulate in their surprise. The fictive boundary of the balustrade barely contains the monumental figures, whose limbs and drapery thrust beyond it. One apostle topples backward, testing the empathy of the viewer into whose space he is in danger of tumbling.

One of the most significant projects that Giulio undertook outside of the constant flow of Federico's commissions was the reconstruction of a house in Mantua to be used as his own residence. The house was purchased in 1538, but it is likely that his transformation of it began in earnest only in 1540, after the death of Federico. In any case, the Casa Pippi was completed by 1544, when Vasari saw it and recorded in astonishment its lordly presence and handsome façade, with its sequence of brightly coloured pediments and lunettes.

The façade was extended in 1800, and there has been confusion about the configuration of Giulio's original

project. However, a drawing of the façade by Giulio has been identified (Magnussen). His alterations to the property included establishing a series of six bays, with a portal of imposing dignity in the third bay from the left. In place of the wide windows above the other bays, the arch over the doorway frames a shallow niche, where a statue of *Mercury* is displayed. The statue functions as a sort of shop-sign, a symbolic allusion to the profession of the owner of the house (Forster and Tuttle, 1973). This personal theme is continued in the frescoes Giulio painted in the *salone*, where Prometheus, the prototypical artist, figures among the Olympian deities. Letters specify that Giulio's studio was on the ground floor of the Casa Pippi; thus the entire configuration of the house can be understood as a statement of his dual role. He expressed his seigniorial status in the size and elegance of his house and proclaimed his professional identity in the components of its decoration.

The application of Giulio's exuberance and sophistication to religious commissions, as seen in the *Assumption of the Virgin*, was apparently well received. In 1540 the Benedictines of San Benedetto Po, near Mantua, entrusted him with the extensive renovation of their abbey church. The medieval structure was a conglomeration of spaces and styles, following earlier renewals. Thus Giulio's task was to reconcile a number of disharmonious elements and to impose a visual coherence, using a modern, that is *all'antica*, manner. He accomplished this by adding framing elements at each end of the church, a vestibule and ambulatory, and new chapels on the right side for balance.

Giulio's true mastery of illusionism is apparent in the interior, where he masked the irregular placement of the side chapels and their bays with a succession of Serlian windows framed by Corinthian pilasters that imposes a visual rhythm strong enough to disguise the discrepancies in their spacing. In his astute management of structures with complicated building histories, Giulio always retained as many original elements as possible and brought them into harmony with key elements of contemporary architectural language.

The church of San Benedetto Po had strong links to the Gonzaga family. Giulio's engagement there was one of the increasing number of religious works that he undertook after the death of Federico Gonzaga, during the regency of Cardinal Ercole Gonzaga. The Cardinal reaffirmed both Giulio's status at court and his control over all artistic matters and became in his turn a keenly interested patron. When fire damaged Mantua Cathedral in April 1545 (Tafuri, 1989 exh. cat.), the Cardinal set Giulio to work on a major reconstruction, envisaging the aggrandizement of the church as a memorial to his reign. Once more Giulio had the challenge of imparting increased majesty and a modern look to a Romanesque church without altering its basic form. His project included the rebuilding of the choir and restructuring of the nave, enlarging it to five aisles. Rows of splendid Corinthian columns, finely detailed and made of Veronese marble, define both the central nave and the side aisles. Vasari remarked on the beauty of the Cathedral's renovation in the account of his visit to Mantua, and

recounts the following exchange (*Vite*, Eng. trans., 1987, p. 231):

> The cardinal then asked Giorgio what he thought of Giulio's works, and he replied, in Giulio's presence, that they were so excellent that he deserved to have a statue of himself put up on every corner of the city, and that since he had brought about the renewal of Mantua, half of the state itself would not be enough reward for his labours and talent. And to this the cardinal replied that Giulio was more the master of the state than he was himself.

II. Working methods and technique.

Giulio's art was grounded in the emulation of antique forms. His goal was to forge a modern style that improved on the achievement of the ancients, using Raphael's mode and methods of realization. In this approach, *disegno* was the conceptual basis for all the visual arts. Giulio developed his ideas in a sequence of intensely worked drawings—compositional sketches, figure studies, *modelli* and cartoons—and brought the concept to life. After this crucial work, he usually orchestrated rather than participated in the manual execution, whether in fresco, on panel or in architectural construction. The function of drawings as intellectual property is clearly illustrated in an incident that occurred while Giulio was employed by Federico Gonzaga. One of the assistants stole a group of Giulio's drawings and fled to Verona. The Duke himself immediately wrote to officials there, demanding the imprisonment of the thief and stating that the drawings were of great significance to him, since they were to be used in his buildings, and he did not want them copied. The ideas of his court artist were 'patented' as representations of himself.

Contemporaries greatly admired Giulio's virtuoso drawing technique. He could give form to concepts with lightning speed (Vasari), and he could spontaneously execute variations on antique motifs as though he had the originals in front of his eyes (Armenini, p. 226). Vasari denigrates Giulio's painting in comparison to his draughtsmanship: 'It can be affirmed that Giulio always expressed his concepts better in drawings than in his finished works or paintings, since in the former we see more vivacity, boldness, and emotion' (*Vite*, p. 212). Vasari also added a complaint about the amount of black pigment that Giulio 'always loved to use when colouring' (p. 213), which he thought diminished the perfection of his final product. It is interesting that he makes this point when describing the scene of the *Adlocutio* and in his discussion of the Fugger Altarpiece, thus indicating that the technique was used both for frescoes and easel paintings.

Vasari's *Vita* of Giulio gives another detail about his working process, as carried out in the decoration of the Palazzo del Te: 'it is true that subsequently nearly all the work was retouched by Giulio, so it is as if it were all done by him' (p. 220), specifying that he learnt this system from Raphael. The master's presence was crucial to the final product, for which he took full responsibility. This is apparent from a letter (Mantua, Ist. Gonzaga, busta 2937) that Federico Gonzaga sent to Ercole II d'Este, Duke of Ferrara, in April 1537, promising to allow Giulio a visit only at the end of the month, since the artist was overseeing

the preparation of some rooms, and without his presence the work could not continue. In addition to the need for the master's final touches, it seems that his continuous presence was necessary because the decorative or construction programmes were approached piecemeal. There is evidence that Giulio's works developed by increments, with decisions and additions made along the way, rather than established in every detail at the inception of the project. A letter (Talvacchia, 1988) indicates that this was the case in the decoration of the Sala di Troia: Giulio mentions his anticipation of the next group of subjects from his literary advisor and promises new and exciting ideas for the paintings still to be executed.

It has been suggested that Giulio was less competent with some of the engineering aspects of his architectural projects, while masterfully in control of the design elements (Belluzzi and Forster, exh. cat. 1989). The same process of conceptual elaboration through detailed drawings, of individual elements as well as overall composition, can be followed in extant drawings of his architectural projects. Wherever possible, he incorporated existing fragments into the fabric of the new structure, as much for ideological as for practical or economic reasons. This is clear in his proposal for the renovation of the Basilica in Vicenza, in which he stressed that it would be a mistake to demolish the historical structure unnecessarily. Giulio's conservative historicism is an interesting contrast to his approach to the use of materials, which is characterized by an exuberant aesthetic of the inauthentic. The illusionism inherent in his use of substitute materials, developed in response to the lack of local building-stone in Mantua, created its own aesthetic. A majestic palazzo that appeared to be a mass of heavy rusticated stone was in fact a core of bricks sheathed in stucco. The contradiction between the viewer's perception of a building and its physical reality was another concept central to Giulio's creations.

Giulio's mastery of illusionism elicited the awe of his contemporaries. Vasari particularly praised the *di sotto in sù* passages in the Sala di Psiche, and Armenini's treatise includes a lyrical appreciation of the ceiling in the Sala dei Giganti, where: 'The gods are foreshortened *di sotto in sù* and spring from the vault through the force of contours in a manner which makes them stand out with so much relief that they appear as if alive, and not painted'. Thus, Giulio gave marvellous form to art and judicious propriety to the subject'. The system that Giulio evolved for illusionistic ceiling painting was regarded as a paradigm, as indicated in Cristoforo Sorte's *Osservationi nella pittura* (passage translated in Hartt, 1958). Sorte recounts his experiences as an apprentice painter in Mantua, when Giulio's assistants were executing his designs in the Sala di Troia. Their method involved the application of a grid to a mirror that reflected the model to be painted, a system that depended on the careful placement of the mirror in relation to the model and to the viewpoint of the painter. According to Sorte, this system attained the best results.

Giulio's greatest technical skill was demonstrated in his drawings (for illustration *see* ORNAMENT AND PATTERN), which are notable for their incisiveness and abundance of invention. His formidable talent as a designer was most successfully realized in his architectural projects and in the ensemble of his complex decorative programmes. The

immediate influence of his work was marked in the architectural treatises of Andrea Palladio and Sebastiano Serlio and in the move towards an increasing elaboration of illusionistic fresco painting.

BIBLIOGRAPHY

EARLY WORKS

G. Vasari: *Vite* (1550, rev. 2/1568); ed. G. Milanesi (1878–85) [Eng. trans. of 2nd edn by G. Bull, abridged, Harmondsworth, 1987]
C. Sorte: *Osservationi nella pittura* (Venice, 1580)
G. B. Armenini: *De' veri precetti della pittura* (Ravenna, 1586; Eng. trans. by E. J. Olszewski, New York, 1977)

MONOGRAPHS

C. D'Arco: *Istoria della vita e delle opere di Giulio Pippi Romano* (Mantua, 1838/*R* 1986, 2/1842)
F. Hartt: *Giulio Romano*, 2 vols (New Haven, 1958/*R* New York, 1981); review by J. Shearman in *Burl. Mag.*, ci (1959), pp. 456–60
Studi su Giulio Romano (San Benedetto Po, 1975)
P. Carpeggiani and C. Tellini Perina: *Giulio Romano a Mantova* (Mantua, 1987)
Atti del convegno internazionale di studi su 'Giulio Romano e l'espansione europea del rinascimento': Mantova, 1989
Giulio Romano (exh. cat. by A. Belluzzi, K. Forster, H. Burns and others, Mantua, Mus. Civ. Pal. Te and Pal. Ducale; 1989)
G.-J. Salvy: *Giulio Romano, une manière extravagante et moderne* (Paris, 1994)
F. Vinti: *Giulio Romano pittore e l'antico* (Florence, 1995)
M. P. Fritz: *Giulio Romano et Raphaël: La vice-reine de Naples, ou, La renaissance d'une beauté mythique* (Paris, 1997)

SPECIALIST STUDIES

Palazzo del Te

E. H. Gombrich: 'The Sala dei Venti in the Palazzo del Te', *J. Warb. & Court. Inst.*, xiii (1950), pp. 189–201
G. Paccagnini: *Il Palazzo Te* (Milan, 1957)
J. Shearman: 'Osservazioni sulla cronologia e l'evoluzione del Palazzo del Te', *Boll. Cent. Int. Stud. Archit. Andrea Palladio*, ix (1967), pp. 434–8
K. Forster and R. Tuttle: 'The Palazzo del Te', *J. Soc. Archit. Hist.*, xxx (1971), pp. 267–93
A. Belluzzi and W. Capezzali: *Il palazzo dei lucidi inganni: Palazzo Te a Mantova* (Florence, 1976)
E. Verheyen: *The Palazzo del Te in Mantua: Images of Love and Politics* (Baltimore, 1977)
B. Allies: 'Palazzo del Te: Order, Orthodoxy and the Orders', *Archit. Rev.*, clxxiii (1983), pp. 59–65
Mantova e l'antico Egitto da Giulio Romano a Giuseppe Acerbi: Florence, 1994

Palazzo Ducale

G. Paccagnini: *Il Palazzo Ducale di Mantova* (Turin, 1969)
B. Talvacchia: *Giulio Romano's Sala di Troia: A Synthesis of Epic Narrative and Emblematic Imagery* (diss., Stanford U., 1981)
——: 'Narration through Gesture in Giulio Romano's Sala di Troia', *Ren. & Reformation*, n. s., x (1986), pp. 49–65
M. Annaloro: *La rustica di Giulio Romano in Palazzo Ducale a Mantova* (diss., U. Florence, 1986–7)
B. Talvacchia: 'Homer, Greek Heroes and Hellenism in Giulio Romano's Hall of Troy', *J. Warb. & Court. Inst.*, li (1988), pp. 235–42
J. Burckhardt: *Giulio Romano: Regisseur einer verlebendigten Antike: Die Loggia dei Marmi im Palazzo Ducale von Mantua* (diss., Zurich, U. Zurich, 1994)

Other specific architectural projects

C. L. Frommel: 'La Villa Madama e la tipologia delle ville romane nel rinascimento', *Boll. Cent. Int. Stud. Archit. Andrea Palladio*, xi (1969), pp. 47–64
K. Forster and R. Tuttle: 'The Casa Pippi: Giulio Romano's House in Mantua', *Architectura*, ii (1973), pp. 104–30
C. L. Frommel: *Der römische Palastbau der Hochrenaissance*, 3 vols (Tübingen, 1973)
R. Lefevre: *The Villa Madama* (Rome, 1973)
N. Dacos: *Le Logge di Raffaello* (Rome, 1977, 2/1986)
H. Lilius: *Villa Lante al Gianicolo: L'architettura e la decorazione pittorica*, 2 vols (Rome, 1981)
M. Tafuri: 'Osservazioni sulla chiesa di San Benedetto in Polirone', *Quad. Pal. Te*, iii (1986), pp. 11–24

B. Magnussen: 'A Drawing for the Façade of Giulio Romano's House in Mantua', *J. Soc. Archit. Hist.*, xlvii (1988), pp. 179–84

Other

H. Dollmayr: 'Raffaels Werkstätte', *Jb. Ksthist. Samml. Allhöch. Ksrhaus*, xvi (1895), pp. 231–63

——: 'Giulio Romano und das klassische Altertum', *Jb. Ksthist. Samml. Allhöch. Ksrhaus*, xxii (1901), pp. 178–220

P. Carpi: 'Giulio Romano ai servizi di Federico II Gonzaga', *Atti & Mem. Accad. N. Virgil. Mantova*, n. s., xi–xiii (1918–20), pp. 35–101

E. H. Gombrich: 'Zum Werke Giulio Romanos', *Jb. Ksthist. Samml. Wien*, n. s., viii (1934), pp. 79–104; ix (1935), pp. 121–50; Ital. trans., *Quad. Pal. Te*, i (1984), pp. 23–79

F. Hartt: 'Raphael and Giulio Romano: With Notes on the Raphael School', *A. Bull.*, xxvi (1944), pp. 67–94

E. H. Gombrich: 'The Style *all'antica*: Imitation and Assimilation', *Acts of the XXth International Congress on the History of Art: New York, 1961*, pp. 31–41

M. Laskin: 'Giulio Romano and Baldassare Castiglione', *Burl. Mag.*, cix (1967), pp. 300–03

J. Shearman: 'Giulio Romano: Tradizione, licenze, artifici', *Boll. Cent. Int. Stud. Archit. Andrea Palladio*, ix (1967), pp. 354–68

R. Quednau: *Die Sala di Costantino im Vatikanischer Palast* (Hildesheim and New York, 1979)

Splendours of the Gonzaga (exh. cat., ed. D. Chambers and J. Martineau; London, V&A, 1981)

C. Gould: 'Raphael versus Giulio Romano: The Swing Back', *Burl. Mag.*, cxxiv (1982), pp. 479–87

P. Joannides: 'The Early Easel Paintings of Giulio Romano', *Paragone*, xxxvi/425 (1985), pp. 17–64

A. Belluzzi: 'Giulio di Raffaello da Urbino', *Quad. Pal. Te*, viii (1988), pp. 9–20

J. Biscontin: 'Antique Candelabra in Frescoes by Bernardino Gatti and a Drawing by Giulio Romano', *J. Warb. & Court. Inst.*, lvii (1994), pp. 264–9

C. Grimm: 'Art History, Connoisseurship and Scientific Analysis in the Restoration of Giulio Romano's *Birth of Bacchus*', *J. Paul Getty Mus. J.*, xxii (1994), pp. 31–41

P. Young and P. Joannides: 'Giulio Romano's *Madonna* at Apsley House', *Burl. Mag.*, cxxxvii/1112 (1995), pp. 728–36

B. Talvacchia: *Taking Positions: On the Erotic in Renaissance Culture* (Princeton, 1999)

BETTE TALVACCHIA

Giunti [Giunta; Giuntalochi; Giuntalodi], **Domenico (di Giovanni)** (*b* Prato, 25 Feb 1505; *d* Guastalla, nr Parma, 28 Oct 1560). Italian architect and painter. The son of Giovanni Giunti, a candlemaker, and of Chiara Miniati, he trained as a painter under Nicolò Soggi (*b c.* 1480; *d* before 1552), a follower of Perugino. Vasari noted that Giunti's face is represented in a fresco by Soggi in SS Annunziata, Arezzo. Information on Giunti's career as a painter is very scarce, however, and it is very difficult to identify works by him. A portrait of 1526 is known, however, as is a later copy of a work by Sebastiano del Piombo. It is known (Deswarte-Rosa, 1988) that Giunti worked from 1532 to 1535 in Rome for the Portuguese ambassador, Don Martinho, after which he came into contact with Antonio Salamanca's etching studio, designing for it the allegorical portrait of an *Old Man* (1537; B. XIV, no. 400; incorrectly attributed to Baccio Bandinelli) and, later, some perspective views of such Roman monuments as the Colosseum and the Pantheon. It is likely that his work as a designer and copier of the paintings of famous masters led him to frequent the imperial circle in Rome and to establish a connection with the Gonzaga family.

In fact, it was more as an architectural designer and for his versatility that Giunti was engaged in 1540 by Ferrante Gonzaga, Viceroy of Sicily, in whose service he remained for the next 20 years. Initially, he was responsible for the design of fortresses and defences for Sicily, although Antonio Ferramolino (*d* 1550) was principally responsible for their construction. Giunti appears to have remained in Sicily until 1546 and during this period worked mainly in Palermo on the personal urban projects of Gonzaga, such as the restructuring of the Castello a Mare (destr. 1922), at the mouth of the harbour, and the designing of a suburban villa with a garden. In 1546, when Gonzaga was appointed Governor of Milan, Giunti accompanied him and continued to operate predominantly as a civil architect rather than as a military one. In particular, he was in charge of the transformation of the apartments (destr.) in the Palazzo Ducale and he prepared the ephemeral decorations and temporary triumphal arches for the entry of the future Philip II of Spain (*reg* 1556–98) at the end of 1548. Around this time Gonzaga also initiated a programme for the renovation of the urban centre of Milan based on criteria of architectural decorum and ease of circulation; it was to be under the control of Giunti, assisted by Nicolò Secco (1513–58), man of letters and seneschal. This programme became amalgamated with a grand project to build a new system of fortifications for the city.

Giunti's most significant work for the Governor, however, was La Gonzaga, known later as Villa Simonetta (now the Scuola Civica di Musica, outside the old city walls. This was erected around the earlier villa La Gualtiera, which dated from the late 15th century and had been purchased in 1547 from the Cavaliere Cicogna. The villa (heavily damaged in World War II) was given a U-shaped plan, with the lateral arms embracing a forecourt, in front of which was a fish-pond that separated it from a large formal garden. The entrance façade facing Milan was treated as a three-storey loggia following antique models: for the ground floor the composition of the Colosseum and, more generally, the strucure of the Septizonium, although it is closer chronologically to the loggias of the Vatican. Somewhat ambiguous in its typology, the building is part villa and part urban palazzo (*see also* MILAN, §I, 3 and fig. 2).

Documentary evidence suggests that between 1549 and 1551 Giunti designed and erected the church of S Paolo Converso (alle Monache), Via S Eufemia, which has a long rib-vaulted nave delimited by lateral chapels and divided into two by a transversal wall. Evidence also suggests that in 1552 he began work on the Franciscan church of S Angelo, Via della Moscova, replacing an earlier church destroyed during the building of the new city walls. The plan follows the lines of a Latin cross. The spacious nave has no aisles but contains eight chapels on either side. These are divided from each other by narrow walls, which on the nave flank are fronted with fluted Ionic pilasters supporting a continuous horizontal entablature. A plain attic storey leads to the great barrel vault of the nave, which is penetrated with large circular windows above each chapel. Also attributed to Giunti (Mezzanotte) is the massive Palazzo Cicogna (destr.), Milan, and it seems he was also consulted (together with Cristoforo Lombardo and Vincenzo Seregni) on the construction of the Loggia at Brescia. Overall, Giunti's work was an integral part of the new climate of building fervour, encouraged by Gonzaga, and shows elements of confrontation and reciprocal exchange of ideas with the most up-to-date aspects

of the local artistic environment, in particular with the work of Cristoforo Lombardo.

Although Gonzaga was removed from his post as viceroy, Giunti continued to work for him and in 1556 was working on modest renovations to the family's properties in the area of Mantua, including the palazzi at Mantua and Pietole. Most importantly, he was in charge of building the new town of Guastalla, an estate purchased by Ferrante in 1539. This was laid out on a pentagonal plan with a rigid urban and social structure, as can be seen from Giunti's surviving architectural drawing (1553; Parma, Archv Stato). However, it was only from 1556 that he worked constantly on the Guastalla project. Giunti continued as the Gonzaga's architect at Guastalla, working for Ferrante's son Cesare until his death, by which time the external walls had been completed and work was commencing on the town centre. In his will, Giunti bequeathed 9000 scudi to assist young men from Prato to study at Pisa. In recognition, the town of Prato commissioned Fermo Ghisoni to paint his portrait (in the Palazzo Comunale, Prato).

BIBLIOGRAPHY

G. Vasari: *Vite* (1550, rev. 2/1568); ed. G. Milanesi (1878–85): 'Soggi, Nicolò'

G. Miniati: *Narrazione e disegno della terra di Prato* (Florence, 1596), pp. 136–40

M. dal Rè: *Ville di delizia, o siano palagi camperecci dello stato di Milano*, i (Milan, 1726)

I. Affò: *Istoria della città e del ducato di Guastalla*, 4 vols (Guastalla, 1785–7) [esp. vols ii and iii]

A. von Bartsch: *Le Peintre-graveur* (1803–21) [B.]

G. Campori: *Gli artisti italiani e stranieri negli stati estensi* (Modena, 1855)

C. Guasti: *Commentari alla vita di Nicolò Soggi* (Florence, 1874)

C. Pini and G. Milanesi: *Scrittura d'artisti italiani* (Florence, 1876)

C. Baroni: 'Domenico Giunti architetto di don Ferrante Gonzaga e le sue opere in Milano', *Archv Stor. Lombardo*, n.s. 3, lxv (1938), pp. 326–57; also in *Palladio*, ii (1938), pp. 128–45

——: *Documenti per la storia dell'architettura a Milano nel rinascimento e nel barocco*, 2 vols (Florence, 1940, Rome, 2/1968)

U. Tarchi: *La villa detta 'La Simonetta' nel suburbio di Milano* (Rome, 1953)

P. Giovio: *Lettere*, ed. G. G. Ferrero, ii (Rome, 1958)

P. Mezzanotte: 'L'architettura milanese dalla fine della signoria sforzesca alla metà del seicento', *Storia di Milano*, x (Milan, 1961–8), pp. 561–645

M. Hirst: 'Sebastiano's *Pietà* for the Commendador Mayor', *Burl. Mag.*, cxiv/834 (1972), pp. 585–95

L. H. Heydenreich and W. Lotz: *Art and Architecture in Italy, 1400–1600*, Pelican Hist. A. (London, 1974), pp. 291–3

A. Scotti: 'Per un profilo dell'architettura milanese (1535–1565)', *Omaggio a Tiziano* (exh. cat., Milan, Pal. Reale, 1977), pp. 97–121

S. Deswarte-Rosa: 'Domenico Giuntalodi: Peintre de D. Martinho de Portugal à Rome', *Rev. A.*, 80 (1988), pp. 52–60

——: 'Les Gravures de monuments antiques d'Antonio Salamanca, à l'origine du Speculum Romanae Magnificentiae', *An. Archit. Cent.*, i (1989), pp. 47–62

S. Leydi: 'I Trionfi dell'Aquila Imperialissima', *Schifanoia*, ix (1990), pp. 9–55

N. Soldini: 'La costruzione di Guastalla', *An. Archit. Cent.*, iv–v (1992–3), pp. 57–87

NICOLA SOLDINI

Giusto, Andrea di. *See* ANDREA DI GIUSTO.

Giusto d'Andrea (di Giusto) (*b* 1440; *d* Florence, 1496). Italian painter, son of the painter ANDREA DI GIUSTO. He was apprenticed to Neri di Bicci in 1458 and spent at least two years in Neri's workshop, interrupted by a period of three months when he worked for Filippo Lippi in 1460. In that year he enrolled in the Compagnia di S Luca. He joined Benozzo Gozzoli in San Gimignano in 1464 to gain experience in fresco and agreed to work for expenses only. Giusto recorded his own part in the decoration of the choir of S Agostino, San Gimignano (1464–5), which included female saints in the window splays (destr.), four apostles in the entrance arch soffit, a large part of the frieze and the first small scene in the vault (possibly a reference to one of the scenes in the lunette of the window wall). He possibly assisted Gozzoli with the execution of two contemporary frescoed altarpieces dedicated to St Sebastian (San Gimignano, S Agostino and the Collegiata) and a panel representing the *Virgin Enthroned with Four Saints* (San Gimignano, Mus. Civ.). Giusto's final collaboration with Benozzo was at Certaldo, where he was responsible for the *sinopia* and painting of the *Deposition of Christ* in the frescoed tabernacle of the Giustiziati (1467–8). The combined influence of Neri di Bicci and Benozzo Gozzoli is evident in the altarpieces attributed to Giusto d'Andrea such as the *Virgin and Child with Saints* (Munich, Alte Pin.). He displayed little invention in his adaptation of their sturdy figures, formalized features and conventional settings.

BIBLIOGRAPHY

Neri di Bicci: *Le ricordanze (10 marzo 1453–24 aprile 1475)* (Florence, Uffizi, MS.2); ed. B. Santi (Pisa, 1976)

G. Vasari: *Vite* (1550, rev. 2/1568); ed. G. Milanesi (1878–85), vol. ii, pp. 89–90, vol. iii, p. 54, n. 4

J. W. Gaye: *Carteggio* (1839–40/*R*1961), i, pp. 212–13

O. Sirén: *A Descriptive Catalogue of the Pictures in the Jarves Collection Belonging to Yale University* (Oxford, 1916), pp. 101–5

A. Padoa Rizzo: *Benozzo Gozzoli, pittore fiorentino* (Florence, 1972), pp. 64–5

D. Cole Ahl: *Benozzo Gozzoli* (New Haven and London, 1996)

AILSA TURNER

Gondi. Italian family of patrons and collectors. Exiled (as Ghibellines) after the battle of Benevento (1266), they were recalled to Florence in 1278 but were excluded thereafter from public life. Bartolomeo Gondi (1492–1577) is mentioned by Vasari as the owner (before 1568) of works by Giotto, Donatello, Fra Angelico, Perugino and Giovanni Antonio Sogliani. His son, Benedetto Gondi (1539–1616), was the friend of Giambologna and executor of his will; his collection included 18 works by Giambologna, and he also purchased works by painters who worked with Giambologna on the chapel of S Antonio in S Marco, Florence: Domenico Passignano (1559–1638), Alessandro Allori (1535–1607) and Giovan Battista Naldini.

The major part of Benedetto Gondi's collection, however, comprised works purchased by his father. The inventory that Benedetto had drawn up in 1609 includes paintings by Andrea del Minga (*fl* 1564; *d* 1596), Pontormo, Maso Finiguerra, Fra Bartolommeo, Daniele da Volterra, Parmigianino, Herri met de Bles (*b* 1510), Friedrich Sustris (*c.* 1540–99), Lucas van Leyden (*c.* 1494–1533) and other anonymous northern artists, sculptures by Donatello and Antonio del Pollaiuolo, architectural plans by Giuliano da Sangallo, studies by Giulio Romano and watercolours by Alessandro Allori.

BIBLIOGRAPHY

G. Corti: 'Two Early Seventeenth-century Inventories Involving Giambologna', *Burl. Mag.*, cxviii (1976), pp. 629–34

G. Corti: 'Two Picture Collections in Eighteenth-century Florence', *Burl. Mag.*, ccxxiv (1982), pp. 502–5

CHIARA STEFANI

Gondola, Andrea di Pietro della. *See* PALLADIO, ANDREA.

Gonzaga. Italian dynasty of rulers, patrons and collectors. In 1328 Ludovico Gonzaga (*d* 1360) seized power from the Bonacolsi family, becoming Capitano of MANTUA. For the next four centuries the Gonzaga ruled the city, acquiring the title of Marchese, and later Duke, of Mantua. The urban development and art life of Mantua was strongly influenced by the patronage of the family: in the mid-15th century (2) Ludovico II Gonzaga, 2nd Marchese of Mantua, employed many artists and architects, among them Leon Battista Alberti and Andrea Mantegna, from other areas in Italy, resulting in a flourishing Renaissance court. Similarly, Ludovico's great-grandson (8) Federico II Gonzaga, 5th Marchese and 1st Duke of Mantua, persuaded Giulio Romano to come to Mantua, where Giulio became the leading painter, architect and town planner.

BIBLIOGRAPHY

The Splendours of the Gonzaga (exh. cat., ed. D. S. Chambers and J. Martineau; London, V&A, 1981–2)

K. Simon: *A Renaissance tapestry: the Gonzaga of Mantua* (New York, 1989)

(1) Gianfrancesco Gonzaga, 5th Capitano and 1st Marchese of Mantua (*b* Mantua, 1 June 1395; *reg* 1407–44; *d* Mantua, 24 Sept 1444). The son of Francesco I Gonzaga, (1366–1407), he succeeded his father as 5th Capitano of Mantua in 1407, while still a minor. In 1409 he married Paola Malatesta, daughter of Malatesta Malatesta. He played a decisive role in steering Mantua towards the humanistic culture of the Renaissance. He was, however, a condottiere by profession and fought first (1421) for Filippo Maria Visconti, 3rd Duke of Milan, although in 1425 he changed his allegiance to the Venetian Republic, for whom he worked for much of his career, reverting to the Milanese camp only in 1437. In 1432 he bought the hereditary title of Marchese of Mantua from Emperor Sigismund of Luxemburg (*reg* 1410–37), thereby legitimizing the Gonzaga rule of Mantua and its territories.

Gianfrancesco did much to improve the city and the Gonzaga residences. In 1408 he built a Carthusian monastery (destr.) outside the city walls, and, on his orders, the Ponte dei Mulini (*c.* 1417; destr.), the principal bridge linking Mantua to the mainland, was covered over and the city walls repaired. At this time Paola Gonzaga enclaved the convent of the Poor Clares of S Paola and founded the adjacent church of Corpus Domini. In 1431 and in 1433 Brunelleschi obtained permission from the Opera del Duomo, Florence, to visit Mantua, where he was apparently consulted about draining systems for the city and may have also advised on urban planning. In 1435 work began on the country villa of Marmirolo (destr.), later one of the most highly decorated of Gonzaga residences, and in 1436 the cloister of the convent of S Agnese was completed. In 1441 work was done on the Palazzo della Ragione, and in 1443 Santa Croce in Corte Vecchia was completed.

In 1422 PISANELLO was recorded living in Mantua; Gianfrancesco gave him the courtesy title of *familiare* in 1439. Much of his Mantuan work has been lost; in 1424–6 he was paid for unspecified work and in 1439 was working for Paola Gonzaga in an unnamed church. He was in Mantua again in 1440–41, and in 1443 Gianfrancesco wrote to the artist in Ferrara asking him to send a canvas of *God the Father* (untraced). In March 1444 Gianfrancesco wrote again to Pisanello saying that he was keeping his rooms in the castle in case he could return to finish an undertaking. It has been suggested (Toesca) that this unfinished project can be identified as Pisanello's incomplete frescoes depicting scenes of *War and Chivalry* in the Corte Vecchia of the Palazzo Ducale and that they were commissioned by Gianfrancesco (Ventura). Other scholars (Paccagnini, Fossi Todorow, Woods-Marsden) believe that they were commissioned by (2) Ludovico II Gonzaga after Gianfrancesco's death.

In 1423 Gianfrancesco persuaded the eminent mathematician and humanist Vittorino da Feltre to enter his service as tutor to his children. Vittorino set up a school in the Casa Giocosa in Mantua, where he educated not only the Gonzaga children but, among others, Federigo da Montefeltro, later Duke of Urbino. Vittorino's wide-ranging humanist education prepared both Federigo da Montefeltro and Ludovico II Gonzaga to be among the most discerning and well-educated patrons of the next generation. Pisanello's medal of *Vittorino da Feltre* was probably commissioned by Ludovico after his tutor's death. Similarly, Pisanello's medal of *Gianfrancesco Gonzaga*, commemorating his martial exploits, is believed to have been struck after the latter's death.

Some time between 1438 and 1444 Leon Battista Alberti dedicated the revised version of his treatise *De pictura* to Gianfrancesco, writing that 'knowing your delight in the liberal arts I hope that you will read it in a moment of leisure . . .; in the understanding of the arts you completely surpass other princes'. According to Baxandall, it is unlikely that the Marchese could read the treatise in the original; however it is known that his children were educated to do so. In his will Gianfrancesco bequeathed 200 ducats for the building of a tribune in SS Annunziata, Florence. He was buried in the chapel of St Louis of Toulouse (the Cappella dei Principi) in S Francesco, Mantua.

BIBLIOGRAPHY

L. B. Alberti: *De pictura* (MS. 1435, rev. 1438); It. trans. as *Della pittura* (MS. 1436); ed. H. Janitschek (Vienna, 1877); L. Mallè (Florence, 1950); Eng. trans. by J. R. Spencer (London, 1956) [Janitschek edn incl. ded. to Gianfrancesco]

F. Amadei: *Cronaca universale della città di Mantova* (Mantua, 1955), i, pp. 712–69; ii, pp. 7–48

G. Coniglio: *Mantova: La storia*, i (Mantua, 1958), pp. 443–59

——: *I Gonzaga* (Milan, 1967), pp. 41–51

M. Baxandall: *Giotto and the Orators* (Oxford, 1971), pp. 126n., 127, 130

M. Fossi Todorow: 'Pisanello at the Court of the Gonzaga at Mantua', *Burl. Mag.*, cxiv (1972), pp. 888–91

G. Paccagnini: *Pisanello alla corte dei Gonzaga* (Milan, 1972)

——: *Pisanello e il ciclo cavalleresco di Mantova* (Milan, 1972)

I. Toesca: 'Lancaster e Gonzaga: Il fregio della sala del Pisanello nel Palazzo Ducale di Mantova', *Civil. Mant.*, vii/42 (1973), pp. 361–77

U. Nicolini: 'Principe e cittadini: Una consultazione popolare del 1430 nella Mantova dei Gonzaga', *Mantova e i Gonzaga nella civiltà del rinascimento: Atti del convegno organizzato dall'Accademia Nazionale dei Lincei e dall'Accademia Virgiliana: Mantova, 1974*, pp. 35–45

I. Toesca: 'A Frieze by Pisanello', *Burl. Mag.*, cxvi (1974), pp. 210–14

——: 'More about the Pisanello Murals at Mantua', *Burl. Mag.*, cxviii (1976), pp. 622–9

——: 'Altre osservazioni in margine alle pitture del Pisanello nel Palazzo Ducale di Mantova', *Civil. Mant.*, xi/65–6 (1977), pp. 349–76

G. Amadei and E. Marani: *I ritratti gonzagheschi della collezione di Ambras* (Mantua, 1978), pp. 33–6

R. Signorini: *In traccia del Magister Pelicanus: Catalogo della mostra documentaria su Vittoriano da Feltre* (Mantua, 1979)

Vittorino e la sua scuola: Umanesimo, pedagogia, arti: Atti del convegno, Fondazione Giorgio Cini: Venezia, 1979, ed. N. Giannetto (Florence, 1981)

G. Müller: *Mensch und Bildung im italienischen Renaissance-Humanismus: Vittorino da Feltre und die humanistischen Erziehungsdenker* (Baden-Baden, 1984)

J. Woods-Marsden: 'French Chivalric Myth and Mantuan Political Reality in the Sala del Pisanello', *A. Hist.*, viii/4 (1985), pp. 397–412

——: 'The Sinopia as Preparatory Drawing: The Evolution of Pisanello's Tournament Scene', *Master Drgs*, lxxxiii–lxxxv (1985–6), pp. 175–92

G. Suitner and D. Nicolini: *Mantova: L'architettura della città* (Milan, 1987)

M. A. Grignani, ed.: *Mantova 1430: Pareri a Gian Francesco Gonzaga per il governo* (Mantua, 1990)

L. Ventura: 'Noterelle pisanelliane: Precisazioni sulla data del ciclo cavalleresco di Mantova', *Civil. Mant.*, 3rd ser., xxvii/2 (1992), pp. 19–53

A. Cicinelli: 'Pisanello a Mantova: Nuovi studi', *Stud. Stor. A.* [Todi], v–vi (1994–5), pp. 55–92

RODOLFO SIGNORINI

(2) Ludovico II Gonzaga, 2nd Marchese of Mantua (*b* Mantua, 5 June 1412; *reg* 1444–78; *d* Goito, 12 June 1478). Son of (1) Gianfrancesco Gonzaga. He was educated at the school run by Vittorino da Feltre at the Casa Giocosa, Mantua. Da Feltre esteemed his intellectual and political abilities highly, an opinion later shared by Bartolomeo Sacchi (il Platina) who tutored Ludovico's children and afterwards became the overseer of the Vatican Library. Ludovico was certainly one of the most intellectually gifted of the Gonzaga rulers; he associated with scholars, employed scribes and illuminators—for example Andrea da Lodi (*fl* 1458–64), who illuminated Boccaccio's *Filocolo* for Ludovico (Alexander)—and purchased items for the Gonzaga library. In 1433 he married Barbara of Hohenzollern (1422–81), niece of Emperor Sigismund of Luxemburg (*reg* 1410–37), with whom he had five sons and five daughters. From 1445 until the Peace of Lodi (1454), Ludovico, an accomplished soldier, was involved in the power struggle between Milan, Venice and Florence. Pisanello made a medal (*c.* 1447; London, V&A) portraying him as a military leader: the obverse carries a portrait bust of Ludovico, bareheaded, under the legend CAPITANEUS ARMIGERORUM MARCHIO MANTUE, and the reverse shows him on horseback, in full armour and crested helmet. This medal could have been made to commemorate Ludovico's appointment as Captain in the service of Florence (he had previously fought on the side of Milan). It was probably Ludovico who commissioned Pisanello's medal of *Gianfrancesco Gonzaga* (*c.* 1447; London, BM), to honour his father. Around 1447 Pisanello also decorated the Palazzo Ducale in Mantua with frescoed scenes of *War and Chivalry* (*in situ*); although unfinished, these are the most impressive examples of the artist's painting to survive. The dating of the work is uncertain; it may have been commissioned by Gianfrancesco.

Ludovico's links with Florence led to cultural exchange. In 1449 he was requested by Cosimo de' Medici to help finance the building of SS Annunziata (*see* FLORENCE, §IV, 3); ten years later Ludovico again became involved in furthering the building work, this time insisting on executive control and appointing Alberti to take charge of the project. Many Florentine artists and architects were employed in Mantua by Ludovico, among them the architects ANTONIO DI CIACCHERI MANETTI and LUCA FANCELLI. The latter, who arrived in Mantua *c.* 1450, provided designs for the windows and the main entrance to the palace that Ludovico built at Revere. Another Tuscan, the engineer Giovanni Antonio d'Arezzo (*fl* 1456–63), took part in the building works on the Palazzo del Podestà and the Ponte dei Mulini. In 1459 Alberti came to Mantua in the retinue of Pope Pius II and provided Ludovico with designs for the church of S Sebastiano and subsequently for the rebuilding of S Andrea, the foundation stone of which was laid in 1472, the year of Alberti's death (*see* ALBERTI, LEON BATTISTA, §III, 2(iii) and figs 4 and 8). A letter from Alberti to Ludovico concerning his ideas for the design of this church has survived (Mantua, Archv Stato; Chambers). Luca Fancelli supervised the construction of both churches. There also survives a bronze bust of *Ludovico Gonzaga* (1450–70; versions Berlin, Skulpgal.; Paris, Mus. Jacquemart-André), which has been ascribed to Alberti.

Probably at the end of 1459 ANDREA MANTEGNA arrived in Mantua, after persistent persuasion, to decorate the chapel of the Castello di S Giorgio, part of the Palazzo Ducale. This was the start of Mantegna's long association with the Gonzaga family, which included his renowned decoration of a room in the Castello di S Giorgio, known as the Camera Picta, later called Camera degli Sposi (1465–74; see colour pls 2, I1 and 2, I2). This historiated portrait gallery of the Gonzaga dynasty includes a reference to Pius II's war against Giacomo Savelli, Lord of Palombara Sabina and leader of Roman barons hostile to the Pope. There is documentary evidence that another Florentine, LUCIANO LAURANA, worked for Ludovico, but his contribution to the architecture of Mantua is hard to establish with certainty.

Other notable cultural events of Ludovico's reign include the introduction of a printing press to Mantua by Pietro Adamo de' Micheli (*c.* 1441–81), who employed two German printers, Georg Butzbach (*fl* ?1471–2) and Paul Butzbach (*fl* ?1471–81), to run it, and the construction of a tower bearing an astrological clock (1473; rest. 1989) that Ludovico commissioned from the astrologer Bartolomeo Manfredi, one of Vittorino's pupils. This clock was described by Pietrodamo de' Micheli in one of the earliest documents to be printed in Mantua.

Ludovico died of pleurisy and was buried in the Cappella dei Principi in the church of S Francesco. His wife died in 1481 and was buried in the chapel of S Anselmo in the cathedral. A tomb was designed for her by Mantegna but it was never erected. Her name is associated with a Missal (Mantua, Mus. Dioc.), known as the Missal of Barbara of Brandenburg, that was illustrated first by BELBELLO DA PAVIA and then, after the intervention of Mantegna, by Girolamo da Cremona. The marked change in style between the earlier and later paintings gives an insight into the extent of Mantegna's influence in Mantua.

BIBLIOGRAPHY

B. Hofmann: *Barbara von Hohenzollern, Markgräfin von Mantua* (Ansbach, 1881)

F. Amadei: *Cronaca universale della città di Mantova*, ii (Mantua, 1955), pp. 49–234

E. Marani and C. Perina: *Mantova: Le arti*, ii (Mantua, 1961)

L. Mazzoldi: *Mantova: La storia*, ii (Mantua, 1961), pp. 3–35

U. Meroni: *Mostra dei codici gonzagheschi, 1328–1540* (Mantua, 1966)

G. Coniglio: *I Gonzaga* (Milan, 1967)

G. Paccagnini: *Pisanello e il ciclo cavalleresco di Mantova* (Milan, 1972)

L. Pescasio: *Pietro Adamo de' Micheli protoeditore mantovano* (Mantua, 1972)

Libri stampati a Mantova nel quattrocento (exh. cat., ed. G. Schizzerotto; Mantua, Bib. Com., 1972)

J. Alexander: 'The Scribe of the Boccaccio *Filocolo* Identified', *Bodleian Lib. Rec.*, ix (1977), pp. 303–4

D. S. Chambers: 'Sant'Andrea at Mantua and Gonzaga Patronage, 1460–1472', *J. Warb. & Court. Inst.*, xl (1977), pp. 99–127

A. Calzona: *Mantova città dell'Alberti: Il San Sebastiano: Tomba, tempio, cosmo* (Parma, 1979)

R. Signorini: *In traccia del Magister Pelicanus: Catalogo della mostra documentaria su Vittorino da Feltre* (Mantua, 1979)

C. Vasić Vatovec: *Luca Fancelli architetto: Epistolario gonzaghesco* (Florence, 1979)

R. Signorini: 'Acquisitions for Ludovico II Gonzaga's Library', *J. Warb. & Court. Inst.*, xliv (1981), pp. 180–83

Vittorino e la sua scuola: Umanesimo, pedagogia, arti: Atti del convegno, Fondazione Giorgio Cini: Venezia, 1979, ed. N. Giannetto (Florence, 1981)

R. Signorini: 'Ludovico muore', *Atti & Mem. Accad. N. Virgil. Mantova*, n.s., i (1982), pp. 91–129

——: 'Inediti su Pietroadamo de' Micheli: Il protostampatore, l'uomo di legge e la sua morte violenta', *Civil. Mant.*, n.s., i (1983), pp. 43–62

——: *Opus hoc tenue: La Camera Dipinta di Andrea Mantegna, lettura storica iconografica iconologica* (Mantua, 1985)

J. Woods-Marsden: 'French Chivalric Myth and Mantuan Political Reality in the Sala del Pisanello', *A. Hist.*, viii/4 (1985), pp. 397–412

P. Carpeggiani and C. Tellini: *Sant'Andrea in Mantova: Un tempio per la città del principe* (Mantua, 1987)

G. Suitner and D. Nicolini: *Mantova: L'architettura della città* (Milan, 1987)

G. Rodella: *Giovanni da Padova: Un ingegnere gonzaghesco nell'età dell'Umanesimo* (Milan, 1988)

R. Signorini: *La più bella camera del mondo: La camera dipinta di Andrea Mantegna detta "degli Sposi"/The Most Beautiful Room in the World: The Painted Room by Andrea Mantegna called "degli Sposi"* (Mantua, 1992)

A. Calzona and L. Volpi Ghirardini: *Il San Sebastiano di Leon Battista Alberti* (Florence, 1994)

L. B. Alberti (exh. cat., ed. J. Rykwert and A. Engel; Mantua, 1994)

G. Malacarne: *Barbara Hohenzollern del Brandeburgo: Il Potere e la Virtù: Die Macht und die Tugend* (Mantua, 1997)

P. Carpeggiani and A. M. Lorenzoni, eds: *Carteggio di Luca Fancelli con Ludovico Federico e Francesco Gonzaga marchesi di Mantova* (Mantua, 1998)

RODOLFO SIGNORINI

(3) Federico I Gonzaga, 3rd Marchese of Mantua (*b* Mantua, 2 July 1441; *reg* 1478–84; *d* Mantua, 14 July 1484). Son of (2) Ludovico II Gonzaga. On 7 June 1463 he married Margherita of Bavaria, daughter of Albert II the Pius, Duke of Bavaria (*reg* 1438–60). He was educated by Ognibene of Lonigo, a pupil of Vittorino da Feltre, but was most probably more interested in war and government than books. Bartolomeo Sacchi (il Platina) dedicated his *De principe* to Federico. He was a faithful ally of the Sforzas and energetically defended Ferrara against attacks by the Venetians. Like his father, he was interested in architecture. In 1480 he commissioned Luca Fancelli to build the Domus Nova, a wing of the Palazzo Ducale in Mantua. He is portrayed in a medal by Bartolo Talpa (*fl c.* 1495) and perhaps together with his wife in a fine fireplace frieze, originally in the palazzo at Révere and now in the Palazzo Ducale, Mantua. There is another portrait of Federico in Mantegna's Camera Picta, later called Camera degli Sposi (1465–74; see colour pl. 2, I2), in the Castello di S Giorgio, part of the Palazzo Ducale. Posthumous portraits of him can be found in the Sala dei Marchesi (Mantua, Pal. Ducale) and in one of the triumphs painted by Tintoretto in 1579 for the Palazzo Ducale: the *Battle of Legnano* (Munich, Alte Pin.), which records an imaginary, rather than an actual, event. Further portraits of him and his wife are in the collection at Schloss Ambras, Innsbruck.

BIBLIOGRAPHY

F. Amadei: *Cronaca universale della città di Mantova*, ii (Mantua, 1955), pp. 235–66

L. Mazzoldi: *Mantova: La storia*, ii (Mantua, 1961), pp. 35–45

E. Marani and C. Perina: *Mantova: Le arti*, ii (Mantua, 1961), pp. 91–5

P. Eikemeier: 'Der Gonzaga-Zyklus des Tintoretto in der Alten Pinakothek', *Munchn. J. Bild. Kst*, xx (1969), pp. 75–142

G. Amadei and E. Marani: *I ritratti gonzagheschi della collezione di Ambras* (Mantua, 1978), pp. 41–4

R. Signorini: *Opus hoc tenue: La Camera Dipinta di Andrea Mantegna: Lettura storica iconografica iconologica* (Mantua, 1985)

——: 'Per la storia di S Anselmo e delle sue traslazioni', *Sant' Anselmo, Mantova e la lotta per le investiture: Atti del convegno: Bologna, 23–25 May 1986*, pp. 102–3

M. G. Vaccari: 'I Fasti Gonzagheschi', *De gli Dei la memoria, e de gli Heroi*. (exh. cat., Mantua, Pal. Ducale, 1986), pp. 21–4

R. Signorini: 'La malattia mortale di Barbara di Brandeburgo Gonzaga, seconda marchesa di Mantova', *Civil. Mant.*, n.s. 15 (1987), pp. 1–30

——: *La più bella camera del mondo: La Camera Dipinta di Andrea Mantegna detta "degli Sposi"/The Most Beautiful Room in the World: The Painted Room by Andrea Mantegna called "degli Sposi"* (Mantua, 1992)

RODOLFO SIGNORINI

(4) Cardinal **Francesco Gonzaga** (*b* Mantua, 15 March 1444; *d* Bologna, 21 Oct 1483). Son of (2) Ludovico Gonzaga II. He became a cardinal in 1461 and thereafter lived mainly in Rome; from 1463 he had a summer residence at Santa Agata dei Goti, and from 1467 he occupied the palace at San Lorenzo in Damaso, where he commissioned murals with mythological subjects (1479; destr.) for the ornamental garden. He revisited Mantua only for short periods and in the 1470s was resident intermittently at Bologna as papal legate. Andrea Mantegna portrayed him as a boy (*c.* 1460; Naples, Capodimonte) and in the *Meeting Scene* (*c.* 1474) of the Camera Picta in the Palazzo Ducale, Mantua, and probably helped to excite his interest in antique objects. Mantegna's and Francesco's celebrated discussion at the spa of Porretta (1472) about his collections cannot in fact have happened, because the Cardinal's doctors had advised against his taking the waters then. He also knew Leon Battista Alberti and was involved in the rebuilding of S Andrea at Mantua (*see* ALBERTI, LEON BATTISTA, figs 6–8), but commented disparagingly on Alberti's design for another Mantuan church, S Sebastiano (*see* ALBERTI, LEON BATTISTA, fig. 4).

There is little evidence that Francesco was learned or exceptionally active as a patron, but he was a liberal spender, whose collecting and connoisseurship were stimulated by such figures as Cardinal Ludovico Trevisan and Cardinal Pietro Barbo (later Pope Paul II) and humanists in his entourage. Correspondence, his will and an inventory made after his death detail his collections of silverware, tapestries, bronze sculpture, jewellery, antique gems, coins, medals and *c.* 200 books. Among those not mentioned, however, was his uncompleted masterpiece, the illuminated *Iliad* or 'Vatican Homer' (Rome, Vatican, Bib. Apostolica, MS. Vat. gr. 1626), the Master of which has been tentatively identified as Gasparo Padovano, an associate of the scribe Bartolomeo Sanvito who was Francesco's steward. The goldsmith Sperandio designed a medal (*c.* 1479–83) bearing Francesco's portrait, and the brothers Antonio and Piero del Pollaiuolo a purse, but Francesco does not seem to have owned any portable

paintings apart from a *Madonna* (untraced) by Botticelli. After his death, his moveables were dispersed by bequests and sales to pay off debts. The cameos, among which was the Felix Gem (Oxford, Ashmolean), were sought by many collectors, including Lorenzo de' Medici (il Magnifico), but it has been disproved that they passed into the Medici collection. Some were, however, undoubtedly held by the Medici bank as loan pledges. Many of his books were acquired by his secretary Giovan Pietro Arrivabene.

BIBLIOGRAPHY

G. Frasso: 'Oggetti d'arte e libri nell'inventario del Cardinale Francesco Gonzaga', *Mantova e i Gonzaga nella civiltà del Rinascimento: Atti del convegno organizzatio dall'Accademia Nazionale dei Lincei e dall'Accademia Virgiliana: Mantua, 1974*, pp. 141–4

D. S. Chambers: 'The Housing Problems of Cardinal Francesco Gonzaga', *J. Warb. & Court. Inst.*, xxxix (1976), pp. 21–58

——: 'Sant'Andrea at Mantua and Gonzaga Patronage, 1460–1472', *J. Warb. & Court. Inst.*, xl (1977), pp. 99–127

C. M. Brown: 'Cardinal Francesco Gonzaga's Collection of Antique Intaglios and Cameos: Questions of Provenance, Identification and Dispersal', *Gaz. B.-A.*, cxxv (1983), pp. 102–4

C. M. Brown, with L. Fusco: 'Lorenzo de' Medici and the Dispersal of the Antiquarian Collections of Cardinal Francesco Gonzaga', *A. Lombarda*, xc/xci (1989), pp. 86–103

D. S. Chambers: *A Renaissance Cardinal and his Worldly Goods: The Will and Inventory of Francesco Gonzaga (1444–1483)* (London, 1992)

——: 'Postscript on the Worldly Affairs of Cardinal Francesco Gonzaga', *Renaissance Cardinals and their Worldly Problems* (Aldershot, 1997)

D. S. CHAMBERS

(5) Gianfrancesco Gonzaga, Conte di Ródigo [Lord of Bozzolo, Sabbioneta, Rivarolo, Viadana and Gazzuolo] (*b* Mantua, 1445; *d* Bozzolo, 28 Aug 1496). Son of (2) Ludovico II Gonzaga. He founded the Bozzolo and Sabbioneta line of the family. As a boy, he was portrayed by Mantegna in the Camera degli Sposi (1465–74; see colour pl. 2, I2) in the Palazzo Ducale, Mantua. He spent much of his early life in the service of Ferdinand I, King of Naples (*reg* 1458–94), and had a distinguished military career. On 17 July 1479 he married the renowned beauty Antonia del Balzo, Princess of Altamura (*d* Gazzuolo, 13 June 1538), and they held a glittering court at the fortress of Bozzolo. The sculptor known as Antico was employed there for some years, probably from 1484. His *all'antica* style reflected Gianfrancesco's pronounced preference for the Antique. From this period date Antico's series of portrait medals of Gianfrancesco and his wife (examples, London, BM and V&A; Bologna, Mus. Civ.; Milan, Castello Sforzesco) and the bronze Gonzaga Vase (Modena, Gal. Estense), decorated with their personal imprese and a frieze of a triumphal procession, with Neptune in a boat drawn by horses and accompanied by marine deities. Gianfrancesco's collection, an inventory of which was made in 1496, comprised both antique and modern copies of Classical works. Among the latter were itemized statuettes of the groups in the Piazza del Quirinale, Rome, known as *Alexander and Bucephalus* or the *Horse Tamers*, an equestrian statuette of *Marcus Aurelius*, bronze busts of *Caesar* and *Pompey*, a *Minerva* and a *Woman with a Cornucopia* (all untraced). Although Antico is named in the inventory only as the maker of two small silver-gilt vases, his bronze statuettes of *Cupid* (Florence, Bargello), *Hercules* (Madrid, Mus. Arqueol. N.) and *Meleager* (London, V&A) undoubtedly originate from this collection. A black-chalk portrait drawing (Florence, Uffizi), probably

of Gianfrancesco, has been attributed to FRANCESCO BONSIGNORI, who is known to have made several portraits of Gianfrancesco in the course of his work (from 1492) for the Gonzaga family. Gianfrancesco was buried in the church of S Francesco, Mantua. His wife Antonia lived to the age of 97, becoming known to the family as 'the mother of all'. She held court at Gazzuolo and corresponded with Isabella d'Este (who married Gianfrancesco and Antonia's nephew, (8) Francesco Gonzaga II), whose literary and musical interests she shared.

BIBLIOGRAPHY

Mostra iconografica gonzaghesca (exh. cat., ed. N. Giannantoni; Mantua, Pal. Ducale, 1937), pp. 54–5; nos 243–50 □

(6) Ludovico Gonzaga (*b* Mantua, 1460; *d* Reggiolo, nr Mantua, 1511). Son of (2) Ludovico II Gonzaga. In 1484 he was nominated Bishop of Mantua but was never confirmed in the title. Much of his life was spent at Gazzuolo, where he established a small Renaissance court. He had a special interest in Classical art, but his lack of wealth and power limited his ambitions; consequently his collection consisted mainly of copies of antique marbles. He was unsuccessful in his bid in 1501–2 for several of the antique vases belonging to the Medici family, yet he did own some originals, for example the sculpted antique heads that he received from Cardinal Federigo Sanseverino (*d* 1516) in 1502 and which he displayed in his study. The sculptor Antico worked at Gazzuolo and made small bronze versions of Classical statues for Ludovico, including one of the *Apollo Belvedere* (1498; version, Frankfurt am Main, Liebieghaus; see ANTICO, fig. 1) and one of *Hercules and Antaeus* (*c.* 1500; version, London, V&A; see also ANTICO, fig. 2). The moulds for these and other statues were made available to Isabella d'Este. Few objects in Ludovico's collection have been identified, except for a group of heads by Antico: a pair of *Julius Caesar* and *Augustus* (*c.* 1500) and a pair of *Julius Caesar* and *Antonius Pius* (*c.* 1510; all Mantua, Pal. Vescovile).

BIBLIOGRAPHY

U. Rossi: 'I medaglisti del Rinascimento alla corte di Mantova, II. Pier Jacopo Alari-Bonacolsi detto l'Antico', *Riv. It. Numi.*, i (1888), pp. 161–94, 433–54

C. M. Brown: 'I vasi di pietra dura dei Medici e Ludovico Gonzaga vescova eletto di Mantova', *Civil. Mant.*, n. s., i (1983), pp. 63–8

A. H. Allison: 'The Bronzes of Pier Jacopo Alari-Bonacolsi Called Antico', *Jb. Ksthist. Samml. Wien*, n.s., liii/liv (1993/4), pp. 37–311

C. M. BROWN

(7) Francesco II Gonzaga, 4th Marchese of Mantua (*b* Mantua, 1466; *reg* 1484–1519; *d* Mantua, 29 March 1519). Son of (3) Federico I Gonzaga. He made his career and reputation as a condottiere and was involved in turbulent political and military events. When Charles VIII, King of France (*reg* 1483–98), invaded Italy in 1494, Francesco assisted in the formation of a league to defeat him, and, as commander of the league's forces, joined battle with Charles at Fornovo on 6 July 1495. He gained the victory but only with heavy loss of life. Despite skilful diplomatic manoeuvring, the security of Mantua was under threat from the French until Francesco's death.

Francesco's patronage of the arts, which was surpassed by that of his wife, Isabella d'Este (see ESTE, (6)), was

supported by state revenues and military stipends. It was essentially strategic and pragmatic in nature, a characteristic most strongly expressed in the sculpture, music and the applied arts that Francesco patronized. His terracotta portrait bust (*c.* 1498; Mantua, Pal. Ducale) was modelled by Gian Cristoforo Romano. The medallists Bartolommeo Melioli (1448–1514), Gianfrancesco Ruberti della Grana (*fl* 1483–1526) and Gian Marco Cavalli all executed portrait medals of Francesco in armour in a strong classicizing style. In 1510 Francesco founded the first Gonzaga *cappella*, taking advantage of the availability of good musicians caused by Alfonso d'Este's temporary disbandment of the Este *cappella*.

In the applied arts coinage was designed and minted to a high standard from 1497 to 1510, the design being similar to that of the medals. Francesco also had poems and books dedicated to him. Battista Spagnoli commemorated the Battle of Fornovo in his *Trophaeum Gonzagae pro Gallis expulsis* (1498). The books dealt with horses, falconry and agricultural science and were either derivatives or copies of earlier works. They reveal the stagnation of some scientific learning in the Renaissance. Francesco admired Andrea Mantegna and made him a grant of land in 1492; he may have commissioned Mantegna's series of the *Triumphs of Caesar* (London, Hampton Court, Royal Col.), the military theme of which would have appealed to him. The *Madonna of Victory* (1495–6; Paris, Louvre; *see* MANTEGNA, ANDREA, fig. 5), commissioned from Mantegna to celebrate the victory at Fornovo, shows Francesco in full armour. A portrait drawing of Francesco, attributed to Francesco Bonsignori, also survives (1492–1500; Dublin, N.G.). Domenico Morone painted the *Expulsion of the Bonacolsi from Mantua* (1494; Mantua, Pal. Ducale; for illustration *see* MANTUA) for Francesco.

BIBLIOGRAPHY

G. Coniglio: *I Gonzaga* (Milan, 1967/*R* Varese, 1987), pp. 101–249, 501–8

M. Cattafesta: *Mantovastoria* (Mantua, 1974/*R* 1984), pp. 169–84, 543

C. Mozzarelli: *Mantova e i Gonzaga dal 1382 al 1707* (Turin, 1987), pp. 37–49, 133–9

GORDON MARSHALL BEAMISH

(8) Federico II Gonzaga, 5th Marchese and 1st Duke of Mantua (*b* Mantua, 1500; *reg* 1519–40; *d* Mantua, 1540). Son of (7) Francesco II Gonzaga. He succeeded his father at the age of 19, having spent three years of his childhood (1510–13) in Rome as a hostage at the court of Pope Julius II. This experience, together with the influence of his mother, Isabella d'Este, disposed him to appreciate Roman art, both ancient and modern. His early familiarity with Michelangelo's decoration of the Sistine Chapel (see colour pl. 2, V2) and Raphael's work in the Stanza della Segnatura nourished a taste for large-scale fresco decoration featuring writhing, muscular forms and impressive illusionist effects. Soon after becoming Marchese, Federico lent military support to the Holy Roman Emperor Charles V (*reg* 1519–56) against the French king, Francis I (*reg* 1515–47), who was attempting to capture Pavia; Federico was thus awarded the device of Mount Olympus in 1522. This device, which can be seen on the obverse of Federico's medals, consists of a mountain with an ascending, spiral road and an altar inscribed FIDES, together with a female figure holding a sword and a cornucopia. As a further favour, the Emperor created him a duke in 1530.

Federico was an active patron of contemporary artists. He failed, however, to acquire works by Sebastiano del Piombo or Michelangelo, despite strenuous attempts to do so, though he did acquire several by Correggio— *Loves of Jupiter*: *Io* (*see* CORREGGIO, fig. 6) and *Ganymede* (*c.* 1530–32; both Vienna, Ksthist. Mus.), *Danaë* (Rome, Gal. Borghese; see colour pl. 1, XXIV1) and *Leda* (Berlin, Gemäldegal.). In 1529 he commissioned Titian to paint his portrait (Madrid, Prado; see colour pl. 2, XXXV1) and subsequently became the artist's most important patron during the 1530s—acquiring *c.* 1530 his *Madonna and Child with St Catherine and a Rabbit* (*c.* 1528–30; Paris, Louvre) and commissioning from him a series of portraits of 11 Roman emperors (destr. 1734) for the Gabinetto dei Cesari in the Palazzo Ducale, Mantua. These are known through Ippolito Andreasi's drawings (*c.* 1568; Düsseldorf, Kstmus.) and engravings (1593/4) by Aegidius Sadeler II (*c.* 1570–1629). Federico also had a portrait of himself in armour painted by Raphael (untraced).

Federico's most significant achievement as a patron, however, was his employment of Giulio Romano, who was persuaded—probably through the intercession of Pietro Aretino and Federico's ambassador Baldassare Castiglione—to come to Mantua in 1524. For 16 years he played a leading role as architect, painter, designer and town planner. His most important works in Mantua were the design of the Palazzo del Te (1527–34; *see* GIULIO ROMANO, fig. 3) and an extension to the Palazzo Ducale: the Appartamento de Troia (1536–8). The Palazzo del Te, of which Federico was immensely proud, is an idiosyncratic version of a Roman villa, with a variety of orders on its exterior surfaces and lavishly painted interior decorations. The Duke laid great emphasis on the Roman nature of the enterprise, even obtaining a Roman gardener to tend the grounds. The interior paintings, especially the mythological scenes in the Sala di Psiche (*see* GIULIO ROMANO, fig. 4) and the Sala dei Giganti (see colour pl. 1, XXXV1), were characterized by daring illusionism and forceful forms and acted as powerful propaganda for both the artist and his patron. In the Sala dei Venti, in which the frescoes celebrate the reign of the Gonzaga dynasty, the Mount Olympus device is featured in the centre of the ceiling. The Sala dei Cavalli reflects Federico's passion for animals, with portraits of his favourite steeds on the walls. (In 1526 Federico had commissioned from Giulio a marble tomb for one of his dogs.) Although the building was originally intended as a retreat for the Duke and his friends, it quickly became one of the main sights of the town and set an influential pattern for villa and palace design.

BIBLIOGRAPHY

F. Hartt: *Giulio Romano*, 2 vols (New Haven, 1958)

G. Amadei and E. Marani: *I Gonzaga a Mantova* (Milan, 1975)

E. Verheyen: *The Palazzo del Te in Mantua: Images of Love and Politics* (Baltimore and London, 1977)

E. Gombrich: *The Sala dei Venti in the Palazzo del Te: Symbolic Images*, Studies in the Art of the Renaissance (London, 1985)

S. Nassari: *Giulio Romano pinxit et delineavit: Opere grafiche autografe di collaborazione e bottega* (Rome, [*c.* 1993])

B. Bockmann: 'Die Fassade von San Sebastiano in Mantua: Neue Dokumente', *Kstchron.*, xlvii/9 (Sept 1994), pp. 537–42

D. Bodart: 'Tiziano, Federico Gonzaga e l'affare delle terre del Trevigiano', *Quad. Pal. Te*, ii (1995), pp. 26–33

C. M. Brown and G. Delmarcel: *Tapestries for the Courts of Federico II, Ercole and Ferrante Gonzaga, 1522–63* (Seattle and London, 1996)

<div style="text-align:right">ANABEL THOMAS</div>

(9) Cardinal **Ercole Gonzaga** (*b* Mantua, 1505; *d* Trento, 2 March 1563). Son of (7) Francesco II Gonzaga. He was destined for an ecclesiastical career and in May 1521 succeeded his uncle Sigismondo Gonzaga as Bishop of Mantua. At the insistence of his mother, Isabella d'Este, he went to Bologna in December 1522 to complete his education and in 1525 went to Rome, where he was made a cardinal in 1526 through Isabella's influence. In 1540 he became Regent of the Mantuan state after the death of his brother (8) Federico II Gonzaga, 5th Marchese and 1st Duke of Mantua, whose heir, Francesco Gonzaga (1533–50), was only seven years of age. After Francesco's death, Ercole again became regent, this time for the future 3rd Duke, (13) Guglielmo Gonzaga. In both cases Ercole's administration was astute. After the death of Pope Paul IV (1559), he was a favourite candidate for the papacy, but the opposition of the Farnese prevented his election. In 1561 he presided over the Council of Trent and guided the proceedings with great sagacity.

His patronage, both official and personal, was motivated by his passionate belief that the arts could serve the Counter-Reformation. He appointed Giulio Romano prefect of the Fabbriche Ducali. Giulio was as great an asset to Gonzaga prestige as Alberti and Mantegna had been. His great skill at modernizing existing buildings was shown in the modifications (begun 1545) to the cathedral of S Pietro, Mantua. The relatively cramped Romanesque interior was transformed so that, in accordance with Counter-Reformation thought, the liturgy could be observed by the whole congregation. At the same time his plans satisfied the Cardinal's wish to spend as modestly as possible and to leave the aspect of the Piazza Sordello unchanged. The completion of the project was the climax of a programme of church improvements initiated by Ercole in the diocese of Mantua, although Vasari emphasized that this project attracted Ercole's particular interest (*see* GIULIO ROMANO). Giulio was involved in producing designs not only for the modification of buildings but also for smaller objects for Ercole (e.g. design for a salt cellar; Oxford, Christ Church). A few days after Giulio's death in 1546, Ercole wrote to his brother (10) Ferrante Gonzaga: 'The most grievous loss of our Giulio Romano hurts me so much that I seem to have lost my right hand I tell myself that the death of that rare man will at least have helped me by ridding me of the appetite for building, for silverware, for paintings etc.' In 1549 GIOVANNI BATTISTA BERTANI assumed responsibility for overseeing the ducal buildings. He also published (1558) a translation of Vitruvius's commentary on the Ionic order, which he dedicated to Ercole.

It is known that Ercole commissioned paintings from Titian, Veronese, Battista dell'Angolo del Moro, Domenico Brususorci and Paolo Farinati; most of these commissions were related to the decoration of the newly refurbished cathedral. Other well-known artists who worked for the Cardinal included BENVENUTO CELLINI, who made a seal—known only from the sealing wax

impression of it on six manuscripts in the Curia Vescovile, Mantua.

BIBLIOGRAPHY

G. Coniglio: *I Gonzaga* (Milan, 1967/*R* Varese, 1987), pp. 294–318, 501–8

M. Cattafesta: *Mantovastoria* (Mantua, 1974/*R* 1984), pp. 211–13, 544

C. Mozzarelli: *Mantova e i Gonzaga dal 1382 al 1707* (Turin, 1987), pp. 51–84, 133–9

C. M. Brown: 'Painting in the Collection of Cardinal Ercole Gonzaga after Michelangelo's Vittoria Colonna drawings and by Bronzino, Giulio Romano, Fermo Ghisoni, Parmigianino, Sofonisba Anguissola, Titian and Tintoretto', *Atti del convegno internazionale di studi su Giulio Romano e l'espansione europea del Rinascimento: Mantova, 1989*

<div style="text-align:right">GORDON MARSHALL BEAMISH</div>

(10) **Ferrante** [Ferdinando] **Gonzaga** [Principe di Ariano; Duca di Traetto; Duca di Molfetta; Lord of Guastalla] (*b* Mantua, 28 Jan 1507; *d* Brussels, 16 Nov 1557). Son of (7) Francesco II Gonzaga. He had a distinguished military career in the service of the Holy Roman Emperor Charles V (*reg* 1519–56), to whose court in Spain he was sent to be a page in 1523. Returning to Italy in 1526, he fought alongside the imperial troops in the Sack of Rome in May 1527 and was, as Commander-in-Chief of the forces of Charles V, present at the siege of Florence in August 1530. In 1530 he married Isabella da Capua, Princess of Molfetta (*d* 1559). When Charles V made Ferrante a Knight of the Golden Fleece in 1531, the latter's ceremonial collar was designed by Giulio Romano. In 1533 Ferrante commissioned Sebastiano del Piombo to produce a painting as a diplomatic gift for Francisco de los Cobos, secretary to Charles V. It was a *Pietà* (Seville, Casa Pilatos) for de los Cobos's funerary chapel in S Salvador, Ubeda, Andalucia, and was completed by 4 October 1539. Sebastiano also produced a copy of the painting for Ferrante.

Ferrante was Viceroy of Sicily (1535–46) and then Governor of Milan (1546–55). He initiated a number of military building projects, including the fortifications of Guastalla, and in 1549 he employed the architect Domenico Guinti ('da Lodi') to supervise the urban development of Guastalla. Ferrante was involved, *c.* 1545, with his brother (9) Cardinal Ercole's plans for Giulio Romano to remodel the interior of Mantua Cathedral and contributed a considerable sum to the project. Ferrante also had a taste for the intricate and bizarre; this is reflected in his commissions for applied arts from Giulio Romano and Leone Leoni. During the 1540s the former produced for Ferrante a number of designs for silverwork; correspondence between Ferrante and the artist for the years 1542–6 make reference to these. Designs for a covered dish (Chatsworth, Derbys) and a salt-cellar (London, V&A, E. 5131–1910) possibly date from this period. Leoni produced a double-sided lead medal (diam. 71 mm, *c.* 1555; London, BM) of Ferrante wearing the collar of the Order of the Golden Fleece, the reverse depicting *Hercules Destroying the Hydra*. Ferrante died from injuries received at the battle against the French at St Quentin (Aug 1557). His body was transported back to Mantua, and he was buried in the wall of the sacristy of Mantua Cathedral.

BIBLIOGRAPHY

A. de Ulloa: *Vita del valorosissimo e Gran Capitano Don F. Gonzaga, Principe di Molfetta* (Venice, 1563)

G. Campori: 'Sebastiano del Piombo e Ferrante Gonzaga', *Atti e memorie delle R. R. Deputazioni di storia patria per le provincie modenesi e parmensi*, ii (Modena, 1864), pp. 193–8

T. Cagnolati: *Il crepuscolo di Ferrante Gonzaga* (Reggio Emilia, 1928)

M. Hirst: 'Sebastiano's Pietà for the Commendador Mayor', *Burl. Mag.*, cxiv (1972), pp. 585–6

C. M. Brown and G. Delmarcel: *Tapestries for the Courts of Federico II, Ercole and Ferrante Gonzaga, 1522–63* (Seattle and London, 1996)

HELEN GEDDES

(11) Vespasiano Gonzaga, Duca di Sabbioneta (*b* Fondi, 6 Dec 1531; *d* Sabbioneta, 26 Feb 1591). He was the only son of Luigi Gonzaga (1500–32), called Rodomonte, Lord of Sabbioneta, and Isabella Colonna (*d* 1570). Vespasiano married firstly, in 1549, Diana de Cardona; secondly, in 1567, Anna of Aragon (*d* 1567); and lastly, in 1582, Margherita Gonzaga (*d* 1628). He was educated at Naples by his aunt Giulia Gonzaga. He had a distinguished military career in imperial and Spanish service and between 1568 and 1577 was employed by Philip II, King of Spain (*reg* 1556–98). Through his campaigns he acquired a practical knowledge of military architecture and urban planning and in the 1550s he began developing SABBIONETA (19 km south-west of Mantua), both as a fortress and as a civic and administrative centre. He wished to create an ideal city and an artistic centre to rival Mantua. He established a Hebrew printing press and opened a renowned mint (1558–91). He was given a dukedom by Emperor Rudolf II (*reg* 1576–1612) in 1577 and, after his return from Spain in the same year, he embarked on an extensive urban planning programme in Sabbioneta, which he personally supervised. During this period the Villa or Casino (begun 1577), the Corridor Grande, the Porta Imperiale (1579) and the churches of the Assunta (begun 1580) and Incoronata (begun 1586), as well as a hospital, a school and private housing, were built. He built a private residence, the Palazzo del Giardino (1584), decorated with frescoes depicting antique mythological subjects by Bernardino Campi and followers of Giulio Romano. In 1588 Vespasiano commissioned a theatre to be built for the Gonzaga court; it was designed by the architect Vincenzo Scamozzi (*see* SCAMOZZI, (2), fig. 2), and work began in 1590.

In 1556 Vespasiano had begun collecting Gonzaga portraits, and the Sala degli Antenati in the Palazzo Ducale (begun 1554) was decorated by Alberto Cavalli *c.* 1575 with stucco representations of his ancestors. Around 1587 Vespasiano commissioned 12 wooden figures on horseback (four extant; Sabbioneta, Pal. Ducale) of himself and his forebears from a Venetian wood-carver, as yet unidentified. In the polychrome equestrian statue of *Vespasiano Gonzaga* (2.52×2.18×1.10 m), he wears the insignia of the Order of the Golden Fleece bestowed on him in 1585 by Philip II. According to Vasari, Vespasiano possessed a *St Jerome* and a *Nativity* by Giulio Romano. The Galleria degli Antichi (begun 1583), adjacent to the Palazzo del Giardino, was also built to house his collection of antique sculptures. Vespasiano was buried in the church of the Incoronata, Sabbioneta, in a monumental tomb designed and executed by Giovanni Battista della Porta. The seated bronze statue of him dressed in Roman armour by Leone Leoni (probably executed 1574–7), formerly in the Piazza Grande in front of the Palazzo Ducale, was incorporated into the sepulchral monument in 1592.

BIBLIOGRAPHY

I. Affo': *Vita di Vespasiano Gonzaga* (Parma, 1780/*R* Mantua, 1975)

A. Carli: *Vespasiano Gonzaga, duca di Sabbioneta* (Florence, 1878)

G. Guidetti: *La zecca di Sabbioneta* (Mantua, 1966)

K. W. Forster: 'From "Rocca" to "Civitas": Urban Planning at Sabbioneta', *L'Arte*, ii/1 (1969), pp. 5–40

G. Guidetti: *Vespasiano Gonzaga nei suoi stemmi, motti, sigilli* (Reggio Emilia, 1970)

G. Faroldi: 'Vita di Vespasiano Gonzaga Colonna, duca di Sabbioneta', *Sabbioneta e Vespasiano Gonzaga*, ed. E. Marani (Sabbioneta, 1977)

M. Bini, ed.: *Sabbioneta, piccola reggia padana* (Modena, 1994)

HELEN GEDDES

(12) Cesare Gonzaga (*b* Mantua, 1536; *d* Guastalla, 1575). Son of (10) Ferrante Gonzaga. He inherited the titles Principe di Ariano, Duca di Molfetta and Lord of Guastalla from his father. Cesare served Philip II (*reg* 1556–98) as Captain General of the imperial troops in Lombardy and in 1560 married Camilla (*d* 1582), eldest daughter of Carlo Borromeo, Archbishop of Milan. His activity as a patron included employing Francesco da Volterra to complete work on Guastalla and commissioning from Leone Leoni a life-size cast-bronze statue of *Ferrante Gonzaga*, which dominates the Piazza Mazzini, the main square of the town. Giorgio Vasari described at length the 'ravishing antiquarium and studio made by il signor Cesare Gonzaga' in the family palace at Mantua, which was on the site of the present Accademia Nazionale Virgiliana and which also contained two celebrated pictures attributed to Raphael but actually by Giulio Romano: the *Virgin with the Cat* (Naples, Capodimonte) and the *Virgin with the Basin* (Dresden, Gemäldegal. Alte Meister). The Classical marbles of the collection were described by Ulisse Aldrovandi (MS., Bologna U., Fond. Aldrovandi). The centrepiece of the antiquarium was an elaborate coin cabinet inset with semiprecious stones and embellished with marble colonnettes and antique statuettes, the acquisition of which was the subject of several letters to Cesare Gonzaga from his archaeological adviser in Rome, Bishop Girolamo Garimberto. These letters, which mention other acquisitions and discuss the restoration of a group of antique heads acquired by Cesare when he was in Rome (1560–62), provide remarkable insights into the contemporary Roman art market.

On Cesare's death, a comprehensive inventory of the contents of his gallery was compiled, thus making his short-lived collection (which was moved to Guastalla by his son and heir Ferrante II Gonzaga in 1587) better documented than many others of the period. With the dispersal of the collection, first in 1671, when half the antiquities were shipped to Mantua, then in 1746, after the extinction of the Gonzaga of Guastalla line, it is virtually impossible to identify any of the objects Cesare owned, though it is possible to identify types. For example the 'satyr with a youth . . . teaching the youth to play the panpipes' was clearly a Roman copy of the late Hellenistic *Pan with Apollo* by Heliodorus (Rome, Mus. N. Romano).

BIBLIOGRAPHY

D. A. Franchini and others: *La scienza a corte: Collezionismo eclettico nature e immagine a Mantova fra Rinascimento e Manierismo* (Rome, 1979), pp. 188–91 [transcription of Aldrovandi's MS.]

C. M. Brown with A. M. Lorenzoni: *Cesare Gonzaga and Gerolamo Garimberto: Two Renaissance Collectors of Greco-Roman Art* (London and New York, 1993)

C. M. BROWN

(13) Guglielmo Gonzaga, 3rd Duke of Mantua (*b* Mantua, 1538; *reg* 1550–87; *d* Goito, 14 Aug 1587). Son of (8) Federico II Gonzaga. The early death of Francesco Gonzaga, 2nd Duke of Mantua (1533–50), meant that, for the second time, (9) Cardinal Ercole Gonzaga was Regent. His influence was considerable: the young Guglielmo fervently supported the Counter-Reformation. He married Eleonora of Austria (1534–95) in 1561, thus reaffirming the Habsburg link. His patronage was chiefly concerned with ecclesiastical building and liturgical music. Like his uncle Ercole, Guglielmo believed the arts were a potent force in the aims of the Counter-Reformation; this was most strongly manifest in the construction, decoration and liturgical operations of the palatine basilica of S Barbara (1561–72) in Mantua. Giovanni Battista Bertani supervised the project. Pope Pius IV conferred special status on the basilica, which thus had its own liturgy, missal and breviary; the furnishings, including a fine organ by Graziadio Antegnati of Brescia, and relics were of high quality and importance. Mantua thus gained considerable prestige. The dominance of the S Barbara project created a conservative environment at court, which changed dramatically after Guglielmo's death.

BIBLIOGRAPHY
G. Coniglio: *I Gonzaga* (Milan, 1967/*R* Varese, 1987), pp. 319–55, 501–8
M. Cattafesta: *Mantovastoria* (Mantua, 1974 /*R* 1984), pp. 215–23, 545
C. Mozzarelli: *Mantova e i Gonzaga dal 1382 al 1707* (Turin, 1987), pp. 61–89, 133–9
P. Carpeggiani: *Bernardino Facciotto: Progetti cinquecenteschi per Mantova e il Palazzo Ducale* (Milan, 1994)

GORDON MARSHALL BEAMISH

Gottardo de Scottis [Scotti] (*b* Piacenza; *fl* Milan, 1454–85). Italian painter. He is first documented in 1454 as a native of Piacenza. Between 1456 and 1470 he appears frequently in the account-books of Milan Cathedral working on commissions from various members of the Sforza court. He is also recorded working for the Borromeo family during the same period. His work seems to have consisted of minor tasks, such as the gilding of statues and the design of processional banners and embroidered altarcloths.

In 1472 Gottardo and the painter Giacomo Vismara (*fl* 1470s) estimated Zanetto Bugatto's frescoes in S Maria delle Grazie outside Vigevano. He may have been at work on Duke Galeazzo Maria Sforza's chapel in the Castello Sforzesco, Milan, in 1473 and was part of the team that painted the ducal chapel in Pavia in 1474. In 1475 he was commissioned to paint a *Maestà* (untraced) for the high altar in Milan Cathedral and was listed as a member of the Milanese painters' guild in 1481. In 1485 he was referred to as painter to the cathedral. Only two pictures can reasonably be ascribed to the artist. The first, a triptych of the *Madonna of Mercy* (Milan, Mus. Poldi Pezzoli), is signed *Gotardu[s] [de] [S]cotis de Mello Pinsit* ('Mello' is probably an abbreviation for Milan). It is a competent work showing the influence of Vincenzo Foppa in its heavy figures and detailed architectural forms. Similar characteristics can be seen in four small panels of the *Annunciation, Nativity, Massacre of the Innocents* and *Christ among the Doctors* (Milan, Cologna priv. col.), which have been convincingly attributed to Gottardo.

BIBLIOGRAPHY
F. Malaguzzi-Valeri: *Pittori lombardi del quattrocento* (Milan, 1902)
G. Biscaro: 'Note di storia dell'arte e della cultura a Milano dai libri mastri Borromeo, 1427–1478', *Archv Stor. Lombardo*, xvi (1914), pp. 72–108
M. Salmi: 'Bernardino Butinone', *Dedalo*, x (1929–30), p. 401
M. Natale: *Museo Poldi Pezzoli: Dipinti* (Milan, 1982), pp. 72–4

E. S. WELCH

Gozzoli, Benozzo [Benozzo di Lese] (*b* Florence, *c.* 1420–22; *d* Pistoia, 4 Oct 1497). Italian painter. He was one of the most prolific fresco painters of his generation. Active principally in Tuscany, but also in Umbria and Rome, he had a facility for satisfying current tastes that secured him a steady stream of commissions throughout his career.

1. Life and work. 2. Working methods and technique.

1. LIFE AND WORK. The origin of the name Gozzoli is unclear. Vasari first appended it to Benozzo in the second edition (1568) of the *Vita* without explanation.

Benozzo's earliest recorded work is an *Ascension of Christ* (1439; untraced) painted for a shroud for the Confraternity of S Maria delle Laudi e di Sant'Agnese affiliated to S Maria del Carmine, Florence. He may have trained as a painter with Fra Angelico, and his hand has been identified in some of the cell frescoes (*c.* 1440–45) in S Marco, Florence. On 24 January 1445 he signed a contract with Lorenzo Ghiberti and Vittorio Ghiberti I to work for three years on the east doors of the Florentine Baptistery. Although in the contract he is described as a painter, he appears to have assisted with the chasing of the cast panels and decorative borders of the doors. In 1447 Benozzo broke his contract with the Ghiberti workshop and went to Rome to join Fra Angelico as his chief assistant on the decoration of the chapels of S Pietro (destr.) and Pope Nicholas V in the Vatican palace. In summer 1448 he assisted Fra Angelico on the chapel of S Brizio in Orvieto Cathedral. He was unsuccessful in his application to continue the S Brizio frescoes when he returned to Orvieto in 1449, but he did receive some private commissions in that town. A panel of *St Ursula* (Washington, DC, N.G.A.) probably dates from this time.

Benozzo's earliest signed and dated work is the fresco of the *Virgin and Child Enthroned* (1450; partially destr.) in S Fortunato near Montefalco, Umbria. In the same church he painted frescoes of *St Fortunatus Enthroned* (above the altar) and of the *Virgin and Child with Saints* (in a lunette above the entrance). He also painted an altarpiece of the *Virgin Presenting a Girdle to St Thomas* (Rome, Pin. Vaticana). Although its five predella scenes of the *Life of the Virgin* are conventional in iconography and narrative organization, their compositional coherence illustrates a grasp of formal design that was developed in later, larger works.

While still in Montefalco, Benozzo completed, in 1452, two fresco cycles in S Francesco: in the chapel of St Jerome (partially destr.), which appears to be largely the work of assistants; and in the choir, where he painted 12 scenes from the *Life of St Francis*. In the latter he achieved a balance between formal and iconographic demands in the sequence of episodes and organization of scenes, which were selected to emphasize the parallel between the life of Christ and that of St Francis. Although Benozzo

did not use pictorial space for narrative ends in as complex a way as Paolo Uccello or Piero della Francesca, he was conscious of its dramatic potential. The scene of *St Francis Receiving the Stigmata* is divided between lunettes so that the divine rays from the seraph, in the lunette above the single window of the central wall, appear to cut across the corner of the vault to St Francis kneeling in the lunette on the right. The visual impact is heightened by the lighting of the scene, which corresponds with the fall of natural light.

In 1453 Benozzo painted a fresco cycle (destr. 1632) in the Franciscan church of S Rosa, Viterbo. Watercolours exist (Viterbo, Mus. Civ.) that show densely crowded compositions and architecture that is overtly antique in character. An altarpiece completed three years later for the Compagnia di S Girolamo, Perugia (1456; Perugia, G.N. Umbria), may have been painted in Rome, where Benozzo was employed before 1458 on a fresco cycle (destr.) of the *Life of St Anthony of Padua* in the Albertini family chapel, S Maria in Aracoeli. The frescoed altarpiece of *St Anthony with Donors* survives.

In 1459 Benozzo began work in Florence on frescoes in the private chapel of the Palazzo Medici; they were probably finished in 1461. The *Journey of the Magi* covers three walls of the chapel, while in the sanctuary ranks of angels look towards the altarpiece of the *Virgin Adoring the Christ Child*. Three separate processions wind across rocky terrain and fertile valleys. The high horizon level of the frescoes, the compact groups of figures and the decorative pageantry recall tapestries. The cycle further differs from other frescoes executed by the artist in the extensive use of rich colours such as azure, vermilion and gold (see colour pl. 1, XXXV2), reflecting the taste of the patron Piero de' Medici. Benozzo frequently introduced portraits into his work, for contemporary interest and variety. Here, members of the Medici family have been identified in the young king's procession, which includes a self-portrait of the artist; the words *Opus Benotii* are on the border of his red cap. The treatment of their features, and of other portrait heads in the retinues, distinguishes them from the standardized faces of the kings and pages. Benozzo wrote three letters to Piero de' Medici about this commission, acknowledging Piero's criticism of cherubim, informing him of his progress and requesting money to buy more materials.

In 1461 Benozzo was commissioned to paint an altarpiece, the *Virgin and Child Enthroned with Saints and Angels* (London, N.G.; see fig. 1), for the Confraternity of the Purification, affiliated to S Marco, Florence. The contract stipulated that the composition of the main panel was to be based on Fra Angelico's high altarpiece in S Marco. In contrast to the main panel, the predella scenes (London, N.G.; Berlin, Gemäldegal.; Washington, DC, N.G.A.; Milan, Brera; Philadelphia, PA, Mus. A.), with stories of the attendant saints, are more inventive and anecdotal.

Two years later Benozzo was commissioned by Domenico Strambi, a distinguished Augustinian theologian, to paint a cycle of 17 scenes from the *Life of St Augustine* (1463–5) in the choir of S Agostino, San Gimignano. The two most important events in the saint's life, his *Conversion to Christianity* and his *Baptism* (April 1464), occupy the

central register of the altar wall. In *Augustine Teaching Rhetoric in Rome* (see fig. 2), the students are arranged around the central seated figure of Augustine. Their symmetrical grouping is emphasized by the antique architecture, but the solemnity is relieved by the animated facial features of the figures and by the small dog in the foreground. Despite an interruption of the work by an outbreak of plague in the town in 1464, Benozzo was able to complete, in addition to the Augustinian cycle, two frescoed, votive images of *St Sebastian*, in S Agostino and in the Collegiata.

In 1465 Benozzo served on a committee with Alesso Baldovinetti and Neri di Bicci to evaluate a fresco of *Dante* by Domenico di Michelino in Florence Cathedral. The following year he was contracted to work in the Palazzo Comunale, San Gimignano, on, among other projects, the restoration of Lippo Memmi's *Maestà* (1317; *in situ*). The frescoed tabernacles in the Tuscan towns of Monteoliveto, Certaldo and Castelfiorentino of this date are substantially the work of assistants, two of whom are recorded by name: Andrea di Giusto and Pier Francesco Fiorentino.

Benozzo's most ambitious undertaking was the completion of the 14th-century fresco decoration in the Camposanto, Pisa, which, according to Vasari, would have daunted a 'legion of painters'. Benozzo's trial piece, the *Drunkenness of Noah*, was approved in 1468, and he was commissioned to paint a further 24 scenes from the Old Testament. In the use of anecdotal detail, the scenes relate closely to the contemporary frescoes of Domenico Ghirlandaio and Cosimo Rosselli in the Sistine Chapel. Benozzo continued to work on the cycle until at least 1484. The frescoes suffered severe damage in 1944 but have been recorded in 19th-century engravings and photographs (Pisa, Camposanto).

While in Pisa, Benozzo also painted a fresco cycle (destr.), an altarpiece (Pisa, Mus. N. S Matteo) for the nuns of S Benedetto, and a panel of the *Triumph of St Thomas Aquinas* (Paris, Louvre), originally placed behind the Bishop's throne in the cathedral. Dating from the same period are frescoed tabernacles in the north Tuscan towns of Legoli and Castelnovo d'Elsa, and a fresco of the *Journey of the Magi* in the chapel of the Addolorata, Volterra Cathedral. The artist relied increasingly on assistants in his later works.

Benozzo's last years were divided between Pisa, Florence and Pistoia. In 1497 he evaluated frescoes by Alesso Baldovinetti in Santa Trìnita, Florence, together with Cosimo Rosselli, Pietro Perugino and Filippino Lippi. Two late works, a *Resurrection of Lazarus* (Washington, DC, N.G.A.) and a *Crucifixion* (Florence, Mus. Horne), were painted in Pistoia just before he died. He was buried in the cloister of the church of S Domenico.

Although Benozzo enjoyed considerable popularity among contemporaries, his influence on succeeding generations was limited. His style was assimilated by minor artists who may have worked as his assistants on projects outside Florence. It was not until the 19th century, when Carlo Lasinio's engravings of the frescoes in the Camposanto were published, that interest in Benozzo's work was renewed.

2. WORKING METHODS AND TECHNIQUE. Benozzo followed the traditional Florentine practice of working out

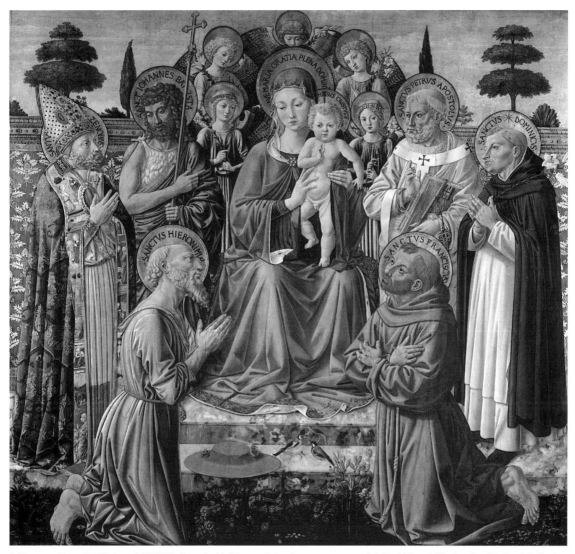

1. Benozzo Gozzoli: *Virgin and Child Enthroned with Saints and Angels*, tempera on panel, 1.62×1.70 m, 1461 (London, National Gallery)

ideas in small drawings that were then scaled up. He sometimes used cartoons to transfer drawings onto walls or panels, and there are traces of pouncing on some frescoes. The underdrawings of his frescoes vary from simple contours, which establish the scale and general configuration of the scene, to more precise shading and perspectival grids; these were often modified as the work progressed. Benozzo usually worked in true fresco (*buon fresco*), reserving the dry technique (*fresco a secco*) for such details as faces and architectural ornament.

Most of Benozzo's panel paintings were executed in egg tempera, but at least two of his last works from Pistoia, the *Resurrection of Lazarus* and the *Crucifixion*, are in oil. Compositions are based on standard formulae and rarely display the energy and inventiveness of the artist's narrative frescoes. Contours are sharply defined, and a lack of aerial perspective gives a hardness to the imagery.

Over 100 sheets of drawings have been attributed to Benozzo and his workshop. Some are related directly to specific projects; others may have been used as general reference material. Most were made on coloured grounds in silverpoint or pen and ink heightened with white. They are inconsistent in quality but at their finest have a confidence and sensitivity of handling seen, for example, in the preliminary studies of angels for the chapel in the Palazzo Medici (Harewood House, W. Yorks).

Benozzo tended to use well-tried solutions for his figures, often reusing drawings or repeating or reversing cartoons, which sometimes reduced his figures to stereotypes; he was not adventurous in his portrayal of emotional interaction. In his early work he subdivided scenes so that each narrative episode was confined to the limits of its setting. In his later cycles, at San Gimignano and Pisa, he extended the narrative field, allowing figure groups within a scene to share a common foreground. His scenes are sometimes overcrowded, and the scale of figures can be exaggerated in proportion to their setting. However, he achieved a visual harmony through his use of colour and

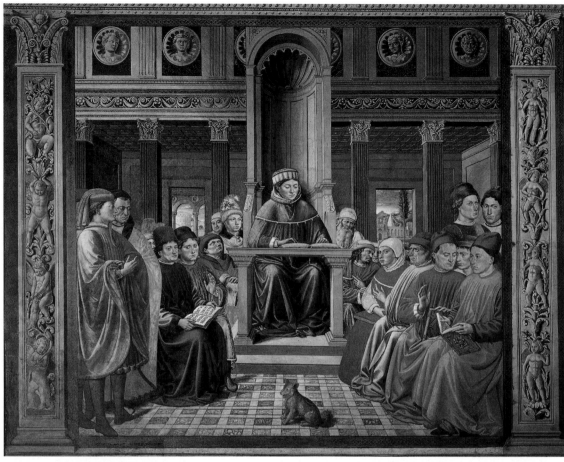

2. Benozzo Gozzoli: *Augustine Teaching Rhetoric in Rome* (1463–5), fresco, S Agostino, San Gimignano

design. The polychrome buildings of his paintings and their increasingly elaborate ornament, inspired by contemporary *sgraffito* and stucco decoration, complement the colourful costumes of the figures they frame. A palette of whites, light greens and pinks characterizes the Franciscan scenes at Montefalco, while bold maroons and blues dominate the Augustinian cycle at San Gimignano.

BIBLIOGRAPHY
G. Vasari: *Vite* (1550, rev. 2/1568); ed. G. Milanesi (1878–85), pp. 45–63
C. Lasinio: *Pitture a fresco del Camposanto di Pisa disegnate e incise* (Florence, 1812)
G. Gaye: *Carteggio inedito di artisti*, 8 vols (Florence, 1840), i, pp. 191, 209, 271
L. Pecori: *Storia di San Gimignano* (Florence, 1853/R Rome, 1975)
E. Müntz: *Les Arts à la cour des papes* (Paris, 1878)
———: *Les Arts à la cour des papes, nouvelles recherches* (Paris, 1884)
L. Fumi: *Il duomo di Orvieto* (Rome, 1891)
M. Wingenroth: *Die Jugendwerke des Benozzo Gozzoli* (Heidelberg, 1897)
E. Contaldi: *Benozzo Gozzoli* (Milan, 1928)
G. Hoogewerff: *Benozzo Gozzoli* (Paris, 1930)
M. Lagaisse: *Benozzo Gozzoli: Les Traditions trécentistes et les tendances nouvelles chez un peintre florentin du '400* (Paris, 1934)
P. Bargellini: *La fiaba pittorica di Benozzo Gozzoli* (Florence, 1946)
P. Pouncey: 'A Drawing by Benozzo Gozzoli for his Fresco Cycle at Viterbo', *Burl. Mag.*, lxxix (1947), pp. 9–13, 98
R. G. Mather: 'Documents Mostly New Relating to Florentine Painters and Sculptors of the Fifteenth Century', *A. Bull.*, xxx (1948), p. 40
E. Borsook: *The Mural Painters of Tuscany from Cimabue to Andrea del Sarto* (London, 1960, rev. Oxford, 2/1980), pp. x, xxxi, xliii–xliv, xlvi, l, 47, 107, 110–11

M. Bucci and L. Bertolini: *Camposanto monumentale di Pisa* (Pisa, 1960)
A. Boschetto: *Gli affreschi di Benozzo Gozzoli nella chiesa di San Francesco a Montefalco* (Milan, 1961) [excellent pls]
A. Grote: 'A Hitherto Unpublished Letter on Benozzo Gozzoli's Frescoes in the Palazzo Medici-Riccardi', *J. Warb. & Court. Inst.*, xxvii (1964), pp. 321–2
E. Gombrich: 'The Early Medici as Patrons of Art', *Norm and Form: Studies in the Art of the Renaissance*, i (London, 1966, rev. Oxford, 4/1985), pp. 35–57
P. Scarpellini: *Benozzo Gozzoli* (Milan, 1966)
B. Degenhart and A. Schmitt: *Corpus der italienischen Zeichnungen, 1300–1450*, 4 vols (Berlin, 1968), i, pp. ii–iv
E. Berti Toesca: *Benozzo Gozzoli: Gli affreschi della Cappella Medicea* (Milan, 1970) [excellent pls]
M. Meiss: *The Great Age of Fresco* (London, 1970), pp. 13, 56–7, 162, 228
A. Padoa Rizzo: *Benozzo Gozzoli: Pittore fiorentino* (Florence, 1972)
A. Caleca, G. Nencini and G. Piancastelli: *Pisa: Museo delle sinopie* (Pisa, 1979)
K. Christiansen: 'Early Renaissance Narrative Painting in Italy', *Met. Mus. J.* (1982), pp. 3–56
F. Ames-Lewis and J. Wright: *Drawing in the Italian Renaissance Workshop* (London, 1983)
S. Pasti: 'Lo scomparso ciclo di affreschi di S Rosa da Viterbo di Benozzo Gozzoli e la sua influenza nel Viterbese: Gli affreschi dell'Isola Bisentina', *Il '400 a Roma e nel Lazio: Il quattrocento a Viterbo* (Rome, 1983), pp. 159–78
D. Cole Ahl: 'Benozzo Gozzoli's Frescoes of the *Life of St Augustine* in San Gimignano: Their Meaning in Context', *Artibus & Hist.* (1986)
A. Padoa Rizzo: 'L'attività di Benozzo Gozzoli per la Compagnia di Santa Maria delle Laudi e di Sant'Agnese (1439, 1441)', *Riv. A.*, xli (1991–2), pp. 203–11
———: *Benozzo Gozzoli: Catalogo completo* (Florence, 1992)

C. Acidini Luchinot, ed.: *Benozzo Gozzoli: La Cappella dei Magi* (Milan, 1993); Eng. trans. as *The Chapel of the Magi: Benozzo Gozzoli's Frescoes in the Palazzo Medici-Riccardi, Florence* (London and New York, 1994)

F. Ames-Lewis: 'Benozzo Gozzoli's Rotterdam Sketchbook Revisited', *Master Drgs*, xxxiii/4 (Winter 1995), pp. 388–404

C. A. Luchinat: 'Benozzo Gozzoli's Chapel of the Magi Restored and Rediscovered', *Early Medici and their Artists*, ed. F. Ames-Lewis (London, 1995), pp. 125–33

D. Cole Ahl: *Benozzo Gozzoli* (New Haven and London, 1996)

R. J. Crum: 'Roberto Martelli, the Council of Florence and the Medici Palace Chapel: Reinterpretation of B. Gozzoli's Frescoes', *Z. Kstgesch.*, lix/3 (1996), pp. 403–17

AILSA TURNER

Granacci, Francesco (*b* Villamagna, 1469; *d* Florence, 30 Nov 1543). Italian painter and draughtsman. A contemporary of Michelangelo and Fra Bartolommeo, he trained in Florence, with Michelangelo, in the workshop of Domenico Ghirlandaio, and the two then studied sculpture in the Medici garden at S Marco (*see* FLORENCE, §V, 2) under the supervision of Bertoldo di Giovanni. After Ghirlandaio's death in 1492, Granacci completed the altarpiece of *St Vincent Ferrer* (Rimini, Pin. Com. & Mus. Civ.), probably executing the figure of St Roch. His first documented works date from *c.* 1515, but the paintings identified with his earlier period are executed in a competent, inexpressive version of Ghirlandaio's style. These include the *Holy Family* (Honolulu, HI, Acad. A.), which is awkwardly composed for the tondo format, and a conventional *Virgin and Child Enthroned with St John the Baptist and the Archangel Michael* (Berlin, Bodemus.). Ambitions for a more monumental style are apparent in the *Rest on the Flight into Egypt* (*c.* 1494; Dublin, N.G.), which is notable for its charming exotic setting and luminous colour. The sculptural emphasis and compact figure grouping in this painting may reflect Michelangelo's influence, although the suggestion that he supplied a sketch for the composition is no longer generally accepted. Four lively narrative scenes from the *Life of St John the Baptist* (Cleveland, OH, Mus. A.; Liverpool, Walker A.G.; New York, Met.), not entirely autograph, also probably date from this period. In 1508 Granacci went to Rome to assist Michelangelo in painting the ceiling of the Sistine Chapel in the Vatican but was dismissed after only a brief stay.

The paintings Granacci executed after his return to Florence increasingly reflected the contemporary Florentine classical style, particularly the works of Fra Bartolommeo. This is evident in two versions of the *Madonna della Cintola* (ex-Earl of Warwick priv. col., see Holst, 1974, fig. 36; Sarasota, FL, Ringling Mus.), in which he attempted with only partial success a compositional type derived from Fra Bartolommeo. In another painting of this period, of the *Virgin and Child Enthroned with Saints* (Florence, Accad.), the figures are more broadly modelled and again there are echoes of Bartolommeo, particularly in the upswept drapery in the background. A *Portrait of a Man in Armour* (London, N.G.), with a window view of Florence, is thought to date from this period.

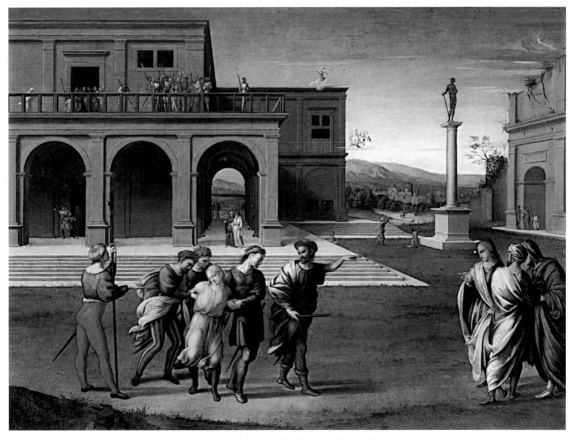

Francesco Granacci: *Arrest of Joseph*, oil on panel, 0.96×1.30 m. *c.* 1515 (Florence, Palazzo Davanzati)

According to Vasari, Granacci was often employed by the Medici to design scenery and festive decorations, including for the visit to Florence of Pope Leo X in 1515. His earliest documented works were painted soon after 1515, two scenes from the *Life of Joseph* from a series for the bedroom of PIERFRANCESCO BORGHERINI, to which Andrea del Sarto, Bachiacca and Pontormo also contributed. Granacci's scenes, *Joseph Presenting his Father to Pharaoh* (Florence, Uffizi) and the *Arrest of Joseph* (c. 1515; Florence, Pal. Davanzati; see fig.), are sparely populated with small figures in precisely drawn architectural settings. Although the treatment is essentially conservative, recalling *cassone* decorations of the 15th century, the attenuation of the figures and their mannered poses, particularly in the *Arrest*, suggest influence from Pontormo. No hint of Mannerism appears in his painting of the *Trinity* (Berlin, Bodemus.) surrounded by sentimentally pretty putti, also painted for the Borgherini bedroom. A major altarpiece of this period, the *Virgin and Child with SS Francis and Zenobius* (Florence, Accad.), executed for the convent of S Gallo, again evokes the classicism of Bartolommeo, here with increased ease and coherence and more subtle modelling of the figures. This greater assurance is also apparent in the *Holy Family* (Duke of Buccleuch priv. col.), one of a number of compositions based on the Dublin *Rest on the Flight* (e.g. Greenville, SC, Bob Jones U. Gal. Sacred A.).

Around 1517 Granacci was again in contact with Michelangelo, who, according to Vasari, provided him with the design for the central panel (untraced) of his high altarpiece for the convent of S Apollonia in Florence. Four side panels for this altarpiece survive, half-length figures of *St Apollonia, St Jerome, St John the Baptist* and *Mary Magdalene* (all Munich, Alte Pin.), as well as an *Annunciation* (Corsham Court, Wilts) and predella panels showing scenes of martyrdom (Florence, Accad. and I Tatti). The fuller figure types on the four panels of saints and their elaborate drapery support Vasari's account of Michelangelo's involvement. In the predella panels the figures are treated with greater freedom, and their tapering limbs and small heads are clearly indebted to Pontormo, although they lack his expressive intensity. Such slender tapered figures also appear in Granacci's painting of the *Entry of Charles VIII into Florence* (Florence, Uffizi), possibly commissioned in connection with the wedding in 1518 of Lorenzo de' Medici.

Unlike Pontormo and other younger artists, Granacci confined his use of Mannerist elements mainly to small-scale works and continued to follow conventional formulae in his major paintings, notably in the *Virgin and Child with Four Saints* (Montemurlo, Pieve), commissioned in 1521. A delicately drawn *Sacra conversazione* (London, BM) shows a composition similar to the Montemurlo Altarpiece. In the *Pietà with SS Peter and Stephen* (c. 1525; Fiesole, S Pietro a Quintole), the ungainly central group recalls northern European examples rather than Michelangelo's supple sculpted version (Rome, St Peter's; *see* MICHELANGELO, fig. 1). An appealing lunette of the *Adoration of the Shepherds* (Florence, SS Annunziata) includes figures repeated from his fresco of the subject (Monte Acuto, Villa Blasi Foglietti), notably the wistful St Joseph leaning on his staff. Perhaps the most impressive

work of Granacci's maturity is the *Virgin in Glory with Saints* (Florence, Accad.), painted for the high altar of S Giorgio dello Spirito Santo, Florence, a graceful, balanced version of the Fra Bartolommeo composition he had attempted earlier. Among his later works is a depiction of a mass crucifixion, the *Martyrdom of the Ten Thousand* (Florence, S Simone).

In Vasari's account of his life, Granacci is described as an easygoing character who avoided undue thought or effort. This view seems to be borne out by the derivative nature of much of his work and by his frequent repetition of compositions. His drawings, particularly those in chalk (Florence, Uffizi), and some of his small-scale works show a liveliness lacking in his larger paintings. Although there are indications in his work that he was attentive to the innovations of younger painters, his response was superficial, an adoption of detail rather than substance, and never seriously challenged his allegiance to the tradition in which he was trained.

BIBLIOGRAPHY

Thieme–Becker

G. Vasari: *Vite* (1550, rev. 2/1568); ed. G. Milanesi (1878–85), v, pp. 339–45

J. A. Crowe and G. B. Cavalcaselle: *A New History of Painting in Italy* (London, 1866), iii, pp. 534–41

S. Freedberg: *Painting of the High Renaissance in Rome and Florence* (Cambridge, MA, 1961), pp. 75–6, 211–12, 490–95

F. Zeri: 'Eccentrici fiorentini', *Boll. A.*, 2nd ser., xlvii/1 (1962), pp. 227–36

C. von Holst: 'Three Panels of a Renaissance Room Decoration at Liverpool and a New Work by Granacci', *Annu. Rep. & Bull., Walker A.G., Liverpool*, i (1970–71), pp. 32–7

——: *Francesco Granacci* (Munich, 1974) [full bibliog.]

A. Braham: 'The Bed of Pier Francesco Borgherini', *Burl. Mag.*, cxxi (1979), pp. 754–65

Il primato del disegno (exh. cat., ed. L. Berti; Florence, Pal. Strozzi, 1980), pp. 124–5

G. Briganti, ed.: *La pittura in Italia: Il cinquecento* (Milan, 1987, rev. 1988), pp. 303, 736–7

Making and Meaning: The Young Michelangelo (exh. cat. by M. Hirst and J. Dunkerton, London, N.G., 1994)

LUCINDA HAWKINS

Grandi. Italian family of sculptors and bronze-casters from Vicenza, active there and elsewhere in the Veneto *c.* 1507–*c.* 1570. Lorenzo Grandi and his son the stone-cutter Gian Matteo Grandi (*d* 1545) both probably helped to train Lorenzo's younger son, Vincenzo (di Lorenzo) Grandi (*b* Vicenza, before 1500; *d* Padua, before 2 Aug 1578). Vincenzo would later work with Gian Matteo's son, Gian [Giovanni] Girolamo Grandi (*b* ?Vicenza, 1508; *d* Padua, 23 March 1560). By 1507 Vincenzo was in Padua, where he is recorded working on architectural ornament for a house belonging to Francesco dei Candi. In 1521, together with Gian Matteo, he completed the architectural elements of the monument to *Bishop Antonio Trombetta* (Padua, Il Santo), its bronze bust being executed by Andrea Riccio. The double cornucopia-like console supporting the niches of the monument is strongly reminiscent of the ornament used in the Lombardo family's architecture. In 1527 Vincenzo was paid for a *Lion of St Mark* for the Loggia del Consiglio, Padua.

From the late 1520s Vincenzo collaborated increasingly with his nephew, Gian Girolamo, and in 1532 they executed a fireplace for the Sala Grande of the newly restored Trent Castle, the residence of the Prince-Bishop

Bernardo Cles (1485–1539). The following year several Paduan sculptors were summoned to Trent and a workshop set up: the marble workers were under Vincenzo's direction, the bronze workers under Gian Girolamo. Several projects for architectural decoration in the castle were executed by the workshop, including the portal of S Virgilio. During this period the Grandi were also commissioned by Giovanni Antonio Zurletta to produce one of their most successful works, the marble *Cantoria* ('*Singing Gallery*') for S Maria Maggiore, on which they worked until 1542. The richly carved marble foliage of the architecture, narratives, putti and niche figures of the *Sibyls*, as well as Gian Girolamo's assured classical bronze portrait medallions on the underside of the *Cantoria*, attest to the sculptors' familiarity with the sculpture recently executed by Tullio Lombardo among others in the Cappella del Santo in Padua. Gian Girolamo's bronze-casting during his period in Trent included a number of domestic objects, such as a small bucket and a doorknocker, both with the arms of Cardinal Cles (both Trent, Mus. Prov. A.), as well as handbells and book cover decorations.

By 1542 Vincenzo and Gian Girolamo had returned to Padua, where they were assigned the final relief for the Cappella del Santo. The commission was never fulfilled, however, and the relief was eventually re-assigned in 1554 to Paolo Pelucca (*fl* 1554), a minor Florentine sculptor, although Gian Girolamo did complete a classicizing pilaster for the same chapel in 1542. Evidence of a bronze workshop in Padua is provided by the commission in 1544 from the Chapter of Padua Cathedral for a tabernacle (destr.) in bronze and marble. The next year the Grandi were active on the monument to *G. Antonio de' Rossi* (Padua, Chiostro del Noviziato al Santo, ex-S Giovanni di Verdara). Its architectural design by Vincenzo relates to their earlier *Trombetta* monument; the portrait bust of de' Rossi was executed by Gian Girolamo. The monument to *Simone Ardeo* (1548; Padua, Il Santo) has also been attributed, without documentation, to the Grandi; it was designed to emulate the nearby *Trombetta* monument, although its more sophisticated classicism suggests that it was designed by Gian Girolamo alone. His signed and dated monument to *Fra Girolamo Confalonieri* for the former church of the Crociferi, Padua (1549; moved to S Maria Maddalena; destr.), was highly praised (Petrucci, p. 142 and Rossetti, p. 250). After his nephew's death in 1562, Vincenzo was unsuccessful in securing Danese Cattaneo's uncompleted commission in the Santo, but may have been responsible for the tomb of *Isabella Alidosio* (1571) and the tomb of *Ippolito da Porto* (1572; both Vicenza, S Lorenzo).

BIBLIOGRAPHY
G. B. Rossetti: *Descrizione delle pitture, scultore ed architetture di Padova*, 2 vols (Padua, 1765)

N. Petrucci: *Biografie degli artisti Padovani* (Padua, 1858)

F. Cessi: *Vincenzo e Gian Girolamo Grandi, scultori (secolo XVI)* (Trent, 1967) [for earlier bibliog.]

S. Blake Wilk: 'La decorazione cinquecentesca della Cappella dell'Arca di S. Antonio', *Le sculture del Santo di Padova*, ed. G. Lorenzoni (Vicenza, 1984), pp. 109–72

Il 'Magno Palazzo' di Bernardo Cles, Principe Vescovo di Trento (exh. cat. by E. Chini and F. de Grammatica, Trent, Pal. Magno, 1985), pp. 32, 68

Bernardo Cles e l'arte del rinascimento nel Trentino (exh. cat., ed. E. Chini; Trent, Castello Buonconsiglio, 1985–6), pp. 142, 148–9, 182

ANTONIA BOSTRÖM

Grandi, Ercole (*b* Ferrara, *c.* 1463; *d* Ferrara, before 1 Nov 1525). Italian architect and painter. Vasari confused him with Ercole de' Roberti, a mistake that was corrected only in the early 20th century (Venturi, 1914). He is recorded as a master in 1489 at the Este court in Ferrara. In 1495 he prepared the drawings for the façade, the interior and the marble decoration of S Maria in Vado, Ferrara, executed by Biagio Rossetti and Bartolomeo Tristano (*d* 1519), with Antonio di Gregorio (*d* 1503). The church was later radically altered, however. Also in 1495 Grandi produced a design (see Zaccarini, fig. 1) for a bronze equestrian statue of Ercole I d'Este, of which only the pedestal was made (untraced). He has also been credited with the design for the Porta dei Leoni at the Palazzo Castelli and the pilaster decoration on the Palazzo dei Diamanti, both in Ferrara (Venturi, 1888).

Grandi's activities as a painter are difficult to identify, as no work ascribed to him is supported by documentary evidence or an inscription. A painting of *St George* (Rome, Pal. Corsini), with Grandi's monogram inscribed on the horse's saddle, has long been accepted as being a youthful work by Francesco Francia. According to Vasari, Grandi painted a predella (untraced) for the altarpiece by Lorenzo Costa (i) in S Petronio, Bologna. Venturi (1888) suggested that he was in Bologna working with Francia and Costa between 1489 and 1495, when he painted a *Crucifixion* (ex-Gal. Santini, Ferrara). One work that has been convincingly attributed to him is the *Assumption of Mary Magdalene* (Ferrara, Pin. N.) made for S Maria in Vado, where Grandi also worked as an architect. Grandi has been credited (Berenson) with an interesting sequence of eight tempera scenes from the Old Testament (*c.* 1500), which show the influence of Costa (some untraced; examples in Bergamo, Accad. Carrara B.A. and London, N.G.).

Grandi's major surviving works are the ceiling frescoes at the Palazzo Costabili (formerly Scrofa–Calcagnini) in Ferrara dating from the early 16th century. These are modelled on Andrea Mantegna's frescoes in the Camera degli Sposi in Mantua (1465–74; Pal. Ducale; see colour pl. 2, I1), one of the first attempts to create the illusion of open sky. The *Martyrdom of St Sebastian* (Ferrara, Pin. N.), which Grandi painted for S Paolo in Ferrara, showing finely drawn portraits of the Mori family, can be classed as a late work.

BIBLIOGRAPHY
Thieme–Becker

G. Vasari: *Vite* (1550, rev. 2/1568); ed. G. Milanesi (1878–85), iii, pp. 141–8

A. Venturi: 'Ercole Grandi', *Archv Stor. A.*, i (1888), pp. 193–201

B. Berenson: *North Italian Painters of the Renaissance* (New York, 1907), p. 211

F. Filippini: 'Ercole Grandi, pittore ed architetto', *Atti & Mem. Regia Deput. Stor. Patria Prov. Romagna*, iv (1914), pp. 414–49

A. Venturi: *Storia*, vii (1914)

F. Filippini: 'Ercole da Ferrara ed Ercole da Bologna', *Boll. A.: Min. Pub. Istruzione*, xi (1917), pp. 49–63

D. Zaccarini: 'Il disegno di Ercole Grandi per il monumento ad Ercole I D'Este', *L'Arte*, xx (1917), pp. 159–67

SUSANNE KIEFHABER

Grandi, Ercole (di Giulio Cesare) de'. *See* ROBERTI, ERCOLE DE'.

Grazioli da Salò. *See* SALÒ, DA.

Grechetto [Greco], **il**. *See* CESATI, ALESSANDRO.

Gregory XIII, Pope [Boncompagni, Ugo] (*b* Bologna, 1 Jan 1502; elected 1572; *d* Rome, 10 April 1585). Italian pope and patron. He received a doctorate in canon and civil law in 1530 from the University of Bologna, where he remained for eight years as Professor of Law. He moved to Rome in 1539 and held several important judicial posts under Paul III, Pius IV and Pius V until his election as their successor in 1572. His principal biographer, Marc Antonio Ciappi, states that the Pope was concerned to emulate 'in customs and actions' his namesake, Gregory the Great. His patronage reflected this concern. Near the provisional hostel set up in the Campo Santo beside St Peter's, pilgrims were greeted with a cycle of the *Life of Gregory the Great* painted by Lorenzo Sabatini; in the church of SS Cosma e Damiano the Pope ordered that the figure of S Felice in the apse mosaics be replaced with one of Gregory the Great. He also venerated Gregory of Nazianzus, whose relics he had transferred in a triumphal procession (1580) from S Maria di Campo Marzo to the new Cappella Gregoriana in St Peter's. He fostered the development of Greek Orthodox rite in Rome with the founding of S Atanasio, constructed by Giacomo della Porta. Like his predecessor, Gregory encouraged the cult of the Early Christian saints, an interest that found expression in his art patronage when he commissioned Niccolò Circignani (called il Pomarancio) and Matteo da Siena (1533–88) to paint vivid scenes of martyrdom in S Stefano Rotondo in 1582.

Among other painters who received support from Gregory XIII were Giorgio Vasari and Federico Zuccaro, who painted, respectively, the frescoes of the *Battle of Lepanto* and the *St Bartholomew's Day Massacre* (both 1572) in the Vatican's Sala Regia. Tommaso Laureti painted the vault of the Sala di Costantino with the *Triumph of Christian Faith*. Raffaellino da Reggio, Marco da Faenza (*d* 1588) and Antonio Tempesta worked on the vault frescoes of the Galleria delle Carte Geografiche, a gallery designed by Ottaviano Mascherino, papal architect, as a fourth storey to the west corridor of the Cortile del Belvedere. The 'carte' were topographical frescoes designed by the noted architect, astronomer and mathematician Ignazio Danti (who also enabled the Pope to achieve his reform of the Julian Calendar; *see* DANTI, (2)) and painted by his brother Antonio Danti (*c.* 1530–after1597). The observatory known as the Torre dei Venti was built at the northern end of the gallery and contained the Sala della Meridiana, which Pomarancio and Cristoforo Roncalli (*c.* 1553–1626) decorated with allegorical representations of the winds, while Matthijs Bril (1550–83) and Paul Bril (*c.* 1554–1626) frescoed imaginary *vedute* of Rome in the suite of rooms above. Under Gregory's benefaction, the Accademia di San Luca was accorded official statutes (1577) and Girolomo Muziano, who had urged this development, became its first president (*see* ROME, §VI).

Gregory was a notable patron of architecture and public works, described by the French writer Montaigne, on his visit to Rome in 1580, as 'très-magnifique en bastimans publiques et reformation des rues'. In preparation for the Holy Year of 1575, he reopened ancient roads, such as the Via Tuscolana, and laid new ones, most notably the Via Merulana, linking S Maria Maggiore with the Lateran and the Via Gregoriana, leading from the Monte Cavallo to Trinità dei Monti. The papal bull known as 'Quae publice utilia' (1574) was of importance in regulating the façades of private buildings along the city's main thoroughfares. The ancient Pons Senatorum (Ponte Rotto) was rebuilt by Matteo da Castello (*c.* 1525 - after 1604), and the architect Martino Longhi I converted the planetarium of the Baths of Diocletian into granaries. In 1574 the Acqua Vergine, supplying water to the most populated quarters of Rome, was renovated. Giacomo della Porta was commissioned to design four fountains: for the Piazza del Panteon, Piazza Colonna and two for the Piazza Navona (all 1574–5; *in situ*; *see* PORTA, GIACOMO DELLA, fig. 1). He also designed the more fanciful Fontana delle Tartarughe in Piazzetta Mattei (1581–4; *in situ*). At S Giovanni in Laterano, Giacomo del Duca was commissioned to design a new rusticated portal leading through the Aurelian wall from the Via Latina. Restorations were made to the portico of the basilica and the Scala Santa was re-erected along the south side of the portico. Some work was also done to S Giovanni in Fonte, where the Boncompagni dragons appear on the coffered ceiling. The restoration of the portico at S Maria Maggiore, for which ancient columns were transported from old St Peter's, is generally ascribed to Martino Longhi I (Baglione). Other restorations were made to the medieval porch of S Maria in Trastevere; and under Gregory's patronage the painter Girolamo Siciolante completed the gilt coffering over the nave of S Maria in Aracoeli, begun in Pius V's pontificate.

Gregory XIII was responsible for initiating the construction (1583) of the Palazzo del Quirinale, planned as a summer retreat and designed in its first stages by Mascherino. He also spent considerable sums on furthering work on St Peter's (*see also* ROME, §V, 1(ii)(a)). He commissioned a fresco over the central portal of the façade (destr. 1605) depicting Christ bearing the message 'pasce oves meas' while the Pope kneels before him accompanied by a flock of sheep. Despite Gregory's support, work on Michelangelo's design (which was recorded on a papal medal of 1572) progressed slowly. The dome was still unfinished in June 1584, by which time della Porta had succeeded Jacopo Vignola as Maestro della Fabbrica (master of the Works). The Cappella Gregoriana, which in Michelangelo's Greek-cross plan would have stood just inside the narthex of the basilica, was consecrated in 1578. It housed the icon of the *Madonna del Soccorso* and had ceiling mosaics by Muziano and walls decorated by Cesare Nebbia and Paul Bril.

BIBLIOGRAPHY

M. A. Ciappi: *Compendio delle heroiche et gloriose attioni et santa di vita di Papa Gregorio XIII* (Rome, 1591)

G. Baglione: *Vite* (1642); ed. V. Mariani (1935), p. 68

L. von Pastor: *Geschichte der Päpste seit dem Ausgang des Mittelalters*, 24 vols (Freiburg, 1891–1924; Eng. trans. as *History of the Popes*, ed. R. F. Kerr, London, 1930), xx, pp. 560–630

H. Röttgen: 'Zeitgeschichtliche Bildprogramm der katholischen Restauration unter Gregor XIII (1572–85)', *Münch. Jb. Bild. Kst.*, xxvi (1975), pp. 89–122

M. F. dell'Arco, ed.: *La Roma dei Longhi: Papi e architetti tra Manierismo e Barocco* (Rome, 1982)

A. Herz: 'Vasari's "Massacre" Series in the Sala Regia: The Political, Juristic and Religious', *Z. Kstgesch.*, xlix (1986), pp. 45-54

P. Jacks: 'A Sacred Meta for Pilgrims in the Holy Year 1575', *Architectura*, XIX (1989), pp. 42–72

R. Eitel-Porter: 'Cesare Nebbia at the Vatican: The "Sale dei Foconi"', *Apollo*, cxlii/405 (1995), pp. 19–24

J. Freiberg: 'In the Sign of the Cross: The Image of Constantine in the Art of Counter-Reformation Rome', *Piero della Francesca and his Legacy*, ed. M. A. Lavin (Washington, DC, 1995), pp. 66–87

PHILIP J. JACKS

Grigi, de'. Italian family of architects and sculptors.

(1) Guglielmo [Vielmo] **de' Grigi** (*b* Alzano, Bergamo, *c.* 1480; *d* Venice, ?1550). Almost all of his recorded works are in Venice, the first being at the Procuratie Vecchie in Piazza S Marco, which were rebuilt after the fire of 1512. From 1517 he was chief assistant there to the *proto* (chief architect), Pietro Buon (ii), to whom he may have been related. The nickname of 'i Bergamaschi' by which the Buon family are sometimes known is also occasionally used more broadly to include Guglielmo, who shared the Buons' Lombard origins. Due to his subordinate position, Guglielmo would have had little influence on the basic design of the Procuratie Vecchie, which had already been established by Pietro Buon after an initial design probably by Mauro Codussi. Guglielmo was chiefly responsible for the top storey of the façade (*c.* 1517–20), with its decorative oculi and crenellation. Such decorative touches were to become Guglielmo's most clearly identifiable characteristic, and, although he has been cited as a follower of Codussi, he shows the greater influence of Pietro Lombardo in his light, decorative style. In particular, his delicate low relief mouldings are typically Lombard features. In 1519 he completed the Porta Portello, Padua, one of the city's gates, and even here, despite its military function, the gate is faced with a light screen of Istrian stone, with free-standing paired columns. His next significant work was the altar (*c.* 1524) of Scaligera Verde, a member of the della Scala family, in SS Giovanni e Paolo, Venice, transferred there from the suppressed Servi church. In the same year he was also commissioned to build the high altar (completed 1534) at S Salvatore, where he also carved the altar of St Jerome.

Among many attributions to Guglielmo's later career, two are of particular importance. The first is the Palazzo dei Camerlenghi (1525–8; see fig.), now recognized as Guglielmo's work although it has also been attributed to Pietro Buon and to Antonio Scarpagnino. The original building's basic structure had survived the disastrous fire that destroyed the Rialto district of Venice in 1514 but was in poor condition, and Guglielmo was recommended to the Venetian government by Scarpagnino, who was responsible for replanning the whole zone. The building housed the city's treasurers' offices and was considered sufficiently prestigious to be faced entirely with stone. Guglielmo strengthened and refaced the surviving structure, and the work was completed within three years. The highly distinctive façades are typical of his work; they show the influence of Pietro Lombardo and have extensive low-relief carving and inset marble panels. A slightly later, fully documented work is the Miani (Emiliani) Chapel at S Michele in Isola, north of Venice. It is attached on one side to Codussi's slightly earlier church of S Michele and was begun to Guglielmo's design in 1527, although only

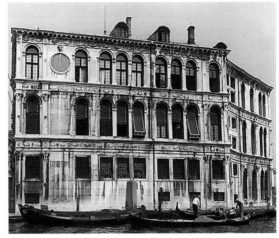

Guglielmo de' Grigi: Palazzo dei Camerlenghi, Venice, 1525–8

completed in 1543. The site was a very difficult one, bounded on two sides by the open lagoon, and the hexagonal chapel was built of the white Istrian stone used in the façade of Codussi's church. The style of the chapel is sympathetic to the church but its unusual form renders it clearly distinct; indeed some of Guglielmo's richly detailed decorative work seems excessively fussy in contrast with Codussi's disciplined order. The chapel is crowned with a highly distinctive dome, again all of white stone.

Many other minor works are attributed to Guglielmo. Among the more likely are the side portal of S Francesco della Vigna and the fine portal of Palazzo Tasca near S Lio, the latter transferred from the Tasca palace at Portogruaro. As in so much of his work, columns predominate, with their flutes, pronounced entasis and sharply defined bases and capitals. Two other Venetian palaces are sometimes ascribed to Guglielmo: the Palazzo Cappello Trevisan 'in Canonica' incorporates many Lombard motifs and may be the product of a collaboration between Guglielmo and Pietro Buon, while the Palazzo Coccina Tiepolo is a stronger attribution, since the Coccina family came from Bergamo and the house was completed by Guglielmo's son Giovanni Giacomo (*see* (2) below). Guglielmo also worked for a time at the Scuola Grande di S Rocco, Venice. Other ecclesiastical works included a model (1534) for the lost church of S Antonio, and one of his last works was another lost church, S Maria delle Vergini, where he directed operations until his death.

(2) Giovanni Giacomo de' Grigi (*fl* 1549; *d* Venice, 1572). Son of (1) Guglielmo de' Grigi. He had a long association with the Scuola Grande di S Rocco. In 1549 he was appointed *proto* to the works on the death of Antonio Scarpagnino, although by the time of his appointment much of the main fabric was already complete, and his own works were chiefly confined to interior decorations. He remained there until 1560, when he left after one of the many notable disputes that characterized relations between the Scuola Grande and its architects. In the same period he completed the Palazzo Coccina Tiepolo, incorporating several elements traceable to other

sources: the single lights, for example, recall Palladio, while the high-level oculi are characteristic of Jacopo Sansovino. The house was complete by *c.* 1560, and almost immediately afterwards Giovanni Giacomo was employed by Gerolamo Grimani II to complete his great palazzo begun in 1556 by Michele Sanmicheli. Here he continued the robust, powerful classicism of his predecessor with the addition of a second *piano nobile*, and he continued to work there intermittently until his death. One of his last recorded works dates from 1567, when he signed a contract with the monastery of S Giorgio Maggiore to assist Palladio in the reconstruction of the church. However, little had been completed at his death. Giovanni Giacomo remains a rather elusive figure, whose work lacks the characteristic lightness of detail of his father. It is instead more closely related to the work of Sanmicheli and Palladio, although lacking the clarity of purpose of either of these masters.

BIBLIOGRAPHY

Portoghesi

A. Venturi: *Storia* (1901–40)

A. Mazzucato: *La Scuola Grande e la chiesa di S Rocco in Venezia* (Venice, 1953)

L. Angelini: *Bartolomeo Bono e Guglielmo d'Alzano: Architetti bergamaschi in Venezia* (Venice, 1961)

E. Bassi: *Palazzi di Venezia* (Venice, 1976)

F. Forlati: *S Giorgio Maggiore* (Padua, 1977)

J. McAndrew: *Venetian Architecture of the Early Renaissance* (Cambridge, MA, and London, 1980)

M. Tafuri: *Venice and the Renaissance* (Cambridge, MA, and London, 1989)

RICHARD J. GOY

Grillandai. *See* GHIRLANDAIO.

Grimani. Italian family of statesmen, ecclesiastics, collectors and patrons. They had settled in Venice by the 10th century, and their wealth was derived from trade with the eastern Mediterranean; one branch of the family settled on Crete in the early 13th century. The Venetian Grimani emerged as prominent members of the hereditary nobility in the 13th and 14th centuries and advanced their influence through holding offices in the Republic and later in the Church. The most important branch was that of S Maria Formosa, notably the descendants of (1) Antonio Grimani, who became doge of Venice in 1521. Of his sons, (2) Domenico Grimani, the eldest, became Cardinal Patriarch of Aquileia, while Gerolamo Grimani I's extensive family included (3) Marino Grimani, (4) Marco Grimani, (7) Giovanni Grimani, all of whom became Patriarch of Aquileia, and (5) Vettor Grimani. (6) Gerolamo Grimani II belonged to the S Luca branch of the family.

BIBLIOGRAPHY

O. Logan: *Culture and Society in Venice* (London, 1972)

JOHN LAW

(1) Antonio Grimani, Doge of Venice (*b* Venice, 28 Dec 1434; *reg* 1521–3; *d* Venice, 7 May 1523). A fortune amassed mostly through trade with the eastern Mediterranean made him one of the richest men in Venice, able to afford a cardinalate for his son (2) Domenico Grimani in 1493. Antonio began his political career relatively late but attained the high office of Procurator of S Marco. As commander of the naval forces of the Venetian Republic, he captured the coastal cities of Apulia in 1495 but was disgraced in 1499 after his failure to destroy a Turkish armada at the Battle of Zonchio. He spent the following years in exile, largely in Rome, where he acquired a villa on the Quirinale; he was recalled to Venice in 1509 on account of his wealth, experience and family connections. He was restored to the procuratorship and in that capacity paid for the final stage of work on the campanile in the Piazza S Marco (1510–14), giving it its characteristic pyramidal roof, and urged repairs to the Procuratie Vecchie: the architects included Bartolomeo Buon (ii). On 6 July 1521 Antonio was elected doge and tried to exercise that office in ostentatious and princely style but at the age of 87 was too decrepit to make much impact on government. Titian painted his portrait (1523; destr. 1571), and likenesses of Antonio were produced in marble and bronze (all untraced). *Doge Antonio Grimani Adoring Faith and St Mark in Glory* by Titian in the Sala delle Quattro Porte of the Doge's Palace is a posthumous celebration, ordered by the Senate in 1555 and eventually completed by Marco Vecellio *c.* 1600. Four medals with Antonio's portrait were also cast, one by Vittore Gambello. A memorial to Antonio, as well as his tomb in S Antonio di Castello (destr. 1807), were never completed.

BIBLIOGRAPHY

A. Armand: *Les Médailleurs italiens* (2/1883–7)

T. Okey: *The Old Venetian Palaces* (London, 1907)

G. F. Hill: *Corpus* (1930)

A. Da Mosto: *I Dogi di Venezia* (Milan, 1939), pp. 153–8

J. McAndrew: *Venetian Architecture of the Early Renaissance* (Cambridge, MA, 1980), pp. 415–16

G. Benzoni, ed.: *I Dogi* (Milan, 1982)

D. S. Queller: *The Venetian Patriciate* (Urbana and Chicago, 1986), pp. 164–6, 233

JOHN LAW

(2) Domenico Grimani, Cardinal Patriarch of Aquileia (*b* Venice, Feb 1461; *d* Rome, 27 Aug 1523). Son of (1) Antonio Grimani. He graduated in arts from the university of Padua (1487), and an interest in philosophy brought him into contact with Lorenzo de' Medici, Giovanni Pico della Mirandola (1463–94) and Angelo Poliziano. Domenico eventually embarked on an ecclesiastical career, acquiring the offices of protonotary and apostolic secretary in 1491. His father's wealth and influence secured him a cardinalate in 1493 and other high ecclesiastical benefices, notably the patriarchate of Aquileia in 1497, which he renounced in favour of his nephew (3) Marino Grimani in 1517. Although a pluralist and absentee bishop, Domenico was sufficiently regarded as an ecclesiastic to participate in the condemnation for heresy of the German humanist and theologian Johannes Reuchlin (1455–1522).

Domenico's learning attracted the praise of such scholars as Erasmus (1466–1536), but he is best remembered as a lavish, but discerning collector of books, Classical antiquities and contemporary works of art. Of his 15,000 volumes, he left 8000 to found a public library in the Venetian monastery of S Antonio di Castello (destr. 1807). One of the few surviving works is the Grimani Breviary (*c.* 1510–20; Venice, Bib. N. Marciana, MS. lat. I.99). This lavishly illuminated liturgical text was acquired for 500 ducats *c.* 1520; it is regarded as a masterpiece of South Netherlandish manuscript painting. Its ornate binding has been attributed to Vittore Gambello and includes medallion portraits of the Cardinal Patriarch and his father. Although left by Domenico to the State, his nephews (3)

Marino Grimani and (7) Giovanni Grimani retained its use until 1594. Domenico acquired most of his important collection of Classical antiquities, which included marbles, bronzes, gems and medallions, during his periods of residence in Rome; statues of *Marcus Agrippa* and *Augustus* (now Venice, Mus. Archeol.), for example, were removed from the Pantheon to the Palazzo Grimani near S Maria Formosa, Venice. He bequeathed the smaller items to Marino; the bronzes and marbles, including Hellenistic and Roman works, were left to the Venetian Republic, which began to exhibit them in the Doge's Palace from 1525. The bequest influenced such artists as Titian, and, together with Giovanni's collection, it constituted the foundation of the Museo Archeologico in Venice.

Domenico's taste also extended to contemporary artists. He possessed works by Raphael, including the cartoon (1515–16; destr.) for the tapestry of the *Conversion of St Paul* (Rome, Pin. Vaticana), and by Titian and Giorgione, and possibly drawings by Leonardo and Michelangelo. Northern painters represented in his collection included Albrecht Dürer (1471–1528), Hans Memling (1430/40–1524), Joachim Patinir (*c.* 1480–1524) and five works (the last in Venice, Doge's Palace) by Hieronymous Bosch (*c.* 1450–1510); other paintings were left to (4) Marco Grimani and Marino Grimani. In Venice, Domenico lived in the Palazzo Grimani and in a villa on Murano. In Rome the Grimani maintained their villa on the Quirinale, and from 1505 Domenico also resided in considerable splendour at the Palazzo di S Marco (now Palazzo di Venezia; from 1455). His likeness is preserved in several medals, including one by Gambello and two by Sperandio. A portrait (Windsor Castle, Berks, Royal Col.), possibly of Domenico, has been attributed to Domenico di Bernardino Capriolo. Domenico was buried, according to his wishes, in SS Giovanni e Paolo, Rome, but the Grimani secured permission to transfer his body to Venice, though his tomb in S Francesco della Vigna is lost.

BIBLIOGRAPHY

A. Armand: *Les Médailleurs italiens* (2/1883–7)

P. Paschini: 'Le collezioni archeologiche dei prelati Grimani del cinquecento', *Atti Pont. Accad. Romana Archeol.*, n. s. 2, v (1926–7), pp. 149–90

G. F. Hill: *Corpus* (1930)

C. H. Collins Baker: *Catalogue of the Principal Pictures in the Royal Collection at Windsor Castle* (London, 1937), p. 177

P. Paschini: *Domenico Grimani di San Marco* (Rome, 1943)

R. Gallo: 'Le donazioni alla Serenissima di Domenico e Giovanni Grimani', *Archv Ven.*, n. s. 4, l–li (1952), pp. 34–77

M. Perry: 'The *Statuario Pubblico* of the Venetian Republic', *Saggi & Mem. Stor. A.*, viii (1972), pp. 76–252

M. J. C. Lowry: 'Two Great Venetian Libraries', *Bull. John Rylands Lib.*, lvii (1974–5), pp. 128–66

P. Paschini: *Storia del Friuli* (Udine, 1975)

M. Perry: 'Cardinal Domenico Grimani's Legacy of Ancient Art to Venice', *J. Warb. & Court. Inst.*, xli (1978), pp. 215–44

JOHN LAW

(3) Marino Grimani, Cardinal Patriarch of Aquileia (*b* Venice, *c.* 1488; *d* Orvieto, 28 Sept 1546). Grandson of (1) Antonio Grimani. His ecclesiastical career was successful in terms of his accumulation of benefices, and he became Bishop of Ceneda (now Vittorio Veneto) in 1508, Patriarch of Aquileia (*reg* 1517–29, 1538–45) and a cardinal in 1527. Although ambitious and favoured by his family's wealth and influence, he was interested in theology and reform and defended the rights of his sees and of the papacy. He shared his family's luxurious lifestyle and cultural tastes. Much of his considerable library was inherited from (2) Domenico Grimani, from whom he probably also acquired some works by contemporary artists. In addition he owned a collection of antiquities largely comprised of medals and small pieces in marble and bronze. According to Vasari, Marino employed GIULIO CLOVIO and owned *Christ Carrying the Cross* (*c.* 1530; Madrid, Prado) by Sebastiano del Piombo.

In 1529 Marino recommended Jacopo Sansovino to carry out repairs to S Marco, and Marino and his brother (5) Vettor Grimani were also among the wealthy patrons who defrayed the cost of building Sansovino's S Francesco della Vigna (*c.* 1537), in which they acquired a family chapel. Together with Vettor and another brother, (7) Giovanni Grimani, Marino employed a number of Roman-influenced artists to decorate the interior of the family palace near S Maria Formosa (1537–40): Federico Zuccaro, Francesco Salviati, Giovanni da Udine, Giovanni Battista Franco and Camillo Capelli (Mantovano; *fl* 1514; *d* 1568). Marino employed Pordenone or, more probably, Pomponio Amalteo to fresco a celebration of *Justice* (1535–6) in the loggia of the council hall in Ceneda (1535–9); the loggia itself was possibly designed by Sansovino. Other architectural commissions assigned to Giovanni da Udine in Aquileia and Udine were never executed. Marino's tomb in S Francesco della Vigna has disappeared, but three portrait medals of the Cardinal survive, two attributed to Giovanni Cavino and one (*c.* 1535) to Niccolò Cavallerino della Mirandola (*fl* 1523). Marino died in debt, but much of his library and collection of antiquities was acquired by (7) Giovanni Grimani.

BIBLIOGRAPHY

G. Vasari: *Vite* (1550, rev. 2/1568); ed. G. Milanesi (1878–85), v, pp. 565–86; vii, pp. 73–134, 557

A. Armand: *Les Médailleurs italiens* (2/1883–7)

G. F. Hill: *Corpus* (1930)

P. Paschini: 'Il mecenatismo del Cardinale Marino Grimani', *Miscellanea in onore di Roberto Cessi*, ii (Rome, 1958), pp. 79–88

——: *Il Cardinale Marino Grimani ed i prelati della sua famiglia* (Rome, 1960)

——: *Storia del Friuli* (Udine, 1975)

JOHN LAW

(4) Marco Grimani, Patriarch of Aquileia (*b* Venice, *c.* 1494; *d* Rome, July 1544). Grandson of (1) Antonio Grimani. Family wealth and influence secured him the secular office of Procurator of S Marco in 1522. He entered the Church after the death of his wife in 1526 and succeeded his brother (3) Marino Grimani as Patriarch of Aquileia in 1529, although he probably never took holy orders. In 1538 he returned the see to Marino but retained the title of Patriarch, and in the same year was papal legate with a crusading fleet. In 1543–4 he was entrusted with a sensitive embassy to Scotland. Little is known concerning his collecting or patronage, although he is known to have acquired some items from the collection of paintings and antiquities of his uncle (2) Domenico Grimani. His tomb in S Francesco della Vigna in Venice is lost.

BIBLIOGRAPHY

P. Paschini: *Il Cardinale Marino Grimani ed i prelati della sua famiglia* (Rome, 1960)

——: *Storia del Friuli* (Udine, 1975), p. 799
C. Burns: 'Marco Grimani in Scotland', *Ren. Stud.*, ii (1988), pp. 299–311
JOHN LAW

(5) Vettor Grimani (*b* Venice, 1495–7; *d* Venice, 24 Aug 1558). Grandson of (1) Antonio Grimani. In 1521 he married Isabetta, daughter of the procurator Girolamo Giustinian and Agnesina Badoer, builders of the Castello Giustinian at Roncade (1511–13). He was elected Procurator of S Marco in 1523. In 1527–8 he acquired the Cá del Duca, the basement of an unfinished palazzo on the Grand Canal, begun for Andrea Cornaro by Bartolomeo Buon (i). Grimani intended to build on its foundations a vast palace in the latest Tuscan–Roman style; only a wooden model (untraced) was made and a presentation drawing of the plan (Venice, Correr, no. III.6038), attributed to Michele Sanmicheli (Lewis, 1972) or Jacopo Sansovino (Foscari and Tafuri, 1981). Vettor was the moving force behind Sansovino's project for the rebuilding (1534–42) of S Francesco della Vigna, Venice: two large wooden models for this project (untraced) were inventoried in his estate. Four of Sansovino's civic works also owe their origin, character or completion to Grimani's efforts: the Marciana library, the Loggetta (*see* SANSOVINO, (1), fig. 3), S Geminiano and the Scala d'Oro in the Doge's Palace. With his brother (7) Giovanni Grimani, he played a leading role in commissioning the sumptuous decoration of the Palazzo Grimani at S Maria Formosa (rebuilding attributed to Sanmicheli, 1556), which included ceiling decorations by Francesco Salviati. Vettor served as ambassador to Emperor Charles V (*reg* 1519–56) in 1543 and to Henry II of France (*reg* 1547–59) in 1547. He was also knighted and was a candidate for doge in 1553. A superb sculptured bust (terracotta, Providence, RI Sch. Des., Mus. A., 1954.167; marble, London, V&A, A.11–1970) has been identified tentatively as his likeness. A secure portrait is a fine uniface lead medal (London, BM) by the so-called 'Venetian medallist of 1550', perhaps Danese Cattaneo.

BIBLIOGRAPHY
G. F. Hill: 'Eight Italian Medals', *Burl. Mag.*, xiv (1908–9), p. 216
D. Lewis: 'Un disegno autografo del Sanmicheli e la notizia del committente del Sansovino per S Francesco della Vigna: Nuovi appunti per il mecenatismo artistico del Procuratore Vettor Grimani', *Boll. Civ. Mus. Ven. A. & Stor.*, xvii (1972), pp. 7–36
——: 'Proposals for the Grimani Tombs at S Francesco della Vigna, Venice', *The Drawings of Andrea Palladio* (exh. cat., Washington, DC, N.G.A., 1981), pp. 186–7, no. 111
A. Foscari and M. Tafuri: 'Un progetto irrealizzato di Jacopo Sansovino: Il palazzo di Vettor Grimani sul Canal Grande', *Boll. Civ. Mus. Ven. A. & Stor.*, xxvii (1981), pp. 71–87
D. Lewis: 'Patterns of Preference: Patronage of Sixteenth-century Architects by the Venetian Patriciate', *Patronage in the Renaissance*, ed. G. Lytle and S. Orgel (Princeton, 1981), pp. 354–80
A. Foscari and M. Tafuri: *L'armonia e i conflitti: La chiesa di San Francesco della Vigna nella Venezia del '500* (Venice, 1983)
DOUGLAS LEWIS

(6) Gerolamo Grimani II (*b* Venice, *c.* 1500; *d* Venice, 30 April 1570). Statesman and patron, from the S Luca branch of the family. He had a prominent political career, becoming Procurator of S Marco in 1560. He devoted considerable attention and money (40–50,000 ducats) to the building of an imposing palazzo on the Grand Canal, on a site he acquired from the Contarini in 1556. The palazzo was designed by Michele Sanmicheli (*see* SANMICHELI, MICHELE, fig. 2), who supervised the construction of the first floor before his death in 1559. From *c.* 1560 to 1572 work was continued, and the design modified, by Giovanni Giacomo de' Grigi; it was completed *c.* 1575, after Grimani's death, by Giovanni Antonio Rusconi. The Palazzo Grimani is distinguished from its neighbours by its sheer scale, and by the bold forms of its classically inspired façade.

BIBLIOGRAPHY
L. Heydenreich and W. Lotz: *Architecture in Italy, 1400–1600*, Pelican Hist. A. (Harmondsworth, 1974), pp. 220–22
E. Bassi: *Palazzi di Venezia* (Venice, 1976), p. 146
D. Howard: *The Architectural History of Venice* (London, 1980), pp. 155ff
JOHN LAW

(7) Giovanni Grimani, Patriarch of Aquileia (*b* Venice, *c.* 1500; *d* Venice, 3 Oct 1593). Grandson of (1) Antonio Grimani. He entered the Church and acquired the benefices that the Grimani regarded as their own: the bishopric of Ceneda (1520) and the patriarchate of Aquileia (1545). The suspicion that he held unorthodox views on such central aspects of Catholic doctrine as Grace and Predestination, however, interrupted and curtailed his career, although he was cleared of heresy at the Council of Trent in 1563. He acquired a reputation as a man of learning and a collector. The historian Paolo Paruta (1540–98) chose him as an interlocutor in his *Della perfettione della vita politica* (Venice, 1579/*R* 1599). Giovanni acquired part of the collection of antiquities belonging to his brother (3) Marino Grimani and augmented it to create one of the largest collections of Greek and Roman marbles, bronzes, medals and cameos in 16th-century Venice. He also collected contemporary works, including paintings by South Netherlandish artists and Giorgione.

Giovanni took a leading role in remodelling the Palazzo Grimani near S Maria Formosa (completed 1569). The design of the entrance has been attributed to Michele Sanmicheli, while that of the building itself has been credited to the Patriarch. It is certain, however, that Giovanni played a leading role in commissioning the decoration of its interior (*see* (3) above). Giovanni was also responsible for commissioning the decoration (*c.* 1560) by Battista Franco, Federico Zuccaro and the sculptor TIZIANO ASPETTI of the Grimani Chapel in S Francesco della Vigna; this, designed by Jacopo Sansovino, was the burial-place of several of the Grimani, and Giovanni himself was later buried there. Aspetti was particularly close to the Patriarch and was a member of his household; he also executed the bronze statues of *Moses* and *St Paul* that flank the principal entrance to S Francesco della Vigna. Giovanni commissioned Palladio to design the façade (1565) of this church and also persuaded the commune of S Daniele in Friuli, which was under his jurisdiction as Patriarch, to accept a design by Palladio for one of its gates (the Porta Palladio, 1579). Like his uncle (2) Domenico Grimani, Giovanni left most of his collection to the Venetian Republic, and a new site to display the Grimani bequests was begun next to the Libreria Marciana before his death.

BIBLIOGRAPHY
T. Okey: *The Old Venetian Palaces* (London, 1907), pp. 153–4
G. Zorzi: *Le opere pubbliche e i palazzi privati di Andrea Palladio* (Venice, 1965), pp. 87–8

J. S. Ackerman: *Palladio* (Harmondsworth, 1966), pp. 140–41, 143–4
P. Paschini: *Storia del Friuli* (Udine, 1975), pp. 811–14, 819–23
E. Bassi: *Palazzi di Venezia* (Venice, 1976), pp. 228–35

For further bibliography *see* §(2) above.

JOHN LAW

Gritti, Andrea, Doge of Venice (*b* Bardolino, nr Verona, April 1455; *d* Venice, 28 Dec 1538). Italian statesman and patron. In his youth he accompanied his grandfather, Triadano Gritti, on journeys to England, France and Spain, and he studied in Padua. His first career was as a successful grain merchant based in Constantinople, where he also served as a diplomat and spy. In 1509 he led the Venetian forces in the recapture of Padua during the Wars of the League of Cambrai. Three years later he was imprisoned by the French at Brescia and taken to France, where he formed a friendship with Francis I (*reg* 1515–47). In 1517 he led the Venetians in their triumphal re-entry into Verona. Despite these wartime triumphs, Gritti's election as Doge of Venice on 20 May 1523 was not a popular one among the more powerful members of the patriciate. During his dogeship, the Venetian constitution limited his personal power. Nevertheless, he was able to express his ambitious character through his imaginative patronage.

Titian, who recorded Gritti's likeness (*Andrea Gritti*, disputed date; Washington, DC, N.G.A.), first received his salary as official painter to the Venetian Republic in 1523. At the start of his reign, Gritti also commissioned from Titian a fresco of *St Christopher* with Venice in the background for the wall of the staircase to the ducal apartments in the Doge's Palace (*in situ*). In the same year Gritti witnessed the completion of the Doge's private chapel of S Nicolò rebuilt by Giorgio Spavento and decorated with a fresco (destr.) by Titian of the Doge himself as a donor figure before the Virgin and Child, St Nicholas and the four Evangelists (fragments, Venice, Doge's Palace, Sala della Quarantia Criminal). The chapel also housed a relief tabernacle by an unknown sculptor depicting *St Andrew Presenting Doge Gritti to SS Nicholas and Bernardino* (now Venice, S Marco, chapel of S Clemente).

Barbarigo claimed that Gritti had intended to extend the Doge's Palace on the far side of the Ponte della Paglia but was prevented by the outbreak of war against the Turks in 1537. Within the palace, most of Gritti's efforts were concentrated on the part of the building where important visitors were received. In the anteroom between the staircase of the ducal apartments and the chapel of S Nicolò, Gritti installed the collection of antique sculpture bequeathed (1523) to the Republic by Cardinal Domenico Grimani. For the nearby Sala del Collegio, he commissioned an altarpiece (1531) by Titian, of the *Madonna and Child with SS Mark, Alvise (Louis), Marina and Bernardino* (destr. 1574, replaced with a new version by Tintoretto). For the large meeting-room (destr. 1577) in the wing over the Piazzetta, Gritti commissioned a coffered ceiling from Sebastiano Serlio in 1531, the compartments of which were painted (1532–8) by Pordenone.

In 1529 the Doge persuaded the procurators of S Marco to employ Jacopo Sansovino as their *proto* (chief architect) and took a personal interest in his remodelling of the Piazza S Marco as a Roman-style forum from 1536

onwards. In 1534 Gritti laid the foundation stone of Sansovino's church of S Francesco della Vigna. The Gritti family palace was completely rebuilt during Gritti's reign. It consists of two corner blocks linked by an enclosed courtyard. The block opposite the church is dated 1525, while the block over the canal was begun about ten years later. The architect of this huge project is not known, but Antonio Scarpagnino may have been responsible.

Much of Gritti's personal wealth was spent on public projects. In 1525 he ordered a new ducal processional umbrella, and in 1532 he and his illegitimate son Alvise each anonymously donated the huge sum of 200,000 ducats towards the rebuilding of the Rialto Bridge. Such vast expenditure reduced his personal income to a mere $143\frac{1}{2}$ ducats at the time of his last tax return in 1537. Perhaps his most blatant attempt at self-glorification was the tapestry (Venice, Mus. S Marco) made in Flanders in 1532 for the high altar of S Marco, depicting the Lion of St Mark with Venice in the background and surrounded by trophies and symbols of his own achievements. Gritti presided over Venice's economic and political recovery after the Cambrai Wars, leaving potent symbols of the State's resurgence in the form of works of art.

BIBLIOGRAPHY
N. Barbarigo: *Vita di Andrea Gritti doge di Venezia* (Venice, 1793) [trans. by C. Volpi of 16th-century Latin text]
A. da Mosto: *I dogi di Venezia* (Venice, 1939), pp. 158–63
D. Howard: *Jacopo Sansovino: Architecture and Patronage in Renaissance Venice* (New Haven and London, 1975, rev. 1987)
S. Bettini and others: *Tiziano e Venezia: Convegno internazionale di studi: Venezia, 1976*
A. Olivieri: 'Capitale mercantile e commitenza nella Venezia del Sansovino', *Crit. Stor.*, xv/4 (1978), pp. 44–77
R. Finlay: *Politics in Renaissance Venice* (London and New Brunswick, 1980)
A. Foscari and M. Tafuri: *L'armonia e i conflitti: La chiesa di San Francesco della Vigna nella Venezia del '500* (Turin, 1983)
M. Tafuri, ed.: 'Renovatio urbis': Venezia nell'età di Andrea Gritti (1523–1538) (Rome, 1984) □

Grotesque. French term derived from the Italian *grottesco*, describing a type of European ornament composed of small, loosely connected motifs, including scrollwork, architectural elements, whimsical human figures and fantastic beasts, often organized vertically around a central axis.

1. Origins. 2. Renaissance development.

1. ORIGINS. Grotesque ornament was inspired by the archaeological discovery at the end of the 15th century, of the ancient Roman interiors of the Domus Aurea of Nero in Rome, and by subsequent finds of other palaces, tombs and villas in and around Rome and Naples. The interior walls and ceilings of these underground rooms, known as *grotte*, were painted in a light and playful manner previously unknown to those familiar only with the formal grammar of Classical ornament derived from more accessible antique ruins. A ceiling in such a room might be covered with an interlocking arrangement of compartments containing mythological or allegorical scenes depicted as *trompe l'oeil* cameos, or it might be subdivided into areas dominated by a single such compartment with the remaining space filled with a variety of motifs, symmetrically

organized but otherwise unrelated either by scale or subject-matter. Vitruvius, in his treatise *On Architecture* (*c.* 15 BC), Book VII, had contemptuously described this kind of painting: 'Reeds are substituted for columns, fluted appendages with curly leaves and volutes take the place of pediments, candelabra support representation of shrines, and on top of their roofs grow slender stalks and volutes, with human figures senselessly seated upon them.' This play of fantasy and appeal to the realm of the senses, as opposed to the monumental solemnity of much rediscovered Roman architecture and sculpture, captured the imagination of Renaissance artists and revived the medieval predilection for the fanciful and the monstrous seen in the ornament in the margins of medieval manuscripts or the stone gargoyles of abbeys and cathedrals.

2. RENAISSANCE DEVELOPMENT. Soon after its discovery at the end of the 15th century, Classical grotesque ornament was copied and disseminated by the drawings of Italian artists, mostly from Umbria and Florence. However, many artists were uncomfortable with the loose organization of unconnected elements and sought to impose a structure that would enable them to use the motifs in a more orderly manner. They therefore employed a vertical format based on the pilaster and traditional candelabrum type of framework, with individual motifs placed one above the other and connected by a central axis; the engravings of Giovanni Pietro da Birago (late 15th-century; London, V&A) are some of the earliest examples of this format. The decorative candelabrum also appeared in such frescoes as those (1489–93) by Filippino Lippi in the Carafa Chapel in S Maria sopra Minerva in Rome, in the Collegio del Cambio (1499), Perugia, by Perugino, in the chapel of the Assumption (1499–1503) at Orvieto Cathedral by Luca Signorelli, and in the fresco cycle (1492–4) of the Appartamento Borgia in the Vatican by Bernardino Pinturicchio. Engravings of grotesque designs were also circulated to craftsmen in other media: silversmiths, goldsmiths and sculptors adapted the designs engraved by Nicoletto da Modena, Giovanni Antonio da Brescia, Agostino dei Musi, Enea Vico and by Marcantonio Raimondi and his school. In Raphael's painted interiors in the Vatican, the *stufetta* (1516) of Cardinal Bernardo Bibbiena (for illustration *see* GIOVANNI DA UDINE and colour pl. 2, XXI2) and the Vatican Loggia (1518–19), grotesque ornament was developed into complete decorative schemes. In the Loggia, the candelabrum motif was used extensively, dividing the entire surface of the wall into some 200 vertical strips within which a compendium of Classical motifs mingled with fantastic birds and animals, fruit and foliage, scrollwork and abstract ornament (see fig.). A new element was also introduced in the irregularly shaped compartments of the vaulted ceiling by allowing sections of the bandwork border to penetrate the space of the design, producing a kind of internal scaffolding on which individual motifs could be supported. This innovation was developed further by Raphael's successors in bandwork and strapwork that firmly enclosed and anchored the whimsical grotesques. His style was immediately imitated by his assistants: Giovanni da Udine at the Villa Madama in Rome (1525), and Giulio Romano at the Palazzo del Te in Mantua (mid-1520s–*c.* 1535).

Grotesque design by Raphael's workshop for a pilaster in the Vatican Loggia, 1518–19; engraving by Giovanni Ottaviani after Gaetano Savorelli and Pietro Camporese from *Loggie di Raffaele nel Vaticano* (Rome, 1772)

BIBLIOGRAPHY

Vitruvius: *De architectura* (*c.* 15 BC); Eng. trans. by M. H. Morgan as *The Ten Books on Architecture* (Cambridge, MA, 1914/*R* New York, 1960)
D. Guilmard: *Les Maîtres ornemanistes* (Paris, 1880)
P. Jessen: *Der Ornamentstich* (Berlin, 1920)
——: *Meister des Ornamentstiches* (Berlin, 1923)

J. Baltrušaitis: *Réveils et prodiges* (Paris, 1960)
P. Ward-Jackson: 'Some Main Streams and Tributaries in European Ornament, 1500–1750', *V&A Mus. Bull.*, 3 (1967), pp. 58–70, 90–103
N. Dacos: *La Découverte de la Domus Aurea et la formation des grotesques à la Renaissance* (London and Leiden, 1969)
C. Ossola: *Autunno del rinascimento* (Florence, 1971)
M. P. Mannini: 'Chimere, capricci, ghiribizzi e altre cose: esempi periferici di grottesca del tardo Cinquecento', *Ann. Fond. Stud. Stor. A. Robert Longhi*, i (1984), pp. 71–86
A. Chastel: *La Grotesque* (Paris, 1988)
M. Faietti and A. Nesselrath: 'Bizar pin che reverso di medaglia: Un Codex avec grotesques, monstres et ornements du jeune Amico Aspertini', *Rev. A.*, cvii (1995), pp. 44–88
P. Morel: *Les Grotesques: Les Figures de l'imaginaire dans la peinture italienne de la fin de la Renaissance* (Paris, 1997)
E. Miller: *16th-century Italian Ornament Prints in the Victoria and Albert Museum* (London, 1999)

MONIQUE RICCARDI-CUBITT

Guacialoti [Guacialotti; Guazzalotti], **Andrea** (*b* Prato, 1435; *d* Prato, 9 Nov 1495). Italian medallist. Working for a series of papal and ecclesiastical patrons in Rome, Guacialoti, who was himself a member of the clergy, seems to have maintained his residence primarily in Prato, where his family, of distinguished Florentine origins, had settled. Besides being a medallist and bronze-founder, he became a papal scriptor, a canon of Prato and priest of Ajolo (Iolo), near Prato. He established a foundry in Prato, where he accepted commissions to cast the works of other artists as well as producing a series of medals. He cast Bertoldo di Giovanni's medal commemorating the *Pazzi Conspiracy* (26 April 1478; Hill, no. 915), which had been made at the request of Lorenzo de' Medici (the Magnificent). On 11 September 1478, Guacialoti sent four examples of the medal to Lorenzo, accompanied by a letter referring to Bertoldo.

Guacialoti's own medals are grouped around three signed pieces with their variants. The first of these is a medal of *Pope Nicholas V* (H 740–41), which is crude in comparison with Guacialoti's other work, itself not notably refined. The second signed medal, of *Niccolo Palmieri, Bishop of Orte* (H 742–4), is one of Guacialoti's finest portraits, and the inscription on some variants indicates that the artist was a member of the Bishop's household around 1467, when the medal was cast. The third signed medal is Guacialoti's most interesting and daring; it commemorates the *Recovery by Alfonso of Aragon, Duke of Calabria, of Otranto from the Turks in 1481* (H 745–6). Alfonso is shown on the obverse in three-quarter view, a departure from the normal profile portrait that is not entirely successful.

Guacialoti's portrait style is distinctive enough to allow the secure attribution to him of a group of medals. Some of the portraits verge on caricature, for example those of *Calixtus III* (H 747) and *Pius II* (H 749). In some pieces, notably those of *Niccolo Palmieri, Alfonso of Aragon* and *Sixtus IV* (H 751), details of the reverse scenes and parts of the inscriptions are crudely engraved. In contrast to the appealing and strongly characterized portraits, the subjects of Guacialoti's reverses were often lifted bodily from the works of other artists. For a medal of *Sixtus IV* he used the Pelican in her Piety from Pisanello's medal of *Vittorino da Feltre* (H 38), and he relied on groups or individual figures found in the medals of Cristoforo di Geremia: part

of the crowd on the reverse of the *Alfonso of Aragon* medal is drawn from Cristoforo's medal of *Lodovico Scarampi* (H 756), and the reverses of two medals of *Sixtus IV* are copied from Cristoforo's medals of *Paolo Dotti* (H 758; the figure of Constantia) and *Constantine* (H 755).

BIBLIOGRAPHY
Forrer
J. Friedländer: *Die italienische Schaumünzen des fünfzehnten Jahrhunderts* (Berlin, 1880/*R* Bologna, 1976), pp. 130–38
G. F. Hill: *Corpus*, i (1930), pp. 191–5 [H]
G. Pollard: *Italian Renaissance Medals in the Museo Nazionale del Bargello*, i (Florence, 1984), pp. 305–13

STEPHEN K. SCHER

Gualdo, Matteo da. *See* MATTEO DA GUALDO.

Gualtieri di Giovanni (da Pisa) (*b* Pisa, ?1370; *d* Siena, after 1445). Italian painter. He had settled in Siena by 1409. He may be the Gualtieri di Giovanni documented in Pisa in 1400–06 (Tanfani Centofanti). Between 1409 and 1411 he frescoed the vaults of the sacristy chapels of Siena Cathedral. Subsequently he did further decorative work in the cathedral (1414, 1415, 1424) and in the canon's house (1416), where he was helped by his son Giovanni. Previously known as one of the Masters of the Sacristy of Siena Cathedral and credited with a major part in the fresco decoration there, it is now evident that his role was very minor (Mongellaz, 1985).

In October 1432 Gualtieri and Cecchino da Verona (?1370–1450) assessed Sassetta's altarpiece of the *Virgin and Child with Saints* (the '*Madonna of the Snow*'; Florence, Pitti; *see* SASSETTA, fig. 1), painted for Siena Cathedral. In 1439 he painted the vault of the Pellegrinaio of the hospital of S Maria della Scala, Siena. Boskovits suggested that a group of works given to the Master of San Davino should be attributed to Gualtieri. This anonymous Master probably trained in Pisa and was named after the *Burial of St Davino* (Florence, Acton priv. col.); his later works have strong affinities with those of Taddeo di Bartolo.

BIBLIOGRAPHY
L. Tanfani Centofanti: *Notizie di artisti tratte dei documenti pisani* (Pisa, 1897), p. 283
M. Boskovits: 'Su Niccolo di Buonaccorso, Benedetto di Bindo e la pittura senese del primo quattrocento', *Paragone*, xxxi/2 (1980), pp. 2–22 (18–19, n. 31)
J. Mongellaz: 'A propos d'une fresque peu connue de la cathédrale de Sienne', *Fond. Stud. Stor. A. Roberto Longhi, Firenze: An.*, i (1984), pp. 27–34
——: 'Reconsidération de la distribution des rôles à l'intérieur du groupe des Maîtres de la Sacristie de la Cathédrale de Sienne', *Paragone*, xxxvi/2 (1985), pp. 73–89

JACQUELINE MONGELLAZ

Guasparri di Spinello. *See* SPINELLI, (1).

Gubbio [Lat. Igurium]. Italian city on the south-western slope of Mt Ingino in Umbria.

1. HISTORY AND URBAN DEVELOPMENT. Traces of human settlements dating back *c.* 130,000 years have been found in the area. It is thought that the settlement preceding Gubbio was situated on the slope of Mt Ingino above the Camignano River, and surrounded by a wall with three gates. It was probably divided north–south by the Via Augurale, on which were the *comitium* and the

forum. The ruins of a castle (c. 1000 BC) on the peak of Mt Ingino and part of a polygonal wall on the opposite slope are all that survives from this early phase.

In the Roman period, Gubbio, mentioned by Pliny the elder among the *municipia* in the *Natural History*, spread to the more level area below the earlier settlement and continued to grow until the 4th century AD. The town ceased to thrive during the 5th and 6th centuries AD especially after its destruction by the Goths in 542.

Gubbio was probably occupied by the Lombards in the 7th and 8th centuries. It was reconstructed on the slopes of Mt Ingino. In the 10th and 11th centuries a new nucleus developed, separated from the old centre by the Camignano River. A disastrous fire in 1127 was followed by a reconstruction mainly concentrated north-east of the town on land obtained through a papal and imperial grant. There is documentary evidence that the first communal organization dates from that period, and the first public square was constructed there at the end of the 12th century, with a town hall and cathedral.

Gubbio was continually at war with Perugia. In the 13th century a new ring of walls (partly extant) was built, and a new nucleus was formed some way downhill, with the rebuilt church of S Giovanni and the Bargello Palace. Still further downhill was the church of S Francesco, facing the market square. The district of S Pietro was extended on a regular plan from 1234, and in the 1260s and 1270s the city was subdivided into quarters (S Pietro, S Andrea, S Giuliano and S Martino). It was undoubtedly in connection with this development that in 1321 the Guelph commune decided to construct a new city centre below the original one, at the point where the four quarters met. It consisted of the rectangular Piazza della Signoria (begun 1322) projecting from the mountainside and supported on arches, facing the valley on one side and flanked on its two short sides by two tall public buildings: the Palazzo dei Consoli (or del Popolo; 1332–41) and the Palazzo Pretorio (completed 1348–9). The piazza was given its present size and form only after 1480, when the commune decided to extend it on new arches constructed between the two palaces.

From 1384 Gubbio was ruled by the Montefeltro family, and in that year Antonio Montefeltro set about reinforcing the existing castle (destr.) and the walls. In 1480 the commune presented Federigo II Montefeltro with a new Palazzo Ducale (begun c. 1476) built in the old cathedral square. The medieval Palazzo della Guardia formed its nucleus, the cathedral square became the courtyard, and a water-tank and service areas were located in Corte Vecchia. The design of the courtyard and the interiors recalls the Palazzo Ducale in Urbino, supporting the attribution of the plan to Francesco di Giorgio Martini (*see* FRANCESCO DI GIORGIO MARTINI, §1), who is named in a document as having designed at least one room, perhaps the *studiolo*. Francesco di Giorgio Martini is named again in contracts of 1481 and 1486 for new ravelins to protect the city gates. Gubbio subsequently enjoyed a long period of peace, with only a few interruptions. During this time most construction work within the walls involved the enlargement of buildings and remodelling of façades, but a few new public buildings and churches were added.

BIBLIOGRAPHY
R. Paci: *Politica ed economia in un comune del ducato di Urbino: Gubbio tra '500 e '600* (Urbino, 1966)
C. Spaziani: *La chiesa e l'abbazia di S Pietro in Gubbio* (Gubbio, 1966)
G. Martines: 'Il Palazzo Ducale di Gubbio', *Ric. Stor. A.*, vi (1977), pp. 89–110
A. L. Prosdocimi: *Le tavole di Gubbio* (Padua, 1978)
G. Venturini: 'Il Palazzo Ducale di Gubbio, riscoperta di antiche strutture urbane', *Ric. Stor. A.*, xi (1980), pp. 70–74
P. Micalizzi: 'Gubbio, l'architettura delle piazze comunali', *Stor. Città*, 18 (1981), pp. 77–116
G. Cerboni Baiardi, G. Chittolini and P. Floriani, eds: *Le arti* (1986), ii of *Federico di Montefeltro: Lo stato, le arti, la cultura* (Rome, 1986), pp. 151–85
P. L. Menichetti: *Storia di Gubbio dalle origini all'unità d'Italia*, 2 vols (Città di Castello, 1987)
O. Lucarelli: *Memorie e guida storica di Gubbio* (Città di Castello, 1988)
P. Micalizzi: *Storia dell'architettura e dell'urbanistica di Gubbio* (Rome, 1988)
C. H. Clough: 'Art as Power in the Decoration of the Study of an Italian Renaissance Prince: The Case of Federico da Montefeltro', *Artibus & Hist.*, xvi/31 (1995), pp. 19–50
FRANCESCO PAOLO FIORE

2. CENTRE OF MAIOLICA PRODUCTION. This small Umbrian town owes much of its fame during the Renaissance to the work of GIORGIO ANDREOLI, known as 'Mastro Giorgio'. Andreoli was a very competent potter who was respected by both clientele and colleagues, who sent their most important works to him to be finished with a brilliant, metallic lustre (a thin film of metal deposited over the tin glaze during a third firing). Lustres applied in Gubbio included gold and ruby (e.g. two-handled vase, c. 1500–25; London, Wallace).

BIBLIOGRAPHY
G. Mazzatinti: 'Mastro Giorgio', *Il Vasari*, iv (1931), pp. 1–16, 105–22
F. Filippini: 'Nuovi documenti intorno a Mastro Giorgio e alla sua bottega (1515–1517)', *Faenza*, xxx (1942), pp. 76–7
G. Polidori: 'Errori e pregiudizi su Mastro Giorgio', *Stud. A. Urbin.*, ii (1953), pp. 13–29
C. Fiocco and G. Gherardi: *Gubbio, altri centri, lo Storicismo*, ii of *Ceramiche umbre dal Medioevo allo Storicismo* (Faenza, 1989)
——: *Museo comunale di Gubbio: Ceramiche* (Perugia, 1995)
P. Mattei and T. Cecchetti, eds: *Mastro Giorgio: L'uomo, l'artista, l'imprenditore* (Perugia, 1995)
La tradizione ceramica in Umbri dall'antichità al Novecento: Deruta, Gualdo Tadino, Gubbio, Orvieto (exh. cat., ed. G. C. Bojani and T. Seppilli; Perugia, Rocca Paolina, Sale Cannoniera, 1995)
CARMEN RAVANELLI GUIDOTTI

Guercia, Jacopo della. *See* JACOPO DELLA QUERCIA.

Guerra, Giovanni (*b* Modena, 1544; *d* Rome, 29 Aug 1618). Italian painter and draughtsman. Having arrived in Rome in 1562, he joined the Accademia di S Luca and the Virtuosi al Pantheon and set up in business with the painter Cesare Nebbia. Together they undertook important commissions from Sixtus V and Clement VIII, for which Guerra 'invented' the stories and Cesare Nebbia executed designs that were then frescoed by a large team of painters. Their projects in Rome included the decoration of the Salone Sisto of the Vatican Library (1585–9) and of the Scala Santa at Porta S Giovanni. Guerra's only documented autograph paintings are frescoes in the Palazzo Cenci (1590; *in situ*). He was a keen exponent of late Roman Mannerism and partly also of Lombard Mannerism. Many of his drawings have survived and include his scenes from the *Lives of the Seven Legendary Kings of Rome* (Paris, Louvre); scenes from the *Life of St Paul* (Paris,

Ecole N. Sup. B.-A.); a substantial series of drawings of *Allegories* and *Signs of the Zodiac* (1593–1603; Paris, Ecole N. Sup. B.-A.); the *Book of Judith* (*c.* 1606; New York, Columbia U., Avery Archit. & F.A. Lib.); a series of drawings of villas, gardens and fountains (1601–4; Vienna, Albertina); and the *Libro di immagini con storie di San Geminiano* (Modena, Archv Stor.). His brother Gaspare Guerra (1560–1622) was also a painter. Giovanni Battista Guerra (*fl* 1586–after 1634), another brother, was an architect and gilder.

BIBLIOGRAPHY

G. Baglione: *Vite* (1642)

Libri di immagini, disegni, e incisioni di Giovanni Guerra (Modena 1544– Roma 1618) (exh. cat. by E. Cecchi Gattolin and E. Parma Armani, Modena, Pal. Musei, 1978) [complete bibliog.]

E. Cecchi Gattolin: 'Precisioni e aggiunte per Giovanni Guerra', *Ant. Viva*, xviii/4 (1979), pp. 16–27

G. Briganti, ed.: *La pittura in Italia: Il Cinquecento* (Milan, 1987, rev. 2/ 1988), p. 738

FIORENZA RANGONI

Guglielmo del Magro. *See* GIRALDI, GUGLIELMO.

Guidetti, Guidetto (*b* ?1495; *d* Rome, before 20 Nov 1564). Italian architect. He was of Florentine origin and trained there as an architect, later settling in Rome. He is first mentioned there as being among the contributors to the expenses of the church of S Giovanni dei Fiorentini, in 1520. His first important patron in Rome was Cardinal Federico Cesi, for whom his first work was at the Giardino dei Cesi (1545–50), a sculpture garden at his palace near the Vatican (*see* ROME, fig. 16). Guidetti designed several garden structures, the most prominent of which was the Antiquarium, a sculpture museum in the form of a Greek cross (destr. 1940). He later worked at the Cesi palaces at Acquasparta (1562) and Cantalupo in Umbria. The Cardinal also commissioned the church of S Caterina dei Funari (1559–64), Rome. Guidetti's design was based on Il Gesù, but the rather flat pilastered façade was derived from Santo Spirito (1538–45) in Sassia by Antonio da Sangallo (ii). The Cesi Chapel in S Maria Maggiore, Rome, a severe Mannerist Greek-cross composition, is also attributed to Guidetti. Of his extensive works (1559–64) at the convent of S Maria sopra Minerva, only the cloister remains. This was a modest design: two identical storeys of five bays of open arcades on each side of a rectangular plan resulted in stretched bays on one pair of sides.

In 1563 Guidetti was commissioned by Pope Pius IV to produce working drawings for the Palazzo dei Conservatori at the Piazza del Campidoglio in Rome, 'in accordance with Michelangelo's instructions', which are shown in various sketches by Michelangelo (London, BM; Oxford, Ashmolean; Vienna, Albertina; Florence, Casa Buonarroti). Work began in June 1563; Giacomo della Porta continued the works after Guidetti's death until their completion in 1584.

BIBLIOGRAPHY

P. Tomei: 'Guidetto Guidetti', *Riv. Reale Ist. Archeol. & Stor. A.*, viii (1940), pp. 62–83

P. Pecchiai: 'L'architetto Guidetto Guidetti aiuto de Michelangelo nella fabbrica del Campidoglio', *Riv. Reale Ist. Archeol. & Stor. A.*, ix (1942), pp. 253–9

——: *Il Campidoglio nel cinquecento sulla scorta dei documenti* (Rome, 1950), pp. 21–5

G. de Angelis d'Ossat and C. Pietrangeli: *Il Campidoglio di Michelangelo* (Milan, 1965)

L. H. Heydenreich and W. Lotz: *Architecture in Italy, 1400–1600*, Pelican Hist. A. (Harmondsworth, 1974), p. 250

A. Melograni: 'Il cantiere cinquecentesco di S Caterina dei Funari e le pitture della cappella Cesi', *Stor. A.*, lxvi (1989), pp. 219–39

S. Benedetti and G. Zander: *L'arte in Roma nel secolo XVI*, Storia di Roma, xxix/1 (Bologna, 1990)

ZILAH QUEZADO DECKKER

Guidi, Giovanni di ser Giovanni. *See* SCHEGGIA.

Guido di Piero da Mugello. *See* ANGELICO, FRA.

Guindaleri, Pietro (*b* Cremona; *fl* 1464–1506). Italian illuminator. There is no evidence for his activity in Cremona, but like his almost exact contemporary, the Paduan painter Andrea Mantegna, Guindaleri was a life-long court artist of the Gonzaga at Mantua. In a letter of 30 November 1489 to Francesco II Gonzaga, the artist stated that he had entered the service of the Marchese's grandfather, Ludovico, 25 years earlier, in 1464. Probably one of the first books that he decorated for the Gonzaga is the copy of Boccaccio's *Il filocolo* (Oxford, Bodleian Lib., MS. Canon. Italiani 85), the text of which was scheduled to be completed for Marchese Ludovico at the beginning of 1464. Its miniature of *Horsemen in a Piazza* (fol. 114*v*) includes foreshortened horses of a type that derives ultimately from the work of Pisanello, Mantegna's predecessor as court painter to the Gonzaga. Comparisons have also been drawn between the miniatures in the Oxford Boccaccio and the frescoes painted around 1470 in the Palazzo Schifanoia at Ferrara.

The miniatures by Guindaleri in the copy of Petrarch's *Canzoniere* and *Trionfi* (London, BL, Harley MS. 3567) are probably close in date to those in the Oxford Boccaccio. This manuscript, executed for Ludovico's son, Cardinal Francesco Gonzaga, was written by the scribe Matteo Contugi of Volterra, who in 1463–8 also wrote the text of the Turin Pliny, decorated years later by Guindaleri (see below). Its white-vine leaf and latticework borders are much more sober than the rich woven decoration on gold that frames the decorated pages of the Oxford manuscript. This suggests that the borders of one, or possibly both, books are not by Guindaleri. In the miniature of the *Triumph of Time* (fol. 184*r*) of the London Petrarch (see fig.), the rendering of the edge of the tiled piazza, which emphasizes the termination of pictorial space, recalls the practice of Jacopo Bellini in two of his Paris drawings (Paris, Louvre, fols 28*r* and 41*r*). Similarly, the archway in the miniature of the *Triumph of Cupid* (fol. 149*r*) is reminiscent of that in Bellini's drawing of the *Flagellation of Christ* (fol. 8*r*).

Papers in the Gonzaga archives indicate that in 1469 Guindaleri was designing patterns for brocade and between 1479 and 1484 decorated a large Book of Hours (untraced) for Francesco's brother Sigismondo (1469–1525). The copy of Pliny's *Natural History* (Turin, Bib. N.U., MSS. I–I, 22–3), on which Guindaleri was engaged between 1489 and 1506, includes several 'architectural text pages' of the type favoured by Paduan and Venetian illuminators. In these folios, the traditional relationship of decoration and script is abandoned and the text depicted

Pietro Guindaleri: *Triumph of Time*, miniature from Petrarch: *Canzoniere* and *Trionfi, c.* 1464 (London, British Library, Harley MS. 3567, fol. 184*r*)

as though it were inscribed on a placard fixed to a massive triumphal arch or similar antique monument. Even here, towards the end of Guindaleri's career, the influence of Bellini recurred in the archway on folio 22*r*; its keystone carved in the form of a cupid is a device that occurs in the Paris drawings (fols 8*r* and 35*r*). In 1506, at the time of his death, Guindaleri was engaged on the decoration of a Pliny manuscript (untraced) for Francesco Gonzaga's wife, Isabella d'Este.

Mantegna's support of his follower, the illuminator Girolamo da Cremona, at the Mantuan court in 1461 is well known and it is probable that Mantegna was also involved in manuscript illumination. He doubtless found Guindaleri's classicizing miniatures congenial, but it would be incorrect to characterize the latter's style as 'Mantegnesque'. Guindaleri's general preference for monumental architectural settings peopled by tiny figures, as well as the derivation of spatial devices and specific motifs in the London Petrarch and the Turin Pliny, imply that he was a student of Bellini and a contemporary, rather than a follower, of Mantegna.

BIBLIOGRAPHY

A. Luzio: 'Isabella d'Este e Francesco Gonzaga promessi sposi', *Archv Stor. Lombardo*, ix (1908), pp. 59–60

U. Meroni: *Mostra dei codici gonzagheschi: La Biblioteca dei Gonzaga da Luigi I ad Isabella, 1328–1520* (Mantua, 1966), pp. 56–7, 80–81, pls 105–8

O. Pächt and J. J. G. Alexander: *Illuminated Manuscripts in the Bodleian Library, Oxford* (Oxford, 1966–73), ii, p. 40

G. M. Canova: *La miniatura veneta del rinascimento* (Venice, 1969), p. 147

Splendours of the Gonzaga (exh. cat., ed. D. S. Chambers and J. T. Martineau; London, V&A, 1981–2), pp. 112, 114–15

T. Kren, ed.: *Renaissance Painting in Manuscripts* (New York and London, 1983), pp. 96–8

B. Degenhart and A. Schmitt: *Jacopo Bellini: The Louvre Album of Drawings* (New York, 1984), pls 4, 31, 40, 48

MARK L. EVANS

H

Herri. *See* ERRI.

Historia. *See* ISTORIA.

Humanism. Term invented in the 19th century, most commonly used to designate developments relating to the revival of Classical literature and learning in European culture from roughly 1300 to 1600. In other contexts, not covered here, it refers to post-Enlightenment programmes of educational reform promoting Classical studies in early 19th-century Germany and, broadly, to currents of opinion that accentuate the worthiness and potential of human beings either with or (often) without assistance from any religious tradition. So prominent is the 'revival of antiquity' in accounts of the transition from medieval to early modern Europe that 'renaissance' and 'humanism' are often used as overlapping, even interchangeable, concepts. Scholars in the 20th century seeking greater precision have proposed a variety of more highly differentiated definitions of the terms. None commands scholarly consensus. References to 'the humanist movement' are likewise as controverted as they are commonplace, and they highlight similarities if not direct linkages among a wide range of figures, elements and activities. Scholars routinely advise that Renaissance humanism is a broad, complex and multi-faceted category embracing numerous chronological, regional, disciplinary and individual variations.

1. Humanism in 15th-century Italy. 2. Humanism and the visual arts.

1. HUMANISM IN 15TH-CENTURY ITALY. The word 'humanist' (It. *umanista*) emerged in 15th-century Italy. It was apparently first applied to teachers of Classical letters devoted, following Roman precedents, to the advancement of the *studia humanitatis* (liberal arts), chiefly grammar, rhetoric, poetry, history and moral philosophy. This was a development of the tradition of Classical rhetoric, which, despite much neglect, persisted in the West. Skills (*ars dictaminis*) for the task of official letter-writing were revived in 11th-century chanceries, and the admiration for Classical writing and declamation in some legal and church circles in 13th-century Italy has been seen as proto-humanism by some scholars. From the 14th century the teacher–scholars typical of humanism sought to enlarge this course of study to include the full cycle of liberal arts and to put familiarity with the Classical heritage to new practical application. The term humanist was soon applied to others with similar interests.

Key figures in the 14th century were FRANCESCO PETRARCH, commonly called the founder of Italian humanism, and Giovanni Boccaccio. Petrarch, the first modern poet to be crowned as Poet Laureate on the Capitoline Hill in Rome (1341), was an enthusiastic and tireless advocate of Classical materials, genres and styles. He was the first to characterize the period after the fall of Rome as the 'dark ages', from which the glories of antiquity deserved to be reborn. The fame of Boccaccio, Petrarch's friend and associate, was based on his *Decameron* (c. 1353), a collection of vernacular short stories, his work with Classical texts and his memorials of illustrious men and women of antiquity. His compendium of Classical mythology, *De genealogia deorum gentilium* (1373), and Petrarch's *Trionfi* (c. 1343) were important sources for Renaissance writers and artists. Such figures inspired an increased interest in Classical antiquity, especially among the well-to-do laity of urban Italy and those aspiring to that status. This response in turn signalled a growing acceptance of the *studia humanitatis* as a pedagogical pathway leading to practical wisdom and to the perfecting of human character. The theoretical basis for humanist education beyond the university was set forth by Pietro Paolo Vergerio (1370–1444); its utility was asserted by Vittorino da Feltre and Guarino da Verona, whose schools became models for schoolmasters and tutors in Italy and then beyond. As such programmes spread, Classical studies were acknowledged as invaluable for creative endeavour in personal, civil, cultural and even ecclesiastical affairs.

A striking example of the character and effects of early humanism can be seen in the republic of Florence during the first half of the 15th century. Distinguished chancellors such as Coluccio Salutati (1331–1406), Leonardo Bruni and Poggio Bracciolini were themselves humanists by training or avocation. Around them formed coteries of patricians and others who undertook or financed humanistic pursuits. Their interests were never merely antiquarian. Classical models of eloquence in speaking and writing proved beneficial in statecraft, public policy debate and diplomacy. From Greco-Roman civilization came lessons and examples of the virtues of a free, patriotic citizenry. Their goal was to match, perhaps to excel, the public and cultural achievements of ancient Athens. Writers since Baron (1955) have portrayed Florentine civic humanism as the paradigm of Renaissance humanism. During this period humanists advocated the *vita activa*. Involvement in practical affairs and the desire to gain lasting fame by virtuous and noble deeds were encouraged; but these

interests were not limited to republican Florentines. Humanists were welcomed, patronized and enrolled in service by many civic and religious leaders, some of whom were themselves humanists. Evidence of such ties include *Il principe* (1513; Rome, 1532) by Niccolò Machiavelli (1469–1517), advice to a ruler, apparently modelled on Cesare Borgia, and *Il libro del cortegiano* by Baldassare Castiglione (Venice, 1528), depicting life at the court of Guidobaldo da Montefeltro, Duke of Urbino.

Florence was also the setting for another notable development in humanism during the first half of the 15th century, the revival of Greek studies. Petrarch and Boccaccio were advocates but not masters of Greek. Florentine chancellors invited to the city scholars from Greece, most notably Manuel Chrysoloras (*c.* 1350–1415), who taught many leading humanists including Bruni, Vergerio, Palla Strozzi and Niccolò Niccoli. Bruni distinguished himself by translating the works of Plato and increasing the awareness in the West of the moral and political thought of Aristotle. Ambrogio Traversari, prior of S Maria degli Angeli, Florence, pioneered the study of Greek patristic literature. Influential in Florence and elsewhere were contacts with Byzantine scholars who came to the West in the 1430s to attempt a reunion of the Eastern and Western churches and after the fall of Constantinople (1453).

Humanism is perhaps best characterized in terms of the undertakings most typical of those who shaped it. About 1450 there were humanists throughout urban Italy, notably in Naples, Milan, Venice, Mantua, Ferrara, Rimini, Urbino and papal Rome. They were professors, schoolmasters, tutors; chancery officials, diplomats, civil servants; some were ecclesiastics; others were leisured individuals of independent means. Humanists aspired to fluency in the pure form of ancient languages—Latin, Greek and, to a lesser extent, Hebrew—rather than corrupt medieval versions. Fascination with letters extended from literacy to grammar, lexicography, rhetoric, philology and handwriting. From humanist adaptations of manuscript hands are derived typographical forms, for example the antique and italic types that remain in use. Humanists were eager to collect lost or forgotten classics, for which they often travelled far afield. Bracciolini's manuscript finds—Ciceronian orations in Cluny, Quintilian's rhetoric in St Gall—were spectacular but not unique. Some of Europe's finest libraries were founded or enlarged in order to accommodate the texts collected by humanists. Cosimo de' Medici, a patron of humanism, established the first public library in Florence in 1444 to house the book collection of Niccoli, and popes, beginning with Nicholas V, built up the Vatican Library. Classical art and artefacts were also desired by humanists, who helped make fashionable the display of authentic and simulated antiquities. Humanists such as Bracciolini, Flavio Biondo and Cyriac of Ancona were among the first to make extensive archaeological surveys of the sites and monuments of the Classical world, both in Rome and further afield.

Collecting and surveying were rarely ends in themselves; humanists wanted to put Classical materials into public circulation. As editors, translators and commentators they laid the groundwork for much modern philological, literary and historical criticism. Lorenzo Valla (1407–57), for example, used new humanist standards of source criticism to question the authenticity of the Apostles' Creed, to expose as a forgery the Donation of Constantine—a document used to defend papal claims to temporal power—and to compare the Latin Vulgate to the Greek New Testament. Knowledge of the classics was also revealed in new literary works, both imitative and innovative. Humanists wrote letters, both public and private, and orations; novelle, aphorisms, epigrams, satires, eclogues and elegies; epic, lyrical and didactic poetry; histories of ancient and recent times; dialogues, tracts and treatises on moral philosophical concerns—human nature, the family, love, virtue and vice, politics, happiness, freedom, fortune and fate. The printing press and increased literacy opened up new markets for humanist writings: the Aldine Press, founded in 1495 by Aldus Manutius (1447–1515) of Venice, was one of the earliest and most renowned sources of such publications.

Summaries of 'humanist thought' based on samplings of these writings display certain recurring thematic emphases: human dignity, freedom and autonomy; critical reasoning; tolerance and toleration; mundane, humane and humanitarian values; appreciation of the sensory and historical world. Such listings, apt as they may be, are invariably too generalized. Humanists cared about living nobly, wisely and well; they mined the golden wisdom (*aurea sapientia*) of Classical antiquity for guidance, but they subscribed to no one philosophy or system of thought.

A development that came to fruition in the second half of the 15th century complicates any discussions of the topic. The encounter with the writings of antiquity reawakened interest in metaphysics as well as the liberal arts. The tradition of scholastic Aristotelianism was reshaped by the Paduan philosopher Pietro Pomponazzi (1462–1525) and others into a neo-Aristotelianism; Giordano Bruno (1548–1600) added elements from Neo-Platonism, the theories of Nicolaus Copernicus (1473–1543) and hermetic thought to construct a grand form of pantheism. Even more striking was the resurgence and recasting of the equally long-established (and variegated) Platonic tradition. The German philosopher Nicholas of Cusa (1401–64) identified God as the point of unity upon which all multiplicity intersects. Neo-Platonic studies flourished at the informal Platonic Academy in Florence sponsored by the Medici and led by Marsilio Ficino, whose masterworks, *De religione christiana* (1474) and *Theologia platonica* (1469–74), fashioned a speculative synthesis of philosophy and theology. His associate, Giovanni Pico della Mirandola (1463–94), brought neo-Pythagorean, hermetic, mystical and cabbalistic traditions into the mix. Whether the turn to metaphysics represented a development or a deviation from the humanist movement is disputed. Neo-Platonism left such a strong imprint on later humanists that distinctions are overdrawn. Beginning with Cristoforo Landino, Angelo Poliziano and Pietro Bembo, a vast outpouring of humanist poetry and prose derived from this tradition, permeated by themes, allegories and sensibilities.

2. HUMANISM AND THE VISUAL ARTS. The problems of defining humanism in relation to art are compounded by the notion of 'renaissance' art. Some scholars unhesitatingly speak of 'the arts in the age of humanism' and

even 'the art of humanism'; others resolve to treat the arts in terms independent of any such associations. This division reflects a healthy suspicion about relying on broad categories such as 'humanism' and 'renaissance' in historical inquiry generally and in art history and criticism in particular. There is an increasing tendency for scholars to explore issues and employ methods that break free of traditional debates about the phases, schools and types of both 'renaissance thought' and 'renaissance style'.

Humanists were first and foremost men of letters. Insofar as they involved themselves with the visual arts, Classical or contemporary *all'antica*, they did so because of what they deemed common interests. They were often employed to devise iconographic programmes for artists. For their part, many artists and works of art displayed a familiarity with sources, tastes and ideals in favour among not only humanists but patrons and other segments of the public educated along humanist lines. Historians thus face a dilemma. It is easy to speak, at a general level, of manifold commonalities, correlations and connections between humanism and the arts; when to label any specific artist or work of art 'humanist' is another, and contested, question.

At first sight evidence of such connections appears in two fields. There are those instances in which writers and artists comment on one another with appreciation, as when Petrarch likened Simone Martini (*c.* 1284–1344), and Ugolino Verino likened Sandro Botticelli, to Apelles. There were also various allusions to the dawning of a new age with Dante, Petrarch, Cimabue (*c.* 1240–1302), Giotto and Duccio (*fl* 1278–1319). Of greater moment is the inclusion of arts in humanistic memorializations of the illustrious, notably the accounts of artists' lives written by Vasari. Notoriously unreliable as histories, such testimonials are telling primary sources nonetheless. Humanism also played a part in changing the status of visual artists, a process begun by Leon Battista Alberti in the 15th century. Humanists tended to view artists as practitioners of the high-status liberal arts, rather than the mechanical, and hence to urge them to study the humanities.

By the same token, causes for which humanists laboured were treated by artists. Noteworthy examples include Taddeo di Bartolo's fresco cycle of *Cardinal and Political Virtues* (1413–14; Siena, Pal. Pub.), *Young Boy Reading Cicero* (mid-1460s; London, Wallace) by Vincenzo Foppa, the zodiacal triumphs (*c.* 1469; Ferrara, Pal. Schifanoia; *see* FERRARA, fig. 2) by Francesco del Cossa and others, Botticelli's *Pallas and the Centaur* (Florence, Uffizi) and *A Youth Presented to the Liberal Arts* (1491; Paris, Louvre), Raphael's *School of Athens* (1509–11; Rome, Vatican, Stanza della Segnatura; *see* ITALY, fig. 15) and Paolo Veronese's *Triumph of Venice* (*c.* 1582; Venice, Doge's Pal.). Humanists were frequently the subject of portraits. Cardinal Bessarion (?1403–72), prelate–scholar and translator of Greek texts, is portrayed in the *Vision of St Augustine* (1502–7; Venice, Scuola S Giorgio degli Schiavoni) by Vittore Carpaccio. Lorenzo Lotto's portrait of *Andrea Odoni* (1527; London, Hampton Court, Royal Col.; *see* LOTTO, LORENZO, fig. 3) shows the collector surrounded by his antiquities. Raphael painted *Baldassare Castiglione* (*c.* 1514–15; Paris, Louvre; *see* RAPHAEL, fig. 8) as the ideal courtier.

A second field of observation reveals instances in which writers and artists were connected by ties of patronage. Filippo Brunelleschi, Lorenzo Ghiberti, Donatello and Masaccio worked in Florence during the great era of civic humanism. Botticelli and Michelangelo were closely associated with Ficino and other leading Neo-Platonists in the circle of Lorenzo de' Medici. The Gonzagas in Mantua protected humanists including Castiglione and Vittorino da Feltre as well as the painter Andrea Mantegna. Popes Julius II and Leo X assembled a remarkable group of scholars and artists in Rome, notably Pietro Bembo, Donato Bramante, Leonardo da Vinci, Michelangelo and Raphael. Francis I patronized Budé, Leonardo, Rabelais, Sebastiano Serlio and artists of the Fontainebleau schools, such as Rosso Fiorentino and Francesco Primaticcio. Such connections suggest extensive relations between humanist men of letters and visual artists. Much of the evidence, however, is circumstantial, the relations tangential, and the extent of the impact of patrons and patronage on artists is the subject of much fresh, often revisionist, research based on archival resources and methods derived from social history.

Other connections between literary humanism and the visual arts are discernible. Humanism was demonstrated in writings as well as in works of art by, among others, Alberti, Ghiberti, Leonardo, Michelangelo, and Benvenuto Cellini. Alberti is particularly important, as he articulated humanist views, setting the arts, and discussion of the arts, on a new, higher level, establishing the basis of academic art theory. Especially significant was his study of the rediscovered texts of Vitruvius, his appreciation of the architecture of Brunelleschi and, related to both, his reflections on proportion, balance, harmony and perspective. None of the procedures Alberti advocated was a humanist invention. He made them humanist by the adoption of mathematical, didactic and Classical principles. His thoughts on perspective were often reviewed and augmented by strains of Neo-Platonism and Neo-Pythagoreanism, later exploited in theoretical treatises by Piero della Francesca, Leonardo and Andrea Palladio, and in such bold explorations of visual space as those of Paolo Uccello. The revival of Classical architectural forms in the works of Bramante, Leonardo, Palladio and Serlio owed much directly or indirectly to Alberti's influence.

Humanists and artists alike were devotees of the cult of antiquity. Inasmuch as humanists led a revival of Greek and Roman literary models, it is tempting to attribute the prevalence of Classical forms and subjects in the arts to humanist influence; but the complexities of the situation justify caution. Both writers and artists drew on a far wider range of Classical forms and contents than did their medieval predecessors. For both, Classical precedents served as points of departure for creative endeavours, and these developments in letters and arts were concurrent and mutually reinforcing.

Literary humanism gave artists access to larger portions of the Classical heritage. More significantly, it helped legitimize an expanded range of artistic ventures, even those that artists undertook for reasons related to aesthetics, technique or commerce. A standard humanist notion about art was the reversal of Horace's dictum 'ut pictura poesis' ('as is painting so is poetry'; *Ars poetica* 361; *see* UT

PICTURA POESIS). The rise in status of the visual arts in the Renaissance is reflected in the extension of literary comparisons to comparisons between the visual arts, such as PARAGONE, the dispute about the relative merits of painting and sculpture. Thus artists profited from humanist valuations of Classical mythology, depictions of life past and present, and the nobility and beauty of man—a theme expressed in depictions of the human figure, clothed or nude, idealized or individualized. Humanist concern for philological–historical accuracy was matched by that of many artists for the authenticity of architectural and other details in the treatment of religious as well as secular subjects. The attentiveness of Mantegna in this respect, for example in *St Sebastian* (*c.* 1480; Paris, Louvre), his frescoes (1453–7; most destr. 1944) in the Ovetari chapel of the church of the Eremitani, Padua (*see* MANTEGNA, ANDREA, fig. 1), and the *Triumphs of Caesar* (*c.* 1484–94; London, Hampton Court, Royal Col.), was a quality prized by numerous others.

Humanism also placed new emphasis on those whose virtues and deeds made a mark on human history. This was given artistic expression in various ways. It is evident, for example, in equestrian statuary: Donatello's *Gattamelata* (1447–53; Padua, Piazza del Santo; *see* DONATELLO, fig. 4), depicting the condottiere Erasmo da Narni (1370–1443), Andrea del Verrocchio's monument (*c.* 1485; Venice, Campo SS Giovanni e Paolo) to Narni's successor *Bartolomeo Colleoni* (1400–76; *see* VERROCCHIO, ANDREA DEL, fig. 4), and Leonardo's plans (Windsor Castle, Berks, Royal Lib.) for a monument in Milan to Gian Giacomo Trivulzio (1441–1518). The same impulse appears in painted equestrian portraits, such as Uccello's *Sir John Hawkwood* (1436; Florence Cathedral; *see* UCCELLO, PAOLO, fig. 1), Castagno's *Niccolò da Tolentino* (*c.* 1456; Florence Cathedral; *see* CASTAGNO, ANDREA DEL, fig. 4) and *Charles V at Mühlberg* (*c.* 1548; Madrid, Prado) by Titian.

Artists were also commissioned to contribute to galleries of heroes. Uccello drew on Petrarch and Boccaccio for figures (destr.) adorning the Casa Vitaliani in Padua (1444–8). Castagno featured illustrious men and women (*c.* 1450; Florence, Uffizi; *see* colour pl. 1, XXI1) in scenes for the gallery of the Villa Carducci, near Florence. Pietro Perugino memorialized figures from Livy and Plutarch in the Sala dell'Udienza (*c.* 1500) of the Collegio del Cambio, Perugia. Among other examples are Masaccio's procession of famous men of Florence (*c.* 1422; destr. 1598–1600) in S Maria del Carmine, Florence, and the portraits of 28 famous men (*c.* 1473–6; Paris, Louvre; Urbino, Pal. Ducale) that were painted for the *studiolo* of Federigo da Montefeltro's ducal palace at Urbino and are attributed to Justus of Ghent (*fl c.* 1460–80). Of similar inspiration were such distinguished funerary works of the Renaissance as Bernardo Rossellino's tomb of *Leonardo Bruni* (*c.* 1445–50; Florence, Santa Croce; for illustration *see* ROSSELLINO (1)) and Michelangelo's designs for the tombs of the Medici (1520–34; Florence, S Lorenzo; *see* colour pl. 2, V1) and *Julius II* (from 1513; Rome, S Pietro in Vincoli; *see* colour pl. 2, VII2).

Intimacy between writers and artists is indicated by artistic renderings of humanist texts and programmes. Close investigation, however, reveals that allegations of direct dependence or collaboration are often hard to prove. Coluccio Salutati's *De laboribus Herculis* (*c.* 1391), on the meanings of Classical legends, prepared the way for many artistic renderings of the hero. Lorenzo Ghiberti's *Gates of Paradise* (*c.* 1435; Florence, Baptistery; *see* colour pl. 1, XXXI2) is attributed to a programme by Traversari. Titian's mythological paintings for the *studiolo* of Alfonso I d'Este, Duke of Ferrara and Modena, were derived from the *Imagines* of Philostratus the elder. The first of the series for the *studiolo*, Giovanni Bellini's *Feast of the Gods* (*c.* 1514; Washington, DC, N.G.A.), links Bellini to Pietro Bembo, just as Mantegna's and Perugino's mythological scenes (Paris, Louvre) for Isabella d'Este's *studiolo* in Mantua link them to her artistic adviser Paride da Ceresara. Botticelli's *Calumny of Apelles* (1490s; Florence, Uffizi) follows an ekphrasis in Lucian of Samosata, while his *Primavera* (*c.* 1478; Florence, Uffizi; *see* BOTTICELLI, SANDRO, fig. 2) and *Birth of Venus* (*c.* 1485; Florence, Uffizi; *see* BOTTICELLI, SANDRO, fig. 3) are apparently based on the writings of Angelo Poliziano. They are certainly suffused with Neo-Platonism, as are Titian's *Sacred and Profane Love* (*c.* 1515; Rome, Gal. Borghese; *see* TITIAN, fig. 1) and much of Michelangelo's art. *Arcadia* (Naples, 1504) by Jacopo Sannazaro (1456–1530) inspired innumerable pastorals in both poetry and painting.

The sources and forms of Renaissance humanism were diverse, as were its effects, including those on the visual arts. Connective links such as those suggested above show that interdisciplinary inquiries remain very much in order.

BIBLIOGRAPHY

G. Vasari: *Vite* (1550, rev. 2/1568); ed. G. Milanesi (1878–85)

K. van Mander: *Schilder-boek* ([1603]–1604)

J. Burckhardt: *Die Cultur der Renaissance in Italien* (Basle, 1860, 15/1926); Eng. trans., 2 vols (London and New York, 1929/*R* 1958)

E. Panofsky: *Studies in Iconology: Humanistic Themes in the Art of the Renaissance* (New York, 1939)

O. Benesch: *The Art of the Renaissance in Northern Europe: Its Relation to the Contemporary Spiritual and Intellectual Movements* (Cambridge, MA, 1945)

E. Garin: *Der italienische Humanismus* (Berne, 1947); rev. as *L'umanesimo italiano: Filosofia e vita civile nel rinascimento* (Bari, 1952; Eng. trans., Oxford and New York, 1965)

M. Cosenza: *Biographical and Bibliographical Dictionary of the Italian Humanists and of the World of Classical Scholarship in Italy, 1300–1800* (New York, 1952; rev., 6 vols, Boston, 2/1962–8)

M. Gilmore: *The World of Humanism, 1453–1517* (New York, 1952)

H. Baron: *The Crisis of the Early Italian Renaissance*, 2 vols (Princeton, 1955, rev. 1966)

P. O. Kristeller: *The Classics and Renaissance Thought* (Cambridge, MA, 1955); rev. as *Renaissance Thought*, 2 vols (New York, 1961–5)

E. Panofsky: *Renaissance and Renascences in Western Art*, 2 vols (Stockholm, 1960)

A. Chastel: *Arte e umanesimo a Firenze al tempo di Lorenzo il Magnifico* (Turin, 1964)

——: *The Age of Humanism: Europe, 1480–1530* (New York, 1964)

P. O. Kristeller: *Eight Philosophers of the Italian Renaissance* (Stanford, 1964)

R. Weiss: *The Spread of Italian Humanism* (London, 1964)

D. Hay, ed.: *The Age of the Renaissance* (New York and London, 1967)

H. Baron: *From Petrarch to Leonardo Bruni: Studies in Humanistic and Political Literature* (Chicago, 1968)

M. Cosenza: *Checklist of Non-Italian Humanists* (Boston, 1969)

G. Holmes: *The Florentine Enlightenment, 1400–1500* (New York, 1969)

K. Clark: *The Art of Humanism* (Cambridge, 1970)

C. Trinkaus: *'In Our Image and Likeness': Humanity and Divinity in Italian Humanist Thought*, 2 vols (London, 1970)

M. Baxandall: *Giotto and the Orators: Humanist Observers of Painting in Italy and the Discovery of Pictorial Composition, 1350–1450* (Oxford, 1971)

L. Spitz: *The Renaissance and Reformation Movements*, 2 vols (St Louis, 1971)

P. Burke *The Italian Renaissance: Culture and Society in Italy* (New York, 1972; 2/Princeton, 1999)

E. Gombrich: *Symbolic Images: Studies in the Art of the Renaissance* (London, 1972)

H. Oberman and C. Trinkaus, eds: *The Pursuit of Holiness in Late Medieval and Renaissance Religion* (Leiden, 1974)

T. Brady and H. Oberman, eds: *Itinerarium Italicum: The Profile of the Italian Renaissance in the Mirror of its European Transformations* (Leiden, 1975)

P. O. Kristeller: *Renaissance Thought and its Sources* (New York, 1979)

E. Fryde: *Humanism and Renaissance Historiography* (London, 1983)

C. Trinkaus: *The Scope of Renaissance Humanism* (Ann Arbor, 1983)

B. Kohl: *Renaissance Humanism, 1300–1550: A Bibliography of Materials in English* (New York and London, 1985)

B. Cole: *Italian Art, 1250–1550: The Relation of Renaissance Art to Life and Society* (New York, 1987)

A. Rabil, ed.: *Renaissance Humanism: Foundations, Forms and Legacy*, 3 vols (Philadelphia, 1988)

Bibliografia italiana di studi sull'umanesimo ed il rinascimento (1989–) [annual publication; bibliographies for 1985–8 in *Rinascimento*, ser. 2, xxvi–xxix]

A. Goodman and A. MacKay, eds: *The Impact of Humanism on Western Europe* (London and New York, 1990)

J. Henderson and T. Verndon, eds: *Christianity and the Renaissance: Image and Religious Imagination in the Quattrocento* (Syracuse, NY, 1990)

J. Monfasani and R. Musto, eds: *Renaissance Society and Culture: Essays in Honor of Eugene F. Rice, Jr* (New York, 1991)

U. Jaitner–Hahner: *Humanismus in Umbrien und Rom* (Baden-Baden, 1993)

JAMES O. DUKE

I

Ibi, Sinibaldo (*b c.* 1475; *d c.* 1550). Italian painter. He initially showed great promise, closely following the style of his master Perugino, Raphael and Bernardino Pinturicchio, but the individuality and quality of his work progressively diminished. In 1496, with Berto di Giovanni, Eusebio da San Giorgio, Lattanzio di Giovanni (*d* 1534) and Lodovico di Angelo (1481–1522), he took a year's lease on a workshop near the Porta Eburnea in Perugia. In 1504 he executed a church banner dedicated to St Ubaldo for Gubbio Cathedral (Gubbio, Mus. & Pin. Com.). In 1507 he painted a panel in Gubbio Cathedral for Girolamo and Maddalena Bentivoglio, depicting the *Virgin between SS Sebastian and Ubaldo*. In 1509, commissioned by a lay confraternity, he executed another church banner depicting the *Madonna of Mercy* (Gubbio, Ranghiasci priv. col.). This banner, which strongly reflects the influence of Timoteo Viti, is generally regarded as his best work. Ibi often collaborated with other members of the Perugia school of painting: from 1508 to 1510 he and Berto di Giovanni painted a *Virgin and Child with Saints* for S Agostino, Perugia. In 1512 he is recorded as treasurer of the painters' guild of Perugia, an office he held again in 1523, 1535, 1540 and finally in 1548. He often appears as an assessor of works by his contemporaries, and in 1514 he and Fiorenzo di Lorenzo helped to resolve a dispute involving Eusebio da San Giorgio.

BIBLIOGRAPHY
Thieme–Becker
A. Mariotti: *Lettere pittoriche perugine* (Perugia, 1788/R Bologna, 1975)
J. A. Crowe and G. B. Cavalcaselle: *A New History of Painting in Italy* (London, 1866/R New York, 1980), pp. 338–9, 344–6
W. Bombe: *Geschichte der Peruginer Malerei*, Italienische Forschungen, v (Berlin, 1912), pp. 334–5
E. Jacobsen: *Umbrische Malerei* (Strasbourg, 1914), p. 139
SUSANNE KIEFHABER

Imola, Innocenzo da. *See* INNOCENZO DA IMOLA.

Impicchati, Andreino degli. *See* CASTAGNO, ANDREA DEL.

India, Bernardino (*b* Verona, 1528; *d* Verona, 1590). Italian painter. After the death of his father in 1545, he was brought up by his maternal grandparents, from whom he derived the surname India. He is sometimes referred to as India *il vecchio* ('the elder') to distinguish him from his nephew Tullio India. He was trained in the workshop of Gian Francesco Caroto but proved particularly receptive to the Mannerism emanating from Mantua and Parma.

He first worked as a fresco painter in buildings designed by Palladio: the Palazzo Thiene, Vicenza, and the Villa Poiana, Poiana Maggiore, near Vicenza. In the Palazzo Thiene, India decorated three rooms with mythological and fantastic scenes (1555–6), the forms of which reveal the influence of Parmigianino. His works (*c.* 1560) in the Villa Poiana are inspired by the Mannerist style of Mantua. The frescoes in the Palazzo Canossa, Vicenza, and the lateral façade of the Palazzo Fiorio della Seta (three panels Verona, Castelvecchio) are of slightly later date. In his later works, beginning in the 1570s, he approached Veronese's use of colour, as can be seen in the numerous altarpieces created for churches in Verona, for example the *Nativity* (1572) and the *Virgin and Child with St Anne* (1579; both Verona, S Bernardino). In the *Conversion of St Paul* (1584; Verona, SS Nazaro e Celso) India created a fusion of Giulio Romano's monumentality and Veronese's use of colour. His final work, the altarpiece depicting the *Martyrdom of St Degnamerita* (1590; Verona, Castelvecchio), demonstrates his skilful use of light.

BIBLIOGRAPHY
Thieme–Becker
L. Magagnato: 'Bernardino India', *Cinquant'anni di pittura veronese, 1580–1630* (exh. cat., Vicenza, 1974), pp. 79–80
B. Mazza: 'Bernardino India', *Maestri della pittura veronese*, ed. P. Brugnoli (Vincenza, 1974), pp. 253–60
Palladio e la Maniera: I pittori vicentini del '500 e i collaboratori del Palladio, 1530–1630 (exh. cat. by V. Sgarbi, Vicenza, S Corona, 1980), pp. 66–73
FILIPPO PEDROCCO

Ingannati, Pietro degli (*fl* Venice, 1529–48). Italian painter. Probably from the Veneto, he was formerly confused with Francesco Bissolo, whose work sometimes resembles Ingannati's. He possibly trained in the workshop of Alvise Vivarini. The *Virgin and Child with Four Saints* (ex-Kaiser-Friedrich Mus., Berlin; destr. 1945) and the *Virgin and Child with Two Saints* (Vercelli, Mus. Civ. Borgogna), both datable for stylistic reasons to the first decade of the 16th century, are his earliest signed works. The paintings show the influence of Giovanni Bellini with regard to composition, but stylistically Ingannati's work is closer to the figurative language, first of Lazzaro Bastiani and later of Marco Basaiti and Benedetto Diana. He was strongly influenced by the later works of Giovanni Bellini and Vincenzo Catena and superficially acknowledged the innovations of Giorgione. Ingannati also looked to the work of Palma Vecchio in, for example, the *Portrait of a Man* (Venice, Coin priv. col.).

Like Rocco Marconi, Ingannati adapted the compositional type known as the SACRA CONVERSAZIONE to show half- or full-length figures seated in a landscape, the composition dependent upon Titian, but the figurative types repeating those of Giovanni Bellini. In his later years he continued to exploit techniques from 50 years earlier, as is shown by the fact that, beyond the rounded shapes and rich, fresh colours, the Virgins of his last *sacre conversazioni* are based on Giovanni Bellini's *Madonna and Child* (*Madonna of the Meadow*, London, N.G.). Other works by Ingannati include the signed *Female Martyr* (Portland, OR, A. Mus.), *Christ Giving a Blessing with Four Saints* (Milan, Marinotti priv. col.), the *Adoration of the Magi* (Perugia, G.N. Umbria), the *Portrait of a Woman* (Berlin, Staatl. Museen Preuss. Kultbes.) and the *Virgin and Child with Mary Magdalene* (ex-Gentner priv. col., Worcester, MA). Other works include various *sacre conversazioni* as well as several paintings derived from Giovanni Bellini's *Virgin and Child with a Bird* (Zurich, Schrafl priv. col.). His last signed work, the *Holy Family with St John the Baptist and St Ursula* (untraced, see Caccialupi, fig. 25), is dated 1548.

BIBLIOGRAPHY

Thieme–Becker
A. Venturi: *Storia* (1901–40), vii/4, p. 584
B. Berenson: *Venetian School* (1957), i, pp. 91–2
F. Heinemann: *Giovanni Bellini e i Belliniani*, 2 vols (Venice, 1962), i, pp. 107–11
P. Caccialupi: 'Pietro degli Ingannati', *Saggi & Mem. Stor. A.*, 11 (1978), pp. 21–43, 147–62 [incl. bibliog.]
A. Tempestini: 'La *Sacra Conversazione* nella pittura veneta dal 1500 al 1516', *La pittura nel Veneto: Il Cinquecento*, iii [in preparation]

ANCHISE TEMPESTINI

Innocent VIII, Pope [Cibo, Giovanni Battista] (*b* Genoa, 1432; elected 29 Aug 1484; *d* Rome, 25 July 1492). Italian pope and patron. Though he was a poor administrator and left the church in a state of disarray, he did not neglect the renovation of Rome and the Vatican begun by his predecessors. He commissioned the ciborium of the Holy Lance for St Peter's (fragments, Rome, Grotte Vaticane), rebuilt S Maria in Via Lata and continued the restoration and embellishment of S Giovanni in Laterano. At St Peter's he continued the Benediction loggia begun by Pius II, built a palace adjoining the atrium for the Curia, erected the fountain to the right of the obelisk in St Peter's Square and in 1486 commissioned from Gian Cristoforo Romano a statue of *St Peter* for the steps in front of the façade (untraced; possibly unexecuted).

Innocent's major architectural project at the Vatican was the Villa Belvedere that he built between 1485 and 1487 at the northern end of the Vatican hill. In the 16th century the villa was connected with the Vatican palace by Bramante's Cortile del Belvedere (see colour pl. 1, XVII). The villa was altered by Pius VI, and its loggia is now the Galleria delle Statue of the Musei Vaticani. The original exterior was crowned by a crenellated parapet. Its long central segment containing the loggia and framed by shallow projecting blocks at either side had its prototype in Late Antique imperial villas. The loggia is decorated with a rich stucco vault in the manner of Roman vaults in the then recently discovered Golden House of Nero and with illusionistic frescoes by Pinturicchio, of which only fragments remain, imitating the mural decorations in

ancient Roman villas. These transformed the loggia into an airy hall with views of Monte Mario to the north and of imaginary landscapes 'in the Flemish manner' (Vasari) of Rome, Milan, Genoa, Florence, Venice and Naples to the south. In the lunettes Pinturicchio painted pairs of putti with musical instruments and the Cibo arms. The interior of the villa's chapel contained frescoes and an altarpiece with the *Baptism* by Andrea Mantegna (destr.). From his accession, Innocent had sought to secure the services of Mantegna, who was in the employ of Francesco Gonzaga, 4th Duke of Mantua; Mantegna finally came to Rome in 1486. He was there again in 1487 and is recorded as leaving the city in 1490.

Innocent VIII was the first pope to enter into diplomatic relations with the Ottoman empire, when in 1489 he agreed to detain Sultan Bayezid II's brother and potential rival, Jem, in Rome, in return for an annual payment of 40,000 ducats and the gift of the relic of the Holy Lance that was supposed to have pierced Christ's side at his Crucifixion. The reception of the relic by Innocent VIII in Rome on 31 May 1492 marked the high-point of his pontificate. To house it, he commissioned a tabernacle with a fresco by Pinturicchio (completed 1495; destr.), and in the seated image that Antonio Pollaiuolo sculpted for his tomb (1492–8) at St Peter's he is shown holding the relic of the Holy Lance aloft in his right hand.

BIBLIOGRAPHY

G. Vasari: *Vite* (1550, rev. 2/1568); ed. G. Milanesi (1878–85)
L. Pastor: *Geschichte der Paepste seit dem Ausgang des Mittelalters*, iii (Freiburg, 1895, 11/1955), pp. 207–335
E. Muentz: *Les Arts à la cour des papes Innocent VIII, Alexandre VI, Pie III* (Paris, 1898), pp. 13–138
D. Redig de Campos: *Il Belvedere di Innocenzo VIII in Vaticano* (Vatican City, 1958)
S. Sandstroem: 'The Programme for the Decoration of the Belvedere of Innocent VIII', *Ksthist. Tidskr.*, xxix (1960), pp. 35–75
J. Schulz: 'Pinturicchio and the Revival of Antiquity', *J. Warb. & Court. Inst.*, xxv (1962), pp. 35–55
D. R. Coffin: 'Pope Innocent VIII and the Villa Belvedere', *Studies in Late Medieval and Renaissance Painting in Honor of Millard Meiss*, ed. I. Lavin and J. Plummer (New York, 1978), pp. 88–97
J. Alexander: 'Fragments of an Illuminated Missal of Pope Innocent VIII', *Pantheon*, xxxviii (1980), pp. 377–82
M. J. Gill: 'Antoniazzo Romano and the Recovery of Jerusalem in Late Fifteenth-century Rome', *Stor. A.*, lxxxiii (1995), pp. 28–47

HELLMUT WOHL

Innocenzo da Imola [Francucci, Innocenzo] (*b* Imola, *c.* 1490; *d* Bologna, *c.* 1545). Italian painter. He probably trained with Francesco Francia in Bologna *c.* 1508 and then with Mariotto Albertinelli in Florence for a period between 1510 and 1515. His earliest known work, the *Virgin and Child with SS Sebastian, Roch, Cosmas and Damian*, signed and dated 1515, is in the Chiesa Archipretale at Bagnara, Ravenna. It is a classical composition of Florentine derivation, with the Virgin and Child appearing on a cloud above the four saints. His Florentine training is even more evident in the *Virgin and Child with SS John, Apollinaris and Catherine and a Bishop*, signed and dated 1516, for S Apollinare at Cásola Valsenio, near Bologna.

In 1517 Innocenzo moved to Bologna, where he painted frescoes for the chapel of the Sacristy of S Michele in Bosco, representing the *Assumption of the Virgin*, the *Annunciation*, the *Resurrection* and *St Michael* (damaged). The use of Florentine models is enriched here by a

monumental, classicist accent suggested by Raphael's *Ecstasy of St Cecilia* (1515; Bologna, Pin. N.), which was in Bologna from that time. A Raphaelesque prototype, *St Michael* (Paris, Louvre), directly inspired the *Virgin in Glory with St Michael the Archangel between SS Peter and Benedict* (1521–2; Bologna, Pin. N.), also painted for S Michele in Bosco. In 1526 Innocenzo began working on commissions for Faenza. He painted an altarpiece, the *Virgin and Child with Saints and the Archangel Raphael with Tobias* (1527; Forlì, Pin. Civ.), for S Francesco. The formula of Florentine grace plus the more modern Raphaelesque classicism appears again in the *Virgin with Child and Saints* (1532; St Petersburg, Hermitage). One of the best works by Innocenzo in Bologna, the altarpiece of the *Virgin and Child with the Eternal Father and Saints* (dismantled), painted for S Mattia, introduces a new attention to colour, which approaches the work of Girolamo da Carpi. Its original form has been reconstructed by Zeri.

Among the works of Innocenzo's maturity was the important commission of 1533 for S Giacomo Maggiore in Bologna: the altarpiece of the *Virgin and Child with Saints* (*in situ*) and the frescoes representing the *Assumption of the Virgin, Christ and St Paul* (*in situ*). A greater freedom in his use of models and increased attention to colour modulation can be seen in the *Crucifixion* (1539; Bologna, S Salvatore), although the faces, especially that of St John, still reflect the influence of Raphael. Innocenzo's artistic career ended with an ambitious project, the decoration of the Palazzino della Viola in Bologna, begun after 1541, where for the first time he dealt with mythological subjects including *Diana and Actaeon* and *Apollo and Marsyas* (damaged; some *in situ*), and here again he looked to the model of Raphael. His pupils included Prospero Fontana.

BIBLIOGRAPHY

Thieme–Becker: 'Francucci, Innocenzo'

G. Vasari: *Vite* (1550, rev. 2/1568); ed. G. Milanesi (1878–85), v, p. 185; vii, p. 406

C. C. Malvasia: *Felsina pittrice* (1678); ed. G. Zanotti (1941), p. 118

R. Galli: 'Innocenzo da Imola: I tempi, la vita, le opere', *La Mercanzia*, vi/2–4 (1951)

Mostra delle opere di Innocenzo da Imola (exh. cat. by R. Buscaroli, Imola, Pin. Civ., 1951)

R. Longhi: *Opere complete*, v (Florence, 1956), pp. 161, 191

F. Zeri: 'Two Fragments by Innocenzo da Imola', *J. Walters A.G.*, xxxiii–xxxiv (1970–71), pp. 59–63

D. Ferriani: 'Innocenzo Francucci detto da Imola', *Pittura bolognese del '500*, ed. V. Fortunati Pietrantonio, i (Bologna, 1986), pp. 59–66 [good bibliog.]

FRANCESCA CAPPELLETTI

Ippolito del Donzello. *See* DONZELLO, (2).

Isaia da Pisa (*fl* 1447–64). Italian sculptor. His grandfather, Giovanni di Gante, was a stone-carver, and his father, Pippo di Giovanni de Ghante da Pisa, who worked with Donatello on the Brancacci monument in the Baptistery in Florence in 1426, was documented at the Vatican in 1431 (Müntz). This suggests that Isaia was taken to Rome as a youth. He was probably active as a sculptor before 1447, since Filarete, who was forced to flee Rome at that date, mentioned Isaia in his *Trattato*. Isaia's oeuvre is not easy to define, because the sculptures for which payments exist were all collaborative works. However, a corpus has

been assembled, based in part on the style of one of the lunette reliefs from the Tabernacle of St Andrew (Rome, Grotte Vaticane), a project on which he collaborated with PAOLO ROMANO in 1463–4. Porcellio Pandone wrote a poem in his honour (*Ad immortalitatem Isaiae Pisani marmorum celatoris*) in which, in the tradition of humanist hyperbole, he compared him to Pheidias, Polykleitos and Praxiteles (Battaglini). Although his work has been called monotonous, the influence of late Roman sculpture on Isaia's style reflects the classicizing taste of his time.

Porcellio described several works by Isaia, including the tomb of *Eugenius IV* (Rome, S Salvatore in Lauro, ex-refectory). Of his work on this tomb, little more than the effigy of the Pope remains, which was also described by the humanist Maffeo Vegio (Kühlenthal), who praised its magnificence. Isaia probably worked on it between the death of Eugenius in 1447 and the sculptor's departure for Naples in 1455. The effigy of *St Monica* (Rome, S Agostino), attributed to Isaia by Porcellio, was probably part of a chapel erected by Vegio in S Agostino and may have been begun by Isaia in 1455 and completed by assistants (Montevecchi). Another early work is the tomb of *Antonio Martínez Chiaves*, the Cardinal of Portugal, originally in S Giovanni in Laterano, Rome. The commission for the tomb was initially given to Filarete; Isaia had apparently not yet completed it in 1449, when Filarete attempted to return to Rome to reclaim the commission. The sculptures from the dismantled tomb are incorporated in two monuments, a Baroque resetting of the *Chiaves* tomb and the tomb of *Cardinal Giulio Acquaviva* (*d* 1574), both in S Giovanni in Laterano. The original tomb can be reconstructed from a drawing (Kühlenthal). The effigy and half-length figures in the centre are flanked by standing allegories in niches; it is probably the first example of a scheme that was to become characteristic of Roman tombs. Isaia's execution of the sculpture does not necessarily imply that he invented the format, but the figures, with their overt references to antique models—*Temperance*, for example, derives from the Venus Genetrix type —is as forward-looking as the design itself. This *all'antica* style helps to explain Isaia's popularity with his humanist patrons; Porcellio Pandone mentioned that he himself owned two works by Isaia of riding figures of Nero and Poppaea, presumably reliefs (both untraced), and Alfonso I and Pius II, the latter a noted humanist, favoured allusions to the Classical past in their commissions.

From 1455 to 1458 Isaia worked on the Arch of Alfonso I of Aragon at the Castelnuovo, Naples (*see* NAPLES, §3). His precise contribution to the sculptural programme is controversial: Hersey argued that Isaia was the master responsible for the frieze of *Alfonso of Aragon's Triumphal Procession* and its surrounding sculptural detail, but Kruft and Malmanger limited Isaia's and his shop's contribution to the lower fields of the arch. Although both the *Fortitude* and the female genius guiding the King's chariot have been attributed to Paolo Romano, stylistically they are closer to Isaia. Other works that have been plausibly attributed to Isaia include the sacrament tabernacle for S Maria Maggiore (destr.; fragments Rome, S Maria Maggiore, sacristy of the Chapel of Sixtus V; Chicago, IL, A. Inst.; see Middeldorf), a relief of *Apollo* (Warsaw, N. Mus.; see Kaczmarzyk) and the marble high-relief *Virgin and*

Child, known as the Orsini *Madonna* (Rome, Grotte Vaticane), which can be identified with a commission of 1451 by Cardinal Pietro Barbo (the future Pope Paul II) in honour of his uncle Eugenius IV (Caglioti). It is evident that Isaia, like many of his contemporaries, worked with a large number of assistants, and a series of works in locations around Viterbo may be derived from his designs (Negri Arnoldi). One of his last documented activities was working on the construction of the Benediction Loggia for Pius II in 1463–4. After the death of the Pope in 1464, he and Paolo Romano may have worked for private patrons, although it is unlikely that Isaia survived for many years after this date.

BIBLIOGRAPHY
Thieme–Becker

Filarete [A. Averlino]: *Trattato d'architettura* (MS. *c.* 1460–65); Eng. trans. and ed. J. Spencer as *Treatise on Architecture* (New Haven, 1965), pp. 45–77 [facs. of MS.]

G. Vasari: *Vite* (1550, rev. 2/1568); ed. G. Milanesi (1878–85), ii, pp. 472n, 484

A. Battaglini: 'Memoria sopra uno sconosciuto egregio scultore del secolo XV e sopra alcune sue opere', *Atti Pont. Accad. Romana Archeol.*, i (1821), pp. 115–32 [complete text of poem by Porcellio]

E. Müntz: *Martin V–Pie II 1417–1464* (1878), i of *Les Arts à la cour des papes pendant le XVe et le XVIe siècle: Recueil de documents inédits*, ed. E. Thorin (Paris, 1878–82)

A. Venturi: *Storia* (1901–40), vi, pp. 374–87

F. Burger: 'Isaia da Pisa: Plastische Werke in Rom', *Jb. Kön.-Preuss. Kstsamml.*, xxvii (1906), pp. 228–44

L. Ciaccio: 'Scultura romana del rinascimento primo periodo (sino al Pontificato di Pio II)', *L'Arte*, ix (1906), pp. 165–84

A. Riccoboni: *Roma nell'arte: La scultura nell'evo moderno dal quattrocento ad oggi* (Rome, 1942), pp. 8–14

U. Middeldorf: 'The Tabernacle of S. Maria Maggiore', *Bull. A. Inst. Chicago*, xxxviii (1944), pp. 6–10

J. Pope-Hennessy: *Italian Renaissance Sculpture* (London, 1958, rev. 3/Oxford, 1985), pp. 65, 319–20

C. Seymour jr: *Sculpture in Italy, 1400–1500*, Pelican Hist. A. (Harmondsworth, 1966), pp. 118, 134, 137–8, 156, 264–5

V. Golzio and G. Zander: *L'arte in Roma nel secolo XV* (Bologna, 1968)

G. C. Sciolla: 'Fucina aragonese a Castelnuovo, I', *Crit. A.*, n. s. 2, xix/123 (1972), pp. 15–36

G. Hersey: *The Aragonese Arch at Naples, 1443–1475* (New Haven, 1973)

D. Kaczmarzyk: 'Isaia da Pisa, auteur présumé du bas-relief d'Apollon au Musée National de Varsovie', *Bull. Mus. N. Varsovie/Biul. Muz. N. Warszaw.*, xv/1–2 (1974), pp. 28–32

H. W. Kruft and M. Malmanger: 'Der Triumphbogen Alfonsos in Neapel: Das Monument und seine politische Bedeutung', *Acta Archaeol. & A. Hist. Pertinentia*, vi (1975), pp. 213–305

M. Kühlenthal: 'Zwei Grabmäler des frühen Quattrocento in Rom: Kardinal Martinez de Chiaves und Papst Eugen IV', *Röm. Jb. Kstgesch.*, xvi (1976), pp. 17–56

F. Negri Arnoldi: 'Isaia da Pisa e Pellegrino da Viterbo', *Il quattrocento a Viterbo* (Rome, 1983), pp. 324–40

B. Montevecchi: *Sant'Agostino*, Chiese Roma Illus. (Rome, 1985)

F. Caglioti: 'Precisione sulla 'Madonna' di Isaia da Pisa nelle Grotte Vaticane', *Prospettiva* [Florence], 47 (1986), pp. 58–64

□

Istoria [historia]. Term first used in the 15th century to refer to the complex new narrative and allegorical subjects that were then enlarging the repertory of painters. While remaining in use, its meaning became less clearly defined and more generalized in the 16th century. It appeared prominently for the first time in Books II and III of Leon Battista Alberti's pioneering treatise on painting, *De pictura* (written 1435), where the author referred to *historia* as the most ambitious and most difficult category of works a painter can attempt.

Alberti explained that they derive from the finest texts of Christianity and antiquity and involve numerous figures. Educated friends of the artist may supply him with an *inventione*; his visualization of the words is an *istoria*. He further explained that the *istoria* is for the painter what the colossal statue was in antiquity for the sculptor, except that the painter's project requires greater intelligence (*ingenium*): variety, decorum and dignity are requisite. The painting must be eloquent and hold the attention of both the senses and the mind of the spectator. Alberti gave such examples as Timanthes' lost painting of the *Sacrifice of Iphigenia*; Apelles' lost *Calumny*; ancient representations of the *Three Graces*; a well-known, but unidentified *istoria* in Rome showing the *Bearing of the Dead Meleager*, possibly the one formerly housed at the Palazzo Sciarra, Rome, and now lost (Bober, Rubinstein and Woodford, 1987, p. 147); and Giotto's *Navicella* (destr.) in St Peter's, Rome. Apelles' lost *Calumny* was re-created later in the century by Botticelli (Florence, Uffizi) and Mantegna (drawing; London, BM); the *Three Graces* was re-created by Botticelli (*Primavera*; Florence, Uffizi; *see* BOTTICELLI, SANDRO, fig. 2) and Raphael (Chantilly, Mus. Condé); and the *Meleager* was transformed into a relief *all'antica* of the *Pietà* by Luca Signorelli (see fig.).

The complexity of the endeavour is such that Alberti suggested the use of preparatory drawings. He recommended nine or ten figures, ranging in age and attitude. The nude should be shown only with modesty, and any ugliness in live models ameliorated. Movement should be used to convey emotion; expression to engage the viewer's attention. One figure in particular should address the viewer. Although figures are the essence of the *istoria*, Alberti allowed for the inclusion of animals, landscape and buildings. He thus expected the artist to be broadly knowledgeable. The concept of *istoria* provided Alberti with his highest level of generality for analysing pictures. Proposing that the spectator should 'enter' not only the space of a picture but also the experience depicted, he understood an *istoria* to be more than simply narrative subject-matter, rather it represented an instant of an idealized but essentially true reality, a reality that accorded with nature and with art. Exacting in both its naturalism and its decorum, an *istoria* could achieve both likeness and beauty and create a context in which beauty asserts its proper prevalence over mere conspicuousness. In an *istoria*, the senses serve the mind rather than distracting it.

The discussion that preceded Lorenzo Ghiberti's creation of the doors of the Baptistery, Florence (*Gates of Paradise*, ?1426–52; see colour pl. 1, XXXI2) included some precedent for Alberti's concept of *istoria*, though the subject of the debate was the programme to be given to the artist rather than specifically what he would create (Krautheimer and Krautheimer-Hess, 1956, doc. 52). Leonardo Bruni and Niccolò Niccoli both used the word, Bruni specifying that the '*historie*' should be 'illustri' (clear) and 'significanti' (meaningful). He stressed variety as part of the first quality. In his mid-15th-century *commentarii*, Ghiberti used the word of his compositions on both sets of doors (*I commentarii*; ed. J. von Schlosser, Berlin, 1912).

Leonardo not only composed *istorie* but also mused on the challenge in his notebooks. Like Alberti, he cautioned against crowding yet recommended variety. He also em-

Luca Signorelli: *Pietà* (1499–1504), detail of fresco, chapel of S Brizio, Orvieto Cathedral

phasized the expressive function of movement while stipulating that decorum be observed. Leonardo's recommendations on how to represent a battle or a night scene, a storm or a deluge, follow on from Alberti's suggestions for *istorie*, though they rely less on the authority of literature and more on actual observation. Nor was this sort of theorizing restricted to Florence. Jacopo de' Barbari of Venice in a letter of 1500–1501 (Serrolini, 1944) closely associated poetical invention in painting and the need for copiousness in an *istoria*; Dürer (1471–1528) wrote to Willibald Pirckheimer (1470–1530) in 1506 that he had seen no *historien* of interest in Venice. Mantegna and then Raphael perfected the type, emphasizing the dramatic interaction of figures without disrupting the compositional wholeness of the group.

After Alberti, the word *istoria* continued to be an important part of the vocabulary for thinking about art, although it did not always have the prestigious connotation he gave it. It might designate little more than the difference between a narrative subject and an iconic one, as when Vasari referred to the Martelli *David* (Washington, DC, N.G.A.) of Donatello as an *istoria*. He elsewhere refers to the *istoria* as a type that might involve between four and twenty figures, the crucial requirement being their mutual integration. This is the standard 16th-century definition: an *istoria* is a painting or relief sculpture in the grand manner, copious, unified and likely to be didactic. Giovanni Battista Armenini acknowledged (1587) that in his day *istorie* were usually relegated to ornamental friezes and recommended a choice of subject appropriate to the patron and to the function of the room. For a patron who has accomplished no great deed, the deeds of renowned Romans could be substituted.

Though often *istorie* had been compared with *favole* or *poesie*, during the Counter-Reformation the contrast was emphasized. Galileo Galilei called Torquato Tasso's poetry a collection of *favolette*, like sketches by Baccio Bandinelli or Parmigianino, whereas Ariosto provided *storie integre*. A corresponding phenomenon is the reversal of the connotations of *istorie* and *inventione*: whereas for Alberti the latter made the former possible, later writers often think of the *istoria* as provoking the *inventione*. The *istoria*, in this newer formulation, must be faithful to what actually occurred. Giovanni Andrea Gilio da Fabriano cites Gregory the Great on pictures as the books of the illiterate (Barocchi, 1961): the painter's role is one of a humble translator, whose business is accuracy rather than inventiveness and displays of genius. Michelangelo's *Last Judgement* (1541; Rome, Vatican, Sistine Chapel; see colour pl. 2, VII3), with its Dantesque flavour, is at issue, as is Raphael's *Fire in the Borgo* (Rome, Vatican, Stanze di Raffaello; see RAPHAEL, fig. 4) with its visual reference to Troy. For Giovanni Paolo Lomazzo, however, such caution applied only to sacred stories and those in dignified places: he also allowed for *istorie* that are neither grand nor serious, nor differentiated from fictions. Both Paolo Pino and Raffaello Borghini (c. 1537–88) theorized about the devising of *istorie* that did not depend on texts—as,

earlier, had Leonardo, not to mention Apelles. Borghini cited Michelangelo as such an artist, for example, in his cartoons for the *Battle of Cascina* (destr.).

The early concept of *istoria* referred to but few existing works. By the 16th century the word was applied to a plethora of works, including prints by Lucas van Leyden (1494–1533). Rather than suggesting extraordinary ambitiousness, it stipulated only a many-figured scene presented with optimal vividness. No longer did the concept preside over the triumvirate of invention, colouring and design: *istoria* had become a means rather than an end. For Alberti, to construct an *istoria* was to claim *ingenium*; for Lodovico Dolce, in his *Dialogo della pittura* (1557), the *istoria* is no more than the artist's material, to which must be added some ingenious composition and design if there is to be praiseworthy invention.

BIBLIOGRAPHY

L. B. Alberti: *De pictura* (Basle, 1540); trans. and ed. C. Grayson as part of *On Painting and on Sculpture* (London, 1972)
L. Dolce: *Dialogo della pittura* (Venice, 1557); trans. and ed. M. W. Roskill as *Dolce's 'Aretino' and Venetian Art Theory of the Cinquecento* (New York, 1968)
R. Borghini: *Il Riposo* (Florence, 1584); ed. M. Rosci (Milan, 1967), p. 61
G. Lomazzo: *Trattato dell' arte della pittura, scoltura et architettura* (Milan, 1584); ed. R. Ciardi in *Scritti sulle arti* (Florence, 1974)
G. B. Armenini: *De' veri precetti della pittura* (Ravenna, 1587; Eng. trans., New York, 1977), bk III, chaps x, xiv
G. Galilei: *Considerazioni al Tasso* (Rome, 1793); x of *Opere*, ed. A. Favaro, A. Garbasso and G. Abetti, 20 vols (Florence, 1968)
L. Serrolini: *Jacopo de' Barbari* (Padua, 1944), pp. 105–7
R. Krautheimer and T. Krautheimer-Hess: *Lorenzo Ghiberti* (Princeton, 1956, rev. 3/1982) [doc. 52: Bruni's letter]
P. Barocchi: *Trattati d'arte del cinquecento fra Manierismo e Controriforma* (Bari, 1961) [incl. Gilio da Fabriano's *Dialogo . . .* (1564)]
M. Baxandall: *Giotto and the Orators* (Oxford, 1971), pp. 130–34
C. Hope: 'Artists, Patrons and Advisers in the Italian Renaissance', *Patronage in the Renaissance*, ed. G. Lytle and S. Orgel (Princeton, NJ, 1981), pp. 293–343
H. Mühlmann: *Ästhetische Theorie der Renaissance: Leon Battista Alberti* (Bonn, 1981), pp. 161–72
P. P. Bober, R. Rubinstein and S. Woodford: *Renaissance Artists and Antique Sculpture: A Handbook of Sources* (London, 1987)
D. Rosand: '*Ekphrasis* and the Renaissance of Painting: Observations on Alberti's Third Book', *Florilegium Columbianum: Essays in Honor of Paul Oskar Kristeller* (New York, 1987), pp. 147–65

PATRICIA EMISON

Italy [Repubblica Italiana]. South European country. Mainland Italy occupies a peninsula (1200 km from north to south) bordered by the Tyrrhenian Sea to the west, the Ionian Sea to the south and the Adriatic Sea to the east (see fig. 1). The principal offshore islands of Italy are Sicily and Sardinia. To the north the Alps form the mountainous border with France, Switzerland, Austria and Slovenia. The Appennines are a limestone range running right down the peninsula into Sicily. Active volcanoes include Mt Vesuvius near Naples and Mt Etna in Sicily. The many and varied regions of Italy include Piedmont and Lombardy in the north, which occupy the plain of the River Po and are home to TURIN and MILAN respectively; the Venetias to the east, including VENICE; Emilia Romagna to the north-east of the Apennines, with its major town of BOLOGNA; Liguria, a coastal region to the west of the Apennines that includes GENOA (see fig. 2); fertile Tuscany, with its great artistic centres of FLORENCE and SIENA; Umbria, the heartland of the Etruscan civilization in Central Italy; Latium, the cradle of the Roman civiliza-

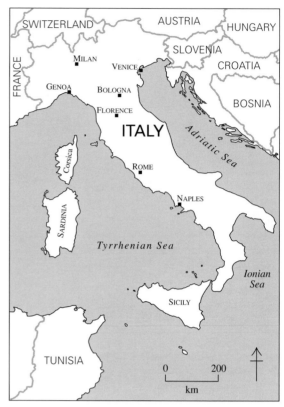

1. Map of Italy; those areas with separate entries in this dictionary are distinguished by CROSS-REFERENCE TYPE

tion, with ROME, Italy's capital, at its centre (see fig. 3); and Campania, which runs along the Bay of NAPLES (see fig. 4). The climate is continental in North Italy, harsh in the mountainous regions but temperate and Mediterranean in most of the country. Italy has been the home of several cultures of the greatest importance for Western art, from the mighty Roman Empire to the artistic flowering of the RENAISSANCE. This survey covers the art of the country during the Renaissance and Mannerist periods.

I. Introduction. II. Architecture. III. Painting. IV. Sculpture. V. Interior decoration. VI. Furniture. VII. Ceramics. VIII. Glass. IX. Metalwork. X. Objects of vertu. XI. Textiles. XII. Patronage. XIII. Collecting and dealing. XIV. Museums. XV. Art education. XVI. Historiography.

I. Introduction.

In the late 8th century BC Greek colonists settled in South Italy and Sicily, and at the same time the Etruscan civilization developed in Central Italy. Rome itself was ruled by Etruscan kings in the 6th century BC. Under the Roman Republic (509–27 BC), Etruscan power declined, and Italy began to be unified under Roman rule. The power of Rome and Italy extended under the Empire (31 BC–AD 476), although the importance of Roman provinces abroad gradually exceeded that of Italy itself, until in AD 330 Constantinople (now Istanbul) became the new capital of the Empire. Successive waves of invasions, first by Germanic barbarian tribes in the 4th and 5th centuries and then by the Lombards (568–774), combined with the growing power of the papacy centred on Rome, all

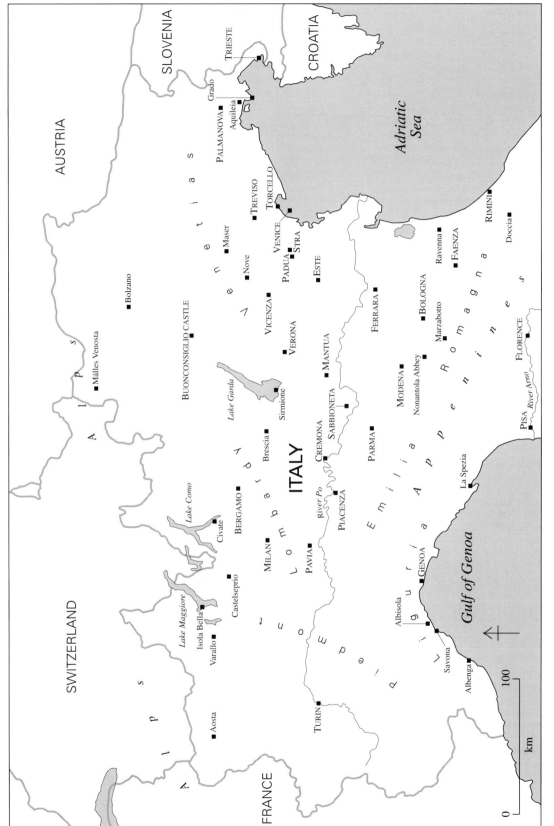

2. Map of North Italy; those sites with separate entries in this dictionary are distinguished by CROSS-REFERENCE TYPE

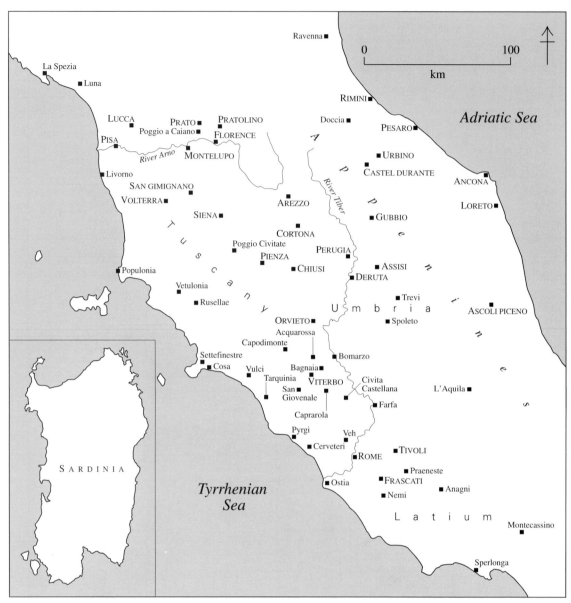

3. Map of Central Italy; those areas with separate entries in this dictionary are distinguished by CROSS-REFERENCE TYPE

contributed to the severing of political ties with the Byzantine Empire in the East. For a short period in the 9th century North Italy was part of the Frankish empire, and in 962 the German king Otto I was crowned Holy Roman Emperor at Rome. The medieval period was characterized by the struggle for supremacy between the papacy and the Empire, though theoretically they were the spiritual and temporal arms of the same entity. Many North Italian cities became powerful and independent city states, though divided in their allegiance to the emperors or the popes. South Italy followed a different course: Arab influence was strong from the 9th century, but from the mid-11th century the Normans established control there, with Roger II (reg 1130–54) becoming King of Sicily in 1130. Charles of Anjou (reg 1266–85) ruled as King of

Naples and Sicily from 1266, and in the 15th century the so-called Kingdom of the Two Sicilies became a Spanish possession.

The 14th century was a period of weakening papal and imperial authority in Italy. Far from being a unified nation state, 15th-century Italy comprised some 20 independent states, among which the political boundaries were constantly redrawn. Each city-state had its own government, some broadly democratic (Siena), others oligarchic (Venice). Many were dominated by powerful ruling families, Florence by the DE' MEDICI, Mantua by the GONZAGA, Ferrara by the ESTE, Urbino by the DELLA ROVERE. Most were involved in interstate wars for the first half of the 15th century, with treatises made and broken, and allegiances shifted. But the Peace of Lodi (1454) established

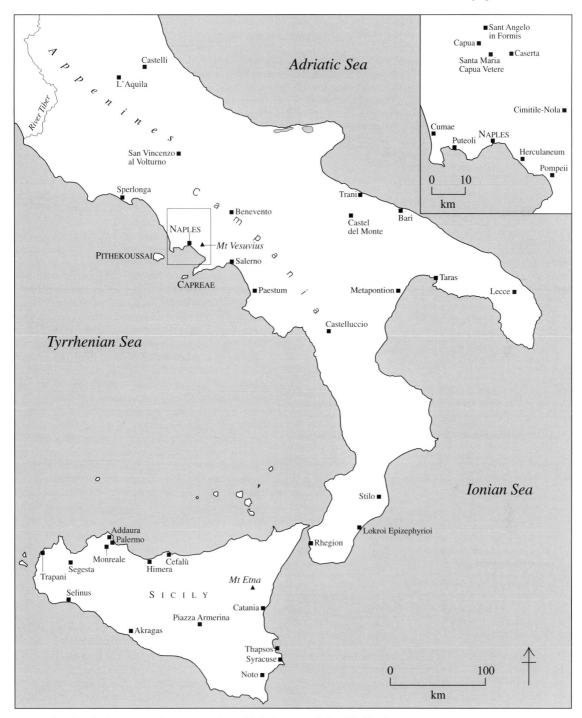

4. Map of South Italy; those sites with separate entries in this dictionary are distinguished by CROSS-REFERENCE TYPE

a Pact of non-aggression between Venice, Milan, Florence, Naples and Pope Nicholas V, thus binding the five major powers and indirectly many smaller powers in a peace agreement that lasted, with little interruption, for 25 years.

This period of relative stability ended in 1494, when the army of Charles VIII, King of France (*reg* 1483–98) entered Italy. The invasion marked the beginnings of the Wars of

Italy, a period of almost unremitting intervention in Italy by France and Spain, into which the Italian powers were constantly drawn. Most disastrously, this Franco-Imperial struggle resulted in the Sack of Rome (1527) when the mutinous armies of Emperor Charles V (*reg* 1519–58) attacked and occupied the city for a year, destroying palaces, churches and houses. It was not until the Peace

of Câteau-Cambrésis in 1559, establishing Spanish control or influence over much of Italy, that this period of invasion was concluded.

However, with the exception of the Sack of Rome, the wars and battles fought within Italy during the Renaissance did not curtail its cultural development. City sieges were infrequent, with most of the fighting done in the countryside. Art was frequently employed as a weapon by interstate rivals, each attempting to establish the predominance of his city. While political life of each city-state was constantly uncertain, artists within each flourished.

BIBLIOGRAPHY

J. Burckhardt: *The Civilisation of the Renaissance in Italy* (Harmondsworth, 1900)

A. Blunt: *Artistic Theory in Italy, 1450–1600* (Oxford, 1940)

D. Mack Smith: *Italy: A Modern History* (Bari, 1959, rev. London, 2/1969)

D. Hay: *The Italian Renaissance* (Cambridge, 1961)

H. Hearder and D. P. Waley, eds: *A Short History of Italy* (Cambridge, 1963)

E. Panofsky: *Renaissance and Renascences in Western Art* (London, 1965)

G. Procacci: *Histoire d'Italie* (Paris, 1968); trans. by A. Paul as *A History of the Italian People* (London, 1970)

R. Klein and H. Zerner: *Italian Art, 1500–1600: Sources and Documents* (Englewood Cliffs, NJ, 1966)

D. S. Chambers, ed.: *Patrons and Artists in the Italian Renaissance* (London, 1970)

F. Hartt: *History of Italian Renaissance Art: Painting, Sculpture, Architecture* (London, 1970, rev. New York and London, 4/1994)

J. R. Hale: *Renaissance Europe, 1480–1520* (London, 1971)

C. E. Gilbert: *Italian Art, 1400–1500: Sources and Documents* (Englewood Cliffs, NJ, 1980)

P. Burke: *Culture and Society in Renaissance Italy, 1420–1540* (London, 1972); rev. as *The Italian Renaissance: Culture and Society in Italy* (Princeton, 1986)

J. Hale, ed.: *A Concise History of the Italian Renaissance* (London, 1981)

M. Wackernagel: *The World of the Florentine Renaissance Artsits* (Princeton, 1981)

B. Cole: *The Renaissance Artist at work: From Pisano to Titian* (LOndon, 1983)

J. J. Norwich: *The Italian World: History, Art and Genius of a People* (London, 1983)

B. Kempers: *Kunst, macht en mecenaat* (Netherlands, 1987); Eng. trans. by B. Jackson as *Painting, Power and Patronage: The Rise of the Professional Artist in the Italian Renaissance* (Harmondsworth, 1992/R 1994)

A. Cole: *Virtue and Magnificence: Art of the Italian Renaissance Courts* (New York, 1995)

L. Andrews: *Story and Space in Renaissance Art: The Rebirth of Continuous Narrative* (Cambridge, 1998)

D. Rowland: *The Culture of the High Renaissance: Ancients and Moderns in Sixteenth-century Rome* (Cambridge, 1999)

H. Wohl: *The Aesthetics of Italian Renaissance Art: A Reconsideration of Style* (Cambridge, 1999)

□

II. Architecture.

The stylistic changes in Italian architecture beginning in the 15th century involved the abandonment of the Gothic usages of the previous centuries in favour of a return to the architectural vocabulary and proportional system of Roman antiquity, interpreted in a way that met the social and religious requirements of a new epoch: the RENAISSANCE.

1. Early Renaissance, *c.* 1400–*c.* 1500. 2. High Renaissance, *c.* 1500–*c.* 1520. 3. Late Renaissance and Mannerism, *c.* 1520–*c.* 1600.

1. EARLY RENAISSANCE, *c.* 1400–*c.* 1500.

(i) Tuscany. (ii) Lombardy. (iii) The Marches and the Veneto. (iv) Rome.

(i) Tuscany Italian Renaissance architecture originated in Florence *c.* 1420, in the work of FILIPPO BRUNELLESCHI,

alongside similar developments in painting and sculpture. Besides the adoption of the Classical system of proportions, consistently applied to plans and elevations, Brunelleschi's most influential innovations were the round-headed arch on columns and the employment of the Classical orders, Corinthian being his own preference. He reintroduced the hemispherical dome combined with pendentives, previously unknown in Central Italy but employed in Byzantine architecture. Brunelleschi's use of grey *pietra serena* elements with white stucco walls became the characteristic colour scheme of Florentine Renaissance interiors. He employed these features in all his own works, beginning with the loggia of the Ospedale degli Innocenti (from *c.* 1419; see colour pl. 1, XVI2), in the longitudinal churches of S Lorenzo, with the Old Sacristy (1419–29), and Santo Spirito (from 1436; *see* RENAISSANCE, fig. 1), as well as the Pazzi Chapel (begun *c.* 1430), Santa Croce (*see* BRUNELLESCHI, FILIPPO, figs 5 and 6), which is traditionally attributed to him. They provided the model for the rest of the century in Florence: clear, uncluttered lines, systematic proportions and use of *all'antica* vocabulary.

Although Brunelleschi employed individual Classical motifs, he did not 'revive' Classical architecture: his most frequent sources were such Tuscan Romanesque buildings as the Florentine Baptistery. The Classical revival was effected by the other major innovator of the century, LEON BATTISTA ALBERTI, who applied his theoretical knowledge of ancient Roman architecture to his own projects, adapting Classical vocabulary for contemporary building types. Between them, Brunelleschi and Alberti created the early Renaissance style in architecture, which spread throughout Italy during the century. Brunelleschi's influence was due principally to his achievement in erecting the dome of Florence Cathedral, designed in 1418 (*see* FLORENCE, fig. 1). His resolution of the problem of roofing over the largest space since antiquity, for which he not only devised the double-shell dome but also a system for its erection without centering, was Brunelleschi's most important technical invention (*see* BRUNELLESCHI, FILIPPO, fig. 1). Forced to build it with a Gothic curve, since there was no possibility of external buttressing, Brunelleschi exploited this for the visual effect of red brick cells with white stone ribs.

In Brunelleschi's last works, Santo Spirito and the barely started S Maria degli Angeli (1434; abandoned on his death), the planarity of his earlier works was replaced by a greater plasticity of forms, with the use of engaged columns instead of pilasters, and semicircular chapels. The major innovation at S Maria degli Angeli was the employment of a circular plan, influenced by the Temple of Minerva Medica, Rome. The centrally planned church became a significant development of the Renaissance, evolving throughout the 15th century and reaching maturity in the 16th. Alberti described the circle as the perfect shape in Nature and its derivations—rectangular and polygonal—as ideal for the 'temple' or church (*De re aedificatoria* IV). Alberti himself employed the Greek-cross plan, at S Sebastiano (from 1460; *see* §(ii) below), Mantua, possibly derived from such Early Christian tombs as that of Galla Placidia, Ravenna. The basilican type was, however, most frequently employed for liturgical reasons.

Florentine palace design was transformed (*see* FLORENCE, §I, 2; *see also* PALAZZO), producing buildings with a symmetrical structure, the façades divided into rectangular bays, three storeys high, each storey differentiated slightly—the *piano nobile* being the most splendid—crowned with a Classical cornice. The central, rectangular, arcaded courtyard became an essential feature. MICHELOZZO DI BARTOLOMEO designed the earliest, the Palazzo Medici (1444–60; now Palazzo Medici–Riccardi; *see* PALAZZO, fig. 1). Its façade is graduated from rusticated, rock-faced blocks on the ground floor, via a sharply channelled but smooth-faced treatment on the *piano nobile* to completely smooth ashlar on the top floor. The upper two storeys have regularly disposed, round-headed, biforate windows with a central colonette. The basic plan was followed by all other palace builders in Florence and was exported elsewhere, for example Urbino and Ferrara. Florentine influence is also apparent in Giuliano da Maiano's Palazzo Cuomo (begun 1466; *see* MAIANO, (1)) in Naples. Giuliano was the greatest exponent of Florentine taste in Naples. In Florence variations were confined to exteriors, which could be rusticated (e.g. Palazzo Gondi, 1490s; Palazzo Strozzi, begun 1489; see fig. 5) or covered with *intonaco* (e.g. Palazzo Pazzi–Quaratesi, 1460s), perhaps with *sgraffito* decoration.

Only Alberti's Palazzo Rucellai (begun *c.* 1453; *see* ALBERTI, LEON BATTISTA, fig. 2) differed significantly. Its façade has three orders of pilasters, each with its own entablature, applied decoratively, not structurally. In accordance with Alberti's theoretical beliefs, the windows, although round-headed, have a lintel below the arch, supported by the central colonette. It was not emulated in

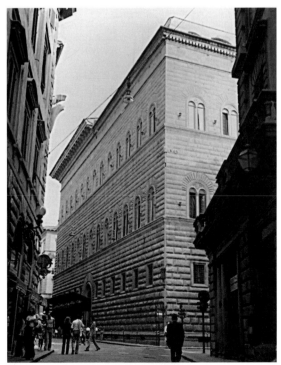

5. Benedetto da Maiano, Giuliano da Sangallo and Cronaca: Palazzo Strozzi, Florence, begun 1489

Florence, and its successors are found outside Florence, at Pienza and Rome (*see* §(iv) below). In the 15th century such palaces were for residence only. Rooms ran in a single file around the courtyard and usually had no specific purpose, except for the room used by the head of the household. A contemporary description of the Palazzo Medici records a splendidly decorated interior with wooden panelling articulated by *all'antica* pilasters and gilding, contrasting with the sober exterior. Only the chapel, frescoed (1459–61) by Benozzo Gozzoli, remains to give some indication of its original appearance (see colour pl. 1, XXXV2).

Models were produced for the major projects, and they were usually of wood (e.g. Giuliano da Sangallo's for the Palazzo Strozzi; now in Florence, Pal. Strozzi; *see* SANGALLO, DA, (1)). However, Brunelleschi's model for the dome of Florence Cathedral used full-sized bricks. Most building workers were members of the Arte di Maestri del Legname e delle Pietra (woodworkers' and stonemasons' guild), except for carpenters and metalworkers who had separate guilds.

As well as being a working architect, Alberti also wrote treatises on numerous subjects, including the first architectural treatise since antiquity, *De re aedificatoria* (Florence, 1485), modelled on Vitruvius and his own studies of Roman ruins. These studies set a pattern for later generations of architects. He first employed the temple front for the upper storey of the façade (*c.* 1458–70) of S Maria Novella (*see* FLORENCE, fig. 13), partially erected in the 14th century. Alberti designed the upper storey to harmonize with the lower by retaining the coloured marbles and applied a tetrastyle façade, with triangular pediment carried on pilasters, to the upper storey, the width only of the nave. He employed large volutes to link together the wide lower storey and narrow upper storey, a final resolution to the problem.

Alberti's ideas were also influential in the planning of PIENZA, the birthplace of Pius II, which was a rare example of 15th-century urban planning. Built between 1459 and 1464, the principal religious and government buildings are organized symmetrically around the trapezoid-shaped piazza, and some 40 buildings were either erected or refurbished. The cathedral is the main focus, opposite the Palazzo Comunale, with the Palazzo Piccolomini and the Episcopal Palace on either side. The architect Bernardo Rossellino (*see* ROSSELLINO, (1), §2) based the pilastered façade of the Palazzo Piccolomini on that of the Palazzo Rucellai. It follows the Florentine palace plan, set around a central courtyard. The most novel feature is the three-storey loggias at the rear overlooking the valley towards Monte Amiata, bringing together an urban domestic building and open countryside, for the aesthetic pleasure of the view. Pius was much concerned with the comfort of the interior, ordering that rooms be high, with polished brick floors and fireplaces. Cisterns to collect water for distribution throughout the palace were installed on the roof. The internal layout of Pienza Cathedral was also dictated by Pius, who wished to emulate the hall churches he had admired in Austria. The façade, however, is *all'antica*, having a triumphal arch motif.

(ii) Lombardy. Alberti's influence was above all outside Florence. His friendship with such important patrons as

Pope Nicholas V, Lionello d'Este, Marchese of Ferrara (*see* ESTE, (3)), and Federigo da Montefeltro, Count (later Duke) of Urbino (*see* MONTEFELTRO, (1)), influenced their architectural projects. Throughout the 15th century the Renaissance style was gradually disseminated, especially in the princely states where rulers were anxious to show themselves as cultured patrons. The new style was usually adapted piecemeal into the regional style.

Alberti's most influential designs were in Mantua, for the churches of S Sebastiano (begun 1460) and S Andrea (begun 1472), built under the patronage of the 2nd Marchese, Ludovico II Gonzaga (*see* ALBERTI, LEON BATTISTA, figs 4–8). In addition to the innovation of the Greek-cross plan for S Sebastiano, Alberti's design for the basilican church of S Andrea, begun only in the year of his death, was also innovative and influential. This church is aisleless with side chapels that are alternately large, with a high arched entrance, and small, with a rectangular entrance. The walls support the first large-scale barrel vault of the Renaissance, derived from the Roman baths and the Basilica of Maxentius, again demonstrating Alberti's skill in adapting antique forms to a modern building type. Subordinate spaces are organic continuations of the main space. The façade combines the Classical temple front, of triangular pediment on giant pilasters, and the triumphal arch.

Although the Gothic cathedrals of Milan and Pavia were still under construction, Duke Francesco Sforza of Milan (*see* SFORZA, (1)), who had received a humanist education and was allied with Florence, was anxious to introduce the new style into his capital. To that end he brought FILARETE to work for him. Filarete's major project was the Ospedale Maggiore (begun 1465; continued and altered by Giovanni Antonio Amadeo), the original appearance of which is recorded only in Filarete's treatise, the *Trattato di architettura* (1461–4), which describes the ideal city of Sforzinda, and was dedicated to the Duke. Filarete's advocacy of the centrally planned form proved important in the development of architectural theory in Milan. Michelozzo had been employed by the Medici in Milan to design a palace to serve as the headquarters of their bank, again known only from a Filarete drawing. His design for the Portinari Chapel (before 1468) of S Eustorgio reveals his sensitivity to the Milanese love of decoration, which he combined with Florentine emphasis of the wall plane. This chapel was one of the most important examples of the introduction of Florentine ideas into Milan.

However, it was only the arrival (*c.* 1480) of Donato Bramante that brought Milanese architecture up to date. Duke Ludovico Sforza immediately employed Bramante, initially at S Maria presso S Satiro (1482–6) and in rebuilding the choir (1492; *see* BRAMANTE, DONATO, fig. 2) of the newly completed S Maria delle Grazie. Amadeo and Dolcebuono are also documented there. Bramante used his painter's knowledge of *trompe l'oeil* to design the false choir at S Maria presso S Satiro. It is only 500 mm deep but gives the illusion of an imposing barrel-vaulted structure, three bays deep (*see* BRAMANTE, DONATO, fig. 1). In S Maria delle Grazie, Bramante was charged with turning the eastern end into a Sforza mausoleum. He created a centrally planned addition to the nave, with a square crossing crowned by a hemispherical dome, extending the choir itself and terminating the choir and transepts with apses. The overall concept is one of grandeur, enhanced by Bramante's manipulation of light, which floods the choir, separating it from the dark Gothic nave, producing a dramatic climax.

With Leonardo da Vinci, who was in Milan *c.* 1482–99 (*see* LEONARDO DA VINCI, §I, 2), Bramante explored the possibilities of central planning, which was to be of importance in his plans for St Peter's and which influenced his immediate followers. In the cloisters (1497) of S Ambrogio, Milan, Bramante employed three Classical orders for the first time, applying a different one to each of the three cloisters, which anticipates his works in Rome.

(iii) The Marches and the Veneto. In Urbino, Federigo da Montefeltro appointed Luciano Laurana, Ingegniere et Capo di Tutti li Maestri (1468), to rebuild and extend his medieval palace, continuing the work of Maso di Bartolomeo (*see* URBINO, §4). The palace links together two separate buildings in an irregular plan and has two main façades. Federigo's wish to employ a Florentine architect indicates a knowledge of and desire to copy the Florentine palace. The principal façade, of three storeys, is symmetrically organized, with three regular doorways and evenly spaced windows on the *piano nobile*. The Palazzo Ducale at Urbino became the model for a ruler's palace. It incorporates public and private rooms, and the public reception rooms are reached by the monumental staircase from the *cortile* or courtyard (begun *c.* 1466; for illustration *see* LAURANA, LUCIANO), where the encircling inscription would remind visitors of Federigo's achievements. The courtyard, of the Palazzo Medici type, is here treated with greater sophistication, employing piers at the corners, giving an impression of greater support. The private rooms are located behind a second façade, a three-tiered loggia flanked by towers, overlooking the valley beyond, as at the Palazzo Piccolomini in Pienza.

The Renaissance style became fashionable in Venice in the 1480s, with the arrival of Pietro Lombardo (*see* LOMBARDO, (1)) and Mauro Codussi from Lombardy. Neither Michelozzo, who designed a library, nor Filarete, employed by the Duke of Milan to erect a palace there, had made any impact on the city's architecture. The Arsenal Gateway (*c.* 1451) was based on the Arch of the Sergii (*c.* 29–28 BC) at Pola (now Pula, Croatia) but had no immediate descendants. Codussi's S Michele in Isola (1469–77; *see* CODUSSI, MAURO, fig. 1) is the clearest expression of the new style, which is also seen in the Renaissance forms and unified design of the façade of S Zaccaria (see fig. 6). The Byzantine architecture of S Marco continued to dominate church architecture. This is most apparent in the prevalence of the centrally planned church with multiple domes, of which Codussi's S Maria Formosa (begun 1492) and S Giovanni Crisostomo (begun 1497) are examples. Although these both have Greek-cross plans, they do have a principal orientation. Codussi employed the Brunelleschian scheme of column or pilaster plus arch and his own system of proportions.

Florence provided the model for changes to Venetian palaces, adapted to the requirements of the canal city. Irregular façades overlooking the canals were made sym-

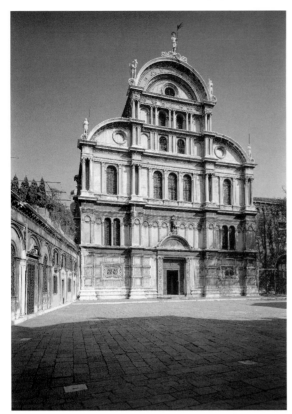

6. Antonio Gambello and Mauro Codussi: façade of S Zaccaria, Venice, 1458–90

metrical around the ground-floor entrance hall. Windows were confined to the front and rear façades, and in order to maximize light the *salone* on the *piano nobile* extended the full depth of the building, above the entrance, with large, round-headed windows grouped together in the centre, usually in threes as in the Palazzo Loredan (now Palazzo Vendramin–Calergi; begun *c.* 1502; *see* CODUSSI, MAURO, fig. 2). Codussi here employed a Classical order of engaged columns with entablature, radically different from the Gothic features of the earlier part of the century. Unlike Florentine palaces, those in Venice were occupied by several households and might also be used as business premises.

(iv) Rome. The state of Rome had greatly deteriorated during the Avignon residence of the popes (1309–73). On their return to Rome, successive popes found their funds deployed entirely on restoring the principal churches. NICHOLAS V, with Alberti and Rossellino as his architectural advisers, had ambitious plans for urban renewal but these were only effected in the 1480s by Sixtus IV (*see* ROME, §II, 1). Nicholas's principal contribution was the restoration of the ancient walls and the rebuilding of the choir of Old St Peter's (destr.; *see* ROME, §V, 1(i)(a)). The latter, designed by Rossellino, was the first work of Renaissance architecture in Rome, together with the Benediction Loggia (destr.) erected in front of the basilica by Pius II. The loggia employed a system of piers articulated by engaged columns on pedestals, adapted

from the Colosseum. The proximity of the ancient sites was of major importance to the development of Roman Renaissance architecture. Although predominantly designed by such Tuscans as JACOPO DA PIETRASANTA, the architect of S Agostino (1479–83), a new monumentality distinguished Roman church interiors. Rather than a column and arch system, the arcade is borne by piers, with engaged columns, carrying groin vaulting, as in S Maria del Popolo (1472–7). By contrast, façades, which were of travertine stone, were planar, employing pilasters as decoration.

Few 15th-century Roman palaces survive. The Palazzo di S Giorgio (*c.* 1485–*c.* 1511; now Palazzo della Cancelleria; *see* ROME, §V, 6), built for Cardinal Raffaele Riario, conforms to the Florentine palace type, with a central courtyard after the Urbino model (see fig. 7) while the façade is inspired by the Palazzo Rucellai. The travertine revetment of the main façade (completed by 1495) has applied pilaster orders. The round-headed windows set in rectangular frames derive from the Porta dei Borsari (1st century). The large palace incorporated shops for rent into its ground-floor, an antique device, which was used here for the first time in the Renaissance. The more common Roman palace type, with a stuccoed façade and stone cross-mullioned windows, prevailed to the end of the century, exemplified by the Palazzo S Marco (now Palazzo Venezia) built by Cardinal Pietro Barbo from 1455, adjoining his titular church. It employs individual features based on antique prototypes, including the coffered, barrel-vaulted entrance hall and the two-storey arcades of the incomplete courtyard (see fig. 8) with rectangular piers and engaged columns, Tuscan below—on high pedestals, supporting an entablature that breaks forwards over them —and Corinthian above; features that later became popular.

By the end of the 15th century architects had become more informed about the ancient ruins, and a visit to Rome to study them was essential. Giuliano da Sangallo's numerous drawings of antiquities reveal the depth of such studies, and this knowledge was applied in the treatment of architectural forms, although ancient Roman techniques were revived only in the early 16th century.

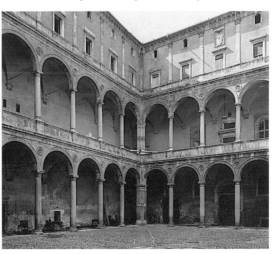

7. Palazzo della Cancelleria, Rome, courtyard, *c.* 1485–*c.* 1511

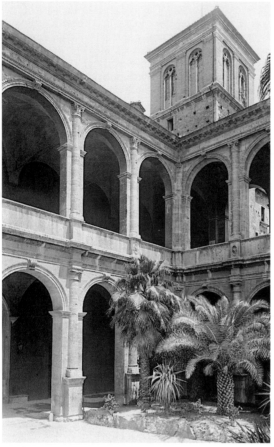

8. Palazzo Venezia, Rome, courtyard, *c.* 1455–71

2. HIGH RENAISSANCE, *c.* 1500–*c.* 1520. In the early 16th century a new style emerged, and Rome replaced Florence as the centre where major innovations occurred; their influence would be dominant for centuries. The papacy, now firmly re-established and with many building and decorative schemes in mind to restore Rome to its ancient splendour, drew artists from all over Italy. Bramante, who arrived *c.* 1500, was responsible for the development of the new architectural style.

Bramante studied the ancient remains at first hand, and such studies inform his architecture, from his first major Roman commission, the cloister (1500–04) of S Maria della Pace, for Cardinal Oliviero Carafa (*see* CARAFA, (1)). This developed further his concern, evinced in the S Ambrogio cloisters, with applying the orders in combination, here in a single structure. The arcade is carried on Doric piers with Ionic pilasters carrying the entablature; above, Composite piers alternate with Corinthian columns to support the upper entablature. Bramante was commissioned *c.* 1502 to erect a church on the supposed site of St Peter's martyrdom, at S Pietro in Montorio, the Tempietto (*see* BRAMANTE, DONATO, fig. 4). The first wholly circular building of the Renaissance, the Tempietto was highly influential; Bramante's contemporaries acknowledged his achievement in the use of the Classical vocabulary, and the Tempietto was illustrated by SEBASTIANO

SERLIO in his treatise (Book III) among the examples of Classical works. It is this correct use of antique motifs that categorizes High Renaissance architecture. But even as Bramante achieved this synthesis of the Classical vocabulary, the need to adapt and invent imposed by the requirements of Christian architecture points towards the failure of those rules.

Despite its novelty, it was not the Tempietto but the project to rebuild St Peter's that was the most influential in Rome. This was initiated by Julius II (*see* ROVERE, DELLA, (2)), whose policies continued those of Sixtus IV, through the construction of new thoroughfares and the aggrandizement of Rome's appearance through new buildings (*see* ROME, §II, 2). The foundation stone of St Peter's was laid in 1506 (*see* ROME, §V, 1(ii)(a)). Bramante designed a centralized plan, a cross inscribed in a square, the central dome borne on four massive crossing piers, articulated by a giant order, with subsidiary chapels around the crossing and corner towers (*see* ROME, fig. 5). The crossing piers and barrel vaulting of one arm were erected but, despite the appointment of numerous successors after Bramante's death, including Raphael and Giuliano da Sangallo, little progress was made before the appointment in 1546 of Michelangelo (*see* MICHELANGELO, §I, 4) as Architetto della Fabbrica. He revived Bramante's Greek-cross plan, greatly strengthening and enlarging the crossing piers and simplifying the organization of the interior. He completed the coffered barrel vaults around the crossing, but the liturgical requirement of a nave led to changes to his plans after his death. Both interior and exterior are articulated by a giant Corinthian order, carrying an entablature that encircles and binds together the whole (*see* ROME, fig. 6). Michelangelo left a wooden model (1558–61) for a double-shell, hemispherical dome, subsequently altered to a pointed profile by GIACOMO DELLA PORTA in the 1580s.

The interest in centrally planned churches led to the erection of a number of them in the early 16th century, often on the outskirts of provincial towns, for example Cola da Caprarola's S Maria della Consolazione (from 1508; see fig. 9), Todi, and Antonio da Sangallo (i)'s Madonna di S Biagio (begun 1518; for illustration *see* SANGALLO, DA, (2)), Montepulciano, both of which were developed from the Greek cross. The former has a square plan with huge apses projecting from each side, emphasizing its space-moulding appearance; the latter a Greek cross with barrel-vaulted arms and corner towers.

Roman palaces assumed an increased monumentality, giving the city a more impressive aspect, beginning with Bramante's Palazzo Caprini (House of Raphael; *c.* 1510; destr.; *see* BRAMANTE, DONATO, fig. 6). The two-storey façade was divided horizontally into a commercial lower storey, with shops inserted into arched openings, the wall surfaces heavily rusticated, and a *piano nobile* with an engaged Doric order. The substitution of coupled half-columns for pilasters to articulate the wall gives a greater plasticity to the surfaces. Its influence was widespread, and it became the model for aristocratic palaces in Rome, Venice, Verona, Genoa and Bologna.

Contemporaneously, however, Antonio da Sangallo (ii) (*see* SANGALLO, DA, (4)) established a more sober palace style with stuccoed façades, and stone used only for quoins and aedicular windows, as in his Palazzo Farnese (begun

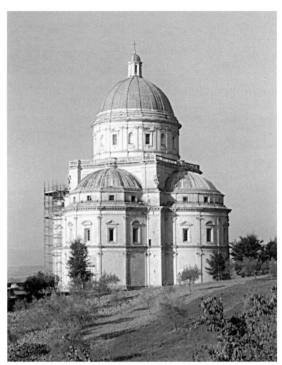

9. Cola da Caprarola: S Maria della Consolazione, Todi, begun 1508; perhaps designed by Bramante

1514; completed by Michelangelo after 1545; *see* ROME, §V, 7 and PALAZZO, fig. 2). Michelangelo designed the more sculpturesque appearance of the upper storey of the courtyard, employing overlapping pilasters to create a constant advance and recession. Ground-floor shops were abandoned, as being inappropriate for the owner's status.

A new architectural type that was developed in the 16th century was the *villa suburbana,* usually located just outside the city wall, where cardinals and nobles retired for a day's leisure (*see* VILLA). The earliest was a villa in Rome, designed by Baldassare Peruzzi (1508–11; now the Villa Farnesina; *see* PERUZZI, BALDASSARE, fig. 1) for Agostino Chigi (i) (*see* CHIGI, (1)). It was relatively simple, a U-shape with open loggia in the central bay, frescoed by Raphael and his workshop with mythological scenes, the façade having applied pilasters enlivened by grisaille decoration (destr.). Raphael's design for the Villa Madama (from 1518; with Antonio da Sangallo (i)) for Cardinal Giulio de' Medici (later Pope Clement VII; *see* MEDICI, DE', (9)), on the side of Monte Mario, deliberately drew on Classical texts describing ancient villas, following Vitruvius on the disposal of rooms. He exploited the hillside site to include hidden grottoes and a nymphaeum, and a Roman theatre was planned at the top of the slope. The garden loggia (*see* RAPHAEL, fig. 9), with a domed central bay opening from the circular courtyard, was decorated by Giulio Romano with frescoes and stuccowork based on those recently discovered in the Domus Aurea of Nero. Such features were exploited throughout the century, as in the Villa Giulia (from 1552) for Pope Julius II in Rome, by JACOPO VIGNOLA, Vasari and Bartolomeo Ammanati, and Vignola's Villa Farnese (from 1552) at Caprarola (*see*

CAPRAROLA, VILLA FARNESE), a combination of palace and villa. Gardens (*see* GARDEN, §II) were a vital feature of the *villa suburbana*, with hidden areas, unexpected fountains and nymphaea, which the improved hydraulic technology permitted, as in the later garden of fountains (1567–8) at the Villa d'Este, TIVOLI, by PIRRO LIGORIO.

Roman developments of the early 16th century were disseminated through Italy by the followers of Bramante and Raphael, especially after the Sack of Rome (1527), which led to the dispersal of artists from the city. Giulio Romano became court artist at Mantua, where he designed the Mannerist Palazzo del Te, the *villa suburbana* on the outskirts of the city, each façade of the single-storey building and its courtyard being different (*see* GIULIO ROMANO, fig. 3). The classical vocabulary has been treated with wit and imagination, structural members apparently collapsing and entablatures crumbling. The villa's garden loggia depends heavily on that of the Villa Madama.

In the later 16th century Andrea Palladio developed a new, highly influential villa style. The country villa was well known from antiquity, and both Vitruvius' and Pliny the younger's descriptions were examined for ideas in the Renaissance. The Medici in 15th-century Florence had made retreat to the country villa fashionable, but only at the end of the century was the fortified appearance of the earlier villas abandoned for the more refined appearance of the villa (1485–94) at Poggio a Caiano (*see* POGGIO A CAIANO, VILLA MEDICI) by Giuliano da Sangallo, where a temple front was applied for the first time in such a context. Palladio's villas were on extensive properties, frequently working farms, and his designs brought the farm buildings into the fabric of the building, although treated in such a way that their working function is entirely hidden. Palladio set out all his designs in Book II of his treatise *I quattro libri* (1570). The buildings were symmetrically organized around a central axis, their proportions related to musical harmonies. The façade invariably incorporated an adaptation of the Classical temple portico, as in his most influential villas, the Villa Barbaro (completed by 1558; *see* MASER, VILLA BARBARO, with illustration) and the Villa Rotonda, or Villa Capra (begun *c.* 1565/6; *see* PALLADIO, ANDREA, fig. 6 and VICENZA, §2).

3. LATE RENAISSANCE AND MANNERISM, *c.* 1520–*c.* 1600. The increased plasticity and restless advance and recession of planes became more marked throughout the century. Bramante's influence continued after his death (1514), but by Raphael's death in 1520 the newly established rules were already breaking down, leading to the Mannerist style in which the Classical vocabulary is employed in non-canonical ways (*see* MANNERISM). The practitioners were fully versed in the 'correct' usage but deliberately flouted the rules. Thus in the Palazzo Branconio dell'Aquila (1519; destr.), Rome, by RAPHAEL, the half-columns of the ground-floor appeared to support the upper storeys, but had only a niche above them, and the order on the *piano nobile* is confined to the aediculae around the windows. Above the windows an attic storey had an exuberant stucco decoration. Baldassare Peruzzi's curved façade of the Palazzo Massimo alle Colonne (1532–5; *see* PERUZZI, BALDASSARE, fig. 4) also employs an order

only on the ground-floor, in the loggia that supports the solid superstructure of rusticated wall.

(i) Florence. (ii) Rome. (iii) The Veneto.

(i) Florence. Florentine architecture of the 1520s and 1530s was heavily influenced by the work of Michelangelo, who developed his own Mannerist style, also based on a thorough grounding in Classical forms. In the New Sacristy (1519–34), S Lorenzo (*see* FLORENCE, §IV, 5), he retained the cube and dome of Brunelleschi's Old Sacristy, with stucco walls and *pietra serena* elements, but transformed it into a tightly compressed organization of architectural and sculptural forms. He raised the height of the chapel by inserting an attic, with blind, pedimented windows between cube and dome, and inserted wholly innovative wedge-shaped windows into the lunettes above. Tabernacles are squeezed above the doors in the side bays, as though there were insufficient space for them. The broken bases of their pediments became a much more elaborated feature during the century.

In the vestibule to the Biblioteca Laurenziana (begun *c.* 1524; *see* MICHELANGELO, §I, 4 and fig. 8), the library attached to the church of S Lorenzo, Michelangelo's inventions were taken further. Because the entrance to the vestibule is at a lower level than that into the library, he treated the lower part of the wall as a basement, dividing it into alternating bays of wall surface and paired volutes. In the Laurenziana Michelangelo's apparently wayward treatment of Classical forms was to an extent necessitated because it was constructed above already extant buildings. However, his solutions were adopted as innovative features by such followers as Giorgio Vasari (*see* VASARI, (1)) in his designs for the Palazzo degli Uffizi (1559–74; *see* FLORENCE, §IV, 10 and fig. 3) and BARTOLOMEO AMMANATI, who enlarged and modernized (1560–77) the Palazzo Pitti (*see* FLORENCE, §IV, 9 and colour pl. 1, II2) and executed the staircase in the Laurenziana vestibule. The influence of S Lorenzo is also apparent in GALEAZZO ALESSI's work at S Maria presso S Celso, Milan, from 1565.

(ii) Rome. One of the major architectural projects in Rome was the rebuilding of the Capitoline Hill (after 1546), the heart of secular Roman government, which was then a ruin. Michelangelo clothed the 15th-century Palazzo dei Conservatori with a new façade, balanced by an identical, new building facing it, the Palazzo Nuovo, creating a wedge-shaped piazza (as at Pienza), approached by the ramped stairway up the hill (*see* MICHELANGELO, fig. 9). The Palazzo del Senatore at the head was also given a new façade, with a monumental staircase providing an entrance at *piano nobile* level. Michelangelo employed a giant Corinthian order of pilasters to unify the three structures. In the centre of the oval piazza that he laid out, Michelangelo placed the ancient statue of *Marcus Aurelius*, mounted on an oval pedestal, which he himself had designed. Other architects involved in the scheme were GUIDETTO GUIDETTI and GIACOMO DELLA PORTA. Michelangelo's most striking Mannerist work in Rome, however, was the Porta Pia (1561–4; see fig. 10); its carefully worked out design incorporates a mixture of

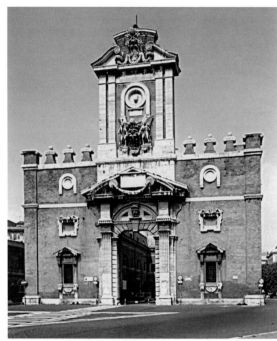

10. Michelangelo: Porta Pia, Rome, 1561–4

eccentric elements, broken pediments, displaced sections of the orders, overlapping planes and fantastic ornamental details.

Church building in Rome had suffered a hiatus following the 1527 sack and 1530 flood, which devastated the city. From the mid-century, however, in a mood of penitence, many churches were rebuilt and new orders were founded, requiring new churches. Most important were the Jesuits, for whom Il Gesù was built by JACOPO VIGNOLA (*see* ROME, §V, 3), and the Oratorians, who built S Maria in Vallicella (from 1575), to the designs of Martino Longhi (i). Il Gesù (1568–73), financed by Cardinal Alessandro Farnese, is a descendant of S Andrea, Mantua, having no aisles, but side chapels in the massive walls, which support the barrel vault of the nave. The nave is unusually wide, to enable the maximum numbers of people to see and hear the priest, of paramount importance for Counter-Reformation masses. The transepts are wide but shallow, barely protruding beyond the line of the exterior wall. The dome is supported by a very high drum, enhancing its visibility from the surrounding cramped streets. Il Gesù became one of the 16th century's most influential buildings, for as the Jesuits travelled the world they modelled churches on it everywhere. Vignola also revived the centrally planned church in later 16th-century Rome, at S Andrea (1561) in Via Flaminia and S Anna dei Palafrenieri, both small in scale but introducing the oval plan, which was influential for the development of the Baroque, in that it appeared to reconcile centrality with directionality.

Church façades became more monumental, projecting a powerful image of the Church Triumphant. Typically they were symmetrically balanced around a massive portal, building up from quieter outer bays, with paired pilasters at the corners, to paired pilasters and engaged columns framing the massive central portal where the entablature

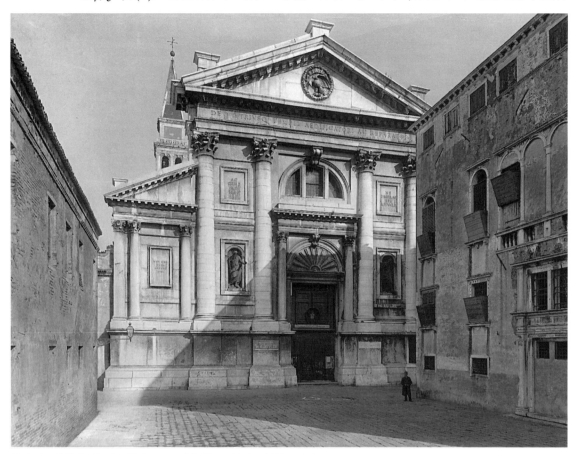

11. Andrea Palladio: façade of S Francesco della Vigna, Venice, 1562–*c.* 1570

projects forwards and is intersected by a monumental pediment. Above, the bays culminate in a central tabernacle. Side bays contain niches, so that little of the wall surface remains and a constant movement backwards and forwards is maintained without rest. Volutes link upper and lower elements, now with an increased monumentality and plasticity. This begins with Giacomo della Porta's design for the Gesù façade (completed 1577; *see* ROME, fig. 14), reaching fruition only at the end of the century with that of S Susanna (1597–1603) by Carlo Maderno (1555/6–1636), which looks forward to the Baroque, in the way that Mannerist tension and ambiguity are resolved by the substitution of steadily cumulative plasticity directed towards the centre.

(iii) The Veneto. A more formal Roman Renaissance style was transmitted to Venice by Jacopo Sansovino who fled there in 1527, as did SEBASTIANO SERLIO. In 1529 Sansovino was appointed *proto* to the procurators of S Marco, with responsibility for the architecture of the Piazza di S Marco. Here he designed the Libreria Marciana (1537; now the Biblioteca Nazionale Marciana; *see* VENICE, §IV, 5(i)) in the Roman Renaissance style, the Zecca (public mint; 1535–7) and the three-bay loggetta (*c.* 1537– 42; *see* SANSOVINO, JACOPO, fig. 3) at the foot of the campanile. The two-storey arcades of the library façade, with a Doric order of engaged columns, point to the

ancient Theatre of Marcellus, Rome, as source, but the balconies of each storey and the swags of the upper cornice are typically Venetian. The whole of the piazza was given a similar treatment, turning it into a spectacular atrium for the basilica. As with the Capitoline Hill, the regularization of façades of buildings with disparate functions gives a unified appearance to an important urban space.

The Zecca, needing to appear strong and impregnable, has a rusticated façade, although the rustication is treated in a more playful manner than formerly and covers even the Doric half-columns of the *piano nobile* in the form of banding (a feature found also at the Palazzo del Te, Mantua). The probable source was the Porta Maggiore, Rome, which was characteristic of the Mannerist phase of later Imperial architecture. Sansovino also adapted the Classical vocabulary for his palace façades, combining monumentality and correct use of the orders with the requirements of the Venetian palace for large windows and canal entrance, as in the Palazzo Corner della Cà Grande (begun 1545), ultimately derived from Bramante's Palazzo Caprini, Rome.

In his design for the monastic church of S Francesco della Vigna (from 1534), however, Sansovino relied more on the architecture of his native Tuscany, deriving its aisleless, barrel-vaulted interior, with side chapels, from S Salvatore al Monte (1490–1504) by CRONACA. The façade (1562–*c.* 1570; *see* fig. 11) was built by Palladio, who

succeeded Sansovino in 1570 as municipal architect. It continues the tradition of adapting the Classical temple façade, into which he introduced the novel feature of a thermal window. In his own church interiors for S Giorgio Maggiore (from 1566; *see* PALLADIO, ANDREA, §I, 1(iii)) and Il Redentore (begun 1576; *see* PALLADIO, ANDREA, fig. 7), both in Venice, Palladio depended on Bramante's moulded architecture and the Roman example. Nevertheless, Palladio believed, like Michelangelo, that just as Christianity was superior to pagan religions, so Christian churches should surpass ancient temples.

The sack of Rome also caused MICHELE SANMICHELI to return to his native Verona, where he introduced the Roman style, both antique and contemporary. The Venetian government put him in charge of its fortifications (*see* VERONA, §1), but his best-known works are the pilgrimage church of the Madonna di Campagna (1559), San Michele Extra, near Verona, and the city gates of Verona, although he also designed palaces. The Madonna di Campagna derives in part from Bramante's Tempietto, having a domed rotunda surrounded externally by a Doric colonnade, but projecting above it into a high drum supporting a Pantheon-type dome, with hemispherical interior and saucer-shaped exterior. It also follows Antonio da Sangallo (ii)'s S Maria di Monte d'Oro (begun 1523), near Montefiascone. The influence of Bramante is also apparent in Sanmicheli's palace designs, including the Palazzo Pompei (previously Lavezola; ?1530s) based on the Palazzo Caprini. Sanmicheli's city gates, the Porta Nuova (1535–40) and Porta Palio (*c.* 1547; *see* SANMICHELI, MICHELE, fig. 4), both incorporate a triumphal arch motif into a rusticated surface.

Outside Rome, the major innovations of the later 16th century were those of Palladio. While his urban palaces derive largely from the Roman High Renaissance style, he nevertheless introduced novel features: in the loggias of Palazzo Chiericati (from 1550), Vicenza, for example, the façade unexpectedly consists of a central bay with a ground-floor loggia and solid *piano nobile* and two-tiered loggias on either side (*see* PALLADIO, ANDREA, fig. 2). It presents the appearance, therefore, less of a private residence than of a public square based on the Roman forum. Of the later 16th-century architects, Palladio had the greatest influence.

BIBLIOGRAPHY

Portoghesi
A. Venturi: *Storia* (1901–40)
J. Durm: *Die Baukunst der Renaissance* (Leipzig, 1914)
J. Baum: *Baukunst und dekorative Plastik der Frührenaissance* (Stuttgart, 1920)
D. Frey: *Architettura della rinascenza* (Rome, 1924)
W. J. Anderson and A. Stratton: *The Architecture of the Renaissance in Italy* (London, 1927)
G. Giovannoni: *Saggi sull'architettura del rinascimento* (Milan, 1935)
J. S. Ackermann: 'Architectural Practice in the Italian Renaissance', *J. Soc. Archit. Historians*, xiii/3 (1954), pp. 3–11
W. Lotz: 'Architecture in the Later Sixteenth Century', *Coll. A. J.*, xvii/2 (1958), pp. 129–39
R. Bonelli: *Da Bramante a Michelangelo: Profilo dell'architettura del cinquecento* (Venice, 1960)
L. Heydenreich: 'Il bugnato rustico nel quattro- e nel cinquecento', *Boll. Cent. Int. Stud. Archit. Andrea Palladio*, ii (1960), pp. 40–41
B. Lowry: *Renaissance Architecture* (London, 1962)
M. Tafuri: *L'architettura del manierismo nel cinquecento europeo* (Bari, 1966)
E. Battisti: 'Storia del concetto di manierismo in architettura', *Boll. Cent. Int. Stud. Archit. Andrea Palladio*, ix (1967), pp. 204–10
W. Hager: 'Strutture spaziali del manierismo nell'architettura italiana', *Boll. Cent. Int. Stud. Archit. Andrea Palladio*, ix (1967), pp. 257–71
L. Benevolo: *Storia dell'architettura del rinascimento* (Bari, 1968)
P. Murray: *The Architecture of the Italian Renaissance* (London, 1969; rev. 3/1986/R 1988)
M. Tafuri: *L'architettura dell'umanesimo* (Bari, 1969)
H. Burns: 'Quattrocento Architecture and the Antique: Some Problems', *Classical Influences on European Culture, 500–1500*, ed. R. R. Bolgar (London, 1971), pp. 269–87
L. Heydenreich and W. Lotz: *Architecture in Italy, 1400–1600*, Pelican Hist. A. (Harmondsworth, 1974)
R. Pane: *Il rinascimento nell'Italia meridionale*, i (Milan, 1975)
G. Hersey: *Pythagorean Palaces: Magic and Architecture in the Italian Renaissance* (Ithaca, 1976)
L. Benevolo: *The Architecture of the Renaissance* (London, 1978)
A. Bruschi and others: *Scritti rinascimentali di architettura* (Milan, 1978)
W. Lotz: *Studies in Italian Renaissance Architecture* (Cambridge, MA, 1981)
A. Buck and B. Guthmueller, eds: *La città italiana del rinascimento fra utopia e realtà* (Venice, 1983)
K. Bering: *Baupropaganda und Bildprogrammatik der Fruehrenaissance in Florenz, Rom und Pienza* (Frankfurt am Main, 1984)
R. DeFusco: *L'architettura del quattrocento* (Turin, 1984)
J. Onians: *Bearers of Meaning* (New Jersey, 1988)
G. Ive: 'Demand and Supply in Renaissance Florence', *Architecture and the Sites of History: Interpretations of Buildings and Cities*, ed. I. Borden and D. Dunsten (Oxford, 1995), pp. 119–30
J. Melvin: City of Spectacle: Renaissance and Baroque Rome, *Architecture and the Sites of History: Interpretations of Buildings and Cities*, ed. I. Borden and D. Dunsten (Oxford, 1995), pp. 131–46
T. Tuohy: *Herculean Ferrara: Ercole d'Este (1471–1505) and the Invention of a Ducal Capital* (Cambridge, 1996)

LYNDA STEPHENS

III. Painting.

Painting in Florence during the 14th century was dominated by GIOTTO, whose frescoes of *c.* 1305 in the Arena Chapel, Padua (*see* PADUA, fig. 2 and colour pl. 1, XXXIV2), are distinguished by their unprecedented naturalism, psychological realism and monumentality. Giotto's numerous Florentine followers continued his mastery of the human form and pictorial space. Towards the mid-14th century in Florence, the formal hieraticism and sombre religious tenor of 13th-century painting were reasserted, but in the second half of the 14th century the naturalism of Giotto's art was revivied with a heightened interest in anecdotal detail and his achievements in empirical perspective were developed with impressive sophistication. The late 14th-century revival of interest in the painting of Giotto in Florence was paralleled in North Italy in the frescoes in Verona and Padua by Altichiero (*fl* 1369) and Jacopo Avanzi (*fl* 1363–84). These artists' efforts in furthering Giotto's innovations in empirical perspective benefited also from the achievements of the early 14th-century Sienese masters and anticipated the innovations in perspective made in Florence in the early 15th century.

Florence continued to be the most vigorous and influential centre of production in the 15th century, and scholars have traditionally divided Quattrocento painting in Italy into three stylistic categories based primarily on developments in the Tuscan capital. The earliest, the International Gothic style, which was prevalent throughout Europe, flourished in the first decades of the century in Florence; it was displaced by the style of the early Renaissance that emerged in the 1420s. In the last two decades of the century, Leonardo da Vinci developed a simplified, classicizing art that laid the foundations for the

High Renaissance style, which flourished in Rome under the patronage of Pope Julius II in the early 16th century. Developments in painting were linked to the revival of interest in antiquity and to a related interest in naturalism and illusionism. Humanist attitudes about the dignity of the individual and faith in the human potential for achievement, as explicated, for example, in Giovanni Pico della Mirandola's *Oration on the Dignity of Man* (Florence, 1496), and the humanist emphasis on historical consciousness help to explain the increasing importance of new genres such as portraiture, self-portraiture, mythology and Classical history.

In the first two decades of the 16th century the dominant artistic style was that of the High Renaissance. By 1520 the balance of artistic intentions was shifting, and style was developing in a number of ways that would collectively come to be known as MANNERISM. Awareness of antique philosophy and literature, art and architecture remained seminal to the development of subject-matter and artistic style in this period. Painters, once equated with craftsmen, won equal status with practitioners of the traditional liberal arts. Heightened artistic consciousness intensified stylistic interaction between painting and sculpture and provoked debate as to the comparative values of each, the PARAGONE. Cross-currents of artistic practice were accelerated by the travels of artists and patrons and by the dissemination of drawings and prints.

BIBLIOGRAPHY

C. Cennini: *The Craftsman's Handbook: Il Libro dell'Arte* (*c.* 1390), trans D. V. Thompson, Jr (New York, 1954)
P. Pino: *Dialogo di pittura* (Venice, 1548); ed. E. Camesasca (Milan, 1954)
G. Vasari: *Vite* (1550, rev. 2/1568); ed. G. Milanesi (1878–85)
L. Dolce: *Dialogo della pittura intitolato l'Aretino* (Venice, 1557), ed. and Eng. trans. by M. Roskill (Princeton, 1968)
J. A. Crowe and G. B. Cavalcaselle: *A History of Painting in North Italy*, 2 vols (London, 1871); rev. 2, ed. T. Borenius, 2 vols (New York, 1912/*R* 1972)
J. Burkhardt: *Das Altarbild* (1893–4); Eng. trans. as *The Altarpiece in Renaissance Italy*, ed. P. Humphrey (Oxford, 1988)
J. Pope-Hennessy: *The Portrait in the Renaissance* (New York and London, 1966)
A. R. Turner: *The Vision of Landscape in Renaissance Italy* (Princeton, 1966, rev. 2/1974)
B. Berenson: *Central and North Italian Schools* (1968)
——: *The Italian Painters of the Renaissance* (London, 1968)
F. Hartt: *History of Italian Renaissance Art: Painting, Sculpture, Architecture* (London, 1970, rev. New York and London, 4/1994)
E. Gombrich: *Norm and Form: Studies in the Art of the Renaissance* (London and New York, 1971)
P. Burke: *Culture and Society in Renaissance Italy, 1420–1540* (London, 1972); rev. as *The Italian Renaissance: Culture and Society in Italy* (Princeton, 1986)
S. Y. Edgerton jr: *The Renaissance Rediscovery of Linear Perspective* (New York, 1975)
J. R. Hale: *Italian Renaissance Painting from Masaccio to Titian* (New York, 1977)
C. E. Gilbert: *Italian Art, 1400–1500: Sources and Documents* (Englewood Cliffs, 1980)
J. R. Hale, ed.: *A Concise Encyclopædia of the Italian Renaissance* (London, 1981)
M. Wackernagel: *The World of the Florentine Renaissance Artist* (Princeton, 1981)
B. Cole: *The Renaissance Artist at Work* (New York, 1983)
B. Schultz: *Art and Anatomy in Renaissance Italy* (Ann Arbor, 1985)
N. Heller: *Women Artists: An Illustrated History* (New York, 1987)
M. A. Lavin: *The Place of Narrative: Mural Decoration in Italian Churches, 431–1600* (Chicago, 1990)
P. Humfrey and M. Kemp, eds: *The Altarpiece in the Renaissance* (Cambridge, 1991)
B. Kempers: *Kunst, macht en mecenaat* (Netherlands, 1987); Eng. trans. by B. Jackson as *Painting, Power and Patronage: The Rise of the Professional Artist in the Italian Renaissance* (Harmondsworth, 1992/*R* 1994)
J. Shearman: *Only Connect: Art and the Spectator in the Italian Renaissance* (Princeton, 1992)
E. Boorsook and F. S. Gioffredi, eds: *Italian Altarpieces 1250–1550: Function and Design* (Oxford, 1994)
A. Cole: *Virtue and Magnificence: Art of the Italian Renaissance Courts* (New York, 1995)
D. Norman, ed.: *Siena, Florence and Padua: Art, Society and Religion, 1280–1400* (New Haven and London, 1995)
F. H. Jacobs: *Defining the Renaissance Virtuosa: Women Artists and the Language of Art History and Criticism* (Cambridge, 1997)
A. Thomas: *The Painter's Practice in Renaissance Tuscany* (Cambridge, 1997)
C. Bambach: *Drawing and Painting in the Italian Renaissance Workshop: Theory and Practice, 1300–1600* (Cambridge, 1999)

1. Introduction. 2. Early Renaissance, *c.* 1400–*c.* 1500. 3. High Renaissance and Mannerism, *c.* 1500–*c.* 1600.

1. INTRODUCTION.

(i) Humanism, the Antique and illusionism. (ii) Format. (iii) Technique. (iv) Subject-matter and patronage. (v) Status of the artist.

(i) Humanism, the Antique and illusionism. The humanist union of Christianity with ancient literary and philosophical traditions was centred in Florence, where it was important for the development of attitudes about painting and art in general (*see also* HUMANISM, §1). Leading Florentine humanists included Poggio Bracciolini, Coluccio Salutati (1331–1406), Leonardo Bruni and Niccolò Niccoli. Cosimo de' Medici charged Bracciolini and others with the task of retrieving Classical manuscripts from monasteries throughout Europe, where they had remained in obscurity since the Middle Ages. A manuscript copying business, organized by the humanist bookseller Vespasiano da Bisticci, guaranteed that an increasing number of Classical texts were available. Neo-Platonism flourished around Lorenzo de' Medici, and the ideas of his humanist protégés, especially Marsilio Ficino, Angelo Poliziano and Pico della Mirandola, were given visual expression in the art of Sandro Botticelli and others.

Renaissance architects and sculptors drew inspiration from surviving works of antique architecture and sculpture, but there were few painted models. Painters, however, could and did study works of antique sculpture and also new works of sculpture, inspired by antique models, by such artists as Donatello and Nanni di Banco, as well as surviving monuments of ancient architecture and the new Renaissance architecture of Brunelleschi. Despite the lack of actual models, pictorial illusionism, a major factor in ancient painting, was encouraged by a passage from Pliny (*Natural History* XXXV.xxxvi.65) that described an ancient painting contest in which Zeuxis created a painting of grapes that was so realistic that birds flew up to the fruit. Zeuxis lost the contest, however, when he requested that a draped curtain that was actually a painted one be removed from a work by his rival Parrhasios. The most exacting examples of illusionistic painting demonstrate sharp outlining of forms, a unified light source, careful and vigorous modelling and space created with repoussoirs and scientific and atmospheric perspective. That truth to nature was often used as the yardstick by which to judge paintings is confirmed by literary sources, including writings by Leonardo and Girolamo Savonarola.

Scientific perspective was perhaps the most important single device used by Renaissance painters to create an illusion of space. It allowed the development of measurable illusionistic space and also controlled the relative diminution of figures and objects within that space; in addition, it encouraged the study of complex forms represented in foreshortening. Scientific perspective was developed by Brunelleschi, probably in 1413, out of his interest in recording ancient architectural remains, but a series of simple rules made it available to all artists. The system was codified and examined in some detail by Leon Battista Alberti in his treatise *De pictura* (1435).

In the 15th century there was an increased interest in writing about art and important developments in art theory, especially in the writings of Alberti. His *De pictura* was highly influential and provided a theoretical basis for painting; his ideas became the basis for the development of 16th-century Italian art theory (*see* ALBERTI, LEON BATTISTA, §II, 1). Several artists studied figural proportion: Piero della Francesca wrote a treatise on the subject, *De prospectiva pingendi* (*see* PIERO DELLA FRANCESCA, §III), and Leonardo planned a similar work (*see* LEONARDO DA VINCI, §III).

(ii) Format. A large altarpiece produced at the beginning of the century was usually a polyptych, a complex grouping of many panels, including narrative predellas and saints in pinnacles, within an exuberant, elaborately carved Late Gothic frame, the gold background and repeated forms of the frame giving unity to the whole (*see* GENTILE DA FABRIANO, fig. 3). By the end of the century the typical altarpiece consisted of a *pala* (panel) set within classicizing pilasters and an entablature and enclosing a single illusionistic narrative or religious grouping (see colour pl. 1, XII2). Private devotional works changed from small triptychs with folding wings to rectangular or round-arched panels within classicizing frames. During the second half of the century, terracotta relief sculpture such as that produced by the della Robbia workshop (see colour pl. 2, XXIV1) came to rival and even replace the traditional painted devotional panels in the home. In the course of the 15th century popular new painting types included the polygonal or round *desco da parto* (birth salver) painted on both sides and *cassone* chests with narrative scenes and figures painted on the front and sides, as well as inside. Late in the century the tondo became a popular format for domestic religious images (see colour pl. 1, XXXIX1). The decorative borders for fresco paintings and large fresco cycles were gradually simplified and usually featured Classical Corinthian pilasters and entablatures (see colour pl. 2, III1).

Any assessment of Italian Renaissance painting is tentative because a high percentage of works are lost. Some documented categories, such as the *pitture infamanti* of executed criminals that were painted on the outside of public buildings, do not survive in a single example.

(iii) Technique. The attention to precise detail and the subtle luminosity that were made possible by the new oil technique developed in the early 15th century by Netherlandish artists gradually transformed Italian painting in the second half of the century. Jan van Eyck (*c.* 1395–1441) and his works were well known in Italy. Alfonso I of

Aragon, King of Naples and Sicily, owned at least three of his paintings, as well as works by Rogier van der Weyden (*c.* 1399–1464) and other Netherlandish artists. The collection of Isabella d'Este, Marchesa of Mantua, included a painting by van Eyck, as did the Medici collection in Florence. Rogier van der Weyden worked for the Este family at Ferrara between 1449 and 1451. He is said to have been in Rome in 1450 and he also may have visited Florence. Antonello da Messina's understanding of Netherlandish technique surpassed that of any of his Italian contemporaries. His sojourn in Venice (1475–6) transformed the development of Venetian painting. Justus of Ghent (*fl c.* 1460–80) and the Spaniard Pedro Berruguete (*c.* 1450–*c.* 1500) both worked in a Netherlandish style between 1473 and 1482 for Federigo da Montefeltro, Duke of Urbino. Hugo van der Goes's Portinari Altarpiece (*c.* 1473–8; Florence, Uffizi), commissioned by the Florentine banker Tommaso Portinari in Bruges for the family chapel in S Egidio, Florence, had a pronounced impact on Florentine artists when it arrived in the city in 1483. Certain of Leonardo's early works show an awareness of Netherlandish oil technique. His technique of colour modelling, which unifies the painting by developing a tonal structure that moves towards a darker tonality, rather than towards white as in tempera painting, is based on Netherlandish practice.

(iv) Subject-matter and patronage. The vast majority of Renaissance paintings were still religious in subject. The 14th-century interest in painted narrative cycles that filled chapels, confraternities and other appropriate settings continued into the 15th century. Important religious cycles were painted by Masaccio and Masolino (Florence, S Maria del Carmine, see colour pls 2, II3 and 2, III2; Rome, S Clemente, destr.), Masolino (1435; Castiglione Olona, Baptistery; see colour pl. 2, VI2), Fra Filippo Lippi (1452–66; Prato Cathedral), Fra Angelico (1438–44, Florence, S Marco, see colour pls 1, III1 and 1, III2; 1448–9, Rome, Vatican, chapel of Nicholas V; *see* ANGELICO, FRA, fig. 6), Benozzo Gozzoli (1459, Florence, Pal. Medici–Riccardi, see colour pl. 1, XXXV2; 1465, San Gimignano, S Agostino; *see* GOZZOLI, BENOZZO, fig. 2), Piero della Francesca (1452–7; Arezzo, S Francesco; see colour pl. 2, XVI1), Andrea del Castagno (1447; Florence, S Apollonia, Cenacolo), Alesso Baldovinetti (Florence, Santa Trìnita; destr.), Mantegna (1454–7; Padua, Eremitani, Ovetari Chapel, *see* MANTEGNA, ANDREA, fig. 1; mostly destr. 1944), Ghirlandaio (1483–6, Florence, Santa Trìnita, *see* GHIRLANDAIO, (1), fig. 2; 1485–90, Florence, S Maria Novella, see colour pl. 1, XXXII2), Melozzo da Forlì (1477–80; Rome, SS Apostoli, frags in Rome, Vatican, Pin. Vaticana, see colour pl. 2, IV4) and Filippino Lippi (1487–1502; Florence, S Maria Novella, Strozzi Chapel, *see* LIPPI, (2), fig. 4; Rome, S Maria sopra Minerva) and in the Sistine Chapel in the Vatican (1481–3). Paintings were also incorporated into complex decorative schemes with architecture and sculpture, as at the chapel of the Cardinal of Portugal (Florence, S Miniato), which has paintings by Antonio and Piero Pollaiuolo and Baldovinetti (*see* FLORENCE, §IV, 7).

In the Republics civic commissions from the state increased. In Venice, the Doge's Palace was decorated with frescoes by Gentile da Fabriano, Pisanello, Gentile

Bellini, Alvise Vivarini and Carpaccio, all destroyed by fire in 1574 and 1577 (*see* VENICE, §IV, 4(ii)). The various *scuole* commissioned cycles from Carpaccio (1490s, Scuola di Sant'Orsola, see colour pl. 1, XIX1; 1494, Scuola Grande di S Giovanni Evangelista) and Gentile Bellini (1496; Scuola Grande di S Giovanni Evangelista; see colour pl. 1, X3). Other public decorations include the Pellegrinaio in the Ospedale di S Maria della Scala, Siena (*see* SIENA, fig. 3), the frescoed monuments to famous condottieri in Florence Cathedral by Uccello (1436; *see* UCCELLO, PAOLO, fig. 1) and Castagno (1456; *see* CASTAGNO, ANDREA DEL fig. 4) and the frescoes (1481–5) by Ghirlandaio in the Sala dei Gigli in the Palazzo della Signoria (later Palazzo Vecchio), Florence. Decorative cycles commissioned by rulers of city states elsewhere include Mantegna's frescoes (1465–74) in the Camera degli Sposi in the Palazzo Ducale, Mantua (see colour pls 2, I1 and 2, I2), and his *Triumphs of Caesar* series (1487–94; London, Hampton Court, Royal Col.), the frescoes of *The Months* (completed 1470) at the Palazzo Schifanoia, Ferrara, by Francesco del Cossa and Ercole de' Roberti (*see* FERRARA, fig. 2), works by Justus of Ghent and Pedro Berruguete for the *studioli* of Federigo da Montefeltro at Urbino (*see* STUDIOLO, fig. 1) and Gubbio and works by Perugino and Mantegna for the *studiolo* of Isabella d'Este in Mantua. The frescoes in the Borgia Apartments in the Vatican (1492–5) were commissioned by Pope Alexander VI from Bernardino Pinturicchio (*see* ROME, §V, 1(iii)(b)). Many secular works are lost, including several documented cycles in palaces in Ferrara.

There was an increasing interest in the use of narrative sequences for palazzo and villa decoration. The rapidly increasing wealth of the banking and mercantile class, especially in Florence, meant that businessmen could afford to decorate their town houses with works of art. While most of these paintings were religious in nature, some began to feature mythological or historical subjects. Uccello's three large paintings of the *Rout of San Romano* (1430s and mid-1450s; Florence, Uffizi; London, N.G. (*see* UCCELLO, PAOLO, fig. 3); Paris, Louvre; see colour pl. 2, XXXVII1) feature a very recent historical event (1432) and decorated a bedroom wall in the Medici town house on Via Larga, Florence (now Palazzo Medici–Riccardi).

Themes from Classical history and mythology were first commonly represented on *cassone* panels (*see* CASSONE, §1) and *spalliere*, long rectangular panels, or series of panels, set into wainscoting that furnished the town houses of the Florentine merchant classes and that had been produced in the workshops of such artists as Apollonio di Giovanni, Pesellino and Scheggia (*see* SPALLIERA). Popular themes included lives of *Famous Men and Women*, Petrarch's *Triumphs* and subjects from Classical history and Ovid.

Large-scale paintings of mythological subjects were at first rare. Among the earliest documented examples are Antonio and Piero Pollaiuolo's three large canvases depicting the *Labours of Hercules* (untraced; painted *c*. 1460 for the Medici town house in Florence). Two of the compositions survive (Florence, Uffizi; see colour pl. 2, XVIII2), replicated on small-scale panels. Large-scale mythological and Classical works appeared by the 1470s and 1480s, for example Botticelli's *Primavera* and the *Birth*

of *Venus* (see BOTTICELLI, SANDRO, figs 2 and 3) and Mantegna's *Triumphs of Caesar*. A special interest in ancient themes is evident in the works of Piero di Cosimo at the end of the century. Some artists, for example Botticelli, tried to re-create the *Calumny*, an allegorical painting by the Greek painter Apelles described in a famous *ekphrasis* by the Greek author Lucian. Nudes and paintings of mythological themes were probably among the works of art that were burnt by the followers of Savonarola in the 1490s. Secular decorations include Andrea del Castagno's

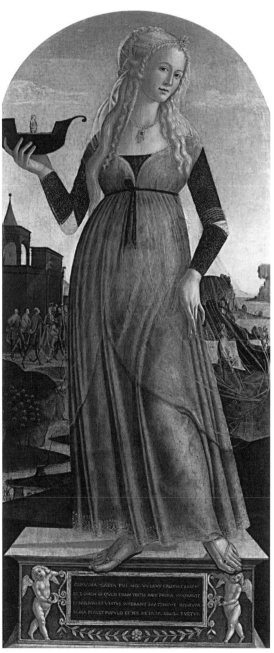

12. Neroccio de' Landi and the Griselda Master: *Claudia Quinta*, panel, 1.05×0.46 m, *c*. 1495 (Washington, DC, National Gallery of Art)

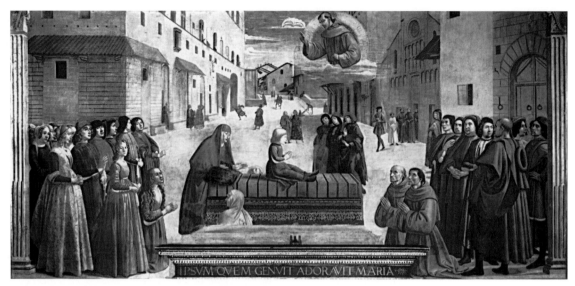

13. Domenico Ghirlandaio: *St Francis Restoring a Child to Life*, fresco from the *Life of St Francis* cycle (1479–85) in the Sassetti Chapel, Santa Trinita, Florence

series of *Famous Men and Women* (1449–51; ex-Villa Carducci, Legnaia; Florence, Uffizi; see colour pl. 1, XXI1) and the cycle of eight *Famous Men and Women* by various Sienese artists that includes Neroccio de' Landi's and the Griselda Master's *Claudia Quinta* (*c.* 1495; Washington, DC, N.G.A.; see fig. 12).

Portraiture of men and women of the mercantile and banking class began in Florence with profile representations modelled on those depicted on ancient coins and medals (*see* BALDOVINETTI, ALESSIO, fig. 2), but during the second half of the century the three-quarter view became common. The inclusion of donors the same size as Christ, the Virgin and saints is found in works by Masaccio (see colour pl. 2, III1) and Gentile da Fabriano in the 1420s. By the end of the century Ghirlandaio's frescoes (see fig. 13; see also fig. 39 below) and Gentile Bellini's and Vittore Carpaccio's paintings for the Venetian *scuole* (*see* CARPACCIO, (1), figs 2 and 4 and colour pl. 1, XIX2) are crowded with portraits of citizens gathered at the margins of religious narratives against a backdrop of Florentine or Venetian architecture.

(v) Status of the artist. Beginning in the 15th century artists gradually began to sign their works or to include a self-portrait in the painting (e.g. Benozzo Gozzoli, Botticelli, Gentile Bellini and Andrea Mantegna) as a sign of their accomplishment. Some artists achieved individual fame, as indicated in humanist and other writings, and the status of the artist as an intellectual was promoted by Alberti's treatises. The perceived importance of perspective and geometry for artists, not to mention the usefulness of some Classical knowledge, helped to elevate painting above the mechanical arts to a new status as a liberal art. Communities and rulers were proud of artists who achieved an international reputation and who received commissions from other city states. Such artists often travelled widely, and their works were sent as gifts from one ruler to another. Those rulers of the various city states

who had had a humanist education, such as Federigo II Montefeltro, Duke of Urbino; Gianfrancesco Gonzaga, 1st Marchese of Mantua, and his son Ludovico, 2nd Marchese of Mantua; Lionello d'Este, Marchese of Ferrara; Sigismondo Pandolfo Malatesta and Isabella d'Este, Marchesa of Mantua, began to retain artists at their courts as *stipendiati* and used works of art both to enhance their prestige and to promote their roles as enlightened rulers. The acceptance of artists at noble courts eventually helped to establish the basis for the respect accorded to Leonardo, Michelangelo, Raphael and Titian in the 16th century. The rise in social status enjoyed by the foremost Renaissance artists was supported by reports of the esteem accorded to artists in antiquity, as evidenced by passages in Pliny. Painters were commonly active in other areas of intellectual and cultural life, such as architecture, writing and science, as is seen in the careers of Leonardo, Michelangelo, Bramante and Francesco di Giorgio Martini.

At the same time, however, documents such as Neri di Bicci's *Ricordanze* give a clear indication of the many mundane tasks carried out in a typical 15th-century workshop: painting trade signs, banners, coats-of-arms, furniture, frames and cheap gessoed *Virgins*, designing tournament costumes and temporary decorations for festivals and gilding horse-trappings. Many aspects of the painter's life had changed little since the Middle Ages. The training of apprentices, for example, was still carried on in the workshop and could take as long as 13 years. Painters and apprentices were still subject to guild membership and rules, except in Florence, where membership of the Arte de' Medici e Speziali was not required and foreign artists could practise without fear of recrimination. Family dynasties, a result of the workshop tradition, were encouraged by guild rules and were common. In Florence, in the second half of the 15th century the two most successful workshops were those of Domenico Ghirlandaio and Andrea del Verrocchio, both of whom operated on a large scale. Verrocchio's workshop, in addition to turning out

large quantities of paintings, engaged in sculptural and engineering projects. It employed a large workforce, from *garzoni* (shop-boys) to apprentices and assistants of varying skill.

2. EARLY RENAISSANCE, *c.* 1400–*c.* 1500. There were other centres of production than Florence—Bologna, Ferrara, Mantua, Milan, Naples, Padua, Rome, Siena, Venice and Verona—but interaction with Florentine painters or their work, especially in the period *c.* 1440–70, was common. Many of these centres were dominated by a single artist or a small group of artists practising a unified style, usually under the inspiration of Florentine precedents. Later in the century other centres rose in importance and in turn exported their styles. Perugino and Raphael carried Umbrian trends to Florence, the Paduan style was carried to the Marches by Carlo Crivelli, and the Venetian style had an impact throughout the Veneto and was even practised in Constantinople by Gentile Bellini.

(i) Florence. (ii) Other centres.

(i) Florence. The International Gothic style in Italy is characterized by marginal realism, especially in the rendering of animals and plants, tall, elegant figures, extravagant decorative drapery patterns and 'doll's house' architecture. Florentine painters who worked in this style include Lorenzo Monaco, Masolino, the Master of 1419, Gentile da Fabriano (whose *Adoration of the Magi* (1423; Florence, Uffizi; *see* GENTILE DA FABRIANO, fig. 3) illustrates the style at its most characteristic) and the young Paolo Uccello.

Masaccio's new Renaissance style, which emerged in Florence in the 1420s, combined the weight and mass of Giotto's figures with a more subtle understanding of figural construction derived from a study of the Antique and nature, as well as the Classically inspired contemporary sculpture of Donatello and Nanni di Banco. In reaction to the prevailing International Gothic style, his works are, as the humanist Cristoforo Landino wrote, 'pure and without ornamentation'. Masaccio's serious, noble figures were placed in classicizing architectural settings within a coherent illusory space made possible by the new developments of scientific and atmospheric perspective. Masaccio's naturalistic style influenced the second generation of Florentine painters, Fra Angelico, Fra Filippo Lippi and Paolo Uccello, and had an impact on virtually all later Renaissance painting.

Later artists added their own emphases. Domenico Veneziano specialized in subtlety of lighting, as for example in the *Annunciation* (*c.* 1445; Cambridge, Fitzwilliam; see fig. 14), part of the predella from the *St Lucy* altarpiece (Florence, Uffizi; see colour pl. 1, XXVIII1). Andrea del Castagno concentrated on achieving sculpturesque effects, and Antonio and Piero Pollaiuolo powerful movement. Several artists began to take a more scientific approach to art. Antonio Pollaiuolo was followed in his interest in anatomy by Leonardo and Michelangelo. A new interest in mythological and allegorical themes, surely based on humanist interests, is evident in works from the second half of the century. Botticelli's *Primavera* and the *Birth of Venus*, two of the earliest large-scale paintings of mythological subjects since antiquity (*see* BOTTICELLI, SANDRO, figs 2 and 3), exhibit a complex iconography that relates to Neo-Platonic debates of the period.

When Pope Sixtus IV wanted to fresco the Sistine Chapel in the Vatican Palace, between 1481 and 1483 (*see* ROME, §V, 1(iii)(b)), he called to Rome the Florentines Domenico Ghirlandaio, Botticelli (see colour pl. 1, XIII2) and Cosimo Rosselli; the last was assisted by Piero di Cosimo. The other painters commissioned by Sixtus—Luca Signorelli, Perugino and Bernardino Pinturicchio (*see* ROME, fig. 10)—had all been influenced by Florentine innovations. The Florentine style had already been carried to Rome by Masaccio, and Uccello had worked in Venice

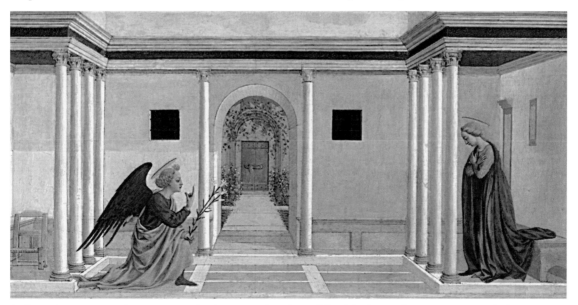

14. Domenico Veneziano: *Annunciation*, panel, 273×540 mm, from the predella of the *St Lucy* altarpiece, *c.* 1445 (Cambridge, Fitzwilliam Museum)

(1425–*c.* 1430) and Padua (1445–6). Filippo Lippi, Fra Angelico, Andrea del Castagno, Antonio del Pollaiuolo and Leonardo were among the numerous artists who carried Florentine innovations to many parts of Italy. The Florentine sculptor Donatello lived in Padua from 1443 to 1453, and his works were greatly influential there as well as in Venice, Siena, Naples and Rome. Ghiberti's and Donatello's work on the font in the Siena Baptistery also influenced painters. Among the artists who came to Florence to study and/or work in the 15th century were Piero della Francesca, Perugino and Raphael from Umbria, and Domenico Veneziano and Jacopo Bellini from Venice. In the 1490s the preaching of Savonarola turned patrons and artists away from the humanist interests of preceding decades and led to the destruction of many secular works of art.

(ii) Other centres. Painting in Siena in the 15th century is generally deemed conservative in comparison to that of Florence. Sienese patrons continued to admire the Byzantine Gothic work of the 14th century, and religious attitudes in Siena suggest the impact of a central cultural figure in 15th-century Sienese life, St Bernardino of Siena (1380–1444, *can* 1450). Domenico di Bartolo, Vecchietta and the other painters who worked on the fresco cycle (1441–4) depicting the activity of the hospital in the Pellegrinaio (hostel for pilgrims) at the Ospedale di S Maria della Scala, Siena (*see* SIENA, §III, 2 and fig. 3), adapted many Florentine elements. At the same time Sassetta, Giovanni di Paolo and others continued the venerable Sienese tradition of Duccio (*fl*1278) and Simone Martini (*c.* 1284–1344), of delicate figures against a gold ground, and restricted their interest in Florentine innovations to spatial effects in the landscapes and architectural settings in narrative scenes. Sienese patrons kept alive the demand for goldbacked *Virgins* and altarpieces such as those produced by Sano di Pietro until late in the century. The tense, linear and dramatic style of the Florentines Castagno and Antonio Pollaiuolo influenced the works of Vecchietta and Matteo di Giovanni. Other Sienese artists influenced by Florence were Neroccio de' Landi and Francesco di Giorgio Martini. An unusual opportunity was given to 15th-century Sienese painters when they were asked to create compositions to be executed in stone for the pavement of their Cathedral (see colour pl. 2, XXX2). Although somewhat worn and restored, pavement compositions by Pinturicchio, Matteo di Giovanni, Neroccio de' Landi and others survive. (*See also* SIENA, §II.)

In Padua, the interest in archaeology and in antique decorative motifs found in the works of Andrea Mantegna was probably inspired by the Classical interests of his teacher Francesco Squarcione. Donatello's presence in Padua also had an important impact on the development of Mantegna's style. Mantegna later took the Paduan style to Mantua and Ferrara. Carlo Crivelli carried it to the Marches, and it was promoted in Venice by the Bellini family. (*See also* PADUA, §2.)

In Venice, the International Gothic style as interpreted by Jacobello del Fiore, Paolo Veneziano and Antonio Vivarini gradually gave way to Florentine interests in space and scientific perspective, as may be seen in the dramatic

vistas in the sketchbooks of Jacopo Bellini (*see* BELLINI, (1), fig. 2). In the works of his son Giovanni Bellini, the influence of the linear and sculpturesque style of Mantegna was at first paramount, but, apparently captivated by Antonello da Messina's use of the Netherlandish oil technique, Bellini gradually created a successful fusion of colour, light and atmosphere (see colour pls 1, XI1–1, XII2) that laid the foundation for the developments of Giorgione and Titian in the 16th century. His brother Gentile Bellini and Vittore Carpaccio excelled at recording the full panoply of Venetian life, culture and customs in their works. (*See also* VENICE, §II, 1 and 2.)

Working in centres in Umbria and the Marches, Piero della Francesco created his own serene vision of Renaissance clarity based on Florentine models. In Naples, Niccolò Colantonio shows the influence of Flemish and French models. At Perugia, the most important artists were Giovanni Santi (the father of Raphael) and Perugino. In Bologna, Francesco Francia, a goldsmith, only began to paint in the 1490s. Rome had no native school worthy of papal patronage. In Milan, Bramante worked in the style of Mantegna before turning to architecture, and Leonardo exerted a great influence on the local tradition during his residency at the Sforza court (*c.* 1482–99). Other painters active in Lombardy included Vincenzo Foppa and il Bergognone. The major painters in Ferrara were Cosimo Tura, Francesco del Cossa and Ercole de' Roberti; those in Modena were Agnolo and Bartolommeo degli Erri.

BIBLIOGRAPHY

M. Levey: *The Early Renaissance* (Harmondsworth, 1967)
F. Ames-Lewis: *Drawing in Early Renaissance Italy* (New Haven and London, 1981)
M. Baxandall: *Painting and Experience in Fifteenth-century Italy* (Oxford, 1988)

DAVID G. WILKINS

3. HIGH RENAISSANCE AND MANNERISM, *c.* 1500–*c.* 1600.

(i) Florence. (ii) Rome. (iii) Venice. (iv) Other schools and artists.

(i) Florence. Artistic patronage during the 16th century was affected by political upheaval. Leonardo da Vinci and MICHELANGELO were in Florence periodically during the first decade, and both were central to the realization of High Renaissance art. Leonardo evolved idealized and monumental figures and harmonious compositions built on interdependent forms. He exploited the new oil medium to create subtle modulation of tone, soft *sfumato* effect and atmospheric perspective, achieving a unified mood of figures and setting. The transformation from the bright naturalism of 15th-century altarpieces is exemplified by Leonardo's *Virgin of the Rocks* (*c.* 1490–1508; London, N.G.; *see* LEONARDO DA VINCI, fig. 2). Michelangelo's art was influenced by the philosophy of NEO-PLATONISM. His Doni *Tondo* (1503–4; Florence, Uffizi; see colour pl. 2, IV3) is another example of traditional iconography reconsidered, combining male nudes derived from antique art with Christian imagery.

The art of Leonardo and Michelangelo was based on drawing (see colour pl. 1, VII1), which remained significant for quick notation and for drawing from life and from antique exemplars. It was the basis of the Central Italian concept of *disegno*, intellectualized, structural form and

composition. Drawing in metalpoint was superseded by pen and ink, black chalk and red chalk. In the High Renaissance painters made increasing use of the cartoon, a full-size preparatory drawing that was particularly important for the accurate transfer of design in fresco, the traditional medium for Florentine decorative art. In 1504 Leonardo and Michelangelo were commissioned to paint two battle scenes in the new council hall, the Sala del Gran Concilio, of the Palazzo della Signoria. Neither work was completed, but Leonardo's complex composition and Michelangelo's cartoon of the male nude in vigorous action (both recorded in copies) would be highly influential.

Raphael was in Florence on and off between 1504 and 1508 and responded to stylistic developments there. By late 1508, when Leonardo, Michelangelo and Raphael had left Florence, FRA BARTOLOMMEO and ANDREA DEL SARTO were the leading painters there. Del Sarto, who had assimilated the underlying Classical values of Leonardo and Michelangelo, also evolved an effective chiaroscuro and borrowed from the engravings of Albrecht Dürer (1471–1528), which were becoming available in Italy. The demand for portraiture was growing, and Leonardo's lessons—of breadth of form, turning figure and psychological presence in the half-length portrait—were fully assimilated in the second decade. Del Sarto's *Portrait of a Man* (c. 1517; London, N.G.) projects physical and mental alertness as the figure turns in space to engage with the viewer.

By c. 1515–18 Pontormo and ROSSO FIORENTINO had transformed del Sarto's classical art into a disturbing and irrational form of Mannerism. Pontormo united decentralized composition, irrational depiction of space, attenuated figures and exaggerated poses. He adopted irregular line from Dürer's prints and evolved a palette of light, bright colours, for example in the *Lamentation* (c. 1528; Florence, S Felicità; *see* PONTORMO, fig. 2). Rosso distorted figures into cyphers of emotional condition, and in Rome (1523–7) he adopted extremes of *contrapposto* and foreshortening.

Hopes for a renewal of the Republic ended with the accession of Cosimo I de' Medici as Duke of Florence in 1537 (*see* MEDICI, DE', (14)). Court patronage then dominated second-generation Mannerism. Agnolo Bronzino's paintings were sophisticated artifices in frozen elegance with a formal beauty of line and surface. His nudes displayed sexuality but pretended none, as in the allegory *Venus, Cupid, Folly and Time* (c. 1544–5; London, N.G.; *see* BRONZINO, fig. 2). His masklike portraits contrasted with the sensitive nervosity of Pontormo's. A great programme of decoration was instigated by Cosimo's personal appropriation of the Palazzo della Signoria (1540). Bronzino and Francesco Salviati made significant contributions, in which subject and content were subservient to formal aesthetics (*see* SALVIATI, FRANCESCO, fig. 2).

The decorations designed by Giorgio Vasari (*see* VASARI, (1)) used stylized formulae to tedious effect, with obscure intellectual conceits. In this late form of Mannerism, known as High Maniera, Vasari's was the pervading influence. He subcontracted some of the decorative work, as in the *studiolo* (designed 1570; *see* STUDIOLO, fig. 2) for Cosimo's son Francesco (*see* MEDICI, DE', (16)), as well as

altarpieces for S Maria Novella and Santa Croce. During the last three decades a tired version of Maniera artifice was continued by painters, including Alessandro Allori (1535–1607), GIROLAMO MACCHIETTI and MIRABELLO CAVALORI. Others more successfully sought a way out of Maniera conventions. SANTI DI TITO, for example, achieved a return to conventional form and clarity of composition and content, as in his *Vision of St Thomas Aquinas* (1593; Florence, S Marco). By this time, Vasari had done much to formalize the status of painters and painting with the publication of his artists' lives, the *Vite* (1550; revised 1568). His initiatives resulted in the founding of the first artists' academy, the Accademia del Disegno (1563).

(ii) Rome. Pope Julius II (*see* ROVERE, DELLA, (2)) transformed Rome into the artistic centre of Central Italy. He compelled Michelangelo to fresco the ceiling of the Sistine Chapel (1508–12; *see* ROME, fig. 9) and by 1509 had commissioned Raphael to fresco the Stanza della Segnatura (both Rome, Vatican). Michelangelo's art was rooted in the expressive possibilities of the human form, and in the Sistine ceiling his idealized male nudes and figures were developed with monumental force or in extreme torsion (see colour pl. 2, VI2). His influence was extended through Sebastiano del Piombo, in Rome from 1511, for whom he supplied figure studies for such important commissions as the *Raising of Lazarus* (1517–19; London, N.G.; *see* SEBASTIANO DEL PIOMBO, fig. 3).

Raphael's work in the Vatican set the standard of intellectual and executive ability required of the High Renaissance artist. He accommodated the decorative and propaganda intentions of his patrons, combining Christian and pagan iconography, realism, idealism and grace. He first projected a fully realized response to the monumental ruins of ancient Rome in the *School of Athens* (c. 1510–12; Rome, Vatican, Stanza della Segnatura; see fig. 15). He went on to create a chiaroscuro of expressive and dramatic force, and to stretch the classical style to its limits. Raphael's altarpieces and portraits epitomize High Renaissance achievement: the visionary *Sistine Madonna* (c. 1513–14; Dresden, Gemäldegal. Alte Meister); the *Transfiguration* (1517–20; Rome, Pin. Vaticana; *see* RAPHAEL, fig. 6), which includes two narrative subjects; the innovative three-quarter length, seated and turned *Pope Julius II* (c. 1512; London, N.G.); the courtly dignity of *Baldassare Castiglione* (c. 1514–15; Paris, Louvre; *see* RAPHAEL, fig. 8). His collaboration with the engraver MARCANTONIO RAIMONDI extended the artistic and commercial potential of engraving (*see* RAPHAEL, fig. 7). Raphael employed a large workshop to execute his designs for various commissions from c. 1515, expanding the vocabulary of decorative art from antique examples.

After Raphael's death in 1520, his former assistants led Rome in the development of a new post-classical style, Mannerism. Giulio Romano, for example, used rhythmic tensions, heavily sculptural form, selfconscious poses and exaggerated perspective recession, as in the *Holy Family with SS James, John the Baptist and Mark* (?c. 1522; Rome, S Maria dell'Anima; *see* GIULIO ROMANO, fig. 2). He also made purely erotic drawings, which were engraved by Marcantonio. Rome continued to attract painters, includ-

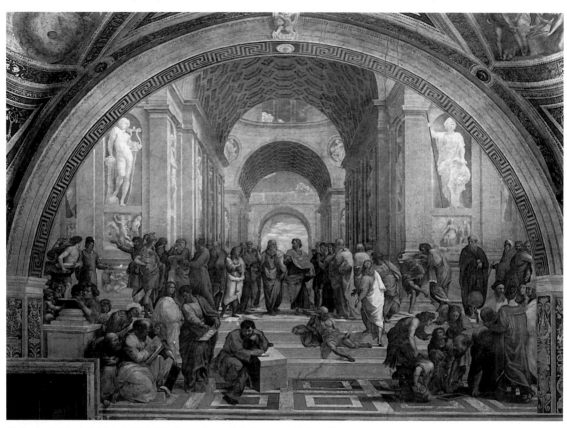

15. Raphael: *School of Athens* (*c.* 1510–12), fresco, Stanza della Segnatura, Vatican, Rome

ing PARMIGIANINO in 1523, who assimilated the artifice of Mannerist aesthetics, as seen in the *Virgin and Child with SS John the Baptist and Jerome* (1527; London, N.G.).

In 1527 many artists fled after Rome was sacked by imperial troops. Their dispersal affected art elsewhere in Italy, and also in France. The material and psychological devastation of the sack affected the arts for several years. In 1534 Michelangelo returned from Florence. Pope Paul III (*see* FARNESE, (1)) ordered him to paint the altar wall of the Sistine Chapel with the *Last Judgement* (1536–41; Rome, Vatican; see colour pl. 2, VII3). The many nudes offended the increasing pietism of the Counter-Reformation, and after Michelangelo's death (1564) drapery was added to them. From *c.* 1530 Michelangelo extended the function of drawing, producing 'presentation drawings' as independent works. Made as gifts for friends, they introduced an art of personal, intellectual and spiritual communion between artist and recipient (*see* MICHELANGELO, fig. 7 and PRESENTATION DRAWING).

In the second half of the century stylistic trends became more complex. The cult of Michelangelo, the power and energy of human form manifest in his later works, affected such painters as DANIELE DA VOLTERRA and Francesco Salviati. Their work was, however, essentially developed High Maniera in its stylized artifice. Salviati's complex decorative schemes in the Salon dei Fasti Farnesi, Palazzo Farnese, Rome (*c.* 1549–63; *see* SALVIATI, FRANCESCO, fig. 4), exemplify this.

With the sobering influence of the Counter-Reformation, the younger generation sought a classical temper to counter Maniera extremes. GIROLAMO MUZIANO, for example, revived a more natural form and logic of composition. His counter-Maniera style was taken to an extreme in Scipione Pulzone's pietistic art, as in his *Holy Family* (*c.* 1590; Rome, Gal. Borghese; for illustration *see* PULZONE, SCIPIONE). Parallel with this, some artists continued a Mannerist aesthetic, such as Federico Zuccaro, in the 1580s in Rome (*see* ZUCCARO, (2)). All these tendencies of the late century relied directly on various 16th-century precedents. Michelangelo Merisi da Caravaggio (1571–1610), who was in Rome by *c.* 1590, and Annibale Carracci (1560–1609), by 1595, introduced fresh concepts of realism and classicism, which provided new impetus for the next century.

(iii) Venice. Art in Venice was open to various influences: developments in Central Italy, antiquity and her own Byzantine heritage. Dürer's visit in 1505–6 heightened awareness of northern realism and nature. Jacopo Sansovino (*see* SANSOVINO, (1)), PIETRO ARETINO and SEBASTIANO SERLIO, who arrived in 1527, significantly affected Venetian art. Despite the decline of the Venetian Empire, artistic patronage flourished. Experimenting with oil techniques, painters developed a distinctive style, *colorismo*, reliant on the optical experience of light, colour and surface impression.

In the first decade Giorgione introduced innovative subjects that accorded with the interests of humanists and literati, such as *The Tempest* (*c.* 1504; Venice, Accad.; see

colour pl. 1, XXXIII2) and the nude *Sleeping Venus*, completed by Titian (*c.* 1509–10; Dresden, Gemäldegal. Alte Meister; *see* GIORGIONE, fig. 4). He simplified preparatory underdrawing, initiating the Venetian freedom to extemporize during the painting process. His idealized, atmospheric and contemplative style was emulated by many painters. Giovanni Bellini (*see* BELLINI (3)), Giorgione, Titian and others contributed to the transformation of altarpieces and devotional works. Titian first fully realized a new scale, vision and drama in the *Assumption of the Virgin* (1516–18; Venice, S Maria Gloriosa dei Frari; for illustration *see* ALTARPIECE). He went on to explore asymmetrical composition and the dramatic interaction of man and nature.

The State used decorative art in the Doge's Palace to glorify the past. Decoration of *scuole* buildings proved an exceptional opportunity for the development of narrative and serial painting (*see* VENICE, §V). This is traceable through the achievements of the BELLINI family and Vittore Carpaccio (*see* CARPACCIO, (1)) in the 15th century to Titian and Jacopo Tintoretto (*see* TINTORETTO, (1)). Oil on canvas, rather than fresco, was the rule.

By the mid-16th century the scope of portraiture in Italy had been radically extended to include half, three-quarter, full-length and seated figures, and single, double and group portraits. After Giorgione, Titian dominated Venetian portraiture (see colour pl. 2, XXXV1). From the 1530s he developed a sensitive balance of lively realism and idealism, of individual and status, for princely patrons on the mainland. Such patronage opened other opportunities to him, including mythological subjects such as the *Bacchanal of the Andrians* (*c.* 1523–5; Madrid, Prado; *see* TITIAN, fig. 5) for Alfonso I d'Este, Duke of Ferrara. In the 'fancy portrait', a Venetian development of the first two decades, the model was depicted as a character or type. Titian's *Venus of Urbino* (1538; Florence, Uffizi; see colour pl. 2, XXXV3) was an extension of this type, accommodating voyeurism in the viewer. Francesco Salviati visited Venice in 1539–41, introducing his rhetorical, Mannerist style and elongated figures. BONIFAZIO DE' PITATI, PARIS BORDONE, PORDENONE and ANDREA SCHIAVONE also all worked in Venice.

The publications of PAOLO PINO and LUDOVICO DOLCE discussed the relative merits of Venetian *colorismo* and Central Italian *disegno*. Dolce focused on Titian as Venice's most famous practitioner. Titian continued to enjoy important patronage outside Venice, especially for portraits, such as the propagandist *Charles V at Mühlberg* (1548; Madrid, Prado). Through the 1550s and 1560s he executed a series of paintings for Philip II of Spain (*reg* 1556–98), based on Ovid's *Metamorphoses*. In *Diana and Actaeon* (1559; Duke of Sutherland, on loan to Edinburgh, N.G.; see fig. 16) his free brushwork, colour, tone and shifting verticals increase the tension of glance and gesture.

In Venice, the combination of stylistic awareness and ambitious patronage produced innovative decorative schemes for Church and State. Illusionistic ceiling painting was adopted, using canvases inserted into geometrically compartmentalized wooden ceilings rather than fresco. Titian initiated a 45% angle of perspective for greater legibility from the ground, for example in *Cain and Abel* (1542–4; Venice, S Maria della Salute). By 1555 Paolo

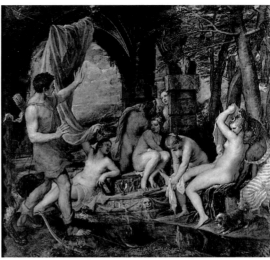

16. Titian: *Diana and Actaeon*, oil on canvas, 1.88×2.03 m, 1559 (Duke of Sutherland, on loan to Edinburgh, National Gallery of Scotland)

Veronese was resident in Venice and had begun work in S Sebastiano. Continuing into the 1570s, he decorated the whole church, a unified programme that was novel in Venetian churches. Consciousness of style led Jacopo Tintoretto from an early synthesis of forms derived from Michelangelo and Titian's use of colour to atmospheric evocation. He used Mannerist devices, such as repoussoir forms (in the very foreground) and the placement of significant figures in the middle-ground. His vitality and epic scale transformed the decoration of churches and *scuole*, climaxing in his extensive programme for the Scuola Grande di S Rocco, 1565–87 (*see* VENICE, §V, 4 and fig. 12). With the *Marriage at Cana* (1561; Venice, S Maria della Salute) he initiated a new genre for Venice, the great feast scene. This was developed variously by himself and Veronese. Veronese's rich colour (see colour pl. 2, XXXVIII4) and elegance of architectural settings affected a secular splendour, but with subtly controlled composition and content (*see* VERONESE, PAOLO, fig. 4). By the 1570s Titian and Veronese were assimilating Tintoretto's tonal force and dematerialized form, yet all retained artistic individuality. They responded to different commissions with versatility. The State's continuing employment of leading painters in the Doge's Palace culminated in the redecoration of the Sala del Maggior Consiglio, after a fire in 1577 (*see* VENICE, §IV, 4(ii)). Veronese's ceiling with the *Apotheosis of Venice* (*c.* 1583; *see* VENICE, fig. 10) and Tintoretto's epic *Paradise* (1588–92) epitomize the decorative and ideological harmony of Venetian painting. By the end of the century, however, Venetian painting had lost the vigour of innovation.

In the Veneto, Jacopo Bassano created a novel rustic style, as in *Adoration of the Shepherds* (1568; Bassano del Grappa, Mus. Civ.; *see* BASSANO, (2), fig. 3). This type became popular through Europe. Development of the working country villa offered new decorative scope. At the Villa Barbaro, Maser, Veronese showed sensitivity to Andrea Palladio's architecture in his inventive frescoed allegories, landscapes and illusionistic caprices (*c.* 1561;

see colour pl. 2, XXXIX1). BATTISTA ZELOTTI established a career in villa decoration.

(iv) Other schools and artists. Court patronage dominated Mantua and Ferrara. ANDREA MANTEGNA was painter to the Gonzaga in Mantua until his death in 1506. In 1524 Giulio Romano arrived as court artist to Federico II Gonzaga, 5th Marchese and later 1st Duke of Mantua (*see* GONZAGA, (9)). Giulio revitalized Mantuan art. His brutal, lascivious and humorous decoration of the Palazzo del Te (*c.* 1532–4) exploited the building's informal function, and his forceful illusionism and exaggeration of form had a wide impact. Federico Gonzaga also patronized Titian, who assimilated something of Giulio's style. In Ferrara Alfonso I d'Este (*see* ESTE, (8)) pressed for artistic contributions to his court from leading painters of Venice and central Italy, although Dosso Dossi effectively updated the local fanciful and courtly style by introducing the styles of Venetian art and Raphael (*see* DOSSI, (1)). The fantastic landscapes of NICOLÒ DELL'ABATE, a Modenese painter, owed much to the Ferrarese school, which declined after Alfonso's rule.

LORENZO LOTTO worked for provincial patrons in the Marches during several extended periods, as well as in Venice, Rome, Bergamo and Treviso. Aware of the mainstreams of painting, he developed a singular, intense style, as seen in the *Visitation* (*c.* 1535; Jesi, Pin. Civ.). Venetian influence spread through North Italy to Brescia and Bergamo. Here, men of the increasingly important professional classes supported a burgeoning portrait business. In this, MORETTO da Brescia and his pupil Giovanni Battista Moroni overlaid Brescian naturalism with stylistic elements from Giorgione and Titian. By the late 1520s Moretto had adopted the northern, full-length, independent portrait. Moroni's greater realism is seen in *The Tailor* (*Portrait of a Man; c.* 1570; London, N.G.; *see* MORONI, GIOVANNI BATTISTA, fig. 2), which exceptionally represents a working artisan.

In Parma, Correggio used a broad knowledge of Italian art to evolve a style of energized illusionism and intense emotion that anticipated the Baroque, culminating in the *Assumption of the Virgin* (*c.* 1526–30; Parma Cathedral; *see* CORREGGIO, fig. 4). In his oil paintings he combined a soft *sfumato* derived from Leonardo with delicate colouring (see colour pl. 1, XXIV1). In 1530 Parmigianino returned from Rome, bringing the exaggerated aesthetics of Roman Mannerism, for example in his *Virgin and Child with SS John the Baptist and Jerome* (*Vision of St Jerome*, 1527; London, N.G.; see fig. 17).

The expressive value of Sienese art was already modified by 15th-century Florentine rationalism. DOMENICO BECCAFUMI was outstanding as the Sienese painter who met contemporary developments on his own terms. He was in Rome in 1510–12 and knew the work of Raphael and Michelangelo. Returning to Siena in 1513, he increasingly heightened the emotional tenor of his work with effects of shot-colour or surprising hues (see colour pl. 1, IX1) reminding one of the force of colour in Michelangelo's Sistine Chapel ceiling (see colour pl. 2, VI1).

In Italy a few women painters were materially successful. Foremost was Sofonisba Anguissola (*see* ANGUISSOLA, (1)) of Cremona. A noblewoman, she was taught painting

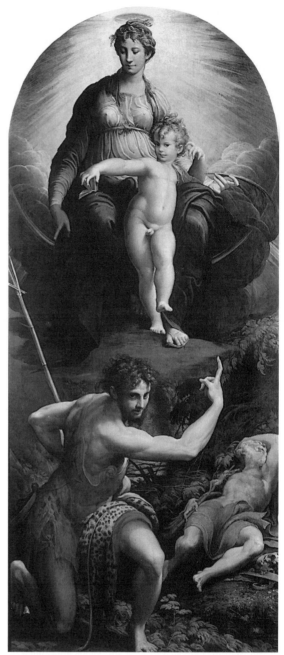

17. Parmigianino: *Virgin and Child with SS John the Baptist and Jerome* (*Vision of St Jerome*), oil on panel, 3.43×1.49 m, 1527 (London, National Gallery)

as a dilettante skill but exceptionally achieved international fame. Lavinia Fontana of Bologna and Fede Galizia (1578–1630) of Milan were, like Marietta Tintoretto (*see* TINTORETTO, (2)), daughters of painters. Portraits of women were deemed suitable subjects: Fontana made her name with portraits of Bolognese noblewomen. *Woman with a Lapdog* (late 1590s; Baltimore, MD, Walters A.G.) exemplifies the suggestion of activity and presents character in her elegant images. Sofonisba's portraits included such innovative works as *Lucia, Minerva and Europa*

Anguissola Playing Chess (1555; Poznań, N. Mus.). Social decorum prohibited women from studying the life-model and thus hindered their participation in the prestigious area of large, narrative painting. Nonetheless, Fontana produced religious and mythological subjects for private and public commissions (for illustration *see* FONTANA (ii), (2)). Galizia broadened her range by exploring the new genre of still-life. Recognition of the talents of a few women owed something to Renaissance emulation of similarly limited antique precedent. Professional women painters were seen as acting atypically, however, in what was deemed to be properly the male preserve of an intellectual and creative art.

BIBLIOGRAPHY

W. Friedlaender: *Mannerism and Anti-Mannerism in Italian Painting* (New York, 1957, rev. 2/1964, intro. D. Posner, *R* 1990)

P. Barocchi, ed.: *Trattati d'arte del cinquecento*, 3 vols (Bari, 1960–62)

S. J. Freedberg: *Painting of the High Renaissance in Rome and Florence*, 2 vols (Cambridge, MA, 1961/*R* New York, 1972, rev. 2/1985)

J. Shearman: *Mannerism*, Style & Civil. (Harmondsworth, 1967/*R* 1990)

S. J. Freedberg: *Painting in Italy, 1500–1600*, Pelican Hist. A. (Harmondsworth, 1971, rev. New Haven and London, 3/1993)

M. Levey: *High Renaissance* (London, 1975)

Women Artists, 1550–1950 (exh. cat. by A. Sutherland Harris and L. Nochlin, Los Angeles, CA, Co. Mus. A.; Austin, U. TX, A. Mus.; Pittsburgh, PA, Carnegie Mus. A.; New York, Brooklyn Mus.; 1976–7)

G. Briganti, ed.: *La pittura in Italia: Il cinquecento*, 2 vols (Milan, 1987)

M. Hall: *After Raphael: Painting in Central Italy in the Sixteenth Century* (Cambridge, 1999)

JESSICA HARNESS

IV. Sculpture.

The 15th and 16th centuries in Italy constituted one of the most vibrant epochs in the history of world sculpture. It is best divided into three periods, on broad, stylistic criteria: early Renaissance (*c.* 1400–*c.* 1480), High Renaissance (*c.* 1480–*c.* 1530) and Mannerism (*c.* 1530–*c.* 1600). These dates are approximate, as Italy was not then unified and progress varied between city states. Further divisions must be made to take account of the diverse approaches to sculpture in the city states, both in materials and in themes.

Florentine sculptors rarely relinquished the stylistic initiative and quickly appropriated and adapted innovations that emerged elsewhere, for example Mannerism, from Rome. Rome did not play a leading role, owing to schisms in the Church, and to the Reformation, which checked papal expenditure. Certain popes did lavish money on sculpture, but each tended to employ favourites from his native city, and there seems not to have been sufficient continuity in patronage to support a major, homogeneous school of sculpture. Venice flourished during the whole period, and the doges appreciated sculpture as a means of symbolizing her achievements. Visiting artists from Tuscany (e.g. Donatello and Jacopo Sansovino) stimulated her out of her innate conservatism and spurred her cautious adoption of successive styles. Other city states came to prominence for limited periods: Milan, Siena, Bologna, Urbino, Ferrara, Padua, Mantua, Genoa, Naples and Sicily all boasted local schools of sculpture, which on occasion gave birth to master sculptors or masterpieces.

These bursts of activity resulted in an efflorescence of sculpture all over Italy, with particular local flavours but of a consistently high quality, both in creative imagination and in terms of technique. Many of the best-known names in the history of art are those of Italian sculptors from these two centuries, such as Lorenzo Ghiberti, Donatello, Andrea Verrocchio, Michelangelo, Benvenuto Cellini, Giambologna, Tullio Lombardo and Jacopo Sansovino.

1. Early Renaissance, *c.* 1400–*c.* 1480. 2. High Renaissance, *c.* 1480–*c.* 1530. 3. Mannerism, *c.* 1530–*c.* 1600.

1. EARLY RENAISSANCE, *c.* 1400–*c.* 1480.

(i) Florence. (ii) Rome. (iii) Lucca, Siena and Bologna. (iv) Venice and the Veneto.

(i) Florence. It was in Florence that a renewed interest in ancient culture, including remains of architecture and monumental sculpture, first emerged, towards the end of the 14th century. This resulted in a new Classically derived style, which appeared first in sculpture. Florence is the only city in which the full development of sculpture may be followed, from the Gothic legacy of the Middle Ages to the sublime productions of the High Renaissance, and thence to the poetic, almost abstracted, grace and wit of Mannerism.

(a) Introduction. The period of Italian art known as the RENAISSANCE is usually regarded as beginning in 1401, the date of a competition to design a new pair of monumental bronze doors for the Baptistery at Florence. Before this date, art was predominantly Gothic and medieval in character; afterwards it was predominantly influenced by the revival of interest in the ancient civilization of the Greeks and Romans. The Baptistery, the Campanile and the Cathedral (*see* FLORENCE, §IV, 1) became the epicentre of sculptural activity in the city in the Renaissance, a showpiece of the latest development in narrative reliefs and in statues devoted to religious subjects. The other centre of sculptural activity in the first quarter of the 15th century was the guildhall, Orsanmichele (*see* FLORENCE, §IV, 2). Each major guild had to furnish one of the external niches with a statue of its patron saint. The guilds felt themselves in direct rivalry, and there was a startling explosion of technical and stylistic innovation, as the greatest sculptors of the day vied to produce the most 'modern' statue.

Private patronage of sculpture existed as well as corporate, but in general it was confined to works for churches. Sacred locations permitted only a limited range of opportunities and subjects, however, and a major feature of the Renaissance is the gradual broadening of the scope of private patronage to encompass entirely new types of sculpture, inspired by ancient models, notably plaquettes and bronze statuettes of Classical subjects. Owing to the private and personal nature of such commissions, the full range of pagan, mythological and occasionally even erotic subjects could be addressed. Consequently it is in these minor fields of sculpture that the broadest exploration of antiquity occurs, and hence the 'real' Renaissance. After *c.* 1425 the pre-eminence of Florence as a centre of sculpture was due to the MEDICI family, who came to own probably the greatest collection of antiquities and perceptively employed a sequence of the finest sculptors: Donatello,

Bertoldo di Giovanni, Verrocchio and Antonio del Pollaiuolo.

(b) Types of sculpture. The pioneering role of sculptors in the early Renaissance was applied in four main types of sculpture: the narrative relief, the statue, the tomb and the portrait. The narrative relief became the first vehicle for the emergence of the Renaissance style, through direct references to ancient Roman sculptural prototypes, notably sarcophagi, as well as a renewed emphasis on realism and drama. The competition for the Baptistery doors in 1401 was won by Ghiberti, whose reliefs of scenes from the *Life of Christ* (*in situ, see* GHIBERTI, (1), figs 1 and 2), while retaining Gothic elements, show the adoption and integration of antique motifs (Krautheimer). In a second set of doors for the Baptistery, showing scenes from the Old Testament (1452; *in situ*; see colour pl. 1, XXXI2), he used larger panels, which enabled him to vie with paintings, in the inclusion of landscapes or architectural settings, just as DONATELLO was beginning to do in the same decade.

Ghiberti avoided the excesses of violence or drama that inspired some of Donatello's greatest relief sculpture. Trained by Ghiberti, Donatello soon evolved a personal style, influenced by ancient Roman models. This he expressed in a low-relief technique (*rilievo schiacciato*) that he invented between *c.* 1415 and 1425. He drew on the surface of the marble with a pointed chisel, indicating depth pictorially, by perspective rather than by physically excavating the marble. His contemporaries, MICHELOZZO DI BARTOLOMEO, NANNI DI BANCO and Luca della Robbia (*see* ROBBIA, DELLA, (1)), all preferred the ancient Roman convention of high relief, which is easier to control in the carving.

At the beginning of the 15th century, as in the Middle Ages, almost all statues were made for architectural settings, usually niches in churches. As the Renaissance evolved, the statue began to be liberated from such constraints, to be set at the centre of a courtyard, for example, or over a fountain basin. By the turn of the century, statues on grandiose pedestals began to be used to dominate squares and to articulate urban plans. Ultimately, in the 16th century, this formal approach was challenged by the Mannerist idea of scattering statues in gardens, to be encountered unexpectedly.

The principal destinations for statues in the first third of the 15th century in Florence were the cathedral complex and the guildhall. For the cathedral façade and Campanile a number of marble statues were carved by the earliest representatives of Renaissance figure sculpture, Nanni di Banco, Donatello and NANNI DI BARTOLO. Donatello created a series of horrifyingly emaciated *Prophets* (all Florence, Mus. Opera Duomo), derived from ancient Roman portraits. To Orsanmichele, Ghiberti contributed three saints cast in bronze (*see* GHIBERTI, (1) fig. 3), and Nanni di Banco made a particularly impressive group of four saints resembling Roman senators (for illustration see NANNI DI BANCO). The undoubted masterpiece in terms of expressiveness is Donatello's knight in armour, *St George* (*c.* 1414; *see* FLORENCE, fig. 11). Orsanmichele remained a focus of sculptural endeavour for many years; last to arrive was a splendid *St Luke* in bronze by GIAMBOLOGNA (1602).

It was in the essentially private context of Medicean patronage that the emancipation of statuary from ecclesiastical constraints began. In the middle of the century Cosimo de' Medici commissioned from Donatello a statue in bronze of *David* (Florence, Bargello; see colour pl. 1, XXIX1), the first life-size statue of a male nude in the Renaissance, reviving an antique type. The *David* was first recorded in the courtyard of Cosimo's new palace, which was finished in the 1450s. For the garden of the palace, Donatello's *Judith Slaying Holofernes* (*c.* 1465; Florence, Piazza della Signoria; see fig. 18) was the first functioning

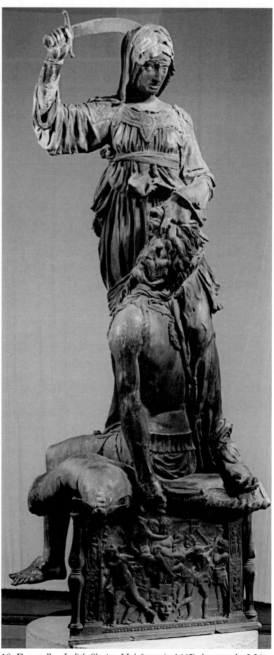

18. Donatello: *Judith Slaying Holofernes* (*c.* 1465), bronze, h. 2.36m, Piazza della Signoria, Florence

fountain statue of the Renaissance, and the first group of two integrated figures designed to be seen from all round.

Tombs in the Middle Ages were, to a greater or lesser extent, free-standing, architectural affairs. Donatello and Michelozzo translated the grand wall-tomb from the Gothic into a Renaissance idiom in the monument to the anti-Pope *John XXIII* (*c.* 1424–7; Florence, Baptistery), in which standard elements were framed in Classical architectural forms. Variations of this 'humanist tomb' (Pope-Hennessy, 1958) were made for most of the 15th century, for example the tombs of the chancellors of Florence (see below), and spread throughout Italy. Originals and variants of ancient Roman sarcophagi were also used (*see* SARCOPHAGUS). Slabs for setting in the floor were converted into the Renaissance idiom, and Donatello introduced a convincing image of the deceased seen in perspective in the tomb slab of *Bishop Pecci* (*c.* 1428; Siena Cathedral).

Possibly the greatest innovation in the repertory of the sculptor during the Renaissance was the revival of the portrait bust. Traditionally, this was held to have occurred only in the 1450s, for example Mino da Fiesole's *Piero de' Medici* (1453; Florence, Bargello; see colour pl. 2, VIII2) and Antonio Rossellino's *Giovanni Chellini* (1456; London, V&A). Ghiberti had applied a self-portrait to his doors for the Baptistery (*c.* 1420), however, and Donatello's painted terracotta likeness of *Niccolò da Uzzano* (Florence, Bargello; *see* DONATELLO, fig. 2) suggests that he too was involved in the deliberate revival of the portrait in bust form *c.* 1430.

By mid-century, still more ambitious portrait statues were made, notably another Roman type, the equestrian monument: Donatello's *Gattamelata* (1447–53; Padua, Piazza Santo; *see* DONATELLO, fig. 4) and Verrocchio's *Bartolomeo Colleoni* (*c.* 1479–92; Venice, Campo SS Giovanni e Paolo; *see* VERROCCHIO, ANDREA DEL, fig. 4), both masterpieces of bronze founding. The concept of the portrait medal, making portraits in multiples, was evident from ancient coinage. The greatest exponents of the medal were Pisanello and MATTEO DE' PASTI, who portrayed many Renaissance rulers and intellectuals (*see* PISANELLO, fig. 2 and ALBERTI, LEON BATTISTA, fig. 1). Original casts were made in gold and/or silver (for illustration *see* GIAN CRISTOFORO ROMANO), and secondary ones in bronze. Analogous portraits were also carved in hardstones or cameos but were rarely reproduced in quantity, for technical reasons.

(c) 'Sweet style'. Ghiberti was a proponent of a moderate and appealing style of sculpture, ennobling humanity and Christianity in an idealized vision amalgamated from Gothic art and Roman remains. Nanni di Banco and Michelozzo also tended to adhere to this norm, but Donatello largely abandoned it from the 1420s. From *c.* 1430 this 'Sweet style' was reinforced by Luca della Robbia, whose *Singing Gallery* (*Cantoria*) for Florence Cathedral (*see* ROBBIA, DELLA, (1), fig. 1) is one of its greatest manifestations. Luca then adapted ceramic glazing techniques to terracotta sculpture and produced a long series of works, including charming images of the Virgin and Child, portrait roundels and coats of arms. The second generation of Renaissance sculptors who came to maturity

c. 1445–55, while Donatello was absent in Padua, absorbed the calm mood and delicacy of detail in Ghiberti's and Luca's mature work: Bernardo and Antonio Rossellino, Desiderio da Settignano and MINO DA FIESOLE. Bernardo developed several of the structural types invented by Donatello and Michelozzo, for instance the sacramental tabernacle and notably the 'humanist tomb', such as those for *Leonardo Bruni* (*d* 1444; for illustration *see* ROSSELLINO, (1)) and *Carlo Marsuppini* (*d* 1453; *see* DESIDERIO DA SETTIGNANO, fig. 1) in Santa Croce. Antonio's splendid tomb for *Cardinal James of Portugal* (*d* 1459) in S Miniato al Monte is part of a complete funerary chapel (*see* FLORENCE, fig. 6), including works by Luca, Antonio Pollaiuolo (*see* POLLAIUOLO, (1)) and ALESSO BALDOVINETTI that is the apogee of the 'Sweet style' and one of the greatest artistic complexes in the world. Mino also carved tombs, including *Count Ugo of Tuscany* (Florence, Badia Fiorentina), and later introduced the style to Rome.

Mino's portrait busts of *Piero I de' Medici* (see colour pl. 2, VIII2) and *Giovanni de' Medici* (both Florence, Bargello) are forceful images, although they lack the finesse of such busts as Antonio's *Giovanni Chellini* (1456; London, V&A). Delicate busts of women and of children were made by Antonio, Desiderio (e.g. Florence, Bargello) and Verrocchio (see fig. 19). Outside Florence, only the nine female busts by FRANCESCO LAURANA are significant: they show a degree of abstraction that appeals particularly to 20th-century viewers. However, the loss of naturalistic painting on the surface may accentuate this effect unduly.

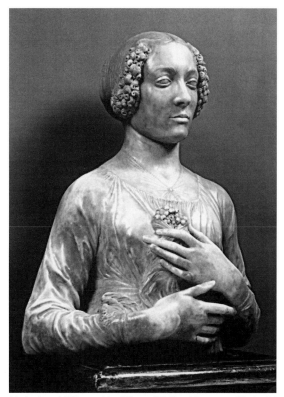

19. Andrea del Verrocchio: *Woman Holding Flowers*, marble, h. 610 mm, 1475–80 (Florence, Museo Nazionale del Bargello)

Each of the Florentine sculptors discussed above executed reliefs of the Virgin and Child. Only Desiderio dared to try *rilievo schiacciato* (very shallow relief), and with great success (e.g. Turin, Gal. Sabauda; Philadelphia, PA, Mus. A.). Their designs were copied throughout central Italy.

(d) 'Dramatic style'. Donatello's major contribution to the history of art was the single-handed creation of a vigorous, and at times horrendous, alternative style in which to convey the darker aspects of the Old and New Testaments. His intensity of feeling and the speed and spontaneity of his work are conveyed by a deliberate lack of finish. The urgency of Donatello's carving can be seen in the low relief of the *Ascension* (1420s; London, V&A; *see* DONATELLO, fig. 3), in which sketchy outlines and masses blocked out with the claw chisel are everywhere apparent. His stucco roundels of the Old Sacristy (1430s; Florence, S Lorenzo) are yet more spontaneous. The carved wood statue of *St John the Baptist* (1438; Venice, S Maria Gloriosa dei Frari) exceeds even his *Prophets* for the Campanile in its 'expressionism'.

Younger sculptors continued Donatello's style for a generation or more: BERTOLDO DI GIOVANNI, Verrocchio and Pollaiuolo. Pollaiuolo's intensely felt, and aggressively linear and angular, style—designed to convey movement —is the direct successor of the late style of Donatello: his observation of anatomy inspired Leonardo da Vinci and Michelangelo to dissect corpses in order to convey inner feelings visually. The intensity of Donatello's style was emulated in Rome by FILARETE, in Siena by VECCHIETTA and in Padua by BARTOLOMEO BELLANO and SEVERO DA RAVENNA. All of his immediate successors applied Donatello's style to the one type of ancient sculpture that he scarcely explored, the independent bronze STATUETTE.

(ii) Rome. The development of sculpture in Rome was sporadic, as explained above. Around 1430 Donatello created two works there in fully Renaissance style, a tomb-slab for Giovanni Crivelli (Rome, S Maria in Aracoeli) and a sacramental tabernacle for St Peter's, which included a masterly low-relief scene of the *Entombment*. A major commission for a pair of bronze doors for St Peter's, intended to rival Ghiberti's Baptistery doors, was awarded to Filarete, who was not able to depict human figures convincingly and nobly (*see* FILARETE, fig. 1). His other significant work of this period was one of the earliest datable bronze statuettes, a reduction of the ancient Roman equestrian *Marcus Aurelius* (Dresden, Skulpsamml.).

Bronze masterpieces in Rome include Vecchietta's striking effigy of *Bishop Girolamo Foscari* (*d* 1463) in S Maria del Popolo and Pollaiuolo's tombs in St Peter's for *Sixtus IV* (1493) and *Innocent VIII* (1498). The local school of the mid-15th century in Rome was composed exclusively of marble sculptors. First and foremost was ISAIA DA PISA, who was obviously indebted to ancient Roman sculpture for his rendering of anatomy and drapery (e.g. *Virgin and Child with SS Peter and Paul*, 1460s; Rome, Vatican, Grotte Vaticane). His tomb for *Cardinal Chiaves* in S Giovanni in Laterano was influential in Rome. Direct Tuscan influence on Roman marble carving came from Mino da Fiesole, who worked there frequently between

1454 and ?1480. From the far north of Italy, Andrea Bregno (*see* BREGNO, (2)) was active in Rome 1465–1501, furnishing sculpture to the Vatican and important churches, notably the *Riario* and *della Rovere* monuments in SS Apostoli.

(iii) Lucca, Siena and Bologna. These cities together constituted the focus of activity of the third great sculptor of the early Renaissance, Jacopo della Quercia. His first surviving commission (1403) was an important one, a marble group of the *Virgin and Child* for Ferrara Cathedral, in which the solid forms and classical faces betoken a potentially Renaissance mentality. The effigy of *Ilaria del Carretto* (*d* 1405; Lucca Cathedral; *see* JACOPO DELLA QUERCIA, fig. 2) rests on a deliberately classicizing tomb chest, with putti supporting swags, derived from Roman sarcophagi; they were some of the earliest of a type of figure that became characteristic of the Renaissance period in Italy. Jacopo's fountain (Fonte Gaia) in the Siena *campo*, completed in 1419, includes a pair of free-standing, virtually nude, female statues with putti (now, very damaged in the Pal. Pub.). In the relief of the *Expulsion from Paradise* on the end panel (*see* JACOPO DELLA QUERCIA, fig. 3), the arrangement of his characteristic robust nudes shows little concern with illusionistic perspective and architectural settings. This is also evident in the gilt-bronze relief of the *Annunication to Zacharias* (1428–30) for the font in the Siena Baptistery, which also has panels by Ghiberti and Donatello. Jacopo's last great commission (1425) was for ten reliefs for the main portal of S Petronio, Bologna (*see* JACOPO DELLA QUERCIA, fig. 4 and colour pl. 1, XXXIV3). In those narrating the *Creation and Fall of Man* (see fig. 20) he set dramatically posed figures against a virtually abstract background, which he did not attempt to penetrate, as did Donatello. The figures in the reliefs of the *Early Life of Christ* are so large, with such exaggerated *contrapposto*, that they seem about to burst the containing frame.

Siena remained a major sculptural centre in the Renaissance, owing not only to Jacopo but also to the contributions of Ghiberti and Donatello to the font, as well as to Donatello's work there 1457–9, including the bronze statue of *St John the Baptist*. Vecchietta, inspired by Donatello, created a relief of the *Resurrection* (1472; New York, Frick) and a tautly muscled *Risen Christ* (1476; S Maria della Scala; *see* VECCHIETTA, fig. 2). He in turn trained Francesco di Giorgio Martini, who practised all three fine arts; in sculpture, his most significant creations are in bronze, narrative scenes with the dramatic intensity of Donatello, a *Deposition* (1476; Venice, S Maria del Carmine; *see* FRANCESCO DI GIORGIO MARTINI, fig. 4) and a *Flagellation* (1476–82; Perugia, G.N. Umbria). His over life-size *Angels* (1497) for the high altar of Siena Cathedral are masterpieces of lively modelling and great charm, continuing the style of Donatello into the period of the High Renaissance.

(iv) Venice and the Veneto. Venice, which was established long after the Roman Empire had fallen, and isolated from mainland Italy, had links by sea with the Near and Far East. The prolonged influence of Byzantine art there, in the Veneto-Byzantine style, delayed the adoption of the

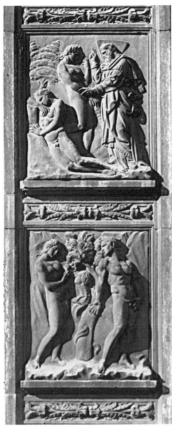

20. Jacopo della Quercia: *Creation of Eve* (top) and *Temptation* (bottom), stone relief panels, (*c.* 1430–35), main portal of S Petronio, Bologna

Gothic style and subsequently that of the Renaissance (only *c.* 1450).

(a) Late Gothic. The interest of Venetian sculptors in antiquity and its revival in Tuscany was strengthened with the arrival in 1416 from Florence of two stone-carvers, Niccolò di Piero Lamberti and his son Piero di Niccolò. Niccolò carved statues for the upper storey of the façade of S Marco (for illustration *see* LAMBERTI, (1)), and he (or another Florentine, Nanni di Bartolo) executed a prominent group of the *Judgement of Solomon* on the Doge's Palace, an effective scene but without the urgency of, for example, Donatello. The native school of sculpture was led by Giovanni BUON (i) and his son Bartolomeo. In 1422 both were working on a new Gothic palace, the Ca' d'Oro: Bartolomeo's splendid well-head for its courtyard (1427–8), with a figure of *Charity* copied from Ghiberti, is one of the finest examples of a class of sculpture that was virtually unique to Venice. For the Scuola Grande della Misericordia they carved a magnificent ogival lunette showing the *Madonna of Mercy* (London, V&A; *see* VENICE, fig. 13). Like the well-head, its figures are in deep relief and carved very broadly, giving a slightly 'abstract' feeling. The style is related to that of Jacopo della Quercia, who was in the Venetian area in this period. In 1438 the Buon sculptors were commissioned to carve the main gateway

to the Doge's Palace, the Porta della Carta, including a statue of *Justice* (positioned 1441; for illustration, *see* BUON (i), (1)). Bartolomeo contributed an excellent bust of *Doge Francesco Foscari* (1423–57; part destr. 1797; Venice, Mus. Opera Pal.) and went on to work on the internal triumphant arch for the same entrance, the Arco Foscari (*see* VENICE, fig. 9), which spans the transition from Gothic to Renaissance style.

(b) Early Renaissance. The arrival of Donatello in Padua in 1443 represented a major stylistic turning point in north-eastern Italy. His dramatic style had been known in Venice for five years previously, since the delivery of his wooden figure of *St John the Baptist* (S Maria Gloriosa dei Frari). In Padua, the full majesty of his Renaissance style was revealed in his equestrian monument to *Gattamelata* (*see* DONATELLO, fig. 4), a life-size bronze *Crucifix*, the statues of the *Virgin and Child* and *Saints* for the high altar of S Antonio and the relief panels of the *Miracles of St Anthony* (S Antonio), with a brilliant use of perspective. His large workshop in Padua was a training ground in Tuscan Renaissance style and thought. Some stone-carving was done there, but the main thrust was modelling sculptures in wax for casting into bronze. The tradition of sculpture in bronze remained strong in Padua and Venice: it was later reinforced by the arrival of another Florentine, Verrocchio, to make his rival equestrian monument of *Bartolomeo Colleoni*, in Venice itself (*see* VERROCCHIO, ANDREA DEL, fig. 4). The tradition of Donatello in Padua was continued by Giovanni d'Antonio Minello de' Bardi (*see* MINELLO, (1)), who modelled statues in terracotta, and in bronzeworking by Donatello's favourite pupil, Bartolomeo Bellano. Bellano's idiosyncratic style can be seen in his masterpiece, a series of bronze reliefs (1484–90; for illustration *see* BELLANO, BARTOLOMEO) for the choir-screen in S Antonio, combining the panoramic landscapes of Ghiberti with the tougher figure style of Donatello. His other major work, the monument to *Pietro Roccabonella* (*d* 1491; Padua, S Francesco), includes a powerful portrait of the humanist professor sitting at his desk reading.

In Venice itself, the Renaissance was first discernible in the work of Antonio Rizzo, notably in the monumental wall-tomb for *Doge Niccolò Tron* (*c.* 1476–80; S Maria Gloriosa dei Frari; for illustration *see* RIZZO, ANTONIO). A rival tomb for *Doge Pietro Mocenigo* (SS Giovanni e Paolo) by Pietro Lombardo was completed in 1481. Rizzo's life-size statue of the Doge is impressive, but Lombardo's figures are livelier and more authentically Classical. Rizzo remained the leading sculptor in Venice, nevertheless, and his masterpieces, nude figures of *Adam* and *Eve* on the Arco Foscari, are among the most memorable and influential statues of the 15th century in Venice. The proportions of the *Eve* are still basically Gothic; the full-bodied Renaissance type of Classical nudes was realized in marble later by the sons of Pietro Lombardo, Tullio and Antonio.

2. HIGH RENAISSANCE, *c.* 1480–*c.* 1530. The beginning of the High Renaissance may be defined as the point at which artists had mastered the complete illusion of reality, through the use of perspective, light and shade, and anatomical knowledge. Sculptors could execute with

ease even colossal figures in marble or bronze and render narratives convincingly in relief. They had reached the goal for which their predecessors had striven in the early 15th century, to equal Greco-Roman art in both realism and harmony. By 1470–80, however, most of the figural work still looked somewhat artificial: the figures were realistic but expressed only a limited range of emotions. In the High Renaissance, artists began to extend the range of expression they had inherited from antique art. The work of the great trio Leonardo, Michelangelo and Raphael is imbued with a feeling of spiritual presence and emotional reality and shows a completely free range of imagination in utilizing the vocabulary of Classical architecture.

(i) Venice. (ii) Florence. (iii) Michelangelo in Florence and Rome. (iv) Impact in Europe.

(i) Venice. Tullio Lombardo produced the most perfectly cogitated tomb in 15th-century Venice, for Doge *Andrea Vendramin* (SS Giovanni e Paolo; *see* LOMBARDO, (2), fig. 1), first mentioned in 1493. His introduction of a unifying architectural structure resembling a Roman triumphal arch heralded the arrival of the High Renaissance. This is also reflected in the tomb sculpture: the figure of *Adam* (New York, Met.) is the most purely Classical of all High Renaissance nudes. The fuller body type in his relief of *Bacchus and Ariadne* (*c.* 1510; Vienna, Ksthist. Mus.) shows Tullio's understanding of Classical sculpture. One of the masterpieces attributed to Antonio Lombardo is a marble bas-relief showing *Venus Anadyomene* (*c.* 1511; London, V&A; *see* fig. 21), perhaps produced for Alfonso I d'Este. The mastery of the Classical nude and its expressive possibilities puts the work on a par with contemporary painted nudes by Giorgione and Titian. Antonio worked on a monumental scale with equal success in the bronze altar and tomb of *Cardinal Giovanni Battista Zen* for S Marco. The life-size group in bronze of the *Virgin and Child* from the altar is the most truly Classical of the whole Italian Renaissance, surpassing all but the greatest Greco-Roman sculptures in intensity of emotion.

The sack of Rome in 1527 by the Germanic troops of Charles V had far-reaching repercussions even in the world of art. The many artists attracted to Rome by the Medici popes, Leo X and Clement VII, were forced to flee. The Florentine Jacopo Sansovino went to Venice: his masterpiece there is the Loggetta in the Piazza S Marco (*see* SANSOVINO, JACOPO, fig. 3), a perfectly integrated complex of architecture and sculpture. It includes life-size bronze figures in the round, which show his characteristic fluent contrapposto and relaxed grace. Bronze was a new medium for Jacopo, previously famed as a marble-carver, and subsequently his best sculpture was modelled, such as the bronze reliefs (*c.* 1540) for the pulpits in the choir of S Marco and a fine door for the Sacristy. Inspired by Jacopo, a little-known sculptor and foundryman, Andrea Bresciano, created a magnificent Paschal candlestick (Venice, S Maria della Salute) on the model of Riccio's one in Padua (Il Santo; *see* RICCIO, ANDREA, fig. 2).

(ii) Florence. Verrocchio, who probably trained with Desiderio da Settignano, developed a mature style in opposition to that of Donatello: two of his major works, the *David* (Florence, Bargello) and the equestrian statue of

21. Antonio Lombardo (attrib.): *Venus Anadyomene*, marble, 406×251 mm, *c.* 1511 (London, Victoria and Albert Museum)

Bartolomeo Colleoni (*see* VERROCCHIO, ANDREA DEL, figs 3–4), patently are intended as comments on Donatello's treatments of the same themes. Much of his best work was for the Medici, including a tomb in the Old Sacristy at S Lorenzo. His basic contributions to the development of sculpture form a prelude to the style of the High Renaissance. In the *Cupid with a Dolphin* (Florence, Pal. Vecchio; *see* colour pl. 2, XXXVIII2), made for the Medici villa at Careggi, he gave to a free-standing figure a sense of movement by the spiral twist of the body, legs and arms, counter-pointed by the wriggling dolphin. His novel and sophisticated composition was not fully utilized until the late 16th century, however, by Giambologna. Verrocchio's other advance was of more immediate relevance to the High Renaissance. In his ambitious group the *Incredulity of St Thomas* on Orsanmichele (*c.* 1466–83; *see* VERROCCHIO, ANDREA DEL, fig. 1), he managed to suggest a psychological link between the two figures, conveying the sympathy of Christ for the weakness of human nature, as exemplified in the doubt felt by St Thomas.

Verrocchio is remembered chiefly as the master of Leonardo, who probably joined his workshop *c.* 1466, in time to see most of the big sculptural commissions executed. This had a profound effect on Leonardo's career, although his most important sculptural project, an equestrian monument begun in 1489 for Ludovico Sforza, was never fully realized (*see* LEONARDO DA VINCI, §II, 3).

Numerous preparatory drawings survive (e.g. Windsor Castle, Berks, Royal Lib.; *see* LEONARDO DA VINCI, fig. 7), and his studies of horses may be reflected in a number of small groups of *Fighting Horsemen* (e.g. Florence, Pal. Vecchio), modelled in terracotta by his associate Giovanni Francesco Rustici. Rustici's grandiose group in bronze of *St John the Baptist Preaching* (1506–11; Florence, Baptistery; for illustration *see* RUSTICI, GIOVANNI FRANCESCO) shows an acute observation of physiognomy, and hence of human character, derived from Leonardo. Rustici also created a bronze statuette of *Mercury* (Cambridge, Fitzwilliam), which spouted water on a Medici fountain.

The other major sculptors in Florence were Andrea Sansovino and his pupil Jacopo Sansovino. Andrea's art was the archetype of High Renaissance sculpture: suavely composed figures and compositions within superb, Classical architectural settings (e.g. the Corbinelli Altar; Florence, Santo Spirito). In the *della Rovere* tombs (Rome, S Maria del Popolo), he aggrandized the 15th-century 'humanist tomb' by adapting the Classical triumphal arch as a frame. Andrea's life-size group of the *Virgin and Child with St Anne* (1512; Rome, S Agostino) and the *Madonna del parto* by Jacopo (1518–21; Rome, S Agostino; *see* SANSOVINO, JACOPO, fig. 2) are classic examples of High Renaissance compositional principles applied to sculpture. Jacopo Sansovino was interested in the relationship between sculpture and painting and made models for painters including Pietro Perugino and Andrea del Sarto. His earliest masterpiece, a statue of *St James* (Florence Cathedral), is an elegant figure with brilliantly carved drapery, a strong contrast to the intensity of Michelangelo's unfinished work for the same series, the *St Matthew* (Florence, Accad.). A statue of *Bacchus* also emulated a figure by Michelangelo (both Florence, Bargello) but is lighter and more graceful. (For Jacopo's later work in Venice *see* §(i) above.)

(iii) Michelangelo in Florence and Rome. Just as Donatello influenced the figural arts in Italy for the first half of the 15th century, Michelangelo dominated the painting, sculpture and architecture of the 16th century: his supremacy was challenged only in painting, by Raphael. Although he studied sculpture only with an expert in bronze, Bertoldo di Giovanni, Michelangelo concentrated on carving marble, largely self-taught. The success of his early statues, such as the *Pietà* (Rome, St Peter's; *see* MICHELANGELO, fig. 1) and the *David* (Florence, Accad.; see fig. 22), brought him to the notice of Pope Julius II, who commissioned him to design a huge tomb for St Peter's. This project, though never completed as originally proposed, occasioned some of Michelangelo's best statues: the *Moses* (Rome, S Pietro in Vincoli; see colour pl. 2, VII2) and the series of *Slaves* (Florence, Accad.; Paris, Louvre; *see* MICHELANGELO, fig. 4). Under Julius's successor, the Medici pope Leo X, Michelangelo was forced to work on architectural projects for the family's parish church of S Lorenzo, Florence, including the New Sacristy (*see* MICHELANGELO, fig. 5), a memorial chapel. The figures representing the four times of day mourning the deceased Medici reclining on the sarcophagi are wonderful examples of his power of evoking an emotional response using anatomy in totally naked figures. Michelangelo endowed

22. Michelangelo: *David*, marble, h. 4.34 m (incl. base), 1501–4 (Florence, Galleria dell'Accademia)

the art of sculpture with unprecedented prestige, expressed at the time ('*terribilità*') in terms of extreme admiration: 'divine', 'terrifying'. His work became known throughout Europe; it was so far advanced that it had little immediate effect, however. Interpretation came from a younger generation, although none approached the emotional intensity of Michelangelo; arguably, no one ever has.

(iv) Impact in Europe. Italian sculptors were invited to England to embellish the great new buildings of the Tudor monarchs and their courtiers; it is often forgotten that the masterwork of Italian High Renaissance bronze-casting is in London, Pietro Torrigiani's tomb of *Henry VII and Elizabeth of York* in Westminster Abbey (1512–18). Other Italian sculptors, including Giovanni de Maiano II, were employed by Cardinal Thomas Wolsey at Hampton Court. A grandiose tomb in the Renaissance idiom was made by Italian sculptors for Henry VIII but was destroyed under the Commonwealth (black marble sarcophagus, London,

St Paul's Cathedral, re-used for the tomb of *Lord Nelson*; bronze candlesticks, Ghent, St Bavo's Cathedral).

By the late 1520s an appreciation of at least the ornamental repertory of Renaissance sculpture was common to England, France and Germany. The French conquest of Milan had brought the Lombard Renaissance style and the works of Leonardo to the attention of the court. This resulted in a new style of château, culminating in the decoration of the palace of Fontainebleau by the Italians Rosso Fiorentino and Francesco Primaticcio, and the recruitment of Leonardo, and later of Benvenuto Cellini, to serve Francis I (*reg* 1515–47). Gothic elements made way for Classical ones; portal figures were replaced by caryatids (e.g. Cellini's *Satyrs* for the Porte Dorée at Fontainebleau); and correct Classical mouldings and the new grotesque ornaments were introduced, as well as roundels with busts. Renaissance sculpture spread thence to the Netherlands on tombs, fireplaces and rood-lofts (in Notre-Dame, Bruges, there is a *Madonna* by Michelangelo himself) and to Germany, especially in bronze-casting at the traditional centres of craftsmanship in metal, Augsburg, Nuremberg and later Munich. Fountains, portraits and such small-scale sculpture as plaquettes and medals were favourites in the lands of the Holy Roman Empire under Maximilian I (*reg* 1493–1519) and Charles V (*reg* 1519–58).

In the Iberian Peninsula, during the 1490s, an extended visit to Portugal by Andrea Sansovino began a swing away from the Gothic style, later reinforced by Torrigiani's terracotta sculptures for Seville (1522; Mus. B.A.). It was further encouraged by influences from the dominions of Spain in Naples and the Netherlands. Michelangelo's work was admired from afar, and a celebrated Mannerist painter and sculptor, Alonso Berruguete (*c.* 1488–1561), brought back the new style from his training in Italy. Its impact was reinforced later in the century by the great bronze statues, magnificent life-size portraits of the Habsburg dynasty and religious figures (Madrid, Prado; Escorial) produced for the Escorial by Leone Leoni and his son Pompeo.

3. Mannerism, *c.* 1530–*c.* 1600. In Italy, meanwhile, sculpture evolved beyond the classicizing stability and harmony of the High Renaissance in directions predicated by some of Michelangelo's works of the 1520s, towards Mannerism.

(i) Florence. (ii) Rome. (iii) Venice. (iv) Milan.

(i) Florence. Emancipated from architecture, sculpture appeared in squares, fountains and gardens, while miniature pieces were sought for the newly fashionable collector's cabinets. Distortions of anatomy and exaggerations of pose and gesture are characteristic of Mannerism but, in sculpture, limits are imposed by the weight and mass of the material. The simple grace of High Renaissance figure style dissolved into a purely sensuous treatment of pose and surface, frequently giving a feeling of sexual ambiguity, as in the *River God* (Paris, Louvre) by Pierino da Vinci; *Nature* (Fontainebleau, Château) by Niccolò Tribolo; and *Honour Triumphant over Falsehood* (Florence, Bargello) by Vincenzo Danti (for illustration *see* Danti, (1)). Tech-

nique was emphasized at the expense of emotional expression. Only in relief, where the figures are attached to a solid background, could the sculptor give rein to his imagination with anything like the freedom of the Mannerist painter. Baccio Bandinelli, Cellini and Pierino abandoned the narrative legibility and attention to perspective of the High Renaissance for an emphasis on the play of forms on the surface and the sinuous contours of individual figures, as in the relief on the base of Cellini's *Perseus* (Florence, Loggia Lanzi; *see* Cellini, Benvenuto, fig. 3) or Danti's *Moses and the Brazen Serpent* (Florence, Bargello).

Michelangelo's groups of *Victory* (e.g. Florence, Pal. Vecchio), showing one figure treading down another, inspired numerous variations of this theme by younger sculptors including Baccio Bandinelli, Bartolomeo Ammanati, Cellini and Danti. Other themes adumbrated by Michelangelo in the New Sacristy tombs were also explored, notably the recumbent 'river-god' pose and the figure in contrapposto, in, for example, Ammanati's Fountain of Neptune (Florence, Piazza della Signoria; *see* Ammanati, Bartolomeo, fig. 2) and Danti's group of *Cosimo I and Virtues* (Florence, Uffizi). In the mid-16th century Giambologna took up several of the ideas in Michelangelo's lapsed commissions, in *Samson Slaying a Philistine* (1560; London, V&A; see fig. 23) and *Florence Triumphant over Pisa* (Florence, Bargello; *see* Giambologna, fig. 1). In 1582 he achieved the highest ideal, according to Michelangelo, a group of three figures, the *Rape of a Sabine* (Florence, Loggia Lanzi; *see* Giambologna, fig. 2). He was also able to emulate the designs of Michelangelo and Leonardo for equestrian monuments with that of *Cosimo I* (Florence, Piazza della Signoria; *see* Giambologna, fig. 5)—the first ever erected in Florence—and produced several excellent public fountains as well as numerous bronze statuettes.

A new range of sculpture also came into being at this time to articulate the formal garden, to ornament the fountain and to inhabit the newly fashionable artificial grotto. In 1537, Cosimo I employed Niccolò Tribolo to create a garden for his Villa di Castello: this included a sequence of fountains; the bronze colossus Appennine, seemingly rising from a pond, by Ammanati; the Fountain of the Labyrinth, by Pierino da Vinci and Giambologna (Florence, Villa La Petraia); and the Fountain of Hercules (for illustration *see* Tribolo, Niccolò), crowned by Ammanati's bronze *Hercules Strangling Antaeus*. A grotto housed life-size coloured marble animals by Cosimo Fancelli (*in situ*), with bronze birds by Giambologna (Florence, Bargello; *see* Giambologna, fig. 4). A larger grotto was built near the Palazzo Pitti, and in 1583 Michelangelo's four unfinished marble statues of *Slaves* (Florence, Accad.) were installed in a setting supervised by Bernardo Buontalenti (*see* Buontalenti, Bernardo, fig. 1 and colour pl. 1, XVIII1), with *Paris and Helen* by Vincenzo de' Rossi (for illustration *see* Rossi, Vincenzo de') and a lovely, humorous Fountain of Venus by Giambologna.

Towards the end of the century, at the ducal villa of Pratolino, Buontalenti installed still more complex grottoes, with moving elements powered hydraulically. Several major fountains were created behind the Palazzo Pitti in

23. Giambologna: *Samson Slaying a Philistine*, marble, h. 2.09 m, 1560 (London, Victoria and Albert Museum)

the Boboli Gardens, including Neptune by Stoldo Lorenzi (*see* LORENZI, (2)) and Ocean by Giambologna. These are examples of the 'cylix type', with one or more circular basins mounted on a central, ornamental stem crowned with a statue. Sculptors created bold figures with strong contours, to be seen against the sky, and surrounded them with bizarre sea-creatures drawn from Classical mythology.

Another, novel, type of statue was engendered by these grottoes and gardens: genre figures of countryfolk, including vintners carrying grapes, harvesters with scythes and fowlers and huntsmen. Attuned to idyllic poetry, such images appeared as well in bronze statuettes by Giambologna and his followers. A more pyramidal fountain type, without raised basins, also originated in Florence in the middle of the 16th century. The Fountain of Neptune, in the Piazza della Signoria, has a central marble colossus by Ammanati, surrounded by bronze statues of marine deities and satyrs, produced by members of his team. This enormous project provided a training ground for younger sculptors, creating variations on such themes from antiquity, subsequently treated by Michelangelo, as the river-god and the fettered slave. Another Fountain of Neptune (1560s; Bologna, Piazza Nettuno; *see* BOLOGNA, fig. 2) was the early masterpiece of Giambologna, who supplied all the figures in bronze, from a handsome, muscular Neptune to Sirens sensuously expressing water from their breasts. The Bolognese fountain is generally accounted superior aesthetically to the one in Florence, and it launched Giambologna's international career. Perhaps his most bizarre fountain is a colossal stone structure of the Appennines, shown as a crouching, hoary old giant, squeezing water out of a dragon's mouth into a pool below (1570–80; Pratolino, Villa Medici; see colour pl. 1, XXXIII3).

(ii) Rome. The concentration on grandiose tombs continued: most important were Bandinelli's wall-monuments to *Clement VII* and *Leo X* (S Maria sopra Minerva) and the erection of Michelangelo's tomb for *Julius II* in its final, abbreviated form (S Pietro in Vincoli) *c.* 1544, with the great seated figure of *Moses* (see colour pl. 2, VII2). Guglielmo della Porta (*see* PORTA, DELLA, (3)) created the next significant tomb, for the Farnese pope *Paul III* (erected 1577; St Peter's) with an effective bronze portrait statue seated above carved recumbent female figures. The emphasis in sculpture remained almost entirely on marble statues for tombs and on portraits, until the last third of the 16th century when papal families began to require garden statuary and amusing fountains for new villas (e.g. Villa d'Este, Tivoli; Villa Aldobrandini, Frascati; Villa Orsini, Bomarzo). The most famous fountain was in Piazza Mattei, the Fountain of the Tortoises (1585) by TADDEO LANDINI: four bronze nude youths holding tortoises notionally supporting a basin. This was among the earliest secular public sculptures in Rome.

(iii) Venice. Jacopo Sansovino's follower Alessandro Vittoria from Trent added to the grace of his master something of the robustness of Michelangelo. In sculpture Vittoria met the challenge of such contemporary painters as Titian and Jacopo Tintoretto, notably in dramatic figures (e.g. *St Jerome*; Venice, SS Giovanni e Paolo and another in S Maria Gloriosa dei Frari) and brilliantly characterized portrait busts (e.g. *Niccolò da Ponte*; Venice, Semin. Patriarcale; *see* VITTORIA, ALESSANDRO, fig. 3). Characteristically of Venice, much of his sculpture was to decorate public buildings, such as the coved stucco ceilings of the Scala d'Oro in the Doge's Palace and in Sansovino's library at S Marco, as well as the caryatids flanking its portal. He also produced excellent bronze statuettes (e.g. *St Sebastian*; New York, Met.). The other prominent sculptor active at the end of the century, whose style was not dissimilar, was Girolamo Campagna (1549–*c.* 1625) from Verona. He

carved dramatic narratives in marble, including a relief of *St Anthony* (1577; Padua, S Antonio) and an *Altar of the Deposition* (Venice, S Giuliano). In bronze, his masterpiece is the magnificent pyramidal altar group of the Trinity and the Four Evangelists supporting a huge globe bearing God the Father (1592–3; Venice, S Giorgio Maggiore). Around Campagna and Vittoria competent, if less imaginative, sculptors formed a veritable 'school': Tiziano Minio and DANESE CATTANEO, immediate followers of Sansovino; and then FRANCESCO SEGALA and Tiziano Aspetti from Padua and Nicolò Roccatagliata (*fl* 1593–1636) from Genoa.

(iv) Milan. One of the greatest Italian sculptors of the Mannerist period, and one of the most influential, because he served Charles V (*reg* 1519–58) both in the Netherlands and in Spain, was Leone Leoni from Milan. He made his name around 1550 with a spectacular series of life-size portrait statues in bronze of the Habsburg rulers, as well as one of *Gian Giacomo de' Medici*, which stands in a fine wall-monument designed by Michelangelo, in Milan Cathedral. He also produced impressive portraits of rulers allegorically trampling personifications of evil: *Ferrante Gonzaga* (Guastalla, Piazza Roma) and *Charles V and Fury Restrained* (Madrid, Prado; *see* LEONI, (1), fig. 1). The latter has an intriguing feature, typical of the Mannerist mentality: the figure is nude but is normally clad in a removable suit of armour; in effect, two statues for the price of one.

BIBLIOGRAPHY

R. Krautheimer: *Lorenzo Ghiberti* (Princeton, 1956, rev. 2/1973)
J. Pope-Hennessy: *Italian Renaissance Sculpture* (London, 1958, rev. New York, 3/1985)
J. Montagu: *Bronzes* (London, 1963)
J. Pope-Hennessy: *Italian High Renaissance and Baroque Sculpture* (London, 1963, rev. 3/New York, 1985)
E. Borsook: *Companion Guide to Florence* (London, 1966, rev. 1988)
A. Radcliffe: *European Bronze Statuettes* (London, 1966)
C. Seymour jr: *Sculpture in Italy, 1400–1500*, Pelican Hist. A. (Harmondsworth, 1966)
J. Pope-Hennessy: *Essays on Italian Sculpture* (London, 1968)
C. Avery: *Florentine Renaissance Sculpture* (London, 1970/*R* 1982)
J. Pope-Hennessy: *The Study and Criticism of Italian Sculpture* (Princeton, 1980)
R. Olsen: *Italian Renaissance Sculpture* (London, 1992)
J. Poeschke: *Donatello and his World: Italian Renaissance Sculpture* (London and New York, 1993)
——: *Michelangelo and his World: Sculpture of the Italian Renaissance* (New York, 1996)
C. Avery: 'Drawing in the Work of Italian Renaissance Sculptors', *Drawing*, xix/3 (1998), pp. 113n17
——: 'Form and Space: Sculpture 1527–1600', *The Oxford Illustrated History of Western Art* (Oxford, 1998), pp. 184–91
S. B. McHam: *Looking at Italian Renaissance Sculpture* (Cambridge, 1998)
C. Avery: 'God as Man and Man as God: The Ideal of Nudity in Italian Sculpture', *Il nudo/ The Nude*, ed. G. Fossi (Florence, 1999)

CHARLES AVERY

V. Interior decoration.

Numerous dwellings dating from the second half of the 15th century and the 16th still exist in Italy. However, only their decoration is authentic, as the furniture, when found, is the result of reconstructions by antiquarians. The lack of original furniture is partly compensated for by the information on interiors gathered from primary sources and contemporary paintings. The latter, while mainly depicting such domestic interiors as rooms or studies, constitute an irreplaceable source for understanding not only the taste of the period but also the function and arrangement of furniture in Renaissance dwellings.

For example, the two bedrooms painted by Vittore Carpaccio at the end of the 15th century in the background of the *Dream of St Ursula* (Venice, Accad.; see colour pl. 1, XIX1) and of the *Birth of the Virgin* (Bergamo, Gal. Accad. Carrara) show respectively the differences between the furnishings in a sophisticated noble residence and the more practical, but no less refined, decoration of a middle-class dwelling. In the first painting the regal solemnity of the room is emphasized by the vast space, dominated by a monumental bed, and such decorative details as the relief work on the architraves over the doors, the sculptures placed on top of the bed and the small painted altarpiece hung to the right of it. The modest workmanship of the few pieces of furniture indicates their temporary arrangement in the room. In the *Birth of the Virgin* an entirely different type of room is depicted. It has much lower ceilings and is more functional, arranged to meet the needs of daily life. The bed is designed as an alcove so as to leave the rest of the room to serve as a sitting-room, and the wooden panel that partially lines the wall in front of the spectator has a shelf to hold several domestic objects. Domenico Ghirlandaio's fresco of the *Birth of the Virgin* (1485–90; Florence, S Maria Novella; *see* SPALLIERA, fig. 1) records the sumptuous late 15th- and 16th-century Florentine interiors that included paintings, glazed terracotta reliefs and multicoloured tapestries as well as elaborate wood panelling. The Borgherini family, when designing a luxurious nuptial suite (1511–15) in the Palazzo Borgherini, Florence, for Pierfrancesco Borgherini, employed Pontormo, Francesco Granacci, Bacchiacca and Andrea del Sarto to decorate panels with scenes from the *Story of Joseph* and had all the wooden furniture executed by Baccio d'Agnolo, the architect who had built the family palace and decorated it with doors and sculpted fireplaces (*in situ*) and inlaid furniture.

By the end of the 15th century the palaces of the nobility, which became steadily larger with vast courtyards often leading to gardens, were made more comfortable through the creation of numerous rooms designed for the needs of daily life or for functions, as can still be seen in the Palazzo Ducale in Urbino (*see* URBINO, §4). Alberti, in *De re aedificatoria*, stated that in royal palaces the apartments for the husband must be separate from those of the wife, just as the servants' quarters were to be set in another part of the palace. Next to the large ceremonial halls, the walls of which were covered with frescoes or tapestries, were the rooms and *studioli* designed to hold the family collections of art, books and precious objects. The walls of such rooms were lined with wooden cabinets, which were either inlaid or painted by the court painter, as in the respective studies of Borso d'Este (built *c.* 1448–65) in the Castello di Belfiore, near Ferrara, and of Piero de' Medici (destr.) in the Palazzo Medici, Florence, which was also decorated with glazed terracotta reliefs by Luca della Robbia. There are further examples in the *studioli* (which can still be visited) of Federigo II da Montefeltro, Duke of Urbino (1473–6), in the Palazzo Ducale, Urbino (*see* STUDIOLO, fig. 1), of Isabella d'Este (1491–8) in Mantua

and of Francesco I de' Medici, Grand Duke of Tuscany (1570–78), in the Palazzo Vecchio in Florence (*see* STUDIOLO, fig. 2).

Up to the end of the 15th century the coffered ceilings, generally divided into squares, were decorated in relief. In the 16th century they were also decorated with paintings and elaborate inlay. The transition from simple painted motifs to inlay occurred gradually; first, such decorative elements as rosettes, acanthus leaves and moulded rods were inserted between the tablets of the coffers, followed by more complicated and creative solutions, where the area created by the crossing beams assumed various geometric forms decorated with elegant inlay that often formed frames for paintings. Fine examples are the coffered ceilings (1520–40) executed from the drawings of Baldassarre Peruzzi in both the Palazzo della Cancelleria and the Palazzo Massimo alle Colonne in Rome, and the later ceilings in the Palazzo Vecchio by Marco, Domenico and Giuliano Del Tasso (1478) in Florence, the Palazzo Ducale by Antonio and Paulo Mola (1506–8) and the Palazzo del Te from drawings by Giulio Romano (1525–34) in Mantua, and the Doge's Palace by Cristoforo Sorte (1581) and the Scuola Grande di S Rocco in Venice.

Stucco was one of the techniques used in the decoration of 16th-century interiors, which, like grotesque decoration, spread throughout Italy following the revival of Classical models by Raphael and his school. Many rooms preserved intact in Roman palaces show the influence of the sophisticated and scenographic classical decorations of the Villa Madama (*c.* 1515–25; *see* RAPHAEL, fig. 9), as do the rooms of the Palazzo del Te, Mantua, where Giulio Romano created (1525–30) not only the wall and vault decorations, but also the floor mosaics based on designs fashionable in ancient Rome. In Genoa the Roman school influenced the decoration of the interiors of the Palazzo Doria (*c.* 1530), the Villa Cambiaso (*c.* 1548), the Palazzo Cataldi (1558) and the Villa Pallavicino delle Peschiere (*c.* 1560). In Venice, Giovanni da Udine decorated the rooms of the Palazzo Grimani (1537–40) with frescoes and with stuccos incorporating festoon motifs, niches and busts in a classical Roman style (see fig. 24). This manner was also used—with variations—in the interiors of the palaces and villas designed by Jacopo Sansovino and Andrea Palladio.

Other decorative innovations introduced in the 16th century were painted maiolica floors (e.g. Cappella dell'Annunziata, S Sebastiano, Venice, 1510), the inclusion of ground-floor open galleries and porticos in the overall decorative scheme, and the increasingly majestic proportions of the staircase, which prepared the way for the dramatic interior decoration of the 17th century.

BIBLIOGRAPHY
G. Mariacher: *Ambienti italiani del trecento e quattrocento* (Milan, 1963)
M. Praz: *La filosofia dell'arredamento* (Milan, 1964)
A. González-Palacios, ed.: *Antiquariato: Enciclopedia delle arti decorative* (Milan, 1981)
A. Schiapparelli: *La casa fiorentina e i suoi arredi nei secoli XIV e XV* (Florence, 1983)
L. Collobi Ragghianti: *Ambienti del rinascimento* (Novara, 1986)
P. Thornton: *The Italian Renaissance Interior, 1400–1600* (London, 1991)
A. Gruber, ed.: *History of Decorative Arts: The Renaissance and Mannerism in Europe* (New York, London and Paris, 1994)
Met. Mus. A. Bull., liii (1996) [special issue devoted to *studiolo*]

ENRICO COLLE

24. Stucco decoration (1537–40) by Giovanni da Udine, Palazzo Grimani, Venice

VI. Furniture.

For much of the 15th century tables were still produced in traditional medieval forms. Movable frames or trestles supported broad and simply decorated timber tops, which were draped with valuable textiles. Chairs, on the other hand, while deriving their X-form from the folding chairs already in use in ancient times, acquired different shapes. The Dantesca chair, for example, had four legs with crossed scissor hinges connected by four bars, while the Savonarola chair, a more elaborate version of this, took its name from a similar seat found in the cell of Girolamo Savonarola in the convent of S Marco in Florence. The design of the bed also changed in accordance with the new concept of interior decoration that took root during the Renaissance: the bedstead took on a monumental form and size, while wooden bed alcoves, enclosed by doors, were still used in the 15th century, an important example being the one (Urbino, Pal. Ducale) owned by Federigo II, Duke of Urbino.

During the 15th century the practice of decorating furniture with intarsia became common in the Veneto, the main craftsmen being the Canozi family from Rovigo. The choir of S Giustina in Padua contains a group of inlaid furniture (1467–77) with representations in linear perspective made by Francesco da Parma and Domenico da Piacenza (*fl c.* 1480), testifying to the spread of Emilian culture in the Veneto area. As for domestic furniture, there are several *cassoni* decorated with pastiglia and partly painted in the Museo di Castelvecchio, Verona, and the Ca' d'Oro, Venice. Small cult objects were also widely dispersed, such as the portable altarpieces and picture frames produced in great number by the workshop of the EMBRIACHI family in Venice.

In the 14th century furniture in Tuscany, as in the rest of Italy, was still simple and functional in design, while in

the 15th century it was embellished with an elaborate array of ornaments covering the traditionally solid form. In Siena the technique of intarsia, already well known in the 14th century, was used on both religious and secular furniture. Pastiglia was also widely used in Siena, particularly in decorating *cassoni*. Even in Florence the *cassoni* and dressers, with their solid architectural forms, were decorated with pastiglia, intarsia and tempera.

In South Italy the art of woodworking did not reach its height in Naples until the first half of the 15th century. Masters from Arezzo and Verona, with the collaboration of local workers, executed the most exacting inlaid work, while masters from Brescia, Rome and the Veneto assisted Neapolitan workers in wood-carving, creating complex decorative forms. Flemish and Neapolitan artists collaborated on furniture inlaid with bone and ivory, which became a particularly widespread form of decoration during the second half of the 15th century.

During the Renaissance, furniture-making, like other areas of fine and applied arts, increasingly took antique models as its source of inspiration. Furniture was decorated with motifs from contemporary architecture, pilasters, cornices and frames, next to which were placed such classical ornaments as vases, volutes, putti and leaf-work. Sometimes the decoration was inlaid and portrayed objects, people or architecture arranged in strict perspective, as in the *studiolo* (1476; *see* STUDIOLO, fig. 1) of Federigo II da Montefeltro in the Palazzo Ducale in Urbino, where the inlaid panels with *trompe l'oeil* designs alternate with classicizing pilasters and entablatures.

Later in the 15th century furniture became increasingly elaborate in decoration: from this time onwards grotesque masks, frond volutes, bean motifs, figures from mythology and geometric designs decorated the wooden surfaces of most domestic furniture (see colour pl. 1, XXXIV4). Mythological or allegorical scenes, executed in plaster, carving or painting, were depicted on *cassoni* (see fig. 25), while legs sculpted in the form of leaves and ending in lions' paws, of classical origin, were specifically adopted

for tables. As the 16th century progressed decorative effects became increasingly sumptuous and robust, sometimes surpassing the form of the furniture itself (see fig. 26). The armchair made its appearance in this period, taking its place beside the traditional Savonarola and Dantesca chairs. The dresser gained considerable grandeur in form, and large beds, deprived of the chests that encircled them previously, were decorated with carved and gilded columns, while tables generally had lyre, balustrade or anthropomorphic legs with rails featuring carved grotesque masks and coats of arms.

Florentine furniture acquired a distinctly majestic air along with an increasing precision in execution. Woodcarving assumed a major role in furniture decoration. Both BACCIO D'AGNOLO and Vasari (creator of the *studiolo* of Francesco I, Grand Duke of Tuscany, in the Palazzo Vecchio; *see* STUDIOLO, fig. 2) provided drawings for furniture and interior decoration. After the technique had been mastered in Milan and elsewhere, during the second half of the 16th century Florentine table-tops were inlaid with hardstones, a technique that was soon adopted for cabinets and cupboards (*see* FLORENCE, §III, 2). Benedetto da Maiano and his brother Giuliano da Maiano (*see* MAIANO, DA, (1) and (2)), for example, executed the inlaid cabinets in the sacristy of Florence Cathedral and the door and ceiling (1476–81) of the Sala dell'Udienza of the Palazzo della Signoria (now Palazzo Vecchio). In 1588 Ferdinando I, Grand Duke of Tuscany, established the Galleria dei Lavori, enlarging and reorganizing the group of craftsmen assembled by Francesco I, and this specialized in the production of pietre dure. (It was later, in 1860, named the Opificio delle Pietre Dure.) The first artist in charge of the factory was Bernardo Buontalenti. The del Tasso family, which began working towards the end of the 15th century in Benedetto's workshop, and took it over after his death, produced a number of significant works. The head of the family, Chimenti or Clemente *il vecchio* (1430–1516), produced furniture for Florentine churches together with his sons Leonardo (1466–?1500)

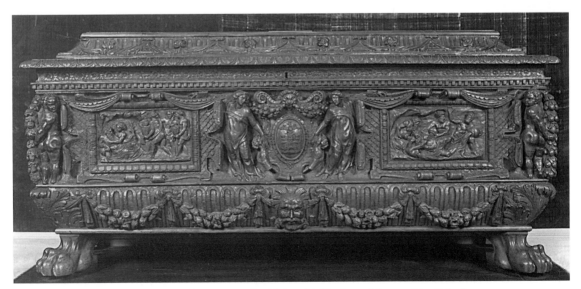

25. *Cassone*, engraved and carved walnut, mid-16th century (San Marino, CA, Huntington Library and Art Gallery)

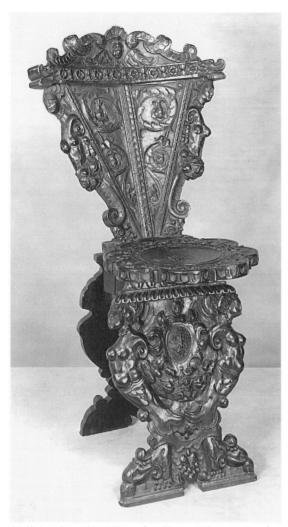

26. Chair, walnut, 1054×533 mm, from Venice, 16th century (London, Victoria and Albert Museum)

and Zanobi (1469–1511). One of Chimenti's two brothers, Domenico *il vecchio* (1440–1508), executed some wood panels in 1475 for the Palazzo della Signoria. From 1488 he was active in Perugia, where, between 1490 and 1493, he carved the tribune, chair back and bench in the Sala dell'Udienza of the Collegio del Cambio. This work contained a variety of decorative motifs that would inspire wood-workers in Tuscany and Umbria for the next 50 years. Among the numerous family descendants, GIOVAN BATTISTA DI MARCO DEL TASSO carved the timber ceiling (*c.* 1550) of the Biblioteca Medicea–Laurenziana, Florence, after the designs of Michelangelo and decorated a number of rooms in the Palazzo Vecchio, displaying skill and decorative virtuosity in a technique that had elements of both engraving and carving.

In Siena, throughout the 15th century and part of the 16th, furniture and particularly *cassoni* were decorated with either pastiglia or paintings of secular subjects. The search for superficial, delicate effects and dense carving, as well as the free translation of grotesque motifs, is typical of Sienese art. In particular they characterize the work of Antonio Barilli (1453–?1529), who carved the choir of the S Giovanni Chapel in Siena Cathedral, which was then transferred to the Chiesa dell'Assunta in San Quirico d'Orcia, and the doors of the Vatican loggia in Rome. The quality of carving in Siena was very high throughout the 16th century, as can be seen in various pieces of furniture where the decoration is expressed as an ordered architectonic scheme.

Renaissance decorative motifs spread to Umbrian craftsmen through the collaboration between an inlayer from the Marches, Mariotto de Pesaro, and the Tuscan carvers Giusto da Incisa and Giovanni da Fiesole (*fl* 1472). The best examples of the new style in Umbria can be seen in the study (*c.* 1480) of the Palazzo Ducale in Gubbio and in the intarsia work of Giuliano da Maiano and Domenico del Tasso *il vecchio*, which influenced ANTONIO BENCIVENNI. In 1508 Bencivenni executed the intarsia work in the Sala dell'Udienza of the Collegio del Cambio in Perugia, which was imitated in numerous Umbrian *cassoni*. Also based on Tuscan models are the cabinets (1494) of Perugia Cathedral, the lectern (1492–7) of S Domenico in Gubbio and the later works of the inlayers Giovan Battista Bastone (*fl* 1505–30) from Perugia and Antonio Senaca, active during the first part of the 16th century.

Craftsmen from North Italy helped to spread a type of intarsia similar to that of the Lendinara family, as exemplified in the work of Andrea Campano from Modena who executed (1530–34) the choir of S Lorenzo in Spello with inlaid figures of saints and town views. The Bergamesque intarsia of S Maria Maggiore, Florence, drawn by Lorenzo Lotto, is clearly echoed in the choir doors (completed 1536) of S Pietro in Perugia by Damiano da Bergamo (*c.* 1490–1549). The choir-stalls (1526–35) of this latter church represent the most ambitious work of the 16th century, executed by various masters from Tuscany, Lombardy and other regions, led by Bernardino Antonibi from Perugia. They have very refined carving using grotesque motifs, which were taken up in the intarsia work by Battista Bolognese (*fl* 1535–7) and others. During this period the Umbrian masters achieved an independent style, and their carving exhibits an eye for detail and a skill that sometimes surpasses their Florentine counterparts. Carving and inserted paintings were often combined, a local characteristic that was already under way at the end of the 15th century. One example of this is the carved and inlaid wardrobes (*c.* 1545–54) of the sacristy of Spoleto Cathedral, the doors of which are also decorated with painted figures by Francesco Nardini (*fl* 1550–60).

Domestic furniture known to be by Umbrian craftsmen is rare. Generally it has a clear architectonic form and is richly carved. An election ballot-box (Gubbio, Pal. Com.) shows Tuscan influence, as do stools and various *cassoni*, including a dowry chest (Perugia, G.N. Umbria) that is supported by sphinxes and decorated with satyrs, leaf volutes and other motifs, as well as with intarsia that displays more energy than Tuscan examples. Tuscan models were adopted for dressers, which were decorated with intricate carvings and grotesque masks on the doors. Venetian influence is also present in some *cassoni* and chairs with twisted bands of curls in the backs.

In Piedmont, at the end of the 15th century, the most common decorative motif on dressers, wardrobes, *cassoni* and doors was the 'pergamena' motif, copied from French furniture, which sometimes also included geometric braids, roses, stars and hearts. The carvings were often combined with plaques of wrought iron, and the hinges became decorative elements as they did in Emilia and some transalpine regions. Examples include the *cassone* (1468) with the Savoy and Piosassco coats of arms, the *cassone* with the coat of arms of the Challant family and the doors from the Valle d'Aosta (all Turin, Mus. Civ. A. Ant.).

In Liguria a flourishing aristocracy commissioned numerous pieces of furniture: the earliest extant domestic furniture dates to the mid-16th century. In 1514, however, Anselmo Fornari (active 1470–1521) from Castelnuovo Scrivia is known to have worked on the choir of S Lorenzo in Genoa. In the early 16th century domestic furniture arrived from Spain and Flanders, which influenced the style of Genoese furniture. Domenico da Vernio completed several *cassoni* in this period, and Perino del Vaga designed some dowry chests for Andrea Doria. Inlaid furniture was produced by Andrea de' Rocchi and Elia de' Rocchi (1500–22), who also carved the tarsia of Savona Cathedral. The Calvi family built elaborate organ cases, and the Garibaldi constructed frames for altarpieces, while the work of Filippo Santacroce (d 1609), the greatest Genoese carver of the 16th century, showed signs of Roman and Tuscan influence as can be seen in the choir of S Ambrogio. Around 1560 the first *bambocci* style chests-of-drawers appeared, characterized by a wealth of high-relief decoration composed of putti, caryatids and heads, which were also used to disguise the handles.

In Lombardy the art of wood intarsia reached its height at the end of the 15th century. The craftsmen who worked during the second half of the century include Lorenzo di Odrisio and Giacomo del Maino (fl 1469–1502), who worked in the Carthusian monastery in Pavia, and Baldino di Surso (fl 1477), who worked in S Michele in Pavia and in Piedmont. In Pavia, Giovanni Pietro Donati (active 1484–1516) and Giovanni Ambrogio Donati (fl 1484–97) executed (1484) the choir of S Francesco, where animals and plants are depicted in a highly stylized manner. In Cremona, Giovanni Maria Platina (c. 1455–1500) executed a monumental wardrobe (1477; Cremona, Mus. Civ. Ala Ponzone) for the sacristy and the choir of the cathedral (1482–9). Two of the most famous Italian inlayers were born in Bergamo and Brescia: Brother Damiano (c. 1480–1542) and RAFFAELLO DA BRESCIA, who helped revive the technique of intarsia and promote its popularity. *Cassoni*, the only Lombardian furniture known from the end of the 15th century, were sometimes decorated with geometric inlay, but more often with pastiglia or paintings. However, during the 16th century, they were increasingly decorated with carvings of plant motifs and with ever-smaller pieces of inlay. The most famous carvers at this time were the Taurini family, originally from France, who worked in Lombardy from the mid-16th century until well into the 17th century. In Valtellina, carving was influenced by Bergamo, where a particular type of chest-of-drawers was developed with four drawers with boxwood and maple inlaid panels; this differed from the Mantuan model, which was made in softwood with three drawers. Some of

the greatest Renaissance carvers were trained in Piacenza, Emilia, such as Domenico da Piacenza (fl 1467–88), creator of the choir (1467–77) of S Giustina in Padua, decorated with intarsia in perspective; Matteo Grattoni (fl 1550–1601), who carved the choir of S Maria di Campagna, near Piacenza; and Pasquale Testa (?1524–1587), who is recorded as working for Ottavio Farnese, 2nd Duke of Parma and Piacenza.

If in the Veneto during the 15th century there was a preference for carving furniture with such Gothic motifs as roses, and double- and lozenge-shaped openings, in the 16th century, thanks to the newly established cultural ties with Florence, Rome and the Low Countries, the local decorative repertory gained a wealth of new additions. Sixteenth-century Venetian furniture is actually very similar to Tuscan furniture, from which it derives its balanced architectonic design and classical decorative motifs. Jacopo Sansovino played a crucial role in this respect; his work spread the use of such decorative motifs as festoons, female heads framed with veils, and tablets with volutes, which were very popular and adopted even in cabinet-making. Apart from painted furniture by such well-known artists as Bonifazio de' Pitati and Andrea Schiavone, various types of furniture were decorated with intarsia, including the wardrobes and the choir (1494–9) of S Maria in Organo in Verona by Fra GIOVANNI DA VERONA, which constitute the finest examples of this craft in the Veneto area. Another notable piece of ecclesiastical furniture is the reliquary chest of Padua Cathedral, which an anonymous local craftsman carved with grotesque motifs. As for secular furniture, the *cassone* played an important part, even though wardrobes, chests-of-drawers and tables were beginning to acquire greater significance. During the first half of the 16th century the *cassone* was linked to the 15th-century types decorated with pastiglia or inlaid in the *certosina* style, but towards the middle of the century more elaborate forms with intricate carving and wooden panels depicting jousts or courtly scenes in pyrography appeared.

BIBLIOGRAPHY

F. Schottmuller: *Wohnungskultur und Möbel der italienischen Renaissance* (Stuttgart, 1921)
M. Tinti: *Il mobilio fiorentino* (Milan and Rome, 1929)
V. Pagliuzzi: 'Mobili del medioevo: Il cassone la cassapanca, il seggiolone dal secolo XII al secolo XV', *A. Illus.*, i (1968), pp. 38–42
C. Alberici: *Il mobile lombardo* (Milan, 1969)
A. González-Palacios: *Il mobile nei secoli*, i (Milan, 1969)
T. Miotti: *Il mobile friulano* (Milan, 1970)
M. Trionfi Honorati: *Il mobile marchigiano* (Milan, 1971)
L. Bandera: *Il mobile emiliano* (Milan, 1972)
G. Cantelli: *Il mobile umbro* (Milan, 1973)
C. Alberici: *Il mobile veneto* (Milan, 1980)
G. Manni: *Mille mobili emiliani* (Modena, 1980)
A. González-Palacios, ed.: *Antiquariato: Enciclopedia delle arti decorative* (Milan, 1981)
M. Boroli and S. Broggi: *Il mobile del rinascimento: Italia* (Novara, 1985)

ENRICO COLLE

VII. Ceramics.

1. Maiolica. 2. Porcelain.

1. MAIOLICA.

(i) Before 1500. (ii) 1500 and after.

(i) Before 1500. The oldest Italian maiolicas considered to be of artistic value date from the end of the 14th century.

During excavations of the Forum Romanum, Rome's civic centre, examples of ceramics were found that can be dated to between the 9th and 12th century and have relief decoration and silica-alkaline glazes. The 13th-century maiolicas were derived from these prototypes, and their style is described as 'archaic'. Recent studies have proved that the centres of production were not only in Central Italy—Florence, Siena, Grosseto, Faenza, Rimini, Orvieto, Assisi, Todi, Rome and Valentano—but also in some northern areas, for example in the Veneto, as well as in South Italy and the Italian islands.

The products from all these areas have a rather thin, off-white glaze and are generally decorated with manganese-brown designs and a copper-green ground; cobalt-blue and iron-yellow were also sometimes used. The decorative themes, which were derived from medieval iconography, consist of stylized animals, monsters taken from the Roman Bestiaries, coats of arms, Gothic calligraphy and floral, vegetal and geometric motifs (e.g. bowl, end of the 14th century; London, V&A). Human figures were only rarely represented. The forms included small bowls, large two-handled dishes, urns, pitchers and albarelli (e.g. of c. 1380–1420; London, BM). Maiolicas decorated with *sgraffito* designs were also produced during this first 'archaic' phase. The technique, long considered to be a speciality of Ferrara, was also adopted, although to a lesser extent, by the potters of Venice (*see* VENICE, §III, 2), Bologna (*see* BOLOGNA, §III), Padua and Calabria.

During the early 14th century there was a gradual evolution of the 'Archaic' style towards a more sophisticated form of decoration known as the 'Severe' style. The first phase is known as the 'green' family (1425–50). Compared with the earlier maiolicas these display a marked improvement in both glaze and decoration. The manganese-brown contours are better defined and more precise and prevented the colours from running. The ornamental elements were influenced by imported Hispano-Moresque wares, and the representations of people and animals were set against a ground of dotted elements or tiny flowers. The most highly valued maiolicas of this period are attributed to Florence and are characterized by their vitality and by the well-painted, rounded figures..

A second, more or less contemporary group, is known as the 'relief-blue' family (1430–60) and includes large albarelli decorated with thickly applied blue and purple oak leaves, coats of arms, fantastic animals and, more rarely, human figures or representations of animals (see fig. 27). These maiolicas, which were for the most part produced in Tuscany, were also copied in such other Italian centres of production as Faenza. The 'Italo-Moresque' family (1450–80), known as such because of the less intense monochrome blue or polychrome decorations, were even more decisively Florentine and were strongly inspired by Islamic lustrewares (e.g. jug, c. 1460–80; Oxford, Ashmolean). Generally the use of turquoise or a yellow-green was intended to imitate a metallic surface. This type of Italian maiolica is less highly valued than the preceding type because the decoration is less incisive and the motifs somewhat monotonous

During the second half of the 14th century FAENZA became the most important centre of ceramic production, developing a distinctive figurative repertory. The town

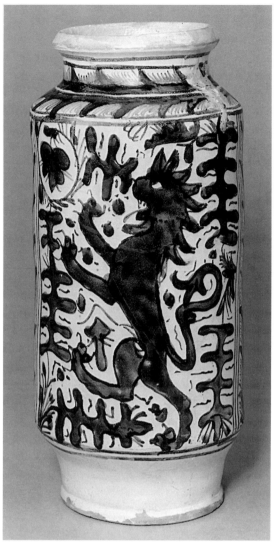

27. Maiolica albarello of the 'relief-blue' family, h. 328 mm, probably from Florence, 1448–51 (London, British Museum)

was under the protection of the Manfredi family (1334–1501). Here, and later in Tuscany and other areas in Central Italy, new styles were developed during the second phase of the 'Severe' style. The 'Gothic-floral' and 'peacock-feather eye' families (1460–95) were developed at the same time. Their decorative elements were inspired by both Islamic and Greco-Roman art. The chromatic range became increasingly rich and more imaginative; blue remained predominant, while the manganese-brown became more red and was accompanied by lively touches of yellow and a brilliant green. The 'peacock-feather eye' decoration was apparently in homage to Cassandra Pavona, the beautiful mistress of Galeazzo Manfredi, Lord of Faenza (d 1480). An important work from this period is the tile pavement in the Vaselli Chapel in S Petronio in Bologna. Executed by Pietro Andrea (fl 1487–1526) from Faenza in 1487, it is decorated with such motifs as 'Persian palmettes', a kind of stylized flower resembling a pine cone, the 'peacock-feather eye' and half-bust portraits.

Judging from the few extant examples, other tile pavements in a similar style were also common in Neapolitan churches.

In addition to these decorative motifs blue tendrils and arabesques painted on a white ground were introduced at the end of the 15th century. This form of decoration, known as *alla porcellana*, proved to be highly successful due to the popularity of the expensive blue-and-white Chinese porcelain that began to be imported into Europe at this time. One characteristic of the work produced towards the end of the 15th century was the frequent use of minute motifs in concentric frames on the reverse of plates and dishes. The popularity of *sgraffito* wares continued, and the style of decoration was influenced by the development of more naturalistic scenes.

(ii) 1500 and after. Although albarelli, pitchers and plates decorated with profiles of knights or maidens accompanied by an amorous phrase, an aphorism or a name were made from the late 15th century, the most outstanding examples dated from the early 16th (see fig. 28). Such objects were exchanged as engagement gifts. Some well-known albarelli with portraits of nobles painted in polychrome were produced in Naples for the court of Aragón. The last phase of the 'Severe' style, which dates from the early 16th century until the first decades of the 17th, is characterized by grotesque decoration. GROTESQUE designs were inspired by the discovery *c.* 1480 of the motifs on the walls of Nero's Domus Aurea (mostly destr. AD 104) in Rome.

The 16th century has appropriately been defined as the golden age of Italian maiolica. During the first two decades Faenza was still the principal centre of production; later important centres included CASTEL DURANTE GIOVANNI and URBINO (*see* URBINO, §3), where such potters as NICOLA DA URBINO, FRANCESCO XANTO AVELLI and FRANCESCO DURANTINO established workshops. Before the 'Beautiful' style was established *c.* 1515, a transitional phase is evident, which is characterized by fantastic decoration in gaudy colours. Wares from Faenza were used as the model and the decoration reworked in a variety of ways in workshops in such centres as Siena, Gubbio, Padua, Venice and at the CAFAGGIOLO CERAMIC FACTORY.

The first *istoriato* (narrative) phase proved to be very popular during the second and third decades of the 16th century. The leading centre in this first phase continued to be Faenza due to the fame of Pietro 'Pirotto' Paterni (*see* PIROTTI), who ran a workshop known as the Casa Pirota (Pirotta). The work of the Pirotti family was so frequently imitated that it is often difficult to identify. *Istoriato* wares were often decorated with historical or mythological themes and were called 'New' style wares. Prints provided the potters with images of contemporary paintings and sculpture; in particular Raphael's work was frequently reproduced on maiolica from Urbino (e.g. dish depicting the *Presentation of Psyche to the Gods by Eros*, based on Raphael's fresco in the Villa Farnesina, see fig. 29).

During the early 16th century technical experiments were carried out, and one of the results was the successful production in DERUTA of lustrewares (see colour pl. 1, XXVII3), until then only imported from Spain. In Gubbio

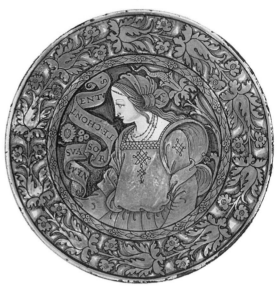

28. Maiolica dish with yellow-brown lustre, inscribed NEMO SUA SORTE CHONTENTUS ('No-one is happy with his own destiny'), diam. 415 mm, from Deruta, *c.* 1500–30 (London, British Museum)

(*see* GUBBIO, §2), another centre for the production of lustrewares, GIORGIO ANDREOLI became a specialist, and potters from neighbouring regions sent their works to him to be given this iridescent gold or red finish. Lustrewares are classified in the phase known as the second *istoriato* or the 'Beautiful' style. One of the typical shapes of this period is the conical vase in the form of a pine-cone. Around the 1520s potters in Faenza introduced the *berrettino* (grey-blue) ground, which was decorated with motifs in contrasting colours (e.g. plate, 1525; London, BM). A variation on this technique was a deep-blue ground decorated with light-blue or gold decoration. In Venice work of this kind was known as *smaltino*.

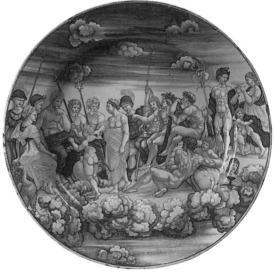

29. Maiolica dish painted with the *Presentation of Psyche to the Gods by Eros*, diam. 481 mm, from Urbino, *c.* 1530 (London, Wallace Collection)

Maiolica sculpture was developed in the workshop of the DELLA ROBBIA family, who practised their art from the 15th century until the end of the 16th. Their work, decorated with vivid colours, consisted largely of low-relief votive icons depicting the Madonna and Child, or basins with holy scenes for use in convents. Girolamo della Robbia also produced such vessels as vases decorated with low-relief garlands of flowers and fruit; his reputation won him the respect of the French king Francis I (*reg* 1515–47) who commissioned him to decorate the loggia (1527; destr. 1792) of the Château de Madrid in the Bois de Bologne, Paris.

Italian maiolica was also popular abroad; potters in Lyons, for example, were very influenced by the *istoriato* style, which they copied. In Spain the style of 16th-century maiolica was imported by a potter from Pisa called Francisco Niculoso (*d* 1529), who was responsible for such outstanding tile pictures framed with friezes and grotesques as those in the Oratory Chapel in the Alcázar, Seville.

Next to the grotesques, another very successful ornamental style was that called *a quartieri*. This involved dividing the ground of an object into areas of different colours filled with various motifs; the central medallion was often filled with a portrait (e.g. dish, *c.* 1520–25; London, Wallace). This decoration was extensively used by the potters of Central Italy and later in Sicily. In Montelupo, at this time, wares were richly decorated for courtiers or for the pontifical court, as indicated by the presence of coats of arms superimposed on the figures.

During the second half of the 16th century Urbino became an increasingly important centre of production largely due to the success of the FONTANA and PATANAZZI families. They were particularly well known for their wares of the third *istoriato* phase, which is distinguished by abundant decorations with historical or mythological scenes framed by friezes or grotesques in a palette dominated by yellow and orange; it is also known as the 'Raphaelesque' style (see colour pl. 1, XXX2). This style was often applied to such highly intricate forms as centrepieces, lobed dishes, cisterns and inkstands with such relief decoration as handles in the shape of griffins. Maestro Domenico (active 1562–8), a Venetian potter, produced an original version of the *istoriato* style, during the second half of the 16th century, which he created using a highly coloured palette; his work includes plates and pitchers decorated with medallions enclosing profiles, with borders of flowers and fruit in blue, yellow, green and orange (e.g. large plate, 1568; Faenza, Mus. Int. Cer.). For over a century these works were imitated by many workshops in Venice and Sicily.

In reaction to the strong figurative nature of the third *istoriato* phase, a more restrained style of decoration came into fashion during the second half of the 16th century, first in Faenza (*see* MEZZARISA, FRANCESCO DI ANTONIO) and subsequently in other workshops in Central Italy. Known as the *compendiario* style, it attempted to emphasize the items' form, and the potters took inspiration from contemporary silverwares. A decoration of blue and yellow was applied to the ground of thick, white enamel. The best-known examples, called *bianchi di Faenza*, were usually sketchily decorated with coats of arms and floral motifs (*see* CALAMELLI, VIRGILIOTTO).

In the rest of Italy maiolica production underwent a different evolution during the 16th century with distinct regional styles that became increasingly influenced by the emergent Baroque style. Wares from the Middle East were still influential, as is seen in the choice of the Paduan workshops to produce *candiana* maiolica decorated with stylized, polychrome flowers inspired by Iznik and Persian designs (*see* PADUA, §3). In such other areas in the Veneto as Bassano and Angarano, the workshops produced the so-called *latesini* wares with milky-white grounds, emulating the *lattimo* glass of the contemporary Muranese glassblowers. These works are often highly decorative, painted with mythological or allegorical scenes set in arcadian landscapes.

BIBLIOGRAPHY

L. Mallé: *Maioliche italiane dalle origini al settecento* (Milan, n.d.)
G. Ballardini: *Corpus della maiolica italiana* (Rome, 1933–8)
——: *La maiolica italiana (dalle origini alla fine del cinquecento)* (Florence, 1938/R Faenza, 1975)
B. Rackham: *Catalogue of Italian Maiolica* (London, 1940, rev. 1977)
——: *Italian Maiolica* (London, 1952)
G. Liverani: *La maiolica italiana fino alla comparsa della porcellana europea* (Milan, 1958)
V. Brosio: *Porcellane e maioliche dell'ottocento* (Milan, 1964, rev. 1980)
J. Scott-Taggart: *Italian Maiolica* (London, 1972)
G. Conti: *L'arte della maiolica in Italia* (Milan, 1973)
G. Batini: *L'amico della ceramica* (Florence, 1974)
B. Rackham: *Capolavori della maiolica italiana* (Faenza, 1976)
G. C. Bojani, C. Ravanelli Guidotti and A. Fanfani: *La donazione Galeazzo Cora: Ceramiche dal medioevo al XIX secolo* (Milan, 1985)
Ceramic Art of the Italian Renaissance (exh. cat. by T. Wilson, London, BM, 1987)
L. Arbace: *Il conoscitore di maioliche italiane del rinascimento* (Milan, 1992)

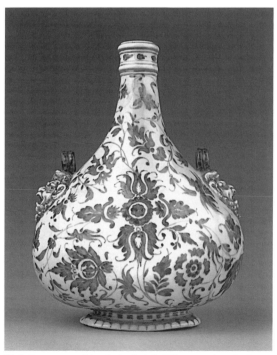

30. Soft-paste porcelain pilgrim flask, h. 264 mm, made at the factory of the Medici in Florence, *c.* 1575–87 (Los Angeles, CA, J. Paul Getty Museum)

J. E. Poole: *Italian Maiolica and Incised Slipware in the Fitzwilliam Museum, Cambridge* (Cambridge, 1997)

LUCIANA ARBACE

2. PORCELAIN. Italy was the first European country to manufacture porcelain; experiments were sponsored by Alfonso II, Duke of Ferrara, conducted between 1561 and 1571 and carried out by the brothers Camillo de Gatti da Urbino (*d* 1567) and Battista de Gatti da Urbino (*d* by 1578). Production, if any, has not been identified. The earliest manufacture for which there is an identifiable corpus of work is the so-called Medici porcelain (soft paste), produced in Florence between *c.* 1575 and *c.* 1587 under the patronage of Francesco I, Grand Duke of Tuscany (*see* FLORENCE, §III, 1). Production included deep dishes, ewers and pilgrim flasks (see fig. 30) decorated in underglaze blue. Systematic manufacture was apparently discontinued after Francesco's death (1587).

BIBLIOGRAPHY
A. Lane: *Italian Porcelain* (London, 1954)
G. Morazzoni and S. Levey: *Le porcellane italiane*, 2 vols (Milan, 1960)
F. Strazzi: *Italian Porcelain* (New York, 1964)
A. Mottola Molfino: *L'arte della porcellana in Italia*, 2 vols (Busto Arsizio, 1976–7)

VIII. Glass.

The history of glass manufacture in Italy from the Middle Ages is almost entirely identified with the history of glass produced in Venice (*see* VENICE, §III, 3). In fact, it would be more accurate to refer to Murano, a city on a small island in the Venetian lagoon. Venetian glassmakers worked in Murano from 1291, when they were transferred there by a decree of the Magistrature of the Venetian Republic for fear of the fires caused by the furnaces in the city itself. Historical research has not yet ascertained what factors may have led to the rise of glassmaking in Venice and the Venetian lagoon. Documents show that glass was made there before AD 1000, and a few ancient documents suggest that the great artistic production of Venetian glass must have continued uninterrupted from Late Roman times (see colour pl. 2, XXXVIII3). Indeed the Venetians adopted and developed decorative styles, typological models and techniques from the Roman traditions.

The great success of the Murano glass industry led not only to the progressive widening of its commercial horizon, but also stimulated the formation and development of other, smaller glassmaking centres in Italy. These were founded by glassmakers who, despite the strict regulations, emigrated from Murano and influenced the development of techniques, tastes and the types of article produced. A major historiographical problem arises from the fact that the technology of glassmaking does not facilitate clear and certain distinctions between products manufactured in different geographical centres. The question is further complicated by the considerable stylistic uniformity of glass due to the predominance of Venetian taste, and the fact that Murano glass articles are not reliably attributable to any particular maker, although the early documents contain plenty of names. All these problems oblige the historian of Italian glassware to concentrate mainly on Venetian production, while verifying those contacts that existed between Venice and other, minor centres of production elsewhere in the peninsula.

Glassmaking seems to have been practised in the small Ligurian town of Altare, near Savona, since the 11th century. At first utilitarian objects were produced, but during the Renaissance pieces became more artistic, undoubtedly due to the contribution of craftsmen from Murano who had initiated the local craftsmen into the secrets of the art. While the activity in Altare is documented by early sources, it has not been possible to identify with certainty any piece produced there, as the typological and aesthetic characteristics were indistinguishable from those of Venetian glass. As they gained experience the Ligurian craftsmen refined their taste and techniques and contributed to the development of technical processes, especially for mirrors. They played an important role in creating the market for glass *à la façon de Venise* throughout Europe as they migrated in great numbers to Provence, Normandy and Belgium. The glassmakers of Altare were organized in a guild, the Università dell'Arte Vitrea, which adopted a statute in 1495 and worked to facilitate contacts and exchanges and establish new glassmaking centres in other countries.

Other glass factories existed in such cities in the Veneto region as Padua, Verona, Vicenza and Treviso. These were of minor importance, and at the end of the 16th century their slight activity completely ceased. However, in Tuscany the development of glass manufacture was more substantial; in Florence it began in the 16th century. Initially the interest of the Tuscan glassmakers was in the production of utilitarian wares, especially everyday tableware. In Florence there were a great number of glassmakers who specialized in the manufacture of drinking glasses. Also well known were the Tuscan *fiasche* (flasks) covered with straw jackets, which were used for transporting wines and other drinks.

The government of Cosimo I, Grand Duke of Tuscany, gave the first stimulus to the production of artistic glass by inviting such noted Venetian craftsmen as Bartolo d'Alvise, who arrived in Florence in 1569. Such masters of other disciplines as the painter Jacopo Ligozzi (1547–1627) and the engraver Stefano della Bella (1610–64) were commissioned to provide designs for glass. There was also a large and widespread production of Venetian-style glassware, which was so similar to Murano glass that it is hard to distinguish it. The importance of Tuscan glassmaking at the end of the 16th century is also documented in the publication *L'arte vetraria* (Florence, 1612) by Abbot Antonio Neri (1576–1614). Drawing on his own vast experience, the author gave a clear and exhaustive account of the systems, methods and typologies of glass manufacture.

BIBLIOGRAPHY
G. Mariacher: *L'arte del vetro* (Verona, 1954)
G. Taddei: *L'arte del vetro in Firenze* (Florence, 1954)
G. Mariacher: *Il vetro soffiato* (Milan, 1960)
——: *Il vetro soffiato: Da Roma antica a Venezia* (Milan, 1960)
——: *Il vetro europeo dal XV al XX secolo* (Novara, 1964)
M. Causa: *L'arte del vetro dal rinascimento ai nostri giorni* (Milan, 1966)
G. Mariacher: *Specchiere italiane e cornici da specchio dal XV al XIX secolo* (Milan, 1969)
C. Bertelli: 'Vetri e altre cose della Napoli angioina' *Paragone*, xxiii/263 (1972), pp. 89–106

PAOLA D'ALCONZO

IX. Metalwork.

1. Gold and silver. 2. Base metals.

1. GOLD AND SILVER. One of the earliest centres of goldsmiths' work in Italy was Venice. FRANCESCO D'ANTONIO was an important goldsmith there during the second half of the 15th century. The powerful traditions of Byzantine art can be seen in the gold altarpiece in S Marco in which Byzantine enamels of the 10th–12th centuries are framed in a base (1345) in the International Gothic style by Giampaolo Boninsegna. The Gothic style remained predominant in Venice until the mid-15th century, as can be seen in the gilded silver candlesticks (1462–71; Venice, Tesoro S Marco) made for the Doge Cristoforo Moro. Sometimes goldsmiths were also sculptors and architects, as in the case of ALESSANDRO VITTORIA, who worked with Sansovino and Veronese at the Villa Barbaro. Two important Venetian objects of the late 15th century were made for Maria de' Medici: a mirror framed with precious stones and a pair of candlesticks in silver-gilt and rock crystal. Venice also produced much silver and gold tableware and cutlery during the 15th and 16th centuries.

The Renaissance vocabulary of forms was developed most strongly in Florence. Although goldsmiths in Florence had been obliged to stamp their work from as early as 1322, they had no official guild of their own during the Renaissance, but belonged to the Arte dei Mercanti di Por S Maria. The many goldsmiths' workshops in Florence provided training for some of the greatest names of the Renaissance. Filippo Brunelleschi became a master goldsmith in 1404, and Lorenzo Ghiberti (*see* GHIBERTI, (1)) served his apprenticeship with the goldsmith Bartolo di Michele, in turn training DONATELLO and Luca della Robbia. The silver altar of *St John the Baptist* (Florence, Mus. Opera Duomo) for the Baptistery contains four relief panels dating from the 15th century, among them the panel by ANDREA DEL VERROCCHIO of the *Beheading of St John the Baptist* (1477–80) on the right side of the antependium (see fig. 31). The statue of *St John* in the central niche of the altar is the work of MICHELOZZO DI BARTOLOMEO, who was probably also trained by Ghiberti.

The production of goldsmiths' work in Florence was boosted by the patronage of the Medici family in the 15th and 16th centuries. The technical expertise and formal refinement of Florentine work in this period can be seen in the golden artefacts in the Museo degli Argenti in the Palazzo Pitti, especially in the precious mountings of the Medici vases. The Florentine style, which was applied to decorative arts and objects made from precious stones set in gold or silver mounts in the 16th century, reigned supreme, and the grand ducal workshops worked on commissions from the Medici, making precious gifts for aristocrats and visiting diplomats from other European courts. The quality of design, the exquisite taste and the perfection of the modelling in bronze, jasper, lapis lazuli

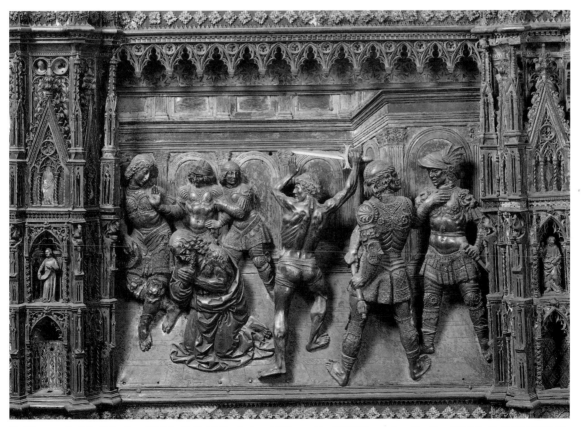

31. Silver panel of the *Beheading of St John the Baptist* by Andrea del Verrocchio, 360×380 mm, from the altar of *St John the Baptist*, 1477–80 (Florence, Museo dell'Opera del Duomo)

or rock crystal were enhanced by the precious gold and silver mounts.

One of the most important works from Genoa in the 15th century is the *Ark of St John the Baptist* (1433; Genoa Cathedral) by Teramo Danieli and Simone Caldara. Also held in the cathedral is the 16th-century *Cask of the Corpus Domini*, made through a collaboration between local and Nordic craftsmen. Prolific quantities of goldsmiths' work were produced in Sicily from the 14th century, mainly by Catalan and Tuscan craftsmen based in Palermo, Catania and Messina. The Catalan influence remained dominant in the 15th century, but by the 16th century, Renaissance forms had spread, though still linked to Spanish models, as in the work of Paoli Gili in Palermo. In the second half of the 16th century the measured, classical forms described in the treatises of Juan de Arje were disseminated by Nabilio Gagini.

Although statutes had existed in Rome from as early as 1358, in 1509 a new guild was formed, the Università degli Orefici Argentieri e Gioiellieri dell'Alma Città di Roma. Laws defined the standards for precious metals, and hallmarks of both the goldsmith and the assayer became obligatory. BENVENUTO CELLINI, the most renowned goldsmith in the 16th century, trained in Florence, but came to Rome in 1519 and worked as a medallist and goldsmith. In 1540 her went to Fontainebleau, where he worked as a sculptor in an elegant international Mannerist style for Francis I (*reg* 1515–47). With the exception of the famous salt-cellar, modelled in Rome for Ippolito d'Este in 1540 and finished in 1543 in France for Francis I (Vienna, Ksthist. Mus.; *see* CELLINI, BENVENUTO, fig. 4), none of his celebrated works survive, not even the gold, jewel-studded morse for Pope Clement VII, which was mentioned in his *Vita* (written *c.* 1558–67).

Cellini moved back to Florence in 1545, at the time of Cosimo I, and worked there as a sculptor, goldsmith and jeweller for the rest of his life. The secrets of his prodigious technique are explained in detail in the *Trattato dell'oreficeria*, published in Florence in 1568 with the *Trattato della scultura*. Documents in the Medici archives from the time of Cosimo and Francesco de' Medici mentioned the presence in Florence of many foreign artists (especially Flemish craftsmen) and frequent interaction with Milanese craftsmen, who were experts in carved rock crystal. In the second half of the 16th century the Florentine pietre dure workshops underwent a considerable development, and elaborate pieces were produced with precious settings and sinuous lines that anticipate the formal language of the Baroque.

Among the artists recorded in Cellini's *Vita*, CARADOSSO is mentioned as an excellent goldsmith, active in Milan, Venice and Rome. None of his precious metalwork has survived. His most famous piece, the papal tiara made for Julius II, was destroyed and is known from a later drawing (London, BM). VALERIO BELLI, the most celebrated Italian engraver of rock crystal and gems, is the author of a casket composed of 20 panels of rock crystal commissioned by Pope Clement VII, who gave it to Francis I (Florence, Pitti, *see* fig. 33 below). These kind of refined objects in rock crystal and metal were also typical of the taste of the Farnese court; the famous Farnese Casket (Naples, Capodimonte) reflects the cultured taste of Cardinal Alessandro Farnese,

combined with the formal language of Michelangelo and Cellini. A silver-gilt altar cross and two candlesticks (Rome, St Peter's) were made for the same great patron by the assayer of the Papal Mint, ANTONIO GENTILI, who was from Faenza but worked in Rome for the papal court, where he was inspired by the works of Michelangelo. In Mantua GIULIO ROMANO designed silver tableware for Federico Gonzaga, designs illustrated in the *Libro de disegni per far vasella di argento et oro*.

Cutlery in precious metals was produced in Milan, for example the 'Trivulzio' knives (Milan, Castello Sforzesco), with handles in nielloed silver, and cutlery (Milan, Mus. Poldi Pezzoli), the handles of which are decorated in relief. Milan was the centre for production of hardstone objects of vertu mounted in precious metals, gemstones and hardstones.

Naples boasts a long tradition of goldsmiths' work, with roots in antiquity, but was heavily influenced by French and, later, Florentine styles. In 1437 Alfonso I of Aragón conferred on the Neapolitan goldsmiths the privilege of marking silverwork. A statute was granted for the Corporazione degli Orefici, confirmed in 1505. Important Neapolitan works of the time are mainly devotional, such as the silver bust of the *Apostle St Bartholomew* signed by F. Leone (1470; Naples, S Chiara) or that of *St Felicita* from a few years later (Cava dei Tirreni Abbey). Neither work has any trace of Renaissance style, while there is a clear stylistic progression in two slightly later works, the *St Brunone* (*c.* 1520; Serra San Bruno, Certosa) and the *St Vitaliano* (Catanzaro Cathedral), which bears the mark of the Neapolitan master Domenico Mazzola. Apart from Sicily, the capital city of Naples remained the only town in South Italy until the declaration of the Kingdom of Italy (1861) to have an independent goldsmiths' guild with its own mark. After Naples the towns of Teramo, L'Aquila and Sulmona in the Abruzzo were the most important centres of goldsmith production; in the second half of the 15th century the region developed an original decorative language and innovative forms, but Naples continued to dominate the artistic culture of the south while under Aragonese and Spanish rule.

BIBLIOGRAPHY

M. Accascina: *L'oreficieria italiana* (Florence, 1934)
M. Morassi: *Antica oreficeria italiana* (Milan, 1936)
G. Morazzoni: *Argenterie genovesi* (Milan, 1951)
F. Rossi: *Capolavori di oreficeria italiana dall'XI al XVIII secolo* (Milan, 1956)
C. Bulgari: *Argentieri, gemmari ed orafi d'Italia* (Rome, 1958–74)
A. Lipinsky: *Oreficeria e argenteria in Europa dal XVI al XIX secolo* (Novara, 1965)
K. Aschengreen Piacenti: *Il Museo degli Argenti a Firenze* (1967)
S. Fornari: *Gli argenti romani* (Rome, 1968)
H. Honour: *Orafi e argentieri* (Milan, 1972)
E. Catello and C. Catello: *Argenti napoletani dal XVI al XIX secolo* (Naples, 1973)
M. Accascina: *Oreficerie in Sicilia dal XII al XIX secolo* (Palermo, 1974)
E. Catello and C. Catello: *L'Oreficeria a Napoli del XV secolo* (Cava dei Tirreni, 1975)
M. Accascina: *I marchi delle argenterie e oreficerie siciliane* (Trapani, 1976)
R. Bossaglia and M. Cinotti: *Tesoro e Museo del Duomo* (Milan, 1978)
E. Catello, G. Mabille and H. Brunner: *Gli argenti: Italia, Francia, Germania* (Milan, 1981)
O. Zastrow: *L'Oreficeria in Lombardia* (Milan, 1981)
M. Petrassi: *Gli argenti italiani* (Rome, 1984)
G. C. Sambonet: *Gli argenti milanese* (Milan, 1987)
G. Roccatagliata: *Gli argenti genovesi* (Genoa, 1990)

D. Liscia Bemporad, ed.: *Argenti fiorentini* (Florence, 1992)
Currency of Fame: Portrait Medals of the Renaissance (exh. cat., ed. S. K. Scher; Washington, DC, N.G.A.; New York, Frick; Edinburgh, N.G.; 1994)
M. Kemp: '"Wrought by No Artist's Hand": The Natural, the Artificial, the Exotic and the Scientific in some Artifacts from the Renaissance', *Reframing the Renaissance: Visual Culture in Europe and Latin America, 1450–1650* (New Haven and London, 1995), pp. 176–96, 329–31
A. Gandolfi and E. Mattiocco: *Ori e argenti d'Abruzzo al Medioevo al XX secolo* (Pescara, 1996)
Magnificenza alla corte dei Medici: Arte a Firenze alla fine del Cinquecento (exh. cat., Florence, Pitti, 1997–8)

ANGELA CATELLO

2. BASE METALS. Copper, used in the manufacture of arms, utensils and church and domestic furnishings, is found in its natural state in numerous deposits in various parts of Italy, for example in the Campigliese and in Val di Cecine, and especially on the islands of Elba and Sardinia. Bronze was also used for many church furnishings. Candelabra, lamps, censers and stational and processional crosses were made of bronze, sometimes gilded to imitate gold. Bronzeworkers practised their art in the same workshops as goldsmiths. Bronze was also widely used for architectural decoration from the 11th century (for a detailed survey of the cast-bronze doors produced in Italy during the Renaissance period, *see* DOOR). Through its close relationship with the Byzantine Empire, where bronze-casting was widely practised, Venice enjoyed the services of excellent bronze founders; Venetian artisans cast Andrea Pisano's doors for the Baptistery, Florence, and the tabernacle railings of Orsanmichele, Florence.

During the 13th and 14th centuries Siena was a leading centre in the production of wrought iron; the Sienese 'magistri clavari', mentioned in contemporary documents for their ability to forge keys and locks, laid new foundations for the craft of ironworking. They sought to decorate such domestic items of basic form as oil lamps, andirons, coffers, lanterns and harness rings. They continued to excel in monumental works, for example the railings by Jacopo di Lello for Orvieto Cathedral, the railings of the Cappella del Sacro Cintolo, Prato Cathedral, and those of the Palazzo della Signoria, Siena. A guild of *fabbri* (smiths) was founded in Florence in the second half of the 13th century. The Republic ordered lanterns, standard-holders and torch-holders from the guild, to be placed outside the most important palazzi. A number of prominent families installed wrought-iron architectural pieces, notably the Strozzi in the 15th century, who had their *ferri* produced by Niccolò Caparra, described by Vasari as a 'master who in the working of iron had no equals'.

Bronze was widely used in the Renaissance for decorative arts, as it could be splendidly finished by chiselling and gilding, or by burnishing it to provide a glossy, dark surface. It was used for such architectural fittings as handles, door-knockers, torch-holders, flagpoles and harness rings. In domestic interiors it was used for sconces, writing equipment, fireplace furniture, lamps and furniture mounts. Small bronze statues of an essentially decorative nature were extremely popular and were often displayed in 16th-century *studioli*. These could be made more refined and elaborate by the use of dark lacquers or gilding.

Such small-scale decorative works of art continued to be produced throughout the 16th century. Medals, usually of

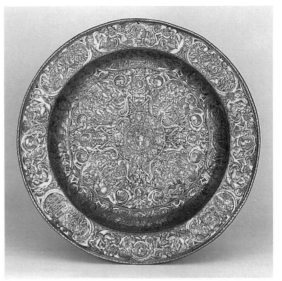

32. Brass dish by Horatio Fortezza, diam. 450 mm, made in Venice, 1562 (London, Victoria and Albert Museum)

bronze, were struck for commemorative purposes or as a form of portraiture. Plaquettes, commonly made of bronze, developed in Italy in the mid-15th century and remained important until the mid-16th century. Debate continues as to their original function. There were also lead castings of 16th-century medals and plaquettes: the material was cheaper and more malleable than bronze, but many of these lead items probably served as models for goldsmiths and bronzeworkers. Objects for domestic use during the Renaissance were also produced in copper, often gilded, using the same forms as those of precious metals.

In Italy, unlike Flanders and Germany, the only noteworthy brass works of art were produced in Venice during the 16th century. At first the ornament and techniques (engraving or inlay) were reproduced from pieces imported from the East, such as plates, cups, candle holders and incense burners. During the course of the 16th century, however, the decorations reflected the classicizing influence of the Renaissance (see fig. 32).

Venice was also a centre for the production of articles in pewter during the 16th century. Employed at first only to copy pieces originally made in precious metal, the use of pewter gradually spread throughout North Italy. In Venice the activity of pewterers was greatly increased by the immigrant Flemish workers who settled there. Gradually the pewterers distanced themselves from silversmiths, although they continued to copy their models and use the same moulds. The expansion of the pewter trade was favoured by the Venetian sumptuary laws.

ANGELA CATELLO

X. Objects of vertu.

1. Hardstones. 2. Wax modelling. 3. Coral. 4. Niello and enamel. 5. Jewellery.

1. HARDSTONES.

(i) Rock crystal. (ii) Other.

(i) Rock crystal. In Italy rock crystal was extracted in large quantities near the St Gotthard Pass. In the Middle Ages,

Venice was one of the most important centres for the working of rock crystal. After the sack of Constantinople in 1204, many antique pieces were brought to Venice from East Asia, including some vases that are still in the Tesoro di S Marco. This undoubtedly stimulated the spread of the art of carving hardstones. There must also have been some production in other Italian centres, for in the 12th century Abbot Suger of Saint-Denis Abbey in France obtained vases of sardonyx and rock crystal from Roger II of Sicily (*reg* 1130–54). The northern European tradition of work in rock crystal had a direct influence on Venetian production. The guild of workers in rock crystal is documented in Venice from 1284. It was regulated by a statute with rigorous obligations and rights; for example, it was forbidden to make false rock crystal of white glass. The craft was strongly encouraged, and each workshop had the right to train two apprentices, while artisans who decided to practise their craft in another city were subject to a fine.

The main production was of beads; one section made large beads, another rosaries (in which case the artisans were called *paternostrai*), and yet another made small beads, sometimes called *margherite*, whose makers were called masters of the *arte sottile* or *margheritai*. Objects in rock crystal were commissioned mainly by the Church and the Italian courts and usually took the form of crosses, caskets, reliquaries, pyxes or altar decorations, as, for example, the important altar (1290; Berne) of Andrew III of Hungary (*reg* 1290–1301), decorated with engraved rock crystal panels, panels of cabochon pietre dure and astylar crosses, in which can be seen miniature paintings on parchment. The work of the Venetian rock crystal carvers can also be found in Tuscany; a cross in Santa Croce, Florence, is signed and dated MCCC MAGISTER BERTUCIUS AURIFEX VENETUS ME FECIT.

Examples of rock crystal and pietre dure vases begin to appear in the inventories of the treasuries of the major Italian churches from the second half of the 13th century. During the Renaissance rock crystal carving reached its fullest development. The high level of quality attained by the Venetian craftsmen during this period can be seen in the work of such artisans as Valerio Belli of Vicenza, a medalmaker and gem-engraver. He produced important pieces decorated with engraved crystal plaques, such as two gilded silver candelabra with rock crystal, lapis lazuli and other gems (1510–15; London, V&A). Belli was working *c.* 1515 in Rome, where he produced an enamelled gilded silver plate inset with small rock crystal plaques for Leo X, whose enamelled coat of arms appears on the bottom (Munich, Residenz). Belli's most celebrated work is undoubtedly the casket (1530–32; Florence, Pitti) made for Clement VII; the gilded silver has enamelled decorations and 24 small crystal plaques engraved with scenes of the *Passion* (see fig. 33). It was sent as a gift in 1533 to Francis I of France (*reg* 1515–47) on the occasion of the marriage of his son, the future Henry II (*reg* 1547–59), to Catherine de' Medici. The casket returned to Florence with Christine of Lorraine, who married Ferdinando I de' Medici in 1589.

Another renowned engraver and medalmaker was GIOVANNI BERNARDI from Castelbolognese. He worked for Alfonso I d'Este in Ferrara after 1520, and from 1529 in Rome. He, too, produced an important casket (Naples,

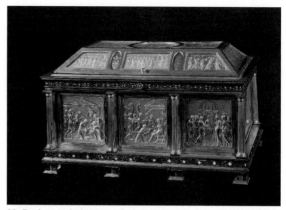

33. Rock crystal plaques and enamel decorations on a gilded silver casket by Valerio Belli, 267×150×145 mm, 1530–32 (Florence, Palazzo Pitti, Museo degli Argenti)

Capodimonte), begun in 1548 in collaboration with the goldsmith Manno di Bastiano Sbarri. The casket was commissioned by Alessandro Farnese, for whom Bernardi had made small rock crystal plaques carved with Classical subjects based on engravings by Perino del Vaga. Bernardi engraved a scene of *Noah's Ark* on a rock crystal plate (Florence, Pitti) taken from further drawings by Perino.

During the 16th century rock crystal carving became one of the most important crafts in Milan (*see* MILAN, §III, 1 and colour pl. 2, VIII1). Among the most notable workshops in Milan were those run by the Miseroni and SARACCHI families. Specialist workshops sprang up all over Europe, and many Italian masters were commissioned to work in the major courts. In the grand ducal workshop, the Galleria dei Lavori, in Florence, rock crystal carving was first practised by Milanese craftsmen (*see* FLORENCE, §III, 2).

BIBLIOGRAPHY
E. Kris: *Meister und Meisterwerke der Steinschneidekunst in der italienischen Renaissance* (Vienna, 1929/*R* 1979)
W. Holzhausen: 'Bergkristallarbeiten des Mittelalters', *Z. Bild. Kst*, 64 (1930–31), pp. 199–205, 216–21
H. R. Hahnloser: 'Scola et artes cristellariorum de veneciis, 1284–1319: "Opus venetum ad filum"', *Venezia e l'Europa. Atti del XVIII Congresso internazionale di storia dell'arte: Venice, 1956*
H. R. Hahnloser, ed.: *Il tesoro di S Marco* (Rome and Florence, 1971)
H. R. Hahnloser: 'Opere di tagliatori veneziani di cristallo di rocca e di pietre dure del medioevo in Toscana', *Civiltà delle arti minori in Toscana. Atti del I convegno: Arezzo, 1971*
Palazzo Vecchio: Committenza e collezionismo medicei (exh. cat., Florence, Pal. Vecchio, 1980)
C. Strocchi: 'Cristalli di rocca: Una rivisitazione', *MCM*, 3 (1986), pp. 31–5

ANNA MARIA MASSINELLI

(*ii*) *Other*. The technique of carving pietre dure and polychrome marbles developed in a few cities during the Middle Ages. In Venice carvers of rock crystal (*see* §(i) above) also worked in jasper, serpentine, porphyry and various kinds of marble. In Rome the ancient art of mosaic had never died out. At the court of Frederick II of Sicily (*reg* 1295–1337) glyptic art was practised by specialized craftsmen who may have emigrated after the sack of Constantinople in 1204; one cameo traceable to Frederick II's court is the onyx cameo carved with a scene of animals entering the Ark. Medieval cameos usually depicted biblical and allegorical subjects.

The 15th-century humanist interest in the Classical past and the subsequent collecting of works of art from antiquity meant that antique pietre dure vases and cameos were used as models for Renaissance sculptors and gem-engravers. The interest in antiquity was so prevalent that there was a wide production of cameos imitating antique prototypes (*see* GEM-ENGRAVING). There were, however, also subjects based on contemporary history or portraiture, for example the renowned large onyx cameo portrait of *Cosimo I de' Medici, Eleonora of Toledo and their Children* (*c.* 1557–62; Florence, Pitti; see fig. 34), made by the Milanese GIOVANNI ANTONIO DE' ROSSI, who was active in Venice, Florence and Rome. Giuliano di Scipione Amici and Gaspare dei Tazoli were employed by the papal court in Rome, and Domenico Compagni, known as Domenico dei Cammei, worked for Ludovico Sforza, Duke of Milan. In Florence, Piero di Neri dei Rezzuti and Giovanni delle Opere, nicknamed 'delle Corniole' (*c.* 1470–1516), are documented as working for Lorenzo the Magnificent. A collaborator of Giovanni delle Corniole was Pier Maria Serbaldi da Pescia (*c.* 1455–after 1522), who carved the first Renaissance sculpture in porphyry, the *Venus with Cupid* (Florence, Pitti). Domenico di Polo, who served his apprenticeship in their workshop, carved a seal in stone plasma with the engraved image of *Hercules*, symbol of the Florentine Republic, for Cosimo I de' Medici, and a series of five cameos in pietre dure with the portrait of *Alessandro de' Medici* (Florence, Pitti).

During the 16th century, especially in Milan, craftsmen moved away from Classical themes to religious subjects or portraits. Mythological images were still carved on vases or plaques for use in furniture and showed a marked taste for richly detailed landscape backgrounds. The great technical virtuosity of the Milanese craftsmen working in pietre dure around the middle of the 16th century can be seen in several vases, especially those in rock crystal (*see*

§(i) above and colour pl. 2, VIII1), and in furniture. Morigia mentioned, for example, that the workshop of Gasparo Miseroni produced for Emperor Rudolf II (*reg* 1576–1612) an inlay of jasper, lapis lazuli and crystals for an ebony table (untraced), designed by Giuseppe Arcimboldo (1527–93) and executed by Giuseppe Guzzi. An example of Milanese furniture of this type is the spinet signed and dated 1577 by the Milanese Annibale de' Rossi (London, V&A), which is adorned with cabochon stones set into panels of carved ivory with a keyboard of ivory and lapis lazuli. In Rome from the mid-16th century, table-tops were made in pietre dure and differently coloured marbles, often set in geometric patterns, usually with a large central panel framed by smaller bands. Combinations of inlays of different design can be seen in the fronts of cabinets made in Rome, such as the sumptuous cabinet at Stourhead House, Wilts.

From the mid-16th century the art of pietre dure was widespread in all the major Italian cities. Florence, which had imported the techniques of mosaic, sculpture and gem-engraving, became the most important centre for this art (*see* FLORENCE, §III, 2). Francesco Ferrucci del Tadda carved porphyry sculpture for Cosimo I de' Medici, whose interest in hardstones passed to his sons Francesco I and Ferdinando I. Milanese craftsmen were brought in to work

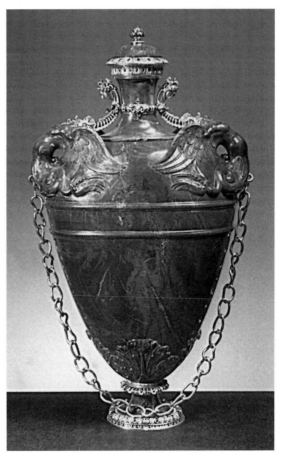

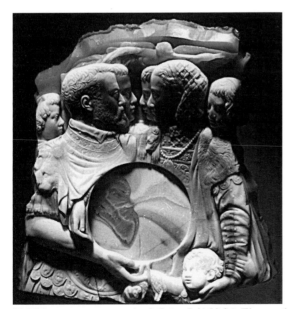

34. White onyx cameo portrait of *Cosimo I de' Medici, Eleonora of Toledo and their Children* by Giovanni Antonio de' Rossi, h. 188 mm, *c.* 1557–62 (Florence, Palazzo Pitti, Museo degli Argenti)

35. Lapis lazuli vase designed by Bernardo Buontalenti with enamelled gold mounts by Jacques Bijlivert, h. 405 mm, 1583 (Florence, Palazzo Pitti, Museo degli Argenti)

on carved pietre dure vases with gold mounts, as in the lapis lazuli vase (see fig. 35), designed by Bernardo Buontalenti for Francesco I with mounts by Jacques Bijlivert (1550–1603), and on inlaid cabinets and tables. In 1588 the grand ducal workshop, the Galleria dei Lavori, was formally established.

The use of pietre dure for furniture decoration is also documented in Venice, although it is hard to identify the production of that city. There was a renowned cabinet (untraced) that belonged to Cardinal Grimani. Built in Venice in the second half of the 16th century, it was decorated with inlay and columns of polychrome marble and pietre dure and had 72 antique cameos set into the front.

BIBLIOGRAPHY

Morigia: *La nobilità di Milano* (Milan, 1595)
R. Ruotolo: 'La decorazione in tarsia e commessa a Napoli nel periodo tardomanierista', *Ant. Viva*, xiii/1 (1974), pp. 55–6
Palazzo Vecchio: Committenza e collezionismo medicei (exh. cat., Florence, Pal. Vecchio, 1980)
A. González-Palacios: 'Mosaici e pietre dure', *Quad. Antiqua.* (1982)
A. González-Palacios and S. Roettgen: *The Art of Mosaics: Selections from the Gilbert Collection* (Los Angeles, 1982)
M. I. Catalano: 'Marmi policromi e pietre dure', *Il seicento a Napoli* (exh. cat., Naples, Villa Pignatelli, 1984), pp. 386–7
Splendori di pietre dure (exh. cat., Florence, Pitti, 1988)
A. M. Massinelli: 'Lo studiolo "nobilissimo" del patriarca Giovanni Grimani', *Riv. Archaeol.*, vii (1990), pp. 41–50
A. M. Giusti: *Pietre Dure: Hardstone in Furniture and Decoration* (London, 1992)

ANNA MARIA MASSINELLI

2. WAX MODELLING. From the Middle Ages ephemeral wax devotional objects, particularly ex-votos, were used in Italian churches. Vasari noted that most such effigies were rather crude, and that high-quality pieces were produced only by such artists as Andrea del Verrocchio. According to Vasari, he produced three wax statues in collaboration with one Orsino Ceraiuolo that were offered ex-voto for Lorenzo the Magnificent's escape from the plot in which his brother Giuliano de' Medici was killed. Vasari also stated that by the mid-15th century realistic representation of the human figure and illusionistic rendering of details in wax modelling were already established. The church of SS Annunziata in Florence was well known for its abundance of wax votive statues in the second half of the 16th century, although such works must certainly have been widespread throughout Italy until the 17th century, after which they became rarer and eventually disappeared.

Wax was used during the Renaissance for the production of models for sculptures or medals. From the first half of the 16th century three-dimensional works in wax were also used as models for paintings. In 1510, for example, the sculptor Jacopo Sansovino made a wax sculpture (London, V&A) of the *Deposition* for the painter Perugino. Despite its original purpose, this was the first wax creation judged by contemporaries to have intrinsic artistic value and was purchased as such by a member of the Gaddi family.

In the first half of the 16th century there was also a vogue for small portraits in white wax, for example those produced by Alfonso Lombardi of Ferrara. According to Vasari, these included portraits of such illustrious contemporaries as *Emperor Charles V*, *Pope Clement VII* and *Ludovico Ariosto*, although none has been preserved. In the second half of the 16th century naturalistic colouring was applied to similar portraits, made usually in the form of medals, the characteristic features of which, including the use of a profile view and the realistic approach, are similar to those in gold and silver. The most important portraitists in wax were, in fact, goldsmiths, for example PASTORINO PASTORINI of Siena and Antonio Abondio (1538–91) of Trent. These small wax portraits were essentially for private use; in 16th-century Italy they were often displayed alongside precious gems, as was the custom with miniatures in northern Europe. Later, as the genre became more popular, they were hung on walls. Towards the end of the 16th century the production of statuettes in coloured wax became widespread in Italy. There was also a fashion for various kinds of relief sculpture in wax that can be classified into three types: those in white or coloured wax on a base of dark stone; those with figures and background both in coloured wax; and *tableaux*, which are wide, deep plaques with fully rounded wax figures.

BIBLIOGRAPHY

G. Masi: 'Appunti d'archivio: La ceroplastica a Firenze nel XV–XVI secolo e la famiglia Benintendi', *Riv. A.*, ix (1916), pp. 124–42
M. Bucci: *Anatomia come arte* (Florence, 1969)
D. Lightbown: 'Le cere artistiche del cinquecento', *A. Illus.*, iii (1970), pp. 30–39, 46–55
E. J. Pyke: *A Biographical Dictionary of Wax Modellers* (London, 1973)
Congresso internazionale sulla ceroplastica nella scienza e nell'arte. Atti del I congresso: Firenze, 1977
A. González-Palacios: 'Arti decorative e arredamento', *Civiltà del settecento a Napoli*, ii (exh. cat., Naples; Florence; 1979–80)

PAOLA D'ALCONZO

3. CORAL. In ancient Rome coral was considered a precious material; apart from its decorative uses in jewellery, for example in necklaces, seals, cameos and rings, it was thought to afford powerful protection against the evil eye. During the Middle Ages coral was used mainly in jewellery and for the decoration of goldsmiths' work and textiles. In the 14th and 15th centuries it was often left in its natural form, as in the candelabra in the Scuola Grande di S Rocco, Venice, whose arms, mounted on a silver base, consist solely of coral branches. In Naples the art of coral-carving was strongly promoted by the Aragón dynasty, which in the 15th century commissioned a large number of works that revealed a strong Spanish influence. The renowned Sicilian coral-carving developed between the 15th and 16th centuries, Trapani and Messina being the two major centres. In Trapani the work was almost all done by Jews, and when they were expelled from the island for political reasons in 1492 there was a serious crisis in the production of coral-carving. Throughout the 16th century and until the 18th century Trapani was the most important centre of coral-working. Other Italian cities, for example Amalfi, Florence and Naples, followed the Sicilian lead. Genoa, where, unlike Trapani, craftsmen did not specialize in a particular technique, was also renowned in the 16th century. Coral worked in Genoa was frequently exported, especially to India, Spain and Armenia.

BIBLIOGRAPHY

G. Tescione: *Il corallo nella storia e nell'arte* (Naples, 1965)
P. Leone de Castris: 'Corallo', *Antiquariato: Enciclopedia delle arti decorative*, ed. A. González-Palacios, xvi (Milan, 1981), pp. 400–02
B. Liverino: *Il corallo: Esperienze e ricordi di un corallaio* (Bologna, 1983)

FERNANDA CAPOBIANCO

4. NIELLO AND ENAMEL. Although a few medieval Italian works in niello are extant, the greatest development of this art took place during the Renaissance. Tuscany was the main area of production of niello, not only for such religious objects as paxes, reliquaries and antependiums but also for such secular pieces as side-arms, caskets, bookbindings and buckles. Along with Antonio del Pollaiuolo, Filippo Brunelleschi, Matteo di Giovanni and Bardinelli—who all often used niello—the Florentine masters of the art included Maso Finiguerra, who made the splendid niello pax with a depiction of the *Coronation of the Virgin* in the centre (*c.* 1452; Florence, Bargello; for illustration *see* FINIGUERRA, MASO).

In Bologna, another important centre for niello work, a well-known master of the art was Francesco Francia, who produced gilded silver frames for paxes, often with a Pietà in niello. Other artists of the late 15th century and the early 16th who used niello included the sculptor and medallist Caradosso, who worked in Milan and Rome; Giovanni di Turino in Siena; Giacomo della Porta in Modena; and Peregrino da Cesena, as well as Benvenuto Cellini, Marcantonio Raimondi and Nicoletto da Modena. After the first half of the 16th century niello disappeared from the work of Italian goldsmiths; it was later used mainly for bookbindings throughout Europe.

BIBLIOGRAPHY

A. Lipinsky: *Oro, argento, gemme e smalti: Tecnologie delle arti dalle origini alla fine del medioevo* (Florence, 1975)

P. Leone de Castris: 'Niello', *Antiquariato: Enciclopedia delle arti decorative*, ed. A. González-Palacios, xli (Milan, 1981), p. 1018

FERNANDA CAPOBIANCO

5. JEWELLERY. The use of jewellery increased in Italy in the 13th century, when the necklines of dresses were adorned with jewelled borders in the antique Byzantine fashion. Rings are rarely found in inventories of the period. The symbolic value of stones was very important: sapphire was associated with virtue in Heaven and celestial beatitude on Earth, and emeralds stood for wealth. Coral was a popular ornament (*see* §3 above), and sales at huge prices are registered in notarial archives, especially in Genoa. The detailed sumptuary laws, which differed in the various Italian states, are useful guides for reconstructing the different ways in which jewellery was used, but it is difficult to establish to what extent these laws were obeyed.

In the 14th century a typical form of jewellery was the paternoster, a rosary without a cross worn around the neck or the waist. Valentina Visconti (1366–1408) had one with enamel and pearls, while 14th-century Venetian documents mention numerous paternosters in crystal, amber, coral and silver. Ornaments of gold, pearls and precious stones were sewn to clothing; rings were usually made with a single gem mounted in a smooth setting of great value. In Florence a sumptuary law of 1355 prohibited the wearing of more than two rings, each of which could have only one gem; in Naples, however, rings of more elaborate design were made, and gem-engraving was practised.

In the Renaissance gem mountings were more refined, and the quality of the goldsmith's work was almost more important than the value of the stones. In Florence at the time of Lorenzo the Magnificent there were no less than 44 goldsmiths, and the art of GEM-ENGRAVING was revived, notably by Giovanni delle Corniole. The Florentine idea of elegance favoured the whiteness of pearls, which were wound in long strings around the hair of Tuscan noblewomen. Another common form was the *vezzi*, short necklaces, often of coral or pearls; *vezzi* of black pearls can be seen in Antonio del Pollaiuolo's *Portrait of a Lady* (Milan, Mus. Poldi Pezzoli).

Vittoria Camponeschi Carafa, the mother of Pope Paul IV, had in her dowry a necklace of alternating silver and coral beads. The massive buckles favoured in the 14th century were converted into pendants and worn around the neck, suspended from ribbons or pearl necklaces. These often consisted of a circular section with a central gem, from which three pearls hung (see, for example, Domenico Ghirlandaio's portrait of *Giovanna Tornabuoni*; Madrid, Thyssen-Bornemisz Col.). Up to four or five rings were worn on each hand. In North Italy earrings were rare, but in the south they were more common. Neapolitan inventories list some in the form of the sun, and in the fresco of *The Triumph of Death* at Palermo (Gal. Reg. Sicilia) the ladies wear beautiful earrings shaped like leaves.

The use of jewels to decorate dresses was elaborate. In 1468 Bona of Savoy, the bride of Galeazzo Maria Sforza, Duke of Milan, had a gown embroidered with pearls and rubies of the fabulous value of 50,000 ducats, while the dowry of Anna Maria Sforza, the wife of Alfonso I d'Este, Duke of Ferrara and Modena, contained 22,000 jewelled pins for clothing. Men wore great golden chains, medallions and brooches on their hats, and rings with gems and engraved stones. More than extravagant luxury, great collections of jewels were meant to display flourishing economic stability for political ends: Ludovico Sforza, Duke of Milan, showed his gem collections to foreign ambassadors and princes.

In the 16th century, at the height of Renaissance elegance, precious golden hair-nets embroidered with gems appeared. On their foreheads noblewomen would wear a splendid single gem or pearl, held by a light veil or slender chain. Rich trimmings adorned their gowns, and long jewelled fillets emphasized the cut of the garment. Necklaces became very rich, hanging in long cascades with alternating parts of finely chiselled gold, gems or enamel. In the 16th century, especially in Florence, splendid jewels, trinkets, buckles and pendants were finely chiselled and enamelled with images of animals and mythological figures, among other things; although no known pieces are attributed to him, Benvenuto Cellini described his work in this style in his books. Rings were worn less often in Italy than in northern Europe, and they were usually sober in form; engraved stones were increasingly favoured for rings, medallions and brooches. During the 16th century the vogue for earrings spread to the north of Italy; peculiar to Venice were earrings composed of a small ring to which a little fabric ribbon was tied. In Naples the combination of blue and white was frequently used, for example aquamarines and diamonds or pearls and blue enamel; this was probably derived from the Hispano-Moresque tradition.

BIBLIOGRAPHY

A. Castellani: *Della oreficeria italiana* (Rome, 1872)

A. Bertoletti: *Le arti minori alla corte di Mantova nei secoli XV–XVI–XVII* (Milan, 1889)

P. Lanza di Scalea: *Donne e gioielli in Sicilia nel medioevo e nel rinascimento* (Palermo, 1892)

F. Malaguzzi Valeri: *La corte di Ludovico il Moro*, 3 vols (Milan, 1917)

M. Accascina: *L'oreficeria italiana* (Florence, 1934)

R. Berliner: *Italian Drawings for Jewellery* (New York, 1940)

C. G. Bulgari: *Argentieri, gemmari ed orafi d'Italia*, 4 vols (Rome, 1958)

G. Tescione: *Il corallo nella storia e nell'arte* (Naples, 1965)

G. Gregorietti: *Il gioiello nei secoli* (Milan, 1969)

L'oreficeria della Firenze del '400 (exh. cat., Florence, Ist. Stor. A., 1977)

Ori ed argenti di Sicilia (exh. cat., Trapani, Mus. Reg., 1989)

STEFANO ALUFFI-PENTINI

XI. Textiles.

1. Silk. 2. Lace. 3. Tapestry. 4. Embroidery.

1. SILK. Silk-weaving was introduced into Sicily by the Fatimid Arabs, who controlled the island until its conquest by the Normans in AD 1071. The silks attributed to Sicily, for example those used in the coronation mantle of the Holy Roman Emperors (1133–4; Vienna, Schatzkam.) made for Roger II (*reg* 1130–54) and a 12th-century fragment (Hannover, Kestner-Mus.) inscribed 'made in a workshop of the realm', show a mix of Islamic and Byzantine influences.

By 1300, however, silk-weaving was more strongly established in the northern city states. They had long been involved in the silk trade, and from the 8th century to the 12th there had been a special relationship between Venice and the Byzantine Empire, with Venice providing naval support against the Empire's enemies in return for lucrative trading rights. The sacking of Constantinople (1204) and the decline of the Empire encouraged the introduction of sericulture to Italy and the establishment of silk-weaving in Venice, Genoa, Lucca, Florence and later Milan and other cities. As early as 1265 Venetian statutes refer to the weaving of a variety of pure and mixed silks.

The patterns encompassed plant, animal and heraldic motifs and even large-scale pictorial panels, such as the antependium (Regensburg Cathedral) with the figure of Bishop Heinrich von Rotteneck (*reg* 1277–93). The Vatican inventory of 1295 includes one silk from Genoa and many from Venice and Lucca with patterns of birds in roundels, their heads and claws brocaded with gold thread. Such silks continued to be purchased by the English court into the 1320s.

Italian silks were dramatically affected, however, by the opening-up of trade with East Asia following the establishment of the Mughal empire in the 13th century. In the 14th century dragons and phoenixes replaced the rather stylized birds and animals, while asymmetrical patterns, full of movement and often with a marked diagonal bias, replaced the rows of roundels. Different weaves were also adopted including lampas, five-shaft satin (used for both plain fabrics and damask) and velvet. Plain velvet had been woven in the late 13th century, but first stripes and then small floral patterns were introduced; by 1376 three-colour velvets in two heights of pile were being woven in Lucca (*see* LUCCA, §2). Although plain silks continued to make up the bulk of Italian production, it was for these richly patterned goods that Italy was renowned.

The fanciful designs of the 14th century continued into the 15th, but, as foliage became a more dominant feature, they were replaced by formally arranged compartments containing pineapples or similar fruits and, later in the century, by large, asymmetrical undulating stems bearing fleshy leaves enclosing or terminating in large fruits. Lampas was largely replaced by damask and velvet, which in the mid-15th century was often woven in monochrome with voided patterns delicately outlined on the plain silk grounds. Polychrome and pile-on-pile velvets were also produced and, later in the 15th century, the silk grounds were increasingly replaced with gold cloth on which details of the pattern were defined with thin lines of velvet, while more substantial areas of pile were ornamented with loops of gold. Brocading was also used. Such expensive fabrics were made to order, as in the case of the vestments (1499–1502; Stonyhurst, Lancs) woven in Florence for Henry VII of England (*reg* 1485–1509).

Some large-scale velvets and other silks in a 15th-century style continued to be woven throughout the 16th century, but new designs were introduced based on curvilinear lattices and sinuous arabesques entwined by or enclosing plants and animals. These large-scale patterns were woven in *ciselé* (cut and uncut pile) velvet, brocatelle, damask and brocaded satin, fabrics which were also used for the small-scale patterns woven for use in dress from the mid-16th century. These designs were composed of small motifs—sprigs, broken branches, 'S'-shapes, birds and animals—sometimes enclosed in diapers but often simply arranged in straight or staggered rows. Towards the end of the 16th century and into the 17th rows of left-right curving sprigs were particularly popular.

BIBLIOGRAPHY

F. Podreider: *Storia dei tessuti d'arte in Italia* (Bergamo, 1928)

T. Broggi: *Storia del serificio comasco: La tecnica, i: Dalla origine alla fine del settecento* (Como, 1958)

D. King: 'Some Unrecognised Venetian Woven Fabrics', *V&A Mus. Yb.* (1969)

D. Devoti: *L'arte del tessuto in Europa* (Milan, 1974)

R. B. Fanelli: *Il Museo del tessuto a Prato: La donazione Bertini* (Florence, 1975)

Tessuti italiani del rinascimento: Collezioni Franchetti, Carrand (exh. cat., Florence, Bargello, 1981)

Tessuti serici italiani, 1450–1530 (exh. cat., Milan, Castello Sforzesco, 1983)

L. Monnas: 'Developments in Figured Velvet Weaving in Italy during the 14th Century', *Bull. Liason Cent. Int. Etud. Textiles Anc.*, lxiii–lxiv (1986), pp. 63–100

M. King and D. King: *European Textiles in the Keir Collection, 400 BC to 1800 AD* (London, 1990)

C. Zanier: 'Current Historical Research into the Silk Industry in Italy', *Textile Hist.*, xxv/1 (Spring 1994), pp. 61–78

Seta e la sua vita (exh. cat., ed. M. T. Lucidi; Rome, Pal. Expos., 1994)

□

2. LACE. Cutwork and silk and metal-thread bobbin laces began to be made in Italy *c.* 1550. Venice soon emerged as a leading centre, and cutwork, in addition to fine embroidery, was made in the convent workrooms there. Italian cutwork, heavier than the Flemish equivalent, soon developed flowing patterns or more naive figurative ones. Cutwork and *reticella* with figurative and geometrical patterns continued to be made in parts of the eastern Mediterranean formerly ruled by Venice until the 20th century. An important series of pattern-books for needle lace of all types, including *lacis*, was published in Venice from the 1540s. Bobbin lace was also made there, while other important centres were Genoa and Milan. Milan, also noted originally for silk and metal lace, developed a

part lace in which bobbin-made tapes were formed into designs imitating the soft patterns of Flemish lace, like contemporary Venetian tape lace.

BIBLIOGRAPHY

G. Romanelli Marone: *Lavori artistici femminili: Trine a fuselli in Italia* (Milan, 1902)
E. Ricci: *Old Italian Lace*, 2 vols (London and Philadelphia, 1913)
A. Mottola Molfino and T. Binaghi Olivari: *I pizzi: Moda e simbolo* (Venice, 1977)
Cinque secoli di merletti europei: I capolavori (exh. cat., ed. D. Davanzo Poli; Burano, Consorzio Merletti, 1984)
D. Davanzo Poli: *Il merletto veneziano* (Novara, 1998)

PATRICIA WARDLE

3. TAPESTRY.

(i) Before 1500. (ii) 1500 and after.

(i) Before 1500. The use of woven tapestry in Italy seems to have survived from antiquity into modern times almost without hiatus. During the early Middle Ages, however, probably only the very wealthiest sectors of society could afford these luxury weavings. Monumental woven representations, as well as sets of unrivalled dimensions, were used in St Peter's and other major basilicas in Rome. Tapestries were probably also employed to a lesser extent at the courts of kings and powerful overlords, although documentation is scarce and other textile hangings must have predominated. There are no records of where these tapestries were woven, but since the technique was known all over the Roman Empire, many may have been created locally.

The modern Italian term for woven tapestry, *arazzo*, derives from the phrase 'cloth' or 'hanging of Arras' (It. *panno di Arazzo*, evolving to *panno de razo* and other variants), which is found in the Middle Ages in so many European languages. It indicates that by the late 14th century in Italy, as elsewhere, when tapestries had become a more usual and even necessary luxury accoutrement, the production centre from which the finest examples were obtained was Arras in France. Tapestries acquired in the 15th century from the north, through such middlemen as the Medici Bank of Florence, were either bought ready-made from weaver-merchants' stocks or were specially ordered according to the purchaser's requirements. A drawing or cartoon by an Italian artist was provided in some cases; such major artists as Leonardo da Vinci and Botticelli painted cartoons to be sent north for weaving. In Italy, as in northern Europe, tapestries were displayed for pomp, and sets were regularly loaned among allies, to achieve greater splendour for weddings and other grand occasions, or to decorate the chambers of a visiting notable.

By the early decades of the 15th century the increasing quantities of tapestries collected required major maintenance. Apparently, some collections justified the hiring of full-time, specialized foreign artisans, as opposed to locally trained upholsterers. Documents for this phenomenon at the courts of Mantua (from 1420) and Ferrara (from 1436) indicate that most of these workers had been trained in Flanders or France as master or journeyman weavers. They also acted as intermediaries for the purchase of tapestries from their homelands and set up looms of their own to weave smaller, but in many cases possibly choicer,

pieces for their patrons. Court weavers are also documented at the papal court in Rome (from 1451/2–6), in Modena (1457, 1488), Correggio (1460–1506), Milan (by 1456), Urbino (*c.* 1470) and Naples (*c.* 1498). Numerous tapestries by them are recorded, although at this time the masters were never numerous enough, nor was the weaving sufficiently economical to affect the rate of importation from northern Europe. Only two pieces (*c.* 1475–6; Lugano, Col. Thyssen–Bornemisza, and Cleveland, OH, Mus. A.), woven in Ferrara, which had the greatest number of court weavers in the 15th century, can still be identified.

Such masters filled a need for direct contacts: they not only facilitated relations during recurrent political turmoil in northern tapestry-producing areas, but, perhaps more importantly, they could obviate or unite with the services of traditional tapestry-ordering channels to assure more satisfactory results. By weaving certain commissions on site, they afforded their patrons more personalized and closer artistic and economic control. Thus, at about the same time as their appearance as full-time, court employees in Italy, northern masters also began roaming the peninsula as itinerant weaver-merchant-restorers. They catered to lesser noblemen, wealthy merchants and city governments, with a selection of wares for sale or to order. Alternatively, they offered the possibility of setting up looms temporarily, to execute a major project. Such commissions allowed a master weaver to test whether an area might support a permanent workshop, as suggested by extant contracts, which record the training of local apprentices, for example the contract of Reinaut Woutersz. (known in Italy as Rinaldo Boteram or Rinaldo di Gualtieri; *fl* 1438–81) from Brussels in Siena. With the permission of Niccolo III d'Este, Marchese of Ferrara, for whom he may already have worked, Woutersz. went to Siena in 1438 and stayed until 1442, working on both public and private commissions. He was followed in 1443 by Giachetto di Benedetto da Razzo (*fl* 1441–57), whom the city of Siena contracted to teach for up to ten years and to weave three large tapestries (*Good Government, Peace* and *War*, all untraced) after Simone Martini's frescoes in the Palazzo Pubblico. Other temporary workshops are recorded in Florence (1455–7 and 1476–80), Bologna (*c.* 1460), Todi (1460), Perugia (1463–7), Ferrara (1464), Genoa (1496) and elsewhere. Apparently only in Venice (by 1421) and Milan, however, did independent weaver-merchants find it profitable to settle on a long-term basis.

Woutersz. is among the best documented of these ambulatory masters. After his stay in Siena, he worked for the courts of Ferrara (1444–8), Mantua (1449–57) and Modena (1457). He finally set up an independent shop in Venice (*see* VENICE, §III, 4), after which he seems to have concentrated on importing tapestries from Brussels, actively maintaining his court contacts in Ferrara and Mantua until at least 1481. Another peripatetic master was Livinus Gilii de Burgis (*fl* 1444–after 1473), who was recorded at various times at the Ferrara court (1444, 1463 and *c.* 1473), Florence (1455–7) and Milan (from 1463).

The themes of Italian tapestries at this time were much the same as Flemish ones: religious, mythological, historical, heraldic and allegorical. It seems, however, that fewer tapestries with such representations as millefleurs, *verdures*, landscapes or genre pieces were woven in Italy, probably

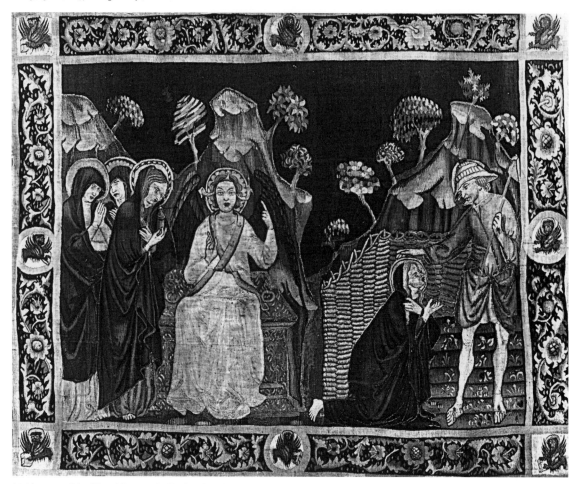

36. Tapestry of the *Three Marys at the Tomb and Noli me tangere* from the *Passion* cycle, *c.* 2.02×11.30 m, designed and woven in ?Venice, *c.* 1420–30 (Venice, Museo di San Marco)

because northern centres were so specialized in their design and mass-produced them so economically; mass-production would never, in fact, be a major factor in Italian tapestry weaving. Unlike in the north, where weavers relied on the use of cartoons for multiple sets, designs for Italian patrons were generally conceived to be woven only once, although some popular ones were later repeated. Another difference in Italian cartoons was that they were apparently almost always fully coloured—early northern tapestry cartoons were rarely coloured at all——whether they were to be woven locally or in the north. A third major difference between Italian and northern tapestries is the treatment of borders: northern tapestries had no borders until approximately the 1490s, whereas the *Passion* cycle (*c.* 1420–30; Venice, Mus. S Marco; see fig. 36) for the cathedral of S Marco, Venice (the earliest preserved tapestries from Italian designs) already had framing borders like those in contemporary Italian painted wall decoration.

(ii) 1500 and after. Few Italian courts that had employed tapestry weavers in the 15th century continued to do so into the 16th. Ferrara and Mantua, from which docu-mented tapestries have survived, and Correggio are exceptions. In the early 16th century a group of independent weavers was hired by Gian Giacomo Trivulzio, Marchese di Vigevano, near Milan, to produce *The Months* series (Milan, Castello Sforzesco). Apparently only in Milan and Venice were independent weavers continuously active from the 15th century through the first decades of the 16th.

Sixteenth-century production at the marriage-related courts of Ferrara and Mantua was limited, however, until 1536, when the brothers Giovanni Karcher (*fl* 1517–62) and Nicolas Karcher (*d* 1562) in Ferrara (*see* FERRARA, §3) brought in a group of Brussels weavers, including Jan Rost (*fl* 1535–64), as reinforcements. Soon, production in Ferrara was so vigorous that Nicolas Karcher could set up his own workshop in Mantua in 1539 (*see* MANTUA, §3). In 1545, both Nicolas Karcher and Rost moved to Florence, to found independent workshops with subventions from Cosimo I, Duke of Florence (*see* FLORENCE, §III, 3). In 1554 Nicolas Karcher returned to Mantua, where he had maintained a small workshop, while his and Rost's students were organized by the Duke into a court workshop, the Arazzeria Medicea (est. 1554). Weaving died out in Mantua in the 1560s and in Ferrara in the early

1570s, but the Arazzeria Medicea continued for almost 200 years producing tapestries for both the Medici and private patrons (see colour pl. 1, XXX1).

During the 16th century Italian workshops wove cycles of large tapestries and thus made some limited inroads into local importation from the north. Unlike most large Flemish cycles, the majority of Italian ones were carefully sized to fit specific areas. An interesting illustration of the dynamics of tapestry commissioning in Italy, in a set woven for a predetermined space, is the *Marian and Eucharistic* cycle (1562–1633) for Como Cathedral, which, because of the church's finances, took over 70 years to complete. Various cartoon painters were employed on the project including Giuseppe Arcimboldo (1527–93), Sebastiano II Filippi (*c*. 1532–1602), Alessandro Allori (1535–1607) and Giovan Battista Recchi (*c*. 1590/1600–*c*. 1650); because of changing politics, economics and logistics, the weaving was executed in Brussels, Ferrara and Florence.

Sixteenth-century Italian painters continued the practice of making coloured cartoons, best illustrated by Raphael and his school's cartoons for Pope Leo X's set of the *Acts of the Apostles* (cartoons, London, V&A, *see* RAPHAEL, fig. 5; tapestries, Rome, Pin. Vaticana). In fact, these and other Raphael school cartoons for papal court tapestries sent to Brussels for weaving from *c*. 1515 to 1523 inspired Bernard van Orley I (*c*. 1488–1541) to revolutionize Flemish cartoons by adding colours and introducing High Renaissance spatiality and monumentality. The more varied colours and compositions of Italian tapestries may result not only from the Italian cartoons, but also from the Flemish weavers' reluctance to use dyes traditionally considered unstable or inferior and the painters' and weavers' inability to break completely with their long tradition of perspectiveless tapestry design.

Throughout the 16th century Italian tapestry borders continued to be more innovative than Flemish ones. They sometimes imitated Flemish fruit and flower garland models but more often displayed a great range of other types of motifs, from imitations of carved or geometric frescoed frames (see fig. 37) to tied-back curtains. Many were carefully coordinated with the central theme of the tapestry. From the 1540s, a recognizable local style of compartmentalized tapestry border evolved in Florence, which was especially favoured by Francesco Salviati, Johannes Stradanus and Alessandro Allori (1535–1607). This style later influenced the designs for tapestry borders by Peter Paul Rubens (1577–1640), which in turn revolutionized Flemish border design in the 1620s.

BIBLIOGRAPHY

EWA: 'Arazzo'

L. F. E. Müntz: *Histoire de la tapisserie en Italie, en Allemagne*, i of *Histoire générale de la tapisserie* (Paris, 1878–84)

J. Del Badia: 'Sulla parola "arazzo"', *Archv. Stor. It.*, xxv (1900), pp. 87–90

A. Schiaparelli: *La casa fiorentina e i suoi arredi nei secoli XIV e XV* (Florence, 1908/*R* with vol. of tables, ed. M. Sframeli and L. Pagnotta, 1983), i, pp. 194–290

M. Viale Ferrero: *Arazzi italiani* (Milan, 1961)

D. Heinz: 'Die italienische Tapisseriekunst bis zum Ende des 16. Jahrhunderts', *Europäische Wandteppiche*, i (Brunswick, 1963), pp. 257–76

M. Viale Ferrero: *Arazzi italiani del Cinquecento* (Milan, 1963)

J. Shearman: *Raphael's Cartoons in the Collection of Her Majesty the Queen and the Tapestries for the Sistine Chapel* (London, 1972)

M. Stucky-Schürer: *Die Passionsteppiche von San Marco in Venedig* (Bern, 1972)

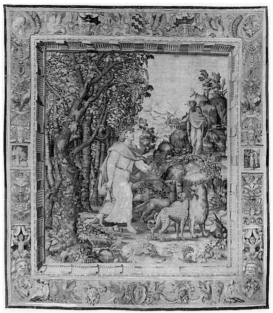

37. Tapestry of the *Meeting of Dante and Virgil*, 5.27×4.70 m, designed by Francesco Salviati and woven in the workshop of Jan Rost, Florence, *c*. 1547–9 (Minneapolis, MN, Minneapolis Institute of Arts)

M. Siniscalco Spinosa: 'Italia', *Gli arazzi*, ed. A. González-Palacios (Milan, 1981), pp. 4–27

M. Viale Ferrero: 'Arazzo e pittura', *Stor. Archv. It.*, iii/4, pp. 117–58

Arazzi del Cinquecento a Como (exh. cat., ed. N. Forti Grazzini; Como Cathedral, 1986)

B. Davidson: 'The *Furti di Giove* Tapestries Designed by Perino del Vaga for Andrea Doria', *A. Bull.*, lxx/3 (1988), pp. 424–50

P. Boccardo: *Andrea Doria e le arti* (Rome and Milan, 1989)

C. Adelson: *The Tapestry Patronage of Cosimo I de' Medici, 1545–1553*, 4 vols (diss., New York U., 1990)

B. Davidson: 'The *Navigatione d'Enea* Tapestries Designed by Perino del Vaga for Andrea Doria', *A. Bull.*, lxxii/1 (1990), pp. 35–50

N. Forti Grazzini: *Il patrimonio artistico del Quirinale: Gli arazzi* (Rome and Milan, 1994), i, pp. 15–168

C. M. Brown and G. Delmarcel: *Tapestries for the Courts of Federico II, Ercole and Ferrante Gonzaga, 1522–63* (Seattle and London, 1996)

Gli arazzi dei Farnese e dei Borbone: Le collezioni dei secoli XVI–XVIII (exh. cat., Colorno, Pal. Ducale, 1998)

CANDACE J. ADELSON

4. EMBROIDERY. The Italian embroidery industry was linked to that of woven silk (*see* §1 above) and, although not as important, enjoyed a comparable international reputation. One of the earliest references to both crafts relates to the Tiraz workshop in Palermo, Sicily, where the magnificent coronation mantle of the Holy Roman Emperors (1133–4; Vienna, Schatzkam.) was made for the Norman king of Sicily, Roger II (*reg* 1130–54). The ground of red figured samite is worked with couched gold thread and some silk. Seed pearls decorate the border and outline the stylized palm tree and lions attacking camels, and the mantle is further decorated with cloisonné enamel plaques and precious stones. The continuing influence of the Near East can be seen in the design of roundels containing birds and animals that decorates the red silk and gold-embroidered chasuble in Anagni Cathedral, near Rome, which was a gift from Pope Boniface VIII (*reg* 1294–1303), while Venetian embroideries, such as the gold-embroidered

antependium (*c.* 1330; London, V&A) designed by Paolo Veneziano (*fl c.* 1310–60s), show a strong Byzantine influence.

The embroiderers worked within close-knit communities of craftsmen in the city states, and in Florence, for example, they formed a section within the silk guild. Embroidered vestments of *opus florentinum, opus venitum* and *opus romanum* are listed in the Vatican inventory of 1295, and another of Boniface VIII's gifts to Anagni Cathedral is an antependium (*in situ*) made in Rome *c.* 1300. Worked with couched gold thread and coloured silks in split stitch, it is embroidered with figures set within two tiers of arcades. Florentine embroiderers used the same techniques, but their works show the influence of such local artists as Bernardo Daddi (*fl c.* 1320–48), to whose workshop are attributed the designs for two mid-14th-century antependia: one depicts the Coronation of the Virgin, scenes from the life of the Virgin and saints in arcades and is signed IACOBO CAMBI, 1336 (Florence, Bargello), and the other is embroidered with a central Crucifixion scene and is signed GERI LAPI RACNAMATORE ME FECIT IN FLORENTIA (?*c.* 1336; Manresa, Catalonia, church of S María). The links between embroidery and painting were emphasized technically by working the couched gold thread of the grounds over cords to form raised foliate patterns echoing those of the panel paintings.

Individual workshops compiled books of designs for use in several media, and artists of the calibre of Andrea del Sarto and Sandro Botticelli provided patterns specifically for embroidery. In 1469 Antonio del Pollaiuolo (*see* POLLAIUOLO, (1)) was commissioned to design the decorative panels depicting scenes from the *Life of St John the Baptist* for a set of vestments (*c.* 1469–80; Florence, Mus. Opera Duomo; see fig. 38) for the Baptistery in Florence. They were worked by 11 embroiderers, including Coppino di Giovanni di Bramante from Mechelen, possibly one of the Flemish embroiderers who introduced the *or nué* technique to Italy; this features extensively in the Baptistery panels, which also illustrate a skilled use of perspective.

With the exception of such rare pieces as the quilted cover (*c.* 1400; London, V&A, and Florence, Bargello) illustrating the *Story of Tristan*, little early secular embroidery survives, although it does appear in records and in paintings from the 15th century onwards. By that time pattern design was emerging as a distinct discipline, the impact of which was increased by the invention of the printing press and the publication, in the 16th century, of a series of embroidery pattern books, such as *Gli universali di tutte e bei dissegni, raccami e moderno lavori* (Venice, 1532) by Zoppino, illustrating all aspects of Late Gothic and Renaissance taste. Examples of the patterns survive mainly as borders on linen furnishings and items of dress; they are worked with monochrome silk in outline stitches or left voided in a ground covered with cross stitch. Alternatively, they were embroidered with white linen thread and elaborated with raised details and openwork. Grounds of linen *lacis* and of linen or silk burato were also used, the latter commonly decorated with all-over patterns in bright floss silks. The use of more complex designs worked in polychrome silks and metal threads is recorded in paintings and archives and survives in such rare pieces as the mid-16th-century cover of fine linen decorated with

38. Embroidered panel with *or nué* and split stitch, *Carrying of St John*, from the *Life of St John the Baptist*, designed by Antonio del Pollaiuolo for the Florence Baptistery vestments, *c.* 1469–80 (Florence, Museo dell'Opera del Duomo)

the *Loves of Jupiter and Neptune*, based on Ovid's *Metamorphoses* (Frankfurt am Main, Mus. Ksthandwk; Vienna, Österreich. Mus. Angewandte Kst).

BIBLIOGRAPHY

E. Ricci: *Ricami italiani* (Florence, 1925)
B. Kurth: 'Florentine Trecento-Stickerein', *Pantheon*, viii (1931), pp. 455–62
G. Morazzoni: *Ricami genovesi* (Milan, 1954)
A. Santangelo: *Tessuti d'arte italiani dal XII al XVIII secolo* (Milan, 1959; Eng. trans., London, 1964)
L. Mortari: *Il tesoro della cattedrale di Anagni* (Rome, 1963)
M. Schuette and S. Müller-Christensen: *Das Stickereiwerk* (Tübingen, 1963; Fr. trans., Paris, 1963; Eng. trans., London, 1964)
R. Grönwoldt: 'Some Groups of Renaissance Orphreys of Venetian Origin', *Burl. Mag.*, cvii (1965), pp. 321–40
D. King: 'A Venetian Embroidered Altar Frontal', *V&A Mus. Bull.*, i/4 (1965), pp. 14–25
D. van Fossen: 'A Fourteenth-century Embroidered Florentine Antependium', *A. Bull.*, l (1968), pp. 141–52
A. Garzelli: *I ricami nella attività artistica di Pollaiuolo, Botticelli, Bartolo di Giovanni* (Florence, 1973)
P. Johnstone: 'Italy', *Needlework: An Illustrated History*, ed. H. Bridgeman and E. Drury (London, 1978), pp. 109–45
E. Parma: *Ricami e maioliche genovesi del seicento a Gerusalemme* (Genoa, 1992)

XII. Patronage.

An exceptionally rich tradition of patronage developed in Italy. Until the rise of art collecting in the Renaissance, patronage broadly determined the history of architecture and the visual arts. Individual patrons, groups and institutions sought to display their worldly power or religious belief by commissioning works of art, the subjects and,

sometimes, style of which they themselves dictated; each era set its stamp on art, and patrons freely commissioned changes to existing buildings. The history of patronage is not only a matter of the quantities of commissions issued by one group or another for this or that kind of art, but also of changes in the nature of relationships within which artists worked, and of attitudes to this.

The rich artistic developments of 15th-century Florence were encouraged above all by merchant families and, although noblemen and clergy continued to play a part as they had done in the medieval, private commissions gradually became pre-eminent. Above all, the MEDICI issued commissions for churches and chapels and encouraged the innovations of Filippo Brunelleschi, Michelozzo di Bartolomeo, Leon Battista Alberti and Donatello. Merchant families displayed their wealth and power in the decoration of chapels, where they had themselves, their children, parents, relatives and name saints depicted. Around 1478 Francesco Sassetti commissioned Domenico Ghirlandaio to decorate a chapel in Santa Trìnita; within the cycle of the *Life of St Francis* (see fig. 13 above) Ghirlandaio included Sassetti, his family and Lorenzo de' Medici, his employer at the Medici bank (see fig. 39). Sassetti's most important business partner, Giovanni Tornabuoni, had the same painter execute an altarpiece and frescoes in the Cappella Maggiore in S Maria Novella.

In the 15th century even the rulers of such small towns as Foligno and Rimini began to enrich their courts with works of art, while a great era of courtly patronage opened in Ferrara, Mantua and Urbino. Rulers commissioned paintings of saints, historical events, personifications of the arts, portraits of famous men and of themselves, their families and courtiers. Their court painters, among whom were Piero della Francesca, Mantegna and Raphael, thus gained social status, as of course did Leonardo da Vinci, Michelangelo and Titian, who were also in demand by a republican and international clientele. Vasari, successful court painter and architect to Cosimo I de' Medici, proudly described in his *Vite* the increasing artistic and social opportunities afforded to his profession, which he linked directly to the patronage of rulers, clergy and merchants.

In the 16th century, as the pontiff became increasingly influential as statesman and military commander in a European context, the papal court became the pre-eminent centre of culture, and Julius II (*see* ROVERE, DELLA, (2)), who is among the most celebrated of Italian patrons, and Leo X (*see* MEDICI, DE', (7)) issued a multitude of commissions for frescoes, portraits (see colour pl. 1, XVIII3), altarpieces, tombs and buildings. Michelangelo decorated the Sistine Chapel, and in the Vatican Stanze Raphael created a series of monumental narrative frescoes, of unprecedented formal and iconographical complexity, which gave visual expression to the history and authority of the Papal State; many lesser patrons were to see the possibilities of this new kind of history painting. In Florence, Cosimo I de' Medici (*reg* 1537–74) initiated a new aristocratic patronage; Giorgio Vasari's decoration of the Palazzo Vecchio (see colour pl. 2, XXXVII3) extolled Medici traditions of patronage; commissions for tapestries, portraits and pictures displayed Cosimo's new princely splendour (for illustration *see* MEDICI, DE', (14)). Venice lacked a court, and the chief patrons were the State, religious communities and churches, and the lay confraternities, or *scuole*; the most magnificent commissions were those for the decoration of the Doge's Palace (see colour pl. 2, XII2).

BIBLIOGRAPHY

G. Vasari: *Vite* (1550, rev. 2/1568); ed. G. Milanesi (1878–85)

F. Haskell: *Patrons and Painters: A Study in the Relations between Italian Art and Society in the Age of the Baroque* (London, 1963)

P. Hirschfeld: *Mäzene: Die Rolle des Auftraggebers in der Kunst* (Munich, 1968)

M. Baxandall: *Painting and Experience in 15th-century Italy* (Oxford, 1974)

P. Burke: *Tradition and Innovation in Renaissance Italy: A Sociological Approach* (London, 1974)

G. F. Little and S. Orgel, eds: *Patronage in the Renaissance* (Princeton, 1981)

Della casa al museo: Capolavori da fondazioni artistiche italiane (exh. cat., Milan, Mus. Poldi-Pezzoli, 1981–2)

E. L. Goldberg: *Patterns in Late Medici Art Patronage* (Princeton, 1983)

C. Riebesell: *Die Sammlung des Kardinal Alessandro Farnese: Ein 'studio' für Künstler und Gelehrte* (Weinheim, 1989)

E. Schiferl: 'Italian Confraternity Art Contracts: Group Consciousness and Corporate Patronage, 1400–1525', *Crossing the Boundaries: Christian Piety and the Arts in Italian Medieval and Renaissance Confraternities*, ed. K. Eisenbichler (Kalamazoo, MI, 1991), pp. 121–40

B. Kempers: *Painting, Power and Patronage: The Rise of the Professional Artist in Renaissance Italy* (London, 1992)

S. de Blaauw: *Cultus et decor: Liturgia e architettura nella Roma tardoantica e medievale*, 2 vols (Rome, 1994)

M. Seidel: 'The Social Status of Patronage and its Impact on Pictorial Language in Fifteenth-century Siena', *Italian Altarpieces, 1250–1550: Function and Design* (Oxford, 1994), pp. 119–38

J. Med. & Ren Stud., xxiv/2 (Spring 1994) [issue dedicated to Renaissance art patronage]

M. Hollingsworth: *Patronage in Renaissance Italy*, 2 vols (London, 1994–6)

Ren. Stud., x/2 (June 1996) [issue dedicated to women patrons of Renaissance art]

B. KEMPERS

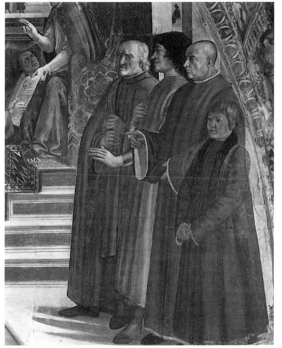

39. Domenico Ghirlandaio: *St Francis, Francesco Sassetti and Lorenzo de' Medici*, detail from a fresco of the *Life of St Francis* cycle (1479–85) in the Sassetti Chapel, Santa Trìnita, Florence

XIII. *Collecting and dealing.*

In ancient Rome, Greek works of art, acquired as spoils from all over the Hellenic world, were displayed in galleries and temples. Collecting in the modern sense began in earnest in Italy in the 14th century, when the necessary conditions developed: the existence of an art market with dealers, the practice of connoisseurship or the ability to distinguish authenticity and quality, and the availability of works of art. As Italy was acknowledged to have produced the greatest artists in the Western world, Italians tended to collect Italian works of art, as did collectors in the rest of Europe. Flemish paintings of the 15th century were the only foreign works regularly to enter Italian collections in the Renaissance. The Este of Ferrara and the Medici of Florence acquired Flemish pictures from their agents in the Netherlands, for by the 15th century the commercialization of artistic production was well under way. Only relatively few pictures were actually commissioned in northern Europe; Netherlandish works of art were sent to Italy in the normal course of international trade.

1. MIDDLE AGES–17TH CENTURY. In the Middle Ages Church and State dominated art patronage and collecting. Commissions from individuals were rare. The earliest collectors' rooms of paintings were in bishops' palaces and church sacristies, for example the treasury of S Marco, Venice, which still has precious Byzantine goldsmith work, reliquaries and icons, mostly acquired as booty during the Crusades. The conquest of Constantinople produced an especially rich hoard. Objects in church treasuries were collected for the costliness of their materials and their religious associations rather than as works of art in their own right. By the 15th century private patronage from individuals became increasingly common, and special objects were commissioned such as the devotional pictures of the *Virgin* or the *quadri da sposi*, for example the nuptial bed commissioned by Pierfrancesco Borgherini (see below), as well as allegorical pictures which resulted from a special relationship between artist and patron. These new classes of objects, as distinct from more monumental painting and sculpture for public places, created the materials for collecting.

The impetus for collecting, according to Burckhardt, developed in Renaissance Italy through the power of private patronage, which brought into being a whole new kind of easily portable object that could be bought and sold, an art that was made not only for secular and ecclesiastical princes but for the enjoyment of middle-class and patrician householders. With portable and saleable art came dealers. Indeed, it was a furniture painting by Pontormo and others on the Borgherini marriage bed that provoked the first international dealer in the history of painting, GIOVANBATTISTA DELLA PALLA, to act unscrupulously to obtain it for Francis I of France, although, as Vasari related in Pontormo's *Vita*, Borgherini's patriotic wife prevented the acquisition. (Of all the works known to have reached Francis I (*reg* 1515–47), only one survives: Niccolò Tribolo's *Nature*; see fig. 40.)

Collecting ancient sculpture, as distinct from contemporary painting, existed in the early 15th century on a significant scale, although we have no detailed knowledge

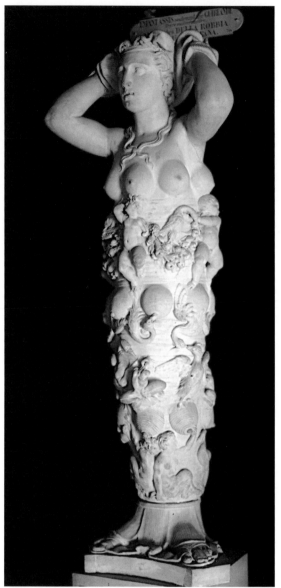

40. Niccolò Tribolo: *Nature*, marble, *c.* 1528 (Paris, Musée du Louvre)

of it, but by the early 16th century there were specialized dealers such as Baldassare del Milanese in Rome, through whom Michelangelo sold his forged *Sleeping Cupid*. Similarly, as Held and Bury have shown, there were also specialist dealers in drawings and prints by that date, especially in the Netherlands. Collecting was accompanied by the beginnings of art history, most notably Vasari's *Vite*, in which he gave the first systematic account of the development of contemporary art, providing in anecdotal and methodical form a reassuring explanation of the importance of Italian art for collectors. His own collection of drawings (see VASARI, (1), fig. 11) stimulated a new fashion in collecting and in turn altered the form and function of drawing itself, for once drawings became collectors' items artists produced finished drawings as works of art in their own right.

By the end of the 16th century dealing in painting had so increased and international collecting had developed on such a large scale that the Grand Duke Ferdinando I de' Medici issued a decree in 1601 forbidding the exportation from Florence of works of art by 18 listed masters. The original list was drawn up by a committee of 12 artists from the Accademia del Disegno. Starting with Michelangelo and Raphael, it went on to Andrea del Sarto, Domenico Beccafumi, Rosso Fiorentino, Leonardo, Franciabiagio, Perino del Vaga, Pontormo, Titian, Francesco Salviati, Bronzino, Daniele da Volterra, Fra Bartolommeo, Sebastiano del Piombo, Filippino Lippi, Correggio and Parmigianino. With the exception of Filippino Lippi, those artists whose works were most sought after were masters of the High Renaissance, which indicates that the collecting of painting in the 16th century involved contemporary artists' works rather than those by Old Masters from the 14th or the 15th century, although Flemish and Netherlandish paintings from the earlier period were sometimes bought.

It was usual to buy pictures from painters' workshops but on occasion they were on sale at church doors and at fairs, such as the one represented by David Vinckboons (1576–1633) in his painting of *Market Stalls* (1608; Brunswick, Herzog Anton-Ulrich Mus.), which shows pictures and other objects for sale in the market place. It is quite possible that even earlier, in the 15th century, the Antwerp fairs were significant markets for the sale of pictures that were often bound for Italy, but without documentary evidence this must remain a speculation. Art exhibitions were reasonably frequent occurrences in Venice, even in the 16th century, for example in the Piazza S Marco on Ascension Day or in the Campo S Rocco on the saint's feast day.

From the same city came the first reasonably systematic account of patrician private collections: the *Notizia d'opere del disegno*, written between 1521 and 1543 by the Venetian patrician MARCANTONIO MICHIEL. The author was a connoisseur of a new kind, who had travelled extensively, and who recorded the most notable works of art in the Veneto in the houses of aristocrats, writers and politicians, such as Pietro Bembo, the Cornaro family and the Grimani. Although Michiel's notes are always said, quite rightly, to demonstrate the wealth of Venetian collections, he was in fact extremely selective in what he chose to describe. In one instance, that of the collection of GABRIELE VENDRAMIN, remembered as the first owner of Giorgione's *The Tempest* (see colour pl. 000), several later inventories record the richly varied content of his collection and reveal how much richer the collection was than Michiel's notes would suggest.

The earliest protective legislation against the export of works of art occurred in Renaissance Rome, where the pontifical government recognized the spiritual and political values of their artistic patrimony. From the 15th century there were ever-increasing signs of a growing preoccupation with the conservation and protection of ancient, medieval and modern works in a city that was continually developing. This can be traced, for instance, in Petrarch's letters concerning the preservation of Rome, in the Bull against the demolition of ancient buildings promulgated by Pius II (1462), in the Bull against the removal of works of art from churches by Sixtus IV (1474), as well as from the brief that Leo X assigned Raphael (1516). Later decrees made by Paul III (1534), Pius IV (1562) and Gregory XIII (1574) reveal a preoccupation with how to prevent national treasures from being appropriated. These attempts to safeguard the heritage of Rome preceded the firm legislation of 1624, when Cardinal Pietro Aldobrandini made it an offence to export works of art from the Pontifical States without a licence, and the even more rigorous edict of Cardinal Sforza in 1646, which made it clear that disciplinary measures would be taken against anyone who attempted to plunder or steal any beautiful work of art from Rome.

BIBLIOGRAPHY

M. Michiel: *Notizia d'opere di disegno nella prima metà del secolo XVI, esistenti in Padova, Cremona, Milano, Pavia, Bergamo, Crema e Venezia* (MS., 1521–43); ed. J. Morelli (Bassano, 1800, rev. Bologna, 1884)

C. A. Levi: *Le collezioni veneziane d'arte e d'antichità dal secolo XIV ai nostri giorni* (Venice, 1800)

J. Burckhardt: 'Die Sammler', *Beitr. Kstgesch.* (Basle, 1898), pp. 297–510

R. Lanciani: *Storia degli scavi di Roma e notizie intorno le collezioni romane di antichità* (Rome, 1902)

E. Jacobs: 'Das Museo Vendramin und die Sammlung Reynst', *Repert. Kstwiss.*, xlvi (1925), pp. 15–39

F. Lugt: 'Italiaansche kunstwerken in Nederlandsche verzamelingen van vroeger tijden', *Oud Holland*, liii (1936), pp. 97–135

J. Held: 'The Early Appreciation of Drawing', *Latin American Art and the Baroque Period in Europe: Studies in Western Art III: Acts of the 20th International Congress of Art: The History of Art: New York, 1961*, pp. 79ff

K. Garas: 'Giorgione et giorgionisme au XVIIe siècle', *Bull. Mus. Hong. B.-A.*, xxv (1964), pp. 51–80

S. Savini-Branca: *Il collezionismo veneziano del '600* (Padua, 1965)

L. Berti: *Il principe dello studiolo* (Florence, 1967)

J. Fleming: 'Art Dealing in the Risorgimento', *Burl. Mag.*, cxv (1973), pp. 4–16; cxxi (1979), pp. 492–508, 568–80

A. Emiliani: *Una politica dei beni culturali* (Turin, 1974)

L. Campbell: 'The Art Market in the Southern Netherlands in the Fifteenth Century', *Burl. Mag.*, cxviii (1976), pp. 188–98

A. Emiliani: *Leggi, bandi e provvedimenti per la tutela dei beni artistici e culturali negli antichi stati italiani, 1571–1860* (Bologna, 1978)

J. Anderson: 'A Further Inventory of Gabriel Vendramin's Collection', *Burl. Mag.*, cxxi (1979), pp. 639–48

P. Barocchi: 'Storiografia e collezionismo dal Vasari al Lanzi', *Storia dell'arte italiana*, ii (Turin, 1979), pp. 28–35

F. Haskell: 'La dispersione e la conservazione del patrimonio artistico', *Storia dell'arte italiana*, x (Turin, 1981), pp. 5–35

F. Haskell and N. Penny: *Taste and the Antique* (New Haven and New York, 1981)

J. Alsop: *The Rare Art Traditions: The History of Art Collecting and its Linked Phenomena wherever these Have Appeared* (London, 1982)

M. Bury: 'The Taste for Prints in Italy to *c.* 1600', *Prt Q.*, ii (1985), pp. 12–26

J. Anderson: 'Il collezionismo e la pittura del cinquecento', *La pittura in Italia: Il cinquecento*, ed. G. Briganti (Milan, 1987, rev. 1988), i, pp. 559–68

J. Anderson: 'Collezioni e collezionisti della pittura veneziana del quattrocento: Storia, sfortuna e fortuna', *La pittura veneta del quattrocento*, ed. M. Lucco (Milan, 1989)

K. Pomian: *Collezionisti, amatori e curiosi: Parigi–Venezia, XVI–XVIII secolo* (Milan, 1989)

J. Hist. Coll. (1989–)

JAYNIE ANDERSON

XIV. Museums.

1. Renaissance collections. 2. The Renaissance gallery.

1. RENAISSANCE COLLECTIONS. In the Middle Ages the Church fulfilled the role of public art museum. Church treasuries, secure and apart, displayed to the faithful devotional objects: reliquaries, liturgical vessels, crosses

and missals. Those of Monza Cathedral and of S Marco in Venice have survived almost intact. The STUDIOLO, a small chamber, secluded and secretive, resembling part monastic cell, part treasury, devoted to study and to the placement of rare objects, developed from these displays. This development took place primarily in Italy at the end of the 14th century, and by the mid-15th many Renaissance courts had *studioli*, often decorated with intarsia panels (recommended by Alberti) or with series of famous men or Roman emperors. The objects included natural curiosities, objects from archaeological excavations, small pictures, miniatures and finished drawings. A 1492 inventory of the Medici palace reveals the peculiar character of the objects in the *studiolo* of Lorenzo the Magnificent; it included ancient vessels of pietre dure, gold liturgical objects, small mosaics, engraved stones, statuettes, coins and medals. There were only a few paintings: small panels attributed to Jan van Eyck (*c.* 1395–1441), Giotto and Andrea Mantegna.

Isabella d'Este (*see* ESTE, (6)), a ruthless collector of rare things, created a new kind of display in the Appartamento della Grotta in the Corte Vecchia of the Palazzo Ducale at Mantua (1522), which united picture gallery and cabinet. Here, through an enclosed garden with Classical statues, one entered the grotto, with intarsia-decorated cabinets, vases and small antique sculptures; beyond the grotto lay the *studiolo*, with a splendid series of paintings by Mantegna, Lorenzo Costa and Perugino.

HUMANISM encouraged the collection of ancient art and Rome was the centre of such collections. Maarten van Heemskerck (1498–1574) filled a sketchbook with drawings of displays of statues in Roman courtyards and gardens (1532–6; Berlin, Kupferstichkab.; see fig. 41; *see also* ROME, figs 4 and 16). The arrangement of the display was sometimes casual, the statues picturesquely exhibited in a fragmentary state; or they might be restored and arranged decoratively, as in the courtyard of the Palazzo della Valle (*see* ROME, fig. 2), belonging to Cardinal Andrea della Valle (1463–1534), where the display, designed by the sculptor Lorenzo Lotti, was admired by Giorgio Vasari. In Florence, too, the larger antique statues were placed in the garden or courtyard of the Medici palace and in a Medici garden at Piazza S Marco (*see* FLORENCE, §V, 2).

Under Julius II the most important Classical statues in Rome were brought to the Vatican. Here, to display them, Donato Bramante designed a statue court, the Cortile del Belvedere (*c.* 1508; *see* ROME, fig. 8), fragrant with orange trees and the play of fountains, adjoining the Villa Belvedere of Innocent VIII. The statues were displayed in decorated niches and antique masks set into the walls. The *Laokoon* was brought there immediately after its discovery in 1506; in 1509 there followed the *Apollo Belvedere* (both *in situ*) and in 1512 the *Cleopatra* (also known as the *Sleeping Ariadne*; Rome, Mus. Pio-Clementino). These great works of art became the property of the pope, partly as a symbol of prestige but also to guarantee their preservation and accessibility. Venetian collectors displayed a similar pride in preserving their heritage, and in 1523 Cardinal Domenico Grimani left his collection of antiquities to the city. These were later displayed, with his nephew Giovanni Grimani's 200 antique marble works, in Sansovino's Libreria Marciana and the Statuario Pubblico was established in 1596 as the first public archaeological museum. The collection constituted the nucleus of the present Museo Archeologico.

In the late 16th century museums and cabinets aimed at universality. Encyclopedic collections attempted to satisfy man's interest in his place in the universe; they included both *naturalia* (metals, minerals etc) and *artificialia* (works of art ingeniously wrought from such natural objects). The arrangement of princely and aristocratic scientific collections tended to follow an abstract and schematic scheme; in Francesco de' Medici's *studiolo* (1570–71; Florence, Pal. Vecchio) objects were stored in cupboards decorated by paintings that symbolized their qualities. The collections of private individuals were often linked to scholarly interests; for example, those of Ulisse Aldrovandi (1522–1605) in Bologna, Ferrante Imperato (1550–1625) in Naples and Francesco Calzolari (1522–1609) in Verona aided their scientific research into the natural world; Aldrovandi used artists to illustrate his collection and in turn his collection was studied by artists. Such museums also included material intended to supply visual information about history and geography.

The collection of PAOLO GIOVIO in Como (described in his *Musaei Joviani descriptio* (1546)) was the most famous of many collections of portraits of famous men (parts survive; Como, Civ. Mus. Archeol.). His museum was copied by Cristofano dell'Altissimo (*d* 1605) for Cosimo I de' Medici between 1552 and 1556, and this collection remains intact (Florence, Uffizi). The portraits were displayed in the Sala del Mappamondo (completed 1583) in the Palazzo Vecchio, where the cabinets of walnut were decorated with maps painted by Ignazio Danti and Stefano Buonsignori (1565–81).

2. THE RENAISSANCE GALLERY. Towards the end of the 16th century buildings began to be erected for the display of collections of Classical sculpture; sometimes these were centrally planned, but more frequently they were long galleries. In Florence Francesco I de' Medici commissioned Bernardo Buontalenti to transform the

41. Maarten van Heemskerck: *Display of Roman Sculpture in the Loggia of the Villa Madama, Rome*, pen and brown ink, 179×214 mm, *c.* 1535 (Berlin, Kupferstichkabinett)

second floor of Vasari's Uffizi Palace, built as an administrative centre (*uffizi*: 'offices'), into an art gallery with large windows for lighting. The Uffizi (*see* FLORENCE, fig. 3) could be visited and constituted the first purpose-built art gallery. Under Ferdinando I the ancient statues were arranged along the corridor leading across the Ponte Vecchio to the Palazzo Pitti: one of the first instances of the protection of major works under cover, distinguishing them from less valuable sculpture destined for gardens or façades.

The Uffizi retained the universality of 16th-century collections. It incorporated goldsmiths' and engravers' workshops, a room displaying scientific instruments and an armoury that included antique and modern weapons and miscellaneous exotic and curious objects. The *artificialia* most highly valued for their materials or their art were collected in Buontalenti's tribune (designed *c.* 1580), an octagonal room lit from above and glowing with mother-of-pearl, scarlet lacquer and *pietra serena*. The inventory of 1589 describes a cabinet at the centre, inlaid with pietre dure and containing small precious objects. The greater part of the collection was displayed on shelves running along the walls, alternating antique sculptures and modern bronzes with items of virtuoso craftsmanship and small paintings (some originals, others small copies of famous works on copper). Above hung a series of the most famous High Renaissance pictures. The tribune became celebrated throughout Europe and established a pattern for much later museum design.

Galleries, decorated with iconographically elaborate fresco cycles and intended to display antique sculptures, were built throughout Italy. In the Palazzo Ducale at Mantua, the Galleria della Mostra (finished 1612), designed by Antonio Maria Viani (*fl* 1582), also displayed paintings, set in a regular sequence of rectangular spaces in decorated walls, and cupboards full of objects in precious materials. At Sabbioneta, Vespasiano Gonzaga built a statue gallery (1583–90) almost 91 m long. Federico Zuccaro designed a gallery for Charles-Emanuel I of Savoy in Turin (1606–7; destr.). The most splendid sculpture galleries, however, were built in Rome, at the Villa Medici (*c.* 1580), the Palazzo Sacchetti, the Palazzo Rucellai and the Palazzo Farnese.

BIBLIOGRAPHY
PERIODS AND STYLES OF COLLECTING
Enc. A. Ant.: 'Collezioni archeologiche'
W. Liebenwein: *Studiolo* (Berlin, 1977)
W. Prinz: *Die Entstehung der Galerie in Frankreich und Italien* (Berlin, 1977)
F. Haskell and N. Penny: *Taste and the Antique: The Lure of Classical Sculpture, 1500–1900* (New Haven and London, 1981)
P. Barocchi and G. Ragionieri, eds: *Gli Uffizi quattro secoli di una galleria: Atti del convegno: Firenze, 1982* (Florence, 1983)
A. Lugli: *Naturalia et mirabilia* (Milan, 1983)
C. Franzoni: 'Rimembranze d'infinite cose: Le collezioni rinascimentali di antichità', *Memoria dell'antico nell'arte italiana*, i (Turin, 1984), pp. 301–60
O. Impey and A. Macgregor, eds: *The Origin of Museums* (Oxford, 1985)

INDIVIDUAL COLLECTIONS
L. Lanzi: 'La Real Galleria di Firenze accresciuta e riordinata', *Nuovo G. Lett. Italia*, xlvii (1782/*R* Florence, 1982)
A. Venturi: *La R. Galleria Estense di Modena* (Modena, 1882)
C. A. Levi: *Le collezioni veneziane d'arte e d'antichità dal secolo XVI ai nostri giorni* (Venice, 1900)
F. Malaguzzi Valeri: *Catalogo della Pinacoteca di Brera* (Milan, 1908)
A. de Rinaldis: *Museo Nazionale di Napoli: Guida*, i–ii (Naples, 1911)

S. Moschini Marconi: *Gallerie dell'Accademia di Venezia*, i–iii (Rome, 1955–70)
A. Emiliani, ed.: *La Pinacoteca Nazionale di Bologna* (Bologna, 1967)
A. Falchetti, ed.: *La Pinacoteca Ambrosiana* (Vicenza, 1969)
Palazzo Vecchio: Committenza e collezionismo medicei (exh. cat., Florence, Pal. Vecchio, 1980)
C. Pietrangeli: *I Musei Vaticani: Cinque secoli di storia* (Rome, 1985)
Omaggio a Donatello, 1386–1986: Donatello e la storia del museo (exh. cat., Florence, Bargello, 1985–6)
R. Grandi, ed.: *Il Museo civico d'arte industriale Davia Bargellini* (Bologna, 1987)
'Una città e il suo museo', *Boll. Mus. Civ. Ven.*, xxx/1–4 (1988)
La prima dona del mondo: Isabella d'Este (exh. cat. by S. Ferino-Pagden, Vienna, Ksthist. Mus., 1994)
S. Cassani, ed.: *La collezione Farnese*, 2 vols (Naples, 1995)

SIGNIFICANT ISSUES AND FIGURES
F. Haskell: *Rediscoveries in Art* (New York, 1967)
L'Umbria: Manuali per il territorio, 2 vols (Rome, 1977–8)
K. Pomian: *Collectionneurs, amateurs et curieux, Paris, Venise: XVIe–XVIIIe siècle* (Paris, 1987; It. trans., Milan, 1989)
ALESSANDRO CONTI

XV. Art education.

1. Apprenticeships. 2. Academies. 3. Education of women artists.

1. APPRENTICESHIPS. The identity of the artist in medieval times was ambiguous, and expertise in any of the visual arts was accepted as a qualification to design and supervise the erection of important buildings, as was the case with Giotto; the trades of sculptor, mason and architect were not rigidly distinguished from each other either. Training at first was from father to son, or from an older member of a family to a younger one, in circumstances of some secrecy, which is one of the reasons why so few technical drawings have survived from this period. Formal apprenticeships emerged in the 13th century in the context of the craft guild system.

Workshop or bound apprenticeship also became a fully regulated system for lay artists. Dictated by the commercial guilds, it was promoted indiscriminately among all would-be craftsmen. The pupil, usually aged 13, was taken into the house of a recognized master for a training period lasting three to seven years. Paid a small annuity, the apprentice would, in Cennino Cennini's words: 'agree to stay with him, with love of obedience, submitting to serve him in order to attain perfection in the art'. Grinding and mixing colours, in addition to preparing panel and wall surfaces, for example, formed the basic foundation of the apprentice's training. These mechanical labours were followed by drawing exercises, which included making copies of the master's study sheets and then of his paintings. The young Michelangelo, for example, who was active when a new concept of art education was beginning to emerge, copied Giotto's images at Santa Croce, Florence. Also, as a young man, Giorgio Vasari (*see* VASARI, (1)), one of the founders of a new system of artistic education in the late 16th century, copied the works of established painters in Urbino.

In late 16th-century Florence the apprentice was encouraged to continue his study in Rome. As a journeyman, he could become his master's assistant, and after three or four years he was allowed to submit a test piece to be evaluated, not only by his master, but also by the guild representatives. He would then be able to work as a master craftsman and to acquire a permit to establish his own

workshop. Apprenticeship remained such a popular system of artistic instruction in Italy that it continued to flourish even after the introduction of art academies.

During the Renaissance, the nature of an architect's education depended substantially on his class origins. The sons of gentlemen studied literature and science; those who made the transition to architecture from the building trades had very little general education. Vasari nowhere referred to schools of architecture where formal training was given. Where he mentioned such matters in his biographies of architects, he generally said that his subject was articled to a practising architect. As in the Middle Ages, architecture was often practised in conjunction with another profession, and both Filippo Brunelleschi and Baldassare Peruzzi learnt the first elements of design in a goldsmith's workshop. A frequent component of the architect's training was the study of the Antique, generally by way of measuring the remains of ancient Roman buildings and their details, a taste for which was often evinced by practitioners of other trades such as sculpture or joinery. For the first Renaissance students the very fabric of the ruins was a school of architecture, to be examined for hints as to how bricks were laid and stone blocks cramped together.

2. ACADEMIES. There were few successsful attempts in the late 15th century to develop a new concept of artistic instruction that promoted knowledge more than skill. Those that did succeed took the form of private teaching establishments, which were not subject to guild regulations and in which promising artists were no longer considered mere artisans. One of the first, in the late 1480s, was the academy that Lorenzo the Magnificent instituted in his garden at the Piazza S Marco (see FLORENCE, §V, 2). The collection of antique and modern statuary that the garden had housed was reorganized to form a centre of practice for such promising young sculptors as Michelangelo. Such an establishment was new in Florence but not entirely unknown elsewhere in Italy. Basing artistic training on the study of ancient as well as contemporary reliefs, drawings and icons had been the guiding principle of the innovative *studium* that FRANCESCO SQUARCIONE had established in Padua in the 1440s. However, the Medicean centre differed from its Paduan precursor in that it did not advocate the traditional method of education through tutelage. Unlike Squarcione, BERTOLDO DI GIOVANNI, who supervised Lorenzo's collection of art works, does not seem to have acted as master–teacher to the apprentice–pupils.

Leonardo da Vinci is said to have founded an academy at the castle of Ludovico Sforza in Milan during the 1490s, but its existence has not been proved. It was known as an intellectual circle rather than an institution where art was taught, and this Accademia Leonardi Vinci may have taken the form of debates, which Leonardo either initiated or attended. It may have produced, at least in part, the treatise on painting that Leonardo prepared from 1489 to 1518, which had a far-reaching impact on the development of an academic art education.

Besides the Medicean garden, the only documented private establishments for artistic training to embody new ideas were those of BACCIO BANDINELLI in Rome and Florence during the 1530s and 1540s respectively. The first, referred to as the Accademia di Bacchio Brandin, operated in the Cortile del Belvedere at the Vatican under the patronage of Pope Clement VII. In an engraving by Agostino dei Musi from 1531, it is shown as a centre where both experienced and inexperienced artists examined, copied and perhaps discussed statuettes of male and female nudes. Thus the emphasis of the academy appears to have been on learning through theoretical study as well as imitation. In engravings by ENEA VICO *c.* 20 years after Musi's, Bandinelli's second studio, called the Accademia, is shown to have grown in size and changed somewhat in essence. Bandinelli's Florentine school included not only various statuettes but also different sections of human skeletons, which would have been used for anatomy demonstrations. In addition, it appears to have encouraged aspiring artists—whom Vico shows divided into diverse groups and immersed in diverse activities rather than in copying one given cast—to draw from their imagination (see fig. 42).

One of the principal purposes of the Accademia del Disegno, founded in Florence as the Accademia e Compagnia del Disegno in 1563, was to create an official institution for the teaching of painting, sculpture and architecture (*see also* FLORENCE, §V, 1). In this sense, the Accademia e Compagnia del Disegno was to resemble the Accademia Fiorentina (founded 1542), which had also been founded under the patronage of Cosimo I de' Medici to promote the study of the arts and letters. Cosimo demonstrated his regard for the Accademia del Disegno as a worthwhile institution for artistic training by sending his son Giovanni de' Medici to study there. He later became a painter and architect. The academy formulated an educational programme, which was only partially implemented. Three senior members were to be elected annually by its officers to serve as teachers, either at the academy meeting place or in their own workshops. The other members were obliged, under financial penalty, to help promising artists. For teaching, the academy built up a studio collection of artworks: preparatory drawings, cartoons, sculptural models and architectural designs, in addition to examples of ancient sculpture. Anatomy classes, conducted at the hospital of S Maria Nuova, were also required. The programme also promoted the use of lectures in mathematics and perspective, to be presented at the academy meeting-place. The academy's programme did not replace workshop practice, however, and attempts in the late 16th century to introduce life-drawing classes and various courses on theory failed: the academy remained a fundamentally administrative organization. Nevertheless, it produced an academic curriculum that helped to change the concepts and some of the methods of traditional artistic practice.

Even more than the Accademia del Disegno in Florence, the Accademia di S Luca in Rome, founded on 14 November 1593 under the patronage of Pope Sixtus V, regarded the promotion of art education as its primary concern (*see* ROME, §VI). The programme included tuition for aspiring artists and theoretical study for all members. Formal classes were given in architecture in the same way as they were in painting and sculpture. Twelve visiting teachers were appointed annually, each to be on duty for

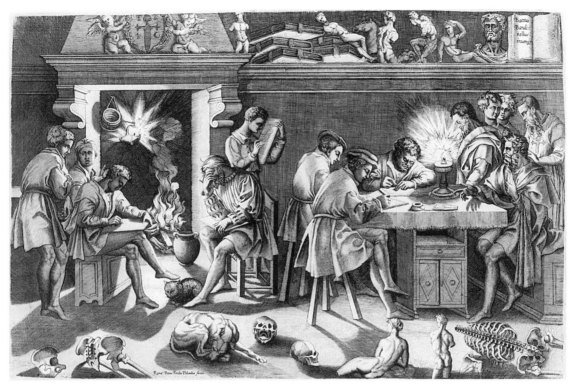

42. Enea Vico: *Baccio Bandinelli's Academy, Florence*, engraving, 306×525 mm, *c.* 1551 (London, British Museum)

one month and train beginners to draw from life and from art works. Daily lectures on such topics as the nature of *disegno*, the pre-eminence of painting, composition and motion were also scheduled.

3. EDUCATION OF WOMEN ARTISTS. The few women artists known to have been active during the late Middle Ages (e.g. the miniaturists Allegra and Donella) had learnt their art in convents, where the education of daughters of wealthy families often included copying and decorating manuscripts. Most, if not all, of those who succeeded as artists throughout the early Renaissance had been trained in a similar fashion, for example Maria Ormani and Francesca da Firenze, who were both nuns. In the late Renaissance, female artists were either daughters of male artists, such as Lavinia Fontana (*see* FONTANA (ii), (2)), who was able to learn the rudiments of her art at home, or members of noble families such as Sofonisba Anguissola (*see* ANGUISSOLA, (1)), who gained what was then an exceptional education for a woman. Aspiring female artists had no recourse to the kind of artistic instruction available to their male counterparts. In the late 14th century, the Painters' Guild in Perugia ignored their existence altogether, as did the University of Painters in Rome 100 years later.

BIBLIOGRAPHY

C. Cennini: *Il libro dell'arte* (MS.; *c.* 1390); trans. and notes by D. V. Thomson jr (1933)
N. Pevsner: *Academies of Art Past and Present* (London, 1940, rev. New York, 1973)
D. Mahon: 'Art Theory in the Newly-founded Accademia di San Luca, with Special Reference to "Academic" Criticism of Caravaggio', *Studies in Seicento Art and Theory* (London, 1947/*R* Westport, CT, 1971), pp. 155–91
S. Macdonald: *The History and Philosophy of Art Education* (London, 1970), pp. 21–5
M. A. Jack: 'The Accademia del Disegno in Late Renaissance Florence', *16th C. J.*, vii/2 (1976), pp. 3–20
T. Maldonado: 'Arte, educazione, scienza: Verso una nuova creatività progettivale', *Casabella*, xlii (1978), pp. 10–16
C. Dempsey: 'Some Observations on the Education of Artists in Florence and Bologna during the Later Sixteenth Century', *A. Bull.*, lxii (1980), pp. 552–69
M. Wackernagel: *The World of the Florentine Renaissance Artist* (Princeton, 1981), pp. 328–37
B. Cole: *The Renaissance Artist at Work* (New York, 1983), pp. 30–34
A. M. Fundaro and others: 'La didattica', *L'Architettura*, xxix (1983), pp. 901–15
A. Hughes: '"An Academy for Doing", 1: The Accademia del Disegno, the Guilds and the Principate in Sixteenth-century Florence', *Oxford A. J.*, ix/1 (1986), pp. 3–10
W. Chadwick: *Women, Art and Society* (New York, 1990)
YAEL EVEN

XVI. Historiography.

In Italy literature on art that combines a notion of history with a sense for the artist's individuality emerged during the Renaissance. The humanist view that history is made up of the stories of individuals led to the revival of the Classical tradition of famous men (*viri illustres*). Dante's, Petrarch's and Boccaccio's praise of Giotto and Simone Martini (*c.* 1284–1344) introduced the concept of artistic fame, which prepared the ground for the genre of the artist's biography.

The first in a long line of writers of artists' lives was Filippo Villani (*c.* 1325–*c.* 1405). The chronicle of his native Florence (1381–8) included biographies of such

painters as Cimabue (*fl* 1272), Giotto and Taddeo Gaddi (*fl* mid-1320s. In the writings of the Florentine sculptor LORENZO GHIBERTI, art was for the first time treated in the context of historical development. Ghiberti focused on questions of style and quality, with only a distant interest in anecdotal reports on artists' lives. In his three *Commentarii* (*c.* 1447–55), he discussed art from antiquity to his own time, including in Book 2 the first autobiographical account of an artist.

In the course of the 15th century Villani's inclusion of accounts on artists in conventional history was widely imitated. CRISTOFORO LANDINO, best known for his translation of Pliny, added a survey of artists and a list of Florentine cultural milestones to his commentaries on Dante (Florence, 1481) and Horace (Florence, 1482). Catalogues of artists were often appended to municipal or national histories, such as *De laudibus patavii* (*c.* 1440) by Michele Savonarola (*c.* 1385–1464), *Speculum lapidum* (Venice, 1502) by Camillo Leonardi (*fl* late 15th century to early 16th) and *De illustratione urbis Florentiae* (1512) by Ugolino Verino (1438–1516). Bartolomeo Facio's *De viris illustribus*, written in 1456 at the court of Alfonso I of Naples, was the first Italian book to include information on artists outside Italy (*see* FACIO, BARTOLOMEO), commending the work of the Netherlandish painters Jan van Eyck (*c.* 1395–1441) and Rogier van der Weyden (*c.* 1399–1464). Similarly, Giovanni Santi's *La vita e le geste di Federico di Montefeltro duca d'Urbino*, written between 1484 and 1487, included a section on painting (*Disputa della pictura*) with comments on contemporary Italian as well as northern artists. The first work devoted to a single artist, the *Vita di Filippo Brunelleschi* (Florence, ?1480s), has been attributed to Antonio Manetti (1423–97). The influential writings of the humanist and architect Leon Battista Alberti, as well as the notebooks of Leonardo da Vinci, mark the peak of a tendency in 15th-century Italy to focus on art theoretical issues and matters linked to the natural sciences at the expense of historical thinking, which was taken for granted.

By far the most important figure for the historiography of the 16th century, and in some respects the founder of art history, was Giorgio Vasari, but his work was to some extent foreshadowed by that of Antonio Billi (*fl* 1500–30), the Anonimo Magliabechiano (*fl c.* 1537–57) and Giovanni Battista Gelli (1498–1563). Billi's *Libro* (1516–35), a collection of notes on artists, became Vasari's most important source for the early period. The author known as the Anonimo Magliabechiano drafted a concise history of painting, similar to Vasari's first edition of the *Vite*, but he abandoned the project when the latter appeared in 1550. The same happened to a similar project of Venetian origin, the so-called *Anonimo Morelliano*, written by MARCANTONIO MICHIEL, which also remained unfinished as a result of the publication of Vasari's *Vite*. In an incomplete manuscript, Giovanni Battista Gelli left 20 short biographies of artists, typically Florentine in their point of view. A summary was published in the introduction to his two lectures on Petrarch's sonnets in praise of

Simone Martini (Florence, 1549). Closer to Vasari was the historical approach of PAOLO GIOVIO, who sought to accompany the portrait gallery in his villa at Lake Como with a text on the lives of famous men that would have included artists, but which remained incomplete.

All these writings, however, are overshadowed by the achievement of the learned artist Giorgio Vasari (*see* VASARI, (1)), whose *Vite*, dedicated to Cosimo I de' Medici, were published in two editions (1550, 1568) and long remained the canonical model for later writers. Carefully making use of earlier texts, Vasari gave the genre of artists' biographies a new overall structure by organizing the lives from Cimabue to Michelangelo according to the Classical model of the three stages of human life. This division of the work into infancy, youth and maturity expressed his identification of the progress of art with a development in the imitation of nature. In the 1550 edition he continued the tradition of including biographies only of deceased artists, with the exception of Michelangelo, who for him represented the summit of perfection. The edition of 1568 introduced engraved portraits of artists and, more importantly, an additional fourth section in which Vasari described his own time. His writing was influenced by Florentine patriotism, which so stirred his imagination that truth sometimes suffered. His attempt to link the events of an artist's life with his work resulted in biographies rich in colourful anecdotes.

There is no author of artists' lives immediately following Vasari, with the exception of Raffaele Borghini (*c.* 1537–1588), whose third and fourth books of *Il riposo* ... (Florence, 1584) included lives of artists that are valuable for the later period not covered by Vasari. The rising status of the artist inspired individual biographies, among them Ascanio Condivi's life of Michelangelo (Rome, 1553) and autobiographies by Benvenuto Cellini, Baccio Bandinelli, Raffaello da Montelupo and Giovanni Paolo Lomazzo. Another form of art literature gained importance during the 16th century: the guidebook, linking topography with historiography. Noteworthy are Francesco Sansovino's *Venetia città nobilissima et singolare descritta* (Venice, 1581; *see* SANSOVINO, (2)) and Francesco Bocchi's guide to the *Bellezze di Firenze* (Florence, 1591).

BIBLIOGRAPHY

E. Panofsky: *Idea: Ein Beitrag zur Begriffsgeschichte der älteren Kunsttheorie* (Leipzig, 1924); Eng. trans. as *Idea: A Concept in Art Theory* (New York, 1968)

J. von Schlosser: *Die Kunstliteratur* (Vienna, 1924); updated Fr. trans. as *La Littérature artistique*, ed. P. di Paolo Stathopoulos (Paris, 1984)

——: 'Über die ältere Kunsthistoriographie der Italiener', *Mitt. Österreich. Inst. Geschforsch.*, xliii (1929), pp. 46–76

A. Blunt: *Artistic Theory in Italy, 1450–1600* (London, 1935)

L. Venturi: *Storia della critica d'arte* (Florence, 1948)

E. H. Gombrich: 'Kunstliteratur', *Atlantisbuch der Kunst: Eine Enzyklopädie der bildenden Künste* (Zurich, 1952), pp. 665–79; Eng. trans. as 'The Literature on Art', repr. in *A. Doc.*, xi/1 (1992), pp. 3–8

E. Gilmore Holt, ed.: *A Documentary History of Art*, 2 vols (Princeton, 1958)

L. Grassi: *Teorici e storia della critica d'arte*, 3 vols (Rome, 1970–79)

G. Bazin: *Histoire de l'histoire de l'art de Vasari à nos jours* (Paris, 1986)

U. Kultermann: *Geschichte der Kunstgeschichte: Der Weg einer Wissenschaft* (Munich, 1990)

STELLA VON BOCH

J K

Jacobello d'Antonio [Jacopo di Antonello; ?Pino da Messina] (*b* ?Messina, ?*c.* 1456; *d* ?*c.* 1488 or after 1508). Italian painter, son of ANTONELLO DA MESSINA. He is first documented in his father's will of February 1479, in which he is named as the chief beneficiary. Documents between then and 1482 indicate that he assumed responsibility for the workshop and for completing work left unfinished by his father; in early 1480 he took his cousin Antonio de Saliba into the *bottega* as an apprentice. The documentary silence after the early 1480s has led to the suggestions that he may have 'emigrated' to Venice, which he probably first visited with his father in 1475–6, or, more likely, that he died young, before 1490.

A *Virgin and Child* (1480; Bergamo, Gal. Accad. Carrara) is Jacobello's only surviving signed and dated work; its *cartellino* bears a tribute to his deceased father. The painting may originally have been commissioned from Antonello, although the execution is entirely by Jacobello (Previtali). The poses are derived from his father's work: the Virgin from the *St Gregory* altarpiece (1473; Messina, Mus. Reg.) and the Child from the S Cassiano Altarpiece (1475; fragments, Vienna, Ksthist. Mus.; *see* ANTONELLO DA MESSINA, fig. 2). Analogies can also be drawn with the slight harshness and calligraphic touch of the Benson–Mackay *Virgin and Child* (Washington, DC, N.G.A.), considered a father–son collaboration, but both works are poorly preserved. Jacobello's collaboration in several of Antonello's other late works, including his *Pietà* (Madrid, Prado), has also been proposed: this would explain not only the enamel-like surface (unlike the more delicate finish of his father's work) but also the slightly obvious appeal to religious emotionalism (which his father tended to handle with greater subtlety).

The attribution of an imposing *Virgin and Child* (Syracuse, Archbishop's Pal.), with its strong reminiscences of Antonello's S Cassiano Altarpiece in composition and spatial organization, has received some support. However, its indebtedness to the more rigorous stylistic characteristics of the turn of the century creates problems if the case for Jacobello's early demise is sustained.

BIBLIOGRAPHY
G. di Marzo: *Di Antonello e dei suoi congiunti* (Palermo, 1903/*R* 1983), pp. 23–85 and documents [app.]
Antonello e la pittura del '400 in Sicilia (exh. cat., ed. G. Vigni and G. Caradente; Messina, Pal. Comm., 1953), pp. 79–80
S. Bottari: *La pittura del '400 in Sicilia* (Messina and Florence, 1954), pp. 58–62, 87–8
M. G. Paolini: 'Antonello e la sua scuola', *Stor. Sicilia*, v (1979), pp. 50–51
G. Previtali: 'Da Antonello da Messina a Jacopo di Antonello, 2: Il Cristo deposto del Museo del Prado', *Prospettiva*, xxi (1981), pp. 45–57
Antonello da Messina (exh. cat., ed. A. Marabottini and F. Sricchia Santoro; Messina, Mus. Reg., 1981), pp. 212–16
F. Sricchia Santoro: *Antonello e l'Europa* (Milan, 1986), pp. 137–42

JOANNE WRIGHT

Jacobello del Fiore (*fl* Venice, 1400; *d* 1439). Italian painter. Together with Niccolò di Pietro and Zanino di Pietro, he was one of the most important Venetian painters of the first third of the 15th century. His work marks the transition from a local, retardataire style based on the example of Paolo Veneziano and his school to a fully developed Late Gothic style of remarkable decorative complexity. However, to a greater degree than his two contemporaries, Jacobello's work remained tied to Venetian precedent, and it has been undervalued. He was the most refined Venetian painter of his generation and a narrator of exceptional skill who influenced such artists as Michele Giambono and, to a lesser degree, Antonio Vivarini.

1. EARLY LIFE AND WORKS. Jacobello was active as a painter in Venice as early as 1400, but his earliest documented works were all destined for places on the Adriatic coast. In 1401 he was in Pesaro, where he painted an altarpiece for the church of S Cassiano. This was followed in 1407 by the triptych with the *Madonna of Mercy* in the centre for Montegranaro, outside Pesaro; its inscription reads *in venezia* and it must have been sent from Venice to the church for which it was commissioned. A third picture for Pesaro, an altarpiece of 1409, has also been documented. Of these three works, only the second can be identified with certainty, though it is possible that the altarpiece of 1409 is identical with a polyptych from S Francesco, Pesaro (Pesaro, Mus. Civ.). Conservative—almost retardataire—in design, with stiff, schematic figures, the two surviving altarpieces evolved from a purely local Venetian training and show no awareness of the international or courtly style introduced into Venice by Michelino da Besozzo and Gentile da Fabriano. It is small wonder that Jacobello's audience was drawn not from the university environment of Padua or the Lombard-oriented culture of Verona, but from provincial centres along the Adriatic and from the signory of Venice.

On 11 January 1412 Jacobello's annual stipend from the signory, the considerable sum of 100 ducats, was reduced to 50 because of the war Venice was conducting in Dalmatia. Jacobello was probably among the artists who, between 1409 and 1415, decorated the Sala del

Maggior Consiglio in the Doge's Palace in Venice. This was the most important Venetian commission of the first half of the 15th century, responsible for putting Venetian artists in direct contact with the most advanced painters of the mainland. Gentile da Fabriano and Pisanello are both known to have painted a scene, and Michelino da Besozzo, whom circumstantial evidence indicates was in Venice at least between 1410 and 1414, probably participated as well. It was, in any event, after 1410 that Jacobello's work underwent a transformation. For the Doge's Palace in 1415 he painted a heraldic *Lion of St Mark* (*in situ*): Michelino's influence is apparent in its softly modelled forms, in the decorative sweep of its wings and in the abstract pattern created by its tail. It was perhaps at the same time that Jacobello painted the *Madonna of Mercy* (Venice, Accademia; the inscription and date, 1436, are false), in which both the heavy-limbed child and the broad areas of raised pastiglia decoration are derived from Michelino and used to a marvellously decorative effect.

2. THE 'TRIPTYCH OF JUSTICE'. Jacobello's next dated work, the great *Triptych of Justice* painted for the Magistrato del Proprio in the Doge's Palace (1421; Venice, Accad.; see fig. 1), marks the beginning of an indigenous Venetian Late Gothic style. In 1648 Ridolfi recorded that the painting was installed above an *armaio* (cupboard) and inscribed: *1421. 23. Novembrio. Jacobellus de Flore Pinxt*; the present, abbreviated name and date on the centre panel obviously derive from the original inscription. The Magistrato del Proprio was a civil and criminal court, and the commission celebrated both functions.

In the centre panel, seated on the hindquarters of two lions (a reference to Solomon's throne), is a crowned figure personifying both Justice and Venice. In one hand she holds the scales with which the evidence is weighed, and in the other a sword, the means of punishment. Her breastplate is emblazoned with a sun in relief. A figure identical save for the substitution of a scroll for the scales was carved, possibly in 1422, on a roundel of the Doge's Palace facing the Piazzetta, and it is identified by an inscription as *Venecia*. Crowning the Porta della Carta is a similar figure, executed some two decades later by Barto-

lomeo Buon (i), identified as *Justicia*. The scroll behind Jacobello's figure is inscribed with a Latin distich: 'I will carry out the admonition of the angels and the holy word: gentle with the pious, harsh with the evil, and haughty with the proud'. To the left, St Michael uses the sword to slay an extravagantly oriental dragon, while the scroll he holds urges Venetia–Justitia to reward or punish according to merit and to 'commend the purged souls to the scales of benignity'. To the right Gabriel, his movement encumbered by a welter of drapery, raises his right hand while with his left hand he unfurls a scroll identifying himself as the messenger of the virgin birth and of peace among men and urging Venetia–Justitia (now equated with the Virgin) to lead men through the darkness. The pose of each figure is echoed by the pattern made by the individual scrolls. As with Michelino, the shape of the picture field, delimited by the frame (which is in large part original), played a determining role in the composition of each panel. Gilded pastiglia is used with an abandon that is almost without parallel. Jacobello's *Justice* triptych established the pattern of Venetian painting for more than a decade. Giambono's *St Michael* (Florence, I Tatti) pays homage to it and so also does Michele di Matteo's altarpiece of the *Virgin with Saints* (Venice, Accad.).

3. THE 'LIFE OF ST LUCY' AND FINAL YEARS. Jacobello's masterpiece is the series of scenes illustrating the *Life of St Lucy* (Fermo, Pin. Com.). These were commissioned for a coastal town on the Adriatic, and, although it has been argued that they were painted in Fermo, they may well have been painted in Venice and then dispatched to the church of S Lucia, where they are first mentioned in an inventory of 1728. Originally they must have been arranged in two superimposed tiers on either side of a central panel or sculpted image of the saint, similar to the altarpiece painted in Paolo Veneziano's workshop in the mid-14th century for the abbey church of S Lucia in Jurandor, near Baska (Trieste, Mus. Civ. Stor. & A.). This type of altarpiece derives from Romanesque dossals, and it continued to be employed into the third quarter of the 15th century, when Bartolomeo Vivarini painted the altarpiece of the *Virgin* (now in a false frame; New York, Met.).

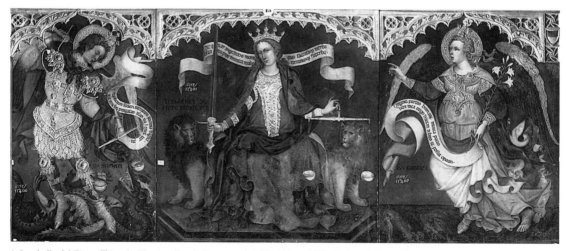

1. Jacobello del Fiore: *Triptych of Justice*, oil and gilt on panel, 1.97×4.82 m, 1421 (Venice, Galleria dell'Accademia)

With only one exception, Jacobello illustrated the same events from St Lucy's life as had Paolo Veneziano. In the first scene St Lucy visits the tomb of St Agatha, who appears to her in a dream; in the second, she distributes her possessions to the poor; in the third she refuses to sacrifice to idols; in the fourth oxen are unable to drag her to a brothel; in the fifth an unsuccessful attempt is made to burn her at the stake; in the sixth she is stabbed in the throat; in the seventh she receives Holy Communion before dying; and in the eighth she is buried. Jacobello employed a good deal more architecture and landscape than had Paolo to describe the setting of each scene, but he nonetheless remained faithful to his predecessor's conception of narrative. Although Jacobello's flowering meadows and curving rocky hills must derive from scenes similar to those of Gentile da Fabriano's polyptych of the *Coronation of the Virgin* (Milan, Brera; *see* GENTILE DA FABRIANO, fig. 2), Jacobello has in no sense tried to emulate the naturalism that distinguishes Gentile's scenes. His buildings have the toy-like fragility of Paolo Veneziano's cover for the Pala d'Oro (Venice, Mus. S Marco), and, for example in *St Lucy Distributing her Possessions* (see fig. 2), there is a total inconsistency between the upper and lower storeys. The figures move almost as if they were dancing, only occasionally seeming to set their feet on the ground. 'Jacobello held to the Greek [Byzantine] style', wrote Vasari, and in a sense he was correct, although his verdict perhaps obscures two facts. The first is that Jacobello's work was of primary importance to the sub-sequent generation of artists, like Giambono. The second is that Jacobello's approximation to the narrative style of Paolo Veneziano occurs in his mature, not in his youthful, work and is at least partially a reaction to contact with those three great non-Venetians: Michelino, Gentile and Pisanello. This has not always been grasped, and the *St Lucy* series has been dated relatively early in Jacobello's career. However, if the scenes are compared to the indisputably early *Adoration of the Magi* triptych (Stockholm, Nmus) or the small scene of *Tobias with the Angel* (Tulsa, OK, Philbrook A. Cent.), where the forms are stiffer, the figures more schematic and the decorative sense less evolved, an early dating proves untenable. In this sense, Jacobello's development runs parallel to that of Zanino and Niccolò di Pietro, though his frame of reference was exclusively local.

Jacobello died in 1439, but there is no securely documented work after 1421 and almost two decades of activity are therefore a matter of speculation. He had an adopted son, Ercole del Fiore, who in 1461 stated that he was a painter, and it may be that Ercole acted as an assistant in Jacobello's shop and is the author of such weak pictures as the *Coronation of the Virgin from Ceneda* (Venice, Accad.) or other related works that have been associated with Jacobello. The most important of these is an altarpiece painted for S Pietro, Fermo (Denver, CO, A. Mus.), which Zeri argued is an early work, but which is certainly later than the *St Lucy* series and not necessarily by Jacobello.

BIBLIOGRAPHY

I. Chiappini di Sorio: 'Per una datazione tarda della Madonna Correr di Jacobello del Fiore', *Boll. Mus. Civ. Ven.*, 4 (1968), pp. 11–25

F. Zeri: 'Jacobello del Fiore: La pala di S Pietro a Fermo', *Diari Lavoro*, i (1971), pp. 36–40

I. Chiappini di Sorio: 'Note e appunti su Jacobello del Fiore', *Not. Pal. Albani*, ii (1973), pp. 23–8

S. Sinding-Larsen: *Christ in the Council Hall: Studies in the Religious Iconography of the Venetian Republic*, Acta Archaeol. & A. Hist. Pertinentia, v (1974), pp. 56, 67, 167–75

K. Christiansen: *Gentile da Fabriano* (Ithaca, NY, 1982), pp. 70–71, n. 15

'K. Christiansen: 'La pittura a Venezia e in Veneto nel primo quattrocento', *La pittura in Italia: Il quattrocento*, i (Milan, 1987), pp. 124–8

M. Lucco: Venetia 1400–1430', *La pittura nel Veneto: Il quattrocento*, i (Milan, 1989), pp. 13–34

E. Negro: 'Jacobello del Fiore e Pesaro agli albori del'400', *Ant. Viva*, xxxiii/6 (1994), pp. 20–25

KEITH CHRISTIANSEN

Jacometto Veneziano (*fl* Venice, 1472–97). Italian painter and illuminator. Knowledge of the artistic activity of Jacometto is based almost exclusively on the notebooks of Marcantonio Michiel, who recorded a number of his works in the patrician houses of Venice and Padua in the first half of the 16th century. In Pietro Bembo's house Michiel saw a small picture with scenes from the life of a saint, and portraits of Bembo as a child of eleven and of his brother Carlo as a newborn baby in 1472; in the house of Francesco Zio Michiel saw four miniatures by Jacometto in a Book of Hours; in the house of Zuanantonio Venier he saw a small picture with animals painted in chiaroscuro; in the house of Antonio Pasqualino he saw a number of drawings; in the house of Gabriele Vendramin he saw a portrait painted (or ?drawn) in chiaroscuro, and a small book of vellum with pen drawings of animals and candelabra; and finally, in the house of Michele Contarini in 1543 the author saw 'a little portrait of Messer Alvise

2. Jacobello del Fiore: *St Lucy Distributing her Possessions*, 700×520 mm, panel from the *Life of St Lucy* altarpiece, tempera and gilt on panel, *c.* 1410 (Fermo, Pinacoteca Comunale)

Contarini . . ., who died some years ago; and on the same panel there is a portrait of a nun of San Secondo. On the cover of these portraits there is a small (?)deer in a landscape; and their leather case is decorated with foliage stamped with gold. This most perfect work is by the hand of Jacometto.'

It is clear from the testimony of Michiel that Jacometto practised chiefly as a manuscript illuminator and as a painter of small-scale panels, most of which were portraits. It is also clear that his work was much in demand among patrician collectors, and that, unlike most art of the generation before Giorgione, it was much admired by Michiel himself. The high reputation the artist enjoyed among his contemporaries is confirmed by the humanist Michele da Placiola, who in a letter of September 1497 praised the young Giulio Campagnola by saying that his miniatures 'are not inferior to those of the late Jacometto, who was the best in the world'.

Unfortunately, none of the works recorded by Michiel has survived, with the probable exception only of the portrait of *Alvise Contarini*, together with its companion-piece and their painted covers, which most modern scholars identify with a pair of miniature portraits of a man and woman on panel in the Lehman collection (New York, Met.). The identification is confirmed by the extraordinary delicacy of their handling, and also by their stylistic relationship with Flemish painting and with the art of Antonello da Messina. Michiel had said, in fact, of Antonello's *St Jerome* (London, N.G.), which he considered to be by Jan van Eyck (*c.* 1395–1441) or Memling (1430/40–1494), that he thought the face had been painted, and the whole figure repainted, by Jacometto. On the basis of the Lehman portraits, a number of other portraits have been attributed to the artist. Some of these attributions are controversial, because of the difficulty of comparing the style of works painted on a different scale; but among the most convincing are three male portraits (London, N.G., nos 2509, 3121; New York, Met., no. 49.7.3). Evidence that Jacometto did on occasion work on a larger scale is provided by a Venetian inventory of 1564, which lists a 'large portrait' by him. Similarly, a number of manuscript illuminations and incunabula have also been attributed to the artist by analogy with the Lehman portraits; these attributions, too, remain controversial.

BIBLIOGRAPHY

Thieme–Becker

M. A. Michiel: *Notizia d'opere di disegno* (MS. before 1552); ed. G. Frizzoni (Bologna, 1884); ed. T. Frimmel as *Der Anonimo Morelliano* (Vienna, 1888), pp. 20, 22, 82, 94, 98, 108, 112, 114

T. Frimmel: 'Bemerkungen zu Jacometto Veneziano', *Stud. & Skiz. Gemäldeknd.*, ii (1915–16), pp. 16ff

G. Gronau: 'Zu Jacometto Veneziano', *Stud. & Skiz. Gemäldeknd.*, ii (1915–16), pp. 48ff

Italian Illuminated Manuscripts from 1400 to 1550 (exh. cat. by O. Pächt, Oxford, Bodleian Lib., 1948)

M. Davies: *The Earlier Italian Schools*, London, N.G. cat. (London, 1951, 2/1961/R 1986), pp. 257–60

F. Heinemann: *Giovanni Bellini e i Belliniani*, 2 vols (Venice, 1962)

J. Pope-Hennessy: *The Portrait in the Renaissance* (Princeton, 1966)

G. Mariani Canova: *La miniatura veneta del rinascimento* (Venice, 1969)

O. Pächt and J. J. G. Alexander: *Illuminated Manuscripts in the Bodleian Library, Oxford: Italian School* (Oxford, 1970)

B. Fredericksen and F. Zeri: *Census of Pre-nineteenth-century Italian Paintings in North American Public Collections* (Cambridge, MA, 1972), p. 100

F. Zeri: *Italian Paintings: Venetian School*, New York, Met. cat. (New York, 1973), pp. 34–6

L. Armstrong: *Renaissance Miniature Painters and Classical Imagery: The Master of the Putti and his Venetian Workshop* (London, 1981)

J. Pope-Hennessy: *Italian Paintings* (1987), i of *The Robert Lehman Collection* (Princeton, 1987), pp. 240–43

PETER HUMFREY

Jacopo, Mariano del Buono di. *See* MARIANO DEL BUONO DI JACOPO.

Jacopo (di Paride Parisati) da Montagnana (*b* Montagnana, ?1440–50; *d* Padua, between 20 April and 14 Aug 1499). Italian painter. He began his career in Padua, where between 1458 and 1461 he was trained by the little-known Bolognese artist Francesco Brazalieri (1410–after 1484). According to Vasari and Ridolfi, he was a pupil of Giovanni Bellini; although no formal relationship is documented, it is clear that Jacopo was strongly influenced by the Venetian painter. The dominant influence on his art, however, was Andrea Mantegna, whose altarpiece for S Zeno, Verona, was painted in Padua in 1457–9. Jacopo is recorded in 1469 as a member of the painters' guild of Padua. His principal surviving and securely attributed works are nearly all frescoes in Padua, Belluno and Monteorte. A wider range of his activities is suggested by the papal vestments (Padua, Santo) that he designed for Sixtus IV in 1472.

Most of Jacopo's major projects have been badly damaged or completely destroyed. Of works executed in the Santo, Padua, nothing remains of the frescoes of 1469–77 for the Gattamelata Chapel and only one scene, the *Mystic Marriage of St Catherine*, survives from the frescoes of 1487–8 for the Chiostro del Noviziato. Only fragments remain of a remarkable fresco cycle (1489–90) of scenes from *Roman History* in the Palazzo dei Nobili, Belluno, which was destroyed in 1838 along with his frescoes on its façade. The interior frescoes, with their celebration of Classical civic virtues, were recorded in engravings by Melchiorre Toller (1800–46) and in drawings by Ippolito Caffi (1809–66).

Of Jacopo's surviving work, the frescoes of scenes from the *Lives of SS Stephen and Paul* and the *Life of Christ* in S Stefano, Belluno, date from 1485–6. In Padua he was commissioned by Bishop Pietro Barozzi (*d* 1507) to decorate his private chapel at the Palazzo Vescovile, where in 1494 he produced figures of the *Evangelists* and *Church Fathers* on the ceiling and *Christ among the Apostles* on the walls, and in 1495 an altarpiece of which the central *Annunciation*, depicted in an extensive architectural setting in sharp perspective, is flanked by panels of the *Archangels Michael* and *Raphael with Tobias*. The sanctuary of Monte Ortone, Monteortone, contains his most important extant work, a cycle of 1494–7 incorporating scenes from *Genesis* and the *Life of the Virgin* as well as representations of *Prophets* and *Church Fathers*. The prominent architectural elements rendered in perspective make clear his continuing debt to Mantegna. The two panels of the *Annunciation* (Venice, Accad.), which were originally organ shutters for Monte Ortone, probably date from the same years as the fresco cycle. The cleaned panels reveal Jacopo's ability and sensitivity as a colourist but, in comparison with Mantegna or the leading contemporary painters of Venice, his work has something of an awkward and provincial quality.

BIBLIOGRAPHY
G. Vasari: *Vite* (1550, rev. 2/1568); ed. G. Milanesi (1878–85), iii, p. 170
C. Ridolfi: *Meraviglie* (1648); ed. D. von Hadeln (1914–25), i, pp. 78, 91
A. Moschetti: 'Di Jacopo da Montagnana e delle opere sue', *Boll. Mus. Civ. Padova*, n. s. i, 3 (1925), pp. 149–58; n. s. iv, 3–4 (1928), pp. 165–219; n. s. vi, 1–4 (1930), pp. 122–88; n. s. x–xi (1934–9), pp. 31–90; also as book (Padua, 1940)
C. Furlan: 'Jacopo da Montagnana', *Dopo Mantegna: Arte a Padova e nel territorio nei secoli xv e xvi* (exh. cat., ed. F. Feltrin; Padua, Pal. Ragione, 1976), pp. 35–9
M. Lucco: *Catalogo del Museo Civico di Belluno*, 2 vols (Vicenza, 1983), i, pp. 5–7; ii, pp. 182–3
——: 'La pittura del secondo quattrocento nel Veneto occidentale', *La pittura in Italia: Il quattrocento*, ed. F. Zeri (Milan, 1987), i, pp. 147–83; ii, p. 656
 JOHN G. BERNASCONI

Jacopo da Pontormo. *See* PONTORMO, JACOPO DA.

Jacopo de' Barbari. *See* BARBARI, JACOPO DE'

Jacopo della Pila. *See under* MINO DEL REAME.

Jacopo della Quercia [della Fonte; della Guercia; di Pietro d'Angelo] (*b* Siena, ?1374; *d* Siena, 20 Oct 1438). Italian sculptor. He was the most significant non-Florentine sculptor of the 15th century: a transitional figure in the development of Italian Renaissance sculpture, who infused the Late Gothic art of Nicola Pisano (*c.* 1220/5–before 1284) with a new appreciation of antiquity, paving the way for such later artists as Antonio Federighi and Francesco di Giorgio in Siena, Niccolò dell'Arca in Bologna and, most notably, Michelangelo. He worked for a wide spectrum of patrons—the papal states, noble and mercantile families and the cities of Siena and Florence—and was the only Sienese artist of his century to achieve a truly national reputation.

1. Life and work. 2. Working methods and workshop. 3. Critical reputation.

1. LIFE AND WORK.

(i) Early style: works in Lucca and Ferrara, to 1408. (ii) The Fonte Gaia, Siena (1408–19), the Trenta Chapel, Lucca (1412–22), and related works. (iii) The late years, 1425–38: reliefs for S Petronio, Bologna, and other works.

(i) Early style: works in Lucca and Ferrara, to 1408. Jacopo was the son of Piero d'Angelo (*fl* 1370–1410), a minor goldsmith and sculptor, and had a brother, Priamo (1438–67), who was a painter. His birthdate is uncertain; Vasari described in his *Lives* (1568) an equestrian statue (untraced), carved when Jacopo was 19, for the funeral of the condottiere Giovanni d'Azzo Ubaldini (*d* 1390). This would suggest a birthdate of 1370–71, but Vasari later asserted that Jacopo died in 1438 at the age of 64, indicating a birthdate of 1374. This has been extended to 1375 (Seymour) or even 1380 (Beck); Jacopo remains, at all events, a contemporary of his Florentine rivals and collaborators Brunelleschi, Ghiberti and Donatello. He presumably received his first training from his father, the only known works by whom are three gilded angels (untraced), carved for the main altar of Siena Cathedral and a stiff, somewhat retardataire polychromed wooden *Annunciation* (Benabbio, nr Lucca, S Maria). A modest role for Jacopo in the carving of the Benabbio group has often been suggested. Piero was documented in Lucca from 1391 to 1394, where one of his patrons was the city's ruler, Paolo

Guinigi (*d* 1432), later to become a patron of Jacopo. The latter may have accompanied his father from Siena to Lucca, commencing what became a frequent practice of travelling between these cities. Lucca had a long and rich sculptural tradition and an apprenticeship with a Lucchese master should not be ruled out, though it was from the works of Pisano and Arnolfo di Cambio (*fl* 1265–1302) in Siena Cathedral that Jacopo learnt his true craft. In Pisa, which he doubtless visited, he must have studied the rich repository of antiquities located in the Camposanto; his earliest extant pieces reveal a thorough assimilation of both Roman techniques and motifs. However, no convincing hypothesis concerning his early work has been advanced. A depiction of the *Man of Sorrows* (now inserted into the Altar of the Sacrament) and a relief from the tomb monument of *St Aniello* (both Lucca Cathedral) have been suggested as examples of Jacopo's youthful work in Lucca, but neither is entirely convincing. Seymour

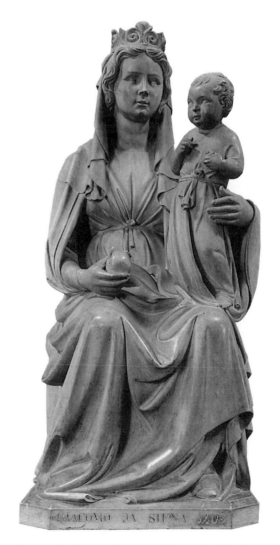

1. Jacopo della Quercia: *Virgin and Child*, marble, 1403 (Ferrara, Museo del Duomo)

postulated an alternative Bolognese journey and apprenticeship, and did not rule out a trip to France.

The need to establish a significant early body of works for Jacopo is particularly critical considering the importance of the artist's first firmly fixed activity: an invitation, in 1400–01, to participate in the prestigious competition for the bronze doors of the Baptistery in Florence. The impressive list of competitors included Ghiberti (the eventual winner), Brunelleschi, Niccolò di Pietro Lamberti, Simone da Colle, Niccolò d'Arezzo and Francesco di Valdambrino. Jacopo's trial piece no longer exists, but Vasari's contention that it was well-designed but lacked a knowledge of true perspective is prophetic of the artist's later relief style. Vasari further claimed that while in Florence Jacopo also designed the crowning relief of the Porta della Mandorla (Florence Cathedral), an assertion surprisingly still repeated by some modern scholars (Brunetti).

Jacopo travelled next to Ferrara, where his first extant documented sculpture can be found. In 1403 he was contracted to carve the marble statue of the *Virgin and Child* (see fig. 1) for the Silvestri Chapel in the cathedral (Ferrara, Mus. Duomo; the date of 1408 on the back of the monument is not original). The Virgin, a full, thickset figure, sober and unadorned, is seated on a modest throne and stylistically follows the tradition of Arnolfo di Cambio. The severely frontal figure stares vacantly ahead, and the rigid lines of the statue are only partially relieved by the gentle flow of her mantle and veil. A statuette of *St*

Maurelius (Ferrara, Mus. Duomo) is the only other work associated, however tentatively, with this Ferrarese period.

By 1406 Jacopo was again in Lucca, where he began work on the tomb of *Ilaria del Carretto* (1405–7/8; Lucca Cathedral; see fig. 2), the young and beautiful second wife of Paolo Guinigi; she died in childbirth on 8 December 1405. This work represents a landmark in Renaissance funerary design, though what survives is not the complete monument, which was dismantled in 1430 when Guinigi was expelled from Lucca. The original design probably included a canopy to crown the sarcophagus bearing the recumbent effigy. Compared to the massive, simplified forms of Jacopo's earlier work in Ferrara, the figure of Ilaria is a masterpiece of delicacy, intricacy and finesse. Her head gently resting on a pair of puffy, tasselled pillows, Ilaria lies in eternal repose, her hands softly folded across her chest. In a side view, beautifully swelling curves rise in a sweep from the faithful dog curled at her feet to the high wide collar of the Gothic dress that frames her lovely face. The most unusual feature of the tomb, however, is the frieze of nude putti carrying heavy swags of leaves and fruits that decorates the sides of the sarcophagus. Though putti were a familiar motif on Classical funerary monuments, this is the first use of them on a large scale in the Renaissance. Their robust, fleshly forms stand out in marked contrast to the delicate, fine-boned effigy of Ilaria. Bacci was the first to note the marked distinction in style between the aggressive putti on the south side and the more reticent figures on the north side of the tomb. The

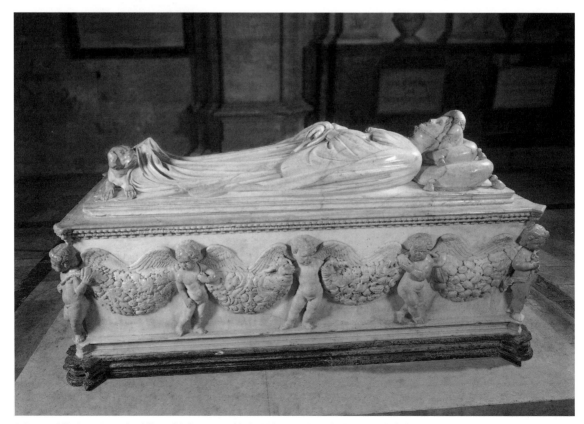

2. Jacopo della Quercia: tomb of *Ilaria del Carretto*, marble, h. 880 mm, 1405–7/8 (Lucca Cathedral)

latter are the work of Francesco di Valdambrino, a frequent early collaborator who is documented in Lucca during the period of the tomb's construction.

(ii) The Fonte Gaia, Siena (1408–19), the Trenta Chapel, Lucca (1412–22), and related works. In December 1408 Jacopo, having returned to Siena, signed a contract to build a new fountain in the Piazza del Campo, the central space of the city: the prestigious commission indicates that he was recognized as Siena's leading sculptor. The Fonte Gaia (Siena, Pal. Pub.; the version in the Piazza del Campo is a copy) took its name ('fountain of joy') from the festivity that greeted the arrival of water when it was first brought to this hilltop site in the mid-14th century. The Fonte Gaia was dedicated to the Virgin, traditional protectress of the city, and its iconography was intended to harmonize with and expand on the themes of good government found in the 14th-century frescoes in the Palazzo Pubblico opposite. The contract was modified in January 1409 to specify a greater number of figures and an increased payment. A brown ink drawing on vellum, preserved in two sections (New York, Met.; London, V&A) details the new plan. The fountain was to include reliefs of the *Virgin and Child* (this central section is missing from the drawing) surrounded by the four *Cardinal Virtues, Faith*, the *Angel Gabriel* and the *Virgin Annunciate*. Two free-standing statues, the *Rhea Silvia* and the *Acca Larentia*, the real and adopted mothers of the twins Romulus and Remus, legendary founders of Siena, were to be placed at the corners. The scheme was altered yet again in 1415. The fountain as it is now consists of a large rectangular basin, with multiple spouts, surrounded by low walls on three sides, the remaining portion open to allow for direct access to the piazza. The interior of the walls is decorated with shallow niches containing large-scale figures in high relief of the *Virgin and Child*, flanked by *Angels* and by the *Theological and Cardinal Virtues* and *Wisdom*, plus scenes of the *Creation of Adam* and the *Expulsion from the Garden* and at the corners, as originally planned, the *Rhea Silvia* and the *Acca Larentia*.

Progress was extremely slow. Jacopo began to carve the figures in 1414, but did not finish until 1419. The unusually porous material used for the fountain has deteriorated, making it hard to determine the style and chronology of specific parts. But the sections generally agreed to be later—the free-standing figures and the Genesis scenes, Jacopo's first attempt at narrative sculpture—reveal his growing confidence. The former are among the earliest free-standing nude female figures of the Renaissance. (Bacci attributed the *Rhea Silvia* to Francesco di Valdambrino, on purely stylistic grounds.) The relief of the *Creation* depicts a powerfully muscular but generalized figure of Adam, who strains upwards towards a downward-inclining God the Father. The figures are tightly compressed in the foreground plane with little attention to depth or indication of landscape setting. Janson (1962) has suggested certain parallels between the pose of Adam and the Early Christian ivory of *Adam in the Garden* (AD 400; Florence, Bargello). Andrea Pisano's reliefs for the Campanile (Florence) also provide stylistic and iconographic precedents, yet no direct borrowing can be recognized as Jacopo assimilated and internalized all his sources. The

Expulsion (see fig. 3) is both better preserved and more dramatic. The figures of Adam, Eve and the Avenging Angel, all shown parallel to the relief plane, appear too large to have passed through Jacopo's gates of Paradise. The Angel must use physical force to expel the sinners. The striding pose of Adam can be related to an antique source—a Meleager-type sarcophagus (e.g. Pisa, Camposanto, no. 64)—yet it is modified by an awareness of Nicola Pisano's figure style.

The reason for Jacopo's dilatoriness in completing the fountain was that he accepted commissions elsewhere. One of these was for a carved marble statue of an *Apostle* (1411–13; though *c.* 1420 according to del Bravo) for Lucca Cathedral, originally placed high on the north flank of the exterior as part of a series of twelve figures. Intended to be seen from below at a distance, both the upper torso and the head are enlarged. This vigorous, youthful figure has been likened to Giovanni Pisano's *Prophets* (Siena, Mus. Duomo) for the façade of Siena Cathedral or even to Donatello's *St George* (Florence, Bargello; *see* FLORENCE, fig. 11). The main alternative to work on the Fonte Gaia came, however, from Lorenzo Trenta, a wealthy merchant from Lucca, who contracted Jacopo to design his family chapel in S Frediano, Lucca. Work on the Trenta Chapel (1412–22) continued concurrently with the Fonte Gaia over the next decade, being interrupted in December 1413 when Jacopo and his assistant Giovanni di Francesco da Imola (*d* before 13 Jan 1425) were

3. Jacopo della Quercia: *Expulsion from the Garden*, marble, relief sculpture from the Fonte Gaia, formerly in the Piazza del Campo, Siena, 1414–19 (Siena, Palazzo Pubblico)

denounced, in a letter sent to the city's ruler Paolo Guinigi, for theft, rape and sodomy. Jacopo somehow escaped punishment altogether, but his assistant was imprisoned for three years. Perhaps these circumstances explain why Jacopo was suddenly available to begin work on the Fonte Gaia in Siena in 1414. He returned to Lucca in March 1416, but only after he had been supplied with a letter of safe conduct.

Jacopo's first work in the Trenta Chapel consisted of an intricately carved marble altar dedicated to the patron saints of the chapel: Richard, Jerome and Ursula. This is basically a conservative *sacra conversazione* with the *Virgin and Child* enthroned against a cloth of honour in a shallow central niche. To the viewer's left and right, standing in self-contained niches framed by pilasters, are *SS Ursula and Lawrence* and *SS Jerome and Richard*. All the niches are surmounted by steeply pitched gables. Half-length figures of the *Prophets* are located on pinnacles above the saints; some sort of decorative element once also rose above the niche containing the *Virgin and Child*. Likewise missing are the Gothic finials planned to complete the elaborate frame. At the base is an elaborate historiated predella with scenes from the *Lives of the Saints* enframing a central *Lamentation*. The saints of the Trenta altar bear a striking resemblance to the *Virgin* and the *Virtues* from the Fonte Gaia, having the same small oval heads with pointed chins and thick necks. The remoteness of expression harks back to the Ferrara *Madonna*, but now the figures are wrapped in heavy draperies with elaborate convoluted folds. While some parts of the work are Giovanni da Imola's, most scholars assign to Jacopo the major share of the execution. The inscription at the base has the date of 1422, which may apply to the completion of the predella. The predella scenes, especially the bold *Martyrdom of St Lawrence*, are clearly more complex and more dependent on dramatic tension. Conceivably they could belong to this later date.

Jacopo also designed for the chapel the tomb effigies (1416) of *Lorenzo Trenta* (d 1439) and his wife, *Isabetta Onesti* (d 1426). The tomb slabs, set into the pavement in front of the altar, have suffered considerable wear. Compared to the high relief of the Ilaria monument, the Trenta tombs offered only a moderate degree of projection. Lorenzo Trenta is shown recumbent with his head, swathed in a voluminous turban, resting on a huge pillow. His body is slightly inclined towards his wife. The effigy of Isabetta complements that of her husband, although she appears to be more active, her drapery more agitated and linear. This effigy has been attributed (Seymour, 1973) to Giovanni da Imola, but both are inscribed 1416, a year when he was still in prison.

Already busy in both Siena and Lucca, with the Fonte Gaia still relatively untouched and the Trenta Chapel awaiting completion, Jacopo took on yet another project. In 1416 Lorenzo Ghiberti advised the authorities on the creation of a new font in the Siena Baptistery. Ghiberti designed the hexagonal marble basin with panels for six bronze narrative reliefs, which he planned to be separated by bronze statuettes of the *Virtues* set in shallow niches. Ghiberti executed two of the reliefs, including the most prominent, the *Baptism of Christ*, but it soon became apparent that Sienese participation was politically advisable, and Jacopo was brought into the project. On 16 April

1417 Jacopo was awarded two reliefs, to be completed within a year: the *Annunciation to Zacharias* and the *Banquet of Herod* (the latter later given to Donatello), with the remaining scenes assigned to Turino di Sano and his son, Giovanni Turini. But lacking experience in working with bronze, Jacopo procrastinated. In autumn 1419 a new contract had to be drawn up; the following year the authorities threatened to begin legal action against Jacopo, who countersued. The dispute was finally settled in August 1425, but the Sienese had to wait until July 1430 for the final delivery.

Exactly what preoccupied Jacopo between 1419, when the last payments for the Fonte Gaia were recorded, and 1425, the onset of the S Petronio commission, is hard to identify. No major new projects were begun, and he appears to have been in Siena for most of the time. In 1420 he was elected prior for the Terzo di Martino along with his colleague, Domenico di Niccolò de' Cori. In 1421 he received a commission to carve an *Annunciation* for the Collegiata in San Gimignano (*in situ*). The two life-size, polychromed wooden statues represent his sole documented effort in this medium, so popular in Siena where marble was often difficult to obtain. The grouping of the figures is deliberately conservative in style, recalling the International Gothic idiom of the Ilaria effigy. Jacopo's stylistic range can be seen in his ability to be innovative on the one hand, and respectful of past traditions on the other. The latter characteristic is particularly visible in the delicate swaying stance of the long-limbed, high-waisted, lithesome *Virgin*, who places her arm protectively across her chest. The figure of *Gabriel* is less conventional yet he complements the *Virgin* completely in terms of posture and glance. The delicate polychromy and the gilding serve to enhance both the youth and the ethereal quality of the two figures. The general sophistication of this group suggests that Jacopo was no novice at working in wood, which has led scholars to attribute a number of other wood sculptures to him. The most widely accepted attributions are: a *Virgin with Saints* from S Martino (*c.* 1423–5; Siena, Mus. Duomo); a *Virgin and Child* (*c.* 1430; Paris, Louvre) and a *St John the Baptist* (*c.* 1430; Siena, S Giovanni).

(iii) The late years, 1425–38: reliefs for S Petronio, Bologna, and other works. The last years of Jacopo's life were perhaps his most active and productive. He seems to have divided his time equally between Siena and Bologna, finishing one much delayed project while beginning another. The Siena Baptistery authorities, surprisingly in view of earlier delays, commissioned him in 1427 to design the upper portion of the baptismal font. This consists of a hexagonal marble tabernacle set on a thick, fluted base that rises from a pillar in the centre of the basin. Five of the six faces of the tabernacle contain marble prophets, clothed in voluminous draperies and situated before scallop-shaped niches defined by pilasters. Only one of these prophets, the *King David*, facing the entranceway, has been specifically identified, although all are highly individualized. The remaining face consists of a small *sportello*, or door, behind which the baptismal oil would have been kept, ornamented with a gilt bronze relief of the *Virgin and Child* by Giovanni Turini. The tabernacle is capped by a heavy cornice, above

which rises a dome with six small pediments. Originally six gilt music-making putti, by Donatello and Turini, were placed at the corners (four *in situ*). On top of the dome are two diminishing pillars that serve as the base for the marble statue of *John the Baptist*, attributed to Jacopo in most recent literature. The major work on the tabernacle was finished by 1430, although the font itself was not completed for four years.

Jacopo received final payment in August 1430 for his relief of the *Annunciation to Zacharias* on the lower part of the font. This is adjacent to Donatello's *Banquet of Herod* and tries to re-create that work's illusion of space. In earlier reliefs, Jacopo had allowed the figures, set against essentially flat architectural backgrounds, to dominate. In the *Annunciation*, however, he set his figures within a complicated temple consisting of three bays connected by massive arches. This arcade-like arrangement deliberately resembled Donatello's banquet hall but lacked his manipulation of perspective to provide a coherent space. Jacopo even tried to rival Donatello's manner of modelling forms, which varied from figures seen almost entirely in the round to those in low relief in the background. The stance of the figures, particularly that of Zacharias, is difficult to comprehend, indicating the sculptor's fundamental indifference to anatomy.

Jacopo's reliefs in Istrian stone for the Porta Magna of S Petronio in Bologna (see fig. 4) are much more successful. These sculptures, his preoccupation during the last thirteen years of his life, are recognized as his masterworks. On 28

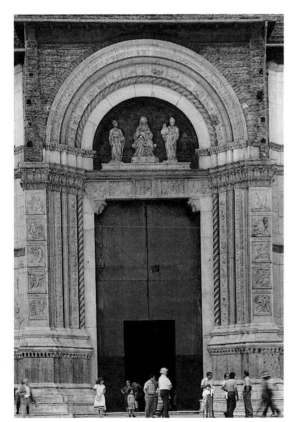

4. Jacopo della Quercia: Porta Magna, S Petronio, Bologna, 1425–30

March 1425 he was commissioned to design a complicated portal for the west façade of this late medieval church, located in the very heart of the papal states, and produced a design for a round-arched entranceway framed by historiated pilasters with Old Testament reliefs, eighteen busts of prophets, five New Testament reliefs in the architrave above the door, decorative colonnettes and a lunette above the door containing free-standing statues of the *Virgin and Child*, *St Petronius* and the patron, Cardinal *Lodovico Alemanno*, papal legate to Bologna. Beck (1970) has established that the *Virgin and Child*, the prophet busts, the lintel reliefs and the colonnettes were all carved first, during the period 1426–September 1428, while the Old Testament scenes and *St Petronius* were added in 1429/30. The original plan was modified in 1428: Jacopo's idea had been for a kneeling figure of the papal legate being presented to the Virgin Mary by Pope Martin V, but the legate had to be replaced by a figure of St Ambrose when the Bolognese rebelled and evicted Cardinal Alemanno.

The adjacent statue of *St Petronius* is a powerful figure, the expressive quality of his face heightened by the nervous chisel strokes of his short, cropped beard. As befits the city's patron saint, he holds a model of Bologna, complete with its huge towers, in his right hand. (The third free-standing figure, *St Ambrose*, was carved in 1510 by Domenico Aimo.)

As a group, the Old Testament panels (see colour pl. 1, XXXIV3) are carved in lower relief than those in the lintel and are higher rather than wider, thus allowing the heroic nude figure to dominate the relief field. Although relatively small in size, Jacopo's figures give the impression of monumentality. In the *Creation of Adam*, the figural arrangement is the exact reverse of the scene from the Fonte Gaia. Jacopo has even retained the unusual triangular halo of God the Father. The arrangement of the figures, however, seems less tightly compressed. The body of Adam is also more idealized than the earlier work, but is still in Jacopo's typical style—thick-necked, heavy-limbed and with an exaggerated musculature that gives little hint of the skeletal structure underneath. The convoluted, tubular drapery folds of God's robes are typical of the artist's late manner. The *Temptation* is one of the most innovative scenes iconographically as it shows Adam and Eve at equal fault for the Fall. Adam glares angrily at Eve, who has her eyes closed. The two figures are shown on either side of the Tree of Knowledge, whose large central form bisects the relief plane.

The *Expulsion* also takes its basic format from the Fonte Gaia, except that, instead of obediently striding forward, Adam now turns his head and raises his arms in defiance, and a mountain closes off the space to the right, further reducing any sense of depth. Here, as in the *Annunciation to Zacharias*, Jacopo again avoided the Florentine science of perspective.

With so many sculptures to carve for the Portal, Jacopo was frequently absent from Siena. In 1434 the Sienese, however, finally lured him back with the promise of a new project: he was commissioned to design a small loggia on one of the major thoroughfares that runs parallel to the Piazza del Campo. The Loggia di San Paolo, or della Mercanzia, was only partially complete at his death.

Attributed to Jacopo are the elaborate capitals of the lower storey, as well as the design for the six niches on the massive piers. These were intended to house statues, which Jacopo was also to have supplied. However, they were not carved until the late 1450s and early 1460s and then by Antonio Federighi and Vecchietta.

In addition to the new commission, further honours were awarded to Siena's leading artist. In 1435 he was knighted, was again selected Priore to the city council and also named Operaio of the cathedral, a powerful and influential appointment that put him in charge of a large workshop. During these final years he became involved with the decoration of a chapel belonging to Cardinal Antonio Casini in Siena Cathedral. A fragmentary relief (Siena, Mus. Duomo) depicting the kneeling cardinal being presented to the Virgin and Child by his patron saint, Anthony Abbot, is associated with him. While the conception may indeed be Jacopo's, the work depended on assistants for much of the actual execution. The Vari–Bentivoglio monument (Bologna, S Giacomo Maggiore) and the tomb of *Antonio Budrio* (S Michele in Bosco) are also attributed to Jacopo with considerable workshop participation.

Jacopo was buried in the church of S Agostino in Siena. Soon after his death, his executor, Priamo della Quercia, was confronted by the cathedral authorities over his brother's unsanctioned use of assistants from the cathedral workshop for his own purposes and his misappropriation of money and materials. Priamo was obliged to make a substantial repayment.

2. WORKING METHODS AND WORKSHOP. Jacopo della Quercia was unusually versatile, being able to create diverse works in three different media: marble, bronze and wood. He was, however, primarily a carver, with marble his preferred medium. He appears to have been particular about the condition of his marble blocks, making several documented trips to the Carrara quarries, near Lucca, early in his career, and later to Milan, Verona, and Venice in connection with the acquisition of stone for the Porta Magna. Interestingly, he often developed a different style for his works carved in wood. Although there are fewer attributable works in this medium, they are of equal quality to some of his best sculptures in marble. He appears to have done only the carving; the polychroming or gilding was assigned to other masters. These painters were skilled artisans in their own right. The San Gimignano statue of the *Virgin* is inscribed on the base M. CCCC. XXVI MARTINUS BARTHOLOMEI PINXIT, while the *Gabriel* is inscribed with Jacopo's name. Here the painter, Martino di Bartolomeo (*d* 1434/5), seems to claim equality with the sculptor. Jacopo's highly active bottega probably produced various wooden sculptures associated with his name, among them the *St Leonard* (*c.* 1411; Massa, S Maria degli Ulivi), the *Annunciation* (*c.* 1410; Berlin, Gemäldegal.) and a *Virgin Annunciate* (*c.* 1410; Siena, S Raimondo al Refugio). Related to the wooden sculptures are a series of half-length terracotta and stucco versions of the *Madonna* (e.g. Florence, Fond. Romano and Mus. Bardini; Washington, DC, N.G.A.), which are usually assigned to his bottega, but must ultimately be traceable back to a lost prototype by Jacopo.

Jacopo is known to have worked in bronze as early as 1401–2 in Florence when competing for the Baptistery doors. Thirty years later he seems to have met with only slightly greater success when his *Annunciation to Zacharias* was finally completed. His reluctance to work in this medium is further demonstrated by his insistence on retaining for himself only the marble portions of the Baptistery Tabernacle while delegating the bronze areas to associates.

Since many of his projects involved multiple pieces, Jacopo often had to rely on drawings to clarify his complicated schemes to his patrons. For the Fonte Gaia he himself provided the drawing illustrating the first (1408) plan, now subdivided into two fragments (New York, Met.; London, V&A). As Vasari noted, the drawing is extremely detailed, more befitting the hand of a painter of miniatures than a sculptor. The second contract for the Fonte Gaia, dated 22 January 1419, specified, again, a full-scale drawing to be displayed on the wall of the Palazzo Pubblico, overlooking the proposed site of the fountain. The contract for the Porta Magna, dated 28 March 1425, mentioned a pen-and-ink drawing by Quercia ('fatto di suo mano'), since lost and known only through a 16th-century copy by Peruzzi (Bologna, S Petronio, Sacristy). The painter Sassetta, at Jacopo's own request, received payment for a full-scale drawing of the Siena Baptistery font in December 1427.

The demands placed on the artist by his patrons and his practice of accepting multiple commissions led Jacopo, in his later years, to rely more and more on his bottega to handle the overload and to cope during his prolonged absences. He had two workshops: one in Siena, the other in Bologna, both manned by an extremely capable and trusted group of associates who were later mentioned in his will. In Bologna the workshop was headed by Cino di Bartolo (*d* 1474), while in Siena Pietro di Tommaso del Minella (1391–1458) was most often in charge, particularly in connection with the construction of the Loggia di San Paolo. Among other artists listed at various times in Jacopo's employ, we find the names of Castorlo di Nanni (*fl* 1440s), Paolo and Tonio di Baccio and the young Antonio Federighi. None, with the exception of Federighi, produced important work independently. Despite all the assistance he received from colleagues and shophands, Quercia was rarely able to meet a promised deadline. He was in fact a poor manager, both of materials and of time, and in his last years was accused of misusing funds, materials and even *garzoni* from the cathedral workshop.

3. CRITICAL REPUTATION. Jacopo della Quercia was held in high regard by his own colleagues, contemporaries and rivals. Ghiberti discussed him in his *Commentarii* in connection with the Florentine competition. Antonio Filarete, in his *Trattato di architettura*, proclaimed him one of the finest sculptors in Italy, as did Giovanni Santi in his comments on the arts presented *c.* 1492 to Federico da Montefeltro, Duke of Urbino. Michelangelo held him in high esteem and based his own Genesis scenes (Rome, Vatican, Sistine Chapel ceiling) on Jacopo's reliefs for the Porta Magna. Giorgio Vasari devoted a section of his *Lives* to Jacopo and expanded it in the second edition (1568). With support of this kind, his reputation remained high,

especially in Italy. Outside Italy the tomb of *Ilaria del Carretto* was his most celebrated work. John Ruskin (1819–1900), who saw the tomb in 1845, was deeply moved by it and wrote that it had inspired his 'true study of Italian, and all other art'.

In the 20th century interest in Jacopo della Quercia was considerably heightened after the exhibition of Sienese art held in London in 1904 by the Burlington Fine Arts Guild, and since that time major monographs have been published by Supino (1926), Bacci (1929), Seymour (1973) and Beck (1991). An exhibition held in Siena in honour of the sexcentenary of his birth (1974) presented not only Jacopo's career but also his relationship to his sources, contemporaries and followers.

BIBLIOGRAPHY

EARLY SOURCES

G. Vasari: *Vite* (1550, rev.2/1568); ed. G. Milanesi (1878–85), ii, pp.109–30
G. Milanesi: *Documenti per la storia dell'arte senese*, 3 vols (Siena, 1854–6)
S. Borghesi and L. Banchi: *Nuovi documenti per la storia dell'arte senese* (Siena, 1898)
L. Ghiberti: *I commentarii*, Book 2, in *Lorenzo Ghibertis Denkwürdigkeiten*, ed. J. Schlusser (Berlin, 1912), pp. 35–51
A. Filarete: *Treatise on Architecture*, ed. J. R. Spencer (New Haven, 1965)
G. Santi: *La vita e la gesta di Federico di Montefeltro duca d'Urbino*, ed. L. Michelini Tocci, Studi e Testi, 305–6 (Vatican City, 1985)

GENERAL

Thieme–Becker
E. T. Cook and A. Wedderburn, eds: *The Works of John Ruskin* (London, 1903–12), xi, p. 239; xxviii, p. 146; xxxiv, pp. 171–2
C. Ricci: *Il Palazzo Pubblico di Siena e la mostra d'arte senese* (Bergamo, 1904)
Antica arte senese (exh. cat., Siena, Pal. Pub., 1904)
P. Schubring: *Die Plastik Sienas im Quattrocento* (Berlin, 1907)
C. Raggianti: 'Scultura lignea senese e non senese', *Crit. A.*, xviii (1950), pp. 480–96
J. Pope-Hennessy: *Italian Gothic Sculpture*, iii of *An Introduction to Italian Sculpture* (London, 1955, rev. 1972/R New York, 1985)
H. W. Janson: *History of Art* (New York, 1962), p. 311
Scultura dipinta: Maestri di legname e pittori a Siena (exh. cat., Siena, Pin. N., 1987)

MONOGRAPHS

C. Cornelius: *Jacopo della Quercia: Eine kunsthistorische Studie* (Halle, 1896)
I. B. Supino: *Jacopo della Quercia* (Bologna, 1926)
P. Bacci: *Jacopo della Quercia: Nuovi documenti e commenti* (Siena, 1929)
Catalogo della mostra di scultura d'arte senese del XV secolo nel quinto centenario della morte di Jacopo della Quercia (1438–1938) (exh. cat., Siena, Pal. Pub., 1938)
L. Biagi: *Jacopo della Quercia* (Florence, 1946)
A. Bertini: *L'opera di Jacopo della Quercia* (Milan, 1962)
O. Morisani: *Tutta la scultura di Jacopo della Quercia* (Milan, 1962)
C. Seymour jr: *Jacopo della Quercia Sculptor* (New Haven and London, 1973) [with critical bibliog.]
Jacopo della Quercia nell'arte del suo tempo (exh. cat., ed. G. Chelazzi Dini; Siena, Pal. Pub.; Grosseto, Mus. Archeol.; 1974)
J. Beck: *Jacopo della Quercia*, 2 vols (New York, 1991)

SPECIALIST STUDIES

V. Davia: *Le sculture delle porte della basilica di San Petronio* (Bologna, 1834)
C. F. Carpellini: *Di Giacomo della Guercia e della sua fonte nella piazza del Campo* (Siena, 1860, 2/1869)
A. Michel: '*La Madone et l'Enfant*: Statue en bois peint et doré attribuée à Jacopo della Quercia', *Mnmts Piot*, 3 (1896), pp. 261–9
I. B. Supino: *Le sculture delle porte di San Petronio in Bologna* (Florence, 1914)
E. Lazareschi: 'La dimora a Lucca di Jacopo della Guercia e di Giovanni da Imola', *Bull. Sen. Stor. Patria*, xxxii (1925), pp. 63–97
E. Caratti and R. Longhi: 'Un'osservazione circa il monumento d'Ilaria', *Vita artistica*, i (1926), pp. 94–6
P. Bacci: 'Le statue dell'Annunciazione intagliata nel 1421 da Jacopo della Quercia', *La Balzana*, i (1927), pp. 149–75

G. Brunetti: 'Jacopo della Quercia and the Porta della Mandorla', *A. Q.* [Detroit], xv (1952), pp. 119–31
R. Krautheimer: 'A Drawing for the Fonte Gaia in Siena', *Bull. Met.*, x (1952), pp. 265–74
N. Rondelli: 'Jacopo della Quercia a Ferrara, 1403–1408', *Bull. Sen. Stor. Patria*, n. s. 2, lxxi/23 (1964), pp. 131–42
A. C. Hanson: *Jacopo della Quercia's Fonte Gaia in Siena* (London, 1965)
C. Ragghianti: 'Novità per Jacopo della Quercia', *Crit. A.*, xii (1965), pp. 35–47
A. M. Matteucci: *La Porta Magna di San Petronio in Bologna* (Bologna, 1966)
H. Klotz: 'Jacopo della Quercias Zyklus der *Vier Temperamente* am Dom zu Lucca', *Jb. Berlin. Mus.*, ix (1967), pp. 81–99
J. T. Paoletti: *The Baptistery Font at Siena* (diss., New Haven, CT, Yale U., 1967)
A. Kosegarten: 'Das Grabrelief des San Aniello Abbate im Dom von Lucca: Studien zu den früheren Werken des Jacopo della Quercia', *Mitt. Ksthist. Inst. Florenz*, xiii/3–4 (1968), pp. 223–72
C. Seymour jr: '"Fatto di suo mano": Another Look at the Fonte Gaia Fragments in London and New York', *Festschrift Ulrich Middeldorf*, ed. A. Rosengarten and P. Tigler (Berlin, 1968), pp. 93–105
J. H. Beck: *Jacopo della Quercia e il portale di San Petronio: Ricerche storiche, documentarie e iconografiche* (Bologna, 1970)
C. del Bravo: *Scultura senese del quattrocento* (Florence, 1970)
M. Paoli: 'Jacopo della Quercia e Lorenzo Trenta: Nuove osservazioni e ipotesi per la cappella in San Frediano di Lucca', *Ant. Viva*, xix/3 (1980), pp. 27–36
A. Emiliani and others: *Jacopo della Quercia e la facciata di San Petronio a Bologna: Contributi allo studio della decorazione e notizie sul restauro* (Bologna, 1981)
C. Gnudi: 'Per una revisione critica della documentazione riguardante la "Porta Magna" di San Petronio', *Jacopo della Quercia e la facciata di San Petronio a Bologna*, ed. R. Manaresi (Bologna, 1981), pp. 13–118
J. Beck and A. Amendola: *Ilaria del Carretto di Jacopo della Quercia* (Milan, 1988)
C. Fischer: 'Ghirlandaio and the Origins of Cross-hatching', *Florentine Drawing at the Time of Lorenzo the Magnificent: Papers from a Colloquium held at the Villa Spelman: Florence, 1992*, pp. 245–53
Cavaliere da San Cassiano (exh. cat., ed. G. Rasario; Florence, Bargello, 1995)

ELINOR M. RICHTER

Jacopo del Meglio. *See* COPPI, GIACOMO.

Jacopo del Sellaio. *See* SELLAIO, JACOPO DEL.

Jacopo di Antonio (*d* Florence, 13 Dec 1454). Italian painter. He was a pupil of Andrea del Castagno (Vasari). His only surviving work is a series of cherubs (docmented 1451) painted to frame Giotto's Badia Polyptych (Florence, Uffizi). Of secondary importance (and consequently perhaps not entirely by his hand), this work has some charm and was admired by Jacopo's contemporaries. The putti are stylistically close to paintings grouped under the name of the MASTER OF PRATOVECCHIO (*see* MASTERS, ANONYMOUS, AND MONOGRAMMISTS, §I) and particularly to fragments of a fresco from the church of Ognissanti, of identical date. Jacopo di Antonio was the cousin of Giovanni di Francesco, and it is possible that he, rather than Giovanni, may have painted a triptych commissioned by the nuns of the convent del Paradise, Pian di Ripoli, near Florence. This triptych may perhaps be identified with the *Virgin and Child with SS Bridget and Michael*, known as the Poggibonsi Altarpiece (Los Angeles, CA, Getty Mus.) painted *c.* 1450. If so, Jacopo may perhaps be identified with the Master of Pratovecchio; further evidence suggests that he worked for the same localities as this artist.

BIBLIOGRAPHY

G. Vasari: *Vite* (1550; rev. 2/1568); ed. G. Milanesi (1878–85), ii, p. 682
U. Procacci: 'Di Jacopo di Antonio e delle 'compagnie' di pittori nel corso degli Adimari nel XV secolo', *Riv. A.*, xxxv (1960), pp. 3–70

F. Hartt and G. Corti: 'New Documents Concerning Donatello, Luca and Andrea della Robbia, Desiderio, Mino, Uccello, Pollaiuolo, Filippo Lippi, Baldovinetti and Others', *A. Bull.*, xliv (1962), p. 162

U. Procacci: 'La tavola di Giotto dell'altare maggiore della chiesa della Badia fiorentina', *Scritti di storia dell'arte in onore di Mario Salmi*, ii (Rome, 1962), pp. 9–45

A. Padoa Rizzo: 'Ristudiando i documenti: Proposte per il "Maestro di Pratovecchio" e la sua tavola eponima', *Studi di storia dell'arte sul medio evo e il rinascimento nel centenario della nascita di Mario Salmi*, ii (Florence, 1993), pp. 579–99

ANNA PADOA RIZZO

Jacopo Filippo d'Argenta [Jacopo Filippo de' Medici] (*b* Argenta, Emilia, *c.* 1438; *d* ?Ferrara, *c.* 1501). Italian illuminator. In 1456 he was a *garzone* not yet of age in the workshop of the illuminator Taddeo Crivelli, then working on Borso d'Este's Bible (Modena, Bib. Estense MS. V. G.12, lat. 422–3). In 1469 Jacopo was in Bologna. From 1477 until 1501 he produced most of the decoration in fourteen Antiphonals and two Graduals for Ferrara Cathedral (Mus. Duomo; two excised leaves in Cleveland, OH, Mus. A.). While in Ferrara in the early 1490s, Jacopo also painted most of the decoration of eight Antiphonals and five Graduals for the convent of S Francesco, Brescia (Brescia, Pin. Civ. Tosio-Martinengo). The frontispiece for a copy of Pliny's *Natural History* (Turin, Bib. N.U.), a miniature of the *Virgin and Child* in a Book of Hours (Basle, Kstmus.) and single miniatures (New York, Met.; Washington, DC, N.G.A.; ex-Wildenstein Col., Paris) have also been attributed to Jacopo.

With his main collaborator, Fra Evangelista da Reggio, Jacopo developed a highly successful page layout with sumptuous borders that included medallions derived from those in the Bible of Borso d'Este but with ornamental frames made of larger, crisper elements. He also designed robust decorative initials that frame figures set against rocky, visionary landscapes. Jacopo's style is characterized by rigid and incisively drawn forms and the juxtaposition of sharp, contrasting tonalities. He was overwhelmingly influenced by Cosimo Tura's works of *c.* 1470, which he freely adapted in his miniatures.

BIBLIOGRAPHY

E. Calabi: 'I corali miniati del convento di S Francesco a Brescia', *Crit. A.*, xiii (1938), pp. 57–67, pls 36–43

B. G. Vigi: 'Jacopo Filippo d'Argenta, il maggior miniatore dei corali della cattedrale di Ferrara', *La Bibliofilia*, lxxxv (1983), pp. 201–22

PATRICK M. DE WINTER

Jami, Domenico de. *See* AIMO, DOMENICO.

Jaquerio, Giacomo (*b* Turin, *c.* 1380; *d* Turin, 27 April 1453). Italian painter. He is first mentioned in 1401 in Geneva, where he painted an allegorical fresco of the punishments of hell for the Dominican convent of Plain Palais (destr.). The fresco is recorded in a 16th-century print containing an inscription that states that it was painted by *Jacomo Jaquerio de Civitate Taurini*. Jaquerio moved between Turin and Geneva throughout his life. By 1403 he had joined the service of Ludovico, Duke of Acaia, the ruler of Turin. That year he was paid for unknown work in the Duke's castle (now Palazzo Madama) in that city, and in 1407 and 1408 he was recorded in the Acaia palazzo in Pinerolo.

By 1411 Jaquerio had returned to Geneva, where he produced two images of *St Maurice* for a new patron, Amadeus VIII, 1st Duke of Savoy and the future antipope Felix V. His service for Ludovico of Acaia continued, however, and from 1415 to 1418 Jaquerio was in Pinerolo again. There he provided stained glass for a chapel and frescoes.

By 1426 the cadet branch of the Acaia had died out, and its territories were absorbed by the Duchy of Savoy. Thereafter Giacomo Jaquerio was called the 'pittore di nostro signore' at the court of Amadeus VIII. Documents from 1426 to 1429 show that he frescoed the Savoy family chapel in the castle (destr. 1626) of Thonon on Lake Geneva. Jaquerio also carried out his duties as a court artist, painting the Savoy arms on the gates of San Maurizio Canavese, near Turin, in 1428 and several jousting lances for the Duke.

For most of 1430 Jaquerio was in Geneva, where he made a deposition in favour of Baptista da Mantova, a Benedictine preacher accused of heresy. The artist's strong religious fervour, which may explain some of the unusual iconography in his frescoes, is shown by the fact that he listened to this preacher whenever possible in both Turin and Geneva. Records after 1430 are scarce; he was noted in Turin in 1440.

Jaquerio left only one signed work, a frescoed *Virgin and Child with Saints* in the church of S Antonio di Ranverso, outside Turin. Two cycles of the *Life of St Anthony* and the *Life of St Biagio* in the same church have also been attributed to Jaquerio and his school. Jaquerio's figures are created with strong outlines and have vibrant, caricatured faces. In his most impressive work in Ranverso, the fresco of the *Road to Calvary*, the figures verge on the grotesque. The influence of Jean Bapteur (*fl* 1427–57) has been noted in Jaquerio's work. The most secure attributions to Jaquerio are two panels representing the *Liberation of St Peter* and the *Salvation of St Peter* (Turin, Mus. Civ. A. Ant.). In Geneva, two further works have been given to him or a close follower: a detached fresco with angels from the church of Notre Dame (Geneva, Mus. A. & Hist.) and a *Madonna of Mercy* in St Gervais.

Numerous 15th-century Piedmontese paintings have been attributed to or associated with Jaquerio, but the definition of his oeuvre has been complicated by the discovery of a stylistically similar artist, Aimone Dux of Pavia, who is known to have been at the Savoy court in 1417 and to have worked in Piedmont until 1461; the signature *Aymo Dux* has been discovered on a cycle of *Virtues and Vices* (Villafranca Piemonte, Cappella di Missione) that shares many of Jaquerio's characteristics. Works formerly attributed to Jaquerio are therefore now often given to Dux. These include a fresco cycle of standing saints in the courtyard of the Castle of Fenis, near Aosta, the *Nine Worthies* and the *Fountain of Youth* in the main hall of the Castello della Manta, Manta, and the *Life of St Peter* in S Pietro, Pianezza, near Turin.

BIBLIOGRAPHY

G. Bertea: 'Gli affreschi di Giacomo Jaquerio nella chiesa dell'abbazie di Sant'Antonio di Ranverso', *Atti. Soc. Piemont. Archeol. & B.A.*, viii (1914), pp. 194–207

A. C. Murat: 'Considerazione della pittura piedmontese verso la metà del secolo XV', *Boll. Stor.-Bibliog. Subalp.*, xxxviii (1936), pp. 43–79

N. Gabrielli: 'Un dipinto su tavola di Giacomo Jaquerio', *Boll. Stor.-Bibliog.-Subalp.*, xliii (1941), pp. 197–201

V. Viale: 'Notizie di una pittura di Giacomo Jaquerio a Ginevra', *Atti Soc. Piemont. Archeol. & B.A.* (1947), pp. 42–3

R. Carità: 'La pittura del ducato di Amadeo VIII: Revisione di Giacomo Jaquerio', *Boll. A.*, xli (1956), pp. 109–22

N. Gabrielli: 'Aimone Duce: Pittore a Villafranca Sabauda', *Studies in the History of Art Dedicated to William E. Suida* (London, 1959), pp. 81–5

A. Griseri: 'Nuovi referimenti per Giacomo Jaquerio', *Paragone*, x/115 (1959), pp. 18–35

——: 'Percorso di Giacomo Jaquerio', *Paragone*, xi/129 (1960), pp. 3–16

C. Gardet: 'De la peinture dans les états de Savoie au XVième siècle', *Genava*, ii (1963), pp. 407–43

A. Griseri: *Jaquerio e il realismo gotico in Piemonte* (Turin, 1965)

Giacomo Jaquerio e il gotico internazionale (exh. cat., ed. E. Castelnuovo and others; Turin, Pal. Madama, 1979)

E. Castelnuovo: 'Postlogium Jaquerianorum', *Rev. A.*, lii (1981), pp. 41–6

E. Rossetti Brezzi: *La pittura in Valle d'Aosta tra la fine del 1300 e il primo quarto del 1500* (Turin, 1989)

E. S. WELCH

Julius II, Pope. *See* ROVERE, DELLA, (2).

Julius III, Pope. *See* MONTE, DEL (1).

Klovic, Juraj. *See* CLOVIO, GIULIO.

L

Labacco [Abacco; Dall'Abacco; l'Abacco], **Antonio** (*b* nr Vigevano, ?1495; *d* after 14 Aug 1567). Italian architect, engraver and writer. He is thought to have been in Rome by 1507, but the first specific record of him dates from 1526 when, together with Antonio da Sangallo (ii), Pier Francesco da Viterbo and Michele Sanmicheli, he worked for Pope Clement VII on the fortifications of Parma and Piacenza. After the sack of Rome in 1527, he was as much involved with restoration efforts as he was with recording antique monuments and participating in new building projects. Many existing drawings, some of them from the collection of Vasari (Florence, Uffizi), relate Labacco's work to that of Sangallo, who commissioned him in 1539 to execute the large wooden model, now in the Vatican Museum, of his design for St Peter's, Rome. The model required at least seven years to execute, and it was finished only after Sangallo's death in 1546. Between 1546 and 1548, Labacco also published three engravings of Sangallo's design.

Some drawings of particular interest by Labacco (Florence, Uffizi) include Leon Battista Alberti's S Sebastiano in Mantua (UA 1779A); a mantel design bearing the inscription 'IVLIS LIGURVM POM' (Julius II; UA 1058A recto); a project for S Giovanni dei Fiorentini (UA 1796A), a version of which, published in his *Libro* (see below), is said to be 'our own invention' and is thought to have influenced Baldassare Longhena's design for S Maria della Salute (begun 1631) in Venice; and a plan and elevation of the small nave of S Giacomo degli Spagnoli, Rome (UA 906), for which Labacco collaborated with Sangallo and his circle in its restoration.

Labacco is documented as having participated in works executed for the conclave of 1550 following the death of Pope Paul III; and in 1564, with such artists as Jacopo Vignola, he was paid for work relating to the conclave of 1559. The last record of his activity dates from 1567 for works at S Giovanni in Laterano as well as at the Lateran Baptistery (S Giovanni in Fonte).

Labacco's most important and influential work is his *Libro d'Antonio Labacco appartenente a l'architettura* (1552), with engravings by his son Mario Labacco (*c.* 1530–after 1587). In this book he tried to reconstruct some of the major Roman monuments on the basis of their ruins, acknowledging his indebtedness to the studies of Sangallo and Donato Bramante. A possible collaboration has been suggested between Labacco and Vignola, whose treatises, of the same format, are often bound together in a single volume.

WRITINGS
Libro d'Antonio Labacco appartenente a l'architettura nel qual si figurano alcune notabili antiquita di Roma (impresso a casa nostra, Roma, 1552)

BIBLIOGRAPHY
G. Vasari: *Vite* (1550, rev. 2/1568); ed. G. Milanesi (1878–85)
T. Ashby: 'Il libro d'Antonio Labacco appartenente all'architettura', *La Bibliofilia*, xvi (1914), pp. 289–309
G. Giovannoni: *Antonio da Sangallo il giovane*, i (Rome, 1959), pp. 144–7
M. Pepe: 'I Labacco architetti e incisori', *Capitolium*, xxxviii (1963), pp. 24–7
C. Thoenes: 'La regola delli cinque ordini del Vignola', *Les Traités d'architecture de la renaissance: Actes du colloque: Tours, 1981*, pp. 269–79
H. Zerner: 'Du Mot à l'image: Le Rôle de la gravure sur cuivre', *Les Traités d'architecture de la renaissance: Actes du colloque: Tours, 1981*, pp. 281–94
H. Saalman: 'Alberti's San Sebastiano in Mantua', *Renaissance Studies in Honor of Craig Hugh Smyth*, ed. A. Morrough and others (Florence, 1985), ii pp. 645–52

MARIA A. PHILLIPS

Lafréry, Antoine [Lafreri, Antonio] (*b* Orgelet, Jura, 1512; *d* Rome, 20 July 1577). French engraver and print publisher, active in Italy. He is known to have worked in Rome from 1544 onwards, on the evidence of three plates dated and signed *Antonii Lafrery sequani formis*. He became famous for his work as a publisher. Most of his engravings from 1544 to 1553 were copies of works by his rival Antonio Salamanca, whose associate he became in 1553. Their contract was broken in 1563 by Salamanca's son Francesco. Lafréry's most important work, the *Speculum romanae magnificentiae*, was by its nature unfinished. It was an album of plans and views of Rome, executed between 1545 and 1577 by the best engravers in Rome. By 1567 it comprised 107 plates. The project, intended to give an account of ancient Rome, contained numerous reconstructions and extended to the architectural work of Michelangelo's period (*see* BRAMANTE, DONATO, fig. 6), as well as to some events and festivals. The plates were captioned in Latin and in 1575 the collection was given a title page. The success of the project gave rise to various new editions, and some plates were replaced. Lafréry's edition of the *Vestigi dell'antichità di Roma*, engraved by Etienne Dupérac (*c.* 1525–1601), was more particularly concerned with giving an account of ancient Roman sculpture, both public and private. Lafréry's catalogue, published in 1572, was the first of its kind, both in the realm of engravings and in that of books. It mentioned some 500 titles, including an *Atlas* which comprised 35 views of the city and 80 maps and marked the beginning of modern cartography. On Lafréry's death, his property was inherited

by his cousins: Etienne Duchet (*d* 1583), who sold his share to Paolo Graziani in 1582, and Claude Duchet (*d* 1587) who executed exact copies of Lafréry's engravings.

BIBLIOGRAPHY

F. Roland: 'Un Franc-comtois Editeur et marchand d'estampes à Rome au XVIe siècle: Antoine Lafréry', *Mém. Soc. Emul. Doubs*, n. s. 7, v (1910), pp. 320–78

Mirror of Marvellous Rome: 16th-century Engravings (exh. cat. by R. McGinnis, Binghamton, SUNY, 1979)

SOPHIE BIASS-FABIANI

Lamberti. Italian family of artists. Both (1) Niccolò di Piero Lamberti and his son (2) Piero di Niccolò Lamberti produced sculpture of average quality, but they were important for exporting the Tuscan style to Venice, where they were active in the late 1410s and 1420s.

(1) Niccolò di Piero [Pietro] **Lamberti** [il Pela] (*b* Florence, *c.* 1370; *d* Florence, 1451). Sculptor and architect. Vasari confused him with Niccolò di Forzore Spinelli of Arezzo, a mistake that was not rectified until 1928. The first certain reference to Niccolò di Piero Lamberti occurs in the records of Florence Cathedral in 1391, when he was called *magister*, implying that by that date he was an independent artist. Consequently he must have been born by 1370 and possibly earlier. It has been suggested that Niccolò was one of the carvers in the first campaign of work on the Porta della Mandorla of Florence Cathedral, but there is no explicit connection between Niccolò and this commission until 1406, when work was already under way on the decorative mouldings framing the tympanum. Niccolò was married in Florence in 1392.

In 1395 Niccolò was awarded his first major figural commission for the over life-size statues of *St Augustine* and *St Gregory* for the cathedral façade (Florence, Mus. Opera Duomo). The figures were finished in 1401 and were partially recarved in the 16th century. Piero di Giovanni Tedesco was given the commission for the other two doctors of the church at the same time. In 1395–6 Niccolò was paid for carving a marble *Virgin and Child* (untraced) for the cathedral, which is sometimes incorrectly identified with the *Madonna della Rosa* by Francesco di Simone Ferrucci on Orsanmichele, Florence. He was given a number of minor commissions by the cathedral in 1396 and 1401; most seem never to have been completed. Ghiberti records in his *Commentarii* that Lamberti participated in the competition for the bronze doors of the Florence Baptistery in 1401. In 1402 Lamberti was paid for a lunette of the *Virgin and Child* and an angel (both *in situ*) for the Porta dei Canonici of the cathedral. Between 1403 and 1406 he carved the figure of *St Luke* (Florence, Bargello) for the notaries' guild at Orsanmichele and also designed the niche that housed the statue. The figure conforms to the late Florentine Gothic style.

In 1403 the Venetian Doge Michel Steno asked the Florentine Signoria for permission for Lamberti to go to Venice to work on the Doge's Palace in the capacity of architect, so presumably by that date Lamberti had experience as a builder. The refusal of the Signoria to grant Niccolò leave may reflect either his importance to the Florentine authorities or the fact that they feared his absence would jeopardize the completion of commissions

he had already been awarded. Niccolò became an architectural adviser for Florence Cathedral in 1404. In 1408 he was awarded the commission for the seated marble statue of *St Mark* (Florence, Mus. Opera Duomo; see fig.) for the façade; around the same time Donatello undertook to carve *St John the Evangelist* (*see* DONATELLO, fig. 1), Nanni di Banco *St Luke* and Bernardo Ciuffagni *St Matthew* (all Florence, Mus. Opera Duomo). Niccolò's *St Mark* suffers from excessive embellishment and overworked detail, which would suggest that he attempted to counter the younger sculptors' stylistic innovations by emphasizing his technical expertise. These statues were finished in 1415. In 1410 Niccolò was involved with the construction of the niche for the linen-drapers' guild at Orsanmichele, and from 1411–13 he worked in Prato carving the tomb slab of *Marco Datini* in S Francesco and contributing to the design of the cathedral façade.

By October 1416 Niccolò was in Venice, where he stayed for over a decade. His major work there was apparently the design and carving of statues for the upper façade of S Marco. With few exceptions, such as the standing figure of *St Mark* crowning the central gable, Niccolò's specific contribution to this commission is disputed. He may well have functioned more as a *capomaestro* than as a sculptor in a large workshop in which Lombard carvers took a dominant role. Lamberti was in Bologna in 1428, when he served as an arbiter for a contract. He contributed some unspecified work to the Palazzo degli Anziani in 1429 and seems to have remained

Niccolò di Piero Lamberti: *St Mark*, marble, h. 2.15 m, 1408–15 (Florence, Museo dell'Opera del Duomo)

in Bologna until 1439. On the death of Jacopo della Quercia in 1438, Niccolò received some materials from his workshop, which may indicate a close friendship or working relationship between the two. There are no references to Lamberti between 1439 and 1451, when he died.

(2) Piero [Pietro] **di Niccolò Lamberti** (*b* Florence, *c.* 1393; *d* Venice, 1435). Sculptor, son of (1) Niccolò di Piero Lamberti. He seems to have been trained in his father's shop; he is first recorded in 1410 for some very minor work—probably polishing stone—on the Linaiuoli niche at Orsanmichele. On 2 May 1415 Piero matriculated in the stonemason's guild. Little is known of his work in Florence. A 'Petrus de Florentia' mentioned in the will of Cristoforo Campione in Venice in 1416 is generally believed to refer to Piero di Niccolò, suggesting that he moved to Venice with his father that year. Piero was again in Florence in 1418, when he made the sarcophagus (but not the arch that frames it) for the tomb of *Onofrio Strozzi* in the sacristy of Santa Trìnita, a work that does not demonstrate great accomplishment in figure carving. Piero's first recorded commission in Venice dates from 1423, when he and Giovanni di Martino da Fiesole carved the Late Gothic canopied wall tomb of *Tommaso Mocenigo* in SS Giovanni e Paolo. His only other extant documented sculpture is the tomb of *Raffaello Fulgosio* (Padua, Santo), commissioned in 1429, on which he collaborated with the Tuscan Giovanni di Bartolomeo da Firenze. He is recorded as living in Verona in 1434.

BIBLIOGRAPHY

Thieme–Becker

L. Ghiberti: *Commentarii* (MS before 1455); ed. von Schlosser (1912), p. 46

G. Vasari: *Vite* (1550, rev. 2/1568), ed. G. Milanesi (1878–85), ii, p. 225, n.

C. de Fabriczy: 'Niccolò di Piero d'Arezzo', *Archv Stor. It.*, 5th ser., xxix (1902), pp. 308–27

G. Fiocco: 'I Lamberti a Venezia', *Dedalo*, viii (1927–8), pp. 287–314, 343–76, 432–58

U. Procacci: 'Niccolò di Pietro Lamberti, detto il Pela di Firenze e Niccolò di Luca Spinelli d'Arezzo', *Vasari*, i/4 (1928), pp. 300–16

M. Lisner: 'Zur frühen Bildhauerarchitektur Donatellos', *Munchn. Jb. Bild. Kst*, ix–x (1958–9), pp. 72–127 (94–101, 113–17)

M. Wundram: 'Niccolò di Pietro Lamberti und die Florentiner Plastik um 1400', *Jb. Berliner Mus.*, iv (1962), pp. 78–115

G. R. Goldner: *Niccolò and Piero Lamberti* (Ann Arbor, 1973)

——: 'Two Statuettes from the Doorway of the Campanile in Florence', *Mitt. Ksthist. Inst. Florenz*, xviii (1974), pp. 219–26

——: 'The Tomb of Tommaso Mocenigo and the Date of Donatello's "Zuccone" and the Coscia Tomb', *Gaz. B.-A.*, 6th ser., lxxxiii (1974), pp. 187–92

W. Wolters: *La scultura veneziana gotica* (Venice, 1976)

G. R. Goldner: 'Niccolò Lamberti and the Gothic Sculpture of San Marco in Venice', *Gaz. B.-A.*, 6th ser., lxxxix (1977), pp. 41–50

——: 'The Decoration of the Main Façade Window of San Marco in Venice', *Mitt. Ksthist. Inst. Florenz*, xxi (1977), pp. 13–34

R. Munman: 'The Evangelists for the Cathedral of Florence: A Renaissance Arrangement Recovered', *A. Bull.*, lxii (1980), pp. 207–17

A. M. Schultz: 'Revising the History of Venetian Renaissance Sculpture: Niccolò and Pietro Lamberti', *Saggi & Mem. Stor. A.*, xv (1986), pp. 9–61, 137–222

JOHN T. PAOLETTI

Lame, Biagio dalle. *See* PUPINI, BIAGIO.

Lamia, Domenico. *See* AIMO, DOMENICO.

Lanci [Lancia], **Baldassare** [Baldassare da Urbino] (*b* Urbino, 1510; *d* ?Siena, 1571). Italian engineer and architect. According to Vasari, he was a pupil of the Urbino artist Girolamo Genga, so his earliest career was perhaps in painting. His reputation, however, rests on his skills as a military engineer, in which capacity he was first employed by the Signoria of Lucca, where he lived for some years from 1544. His most notable achievements were the many works executed for Cosimo I de' Medici in a period of extraordinary activity from 1559 (when Siena passed into Florentine hands) until Lanci's death. Cosimo began new defensive works at Siena immediately after annexing it. The trapezoidal Spanish fort was replaced by a large rectangular fort with great bastions at the corners. Lanci supervised the works, which employed 800 men in 1560, but important decisions were referred to Cosimo. This was the most urgent of Cosimo's many works, and although Lanci went to Malta in late 1561 to supervise works at Valletta, the fortress was ready for its garrison by the end of 1563. Most of the masonry survives, the bullnose bastions prominently displaying the Medici arms.

From 1564 Lanci reorganized the important hill fortress of Radicofani, which occupied a strategic site on the road towards Rome and had been seriously damaged in the Sienese wars. As well as rebuilding the old fort, three further enclosures were fortified: Castel Morro, the Borgo and the Fortezza di Sopra. Castel Morro was completed in 1564–5, the others in 1568–77. After Lanci's death, the work was supervised by his son Marino Lanci (*d* 1574) and then by Simone Genga (*c.* 1530–*c.* 1595). In the same period Lanci designed the perimeter walls of Terra del Sole, an entirely new Medici settlement on the north-east border of Tuscany, towards Forlì. He is also believed to have designed the Palazzo del Capitano di Piazza and the Palazzo Pretorio. The former is a rather anachronistic 'castle' reminiscent of Michelozzo di Bartolomeo's work on the Medici villas at Cafaggiolo and Il Trebbio, all characterized by asymmetrical, picturesque compositions with prominent machicolation; in Lanci's building, this extends around the whole perimeter. The Palazzo Pretorio is more sophisticated, especially in the courtyard, which has two superimposed colonnades, all in brick and with attractive semicircular arcades. This work is sometimes attributed to Bernardo Buontalenti.

From 1565 Lanci was also rebuilding the fortifications of the small town of Grosseto, which Florence had acquired as part of Sienese territory. The previous fortifications had formed a simple rectangle, but Lanci's new walls enclosed the entire settlement in a slightly irregular hexagon and made Grosseto the chief fortress of the Maremma. From 1567 Lanci was assisted by his son, and the last two of the six bastions were completed in 1575–6 by Simone Genga. The walls defined the extent of the town until recent times and still largely survive. In March 1570 Lanci went with Cosimo to Montalcino to design a new bulwark incorporating an older castle. This was built at the same time as Grosseto and in only a few months, being virtually complete by Lanci's death.

Lanci's other important work for the Medici was a long series of coastal defences down the newly acquired Sienese shoreline, particularly around Monte Argentario. Some of these incorporated existing defences, such as those at Le

Saline and Castel Marino, but most were new, in the form of some 30 isolated fort-towers from the mouth of the Ombrone to the border with the papal states. Many were built to a standard design, and they were about 12 m tall, with square plans and splayed, reinforced bases. They were virtually windowless, and the small entrance door was on the first floor, reached by steps and a drawbridge. At the top was a crenellated gun platform, while the basement contained a large water tank. A few, such as those at Ciana and Talamone, are circular in plan. Some were completed after Lanci's death by Simone Genga. Many survive, although most are damaged and a few lost entirely.

Lanci also produced ecclesiastical and theatrical designs. The church of S Maria della Rosa (1585) at Chianciano (nr Montepulciano), on a Greek-cross plan with an apse, was built to his design.

BIBLIOGRAPHY
Thieme–Becker

G. Vasari: *Vite* (1550, rev. 2/1568); ed. G. Milanesi (1878–85), vi, p. 325; vii, pp. 616–17

F. Chigi: *Guida di Siena* (Siena, 1625)

G. A. Pecci: *Relazione delle cose più notabili della città di Siena* (Siena, 1752)

A. Venturi: *Storia* (1901–40), xi/2, pp. 659–62

A. L. Maggiorotti: *Gli architetti militari italiani* (Rome, 1933)

F. Gurrieri and others: *Architettura e interventi territoriali nella Toscana Granducale* (Florence, 1972)

L. Rombai, ed.: *I Medici e lo stato senese, 1555–1609: Storia e territorio* (Grosseto, 1980) [esp. papers by E. Coppi and C. Borsarelli]

L. Bortolotti: *Siena* (Bari, 1983)

M. Forlani-Conti and C. Pescatori Ciappi: *Le fortificazioni di Grosseto* (Florence, 1989)

M. A. Giusti: *Edilizia in Toscana dal XV al XVII secolo* (Florence, 1990)

RICHARD J. GOY

Landi (del Poggio), Neroccio (di Bartolommeo di Benedetto) de' (*b* Siena, 1447; *d* Siena, 1500). Italian painter and sculptor. Born into the noble Sienese family of Landi del Poggio, he probably learnt painting and sculpture from Lorenzo di Pietro, called Vecchietta, the teacher of almost all Sienese artists of the second half of the 15th century. Neroccio is first documented in 1461 when he was employed as a *garzone* ('shop boy') with the Cathedral Works of Siena. By 1468 he was working independently and completed his first documented commissions, a panel for Fra Giovanni, a certain rector of the Compagnia di S Girolamo, and a polychrome terracotta of the saint for the same confraternity.

At this time, Neroccio formed a partnership with the Sienese painter and architect Francesco di Giorgio Martini, with whom he collaborated on numerous *cassone* paintings and altarpieces. Francesco di Giorgio's influence on the younger Neroccio was significant, and he was primarily responsible for encouraging Neroccio's delicate figure style and pastel palette. This is particularly evident in the lunette of the *Annunciation* (*c.* 1475; New Haven, CT, Yale U. A.G.), where the pastel-coloured figures of the Virgin and the Archangel Gabriel weave a lyrical pattern across the regular geometric design of the architecture. The interplay of line and colour, although rooted in the tradition of 14th-century Sienese painting (i.e. Simone Martini), was a fundamental element that Neroccio derived almost exclusively from Francesco. Second in influence was Liberale da Verona, a North Italian painter who worked in Siena as an illuminator and with whom Francesco di Giorgio and Neroccio may have collaborated in the early 1470s.

Neroccio and Francesco di Giorgio Martini formally dissolved their partnership in 1474. That year Neroccio carved a full-length polychrome wooden statue of *St Catherine of Siena* for the oratory of S Caterina, Fontebranda. In the modelling of the saint's face Neroccio established the characteristics that he later repeated in his paintings of the Virgin: full cheeks, lowered eyes and a narrow chin. In 1476 Neroccio executed one of his finest altarpieces, the signed and dated *Virgin and Child with SS Michael and Bernardino* (Siena, Pin. N.; see fig.). The slender Virgin of the central panel of the triptych is drawn with elegant rhythmic lines. Translucent drapery, which Neroccio was particularly skilful at painting, frames her face and falls loosely over her shoulders. The gold leaf of the background enhances her regal appearance.

During the 1480s Neroccio received a variety of commissions that show his great versatility in working in different media. In 1480 he painted a *biccherna* (tax record cover; Siena, Archv Stato) of the *Virgin Recommending the City of Siena to Christ*. He designed the *Hellespontine Sibyl* in 1483 for the marble inlay decoration of the pavement in Siena Cathedral. He also executed two major sculptures for the cathedral: the sepulchral monument to *Bishop Tommaso Testa Piccolomini* (1485) and a marble statue of *St Catherine of Alexandria* (1487) for the new chapel of St John the Baptist.

The greater part of Neroccio's production, however, comprises small devotional paintings of the Virgin holding the Infant Christ, who is adored by two half-length saints of smaller proportion tightly wedged into the corners behind the Virgin. Intended primarily for private devotion, these images were repeated with little variation of design. Most of them are undated, and there are few stylistic indications of their chronological sequence. In addition, Neroccio's assistants also participated in their production, thus confusing the matter of attribution. A few masterly examples, credited totally to Neroccio's hand, are, however, extant and show his graceful drawing and exquisite translucent coloration, for example the *Virgin and Child with SS John the Baptist and Mary Magdalene* (1490s; Indianapolis, IN, Mus. A.). Neroccio's late work consists of several important commissions, which he signed and dated. One noteworthy example is the altarpiece from Rapolano, depicting the *Virgin and Child with SS Anthony Abbot and Sigismund* (1492–6; Washington, DC, N.G.A.). While Neroccio's paintings are notably conservative in composition, his drawing and transparent luminosity of colour place him among the most talented Sienese artists of the 15th century.

BIBLIOGRAPHY
G. Coor: *Neroccio de' Landi* (Princeton, 1961)

B. Berenson: *Central and North Italian Schools* (1968)

B. Cole: *Sienese Painting in the Age of the Renaissance* (Bloomington, 1985)

GENETTA GARDNER

Landini, Taddeo (*b* Florence, *c.* 1561; *d* Rome, 13 March 1596). Italian sculptor and architect. His earliest surviving works were executed in Rome between 1582 and 1585; for example, for the Ricci Chapel in the church of Santo

Neroccio de' Landi: *Virgin and Child with SS Michael and Bernardino*, panel, 1.56×1.81 m, 1476 (Siena, Pinacoteca Nazionale)

Spirito, Florence, he carved a marble copy of Michelangelo's *Risen Christ* (Rome, S Maria sopra Minerva). In 1585 he executed a gilt-bronze seated statue of *Pope Sixtus V* (destr. 1590), which was erected in the Palazzo dei Conservatori in 1587 and is now known only from a woodcut. The Pope's lively pose demonstrates Landini's adherence to the sculptural formula of Guglielmo della Porta's *Pope Paul III*, recognizable also in Landini's bronze figure of *St John the Evangelist* (Rome, S Giovanni in Laterano, Baptistery), probably designed around the same time.

Between 1585 and 1588 Landini executed his most famous work, the so-called Fonte delle Tartarughe (Rome, Piazza Mattei), named after the tortoises (added in 1658) that clamber from the bronze youths' hands into the upper basin of the fountain. Although the overall design was made in collaboration with Giacomo della Porta, Landini was solely responsible for the spirited boys, whose lively poses and arrangement around the basin recall Florentine fountain designs of the previous generation. During this time he also produced the half-length figure of a *Triton*

for the Fontana del Moro at the southern end of the Piazza Navona in Rome. The relief of *Christ Washing the Feet of the Disciples* (Rome, Pal. Quirinale), made for the Cappella Gregoriana in St Peter's, illustrates a shift in Landini's stylistic development, away from the influence of Giambologna's works to that of works by Lombard sculptors in Rome. A figure of *Winter* (Florence, Ponte Santa Trìnita) continues in the vein of Giovanni Battista Caccini's earlier figures for the same bridge.

As papal architect for popes Gregory XIII, Sixtus V and Clement VIII, Landini was involved in various projects, including engineering works. He designed a new ceiling for the Lateran Church in 1592, and in 1593, with Giacomo della Porta, he travelled to Rieti to survey the flood area of Lake Piediluco. The following year, with Carlo Maderno (1555/6–1629) and Carlo Lombardi, he was required to visit Ponte Felice, the lake at Perugia and other locations. Under the direction of Carlo Fontana (1638–1714), he was involved in the restoration of the Teatro del Belvedere and the rebuilding of the Tiber bridge near the Borghetto in Rome.

BIBLIOGRAPHY
C. Ricci: 'Statue e busti di Sisto V', *L'Arte*, xix, (1916), pp. 163–74
M. Guidi: *Le fontane barocche di Roma* (Zurich, 1917), pp. 23, 61–3
W. Hager: *Die Ehrenstatuen der Päpste* (Leipzig, 1929), pp. 52–3, pl. 19
B. Wiles: *The Fountains of the Florentine Sculptors* (Cambridge, MA, 1933), pp. 102–3, 135
A. Venturi: *Storia*, x (1937), pp. 874–85
T. Eser: 'Der "Schildkrötenbrunnen" des Taddeo Landini', *Röm. Jb. Bib. Hertz*, xxvii–xxviii (1991–2), pp. 201–82

ANTONIA BOSTRÖM

Landino, Cristoforo (*b* Florence, 1424; *d* Borgo alla Collina, nr Pratovecchio, 24 Sept 1498). Italian humanist and writer. After studying at Volterra, he moved to Florence. In 1458 he began lecturing at the Florentine Studio (the university) on poetry and rhetoric, also working as a secretary in the chancellery after 1483. He became a member of Marsilio Ficino's circle, whose Neo-Platonic philosophy he applied to the interpretation of poetry.

A champion of the Italian language, Landino produced a vernacular translation of Pliny the elder's *Natural History* in 1473. In his version of the books devoted to art (XXXIV–XXXVI), he coined a number of terms, closely based on their Latin originals, which enriched the vocabulary of 15th-century art criticism: for instance, *disposizione* (arrangement), *florido* (flowery) and *duro* (hard). In the preface to his *Comento sopra la Comedia di Dante Alighieri* (1481), Landino gave a brief account of distinguished Florentine painters and sculptors. He began with a discussion of ancient art, based on Pliny, and then, drawing heavily on Filippo Villani, described the work of Cimabue, Giotto and other 14th-century painters. In his characterizations of 15th-century artists Landino, in the opinion of Baxandall (*Convegno*), was acting as a mouthpiece for the views of his friend Leon Battista Alberti, and his account of contemporary art can be read as an illustration, by means of concrete examples, of the artistic concepts and terminology of Alberti's *De pictura*, which reached a wide audience through Landino's popular work.

Landino praised Masaccio for his ability to imitate nature, his seemingly effortless fluency (*facilità*), his mastery of perspective and his ability to give objects a rounded appearance or relief (*rilievo*). He described Masaccio's compositional style as plain and clear (*puro senza ornato*), whereas that of Filippo Lippi was polished and finished (*ornato*). Lippi's work is also pleasing and full of grace (*grazioso*), and he was skilled in both relief and colouring (*colorire*), that is, the tonal representation of light reception. His paintings achieve a balance between variety (*varietà*) and composition (*composizione*) by organizing a diversity of subject-matter into a single, coherent effect, a quality Landino also found in the sculptures of Donatello, whom he called a great imitator of the Ancients. Andrea del Castagno enjoyed executing difficult things with great facility, excelling in linear design and the use of foreshortening (*scorci*). Paolo Uccello, because he had a good understanding of perspective, also handled foreshortening skilfully, as well as achieving great mastery in the depiction of animals and landscape. Landino refers to the paintings of Fra Angelico as charming (*vezzoso*) and devout (*divoto*), a term used at that time to denote a type of sermon that avoided unnecessary elaboration and was easily understood. Landino concluded by mentioning a number of 15th-century sculptors, including Desiderio da Settignano,

Lorenzo Ghiberti—singling out for praise his *Gates of Paradise* for the Florentine Baptistery (see colour pl. 1, XXXI2)—and Antonio and Bernardo Rossellino.

In his dialogue *Disputationes camaldulenses* (*c.* 1474), Landino cast Alberti as a character in Books III and IV, a Neo-Platonic, allegorical explanation of Virgil's *Aeneid*. According to Preimesberger, this interpretation of Aeneas's voyage from Troy to Italy as a spiritual odyssey from the sensual to the contemplative life later influenced the scheme of Pietro da Cortona's Gallery of Aeneas (Rome, Pal. Doria–Pamphili).

WRITINGS
Comento di Cristoforo Landino fiorentino sopra la comedia di Dante Alighieri poeta fiorentino (Florence, 1481); preface in *Scritti critici e teorici*, ed. R. Cardini, i (Rome, 1974), pp. 100–164

BIBLIOGRAPHY
E. Müller-Bochat: *Leon Battista Alberti und die Vergil-Deutung der Disputationes Camaldulenses: Zur allegorischen Dichter-Erklärung bei Cristoforo Landino* (Krefeld, 1968)
M. Baxandall: *Painting and Experience in Fifteenth-century Italy* (Oxford, 1972, rev. 2/1988), pp. 114–51 [detailed analysis of the preface to Landino's *Comento sopra la Comedia di Dante*]
——: 'Alberti and Cristoforo Landino: The Practical Criticism of Painting', *Convegno internazionale indetto nel V centenario di Leon Battista Alberti: Roma–Mantova–Firenze, 1972*, pp. 143–54
R. Preimesberger: 'Pontifex romanus per Aeneam praesignatus: Die Galleria Pamphilj und ihre Fresken', *Röm. Jb. Kstgesch.*, xvi (1976), pp. 221–87
A. Field: *The Origins of the Platonic Academy of Florence* (Princeton, 1988), pp. 231–68

JILL KRAYE

Lanino, Bernardino (*b* Vercelli, 1509–13; *d* after 26 Nov 1581). Italian painter and draughtsman. In 1528 Lanino was apprenticed to Baldassarre de Cadighis of Abbiategrasso in Vercelli, but from 1530 he was associated with Gaudenzio Ferrari, then the most important painter in Vercelli. Lomazzo claimed that Lanino was Gaudenzio's pupil. By 18 November 1533 he was already a master painter. His early works, such as the *Virgin and Child with Saints* (Turin, Gal. Sabauda), painted for S Eusebio, Ternengo, show how he had assimilated Gaudenzio's delicate effects, and interpreted them in soft, misty brushstrokes. After Gaudenzio moved to Lombardy (*c.* 1534) and later established himself in Milan (*c.* 1539–46), Lanino became the most active painter in the region; from this period date the *Virgin and Child with Saints* (1539), painted for SS Pietro e Paolo, Borgosesia (*in situ*), and *Virgin and Child with Saints* (1543; London, N.G.), painted for Francesco Strata's chapel in S Paolo, Vercelli. Other altarpieces of this date include the *Assumption of the Virgin* (signed and dated 1543; Biella, S Sebastiano) and frescoes of scenes from the *Life of the Virgin* in Novara Cathedral (1546–53).

Between 1540 and 1560 Lanino made several visits to Milan; his *Assumption* at Biella reveals that he was already familiar with the styles of Bernardino Luini and Marco d'Oggiono. His works in Milan include the frescoes of scenes from the *Life of St Catherine* (1546–8), in the form of a gigantic altarpiece, in S Caterina presso San Nazzaro, on which Giovanni Battista della Cerva may also have collaborated, and frescoes of scenes from the *Life of St George* (*c.* 1548–50) in S Ambrogio. Lanino also frescoed the pendentives of the cupola in S Maria dei Miracoli, Saronno, with scenes from the *Old Testament* (1547); the

cupola had been previously painted by Gaudenzio. Lanino adapted to the changes in taste that followed the Counter-Reformation, and at the end of his life reverted to his youthful style formed under the influence of Gaudenzio, as is evident in *Virgin and Child with SS Francis and Bernardino*, known as the *Madonna del Cane* (1563; Vercelli, Mus. Civ. Borgogna). He was an accomplished draughtsman, often using pen and wash with white highlights for his compositional studies, such as the *Crucifixion with Saints* (Turin, Bib. Reale), a study for a fresco in S Antonio Abate in Vercelli. With the help of his workshop, he continued to produce large numbers of paintings until his death. Lanino was the son-in-law of the painter Gerolamo Giovenone the elder (*fl* 1513–*c.* 1552); his sons Pietro Francesco Lanino (*c.* 1552–after 1604) and Gerolamo Lanino (*b* 1555) were also painters active in Vercelli.

BIBLIOGRAPHY
Thieme–Becker
G. P. Lomazzo: *Trattato dell'arte* (Milan, 1584)
B. Berenson: *Central and North Italian Schools*, i (1968), pp. 206–9
Gaudenzio Ferrari e la sua scuola: I cartoni cinquecenteschi dell'Accademia Albertina (exh. cat., ed. G. Romano; Turin, Accad. Albertina, 1982)
Bernardino Lanino (exh. cat., ed. G. Romano and P. Astrua; Vercelli, Mus. Civ. Borgogna, 1985) [with full bibliog.]
Bernardino Lanino e il cinquecento a Vercelli, ed. G. Romano (Turin, 1986)
RICCARDO PASSONI

Lapo (Portigiani), Pagno di. *See* PAGNO DI LAPO.

Lappoli, Giovanni Antonio (*b* Arezzo, 1492; *d* Arezzo, 1552). Italian painter. He was the son of a painter, Matteo Lappoli (*d* 1504). He learnt the rudiments of his art from Domenico Pecori (*c.* 1480–1527) in Arezzo, then completed his training in Florence, where he frequented the workshops of Andrea del Sarto and Pontormo and came into contact with the most important painters of the time, including Agnolo Bronzino and Rosso Fiorentino. He initially concentrated on musical interests, but was persuaded to resume painting *c.* 1523 by Perino del Vaga. When the plague reached Florence, he returned to Arezzo, where he was commissioned to paint several works (most untraced). In 1524 Rosso, in Arezzo on his way to Rome, gave Lappoli a drawing to use for his painting of the *Visitation* (Arezzo, Badia). According to Vasari, Lappoli went to Rome in 1527 and suffered during the Sack. He returned to Arezzo, where he painted an altarpiece for S Francesco, the *Adoration of the Magi* (Arezzo, S Domenico), also from a drawing by Rosso. The decisive influence of Rosso is evident in Lappoli's few surviving works: the *Virgin and Child with Saints*, the *Allegory of the Immaculate Conception* (both Montepulciano, Mus. Civ.) and *Virgin and Child with Saints* (Bibbiena, S Maria del Sasso). His paintings did not, however, do justice to the quality of Rosso's drawings.

BIBLIOGRAPHY
E. A. Carrol: 'Lappoli, Alfani, Vasari and Rosso Fiorentino', *A. Bull.*, xlix (1967), pp. 297–304
M. Lenzini Moriondo: *Arte in Valdichiana* (exh. cat., Cortona, Fortezza Girifalco, 1970), pp. 44–5
B. Giordano: *S Maria del Sasso: Un fiore del rinascimento in Casentino* (Cortona, 1984), pp. 90–91
D. Franklin: 'Documents for Giovanni Antonio Lappoli's *Visitation* in Sante Flora e Lucilla in Arezzo', *Mitt. Ksthist. Inst. Florenz*, xli/1/2 (1997), pp. 197–205
FIORENZA RANGONI

Lari, Antonio Maria [il Tozzo] (*fl* ?1521; *d* Rome, ?1549). Italian architect and painter. He appears to have studied with Baldassarre Peruzzi, architect to the Republic of Siena, a post that Lari himself held from December 1537. Especially active as a military architect following the Battle of Camollia (1526), Lari was also employed as a painter on minor commissions and was responsible for a compendium (destr.) that apparently brought together a series of drawings of Roman buildings and translations of Archimedes and Polybius. Lari travelled extensively on behalf of the Sienese government: he visited the major Sienese defensive sites and planned renovations and new works. In 1537 he is recorded at Cetona, Sarteano and Chiusi to inspect fortifications. In 1538, 1539, and 1540 he revisited the same towns; in 1540 and 1542 he also visited such towns in the Maremma region as Orbetello, Grosseto and Talmone. Trips to the Maremma may have been undertaken in response to the resurgence of Turkish naval power after their victory at Prevesa in 1538.

Lari's task was to inspect the state of the defences, plan improvements and repairs, and oversee the craftsmen employed on the works. In 1539 Lari was appointed architect for the monastery and church of S Maddalena, Siena. In 1540 he recast the interior of Grosseto Cathedral in Renaissance style (altered 1662–9 by Fra Gregolini and Fra Cappucci). Other works in Siena that have been attributed to Lari include the façade of the Palazzo Nuti Palmieri and the church of S Marta. From 1545 he seems to have been employed as architect for the fortress of Pitigliano. When the count, Gianfrancesco Orsini, was deposed by his son, Lari followed him to Rome, where he spent his last years.

BIBLIOGRAPHY
G. Vasari: *Vite* (1550, 2/1568); ed. G. Milanesi (1878–85)
E. Romagnoli: *Biografia cronologica de' bellartisti senesi, 1200–1800*, vii (Siena, 1835, 2/1976), pp. 17–38
S. Borghesi and L. Banchi: *Nuovi documenti per la storia dell'arte senese* (Siena, 1898, 2/1970)
S. Pepper and N. Adams: *Firearms and Fortifications: Military Architecture and Siege Warfare in Sixteenth-century Siena* (Chicago, 1986)
NICHOLAS ADAMS

Lascaris, Giovanni Giorgio [Zuan Zorzi]. *See* PYRGOTELES.

Lastricati, Zanobi (di Bernardo) (*b* Florence, 13 Dec 1508; *d* Florence, 14 April 1590). Italian sculptor and bronze-caster. He is first mentioned in connection with the casting of the bronze putti, after terracotta models by Pierino da Vinci, which are placed around the rim of the basin of Niccolò Tribolo's *Fountain of Hercules* (*c.* 1546; for illustration *see* TRIBOLO NICCOLÒ) for the Medici villa at Castello. In 1548, together with his brother Alessandro (*d* 1575), also a founder, he assisted Benvenuto Cellini in the casting of the *Medusa* for the *Perseus* group (Florence, Loggia Lanzi; *see* CELLINI, BENVENUTO, fig. 6). The bronze *Mercury* that Vasari says Lastricati cast after a model by 'Ciano profumiere' (the sculptor Bastiano di Francesco d'Jacopo) for the courtyard of Lorenzo Ridolfi's palazzo in via Tornabuoni, Florence, has been identified as the signed bronze now in the Walters Art Gallery, Baltimore, MD, and dated to 1549–51.

Lastricati was paid in 1556 for 'campanelle a diamanti' (probably bronze door-knockers in the form of the Medici diamond ring) for new apartments in the Palazzo Vecchio, and in 1560 he cast Vincenzio Danti's bronze *sportello* ('safe-door'; Florence, Bargello) for Cosimo I's antechamber there. In 1564 he was chosen by the Accademia del Disegno as *provveditore* ('comptroller') for Michelangelo's obsequies, for which he designed the marble figure of *Fame* (drawing, Munich, Staatl. Graph. Samml.) for the pyramid surmounting the catafalque in the church of S Lorenzo, Florence. The following year, in collaboration with Giovanni Vincenzo Casali (*c.* 1540–93), he supplied six temporary statues (destr.) on the Porta al Prato for the triumphal entry into Florence of Joanna of Austria, bride of Francesco I de' Medici. Between 1570 and 1571, in collaboration with Danti, he completed the gesso figure of *Cosimo I de' Medici as Joshua* for the chapel of S Luca in SS Annunziata. For the festivities for the baptism of Filippo de' Medici in 1577 he supplied a terracotta puppet on a cart. The last years of his life were spent working at the Medici fort in Siena, probably as an artillery founder (*bombardiere*). Vasari described him as a good and able marble sculptor and bronze-caster.

BIBLIOGRAPHY

G. Vasari: *Vite* (1550, rev. 2/1568); ed. G. Milanesi (1878–85), v, p. 199; vi, p. 124; vii, pp. 306, 640; viii, p. 618

G. Palagi: *Di Zanobi Lastricati scultore e fonditore fiorentino del sec. XVI* (Florence, 1871)

R. Wittkower: *The Divine Michelangelo* (London, 1964), pp. 19, 89, 105–6, 154, 156, 160–61

D. Summers: 'The sculptural program of the Cappella di San Luca in the Santissima Annunziata', *Mitt. Ksthist. Inst. Florenz*, xiv (1969–70), pp. 67–90

M. Spallanzani: 'The courtyard of Palazzo Tornabuoni-Ridolfi and Zanobi Lastricati's bronze Mercury', *J. Walters A.G.*, xxxvii (1978), pp. 6–21

G. Corti: 'Il testamento di Zanobi Lastricati, scultore fiorentino del cinquecento', *Mitt. Ksthist. Inst. Florenz*, xxxii (1988), pp. 580–81

A. Boström: 'Zanobi Lastricati, Cellini and Cosimo de' Medici: Mistaken Identities and a Newly Discovered Document', *Burl. Mag.*, cxxxvi / 1101 (1994), pp. 835–6

ANTONIA BOSTRÖM

Lattanzio da Rimini (*b* Rimini; *fl* 1492–1524). Italian painter. He is first recorded in 1492 as one of several assistants of Giovanni Bellini working in the Doge's Palace in Venice. Further evidence of his close and lasting association with Bellini is provided by a signed *Virgin and Child* (Berlin, Schloss Köpenick; destr.), the design of which corresponded to that of Bellini's *Virgin and Child with Two Saints* (Frankfurt am Main, Städel. Kstinst. & Städt. Gal.), and by the letters 'd. Jo. B.' ('discipulus Johannis Bellini') that follow his signature on an altarpiece of *SS Peter, John the Baptist and John the Evangelist* (1505) in Mezzoldo, province of Bergamo. But Lattanzio also followed an independent career: in 1499, for example, he signed a *St Mark Preaching in Alexandria* (destr.), one of four scenes of the *Life of St Mark* executed by four different painters (including Cima da Conegliano and Giovanni Mansueti) for the chapel of the silkweavers in the church of the Crociferi in Venice. A compositional drawing (ex-Chatsworth, Derbys, see Heinemann, ii, pl. 306) has been plausibly identified as a preliminary sketch for it. Lattanzio's most important work is a polyptych of *St Martin and the Beggar with Saints*, painted for the parish church of S Martino, near Piazza Brembana, Bergamo (*in situ*), commissioned in 1500 and completed in 1504. Despite a certain timidity and naivety in the figures, which show the influence of Cima as well as of Bellini, the work reveals an attractive decorative sense in the simplified treatment of form and colour and in the extensive mountainous landscape. From 1509 to 1524 Lattanzio is recorded in Rimini, but no works from this period are known.

BIBLIOGRAPHY

Thieme–Becker

A. Venturi: *Storia* (1901–40), vii/4, pp. 600–02

G. Ludwig: 'Archivalische Beiträge zur Geschichte der venezianischen Malerei', *Jb. Kön.-Preuss. Kstsamml.*, xxvi (1905) [suppl. with documents], pp. 26–34

L. Venturi: *Le origini della pittura veneziana* (Venice, 1907)

G. Fiocco: 'Piccoli maestri: Lattanzio da Rimini', *Boll. A.*, n.s. 2, ii (1922–3), pp. 363–70

H. Tietze and E. Tietze-Conrat: *The Drawings of the Venetian Painters of the 15th and 16th Centuries*, 2 vols (New York, 1944)

B. Berenson: *Venetian School* (1957), i, pp. 95–6

F. Heinemann: *Giovanni Bellini e i belliniani* (Venice, 1962), i, pp. 111–14; ii, pp. 278–85

P. Zampetti: *A Dictionary of Venetian Painters: The 14th and 15th Centuries* (Leigh-on-Sea, 1969), pp. 65–6

PETER HUMFREY

Laurana [de la Vrana], **Francesco** (*b* Vrana, nr Zara [now Zadar, Croatia]; *d* Marseille, before 12 March 1502). Italian sculptor and medallist. He was one of the most significant and most complex sculptors of the 15th century—complex because of his activities within varying cultural circles and his exposure to differing influences. His best works evolved in the workshop tradition in collaboration with other artists. His portrait busts reveal a creative individuality that was seen as particularly fascinating in the late 19th century. Though it is impossible to chart his stylistic development, his later work made in France shows some assimilation of northern realism, which is absent from the work executed in Italy.

1. Life and documented work. 2. Portrait busts.

1. LIFE AND DOCUMENTED WORK. It seems that Laurana began his career in Ragusa (now Dubrovnik, Croatia), and he probably trained first with the sculptor Pietro di Martino da Milano, who was active in Ragusa between 1431 and 1452. From 1453 both sculptors were working in Naples, and from 1461 in Provence. Laurana was also influenced by the work of Giorgio da Sebenico (*fl* 1441–1473). He is first mentioned in a document of 17 July 1453, which records payments to Pedro Juan (*d* ?1445), Pietro di Martino da Milano, Paolo Romano and Laurana for their work on the Castel Nuovo in Naples (*see* NAPLES, §3). In 1458 Laurana was among the sculptors engaged to work on the completion of the Triumphal Arch at Castel Nuovo. While he can no longer be said to have had any part in its design, Laurana made considerable contributions to the sculptures on the arch. Both the seated *Virgin and Child* in S Agostino della Zecca, Naples, and the *Virgin and Child* in the portal lunette of the chapel of S Barbara in the Castel Nuovo may date from this time. From 1461 to 1466 Laurana worked in Provence, largely in Marseille. During this period he made medals for René I, Duke of Anjou, and his circle. The designs of the medals, which show a familiarity with those from the circles of Pisanello and Matteo de' Pasti, combine Late

Gothic elements with Classical motifs based on Roman medals. They have the same technical shortcomings as those of Pietro di Martino da Milano. In 1464 he worked on a fountain (destr.) for Puy-Sainte-Réparade, near Aix-en-Provence.

There is evidence that Laurana was in Sicily from May 1468 until September 1471, but he may have arrived earlier and left later. At first he worked in Partanna, near Castelvetrano, and Sciacca. On 2 June 1468 Laurana and Pietro de Bonitate (*fl* 1468–95) were commissioned by Antonio Mastrantonio to work on his family chapel in S Francesco d'Assisi, Palermo, for which they provided a statue of the *Virgin and Child* and the figural decoration of the entrance arch (*in situ*), and a tomb (untraced). In 1469 Laurana was commissioned to make a copy of the 'Trapani Madonna' (*Virgin and Child*; Trapani, SS Annunziata) by Nino Pisano (*fl* 1334–60s) for the Chiesa Matrice, Erice, following the confiscation by the Palermo authorities of a statue of the *Virgin and Child* (Palermo Cathedral) that he had already completed. The statue in Erice was eventually executed by Domenico Gagini. Laurana was last mentioned in Palermo on 28 September 1471, but he seems to have stayed on the east coast of Sicily that year. The statue of the *Virgin and Child* (from Noto Antica) in the Chiesa del Crocifisso, Noto (Syracuse), is signed and dated 1471, and the *Virgin and Child* in S Maria della Medaglia, Palazzolo Acreide, may date from the same year. The *Virgin and Child* (Messina, Mus. Reg.; see fig. 1) from S Agostino, Messina, stands stylistically between Francesco Laurana and Pietro de Bonitate. Laurana's work in Sicily shows the influence of the French sculpture that he had seen in Provence.

In 1474 Laurana was back in Naples; it is not known how long he stayed, but on 26 March that year he was paid for the statue of the *Virgin and Child* above the portal of the chapel of S Barbara in the Castel Nuovo in Naples. The figure follows the Sicilian madonnas in type and style. The *Virgin and Child* (Naples, Capodimonte), which was formerly in S Maria Mater Domini in Naples and is attributed to him, may date from this period. A door frame in Santeramo in Colle, Apulia, has been plausibly attributed to Laurana, although there is no documentary evidence that he stayed there.

Between 1475 and 1483 Laurana was in southern France working chiefly in Avignon and Marseille. From 1475 he worked with the sculptor Tommaso Malvito (*fl* 1476–1508) on the Saint-Lazare Chapel in the Old Cathedral, Marseille. It has been plausibly suggested that the decorative parts are largely the work of Malvito, while Laurana was principally responsible for the statues. In 1478 Laurana took up René of Anjou's commission for a sculpted marble altarpiece of *Christ Carrying the Cross* for the chapel of the Celestines in Avignon (now in S Didier), which, according to the inscription, was erected in 1481. Some parts of the relief, which is partially polychromed, reveal a rather crude realism.

Legal documents exist mentioning that Laurana was in Marseille on 27 May 1483 and in December 1492 but nothing certain is known of his work between these dates. It is even unclear whether he continued to sculpt, since between 1493 and 1502 references to his presence in Marseille do not mention his artistic activities. It has been

1. Francesco Laurana: *Virgin and Child*, marble, *c.* 1470 (Messina, Museo Regionale Messina)

suggested that he worked in Genoa, Rimini and Urbino and visited Sicily for a second time, and attributions of works have been conjectured. All these suppositions are improbable, and the attributions are stylistically implausible.

2. PORTRAIT BUSTS. Laurana is best known for his female portrait busts, but these pose the greatest problem

of attribution. None of them is documented, signed or dated. The busts of only two sitters can be positively identified by their inscriptions, those of *Battista Sforza* (Florence, Bargello) and *Beatrice of Aragon* (New York, Frick). The latter was probably executed in Naples before 1476, before the Princess's marriage to Matthias Corvinus, King of Hungary (*reg* 1458–90), and her departure for Hungary. The chronology and identification of the other busts (Palermo, Gal. Reg. Sicilia, see fig. 2; Washington, DC, N.G.A.; New York, Frick; Vienna, Ksthist. Mus.; Paris, Louvre; Paris, Mus. Jacquemart-André) are as yet unproven, and little is known about their function and original location. Several male busts have also been attributed to Laurana, the most convincing being a bust of the young *Ferdinand of Aragon* (Berlin, Skulpgal.) and that of a young nobleman (Stockholm, Nmus.). The portrait bust of *Francesco II del Balzo* (Andria, S Domenico) is by Domenico Gagini. The attribution and function of a further group of marble female masks (Aix-en-Provence, Mus. Granet; Bourges, Hôtel Jacques Coeur; Le Puy, Mus. Crozatier; Villeneuve-lès-Avignon, Mus. Mun.; Berlin, Staatl. Museen; Milan, Castello Sforzesco; Turin, Gal. Sabauda; New York, Met.) remain controversial. They all appear to have southern French origins.

Laurana's style is characterized by an extreme refinement of facial expression, which strives to achieve a balance between idealization and individual interpretation. This is particularly true of the portrait busts, and makes it all the more difficult to identify the sitters.

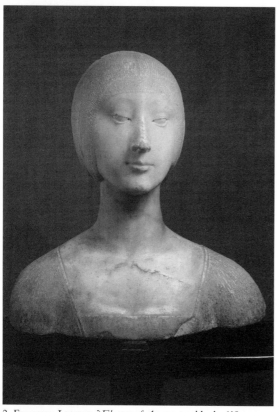

2. Francesco Laurana: ?*Eleanor of Aragon*, marble, h. 410 mm, *c.* 1470 (Palermo, Galleria Regionale della Sicilia)

BIBLIOGRAPHY
A. Heiss: *Francesco Laurana, Pietro da Milano*, ii of *Les Médailleurs de la Renaissance* (Paris, 1882)
F. Burger: *Francesco Laurana: Eine Studie zur italienischen Quattrocento-skulptur* (Strasbourg, 1907)
W. Rolfs: *Franz Laurana*, 2 vols (Berlin, 1907)
W. R. Valentiner: 'Laurana's Portrait Busts of Women', *A.Q.* [Detroit], v (1942), pp. 273–99
R. Petrovich: ' "Questi schiavoni" II: Luciano and Francesco Laurana', *Gaz. B.-A.*, n. s. 5, xxxi–xxxii (1947), pp. 64–80
R. Causa: 'Sagrera, Laurana e l'Arco di Castelnuovo', *Paragone*, n. s., v (1954), pp. 3–23
E. Tietze-Conrat: 'A Relief Portrait by Francesco Laurana', *Allen Mem. A. Mus. Bull.*, xii (1955), pp. 86–90
M. d'Elia: 'Appunti per la ricostruzione dell'attività di Francesco Laurana', *Stud. & Contrib. Ist. Archeol. & Stor. A. U. Bari*, ii (1959), p. 23
S. Bottari: 'Un'opera di Francesco Laurana', *Boll. A.*, xlv (1960), pp. 213–16
R. W. Kennedy: *Four Portrait Busts by Francesco Laurana* (Northampton, 1962)
B. Patera: 'Sull'attività di Francesco Laurana in Sicilia', *An. Liceo Class. 'G. Garibaldi' Palermo*, ii (1965), pp. 526–50
D. Bernini: 'Francesco Laurana, 1467–1471', *Boll. A.*, li (1966), pp. 155–63
M. Chiarini: *Francesco Laurana* (Milan, 1966)
G. L. Hersey: *Alfonso II and the Artistic Renewal of Naples, 1485–1495* (New Haven, 1969); review by H.-W. Kruft in *Kunstchronik*, xxiii (1970), pp. 152–65
H.-W. Kruft: 'Die Madonna von Trapani und ihre Kopien', *Mitt. Ksthist. Inst. Florenz*, xiv (1970), pp. 297–322
U. Middeldorf and H.-W. Kruft: 'Three Male Portrait Busts by Francesco Laurana', *Burl. Mag.*, cxiii (1970), pp. 264–7
H.-W. Kruft: 'Pietro da Bonate und der Frühstil Francesco Lauranas', *Stor. A.*, 15–16 (1972), pp. 223–35
G. L. Hersey: *The Aragonese Arch at Naples, 1443–1475* (New Haven, 1973)
H.-W. Kruft and M. Malmanger: 'Francesco Laurana: Beginnings in Naples', *Burl. Mag.*, cxvi (1974), pp. 9–14
V. Gvozdanovic: 'The Dalmatian Works of Pietro da Milano and the Beginnings of Francesco Laurana', *A. Lombarda*, xlii–xliii (1975), pp. 113–23
——: 'Das Portal der Capella di Santa Barbara im Castelnuovo zu Neapel', *Acta Archaeol. & A. Hist. Pertinentia*, vi (1975), pp. 307–14
H.-W. Kruft and M. Malmanger: 'Der Triumphbogen Alfonsos in Neapel', *Acta Archaeol. & A. Hist. Pertinentia*, vi (1975), pp. 213–305
B. Patera: 'Francesco Laurana a Sciacca', *Stor. A.*, 38–40 (1980), pp. 167–84
——: 'Francesco Laurana e la cultura lauranesca in Sicilia', *Quad. Ric. Sci.*, civ (1980), pp. 211–30
E. Mognetti: 'Francesco Laurana, sculpteur du Roi René en Provence', *Le Roi René en son temps, 1382–1481* (exh. cat., Aix-en-Provence, Mus. Granet, 1981), pp. 133–83
F. Robin: *La Cour d'Anjou-Provence: La Vie artistique sous le règne de René* (Paris, 1985)
B. Patera: *Francesco Laurana in Sicilia* (Palermo, 1992)
H.-W. Kruft: *Francesco Laurana, ein Bildhauer der Frührenaissance* (Munich, 1995)
HANNO-WALTER KRUFT

Laurana [Dellaurana], **Luciano** (*b* Zara, Dalmatia [now Zadar, Croatia] or La Urana, nr Zara; *d* Pesaro, 1479). Italian architect. The suggestion that he studied in Florence under Filippo Brunelleschi and in Venice comes from Vasari's mention in his life of Brunelleschi of a 'Slavonian' architect, who is not necessarily identifiable with Laurana. Laurana clearly knew the work of Brunelleschi and certainly had an affinity with Alberti, whom he could have met in Mantua. It also has been suggested that Piero della Francesca influenced his architectural and decorative designs in the Palazzo Ducale in Urbino (Salmi). Laurana was credited by Baldi (1590) with the design of the Palazzo Ducale in Urbino and praised as its architect also by Giovanni Santi. His name appears as architect to Federigo

II da Montefeltro, at that time Count of Urbino, before those of Francesco di Giorgio Martini, Baccio Pontelli, Fra Carnevale and Scirro Scirri in the list of court officials. He was clearly well versed in geometry and mathematics, and his formative influences probably included the Roman monuments in Dalmatia and Istria.

The earliest surviving reference to Laurana records him in Fano in 1464 working on the Porta Maggiore. He is subsequently mentioned in two letters dated 8 May 1465, one from Ludovico II Gonzaga, 2nd Marchese of Mantua, to Alessandro Sforza, Count of Pesaro, and another from Ludovico's wife, Barbara of Brandenburg, to Laurana asking him to come to Mantua from Pesaro. The Palazzo Prefettizio on the main square in Pesaro has been attributed to him by some writers on the basis of the window treatment, but there is no documentary confirmation, and the building has also, dubiously, been attributed to Giorgio da Sebenico (*fl* 1441–73). While there are similar windows by Laurana in the Palazzo Ducale in Urbino, it should be noted that the building of the palazzo was already quite advanced when he was in Pesaro. Still more uncertain is the attribution to him of the new church of the Osservanza in Pesaro, built in 1465–9 and demolished in the 16th century; it is recorded in an intarsia picture in the choir of S Agostino, Pesaro.

On 2 January 1466 Ludovico II Gonzaga promised to send Laurana again to Alessandro Sforza in Pesaro 'for that building of his', possibly the Palazzo Ducale in nearby Urbino, for which Sforza might have offered his architect. On 20 March of that year Federigo da Montefeltro's 'brother' Ottaviano Ubaldini asked Ludovico if Laurana could meet Federigo in Milan to present the plan of the palace to him. In 1467 Laurana seems to have been settled in Urbino as the 'ingegnero del signore' (the lord's engineer), according to a document fixing payment for building works in the palace. On 10 June 1468 Federigo issued a brief (the so-called *Patente*) naming him to supervise the execution of the Palazzo Ducale.

According to Rotondi's reconstruction of the palace, Laurana must have begun work there after the completion of the Jole wing and the building at right angles to it extending downhill. In the six years of his residence in Urbino he built much of the cortile between these two wings, part of the structure on the valley side, and the long wing on the main square that runs from the grand double stairway to the façade of the *torricini* (the small towers) at its western end. It is doubtful whether he also laid the foundations of the Veglie wing, extending towards the Castellare; this is better attributed to Francesco di Giorgio Martini, along with the wing under the *giardino pensile* (hanging garden).

The *cortile* or courtyard (see fig.) is certainly Laurana's finest architectural work, brilliantly uniting the influences of Alberti and Brunelleschi, with arches on columns with antique-style capitals and corners with L-shaped piers that incorporate half-columns and taller pilasters, as Brunelleschi had done at the end of the portico of the Ospedale degli Innocenti in Florence (see colour pl. 1, XVI2). This solution is echoed on the corners of the upper floor by the novel juxtaposition of pilaster and pilaster strip. The cortile of the Castello di S Giorgio in Mantua has been attributed to Laurana on the basis of a rather similar corner

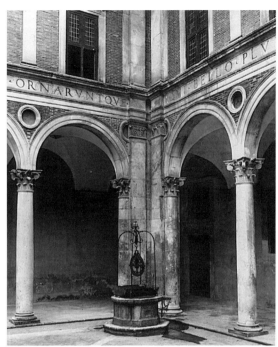

Luciano Laurana: *cortile* or courtyard (begun *c.* 1466) of the Palazzo Ducale, Urbino

solution, although documents indicate that it was built by Luca Fancelli to a design by Andrea Mantegna. Another notable invention by Laurana in the palace at Urbino is the grand staircase, which has an entrance flight from the cortile leading to a wide double flight with a free-standing column at the end of the dividing wall. This arrangement, however, together with the asymmetrical placement of the entrance door, created problems for the design of the façade, finished later by Francesco di Giorgio Martini. While the original plan for the west façade with the towers is traceable to Laurana, it is difficult to relate the triumphal loggia to the cortile.

In the last years of his residence in Urbino Laurana, probably supervised the construction of the first phase of the monastery of S Chiara, recorded in a survey (Florence, Bib. Medicea–Laurenziana) by Francesco di Giorgio Martini, who later built the monastery to his own design. Baldi attributed to Laurana architectural perspective drawings, which some writers (e.g. Budinich, Kimball, Krautheimer) have identified as three perspective views of Urbino (Baltimore, MD, Walters A.G.; Berlin, Gemäldegal.; Urbino, Pal. Ducale). The architectural forms of the buildings, however, seem closer to those of Giuliano da Sangallo.

In 1471 Luciano bought a house near Urbino, but by 1472 he was no longer referred to as Federigo's architect. From 1472 to 1474 he was in Naples as master of artillery. There is no evidence that his departure was due to a conflict with Federigo, whose gift of land to his daughter was confirmed by Ubaldini in 1482. Laurana was again in Pesaro in 1474, when he began work on the Rocca Costanza, a large quadrilateral fortress with circular towers at the corners. The cortile of the fortress was completed later on two sides with arches on pillars with the coat of

arms of Giovanni Sforza (1503–5). Laurana died after beginning the bridge on the sea side of the fortress of Senigallia, completed by Baccio Pontelli.

See also URBINO, §4 and fig. 3.

BIBLIOGRAPHY

G. Santi: *La vita e le gesta di Federico da Montefeltro duca d'Urbino: Cronaca* (1482–7; Rome, Vatican, Bib. Apostolica, MS. Vat. Ottob. lat. 1305); ed. L. Michelini Tocci (Vatican City, 1985)

B. Baldi: *Versi e prose* (Venice, 1590)

C. Budinich: *Un quadro di Luciano Dellaurana nella galleria annessa all'Istituto di belle arti di Urbino* (Trieste, 1902)

——: *Il palazzo ducale di Urbino* (Trieste, 1904)

A. Colasanti: *Luciano Laurana* (Rome, 1922)

G. Pacchioni: 'L'opera di Luciano Laurana a Mantova, *Boll. A.*, n. s., iii (1923–4), pp. 97–111

F. Kimball: 'Luciano Laurana and the "High Renaissance"', *A. Bull.*, x (1927), pp. 124–51

R. Filangieri: 'L'architettura della reggia aragonese di Napoli', *L'Arte*, xxxi (1928), pp. 32–5

F. Filippini: 'Luciano da Laurana a Pesaro', *Melozzo Forlì* (April 1939), pp. 352–8

M. Salmi: *Piero della Francesca e il Palazzo Ducale di Urbino* (Florence, 1945)

R. Krautheimer: 'The Tragic and the Comic Scene of the Renaissance: The Baltimore and Urbino panels (Luciano Laurana)', *Gaz. B.–A.*, n. s. 5, xxx (1948), pp. 327–46

L. M. Tocci: 'I due manoscritti urbinati dei privilegi dei Montefeltro con un'appendice lauranesa', *La Bibliofilia*, lx (1958), pp. 208–57

G. Franceschini: *Figure del rinascimento urbinate* (Urbino, 1959)

F. da Montefeltro: 'Patente a Luciano Laurana', *Scritti rinascimentali di architettura*, ed. A. Bruschi and C. Maltese (Milan, 1978), pp. 1–22, iv of *Trattati di architettura*, ed. P. Portoghesi and N. Carboneri

M. G. Ciardi Duprè Dal Poggetto: 'La "città ideale" di Urbino', *Urbino e le Marche prima e dopo Raffaello* (Florence, 1983), pp. 71–8

S. Eiche, M. Fenquellucci and M. Casciato: *La corte di Pesaro: Storie di una residenza signorile*, ed. M. R. Valazzi (Modena, [1986]), pp. 13–56

M. Ferretti: ' "Casamenti sue prospective": Le città degli intarsiatori', *Imago urbis: Dalla città reale alla città ideale* (Milan, 1986), pp. 96–7

A. Tonnesmann: 'Le palais ducal d'Urbino: Humanisme et réalité sociale', *Architecture et vie sociale: L'organisation intérieure des grandes demeures à la fin du Moyen Age et à la Renaissance: Actes du colloque: Tours, 1988*, pp. 137–53

G. Volpe, ed.: *Matteo Nuti, architetto dei Malatesta* (Venice, 1989), pp. 58–62

W. Lutz: *Luciano Laurana und der Herzogspalast von Urbino* (Weimar, 1995)

FRANCESCO PAOLO FIORE

Laureti [Lauretti], **Tommaso** [Siciliano] (*b* Palermo, ?1530; *d* Rome, 1602). Italian painter, designer and engineer. A pupil of Sebastiano del Piombo, he spent his formative years in Bologna in the circle of Ignazio Danti. He was working there between 1563, if not earlier, and 1582, though he was recorded as working in 1579 for Alfonso II d'Este, Duke of Ferrara. He was closely involved in redesigning the Piazza Nettuno in Bologna, providing the designs and the hydraulic engineering for fountains, one of which—the Fountain of Neptune (1566)—was adorned with bronze sculptures by Giambologna (*see* BOLOGNA, fig. 2), while the Fonte Vecchia (1565) was undertaken by Laureti in collaboration with Giacomo della Porta.

Laureti's major religious paintings were executed for the church of S Giacomo Maggiore, including altarpieces of *Christ with SS James and Augustine* (1574) and the *Virgin and Child with SS William of Gallone, Duke of Aquitaine, Agatha and Cecilia* (1580–82), and decorations showing *St Augustine's Funeral Procession* in the Bianchetti Chapel (1577). His style, with its strong lighting effects, powerfully foreshortened figures and devotional intensity, is broadly consistent with other Bolognese art of the Counter-Reformation and reflects a keen interest in the work of Correggio. His major secular decoration in Bologna was an illusionistic frescoed ceiling and frieze in the Palazzo Viziani (now Palazzo Sanguinetti), undertaken in 1582. This was the only actual work of art illustrated in Danti's influential commentary on Jacopo Vignola's *Le due regole della prospettiva pratica* (Rome, 1583). The section of the design illustrated shows an elaborate fictive architecture that extends the apparent height of the room through perspective trickery. A device for demonstrating perspective is attributed to Laureti in the same treatise.

In 1582 Laureti was among the artists and intellectuals from Bologna attracted to Rome to the court of the Bolognese pope, Gregory XIII, who exhibited a pronounced taste for illusionistic painting in his campaign of decoration in the Vatican. Laureti's most conspicuous scheme there was his decoration, showing the destruction of idols and triumph of Christianity, for the vault of the Sala di Costantino, the walls of which had been frescoed by Raphael and his school. The lunettes and spandrels show a competent but rather heavy-handed version of Raphael's figure style, typical of the period, but his ceiling painting of the *Triumph of Christian Faith* plays to his strengths in constructing perspectives of architecture. A clearly defined box of space is punctuated at the rear by a deep recession, in front of which a crucifix is emphatically placed. The broken limbs of a pagan idol lie on the pavement below the crucifix, and the scene as a whole acts as a lucid statement of a Counter-Reformation theme.

During the early 1590s Laureti undertook a series of frescoes of Roman history in the Sala dei Capitani of the Palazzo dei Conservatori for Pope Clement VIII. He was elected to the Accademia di S Luca in 1595 and to the Congregazione dei Virtuosi dal Pantheon in 1600. He belonged to a group of artists in late 16th-century Rome who regarded themselves as the guardians of orthodoxy in the Raphael tradition. His long and successful career indicates a contemporary reputation that stands in marked contrast to his posthumous neglect.

BIBLIOGRAPHY

J. Vignola: *Le due regole della prospettiva pratica con i commentari del R. P. M. Egnatio Danti* (Rome, 1583)

A. Venturi: *Storia* (1901–40), v, pp. 767–76

E. Sjöstrom: *Quadratura: Studies in Italian Ceiling Painting* (Stockholm, 1978)

MARTIN KEMP

Lauro Padovano (*fl c.* 1471–1508). Italian painter and illuminator. He may be identifiable with a certain 'Laurum de sancto Johanne de Padua' documented in 1482 in Rome as having given a professional opinion on the frescoes on the walls of the Sistine Chapel in the Vatican Palace. In 1508 Bartolomeo Sanvito possessed two works executed by Lauro for the opening hours of a Book of Hours or the Office, which would seem to suggest that he was active as an illuminator. Documentary evidence indicates that Lauro was familiar with Mantegna's Paduan works and that he worked with Giovanni Bellini at least before his visit to Rome. The main source for the reconstruction of Lauro's oeuvre is Marcantonio Michiel, who mentioned an altarpiece (1468–71; untraced) in S Maria della Carità, Venice, by Giovanni Bellini, dedicated to St John the

Evangelist, with a predella painted by Lauro Padovano. A panel representing the *Legend of Drusiana* (Berchtesgaden, Schlossmus.) has been identified as belonging to the Carità predella and its style was used as the basis for a catalogue of Lauro's works until its recent attribution to Leonardo Bellini. Two panels depicting the *Martyrdom of St John the Evangelist* (ex-Vieweg priv. col., Brunswick; see Bauer Eberhardt, pp. 50, 68) and the *Resurrection of Drusiana* (Bergamo, Accad. Carrara B.A. & Liceo A.) have also been linked to the predella and attributed to Lauro. Through comparisons with these two panels, formerly ascribed to Francesco Bonsignori, a group of illuminated manuscripts collected under the name of Bartolomeo Sanvito has been attributed to Lauro. These include Cicero's *De officiis* (1497; Eton, Berks, Coll. Lib., MS. 149), Petrarch's *Rime e trionfi* (1490–1500; London, Sotheby's, 20 June 1978, no. 2989) and an Evangeliary (1509; Padua, Bib. Capitolare, Cod. E. 27). Lauro Padovano has been proposed as the Master of the Vatican Homer, but it is more probable that the latter is to be identified with Gaspare Padovano.

BIBLIOGRAPHY
M. Michiel: *Notizia di opere di disegno* (MS., *c.* 1520–40); ed. G. Frizzoni (Bologna, 1884)
F. Heineman: *Bellini e i Belliniani* (Venice, 1962), pp. 63–4, 75, 241–3, 283–4
G. Robertson: *Giovanni Bellini* (Oxford, 1968), pp. 47–50
U. Bauer Eberhardt: 'Lauro Padovano und Leonardo Bellini als Maler, Miniaturen und Zeichner', *Pantheon*, xlvii (1989), pp. 49–82

FEDERICA TONIOLO

Lecce, Matteo da. *See* PÉREZ DE ALESIO, MATEO.

Leno [Leni; de Lenis], **Giuliano** (*b* Rome, after 1467; *d* Rome, 12 Sept 1530). Italian building contractor and engineer. He was born into a minor but wealthy aristocratic family, whose members had made their careers in the papal service since the 14th century, mostly as lawyers or clerics. From the late 15th century Leno was engaged in a variety of agricultural and commercial activities, but his enterprises also included the management of numerous building projects, through which he was able to contribute to the realization of the major architectural creations of his friend Bramante. As the proprietor of quarries and lime-kilns and an owner of buffaloes, carts and barges for road and river transport, he was able to establish himself as an independent entrepreneur, supplying materials, tools and above all management and short-term funding for the papal building works. His knowledge of the workings and personalities within the administrations of both Rome and the papal court, his cordial rapport with the Roman aristocracy, to which he was closely related, and his control over the city gates, which he acquired under contract in the 1490s, placed him in a position of unrivalled commercial power as a contractor in the 1510s and 1520s and allowed him to accumulate great wealth, as well as a reputation for avarice.

In 1510–11 Leno was involved in the principal building projects of Pope Julius II (*reg* 1503–13): in 1510 at the Vatican Palace and the Palazzo dei Tribunali (in all probability from the inception of the works there) and in 1511 at St Peter's. On 17th June and 7 August 1510 he also undertook to construct two cloisters and a cistern at the church of S Pietro in Vincoli at the Pope's expense.

Having established himself on the site of St Peter's under Pope Julius II, albeit with a limited range of tasks, Leno continued to undertake a steady flow of projects on behalf of Pope Leo X (*reg* 1513–21). These included works commissioned in association with the latter's coronation and the stables built from 1515 in the papal villa at Magliana. On behalf of the Fabrica (Cathedral Works) of St Peter's he also drew up contracts with the stone-carvers who supplied capitals (1513–14, 1521), with the foremen for foundations (1514) and for the supply of quarried stone (1514). As well as a down payment, Leno gave the supplier the already established quarry, lent him props, picks and hammers for quarrying and guaranteed a fixed rate of payment in exchange for regular supplies over a period of time.

Subsequent papal projects in which Leno was involved include the construction of the Rocca di Civitavecchia, the seaport of Rome. During the years leading up to the Sack of Rome, Pope Clement VII (*reg* 1523–34) made use of Leno's organizational powers in a military context, sending him with Antonio da Sangallo (ii), Battista da Sangallo, Michele Sanmicheli, Antonio Labacco and others to inspect the fortifications of Parma and Piacenza. At the same time Leno also visited Modena, where he was consulted in relation to the alterations to the cathedral choir. In February 1527, as commissioner for the papal artillery, he was captured by the imperial forces of Charles V (*reg* 1519–56) near Rome. He was subsequently empowered to cede Parma and Piacenza to the Emperor, after which he was sent to Perugia.

Leno's other building works were generally related indirectly to papal projects. In 1510, for example, he signed a contract for the construction of houses in the Planca Gardens, which had been opened up as a result of the opening of the Via Giulia. Further along the same road, adjacent to the abandoned site of the Palazzo dei Tribunali, he began in 1514 a building of his own (later the Palazzo Sacchetti), the only known instance of an independent project by Leno. The remains of Leno's building, comprising the ground-floor and rows of shops on three sides of the plot, do not, however, demonstrate any architectural merit. When Antonio da Sangallo (ii) later resumed work on the site with a design of his own for the palazzo, he had to exercise particular ingenuity to incorporate a main staircase satisfactorily.

BIBLIOGRAPHY
Thieme–Becker
G. Vasari: *Vite* (1550, rev. 2/1568); ed. G. Milanesi (1878–85)
B. Niccolò and others, ed.: *I diarii di Marino Sanuto*, 2 vols (Venice, 1879)
R. Lanciani: *Storia degli scavi di Roma*, 4 vols (Rome, 1902–7)
K. Frey: 'Zur Baugeschichte des St Peter', *Jb. Preuss. Kstsamml.*, xxxi (1910), pp. 1–95
T. Amayden: *La storia delle famiglie romane*, ed. A. Bertini, ii (Rome, 1914), pp. 6–8
A. Mercati: *Le spese private di Leone X* (Roma, 1927), p. 108
C. L. Frommel: *Der römische Palastbau der Hochrenaissance*, ii (Tübingen, 1973), p. 300
——: 'Die Peterskirche unter Papst Julius II im Licht neuer Dokumente', *Röm. Jb. Kstgesch.*, xvi (1976), pp. 57–136
R. Pacciani: 'New Information on Raphael and Giuliano Leno in the Diplomatic Correspondence of Alphonso I d'Este', *A. Bull.*, lxvii/1 (1983), pp. 137–45
A. Bedon: 'I Maffei e il loro palazzo in via della Pigna', *Quad. Ist. Stor. Archit.*, n. s. i/12 (1988), pp. 45–64
C. L. Frommel: 'Il cantiere di S Pietro prima di Michelangelo', *Les Chantiers de la Renaissance* (Paris, 1991), pp. 175–90

PIER NICOLA PAGLIARA

Leo X, Pope. *See* MEDICI, DE', (7).

Leonardo, Benedetto di. *See* MAIANO, DA, (2).

Leonardo (de' Molinari) da Besozzo [Bissucio; Bisuccio] (*fl* 1421–81). Italian painter and illuminator. Son of the Lombard painter MICHELINO DA BESOZZO, he is documented in 1421 as his father's assistant in Milan Cathedral. Shortly afterwards he travelled south, arriving in Naples by 1438, when he painted the panel depicting *St Anthony of Padua* (Naples, S Lorenzo), of which only the crown of angels at the top remains. In S Giovanni a Carbonara (Naples), probably towards the end of the 1430s, he worked in the chapel of Sergianni Caracciolo, painting scenes from the *Life of the Virgin* and scenes of *Hermitic Life*, with the painter Perrinetto da Benevento and assistants. Leonardo can be credited with the *Nativity*, inscribed below with his name, the *Annunciation*, the *Coronation of the Virgin* and the last of the *Hermit* scenes. Probably later, in the same church, Leonardo also painted some figures of saints in the Mausoleum of King Ladislas. From 1454 Leonardo is documented as court painter to Alfonso of Aragon, King of Naples. In 1458 he frescoed the ceiling (destr.) of the Camera degli Angeli in the tower of Beverello at Castelnuovo, Naples.

Leonardo da Besozzo was also active as an illuminator; his paintings often resemble illuminated pages in their use of bright, *cangianti* (It.: 'changing'; 'shot', as in 'shot silk') colours and in the extreme Late Gothic refinement of the details. Between 1440 and 1446 he illuminated a *Cronaca universale* (Milan, Crespi Col.), a signed manuscript, which illustrates the traditional history of mankind through portraits of famous men and mythological narratives from the Creation to 1395, in 38 decorated pages with three tiers of illuminations.

Leonardo would have had the opportunity to return to Lombardy with Alfonso in 1459, when many artists were leaving Naples, and certain fresco cycles in Lombardy have been attributed to him on stylistic grounds. These include a detached fresco showing the *Virgin and Child with Two Saints* (Milan, S Calimero; ex-S Rocco, Milan) and a cycle of frescoes in the apse of the small church of S Margherita Casatenovo (Besana in Brianza), datable to 1463.

The painting of Leonardo da Besozzo unites the typical Lombard features of courtly Gothic with a firmer conception of space and a more pronounced realism. These formal qualities, which ultimately pointed towards humanism, were accessible to Leonardo through his direct knowledge of Tuscan art, especially that of Masolino da Panicale and of Neapolitan Netherlandish painting of the 15th century.

BIBLIOGRAPHY
G. Urbani: 'Leonardo da Besozzo e Perinetto da Benevento', *Boll. A.*, xxxviii (1953), pp. 297–306
A. Putaturo Murano: *Miniature napoletane del rinascimento* (Naples, 1973)
A. Cirillo Mastrocinque: 'Leonardo da Besozzo e Sergianni Caracciolo in San Giovanni a Carbonara', *Napoli Nob.*, xviii (1978), pp. 41–9
F. Navarro: 'La pittura a Napoli e nel Meridione nel quattrocento', *La pittura in Italia: Il quattrocento*, ii (Milan, 1988), pp. 446–73, 661–2
F. Paliaga: 'Quattro persone che ridono con un gatto', *Achad. Leonardi Vinci: J. Leonardo Stud. & Bibliog. Vinciana*, viii (1995), pp. 143–57

GIOVANNA CASSESE

Leonardo da Vinci (*b* Anchiano, nr Vinci, 15 April 1452; *d* Amboise, nr Tours, 2 May 1519). Italian painter, sculptor, architect, designer, theorist, engineer and scientist. He was the founding father of what is called the High Renaissance style and exercised an enormous influence on contemporary and later artists. His writings on art helped establish the ideals of representation and expression that were to dominate European academies for the next 400 years. The standards he set in figure draughtsmanship, handling of space, depiction of light and shade, representation of landscape, evocation of character and techniques of narrative radically transformed the range of art. A number of his inventions in architecture and in various fields of decoration entered the general currency of 16th-century design.

Although he brought relatively few works to completion, and even fewer have survived, Leonardo was responsible for some of the most influential images in the history of art. The '*Mona Lisa*' (Paris, Louvre; see colour pl. 1, XXXVI3) may fairly be described as the world's most famous painting. When the extent of his writings on many branches of science became increasingly apparent during the 19th century, he appeared to epitomize the idea of the universal genius and was hailed as one of the prophets of the modern era. More recent assessments of his intellectual achievements have recognized the medieval and Classical framework on which his theories were constructed but have done nothing to detract from the awesome range and intensity of his thought.

I. Life and works. II. Stylistic development and technique. III. Theory. IV. Character and personality. V. Influence and posthumous reputation.

I. Life and works.

Leonardo's father, Ser Piero da Vinci (*d* 1504), came from a family of property owners and notaries in the Tuscan hill-town of Vinci. Leonardo was the illegitimate first child of Ser Piero and Caterina, who later married a local man. His father subsequently married four times. Tax returns and other references indicate that Leonardo was brought up in his paternal grandfather's house, as a member of an extended family, and enjoyed a particularly close relationship with his uncle Francesco da Vinci. His father pursued a successful career as a notary and from 1469 appears to have been more or less permanently based in Florence with a flourishing legal practice, including work for the Florentine government.

1. First Florentine period, 1472–c. 1482. 2. First Milanese period, c. 1482–99. 3. Second Florentine period, 1500–mid-1508. 4. Second Milanese period, mid-1508–1513. 5. Rome and France, after 1513.

1. FIRST FLORENTINE PERIOD, 1472–c. 1482. The first reference to Leonardo as an artist occurs in 1472, when he was required to pay his dues to the painters' Compagnia di S Luca in Florence. His apprenticeship in the studio of the sculptor Andrea Verrocchio is recorded by Vasari and confirmed by a reference in 1476 to his continued residence there, but the date at which this apprenticeship started is unknown. Verrocchio's workshop, which undertook a wide range of commissions, including sculpture in bronze, stone and terracotta, decorative work in metals and various stones, paintings and at

least one major feat of engineering (the orb on the top of the lantern of Florence Cathedral), provided a solid grounding for Leonardo's subsequent versatility. Verrocchio was himself an inventive artist, particularly in figure sculpture, in which he pioneered a freedom of movement and viewpoint.

The first dated indication of Leonardo's ability as an artist is a remarkable pen-and-ink drawing of a *Tuscan Landscape* dated 5 August 1473 (Florence, Uffizi), which already signals an exceptional talent and mind at work. The subsequent record of his activities before his move to Milan *c.* 1482 is sparse. In 1476 he was accused anonymously of sodomy, but no prosecution was sustained. His receipt of an official commission in January 1478 for an altarpiece in the chapel of S Bernardo in the Palazzo della Signoria indicates his growing reputation. The altarpiece was not executed by Leonardo and was eventually supplied by Filippino Lippi (Florence, Uffizi). The note on one of his drawings, the *Studies of Heads and Machines* (1478; Florence, Uffizi), saying that he 'began two Virgin Marys', probably refers to small panels rather than the altarpiece. A year later he made an annotated drawing of the *Hanged Body of Bernardo Baroncelli* (Bayonne, Mus. Bonnat), the murderer of Giuliano de' Medici, brother of Lorenzo the Magnificent, which may have been connected with a project to depict the traitors on the outside of the Palazzo del Podestà in the customary manner. The second recorded commission from this period was in March 1481 for an altarpiece in S Donato a Scopeto. Although the subject is not recorded, the unfinished panel of the *Adoration of the Magi* (Florence, Uffizi; see fig. 1) was almost certainly intended for this destination. Filippino Lippi subsequently provided a completed altarpiece of the same subject (Florence, Uffizi).

The visual record of Leonardo's work from this first Florentine period includes a remarkable group of inventive drawings for varied artistic projects. These, together with notes and an inventory of works completed just before or after his arrival in Milan (Milan, Bib. Ambrosiana, Cod. Atlantico, fol. 324r), also show the first signs of the broadening range of his interests. The surviving drawings illustrate machinery (including the precise gearing of scientific instruments), aspects of military engineering, as well as optical phenomena and geometry, and the inventory lists studies made from nature, detailed representations of surface anatomy, portrait and compositional drawings, together with 'some machines for ships' and 'some machines for water'. Besides the drawings, there is a small body of paintings that can be attributed in whole or in part to him (*see* §II, 1 below).

2. FIRST MILANESE PERIOD, *c.* 1482–99. At some date after the last recorded payment from S Donato for the *Adoration of the Magi* (Sept 1481), Leonardo left Florence for Milan. He is not firmly documented there until April 1483, but it is likely that he moved during the course of 1482. In the draft of the letter in which he outlined his talents to Ludovico Sforza ('il Moro'), ruler of Milan and Duke of Bari, he concentrated on his capabilities as a military engineer, promising to 'apprise you of my secrets' (Cod. Atlantico, fol. 391r). He listed ten categories of military devices for use on land and sea, ranging from bridges and tunnels to guns and mortars 'outside the common use'. Only at the end of the letter did he mention that he could 'undertake sculpture of marble, bronze and clay, similarly in painting whatever can be done, to bear comparison with anyone else, whoever he is'. He also mentions that 'work on the bronze horse may be taken on'. This refers to the long-standing scheme to erect an equestrian memorial to Francesco Sforza, Ludovico's father and the first Sforza Duke of Milan, a project for which initially Antonio Pollaiuolo appears to have been considered. The tone of the letter suggests that Leonardo hoped his move to Milan would provide greater opportunities to develop the full scope of his work than had been possible in Florence. It remained true throughout his life that his activities flourished better within a court and in receipt of a regular income than when he needed to make a living from the completion of commissioned works of art.

The first notice of Leonardo's activity in Milan occurs in a contract for work on an altarpiece. In company with the brothers Ambrogio and Evangelista de' Predis, he agreed to provide the painted decoration and panels for a large sculpted altarpiece by the wood-carver Giacomo di Damiano (*fl* 1469–1502) for the Confraternità dell' Immacolata Concezione in their chapel in S Francesco Grande, Milan. In addition to polychroming and gilding the wooden architecture and sculpture, the painters were expected to provide paintings of the Virgin, prophets and angels to be set in the frame.

The subsequent history of this commission, which went through a series of protracted legal wrangles, involves some of the lengthiest and most confusing documentation for any Renaissance painting. The dispute centred on the confraternity's claims that the painters had failed to fulfil their obligations and the painters' assertion that the value of the panel of 'Our Lady done in oils' was far greater than the sum the confraternity was offering to pay. By the time a procurator was appointed in 1496 to settle the

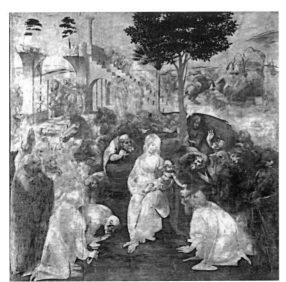

1. Leonardo da Vinci: *Adoration of the Magi*, oil on panel, 2.43×2.46 m, *c.* 1481 (Florence, Galleria degli Uffizi)

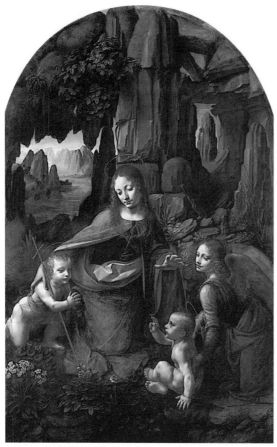

2. Leonardo da Vinci: *Virgin of the Rocks*, oil on panel, 1.89×1.20 m, mid-1490s (London, National Gallery)

appears to be wholly in the style of the 1480s, while the London version exhibits features of Leonardo's work from the mid-1490s, even if it is not wholly by him.

The nature of Leonardo's engagements at the Sforza court is unclear in the 1480s. His *Portrait of a Lady with an Ermine* (Kraków, Czartoryski Col.; see fig. 3), presumed to be the portrait of Ludovico Sforza's mistress *Cecilia Gallerani* that was celebrated in a Milanese poem, should be dated, on new evidence, to *c.* 1490–91. In 1487 Leonardo submitted a model for the scheme to design a *tiburio* (crossing tower) for Milan Cathedral, although he did not undertake the commission. It is also to this period that the Codex Trivulziano (Milan, Castello Sforzesco), the first of his surviving notebooks, can be dated. For the rest of his life he kept notebooks written in mirror handwriting and filled with drawings and diagrams that record various intellectual endeavours and scientific investigations in which he was involved. The Codex Trivulziano contains, among other things, studies for the *tiburio*, philosophical aphorisms and Latin word lists. A sheet in pen and ink, with *Two Studies of a Human Skull* (Windsor Castle, Royal Lib., 19059*r*), dated 1489, is one of a series of anatomical investigations concerned with the brain, nervous system and senses. Although there had been earlier signs of his interest in a range of scientific and technical matters, sustained explorations of questions lying outside his immediate professional involvements are fully documented only from the late 1480s.

During the 1490s Leonardo was involved with ceremonial activities at the Sforza court, with painting and

dispute, Ambrogio de' Predis and Leonardo had appealed to a higher authority, probably the Duke. By 1503 matters were still not resolved, by which time Leonardo had left Milan. In 1506 arbitrators stipulated that Leonardo had to complete the painting of 'the most glorious Virgin Mary' within two years at an agreed price. The painting was finished by August 1508, when Ambrogio, on Leonardo's behalf, was given permission to remove the painting from its frame to make a copy.

Of the two surviving versions of the painting, now known as the *Virgin of the Rocks*, one (London, N.G.; see fig. 2) is known to have come from the altarpiece in S Francesco Grande, while the early history of the other version (Paris, Louvre; see colour pl. 1, XXXVII1), stylistically the earlier of the two, is unclear. Attempts have been made to reconcile the written evidence and the two paintings, but none can be confirmed. The two most straightforward hypotheses are either that the Louvre painting was completed but withheld by the artists and sold privately elsewhere, while the London panel was a second version, made to fulfil the legal requirements; or that either the Louvre painting or some other part of the altarpiece was incomplete until 1508, and that the London version was the copy made in that year and substituted for the original. The stylistic evidence marginally favours the former hypothesis, in that the Louvre *Virgin of the Rocks*

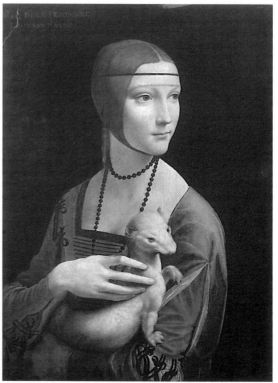

3. Leonardo da Vinci: *Portrait of a Lady with an Ermine* (Cecilia Gallerani), oil on panel, 534×393 mm, *c.* 1490–91 (Kraków, Czartoryski Collection)

sculpture and with his own intellectual pursuits in a growing range of natural, physical and mathematical sciences. Typical of his work as a court artist were his admired stage designs for the *Festa del paradiso*, a spectacle by Ludovico's leading court poet, Bernardo Bellincioni, composed in 1490 as a wedding celebration. The same year he resumed serious work on the equestrian monument to *Francesco Sforza*. In 1497 he is documented as nearing the completion of the *Last Supper*, begun *c.* 1495, in the refectory of S Maria delle Grazie, Milan (*in situ*), and in 1498 he was painting the mural decoration of the Sala delle Asse (Milan, Castello Sforzesco). His notebooks also suggest that he participated in various architectural and engineering projects, including the extensive schemes for canalization, urban planning and decoration in Vigevano, close to Ludovico's birthplace.

In his scientific work, Leonardo began to embrace a variety of concerns. Anatomy and optics were central among these, but he also embarked on detailed investigations of statics and dynamics, with an almost obsessional interest in the complex patterns of motion in water. His notebooks reflect a sustained campaign of self-education in the basic theoretical concepts of Classical and medieval science, and in the elements of mathematics. In this latter ambition he was greatly aided by the arrival of the mathematician Luca Pacioli at the court in 1496, and the following year they collaborated on the illustrations of geometrical bodies in Pacioli's *De divina proportione*, which was eventually published in Venice in 1509.

The visual record of Leonardo's artistic products during the 1490s is disappointingly meagre. The project for the huge equestrian monument to *Francesco Sforza* progressed to the point at which the full-sized clay model could be exhibited in 1494, but the bronze was never cast, and the model seems not to have survived Ludovico's fall in 1499. The *Last Supper* was his major completed achievement. Early viewers testify to its extraordinary impact; however, the partly experimental technique led to the wall painting's rapid deterioration, and it exists today only as a fragmented ghost of its former presence. Although the Duke requested in 1497 that Leonardo start on 'the other wall' when he finished the *Last Supper*, no sign remains of other work by him in the refectory. The portraits of the *Duke and Duchess and their Children* added to Giovanni Donato da Montofano's *Crucifixion* on the opposite end wall are too damaged to permit a definite judgement, but the underdrawings appear too routine to be attributed confidently to Leonardo.

Leonardo's decorative painting in the Sala delle Asse, depicting trees intertwined as a great bower, also survives in an incomplete and heavily restored form. It seems likely that he was responsible for other work in the suite of rooms in the Castello Sforzesco, which Ludovico was transforming and extending, but no traces survive. Three portraits of more or less autograph quality—the *Portrait of a Musician* and the *Portrait of a Woman in Profile* (both Milan, Bib. Ambrosiana) and the *Portrait of a Woman*, known as '*La Belle Ferronnière*' (Paris, Louvre; see colour pl. 1, XXXVI2)—may also be assigned to his period at the Sforza court. When Ludovico fled Milan in 1499, in the face of the invading armies of the French king Louis XII, Leonardo sent money to Florence for safekeeping.

Although he apparently entered into some kind of agreement with the King, he left Milan in December. He stayed briefly in Mantua, where he made a portrait drawing of *Isabella d'Este* (damaged version, Paris, Louvre; for illustration *see* ESTE (6)), and in Venice, where he appears to have given some advice on hydraulic engineering. His visit to Mantua is not surprising in view of the close links between the Sforza and the Este families, and of Isabella's known interest in Leonardo's art.

3. SECOND FLORENTINE PERIOD, 1500–MID-1508. In April 1500 Leonardo returned to Florence, where he was faced with the prospect of re-establishing his career. During the next six years Isabella d'Este endeavoured to obtain a painting from him. She hoped that he would make a painting based on the portrait drawing and subsequently that he would provide a subject painting—at one point she suggested an image of Christ at the age of 12. The correspondence in which Isabella pursued her frustrating quest provides the best evidence for Leonardo's activities immediately after his return to Florence. Her plenipotentiary in Florence, the Carmelite Fra Pietro da Novellara, wrote to her on 3 and 14 April 1501, mentioning the painter's obsession with geometry and that his pupils were making copies of his paintings to which he occasionally put his hand. The letters also describe two works by Leonardo. One was a small panel painting for Florimond Robertet, the secretary to the French king, which showed the Virgin and Child contesting the possession of a yarnwinder. Later known as the *Madonna of the Yarnwinder*, the best versions of this much copied painting are in the Duke of Buccleuch's collection and a New York collection.

The other work was a large-scale cartoon (untraced) of the *Virgin and Child with St Anne and a Lamb*, in which the life-sized figures were cunningly compressed into a compact group. The cartoon seems to have been drawn when Leonardo was involved with a commission for an altarpiece for SS Annunziata (later finished by Pietro Perugino), which was apparently ceded to him on his return to Florence by Filippino Lippi. Leonardo was provided with accommodation in the monastery of SS Annunziata, and it was there in 1501 that he exhibited his cartoon to large crowds, though it was probably not intended as the design for the altarpiece.

That Republican Florence did not provide the most appropriate arena for Leonardo's talents is perhaps indicated by the fact that in 1502 he accepted the appointment as Cesare Borgia's 'architect and general engineer', with responsibilities that took him to Urbino and other Central Italian cities. The most spectacular product of his work for Cesare is the *Map of Imola* (Windsor Castle, Royal Lib., 12284). In 1503 he was again in Florence and appears to have been one of the engineers involved in Machiavelli's ill-fated plans to divert the River Arno around Pisa, when Florence was at war with the city.

Later in the same year Leonardo received the highly prestigious commission for a wall painting of the *Battle of Anghiari* (destr.) in the Sala del Maggior Consiglio, the great new council hall in the Palazzo della Signoria, which the Republic had erected after the expulsion of the Medici in 1494. The subject was to commemorate a Florentine victory over the Milanese in 1440. Leonardo was provided

with a room in S Maria Novella in which to make the huge cartoon (destr.), and work seems to have proceeded steadily, although it was interrupted during the autumn of 1504, when the Florentine authorities sent him to Piombino to advise on fortifications. Payments were made for materials during 1504, and one of his own notes (Madrid, Bib. N., MS. II, fol. 2r) provides evidence that he was actually painting on the wall in the summer of 1505. In 1504 Michelangelo received the commission to paint the *Battle of Cascina* (unexecuted) as a companion piece to the *Battle of Anghiari* and joined Leonardo as an apparently unsympathetic rival.

However, there were growing signs that Leonardo might eventually fail to complete the commission. His characteristically experimental technique was running into trouble, and his notebooks testify that his diverse intellectual concerns were again coming to the fore, including studies of bird flight and geometry. Finally, in 1506 a train of events marked the abandonment of the project. In May he was granted leave of absence to work in Milan for three months, perhaps in response to the settlement of the litigation surrounding the *Virgin of the Rocks*. Although he returned to Florence briefly in March 1507, and for a longer period from September to the following spring, his residence in Florence was effectively at an end. The winter of 1506–7 was apparently occupied with the study of anatomy, bird flight and mathematics. The last of his substantial artistic involvements in Florence seems to have been the assistance he provided, according to Vasari, to Giovanni Francesco Rustici, who was making the bronze group of *St John the Baptist Preaching between a Pharisee and a Levite* (1506–11) for the exterior of the Florentine Baptistery (*in situ*).

It is difficult to assign a single, finished, wholly autograph painting to the years 1500 to 1508. It is reasonable to assume that the *Madonna of the Yarnwinder* was completed, but even that might not have been entirely by Leonardo. The incomplete and partly ruined painting of the *Battle of Anghiari* survived until the remodelling of the council hall in the 1560s, and, although strenuous efforts have been made to discover it under the later paintings by Vasari, it has not so far reappeared. A number of projects for compositions of the Virgin and Child can be dated to these years, as can an innovative design for a painting of an *Angel of the Annunciation* (untraced), which developed into the later composition of *St John the Baptist* (Paris, Louvre). He also began work on a composition of *Leda and the Swan* (see fig. 4), experimenting with a kneeling figure of Leda (reflected in versions by followers) and a standing version, the latter known to Raphael in Florence as a developed design, cartoon or unfinished painting. The final version of *Leda* (untraced) may not have been completed until after 1513.

The painting generally regarded as the central product of these years is the so-called '*Mona Lisa*' (Paris, Louvre; see colour pl. 1, XXXVI3), although even it presents some problems of dating. The identity of the sitter was for many years uncertain, but Vasari's claim that the lady in the portrait was 'M[ad]o[n]na Lisa', the wife of Francesco del Giocondo (hence the alternative name of '*La Gioconda*' or '*La Gioconde*'), was confirmed in 1991 with the publication of the 1525 death inventory of Leonardo's assistant

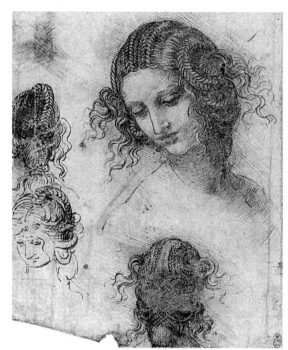

4. Leonardo da Vinci: *Study for the Head of Leda* for *Leda and the Swan* (untraced), pen and ink over black chalk, 200×162 mm, 1500–08 (Windsor, Windsor Castle, Royal Library)

of 30 years, GIAN GIACOMO CAPROTTI, who seems to have been in possession of a number of his master's works, including this portrait (see Shell and Sironi). In 1495 Lisa Gherardini (*b* Florence, 1479) married Francesco del Giocondo, an important figure in the Republican government, whose portrait Leonardo is also thought to have painted. Earlier confusion over her identity arose, among other things, from what was previously thought to be the earliest reference to the portrait, written by Ambrogio de' Beatis on a visit to Leonardo in France in 1517; he described a portrait of 'a certain Florentine lady made from nature at the instigation of the late Magnificent Giuliano de' Medici' (the Duc de Nemours), who was Leonardo's patron in Rome after 1513, and it had long been assumed that he was referring to the '*Mona Lisa*'. (It is now thought likely that the work de' Beatis saw on this visit was the portrait of another Florentine woman.)

According to Vasari, Leonardo began the portrait of *Lisa del Giocondo* between his arrival in Florence in 1500 and the commencement of his work on the *Battle of Anghiari* late in 1503; after four years, however, the work was still unfinished. The appearance of the picture lends support to the idea that it was painted over an extended period, since the craquelure of the face suggests that it was executed at a different time from the hands, which exhibit the thinness of his latest manner of painting.

4. SECOND MILANESE PERIOD, MID-1508–1513. From the summer of 1508 to September 1513 Leonardo was resident in or near Milan, working initially for the French rulers of the city under the direct supervision of the governor, Charles II d'Amboise, Comte de Chaumont

(1473–1511). He appears to have taken up a range of duties broadly equivalent to those he had performed at the Sforza court, including providing designs for ephemeral items of courtly entertainment. He also embarked on designs for another equestrian monument, for Gian Giacomo Trivulzio, an Italian general who was serving the French. The scheme progressed as far as a detailed specification and costing of the life-size horse and rider, with a substantial base and secondary sculpture (Cod. Atlantico, fol. 179*r*a). The architectural work Leonardo is known to have undertaken for Charles d'Amboise is not clearly identifiable. Charles's project may have been for the kind of airy, colonnaded villa with which Leonardo had been experimenting since his first Milanese period (e.g. Cod. Atlantico, fol. 158*r*a). He may also have been involved in the plans for the church of S Maria alla Fontana, Milan, but the executant of the work is firmly documented as Giovanni Antonio Amadeo. After the reinstatement of the Sforza regime in 1512 under Ludovico's son Massimiliano, Leonardo remained in Lombardy for more than a year.

Among Leonardo's scientific endeavours during this second Milanese period is a series of outstanding anatomical drawings of human musculature and the skeletal system. His exploration of certain geometrical questions, particularly problems of transformation of volume and area (e.g. the squaring of the circle), became increasingly obsessive, as did his investigation of the dynamics of fluids, whether in the guise of the motion of water or in such related forms as the turbulent flow of the blood in vessels of the human body.

The only documented painting completed on Leonardo's return to Milan was the *Virgin of the Rocks*: the style of the second version (London, N.G.) is consistent with its having been begun in the late 1490s and subsequently finished by Leonardo with studio assistants on his return to Milan. By contrast, the only autograph painting that can be wholly assigned with some confidence to this period is the *St John the Baptist* (Paris, Louvre), which developed from his Florentine *Angel of the Annunciation* and is reflected in pupils' drawings datable *c.* 1509. The Virgin and Child compositions on which he was working for Louis XII cannot be certainly identified with any of the surviving paintings, although it is highly likely that one of them was a variant of the theme of the Virgin and Child with St Anne. Two main types of this composition are known: the version that included the lamb, as in the lost cartoon of 1501 and a surviving painting (Paris, Louvre), and the type in which the young St John is integrated into the narrative, as in the Burlington House Cartoon (London, N.G.). The latter has sometimes been dated to 1490–1500, but the style of its draughtsmanship and of the closest preparatory drawing (pen and ink over black chalk; London, B.M.) is increasingly recognized as belonging to *c.* 1505–7. The Louvre *Virgin and Child with St Anne and a Lamb* (see fig. 5) is not clearly datable by reference to other paintings, but the related drawings (Windsor Castle, Royal Lib., 12527, 12530, 12533), handling of colour and treatment of the landscape suggest a late date, perhaps *c.* 1515.

5. ROME AND FRANCE, AFTER 1513. In October 1513 Leonardo visited Florence on his way to Rome, where he was accommodated in the Belvedere under the patronage of Giuliano de' Medici, Duc de Nemours. He appears to have been involved with the military work that Giuliano was undertaking for the Medici pope, Leo X, and worked on the design and manufacture of burning mirrors that could have military and civil uses. The continued intensity and variety of his intellectual endeavours, particularly in anatomy (cardiology and embryology), optics and geometry, coupled with his travels in Giuliano's service, do much to explain the reported impatience of Pope Leo, who doubted whether Leonardo would ever finish anything.

It is possible that Leonardo was present at Bologna in 1515 at the meeting between Leo X and the new French king, Francis I (*reg* 1515–47). His elaborate red chalk drawing of the *Allegory of the Wolf and Eagle* (Windsor Castle, Royal Lib., 12496) may well refer to the concordat between pope and king. In any event, Francis was as enthusiastic about Leonardo's work as his predecessor and succeeded in attracting Leonardo to France at some point between August 1516 and May 1517. For the rest of Leonardo's life, Francis seems to have acted as an ideal patron—actively promoting new projects and keen to exploit the range of Leonardo's talents, but also understanding of the artist's character as a natural philosopher or seer. Leonardo was clearly regarded as an ornament of the court and, as such, was visited by Cardinal Louis of

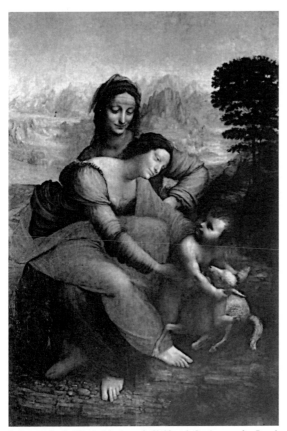

5. Leonardo da Vinci: *Virgin and Child with St Anne and a Lamb*, oil on panel, 1.68×1.30 m, *?c.* 1515 (Paris, Musée du Louvre)

Aragon's party on 10 October 1517, the occasion recorded by Ambrogio de' Beatis, who was the Cardinal's secretary. As 'first painter and engineer' to the King, Leonardo was provided with accommodation at the manor house of Clos-Lucé, Amboise.

Leonardo's final years have often been seen as dominated by his geometrical obsessions and a growing sense of pessimism, expressed most vividly in the visions of cataclysmic storms in his series of drawings of *A Deluge* (Windsor Castle, Royal Lib.; see fig. 6). His health was also apparently deteriorating. De' Beatis reported that some paralysis was affecting his right side, probably as the result of a stroke. However, a study of folios and notebooks datable to the period 1516–19 reveals a remarkable range of continuing activities. There are only occasional signs of physical frailty. His assistants, most prominent among whom was the well-born FRANCESCO MELZI from Lombardy, probably played an increasing role in the physical work, but his inventiveness appears undiminished.

As in his two Milanese periods, Leonardo furnished designs for courtly entertainments, including a revised version of his design for the *Festa del paradiso* of 1490. His most ambitious project was for a huge royal palace at Romorantin, with associated canalization. A scheme was devised for an extensive residence, translating French château design into the language of the Renaissance.

Leonardo's concerns extended from the overall conception to such details as the design of toilet doors with counterweights. Although the project did not materialize, echoes of Leonardo's ideas can be seen in subsequent French château design.

The evidence of Leonardo's involvement with painting in France is equivocal, relying on secondary sources from later in the 16th century. It is virtually certain that the '*Mona Lisa*', the *St John the Baptist*, the *Leda* and the *Virgin and Child with St Anne* were taken by Leonardo to France, where some may have been completed. He probably made an anamorphic painting for Francis I depicting a fight between a dragon and a lion in such a way that it made sense only when viewed from a shallow angle. A composition with a half-length female nude, known as the '*Monna Vanna*', which exercised a notable influence on a series of erotic paintings from the school of Fontainebleau, may also have depended on a prototype by Leonardo himself, possibly a drawing or cartoon (such as that in Chantilly, Mus. Condé). However, de' Beatis's testimony that illness had left Leonardo unable to undertake painting needs to be taken seriously, and it is unlikely that any wholly autograph paintings were initiated and completed in France.

On 23 April 1519 Leonardo drew up his will, bequeathing most of his drawn and written legacy to Melzi.

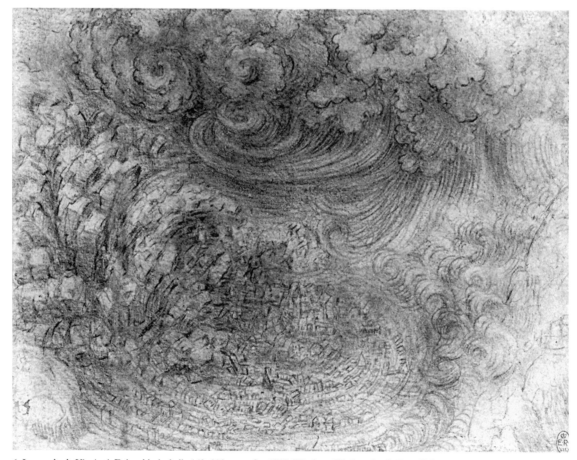

6. Leonardo da Vinci: *A Deluge*, black chalk, 163×210 mm, after 1513 (Windsor, Windsor Castle, Royal Library)

Following Leonardo's death, Melzi wrote movingly to the painter's brothers in Florence, one of whom's son, PIERINO DA VINCI, became a sculptor. Several of Leonardo's paintings seem to have come into the hands of his assistant Caprotti, who had also travelled with his master to the French court. On 12 August 1519 Leonardo was buried in the church of St Florentin at Amboise, although his remains are thought later to have been transferred to the chapel of St Hubert at the château of Amboise.

II. Stylistic development and technique.

1. Paintings. 2. Drawings. 3. Sculpture. 4. Architecture. 5. Ephemeral designs.

1. PAINTINGS. Leonardo completed relatively few paintings, and no more than ten surviving works are generally accepted as being finished wholly by him. A further three autograph paintings remain unfinished, while a small group of works may be classified as studio products in which he played a greater or lesser role. Early sources, particularly Vasari and Giovanni Paolo Lomazzo, refer to a number of paintings now unknown, but there is often no way of telling if these works were indeed by Leonardo himself. Additionally, there is a host of Leonardesque paintings by followers, ranging from presumed copies of original works to free variations on Leonardo's compositions. Many of the Leonardesque paintings originated from Milan, where artists may have had access to originals brought back from France by Caprotti, whose own copies, as well as those by others, transmitted the conventional image of the 'Leonardesque' to later ages.

(i) First Florentine period, 1472–c. 1482. (ii) First Milanese period, c. 1482–99. (iii) Second Florentine period, 1500–mid-1508. (iv) Second Milanese period, mid-1508–1513. (v) Rome, c. 1515. (vi) 'Leonardesque' paintings and painters.

(i) First Florentine period, 1472–c. 1482. Besides the documented *Adoration of the Magi* (1481–2; Florence, Uffizi), left unfinished when Leonardo departed for Milan, there is a reasonable consensus of opinion on the attribution of other surviving paintings to this period, though less agreement about dating. Of the Virgin and Child paintings most closely associated with Leonardo in the 1470s (when, according to his own notes, he had begun 'two Madonnas'), the *Virgin and Child with a Vase of Flowers* (c. 1474–6; Munich, Alte Pin.) is the least fluent compositionally and stylistically the closest to works produced in Verrocchio's studio; the Benois *Madonna and Child* (c. 1479–81; St Petersburg, Hermitage) is close in conception to the *Adoration*, while the *Virgin and Child* known as the '*Madonna Litta*' (c. 1480–85; St Petersburg, Hermitage) gives a very awkward impression and can at best be seen as painted largely by another hand. Leonardo's inventory of 1481–2 refers to a Madonna 'in profile', but this has not been certainly identified.

Among the elements of the *Virgin and Child* in Munich recognizable as motifs common in Verrocchio's studio are the spiral knots of hair, the bunched drapery of the bodice held by a jewel, the precious gesture of the hand holding a carnation and the meticulous observation of the vase of flowers. The composition is assembled by adding one detail to another but is not conceived as a whole, and it is characteristic of such compositions produced in Florence at this period. However, Leonardo endeavoured to imbue the drapery and the motion of the Child with vigour and variety, and the flower buds are about to burst open, imparting a sense of superabundant vitality. The effects of atmospheric perspective in the strange, mountainous landscape are recognizably Leonardesque, and the puckered and wrinkled paint surface also bears witness to his experiments with the oil medium, even at this early date.

The Benois *Madonna*, by contrast, is a far more integrated composition. The figures are combined in such a way as to forge a new kind of formal and emotional interaction. This is achieved both through the interweaving of the motions and gestures and by the rhythmic interplay of curves in the composition. The emotional vitality of the Virgin reflects Leonardo's debt to 15th-century Florentine sculpture and may depend directly on the low-relief Madonnas traditionally attributed to Desiderio da Settignano. The light has an unprecedented directness and force, creating an almost exaggerated sense of relief, which is only partly disturbed by the blank (possibly overpainted) view through the window.

The arrangement of the '*Madonna Litta*' is characteristic of the ambitions that tended to strain Leonardo's compositions to breaking-point. The Virgin tenderly cradles the Child, who sucks from his mother's breast and twists restlessly to look at the spectator. It is not easy to recognize the handling of the figures as the work of Leonardo. The generalized surfaces and simplified contours suggest a laboured attempt to emulate Leonardo's style, though the graded recession of hills in the landscape is captured with a subtlety difficult to attribute to an assistant or follower.

Although the Munich Virgin is the earliest of these three compositions, it is not the earliest painting that can be attributed to Leonardo. The *Annunciation* (c. 1473; Florence, Uffizi; see colour pl. 1, XXXVII), from the convent of Monte Oliveto, can be seen to an even greater degree as an assemblage of motifs from his earliest experiences of Florentine art. The influence of Verrocchio is paramount, particularly in the antique-style pedestal of the Virgin's reading-desk and emphatically sculptural draperies. The perspective of the house and tiled pavement on the right has been assembled in an almost mechanical manner over a series of geometrical lines incised in the gesso priming of the panel. The paint handling and conception of form are rather uneven, reflecting the young artist's search for appropriate ways of capturing a wide variety of natural effects. The depiction of the plants, including the Angel's lily, and the blue haze of the distant mountains indicate that Netherlandish art was already an important source of inspiration.

An attempt to combine the striking effects of surface naturalism in Netherlandish art with the formal values of the Florentine tradition is also apparent in the only surviving portrait from this period, that of *Ginevra de' Benci* (c. 1476; Washington, DC, N.G.A.). The sitter's name is indicated by the punning, heraldic device of the juniper bush (It. *ginepro*) behind her head, while the back of the panel is decorated with a wreath of palm and juniper and the motto *virtutem forma decorat* ('beauty adorns virtue') that appears to have been given to her by Bernardo Bembo. The decorative motif on the reverse confirms that

the painting has been cut down by as much as a third at the bottom. It is likely that the sitter's hands were originally included, as in Verrocchio's marble bust of a *Woman Holding Flowers* (Florence, Bargello). (A silverpoint *Study of Arms and Hands* (*c.* 1476; Windsor Castle, Royal Lib., 12558) may indicate Leonardo's intentions.) The sense of brilliant striving for effects of light and texture in the painting is again reflected in Leonardo's technical experiments; he softened the modelling of the flesh by pressing his fingers into the wet paint. The wrinkled paint surface in the landscape results from his use of oily glazes to convey a nebulous atmospheric recession equivalent to that in his pen drawing of a *Tuscan Landscape* dated 1473 (Florence, Uffizi), though the painting probably dates from at least three years later.

A comparable quality can be seen in the landscape background on the left in Verrocchio's *Baptism* (Florence, Uffizi; see VERROCCHIO, ANDREA DEL, fig. 5), originally from the monastic church of S Salvi outside Florence. Leonardo's contributions to his master's picture may also be recognized in the angel on the far left (as testified by Albertini in 1510), in the water and probably in the glazes that model the face and body of Christ. Although it would be natural to assume that these contributions represent Leonardo's earliest known attempts at painting (i.e. *c.* 1470), the pose of the angel and delicately vivacious handling of paint suggest a technique at least as advanced as that of the portrait of *Ginevra de' Benci* and thus a date of *c.* 1476.

None of these examples of Leonardo's work, ambitious though they are, anticipates fully the extraordinary innovations revealed in the large-scale, unfinished *Adoration of the Magi* (see fig. 1 above). This was a popular subject for altarpieces in 15th-century Florence, not least as a reflection of the activities of the Compagnia de' Magi, a lay body responsible for organizing a great procession on the day of Epiphany. Florentine paintings of the subject, taking their cue particularly from Gentile da Fabriano's Strozzi Altarpiece (1423; Florence, Uffizi; see GENTILE DA FABRIANO, fig. 3), had developed a rich, processional and even clamorous quality. Leonardo's preparatory studies, including the pen-and-ink compositional sketch (Paris, Louvre), show that he found his starting-point in this tradition. However, he invested every element in his composition with a fresh emotional charge, ranging from the contemplative absorption of the old man on the extreme right, through the intense reverence of the Magi, to the overt violence of the horsemen in the background. The emotional postures, gestures and faces are incorporated into a composition in which unprecedented dynamism is orchestrated within a rigorously controlled structure. The arc of adoring figures and the pyramidal disposition of the Virgin and kneeling Magi are given additional articulation by the trees, while the turbulence of the background takes place in some form of ruined architectural structure that was calculated with the highest degree of perspectival exactitude; this is also evident in the pen-and-ink study of the architectural background (Florence, Uffizi).

Reading the *Adoration* is not easy. It is not only unfinished in the conventional sense, but many of its forms are still in an emergent state. The fluidity of Leonardo's preliminary drawings is sustained into the underpainting itself, in a manner exceptional in a 15th-century painting. The identification of the background figures is particularly difficult, although the sense of turmoil and the destruction of the old order—symbolized also in the ruined architecture—are based on Florentine precedents. The retinue accompanying the Magi has been transformed into a series of urgently involved witnesses to the divine mystery, who are far removed from their traditionally supportive, decorative and anecdotal roles. The two flanking figures, one deeply pensive and the other youthfully romantic, may have been inspired by the framing figures on antique sarcophagi (also used by Donatello), but they play an unprecedented psychological role in the drama.

The rich tonal effects in the underpainting are also present in the panel of *St Jerome* (*c.* 1481–2; Rome, Vatican, Pin.), also unfinished, in which a foreshortened, contorted kneeling pose complements the sharply characterized expression of penitence in the saint's face. The physiognomy of the roaring lion, echoing St Jerome's torment, recalls the drawings in which Leonardo compared human and animal expressions (e.g. *Sheet of Studies with the Virgin and Child and Saints*, Windsor Castle, Royal Lib., 12276*r*), while the saint's sinewy neck must have been based on the kind of anatomical studies that were listed in his inventory of 1481–2.

The other strongest candidates for autograph paintings by Leonardo of this period are the *Virgin and Child*, called the Dreyfus *Madonna* (Washington, DC, N.G.A.), and the predella panel of the *Annunciation* (Paris, Louvre) from the altarpiece commissioned from Verrocchio but executed by Lorenzo di Credi and representing the *Virgin and Child Enthroned with SS John the Baptist and Donatus of Arezzo* (1475–80; Pistoia Cathedral; see LORENZO DI CREDI, fig. 1). Both attributions have their supporters, but the Dreyfus *Madonna* may perhaps be better attributed to Verrocchio himself, while the *Annunciation* displays weaknesses in structure and handling that suggests that it is by another of Verrocchio's pupils.

(ii) *First Milanese period, c. 1482–99.* The troubled history of the commission in 1483 for the painted sections of the altarpiece of the Confraternity of the Immaculate Conception has led a few commentators to assume that the central image, the *Virgin of the Rocks* (Paris, Louvre; see colour pl. 1, XXXVII1), was not wholly completed during the first Milanese period. However, as far as can be judged beneath its layers of darkened varnish, the painting appears, in its delicate characterization of form and vitality of touch, to belong wholly to the 1480s. A devotional image of the Virgin has been translated into a scene of considerable formal, colouristic, iconographical and psychological complexity. The figures in the landscape setting depend distantly on Filippo Lippi's altarpiece of the *Virgin Adoring the Christ Child with SS Romuald and John the Baptist* (*c.* 1459; Berlin, Gemäldegal.), for the chapel in the Palazzo Medici, Florence, but Filippo's image does not approach the subtle spatial interplays of glance, gesture and directional light. This is the most advanced expression to date of Leonardo's insistence on the dominance of tone over colour. Only the swathe of yellow lining of the

Virgin's robe is allowed to assert itself independently of the tonal scheme, and even this merges into the substratum of shadow at the edges. The painting's complex iconography centres on an apocryphal narrative of the meeting of the Virgin and Child with St John and the Angel Uriel in the wilderness. The theme is underscored by botanical symbolism associated with Mary, while the rocky cavern in the distance may be drawn from the 'dove . . . in the clefts of rock' in the *Song of Songs* (ii.14) and refer to Mary's virginity. Whatever the intended meaning, the forms bear witness to Leonardo's intense scrutiny of nature and his recreation of natural forms in imaginative compounds that endow them with an aura of strangeness.

The formal and psychological suavity of the *Virgin of the Rocks* can also be recognized in the *Portrait of a Lady with an Ermine* (see fig. 3 above), thought to represent Cecilia Gallerani, one of Ludovico Sforza's mistresses. The animal in her arms appears to be a punning reference to her name (Gr. *galé=ermine*), as well as standing as an emblem of purity. The implied narrative of the sitter turning to look at an unseen companion gives the portrait an unprecedented freshness and permits a new kind of psychological communication in portraiture, only partly foreshadowed in Verrocchio's portrait busts. In spite of some inelegant overpainting of the background, which was originally grey, the portrait possesses a remarkable harmony of line, space, light and colour, without compromising the natural observation of forms and textures.

None of the other Milanese portraits associated with Leonardo achieves such a high level of complexity and innovation. Of these, the unfinished *Portrait of a Musician* (Milan, Pin. Ambrosiana) is the most widely accepted, the head possessing a sense of underlying structure and life characteristic of Leonardo's documented works. Moreover, the highlit spirals of hair share the febrile energy of Ginevra's curls. By comparison with the *Portrait of a Lady with an Ermine*, two unidentified female portraits associated with Leonardo appear superficially routine. Yet the head of the *Portrait of a Woman in Profile* (Milan, Pin. Ambrosiana) has a vibrancy of contour that escaped the best of his associates, and '*La Belle Ferronnière*' (Paris, Louvre; see colour pl. 1, XXXVI2) is more interesting than it might initially appear. Although the parapet in the latter prevents the figure from asserting its full presence, the motif of the glance, almost, but not quite, meeting the spectator's, is full of Leonardesque ingenuity. The painting of the accessories is more vital than most of the details in the Ambrosiana female portrait and may be substantially by Leonardo himself. The sitter has been tentatively identified as Ludovico's later mistress Lucrezia Crivelli, whose portrait by Leonardo is also described in a poem. If so, it would date from the mid-1490s, which is consistent with his style.

The most important painting of Leonardo's first Milanese period was the *Last Supper* on the end wall in the refectory of S Maria delle Grazie. Hailed originally as a triumph of illusionistic naturalism, it may now be described as the most famous wreck in the history of art. Leonardo's mediative methods of painting and his insistence on a full range of optical effects led him to seek an alternative to the true fresco technique. Analysis has revealed that he first primed the wall and then painted the mural in a manner resembling tempera painting on panel. Painting *a secco* (on dry plaster) was far from uncommon, but Leonardo's layered technique, which appears to have encouraged dampness to accumulate in the underlying plaster, resulted in imperfect adhesion. The restoration campaign begun in 1980 and completed in 1999, devoted to the removal of all later overpainting, has confirmed that in large areas only scattered flakes of original paint remain.

Even in its unhappy state, the grandeur and ingenuity of the conception of the *Last Supper* remain discernible. Leonardo created a compelling effect of a perspectival space opening off the refectory, but rendered the relationship between the illusionistic and real spaces deeply ambiguous at its margins. The ceiling passes upwards behind the lunettes to an imprecisely defined point, while the planes of the side walls do not precisely coincide with those of the refectory. The crowding and relative heights of the figures also subvert the requirements of strictly naturalistic logic for the sake of narrative effect. However, the restoration has revealed that many details were painted with consummate naturalistic skill and vibrant colour, including the still-life objects on the table—wine glasses, fruit, plates—and the folds of the cloth. The *Last Supper* is the supreme demonstration of Leonardo's belief that poses, gestures and facial expressions should reflect the 'notions of the mind' in a specific emotional context. Although it is anachronistic to read the painting as a 'frozen moment'—the gestures are meant to be read cumulatively, and successive moments in the biblical narrative are represented—the dominant intention is to convey the varieties of reaction to the central charge of Christ's impending betrayal. The theme of the Institution of the Eucharist, signalled by Christ's gestures towards the wine and bread, would also have been readily understood. The painting presents a rich series of themes for contemplation by the monks dining in the refectory.

The heavily restored remains of the decoration of the Sala delle Asse in the Castello Sforzesco, Milan, provide the most substantial visual indication of the inventiveness with which Leonardo performed his court duties. The motif of the regularly intertwined branches of the trees, interwoven with a meandering gold rope in one of his favourite knot patterns, succeeds superbly as decoration, without losing his characteristic sense of the natural vitality of living forms. The fragmentary underpainting on one of the walls, depicting roots insinuating themselves among rocks, suggests that the whole room was to be transformed into a bower. The heraldic shield of Ludovico Sforza and Beatrice d'Este in the central oculus and laudatory inscriptions make obvious dynastic references. The motif of interweaving may itself function as a kind of *impresa* (heraldic motif) of the union of Ludovico and his wife.

(iii) Second Florentine period, 1500–mid-1508. The two works on which Leonardo was most immediately engaged in Florence were the lost cartoon of 1501 representing the *Virgin and Child with St Anne and a Lamb* and the *Virgin of the Yarnwinder*, of which numerous versions and variants are known. Examination of the versions belonging to the Duke of Buccleuch and another private collection have revealed comparable *pentimenti*, underdrawings and stylistic characteristics that suggest that Leonardo played a role

in their design and perhaps also in their execution. They are probably studio realizations of Leonardo's invention. Fra Pietro da Novellara described the lost cartoon as showing St Anne rising from her seat to restrain the Virgin from separating the Child from the lamb. The best records of it may be a drawing (Geneva, priv. col., see Clark, 1939, rev. 1988, p. 33), which appears to imitate Leonardo's graphic style, and the rather wooden painting of the same subject attributed to Brescianino (Berlin, Bodemus.). The importance of these two works by Leonardo was that they demonstrated to the Florentines a dynamic new way of incorporating symbolism into an anecdotal type of Virgin and Child. The meaning of the symbols of the passion—the cross-shaped yarnwinder and the sacrificial lamb—is built in to the physical and psychological aspects of the interaction between the figures.

Documentary records confirm early accounts that Leonardo also used an experimental technique for the *Battle of Anghiari*, painting *a secco* on a sealed and primed wall surface, but on this occasion using oil as his chief binding medium. The sources further suggest that the paint proved reluctant to dry, but it is not known if the problems were sufficiently severe in themselves to lead to his abandonment of the project. The one section of his painting—apparently the central portion—that survived until the 1560s, albeit in an unfinished state, was recorded in paintings and drawings, and in an engraving by Lorenzo Zacchia. There are two painted copies of reasonable quality (Florence, Uffizi; Munich, G. Hoffman priv. col.), while the most artistically attractive of the graphic versions is the drawing (Paris, Louvre) that appears to have been reworked by Peter Paul Rubens (1577–1640). Together with the preparatory drawings, the copies show that Leonardo's battle centred on a turbulent fight for a standard, in which rearing horses, elaborately armoured warriors and struggling foot soldiers were compressed into a tight knot of explosive action. Even in the copies the force and conviction of the contorted men and horses, together with their savagely bestial expressions, give an impression of unprecedented power. However, the detailed effects of dust, mingled with blood, rising in the air and the churned-up water in the river can only be envisaged through reading the descriptions in his notebooks. The fragmentary nature of the visual evidence works against a full-scale reconstruction of Leonardo's scheme for the whole wall and makes it difficult to read the narrative of the central group. However, Neri di Gino Capponi's manuscript account of the battle indicates that the capture of the Milanese standard was the crucial event, and it may therefore be possible to identify the horsemen to the left as Milanese struggling to retain their grip of the standard in the face of the Florentine assault from the right.

The remarkable power of Leonardo's second major invention of the period, the '*Mona Lisa*' (see colour pl. 1, XXXVI3), results from his exceptional translation of an individual image into an archetype with deliberately universal connotations. None of the elements is unprecedented on its own: a portrait extending below the bust to include the hands had already been used by Verrocchio in his marble *Woman Holding Flowers* and by Leonardo in *Ginevra de' Benci*; the setting of a figure above a distant landscape had been exploited in Piero della Francesca's portraits of *Federigo da Montefeltro* and *Battista Sforza* (both Florence, Uffizi), and a comparable directness of expression, with the slight smile, had been developed in portraits by Antonello da Messina. But the effect of the ensemble has no parallel in earlier art.

Yet the novelty of the '*Mona Lisa*' is partly a matter of form and technique. The monumental amplitude of the figure is emphasized by the sweeping contours of drapery and by the stabilizing devices of the wall behind the figure and framing columns. The form is modelled softly yet insistently in Leonardo's *sfumato* (It.: 'smoked') manner, in which the contours are rendered elusive under a veil of intervening atmosphere. More profound is the question of the implicit imagery in which woman and landscape together bear witness to the inner life of both human and earthly forms as reflections of cosmic motions. Leonardo was fascinated by the ancient idea of microcosm, in which the human body was regarded as a reflection on a reduced scale of the structures and processes of the world as a whole. In the '*Mona Lisa*', the analogy is underscored by parallels in the treatment of the curvaceous flow in the hair, draperies, embroidery patterns and rivers and valleys in the landscape. The subtle interplay between universal values and the particularity of the individual woman has been a crucial factor in the enduring fascination of Leonardo's image.

Leonardo seems to have started to work on his composition of *Leda and the Swan* at the same time he was planning the *Battle of Anghiari*. Initially he showed Leda in a complex kneeling pose, probably inspired by an antique statue of Venus, as in a pen drawing (Windsor Castle, Royal Lib., 12337*r*). Although this idea was taken up by his followers, he apparently abandoned it in favour of a standing Leda, in which a more mellifluous motion could be orchestrated. The basic pose, relying on the sinuous, triple turn of head, torso and hips around the central axis of her body, was established at least in a developed drawing or cartoon during this period in Florence. It was studied by Raphael and set new standards of figural complexity for the younger generation of Italian artists. The painting in its final form, with the four children bursting from the eggs, may not have reached completion until after 1513. The best variants (Florence, Pal. Vecchio; Wilton House, Wilts; London, Hyde priv. col.) suggest that it contained rich allusions to the generative powers of nature as expressed in the human, animal and vegetable kingdoms.

The *Angel of the Annunciation* (best copy, Basle, Kstsamml.) is an unjustly neglected work. The Angel conveys the message of the Annunciation directly at the viewer, who becomes the privileged recipient standing in the place of the Virgin Annunciate. This remarkable conception may have arisen during Leonardo's involvement with Rustici's sculptural group of *St John the Baptist Preaching*, (for illustration *see* RUSTICI, GIOVANNI FRANCESCO) which exploits a comparably direct communication between saint and spectator. The original painting was recorded in the collection of Duke Cosimo I de' Medici in the 16th century, and a drawing (Windsor Castle, Royal Lib., 12328*r*) records Leonardo's initial idea.

(iv) Second Milanese period, mid-1508–1513. The best evidence of Leonardo's style during his second Milanese

period is provided by the *St John the Baptist* (Paris, Louvre), which represents the extreme development of his ideas on the treatment of light and shade to achieve atmospheric effects and describe three-dimensional objects. The figure emerges from a dark background, with the light, falling from above left, highlighting parts of the saint's head and shoulders and creating a sense of sculptural volume. The internal modelling and shaded contours are described with an extreme of ambiguous softness, even allowing for the yellowed varnish. The elusiveness of precise form corresponds to the conviction in Leonardo's optical writings that the mechanisms of vision result in complex ambiguities of space, form and colour. Leonardo also attempted to convey the inner motions of the character's mind. The saint's angelic smile had featured in earlier Florentine art, but Leonardo's exaggerated attempt to make the expression convey a sense of spiritual knowingness has resulted in a presence that many viewers have found enigmatically disturbing. The pointing gesture, here as elsewhere in his art, alludes to the other-worldly source and immaterial power of the creator of the world.

A related project was for a painting of *St John the Baptist Seated in a Landscape*. A damaged but autograph drawing (ex-Mus. Baroffio, Varese; stolen 1973) shows the fully developed pose of the saint as it appears in a painted version (Paris, Louvre), in which, however, the figure has the attributes of Bacchus, perhaps as a result of a later intervention. Although demonstrably close to Leonardo in composition and spirit, the painting appears to be by an accomplished follower.

(v) Rome, c. 1515. Although the *St John* was at one time assumed to be the last of Leonardo's surviving paintings, it now seems more likely that the *Virgin and Child with St Anne and a Lamb* (Paris, Louvre; see fig. 5 above) occupies this place. The forms of the draperies, rocks and landscape and the optical subtleties can best be aligned with his drawings and writings around 1515, when he was in Rome. The composition takes up the experiments of the lost cartoon of 1501; the integration of the three figures and the lamb is achieved by the shaping of their forms into a series of interlocking curves. The fluency of the motion disguises the physical improbability of the pyramidal group. Compared to the 1501 design described by Fra Pietro, St Anne no longer restrains the Christ Child from embracing the sacrificial lamb, but the underlying symbolism remains the same. The painting technique is characterized by the fluid use of translucent glazes of oil paint to create effects of softness, translucency and transparency. Typical of Leonardo's interests are the translucent veins of coloured minerals in the pebbles near St Anne's feet. There is a compelling sense of motion and flux, both in the physical forms of the natural world and in the infinite optical variables of mists, refractions and reflections.

(vi) 'Leonardesque' paintings and painters. No artist ever inspired more copies, variants and pastiches than Leonardo. Fra Pietro's testimony confirms that copying was practised in Leonardo's studio, and some of the best versions of his paintings, such as the *Angel* in Basle, may be studio products, often assumed to be autograph by later owners. The working of variations on Leonardo's favourite themes appears to have become something of an industry in Milan after his departure in 1513; the precise relationship of many of these pictures to Leonardo's own paintings and drawings is often obscure. There is a marked tendency among optimistic owners and art historians to hail the more convincing of the Leonardesque paintings as long-lost originals.

Variants that appear to reflect inventions by Leonardo himself include images of *Christ the Redeemer, Christ and the Doctors in the Temple, Christ Carrying the Cross,* the *Christ Child and the Infant St John at Play,* and the *Kneeling Virgin with the Christ Child and St John and a Lamb.* The firm attribution of the majority of the versions and variants of these and other Leonardesque paintings remains impossible, given the present state of knowledge of the minor artists who followed Leonardo. Only the personalities of the more independent masters, Andrea Solario and Bernadino Luini, have been satisfactorily defined. Among those in his immediate orbit, Giovanni Antonio Boltraffio, Giovanni Ambrogio de Predis and Cesare da Sesto painted in styles that can be characterized to greater or lesser degrees, but the full parameters of their styles have not been established securely, and other followers, including Francesco Melzi and Gian Giacomo Caprotti, remain shadowy, apart from the occasional signed or documented work.

2. DRAWINGS. Leonardo was one of the most innovative and fertile draughtsmen of any age. In his hands the practice of drawing became a flexible extension of creative thought, not only expressing a series of new ideas in teeming abundance but also becoming, through a rapid confusion of scribbled alternatives superimposed on each other, a way of permitting chance configurations to aid the inventive process. Drawing became a form of visual thinking rather than a merely functional means for the design of a picture.

At the beginning of his career Leonardo achieved mastery of the two most important drawing techniques of the period, metalpoint and pen and ink. The *Study of Arms and Hands* (Windsor Castle, Royal Lib., 12558) that may have served for the portrait of *Ginevra de' Benci* is drawn in silverpoint with white heightening on pink prepared paper and demonstrates a meticulous control of parallel hatching to suggest graded relief. One of the last instances in which Leonardo used this traditional medium, his *Studies of a Standing Horse,* seen from the side and front (*c.* 1490; Windsor Castle, Royal Lib.; see fig. 7), probably for the Sforza monument, may be regarded as having taken the potential of silverpoint to its limits.

Leonardo's work in pen exhibited from the first an exceptional vitality of touch, as in the *Tuscan Landscape* (1473; Florence, Uffizi), which is characterized by an extraordinary suggestion of life and atmosphere. In the drawings for the *Adoration of the Magi* and various Virgin and Child compositions of the 1480s and early 1490s he evolved a graphic style of unprecedented rapidity and suggestiveness. Other Renaissance draughtsmen, including Verrocchio, had used pen and ink for quick sketches, but no one had approached Leonardo's bold and dynamic method of 'brainstorming', in which alternative forms emerge from a tangled confusion of lines. The rapid pen

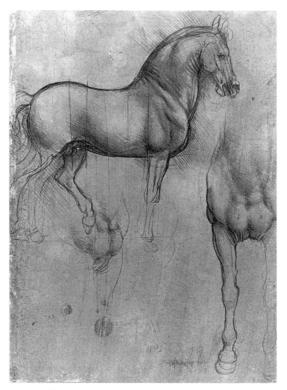

7. Leonardo da Vinci: *Studies of a Standing Horse*, silverpoint on blue prepared paper, 214×160 mm, *c.* 1490 (Windsor, Windsor Castle, Royal Library)

more flexible media of red and black chalk during the 1490s, above all in the studies for the *Last Supper*. The red-chalk drawings for Apostles' heads, sometimes on reddish prepared paper, such as the *Head of Judas* (Windsor Castle, Royal Lib., 12547), make subtle interplay between softly luminous shading, rhythmic contours and selective areas of dense shadow. The heads of shouting warriors for the *Battle of Anghiari* (e.g. Budapest, Mus. F.A.; see fig. 9) represent the high-point of this technique. The softer and grainier black chalk was particularly suited to creating effects of *sfumato* modelling. When combined with white heightening, as in a *Study of a Sleeve* for St Peter in the *Last Supper* (Windsor Castle, Royal Lib., 12546), or with heightening and wash, as in studies of drapery (Windsor Castle, Royal Lib., 12530; Paris, Louvre) for the Louvre *St Anne*, extraordinarily rich effects of light and shade could be attained. Comparable effects were achieved with charcoal and white heightening in the cartoon of the *Virgin and Child with SS Anne and John the Baptist* (London, N.G.), which retains a far greater degree of fluidity and lack of resolution than would have been normal in a full-scale drawing. Black chalk was also the favoured medium for his drawings of *A Deluge* (e.g. Windsor Castle, Royal Lib.; see fig. 6 above), where its sombre, atmospheric qualities were ideally suited to such dark expressions of cosmic violence.

Leonardo was also an innovator in the use of colour in drawings. His geographical studies use coloured washes to distinguish forms in flat maps according to a convention or colour code, and also for more naturalistically descrip-

studies of the *Virgin and Child with a Cat* (*c.* 1478–81; London, BM; see fig. 8) show the complex interweavings of bodies in motion that become possible with this approach. On the *verso* of this sheet, the design was traced through in reverse, becoming the starting-point for a further series of variations that were clarified by the addition of an ink wash. Such paintings as the Benois *Madonna* reflect the way in which complex motions can be orchestrated through this manner of sketching.

Throughout Leonardo's career, pen and ink remained the technique he most regularly used, not only for preliminary sketches but also for scientific illustrations and representations of machinery and architecture. During the late 1490s his system of shading with pen underwent an important and influential change: the use of diagonal parallel hatching, which moved from top left to bottom right (he was left-handed), was progressively replaced by curved pen strokes that follow the forms. The drawings for the *Leda* from 1506 onwards, such as the *Study for the Kneeling Leda* (pen and ink over black chalk; Chatsworth, Derbys) represent the extreme development of this graphic style.

For the study of the component parts of compositions, Leonardo often turned to other media. Early in his career he seems to have made studies of draperies arranged on lay figures using a fine brush and white heightening on linen (Paris, Louvre, and elsewhere) in the manner of his master, Verrocchio, and contemporaries such as Domenico Ghirlandaio, but he progressively used the softer and

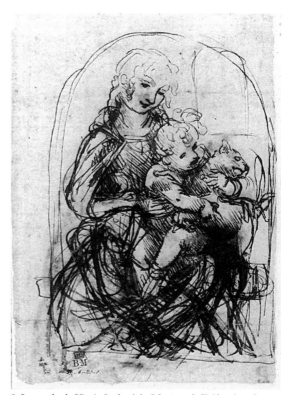

8. Leonardo da Vinci: *Study of the Virgin and Child with a Cat*, pen and brown ink, 132×96 mm, *c.* 1478–81 (London, British Museum)

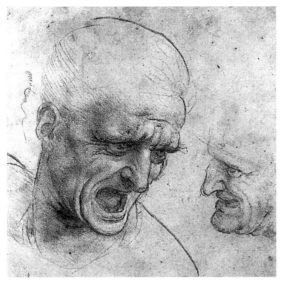

9. Leonardo da Vinci: *Studies of the Heads of Shouting Warriors* for the *Battle of Anghiari*, black and red chalk, 191×188 mm, *c.* 1504–5 (Budapest, Museum of Fine Arts)

tive purposes, as in the *Bird's-eye View of Arezzo, Borgo San Sepolcro, Perugia, Chiusi and Siena* (1502; Windsor Castle, Royal Lib., 12680). His use of coloured pastels, mentioned in 16th-century sources, cannot be demonstrated in fully autograph drawings, but artists in his circle, most notably Giovanni Antonio Boltraffio, certainly exploited the technique.

In his scientific and technical drawing Leonardo experimented with many of the illustrative techniques used in later textbooks, including various forms of solid section, transparency of overlying parts and exploded diagrams of components. He pushed the descriptive potential of static drawing on a flat surface towards its ultimate limits.

3. SCULPTURE. That Leonardo practised as a sculptor is not in doubt, but attempts to attribute surviving sculpture to him have met with generally unsatisfactory results. Vasari was probably correct in saying that Leonardo made terracotta heads of women and children (perhaps of the infant Christ or the infant St John) early in his career, since such heads were part of the stock-in-trade of a sculptor's studio in the 1470s. When he advertised his services to Ludovico 'il Moro', he claimed proficiency in 'sculpture, in marble, bronze and clay', but the subsequent records of his sculptural activity suggest that he worked as a modeller rather than as a carver.

Leonardo's most substantial sculptural undertaking was the great equestrian monument to *Francesco Sforza* that was intended to be cast in bronze in Milan. The first record of his direct involvement occurs only in 1489, when the Duke expressed doubts about Leonardo's ability to complete the work. In April 1490 Leonardo himself noted that he 'restarted the horse' (Paris, Inst. France, MS. C, fol. 15*v*). By this time it is likely that he had set aside his technically impractical scheme for a rider on a rearing horse and reverted to the more traditional walking pose, as in Donatello's *Gattamelata* (*c.* 1447–53; Padua, Piazza

del Santo; *see* DONATELLO, fig. 4) and Verrocchio's *Bartolommeo Colleoni* (*c.* 1479–92; Venice, Campo SS Giovanni e Paolo; *see* VERROCCHIO, ANDREA DEL, fig. 4), but on a scale of three times life size. In 1491 and 1492 he worked on the full-scale clay model, which made a great impact when it was shown as part of the marriage celebrations of Bianca Maria Sforza and Emperor Maximilian (*reg* 1493–1519). The surviving records of Leonardo's project in his drawings and manuscripts are far from complete, but include beautiful studies of horses from life (e.g. fig. 7 above), proportional studies, for instance the silverpoint measured drawing of a *Horse in Profile to the Left* (Windsor Castle, Royal Lib., 12319) and elaborate schemes for the casting of the colossus mainly in the second Madrid codex (Madrid, Bib. N., MS. 8936). The drawings show his concern to capture the nervous vitality of a highly bred horse, both in its overall motion and in the rhythmic grace of individual parts. There is little indication of the intended pose of the rider, who may not even have been included in the clay model that was exhibited. The bronze was never cast, and the model was destroyed.

Leonardo's plans for the equestrian monument to Gian Giacomo Trivulzio are recorded in a series of pen drawings (Windsor Castle, Royal Lib., 12353, 12355, 12356), which show that an energetically striding horse and gesturing rider were to have been mounted on an elaborate architectural base. The base was to have contained a recumbent image of Trivulzio on his sarcophagus, and a series of eight 'captives' (bound nude male figures) were to have been attached around its margins in a manner comparable to Michelangelo's projected scheme for the tomb of *Pope Julius II*. Leonardo's project was destined not to reach even the stage of a full-scale model, although some later drawings, such as the black-chalk study showing a fallen soldier trampled beneath his horse's hooves (Windsor Castle, Royal Lib., 12354) which may date from 1511, show that he continued to meditate on the possibility of reviving his earlier idea for a rearing horse.

The most tangible surviving evidence of Leonardo's qualities as a sculptor occurs in Rustici's bronze group of *St John the Baptist Preaching*. Although there is no direct documentation of Leonardo's involvement with this group, Vasari's account of Leonardo's participation is supported by the visual evidence. The complex yet monumentally graceful poses, the individual characterizations and contrasted expressions speak the language pioneered by Leonardo in the *Last Supper*, while the intricate communication between the figures and the spectator on the ground below can be seen as the realization of ideas with which Leonardo had long been experimenting. The precise roles of Rustici and Leonardo are impossible to disentangle, but it is clear that Leonardo's presence resulted in Rustici working on a higher plane than in any of his wholly independent works.

The high probability that Leonardo worked on smaller-scale sculpture in his studio, either in terracotta or wax, has encouraged a search for surviving examples or, more realistically, bronzes dependent on his models. The surviving terracotta that deserves the most serious consideration is a bust of the *Infant Christ* (ex-Galludt priv. col.; *see* Pedretti, 1957, and Kemp, 1981), but, in the absence of

any direct evidence of Leonardo's handling of terracotta, the attribution remains provisional. Among the bronzes that bear some resemblance to Leonardo's designs, the best contenders are a series of small-scale rearing horses with riders. Two versions (Budapest, N. Mus.; Louisville, KY, Speed A. Mus.), the latter probably representing *Marcus Curtius*, can be related to drawings of rearing horses of the *Battle of Anghiari* type, such as the sheet of studies of *Horses, a Cat and St George and the Dragon* (Windsor Castle, Royal Lib., 12331). However, the generalized anatomy of the Budapest horse suggests that it is at best a later variant of a Leonardo design, while the *Marcus Curtius* has an awkwardness in proportion and balance that points to a follower, possibly Rustici.

The topic of Leonardo and sculpture, if examined through the master's surviving work, is not encouraging, but it would be wrong to underestimate its importance. Sculptural values, particularly those of Verrocchio, exercised a notable impact on Leonardo's vision of form and communication in space, and some of his own ideas were absorbed into the sculptural tradition.

4. ARCHITECTURE. Discussion of Leonardo's contribution to architecture is as problematic as that of his contribution to sculpture. Although he may never have built anything, documents and drawings contain tantalizing glimpses of unrealized projects and brilliant inventions, and in his letter to Ludovico Sforza he claimed to be the equal of anyone in architecture, capable of designing public and private buildings. His architecture may be described as being in the spirit of Brunelleschi, combining a reverence for the proportional principles of antique buildings (as expounded by Vitruvius) with a relatively undogmatic use of the Classical vocabulary and an inventive ingenuity in matters of engineering.

Leonardo's architectural projects were of two kinds. The first were practical, completing or renovating extant buildings and working as a military architect; the second were theoretical and included schemes for ideal cities and plans for many types of building. It is possible that the designs in Codex B (Paris, Inst. France) were intended to initiate a treatise on architectural building types, while the first Madrid manuscript (Madrid, Bib. N.) deals with principles of construction. The treatment of churches in Codex B, consisting of illustrations with only a minimal commentary, may have influenced later writers on architecture, particularly Serlio. Leonardo's architectural drawings, together with those of Francesco di Giorgio Martini (one of whose architectural manuscripts Leonardo owned) and of Giuliano da Sangallo, are among the earliest known. Since no drawings of this date survive by Bramante (who worked in Milan as court architect alongside Leonardo for 19 years), they are crucial in illustrating the evolution of the High Renaissance style.

Leonardo's series of structural studies for the *tiburio* over the crossing of Milan Cathedral (1487–8; e.g. Cod. Atlantico, fol. 310*r*b; Cod. Trivulziano) show that he attempted to devise an architectural 'skeleton' that had more affinities with the principles of Gothic ribs than with Roman structures, while the shape of his dome pays obvious homage to Brunelleschi's at Florence Cathedral.

The fundamental principle behind Leonardo's schemes of urban planning, developed in connection with schemes for Milan and Vigevano, was to devise a functioning 'body' in which canals, roads and pavements would permit an efficient and healthy environment, with a highly organized stratification of social activities. The designs in Codex B (fols 16*r*, 37*v*) illustrate ideal schemes for raised pedestrian precincts and a subterranean canal system that had little hope of realization, but the planning undertaken by Ludovico Sforza at Vigevano in the 1490s appears to reflect the translation of Leonardo's ideas into reality.

The most impressive and coherent set of Leonardo's architectural drawings is the series of church designs in Codex B (fols 17*v*, 18*v*, 21*r*) and Ashburnham I (Paris, Inst. France, MS. B.N. 2037), which show his variations on centralized and Latin cross plans. Some represent free experiments with a variety of geometrical schemes, while a few (e.g. Ashburnham I, fol. 5*v*) depict relatively resolved structures in which complex aggregations of plastic form are erected over intricate geometrical ground-plans. The more compact of the centralized structures, relating to Brunelleschi's unfinished S Maria degli Angeli in Florence, may have been intended as a Sforza mausoleum on a limited scale rather than as a full-sized church.

Leonardo's inventiveness as a military architect was given full expression when he was in service with Cesare Borgia in 1502–3. His mission to Piombino on behalf of the Florentine government appears to have stimulated some remarkable schemes for fortified structures, ranging from projects for specific locations to great, ideal schemes for impregnable fortresses (e.g. Cod. Atlantico, fol. 41*r*a, 48*r*b). Massive, block-like structures, with curved or slanting profiles to deflect bombardments, are disposed around circular or polygonal plans, with elaborate passages for the internal circulation of forces. Although the grander schemes inevitably remained unrealized, it is reasonable to think that Leonardo's advice on modifications to existing structures were taken in hand by his patrons.

The grandest of Leonardo's plans for a residential structure dates from the last years of his career, when he was in France. His scheme for the château at Romorantin, involving a large rectangular palace block, formal gardens and a rectangular network of canals, has been reconstructed by Pedretti (1972) from a group of sketches (especially Cod. Atlantico, fol. 76*r*b; London, BL, MS. Arundel, fol. 270*r*). The style appears to marry indigenous French elements, such as the round corner towers, with Italian Renaissance elements in a way that is typical of Leonardo's undogmatic exploitation of Classical vocabulary. His sense of form and function ultimately took precedence over strict allegiance to Classical rules.

5. EPHEMERAL DESIGNS. A significant factor in Leonardo's value to his courtly patrons was his ability to organize visual entertainments, particularly those connected with celebrations. His involvement with the design of courtly ephemera is relatively well documented, but the visual record is meagre. Only a few drawings in his surviving notebooks relate directly to known schemes. The most substantial autograph record relates to a pageant on the occasion of the weddings of Ludovico and Anna Sforza to Beatrice and Alfonso d'Este in 1491. A drawing

of a richly caparisoned horse is accompanied by a note that explains an astonishingly rich series of symbolic allusions involving peacock feathers, a wheel of fortune and the Cardinal Virtues (MS. Arundel, fol. 250*r*). His drawings for allegorical compositions illustrating the Sforzas' reign show a comparable elaboration of arcane allusions, extreme even by Renaissance standards.

Leonardo was also involved in theatrical design, specializing in effects that required large-scale machinery. His drawings for 'Pluto's Paradise' (MS. Arundel, fol. 231*v*) show a scheme for the opening of a mountain to reveal Pluto and his attendants who play harsh percussion instruments. As a musician of some reputation himself (he played the *lira di braccio*), Leonardo was well placed to design effects that would work in concert with instrumental and vocal compositions. Contemporary accounts survive of his most famed design for Bellincioni's *Festa del paradiso*, which involved a great, glowing celestial hemisphere adorned with stars and planets. A slight drawing (Cod. Atlantico, fol. 385*r*b), apparently dating from this late period in Milan in the 1490s, suggests that he should also be credited with the invention of the shallow, perspectival stage set normally associated with Baldassare Peruzzi and illustrated in Sebastiano Serlio's treatise on architecture (1537–51).

Evidence of his more general work as a designer of courtly diversions is fragmentary. His notebooks contain designs for pictograms (picture writing), portable pavilions, festive architecture, automata, fountains and written outlines for amusing contrivances. Such employment was both advantageous and irksome for Leonardo: advantageous in that it helped to justify his salary at court, but irksome in that it occupied considerable amounts of time with no enduring result.

III. Theory.

No one was ever more insistent than Leonardo on the intellectual nature of the visual arts. Painting was defined as 'the sole imitator of all the visible works of nature' and as 'a subtle invention which with subtle speculation considers the nature of all forms' (Rome, Vatican, Bib. Apostolica, MS. Urb. lat. fol. 4*v*). His aspiration was that the artist should be able to construct a created world on the basis of a comprehensive understanding of causes and effects in the natural world. Given his belief in painting as the ultimate end of science, it is impossible to draw any strict line between his art theory and his scientific work as a whole.

There is no rounded or fully coherent collection of Leonardo's views on painting. The so-called *Trattato della pittura* by Leonardo is a posthumous selection from his manuscripts (some surviving but the majority untraced) probably compiled by Francesco Melzi. Although it contains some sustained and relatively well-organized sections—most notably that concerning the *paragone*, the comparison of the arts—it is on the whole a patchy, repetitive and sometimes contradictory anthology of notes from various dates. Questions of light and colour, motion, gesture and botany are relatively well represented, while his more mathematical concerns (particularly perspective) are treated in a misleadingly cursory manner, and the

detailed science of human anatomy is not represented at all.

Leonardo's concerns in the earliest of his surviving theoretical writings are closely aligned with those of his Florentine predecessors. He believed that the artist should master the kind of disciplines recommended by Leon Battista Alberti and Lorenzo Ghiberti: orthodox perspective construction, anatomy, proportion, the depiction of light and shade and the use of motion and gesture in narrative compositions. However, his exhaustive and inventive explorations not only led him to points of greater elaboration than his predecessors but also undermined the certainties on which Alberti's theory of imitation was founded.

Leonardo's optical researches, increasingly undertaken within the framework of the medieval geometry of vision, convinced him that the simple perspective used by painters corresponded only in a highly schematized manner to the way in which forms in space are actually seen by the eye. His investigation of the anomalies of orthodox perspective, particularly with respect to wide-angle vision, led him to consider methods of portrayal that involved lateral recession, but he did not develop a fully consistent alternative system. In his paintings following the *Last Supper*, he relied increasingly on creating effects of atmospheric perspective by means of deliberately blurring the clarity of detail and form in the distance, and progressively modifying colour. Although he became increasingly aware of the myriad variables and transitory effects of visual phenomena, he did not surrender his view that all the causes should be wholly codified and the full variety of effects mastered. The laborious and repetitive analyses of light and colour that survive in unfinished form in his notebooks testify to a heroic, if doomed, effort to construct a comprehensive visual science of painting.

Central to Leonardo's ambitions as an artist, as it had been to the Florentine tradition, was the portrayal of the human figure as a communicative vehicle of action, thought and emotion. His researches into the structure and functioning of the human body went far deeper than those of earlier artists, and indeed far deeper than those of Michelangelo in the next generation. To some extent this is a reflection of his fascination with anatomy and physiology in their own right, but it also relates to his conviction that the artist must understand the deepest causes of motion and emotion if he is to create figures that can function adequately as imitations of nature.

The most famous and sustained passages of art theory are contained in those earlier sections of the *Trattato* devoted to the PARAGONE. The general thrust of Leonardo's arguments is to demonstrate the superiority of painting over the arts of the ear, poetry and music, and over sculpture, the other major visual art. Since he seemed to identify poetry as a form of visual description, he had little difficulty in demonstrating the superior representational power of painting, and since he regarded the simultaneous perception of a harmonious composition as preferable to a sequential progression of effects, he was able to claim its superiority over music. His chief argument against sculpture was that it involved the mastery of only a limited number of visual variables with which the painter must grapple. The true end of his *paragone* is to prove that

painting must be considered as a liberal art, indeed, the supreme liberal art, rather than as a manual craft.

Reading Leonardo's theory, it might be assumed that his own creations would appear more obviously naturalistic or 'photographic' in their representation of nature than they actually are. In his paintings and drawn compositions a sense of imagination and free invention is openly apparent, and not infrequently the effect involves elements of mystery, ambiguity and fantasy. His fascination with the demonic and grotesque, most notably expressed in his series of caricatured heads, for instance the pen drawing of *Five Grotesque Heads* (Windsor Castle, Royal Lib., 12495), stands in marked contrast to his rational search for the principles of beauty in nature. To some extent the fantastic properties in his creations can be explained in his own terms, in that he acknowledged the merits of the faculty of *fantasia* (imagination) and the necessity for *invenzione* in the creation of his own world of forms, but in the final analysis there were qualities in his imaginative life as expressed in his art that eluded his own rational definitions of the means and ends of painting.

IV. Character and personality.

Contemporary accounts testify to the attractiveness of Leonardo and of the care with which he presented himself to the world. Together with the more personal aspects of the notebooks, they convey the picture of someone who was gentle, with a great respect for living things (he was probably a vegetarian), fastidious in personal habits, self-conscious in dress, gracious in manner, yet retaining a core of remoteness, reserve and impersonality. He fitted well into the courtly milieu of Milan under the Sforzas, appearing at ease within the court's ambience of snobbish refinement. Against this image of gentility must be set his continued involvement with the violent machinery of war, which appears to have fascinated him emotionally as well as presenting him with an irresistible series of technical challenges. Much has been made of his supposed homosexuality, and such evidence as is available suggests homosexual rather than heterosexual inclinations, but it is doubtful whether the notebooks and other documents provide sufficient material for a full-scale psychoanalysis in the Freudian manner.

Leonardo showed signs of secrecy and protectiveness towards his own inventions. He noted that he should test the wing of his flying machine out of sight of others, and he accused a German colleague in Rome of stealing one of his inventions. His notebooks are written in mirror writing, but this eccentricity may be explained in part by the fact that he was left-handed. The general impression is that he was ready to share his views with others, and that the organization of his studio facilitated the transmission of his ideas and inventions into a wider domain.

The traditional portrait image of Leonardo in old age, as a handsome, bearded and long-haired seer, originated at a time when people still recalled his appearance, but the so-called *Self-portrait* drawing in red chalk (Turin, Bib. Reale) cannot be taken unquestionably as representing the painter himself. Although the case for dismissing it as a forgery (Ost, 1980) is weak, it may have originated considerably earlier than its customary date of *c.* 1512 and

could not therefore be a portrait of the artist himself as an aged man. None of the supposed portraits of the young Leonardo in his own works or those of others (such as Verrocchio's bronze statue of *David*; Florence, Bargello) possesses a secure foundation in fact.

V. Influence and posthumous reputation.

There has never been a period in which Leonardo's greatness has not been acknowledged, though perceptions of the nature of his achievements have differed widely and have often not been founded on a secure sense of what he actually accomplished. Some of the most famous accounts, such as that by Walter Pater (1869), were based on an image of the Leonardesque rather than a clear conception of his actual oeuvre.

There was virtually no major aspect of the visual arts in 16th-century Italy (and to some degree in Europe) that remained untouched directly or indirectly by Leonardo's innovations. Each of his major narrative paintings made a significant contribution to the tradition of history painting. The complex orchestration of a crowd in his *Adoration of the Magi* was adopted in such works by Raphael as the *Disputa* and *School of Athens* (both Rome, Vatican, Stanza della Segnatura); the *Last Supper*, as much through engravings as the original, continued to influence artists as diverse as Rembrandt and Rubens; and the *Battle of Anghiari*, with Michelangelo's *Cascina* cartoon for its companion piece, became the 'school' for young artists who wished to achieve complex interlocking spatial patterns of figures in motion. The pyramidal yet fluent groups of his Virgin and Child compositions set the norm for younger artists, most notably Raphael. His portraits established the ambition to evoke the inner life of sitters, at the same time as setting new goals in formal sophistication for portrait painters such as Bronzino. A large number of his formal motifs were transmitted across Europe through copies, variants and pastiches of his compositions. Even major northern masters such as Quinten Metsys and Hans Holbein the younger proved susceptible to the seductiveness of Leonardo's inventions.

Leonardo's technique of making free sketches also exercised a profound influence on Italian creative methods, most radically those of the young Raphael, but also of Michelangelo. His revelation of the descriptive and evocative powers of red and black chalk inspired generations of figure draughtsmen in Italy, and, through them, in France and elsewhere. Although only a few of his drawings were directly engraved before the 18th century, a number of his characteristic obsessions, such as proportional studies and caricatured physiognomy, stimulated direct imitation.

None of Leonardo's major successors adopted his softly shadowed style of painting precisely, but his emphasis on tonal modelling and the principles of his *sfumato* ensured the passing of what Vasari regarded as the 'dry' manner of the Quattrocento. His technique has sometimes been credited with laying the foundations for the soft handling of form by Giorgione, but the Venetian colouristic blurring of contour is very different from Leonardo's shadow-based system. More obvious heirs may be seen in Antonio

Correggio (particularly the early work) and Caravaggio (1571–1610) at the end of the 16th century.

In sculpture, architecture and stage design Leonardo's influence is harder to define, in the absence of certainly autograph surviving works. His clearest impact was on the architecture of Donato Bramante, who responded to the complex spatial geometry of his colleague's schemes for centralized churches in his designs for the east end of S Maria della Grazie, Milan, and his plan for St Peter's in Rome. Contemporaries testify to the impact of Leonardo's various designs for theatrical spectacles and festivities, and it appears likely that he played a crucial role in the invention of the perspective stage design.

The range, diversity and depth of Leonardo's scientific interests lay beyond most of his contemporaries and successors in the world of art, but his theories of art did seep into general circulation, although none was directly published before 1651. Perhaps the most significant impact was on Albrecht Dürer (1471–1528), whose ambitions in the theories of proportion and physiognomy come closest in spirit to those of Leonardo. The anthology of Leonardo's writings, the *Trattato della pittura*, circulated in various abridged manuscripts in the 16th century and the early 17th, particularly in Italian academic circles. The new generation of academically minded artists in early 17th-century Italy welcomed Leonardo's insistence on controlled expression in figure style and rational analysis of the forms of nature. One painter–theorist in the orbit of Domenichino (1581–1641), Matteo Zaccolini (1574–1630), compiled four manuscript treatises in a consciously Leonardesque vein, but they were never published, and their impact was limited.

Leonardo's enduring reputation as the founder of the High Renaissance was ensured by his position at the start of the third part of Vasari's *Vite*, and Vasari's portrait—including his reservations about the erratic variety of Leonardo's obsessions—dominated interpretations of Leonardo well into the 19th century. The earlier life by Paolo Giovio and the perceptive comments by Giovanni Paolo Lomazzo exercised less impact. The first serious attempt to come to terms with the range of Leonardo's legacy was undertaken by the great patron, antiquarian and arbiter of taste in 17th-century Rome, Cassiano dal Pozzo (1588–1657). Although Cassiano and his collaborator, Conte Galeazzo Arconati (*c.* 1592–1648), did not succeed in their aim of bringing Leonardo's manuscripts to publication, Cassiano was responsible for providing the manuscript, albeit abridged, of the *Trattato della pittura*, illustrated by Nicolas Poussin (1594–1665), that Paul Fréart Sieur de Chambray took to France and that was used in Raphael Trichet du Fresne's first edition of the *Trattato* (1651). The treatise appeared in France at a crucial stage in the development of the Académie Française and was welcomed by Charles Lebrun (1619–90) as providing an authentic pedigree for his ideas of rhetorical expression in academic painting.

Leonardo's reputation during the 17th and 18th centuries was not based on clearly defined knowledge of his actual oeuvre. Versions and pastiches were paraded as Leonardo's own work in the absence of a substantial body of surviving paintings by the master, although a few artists of the highest sensitivity, such as Antoine Watteau (1684–1721), do seem to have responded perceptively to the few autograph works available. By the late 18th century the situation was changing. The 'rediscovery' of the drawings in the British Royal Collection, some of which were subsequently engraved, gave a clearer idea of his draughtsmanship. Giovanni Battista Venturi's transcription of some of his notes on water and other matters evinced a renewed interest in his manuscripts, and Giuseppe Bossi's publication on the *Last Supper* in 1810, reviewed so tellingly by Goethe, represented a pioneering attempt to subject Leonardo's career to scholarly examination.

Great advances were made around 1900 in two main directions. First came the systematic scrutiny and publication of Leonardo's scattered and diminished (if still extensive) legacy of manuscripts. Jean Paul Richter's anthology, *The Literary Works of Leonardo da Vinci* (1883), is still a standard point of reference, particularly in conjunction with Carlo Pedretti's *Commentary* (1977). A wave of facsimiles, transcriptions and translations of the manuscripts in various European locations (most notably Milan and Paris), under the guidance of such scholars as Gerolamo Calvi, Giovanni Piumati and Charles Ravaisson-Mollien, brought the range of Leonardo's mind into the public domain. Gabriel Séailles (1892) and Paul Valéry (1895) made the first attempts to grapple with this new, 'universal' Leonardo. Second came the establishment of a firmly documented chronology for Leonardo's career. Eugene Müntz, Francesco Malaguzzi Valeri, Waldemar von Seidlitz, Giovanni Poggi and Paul Müller-Walde played significant roles, but the most lasting contribution was made by Luca Beltrami, whose *Documenti e memorie riguardanti la vita e le opere di Leonardo da Vinci* (1919) remains the basic source for Leonardo's biography. Calvi's book on the dating of the manuscripts was equally fundamental in laying down the groundwork for a chronological understanding of Leonardo's mind and graphic style.

Since the beginning of the 20th century an enormous body of literature on Leonardo has been published, much of it valueless, but a certain proportion contains material that has clarified his historical position and artistic stature. The study of the manuscripts has been substantially advanced by Edmondo Solmi's researches into the sources for Leonardo's opinions, while the more recent studies by Augusto Marinoni and Carlo Pedretti (the latter of whom has scrutinized Leonardo's legacy in considerable detail) have revealed that meticulous scholarship can still lead to new discoveries.

The greatest contribution to the picture of Leonardo as an artist was made by Kenneth Clark. His catalogue of Leonardo's artistic drawings at Windsor (1935) established an authoritative chronology, continuing the pioneer work of Anny Popp, and provided a compelling critical assessment of Leonardo as a draughtsman. He used this scholarly foundation as the basis for his relatively brief monograph (1939), which remains the most elegantly evocative account of the artist's creative personality.

Full-scale monographs continue to appear in large numbers. Among the most regularly cited in English are those by Ludwig Heydenreich (1954), Cecil Gould (1975), Carlo Pedretti (1973), Jack Wasserman (1975) and Martin Kemp (1981). Studies devoted to particular aspects of

Leonardo's work include those by A. E. Popham on his drawings, Vasilij Zubov (particularly valuable on his scientific thought), E. H. Gombrich on his water studies, Kenneth Keele on anatomy, Pedretti on architecture, Pietro Marani on fortifications, Ladislao Reti on the Madrid manuscripts and Kim Veltman on perspective. The literature on Leonardo is now so discouragingly vast that it can only be mastered as a whole by a full-time 'Leonardista'.

WRITINGS

P. Fréart, ed.: *Trattato della pittura* (Paris, 1651)

G. Venturi, ed.: *Fragments tirés des manuscrits de Léonard de Vinci* (Paris, 1797); and in G. B. de Toni: *Giambattista Venturi e la sua opera vinciana* (Rome, 1924)

C. Ravaisson-Mollien, ed.: *Les Manuscrits da Léonard de Vinci*, 6 vols (Paris, 1881–91)

H. Ludwig, ed.: *Leonardo da Vinci: Das Buch von der Malerei*, 2 vols (Vienna, 1882) [the Codex Urbinas in the Vatican, Rome; the standard critical edn of the *Trattato della pittura*]

J. P. Richter, ed.: *The Literary Works of Leonardo da Vinci*, 2 vols (London, 1883, rev. 1970); and in C. Pedretti: *The Literary Works of Leonardo da Vinci, edited by J. P. Richter: Commentary*, 2 vols (Oxford, 1977)

L. Beltrami, ed.: *Il codice di Leonardo da Vinci della Biblioteca del Principe Trivulzio in Milano* (Milan, 1891)

T. Sabachnikoff, G. Piumati and C. Ravaisson-Mollien, eds: *I manoscritti di Leonardo da Vinci: Codice sul volo degli uccelli e varie altre materie* (Paris, 1893)

G. Piumati, ed.: *Il Codice Atlantico di Leonardo da Vinci nella Biblioteca Ambrosiana di Milano*, 35 vols (Milan, 1894–1904)

T. Sachnikoff and G. Piumati, eds: *I manoscritti di Leonardo da Vinci della Biblioteca Reale di Windsor* (Paris, 1898)

G. Calvi, ed.: *Il codice di Leonardo da Vinci della Biblioteca di Lord Leicester in Holkham Hall* (Milan, 1909) [Codex Leicester, now called Codex Hammer]

D. C. L. Fonahn and H. Hopstock, eds: *Quaderni d'anatomia*, 6 vols (Kristiania, 1911–16)

I manoscritti e i disegni di Leonardo da Vinci: Il Codice Arundel 263, Reale Commissione Vinciana, 4 vols (Rome, 1923–30) [Arundel Codex, London, BM]

Il Codice Forster I, etc, Reale Commissione Vinciana, 5 vols (Rome, 1930–36) [Forster Codex, London, V&A]

I manoscritti e i disegni di Leonardo da Vinci: Il Codice A, Reale Commissione Vinciana (Rome, 1938)

E. MacCurdy, ed.: *The Notebooks of Leonardo da Vinci*, 2 vols (London, 1938)

I manoscritti e i disegni di Leonardo da Vinci: Il Codice B, Reale Commissione Vinciana (Rome, 1941)

A. M. Brizio, ed.: *Scritti scelti di Leonardo da Vinci* (Turin, 1952, rev. 2/1966)

A. Marinoni, ed.: *Leonardo da Vinci: Scritti letterari* (Milan, 1952, rev. 2/1974)

A. P. MacMahon, ed.: *Treatise on Painting by Leonardo da Vinci*, 2 vols (Princeton, 1956) [facs. and trans.]

C. Pedretti, ed.: *Leonardo da Vinci on Painting: A Lost Book (Libro A)* (London, 1965)

A. Courbeau and N. De Toni, eds: *The Manuscripts in the Bibliothèque de l'Institut de France, Paris* (Florence, 1972)

A. Marinoni, ed.: *Il Codice Atlantico di Leonardo da Vinci*, 24 vols (Florence, 1973–80)

L. Reti, ed.: *The Madrid Codices*, 5 vols (New York, 1974)

A. Marinoni, ed.: *Il codice sul volo degli uccelli di Leonardo da Vinci nella Biblioteca Reale di Torino* (Florence, 1976; Eng. trans., New York, 1982)

I. Richter, ed.: *Selections from the Notebooks of Leonardo da Vinci* (Oxford, 1977)

C. Pedretti, ed.: *The Codex Atlanticus: A Catalogue of its Newly-restored Sheets*, 2 vols (Los Angeles, 1978)

K. Keele and C. Pedretti, eds: *Leonardo da Vinci: Corpus of Anatomical Studies in the Collection of Her Majesty the Queen at Windsor Castle*, 3 vols (London, 1978–80)

A. Marinoni, ed.: *Il codice di Leonardo da Vinci nella Biblioteca Trivulziana di Milano* (Florence, 1980; Eng. trans., New York, 1982)

C. Pedretti, ed.: *The Codex Hammer of Leonardo da Vinci* (Florence, 1987)

M. Kemp and M. Walker, eds: *Leonardo on Painting: An Anthology of Writings by Leonardo da Vinci with a Selection of Documents Relating to his Career as an Artist* (London, 1989)

C. J. Farago, ed.: *Leonardo da Vinci's 'Paragone': A Critical Interpretation with a New Edition of the Text in the Codex Urbinus* (Leiden, 1992)

A. Marinoni, ed.: *I Codici Forster del Victoria and Albert Museum di Londra* (Florence, 1992)

BIBLIOGRAPHY
EARLY SOURCES

L. Pacioli: *De divina proportione* (Venice, 1509)

F. Albertini: *Memoriale di molte statue et picture che sono nella inclyta ciptà di Florentia* (Florence, 1510); ed. H. Horne (London, 1909); also in L. Beltrami: *Documenti e memorie riguardanti la vita e le opere di Leonardo da Vinci* (Milan, 1919)

P. Giovio: *Elogia virorum illustrum* (MS.; *c.* 1527); in *Gli elogi degli uomini illustri*, ed. R. Meregazzi (Rome, 1972), viii of *Pauli Iovii opera*, p. 229

Il Codice Magliabechiano (MS.; *c.* 1540); ed. C. Frey (Berlin, 1892), pp. 51–2; ed. C. Fabriszy as *Il codice dell'anonimo Gaddiano* (Florence, 1893), pp. 76–8

G. Vasari: *Vite* (1550, rev. 2/1568); ed. G. Milanesi (1878–85), iii, p. 371; iv, pp. 17–53; vi, pp. 136, 246, 600

M. Bandello: *Le novelle* (Lucca, 1554); ed. F. Picco (Milan, 1973) [dedication of no. lviii]

G. P. Lomazzo: *Trattato dell'arte della pittura, scultura ed architectura* (Milan, 1584); in *G. P. Lomazzo: Scritti sulle arti*, ed. R. P. Ciardi, 2 vols (Florence, 1973–4)

——: *Idea del tempio della pittura* (Milan, 1590); in *G. P. Lomazzo: Scritti sulle arti*, ed. R. P. Ciardi, 2 vols (Florence, 1973–4)

MONOGRAPHIC STUDIES AND CATALOGUES RAISONNÉS

C. Amoretti: *Memorie storiche su la vita, gli studi e le opere di Leonardo da Vinci* (Milan, 1804)

W. Pater: 'Leonardo da Vinci' (1869), *Studies in the History of the Renaissance* (London, 1873)

G. Séailles: *Léonard de Vinci: L'Artiste et le savant* (Paris, 1892)

P. Valéry: 'Introduction à la méthode de Léonard de Vinci', *Nouv. Rev.* (15 Aug 1895); *Nouv. Rev. Fr.* (1919); Eng. trans. by T. McGreevy (London, 1929)

P. Müller-Walde: *Leonardo da Vinci: Lebensskizze und Forschungen über sein Verhältnis zur Florentiner Kunst und zu Rafael* (Munich, 1899)

E. Müntz: *Léonard de Vinci: L'Artiste, le penseur et le savant* (Paris, 1899)

E. Solmi: 'Le fonti dei manoscritti di Leonardo da Vinci', *G. Stor. Lett. It.*, suppl. (1908), 10–11, pp. 1–344

W. von Seidlitz: *Leonardo da Vinci, der Wendepunkt der Renaissance*, 2 vols (Berlin, 1909)

S. Freud: *Eine Kindheitserinnerung des Leonardo da Vinci* (Vienna, 1910; Eng. trans., London, 1957)

L. Beltrami: *Documenti e memorie riguardanti la vita e le opere di Leonardo da Vinci* (Milan, 1919)

G. Poggi: *Leonardo da Vinci: La 'Vita' di Giorgio Vasari, nuovamente commentata e illustrata con 200 tavole* (Florence, 1919)

G. Calvi: *I manoscritti di Leonardo da Vinci del punto di visto cronologico, storico e biografico* (Bologna, 1925)

H. Bodmer: *Leonardo: Des Meisters Gemälde und Zeichnungen*, Klass. Kst Gesamtausgaben (Stuttgart, 1931)

K. Clark: *Leonardo da Vinci: An Account of his Development as an Artist* (Cambridge, 1939, rev. Harmondsworth, 3/1967); rev. and ed. M. Kemp (1988)

L. Heydenreich: *Leonardo da Vinci*, 2 vols (Basle, 1954; Eng. trans., London, 1954)

C. Pedretti: *Studi vinciani* (Geneva, 1957)

V. P. Zubov: *Leonardo da Vinci* (Moscow, 1961; Eng. trans., Cambridge, MA, 1968)

C. D. O'Malley, ed.: *Leonardo's Legacy* (Los Angeles, 1969) [invaluable essays]

C. Pedretti: *Leonardo da Vinci: A Study in Chronology and Style* (London, 1973)

L. Reti, ed.: *The Unknown Leonardo* (London, 1974)

C. Gould: *Leonardo: The Artist and Non-artist* (London, 1975)

J. Wasserman: *Leonardo da Vinci* (New York, 1975)

A. Chastel: *The Genius of Leonardo da Vinci: Leonardo da Vinci and the Art of the Artist* (New York, 1981)

M. Kemp: *Leonardo da Vinci: The Marvellous Works of Nature and Man* (London, 1981, rev. 2/1988)

E. Belloni and P. Rossi, eds: *Leonardo e l'età della ragione* (Milan, 1982)

E. Winternitz: *Leonardo da Vinci as a Musician* (Milan, 1982)

L. D. Ettinger and A. Ottino della Chiesa: *The Complete Paintings of Leonardo da Vinci* (Harmondsworth, 1985)

P. Marani: *Leonardo: Catalogo completo* (Florence, 1989)

A. R. Turner: *Inventing Leonardo* (New York, 1993)

PERMANENT COLLECTION AND EXHIBITION CATALOGUES

K. Clark: *The Drawings of Leonardo da Vinci in the Collection of His Majesty the King* (London, 1935); rev. with C. Pedretti as *The Drawings of Leonardo da Vinci in the Collection of Her Majesty the Queen*, 2 vols (London, 1969)

A. E. Popham and P. Pouncey: *Italian Drawings: The Fourteenth and Fifteenth Centuries*, London, BM cat., 2 vols (London, 1950)

K. T. Parker: *The Catalogue of the Collection of Drawings in the Ashmolean Museum, II; The Italian Schools* (Oxford, 1956)

J. Byam Shaw: *Drawings by Old Masters at Christ Church, Oxford*, 2 vols (Oxford, 1976)

L. Cogliati Arano and A. Marinoni: *Disegni di Leonardo da Vinci e della sua cerchia alle Gallerie della Accademia di Venezia* (Milan, 1980)

——: *Disegni di Leonardo da Vinci e della sua cerchia alla Biblioteca Ambrosiana di Milano* (Milan, 1981)

C. Pedretti: *Landscapes, Plants and Water Studies in the Collection of Her Majesty the Queen at Windsor Castle* (London and New York, 1982)

C. Pedretti and G. Dalli Regoli: *I disegni di Leonardo da Vinci e della sua cerchia nel Gabinetto di Disegni e Stampe della Galleria degli Uffizi a Firenze* (Florence, 1985)

C. Pedretti: *Horses and Other Animals: Drawings by Leonardo da Vinci in the Collection of Her Majesty the Queen at Windsor Castle* (London and New York, 1987)

Leonardo da Vinci: Engineer and Architect (exh. cat., ed. P. Galuzzi; Montreal, Mus. F.A., 1987)

Leonardo da Vinci (exh. cat. by M. Kemp and J. Roberts, London, Hayward Gal., 1989)

C. Pedretti: *I disegni di Leonardo da Vinci e della sua cerchia nella Biblioteca Reale di Torino* (Florence, 1990)

C. Pedretti and P. Trutty Coohill: *The Drawings of Leonardo da Vinci and his Circle in the American Collections*, 2 vols (Florence, 1993)

Leonardo da Vinci: A Curious Vision (exh. cat. by M. Clayton, London, Queen's Gal., 1996–7)

SPECIALIST STUDIES
Painting

G. Bossi: *Del cenacolo di Leonardo da Vinci* (Milan, 1810); rev. by J. W. von Goethe in *Kst & Altert.*, I/iii (1817); Eng. trans. in *Goethe on Art*, ed. J. Gage (London, 1980)

F. Malaguzzi Valeri: *La corte di Ludovico il Moro, ii: Bramante e Leonardo* (Milan, 1915)

J. Wilde: 'The Hall of the Great Council of Florence', *J. Warb. & Court. Inst.*, vii (1944), pp. 65–81

E. Garin: 'La cultura fiorentina nell'età di Leonardo', *Medioevo e Rinascimento* (Florence, 1954, rev. 4/1980)

J. Shearman: 'Leonardo's Colour and Chiaroscuro', *Z. Kstgesch.*, xxv (1962), pp. 13–47

L. Steinberg: 'Leonardo's *Last Supper*', *A.Q.* [Detroit], xxxvi (1973), pp. 297–410

R. McMullen: *'Mona Lisa': The Picture and the Myth* (Boston, MA, 1975)

G. Sironi: *Nuovi documenti riguardanti la 'Vergine delle Rocce' di Leonardo da Vinci* (Milan, 1981)

H. T. Newton and J. Spencer: 'On the Location of Leonardo's *Battle of Anghiari*', *A. Bull.*, lxiv (1982), pp. 45–52

E. Winternitz: *Leonardo da Vinci as a Musician* (New Haven, 1982)

D. A. Brown: *Leonardo's 'Last Supper': The Restoration* (Washington, DC, 1983)

J. Shell and G. Sironi: 'Salai and Leonardo's Legacy', *Burl. Mag.*, cxxxiii/1055 (1991), pp. 95–108

C. Farago: 'Leonardo's *Battle of Anghiari*: A Study in the Exchange between Theory and Practice', *A. Bull.*, lxxvi (1994), pp. 301–30

M. Kemp: 'From Scientific Examination to the Renaissance Market: The Case of Leonardo da Vinci's *Madonna of the Yarnwinder*', *J. Med. & Ren. Stud.*, xxiv (1994), pp. 259–74

Drawing

A. E. Popp: *Leonardo da Vinci: Zeichnungen* (Munich, 1928)

A. E. Popham: *The Drawings of Leonardo da Vinci* (London, 1946, rev. 1994)

E. H. Gombrich: 'Leonardo's Methods of Working Out Compositions', *Norm and Form* (London, 1966)

H. Ost: *Das Leonardo-Porträt in der Königliche Bibliothek Turin und andere Falschungen des Giuseppe Bossi* (Berlin, 1980)

D. A. Brown: 'Verrocchio and Leonardo: Studies for the Giostra', *Florentine Drawing at the time of Lorenzo the Magnificent: Papers from a Colloquium held at the Villa Spelman: Florence, 1992*, pp. 99–109

G. Dillon: 'Una serie di figure grottesche', *Florentine Drawing at the time of Lorenzo the Magnificent: Papers from a Colloquium held at the Villa Spelman: Florence, 1992*, pp. 217–30

G. Dalli Regoli: 'Leonardo e Michelangelo: Il tema della 'battaglia' agli inizi del Cinquecento', *Achad. Leonardi Vinci, J. Stud. & Bibliog. Vinciana*, vii (1994), pp. 98–106

C. Pedretti: 'Leonardo a Venezia', *Tempi di Giorgione*, ed. R. Maschio (Rome, 1994), pp. 96–109

J. J. Nathan: *The Working Methods of Leonardo da Vinci and their Relation to Previous Artistic Practice* (diss., London, U. London, Courtauld Inst.)

Sculpture

F. Malaguzzi-Valeri: *Leonardo da Vinci e la scultura* (Bologna, 1922)

W. R. Valentiner: 'Two Terracotta Reliefs by Leonardo', *Studies in Renaissance Sculpture* (London, 1950), pp. 178–92

M. V. Brugnoli: 'Documenti, notizie e ipotesi sulla scultura di Leonardo', *Leonardo, Saggi & Ric.* (Rome, 1954), pp. 359–89

V. Bush: 'Leonardo's Sforza Monument and Cinquecento Sculpture', *A. Lombarda*, l (1978), pp. 47–68

M. Agghàzy: *Leonardo's Equestrian Statuette* (Budapest, 1989)

M. Kemp: 'Cristo Fanciullo', *Achad. Leonardi Vinci: J. Leonardo Stud. & Bibliog. Vinciana*, iv (1991), pp. 171–6

M. T. Fiorio: 'L'altro termine del paragone: Riflessi leonardeschi sulla scultura milanese', *Achad. Leonardi Vinci, J. Leonardo Stud. & Bibliog. Vinciana*, vii (1994), pp. 107–12

D. Cole Ahl, ed.: *Leonardo da Vinci's Sforza Monument Horse: The Art and the Engineering* (Bethlehem, PA, and London, 1995)

Architecture and design

K. T. Steinitz: 'Leonardo architetto teatrale e organizzatore di feste', *Lett. Vinc.*, ix (1969), pp. 5–21

C. Pedretti: *Leonardo da Vinci: The Royal Palace at Romorantin* (Cambridge, MA, 1972)

——: *Leonardo architetto* (Milan, 1978; Eng. trans., London, 1986)

P. Marani: *L'architettura fortificata negli studi di Leonardo da Vinci* (Florence, 1984)

P. C. Marani: 'L'architettura militare di Leonardo da Vinci fra tradizione, rinnovamento e ripensamento', *Architettura militare nell'Europa del XVI secolo: Atti del convegno di studi: Florence, 1986*, pp. 49–59

——: 'Leonardo urbanista e l'antico: Riflessioni ed ipotesi', *Rac. Vinc.*, xxvi (1995), pp. 3–41

Science, anatomy and theory

E. Solmi: 'Le fonti dei manoscritti di Leonardo da Vinci', *G. Stor. Lett. It.* (1908), suppl. 10–11, pp. 1–344; (1911), pp. 312–27

G. B. de Toni: *Le piante e gli animali di Leonardo da Vinci* (Bologna, 1922)

M. I. Hart: *The Mechanical Investigations of Leonardo da Vinci* (London, 1925, rev. Berkeley, 2/1963)

E. Panofsky: *The Codex Huygens and Leonardo da Vinci's Art Theory* (London, 1940)

C. D. O'Malley and J. B. de C. M. Saunders: *Leonardo da Vinci on the Human Body* (New York, 1952)

E. Garin: 'Il problema delle fonti del pensiero di Leonardo', *La cultura filosofica del rinascimento* (Florence, 1961), pp. 388–401

M. Kemp: '*Il concetto dell'anima* in Leonardo's Early Skull Studies', *J. Warb. & Court. Inst.*, xxxiv (1971), pp. 115–34; rev. in 'From "Mimesis" to "Fantasia"', *Viator*, viii (1977), pp. 361–2, 379–81

E. H. Gombrich: 'Leonardo da Vinci's Method of Analysis and Permutation: The Grotesque Heads', *The Heritage of Apelles* (London, 1976), pp. 57–75

A. Marinoni: *Le matematica di Leonardo da Vinci* (Milan, 1982)

K. Keele: *Leonardo da Vinci's Elements of the Science of Man* (London, 1983)

K. Veltman: *Studies on Leonardo da Vinci, i: Linear Perspective and the Visual Dimensions of Science and Art* (Berlin, 1986)

W. Emboden: *Leonardo da Vinci on Plants and Gardens* (London, 1987)

M. W. Kwakkelstein: *Leonardo da Vinci as a Physiognomist: Theory and Drawing Practice* (Leiden, 1994)

M. Macagno: 'Transformation Geometry in the Manuscripts of Leonardo da Vinci', *Rac. Vinc.*, xxvi (1995), pp. 43–91

School

W. Suida: *Leonardo und sein Kreis* (Munich, 1929)

P. Marani: *Leonardo e i Leonardeschi a Breva* (Florence, 1987)

SPECIALIST BIBLIOGRAPHIES

E. Verga: *Bibliografia vinciana, 1493–1930* (Bologna, 1931)

K. T. Steinitz: *Leonardo da Vinci's 'Trattato della pittura': A Bibliography* (Copenhagen, 1958)

A. Lorenzi and P. Marani: *Bibliografia vinciana, 1964–79* (Florence, 1982)

J. Ludmer: *Carlo Pedretti: A Bibliography of his Work on Leonardo da Vinci and the Renaissance* (Los Angeles, 1984)

M. Guerrini: *Biblioteca Leonardiana, 1493–1989*, (Vinci, 1991)

MARTIN KEMP

Leonbruno [de Leombeni; de Liombeni; Leombruno], **Lorenzo** (*b* Mantua, 1489; *d* ?Mantua, late 1537 or after). Italian painter. He was trained in the workshop of Andrea Mantegna and worked as an assistant to Pietro Perugino in Florence between 1504 and 1506. He also had formative contact with several Emilian artists, including Correggio and Dosso Dossi, whom he probably met in Mantua before going to Florence. In 1511 he briefly visited Venice and returned to Mantua the following year to work under Lorenzo Costa the elder on frescoes of *Apollo and the Nine Muses* in the Palazzo di S Sebastiano, Mantua (destr.); he possibly assisted Costa on later commissions as well. Leonbruno worked under the patronage of Isabella d'Este, Marchesa of Mantua, and, later, of her son Federico II, 1st Duke of Mantua. In 1521, on the recommendation of Baldassare Castiglione, he went to Rome to study antique art and the work of Michelangelo and Raphael. On returning to Mantua, he worked on the decoration of the Castello di Corte and the Palazzo Ducale, two projects that constituted a large proportion of his work as a court painter for Federico; in the Castello di Corte he painted two rooms with various decorations, paintings and grotesques.

Between 1521 and 1523 Leonbruno produced various mythological scenes, decorative motifs and medallions for the lunettes and ceiling of the room known as Isabella d'Este's Schalcheria in the Grotta of the Palazzo Ducale. This project reveals the influence of Mantegna and Perugino, but its hunting motifs also make it reminiscent of Correggio's Camera di S Paolo in Parma. In 1524 he began designing the decorations for the Palazzo di Marmirolo (destr. 1798), Mantua, but his work there was suspended as a result of Giulio Romano's arrival. After working in Milan in 1531–2 as a military designer for Francesco Maria Sforza, Duke of Milan, he returned to Mantua, where he is last documented on the payroll of the court at the end of 1537. Besides his frescoes in various palaces he executed a number of panels with decorative and mythological subjects such as the *Calumny of Apelles* (*c.* 1525; Milan, Brera). Notwithstanding the interest of the Mantuan court in the Antique, Leonbruno also executed several religious works, among the most successful of which are the two examples of the *Nativity* (Worcester, MA, A. Mus.; London, ex-Christie's, 1977). Both paintings are datable to Leonbruno's middle period when he was under the influence of Costa. They are characterized by precise landscape details and brilliant colours, features that are also found in the mythological scenes of the Schalcheria, and represent Leonbruno at his best.

BIBLIOGRAPHY

G. B. Intra: 'Lorenzo Leombruno e Giulio Romano', *Archv Stor. Lombardo*, 2nd ser., ii (1887), pp. 569–73

C. Gamba: 'Lorenzo Leombruno', *Rass. A.*, v (1906), pp. 65–70

G. Fogolari: 'Un dipinto allegorico di Lorenzo Leombruno nel Museo di Verona', *Madonna Verona*, iii (1908), pp. 127–9

C. Gamba: 'Un nuovo dipinto del Leombruno', *Rass. A.*, ix (1909), pp. 30–31

P. K[risteller]: 'Ancora del Leombruno', *Rass. A.*, ix (1909), p. 186

E. Marani and C. Perina: *Mantova: Le arti*, II/i (Mantua, 1961), pp. 392–9

F. Russell: 'Saleroom Discoveries: A Nativity by Lorenzo Leonbruno', *Burl. Mag.*, cxix (1977), p. 601

□

Leonelli (da Crevalcore), Antonio. *See* ANTONIO DA CREVALCORE.

Leoni. Italian family of sculptors, medallists and collectors. (1) Leone Leoni and his son (2) Pompeo Leoni gained their reputations in service to the Habsburg Holy Roman Emperor Charles V (*reg* 1519–56) and his son Philip II, King of Spain (*reg* 1556–98). They are particularly noted for their bronze busts and portrait statues of the leading members of the Spanish Habsburgs. Leone was also one of the most outstanding medallists of the 16th century.

(1) Leone Leoni (*b* ?Menaggio, nr Como, *c.* 1509; *d* Milan, 22 July 1590). He was probably born in Menaggio on Lake Como, though his parents were from Arezzo, and throughout his life Leone referred to himself as Aretine. It is probable that his formative years were spent learning the trade of goldsmith, perhaps in Venice or Padua. The classicism and idealism of this school formed the basis of his style. Some time after 1533 he is recorded in Venice with his wife and infant son Pompeo, living under the protection of Pietro Aretino, to whom he was related. While in Venice, Leone worked as a goldsmith and made medals and statuettes (none of which can be identified). Leone's skill and connections secured him a position at the mint in Ferrara, although he was forced to abandon this when accused of counterfeiting, the first of several misadventures that were to plague his life. Through Pietro Aretino, Leone received an introduction to the poet Pietro Bembo, and in 1537 he travelled to Padua to prepare Bembo's portrait medal (untraced).

By the autumn of 1537 Leone had moved to Rome, where he remained for the next three years working as an engraver in the papal mint. There he became acquainted with the major artists at the papal court, including Michelangelo and Baccio Bandinelli, who had a strong influence on his work. He also became familiar with the city's key works of ancient and contemporary art. The Roman sojourn was one not only of intense study but also of renewed controversy. In 1538 he was a prime witness against Benvenuto Cellini, who had been charged with stealing papal jewels during the Sack of Rome (1527). Later, according to Cellini, Leone had attempted to poison him while he was imprisoned in the Castel Sant'Angelo by sprinkling a ground diamond on his salad. Leone's fortunes took a turn for the worse early in 1540, when, in response to a personal affront, he attacked and maimed with a dagger Pellegrino di Leuti, the papal jeweller. Leone was sentenced to have his right hand cut off, and only the last-minute intervention of powerful friends spared him, although the new sentence might have been considered even worse: an indefinite period as a galley slave in the papal fleet. Leone was chained to an oar for about a year until he was unexpectedly released in Genoa through the intervention of Andrea Doria I, admiral of the imperial fleet.

Leone remained in Doria's service until early 1542, when he moved to Milan to begin work in the imperial mint. His career as a coiner and medallist flourished, and he produced impressive medals of *Daniele and Martin d'Anna* (1544–5; Milan, Castello Sforzesco), Flemish merchants residing in Venice, and of *Isabella of Portugal* (*c.* 1545; Vienna, Ksthist. Mus.), the late wife of Charles V, for Pietro Aretino. By 1546 he had been named master

general of the mint of Parma and Piacenza and enjoyed a growing reputation for his medallic portraits.

Following Charles V's victory over the Protestant princes at Mühlberg in 1547, Leone proposed to erect an equestrian portrait to the Emperor in Milan. In 1548 he was invited by Charles V's adviser, Antoine Perrenot de Granville, Bishop of Arras, to discuss his proposal at the imperial court in Brussels, where he arrived in March 1549. After lengthy consultations with the Emperor, Leone received a commission for portrait busts and statues, the most important being an over life-size bronze, two-figured composition ultimately realized as *Charles V and Fury Restrained* (1549–55; Madrid, Prado; see fig. 1). The group is a sophisticated exercise in imperial propaganda, replete with Classical allusions celebrating the Emperor as Augustus, who, having chained Fury, initiates a new era of peace. Leone's bronze is both a technical and conceptual *tour de force*, as the suit of half armour can be removed to reveal Charles V in heroic nudity, a device never seen before in Western sculpture.

Leone's period at court resulted in additional commissions from the Emperor and his sister Mary of Hungary for medals, portrait busts and statues of members of the imperial family. The most notable of these are: the bronze bust of *Charles V Supported by an Eagle* (1551–5; Madrid, Prado; second version, Vienna Ksthist. Mus.); the bronze bust of *Mary, Queen of Hungary* (1550–53; Vienna, Ksthist. Mus.); and the bronze statues of *Empress Isabella* (1555), *Mary, Queen of Hungary* (*c.* 1549–53) and *Prince Philip* (1549–51; all Madrid, Prado). In the sculpted portraits of the Emperor and Prince Philip, Leone developed an idealized style rooted in the classicism of his medallic training and related to the grand imperial portraits of Titian. His iconography is rich in references to Roman imperial art and celebrates Charles and Philip as the legitimate heirs of the Roman emperors. This imagery was conceived at the height of Habsburg power and at the moment when Charles was promoting Philip's claim to be his successor as Holy Roman Emperor.

In order to advance these projects, Charles V granted Leone a confiscated house near Milan Cathedral, ennobled him and made him an imperial knight, honours not lightly bestowed on an artist. Leone returned to Milan and worked on imperial commissions for the next seven years. In 1556 he accompanied his sculptures to Brussels, where the Emperor was residing on the eve of his retirement. Charles V asked the artist to travel with him to Spain, but Leone fell ill and sent Pompeo in his place. Many of the portrait bronzes were finished only in 1564, when Leone made a brief trip to Madrid. Indeed it appears that none was ever exhibited during the lifetime of Charles or Philip, as they are all recorded in an inventory of Pompeo's studio at his death.

The death of Charles V and his sister Mary in 1558 ended an important phase in Leone's career. His sources of patronage shifted away from Spain to Italy when in 1560 he received, on the recommendation of Michelangelo, a commission from Pope Pius IV to erect a tomb for the latter's brother Gian Giacomo de' Medici in Milan Cathedral. This project was completed in 1563 and is one of Leone's finest achievements. The life-size, bronze standing portrait statue of *Gian Giacomo de' Medici* dressed

in armour and the two flanking seated bronze allegorical figures of *Peace* and *Military Virtue* are extraordinarily refined and reveal the stylistic influence of both Michelangelo and Sansovino.

In 1560 Leone also received a commission to erect a bronze monument to Ferrante Gonzaga (*d* 1557), the late governor of Milan in the Piazza Roma, Guastalla. *Ferrante Gonzaga Triumphant over Evil and Envy* was the artist's second two-figured group and shows Gonzaga standing over a hydra and prostrate satyr, who falls backwards off the base. Although Leone had seen Cellini's *Perseus and Medusa* in the Loggia dei Lanzi in Florence on his return to Milan from Rome in 1560, his group has none of the mannered elegance of Cellini's work. Leone's satyr is, in fact, a colossal version of one of Andrea Riccio's small bronzes, while the armed portrait of Gonzaga continues the classicized realism seen in his earlier busts and statues.

Between 1565 and 1567 Leone undertook the reconstruction of the house given to him in 1549 by Charles V. Now known as the Casa degli Omenoni ('House of the Big Men' in Milanese dialect), it is one of Milan's most distinctive architectural landmarks. Its unusual façade includes a frieze relief showing two lions attacking a satyr, two half-length caryatids flanking the central portal and six herms (double life-size barbarian prisoners, which gave the house its nickname; see fig. 2). Imposing figures of this kind had never been seen before on the façade of a house or palazzo. According to Vasari, Leone dedicated his home to Marcus Aurelius, then considered the most virtuous of the ancient emperors. Thus the prisoners, each identified by an inscription as a tribe conquered by the emperor, together with a plaster cast of the Capitoline equestrian portrait of *Marcus Aurelius* in the centre of the courtyard, were part of a programme in which Leone presented himself to the public not as an artist but as a gentleman in the social milieu of the Habsburg empire.

Leone's last major commission from an Italian patron was from Vespasiano Gonzaga, Duke of Sabbioneta, for his portrait statue (Sabbioneta, church of the Incoronato). Probably executed between 1574 and 1577, the life-size seated bronze shows Vespasiano armed and extending his right arm outward in a gesture directly related to that in the *Marcus Aurelius*. The statue was erected in the central square of Sabbioneta in 1588 and served as the symbolic centrepiece of Gonzaga's ideal city. The last decade of Leone's life was occupied by his first major commission (1579) for the Habsburgs since the death of Charles V in 1558. This was for 15 colossal gilt-bronze statues for the high altar retable in the Capilla Mayor at the Escorial, near Madrid. Undertaken with Pompeo, this was the crowning achievement of his career. The majestic, broadly conceived statues convey the heroic vigour of the Counter-Reformation Church and are important prototypes for similar stylistic developments in Rome.

Leone was also known for his art collection. He had assembled a considerable number of plaster casts of both ancient and modern works, including, in addition to the equestrian portrait of *Marcus Aurelius*, Michelangelo's *Risen Christ* (Rome, S Maria sopra Minerva), the *Apollo Belvedere* and the *Laokoon* (both Rome, Vatican, Mus. Pio-Clementino). These were complemented by his collection of paintings and sculptures, forming perhaps the first

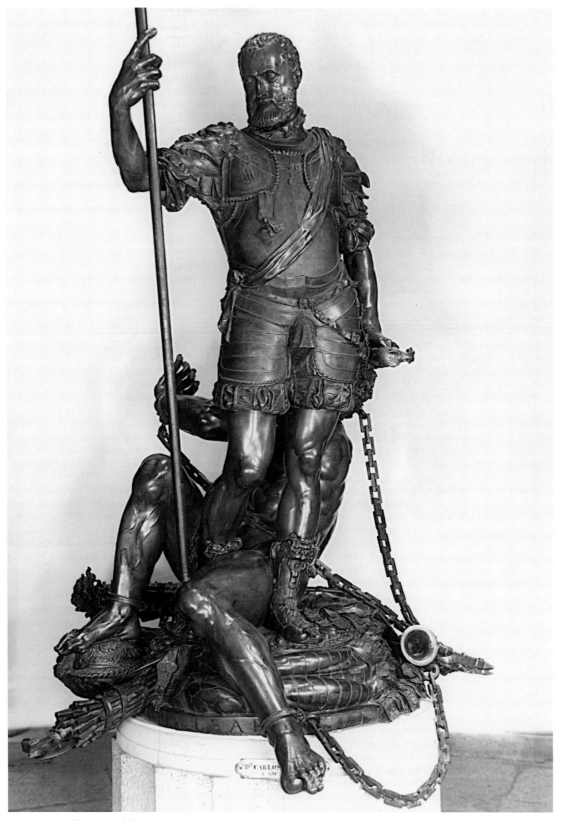

1. Leone Leoni: *Charles V and Fury Restrained*, bronze, h. 2.51 m, 1549–55 (Madrid, Museo del Prado)

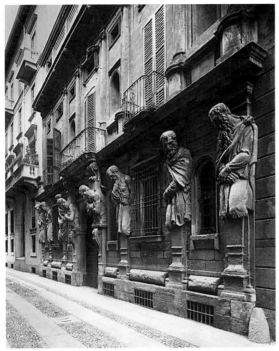

2. Leone Leoni: façade of the Casa degli Omenoni, Milan, 1565–7

private gallery in Milan. The collection was displayed in an octagonal room on the *piano nobile* and included Correggio's *Jupiter and Io* (Vienna, Ksthist. Mus.) and *Jupiter and Danaë* (Rome, Gal. Borghese; see colour pl. 1, XXIV1), two wax sculptures and drawings by Leonardo da Vinci, drawings by Michelangelo and paintings by Titian, Tintoretto and Parmigianino among others. His gallery rivalled those of many nobles and, along with the façade of his home, was additional evidence of his discernment, means and elevated social status.

(2) Pompeo Leoni (*b* ?Venice, *c.* 1533; *d* Madrid, 13 Oct 1608). Son of (1) Leone Leoni. He has long been overshadowed by his father, although he was an accomplished sculptor who produced an impressive body of work. This is partly due to their close working relationship, which continued until Leone's death. Pompeo was trained by Leone, assisted him with the commissions from Charles V and Mary, Queen of Hungary, and accompanied these works to Spain in 1556 on the retirement of Charles V. Soon after his arrival in Spain, Pompeo entered the service of the regent, Joanna of Austria. He produced several medals in 1557, but in 1558 work came to a halt when he was sentenced by the Inquisition to a year's confinement in a monastery because of his unorthodox opinions. In 1564 he helped to complete his father's bronzes, and in 1570 he designed a series of colossal, fictive bronze statues for the triumphal arches erected to celebrate the entry into Madrid of Anne of Austria, Philip II's new wife.

During the 1570s Pompeo received important commissions for marble sepulchral effigies: the kneeling figure of *Joanna of Austria* (1574) for her tomb in the convent of Las Descalzas Reales, Madrid; the sensitive and naturalistic portrait of the Inquisitor General, *Cardinal Diego de*

Espinosa (1577), in the church of Martín Muñoz de las Posadas, Segovia; and the elaborate Italianate tomb of *Fernando de Valdés* (1576) at the collegiate church, Salas. However, all private work stopped in 1579 with the commission from Philip II for 15 bronze statues for the colossal retable of the Capilla Mayor at the Escorial, near Madrid. Pompeo travelled to Milan in 1582 to collaborate on the project with his father. He returned in 1589 and installed the statues in 1591. Pompeo's last great project was the commission from Philip II for the kneeling effigies of himself, Charles V and eight other members of the Habsburg family that now flank the high altar of the Capilla Mayor. These over life-size, gilt-bronze figures of extraordinary quality and detail kneel in perpetual veneration towards the Sacrament Tabernacle on the altar, pious expressions of Habsburg eucharistic devotion and dynastic supremacy. Like his father, Pompeo was also an avid art collector. He assembled an impressive number of works, including notebooks by Leonardo da Vinci (the *Atlantic Codex*, Milan, Bib. Ambrosiana; another at Windsor Castle, Berks, Royal Lib.).

BIBLIOGRAPHY
E. Plon: *Leone Leoni, sculpteur de Charles-Quint, et Pompeo Leoni, sculpteur de Philippe II* (Paris, 1887)
G. Proske: *Pompeo Leoni: Work in Marble and Alabaster in Relation to Spanish Sculpture* (New York, 1956)
M. Mezzatesta: 'The Façade of Leone Leoni's House in Milan, the Casa degli Omenoni: The Artist and the Public', *J. Soc. Archit. Hist.*, xliv (1985), pp. 233–49
J. Pope-Hennessy: *Italian High Renaissance and Baroque Sculpture* (New York, 1986)
Los Leoni, 1509–1608: Escultores del renascimento italiano al servicio de la Corte de España (exh. cat., ed. J. Urrea; Madrid, Prado, 1994)
 MICHAEL P. MEZZATESTA

Leopardi [Liompardi], Alessandro (*fl* 1482–1522). Italian bronze-founder. Born into a well-known Venetian family, he is mentioned in 1482, first as a goldsmith and then as a jeweller, which suggests that he might have been carving hard stones. In 1484 he was employed at the Mint as an engraver of dies. Exiled in August 1487 for his part in an inheritance fraud, he was recalled from Ferrara in September 1488 to cast the equestrian statue of *Bartolomeo Colleoni* (*see* VERROCCHIO, ANDREA DEL, fig. 4) from the clay model left by Verrocchio at his death. He completed the casting, putting his signature on the girth strap (ALEXANDER LEOPARDUS V.F. OPUS), and designed and executed the high pedestal with marble columns and bronze frieze himself. His execution of the pedestal clearly shows his familiarity with the Classical orders. The monument was erected in the Campo SS Giovanni e Paolo in 1494. He was employed again at the Mint in January 1496, working as master engraver of dies alongside Vittore Gambello, and he was still drawing a salary for this position in November 1521. He appears to have died early in the following year.

Leopardi's casting of the monument to *Colleoni* established his reputation as a founder. In January 1496 he was considered for a commission to cast bronze doors for the entrance of the Doge's Palace. In 1500 he cast pieces of artillery for the Venetian state. On 19 January 1504, in partnership with Antonio Lombardo, he undertook a project for a chapel in honour of Cardinal Giovanni Battista Zen in S Marco, Venice, which was to include

three statues, a ciborium and a bronze tomb. However, though he was to have overseen the whole project, he immediately dissociated himself from the commission and was officially replaced by two other founders in May 1505. During this period he was engaged in casting three large bronze bases (see fig.) to carry the Venetian standards in front of S Marco. He was responsible for designing as well as casting these standard bases, which are decorated reliefs of marine processions, reminiscent of masked Venetian festival parades. The friezes of nymphs astride Tritons show the influence of Mantegna's engraving of the *Battle of the Sea Gods*. In the context of Venetian sculpture of the early 16th century Leopardi's standard bases are original and markedly different from the contemporary neo-classical works of the Lombardo family. The central one is dated August 1505 and the flanking pair must have been completed by July 1506. After this commission, no further works in bronze by Leopardi are known.

On the basis of this very personal work, attempts have been made to attribute various other statuettes and bronze reliefs to Leopardi, but these attributions have more often been based on similarities of subject-matter than on stylistic aspects. There is no evidence to suggest that his output was in any way comparable to that of the Paduan bronze founders. He seems, rather, to have created for himself a higher position in society, becoming a member of the group of Venetian humanists that included the philosopher Niccolò Leonico Tomeo and the scholar Marco Sanudo for whom he probably made scientific instruments. Leopardi was also active as an architect and civil engineer. He worked on the fortifications of Padua (1510) and Treviso (1511), and drew up plans for the rebuilding of the Scuola della Misericordia (1504–7) and the Fabbriche di Rialto (1514), both in Venice, but they were not adopted. He was appointed architect for the

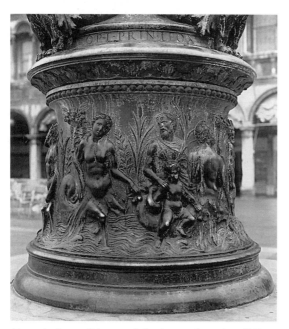

Alessandro Leopardi: bronze relief sculptures of nymphs and Tritons on standard base, Piazza S Marco, Venice, 1505–6

reconstruction of S Giustina in Padua in 1521 but was dismissed after a year.

BIBLIOGRAPHY

E. Cigogna: *Delle inscrizioni veneziane*, ii (Venice, 1827), pp. 297–301
M. Testolini: 'Ricerche attorno ad Alessandro Leopardi', *Archv Ven.*, iii (1872), pp. 246–50
W. Stedman Sheard: 'Note on the Proportions of the Base of the Colleoni Monument', in C. Seymour: *The Sculpture of Verrocchio* (London, 1971), pp. 182–4
B. Jestaz: 'Requiem pour Alessandro Leopardi', *Rev. A.*, lv (1982), pp. 23–34
G. Bonfiglio Dosio, ed.: *Il 'Capitolar dalle brocche' della Zecca di Venezia* (Padua, 1984)

BERTRAND JESTAZ

Ler, de. *See* ERRI.

Lese, Benozzo di. *See* GOZZOLI, BENOZZO.

Liberale (Bonfanti) da Verona [Liberale di Jacopo dalla Biava] (*b* Verona, *c.* 1445; *d* Verona, 1527–9). Italian illuminator, painter and woodcut designer. His father, the baker Jacopo, came from Monza; his mother, Jacoba, was the daughter of the Veronese painter Zeno Solimani (*fl c.* 1438) and sister of the painter Nicolò Solimani (*fl c.* 1462–1493). The latter, according to Vasari, was Liberale's teacher (but mistakenly called Vincenzo di Stefano in the *Vite*). Liberale is documented in Verona in 1455 and 1465, but works from this period are not known. His career thereafter may be divided into two periods: as a young artist he was based in Siena, where his work on a group of choir-books for the cathedral demonstrates his originality as an illuminator; in or soon after 1476 he returned to Verona, where he established himself as one of the city's major painters. During both periods he travelled and worked in other centres.

1. Siena, *c.* 1467–76. 2. Verona, *c.* 1476 and after.

1. SIENA, *c.* 1467–76. Called to Siena before 1467 by the Olivetans, Liberale illuminated four choir-books (Chiusi, Mus. Cattedrale, Cods A, Q, R and Y) for the abbey of Monte Oliveto Maggiore. The miniatures show a mixture of styles: Sienese influences, especially the Late Gothic ornament of Sano di Pietro, are combined with such stylistic components from the Veneto and Emilia as sculpturally modelled, animated draperies, expressive physiognomies and tense, nervous gestures. Liberale worked as an illuminator for Siena Cathedral from 1467. After a trial piece (*Christ in Majesty*, U. Birmingham, Barber Inst.), until 1476 he painted miniatures for 16 choir-books and a Missal. He was the first important and most prolific illuminator of this well-preserved series of liturgical books (all Siena, Bib. Piccolomini), and this well-documented nine-year period was the most creative phase of his artistic activity.

The imaginative early miniatures of Graduals 24.9, 20.5 and 25.10 reflect great artistic freedom. Executed between 1467 and autumn 1470, the scenes, full of fresh liveliness, testify to a rapid development and heightening of Liberale's capacity for figural expression and dramatic action in increasingly daring compositions. High points are such brilliant illustrations as the eloquent, ingeniously composed double scene with the *Parable of the Mote and the Beam* and the *Blind Leading the Blind* (1468; Gradual 24.9,

fol. 1*r*), or the boldly drawn, furious *North Wind* (1470; Gradual 20.5, fol. 36*v*). Florentine influence was transmitted in part by Liberale's colleague Francesco Rosselli. Alongside these works he executed devotional images, *cassoni* and a predella, which reveal the influence of Sienese painting shifting from the work of Sano to that of Francesco di Giorgio Martini and Neroccio de' Landi.

When GIROLAMO DA CREMONA illuminated three folios of Gradual 28.12 in Siena in early 1470, no noticeable stylistic exchange with Liberale took place. The situation changed abruptly in December 1470. For the most part autonomous up to that point, Liberale received the unfinished gradual with the three miniatures by Girolamo and the commission to decorate further folios after his model. These works, paid for in March 1471, reveal a radical stylistic change in Liberale's ornament: antique scrolls, Ferrarese-influenced fleurons with filigree backgrounds and pearl decoration in the style of Girolamo. Liberale thus abandoned his usual repertory with its Gothic elements and its integration of studies from nature, since this pleased his patrons less than that of the Cremonese artist. On the other hand, Liberale's illustrative style, full of ebullience and charged with tension, remained hardly influenced and, in the expressive dynamism of the *St Michael* (fol. 80*v*), underwent further intensification. The *Crucifixion* (fol. 181*v*) of the Missal (Siena, Bib. Com. Intronati, MS. X.*II*.3), completed in April 1471 for the cathedral, also shows Liberale's typical figures in an orientalizing framework of decorative elements that he derived from Girolamo.

In the following year Liberale executed for Viterbo Cathedral his most inspired painting, the altarpiece of the *Salvator mundi with Four Saints* (*in situ*), dated 1472. After the resumption of his Sienese work in August 1472, Liberale found in the elder Girolamo da Cremona, who for the first time was contemporaneously engaged on the choir-book project, an artistic equal, albeit a more experienced one, and a highly influential colleague. They competed with each other and in the following months spurred each other on to exceptional achievements. Liberale's work was at its peak in the illustration of Gradual 21.6, where spectacular spiritual tension and dramatic intensity is displayed in the *Christ Healing the Possessed* (fol. 2*r*) and in the turbulent *Christ Driven from the Temple* (fol. 74*v*). Under the direct influence of the contemporary masterpieces in Gradual 23.8 by Girolamo, Liberale enlivened the extensive ornamental parts with imaginative antique motifs executed with exceptional care. He adopted the darker, intensely glowing palette of his colleague in the process and began to loosen up the expression and gestures of his figures, as is clear in the *Miracle of the Loaves and Fishes* (fol. 39*r*). Girolamo, for his part, was briefly inspired to livelier representations and more animated draperies. Despite the quality of Liberale's work, the more experienced and efficient Girolamo was for the most part better paid.

The recognition that he had lost his position as dominant illuminator for the Opera del Duomo led to an artistic crisis and explains Liberale's pronouncedly mannered style of illumination from 1473: his settings lost their spontaneity and vitality; resigned melancholy and frustrated indifference overpower the physiognomies of his figures,

with their tired, schematic gestures. In 1473 Liberale worked on Graduals 23.8, 16.1, 19.4, 18.3 as well as on parts of 17.2 and 22.7 in close contact with Girolamo. Despite their technical impeccability, his scenes lack artistic engagement, and his figures the inner motivation found in his works up to 1472. The hypothesis of a division of labour (design by Liberale, painting by Girolamo) has been disproved and the contrary documented: after the completion of Graduals 17.2 and 22.7, Liberale completed four miniatures in Antiphonal 10.L during September 1474, which Girolamo had left unfinished after his departure from Siena in early 1474. After that Liberale illuminated the historiated folios of Antiphonal 1.A (see fig.). All these works, carried out with reference to Girolamo, are identical in style to those created before the latter's departure.

Evidence of private commissions is provided by three miniatures from a Book of Hours from the Piccolomini family (Philadelphia, PA, Free Lib., Lewis MS. 118), as well as *cassone* panels (e.g. New York, Met.) and devotional paintings. Between November 1474 and June 1475 Liberale painted an altarpiece of the *Virgin and Child with Two Saints* (*in situ*) for the Olivetan church of S Francesca Romana in Rome.

Again in Siena, a final, ten-month phase of work on the liturgical books followed, in collaboration with the Milanese artist Venturino Mercati (*fl c.* 1473–9), who executed only ornamental initials. After completion of Antiphonal 10.L, they illuminated the Antiphonals 13.O, 3.C and 12.N, with Liberale consistently working on the front section. The financial crisis of the Opera del Duomo,

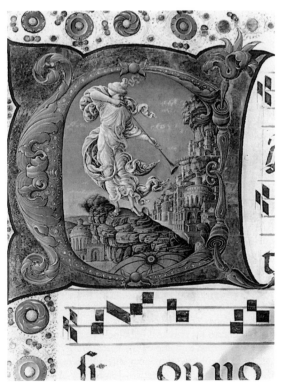

Liberale da Verona: *Angel of the Last Judgement*; historiated initial from an Antiphonal, 1474 (Siena, Biblioteca Piccolomini, 1.A, fol. 133*r*)

which led to a five-year interruption in the refurbishing of the choir-books, was one of the reasons for Liberale's return to North Italy.

2. VERONA, *c.* 1476 AND AFTER. A painting of the *Virgin Reading a Book* (Joensuu, Taidemus.) attributed by E. Fahy turns out to be the missing link that in style connects Liberale's Sienese work with his later Veronese paintings. Free from external constraints, Liberale's narrative talent and brio was revealed in the witty pictorial ideas of a printed *Aesop* (Verona, 1479). The masterful inventions of its 68 woodcuts were iconographically influential for decades. Although artistically superior to other local painters, Liberale was again forced to seek work outside Verona. In 1481 he was contracted, together with his uncle Nicolò Solimani, who lived in Mantua, to decorate a chapel in the church of the Annunziata, Rovato, with an extensive pictorial programme. The lost frescoes are his earliest documented wall paintings.

Two paintings for altars dedicated to St Sebastian testify to a later sojourn in Venice: the winged altarpiece probably commissioned for Verona by Alessandro Miniscalchi (ex-Albarelli priv. col., Verona; centre panel, Berlin, Kaiser-Friedrich Mus., destr.) and the *Martyrdom of St Sebastian* panel (Milan, Brera; see colour pl. 1, XXXVII.2), originally in Ancona. Both versions are formally based on Venetian models by Antonio Rizzo and Antonello da Messina. The version in Milan, with its Venetian canal view, shows a single-point perspective construction, exceptional in Liberale's oeuvre, which was inspired by paintings of Jacopo Bellini and his school. In Venice Liberale was also influenced by Bartolomeo Vivarini. Liberale's growing reputation culminated in 1487 with the commission for a huge *ancona* with the *Assumption of the Virgin* (untraced) for the high altar of the Olivetan church of S Elena in Venice, to be consigned in 1489 in Verona. Liberale married there the same year. The Olivetan *Virgin with Four Saints* (Berlin, Gemäldegal.) and the predella painted for a sculptural altar of the Virgin for Verona Cathedral (Verona, Pal. Vescovile) both date from 1489. Grouped with these paintings, which are characterized by feverish theatricality and sculptural, metallic drapery style, are two major works, the emotional *Pietà* (Munich, Alte Pin.), and the richly coloured composition of unusual iconography, the *Adoration of the Magi* (Verona Cathedral), in which Liberale interpreted his home town as a *minor Ierusalem*.

Liberale was, with Domenico Morone, the most active painter in Verona. He influenced the style of the Veronese artists Cristoforo Scacco (*fl c.* 1493–1500), Giovanni Maria Falconetto, Francesco Dai Libri and the exuberant proto-mannerist Francesco di Bettino (*fl c.* 1495), who was deeply impressed by Bernardino Butinone. His closest followers were Nicola Giolfino, Gian Francesco Caroto, Giovanni Caroto, Antonio da Vendri (*fl c.* 1485–1545) and Francesco Torbido. His professional success around 1490 reflected his personal happiness as demonstrated by the intimate pen drawing of the *Nursing Mother* (Vienna, Albertina), probably of his first wife, Ginevra, with one of their daughters. The virtuoso drawing of *Musicmaking Angels* (London, BM) is a sketch for the frescoes of the Bonaveri Chapel in S Anastasia, which, together with the altarpiece of the *Assumption of St Mary Magdalene* (*in situ*),

were his main accomplishments of the early 1490s. The figures—some vital and lively and some inexpressive and hastily painted—show variations in quality. These signs of failing creative ability are corroborated by the fact that the Olivetans of S Maria in Organo commissioned the 50-year-old painter as an illuminator of subordinate status to Francesco and Girolamo dai Libri.

During the last 30 years of his life, Liberale's work became conservative, although he continued to find customers, not only for numerous devotional paintings, but also for large public altarpieces and frescoes (lower church, S Fermo Maggiore). A Breviary (Treviso, Bib. Com., MS. 888) documents Liberale's late attempt to modernize his formal repertory as an illuminator. His will of 1527 indicates that he was at work on an *Assumption of the Virgin* for Verona Cathedral.

BIBLIOGRAPHY

G. Vasari: *Vite* (1550, rev. 2/1568); ed. G. Milanesi (1878–85), pp. 274–80

R. Brenzoni: *Liberale da Verona* (Milan, 1930)

E. Carli: *Miniature di Liberale da Verona dai corali per il Duomo di Siena* (Milan, 1953)

C. Del Bravo: *Liberale da Verona* (Florence, 1967) [with earlier bibliog.]

B. Berenson: *Central and North Italian Schools* (1968), pp. 209–14

H.-J. Eberhardt: 'Das Testament des Liberale da Verona', *Mitt. Ksthist. Inst. Florenz*, xv (1971), pp. 219–25

R. Brenzoni: *Dizionario di artisti veneti* (Florence, 1972), pp. 172–8

M. G. Ciardi Dupré: *I corali del Duomo di Siena* (Milan, 1972)

F. Bisogni: 'Liberale o Girolamo?', *A. Illus.*, vi (1973), pp. 400–08

G. Mardersteig and L. Magagnato: *Liberale ritrovato nell'Esopo veronese del 1479* (Verona, 1973)

H.-J. Eberhardt: 'Liberale da Verona', *Maestri della pittura veronese*, ed. P. Brugnoli (Verona, 1974), pp. 101–12

L. Menegazzi: 'Il *Breviarium Cartusianum* di Treviso', *Crit. A.*, n.s., xliii (1978), nos 160–62, pp. 67–78

M. T. Cuppini: 'L'arte a Verona tra XV e XVI secolo', *Verona e il suo territorio*, IV/i (Verona, 1981), pp. 241–522

H.-J. Eberhardt: 'Sull'attività senese di Liberale da Verona, Girolamo da Cremona, Venturino da Milano, Giovanni da Udine e Prete Carlo da Venezia', *La miniatura italiana tra Gotico e Rinascimento: Atti del II congresso di storia della miniatura italiana: Cortona, 1982*, i, pp. 415–34

Codici liturgici miniati dei Benedettini in Toscana (exh. cat., ed. M. G. Ciardi Dupré Dal Poggetto; Florence, Certosa del Galluzzo, Pin., 1982)

H.-J. Eberhardt: *Die Miniaturen von Liberale da Verona: Girolamo da Cremona und Venturino da Milano in den Chorbüchern des Doms von Siena* (Munich, 1983)

G. Mariani Canova: 'Miniatura rinascimentale veronese', *A. Ven.*, xl (1986), pp. 278–84

Miniatura veronese del Rinascimento (exh. cat., ed. G. Castiglioni and S. Marinelli; Verona, Castelvecchio, 1986)

A. De Marchi: 'Liberale da Verona', *La pittura in Italia: Il quattrocento*, 2 vols, ed. F. Zeri (Milan, 1986, rev. 2/1987), ii, pp. 664f

L. Rognini: 'Per la genealogia di Liberale da Verona: I Solimani pittori', *Civiltà Veron.*, ii/6 (1986), pp. 13–20

Paintings in Renaissance Siena, 1420–1500 (exh. cat., ed. K. Christiansen, L. B. Kanter and C. B. Strehlke; New York, Met., 1988–9) [entries by K. Christiansen; bibliog.]

Francesco di Giorgio e il Rinascimento a Siena, 1450–1500 (exh. cat., ed. L. Bellosi; Siena, S. Agostino, 1993) [entries by L. Bellosi and A. De Marchi]

The Painted Page: Italian Renaissance Book Illumination, 1450–1550 (exh. cat., ed. J. J. G. Alexander; London, RA, 1994)

S. Tumidei: 'Liberale da Verona: Un "aggiunta per gli senesi"', *Nuovi Stud.*, i/2 (1996), pp. 5–9

M. Danzi: 'Per Liberale da Verona (1487)', *Rinascimento*, 2nd ser., xxxvii (1997), pp. 235–41

Calligrafia di Dio: La miniatura celebra la parola (exh. cat. by G. Mariani Canova and others, Località Bresseo, Abbazia, 1999), p. 204

HANS-JOACHIM EBERHARDT

Liberatore, Niccolò di. *See* NICCOLÒ DA FOLIGNO.

Libri, dai. Italian family of artists. The best-known member of the family is (2) Girolamo dai Libri, the son of (1) Francesco dai Libri and grandson of Stefano 'a Libris' (*b* before 1433; *d* after 1473), who was also an illuminator. They were principally active in Verona.

(1) Francesco dai Libri (*b c.* 1450; *d* after 1503). Illuminator. He was known only from documents and references in Giorgio Vasari's *Vite* until the discovery of an illuminated initial signed by him in the *Liber perfectionis vitae* (1503; Padua, Bib. Semin., MS. 432, fol. 1*r*). Works now attributed to Francesco are the miniatures in the style of Andrea Mantegna in a Greek and Latin Psalter (Milan, Castello Sforzesco, MS. 2161), those in the *Statuta et ordinamenta domus mercatorum* (Verona, Castelvecchio) and fragments depicting the *Adoration of the Magi* (Paris, Mus. Marmottan, 56), the *Entombment* (U. London, Courtauld Inst. Gals) and the *Pietà* (Cleveland, OH, Mus. A., 51.394). Although Mantegna was the dominant influence on his style, Francesco was still open to ideas from Paduan and Ferrarese illuminators inspired by Girolamo da Cremona and Liberale da Verona. He preferred the portrayal of a pleasant, ordinary ambience to the idealized, classical world of Mantegna, and his illuminations are robustly drawn and brilliantly coloured.

(2) Girolamo dai Libri (*b* ?Verona, 1474–5; *d* ?Verona, ?2 July 1555). Illuminator and painter, son of (1) Francesco dai Libri. He was evidently trained by his father, but he received commissions for altarpieces as well as manuscripts. Documents indicate that he lived in Verona all his life, but an early miniature of the *Nativity* (Brescia, Pin. Civ. Tosio–Martinengo, MS. II, B.I.3, fol. 5*r*), the only work by him in a series of choir-books almost certainly painted in Ferrara, suggests that he may have spent some time there. Vasari's record that he worked as an illuminator in the monastery of S Salvatore in Candiana (Padua) may be true, as some of Girolamo's surviving miniatures were executed for the abbey. The only record of Girolamo's views on his art occurs in a register of 1544: 'a good and worthy painter must know how to imitate nature well and to feign that which nature makes, and he must be universal in depicting landscapes, figures of every kind, animals and scenes and houses and in general all the things that nature produces' (Brenzoni).

Many of Girolamo's early miniatures, almost all detached leaves from choir-books, show that the hard, archaeological style of Mantegna, learnt from his father, was moderated by a particular sweetness. In various miniatures of the *Nativity* painted in the 1490s, for example, the scene is depicted as a domestic idyll set in a peaceful landscape (Brescia, Pin. Civ. Tosio–Martinengo, MS. II, B.I.3, fol. 5*r*; Cleveland, OH, Mus. A., 53.281; Verona, Castelvecchio, 4468 (1769); New Haven, CT, Yale U. A.G).

According to Vasari, the altarpiece of the *Deposition* (2.7×1.5 m) in the parish church of Malcesine, near Verona, was painted when Girolamo was only 16. The apparent influence of Bartolommeo Montagna's fresco of the *Pietà* (1500; Vicenza, sanctuary of Monte Berico) suggests, however, that it was painted in the early 16th century. Paintings dating from the first decade of the 16th century,

such as the *Nativity with Rabbits* (Verona, Castelvecchio), the *Virgin and Child with SS Bartholomew and Zeno* (Berlin, Bodemus.) and the altarpiece of *SS Roch, Job and Sebastian* (Verona, S Tomaso Cantuariense), the last probably painted at the time of the plague of 1510, demonstrate Girolamo's evolution from a style based on precise draughtsmanship and minute, naturalistic detail typical of late 15th-century taste towards a softer more mellow manner.

From his years of collaboration with Francesco Morone (particularly in the second decade of the 16th century) Girolamo acquired a more delicate and softer way of painting and a passing interest in Vittore Carpaccio. Morone and Girolamo both preferred a discreet, unemphatic painting style that focused on the everyday quality of figures and objects. They collaborated on the organ doors (1515–16) of S Maria in Organo (now in the parish church of Marcellise, nr Verona). The allocation of work is disputed, but Vasari's attribution to Girolamo of the *Nativity* and *SS Catherine and Mary Magdalene* is probably correct. They are stylistically comparable with the *Virgin and Child with Saints* (New York, Met.) and the *Virgin and Child with St Anne* (1518; London N.G.). The *Christ with the Woman of Samaria* (1.5×1.8 m) in the parish church of Monteforte near Verona combines a broad, airy landscape typical of Girolamo with a background cavalcade that is more characteristic of Morone, whose style is especially apparent in the figure of Christ.

Although Girolamo received numerous commissions for illuminating manuscripts, for example a series of choir-books for the Olivetan monastery at S Maria in Organo in 1519–20, this activity as a book illustrator can now be traced only in scattered works, under other names, in various museums and libraries. Works now identified include the *Miserere* (New York, Met., 12.56.3), *Pentecost* (Stockholm, Nmus., B 1386), *David the Musician* (Budapest, Mus. F.A., 3131) and the *Ascension* (Cincinnati, OH, A. Mus., 1950.34).

The predella with scenes from the *Lives of SS Blaise and Juliana* (Verona, SS Nazaro e Celso) and the *Virgin and Child with SS Lorenzo Giustiniani and Zeno* (oil on canvas; Verona, S Giorgio in Braida; see fig.), both painted in 1526, illustrate the essential conservatism yet high quality of Girolamo's art; he was not greatly influenced by the new developments in Rome, Florence and Venice, even when these were adopted by other Veronese painters. The so-called *Baptism of Christ with Ibis* (Verona, Castelvecchio), restored after much 19th-century repainting, is now dated to the end of the 1520s. In the *Virgin and Child of the Parasol* (1530; Verona, Castelvecchio), Girolamo's landscape painting, with the use of vivid greens and deep perspective, reaches its culmination. The *Virgin and Child of the Oak Tree* (Verona, Castelvecchio), perhaps his finest work, with its measured distribution of volumes and fine colour scheme, must have been painted after 1533: its composition and low viewpoint are similar to an altarpiece by Giovanni Girolamo Savoldo, which was installed that year in S Maria in Organo, Verona.

Only manuscript illumination survives from Girolamo's later years: psalters and hymnals for the Benedictine abbey of San Benedetto in Polirone (1554 and 1555; Mantua, Mus. Diocesano, MSS S1, 6T, 3). Although they may lack

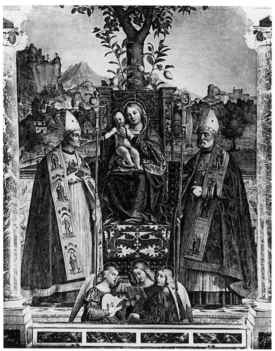

Girolamo dai Libri: *Virgin and Child with SS Lorenzo Giustiniani and Zeno*, oil on canvas, 1526 (Verona, S Giorgio in Braida)

invention, they still show a lively and spirited use of colour. Vasari's record that Girolamo trained Giulio Clovio in S Salvatore in Candiana is perhaps illustrated by the beautiful initial page of a Psalter (Paris, Mus. Marmottan, 90) produced there, which combines Girolamo's style with a rich margin decoration of allegorical figures and cameos characteristic of Clovio.

BIBLIOGRAPHY

DBI; Thieme–Becker

G. Vasari: *Vite* (1550, rev. 2/1568); ed. G. Milanesi (1878–85), v, pp. 327–31

B. Dal Pozzo: *Le vite dei pittori, degli scultori et architetti veronesi* (Verona, 1718)

L. Di Canossa: 'La famiglia Dai Libri', *Atti & Mem. Accad. Agric., Sci. & Lett. Verona*, xii (1912), pp. 85–124

R. Wittkower: 'Studien zur Geschichte der Malerei in Verona', *Jb. Kstwiss.*, iv (1927), pp. 185–222

E. Calabi: 'I corali, miniati del convento di S. Francesco a Brescia', *Crit. A.*, iii (1938), pp. 57–67

M. Levi D'Ancona: 'A Masterpiece by Girolamo Dai Libri', *V&A Mus. Yb.*, i (1969), pp. 16–26

R. Brenzoni: *Dizionario di artisti veneti* (Florence, 1972), pp. 102–4

H. J. Eberhardt: 'Girolamo dai Libri', *Maestri della pittura veronese*, ed. P. Brugnoli (Verona, 1974), pp. 141–52

Miniatura veronese del rinascimento (exh. cat., ed. G. Castiglioni and S. Marinelli; Verona, Castelvecchio, 1986) [contains essays by G. Castiglioni: 'Un secolo di miniature veronese, 1450–1550', pp. 45–99, 239–76; H. J. Eberhardt: 'Nuovi studi su Domenico Morone, Girolamo Dai Libri e Liberale', pp. 101–51; and U. Bauer-Eberhardt: 'Aggiunte a Girolamo Dai Libri', pp. 153–61]

S. Marinelli: 'Seguito alla "Miniatura veronese del Rinascimento"', *Verona Illus.*, ii (1989), pp. 53–9

GINO CASTIGLIONI

Licinio. Italian family of painters.

(1) Bernardino Licinio (*b* Venice, *c.* 1490; *d* Venice, after 1549). Born in Venice of Bergamese descent, he was trained within the tradition of Giovanni Bellini, possibly in his workshop, and followed a successful career in the city. His own workshop produced half-length panels of the Virgin and Child, altarpieces and numerous individual and group portraits. Although not an innovator, Bernardino remained open to developments in contemporary Venetian painting. Whereas his early paintings, such as the *Adoration of the Shepherds* (Brescia, Pin. Civ. Tosio–Martinengo) and the *Portrait of a Courtesan* (ex-Dal Vecchio priv. col., Genoa), are close in mood to Giorgione, the religious paintings from the 1520s and 1530s frequently reflect the work of Titian. For example, the signed and dated triptych of the *Resurrection* (1528; Lonato, S Giovanni Battista) was influenced by Titian's polyptych of the same subject (1522; Brescia, SS Nazzaro e Celso; *see* TITIAN, fig. 7). Increasing workshop intervention occurs in the paintings from the 1530s onwards and the workshop paintings frequently repeat established formal models. Bernardino's signed and dated *Virgin and Child Enthroned with Saints* (1535; Venice, S Maria Gloriosa dei Frari) recalls Titian's work in the pose and expression of the saints but, in contrast to Titian's innovative treatment of altarpiece conventions, Bernardino adheres to the traditional figurative scheme, arranging the saints symmetrically around the central figures of the enthroned Virgin and Child.

Bernardino was active as a portrait painter and his rather conservative skills are perhaps best represented in this genre. Here too he looked to the work of his Venetian contemporaries. Two signed and dated works, the *Portrait of a Man Holding a Missal* (1524; York, C.A.G.) and the portrait of *Stefano Nani* (1528; London, N.G.), are indebted to Lorenzo Lotto and Titian respectively. Bernardino also painted a number of group portraits. These include the *Family Group* (London, Hampton Court, Royal Col.), the *Portrait of a Sculptor with Five Apprentices* (Alnwick Castle, Northumb.) and the portrait of *Arrigo Licinio and his Family* (Rome, Gal. Borghese). The last represents the family of Bernardino's elder brother, also recorded as a painter and includes a portrait of (2) Giulio Licinio offering his mother a bowl of roses. The work was possibly a collaborative effort, with certain passages painted by Giulio, who worked in his uncle's shop.

Vasari confused Bernardino with his contemporary Pordenone. This error persisted until the early 20th century. In the 19th century many of his works were attributed to Pordenone, although Bernardino's work is in marked contrast to Pordenone's Mannerist innovations. While accommodating the taste for Central Italian and Roman art in his work from the 1530s onwards, Bernardino remained a painter within the mainstream of the Venetian tradition.

(2) Giulio Licinio (*b* Venice, *c.* 1527; *d* ?Venice, after 1584). Nephew of (1) Bernardino Licino. He was the son of the painter Arrigo Licino and younger brother of Fabio Licinio, who was trained as a goldsmith and practised as an etcher. Giulio was trained in the workshop of his uncle Bernardino and worked as his assistant. In 1556 he was among the painters competing for the commission to furnish the ceiling tondi for the Biblioteca Marciana, Venice. The artists were invited to provide three paintings

each, their work to be judged by Titian and Sansovino. Giulio was awarded the commission to paint three allegorical compositions, *Vigilance and Patience* and *Glory and Beatitude* (Venice, Bib. N. Marciana) and the *Virtuous Acts*. The first two conform to the Central Italian Mannerist style common to the painters involved in the decorative project, among them Andrea Schiavone, Giuseppe Salviati and Paolo Veronese. In 1559 Giulio left Venice to work in Augsburg. In the 1570s and 1580s he was recorded as again resident in Venice. Other works by Giulio include the signed *Pietà* (Graz Cathedral) and the signed altarpiece in the parish church of Lonno in Val Serianna.

BIBLIOGRAPHY
A. Venturi: *Storia* (1901–40)
L. Vertova: 'Bernardino Licinio', *I pittori bergamaschi: Il cinquecento*, i (Bergamo, 1975)
The Genius of Venice (exh. cat., ed. C. Hope and J. Martineau; London, R.A., 1983), pp. 174–5

Ligorio, Pirro (*b* Naples, *c.* 1513; *d* Ferrara, 26 Oct 1583). Italian architect, painter, draughtsman and antiquary. He is best known for his designs for the Casino of Pius IV in the Vatican and his gardens for the Villa d'Este at Tivoli, which greatly influenced Renaissance garden design. His work reflects his interest in the reconstruction of Classical antiquity, although this was sometimes based on fragmentary information, and his painting and architecture are closely dependent on classicism with a richness of detail associated with Roman Imperial art.

1. Early activity. 2. Papal service. 3. Tivoli and Ferrara.

1. EARLY ACTIVITY. He was presumably born into a noble family and probably moved to Rome in 1534. At first he was active producing decorative paintings for palaces: Giovanni Baglione recorded numerous houses in Rome with façades frescoed by Ligorio in a distinctive yellow monochrome in the manner of Polidoro da Caravaggio or Baldassare Peruzzi. The only extant example of his figurative painting is a fresco depicting the *Dance of Salome* (*c.* 1544; Rome, Oratory of S Giovanni Decollato). In 1546 he agreed to paint a processional banner (untraced) for the Confraternity of S Maria at Rieti. Two years later he was proposed for membership in the Confraternity of the Virtuosi al Pantheon, a fraternity of artists.

At least as early as the 1540s Ligorio was also pursuing archaeological investigations, noting, for example, the discovery in 1546 of the remains of the Arch of Augustus in the Forum Romanum. In 1549 he entered the service of Cardinal Ippolito II d'Este of Ferrara as court archaeologist; he was also employed as a painter, being paid for the decoration of the salon in the Cardinal's newly acquired palace of Monte Giordano in Rome. Ligorio is first mentioned in the Vatican records on 23 November 1549 on his appointment as overseer of the fountain in the square of St Peter's.

Ligorio's major publications, especially those regarding Roman archaeology, date from the 1550s. Between 1552 and 1561 he published three maps of the city of Rome, of which two (1553 and 1561) were archaeological reconstructions. *Delle antichità di Roma* (Venice, 1553) is concerned with the ancient theatres and circuses; its copyright notice also covered some engraved reconstructions of antiquities. Seven engravings were issued separately between 1552 and 1558, including reconstructions of the Circus Maximus and the Aviary of Varro. The Venetian humanist Daniele Barbaro and Andrea Palladio met Ligorio during their visit to Rome in 1554, probably drawn by his renown in archaeology.

2. PAPAL SERVICE. Ligorio's entry into papal service was eased in 1555 by the election of a fellow Neapolitan as Pope Paul IV. In April 1557 Ligorio was recorded on the papal roll as 'designator' and in January 1558 he was appointed architect of the Vatican Palace, while his predecessor Sallustio Peruzzi remained at his original (and lesser) salary. Ligorio's first appointment may have been occasioned by the commission to design a reliquary for the chapel that Peruzzi had begun for the new papal apartment in the Belvedere Court. The reliquary was later cast in bronze and sent to Milan, where it was altered by Pellegrino Tibaldi and installed in the cathedral. Ligorio worked on the chapel until September 1558, including painting two angels (destr.). He was also given an ill-advised commission to improve the lighting of the Sala di Costantino, but the project was abandoned before too much damage was done to the existing decoration. At this time he began to prepare illustrations for *Fabulae centum ex antiquis auctoribus* (Rome, 1563) by his friend Gabriele Faerno (*d* 1561).

As papal architect Ligorio's main project was to design a new *casino* in the Vatican gardens as an afternoon retreat for the Pope. Work on the structure, which began in May 1558, stopped in November but was resumed in May 1560 after the accession of Pius IV, who was determined to complete many of his predecessor's architectural projects. The *casino* complex is one of the most charming secluded retreats ever built (see fig. 1). It faces a separate free-standing loggia across an oval courtyard, with a pair of entrance arches at the two narrow ends. The arrangement appears to be based on reconstructions of naumachias, as depicted on Roman coins. The courtyard is bordered by benches and has a fountain at the centre. Another fountain is placed on the garden side of the loggia. The exterior walls are encrusted with lavish stuccowork, presenting a decorative repertory closely modelled on motifs from ancient tombs. The figural reliefs celebrate Pius IV, after whom the *casino* came to be named. The design of the ground floor facing the courtyard faintly recalls Baldassare Peruzzi's Palazzo Massimo alle Colonne, Rome. The *casino*, with its asymmetrically placed belvedere tower, is reminiscent of earlier villa buildings. The interiors are lavishly decorated with paintings and stuccowork by Federico Barocci, Federico Zuccaro and others.

Ligorio also undertook extensive work on the repair and redecoration of the Vatican Palace. In July 1560 the Loggia della Cosmografia, the uppermost of Bramante's tier of loggias attached to the east side of the palace, was being repaired and decorated with frescoed maps, and in September the rooms of the Borgia Apartment were being redecorated, especially the Sala dei Pontefici. By November the major building campaign was under way with Ligorio's design to revise and complete the monumental Belvedere Court. As well as completing the long western

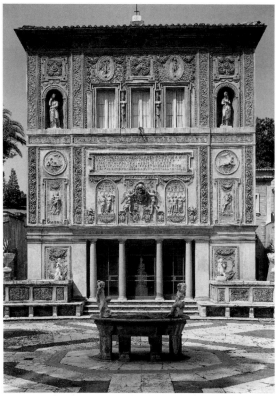

1. Pirro Ligorio: façade of the Casino of Pius IV, Vatican, Rome, 1558–62

side, he added a curved auditorium in the lower court, backing on to the Vatican Palace, and vaulted the semicircular exedra at the north end, thus converting it into a huge niche. In 1560 he was made an honorary citizen of Rome in recognition of his contributions to the city and the papal court.

A drawing by Ligorio of the route of the Acqua Vergine (Florence, Uffizi, cat. no. 4236A) would appear to confirm his claim that he suggested a plan to improve Rome's water supply by repairing the ancient aqueduct. Another papal commission was the Palazzina of Pius IV (1561–4), set above the public fountain that had been built for Julius III on the Via Flaminia. In 1563 Ligorio began to erect a building to house papal conclaves at the Vatican, but this was soon converted into a papal archive. In the following year he undertook several important commissions outside the Vatican Palace, including refurbishing the north transept façade of S Giovanni in Laterano. Work also began on his design for a new court for the Palazzo della Sapienza, but was interrupted in September 1565. He received his most prestigious commission in August 1564 when he was appointed to succeed Michelangelo as architect of St Peter's. Little was accomplished under Ligorio's direction, however, except work on the entablature of the dome's drum and the cutting of some capitals for the chapels.

On 31 July 1565 Ligorio was accused of financial larceny and imprisoned in the Torre di Nona for 22 days. He was apparently cleared of the charge and by October was supervising repairs to the Sistine Chapel. He remained in papal service for a short time after the election of Pius V in 1566: with Sallustio Peruzzi's assistance he was in charge of the decorations for the papal coronation. He was commissioned to design a lavish tomb for *Pope Paul IV* (1566; Rome, S Maria sopra Minerva). This is set against a wall within a strong architectural frame and employs a rich variety of polychromatic marbles; above the sarcophagus is a rectangular niche containing a seated figure of the pope by Giacomo Cassignola (*d* 1588). Between 1566 and 1569 a new Palace of the Inquisition (now the Palazzo del S Uffizio) was built to the plans of Ligorio and Peruzzi. Early in 1567, as if foreseeing a change in his career, Ligorio sold to Cardinal Alessandro Farnese his collection of ancient medals and his first manuscript encyclopedia of antiquities, the *Libri dell' antichità di Roma* (Naples, Bib. N.); by at least June he had been succeeded as architect of the Vatican Palace by Nanni di Baccio Bigio.

3. TIVOLI AND FERRARA. In 1550 Cardinal Ippolito II d'Este bought some land at Tivoli on the hillside below the governor's palace, which was housed in the monastery of S Maria Maggiore, as the setting for a magnificent villa and gardens (*see* TIVOLI, §3). In the following years, in his capacity as court archaeologist, Ligorio explored the antiquities of Hadrian's nearby villa and helped lay out the gardens of the Villa d'Este, devising an elaborate iconographic programme in honour of the Cardinal. The latter was exiled between 1555 and 1559, however, and little was achieved until 1560. After Ligorio left papal service, he resided in Tivoli during the summers of 1567 and 1568, in which years he produced the designs for statues of nymphs for the great Fountain of Tivoli in the gardens and the figure of *Roma* for the Fountain of Rometta (see fig. 2).

At the end of 1568 Ligorio was appointed court antiquary to Alfonso II d'Este, Duke of Ferrara, where his varied duties principally involved the organization of the ducal collection of antiquities. He was also appointed a Lector at the University of Ferrara and collaborated with Cornelio Bentivoglio I on the designs (1569; Ferrara, Civ. Bib. Ariostea) of the theatrical apparatus for an allegorical tournament or naumachia entitled *L'isola beata*. In November 1569 he completed a number of drawings of the *Story of Hippolytus* (New York, Pierpont Morgan Lib., MS. M. A. 542), which were probably intended for an unexecuted series of tapestries, presumably for the Villa d'Este at Tivoli.

Much of Ferrara was severely damaged in an earthquake in 1570 and Ligorio's diary (Turin, Archv Stato, MS. J.a.II, 15) records the further shocks in the following months. In 1571, while repairing the Castello Estense, he took the opportunity to design and build a library and museum for antiquities, decorated with a large map of Rome. He was commissioned to design the tomb of *Ludovico Ariosto* (1573; Ferrara, S Benedetto, destr.); this was replaced in 1612 by a more sumptuous monument (now Ferrara, Civ. Bib. Ariostea), which retained two of Ligorio's allegorical figures, *Poetry* and *Glory*. At this time he also prepared many of the illustrations for the second edition of *De arte gymnastica* (Venice, 1573) by Girolamo Mercuriale (1530–1606). In 1574 Ligorio designed six richly decorated,

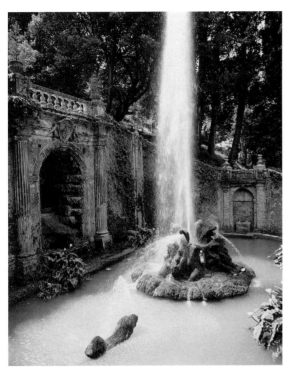

2. Pirro Ligorio: Fountain of Rometta (1567–8) at the Villa d'Este, Tivoli (1550–72)

temporary triumphal arches for the procession through Ferrara of Henry III of France (*reg* 1574–89). As propaganda in the fight between Florence and Ferrara over precedence in court ceremonies, Ligorio made drawings illustrating the genealogy of the Este family for a series of frescoes to decorate the courtyard of the Castello Estense; these were completed in 1577 by Bartolommeo Faccini (1532–77) and Girolamo Faccini (1547–before 1616). At about the same time the frescoes by Sebastiano Filippi II in the two Sale dei Giocchi and the Sala dell'Aurora in the Castello Estense probably also followed Ligorio's designs. He was made an honorary citizen of Ferrara in 1580, enabling him to claim that he was a 'patrician' of Naples and a citizen of both Rome and Ferrara.

Ligorio left a substantial body of manuscript writings in addition to his *Libri dell'antichità di Roma*. The most notable collection (Turin, Archv Stato) comprises some 30 volumes, most of which belong to another encyclopedia of antiquities. During the 19th century much of his antiquarian information, which he had reconstructed from fragmentary inscriptions and archaeological sites, was considered suspect, but this view has been reconsidered. His reconstructions are now believed to be reasonably accurate, given the level of archaeological information then available, and many of the inscriptions formerly labelled as forgeries have been recognized as genuine.

UNPUBLISHED SOURCES

Ligorio's copious manuscript writings are held by several libraries, including the following:

Eton, Berks, Coll. Lib., Topham Coll., Bn 10, fol. 53
Ferrara, Civ. Bib. Ariostea, MS.I, 217 and MS.II, 384
Naples, Bib. N., MSS XIII.B, 1–10 (*Libri dell'antichità di Roma*)
Oxford, Bodleian Lib., MS. Canon. ital. 138 (*c.* 1545–9)

Paris, Bib. N., MS. ital. 1129
Turin, Archv Stato, MSS J.a.II, 1–16; J.a.III, 3–16 (including *Libri dell'antichità*)

WRITINGS

Libro di M. Pyrrho Ligori napolitano, delle antichità di Roma, nel quale si tratta de' circhi, theatri, & anfitheatri (Venice, 1553)
Fragmento d'istoria dell'antichità della nobilissima città di Ferrara (Venice, 1676)
Descriptio superbae et magnificentissimae villae Tiburtinae Hadrianeae (MS.; Paris, Bib. N., MS. ital. 1129); ed. J. G. Graevius, *Thesaurus antiquitatum et historiarum Italiae*, viii/4 (Leiden, 1723)

BIBLIOGRAPHY

G. Baglione: *Vite* (1642); ed. V. Mariani (1935), pp. 9–11
F. Cerasoli: 'Il monumento di Paolo IV nella chiesa della Minerva', *Stud. & Doc. Stor. & Dir.*, xv (1894), pp. 131–4
R. Ancel: 'Le Vatican sous Paul IV: Contribution à l'histoire du palais pontifical', *Rev. Bénédictine*, xxv (1908), pp. 48–71
W. Friedländer: *Das Kasino Pius des Vierten* (Leipzig, 1912)
P. Tomei: 'Gli architetti del Palazzo della Sapienza', *Palladio*, v (1941), pp. 270–82
J. S. Ackerman: *The Cortile del Belvedere*, Stud. & Doc. Stor. Pal. Apostol. Vatic., iii (Rome, 1954)
D. R. Coffin: 'Pirro Ligorio and Decoration of the Late Sixteenth Century at Ferrara', *A. Bull.*, xxxvii (1955), pp. 167–85
H. Thelen: *Der Palazzo della Sapienza in Rom*, Röm. Forsch. Bib. Hertziana, xvi (1961), pp. 285–307
E. Mandowsky and C. Mitchell, eds: *Pirro Ligorio's Roman Antiquities: The Drawings in MS. XIII.B.7 in the National Library in Naples*, Stud. Warb. Inst., xxviii (London, 1963)
D. R. Coffin: 'Pirro Ligorio on the Nobility of the Arts', *J. Warb. & Court. Inst.*, xxvii (1964), pp. 191–210
J. Wasserman: 'Giacomo della Porta's Church of the Sapienza in Rome and Other Matters Relating to the Palace', *A. Bull.*, xlvi (1964), pp. 501–10
J. A. Gere: 'Some Early Drawings by Pirro Ligorio', *Master Drgs*, ix (1971), pp. 239–50
M. Fagiolo and M. L. Madonna: 'La Casina di Pio IV in Vaticano: Pirro Ligorio e l'architettura come geroglifico', *Stor. A.*, xv–xvi (1972), pp. 237–81
——: 'La "Roma di Pio IV": La "Civitas Pia", La "Salus Medica", La "Custodita Angelica"', *A. Illus.*, 51 (1972), pp. 383–402
P. Barocchi, ed.: *Scritti d'arte del cinquecento* (1973), xxxii of *La letteratura italiana: Storia e testi* (Milan and Naples, 1971–7)
R. E. Keller: *Das Oratorium von San Giovanni Decollato in Rom: Eine Studie seiner Fresken* (Rome, 1976)
G. Smith: *The Casino of Pius IV* (Princeton, 1977)
S. Benedetti: 'Un'aggiunta a Pirro Ligorio: Il tabernacolo di Pio IV nel Duomo di Milano', *Palladio*, xxvii (1978), pp. 45–64
M. L. Madonna: 'L'"Enciclopedia del mondo antico" di Pirro Ligorio', *Primo congresso nazionale di storia dell'arte: Roma, 1978*, pp. 257–71
D. R. Coffin: *The Villa in the Life of Renaissance Rome* (Princeton, 1979)
M. Fagiolo: 'Il significato dell'acqua e la dialettica del giardino: Pirro Ligorio e la "filosofia" della villa cinquecentesca', *Natura e artificio*, ed. M. Fagiolo (Rome, 1979), pp. 176–89
J. S. Weisz: *Pittura e misericordia: The Oratory of S Giovanni Decollato in Rome* (diss., Cambridge, MA, Harvard U., 1982)
J. Bentini and L. Spezzaferro, eds: *L'impresa di Alfonso II* (Bologna, 1987)
R. W. Gaston, ed.: *Pirro Ligorio: Artist and Antiquarian* (Florence, 1988)
A. Brent: 'Ligoro's Reconstruction of Hippolytus Statue and the Recovery of the Hippolytan Corpu's, *Medieval Codicology, Iconography, Literature and Translation: Studies for Keith Val Sinclair*, P. R. Monks and D. D. R. Owen, eds. (Leiden, New York and Cologne, 1994), pp. 1–11
C. Volpi, ed.: *Libro dei disegni di Pirro Ligorio all'Archivio di Stato di Torino* (Rome, 1994)
M. Fagiolo: 'Le paradis de la mémoire: Des jardins citadelles de Dante et Ligorio à la "cité du soleil" de Versailles', *Le jardin, art et lieu de mémoire*, ed. M. Mosser and N. Philippe (Besançon, 1995), pp. 54–86
P. Tosini: 'Federico Zuccari, Pirro Ligorio e Pio IV: La Sala del Buon Governo nell'appartamento di Belvedere in Vaticano', *Stor. A.*, lxxxvi (1996), pp. 13–38

For further bibliography see TIVOLI, §3

DAVID R. COFFIN

Lilli, (Giovanni) Andrea [d'Ancona; Lilio, Andrea] (*b* Ancona, *c.* 1570; *d* ?Ascoli Piceno, after 1635). Italian

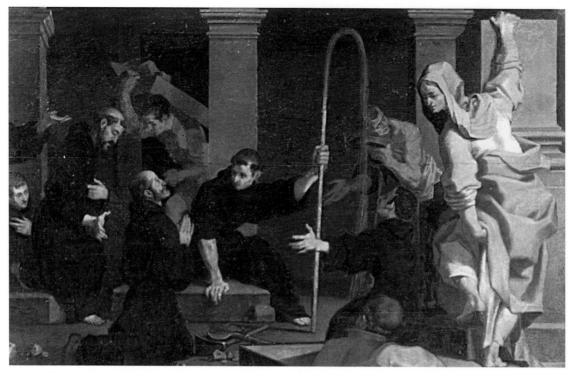

Andrea Lilli: scene from the *Life of St Nicolas of Tolentino*, oil on panel, 530×930 mm, *c.* 1597–1601 (Ancona, Pinacoteca Comunale)

painter and draughtsman. He arrived in Rome during the papacy of Sixtus V (1585–90) and is documented there as a member in 1601 of the Accademia di S Luca and Segretario dell'Accademia in 1602. He worked principally with Giovanni Guerra and Cesare Nebbia. With these and other artists, including Francesco Vanni (1563–1610), Ventura Salimbeni, Ferraú Fenzone (1562–1645) and Antonio Viviani (1560–1620), he participated in many of the painting projects commissioned by Sixtus V, for example frescoes in the Salone Sistino of the Biblioteca Apostolica Vaticana, the Scala Santa and the Sistine Chapel, S Maria Maggiore. His presence in Rome was not unbroken; he returned several times to the Marches, where many of his paintings remain.

Examples of Lilli's altarpieces include the panel depicting the *Death of Ananias and Sapphira* (Rome, Ospedale di Santo Spirito in Sassia), which reveals a direct link with early Tuscan Mannerism, especially Pontormo, to whom the panel was for a long time attributed, and the signed and dated *Road to Calvary* (1589; Oggiono, parish church), which is quite different with a more strongly accentuated chiaroscuro contrast and a more personal style. His altarpieces reveal a less easily definable stylistic development than the somewhat predictable Mannerism of such frescoes as the *Birth of the Virgin*, the *Adoration of the Shepherds* and the *Anastasis* (all 1591–3; Rome, S Maria Maggiore). One of his most successful paintings is the panel representing the *Miraculous Draught of Fishes* (Rome, S Giovanni in Laterano), where the formal energy is held in check within a remarkably restrained composition. The still-life of the fish in the net and the shimmering marine landscape in the background are particularly skilfully executed.

Between 1597 and 1601 Lilli was in Ancona, where he painted the *Virgin Crowning St Nicholas of Tolentino* (ex-Pin. Com., Ancona), a series of small panels depicting scenes from the *Life of St Nicholas of Tolentino* (see fig.) and *Four Saints in Ecstasy* (all Ancona, Pin. Com.). These clearly define the various aspects of his style, namely figures in contorted poses, acid and discordant colours, a heightened expressionism and extravagant draperies, all in an atmosphere of mystical spirituality. Among his most impressive works, executed after he returned to Rome, is the canvas *Saints in Glory* (1604) for the high altar of the Nolfi Chapel, Fano Cathedral. The *Miracles of St Anthony of Padua* (Barcelona, Mus. A. Catalunya) and the *Virgin with Angels and Saints* (Apiro, collegiate church) belong to this period, but the number of commissions offered to Lilli began to drop drastically. Around this time, however, he began to produce designs for engravings. His last work, signed and dated 1631, is the *Crucifixion with SS Charles and Ubaldus* (Ancona, S Giovanni Battista). Lilli was documented living in Rome in 1635; he reportedly died while working on frescoes depicting the *Life of St Benedict* in the cloisters of the convent of S Angelo Magno, Ascoli Piceno.

Lilli's reputation increased in the later 20th century; he was formerly, and erroneously, regarded as a follower of Federico Barocci. His early works reveal affinities with early Sienese Mannerism, with which he became acquainted through Francesco Vanni and Ventura Salimbeni. Although undoubtedly eclectic, his style indicates a certain intellectual curiosity as seen, for example, in his interest in Caravaggio (1571–1610), from whom he took certain formal features that he grafted on to his own strictly Mannerist background.

BIBLIOGRAPHY
Andrea Lilli nella pittura delle Marche tra cinquecento e seicento (exh. cat., ed. L. Arcangeli and P. Zampetti; Ancona, Pin. Com., 1985) [with full bibliog.]
FIORENZA RANGONI

Liombeni, Lorenzo de. *See* LEONBRUNO, LORENZO.

Liompardi, Alessandro. *See* LEOPARDI, ALESSANDRO.

Lippi. Italian family of painters and draughtsmen. (1) Fra Filippo Lippi, a Carmelite monk who was one of the leading Florentine painters of the mid-15th century, had a son by Lucrezia Buti, the nun he abducted in 1456. This son, (2) Filippino Lippi, became in turn one of the leading Florentine painters of the late 15th century.

BIBLIOGRAPHY
G. Vasari: *Vite* (1550, rev. 2/1568); ed. G. Milanesi (1878–85), ii, pp. 611–46, iii, pp. 461–92
I. B. Supino: *Les Deux Lippi* (Florence, 1904)
U. Mengin: *Les Deux Lippi* (Paris, 1932)
B. Berenson: *Florentine School* (1963), pp. 111–14

(1) Fra Filippo (di Tommaso) Lippi (*b* Florence, *c.* 1406; *d* Spoleto, 9 Oct 1469). He was one of the leading painters in Renaissance Florence in the generation following Masaccio. Influenced by him in his youth, Filippo developed a linear, expressive style, which anticipated the achievements of his pupil Botticelli. Lippi was among the earliest painters indebted to Donatello. His mature works are some of the first Italian paintings to be inspired by the realistic technique (and occasionally by the compositions) of Netherlandish pioneers such as Rogier van der Weyden (1399–1464) and Jan van Eyck (*c.* 1395–1441). Beginning work in the late 1430s, Lippi won several important commissions for large-scale altarpieces, and in his later years he produced two fresco cycles that (as Vasari noted) had a decisive impact on 16th-century cycles. He produced some of the earliest autonomous portrait paintings of the Renaissance, and his smaller-scale *Virgin and Child* compositions are among the most personal and expressive of that era. Throughout most of his career he was patronized by the powerful Medici family and allied clans. The operation of his workshop remains a matter of conjecture.

1. Life and work. 2. Working methods and technique. 3. Workshop organization.

1. LIFE AND WORK.

(i) Before 1437. (ii) 1437–52. (iii) 1452–69.

(i) Before 1437. Lippi is first documented on 18 June 1421, when he took vows at the Carmelite monastery of S Maria del Carmine in Florence. Since the minimum age for entering the order was 15, he was probably born *c.* 1406. He appears in the annual records of the monastery from 1422 to 1432. On 7 November 1428 he was given permission to spend the following year at the Carmelite monastery in Siena. Here he may have come into contact with Domenico di Bartolo, who, according to Vasari, painted the high altar of S Maria del Carmine in Florence. In Siena, Lippi could have seen sculptural works such as the font in the baptistery with relief panels by Jacopo della Quercia, Lorenzo Ghiberti, Donatello and others, as well

as polychromed wooden statues by Jacopo della Quercia and Domenico di Niccolò de' Cori.

There are no records relating to Lippi's training and no surviving documented paintings by his hand from before 1437. As a monk, he was apparently exempt from membership of the Arte dei Medici e Speziali or the Compagnia di S Luca. He is first referred to as a painter in 1430 in the accounts of S Maria del Carmine. Vasari, who is almost the only source for Lippi's early career, stated that his style was formed on Masaccio's Brancacci Chapel frescoes in S Maria del Carmine (*see* MASACCIO, fig. 5 and colour pls 2, II2 and 2, III2) and that his reputation was established by a fresco of *St Martial* (destr. 1568) in the same church. Only one of Lippi's frescoes described by Vasari in the Carmine precincts has survived: the *Reform of the Carmelite Rule* shows Albert of Avogadro, the patriarch of Jerusalem, conferring the rule on the Mount Carmel hermits, an event that took place between 1206 and 1214. While the perspective is awkward and the treatment of anatomy crude, Masaccio's influence is apparent in the facial types and in the simple, unadorned style. The fresco has been convincingly dated to *c.* 1428–30. A gable with the *Madonna of Humility with Three Carmelite Saints and Angels* (Milan, Castello Sforzesco) is very close in style to the Carmine fresco and may have come from there. Indeed an altar dedicated to two of the Carmelite saints, SS Angelo and Albert of Sicily, once formed part of the *tramezzo* of this church. Like the fresco, the gable shows a special concern for expression at the expense of a rational depiction of space. This work should probably be considered an independent work of art rather than a fragment (Christiansen, 1985).

Three small autograph panels survive from the early 1430s: an abraded *Pietà* (Milan, Mus. Poldi Pezzoli), a *Mourning St John the Evangelist* (priv. col., see Christiansen, 1985), and a *Dead Christ with Two Angels* (Esztergom, Mus. Christ.; see De Marchi, 1996). The brilliant linear design and the intense colour range of these works show that Lippi had developed beyond Masaccio's interest in form and anticipate his own mature, highly original style. On 3 May 1431 Lippi paid dues to the Compagnia di S Maria delle Laude e di S Agnese, a confraternity based in the Carmine, of which Bicci di Lorenzo and Masolino were also members. By 1434 he was in Padua, where on 1 July he was paid for some ultramarine for the reliquary cupboard in the basilica of S Antonio. According to the penetrating analysis of De Marchi, two sections of this cupboard may be identified with the *Mourning of St John* and the *Dead Christ*.

Other work is recorded in Padua. On 15 October Lippi and Francesco Squarcione evaluated some work by two local painters. Marcantonio Michiel recorded that he decorated the chapel of the Palazzo del Podestà in Padua and parts of a fresco called the 'Madonna del Pilastro', also in S Antonio (all destr.). Lippi must have spent about two years in Padua, but his whereabouts after this are unknown. It has been suggested (Ames-Lewis, 1979) that he may have made a trip to the southern Netherlands.

(ii) 1437–52. Lippi was a naturally curious artist, open to influence from every quarter, yet highly original and often innovative. Both the setting and the arrangement of the

figures in the Tarquinia *Virgin and Child* (1437; Rome, Pal. Barberini; named from its former location at Tarquinia) seem to have been inspired by a lost *Virgin and Child* by Rogier van der Weyden, and the rendering of light, shadow and texture is profoundly indebted to Netherlandish practice. Possibly for the first time in Italian art, the Virgin is depicted in a domestic setting. Neither she nor the Christ Child has a halo, and the date is inscribed on a *trompe l'oeil cartellino*—a device that later became common but was unknown in Italian painting before this date.

In a letter of 1 April 1438 to Piero di Cosimo de' Medici, Domenico Veneziano reported that Filippo Lippi and Fra Angelico had established themselves as the two most sought-after painters in Florence. He added that Lippi had begun a painting for Santo Spirito that would take years to complete. This was the *Virgin and Child with SS Frediano and Augustine* (Paris, Louvre; see fig. 1), first recorded in a payment of 8 March 1437. Despite Domenico Veneziano's misgivings, the Barbadori Altarpiece, as it was called after its donor, Gherardo di Bartolommeo Barbadori (*d* 1429), was completed before the end of 1439. Vasari described it as 'a work of rare excellence which has

ever been held in the highest esteem by men versed in our arts'. The painting's central vertical axis is stressed by the standing Virgin and Child, reminiscent of Donatello, and by the two columns that relate ambiguously to the arched frame. The two saints kneeling at the Virgin's feet are rigorously modelled and form the base of a stable, pyramidal composition. Both this and the combination of stances were inspired by Masaccio's *Trinity* in S Maria Novella, Florence (see colour pl. 2, III1). The Christ Child probably influenced the same figure in Michelangelo's *Madonna and Child* (Bruges, Notre-Dame). The setting of the Barbadori Altarpiece recalls a church choir, and balustrades and steps in the foreground imply further levels and rooms beyond the frame. Such imaginative spatial design, matched previously in Florence only by the Masaccio *Trinity*, may ultimately derive, like the harmonic relationship between figure and setting, from Lippi's study of frescoes by Altichiero (*fl* 1369–93) and Guariento (*fl* 1338–67/70) during his time in Padua. Contemporary with the Barbadori Altarpiece is the (undocumented) *Annunciation* in S Lorenzo, Florence. The cringeing Virgin is loosely based on that of Donatello's *Annunciation* tabernacle (Florence,

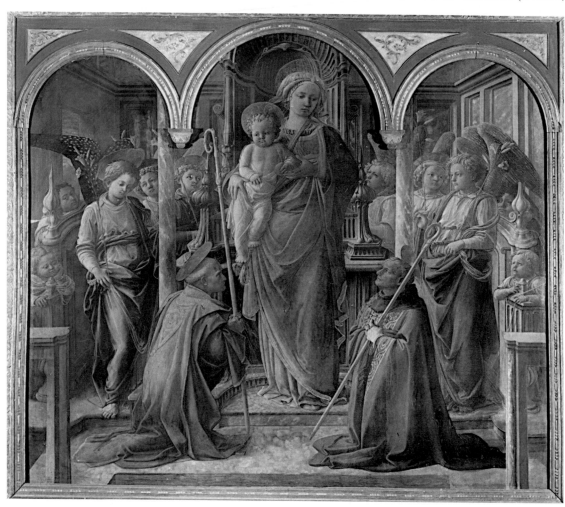

1. Filippo Lippi: *Virgin and Child with SS Frediano and Augustine* (the Barbadori Altarpiece), tempera on panel, 2.08×2.40 m, *c.* 1437–9 (Paris, Musée du Louvre)

Santa Croce), while the richly coloured vestments of the three angels and the illusionistic crystal vase in the foreground are evidence of Lippi's fascination with Netherlandish painting.

Another large-scale commission of this period was the *Coronation of the Virgin* for the high altar of S Ambrogio in Florence (Florence, Uffizi; see colour pl. 1, XXXVIII1). Funding for this began in 1439, but payments were irregular so that work on it lasted until 9 June 1447. It was one of the costliest altarpieces of the 15th century—Lippi alone received 1716 lire. Of the predella, which was paid for in August 1458, all that remains is the *Miracle of St Ambrose* (Berlin, Gemäldegal.; for documentation see Borsook, 1981). The Gothic-style frame (destr.) was apparently designed by Lorenzo Ghiberti, one of the donor's three executors.

Critics have found the composition of the *Coronation* unfocused and additive, probably because of the underplaying of the architectural elements. However, cleaning in 1957–71 revealed a subtly modulated play of light and shade and luminous colours, dependent on Netherlandish qualities of light and colour, which, together with a few beautifully rendered key figures, form guides by which the painting's crowded composition is organized. Vasari recorded the *Coronation*'s immediate critical success and added that it won for Lippi the friendship of Cosimo (il vecchio) de' Medici. A later Medici commission was the *Virgin and Child with SS Francis, Damian, Cosmas and Anthony of Padua* (*c.* 1445; Florence, Uffizi) for the Novitiates' Chapel in Santa Croce. The draperies of the figures at the sides are less convincing than in earlier paintings, and the perspective is eccentric. The idea of placing the figures against an architectural backdrop reminiscent of Michelozzo's designs may have come from Fra Angelico's altarpiece for Bosco ai Frati (Florence, S Marco).

Lippi was also a dedicated portrait painter. His interest in individual likenesses must have been stimulated by a knowledge of Netherlandish portraiture. Lifelike portraits appear in altarpieces such as the Barbadori Altarpiece and the *Coronation*, in both of which Lippi included his own likeness. Two independent portraits by Lippi survive and are among the earliest examples of this genre in Italian Renaissance art. The first, the *Portrait of a Man and a Woman at a Casement* (*c.* 1440; New York, Met.), shows the woman in an interior setting with a landscape viewed through the window behind her profile; her suitor appears through the window. (The sitter in the second, much later example, a *Portrait of a Woman* (?*c.* 1455; Berlin, Gemäldegal.), is also in profile and in an interior setting, but without a landscape view.)

Lippi is last recorded at the Carmine on 8 October 1441. On 27 February 1442 he took up the post of rector at S Quirico a Legnaia, just outside Florence. On 16 May 1447 he was paid for a painting of the Virgin and St Bernard for the Palazzo della Signoria in Florence, which can probably be identified as the *Vision of St Bernard* (London, N.G.), attributed to Lippi's workshop. In 1450 the painter Giovanni di Francesco accused Lippi of not paying him for the restoration of a painting by Giotto, which he had carried out on Filippo's behalf in 1442. Litigation lasted until 1455 when torture on the rack forced

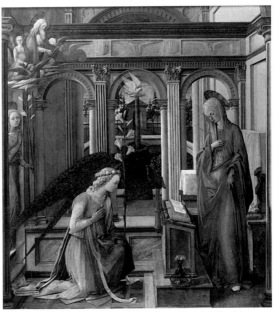

2. Filippo Lippi: *Annunciation*, tempera on panel, 203×186 mm, *c.* 1450 (Munich, Alte Pinakothek)

Lippi to confess to having forged a receipt for the payment. The two men's association appears to have continued nevertheless. Documents reveal that Lippi was brought to court on more than one occasion: in 1451 Antonio del Branca claimed that a painting he had commissioned from Lippi was not the master's own work. The outcome of the case is not known, but since Lippi later received payment for materials, he seems to have won it. On another occasion Lorenzo Manetti accused him of grossly overcharging for an unidentified picture of St Jerome. The case appeared before the Vicario Arcivescovile, who ordered the return of the painting and Manetti's advance payment. Lippi's misconduct was deemed so serious that the arbiter considered ex-communication. On 19 May 1455 Lippi was stripped of his Legnaia benefice, as well as the post of chaplain at the convent church of S Niccolò ai Fieri, Florence, and on 3 January 1456 he was transferred to the chaplaincy of the Augustinian nuns at S Margherita, Prato.

The influence of Fra Angelico is increasingly apparent in Lippi's work from the mid-1440s. The *Adoration of the Magi*, known as the Cook Tondo (Washington, DC, N.G.A.), which Fra Angelico had almost finished by the time he left for Rome in late 1445, was completed by Lippi, who added the foreground figures (with the exception of the Christ Child), most of the Virgin and the figure of the young Magus. There is an obvious attempt to harmonize his style with that of Fra Angelico, the extent of whose influence can be gauged in Lippi's *Annunciation* (*c.* 1450; Munich, Alte Pin.; see fig. 2), executed for the Benedictine nuns' convent of Le Murate, near Florence. Here the features of the Virgin and angel appear more generalized and the figures more elongated and refined, while the localized colours of Lippi's work in the 1430s have yielded to more pervasively bright hues, in keeping with Fra Angelico's luminous palette.

(iii) 1452–69. By 1452 Lippi had moved to Prato. Efforts to engage Fra Angelico to fresco the choir of the local

parish church (later the cathedral) had failed, and on 6 May 1452 Lippi was solicited for this task. Two months later he had begun, but the frescoes were not completed until January 1466. Besides being the most expensive fresco cycle of the 15th century in Tuscany, the Prato frescoes are the most completely documented (see Borsook, 1975). Evidence shows that the long delays are attributable not just to Lippi's lack of application or to his other artistic commitments, but to gross mismanagement and lack of funds.

The vault of the choir is decorated with frescoes of the seated *Evangelists*. Scenes from the *Life of St Stephen*, the titular saint of the cathedral, are painted in three registers on the north wall, while on the south wall is the *Life of St John the Baptist*. The scenes of the *Stoning of St Stephen* and the *Beheading of St John the Baptist* are painted outside chronological sequence across the corners of the altar wall and the north and south walls. In this way they could be seen by the priest while celebrating the Mass, as reminders of Christ's sacrifice. The exact order of execution of the Prato frescoes is unknown, although the two *Nativity* scenes in the lunettes were the first to be painted. The 'doll's house' architectural settings are traditional but also show similarities of detail with Ghiberti's recently completed bronze reliefs for the *Gates of Paradise* of the Florentine Baptistery (see colour pl. 1, XXXI2). The relationship of figures with their setting and the abrupt transitions between foreground and background recall Altichiero's frescoes in Padua, which Lippi had seen in 1434. Both middle registers contain landscapes, rendered in rich shades of light green and rusty orange, whose softly modulated tones and mysterious rock formations convey a deeply romantic response to nature. By contrast, the bottom two scenes are primarily architectural compositions. The *Celebration of St Stephen's Relics* takes place in a monumental nave, and the rows of over life-size portrait figures (including *Pius II*, *Carlo de' Medici* and a self-portrait) are arranged parallel to the picture plane in the foreground and anticipate Ghirlandaio's murals in Santa Trinita, Florence (*see* GHIRLANDAIO, (1), fig. 2). The dancing Salome in the *Feast of Herod*, is a masterpiece of linear design, which looks forward to the art of Lippi's pupil Botticelli.

During his 14 years at Prato, Lippi also painted many panels. On 8 August 1452 he promised to complete a tondo for Leonardo di Bartolommeo Bartolini by 8 December, but it was still unfinished by 16 April 1453. This is identifiable with the *Virgin and Child with Scenes from the Life of the Virgin* (Florence, Pitti; see colour pl. 1, XXXIX1). It is the first painted image of the Virgin in Florentine art to appear on a tondo, a form hitherto associated with the decorative trays known as *deschi da parto*. The background composition recalls Ghiberti's *Jacob and Esau* panel from the Gates of Paradise. Probably dating from the same period as this tondo and the two *Nativity* lunettes at Prato is the *Virgin and Child in a Niche* (Florence, Pal. Medici–Riccardi). Its design resembles contemporary sculpted reliefs of the Virgin, but its appeal depends largely on painterly effects such as the rich, warmly coloured materials, the tender expressions of the two figures and the play of light on the Christ Child's face. From the 1450s Lippi developed the theme of the

Virgin adoring the Christ Child in a woodland setting. His earliest altarpiece with this subject was probably the *Adoration of the Christ Child* (Florence, Uffizi; see fig. 3), painted for the Annalena convent in Florence just after its establishment in 1453. As in the *Virgin and Child* tondo, the principal figures are brought close to the foreground plane, while the romantic wooded setting with its high horizon line recalls the landscapes in the Prato frescoes.

The adoration of the Christ Child was the subject of the central panel of a triptych sent to Alfonso of Aragon (*reg* 1416–58) as a diplomatic present from Giovanni di Cosimo de' Medici early in 1458. Only the side panels, representing *St Anthony Abbot* and *St Michael*, survive (both Cleveland, OH, Mus. A.). Lippi made a sketch of the proposed triptych at the bottom of a letter of 20 July 1457 to Giovanni de' Medici, in which he discusses the materials to be used for this painting. Another Medici commission was the *Adoration of the Christ Child with St Romuald and the Infant John the Baptist* (*c.* 1459; Berlin, Gemäldegal.), intended for the altar of the chapel in the Palazzo Medici, Florence, but later replaced by a copy. Its complicated iconography is perhaps expressive of the pietism of Piero de' Medici and his wife, Lucrezia Tornabuoni.

During the mid-1450s Lippi was engaged on a variety of work. In 1454 he restored the frescoes by Agnolo Gaddi (*fl* 1369–96) of the *Legend of the Holy Girdle* at the parish church in Prato, and on 10 July 1457 he and Domenico Veneziano appraised Pesellino's unfinished *Trinity with Saints* (London, N.G.) for a confraternity in Pistoia. In 1458, after Pesellino's death, Lippi accepted an offer to complete it; by early June 1459 he had finished the main panel. The predella was executed by his workshop. On 1 May 1456 Lippi abducted Lucrezia Buti, a nun in the Augustinian convent of S Margherita, Prato, where he was chaplain. She was soon living with him, to be joined later by her sister and the three remaining nuns from the convent. At first Lippi was not penalized, but on

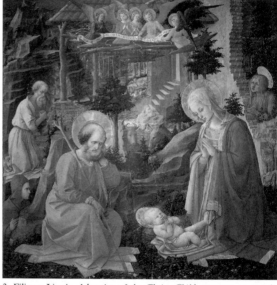

3. Filippo Lippi: *Adoration of the Christ Child*, tempera on panel, 1.37×1.34 m, *c.* 1453 (Florence, Galleria degli Uffizi)

8 May 1461 a public denouncement of him mentioned a son, namely (2) Filippino Lippi. By 1465 Filippo had been stripped of all his benefices, although, according to Vasari, he was permitted to continue living with Lucrezia. In the same year she bore him a second child, a daughter named Alessandra.

Lippi's last works include the *Virgin and Child with Two Angels* (Florence, Uffizi) and frescoes of the *Life of the Virgin* in the apse of Spoleto Cathedral, begun in May 1466. At the end of 1468, some scaffolding was dismantled, suggesting that the upper scene of the *Coronation of the Virgin* (see fig. 4) was complete. The combination of bold compositional design and rich technique, together with the brilliant illusion of distance, including sunset views over the Umbrian hills, suggests that this scene is Lippi's own work. From this date onwards, however, recurring ill-health must have prevented him from working, and the later frescoes, especially the *Nativity*, show the intervention of assistants. After Lippi's death, Fra Diamante took over, completing the cycle by 23 December 1469. For this he received about a fifth of the total fee of 697 ducats.

On the whole, Lippi enjoyed the steady support of loyal and accommodating patrons. Most of his known commissions derived from the Medici and allied families such as the Martelli, Alessandri, Benci and Inghirami. Some of his works served the cause of diplomacy, being sent as gifts to Pope Eugenius IV, Cardinal Marco Barbo and Alfonso V, King of Sicily and Naples. Notwithstanding Lippi's known delays, the Medici remained loyal patrons. Although his early works were for the Carmelite Order, he later worked for other orders and congregations.

2. WORKING METHODS AND TECHNIQUE. Lippi worked both in tempera on panel and in fresco. In early panel paintings such as the *Mourning St John the Evangelist* (priv. col., see Christiansen, 1985) he showed a penchant for finely applied glazes, often placing contrasting hues over each other, as in the figure of Gabriel in the *Annunciation* (Munich, Alte Pin.). Details of clothing and landscape are exquisitely wrought. This attention to technique and use of line must have led to the interest in Netherlandish painting evident in his Tarquinia *Virgin and Child*. The Barbadori Altarpiece depends on sculpture as a source of new pictorial ideas. It was usual for Lippi to experiment continually with his compositions until the desired result had been obtained, and the dramatic spatial effects in the foreground of the Barbadori Altarpiece were apparently a late revision. In the Uffizi *Coronation of the Virgin*, details were suppressed as the painting neared completion, while others were added. X-ray examination of a late *Virgin and Child* (Munich, Alte Pin.) has revealed that the Christ Child was originally placed higher up, in the same pose as that of the Uffizi *Virgin and Child with Two Angels*. In the Prato frescoes black *pastiglia* outlining is used to emphasize the protagonists of each story, and the landscapes are full of the sort of rich detail more often found in panel paintings. In the *Feast of Herod*, Lippi made extensive use of *a secco* technique.

Lippi's only documented drawing is the sketch for an altarpiece made on a letter to Giovanni Cosimo de' Medici of 1457. The drawing of a *Crucifixion with Saints* (early to mid-1440s; London, BM, 1936–10–10–9) is executed in a

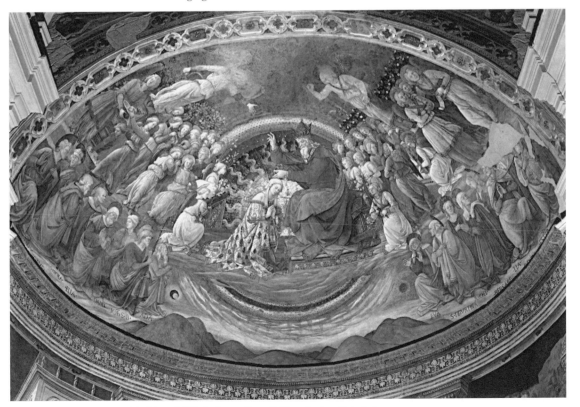

4. Filippo Lippi: *Coronation of the Virgin* (1466–8), fresco, diam. 10.95 m, Spoleto Cathedral

similarly rapid, impressionistic manner. Neither this nor the two figures on a double-sided sheet (late 1430s–early 1440s; London, BM, 1895–9–15–442) can be associated with any known paintings by Lippi. The double-sided sheet contains a standing female saint on the *recto* (probably a Virgin for a projected Crucifixion scene) and a clerical figure on the *verso*. They are executed in metalpoint and black chalk and heightened with white lead, rich in chiaroscuro effects and with vivid emotional expression. A new addition to the small corpus of autograph drawings by Lippi is a copy after Masaccio's figure of *St Peter Baptizing the Neophytes* in the Brancacci Chapel, executed in black chalk and pen and brown ink and heightened with white (Florence, Uffizi, 65). This work eloquently illustrates Vasari's claim that on Masaccio's death his spirit passed into the body of his follower Fra Filippo Lippi.

3. WORKSHOP ORGANIZATION. Vasari reported that Botticelli, Pesellino and Jacopo del Sellaio were among Lippi's pupils, and although there is no documentary evidence, it seems that this statement is true. Botticelli in his earliest years reworked several of Lippi's compositions and is believed to have taught Filippino Lippi. Filippo probably hired Pesellino for specialized work such as painting small-scale narrative scenes, at which he excelled. This was probably the case with the predella (divided between Paris, Louvre, and Florence, Uffizi) that he painted for Lippi's *Virgin and Child with SS Francis, Damian, Cosmas and Anthony of Padua* in the mid-1440s. Motifs from the oeuvre of each of these painters were plagiarized by the anonymous artist (or workshop) dubbed the PSEUDO-PIER FRANCESCO FIORENTINO (*see* MASTERS, ANONYMOUS, AND MONOGRAMMISTS, §I). Jacopo del Sellaio's earliest documented work is modelled on Botticelli rather than Lippi.

From *c.* 1440, when Lippi began work on the Uffizi *Coronation*, he appears to have made regular use of assistants. In 1445 and 1446 small payments were made to Fra Carnevale (described as Lippi's pupil), who may have worked on certain portions of the *Coronation* as well as on others of Lippi's commissions. On 17 July 1447 a 'Fra Diamante di Fra Filippo' received payment for gilding the altarpiece's temporary predella. Two other artists worked as partners in a very minor capacity. At Prato, Lippi was assisted by two *garzoni* named Jacopo and Domenico, the latter perhaps identifiable as Domenico Ghirlandaio. In Spoleto, Piermatteo d'Amelia (*c.* 1450–*c.* 1505) is named as a studio hand. The exact nature of the work assigned to such assistants is unknown, as is the manner of Lippi's workshop organization. Since he was not a member of the painters' guild, he probably had more flexibility in subcontracting or working in partnership. Like Pesellino, Giovanni di Francesco may also have worked with Lippi on a subcontractual basis. As Lippi's reputation grew, commissions of lesser importance were inevitably delegated to assistants, who were trained to counterfeit their master's style. From the mid-1440s, therefore, the quality of pictures produced in Lippi's workshop began to vary, and several of them require critical reappraisal. Those that Berenson assigned to an 'Angelican phase', for instance, may owe their character more to the handiwork of assistants than to the influence of Fra Angelico.

BIBLIOGRAPHY
F. Baldinucci: *Notizie* (1681–1728); ed. F. Ranalli (1845–7), i, pp. 507–13
I. B. Supino: *Fra Filippo Lippi* (Florence, 1902)
H. Mendelson: *Fra Filippo Lippi* (Berlin, 1909) [most of the essential Lippi docs are reproduced]
B. Berenson: 'Fra Angelico, Fra Filippo e la cronologia', *Boll. A.*, xxvi (1932–3), pp. 1–22, 49–66; Eng. trans. in *Homeless Paintings of the Renaissance* (Bloomington, IN, 1969), pp. 199–233 [fundamental for Lippi's chronology]
G. Poggi: 'Sulla data dell'affresco di Fra Filippo Lippi', *Riv. A.*, xviii (1936), pp. 95–106 [documentation for years at the Carmine]
G. Pudelko: 'Per la datazione delle opere di Fra Filippo Lippi', *Riv. A.*, xviii (1936), pp. 45–76
R. Oertel: *Fra Filippo Lippi* (Vienna, 1942) [good on patronage]
M. Pittaluga: *Filippo Lippi* (Florence, 1949) [cat., chronology and extensive illus.]
C. de Tolnay: 'The Autobiographic Aspect of Fra Filippo Lippi's Virgins', *Gaz. B.-A.*, xxxix (1952), pp. 253–64
M. A. Lavin: 'Giovannino Battista: A Study in Renaissance Religious Symbolism', *A. Bull.*, xxxvii (1955), pp. 85–101
M. Meiss: 'Jan van Eyck and the Italian Renaissance', *Atti del XVIII congresso internazionale di storia dell'arte, Venezia e l'Europa: 1955*, pp. 58–69
J. White: *The Birth and Rebirth of Pictorial Space* (London, 1957, rev. 2/1967/R New York, 1972), pp. 170–88
P. Caioli: 'Un altro sguardo sulla vita di Fra Filippo Lippi', *Carmelus*, v (1958), i, pp. 30–72
E. Borsook: 'Fra Filippo Lippi and the Murals for Prato Cathedral', *Mitt. Ksthist. Inst. Florenz*, xix (1975), pp. 1–148
G. Marchini: 'Una curiosità sul Lippi', *Archv. Stor. Prat.*, li (1975), ii, pp. 171–5
——: *Filippo Lippi* (Milan, 1975)
J. Ruda: 'The National Gallery Tondo of the *Adoration of the Magi* and the Early Style of Filippo Lippi', *Stud. Hist. A.*, vii (1975), pp. 6–39
A. Sabatini, ed.: *Atti dei capitoli provinciali dei Carmelitani, 1375–1491* (Rome, 1975), p. 173
M. Boskovits: 'Appunti sull'Angelico', *Paragone*, 313 (1976), pp. 30–54 (45–7)
L. De Angelis and A. Conti: 'Un libro antico della sagrestia di Sant'Ambrogio', *An. Scu. Norm. Sup. Pisa*, ser. 3, vi/1 (1976), pp. 97–109
F. Ames-Lewis: 'Fra Filippo Lippi and Flanders', *Z. Kstgesch.*, xlii (1979), pp. 255–73
E. Borsook: 'Cults and Imagery at Sant'Ambrogio in Florence', *Mitt. Ksthist. Inst. Florenz*, xxv (1981), pp. 147–202
J. Ruda: *Filippo Lippi Studies: Naturalism, Style and Iconography in Early Renaissance Art* (New York, 1982)
E. W. Rowlands: *Filippo Lippi's Stay in Padua and its Impact on his Art* (diss., New Brunswick, NJ, Rutgers U., 1983)
K. Christiansen: 'New Light on the Early Work of Filippo Lippi', *Apollo*, cxxii (1985), pp. 338–43
M. Boskovits: 'Fra Filippo Lippi, i Carmelitani e il rinascimento', *A. Crist.*, 715 (1986), pp. 235–52; repr. in *Immagini da meditare: Ricerche su dipinti di tema religioso nei secoli XII–XV* (Milan, 1994), pp. 397–435 [excellent on Carmelite history and patronage, several erroneous attributions]
Disegni italiani del tempo di Donatello (exh. cat. by A. Angelini, Florence, Uffizi, 1986), pp. 40–53
E. W. Rowlands: 'Filippo Lippi and his Experience of Painting in the Veneto Region', *Artibus & Hist.*, xix (1989), pp. 53–83
J. Shearman: *"Only Connect . . .": Art and the Spectator in the Italian Renaissance* (Princeton, 1992), pp. 70–77
J. Ruda: *Fra Filippo Lippi: Life & Work with a Complete Catalogue* (London, 1993)
F. Ames-Lewis: 'Fra Angelico, Fra Filippo Lippi and the Early Medici', *Early Medici and their Artists*, ed. F. Ames-Lewis (London, 1995), pp. 107–24
M. P. Mannini: 'La bottega tarda di Filippo: *La Nativià con S Giorgio e S Vincenzo Ferrer*', *Natività di Filippo Lippi: Restauro saggi e ricerche*, ed. M. P. Mannini (Prato, 1995), pp. 9–15
A. De Marchi: 'Un raggio di luce su Filippo Lippi a Padova', *Nuovi Stud.*, i (1996), pp. 5–23

ELIOT W. ROWLANDS

(2) Filippino Lippi (*b* Prato, *c.* 1457; *d* Florence, 18 April 1504). Son of (1) Filippo Lippi. He was a painter of

altarpieces, *cassone* panels and frescoes and also an exceptional draughtsman. His success lay in his ability to absorb, without slavishly following, the most popular trends in contemporary painting. He worked in Florence and Rome at a time when patrons were beginning to intermingle personal, religious, social and political ideals in their ambitions for palaces and chapels: with the support of wealthy and erudite patrons, such as Lorenzo de' Medici ('il Magnifico') and Filippo Strozzi, he won important civic and private commissions. Lippi's most distinguished achievement was the decoration of the Strozzi Chapel in S Maria Novella, Florence.

1. Life and work. 2. Working methods and technique.

1. LIFE AND WORK.

(i) Training and early work in Florence and Lucca, before *c.* 1485. (ii) Early maturity, *c.* 1485–7. (iii) Carafa Chapel, Rome, and other contemporary work, 1488–93. (iv) Late work, 1494 and after.

(i) Training and early work in Florence and Lucca, before c. *1485.* Filippino received his first training from his father. He was in Spoleto between 1467 and 1469, when Filippo Lippi was painting the cathedral choir, and there received his earliest technical training in fresco work. His father died in October 1469, and Filippino left Spoleto in 1470, probably with his appointed guardian, Fra Diamante, Filippo's assistant. Around 1472 Filippino was apprenticed to Sandro Botticelli; in 1472 and 1473 his name appears in the ledger of the Florentine Compagnia di S Luca, linked with that of Botticelli.

Several paintings have been assigned to Filippino's early career (1475–81), yet this period remains the most problematic to reconstruct. Not one painting is signed, dated or unquestionably connected to a patron, and each was once attributed to another painter: to a Fra Filippo follower; to Botticelli or a follower; to Ghirlandaio; and most often to 'Amico di Sandro', an entity Berenson fabricated (1899) to identify a painter influenced by, but distinct from, Botticelli and Filippino. Berenson later reassigned Amico's works to Filippino (1932), a judgement with which most scholars concur. Included in the works that have been dated before 1482 are several small, devotional panels and narrative scenes: the *Virgin and Child with the Infant St John the Baptist* (London, N.G.); the *Virgin and Child* (Florence, Uffizi); the *Virgin and Child* (ex-Kaiser-Friedrich Mus., Berlin, destr.); *Tobias and the Angel* (Washington, DC, N.G.A.); the *Adoration of the Christ Child* (St Petersburg, Hermitage); and the *Adoration of the Magi* (London, N.G.). These panels are influenced in various ways by aspects of the art of Fra Filippo, Botticelli and Verrocchio and reveal a burgeoning interest in the kind of landscape enriched with monasteries, castles, bridges, lakes and the activities of people and animals that is present in Filippino's later paintings.

Also often assigned to Filippino's early period are paintings that were once furniture (*cassone*) panels. Among these are five panels showing the *Story of Esther* (one each Paris, Louvre; Chantilly, Mus. Condé; Florence, Mus. Horne; and two panels Ottawa, N.G.); one oblong panel of the *Story of Virginia* (Paris, Louvre) and one oblong panel of the *Story of Lucretia* (Florence, Pitti). All of the panels reflect characteristics of Fra Filippo's figures and architecture, filtered through Botticelli. Fra Filippo's indoor arcades, open-air loggias, piers penetrated with long, rectilinear slots, and multilevel stages appear in the scenes of *Esther, Virginia* and *Lucretia*, but with a greater unity between the paved, urban foreground and the distant countryside. The architecture serves to unify a series of events and to convey the development of the narratives, in which theatrical figures enact desperate events. The panels are not, however, stylistically homogeneous: they should be dated nearer to the 1490s.

In 1481, when Botticelli was called to Rome to decorate the Sistine Chapel in the Vatican, Filippino was probably in Lucca. His *SS Roch, Sebastian, Jerome and Helena* (Lucca, S Michele), in which four saints stand together in a single setting, is one of the earliest paintings securely attributable to him. The panel seems cut at the top and sides and lacks the focal-point that an additional panel or panels would provide. Two panels, one with *SS Bernard and Apollonia* and the other with *SS Paul and Frediano* (Los Angeles, CA, Norton Simon Found.), have been identified (Meiss, 1973) as the tabernacle wings of a single altarpiece in S Ponziano, Lucca, that was described by Vasari. All three panels contain contemplative, lanky figures linked through the proximity of their arms and hands, with twisted fingers and exaggerated joints and veins that reveal Filippino's debt to Botticelli, although gesture and expression are subtler and softer than in Botticelli's art. The saints of these two panels look forward to the physically and psychologically refined and integrated figures that Filippino produced *c.* 1485. His increasing success was marked, in 1482, by his being selected to replace Perugino in the execution of a fresco in the Palazzo della Signoria (now the Palazzo Vecchio), Florence. His earliest recorded commission for the Strozzi family, for a wall hanging in their family chapel in S Maria Novella, Florence, dates from the same year.

(ii) Early maturity, c. 1485–7. Around 1485 Filippino was asked to complete a cycle of frescoes on the *Life of St Peter* in the Brancacci Chapel, S Maria del Carmine, which Masolino and Masaccio had left unfinished nearly 60 years before. Filippino began by completing Masaccio's unfinished scene of the *Raising of the Son of the Prefect of Antioch* on the lower-left wall register. More than half the wall had already been painted, and Filippino harmonized his work with Masaccio's; yet his preference for leaner and less volumetric figures and for breaking solid areas of colour is apparent. Vasari singled out several recognizable portraits, including that of Piero del Pugliese (third from far left), one of the artist's patrons. The composition is enlivened by rhythmic gestures; Filippino's aristocratic figures are restrained and elegant, and the collars, hems and loose-fitting sleeves of their garments delicately trimmed with white. He applied the pigment like thread, tacking bodies together and snapping life into sombre colour combinations. The opposite wall, where Filippino painted the entire register, is considerably more open and lively. He placed three events within one register: *Peter and Simon Magus before Nero, Peter Led to Execution* and the *Crucifixion of Peter* (see colour pl. 1, XXXVIII2). A hallmark of his style is evident here in the animated effect obtained by amalgamating ornamental and human forms:

the soldiers, for instance, are intertwined through gestures, drapery folds, inclined heads, colours of similar hue and value and similar body types.

On 20 February 1486 Filippino completed the *Virgin Enthroned with SS John the Baptist, Victor, Bernard and Zenobius* (Florence, Uffizi; see fig. 1) for one of the governing bodies of Florence, the Otto di Pratica, who had commissioned the altarpiece for a new altar in the council chamber of the Palazzo della Signoria. The prestigious commission marks a critical point in Filippino's career. In this innovative work he replaced the remote and still images of the traditional *sacra conversazione* with life-size, emotive figures, who participate in a developing drama. Nothing is static: Filippino created the dynamism of an unfolding moment by activating nearly every painted inch of the panel and by compressing the figures into a shallow room almost too small to contain them. The walls of this room are reduced to a series of quickly receding, stepped planes that are laden with organic and geometric patterns. The solid forms seem almost to flex under the pressure of the ornate embellishments. There is a clear debt, as often in his career, to sculpture, in particular to the late works of Donatello and to works by Verrocchio; Filippino's figure of John the Baptist is closely modelled on that of Thomas in Verrocchio's group of the *Incredulity of Thomas* (*c.* 1466–83; Florence, Orsanmichele; *see* VERROCCHIO, ANDREA DEL, fig. 1).

Around 1485–7 Filippino painted one of his most renowned works, the *Virgin Appearing to St Bernard* (Florence, Badia Fiorentina; see fig. 2), for the family chapel of Piero del Pugliese in the monastery church of Le Campora at Marignolle near Florence. Pugliese appears at the lower right, near Bernard, who sits outdoors at a writing desk. Filippino showed Bernard as a scholar absorbed in a mystical vision of the Virgin descending to earth, accompanied by angels and offering him spiritual nourishment. Touching her breast with one hand and the page with the other, she enlivens Bernard's text with the milk of wisdom. For the image of Bernard, Filippino looked to Botticelli's archetypal mystic, *St Augustine* (Florence, Ognissanti; see colour pl. 1, XIV1), whose miraculous revelation is materialized by his vibrating body. Yet whereas Botticelli painted a moment suspended in time, Filippino created a temporal and fleeting instant. To this end, he bestirred and particularized every detail of nature. Knowledge of Leonardo's seamless integration of human forms in nature and of his light, with its warm, life-giving qualities, helped Filippino to integrate the things of heaven and earth; the sky still glows after Mary and the angels' descent. They are welcomed on earth by a flourishing nature that bristles with energy. Filippino learnt from Hugo van der Goes's Portinari Altarpiece (*c.* 1473–9; Florence, Uffizi), which entered Florence in May 1483, how to describe seasonal changes in nature and how to populate a hillside with anecdotal information. His landscape backgrounds were also influenced by Antonio del Pollaiuolo and the *Virgin and Child with Angels* (Florence, Uffizi) by Hans Memling (1430/40–94). By 1487 Filippino had become a reputable and popular painter, and it was probably in this year that he began fresco decorations in the Villa Spedaletto (destr.) for Lorenzo de' Medici.

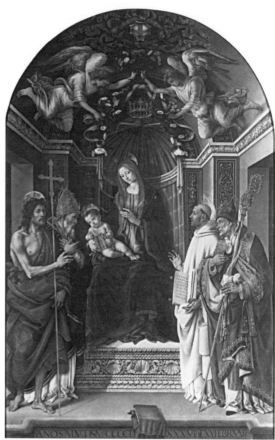

1. Filippino Lippi: *Virgin Enthroned with SS John the Baptist, Victor, Bernard and Zenobius*, oil on panel, 3.55×2.25 m, 1486 (Florence, Galleria degli Uffizi)

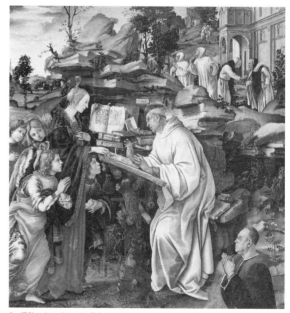

2. Filippino Lippi: *Virgin Appearing to St Bernard*, oil on panel, 2.10×1.95 m, *c.* 1485–7 (Florence, Badia Fiorentina)

(iii) Carafa Chapel, Rome, and other contemporary work, 1488–93. In 1488 Filippino went to Rome on Lorenzo de' Medici's recommendation and accepted a commission from the Neapolitan cardinal Oliviero Carafa (2 Sept 1488) to decorate a burial chapel in the Dominican church of S Maria sopra Minerva. Before starting work, he returned to Florence twice: to make the first of two wills (21 Sept 1488) and in the following year to work on the fresco decoration in the Strozzi Chapel in S Maria Novella, for which he had signed a contract with the wealthy banker Filippo Strozzi on 21 April 1487, in which it was stipulated that the work would be completed by 1 March 1490. Filippino probably also went to Venice, fulfilling another stipulation in the Strozzi contract. He was back in Rome shortly afterwards and, apart from a design submitted to a competition for the Florence Cathedral façade in 1491 (perhaps sent from Rome), is not recorded in Florence again until 1494. Work ended in the Carafa Chapel either by 25 March 1493, when Pope Alexander VI visited it on the Annunciation feast day, or two months later, when he granted indulgences to worshippers at the chapel.

The chapel was dedicated to the Virgin of the Annunciation and to St Thomas Aquinas. On the vault Filippino painted four sibyls—the Cumaean, the Delphic, the Tiburtine and the Hellespontine—each of whom appears with angels, texts, scrolls and plaques. On the altar wall he painted the *Assumption of the Virgin*, surrounding a frescoed altarpiece framed by marble, depicting the *Annunciation with St Thomas Aquinas Presenting Cardinal Carafa to the Virgin*. In the lunette of the west wall he painted a *Miracle of St Thomas* and, beneath this, the *Triumph of St Thomas*. No frescoes remain on the east wall; they were destroyed when a marble wall tomb was made for the Cardinal's nephew, Pope Paul IV, in the later 16th century. Vasari described allegories of Virtues conquering Vices, and these may be the subjects of the lost frescoes. On the stuccoed barrel vault of an oblong chamber behind the east wall are *Stories of Virginia* and allegorical figures designed by Filippino and painted by Raffaellino del Garbo.

Filippino's unique talent was his ability to translate erudite Dominican doctrine into lively tangible forms and to give immediacy and life to the abstract ideas of ancient history. Each sibyl covers more area of the quadrant than earlier vault figures had done, and each prophetess seemingly reaches out to initiate the chain of events on the walls below. The altar wall is most prominently connected with the patron. Filippino painted Carafa inside the very room of the Annunciation, where his presence serves to emphasize the Virgin's role as mediator between heaven and earth. The Virgin ascending to heaven dominates the wall, her figure seeming to increase in volume as she is lifted upwards. Filippino accomplished this illusion by greatly amplifying the drapery that envelops her, thereby drawing attention to the entry of the Virgin's incorruptible body into heaven, where she became a mediator for humanity. Mary is confirmed in her new role as she looks downward from heaven towards the kneeling Carafa. This *Assumption* seems indebted to Mantegna's in the Ovetari Chapel in the church of the Eremitani, Padua, which Filippino may have studied on his way to Venice. In the frescoes of the *Life of St Thomas*, Filippino gave life to the

drama by varying the size and location of the figures. The largest figure in the *Triumph of St Thomas* is a hulking Dominican, a type derived from Fra Filippo and Donatello, which Filippino positioned at the chapel's entrance to introduce and to link the walls of the chapel; the figure probably represents Friar Joachim Torriani, Master General of the Order. In these frescoes Filippino was responding to the relics of the Roman Classical world; there is a wealth of detailed information that includes Roman monuments, descriptive reliefs on giant pilasters, inscribed texts, plaques and scrolls. He must have exchanged ideas with Mantegna and other painters, including Pinturicchio, whose illusionistic architectural constructions in the Bufalini Chapel in S Maria in Aracoeli, Rome, influenced many painters.

(iv) Late works, 1494 and after. Filippino was again in Florence in 1494. He designed a window in Santo Spirito for the Tanai de' Nerli family chapel, depicting *St Martin and the Beggar* (untraced), and painted an altarpiece of the *Virgin and Child and SS Catherine and Martin with Tanai and his Wife*, works that functioned in concert. A presentation drawing (Florence, Uffizi; see fig. 3) for the window shows Filippino's mastery in disposing the figures within a narrow, vertical format: the telescoped niche, the fluidly interlocked figures of Martin, horse and beggar, and the antique elements above and below the group are all bound into one animated and majestic element. Two tritons ceremoniously display the Nerli family crest, and members of the family itself appear prominently in the altarpiece, placed directly below the stained glass. Compared with figures in the altarpiece of 1486, painted for the Palazzo della Signoria, these figures are solid, three-dimensional types with identifiable temperaments. Tanai and Nanna with age-etched faces are portrayed as pious, beseeching people kneeling before the Virgin, yet in the background they stand proudly by their palazzo with one of their children. Filippino subtly inserted anecdotal details about the family where information about saints would normally be expected. The realistic handling of details in this altarpiece reflects an increased interest in Netherlandish art, as well as the influence of Piero di Cosimo's work.

Probably completed after the Nerli altarpiece are the *Annunciation* tondi for the San Gimignano town hall: two large round panels, one showing the *Angel Gabriel* and the other the *Virgin Mary* (both San Gimignano, Mus. Civ.). Filippino understood the subtleties of the drama in Leonardo's *Annunciation* (Florence, Uffizi; see colour pl. 1, XXXVI1), particularly the visual significance of Leonardo's low horizontal wall, which simultaneously separates and connects the Virgin and Gabriel. The solemn drama unfolds in two distinct moments, on two panels with independent perspectives intended for separate inspection. It is the Virgin's chamber that holds the attention longer, with its emphasis on the unseen miracle taking place in her body. The use of diagonals and lighting to this end is similar to the use of angles of the architecture in Leonardo's *Annunciation*. Yet Filippino gave greater immediacy to the drama by giving the Virgin a massive body that glows with light and bends forward, seemingly pulled by the unyielding weight of her cloak. Leonardo's influence is again present in the *Adoration of the Magi* (Florence,

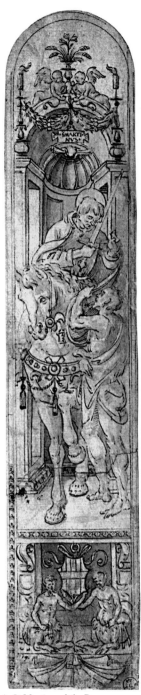

3. Filippino Lippi: *St Martin and the Beggar*, pen and brown ink and brown wash, over traces of black chalk, 382×76 mm, 1494 (Florence, Galleria degli Uffizi)

Leonardo's unfinished work) and orchestrated a range of movements, emotions and physiognomic types (including several portraits) that animate the event with whirling activity.

In 1498 Filippino made a second will, after marrying Maddalena di Pietro Paolo Monti the year before; he also received a prestigious commission for the main council chamber of the Palazzo della Signoria (it was never executed), and he was asked to give advice on repairing the dome of Florence Cathedral. The largest painting he completed that year (dated on the painting) was an outdoor frescoed tabernacle of the *Virgin and Child with SS Stephen, Catherine, Anthony Abbot and Margaret* (Prato, Mus. Com.). Here Filippino once again gave tangibility and immediacy to the mystical presence of the Virgin and Child in a *sacra conversazione*. A three-dimensional niche with side walls positioned at 90° angles afforded him a way to bring the flanking saints into intimate contact with the Virgin and Child, while simultaneously isolating them. Though the saints' figures ostensibly break through the boundaries of the side wall-frames, the honoured positions of the Virgin, weightless and looming as the Queen of Heaven, and of the Infant Jesus as the *Salvator mundi* (Saviour of the World, blessing with his right hand and holding an orb in his left) are manifestly clear. The significance of the Virgin and Child for all time is revealed in the central panel, where sphinxes, the ancient guardians of religious mysteries, support the sacrificial altar table at the Virgin's feet, and plump seraphim, heaven's guardians, encircle the regal couple.

While these and other works were in progress, Filippino continued to paint the Strozzi Chapel, probably completing most of the decoration between 1497 and 1500. The scene of the *Raising of Drusiana* is signed and dated 1502, and the stained-glass window was put in place in 1503. Filippo Strozzi's will had stipulated that the chapel (commissioned in 1487) was to be completed by 1493, and in 1497 Filippino's slow progress led to a court case, after which his fee was increased. Payments to Filippino are documented, but precisely what scenes were completed when is not recorded. On the vault quadrants are the Old Testament patriarchs: *Abraham, Adam, Noah* and *Jacob*. Beneath *Abraham*, on the east wall, are scenes from the *Life of St Philip*, Strozzi's patron saint: the *Crucifixion of St Philip* (lunette) and, below, *St Philip Exorcizing a Demon*. The chapel is dedicated to St John the Evangelist, scenes from whose life are painted on the west wall, below *Noah*: *St John Boiled in Oil* (lunette) and below, the *Raising of Drusiana* (fig. 4). These scenes, enriched with exuberant ornament, much of it derived from antiquity, culminate on the altar wall with a *tour de force* of illusionistic architecture: a Classical triumphal arch, painted in grisaille with touches of colour, surrounding the arched recess that holds Filippo Strozzi's basanite tomb (1491–5) by Benedetto da Maiano. Above the tomb is the great stained-glass window (designed by Filippino before 1497), depicting the *Virgin and Child with SS Philip and John the Evangelist*, with fictive mouldings and grotesque decoration lining the window embrasure. Above the tomb recess are winged genii attending to bones and skulls. Personifications of Virtues, Muses, and Music occupy the lower zone while angels of mythic size stand atop projecting

Uffizi) completed on 29 March 1496 (signed and dated on the back) for S Donato a Scopeto, outside Florence. This painting was commissioned to replace one begun by Leonardo (1472–82; Florence, Uffizi; *see* LEONARDO DA VINCI, fig. 1) but left unfinished on his departure for Milan. Filippino organized figures around a pyramidal structure with the Virgin and Child at the apex (similar to

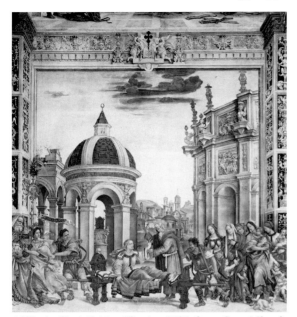

4. Filippino Lippi: *Raising of Drusiana* (1502), fresco, Strozzi Chapel, S Maria Novella, Florence

entablatures supporting inscribed plaques, brandishing banners and holding shields bearing the Strozzi arms by their sides. The Strozzi frescoes are the culminating point of Filippino's quest for illusionism and for unity—not a quiet or inert unity, but the fusion of many richly embellished and interactive parts.

Filippino's late works reflect an interest in volumetric figures, sombre colours and solid, monumental forms arranged formally in open-air settings. In 1501 he painted the *Mystic Marriage of St Catherine, Attended by SS Joseph, John the Baptist, Peter, Paul and Sebastian* for the Isolani family chapel in S Domenico, Bologna, inscribing his name and the date on a stone fragment in the right foreground. His stately Virgin and Child are surrounded by saints who theatrically call attention to their attributes (Peter's keys, Catherine's wheel, Paul's sword, and Sebastian's arrows), and the painting sets up a hierarchy between heaven and earth through the placing of the figures of heaven (God and angels) so far away from the spectator that the saints, who are nearer but elevated to an inaccessible level, seem to occupy a plateau midway between heaven and earth.

So renowned was Filippino in his lifetime that shops in the Via dei Servi, Florence, closed on the day of his burial in S Michele Visdomini, Florence. Early in his career (*c.* 1492–4) the agent of Ludovico Sforza, Duke of Milan, had commented that it would be difficult to choose the foremost among the painters working at Lorenzo de' Medici's Villa Spedaletto, adding that Filippino's art was sweeter, yet less artful, than that of Botticelli. In his *Summa de arithmetica* (Venice, 1494) Fra Luca Pacioli praised Filippino and Botticelli as masters of perspective. In the early 16th century Paolo Cortese, in *De cardinalatu* (1510), recommended that the ideal imagery for a cardinal's chapel could be seen in the Carafa Chapel in S Maria sopra Minerva. Certainly Filippino's knowledge of illusionistic devices and antique ornaments would have interested

Pope Julius II (the dedicatee of Cortese's book), Raphael and Michelangelo. Yet later in the 16th century his fame diminished quite rapidly, and, although he may have influenced 16th- and 17th-century art, he remains in the shadow of Botticelli and Leonardo.

2. WORKING METHODS AND TECHNIQUE. Filippino was a prolific draughtsman, who prepared his panel paintings and frescoes through a series of drawings that included rapid sketches in which he recorded his first ideas; finished composition and presentation drawings; figure drawings; and studies of individual details, such as head and drapery. More drawings have been attributed to him than to any other 15th-century Florentine painter apart from Leonardo, and this may be due to the nature of his training and to his complex iconographical programmes. His compositional drawings are generally in pen and ink, with some wash, on white paper; the first sketches were begun in black chalk, which he later went over with pen and ink. For figure drawings he used metalpoint on coloured prepared paper, enlivened with white lead highlights.

Lippi's early drawings are not connected with specific paintings, but a study for the figure of *St Bernard* (Florence, Uffizi) in the *Virgin Appearing to St Bernard* (*c.* 1485–7) survives, and after this date drawings associated with known paintings increase. In the drawing Filippino conceived the ledge beneath St Bernard as a flat and immobile plank, but in the picture it is tilted. This is characteristic of his tendency to transform the settings in his final works, a tendency confirmed by the exceptionally spirited compositional drawing in pen, brown ink and brown wash (London, BM), for the fresco of the *Triumph of St Thomas* in the Carafa Chapel. In the drawing the figures move freely in space, while in the final composition they are more severely contained by the architecture. These changes satisfied the demands of the patron and also enabled Filippino to include a richer display of ornament. His late metalpoint studies, among which are a *Study for the Head of Piero del Pugliese* (Milan, Ambrosiana) in the Uffizi *Adoration* and the *Head of a Man* (*c.* 1495; Windsor Castle, Berks, Royal Lib.), executed on blue-grey prepared paper with blue heightening, are distinguished by an increasingly expressive use of the medium.

The decoration of the Strozzi Chapel reveals Filippino's confidence and experience as a fresco painter. The contract stipulated that he alone was to execute the murals, in true fresco, and using the most expensive colours, especially lapis lazuli, and gold leaf for the haloes and highlights of the jewellery. The large size of the *giornate* indicates that he worked quickly; no *sinopie* have been found, and he used cartoons for the minor figures and ornament (Borsook, 1970). Several drawings give an idea of the changes in direction that he took while making preliminary studies. The ideas in a preliminary drawing for the *Raising of Drusiana* (Florence, Uffizi), begun in black chalk and gone over in pen and ink with a light use of wash, showing Filippino's interest in the dynamic relationships between figures and architecture, are taken much further in the fresco, where figures nearly explode the parameters of shallow spaces. An abundance of descriptive detail in clothing and in physiognomy interlocks figures into an

excited animation. The architecture is no longer central but placed off balance; planes tilt to intensify the rapid movements of the concentrated masses of people. At least two drawings were done for the patriarchs, showing a change in Filippino's plan for the ceiling figures. One of the two (Florence, Uffizi, 134E) describes calmer, seated figures, while the other, the *Study of Four Seated Nude Men* (Lille, Mus. B.A., 290), defines more active, twisted and volumetric forms that are closer to the complex movements of the painted figures: Adam twists around Seth as the serpent Eve coils about the tree, and Abraham's billowing garments envelop and expand his body nearly to the width of the frame. Filippino enlivened Abraham with light, bright colour changes that are similar to the way patches of light define the muscle tissue of the figures in the Lille drawing. His knowledge of Pollaiuolo's figures for the tomb of *Sixtus IV* and of antique sculpture, such as the personification of the River Nile in Monte Cavallo in Rome, is apparent. Yet he never laboriously copied sources. His drawn studies of antique ornaments (e.g. Florence, Uffizi, 1636E; 6333–6335E) capture the lively essence of the decoration rather than record archaeological detail.

BIBLIOGRAPHY

G. B. Cavalcaselle and J. A. Crowe: *History of Painting in Italy* (London, 1864)
B. Berenson: 'Amico di Sandro', *Gaz. B.-A.*, xxi (1899), pp. 459–71; xxii (1899), pp. 21–36
——: *The Study and Criticism of Italian Art* (London, 1902)
——: *Drawings of the Florentine Painters*, 3 vols (London, 1903/*R* Chicago, 1938; rev. N. Mariano and L. V. Nicolson, Milan, 1961)
A. Scharf: *Filippino Lippi* (Vienna, 1935)
K. Neilson: *Filippino Lippi* (Cambridge, MA, 1938)
A. Scharf: *Filippino Lippi* (Vienna, 1950)
Mostra di disegni di Filippino Lippi e Piero di Cosimo (exh. cat. by M. Fossi-Todorrow, Florence, Uffizi, 1955)
L. Berti and U. Baldini: *Filippino Lippi* (Florence, 1957)
F. Gamba: *Filippino Lippi nella storia della critica* (Florence, 1958)
E. Borsook: *The Mural Painters of Tuscany: From Cimabue to Andrea del Sarto* (London, 1960, rev. Oxford, 1980)
S. Sandström: *Levels of Unreality* (Uppsala, 1963)
C. Bertelli: 'Il restauro della Cappella Carafa in S Maria sopra Minerva a Roma', *Boll. Ist. Cent. Rest.*, xlii (1965), pp. 145–95
E. Winternitz: *Musical Instruments and their Symbolism in Western Art* (New York, 1967), pp. 166–84
E. Borsook: 'Documents for Filippo Strozzi's Chapel in S Maria Novella and Other Related Papers - I', *Burl. Mag.*, 112 (1970), pp. 737–45
——: 'Documents for Filippo Strozzi's Chapel in S Maria Novella and Other Related Papers - II', *Burl. Mag.*, 112 (1970), pp. 800–04
D. Friedman: 'The Burial Chapel of Filippo Strozzi in Maria Novella in Florence', *L'Arte*, ix (1970), pp. 108–31
M. Meiss: 'A New Monumental Painting by Filippino Lippi', *A. Bull.*, lv (1973), pp. 479–93
I. H. Shoemaker: *Filippino Lippi as a Draughtsman* (London, 1977)
R. Sale: *Filippino Lippi's Strozzi Chapel in Santa Maria Novella* (New York, 1979)
M. Lavin: *The Place of Narrative* (Chicago, 1990)
A. Cecchi: 'Filippino disegnatore per le arti applicate', *Florentine Drawing at the time of Lorenzo the Magnificent: Papers from a Colloquium held at the Villa Spelman: Florence, 1992*), pp. 55–61
J. Nelson: 'Filippino Lippi at the Medici Villa of Poggio a Caiano', *Florentine Drawing at the time of Lorenzo the Magnificent: Papers from a Colloquium held at the Villa Spelman: Florence, 1992*), pp. 159–74
P. Zambrano: '*The Dead Christ* in Cherbourg: A New Attribution to the Young Filippino Lippi', *Burl. Mag.*, cxxxviii/1118 (May 1996), pp. 321–4
The Drawings of Filippino Lippi and his Circle (exh. cat. by G. Goldner and C. C. Bambach, New York, Met., 1997)

MARILYN BRADSHAW

Lippi, Giovanni. *See* BIGIO, NANNI DI BACCIO.

Lodi, Callisto da. *See* PIAZZA, (1).

Lodi, Giovanni Agostino da. *See* GIOVANNI AGOSTINO DA LODI.

Lodi, Giovanni di Domenico da. *See* BATTAGGIO, GIOVANNI DI DOMENICO.

Lomazzo, Giovanni Paolo [Gianpaolo] (*b* Milan, 26 April 1538; *d* Milan, 13 Feb 1600). Italian writer, painter and draughtsman. He is best known for his writings, which include metaphysical discussions of the philosophy of artistic creation at levels of complexity to rival those from any period. He was a conspicuous figure in artistic and intellectual circles in North Italy and a painter of some reputation beyond Milan, but those of his works that survive do not suggest a talent of a higher order than that of a skilled late Mannerist working in an eclectic version of the Lombard style.

1. Early career: paintings and literary activities, 1560–71. 2. Later career: theoretical writings, 1571–91.

1. EARLY CAREER: PAINTINGS AND LITERARY ACTIVITIES, 1560–71. Born to a family of some social status, Lomazzo appears to have received a better education than most painters. Early indications of his artistic abilities led to his studying with the little-known Giovanni Battista della Cerva (*fl*?1540–48), an assistant of Gaudenzio Ferrari (whom Lomazzo appears to have regarded as his real master). Lomazzo's autobiography, published with his *Rime* in 1587, indicates that he received a steady stream of commissions for murals and altarpieces, once he became an independent master. His many connections, among whom was Giuliano Goselini (1525–87), secretary to successive dukes of Milan and a poet of some note, helped to ensure that he was also asked to supply numerous portraits of friends and aristocratic patrons.

He moved at ease within literary circles in Milan and became closely involved in an extraordinary burlesque 'academy' of letters. The Accademiglia dra Vall d'Bregn, founded in 1560, was dedicated to a contrived dialect, which purported to be the ancient language of Swiss wine porters working in Lombardy. The 160 members of the 'academy' were devoted both to social pleasures and to the promotion of a body of serio-comic literature in their deliberately arcane dialect.

In 1562 his frescoed copy (destr.) of Leonardo's *Last Supper* (Milan, S Maria delle Grazie) made for the refectory of the convent of S Maria della Pace, Milan, met with a hostile reception, and Lomazzo left Milan to travel within Italy and perhaps to Flanders, avidly observing a wide range of art. The formative influences on Lomazzo's style were the painters whose works he had seen in Milan, including, besides Leonardo, the Lombard Mannerists such as Aurelio Luini (1530–93) and Gaudenzio Ferrari, and the Bolognese Pellegrino Tibaldi. In these travels he developed a profound admiration for the draughtsmanship of Raphael and Michelangelo (whose 'serpentine' figure style he especially praised), while looking towards the Venetian masters for the handling of colour. By his own testimony he was also affected by the inventiveness of

Albrecht Dürer (1471–1528), whom he called 'the great Druid'. The resulting eclecticism of his style is typical of academic Mannerism in North Italy in the later part of the 16th century.

On his return to Milan in 1565, he undertook many religious and secular works, most of which have been lost or destroyed or remain unidentified. His major surviving cycle of religious paintings (1565) is in the Foppa Chapel of S Marco, Milan. The relatively sober altarpiece of the *Virgin and SS Peter, Paul and Augustine* is dated 1571. The cupola is decorated with grandiloquent images of the *Prophets and Sibyls*, and the apsidal semi-dome with a tumultuous vision of the angelic *Paradise*. The narratives on the walls depict the *Conversion of Saul* (almost obliterated) and the *Fall of Simon Magus*, who plunges headlong into the space of the mural in abrupt perspective. In his figure style Lomazzo strove to combine monumentality and complexity, exploiting rhetorical gestures to convey meaning. The vault figures are strongly foreshortened, and a preparatory drawing (Princeton U., NJ, A. Mus.; see fig.) shows that he used the *quadratura* technique of schematizing the figure into a series of box-like components to facilitate the placing of limbs in perspective.

In 1568 Lomazzo became 'Abbot' or '*Nabad*' of the Accademiglia, and a collection of his own literary com-

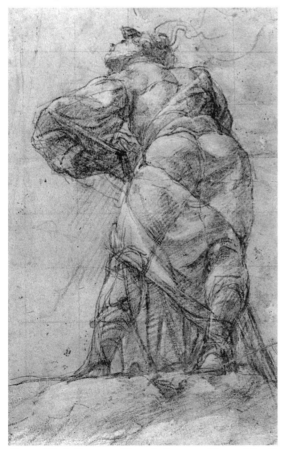

Giovanni Paolo Lomazzo: *Figure Study*, pen and brown ink with black and red chalk, 190×120 mm, *c.* 1565 (Princeton, NJ, Princeton University, Art Museum); for the prophet in the vault fresco (1565), Foppa Chapel, S Marco, Milan

positions was published in 1589 as *Rabisch dra Accademiglia dor compà Zavargna, Nabad dra Vall d'Bregn*. It is in this role that Lomazzo (or 'Zavargna', to give him his dialect name) appears in his *Self-portrait as Abbot of the Accademiglia* (1568; Milan, Brera). This iconographically complex work, painted in a chiaroscuro style that owes as much to Giorgione or Dosso Dossi as to Leonardo or his fellow Milanese artists, is his masterpiece as a painter of secular subjects. The image makes clear allusions to Bacchus as protector of the 'academy' and is loaded with other symbolic references. For instance, the robe signifies the weighty problems of his office, while the straw hat evokes humility. The compasses obviously refer to his insistence on mathematical precision, but, in conjunction with his riveting stare, may also allude to the Michelangelesque dictum that the painter should possess compasses in his eyes rather than his hands.

Lomazzo's dated pictures include: a massive *Quadragesimal Supper* ('Lenten Supper'; 1567; Piacenza, S Agostino; destr. but known through photographs and preparatory drawings in Windsor Castle, Royal Lib., and Oxford, Christ Church); a *Madonna di S Michele* (1570; Busto Arsizio, S Maria di Piazza) for S Romano, Lodi, and a *Crucifixion with the Virgin, St John and Mary Magdalene* (1571; Milan, Brera, on dep. Milan, Semin. Vescovile) for S Giovanni in Conca, Milan. His burgeoning career as a painter was cut short from 1571 by the progressive loss of his sight, and he subsequently devoted himself to his writings in art theory and other literary genres. His work as a painter has not been fully studied, and most of his activity as a portrait painter remains obscure. His leading pupil was Ambrogio Figino, who shared his academic instincts.

2. LATER CAREER: THEORETICAL WRITINGS, 1571–91. In 1584 Lomazzo published his *Trattato dell'arte de la pittura* and in 1590 his *Idea del tempio della pittura*, which contain his main body of writing on the visual arts. In addition to his *Rime* (1587) and *Rabisch* (1589), he also wrote a treatise on the Muses, intended to instruct painters and sculptors (*Della forma delle Muse*, 1591), and a manuscript of dreams and dialogues, *Gli sogni e ragionamento di Giovan Paolo Lomazzo milanese, con le figure de gli spiriti che li racontano* (London, BL).

In the *Trattato* and *Idea*, Lomazzo aspired to create a great, unified theory for the philosophy and practice of art within the context of an elaborate cosmological scheme, which was strongly coloured by Neo-Platonism and astrology, although he also drew on a number of Aristotelian scholastic sources, including St Thomas Aquinas (*see* AESTHETICS). His statements on the divine origins and spiritual transmission of beauty in the *Idea* were paraphrased from the commentary *De amore* (1469) on Plato's *Symposium* by the Renaissance philosopher MARSILIO FICINO. His fusion of astrological metaphysics with late medieval science owed much to Henricus Cornelius Agrippa's *De occulta philosophia* (pubd 1533), while the direct source for his seven-part 'temple of painting' was Giulio Camillo's *L'idea del teatro* (pubd 1550). He was not unfailingly successful in welding the ideas from his various sources into a consistent unity, and the editing of his texts

reflects the problems caused by his blindness, but the whole enterprise is impressive in scope and achievement.

The *Trattato*, the longer, more rambling and scholastic of these two works, is presented in seven books. The first deals with natural and artificial proportions as the harmonic foundations for art. In an elaboration of Albrecht Dürer's theories of proportion, expressed in the *Vier Bücher von menschlicher Proportion* (pubd 1528), Lomazzo outlined a number of systems of human proportion based on lengths both of face and of head and subsequently dealt with the proportions of children, horses and architecture. The second book is devoted to actions and gestures, establishing the principles of decorum and expression. The basic types of human nature are expounded through the four temperaments—choleric, sanguine, phlegmatic and melancholic—and in terms of the astrological influences of the seven planets. The attributes of Mars, for example, will be reflected by a fiery temperament and ruddy colouring, whereas the Sun will incline man in a majestic and 'Apollonian' direction. In Book 3 a scale of seven colours adapted from Aristotelian colour science—white, *palido* (pale or light violet), yellow, red, purple, green and black—is associated with the planets in such a way that the expressive qualities of each colour are identified with the characters of the deities. In his discussion of light in Book 4 he is predisposed to adopt the old and largely discredited notion from the Platonic tradition that seeing rays are emitted from the eye, although his system of classification for light and its behaviour is largely derived from medieval optical science, particularly that of Erasmus Witelo (*c.* 1233–*c.* 1278), whose treatise on optics, *Perspectiva*, dates from the early 1270s. His obsession with classifying and naming categories on the basis of book learning did not prevent Lomazzo here as elsewhere from making a series of sharply perceptive observations of actual phenomena. The spiritual power of light finds practical expression in art in the science of perspective, which he treated theoretically in Book 5 and practically in Book 6. Dealing with perspective constructions wholly in words, with no diagrams, causes virtually insuperable problems in understanding his techniques, but his emphasis on the need to undertake meticulous mathematical construction rather than relying on judgement by eye emerges clearly. His insistence is underlined by his devotion to the perspectival tradition of his Milanese predecessors, above all Bramantino, whose lost writings he quoted. The long sixth and seventh books show how the theories should be put into practice in actual compositions and within various categories of subject. Citing a welter of literary and visual sources, he demonstrated how secular and religious narratives should be depicted and how the painter's cast of characters, such as the saints and planetary gods, should be portrayed.

His *Idea* is dedicated to the exposition of a temple, whose architectural components signify the seven parts of painting. The temple is round in plan and capped by a dome and lantern, rather in the manner of Donato Bramante's *Tempietto* (1499–1502) in the courtyard of S Pietro in Montorio, Rome (*see* BRAMANTE, fig. 4). The role of the peristyle columns is performed by caryatid statues of each of the seven 'governors' of art—Michelangelo, Gaudenzio Ferrari, Polidoro da Caravaggio, Leonardo, Raphael, Andrea Mantegna and Titian. The walls of the temple are built, in ascending order, from proportion, motion, colour, light and perspective (the five 'theories' of painting), while the dome and lantern signify composition and *forma* (the two parts of 'practice'). *Forma* embodies 'all that may be occasioned in the imagination and may be seen by the eye'. Each of the governors corresponds to a planet—Michelangelo to Saturn, Gaudenzio to Jupiter, Polidoro to Mars, Leonardo to the Sun, Raphael to Venus, Mantegna to Mercury and Titian to the Moon. These painters are associated with a series of corresponding attributes, including the elements, the seasons, seven metals and seven animals. The artistic temperament of each artist mirrors that of his planetary deity in such a way as to exercise a characteristic influence over his mastery of each of the seven parts of painting. Although each governor is not precisely associated with a particular part of painting, the artists do show special excellence in certain fields. Raphael is particularly commended for proportion, as is Michelangelo, while a high command of motion is demonstrated by Raphael, Gaudenzio, Polidoro, Michelangelo and Leonardo. Titian, not surprisingly, is accorded particular praise for his handling of colour and shares mastery of light with Leonardo and Raphael.

Although there has been a tendency to dismiss Lomazzo's system as an elaborate piece of astrological nonsense, there is something heroic in his ability to relate the broadest of cosmologies to carefully observed details of the practice of art. His was the first developed and coherent attempt both to demonstrate the universal rules of art as reflections of a single source of divine beauty and to explain how it was possible for different artists to possess different styles of equal merit. His treatises were supreme representatives of the often arcane complexities of late Mannerist art and thought. They proved to be highly vulnerable to any change of taste towards simpler systems, whether naturalistic or idealizing, such as occurred around 1600 in early Baroque theories and practice. Neither treatise was to appear in a second Italian edition until over 200 years later. An English translation by Richard Haydocke of the greater part of the first five books of the *Trattato* was published in 1598, and a French translation of the first book appeared in 1649. Both translations used illustrations based on Dürer's *Vier Bücher*. The modern editions of his writings by Robert Klein and Roberto Ciardi present an opportunity to resurrect Lomazzo from the unjustified neglect into which he fell after his death.

WRITINGS

Trattato dell'arte de la pittura (Milan, 1584); Eng. trans. by R. Haydocke as *A Tracte Containing the Artes of Curious Paintinge, Carvinge & Buildinge* (Oxford, 1598/*R* 1971)
Rime . . . divise in sette libri, nelle quali ad imitatione de' grotteschi usati da' pittori, ha cantato le lodi di Dio . . . con la vita dell'autore (Milan, 1587)
Rabisch dra Accademiglia dor compà Zavargna, Nabad dra Vall d'Bregn (Milan, 1589)
Idea del tempio della pittura (Milan, 1590); ed. R. Klein, 2 vols (Florence, 1974)
Della forma delle muse cavate dagli antichi autori greci e latini: Opera utilissima a' pittori e scultori (Milan, 1591)
R. Ciardi, ed.: *Scritti sull'arte*, 2 vols (Florence, 1974)

BIBLIOGRAPHY

E. Panofsky: *Idea: Ein Beitrag zur Begriffsgeschichte der älteren Kunsttheorie* (1924); Eng. trans. by J. J. S. Peake (Columbia, SC, 1968/*R* New York, 1974), pp. 95–9

E. Spina Barelli: 'Il Lomazzo e il ruolo delle personalità psicologiche nella estetica dell'ultimo manierismo Lombardo', *A. Lombarda*, iii (1958), pp. 119–24

J. Lynch: 'Giovanni Paolo Lomazzo's Self-portrait in the Brera', *Gaz. B.-A.*, 6th ser., lxiv (1964), pp. 189–97

R. Ciardi: 'Struttura e significato delle opere teoriche del Lomazzo', *Crit. A.*, xii (1965), pp. 20–30; xiii (1966), pp. 37–44

J. Lynch: 'Lomazzo and the Accademia della Valle Bregno', *A. Bull.*, xliii (1966), pp. 210–11

G. Ackerman: 'Lomazzo's Treatise on Painting', *A. Bull.*, xlix (1967), pp. 317–26

R. Klein: *La Forme et l'intelligible: Ecrits sur la Renaissance et l'art moderne* (Paris, 1970); Eng. trans. by M. Jay and L. Wieseltier (New York, 1979), pp. 43–61, 62–88, 161–9

M. Kemp: '"Equal Excellences": Lomazzo and the Explanation of Individual Style in the Visual Arts', *Ren. Stud.*, i (1987), pp. 1–26

P. Marani: *Leonardo e i Leonardeschi a Brera* (Milan, 1988), pp. 242–5

M. Kemp: *The Science of Art: Optical Themes in Western Art from Brunelleschi to Seurat* (London and New Haven, 1990), pp. 72–3, 83–4, 269–73

M. V. Cardi: 'Intorno all'autoritratto in veste di Bacco di Giovan Paolo Lomazzo', *Stor. A.*, lxxxi (1994), pp. 182–93

L. Migliaccio: 'Leonardo "auctor" del genere comico', *Achad. Leonardi Vinci: J. Leonardo Stud. & Bibliog. Vinciana*, viii (1995), pp. 158–61

MARTIN KEMP

Lombardi, Alfonso (*b* Ferrara, *c.* 1497; *d* Bologna, 1 Dec 1537). Italian sculptor and medallist. He began his career at the court of Alfonso I d'Este, Duke of Ferrara, where he executed portraits (in stucco, wax and clay) and medals (e.g. London, BM; Weimar, Goethe-Nmus. Frauenplan). In 1516 he moved to Bologna, where he soon established a reputation. His terracotta group of *Hercules and the Hydra*, which was completed on 3 July 1519, was placed in the great hall of the Palazzo Pubblico (now Pal. Com.) there. On 2 December of that year he signed a contract, with his father Niccolò, for a *Death of the Virgin* (Bologna, S Maria della Vita), a group of 14 terracotta figures, over life-size, for which he was paid on 15 June 1522. The fame of this work brought him commissions at Faenza (*Virgin and Child with Saints*, Pin. Com.) and Castelbolognese (*Crucifixion*, S Petronio). Between 1522 and 1524 he executed other works in terracotta: *St Bartholomew* (Bologna, S Maria della Pioggia) and the group of the *Virgin and Child with SS John the Evangelist and John the Baptist* (Ferrara, Pin. Com.). The latter shows Venetian influence, probably absorbed in Ferrara from Antonio Lombardo, who worked there from 1506 to 1516. This work had a strong influence on Emilian sculptors, especially Antonio Begarelli. Lombardi's four terracotta statues of the *Patron Saints* (SS Proclus, Petronius, Dominic and Francis) were erected in the Torre dell'Arengo of the Palazzo del Podestà, Bologna, in August 1525. The following month he began carving sculptures in marble for the façade of S Petronio, Bologna, including the lunette of the *Resurrection* (1527) and the side doors with the *Annunciation* and *Adam and Eve* (1526–32; all *in situ*). These works, executed with his shop, show a change in style, influenced by the school of Sansovino.

While working on S Petronio, Lombardi returned to funerary sculpture, a genre in which he had worked earlier (tomb of *Ercole Buttrigari*, 1522; Bologna, Certosa), executing the tomb of *Amarciotto de' Ramazzotti* (Bologna, S Michele in Bosco). He resumed the terracotta technique for the triumphal arch erected for the coronation in Bologna of Charles V (*reg* 1519–56) as Holy Roman

Emperor in 1530. That year he went to Carrara to get marble for a series of busts for Federico II Gonzaga, 1st Duke of Mantua. These are untraced but are documented in numerous letters. On 20 November 1532 he was commissioned to execute the marble relief of scenes from the *Life of St Dominic* for the saint's tomb (Bologna, S Domenico). This work, finished the following year, was signed *Alphonsus de Lombardis Ferrariensis F.* Shortly afterwards he went in the service of Cardinal Ippolito de' Medici to Rome, where he carved busts of *Clement VII* and *Giuliano de' Medici* (both Florence, Pal. Vecchio, Sala di Leone X). In this period he received the commission for the tomb of Clement VII, for which, according to Vasari, he produced a wax model based on sketches by Michelangelo. After the death of Cardinal Ippolito in 1535, however, the commission was transferred to Baccio Bandinelli, and Lombardi left Rome. On his return to Bologna, he stopped in Florence, where he presented a marble bust of *Charles V* to the Duke, Alessandro de' Medici. Documents indicate that he produced four marble busts of Charles V, though only one is identified (Paris, Mus. Jacquemart-André).

BIBLIOGRAPHY

A. Venturi: *Storia* (1901–40), X/i, pp. 575–601

M. Fanti: 'Il San Procolo della Fabbriceria di San Petronio in Bologna', *A. Ant. Mod.*, II/6 (1959), pp. 183–90

A. Parronchi: 'Il San Sebastiano ligneo di S Maria del Baraccano', *Atti Mem. Accad. Clementina Bologna*, xi (1974), pp. 59–65

F. Bergonzoni: 'I quattro santi protettori di Bologna: Vicende e restauri del voltone del Podestà', *Strenna Stor. Bologn.*, xxvi (1976), pp. 43–70

U. Middeldorf: 'Zu einigen Medaillen der italienischen Renaissance', *Festschrift Wolfgang Braufels* (Tübingen, 1977), pp. 263–5

N. Gramaccini: *Alfonso Lombardi* (Frankfurt am Main, 1980)

CHIARA STEFANI

Lombardo [Lombardi]. Italian family of artists. (1) Pietro Lombardo and his sons, (2) Tullio Lombardo and (3) Antonio Lombardo, were dominant figures in Venetian sculpture and architecture from *c.* 1465 until the death of Tullio in 1532. Because Pietro was born in Carona, the place of origin of the Solari, a famous family of stone-carvers, it is assumed that he was a member of that family. For this reason, members of the Lombardi family are sometimes referred to by the name of Solari, although only Antonio's sons used the name themselves. Pietro transformed Tuscan Renaissance prototypes into a Venetian style, as seen in his earliest projects, the chancel of S Giobbe, Venice, and the tomb of *Antonio Roselli* in S Antonio (Il Santo), Padua, and that of *Doge Pasquale Malipiero* in SS Giovanni e Paolo, Venice. The typical features of this style, a simple, planar architecture covered with beautifully carved low-relief ornament, were so widely imitated that the designation Lombardesque was coined to characterize it as a Venetian phenomenon of the late 15th century and the early 16th.

I. Introduction. II. Family members.

I. Introduction.

The specific roles of Tullio and Antonio in the family workshop cannot be identified before the late 1480s, although such reliable sources as Matteo Collaccio (1486)

and Francesco Sansovino (1581) attest to their participation in the mid-1470s. Presumably they worked alongside other assistants on less important aspects of tombs and architectural projects under Pietro's supervision. The *Bishop Zanetti* tomb in Treviso Cathedral of the late 1480s is probably the first project in which the individual contributions of Tullio and Antonio can be convincingly distinguished. The division of labour, with all three Lombardi working on different sculptures from Pietro's design, gives a fascinating picture of their close collaboration (Munman, 1977). Pietro's correspondence in the 1490s with Francesco Gonzaga, 4th Marchese of Mantua, which reveals that he intended to execute Mantuan commissions in Venice with the help of 25 assistants, is the only documented indication of the size of the workshop, which was evidently very large at that date.

By the 1490s Tullio and Antonio had assumed the dominant role in family commissions, and an increasingly classicizing style is evident in such projects as the tomb of *Doge Andrea Vendramin* (Venice, SS Giovanni e Paolo; *see* (2), fig. 1 below) of the early 1490s. The brothers' deep-seated classicism derived from the collection and study of Greco-Roman works of art. Marcantonio Michiel recorded that Tullio once owned an antique headless marble statue of a woman that he reproduced many times in his own sculpture, and he apparently also restored antique sculpture (Pincus, 1979). According to Pomponius Gauricus, Tullio was the greatest Venetian marble sculptor, and his classicizing works would have appealed greatly to contemporary humanists. Pietro's appointment as *protomagister* of the rebuilding of the Doge's Palace, Venice, in 1498 absorbed most of his time, and thereafter his continued collaboration with his sons seems to have been primarily as an adviser. Yet even when the younger Lombardi were well established in the early 16th century, their cooperation with their father was close, and all three collaborated in the execution of the funerary chapel of Cardinal Zen in S Marco, Venice (Jestaz, 1986).

Antonio's departure for Ferrara in 1506 left Tullio as the *de facto* head of the family workshop. Tullio's architecture made a break from that of his father. Perhaps as early as the 1490s he eschewed the exquisite low-relief ornamentation that had been the Lombardo hallmark and planned buildings that were more classicizing, volumetric and austere than Pietro's. Tullio's death in 1532 occurred just after Jacopo Sansovino's arrival in Venice and marked the end of the Lombardo era, although Antonio's sons, (4) Aurelio Lombardo, (5) Girolamo Lombardo and Ludovico Lombardo [Solari; Ludovico da Ferrara] (1507/8–75), worked as sculptors. The brothers inscribed their most important work, the bronze tabernacle that Pius IV commissioned for the high altar of Milan Cathedral, *Aurelius, Hieronymus et Ludov. Frs. [fratres] Solari Lombardi F.* (Thieme–Becker). Tullio's son, (6) Sante Lombardo, practised as an architect. Girolamo's three sons, Antonio Lombardo (*d* between 4 June 1608 and 14 April 1610), Pietro Lombardo (*d* before 1608) and Paolo Lombardo, were sculptors. Sante's two sons, Tullio Lombardo and Giovanni Girolamo Lombardo, became architects of minor note. More research needs to be done to clarify the details of the careers of the later generations of the Lombardi.

BIBLIOGRAPHY
EARLY SOURCES

M. Collaccio: *Philologica opuscola* (Venice, 1486)

P. Gauricus: *De sculptura* (1504), ed. and trans. A. Chastel and R. Klein (Geneva and Paris, 1969)

Vitruvius: *De architectura*, ed. C. Cesariano (Como, 1521)

M. Michiel: *Notizie d'opera del disegno* (MS. before 1552); ed. T. Frimmel as *Der Anonimo Morelliano* (Vienna, 1888)

F. Sansovino: *Venetia: Città nobilissima et singolare* (Venice, 1581); ed. G. Martinioni (Venice, 1663/*R* New York, 1968)

T. Temanza: *Vite dei più celebri architetti e scultori veneziani che fiorirono nel secolo decimosesto* (Venice, 1778)

GENERAL WORKS

Thieme–Becker

P. Paoletti: *L'architettura e la scultura del rinascimento in Venezia: Ricerche storico-artistiche*, ii (Venice, 1893), pp. 110–13, 135, 178–255

L. Planiscig: *Venezianische Bildhauer der Renaissance* (Vienna, 1921)

L. Coletti: *Catalogo delle cose d'arte e di antichità d'Italia: Treviso* (Rome, 1935), pp. 152–3, 395–9

J. Pope-Hennessy: *Italian Renaissance Sculpture* (London, 1963, rev. Oxford, 3/1985)

C. Seymour jr: *Sculpture in Italy, 1400–1500*, Pelican Hist. A. (Harmondsworth, 1966)

L. Heydenreich and W. Lotz: *Architecture in Italy, 1400 to 1600*, Pelican Hist. A. (Harmondsworth, 1974)

S. M. Connell: *The Employment of Sculptors and Stone Masons in Venice in the Fifteenth Century* (diss., U. London, Warburg Inst., 1976)

J. McAndrew: *Venetian Architecture of the Early Renaissance* (Cambridge, MA, 1980)

R. Lieberman: *Renaissance Architecture in Venice, 1450–1540* (New York, 1982)

N. Huse and W. Wolters: *The Art of Renaissance Venice: Architecture, Sculpture and Painting, 1460–1540* (Chicago, 1990)

SPECIALIST STUDIES

G. Boni: 'Santa Maria dei Miracoli in Venezia', *Archv Ven.*, xxxiii (1887), pp. 236–74

G. Biscaro: 'Pietro Lombardo e la cattedrale di Treviso', *Archv Stor. A.*, 2nd ser., iii (1897), pp. 142–54

——: 'Note storico-artistiche sulla cattedrale di Treviso', *Nuovo Archv Ven.*, xvii (1899), pp. 135–94

——: 'I Solari da Carona', *Boll. Stor. Svizzera It.*, xxxiv/1–7 (1912), pp. 61–77

P. Paoletti: *La scuola grande di San Marco* (Venice, 1929)

L. Planiscig: 'Pietro, Tullio und Antonio Lombardo: Neue Beiträge zu ihrem Werk', *Jb. Ksthist. Samml. Wien*, xi (1937), pp. 87–115

N. Gallimberti: 'La tradizione architettonica religiosa tra Venezia e Padova', *Boll. Mus. Civ. Padova*, lii (1963), pp. 115–92

C. Semenzato: 'Pietro e Tullio Lombardo, architetti', *Boll. Cent. Int. Stud. Archit. Andrea Palladio*, vi/2 (1964), pp. 262–70

F. Zava Boccazzi: *I Lombardo*, I maestri della scultura, lxxii (Milan, 1966)

R. Munman: *Venetian Renaissance Tomb Monuments* (diss., Cambridge, MA, Harvard U., 1968)

J. McAndrew: 'Sant'Andrea della Certosa', *A. Bull.*, li (1969), pp. 15–28

A. Crivelli: *Artisti ticinesi in Italia* (Locarno and Lugano, 1971)

R. Lieberman: *The Church of Santa Maria dei Miracoli in Venice* (diss., New York U., 1972)

A. Markham Schulz: 'The Giustiniani Chapel and the Art of the Lombardo', *Ant. Viva*, xvi/27 (1977), pp. 27–44

R. Munman: 'The Lombardo Family and the Tomb of Giovanni Zanetti', *A. Bull.*, lix (1977), pp. 28–38

E. Ruhmer: 'Paduaner Quattrocento-Plastiken als Bildquellen der Hochrenaissance', *A. Ven.*, xxxii (1978), pp. 61–7

D. Pincus: 'Tullio Lombardo as a Restorer of Antiquities: An Aspect of Fifteenth-century Venetian Antiquarianism', *A. Ven.*, xxxiii (1979), pp. 29–42

P. Sohm: *The Scuola Grande di San Marco, 1437–1550: The Architecture of a Venetian Lay Confraternity* (New York, 1982)

D. Lewis: 'The Sculptures in the Chapel of the Villa Giustinian at Roncade, and their Relation to those in the Giustinian Chapel at San Francesco della Vigna', *Mitt. Ksthist. Inst. Florenz*, xxvii (1983), pp. 307–52

P. Dittmar: 'Die dekorative Skulptur der venezianischen Frührenaissance', *Z. Kstgesch.*, xlvii (1984), pp. 158–85

B. Jestaz: *La Chapelle Zen à Saint-Marc de Venise d'Antonio à Tullio Lombardo* (Stuttgart, 1986)

S. B. McHam: *The Chapel of St Anthony at the Santo and the Development of Venetian Renaissance Sculpture* (Cambridge, 1994)

II. Family members.

(1) Pietro Lombardo [Pietro Solari] (*b* Carona, Lombardy, *c*. 1435; *d* Venice, June 1515). Sculptor and architect.

1. SCULPTURE. He is first documented in Bologna, where he rented a workshop at S Petronio between July 1462 and May 1463, presumably to work on some commission for the cathedral, perhaps the Rossi Chapel chancel (Beck, 1968). By 1464 he and his family had moved to Padua, where his most important work was the wall tomb of *Doge Antonio Roselli* in S Antonio (Il Santo), which he designed in early 1464 and finished by 8 April 1467 (Moschetti, 1913, 1914). The *Roselli* tomb introduced the 15th-century Florentine humanist tomb type into the region and marks the beginning of true Renaissance sculpture in the Veneto. Its derivation from *Carlo Marsuppini* monument in Santa Croce, Florence, (Desiderio da Settignano's *c*. 1453–60; *see* DESIDERIO DA SETTIGNANO, fig. 1), suggests that Pietro visited Florence during his sojourn in Bologna. Pietro interpreted the Florentine model in a way that became characteristic of later Venetian tombs. He transformed it into a more heavily decorated and imposing tomb through the addition of a high base, monumental flanking pilasters, long decorative relief swags and an ornate cornice. At this date he also completed some architectural projects in Padua and Vicenza.

Pietro and his family are first documented in Venice on 11 August 1474, but it seems likely that they arrived soon after 1467. Pietro's first tomb in Venice, that of *Doge Pasquale Malipiero* in SS Giovanni e Paolo, which probably dates from the late 1460s, is also derived from Florentine wall tombs, but by omitting the elaborate enframing architecture of the *Roselli* tomb, Pietro transformed the Florentine prototype into a Venetian type, the pensile wall tomb embellished by a tent-like baldacchino hanging around the doge's sarcophagus.

Pietro's next project, the tomb of *Doge Pietro Mocenigo* (*d* 1476), also in SS Giovanni e Paolo, is his grandest funerary monument. Francesco Sansovino (1581) indicated that both Tullio and Antonio worked on it with Pietro, but their contribution is difficult to isolate. The tomb dates from between 1476 and 1481. The vast wall tomb, arranged in the form of a triumphal arch, fills nearly one-third of the interior façade of the church and originally included 17 figures. The Doge stands on top of his sarcophagus, which is supported by three warriors, in the centre of the arch. This is flanked by three storeys of niches containing figures of warriors and pages on each side. The base is decorated with reliefs of the Labours of Hercules and Roman trophy designs. The standing figure of the Doge in armour, the reliefs of his military victories on the sarcophagus, the absence of a recumbent effigy, the triumphal arch format and allusions to trophies and Hercules all proclaim the triumphant and secular character of the monument. The only religious elements, a relief of the *Three Marys at the Tomb* and the figure of the *Standing Christ* (originally flanked by *St Mark* and *St Theodore*, now transferred to the contiguous *Alvise Mocenigo* monument), are placed at the summit of the monument, so far distant from the spectator as to seem secondary. Originally the

tomb must have been even more spectacular since it was gilded and polychromed, traces of which can be discerned in the niches and figures. The grandeur and format of the *Mocenigo* tomb probably influenced Antonio Rizzo's tomb of *Doge Niccolò Tron* in S Maria dei Frari, Venice (*c*. 1476–80; for illustration *see* RIZZO, ANTONIO), which is almost exactly contemporary, and certainly determined the appearance of a later Lombardo commission, that of the tomb of *Doge Andrea Vendramin* (Venice, SS Giovanni e Paolo), originally in S Maria dei Servi, Venice, in which Pietro's son Tullio played the major role.

During the 1480s the Lombardo shop was very busy with a series of tomb commissions in and around Venice, including the tomb of *Jacopo Marcello* (*d* 1484; Venice, S Maria dei Frari), the tomb of *Lodovico Foscarini* (*d* 1480; ex-S Maria dei Frari, Venice; destr., fragments in south transept wall) and the tomb of *Giovanni Zanetti, Archbishop of Thebes and Bishop of Treviso* (*d* 1484; Treviso Cathedral). These are all pensile wall tombs of modest scale, in which the sarcophagi and commemorative plaques are framed by oval cornices. This format derives from the arrangement of the central section of the *Pietro Mocenigo* tomb, isolated and reshaped as an oval.

The *Niccolò Marcello* monument (*c*. 1481–5; Venice, constructed in S Marina; later moved to SS Giovanni e Paolo), the other major tomb commission probably executed in the 1480s, is a more tightly organized variant of the triumphal arch type that Pietro used first in the *Pietro Mocenigo* monument. Of much smaller scale, it holds only four figures in addition to the recumbent figure of the Doge. The central portion of the tomb is built forward, which emphasizes the effigy, sarcophagus and lunette relief, unlike the sprawling, flat structure of the *Pietro Mocenigo* monument.

2. ARCHITECTURE. In the early 1470s, on the commission of Doge Cristoforo Moro, Pietro supervised the building of the church of S Giobbe, Venice, which had been started by Gambello in the 1450s, and designed the architecture and decoration of its chancel. A letter of 1485 written by Matteo Collaccio establishes the *terminus ante quem* for the completion of the chancel. Although it specifies only that the figure sculpture was carved by Pietro, it is generally agreed that he was responsible for the architecture as well. Pietro created the first Renaissance-style interior in Venice. The chancel's dome supported on pendentives, the articulation of grey *pietra serena* against white plaster and the four tondo reliefs of the *Evangelists* in the spandrels all derive from Brunelleschi's Old Sacristy in S Lorenzo (*see* BRUNELLESCHI, FILIPPO, fig. 2), Florence. The small full-length angels that support the roundels resemble putti carved by Antonio Rossellino, further corroborating Pietro's preoccupation with Florentine models early in his career.

Pietro next supervised the building of the Cappella Maggiore and its cupola for Treviso Cathedral, begun by 1485 or 1486 (Biscaro, 1897, 1899). When the dome collapsed in 1486, Pietro promised to entrust its rebuilding to a capable architect, who in an agreement of 1488 was identified as his son Tullio.

Pietro's other architectural commissions were for major Venetian buildings: S Maria dei Miracoli (see fig.) and the

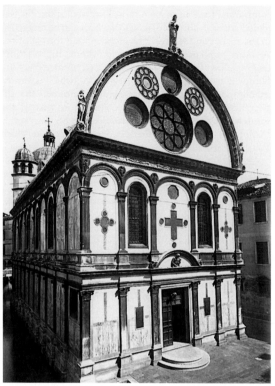

Pietro Lombardo: S Maria dei Miracoli, Venice, 1485–9

Scuola Grande di S Marco (*see* VENICE, §V, 3 and fig. 11). Because of increased popular devotion to a miracle-working image of the Virgin and Child housed there, a competition was held in 1480 to design a new building for the Miracoli. Initially Pietro Lombardo was hired to supervise the construction of a simple votive chapel and told to follow the chosen model (the designer's name is not recorded); however, so much money was collected that in 1485 a new contract was drawn up. It expressly named Pietro as the architect and stipulated that the structure, now apparently regarded as a convent church rather than a chapel, should be vaulted and have a chancel.

Pietro's solution for the revised project was ingenious: he elevated the chancel and placed the sacristy in the crypt-like space below it, connecting it to the altar area with a spiral stair in the bell-tower at the left of the chancel. The architectural elements of the chancel are exquisitely carved with fanciful floral ornaments and mythological marine creatures. The interior and exterior walls of the Miracoli are veneered with coloured marbles, evidently procured from surplus supplies at S Marco. The Miracoli is the only Venetian church other than S Marco so decorated; its simple, aisleless, barrel-vaulted form and lavish incrustation make it seem a bejewelled reliquary casket, an appropriate setting for the miracle-working image it houses. To some extent, this system of marble incrustation was inspired by the Cappella del Perdono in the Palazzo Ducale, Urbino; a Montefeltro emblem is reused at the Miracoli, indicating close connections between the two projects (Lieberman, 1972).

In 1489 Pietro was hired to supervise construction at the Scuola Grande di S Marco, Venice, which had been destroyed by fire in 1485. He designed the lower part of the façade in conjunction with Giovanni di Antonio Buora before they were replaced by Antonio Rizzo and Mauro Codussi in 1490. Francesco Sansovino wrote that Tullio executed the reliefs flanking the two portals of the Scuola. These extremely pictorial reliefs complement the ostentatiously decorated façade, which has been called the most picturesque architectural concept of the 15th century. Its coloured marble veneer, asymmetry, use of statues and pictorial reliefs and non-classical organization of proportions have come to epitomize Venetian taste for extravagance and colour in architecture. In fact, the lobes of its upper façade were probably intended to recall the domes of S Marco, its namesake, and the apparently unorthodox organization of the façade has been shown to reflect the organization and functions of the Scuola's interior (Sohm, 1982).

After serving as Antonio Rizzo's assistant for several years, Pietro became *protomagister* of the Doge's Palace in 1498 when Rizzo was accused of embezzlement and fled from Venice. This position engaged most of Pietro's energies for the rest of his working career (he withdrew in 1511). He supervised the completion of most of the northern part of the courtyard façade of the eastern wing of the palace, but probably was not responsible for its design, which has been attributed either to Rizzo or Codussi.

In 1495 Pietro was commissioned to carve an elaborate altarpiece for the chapel of the Madonna in Mantua Cathedral, for which neither drawings nor model seem to have survived. In 1502 he worked on a new dome for Cividale Cathedral. In 1509 he submitted a model (untraced) for the new building of the Scuola Grande della Misericordia in Venice. Otherwise in his last years Pietro seems to have been active mainly in conjunction with his sons on commissions in which they were the principals. He helped to supervise the construction of the chapel of the Holy Sacrament, designed by Antonio, in Treviso Cathedral, and that by Tullio at S Salvatore in Venice; he played a more limited role in Antonio's work on the Zen Chapel in S Marco. In 1514 Pietro served as the head of the stonemasons' guild in Venice, an indication of the pre-eminent position he held in Venetian architecture even in his last years.

BIBLIOGRAPHY

G. B. Lorenzi: *Monumenti per servire alla storia del palazzo ducale di Venezia* (Venice, 1868), pp. 121–55

A. Moschetti: 'Un quadriennio di Pietro Lombardo a Padova (1464–1467) con una appendice sulla data di nascita e di morte di Bartolomeo Bellano', *Boll. Mus. Civ. Padova*, xvi (1913), pp. 1–99; xvii (1914), pp. 1–43

——: 'Pietro e altri lapidici a Bellano', *Atti Ist. Ven. Sci., Lett. & A.*, lxxxvii/2 (1927–8), p. 1481–1515

L. Planiscig: 'Pietro Lombardi ed alcuni bassirilievi veneziani del 400', *Dedalo*, x (1929–30), pp. 461–81

——: 'Deux reliefs en marbre de Pietro Lombardi', *Gaz. B.-A.*, 6th ser., iv (1930), pp. 1–10

G. Mariacher: 'Pietro Lombardo a Venezia', *A. Ven.*, ix (1955), pp. 36–52

G. Zorzi: 'Architetti e scultori dei laghi di Lugano e di Como a Vicenza nel secolo XV', *Arte e artisti dei laghi lombardi*, ed. E. Arslan, i (Como, 1959), pp. 343–71

E. Bandelloni: 'Pietro Lombardo architetto nella critica d'arte', *Boll. Mus. Civ. Padova*, li/2 (1962), pp. 25–56

A. Meli: 'Cappella Colleoni: I tre santi dell'ancona', *Bergomum*, xxxix/1 (1965), pp. 3–46

J. Beck: 'A Notice for the Early Career of Pietro Lombardo', *Mitt. Ksthist. Inst. Florenz*, xiii (1968), pp. 189–92

C. M. Brown: 'Little Known and Unpublished Documents Concerning . . .Pietro Lombardo . . .II', *L'Arte*, vii–viii (1969), pp. 182–214

R. Munman: 'Giovanni Buora: The "Missing" Sculpture', *A. Ven.*, xxv (1976), pp. 41–61

H. G. Brand: *Die Grabmonumente Pietro Lombardos: Studien zum venezianischen Wandgrabmal des späten Quattrocento* (diss., U. Augsburg, 1977)

R. Munman: 'The Sculpture of Giovanni Buora: A Supplement', *A. Ven.*, xxxiii (1979), pp. 19–28

A. Markham Schulz: 'Pietro Lombardo's Barbarigo Tomb in the Venetian Church of S Maria della Carità', *Art the Ape of Nature: Studies in Honor of H. W. Janson*, ed. M. Barasch, L. F. Sandler and P. Egan (New York, 1981), pp. 171–92

T. Hirthe: 'Mauro Codussi als Architekt des Dogenpalastes', *A. Ven.*, xxxvi (1982), pp. 31–44

A. Markham Schulz: 'Giovanni Buora lapicida', *A. Lombarda*, lxv/2 (1983), pp. 49–72

R. Callegari: 'Bernardo Bembo and Pietro Lombardo: New from the "Nonianum"', *Burl. Mag.*, cxxix (1997), pp. 862–6

(2) Tullio Lombardo (*b* ?*c*. 1455; *d* Venice, 17 Nov 1532). Sculptor and architect, son of (1) Pietro Lombardo.

1. Sculpture. 2. Architecture.

1. SCULPTURE. Tullio, together with his brother Antonio, is first mentioned in a letter of 1475 written by Matteo Collaccio that has been traditionally construed to mean that by the mid-1470s the brothers were active in their father's workshop, contributing to secondary aspects of commissions. Maek-Gérard (1974, 1980), however, argued that Tullio and Antonio were born in Padua in the 1460s, about ten years later than is usually assumed. The later birthdates would explain the difficulty of distinguishing their role in the family workshop before the late 1480s. It would also mean that, since they were born in Padua, both were citizens of the Venetian Empire, which, Maek-Gérard contended, explained their continued receipt of important Venetian commissions in the early 16th century after the Venetian sculptors' guild had curtailed the rights of non-Venetian sculptors.

Tullio's earliest signed sculptures seem to be the figures of four kneeling angels (Venice, S Martino), carved for the shrine of the Holy Sepulchre in S Sepolcro, Venice. Although not finished until 1511, the shrine itself is inscribed 1484, and most historians (except Mariacher, 1954; Jestaz, 1986) date the angels to *c*. 1484. Pomponius Gauricus (1504), a close friend of Tullio's, provided specific information about Tullio's role in the next major sculptural commission awarded to the family workshop. He described the purportedly envious reaction of Antonio Rizzo, a rival sculptor, to the beautiful ornament that Tullio carved for the tomb of *Bishop Zanetti* in Treviso Cathedral in the late 1480s. Tullio is also recorded by Francesco Sansovino as having sculpted marble statues (destr.) for the chancel of S Maria dei Miracoli, Venice, which Pietro had constructed in 1485–9. Details of the elaborate decorative carving of the socle of the chancel arch and pilasters can also be attributed to Tullio.

Sansovino made it clear that Tullio was responsible for the two reliefs of *St Mark Baptizing Anianus* and *St Mark Healing Anianus* flanking the portals on the façade of the Scuola Grande di S Marco, Venice, which must have been sculpted in 1489–90 when his father Pietro designed the façade's lower portion. They are the earliest relief sculptures definitely by Tullio and establish certain principles that can be traced in his later narrative reliefs. The figures are large and are arranged in an isocephalic frieze. They stand crowded together on a projecting ledge before an architectural setting shown in perspective that creates the unprecedented illusion of receding architectural space on a real architectural façade. The reliefs combine a classicism of form and organization that Tullio might have learnt from such triumphal arch reliefs as the *Adlocution of Hadrian* (Rome, Pal. Conserv.) with the theatrical immediacy of *tableaux vivants*. The vaulted architecture shown in perspective may be derived ultimately from Bramante's S Maria presso S Satiro (*see* BRAMANTE, DONATO, fig. 1), Milan (Sheard, 1984, both publications).

In the 1490s Tullio and Antonio assumed the major role in sculptural commissions awarded to the family shop. The most important project of this decade was the tomb of *Doge Andrea Vendramin* (Venice, SS Giovanni e Paolo; see fig. 1), originally in S Maria dei Servi in Venice. The design of the tomb and a large part of its figure sculpture are usually credited to Tullio. Following the death of Andrea del Verrocchio, who had provided the first project for the tomb, Tullio began work after 1488 and had almost finished it *c*. 1493–4.

The tomb is the earliest Venetian Renaissance wall tomb to be so grandly classical. Its architectural structure transforms the pagan triumphal arch type into a Gate of Paradise, before which were originally positioned the nude

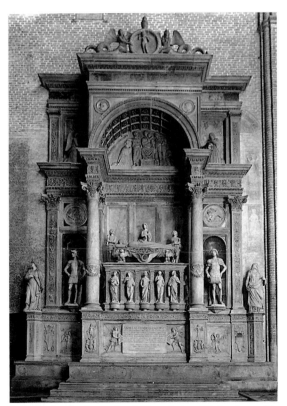

1. Tullio Lombardo: tomb of *Doge Andrea Vendramin*, marble, 10.8×7.8 m at widest part of the base, *c*. 1488–94 (Venice, SS Giovanni e Paolo)

figures *Adam* (New York, Met.) and *Eve* (untraced) and the recumbent effigy of the Doge. The 18 figures that once decorated the tomb, more than on any other Venetian funerary monument of the period, have antique prototypes (Sheard, 1971, 1977, 1978). The figure of *Adam*, signed by Tullio, is the tomb's masterpiece and serves as a paradigm of Tullio's style in figure sculpture. The idealized male nude type derives from antique statues of Apollo, although its unstable contrapposto, unclassical proportions and abstract description of skin surfaces also suggest the influence of Late Antique ivory sculpture (Wilk, 1978).

Tullio's only monumental relief altarpiece, a *Coronation of the Virgin*, for the Bernabò Chapel in S Giovanni Crisostomo, Venice, can be dated *c*. 1500–02. The chapel was redecorated as part of the neo-Byzantine reconstruction of the church as a domed quincunx by Mauro Codussi, and the relief altarpiece adheres to the same stylistic standards. It breaks with conventional iconography of the subject; the isocephalic frieze of Christ, the Apostles and the kneeling Virgin derives from a relief of the *Traditio legis* (Venice, Tesoro S Marco) then considered to be antique but now believed to be a 13th-century copy of an Early Christian prototype (Wilk, 1978).

The next major project in which Tullio was involved was the redecoration of the Cappella dell'Arca di S Antonio in Il Santo, Padua (see fig. 2). The chapel, in which the relics of St Anthony are entombed, was elaborately refurbished with a series of nine monumental marble reliefs illustrating the *Miracles of St Anthony* carved from *c*. 1500 to 1577. Tullio was commissioned to sculpt five of these reliefs, although he completed only two of them, the *Miracle of the Reattached Leg*, begun in 1500, largely finished in 1501 and delivered in 1504, and the *Miracle of the Miser's Heart* (installed in 1525), the commission for which was transferred from Antonio Lombardo to Tullio in 1520.

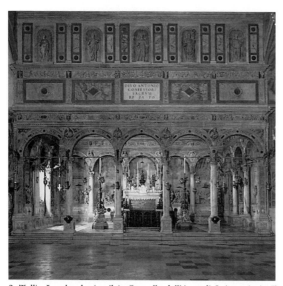

2. Tullio Lombardo (attrib.): Cappella dell'Arca di S Antonio in Il Santo, Padua, design, *c*. 1500; with marble reliefs of the *Miracle of the Reattached Leg* (begun 1500) and the *Miracle of the Miser's Heart* (1520–25), both by Tullio Lombardo, and the *Miracle of the Newborn Babe* (1500–04) by Antonio Lombardo

It seems likely that Tullio was also largely responsible for the design of the chapel's architecture and sculpture, which has previously been attributed to either Andrea Riccio or Giovanni d'Antonio Minelli Bardi (*c*. 1460–1527), a minor Paduan sculptor. Tullio and Antonio were the first artists selected to carve reliefs for the chapel; Tullio was the leading artist associated with the chapel's redecoration from *c*. 1500 until his death in 1532, and he was chosen to carve more reliefs than any other artist. It can be argued that the whole complex must have been planned in detail from the outset, given the chapel's carefully coordinated perspectival illusionism, in which the fictive vaulted architecture of the rear wall reliefs is seen through the real arches of its front wall, and the similar compositional arrangement of all the reliefs. Many aspects of the composition of the reliefs and their perspectival illusionism correspond closely to such documented sculptures by Tullio as the reliefs on the Scuola Grande di S Marco or his *Coronation of the Virgin* altarpiece (Wilk, 1984).

While working on the Paduan project, Tullio must have also executed the tomb of *Doge Giovanni Mocenigo* in SS Giovanni e Paolo, Venice. The Doge died in 1485, but his funerary monument was not erected before 1522, although its sculpture is generally presumed on stylistic grounds to have been carved in the first decade of the 16th century. The bold, undecorated simplicity of the tomb's heavy classical architecture makes a striking contrast to the comparatively two-dimensional structure and profusion of carved ornament of the *Vendramin* tomb of the early 1490s. Tullio seems to have abjured the decorative carving that was the hallmark of Pietro's and his own earlier production; the elegance of the *Mocenigo* tomb depends on its proportions and the beautiful white, grey and caramel-coloured marbles of its austere architecture.

Tullio was selected to carve two more monumental reliefs for the Cappella dell'Arca in the 1520s, but neither was executed. His only other major sculptural commission in this decade was for the funerary chapel of Guidarello Guidarelli in S Francesco, Ravenna, which probably dates to *c*. 1520–25. Only the effigy of the dead soldier in full armour (Ravenna, Mus. N.) and the architectural details of the chapel are extant (see Wilk, 1978). Tullio's last sculptural commissions were probably largely executed by assistants. The tomb for *Matteo Bellati* in Feltre Cathedral, signed and dated 1528, is a simpler version of a well-known Lombardo tomb type, and the carving is of indifferent quality. The *Pietà* that Tullio designed for Rovigo Cathedral in the late 1520s falls into the same category.

Tullio also carved several reliefs of bust-length portraits of young couples that convey an intense poetic mood. They would seem to have been inspired by Roman double-portrait reliefs, but their purpose is uncertain. The relief known as *Bacchus and Ariadne* (*c*. 1500; Vienna, Ksthist. Mus.; see fig. 3) may in fact be a portrait of a youthful couple. It has been suggested that the relief in the Cà d'Oro, Venice, is a portrait of the artist and his wife (Luchs, 1989).

2. ARCHITECTURE. Tullio made his début as an architect rebuilding the Cappella Maggiore and its dome

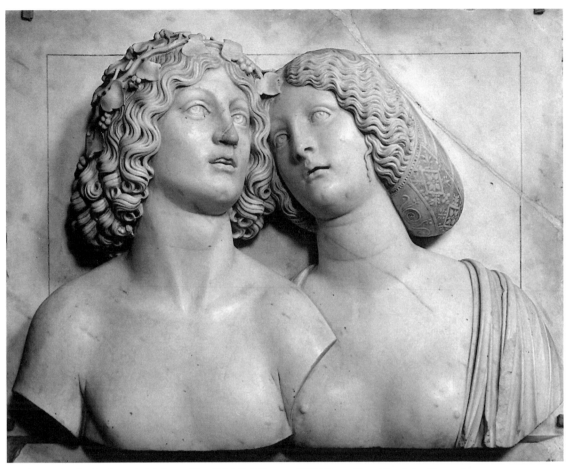

3. Tullio Lombardo: *Bacchus and Ariadne*, marble relief, 560×715 mm, *c.* 1500 (Vienna, Kunsthistorisches Museum)

in Treviso Cathedral. Tullio ratified the 1488 agreement to reconstruct the dome, which had collapsed in 1486 after its remodelling by his father. He may well have supervised the reconstruction from 1486, and the interior's restrained decoration and volumetric organization may reflect a design of Pietro's from which Tullio worked. The next architectural commission usually assigned to Tullio is the church of the Benedictine abbey at Praglia, near Padua, its cloister and some of the contiguous monastic complex (*c.* 1490). The attribution rests on the style of the architecture and local tradition. Tullio is also thought to have assumed the reconstruction of Cividale Cathedral, which Pietro had originally undertaken in May 1502. Pietro then became *protomagister* at the Doge's Palace and probably had no time for projects outside Venice (Paoletti, 1893–7). The reconstruction of Cividale Cathedral dragged on past 1535, after the deaths of both Pietro and Tullio, but the interior organization and simplicity of the architecture again suggest that Tullio was interpreting his father's plan.

It has been argued that the Villa Giustinian at Roncade, the earliest surviving villa in the Veneto, should also be attributed to Tullio and dated *c.* 1495–1510 (Lewis, 1977). Lewis pointed out that the villa, traditionally attributed to an anonymous follower of Mauro Codussi, shows instead features characteristic of the Lombardi and displays a classicism more austere than that of Codussi but connected with other projects attributed to Tullio in these years.

In 1507 Tullio was named as the architect for the rebuilding of S Salvatore in Venice, with Pietro working as his associate. Tullio's role seems to have been to execute Giorgio Spavento's design, which had been approved in 1506 and already begun. Tullio apparently remained the architect in charge of S Salvatore until his death. The church, the most important building in Venice with which Tullio was associated, is a bold extension of the nine cell square plan that creates fascinating spatial plays through its longitudinal and lateral alternation of wide and narrow bays. By 1511 the eastern end, including the transepts and dome piers, had been erected up to the first major cornice. The vaulting of the Cappella Maggiore and apse were not completed until at least 1518, but by 1529 when Doge Andrea Gritti visited it, the major construction was almost finished (McAndrew, 1980; Tafuri, 1983; Burns, 1986).

In 1509 Tullio and Pietro were jointly named the Protos of a new building for the Scuola Grande della Misericordia in Venice, but in 1515 the Scuola was negotiating with Alessandro Leopardi over his model for the building; nothing is known to survive of the Lombardo plans for this commission. Tullio took over the supervision of the Zen Chapel in S Marco in 1512, when work recommenced

after interruptions caused by Antonio's departure for Ferrara in 1506 and by the War of the League of Cambrai, and made significant modifications to its architecture (Jestaz, 1986). In 1506 he had carved two of its column socles. Tullio also worked on the Cappella dell'Argento (destr.) in Ravenna Cathedral in 1515. In 1517 he was paid for a model for the reconstruction of Belluno Cathedral; the building is similar to Treviso Cathedral, the abbey church at Praglia and Cividale Cathedral, so it seems likely that Tullio's plans were executed. Around 1521 Tullio provided plans for the reconstruction of S Giorgio Maggiore, Venice, and its conventual buildings (unexecuted; drawings, Venice, Archv Stato). In 1523 and 1527 he provided door frames and other decorative architectural elements for the Gonzaga family of Mantua.

BIBLIOGRAPHY

C. Ricci: *La statua di Guidarello* (Ravenna, 1897)

A. Moschetti: 'Il monastero di Praglia', *L'Arte*, vii (1904), pp. 324–5

S. Bernicoli: 'Arte e artisti in Ravenna (continuazione)', *Felix Ravenna*, xiii (1914), pp. 551–66

L. Baldass: 'Eine Reliefbüste von Tullio Lombardo', *Jb. Preuss. Kstsamml.*, xlvii (1929), pp. 109–11

L. Planiscig: 'Per il quarto centenario della morte di Tullio Lombardo e di Andrea Riccio', *Dedalo*, xii/3 (1932), pp. 901–24

——: 'Del Giorgionismo nella scultura veneziana all'inizio del cinquecento', *Boll. A.*, 3rd ser., xxviii (1934–5), pp. 146–55

G. Mariacher: 'Problemi di scultura veneziana (II): 3. L'Eva Vendramin', *A. Ven.*, iv (1950), pp. 107–9

——: 'Tullio Lombardo Studies', *Burl. Mag.*, xcvi (1954), pp. 366–74

W. S. Sheard: *The Tomb of Doge Andrea Vendramin in Venice by Tullio Lombardo* (diss., New Haven, Yale U., 1971)

L. Puppi: 'Per Tullio Lombardo', *A. Lombarda*, xvii/1 (1972), pp. 100–03

R. Stone: 'Tullio Lombardo's Adam from the Vendramin Tomb: A New Terminus ante quem', *Marsyas*, xvi (1972–3), pp. 87–8

S. B. Wilk: 'Tullio Lombardo's "Double-portrait" Reliefs', *Marsyas*, xvi (1972–3), pp. 67–86

M. Maek-Gérard: *Tullio Lombardo: Ein Beitrag zur Problematik der venezianischen Werkstatt bis zu den Auswirkungen des Krieges gegen die Liga von Cambrai* (diss., U. Frankfurt am Main, 1974)

C. K. Lewis: *The Villa Giustinian at Roncade* (New York, 1977)

W. S. Sheard: 'Sanudo's List of Notable Things in Venetian Churches and the Date of the Vendramin Tomb', *Yale It. Stud.*, i (1977), pp. 219–68

——: '"Asa Adorna": The Prehistory of the Vendramin Tomb', *Jb. Berlin. Mus.*, 2nd ser., xx (1978), pp. 117–56

S. B. Wilk: *The Sculpture of Tullio Lombardo: Studies in Sources and Meaning* (New York, 1978)

D. Pincus: 'Tullio Lombardo as a Restorer of Antiquities: An Aspect of Fifteenth-century Venetian Antiquarianism', *A. Ven.*, xxxiii (1979), pp. 29–42

W. S. Sheard: 'Giorgione and Tullio Lombardo', *Giorgione: Atti del convegno internazionale di studio per il 5 centenario della nascita: Castelfranco Veneto, 1979*, pp. 201–11

M. Maek-Gérard: 'Die "Milanexi" in Venedig: Ein Beitrag zur Entwicklungsgeschichte der Lombardi Werkstatt', *Wallraf-Richartz-Jb.*, xli (1980), pp. 105–30

D. Pincus: 'An Antique Fragment as Workshop Model: Classicism in the Andrea Vendramin Tomb', *Burl. Mag.*, cxxiii (1981), pp. 342–7

P. Stepan: *Die Reliefs der Cappella del Santo in Padua: Quellenstudien und Untersuchungen zu ihrer Ikonographie* (diss., Munich, Ludwig-Maximilians-U., 1982)

M. Tafuri: '"Pietà" repubblicana, neobizantinismo e umanesimo: Giorgio Spavento e Tullio Lombardo nella chiesa di San Salvador', *Ric. Stor. A.*, xix (1983), pp. 5–36

S. B. Wilk: 'Titian's Paduan Experience and its Influence on his Style', *A. Bull.*, lxv (1983), pp. 51–61

The Genius of Venice (exh. cat., ed. J. Martineau and C. Hope; London, RA, 1983), pp. 365–7

W. S. Sheard: 'The Birth of the Monumental Classicising Relief in Venice on the Façade of the Scuola di San Marco', *Interpretazioni veneziane: Studi di storia dell'arte in onore di Michelangelo Muraro*, ed. D. Rosand (Venice, 1984), pp. 149–74

——: 'Bramante e i Lombardo: Ipotesi su una connessione', *Venezia–Milano* (Milan, 1984), pp. 25–56

S. B. Wilk: 'La decorazione cinquecentesca della cappella dell'Arca di S Antonio', *Le sculture del Santo di Padova*, ed. G. Lorenzoni (Vicenza, 1984), pp. 109–72

C. Carpanese and S. Trolese: *L'abbazia di Santa Maria di Praglia* (Milan, 1985)

A. M. Odenthal: *Die Kirche San Giovanni Crisostomo in Venedig: Ein Beitrag zur venezianischen Sakralarchitektur des späten 15. Jahrhunderts* (diss., Bonn, Rhein. Friedrich-Wilhelms-U., 1985)

P. Stepan: 'Die Reliefs der Cappella del Santo in Padua', *Das Münster*, xxxviii (1985), pp. 55–6

C. E. Burns: *San Salvatore and Venetian Church Architecture, 1490–1530* (diss., New York U., 1986)

A. Luchs: 'Tullio Lombardo's Cà d'Oro Relief: A Self-portrait with the Artist's Wife?', *A. Bull.*, lxxi (1989), pp. 230–36

C. M. Brown: 'Tullio Lombardo and Mantua . . .', *A. Ven.*, lxiii (1989–90), pp. 121–30

M. T. Fiorio: 'Between Milan and Venice: The Role of Sculpture', *Leonardo and Venice* (Milan, 1992), pp. 137–54, 388–95

A. Luchs: *Tullio Lombardo and Ideal Portrait Sculpture in Renaissance Venice, 1490–1530* (Cambridge, 1995)

(3) Antonio Lombardo (*b ?c.* 1458; *d* Ferrara, ?1516). Sculptor, son of (1) Pietro Lombardo. Unlike Pietro and his brother Tullio, he practised sculpture exclusively, and he worked in bronze as well as marble. He was trained in his father's workshop, but his specific role is difficult to discern before the funerary monument to *Bishop Zanetti* in Treviso Cathedral in the late 1480s. He has been convincingly credited with the carving of the extremely realistic portrait of the deceased bishop and with the eagle and some of the decorative carving on the sarcophagus (Munman, 1977). Much of the decorative carving on the base of the *Vendramin* tomb (Venice, SS Giovanni e Paolo) has also been attributed to Antonio (Sheard, 1971), as has the relief of the *Baptism* on the *Giovanni Mocenigo* monument (Venice, SS Giovanni e Paolo; *see* (2), fig. 1 above).

Antonio's first signed and documented sculpture is his monumental relief of the *Miracle of the Newborn Babe* for the Cappella dell'Arca in Il Santo, Padua. The relief was commissioned in 1500 and finished in 1504. Antonio's sculpture met with such favour that in 1501 he was hired to carve the *Miracle of the Miser's Heart*. Although he never executed the relief (Tullio replaced him in 1520), Antonio must have worked out a basic composition because a drawing of the subject (England, priv. col., see 1980 exh. cat.) reflects Antonio's style in the *Newborn Babe* relief.

The executed relief of the *Miracle of the Newborn Babe* has been characterized as an antique scene into which two friars have strayed (Pope-Hennessy, 1963). Together with Tullio's contemporary relief of the *Miracle of the Reattached Leg*, it set the standard for the remaining seven reliefs in the chapel. Nevertheless, there are distinctions between Antonio's and Tullio's interpretation of the set compositional formula: Antonio's figures are understated in their emotional reaction, more three-dimensional, full-bodied, softly sensuous and languid, whereas Tullio's are tense and melodramatic.

Antonio's other major commission, the funerary chapel of Cardinal Zen in the narthex of S Marco, Venice, was begun in late 1503 in collaboration with Alessandro Leopardi. By May 1505 Leopardi had withdrawn from the project leaving Antonio in charge with Tullio helping him.

Before Antonio went to Ferrara in 1506, he had finished the over-life-size bronze of the *Virgin and Child*, known as the *Madonna della Scarpa*, on the chapel's altar and the altar baldacchino with the relief of *God the Father and Angels*. Between 1512 and its completion in 1521, Tullio took charge of the project. The Cardinal's sarcophagus and altar antependium were executed by Paolo Savin, but the elaborate description of the chapel in the Cardinal's will (1501) makes it likely that the ensemble was planned before his death (Jestaz, 1986).

In 1506 Antonio was called to Ferrara by Alfonso I d'Este, Duke of Ferrara, to work on his private apartments in the Castello. He was involved with this commission until his death. For it he carved a number of mythological and decorative reliefs in marble, of which 30 survive (St Petersburg, Hermitage; Florence, Bargello). Of the 28 reliefs in St Petersburg, 2 are larger and illustrate mythological themes, traditionally identified as the *Forge of Vulcan* and the *Contest between Minerva and Neptune*, although their precise subjects are uncertain. The two reliefs in Florence depict *?Venus* and *Apollo*. The assumption that Antonio's reliefs complemented the bacchanals by Titian and other painters in Alfonso's Camerino di alabastro has been challenged by indications that the sculptures were intended for another room in the palace. It has also been suggested that these themes, which are unusual in Renaissance art, were inspired by Pausanias' description of the sculptures by Phidias at the Parthenon, Athens. Although the text of Pausanias was not published until 1516, it was known to Pomponius Gauricus, a friend of the Lombardi, who alluded to it in his own treatise published in 1504. Not only the subjects of the reliefs but their many quotations from ancient art bespeak Antonio's conscious emulation of the Greco-Roman past (Hope, 1971; Goodgal, 1978).

BIBLIOGRAPHY

J. von Schlosser: 'Aus der Bildnerwerkstatt der Renaissance, III: Eine Reliefserie des Antonio Lombardo', *Jb. Ksthist. Samml. Allhöch. Ksrhaus.*, xxxi (1913/14), pp. 87–100

G. de Nicola: 'Notes on the Museo Nazionale of Florence—IV', *Burl. Mag.*, xxxi (1917), pp. 174–7

W. Stechow: 'The Authorship of the Walters "Lucretia"', *J. Walters A. G.*, xxiii (1960), pp. 72–85

J. Pope-Hennessy: *Catalogue of Italian Sculpture in the Victoria and Albert Museum*, i (London, 1964), pp. 353–7

C. Hope: 'The "Camerini d'alabastro" of Alfonso d'Este', *Burl. Mag.*, cxiii (1971), pp. 641–50, 712–21

W. S. Sheard: *The Tomb of Doge Andrea Vendramin in Venice by Tullio Lombardo* (diss., New Haven, Yale U., 1971)

E. Ruhmer: 'Antonio Lombardo: Versuch einer Charakteristik', *A. Ven.*, xxviii (1974), pp. 39–73

J. Biscontin: 'Une Frise de marbre d'Antonio Lombardo au Musée du Louvre', *Rev. Louvre*, xxv/4 (1975), pp. 234–6

D. Goodgal: 'The Camerino of Alfonso I d'Este', *A. Hist.*, i (1978), pp. 162–90

D. Lewis: 'The Washington Relief of *Peace* and its Pendant: A Commission of Alfonso d'Este to Antonio Lombardo in 1512', *Collaboration in Italian Renaissance Art*, ed. J. Paoletti and W. S. Sheard (New Haven, 1978), pp. 233–44

Disegni veneti di collezioni inglesi (exh. cat., ed. J. Stock; Venice, Fond. Cini, 1980), p. 24, cat. no. 3

The Genius of Venice, 1500–1600 (exh. cat., ed. J. Martineau and C. Hope; London, RA, 1983), pp. 363–5

U. Schlegel: 'Mars, Venus und Amor: Ein Relief von Antonio Lombardi', *Mitt. Ksthist. Inst. Florenz*, xxviii (1984), pp. 65–76

B. Jestaz: *La Chapelle Zen à Saint-Marc de Venise d'Antonio à Tullio Lombardo* (Stuttgart, 1986)

W. S. Sheard: 'Antonio Lombardo's Reliefs for Alfonso d'Este's Studio di Marmi . . .', *Titian 500*, ed. J. Manca, *Stud. Hist. A.*, xlv (1994)

SARAH BLAKE McHAM

(4) Aurelio Lombardo (*b* Venice, *c.* 1501; *d* Recanati, 9 Sept 1563). Sculptor and bronze-caster, son of (3) Antonio Lombardo. He is first documented in Ferrara, in 1524 and 1529. From 1539 he was in Loreto, where he and his brother (5) Girolamo Lombardo made a series of marble statues of *Prophets* for the Santa Casa in the basilica (*in situ; see* LORETO, §II, 1(ii)). The precise contribution of each brother is still debated. Aurelio also worked in bronze, and for the chapel of the Holy Sacrament in the basilica he made a bronze cornucopia candleholder (1547–8) and a chandelier (1547–50) with *all'antica* motifs of cornucopias and putti. In 1550 he was in Recanati, where he and his brothers Girolamo and Ludovico Lombardo (1507/8–75) established a bronze foundry. With them he executed for Pope Pius IV a bronze cylindrical tabernacle with reliefs of scenes from the *Life of Christ* (1560) for Milan Cathedral (*in situ*). His work was stylistically similar to that of (2) Tullio Lombardo and Antonio, as is seen in the door of a marble tabernacle, with two angels and a figure of God the Father (Loreto, Pal. Apostolico) also made for the chapel of the Holy Sacrament.

BIBLIOGRAPHY

Thieme–Becker

G. Vasari: *Vite* (1550, rev. 2/1568); ed. G. Milanesi (1878–85), iv, p. 520; vi, p. 480; ix, p. 88

F. Grimaldi: *Loreto: Basilica della Santa Casa* (Bologna, 1975)

F. Grimaldi and K. Sordi: *Scultori a Loreto: Fratelli Lombardi, Antonio Calcagni e Tiburzio Vergelli: Documenti* (Ancona, 1987)

□

(5) Girolamo Lombardo (*b* Ferrara, *c.* 1505–10; *d* Loreto, between 17 Jan 1584 and 12 June 1589). Sculptor and bronze-caster, son of (3) Antonio Lombardo. According to Vasari, he was a pupil of JACOPO SANSOVINO and worked with Tiziano Minio and Danese Cattaneo on the decorative sculpture for Sansovino's Loggetta (*c.* 1537–42) in the Piazza S Marco, Venice (*in situ*). His precise contribution is debated, but he may have executed marble reliefs of mythological subjects. Vasari also mentioned that he worked in *mezzo rilievo* on the decoration of Sansovino's Libreria Marciana (1532–48) in Venice with Cattaneo, Bartolomeo Ammannati and Tommaso Lombardo. He may have executed the relief panels of garlands and putti for the soffits of the Library. In 1543 he left Venice for Loreto, where he and his brother (4) Aurelio Lombardo executed a series of marble statues of *Prophets* for the Santa Casa in the basilica (*in situ*).

From 1550 Girolamo lived in Recanati. In Rome *c.* 1560 he and Aurelio were commissioned by Pope Pius IV to make a bronze tabernacle for Milan Cathedral (*in situ*), with reliefs of scenes from the *Life of Christ* (1560). From 1568 to 1576 he worked on the bronze doors on the north and south sides of the Santa Casa at Loreto with his brother Ludovico Lombardo (1507/8–75), Tiburzio Vergelli and Antonio Calcagni. The doors were decorated with narrative scenes from the *Life of Christ*. In 1570 he made a bronze tabernacle for the chapel of the Holy Sacrament in Fermo Cathedral (*in situ*). After 1572 he worked as a papal bronze-caster. He executed a bronze

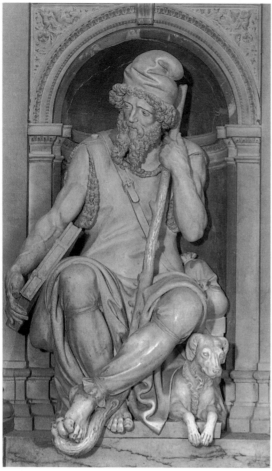

Girolamo Lombardo: *Amos*, marble, 1578–9 (Loreto, S Maria di Loreto, Santa Casa)

statue of *Pope Gregory XIII* (1575; destr.) for Ascoli Piceno. Girolamo also produced another statue of a prophet, *Amos*, for the Santa Casa, Loreto (1578–9; *in situ*; see fig.). In 1581 he made a bronze cornucopia candleholder to match one made earlier by Aurelio for the chapel of the Holy Sacrament in Loreto. In 1583 he completed the bronze statue of the *Virgin and Child* above the main portico of the Santa Casa at Loreto (*in situ*), executed with his son Antonio Lombardo (*d*between 4 June 1608 and 14 April 1610).

BIBLIOGRAPHY

Thieme–Becker

Vasari: *Vite* (1550, rev. 2/1568); ed. G. Milanesi (1878–85), iv, pp. 514, 519; vi, pp. 479ff

F. Grimaldi: *Loreto: Basilica della Santa Casa* (Bologna, 1975)

F. Grimaldi and K. Sordi: *Scultori a Loreto: Fratelli Lombardi, Antonio Calcagni e Tiburzio Vergelli: Documenti* (Ancona, 1987)

☐

(6) Sante Lombardo (*b* Venice, 1504; *d* Venice, 1560). Architect, son of (2) Tullio Lombardo. He had a career of limited importance as an architect in Venice. He was *protomagister* at the Scuola Grande di S Rocco between 1524 and 1527, executing a model apparently designed by his predecessor, Pietro Bon; Tullio served as the respon-

sible architect because Sante was only 20 years old when he became *proto*. Sante evidently made little progress before his replacement by Antonio Scarpagnino, who completed the building.

Sante is also credited with the design of S Giorgio dei Greci, the Greek national church in Venice. Construction was begun in 1539, but was finished in 1561 by Giovanni Antonio Chiona. Sante was one of the architects involved in the Palazzo Malipiero–Trevisan, one of the most striking Lombardesque private buildings in Venice, but his role there is unclear. The rebuilding of S Felice, Venice, in 1551–6 in the form of a neo-Byzantine domed quincunx in imitation of Codussi's S Giovanni Crisostomo has also been attributed to Sante. Sante's two sons also became architects of minor note, but more research needs to be done to clarify the details of their careers.

BIBLIOGRAPHY

R. v. d. Malsburg: *Die Architektur der Scuola Grande di San Rocco in Venedig* (diss., Heidelberg, Ruprecht-Karls-U., 1976)

V. Willmes: *Studien zur Scuola di San Rocco in Venedig* (Munich, 1985)

SARAH BLAKE McHAM

Lombardo, Costanzo. *See* COSTANZO DA FERRARA.

Lombardo, Cristoforo [il Lombardino] (*b* Milan, ?1480–90; *d* Milan, Oct 1555). Italian sculptor and architect. He first trained as a mason, probably in the workshop of Milan Cathedral, but then dedicated himself to sculpture and is first recorded as a sculptor in a payment made to him by the Veneranda Fabbrica in 1510. In 1513–14 he went to Rome and on his return to Milan was readmitted among the sculptors at the cathedral. He collaborated on commissions accepted by Bambaia, including the funerary monument of *Lancino Curzio* in 1515 (Milan, Castello Sforzesco) and, in the following years, the monument to *Gaston de Foix* (begun *c.* 1517; dismembered; fragments in Milan, Ambrosiana, Castello Sforzesco and elsewhere; for illustration *see* BAMBAIA).

Lombardo also practised architecture in the cathedral workshop and was commissioned in 1518 to build a pinnacle and two rainwater ducts beneath the lantern staircase. In 1526, due to his experience as a sculptor and architect, he succeeded Andrea da Fusina as engineer of the Fabbrica del Duomo (Cathedral Works), a position that he held until his death. He developed a perfect understanding of the Gothic structure, which he respected, although he isolated the loadbearing structure from the decorative elements. From 1538 he was engaged on plans for the north portal (on the site of the present altar of the *Madonna dell'albero*). For this he prepared a number of drawings and at least two models, arriving at a solution embodying a three-arched opening with a clear distinction between architectural structure and sculpted reliefs, as can be seen in the great wooden model of the cathedral (Milan, Mus. Duomo). He himself executed one of the reliefs intended for the door, depicting the *Presentation of the Virgin*; this is now positioned, with the others executed at the same time by other artists, on the left pier at the entrance to the Lady Chapel.

Lombardo's work for Milan Cathedral also included designs for some of the religious furnishings, often in collaboration with Bambaia. He was certainly responsible

for the architectural design of altars and tombs, including the *Caracciolo* monument (1538–48) in black stone with a Doric order in the ambulatory, and the Altar of the Presentation (1543) in the right transept. In both of these works the architectural elements are treated quite autonomously and serve to coordinate the areas intended for reliefs and statues. For the Altar of the Presentation, Lombardo also executed the statue of *St Catherine*.

In his capacity as engineer of the Cathedral Works, Lombardo was often called on to supervise and advise on other religious buildings in Milan. From 1530 he worked at Bramante's S Maria presso S Celso, overseeing the completion of the aisles and their marble facing, and also the coffering of the ceiling, a job that took 20 years to complete. From 1532 he was occupied with the marble floor of S Satiro, which was still being executed 20 years later: further drawings and designs were requested from him in 1551. In 1532 he assessed the value of the work on the marble font of S Stefano in Brolo, and he remained in the service of the Maintenance Committee of this church for a number of years, working on the choir (destr.) in 1538. From 1537 he worked on the church of S Eustorgio. He also worked (from 1534) for Massimiliano Stampa (*d* 1552), restructuring the latter's city houses into a palace, the Palazzo Stampa di Soncino (altered in the 19th and 20th centuries). He endowed the entrance with a lofty tower, articulated with features inflected as coupled columns at ground-floor level, as pilasters on the next two floors, and thereafter as lesene framing, the whole crowned with a double eagle on two tall columns with the motto 'plus ultra', the emblem of Charles V (*reg* 1519–56). Subsequent architectural projects include the construction of the church of S Caterina della Chiusa (destr.), which is known through 19th-century reliefs by Luigi Cagnola. The façade features superimposed orders with strict classical detailing and delicate mouldings around the voids. Similar skill in the disposition of wall spaces can be found in the interior of the centrally planned chapel of S Caterina presso S Nazaro (1541–2), which is attributed to Lombardo. Around 1542 he submitted a design for the completion of the Certosa di Pavia (a trace of which remains in a drawing in Milan, Castello Sforzesco; Bianconi Col.), which was subsequently executed under his supervision. Between 1545 and 1547 Lombardo is recorded as active at the sanctuary of the *Madonna dei Miracoli* (1498), Saronno, and from 1547 he worked on the completion of the Trivulzio Chapel in S Nazaro.

As architect to Milan Cathedral, Lombardo was also often concerned with matters relating to the cathedral square, especially on such festive occasions as the entry in 1541 of Emperor Charles V and that of King Philip II of Spain (*reg* 1556–98). In 1541 the floats and displays were designed by Giulio Romano, who was also asked for an opinion on the north transept door of the cathedral. Through Giulio's intervention, Lombardo was called to Bologna in 1545 to provide a drawing for the façade of S Petronio in collaboration with Giulio, and Giulio's influence can be seen in Lombardo's later works, for example the octagonal lantern of the church of S Maria della Passione, which he worked on in 1550–51. Inside, the half columns at the angles between the chapels are projected upwards above the entablature as wall strips and then into

the vault as ribs, giving a marked vertical thrust. From 1552 Lombardo suffered increasingly from gout, forcing him to delegate part of the site-work in all his commissions to his collaborator Vincenzo Seregni.

BIBLIOGRAPHY

Annali della fabbrica del Duomo di Milano dall'origine fino al presente, iii (Milan, 1880)

C. Baroni: *Documenti per la storia dell'architettura a Milano nel rinascimento e nel barocco*, i (Florence, 1940); ii (Rome, 1968)

P. Mezzanotte: 'S Caterina alla Chiusa e Cristoforo Lombardo', *Palladio*, vii (1943), pp. 23–6

G. Treccani degli Alfieri, ed.: *Storia di Milano*, viii (Milan, 1957)

G. Struffolino Krüger: 'Qualità, valore, armonia nell'architettura della chiesa di S Caterina presso S Nazaro', *A. Lombarda*, xii (1967), pp. 37–48

M. G. Albertini Ottolenghi, R. Bossaglia and F. R. Pesenti: *La Certosa di Pavia* (Milan, 1968)

R. Bossaglia: 'La scultura', *Il Duomo di Milano*, ii (Milan, 1973), pp. 65–176

H. Heydenreich and W. Lotz: *Art and Architecture in Italy 1400–1600*, Pelican Hist. A. (Harmondsworth, 1974)

Omaggio a Tiziano: La cultura artistica milanese nell'età di Carlo V (exh. cat., ed. G. Bologna; Milan, Pal. Reale, 1977), pp. 97–131

A. Scotti and others: *S Maria della Passione e il Conservatorio G. Verdi a Milano* (Milan, 1982)

Giulio Romano (exh. cat., intro. E. Gombrich; Mantua, Pal. Te and Pal. Ducale, 1982) [incl. prev. unpubd designs for S Petronio façade, 1545]

AURORA SCOTTI TOSINI

Lombardo, Tommaso [da Lugano] (*fl c.* 1536–50). Italian sculptor. He is first recorded as an assistant of Jacopo Sansovino in Venice from 1536 to 1546. He may have trained previously with Sansovino since his role during these years was that of factotum who carried out Sansovino's ideas efficiently and faithfully. With Luca Lancia he blocked out the marble *Virgin, Child and Angels* (Venice, Doge's Pal., chapel), and he also worked on the first of the marble *pergoli* (balconies) designed by Sansovino for the choir of S Marco (1536–7). At the same time he supervised the production of the bronze reliefs for the first *pergolo*. In 1542–4, he was in charge of another set of bronze reliefs for the second *pergolo*, and he also oversaw the early stages in the production of Sansovino's bronze sacristy door for S Marco (1546).

Vasari, who was unusually well informed about Sansovino's followers, ascribed to Tommaso unspecified carved figures for the library of S Marco, probably some of the river gods and victories on the spandrels. He also stated that Tommaso left Sansovino's workshop just before the creation of one of his major surviving works, the marble altarpiece of the *Virgin, Child and Infant Baptist* (*c.* 1546–7; Venice, S Sebastiano). Tommaso's other known statue, a marble *St Jerome* (?before 1547), was for the chapel of Hieronimo Priuli in S Salvatore, Venice. Vasari also mentioned a lost bust of the Emperor Charles V (*reg* 1519–56) and stucco decorations (unidentified). Antonio Foscari has recently called attention to a terracotta model for the group in S Sebastiano, a work formerly in a private collection in Venice.

Tommaso's critical reputation has never been high: Francesco Sansovino observed that the altarpiece in S Sebastiano was a copy of a group by his father, Jacopo, in the Loggetta in Venice, and the *St Jerome* and its relief of *God the Father* invite comparison with motifs from other works by Jacopo Sansovino. They reveal a craftsman of good technical ability though devoid of imagination. It

was this that made Lombardo, with his self-effacing personality, a valued collaborator of Sansovino.

BIBLIOGRAPHY

G. Vasari: *Vite* (1550, rev. 2/1568); ed. G. Milanesi (1878–85), vii, p. 520
A. Venturi: *Storia* (1901–40), x/3, pp. 58–63
E. Ybl: 'Tommaso Lombardos Altarstatuen in Bissone', *Z. Schweiz. Archäol. & Kstgesch.*, viii (1946), pp. 53–6
B Boucher: 'Jacopo Sansovino and the Choir of St Mark's', *Burl. Mag.*, cxviii/881 (1976), pp. 552–66
——: 'Jacopo Sansovino and the Choir of St Mark's', *Burl. Mag.*, cxxi/912 (1979), pp. 155–68
A. Foscari: 'T. Lombardo da Lugano nella bottega di Jacopo Sansovino', *Venezia A.*, ix (1995), pp. 141–5

For further bibliography *see* SANSOVINO, (1).

BRUCE BOUCHER

Longhi [Lunghi] **(i).** Italian family of painters. They flourished during the 16th century and the early 17th. The Mannerist painter (1) Luca Longhi, who produced mainly religious paintings and portraits, trained two of his children, (2) Francesco Longhi and (3) Barbara Longhi. They collaborated with him on several of his later works, including the *Marriage of Cana* (1579–80; Ravenna, Bib. Com. Classense), which incorporates portraits of Barbara and Francesco Longhi.

(1) Luca Longhi (*b* Ravenna, 10 Jan 1507; *d* Ravenna, 12 Aug 1580). His earliest works, such as the *Marriage of St Catherine* (1529–32; Ravenna, Pin. Com.), show the influence of Baldassare Carrari (*fl* 1489–1516), Francesco Zaganelli and Niccolò Rondinelli, but he also learnt from the works of mainstream painters, in particular Giorgio Vasari, as is evident in his *Circumcision* (1561; ex-S Benedetto, Ferrara; Ferrara, Pin. N.), in which he introduced portraits of Dante Alighieri, Michelangelo and Titian among the spectators. Vasari claimed that Luca Longhi never left Ravenna, and this isolation no doubt contributed to his limitations. However, he was a skilled portrait painter, his subjects being local dignitaries, patricians and professional men, such as *Girolamo Rossi, Raffaele Rasponi* and *Giovanni Arrigoni* (all 1567; all Ravenna, Accad. B.A.).

BIBLIOGRAPHY

G. Vasari: *Vite* (1550; rev. 2/1568); ed. G. Milanesi, vii (1881), p. 420
A. Pigler: 'Zur Bildniskunst von Luca Longhi', *Pantheon*, xv (1935), pp. 120–24
Luca Longhi e la pittura su tavola in Romagna nel cinquecento (exh. cat., ed. J. Bentini; Ravenna, Loggetta Lombard., 1982), pp.13–78

(2) Francesco Longhi (*b* Ravenna, 10 Feb 1544; *d* Ravenna, 1618). Son of (1) Luca Longhi. He received his early training in his father's workshop and was influenced by the works of Giorgio Vasari and Marcello Venusti; elements from their paintings can be seen in the figure of Christ in his *Crucifixion with the Virgin and SS John, Apollinare and Vitale* (Ravenna, Pin. Com.). He also looked to the works of Federico Zuccaro, Correggio and, above all, Gian Francesco Modigliani (*fl* 1598–?1609). Like his father, Francesco Longhi executed mainly altarpieces for local churches (1586, 1604, Ravenna, S Giovanni Battista; 1605, Ravenna, S Maria in Porto).

BIBLIOGRAPHY

Luca Longhi e la pittura su tavola in Romagna nel cinquecento (exh. cat., ed. J. Bentini; Ravenna, Loggetta Lombard., 1982), pp. 169–77

(3) Barbara Longhi (*b* Ravenna, 1552; *d c.* 1638). Daughter of (1) Luca Longhi. She assisted her father with large altarpieces and copied many of his works. Her own work often resembles his but is on a smaller scale. She was also indebted to contemporary Florentine and Bolognese painters. Of her 15 known works (Cheney), 12 are small *Virgin and Child* compositions, which Vasari praised for their 'purity of line and soft brilliance of colour' (Vasari, 1568; Cheney, p. 16). Her early works are simple compositions, using a limited palette and emphasizing linearity over modelling. *St Catherine of Alexandria* (1589; Ravenna, Pin. Com.) was painted for the monastery of Classe in Ravenna and is probably a self-portrait of the artist. After 1590 Longhi's colour became more brilliant, and her figures attained a certain monumentality. She also began to employ the device of a curtain draped around a column (taken from such painters as Correggio and Parmigianino) and of an area opening out onto a landscape or sky in the background of her compositions, as in *Virgin and Child with St John the Baptist* (*c.* 1595–1600; Dresden, Gemäldegal. Alte Meister). The *sfumato* technique and the pyramidal composition are reminiscent of Leonardo and of Raphael's Florentine works (1506–8). After 1600 she seems to have abandoned full-figure compositions in architectural settings in preference for simple pious images. The *Virgin with Sleeping Child* (*c.* 1600–05; Baltimore, MD, Walters A.G.), one of her most devotional paintings, avoids narrative or Mannerist pictorial riddles and concentrates on the viewer's intimate relation to the figures depicted. As with most of her work, it reflects the intense religious ideals of the Counter-Reformation.

BIBLIOGRAPHY

L. D. Cheney: 'Barbara Longhi of Ravenna', *Woman's A.J.*, ix (1988), pp. 16–20

□

Longhi [Longo; Lunghi; Lungo] **(ii).** Italian family of architects and masons. They were originally from Viggiù on the Lombard–Swiss border, but the three most prominent members of the family, the architects (1) Martino Longhi I and his son Onorio Longhi (1568–1619) and Onorio's son Martino Longhi II (1602–1660), were active in Rome from the late 16th century until the first half of the 17th. Their careers reflect the changes that took place in Italian architecture from the period of the late Renaissance, when Martino I was active, to the High Baroque.

BIBLIOGRAPHY

I. Longhi: Una famiglia di architetti tra manierismo e barocco (exh. cat., ed. L. Patetta; Viggiù, Mus. Enrico Butti; Rome, Accad. N. S Luca, 1980)
La Roma dei Longhi: Papi e architetti tra manierismo e barocco (exh. cat., ed. M. Fagiolo dell'Arco; Rome, Accad. N. S Luca, 1982)

(1) Martino Longhi I [the elder] (*b* Viggiù, *c.* 1534; *d* Rome, *c.* 1591). He seems to have begun his career in the masonry trade in Viggiù. The first records of his architectural activity date from 1562–7, when he was involved in the planning of Schloss Hohenems, near Bregenz, for the family of Cardinal Marcus Sitticus Altemps, and the church of Santa Croce (1566–72), Bosco Marengo, which was commissioned directly by Pope Pius V for his home town. Influenced no doubt by his Austrian patron, as well as by his contacts with the architect Jacopo Vignola, Longhi

settled in Rome *c.* 1569 and remained there for the rest of his life.

Longhi's first Roman commission of consequence was the Villa Mondragone in FRASCATI, begun in 1573 for Cardinal Altemps. Longhi's design of the villa and Altemps's close friendship with the newly elected Pope Gregory XIII led to his appointment as papal architect. In this capacity he oversaw the expansion (1575) of the courtyard of S Damaso in the Vatican Palace and remodelled part of the Baths of Diocletian in order to turn it into a granary (plans, Rome, Accad. N. S Luca). His career continued to flourish even after he was replaced as papal architect by Ottaviano Mascherino in 1577. Longhi built the handsome two-tiered bell-tower (1578) on the Palazzo Senatorio and was soon actively involved in the construction of the Palazzo Cesi (now Palazzo Mellini; plans, Rome, Accad. N. S Luca, MS. 2401; rebuilt mid-19th century), the Palazzo Altemps and the Palazzo Deza (now Palazzo Borghese). The latter, situated near the Tiber, brought Longhi his greatest fame. He was responsible for the wing facing the Via di Monte d'Oro, which is the longest palazzo elevation in Rome and is clearly divided into three storeys, with three deep mezzanine levels. Its relative decorative plainness is compensated for by its impressive scale. He was probably also responsible for the courtyard, which was later completed by Flaminio Ponzio.

As a designer of churches, Longhi remodelled the interior and built the lower storey of the façade of S Maria della Consolazione (after 1581). In 1584 Cardinal Altemps commissioned the Altemps Chapel in S Maria in Trastevere, which was frescoed by Pasquale Cati (*c.* 1550–*c.* 1620) with figures and themes associated with the Altemps family. Longhi continued the construction of S Maria in Vallicella (1586–90; plans, Rome, Archv Congregazione Oratorio) and designed the façade of S Girolamo degli Schiavoni (1587–90).

Throughout his career Martino the elder seldom broke from the prevailing architectural conventions of Vignola, his presumed mentor. His work, like that of his contemporaries Domenico Fontana, Mascherino and Francesco da Volterra, is characterized by a bland conformity that hardly anticipates the vitality and inventiveness of the coming Baroque. Longhi's façade of S Girolamo degli Schiavoni gives the clearest idea of his personal style, since he was in complete control of the construction from beginning to end; it typifies in both its flatness and its reliance on earlier Roman models (e.g. Vignola's Il Gesù) the timidity and unadventurous attitude of its age. Only in the courtyard of the Palazzo Deza—if indeed it may be attributed to him—did Longhi introduce new vocabulary and syntax into the grammar of Roman Late Mannerism.

BIBLIOGRAPHY

G. Baglione: *Vite* (1642); ed. V. Mariani (1935), pp. 68–9
H. Hibbard: 'The Architecture of the Palazzo Borghese', *Mem. Amer. Acad. Rome*, xxvii (1962), pp. 83–93
G. Koksa: *S. Girolamo degli Schiavoni* (Rome, 1971)
M. Bevilacqua: 'Palazzetto Cenci a Roma: Un aggiunta per Martino Longhi il Vecchio e un contributo per Giovanni Guerra pittore', *Boll. A.*, lxx (May/Aug 1985), pp. 157–88
C. Bertsch: 'Brief und Pläne von Martino Longhi d. Ä. aus dem Palastarchiv zu Hohenems', *Röm. Jb. Kstgesch.*, xxvi (1990), pp. 171–84

JOHN VARRIANO

Longhi [Lunghi], **Silla** [Giacomo, Scilla; Silla, Giacomo; Silla da Viggiù] (*b* Viggiù, nr Varese, 1569; *d* ?Rome, *c.*

1622). Italian sculptor. He executed reliefs (*c.* 1557) for pinnacles on the façade of S Petronio, Bologna, according to Baglione. In 1568–72 he completed eight reliefs from scenes from the *Life of St Sylvester* for the abbey of Nonántola (Modena). By 1578 he was established in Rome, where *c.* 1581 he executed a *Triton* for Giacomo della Porta's Moro Fountain in Piazza Navona (*see* PORTA, GIACOMO DELLA, fig. 1). In Naples that year he completed the tomb of *Caterina Orsini* (Naples, S Caterina a Formiello). His drily carved relief of the *Coronation of Pope Pius V* (Rome, S Maria Maggiore, Cappella Sistina) was completed by 1586. In 1588–90 he worked on reliefs of the *Story of Aaron* and on a single figure of *Aaron* for the chapel of the SS Sacramento and an *Angel* for the transept of the S Giovanni in Laterano, Rome. His later works in Rome include the meticulously carved kneeling figure of *Pope Paul V* (1608), the statically posed statue of *Pope Clement VIII* (both S Maria Maggiore, Cappella Paolina) and the reclining figure of *Cardinal Alessandrino* for his tomb by Giacomo della Porta (*c.* 1611; S Maria sopra Minerva), in which the rippling draperies and characterization of the head give a more lively feeling than Longhi's earlier works.

BIBLIOGRAPHY

G. Baglione: *Vite* (1642); ed. V. Mariani (1935), pp. 120–21
A. Venturi: *Storia* (1901–40), x, pp. 601–6
J. Pope-Hennessy: *Italian High Renaissance and Baroque Sculpture* (Oxford, 1963, rev. 2/1985), pp. 423, 426
M. C. Donati: 'Gli scultori della Cappella Paolina in Santa Maria Maggiore', *Commentari*, xviii (1967), pp. 231–60

ANTONIA BOSTRÖM

Loredan, Leonardo, Doge of Venice (*b* 6 Nov 1436; elected 1501; *d* Venice, 22 June 1521). Italian ruler and patron. He was born into a noble family of Venetian rulers and patrons. Apart from Leonardo, the family's most conspicuous patron in the 15th century was Andrea di Nicolo Loredan (*d* 1513), who paid for the choir of S Michele in Isola, Venice (begun 1469), by Mauro Codussi, and employed Codussi to design his palace at S Marcuola, Venice (begun *c.* 1502; now Palazzo Vendramin–Calergi; *see* CODUSSI, MAURO, fig. 2).

Leonardo Loredan received a humanist education, subsequently making his fortune in Levantine trade while rising through the governing hierarchy of Venice. By 1489 he was an overseer of the building of S Maria dei Miracoli, Venice, by Pietro Lombardo, his only known involvement with the arts until his election as Doge. His long reign was dominated by the wars of the League of Cambrai (1508–17), but despite this the visual arts flourished. Although Venetian rulers were discouraged from commemorating themselves in public monuments or images, Loredan did not observe this tradition. There are relief portraits of him on the three bronze bases for standards (1505–6) by Alessandro Leopardi (for illustration *see* LEOPARDI, ALESSANDRO) in front of S Marco, Venice, and he is glorified in inscriptions on the Porta d'Ognissanti (now Porta Portella) in Padua by Guglielmo de' Grigi. His projects included the renovation of the Doge's Palace in Venice, where his arms are displayed on the exterior of the chapel of S Nicolo (1505–*c.* 1520), by Giorgio Spavento and Antonio Scarpagnino, and the upper two storeys of the façade on the Rio di Palazzo, by Antonio Rizzo and

Lombardo. For the Sala degli Scarlatti he commissioned an unusual and influential votive relief, attributed to Lombardo, in which he is presented to the Virgin and Child by three saints. Fires at the Rialto necessitated the rebuilding of the Fondaco dei Tedeschi by Giorgio Spavento (for illustration *see* SPAVENTO, GIORGIO) and Scarpagnino (1505–8) with façade frescoes (destr.) by Giorgione and Titian, and the Palazzo dei X Savi by Scarpagnino (1520–21). Portraits of Loredan by Giorgione and Titian are untraced, but among surviving likenesses are Giovanni Bellini's masterpiece (London, N.G.; *see* BELLINI, GIOVANNI, fig. 4), a votive portrait by Vincenzo Catena (Venice, Correr), Bellini's portrait of the Doge with his four sons (Berlin, Bodemus.), and six portrait medals.

BIBLIOGRAPHY

M. Brunetti: 'Due dogi sotto inchiesta: Agostino Barbarigo e Leonardo Loredan', *Archv Ven.-Trident.*, vii (1925), pp. 278–329
O. Logan: *Culture and Society in Venice, 1470–1790* (London, 1972)
B. Jestaz: 'Requiem pour Alessandro Leopardi', *Rev. A.*, lv (1982), pp. 23–34
G. Gullino: 'I Loredan di Santo Stefano: Cenni storici', *Palazzo Loredan e l'istituto veneto di scienze, lettere ed arti* (Venice, 1985), pp. 11–33
E. Merkel: 'Il mecenatismo artistico dei Loredan e il loro palazzo a Santo Stefano', *Palazzo Loredan e l'istituto veneto di scienze, lettere ed arti* (Venice, 1985), pp. 53–71
J. Meyer zur Capellen: *Gentile Bellini* (Stuttgart, 1985), pp. 187–90

PAUL H. D. KAPLAN

Lorenzetto. *See* LOTTI, LORENZO.

Lorenzi. Italian family of artists.

(1) Battista (di Domenico) Lorenzi (*b* Settignano, *c.* 1527–8; *d* Pisa, 7 Jan 1592). Sculptor and architect. He trained in the Florentine workshop of Baccio Bandinelli from 1540. Between 1558 and 1559 he collaborated with Vincenzo de' Rossi in Rome on a statue for the monument to *Paul IV* (destr.). Battista had returned to Florence by 1563, when he undertook a cycle of the *Four Seasons* (completed *c.* 1570; untraced) for the residence in Paris of the abate Giovambattista Guadagni (*d* 1591). In 1564, the year of his election to the Florentine Accademia del Disegno, he provided a figure of *Painting* for Michelangelo's catafalque and for Michelangelo's tomb in Santa Croce, Florence, the portrait of *Michelangelo* and the figure of *Sculpture* (later transformed into *Painting*). His terracotta model for *Sculpture* (London, V&A) differs considerably from the final more complex and monumental figure (completed 1574).

In 1568 Alamanno Bandini commissioned one of Battista's most successful compositions, the group of *Alpheus and Arethusa* (New York, Met.). At the same date Battista carved a fountain figure of a *Triton with Dolphins* (Palermo, Mus. Reg.) for Cosimo I de' Medici. A figure of *Ganymede* (Florence, Boboli Gdns) has been attributed to him (Keutner). In 1573 Battista began his association with Jacopo Salviati, for whose Florentine palazzo in the Via del Corso (formerly Palazzo Salviato–Capponi, now Palazzo Nonfinito) he carved a marble figure of *Perseus*, sandstone figures of the river god *Mugnone* (*c.* 1577; *in situ*) and a *Washerwoman* (*c.* 1577–82; Florence, Giard. Gherardesca). From 1583 to 1588 Battista was sculptor and architect to the Opera del Duomo (Cathedral Works) in Pisa. There he was engaged on the rebuilding of several areas of the cathedral, and he designed the bronze *Lampada di Galileo*, erected in 1586, and *St Ephysius* (erected in 1592) for the transept. In 1588–9 he contributed to the decorations for the wedding of Ferdinando de' Medici and executed the façade figures of *St Miniatos* and *St Antoninus* for Florence Cathedral.

BIBLIOGRAPHY

G. Vasari: *Vite* (1550, rev. 2/1568); ed. G. Milanesi (1878–85), vi, p. 82; vii, p. 305; viii, p. 618
R. Borghini: *Il riposo* (Florence, 1584); ed. M. Rosci (Florence, 1967)
L. Tanfani Centofani: *Notizie di artisti tratte dai documenti pisani* (Pisa, 1897), pp. 51, 77–9, 205–7, 217, 454, 473
R. Papini: *Catalogo delle cose d'arte e di antichità d'Italia*, part 1, fasc. II (Rome, 1912), pp. 59, 63, 67, 74–5, 94, 189
H. Utz Kissel: *Battista Lorenzi: Studien zur Entwicklung der Florentiner Skulptur in der zweiten Hälfte des 16. Jh.* (Munich, 1968)
H. Utz: 'Skulpturen und andere Arbeiten des Battista Lorenzi', *Met. Mus. J.*, vii (1973), pp. 37–64
Il Ganimede di Battista Lorenzi (exh. cat., ed. H. Keutner and others; Settignano, Misericordia, 1982)
R. P. Ciardi, C. Casini and L. Tongiorgi Tomasi: *La scultura a Pisa fra quattrocento e seicento* (Pisa, 1987), pp. 25, 100, 152, 178, 183, 218–25, 227, 230, 233, 236, 247

ANTONIA BOSTRÖM

(2) Stoldo (di Gino) Lorenzi (*b* Settignano, 1534; *d* Pisa, 2–6 Sept 1583). Sculptor, nephew of (1) Battista Lorenzi. He was first apprenticed as a carver in his father's workshop and then trained as a painter with Michele Tosini in Florence. By 1550, however, he was apprenticed to the sculptor Niccolò Tribolo. Stoldo's first patron was Luca Martini (*d* 1561), a poet and writer, who was the administrator of Pisa under Cosimo I de' Medici, Grand Duke of Tuscany. Martini housed Stoldo in Pisa *c.* 1555–62, during which time the sculptor also received commissions from S Maria della Spina for an *Annunciation* group and from Cosimo I for a marble *stemma* flanked by personifications of *Religion* and *Justice* for the palazzo of the Cavalieri di S Stefano. His most notable work for Martini is a marble relief of *Cosimo I Receiving Tribute from the Towns of Tuscany* (*c.* 1555; Holkham Hall, Norfolk). Once thought to be by Michelangelo, the relief was commissioned as a pendant to Pierino da Vinci's *Pisa Restored* (1552–3; Rome, Pin. Vaticana; for illustration *see* PIERINO DA VINCI), which Stoldo completed after Pierino's death. In 1565, he worked on the decorations for the wedding of Francesco I de' Medici and Joanna of Austria, which gained him a series of important commissions in Florence, including the statue of *Abraham* (1565) for the chapel of S Luca in SS Annunziata, the bronze *Neptune* (1565–8; Florence, Boboli Gdns) for Cosimo I, and the bronze *Amphitrite* (or *Galatea*, 1573; Florence, Pal. Vecchio) for the *studiolo* of Francesco, commissioned by the Accademia del Disegno, of which Stoldo was now a member. In the autumn of 1573 he went to Milan to work on sculpture for S Maria presso S Celso, including statues of the *Annunciation* and reliefs of the *Flight into Egypt* and the *Adoration of the Magi* on the façade. Apparently due to differences with Annibale Fontana, with whom he shared the commission, Stoldo returned to Tuscany in 1582. At the time of his death, he was working for Pisa Cathedral.

BIBLIOGRAPHY

J. Pope-Hennessy: *Italian High Renaissance and Baroque Sculpture* (Oxford, 1963, rev. New York, 2/1985), pp. 87, 100, 360, 377, 380, 400

H. Utz: 'Pierino da Vinci e Stoldo Lorenzi', *Paragone*, xviii/211 (1967), pp. 47–69
W. O. Hassall and N. B. Penny: 'Political Sculpture at Holkham', *Connoisseur*, cxcv/785 (1977), pp. 207–11

CORINNE MANDEL

Lorenzino da Bologna. *See* SABATINI, LORENZO.

Lorenzo, Duke of Urbino. *See* MEDICI, DE', (11).

Lorenzo, Antonio di Niccolò di. *See* ANTONIO DI NICCOLÒ DI LORENZO.

Lorenzo (di Cecco di Pascolo), Fiorenzo di. *See* FIORENZO DI LORENZO.

Lorenzo da Bologna (*fl* 1465–1508). Italian architect. A document dated 1467 states that he lived in Candiana, near Padua, and possibly worked at the monastery of S Michele. Another document of the same year states that he had married 2 years earlier in or around Padua (Rigoni, p. 165). Lorenzo worked in Vicenza from 1476 on the extension of the choir and sacristy at the basilica of Monte Berico (completed 1480 and 1481 respectively; destr. 1824). In 1480 he joined the Vicenza corporation of masons and stonecutters as an engineer and began work on the Casa Valmarana (now Casa Bertolini); its façade is characterized by a rhythmic composition that updates the Venetian Late Gothic tradition through the use of the architectural vocabulary of the early Renaissance.

From 1481 Lorenzo worked on the new choir, presbytery and crypt of the 13th-century church of S Corona, Vicenza, where, possibly at the patron's wishes, Renaissance stylistic elements define a space that remains Gothic. This effect can also be observed in the contemporary apse of the cathedral (completed 1558–65, with the drum and dome by Andrea Palladio), and in the chapel of the Most Holy, which was annexed to the same building in 1483. Other notable buildings in Vicenza that can be attributed to Lorenzo include the 15th-century part of the Palazzo Thiene (*c.* 1489), its façade (rest. 1872) characterized by a plinth in smooth ashlar and by faceted quoins framing a richly painted architecture at first-floor level. The harmonious balance of the proportions in the church of S Rocco (1485), which has a single space covered by a vault and interrupted halfway by a *cantoria* (singing gallery) on round arches supported by polygonal columns, represents his best achievement.

From 1489 Lorenzo was active in Padua, where he built the upper gallery of the double cloister in the monastery of S Giovanni di Verdara (1490) and began work on the great cloister (1496; with the intarsia artist Pietro degli Abati from Modena). His work on the transept, presbytery and apse of Montagnana Cathedral, which contains recurrent motifs from his religious architecture, such as semidomes and small hanging arches in terracotta decorated with shells, probably dates from the late 1490s. Lorenzo da Bologna was an eclectic architect, employing motifs derived from the architectural work of Filippo Brunelleschi and Leon Battista Alberti that he saw in Mantua. He may thus be considered the first disseminator of Tuscan Renaissance architecture in the Venetian hinterland.

BIBLIOGRAPHY
G. Lorenzoni: *Lorenzo da Bologna* (Venice, 1963)
R. Cevese: 'L'architettura vicentina del primo rinascimento', *Boll. Cent. Int. Stud. Archit. Andrea Palladio*, vi/2 (1964), pp. 199–213
E. Rigoni: *L'arte rinascimentale in Padova: Studi e documenti* (Padua, 1970), pp. 141–85
M. Morresi: 'Contra' Porti a Vicenza: Una famiglia, un sistema urbano e un palazzo di Lorenzo da Bologna', *An. Archit. Cent.*, ii (1990), pp. 97–120
——: 'Palazzo Porto-Breganze a Vicenza: Una precisazione per Lorenzo da Bologna', *An. Archit. Cent.*, iii (1991), pp. 32–9

ADRIANO GHISETTI GIAVARINA

Lorenzo di Credi [Lorenzo d'Andrea d'Oderigo] (*b* Florence, *c.* 1456; *d* Florence, 1536). Italian painter and draughtsman. He was a fellow pupil of Leonardo da Vinci and Perugino in the workshop of Andrea del Verrocchio. In 1482–3 he took over the workshop, and by 1490–1500 he occupied an important position in Florentine art life. He is known primarily for his devotional paintings, although he was also much in demand as a portrait painter and was a sensitive draughtsman.

1. 1457–*c.* 1480. 2. *c.* 1480–1500. 3. 1501–36.

1. 1457–*c.* 1480. He was the son of the goldsmith Andrea di Oderigo Barducci who died leaving his family in difficult economic circumstances. The name Credi (Tancredi) had belonged to a forebear and was also given to an elder brother of Lorenzo's. By 1480, according to the *catasto* (land registry declaration) made by Lorenzo's mother, Lisa, he was already working in Andrea del Verrocchio's workshop for the very low wages of 12 florins a year. However, it is not known precisely how Verrocchio's workshop was organized, and it is possible that in addition to official wages his pupils were also given partial payment for the work they executed to Verrocchio's designs or on which they collaborated.

Besides Leonardo and Perugino, it is probable that other artists were associated with the workshop, including Botticelli, Domenico Ghirlandaio and Francesco di Simone Ferrucci. Despite their youth, these artists were entrusted with important works and often carried them out in collaboration with each other or their master. It is therefore difficult to make any firm attributions for paintings executed in Verrocchio's workshop during the 1470s and 1480s.

Lorenzo was probably singled out early as the best-suited for painting devotional works destined for an affluent but not over-sophisticated clientele. It is likely that by the age of 20, *c.* 1476, he was producing small, technically proficient panels of the Virgin and Child and of saints at prayer. These works are not particularly innovative in terms of composition, but their settings and landscapes are well constructed and painted in meticulous detail, and the figures are carefully arranged in the picture space. The clear, thin impastos of colour are painstakingly laid on and the paint surfaces appear polished and shining. Many of these works are derived from early paintings of Botticelli and Leonardo, but other features suggest an awareness of contemporary South Netherlandish painting, a common characteristic in Verrocchio's workshop. Examples of these devotional works are the Virgin and Child paintings in Dresden (Gemäldegal. Alte Meister), Stras-

bourg (Mus. B.-A.), Mainz (Altertumsmus. & Gemäldegal.) and Turin (Gal. Sabauda). A *St Sebastian* (Modena, Gal. & Mus. Estense) also belongs to this group.

In 1475, or soon afterwards, Verrocchio was commissioned to provide an altarpiece in memory of Donato de' Medici, Bishop of Pistoia (*d* 1466), for his tomb in the oratory of the Vergine di Piazza, near Pistoia Cathedral. The predella of this *sacra conversazione* is now dismantled: the central panel, a small *Annunciation* (Paris, Louvre) is attributed to Leonardo (sometimes to Leonardo in collaboration with Lorenzo di Credi), while a second panel showing a scene from the *Life of St Donatus of Arezzo* (Worcester, MA, A. Mus.) is entirely by Lorenzo; the third panel is untraced, though some scholars have suggested that a small *Birth of the Virgin* (Liverpool, Walker A.G.), an early work by Pietro Perugino, is the missing panel. The main panel of the altarpiece showing the *Virgin and Child Enthroned with SS John the Baptist and Donatus of Arezzo* (Pistoia Cathedral, Cappella del Sacramento; see fig. 1) is important in the development of the *sacra conversazione*, both in the rigorous perspectival construction of the architectural elements and in the use of deeply receding landscape views which open up behind the saints. Although it is probable that the work owes its conception to Verrocchio and Leonardo, it was executed by Lorenzo di Credi. There are parallels with Fra Angelico's early *sacre conversazioni* and with the work of Lorenzo's closest colleagues, particularly Leonardo, some of whose studies he may have used as a basis for the figures of the Virgin and John the Baptist. The influence of Netherlandish painting is also apparent, especially in the landscape (the trees are highlighted by tiny dots of light), and in the northern appearance of the town on the left. The splendid carpet is recognizably Anatolian in origin, of the type usually attributed to the town of Ushak, and recalls similar carpets in the work of Jan van Eyck (*c.* 1395–1441) and Hans Memling (1430/40–1494).

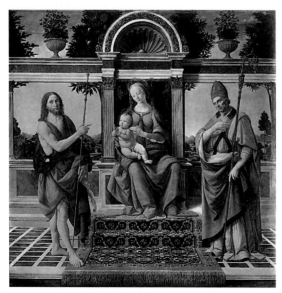

1. Lorenzo di Credi: *Virgin and Child Enthroned with SS John the Baptist and Donatus of Arezzo*, tempera and oil on panel, 1.87×1.90 m, *c.* 1475–80 (Pistoia Cathedral, Cappella del Sacramento)

2. *c.* 1480–1500. About 1480 Verrocchio was called to Venice to design the equestrian monument to the condottiere Bartolomeo Colleoni (Campo SS Giovanni e Paolo; *see* VERROCCHIO, ANDREA DEL, fig. 4). He settled in Venice and died there in 1488. After Leonardo's departure for Milan between 1482 and 1483, Lorenzo remained in Florence to run Verrocchio's workshop, taking over the many commissions which had been left incomplete at his master's departure. Before his death, Verrocchio named Lorenzo as his heir and the executor of his will. Under Lorenzo's guidance, the workshop gradually changed direction. Verrocchio's other pupils were established as independent masters and the activity of the workshop became more restricted and specialized, supplying mainly small-scale panel paintings of the *Virgin*, the *Nativity* and the *Annunciation*, as well as portraits. Lorenzo must have been much sought after as a portrait painter since he left an extensive series of small-scale drawings of heads done in silverpoint and white lead on pink, grey, yellow and brown paper. These vary from smooth-faced children and youths such as the *Portrait of a Young Boy* (Paris, Louvre, 1782) to the *Head of an Old Man* (Paris, Louvre, 1779) in which the aging skin is etched in a dense mesh of wrinkles. Vasari valued Lorenzo's drawings highly and some, including the *Portrait of a Young Girl* (Paris, Louvre, 1738), were collected in his *Libro de' disegni*.

The attributions of some of Lorenzo's most important portraits, ascribed to him by early sources, have been disputed by modern scholars. They include the presumed portrait of *Andrea Verrocchio* (Florence, Uffizi), alternatively thought to be a portrait of Perugino, and the *Portrait of a Man* (Washington, DC, N.G.A.), which an early and seemingly reliable inscription on the back describes as a self-portrait of Lorenzo. Both paintings have also been attributed to Perugino. It is particularly difficult to accept the attribution of the Washington portrait to Perugino since the pose of the lean-faced man, his head thrust slightly back and his gaze fixed on a point outside the picture, is strongly suggestive of the artist painting his reflection in a mirror.

Besides the numerous mannered devotional paintings destined for churches and chapels, Lorenzo also painted more sophisticated and original works, such as the *Venus* (Florence, Uffizi; see fig. 2), in which a naked, athletic young woman appears against a dark background, draped in a light, transparent veil. This painting of a female nude has no equal in Tuscan painting of the time, although an interesting comparison can be made with Botticelli's *Birth of Venus* (*c.* 1485; Florence, Uffizi; *see* BOTTICELLI, SANDRO, fig. 3) and there are also close affinities with the work of contemporary Flemish and German masters such as Lucas Cranach (1472–1553) the elder and Hugo van der Goes (*c.* 1440–82). By the end of the 15th century the circulation of prints was fairly widespread, and paintings from north of the Alps were sought after and appreciated in Italy.

The *sacra conversazione* painted for the chapel of the Mascalzoni in S Maria Maddalena de' Pazzi in Florence (1493; Paris, Louvre) is a more static and sentimental version of the Pistoia altarpiece, though Vasari admired it for its chromatic qualities. Vasari claimed that Lorenzo

with white, yellow, pink and green, recalling a terracotta by Luca della Robbia, an artist whom Lorenzo admired.

In the 1490s Lorenzo appears to have been affected by Savonarola's preaching, although the extent to which he was involved in the Friar's movement is unclear. He was in contact with Fra Bartolommeo, one of Savonarola's most faithful supporters, and produced some works of a markedly devout tendency, devised in accordance with overtly didactic purposes: to this group belong an *Adoration of the Shepherds* (Florence, Uffizi) painted for the Franciscan monastery of S Chiara in Florence, a *St Mary Magdalene in Penitence* (or possibly *St Mary of Egypt*) (ex-Kaiser-Friedrich Mus., Berlin, destr.) and a *St Francis Receiving the Stigmata* (Ajaccio, Mus. Fesch). In all three paintings, the attitudes of the figures, whose faces are bent over hands clasped in prayer or raised in ecstasy towards the godhead, reveal a type of religious sentiment close to that demanded by Savonarola's most fervent supporters, the '*piagnoni*' (snivellers). The *Adoration of the Shepherds* was commissioned by Jacopo Bongianni, who had close links with Savonarola's circle. It has been suggested that the elderly man kneeling on the left of the painting is a portrait of Bongianni; certainly his sharply characterized features, which are probably copied from a portrait, distinguish him from the shepherds and the figure of St Joseph.

3. 1501–36. As a prominent member of Florentine art life, Lorenzo took part in several important arbitrations, including the installation of the lantern of Florence Cathedral, the placing of Michelangelo's statue of *David* (Florence, Accad.; *see* ITALY, fig. 22) in 1504, the appraisal of the frescoes by Ridolfo Ghirlandaio in Palazzo Vecchio in 1514 and that of Bandinelli's *St Peter* placed in the cathedral in 1517. He also restored several famous works, including, in 1501, a *Virgin and Child Enthroned with Saints* (Fiesole, S Domenico) by Fra Angelico, which he transformed from its original triptych format into a unified space, replacing the gold background with a landscape. In Florence Cathedral he also restored Benedetto da Maiano's wooden Crucifix and the two frescoes of condottieri by Paolo Uccello and Andrea del Castagno (all *in situ*; *see* UCCELLO, PAOLO, fig. 1, and CASTAGNO, ANDREA DEL, fig. 4).

In common with his contemporaries, Lorenzo seems to have drawn inspiration from the experiments made by Leonardo at the end of the 15th century; Lorenzo's *Portrait of a Young Woman* (New York, Met.) suggests that he may have seen Leonardo's '*Mona Lisa*' (Paris, Louvre; *see* colour pl. 1, XXXVI3) or sketches and drawings connected with it. In another medium-sized panel, the *Virgin and Child with the Infant St John the Baptist* (Kansas City, MO, Nelson–Atkins Mus. A.) the position of the seated Virgin, whose leg is thrust forward diagonally from left to right, betrays Lorenzo's reworking of Leonardo's *Virgin and Child with SS Anne and John the Baptist* (Paris, Louvre), for which the latter had made numerous studies.

While Lorenzo was certainly aware of the innovations of Piero di Cosimo, Fra Bartolommeo and Raphael, this did not lead to any radical changes in his design of large-scale altarpieces. In the *Virgin and Child Enthroned with SS Sebastian and John the Evangelist* (before 1516; Dresden, Gemäldegal. Alte Meister), only the treatment of the

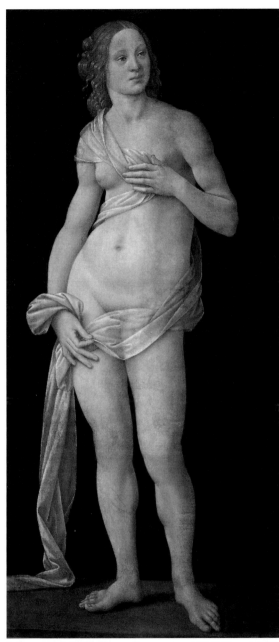

2. Lorenzo di Credi: *Venus*, oil on canvas, 1.51×0.69 m, *c.* 1490 (Florence, Galleria degli Uffizi)

obtained particularly pure and gleaming surfaces by grinding his colours extremely fine, distilling his own oils and by keeping his colours separate by using a different brush for each one, a method that required patience and a great deal of time.

Lorenzo's fragile creativity was better expressed in the smaller works that he painted in the last years of the 15th century, such as the *Annunciation* (Florence, Uffizi; *see* colour pl. 1, XXXIX2), in which the two figures are shown under an exquisitely decorated loggia, and the *Virgin and Child with the Infant St John* (Rome, Gal. Borghese), a tondo based on the colour harmony of a dominant blue

drapery shows some attempt to come to terms with contemporary artistic developments, the composition is based on 15th-century prototypes. His later compositional drawings, some of them executed in pen and ink, are more crowded and dynamic than before. Only in these drawings and in his smaller paintings is there any concession to modernity. This can be seen in the panel of the *Crucifixion* (U. Göttingen, Kstsamml.), possibly a *modello*, in which the colour is laid on in a very thin layer, revealing the preliminary drawing beneath. Stylistically, the holy women, arranged rhythmically around the swooning Virgin are particularly effective.

After 1520 Lorenzo's output decreased; possibly one of his last autograph works is the *St Michael* painted for the Sagrestia dei Canonici in Florence Cathedral (*in situ*). In 1531 he put himself in the care of the Ospedale di S Maria Nuova, receiving a life annuity; in the same year he made his will, distributing his few remaining possessions among his relatives, his pupils and his serving woman. Of his numerous assistants, most of whom were mediocre painters, only Giovanni Antonio Sogliani can be easily identified. Another distinctive hand is that of the Master of the Santo Spirito Conversazione, who takes his name from the *sacra conversazione* of the *Virgin and Child with SS John the Evangelist and Jerome* in the Ridolfi Chapel in Santo Spirito, Florence.

BIBLIOGRAPHY

Thieme–Becker: 'Credi, Lorenzo di'
G. Vasari: *Vite* (1550, rev. 2/1568); ed. G. Milanesi (1878–85), vol. iv, pp. 563–76
B. Degenhart: 'Di alcuni problemi di sviluppo della pittura nella bottega del Verrocchio, di Leonardo e di Lorenzo di Credi', *Riv. A.*, xiv (1932), pp. 263–300, 403–44
——: 'Die Schüler des Lorenzo di Credi', *Münch. Jb. Bild. Kst*, ix (1932), pp. 95–161
B. Berenson: 'Verrocchio e Leonardo: Leonardo e Lorenzo di Credi', *Boll. A.*, n.s. 3, xxvii (1933–4), pp. 193–214, 241–64
G. Dalli Regoli: *Lorenzo di Credi* (Milan, 1966)
F. W. Kent: 'Lorenzo di Credi, his Patron Jacopo Bongianni and Savonarola', *Burl. Mag.*, cxxv (1983), pp. 539–41
G. Dalli Regoli: 'La Madonna di Piazza: "… Ce n'è d'assai più bella, nessuna più perfetta"', *Scritti di storia dell'arte in onore di Federico Zeri*, i (Milan, 1984), pp. 213–32
G. M. J. Weber: 'Ein Gemälde Leonardos für Dresden?: Der Ankauf eines Madonnenbildes von Lorenzo di Credi im Jahr 1860', *Dresdn. Ksthl.*, xxxix/6 (1995), pp. 166–72
A. Padoa Rizzo, F. Falletti and L. Pennucci: '*Madonna di piazza*', *Medici, il Verrocchio e Pistoia: Storia e restauro di due capolavori nella cattedrale di S Zeno: Il monumento al cardinale Niccolò Forteguerri, la Madonna di piazza*, ed. F. Falletti (Livorno, 1996), pp. 65–82

G. DALLI REGOLI

Lorenzo Monaco [Piero di Giovanni] (*b* ?1370–75; *d* ?Florence, ?1425–30). Italian painter, illuminator and draughtsman. His name means Lorenzo the Monk, and he was a member of the Camaldolese Order. His mystical and contemplative works, distinguished by their sinuous line and radiant, high-keyed colour, represent the culmination of the Late Gothic style in Florence at the onset of the Renaissance. He is remembered principally for his paintings on panel and in illuminated manuscripts, but he also worked to a limited extent in fresco, and a few drawings have also survived. His altarpiece of the *Coronation of the Virgin* (1414; Florence, Uffizi), painted for his own monastery, is a virtuoso display of the exquisite craftsmanship and brilliant colour of late medieval art.

1. Life and work. 2. Working methods and technique. 3. Critical reception and posthumous reputation.

1. LIFE AND WORK.

(i) Before 1414. (ii) 1414 and after.

(i) *Before 1414.* He was born Piero di Giovanni but took the name Lorenzo when he entered the Camaldolese Order in the convent of S Maria degli Angeli in Florence. Neither the date nor the place of his birth is known. He is recorded as having taken his simple vows and received minor orders on 10 December 1391; in September 1392 he took solemn vows and was ordained subdeacon. He was ordained deacon in 1396 and, since contemporary practice appears to have been to advance to the diaconate at about the age of 21, this would suggest a birth date in the mid-1370s. His earliest identifiable works of art can be dated to the mid-1390s. The fact that he entered a Florentine convent strongly supports the idea of a Florentine origin, and early documents refer to him as of the 'popolo di S Michele Bisdomini', a parish located not far from S Maria degli Angeli. However, Siena has also been proposed as his place of birth, as his sinuous line and delicate colour are stylistically close to the art of contemporary Sienese painters. Moreover, a document of 29 January 1415 refers to him as 'don Lorenzo dipintore da siene'. Whether or not 'siene' (which would be a strange spelling) refers to the city of Siena and why he is not referred to in this way in earlier documents remain questions to plague the biographer.

It is not known where Lorenzo trained. Vasari stated that he was apprenticed to Taddeo Gaddi (*fl* 1320, *d* 1366), but this is impossible, since Taddeo was dead by 1366. However, Lorenzo's style is akin to that of Taddeo's youngest son, Agnolo Gaddi (*fl* 1369–96), and he may have trained in Agnolo's shop. It has also been suggested that he was trained as a manuscript illuminator in the scriptorium of S Maria degli Angeli, which was renowned for its illuminated volumes. This latter theory is supported by similarities between his early work and the contemporary works of Don Simone Camaldolese and Don Silvestro dei Gherarducci (1339–90), major manuscript painters who worked for S Maria degli Angeli in the late 1390s.

At around the time he was made deacon (1396), Lorenzo seems to have taken up residence outside the convent and established a private workshop, although he continued to follow the religious life. The location of this shop is not known, but he is recorded as operating a shop (perhaps the same one) in the parish of S Bartolo in Corso in early 1402. January 1399 marks his earliest recorded commission, an altarpiece (untraced) executed for the second Ardinghelli Chapel in S Maria del Carmine, Florence. His earliest identifiable works are a group of miniatures representing saints and prophets in initial letters in choir-books in the Biblioteca Medicea–Laurenziana in Florence (MSS Cor. 1, 5 and 8; see fig. 1), dated 1396, 1394 and 1395 respectively. The dates inscribed in the volumes cannot be taken as the dates of the illuminations, as they are clearly specified as the dates of the completion of the volumes, that is of the writing, and the decorations may not have been added immediately. Nevertheless, it is relatively safe to assume that these volumes were ornamented in the final years of the 14th century. They reveal

1. Lorenzo Monaco: *St Romualdo*, miniature from a choir-book, *c*. 1395–1400 (Florence, Biblioteca Medicea–Laurenziana, Corale n. 8, fol. 76*r*.)

origin of Lorenzo's style. The modest scale of the picture suggests a private, devotional function, perhaps as the wing of a diptych. It also places it technically within the realm of miniature painting, although the composition has a monumentality not to be found in most of Lorenzo's manuscript paintings and small-scale predella panels. The most immediate source of the composition and conception is Giotto's Ognissanti *Madonna* (Florence, Uffizi; *see* GIOTTO, fig. 6). Lorenzo has taken over the poses of the Virgin and Child and has placed them within an architectural setting similar to that used by Giotto. The pointed barrel vault of the throne's interior clearly establishes the spatial relationship between the two figures and their surroundings. The placement of the attendant angels, who envelop the finials of the arms of the throne with their

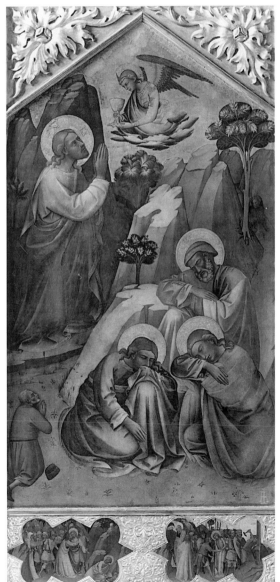

2. Lorenzo Monaco: *Agony in the Garden*, tempera on panel, 1.91×1.12 m, ?*c*. 1399 (Florence, Accademia di Belle Arti e Liceo Artistico)

a youthful hesitation in the relationship of the figures to their enframing letters and a certain dependence on the work of such older illuminators in the scriptorium as Don Simone and Don Silvestro, a hesitation and dependency not apparent in the illuminations of a choir-book dated 1409 (Florence, Bib. Medicea–Laurenziana, MS. Cor. 3). However, the calligraphic use of line and the delicate colour tones that characterize Lorenzo's later works are already in evidence. The loss of the Ardinghelli Altarpiece of 1399 is particularly unfortunate, as it would provide a basis for comparing Lorenzo's work in two media at approximately the same date and would possibly clear up the question of whether he was initially trained as a painter of panels or of manuscripts.

Lorenzo's large panel of the *Agony in the Garden* (Florence, Accad. B.A. & Liceo A.; see fig. 2) is a dramatic and expressive work that may date from this period. The *Virgin and Child Enthroned, with Two Angels* (Cambridge, Fitzwilliam; see fig. 3), a characteristic early work, from the first years of the 15th century, supports the Florentine

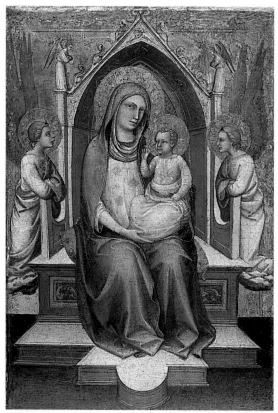

3. Lorenzo Monaco: *Virgin and Child Enthroned, with Two Angels*, tempera on panel, 324×212 mm, before 1410 (Cambridge, Fitzwilliam Museum)

sleeves and who cross the pierced openings of the structure with their torsos, further establishes a solid, tangible space. This is contrasted with the neutral gold ground with its elaborately tooled border that functions as pure ornament, almost in the way that the decorative edging of a manuscript page might function. At the same time, the colours, the Child's wrap of deep raspberry-pink fading to almost pure white in the highlights, the Virgin's steely blue mantle similarly modulated from total saturation to the palest tint, and the touches of vermilion in the cushion of the throne, the wings of the angels and the linings of their metallic blue-white mantles, all point to a dependence on the Orcagna tradition of the second half of the 14th century. At the same time, the softening of faces, both in modelling and in the mood they convey, and the humanizing of attitudes, show a familiarity with Spinello Aretino's and Agnolo Gaddi's revival of Giotto's style in the late 14th century. However, the sinuous lines of the drapery contours and the decorative features, such as the ornamentation of the throne and the delicate, golden feathering of the angels' wings, are indicative of the Late Gothic style. Lorenzo Monaco's art is thus in the tradition of late 14th-century Florentine painting, close in time and style to that of such practitioners as Gherardo Starnina and the Master of the Bambino Vispo.

Lorenzo's only surviving documented work is the Monte Oliveto Altarpiece, with the *Virgin and Child*

Enthroned, Attended by SS Bartholomew, John the Baptist, Thaddeus and Benedict (Florence, Accad. B.A. & Liceo A.), which is documented to 1407 and 1411 and bears an inscribed date of 1410. This picture draws on a similarly wide range of stylistic sources. In the same period Lorenzo painted four scenes from the *Infancy of Christ* (two, London, Courtauld Inst. Gals; one, New York, Met.; one, Altenburg, Staatl. Lindenau-Mus.) for an untraced altarpiece, and four paintings of *Prophets* (all New York, Met.) in which the figures are more sculptural and three-dimensional and may date from *c.* 1408–10.

Among Lorenzo's paintings on panel, one of the more unusual formats, which he utilized on several occasions, is that of the *croce sagomata* (cut-out cross), in which the crucified Christ is depicted hanging on the cross as in a Crucifixion scene, but with the cross and figure free-standing. This creates something of an illusion of sculpture. The carved Crucifixes by Donatello and Brunelleschi might indicate the growing popularity of such three-dimensional images in the early 15th century, as distinguished from the painted crosses that enjoyed acclaim in the 13th and 14th centuries. Lorenzo's works of this kind include the *Crucifix* (Florence, Accad. B.A. & Liceo A.), a *Crucifix* in the museum of S Maria delle Vertighe in Monte San Savino, Tuscany, and the dramatic and expressive *Crucifix with the Mourning Virgin and St John the Evangelist* (Florence, S Giovannino dei Cavalieri), which may be the work described by Vasari as being in the church of the Romiti di Camaldoli (S Salvatore) outside Florence. In this last-named work he added cut-out figures of the Virgin and St John to create a larger tableau. Lorenzo appears to have played a major role in popularizing the *croce sagomata* form, which survived until the end of the 15th century.

(ii) 1414 and after. The most ambitious of Lorenzo's surviving works is the great *Coronation of the Virgin* (5.12×4.50 m; Florence, Uffizi). This picture, painted for his own convent of S Maria degli Angeli and dated February 1413 (NS 1414), is his only signed and dated work and shows him at the height of his power. The rather lengthy inscription indicates that he was still following the religious life, though he had been living outside the convent for around 18 years. Although enclosed within a tripartite frame that recalls the triptych format popular in 14th-century altarpieces, the pictorial field is unified into a single space. In the upper centre, in front of a Gothic ciborium from which angels look on, Christ places the crown on the head of his mother, who is dressed in the white of the Camaldolese habit. Crowds of saints, ten on either side (and all male, as befits a convent of men), witness the event. From a pinnacle above the central field a Blessing Redeemer looks down, while the Annunciation is re-enacted in the two pinnacles over the side compartments. Ten prophets grace the pilasters of the frame, and a predella of six laterally elongated quatrefoils offers four stories from the *Legend of St Benedict* flanking the *Nativity* and the *Adoration of the Magi*.

The great courtly ritual represented on the principal field has its roots in Florentine tradition, going back to the Baroncelli Altarpiece (*c.* 1330; Florence, Santa Croce) from Giotto's workshop and developed by numerous followers of Giotto in the second half of the 14th century. The

graceful sway of the bodies arrayed in syncopated ranks plays against the sinuous rhythms of their drapery. The delicate colours—perhaps appearing more pastel-toned than intended, due to a 19th-century cleaning with soda—are a perfect complement to these linear rhythms, setting off the folds under a veil of almost translucent tonalities. Thus a balance is achieved between the three-dimensional elements of illusionism and the decorative qualities of pure surface pattern. The predella panels create a similar fusion of decorative line and colour with functional space and drama. The awkward frame of the quatrefoil shape is made to harmonize with the architectural and compositional elements within the paintings, so that a chevron pattern links the six subjects together horizontally, while at the same time they function individually as dramatic narratives within a functional, if abbreviated, space.

Lorenzo and his shop used the S Maria degli Angeli (Uffizi) *Coronation* as a model for another major Camaldolese commission, probably very shortly thereafter. Originally painted for the monastery of S Benedetto fuori della Porta a Pinti, outside Florence, and seen by Vasari in S Maria degli Angeli (where it was placed after the destruction of S Benedetto), this is surely the *Coronation of the Virgin* of which the major panels are now in the National Gallery, London. (For the history and reconstruction of this work, see Eisenberg, pp. 138–45.) Of generally inferior quality compared with its prototype, it demonstrates the popularity of Lorenzo's style with a segment of the artistic public, and the way in which that style was treated by his immediate following.

The *Annunciation with SS Catherine of Alexandria, Anthony Abbot, Proculus and Francis of Assisi* (*c.* 1418; Florence, Accad. B.A. & Liceo A.) develops Lorenzo's use of complex rhythms and lyrically graceful figures. The *Adoration of the Magi* (Florence, Uffizi; see colour pl. 1, XL2), of uncertain provenance, dates from the early 1420s and is distinguished by the aristocratic elegance and exoticism of the figures. An altarpiece of the *Deposition* (Florence, Mus. S Marco) was commissioned by Palla Strozzi for the sacristy of Santa Trinita, Florence. Begun by Lorenzo Monaco, probably *c.* 1420–22, it was finished by Fra Angelico. The painted frame by Lorenzo survives; the three pinnacle panels, with the *Resurrection*, a *Noli me tangere* and the *Holy Women at the Tomb*, remain with the altarpiece, while three small panels intended as predella scenes, the *Nativity*, the *Legend of St Onuphrius* and *St Nicholas Calming the Storm* (Florence, Accad. B.A. & Liceo A.), are now separate.

In this late period, probably after 1420, Lorenzo undertook the decoration of the Bartolini Salimbeni Chapel in Santa Trinita, Florence, his first and only known attempt at fresco painting. The programme, probably the most complex he ever undertook, consisted of eight scenes from the *Life and Legends of the Virgin* on the walls, *Four Prophets* on the vault and *Four Saints* on the soffits of the entrance arch (all *in situ*). The scheme was completed with the addition of an altarpiece of the *Annunciation* (see fig. 4), with a predella of four scenes, the *Visitation*, the *Nativity*, the *Adoration of the Magi* and the *Flight into Egypt* (all *in situ*). The frescoed scenes were all taken from the apocryphal literature, while those that make up the

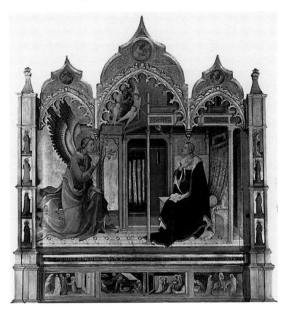

4. Lorenzo Monaco: *Annunciation* (Bartolini Salimbeni Altarpiece), tempera on panel, 3.00×2.74 m, after 1420 (Florence, Santa Trinita)

altarpiece were all scriptural. On the axis of the chapel, the *Assumption of the Virgin* on the exterior wall above the entrance aligns with the *Miracle of the Snow* in the lunette of the back wall, which in turn is situated directly above the *Annunciation* in the altarpiece. It is known that two feast days were singled out for special celebration in this chapel, the Feast of the Annunciation on 25 March and an unspecified feast in August. The Miracle of the Snow was commemorated on 5 August and the Assumption of the Virgin on 15 August. Perhaps the otherwise unspecified August celebration combined and commemorated both of these events. The entire complex was undoubtedly arranged to suit the needs of particular Marian devotions associated with the chapel and its donors.

In devising the eight scenes from the Marian legend, Lorenzo depended on the numerous cycles existing in and around Florence, in particular those of the Gaddi family workshop. He once again demonstrated his reliance on Florentine traditions and, in particular, on the tradition initiated by Giotto. The altarpiece of the *Annunciation*, however, suggests that Lorenzo had encountered the new naturalism of the 1420s. Its iconography depends on a Sienese, rather than a Florentine tradition, but an attempt has been made to depict the architectural setting more convincingly, on a scale somewhat in accord with that of its occupants. The space is complex, with room opening on room, revealing a labyrinth of spaces. Nevertheless, it retains the insubstantiality of Lorenzo's earlier structures, which served more as backdrops to set the scene than as actual, inhabitable spaces. The figures, too, have become more voluminous, wrapped in fabric heavier than that of the figures in the Uffizi *Coronation*, but at the same time retaining all of their courtly elegance. As the angel Gabriel alights to deliver his greeting to Mary, he does not rest on the patterned floor so much as hover in front of it. The inverted perspective of the floor patterning might appear

to encourage this perception on the main panel, but in the *Visitation* panel of the predella, Elizabeth similarly seems to float in front of the unarticulated ground rather than to rest on it; and in the *Nativity* of the predella Joseph, sitting on the ground at the lower right, appears to hover on his elegantly outspread mantle like some mystic levitating on a magic carpet. The colour scheme has altered, with greater use of more sombre, earthy colours, especially in the grounds, to set off the increasingly complex arrangements of softer, more delicate colours in the figures.

Lorenzo Monaco's death, like his birth, is not recorded. In the 14th and 15th centuries religious houses kept their own death records, separate from the secular *libri dei morti* kept by the Comune, but such records for S Maria degli Angeli have not survived. A marginal notation in another document from the convent indicates that he died on 24 May, but the year is not specified. A contract for an altarpiece dated 3 March 1421 (NS 1422) indicates that he was still living at that time. Vasari stated that he died at the age of 55, but gave no indication of the year. If his age is given correctly and the supposition of his birth date in the middle years of the 1370s is also correct, he would then have died sometime in the middle to late 1420s. This date would be consistent with the style of the works judged to be his latest, which demonstrate a growing sense of naturalism, commensurate with the developments in the art of Masaccio and Fra Angelico in the 1420s.

2. WORKING METHODS AND TECHNIQUE. Most of Lorenzo Monaco's works are in tempera on panel; he was supremely gifted as a colourist, and his sharp greens and yellows, bright pinks and blues are softly modelled and orchestrated contrapuntally; his craftsmanship in gold was exquisitely refined, and each of the haloes in the vast *Coronation of the Virgin* bears a different design. He prepared his pictures with drawings, some of which have survived; a drawing of *Six Kneeling Saints* (Florence, Uffizi) is a preparatory study for a group in either the Uffizi or the London *Coronation of the Virgin*. An unusual pair of drawings, the *Visitation* and the *Journey of the Magi* (both Berlin, Kupferstichkab.), in pen and brush with brown ink, coloured washes and tempera on parchment, fall somewhere between manuscript illuminations, presentation drawings and working drawings. A somewhat rare example of *verre églomisé* painting depicting the *Virgin of Humility with SS John the Baptist and John the Evangelist* (Turin, Mus. Civ. A. Ant.), although executed primarily by Lorenzo's shop, represents another graphic medium that Lorenzo explored.

Technical elements in the execution of the frescoes in the Bartolini Salimbeni Chapel in Santa Trìnita, such as the irregularity of the *giornate*, which do not always coincide with complete figures and which occasionally cut through haloes and other elements, indicate his lack of familiarity with the medium. The blue background, painted *a secco*, has vanished. Detailed drawings must have existed for these frescoes. The *sinopie* that have been uncovered are very brief and sketchy, indicating that the compositions must have been worked out extensively on paper. The chapel was whitewashed in the early 18th century, and the paintings were unknown until 1887, when they were cleaned and restored by Augusto Burchi. A restoration in 1961–2 undid some of the damage done by Burchi's attempt to re-create the original condition of the paintings, but the paintings are in very poor condition. In places the *intonaco* has entirely fallen away, revealing the underlying *sinopie*.

Lorenzo directed a large workshop, and the inscription on the Uffizi *Coronation of the Virgin* emphasizes that it was a collaborative work. The extensive collaboration of the workshop, even in smaller works, has been discussed by Eisenberg, who has stressed that this shop produced many devotional images, such as the *Virgin and Child Enthroned* (*c.* 1418; Edinburgh, N.G.), for which Lorenzo supplied only the design.

3. CRITICAL RECEPTION AND POSTHUMOUS REPUTATION. Early sources, other than the scant documentation about his life and work in S Maria degli Angeli, reveal little about Lorenzo Monaco. He is not mentioned at all by Ghiberti in his autobiographical *I Commentarii* (written *c.* 1447–55), even though the stylistic affinity of the two artists would suggest that they represent the sculptural and painterly incarnations of the same spirit. Albertinelli (1510) said very little; *Il libro di Antonio Billi* (written *c.* 1516–30) and the manuscript by the Anonimo Magliabechiano (written *c.* 1537–42) pay him sparse attention, mentioning only a handful of works (mostly untraced). Vasari devoted a *Vita* to him but, apart from praising his virtue and listing a small number of his most important works (mostly untraced), he provides little concrete information, filling much of the chapter with an estimation of the contemplative life and of other monk painters from S Maria degli Angeli. However, the minimal information provided by Vasari remained virtually the sole source of Lorenzo Monaco's biography and critical assessment until the latter part of the 19th century.

Modern critical assessment of Lorenzo Monaco's style began with Carlo Pini and Gaetano Milanesi in the mid-19th century. A.-F. Rio, in 1861, lumped Lorenzo together with Gentile da Fabriano and Fra Angelico as manifestations of a 'mystical school' of Florentine painters. It was J. A. Crowe and G. B. Cavalcaselle, in 1864, who set the appreciation of Lorenzo's work on a new path. Proposing him as one of the legitimate heirs of Giotto, they found in his work a depth and feeling akin to that of the earlier master, such that they recognized and identified as his paintings some that were then attributed to Giotto himself, to Taddeo Gaddi and to other 14th-century painters. Crowe and Cavalcaselle began the reconstitution of his oeuvre that culminated in the *Lists* of Bernard Berenson that first appeared in 1909. At the start of the 20th century Roger Fry recognized the quality of Lorenzo's work; but Osvald Sirén wrote the first complete monograph on the artist in 1905.

Lorenzo Monaco does not seem to have been highly regarded in the years following his death. His style was not widely imitated. Only a handful of artists followed immediately in his footsteps, though none of them ranked in the first order of 15th-century Florentine painters, and they were mostly of an archaicizing temperament. Although Lorenzo was apparently esteemed in his lifetime, especially by his brethren in S Maria degli Angeli, his work fell from favour not long after, and even his great

Coronation altarpiece for the convent was replaced in the 16th century with a painting by Alessandro Allori, Lorenzo's work being relegated to the provincial convent of the Order at Cerretto. Many of his works hung in museums with attributions to better-known artists until the 'rediscovery' of Lorenzo in the late 19th century and in the 20th.

BIBLIOGRAPHY

F. Albertinelli: *Memorie di molte statue et picture sono nella inclyta ciptà di Florencia . . .* (Florence, 1510/*R* Letchworth, 1909)

A. Billi: 'Il libro di Antonio Billi' (MS. *c.* 1516–30; Florence, Bib. N.); ed. C. von Fabriczy, *Archv. Stor. It.*, ser. 5, vii (1891), pp. 299–368

Anonimo Gaddiano [Magliabechiano]: 'Il codice dell'Anonimo Gaddiano nella Biblioteca Nazionale di Firenze' (MS. *c.* 1537–42; Florence, Bib. N.); ed. C. von Fabriczy, *Archv. Stor. It.*, ser. 5, xii (1893), pp. 15–94, 275–334

G. Vasari: *Vite* (1550; rev. 2/1568); ed. G. Milanesi (1878–85), ii, pp. 17–32

A.-F. Rio: *De l'art chrétien*, i (Paris, 1836, 2/1861–7)

J. A. Crowe and G. B. Cavalcaselle: *A New History of Painting in Italy* (London, 1864), i, pp. 551–8

R. E. Fry: 'Florentine Painting of the Fourteenth Century', *Mnthly Rev.*, iii (1901), pp. 112–34

——: 'Pictures in the Collection of Sir Hubert Parry at Highnam Court, near Gloucester: I', *Burl. Mag.*, ii (1903), pp. 117–31

O. Sirén: *Don Lorenzo Monaco* (Strasbourg, 1905)

R. van Marle: *Italian Schools* (1923–38), ix, pp. 115–69

M. Meiss: 'Four Panels by Lorenzo Monaco', *Burl. Mag.*, c (1958), pp. 191–8

E. Borsook: *The Mural Painters of Tuscany: From Cimabue to Andrea del Sarto* (London, 1960, rev. Oxford, 1980)

B. Berenson: *Florentine School* (1963)

G. P. de Montebello: 'Four Prophets by Lorenzo Monaco', *Bull. Met.*, xxv/4 (1966), pp. 155–68

C. Gardner von Teuffel: 'Lorenzo Monaco, Filippo Lippi und Filippo Brunelleschi: Die Erfindung der Renaissancepala', *Z. Kstgesch.*, xlv (1982), pp. 1–30

M. Eisenberg: *Lorenzo Monaco* (Princeton, 1989) [complete cat. and bibliog.]

D. Gordon: 'The Altarpiece by Lorenzo Monaco in the National Gallery, London', *Burl. Mag.*, cxxxvii/1112 (1995), pp. 723–7

JAMES CZARNECKI

Lorenzo the Magnificent. *See* MEDICI, DE', (5).

Loreto. Italian city in the Marches, *c.* 31 km from Ancona. It is a centre of Marian pilgrimage, the building of the Santa Casa in the sanctuary of S Maria di Loreto (*see* §II, 1 below) having served as a focus for pilgrims since the first half of the 14th century.

I. History and urban development. II. Buildings.

I. History and urban development.

The origins of the city date from the first half of the 14th century, contemporaneous with the rise and spread of the Loretan cult of the Virgin. The cult derived from the claim that the house of the Virgin (the Santa Casa) was miraculously transported from Nazareth to Loreto. The sanctuary of S Maria (begun 1469) was built over the house and attracted numerous pilgrims. Ancillary structures for the use of the resident clergy and the pilgrims, such as houses and a hospital, developed in the immediate vicinity of the sanctuary; the townspeople, meanwhile, established themselves at the same distance towards the present north wing of the papal palace (Palazzo Apostolico; *see* §II, 2 below), along the ridge of a spur then known as Monte Prodo both owing to the conformation of the land and because

the final section of the access road from Rome to the sanctuary ran along this ridge. The oldest of these houses, on the Corso Boccalini and the Via Asdrubal, are modest dwellings of one or two storeys, generally very small and often with extremely narrow doors and windows.

The urban plan was dictated by the basilica and the Palazzo Apostolico (begun in *c.* 1510 by Donato Bramante), facing each other across the Piazza della Madonna (see fig. 1), and their need for protection led to the construction of a ring of fortified walls round the whole built-up area. The fortifications, based on a plan (Florence, Uffizi) by Antonio da Sangallo (ii), were executed (1517–20) by Cristoforo Resse (*fl* 1518; *d* 1521) from Imola. The walls were built along the crest of the hill, with two towers inserted at the most distant points and with an enlargement in the centre to accommodate the sanctuary complex. During the final two decades of the 16th century, by which time Loreto had been granted the status of a city, the process of expansion outside the walls was organized and dictated by a later ring of fortifications, known as the Sistine addition, after Pope Sixtus V. Despite the lack of continuity in the work carried out in the two previous centuries, the city at the time of Sixtus V was singularly unified and functional: the sanctuary was not only a religious centre but also the motivating element in the development of the city, representing the acropolis of the entire community.

BIBLIOGRAPHY

E. Dupré-Theseider: 'Loreto e il problema della città santuario', *Stud. Picena*, xxix (1961), pp. 96–105

K. Weil Garris: 'Cloister Court and City Square', *Gesta*, xii (1973), pp. 123–32

F. P. Fiore: 'La "città felice" di Loreto', *Ric. Stor. A.*, iv (1977), pp. 37–55

F. Grimaldi, ed.: *La città murata di Loreto* (Loreto, 1979)

——: *Felix civitas Lauretana* (Loreto, 1981)

F. Grimaldi and A. Mordenti: *Guida degli archivi lauretani*, 2 vols (Rome, 1985–6)

F. Grimaldi and K. Sordi: *La villa di Santa Maria di Loreta: Strutture socio-religiose sviluppo edilizio nei secoli XIV–XV* (Ancona, 1990)

F. Grimaldi: *Il libro lauretano: Secoli XV–XVIII* (Macerata, 1994)

II. Buildings.

1. S Maria di Loreto. 2. Palazzo Apostolico.

1. S MARIA DI LORETO. The sanctuary consists of the basilica of S Maria, beneath the dome of which is situated the Santa Casa (*see* §(ii) below), the Holy House of the Virgin, encased within a structure designed by Bramante in 1509. The birthplace of the Virgin in Nazareth was popularly believed to have been rescued from infidels by angels, who transported it first to Tersatto in Dalmatia on 10 March 1293, later (10 December 1294) to a forest in Recanati, and finally to its present location in December 1295. There is, however, no record of a shrine in Nazareth before the 13th century, and no record of consternation at its loss in 1293; and no account of the translation can be found before 1472. In Loreto, the original shrine seems to have consisted of a votive image of the *Virgin and Child* under a canopy. Fragments of frescoes attributed to 14th- and 15th-century Umbrian painters are visible inside the core of the Santa Casa itself, together with an early 14th-century Umbrian painted *Crucifix*. The shrine attracted pilgrims in such numbers that in 1469 Nicolò delle Aste, Bishop of Recanati, decided to build a larger church.

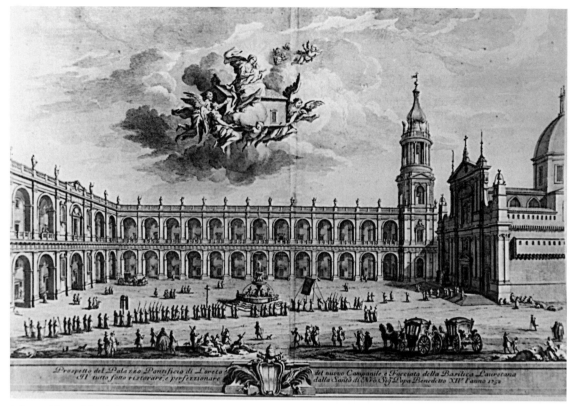

1. Loreto, Piazza della Madonna, with (left) the Palazzo Apostolico, begun *c*. 1510 by Donato Bramante, and (right) the bell-tower (1750–54, by Luigi Vanvitelli) and façade (begun 1571, by Giovanni di Francesco Ribaldi) of the basilica of S Maria; engraving by G. Vasi, 0.87×1.32 m, Rome, 1752 (Loreto, Archivio Storico Santa Casa)

At his death the same year, Pope Paul II took over the project, and had a new plan drawn up. It was then that the legend identifying the church with the Virgin's house was propagated.

(i) Basilica. (ii) Santa Casa.

(i) Basilica.

(a) Architecture. The basilica of S Maria is a domed building 93 m long, the apse, transepts and associated chapels radiating from the crossing to give an impression reminiscent of a Greek cross. The eastern arm and transepts are aisled, with apses in echelon; there are octagonal sacristies in the corners of the crossing. The nave has seven bays. Begun in Gothic style, the building was changed by subsequent alterations. The architect is unknown: the earliest evidence is a receipt left in 1470 from a master mason, Giovanni di Alberto, to the new bishop of Recanati, for payment for work in the church by him and his partners. In 1471 Marino Cedrini contracted to continue the building, but by April 1482 Giuliano da Maiano was construction engineer in charge, and he probably supervised the preparation of timber for the apse roofs and centring for the drum of the dome. The fortifications (see fig. 2) for the east end of the church are attributed to Baccio Pontelli, and building work on them began in 1488. The crenellated parapet projecting on corbels, with an internal walkway and machicolations,

gives a strongly fortress-like character to the apse area. In 1499 Giuliano da Sangallo contracted to vault the dome (completed 1500); but the piers were too weak, and Pietro Amorosi (*fl c.* 1490–1512), then Bramante, undertook consolidation work. Antonio da Sangallo (ii) later thick-

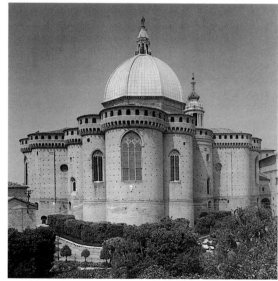

2. Loreto, S Maria, exterior of the east end, fortifications begun 1488

ened the piers and added semicircular arches, thus changing the Gothic lines of the crossing into Renaissance style.

In the mid-16th century the apse chapels were modified and new chapels added along the sides of the nave, by enlarging existing niches, in response to the requirements of the Counter-Reformation. The façade of the church (see fig. 1 above) was begun in 1571 to designs by Giovanni di Francesco Ribaldi (*d* ?1580), known as Boccalini, who built it up to the lower cornice. The work was completed in 1587 by Lattanzio Ventura (*fl* 1575–87). Its three bays, divided by paired Corinthian pilasters, correspond to the nave and aisles; the gable wall rises above roof level, but is in keeping with Boccalini's lower storey. During the second half of the 19th century the apsidal chapels were restored to their original state by the demolition of the vaulted ceilings and the removal of the paintings from the walls (*see* §(b) below). The piers of the dome were freed of their arch supports and buttressing under the supervision of Giuseppe Sacconi.

(b) Decoration. The interior of the basilica is lavishly decorated. The earliest work was carried out by LUCA SIGNORELLI and Melozzo da Forlì. Signorelli painted frescoes (?1483; *in situ*) in the sacristy of St John, representing a choir of angels and beneath them the four *Evangelists* and four *Doctors of the Western Church*, the *Apostles* and the *Conversion of St Paul*. Melozzo da Forlì was responsible for the decoration (*in situ*) of the sacristy of St Mark, where in a foreshortened architectural setting he painted eight angels supporting the symbols of the Passion, together with eight prophets who foretold it. On one wall is depicted the *Entry into Jerusalem*. Signorelli returned to Loreto during the first decade of the 16th century in order to paint the medallions (*in situ*) on the vault of the church. During the 16th and 17th centuries Lorenzo Lotto, Pellegrino Tibaldi and Federico Zuccaro, among others, were responsible for the decoration of one or more of the chapels. (In 1605 Cristoforo Roncalli was commissioned to decorate the sacristy of the treasury and the dome, where he exalted the Virgin in representations of her earthly life and celestial glory such as the *Coronation of the Virgin* (studies, Loreto, Santuario S Casa, Bib.). In the late 19th century, the apsidal chapels were redecorated after modifications to the structure necessitated the removal of the original paintings (many now in Loreto, Pal. Apostolico).)

The main entrance doors (1590–1610) to the church were cast in bronze by Antonio Lombardi and his sons; the doors depict scenes from the Old and New Testaments. Before the façade is a bronze statue (*c.* 1589) of *Sixtus V* by ANTONIO CALCAGNI, with a richly decorated pedestal incorporating reliefs of the *Four Virtues*.

BIBLIOGRAPHY

F. Grimaldi: *Loreto: Basilica della Santa Casa* (Bologna, 1975)
K. Weil-Garris: *The Santa Casa di Loreto: Problems in Cinquecento Sculpture*, 2 vols (New York and London, 1977)
F. Grimaldi: *La chiesa di Santa Maria di Loreto nei documenti dei secoli XII–XV* (Ancona, 1984)
G. Santarelli, ed.: *La congregazione universale della Santa Casa 1883–1983* (Loreto, 1985)
F. Grimaldi, ed.: *La basilica della Santa Casa di Loreto: Indagini archeologiche geognostiche e statiche* (Ancona, 1986)
F. Grimaldi and K. Sordi: *Scultori a Loreto: Fratelli Lombardi, Antonio Calcagni e Tiburzio Vergelli: Documenti* (Ancona, 1987)
——: *Pittori a Loreto: Committenze tra '500 e '600* (Ancona, 1988)
F. Grimaldi: *Il sacello della Santa Casa* (Loreto, 1991)
Il progetto di Sisto V: Territorio, città, monumenti nelle Marche, Rome, Poligrafico dello Stato cat. (Rome, 1991)
S. Prosperi Valenti Rodinò: 'I disegni di Federico Zuccari per Loreto', *Disegni marchigiani dal Cinquecento al Settecento: Atti del convegno "Il disegno antico nelle Marche e dalle Marche": Monte San Giusto, 1992*, pp. 47–55
F. Grimaldi: *Historia della chiesa di Santa Maria di Loreto* (Loreto, 1993)
F. Grimaldi, ed.: *Il santuario di Loreto: Sette secoli di storia arte devozione* (Loreto, 1994)

FLORIANO GRIMALDI

(c) Influence. The exceptionally large size of S Maria di Loreto, the enormous popularity of the relic it enclosed and the direct interest of the popes in the project all contributed to the fame of the church and stimulated the imitation of its spatial and structural arrangements, despite the somewhat outmoded Late Gothic style of its architecture. Already in the 1480s many architects, especially those linked with nearby Urbino, adopted the plan, often combining it with other forms. In his treatise on architecture, Francesco di Giorgio Martini discussed various forms of temple, one of which he illustrated with plans resembling Loreto. A closer similarity to S Maria is found in the plan of Pavia Cathedral; the design of 1488 was significantly influenced by Bramante, who was perhaps aware of the works at Loreto. The influence of S Maria can also be detected in some of Leonardo da Vinci's studies and drawings and in Bramante's early designs (1505–6) for St Peter's, Rome, particularly in the octagonal sacristies with entrances on the diagonals, as well as in the expansion of the central octagon, with the dome positioned above the tomb of St Peter.

Distant echoes of the theme re-emerge in studies and projects by Bramante's pupils and followers, including Baldassare Peruzzi and Antonio da Sangallo (ii). A simplified form of S Maria can perhaps be seen in Girolamo Genga's S Giovanni Evangelista (begun 1543), Pesaro. Nevertheless, the Loreto plan was rarely adopted in the numerous churches which, from the 16th century onwards, were dedicated to Our Lady of Loreto, despite the fact that the appearance of S Maria was widely known from engravings and the plan was included in the Venetian edition (1567) of the *Libro d'Antonio Labacco appartenente all'architettura* and in subsequent editions. A degree of interest, even at a theoretical level, is also evident from its inclusion among the plans (Florence, Uffizi) of the churches of Tuscany and Italy drawn by Giorgio Vasari *il giovane*, even if its interpretation is somewhat loose or sometimes incorrect.

BIBLIOGRAPHY

L. H. Heydenreich: *Die Sakralbau-Studien Leonardo da Vinci's* (Engelsdorf-Leipzig, 1929/R Munich, 1971)
G. Giovannoni: *Antonio da Sangallo il giovane* (Rome, 1959), pp. 187–8, 252
A. Bruschi: *Bramante architetto* (Bari, 1969)
L. H. Heydenreich and W. Lotz: *Architecture in Italy, 1400–1600* (Hardmondsworth, 1974), pp. 106, 177, 235
A. Weege: 'La ricostruzione del progetto di Bramante per il Duomo di Pavia', *A. Lombarda*, lxxxvi–vii (1988), p. 140
L. Patetta: *Storia e tipologia* (Milan, 1989)
F. Citterio and L. Vaccaro, eds: *Loreto Crocevia religioso tra Italia, Europa e Oriente* (Brescia, 1997)

ARNALDO BRUSCHI

(ii) Santa Casa.

(a) Architecture and sculpture. In 1509 Pope Julius II commissioned Donato Bramante to construct a rectangular structure within the basilica of S Maria to enclose the Santa Casa (*see* §1 above). Bramante gave the small, humble house (*c.* 9.5×4.0 m internally) an elegant marble shell (see fig. 3). He used fluted Corinthian half columns resting on pedestals and supporting an entablature, cornice and balustrade to articulate the main storey. The structure has two doorways on each of its long (north and south) sides, with an altar set against one of the short ends. Work continued after Bramante's death in 1514, the richly perforated architectural revetment being installed only in 1532–4; the balustrade was added in 1537.

The lavish sculptural decoration includes nine marble panels carved in a horizontal format in high relief depicting scenes from the *Life of the Virgin*. Bramante had chosen Giovanni Cristoforo Romano to be his sculptor, but Romano died soon after and was succeeded by Andrea Sansovino in 1513. Progress was interrupted during the papacy of Adrian VI (*reg* 1521–1523). After the Pope's death, Sansovino tried, unsuccessfully, to engage Michelangelo in the project. Further delays were caused by the Sack of Rome in 1527 and Sansovino's death two years later. Sansovino's reliefs of the *Annunciation* (1518–22) and the *Adoration of the Shepherds* (1518–24) each comprise two slabs of marble; his *Marriage of the Virgin* (begun 1527) was finished by Niccolò Tribolo in 1533. The *Adoration of the Magi* by Raffaello da Montelupo dates from the period when he and Baccio Bandinelli worked on the *Birth of the Virgin*, and Tribolo and Francesco da Sangallo collaborated on the *Translation of the Holy House of Nazareth*, 1533. Also that year, Montelupo completed his *Visitation* and Sangallo added the relief of *Mary and Joseph Completing the Census*. Three years later Sangallo finished the last narrative of the *Dormition of the Virgin*.

The reliefs are framed by ten pairs of statues placed one above the other in niches flanked by half columns, with the lower niches containing seated prophets. These statues (for illustration *see* LOMBARDO, (5)) date from the 1540s; they echo the high relief of the narrative panels, as they

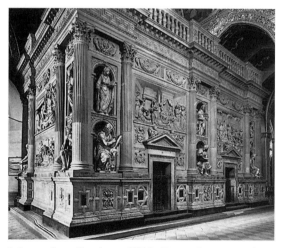

3. Loreto, Santa Casa, begun 1509 by Donato Bramante; sculpture by Andrea Sansovino and others

project from the niches, but they also disrupt the harmony of the architectural planes. The Santa Casa was completed by bronze doors (installed 1568–76) with their eight scenes from the *Life of Christ*.

BIBLIOGRAPHY

J. Pope-Hennessy: *Italian High Renaissance and Baroque Sculpture* (London, 1970)
K. Weil-Garris: *The Santa Casa di Loreto: Problems in Cinquecento Sculpture*, 2 vols (New York, 1977)

EDWARD J. OLSZEWSKI

(b) Influence. The concept of protecting the Santa Casa beneath a dome was not new and was repeated, for example in S Maria della Consolazione, Todi, with its chapel of the Miracle, in St Peter's, Rome, with Bramante's 'tegurio' or shelter (1513; destr. 1592) over the papal altar and St Peter's tomb, and in S Maria degli Angeli, Assisi, with the chapel of the Porziuncola, as well as in many churches dedicated to Our Lady of Loreto from the 16th to the 18th centuries. While the plan of the main church is often radically different from S Maria di Loreto (*see* (i) above), the small chapel within is invariably reminiscent of the Santa Casa, in a more or less literal interpretation. Meticulous attention was often paid to detail and size, and in several cases even the decoration emulated the style of Bramante, as for example in the sanctuary of Macereto (begun 1538), near Visso. In the 17th and 18th centuries the Santa Casa served as a model for countless churches and chapels in such countries as Italy, Switzerland, Germany, Bohemia, Hungary, Poland and even in Mexico and California.

BIBLIOGRAPHY

L. Patetta: *Storia e tipologia* (Milan, 1989), pp. 121–41

ARNALDO BRUSCHI

2. PALAZZO APOSTOLICO. The design of the main palazzo (see fig. 1 above) is attributed to Bramante and was probably planned when he accompanied Pope Julius II to Loreto in 1507 or 1510. According to his original conception, the palazzo was to have been erected on three sides of a piazza in front of the basilica, with an entrance portico, and a loggia running along the entire upper floor. Twin towers were to be constructed on the western side to reinforce—together with the four existing towers of the basilica—the systematically organized defences of Loreto (*see* §I above). Bramante's project therefore provided for a building that could serve as both a sanctuary and a fortress, as well as fulfilling the more regular needs of clerics and pilgrims as a hospice and a residence.

Work on the palazzo was supervised by many architects. Gian Cristoforo Romano was succeeded in 1512 by Andrea Sansovino who held control until 1517 when work was temporarily directed by Cristoforo Resse and then by Antonio da Sangallo (ii) himself. Progress was slow and at the death of Pope Clement VII in 1534 only the first eight bays on the north side were complete. By 1558 Galasso Alghisi had reached the construction of the 11th pier. The ground floor arcade supports a deep frieze decorated with triglyphs and metopes containing, in the first eight bays, the coats of arms of Pope Leo X and Pope Clement VII. In 1564 work began under Boccalini on the upper loggia. Pope Urban VIII gave instructions in 1643 for the construction of the south wing, but owing to difficulties

with landowners in the area this work never got under way, and the piazza has since then remained incomplete. (Vanvitelli designed (1751) the balustrade and decoration of the western section, and his designs were executed by Pietro Bernasconi (*d* 1767).)

The palazzo is now the art gallery and houses many studies for works of art in the basilica along with paintings formerly hanging there, among them the *Presentation in the Temple* by Lorenzo Lotto. The ceiling of the Sala de Tinello was decorated by Gaspare Gasparini in 1584. There is an extensive collection of tapestries and pharmaceutical pottery associated with medication provided to pilgrims, including examples by Orazio Fontana.

BIBLIOGRAPHY
F. Grimaldi: *Loreto: Palazzo apostolico* (Bologna, 1977)
Le ceramiche da Farmacia della Santa Casa di Loreto (Rome, 1979)
L. Colapinto, F. Grimadi and A. Bettini: *L'antica spezieria della Santa Casa di Loreto* (Falconara, 1994)
M. C. Marzoni: 'Il Palazzo Apostolico di Loreto', *Quad. Ist. Stor. Archit.*, xxiii (1994), pp. 39–60

FLORIANO GRIMALDI

Lotti, Lorenzo (di Lodovico di Guglielmo) [Lorenzetto] (*b* Florence, 1490; *d* Rome, 1541). Italian sculptor and architect. He may have been associated with the workshop of Andrea Sansovino in Florence. The classicism of Fra Bartolommeo, Andrea del Sarto and others working in Florence during the early 16th century also seems to have influenced his artistic development. In 1514 he helped complete the cenotaph for *Cardinal Niccolò Forteguerri* (Pistoia Cathedral) begun by Andrea del Verrocchio in 1477, carving the figure of *Charity*. In Rome, according to Vasari, he worked as a sculptor and architect and restorer of antiques. He was much influenced by Raphael, whom he assisted in the decoration of the Vatican loggias (Dacos, 1977), and who was instrumental in obtaining important commissions for him in Rome. Lotti may have designed the Palazzo Vidoni–Caffarelli, though this palace is also attributed by some to Raphael.

In 1519 Lotti was designated in the will of Agostino Chigi to execute sculptures in the Chigi Chapel in S Maria del Popolo, Rome. The figures of *Elijah* and *Jonah*, as well as the relief of *Christ and the Adultress* on the chapel's altar, appear to have been based on designs by Raphael yet are rather weak in execution. The dynamic pose of *Jonah* reflects the impact of such proto-Mannerist figures as the *ignudi* painted by Michelangelo in the Sistine Chapel (Rome, Vatican; see colour pl. 2, VI2), but the overall effect is awkward. Lotti carved a *Virgin and Child* (1520) for the tomb of *Raphael* in the Pantheon, Rome, the tomb of *Bernardino Cappella* in S Stefano Rotondo and also a large statue of *St Peter* (1535) for the Ponte S Angelo, Rome.

Lotti designed and decorated the garden court displaying sculpture (completed *c.* 1536) in the second, later Roman palace of Cardinal ANDREA DELLA VALLE, according to Vasari, who claims it had much influence on contemporary Roman taste.

BIBLIOGRAPHY
Thieme–Becker
G. Vasari: *Vite* (1550, rev. 2/1568); ed. G. Milanesi (1878–85), iv, pp. 248, 557, 577
J. Pope-Hennessy: *Italian High Renaissance and Baroque Sculpture*, ii (London, 1963), pp. 43–5

N. Dacos: *Le logge di Raffaelo* (Rome, 1977)
N. Nobis: *Lorenzetto als Bildhauer* (Bonn, 1979)
Fabbriche romane del primo '500 (exh. cat., Rome, Pantheon; Bari, Castello Svevo; 1984)
C. Magnusson: 'Lorenzetto's Statue of Jonah and the Chigi Chapel in S Maria del Popolo', *Ksthist. Tidskr.*, lvi/1 (1987), pp. 19–26

STEVEN BULE

Lotto, Lorenzo (*b* Venice, *c.* 1480; *d* Loreto, 1556). Italian painter and draughtsman. He had a long and often prosperous career as a painter, and, although he travelled widely, his style retained a close affinity with the paintings of his native Venice. He was one of an outstanding generation of painters, including Giorgione, Titian, Palma Vecchio and Pordenone, who appeared in Venice and the Veneto during the first decade of the 16th century. In comparison with his contemporaries, Lotto was a fairly traditional painter in that he worked primarily in the long-established genres of altarpieces, devotional pictures and portraiture. Such paintings were popular in the Venetian provinces and the Marches where Lotto spent much of his career and where he often received more money for his commissions than he could obtain in Venice. His most important commissions were for altarpieces, and he is perhaps best known for a series of *sacre conversazioni* in which he skilfully varied the symmetrical groupings of figures found in earlier Venetian treatments of the subject by Giovanni Bellini and Alvise Vivarini.

Precedents in Venice were also important for Lotto's early efforts in bust-length portraiture, but from 1525 he made a considerable contribution to the development of the three-quarter-length portrait. He painted many private devotional paintings but only a few of the historical, mythological or allegorical scenes that were popular in North Italy in this period. Lotto is one of the best-documented painters of the 16th century: 40 autograph letters dating from 1524 to 1539, a personal account book covering the years 1538 to 1554 (the *Libro di spese diverse*) and many notarial acts survive, as well as 75 signed paintings and numerous securely attributed works.

1. Life. 2. Work. 3. Working methods and technique. 4. Critical reception and posthumous reputation.

1. LIFE.

(i) The Veneto, the Marches and Rome, 1503–12. In his will of 1546, Lotto claimed he was born in Venice, the son of a certain Tomaso, and was aged about 66: his birth date is derived from this statement. The first document (1503) about Lotto refers to him as the son of the 'late Thomas of Venice' and states that he was a painter in Treviso. Nothing is known about his apprenticeship, though a good knowledge of contemporary Venetian painting is apparent in his earliest works. His first paintings include two altarpieces for S Cristina al Tiverone, Treviso (1505; *in situ*) and Asolo Cathedral (1506; *in situ*), as well as several portraits and devotional paintings. While in Treviso, he enjoyed the patronage of Bishop Bernardino de' Rossi, whose portrait he painted (Naples, Capodimonte; see fig. 1). He left Treviso in the autumn of 1506 and travelled to Recanati to begin work on the high altarpiece of the Dominican church of S Domenico (Recanati, Pin. Civ.; see colour pl. 1, XXXIX3). The altarpiece is a large, two-tiered polyptych comprised of six panels (completed

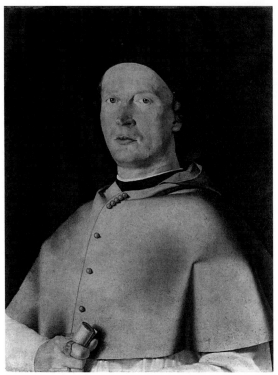

1. Lorenzo Lotto: *Bishop Bernardino de' Rossi*, oil on panel, 540×410 mm, 1505 (Naples, Museo e Gallerie Nazionali di Capodimonte)

1508). His later work for other Dominican churches and his request in 1542 to be buried in a Dominican habit suggest a close, if informal, association with the Order throughout much of his career.

Lotto was employed subsequently on the prestigious decoration of the Vatican Palace in Rome, a commission probably arranged by the papal architect Bramante, who visited Loreto, near Recanati, in 1508. On 7 March 1509 Lotto was paid for work 'in the upper rooms of the pope': exactly where and what he was painting is not known as there is no trace of his work in the Vatican. Raphael's rapid ascendancy in the Vatican project probably meant that Lotto did not continue to work there much beyond the end of 1509. He appears in the Marches again on 18 October 1511, the date of his contract for the *Entombment* (Jesi, Pin. Civ.) commissioned by the confraternity of the Buon Gesù in Jesi. He also completed two altarpieces in Recanati at this time, the *Transfiguration* (Recanati, Pin. Civ.) and the fresco of *St Vincent Ferrer* (Recanati, S Domenico).

(ii) Bergamo, 1513–25. In May 1513 Lotto arrived in Bergamo to paint the high altarpiece (completed 1516; Bergamo, S Bartolommeo) in the Dominican church of S Stefano. The patron of this altarpiece, one of the largest ever undertaken in North Italy, was Conte Alessandro Martinengo-Colleoni, the grandson of the famous condottiere Bartolomeo Colleoni. Lotto finished five other altarpieces in Bergamo between 1521 and 1523. All of them are still to be found in the city's churches, three in their original location (see fig. 2). During 1524 and 1525

he concentrated on wall paintings. The most extensive are those depicting the *Lives of SS Barbara and Brigid of Ireland* (1524) in the Suardi oratory of the Villa Suardi, Trescore Balneario (nr Bergamo), with the unusual portrayal of Christ with vines sprouting from his fingers in literal illustration of the words 'I am the vine, you are the branches'. Throughout his stay in Bergamo, Lotto also executed paintings for various households there. Twenty-four private paintings, mainly of religious subjects, are either documented or attributable to him during this period. He was also commissioned to design 33 Old Testament stories and their symbolic covers for the intarsia panels in the choir of S Maria Maggiore, Bergamo (1524–30; *in situ*).

(iii) Venice, 1525–32. Lotto arrived in Venice on 20 December 1525. He spent his first months in the Dominican monastery of SS Giovanni e Paolo, possibly in connection with the altarpiece of *St Antonino* there, which he completed in 1542. He had to leave the monastery after a few months because of a disagreement with the Dominican Fra Damiano, an intarsia artist in Bergamo and Bologna. Apart from a brief eight-day trip in early 1526, he remained in Venice until 1532. Compared to Bergamo, Venice offered the prospect of greater wealth and fame and was more convenient for shipping altarpieces to the Marches, commissions for some of which Lotto had arranged during a brief visit to the Marches in late 1523. While in Venice, he painted at least five altarpieces for churches in the Marches and an altarpiece of the *Assumption* (1527) for S Maria Assunta, Celana, near Bergamo (*in situ*). The only altarpiece for a Venetian church completed during this period was that of *St Nicholas of Bari in Glory* (*c.* 1529; Venice, S Maria dei Carmini). His paintings for

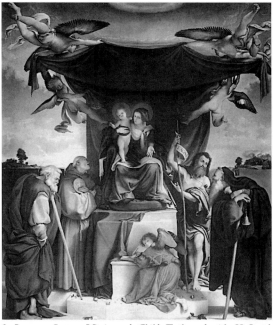

2. Lorenzo Lotto: *Virgin and Child Enthroned with SS Joseph, Bernardino, John the Baptist and Anthony Abbot*, oil on canvas, 3.00×2.75 m, 1521 (Bergamo, S Bernardino)

3. Lorenzo Lotto: *Andrea Odoni*, oil on canvas, 1.04×1.16 m, 1527 (London, Hampton Court, Royal Collection)

private households were much more in demand by Venetian patrons: eighteen such paintings can be dated between 1526 and 1532, including ten portraits (see colour pl. 1, XL1). Notable among these portraits are those of three-quarter-length figures leaning against a table, as in the portrait of *Andrea Odoni* (1527; London, Hampton Court, Royal Col.; see fig. 3), which influenced Titian's portrait of *Jacopo Strada* (1568; Vienna, Ksthist. Mus.).

(iv) Venice, the Veneto and the Marches, 1532–56. After the relatively long periods in Bergamo and Venice, Lotto changed residence frequently during the last 24 years of his life. He had moved from Venice to Treviso by 29 August 1532. Thereafter he seems to have spent most of the next seven years in the Marches: he is documented in Jesi in 1535, in Ancona in 1538 and in Macerata in 1539, during which time he painted several altarpieces, including the *Crucifixion* (Monte San Giusto, S Maria in Telusiano) and the *Madonna of the Rosary* (Cingoli, S Nicolò). He returned to Venice in January 1540 and stayed there for two years, before moving to Treviso in October 1542. He went back to Venice in December 1545 and painted the altarpiece of the *Virgin and Child with Four Saints* (1546; Venice, S Giacomo dall'Orio). Lotto's account book shows, however, that it was becoming increasingly difficult for him to earn a living as a painter in Venice. He left Venice in 1549 to return to the Marches to paint the *Assumption* (1550) for S Francesco delle Scale, Ancona (*in situ*). He spent the final two years of his life as an oblate in the Santa Casa of Loreto, during which time he executed various decorations for the basilica of S Maria and other works in the collection of the Palazzo Apostolico.

DAVID OLDFIELD

2. WORK.

(i) Religious. In the first half of the 16th century, the span of Lotto's career, painters significantly expanded the vocabulary of forms and images that had characterized religious paintings in Italy since the early 14th century. The leading innovators, Fra Bartolommeo, Raphael and Titian, were established as independent masters by the first decade of the 16th century, and Lotto was their contemporary. The paintings he executed as he travelled around North Italy record his interest in the work of his peers and demonstrate his capacity for invention and for original syntheses of traditional forms. The largest and most costly works undertaken by Lotto were altarpieces (with the possible exception of his fresco projects). As they were in churches accessible to the public, his altarpieces helped to establish his reputation each time he moved to a new city. The extent of his travels and the distances involved were not unusual: virtually all his Venetian and Tuscan contemporaries executed long-distance commissions for altarpieces. Lotto did, however, remain for unusually long periods in places where his work was in demand, no doubt partly because he was not tied to a family workshop in Venice, like Titian and others.

The fact that many of Lotto's patrons were provincial, and not from the artistic capitals of Rome, Florence and Venice, has led writers to conclude that most were unsophisticated. This is not the case, as research since the 1970s has revealed. His private patrons were often wealthy, and they included well-educated merchants, professionals and members of the nobility; the confraternities that employed him were highly respected community institutions, and the altarpieces they commissioned were for prestigious and highly visible locations. The assumption that Lotto's career declined from the 1540s is also mistaken. In the Marches, for example, his career began auspiciously with the *Virgin and Child with Saints* (1508; Recanati, Pin. Civ.; see colour pl. 1, XXXIX1) for S Domenico in Recanati and ended with major works commissioned by noble families for prominent locations: the *Assumption* (1550) for S Francesco delle Scale, Ancona (*in situ*), and an altarpiece (1555; destr.) for Jesi Cathedral.

Lotto completed nearly 40 altarpieces, responding to the demands of a wide variety of patrons and sites and to a lively climate of artistic invention. They are as remarkable for their diversity of form and subject as they are for the acknowledged individualism of his style. The settings of his earliest *sacre conversazioni* are the luminous pavilions and vaulted halls traditional in Venetian altarpieces. His experiences in Rome in 1508–9 alongside Raphael and Bramante inspired the more grandiose architecture in the *Virgin and Child with Saints* (the 'Pala Martinengo', 1516; Bergamo, S Bartolommeo), which was supplanted from the 1520s by less defined, more dramatically lit settings that signalled the growing influence of Titian. The elegant figures of the *Virgin and Child with Saints* (1521; Bergamo, Santo Spirito) and the dramatically foreshortened angels in another altarpiece of that subject (1521; Bergamo, S Bernardino; see fig. 2 above) are clear evidence of his study of Raphael's altarpieces. Raphael's visionary Virgins inspired Lotto's *Virgin in Glory with SS Andrew and Jerome* (1535; Rome, priv. col.; see 1983 exh. cat., fig. 51), painted for S Agostino in Fermo.

The subject-matter of Lotto's altarpieces and other religious pictures reflects the conventional attitudes and devotions of early 16th-century patrons and painters. His narrative altarpieces depicting the lives of the saints and the Holy Family and his *sacre conversazioni* are distinguished by the affecting realism of the figures' relationships to one

another and to the viewer, revealed in such details as the Christ Child reaching out to St Joseph in the *Virgin and Child with Two Saints* (1526; Jesi, Pin. Civ.), and the angels throwing rose petals towards the viewer in the *Madonna of the Rosary* (1539; Cingoli, Mus. Civ.). They also indicate his willingness to experiment with novel formats, as in the *St Lucy* altarpiece (1532; Jesi, Pin. Civ.) in which a scene depicted in the main panel is repeated in the predella.

In the *Lamentation* (*c.* 1530; Monte San Giusto [Marches], S Maria della Pietà; see fig. 4), arguably Lotto's finest altarpiece, the Virgin and mourners, traditionally placed at the foot of the cross, are brought closer to the viewer. The figures are at eye-level, life-size, and painted in the brilliant colours typical of the artist's work of the 1530s. The emotive power of this altarpiece has been seen as a harbinger of Counter-Reformation piety, but it is more accurately regarded as Lotto's contribution to the development of emotionally evocative imagery of a type he may have encountered first in the late works of Sandro Botticelli.

Lotto's three fresco cycles, executed in a brief period in the mid-1520s, and his devotional pictures, which occupied him throughout his career, are characterized by the same diversity of form and subject and the same novel combinations of traditional, contemporary and idiosyncratic elements. His frescoes of scenes from the *Life of St Barbara*, for example, part of the cycle (1524) for the Suardi oratory, depict the stories as a continuous narrative, a notably old-fashioned device. The settings are inspired by the tradition of perspectival illusionism in intarsia decoration (Lotto was just beginning his intarsia designs

for S Maria Maggiore in Bergamo) and perhaps by early 16th-century perspective designs for stage sets. The iconography of this particularly interesting cycle has been interpreted as a response to the threat of the Protestant Reformation. The meanings of the cycle are still debated, however, and it has yet to be considered within the context of Lotto's career as a Venetian painter working within the Venetian sphere of influence.

Lotto's devotional pictures typically follow a compositional formula derived from the Bellini workshop in Venice: a half- or three-quarter-length Virgin and Child with one or more saints arranged horizontally in front of a neutral background or a combination of architecture and landscape. He and Titian developed the expressive potential of this type of painting in such works as Titian's *Virgin with a Rabbit* (Paris, Louvre) and Lotto's *Virgin and Child with Two Saints and an Angel* (Vienna, Ksthist. Mus.), both painted *c.* 1530. Lotto's skilful depiction of the play of light and shade, the colour and texture of surfaces and the atmospheric beauty of the distant landscape demonstrate his secure position within the Venetian artistic tradition identified with his more famous contemporary. In addition, the interconnected gestures and glances that link the figures across the composition recall the works of Correggio, whose relationship to Lotto has yet to be explored.

Lotto's religious works also include his designs for a series of intarsia panels for the choir of S Maria Maggiore in Bergamo. In 1523 Lotto and another Venetian artist, Andrea Previtali, submitted designs for the choir structure and the intarsia decoration. The following year Lotto received the commission for the intarsia designs, to be executed as coloured drawings, and for intarsia covers for the 33 main panels, to be submitted as chiaroscuro drawings. The subjects for the main panels, all scenes from the Old Testament, were selected by Girolamo Terzi, a member of the Franciscan Order in Bergamo. It is clear from the correspondence, however, that Lotto was allowed to choose from a selection of subjects, that he suggested some himself and that he disagreed with some of Terzi's choices. He had more freedom with the choice of subjects for the covers, as the contract stipulated only that they should relate to the stories depicted on the panels. It has been suggested that the cover designs indicate Lotto's interest in hieroglyphics, but he referred to them as 'imprese', that is images accompanied by short phrases that together comment on the significance of the narrative.

(ii) Portraits and mythological subjects. Portraiture formed a significant portion of Lotto's work, and his more than 40 surviving portraits are widely admired. They are a virtual catalogue of the fertility of invention and freedom from convention that characterized Italian painting in the first half of the 16th century. His exploration of his sitters' states of mind and of new compositional ideas demonstrates his knowledge of the refashioning of portraiture that was begun by Leonardo and continued by Raphael, Giorgione and Titian. Lotto's portraits are not, however, easily confused with those of his contemporaries, and they reflect to an unusual degree the style and approach to subject-matter of his other paintings. His subjects usually confront the viewer directly. They are idealized but partic-

4. Lorenzo Lotto: *Lamentation*, oil on panel, 4.5×2.5 m, *c.* 1530 (Monte San Giusto, S Maria della Pietà)

ularized through specific contexts of material setting, time and circumstance.

Lotto's earliest portraits (see fig. 1 above) are bust-length and half-length figures depicted against dark grounds, and the detailed recording of their physiognomies recalls his training in the Venetian orbit of Antonello da Messina and Giovanni Bellini. During the second and third decades of the 16th century his formal repertory expanded dramatically: settings are larger and described in greater detail, figures turn and gesture in more ample spaces, and he painted portraits that include more than one figure (see colour pl. 1, XL1). As has been noted, his return to Venice at the end of 1525 coincided with a change in his portraiture towards a more dramatic and sophisticated presentation, probably calculated to impress an urbane clientele, for example the portrait of *Andrea Odoni* (fig. 3 above). Although some of his late portraits are less striking, they retain the intensity of characterization that is one of his singular contributions to the history of portraiture.

Lotto's account book, the *Libro di spese diverse*, indicates that his portrait patrons belonged to the same social groups as the patrons of his religious pictures. It also provides valuable information about the identity of his sitters, although many of the portraits he described cannot be matched with surviving works. Both the account book and Lotto's numerous letters suggest that he was acutely aware of his own state of mind and reputation and very attuned to the material aspects of personal appearance, especially clothing and jewellery. It is not surprising, therefore, that his portraits show considerable sensitivity to the relationship between the sitter's inner state and its outward manifestations.

Lotto's use of puns, emblems and symbols in his portraits is only beginning to be understood. The meanings of the lizard, rose petals and gold jewellery strewn across the table in the *Portrait of a Young Man in his Study* (*c.* 1527; Venice, Accad.) or the putto supporting himself on a scale in the *Portrait of a 37-year-old Man* (*c.* 1542; Rome, Gal. Doria–Pamphili) have yet to be deciphered convincingly. In the celebrated *Triple Portrait of a Jeweller* (*c.* 1527; Vienna, Ksthist. Mus.) the sitter, who is shown in three different poses, may be participating in a commentary on his own image. Other clues to the understanding of Lotto's portrait iconography may lie in further study of his religious imagery and his few pictures of mythological and allegorical subjects, among them the *Allegory of Marriage* (*Venus and Cupid*; *c.* 1526; New York, Met.), the *Triumph of Chastity* (*c.* 1531; Rome, Pal. Rospigliosi–Pallavicini) and two early portrait covers, an *Allegory* (for the portrait of *Rossi*; see fig. 1 above) and *Plutus and the Nymph Rhodos* (both 1505; Washington, DC, N.G.A.).

LOUISA C. MATTHEW

3. WORKING METHODS AND TECHNIQUE. Information about Lotto's technique can be found in the *Libro di spese diverse*. His purchase of materials from August 1540 to June 1544 is noted in considerable detail and gives a good idea of the preliminary preparation for a painting. A typical painting would be comprised of a canvas and stretcher, a glue and gesso ground and a thin white layer of priming beneath the paint layers. Lotto also painted on wooden supports, though mainly in the first part of his career, as in the *Virgin and Child with Four Saints* of *c.* 1506 (Edinburgh, N.G.). The only documented murals by Lotto are those painted in Bergamo in 1524–5. Much of his expertise in the technique of fresco may have been gained from his work in the Vatican in 1509 rather than from his earlier training in the Veneto.

The colours that Lotto bought (listed in his *Libro*) are the common ones of the period: small quantities of *cinaprio* and *lacca di grana* for red, *verderame* for green, *giallo di Fiandra* for yellow, lapis lazuli and *azzurro grosso* for blue and large quantities of white and black. His preferred medium was linseed oil, but other oils, such as walnut, were also used. He applied his colours in smooth, meticulous brushstrokes with a distinct separation between different tones, a result of his training in the late-15th-century Venetian technique.

Lotto maintained the clear and well-defined forms of his early paintings throughout most of his career in contrast to the sketchy, hazy outlines adopted by some of his Venetian contemporaries, such as Giorgione and Titian. His traditional approach to the application of colours is not surprising when it is remembered that he was away from the Veneto (except for brief visits) from 1506 to 1525, the crucial years in the development of the new painterly style in Venice. The tone of his colours, however, underwent several changes. The works of his first years (1503–6) are distinguished by the purity of the colours and strong lighting, with the notable exception of *St Jerome* (1506; Paris, Louvre), which is a masterful imitation of the colourful and moody landscapes of Giorgione. The strong contrasts between light and dark in Lotto's early works become less harsh after his trip to Rome in 1509 when he began to add a middle tone to lighten the purity of his colours. This change can be seen when the stiff, wrinkled drapery in his early works (e.g. *Mystic Marriage of St Catherine*, *c.* 1506; Munich, Alte Pin.) is compared with the slight channels and pockets of softly curved material that are a major trait of his later style (e.g. *Virgin and Child with SS Jerome and Nicholas of Tolentino*, 1521; London, N.G.). After his arrival in Venice in 1525, Lotto increasingly adopted the mixed hues popularized by Titian (for instance, reds are tinged with blue).

Though he must have drawn extensively, drawings by Lotto are rare. Only a dozen can be securely attributed to him throughout his long career, and the earliest of these are two drawings executed during his time in Bergamo. The importance of drawing to him is shown by X-ray photographs of several of his paintings, which reveal very few changes from the original design. There is also relatively little difference between his drawings and the final painted version in the rare cases when both survive, as is the case with his squared-up drawing in black chalk of an *Apostle* (New York, Pierpont Morgan Lib., ex-Scholz priv. col.) for the *Assumption* of 1527 (Celana, S Maria Assunta). His meticulous draughtsmanship is reminiscent of late 15th-century Venetian drawings, as can be seen in his two carefully drawn poses for *St Joseph* (black chalk on grey paper, Milan, Bib. Ambrosiana) with the back view later duplicated in the S Bernardino Altarpiece of 1521 (fig. 2 above). His preliminary study (pen and brown ink, *c.* 1529; New York, Pierpont Morgan Lib., ex-Scholz priv.

col.) for the intarsia panel of *Samson Slaying the Philistines with a Jawbone* contains precisely drawn figures and buildings that correspond exactly with the intarsia panel even though it would have been followed by a more finished drawing with the colours noted for the intarsia worker, as in the drawing of *Judith and Holofernes* (pen and brown wash, heightened with white highlights, *c.* 1527; London, BM, ex-Pouncey priv. col.). Lotto does not appear to have adopted the method of working out poses and compositions, as was done by his Florentine and Venetian contemporaries, but some of his drawings of compositions, such as the squared-up study of a *Double Portrait* (pen and brown ink, *c.* 1523; Amsterdam, Rijksmus.) or his sketch (black chalk, *c.* 1527; Siena, Bib. Com. Intronati) of the S Floriano altarpiece, are drawn in a quick, fluid style.

The influence of Lotto's trip to Rome is noticeable in the increased complexity of the poses, gestures and arrangement of the figures in his paintings after 1509. This change coincided with an increase in his commissions with narratives after an early period dominated by *sacre conversazioni* and portraits. An example of this change can be seen in the athletic poses and skilful foreshortening of the celestial angels in his altarpieces in Bergamo. After his arrival in Venice in 1525, Lotto imitated the energetic composition of Titian's *Assumption of the Virgin* (1516–18; Venice, Frari) and the large, muscular figure of Pordenone's *St Christopher* (1528; Venice, S Rocco) in his own versions of those subjects (Celana, S Maria Assunta; Berlin, Gemäldegal.).

Given Lotto's peripatetic career, the contents of his workshop had to be limited and portable. He relied heavily on life studies to add variety to his work: in the *Libro di spese diverse* there are payments for the drawing of poor people, naked men and women, a child, a peasant woman's head and a beard. He also had a small collection of reliefs and statuettes, as noted in his testament of 1546. Other objects of inspiration were his own drawings and engravings by contemporary artists. These items would have been useful for the instruction of his apprentices. During his busy years in Bergamo he had at least two apprentices in his workshop, but during his last years he employed only one.

4. CRITICAL RECEPTION AND POSTHUMOUS REPUTATION. During his lifetime, Lotto's influence and reputation were greatest in the provinces of Bergamo and the Marches, where his altarpieces were among the most prominent public commissions during the first half of the 16th century. He was not as highly regarded in Venice, although his portraits achieved a certain popularity as witnessed by the large number that have survived. His portrait of *Andrea Odoni* (fig. 3 above) was mentioned by the Venetian Marcantonio Michiel, who also noted some of his public and private paintings in Bergamo. Some Venetians may have shared Ludovico Dolce's criticism of Lotto's altarpiece of *St Nicholas of Bari in Glory* for its 'bad colours'. Giorgio Vasari and Giovanni Paolo Lomazzo, however, praised the same altarpiece for its beautiful landscape. Both Vasari and Pietro Aretino, in a letter dated 1548, comment on Lotto's virtuous demeanour towards the end of his life. Carlo Ridolfi included a brief biography

of Lotto with a list of paintings in his *Le meraviglie dell'arte* (1648), and in 1797 Francesco Tassi provided a good survey of Lotto's work in Bergamo.

It was only at the end of the 19th century that Lotto's paintings received any lengthy critical acclaim and attention. Berenson's monograph of 1895 was largely responsible for introducing the painter to the general public. His somewhat romantic view of Lotto as a melancholic soul constantly on the move has been gradually replaced by a more objective analysis of his works as more documents on his career have come to light. The Lotto exhibition in Venice in 1953 and the monographs of that year firmly established the artist as a major Venetian painter and emphasized his stylistic development. The discovery and publication of Lotto's letters to the Misericordia in Bergamo in 1962 by Chiodi and a new edition of Lotto's *Libro di spese diverse* by Zampetti in 1969 were major contributions to the documentation of the painter. Recent work on Lotto has focused more on his patronage, iconography and religious beliefs, as can be seen in the conference papers (1980) for the fifth centenary of his birth. The large exhibition in Ancona in 1981, *Lorenzo Lotto nelle Marche*, provided ample evidence of Lotto's importance for 16th-century painting in the Marches. His reputation within a Venetian context was enhanced by the selection of his paintings for *The Genius of Venice* exhibition in London (1983–4).

UNPUBLISHED SOURCES

Bergamo, Bib. Civ. A. Mai [letters by Lotto and other doc. relating to the intarsia panels of the choir of S Maria Maggiore, Bergamo (1525–32)]

WRITINGS

Libro di spese diverse (1538–54; Loreto, Archv Stor. S Casa); ed. P. Zampetti (Venice, 1969)
L. Chiodi, ed.: *Lettere inedite di Lorenzo Lotto su le tarsie di S Maria Maggiore in Bergamo* (Bergamo, 1962, 2/1968)

BIBLIOGRAPHY

EARLY SOURCES

P. Aretino: *Lettere*, 6 vols (Venice, 1538–57); ed. E. Camesasca, 3 vols (Milan, 1957–60)
G. Vasari: *Vite* (1550, rev. 2/1568); ed. G. Milanesi (1878–85), v, pp. 249–53
M. Michiel: *Der Anonimo Morelliano* (MS., before 1552); ed. T. Frimmel (Vienna, 1888), pp. 62–8, 84
L. Dolce: *L'Aretino, ovvero dialogo della pittura* (Venice, 1557)
C. Ridolfi: *Meraviglie* (1648); ed. D. von Hadeln (1914–24)
F. M. Tassi: *Vite de' pittori, scultori e architetti bergamaschi*, i (Bergamo, 1797), pp. 116–31
L. Lanzi: *Storia pittorica della Italia*, ii (Pisa, 1815), pp. 84–6
G. P. Lomazzo: *Scritti sull'arte*, ed. R. P. Ciardi (Florence, 1974), i, pp. 251, 358, 365; ii, p. 409

MONOGRAPHS, EXHIBITION CATALOGUES AND SYMPOSIA

B. Berenson: *Lorenzo Lotto* (New York, 1895, 3/1956)
A. Banti and A. Boschetto: *Lorenzo Lotto* (Florence, 1953)
L. Coletti: *Lorenzo Lotto* (Bergamo, 1953)
P. Zampetti: *Mostra di Lorenzo Lotto* (Venice, 1953)
M. Seidenberg: *Die Bildnisse des Lorenzo Lotto* (Lorrach, 1964)
P. Pouncey: *Lotto disegnatore* (Vicenza, 1965)
G. Mascherpa: *Lorenzo Lotto a Bergamo* (Milan, 1971)
G. Mariani Canova and R. Pallucchini: *L'opera completa del Lorenzo Lotto* (Milan, 1974)
F. Grimaldi, ed.: *Lorenzo Lotto a Loreto e Recanati* (Loreto, 1980)
Bergamo per Lorenzo Lotto: Bergamo, 1980
Lorenzo Lotto a Treviso: Ricerche e restauri (exh. cat., ed. G. Dillon; Treviso, Mus. Civ. Bailo, 1980)
Lorenzo Lotto: Atti del convegno internazionale di studi per il V centenario della nascita: Asolo, 1980
Lorenzo Lotto nelle Marche: Il suo tempo, il suo influsso (exh. cat., ed. P. dal Poggetto and P. Zampetti; Ancona, 1981)

F. Colalucci: *Lotto* (Florence, 1994)

J. Bonnet: *Lorenzo Lotto* (Paris, 1996)

P. Humfrey: *Lorenzo Lotto* (New Haven and London, 1997)

Lorenzo Lotto, Rediscovered Master of the Renaissance (exh. cat. by D. A. Brown, P. Humfrey and M. Lucco, Washington, DC, N.G.A.; Bergamo, Accad. Carrara B.A.; Paris, Grand Pal.; 1997–9)

SPECIALIST STUDIES

Specific works

G. Annibaldi: 'Dei pittori in Jesi che portano l'aggiunto da Fano', *Rass. Bibliog. A. It.*, iii (1900), pp. 205–11

G. Abbruzzeti: 'Di alcuni dipinti di Lorenzo Lotto a Jesi', *Rass. Bibliog. A. It.*, v (1902), pp. 62–71, 134–8

C. Caversazzi: 'Una dama bergamasca di quattrocent' anni fa riconosciuta in un ritratto del Lotto', *Bergomum*, vii (1913), pp. 23–5

G. Frizzoni: 'Intorno a Lorenzo Lotto e ad una sua pala smembrata', *Rass. A.*, vii (1916), pp. 45–50

A. M. Ciarafani: 'La Natività di Lorenzo Lotto nella R. Pinacoteca di Siena', *Boll. A.*, xxix (1936), pp. 319–29

J. Wilde: 'The Date of Lotto's St Jerome in the Louvre', *Burl. Mag.*, xcii (1950), p. 350

C. Gould: 'Lorenzo Lotto and the Double Portrait', *Saggi & Mem. Stor. A.*, v (1966), pp. 45–51

L. O. Larsson: 'Lorenzo Lottos Bildnis des Andrea Odoni in Hampton Court: Eine typologische und ikonographische Studie', *Ksthist. Tidskr.*, xxxvii (1968), pp. 21–33

H. A. van der Berg-Nöe: 'Lorenzo Lotto e la decorazione del coro ligneo di S Maria Maggiore in Bergamo', *Meded. Ned. Inst. Rome*, xxxvi (1974), pp. 145–60

C. Cohen: 'The Modello for a Lost Work by Lorenzo Lotto', *Master Drgs*, xiii (1975), pp. 131–5

M. von Hall: 'Messer Marsilio and his Bride', *Connoisseur*, cxci (1976), pp. 192–217

G. A. Dell'Acqua: *La Pala Martinengo di Lorenzo Lotto: Studi e ricerche in occasione del restauro* (Bergamo, 1978)

R. Goffin: 'A "Madonna" by Lorenzo Lotto', *Bull. Mus. F.A., Boston*, lxxvi (1978), pp. 34–41

F. Cortesi Bosco: *Gli affreschi dell'Oratorio Suardi* (Bergamo, 1980)

A. Chastel: 'Le Portement de croix de Lorenzo Lotto', *Rev. Louvre* (1982), pp. 266–72

E. Nightlinger: 'An Iconographical Study of Lorenzo Lotto's *Christ Taking Leave of His Mother*', *Source*, xiv/1 (Autumn 1994), pp. 11–17

E. M. dal Pozzolo: *Lorenzo Lotto ad Asolo: Una pala e i suoi segreti* (Venice, 1995)

J. Gardner: *'Sant' Antonio*, Lorenzo Lotto and Dominican Historicism', *Ars naturam adiuvans: Festschrift für Matthias Winner*, ed. V. V. Flemming and S. Schutze (Mainz, 1996), pp. 139–49

C. Pirovano, ed.: *Lotto: Gli affreschi di Trescore* (Milan, 1997)

Other

H. von Tschudi: 'Lorenzo Lotto in den Marken', *Repert. Kstwiss.*, ii (1879), pp. 280–97

G. Bampo: 'Spigolature dall'archivio notarile di Treviso: Documenti inediti intorno a Lorenzo Lotto e ad uno suo discepolo', *Archv Ven.*, xxxii (1886), pp. 169–76, 415–21

P. Gianuizzi: 'Lorenzo Lotto e le sue opere nelle Marche', *Nuova Riv. Misena*, vii (1894), pp. 35–47

A. Pinetti: 'Cronostoria artistica di S Maria Maggiore', *Bergomum*, xxii (1928), pp. 65–76, 97–111, 129–53

C. Caversazzi: 'Un discepolo bergamasco di Lorenzo Lotto', *Bergomum*, xxiv (1940), pp. 122–8

E. Zocca: 'Le decorazioni della Stanza dell'Eliodoro e l'opera di Lorenzo Lotto a Roma', *Riv. Ist. N. Archeol. & Stor. A.*, ii (1953), pp. 329–43

I. Chiappini di Sorio: 'Lorenzo Lotto nelle Marche', *A. Ven.*, xvi (1962), pp. 146–8

G. Liberali: 'Lotto, Pordenone e Tiziano a Treviso', *Mem. Ist. Ven. Sci., Lett. & A.*, xxxiii (1963), pp. 1–89

P. Zampetti and F. Cortesi Bosco: 'Lorenzo Lotto a Bergamo', *I pittori bergamaschi dal XIII al XIX secolo: Il cinquecento*, i (Bergamo, 1975), pp. 1–86

F. Cortesi Bosco: 'La letteratura religiosa devozionale e l'iconografia di alcuni dipinti di Lorenzo Lotto', *Bergomum*, lxxi (1976), pp. 3–25

L. Chiodi: 'Quattro lettere inedite di Lorenzo Lotto', *Bergomum*, lxxi (1977), pp. 17–36

D. Wronski Galis: *Lorenzo Lotto: A Study of his Career and Character, with Particular Emphasis on his Emblematic and Hieroglyphic Works* (Ann Arbor, 1980)

P. Zampetti, ed.: 'Lorenzo Lotto nel suo e nel nostro tempo', *Not. Pal. Albani*, ix/1–2 (1980) [whole issue]

P. Zampetti: 'Lorenzo Lotto', *The Genius of Venice, 1500–1600* (exh. cat., ed. C. Hope and J. Martineau; London, RA, 1983), pp. 175–82

A. Cascia, ed.: 'Omaggio a Lorenzo Lotto', *Not. Pal. Albani*, xiii/1 (1984) [whole issue]

D. Oldfield: 'Lorenzo Lotto's Arrival in Venice', *A. Ven.*, xxxviii (1984), pp. 141–5

F. Cortesi Bosco: *Il coro intarsiato di Lotto e Capoferri* (Bergamo, 1987)

L. C. Matthew: 'New Evidence for Lotto's Career in Jesi', *Burl. Mag.* (Sept 1988), pp. 693–7

S. Beguin: 'Lotto disegnatore', *Disegni marchigiani dal Cinquecento al Settecento: Atti del convegno "Il disegno antico nelle Marche e dalle Marche": Monte San Giusto, 1992*, pp. 19–30

F. Cortesi Bosco: 'Sulle tracce della committenza di Lotto a Bergamo: Un epistolario e un codice di alchimia', *Bergomum*, xc/1 (Jan–March 1995), pp. 5–42

B. Andreae: 'Lorenzo Lotto in Ponteranica und lInfinito von Giacomo Leopardi', *Ars naturam adiuvans: Festschrift für Matthias Winner*, ed. V. V. Flemming and S. Schutze (Mainz, 1996), pp. 132–8

DAVID OLDFIELD

Louis, Duke of Savoy. *See under* SAVOY.

Lucca [anc. Luca]. Italian city in Tuscany, capital of the province of Lucca. Situated about 80 km west of Florence in the Arno Valley, the walled city, which was known for its silk trade, retains much of its medieval urban character and rich heritage of architecture. The first people to settle in the curve of the River Serchio, where Lucca now stands, were apparently Ligurian—the city's name is thought to derive from the Celtic-Ligurian root *luk* ('marshy place'). Some scholars believe the area was colonized by the Etruscans from the 7th century BC. Roman Luca was founded as a Latin colony in 180 BC and became a *municipium* in 89 BC. The grid plan of the Roman nucleus, centred on the *cardo* and *decumanus* that crossed at the forum (near the present Piazza S Michele), is still discernible in the south-western part of the city. Heavy walls enclosed the city on four sides, wider on the north to include the Roman theatre (near S Agostino).

Before AD 570 Lucca was conquered by the Lombards, under whom it became the seat of the most powerful of the three duchies established in Tuscany. Its importance grew when the Via Francigena (Via Romea) was routed through its territory, as this road was the main link between Rome and the transalpine lands throughout the Middle Ages. Lucca later became the capital of the marquisate of Tuscany. During the 11th-century civil wars known as the Investiture Contest it sided with the Holy Roman Emperor, subsequently gaining privileges that allowed the expansion of its silk industry and the operation of its banks throughout Europe. The city enjoyed a sustained period of prosperity in the 12th and 13th centuries and in 1162 was formally recognized as a free *comune*.

In the course of the 14th century Lucca was torn by internal struggles and wars with its neighbours. It was ruled by several powerful lords, notably Castruccio Castracani degli Antelminelli from 1316 to 1328. The city was later held by Pisa until 1369, when it became a republic, retaining its independence for 400 years except for a period (1400–30) of rule by Paolo Guinigi. In 1494 the Palazzo del Podestà (now Palazzo Pretorio; enlarged 1588), Piazza S Michele, was begun. During the 16th century several important urban projects were carried out. The piazzas in the religious centre around the 11th-century

cathedral (Piazza Antelminelli, Piazza del Duomo and Piazza S Giovanni) were regularized; and a political and business centre was established between Piazza S Michele, where the notaries' shops were concentrated, and the Palazzo Pubblico to the south, originally the 14th-century seat of the lords of Lucca. This building (later Palazzo degli Anziani; now Palazzo della Provincia) was completely rebuilt (1577–81; *c.* 1730) to a monumental design by Bartolomeo Ammanati.

The most important public project of this period, however, was the construction of a new circuit of city walls, which still survive. Sporadic efforts had been made in the late 15th century to modernize the old walls, but the subsequent expansionist policies of Florence made it imperative to strengthen Lucca's defences. Advice and plans were sought from the most eminent fortifications experts, but no comprehensive plan was ever adopted and the construction work (1544–1650) was directed by a series of engineers, including Baldassare Lanci, FRANCESCO PACIOTTO and Muzio Oddi (1569–1639). The new brick walls were fortified by orillion bastions with three gates, an internal stepped rampart (now planted with trees) and a moat beyond. On the north and south sides the new walls followed the medieval line; on the west they extended out to a point, and on the east they took in a large area of gardens and vegetable plots; they never had to sustain an enemy assault, however. In the 16th century several palaces inspired by Florentine and Emilian architecture were built in Lucca, being harmoniously inserted into the city's medieval fabric. Such palaces were generally built around an inner court, with rusticated portals and quoins and grilled windows. Many fine villas were also built in the environs of the city at the same time.

The interior of the cathedral was rebuilt in Gothic style in the 14th–15th centuries and has an aisled nave and transepts. It contains several works by Civitali, including an octagonal marble Tempietto (1480s) in the left aisle housing the Volto Santo, a wooden Crucifix (probably 11th century); the pulpit; and the tomb of *Pietro da Noceto* (1472; for illustration *see* CIVITALI, MATTEO). Other important works include the tomb of *Ilaria del Carretto* (1405–7/8; *see* JACOPO DELLA QUERCIA, fig. 2).

BIBLIOGRAPHY

J. Ross and N. Erichsen: *The Story of Lucca* (London, 1912)
A. Mancini: *Storia di Lucca* (Florence, 1950)
P. Pierotti: *Lucca: Edilizia e urbanistica medievali* (Milan, 1965)
M. Fulvio: *Lucca: Le sue corti, le sue strade, le sue piazze* (Empoli, 1968)
G. Bedini and G. Fanelli: *Lucca: Spazio e tempo dall'ottocento a oggi* (Lucca, 1971)
I palazzi dei mercanti nella libera Lucca del '500: Immagine di una città-stato al tempo dei Medici (exh. cat., ed. I. Belli Barsali; Lucca, Pal. Prefettura, 1980)
R. Martinelli and G. Puccinelli: *Lucca: Le mura del cinquecento (vicende costruttive dal 1500 al 1650)* (Lucca, 1983)
R. Manselli: *La repubblica di Lucca* (Turin, 1986)
M. Paoli: *Arte e committenza privata a Lucca nel trecento e nel quattrocento* (Lucca, 1986), pp. 17–54
I. Belli Barsali: *Lucca: Guida alla città* (Lucca, 1988)

DONATA BATTILOTTI

Luchino di Giovanni Belbello. *See* BELBELLO DA PAVIA.

Luciani, Sebastiano. *See* SEBASTIANO DEL PIOMBO.

Lugano, Tommaso da. *See* LOMBARDO, TOMMASO.

Luini, Bernardino (*b* ?Luini, *c.* 1480–85; *d* ?Lugano, before 1 July 1532). Italian painter and draughtsman. He was one of the generation of Lombard painters active around 1500 who, influenced by Leonardo and Raphael, blended High Renaissance innovations with indigenous Milanese elements to create a Lombard Renaissance style. Luini's paintings were extremely popular with both collectors and critics from *c.* 1790 to the end of the 19th century. This widespread popularity, however, had unfortunate consequences: many of his frescoes were detached from their original settings, many of the panel paintings were transferred to canvas and other works were heavily restored. As a result, few survive in a good state. About 700 works are attributed to Luini, but many of these attributions are over optimistic. An additional problem is the scarcity of documentation on the painter's life and work.

1. Life and work. 2. Critical reception and posthumous reputation.

1. LIFE AND WORK. According to Lomazzo (1585, p. 421), both Luini and Gaudenzio Ferrari were taught by Gian Stefano Scotto, an obscure artist who worked at Milan Cathedral from 1485 to 1520 but to whom no works can be securely attributed. Vasari mentioned Luini among Leonardo's Milanese followers. Lomazzo (1585, 1590) further said that Luini's son Aurelio possessed a small book (untraced) containing about 50 caricatures drawn in red chalk by Leonardo and also owned Leonardo's cartoon of the *Virgin and Child with St Anne and the Infant St John* (London, N.G.), which he may have bought from the estate of Francesco Melzi. Bernardino Luini painted a copy (Milan, Ambrosiana) of Leonardo's cartoon, suggesting that there was probably some connection between the two artists. Quotations from Leonardo can be recognized in many of Luini's works: the head of the Virgin in the *Virgin and Child of the Rose Garden* (Milan, Brera; see colour pl. 1, XXXIX4) is very Leonardesque, the various versions of *Salome with the Head of the Baptist* (Boston, MA, Mus. F.A.; Paris, Louvre) show the use of Leonardo's *sfumato*, while the *Christ Blessing* (Milan, Ambrosiana) is based on a compositional device of Leonardo's. Several of Luini's works were formerly attributed to Leonardo himself.

Cesariano mentioned that Luini visited Rome but failed to give the date. Luini would seem to have been familiar with Raphael's Roman paintings and adopted his innovations in terms of design and the depiction of space. He seems to have known Peruzzi's frescoes in the Bishop's Palace at Ostia and in the Villa Farnesina in Rome and also Sodoma's frescoes in the monastery of Monteoliveto Maggiore, outside Siena, and at S Anna in Camprena, Siena (Binaghi Olivari, 1985). Critics have rightly stressed Luini's stylistic relationship with Milanese painters such as Foppa, Bergognone, Solario, Bramantino and Zenale. They have also traced the roots of his classicism to Florentine and Venetian influences, even postulating that Luini was in contact with Venetian culture on the assumption that it was he who signed himself 'Bernardinus Mediolanensis' on the *Virgin and Child with Saints* (1507; Paris, Mus. Jacquemart-André); however, this painting is manifestly not the work of Luini and stylistically would seem to be of Veronese origin.

The earliest known work by Luini is the polyptych with the *Virgin and Child*, the *Annunciation*, *God the Father* and various saints in the parish church of Maggianico, Como, painted shortly after 1510. Its vertical, multi-partite format is retardataire, but the figures show that Luini's style was already fully developed. The fresco of the *Virgin and Child Enthroned with Musician Angels* painted in 1512 in the abbey of Chiaravalle, near Milan, is also conventional in design but has an attractive landscape setting. No earlier works can be securely attributed to Luini. The altarpiece of the *Virgin and Child with SS James and Philip and Members of the Busti Family* (Milan, Brera), dated 1515 and often attributed to him, cannot be included in his oeuvre and is stylistically closer to Zenale.

The small chapel of the Sacrament in S Giorgio al Palazzo, Milan, was entirely decorated by Luini in 1516, with frescoes on the walls of scenes from the *Passion* and an altarpiece of the *Deposition* (see fig.). Against a dark ground, 16 mourners grieve over the body of Christ, laid horizontally in the foreground. Although the facial expressions owe much to Leonardo, the hieratic gestures and the suppression of extraneous detail are Luini's own contribution. In 1516–17 he executed the frescoes and panel paintings for the new church of the monastery of S Marta,

of which some fresco fragments and the altarpiece of the *Annunciation* (all Milan, Brera) survive. The *Annunciation* combines an ambitious, classicizing architectural setting with a flurry of quintessentially Lombard angels.

In the decade from 1510 to 1520 Luini was apparently fully aware of the innovations of Leonardo and Raphael and was able to apply them in part to his own work, but his style remained archaic in his use of rigid gestures, which emphasize the symbolic significance of each figure but fail to characterize the individuals or unite the composition. The curious mixture of the innovative and the archaic is also present in the work of several of Luini's Lombard contemporaries; it would seem to have been unique to the Duchy of Milan around this time.

The frescoes of scenes from the *Life of St Joseph* (Milan, Brera) from S Maria della Pace can be dated *c.* 1520–21; the fresco of the *Virgin and Child with SS Anthony Abbot and Barbara* (Milan, Brera) is dated 1521 and the fresco of *Christ Crowned with Thorns* (Milan, Ambrosiana) was painted between October 1521 and March 1522 for the oratory of S Corona, Milan. For Gerolamo Rabia, Luini frescoed two buildings, a palazzo near S Sepolcro in Milan and a country house, the Villa Pelucca, at Sesto San Giovanni, near Monza. The frescoes were later detached,

Bernardino Luini: *Deposition*, panel, 2.07×1.75 m, 1516 (Milan, S Giorgio al Palazzo)

and only fragments of each cycle survive. Those for the palazzo, probably executed between 1521 and 1523, illustrated the stories of *Cephalus and Procris* and of *Europa* (Washington, DC, N.G.A.; Berlin, Bodemus.). The more extensive frescoes for the Villa Pelucca (?1524) included a chapel dedicated to St Catherine, a large saloon decorated with scenes from the book of Exodus and smaller rooms with stories from Ovid (fragments in Milan, Brera). These are decorative narrative scenes in landscape settings; the colour is light and fresh, as in the *Gathering of Manna*, but in treatment and style the frescoes look back to the 15th century.

Luini worked on three separate fresco campaigns in S Maurizio, Milan. He frescoed scenes from the *Passion* and saints for Alessandro Bentivoglio and his wife, Ippolita Sforza, probably *c.* 1513–15, and for Giovanni Paolo and Violante Sforza da Caravaggio he painted the *Martyrdom of St Maurice* and saints and donors in 1522–4 (Binaghi Olivari, 1979). These frescoes were painted on both sides of the transverse chancel arch. Finally, in 1530, he frescoed the *Flagellation* and scenes from the *Life of St Catherine* in the Besozzi Chapel.

Another important fresco campaign was the scenes from the *Life of the Virgin* (1525) in the sanctuary of S Maria dei Miracoli, Saronno. The combination of severe classicizing architecture and solemn, idealized figures in the *Marriage of the Virgin* and the soaring architecture, freely painted landscape and fresh colour of the *Presentation in the Temple* make this cycle one of the high points in Lombard Renaissance art. In 1531 Luini received payment for further frescoes in the sanctuary, on the ceiling of the chapel of the Last Supper (now badly damaged) and four saints on the end walls of the nave.

The gigantic fresco of the *Crucifixion* (1529–32) in S Maria degli Angioli, Lugano, is a work of great stylistic and compositional novelty. Behind the crosses Luini introduced the complete story of the *Passion* in a series of small scenes set in a continuous landscape. The visual unity of this complex work is maintained by the simplicity of the forms. Situated on the transverse arch at the church's crossing, it visually overwhelms the congregation, impressing on them the significance of the Passion. In the same church he frescoed a *Virgin and Child with the Infant St John* in 1530.

Even with Luini's securely dated works it is difficult to trace any stylistic evolution. The *Virgin and Child with SS Anthony Abbot and Barbara* of 1521 is very similar to the painting of the same subject of 1512; the compositional schemes of the two polyptychs in Legnano and Mendrisio painted in 1523 are archaic compared with the *Christ Crowned with Thorns* of 1521–2, and the innovative Lugano *Crucifixion* of 1529 was followed by the outdated schemes of the late frescoes at Saronno. Luini's numerous easel paintings are almost impossible to date. These include the famous *Virgin and Child of the Rose Garden* (Milan, Brera), in which the Virgin and Child, set before a rose-garlanded trellis, are portrayed with a bland, idealized classicism (see colour pl. 1, XXXIX4). Also of uncertain date are the Leonardesque *Christ among the Doctors* (London, N.G.) and the *Christ among the Children* (sold London, Colnaghi's, 1984; see *Burl. Mag.*, xccvi, 1984, p. xl).

Luini used drawings primarily to determine compositional schemes, as in the pen study of the *Deposition* (Paris, Louvre) for the painting in S Giorgio in Palazzo. From Leonardo he borrowed certain facial types and the use of chiaroscuro, later also adopting red chalk as a medium. With this he achieved a delicate tonality, as in the *Studies of the Face and Bust of a Woman* (Milan, Ambrosiana), in which, typically, he idealized the model.

During the period of French rule in Milan at the beginning of the 16th century, a group of influential people were drawn by the teachings of Amedeo Mendez da Silva (1420–82) and the order he founded in Lombardy, the Amadeiti. They shared Mendez's expectations of radical civil and religious reforms, which he had prophesied in his text *Apocalypsis nova* (Milan, Castello Sforzesco). Many members of this circle were Luini's patrons, notably Cardinal Bernardino Carvajal, who commissioned the *Virgin and Child* in the abbey of Chiaravalle, and Gerolamo Rabia. Luini's relationship to this politically powerful, culturally heterodox group makes it necessary to reassess his work.

2. CRITICAL RECEPTION AND POSTHUMOUS REPUTATION. Vasari first praised the grace of Luini's images, and that theme was taken up by the few commentators in the 17th and 18th centuries. Caravaggio, however, responded differently in adapting more enigmatic or dramatic compositions from Luini in his *Salome* (London, N.G.) and the angel in the *Seven Acts of Mercy* (Naples, Pin. Pio Monte della Misericordia).

With the advent of Neo-classicism in Europe, the formal elegance of Luini's style and the richness of his repertory of classical forms made him one of the most studied, collected and popular painters of the 19th century. Lanzi's authoritative study (1789), which eulogizes the painter and discusses his work at length, had done much to spread his fame. In 1811 Fumagalli reproduced some of his paintings and thereafter many reproductive engravings were made of Luini's works, which helped to popularize them. Between 1811 and 1821 the Brera Accademia detached Luini's most important fresco cycles from the Milanese monasteries of S Maria della Pace and the Vetere and from the Villa Pelucca in Sesto San Giovanni and displayed them in the Pinacoteca. Public and private collectors began to compete for his paintings; Giovanni Battista Sommariva, one of the most important collectors of the early 19th century, possessed four works by Luini, of which three were fresco fragments from the Villa Pelucca. Burckhardt (1855) valued the painter highly.

In England, John Ruskin (1819–1900) made a decisive contribution to the appreciation of Luini (see Evans and Whitehouse). In 1846 he praised his paintings in Como Cathedral; in 1862 he copied the *St Catherine* (Milan, Monastero Maggiore) and visited the sanctuary at Saronno. In 1864 the Arundel Society issued colour prints of the *Presentation in the Temple* and the *Dispute* at Saronno.

Beltrami's monograph of 1911 concluded more than a century of research. Luini's reputation as a 'graceful' painter came to an end when Venturi characterized him as a 'genteel painter, but without much imagination, monotonous in his inventions, unable to create a style of his own'. Post-war studies have attempted to set the

painter in his historical context and to assess his role in the creation of an indigenous Milanese style.

BIBLIOGRAPHY

C. Cesariano: *Di Lucio Vitruvio Pollione de architectura libri dece* (Como, 1521), fol. 48 *v*
G. Vasari: *Vite* (1550, rev. 2/1568); ed. G. Milanesi (1878–85), iv, p. 585; vi, pp. 519–20
G. P. Lomazzo: *Trattato dell'arte della pittura, scoltura et architettura* (Milan, 1585), pp. 171, 360, 421
——: *Idea del tempio della pittura* (Milan, 1590); ed. R. P. Ciardi as *Gian Paolo Lomazzo: Scritti sulle arti* (Florence, 1973–4), i, p. 290
G. C. Sacco: *Stato della veneranda ed insigne Confraternità del SS Sacramento* (Monza, 1652), p. 8
S. Latuada: *Descrizione di Milano* (Milan, 1737–8)
L. Lanzi: *Storia pittorica della Italia* (Bassano, 1789); ed. M. Capucci (Florence, 1968–74), ii, pp. 310–13
I. Fumagalli: *Scuola di Leonardo da Vinci in Lombardia* (Milan, 1811)
J. Burckhardt: *Der Cicerone* (Basle, 1855; It. trans., Florence, 1952), i, pp. 949–51
A. Ratti: 'Il secolo XVI nell'abbazia di Chiaravalle di Milano', *Archv Stor. Lombard.*, 3rd ser., ix (1896), p. 99
A. Venturi: *Storia: IX* (1901–40/R 1967), ii, pp. 744–68
L. Beltrami: *Luini, 1512–1532* (Milan, 1911)
A. Ottino Della Chiesa: *Bernardino Luini* (Novara, 1956)
J. Evans and J. H. Whitehouse, eds: *John Ruskin: The Diaries* (Oxford, 1956–9), i, p. 349; ii, pp. 561–4, 722, 905
M. L. Ferrari: 'Zenale, Cesariano e Luini: Un arco di classicismo lombardo', *Paragone*, xviii/211 (1967), pp. 18–38
Sacro e profano nella pittura di Bernardino Luini (exh. cat., ed. G. Mulazzani and M. T. Binaghi; Luini, 1975)
M. T. Binaghi Olivari: 'I francesi a Milano (1499–1525): Arti figurative e moda', *An. Ist. Stor. It.-Ger. Trento*, v (1979), pp. 104–6
L. Mravik: 'Stefano Scotto, maître de Gaudenzio Ferrari?', *Bull. Mus. Hong. B.-A.*, liii (1979), pp. 59–68
Zenale e Leonardo (exh. cat., ed. C. Pirovano; Milan, Mus. Poldi Pezzoli, 1982), pp. 101–4
M. T. Binaghi Olivari: Notes in *Andrea Solario en France* (exh. cat., ed. S. Béguin; Paris, Louvre, 1985), n. 2, p. 108
F. Moro: 'Il politicco di Maggianico e gli esordi di Bernardino Luini', *Archv Lecco* (1986), pp. 129–71
G. Bora: 'Per un catalogo dei disegni dei leonardeschi a Milano: Indicazioni e problemi di metodo', *Rac. Vinc.*, xxii (1987), pp. 139–82 (174–6)
Disegni e dipinti leonardeschi dalle collezioni milanesi (exh. cat., Milan, Pal. Reale, 1987)
Pinacoteca di Brera: Scuola lombarda e piemontese, 1300–1535 (Milan, 1988)
M. T. BINAGHI OLIVARI

Lunghi. *See* LONGHI (i).

Lunghi, Silla. *See* LONGHI, SILLA.

Lurago Italian family of architectural sculptors and stone masons. They originated from Pellio Superiore Intelvi, near Como, and worked in Genoa during the mid- to late 16th century. The brothers (1) Giovanni Lurago and (2) Rocco Lurago played an important part as artisans in translating the abstract ideas of Galeazzo Alessi, Bernardino da Cantone, Giovanni Battista Castello and other architects who worked in and around the Strada Nuova (now the Via Garibaldi) into the finely carved details that distinguish the Genoese High Renaissance school.

(1) Giovanni Lurago (*fl* Genoa, *c.* 1548–71). He worked for Galeazzo Alessi, carving columns for the loggia of the villa of Luca Giustiniani in Albaro. He executed the carved ornament of the Moroza Fountain (1558; destr.) in the piazza at the east end of the Strada Nuova, in light-coloured Finale stone, which often appears as his preferred material for architectural decoration. Giovanni was elected Console dell'Arte dei Maestri Ante-

lami with Filippo Carabio in 1560. On the Strada Nuova, Giovanni and members of his workshop carved the beautiful front and side façades of the palazzo of Agostino Pallavicino in grey charcoal-coloured Promontorio stone, which interplays with the cream marble elements in Alessi's Mannerist façade. Giovanni's workshop sculpted 16 columns for the courtyard of the Palazzo Spinola (now Doria) in 1564, according to designs by Castello. Another major work is the beautiful façade of the Palazzo Grimaldi (now Tursi, the Municipio) on the Strada Nuova. Giovanni, together with Gioannetto Carlone and their workshops, executed this after designs by Domenico Ponzello and Giovanni Ponzello in Finale stone in high relief with socles, rusticated and fluted pilasters, grotesque frames, medallions and masks.

From the late 1540s until 1571 Giovanni was probably Genoa's most famous mason. He provided many palazzi, villas, churches, chapels, piazzas and streets with finished carved stone decorations, either pre-made or on commission. He worked within a highly specialized market system of construction trades and workshops. Although he did not design any of the major palazzi of his day, Giovanni certainly added to their architectural splendour.

(2) Rocco Lurago (*fl* Genoa, *c.* 1558–97). Brother of (1) Giovanni Lurago. He rented space in one of Giovanni's workshops in 1558. Between 1567 and 1571 he was commissioned to work on stone carvings on the façade of Santa Croce di Bosco Marengo in Piedmont, where he played a minor role under the architects Ignazio Danti (1536–86) and Martino Longhi the elder. By 1571 he was referred to as a master stone-carver. Rocco's major Genoese commission was his carving (1583) with Giovanni Pietro Orsolino of the Doric columns and balustrades for the seaward loggia of Giovanni Andrea I Doria's villa in Fassolo after designs by Giovanni Ponzello and Giuseppe Forlano (*d* 1593) (documents, Rome, Pal. Doria–Pamphili). Rocco enjoyed particular fame after Soprani's attribution to him of the Palazzo Grimaldi on the Strada Nuova. However, Poleggi proved that this was in fact the work of the Ponzello brothers.

BIBLIOGRAPHY

R. Soprani: *Vite* (1674); ed. C. G. Ratti (1768–9), i, pp. 419–20 [unreliable]
E. Poleggi: *Strada Nuova: Una lottizzazione del cinquecento a Genova* (Genoa, 1968–72)
E. Poleggi, ed.: *Galeazzo Alessi e l'architettura del cinquecento, Atti del convegno internazionale di studi: Genova, 1974* (Genoa, 1975)
GEORGE L. GORSE

Luzzo, Lorenzo (*b* Feltre, *c.* 1485; *d* Venice, 14 Dec 1526). Italian painter. The Luzzo family is documented from the end of the 15th century in Feltre and also from 1475 in Zara, where Bartolomeo Luzzo, the father of Lorenzo, Pietro and Giovanni, was recorded as '*ceroycus et salariatus Zare*'. Although according to Pasole's 1580 chronicle of the city of Feltre, Lorenzo's brother Pietro was recorded as a painter there in 1580, this is an error, for Pietro was actually a shoemaker. The earliest documents relating to the painter Lorenzo date from 1511: in these, he is described as 'of Feltro' when he was working at Zara and 'of Zara' when he was working at Feltro——suggesting that he moved easily from one city to

another. Vasari referred to Lorenzo as 'Morto da Feltre', but there is no archival evidence to support this nickname; he also incorrectly stated that Luzzo died during skirmishes at Zara. During his time in Zara, Luzzo was active in the community, married and studied with a Pisan painter named Nicolo Brazzo. There are also documentary records of his stay in Feltre: commissions from the community, contested payments, membership in the local confraternities, tax records etc.

There are two dated paintings by Luzzo, the *Virgin and Child with SS Stephen and Victor* (1511; Berlin, Gemäldegal.) and the *Christ with SS Anthony Abbot and Lucy* (1522; Feltre, church of the Ognisanti, sacristy). Both show the limitations of the artist's figurative style; the earlier work reveals the influence of Giorgione and Titian, while the later work shows the impact of the work of both Raphael and Sebastiano del Piombo, perhaps experienced firsthand during a visit to Rome. The corpus of other known paintings by Luzzo is not large. Dating from *c.* 1504 are the panel paintings of *St Francis* and the *Blessed Bernardino Tomitano* (Feltre, S Maria degli Angeli), probably the remains of an articulated polyptych, which follow in date the earlier *Lamentation* (Feltre, Mus. Civ.). Closely linked in style with the *St Stephen* altarpiece of 1511 is the *Virgin and Child between SS George and Victor* (Villabruna Parish Church), and also assignable to the second decade is the *Holy Family with St Jerome* (untraced; ex-priv. col., France). After this would have come the *Virgin and Child with SS Vito and Modesto* (Venice, Accad.), painted for the church at Caupo, on the back of which are visible some drawings by the artist.

Between 1515 and 1519 Luzzo painted the *Martyrdom of St Stephen* on the façade of S Stefano (destr. early 19th century), Feltre, and *Astrea with SS Mark, Victor and Andrew* on the lower walls of the Loggia Pubblica, Feltre (perhaps still in situ), a work painted as a public demonstration of the city's loyalty to the Venetian Republic. An altarpiece for the church of Santo Spirito, Feltre, is untraced. Some of the most beautiful houses in Feltre are still adorned with façade frescoes by Luzzo, though most are in poor condition: in the Via Tezza are *Curtius Flinging himself into the Gulf* and *Judith with the Head of Holofernes*, and in the Via Battisti is *Jupiter and Antiope*, which is unusual in representing an erotic theme in a public context at a time when such subjects were generally restricted to private collectors' cabinets. On the façade of the Casa Crico are depictions, among others, of *Christ and the Adulteress* and *Abraham and Isaac*. Frescoed on the interior of the Casa de Mezzan is an *Adoration of the Magi* from 1521–3. Dating from *c.* 1525 is a sgraffito façade decoration on the cathedral showing *St Prosdocimo between SS Victor and Corona* (central figure damaged).

The surviving works in Zara consist of the central part of a polyptych with the *Virgin and Child Enthroned* (Zara, Mus. A. Sacra), which can be dated slightly after 1505 on account of the obvious link with Giovanni Bellini's altarpiece for S Zaccaria, Venice; a badly restored *Assumption* from 1512–14 (Zara, Mus. A. Sacra), which has traces of a signature and in which one of the Apostles has the same face as the figure of St Joseph in the canvas of the *Holy Family with St Jerome* formerly in a French private collection; and, finally, an altarpiece with *St Stephen* (Zara, S

Simeone), which may be a work by Luzzo from the early 1520s.

BIBLIOGRAPHY

B. Pasole: *Breve compendio delle cose più notabili dell'antichissima et nobilissima città di Feltre cominitado dalla sua fondatione sino all'anno dell'humana salute 1580* (Feltre, 1778)

M. Caffi: 'Il Morto da Feltre e Lorenzo Luzzo da Feltre', *Archv Stor. Lombardo*, xvi (1889), pp. 939–50

A. Protti: 'Arte retrospettiva: il Morto da Feltre', *Emporium*, xxxii/188 (1910), pp. 139–43

P. Molmenti: 'Il Morto da Feltre', *Marzocco*, xv/41 (1910)

R. Zotti: *Morto da Feltre* (Padua, 1911)

D. Hülsen: 'Morto da Feltre', *Mitt. Ksthist. Inst. Florenz*, ii (1912–17), pp. 81–9

G. Biasuz: *I pittori feltrini (Luzzo, Marascalchi, Turro)* (Feltre, 1948)

Museo Civico di Feltre. Catalogo della Pinacoteca (exh. cat., ed. F. Valconover; Venice, 1954)

S. Claut: 'Regesto Luzzo', *Archv Stor. Belluno, Feltre & Cadoro*, liii/238–9 (1982), pp. 53–60

I Petricioli: 'Slika Lorenza Luzza u Zadru', *Peristil*, xxv/25 (1982), pp. 87–92

S. Claut: 'Una nova città', *Eidos*, i/1 (1983), pp. 43–4

——: 'Pittori veneti del Cinquecento in Dalmazia: Lorenzo Luzzo e Nicolò de Stefani', *Ant. Viva*, xxxiii/1 (1994), pp. 23–8

M. Lucco: 'Sul Luzzo, il Marascalchi e il Cinquecento a Feltre', *Archv Stor. Belluno, Feltre & Cadoro*, lxvi/291 (1995), p. 117

S. Claut: 'Lorenzo Luzzo per la Cattedrale di Feltre', *Archv Stor. Belluno, Feltre & Cadoro*, lxvii/294 (1996)

——: 'Feltre e Belluno', *La pittura nel Veneto. Il Cinquecento*, i (Milan, 1996), pp. 284–8

SERGIO CLAUT

Lysippus the younger (*fl* Rome, *c.* 1470–84). Italian medallist. The identity of this medallist, who named himself after the ancient Greek sculptor Lysippos of Sikyon (*fl c.* 370–300 BC), has not been established, although Raffaele Maffei in 1506 (*Commentariorum urbanorum* (Rome, 1506), xxi, p. 300 *v*) said he was the nephew of the Mantuan medallist Cristoforo di Geremia. Maffei referred to him by his pseudonym, and two of his medals are signed with this name, one of them, that of *Martinus Phileticus*, Professor of Greek at Rome, in Greek. Maffei also stated that in his youth Lysippus produced a medal of *Sixtus IV*, and it would appear that Lysippus spent his career at the papal court in Rome, modelling a large number of medallic portraits of papal officials.

Lysippus's style is established by the two signed medals, that of *Martinus Phileticus* (*c.* 1473; Hill, *Corpus*, no. 789) and one of *Giulio Marascha*, known only from a 17th-century engraving (H 788). Working from these two medals, approximately 28 others have been attributed to Lysippus. They are distinguished by inscriptions in fine, clear and balanced classical lettering, both Greek and Latin; the frequent use of a heavy foliate moulded border; a delicate, detached leaf or pair of leaves; and a consistency of portrait types. They usually show a young cleric with longish hair wearing a round cap and a high-necked gown. The truncation of the bust is almost always hollow, steeply curved and ends in a sharp point at the sternum. Although the busts are standardized and have a rather static quality, the portraits themselves are sensitively modelled, refined and individualized.

From his Classical pseudonym and the style and iconography of his work, Lysippus the younger appears to have been a member of a humanist circle in Rome. The subject-matter of the reverses of his medals is neither imaginative nor visually exciting and includes simple inscriptions, heraldic devices, Classical figures derived

from Roman coins, and emblems. The reverse of the *Phileticus* medal, the Pelican in her Piety, is copied from Pisanello's medal of *Vittorino da Feltre* (H 38).

Two of the medals attributed to Lysippus, those of *Catelano Casali of Bologna* (H 790) and *Raffaello Riario, Cardinal of San Giorgio* (H 791), are dated 1478. Among the medals attributed to him, several are representative of his style: *Malitia Gesualdi* (Hill, *Corpus*, no. 795), *Francesco Massimi* (H 799), *Sixtus IV* (H 806) and a series of medals of the jurist and poet *Giovanni Alvise Toscani* (*d* 1475), of which the largest (72 mm; H 812) is one of his most impressive works. Somewhat atypical of his work, though generally included in his oeuvre, is the large medal of *Raffaele Maffei da Volterra* (H 797), which does not have the characteristic sharp truncation of the bust, but which is otherwise very much in Lysippus's style, and that of *Giovanni Battista Orsini* (H 801), which, although similar in many respects to the Maffei medal, is even less like Lysippus's known style.

One securely attributed medal has often been proposed as Lysippus the younger's self-portrait. It depicts a young man facing left with a ring of curly hair showing beneath the edge of a round hat and wearing a high-necked, buttoned gown (H 796). The inscription, DI LA IL BEL VISO E QUI IL TVO SERVO MIRA ('On that side admire your own beautiful visage and on this that of your servant'), implies that the plain reverse was originally polished as a mirror in which his lovers could catch their own reflection.

BIBLIOGRAPHY
Forrer
J. Friedländer: *Die italienischen Schaumünzen des fünfzehnten Jahrhunderts* (Berlin, 1880/*R* Bologna, 1976), pp. 126–7
A. Armand: *Les Médailleurs italiens des quinzième et seizième siècles* (Paris, 1883/*R* Bologna, 1966), pp. 54–6
C. von Fabriczy: *Medaillen der italienischen Renaissance* (Leipzig, 1903), pp. 79–80
G. F. Hill: 'The Medallist Lysippus', *Burl. Mag.*, xiii (1908), pp. 274–86; xvi (1909), pp. 25–6
G. Habich: *Die Medaillen der italienischen Renaissance* (Stuttgart, 1924), pp. 82–3
G. F. Hill: *Corpus*, i (1930), pp. 205–11 [H]
R. Weiss: 'Une Médaille à demi connue de Lysippus le jeune', *Schweiz. Münzbl.*, x/37 (1960), pp. 7–10
G. F. Hill and G. Pollard: *Renaissance Medals from the Samuel H. Kress Collection at the National Gallery of Art* (London, 1967), p. 43
G. Pollard: *Italian Renaissance Medals in the Museo Nazionale del Bargello*, i (Florence, 1984), pp. 334–41
The Currency of Fame: Portrait Medals of the Renaissance (exh. cat., ed. S. K. Scher; Washington, DC, N.G.A.; New York, Frick; 1994), pp. 120–21, 387
L. Waldman: 'The Modern Lysippus: A Roman Quattrocento Medalist in Context', *Perspectives on the Renaissance Medal*, ed. S. K. Scher (New York, 1999)

STEPHEN K. SCHER